THE FOCAL

Encyclopedia
of
Photography

THE FOCAL

Encyclopedia
of
Photography

THIRD EDITION

EDITED BY

Leslie Stroebel *and* Richard Zakia

Focal Press
Boston • London

Focal Press is an imprint of Butterworth–Heinemann.

Copyright © 1993 by Butterworth–Heinemann

Ⓡ A member of the Reed Elsevier group

∞ Recognizing the importance of preserving what has been written, Butterworth–Heinemann prints its books on acid-free paper whenever possible.

Library of Congress Cataloging-in-Publication Data
The Focal encyclopedia of photography/edited
 by Leslie Stroebel and Richard Zakia; illustrated by Wes Morningstar.—3rd ed.
 p. cm.
 ISBN 0-240-80059-1 (hardcover) ISBN 0-240-51417-3 (paperback)
 1. Photography—Encyclopedias. I. Stroebel, Leslie D. II. Zakia, Richard D.
Tr9.F6 1993
770'.3—dc20 92—44267
 CIP

British Library Cataloguing-in-Publication Data
A catalogue record for this book is available from the British Library.

The publisher offers special discounts on bulk orders of this book.
For information, please contact:
Manager of Special Sales
Butterworth–Heinemann
313 Washington Street
Newton, MA 02158–1626
Tel: 617-928-2500
Fax: 617-928-2620

For information on all Focal Press publications available, contact our World Wide Web home page at: http://www.bh.com/fp

10 9 8 7 6 5 4 3 2 1

Printed in the United States of America

Preface

The first edition of the *Focal Encyclopedia of Photography* was published in 1956 in two volumes. A desk copy appeared in 1960 and a revised desk copy was published in 1969. This third edition updates material from the previous edition that is still relevant and includes numerous new topics related to changes and advances made in the broad field of photography during the intervening years. The extent of the change in our photographic vocabulary is evidenced by the fact that only about one in four of the terms in this edition appeared in the preceding edition.

Photography is sometimes described as being both an art and a science. The primary application of photography is as a medium of visual communication, but its success in this role depends upon technology. Not only does photography include a large number of areas of interest and specialization, but it borders on, interacts with, and shares commonalties with a number of other disciplines. Thus, this edition includes many topics where photography is related to other disciplines—such as aesthetics, business practices, chemistry, communications, computers, education, electricity and electronics, history, light and light measurement, optics, photomechanical reproduction, physics, sound, standards, and visual perception.

Three major disciplines that are variously included under the broad heading of photography and excluded as being separate fields are motion-picture photography (cinematography), video, and electronic still photography (still video). Terms in these areas that were judged to be important for a basic understanding of the processes and for interdisciplinary communication with photographers have been included. Esoteric terms that would be of interest only to individuals specializing in those fields have been excluded. It should be noted that the term *imaging* has been substituted for *photography* in many applications in recent years, apparently because imaging suggests a more inclusive coverage. Although it might have been appropriate to use *imaging* in the title of this third edition, the term *photography*, which has served us well for over 150 years, deserves to be preserved.

The writeups for the terms in this encyclopedia vary in length from concise definitions to comprehensive articles. To avoid excessive repetition, the reader is occasionally directed to a different entry. Whereas the various types of camera lenses are listed alphabetically throughout the encyclopedia, for example, these entries are cross-referenced *See Lens types,* where all of the writeups are grouped together. A similar approach is used for camera types, filter types, photographic effects, and photographic organizations.

The titles of related topics are listed at the end of some writeups as *See also*: for readers who seek additional information on a subject, and the authors of some articles have included one or more recommended books.

The historical aspects of major topics are generally included in articles on those subjects, but a chronology of *Advances in Photographic Technology* is included under that heading. Biographies of individuals are arranged alphabetically by the last name, but an overview appears under the heading of *Biographies.* Similarly, individual nonsilver processes, photographic fields and careers, and photographic processes appear throughout the encyclopedia in alphabetical order, but overviews appear in the entries for the category titles.

We were indeed fortunate in obtaining the enthusiastic cooperation of the large number of distinguished experts from the United States, Canada, and England who provided the manuscripts for this third edition. Their names and affiliations follow this preface. We are indebted to many of our colleagues at the Rochester Institute of Technology, including those who contributed articles, for their invaluable help. Appreciation is also extended to our friends at Focal Press, with whom it has been a pleasure to work, including Karen Speerstra, Publishing Director, whose vision and administrative skills launched the project and kept it on course, and Susie Shulman, our Managing Editor and liaison person, who coordinated operations with precision and grace.

The Focal Encyclopedia of Photography

THIRD EDITION

Edited by Leslie Stroebel and Richard Zakia

Publishing Director
Karen Speerstra

Managing Editor
Susie Shulman

Illustrators

J. Wesley Morningstar Andrew T. Swartz
Patricia S. Purtell Jaime N. Vos

Contributors

Peter Z. Adelstein
Consultant, Image Permanence Institute
Rochester Institute of Technology
Rochester, New York

Mary Street Alinder
Photographic Historian, Curator, Lecturer
Owner, Alinder Gallery
Gualala, California

Greg Barnett
Operations Manager
School of Photographic Arts and Sciences
Rochester Institute of Technology
Rochester, New York

Paul M. Borsenberger
Senior Research Associate
Copy Products Division
Eastman Kodak Company
Rochester, New York

Michael H. Bruno
Executive Director
Technical Association of the Graphic Arts (TAGA)
Graphic Arts Consultant, Writer, Editor
Bradenton, Florida

John B. Bunch
Associate Professor
Curry School of Education
University of Virginia
Charlottesville, Virginia

John A. Ciampa
Associate Professor
Director, American Video Institute
Rochester Institute of Technology
Rochester, New York

George M. Cochran
President, Cochran Films
New York, New York

Michael A. Covington
Associate Research Scientist
Artificial Intelligence Programs
The University of Georgia
Athens, Georgia

Ira Current
Associate Professor Emeritus
School of Photographic Arts and Sciences
Rochester Institute of Technology
Rochester, New York

Andrew Davidhazy
Professor
School of Photographic Arts and Sciences
Rochester Institute of Technology
Rochester, New York

Phil Davis
Professor Emeritus of Art
University of Michigan
Ann Arbor, Michigan

Denis Defibaugh
Assistant Professor
School of Photographic Arts and Sciences
Rochester Institute of Technology
Rochester, New York

John Gustav Delly
Senior Research Microscopist and Professor
McCrone Research Institute
Chicago, Illinois

Joe DeMaio
Owner, DeMaio Photography
Madison, Wisconsin

Stephen J. Diehl
Assistant Professor
School of Photographic Arts and Sciences
Rochester Institute of Technology
Rochester, New York

William W. DuBois
Associate Director
School of Photographic Arts and Sciences
Rochester Institute of Technology
Rochester, New York

John Durniak
Columnist, Photography
The New York Times
New York, New York

Jill Enfield
Faculty, Photography
Parsons School of Design
New York, New York

James Enyeart
Director, International Museum of Photography
George Eastman House
Rochester, New York

John Fergus-Jean
Assistant Professor
Director of Undergraduate Studies
Photography and Cinema
The Ohio State University
Columbus, Ohio

Michael Flecky
Associate Professor
Fine and Performing Arts
Creighton University
Omaha, Nebraska

Kathleen C. Francis
Independent Writer
Rochester, New York

Paul Quennell Fuqua
Independent Writer/Photographer
Arlington, Virginia

Thomas A. Gorham
Product Service Director
Photographic Products Group,
Customer Equipment Service Division
Kodak Canada Inc.
Toronto, Ontario, Canada

Richard K. Hailstone
Associate Professor
Center for Imaging Science
Rochester Institute of Technology
Rochester, New York

Grant Haist
Eastman Kodak Company (retired)
Writer, Photographer
Rochester, New York

Klaus B. Hendriks
Director, Conservation Research Division
National Archives of Canada
Ottawa, Ontario, Canada

Theron T. Holden
Technical Writer, Photo Marketing Association
Graflex (Retired)
Rochester, New York

J. M. Holm
Assistant Professor
School of Photographic Arts and Sciences
Rochester Institute of Technology
Rochester, New York

Tomlinson Holman
Associate Professor
School of Cinema-Television
University of Southern California
Los Angeles, California

Roger W. Horn
President
Leica Camera Inc.
Northvale, New Jersey

R. W. G. Hunt
Visiting Professor of Physiological Optics
Optometry and Visual Science
City University
London, England

Fil Hunter
Photographer
Alexandria, Virginia

J. Gordon Jarvis
Manager (Retired)
Electrophotographic Systems Laboratory
Kodak Research Laboratories
Eastman Kodak Company
Rochester, New York

Ron Jegerings
Technical Editor
Photo Life Magazine
Markham, Ontario, Canada

John H. Johnson
Instructor, Art
Learning Tree University
Chatsworth, California

President, Tamarack Productions, Inc.
Burbank, California

Robert H. Johnston
Professor, Special Assistant to the President
Acting Director, Center for Imaging Science
Rochester Institute of Technology
Rochester, New York

William C. Klein
Adjunct Faculty
School of Photographic Arts and Sciences
Rochester Institute of Technology
Rochester, New York

Russell C. Kraus
Professor
School of Photographic Arts and Sciences
Rochester Institute of Technology
Rochester, New York

Len LaFeir
Manager, Aerial Systems
Eastman Kodak Company
Rochester, New York

John J. Larish
Principal, Jonrel Imaging Consultants
Fairport, New York

Michael E. Leary
Division Chairman
Language Arts Division
West Valley College
Saratoga, California

Howard Lester
Associate Professor
School of Photographic Arts and Sciences
Rochester Institute of Technology
Rochester, New York

Howard LeVant
Associate Professor
School of Photographic Arts and Sciences
Rochester Institute of Technology
Rochester, New York

Arnold W. Lungershausen
Senior Development Engineer
Government Systems Division
Eastman Kodak Company
Rochester, New York

James A. McDonald
Director Emeritus
Winona School of Professional Photography
Mount Prospect, Illinois

Angus McDougall
Professor Emeritus
School of Journalism
University of Missouri
Columbia, Missouri

Mark Maio
Clinical Assistant Professor, Ophthalmology
State University of New York at Buffalo
Buffalo, New York

President, Ophthalmic Photographers' Society
Amherst, New York

Roxanne E. Malone
Adjunct Faculty
School of Photographic Arts and Sciences
Rochester Institute of Technology
Rochester, New York

Dana G. Marsh
Associate Professor
Center for Imaging Science
Rochester Institute of Technology
Rochester, New York

Warren L. Mauzy
Manager, Environmental Safety and Technology
Ilford Photo Corporation
Paramus, New Jersey

Glenn C. Miller
Associate Professor
School of Photographic Arts & Sciences
Rochester Institute of Technology
Rochester, New York

Michael More
Communications and Public Affairs
Eastman Kodak Company
Rochester, New York

Judith L. Natal
Assistant Professor of Art
Nazareth College of Rochester
Rochester, New York

Fatima NeJame
Director
Palm Beach Photographic Workshops
Boca Raton, Florida

David A. Page
Fine Arts Photographer
Department of Art and Art History
Duke University
Durham, North Carolina

Allie C. Peed, Jr.
Adjunct Faculty
School of Photographic Arts and Sciences
Rochester Institute of Technology
Rochester, New York

Director, Publications and Photo Information (Retired)
Consumer/Professional and Finishing Markets
Eastman Kodak Company
Rochester, New York

Jeff B. Pelz
Instructor
Center for Imaging Science
Rochester Institute of Technology
Rochester, New York

Michael R. Peres
Assistant Professor
Chairman, Biomedical Photographic Communications
School of Photographic Arts and Sciences
Rochester Institute of Technology
Rochester, New York

Robert S. Persky
Publisher
The Photographic Arts Center, Ltd.
New York, New York

Dennis W. Pett
Professor Emeritus
Instructional Technology
Indiana University
Bloomington, Indiana

Barbara Polowy
Art and Photography Librarian
Wallace Library
Rochester Institute of Technology
Rochester, New York

Sidney F. Ray
Senior Lecturer, Communication
Polytechnic of Central London
London, England

Harry E. Roberts
Senior Technical Associate (Retired)
Research Laboratories
Eastman Kodak Company
Rochester, New York

Robert M. Rose
Manager
Marketing Systems
Ilford
Paramus, New Jersey

Joel Samberg
Manager
Employee Communications
AGFA Division, Miles Inc.
Ridgefield Park, New Jersey

Larry A. Scarff
Staff Image Scientist
Image Sciences
Itek Optical Systems
Lexington, Massachusetts

George Schaub
Faculty, Photography
Parsons/New School
New York, New York

Editorial Director
Photo Trade Magazines
PTN Publishing Company
Melville, New York

John R. Schott
Professor
Head, Digital Imaging and Remote Sensing Laboratory
Center for Imaging Science
Rochester Institute of Technology
Rochester, New York

Paul Robert Schranz
Professor, Art
Governors State University
University Park, Illinois

Contributing Editor
Darkroom and Creative Camera Techniques
Preston Publications
Niles, Illinois

Martin L. Scott
Consultant, Scientific Imaging
Rochester, New York

Thomas H. Shay
Director, Corporate Communications
Fuji Photo Film U.S.A., Inc.
Elmsford, New York

William Shipman
Senior Optical Engineer
Naval Surface Warfare Center
Dahlgren, Virginia

James F. Steele
Education Coordinator
Professional Imaging
Eastman Kodak Company
Rochester, New York

Leslie Stroebel (Contributor and **Editor**)
Professor Emeritus
School of Photographic Arts and Sciences
Rochester Institute of Technology
Rochester, New York

Sabine Süsstrunk
Instructor
School of Photographic Arts & Sciences
Rochester Institute of Technology
Rochester, New York

Michael Teres
Associate Professor, Art
State University of New York at Geneseo
Geneseo, New York

Hollis N. Todd
Professor Emeritus
School of Photographic Arts and Sciences
Rochester Institute of Technology
Rochester, New York

Richard W. Underwood
Technical Assistant (Retired) to Director of Photography
Photography and Television Technology
NASA-Lyndon B. Johnson Space Center
Houston, Texas

Allan D. Verch
International Press and Publicity Manager
Polaroid Corporation
Cambridge, Massachusetts

John Paul Vetter R.B.P.
Consultant, Medical Media Imaging
Pittsburgh, Pennsylvania

William D. Vining
Engineer, Photo-Instrumentation
Redstone Technical Test Center
Redstone Arsenal, Alabama

Allen Vogel
Assistant Professor
School of Photographic Arts and Sciences
Rochester Institute of Technology
Rochester, New York

Peter Walker
Du Pont Imaging Systems
Wilmington, Delaware

Howard Wallach
Director, Photography Program
Abraham Lincoln High School
Brooklyn, New York

Rosemary Welsh
Assistant Professor, Art
Wells College
Aurora, New York

Richard D. Zakia (Contributor and **Editor**)
Professor Emeritus
School of Photographic Arts and Sciences
Rochester Institute of Technology
Rochester, New York

Vici Zaremba
Owner, Indian River Photography Workshops
Antwerp, New York

Thomas H. Zigon
Instructor
School of Photographic Arts and Sciences
Rochester Institute of Technology
Rochester, New York

The following individuals prepared entries for the previous (1969) edition of the *Focal Encyclopedia of Photography* which have been reproduced here:

D. Fry
George H. Lunn
L. A. Mannheim
P. B. Meadway
Frederick Purves
D. A. Spencer

A Ampere; Angstrom unit; CIE standard illuminant (2855.5 K); Automatic

a Absorption coefficient

A&B Designation of motion-picture film rolls or orientations

AAVT Association of Audio-Visual Technicians

ABC Automatic beam control

AC Alternating current

AC/DC Alternating current/direct current

ACTV Advanced compatible television

ACVL Association of Cinema and Video Laboratories (USA)

AD Analog-to-digital

ADC Analog-to-digital converter

ADP Automatic data processing

ADT Automatic data transmission; Automatic double tracking

AE Automatic exposure

AECT Association for Educational Communications & Technology

AES Audio Engineering Society (USA)

AF Automatic focus; Audio frequency

AFC Automatic frequency control

AFNOR Association Français de Normalisation (France)

AFP Association of Federal Photographers

AFPF Association Française de Production de Films (France)

AFS Aerial film speed

AG All-glass

Ag Silver

AGC Automatic gain control

AgX Silver halide

AHSP Association for High Speed Photography

AIGA America Institute of Graphic Arts

AIIM Association for Information and Image Management

AIPAD Association of International Photography Art Dealers

AL Automatic loading

alpha Absorption factor/absorptance (Greek letter *a*)

ALU Arithmetic logic unit

AM Amplitude modulation

AMI Amplified MOS intelligent imager

AMII Association for Multi-Image International

amp Ampere

AN Antinewton

ANSI American National Standards Institute

APA Advertising Photographers of America; Architectural Photographers of America

APAG American Photographic Artisans Guild

APCL Association of Professional Color Laboratories (Joined PMA 1989)

APEX Additive System of Photographic Exposure

API Associated Photographers International

APIP Association of Professional Investigative Photographers

APL Association of Photographic Laboratories

APSA Associate of the Photographic Society of America

APSE Abstracts of Photographic Science & Engineering (1962–1972)

AR Aspect ratio; Analytical reagent

ARPS Associate of the Royal Photographic Society

ASA Acoustical Society of America; Formerly, American Standards Association; ANSI film-speed system

asb Apostilb

ASC American Society of Cinematographers

ASCII American Standard Code for Information Interchange

ASFP Association of Specialized Film Producers (UK)

ASIFA Association Internationale du Film d'Animation

ASMP Society of Photographers in Communications (formerly, American Society of Magazine Photographers)

ASP American Society of Photogrammetry

ASPP American Society of Picture Professionals

ASPRS American Society of Photogrammetry and Remote Sensing

ASTM American Society for Testing Materials

ATSC Advanced Television Systems Committee (USA)

auto Automatic

AV Audiovisual

A$_v$ Aperture value (APEX)

AVA Audio Visual Association (UK)

AVC Automatic volume control

AVMA Audio Visual Management Association

AWG American wire gauge

A & B ROLL Standard technique for preparing a motion-picture camera original (negative or reversal) for release printing. In conformance with editorial decisions made on a

work print, original shots are separated into two rolls, called A & B rolls, alternating each shot with black leader in a checkerboard pattern. This technique allows invisible splices, some basic optical effects such as dissolves and double exposures, and efficiency in making printing adjustments between different shots. In special cases a "C" roll or additional rolls might be required. *H. Lester*

Syn.: *Checkerboard cutting.*
See also: *Conforming.*

A & B WIND A way of designating the relationship between the emulsion side of motion picture film and the working sprocket holes. Most camera originals are B wind. Prints made on a standard contact printer, where print stock and negative are placed emulsion to emulsion, would be A wind. When preparing for release printing, all print materials, picture and optical sound, must be the same wind. When projecting, A wind film would be run with the emulsion facing the lamp, and B wind would be run with the emulsion facing the screen. *H. Lester*

Syn.: *A or B types.*

ABBE NUMBER Number indicating the extent of dispersion of light of different wavelengths after refraction by a transparent medium such as glass. Introduced by Ernst Abbe (1840–1905) and also referred to as the constringence, V number or v-value, it is the ratio $(n_d - 1)/(n_F - n_C)$, where n_d, n_F and n_C are the refractive indices for the d spectral line (yellow) of helium, and the F (cyan) and C (red) lines of hydrogen, respectively. The number is usually in the range 20 to 90, and a high value indicates small dispersion. *S. Ray*

Syn.: *V number, Constringence, v-value.*
See also: *Optics.*

ABBOTT, BERENICE (1898–1992) American photographer. During the 1920s learned photography from Man Ray while working as his assistant in Paris. Met Atget shortly before his death in 1927. Greatly moved by his work, she rescued both his prints and negatives from oblivion, promoting and publishing them. Returned to the United States (1929), where she photographed New York City with an 8 × 10-inch view camera, capturing buildings, streets, and bridges with a straightforward, clear eye. Also known for her portraits.

Books: *Berenice Abbott: Photographs.* New York: Horizon Press, 1970. *M. Alinder*

ABERRATIONS See *Lenses.*

ABNEY, SIR WILLIAM (1843–1920) English chemist, writer, and educator. Discovered hydroquinone as a developing agent (1880). Invented gelatin chloride printing-out paper (POP) (1882). Developed infrared-sensitive emulsion to help chart the solar spectrum. Served as president of the Royal Photographic Society of Great Britain for five years, the first photographic authority to assume that position.
M. Alinder

ABRASION REDUCTION Scratches and abrasions due to handling and/or processing and printing, may sometimes mar the appearance of photographs. Steps to minimize this problem include (1) design and use of equipment to avoid contact with the image surfaces of the materials during handling and storage, (2) treatment to lubricate the surfaces such as the application of waxes or other low friction materials like silicones, and (3) coating with lacquers or other protective materials. If the lacquer type coatings become scratched or abraded, they may be removed with suitable solvents. A new coating may then be applied to restore the unblemished image. *I. Current*

ABRASIONS AND SCRATCHES Abrasion marks are usually lines that are seen on processed film due to the sliding of the sensitized emulsion under pressure over surfaces before processing. They may appear darker or lighter than the surrounding area, depending on a number of factors including whether the abrasions occurred prior to or after exposure, and whether the processing was negative or reversal. Abrasion marks also occur on papers but are now less common due to improved surface coatings. The abrasion marks may or may not be visible as a deformity when viewed by reflected light. Dark lines on negatives will, of course, print as light lines on prints.

Scratches are visible physical deformities in the emulsion surface or base of photographic materials, and they may occur either before or after processing. The defect can be seen on the original and on any print or duplicate made from it. In some cases, scratches in the base may be rendered less visible by application of a material of similar index of refraction as that of the surface. Vaseline petroleum jelly, for example, when applied to base scratches in a negative, then buffed to remove excess, sometimes reduces their appearance on a print made from the negative. There are proprietary materials that serve the same purpose. *I. Current*

See also: *Kink marks; Pressure marks.*

ABRASIVE REDUCERS Fine abrasive materials, usually a mineral, used to reduce the density of silver in a local area of a negative. The particle size must be small enough not to reveal evidence of abrasion when the negative is printed or enlarged. The reducing action is most effectively accomplished by picking up a small amount of the material on a tuft of cotton and gently rubbing the area to be reduced. This method is often more practical than attempting local reduction by chemical means. *I. Current*

ABSOLUTE See *Kelvin (K).*

ABSOLUTE HUMIDITY The amount of water vapor present in a given volume of air or gas; usually expressed in milligrams per liter. It is related to dewpoint and relative humidity in that it is a measure of the amount of water vapor present in the air. Absolute humidity is the most independent measure in that it is not dependent on barometric pressure or temperature. It is not the most commonly used measure, however, because it is not, by itself, a good predictor of condensation or the drying ability of the air. *J. Holm*

ABSOLUTE PHASE The phase of a waveform with respect to the origin. There are no limits to the values that absolute phase can take on. *J. Holm*

See also: *Phase; Relative phase.*

ABSOLUTE TEMPERATURE The temperature in kelvins above absolute zero. A temperature increment of 1 kelvin is defined to be equal to a temperature increment of 1° C (centigrade or Celsius). Both scales define an increment of 100 degrees between the freezing point and boiling point of pure water at a barometric pressure of 760 torr. The difference between the absolute, or Kelvin, scale and the centigrade, or Celsius, scale lies in the placement of the zero point. The Kelvin scale places zero at absolute zero (–273.15° C), and the Celsius scale places zero 0.01 degrees below the triple point of water (the temperature where the solid, liquid, and gas phases exist simultaneously and in equilibrium) at 760 torr. *J. Holm*

See also: *Kelvin and Celsius scales.*

ABSOLUTE ZERO The temperature where all atomic vibratory motion ceases, and no more heat can be extracted from a substance. This temperature is defined to be 0° K or –273.15° C. *J. Holm*

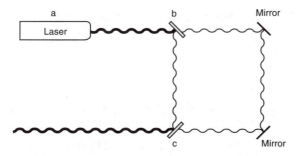

Absolute phase. A laser source (a) emits coherent monochromatic light that is split into two components by a beam splitter (b). One component passes through B and is reflected from two mirrors to combine with the component reflected from beamsplitters B and c. The two components in this case have the same relative phase but different absolute phase because they traveled different distances. If the difference in absolute phase is not an integral number of wavelengths, the relative phases will also be different.

ABSORPTANCE The fractional part of incident radiation that is not reflected or transmitted (either directly or by scattering), i.e., the amount of absorption occurring in a particular situation, with absorptance = 1 − (reflectance + transmittance).
<div align="right">J. Holm</div>

See also: *RAT formula.*

ABSORPTION (1) The process by which radiation incident on a substance is converted to another form of energy that remains in the substance. All substances absorb some of the radiation that falls on or passes through them. Absorbed light energy is usually converted to heat, but may be transformed into light of another color and emitted, or may result in some chemical or electronic change in the substance, as is the case with photographic emulsions and electronic detectors. The amount of absorption that will occur in a given situation is dependent on the wavelength of the incident radiation. Selective absorption is largely responsible for natural colors, since most natural light contains at least some of all of the wavelengths of light whereas strong colors contain predominantly only a limited range of wavelengths.

(2) The process by which a material is assimilated into a substance, such as the absorption of a liquid by a gelatin.
<div align="right">J. Holm</div>

ABSORPTION CURVE A graphic representation of the proportion of light or radiation absorbed by a specific sample, plotted with respect to the wavelength of the light or radiation. Absorption curves are most commonly provided for filters, in which case the convention is to plot the transmission density of the filter as a function of wavelength.
<div align="right">J. Holm</div>

ABSORPTION (SOUND) The property of materials to turn incident acoustical energy into heat. Absorption of the materials on the surfaces of a room is usually the only factor available to control reverberation time, since absorption and room volume (three-dimensional size) are the only classical factors affecting reverberation time. Also used to describe losses that occur during transmission through a medium, such as air absorption.
<div align="right">T. Holman</div>

See also: *Air absorption.*

ABSTRACT PHOTOGRAPHY Abstract photography excerpts reality. It focuses on one aspect of a subject or obliterates recognizability in an effort to deal only with tone, form, light, and movement. Some who appreciate abstract photography compare it to poetry.

Photographers bent on abstraction often start with a familiar object. Then, by choosing an unfamiliar angle, an intensely closeup or distant view, unusual lighting, odd color, and/or an unexpected film such as infrared, they force the viewer to look at the object in a new way.

Alternatively, abstract photographers may introduce movement in subject or lighting during exposure. They may expose film without a camera, or they may add chemicals during processing to create a visual effect. Their results might be compared to nonrepresentational modern art.

In abstract photographs, the viewer sees the unseen, detects the hidden texture, notices patterns and shapes, discovers new relationships. Abstract photographs play on emotions, engage the mind, and invite viewers to blend their thoughts and experiences with the visual presentation.

Early Examples As early as 1881, Thomas Eakins, Eadweard Muybridge's collaborator, took superimposed action shots. They foreshadowed the multiple electronic flash pictures later taken by Harold E. Edgerton (1903–1990) of such subjects as a golf swing and a drop of milk splashing in a bowl.

Paul Strand (1890–1976) concentrated on patterns created by city shadows; he focused sharply on such ordinary household items as kitchen bowls. Photographs taken by Edward Weston about 1930 revealed aesthetic qualities in straight, geological photographs of natural landscapes; his subjects eventually included such natural forms as sand dunes, rocks, shells, and peppers.

Aaron Siskind (1903–1991) photographed subjects such as peeling paint, water-stained stone, and subject fragments in his effort to create "a new object" with "its own meaning and its own beauty." Harry Callahan (1912–) sought to intensify such subjects as Chicago tramways and Cape Cod waters by showing them in his own particular way.

The first photographer who deliberately made abstract photographs was Alvin Langdon Coburn (1882–1966). His vortographs (1916–1917) reproduced fragmentary images of such small objects as pebbles and broken glass reflected in three mirrors clamped together as in a kaleidoscope. Coburn, who believed all black-and-white photography to be abstraction, wanted to see if he could get people to respond to shapes and tones alone.

Christian Schad made schadographs in 1918 by placing bits of paper and other flat objects on a sensitive emulsion and then exposing the composition to light; the result looked like the Cubist collages of the time. By 1922, Man Ray (1890–1976), László Moholy-Nagy (1895–1946), and others had developed rayographs, photograms, and other methods of producing images without the use of a camera. Man Ray and Moholy-Nagy also pioneered more strictly photographic methods of making abstracts such as the use of

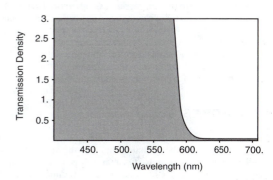

Absorption curve. Spectrophotometric curve for a Wratten 29 red filter.

negative prints, multiple exposures on either plate or paper, and the process now known as the Sabattier effect.

In the 1920s and 30s, Francis Bruguiere (1879–1945) worked with light patterns on paper sculptures, reversed tonalities, and incorporated fantasy/surreal elements in multiple prints. Lotte Jacobi (1896–) worked with a moving light source and even captured the traces made by attaching a light to a swinging pendulum.

Today, techniques used to produce nonrepresentational patterns range from splashing chemicals on film or paper to manipulating electronic signals to expose film or paper directly or create a screen image to be photographed. Methods of distorting recognizable subjects made use of such equipment as extreme-wide-angle lenses and distorting mirrors.

Contemporary abstract photographs are produced with a wide range of techniques, including montage, toners, and cutting and pasting. In what might be seen as a merging of the two classical definitions of abstract photography, some new photo artists use the clarity and enlargability of the modern photographic image—and virtually obscure the object in an attempt at personalization. Others take advantage of the manipulative power of the computer. *K. Francis*

ACADEMY The Academy of Motion Picture Arts and Sciences. A major organization of motion-picture producers and workers. *H. Lester*

ACADEMY LEADER A count-down cueing leader placed at the head and tail ends of a roll of motion-picture release print, designed and standardized by the Academy of Motion Picture Arts and Sciences. Now replaced by *Society* leader, designed by the Society of Motion Picture and Television Engineers. *H. Lester*

ACADEMY MONO A conventional monaural optical sound track format intended to be used with a rather strong high-frequency rolloff in playback. The rolloff is necessitated by the need to suppress audible noise due to grain of the motion-picture print. The rolloff is accomplished in two possible ways: in a conventional monaural theater it may be loudspeaker and screen high-frequency losses, while in a stereophonic-equipped theater playing a monaural print, it may be an electrical filter. *T. Holman*

ACCELERATOR (1) Alkaline compounds, added to developing solutions, are called accelerators because they increase the rate of development. Alkalis, such as hydroxides and carbonates, convert the developing agent into the form that is the most efficient for transfer of electrons to the exposed silver halide. Other compounds, such as gelatin softeners, surface active agents, and electron transfer agents, also accelerate development. (2) A computer hardware device for speeding up the central processing unit (CPU). Input and output devices (I/Os) run faster. Applications run faster. Overall speed may still be limited by the bus speed as well as by the video card. Special video accelerators attempt to speed up the display on the monitor. The more bits to be displayed, the slower the display changes are. Full-color displays (24 bit) often are very slow and can be speeded up by a video accelerator. *G. Haist and R. Kraus*

ACCESSORIES See *Camera accessories.*

ACCESSORY SHOE A metal bracket connected to, or part of, the camera body that forms an attaching base for small electronic flash units. On many newer cameras, the shoe is designed into the body and is "hot" (connected to the flash synchronization switch), eliminating the need for PC connecting cords. On some older rangefinder and technical cameras, the accessory shoe was used to hold special view-finders. *P. Schranz*

ACCOMMODATION The ability of the lens in the human eye to change shape to bring into focus objects at various distances. *L. Stroebel and R. Zakia*
See also: *Vision, the human eye.*

AC/DC, ac/dc Signifies that a device will satisfactorily operate on either alternating or direct current. *W. Klein*

ACETATE The term sometimes used for cellulose acetate, the material used to manufacture safety base for film. This type of material has largely replaced the highly inflammable cellulose nitrate base previously used.

The term is sometimes used in reference to a sheet of cellulose acetate used for an art overlay, or for a *cel* in motion picture animation. *I. Current*

ACETATE FILM BASE Usually called *triacetate* film base. The full name is cellulose triacetate. The support for most roll films. Formerly called safety base to distinguish it from nitrate base, which was flammable. A *diacetate* base made briefly in the 1930s proved to be chemically and dimensionally unstable. *M. Scott*
See also: *Support.*

ACETIC ACID Clear, corrosive liquid (CH_3COOH, molecular weight 60.05) with a pungent odor resembling vinegar. Glacial acetic acid (99.5%) must be diluted with water first for most photographic uses. A photographic grade (28%) is more practical for acid and acid-hardening fixing baths, clearing and stop baths, toners, and other processing solutions. *G. Haist*

ACETONE A highly volatile and flammable but pleasant smelling colorless liquid (CH_3COCH_3, molecular weight 58.05; also called dimethylketone) that mixes in all proportions with alcohol, ether, or water. Used in some black-and-white and color developers, film cements, and varnishes. *G. Haist*

ACHROMATIC Term applied to a lens corrected for longitudinal chromatic aberration to bring light rays of two colors (wavelengths) in the visible spectrum to the same focus. The term is also used in physics to describe colors that have no hue or saturation and possess only lightness. White, gray, and black are examples of achromatic colors. *S. Ray*
Syn.: *Color corrected (lens).*
See also: *Apochromat; lens aberrations; Lenses.*

ACHROMATIC COLORS Colors devoid of hue (as distinct from chromatic colors, which are those exhibiting hue). The names white, gray, black, neutral, and colorless are commonly used for achromatic colors. *R. W. G. Hunt*

ACHROMATIC STIMULUS A stimulus that is chosen to provide a reference that is regarded as achromatic in colorimetry. *R. W. G. Hunt*
See also: *Achromatic colors.*

ACID/ACIDIC Certain chemical compounds, called *acids*, separate in aqueous solution to produce hydrogen ions, H^+ (electron acceptors). Acids react with alkaline substances containing hydroxyl ions, OH^- (electron donors), to produce a salt and water.

Water contains equal numbers of H^+ and OH^- and is said to be neutral. An excess of hydrogen ions, H^+, produces an acidic solution. On the pH scale, acidic solutions are represented by numbers less than 7. *G. Haist*
See also: *Chemicals; Chemical symbols; Hydrogen ion concentration/pH.*

ACID- AND LIGNIN-FREE PAPER Acid- and lignin-free paper and mount boards are made from purified wood pulp that has had the lignin bleached out. Lignin is an organic substance that in the tree binds the cellulose together; essentially it is the woody fiber in paper made from wood. Lignin is present in large quantities in cheap paper products like cardboard and in low-quality papers and mount boards. When the lignin in paper breaks down, it releases acids and peroxides that not only make the paper brittle but also discolor the paper and transfer the acids to any photographs that may be in contact with the paper surface. The paper and mount board made from acid- and lignin-free wood pulp is archival and is available as conservation board. Photographic storage papers and boxes made from a lignin-free pulp are very high in alpha cellulose fibers. *M. Teres*

ACID FIXER See *Fixing bath.*

ACID RINSE See *Stop bath.*

ACRYLIC TRANSFER One of the simplest, most direct methods of transferring a commercially printed image from one support to another. Acrylic or polymer medium is coated over the original image and once dry is lifted from the original paper support and transferred to any secondary surface, which includes fabric, acetate, paper, wood, glass and ceramics. *J. Natal*

ACTINIC A property of radiation energy that is effective in producing electronic or chemical effects. In photography, the effective wavelengths of radiation may be dependent on the spectral sensitization of the photographic material.
 G. Haist

ACTION (1) A subject's movement within a motion picture camera's area of view. (2) A motion-picture director's command to begin the activity to be filmed. *H. Lester*

ACTION PHOTOGRAPHY See *Sports photography.*

ACTIVATOR A chemical solution that promotes the development of an exposed photographic material that contains all or part of the developing agents in the emulsion layer. A simple activator may be only a water solution of a strong alkali, such as sodium hydroxide, but often contains a preservative to prevent discoloration and a restrainer to limit nonimage development. *G. Haist*

ACUITY A measure of the ability of a person to detect visual detail. The Snellen eye chart, which contains black letters of various sizes, is one target used for testing this aspect of vision. *H. Todd*
 See also: *Visual acuity.*

ACUTANCE A numerical value that correlates to some extent with subjective image sharpness. The term *acutance* is generally reserved for photographic edge sharpness as measured with images formed in light-sensitive materials, as distinct from optical images. Acutance is determined by printing a sharp knife edge in contact with the material being tested, using a point source of light or a collimated beam. Scatter of the exposing light in the emulsion layer causes the developed image of the knife to be diffused, producing an s-shaped density distribution. Acutance is the geometrical average of the slopes at different points on the edge trace divided by the density difference between the limits of the trace. *L. Stroebel*
 See also: *Edge gradient.*

ADAMS, ANSEL (1902–1984) American photographer, author, teacher, and environmentalist. Introduced to his two greatest loves, photography and Yosemite National Park, during a family vacation (1916). Became known for his interpretation of the American West in grand, sweeping landscapes. Made his breakthrough image in 1927, *Monolith, the Face of Half Dome,* when he visualized the finished print before the exposure of the negative, not how it appeared in reality but his emotional response to the scene. Met Stieglitz (1933), who gave Adams a solo exhibition at An American Place (1936). The most famous of all his images is *Moonrise, Hernandez, New Mexico* (1941). Provided both photographs and text in the book, *Born Free and Equal* (1944), in testament to the plight of incarcerated Japanese-American citizens. Known for his technical expertise shared with thousands of workshop students since 1936 and from his many books on technique, beginning with *Making a Photograph* (1935). Author of over 40 photography books. Cofounder, *Aperture* (1952), and founding member and president, The Friends of Photography (1967–1984). A leader of the Sierra Club (1934–1971), and outspoken environmentalist. Awarded the Presidential Medal of Freedom (1979).
 Books: *Ansel Adams: An Autobiography.* Boston: Little, Brown, 1985. *Examples: The Making of 40 Photographs.* Boston: Little, Brown, 1983. *M. Alinder*

ADAMSON, ROBERT (1821–1848) See *Hill and Adamson.*

ADAPTATION A process of adjustment of a perceptual system to the environment, such as a decrease in the sensitivity of the visual system with an increase in the illumination level. *L. Stroebel and R. Zakia*
 See also: *Vision, adaptation.*

ADAPTER A device that makes it possible to combine two things that would otherwise be incompatible because of differences in size, shape, etc. A filter, for example, can be used with camera lenses having different diameter barrels by using a step-up or a step-down adapter. *L. Stroebel*

A/D CONVERTER Analog-to-digital converter. A scanner or other device that transforms analog input, such as a continuous-tone photograph, into a series of numbers or on–off impulses that can be stored and manipulated by a computer. *L. Stroebel*

ADDITIVE COLOR PROCESS A process in which colors are produced by adding together separately controlled lights, usually red, green, and blue, as distinct from a subtractive process, in which, by means of dyes or pigments, colors are produced by removing light from different parts of the spectrum in the same beam. *R. W. G. Hunt*
 See also: *Additive synthesis.*

ADDITIVE SYNTHESIS Addition of the lights in an additive process. The main methods used are superimposing the images from separate projectors (triple projection method), breaking the images into adjacent areas that are too small to be resolved visually (mosaic method), and presenting the images in succession at a rate that is too fast to be seen (successive frame method). *R. W. G. Hunt*

ADDITIVE SYSTEM OF PHOTOGRAPHIC EXPOSURE Also known as the APEX System, the additive system of photographic exposure is a method of using logarithms for the lens aperture (A_v), exposure time (T_v), light level (B_v), film speed (S_v), and exposure (E_v), so that all calculations involving these factors are reduced to addition

or subtraction of small integers, as indicated in the camera exposure equation: $A_v + T_v = B_v + S_v = E_v$.

To be more specific $A_v = \text{Log}_2 f^2$ (f being the lens f-number); $T_v = \text{Log}_2 1/T$ (T being the exposure time in seconds); $B_v = \text{Log}_2 B/6$ (B being the light level in footcandles); $S_v = \text{Log}_2 kS$ (S being the arithmetic film speed and k a constant); E_v = exposure value.

For example, when film speed (S_v) is 6 and the light level (B_v) is 8, the exposure (E_v) is 14. Any combination of lens aperture (A_v) and exposure time (T_v) with a sum of 14 may be used, such as 6 and 8, 7 and 7, and 8 and 6.

This form of expression of the camera exposure equation is of interest in connection with the exposure value scale marked on many exposure meters and some older cameras and also in connection with ISO logarithmic speeds, which correspond with S_v.

Additive System of Photographic Exposure

Time Value	0	1	2	3	4	5	6	7	8	9	10
Shutter Speed	1	$1/2$	$1/4$	$1/8$	$1/15$	$1/30$	$1/60$	$1/125$	$1/250$	$1/500$	$1/1000$

Each higher time value reduces the exposure by one-half.

The terms in the exposure equation all carry whole-number integers and are thus easy to manipulate mathematically. These terms are also known as unit values, and some cameras even carry such unit values for their aperture and shutter speed settings. Adding together the unit value for the lens aperture and the unit value for the shutter speed thus gives the exposure value, and there is a wide range of possible combinations of aperture unit value and time unit value to correspond to the same exposure value. (This disregards for the moment the reciprocity effect caused by extremely short, or more usually long exposure times.)

Further, if the unit value for the light (B_v in the exposure equation) is known or can be determined from an exposure reading, it is only necessary to add it to the logarithmic film speed value to get the required exposure setting on the camera. The use of the logarithmic scale to the base 2 means that every change of one step in any unit value corresponds to a one stop change of exposure, in the same way as with the exposure value scale.

This manner of expressing camera exposure was more of interest in connection with exposure value scales marked on a number of older camera shutters but has fallen into disuse with the introduction of built-in exposure meters and automatic, electronic exposure systems.

Books: Spencer, D.A. *Focal Dictionary of Photographic Technologies.* 1st ed. New York: Focal Press/Prentice-Hall, 1973.

J. Johnson

ADDRESS A name or numeral that designates a particular location in computer memory. *R. Kraus*

ADDRESSABLE RESOLUTION In electronic imaging, the maximum number of locations addressable at one pixel per location. *R. Kraus*

ADHESIVE Bonding agents that attach one kind of material to another, such as to mount a photographic print to a support surface or substrate. Photographic adhesives fall into two major categories—wet and dry. Dry mounting materials are available in two basic types, those that are applied with heat and those that are pressure-sensitive. Wet mounting adhesives include glues, pastes, rubber cement, and mounting sprays. *M. Teres*

See also: *Dry mounting.*

ADJACENCY EFFECTS Nonuniform densities in image areas when a region of great exposure lies next to one of low exposure. The cause is diffusion of fresh developer from a low-density area into one of high density, and the reverse—diffusion of exhausted developer from the high-density area into the low-density area.

Proper agitation during development plays only an indirect role, since the adjacency effects are associated with movement of chemicals from the thin layer of developer that adheres to the emulsion (the laminar layer) and diffusion within the emulsion itself. *H. Todd*

See also: *Photographic effects.*

ADSORPTION The concentration of a gas, liquid, or dissolved substance on a solid surface distinguishes adsorption from absorption, which involves a more-or-less uniform penetration. Spectral sensitizing dyes and developing agents need intimate contact with the surface of a silver halide crystal to be most effective. *G. Haist*

ADVANCE The difference between a point on a motion-picture sound track and its corresponding picture image. The sound track of a release print is placed in advance of its synchronized image to allow adequate placement of the projector's magnetic or optical sound reader. *H. Lester*

ADVANCES IN PHOTOGRAPHIC TECHNOLOGY

1200s Simple glass lenses were introduced.

1472 Leonardo da Vinci: discovered the multicolored nature of white light.

1676 Sturm, J.C.: Portable camera obscura with reflex mirror and focusing lens.

1704 Newton, Sir Isaac: Published Opticks in which he presented his discoveries in optics and elaborated on his corpuscular theory of light.

1725 Schulze, J.H.: Experiments on light sensitivity of silver salts; contact images (from stencils) on liquid mixtures of chalk and silver nitrate in a bottle; no fixing.

1758 Dolland, John: Invented the achromatic lens.

1777 Lichtenberg, G.C.: Developed electrostatic discharge patterns with dry powder.

1777 Scheele, C.W.: Blackening of silver chloride in the violet and the blue of the spectrum quicker than by other colors.

1800 Herschel, Sir William: Discovered infrared radiation.

1800 Wedgwood, T.: Contact copying of silhouettes, leaves, etc., on leather sensitized with silver nitrate; no fixing.

1801 Ritter, J.W.: Blackening of silver chloride by ultraviolet radiation.

1815–1820 Brewster, Sir David: Invented the optical system of the future parlor stereoscope.

1816 Niépce, J. Nicéphore: Camera photographs on paper sensitized with silver chloride; partially fixed.

1819 Herschel, Sir John F.W.: Discovery of thiosulfates and of the solution of silver halides by "hypo."

1822–1825 Niépce, J. Nicéphore: Copying of engravings on glass, zinc, and pewter sensitized with bitumen. Further attempts at direct photography.

1826 Niépce, J. Nicéphore: First photograph from nature on pewter sensitized with bitumen (exposure 8 hours). Bellows for photographic camera; iris diaphragm.

1827 Niépce, J. Nicéphore: First prints from etched heliographic plates.

1833 Florence, Hercules: Worked with paper sensitized with silver salts and coined the word *photography* in Brazil, but his achievements were not widely recognized until 1973.

1835 Talbot, W.H. Fox: "Photogenic drawings," copied on paper sensitized with silver chloride; fixed with potassium iodide or by prolonged washing in salt water. Also tiny camera photographs.

1835–1837 Daguerre, L.J.M.: Daguerreotype (direct photography on silvered copper plates with a silver iodide surface); development of the latent image by mercury vapor, 1837, fixing with salt solution.

1838 Morse, S.F.B.: Demonstrated his telegraph system.

1839 Bayard, H.: Direct positive photographs on paper (silver chloride paper blackened by light, then impregnated with potassium iodide and exposed in the camera).

1839 Daguerre, L.J.M.: Publication of working instructions for the daguerreotype by the French Government.

1839 Experimental photographic portraits in France and U.S.A.

1839 Herschel, Sir John F.W.: Generally credited with the first use of the word "photography." (See 1833.) Independent invention of a photographic process in glass.

1839 Ponton, Mungo: Light sensitivity of a paper impregnated with potassium bichromate—the basis of many printing processes.

1839 Reade, J.B.: Photomicrographs in the solar microscope on paper sensitized with silver nitrate and gallic acid (by printing out or by development with gallic acid); fixing with thiosulphate.

1839–1841 Donné, A.; Berres, Joseph; Grove, W. R.; Fizeau, H.L.: Transformation of daguerreotypes into etched printing plates.

1840 Draper, J.W. First successful daguerreotype portrait.

1840 Fizeau, H.L.: Gold toning of daguerreotypes.

1840 Goddard, J.F.: Use of bromine for the acceleration of daguerreotype plates.

1840 Petzval, J.: Portrait lens (first application of calculation for the investigation of a lens type).

1840 Soleil, J.B.F.: Actinometer for exposure time determination.

1840 Wolcott, A.: Patents for mirror camera in U.S.A.

1840 Wolcott, A.: Opened world's first photographic portrait studio in New York.

1841 Beard, R.: Opened first photographic portrait studio in Europe.

1841 Claudet, A.: Red light for dark room.

1841 Talbot, W.H. Fox: Calotype process (negatives on silver iodide paper impregnated with silver nitrate and gallic acid; development of the latent image by gallic acid, positive prints from these paper negatives).

1842 Herschel, Sir John F.W.: Ferro-prussiate paper and other processes using iron salts.

1843 Claudet, A.F.J.: Use of painted backgrounds for portraiture.

1844 Fizeau, H.L., and Foucault, L.: Discovery of reciprocity failure on daguerreotypes; photographic photometry.

1844 Hunt, R.: Ferrous oxalate process, ferrous sulphate development.

1844 Talbot, W.H. Fox: Published part I of the *Pencil of Nature,* the first photographically illustrated book.

1845 Martens, F. von: Panoramic camera for daguerreotypes.

1847 Blanquart-Evrard, L.D.: Modification of Calotype process.

1847 Mathieu, P.E.: Gold toning of positive prints on paper.

1847 Niépce de St. Victor, C.F.A.: Negatives on glass by the albumen process.

1848 Becquerel, Edmond: Attempts at color photography (heliochromy) on silver plates that were incompletely chlorinated.

1848 Niépce, A.: Albumen process.

1849 Brewster, Sir David: Lenticular stereoscope prototype. Introduced 1851. Suggests binocular camera, prototype 1853.

1850 Blanquart-Evrard, L.D.: Albumen paper for positive prints.

1850 Humphrey, S.D.: Publication of the first photographic journal: *The Daguerreian Journal,* New York.

1850 Le Gray, G.: Waxed paper process.

1851 Archer, F.S., and Fry, P.W.: Ambrotypes (negative collodion-on-glass photos with black background giving positive effect).

1851 Archer, F.S.: Wet-collodion process.

1851 Blanquart-Evrard, L.D.: Prints by development.

1851 Claudet, A.: Duboscq, J.: Animated photographs (in Zoetrope and Phenakistoscope) suggested.

1851 Dodero: Portraits on visiting cards, popularized by Disdéri.

1851 Regnault, V.: Use of pyrogallol as developer (physical development).

1851 Talbot, W.H. Fox: Photograph of an object in rapid movement by using an electric spark.

1852 Laussedat, A.: Photography applied to surveying.

1852 Lemercier, Lerebours, Barreswil, and Davanne: Photolithography with halftones on grained stone sensitized with bitumen.

1852 Martin, A.A.: Positive-looking images by the wet-collodion process on a blackened metal support (ferrotypes).

1852 Talbot, W.H. Fox: Insolubilization of bichromated gelatin by light; first experiments with halftone heliogravure.

1852–1853 Delves, J.; Highley, S.; Shadbolt, G.: Photomicrographs by the wet-collodion process.

1853 Dancer, J.B.: Prototype of stereo-camera with two lenses.

1853 Dancer, J.B.: Microphotographs by the wet-collodion process.

1853 Gaudin, M.A.A.: Use of potassium cyanide as fixing agent for silver images; experiments with gelatin as carrier for silver images.

1853 Martin, A.A.: Tintype process (wet collodion).

1854 Brébisson, A. de: Salted paper with starch, for positive prints.

1854 Cutting, J. Ambrose: Patented ambrotype process.

1854 Melhuish, A.J. and Spencer, J.B.: Roll-holders for sensitive paper negatives.

1854 Nègre, C.: Photo engravings giving halftone with bitumen-coated steel plate.

1855 Lafon de Camarsac, P.M.: Photographs on enamel and porcelain (burnt-in).

1855 Niépce de St. Victor, C.F.A.: Heliogravure with bitumen on steel.

1855 Poitevin, A.L.: Photolithography on stone sensitized with bichromated gelatin, glue, albumen or gum—principle of collotype; first attempts to obtain *carbon* prints.

1855 Relandin: Roller-blind shutter mounted on the lens.

1855 Taupenot, J.M.: Negatives on collodio-albumen dry plates prepared in advance and requiring only a complementary sensitization.

1856 Martin, A.A.: Dry tintype process.

1856 Norris, R. Hill: Collodion dry plates preserved with gum arabic or gelatin put on the market.

1856 Pretsch, P.: Photogalvanography (halftone intaglio copper printing plates by galvanoplastic molding from bichromated gelatin reliefs).

1857 Grubb, Thomas: Aplanat lens.

1857 Woodward, J.J.: Solar enlarger.

1858 Tournachon, G.F. ("Nadar"): Photography from the air in a free-floating balloon.

1859 Asser, E.J. and James, Sir H.: Photozincography.

1859 Bunsen, R., and Roscoe, H.E.: Use of magnesium to provide artificial light.

1860 Joubert, F.: "Phototype" (collotype).

1860 Willème, F.: Photosculpture.

1861 England, W.: Focal plane shutter.

1861 Fargier, A.: Halftone pigment images on bichromated gelatin with transparent support, exposed from the back.

1861 Maxwell, J. Clerk: Three-color separation, and color synthesis by multiple projection.

1861 Russell, C.: Dry-collodion plates preserved with tannin.

1862 Leahy, Thomas, and Russell, C.: Alkaline developer

(pyrogallol-ammonia) for chemical development; reversal by dissolving the first negative and development of the remaining silver salt.

1864 Bolton, W.B., and Sayce, B.J.: First workable collodion emulsion.

1864 Ducos du Hauron, L.: Patent for an apparatus for animated photography (camera and projector) made by J. Duboscq.

1864 Swan, Sir Joseph W.: First successful carbon process (with double transfer).

1864 Woodbury, W.B.: Multiplication of carbon prints by molding (Woodbury-type).

1865 Simpson, G. Wharton: Positive collodio-chloride emulsion for printing-out papers, made by J.B. Obernetter (1868).

1865 White, W.: Magnesium flash powder.

1866 Sanchez, M., and Laurent, J.: Baryta coating of photographic papers.

1866 Steinheil, A.: Aplanat lens (rectilinear).

1867 Cook, H.: Opera-glass camera and plate change-box for dry collodion plates.

1868 Albert, J.: Perfected collotype (use of glass plates as supports).

1868 Cros, C.: Principle of three-color separation and synthesis.

1868 Ducos du Hauron, L.: Three-color photography and the various methods of achieving it; subtractive color synthesis.

1868 Harrison, W.H.: Experiments with positive silver bromide gelatin emulsion for chemical development.

1869 Ost, A.: Citric acid stabilization of printing-out papers.

1870 Dagron, P.R.P.: Use of miniature photographs for the pigeon post during the Siege of Paris.

1871 Maddox, R.L.: First gelatin dry plates. Extremely slow. Improved by J. Burgess (1873), R. Kennett (1874) and C. Bennett (1878).

1872 Gillot, C.: Line blocks on zinc, using the etching technique of F. Gillot (1850).

1873 Mawdsley, P.: Gelatin bromide paper for negatives and positives.

1873 Vogel, H.: Dye sensitization for the green (basis of orthochromatic plates).

1873 Willis, W.: Platinum paper for development (sold commercially in 1878 after various improvements).

1873–1874 Johnston, J.; King, J.: Silver bromide gelatin emulsion (negative) prepared with excess bromide and washed before coating.

1874 Janssen, P.J.: Photographic revolver for the chronophotographic study of the Venus transit.

1875 Warnerke, L.: Stripping-film paper on reels in a rollholder for 100 exposures.

1876 The Liverpool Dry Plate Co. began manufacture of R. Kennett's gelatin dry plates.

1877 Carey-Lea, M.: Ferrous oxalate developer.

1877–1885 Muybridge, E.: Study of the movement of animals by instantaneous photography and chronophotography.

1878 Monckhoven, D.C.E. van: Preparation of silver bromide gelatin emulsions in the presence of ammonia.

1878 Swan, J.W., and Bennett, C.: Increase in the speed of silver bromide gelatin emulsions by ripening in a neutral medium.

1878 Wratten, F.C.L.: "Noodling" of silver bromide gelatin emulsions before washing.

1879 Kliç, K.: Photogravure on copper by transfer of a carbon print after graining with resin.

1879 Swan, J.W., also Eastman, G.: Machine for coating plates.

1880 Abney, Sir W. de W.: Use of hydroquinone as developer.

1881 Cros, C.: Dyeing of gelatin by imbibition ("hydrotypy").

1881 Eder, J.M., and Pizzighelli, G.: Silver chloride gelatin emulsion (positive) for chemical development.

1881 Horgan, S.: Halftone photomechanical reproduction process.

1881 Pumphrey, A.: Magazine camera (for gelatin sheet film).

1882 Attout, P.A. and Clayton, J.: Commercial manufacture of orthochromatic silver bromide gelatin plates.

1882 Abney, Sir W. de W.: Silver chloride gelatin emulsion for printing-out papers manufactured commercially in 1886 by Liesegang.

1882 Berkeley, H.B.: Use of sodium sulfite in developers.

1882 Meisenbach, G.: Commercial production of halftone blocks (line screen turned at 90° in the middle of the exposure).

1882–1896 Marey, E.J.: Chronophotography on fixed plates and on movable films (photographs in rapid succession at equal time intervals).

1883 Farmer, H.E.: Single-bath reducer (with ferricyanide and thiosulfate).

1884 Kayser, H.: Plate changing magazine.

1884 Nipkow, P.: First described the essential elements of a viable TV system.

1885 Urie, John, sen. and jun.: Patent for automatic positive printing machine.

1886 Ives, F.E.: Halftone blocks with crossed screen and square diaphragm.

1886 Urie, John, sen. and jun.: Patent for continuous positive print processing machine.

1887 Bausch, E.: Central shutter with blades forming, also an iris diaphragm.

1887 Goodwin, H.: Patent (granted only in 1898) for the manufacture of celluloid rollfilm coated with silver bromide gelatin emulsion.

1887 Hertz, Heinrich: The father of wireless communication; demonstrated the radiation of electromagnetic waves.

1887 Pizzighelli, G.: Platinum paper for printing-out.

1888 Anschutz, O.: Patented focal plane shutter with 1/1000 second exposure time.

1888 Carbutt, J.: Silver bromide gelatin coated celluloid sheet film.

1888 Eastman Kodak Co.: Introduction of the first "Kodak" roll film camera.

1888 Hurter, F. and Driffield, V.: Patented actinograph, a slide-rule type exposure calculator.

1888–1889 Andresen, M.: Use of para-phenylenediamine and Eikonogen as developers.

1889 Edison, T.A.: Use of flexible Eastman film for Kinetoscope pictures.

1889 Enjalbert, T.E.: Portrait automaton for ferrotypes.

1889 Lainer, A.: Stabilization of fixers with bisulphites.

1889 Namias, R.: Acid permanganate reducer.

1889 Rudolph, P.: First anastigmat lens (Protar) introduced by Zeiss.

1890 Bonnet, G.: Bichromated glue process for block-making (so-called "enamel" process).

1890 Hurter, F., and Driffield, V.C.: Scientific investigation of emulsion characteristics; creation of photographic photometry and sensitometry.

1891 Andresen, M.: Use of para-aminophenol as developer.

1891 Bogisch, A.: Use of metol, glycin and diaminophenol as developers.

1891 Edison, T.A.: Kinetoscope giving the illusion of movement by viewing images representing phases of a short scene.

1891 Lippmann, G.: Color photography by the interference method.

1891 Turner, S.N.: Daylight-loading film rolls (Kodak).

1892 Ives, F.E.: One-shot color camera.

1893 von Hoegh, E.: First double anastigmat lens (Dagor) introduced by Goerz.

1893 Schumann, V.: Emulsions with negligible gelatin content, sensitive for the extreme ultraviolet.

1893 Taylor, H.D.: Anastigmatic objectives with three uncemented lenses (Cooke lens).

1894 Ives, F.E.: Patents photochromoscope, later called "Kromskop," viewer for seeing single or stereoscopic photographs in color (invented 1892).

1894 Rouillé-Ladevéze, A.: Gum-bichromate prints for pictorial photography.

1895 Kliç, K.: Intaglio screen photogravure and rotogravure introduced. (Invented 1890.)

1895 Lumière, A. and L.: Cinematograph.

1895 Roentgen, W.C.: Discovery of x-rays and of radiography.

1896 Méliès, G.: Directing of films; cinematographic effects and illusions.

1897 Braun, K.F.: Invented the cathode ray tube (CRT).

1898 Acres, Birt: First narrow-gauge cine film (17.5 mm., Birtac camera).

1900 Lumière, A. and L.: "Photorama" for the taking and the projection of panoramic pictures of 360°.

1900–1905 Von Bronk, O.: Described electrolytic electrophotography with a photoconductor.

1901 Eichengrün, A.: Safety films from cellulose acetate.

1901 Gaumont, L.: Synchronization of a cinematograph with a phonograph.

1901 Marconi, M.G.: Made the first transatlantic wireless transmission.

1901 Pulfrich, C.: Stereocomparator for the accurate exploitation of stereo pairs in terrestrial photogrammetry.

1902 Deckel, Fr.: Compound shutter.

1902 Deville, E.: Principles of an apparatus for stereophotogrammetric restitution.

1902 Eastman Kodak Company: Gelatin backing on films to prevent curl (commercially introduced); daylight development tank.

1902 Lüppo-Cramer, H.: Metol-hydroquinone developer.

1902 Rudolph, P.: Tessar anastigmat lens introduced by Zeiss.

1902 Traube, A.: Ethyl Red used as color sensitizer; this was the first sensitizer of the isocyanine series.

1904 Fleming, J.A.: Invented the diode vacuum tube rectifier and detector.

1904 Goerz, C.: Pneumatic lens shutter using one set of overlapping blades for the shutter and the iris diaphragm.

1904 Johnston, W.: Patented panoramic camera design that was later labelled *cirkut* camera.

1904 König, E., and Homolka, B.: Ortho and panchromatic sensitizers (Orthochrome, Pinachrome, Pinacyanol).

1904 Korn and Glatzel: Phototelegraphy.

1904 Rawlins, G.E.: Fatty ink processes (*oil prints*) applied to artistic photography.

1905 Brehm, F.: Patented first cirkut camera to be commercially manufactured.

1906 Courtet, E. (pseudonym Cohl): Animated films.

1906 DeForest, Lee: Invented the triode vacuum tube amplifier.

1906 Wratten and Wainwright Ltd.: First commercial panchromatic plates.

1907 Goldschmidt, R.B.: Photographic reduction of documents for library use.

1907 Homolka, B.: Color development with leuco dyes.

1907 Lumière, A. and L.: Autochrome plate for color photography introduced.

1907 Smith, C.A., and Urban, C.: Kinemacolor, first commercial additive two-color cine process.

1907 Welbourne Piper, C., and Wall, E.J.: Bromoil process.

1908 Belin, E.: Phototelegraphy on telephone lines.

1908 Clerc, L.P.: Theory of the photogravure screen.

1908 Keller-Dorian, A.: Patent for lenticular color process for cinematography.

1910 Dufay, L.: Regular screen process of additive color photography.

1910 Goldberg, E.: Molded neutral grey wedges for sensitometry.

1911 Lauste, E.A.: First experiments in talking films.

1912 Armstrong, E.H.: Developed the electronic oscillator.

1912 Deckel, Fr.: Compur shutter introduced.

1912 Fischer, R.: Multi-contrast paper.

1912 Fischer, R., and Siegrist, H.: Color development based on formation of indamine and indophenol dyes (later employed in three-color photography).

1912 Gaumont, L.: Three-color cinematography by simultaneous additive synthesis.

1914 Eastman Kodak Co.: First Kodachrome process (two-color subtractive).

1919 Adams, E.Q., and Haller, H.L.: Discovery of cryptocyanine, the first practical sensitizer for infrared.

1920 Lüppo-Cramer, H.: Desensitization.

1920 Pope, Sir William J., Mills, W.H., and Hamer, Miss F.M.: Constitution of the color sensitizers of the cyanine group.

1921 Belin, E.: Transmission of pictures by wireless.

1921 Bocage, A.: Radiographic tomography of living objects.

1921 Duclaux, J., and Jeantet, P.: Sensitization for the far ultraviolet by putting a fluorescent layer on the emulsion.

1923 Eastman Kodak Co.: Reversal processing of 16-mm film, leading to widespread amateur cinematography.

1923 Koegel, G.: Diazo prints developed with ammonia vapor.

1923 König, W.: Preparation fo di- and tri-carbocyanines, sensitizers for the extreme red and the near infrared.

1924 Barnack, O.: Leica camera using 35-mm film, manufactured by Leitz.

1924 Sheppard, S.E., and Punnett, R.F.: Discovery and identification of active impurities in gelatin, which led to the preparation of very rapid emulsions.

1924 Zworykin, V.R.: Invented the Iconoscope TV camera tube.

1925 Séguin, A., and L.: Practical use of a condenser discharge in a rare gas for the photography of very rapid movements.

1927 Beginning of universal use of sound films.

1928 Arens, H., and Eggert, J.: Density surfaces for various types of emulsion.

1928 Commercial microfilming on 16-mm film in rotary camera.

1928 Eastman Kodak Co.: Lenticular additive color amateur motion picture film. First Kodacolor film.

1928 Franke & Heidecke: Rolleiflex twin-lens reflex camera introduced.

1928 Hamer, Miss F.M.: Polymethine sensitizers derived from benzothiazoles with alkyl substitution on the middle carbon.

1929 Ostermeir, J.: Flashbulb: Combustion of aluminum wire or foil in oxygen in a sealed bulb.

1931 Schmidt, B.: Catadioptric lens with large aperture.

1932 Technicolor Corp.: First full-length color motion picture films produced using the imbibition color transfer process.

1932 Western Electric Instrument Corp.: Weston Universal 617 photoelectric exposure meter.

1935 Birr, E.J. (Agfa): Triazaindolizines (azaindene) emulsion stabilizers.

1935 Brooker, L.G.S., and Keyes, G.H.: Preparation of tetra- and penta-carbocyanines.

1935 Heisenberg, E.: Emulsion for direct positives and prints, without inversion of a provisional negative.

1935 Laporte, M.: Electronic flash with white light.

1935 Mannes, L.D., and Godowsky, L. (Kodak): Subtractive three-color separation with superimposed emulsion layers, the color couplers added to the developers, and color separation obtained by controlled differential dye bleaching. (Early Kodachrome process).

1935 Merocyanine spectral sensitizers discovered independently by J.D. Kendall (Ilford) and L.G.S. Brooker (Kodak).

1935 Selenyi, P.: Described dry powder development of charge patterns formed on an insulating layer.

1936 Kine: Exakta 35-mm single-lens reflex camera.

1936 Koslowski, R.: Discovers gold sensitization of silver halide emulsions, but discovery is kept a trade secret by Agfa until 1945.

1936 Land, E.H.: Stereoscopic projection with two projectors equipped with polarizing filters; viewers used polarizing spectacles.

1936 Strong, J.: Reflection-diminishing coatings with insoluble fluorides on lens surfaces.

1936 Wilmanns, G., Kumetat, K., Frohlich, A., and Schneider, W. (Agfa): Fat-tail couplers incorporated in the emulsion layers of color films. Used in Agfacolor films.

1937 Mees, C.E.K. (Kodak): Supersensitization using the combination of two sensitizing dyes giving higher sensitivity than the sum of their individual effects.

1938 Carlson, Chester F.: Invented electrostatic electrophotography, later called xerography.

1938 Kodak: Super 620 camera with automatic photocell exposure control.

1938 Mannes, L.D., Godowsky, L., and Wilder, L. (Kodak): Improved Kodachrome process based on selective reexposure.

1938 Mott, N.F., and Gurney, R.W.: Theory of latent image formation.

1938 Trivelli, A.P.H., and Smith, W.F. (Kodak): Independently discover gold sensitization of silver halide emulsions.

1938–1939 Staehle, H.C. (Kodak): Cardboard mount for 35-mm color slides.

1939 Agfacolor negative-positive color printing process.

1939 Dumont: first commercial TV sets.

1939 Edgerton, H.E.: Improvement in electronic flash lamps.

1939 James, T.H.: Investigations of the kinetics of development.

1939 Jones, L.A.: Experimental basis of the standardization of the sensitometry of negative emulsions.

1939 Leermakers, J.A., Yackel, E.C., and Hewitson, E.H. (Kodak): Improved gold sensitization using silver halide emulsions made with inert gelatin and sensitized with thiosulfate, thiocyanate, and a water-soluble gold salt.

1940 Ardenne, M. von: Investigation of the structure of developed images with an electron microscope.

1940 Weisberger, A. (Kodak): Low alergenic alkylsulfonamidoalkyl substituted phenylenediamine color developers.

1941 High-resolution plates permitting 750-times enlargement.

1941 Nietz, A., and Russell, F. (Kodak): Thiocyanate ripened silver halide emulsions.

1942 Atanasoff, J.V., and Berry, C.: Built the first electronic digital computer.

1942 Carroll, B.H., and Allen, C.F.H. (Kodak): Quaternary ammonium salt development accelerators used to increase sensitivity.

1942 Gaspar, B.: Oxonol filter and backing dyes.

1942 Kendall, J.D.: Patent on Phenidone, a new developing agent (1-phenyl-3-pyrazolidone).

1942 Rott, A. (Gevaert): Reversal images produced by the silver salt diffusion image transfer process. Also discovered independently by E. Weyde at Agfa. Evolved into document copying and instant photography.

1942 Silver halide–sensitized zinc plates for rapid photolithography.

1943 Jelley, E.E., and Vittum, P.W. (Kodak): Oil-in-water dispersions of nondiffusing couplers. Process currently used in most incorporated-coupler color materials.

1944 Gaspar, B.: Color separation by sensitivity differential. System used in most color print materials.

1944 Stauffer, R.E., Smith, W.F., and Trivelli, A.P.H. (Kodak): High contrast images produced by the hydrazine effect.

1945 Multicontrast photographic papers with the contrast depending on the color of the exposing light.

1946 Back, F. (Zoomar Corp.): Designed zoom lens for 16-mm motion-picture cameras.

1946 Blackner, L.L., Brown, F.M., and Kunz, C.J.: Rapid processing and projection of images 15 seconds after taking.

1946 Evans, R.M.: Introduced the photofinishing concept that the total light reflected from each print should integrate approximately to a neutral hue.

1946 Ilford, Kodak: Improved nuclear track materials for recording nuclear particles.

1946–1950 Kodak/Time-Life scanner for halftone separation negatives.

1947 Blake, R.K., Stanton, W.A., and Schulze, F. (DuPont): Polyethylene glycols used as development modifiers to increase sensitivity and contrast.

1947 Gabor, D.: The theory of holography which became feasible after the introduction of lasers in 1960.

1947 Magnetic recording begins to replace photographic sound recording in motion picture films.

1948 Bardeen, J., Brattain, W., and Shockley, W.: Transistors, making miniature photocells and microelectronic circuits possible.

1948 Battelle Memorial Institute introduced the amorphous selenium photoconductor (Bixby, W.E.), corona charging (Walkup, L.E.), two-component dry xerographic development (Walkup, L.E. and Wise, E.N.) and electrostatic toner transfer to plain paper (Schaffert, R.M.).

1949 General introduction of safety cellulose ester film base for 35-mm motion picture films.

1949 Zeiss Contax S 35-mm single-lens reflex camera with pentaprism for eye-level viewing.

1950 Fallesen, G.E. (Kodak): Internal-image emulsion reversal process.

1950 Haloid-Xerox flat plate xerographic camera for plain-paper copies and lithographic printing plates.

1950 Hanson, W.T. (Kodak): Colored couplers used for integral masking.

1950 Kendall, W.B., and Hill, G. (Kodak): Autopositive materials, based on Herschel reversal, comprising fogged silver chloride emulsions containing a desensitizer.

1950 Norwood, D.: Incident-light exposure meter with a hemispherical light diffuser.

1950 RCA (Forgue, S.V., Goodrich, R.R., and Weimer, P.K.): Introduced the Vidicon TV camera tube.

1950 Russell, H.D., Yackel, E.C., and Bruce, J.S.: Principles of stabilization processing.

1950 Sprague, R.H. (Kodak): Sulfosubstituted cyanine dyes.

1951 Hanson, W.T., and Groet, N.H. (Kodak): Incorporated coupler color negative film having an improved sensitivity graininess ratio, produced by double coated emulsion layers having the same spectral sensitivities but different overall sensitivities, with the more sensitive emulsion containing a low concentration of coupler. Used in Eastman Color Negative Motion-Picture Film.

1951 Ives, C.E. (Kodak): Improved internal-image reversal process using hydrazine fogging agents.

1951 Brooker, L.G.S., and Keyes, G.H. (Kodak): Solubilized merocyanine dyes.

1951 Davey, E.P., and Knott, E.B. (Kodak): Halide conversion internal-image emulsions.

1952 Lowe, W.G., Jones, J.E., and Roberts, H.E. (Kodak): Sulfur plus gold plus reduction sensitization.

1952 Yutzy, H.C., and Yackel, E.C.: Colloid image transfer process used in the Kodak Verifax document copying process.

1953 Haloid-Xerox Copyflo xerographic microfilm enlarger.

1953 Miller, C.E., and Clark, B.L.: Thermal imaging system of the type used in the 3M Thermofax document copying process.

1953 NTSC standard for color TV was announced.

1954 Minsk, L.M.: Photosensitive polyvinylcinnamate polymers used in photoengraving, lithography, and in the preparation of printed circuits. (Kodak Photo Resist).

1954 Univac: 1103 digital computer with magnetic-core memory.
1954 Young, C.J. and Grieg, H.G., (RCA): Demonstrated the Electrofax xerographic document copying process; expendable spectrally sensitized zinc oxide photoconductor and magnetic brush development.
1955 Carroll, B.H., and Spence, J. (Kodak): Use of acid substituted cyanine dyes to reduce unsensitizing of incorporated coupler emulsions.
1955 Haloid-Xerox: Xeroradiography with aerosol development.
1955 Poly (ethyleneterephthalate) film supports. (DuPont)
1955 Riester, O.H. (Agfa): Alkane sultone synthesis of sulfoalkyl substituted cyanine dyes.
1955 Schouwenaars, M.A. (Gevaert): Reduction gold-fogged silver halide direct-positive emulsions.
1955 Yule, J.A.C., and Maurer, R.E. (Kodak Autoscreen Film): Prescreened *lith* films.
1955–1956 Logetronics enlarger/printer with optical feedback.
1956 Heseltine, D.W. (Kodak): Neopentylene infrared spectral sensitizers.
1956 Metcalfe, K.A., and Wright, R.D.: Described high-resolution xerographic development with toner particles dispersed in an insulating carrier liquid.
1956 Polyethylene resin–coated paper supports. (RC papers)
1956 Russell, T.A. (Kodak): Simultaneous multilayer coating.
1957 Ginzberg, C.P. (Ampex): Developed the magnetic tape video recorder.
1958 Agfa: Planographic printing plates prepared using the silver salt diffusion transfer process.
1959 Kilby, J. (Texas Instruments) and Noyce, R.N.: Invented the integrated circuit chip.
1959 Russell, H.D., and Kunz, C.J. (Kodak): Roller transport processing of radiographic films.
1959 3M:Filmac 100 Reader-Printer: zinc-oxide-photoconductor-coated foil and electrolytic development.
1959 Voigtlander: Optical compensation zoom lens for 35-mm single-lens-reflex camera.
1959 Xerox: 914 plain-paper xerographic document copier; radiant-heat toner fusing.
1959 Haloid, Xerox: Xerography—Introduction of the xerographic document copying system.
1960 Maiman, T.: Introduction of lasers, making holography possible.
1960–1965 Philips: Audio cassette magnetic tape recorder.
1961 Apeco: Document copier with zinc oxide paper and magnetic brush xerographic development.
1961 Hunt, H.D. (DuPont): Internal-image direct print emulsions containing a stannous salt halogen acceptor.
1961 Luckey, G.W., and Hoppe, J.C. (Kodak): Very high speed film using an image intensification system comprising a fogged internal-image silverchlorobromide emulsion blended with a surface-sensitized silver bromoiodide emulsion.
1961 Rogers, H.G. (Polaroid): Dye-developer color image-transfer process. Process used in Polacolor films.
1962 Dann, J.R., and Chechak, J.J. (Kodak): Thiopolymer sensitizers for silver-halide emulsions.
1962 IBM: Introduced magnetic disk computer program and data storage.
1962 SCM: Model 33 document copier with zinc oxide paper and liquid xerographic development.
1962 Williams, J., and Cossar, B.C. (Kodak): Thioether ripened silver-halide emulsions.
1962–1963 Bruning: Copytron 1000 microfilm enlarger with zinc oxide paper and magnetic brush xerographic development; precursor of the Model 2000 copier and the TCS lithographic plate maker.
1964 Sorensen, D., and Shepard, J. (3M Corp.): Photothermographic system using silver halide, the silver salt of an organic acid, and a reducing agent.
1966 Barnes, J.C., and Rees, W.: 90-second processing of radi-

ographic films using a hardening developer. Kodak X-OMAT system.
1966 McBride, C.E. (Kodak): High-speed thioether ripened direct-print emulsions processed by photodevelopment.
1966 Weyerts, W.J., and Salminen, W.M. (Kodak): Improved dye-developer color image transfer process using quaternary salts that form methylene bases. System used in Polacolor films.
1967 Dunn, J.S. (Kodak): Selenium plus gold sensitized silver-halide emulsions.
1967 Gotze, A., and Riester, O. (Agfa): Fogged direct-positive emulsions containing phenylindole electron-accepting sensitizing dyes.
1967 Porter, H.D., James, T.H., and Lowe, W.G. (Kodak): Covered grain (core/shell) internal-image emulsions.
1967 Xerox: 2400 xerographic copier with hot-roller toner fusing.
1967 Xerox: 6500 xerographic color document copier.
1968 Bahnmuller, W.: Mechanism of iridium sensitization.
1968 Berriman, R.W. (Kodak): Iridium doped reduction-gold fogged internal-image photobleach direct-positive silver-halide emulsions.
1968 Kitze, T.J. (Kodak): Incorporated developer papers containing a hardener precursor designed for rapid stabilization processing.
1968–1973 Phototypesetters for the graphic arts introduced by Mergenthaler, Compugraphic, and others.
1968–1978 Scanners for graphic arts halftone separations introduced by Hell, Crossfield, and others.
1969 Barr, C.R., Thirtle, J.R., and Vittum, P.W. (Kodak): Couplers that release developer inhibitors that improve graininess, DIR couplers. Used in Kodacolor II-type materials.
1969 Bell Labs (Boyle, W.S., and Smith, G.E.): Invented the charge-coupled device (CCD) photocell array.
1969 Brooker, L.G.S., and Van Lare, E. (Kodak): Imidazoquinoxaline electron-accepting spectral sensitizers.
1969 Morgan, D., and Shely, B. (3M Corp.): Improved photothermographic materials using silver halide, the silver salt of an organic acid, and a reducing agent in which the silver halide is formed *in situ* by reacting halide ions with the silver salt of the organic acid.
1970 IBM: xerographic copier with an organic photoconductor.
1970 Illingsworth, B.I. (Kodak): Reduction-gold fogged monodispersed photobleach direct-positive silver-halide emulsions.
1971 3M: xerographic copier using monocomponent developer.
1972 James, T.H., Babcock, T.A., and Lewis, W.C. (Kodak): Hydrogen sensitization.
1972 Kodak: 110-film format and camera.
1972 Kodak: Three-solution rapid process for color papers. System used for processing Ektacolor papers.
1972 Land, E.H. (Polaroid): SX-70 camera and integral color image transfer system.
1972 Philips: videodisc with laser and photodiode readout; precursor of the compact disk (CD).
1972 Schwan, J.A., and Graham, J.L. (Kodak): Spectrally sensitized color films designed to be exposed under several types of illumination. Universal sensitization.
1973 Evans, F.J. (Kodak): High speed internal-image core/shell silver-halide emulsions for use in the internal-image reversal process.
1975 Fleckenstein, L.J, and Figueras, J. (Kodak): Immobile sulfonamidophenol dye-release compounds of the type used in Kodak Instant Print Film.
1975 IBM: Model 3800 xerographic computer; scanning HeNe laser exposure.
1975 Kodak: Ektaprint 100 xerographic document copier; belt-form aggregate-type organic photoconductor (Light, W.L., and Dulmage, W.J.), flash exposure, recirculating document feeder and conductive magnetic brush development.

1977 Kodak: Ektavolt organic photoconducting films.

1978 Polaroid: Sonar ultrasound rangefinding system.

1979 Canon: Sure Shot camera with infrared rangefinding system.

1980 Nippon: Sheet Glass introduced with Selfoc gradient-index optics array.

1981 Sony: electronic still camera and thermal dye sublimation printing process.

1982 Kodak: Disk film format and camera.

1983 Canon: digital electronics copier with document scanner and xerographic printer.

1983 Canon: LBP-CX xerographic computer printer with semiconductor laser.

1983 Canon: personal xerographic copier with photoconductor, charger wires, and developer in a replaceable cartridge.

1983 Improved high-contrast emulsions containing arylacylhydrazide derivatives. Used in graphic arts films such as Kodak Ultratec Film.

1984 Abbott, T.I., and Jones, C.G.: Improved radiographic films containing high-aspect ratio spectrally sensitized silver-halide grains. Used in Kodak T-Mat Radiographic films.

1984 Bando, S., Shibahara, Y., and Ishimaru, S. (Fuji): Improved high-speed octahedral silver-bromoiodide double-structured grains having a silver-bromide core and a silver-bromoiodide shell.

1984 Epson and Casio: xerographic computer printers using liquid crystal (LCD) arrays with gradient-index optics.

1984 Kofron, J.T., Booms, R.E., Jones, C.G., Haefner, J.A., Wilgus, H.S., and Evans, F.J. (Kodak): Incorporated coupler color-negative films with improved speed/graininess characteristics resulting from the use of high-aspect-ratio tabular grain spectrally sensitized silver-halide emulsions. Used in Kodacolor negative films such as Kodacolor VR 1000 Film introduced in 1983.

1984 Solberg, J.C., Piggin, R.H., and Wilgus, H.S. (Kodak): Improved high-speed tabular grain silver-bromoiodide emulsions with the iodide concentrated in discrete areas.

1986 Kodak: 1.4-million pixel CCD array.

1986 Kodak: Ektaprint 1392 computer xerographic printer with light-emitting diodes (LED's) and gradient-index optics.

1986 Kodak: Signature color-proofing system for the graphic arts; organic photoconducting film and liquid xerographic developers.

1988 Fuji: Heat-developable color-image-transfer photographic materials containing heat-decomposable alkali precursors and sulfonamidophenol dye-release compounds.

1988 Konica: Color photothermographic image-transfer process using a color developer precursor and immobile couplers that form diffusible dyes.

1989 Canon: CLC 500 Color Copier with digital electronics.

1989 Kodak: 4-million pixel CCD array.

1990 Kodak: Kodak Ektacolor RA-4 rapid-access process for processing color papers.

1990 Kodak: 35-mm Rapid Film Scanner; CCD array.

1991 Kodak: Professional Digital Camera System (DCS); color CCD; fits Nikon F3 camera body.

1991 Kodak: Photo CD (compact disc) System.

1991 Kodak: XL 7700 Digital Continuous Tone Printer; thermal dye-sublimation transfer process.

<div align="right">

H. Roberts
J. G. Jarvis

</div>

ADVANCING AND RECEDING COLORS Colors that, in the absence of conflicting depth cues, systematically tend to appear to be closer to the viewer or farther away from the viewer than the actual distance. Red is perceived as an advancing color and blue as a receding color. *L. Stroebel*

See also: *Perspective.*

ADVERTISING PHOTOGRAPHY Advertising photography, as the name implies, consists of the branch of professional photography concerned with making photographs to be used to publicly announce, praise, or otherwise promote the sale of a product, a service, etc. Before the invention of the halftone photomechanical reproduction process, photographs had to be converted to line drawings by an artist in order to be reproduced in newspapers and other publications, which restricted the direct use of advertising photographs to the viewing of original photographs by a limited number of people. Even after the invention of practical color films, there was another delay before it became possible to reproduce color photographs with photomechanical processes for mass distribution. Thus, the demand for advertising photographs increased as the processes for reproducing the photographs improved, and the cost of mass distribution decreased until it is now impossible to escape a bombardment of photographic reproductions used for advertising in newspapers, magazines, fliers, catalogs, posters, and billboards, plus television commercials.

The enormous demand for advertising-type photographs is being met by a large number of professional photographers. Producers of advertising photographs range from one-person studios to large organizations, and studios that specialize in one subject area to those that accept a wide range of assignments. Advertising photographers are just one link in the chain of people and organizations involved in the production of advertisements, and they must produce photographs that satisfy the client and/or advertising agency on one side and those on the other side who are responsible for reproducing the photographs for mass distribution and potential customers.

Various paths are possible to becoming an advertising photographer, including formal education in a college or trade-school photographic program, working in an advertising studio to obtain on-the-job training, and, as is commonly done, obtaining a formal education in photography and then working for a limited period of time as an assistant to an established advertising photographer. *G. Cochran*

See also: *Catalog photography; Commercial photography; Professional photography.*

AERIAL CAMERA See *Camera types.*

AERIAL FOCUSING See *Aerial image.*

AERIAL FOG Nonimage-forming density resulting from the oxidation by air of certain developing agents on the surface of the emulsion being developed. The effect is stimulated by frequent or prolonged removal of photographic material from the developing solution. *L. Stroebel and R. Zakia*

See also: *Fog, dichroic.*

AERIAL IMAGE A real image formed on a plane in space and not on a visible surface such as a focusing screen. It may be observed by a magnifier or other optical instrument that limits the depth of field of the eye to that plane.

It is a bright image and may be focused conveniently on a given plane such as a focusing screen, where the usual image seen by scattered light is too dim, by providing a clear central spot with an engraved cross or fiducial mark. Focus is adjusted visually until there is no parallax shift observed between the cross and the aerial image when the eye is moved laterally.

In copying and special effects camera work, an aerial image of a background scene is projected in the plane of a condenser lens to be combined with titles or foreground images. *S. Ray*

Syn.: *No-parallax focusing; Clear-spot focusing.*

See also: *Viewfinders.*

AERIAL PERSPECTIVE The appearance that objects are at a greater distance than they actually are due to haze, a scattering of light by particles in the air. The haze reduces the contrast by lightening the darker subject tones, an effect that increases with increasing object distance. *L. Stroebel*
See also: *Perspective.*

AERIAL PHOTOGRAPHY Improved imaging methods for aerial photography have significantly changed this technology area over the last several years. Before the introduction of real-time, digital imaging sensors, this field made nearly exclusive use of high resolution photographic products to collect imagery from aircraft and space-borne platforms. The imaging process consisted of preplanned flight paths with specifically identified locations to be photographed. Pilots would fly the route, and the camera would operate automatically to acquire the specified target regions. The plane would then return to its base, where the film was unloaded, processed, duplicated, and distributed as required. This process could take from several hours to as much as several weeks (or even months) before users of the imagery could gain access to the photographic product.

Recent advances in aerial imaging for reconnaissance applications have centered around the need for rapid transmission and exploitation of collected imagery. Real-time sensors that transmit digital imagery to the ground at the instant it is acquired have significantly altered the functions, uses, and applications for aerial imagery. Film cameras are still used to provide information to satisfy requirements when the timeliness or availability of image products is not critical to the information being sought. Film systems can usually be obtained for less initial cost than comparable electro-optical (EO) systems, provide good image resolution, and have the advantage of a long-standing base of technology and available equipment for film analysis. For real-time applications, however, EO, thermal, multispectral, and other digitally-based imaging sensors surpass film in their ability to provide important time-critical information.

EO sensors using linear or area-array charge coupled devices (CCDs) are rapidly becoming the replacement for panchromatic (black-and-white) film-based reconnaissance systems. Linear arrays containing 10,000 pixels are now available that can provide ground details and area coverage nearly equivalent to film systems. Digital sensors that acquire imagery in regions other than the visible spectrum include thermal, radar, and multispectral systems. Thermal sensors add the advantage of being able to collect imagery at night and locate sources of heat, which usually indicate some form of activity. Imaging radar sensors can be used to "see" through clouds, smoke, and haze. Space-borne multispectral cameras (such as the U.S. Landsat and French SPOT systems) have been used to assess natural disaster damage (e.g., the Chernobyl nuclear reactor explosion, Alaska oil spill effects, and oilwell fires in Kuwait). Each of these sensor types has been used for aerial photography missions to provide essential information not achievable with film systems.

Although real-time digital systems provide rapid transmission of imagery to ground-based receiving stations, they require computer-based image processing equipment to display and enhance the image. The image-processing technology associated with digital-image products has grown rapidly with the availability of faster and more powerful computers and image workstations. There are several technical societies currently emphasizing or specializing in image processing capabilities: SPIE, the International Society for Optical Engineering; SID, the Society for Information Display; and IS&T, the Society for Imaging Science and Technology. Processing techniques range from simple manipulation of gray-scale reproduction and image sharpening to sophisticated image perspective transformations, sensor-fusion techniques, geo-positioning, and automatic object identification and recognition by expert system algorithms.

The field of aerial photography encompasses many diverse disciplines. The major categories related to aerial imaging and their associated technical specialties include camera and platform design (optical, mechanical, and electrical engineering); image transmission and receiving (electrical engineering, signal processing, computer science); image processing and reconstruction (computer science, image science, image processing), and image display and hard-copy reproduction (image science, psychophysical, and vision research). Each user and application area also requires specialized training in order to best use the imagery products from these diverse sensors.

Commercial users and applications for aerial imagery include regional and urban planning, forestry, ecological and environmental studies, population surveys, crop production and vegetation studies, geology, mining, and natural resource exploration. The American Society for Photogrammetry and Remote Sensing (ASPRS) is the leading technical association that describes the uses, applications, and current processes related to aerial imaging products. *L. Scarff*
See also: *Photogrammetry; Remote sensing.*

AESTHETICS Aesthetics is a philosophically based verbal narrative used to explain visual phenomena. Usually, aesthetics may be defined as a system or organization for what is considered beautiful or pleasing in interpretations of optical, spatial, and tactile experience. As a philosophical construct, aesthetics deals with the concepts of art and beauty proposed by the thinkers of various periods in human history.

It has become commonplace to state that art is philosophy visualized, or to argue that all practice is preceded by theory. In the case of any image-making practice, the notion of what the image is about, why it exists, why it is important, and what it means is directly relevant to the making of the image. In today's thought, the process of making the image is no longer seen as simply a neutral process, instead, it is fraught with meaning and tied to cultural norms and practices.

Photographic aesthetics, or an aesthetics of photography, operates within this system of thought. The desire to perfect visual accuracy is generally associated with the Renaissance. The reintroduction of mimesis, or a copy of the visible world indicating divine thought and divine creation, became the goal and ideal in Renaissance art, and the use of aids to vision, such as the camera obscura and mathematical modes of codifying perspective, developed at the same time.

The idea of the development and investigation of photography as a separate medium, unique unto itself, or the concept of the camera as yet another tool or medium making images within the tradition of art are both strands of identification and conceptualization tied to systems of aesthetic thought. If the identification of the medium is tied to aesthetic thought, so too are the various means of classification and judgment under the general rubric of photo-aesthetics. Arguments over the image as a reflection of reality, or as the representative schema of the modern mind have a history in the development of thought that attempts to put aesthetic ideas, or sensations of beauty within a scientific framework of identification and understanding since the eighteenth century. Mechanical devices such as the physionotrace, the camera lucida, and the popularity of the silhouette all testify to the growing emphasis on "reality" as a necessary goal of art. It was, however, still a "reality" subject to variations on validation by an ideal.

Questions of the ideal or the real can be seen in concepts of idealized images as early as the classical Greek philosophers. Plato located perfection beyond the heavens where ideas have being. Aristotle instituted an instrumental view of art in his *Poetics,* through his notion of catharsis, or arousing

the emotions and cleansing the heart of passions through fear and pity. Aristotle introduced the idea of motion through time into art; an idea that challenges the stability of permanent and ideal perfection in platonic ideals.

The term *aesthetics* was first coined by Alexander Gottlieb Baumgarten (1714–1762). His prime contribution was to define aesthetics as a science of the theory of imagination, to establish taste as a criterion of perfection, and to set the text for aesthetics as a branch of philosophy, for art criticism and for theories of culture during almost the next one hundred years. Taste was also a major aesthetic category in the work of the eighteenth-century British philosophers as they attempted to establish definitions as necessary conditions for the identification of a work of art. Baumgarten's work also led to Immanuel Kant's (1724–1804) *Critique of Judgment* which established as an *a priori* (or previously existing) judgment the categories of space, time, and causality. Kant saw these as the necessary conditions of orderly sense perception since they exist in nature. The *a priori* condition of taste, in Kant's thought, is that of design or system. This system operates within us, and we impute it to the exterior world. This principle of design is another name for the pleasure we feel or sense in judging what is beautiful. This pleasure does not arise from need, desire, or bodily wants, and thus is disinterested. Since this pleasure is of the mind, and is devoid of all personal advantage, it applies to everyone, and hence, is universal. From these intimations of morality in the pleasures of the mind we can move to intimations of the sublime, which reduces the significance of the human being through the human instinct for a spiritual being. Sublimity refers to size or power, to expanses beyond the orderly in nature, to a supreme being. The power that creates the beautiful, or the sublime in artistic making is, for Kant, "Nature working as reason in man." Genius is the faculty of aesthetic ideas or pictures to which no intellectual idea is adequate. In this system of thought, beauty and organic nature are ultimately parallel phenomena. Beauty of nature can be regarded, says Kant as "a kind of objective purpose of nature," and from this point, the idea of a close kinship between organic nature and art enters in the systematic thought we now identify as romanticism. This kinship is the underlying concept motivating the desire to fix the image as early as Wedgwood's attempts at light prints at the opening of the nineteenth century, through Niépce's recording of the negative image, to Daguerre's experiments with direct positive techniques and the resulting publication of the process in 1839, which is generally cited as the beginning of photography, the genesis of photo-history, when the photograph enters time as the miraculous mirror that can stop time and hold it as a record.

Even the most cursory reading of this historical tradition of aesthetic thought indicates concerns that dominate thinking about photography into the twentieth century. Disinterestedness, a sense of sublime, an implied transcendence, and the correlation of the image with an "out there" in nature is still implied in various patterns of identification and judgment about photographs. The temporal dimension, the ability to record time and document time, and thus to visualize history, becomes the essential characteristic of the medium. Whether through acceptance or repudiation, modern concerns are indebted to and successors of these projects to create a system of thought that would give systematic and scientific validity to concepts of creativity and image making, what had been previously thought to be a mysterious and ephemeral relationship between the mind of God, man, and the world.

To these scientific systems of thought based on reason, to the development of categories surrounding the identification of the beautiful, sublime, and eventually the picturesque in British philosophical thought, the Romantics added the no-

tion of depth of feeling. In the early nineteenth century, the romantics believed that music is nothing but a perfect form of hearing, and painting a perfection of seeing. According to Katharine Gilbert and Helmut Kuhn, in their comprehensive study, *A History of Esthetics,* "perfection of visibility came to mean the transfiguration and spiritualization of appearance, the absorption of terrestrial dawn into mystical daylight." And, as the improvements in lenses, sensitizing, and toning developed, the mechanical ability to manifest these ideas became possible in photography. W. H. Talbot made contact prints and camera negatives with silver chloride paper; John F. W. Herschel developed the use of a hypo as a fixing bath; the calotype was perfected; and in 1844 Talbot began publishing *The Pencil of Nature.*

One of the offshoots of romantic philosophy was a development of utopian thought in which life itself was to be incorporated into this mystical light; art and life were bound together like an organic whole. Nature and the realm of all phenomena led directly to the absolute; the genius of the artist was the vehicle for this movement of nature to absolute. In Britain, S. T. Coleridge placed the fine arts on the grid of being and knowledge. The dynamic unity of the fine arts (through Kantian influence) held a middle position between spirit's self-relation in the pure sciences and the examples of mentally established order in the physical world. Through the *a priori* of taste, the arts illustrate the mind's self-determination. Since they are also concerned with the physical realities of sound and color, they are a compromise between mind and matter, spirit and sense with an echo of the divine.

The technical developments of albumen paper, the invention of the collodion process, the mass production of prints to illustrate books, architectural photography, travel views, picture factories, and the gradual development of allegorical pictures in daguerreotypes, callotypes, and other processes testify to this visualization of mechanics, mind and matter in the actual sphere of photography, and a desire to echo the divine through allegory.

The American transcendentalist, Ralph Waldo Emerson (1803–1882), voiced the opinion that the influence of the British romantics, Wordsworth, Coleridge, and Carlyle, had been more readily received in the United States than in England because "the new love of the vast finds . . . in America a most congenial soil." It was in the United States that the equation between the virgin land and some sort of eternal mysticism was often manifest in written or visual form in the poetry of Whitman as well as the writings of Emerson and others. History still unfolds in America on a millennial model, and the photographs of the Civil War gave the validation of veracity to this new apocalyptic battle. History was held as a vision to be recounted in images as well as words. The photograph becomes memory at this juncture. Not only can photography substitute for mind and memory, it can, ten years after the war, record motion through the successful experiments of Muybridge and Eakins.

To this emphasis on imagination, John Ruskin adds the capacity of vision, the visualization that grasps the essence in what it beholds. Like the other British romantics, Ruskin had a profound effect on artistic theory and practice in the United States. For Ruskin, seeing was an envisaging power. Everything produced by the artist, no matter how abstract, first was seen in nature, according to this line of reasoning. No matter how geometric the organization, it evolved at first from something seen in the reality of nature. Through his remarkable sight, the artist moves to insight into the laws and structures of the universe. Art becomes the imitation of nature; it springs from instinct, finds its object in natural laws. From here, Ruskin determines that (in his *Lectures on Art*) "The beginning of art is in getting our country clean and our people beautiful." For Ruskin, machinery in place of hand-labor prevented expression in human output; this thinking

was followed by the Pre-Raphaelites and others expressing the belief that "art," in the words of William Morris, "is man's expression of his joy in labor." At the same time, the process of making the photograph itself is simplified and shortened—with the invention by Maddox of gelatin dry plates—and with the invention of the hand-held camera and George Eastman's camera, the making of images becomes a realization in visual form of the utopian ideals and dreams of democratic equality.

William Morris rejected the removal of art from use, of design from ordinary things, and the placing of art in the class of luxury. The democratization of art, the re-establishing of an equation between ornamentation and utility, and the belief that the fusion of art and life meant freedom to be achieved in the fusion of social experience and esthetics expression became dominant concepts in aesthetic thinking at the end of the nineteenth century. The denigration of the machine was met by the belief that mechanization would enrich the lives and experiences of the humble, the proletariat, the working class. The machine also offered material and technological progress, and by the end of the nineteenth century, a new aesthetic idea was developing. In place of the universal absolute, the conviction was growing that art must come from the social and material conditions in which it arises.

One more strand adds to a developing system that feeds into photoaesthetics—that of aesthetic idealism in the latter part of the nineteenth century. Aesthetics was central to German idealism, which moved beyond Kant's belief in a creative power in the human being to a theory of absolute creativeness. The artist creates imaginary worlds because he partakes, as an intelligent creature, of the universal life that gives rise to the real world. The artist is the exemplar of the human creator, and every mind has the formative drive to build reality. Carried to a logical conclusion, the Idealists believed that reality is a creation of the mind, that the absolute reveals itself in cognitive processes. The Idealist philosophers believed that art is present real existence, recognized and experienced in its essence. In this system of thought the real and ideal worlds, the universe and the mind, spring from the same root, and images prove to be symbols of the absolute.

In his aesthetic writings, Walt Whitman proclaimed that the third period in history would be the one in which political and economic chaos and change would be shaped into the greatest artistic cosmos yet known to the world. He was prescient. The democratic views and vistas of artistic expression to be put into every hand became possible through the use of the camera, making this vision a reality. By the end of the nineteenth century, amateur photography was possible, anastigmat lenses had been developed, and platinum paper and reproduction through photogravure had extended the influence and effect of the photographic image.

The camera entered a nineteenth century dominated by this romanticism as a mode of picture making capable of producing an image identified as the pencil (brush) of nature, a medium that would destroy painting, or so Paul Delaroche is rumored to have said. This mechanical device, based as it was on the optics of human vision—the direct offspring of science—could capture, or take the measure or the image of a reality and give it a quasimaterial substance, albeit one that was only a silver shadow on a metal plate. The new medium could capture reality, make visible the poetic dream, and make manifest every metaphysical intuition about space, time, and causality previously imagined. Gradually, photographic reality was within the province of almost everyone; it was the democratic medium. It seemed as if it was the fulfillment of the dreams outlined prior to its development, or as E. H. Gombrich would have it (in *Art and Illusion*), a realization in a "making" of the schema that existed prior to it, a

schema that existed in aesthetic ideas throughout the eighteenth and nineteenth centuries.

The argument between identifying photographs as art or as not-art, from the vantage point of "taking" or "making," has remained dominant and can be identified as two strands in aesthetic thinking about the medium since the end of the nineteenth century. Early attention to photography in the nineteenth century was intent upon sorting the claims of the medium of photography as both art and science. Questions multiplied in aesthetic thought and criticism about whether or not photography was a mechanical medium that simply recorded reality with minimal interference from the photographer or whether it was like traditional art media, capable of including the photographer's response, the artist's personal vision. By the end of the century, photographic exhibitions in salons were organized in London, Paris, Vienna, and Hamburg, and the debate over the artistic merits of the image began in earnest.

As Beaumont Newhall tells us, the writer of the first newspaper account of photography in 1839, after praising the exactitude and wealth of detail in the daguerreotypes he saw, remarked: "Let not the draftsman and painter despair; M. Daguerre's results are something else from their work, and in many cases cannot replace it." Twenty years later, Lady Eastlake could not accept photography as an art—but lauded the "something else" as "that new form of communication between man and man—neither letter, message nor picture" (quoted from *Photography: Essays & Images,* New York: Museum of Modern Art, 1980).

The Pictorialists, or pictorial photographers, as they called themselves, were intent upon achieving recognition for photography as a fine art. In order to win acceptance for themselves as artists and for the new medium as art, they worked the medium in order to imitate the effects of painting. They eliminated sharp detail by using soft focus, printed negatives on textured paper, set up scenarios of allegorical tableaus and even attempted to alter the negative and the print by pigment, brush, or burin. They aspired to add beauty to the representation of truth. Throughout the last three decades of the nineteenth century, the gloss of the middle ages was added through allegory, and different points in time were used in combination printing to enhance nature, to move it to the realm of the "essence," to find the emotional equivalents for romantic theorizing about art.

Like their counterparts in Victorian painting, the Pictorialists were interested in mixture of the real and the ideal, an evocative symbolism, and a purity of expression. Henry Peach Robinson's *Pictorial Effect in Photography,* published in 1869, went through many editions and became a veritable handbook for pictorialism, for the production of art photographs. The composition and design advocated were based upon principles governing academic painting, and the advice offered was to use any means to avoid the mean, bare, and ugly. Reality here, as with the philosophical aestheticians, need the sanctification of "art." Artistic photography wished to release the medium from the bondage of science and technology, to move it to a higher realm. For Alfred Steiglitz, "pure photography" was a process in which no retouching played a part; but he also insisted that what mattered was the photographer's intent, taste, and vision.

Stieglitz established a Photo-Secession Group in order to advance photography as applied to pictorial expression. In this he was acting as the various developing European modernists in painting did, banding together into groups at the beginning of the twentieth century. By the 1910 Photo-Secession Group exhibit in Buffalo at the Albright Knox Gallery, the ranks had split in terms of the definition of pure photography: pictorial effects of painterly subjects and treatment were giving way to true photographic themes and textures. True photography, which came to be identified as straight photography, relied on

the basic properties of camera, lens, and emulsion. Even here, however, poetic reverie, expressive content, and a dramatic handling of the medium was paramount for Stieglitz in his equivalents, where form becomes almost abstracted from any illustrative indications. While pictorialism continued, the rising tide was an approach to photography through realism. This realism brought validation to another aspect of photographic "truth," the documentary photograph.

Another realization insistent throughout the last decades of the nineteenth century was that of the truth of the photographic record. The very thing that the painter might ignore or leave out was rendered with accuracy in the photograph. The evocation of time and the belief in the fundamental accuracy and authenticity of the photograph is part of the "something else" recognized by the early critics of the new medium. The ruins of war and the images of the dead leave an image believed to be a true witness to historical reality. This is how the Civil War photographs of Alexander Gardner and Mathew Brady were perceived, and the truth of photographic vision as document spurred the recording of expansion and conquest at home and abroad. The truth of the photographic record seemed the perfect realization of the desired link between art and life, and of the equation between ornamentation and utility governing the Arts and Crafts Movement at the end of the nineteenth century.

Advances in perception and developments in psychology entered the concerns of aesthetics at the end of the nineteenth century. The absolute in nature or in the realm of ideation gradually gave way to an emphasis on vision as a primary aspect of image making. The eye and the mind take precedence over spirit, matter, and nature in establishing links in aesthetic thought. Developments in optics, and subsequent advances in color theorizing based upon these developments, brought about the primacy of vision in painting in impressionism and visualization as primary to photography.

The early twentieth century aestheticians inherited the importance of identifying art as symbolization and the artist as one who can visualize what everyone senses or feels. Expression is not some personal urge in the artist, but a gift of awareness that can render surrounding events and transform these transient or fleeting ideas into images. The artist becomes identified as prophet, the one who reveals social currents beneath the surface to the realm of the known, to art. These concerns are continually shaped and re-shaped through approaches to systemization as theoreticians and aestheticians attempt to develop a science of signs to codify these intuitions of symbols, and establish some orderly understanding and comprehension of the meaning of meaning. Not only were these intuitions codified, but they began to be institutionally promulgated through universities, schools, salons, exhibiting groups, the establishment of journals and other publications. Galleries, photographic exhibition groups, newspaper criticism, and the reproduction and distribution of photographic images through photojournalism all tended to quickly establish new conventions and convictions about image making.

Philosophy and the branch that concerns us here, aesthetics, moved to a linguistic model at the beginning of the twentieth century in the work of Fernand Saussere in France and Charles Pierce in the United States. This search for a science of meaning codifies the organization of emotional intuition, a sense of beauty, the articulation of feeling, the relationship between mind and matter, and other traditional aesthetic concerns into a model that indicates relationships at the level of structure.

The concept of a language of vision, of the organization of perception on a linguistic model explained perceptual concepts and intuitions. The vague generalities of making and organizing materials that formerly existed in sporadic publications of royal academies or published lectures were now available in multiple instructional books, periodicals, and journals. Ideas were reinforced in both theory and practice. A process articulated and systematized through description of the object, emotions surrounding the object, the effect upon the viewer, and the achievement of the aim or goal realized in the image reinforced the instructions on how to produce the image.

Description, codification, and the organization of models through which we can understand artistic practices is best seen in the concept of style. Style is an organizing tool. Visual phenomena can be arranged into historical or period styles—categories of style based upon media, expressive content, or function. Photography is stylistically within the historical category of "modernism," and within this period style delineations can be seen based upon definitions of the medium and approaches to it. Style can be seen as expressive, as abstract, as objectively accurate, or as functional in definitions that encompass all media. Beaumont Newhall has established four categories or four trends within modern photography dominant in Europe and America since 1910. They are straight, documentary, formalistic, and equivalent approaches to the medium.

In the middle of the twentieth century, straight photography—the ability of the camera to record exact images in rich texture and detail—was the dominant ideal in photography. This strand of photographic image making, elaborate in detail and carefully printed, maintains close contact with the world "out there," with reality. It interprets the human condition and the environment, and is considered the classic approach to photography, an approach that reproduces the world in a fundamental, monochromatic vision. The image is previsualized, and one of the essential ideas of straight photography is the decisive moment, that point at which the meaning of the idea, intention, or goal is most significant.

Significance is essential to the continuation of photography as metaphor or symbol. For photographers following Stieglitz and his idea of equivalents, such as Minor White, the camera is a metamorphosizing machine, and the photograph is a mirage. Reality and symbol, the continuation of the definitions established by the eighteenth-century aestheticians are echoed in the work of photographers following in this tradition. Surrealism as a general art movement in the twentieth century merges the aspect of photography with the equivalent.

Documentary photography is an aspect of straight photography, dedicated to photographic truth and reality, an approach in which subject matter is primary. This is generally journalistic photography, and the print may or may not be a final product, since the image and not the print is the major concern.

Photography as an extension of vision, as an extension or exploitation of the medium, as process oriented instead of subject oriented has been identified as formalistic photography. Alterations of space and size relationships, tonal reversals, and deliberate incorporation of the accidental are all considered aspects of an approach which has as its goal the search for form itself.

Style may operate on several levels of organization and definition, but the means of making a photograph has been codified, almost regardless of style, into principles of organization and production that apply to image making in general, to the linguistic understanding of elements of vision, or to the language of images, or to the elements of design. It is interesting to see just how universal most of these descriptions for visual organization on a perceptual and linguistic model are.

AESTHETIC THEORIES OF RECEPTION Anthropological approaches, psychological approaches, and more sophisticated sociological models have fused with aesthetic

thought and tend to undercut the concept of direct artistic intentionality, so that the social prophecy of the artist develops not out of his or her conscious mind, but from a subconscious level of motivation of which the artist may or may not be aware. For example, Freud believed in *primary process thought,* which is essentially grammarless. The artist uses this kind of thought and moves it from its raw form through systems and structures of the culture into art. The artist is no longer the embodiment of genius, but a person of sensitivity who acts as a conduit of symbolic visualization. In the late twentieth century, there has been a movement in aesthetics awareness away from the nature of the art object to the reception of it by a viewer, to aesthetics contemplation. Imaginative insights have replaced the absolutes of the eighteenth and nineteenth centuries, but utopian dreams remain, as prophecies become social commentaries.

All modern approaches to photo-aesthetics are concerned with the structure of the photograph, the uniqueness of this mechanical mode of image making and its potential for reproduction; generally, this is identified as an aesthetic of formal analysis. From Kant on, works of art had the ability to promote a disinterested appreciation in the viewer. Differences were put aside in favor of analyses based on formal values that pleased both the individual and had the potential to be universal. What is called postmodern photo-aesthetics is not concerned with the arguments of fine-art photography versus the particularity of the medium, but instead, with photography as the major part of contemporary image environments. Photo-aesthetics blurs the boundaries and distinctions between journalistic photography, advertising photography, documentary photography, and so forth. The concern is not only with structure, but with how the photograph functions in society, with its culture. Contemporary critical and aesthetic thinking disagrees that there is universal visual experience and sees any sort of representation as a social construct.

The notion of Kantian disinterdness still colors concepts of advertising, or commercial photography, which infers that if it is directly tied to interest, it cannot have aesthetic merit. Yet these images function in society in the exchange of goods and materials. They involve viewers in photographic illusions of realities and fantasies and function as stimulants of the desire to acquire. Contemporary critics tend to believe that representation at any level is an act of power, and it is an illusory transcendence that gives the illusion of "form" and "essence" to art. For professional, or commercial, photographers, the same application of principles of design and composition go into the making of the image.

Amateur imagery, too, meets with the same sort of disavowal. Everyone has the potential to make or create an image, and so we do, capturing and preserving those "moments in time" that are decisive only for personal, intimate lives. These photographs, which now exist in albums and family archives by the millions, do not necessarily create eternal verities, but they do stop time and operate as a substitute of individual memory. The lives of ordinary people enter history—the democratic desire of the nineteenth-century utopians is fulfilled in the snapshot album.

The spread of the super structure of exhibitions, galleries, collections, and exhibits of photographs is now bolstered with an extensive critical apparatus. Professional exhibits, curators, experienced judges with academic and artistic credentials, all provide a "discourse" of photography into which images enter. These critical structures are unified in that they all address the organization of the visual elements, the technical expertise of the photographer, and the resolution of a high degree of recognition as a factor in representation. Documentary criticism must relate a message, a story; it can have a social science application, and can operate as a visual adjunct to a verbal documentary.

Physical science is heavily dependent upon a complex technology of microscopic lenses, electron microscopes, and other paraphernalia of magnification in order to visualize the microscopic world. Geology moves into the other direction; the aerial photograph enlarges the distance while creating abstract patterns of the earth's surfaces. The camera goes beneath the sea, to the moon, and out into space to bring back information. The photograph in this usage produces an image that is a reality of nature, and a visualization of the unseen that becomes a fact. The photograph adds something new to the physical world and to the realm of information and knowledge. It is, in this sense, part of a global communication network and extends, as Marshall McLuhan informed us thirty years ago, the neurological system in human beings outward into the universe.

Criticism is the explanation of photography, and like the developing systems of making images, is dependent upon aesthetic considerations. Whether or not an image is good is still a question, but it is no longer answered in terms of a relationship between mind, matter, man, nature, and God. Nor does it postulate an identification with an absolute. At the simplest level, photographic criticism explains how well the image meets the criteria of the language of vision, how well it meets the goals of its execution.

Journalistic critics working for newspapers and magazines are cautioned to consider the nature of the readers, and they tend to approach criticism from this kind of identification. Philosophic criticism moves away from this approach to "deconstruct" the image; to explain it not in its own terms, but how it moves against a supposed identification, or how it intersects issues and ideas in the society.

The impetus for much contemporary, or postmodern, criticism is the seminal essay by Walter Benjamin, "The Work of Art in the Age of Its Technical Reproducibility." Benjamin does not believe that the photograph reproduces "reality." Rather, he thinks that the photograph unmasks or reveals the real world and overthrows the authority of nontechnical perception as well as the authority of the original. Rather than reinforcing natural visual perception, the photograph overturns it. It does this by making visible the unseeable; it demonstrates not visual perception, but what is *not* seen.

Marxist critics follow Benjamin's idea in declaring that visual images are ideological constructs, that they represent not visible reality, but the reality of "false consciousness" — systems of thought held by the power elite in order to reveal the nature of class relations. Ideology offers people a way of rationalizing their existence so that they are unaware of their domination.

Semiotics defines all systems as systems of social signification, and it defines images as manipulations of systems of signs. A photograph doesn't resemble the world, it denotes it, it identifies it within a visual system. Semiotics depends on linguistic sign systems as a model, and images depend upon verbal structures such as criticism and philosophy for their justification, rather than any universal visual experience.

Feminist criticism, too, sees representation as an act of power; and for a feminist critic masculine dominance is the ideology, or hidden consciousness, of Western culture in its development under the name of the father, the patriarchal system of male dominance since Roman times. This critical system opens up patriarchy with the intention of a radical change in the structures of dominance and powerlessness that operate in society. It functions in much the same way as the utopian romanticism at the end of the nineteenth century in its hope to revise and reform social practices.

What all of these models have in common is a denial of essence, of authorial intention, of visual equations with reality, and of a transcendental element to the image. None deny the power of images or of photographs. Quite the contrary! It is this power to capture time, to reinform memory, to recreate the world that fascinates aestheticians and critics

alike. What they agree upon is the fact that photography is the most important event in the development of the plastic arts, and that the photograph is involved with "reality." It is the definition of reality that has changed and is now open to question. Contemporary theorists believe reality is made by the symbols into which we enter and which we make, through ever-expanding mechanical means, altering our intimations of space, time, and causality

Books: Berger, John, *Ways of Seeing.* London: Penguin, 1977; Gombrich, E. H., *New Light on Old Masters; Studies in the Art of the Renaissance IV.* Chicago: University of Chicago, 1986; Grundberg, Andy, *Crisis of the Real: Writings on Photography, 1974–1989.* New York: Aperture, 1990; Hoffman, Katherine, *Explorations in the Visual Arts Since 1945.* New York: Harper and Row, Icon Editions, 1991; Jussim, Estelle, *The Eternal Moment: Essays on the Photographic Image.* New York: Aperture, 1989; Scharf, Aaron, *Art and Photography.* Baltimore, Penguin Books, 1974; Sontag, Susan, *On Photography.* New York: Farrar, Straus & Giroux, 1977; Szarkowski, John, *Photography Until Now.* New York: Museum of Modern Art, 1989; *Benjamin: Philosophy, Aesthetics History.* Gary Smith, ed. Chicago, University of Chicago Press, 1989; *Photography: Essays & Images.* Newhall, Beaumont, ed. Boston: New York Graphic Society, 1980; *Post Modern Philosophy and the Arts.* Silverman, Hugh J., ed. New York and London: Routledge, 1990..　　　*R. Welsh*

AESTHETIC ORGANIZATION AND PRODUCTION OF PHOTOGRAPHIC IMAGES There is almost no lack of agreement regarding the aesthetic production of images. Most of the literature indicates a concentration on the organization and handling of the language of vision or the elements of art. A perceptual model is primary in understanding the aesthetic production of photographic images; the "how-to" of making an excellent photograph concentrates, of course, on the knowledge of camera use and darkroom procedures, but also of prime importance is the design, composition, and ordering of the elements in the previsualization, or the printing of the image. With the growing importance of color in photography, color optics and color harmonies move to importance along with the more traditional gray scale information of tonal harmonies in black, white, and gray.

Color Harmony Color harmony is an arrangement of colors that creates a pleasing affect and effect in the visual perception of an image. Expressive harmony can also be achieved through discordant color combinations.

All theories of color harmony assume that harmony is a sensation provided by relationships and proportions of the components of color: hue, value, and intensity or chroma. Colors are often classified in terms *warm* or *cool* because of age-old associations of color with sky, earth, foliage, fire, blood, and ice. These thermal illusions have spatial sensations—warm colors project or advance, cool colors recede because the wavelengths at the violet-red, or warm, end of the spectrum are stronger, more visible, than the ones at the blue-violet, or cool, end.

Twentieth-century research offers evidence to explain psychological and physiological responses to color as the rationale for color harmony. In 1931, Selig Hecht argued that harmony has a neurological source; the brain classifies the world of related colors because the normal eye can separate the visible spectrum with complete certainty into about 180 patches of hues that cannot be made to resemble one another by varying their intensities. At mid-century, Robert Gerard, a California clinical psychologist, researched physical and psychological response to color and discovered that response to red and blue differed in increases in blood pressure, respiration, heart rate, muscular activity, and the frequency of eye movement and brain waves. Red raised and increased the responses; blue had a calming effect and lowered responses.

Color can function harmoniously by giving spatial quality to the picture plane or visual field and attracting and directing the spectator's attention. It can create a line of vision, interest through balance, and visual tension. Colors can promote illusions of harmonious movement and serve as a vehicle of personal expression. Color symbolizes ideas and associations, and visualizes emotional facts or statements. Even before Newton's prismatic discoveries, seven was the alchemist's magic number. For Christianity, seven was the union of earth (four) and heaven (three). The seven colors identified by Newton: red, orange, yellow, green, blue, indigo, and violet, may have been influenced by these prior beliefs; nevertheless, they remain as primary. Even today, associations of these colors with personality traits and physiognomic types continues.

Books: Birren, Faber, *Color Perception in Art.* West Chester, Pennsylvania: Schiffer Publishing Ltd., 1986; de Grandis, Luigina, *Theory and Use of Color.* trans. John Gilbert. Englewood Cliffs, N.J. and New York: Prentice-Hall and Abrams. 1986; Hirsch, Robert, *Exploring Color Photography.* Dubuque, Iowa: Wm. C. Brown Publishers, 1989; Sloane, Patricia, *The Visual Nature of Color.* New York: Design Press, 1989.

R. Welsh

AFOCAL LENSES See *Lens types.*

AFTERIMAGE A visual image that more or less resembles the stimulating field, is seen after the stimulus has been removed, and moves with the eyes, such as the spots seen after looking directly at a camera flash when it is fired. Afterimages may alternate between being negative images and positive images with respect to both lightness and hue.

L. Stroebel and R. Zakia

See also: *Visual perception, poststimulus perceptions.*

AFTERRIPENING A chemical treatment in the manufacture of a photographic emulsion that consists of heating the emulsion in the presence of chemical ripeners, such as gold, sulfur, and other compounds. This digestion may last many minutes, resulting in chemical deposits on the surface of the silver halide crystals. This chemical sensitization improves the efficiency of latent image formation during exposure to actinic radiation.　　　*G. Haist*

AFTERTREATMENT Often synonymous with postprocessing, aftertreatment usually refers to methods of modifying the appearance of the finished photograph, and correcting errors in exposure and development. These methods include (1) wet chemical treatments such as with reducers, intensifiers, toners, dye treatments, and hardeners (2) work on the dry negative or print such as with abrasive reduction, spotting, retouching, opaqueing, local dyeing, varnishing, pressing, or straightening.　　　*I. Current*

AGENCIES Professional photographers may, in the regular course of business, deal with three types of agencies: advertising agencies, picture or news agencies, and stock photo agencies.

ADVERTISING AGENCIES Advertising agencies (ad agencies) are the agents of an advertiser. The ad agency assigns the photographer a specific job, usually at a fixed fee that may or may not include out-of-pocket expenses. Out-of-pocket expenses may include film, processing, models, props, and travel. In some instances, particularly where the name of the model is specified, the agency directly employs the model. The agency, on behalf of its client, the advertiser, usually attempts to contract for all rights to the photographs including the copyright. The issue of who owns the copyright on the work produced during the shoot is important to

photographers who use commissioned shoots as opportunities to expand their library of stock photographs.

PICTURE AGENCIES Picture, news, or photographic agencies are agents of the photographer. They obtain assignments for photographers from clients. They may also maintain stock files, but historically they have been known for their coverage of current events. There is a blurred line between the terms *picture agency* and *stock agency*. For instance, The Picture Agency Council of America is a trade association of stock agencies. Perhaps the best known of the picture agencies is Magnum. Among its founders were Henri Cartier-Bresson, Robert Capa, and David "Chim" Seymour.

STOCK AGENCIES Stock Agencies or stock houses are also agents of the photographer. They maintain libraries of existing images, usually by many photographers, and license the use of those images to clients. The license is usually for one-time use.

A stock agency may be a general agency, that is, it maintains extensive files on almost every conceivable subject matter, or a specialized agency. A specialized agency may limit its library to photographs relating to a single subject. That subject may be as encompassing as a single country, sports, or celebrities, or as narrow as a single occupation.

The search of a stock agency's files for a requested image may involve either agency personnel or independent researchers. One or more selected images are provided to the client for final selection. In recent years, many stock houses have imposed a search fee whether or not an image was licensed. The license fee is shared with the photographer. The search fees are retained by the stock house

Books: *ASMP Stock Photography Handbook.* New York: American Society of Magazine Photographers, 1989; Engh, Rohn, *Sell & Re-Sell Your Photos.* Cincinnati: Writer's Digest Books, 1991; McDarrah, Fred W., *Stock Photo Deskbook (Third Edition).* New York: The Photographic Arts Center, Ltd., 1989.

R. Persky

See also: *Business Practices, selling and licensing images; One-time use; Picture agency.*

AGFA DIVISION OF MILES, INC.
Agfa evolved from a German factory that made chemicals and dyestuffs. In the early 1920s manufacturing of photographic products became dominant and the acronym Agfa was adopted as the company name. Agfa developed a grain-screen process in 1916 that enabled color transparencies to be produced. Agfa patented a triple layer reversal color film in 1935 that went into production as Agfacolor New Reversal Film in 35-mm and 8-mm sizes in 1936. Four years later Agfa introduced a subtractive color negative film.

Agfa Photo Imaging Systems, based in Ridgefield Park, New Jersey, operates within the Agfa Division of Miles, Inc. Agfa manufactures and distributes photographic films, processing equipment, paper, and chemicals to the minilab/retail, professional, wholesale, and consumer markets. Agfa, a leader in imaging technologies, is a complete full-system supplier to the photofinishing market.

Agfa Division reported combined net sales of just under $1 billion in 1991 and employs nearly 4,500 people in the United States, with facilities in more than 70 locations nationwide.

(Courtesy of J. Samberg, Corporate Communications, AGFA Division, Miles, Inc.)

AGING
The chemical, physical, and sensitometric characteristics of the change in photographic materials with time, often adversely. A high-humidity, high-temperature environment in an incubator is used as an accelerated test to provide information on the aging or resistance of the material to change. An estimate of the natural useful life of the photo-material is often indicated as a limit date on the package of the material.

G. Haist

AGITATION
The primary function of agitation is to keep photographic solutions in motion during processing to guarantee uniformity of action.

THEORY Although agitation is an important factor in all processing steps, it is most critical during the image-forming stage. Agitation is one of the major factors—in addition to developer composition, time, and temperature—that affects the degree and uniformity of development.

In development, a stagnant layer of solution, called a laminar layer, forms on the emulsion surface. As the developer absorbed by the gelatin is used up, fresh developer must diffuse from the bath into the emulsion to maintain the rate of reaction. The laminar layer contains a high concentration of bromide, a restrainer, and other development by-products that slow down the diffusion of fresh developing agents into the gelatin. If this layer does not have the same thickness everywhere, different densities can result in uniformly exposed areas. Agitation increases the uniformity and decreases the thickness of the stagnant layer, therefore affecting the rate and uniformity of development.

An additional function of agitation is to maintain a random mix of both fresh and exhausted developer throughout the solution and to guarantee that each part of the emulsion is exposed to the same developer composition and temperature. Without agitation, the heavier development by-products tend to settle to the bottom of the processing unit.

Agitation is generally extremely important in the first few minutes of the developing process, because at this stage swelling of the gelatin occurs. The risk of uneven development can be reduced if an emulsion is presoaked before processing.

Agitation has a greater influence on the final result when the development time of a material is short. Density and gamma can be increased by 30 to 100% by high agitation. In general, uniformity is less of a problem with materials that are developed to gamma infinity, such as photographic papers and graphic arts films, than with materials developed to a low contrast index, as with most pictorial negative films.

Agitation is difficult to standardize and is highly operator-dependent, especially for tray and tank processing. The manufacturers' data about the speed and contrast index of emulsion-developer combinations are given in terms of time, temperature, and method of agitation. Developing time may need to be adjusted to compensate for personal agitation habits. In any case, the recommended guidelines should be followed. A good example is the difference between tray and tank processing for sheet film. Tray processing usually requires constant agitation, which results in a contrast gain. In order to offset this gain, the recommended developing times are shorter for tray processing than for tank processing, which requires intermittent agitation to obtain uniform development.

Although agitation is normally required to obtain good results, when using high-acutance developers, agitation has to be kept to a minimum as to not counteract the edge effect. Low contrast and compensating developers may also take advantage of the restraining action of developer by-products and be adversely affected by too much agitation.

METHODS OF AGITATION Correct agitation is dependent on the processing method used.

Tray Processing One of the most common ways to develop sheet films and paper. In tray shuffling, the sheets are immersed in the solution and then shuffled from bottom to top. This method provides good agitation and high throughput, but carries a high risk of emulsion damage through handling. Presoaking can diminish the sheets' tendency to stick together.

In tray rocking, a sheet of film or paper is immersed in the

developer with the emulsion up. Agitation occurs through rocking the tray in a nonrepetitive pattern to ensure random flow. If the agitation is directional, i.e., if only the same side of the tray is lifted, standing waves can occur that result in bands of different densities across the emulsion.

Tube Processing A film is inserted into a narrow tube that is then filled almost to the top with the processing solution. By gently rocking the tube, one can move the air bubble from one end to the other, allowing the solution to flow evenly over the emulsion surface. Tube rocking produces quite uniform development.

Small Tank Processing Roll films are wound on spiral reels and processed in light-tight tanks. Agitation occurs by lifting or tilting or inverting the tank, moving it in a swirling pattern, or rolling it back and forth. These tanks usually give good results with the proper technique. If the agitation is too vigorous and continuous, an unevenness of density can occur because of the streamlined flow of developer, leading to increased local agitation, especially at the perforation holes of 35-mm film. Some small tanks have a spindle that fits into the reel, and the film is agitated by twisting the reel. This agitation method requires that the tank remain upright.

Tank Processing Lines of tanks, each with a different processing chemical are set up in a temperature-controlled environment. Processing is accomplished by moving the film from one tank to the next at the appropriate time.

With lift and drain tanks, agitation occurs by lifting the film out of the processing bath, letting it drain, and returning it to the tank, alternating the corners. This level of agitation is relatively low, requiring longer processing times. The perforation holes of film hangers can lead to streaking, especially with over-agitation.

With deep tank and the automated dip-and-dunk processors, the best way to agitate the solutions is using a nitrogen burst system. A perforated gas distributor grid called a plenum is placed at the bottom of the tank. Nitrogen, which has no chemical effect on the developer, is intermittently released. Compressed air can be used for other processing steps, such as the stop bath, fix, and water tank. The pressure of the gas is adjusted to cause an appropriate rise in the solution. The duration of the burst is dependent on the amount of solution a tank contains, as each burst should result in full turbulence of the bath. If the gas is allowed to flow continuously, the repetitive bubble pattern will result in streaks. The bubble pattern is determined by the gas pressure, the grid design, and the size of the perforation holes. Once pressure and duration are adjusted for a specific tank, agitation is controlled by the frequency of the bursts. This system provides vigorous and uniform agitation, provided it has been adjusted properly. Occasionally, the perforations in the dis-

Small tank processing.

Tray processing.

Tray rocking.

Tank processing.

Tube processing.

Gaseous burst agitation.

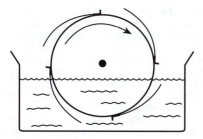

Drum processing (inside loading).

Drum processing (outside loading).

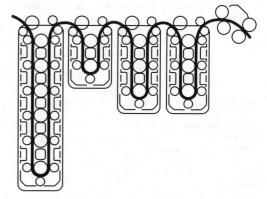

Roller transport processing.

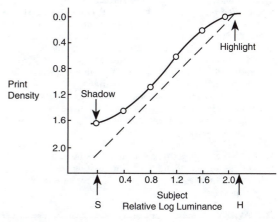

Continuous strand processing.

tributing grid tubes become plugged, leading to uneven bubble patterns and nonuniform development.

Drum Processors With inside-loading drums, film or paper is loaded emulsion side facing in inside a cylindrical drum that rotates constantly on motor driven rollers. The immersion of the emulsion is only intermittent, as the small amount of chemistry used inside the drum stays at the bottom. Although somewhat directional, this method gives good results but usually requires an adjustment of temperature or developing time compared to the tray or tank processing. Some roller devices intermittently reverse the direction of rotation, which improves the randomness. After loading the sensitized material in the dark, such drums can be operated with the room lights on, including adding and draining solutions.

With outside-loading drums, the film or paper is placed on the outside of the drum, emulsion facing out. The chemicals are then placed in a trough through which the bottom of the drum passes. Randomness is maintained by rotating the drum at a moderately high speed to cause turbulence. Different solutions are introduced by draining and refilling the trough.

Roller Transport Processing Used for both film and print material, these fully automated machines provide agitation by the continuous movement of the emulsion through the processing solutions. Although the transport and the squeezing effect of the rollers provide for vigorous agitation, it is somewhat directional. The small streaming effect is usually only apparent on sensitometric wedges and results in a small difference in contrast of two identical wedges when the leading end is reversed. It is therefore important that all processing control strips are fed through the machine in the same way in order to get consistent results.

Continuous Strand Processors Designed for long lengths of photographic material such as movie film or roll paper, only have rollers at the top and bottom of each tank. In these processors, agitation through movement is usually supplemented with gas burst systems. *S. Süsstrunk*

See also: *Developing; Fixing; Machine processing; Tank and tank processing.*

AIM CURVE A graph showing the relationship between the tones in a preferred image and those of the subject. Data for such a graph are obtained from an experiment in which viewers select the photographic image they like best. *H. Todd*

See also: *Tone reproduction.*

AIR ABSORPTION Losses in propagation beyond those expected from considerations of sound spreading out over distance; greater at high frequencies than at low ones, and a complex function of humidity. *T. Holman*

AIR BELLS Bubbles of air that adhere to the surface of film and printing paper. Unless removed, by brushing the

Aim curve.

surface or by sufficient agitation, these bubbles prevent the developer from carrying out its function, leaving spots of lower density with nonreversal materials and higher density with reversal materials. Bubbles on the surface during washing interfere with the removal of processing chemicals.

L. Stroebel and R. Zakia

See also: *Processing defects.*

AIRBRUSHING Airbrushing is a procedure that enables an artist to create images or a retoucher to color or modify photographs, including to introduce cloud effects, remove unwanted backgrounds, and generally enhance photographs by applying a fine spray of liquid colorant.

OPERATION About the size of and shape of a fountain pen, the airbrush projects a cone-shaped spray of liquid colorant from a nozzle in its tip to a surface by means of compressed air. Behind the nozzle is a reservoir for the spray material, and above that a button that is manipulated by the operator's forefinger to control the spray pattern. The button can be pressed down to allow air to enter from the reservoir and pass through the nozzle, and it can be pressed back to allow color to be drawn from the reservoir to the nozzle. By adjusting the distance, it is possible to control the covering power of the brush from a fine hairline to a band of color up to 2 inches wide. Below the control button is the connection to the source of compressed air at about 30 pounds per square inch. The air must be free of moisture and oil.

Water, light oil, or alcohol-soluble colors can be used in the airbrush, but all pigmented colors must be finely ground and free from sediment or lumps. For details on use of the air brush, one should consult the instruction manual provided by the maker of the instrument.

To draw a very fine line, the nozzle is held practically touching the paper, but at an angle to allow the released air to escape. For filling broad areas of solid color, the nozzle is held from three to four inches from the surface, and the area filled with steady, even overlapping strokes.

Graduated shading is produced by controlling the distance the finger button is drawn back in relation to the distance of the brush from the paper. If the button is drawn back very slightly with the nozzle some distance from the surface, an almost imperceptible amount of color is applied. This can be graded up to solid color by gradually drawing back the finger button. A stippled finish can be produced by reducing the air pressure.

STENCILS AND MASKS It is possible to confine the effect of the brush within sharp boundaries by cutting a stencil to mask the remainder of the area. The typical stencil makes use of a special transparent varnish paper that will adhere lightly but firmly to the surface of the photograph. The outline of the area to be sprayed is cut with a sharp-pointed stencil knife, and the cut-out portion removed. For some subjects, such as portraits or landscapes, it may be desirable to produce a soft outline. A mask outline can be traced onto stiff paper or cardboard which is then cut out. The farther the mask is placed away from the surface when the spray is applied, the softer the outline.

CLEANING It is important to keep the airbrush scrupulously clean. If color is allowed to harden in the fluid nozzle, the instrument will probably be damaged. *I. Current*

See also: *Retouching.*

AIR KNIFE A jet of air from a slit aperture, used to remove the surface liquid from film as it leaves processing solutions or the wash. *L. Stroebel and R. Zakia*

Syn.: *Air squeegee*

AIRY DISK Named after George Airy, Astronomer Royal in 1830, airy disk is the central area of the image of a point source of light as produced by a perfect, aberration-free lens. Diffraction effects and interference at the aperture produce the Airy pattern of alternating light and dark rings around the central bright disk of finite size. The diameter of the Airy disk is that of the first dark ring in the pattern and is given by $2.44\lambda N$, for light of wavelength λ and lens of relative aperture N with a circular aperture. It has importance in the theory of resolving power of lenses. *S. Ray*

Syn.: *Image patch.*

See also: *Optics; Physical optics.*

ALBERT EFFECT See *Photographic effects.*

ALBUM In its simplest form an album is a blank-paged book onto which snapshots or other memorabilia can be attached. Albums are a convenient way of displaying photographic prints so that the photographs can be protected while they are viewed. Some albums have a fixed number of pages, and when they are filled up, another album is started. Some are held together with a shoelace-style string or are loose-leaf book style, which allows additional pages to be inserted whenever the album is filled. Multiring, D ring, and other loose-leaf types allow for the addition, deletion, or rearrangement of the pages. These types of albums permit the pages to turn easily and lie flat. The page inserts can either be made of an archival (acid- and lignin-free) paper, or nonarchival-type papers.

Clear polypropylene pockets or archival mylar page-protector sheets come with a variety of standard print-sized openings into which one can slip mounted or unmounted photographs. Because polypropylene is a semistiff plastic, it can also be used to store unmounted negatives or slides. These convenient loose-leaf pages display and protect the surface of photographic materials from fingerprints and dirt.

"Magic" plastic-paged albums are also referred to as magnetic albums. These albums are made up of paper pages covered with an adhesive, enclosed under a liftable plastic cover sheet, usually acetate, bound with a spiral or comb plastic binder and inserted into a soft-covered album. The materials that are used to manufacture these albums are nonarchival and probably will damage the photographs that are stored in them. The pages will discolor where the adhesive strips coat the paper, causing yellowish lines on the surface of the page. These albums should only be used to store snapshots that are not intended to be kept for long periods of time. Such albums are convenient to carry photographs in, offer protection from casual handling, protect the photographs from fingerprints, and offer water resistant surfaces that protect the snapshots. The plastic-paged album is an ideal way to share images at luncheon meetings or parties where food and beverages are being served. Plastic-paged albums also offer protection from a young child's crayons.

The wedding album ranges from the basic plastic comb-bound proof book to the luxurious handcrafted, lacquered, hardwood-covered album. Also available are padded bonded-leather albums with foil-stamped lettering or designs, golf leaf embossing and optional tarnish-proof cameo frames embedded into the album cover, often with a genuine silk moire linings on the inside cover. The number of pages that can be inserted in a wedding album depends upon the style of the album. The page inserts are available in a variety of styles with multiple openings for different print sizes in a variety of configurations. The pages for these albums are held together with three types of devices. The post-type screw connection fastens the front and back covers together with a threaded screw and post kit; an extension post permits album expansion to accommodate more page inserts. Some post-style preview albums are available with foldout pages with multiple windows. The pin-type connection uses long wire-like pins inserted through a hinge-like

device at the edge of the page which in turn is inserted into a free turning union upon which the page pivots. The multiring opening/closing device, metal or plastic, is similar to a combination of loose-leaf type page and comb binders.

There are several ways to attach photographs to album pages. The simplest is with pressure-sensitive photo mounting corners. These self-adhesive corner pocket triangles are slipped over the edge of the print and tacked down to the album page. Double stick tape, or double stick pads, can also be applied to the back of the print and then placed into the album. Prints can be dry mounted in a hot dry-mount press if the album pages are removable loose-leaf pages. Cold-mount pressure-sensitive adhesive can be used to attach the print to the album with a special squeegee.

The base pages of wedding-style albums accept any number of different precut mat openings that overlay the photographs. Some pages allow the mounts to be slipped into an open-sided page and then the photograph inserted. Other albums have you insert the photograph into a precut mat and then slide the combination into a page opening. The page design is usually square so that the page inserts can be rotated, which allows the same mat to be configured either vertically or horizontally. For some style albums, the mats are designed with a self-stick adhesive under a protective peel-off backing, which allows the prints to be held in place on the support page. There are several single 8×5, 4×5, or $3\frac{1}{2} \times 5$ formats, two vertical and two horizontal, four vertical, and four horizontal. In addition to single-size formats, there are mixed formats that offer opportunities to display more than one size on the same page, such as one vertical, square or oval 5×7 and two 4×5s, etc. *M. Teres*

See also: *Presentation folders.*

ALBUMEN PROCESS

During the early development of photography, people struggled to find a clearer base on which to coat emulsions than the uncoated paper used by W. H. Fox Talbot. A relative of Joseph-Nicéphore Niépce, Claude Felix Abel Niépce de St. Victor, devised a method for coating beaten egg whites combined with potassium iodide and sodium chloride on glass, and published the system in 1848. Dry, coated plates were sensitized in silver nitrate, and developed after exposure in gallic acid. These plates had low sensitivity but excellent sharpness, and were better suited to landscape and architectural rendering than to portraiture. The albumen negative process was soon replaced by collodion because of the tendency of the albumen to crack and flake, and the filing of defensive patents by Fox Talbot. Albumen continued to be used on glass to make positive lantern and stereoscopic glass slides, sometimes called hyalotypes.

Albumen coatings on paper had a longer life in the market. Louis Blanquart-Evrard published a paper in 1850 in which he described the coating of paper with albumen combined with ammonium or sodium chloride. The dry paper was sensitized by floating it on a silver nitrate solution and drying. Although most people used this process for printing out, Blanquart-Evrard developed out in gallic acid to produce many more prints in a day. Precoated papers were sold commercially. *Cartes de visite*, cabinets, and stereo cards printed from collodion negatives on albumen paper were immensely popular through the 1890s, keeping the chickens of Europe busy. *H. Wallach*

See also: *Collodion; Hyalographic process.*

ALCOHOL

A class of organic compounds, containing an -OH group, whose liquid members are often used to hold chemicals of low solubility in water solution.

Ethyl alcohol (CH_3CH_2OH, molecular weight 46.05) is also called ethanol, grain alcohol, or alcohol. This clear, colorless, flammable liquid of characteristic odor can cause human disorientation if imbibed in sufficient quantity. The absolute grade is almost 100% ethyl alcohol, but many industrial grades are denatured (made unfit for human consumption).

Methyl alcohol (CH_3OH, molecular weight 32.03, also called methanol or wood alcohol) is a clear, colorless liquid that is volatile, flammable, and highly poisonous if ingested. It mixes with water, ether, and other alcohols. Methyl alcohol is used in small quantity with ethyl alcohol to make that alcohol unfit for drinking, thus avoiding governmental taxation.

Methyl, ethyl, and other alcohols, such as isopropyl and benzyl, are useful in the preparation of photographic emulsions and in concentrated developers, where they increase solubility and activity, as well as for drying or cleaning photographic materials. *G. Haist*

ALGORITHM

In computers, an algorithm defines the number of steps or the extent of the process required to solve a coding problem. It is a structured step-by-step course of action. *R. Kraus*

ALIASING

Low- and medium-resolution computer imaging systems display normally smooth edges as jagged edges. These *jaggies* are known as aliasing. It may result from undersampling the spatial frequency, or when the detail exceeds the display ability of the monitor. *R. Kraus*

ALKALI

Alkalis are compounds, often called chemical bases, that separate in water to produce hydroxyl ions (OH^-) that act as electron donors. Alkalis react with acidic substances (H^+) to produce a salt and water.

Water contains equal numbers of H^+ and OH^- and is neutral, neither acidic nor basic. Alkaline water solutions containing excess OH^- are represented by numbers above 7 on the pH scale. *G. Haist*

See also: *Chemicals; Chemical symbols; Hydrogen ion concentration/pH*

ALKALINE BATTERY

A nonrechargeable battery that uses a zinc anode, manganese dioxide cathode, and an aqueous solution of potassium hydroxide (alkaline, rather than an acid or metal salt) electrolyte. *W. Klein*

See also: *Battery.*

ALLEGORICAL PHOTOGRAPHY

Photography in which the image becomes a visual reference for some well known idea or theme drawn from religion or mythology. For example, a photograph of a woman leaning forward and admiring herself in a mirror can remind one of the Narcissus myth.

Two of the early pioneers in allegorical photography using composite images were Oscar Gustave Rejlander (1813–1875) and Henry Peach Robinson (1830–1901). Two of Rejlander's important composite photographs are, *Two Ways of Life* (1857) and *Hard Times* (1860).

Loosely based on Raphael's fresco *School of Athens,* Rejlander's photograph, *Two Ways of Life,* represents an allegory of the choice one must make between good and evil, between work and idleness. The allegorical theme is similar to that used in emblematic literature warning against idleness and praising work. Rejlander's composite photograph was intended to compete with paintings entered in an art exhibitions. The composite print was made from some 30 separate negatives posed for by a number of models both clothed and unclothed. Even though one of the five versions of the work was purchased by Queen Victoria, critics termed it unsuccessful as allegory. Reflecting the narrowness of that time period, they reasoned that any work of art should not depend upon mechanical means.

The photograph *Hard Times* was a social commentary as relevant today as it was in 1860. The photograph consists of a forlorn unemployed father, carpenter tools by his side,

sitting by the bedside of his wife and child who are asleep in the bed. The allegory of being unemployed and not being able to provide for your loved ones has a contemporary ring to it, as do most allegories.

Robinson's composite photograph, *Fading Away,* shows a young sick girl lying half upright in front of a partially draped window with what appears to be her mother and grandmother by her side in quiet contemplation. A man, presumably her father or husband, stands with his back to her in a hopeless position looking out the window. To his right side is a stand with some flowers in a vase. One of the flowers is drooped and a few petals have fallen and lie still on the top of the stand. It is interesting to compare this photograph by Robinson to a 1992 advertisement in which a large color photograph shows a young man lying in bed dying of AIDS. His father is by his side sharing the sadness and trying to comfort his son, while the mother and sister in remorse are off to one side. The photograph was not posed and it represented a real situation. The family gave the company permission to use this very personal photograph so that it might help the fight against AIDS. Nevertheless, the ad received a considerable amount of criticism from those who felt that the use of such a photograph in a commercial advertisement was inappropriate.

In the nineteenth century there were critics who denounced the use of photography to convey allegory and moral message, yet these themes continued, particularly with the pictorialist photographers. In one of Camille Silvy's photographs, *Mrs. John Leslie as Truth* (1861), the central and only figure is a model dressed in a large white gown that graces the floor. She holds a white flower in her hand as she looks up towards the heavens with glassy eyes and an angelic expression. Behind her, and covering most of the background, are contrasting dark clouds.

Allegorical photography, although different in technique from that of the nineteenth century, continues to be practiced today by such well known photographers as Duane Michals and Sebastiao Salgado.

At the age of 40, Michals photographed himself as the devil. Wearing a black sweater, he placed his hands on his forehead with his thumbs sticking up as horns, his mouth open and his tongue sticking out as far as it will go. The lighting is harsh and contrasty, one side of the face is black with no detail, and the expression is frightening.

In a sequence of photographs called *The Human Condition* (the same title given a painting by Magritte, who greatly influenced Michals), the first photograph shows an ordinary man standing at a subway station facing the camera. As the sequence progresses, the man becomes less and less visible as a bright, oval shaped white light engulfs him. In the progression the man is transformed into a galaxy of stars. Michals writes of this sequence, "I think we are all stars but don't know it . . . we are all, each one, a universe but we don't know it. We walk heavy to the earth and we are pulled down by the gravity of our ignorance . . . " (*Duane Michals; the Photographic Illusion.* Thomas Y. Crowell Co., Los Angeles, CA: 1975, p.27).

In Salgado's powerful black-and-white photographs of the Brazilian miners, hordes of near-naked men are seen swarming and scratching for gold in the hilltops. All day long they carry bushels of dirt from the top of the hills to the bottom to filter it in streams, searching for gold. From the distance the photograph was taken, the hills look like they are covered with thousands and thousands of busy ants. The photograph brings to mind the suffering and sorrow of the poor and their subjugation throughout history. One of the men carrying a large plank on his shoulder as he ascends up the hill looks like a Christ figure carrying his cross. One can also find reference to a religious theme in his 1990 photographs of the hundreds of smoldering and burning oil wells

in Kuwait after the Persian Gulf war. One photograph in particular shows a worker drenched and dripping in black oil from head to foot, exhausted and lying helplessly in a pocket of sand. His posture is such that is recalls the famous *Pietà* sculpture by Michelangelo, in which Jesus, after being taken down from the cross, lies helplessly in his mother's arms.

One can think of allegories as a kind of a code that is repeated throughout history, in paintings, sculpture, literature, motion pictures, television, theater, and still photography. The themes are the same and the variations many. Roland Barthes reminds us that "A code cannot be broken, only played off." The same can be said for allegories.

Books: Davenport, Alma. *The History of Photography: An Overview.* Focal Press, Boston: 1991; Rosenblum, Naomi. *A World History of Photography.* Abbeville, New York: 1981.

R. Zakia

See also: *Photojournalism; Surrealism.*

ALPHA CHANNEL Unused 8-bit portion of a 32-bit image. It can be used as a mask to apply filters, color changes, or overlay graphics on top of an image. The alpha channel can be used to control the opacity of the image.

R. Kraus

ALPHANUMERIC TARGET A resolving power test object in which the target elements consist of block letters and numbers, each of which contains three parallel bars. Variability tends to be lower with alphanumeric targets than with conventional resolving power targets since the observer is required to identify the set of characters selected. *L. Stroebel*
See also: *Input.*

ALTERNATING CURRENT (AC, ac) Any electrical current that periodically reverses the direction of flow. When used to describe power sources, it refers to the sinusoidal variation of current that rises from zero to a maximum in one direction, falls to zero, rises to a maximum in the other direction, returns to zero, and continues to repeat this cycle. The abbreviation AC, or ac, is invariably used to describe a voltage that reverses polarity in a similar manner, for example, ac voltage. *W. Klein*

ALVAREZ BRAVO, MANUEL (1902–) Mexican photographer, filmmaker, and publisher. Born to a family of artists, photography finally claimed him with the purchase of his first camera (1924). Explored its possibilities while working as an accountant. His images have deep cultural roots and speak directly of the Mexican people. Met Modotti (1927), who encouraged his photography, introducing him to Diego Rivera and Edward Weston. Following Modotti's deportation (1930), assumed her position as photographer for *Mexican Folkways.* After meeting André Breton (1938), became interested in surrealism, reflected in his photographs that go beyond straight document to find the world as daydream. Found full-time employment as a cinematographer (1943–1959). Earlier had filmed Eisenstein's *Que Viva Mexico* (1930–1931). Cofounder and director, since 1959, El Fondo Editorial de la Plastica Mexicana, publishers of fine arts books.

Books: Paz, Octavio, *Manuel Alvarez Bravo.* Mexico City: Circulo Editorial, 1982; Livingston, Jane, *M. Alvarez Bravo.* Boston: Godine, 1978. *M. Alinder*

ALYCHNE In colorimetry, the surface in a tristimulus space that represents the locus of color stimuli of zero luminance. This surface passes through the origin of the space, and it intersects any chromaticity diagram in a straight line, which is also called the alychne; this line lies wholly outside the domain of chromaticities bounded by the spectral locus and the purple boundary. *R. W. G. Hunt*

AMATEUR PHOTOGRAPHY Amateur photography refers to photographs taken for love, not money. Often, such photography is equated with simple aim-and-shoot picture taking, but amateur photographic ranks include the whole range of photographers who enjoy seeking out, taking, even developing and printing their own pictures.

Advanced amateur photographers—so-called serious amateurs—are reputed to be among the world's most knowledgeable and most elaborately equipped photographers. Although some amateurs aspire to—and do—become professional photographers, most simply want to take more and better pictures.

History When the Eastman Dry Plate and Film Company introduced the No. 1 Kodak camera in 1888, the self-contained, roll-film camera gave birth to the era of amateur photography. Important aspects of the camera included size small enough to be held in the hands; easy, fixed-focus, one-shutter-speed operation; and convenience (100 exposures could be made before returning the camera to Kodak for processing). For the first time, photographers did not need to be technicians. Kodak's advertising slogan—"You push the button. We do the rest."—epitomized the philosophy of snapshot photography that emerged.

One year later, George Eastman and his research chemist perfected the first commercial transparent roll film. The availability of this film made possible Thomas Edison's motion picture camera and projector in 1891, which, in turn, led to amateur movie-making with the introduction of 16-mm reversal black-and-white film by Eastman Kodak Company in 1923.

By 1924, Ernst Leitz in Germany had begun production of the Leica camera, the camera that established 35-mm photography and introduced the idea of a system with a camera body and a number of attachments or accessories.

In 1947, Edwin H. Land introduced Polaroid "one-step photography"—popularly known as instant photography—with a black-and-white film that yielded a positive print. In 1963, instant-loading snapshot cameras arrived with the Kodak Instamatic camera line and the Kodapak film cartridge with build-in, prethreaded, take-up spool.

Since that time, picture taking has proliferated among amateurs. Instant loading and other easy-operation features have come to 35-mm photography. The 35-mm camera has become the tool of choice for most picture takers. The 35-mm camera now exists in every possible configuration, from compact, fixed-focus, aim-and-shoot to autoexposure SLR with telephoto zoom lens and motor drive. Even single-use 35-mm cameras, made specially for panoramic photography, sea-and-sand photography, and telephoto sports pictures, have a following.

The majority of amateur photographers today choose to use a color negative film. After developing and printing, often at a one-hour minilab, the exposed film yields an envelope of negatives and prints. Although manufacturers such as Kodak offer a range of film speeds to match picture taking situations, most amateurs lean toward the slower 100-speed film, which tends to be less expensive than the higher-speed films. Serious amateurs sometimes have a favorite film like Kodachrome slide film that they will use, in its various incarnations, for a lifetime. Others experiment regularly, not only with the latest amateur films but also with special-purpose and professional films.

Snapshooters acquire information about picture taking from broadcast and print advertising and publicity, newspaper photo columns, features in general-interest magazines, and, of course, other snapshooters. The more dedicated segment often subscribes to such magazines as *Popular Photography* and *Petersens's Photographic*. Serious amateurs also may belong to clubs, even national organizations, devoted to amateur photography.

Club-, magazine-, and manufacturer-sponsored photo contests attract amateur photographers at all experience levels, using all manner of equipment. Most winners simply accept their prize and take more pictures for the love— or the fun—of taking them. A few, often those already working with the finest equipment and the most carefully chosen film, use contest success as a stepping-stone to paying assignments—and subsequent loss of amateur status.

K. Francis

See also: *Snapshot photography.*

AMBIENCE Generally speaking, ambience is widely used as a synonym for ambient noise. In film and video sound production, the term is used more specifically to mean the background sound accompanying a scene, whether present in the original production recording (where a better term for it is *presence*), or deliberately added—in sound effects editing in order to provide an acoustic space around the rest of the dialog and sound effects. Ambience helps establish the scene and works editorially to support the picture editing by, for example, staying constant across a picture cut to indicate to the audience that no *change of space* has occurred, but rather only a simple picture edit. Conversely, if ambience changes abruptly at a picture cut, an indication is made to the listener that the scene has also changed.

T. Holman

See also: *Ambient noise; Presence; Sound-effects editing.*

AMBIENT LIGHT Often used synonymously with *available light.* The term is also used to describe general, even illumination of a scene from no apparent direction. The second use usually compares such lighting with directional or localized illumination added to the same scene.

F. Hunter and P. Fuqua

See also: *Available light.*

AMBIENT NOISE The acoustic noise present at a location (which includes a set) without considering the noise made by the production. A preferred term is *background noise,* so that ambient noise and ambience (which may be deliberately added) are not confused. *T. Holman*

See also: *Ambience.*

AMBIGUOUS FIGURE An image that can be seen in more than one way with respect to its physical reality. Most such figures involve alternations between figure and ground, or in depth orientation. *L. Stroebel and R. Zakia*

See also: *Figure-ground; Optical illusions.*

AMBROTYPE PROCESS Cheaper, easier, and less toxic than the daguerreotype, but packaged in a similar case, the ambrotype was a popular portrait medium in the 1850s. Frederick Scott Archer, inventor of the collodion process, and Peter W. Fry suggested in 1851 that a collodion negative could be made to look like a positive. Nitric acid or mercuric chloride was added to the developer, bleaching and reducing negative density. A black background was made of paper or lacquer. A patent was issued to James Ambrose Cutting in 1854 for an improved process that added camphor and potassium bromide to the developer and that used fir balsam as a cement for a glass cover plate. *H. Wallach*

AMERICAN NATIONAL STANDARDS INSTITUTE (ANSI) The national standardizing organization of the United States of America. *P. Adelstein*

**AMERICAN STANDARD CODE FOR INFORMA-
TION INTERCHANGE (ASCII)** This is a 7-bit
encoding system that is capable of generating 128 charac-
ters. Every computer character, including control characters,
is assigned a binary number according to the ASCII protocol.
The translation of keystrokes into ASCII and then into
binary allows the computer to read the data. *R. Kraus*

AMERICAN STANDARD OBSERVER The relative
average response of a number of persons with normal color
vision to wavelengths of light, which is represented in graph
form as the luminosity function. This average response is
basic to photometric and colorimetric measurements.
 L. Stroebel and R. Zakia
Syn.: *Luminosity function; Visibility function (obsolete).*
See also: *Photometry and light units.*

AMERICAN WIRE GAGE In the United States, the
standard gage used to designate the size of round wires based
on the wire's diameter. Wire is listed according to gage num-
bers from 0000 (460 mils diameter) to 40 (3.145 mils diam-
eter). Note that the smaller the diameter of the wire, the
larger the gage number. *W. Klein*

AMIDOL The common name for 2,4-diaminophenol di-
hydrochloride [$(NH_2)_2C_6H_3OH \cdot 2HCl$, molecular weight
197.07], whose fine white crystals are soluble in water or al-
kaline solutions or slightly soluble in alcohol. Amidol is a
developing agent in water solution but is more rapid acting
in weak alkaline solution, such as provided by sodium sul-
fite. Oxidizes rapidly in alkaline aqueous solutions. Greatly
admired for its rich black image tones on bromide papers and
transparencies for projection. *G. Haist*

AMMONIA A colorless gas with a pungent odor, ammo-
nia (NH_3, molecular weight 17.00) is dissolved in water to
form ammonium hydroxide (NH_4OH, molecular weight
35.05), a colorless liquid with escaping ammonia gas that
irritates the eyes. The concentrated solution contains about
30% ammonia (the photo grade is 27% minimum), miscible
with water and alcohol with a strong alkaline reaction.
 Ammonium hydroxide is used in the preparation of some
photographic emulsions, as an accelerator or solvent in
developing solutions, and for hypersensitizing silver halide
materials. Ammonia gas is used for dry development of
silver halide and diazo materials. *G. Haist*

AMMONIUM BICHROMATE Used for sensitizing carbon
tissue in carbon printing, carbro, gum bichromate, and some
photomechanical processes. In process work, it is largely used
as a sensitizer with fish-glue for printing halftone images on
zinc or copper. It is believed to be twice as sensitive to light as
potassium bichromate. Formula $(NH_4)_2Cr_2O_7$. Molecular
weight: 252. Characteristics: Orange crystals. Solubility:
Freely soluble in water at room temperature. *J. Natal*

AMMONIUM DICHROMATE Another name com-
monly used for ammonium bichromate. *J. Natal*
See also: *Ammonium bichromate.*

AMMONIUM THIOSULFATE The colorless plates or
needlelike crystals of ammonium thiosulfate [$(NH_4)_2S_2O_3$,
molecular weight 148.21] are readily soluble in water but not
alcohol. A clear, colorless solution (56% minimum, 60%
maximum) is the commercial form.
 The ammonium salt often replaces the sodium salt for
rapid fixing baths, reducing the fixation time to about one-
quarter. Ammonium thiosulfate is more rapid acting than
sodium thiosulfate at lower temperatures and in the presence
of increasing amounts of iodide. *G. Haist*

AMPERE (A, Amp) The basic unit of electric current
intensity. The current is said to be 1 ampere when 1 coulomb
of electric charge (6.25×10^{18} electrons) flows in a circuit in
1 second. *W. Klein*
See also: *Electrical current.*

AMPHITYPE One of the many curious and interesting
printing processes invented by Sir John Herschel. It
depends upon the light sensitivity of ferric, mercuric, and
lead salts, and it gives a rich, vigorous print that can be
viewed from both sides of the paper or as a transparency. A
sheet of paper is prepared with a solution, either ferric-tar-
trate or ferro-citrate of protoxide, or peroxide of mercury,
and then with a saturated solution of ammonia-citrate of
iron. Exposed in a camera for a time varying from half an
hour to five or six hours, a negative is produced on the
paper that gradually fades in the dark, but may be restored
as a black positive by immersion in a solution of nitrate of
mercury. *J. Natal*

AMPHOTERIC Certain molecules can act either as an
acid or a base. These molecules are said to be *amphoteric*
(derived from the Greek word for *both*) and can accept or
donate a hydrogen ion. Water is amphoteric, as are certain
acids, such as HCO_3^-, HSO_4^-. Gelatin, for example, has
both amino, $-NH_2$, and carboxyl, $-COOH$, groups that influ-
ence its solubility in water solutions. *G. Haist*

AMPLIFICATION See *Audio amplification.*

AMPLITUDE (1) The size dimension of a waveform, usu-
ally represented graphically in the vertical plane. The size
represents the strength of the unit being measured, for
example, sound pressure level for sound.
 (2) The strength of an analog signal. In computer imaging,
it is the voltage level that represents a brightness of a given
point in the image. *T. Holman and R. Kraus*

ANAGLYPH Two superimposed images of different
colors, such as red and green, representing slightly different
angular views of the same subject. When viewed through fil-
ters of the same colors, each eye sees the corresponding left
or right image, but the viewer perceives a single fused three-
dimensional image. *L. Stroebel*

ANALOG Identifying a measuring instrument in which
the value appears on a scale from which the user takes the
result. Mercury thermometers are analog instruments. Con-
trast with *digital*. *H. Todd*

ANALOG AUDIO Any signal representation of sound
such as electrically, mechanically, magnetically, electromag-
netically or by means of light, where the signal waveform is
transmitted or stored in direct, 1:1 correspondence with
sound. The amplitude dimension of the audio signal is repre-
sented by way of a direct analogy between a voltage, dis-
placement of position (such as for the phonograph or an
analog optical sound track), or strength of magnetic flux
(analog tape recording), for example, and the signal. Analog
systems may also employ modulation and demodulation
such as frequency modulation (FM) where audio is imposed
on a carrier frequency such as a radio frequency by way of
modulation; despite the modulation/demodulation cycle the
audio remains in analog form since no digitization has
occurred. *T. Holman*

ANALOGOUS COLORS Colors that are considered to
harmonize and that are close to each other in a color circle.
 R. W. G. Hunt

ANALYSIS PROJECTOR A motion-picture projector capable of projecting a single frame at a time and at speeds other than the standard 24 frames per second. *H. Lester*

ANALYTICAL DENSITY A measure of a color photographic image intended to estimate the absorption of a single dye layer, which is approximately proportional to the dye concentration and thus useful in the analysis of the makeup of the image.

Analytical density measurements are difficult to make with three-layer color films because of the unwanted absorption of light by each of the layers. When required for research purposes, *analytical* densities can be measured by exposing only one of the three emulsion layers using a narrow-band filter or by coating the layers separately.

The alternative type of measurement is that of estimating *integral* densities, that is, the absorption of the three layers superimposed. *Integral* densities are useful for printing and process control purposes. *M. Leary and H. Todd*

ANAMORPHIC (1) A lens or lens system containing some cylindrical surfaces or prisms, designed to produce images having different horizontal and vertical scales of reproduction. (2) An image having different horizontal and vertical scales of reproduction. Mirror surfaces that are not flat will reflect a distorted or anamorphic image. *R. Zakia*

ANASTIGMAT A lens in which all primary lens aberrations, including astigmatism, have been corrected in design. The first commercially available anastigmat was the Zeiss Protar lens of 1889, designed by Paul Rudolph after the introduction of suitable optical glasses from Jena. Almost all modern lenses are well corrected for astigmatism. *S. Ray*

See also: Lenses; Lens history; Stigmatic.

AND/OR In computers, the logical operators are generally part of the arithmetic logic unit (ALU). It provides for the combining of two images pixel by pixel. The *and* function is used to mask off a portion of the image. The *or* function is used to add subimages into a composite output. *R. Kraus*

ANGLE OF ACCEPTANCE Angle subtended at the central of the entrance pupil of a lens by the apex of a right circular convergent cone of rays from the subject, the rays emerging to form the image circle of the lens. This angle may be equal to or greater than the field *angle of view* of the lens, depending on the film format used. Lenses for view cameras have additional angular coverage or *extra covering power* to permit the use of displacement movements without vignetting or cutoff. *S. Ray*

See also: Covering power.

ANGLE OF CONVERGENCE In depth perception, the angle formed between lines from an object point being examined and each eye. As the object moves closer, the angle increases. In a stereo camera or other stereo device, the angle formed between the axes of a pair of lenses.

L. Stroebel and R. Zakia

See also: Perspective, stereophotography; Vision, eye movements.

ANGLE OF COVERAGE Angle subtended at the rear nodal point of a lens by the diameter of a circle corresponding to the largest field over which the lens produces an image of acceptable sharpness and illumination (that is, the circle of good definition). *S. Ray*

ANGLE OF INCIDENCE The angle between a ray of light incident on a surface and the vertical (normal) to the surface at that point. For specular reflection, i.e. nonscat-

tering as from a mirror, the angle of reflection is equal to the angle of incidence. *S. Ray*

ANGLE OF REFLECTION Angle between a reflected ray of light as it leaves a surface and the vertical (normal) to the surface at that point. Equal to the angle of incidence of the ray. *S. Ray*

ANGLE OF REFRACTION Angle between a deviated ray of light that has passed through the boundary (interface) between two transparent media and the vertical (normal) to the boundary surface at the point of emergence in the second medium. This angle depends on the angle of incidence of the ray and the ratio of the refractive indices of the two media. *S. Ray*

See also: Snell's law.

ANGLE OF VIEW Angle subtended at the center of the entrance pupil of the lens by the subject field or area delineated by the image format of the camera. Generally the value for the diagonal extent is quoted, this being the largest for the horizontal, vertical, and diagonal dimensions of a rectangular or square format. For an aberration-free lens of focal length f and format dimension k, the corresponding angle of view W is given by $W = 2 \tan^{-1} (k/2f)$. It normally is equal to the corresponding angle subtended at the format by the emergent rays, except in the case of lenses that have pincushion or barrel distortion, such as fisheye types. *S. Ray*

Syn.: *Angle of field.*
See also: *Covering power; Appendix N.*

ÅNGSTRÖM (Å) A metric unit of length equal to 10^{-10} meter, or 0.1 nanometers, named for the Swedish physicist A. J. Ångström. This unit has been replaced by the nanometer, 10^{-9} meter, as the most common unit for expressing the wavelengths of various colors of light. *J. Holm*

ANGULAR MAGNIFICATION The ratio of the emergent to the incident angle for a ray of light through conjugate planes of an optical system. *S. Ray*

ANGULAR RESOLUTION The least possible separation, in degrees, of two points of light that permits a viewer to distinguish them from a single point. For a visual telescope, the value is $1.22 \lambda/d$, where λ is the wavelength and d is the aperture diameter. *H. Todd*

See also: *Resolution; Resolving power.*

ANHYDROUS A term used to describe solid chemical substances that are free of strongly held molecules of water (water of crystallization). *Desiccated* is a similar term, indicating the near absence of a hydrating compound. For example, sodium sulfite (Na_2SO_3, molecular weight 126.06) is the anhydrous form with about 98% sodium sulfite; the desiccated form is about 97% sodium sulfite. *G. Haist*

ANILINE PROCESS A process patented by William Willis in 1864 for reproducing, without a negative, drawings made on transparent paper. It is an inexpensive and permanent process. The paper is sensitized with a solution of ammonium bichromate and exposed under the drawing. Then it is developed by exposure to the fumes of a suitable aniline dye. The finished print is of a bluish-black color. *J. Natal*

ANIMATION An approach to motion-picture or video production used most often to create screen realities that could not naturally exist—by making inanimate objects, such as cartoon drawings or puppets, appear to move of their own accord. Animation is frame-by-frame motion-picture or

video production. While live action cinematography records actual events as a series of still pictures (frames) exposed rapidly one after the other (24 per second for film, and 30 per second for video), animation *creates* moving events by recording, one frame at a time, an organized sequence of still drawings or objects. In both cases, when the sequence is projected normally, the audience perceives, thanks to the phi phenomenon and persistence of vision, a continuous moving image.

When creating animation, each image is slightly altered from the one before, showing a change in position that corresponds to the change in position during a 24th (or a 30th) of a second for a similar natural movement. In creating the illusion of movement animated objects are also imbued with a sense of life and even personality, particularly when they interact and seem to respond to one another. While animation is a powerful story-telling tool, usually identified with cartoons, it is also a regular part of most film productions, being used in the creation of special effects and titles. Its potential for visual expression, narrative uniqueness, and the creation of imaginary screen realities is limited only by the animator's imagination and the practical difficulty of creating thousands of individual coordinated images.

EARLY DEVELOPMENTS OF ANIMATION In 1824, at the same time work was being done that led to the creation of the first photographs, Peter Roget, Frenchman and author of *Roget's Thesaurus,* published his *Persistence of Vision with Regard to Moving Objects.* The popularization of this concept, that the eye will meld still images together if they are presented rapidly enough and with sufficient light, led to the development of a variety of very popular toys and novelty devices that successfully created the illusion of movement or combined images in an interesting way. The *thaumatrope* was a disc with a drawing on each side. When the disc was spun, the images appeared to combine—the animal appeared to be in the cage, or the ball became balanced on the seal's nose. The *zoetrope* and *phenakistiscope* were two of the most popular versions of a rotating drum device, in which a strip of drawings was placed on the inside wall of a shallow drum and viewed through vertical slits in the drum wall. The slits worked like the shutter in a modern motion-picture projector, interrupting the images to allow a sequence of different images to be seen in the same position. The *praxinoscope* also used a circular strip of drawings in a rotating drum. In this case however, the images were reflected from a central circular set of mirrors and viewed through a single opening. Also popular, and still common, was the *flipbook,* a bound sequence of drawings that gave the illusion of movement when rapidly flipped through. Projection systems were also developed using magic lanterns and rotating wheels mounted with a sequence of drawings on slides, and in one case a giant praxinoscope.

While these devices were limited in many ways, presenting little variety in one- or two-second segments of simple action, and depending for popularity on the novelty of seeing drawings move, they were an important part of the chain of experimentation and commercialization that led to the development of motion pictures. In 1888 George Eastman made roll film available through his patented process of applying a light-sensitive emulsion to a flexible celluloid strip. In contrast to the previous techniques of using glass or metal plates for the emulsion, roll film allowed the photography of a rapid sequence of images over an extended period of time. In 1895, the Lumiére brothers presented in Paris the first theatrical projection of movies for a large audience. In 1899 J. Stuart Blackton and Albert E. Smith, founders of the Vitagraph company, successfully faked news footage of Spanish American War naval battles using animation techniques, cutouts, and some water, smoke, and gunpowder. In 1906 Blackton went on to produce *The*

Humorous Phases of Funny Faces, generally considered to be the first animated cartoon film, with drawings done in chalk on a blackboard. Later in the same year, Emile Cohl, a French artist, began working on a series of short animations using charming, though crude, white on black stick figures. A significant step forward in the development of character animation was made when Winsor McCay, a successful newspaper comic strip artist, produced *Gertie the Dinosaur* in 1914. Gertie possessed a distinct and endearing personality and demonstrated a smoothness of animation and elegance of drawing that is still impressive today. McCay used more than 5000 drawings for Gertie, and an assistant traced the backgrounds.

With both a commercial market and creative potential established, animation studies and techniques for more efficient production quickly began to develop. By 1915 peg bars for registering drawings, cel animation, and a system for rotoscoping had all been patented. Influenced by competition among studios, technological advances, and economic, social, and market factors, the history of animation has been one of continual evolution and change in style and technique and is today entering a new era as computer technology allows animators to deal with imagery or a complexity previously impractical or impossible to achieve.

ANIMATION TECHNIQUES Because of the extensive time and labor involved in frame-by-frame filmmaking and the variety of imagery and effects that can be achieved, many animation techniques have been developed to allow the greatest efficiency in producing the desired results. Some of the most common are described in the following paragraphs.

Cel Animation Drawings are made on clear sheets of cellulose acetate (called *cels*) that can be overlaid and combined when they are photographed. This technique, standard for cartoons since its invention in 1915, allows the separation of static and moving picture elements and requires the minimum amount of drawing and coloring. For instance, only one background drawing may be necessary to go with a long series of drawings for a complicated character movement, or only the moving parts of a character may be animated with separate drawings. This technique may also simplify production procedures, allowing different characters to be animated separately, and provides an image consistency frame by frame that would be difficult to achieve if the backgrounds had to be traced and redrawn for every frame.

Cutout Animation Instead of making individual drawings for each increment of movement, cutout figures, usually with jointed limbs, can be placed directly on the animation stand, photographed, and then moved slightly before exposing the next frame. This technique creates a unique visual style and requires a minimum amount of drawing or artwork preparation, making it particularly popular with students and others working without the aid of a large staff of animators.

Drawing on Paper While cel animation creates a look particularly suited to cartoons, animators might choose, for the sake of an alternative graphic style, to design each frame to be exposed from an individual complete drawing. This approach is most likely with very short films, abstract films, films exploiting a unique drawing style, personally expressive films, and stylized cartoons involving little background or character detail.

Three-Dimensional Animation Animation of puppets, clay models, or any real (as opposed to drawn) objects or people. Sometimes called stop-motion animation, the object is photographed for one frame, then its position is slightly altered and the next frame is exposed, followed by another slight object move and then another exposure, and on and on. A few seconds of stop-motion animation might take several hours to shoot. While two-dimensional animation is

recorded on an animation stand, and changes in point of view, or lighting effect, are handled by changing the drawings, three-dimensional animation uses procedures more similar to that of live-action production. Shooting takes place on real location or with sets that must be built and dressed. The single-frame camera is positioned as it would be for live-action, changes in point of view are handled by repositioning the camera, and lighting techniques are the same as for live action.

Pixilation A three-dimensional technique involving the frame-by-frame shooting of live actors and normal sized props. Using this technique, a person could appear to glide, rather than walk, down a street, or appear to be dancing along a large variety of props.

Claymation Claymation is a trade name for a clay model technique capable of subtle lifelike expression and dramatic transformations. Layers of clay are built around a wire armature, allowing practical control of incremental change in both position and surface appearance of the clay models.

Scratch-off Starting with completed artwork, the animator scrapes off or erases part of the image between exposures. Scratch-off often is filmed in reverse, so that rather than seeming to disappear, the material appears to be growing into a finished image. This technique is also called wipe-off or scratch-back.

Special Techniques By combining and modifying standard techniques and developing unique approaches to the creation of the original images, animators are continually developing new techniques that reflect individual expressive goals and interests. The cameraless technique of painting directly on motion picture film is an interesting example. Pinscreen technique creates images from the shadows of thousand of steel pins whose configuration is altered between exposures. Animations have been created drawing with sand, glass beads, or modeling clay, spread across bottom-lit glass plates. Photokinesis is a technique of using static artwork that is moved beneath the camera between exposures, creating the illusion of movement. By recording a series of dissimilar static images, such as still photographs, for only two or three frames each, one after the other, animators can achieve unusual illusions of movement and image combination.

Computer Animation Animation using digital computers as the principal tool for the creation of the individual images is a quickly growing field that is beginning a new era of possibility for frame-by-frame production, providing a relatively rapid system for incrementally altering complex images in fine detail that would be impossible or impractical using traditional techniques. The computer deals with images as digital information describing each pixel (point of light) that makes up the image. A typical TV monitor uses more than a quarter of a million pixels for each image, while high resolution systems might use several million pixels. Photographs or drawings may be entered into the computer via a video camera, or frames may be grabbed directly from a videotape. One can also draw directly into the computer using a mouse, electronic pencil, and screen, or writing by directions through the computer's keyboard. The computer can then be directed to manipulate the image in any number of ways, which it does by altering each appropriate pixel. Once a final image is created, it can be fed directly to a frame-by-frame video recorder, or filmed off a CRT screen, or printed out on paper and photographed on a traditional animation stand.

A dramatic application of this technology popular for the creation of special effects in live-action science fiction films and TV commercials, is called *morphing* and involves the apparent realistic transformation of a person or object into another person, creature, shape, or object.

Computers can also handle a great deal of the work that traditionally is accomplished by tedious hand drawing. Given two key images, the computer can create all the in-between images necessary for smooth animation. Describe a light source and the computer can add proper shadow detail. Create a change in point of view, and the computer will redraw the image, maintaining proper perspective and object relationships. In accordance with programmed instructions, the computer will also combine images and add backgrounds, color, and surface texture.

Computers have also been used effectively to enhance traditional animation techniques, as with programmable control systems used with stop-motion and animation stand photography, and automated ink and paint systems.

PRODUCTION PROCEDURES Because of the great amount of time and effort required for each frame, animation requires considerable planning, organizing, and checking throughout the production process. Major studios have established routines for assigning responsibility and guiding the production through their individual systems.

Starting from an initial idea, a script is developed, including all dialog and descriptions of action. Once approved, a visual presentation of the script, called a storyboard, is produced. Looking something like a comic strip, the storyboard presents a drawing of each shot within a scene, with lines of dialog or action descriptions written below. Presenting an overview of the film at a glance, the storyboard is a convenient format for modifying and improving the directorial and visual plan and becomes a useful guide throughout the production.

Unlike live-action production, where the sound is recorded during or after filming, with animation the sound is recorded before production begins. It is immediately transferred to sprocketed magnetic motion picture films, allowing an exact frame-by-frame analysis of the placement of each word, sound effect, or musical beat, which is written out on charts called *bar sheets,* which then become guides for the director or animator as to the timing and placement of mouth movements and actions. A frame-by-frame plan called an *exposure sheet* might also be developed at this time.

Before the final drawings are begun, animators will test their movement plan by making pencil tests, filming or videotaping rough sketches done on paper. Key animators will then make drawings for the extreme points of movement, and assistant animators, called *in-betweeners,* will make the intermediary drawings. Other artists might be drawing the background scenes, and inkers and painters will complete the drawings. A detailed exposure sheet is prepared to guide the camera operator through the frame-by-frame recording, which may involve moving or changing several cels and moving the camera for each frame.

Because of all the advance planning for every single frame, editing for animation is usually a matter of making minor adjustments and preparing the picture and sound for release printing, unlike live-action editing, which is a major creative part of the production process.

ANIMATION PHOTOGRAPHY Two-dimensional animation is generally filmed or taped on a specially built animation stand, which is a solidly built table-like platform for holding and moving artwork, with a vertical crane arm rising from the back for the camera. Camera and artwork registered in peg bars can be moved in small increments with great precision, and both must be protected from extraneous vibration or off-axis movement during exposure. A glass platen is usually used to hold the artwork in place on the surface of the platform called the compound. The image can be bottom-lit through the compound, or lit with a lamp placed on each side of the compound at 45 degrees to both camera and platform.

It is easier to create many movements such as tilts, pans, trucks, and fades during the filming stage than it is to do by

drawing, so the animation camera operator often maintains several sequences of incremental change between every exposure. At 24 frames per second, a few seconds of screen time might take many hours to shoot.

Books: Laybourne, K., *The Animation Book.* New York: Crown Publications, 1979; White, T., *The Animators's Workbook.* New York: Watson-Guptill Publications, 1986; Hearn, D., and Baker, M. P., *Computer Graphics.* Engelwood Cliffs, N.J.: Prentice-Hall, 1986. *H. Lester*

See also: *Motion-picture photography; Optical effects; Optical printer; Rotoscope; Video.*

ANISOTROPIC A transparent crystalline optical material that has different properties in different directions, for example, a material such as calcite, which is birefringent (doubly refracting) and polarizes transmitted light. *S. Ray*

ANODE The positive terminal of an electrical load from which electrons flow in the external circuit. Inside the load device, however, the electrons flow toward the anode as in an electron tube. The negative terminal of a source, such as a battery, is its anode because it is the source of electrons for the external circuit. *W. Klein*

See also: *Battery cathode.*

ANOMALOSCOPE An instrument that present monochromatic yellow and mixtures of red and green stimuli to a viewer for the purpose of studying color perception.
L. Stroebel and R. Zakia

See also: *Colorimetry.*

ANOMALOUS COLOR VISION A chronic abnormal perception of certain colors involving a decrease in sensitivity of one of the three color vision systems and a shift in wavelength of maximum sensitivity of that system. The three types of such defective color vision are: protanomaly (decreased red sensitivity), deuteranomaly (decreased green sensitivity), and tritanomaly (decreased blue sensitivity).
L. Stroebel and R. Zakia

See also: *Defective color vision; Dichromatism; Monochromatism; Vision, color vision.*

ANOMALOUS DISPERSION Dispersion of light or other radiation due to the functional dependence of the index of refraction on wavelength in a lens where the index of refraction decreases as the wavelength decreases. *J. Holm*

See also: *Dispersion.*

ANSCO The name *Ansco* is associated with the earliest manufacturer of photographic materials in the United States. In later years, until 1981, it was the only domestic manufacturer to compete with Kodak in offering a full line of photographic materials and equipment.

In 1842, three years after Daguerre published his process for producing an image by the action of light, Edward Anthony, a civil engineer living in New York City, became a supplier of chemicals, cameras, and equipment for carrying out the process. In 1852 Henry T. Anthony became a partner in the firm. In 1853 they conducted the world's first photo contest.

A historical memorial plaque at 308 Broadway, New York City, was dedicated in 1942 with the following inscription: "Here Edward Anthony 100 years ago opened the first photographic supply house in the United States. He laid the foundation for the popularity of the art and science of American Photography 1842–1942."

A division of the Scoville Manufacturing Company of Waterbury, Connecticut made brass plates which, when silvered, were used in making daguerreotypes. After the Civil War the company moved to New York City, where it purchased the American Optical Company, which also supplied photographic materials.

When, in the 1850s, the wet collodion process brought on the demise of daguerreotypes, the Anthonys adapted by coming forth with a new line of supplies. In 1860 Anthony products were used to make the first aerial photograph, one showing Boston Harbor. They supplied materials to photographer Mathew Brady and other photographers during the Civil War.

The Anthonys also supplied materials and equipment to W. H. Jackson for his pictures of Yellowstone Park during the Hayden Survey in 1871, Grand Teton National Park in 1872, the Colorado Rockies in 1874, and Mesa Verde in 1875.

In 1880 the Anthonys offered a Defiance Dry Plate of their own manufacture, and in 1882 took on the entire output of Eastman plates for distribution. In 1901 a merger formed the Anthony and Scoville Company, which included a number of other manufacturers. One of these was the Monarch Paper Company, which owned a factory at Binghamton for the production of roll film and cameras. In 1902 the company name was changed to Ansco.

In the mid-1880s Reverend Hannibal Goodwin of Newark, New Jersey, was experimenting with nitrocellulose to find a flexible material that could be wound in a roll for picture taking, as a replacement for the heavy glass plates then in use. His experiments were successful, and on May 2, 1887, he applied for a patent, and 11 years later, in 1898, he was granted U. S. Patent number 610,861. Twelve broad claims offered protection for Goodwin's work. With this potential, Goodwin formed the Goodwin Camera and Film Company whose main asset was the patent.

Appreciating the value of the protection offered by the Goodwin patent and the potential of the product described by it, Anthony-Scoville Company bought the Goodwin Camera and Film Company and proceeded to market flexible film. The name was changed to Ansco, and roll film was marketed under the name of Ansco Speedex and developing-out papers under the name of Noko and Cyko. The Eastman Company also marketed flexible film for which patent applications were pending.

In 1902 Ansco sued Eastman for infringement of the Goodwin patent. This litigation dragged through the courts until 1914, when Eastman offered a settlement for $5 million, which the plaintiff gladly accepted. Part of the proceeds were used to pay a large dividend to unhappy stockholders who had received no dividends for a number of years, and the rest was used to build a nitration plant at nearby Afton, New York, to make film grade nitrocellulose, a main ingredient in flexible film base. Ansco was severely affected by the shortage of nitrocellulose brought on by the First World War. The Afton plant was never used to any extent because by the time it was completed the war was winding down, and film grade nitrocellulose for civilian use was on the open market at a lower cost.

In 1928 the company, then known as Ansco Photo Products, merged with the German company Agfa Products, Inc. under the name of Agfa Ansco Corporation. This merger brought in European scientists along with the scientific developments achieved in Europe.

Ansco produced the first American-made miniature camera, called the Memo. This camera was made and sold in the early 1920s, about the same time as E. Leitz of Germany produced the first Leica camera. The Memo produced single frame 18 × 24-mm pictures on perforated 35-mm motion picture film, and had a unique film transport mechanism and film cartridge. The Memo was part of a family of miniature camera products, including a transparency printer, a paper print printer, and the Memo projector.

The company produced the first American non-screen

x-ray film in 1936, introduced a direct copy film, and won an Academy Award (Oscar) from the National Academy of Motion Picture Arts and Sciences for an infrared motion picture film. It won a second Oscar in 1937 for Superpan Supreme and Ultra Speed Pan motion picture films, and introduced Superpan Press, the first American high-speed film. In 1939 the name was changed to General Aniline & Film Corporation (GAF).

In 1941, during the Second World War, the company was taken over by the Alien Property Custodian. Several company officials were suspended because of their German origin. Nevertheless, the manufacture of cameras was replaced by precision instruments, and the manufacture of the first American dye-coupler film, Ansco Color, was begun for military use. The name *Agfa* was dropped in 1943, and an Army-Navy "E" for excellence was awarded to the company in 1944.

In 1945 Printon, a direct reversal color film on white opaque base, was offered for professional use; the Ansco Automatic Reflex camera was produced in 1947; Ansco Jet Paper in 1954, along with the first LVS Camera, the Super Regent; Super Hypan motion picture film in 1958; Versapan in 1959; and the Autoset became the first camera used in space by astronaut John Glenn. In 1961 Super Anscochrome film was used to make the first color photographs of the earth. The Anscochrome family of films made user processing a reality.

Beginning in the 1960s GAF's expansion efforts spread the company's assets too thin, and in 1981 the company sold off its photographic operations, along with others, cutting income in half. The company had earlier stopped using the Ansco name, and in 1978 the trademark was sold to W. Haking Enterprises Limited, a Hong Kong company. *I. Current*

ANSI STANDARDS See *Standards (photographic).*

ANSWER PRINT The first print of a motion picture made in release print form, with combined picture and sound track, incorporating color and exposure corrections, scrutinized carefully for changes that may need to be made in subsequent prints. *H. Lester*
Syn.: *First trial print.*

ANTHOTYPE A process name derived from the Greek word for flower. Sir John Herschel had conducted a long series of experiments on the bleaching effect of light on the juices of various flowers. Dyes were extracted from freshly picked flowers by pulverizing them with alcohol. Dye-coated paper was then exposed to ultraviolet radiation. In most cases, it took weeks to complete a printing-out exposure, and Herschel complained that the English weather delayed the experiments and the images were not permanent. This process was also referred to as *nature printing.* *J. Natal*

ANTHROPOLOGICAL PHOTOGRAPHY Photographers have long used the documentary and social documentary approach to show the workings of the social world. Anthropological photographers have gone further by extending the documentary approach and combining it with scientific method. This creates a more narrowly focused and tangible basis to order, interrelate, synthesize, and finally interpret visual and written information. When used in this way, photography is a valuable tool in anthropological research.

Photography serves several spheres involved in anthropological research: physical anthropology, a natural science involved with the biological aspects of human beings such as racial differences, human origins, and evolution; cultural anthropology, which studies human behavior; archaeology, which describes and dates the remains of ancient buildings,

tools, and pottery that describe a culture; and applied anthropology, which uses the research done by cultural and physical anthropologists to formulate social, education, and economic policies.

As a research tool, photography creates a special category of document in which the medium's inherent verisimilitude is used as a visual counterpart to written observation. It is because photography can merge direct observation with realistic representation that it functions well in this capacity. Thus, for the anthropologist, photography is an objective and commonly understood visual language; a visual basis for data collection and analysis; a reliable means of gathering, ordering, and interpreting visual information; a system of visual notation for the filing and cross-filing of data; a consistent means of observation from one circumstance to the next; a concrete visual record for extended analysis; and a control factor that adds stabilization to direct visual observation.

Most of the photographic evidence that finds practical use in anthropological research falls into one of these categories: counting, measuring, comparing, qualifying, and tracking. The primary applications of anthropological photography are to demonstrate patterns—in cultural diversity and integration, societal control, religious behavior, marriage customs, festivals, and so on—and to document the effects of these patterns on both the culture and the environment. For the anthropologist, photography allows the wholeness of each piece of behavior to be preserved while maintaining the spatial and contextual separation necessary for cross-referencing and scientific study.

Many social-documentary projects to some degree serve an anthropological function. For example, the work by John Thomson, Lewis Hine, photographers of the Farm Security Administration, and Paul Strand in the Mexican Portfolio, report on the human condition. More purely anthropological studies also exist. Edward S. Curtis's monumental documentation of the native tribes of North America, *The North American Indian, 1907–1930,* in twenty photographically illustrated volumes and twenty portfolios, documents in 2,228 photographs a rapidly disappearing American Indian culture through its architecture, customs, and appearance.

Perhaps the seminal model for current visual anthropologists is the study done by Gregory Bateson and Margaret Mead, *The Balinese Character: A Photographic Analysis,* in 1942. This study used more than 25,000 35-mm exposures in addition to 22,000 feet of movie film. By placing relevant photographs side by side, the study pointed to intangible relationships found in different types of standardized cultural behavior patterns. It viewed the Balinese culture as a system of understandings and behaviors that also functioned as an expression of personal identity and experience. This study broke ground for much of the current methodology used in the quantification and correlation of photographic data in accordance with standard anthropological practice.
 J. Fergus-Jean

ANTHROPOMORPHIC Attributing human characteristics to a god, animal, or inanimate object; for example, a tree with bark that has an arrangement suggesting eyes, nose, and mouth. *L. Stroebel and R. Zakia*
See also: *Mechanomorphic.*

ANTIALIASING A computer algorithm designed to smooth jagged edges in an image. This can be accomplished by blending an object with its background in a smooth transition. This technique is often used to accomplish the appearance of smooth, large text on a display. *R. Kraus*

ANTIFOGGANT Antifoggants are compounds that limit nonimage formation (fog) during development of silver halide emulsions. Such compounds may be contained in the

photographic material or in the developing solution. Anti-foggants may act by combining with silver ions to produce compounds that are less soluble than silver bromide but also may inhibit development by adsorption to the silver of the latent image. Effective compounds include triazoles, tetra-zoles, thiazoles, oxazoles, thiazolidines, and other organic compounds, usually containing sulfur or/and nitrogen. Certain noncarbon compounds, such as potassium bromide or iodide, in developers also limit fog formation during development. These compounds are often called restrainers. *G. Haist*

ANTIHALATION COATING

Most modern films have some form of protection from halation, the broadening of images of bright objects. In the absence of halation protection, light not completely absorbed by the emulsion is reflected from the interfaces of emulsion and base, base and air, or base and pressure-plate. The reflected light obscures image detail adjacent to bright objects.

There are several forms and positions of halation protection: within the emulsion itself (intergrain absorbers), between emulsion layers, under the emulsion, within the base material, and on the back of the film. Dyes, pigments, and colloidal silver are used. Except for those within the base itself, all agents are dissolved away or decolorized in processing. Absorbers within the base material work twice, first on the ray from the lens as it leaves the emulsion, and then on its diminished reflection from the back surface of the base.

Since reversal processing involves a silver bleaching stage, any colloidal silver halation protection automatically disappears during processing. For this reason some black-and-white reversal films may not be suitable for processing to a negative. *M. Scott*

See also: *Halation.*

ANTILOG See *Logarithms.*

ANTINEWTON

Treatment applied to a glass surface that is in contact with a film base so that the characteristic colored interference fringes known as Newton's rings cannot form in the thin film of trapped air between the glass and base. It is available for glasses used in slide mounts or cover glasses for negative carriers in enlargers and consists of very light etching by acid of the glass surface in question. *S. Ray*

See also: *Newton's rings.*

ANTIOXIDANT

A chemical present in a photographic emulsion or developer to protect other chemicals from degradation is called an *antioxidant.* In emulsions, antioxidants such as sodium benzene-sulfinate help extend the useful life of the photographic material. In developers, sodium sulfite removes absorbed oxygen from the solution or limits the catalytic effect of the oxidation products of developing agents. Hydroquinone and some derivatives, or ascorbic acid, in small quantities are sometimes used as antioxidants. *G. Haist*

ANTIREFLECTION See *Lenses, lens coating.*

ANTISTATIC

An agent, grounding device, or electrostatic field intended to prevent or eliminate the accumulation of electrostatic charges. The slight friction resulting from the unwinding of a reel of photographic film or paper generates high voltage electrostatic charges, for example. These charges may result in two types of problems: (1) static fog marks on unprocessed film or paper are caused by a spark discharge, and (2) dust attracted by the static charge on processed film will be printed in the photographic printer. Each problem is handled in a different way. For fog marks, an antistatic coating containing a hygroscopic or a conductive substance is applied to the back of the film to provide a

discharge path and prevents the static charge from accumulating to a value great enough to cause a spark. For dust, the static charge on the processed film can be discharged by ionized air. The air is usually ionized by means of a corona discharge generated by a device known as a static eliminator. *W. Klein*

See also: *Corona discharge; Static eliminator.*

ANTI-STOKES EFFECT

The effect produced when some of the vibrational or heat energy of an electron is transformed into radiant energy in a transition. The result of this transformation in fluorescence is that photons with shorter wavelengths (and therefore higher energy) than the incident exciting radiation can be emitted. This effect is noteworthy in that typically the wavelength of radiation emitted in fluorescence is longer than that of the exciting radiation. The anti-Stokes effect disappears at low temperatures. *J. Holm*

ANTI-VIRUS

A software designed to identify and or reject "diseased" software covertly placed into a computer. The virus is designed to disorient, slow down, or "kill" the computer's operating system or data files or the hard disk's directory. *R. Kraus*

A OR B TYPES See *A & B wind.*

APERTURE

(1) Generally, an opening in a plate that otherwise obstructs radiation. (2) In optical systems, the diameter of an opening in a plate that otherwise obstructs radiation. In the case of a noncircular opening, the diameter of a circular opening with the same area. Not to be confused with effective aperture, relative aperture, effective relative aperture, *f*-number, or effective *f*-number, although aperture is often loosely used instead of *f*-number. (3) An opening in a plate, located close to the film plane of a camera or projector, that delimits the area of illumination. (4) An opening in a slide or microfilm mount. *J. Johnson*

APERTURE PRIORITY

A camera autoexposure operating mode that adjusts the shutter automatically for changes in exposure when the photographer manually sets the aperture. This is the autoexposure mode of preference when depth of field is a stronger concern than subject or camera movement. *P. Schranz*

APERTURE STOP

The diaphragm in an optical instrument such as a camera, telescope, or microscope that limits the area of the lens through which light can pass to the field stop. The aperture stop may be within or outside the optical system. *S. Ray*

APERTURE VALUE (A_v)

An integer that corresponds to the logarithm to the base 2 of the *f*-number squared, expressed in symbol form as $A_v = \log_2(f - N)^2$. Used in the additive system of photographic exposure. *J. Johnson*

See also: *Additive system of photographic exposure.*

APLANAT

A lens corrected to render an image as free as possible from spherical aberration and coma. The use of a minimum of two elements in such a design also allows correction of chromatic aberration. The lens can be used at full aperture, but this is of moderate value. *S. Ray*

APOCHROMAT

A lens that has been color corrected for three primary spectral colors (wavelengths) as opposed to achromatic lenses, which are corrected for two only. Originally the term only applied to microscope objective lenses and process lenses. *S. Ray*

See also: *Achromatic; Lenses, lens aberrations; Superapochromat.*

APOSTILB (asb) A unit of luminance; the luminous intensity emitted or reflected from a surface per unit projected area. A surface whose luminance is 1 apostilb emits (or reflects) 1 lumen per square meter into a hemisphere, and $1/\pi$ lumens per square meter per steradian $[(\text{lm})/\text{m}^2 \cdot \text{sr})]$. The preferred unit is the candela per square meter (cd/m^2). [1 asb = $(1/\pi)\text{cd}/\text{m}^2$] *J. Pelz*

See also: *Photometry and light units.*

APPARENT POWER In alternating current circuits, the product of voltage and current. Units are volt-amperes (VA) and kilovolt-amperes (kVA). True or actual power is equal to apparent power multiplied by the power factor of the circuit.
W. Klein

Syn.: *Phantom power.*
See also: *Power; Power factor.*

APPLICATION A computer program written for a specific purpose such as a drawing program. *R. Kraus*

AQUATINT Another name for the gum bichromate process, associating the process with a fine-art term for an etching process with very soft tonal effects in intaglio printmaking. *J. Natal*

See also: *Gum bichromate printing process; Carbon process.*

ARABIN PRINTING PROCESS A variation of the gum bichromate process credited by Nelson K. Cherril, who published an account of it in 1909. *J. Natal*

See also: *Gum bichromate printing process.*

ARBUS, DIANE (1923–1971) American photographer. With husband, Allan Arbus, worked as New York fashion photographer. Determined to expand her photographic expression, studied with Lisette Model (1955–1957). From then until her suicide, Arbus produced a riveting series of direct portraits of people from the edges of society, in body or emotions, such as the disturbing, *Child with a Toy Hand Grenade in Central Park, New York* (1962). She was the first American photographer to be selected to be exhibited at the Venice Biennale (1972).

Books: Bosworth, Patricia, *Diane Arbus: A Biography.* New York: Knopf, 1984; *Diane Arbus.* Millerton, NY: Aperture, 1972. *M. Alinder*

ARCHAEOLOGICAL PHOTOGRAPHY The field of archaeology has undergone major changes during the past several decades. What started out, over a century ago, as a hunt for treasures from the past, has moved into an area of scientific study involving scholars from multiple disciplines. Teams of scholars now apply their knowledge and skills to the study of ancient humans, working on complex sites that may take years to complete. Specialists work along with generalists to uncover the maximum knowledge from artifacts and the structures that are excavated. Photography and the photographer play a major role on every excavation. Their contributions fall into a number of categories: site photography involving underwater, ground, and aerial photography; object photography including image cataloging, image recording, and photography to supplement field notes; laboratory and studio photography; and photography for publication, lecturing, and teaching.

Archaeological photography, like scientific photography, must provide a precise and accurate representation as opposed to an artistic interpretation. The photograph must be sharp, well lighted, indicate clear detail, and maintain normal perspective. The photographer must interact with other members of the excavation team and be prepared to be extremely creative in using techniques to record the data being photographed. Ladders, balloons, bipods, and giant tripods, reaching 30 or more feet into the air, all have a purpose in the photographer's repertoire. Photographs must be taken continually, usually under great pressure, and usually within a difficult environment. Heat, dust, and moisture can be common problems, depending on site location. Every photograph must contain a carefully placed scale parallel with the object photographed and must be placed on the same plane. This allows accurate measurements to be taken from the photograph. Most photographs must be taken early in the morning or late in the afternoon to take advantage of raking light. Raking light provides a much more clearly defined image. Pictures made during the day tend to be flat and shadowless, with poorly defined edges.

Most archaeological photography is done with 35-mm cameras. The ease of handling, the availability of interchangeable lens configurations, and the small size of the film makes this the preferred instrument. Roll-film cameras that take 120 film are used for picture making where a larger format is needed. Single-lens-reflex cameras or twin-lens-reflex cameras are preferred for ease of handling. Some excavations still make use of view cameras, usually 4×5, for architectural photography or for specific object photography where a larger negative size is beneficial or when lateral and rotational adjustments of the front and rear standards can help correct perspective. Micro, macro, telephoto, and fish-eye lenses are used, each for specific purposes. Catadioptric lenses are often preferred for their smaller size when a long focal length lens is needed. Telephoto lenses are often used to photograph pottery to assist in avoiding strong perspective.

Special equipment and techniques are used in photomicrography and in filming with infrared film. Infrared photography is often used in copying ancient documents. Underwater photography has developed into a science of its own. At times, images must be made with ultraviolet radiation, especially when photographing geological specimens.

One of the most important tools used in archaeological photography is the exposure meter. Selecting the best exposure for a picture is as important as any other technique the photographer uses. Photographers usually carry two types of exposure meters as a check on the readings and as a backup in case of damage. The light meter is as important to archaeological photographers as the camera they use. Another important piece of equipment is the tripod. It must be heavy and sturdy to be effective. It must be flexible to function under many different situations and prevent vibration or movement during the picture-making process.

Today, the photographer must be familiar with the use of the video camera. Video is increasingly being used to document and record excavations and objects. The use of image, movement, and sound along with ease of editing makes this an important tool.

Lastly, archaeological photography now involves the computer. Computers can scan images, enhance images, store vast quantities of images, and retrieve them using hypercard technology. With digital photography emerging, archaeological photography will have new tools to apply to the recording, analysis, enhancement, documenting, storing, and retrieving of the vast amount of material resulting from the scientific excavation of ancient sites. Magneto-optical disc drives using read, write, and erase technology can store gigabytes of material. This tremendous storage capability makes the handling of black-and-white and color images possible.

Recent advances in software provide inexpensive tools for use in archaeological photography. The photographer can overlay images, actually overlaying a reconstruction rendering over the photograph of the excavated area. Lecture material can be made more readily, including numerous type fonts. Software packages can create three-dimensional shaded drawings or use scanned-in xeroradiographs of objects to

show construction techniques or other technological details. The development of inexpensive color scanners allows the photographer to scan in textual material, enhance it, and print out a photographic image ready for publication. Archaeological photography has moved into new dimensions. The archaeological photographer of the future will have to be expert in photographic techniques, creative in using the camera to get the maximum information recorded, and be familiar with electronic imaging. The personal computer will extend the role of archaeological photography by allowing images to be transmitted on networks and by allowing the manipulation of visuals never before possible.

Archaeological photography is a constantly changing and developing field. As electronic imaging becomes more and more affordable and available, it will enhance the visual applications of the field of photography. *R. Johnston*

ARCHER, FREDERICK SCOTT (1813–1857) English inventor and sculptor. Discovered the glass plate, wet collodion process, which greatly reduced exposure times and rendered a reproducible negative of unrivaled clarity. Presented his discovery as a free gift to the world (March 1851). Archer's collodion wet plate process superseded both the daguerreotype and calotype and was the primary process used by photographers for 30 years. Author of the *Manual of the Collodion Photographic Process* (1852). Invented the ambrotype process, or collodion positive on glass, and also introduced the stripping of collodion films, since applied in much photomechanical work. However, since Archer had not patented the collodion process, he died unheralded and impoverished. *M. Alinder*

ARCHITECTURAL PHOTOGRAPHY Architectural photography is dominated by photographs of entire buildings and exterior and interior sections of buildings, but the field includes closeup photographs of building details and even photographs of other structures such as bridges, towers, arches, sculptures, walls, and monuments. Most buildings are constructed for utilitarian purposes, but architecture is considered to be one of the fine arts, and photographs of buildings are made for both commercial and expressive purposes.

Buildings were popular subjects with early photographers, as were landscapes, and because buildings and their surroundings cannot be separated, many photographers developed expertise in both architectural and landscape photography. Photographs of historical structures and buildings having unique architectural styles in other countries held special fascination for the public, which previously had access only to drawings. An amateur photographer, Jean Baptiste Louis Gros, made the first daguerreotype images of the ancient Parthenon in Athens in 1840, only a year after the public announcement of the daguerreotype process. As described by Naomi Rosenblum in *A World History of Photography* (revised edition, Cross River, New York, 1984, p. 18), "After returning to Paris, he was fascinated by his realization that, unlike hand-drawn pictures, camera images on close inspection yielded minute details of which the observer may not have been aware when the exposure was made."

Photographers soon realized that it was necessary to keep the camera level to prevent the vertical lines on buildings from converging in the photograph. Rising-falling fronts were added to cameras so that the image could be moved up or down on the ground glass without tilting the camera, with tilt and swing adjustments appearing on later models. Large-format view cameras have long been the preferred camera of architectural photographers, although the most popular sizes have decreased over the years from 8×10 and larger to 4×5, in response to increases in the quality of lenses and films. Even 35-mm cameras became architectural cameras with the introduction of the perspective-control (PC) lens, a wide-angle lens that can be shifted off center to position the image without tilting the camera.

The basic task of architectural photographers is to represent three-dimensional architectural subjects realistically and attractively in two-dimensional photographs. Because of the nature of the subject, they are faced with special challenges.

CAMERA PLACEMENT For exterior views of buildings, the camera is normally positioned to emphasize the front of the building while also showing one side of the building to reveal form. Ideally, the camera distance would be determined by the type of perspective desired—normal, strong, or weak—but in practice this is seldom possible because of obstructions that limit the camera distance and distracting objects that would appear in the foreground. As a result, the camera is placed in the best position available, and a lens is selected that provides the desired angle of view. Thus, the photographer needs a choice of lenses covering a range of focal lengths, but all must have sufficient covering power to allow the view-camera movements to be used.

With interior views, the camera can seldom be placed far enough away from the area of interest for a normal focal-length lens to be used. Although the strong perspective that results from using short focal length wide-angle lenses creates a false impression of distance and space, the effect is usually welcomed because it makes the area appear more spacious than it really is.

LIGHTING Conventional lighting for exterior views consists of having the sun in a position that illuminates the front of the building while the visible side of the building is in the shade, a lighting effect that emphasizes the relief detail on the front surface of the building and the three-dimensional form of the building as a whole. Because the lighting changes constantly between sunrise and sunset, the photographer must anticipate when the desired lighting effect will occur. A hazy sun or light overcast is sometimes preferred for a less contrasty effect.

Alternative lighting effects include night photographs of buildings having exterior lighting or that can be "painted" with multiple firings of electronic flash units, and double exposures, one at dusk to record a sky tone and one after dark to record the normal building lighting.

The task of lighting interior views is greatly complicated by the use of color films. Even where the existing lighting is satisfactory, it may be necessary to use color-correction filters on the camera lens, especially with transparency films. When it is necessary to combine existing room illumination with supplementary flash or tungsten lighting and/or a daylight scene visible through a window, the task becomes more difficult.

In cities, there is a large enough market for architectural photographs that professional photographers can specialize in this field. Architectural photographs find many different uses by individuals and organizations in diverse fields. At one extreme, a cover photograph for a national magazine might involve the combined efforts of a number of specialists in addition to those of the photographer and many hours of preparation before the photograph is actually made. At a lower lever, a local real estate agent might make hand-held photographs with a instant-picture camera to show to potential clients. In between are all the architectural photographs made for documentation, information, advertising, and display, and for publication in newspapers, brochures, catalogs, magazines, and books.

Some architectural photographers develop distinctive styles, but it is important for professional architectural photographers to determine the needs of their clients and to make suitable photographs that meet those needs.

Books: McGarth, Norman. *Photographing Buildings Inside and Out.* New York: Whitney Library of Design/Watson-Guptill, 1987. Shulman, Julius. *The Photography of Architecture and*

Design. New York: Whitney Library of Design/Watson-Guptill, 1977. *W. DuBois*

ARCHIVAL Often used to imply as having long-lasting properties. The use of this term is discouraged, since it cannot be defined consistently for different applications.
 K. B. Hendriks

See also: *Image permanence.*

ARCHIVAL QUALITY Meaning to have long-lasting properties, or similar implications. *K. B. Hendriks*
See also: *Image permanence.*

ARCHIVE In electronic imaging, long-term storage of an image, typically on a magnetic tape or disk. *L. Stroebel*

ARC LAMP A lamp that produces light by creating a luminous bridge in a gap between two electrodes. When the arc is in a sealed tube, the spectral composition and intensity of light are controlled by the material in the tube (e.g., mercury or sodium). In a carbon arc lamp, the arc is in air and the type of light produced depends on the composition of the two carbon rods. *R. Jegerings*
See also: *Carbon arc lamp; Metal halide lamp; High intensity discharge lamp; High-pressure lamp; Xenon lamp; Zirconium lamp.*

AREA CONVERSION See *Appendix L.*

AREA PROCESSING See *Neighborhood processing.*

ARITHMETIC EQUIVALENTS OF LOGARTHIMS
See *Appendix F.*

ARITHMETIC LOGIC UNIT (ALU) A component found on the computer motherboard that performs multiplications, additions, or logical operations on data, including images. *R. Kraus*

ARRAY The holding of the image in a two dimensional (*x, y*) configuration. This structure or matrix on the *y* axis equals the number of lines that makes up the image. The *x* axis equals the number of pixels per line. *R. Kraus*

ARRAY PROCESSOR Specific computer hardware designed to hold the image in the form of a two-dimensional array. Such devices are "hung onto" the central processing unit (CPU). The device allows for fast image processing. Some array processors have built-in algorithms for specific image processing. *R. Kraus*

ART DIRECTOR (1) In advertising and editorial photography, the person who is responsible for layouts and who usually supervises and coordinates the work of photographers, artists, printers, etc. (2) In motion-picture photography and video, the person who has the responsibility of supervising those aspects of a production that involve sets, props, etc. *L. Stroebel*

ARTIFICIAL DAYLIGHT Artificial light that has approximately the same spectral quality as photographic daylight, which has a color temperature of 5500 K. Obtained in sensitometers with a tungsten light source and filtration to determine film speeds, for example. *R. Jegerings*

ARTIFICIAL HIGHLIGHT A light-colored object, such as a white card, which when placed in the scene enables the brightness of this brightest highlight to be conveniently measured by an exposure meter. Technique used when exposure should be based on highlights. In zone system terminology, the lightest tone with detail is zone VIII, which is properly placed by opening up three stops from the original exposure reading. Also used when photographing in near dark conditions when low light levels for reading midtone 18% gray are impossible (because of the meter's sensitivity limits under low light), in which case the white card (90% reflectance) is read and the film speed is divided by 5 (90%/18%) to reposition the exposure back to a proper mid-gray. *J. Johnson*
See also: *Zone system.*

ARTIFICIAL LIGHT Man-made illumination, as distinct from natural light from the sun, sky, moon, stars, lightning, etc. Electricity is the power supply for most artificial light, but combustion is used in flashlamps. *R. Jegerings*
See also: *Light sources.*

ARTIFICIAL MIDTONE An 18% reflectance gray card that is used for luminance (reflected-light) exposure meter readings, where it serves as a substitute for a medium-tone area in the scene being photographed. In zone system terminology, this tone is known as zone V or subject value V.
 J. Johnson
See also: *Exposure meters; Luminance meter; Zone system.*

ARTIFICIAL STAR An illuminated pinhole small enough in size so that at a specified distance it effectively serves as a point source of light for the purpose of testing lenses. *L. Stroebel*
See also: *Lenses, lens testing.*

ARTIGUE PROCESS A modification of the carbon process, named after its inventor, Frederic Artigue, in 1878 but reintroduced after improvements and modifications by his son Victor in 1893. The paper, which was commercially available, was coated with a very fine pigment black (or two other monochrome colors) and suspended in a solution of a colloid substance. Before printing, it had to be sensitized in a solution of potassium dichromate. Once dry, it was contact-printed to a negative. An essential feature of the process was the method of development. A very fine sawdust was supplied by the manufacturer of the paper, which was then mixed with water to a thick soup consistence. The print was soaked in tepid water, and then the sawdust-water mixture was poured over the print repeatedly to remove the unexposed and unhardened pigment. The prints produced by this process are characterized by a delicate, velvety, matt surface, full tonal graduation, and the deep, rich black shadows with full detail. The introduction of the gum bichromate process lessened the demand for this print process but did not surpass the delicate quality and richness of the image. *J. Natal*
See also: *Gum bichromate printing process.*

ARTISTIC Description applied to an object or an image or a related factor (e.g., arrangement, lighting, cropping) possessing qualities that induce in the viewer an impression of aesthetic excellence. Generally, the description applies to values other than commercial or practical. *R. Welsh*

ART MULTIPLE LAWS The state statutes that mandate the disclosure of certain facts regarding art multiples, including photographic prints offered and sold as limited editions. The required disclosure includes such information as the size of the edition, the particular process used, and the date the edition was printed. *R. Persky*
See also: *Business practices, legal issues.*

ART PHOTOGRAPHY See *Fine-art photography.*

ARTWORK A general term to describe all illustration copy used in preparing a job for printing. *M. Bruno*

ASA (1) Abbreviation for Acoustical Society of America. (2) (obs.) Abbreviation for American Standards Association, forerunner of American National Standards Institute. *T. Holman*

ASA FILM SPEED See *Film speed*.

ASCII American Standard Code for Information Interchange, a byte coding for the standard character set used by most computers; used to transfer text files between computers. *L. Stroebel*

ASCORBIC ACID L-Ascorbic acid ($C_6H_8O_6$, molecular weight 176.12; also known as vitamin C) occurs as plates or needles that are soluble in water and alcohol. A related compound, D-isoascorbic acid or its sodium salt, has only about 1/20 the biological activity of vitamin C but may be used as a developing agent to replace L-ascorbic acid.

Ascorbic acid acts as a strong developing agent at higher alkalinities but is often combined with Metol or Phenidone, where the combined developing action is greater than the sum of the individual activity alone, an effect known as superadditivity. *G. Haist*

ASPECT RATIO The width-to-height proportions of an image format, commonly used in motion-picture photography and video. The aspect ratio for conventional motion pictures is 1.33 to 1, but wide-screen aspect ratios range from 1.8 to 1 to 3 to 1. *L. Stroebel*

ASPHERIC LENS See *Lens types*.

ASSOCIATION FRANÇAISE DE NORMALISATION (AFNOR) The national standardizing organization of France. *P. Adelstein*

ASSOCIATIONS See *Organizations*.

ASTIGMATISM A primary monochromatic aberration of a lens as a result of which oblique bundles of parallel rays from an off-axis object point are brought to a focus as a line rather than a point.

This line has a radial (sagittal) orientation to the optical axis in one focal surface and tangential (meridional) in a second more distant surface. In a focal surface intermediate between these two, the line image reduces to a disc termed the circle of least confusion. These astigmatic image surfaces may be manipulated and flattened to an acceptable common surface approximately to the Gaussian focal plane by use of lens elements with opposite and different individual amounts of astigmatism and by use of suitable optical glasses.

In impaired human vision astigmatism is caused by unequal curvatures of the cornea in two inclined meridia and alleviated by eyeglasses using toric lenses. *S. Ray*

See also: *Anastigmat; Lenses, lens aberrations; Radial line/ray; Tangential line/ray.*

ASTRONOMICAL CAMERA See *Camera types*.

ASTROPHOTOGRAPHY Astrophotography is the photography of the moon, planets, stars, and other celestial objects. Most modern astronomical discoveries are made photographically for two reasons: the camera provides a permanent record and, by making time exposures, it can record images that are too faint for the human eye to see. Many faint celestial objects, such as the Horsehead Nebula, are invisible to the human eye even with large telescopes but are easily photographed with proper equipment. Additionally, some photographic emulsions can "see" into the infrared and ultraviolet.

HISTORY The entire history of photography has been closely linked to astronomy. The word *photography* was coined by the astronomer Sir John Herschel in 1839; in the same year Louis Daguerre is said to have made the first astronomical photograph, a daguerreotype of the moon.

With the advent of dry plates around 1880 came a flurry of astronomical discoveries, including the discovery of many faint nebulae, the spiral structure of galaxies, and extensive mapping of faint stars. An international project to photograph the entire sky, the *Carte du Ciel* project, was organized in 1887 but never completed.

The three main kinds of photographic observations took shape quickly: *astrometry* (position measurement for mapping), *photometry* (measurement of brightness), and *spectrography* (study of chemical composition as indicated by emission or absorption at particular wavelengths).

Observatories built since 1900 have been designed mainly for photographic work. From 1949 to 1956 the entire sky

Astigmatism. Primary astigmatism of zone (Z) of a simple lens (L) as shown by the appearance of the image of a spoked wheel P, imaged at the sagittal (S), circle of least confusion (C), and tangential (T) foci.

visible from Mount Palomar, California, was photographed with a 1.2 meter (48 inch) *f*/2.5 Schmidt camera, and prints of the resulting *Palomar Sky Survey* have been used by astronomers worldwide. A second survey is being undertaken now, using better emulsions, and the southern sky is being surveyed with similar equipment in Australia and Chile.

In recent years there has been a shift toward electronic imaging rather than photography. Photometry has been done with photomultiplier tubes since the 1950s. Charge-coupled devices (CCDs) came into wide use for all types of work in the 1980s because of their sensitivity to faint light and their ability to deliver an image directly to a computer for analysis. Computers are also used to process images obtained photographically; the computer can enhance local contrast and bring out faint detail. Precision astrometry of wide fields continues to be done with photographic emulsions, often on glass plates rather than film in order to rule out shrinkage.

AMATEUR ASTROPHOTOGRAPHY Astronomical observation has been a popular hobby since Victorian times, and amateurs, rather than professionals, continue to do valuable observation work. Because they are so numerous, amateurs can watch constantly for comets, novae, and transient phenomena on planetary surfaces, all of which would be missed by research observatories carrying out preplanned programs. Moreover, the beauty of the far reaches of the universe is a reward in itself; many amateurs observe simply for enjoyment, without attempting scientific projects.

Since the 1960s, photography has been an increasingly important part of amateur astronomy. With modest equipment, amateurs today can take wide-field pictures of nebulae and star clouds that rival the best observatory pictures from the 1940s. Amateur photographs of Mars and Jupiter rival the work of observatories today. New flat-field telescope designs (Schmidt–Cassegrain and Maksutove–Cassegrain) have been developed mainly for amateur use, including photography.

TECHNICAL CHALLENGES The technical challenges of astrophotography are numerous, and astronomical research has often stimulated development of photographic materials and techniques.

Brightness Range The surface of the sun is 1 million times brighter than the sunlit surface of the earth or a typical planet, which in turn is more than 1 million times brighter than a typical galaxy or nebula. Obviously, techniques for photographing different objects differ widely. The faintest astronomical objects require exposure times measured in hours.

Image Size The apparent size of celestial objects is measured as an angle with the observer or camera at the vertex. The sizes of some typical objects are 10 degrees (large faint nebulae), 3 degrees (Andromeda galaxy), 0.5 degrees (sun or moon), 0.1 degree (typical distant galaxy), down to 0.01 degree (Jupiter) or less for the other planets. Some types of astrophotography require wide-field cameras, while other require high magnification.

Star Images All stars except the sun are so far away that their apparent size is effectively zero, i.e., they are point sources of light. This means that the brightness of a star image depends on the diameter of the telescope or lens, not the *f*-ratio (the image should be a point regardless of focal length).

Star brightnesses are measured in *magnitudes,* an ancient Greek system that was originally defined as first class, second class, and so on (lower numbers are brighter). Stars visible to the naked eye on a typical night range from magnitude 0 or 1 to 6; each magnitude corresponds to a factor of 2.512 in brightness. The largest telescopes can reliably photograph stars down to about magnitude 21.

Diffraction-Limited Resolution The resolution of almost any telescope is limited by diffraction, not by aberrations, and is approximated by the formula

Resolution (arc-seconds) = 0.115 / aperture (in meters)

This is called the *Dawes limit* and is about 0.6 arc-second for a 0.2 meter (8 inch) telescope.

"Seeing" The turbulence of the earth's atmosphere limits the angular resolution of even the largest telescopes to less than 1 arc-second most of the time.

The telescope aperture that gives the best resolution depends on conditions. Generally, for best results, the Dawes limit of the telescope should be several times better than the atmospheric limit. Turbulence, however, is organized into patches or cells, and if the telescope is too large, many different cells will be in front of it at the same time, making the image worse than in a smaller telescope.

Optimum apertures range from 4 to 6 inches in very unsteady air (as in daytime solar observation), through 8 to 12 inches under good conditions at an average site, up to 30 or 40 inches under excellent conditions at the best possible sites. Telescopes larger than this do not show any more detail; their only advantage is that they gather more light.

High-resolution imaging of the planets also relies heavily on image processing, either by computer or in the observer's brain. A trained visual observer can see much more detail with any telescope than that telescope can photograph for two reasons: observers can take advantage of fleeting moments of steadiness that the camera is unlikely to capture, and observers can train themselves to recognize detail at very low contrast. The computer, of course, can enhance the local contrast in a photograph and combine many images taken in rapid succession, thereby subtracting out the constantly varying effect of the atmosphere. Indeed the best computer-enhanced photographs of the planets look much like drawings done by a trained observer.

Because it is outside the atmosphere, the 2.4 meter (94 inch) Hubble Space Telescope, even with its defective optics, far surpasses every telescope on earth.

Sky Glow Near urban areas, reflected artificial light is a serious problem; the lights of San Diego now interfere measurably with the observatory of Mount Palomar. If the light has a discontinuous spectrum (e.g., from sodium or mercury streetlights), it can to some extent be filtered out with special dichroic filters. Light pollution has drawn some opposition on environmental as well as astronomical grounds; clearly, light thrown up into the sky is wasted energy. Even at the most remote sites, the sky is faintly luminous; this *sky glow* is similar in nature to the aurora borealis.

Guiding The sky is a moving target; that is, the rotation of the earth makes the image move in any exposure longer than a few seconds, unless the telescope is guided. Guiding requires an *equatorial mount* with an axis parallel to that of the earth, and a *clock drive* to move the telescope continuously at the proper rate.

Even with the best clock drives, tracking is not perfect, for two reasons: the movement of any geared-down motor is subject to periodic errors, and the earth's atmosphere introduces small, unpredictable shifts. A third problem is that the equatorial mount may not be perfectly aligned with the earth's axis. Accordingly, the observer must make guiding corrections manually during the exposure or have them made by a photoelectric device. Guiding is done by viewing an off-axis area of the image that does not fall on the film or by using a separate telescope mounted on the main one. For amateur wide-field work, it is common to mount a camera and telephoto lens piggyback on a telescope that is only used for guiding.

Spectrum Emission nebulae emit most of their light at a wavelength of 656.3 nm, in the deep red. Some panchromatic films do not respond to this wavelength, but color films do, which is why color photographs are often so impressive.

Astrophotography. Galaxy M31 in Andromeda. This was a 5-minute exposure with the camera piggyback on a clock-driven telescope; 200-mm lens, f/3.5, hypersensitized Kodak Technical Pan Film. (Photograph by M. Covington.)

Black-and-white films with extended red sensitivity have been developed for scientific use (Kodak Technical Pan, Kodak 103a-F).

Reciprocity Failure Most films perform quite poorly in exposures of more than a few seconds. Manufacturers' data (e.g., in Kodak Publication F-5) indicate which films are the most afflicted, but long exposures cannot be predicted accurately because reciprocity failure varies greatly with temperature, humidity, and emulsion batch.

Kodak, Ilford, and other vendors have made special emulsions for astrophotography (e.g., the Kodak Spectroscopic films 103a-O, 103a-G, IIIa-J), sensitized in a special way to reduce reciprocity failure. Newer general-purpose emulsions also have less reciprocity failure than their predecessors; a striking example is Kodak T-Max 100 film, which performs as well as the Spectroscopic series and is supplied to observatories on glass plates.

A better way to overcome reciprocity failure is to *gas-hypersensitize* the film by baking it in hydrogen and nitrogen. With Kodak Technical Pan Film this produces a tremendous speed increase; with color films it is useful but less dramatic. The alternative is to expose the film at a very low temperature in a *cold camera*; this is a cumbersome setup involving dry ice and a vacuum pump, but the results are spectacular.

SIMPLE TECHNIQUES Several kinds of astrophotography can be carried out with ordinary photographic equipment.

Star Fields With ISO 400 color slide film and a camera on a fixed tripod, make a 20 second exposure of the starry sky with a 50 mm lens at f/2. The resulting image will show more stars than the unaided eye can see, with spectacular colors.

Star Trails In exposures longer than 20 seconds, the revolution of the earth makes the stars photograph as streaks. With a wide-angle lens, aim the camera north and expose for 2 hours at f/5.6; the picture will show how the heavens appear to whirl around the celestial pole.

Comets Use the same technique as for star fields (if the comet is visible to the naked eye). Moonlight, if present, can be attenuated with a light yellow filter.

Meteors and Aurorae (Northern Lights) Same as for star fields or star trails. Remember that even a heavy meteor shower yields no more than one meteor per minute.

Afocal Coupling to a Telescope Any camera can be cou-

pled to any telescope by simply aiming it (with normal lens) into the eyepiece. The camera and telescope can stand on separate tripods; although clumsy, this prevents the shutter from vibrating the telescope. The effective focal length is that of the camera lens times the magnification of the telescope (e.g., 50 mm lens with ×25 telescope = 1250 mm). The f-ratio is the effective focal length divided by the telescope diameter (e.g., if the aforementioned telescope is a 5 inch [125 mm], then the setup described works at f/10).

If the camera is an SLR, focusing is straightforward. Otherwise, focusing requires the aid of a second, small, hand-held telescope (or binoculars), as follows. Set the camera to focus on infinity. Focus the hand-held telescope on the moon or stars. Then use the small telescope to look into the eyepiece of the main telescope and adjust the focus of the main telescope.

Moon Use a long telephoto lens (>500 mm) or an afocally coupled telescope. Steadiness of the air is important. Exposure for the full moon is the same as for any sunlit landscape; the crescent moon requires two or three stops more exposure.

Lunar Eclipses Same as for the uneclipsed moon but with longer exposures. Bracket widely.

Solar Eclipses Except at the moment of totality, heavy protective filters are required. *Use only filters that are known to be safe for sun viewing.* Such filters use layers of aluminum or glass or plastic and are marketed by Celestron, Questar, and other telescope manufactures. Ordinary glass, gelatin, or dichroic filters are *not* safe because they transmit too much infrared. Apart from filtration, techniques are the same as for photographing the moon, and can be tested on the full moon two weeks before the eclipse.

Books: Covington, Michael A. *Astrophotography for the Amateur,* revised edition. Cambridge: Cambridge University Press, 1991. (Overview of practical techniques.) Eccles, M.J.; Sim, M.E.; and Tritton, K.P. *Low Light Level Detectors in Astronomy.* Cambridge: Cambridge University Press, 1983. (Theory of photographic and electronic imaging.) Vaucouleurs, Gérard de. *Astronomical photography.* London: Faber and Faber, 1961. (History of the field.) *M. Covington*

See also: *Space photography.*

ASYNCHRONOUS (1) Motion-picture sound not synchronized with the picture being projected. (2) Start-stop data transmission supplanting the need for a synchronous

clock at the receiving end. (3) Two television signals not synchronized to each other (not genlocked) but of the same scanning standard. *H. Lester*

ATGET, JEAN-EUGÈNE-AUGUSTE (1857–1927)
Photographer. Self-taught. From 1898 onwards produced a kaleidoscopic photographic portrait of Paris, brilliantly documented in over 10,000 images. The city was his subject, not its people, but rather its cobbled streets, shop windows, fountains and statues, dark passageways and alleys. Earned a meager living from sales of photographs to artists, including Braque and Utrillo. The artistic and documentary value of his work was recognized only after his death when his glass plates and prints were rescued and championed by Berenice Abbott.

Books: Szarkowski, John, and Hambourg, Maria Morris, *The Work of Atget*, 4 vols. New York: Museum of Modern Art, 1981, 1982, 1983, 1985. *M. Alinder*

ATKINS, ANNA (1799–1871)
British photographer. One of the first women photographers, though she is known for her cameraless cyanotypes. Atkins learned Talbot's calotype process in 1841. Sir John Herschel taught her his newly invented cyanotype process, producing images commonly known as blueprints, which she mastered by 1843. Laying a selected object upon the cyanotype-sensitized paper, then exposing this to light, produced intensely blue photograms of plants and flowers. Published the first photographically illustrated book, *Photographs of British Algae: Cyanotype Impressions,* in installments (1843–1853).

Books: Schaaf, Larry J., *Sun Gardens, Victorian Photograms by Anna Atkins.* Millerton, NY: Aperture, 1985. *M. Alinder*

ATMOSPHERE
A quality in a photograph that evokes a distinct emotional response in a viewer or that elicits the natural sensations associated with particular scenes. *R. Welsh*
See also: *Mood.*

ATMOSPHERIC PRESSURE
See *Barometric pressure.*

ATOM
All matter on earth is composed of atoms so small that 10^{14} atoms are said to be required to cover the head of a pin. There are 109 distinctive structures of protons, neutrons, and electrons that compose the different atoms that cannot be separated into simpler substances by chemical means. Each of the 109 different atoms is called an *element.* *G. Haist*

ATOMIC THEORY
The concept that all matter is composed of tiny, indivisible particles was first proposed by John Dalton. All the elementary particles, called atoms, of one element have the same mass and properties but differ from all the atoms of another element. Atoms of different elements combine in whole number ratios but remain essentially unchanged. This was the atomic theory of Dalton but does not include any details of the internal structure of the atom, which is still being studied. *G. Haist*

ATTENUATOR
A physical medium for producing a controlled reduction in energy. In the case of photography, a light absorber. A neutral density filter attenuates the different wavelengths of light equally. A color filter selectively attenuates various wavelengths. A gray scale attenuates various amounts of light nonselectively by wavelength. *I. Current*
See also: *Modulator.*

AUDIBLE FREQUENCY RANGE
Usually considered to be between 20 Hz and 20 kHz, although these are not rigid limits. *T. Holman*
Syn.: *Audio frequency.*

AUDIO
A broad term covering the representation of sound electrically or on a medium: *audio tape* is better usage than *sound tape,* although *sound track* persists in the film industry to describe audio accompanying a picture. *T. Holman*

AUDIO AMPLIFIER
An electronic device generally used to increase the voltage or power of an audio signal. Audio amplifiers include, for example:

1. Input transducer preamplifiers such as microphone preamplifiers intended to raise the output of the transducer to a higher nominal level for processing by further circuitry. Specialized preamplifiers in this category include phonograph and magnetic film and tape preamplifiers that have a gain function but also an equalization one to compensate for the transducers and the frequency response employed on the medium to optimize dynamic range.
2. Line-level audio amplifiers that raise the signal level further.
3. Specialized audio amplifiers for processing the signal usually having unity gain but offering features such as equalization.
4. Amplifiers used principally for buffering, that is, preventing unwanted interactions among components.
5. Summing amplifiers used to add together multiple signals, without interactions among them.
6. Audio power amplifiers intended to drive loudspeakers.
T. Holman

See also: *Equalization; Frequency response.*

AUDIO CASSETTE
Any system that uses tape housed in a generally continuous outer shell designed to be interchanged from machine to machine, offering physical tape protection. By far the most popular is the compact cassette standardized by Philips. Under this broad definition falls an endless loop cartridge used in broadcasting and in some film applications that is known as the NAB cartridge. *T. Holman*
See also: *Compact cassette.*

AUDIO ENGINEERING SOCIETY (AES)
A United States–based international group of professionals in audio who include standards-making among their activities. *T. Holman*

AUDIO FREQUENCY
Usually considered to be the frequency range between 20 Hz and 20 kHz, based roughly on the limits of human perception. Below 20 Hz sound is called *infrasonic,* while above 20 kHz it is called *ultrasonic.* Sound pressure at high levels and infrasonic frequencies is more likely to be perceived as vibration rather than as sound. *T. Holman*
Syn.: *Audible frequency range.*

AUDIO MIXER
(1) Audio mixing consoles, and (2) the person who operates them. Generally speaking, the functions of an audio mixing console can be broken into two broad classifications: processing and configuration. Among audio processes are audio amplification, control of levels by way of faders (also known as level controls, potentiometers, and in lay terms, volume controls), equalization, and control over program dynamics by means of limiters, compressors, and expanders. The configuration part of console design has to do with arranging the audio processes in certain preferred orders, in combining signals, and in routing the signals throughout the console. *T. Holman*

AUDIOVISUAL COMMUNICATION
Audiovisual communication refers to the communication of information, concepts, and attitudes through audio and visual media. Photographic visual media include such things as still

pictures, overhead transparencies, slides, filmstrips, and motion pictures.

HISTORICAL BACKGROUND Before 1950, photographic materials used for audiovisual communication consisted largely of still photographs, 3-1/4 × 4-inch lantern slides, filmstrips, and 16-mm motion pictures. Most of these were black-and-white and were used in schools, the military, and in business and industry settings. During the 1950s, high-quality 35-mm color slides replaced lantern slides, color largely replaced black-and-white for filmstrip and film production, and overhead transparencies assumed an important role. Technical developments resulted in slide projectors that could be controlled, first by punched paper-tape programmers and later by electronic control units, which made elaborate multi-image presentations possible. Typically, photography for audiovisual communications was done by photographers with a broad range of skills. The next two decades saw rapid technological advances. Electrostatic copying and other developments made it possible to reproduce photographs more easily and at lower cost. Fast high-quality color films for slides and motion pictures became available. Electrostatic and thermal processes largely replaced the more complex dual-spectrum, diazo, and lithographic film processes for overhead transparency production. Computers assumed important roles in production and presentation. Such developments, coupled with the demand for effective instructional and motivational programs, led to an expansion of audiovisual communication in the 1980s.

CURRENT PRACTICE Still photographs for printed materials and for displays are widely used. Filmstrips are used, particularly in public schools. Motion pictures, although still viable, have been largely superseded by video, especially for classroom presentations. The demand for overhead transparencies for presentation purposes continues to increase. Computers are used to create masters, which are converted to transparencies by thermal or electrostatic methods and by peripheral printing devices. In some instances transparencies are made from art work by conventional color reversal processes. Color slides are used extensively for instruction and for a variety of motivational multi-image presentations.

Although a broad general knowledge of photography is needed by producers, there is need for persons who also have skills in the design of instructional materials and for persons with the complex skills required for creating multi-image presentations. In multi-image shows, the relationships among the images, both simultaneous and sequential, is of more importance than the individual images. Therefore, the skills of a motion-picture photographer, as well as the skills of the still photographer, are needed. In the laboratory, skills of creating quality duplicates, masked and multiple images, and seamless panoramic slides are necessary. An understanding of the use of computers is increasingly important to audiovisual communicators. The words and artwork for a large proportion of all graphic slides are created on a computer, and high-resolution, computer-screen images are photographed with a film recorder in house or by sending the computer disks to a service bureau via mail or over various networks including common carriers.

THE FUTURE The rapid changes in technologies that are taking place in all areas of our society will continue to increase the need for training and public-relation activities, which, in turn, will increase the need for effective audiovisual materials. Computers will play an even more important role in the production of both print and projection media. Digitized images that can be easily manipulated will increase in quality and will become easier and less expensive to produce. Electronic transfer of images, coupled with electronic clip-art systems and ultimately electronic multimedia databases, will change the role of the audiovisual photographer.

In addition to creating original images, photographers will be called upon to choose and manipulate available images to create their audiovisual products.

Organizations of particular interest to the producer of photographic audiovisual materials are the Association for Educational Communications and Technology (AECT), the Association for Multi-Image International (AMII), the International Visual Literacy Association (IVLA), and the Society of Photographers in Communication (SPC).

Books: Bishop, A., *Slides: Planning and Producing Slide Programs.* Rochester, NY: Eastman Kodak, 1986; Kemp, J. and Smellie, D., *Planning, Producing, and Using Instructional Media,* 6th ed. New York: Harper and Row, 1989; Kennedy, M. and Schmitt, R., *Images, Images, Images,* 2nd ed. Rochester, NY: Eastman Kodak, 1981; Pettersson, R., *Visuals for Instruction: Research and Practice,* Englewood Cliffs, NJ: Educational Technology Publications, 1989. *D. Pett*

See also: *Multimedia; Photo CD.*

AURA See *Atmosphere.*

AUTOCHROME PROCESS In 1903, August and Louis Lumière invented the first practical system of color photography. They named it Autochrome, patented it in 1904, and began manufacture in Lyons in 1907. A glass plate was double coated with layers of starch grains dyed red, green, and blue. The spaces between the grains were filled with carbon dust. A panchromatic emulsion was coated on top of the starch grains. Exposure was from the back, through the glass plate so that light was filtered before it was recorded. Reversal processing yielded a positive, laterally correct image viewed from the emulsion side by light that was colored as it passed through the screen.

Revisions of Autochrome replaced the glass plate with sheet film, and the starch grains and carbon dust with resin globules. It was always about 50 times less sensitive than contemporary black-and-white materials. In its grain pattern and its palette, Autochrome resembled French impressionist paintings with its lovely textures and pastel hues. Production ended in the 1930s with the advent of such materials as Kodachrome and Agfacolor. *H. Wallach*

See also: *Additive synthesis; Color synthesis; Dufaycolor; Finlaycolor; Lumière, Auguste and Louis; Screen color processes.*

AUTOCOLLIMATOR A modification of the conventional collimator that incorporates a beam splitter at 45 degrees to the optical axis directing light to the eye after being reflected back from a surface placed at the focal plane of a lens under test. The image of the test target or reticle of the collimator can be viewed directly as formed by the test lens on the surface. Used as a means of collimating and checking lenses, especially on location. *S. Ray*

Syn.: *Reflex autocollimator.*

See also: *Lenses, lens testing.*

AUTOFOCUS A means of obtaining or retaining focus automatically by mechanical or optoelectronic systems. While visual focusing is adequate for many purposes, it can be a slow, inaccurate, and tiring process, especially if continuous adjustments are necessary. Autofocus is especially helpful when using long-focus lenses and when following subjects moving obliquely across the field of view. Various forms of autofocus systems have been devised, operating in various modes. An *active* system will lock focus on the subject and maintain it during changes of distance. A *passive* system will operate on demand and lock focus on the subject. The camera shutter may not be operated until focus is achieved. A *prefocus* feature is useful, as the sensor area will be much smaller than the field of view of the lens, and the composition may be such that the active system would give

sharp focus on an area other than the main subject feature, for example, the background seen between two heads in a double portrait. Multiple sensors across the field of view are a help.

When using nonautofocus lenses with autofocus cameras, it may be possible to use a *focus indication mode* or *assisted focus mode* as an electronic analogue of an optical rangefinder or focusing screen. An LED display lights up in the viewfinder to indicate correct focus has been obtained by manual focusing and the direction of focusing movement required is indicated if focus is incorrect. A *focus maintenance mode* retains sharp focus once this has been set visually and is the system commonly used in autofocus slide projectors and enlargers.

RANGING SYSTEMS One autofocus method is direct measurement of the subject distance. An ultrasound system is used by Polaroid in certain of its cameras. A piezoelectric ceramic vibrator emits a chirp of ultrasonic sound frequencies while the lens moves to focus from it near distance to infinity, or a supplementary aspheric lens is moved behind the prime lens. The elapsed time for the return journey to the subject is proportional to subject distance, and the return echo halts the focusing movement. The system operates in the dark but cannot penetrate glass.

Other methods as used in compact cameras involve some means of scanning the subject area. An *electronic distance measuring* system uses an infrared-emitting diode moving behind an aspheric projection lens to scan its narrow beam across the scene. Its reflectance from a small well-defined zone of the subject is detected as a maximum response from a photodiode, and the scan action is halted, as is the synchronous focusing movement of the camera lens. The Honeywell Visitronic module uses such a subject scan system, where a rotating mirror synchronized to the focusing movement images a zone of the subject onto a photodetector array; this response is compared to the static response of the subject area as seen by a fixed mirror and second detector array. The subsequent correlation signal is a maximum when both mirrors image the same zone and the signal locks the focus travel. This is an electronic analogue of an optical rangefinder. High light levels are preferred for accuracy.

An alternative system uses no moving parts but uses two fixed mirrors imaging zones of the scene across a linear charge-coupled device (CCD) array of 200 or more elements. The focused image area is compared with adjacent image areas along the array, and maximum correlation gives a *base* or distance between the two correlated regions, which relates to the subject distance and an angular subtense. This continuous self-scanning triangulation system may be incorporated into video cameras to operate through the zoom lens.

Systems using an infrared beam can operate in darkness and through glass but can be fooled by unusual reflectances from materials such as dark cloth. The accuracy of the system also depends on how many discrete steps or zones between lens and subject are used to set the lens. A separate closeup focusing range may be available.

IMAGE CONTRAST MEASUREMENT The action of focusing an image on a ground glass screen shows that the image has maximum contrast at sharp focus. Visual focusing is a contrast-judging process, and this may be automated by measurements from the image itself where the image illumination gradient is converted into digital data for analysis. The outputs of adjacent elements of a linear CCD array give indication of the focus of edge details as the rate of change of response. No moving parts are needed, and a suitable autofocus module can be located in an equivalent focal plane in the camera body. Additional refinements include two or more arrays and beam splitters to provide drive information to the motor to attain focus. A micromotor moves the whole lens for focusing or just moves a floating element in the lens. These system operate well in bright light but respond at only moderate speed.

Autofocus. Ranging systems for autofocus cameras. (a) Scanning IR-emitting diode K with aspheric lenses L1 an L2 and photocell P; (b) static system with linear CCD array A. The correlated images at separations *d*1 and *d*2 correspond to distances *u* and *D*, respectively; (c) scanning mirror to correlate images on twin photocells P1 and P2.

Autofocus. Principles of autofocus by phase detection. (a) Subject in focus; (b) focus in front of subject; (c) focus beyond subject. L, camera lens; F, equivalent focal plane; A, lenslet array; C, CCD linear array; B, output signals with time delay t1 etc.

Autofocus. Focus detection by a linear CCD array. (a) A lens imaging a subject S gives a sharp image at focus A and unsharp images at B and C, which have less contrast; (b) graphs of intensity *I* against distance *d* along the subject and its images gives a step or a curve shape; (c) the intensity profile, as a measure of focus, can be determined from a linear array of charge coupled devices (CCD 1, 2, 3, etc.) whose output is proportional to intensity, and the sensor number corresponds to distance. Signal processing techniques detect the sharp or unsharp characteristic.

PHASE DETECTION FOCUSING An alternative, preferred system also uses a linear CCD array but allows operation at low light levels. The CCD array is located behind an equivalent focal plane and behind a registered row of microlenses that act in a similar manner to a prismatic split-image rangefinder. Divergent pencils of rays beyond the correct focus position and refracted to focus on the array, and the separation or *phase* of these focus positions relative to a reference signal is a measure of the focus condition of the camera lens. The phase information operates a motorized focus control in the camera or even in the lens itself. Rapid response and focusing is possible, even in continuous focus mode. Focusing in the dark is possible using a focus-assist system of a brief emission of a deep red beam of light from a dedicated flashgun to project a pattern on the subject.

Other useful features offered by the phase detection system include and *automatic depth of field mode,* where the lens is focused on the near and far points of the scene to be rendered in focus and the automatic exposure determination system in the camera then chooses the appropriate aperture to give the correct depth of field, given an input of data from the lens as to its focal length value.

Another feature is a motion detection mode, where the camera is autofocused at a suitable distance; when a moving subject enters this zone, the camera automatically fires the shutter.

A useful feature is focus prediction, where the autofocus system makes successive measurements on the distance of a moving subject and predicts its new position and resets the lens to this to allow for the time lag involved in the release of the shutter.

One operational disadvantage of autofocus systems using a beam splitter arrangement is that detection is affected by linearly polarized light so that a circular polarizing filter must be used instead of the usual linear type.

Books: Ray, S. *Applied Photographic Optics.* London & Boston: Focal Press, 1988. *S. Ray*

AUTOMATIC CONTROLS Unlike remote controls, automatic controls generally operate without human intervention. There are three general classes of automatic controls: timers, event triggers, and condition responders.

Examples of timers include the self-timer shutter release built into cameras and the timers used in time-lapse photography. These timers may be powered by a wind-up spring or by an electrical motor powered by ac mains or batteries.

The classic example of an event trigger is Muybridge's use of 12 threads attached to 12 cameras to sequentially photograph a horse trotting past the bank of cameras. A more modern example is the use of DX coding of 35-mm film canisters to automatically set camera film speed.

Condition responders are controllers with sensors (or transducers) that monitor light, temperature, voltage, pressure, motion, etc., and react to a change in the quantity being monitored. The automatic exposure setting in certain cameras is an example. The aperture and/or the exposure time of the camera is adjusted according to the luminance of the scene. Condition responders are necessary components in automatic controllers that maintain a constant temperature of the developer in processors and that maintain a constant voltage on the printing lamp in enlargers and color printers. *W. Klein*

AUTOMATIC EXPOSURE Automatic exposure (AE) is a camera metering and exposing system that measures reflected light and sets the shutter and/or aperture for that reading, without assistance by the photographer.

HOW AE WORKS With a typical AE system, light that enters the camera is analyzed by a metering system that takes a general overall reading, a center-weighted reading, a specified spot target reading, or multiple readings from a more elaborate pattern that are then averaged. The camera has a set of in-body sensors that read a pattern printed on the outside of the manufacturer's film cassettes called a DX code that provides the film speed and other pertinent information, and sends it to the camera's program exposure system.

Depending on the amount of light read, either the diaphragm opening, the shutter speed, or a combination of both are adjusted to that reading.

FULL AND SEMIAUTOMATIC SYSTEMS In some automatic exposure systems, certain controls can be set to allow for preferences of what will be controlled automatically. These preferences are called programming modes. If the diaphragm is set manually (aperture priority mode), the photocell reading controls the time of exposure. If the photographer wants to control movement as a priority, the shutter speed can be manually set (shutter priority mode), and the exposure is controlled by the automatic diaphragm. In program mode, neither is manually set.

Program mode on some cameras uses both aperture and shutter speeds from a memory list of most appropriate values (color or black-and-white, and lens focal length). This system uses both small apertures and fast shutter speeds in bright areas. As the light dims, the shutter slows first. After both shutter and aperture are at the limiting values that are appropriate for hand-held use, the camera will indicate the need for flash or use of a tripod. On most automatic exposure systems, program mode also includes flash exposures. Here, the camera metering system operates flash synchronization, flash output, and the diaphragm setting with a dedicated flash unit. This is based on an in-camera constant analysis of light from the flash coming through the lens. These flash units are designed to be used with matching camera bodies to enable communication of information between the two units.

PROBLEMS OF AUTOMATIC EXPOSURE Automatic exposure is very popular among amateurs because of the ease of operation and a tendency to compose with the main objects in the center of the viewfinder. AE can lead to as many incorrect exposures as correct ones when there are conditions of an imbalance of extreme dark and light in the meter sampling area, which can lead to general over- or underexposure. A more accurate reading can be made in many situations by using an exposure locking mechanism. Here, the target can be moved to a specific area, the reflected light read, and locked in, and the image recomposed in the viewfinder. This is usually accomplished by a partial depression of the shutter button. Essentially, the automatic camera is now in a momentary manual mode.

Professional photographers, aware of the shortcomings of automatic exposure systems, commonly either fully override auto exposure or at least work with one of the control modes.

P. Schranz

AUTOMATIC EXPOSURE LOCK Automatic exposure cameras give constant exposure information up to the instant the shutter is tripped. A meter reading of an appropriate middle tone area can be maintained while changing the camera angle by using an exposure locking method. This is usually accomplished by a partial depression of the shutter button.

P. Schranz

AUTOMATIC FOCUS A system found on some cameras that performs an electronic analysis of the distance from the camera to a selected subject and an automated response from the lens focusing system to that distance. It is usually activated by a partial depression of the shutter release.

TYPES OF AUTOFOCUS SYSTEMS Autofocusing systems include three general categories—active autofocus, passive autofocus, and assisted autofocus.

Active Autofocus Active autofocus systems hunt for optimum focus as the distance from the subject to the camera changes. They do not have to be specifically activated at the time the shutter is tripped. This is the system found on some enlargers and many slide projectors. It can also be found on some cameras with a system called trap focusing, where the camera shutter remains locked until an object moves into the predetermined zone of focus and the shutter is automatically released.

Passive Autofocus Passive autofocus is activated on demand and is the most common camera system. The point of focus is chosen by the photographer by positioning the target area in the camera viewfinder on the selected subject area.

There are several ways that passive autofocus is accomplished. In one way, an image, projected onto the viewfinder ground glass, passes through an infrared beam splitter to two photoelectric cells, giving a displaced view. As the servomechanism moves the lens barrel, the split image on the cells is brought into register at the same time as the image is brought into focus. This system works well in bright light and with detailed subjects.

Some autofocus systems are aided by infrared beams in dim light situations. In this case, a spot of infrared radiation is projected on an object as the lens is focused from its nearest point out. When the focusing plane crosses the spot, it stops. This system can also be set up to fire the shutter immediately when the focusing locks on. This is the most common autofocusing system in point-and-shoot cameras. The system works well on scenes that have good separation of forms and those that have the object to be focused on located in the center of the image. On generally flat surfaces, the autofocus target may need to be moved to an edge of the surface. It is also tricked by reflections where the infrared spot will reflect off the surface at an angle away from the camera, and the camera will continue to focus to infinity.

Another autofocus system that is similar to sonar is found on the Polaroid Spectra camera. Before exposure, the camera emits a high pitched chirp sound that reverberates back to the camera from the subject. As the sound is emitted, the camera lens begins focusing out from the closest point of focus. When the echo returns, the lens stops focusing. This type of system can be autofocused even in the dark. The time of travel determines the focusing position. Problems with this system are that the sound will bounce off the larger object in a scene, even if that would not have been the photographer's choice of focus, and the camera will focus on a glass window rather than the scene beyond the window.

There are autofocus systems that read the amount of reflected light from a flash unit to determine the distance. The time it takes for the flash to leave the camera, reflect off an object, and then back to the camera sensor determines the focusing. It is similar to the Polaroid sonar sound system, only substituting light. Electronic circuits estimate the distance and set the lens focus. Caution is needed when photographing very dark or very light subjects because the amount of light absorption can mislead the focusing system.

Assisted Autofocus Assisted autofocus is an electronic analog reading of the composition. The lens is focused manually, but a display light indicates when focus has been achieved. This is helpful in low light or where speed of focusing is essential.

Precautions with Autofocus Each autofocusing system has some peculiarities that can give erroneous results from those wanted by the photographer. Many autofocus systems read off the largest or closest object to the camera but not necessarily the one of most importance to the photographer. In an amateur situation, where composition tends to be

centered in the viewfinder, autofocus is quick and easy. When composition becomes more selective, it is necessary to understand how to override the autofocus mechanism. The autofocus target may be locked onto a specific part of the scene, and while still partially depressing the shutter release, the photographer can recompose the picture. *P. Schranz*

AUTOMATIC LOADING An in-camera film transport system that becomes activated after the film cassette is placed in the camera. The film tongue is pulled out and set at a prescribed take-up mark and then the camera is closed. The film is automatically transported to the first frame. After an exposure, the film is advanced to the next frame and the shutter is cocked. Many of these cameras will automatically rewind the film back into the cassette after the last frame is exposed. Most auto-load system cameras read DX coded film that gives the information on film speed and film length. *P. Schranz*

AUTOMATIC SHUTTER A protective plate inserted between the film and light source in some motion-picture projectors to protect the film from heat damage when stopped or run at slow speed. *H. Lester*

AUTOPOSITIVE A sensitized material for making direct positive images upon chemical development, rather than the normal negative images. This is different from the positive image obtained by reversal processing where a silver negative image is first formed, then bleached, and the remaining silver halide developed to form a positive image. (Note: Autopositive is a Kodak trade name, the first letter of which should always be capitalized.) *I. Current*

AUTORADIOGRAPHY The process of recording the location of radioactive elements in specimens by placing the specimen in contact with a photographic emulsion. The distribution of phosphorus in a plant leaf, for example, can be recorded by first feeding the plant with a phosphate synthesized from radioactive phosphorus. *L. Stroebel*

AUTOTRANSFORMER A single-winding transformer in which the primary coil is a fraction of the entire winding for voltage step-up, or the secondary coil is a fraction of the entire winding for voltage step-down. They are especially useful for making small corrections or adjustments to an available voltage. *W. Klein*

See also: *Transformer.*

AVAILABLE LIGHT Loosely applied, lighting found in the scene of the photograph. The term may include minor manipulation of the lighting by reflectors, gobos, etc., but never the addition of lights intended for photography. *F. Hunter and P. Fuqua*

Syn.: *Existing light.*

AVEDON, RICHARD (1923–) American photographer. Began at *Harper's Bazaar* (1945–1965), where he worked closely with his mentor, Brodovitch, becoming one of the dominant artists in fashion photography. Opened the Richard Avedon Studio in New York City (1946). Staff photographer for *Vogue* since 1966. His personal work includes large-format portraits of the famous and of the common man, isolated by the void of a seamless white backdrop.

Books: *Avedon: Photographs 1947–1977*. New York: Farrar, Straus & Giroux, 1978. *M. Alinder*

AVERAGE GRADIENT The slope (steepness) of a straight line drawn between two points on a curved graph. Since the characteristic curves (D-log H curves) of some modern films do not have a straight-line portion, for these, gamma (the slope of the straight line) cannot be used as an indication of film and development contrast. Contrast index has largely replaced gamma, since it does not require a straight line and it represents the average gradient of the most useful part of the characteristic curve.

M. Leary and H. Todd

See also: *Characteristic curve; Contrast index; Gamma; Gradient.*

AVERAGE SCENE A scene that is characterized by not being dominated by dark or light tones but rather that has a good range of tones including shadows and highlights. More specifically, a scene that has a luminance ratio of 160:1, or a luminance range of seven stops. This is the type scene for which the averaging or integrating type of meter is best suited. Its tonalities when averaged would correspond to a mid-gray tone. *J. Johnson*

See also: *High-key; Low-key; Zone system.*

AXIAL CHROMATIC ABERRATION See *Lenses, chromatic aberrations.*

AXIS An imaginary straight line joining the centers of each spherical surface of a lens and perpendicular to the pole or vertex of each surface. It is a longitudinal axis of symmetry of the lens, and the configuration of the lens elements used is conventionally shown by a vertical section through the axis.

S. Ray

Syn.: *Principal axis; Optical axis.*

AZIMUTH See *Head alignment.*

B

B Bulb, shutter speed setting; CIE standard illuminant; Brightness

BABT British Approvals Board for Telecommunications

BAFTA British Academy of Film and Television Arts

B-&-W Black-and-white

BC Battery capacitor

BCPS Beam candlepower-second

BCU Big closeup

BFI British Film Institute

BISFA British Industrial and Scientific Film Association

bit Binary digit

BJT Bipoloar junction transistor

BKSTS British Kinematograph, Sound, and Television Society

BL Behind lens

Blix Combination bleach and fix color processing solution

BOD Biochemical oxygen demand

bp Boiling point

BP Back projection

B/P Blueprint

BPA Biological Photographic Association

BPMA British Photographic Manufacturers Association

BPS British Photogrammetry Society; Bits per second

BS British Standard

BSI British Standards Institution

BTL Behind-the-lens

B$_v$ Light value (APEX)

B-W Black-and-white

BACK FOCAL DISTANCE The distance between the vertex of the rearmost surface of a lens and the focal plane when the lens is focused on infinity. This distance may be greater or less than the focal length, depending on the form of construction of the lens, e.g., it is significantly less or more for telephoto and retrofocus designs, respectively. Its value determines whether the lens can be used in a reflex camera design. *S. Ray*

Syn.: *Back focus.*

BACK FOCAL LENGTH The focal length as measured from the rear nodal or principal point with light passing from the front of the lens to the back. Residual aberrations or different media in the object and image spaces may cause this to differ from the front focal length. The unqualified term *focal length* normally refers to the back (or rear) focal length. *S. Ray*

BACKGROUND The area behind the main subject as viewed from the camera position or in a photograph, as distinct from the foreground. The total area around a subject, including the background and the foreground, is sometimes referred to as the surround, or in visual perception contexts as the ground, to distinguish this area from the area of interest, which is identified as the figure. Backgrounds are not an essential element of all photographs. In a photograph of a flat textured surface, for example, the entire content of the picture may be the subject and there is no background. In some ambiguous pictures, such as Rubin's drawing that can be perceived either as a vase or as two facing profiles, the background and the figure can trade places in the mind of the viewer with no physical change in the picture.

Even though backgrounds in photographs are of lesser interest to the viewer than the subjects, they are an important element in the composition and they greatly influence the total effect. In picture-making situations where the photographer has no control over the arrangement of objects, control over the background may be limited to choice of the camera position, use of depth of field to alter the sharpness of the background, and waiting for different lighting conditions, or modifying the lighting.

In a studio, the photographer has unlimited control through the choice, positioning, and lighting of the background. Plain backgrounds that do not attract attention are appropriate for some subjects. The choice of a specific background is commonly based on selecting a tone or color that harmonizes with the theme of the picture and that provides appropriate separation from the subject. Separate lighting of the background provides the photographer with even more control, including the introduction of some variation of tone to emphasize a certain area or to produce a more pleasing effect.

The idea of using backgrounds of painted landscapes and interiors to enliven portraits was patented by Antoine Claudet in 1841, only two years after the introduction of the daguerreotype process. Over the years photographers have used a variety of techniques for modifying or changing backgrounds in photographs including applying opaque on the negative to obtain a white background, airbrushing the print, and substituting a different background with pasteup, combination printing, stripping, and other procedures. Professional motion pictures have long used special techniques such as projected backgrounds, optical printing with traveling mattes, and painted glass shots to change backgrounds, and computer programs now provide even greater flexibility and ease in changing backgrounds in video and still-photography images. *L. Stroebel*

See also: *Figure-ground.*

BACKGROUND LIGHT A light pointed at the background for the purpose of producing a halo of light around the subject and providing tonal separation from the background. *F. Hunter and P. Fuqua*

BACKGROUND NOISE The acoustical noise present on a location or set without the presence of the production.
T. Holman

BACKING-UP In the event of a system failure, a backup operating system and backup files are used to restart the system. Backing-up generally refers to making copies of the startup software (operating system) and important applications and data files.
R. Kraus

BACK LIGHTING Lighting by a source behind the subject, as distinct from front lighting, side lighting, etc. Back lighting may produce a light fringe or halo on the subject to define the subject against a darker background or cast a shadow of the subject on the foreground. By itself, back lighting places most of the subject in shadow. It is usually used with additional lighting, possibly of low intensity, as in the case of light reflected to the subject by other surfaces in the environment.
F. Hunter and P. Fuqua
See also: *Contre jour.*

BACK PORCH In video recording, a brief blackout period between the horizontal sync pulse and the start of picture data. This blackout period is considered to be blacker than black. The setting allows for the distinction between a picture signal that is black and the black resulting from no signal.
R. Kraus

BACK PROJECTION The process of projecting an image on a translucent surface for the purpose of viewing or photographing that projected image from the opposite side.
M. Teres
See also: *Rear projection.*

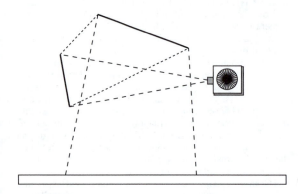

Back projection.

BAFFLE An interior surface designed to obstruct or redirect the passage of light or sound. Examples in photography are the interior blackened ridges of a lens barrel that reduce flare, or an interchangeable interior lining for a lightbank to change the light quality. A bellows unit acts as a light baffle and reduces flare in a view camera, in a collapsible-lens camera, and in an adjustable bellows lens hood.
R. Jegerings

BAG BELLOWS A soft, flexible light seal used to connect the front and back standards on modular-type view cameras when conventional bellows could bind and interfere with focusing and other camera movements.
P. Schranz

BAIRD, JOHN LOGIE (1888–1946) Scottish inventor. Demonstrated the first operating television system (January 1926) by reflecting light from an image onto a photoelectric cell. In 1929, the BBC began experimental transmissions. Within ten years, Zworykin's all-electronic system supplanted Baird's mechanical system.
M. Alinder

BALANCE (1) Physical, psychological, and visual illusions of equilibrium. A compositional factor involving an analogy between distribution of psychological weights in photographs and physical weights on a beam at varying distances from the fulcrum. (2) An instrument used for weighing.
R. Welsh

BALANCE, LABORATORY A device for accurately determining the mass (roughly, weight) of a small amount of substance, for example, a chemical used in making a solution for photographic processing.
H. Todd

BALANCE STRIPE A second stripe of magnetic or other coating on motion-picture film added to the edge opposite the principal sound-recording stripe to prevent uneven winding of the film.
M. Scott

BALDESSARI, JOHN (1931–) Printmaker, photographer, and teacher. Influential contemporary artist whose prints combine photographs, often appropriated, with other media. His subject matter comes from everyday life. Taught for nearly 20 years at California Institute of the Arts.
Books: van Bruggen, Coosje, *John Baldessari*. New York: Rizzoli, 1990.
M. Alinder

BALDUS, EDOUARD-DENIS (1815–1882) French photographer. An architectural photographer, he recorded historic monuments for the French government, commencing in 1851, including a complete documentation of the new wing of the Louvre in over 1500 detail photographs (1854), and several presentation albums handsomely presenting new French railroad lines (1855). Used both calotype and collodion processes. Founding member of Société Héliographique (1851).
M. Alinder

BALL-AND-SOCKET A type of tripod head that when unlocked allows the camera to be tilted or rotated in any direction.
L. Stroebel

BALLAST An electrical device placed in series with an arc lamp or a gaseous-discharge lamp to limit the current through the lamp. An indicator or an autotransformer is commonly used as a ballast for fluorescent, sodium vapor, and mercury vapor lamps.
W. Klein
See also: *Lamps.*

BALLISTIC PHOTOGRAPHY Photographic study of projectiles. Where these move at speeds in the region of 15,000 m.p.h., photography may provide the only means of

Bag bellows on a view camera.

investigating their characteristics in flight. These include velocity, aerodynamics—shape, behavior and shock wave generation—and behavior on impact.

The first ballistic photographs (E. Mach, 1885–86) recorded moving bullets and shells in silhouette against the light of an electric spark.

The result was not a photograph in the generally accepted sense of the word (i.e., formed by a lens) but a record of the shadow of the projectile on the sensitized material. The short duration of the spark and its relatively great distance from the projectile and the sensitized material, combined to give a sharp image.

A similar technique is used today for the same purpose except that an electronic flash tube takes the place of the old open spark between metal electrodes. Photographs made in this way show the projectile as a sharp-edged black silhouette and may also show the pressure waves set up in the air by the passage of the projectile—(like the bow wave of a ship). This phenomenon, known as the schlieren (German for streaks) effect, is caused by the change in the refractive index of the air along the pressure wave and the consequent distortion of the rays of light before they reach the sensitized material. The number, shape, and disposition of the waves provide an indication of the air resistance and stability of the projectile and so are important in designing for range and accuracy.

A high speed camera can record the projectile throughout its travel across the field of view. If the distance traveled across the field is known, this is represented by the width of the film frame; while the time of travel is indicated by the length of film on which the projectile's image appears, providing camera running speed has been accurately measured. So projectile velocity is equivalent to frame width divided by length of film. If ultra-short framing exposures are used, they will "freeze" the projectile's image, showing any erratic behavior in flight.

The main requirement is therefore for good temporal and spatial resolution rather than pictoral accuracy, and for frame-by-frame analysis instead of *slow-motion* moving pictures. Still cameras, when used, generally have special ultra-fast shuttering devices or simple capping shutters for open flash work with short duration and stroboscopic flash. High-speed framing cameras and streak cameras are used more often, the former operating at rates between a few thousand and several million frames per second. The streak instruments may have writing speeds of over 250 feet per second.

For long-range missiles, widely spaced groups of cine theodolites record azimuth and elevation, so that the missiles' positions can be plotted by triangulation. More accurate still are Schmidt multiple-exposure plate cameras, from which the position is deduced by reference to star images.

Conventional projectiles can be followed in much the same way by fast framing cameras covering fixed fields across the estimated trajectory. Flare or tracer indicators assist visibility, and fiducial marks in the cameras, and marker boards sited in the field of view, provide positional references. In this application, the ribbon frame camera, taking long narrow pictures across a 5 ⌐-in.-wide film, can cover a large section of the trajectory at once.

For closer work, velocity may typically be measured by a streak camera. This is aimed across the line of fire, with the optical slit parallel to the trajectory. The projectile is therefore recorded as a streak slanting across the film. Again, distance traveled is measured across the film and time along its length.

The streak camera can also give a pictorial image for aerodynamic study. For this it is mounted with the slit perpendicular to the trajectory and with the film moving in the same direction as the projectile's image. Having found the velocity, the film speed past the slit can be adjusted to match the cal-

culated image speed, resulting in a still picture of the projectile by virtually orthodox moving film photography.

The same principle is applied in a multiple shadowgraph system, in which the projectile is fired through a tube having vertical slits at measured intervals along its length. Collimated light is projected on each slit through ports on the opposite side of the tube. From the slits, optical relays of equal length lead to a single streak camera, recording side-by-side images from the slits as the projectile passes each one. The distance apart between any two images along the film represents the time of flight between the corresponding slits, and hence the velocity.

A shell's behavior on impact—say, with a sheet of armor plate—would normally be studied with a framing camera, photographing the sheet edge-on. Since the entire event might take less than a millisecond, electronic flash is the usual illuminant. It can be triggered by the shell piercing a metal foil or gauze screen in front of the armor plate and making an electrical contact between them.

Other forms of illumination for ballistic photography, apart from conventional sources, include spark gaps, argon bombs and rare gas discharge tubes. Complex circuitry is needed to ensure a square-wave output of constant intensity and, where necessary, rapid stroboscopic repetition. Where the flash duration determines exposure time, sparks can give exposures down to 1/1,000,000 second, while 1/100,000,000 second has been achieved with discharges through rare gases.

Ballistic Photography. Photographing shells and bullets. *Top,* To measure the speed of a missile, a moving film camera is set up so that the image moves along a slit in front of the film while the latter travels across the slit. A, film. B, slit. C, lens. D, shell. *Center,* The resultant picture is a curved smear F, equivalent to the time of travel through the distance E. The mean slope of this smear is also equivalent to the speed. *Bottom,* For a sharp picture of the shell in flight, the image must move across the slit in front of the film, while the latter advances in step with the image. 1, 2, and 3 are projections of the shell progressively recorded in the same relative positions on the film, building up a continuous and sharp picture.

Synchronization, both of the camera with the projectile and of the projectile with the flash, must be exact. Cameras need time to accelerate to high speeds, and electronic timing and frame-counting circuits may be required to program starting the camera, opening the shutter, firing the gun, and triggering the flash. The projectile itself can also initiate events, as already described, by connecting foil screens, cutting light beams, or breaking wire circuits.

Since time is measured in distance along the film, it is usual to flash timing marks on the rebate, through an optical relay from an electronic timer. This compensates for any irregular running of the camera mechanism. *P. Meadway*

BALLISTIC VIDEOGRAPHY

Ballistic synchro photography is based on the principle of synchronizing the rate of movement of an image of a projectile with the rate of film movement or the rate of sweep across static film. This produces a single detailed picture of the projectile as it passes across the line of sight of the camera lens. The analysis and measurement of a single ballistic synchro photograph will provide quantitative information on flight aspect (yaw), spin rate, sabot separation, and velocity. The same record will also show the condition of the projectile and any damage that has occurred.

Immediate access to ballistic instrumentation data is always desired in iterative development tests or in failure analysis of burst fired projectiles. The availability of gated intensified video cameras has provided a capability for shoot-look-shoot testing with near real time results and minimum delay between test firings.

A gated intensified video camera is a solid-state charge-injection device (CID) type chip camera with an image intensifier tube between the lens and the imaging chip. Light from the object of interest is imaged by the lens onto the photocathode of the intensifier. The intensifier amplifies the light and forms an image on its output phosphor screen. This image is transferred to the active area of the CID chip for normal video display. The intensifier can be gated (turned on) for very short intervals and acts as a shutter. Effective exposure times can be as short as 50 nanoseconds (nsec.). Recording asynchronous events is accomplished by inhibiting destructive readout of the image in the CID until the intensifier has been gated.

A typical use of this camera might be to image the attitude and position of a projectile immediately after leaving the gun muzzle. Assume that this projectile is small caliber, spin stabilized, with a velocity of 1000 m/sec and rapid-fired at a rate of 1000 rounds/min in groups of 50 or more.

Traditional instrumentation would include a 35-mm ballistic film camera with 135 meters of film running at 75 m/sec, providing a usable image size of 1.5 mm. However, this film velocity will provide an effective run time of just 1 sec during which only 16 of the 50 rounds will be recorded.

Ballistic videography. Block diagram of gated intensified CID camera.

High speed film and high intensity lighting would be required to compensate for the short exposure time. The film camera would need to be reloaded after each burst, and data on any particular burst firing would not be available until the roll of film is processed, which could be as little as a few hours or, more likely, a few days.

Using a gated intensified video camera offers a cost-effective method for instrumentation of burst fired ballistic events that have a low statistical probability of occurrence. The image of each projectile is available in real time, exposures as short as 0.5 microsecond (μsec.) can be attained with only 150 W of incandescent lighting, the data are stored on videotape, which is available for immediate review, and hard copy prints can be produced in a timely manner. *W. Shipman*

BALTERMANTS, DIMITRI

(1908–1990) Soviet photographer. Self-taught, he became a photojournalist for *Izvestia* in 1939. Admired for his coverage of the Russian front during the Second World War, including the widely published *Grief at Kerch*, grief stricken, babushkaed women searching a field scattered with the bodies of dead civilians massacred by the Nazis. After the war, joined the staff of *Ogoniok* as a photojournalist and later, senior editor.

M. Alinder

BANDPASS FILTER (SOUND)

An electrical filter designed to pass only a certain range of frequencies, while suppressing signals at frequencies outside the range. Bandpass filters are often adjustable as to frequency, and may be composed of a combination of a high-pass filter, and a low-pass filter. An example of the use of a bandpass filter is in limiting the frequency range of a speech recording to a narrow band to simulate speech heard over a telephone.

T. Holman

See also: *High-pass filter; Low-pass filter.*

BANDSTOP FILTER (SOUND)

An electrical filter designed to pass only frequencies lying outside a defined range; both lower and higher frequencies are passed, while ones lying within the range of the filter are suppressed. A bandstop filter is usually used to suppress unwanted noise that lies only in one frequency region. It is similar to a notch filter, but has a broader frequency range of suppression than does a notch filter. *T. Holman*

See also: *Notch filter (sound).*

BAND STRUCTURE

Especially as related to electrons, the energy levels at which an electron can exist in a substance are called bands; the arrangements of these bands is the band structure. The highest band is called the conduction band and has an energy level of zero. An electron in the conduction band can travel freely within the substance, but cannot leave the substance without acquiring some positive energy. Lower bands are typically called valence bands, although the structure can get somewhat complicated, resulting in a variety of designations. Electrons in the lower bands possess negative energy, and are localized within the substance to varying degrees, but not necessarily to one atom. *J. Holm*

See also: *Latent image.*

BANDWIDTH

(1) *See Filter bandwidth.* (2) The frequency range, usually slated from low to high frequency, over which a system has a stated uniform frequency response. Usually, if left unstated, the bandwidth is the frequency range over which the output does not fall more than 3 dB from its midrange value, thus, a specification like "bandwidth from 30 Hz to 20 kHz" probably means ±3 dB from 30 Hz to 20 kHz. Clearly, it is far better when both the frequency range and the response tolerances over the range are given. *T. Holman*

See also: *Frequency response.*

BARE-BULB Bare-bulb lighting refers to the use of a photographic light source without a reflector, typically a flashlamp or an electronic-flash tube. Some on-camera electronic flash units use an optional plug-in bare tube or an interchangeable head. Such electronic flash tubes are protected by clear covers.

The 360-degree lighting angle of a bare bulb can be used for various lighting effects. When used away from reflecting surfaces, or near light-absorbing surfaces, the lighting is effectively that of a point-source; when used inside a light tent or soft box, or placed in front of a white reflector, specular point-source and large-source effects are combined, producing sharp but illuminated shadows. Bulbs and flash tubes should not be used for bare-bulb lighting unless doing so is recommended by equipment manufacturers because of the risk of breakage and burns. *R. Jegerings*

Bare-bulb lighting with an electronic flash tube: (A) away from reflecting surfaces for a point-source lighting effect; (B) in front of a white reflecting flat; and (C) in a lighting tent for a combination of specular and diffused lighting.

BARIUM SULFATE A white, heavy, odorless powder ($BaSO_4$, molecular weight 233.40) that is insoluble in water, alcohol, or dilute acids. A suspension in a gelatin solution can be spread to form a thin, smooth layer (baryta) on photographic paper, producing a surface suitable for coating with a photographic emulsion and for whitening and brightening that layer. *G. Haist*

BARNACK, OSKAR (1879–1936) German designer of the first successful 35-mm camera, the Leica. After first working for Zeiss, joined the firm of Ernst Leitz in 1911 as director of the experimental department. In 1914 produced the Leica prototype, a small roll-film camera using 35-mm motion-picture film. Delayed by First World War, the first Leicas were manufactured in 1924. *M. Alinder*

BARNDOORS Opaque flaps attached to the edges of a light and used to control light spread, for shading effects in the set, and to keep flare-causing light from entering the camera. Two, with one on each side, or four with additional top and bottom flaps, are typically used. The flaps are hinged and blackened so the light spread can be continuously restricted. An open-faced fixture may cast a double-edged shadow, one from the lamp and a less-distinct one from the reflector. *R. Jegerings*

See also: *Gobo; Flag.*

Barndoors shield the background and camera from spill light.

BARNEY A padded jacket fitted to motion-picture cameras to dampen their sound when there is danger of camera noise being recorded on the sound track. Heated barneys might also be used when filming under extremely cold conditions. *H. Lester*

BAROMETRIC PRESSURE/BAROMETER The pressure exerted by the atmosphere as a result of its own weight. Barometric pressure varies with weather conditions (and in fact is an important indicator for weather forecasters) and altitude. Barometric pressure is most commonly measured using a device called a barometer, which uses air pressure to raise a column of mercury. The most common unit of barometric pressure is the *torr*, where 1 torr corresponds to the amount of pressure exerted by a column of mercury 1 millimeter high. Normal atmospheric pressure at sea level is approximately 760 torr, or 15 pounds per square inch (the amount of pressure exerted by a column of mercury 760 millimeters high). Another unit of pressure is the bar, where 1 *bar* is equivalent to 760 torr. One *millibar* is 0.001 bar, or 0.76 torr. The amount of water vapor that air can hold depends on the barometric pressure and the temperature of the air. *J. Holm*

BARREL DISTORTION See *Distortion.*

BAR SHEET A time chart used in the planning of animated motion pictures, showing the frame-by-frame occurrence of words, music, and sound effects, as recorded on the sound track. *H. Lester*

BARYTA COATING A white coating on most fiber-base (non-resin-coated) printing papers under the emulsion to impart smoothness to the image. It is a suspension of barium sulfate in gelatin. Dyes and fluorescent brighteners are often added for a greater appearance of whiteness. *M. Scott*

BASE In photography, the support on which a light-sensitive emulsion is coated, e.g., the flexible plastic of films, the resin-coated or fiber base of printing papers, and the glass or rigid plastic of plates.

In chemistry, a base is an oxide or hydroxide of a metal or metalloid that can combine with acids to form salts. Bases that are soluble in water are alkalis. *M. Scott*

See also: *Support.*

BASE/BASIC See *Alkali.*

BAS-RELIEF A special raised effect obtained by making a contact positive transparency from a negative, binding the two together slightly out of register, and printing from the combination. *R. Zakia*

BATHOCHROMIC SHIFT Movement of an absorption band to longer wavelengths. *R. W. G. Hunt*

BATTERY Technically, a battery is an assemblage of two or more electric cells, although a single cell is now commonly called a battery. Cells are frequently connected in series to increase the available voltage. An automobile battery consisting of six 2-volt cells connected in series has an output voltage equal to the sum of the cell voltages, or 12 volts. The output current capability of several (identical) cells connected in parallel is equal to the sum of the current rating of the cells. When current is drawn from a battery, the voltage measured at the terminals of a battery decreases. The drop in voltage is proportional to the current drawn because of a voltage drop across the internal resistance of the battery. With continued usage, the voltage (even without current flowing) will decrease because of the deterioration of the chemicals that generate the electromotive force. The two broad categories of batteries are primary batteries and secondary batteries. Primary batteries cannot be recharged and must be replaced when their voltage drops below a minimum working value. Secondary batteries can be recharged from an external power supply when they run down. Because some batteries may leak electrolyte, it is good practice to remove batteries from equipment whenever the equipment is not to be used for a couple of months.

The quality and diversity of portable batteries available to the public have vastly improved in recent years. These advances have been in response to the increased popularity of transistorized electronic products, including photographic equipment. The uses of batteries in cameras include providing power for energizing the motors that advance film and automatically focus the camera, firing expendable flash bulbs or electronic flash units, and operating the automatic exposure control mechanism. In video camcorders and electronic still cameras batteries provide power for a multitude of electronic circuits.

Energy density is the energy stored in a fully charged battery and is typically measured in watt-hours per unit weight. Shelf life is the length of time a battery can be stored without an appreciable loss in service life. *W. Klein*

BATTERY CAPACITOR (BC) A power supply consisting of a battery and a capacitor used to fire flash bulbs. The battery charges the capacitor to the full battery voltage, typically from 15 to 30 volts, at a rate limited by the internal resistance of the battery or by a current-limiting resistor. When the shutter contacts close, the charged capacitor rapidly discharges through the low-resistance lamp. The advantage of this method is that it will reliably fire flash bulbs even when the battery is weak. *W. Klein*

Battery. Comparison of Cells/Batteries

System	Carbon–zinc (Leclanche)	Carbon–zinc (heavy duty)	Alkaline	Silver Oxide	Lithium	Nickel Cadmium
Chemistry						
Anode	Zn	Zn	Zn (powered)	Zn	Li	Cd
Cathode	MnO_2	Mno_2	MnO_2	Ag_2O	MnO_2	$Ni(OH)_3$
Electrolyte	NH_4Cl and $ZnCl_2$	$ZnCl_2$	KOH	KOH or NaOH	$LiSO_2$ with organic solvent	KOH
Rechargeable?	No	No	No	No	No	Yes
Cell voltage	1.5 V	1.5 V	1.5 V	1.5 V	3.0 V	1.25 V
Energy density	Low	Low	Moderate	High	High	High
Shelf life	Fair	Fair	Good	Excellent	Excellent	Good
Cost	Lowest	Low	Moderate	High	High	High
Special characteristics	Lowest cost	Designed for heavier output current	High energy and current capacity	Maintains a constant voltage	10-year shelf life; leakproof	Rechargeable; leakproof
Best suited for	Intermittent uses such as flashlights	General use performance better than regular zinc–carbon	Continuous heavy drain loads such as motor drives	Constant voltage applications; portable light meters, cameras, etc.	Still camera electronics, TV remote controllers, smoke detectors	Power packs for electronic flash, video cameras; portable tools
Limitations	Low energy density; prone to leak	Performance lower than alkaline batteries; prone to leak	More costly than zinc–carbon	Available in a limited number of sizes	Available in limited number of sizes	Does not retain its charge as well as nonchargeable batteries do

BAUD In the transmission of data, a unit of measurement of transmission. *R. Kraus*

BAUD RATE The speed of data transmission, usually equivalent to bits per second. Most data transmission protocols support 300, 1200, 2400 to 9600 baud rates over standard telephone lines. Dedicated local area network lines can support baud rates at and about 19,200 baud. The higher the baud rate, the more data can be transmitted in the same time. A gray-scale, low-resolution image would transmit in approximately 2.2 minutes at 19,200 baud as compared to a transmission time of approximately 34.2 minutes at 1200 baud. *R. Kraus*

BAUHAUS The Bauhaus was an academic institution of design and art in Germany from 1919 to 1933. It was founded by Walter Gropius at Weimer, but moved to Dessau in 1925. The university curriculum stressed the importance of combining design needs with aesthetic concerns. Classes were taught in architecture, industrial design, theater design, book design, and photography. Craftsmanship was combined with mass production and the most current information of science and industry. This innovative curriculum was created and taught by Gropius, Mies van der Rohe, Paul Klee, Lyonel Feininger, Wassily Kandinsky, Laszlo Moholy-Nagy, Herbert Bayer, and Lucia Moholy-Nagy. The Bauhaus was closed down by the Nazis in 1933 for the ideological reason that it did not represent the then acceptable political correctness. Laszlo Moholy-Nagy opened the New Bauhaus in Chicago in 1937. *R. Malone*

BAYARD, HIPPOLYTE (1801–1887) French photographer and inventor. In early 1839, spurred on by reports of Daguerre's achievement of positive images, but with little additional information, Bayard produced the first positive images directly in the camera. His independent discovery, almost simultaneous to the very dissimilar processes of Daguerre and Talbot, yielded unique paper photographs. Bayard intentionally created his photographs as art, often expressive in content. Thirty of his prints were the first publicly exhibited photographs on June 24, 1839, in Paris, hung amidst work by Rembrandt and Canaletto. Bayard did not reveal the directions for his process until 1840, to find a public already infatuated with the daguerreotype, made public in August 1839. Bayard's discovery was ignored. Founding member of the Société Héliographique (1851), and was for 15 years (1866–1881) the Honorary Secretary of the Société Française de Photographie.

Books: Jammes, Andre, and Janis, Eugenia Parry, *The Art of the French Calotype*. Princeton: Princeton University Press, 1983. *M. Alinder*

BAYONET MOUNT A system for connecting and disconnecting interchangeable lenses or lens accessories from a camera body. Each lens or accessory has a flange device that fits into a matching flange on the camera body. With only a partial rotation, the lens locks into place. The release of a locking pin and a partial turn removes the lens quickly. *P. Schranz*

Syn.: *K-mount.*

BAZOOKA An adjustable monopod equipped with a pan-tilt head. *L. Stroebel*

BEADED SCREEN A white projection surface covered with small glass balls. The beaded screen is best when it is used in a long and narrow auditorium or in a room with high levels of ambient light that cannot be eliminated. Since most of the light striking the glass beads of the screen is reflected back toward the source, the image, within a limited angle of

view, is very bright. For best viewing results with a beaded screen, the audience should be within a 20° or 30° angle to each side of the projector. This type of projection screen is not very efficient for multiple projector shows, especially if the projectors are spread out across the back of a room. Those people seated closer to one of the projectors will see the image from that projector several times brighter than an image from another projector positioned on the other side of the room. *M. Teres*

BEAM CANDLEPOWER SECOND (BCPS) A unit of on-axis light output of an electronic-flash tube in a specific reflector. BCPS numbers can be converted to flash guide numbers by calculating:
$$\text{GN(feet)} = 0.25 \times \sqrt{S \times B}$$
$$\text{GN(meters)} = 0.075 \times \sqrt{S \times B}$$
where GN is the guide number, S is ISO film speed, B is beam candlepower-second. Because professional electronic-flash heads can be fitted with different reflectors, watt-second and joule provide only a single rating number for a given power pack or electronic-flash unit. *R. Jegerings*

See also: *Effective candlepower second; Guide number; Joule; Watt-second.*

BEAM SPLITTER

PRINCIPALS A beam splitter is an optical device that divides incident light or radiation into two or more portions, usually of unequal percentages, and which may be further differentiated by wavelength band. Selected bands may be preferentially transmitted or reflected. Among the most complex arrangements are the beam splitter blocks used for multi-tube or chip video color cameras. The two types of beam division are simultaneous and tandem.

VARIETIES A simple beam splitter can be an uncoated flat glass surface, where the natural surface reflection of some 4% may be adequate. For example, a thin glass plate at a 45-degree inclination in front of a camera lens can provide sufficient reflected light for techniques of cavity photography or other techniques requiring axial illumination.

A plate beam splitter has a partially silvered coating to give the desired transmission:reflection (T:R) ratio, such as 50:50 or 75:25. A common use is to divert light to an exposure measurement system or to a viewfinder system. In an illumination system, the infrared (heat) component of incident radiation may be reflected or transmitted.

An alternative to partial silvering is to use a perforated mirror made by photofabrication techniques; the pattern of holes or slits in the mirror allows various forms of sampling or *weighting* of the image-forming beam for exposure determination. More importantly, the polarization properties of the transmitted beam are unchanged. Strip mirror systems are used in autofocus cameras and also for varieties of stereoscopic projection.

The plate beam splitter gives two asymmetric beams, as one is reflected and the other transmitted and refracted. Aberrations may occur in an image-forming system. Symmetrical

Bayonet mount. The part on the left is attached to the lens and the part on the right is attached to the camera body.

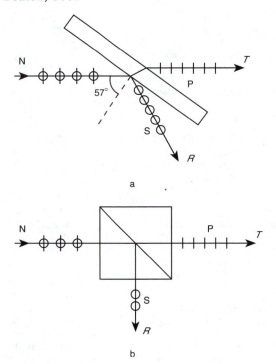

Beam splitter. Polarizing beam splitters: (a) plate type; (b) cube type.

beams are given by either the cube beam splitter or the pellicle beam splitter. The former uses a coating cemented between two 45° prisms to form a cube, and the incident, natural collimated light is split into two orthogonal linearly polarized beams. Metalized glass beam splitters have the disadvantage of considerable light absorption of the transmitted beam, but thin films of bismuth oxide or zinc sulfide operating by interference have almost zero absorption and are preferred. Such prismatic beam splitters are usually of small dimensions for camera use, and the incident light must be collimated (parallel) to avoid introducing aberrations, so are used between lens elements.

The pellicle type uses a very thin membrane of nitrocellulose, typically 5-7 μm thick, with a suitable coating of say zinc sulfide, stretched on a former. The pellicle has virtually no effect on image-forming properties. Replacing the conventional reflex mirror in a camera by a pellicle type allows higher framing rate with a motor drive or a reduced time delay before actuation of the shutter when the release is pressed.

Another form of beam splitter is a mechanical system such as an oscillating or rotating mirror shutter design used in cine cameras that gives alternate transmission (or blocking) and reflection. All the light transmitted by the lens is received either by the film or deflected into the viewfinder system, where further division can take place by a cube beam splitter for sampling for exposure measurement. *S. Ray*

BEATON, CECIL (1904–1980) British photographer and theatrical designer. Began photography as a child, though formally studied the theater. Became a contributor of photographs, illustrations, and articles to *Vogue* (1927), a relationship that continued much of his life and expanded to include fashion photography. In 1929, was the only British photographer included at the important German exhibition, *Film und Photo*. Established himself as a stylish portrait photographer of the glamorous, posing his subjects against decorative settings to great effect. Designed the costumes

and scenery for many important productions, including *My Fair Lady*, both for stage and screen.

Books: Mellor, David, ed., *Cecil Beaton*. Boston: Little, Brown, 1986. *M. Alinder*

BEAT (SOUND) In music, the beat is the underlying meter or rhythm. In sound in general, however, it has an additional meaning. Whenever tones of two or more frequencies are passed through a device exhibiting nonlinear distortion, new tones will be created at new frequencies corresponding to sums and differences of the form $f2+f1$, $f2-f1$, $2f2-f1$, $f2-2f1$, etc., out to higher orders. These new tones are called *beat tones*. *T. Holman*

See also: *Distortion (sound)*

BECHER, BERND (1931–) and **HILLA** (1934–) German photographers. Began their collaborative work in 1959 and married in 1961. The Bechers photograph buildings as typologies, such as hundreds of water towers, often arranged in groupings of multiple prints to form one photographic piece.

Books: *Water Towers*. Cambridge, MA: MIT Press, 1988; *Blast Furnaces*. Cambridge, MA: MIT Press, 1990. *M. Alinder*

BECQUEREL, ALEXANDRE-EDMOND (1820–1891) French physicist. Discovered in 1839 the photogalvanic effect, upon which a century later the first photoelectric light meters were based. Demonstrated in 1840 that an underexposed daguerreotype plate could be intensified by diffused supplementary exposure under red glass (the Becquerel effect). Acknowledged as a founding father of color photography. Achieved natural color images on daguerreotype plates in 1848, though after years of experimentation he was never able to make them permanent. *M. Alinder*

BEERS DEVELOPER Two developers, one containing Metol, the other hydroquinone, were formulated by Roland F. Beers to provide contrast control for the development of photographic prints. A progressive but limited range of contrasts can be obtained by varying the amount of the Metol and hydroquinone solutions with additional water. *G. Haist*

BEERS' LAW The spectral absorption of a substance is proportional to the concentration of the absorbing material in that substance and to the path length through the material. Changes in concentration can thus be offset by changes in path length. Beer's law holds at low and moderate concentrations of nonscattering solutions. It holds only approximately in other cases, especially if the absorbed energy causes a chemical change in the material. *J. Pelz*

BEHIND-THE-LENS (BTL) Behind-the-lens, also known as through-the-lens (TTL), refers to the positioning of exposure meters that are built into many single-lens reflex (SLR) cameras. By positioning the meter behind the lens inside the camera, readings automatically take into account changes in lens focal length, bellows extensions, filters, and other factors that might affect exposure but which might be overlooked when using a separate hand-held light meter. *J. Johnson*

See also: *Cameras, single-lens-reflex; Through-the-Lens.*

BELLOWS A flexible cloth or plastic enclosure, usually corrugated, that forms a light-tight tunnel between the lens standard and the rear standard of a view camera, and between the lens and the film on some other cameras. Its design allows for camera movements such as swing, tilt, rise, fall, and shift. Bellows are used in photomacrography to increase the lens-to-film distance for closeup work. Bellows are also

Bellows.

used on professional lens hoods, allowing for the change of coverage of different focal length lenses.

P. Schranz

See also: *Focusing hoods; Camera types, view camera.*

BELLOWS EXTENSION The distance from the lens to the film plane. Usually refers to a specific situation or the maximum distance that a camera's bellows can be extended because of limits of the bellows, the bed, or the focusing mechanism. If the bellows is extended beyond the focal length of the lens, an increase in exposure should be made to compensate for the decrease in image illuminance at the film plane.

J. Johnson

See also: *Closeup photography, exposure determination; Photomacrography.*

BENCH See *Optical bench.*

BENHAM'S DISK A circular disk having a segmented black-and-white pattern. When the disk is rotated, as on a turntable, it is seen as having color. The time-spaced pulses of black-and-white upset the color signaling system of the retina.

L. Stroebel and R. Zakia

See also: *Optical illusions; Subjective colors; Visual perception, accuracy of visual perceptions.*

BENZENE A clear, colorless, volatile, highly flammable liquid (C_6H_6, molecular weight 78.11) that has some solubility in water but is miscible with acetone, alcohol, carbon tetrachloride, chloroform, ether, and glacial acetic acid. Used as a solvent for oils, waxes, and resins and in the manufacture of lacquers and varnishes.

G. Haist

BENZOTRIAZOLE A white crystalline solid ($C_6H_5N_3$, molecular weight 119.13) with slight solubility in water but greater solubility in alkaline solutions. Used as an organic antifoggant to decrease nonimage development by reacting with silver ions, forming silver compounds that are less developable than silver halides of the emulsion. Image tone may be shifted toward a colder tone.

G. Haist

BERNHARD, RUTH (1905–) American photographer and teacher. In 1930, learned photography and became a successful advertising photographer in New York. Met Edward Weston (1935) and moved to California, opening a portrait studio. Known for her unusual, glowing use of light upon the nude female body and upon common objects, from Life Savers to teapots. A resident of San Francisco for many years, she has taught thousands of students through workshops worldwide.

Books: *The Eternal Body.* Carmel: Photography West Graphics, 1986.

M. Alinder

BEST BOY The chief electrician on a motion-picture set.

H. Lester

BETA PARTICLE (β) An electron moving through a vacuum or some substance but which is not contained in the band structure of the substance (the electron is not trapped in the band structure of the substance, but rather has some positive energy and momentum). The energy of beta particles is typically expressed in terms of electron volts.

J. Holm

BETWEEN-THE-LENS SHUTTER A leaf shutter located next to the iris diaphragm and between the lens elements of a compound lens. At this location, the shutter is placed where the light beam is narrowest, thus increasing shutter efficiency and increasing the synchronization speeds available for electronic flash.

P. Schranz

See also: *Focal plane shutter; Leaf shutter; Shutter; Shutter efficiency.*

BEZOLD-BRUCKE PHENOMENON A change in perceived hue as a function of intensity. Red-wavelength light shifts towards yellow and green-wavelength light shifts towards blue as the intensity of the light increases.

L. Stroebel and R. Zakia

See also: *Color; Psychophysics.*

BIAS (SOUND) To use bias is to add an inaudible dc or ac signal to a desired audio signal in order to overcome nonlinearities of amplification or the medium. In the case of amplifiers, bias is, for example, the dc idle current that is present in the circuit in the absence of a signal. Here the bias serves to place the particular stage of the audio amplifier at an operating point where it can most accommodate the range of signals expected. Ultrasonic ac bias is used in analog tape recording to linearize the tape medium, which would otherwise be highly distorted. Bias in this case is an ultrasonic sine wave signal supplied by a bias oscillator that is simply added brute force to the audio signal, usually after the last stage of amplification and before application to the record head. The bias frequency is usually from 100 kHz upwards in professional machines.

T. Holman

BIAS TRAP An electrical circuit arranged to prevent ultrasonic bias in analog tape machines from interfering with the performance of preceding audio stages. Since ultrasonic bias is often added to an audio signal by simply connecting the output of the bias oscillator and the output of the audio amplifier together, one would short out the other were it not for a frequency selective network placed between the two that has a low impedance for audio frequencies but becomes a high impedance at the bias frequency. Bias traps often contain adjustable elements in order that they be precisely tuned to the bias frequency.

T. Holman

BICHROMATE POISONING Painful rash or small ulcers wherever human skin has been subjected to prolonged exposure to potassium bichromate. It can be easily avoided by the use of rubber gloves.

J. Natal

BICHROMATE PROCESS Bichromate is the usual name for chromium salts of potassium, ammonium, or sodium of the Cr_2O_7 group, which are also called dichromates. Their light-hardening effect in association with organic colloids such as gum, glue, albumen, and gelatin in exploited in a number of photographic and photomechanical processes.

J. Natal

See also: *Gum bichromate printing process; Carbon process; Pigment process.*

BICONCAVE Term applied to a simple, one element lens, indicating that both of its faces curve inward toward the center, so that the lens is thinner at the center than at the edges.

S. Ray

BICONVEX Term applied to a simple, one element lens, indicating that both of its faces curve outward away from the center, so that the lens is thicker at the center than at the edges. *S. Ray*

BILATERAL (SOUND) A term applied to analog variable-area optical sound tracks to describe a sound track that is symmetrical and mirror-imaged about its centerline. The advantage of a bilateral sound track is that its use helps to cancel out variations in output level and the accompanying distortion occurring due to nonuniform illumination across the sound track area. *T. Holman*

Bilateral. *Left,* bilateral monaural optical sound track on a release print. *Right,* dual-bilateral stereo variable area optical sound track on a release print.

BINARY A number system based on exponents to the base 2. Thus with only two symbols, such as 1 and 0 (in electronic circuitry, *on* or *off*), any numerical quantity can be represented. Example: The number 105 can be written 1101001 (on, on, off, on, off, off, on).

A)2^7 2^6 2^5 2^4 2^3 2^2 2^1 2^0

B)128 64 32 16 8 4 2 1

C) 1 1 0 1 0 0 1

Legend
A) Exponents to the base 2 from right to left continue beyond 2^7.
B) The numbers associated with the exponents to the base 2. Each number doubles, all numbers are even except for the number 1.
C) The *symbols* 1 and 0 in binary notation are indicators, *not* numbers. The symbol 1 in binary code means to add the number indicated; a 1 under 64 means to add 64. A 0 under 16 means to not add 16. It is an on-off code. The number 105 in binary code (1101001) is arrived at in the following "game-like" manner:

1. The goal is to find a *set* of numbers that will add up to 105.
2. By inspection, the largest number closest to 105 is 64. Begin with 64. (1 - - - - - -)
3. The next largest number that can be added to 64 is 32, (64 + 32 = 96). (1 1 - - - - -)
4. The next to be added, without exceeding 105, is 8, (96 + 8 = 104). (1 1 0 1 - - -)
5. Now add the number 1 to 104, and the result is 105. (1 1 0 1 0 0 1)
6. The set of numbers, therefore, that add up to 105 are: 64 + 32 + 0 + 8 + 0 + 0 + 1 = 105. In binary form, the symbols 1 1 0 1 0 0 1 (1101001).

Shown as a vertical array:

Exponent	Factor	Binary	On-Off	Sum
2^6	64	1	on	64
2^5	32	1	on	32
2^4	16	0	off	0
2^3	8	1	on	8
2^2	4	0	off	0
2^1	2	0	off	0
2^0	1	1	on	1
				105 total

The same number in the *decimal* system, based on exponents to the base 10, would be:

....................10^3	10^2	10^1	10^0
................1000	100	10	1
	1	0	5

In the decimal system the *symbol* 105 is also the number 105, the sum of (1) hundred, (0) tens, and (5) ones. *R. Zakia*
See also: *Appendix F and G.*

BINDER A group of chemicals that, when combined with magnetic oxide, form a complete magnetic coating for film and tape. The binder has multiple purposes, including long-term binding of the oxide to the base, lubrication to prevent friction at tape and film heads and guides, and reduction of the electrical resistivity of the oxide to prevent the buildup of static electricity, which can discharge at heads and cause crackling noises. *T. Holman*

BINOCULAR DISPARITY The slight difference between the two retinal images when an object is viewed with both eyes due to the difference in position of the two eyes. Without it there would be no stereoscopic depth perception. *L. Stroebel and R. Zakia*
See also: *Binocular fusion; Perspective, stereophotography; Stereopsis; Vision, binocular vision.*

BINOCULAR FUSION The combining of the two images formed by the eyes so that a single image is seen rather than two separate images. *L. Stroebel and R. Zakia*
See also: *Binocular disparity; Perspective, stereophotography; Stereopsis; Vision, binocular vision.*

BINOCULAR VISION See *Vision, binocular vision.*

BIOGRAPHIES Approximately 200 biographies of individuals, listed alphabetically, are included in this encyclopedia. Criteria for inclusion were stringent and the selection limited to those with the greatest influence and importance in the development of photography, from Schulze's discovery of the light sensitivity of silver compounds in 1725 to masters of the twentieth century photography, such as Lange, DeCarava, and Salgardo. Recognition is given scientists who have significantly advanced technical aspects of the medium, to artists whose unique visions have been recognized through books, criticism, museum exhibitions, and awards, and to historians and curators who have shaped the way we see and understand the photographic image.

The task of selection was necessarily exclusionary, and many persons of importance could not be included because of length restrictions. Judgment of historical figures was based on writings of the past, with reevaluation made in light of current scholarship. Care is taken to consult a wide variety of international sources to obtain a considered and balanced view. Key contributions can be obscured by the passage of time or the blinders of prejudice. Effort was made to identify

and include individuals without regard to gender or race. Twenty-five of the biographies are of women. Preference was given to photographers whose work will endure, rather than those successful in the world of commerce. *M. Alinder*

See also: *History, advances in photographical technology.*

BIOLOGICAL CONTAMINANTS

Many living organisms theoretically can cause harm to photographs, among them some common household pests. The only dangerous biological contaminants are fungi and other microorganisms that may feed on the gelatin present in the image layer of contemporary photographs. More likely to be encountered in tropical climates than in moderate zones, mold growth is capable of destroying an image irreversibly. *K. B. Hendriks*

See also: *Conservation, image permanence.*

BIOLOGICAL PHOTOGRAPHY

The broad category of biological photography includes the photographic recording of all things that live or that have lived. Thus, botanical, medical, veterinary, zoological, and other similar photographic subspecialties are all branches of biological photography. In practice, biological photography is perceived to be limited to the photography of those things studied by a biologist. Even with this limitation, the range of subjects and techniques used is likely to exceed any of the above listed subspecialties.

When photographs are made for scientific documentation, the image must present the features of a subject without exaggeration, enhancement, distortion, deliberate obliteration or the addition of details that might lead to misinterpretation by the technical observer. Frequently, an artistic license is exercised and the subject is highlighted, placed in artificial surroundings, and even electronically manipulated to enhance the visual impact for display and publication in public distribution channels. This manipulation is acceptable as long as it does not lead to erroneous conclusions by the viewing public.

In their search for meaningful photographs, biological photographers may have to photograph subjects as small as a submicroscopic specimen that requires the use of an electron microscope, or scuba dive to photograph the life cycle of whales. In pursuit of their assignments, photographers could be required to endure the discomforts of the desert, the cold of the arctic, or the solitude of an adventurer to obtain the decisive image.

Biological photographers must be well versed in the general field of biology, develop a comprehensive knowledge of their client's specialty, and have a genuine interest in scientific investigation as well as an essential knowledge of photographic principles. As photographers acquire experience and reputation, their clients may invite them to assume the role of a scientific investigator, too, an occupation enjoyed and prized by many photographers.

In general, the photographic equipment is portable, with emphasis on the single-lens reflex (SLR) camera system using an extensive variety of lenses and accessories. When an assignment requires large film formats or specialized equipment, the gear is frequently rented for the specific project. The principal recording medium is conventional silver halide film, although with the advent of electronic imaging cameras and the ability to manipulate the image during postproduction stages, magnetic media may well become the preferred technology in the future. In anticipation of the increased use of electronic imaging, the biological photographer should acquire the basic knowledge of computers and electronic-imaging technology.

It is very likely that biological photographers will increasingly conduct their business in their homes. In effect, many professional biological photographers become entrepreneurs and freelance their talent to the multitude of scientific journals and periodicals.

Numerous biological photographs are made by nonprofessional photographers. Investigators of scientific phenomena, researchers, educators, and laboratory workers who need to document their findings commonly resort to making their own photographic records. Because the field is so encompassing and the photographic technology requirements so varied, it is common for them to solicit the advice and services of medical photographers, and, consequently, many have become well versed in scientific photography. All classes of bioscientist, and particularly those that have literary talents, have become notable for their photographs and stories in the popular press. Many of these articles can be found in *National Geographic, Scientific American, Smithsonian,* and other periodicals.

Education and training in biological photography is available at the School of Photographic Arts and Sciences at the Rochester Institute of Technology, which offers a broad range of photographic programs. Information on workshop courses, regional conferences, publications, and certification programs in biological photography can be obtained from The Biological Photographic Association. *J.P. Vetter*

See also: *Biomedical photography; Medical photography; Organizations, photographic; Photographic education.*

BIOLUMINESCENCE

The production of light by a living organism (not using any device), such as the light produced by a firefly. The light is usually produced by chemical means. *J. Holm*

See also: *Chemiluminescence.*

BIOMEDICAL PHOTOGRAPHY

Biomedical photography is essentially the same as medical photography. The prefix *bio* is commonly attached to the term *medical photography* to indicate that the field includes all biological subjects but with an emphasis on the field of medicine, as opposed to *medical photography,* which is perceived to be limited to human and veterinary subjects in the field of medicine. *J.P. Vetter*

See also: *Biological photography; Medical photography.*

BIPACK

Combination of two films, formerly used in motion-picture photography, placed emulsion-to-emulsion and exposed as one. The two are sensitized differently to yield color separation negatives. *M. Scott*

BIPARTITE FIELD PHOTOMETER

A class of visual photometers in which the reference and test fields are placed in close proximity and viewed concurrently. While absolute brightness judgments are impossible, this class of photometers takes advantage of the visual system's sensitivity to differences in brightness (i.e., contrast). In most cases the field is circular and subtends approximately 2 degrees to ensure foveal vision. The most common designs are vertical or horizontal midline divisions and the disc-annulus.

Bipartite field. The visual fields in bipartite field photometers place the unknown and reference fields side by side. Shown are a vertical-midline field, *left,* and a disc-annulus field, *right.*

Bipartite field photometers are capable of providing very accurate measurements if the reference and test fields have the same spectral content. Accuracy and repeatability of measurements fall quickly when the colors of the two fields differ because hue and saturation differences are confounded with luminance differences in the visual system. When it is necessary to make such heterochromatic measurements, visual techniques such as flicker photometry or physical measurements should be used. *J. Pelz*

See also: *Flicker photometer; Heterochromatic photometry; Photometer; Photometry and light units; Visual photometer.*

BIPOLAR JUNCTION TRANSISTOR (BJT)

A three-terminal semiconductor device capable of amplifying current. It is also capable of amplifying voltage when used in a circuit with resistors. Bipolar junction transistors are available in two types—NPN and PNP. Each type transistor consists of two junctions between three layers of semiconductor material. N refers to *n*-type semiconductor; P to *p*-type semiconductor. The three terminals are emitter, base, and collector. Typically, a small current flowing from base to emitter of an NPN transistor will cause a hundred times that amount of current to flow from the collector to the emitter. *W. Klein*

See also: *Semiconductor; Field-effect transistor.*

BIPRISM Combination of two prisms cemented together. A common example is two similar right-angled triangular prisms with hypoteneuse faces in contact. The contact face may be cemented or partially silvered, in the latter case acting as a beam splitter. *S. Ray*

BIRD'S EYE VIEW Representing an object or a scene from a high vantage point, which creates an illusion of looking down on the object or action from a considerable distance. The spectator has the sensation of viewing the scene or action from "on high." Developed as a "cosmological eye view" or "God's eye view" in late renaissance painting. *R. Welsh*

BIREFRINGENCE Property of certain transparent anisotropic crystals whereby an incident beam of natural (unpolarized) light is split by double refraction into two forms of rays, termed the *ordinary* which travel at a fixed velocity related to their wavelength, and the *extraordinary,* which travel with a velocity that varies with direction. The two rays are plane polarized orthogonally to each other. In positive crystals the extraordinary ray travels slower than the ordinary ray and faster in negative crystals. Polarizing filters may be made by using crystals oriented in one direction to absorb one ray and the other emerges plane polarized. *S. Ray*

Syn.: *Double refraction.*

See also: *Filters, polarizing filters; Photo-elastic stress analysis; Quarter wave plate.*

BIT A contraction for binary digit. A bit is the smallest unit of data transfer. As a basic unit it represents an off (0) or on (1) state. In imaging, the more bits, the more tones that can be displayed in a digitized image. A 7-bit image can display 128 tones including black and white. A 3-bit image can only display a total of 8 tones. *R. Kraus*

BITMAP A pixel-by-pixel description of an image, where each pixel is a separate element. *L. Stroebel*

BIT PLANE The storage of graphical images including text as a graphical representation. The image is stored in random-access-memory (RAM) as a pattern of bits in the sequence in which they are scanned (rastered), thus representing the image. *R. Kraus*

BLACK Name given to colors that are very dark and exhibit little or no hue. *R. W. G. Hunt*

BLACK-AND-WHITE (B&W) (b-w) Designation for a photograph, material, or process in which the resulting image contains only tones of gray. Toned prints are commonly included to distinguish them from color prints made on color paper. *Monochrome* would be a better term for toned prints, and perhaps for all black-and-white images. *M. Scott*

BLACKBODY A hypothetical object that absorbs completely all incident radiation and is a perfect emitter of radiation because of incandescence. An approximation to a blackbody can be constructed by making a small hole in a hollow sphere with a blackened interior. Virtually all of the light entering the sphere will be absorbed, so that the only light leaving the sphere will be a result of the incandescence of the interior surfaces of the sphere. An object that is the only source of light in a room with neutral (preferably black) walls will also approximate a blackbody.

The distribution of wavelengths of radiation put out by any incandescent source can be specified in terms of the temperature at which a blackbody emits radiation with the same wavelength distribution. If this temperature is expressed using the Kelvin scale it is called the color temperature. As the color temperature of a source increases, the amount of radiation output by the source increases and the balance of the wavelength distribution of the radiation shifts towards shorter wavelengths.

In reality, absolutely perfect blackbody sources do not exist. This is because gases and other materials between the source and the observer absorb some of the wavelengths emitted. Chemical reactions occurring in the source can also produce line emissions. Also, some amount of light is usually incident on, and therefore reflected by, the incandescent material (although this amount is frequently negligible). In spite of these qualifications, a number of sources do approximate a blackbody sufficiently well to allow the concept of color temperature to be quite useful in photography. Tungsten sources are the most common example.

An interesting side note is that the distribution of wavelengths of radiation emitted by a blackbody is what led Max Planck and others to develop the quantum theory of electromagnetic radiation. The nature of the distribution could not be explained without assuming that the radiation was emitted in small packets called quanta. *J. Holm*

See also: *Color temperature; Quantum theory.*

BLACKBODY LOCUS The arc on a CIE chromaticity diagram made by plotting the locations of blackbody sources at various color temperatures. Since the CIE chromaticity diagram is based on blackbody sources, this arc will pass through the center of the diagram at a color temperature value equivalent to that of the source used for the diagram. The colors of all blackbody sources will fall on this arc when they are plotted on the diagram. *J. Holm*

BLACK LEVEL In setting a video camera to record at an optimal level, the camera recording system should be set so that the black level is 7.5 IEEE units above the no-signal level. This will ensure that black will image well within the contrast range of the system and will be distinguishable from no signal. *R. Kraus*

BLACK LIGHT A colloquial term for ultraviolet radiation, particularly when used to excite visible fluorescence in materials not illuminated by other sources. Black light is typically produced by using a mercury vapor lamp and filtering out the visible emission lines, leaving only the ultraviolet emission lines. *J. Holm*

BLACKNESS Attribute of a visual sensation according to which an area appears to contain more or less black content.
R. W. G. Hunt

See also: *Natural color system.*

BLACK OUT To apply opaque pigment or other opaque material to selected areas on a negative (such as the background) to eliminate unwanted detail in the print. A similar effect can be obtained by carefully applying white opaque pigment to the print.
R. Zakia

BLACK PRINTER A fourth separation added to cyan, magenta, and yellow to extend the range of tone reproduction in four-color process printing.
M. Bruno

See also: *Photomechanical and electronic reproduction, color separation.*

BLACKSCREEN A specially woven, nonfibrillated, ultra thin fabric that is tightly stretched over a frame and placed 1Ω inches in front of a conventional background projection screen. The blackscreen filters out enough of the undesirable studio lighting to prevent screen washout and reduced screen image contrast. Unfortunately, blackscreen absorbs light so that the equivalent of two stops of background exposure is lost. Either longer exposure times, a larger aperture or a brighter projector lamp is necessary to compensate for the loss of light when using a blackscreen.
M. Teres

BLACK-SUN EFFECT See *Photographic effects, solarization.*

BLACK TRACK PRINT A motion-picture prerelease print format with picture elements generally complete but

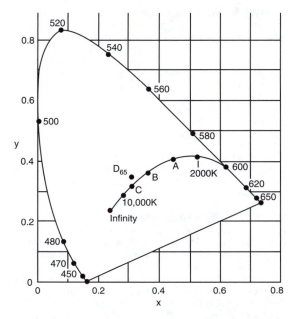

Blackbody locus. CIE chromaticity diagram and blackbody locus. The numerical values on the rim of the diagram correspond to the dominant wavelengths, or the color of spectrally pure light at those wavelengths. The arc penetrating the center of the diagram is the blackbody locus; all blackbody-type sources are located on it. Standard sources A, B, and C are marked as well as sources with color temperatures of 2000 K, 10,000 K, and infinity. The D65 source is slightly off the locus because of atmospheric absorption.

with only printed black in the optical sound track area. The black-track procedure is often used for early answer prints before an optical sound track is available.
T. Holman

BLANQUART-EVRARD, LOUIS-DÉSIRÉ (1802–1872) French photographic publisher, inventor, and photographer. Invented albumen paper (1850). Pioneered archival processing of photographs. Founded at Lille one of the first photographic printing and publishing firms (1851). Blanquart-Evrard's technique of developing out prints, instead of the slow business of printing them out, speeded up the mass production of prints for sale, and enabled the publication of a large number of books and albums illustrated with original photographs. Photographs became commonly available during the 1850s largely due to his efforts.

Books: Jammes, Andre, and Janis, Eugenia Parry, *The Art of French Calotype,* Princeton: Princeton University Press, 1983.
M. Alinder

BLEACH A chemical or solution of chemicals used to convert image silver into a soluble or insoluble silver compound. Bleaching compounds are also used to remove unwanted dyes in some reversal color processes. Bleach chemicals are often combined with silver-solubilizing agents, such as sodium thiosulfate, to form photographic reducers or bleach-fix solutions. Potassium ferricyanide has been widely used for bleaching silver images.
G. Haist

BLEACHOUT PROCESS Process for making hand drawings by going over a photograph with waterproof ink or a graphite pencil, then bleaching away the photographic image to leave the drawing. A pale image is easier to remove. Bleach may be prepared from 0.25 ounces each of flake iodine and potassium iodide dissolved in 5 ounces of water. The print is immersed in this solution until the image disappears. A yellow or brown discoloration may remain. The paper is then rinsed in running water and then fixed in acid or plain hypo.

Line drawings for reproduction that closely resemble photographs can be produced by drawing over a blueprint made from a photographic negative. When the composite image is photographed with blue-sensitive film (or through a blue filter) the blue drops out.
H. Wallach

BLEED A term used by photographers and graphic artists to define an image that runs to the edge of the picture or page without any borders. (1) The edges of the surface act as borders incorporated into the structure. (2) To run a continuous-tone or halftone image off the edge of the paper or support without a border. (3) To spread beyond an original or desired position, resulting in a loss of definition of an image, especially line and dye images. (4) In motion picture photography, an unwanted image produced when a traveling matte has insufficient density to prevent exposure in the masked areas.
R. Welsh

BLEEDING A loss of image definition due to a spreading of the image-forming material, such as dye or ink, beyond the original or desired position.
L. Stroebel

BLEED-THROUGH A defect in photomechanical reproduction in which an image printed on one side of a sheet of paper or other material can be detected on the other side.
L. Stroebel

BLEMISHES Blemishes in photographs are defects, marks, or flaws that are visible and detract from the value of an image. They may be quite small and sometimes become apparent only after magnification or enlargement, but they could be relatively large. They may originate in the subject

photographed, such as pimples or scars. Or they may occur in the photographic process and consist of spots, hairs, dirt, scratches, bubbles, deformations, or other imperfections. Some blemishes are latent and become visible only after a period of time. *I. Current*

BLENDING DISTANCE A method of measuring the graininess of a photographic image by viewing it from gradually increasing distances until the graininess is no longer apparent. *L. Stroebel*

See also: *Blending magnification.*

BLENDING MAGNIFICATION A method of measuring the graininess of photographic images by viewing a series of enlarged images in the order of gradually decreasing magnification, from a specified fixed distance, until the graininess is no longer apparent. *L. Stroebel*

See also: *Blending distance.*

BLIMP A soundproof camera housing that prevents the noise of motion-picture camera mechanisms from interfering with sound recording. Self-blimped or noiseless cameras do not require external blimping since their normal housing effectively eliminates camera noise. *H. Lester*

BLIND SPOT A small, insensitive area on the retina where the optic nerve leaves the retina of the eye.
L. Stroebel and R. Zakia

See also: *Retina; Vision, the human eye.*

BLISTERS Blisters occur when processing fluids or gases are entrapped between the emulsion and the base of photographic materials, or within the base of photographic papers. When gas is evolved, such as when an acid fixer or stop bath reacts with carbonate from the developer to form carbon dioxide, it can be trapped between the emulsion and base causing them to separate and form blisters. These blisters sometimes break leaving a clear spot on the negative or print. Small blisters in film may escape detection until an enlargement is made. High processing temperatures, wide variations in temperature from one bath to another, and sometimes transfer from solutions having high pH to those having low pH without adequate rinses should be avoided to minimize these problems.

A similar reaction can cause gas to form a blister within a paper base in which water may accumulate. This defect may also be aggravated by or caused by excessive agitation and kinking during washing. Modern paper making and sizing techniques have virtually eliminated this problem. *I. Current*

BLIX A commonly used term to describe a combined *ble*aching and fi*x*ing bath for the oxidation and solubilization of a silver image. This is a proprietary term, however, so these solutions are often called bleach-fixing baths. *G. Haist*

BLOCH'S LAW The threshold response to a visual stimulus is a product of the intensity of the light stimulus and the exposure time. Within certain limits, time and intensity are reciprocal. *L. Stroebel and R. Zakia*

See also: *Bunsen–Roscoe Reciprocity Law.*

BLOCK DYES In subtractive processes, a set of hypothetical dyes, each of which absorbs uniformly in only one-third of the spectrum. These dyes usually absorb either from about 580 nm to the red end of the spectrum (the cyan block dye), or from about 490 to about 580 nm (the magenta block dye), or from the violet end of the spectrum to about 490 nm (the yellow block dye). The uniformity of the absorptions means that pairs of block dyes provide stable primaries that are equivalent to a set of additive primaries

with an associated set of color-matching functions. By absorbing in only one-third of the spectrum, each block dye has no unwanted absorptions. *R. W. G. Hunt*

See also: *Color photography; Unstable primaries; Unwanted absorptions.*

BLOCKED UP Identifying highlight image areas that have considerably less than normal detail or local contrast, commonly caused by excessively high overall contrast.
L. Stroebel

BLOCK TRANSFER In computers, the movement of data in a group formation to achieve speed in the transfer. Often a preferred method for moving images from storage to the display monitor, this allows for rapid updating of the image as it is electronically edited. *R. Kraus*

BLOOP (1) An opaque, oblique line painted across an optical sound track to obscure a splice or defect. Also, the tone recorded and the light photographed, for synchronizing picture and sound, with some automatic slating systems. (2) In production sound recording, the term *bloop* is a shortened form of bloop slate. The bloop slate consists of a push button and light connected to an electronic oscillator supplied in portable tape machines to indicate synchronization points between picture and sound.

It is most often used in documentary film production, where the use of the traditional clap board slate may be intrusive to the subject.

In optical sound recording, the term *bloop* refers to making the sound track either transparent or opaque as called for on a negative or positive recording in order to prevent hearing a transient noise, like a click or a pop, particularly at splices. *H. Lester and T. Holman*

BLOW UP To make an enlarged photograph. *L. Stroebel*

BLOWUP An enlarged photograph. *L. Stroebel*

BLUE (1) One of the four visually unique hues, sometimes referred to as psychological primaries, the others being yellow (to which blue is opponent), red, and green. A hue that corresponds to the 400–500 nm wavelength region of the spectrum. (2) Name sometimes given to the red-absorbing (cyan) colorant used in a subtractive process, particularly in the past in the printing industry, where it is also known as *process blue*. *R. W. G. Hunt*

See also: *Unique hue, cyan.*

BLUEPRINT Print made by the ferro-prussiate process. It gives a white image on a blue ground. Sir John Herschel invented the process in 1842 and named it cyanotype. *J. Natal*

See also: *Cyanotype.*

BLUE-SCREEN PROCESS A motion-picture process for combining separate foreground and background images during printing. The foreground objects, for example, actors, are photographed in front of a bright blue background on a negative color film. Positive and negative opaque masks (traveling mattes) made from the color negative are used to protect the print from exposure in the foreground area while the background is being exposed, and vice versa. *R. Zakia*

See also: *Chromakey.*

BLUE-SENSITIVE Specifying photographic emulsions having only their natural sensitivity to blue and ultra-violet radiation, as distinguished from orthochromatic and panchromatic emulsions. *M. Scott*

Syn.: *Color-blind.*

See also: *Color-blind materials.*

BLUE TONERS Toning processes that produce a blue image on black-and-white prints. One of the most common, though less stable, consists of converting the silver image to *prussian blue* ferric ferrocyanide. A more stable and less brilliant blue-gold tone is produced by toning a print made with a warm-tone chloride or chloro-bromide paper using a formula containing gold chloride. A blue dye tone can also be made by converting a black-and-white image to a mordant that then attracts and holds a dye from solution.
I. Current

BLUR Image unsharpness, such as that caused by inaccurate focusing or movement of the subject or the camera during exposure of the film. *L. Stroebel*

BLURRING In computers, the attenuation of high-frequency information in the image through the use of neighborhood averaging. The strength of the blur is determined by the size of the kernel. This technique may be used to remove patterned noise. *R. Kraus*
See also: *Low-pass filter.*

BOARD Generally, in the DOS world a board is a device that plugs into a bus slot to perform a specific task, such as accelerating graphics, driving the monitor, controlling hard and floppy disks, or digitizing video and sound. In the Macintosh world, boards are generally referred to as cards.
R. Kraus

BOARD (SOUND) See *Console (sound).*

BOLOMETER A thermal detector used to measure incident electromagnetic radiation at all wavelengths. Radiation is absorbed by a blackened metal strip or semiconductor whose resistance is a function of temperature. A sensitive circuit compares the resistance of the exposed strip to an identical strip shielded from the incident radiation, providing a measure of the incident radiation's power. Alternatively, a single detector is exposed periodically by a rotating sector shutter, allowing the incident irradiation to be calculated based on the varying signal. The time necessary to make a reading with a bolometer is long compared to instruments available to measure visible radiation. Response times for the bolometer are generally $\geq 1/100$ second, while some semiconductor detectors' response times are less than 1 microsecond. *J. Pelz*
See also: *Radiometry.*

BOOM A long arm that is commonly used in a horizontal position to hold a light source above a subject being photographed but outside the angle of view of the camera, usually supported by a vertical adjustable stand.
L. Stroebel

BOOM OPERATOR The user of a microphone boom, whose other duties often include operation of fishpoles, planting of hidden microphones on the set, and placement of radio microphones and their transmitters on actors. The boom operator often has a sophisticated job to do in balancing among the actors in order to get the best recording of each of them. *T. Holman*
See also: *Fishpole.*

BOOM (SOUND) A mechanical device for holding a microphone in the air, manipulating it in several dimensions by swinging the boom arm and rotating the microphone on the end of the boom. Booms are generally floor-standing, fairly heavy devices. Booms are preferred in fixed-set situations, but their size and weight make them more problematic

for productions shot on location, where the fishpole is more convenient. *T. Holman*
See also: *Fishpole.*

BOOT To *start up* a computer. If the computer is off, this is known as a cold boot. If the computer is on but not operating, a warm boot (restart) is performed. *R. Kraus*

BORDER EFFECT See *Photographic effects.*

BOTANICAL PHOTOGRAPHY Botanical photography ranges from satellite imaging of plant life of large areas of the earth to the photomicroscopy of small specimens. Images are made not only from the light of the visible spectrum but from ultraviolet and infrared radiation as well. Botanical photography is used to effectively communicate information about plants and their relationship to their environment; to record the life histories of individual plants and plant communities; to study the effects of natural diseases, pollution, and other stress factors; and to record plant morphology.

Botanical photography is practiced both in the laboratory and in the field. For maximum camera stability in the field, field equipment must include a sturdy tripod capable of functioning near ground level up to standing height levels or higher. Wide-angle lenses can be used to include more habitat, while longer focal lengths can record hard-to-reach locations or isolate the specimen from distracting surroundings. Lenses capable of 1:1 reproduction are often necessary, especially those in longer focal lengths to provide expanded lens-to-subject working distances, allowing room for reflectors and electronic flash units, and reducing the chance of damage to sensitive plant communities while photographing. For maximum detail, small lens apertures are often used along with fine grain black-and-white and color films. Camera angles that aim straight into the subject minimize distortion. Background reflectance in smaller scenes can be reduced using dark opaque materials, hand held or suspended by a frame. Insertion of black velvet or dark gray cloth or board behind the subject can totally isolate subjects from their natural yet distracting environs.

In the field, the botanical photographer must use ambient light for larger studies. Shooting in bright sunlight should be avoided whenever possible as most films are not capable of rendering significant detail in highlights and shadows in the same exposure. When subject size permits, highlight-to-shadow reflectance ratios can be reduced by use of electronic flash as fill light or by diffusing direct sunlight using semi-transparent plastic or cloth that does not cause a color shift on color film.

Often subjects are encountered in open shade where the light is diffused and less contrasty but can be expected to exceed the color temperature necessary for daylight balanced color films. While prints from color negatives can be color corrected within limits, color transparency materials will display a cool tone unless warming filters such as an 81B or 81C are used during exposure in situations requiring critical color balancing, as in photographing plant diseases with color transparency film. The botanical photographer may have to make test exposures through various warming filters and include an 18% gray card properly positioned to ensure color accuracy. (The gray card test exposure can include a ruler as well as the subject and exposure data. A second identical exposure can be made with only the subject in the photograph.)

Color accuracy is especially difficult when subjects are located in the dim light of deep woods. The green filtering of the forest canopy can be neutralized with magenta filtration (CC10M to CC20M). At smaller aperture settings, the resulting long exposures may require additional filtration and exposure compensations for reciprocity effects

noted by the film manufacturers, a point is reached during long exposures where it is not possible to offset color shifts due to reciprocity effects.

With smaller specimens, artificial light sources such as an electronic flash unit can overcome exposure problems encountered when using slow speed films at small apertures in dim light. While subject movement can be eliminated when using electronic flash, contrast can exceed that of direct sunlight unless the flash is effectively diffused using a diffusion hood or diffusion box placed over the flash or by directing the light through a neutral, semitransparent material placed near the specimen. Pleasing lighting results when the diffused light from the fill flash is one to two stops weaker than the main flash. Powerful flash units of variable output allow for the use of small aperture settings and adjustments in lighting when flat, textured, or transmitted lighting is desired.

Complete control of camera angles, subject positioning, background content and reflection, and lighting can be achieved in laboratory or studio conditions. A copy stand can be modified and used as a photographic platform for studio-quality lighting. Complete smaller specimens or sections of larger ones can be suspended or "floated" over backgrounds using glass and spacers. Lighting can be readily modified to be flat, textured, or transmitted through the subject. To avoid heat damage to fresh or preserved specimens, it is best to work with electronic flash and low intensity modeling lights. Cross-polarization of the light sources and camera lens will provide maximum reductions of surface reflections on the subject and from the glass floater. Some specimens too small for close-up lenses and too large for standard photomicroscopy techniques can be placed into the film gate of an enlarger and greatly magnified onto color film or paper placed at the enlarger base.

Even with the best of equipment and photographic conditions, the botanical photographer must rely on creativity, ingenuity, and experimentation to achieve the most effective images and to advance the field of botanical photography.

S. Diehl and V. Zaremba

BOUGUER–LAMBERT LAW
The fraction of the incident light absorbed by (and therefore the density of) a filter or other absorbing material is independent of the incident power and is directly proportional to the thickness of that material. The law predicts that densities of similarly colored filters are additive; for example, if three neutral density filters of $d = 0.1, 0.3,$ and $0.6,$ were used in series, the total density would equal the sum; $d = 1.0$. Note that it is the fraction of the light arriving at each filter that is absorbed; if 1 unit of light passed through a filter that absorbed half the incident light, a second identical filter would absorb half of the remaining light (i.e., one-quarter of the original value). If the materials do not have identical spectral transmission, the law is applied by adding the densities at each wavelength. The law does not hold if there are multiple reflections between filters or if the material scatters or fluoresces. *J. Pelz*

See also: *Lambert's laws.*

BOUGUER PHOTOMETER
The first reported photometer, designed in 1729 by Pierre Bouguer (1698–1758). It allows the operator to compare the luminous intensities of two sources, each illuminating a translucent paper window. The relative intensity of the unknown source was determined by adjusting the distance of a reference source to match the brightness in the two windows and applying the inverse square law. *J. Pelz*

See also: *Inverse square law; Photometry and light units; Visual photometer.*

BOUGUER'S LAW
See *Lambert's laws.*

BOUNCE LIGHTING
Illumination of the subject by directing light at a large reflective surface, rather than at the subject itself. Since the larger surface, not the smaller lamp, becomes the effective source, shadows are less sharply defined and highlights on highly reflective subjects are larger.

Matt white surfaces best achieve the intended effect of bounce lighting, but also greatly reduce the illuminance. Textured silver surfaces produce a more directional effect with less loss of light. *F. Hunter and P. Fuqua*

See also: *Diffusion.*

BOURKE-WHITE, MARGARET
(1904–1971) American photographer. Studied photography with Clarence White. Became first staff photographer for *Fortune* (1929), specializing in factories and machines. Hired as one of the original four staff photographers for *Life* (1933), where she produced the cover for its first issue in 1936, the Fort Peck Dam, Montana. In 1937, her photographs illustrated Erskine Caldwell's text in *You Have Seen Their Faces,* a gritty document of the American South during the Depression. During the Second World War, became the first woman appointed an official military photographer, courageously photographing from the German attack into Russia (1941) to the liberation of Buchenwald (1945). Continuing her work for *Life* into the 1950s, she documented the world, including India during and after Gandhi and the South African mines. Parkinson's disease slowly stole her strength so that during her last years she was unable to photograph.

Books: *Portrait of Myself.* New York: Simon & Schuster, 1963; Goldberg, Vicki, *Margaret Bourke-White.* Reading, MA: Addison-Wesley, 1987. *M. Alinder*

BOURNE, SAMUEL
(1834–1912) English photographer. Took up photography in the mid-1850s and in 1863 journeyed to India where he became partners with Charles Shepherd, who owned the oldest photographic firm in India. Bourne's photographs of India, especially the Himalayas, became celebrated examples of British expeditionary photography.

Books: Ollman, Arthur, *Samuel Bourne, Images of India.* Carmel, CA: The Friends of Photography, 1983. *M. Alinder*

BOX CAMERA
See *Camera types.*

BPS
Bits per second. See *Baud rate.*

BRADY, MATHEW B.
(1823–1896) American photographer. Opened a daguerreotype portrait studio in New York (1844), eventually followed by one in Washington and another in New York. In 1851 mastered the collodion wet plate process. Photographed many famous Americans, including numerous portraits of President Abraham Lincoln. In 1861 Brady obtained permission from northern government leaders to enter Civil War combat areas with his cameramen. Brady purchased negatives and hired photographers, the most important of whom were Alexander Gardner and Timothy O'Sullivan. All photographs were published under the Brady imprint, though few were made by Brady himself, who was busy with his portrait studios and hobbled by failing eyesight. The result is a stunning, broadly described, visual history of that war. The undertaking impoverished Brady, obliging him to sell his collection of 5000 negatives to the U.S. government. Brady died in a hospital's poor ward.

Books: Meredith, Roy, *Mathew Brady's Portrait of an Era.* New York: W.W. Norton, 1982; Horan, James D., *Historian with a Camera.* New York: Crown, 1955. *M. Alinder*

BRANDT, BILL
(1904–1983) British photographer. An assistant to Man Ray (1929), then became a freelance

photographer working on assignment for a wide variety of clients, including the magazines *Lilliput* and *Harper's Bazaar.* Photographed the sharply defined social castes in Britain during the 1930s, concentrating on the hard life of the working class. During the Second World War, produced strong images of a country struggling through the Blitz. After the war, left documentation to work in a surreal mode, often using a wide-angle lens and producing very high contrast, and sometimes grainy, black-and-white prints. His subjects included nude distortions, portraits of artists and writers, eerily atmospheric landscapes.

Books: *Shadow of Light.* New York: Da Capo, 1977; Haworth-Booth, Mark, and Mellor, David, *Bill Brandt: Behind the Camera.* Millerton, NY: Aperture, 1985. *M. Alinder*

BRASSAI (GYULA HALÀSZ) (1899–1984) French

photographer. Born in Hungary, Brassai, a journalist, arrived in Paris in 1924. In 1930, his friend Kertesz loaned him a hand-held camera to lifelong effect. Fascinated with Paris at night, he recorded life in its bars and streets, producing a body of photographs that speak strongly of a time and place. Commercial photographer for *Minotaure* (1933–1936) and *Harper's Bazaar* (1936–1965).

Books: *Paris at Night.* Paris: Arts et Metiers Graphiques, 1933; *The Secret Paris of the 30s.* New York: Pantheon, 1976. *M. Alinder*

BREAKDOWN Separating out from long rolls a set of
motion-picture sound or picture takes. *H. Lester*

BREATHING (1) Background or system noise levels
varying relative to the desired signal level in sound recording. (2) Repetitive variations in image sharpness caused by defective motion-picture cameras, printers, or projectors incorrectly moving film in and out of its proper plane. *H. Lester*

BREWSTER ANGLE The angle at which only the elec-
tric field component of light (or other radiation) parallel to a nonmetallic glossy surface is reflected by the surface. The Brewster angle is particularly important because light incident at that angle will be polarized upon reflection (the nonpolarized portion being transmitted or absorbed by the material). The Brewster angle is dependent on the index of refraction of the surface (and therefore to some extent on the wavelength of the incident light), but can be determined using the formula: $\phi = \tan^{-1}(n)$, where ϕ is the Brewster angle and n is the index of refraction of the reflecting material. This equation is known as Brewster's law after the man who discovered it empirically, Sir David Brewster, the inventor of the kaleidoscope. *J. Holm*

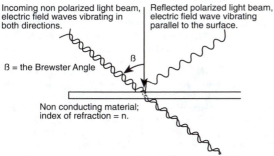

Incoming non polarized light beam, electric field waves vibrating in both directions.

Reflected polarized light beam, electric field wave vibrating parallel to the surface.

ß = the Brewster Angle

Non conducting material; index of refraction = n.

Transmitted partially polarized light beam (could also be absorbed or scattered by material).

Brewster angle. Light reflected at the Brewster angle.

BREWSTER, SIR DAVID (1781–1868) Scottish scien-
tist and educator. Studied optics, lenses, and polarized light. Invented the kaleidoscope (1816). Appointed principal of the United Colleges of St. Salvator and St. Leonard, St. Andrews (1838). Friend and advisor to Talbot, conducting an intense correspondence during the crucial years of Talbot's development of his photographic process, (1839–1843). Unhampered by Talbot's English patent restrictions, Brewster shared his knowledge of the Talbotype (calotype) with his countrymen where it enjoyed early and great popularity. Introduced D.O. Hill to R. Adamson (1843). Brewster's discoveries allowed for the first practical stereoscope (1851). *M. Alinder*

BREWSTER'S LAW See *Brewster angle.*

BRIGHT FIELD A style of glassware lighting in which
the edges of the glass object appear darker than the background. *F. Hunter and P. Fuqua*
See also: *Lightline.*

BRIGHT-FIELD ILLUMINATION In photomicrogra-
phy, an illumination system used with transparent subjects whereby the subject is back-illuminated to produce a silhouette effect. *R. Zakia*

BRIGHTNESS The visual experience that is approxi-
mately correlated with the luminance of objects seen as light sources. Since brightness is a psychological concept, there are no units of measurement as there are for luminance, a psychophysical concept. *L. Stroebel and R. Zakia*
See also: *Lightness; Photometry and light units; Visual perception, perception of lightness/brightness.*

BRIGHTNESS ADAPTATION A process by which a
person's visual perceptual system adjust to changes in levels of illumination. Sensitivity is increased at low levels of illumination and decreased at high levels. *L. Stroebel and R. Zakia*
See also: *Adaptation; Color adaptation; Vision, adaptation.*

BRIGHTNESS CONSTANCY A process whereby the
lightness of a surface is seen as remaining unchanged when viewed under different levels of illumination. A white blouse, for example, is seen as white indoors under low room illumination as well as outdoors in bright sunlight. Because brightness refers to surfaces that are perceived as sources of light rather than as reflecting surfaces, the term *lightness constancy* is preferred. *L. Stroebel and R. Zakia*
See also: *Brunswik ratio; Color constancy; Constancy; Lightness constancy.*

BRIGHTNESS RANGE (1) The visually perceived rela-
tionship between the lightest and darkest areas of a scene. (2) As commonly used by photographers, the ratio of luminances for the lightest and darkest areas of a scene. Preferably, *luminance ratio.* (3) A method of using a luminance (reflected-light) meter. Measurements are made of the darkest and lightest areas of interest and the calculator indicator is set midway between the two readings. *J. Johnson*

BRIGHTNESS RESOLUTION The luminance contrast
range that a pixel is capable of providing. The higher the resolution, the greater the number of gray levels or tones that are capable of being reproduced. This is also referred to as pixel depth or number of bits deep. *R. Kraus*
See also: *Bit.*

BRILLIANCE A quality attributed to an image that is seen
as having a large range of tones with strong gradation and

bright highlights. For example, projected images of transparencies viewed in a darkened room have more brilliance than reflection prints of the same image viewed with normal illumination. Various factors contribute to brilliance, including subject tones, lighting ratio and style, print density and contrast, paper stock tint, and surface sheen.

L. Stroebel and R. Zakia

See also: *Brightness; Contrast; Lightness.*

BRITISH KINEMATOGRAPH SOUND AND TELEVISION SOCIETY (BKSTS)
A British-based professional group with interests in film, video, sound, and television.

T. Holman

BRITISH STANDARDS INSTITUTION (BSI)
The national standardizing organization of the United Kingdom.

P. Adelstein

BRITTLENESS
Brittleness refers to the cracking that occurs in the surface of photographic materials when they are bent through a small radius. When it occurs, the problem is aggravated by low relative humidity, low temperature, or both. Under extreme conditions a film might be completely fractured. There is seldom a problem if temperature and humidity are maintained at satisfactory levels unless the angle of bending is extreme. In the past, humectants have been used as a final rinse after processing; however, modern thin emulsions are seldom, if ever, brittle.

I. Current

BRITTLENESS REDUCTION
The emulsion of a photograph or motion picture film can be fractured if bent backwards through a small radius. This was especially a problem with older materials under dry conditions, and in extreme cases the paper or film could be shattered. An effort to solve the problem was most often made by incorporating wax-like materials during manufacture of the material, by using a rinse containing a humectant (moistening agent such as glycerin) following its processing, or by maintaining the moisture content of the ambient atmosphere. Present-day materials made with thin emulsion coatings and effective additives have practically eliminated problems with brittleness.

Once the emulsion of a print has been cracked, it is practically impossible to restore the surface integrity. If a print has been rolled or has a severe curl, no attempt should be made to straighten it until it has been thoroughly soaked in water, rinsed in a humectant solution, and redried.

I. Current

BROAD LIGHTING
In portraiture, placing the main light on the same side of the subject as the subject's visible ear; the opposite of *narrow* or *short lighting*. The term is meaningful only when the subject does not face the camera directly but both sides of the face can be seen.

The term is also sometimes used to mean general, even illumination of a scene, as in lighting by a *broad light,* or simply a *broad.*

F. Hunter and P. Fuqua

See also: *Narrow lighting; Short lighting.*

BRODOVITCH, ALEXEY
(1898–1971). American graphic designer. Highly influential art director of *Harper's Bazaar* (1934–1958), encouraging the work of many of the world's best photographers through employment. Championed both Avedon and Penn. Responsible for a revolution in fashion photography by his directives to photographers to make visually bold, creative, and individualized images. Known for his aggressive design style that set standards still copied.

M. Alinder

BROMALOID PROCESS
A derivitive of the bromoil process that was commercially introduced in 1951 by G. L. Hawkins, based on the discoveries of Greenhall in 1908,

which combined the silver gelatin print and the pigment process.

J. Natal

BROMIDE PAPER
A high-speed photographic print material, more commonly called enlarging paper. The sensitive salts in the emulsion are mostly silver bromide with a small amount of silver iodide. Invented and first produced in 1873 by Peter Mawdsley.

M. Scott

BROMIDE STREAK
A region of lowered density in areas of a processed image adjacent to high-density areas. The cause is a flow of partially exhausted developer over the material during processing, in situations in which the agitation is inadequate. Bromide streaks were especially noticeable in earlier motion picture, and most especially in titles.

L. Stroebel and R. Zakia

Syn.: Bromide drag.
See also: *Photographic effects.*

BROMIDE-STREAK EFFECT
See *Photographic effects.*

BROMINE ACCEPTOR
Bromine is released during exposure of silver halide photographic materials. To inhibit the attack of bromine on the few atoms of silver of the latent image, bromine acceptors such as gelatin, sodium nitrite, and silver sulfide are present in the emulsion layer. Generally, the term *halogen acceptor* is used, as most photographic emulsions contain halogens other than bromide.

G. Haist

BROMOIL PROCESS
G.E.H. Rawlins introduced the oil process in 1904. He used potassium dichromate to sensitize paper coated with gelatin. Upon exposure, the solubility of the gelatin was reduced, permitting the unexposed areas to absorb more water than the exposed areas. When the matrix was inked with a roller or a brush, the greasy ink adhered to the dry shadows but was repelled by the water-swollen highlights. Transfer to a receiver sheet was introduced in 1911.

Bromoil, introduced in 1907, was a modification of the oil process devised by C. Welborne Piper and Edward J. Wall, Instead of having to make a contact print from a full print-sized negative, one could make an enlargement from a smaller negative on conventional matt-surface bromide paper. The paper was bleached while the gelatin hardened. The bleach, which turns the silver of the image to silver bromide, may include acetic or hydrochloric acid, copper sulfate, copper or sodium chloride, potassium bromide, and potassium dichromate.

Oil and bromoil afford many opportunities for control, manipulation, and personal expression. The inks may be thinned, concentrated, or mixed. The application of the ink can be done with many techniques. Multiple impressions may be made by re-inking the matrix with similar or different color inks. As a consequence of this latitude, and the painterly appearance that resulted, oil and bromoil had substantial followings among photographers who meant their work to be expressive rather than explicit.

H. Wallach

BROWN PRINT PROCESS
Named after the Flemish painter Anthony Van Dyck because of the similarity of the brown tones in his paintings to those produced by this process, the brown print, or Vandyke, process was devised in 1889 by H. Shawcross for plan copying. A negative sepia image was made from a positive master. Later, the process was applied to pictorial photography and the printing of images on fabric. The emulsion consists of ferric ammonium citrate, tartaric acid, and silver nitrate. Exposure is by contact in sunlight or artificial light, and development is in running water with potassium dichromate added to enhance contrast

when required. Fixing is in a weak solution of plain sodium thiosulfate. *H. Wallach*

Syn.: *Vandyke Process.*

BRUGUIERE, FRANCIS JOSEPH (1879–1945) American photographer. Influenced by Frank Eugene and Stieglitz, became a member of the Photo-Secession (1905). Acknowledged as one of the first photographers to conduct a sustained exploration of the making of abstract images using techniques such as multiple exposure and the Sabattier effect. Produced what he termed "light abstractions" in the mid-1920s, abstract photographs of the surfaces of cut paper as revealed by light.

Books: Enyeart, James, *Bruguiere.* New York: Knopf, 1977.
 M. Alinder

BRUNSWIK RATIO The proportional relation of a physical characteristic of an object, such as size, to the perceived characteristic. A ratio of one indicates complete agreement between the physical and perceived characteristic (perfect constancy). A ratio of zero indicates that perception is completely determined by the stimulus on the retina.
 L. Stroebel and R. Zakia

See also: *Constancy; Perspective.*

BRUSH In electronic imaging, the electronic equivalent of an artist's paintbrush, used to modify the color, shape, or size of a computer image. *L. Stroebel*

See also: *Paint.*

BRUSH DEVELOPMENT A technique for agitating processing solutions, recommended for tray processing of plates, in which a soft brush or cotton swab is moved across the surface of the emulsion. *L. Stroebel and R. Zakia*

See also: *Agitation.*

BUCKLE Buckle refers to the unequal shrinking in various areas of a negative or print. Shrinking may, for example, be greater at the edges of the sheet than at the center, or greater near the corners than midway between the corners. With film, this causes a ripple that prevents all areas of a negative from making contact with the paper when contact printed, or from being in focus in the print when enlarged. In some cases *cupping* more adequately describes the effect. This defect may appear only after months or years of storage and tends to be accelerated by poor storage conditions. Since there is a tendency for this to occur at the very edges of paper prints, the defect can be avoided by leaving a wide border around the exposed area until the print is dry, at which time the buckled edges are trimmed off.

The slight and uniform curling of films caused by the shrinking of the gelatin emulsion layers usually does not cause problems in printing but may create focus problems when projecting slides. *I. Current*

Buckle.

BUFFER (1) In computers, a temporary storage area designed to hold data to enhance the performance speed of a particular component of the system. For example, a video buffer enhances the display speed of the video monitor; a CD-ROM buffer enhances the speed of a CD-ROM player. (2) Changes in the alkalinity or acidity of a solution can be resisted over a small range by a buffer. A buffer consists of two chemicals: a mixture of a weak acid and a salt of a strong base combined with that acid, or a mixture of a weak base and a salt of a strong acid combined with that base. Such solutions of chemicals neutralize either an acid or a base. The combination of ammonia and ammonium chloride in water tends to maintain a pH around 9. A solution of acetic acid and sodium acetate resists changes in pH from 3.5. Buffer mixtures are often added to developing solutions to maintain developer activity. *R. Kraus and G. Haist*

BUG An error or malfunction in hardware or software that causes the computer to abort. The term results from the actual discovery of a moth in a Mark I computer's electronic relay. The removal of the moth gave rise to the term *debugging.* *R. Kraus*

BULB EXPOSURE The "B" setting on the shutter speed dial. When activated, the shutter remains open as long as the button is held down. The historical origin comes from a pneumatic shutter that was activated by the air pressure from a squeezable bulb. *P. Schranz*

BULK ERASER (SOUND) See *Degauss.*

BULLOCK, WYNN (1902–1975) American photographer and teacher. First studied photography (1938–1940) with Edward Kaminsky at the Art Center School, Los Angeles; also influenced by Edward Weston. Taught in many venues, most notably at San Francisco State (1945–1958). His photographs were central images in Steichen's exhibition and book, *The Family of Man.* Concerned with interpreting the psychological meaning of photographs and developing a language of photographic symbolism.

Books: *Wynn Bullock.* San Francisco: Scrimshaw Press, 1971.
 M. Alinder

BUMP EXPOSURE A brief exposure without the screen in halftone reproduction. It increases highlight contrast and drops out the dots in the white areas. *M. Bruno*

BUMP IN/OUT Instantaneous appearance or disappearance of a person or object during a motion-picture shot.
 H. Lester

BUNNELL, PETER C. (1937–) American teacher, curator, and historian. His studies included work with Minor White at Rochester Institute of Technology. Curator of photography, Museum of Modern Art, New York City (1966–1972). Since 1972, Bunnell is the McAlpin Professor of the History of Photography and Modern Art, Princeton University, where he has also been the director of The Art Museum and is currently its curator of photography. Author of many books and articles in the field, specializing in the life and work of Minor White, Clarence White, Edward Weston, and Alfred Stieglitz. *M. Alinder*

BUNSEN, ROBERT WILHELM (1811–1899) German professor of chemistry at Heidelberg University. In collaboration with English chemist Sir Henry E. Roscoe, provided many discoveries that established the field of photochemistry. Together discovered the Bunsen-Roscoe law, sometimes called the law of photochemical reciprocity. They also invented the grease-spot meter, one of the first devices

for the measurement of light, and introduced burning magnesium wire as artificial photographic lighting (1859). With R. Kirchhoff, Bunsen laid the foundations of spectrum analysis in 1860. *M. Alinder*

BUNSEN-ROSCOE RECIPROCITY LAW

The response of a radiation-sensitive substance is constant if the quantity of received radiation is fixed, regardless of the rate at which the energy is received by the sample. The law holds for the first stage of latent-image formation but not for the later stages. It holds also for x-ray and gamma-ray exposures with silver-halide emulsions and for some nonsilver-photographic materials exposed to light.

The result of the failure of the "law" is that for unusually short or long exposures times, adjustments from normal must be made in camera settings, and often in development time, in order to obtain a satisfactory image with conventional exposures of silver-halide materials. In part for this reason, the expression *reciprocity law failures,* or RLF, is being replaced by the term *reciprocity effects.*

Note that the equation $H = E \times t$ (exposure is the product of illuminance and time) is a definition of photographic exposure and not a statement of the reciprocity law.

 M. Leary and H. Todd

BURN IN

In darkroom work, refers to the giving of additional exposure to selected areas of an image, typically during the making of an enlargement. The opposite is *dodging,* which is holding back light, thereby reducing exposure in an area of an image. Burning in can be accomplished with a card with a small hole in it that allows additional light to project on the selected area. Care must be taken so that the basic exposure time for burning in an area is long enough so it can be carefully and precisely performed in such a way that the manipulation is not readily apparent in the final print. *J. Johnson*

See also: *Dodge.*

BURN-IN TITLES

In motion-picture photography, a type of lettering or animation effect produced by double exposing the film, either in the camera or in an optical printer. A similar technique can be used in titling slides. *R. Zakia*

BUS

(1) An electrical interconnection among many points, so called since it can be viewed like a bus line, with stops (connections) along its way. Signal buses include main ones, often called mixdown buses; ones intended to send to a multitrack tape recorder, called multitrack buses; and ones to send signals from input channels to outboard devices, called auxiliary buses. Auxiliary buses may be named for their purpose: reverb send (signals sent to a reverberation process) and cue send (signals sent to performers in order to cue them). (2) A network or path within the computer that moves data to and from the central processing unit (CPU) and other input/output devices. *T. Holman and R. Kraus*

BUSINESS PRACTICES

SPECIALIZATION The generic name for individuals who create photographs is, of course, photographer. The majority of professional photographers, that is, photographers who earn their living from taking pictures, tend to distinguish themselves from the millions of amateur photographers by adding a descriptive word or phrase to the designation photographer. The term "professional photographer," while still in use, is no longer sufficiently precise in a world where specialization is revered. The term "freelance" photographer is often used by professionals to indicate that they are willing to undertake any assignment.

No standard terminology has been adopted by those engaged in the business of the creation of images. Nevertheless, custom and usage have given rise to a list of general specialties, which in turn have been further divided into subspecialties. The lines between specialties are not rigid, and the work of a specialist may be used other than in the intended field.

Except in a few instances, for example, underwater, space, and microscopic photography, specialties usually are defined by the ultimate use of the image rather than the environment in which the photographs are taken or the nature of the equipment used.

Some specialties arise out of techniques rather than equipment or end use. Thus, studio photography has specialties such as food photography, and jewelry and silverware photography.

Photographic businesses range in size from one person, who is responsible for all aspects of the business, including the nonphotographic aspects, such as keeping financial records, forwarding sales taxes to the taxing entity, and serving as studio janitor, to large organizations where diverse responsibilities can be assigned to different individuals.

The development of off-the-shelf computer programs for small businesses, some specific-to-particular photographic specialties, has been of assistance to both small and large photographic businesses. The maintenance on computers of data bases of customers and potential customers has simplified the process of maintaining client contact and soliciting new clients. There is a dollar cost in acquiring the computer and the required peripherals, for example, a printer, and an additional dollar cost in acquiring the software. The time required to become proficient in the use of the computer and business software should not be underestimated. Nevertheless, software for assignment cost estimation, billing, filing stock photographs, and financial record maintenance, has introduced a greater degree of efficiency and proficiency in the one-person business. Many larger photographic businesses would be unable to compete successfully if they were not "computerized."

Commercial Photography Commercial photography involves the creation of images for sales and advertising. It ranges in scope from taking a photograph of a local restaurant for use on a postcard to creating a series of photographs for an advertising program scheduled to run in a dozen magazines with international distribution.

Personal Events Photography While personal events photography might be classified as a form of documentary photography, it is a rare wedding photographer who would claim to be a documentary photographer. Specialties in the personal event category include wedding, confirmation, bar mitzvah, portrait, school, yearbook, graduation, and amateur team photography.

Editorial Photography Editorial photography encompasses all images created for use in the editorial sections of print media. The specialties, which are defined by the subject matter of the images, include news, sports, travel, and society photography. Some photographers describe their specialty by the nature of the print media, and these include magazine photographer, newspaper photographer, and the all-encompassing photojournalist. Since there are usually one or more armed conflicts occurring somewhere in the world, there is the specialty of war correspondent. The term "paparazzi" refers to those photographers who are particularly aggressive in obtaining photographs of celebrities.

Documentary Photography Documentary photography is a specialty that tends to straddle a number of media in which it is used. It, in turn, has its own specialties of industrial, investigatory, archeological, combat, and scientific photography.

Scientific Photography This includes the specialties of medical, dental, forensic, space, astronomical or astrophotography, ballistic, biological, geological, microphotography, and underwater photography.

Nature photography Has an identity apart from scientific photography, includes specialties in plants, birds, animals, marine life, insects, and landscape.

Fine Art Photography Fine art photography is photography created for the purpose of being exhibited and sold in the art market. Some images, created as photojournalism or in connection with another specialty, move into the fine art market and become favorites of collectors.

Stock Photography Stock photography refers to existing images available for purchase or rent. Although some photographers specialize only in creating images for stock use, the majority of stock images are the by-products of assignments and personal travel. Stock photography therefore encompasses every other specialty and may, itself, be a specialty for photographers who limit their creation of images to those images intended to be stock images.

LEGAL ISSUES

Licensing and Registration There are few legal requirements impeding the entry of an individual into the profession of photography; very few jurisdictions require licenses. There are no educational requirements, tests to be taken, or physical examinations. If there is a licensing requirement, the payment of a fee is usually the sole "requirement."

Formalities that Depend on Business Entity The other formalities that must be complied with relate to those that apply to any business. If you use a business name other than your own, you must usually register the name with either your local or state government. Usually, the appropriate form can be obtained from the government agency with which you must register or, if unavailable from the agency, a legal stationer. It is usually simple to complete. It may require notarization prior to filing. If you incorporate or enter into a partnership, you should seek advice from an attorney and not rely on a do-it-yourself kit.

Taxes If your business will be in a state or city with a sales tax, you will usually have to register with the tax authorities and obtain a registration number. That number is the one used to remit the sales taxes you collect. The same registration number usually serves as the resale number that you provide to your suppliers when you certify that the photographic materials you are purchasing are for "resale," and therefore free of sales tax. The rules differ in each taxing jurisdiction, but normally only those materials that are resold to your clients are free of sales tax. In jurisdictions where goods used in the production of goods for resale are free of tax, you may find that even your camera and other equipment may be purchased free of sales tax.

If you conduct business as an individual, that is, a sole proprietorship, you will file your federal, state, and local income taxes as usual but with the addition of a schedule that deals with the profit and loss from your business. The federal schedule is known as Schedule C.

If you conduct business as a corporation, you will be required to file tax returns for the corporation in addition to your personal tax returns.

If you conduct business as a partnership, the partnership files an information tax return, and your share of income or loss is reported on your personal tax return.

The choice of the form of a business entity is dependent on many factors, the least of which may be taxation, and a minimum of one consultation with an attorney and/or accountant should be undertaken prior to commencing business.

Copyright Depending on the nature of your assignments, copyright may or may not be a concern. A studio catalog photographer may be less concerned with copyright than a freelance photojournalist. The issue of "work for hire" and copyright remains alive but diminished in importance because of a Supreme Court ruling that clarified the relationship that must exist if the work-for-hire concept, in the absence of an unequivocal agreement, is claimed by your client.

Model Releases, Permissions, Privacy, Rights of Commercial Exploitation The photojournalist who photographs a newsworthy event and sells or licenses the photograph for use in news media is free of the concerns of model releases, permissions, privacy, and rights of commercial exploitation.

If, however, the photograph is used in a different context, the photographer may have to consider whether a model release is required or whether other permissions must be obtained. One illustrative example would be the coverage of a live music concert. Assuming photography was permitted at the concert, a photographer would not be required to obtain model releases or permissions to sell or license photographs taken at the concert to a daily newspaper for use in connection with a story about the concert. If, however, the photographer attempted to exhibit and sell prints, then a different set of rules would come into play. Also, the photographs could not be used, without written permission, in connection with a commercial venture. Some states, notably New York, have statutes that specifically prohibit the use of recognizable images of persons in connection with commercial exploitation without written permission. Such statutes are generally referred to as privacy laws and relate to living persons. A noncommercial exhibition, for example, a museum exhibition of the images taken at the concert, as a practical matter, would not result in any action being taken by the subjects of the images, but the legal issues have not been squarely decided. It might be argued, for instance, that a noncommercial exhibition results in a commercial benefit to the photographer; for example, enhanced credentials may result in higher fees and higher prices for prints at galleries.

The rights of publicity and commercial exploitation exist both in common law and statutory forms, and govern the use of pictures of individuals both in their lifetime and after death.

If there is any possibility that a photograph is to be used other than in a news context, the safest procedure is to obtain a broad release from every recognizable person. It must be noted that the term "recognizable" does not require that a face be seen. Forms of releases can be obtained from professional photographers' associations and photo supply stores.

Particular attention should be paid to state laws relating to releases from minors. If the minor is serving as a paid model, there may be additional requirements relating to hours, working conditions, permits, and consents.

Photographers should not overlook that permission may be required for the taking and use of photographs of buildings and other inanimate objects. If the building is not a public building, you may need the permission of the owner. If the object is a work of art that itself is subject to copyright, you may also need permission. Permission may even be required to photograph in certain public buildings or in certain portions of public buildings.

Art Multiples Laws Photographers who sell into the art market must be concerned with Art Multiples Laws. In general, such laws mandate the disclosure of certain facts regarding prints offered and sold as limited editions, such as the size of the edition, the particular process used, and the date the edition was printed. Although only ten states have such statutes (the number keeps growing), most of the statutes are applicable to prints offered for sale both within the state and to and from the state. California and New York both have Art Multiples Laws. Since both states are the home of major art markets, those photographers who produce limited editions should become informed as to the requirements of those states in addition to any legislation in their home state.

SELLING AND LICENSING IMAGES The major difference between selling photographs and selling most other items is that the same image can often be sold many times. The manufacturer of a camera can only sell it once.

The most common example of selling the same image more than once is the successful stock image. Photojournalists often have their images sold to multiple periodicals. Wedding photographers often sell one album to the bride and groom and a second and third album to the parents of each.

A photographer who is in a good bargaining position need never transfer the copyright with the "sale" of the image. A photographer should merely license the use of an image for a specific one-time use. What is being licensed is "reproduction rights." On the other hand, if the fee is reasonable, there is no reason to insist on retaining the copyright, at the risk of losing the assignment. Requests are rarely made for assignment of copyright in connection with stock photography, but the client may request exclusive use either for a particular time or product line.

Each photographer may develop business by direct contact with potential clients, referrals, space advertising, and direct mail. Although radio and television are not widely used, they should be considered if cost effective.

Often, however, photographers are either too busy to involve themselves in producing future business or lack the organizational or merchandising skills required to market their services. As a result, service businesses have evolved that either market photographers for specific assignments or market existing work.

Many, but not all, commercial photographers are represented by "reps" who make direct contact with clients, usually art directors at agencies or magazines. The rep receives a percentage of the payment to the photographer as a commission.

Photojournalists often work for a picture agency, which accepts assignments for them, or in absence of a specific assignment, attempts to sell and syndicate their work product. Some agencies are organized as cooperatives and others are commercial ventures. In either instance, the photographer pays for the administrative overhead, rent, and marketing costs in the form of a commission or percentage contribution.

Many photographers successfully market their own work as stock photography. Selling stock photography not only involves client contact and other forms of marketing, but also the administrative tasks of researching the requested images, arranging for delivery, billing, and record keeping. For those reasons, many photographers leave all of the work, other than the taking of images, to stock houses or agencies. The stock house markets the work and takes a commission, usually 50% of the fee. Even though the commission appears to be large, a successful stock house will often generate a greater net income for a photographer than the photographer could generate alone. Photographers whose stock work is in demand are, in some instances, able to negotiate a smaller commission.

Fine art photographers, in addition to representing themselves, usually sell their prints through art galleries and private dealers. The gallery may purchase work for resale but the usual arrangement is for the photographer to deliver prints to the gallery on consignment. In a consignment arrangement, title to the prints remains with the photographer until sold. The range for commission normally taken by the gallery is from 30% to 50%. Outright purchase by the gallery results in immediate payment but at a higher discount from retail.

Pricing No area of business practices is less susceptible to hard data than pricing. As with most businesses, pricing is a factor of supply and demand. Photographers who have established reputations can command larger fees because they are sought out by clients. When the photographer is in the position of seeking work, pricing is one of the key considerations in a competitive market.

Professional associations have, from time to time, published guidelines for pricing. Their legal counsel frowns upon the practice for fear of running afoul of price-fixing laws. Nevertheless, a photographer who reads current trade and association publications and attends meetings and conferences can get information on what are the going rates for those who are not super stars. One commercial publisher even publishes guidelines (see Books at the end of this article).

The elements that should be factored into pricing are (1) the direct costs, for example, film, processing, studio rental, travel expenses, and model fees; (2) the indirect costs such as overhead, for example, employee salaries, rent, utilities, professional dues; (3) the time the photographer must devote to the project; (4) the intended use of the image, for example, an image intended for a national consumer magazine campaign normally commands a higher fee than the same image to be used in a limited-circulation trade magazine; and (5) intangibles such as the reputation of the photographer, the prospect of additional business from the client, and the photographer's backlog of assignments. In the fine art photography field, additional elements that should be factored into pricing include (1) whether the print is part of a limited edition, and (2) the physical size of the print.

Professional Associations Professional photographic associations are composed of individuals with a common interest in a particular area of photography. The broad-based associations include the *American Society of Magazine Photographers, Advertising Photographers Of America, National Press Photographers Association,* and *Professional Photographers of America.* Associations with members who have narrower interests include the *American Society of Photogrammetry, Biological Photographic Association, Society of Photographic Scientists and Engineers, Wedding Photographers International,* and *White House News Photographers Association.*

The benefits of association membership include the exchange of ideas, continuing education through publications, meetings, seminars, and symposiums, the opportunity to participate in competitions, have work displayed, and receive awards and titles, and the ability to influence, as part of a group, the course of legislation affecting the profession.

Honorary titles, certificates, and awards bestowed by professional photographic organizations are often displayed by photographers to convey the impression that they are not only highly qualified but that they have received recognition by an organization that might be the equivalent of a license. That practice is more common among professional photographers who deal with the public as opposed to art directors from national magazines.

The titles of an association may, in certain instances, be misleading. ASMP (American Society of Magazine Professionals) encompasses in its membership both those who work or freelance for magazines and those who work for advertisers in the magazines. The former may consider themselves photojournalists and the later commercial photographers. The *Professional Photographers of America* is, in theory, all encompassing, but its membership is heavily weighted with portrait, wedding, and yearbook photographers. Several of the associations have city or regional chapters. Most, with the exception of *ASMP*, admit any photographer willing to pay the requisite fees and dues. *ASMP* requires prior publication of work for full membership.

Books: Crawford, Tad, *Business & Legal Forms For Photographers.* New York: Allworth Press, Inc., 1991; Davis, Harold, *Publishing Your Art as Cards & Posters.* New York: The Consultant Press, Ltd., 1990; DuBoff, Leonard, *The Photographer's Business & Legal Handbook.* Cincinnati: Writer's Digest Books, 1992; Engh, Rohn, *Sell & Re-Sell Your Photos.* Cincinnati: Writer's Digest Books, 1991; Falk, Peter H., Ed. *The Photographer's Complete Guide to Exhibition & Sales Spaces,*

3rd Edition. New York: The Photographic Arts Center, 1992; Jacobs, Lou Jr., *Selling Photographs: Determining Your Rates and Understanding Your Rights.* New York: Amphoto, 1988; Kopelman, Arie, Ed. *ASMP Professional Business Practices in Photography.* New York: American Society of Magazine Photographers, 1986; McDarrah, Fred W., *Stock Photo Deskbook,* 3rd Edition. New York: The Photographic Arts Center, 1989; Perrett, Thomas I., *Gold Book of Photography Prices.* Carson, CA: Research Institute Carson Endowment, 1991; Persky, Robert S., *The Photographer's Guide to Getting & Having a Successful Exhibition.* New York: The Photographic Arts Center, 1987; Persky, Robert S., *The Transactional Legal Guide for Photographers.* New York: The Photographic Arts Center, 1992. *R. Persky*

See also: *Agencies; Copyright; Photographic fields and careers; Organizations, photographic.*

BUZZ TRACK A special type of recorded optical sound test film used in the alignment of the area scanned by optical sound heads (playback devices). It consists of two recordings made outside the usual sound track area with their maximum peaks just touching the outer edges of the area to be scanned, each at a different frequency. The optical sound head is adjusted correctly for lateral position when essentially no sound is heard, while adjusting to one side results in hearing one frequency, and adjusting to the other side results in a different frequency. *T. Holman*

See also: *Optical sound recording.*

BY-PRODUCTS In the processing of silver halide emulsions, oxidized developing agents and bromide or other halide ions, the main product being the silver image. By-products of development can affect the rate and uniformity of subsequent development, and they are used in some color processes to form dyes by reacting with couplers.

L. Stroebel and R. Zakia

See also: *Photographic effects.*

BYTE A group of eight bits. Bits are moved about the computer in groups. These groups may be 8 bits (a byte) 16 bits (2 bytes) or 32 bits (4 bytes). The greater the number of bits moved per cycle, the faster the computer. *R. Kraus*

C

C Capacitance

C Celcius (Centigrade); Chrominance; CIE standard illuminant; Color ; Coulomb; C-mount

c Candela (also cd); Velocity of light in a vacuum

© Copyright

CAD Computer-aided design

CAM Computer-aided manufacture

CAR Computer-aided retrieval

CAT Computerized axial tomography

CAV Constant angular velocity

CC Color compensating (filter)

cc Cubic centimeter (also cu cm)

CCD Charge-coupled device

CCR Camera cassette recorder

CCIR Comite Consultatif International de Radio (International Radio Consultative Committee)

CCU Camera control unit

cd Candela (also c)

CD Compact disc

CD-I Compact disc–interactive

CD-ROM Compact disc–read–only memory

CD-V Compact disc–video

CdS Cadmium sulfide (photocell)

CD-WORM Compact disc–write once/read many

CEI Comite European d'Imprimerie (European printing standards organization)

cell Cellulose acetate sheet

CEPS Color electronic prepress system

CFF Critical fusion frequency; Critical flicker frequency

CG Character generator

CGI Computer graphics interactive; Computer graphics imaging

CGM Computer graphics metafile

cgs Centimeter-gram-second system

CI Contrast index

CID Charge-injection device

CIE Commission Internationale de l'Eclairage (International Commission on Illumination)

cine Cinematography

CIR Color infrared

C-line Radiation having a wavelength of 656.3 nm

CLUT Color look-up table

CLV Constant linear velocity

cm Centimeter

C-mount Lens mount

CMYK Cyan, magenta, yellow, and black

COD Chemical oxygen demand

CODEC Coder/decoder

COM Computer output microfilm

COMMAG Composite magnetic

COMOPT Composite optical

cos Cosine

CP Candlepower

CPD Charge-priming device

CPU Central processing unit

CRA Camera-ready artwork

CRI Color-rendering index

CRT Cathode-ray tube

C/S Cycles per second

CSBTS China State Bureau of Technical Supervision

CSN Federal Office for Standards and Measurement (Czechoslovakia)

CT Continuous tone; Color temperature

CTF Contrast transfer function

CU Closeup

cu Cubic

CYSI/CYG The color you see is the color you get

Cable release.

CABLE RELEASE An accessory used to release the shutter without physically touching the camera body. It is used to prevent camera shake. It consists of a stiff wire encased in cloth, plastic, or metal mesh, a connecting base at one end, and a plunger on the other. When the plunger is depressed, the wire extends into the camera's shutter release mechanism. *P. Schranz*

CACHE In computers, a section of reserved memory designed to allow the central processing unit (CPU) to process data faster. Cache can also be used to speed video access and hard drive access. *R. Kraus*

CADMIUM SELENIDE CELL (CdSe) See *Photoconductive cell.*

CADMIUM SULFIDE CELL (CdS) A photoconductor that increases the conductivity of an electric current when exposed to light and is used in some exposure meters as the light-sensing component. It has greater sensitivity than a selenium photovoltaic cell but requires a battery in the circuit. *J. Johnson*

See also: *Exposure meters.*

CALGON A trade name for polymeric forms of sodium hexametaphosphate having the general formula $(NaPO_3)_n$, where n is 6 or greater. Calgon acts as an inorganic sequestering agent by removing calcium and magnesium ions from photographic solutions before insoluble calcium and magnesium compounds are precipitated. The white, flaky crystals or granules are soluble in water; in fact, unless protected, they may take water from the air and become sticky and start to hydrolyze. *G. Haist*

CALIBRATION TAPE OR FILM A magnetic tape or film prepared under laboratory conditions with recordings having prescribed characteristics. In audio, these characteristics include the absolute level of reference fluxivity sections at a standard frequency such as 1 kHz, and the relative level of different frequencies according to the standard in use. Specialized test tapes or films also are available recorded with low flutter so that flutter due to transports can be measured.

In video, the prescribed characteristics include reference levels for white and black and reference level and phase for color. *T. Holman*

See also: *Fluxivity; Wow and flutter.*

CALLAHAN, HARRY (1912–) American photographer and teacher. Began photography as a hobby (1938). Joined the Detroit Photo Guild, where in 1941 he attended an exhibition and lectures by Ansel Adams that influenced him to seriously pursue photography. Purchased an 8 × 10-inch camera, which he used until 1965, deciding to make only contract prints. His photographs are a deeply personal expression: gentle nudes of his wife, Eleanor, high-contrast studies of weeds on glass, and urban studies of people rushing about the dark canyon bottoms of big city streets. Though most of his work has been in black-and-white, his later photographs are in color. Taught photography at Chicago's Institute of Design (1946–1961) and at Rhode Island School of Design (1964–1977).

Books: Szarkowski, John, ed., *Callahan.* Millerton, NY: Aperture, 1976. *M. Alinder*

CALLIER, ANDRÈ (1877–1938) Belgian physicist. Described the increased contrast of a photograph made using an enlarger rather than contact-printed due to the scattering of light by silver in the negative, termed the *Callier effect* (1909). *M. Alinder*

CALLIER COEFFICIENT (Q FACTOR) The relationship between specular and diffuse densities, expressed as $Q = D_S/D_D$. Callier believed that Q varied with development and image structure (granularity), but that over a limited range of densities Q was a constant for a given photographic material. If this were true, conversion between the two types of density would often be possible. More recent studies, however, show that Q is not a constant at low densities and high development contrast for black-and-white materials; it is nearly constant for color materials because they scatter little light. *M. Leary and H. Todd*

See also: *Callier effect.*

CALLIER EFFECT The result of the scattering of light by a photographic film in an optical system, first investigated by André Callier in 1901. The measured density of a uniform

silver area, illuminated by parallel light, is greater when only the directly transmitted light (but not the scattered light) is recorded, compared with the result when all the transmitted light is captured.

The Callier effect explains the increase in apparent negative contrast when prints are made with a condenser enlarger, compared with those made with a contact printer or with a diffusion enlarger. With a diffusion enlarger, light scattered toward the enlarger lens compensates for light scattered away from the lens. *M. Leary and H. Todd*

See also: *Diffuse density; Doubly diffuse density; Printing density; Specular density.*

CALOTYPE PROCESS Upon his return from a tour of the Continent in 1834, W. H. Fox Talbot was determined to capture the images he had seen on his camera obscura and camera lucida by means of a "natural process." He called his early successes "photogenic drawings," photograms of leaves and lace, and some low resolution views of his ancestral home produced as early as the spring of 1834. He dipped paper in common salt, dried it and brushed on silver nitrate which formed silver chloride. Exposures required an hour or more. Talbot experimented with salt and potassium iodide as fixers, but could not achieve reasonable permanence until Sir John Herschel told him about "hyposulfite of soda," sodium thiosulfate, in February of 1839.

In the fall of 1840, Talbot found a modification of his procedure that produced substantially shorter exposures. He patented the process in February, 1841 and, at first, called it calotype, derived from the Greek word for beautiful. Subsequently, he changed the name to Talbotype. Talbot brushed his paper with silver nitrate and dried it. The paper was then dipped in potassium iodide, rinsed, and dried. It could then be stored in its "iodized" state until just before use when he sensitized it by brushing it with a solution he called "gallonitrate of silver," consisting of silver nitrate, acetic acid, and gallic acid. The paper was dipped in water and dried. An exposure of between 30 seconds and 5 minutes in a camera yielded a latent image, which Talbot developed in the gallonitrate and fixed in either salt, potassium bromide, or sodium thiosulfate. The back of the calotype negative was waxed to facilitate contact printing. Talbot favored photogenic drawing paper for his prints.

The calotype was the first viable negative/positive process. Unlike the daguerreotype, which dominated the 1840s, the calotype permitted an unlimited number of prints to be made from one original image and established the basis upon which most modern photographic processes rest. *H. Wallach*

Syn.: *Talbotype.*

CAMEO LIGHTING A single foreground subject lit against an essentially uniform dark background.
 F. Hunter and P. Fuqua

CAMERA
 DEFINITION A device for controlling light to form a visual record on light-sensitive material. The light is directed into a dark box by an opening in one end that allows only the rays of light from objects within the angle of coverage of the lens to enter. That light forms an inverted image on the opposite side of the box where a sensitized material or other light sensitive receptor records the image. The amount of light that enters is controlled by the size of the opening and the length of time the opening is left uncovered.

Over the past century and a half, there has been great improvement but little change in the fundamental concept of the camera. Today, the light is focused with computer-designed lenses made with extra-low dispersion glass and recorded on superb emulsions. Extremely accurate electronic shutter systems have been created, and now, with the

advent of electronic imaging, these systems have almost unlimited freedom to modify images. At no time in photographic history has the camera been more versatile.

AN EVOLUTION OF DESIGN One can better understand the workings of the camera by following the light path from an object to the film.

Light enters the lens and passes through a regulated opening in a diaphragm that provides control over the amount of light coming into the camera. That light is blocked, however, by the shutter, which can be placed between the lens, behind the lens, or at the back of the camera in front of the film. The shutter is controlled by a timing mechanism that is classified as mechanical, electronic or electromechanical (a combination of both), that opens the shutter for a specified length of time. These two devices, the shutter and the lens diaphragm, control the amount of light that exposes the film, or, in an electronic system, the light- sensitive receptors.

Framing and Focusing the Image On some simple nonfocusing lens cameras, a separate viewfinder works to approximately target what will appear on the film. These are the old point-and-shoot box cameras, and their successors, the instamatic and disc cameras. With lens systems that can critically focus on different distances, there has to be some way to determine if the lens is focused on the desired distance. If the back of the camera could be removed and replaced with a piece of ground glass, the projected image would be visible. In the case of view cameras, that is exactly what happens. When it is time to make an exposure, the film, kept in a light-tight holder with a dark slide covering it, is placed in the same plane of focus as the ground glass. The dark slide is removed and the shutter released. Another viewing system would require two identical lenses mounted in two separate chambers, one above the other, and operating on a unified focusing track. One of the lenses would be used for composing and focusing the image and the other, with a shutter and diaphragm, for exposing film. This would be a smaller system and continuous in operation without having to remove the film holder for focusing each time. Essentially, this describes a twin-lens reflex. The light path of the top viewing lens reflects upward from a 45-degree mirror so that the photographer can peer down into the camera, while the bottom lens with the shutter is directly in line with the film plane.

The camera could again be made smaller if the focusing chamber could also be used to expose the film. In the case of the single-lens reflex, the design is basically the concept of a twin-lens reflex condensed into one chamber. The mirror is in the same position, but is now movable. Just prior to exposure, the mirror is elevated to allow the light to expose the film, during which time there is no image in the viewfinder.

Some cameras, to be made even smaller, use a separate rangefinder focusing system that presents a split image or two superimposed images in the viewfinder. When the images align, the lens is focused on the selected object by means of a coupled focusing mechanism. This simple rangefinding system has become so advanced that it can provide automatic focusing by means of an infrared beam splitter. A microprism equivalent of the rangefinder is used in many single-lens-reflex cameras.

Camera Exposure Meters The amount of light entering the camera needs to be analyzed and controlled to prevent under exposure or overexposure. In earlier cameras, this was done with an independent hand-held exposure meter, which still has advantages for more critical work. With the advent of more self-contained camera systems, exposure meters were placed inside of the camera body. Contemporary electronic metering systems are sophisticated and extremely fast. Exposure analysis can be made and corrected while the actual exposure is being made by measuring light reflected from the film.

Four basic categories of contemporary general-purpose cameras are the simple point-and-shoot, the 35-mm and medium format single-lens reflex, the 35-mm and medium-format rangefinder cameras, and variations of the view camera.

As the need grew for the camera to perform more sophisticated and specialized tasks, cameras were designed to fit those needs.

Cameras are becoming more computerized and more electronic in their exposure analysis, focusing, and shutter operations. The use of digital recording of images on electromagnetic discs, as opposed to traditional silver halide films, is becoming a realistic alternative. The technology exists to rival the resolution of traditional films, but currently only at a prohibitive cost. The trend is perhaps best marked by alternative backs on some cameras that allow for silver halide or digital recording systems on the same body, making the camera more adaptable.

CAMERA HISTORY The viewing of an inverted image through a pinhole in a large room was recorded as far back as fifth century China. In the sixteenth century, Aristotle used this same principle to view solar eclipses. However, it was not until the Renaissance that the concept really began to be worked on in earnest. Scientists and inventors such as Leonardo da Vinci and Girolamo Cardano began making references to the phenomenon of image projection in what then was known as the *camera obscura*. During the sixteenth century, great improvements over the original design were made, which not only improved the camera obscura but also extended its applications.

A problem had existed concerning the dim image that the small hole projected. It was known that if the size of the hole was increased, the sharpness of the image would decrease. To this end, Cardano fitted a bi-convex lens to the camera obscura in 1550, and Daniel Barbaro added a diaphragm that would improve the depth of field in 1568. In 1676, Johann Strum inserted a 45-degree reflex mirror that allowed for the image to be projected to the top of the box onto a sheet of oiled paper, and a ground glass on later versions. The significance was that the user could now use the camera obscura from the outside, and thus it could be greatly reduced in size. The focusing lens became a complex arrangement of separate glass elements in a brass housing that corrected for various aberrations.

The portability of the new camera obscura greatly interested architectural and landscape artists who carried them to various locations to do preliminary traced sketches for paintings. In 1807, William Hyde Wollaston added more portability to realistic sketching with the *camera lucida,* a prism and stand device that projected an image of a scene downward where it could be sketched more easily. The idea of a realistic perspective recording was a much sought aesthetic, and a fundamental reason for photography's later popularity.

It is interesting to note that by the seventeenth century, the box, the lens, the reflex mirror, and the ground glass all existed. It would take another two centuries before the chemistry of the photographic process would become sophisticated enough to be applied to the camera apparatus.

In 1827, Nicéphore Niépce exposed a pewter plate coated with bitumen in a small camera obscura. The 8-hour exposure was the first photographic image. Niépce formed a partnership with Louis Daguerre to continue improving the process. After Niépce's death in 1833, Daguerre continued experimenting with iodized silver plates. In 1835, William Henry Fox Talbot made a one-inch square paper negative using an extremely small camera. The "mousetrap" cameras of Talbot even had removable paper holders by late 1839.

It was in August of 1839 that Louis Daguerre patented the daguerreotype and joined forces with Alphonse Giroux to build the first commercial camera for the new process. The

camera made single exposures, 16.5 x 21.5 cm on daguerreotype plates. Its construction consisted of a two-part box that telescoped into itself to adjust for focusing. At the rear of the camera was a ground glass. Charles Chevalier built a daguerreotype camera with hinged sides that folded for compactness and transport. It seemed apparent from the beginning that the camera was destined to visually explore the outer world, rather than be limited to a studio environment.

An 1840 design called the Wolcott camera used a large concave mirror on the rear of the camera to project an image forward. The image was captured on a small daguerreotype plate in the center on a movable post used for focusing.

Of the many daguerreotype cameras, the 1851 model by the W. & W. H. Lewis Company was one of the more significant advancements. The Lewis camera incorporated flexible leather bellows between the front lens standard and the rear camera box that could be adjusted for focusing.

The demand for daguerreotype portraits was great, but the daguerreotype camera made only one unique image at a time. Negative/positive systems using paper negatives were tried for the purposes of multiple prints from one exposure, but due to the grainy appearance caused by paper fibers, they did not rival the daguerreotypes for detail.

The process that eventually brought about the demise of daguerreotype popularity was the collodion wet plate, made practical by Frederick Archer. The glass plate had to be exposed within minutes of preparation, while the emulsion was wet, and processed immediately. The result was an extremely shortened exposure over the daguerreotype, and a glass negative that could be used for making many prints. The problem with the wet-collodion process was logistics. In the field, the photographer would have to carry numerous glass plates, all of the sensitizing and processing chemistry, and a portable darkroom. Many of the documentary photographers of the Civil War and the exploration of the American West had horse-drawn photographic wagons specifically designed to work with the wet-collodion process.

The public not only wanted more prints, but also more poses. An 1860 wet-collodion camera called the carte-de-visite used a multiple lens system that would make a number of independent exposures on a single glass plate.

Wet-collodion cameras were designed to take plates as small as 2 1/2 x 2 1/2 inches and larger than 12 x 16 inches. Still searching for ways to quench the public's thirst for realism, 1864 saw the debut of the wet-collodion stereograph camera. When used with the proper viewer, this device would yield the illusion of a three-dimensional image.

With the invention of a dry-plate formula for light-sensitive glass plates, photography became more available to the general user, and travel photography became a new industry. Onto the market came a number of cameras that had simple fixed-focus lenses—the forerunners of the point-and-shoot box cameras. Some of the better fixed-focused and adjustable-focus cameras were made by the Rochester Optical Company and H. Walker and Co., and used emulsions from the newly formed Eastman Dry Plate and Film Co. All three of these companies finally came together to form the Eastman Kodak Company in 1907.

A variety of unusual clandestine cameras were also developed during 1869–1180. Some were designed as guns, and others as hidden detective cameras as the photograph became a form of evidence.

One of the first folding 4 x 5-inch wooden view cameras was patented in the mid-1880s by E. & H. T. Anthony Co. in New York. It had a hinged side that allowed it to turn from vertical to horizontal and had a rising/falling front standard, and rear standard tilts, predecessors to movements on contemporary view cameras.

Photography really came to the amateur in 1888 with both the invention of flexible stripping film (roll film) and a camera

named Kodak. The camera made 100 circular exposures on a roll. At the end of the roll, the entire camera was sent to Eastman Kodak for processing, printing, and reloading with new film before being sent back to the photographer.

The popularity of photography continued to grow. Hundreds of different cameras from scores of manufacturers appeared on the market. Among this vast array, there have been several notable cameras that have revolutionized the way the medium has been used.

Sanderson Folding-Bed View Camera This wooden studio/field camera was built in 1895 and is the forerunner to many contemporary wood cameras. The Sanderson camera had front and rear adjustable focusing standards that ran along a horizontal frame on a geared track. The camera also used front and rear tilts and a rising and falling front.

Graflex No. 1a Introduced by Folmer and Schwing in 1898, the No. 1A was one of the first single-lens reflex cameras. The camera had a waist-level fold-out finder and a focal-plane shutter and used roll film. The idea of viewing a scene up to the instant of exposure was most popular with photojournalists and portrait and candid photographers.

Speed Graphic The Speed Graphic, a folding bellows camera that made single 3 1/4 x 5 1/2-inch negatives was introduced in 1911. It was invented by William F. Folmer and distributed by Folmer & Schwing, a division of Eastman Kodak. The camera could be hand held, had interchangeable lenses, and could use either ground-glass or eye level viewfinders. Later versions would become metalized with more available accessories, including synchronized flash. The Speed Graphic and the later Crown Graphic were popular through the 1960s as press cameras.

Leica The original Leica was a 1 3/8 x 2 3/8 x 5 1/4-inch rigid body 35-mm camera with a collapsible anastigmatic lens. It made 40 exposures on a roll of 35-mm motion-picture film. Originally designed by Oskar Barnack in Germany in 1911 as a film testing system, the camera was manufactured and marketed by E. Leitz Co. of Wetzlar, Germany. It was the first camera to have a coupled film advance and shutter cocking mechanism. The first Leica had a simple viewfinder, but later models used rangefinders, interchangeable lenses, and focal-plane shutters.

The camera became an instant success and became the working tool for many photojournalists. It had an extremely quiet shutter (no reflex mirror), a very small size, and a superb quality line of lenses; all of these made it ideal for candid use. The Leica M rangefinder series is still in production today with the M6. It has through-the-lens metering and a battery of lenses from 28 mm to 135 mm.

Since 1976, Leica has also built an R series of cameras that have a single-lens-reflex design. The Leica camera has also become a collectible, as well as an excellent working camera.

See also: *Leica.*

Kodak Autographic The Kodak Autographic was one of the most popular cameras of photographic enthusiasts of the period. Built in 1924, the folding bellows camera made six to ten 3 1/2 x 5 1/2-inch (postcard size) negatives per roll. On the hinged back of the camera was a small sliding panel and a writing stylus. The film was designed with an interleaving black carbon tissue that was written on in the panel with information about the subject photographed. The window was briefly exposed to light and the subsequent written information transferred to the margin of the print. This camera also used a rangefinder coupled to the focusing mechanism. It was popular through the 1930s, and many are still in existence as collectibles, though film for the camera is no longer available. Autographic backs were built separately to fit earlier Kodak cameras.

Rolleiflex The Rolleiflex was a twin-lens reflex camera designed by Dr. Reinhold Heidecke in 1929. The concept of

a twin-lens reflex had been around for some time, but the Rollei was the first to put the concept into an all metal precision camera. It used roll film and created 6 x 6-cm images. The camera had a built-in folding viewing hood. The 1932 version had a coupled film-advance/film-counter system, but the shutter mechanism was still cocked and fired separately. The camera changed little over decades except for the addition of better Zeiss lenses and metering systems. While virtually replaced on the contemporary market by the medium-format single lens reflex, the twin-lens Rollei is, nevertheless, still widely used. There is still one version in production.

See also: *Camera types, twin-lens reflex.*

Minox The 1940 introduction of a rigid-body spy camera changed the style of candid, surveillance, and espionage photography for the next 30 years. The camera made 50 exposures, 8 x 11 mm in size. Closed, the camera measured only 19/32 x 11/16 x 3 1/8 inches. The camera opened sideways to reveal the lens and rangefinder. Closing and opening the camera in a sideways movement cocked the shutter and advanced the film. It had shutter speeds from 1/2 to 1/1000, with B and T, as well.

Polaroid Land Camera The first instant camera was introduced in 1948. Separate rolls of print paper and negative paper were loaded into opposite ends of the camera. After exposure, the negative and positive papers were brought into contact between a pair of rollers. The rollers also broke open a pod of developing agent. After a minute, the camera back was opened and the finished print removed.

See also: *Polaroid; Polaroid photography.*

Contax S Introduced in 1949, the Contax S, manufactured by Zeiss-Ikon in East Germany, was the forerunner of the contemporary single-lens reflex camera. The camera had a built-in pentaprism for eye-level viewing, interchangeable screw-mounted lenses, and a focal-plane shutter.

Sony Mavica The Sony Mavica was the first commercial still-video camera that reproduced images on an electromagnetic disc. Still-video cameras have been accepted more rapidly in the field of photojournalism because there is no processing delay, images can be sent great distances by telephone, and the limited resolving power can be tolerated. The technology for still-video to rival conventional film resolution is available, but the cost is still prohibitive for most users. *P. Schranz*

See also: *Camera types, electronic still camera.*

CAMERA ACCESSORIES

CAMERA ACCESSORIES Simple automatic cameras are meant to be a total self-contained unit for general and amateur photographic use. Besides having automation features of focus, film advance, and metering, many of these cameras are designed with a limited recessed zoom lens. The lens recedes into the body and is protected with a built-in lens cover. In many instances, these small compact, easy-to-use cameras have a low-powered electronic flash unit also built in. While lens interchangeability is not found on these cameras, several manufacturers offer supplementary lens attachments that provide a moderate telephoto or wide angle view. It is difficult, if not impossible, to make any significant changes in accessories on this type of camera.

With more professional equipment, the option for customizing the camera to more specific and varied applications increases. These are called systems cameras.

The system starts out with a basic camera body and an array of available interchangeable lenses including wide angle, telephoto, zoom, fisheye, macro and shift (perspective control). Macro and micro accessories are available for extreme close-up photography including bellows, extension tubes, and microscope adapters. A variety of filters for light and color balance, and special effects can be attached to any of the lenses. A variety of square and round lens hoods or shades are also available to keep out extraneous light.

Many of the 35-mm cameras offer a choice of protective cases in both hard and soft shells. Most come with a neck strap, but a variety of other straps designed for added shoulder comfort are also available. Special harnesses can be substituted for the traditional neck strap to hold the camera close to the body for precarious field work.

On some of the more advanced systems (particularly medium format), there are options to change the viewing system. The ground glass can be interchanged from choices including microprism, 45-degree split rangefinder, plain, or one with scale or grid markings. The viewfinder can also be interchanged among eye-level, waist-level, angled, rotating, magnifying, or diopter-corrected. View cameras also have viewing attachments like angled viewers and magnifiers, as well as the traditional focusing cloth.

While it is fairly common to find a built-in light metering on 35-mm cameras, photographers with medium and large format cameras, and those 35-mm users with specific requirements commonly use an auxiliary metering system. Many exposure meters are designed to be used hand-held off the camera but some medium format cameras have interchangeable viewing hoods that include a metering system. On view cameras, a metering probe can be used to take meter readings at the film plane.

Many medium-format and a few 35-mm cameras have interchangeable backs that allow for data recording and digital analysis. Most medium format SLR cameras have interchangeable film magazines that allow for changing formats or film in mid-roll, and some have special backs for Polaroid instant-picture films.

The film transport system on medium- and 35-mm cameras can be automated with a motor drive to advance the film one frame after each exposure, including multiple frames in rapid succession.

In most cameras, and camera/lens systems, the shutter is built in. In the case of a view camera, shutters can be interchanged between mechanical and electronic types. In either case, the shutter can be released by using cable releases, specially designed pistol grips to avoid hand contact, or by remote control.

View cameras are designed to be used with an external support, and many 35-mm and medium-format camera users elect to use supports to steady the camera. Camera supports include tripods, studio stands, monopods, shoulder gun supports, chest pods, pistol grips and clamps. Motion-picture and video cameras can be steadied during hand-held movement with a floating gyroscope device.

Professional system cameras can be equipped with more powerful electronic flash units, which commonly have adjustable power output.

Special housings are available for some cameras for aerial and underwater photography.

Most professional photographers own several large camera bags to hold many of the accessories listed above. Professional requirements frequently require change, and having an arsenal of accessories at one's disposal is considered a necessity. *P. Schranz*

CAMERA BACK

CAMERA BACK A camera back is the part of a camera that provides a light-tight seal for the film and commonly performs other functions, and is normally hinged, removable, or held in position with springs that allow for the insertion of a film holder. With most 35-mm cameras and some medium-format roll-film cameras, the back contains a pressure plate that holds the film in contact with guide tracks in the body of the camera. The backs for some roll-film cameras include the film-transport mechanism, and even a dark slide so that different types of film can be used and switched

in mid-roll by changing backs. The backs for view cameras and other sheet-film cameras normally include a ground glass for composing and focusing.

Many cameras allow for the substitution of other backs or film holders to increase the usefulness or convenience of the camera. Bulk-film holders can be used with some 35-mm and medium-format roll-film cameras to eliminate the need to change film frequently when doing large-volume production work. Data recording backs are available for some cameras, an important feature for certain types of forensic, technical, and research activities. Accessory backs that accept instant-picture film packs can be used with some roll-film cameras to obtain a proof print before exposing conventional film or to obtain a usable photograph quickly. Electronic-imaging backs can be used on some cameras to allow the photographer to display the image on a monitor as an aid in arranging and lighting a setup, to record the electronic image on a magnetic disc, to digitize the image for computer processing and recording, or even to transmit an image to a remote location for evaluation, approval, processing, recording, or reproduction. Alternative backs for modular view cameras include backs that accommodate larger or smaller sheet-film sizes or roll films, backs that include an exposure meter probe and meter holder, and backs that include functional and convenience features such as a device to close the shutter and stop the lens down to a preselected *f*-number when a film holder is inserted. *P. Schranz*

CAMERA-BACK MASKING The use of a photographic mask, an image, or a transparent base that absorbs light in selected areas, in contact with unexposed film in a camera for the purpose of enhancing the final image. *M. Bruno*

CAMERA DUPLICATES Duplicate negatives or transparencies made by repeated exposures with the original subject and a given camera setup. This eliminates the losses that occur when duplicates are made from a single original. All of the camera "duplicates" are indeed "original." The term *step-and-repeat* is sometimes used, but this more aptly refers to exposing microfiche films where images of different content are exposed in sequence, row by row. *I. Current*

CAMERA EXPOSURE The combination of exposure time and *f*-number used to expose film in a camera, such as 1/60 second and *f*/16. The film actually receives many different exposures, which correspond to the luminances of different parts of the scene, for each camera exposure. *J. Johnson*

CAMERA HISTORY See *Camera, camera history.*

CAMERA LUCIDA/LUCY An artist's drawing aid invented by William Wollaston in 1807 consisting of a right-angle glass prism held by a clamp at eye level above a horizontal drawing board. By looking downward into the prism with one eye, the scene in front of the artist appeared to be superimposed on paper on the drawing board that was seen with the other eye, which allowed the artist to trace the virtual image onto the paper. *P. Schranz*

CAMERA MAGAZINE A film magazine is a light-tight container for a length of film and is designed to be attached to a camera to provide multiple exposures with a single loading. An additional advantage of magazines is that they give the photographer the ability to change film in mid-roll. Cameras that have internal film chanbers require the photographer to either run the entire roll through before switching to another type of film or to rewind the partially exposed roll and then later return the cassette to the camera and advance the film to the same frame before making the next exposure on that roll. Magazines for still cameras typically serve the multiple purposes of protecting the film from extraneous light, transporting the film between exposures, and holding the film flat and motionless while it is being exposed. With motion-picture cameras, the film-advance mechanism is an integral part of the camera rather than the film magazine.

Early development work on film magazines was oriented toward military aerial cameras. Increasing the length of film that could be carried in the camera and making film changes quick and simple were the primary concerns. The Victor Hasselblad Company was a leading pioneer in the development of these early film magazines. Hasselblad used this experience to develop a magazine for its 120-roll-film single-lens reflex cameras that has become one of the most widely used interchangeable film back camera systems in the world. The motion-picture industry has also fostered a considerable amount of development in magazine technology. Requirements for motion-picture magazines include the need to hold very long lengths of film.

In still photography, magazines are most commonly associated with medium format cameras. Interchangeable film backs provide the photographer with a great deal of flexibility. By simply swapping film backs, an image can be recorded with several different film types or even different formats. Removable film backs use a dark slide to keep the magazine light-tight. The speed of reloading the camera is a major concern for many photographers. With several pre-loaded film backs on hand, little time is required to change the magazine and keep shooting. Some 6 × 7-cm cameras offer the option of rotating film backs to allow either vertical or horizontal framing. Many popular cameras that use removable magazines will also accept Polaroid instant-film backs. This gives the photographer the opportunity to preview the final image, checking for proper exposure, composition, and focusing.

The design of most film backs for still cameras is fairly similar. The unexposed film spool is snapped into position on one side of the magazine. The film backing is then threaded over or through a roller or series of rollers to the pressure plate. The pressure plate is a spring-loaded platform where the film is positioned during exposure. The pressure plate is designed to keep the film plane constant from frame to frame. The film is then threaded through more rollers onto an empty take-up spool. An indicator line on the paper film backing must be aligned with an index point in the magazine. This ensures proper synchronization of the film framing. Once the magazine has been closed, the film crank or knob is used to advance the film to the first frame.

Film is advanced through the magazine in one of two ways: Motor-driven cameras automatically advance the film each time an exposure is made, and manual cameras normally use a single lever to both cock the shutter and advance the film. Some older camera designs require the shutter to be cocked and the film to be advanced separately. Interlock mechanisms are used to prevent unintentional multiple exposures, removal of the back without a dark slide inserted, and to ensure that the film is advanced. Most magazines do offer the option of intentional multiple exposures. Indicators on the magazine also show if the film was advanced after the last exposure. This is an important feature when several different magazines are being used in rapid sequence. It helps to prevent placing an uncocked magazine on a cocked camera or visa versa.

Many large-format cameras have adapter backs that allow the use of roll-film magazines. These backs give the photographer the ability to preform image corrections in situations where the use of sheet film is not desired. A unique feature offered by some manufacturers is a variable aperture 2¼ in. roll-film magazine. Adjustable masking blades allow for image sizes from 6 × 6 to 6 × 12 cm. The main disadvantage of using roll film magazines with view cameras is that the

Camera magazine. Film magazine for a medium format single-lens reflex camera. Some magazines have safety features to prevent the dark slide from being removed when the magazine is detached from the camera and to prevent accidental double exposures.

magazine must be removed each time a change in composition or focusing is required. Roll-film magazines that are used in place of sheet-film holders on large-format cameras are commonly identified as *roll-film holders.*

Available for use with certain professional model 35-mm cameras are 250-exposure backs. These magazines were designed for use by sports photographers using high-speed motor drives. They are also used for surveillance and time-lapse photography. Other special-purpose magazines incorporate such features as time and date recorders and pin registration. Custom designed and built magazines are used for extremely high speed cameras and other special applications such as strip photography. *G. Barnett*

See also: *Magazine.*

CAMERAMAN The director of photography or camera operator on a motion-picture set. *H. Lester*

CAMERA MOVEMENT (1) A camera movement is an adjustable part on a camera designed to allow the position or the angle of the lens or the film to be altered. The basic movements are swing (rotation about a vertical axis), tilt (rotation about a horizontal axis), lateral shift, rise and fall, and focus. A revolving or reversible back can also be included. The purpose of camera movements is to alter the shape, sharpness, or placement of the image. Full camera movements are found on most studio and field view cameras.

The rear swings and tilts change the parallel relationship between the film plane and the subject plane and control parallel perspective. For example, when photographing at an angle to the subject, the part of the subject closest to the camera appears larger, with convergence of parallel subject lines with increasing distance from the camera. If the film plane (camera back) can be adjusted to be parallel to the subject plane, convergence will be eliminated.

Although the angle of the plane of sharp focus can be controlled with swing and tilt movements on the back of the camera, the lens movement must be used if the back has been used to control image shape. The optimum focus is obtained for a subject plane when the planes of the subject, film, and lensboard are either parallel or all meet at a common line, a relationship known as the Scheimpflug rule.

After these adjustments have been made, the use of vertical and lateral shifts allows for repositioning the image on the ground glass without changing the corrected camera angles.

When using camera movements, it is most important that the lens chosen has adequate covering power. As movements are used, the format moves from the center of the projected image circle toward the outer edge. If there is inadequate coverage, part of the film will be outside of the image circle, resulting in a vignetting of the image on one or more corners.

(2) A general lack of sharpness in a photographic image can be attributed to many causes, but camera movement during exposure is a frequent source of this problem. Camera movement results from the use of too slow a shutter speed, improper shutter release, or lack of a steady support such as a tripod. Many photographers routinely accept this degradation of image quality without fully understanding it. There are several approaches that can be taken to eliminate camera movement.

Consideration of subject matter is often the criterion for which shutter speed is selected. This is fine if the camera is securely supported by a tripod but can result in an image blurring if the camera is hand held. A general rule is that the slowest shutter speed that should be used on a hand-held 35-mm camera is the reciprocal of the lens focal length in millimeters, for example, $\frac{1}{50}$ second with a 50-mm lens.

To help reduce camera movement, proper technique for release of the shutter is essential. Ideally, the use of a cable release is best. The mechanical advantage of a cable release fires the shutter with an almost fluid action. In practical terms, a cable release can only easily be used on a tripod-mounted camera. For hand-held situations a gentle pressure should be used on the release button; a hard thrusting on the release will introduce movement no matter how firmly the camera is being held. An additional technique that can be used in tripod situations is the use of the shutter's self-timer. By using the timer, the camera is isolated from any external source of movement other than environmental factors such as wind.

Proper support of the camera will almost always reduce or prevent movement. The use of a tripod or even a monopod is highly recommended whenever possible. While it is basically mandatory for large-format camera work, many photographers ignore the tripod for small or medium format. When the situation requires that the camera be hand-held, the likelihood of movement can be reduced with good technique. The camera and lens should each be supported with one hand. Grasping only the camera body will leave the camera unbalanced, especially when using a long lens. If possible, both arms should be rested or pulled in against the body. Take advantage of any objects such as trees, walls, or other firm surfaces that can be used for support. Taking a deep breath and holding it just before releasing the shutter is also helpful in reducing body movement.

One final factor that can contribute to camera movement is the internal mechanisms of the camera itself. Single-lens reflex (SLR) cameras incorporate an internal mirror that must flip up out of the image path when the shutter is released. This jarring motion is most apparent in the medium-format SLRs. Almost all SLRs offer the option of mirror lock-up. Widely used for slow shutter speed macro work, the mirror lock-up can be used in any application where the subject will not be moving once the lens has been focused. *P. Schranz and G. Barnett*

Books: Stroebel, L., *View Camera Technique.* 6th ed. Boston, MA: Focal Press, 1993.

See also: *View camera.*

CAMERA OBSCURA The term *camera obscura* comes from the Latin meaning *dark room.* The camera obscura was, indeed, a room large enough for people to enter. The room had a small opening on the top or one of the sides and a white surface opposite the hole. People could then observe a projected inverted image of objects outside. One of its earliest

applications was the viewing of solar eclipses, thus avoiding eye damage. By the sixteenth century, the obscura had evolved into a box with a lens on it that would allow both more light and better resolution, and a reflex mirror and ground glass that would allow viewing from outside the box. This brought considerable size reduction and portability.

P. Schranz

CAMERA OPERATOR The operator of a motion-picture camera, the person responsible for composing the picture and placing, running, and moving the camera in accordance with the instructions from the director of photography.

H. Lester

CAMERA OPTICAL Any special effect made in a motion-picture camera, as distinct from those made in the printing stage.

H. Lester

See also: *Optical effects.*

CAMERA PROJECTION Image formation by a camera lens whereby all the incident rays converge to a common point or viewpoint in the lens, usually the center of the entrance pupil, and emerge to diverge to the image. If the image is formed on a screen or film surface intersecting this cone of rays orthogonally, then the perspective given is due to such *central projection.*

Another definition is that where a light source is used behind a camera to form an image on the subject plane of a grid (transparency, etc.) placed at the film plane. In copying setups, used to obtain the desired cropping and to focus the camera without looking through the viewfinder. In animation photography, projected images are traced for the preparation of mattes and for composite effects.

S. Ray

See also: *Perspective.*

CAMERA-READY ARTWORK Copy that has been prepared and is ready to be photographed and printed. *M. Bruno*

CAMERA REPAIR Camera repair often follows damage from dropping (or other impact), moisture, temperature extremes, or foreign matter such as sand, dirt, or dust.

The first phase of camera repair rests with the camera owner. If the camera hits pavement (or another hard surface), all pieces should be retrieved immediately and taken with the damaged camera to a repair shop. If the camera falls into fresh or salt water, it's best to immerse the camera in a bucket of fresh water to prevent corrosion or rust during any delay in getting to a repair shop.

Such simple preventive measures as wearing the camera neck strap or wrist strap as intended can reduce the need for camera repair. So can immediate attention to any foreign matter that gets on the camera. Compressed air can be used to remove loose dust and dirt, but special care must be taken around shutter curtains on focal plane shutters. If a camera falls into snow, any packed snow can be removed immediately with a toothbrush. The camera then should be wiped with a clean cloth. Both steps should be taken while the camera remains cold so that snow won't melt and penetrate the interior.

Not all assaults on cameras are obvious. For instance, one 35-mm single-lens reflex camera that went on a family vacation to Cape Cod suddenly stopped working. The owner thought the batteries had run down. When new batteries did not make it work, the owner asked the salesclerk about repair. The salesclerk asked where the camera had been. When the clerk heard "beach," he opened the camera, blew air on its inner mechanism, and completed a courteous, cost-free repair.

Most camera repair is neither free nor immediate. It is accomplished by meticulous, highly skilled technicians who work in shops specializing in camera adjustment and repair or in service departments of large camera stores. Others work directly for camera manufacturers or for motion-picture or television studios or companies that rent motion-picture equipment.

All these technicians use expensive, sophisticated equipment to diagnose problems and a large inventory of parts to complete the actual repair. Manufacturers' blueprints, specification lists, and repair manuals provide needed information for tests and adjustments. Often, repair can be made simply, using hand tools, without replacing any parts. Other times, technicians must fabricate replacement using such shop equipment as lathes and milling machines.

The advent of electronic components and the proliferation of brands and models of cameras has concentrated most camera-repair work in specialized camera-repair shops. They serve many customers through photo retail operations that once might have staffed their own camera-repair departments. Technicians working in these independent repair shops learn to work on a great variety of equipment.

Warranty work and repairs on older equipment tend to be handled by the manufacturer. Technicians who work for a manufacturer become experts in that one manufacturer's equipment. Some relatively inexpensive cameras, which need repair during the warranty period, may be replaced rather than repaired.

In addition to repair work, camera-repair shops also provide maintenance for cameras subjected to heavy use. Regular cleaning includes film transport system, reflex system, and viewfinder. Shutter speed, metering, and other electrical systems can be analyzed and adjusted for optimum performance.

Basically, camera-repair technicians need the attributes of the craftsperson. These include keen eyesight, manual dexterity, and a fondness for mechanical challenges. They also need the communication skills to find out from the customer what's wrong—and the patience and perseverance to complete the repair to the customer's satisfaction.

Many camera-repair technicians are trained on the job by the camera-repair service companies and camera manufacturers where they work. Classroom instruction and correspondence courses can provide the basic technical background and familiarity with electronics needed to start. Seminars and training offered by manufacturers and trade associations update skills.

K. Francis

CAMERA SCRIPT A motion-picture document that includes details of the shooting and lighting plan. *H. Lester*

See also: *Shooting script.*

CAMERA SPEED The frames-per-second rate of a motion-picture camera, normally 24 frames per second. Alternative speeds are used in special situations such as filming slow or fast motion or when filming miniatures.

H. Lester

CAMERA STABILIZATION See *Motion-picture photography, basic features of motion-picture photography.*

CAMERA STANDARD The upright supports that hold the lens board and film back on studio, view, field, and some medium-format cameras. Both the front standard and rear standard are commonly designed to allow for lateral, vertical, and angular adjustments of the lens board and film. "U" or "L" are the most common shapes for standards on monorail cameras.

P. Schranz

CAMERA SUPPORT In the days of glass plates and films with very low sensitivity, it was essential to use a tripod or other camera support in order to achieve a sharp image. Faster films have lessened the need for such camera

Tripod and monopod with telescoping legs. Both supports may have rubber-tipped legs with retractable spikes for use where the spikes will not cause damage.

(Top) Ball and socket head, which allows movement in all directions and then can be locked in place. (Bottom) Pan and tilt head.

Gun stock support.

stabilization, but only when camera supports restrict mobility will professional photographers dispense with them.

The need for portability has seen the development of lightweight, steady tripods of various sizes. Some are made for use with 35-mm and medium-format cameras, and others are made for field and location work with the larger view cameras. The heavier the camera, the heavier and stronger the support must be, but it is not at all uncommon to see a professional photographer using a heavy tripod with a small camera attached.

A tripod is a three-legged stand, almost always adjustable to varying heights through the use of telescoping legs and an adjustable center column. The center column can ride up and down by means of a ratchet and crank handle or it can move freely and be locked in place with the use of a set screw and knob. The center column is topped with a head and base plate to which the camera is attached with a threaded knob that fits into the socket on the camera's underside. On some tripods the threaded knob is reversible to accommodate sockets of two sizes, which represent a difference between cameras made for European and American markets. There are threaded adapters that make using almost any available size screw mount feasible. Available, also, are quick-release adapters that make attaching and removing cameras fast and easy, as may be useful when trying to accomplish a great deal of shooting in a short period of time. One part of the adapter fits onto the base of the camera, the other part onto the tripod. By means of a small level, the camera can be mounted or disengaged in a matter of seconds.

Movement of the tripod head is controlled with knobs or cranks that allow panning and tilting, movement on the horizontal and vertical axes. Normally the head can be locked into position on either or both axes. Ball and socket heads may be used with some cameras on lightweight tripods but are not stable enough to be used for large-format photography.

Studio stands are commonly used when working with large-format cameras, 4 × 5 in, 8 × 10 in. and larger. There are two basic types of studio stands: the single-column type and the bi-post design. The first kind is built with a heavy base on wheels. The stand can be locked down by raising the wheels so the stand sits solidly on its base. The single column rises from the base and an arm perpendicular to the column holds the head on which the camera is mounted. The heads of most of these studio stands are geared to permit slow, steady, and accurate movement of the camera.

Through the use of internal counterweights, the horizontal arm can be moved up and down on the vertical post with little effort, allowing the camera to be placed at the height needed for a particular point of view. The arm can be moved from near the floor level to the top of the post, which may be 7 to 10 feet high. The second type of stand has a flat bed between two large posts mounted on a heavy base. The camera is mounted onto the bed of the stand and is given a range of movements through the use of gears and cranks. This stand will allow for similar movements to the single post stand but will accept heavier cameras. It may also be taller than the single-post stand.

There are many specialized supports for small-format cameras. C-clamps and similar devices with ball joint heads allow for affixing a camera to a sturdy piece of furniture, a ladder, or door frame. Small tripods and braces are designed to be held tightly against one's chest or shoulder with the camera mounted at a right angle to it and held at eye level. Gun stock supports with a built-in trigger attached to the camera's cable release are often used in wildlife photography. Of course there is the ever handy monopod: one telescoping leg with a head at the top to accept the camera and a rubber foot with a retractable spike to keep it steady in various circumstances.

Stabilization of a hand-held small-format camera is sometimes accomplished through the use of a gyroscopic device that attaches to the tripod socket. The battery-driven gyro tends to keep the camera steady by increasing the inertia so that movement is controlled and dramatically reduced. A gyro is most often used when shooting from a moving automobile, boat, or airplane. Larger gyro heads are used with motion-picture and video cameras. These heads and cameras may be mounted on a gimbal so the camera can be held steady and is free floating no matter how the vehicle moves, bumps, or jumps. One widely used gyro stabilizer is the Steadicam. There are small models for hand holding and using with a small motion-picture and video camera. The larger professional models mount on the operator's body, and a

counter-balanced, articulated arm extends outward to the gimbal platform on which the camera is mounted. As the operator moves, any shock is dissipated as it moves toward the camera mounting. The operator does not view directly through the camera, but the camera image is picked up on a small monitor affixed to the arm of the Steadicam, and the operator can frame the scene in this way. A. Vogel

CAMERA SYNC The synchronous relationship between picture and sound when both are originally recorded on the same strip of film in a single system motion-picture camera.
H. Lester

CAMERA TYPES

AERIAL CAMERA A specifically designed camera used to record topography from an airplane. Some aerial cameras are designed to be mounted to the bottom or side of a plane on a special mechanism that uses shock absorbing springs and to be fired by remote control. They are designed and calibrated to make a series of overlapping images along a selected flight path. An additional camera may simultaneously photograph the instrument display of the airplane to indicate the height and tilt of the plane at the time of exposure. The film is held flat against the pressure plate by a glass plate with inscribed markings. These markings are placed at specific intervals and, when combined with data from the instruments about altitude and plane tilt (see instrumentation camera), yield the land distance between the two markings. If the overlap exceeds 50%, stereo three-dimensional images can be made. Aerial cameras have no bellows and the lens focus is locked on infinity since aerial images are seldom made below 300 feet. Shutters are focal plane rotating sector type to allow for speeds up to 1/4000th of a second. A frame finder is used as a viewfinder.

Films can be monochromatic, color, or infrared, depending on the application, and they come in 70-mm rolls yielding 6 x 6 cm images or larger size film in 100-foot rolls yielding 23-cm square images.

Conventional cameras can also be used for aerial photography. Such cameras can be hand held at fast shutter speeds. Holding the camera against any part of the plane picks up the motor and air turbulence vibrations.

Aerial photographs are used for a variety of purposes, including mapping, military intelligence, and agriculture. Much of this work is now done by satellites (Landsat) using both radar and infrared sensors.

See also: *Aerial photography; Remote sensing.*

Astronomical Cameras Large scientific telescopes with tracking mechanisms have photographic path options. Instead of the light being projected through to a viewer lens, the light path is diverted to a photographic recording apparatus in the focal plane of the telescope. Dimensional stability is also essential and glass plates or critically accurate film pressure plates are used. The advantage of using photographic materials in astronomy is that photography allows for weak light intensities to accumulate on film and thus become visible with prolonged exposure. With long exposures, the camera needs to be on a tracking system with the object observed to avoid streaking caused by the earth's rotation or orbital movement. Separate exposures made at different times can be used to track celestial placement. Some astronomical cameras make images that separate radiation wavelengths that yield information about the composition and velocity of the object.

Other cameras can be used with adapters to attach a Schmidt-Cassegrain design long telephoto mirror lens. If using a lens with a telescopic adapter, the normal lens for the camera can be removed, using the telescope's lens only for image formation.

See also: *Astrophotography.*

Box camera.

BOX CAMERA An historical reference used to describe a simple camera having an elementary (usually single element) lens system, one or two apertures, and a hand turned film transport system. There is no adjustable focusing system, and focus is basically a result of depth of field from a point approximately 7 feet away from the camera. The box camera was designed for the general public to take snapshots in good light. The principles of the box camera have been carried over in the form of point-and-shoot cameras. In fact, to take the name more literally, major film manufacturers have added a lens and shutter to a throw-away cardboard camera that resembles a box of film.

CANDID CAMERA A camera small enough to be used without the subject's awareness of the photograph being taken. It allows situations to be recorded naturally without posing. A candid camera may be a regular 35-mm camera used clandestinely, a subminiature camera such as a Minox or 16-mm still camera, or a camera camouflaged to look like something else, such as a package of cigarettes, a woman's compact, or a briefcase. The subminiature camera usually has a wide-angle lens and relatively small aperture. Any focusing or exposure calculations are made before its use. The use of a regular camera with a long focal length lens, as used in surveillance work, would also be considered a candid camera.

CHARGE-COUPLED CAMERA A camera having an integrated circuit photoelectric detector charge-coupled device (a CCD silicon chip instead of film) and used for optical image recording. The CCD chip is located at the focal plane. When light strikes the silicon surface, it releases electrons, similar to what happens with traditional silver halide emulsions. The electrons are read out as pixels, which are small sections of the whole image. The electrical signal is then amplified and sent to a magnetic disc for storage.

See also: *Camera types; electronic still camera; Electronic still photography.*

COPY CAMERA A camera used in making reproductions of two-dimensional documents or pictures. Copy cameras are commonly large in format and may be on a horizontal or vertical frame, although small-format cameras are used when the final image is desired in that size—for example, for storage (microfilming) or projection (audiovisual slides). The lens of a copy camera is specifically designed to have peak definition at mid-apertures, since no real depth of field is necessary, and at relatively short object distances. The copy lens is also apochromatic for sharp color reproduction and designed to render a flat field and freedom from distortion at close object distances. In graphic arts, a copy camera is known as a process camera.

See also: *Copy; Copying.*

DARKROOM CAMERA A process camera installed so that the back projects into a darkroom through a sealed opening in a wall, making it possible to place film in the camera without first loading it into a light-tight holder.

DATA-RECORDING CAMERA A camera or camera back that prints imaging information on the film. Such infor-

mation commonly includes the *f*-number and shutter speed, frame number, time, and date.

DIGITAL-IMAGING CAMERA A camera that transforms visual information into electronic digital information (binary code of 0s and 1s). The information can then be recorded, read, enhanced, or manipulated on a computer.

DISC CAMERA A camera produced by Eastman Kodak from 1982 to 1989. The film consisted of 15 negative 8 x 10-mm frames placed around the edge of a thin 2 1/2 inch circular disc. The film disc was packaged in a light-tight diskette and simply dropped into the back of the camera for loading. The camera itself was only 3 x 4-3/4 x 7/8 inches and came with an electronic automatic shutter, nonfocusing viewfinder, autowinding system, a built-in flash and a 12.5-mm F/2.8 aspheric lens.

DRUM CAMERA A streak or smear camera where the film passes rapidly past a narrow slit near the film plane. The film is wrapped around a cylinder that is then rotated at high speed past the slit opening where the image is formed by a stationary lens. It is used to record ultra-high-speed operations where shutter mechanisms are too slow.

See also: *High-speed photography.*

ELECTRONIC STILL CAMERA A camera (with a conventional optical system) that captures the optical image with either a charged-couple device (CCD) or a metal-oxide semiconductor (MOS) device that converts light to an electronic signal that in turn is recorded on a 2-inch magnetic floppy disc, typically in analog form. Each disc can hold up to 50 images. The recorded images can be displayed on a monitor or can be digitized for computer processing or electronic transmission. Some newer electronic still cameras have built-in digitizing capability. Image resolution has not been as high as with silver-halide photography but is rapidly improving. Electronic still cameras were first used professionally by photojournalists because of the speed with which images could be transmitted by telephone and reproduced on the printed page. Electronic capture devices are now available as replacement backs on conventional view cameras and are being used, especially, for large-volume imaging for catalog production.

See also: *Electronic still photography.*

ENDOSCOPIC CAMERA A camera that uses a fiber-optic probe with a lens at one end and a second fiber optic channel for a transmitted light source. It is used for photographing in confined spaces in machines or in human cavities as an alternative to exploratory surgery. The term has also been applied to small, remote industrial cameras that have their own light sources and are used to photograph the inside of tubes or pipes. The optic probe can be flexible or rigid. In a flexible probe, the channel of light is passed through bundles of optic fibers. The rigid model uses a series of relay lenses.

EYE CAMERA A motion-picture or video camera that records eye movement as it relates to specific visual stimuli. The film is then used as data for behavioral analysis to determine the images that attracted the viewer's attention and in what order.

See also: *Camera types, fundus camera.*

FIELD CAMERA A sheet-film camera portable enough to be easily moved and used on location outside of the studio. The term *field* is frequently used to describe wooden folding flatbed cameras or technical cameras. Field cameras have most, if not all, corrective view camera movements.

FINGERPRINT CAMERA A fixed-focus copy camera and lighting system used to reproduce images of finger prints and other small documents for evidence, records, and distribution among investigative agencies.

FIXED-FOCUS CAMERA Typically, an inexpensive camera that has a fixed point of focus (usually at the hyperfo-

Flatbed camera.

cal distance) and no focusing adjustments. A small aperture (*f*/8-*f*/11) produces a relatively large depth of field.

FLATBED CAMERA Based on an early design for studio view cameras, the flatbed is the common design in wooden field and view cameras and on most technical cameras. The wooden flatbed camera usually has both front and rear extension frames on a geared track. The front and rear camera standards are mounted to these movable frames, allowing for focusing. While flatbed cameras offer only limited movements compared to monorail cameras, many photographers appreciate the lighter weight of wood in the field and the camera's ability to fold flat within itself (commonly without lens) for transportation. One of the most popular flatbed cameras for many years has been the Deardorff. New entries into the market show the continued popularity of this design.

FLOW CAMERA A document-copying camera whereby the document is placed in a revolving cylinder, or scroll, that is synchronized to the camera's film transport system. After each exposure, the document and the camera are advanced. The leader and the trailer of the document automatically tell the camera when to begin and end.

FOLDING CAMERA Any camera that is equipped with a flexible or collapsible bellows that folds into itself for compactness. Wooden view and metal technical cameras with hinged beds or standards, medium-format cameras with hinged covers, and some older 35-mm cameras all have folding capabilities. Besides ease in transport and storage, a folding camera offers safety for the camera body and/or the lens.

See also: *Camera types, field, press, technical, and 35-mm.*

FRAMING CAMERA A high-speed motion-picture camera similar to a streak camera, where there is a fixed piece of film and a rotating mirror and relay optics used to project an image onto the film. Where a streak camera creates a continuous image, the framing camera produces a sequence of individual frames.

See also: *Camera types, streak.*

FUNDUS CAMERA A camera designed to photograph the retina of the human eye for medical purposes.

Syn.: *Ophthalmic camera.*

GALLERY CAMERA A self-contained process camera that uses film holders instead of being operated under darkroom conditions.

See also: *Camera types, process.*

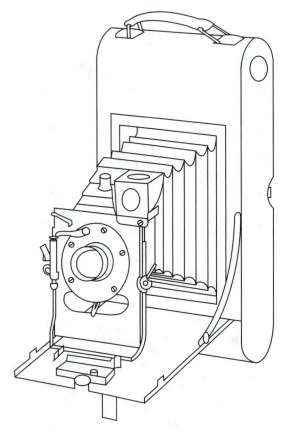

Folding camera.

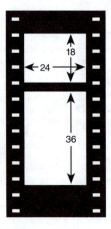

Half-frame camera film format (top) compared with the conventional 35-mm camera format.

GUN CAMERA An aerial gunnery camera for recording the accuracy in hitting targets in combat and in training exercises, typically motion-picture or video.

HALF-FRAME CAMERA A common term for a camera with a film format of 18 x 24 mm, half the size of a normal 35-mm frame.

HIGH-SPEED CAMERA A general term applied to a number of specialized cameras used in making photographs at extremely short exposure times, as in the case of sharp recording of rapidly moving objects.

HIGH-SPEED VIDEO CAMERA A video camera designed to record images over very short exposure times either with a shutter or by applying a short-duration electric field to an image converter where exposure times as short as 1/200,000,000 second have been achieved.

See also: *High speed cinematography.*

HORIZON CAMERA A camera used to photograph a 365-degree circle in a single exposure. A hemispherical lens in the center of a circular drum projects the image onto a strip of film wrapped around the drum's circumference. It is used in conjunction with survey cameras for orientation purposes.

See also: *Panoramic camera.*

IMAGE-CONVERTER CAMERA A camera/lens design using an image tube and a series of secondary emitter couplings (i.e. caesium coated mirrors) to multiply the electron gain, so that the light output is greatly increased over the original input. The light increase allows for exposures of millions of images per second. The image converter camera is used in high speed photography, because it has no moving parts and can be used for single, multiple, or streak recordings. The basic camera consists of a photocathode that projects an image toward a phosphor screen at the rear of the tube. The phosphor screen emits light similar in intensity to the photocathode. Thus, the original light input is turned into electrons, which are then excited further by a low voltage pulse. The electrons reaching the phosphor screen are greatly enhanced over the original light input. The screen then emits a respective increase in light output (as high as 1000x). The enhancement can take place many times over, allowing for extremely fast exposures.

INFRARED CAMERA A camera used to record heat images produced by infrared radiation. When infrared is absorbed, heat is radiated. The image is focused onto a nitrocellulose membrane carrying a gold layer an an oil film. The heat pattern from the infrared produces a pattern of thicknesses on the oil film. The pattern is then illuminated and reproduced on film as a visual image. This type of camera can be used to distinguish distances at night, to detect heat loss in buildings, and in medical applications to discern malignant from benign tissues by their temperature differences.

INSTANT CAMERA A camera that produces a finished picture within a short time after exposure. The first instant camera was the Polaroid Land camera Model 95, introduced in 1948, which used diffusion-transfer type instant film. The Spectra instant camera, introduced in 1986, used instant film that produced a finished picture without transfer to another surface, and therefore the camera contained a mirror to prevent lateral reversal of the image. The term *instant camera* has traditionally been applied to cameras using photochemical photographic systems, but the concept of obtaining a finished picture shortly after exposure also applies to video and electronic still cameras. See also: Camera types, electronic still camera, video camera; Polaroid; Polaroid photography.

INSTRUMENTATION CAMERA A camera used to photograph an instrument display, usually in conjunction with another camera photographing a different activity. The combined display yields both image and documentation of the conditions under which a time sequence or time lapse image was made.

See: *Camera types, aerial.*

MINIATURE CAMERA A term generally used to describe a camera using 35-mm or smaller film format.

See also: *Cameras types, subminiature, 35-mm .*

MIRROR CAMERA A high-speed camera wherein the film is stationary, and a sequence of images is projected onto the film by a series of rotating mirrors. This sequencing can exceed over a million exposures per second.

See also: *Camera types, rotating mirror/prism camera.*

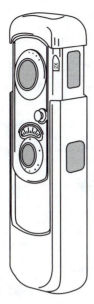

Miniature camera that uses 16-mm film.

MODULAR CAMERA A camera system designed around a basic camera body. The lenses, viewfinders, film backs, and other accessories are interchangeable and varied in their function. The camera can be adapted to a variety of applications, which eliminates the need to purchase additional cameras.

Syn.: *Systems camera.*

MONORAIL CAMERA A type of view camera that uses a single bar, or track, to support the front and rear standards. A monorail view camera offers a large amount of camera movement flexibility, and the single rail helps to reduce the weight of a metal camera.

MOTION-PICTURE CAMERA A camera that records separate still negative and reversal images through an exposing gate, or rotary shutter, in a tightly timed sequence on a long continuous length of film. Motion-picture cameras typically record at 18–24 frames per second, but the images are shown through a projector with a double or triple bladed shutter, which shows each frame two or three times, respectively. The result is the illusion of smooth motion and an absence of flicker. Some motion-picture cameras have variable recording speeds that yield exaggerated fast or slow motion. Some are also equipped to record a soundtrack on the film (optical) or on a magnetic strip running along the side of the film. Motion-picture cameras are built to use different film formats including 8 mm, Super 8 mm, 16 mm, 35 mm, and 70 mm in varying lengths. Many motion-picture cameras are equipped with zoom lenses that allow image size and angle of view to be changed.

MULTI-IMAGE CAMERA A camera designed to record several different images on the same sheet of film. This type of camera is used for motion studies and frequently uses a stroboscopic flash as the recording mechanism.

ONE-SHOT CAMERA A camera with a single optical system that projects the image onto a beam splitter and simultaneously makes three color (red, blue, and green) separation negatives in one exposure.

Syn.: *Beam-splitting camera.*

OPHTHALMIC CAMERA A camera and system used to make a photographic image of the retina. A chin rest holds the head steady while the subject stares at a focusing red light dot. The flash is extremely powerful, but of short duration. This makes it possible to photograph the eye while it is open.

The intensity of the flash also allows the use of a small aperture necessary for depth of field in extreme closeup work.

Syn.: *Fundus camera.*

OSCILLOSCOPE CAMERA A camera used to photograph the face of a cathode-ray tube (television screen) to document the image activity on the screen. One problem with photographing a cathode ray image is that the entire image is never completely present on the screen at any one time. Instead, the image is produced by a repetitive scanning pattern. The image exposure has to be long enough to include a complete cycle of two fields (one frame), 1/30 second. Shorter times will record a partial image. Between-the-lens leaf shutters are better for this type of photography because of the scanning movement of focal-plane shutters.

PANORAMIC CAMERAS A special camera that records an image that has a film format at least twice as long as the film's height. There are three types of panoramic cameras: fixed ultra-wide-lens, rotary, and assemblage.

A fixed ultra-wide-lens camera uses roll or 35-mm film and produces a panoramic image with a width no greater than 3x the height. As long as the camera is parallel to the horizon (a level is needed), there is no visual distortion.

Rotary panoramic cameras scan a scene by rotating the lens and exposing the film through a slit. Accurate panoramic cameras (those reducing curvature of the horizon line) have a curved film plane to keep the point of focus constant as the lens turns. Verticals remain vertical; horizontals are elipsed. If the print is curved during viewing, the horizontal lines become parallel.

For an even greater angle (as much as a full circle), a special rotating camera, called a circuit camera, scans the scene by having the lens and film operating on opposite circular tracks. As the camera turns, an exposure is made through a slit, and the film also turns.

An assemblage panorama can be made using a standard camera and multiple images. The camera is mounted on a specially calibrated rotating head tripod in such a way that the rotation pivots under the rear nodal point of the lens to keep perspective constant. The camera is rotated an exact amount for each exposure, and the sequence of images is assembled for viewing.

See also: *Panoramic photography.*

PINHOLE CAMERA A camera using a small hole made by a needle in a piece of thin opaque material, instead of a lens. The pinhole forms an image by allowing only a single narrow beam of light from each point on an object to reach the opposite surface. Light rays traveling through this pinhole continue in a straight line and form an inverted image on the opposite side of the box, where a piece of photosensitive emulsion is placed to record the image. The pinhole itself should be circular with clean edges, and the opaque material should be thin enough to prevent objectionable vignetting. Image size depends on the distance from the pinhole to the opposite side. The *f*-number of a pinhole is calculated by dividing the pinhole-to-film distance by the

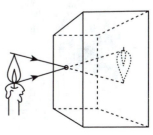

Pinhole camera.

diameter of the pinhole—for example, 5 inches divided by 1/50 inch equals *f*/250. Pinhole images are not critically sharp, but the sharpness appears uniform from within a few inches of the camera to infinity. The relatively long exposure times required prevent the pinhole camera from recording moving objects without blur.

PRESS CAMERA A folding flatbed-type camera having a bellows and equipped with a coupled rangefinder and focusing scale, optical and wire-frame viewfinders, and synchronized flash. The camera reached a peak of popularity with newspaper photographers in the 1940s before being gradually replaced by 35-mm and medium-format cameras. The most widely used press cameras were the 4x5-inch format Graflex Speed Graphic (with focal-plane and lens shutters) and the Crown Graphic (with lens shutter only). These cameras had a drop bed, and rising-falling, shift, and tilt adjustments on the lens but no adjustments on the back.

See also: *Camera types, technical camera.*

PROCESS CAMERA A precision camera used for copying images for reproduction. The camera can make line or halftone negatives of flat copy that can be used to make printing plates. The copy board/copy holder and the film holder must be exactly parallel, and the lens must be a flat-focus type to insure detail fidelity over the whole field and to avoid curvilinear distortion.

There are three types of process cameras: horizontal, semivertical, and vertical. The horizontal (also known as gallery camera) has the copy board and camera operating horizontally along a track. The semivertical camera uses a 45-degree mirror to project the image 90 degrees to a horizontal camera. The vertical camera is a free-standing self-contained unit that has controls for the lens, a copy board, and often contains its own lighting system.

See also: *Camera types, copy, darkroom, gallery, wall; Vacuum back.*

PROGRAMMED CAMERA Automatic camera with autofocus and autoexpose features based on analysis of the subject and lighting and a program on a computer memory chip. The program takes into account focal length, macro settings, whether a dedicated flash is used, and reads film information off the DX code on the film canister. It programs for small apertures and faster shutter speeds in bright areas. As the light dims, the shutter slows first. After both shutter and apertures are at the minimum for hand-held, the camera will indicate the need for flash or use of a tripod. Another attribute of programmed cameras with zoom lenses is zoom locking. Once the autofocus is set for a particular subject size in the viewfinder, changing of the subject-to-camera distance will change the zoom range to maintain the same image size. Other variations include a portrait setting that can zoom in on a subject to frame a head and shoulder, half-length, or full-length portrait.

Flash photography on programmed cameras works with a dedicated flash that has a built-in sensor tied directly to some of the camera exposure controls. Flash output is controlled on the basis of reflected light readings from the flash unit on the focal plane of the camera. Other programmed-flash controls include automatic fill-in flash.

While some programmed cameras have an override mode, others are so automatic they have no readable exposure information.

PULSE CAMERA A camera with a film transport and exposure system activated by an electrical pulse signal (a form of remote triggering). When the signal reaches the camera sensor, the exposure is made and the film is advanced to the next frame.

RADIOISOTOPE CAMERA A camera used to detect flaws in visibly opaque subjects and structures by passing a beam of x-rays through the form and onto a photographic emulsion. The image produced is based on the rate of radiation absorption as the beam passes through the form. Besides its use in medical photography, the radioisotope camera is also used in industry to show flaws in casting, welds, raw materials, and refinished products.

RANGEFINDER CAMERA A camera that has a built-in system for measuring the distance from the camera to the subject without focusing through the lens. The rangefinder is operated by an image that is projected to two view points separated by several inches. One of these viewers is an angled pivoting mirror, or adjustable prism, that superimposes the image from one viewer over another or aligns the two halves of a split field. When the images align, the indicated distance is shown on a scale. Most rangefinder cameras have a coupled rangefinder system that is connected to the lens focusing system, which is part of the camera body. When the overlapping images align, the camera lens is focused on that object distance.

REFLEX CAMERA A type of camera that uses a rectangular or square front-surface mirror, mounted on a 45-degree angle to project an image upward to a ground glass for viewing. In the case of a twin-lens-reflex camera, two separate chambers are used, with coupled lenses of equal focal length. The top chamber holds the mirror for focusing. When the top reflex image is in focus on the ground glass, the

Press camera.

Rangefinder camera (35-mm).

of lens elements needed and which also improves the lens speed. Light enters around the perimeter of the lens and reflects off a mirror before finally striking a curved film plate having the same arc as the mirror. Because of the blocked center, there is no diaphragm, and exposure is controlled with neutral density filters.

SEQUENCE CAMERA A camera with a film-transport system that makes a number of exposures on separate, but sequenced, frames in a short period of time. The action is found on many motorized film backs. A sequenced camera can be set to record a specific number of frames in a designated time limit. It is used in motion studies for sports, investigative photography, and scientific analysis.

SINGLE-FRAME CAMERA A camera that uses a single piece of photographic emulsion at a time. This could be in reference to a pinhole camera or a sheet film camera.

SINGLE-LENS REFLEX CAMERA A camera with a hinged 45-degree mirror behind the lens that reflects light up to a viewing screen, but that flips up momentarily when the shutter is tripped to allow the light to expose the film. The viewfinder image is correct top to bottom but is reversed laterally. When an eye-level pentaprism is used, a series of reflections corrects the lateral orientation. The lens diaphragm automatically opens to its fullest aperture for composing and focusing. At the time of exposure, the lens closes down to the set aperture for correct exposure and the mirror flips up. A focal-plane shutter in front of the film plane opens to expose the film. After exposure, the mirror flips down for continued viewing of the subject. The ability to view the subject up to the instant of exposure is a popular feature, especially with photojournalists and portrait and candid photographers.

Advantages of a single-lens reflex include: 1) no parallax correction is needed because the same lens is used for viewing and exposure; 2) lenses can be interchanged, including

bottom image is in focus on the film. A single-lens reflex camera is similar in concept except there is only one chamber. The mirror used to project the image up for viewing swings up and is momentarily out of the way of the optical path for exposure of the film. The focal-plane shutter then opens to expose the film. This means that the viewing and taking lens are one and the same, which simplifies using interchangeable lenses. Many single-lens reflex cameras, particularly 35 mm, have an eye-level pentaprism mounted about the ground glass, which produces an erect and laterally correct image for eye-level viewing.

Reflex cameras have the option of using through-the-lens metering for exposure, which compensates for loss of light due to filtration or macro focusing.

ROTATING MIRROR/PRISM CAMERA A high-speed recording camera that projects an image onto a rotating mirror for making rapid frame exposures. The rotating mirror reflects the images successively to each of a set of fixed relay lenses arranged in an arc. The arc is situated in front of a static piece of film. The number of exposures depends on the number of lenses used. The arc of mirrors projects successive images on film at speeds up to 10 million frames per second. A rotating prism camera uses a rotating glass block to hold an image stationary and instead moves the recording surface. Its use in high-speed cinematography gives better resolution than an image tube and can be used for color. Its major drawback is size and the fact that the subject needs to be extremely well-lit.

The rotating prism camera is an earlier form of a rapid-imaging camera in which the film is moved continuously, with images projected on the frames by a constantly rotating optical block moving at the same speed. The result is a stationary image formed on each frame.

SCHMIDT CAMERA A camera using a Schmidt projection system. In this system, the lens is replaced by a mirror to form the image. An aspheric lens corrector plate is placed in front of the concave mirror to eliminate spherical and chromatic aberrations, elimination of field curvature requires a curved focal plane. The approximate aperture is quite large (about $f/0.7$). The aspheric lens is made by laminating an organic plastic to glass, which reduces the number

Single-lens reflex camera (35-mm).

special lenses such as macro, wide-angle, zoom, and tele-photos. (Lenses are frequently bayonet mounted for quick change. Due to the single-lens design, autofocus lenses are an option); 3) through-the-lens metering automatically compensates for the addition of filters; 4) there are many accessories available for SLR cameras, including interchangeable prisms, focusing screens, and camera backs, closeup equipment, motor drives, and electronic flash systems; 5) the camera is relatively small in size compared to twin-lens reflex cameras; 6) with a focal-plane shutter, there is only one shutter to test for a variety of lenses; and 7) many of the SLR cameras have a built-in hot shoe for connecting dedicated flash units for programmed exposure. On professional cameras, a PC connector is still available for more professional systems use of electronic flash.

The disadvantages of an SLR, considering its format size restrictions, are minimal. One earlier problem was the possibility of camera shake from the reflex movement of the mirror, and the noise created. Newer cameras have made great strides in reducing the effects of both problems through complex dampening systems. A second concern comes from flash synchronization with a focal-plane shutter. Many cameras in the past could be synchronized only at shutter speeds of 1/60th of a second and slower. With improvements in focal-plane shutter design, synchronized shutter speeds have now reached 1/250th second.

Single-lens reflex cameras also come in medium format sizes of 6 x 4.5 cm, 6 x 6 cm, 6 x 7, and 6 x 8 cm.

The first single-lens reflex camera of note was the 1936 Kine Exakta Model One that had a waist-level focusing system. The 1949 Zeiss-Ikon Contax S added a pentaprism for eye-level viewing and was the forerunner to contemporary SLR cameras. The first single-lens reflex medium format camera was the 1898 Graflex No. 1a introduced by Folmer and Schwing that had a waist-level fold-out finder, used roll film, and had a focal-plane shutter.

Thirty-five millimeter single-lens reflex cameras can be categorized as manual, automatic, and systems cameras.

Thirty-five millimeter manual cameras have a match-needle or electronic-diode metering system that requires the photographer to choose from a variety of aperture and shutter speed combinations. Thirty-five millimeter automatic cameras have a built-in exposure system or a program-mode system that automatically reads film DX codes and functions in aperture priority, shutter priority, or full-program priority including electronic flash controls. Most professional automatic SLR cameras also have manual override for more selective metering. Many automated 35-mm single-lens reflexes are also equipped with autofocus. Thirty-five-millimeter systems cameras have either manual or automatic functions or a combination of both. The difference is that a professional systems camera is more rugged in construction, to stand up to the intense use of a working photographer, and can accept a variety of specialized accessories.

Medium-format SLR systems are roll-film cameras that have modular construction and focal-plane shutters. Optional lenses can have a leaf shutter. Medium-format single-lens reflex cameras are available in 6 x 4.5-cm, 6 x 6-cm, 6 x 7-cm, and 6 x 8-cm film formats. Several also have perspective and focus adjustment camera movements similar to those found on technical and view cameras. Almost all have some form of interchangeable backs.

SLIT CAMERA A high-speed camera in which a strip of film is exposed as it moves behind a rectangular slit aperture.

SMALL-FORMAT CAMERA A term used to describe 35-mm, half-frame 35-mm, and smaller-format cameras.

SPY CAMERA The term *spy camera* can have several meanings and applications: (1) a camera mechanism and lens designed to look like an object other than a camera, i.e., cigarette package, binoculars, cigarette lighter, pen, walking cane, etc.; (2) a clandestinely hidden camera such as a wrist camera, a fiber optic camera, a camera behind a two way mirror; and (3) a small camera that can easily be smuggled into a location for making clandestine 16-mm photographs, for example, a Swiss Tessina, Minox, or other 16-mm still camera.

STEP-AND-REPEAT CAMERA A camera that after each identical exposure automatically moves the light-sensitive emulsion to another position behind a high-resolution lens. The result is a repetition of exact images in rows and columns on a single sheet of film. It is used for preparing printing plates for repetitive images, such as postage stamps or printed circuits.

STEREOSCOPIC (STEREO) CAMERA A stereo camera is really a pair of two identical cameras built into one body with matching lenses mounted approximately 2 1/2 inches apart, which is the approximate distance between human eyes. The lenses are 65 mm apart on 35-mm stereo cameras. The two lenses have linked shutter and aperture settings. A single viewfinder can be placed between the two lenses for framing. The stereo camera makes two half-frame images on 35-mm film, skipping every third frame. When the film is advanced, it advances one-half frame. Thus, each set of stereo frames is separated by two frames. The final images must then be cut and reassembled together, frequently cut again into a square format. The effect of the image recorded twice from slightly different viewing angles, called parallax viewing, is the addition of depth perception.

Stereo camera.

In regular vision, if the left eye sees only the left image and the right eye sees only the right image, the brain will reconstruct the full image with a sense of depth and spatial separation. Viewing stereo images has to be done in such a way that each eye can see only the corresponding left or right photograph, allowing the brain to fuse the two images (except in areas of disparity). This can be done using a stereo viewer, which separates the viewpoints for the two eyes. Objects closer to the camera are recorded with more disparity than those farther away.

Another form of the stereo camera is created with an image splitter mounted on the front of a single lens. In this case, two half-frames are projected adjacent to each other and need to be separated and mounted an appropriate distance apart.

Any camera can make a stereographic image by making one exposure and then moving the camera laterally 2 1/2 inches for the second exposure. This works, providing nothing in the image changes during the lateral shift. The optimum separation, however, changes with object distance, decreasing with closeups and increasing dramatically with high-altitude aerial photographs.

See also: *Nimslo camera; Perspective; Stereophotography.*

STILL-VIDEO CAMERA See *Camera types, electronic still camera.*

STREAK CAMERA A camera in which film moves behind a narrow slit—horizontally, with a vertical slit. If the

camera is used to photograph a white spot on a black wall, the image on the negative will be a straight line. If a white ball is photographed falling so that the image moves up the slit, the image on the negative will be a curved line. In either case, the image does not resemble the subject, but useful information about motion of the subject is recorded, and streak cameras are used as relatively inexpensive high-speed cameras to record for analysis images of rapidly moving objects. Different names may be given to this type of camera when the subject movement is perpendicular to the slit (strip camera), when a subject revolves in front of the camera (peripheral camera), and when the camera rotates in synchronism with the film movement (panoramic camera).

Used to photograph the finish of a horse race, for example, (where such a camera is called a photofinish camera) the camera records a narrow vertical strip at the finish line on the full length of the film and as the horses cross the finish line their relative positions are recorded. If the image of a moving horse is traveling in the same direction and at the same speed as the film is moving past the slit, the length of the image of the horse on the film will be appropriate, but if the speeds do not match, the image will be either elongated or compressed, but the order of finishing is still correct.

See also: *Streak and strip photography.*

STRIKE CAMERA A camera used in military applications to record *hits* of guns or missiles. Some strike cameras are mounted near the gun barrel, or on the targets themselves to record incoming projectiles.

STRIP CAMERA A camera in which film moves past a slit aperture located at the focal plane to photograph objects moving at a right angle to the slit. The result is a continuous image rather than a series of sequenced individual frames.

See also: *Camera types, streak; Streak and slit photography.*

SUBMINIATURE CAMERA A common reference to a group of cameras using formats smaller than 35 mm.

SURVEILLANCE CAMERA A camera that can be transported and operated inconspicuously and yet have a long focal length lens that is capable of resolving small detail at great distances. It is used in research observation and evidence/investigative photography. In scientific research, the surveillance camera is commonly set up to function with an intervalometer that exposes a frame and advances the film at specific timed intervals designated by the photographer (i.e., once a minute, once an hour, once a week). A special data-recording back superimposes information about how and when the exposure was made.

Some surveillance cameras are meant to be seen to deter criminal activity. These are the wide angle cameras mounted on automated teller machines, in toll booths, and in banks. The cameras automatically make images of a subject and then advance the film. They can hold up to 800 frames.

The term *surveillance camera* also refers to a hidden video camera.

SYNCHROBALLISTIC CAMERA A strip camera used to make photographs of rapidly moving projectiles. As the projectile moves, the film is transported at the same speed and in the same direction as the image at the film plane to produce a sharp image.

TECHNICAL CAMERA Typically, a medium to large-format bellows camera equipped with limited front and back camera movements for control or image shape and the angle of the plane of sharp focus. It has interchangeable lenses and backs. It incorporates both a direct view through a ground glass, as well as an optical view finder and a rangefinder system that is coupled to different lenses by extending the bellows out to precalibrated stops along the focusing track. The focusing track also has a focusing scale for each focal length lens.

The camera body is metal and the front flatbed folds up over the lens to form a closed case for transport and protection. The camera also has a drop front for lens tilt or clearance of a wide-angle lens.

The term *technical camera* has also been applied to some monorail view cameras that have precision calibrated rails and movements.

35-MM CAMERA Thirty-five millimeter cameras are so-named because they use strips of double-perforated film having a width of 35-mm, film that was first made for use in motion-picture cameras. Oskar Barnack, the inventor of the Leica camera, for which he received a patent in 1914 but which did not make its public debut until 1925, is generally considered to be the father of 35-mm still cameras. Eric Solomon, who began using a Leica in 1928 to take unposed photographs indoors by existing light of famous people for the illustrated press is credited with popularizing the 35-mm camera and this type of informal photography that was given the label *candid photography.*

For many years coupled rangefinders were used in the better-quality 35-mm cameras to obtain accurate focus, but after the introduction of the single-lens reflex (SLR) Exakta in 1936 and the Contax S with an eye-level pentaprism viewfinder in 1949, SLR cameras gained in popularity and now dominate the 35-mm camera field.

A wide range of special features have been incorporated into various brands and models of 35-mm cameras or offered as optional accessories over the years, including interchangeable wide-angle, telephoto, macro, zoom, fisheye, and perspective-control (PC) lenses, built-in supplementary lenses, autofocus (AF) lenses, follow focus, self-timers, synchronized flash, built-in electronic flash, zoom flash, second-curtain (tailflash) synchronization, built-in exposure meters, through-the-lens (TTL) metering, built-in flash meters, automatic loading, automatic rewind, automatic exposure (AE), aperture-priority automatic exposure, shutter-priority automatic exposure, AF and AE lock, automatic feature override, DX sensors, auto winders, motor drives, extension tubes and bellows units (some with lens tilt, swing, rising-falling, and lateral shift movements), electronic shutters, blade-type focal-plane shutters, interchangeable focusing screens and viewfinders, bulk film backs, data recording backs, split-image ground glass focusing, microprism focusing, liquid-crystal and light-emitting-diode data display, and built-in computers that accept a variety of program cards.

The standard picture area in 35-mm still cameras is 24 x 36 mm. Although this is logically a single frame in still-camera contexts, it has commonly been identified as double frame because it is double the size of the 35-mm motion-picture frame. Some compact 35-mm still cameras use a 24 x 18-mm format. These are commonly referred to as half-frame cameras, but they are sometimes called single-frame cameras because the picture area matches the 35-mm motion-picture format in size.

TRIMETROGON CAMERA A camera used in aerial photography that incorporates three lenses, or a single lens with three focus angles. One of the lenses is focused straight down, while the other two are angled toward the sides. Exposure of the three lenses is simultaneous, and the resulting image shows the complete landscape from horizon to horizon.

TWIN-LENS REFLEX CAMERA A camera that has two identical lenses mounted in two separate chambers, one above the other, and operating on a unified focusing track. The top lens is used for viewing and focusing and the bottom for the actual exposure of the film. The light path of the top viewing lens reflects upward from a 45-degree mirror so that the photographer can peer down into the camera through a pop-up focusing hood, while the bottom lens with the shutter is directly in line with the film plane. The viewfinder image is correct top to bottom but inverted laterally. Except for the offset of the two lens positions, the image on the ground glass is virtually the same as what will be recorded on the

Twin-lens reflex camera.

film. The lens placement difference is negligible at any distance over 10 feet. The closer distances will have some difference called *parallax*. Some of the twin-lens reflexes are compensating. As the lens is focused closer, the difference in displacement is noted in the ground glass. Other systems involve a rising platform between the camera and the tripod mount. After focusing, the platform is raised, moving the taking lens into the exact position the focusing (viewing) lens was in.

Twin-lens reflex cameras use between-the-lens leaf shutters. Contemporary twin-lens reflex cameras use roll film in 120 and 220 sizes.

Many twin-lens reflex cameras did not allow interchangeable lenses because they were thought of as a packaged system and certainly more transportable than their press camera predecessors. At least one camera manufacturer did develop a series of interchangeable lenses for their twin-lens reflex.

The twin-lens reflex camera has slowly given way to the now dominant single-lens medium-format camera. It is, however, still popular today among younger photographers because of the value of the precision equipment available at a used equipment price.

See also: *Camera types, reflex; Rolleiflex.*

ULTRAMINIATURE CAMERA A reference to a group of cameras with a film format of 16 mm or smaller.

See also: *Miniature camera.*

UNDERWATER CAMERA Underwater photography can be done three ways using different types of camera systems. A photographer can use a general camera that is placed in a special water-tight housing made from either plastic or aluminum and constructed to operate to only a specific depth. All of the normal functions of the conventional camera are attached to an extension apparatus that passes through to the outside of the housing to allow the diver access to some of the controls. The lens is set to view through a domed port that corrects for lens aberrations common to photographing through water (curvilinear distortion, chromatic aberrations).

Lenses for small and medium-format underwater photography and special cameras are usually of moderate wide-angle design (35 mm on 35-mm camera and a 55 mm on medium-format cameras) because of the change in the optical angle of view caused by the water. The refractive index of water is much greater than that of air. Variations in water temperature and whether the water is salt or fresh also affect the amount of refraction. Both of these short focal-length lenses under water yield an image similar to that of the corresponding normal focal-length lenses on land. The focus scale on underwater cameras and housings also needs to be calibrated for this distortion. The maximum aperture for most of these lenses should be rather large because of problems with the murkiness of the water caused by silt and microorganisms and the diffusion of light in the water. Con-

centration of suspended matter, such as silt, causes a backscatter of illumination and a subsequent loss of contrast. The compression of a telephoto lens underwater would yield a result looking like a fogged image. Shutter speeds are frequently at 1/30th and faster.

The second type of underwater camera system is a camera specifically built for underwater application. It has larger-than-normal dials and a water-tight camera body and lens. These are usually small 35-mm cameras with viewfinders and distance scales. Cameras such as the Nikonos are good to a depth of about 50 feet.

A third way to photograph under water is to use a conventional land camera controlled by an operator while both are working from a submersible vehicle.

Flash units on underwater cameras need to be out and away from the optical path. Near the path, the resulting flash would reflect against the plankton and silt in the water and reduce image contrast. The flash needs to be in a separate watertight housing on an extended arm away from the camera and at an angle to the subject.

VIDEO CAMERA A camera that converts an optical image into an electronic image that can either be displayed on a monitor or recorded on magnetic tape to be replayed later. The system usually records both image and sound information. Video recording yields much lower production costs than motion pictures. Recording is instantaneous without further processing, but requires a video tape unit for viewing. Unwanted imagery can be magnetically erased from the tape and the tape reused. The term *video camera* has been used to relate to everything from a full television studio camera to a small portable camcorder.

Formats for video tape are Super 8 mm, Beta, VHS, VHS-C, 3/4 inch, 1 inch, and 2 inch. Video cameras can also be used to transmit an image to other electronic sources, such as computers.

See also: *Video.*

VIEW CAMERA View cameras have four major components: a flat bed or rail support base, a front upright and movable standard (either "U" or "L") to hold a lens, a rear upright and movable standard to hold the ground glass and film holder, and a corrugated bellows between the two standards to allow for movement and to create a light-tight tunnel. The length of the bellows allows for the use of a variety of lenses as well as the ability to do closeup work. The camera must be used on a tripod. Although simple in basic design, the view camera remains one of the most versatile cameras in the industry.

Viewing of the optical image is done directly on the ground glass. The ground glass is a sheet of translucent glass, usually with a Fresnel lens to improve brightness uniformity for viewing. The image is inverted, but it appears as it will be recorded. Focusing of the image consists of changing the distance between the lens standard and the film standard.

View cameras use sheet film, usually in double sheet-film holders equipped with protective dark slides. The most common view camera film format is 4 x 5 inch, but view cameras are also available in 8 x 10-inch, 11 x 14-inch, 16 x 20-inch and larger and 6 x 9-cm formats.

What is most versatile about the camera system is the standard movements that can change the shape of images, including eliminating convergence of parallel subject lines, both vertically and horizontally on the ground glass and film, and greatly improve the depth of field by altering the angle of the plane of sharp focus.

Both front and rear standards allow for tilt, swings, rise, falls, and shifts. Shifts, and rising and falling fronts and backs, change the image position on the ground glass.

Rear swings and tilts change image shape and prevent parallel subject lines from converging.

Both front and back swings and tilts alter the angle of the

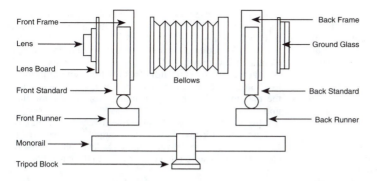

View camera.

plane of sharp focus and depth of field, but the front must be used if the back has been used to control image shape.

With view cameras of modular design, parts can be added or substituted, such as wide-angle bellows, longer or shorter bed, roll-film holder, reflex binocular viewer, larger or smaller format back, and even an electronic-imaging back. The more sophisticated view cameras have incorporated refinements such as through-the-lens metering, depth-of-field scales, telescoping monorails, and computerized controls.

WALL CAMERA See *Camera types, darkroom camera.*

ZENITH CAMERA A camera that photographs star fields with the intent of determining the exact position of the camera, somewhat like a photographic sextant. Zenith cameras are used for surveying and mapping.

Books: Klamin, Charles and Matthew R. Isenberg, *Photographica.* New York: Funk & Wagnalls, 1978; Lothrop, Eaton S., Jr. *A Centruy of Cameras from the Collection of the International Museum of Photography at George Eastman House.* Dobbs Ferry, New York: Morgan & Morgan, Inc., 1973; Rosenblum, Naomi, *A World History of Photography.* New York: Abbeville Press, 1984. *P. Schranz*

See also: *Astrophotography; Leica; Rolleiflex; Streak and strip photography; Video.*

CAMERON, JULIA MARGARET (1815–1879)

English photographer. Began portrait photography at the age of 48 and is most admired for her penetrating closeups, attempting to reveal each sitter's unique personality. Many notables of the Victorian age sat for her, including Browning, Tennyson, Sir John Herschel, Carlyle, Longfellow, and Darwin. Influenced by her friend and neighbor, the Pre-Raphaelite painter G. F. Watts, Cameron created romantic photographic allegories of historical and biblical scenes and characters, and illustrations to Tennyson's *Idylls of the King* (1875). Family, friends, and servants were often conscripted and costumed as models for the Virgin Mary and Jesus or King Arthur and Merlin.

Books: Weaver, Mike, *Julia Margaret Cameron, 1815–1879.* Boston: Little, Brown, 1984; Gernsheim, Helmut, *Julia Margaret Cameron, Her Life and Photographic Work.* New York: Thames & Hudson, 1987; *Annals of My Glass House* (written 1974, published in Gernsheim's biography). *M. Alinder*

CANDELA (cd)

The basic photometric unit of luminous intensity (the time rate of flow of light emitted by a point source in a given direction) in the International System (SI). The original standard candles were superseded in 1948 by the *new candle,* which was renamed the *candela* in 1963. Early luminous intensity standards included candles, flame lamps, and carbon filament incandescent lamps. A 1 candela source emits 1 lumen per steradian (lm/sr).

The standard candela is now defined as the luminous intensity of $1/60$ cm^2 of platinum at its solidification temperature, when viewed through a narrow tunnel made of thorium dioxide. Tungsten filament lamps are used for secondary standards after calibrating them to a standard candela source. *J. Pelz*

See also: *Luminous intensity; Photometry and light units.*

CANDELA PER SQUARE METER (cd/m^2)

The preferred SI unit of luminance; the luminous intensity emitted or reflected from a surface per unit projected area. A surface whose luminance is 1 cd/m^2 emits (or reflects) 1 lumen per square meter per steradian [(lm)/m^2 · sr). The candela per square meter is also known as the nit (nt). *J. Pelz*

Syn.: *Nit.*

See also: *Luminance; Photometry and light units.*

CANDID CAMERA

See *Camera types, candid camera.*

CANDID PHOTOGRAPHY

Candid photography captures one or more persons engaged in a natural, believable activity. Candid photographs are always unposed and often are taken without the knowledge of the subject(s).

What may have been the first candid photograph came together at an English resort in 1892. The photographer, Paul Martin, reportedly muffled the noise of his shutter to capture three vacationers standing on their heads in the sand.

When the term was first coined on January 11, 1930, by the art editor of London's *Weekly Graphic,* candid photography referred to some revealing photographs of politicians taken by Dr. Erich Salomon.

As large-circulation, illustrated magazines proliferated during the 1930s, photojournalistic pictures, many candid in nature, became well known. So did such candid photographers as Henri Cartier-Bresson, Alfred Eisenstaedt, W. Eugene Smith, Robert Capa, and Margaret Bourke-White.

Cartier-Bresson (1908–) believed a photographer should blend in and not influence a subject's behavior; he loved the Leica camera's small size and silent shutter. Eisenstaedt (1898–) became known for his absolutely objective eye. Smith (1918–1978) seemed to memorize every detail of a subject before taking a single picture. Capa (1913–1954) found his brand of immediate candor on the battlefield. Bourke-White (1904–1971) looked for the reality in American military campaigns in North Africa and Germany, guerrilla warfare in Korea, even the Strategic Air Command.

Early in the history of photography, inventors constructed—and even sometimes marketed—cameras designed to be concealed on a person so that photographs could be made without the subject's knowledge. These so-called detective cameras were disguised as parcels, field glasses, even revolvers. All had dry-plate magazines.

Only miniaturization of the camera with the introduction of 35-mm photography in 1924 brought candid photography within reach of the average person. By 1949, the first 35-mm eye-level single-lens-reflex cameras added through-the-lens viewing to the candid photography repertoire.

At times, elaborate façades such as half-silvered mirrors have been installed in public places to facilitate surreptitious picture taking. More often, the candid photographer simply seeks to make the picture taking unobtrusive so that the subject will not become self-conscious and/or strike some unnatural pose.

Candid photographers attempt to become virtually invisible to subjects. Their dress, for instance, tends to blend with, rather than stand out from, the dress of their subjects. Their actions tend to be slow and leisurely because sudden, jerky movements call attention to themselves.

Sometimes, candid photographers will assume a position between their subject and the strongest light source—to make it harder for the subject to see what's going on. Other times, they will look at—and even turn toward—another subject to misdirect the intended subject's attention.

Almost always, candid photographers keep their cameras out of sight or pointed in another direction until the moment when the candid photograph is taken. Some photographers ask subjects to ignore them or play a don't-look-at-the-camera game with children. Others take a flurry of warm-up pictures while subjects get used to the presence of the camera.

As ubiquitous as the camera has become in the 1990s, the candid photographer always must contend with people's inclination to pose. *K. Francis*

CANDLE-FOOT An obsolescent term for the footcandle (lumens per square foot), a unit of measurement of illuminance; the quotient of luminous power incident at a surface and the surface area. The preferred unit is the lux (lumens per square meter). *J. Pelz*

Syn.: *Footcandle.*
See also: *Illuminance; Photometry and light units.*

CANDLEPOWER Obsolescent term for luminous intensity. Frequently (but incorrectly) used as a unit of luminous intensity, in place of the preferred (SI) unit, the candela. *J. Pelz*

See also: *Luminous intensity; Candela; Photometry and light units.*

CANS (SOUND) See *Headphones.*

CAPA, CORNELL (1918–) American museum director and photographer. Born in Hungary, as was his photojournalist brother, Robert. Staff photographer for *Life* (1946–1954). Member of Magnum since 1954. Founder and executive director of The International Center of Photography, New York City, from 1974. *M. Alinder*

CAPACITANCE (*C*) The ability of a capacitor to store an electric charge. Its symbol is C. The capacitance of a capacitor is dependent on three factors: the plate area, the distance between the plates, and the type of dielectric between the plates. The basic unit of capacitance is the farad (F). More practical units are the microfarad (μF), 10^{-6}F, and the picofarad (pF), 10^{-12}F. *W. Klein*

See also: *Capacitor.*

CAPACITOR A device capable of storing electrical energy in an electric field within a dielectric (insulator) between two conducting plates. Formerly called a *condenser.* Two major categories of capacitors are electrolytic and nonelectrolytic. Electrolytic capacitors are classified according to the material of the plates: aluminum or tantalum. The dielectric is a very thin film of aluminum oxide or tantalum oxide, respectively. Electrolytic capacitors are polarized, that is, the polarity of voltage applied to its terminals must correspond to the polarity marked on the capacitor. Nonelectrolytic capacitors are classified according to the dielectric used: air, mica, ceramic, paper, and a variety of plastic films.

Two or more capacitors connected in parallel have a capacitance, C_E, equal to the sum of the individual capacitance: $C_E = C_1 + C_2 + C_3 + ...$

Energy stored in a capacitor, in watt-seconds or joules, is equal to $1/2\ CV^2$, where C is capacitance in farads and V is voltage across the capacitor. This relationship is important to photographers because it is this energy that determines the maximum light energy available from electronic flash units.

After an extended period of not being energized, an electrolytic capacitor may have to be charged and discharged a few times to reform the very thin oxide layer on the positive electrode and restore rated capacitance to the capacitor. *W. Klein*

CAPACITOR MICROPHONE A transducer capable of changing acoustic energy to electrical energy by means of measurement of the small changes in electrical capacitance that result as one or more diaphragms move with respect to a fixed back plate. Both the diaphragm(s) and the back plate are made electrically conductive and are separated by an insulator. The insulator may be air or specially formulated compounds that hold a static charge, called electrets. *T. Holman*

Syn.: *Condenser microphone.*
See also: *Microphone polar patterns.*

CAPA, ROBERT (born André Friedmann) (1913–1954) Hungarian-born photographer. Photographed five wars in 18 years: the Spanish Civil War, the Japanese invasion of China, the Second World War, Israeli independence, and the Indochina War. Naturalized American citizen. Cofounder of the picture agency Magnum (1947). Stated, ". . . if your pictures aren't good enough you're not close enough." Killed in May 1954 by a land mine in North Vietnam while photographing French combat troops.

Books: *Slightly Out of Focus.* New York: Henry Holt, 1947; Whelan, Richard, *Robert Capa.* New York: Knopf, 1985; Manchester, William, *In Our Time. The World as Seen by Magnum Photographers,* New York and London: W.W. Norton, 1989. *M. Alinder*

CAPONIGRO, PAUL (1932–) American photographer. A student of music who added photography to his repertoire, studying with Minor White and Benjamin Chin. Working with a large-format view camera, his vision embraces the natural world to include an apparent galaxy in one perfect apple, running white deer more pictograph than real, and the mysterious stones of Stonehenge.

Books: *The Wise Silence.* Boston: Little, Brown, 1983. *M. Alinder*

CAPRI-BLUE See *Appendix A.*

CAPSTAN (SOUND) The rotating cylindrical shaft against which tape is pressed by a pinch roller in order to impart the correct linear speed to tape or film. The average thickness of the tape must be accommodated in the design in order to produce the correct speed. Typical professional tape speeds are 30, 15, and 7.5 inches per second, while film speeds are 22.5 (70-mm film), 18 (35-mm film), and 7.2 (16-mm film) inches per second. *T. Holman*

See also: *Pinch roller.*

CAPTION Written material that is related to and placed near a photograph or photographic reproduction. Captions credit the photographer, establish ownership and authenticity, and provide a place for a copyright notice. They also usually provide information about what the subject is, where and when the photograph was taken, and perhaps why the

photograph was taken. Essentially, the five *W*'s (who, what, when, where, and why) and *H* (how) should be included in the caption.

The need to identify or provide data that are not clearly evident in the photograph is best managed by captioning the print. It is important to identify the photographer and provide the viewer with a resource for validating the information presented in the photograph. This validation will become even more necessary as still video or computer-enhanced imagery becomes more common. The certification of a photograph is especially important in the case of late breaking news photographs that may be anonymously transmitted over telephone lines.

The caption should not be a verbal description of the photograph but should provide additional information about the subject. Captions should provide information that is not obvious to the viewer but is important for the understanding or interpretation of the photograph. In some cases, the technical information about the photograph, such as the kind of film, the f-stop and the shutter speed used, may be necessary, especially in photographs published in *technical* or *how-to* photographic magazines. Sports events and news photography may require additional information in the caption, such as the name of the subject, the place, date, and the reason or story behind the picture.

In cases where there is a recognizable person in the picture, the name and address of the person(s) being photographed and a signed model release should be obtained to protect yourself and your publisher if the photograph is published. In cases where the subject is or appears to be a minor, get a model release from the parents. When submitting editorial work, many publications provide a style sheet or guide to help determine how the captions should be presented. Attaching the caption with a removable tape to the photograph will ensure that the right caption and photograph will appear together. *M. Teres*

CARBON PROCESS

The fading of prints made by the processes available in the 1840s encouraged a search for a method of making permanent positive prints in pigment. In the 1850s, a variety of such techniques was proposed by A. L. Poitevin, J. Pouncy, and A. Fargier. They relied on the hardening of potassium bichromate when it is exposed to light to make carbon pigment suspended in gelatin or gum insoluble in water after exposure. In the mid-1860s, Sir J. W. Swan introduced a process that used ready-made carbon tissue and transfer sheets manufactured by his firm, Mawson and Swan.

The tissue consisted of finely powdered carbon in gelatin, spread on paper. The photographer sensitized the tissue with potassium bichromate, dried it, and made an exposure by contact. The degree of exposure determined the depth to which the gelatin became hardened, with the gelatin closest to the exposing light becoming hardest. The tissue was then attached to a temporary paper support and soaked to remove the paper backing and the soluble parts of the gelatin, those that had not received a sensitizing exposure. This transfer was necessary to facilitate the removal of the gelatin from the area adjacent to the backing paper. A laterally reversed image was now left on the temporary paper support, unless the exposure had been made from a laterally reversed negative, and the image was transferred to a final support to produce a positive relief image in carbon pigment. Greater exposure through thin areas of the negative produced a greater thickness of carbon in the final print.

The Swan patents were purchased in 1868 by the Autotype Company of England, which introduced improvements to the original process and supplied 50 or more different tissues in 30 colors. Variations on the gum bichromate-based carbon process included Victor Artigue's Artigueotype, shown in

1892; Walter Woodbury's Woodburytype of 1864; the photomezzotint patented by Swan in 1865 which, like the Woodburytype, produced multiple carbon relief images from a master gelatin relief image; and Thomas Manly's Ozotype of 1899 and Ozobrome of 1905, called carbro in an improved version by Autotype in 1919. *H. Wallach*

See also: *Carbro process; Gum bichromate process.*

CARBON TETRACHLORIDE

A clear, colorless, nonflammable liquid (CCl_4, molecular weight 153.82; also called tetrachloromethane) with a characteristic and not unpleasant odor, but the fumes are toxic. Barely soluble in water but miscible in alcohol, benzene, chloroform, and ether. Formerly used as a solvent for cleaning film surfaces or solubilizing oils but now considered too toxic for such uses. *G. Haist*

CARBON TISSUE

The paper prepared for printing in the carbon process. It consists of paper coated with a pigmented gelatin. The color of the pigment used determines the color of the print. Carbon tissue is prepared in two forms, one having the potassium dichromate, which is the light sensitizer, combined with the pigmented gelatin. In the second, the tissue requires sensitizing by immersion in a bath of potassium dichromate before it can be used. There are photomechanical reproduction processes that also can use carbon tissue. An example of this is the photogravure process, which uses the carbon tissue as a photo resist that is transferred onto a copper plate and etched through the exposed gelatin relief image. *J. Natal*

CARBRO PROCESS

The name *carbro* is derived from the main components of the process, carbon tissue, and a bromide print. A close relative of the carbon process, the procedure has its origins in the 1873 discovery of A. Marion that an unpigmented paper sensitized with potassium dichromate, exposed in contact with a negative and held in contact with carbon tissue for a few hours, will cause the carbon pigment on the tissue to become insoluble in water.

In 1899, Thomas Manly introduced a process he called Ozotype that used a printing-out image in contact with a treated carbon tissue. His printing paper was sensitized with potassium dichromate and a manganous salt in gelatin; his tissue was treated with glacial acetic acid, copper sulfate, and hydroquinone. Manly called his 1905 improvement Ozobrome. He now made his print on matt surface, nonsupercoated bromide paper and treated his carbon tissue with potassium dichromate, potassium ferrocyanide, and potassium bromide. When the print and the tissue were held in contact, the gelatin of the tissue became insoluble in water in proportion to the density of the silver on the bromide print. After soaking, the sandwich was separated; the bleached bromide print was saved and could be used to make several more prints. The tissue was removed to a transfer paper where it was washed until only a pigment image remained, treated with alum, washed again, and dried. As an option, instead of transfer, the pigment image could be left on the bleached bromide print, or the appearance of the final print could be intensified by redeveloping the silver image under the pigment.

The carbro process enjoyed substantial advantages over the carbon process. Because the tissue sandwich was made with a print rather than a negative, a small format negative could be used to make a print of any size without the need to make a print-size duplicate negative. Instead of daylight, any light source could be used. Double transfer could be avoided by making a reversed bromide print in the enlarger. Dodging and burning could be used to alter print values. The contrast of the bromide print determined the contrast of the final pigment print. Far less tissue was wasted as a result of exposure

error. Finally, the bromide print could be redeveloped and used to make several more carbro prints.

In 1919, the Autotype Company of England began marketing an improved version of Manly's Ozobrome, which it called carbro. Tricolor carbro produced beautiful color prints from cyan, magenta, and yellow pigmented tissues. Separation negatives were shot through red, green, and blue filters and used to make a matched set of bromide prints.

H. Wallach

See also: *Carbon process.*

CARD In the Macintosh and Amiga world, cards are analogous to boards. *R. Kraus*

See also: *Boards.*

CARDINAL POINTS/PLANES Alternative name for the Gauss points/planes of an optical system, being the three pairs of focal, principal, and nodal points/planes. Such points define the parameters of a lens design, and if the position of an object is also known, then the position and magnification of the image can be calculated. *S. Ray*

Syn.: *Gauss points.*
See also: *Optics.*

CAREY-LEA FILTER A coated suspension in gelatin of colloidal silver of such particle size as to appear yellow. Used in color reversal materials to prevent blue light from reaching the red- and green-sensitive layers. Being metallic silver, it is removed with the image-forming silver in the bleach and fixing baths. *M. Scott*

CARLSON, CHESTER (1906–1968) American scientist. Inventor of the modern photocopy machine. Obtained first patent in 1937, working during the next years to transform his original idea—with the assistance of the German physicist, Otto Kornei—to one that utilized a dry toner controlled by static electricity. Sold the rights to this process in 1947 to Haloid of Rochester, New York, later renamed the Xerox Corporation. *M. Alinder*

See also: *Xerography.*

CARREL In photographic applications, a small cubicle or stall providing a space for a camera, projector, or other piece of equipment so that it can be readily pressed into action. It may be located within a work area, or adjacent with a port for the equipment lens. It may also be capable of being easily transported from one area to another. *I. Current*

CARRIERS Small particles used to charge toners for xerography. Carriers are typically 100 to 200 μm in diameter. In magnetic development, they also provide a means of transport of the toner particles to the latent image. Carriers for cascade development are glass or metal beads. For magnetic brush development, carriers are usually Fe, Co, or Sr ferrites. *P. Borsenberger*

CARROLL, LEWIS (the Rev. Charles Lutwidge Dodgson) (1832–1898) English author of *Alice's Adventures in Wonderland,* mathematics lecturer at Christ Church, Oxford, and amateur photographer (1856–1880). His favorite and most successful subjects were little girls. Helmut Gernsheim's rediscovery of Carroll's photographic work, revealed in his 1949 biography, provided recognition to this previously unknown, though now highly respected, photographer.

Books: Gernsheim, Helmut, *Lewis Carroll, Photographer,* rev. ed. New York: Dover, 1969. *M. Alinder*

CARTE-DE-VISITE A photographic visiting card, usually a full length portrait. The *carte-de-visite* was introduced in 1851 by Dodero, a photographer working in Marseilles. The carte was popularized by André-Adolphe-Eugène Disdéri of Paris in 1854, after he patented a method of producing as many as ten, but usually eight, images on a single photographic plate. The image size was $3\frac{1}{2} \times 2\frac{1}{2}$ mounted on a 4×3 inch visiting card. Disderi produced thousands of *cartes-de-visite* a month. His studios were patronized by wealthy and powerful people, including Napoleon III. The popularity of the carte peaked in the 1860s when the cartes of celebrities were sold by the hundreds of thousands to the public. *M. Teres*

CARTIER-BRESSON, HENRI (1908–) French photographer. First studied painting but changed to photography in 1931 after he purchased a 35-mm Leica camera that became an extension of his eye. Wandered the world with his Leica always at the ready, photographing life without intruding himself. Became the most influential photojournalist of the twentieth century. Cofounder of the picture agency Magnum (1947). Photographed and reported on many major events, including the death of Ghandi and extensive assignments in the Soviet Union, China, and Cuba. Known for the term *The Decisive Moment*—the title of his most important book published in 1952—which is described as the one precise instant when the subject fully reveals itself. Pioneered a style of photographic composition where the placement of each object within the frame, not its real position in the world outside the camera, and its impact upon the rest of the image is the core aesthetic. Studied filmmaking during the 1930s with Paul Strand and worked with Jean Renoir. After escaping from the Germans in 1943, joined the Resistance acting as both a photographer and cinematographer. Retired to draw and paint in Paris in the 1980s.

Books: *Henri Cartier-Bresson, Photographer.* Boston: New York Graphic Society, 1979. *M. Alinder*

CARTRIDGE See *Magazine.*

CASCADE DEVELOPMENT In electrophotography, the use of gravity to bring the toner into contact with the image-bearing support. *L. Stroebel and R. Zakia*

CASCADE PROCESSING (1) Continuous processing method in which the solutions, and/or wash water, are applied as jets of liquid flowing down the strands of film or paper rather than by immersion of the material in tanks. (2) A washing system in which fresh water is fed into an elevated tank from which it flows to one or more lower tanks. The material being processed moves in the reverse direction, from the lowest tank to the highest. *L. Stroebel and R. Zakia*

CASCADING OF FUNCTIONS A procedure of combining the values of a characteristic of the individual elements of an imaging system, such as camera lens, film, projector lens, and printing paper, to determine the value of that characteristic for the entire system. The modulation transfer of a system is found by multiplying the modulation transfer functions of the individual elements. *H. Todd*

CASE, CAMERA A container for storage and transport of a camera, sometimes with associated equipment. To retain their performance with the necessary precision, cameras and their accessories need protection while being stored, transported, and used, especially in the field. Thus, since the inception of photography, camera cases have been important to the photographer.

The most utilitarian form of case is that intended for professional cameras and equipment. Such cases are generally of a boxlike form with a plain hinged cover and constructed of wood, leather, plastic, or metal. Compartments and padding

are usually provided for protection against damage from dropping or other physical abuse. Because considerable weight may be involved, cases are often reinforced at the corners, and are provided with a carrying handle, or handles if excessively large. Cases for aerial cameras, for instance, may be more like large trunks.

Cases intended for modern hand cameras, such as the 35-mm format, are constructed of leather or plastic and are designed to provide good protection for the equipment without being uncomfortable to carry or inviting attention. Some are designed to retain the cameras by means of a screw that attaches the bottom of the case to the tripod socket. In turn, this screw may itself be tapped to accept a tripod screw so that the camera and its case can be attached to a tripod. Other cases retain the camera by means of short leather snap retainers. The flap protecting the lens should be arranged so that there is little likelihood of its flopping into the field of view, and on some cases this flap can be detached. Larger flaps, or *snouts* are available to cover longer focal length or zoom lenses. Shoulder straps are fitted for easy carrying, and small cases for spare rolls of film are often strung on these straps.

Some cases are designed to hold additional lenses, film, and an exposure meter or other camera accessories in addition to one or more cameras. Such cases are usually of more rigid construction and both halves of the top may open out to permit ready access to the equipment. Cases for extended field use tend to be of more rugged construction than those to be used by amateur photographers.

Many cases are designed with adjustable compartments so that photographers can customize them to their particular assembly of equipment and accessories.

Well-fitted soft leather pouches sometimes serve to protect small cameras, lenses, or exposure meters from dust, moisture, or the effects of handling.

The need for a separate camera case has been reduced with some small-format cameras that have attached but movable covers over the lens and other parts of the camera. *I. Current*

CASEIN BICHROMATE PRINTING PROCESS/ CASEIN PIGMENT PROCESS Similar to the gum bichromate process with the exception that casein, which is milk solids dissolved in ammonia, is used instead of gum arabic. The advantage of using casein bichromate is stronger colors and a clearer image quality than is obtained with gum bichromate. *J. Natal*

CASSEGRAIN Form of optical construction much used in catadioptric and catoptric (mirror) lenses, where the light path is folded back on itself twice to shorten considerably the physical length of the unit. Adapted from the astronomical telescope invented by Cassegrain in 1672, the concave main reflector contains a central aperture through which the light from the secondary reflector converges to give a real image at the light receptor. The image can be free from chromatic aberration. *S. Ray*

See also: *Lenses, chromatic aberrations; Lens types, catadioptric.*

CASSETTE In video and audio, a container for tape having a take-up spool and a source spool. The cassette protects the tape and automatically exposes the tape to the record/playback heads when inserted in the camera (camcorder) or recorder/player. The cassette is available in 1-inch, 3/4-inch, 1/2-inch, and 1/4-inch width formats.*R. Kraus*

See also: *Magazine.*

CAST SHADOW Shadow produced on another surface by an object, as distinct from a shaded area on the object itself. Cast shadows clearly establish the relationship of the object to the receiving surface and may prevent an appear-

ance of floating, especially if the object is on a featureless white background. *F. Hunter and P. Fuqua*

CATADIOPTRIC LENS See *Lens types.*

CATALOG PHOTOGRAPHY To one who was born during or before the Second World War, the words *mail-order catalog* conjure up an image of the Sears Roebuck Catalog. Printed on thin paper (which often found usage in the family outhouse), and made up of primitive renderings either drawn or photographed, or a combination of both, the mail-order catalog was home delivered on a regular seasonal basis.

The purpose of the catalog and its unique style of illustration was to introduce a product to potential customers, usually in rural areas, and show what the object being sold *looked like.* The catalog itself relied heavily on the written word for the major part of its message. As was true of most early forms of advertising, catalogs were designed and produced by persons with a background and inclination for the written word.

Over the years, advertisers began to realize that there existed a much larger potential market for catalog sales. They recognized the existence of persons who were not in rural locations who might still enjoy the ease and luxury of shopping from home. Catalogs began appearing that tried to target urban consumers with specialized needs and interests. Many began to focus specifically on one type of merchandise, that is, shoes, sporting goods, or tools, but continued to use the same style that was so successful in earlier publications. The industry soon realized that a new style of design and presentation was going to be necessary to reach these specialty markets.

Before we consider that new style, let us examine the style of the illustrations that existed up to that time. Early catalog illustrations were basically line drawings. They showed the approximate shape of an object and possibly highlighted some simple features. One can find examples in catalogs and magazine and newspaper ads from the late 1890s up to the Second World War. Their primary purpose was to represent merely what the merchandise looked like. Care was taken to show as much detail as possible. With the introduction of photomechanical reproduction of photographs, that style continued. The lighting in the photographs was kept to very low contrast ratios, affording maximum shadow and highlight detail.

As long as the general style of product photography for advertising stayed the same, these simplistic renderings were successful. With the availability, in 1936, of Kodachrome color film, however, magazine and billboard advertising became much more colorful and glamorous. A new style of commercial photography began to be used. This style, often referred to as illustrative photography, attempted to do more than show the customer what a product looked like. Advertisers began to try to create a mood that surrounded the product, thereby enticing the potential customer to buy it. In food photography the expression, "don't photograph the steak, photograph the sizzle," exemplifies this type of illustration.

After considerable experimentation, the catalog industry now realizes that both the old traditional rendering and the new sophisticated illustration have their place. Industrial catalogs need to do little more than give one a clear image of the object, supported by appropriate copy. General household or utilitarian products may show the product in a simple setting that suggests the environment in which it would be used.

Less copy might be used in this case. Big ticket or high-priced luxury items may be shown using models, room sets, or expensive locations. The point is to make potential consumers relate to how the product could enhance their lifestyle. Many of the modern catalogs of this type, for

example, the *Sharper Image* catalog, have virtually become books filled with glamorous magazine-style advertisements.

Over the years an attitude has developed among professional photographers that catalog photography is what one does if no other work is available. This is hardly a realistic view. Some of the largest and most commercially successful photographic studios in the United States are catalog houses. The advantages they offer to both new and experienced photographers are many and varied. They allow for the option of generalization or specialization. Some studios offer the opportunity of shooting one type of situation one day and something totally different the next. Others allow for a photographer to develop a unique level of expertise by specializing in photographing furniture, cars, or some other genre of product.

Economically, catalog photography is a low unit cost/high volume business. Unlike general advertising, it is less affected by economic downturns and recessions. During advertising slowdowns, the volume of business of catalog and mail-order studios tends to hold up very well. Catalog photography is a healthy, viable industry that offers opportunity and financial rewards for technical and creative photographers. *H. LeVant*

CATCHLIGHT A reflection of a light source in the eye. Lack of a catchlight tends to give the subject a lifeless appearance. If none of the lights used for the desired facial lighting produce a catchlight, photographers often add another weak light near the camera just to create a catchlight. Portrait photographers generally feel that there should be only one catchlight, that it should be small, and that it not be centrally positioned on the eye. Commercial and fashion photographers frequently violate all three of these principles. *F. Hunter and P. Fuqua*

CATECHOL Also called pyrocatechol, pyrocatechin, or 1,2-benzenediol, the colorless crystalline solid ($C_6H_4(OH)_2$, molecular weight 110.11) is soluble in water, alcohol, benzene, and ether. Contact with the skin or eyes or ingestion should be avoided.

This developing agent closely resembles hydroquinone in structure and activity. In the presence of low preservative in the developer, the oxidation products stain and tan the gelatin of the developed areas. *G. Haist*

CATHODE The negative terminal of an electrical load to which electrons flow. Although the cathode of an electron tube is the source of electrons within the tube, electrons flow to the cathode in the external circuit. The cathode of a battery, however, is the positive terminal because electrons in the circuit are attracted to it. *W. Klein*

See also: *Anode; Battery.*

CATHODE-RAY TUBE (CRT) An evacuated glass tube used to display data in visual form by the use of a moving electron beam (cathode ray). In this device, a narrow beam of accelerated electrons passes through an electrostatic or magnetic deflecting field before striking a phosphor screen at the end of the tube. It has long been used as the display tube for television, radar, oscilloscopes, and video display terminals. Photographic equipment using the CRT includes video color negative analyzers and electronic enlargers.

A CRT consists of an electron gun (heater, cathode, control grid, and accelerating and focusing anodes), deflection plates or coils, and a fluorescent screen, all enclosed in an evacuated glass bulb or tube.

ELECTRON GUN In an electron gun a cathode is heated indirectly by an incandescent tungsten filament. The elevated temperature releases electrons from the oxide coating of the cathode. The accelerating anodes are at a positive potential with respect to the cathode and attract the electrons. The control grid is held at a negative potential with respect to the cathode. It controls the number of electrons leaving the cathode and therefore the brightness of the display. Typically, between the two accelerating anodes there is a focusing anode that narrows the electron stream into a tight beam and prevents the electrons from striking the accelerating anodes.

DEFLECTING PLATES OR COILS Two methods of moving the electron beam are in current use: electrostatic and magnetic. With electrostatic deflection, two pairs of deflection plates are perpendicular to each other. The electron beam is deflected up and down by an amount determined by the magnitude and polarity of the voltage applied to the vertical deflecting plates. The beam is deflected left and right by an amount determined by the magnitude and polarity of the voltage applied to the horizontal deflecting plates. Typically, the beam moves from left to right with a displacement proportional to time. The beam of electrons is deflected in the direction of the more positive plate. With magnetic deflection, the deflection is determined by the magnitude and polarity of the current flowing through the vertical and horizontal deflecting coils.

FLUORESCENT SCREEN The inside of the end of the tube is coated with various phosphors. When the high-energy electron beam strikes the screen it will glow in a color dependent on the chemical composition of the phosphor. The screen will continue to glow even after the beam has been

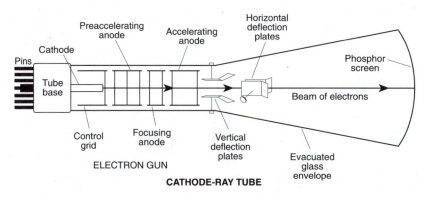

CATHODE-RAY TUBE

Cathode-ray tube (electrostatic deflection). A narrow beam of electrons is displayed as a bright spot on a phosphorescent screen. The position of the spot depends on the voltages applied to the deflecting plates. Its brightness is determined by the voltage applied to the control grid.

removed. The afterglow, called *persistence,* can vary from a few milliseconds to several seconds, depending on the chemical composition of the phosphor used.

THREE-COLOR CRT The phosphor screen in a three-color CRT consists of an array of tiny clusters of red, green, and blue phosphors. Three separate electron guns generate three beams, one each to excite the red, green, and blue phosphor. A shadow mask is positioned in back of the screen. Holes in the mask keep the beam from the red gun, for instance, in line with the red phosphors. The brightness of each color is controlled by the voltage applied to the control grid in each gun. *W. Klein*

See also: *Oscilloscope.*

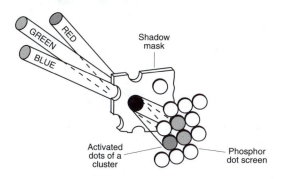

CATHODE-RAY TUBE

Shadow mask of a three-color cathode-ray tube allows only the electron beam from the red electron gun to activate the red phosphor dots. Similarly, the green and blue electron guns are aligned to activate only the green and blue phosphors, respectively.

CATOPTRIC LENS See *Lens types.*

CAUSTIC Bright cusp-shaped curve of light formed by a simple positive lens or concave mirror, where, because of uncorrected spherical aberration the outer zones refract or reflect light more strongly, respectively, to cross the paths of the less deviated central rays. The caustic is the locus of such intersections and can be seen easily on the surface of a liquid in a container such as a cup. *S. Ray*

CCD ARRAY An electronic imaging device that uses many charge-coupled devices (CCDs) to convert a large amount of image information to digital values at the same instant. *L. Stroebel*

CCD COLOR SCANNER An optical scanner that uses a linear CCD array to capture a row of pixels simultaneously. The array is then moved laterally to scan the image.
 L. Stroebel

CEL A thin transparent sheet of cellulose acetate, punched with registration holes, on which an animator's final drawings are painted or copied. The transparent backing simplifies the animator's job, allowing multiple actions to be filmed at the same time and requiring only a single background drawing for a given scene. *H. Lester*

See also: *Animation.*

CEL/CELL/CELLULOID Sheets of cellulose acetate, called *cells* or *cels*, used for a variety of photographic purposes including making image overlays in the process of motion-picture animation where each cell drawing repre-

sents a frame of the animation, and altering the color of light from a light source. Originally, cel and cell were used as shortened forms of celluloid. Animation cells are sometimes referred to as *acetates.*

Celluloid (pyroxylin, low-nitrogen form of cellulose nitrate with various plasticizers) was used as an early flexible photographic base but was discontinued because of flammability. *I. Current*

See also: *Electric cell.*

CELL See *Batteries; Electric cell; Photoconductive cell; Photovoltaic cell.*

CELLULOSE A white insoluble material that is a polymer of 100 to 200 units of the anhydride of glucose, a sugar. All vegetable matter contains this essential substance, but cotton contains alpha-cellulose, the most desirable form for making collodion and film base. Photographic paper base is made from purified wood cellulose. *G. Haist*

CELLULOSE ACETATE Cellulose can be modified by treatment with acetic acid to produce cellulose acetate, a substance that can be coated from solvents to form thin, transparent films suitable as a flexible layer or base for silver halide emulsions. The exact properties of the base are dependent upon the amount of acetic acid incorporated. Cellulose triacetate, containing about 40 to 43% attached acetic groups, does not burn easily, unlike cellulose nitrate, the main constituent of collodion or nitrocellulose film base. *G. Haist*

CELLULOSE NITRATE When cellulose, preferably in the form of purified cotton, is treated with fuming nitric acid and sulfuric acid, a product soluble in alcohol–ether is obtained with a maximum content of about 14% nitrogen (about 12% is considered optimum). Nitrated cellulose, when combined with a plasticizer such as camphor or butyl phthalate, can be coated on a smooth surface to form thin, tough, and transparent films suitable as a flexible base for photographic emulsions. Nitrocellulose was the first practical film base but is highly flammable, sometimes catching fire spontaneously. This film base had better dimensional stability and less water absorption than the less flammable cellulose triacetate safety films. *G. Haist*

CELSIUS SCALE (°C) The technical name for the set of temperature measurements based on the following fixed points: 0°C for the freezing point of pure water and 100°C for the boiling point of pure water. A Fahrenheit temperature may be converted to a Celsius temperature by the following formula: $C = (5/9)(F - 32)$. *H. Todd*

Syn.: *Centigrade.*
See also: *Kelvin.*

CEMENT See *Film cement.*

CENTER OF INTEREST That part of the image to which the eye of the observer is drawn because of compositional emphasis, the arrangement, and lighting of the subject; or the area that has the strongest attraction for the eye of the viewer. *R. Welsh*

See also: *Composition.*

CENTER OF PERSPECTIVE When making a photograph, the front nodal point of the camera lens. When viewing a photograph, a point on a line perpendicular to the photograph at the center and at a distance equal to the focal length of the camera lens multiplied by the magnification.
 L. Stroebel

See also: *Perspective.*

CENTER OF PROJECTION When projecting images with a slide or motion-picture projector, it is necessary to have the optical axis of the lens perpendicular to and level with the center of the screen. Keystone distortion occurs when the angle of the projector to the screen is not 90 degrees. The most frequent reason for this angle displacement is raising the front of the projector in order to raise the height of the image on the projection screen. If the center of the lens is 6 feet above the floor, then the center of the projection screen should be 6 feet above the floor. This alignment avoids keystoning the projected images. If it is not possible to raise the projector to the center of the screen, a perspective-control lens can be used to reduce or prevent keystoning. *M. Teres*

 See also: *Offset lens.*

CENTI- (c) A prefix denoting one one-hundredth (10^{-2}), as in centimeter (cm, one-hundredth of a meter) or centigrade (one-hundredth of the difference between the boiling and freezing points of water). *J. Holm*

CENTIGRADE See *Celsius scale (°C).*

CENTRAL PROCESSING UNIT (CPU) The brain of the computer that performs all calculations and routes data via a bus to and from other computer components. *R. Kraus*

CENTRATION Process of aligning all the centers of curvatures of the elements of a compound lens to a common optical axis. *S. Ray*

CERAMIC PROCESSES Between 1799 and 1802, Thomas Wedgwood and Sir Humphry Davy experimented with a camera obscura and light-sensitive materials with the objective of copying natural and architectural images onto pottery. Only their failure to fix their images satisfactorily kept them from success. The modern practice of coating a ceramic piece with a liquid silver halide emulsion is substantially similar. Exposure is made by either contact or projection printing. The piece is immersed in developer or the developer is brushed on; then it is fixed and washed. A glaze is applied to protect the emulsion. As an alternative, the image may be produced on stripping film, peeled from its backing, adhered to the piece, and glazed.

 A kiln-fired image may be obtained by applying liquid glazes through a photosilkscreen and firing the piece. An alternative version of the bichromate process may be used in which glaze powders replace pigments in each application. Exposure here is by contact, and warm water washes away unexposed material. Another bichromate-based process uses an emulsion of potassium bichromate with gelatin, sugar, and water added. When this emulsion is partially dried and tacky, a positive image is projected on it, further drying the areas receiving the most exposure. Glaze powders may now be applied sparingly. They will adhere to the remaining tacky areas, which correspond to low and middle print values. Firing technique, the type of pottery, and its surface all influence the outcome. *H. Wallach*

 See also: *Bichromate process; Silkscreen printing; Wedgwood, Thomas.*

CGS SYSTEM See *Metric system.*

CHANGEOVER CUES Visual signals, usually dots or circles, indicating to the motion-picture projectionist the time to change from one projector to another without interrupting the continuity of projection. *H. Lester*

CHANGING BAG A flexible container made of several layers of opaque fabric that allows the photographer to handle sensitized materials and load them into a film holder, camera, or daylight processing tank in daylight. It is fitted

Changing bag. The bag usually consists of a light-proof black fabric with sleeves bound by elastic at the outer ends. A zipper permits placing the equipment in the bag.

with two sleeves with elastic at the outer ends, allowing the arms to be inserted without admitting light. *I. Current*

CHANNEL In electronic imaging, the holding of color information in a separate location. Each component of the color data, RGB, is held in a separate channel. In color separation, four channels are used to hold the CMYK data. Channels can be likened to separation negatives or to printing plates. *R. Kraus*

CHANNEL (SOUND) An audio term specifying a given signal path. When audio is physically recorded on film or tape, the term applied to the physical representation on the medium is *track*. Thus, the input of a tape machine may be labeled in channels, while the recording it makes on tape is made on tracks. In console terminology, *channel* applies to both input channels and output channels. Input channels usually represent various single sounds coming into a console for mixing, while output channels represent various combined sounds, for example, all sounds destined for the left loudspeaker represent the L output channel. *T. Holman*

CHARACTERISTIC The whole-number part of a logarithm that specifies the location of the decimal point in the corresponding number. For example, the characteristic of the logarithm 2.301 is 2, meaning that the plain number is in the hundreds: it is 200. *H. Todd*

 See also: *Logarithms; Mantissa.*

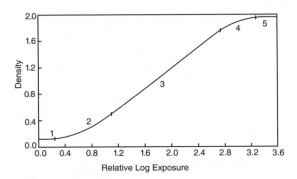

Characteristic (D-log H) curve, showing five of the six regions associated with different exposures.

CHARACTERISTIC CURVE The result, in the form of a graph, of a sensitometric test of a photosensitive material. The plot is variously called the characteristic curve, the H & D curve (named for Hurter and Driffield, the first investigators in this field in the 1880s), and the D-log H curve.

The horizontal axis of the plot is labeled log H (formerly log E). It displays the logarithms of the different exposures (measured in meter-candle-seconds, equivalent to lux-seconds) received by the test sample. These log-H values are related to the tones of the subject. The vertical axis displays the density values produced in the sample as a result of the exposure and development conditions.

CURVE PARTS A characteristic curve may be considered as having six sections. Beginning from the left, they are

1. *Base plus fog level.* For very small log-H values, the curve is horizontal, showing no change in density with increasing log exposure. Subject tones exposed here will not be recorded.
2. *Toe.* In this part of the curve, the density of the sample increases with increasing log exposure in a nonlinear manner. Subject shadows are usually recorded here and will have varying detail, depending on their location within the toe. Negative pictorial speed is based on a specified log exposure within the toe of the curve.
3. *Straight line.* Here the increase in density is directly proportional to the increase in log H. Subject tones exposed in this area will have uniform contrast in the image. For a subject of normal range, and with appropriate camera exposure settings, the midtones and highlights will give log-H values falling in this part of the curve. Gamma, one measure of development contrast, is the slope of the straight line. For black-and-white pictorial films, especially those with one or more emulsion coatings, this middle part of the curve may deviate considerably from a straight line. In part for this reason, contrast index (an average slope) is replacing gamma.
4. *Shoulder.* The shoulder is the region above the straight line, where equal increases in log H produce decreasing density differences. Subject tones will be recorded here only with very large log-H values, caused by an extreme subject tonal range or by overexposure of a normal subject.
5. *Maximum density.* With still greater log-H values, the curve levels out. Any subject areas exposed in this region will have little or no detail in the image.
6. *Reversal.* For some negative materials, beyond the maximum density, density decreases with increasing log H. This area is also called the *region of solarization*. It may be used to produce positive images directly, without the need of reversal processing.

DATA OBTAINED FROM CHARACTERISTIC CURVES

1. *Speed.* Negative pictorial speeds are based on a log H value for a defined point in the toe of the curve. A subject tone giving the log-H value at the speed point will be the darkest subject area holding printable detail in the processed negative. When the curves for two different films are compared, a shift of the speed point to the left represents a decrease in the necessary log H, and thus an increase in speed.

 Speed points for other photographic materials are located at different positions on the D-log H curve because of special imaging needs. For example, speeds for photographic papers and color reversal materials are based on middle regions of the curve; high-density speed points are used for films that record x-rays and for microfilms.
2. *Contrast.* Development contrast may be expressed as the value of gamma or, better, contrast index. For a fixed camera exposure level involving the central part of the characteristic curve, image contrast increases up to some maximum as development increases.

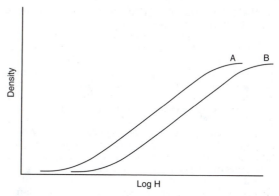

Characteristic curves showing a difference in speed. The film represented by curve A has a higher speed than that represented by curve B.

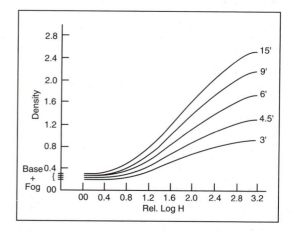

The effects of changed development time on D-log H curves.

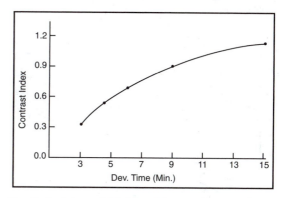

The effects of changed development time on contrast index.

Local contrast, that is, the extent to which detail is recorded in the image, may be measured by the difference in density between adjacent image tones or by the slope of the D-log H curve at a given log-H value. Total contrast is the difference in density between the lightest and darkest image areas. It will be affected by subject tonal range, camera optical system, camera exposure settings, and extent of development.

CHARACTERISTIC CURVES OF BLACK-AND-WHITE PAPERS The D-log H curve varies for photographic papers having the same grade but manufactured to have surfaces of different reflection characteristics. Glossy papers can generate a density range of about 2.0, or a reflectance ratio of about 100:1. For a semimatt paper the range is reduced to about 1.5, equivalent to only 20:1. Since a normal subject will have a luminance ratio of considerably more than 100:1, some compression of tones in the print is inevitable.

The different curves are further notable in that they show for normal development no fog and no straight line. The latter characteristic strongly influences the tone reproduction capabilities of the photographic system.

As development time increases, after a short interval the curve shape remains nearly constant, and the curves shift to the left, indicating an increase in effective speed. For this reason, paper exposure errors can be compensated for, to some extent, by a change in development time.

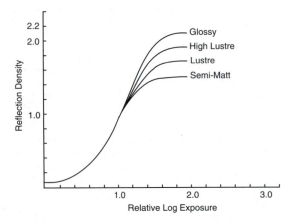

D-log H curves for photographic papers having the same grade but manufactured to have surfaces of different reflection characteristics. The data on the horizontal axis are related to the densities of the negative that will print on the paper. The vertical axis displays the tones that the paper can display and is related to the subject tones that the paper can, at least to some extent, reproduce.

D-log H curves for an ideal negative color film.

CHARACTERISTIC CURVES OF COLOR MATERIALS Analysis of processed color samples is complicated, since they consist of three dye layers. Color density measurements are made with successive illumination by red, green, and blue light. Three characteristic curves are needed to represent each sample. Each of the curves for a color or negative shows approximately the response of one of the dye layers—cyan (red sensitive), magenta (green sensitive), or yellow (blue sensitive). They must be nearly parallel for a neutral image of proper color balance. Speed and contrast of color films and papers are found by using methods similar to those used for black-and-white materials.

M. Leary and H. Todd

See also: *Average gradient; Color sensitometry; Contrast index; Film speed; Gamma; Paper contrast grades; Paper speed.*

CHARBON VELOURS The name originally given to the paper known for its rich velvety appearance, introduced by V. Artigue in France in 1892. A pigment, for example, watercolor pigment, is rubbed into a stiff paste of starch and applied to the paper in a thin uniform coating. It is then sensitized in a 2% solution of potassium dichromate, exposed, and developed in a warm sawdust mixture, as in the Artigue process. *J. Natal*

See also: *Artigue process.*

CHARGE (Q) An excess or deficiency in the number of electrons in or upon an object. An excess of electrons is considered a negative (-) charge; a deficiency of electrons is considered a positive (+) charge. The symbol for electrical charge is Q. The basic unit of charge is the coulomb (C). *W. Klein*

CHARGE BARRIER See *Space charge barrier.*

CHARGE COUPLED CAMERA See *Camera types, charge coupled camera.*

CHARGE-COUPLED DEVICE (CCD) An array of photo sensors that detect and read out light as an electronic signal. *R. Kraus*

CHECKERBOARD CUTTING A standard technique for preparing a motion-picture negative or reversal original for release printing by placing shots, in conformance with editorial decisions made on a work print, onto two rolls (A & B rolls) in a checkerboard pattern, alternating picture with black leader. This method allows invisible splices, some basic optical effects such as dissolves and double exposures, and efficiency in making printer adjustments between different shots. *H. Lester*

See also: *A & B roll.*

CHEESECAKE A slang term for a photograph of a scantily dressed attractive woman, typically made for photojournalistic, poster, or calendar use. *L. Stroebel*

See also: *Erotic photography.*

CHEMICAL COMPOUND A combination of two or more elements producing a substance with distinctive chemical and physical properties, such as silver nitrate, $AgNO_3$, or potassium bromide, KBr. A particular compound always contains the same elements in fixed proportions, regardless of the reactions used to form the compound. *G. Haist*

CHEMICAL DEVELOPMENT The formation of a visible image from a latent image involving the reduction of silver halide grains to silver by a developing agent that is simultaneously oxidized. Contrast with *physical* development, in which the silver that forms the image is supplied from the developer. *L. Stroebel and R. Zakia*

CHEMICAL DISPOSAL Treatment of chemical wastes from the manufacture and processing of photographic materials has become a vital concern in the preservation of a

quality environment. Processing solutions are a potential source of chemical contamination of the water supply. The solutions discharged by the individual photographer need only be well diluted with water and added slowly to the sewer system. Solutions above pH 10 or below pH 4 should be neutralized first. Aeration and chlorination by the local sewage treatment plant can safely and effectively handle such volumes.

Larger volumes of chemical effluents, such as by minilabs, professional photographers, photoprocessing laboratories, or photographic manufacturers, may not be adequately treated by existing water treatment facilities. A flurry of standards expressed in sewer codes and state and federal legislative acts has established limits on the pollution of surface waters, emissions into the air, and the disposal of hazardous substances.

Discharging inadequately treated photographic wastes into water sources may result in a depletion of absorbed oxygen, causing the death of aquatic life or the production of noxious gases. Survival of fish and other aquatic life requires about 5–7 mg of oxygen per liter of water. The biochemical oxygen demand (BOD_5) test measures the amount of oxygen consumed by biological degradation during a 5-day period. A chemical oxygen demand (COD) test requires only 2 hours instead of 5 days to run, but because it measures some chemicals that might not be degraded by microorganisms, the COD test results may not be equivalent to those of the BOD_5 test.

Benzyl alcohol, acetate, sulfite, thiosulfate, and ethylenediaminetetraacetic acid (EDTA) are the highest consumers of oxygen in either test. With the exception of EDTA, they, along with hydroquinone, undergo the most rapid biodegradation. Slower biodegradation is shown by ammonium salts, developing agents, citric acid, and formalin. The presence of these chemicals may require some hours of treatment in an activated sludge aeration tank before discharge into a sewer or surface water.

Borate, bromide, ferrocyanide, nitrate, phosphate, and sulfate (and EDTA) do not biodegrade. Manufacturers of photographic products have minimized or eliminated the use of many of these chemicals. Boron compounds have been replaced in fixing baths and developers, phosphates eliminated as alkalis, and ferricyanide replaced in many bleach baths.

Ferricyanide is especially objectionable because it is converted into highly toxic free cyanide upon standing in sunlit waters. Ion exchange and regeneration and reuse methods have been proposed to limit the discharge of this chemical.

Temperature, pH, chlorine demand, or suspended solids of most effluents are usually not an environmental threat. Strictly regulated by sewer codes are the presence of heavy metals: cadmium, chromium, cobalt, copper, gold, iron, lead, manganese, mercury, molybdenum, nickel, silver, and zinc. Of these metals or their compounds, only those of cadmium, chromium, iron, silver, or zinc are used in sufficient quantities to be of concern.

Silver is present as a thiosulfate complex in fixing and bleach-fix baths and is relatively nontoxic. The complex is converted into insoluble silver sulfide and precipitated through chemical or biological action at a wastewater treatment plant. Prior silver recovery by photoprocessors also minimizes the danger of silver as a pollutant.

Treatment of dichromate bleaches, such as by thiosulfate solutions, will precipitate trivalent chromium hydroxide, and this sludge can be removed. Iron is usually present as stable iron complexes that do not change the taste or appearance of water. Cadmium and zinc are present in such small quantities as not to pose any major threat. Mixed chemical contamination is always of concern, such as insoluble cadmium or mercury combining with water-solubilizing complexing agents.

Information on the exact details of the testing, treatment, recovery, reuse, and disposal of photographic chemicals is often available from the major manufacturers of photographic equipment and materials. *G. Haist*

CHEMICAL FLASH See *Flash, chemical.*

CHEMICAL FOCUS The principal focus for blue light given by a chromatic (uncorrected) simple lens. The name originated from early photography, where materials were sensitive only to the blue-violet region of the spectrum. The eye determined a visual focus in the green region, giving the possibility of a focus error, correctable by a slight increase in the image conjugate of some 0.25% of the nominal focal length. Early chromatic correction of lenses brought the visual and chemical foci coincident. *S. Ray*

Syn.: *Actinic focus.*
See also: *Lenses.*

CHEMICAL FOG Unwanted density formed during image development, which may be the result of chemical action during manufacture, storage, or processing of photographic materials. Chemical fog occurs in both exposed and unexposed areas of the light-sensitive material but is most evident in areas of low exposure, where it obscures detail and lowers image contrast. Excessive development fog may be the result of overenergetic developing agents, the action of silver halide solvents, or the effect of oxygen or chemical fogging agents. A small amount of fog is commonly formed during the normal development of black-and-white films. *G. Haist*

CHEMICAL SAFETY Safe handling of chemicals and solutions simply involes preventing any contact with human skin, eyes, or respiratory system or internal ingestion. safety glasses or shields, an apron or laboratory jacket, and keeping the hands away from the face and mouth, will greatly minimize some of the potential dangers. Not smokng or eating candy or food in work areas will also help to eliminate possible mishaps. A workplace with adequate ventilation, or the use of a respirator, will limit the inhalation of air contaminated with chemical dust, gases, vapors, or fumes.

Good laboratory and darkroom practices should be followed at all times. Label all bottles and containers, keep them closed except when in actual use, and store them in cool dry areas away from sunlight (out of reach of children). Store liquids and processing solutions safely. Breaking a gallon glass bottle of glacial acetic acid is a major disaster. Always add acids and bases slowly and carefully to the surface of the water. Do *not* add water to strong acids and bases. Do not mix chemicals haphazardly, even during final disposal.

Accidents, spills, and mistakes do happen during chemical handling and photographic processing. Clean up promptly all spilled chemicals and solutions. Do not wear sandals, opentoed, or canvas shoes as these provide little protection against spills or dropped containers. Clean gloves, aprons, and clothing or shoes that have become contaminated. Gloves, inside and out, should be clean to avoid chemical contamination of the skin, face, or mouth.

Prompt removal of chemicals from the skin is essential. Wash thoroughly with plenty of water any part of the body that may have contacted chemicals. See a physician if any chemicals reach the eyes, as few substances are not irritating or painful. Chapping of the hands from the drying and cracking effects of alkali on the skin or breaks in the skin from cuts and bruises are major points of entry of poisons into the body. Acidic types of hand cleaners are sometimes recommended fro the removal of highly alkaline solutions, such as color developing solutions.

Certain photographic chemicals and solutions require greater caution because they may cause a skin allergy

called contact dermatitis and a skin sensitization of increased reactivity. Color developing agents and color developing solutions containing *para*-phenylenediamines, especially those of low water solubility, are primary causes of dermatitis. Black-and-white developers containing *para*-methylaminophenol (Metol) or tanning developing agents, such as pyrogallol, also require care in handling. Gelatin hardening agents, particularly formaldehyde, glutaraldehyde, and chromium compounds, are potential sources of irritation.

Certain chemicals that are relatively innocuous by themselves may react dangerously, even explosively, when combined with other chemicals. Other combinations of chemicals may emit poisonous gases, such as cyanide fumes or chlorine. Dangerous mixtures of chemicals are shown in the table.

G. Haist

Dangerous Mixtures of Chemicals

Do Not Combine	With
Acetic acid	Chromic acid, nitric acid, peroxides, and permanganates
Ammonia	Halogens or calcium hypochlorite
Ammonium nitrate	Acids, chlorates, nitrates; combustible materials
Cyanides	All acids
Hydrogen peroxide	Most metals (particularly copper, chromium and iron) and their salts
Iodine	Ammonia
Nitric acid	Acetic, chromic or hydrocyanic acids; flammable substances
Oxalic acid	Silver
Potassium permanganate	Ethylene glycol, glycerol, benzaldehyde, and sulfuric acid
Sulfuric acid	Chlorates, perchlorates, and permanganates

From *Modern Photographic Processing*, vol. 1, by Grant Haist (New York: Wiley, 1979).

CHEMICAL SENSITIZATION
A chemical treatment of a photographic emulsion during the afterripening forms surface specks that are effective in increasing the light sensitivity of the silver halide crystals. Gold compounds (aurothiocyanate), sulfur compounds (thiosulfate), and reducing compounds (stannous salts) may be used alone during the heat treatment of the emulsion but are usually combined for maximum beneficial effect.

G. Haist

CHEMICAL-SPREAD FUNCTION
A method to evaluate how photographic processing changes the size and shape of an ideal point exposure of a photographic material. The point-spread function measures both the chemical-spread function and the effect of light irradiation in the emulsion layer during exposure.

G. Haist

CHEMICAL SYMBOLS
All the substances of photography are composed of just three elementary particles: *electrons, protons,* and *neutrons,* although protons and neutrons are believed to contain smaller components called *quarks.* There are 81 stable and at least 28 unstable distinctive structures of electrons, protons, and neutrons, called *atoms,* that cannot be separated into simpler substances by chemical means. These atoms are called *elements.* Each is assigned an atomic number, and the atomic weight is determined.

Each element is given a name, and a symbol is used to designate it. The symbol is a form of simplified notation, consisting of one or two letters, the first always being capitalized. The symbol Ag, which stands for silver, is derived

from *argentum,* the Latin word for silver. Ag represents one atomic weight of the element silver, that is, 107.87 grams.

Some elemental gases, such as hydrogen (H) or chlorine (Cl), combine with themselves to form molecules consisting of two atoms of hydrogen (H_2) or two atoms of chlorine (Cl_2), the number of atoms being designated by the subscript. Each molecule in this case is twice the atomic weight of each element. These two elements might interact with each other, illustrated by the following chemical notation called an equation: $H_2 + Cl_2 \rightarrow 2HCl$. Sometimes the equation is written $H_2(g) + Cl_2(g) \rightarrow 2HCl(g)$, the (g) indicating that the reactants and products are gases.

The equation, showing the nature, number, and combination of the elements, is simply chemical shorthand, showing in the example above that one molecule of hydrogen reacts with one molecule of chlorine totally to yield (\rightarrow) two molecules of hydrogen chloride. If a reaction is less than complete, two arrows (\rightleftharpoons) may be used, the shorter arrow indicating that a small quantity of reactants is still present; that is, there is an equilibrium between reactants and products.

Two or more elements can react to form a stable molecule called a *compound.* Compounds may interact with each other, as when sodium hydroxide (NaOH) reacts with carbonic acid (H_2CO_3). Such a reaction might be summarized by the equation $2NaOH + H_2CO_3 \rightarrow Na_2CO_3 + 2H_2O$. In water solution, however, the sodium carbonate (Na_2CO_3) splits into charged fragments, called *ions,* so that the following equation might be more representative of the true condition: $Na_2CO_3 + H_2O \rightarrow Na^+ + OH^- + Na^+ + HCO_3^-$. The $^+$ and $^-$ signs indicate the positive and negative charged ions, and the charges on each side of the arrow must be equal. Thus, in water solution a true representation of the neutralization of carbonic acid by sodium hydroxide is given by this ionic equation:

$$2Na^+ + 2OH^- + CO_3 = \rightarrow Na^+ + OH^- + Na^+ + HCO_3^- + H^+ + OH^-.$$

Rather than the ions being held by the attraction of opposite charges, atoms of an element such as carbon combine with other carbon atoms or with other elements by sharing electrons. The vast number of these carbon combinations are called *organic compounds.* Ethane, for example, may be shown as

The lines (–) between the atomic symbols represent shared two-electron bonds. Double (four electron, or =) and triple (six electron, or ≡) bonds also exist, as in acetylene, $HC\equiv CH$ or C_2H_2.

When a hydrogen atom is removed from an organic compound, an organic radical is formed. Such a radical is much more reactive than the parent compound. Radicals are given names somewhat resembling the compound, such as C_2H_6, ethane, whose radical, $C_2H_5^+$ is called ethyl.

Carbon forms various ring structures with other atoms, often with just hydrogen (hydrocarbons). The rings can have the maximum number of hydrogen atoms (saturated compound) or less than the maximum (unsaturated compound), as indicated by

Because it is present in so many compounds, benzene is often written as a hexagon,

(identical) or

with each corner angle assumed to have a carbon with a hydrogen attached to it. Atoms of other elements, especially oxygen, nitrogen, and sulfur, are often present in carbon compounds, either in the ring or on attached groups of atoms.

G. Haist

CHEMICAL TONING The chemical conversion of a metallic silver image into a colored image that can be accomplished by the direct formation of a colored silver salt or by depositing on a silver image, or by partial or complete substitution for the silver image by an insoluble metal compound that is colored. Image tones can range from blue to red, including green, and a variety of browns. *G. Haist*

CHEMILUMINESCENCE The production of light (at temperatures below those required for incandescence) by a chemical reaction. *J. Holm*

CHEMISTRY See *Photographic chemistry.*

CHIAROSCURO The light-and-shade effect in a picture, from Italian *chiaro* (bright) + *oscuro* (dark). The term is applied especially to the use of light to emphasize certain areas and shadows to make other areas less conspicuous to achieve a compositional effect. *L. Stroebel*
 See also: *Lighting.*

CHIP (ELECTRICAL) See *Semiconductor chip.*

CHLORIDE PAPER A slow-speed photographic print material, more commonly called contact printing paper. Its principle light-sensitive ingredient is silver chloride. Distinguished from bromide and chlorobromide papers. *M. Scott*

CHLOROBROMIDE PAPER Photographic printing paper with speed and image tone intermediate to chloride and bromide papers. The sensitive salts of the emulsion are silver bromide and silver chloride in various proportions. *M. Scott*

CHOPPER A shutter used to interrupt a beam of light in an optical instrument. Often used in motion-picture projectors to eliminate or reduce the appearance or flicker by interrupting the light during the projection of each frame. *H. Lester*

CHROMA A characteristic of color that varies with the saturation of hue, the extent to which a color differs from a gray of equal lightness. In the Munsell system of color notation, one of three attributes of colors, the other two being hue and value. *R. W. G. Hunt*

CHROMATIC ABERRATIONS *See Lenses.*

CHROMATIC ADAPTATION See *Color adaptation.*

CHROMATIC COLORS Colors exhibiting hue (as distinct from achromatic colors, those commonly called white, gray, black, neutral, and colorless). *R. W. G. Hunt*

CHROMATICITY An objective specification of the color quality of a visual stimulus, such as a colored light or surface, irrespective of its luminance. Defined in the CIE system of colorimetry either by the combination of the dominant wavelength and purity of a color but excluding its luminance, or by two numbers, x and y, termed the chromaticity coordinates. *R. W. G. Hunt*

CHROMATICITY COORDINATES In colorimetry, the ratio of each of a set of tristimulus values to their sum.
 R. W. G. Hunt

CHROMATICITY DIAGRAM A rectangular diagram on which the composition of a color stimulus is defined in terms of two of its three attributes: lightness or brightness is not shown because it would require a third dimension. A spectral locus, within which all real colors lie, represents hues in terms of wavelengths, and saturation is represented by the position of the color between a white point and the spectral locus. *R. W. G. Hunt*

CHROMATICNESS (1) Natural color system measure of the chromatic content of a color. (2) An alternative term for colorfulness. (3) Perceptual color attribute consisting of the hue and saturation of a color (obsolete). *R. W. G. Hunt*

CHROMATYPES Several variants of photography on paper using chromium salts. Robert Hunt, who coined the name, announced his process in 1843. The paper was prepared with a solution of sulfate of copper and potassium bichromate. It produced direct positive photogenic drawings but was not sensitive enough for use in the camera. *J. Natal*

CHROME FILM Popular term for color transparency film, the trade names of which usually end in *chrome,* e.g., *Agfachrome, Fujichrome, Kodachrome.* Before the 1930s the term meant any black-and-white film with orthochromatic or panchromatic sensitivity. *M. Scott*

CHROMINANCE (1) In television, the part of the signal carrying the color information, as distinct from the brightness information, which is carried by the luminous part of the signal. (2) In video, the color hue and saturation information encoded into signal data by a video camera, later to be displayed by a color cathode ray tube (CRT).
 R. W. G. Hunt and R. Kraus

CHROMOGENIC DEVELOPMENT Development of a color image that uses oxidized developer components to form dyes in the emulsion layers by combining with color couplers incorporated in the emulsion during manufacture. Reduction of the latent image to metallic silver causes the oxidation; dye and silver formation are therefore nearly simultaneous. Bleach and fix remove the silver, leaving a dye image. In a tripack color negative film, yellow, magenta, and cyan dyes are formed in the blue, green, and red sensitive layers, respectively. In chromogenic black-and-white negative film, black dye of varying density is formed. To inhibit

the migration of dyes to neighboring layers, couplers may be attached to long fatty chain molecules too large to be diffused, or they may be dissolved in organic solvents and dispersed in emulsions as oily globules in which the dyes will form upon development.

In 1895, Raphael Eduard Liesegang showed how different developers formed images of varying colors because of insoluble deposits that formed with the metallic silver image. When Alfred Watkins removed the silver image with bleach, a dye image remained. Benno Homolka formed blue indigo and red thioindigo dye images in 1907 by using developers containing indoxyl or thioindoxyl. (He found other developer compounds that yielded different dyes as well.) Potassium cyanide removed the silver image and revealed the dye.

Between 1912 and 1914, Rudolf Fischer took a series of patents that synthesized the work that went before him and laid the groundwork for most modern photochemical color photography. The bleach of an image to silver halide and subsequent redevelopment to form a color image, the process of secondary color development in which oxidized developing agents react with color couplers to form dye, three emulsion layer films with incorporated couplers to produce complementary dyes, and the first use of the word *chromogenic* are all part of Fischer's list of credits. *H. Wallach*

CHROMOPHORE Chemical group in a molecule of a colorant that is responsible for its color. *R. W. G. Hunt*

CHROMOSCOPE A device in which three color-separation positive images, illuminated through filters, are viewed by mirrors as a single image in full color. *M. Teres*

CHRONOPHOTOGRAPHY

Photographic method of analyzing an action by taking a series of still pictures at regular intervals throughout its duration. This method of analyzing motion is very similar to cinematography but lends itself to leisurely study of complex motions without the need for complex recording or projection equipment. Typically, it also yields images that can be reproduced in two-dimensional form.

MUYBRIDGE'S EXPERIMENTS Among the first applications of chronophotography are the investigations conducted in Paris by Professor J. Marey, about 1870, related to human and animal motion by means of various mechanical devices; he called the records chronographs. An American racehorse owner, Governor Leland Stanford of California, doubted the results of some of his investigations into the action of racehorses—in particular that there was ever an instant when a trotting horse had all of its feet off the ground at the same time. E. J. Muybridge, an English photographer living in San Francisco, was commissioned to check Marey's findings.

In 1877 Muybridge succeeded in proving that Marey was right, and in doing so produced what were the first true chronophotographs. These classic pictures were made by

Marey's original chronophotographic camera. O, lens. M, crank for rotating the shutter. D, rotating shutter disc. F, shutter slit. C, plate.

arranging for a horse and rider to pass in front of a row of cameras with shutter releases connected to threads stretched at regular intervals across the path. As the horse came opposite each camera in turn, it broke the thread operating that particular shutter and took its own photograph. The series of photographs, when printed on one sheet, yielded a continuous chronophotograph.

In 1880 Muybridge devised a projection instrument that he called zoopraxiscope to demonstrate the movement. In 1884–1885 he extended his chronophotography to the movement of a great variety of animals and human beings. In this series he used up to 36 cameras with shutters electrically operated by a clockwork device.

MAREY'S SINGLE NEGATIVE Muybridge's experiments prompted Professor Marey to adopt the photographic approach to his own researches. He constructed various cameras with this end in view, aiming at getting the whole series of chronophotographs on the one negative. His first apparatus, constructed in 1882, consisted of a plate camera equipped with a spring motor-driven rotary disc shutter having a number of regularly spaced apertures. As each aperture passed in front of the plate, it recorded the position at that instant of an object moving across the field of the camera. A small object moving quickly recorded a series of separate images on the plate, the space between depending on how fast the shutter was rotated.

If the subject was large in relation to the speed or rotation of the shutter, the successive images overlapped and gave a confused picture. Marey overcame this difficulty by putting his subject into a black suit with a white strip sewn down the arm and leg facing the camera. He then took the photographs against a black background and obtained a series of separate images of the white stripes. In this way he was able to produce records of the movements of the limbs of people walking or running past the camera.

Marey's next development was a "gun" that took a series of pictures of a moving subject and recorded them separately on a single plate. The gun carried a circular plate in front of which was a disc with 12 openings around its circumference. In front of this disc was a second disc pierced with a slit. On pressing the trigger of the gun, a clockwork mechanism rotated the discs. The disc carrying the 12 frames rotated 1/12 of a revolution while the disc carrying the shutter slit revolved once, so that each of the 12 openings appeared in turn behind the lens and was exposed through the slit. The result was a plate carrying 12 separate photographs showing successive attitudes of the moving subject. This gun successfully recorded chronophotographs of birds in flight, taking 12 successive pictures per second with a shutter speed of 1/720 second.

In 1883 the French government established a department of physiological research in Paris, where Marey carried on

Muybridge's chronophotographic setup. A series of cameras were lined up along the track used to photograph the movement. The shutters were tripped as the horse broke the strings stretched across the track.

chronophotographic investigation of the movements used by humans and animals in various forms of activity. Marey subsequently recorded chronophotographic sequences on long rolls of paper and finally, roll film and in 1892 was able to project them.

All of his instruments for this study suffered from an inherent disadvantage: the sensitized material had to be transported fast enough to separate the image and brought to a sudden stop at each instant of exposure. In practice this meant being satisfied with very small images to reduce the amount of shift of the material between each exposure. This type of record is only useful, however, if the individual pictures are large enough to be examined in detail, and the sensitized materials of the time would not permit a high degree of enlargement. For this reason a number of workers in this field chose to develop the Muybridge approach of making the successive exposures in a number of separate cameras.

OTHER SYSTEMS The apparatus used by General Lebert in 1890 consisted of six full-sized cameras mounted in a circle with an electric motor in the center. The motor carried an arm that rotated and operated the shutters of each camera in turn. This arrangement was used for photographing projectiles.

A year or two after this, Albert Londe constructed a camera in which sets of lenses equipped with electromagnetic shutters formed separate images regularly arranged to occupy a single plate. One six-lens camera used a 13×18-cm plate, while one with 12 lenses covered a 24×30-cm plate. With these cameras there was a separate clockwork selector switch, governed by a metronome that operated each of the shutter solenoids in turn, allowing a variable time interval between the successive exposures according to the speed and range of the action to be analyzed.

In the mid-1880s, O. Anschutz, working on similar lines to Muybridge, constructed and used chronophotographic arrangements of up to 20 cameras. Like Muybridge, he devised a method of reproducing the movement from his results. He mounted his pictures on a drum that could be rotated to bring each picture in turn into a viewing aperture. As each picture came into view, it was illuminated by an electric spark, so that as the drum rotated the observer saw a moving picture.

PRESENT-DAY USE Various workers in other countries were also interested in synthesizing movement by means of chronophotographs, but, although chronophotography was directly responsible for the development of cinematography, it pursued its own distinct course right up to the present time. There is a basic difference between the two. In both, a series of still pictures for detailed study, each picture freezing a particular phase of the action. In cinematography the object is to produce a moving picture of the whole event.

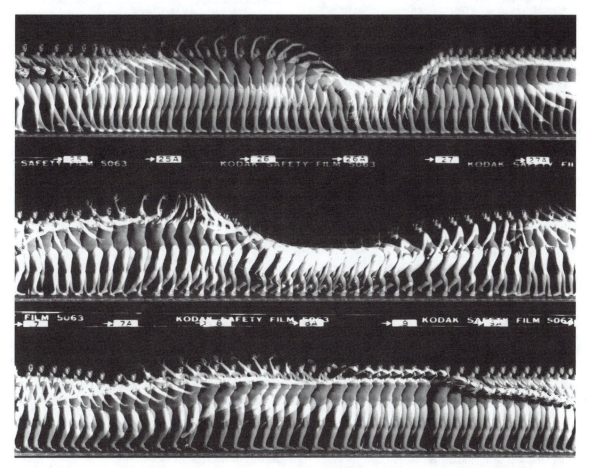

Chronophotograph made with a stroboscopic light source and a 35-mm camera in which the film was rewound into the supply cassette with the shutter held in the open position after first having been advanced to the take up side without exposing it. Photograph by Andrew Davidhazy.

The still pictures taken in chronophotography are usually of a larger format and of a higher standard of definition than motion pictures. Today some of the most important applications of chronophotography are in time-and-motion study.

A special type of chronophotography that is reminiscent of Marey's early apparatus is carried out today with electronic flashes operating as stroboscopic light sources. The subject moves against a dark background and is illuminated by an intermittent flash while the camera shutter is left open. This produces a succession of images on the same plate, each image being displaced both in time and space from the preceding one by an amount that depends on the frequency of the flashes and the speed of the movement.

Chronophotographs can also be made on a single sheet of film with the moving subject remaining essentially in the same general location over time. In this manner H. E. Edgerton, in the mid-1900s, produced a significant body of work examining the motion of athletes, most notably golfers and tennis players, and various animals.

These photographs typically can only record action over a short period of time because the sequence of exposures interferes with images recorded earlier in the action. To overcome this limitation, photographers have swung the camera while recording the action, but this calls for very large dark studios, and the length of time available for recording motion is limited by the time it takes the subject to traverse from one side of the viewfinder to the other.

A variation on this approach, but one that is also a true chronophotograph, involves moving the film while the action, illuminated by a stroboscopic flash, takes place in a restricted location in space against a dark background. The duration of the event that is studied now can be much longer, extending easily into tens of seconds of several minutes at usual sampling, or flashing, rates of 10 flashes per second or so.

Because of the short duration of the flash, it is possible to analyze extremely rapid motion, while movements of a dancer or athlete photographed in this way can produce scientifically informative and artistically beautiful images. *A. Davidhazy*

See also: *Camera history; Electronic flash; Motion study; Special effects; Stroboscopic flash.*

CHRYSOTYPE Sir John Herschel sensitized a sheet of paper with ferric ammonium citrate, contact printed it, and developed the image in a weak solution of gold chloride. The ferrous salts created by exposure to light in turn reduced the gold, which precipitated out as a purple deposit over the image in proportion to the original exposure. Also called chripotype. *J. Natal*

CIBACHROME Originally a process for making color prints from color transparencies, the name is now used for other processes based on the silver-dye-bleach process (color transparencies, graphic arts control systems, etc.). Respected for the permanence of its images. The name was changed to *Ilfochrome* in 1992. *M. Scott*

See also: *Ilford; Silver-dye-bleach system.*

CIE COLOR RENDERING INDEX A Commission Internationale de l'Éclairage (CIE) method of assessing the degree to which a test illuminant renders colors similar in appearance to their appearance under a reference illuminant. *R. W. G. Hunt*

CIELAB SYSTEM Color space in which L^*, a^*, b^* are plotted at right angles to one another. Equal distances in the space represent approximately equal color differences. $L^* = 116(Y/Y_n)^{1/3} - 16$, $a^* = 500[(X/X_n)^{1/3} - (Y/Y_n)^{1/3}]$, $b^* = 200[(Y/Y_n)^{1/3} - (Z/Z_n)^{1/3}]$. *R. W. G. Hunt*

See also: *Colorimetry.*

CIELUV SYSTEM Color space in which L^*, u^*, v^* are plotted at right angles to one another. Equal distances in the space represent approximately equal color differences. $L^* = 116(Y/Y_n)^{1/3} - 16$, $u^* = 13L^*(u' - u'_n)$, $v^* = 13L^*(v' - v'_n)$. *R. W. G. Hunt*

See also: *Colorimetry.*

CIE STANDARDS In colorimetry, internationally accepted standards for illuminants and colorimetric observers, established by the Commission Internationale de l'Éclairage (CIE). *R. W. G. Hunt*

See also: *Colorimetry.*

CINCH MARKS Scratches on motion picture film or videotape caused by one turn on a roll rubbing against another. *H. Lester*

CINE See *Motion-picture photography.*

CINEMA See *Motion-picture photography.*

CINEMACROGRAPHY Motion-picture photography of small objects, not using a microscope. Various techniques are used such as supplemental lenses, extension tubes, and macro lenses designed for close focusing. *H. Lester*

See also: *Photomacrography.*

CINEMASCOPE Trade name for the first commercially successful motion picture wide-screen system using anamorphic lenses for camera and projector, squeezing the imaging horizontally by 50% in the camera and expanding it again in projection. This resulted in a projected aspect ratio of 2.35:1 (with optical sound track) or 2.55:1 (with magnetic sound track). *H. Lester*

See also: *Lens types, anamorphic.*

CINEMATOGRAPHY See *Motion-picture photography.*

CINEMA VERITÉ A motion-picture style popularized in France, with the uncompromising goal of communicating truth or objective reality. Often using documentary production techniques in a fictional context and reminding the audience occasionally of the filmmaking process that exists between them and the recorded event. *H. Lester*

CINEMICROGRAPHY Motion-picture photography through a microscope. *H. Lester*

Syn.: *Cinephotomicrography.*
See also: *Photomicrography.*

CINERADIOGRAPHY Motion-picture photography of x-ray images, usually involving the filming of visible images from a fluorescent screen or a cathode-ray tube. *H. Lester*

See also: *Radiography.*

CINERAMA Trade name for a wide-screen, wraparound, motion picture presentation system, originally using three coordinated projectors, each with film containing one-third of the total image, projecting onto a deeply curved screen, providing for the audience a great sense of involvement. Current Cinerama presentations use a single projector and 70-mm film, with the image distorted in such a way as to compensate for the distortions of a deeply curved screen, eliminating the distraction of noticeable seam lines and simplifying production and presentation. *H. Lester*

CIRCLE OF CONFUSION See *Depth of field; Depth of Field parameters.*

CIRCLE OF GOOD DEFINITION See *Lenses, covering power*.

CIRCLE OF ILLUMINATION See *Lenses, covering power*.

CIRCUIT BREAKER A protective device that opens an electrical circuit when the current through it exceeds the current rating of the circuit breaker. Like a fuse, it is primarily used to protect equipment and wiring from damage due to an overload or a short circuit. Unlike a fuse, the circuit breaker can be reset and reused. *W. Klein*
 See also: *Ground fault circuit interrupter.*

CIRCULAR POLARIZATION See *Quarter wave plate.*

C LANGUAGE A high-level compiler language published by Ritche and Kernighan of Bell Laboratories. C links machine language to conventional, high-level programming languages. It is a concise code that is highly portable between platforms. C is widely used for image-processing programming. *R. Kraus*

CLAPBOARD Two hinged boards slapped together at the beginning or end of a motion picture shot, providing the editor with a reference point for aligning the separately recorded picture and sound. Various automatic or manual electronic clapping systems involving lights and beeps are also available. *H. Lester*
 Syn.: *Clap sticks, Clapper board.*

CLAW See *Pull-down claw.*

CLAYDEN EFFECT See *Photographic effects.*

CLEARING BATH A solution used to prevent or remove stains on photographic materials from the action of another solution, especially the bleach in some toning, intensification, and reversal processes. In some reversal processes, the clearing bath also removes the small amount of silver halides remaining after both negative and positive images have been developed. *L. Stroebel and R. Zakia*
 See also: *Processing.*

CLEAR-SPOT FOCUSING See *Aerial image.*

CLICHE-VERRE A technique that combines qualities of printmaking and photography. A negative is drawn by hand on a transparent or translucent material, usually glass or plexiglass, that has been *smoked* or made opaque. The drawing is made by scratching through the coating to the glass. The image is then contact-printed onto a light-sensitive emulsion. An alternative technique is to use a transparent film or plastic base with opaque inks. Invented by William Henry Fox Talbot around 1835, this method has been rediscovered many times by a variety of artists and photographers using a variety of materials and processes, particularly Camille Corot, the painter. *J. Natal*

CLICK STOP A feature on some lenses whereby there is an audible click and extra tension is felt at certain *f*-number settings, such as whole stops and half stops. The photographer can open or close the lens by listening and feeling the number of clicks rather than having to set the *f*-number visually. *P. Schranz*

CLICK TRACK A sound track usually prerecorded on one track of a multitrack medium to guide musicians and others in making recordings in synchronization to the motion picture and to other sound tracks, consisting of clicks at the correct intervals to correspond to the beat. Use of the click track requires using Sel-sync (playback off the record head) to ensure synchronization. *T. Holman*

CLINICAL PHOTOGRAPHY Medical photography, other than radiography, of parts or the whole of a patient for diagnosis and treatment progress purposes. *L. Stroebel*
 See also: *Biological photography; Medical photography.*

CLIP See *Film clip.*

CLOCK In computers, the regulator of the central processing unit (CPU). It is measured in cycles per second or hertz. Current personal computers may have clock speeds between 20 and 50 megahertz (MHz). Generally speaking, the faster the clock speed the faster the computer will execute the program; however, there are other factors that make it difficult to simply measure clock speed to determine overall computer efficiency. In image-intensive applications clock speed is important. *R. Kraus*

CLONE In electronic imaging, the function by which an exact duplicate of an image or part of an image is made.
 L. Stroebel

CLOSEUP (1) In motion picture photography, a scene or an image in which the scale of reproduction is larger than in other scenes in a sequence, causing the image to appear nearer to the spectator. This is obtained by either moving the camera closer or by using a longer focal length lens. Abbreviated *CU*. (2) In still photography, a photograph in which the scale of reproduction is larger or the angle of view is smaller than is usual. (3) In still photography, specifically a photograph that requires modification of the exposure, equipment, or other factor because of the small distance between subject and camera. For critical work, compensation is made in the exposure when the subject is closer than ten times the focal length. When the subject is closer than twice the focal length, the term *photomacrograph* is preferred. *R. Welsh*

CLOSEUP BELLOWS/TUBE A device placed between the lens and camera body to increase the image conjugate distance and allow focusing at close distance. The camera lens must be interchangeable. The bellows type is of adjustable and variable extension and is more versatile than extension tubes, which are rigid and give a fixed extension. A set of three to five rings may be used in combination. An exposure correction is required for the additional extension *(E)*, and the *f*-number *(N)* is multiplied by a correction factor *(v/f)* where *v* is the image conjugate (i.e. *f* + *E*) for focal length *f*. *S. Ray*

CLOSEUP LENS See *Lens types, supplementary.*

CLOSEUP PHOTOGRAPHY Closeups are photographs of subjects made at close range, i.e., closer than the normal camera focusing mechanism will allow. Anyone who has used an ordinary camera soon learns that to get a larger image of any subject, one has to move closer to the object. As one moves closer to the subject the lens must be refocused by moving the lens farther away from the film; i.e., as the lens-to-subject distance is decreased, the lens-to-film distance must be increased. It is the limited focus travel of the ordinary lens that restricts its use to lens-to-subject distances of 0.4-1 meter, in the case of the typical 35-mm camera with normal lens. Closeup photographs are made either by extending the camera lens farther away from the film than normal through the use of extension tubes or bellows, or by attaching supplementary lenses to the camera lens. Closeups starts

where the closest focusing distance of an ordinary camera lens leaves off (reproduction ratio 1:10 to 1:20) and ends a life-size (reproduction ratio 1:1). Photographs of subjects made at magnifications greater than life-size but less than that which can be made with a compound microscope are in the area of photomacrography. In actual practice, the two areas overlap, and close-up equipment allows one to make photographs of objects up to 24× life-size—or more, while photomacrographic equipment allows one to make photographs of objects less than life-size, or down to about 0.6×.

REPRODUCTION RATIO Reproduction ratio, or scale, is the ratio between the actual dimensions of an object and the dimensions of its image, usually expressed in the form I:O, where I is the dimension in the *I*mage plane, and O is the dimension in the *O*bject plane. It can be expressed as a whole number, a fraction, or a decimal. It is determined by the distance from the subject to the film plane and by the focus setting of the lens. Example 1: If a subject is 96 × 144 mm and it is photographed to just fill the 24 × 36-mm format, the reproduction ratio, taking the 24-mm side, is 24:96, or 1:4. It is reduced to 1/4 of its original size; the decimal reduction is 0.25, the magnification is 0.25×. Example 2: If the film image is the same size as the subject, the reproduction ratio is one to one (1:1 or 1×). Example 3: A specimen measuring only 9.6 × 14.4 mm is photographed to completely fill the 24 × 36-mm film format. The reproduction ratio is 24:9.6 or 2.5:1, the magnification is 2.5×, and the specimen image is now larger than the actual specimen itself.

A normal-type lens at its infinity focus position is one focal length away from the film (measured from the lens image nodal point). For example, if a 50-mm lens on an ordinary 35-mm camera is focused at infinity, the lens-to-film distance is 50 mm. If, for example, a 50-mm extension is added to the 50-mm lens, the image distance is 50 + 50, or 100 mm. The subject distance will be 100 mm also, and the reproduction ratio will be 1:1. If a 100-mm focal length lens is used instead, and it is extended by 100 mm from its infinity focus position, the image distance will be 200 mm; the subject distance will also be 200 mm, and the reproduction ratio is again 1:1. Other focal length lenses can be similarly employed to obtain a 1:1 reproduction ratio—selection of a particular focal length for life-size magnification depends on perspective and working distance desired (longer focal length lenses used at a greater distance produce a weaker perspective and provide more freedom in lighting a specimen).

If a given focal length lens is extended from its infinity focus position by a distance greater than its own focal length, magnification will result. Suppose a 50-mm lens is extended from its infinity focus position by a 100-mm long extension tube—the reproduction ratio will be 2:1, or 2× magnification. To obtain a reproduction ratio of 1:5, the added extension is 1/5, or 0.2× the focal length. For a reproduction ratio of 1:2 the extension is 0.5× the focal length, for 1:1 the extension is one full focal length, and for 4:1, the extension required will be 4× the focal length.

The reproduction ratio can be calculated by dividing the added extension by the focal length of the lens; that is, reproduction ratio = added extension/focal length of lens. To facilitate the determination of the amount of extension when using bellows, many manufacturers mount a metric scale on the bellows' rail. When it is more convenient to measure the total image distance than the added extension, the added extension can be determined by subtracting one focal length from the image distance.

The relationship of the total film-to-subject distance to extension and focal length has led to the development of published Lens Extension Tables. One such set of tables has been computed for focal lengths from 5 mm to 1066.8 mm. The film-to-subject distances range from 5000 ft down to 0.25 ft, in about 60 steps, or to about 4× the focal length (1:1

reproduction ratio); extensions are given in both inches and millimeters.

The reproduction ratio is important in closeup photography not only for scientific and technical purposes, but also because it can be used for the determination of corresponding exposure adjustments, which are especially important at reproduction ratios greater than 1:1.

LENS EXTENSION A common method of making close-ups with normal lenses is to increase the lens-to-film distance through the use of either fixed-length extension tubes, or variable-length bellows. Extension tubes, or *rings*, are cylindrical tubes of different lengths that are used singly or in combination to change the reproduction ratio in fixed steps. Tube lengths vary from 5 mm to 100 mm, and extensions of 250 mm or more are often used. They are fitted together via threads or bayonet-type mechanisms; some allow automatic diaphragm features to be retained. Extension-tube sets are relatively inexpensive but take time to attach and are restricted to specific lengths. These objections are overcome by the use of bellows, which allow continuously variable extension and, therefore, greater versatility and control over lens-to-film distance. Bellows are normally more expensive than extension tubes but for professional use are essential. For even longer extensions, there are extended bellows that attach to normal bellows, and, of course, extension tubes used in conjunction with bellows. Stages that attach to the bellows units are available from several manufacturers, and the apparatus is thus converted from a closeup system into one for photomacrography.

The chief problem in the use of extension tubes or bellows for closeup work lies in the use of ordinary lenses close to the subject. Ordinary camera lenses are corrected to yield optimum performance for subjects located at some distance from the lens, for example, 10 meters to infinity. When they are used at close lens-to-subject distances, the images begin to degrade from aberrations. Optical performance can be markedly improved by using the normal camera lens in reversed position, that is, by mounting the front of the lens to the bellow or extension tubes and directing the rear of the lens toward the subject. Manufacturers supply reversing rings for this purpose. Enlarging lenses are also used for closeup work in this way. A reversed 20-mm lens can be used with a fully extended extension bellows attached to a fully extended normal bellows to obtain 24× life-size images. Higher quality bellows incorporate a scale, graduated in millimeters and/or reproduction ratio, so that the amount of extension may be recorded for computing reproduction ratio and correct exposure, if the camera does not have an automatic exposure feature.

Interest in the closeup range has led to the development and availability of close-focusing or *macro* lenses. These lenses incorporate helical-drive extensions longer than normally provided and allow magnification of 1/2× or 1× (life size) without separate attachments. They are better corrected for closer subjects than normal lenses. These lenses too can be used in conjunction with bellows and extension tubes to increase magnification.

SUPPLEMENTARY LENSES Another common method of making closeup photographs is through the use of positive *supplementary lenses* or *closeup attachment lenses*— also called *pluses*. These are single lenses or achromatic doublets that screw, or are otherwise attached, directly onto the front of a camera lens, just like a filter, and allow the photographer to focus closer. This method is convenient, portable, relatively inexpensive, does not require exposure increase, and maintains automatic lens capability with many cameras, as well as other automatic functions, such as light metering and autofocus.

Supplementary closeup lenses are often supplied by diopter number, for example, 1+, 2+, 3+, 5+, 10+. The

diopter number of a lens is the reciprocal of its focal length in meters. Hence the formula:

$$D = \frac{1}{f}$$

Thus, the diopter number expresses the number of times the focal length (in millimeters) will divide into 1000 mm (one meter). By transposition, the focal length can be calculated:

$$f = \frac{1}{D}$$

At 1+ close-up lens will have a focal length of 1 meter (1000 mm); a 4+ close-up lens will have a focal length of 0.25 meter (250 mm) and so on.

The dioptric power of the camera lens used can also be computed. For example, an ordinary 50-mm camera lens has a dioptric power of 1000 mm (1 meter) divided by 50 mm (0.05 meter), or 20.

To calculate the focal length of a combination of camera lens and supplementary lens, the dioptric power of the supplementary lens is converted to focal length, and then the following equation is used:

$$f_c = \frac{f_1 \times f_2}{f_1 + f_2}$$

where f_c is the combined focal length of the camera lens and supplementary lens, f_1 is the focal length of the supplementary lens, and f_2 is the focal length of the camera lens.

Alternatively, one can convert all values to diopters and then convert their sum to focal length. For example, a 50-mm lens has a power of 20 diopters. Add a 2+ supplementary lens and the sum is 22 diopters. The combined focal length is 1000 mm divided by 22, or, about 45.4 mm.

The combined focal length of the camera lens and supplementary lens is necessary if the photographer wishes to calculate the lens-to-subject distance using the well-known lens equation:

$$u = \frac{v - f}{f}$$

where u is object distance and v is image distance.

Supplementary lenses can be combined to obtain even greater magnification. When combining two such closeup lenses, the higher-numbered one should be attached closer to the camera lens. Image degradation increases dramatically when more than two supplementary lenses are combined.

The number on the supplementary lenses may not indicate diopters. One manufacturer's No. 0, No. 1, No. 2, for example, may actually have diopter powers of 0.7, 1.5 and 3.0 respectively.

Supplementary lenses can also be used in combination with extension rings and bellows in order to minimize the total amount of lens extension. The resulting shorter exposures may, for many subjects, offset the theoretical advantage of using the camera lens with extension tubes alone.

Simple supplementary lenses should not be used with telephoto lenses. Two-element achromats are available for longer focal length lenses for improved performance.

Stopping down the lens will minimize problems introduced by using simple, positive closeup lenses.

Teleconverters are precision optical accessories that can be mounted between compatible lenses and the camera body to obtain a long focal length and close focusing ability. A teleconverter used in combination with a 200-mm close-focusing lens, for example, yields life-size 1:1 images and does so while maintaining a 71-cm (28 in.) minimum object distance. This amount of working distance is advantageous for many biomedical, industrial, and natural history applications; it also allows considerable freedom in arranging lighting.

EXPOSURE DETERMINATION We have seen that going from long-distance photography to closeup photography requires an increase in the lens-to-film distance (image distance). In ordinary photography with normal lenses, the aperture ratio holds; that is, the f-numbers are still determined by the ratio of lens diameter to focal length. Focusing the normal lens from infinity to its closest focus position does not change the lens-to-film distance appreciably. With the increased extensions used in closeup photography and, especially, photomacrography, the aperture ratios are no longer valid. The lens diameter is now divided not into the camera lens focal length but into the focal length plus any extension. In the case of 1:1 photography, the lens is extended by one full focal length, making the lens-to-film distance now two focal lengths, thereby doubling the original distance. Because the aperture represents an area, this number must now be squared to obtain the exposure increase necessary. The equation for the exposure factor in terms of reproduction ratio is:

$$\text{Exposure factor} = (R + 1)^2.$$

The 1 in the equation represents one focal length of any lens used. R is the reproduction ratio, but since the reproduction ratio always corresponds to the *increase* in extension, the R can be thought of as this increase. In the case of a reproduction ratio of 1:5, for example, the exposure factor is $(0.2 + 1)^2 = (1.2)^2 = {\sim}1.4$. At 1:1, the extension required is one focal length; therefore, the exposure factor is $(1 + 1)^2 = 2^2 = 4$. At 4:1, the magnification is 4× (four focal lengths of extension added), and the exposure factor is $(4 + 1)^2 = 5^2 = 25$.

An equation for the exposure factor in terms of image distance is:

$$\text{Exposure factor} = \left(\frac{\text{image distance}}{\text{focal length}}\right)^2$$

This equation is equivalent to the previous one because the image distance is the lens focal length plus any extension, making the equation:

$$\text{Exposure factor} = \left(\frac{\text{extension} + \text{focal length}}{\text{focal length}}\right)$$

or:

$$\text{Exposure factor} = \left(\frac{\text{extension}}{\text{focal length}} + \frac{\text{focal length}}{\text{focal length}}\right)^2$$

but $R = $ extension/focal length, and the second term is 1, bring us back to:

$$\text{Exposure factor} = (R + 1)^2.$$

The $(R + 1)^2$ version is easier to use if scales or rules are substituted in the specimen plane to determine reproduction ratio. The (image distance/focal length)2 version is easier to use if graduated bellows are used to determine image distance (remember to add the focal length to the bellows extension reading to get the entire image distance if the bellows scale reads "0" at the infinity focus position). The exposure time indicated for a selected f-number, with hand-held exposure meters, is multiplied by the exposure factor.

Camera systems with through-the-lens (TTL) meters do not need these exposure factors because the built-in meter

will automatically compensate for light losses due to increased lens-to-film distance.

PUPILLARY MAGNIFICATION Strictly speaking, all of the equations for exposure factors discussed thus far are completely accurate only for lenses that are symmetrical, i.e., those that have the same optical construction on both sides of the diaphragm. If the diaphragm of a symmetrical lens is fully opened, and the lens is held at arm's length and then viewed first through the front side and then through the back side, the disc of light seen will be the same size. True telephoto lenses—not just long focus lenses—are asymmetrical. Viewed from the front and rear they have different diameter discs of light. The same holds true of retrofocus wide-angle lenses. The pupillary ratio or pupillary magnification is found by dividing the diameter of the exit pupil (film side) by the diameter of the entrance pupil (front side). If this pupillary factor is not taken into account, errors in exposure will result. In a symmetrical lens the pupillary magnification is 1. But if the pupillary ratio is some other number, then that number should be divided into the reproduction ratio whenever the exposure increase factor is being calculated:

$$\text{Exposure increase factor} = \left(\frac{R}{PM} + 1\right)^2$$

where PM is the pupillary magnification. The exposure difference can be significant with some lenses. For example, consider a 1:1 reproduction ratio situation. With a symmetrical lens the *PM* will be 1 and the exposure factor will be 4. With a telephoto lens that has a *PM* of, say, 0.4 the exposure factor will be 12.25. A retrofocus lens with a *PM* of, say, 3 will result in an exposure factor of about 1.8. Errors due to ignoring the pupillary magnification become greater as the reproduction ratio increases.

DEPTH OF FIELD Because depth of field increases roughly with the object distance squared, it tends to be very shallow in closeup photographs, even with the lens stopped down to small openings. Also, in general photography there tends to be much more depth of field behind the distance focused on than in front. In closeup photographs the distribution is more nearly equal.

PRACTICAL AIDS Numerical factors essential to closeup photography include reproduction ratio, exposure factor, pupillary magnification, and depth of field at various *f*-numbers. The equation for calculating these various factors have been presented for the sake of understanding their derivation and significance. In fact, however, the practical closeup photographer using equipment without automatic exposure determination seldom has to do all of the calculations implied, as most of these have already been done, recorded, and incorporated in a number of practical aids. Commercially available straight and circular slide rules make determination of exposure factors quite simple. There are also tables that accompany closeup lenses that contain these data. The data are also indicated directly on most closeup lenses, albeit usually in an abbreviated form. With the aid of one or more of these tables or slide rules, little time is actually devoted to calculating any of the required numerical data.

Closeup photography has become quite popular because modern technology has allowed *macro* capability to be built into many amateur point-and-shoot type cameras.

Books: Cooper, J. D., and J. C. Abbott, *Close-up Photography and Copying*. Garden City, N.Y.: Amphoto, 1979; Gibson, H.L., *Close-up Photography and Photomacrography*. Rochester, N.Y.: Kodak, 1970; Tölke, A., and I. Tölke, *Macro Photo and Cine Methods*. London and New York: Focal Press, 1971; Lefkowitz, L., *The Manual of Close-up Photography*. Garden City, N.Y.: Amphoto, 1979. *J. Delly*

See also: *Photomacrography.*

CLUMPING A nonrandom distribution of elements, such as particles of silver in a photographic emulsion, such that groups of the elements are clustered together. Clumping contributes to the appearance of graininess in photographs, but some of the clumping seen in enlarged prints is due to the overlapping of shadows of grains that may be well separated in depth in the emulsion layer. *L. Stroebel*

C-MOUNT The standard screw-type lens mount for 16-mm movie cameras. The major diameter is 1.0 inch with 23 threads per inch, the focal plane being 0.690 inch behind the seating face. *H. Lester*

CMYK Cyan, magenta, yellow, and black, photomechanical reproduction and thermal dye transfer printing colors.
 L. Stroebel

COATING See *Lenses, lens coating.*

COBURN, ALVIN LANGDON (1882–1966) British photographer. A member of the Linked Ring (1903) and also of the Photo-Secession, with solo exhibitions at "291" gallery in 1907 and 1909. His early work, influenced by Whistler, was soft-focus, each image veiled by the mist of pictorialism. Published *Men of Mark* in 1913, recognized as an important volume of portraits of writers and artists of the time. Coburn is often credited with making the first abstract photographs (1917), which he called "vortographs," using a mirrored kaleidoscope attached to his camera.

Books: Weaver, Mike, *Alvin Langdon Coburn, Symbolist Photographer.* Millerton, NY: Aperture, 1986; *Alvin Langdon Coburn, Photographer, An Autobiography.* New York: Praeger, 1966. *M. Alinder*

COCHLEA The inner ear. The organ that converts mechanical sound energy, delivered by way of the outer and middle ear, to electrical impulses for detection by the brain. The fundamental mechanism is a spatially dependent spectrum analyzer, with one end of the membrane stretched in the cochlea responding to high frequencies and the other end to low frequencies, with the membrane covered in hair cells and nerves that make the transduction from mechanical to electrical energy. *T. Holman*

CODE The vernacular for any machine or higher-level language instructions. *R. Kraus*

CODE NUMBERS Numbers printed with ink on the edge of work prints and magnetic sound tracks to give the motion-picture editor convenient reference points for maintaining sound and picture synchronization during the editing process. *H. Lester*

See also: *Film coding.*

COHERENT LIGHT Light that is made up of photons that all have exactly the same wavelength and are all in phase, such as the light emitted by a laser. Coherent light is capable of transferring energy much more effectively than incoherent light because of the lack of destructive interference between the photons. Coherent light is also necessary for holography because of the importance of phase. *J. Holm*

COKE, VAN DEREN (1921–) Historian, photographer, teacher, and curator. Wrote, *The Painter and the Photograph* (1964), describing how photography changed the way many painters worked by allowing them to paint directly

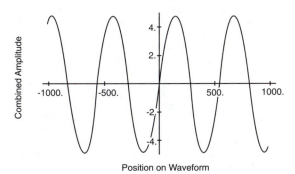

Coherent light. Combination of Coherent Photons and the Resulting Amplitude The amplitude waveform of a photon is represented above. Five coherent photons combined produce the waveform below. (Since coherent photons have identical wavelength and phase, they will have identical waveforms.)

from photographs, and by revealing the unusual perspective of the camera, adopted by such artists as Degas. From 1958, professor at the universities of Florida, New Mexico, and Arizona State. He has also been director of George Eastman House, Rochester, and director of the photography department, San Francisco Museum of Modern Art. *M. Alinder*

COLD-CATHODE LAMP A rapid-start tubular fluorescent light source using an emissive high-voltage cathode. Cold-cathode lamps are often used in *cold-light heads* for enlarging. In most configurations, the tube is bent to form a grid pattern and used behind a diffuser. Cold-cathode special-purpose lamps are relatively expensive but have a long life. *R. Jegerings*

See also: *Fluorescent lamp; Cold light.*

COLD LIGHT Light that is generated without heat or with minimal heat, for example, with a fluorescent-light tube. Cold light has various uses in photography.
 CLOSEUP PHOTOGRAPHY A hot light source may be isolated from the subject and thereby provide cold-light. A special lighting fixture uses one or more fiber-optic light tubes to distance the light source and heat from the subject. The narrow cables also miniaturize source size so shadow formation and specular highlights are more natural, and they are flexible so sources can be more easily maneuvered than large lights.
 ENLARGING *Cold-light heads* for enlarging are dif-

fused-light sources that use fluorescent tubes, usually cold-cathode types bent to form a grid pattern behind a diffuser. They are often said to produce less heat than other heads and prevent negative buckling, but the tube is relatively close to the negative, it does produce some heat, and the head may have a thermostat system for a constant temperature of about 105°F for full light intensity at the start of the exposure. Spectral energy distribution varies with tubes. Fiber optics are also used in enlargers to separate the light source and its heat from the negative. The light source and filter control system may be housed in a separate bench console with light transfer to the negative through fiber-optic tubes. *R. Jegerings*

See also: *Enlargers.*

COLD MIRROR See *Diathermic mirror.*

COLLAGE (from the French *coller,* to glue) The pasting together of torn or cut pieces of existing visual materials such as photographs, pictures in magazines and newspapers, newsprint, and the like to create a new image that can be displayed as it is or photographed and displayed. *R. Zakia*

See also: *Photomontage.*

COLLIMATOR A well-corrected optical system that directs divergent light rays from a source at its rear principal focus into a near parallel emergent beam. The light source may be replaced by a test target, which is then seen at optical infinity when viewed through the collimator. *S. Ray*

See also: *Lenses.*

Combination of Incoherent Photons (Random Wavelength and Phase) and the Resulting Amplitude The waveforms represented above have random wavelength and phase, although the wavelength has been limited to the visible region of the spectrum. The waveform below is the combination of the above waveforms. The power transferred by a waveform is the square of its amplitude.

COLLOID A name for any class of substances—albumen, caramel, gelatin, glue, and starch—which, when dissolved in water, will not diffuse through a parchment membrane. The colloids mentioned here are used in numerous nonsilver process. *J. Natal*

COLLOIDAL CARBON FILTER See *Filter types*.

COLLODION PROCESS Early negative-positive processes used light-sensitive coatings on supports that were more opaque than transparent. As a half-measure, paper negatives were waxed to make them translucent, but glass, the obvious solution, was too difficult to use because the coatings could not be made to stay in place. The problem was solved by Frederick Scott Archer in 1851. He used a mixture of nitrocellulose dissolved in ethyl ether and ethyl alcohol called collodion (based on the Greek word for glue) as a vehicle for coating potassium iodide on glass. Silver iodide was formed by bathing the plate in silver nitrate. The collodion was waterproof when it dried, so the collodion plates had to be used while they were wet or sticky. Archer used pyrogallic acid as a developer before the plate dried, and fixed the plate in sodium thiosulfate.

Later modifications to Archer's process included the substitution of ferrous sulfate as a developer to triple the sensitivity, and the use of potentially dangerous potassium cyanide as a fixer because it worked, washed out faster, and left a fog-free plate.

Collodion was subsequently applied to making direct positives on glass, on the ambrotype, and on black lacquered metal, the tintype. Various methods for making dry collodion plates were basically unsuccessful because of substantial losses in effective sensitivity. In the twentieth century, collodion plates were used in photomechanical reproduction for line and half-tone blockmaking. Plain, unsensitized collodion was used as a covering for wounds and surgical incisions, a glossy coating for albumen paper prints, and an adhesive in the theater for applying false beards and moustaches. *H. Wallach*

See also: *Ambrotype; Tintype; Wet-collodion process.*

COLLOTYPE A screenless printing process of the planographic ink-water type, in which the plates are coated with bichromated gelatin, exposed to continuous-tone negatives, and printed on modified lithographic presses with special arrangements for dampening. *M. Bruno*

Syn.: *Photogelatin.*

COLOR The word *color* is used to mean both a perception in the mind and a stimulus that can produce that perception. Thus, when we say that a red car looks brown when seen in yellow sodium street lighting, *brown* refers to the perception in the mind, but *red* and *yellow* refer to the stimulus. In this article we consider mainly color perception; in the article on *colorimetry*, color stimuli are the main consideration.

THE SPECTRUM When white light is passed through a prism, or diffracted from a suitable grating, it is split up into the various colors of the spectrum. The different parts of the spectrum are identified by quoting the wavelength of the light (in air, or for the highest precision in vacuum). In color science the unit used for wavelength is the nanometer, abbreviated nm (which is 10^{-9} meter). The colors seen in the spectrum change gradually from one to the next as the wavelength is changed, and their appearance depends on the viewing conditions, but the following color names correspond approximately with the following bands of wavelength: violet: 380 to 450 nm; blue: 450 to 490 nm; green: 490 to 560 nm; yellow: 560 to 590 nm; orange: 590 to 630 nm; red: 630 to 780 nm. Radiation having wavelengths in the band below 380 nm is normally invisible to the eye and is called ultraviolet; that in the band above about 780 nm is also normally invisible and is called infrared. Because the sensitivity of the human eye to wavelengths below 400 nm and above 700 nm is very low, the wavelength range for light is sometimes considered to be 400 to 700 nm. When considering trichromatic concepts, the visible spectrum is usually regarded as consisting of a bluish third (up to about 490 nm), a greenish third (from about 490 nm to about 580 nm), and a reddish third (above about 580 nm).

THE VISUAL PHOTORECEPTORS When light is imaged on the eye's light-sensitive surface, the *retina,* it is absorbed by light-sensitive pigments. These pigments are contained in a random mosaic of very small receptors called *rods* and *cones.* Each eye has about six million cones and about a hundred million rods, and these receptors are connected to the brain by about one million nerve fibers from each eye. The rods contain a single light-sensitive pigment, *rhodopsin,* which absorbs most strongly at about 510 nm and less strongly at longer and shorter wavelengths. Although the rod response at one wavelength, say 600 nm, may be very different from that at another, say 500 nm, such responses can be made the same by adjusting the intensities of the stimuli appropriately. The rods cannot, therefore, distinguish between changes in color intensity (saturation) and changes in spectral composition; hence, they do not provide color vision but only colorless perceptions, such as white, black, and shades of gray. This type of vision occurs at low levels of illumination, such as full moonlight and lower.

In the cones, however, there are three different types of pigments: one absorbs light mainly in the reddish third of the spectrum, another mainly in the greenish third, and the other mainly in the bluish third. We refer to these three different types of cones as ρ, γ, and β, the Greek letters rho, gamma, and beta, representing red, green, and blue, respectively.

Because the cones contain more than one type of pigment, they are able to distinguish between changes in intensity and changes in spectral composition. Taking again the example of stimuli of 500 and 600 nm, the 500 nm stimulus gives about half as much ρ as γ response, but the 600 nm stimulus gives more than twice as much ρ as γ response; and this difference in the ratio of ρ to γ response will remain for all intensities. Furthermore, the ratio of β response to ρ and γ response is also different for different wavelengths. These differences in the ratios of the three types of cone responses throughout the spectrum provide the basis of color discrimination.

The numbers of ρ, γ, and β cones are not equal. For every one β cone there ae about 20 γ and 40 ρ cones. The reason for the small number of β cones is that the eye is not corrected for chromatic aberration, so that blue, green, and red light are focused in different planes in the eye. The eye tends to focus on yellow light, so that the blue light image on the retina is not sharp. Hence, there is no need to sample the blue light image at a high spatial frequency, so the number of β cones is reduced.

THE VISUAL COLOR SIGNALS Absorptions of light in the three types of cones generate electrical potentials, and these electrical signals are then coded into an *achromatic* and two *color difference* signals for transmission through the optic nerve to the brain. Although, in the early stages, the signals are analog voltages, when they reach the ganglion cells they are transformed into a series of nerve impulses, all of the same voltage, and the strength of the signal is then represented by the number of nerve impulses per second.

The achromatic signal is produced by *nonopponent* cells summing the voltages produced by the ρ, γ, and β cones in the retina. This signal provides the basis for the perception of *brightness,* which is common to all colors. Because of the greater number of ρ cones and the very much smaller number of β cones, the cone part of the achromatic signal is

Visual photoreceptors (scotopic). Broken line represents the spectral sensitivity of the eye for scotopic (rod) vision, unbroken lines are the spectral sensitivity curves representative of those believed to be typical of the three different types of cones, ρ, γ, and β, of the retina that provide the basis of photopic (color) vision.

The spectrum. Light of wavelength 500 nm results in about half as much ρ response as γ response, whereas light of 600 nm results in more than twice as much ρ response as γ response. It is the differences in the ratios of the ρ, γ, and β responses that enable differences in spectral composition to be detected independently of the amount of light present, thus providing a basis for color vision.

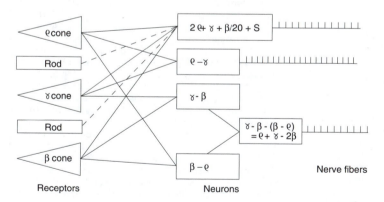

The visual color signals. Greatly oversimplified and hypothetical diagrammatic representation of possible types of connection between some retinal receptors and some nerve fibers.

probably approximately similar to $2\rho + \gamma + (1/20)\beta$, where ρ, γ, and β are the magnitudes of the voltages produced by the three types of cones. The rod signals are probably also transmitted along the achromatic channel to the brain, so that the complete achromatic signal is represented by $2\rho + \gamma + (1/20)\beta + S$, where S represents the rod signals.

At normal daylight levels of illumination, the rods play little or no part, and, in colorimetry and color reproduction, only the cones are considered. The spectral sensitivity of the achromatic channel is then given by adding to the spectral sensitivity of the γ cones twice that of the ρ cones and one-twentieth of that of the β cones (because of nonlinearities in the stim-

ulus–response relationships in the receptors this simple addition is not strictly valid, but it provides a useful approximation). The resultant composite spectral sensitivity can be considered as the basis of the *spectral luminous efficiency function,* or $V(\lambda)$ function; this important function is used to weight spectral power distributions for summation to obtain measures for photometry, such as luminance. The very much smaller number of β cones explains why power at the blue end of the spectrum makes only a small contribution to luminance.

The color-difference signals are produced by *opponent cells* evaluating the differences between the voltages produced by the ρ, γ, and β cones. These color-difference signals

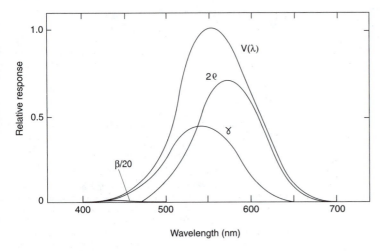

Visual photoreceptors (photopic). The sensitivity, $V(\lambda)$, of the eye to light at normal (photopic) levels of illumination. The contributions of the three different types of cone to this sensitivity are also shown, it being assumed that, compared with the number of γ cones present in the retina, there are twice as many ρ cones and only one-twentieth as many β cones.

are probably approximately similar to $\rho - \gamma$ and $\rho + \gamma - 2\beta$. If these difference signals are zero, this is indicated by the number of nerve impulses per second being at a *resting level;* increases above this resting level then indicate a positive signal, and decreases below it represent a negative signal. The $\rho - \gamma$ signal is positive for reddish colors and negative for greenish colors; the $\rho + \gamma - 2\beta$ signal is positive for yellowish colors and negative for bluish colors. These color-difference signals explain the existence of four *unique hues* in opposed pairs: red and green; yellow and blue. The pairs are opposed in the sense that redness and greenness cannot be perceived together in the same color, and yellowness and blueness cannot be perceived together in the same color; but redness and yellowness, or yellowness and greenness, or greenness and blueness, or blueness and redness can be perceived together in the same color. The situation can then be summarized as follows:

3 Cone Types
ρ sensitive to the reddish third of the spectrum
γ sensitive to the greenish third of the spectrum
β sensitive to the bluish third of the spectrum

3 Signal Types		*6 Unique Colors*
Achromatic	$2\rho + \gamma + (1/20)\beta$	indicates whitish or blackish
Red-green	$\rho - \gamma$	indicates reddish or greenish
Yellow-blue	$\rho + \gamma - 2\beta$	indicates yellowish or bluish
		4 Unique Hues

The existence of *four* unique hues when there are only *three* different types of cones presents an apparent paradox, but the achromatic signal provides two additional unique colors, black and white, so that, including the four unique hues, there are six unique colors. These six colors are in three opposite pairs, so that the trichromacy of the visual system is still present. The white–black pair of unique colors is different from the pairs of opponent hues in that it is possible to perceive both whiteness and blackness in the same color; when no unique hues are present such colors are referred to as *grays.*

As light levels increase, the strengths of the achromatic signal and of the color-difference signals increase, and this results in greater brightness and colorfulness. This is why scenes and pictures look brighter and more colorful at higher levels of illumination than they do at lower levels of illumination.

The degrees of amplification of the voltages produced by the cones, and the concentrations of the pigments, vary to reduce the effects of variations in the level and color of illuminants. By these means the appearances of colors change much less than might be expected when changes occur in the level and color of the illumination, a phenomenon often referred to as *color constancy.*

The relationships between stimulus intensities and magnitudes of visual signals are not usually linear; this means that systems that attempt to represent the domain of different colors as a uniform distribution have to incorporate nonlinear components in their formulations.

CONTRAST The appearance of colors can be markedly affected by the conditions under which they are viewed. For instance, after prolonged viewing of a bright yellow area, colors tend to appear darker and bluer than normal, a phenomenon referred to as *successive contrast.* Similarly, when viewed with a bright yellow surround, colors tend, again, to appear darker and bluer, and this is referred to as *simultaneous contrast.* In these contrast effects, the colors generally become less like the preceding or surrounding conditioning fields, in the sense that the achromatic and color-difference signals of the color considered become less like those of the conditioning fields. A consequence of these effects is that if a reflection print is mounted on a white surround it will look darker than if mounted on a black surround; similarly, a yellow surround will make it look bluer, and a blue surround will make it look yellower, and similarly for other hues.

SUBJECTIVE AND OBJECTIVE COLOR If a reversal transparency film that is balanced for daylight is exposed in tungsten light, the resulting pictures usually have a pronounced orange cast. This is because the tungsten light is orange by comparison with daylight, and the film simply records this orange bias. In the original scene, the eye is able to adapt to the orange color of the tungsten light to largely offset its color bias, but, when viewing the picture, its limited angular subtense results in only a small amount of adaptation taking place. To achieve correct results with the film, it is necessary either to use a bluish filter over the camera lens or to rebalance the film by increasing the speed of the blue layer and decreasing that of the red layer, relative to that of the green layer. When negative films are used, from which positive images are obtained by printing, it is possible to correct for any bias in the color of the camera illuminant by altering the effective color of the printing light; however, this does require the color film to have sufficient exposure latitude to accommodate the bias of the camera illuminant. Another example of this type of situation can occur when photographing interior scenes; even though the film, or filtration, may be chosen for the normal illuminant, bias can be caused by the color of the decoration in the interior. For instance, if a daylight balanced film is used in a room lit by daylight, the presence of pink walls and a red carpet can result in reddish pictures being produced, whereas the eye adapts to the pink

bias of the lighting in the interior and tends to see the colors normally.

Books: Billmeyer, F. W., J., and Saltzman, M., *Principles of Color Technology.* 2nd edition. New York: Wiley, 1981; Hunt, R. W. G., *The Reproduction of Colour.* 4th edition. New York: Van Nostrand Reinhold, and Surbiton, England: Fountain Press, 1987.

R. W. G. Hunt

See also: *Colorimetry.*

COLOR ADAPTATION A process of adjustment of the visual system such that exposure to a given hue results in decreased sensitivity to that hue and an apparent increased sensitivity to the complementary hue. For example, when a person has fully adapted to the light source, either tungsten light or daylight may appear white despite the wide differences in the relative red, green, and blue content in these two sources. *L. Stroebel and R. Zakia*

See also: *Adaptation; Vision, adaptation.*

COLOR ANALYSIS Determination of the amounts of primaries or colorants required in a reproduction, as distinct from color synthesis, the production of a color in an additive or subtractive process. *R. W. G. Hunt*

COLORANTS Typically pigments or dyes that selectively absorb light of various frequencies, such as cyan, magenta, and yellow dyes or filters that are designed to absorb red, green, and blue light respectively. *R. W. G. Hunt*

COLOR ATLAS Collection of surface colors, usually in a systematic arrangement, used for choosing or specifying colors in practical applications. Color atlases have the advantages of being easy to understand, easy to use, and adaptable in terms of the number and spacing of the samples. They also have the following disadvantages: the number of the samples is always limited, so that interpolation is often necessary; they always have a limited gamut of samples; there may be some variations between copies; they may deteriorate as a result of the samples fading or becoming dirty; there is no unique system for arranging the samples; different observers may make different matches between the samples and colors being checked; color matches between the samples and colors being checked may be upset by changes in the color of the lighting; and they cannot readily be used for light sources. *R. W. G. Hunt*

COLOR BALANCE The average overall color of a reproduction. The color balance is dependent on the relative strengths of the three primaries in additive systems and on the relative strengths of the colorants in subtractive systems. *R. W. G. Hunt*

COLOR-BLIND MATERIALS Most light-sensitive chemicals are inherently sensitive only to blue and ultraviolet radiation. The silver halide emulsions up to the 1870s were of this type. (They were called *ordinary* after the invention of spectral sensitization by Vogel in 1873.) Noncolor-sensitized, and hence color-blind, emulsions are still used for some graphic-arts films, contact printing materials, and non-screen x-ray films. *M. Scott*

COLOR BLINDNESS See *Defective color vision.*

COLOR CAST The average overall color of a reproduction relative to some defined or optimum average overall color. *R. W. G. Hunt*

See also: *Color balance.*

COLOR CHART A panel of selected colors that is designed to be photographed for the purpose of evaluating color reproduction quality. *L. Stroebel*

See also: *Input, color chart; Macbeth colorchecker.*

COLOR CHECKER A set of selected colors that approximate the colors of real objects. The gamut of colors is specified by the Inter-Society Color Council, National Bureau of Standards. Color checkers can be used to make an evaluation of the color reproduction qualities of a system such as video camera and monitor. *R. Kraus*

COLOR CIRCLE Arrangement of colors in a circle according to hue, such as red, orange, yellow, green, blue, violet, purple, magenta, and back to red. In the Munsell system, red, yellow, green, blue, and purple. *R. W. G. Hunt*

Syn.: *Hue circle.*

COLOR COMPENSATING (CC) FILTERS Pale transparent filters designed for altering the color of light used for exposing or viewing color images. The colors available usually include red, green, blue, cyan, magenta, and yellow. The strength of the color is often expressed as 100 times the density of the filter's major absorption band; for example, a CC 50 Yellow filter would have a density of 0.50 to blue light. *R. W. G. Hunt*

COLOR CONSTANCY The process by which the color of a surface is perceived as remaining the same when viewed under illumination that varies in color balance. A red apple, for example, is seen as red whether viewed by daylight, tungsten light, or fluorescent light. Color constancy is considered to include brightness constancy. Since color has three basic attributes, color constancy can be subdivided into hue constancy, saturation constancy, and brightness (or lightness) constancy. *L. Stroebel and R. Zakia*

See also: *Constancy; Visual perception, constancy.*

COLOR CONTRAST Relative variation or perceived variations of hue or chroma in a scene or image. The perceived color contrast is typically greater when two colors are adjacent than when they are separated by a neutral area. A blue area, for example, appears to be more saturated when it is surrounded by yellow than when it is surrounded by gray, an effect known as simultaneous contrast. *L. Stroebel and R. Zakia*

See also: *Complementary colors; Simultaneous contrast.*

COLOR-CORRECTED LENS See *Achromatic; Apochromat; Super apochromat.*

COLOR CORRECTION In color reproductions, errors can occur because of the use of incorrect spectral sensitivities at the camera stage, insufficient color gamut at the display stage, and, in the case of subtractive systems, unwanted absorptions of the cyan, magenta, and yellow dyes or inks. In color television, matrixing is used to correct camera spectral sensitivities, but this is not easy to do in photography or in graphic arts printing. In photography and graphic arts, color correction is usually concentrated on correcting for the unwanted absorptions of the cyan, magenta, and yellow colorants.

CORRECTING FOR UNWANTED ABSORPTIONS Corrections for unwanted absorptions are usually achieved in photography by the use of either colored couplers or interimage effects, and in graphic arts by masking or equivalent procedures on scanners at the same time that improvements in tone reproduction and sharpness are usually made.

In masking, low contrast positives are made from the separation negatives and bound up in register with the separations; these masked combinations are then used to make the printing surfaces. For instance, to correct for the unwanted green absorption of the cyan ink, a low-contrast positive is made from the red separation and bound up with the green separation. The effect of this is to remove some magenta ink wherever cyan ink is printed and thus to reduce the green absorption in these areas. In general all three separations

need masking. Equivalent procedures are used on scanners by manipulation of the electronic signals.

If masks are made slightly unsharp, they do not reduce the contrast of fine detail on the separations. Hence, when the contrast is increased again to restore the image contrast to normal, the fine detail is increased in contrast and this makes it look sharper. This is a very useful technique and is widely used, not only in photographic masking but also in scanners and in television.

BLACK INK IMAGE Because cyan, magenta, and yellow inks, at the level of lay-down normally practicable in printing, do not usually produce a good black, a fourth printing surface is also normally prepared that is used to transfer some black ink into the darker parts of the picture. *R. W. G. Hunt*

See also: *Color photography; Separation negatives.*

Books: Hunt, R. W. G., *The Reproduction of Colour.* 4th edition. New York: Van Nostrand Reinhold, and Surbiton, England: Fountain Press, 1987.

COLOR CORRECTION FILTER See *Filter types.*

COLOR COUPLERS Organic compounds that form dyes during chromogenic development of photographic materials and in diazo processes. Almost all photographic color materials have substantive couplers integrated in their three emulsion layers, making it possible to use a single developer to produce the composite dye image. Image-forming couplers in photographic materials are colorless until a silver halide image is developed; then they couple with by-products of the chemical reduction to form cyan, magenta, and yellow dyes in proportion to the silver density developed in each emulsion layer. Most color negative materials also contain color couplers that form an integral mask to correct the printing deficiencies of the cyan and magenta dye images. These are destroyed in proportion to the silver and dye image produced in these layers, so their masking action affects only the other areas of the image layer. A few negative films use colorless couplers to form the corrective mask during development. In either case, it is these masking dyes that give color negatives and overall pinkish-tan or orange-brown appearance. *J. Natal*

COLOR DEFICIENCY Color vision that is deficient in the ability to see color differences, compared to normal observers. About 8% of men have some color deficiency, but only about 2% are seriously deficient. For women, the corresponding figures are about 0.5% and 0.03%. The colors confused, and the average incidence, for the different types of color deficiency may be summarized as follows:

Type of Defect	Colors Confused	Incidence Men	Incidence Women
Protanopia	All reddish and greenish; reds dark	1.0%	0.02%
Deuteranopia	All reddish and greenish	1.1%	0.01%
Tritanopia	All yellowish and bluish	0.002%	0.001%
Protanomaly	Some reddish and greenish; reds dark	1.0%	0.02%
Deuteranomaly	Some reddish and greenish	4.9%	0.38%
Tritanomaly	Some yellowish and bluish	?	?
Rod mono-chromacy	All colors	0.002%	0.002%
Cone mono-chromacy	All colors	Very rare	
Totals		8.0%	0.4%

R. W. G. Hunt

Syn.: *Color blindness.*
See also: *Vision.*

COLOR DENSITOMETER An instrument used to measure the absorption of light by a processed color photographic image. Red, green, and blue filters are placed sequentially in the light path of the reading instrument. The red light absorption is caused mainly by the amount of cyan dye in the image, the green light absorption by the amount of magenta dye, and the blue light absorption by the amount of yellow dye. A visual filter for estimating the total absorption of light by all three dye layers is also provided. *M. Leary and H. Todd*

See also: *Color density; Densitometer; Densitometry.*

COLOR DENSITOMETRY See *Densitometry.*

COLOR DENSITY The result of a measurement with a densitometer of an area in a processed color photographic image. Such a measurement is complicated by the fact that a positive color image contains three superimposed dye layers: a negative image will have more than three because of the presence of color masks. The types of color densities are as follows:

1. *Integral,* found from a measurement of the absorption of light by the combined dye layers. Because each dye absorbs at least some light at every wavelength, little information about the image composition can be obtained from integral densities. Such densities, if properly measured, do indicate the performance of the image in a visual or printing situation.
2. *Analytical,* based on the separate measurement of each dye. Such a measurement is often needed in the monitoring of the manufacture of color photographic materials. The density of a single dye layer can be found either by coating only one sensitive layer on a base or by special exposure and processing methods that generate only one dye in the image.
3. *Spectral,* found by measuring the absorption of a dye image with nearly single wavelengths of light through the entire spectrum. The result of such a difficult measurement is usually shown in the form of a graph.
4. *Wideband,* or broadband, involving the use of filters (blue, green, and red) to select the color of light to be used in the measurement. Different filter sets are chosen, depending on whether the image is to be used for direct viewing or for printing. *M. Leary and H. Todd*

See also: *Analytical density; Color densitometer; Equivalent neutral density; Filter types, status filters; Integral density; Neutral density; Printing density; Visual density.*

COLOR DEPTH In electronic imaging, the number of bits per pixel that supports color display. Eight-bit color depth will support 256 colors, standard video graphics array (VGA). Fifteen-bit color depth will support 32,768 colors, high color, and 24 bits will support 16,777, 216 colors, true color. *R. Kraus*

COLOR DIFFERENCE SIGNAL (1) Visual signal from the retina composed of differences between the cone responses. (2) In television, signals consisting of the differences between the red signal and the luminance signal and between the blue signal and the luminance signal.
 R. W. G. Hunt

COLOR DIFFERENCE UNIT (ΔE) Unit of color difference used in a color difference formula. *R. W. G. Hunt*

See also: *CIELAB system; CIELUV system.*

COLOR DUPLICATING The duplication of color materials is a common procedure undertaken to serve a variety of objectives. Transparencies are duplicated so that originals may be kept in safe storage while copies are subjected to pos-

sible damage or loss. Duplicate transparencies may correct some errors in exposure of color balance of originals, or may alter originals substantially for expressive purposes. Copy negatives are made from a print when the original negative is lost or when the print has been manipulated and more copies of the new version are required. Copy negatives are also made from transparencies when prints need to be made but economic or technical reasons favor negative-positive printing. Materials are also available that produce slides directly from negatives.

Most of the materials available for color duplicating are balanced for 3200 K light sources, the approximate output of many tungsten and tungsten-halogen lamps. Regardless of copying method, the film must be matched to the color temperature of the source. Color balance must still be adjusted with changes in filtration to take into account such factors as differing absorption properties of the dyes in the original and copying materials, aging of emulsions and variations from one emulsion batch to another. With the aid of a densitometer, correct balance may be obtained by the density difference method, comparing test results to a calibrated step-tablet, or the curve-plotting method, in which test-derived curves are compared with reference curves. In the absence of a densitometer, trial and error will have to suffice.

Color duplication materials are exposed with dichroic head enlargers, optical printers, contact printing equipment, or cameras. Any combination of bellows, extension tubes, and macro lens yielding a 1:1 reproduction ratio is appropriate. Dichroic heads, sometimes reversed and used as light boxes, make it easy to establish accurate filtration.

Although the contrast of transparency duplicating films is lower than that of conventional reversal films, it is sometimes necessary to reduce the contrast of an original transparency in order to retain shadow and highlight detail. An unsharp mask is then made and *duped* in contact with the original. *H. Wallach*

See also: *Color internegative; Color reproduction; Color temperature; Densitometry; Photomacrography.*

COLOR ENLARGER See *Enlargers.*

COLOR FAILURE
In color printing, a color bias in a reproduction caused by an imbalance of hues in the original scene, such as a large area of blue sky. *R. W. G. Hunt*

See also: *Subject failure.*

COLOR FILM
A photosensitive material coated on a transparent, flexible support, and capable of making distinguishable records of most subject colors. Typically, color films respond to the relative amounts of red, green, and blue light reflected or emitted by each point in the scene, and record these as a positive or negative image in cyan, magenta, and yellow dyes. Color transparency films resemble the original scene in hue and lightness. Color negative films are complementary in hue and inverted in lightness. *M. Scott*

See also: *Color film types (A, B, F, L, S); Color negative film; Color reversal film; Color slide film; Color transparency film; Transparency materials.*

COLOR FILM TYPES (A, B, F, L, S)
Color transparency films are available in versions for daylight (considered as 5500 K) and for two types of tungsten illumination: Type A (3400–3500 K) and Type B (3100–3200 K). Type F, no longer produced, was for expendable (chemical) flash-bulbs (about 4200 K). Other films have been designated Type L, if their reciprocity characteristics favored the longer exposures, or Type S if the shorter. *M. Scott*

COLOR FILTERS See *Filter types.*

COLOR FORMER See *Color coupler.*

COLOR FRINGING
A noise problem in color video resulting from a registration error in the RGB images; the fringing is most noticeable at the vertical edges of images. Often this is manifested by the appearance of colors that did not exist in the original scene. *R. Kraus*

COLORFULNESS See *Chromaticness.*

COLOR GAMUT
Range of colors involved in original scenes or in systems of reproduction. In additive systems, the color gamut is defined in a chromaticity diagram by the triangle formed by joining the three chromaticity points representing the reproduction primaries. In subtractive systems, the colorants usually have unwanted absorptions; these absorptions affect the luminance factors, and because luminance factors are not shown on chromaticity diagrams, it is more comprehensive to use color spaces. Chromaticity diagrams or color spaces used to show color gamuts should represent the spacing of colors as uniformly as possible. Hence the u', u' chromaticity diagram, and the CIELAB or CIELUV color spaces are usually used. *R. W. G. Hunt*

COLOR GRAPHICS ADAPTER (CGA)
In computers, the original standard for color display on the personal computer. CGA was limited to spatial resolution of 320 × 200 pixels and 4 colors from a palette of 16 colors. In text mode, characters are formed from an 8 × 8 matrix at a resolution of 640 × 200. *R. Kraus*

COLOR HARMONY
An arrangement of colors that creates a pleasing affect and effect in the visual perception of an image. Expressive harmony can also be achieved through discordant color combinations. *R. Welsh*

COLOR HOLOGRAPHY
Extension of monochromatic holographic technique devised by Yuri Denisyuk and Stephen Benton. A full-color hologram may be made by using red, green, and blue lasers, each from a different angle, for recording and matching beams for viewing. A variety of single layer techniques exist, as well. *H. Wallach*

See also: *Hologram; Holography; Rainbow hologram.*

COLORIMETER
An instrument for measuring colors. Visual colorimeters are sometimes used in research work, but practical colorimetry is usually carried out with photoelectric instruments in which the light from the sample is passed through three filters onto a photoelectric detector.
R. W. G. Hunt

COLORIMETRIC COLOR REPRODUCTION
Reproduction in which the chromaticities and relative luminances are the same as those in the original scene. *R. W. G. Hunt*

See also: *Color reproduction objectives.*

COLORIMETRY
Color is normally perceived as a result of light entering the eye. Most colored objects are seen as a result of the light reflected by them from a light source, the particular color of the object depending on the different fractions of light reflected at all the wavelengths throughout the visible spectrum. (The unit used for expressing wavelengths in color is the nanometer, nm, which is 10^{-9} meter.) By proportioning the power emitted by the light source according to these fractions, at each wavelength, the *spectral power distribution* of the color stimulus is obtained, and this is the fundamental physical measure of any color stimulus. Colorimetry provides means for converting these purely physical data into psychophysical measures that correlate with various aspects of color perception.

The relative spectral power distributions of standard illuminants A (S_A), B (S_B), C (S_C), and D_{65}.

The psychophysical measures used in colorimetry provide methods of assessing three different aspects of color perception: (1) whether two colors match one another; (2) the perceptual magnitude of the difference between two colors that do not match one another; and (3) the appearance of colors under various conditions of viewing. Color matching is determined by the use of standardized sets of *color-matching functions,* and these have been well established for many years. Color differences are determined by standardized *color difference formulas;* these are still being improved. Color appearances are determined by correlates of perceptual attributes obtained from color spaces or from models of color vision; these are still being developed.

SPECTRAL POWER DISTRIBUTIONS The basic input data for most colorimetric computations are the appropriate spectral power distributions. These are usually derived by multiplying the spectral reflectance factor, or the spectral transmittance factor, of each color considered by the spectral power distribution of a chosen illuminant, at regular wavelength intervals throughout the spectrum.

ILLUMINANTS Many different types of illuminants occur in both original scenes and in picture-viewing situations.

Incandescent Light Sources Incandescent light sources are hot bodies, such as the sun, red-hot objects, and tungsten lamp filaments. The hotter the source, the more radiation is produced, and the greater the ratio of blue to red light becomes. Planckian radiators consist of heated enclosures with small apertures from which the radiation emerges. The spectral composition of the radiation from Planckian radiators depends only on the temperatures of their interiors; these temperatures are expressed in kelvins, K, which are equal to 273 plus the temperature in Celsius, C. The color of whitish illuminants is often denoted by their *color temperature* or by their *correlated color temperature.* Color temperature is defined as the temperature of the Planckian radiator that has the same color. Correlated color temperature is defined as the temperature of the Planckian radiator that is most similar in color.

The spectral power distributions of tungsten filament lamps are almost identical to those of Planckian radiators whose temperatures are about 50 K greater than those of the corresponding lamp filaments. Because tungsten melts at a temperature of about 3700 K, tungsten filament lamps have color temperatures of about 3000 K, or about 3200 K in the case of *tungsten halogen lamps,* in which the envelope is filled with a halogen gas.

Daylight All daylight originates from the sun, the temperature of which is millions of degrees at its center, but only about 5800 K at its surface. Because the light from the sun has to pass through both its own atmosphere and that of

the earth, its correlated color temperature as seen from the surface of the earth is about 5500 K when high in the sky but is much lower when near the horizon. Daylight consists of mixtures of direct light from the sun and indirect light from the sun reflected or diffused by clouds or scattered by the earth's atmosphere. As a result, the spectral power distributions of daylight are quite variable, correlated color temperatures often varying from about 2000 K to about 20,000 K.

Standard Illuminants For colorimetry, the Commission Internationale de l'Éclairage (CIE) has standardized several illuminants including

Standard illuminant A (S_A), representing tungsten lamps at 2856 K

Standard illuminant D_{65} representing average daylight (6504 K)

Standard illuminant C(S_C) representing a bluish daylight (6800 K)

Standard illuminant B (S_B) representing sunlight (4900 K); obsolete.

The CIE standard D illuminants make up a range, of which the following are the most important:

Standard illuminant D_{75}, representing cold daylight (7504 K); used for critical inspection of yellowish colors.

Standard illuminant D_{65}, representing average daylight (6504 K); widely used in colorimetry.

Standard illuminant D_{55}, representing sunlight plus skylight (5503 K); used for balancing daylight films.

Standard illuminant D_{50}, representing warm daylight (5003 K); used in the graphic arts industry.

Also used in colorimetry is the theoretical equi-energy stimulus, S_E, which has the same amount of energy or power per unit wavelength throughout the spectrum.

Gas Discharge Lamps When an electric current is passed through a gas it can be made to emit light, the spectral power distribution of which depends characteristically on which particular gas is used. If the gas is sodium at low pressure, light is only emitted in two lines (extremely narrow bands of wavelength) in the yellow-orange part of the spectrum. If the sodium gas is at higher pressure, the emission is broadened spectrally but little or no blue light is emitted. If the gas is mercury, then light is emitted in a few spectral lines in the blue, green, and yellow parts of the spectrum, but no light is emitted in the red part. If metal halides, or other suitable additives, are included in the mercury gas, then light can be made to be emitted throughout the spectrum but usually with many peaks and troughs of spectral power at different wavelengths. If the gas is xenon, then light is emitted throughout the spectrum with only milder fluctuations with wavelength; xenon gas is widely used in discharge lamps for

electronic flash photography and also for continuously run discharge lamps for projecting professional motion picture films.

Fluorescent Lamps Fluorescent lamps contain mercury gas at low pressure and produce a spectrum of lines. The interiors of the lamp tubes are covered with phosphors that convert the ultraviolet radiation of the spectrum to visible light, and this increases the efficacy (light output per unit of electric power consumed) and improves the spectral composition of the light. Many different types of lamps are used, varying from those having high efficacy but poor color rendering to those having low efficacy but good color rendering.

Flash Bulbs The older source for flash photography was the flash bulb, consisting of an aluminum or zirconium wire in an envelope containing oxygen. Color temperatures of 3800 K for aluminum, or 4000 K for zirconium, were obtained, and with a blue filter coating the envelopes, the temperatures were raised to 5500 K for use with daylight type color films.

**Correlated Color Temperatures
of Commonly Used Light Sources**

Source	K	10^6/K
Typical north skylight	7500	133
Typical average daylight	6500	154
Fluorescent lamps (northlight or Color-matching)	6500	154
Xenon (electronic flash or continuous)	6000	167
Typical sunlight plus skylight	5500	182
Blue flash bulbs	5500	182
Carbon arc for projectors	5000	200
Sunlight at solar altitude 20 degrees	4700	213
Fluorescent lamps (cool white or daylight)	4300	233
Sunlight at solar altitude 10 degrees	4000	250
Clear flashbulbs	3800	263
Fluorescent lamps (white or natural)	3500	286
Photoflood tungsten lamps	3400	294
Tungsten-halogen lamps	3300	303
Projection tungsten lamps	3200	312
Studio tungsten lamps	3200	312
Fluorescent lamps (warm white)	3000	333
Tungsten lamps for floodlighting	3000	333
Tungsten lamps (domestic, 100 to 200 watts)	2900	345
Tungsten lamps (domestic, 40 to 60 watts)	2800	357
Sunlight at sunset	2000	500
Candle flame	1900	526

The Kelvin scale is quite nonuniform with regard to color differences, but a reciprocal scale is much more uniform; in this table, therefore, red values of 10^6/K are shown in addition to values of K.

SPECTROPHOTOMETRY Spectrophotometry is the measurement of the proportion of incident radiant power transmitted by, or reflected from, a sample, in a narrow spectral band; it commonly provides the values of reflectance factor or transmittance factor that, when combined with the spectral power distribution of the chosen illuminant, produces the spectral power distributions needed in colorimetry. Spectroradiometry is the measurement of the absolute amount of radiant power emitted by a source, or transmitted by, or reflected from, a sample, in a narrow spectral band. Telespectroradiometry is spectroradiometry conducted through a telescope from a specified observing position. Such measurements are often made relative to those involving the perfect diffuser, which is defined as an ideal isotropic diffuser with a reflectance (or transmittance) equal to unity.

By *isotropic* is meant that the radiation is reflected (or

transmitted) equally strongly in all directions, so that the perfect diffuser has a luminance that is independent of the direction of viewing; by a *reflectance,* or *transmittance equal to unity* is meant that the perfect diffuser reflects, or transmits, all the light that is incident on it at every wavelength throughout the visible spectrum.

Geometries of Illumination and Viewing The geometry of illumination and viewing can have a profound effect on spectral power distributions, and hence on the appearance, of colors, unless they are completely matt, or unless the illumination is completely diffuse. With reflecting materials, some light is always reflected from the topmost surface and, except in the case of metals, this light has the same color as that of the illuminant and is hence normally white. The light that penetrates into the material is affected by any colorants in it and is therefore usually colored. The light seen by the observer is therefore usually a mixture of white light from the top surface and colored light from the body of the material. The proportions of the white and colored light depend markedly on the geometry of illumination and viewing. The proportion of white light is minimal when the incident light comes mainly from a single direction, and the direction of view is nearly along the same path; conversely, it is maximal when the direction of viewing is near the specular (mirror-image) direction of the incident light. For matt samples, some white light is reflected in all directions and can therefore never be avoided; for glossy samples in directional illumination, the white light is reflected mainly in only one direction and can be avoided; it is for this reason that glossy samples often appear more colorful than matt samples. The Commission Internationale de l'Éclairage (CIE) has standardized four different geometries of illumination and viewing for colorimetry: normal illumination and 45 degree viewing; 45 degree illumination and normal viewing; normal illumination and diffuse viewing; and diffuse illumination and normal viewing. Spectral power distributions often depend markedly on which of these conditions has been used for the measurements, and it is therefore necessary in any colorimetric measurement to specify which condition has been used. (Similar considerations apply to densitometry, for which internationally agreed upon specifications also exist.)

Spectrophotometry of Fluorescent Samples White light illumination of the sample is essential for the spectrophotometry of fluorescent samples, dispersion into a spectrum occurring subsequently. If samples are illuminated with monochromatic light, any light produced by fluorescence, although normally of a different wavelength, will be assessed as though it has the same wavelength as the incident light, and this leads to gross errors in the data. Filtered xenon is one useful way of approximating a D_{65} source for illuminating fluorescent samples for spectrophotometry.

METAMERIC COLORS Two color stimuli can have very different spectral power distributions and yet be perceived as the same color: such pairs of colors are known as *metameric colors.* The two spectral power distributions shown by the full lines are for two stimuli that are a metameric pair. The phenomenon of metamerism can be explained with the aid of the sensitivity curves of the light-sensitive receptors in the retina of the eye that are used for color vision. These receptors are called *cones,* and there are three different types, which can be referred to as ρ, γ, and β, each of which has a different spectral sensitivity, and these three different spectral sensitivities are represented by the broken lines. (The exact shapes of these curves are still a matter of some debate, but the set shown is one possible set, and can be used for qualitative discussions.) The spectral power distributions of metameric pairs of stimuli cross in each of the ρ, γ, and β sensitivity bands as is the case for the pair shown and this enables them to result in equal stimula-

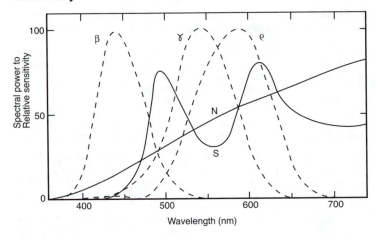

Metameric colors. Solid lines, the spectral power distributions of two stimuli, N and S, that are metameric for the CIE standard colorimetric observer. *Broken lines,* spectral sensitivities representative of those believed to be typical of the three different types of cones, ρ, γ, and β, of the retina of the eye.

tion of the ρ, γ, and β cones. Thus, the stimulus, S, represented by the undulating solid line would result in greater stimulation of the ρ cones in the long-wavelength part of the ρ band but less in the short-wavelength part of the ρ band, compared to the stimulation of the ρ cones by the stimulus, N, represented by the smooth solid line; the excess in one part can be exactly balanced by the deficit in another, so that the effects of the two stimuli on the ρ cones can be the same. Similarly, because the spectral power distributions of the two stimuli S and N cross in the γ band, they can produce equal stimulations of the γ cones; and the crossover in the β band can result in equal stimulations of the β cones. If two stimuli result in equal stimulations of all three types of cones, ρ, γ, and β, they will look alike, because the brain has no access to the spectral power distributions, and color perception depends entirely on signals based on the responses of the different types of cones in the retina. The retina also contains another type of receptor called *rods,* with a spectral sensitivity intermediate on the wavelength axis between the sensitivities of the γ and β cones. The main function of the rods is to provide monochromatic vision at levels of illumination of less than a few lux, which are below those that are adequate to stimulate the cones. At levels of illumination sufficiently high for color vision to be functioning normally, however, the rod response is quite small and is disregarded in normal colorimetry.

R, G, B COLORIMETRY Because the three types of cones are sensitive mainly in the reddish, the greenish, or the bluish third of the spectrum, additive mixtures of red, green, and blue lights can be made to stimulate the cones in a wide variety of degrees, and hence a wide variety of colors can be produced. Such mixtures can be used to match other colors, and when this is done each match comprises a metameric pair of stimuli that produce the same ρ, γ, and β responses. The additive mixture of the red, green, and blue lights can be achieved in various ways: for example, the lights can be projected on top of one another on a white screen; or they can be passed into a diffusing device such as an integrating sphere or a box of mirrors; or they can be viewed in small adjacent areas that are too small to be resolved by the eye, as in typical television or visual display devices. The red, green, and blue lights can be narrow monochromatic bands of the spectrum or broader bands as obtained by filtering a source of white light, such as from a tungsten lamp. The amounts of red, green, and blue light needed to match a particular color can then be used as the basis for a colorimetric measure.

Choice of Matching Stimuli The matching stimuli that are used in the additive mixture of lights should be red, green, and blue in color, because this results in the widest gamut of colors that the mixtures can produce. For the same reason, their colors should not be pale, but they need to produce as much light as possible in order to be able to match bright colors. It is also a requirement that the three matching stimuli be independent; by this is meant that any one must not be matchable by the other two (this condition is normally satisfied by choosing red, green, and blue lights).

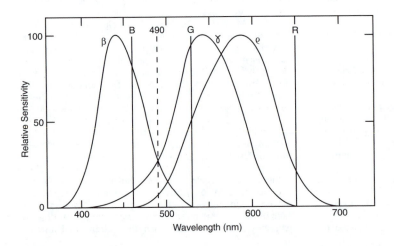

R, G, B Colorimetry. The ρ, γ, and β curves, together with red (R), green (G), and blue (B) monochromatic color-matching stimuli of wavelengths 650, 530, and 460 nm, respectively. A blue-green wavelength of 490 nm is also indicated.

Colors That Cannot Be Matched Although additive mixtures of red, green, and blue lights can produce a wide range of colors, there are some that cannot be matched. For instance, when trying to match deep blue-green colors, it is usually found that, while the same hue and brightness can be produced, the mixture is too pale. This phenomenon is in fact predicted by the shapes of the spectral sensitivity curves of the ρ, γ, and β cones as shown. It is assumed that the three matching stimuli are monochromatic lights of wavelengths 650 nm for the red, 530 nm for the green, and 460 nm for the blue, and that the attempt is being made to match light of 490 nm, which is a blue-green color from the spectrum. The scale of relative sensitivity on the ordinate is assumed to be for unit amounts of power, so that it is possible to read off the responses of the ρ, γ, and β cones for the red, green, and blue matching stimuli, and for the light of 490 nm, as follows:

	ρ	γ	β	ρ	γ	β
For unit power of R	24	0	0			
For unit power of G	56	92	0			
For unit power of B	0	9	78			
For unit power of 490 nm	8	26	26			

It is now required to find the amounts of red, green, and blue (R, G, and B) needed to match the 490 nm light. We proceed as follows:

	ρ	γ	β	ρ	γ	β
1/3 power unit of B				0	3	26
1/4 power unit of G				14	23	0
Hence 1/3 of B + 1/4 of G				14	26	26
1/4 energy unit of R	6	0	0			
Hence 1 of 490 nm + 1/4 of R	14	26	26			

Thus, 1 of 490 nm + 1/4 of R is matched by 1/4 of G + 1/3 of B, or 1 of 490 nm is matched by −1/4 of R + 1/4 of G + 1/3 of B. The negative sign is used here only to indicate that the red light is added to the color being matched, instead of to the green and blue lights; there is no such thing as negative light.

Basic Algebra of R, G, B Colorimetry Suppose a color (C) is matched in a colorimeter by an amount, R_L of matching stimulus (R), G_L of matching stimulus (G), and B_L of matching stimulus (B). This is usually written as:

$$(C) \equiv R_L(R) + G_L(G) + B_L(B)$$

It is convenient to calibrate the instrument by standardizing on a match to some specified white:

$$(W) \equiv R_{LW}(R) + G_{LW}(G) + B_{LW}(B)$$

If photometric units are used, typical results for a match on 1 watt of equi-energy white are

$$R_{LW} = 62 \text{ lumens}$$
$$G_{LW} = 162 \text{ lumens}$$
$$B_{LW} = 8 \text{ lumens}$$

so that

$$232 \text{ lm (W)} \equiv 62 \text{ lm (R)} + 162 \text{ lm (G)} + 8 \text{ lm (B)}.$$

It is more in keeping with our psychological impression of white being biased toward no particular color, if we use a different system of units in which matches on white are made by using equal quantities of each matching stimulus. By convention, white is usually regarded as being represented by 100, so that new units can be defined as follows:

1 unit of red = 0.62 lumens
∴ 100 units of red = 62 lumens

1 unit of green = 1.62 lumens
∴ 100 units of green = 162 lumens

1 unit of blue = 0.08 lumens
∴ 100 units of blue = 8 lumens

Therefore, using these new units

$$232 \text{ lm (W)} \equiv 100(R) + 100(G) + 100(B)$$

and the expression for the match on the color (C), using the new units is

$$(C) \equiv (1/0.62)R_L(R) + (1/1.62)G_L(G) + (1/0.08)B_L(B)$$

and this is written as: $(C) \equiv R(R) + G(G) + B(B)$, where R, G, B are the *tristimulus values.*

Chromaticity The magnitudes of the tristimulus values vary with the amount of light in the sample relative to the amount in the *reference white* (the white used for defining the units), but important color properties of the sample are related to the *relative* magnitudes of the tristimulus values. It is therefore informative to calculate the *chromaticity co-ordinates:*

$$r = R/(R + G + B)$$
$$g = G/(R + G + B)$$
$$b = B/(R + G + B)$$

Since $r + g + b = 1$, if r and g are known, b can be deduced as $1 − r − g$. It is therefore convenient to plot g against r in a two-dimensional *chromaticity diagram*. The red matching stimulus is matched by itself, so that G and B are both zero, and hence $r = 1$, $g = 0$, and $b = 0$; the red matching stimulus is therefore represented by the point at $r = 1$ on the r axis, and labeled R. Similarly, the green matching stimulus is represented by the point at $g = 1$ on the g axis, and is labeled G; and the blue matching stimulus is represented by the point $r = 0$ and $g = 0$, and is labeled B. For the reference white, W, it was arranged that $R = G = B$, and hence $r = g = b = 1/3$. If, for some other color, $R = 8$, $G = 48$, $B = 24$, for example, then $r = 0.1$, $g = 0.6$, and $b = 0.3$; this indicates that, in the color match, there is 10% of R, 60% of G, and 30% of B, and that the color is therefore a bluish green.

Additivity If a color, C, is matched by tristimulus values, R_1, G_1, B_1, and another color C_2, by tristimulus values, R_2, G_2, B_2, it is found by experiment that an additive mixture of the two colors, C_1 and C_2, is matched to a close approximation by tristimulus values, $R_1 + R_2$, $G_1 + G_2$, $B_1 + B_2$. This is known as *additivity*. On the chromaticity diagram, the color C_3 is represented by a point lying on the straight line joining the points representing the colors C_1 and C_2.

Properties of r,g Chromaticity Diagrams Some of the more important properties of r,g chromaticity diagrams are illustrated.

The line joining white and a color represents pale colors of a similar hue.

Because colors in the blue-green part of the spectrum require negative amounts of red light in their match, they plot in the negative r part of the diagram. It is clear from the diagram that mixtures of the green and blue matching stimuli, which must lie on the line GB, will be nearer the white point, and therefore paler, than blue-green colors of the spectrum. If some of the red matching stimulus is added to the blue-green spectral color, however, the mixture will be represented by points on the line joining R to the point representing the spectral blue-green; if the amount of red matching stimulus is adjusted appropriately, the mixture can be made to be represented by a point lying on the line GB. This situation then corresponds to the spectral blue-green plus the red matching stimulus, being matched by a mixture of just the green and blue matching stimuli. Colors in the yellow part of the spectrum require small negative amounts

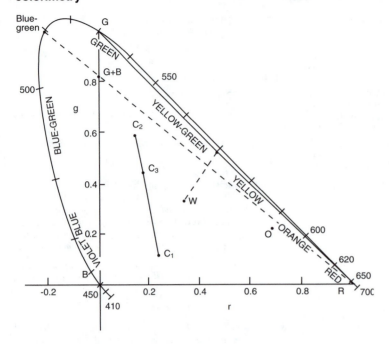

Chromaticity. An ρ,γ chromaticity diagram for the R, G, and B matching stimuli. W shows the point representing the white that was used for normalizing the units for expressing the amounts of the matching stimuli. C_3 is the point representing the additive mixture of colors represented by the points C_1 and C_2. The broken line from W represents a series of colors of similar hue. A blue-green color in the spectrum, having had some of the red matching stimulus added to it, can be matched by a mixture of the green and blue matching stimulus. The point W represents not only the reference white, W, but also similar grays, and black; and a point such as 0, can represent not only an orange color but also similar darker colors such as some browns.

of blue light in their match, and they plot just above the line for which $r + g = 1$; this is the line, RG, joining the points representing the red and green matching stimuli. Colors in the violet and extreme red parts of the spectrum require small negative amounts of green matching stimulus in their match, and they plot in the negative g part of the diagram; this is also true of purple colors consisting of additive mixtures of light from the two ends of the spectrum.

The line joining the two ends of the spectrum is called the *purple boundary.* All colors are represented by points lying within the area bounded by the spectral locus and the purple boundary; this is because the spectral locus is never concave, and additive mixtures of spectral lights must therefore always lie inside the locus.

Only colors represented by points lying inside the triangle RGB can be matched by mixtures of the three matching stimuli.

Because r and g are ratios, respectively, of the R and G tristimulus values, to the sum of all three tristimulus values, $R + G + B$, it follows that if R, G, and B are all multiplied or divided by the same factor, r and g are not changed, and the point representing the color considered is not changed in position. This means that the point representing any color is not changed in position by changes in the level of illumination or by changes in relative luminance; hence, white and grays plot at the same point, W, and an orange and a brown may plot at the same point, O.

Changing Matching Stimuli from R, G, B to R′, G′, B′ If the colors of the red, green, and blue matching stimuli are changed, then, in general, the amounts of them required to match any particular color will also change. It is also possible to choose a different reference white on which to base the units used for expressing the amounts of red, green, and blue used in matches. Such a change from one set, R, G, B, and W, to R′, G′ B′, and W′, for the red, green, and blue matching stimuli and the reference white, results in a new chromaticity diagram that is similar in its general features to that shown but different in detail.

Color-matching Functions The tristimulus values of monochromatic stimuli of equal radiant power per small wavelength interval throughout the spectrum are known as

color matching functions. Different sets of matching stimuli result in different sets of color-matching functions.

CIE SYSTEM The internationally agreed upon system of colorimetry was set up by the Commission Internationale de l'Éclairage (CIE), and, although based on red, green, and blue color matching, it uses a new set of tristimulus values, X, Y, and Z. RGB systems have two disadvantages. First, there is no one unique set of red, green, and blue matching stimuli to choose; and, second, some colors require negative amounts in their matches. In setting up the XYZ system the CIE also took the opportunity to incorporate into the system the photopic luminous efficiency function $V(\lambda)$, on which international photometric measures are based. The two photometric measures most widely used in colorimetry are *luminance,* and *luminance factor.*

Luminance Luminance is calculated as

$$L = c(P_1 V_1 + P_2 V_2 + \ldots \ldots)$$

where, at wavelengths λ_1, λ_2, etc., P_1, P_2, etc., are the radiant powers of the color considered, and V_1, V_2, etc., are the values of the $V(\lambda)$ function.

If P is in watts per steradian and per square meter, and the constant $c = 683$, L is in candelas per square meter (cd/m^2). Luminance correlates (but only very approximately) with *brightness.*

Luminance Factor Luminance factor is calculated as

$$L/L_n$$

where L is the luminance of the color considered, and L_n is the luminance of the perfect diffuser identically illuminated. Luminance factor correlates with *lightness.*

CIE Standard Colorimetric Observer The CIE standard colorimetric observer is defined in terms of color-matching functions for a set of precisely defined monochromatic matching stimuli:

Red	700 nm
Green	546.1 nm
Blue	435.8 nm

The wavelengths used for the green and blue matching stimuli are prominent lines in the mercury spectrum, and this

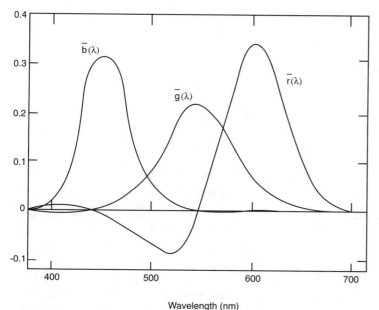

Wavelength (nm)

Color-matching functions. The color-matching functions for the CIE 1931 standard colormetric observer, expressed in terms of matching stimuli R, G, and B, consisting of monochromatic stimuli of wavelengths 700, 546.1, and 435.8 nm, respectively, with the units such that equal amounts of R, G, and B are required to match the equi-energy stimulus, S_E.

facilitates wavelength calibration. The wavelength chosen for the red matching stimulus is in a part of the spectrum where the hue changes only very slowly with wavelength so that the effects of any errors in wavelength calibration are minimized.

The units used for expressing the amounts of the matching stimuli are such that equal amounts are needed to match the equi-energy stimulus, S_E (which has equal amounts of energy, or power, per constant wavelength interval throughout the visible spectrum). The luminances of the units, L_R, L_G, and L_B, are such that they are in the ratios

$$L_R:L_G:L_B::1.0000:4.5907:0.0601$$

The color-matching functions for these matching stimuli and units are denoted by the symbols $\bar{r}(\lambda)$, $\bar{g}(\lambda)$, and $\bar{b}(\lambda)$. Because equal amounts of R, G, and B are needed to match the equi-energy stimulus, the areas under the three curves are equal (subtracting negative areas from positive areas for each curve).

Calculation of Tristimulus Values, R, G, and B The amounts of R, G, and B needed to match a color can be calculated from its spectral power distribution as follows:

$$R = k(P_1\bar{r}_1 + P_2\bar{r}_2 + P_3\bar{r}_3 + P_4\bar{r}_4 + \ldots\ldots)$$
$$G = k(P_1\bar{g}_1 + P_2\bar{g}_2 + P_3\bar{g}_3 + P_4\bar{g}_4 + \ldots\ldots)$$
$$B = k(P_1\bar{b}_1 + P_2\bar{b}_2 + P_3\bar{b}_3 + P_4\bar{b}_4 + \ldots\ldots)$$

where at wavelengths λ_1, λ_2, etc., P_1, P_2, etc., are the radiant powers of the color considered, and \bar{r}_1, \bar{r}_2, \bar{g}_1, \bar{g}_2, \bar{b}_1, \bar{b}_2, etc., are the values of the $\bar{r}(\lambda)$, $\bar{g}(\lambda)$, $\bar{b}(\lambda)$ color-matching functions, respectively. The justification for calculating these summations is the additivity of color matches. As far as k is concerned, it is a suitably chosen constant.

Calculation of Luminance Luminance is proportional to

$$L_R R + L_G G + L_B B$$

Calculation of X, Y, Z from R, G, B To avoid negative numbers in color specifications, new tristimulus values, X, Y, and Z, are calculated, where

$$X = 0.49R + 0.31G + 0.20B$$
$$Y = 0.17697R + 0.81240G + 0.01063B$$
$$Z = 0.00R + 0.01G + 0.99B$$

For the equi-energy stimulus, S_E: $X = Y = Z$.

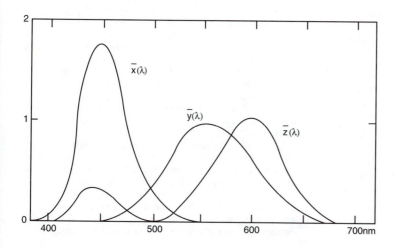

The CIE color-matching functions for the 1931 standard colorimetric observer expressed in the XYZ system.

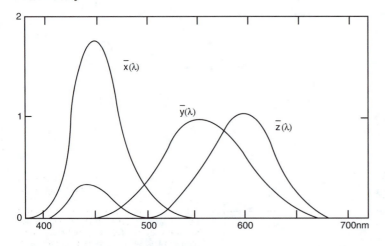

The CIE color-matching functions for the 1931 standard colorimetric observer expressed in the XYZ system.

The coefficients 0.17697, 0.81240, and 0.01063 are in the same ratios as 1.0000, 4.5907, and 0.0601, the relative luminances of the units used for measuring the amounts of red, green, and blue. Hence, Y is proportional to the luminance, L. Thus, for two colors, 1 and 2,

$$Y_1/Y_2 = L_1/L_2$$

CIE Color-Matching Functions $\bar{x}(\lambda)$, $\bar{y}(\lambda)$, $\bar{z}(\lambda)$ For each wavelength, λ, of the spectrum, the X, Y, Z amounts, \bar{x}, \bar{y}, \bar{z} are derived from the R, G, B amounts, \bar{r}, \bar{g}, \bar{b}, thus:

$$\bar{x}(\lambda) = 0.49\bar{r}(\lambda) + 0.31\bar{g}(\lambda) + 0.20\bar{b}(\lambda)$$

$$\bar{y}(\lambda) = 0.17697\bar{r}(\lambda) + 0.81240\bar{g}(\lambda) + 0.01063\bar{b}(\lambda)$$

$$\bar{z}(\lambda) = 0.00\bar{r}(\lambda) + 0.01\bar{g}(\lambda) + 0.99\bar{b}$$

Because $X = Y = Z$ for the equi-energy spectrum, the areas under the three curves are equal to one another.

Calculating X, Y, and Z from Spectral Power Distributions The CIE tristimulus values, X, Y, and Z can be calculated from spectral power distributions by using the CIE color-matching functions, $\bar{x}(\lambda)$, $\bar{y}(\lambda)$, and $\bar{z}(\lambda)$, as follows:

$$X = k(P_1\bar{x}_1 + P_2\bar{x}_2 + \ldots\ldots)$$
$$Y = k(P_1\bar{y}_1 + P_2\bar{y}_2 + \ldots\ldots)$$
$$Z = k(P_1\bar{z}_1 + P_2\bar{z}_2 + \ldots\ldots)$$

where, at wavelengths λ_1, λ_2, etc., P_1, P_2, etc., are the spectral powers of the color considered, and \bar{x}_1, \bar{x}_2, \bar{y}_1, \bar{y}_2, \bar{z}_1, \bar{z}_2, etc., are the values of the $\bar{x}(\lambda)$, $\bar{y}(\lambda)$, $\bar{z}(\lambda)$ color-matching functions, respectively. Because the Y tristimulus value is proportional to luminance, it necessarily follows that the $\bar{y}(\lambda)$ function is the same as the $V(\lambda)$ function, which is used to evaluate luminance. The constant k is usually chosen so that $Y = 100$ for the perfect diffuser; Y then gives the luminance factor expressed as a percentage.

Colorimetry in the X, Y, Z System If the constant k is chosen so that Y is equal to a photometric measure, such as luminance, L, absolute tristimulus values are obtained, and these are distinguished by the subscript L. Absolute tristimulus values:

$$X_L, Y_L, Z_L$$
$$Y_L \text{ is equal to } L$$

It is usually the practice to express photometric values separately from colorimetric measures, however, and tristimulus values are normally evaluated relative to a reference white. Tristimulus values: X, Y, Z,

$$X = 100X_L/Y_{Ln}$$

$$Y = 100Y_L/Y_{Ln}$$
$$Z = 100Z_L/Y_{Ln}$$

The subscript n indicates that the value is for the perfect diffuser; Y then gives the luminance factor expressed as a percentage.

Chromaticity Coordinates, x, y, z As in the RGB system, it is helpful to derive from the XYZ tristimulus values, equivalent chromaticity coordinates, as follows:

$$x = X/(X + Y + Z)$$
$$y = Y/(X + Y + Z)$$
$$z = Z/(X + Y + Z)$$
$$x + y + z = 1$$

By plotting y against x, an xy chromaticity diagram is obtained.

Sets of Variables Commonly Used The following sets of variables are commonly used in colorimetry:

$$X, Y, Z, L$$
$$x, y, Y, L$$
$$x, y, L \text{ (for light sources)}$$

Properties of the x,y Chromaticity Diagram The equi-energy stimulus, S_E, is situated at $x = 1/3$, $y = 1/3$.

Values of x and y are not changed by changes in level of illumination or by changes in luminance factor; hence, grays and white plot at the same point, W; and an orange and a brown may plot at the same point, O.

An additive mixture, C_3, of two colors, C_1 and C_2, is represented by a point on the line joining the points representing the two component colors, C_1 and C_2.

Because the spectral locus is never concave, all colors lie within the spectral locus and the purple boundary.

Additive mixtures of red, green, and blue primaries can only match colors lying within the triangle formed by the three points representing the chromaticities of the three primaries. Colors represented by points lying outside the triangle will require negative amounts of one (or sometimes two) of the primaries.

Dominant Wavelength and Excitation Purity The x,y chromaticity diagram can be used to provide correlates of the hues and saturations of colors. The color considered is C, and the reference white is at N. It should be noted that the reference white is in this case different from the equi-energy stimulus, S_E; this will usually be the case, because S_E is not available as a real source of light. A straight line is drawn from N through C to meet the spectral locus at D. The wavelength at

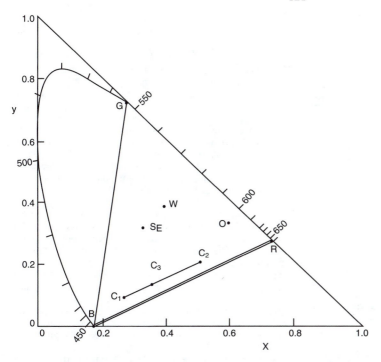

Chromaticity diagram. The x,y chromaticity diagram, S_E shows the point representing the equi-energy stimulus that is used for normalizing the units for expressing the amounts of the X, Y, and Z tristimulus values. Whites are represented by points such as W. C_3 is the point representing the additive mixture of colors represented by the points C_1 and C_2. R, G, and B represent red, green, and blue matching stimuli; only colors lying within the RGB triangle can be matched by them without having to use negative amounts. The points S_E and W can represent not only whites but also similar grays and blacks; and a point such as O, can represent not only an orange color but also similar darker colors such as some browns.

the point, D is the *dominant wavelength, λ_d.* If the color is situated at a point such as C′, then the line from N meets the purple boundary at D′ instead of meeting the spectral locus; in this case the line is produced backwards to meet the spectral locus at the point D_c, and the wavelength at this point is the *complementary wavelength, λ_c.* Dominant wavelength and complementary wavelength correlate approximately with the hues of colors.

Excitation purity, p_e, is equal to the ratio NC/ND or NC′/ND′. If C or C′ is close to N, the excitation purity will be nearly zero and the color will be pale; if C or C′ is near D or D′, then the excitation purity will be nearly unity and the color will be vivid. Excitation purity correlates approximately with the saturations of colors.

Color Perceptions and Their Colorimetric Correlates in the X, Y, Z System The XYZ system provides the following measures that correlate with the color perceptions shown:

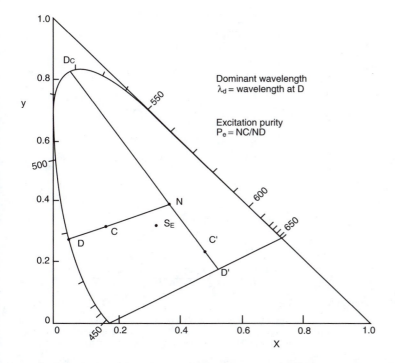

Dominant wavelength
λ_d = wavelength at D

Excitation purity
P_e = NC/ND

Dominant wavelength. The derivation on the x,y chromaticity diagram of dominant wavelength, λ_d, complementary wavelength λ_c at D_c, and excitation purity, p_e = NC/ND or NC′/ND′.

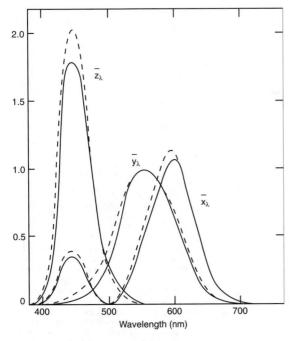

Effect of field size. The CIE color-matching functions for the 1931 standard colorimetric observer (solid lines), and for the 1964 supplementary standard colorimetric observer (broken lines).

Perception	Correlate
Brightness	Luminance, L
Lightness	Luminance factor, L/L_n
Hue	Dominant wavelength, λ_d (or λ_c)
Saturation	Excitation purity, P_e

Methods of Obtaining X, Y, and Z There are four main ways in which the XYZ tristimulus values can be obtained in practice.

1. Colors can be compared with calibrated samples in a color atlas or other suitable collection of colors. Although this is a very simple method, it has several disadvantages. First, interpolation between samples is usually required; second, extrapolation beyond the range of samples may sometimes be necessary; third, the same light source should be used for making the comparisons as was used for the calibration of the samples; fourth, the method is not very precise.

2. Colors can be matched visually in an RGB colorimeter and the readings R, G, B, transformed to X, Y, Z, by equations of the form

$$X = a_1 R + a_2 G + a_3 B$$
$$Y = a_4 R + a_5 G + a_6 B$$
$$Z = a_7 R + a_8 G + a_9 B$$

The coefficients in the equations depend on the particular red, green, and blue matching stimuli and reference white being used. Although this method is too slow for practical applications it is used for research and other special tasks. The precision is usually rather low unless the results from a large number of matches are averaged.

3. Tristimulus values can be calculated from spectral power distribution data:

$$X = k(P_1 \bar{x}_1 + P_2 \bar{x}_2 + \ldots)$$
$$Y = k(P_1 \bar{y}_1 + P_2 \bar{y}_2 + \ldots)$$
$$Z = k(P_1 \bar{z}_1 + P_2 \bar{z}_2 + \ldots)$$

This is the preferred method because it uses the basic physical data of the spectral power distribution as input and then depends only on computations using standardized color-matching functions.

4. Light can be measured from samples with three photocell filter combinations having spectral sensitivities equal to $k_1 \bar{x}(\lambda)$, $k_2 \bar{y}(\lambda)$, $k_3 \bar{z}(\lambda)$, where k_1, k_2, k_3 are suitable constants. This method has the advantages of using fairly simple apparatus and being of potentially high precision, but the accuracy is limited by the difficulty of matching the color-matching functions exactly.

Effect of Field Size on Color Matching Because the sensitivity of the retina is not uniform over its area, color matches made in one field size may differ from those made in another. The CIE has therefore provided two standard colorimetric observers, the 1931 observer for 2 degree field sizes (which is the one we have considered so far), and the 1964 observer for 10 degree field sizes. For intermediate sizes, the 1931 observer is used for all fields up to 4 degrees, and the 1964 observer for all fields over 4 degrees. In color reproduction, the 1931 observer is used because most elements of pictures are less than 4 degrees in angular subtense.

Center of Gravity Law of Color Mixture If two colors C_1 and C_2 are represented by points, C_1 and C_2, in a chromaticity diagram, then, the additive mixture of the two colors is represented by a point, C_3, lying on the line joining C_1 and C_2. The exact position of C_3 on the line depends on the relative intensities of C_1 and C_2 and is calculated as follows:

$$\frac{C_1 C_3}{C_2 C_3} = \frac{m_2/y_2}{m_1/y_1}$$

This means that C_3 is at the center of gravity of weights m_1/y_1 at C_1 and m_2/y_2 at C_2, and hence the result is referred

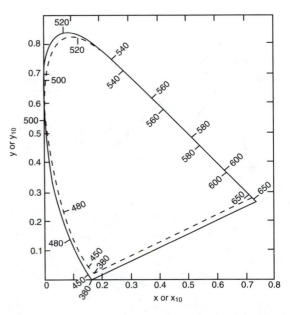

Effect of field size. The CIE x_{10}, y_{10} chromaticity diagram (broken lines), compared with the CIE x,y chromaticity diagram (solid lines).

to as the *Center of Gravity Law of Color Mixture*. In the u',v' chromaticity diagram (to be described later), the Center of Gravity Law of Color Mixture still applies, but the weights used become m_1/v'_1 and m_2/v'_2.

COLOR DISCRIMINATION The CIE XYZ system provides the basis for colorimetric measures, but it suffers from the disadvantage that equal differences in *XYZ* tristimulus values, or equal distances on the x,y chromaticity diagram, do not correspond to equal perceptual color differences. The CIELUV and CIELAB systems have therefore been added to provide more perceptually uniform measures. They were to some extent conceived as approximations to the Munsell system.

The Munsell System The Munsell system provides an arrangement of surface reflecting colors that results in an approximately uniform color space. In other words, the perceived difference in color between any two samples is proportional to their distance apart in the space. Munsell samples are available as individual chips or as sets of chips mounted in albums that can be used as color atlases. In the Munsell system, a correlate of lightness, Munsell value, is considered as a vertical axis; planes of constant Munsell hue, each containing colors of the same perceptual hue, radiate from this vertical axis at various angles to form a complete circle; and distance of a sample from the vertical axis represents Munsell chroma, a correlate of perceived chroma (saturation with allowance for lightness). The value axis has a value of 10 at the top, representing white (taken as the perfect diffuser), and 0 at the bottom, representing black, while values in between represent the gray scale. The hue scale is divided into five main segments by Munsell hue planes denoted red, yellow, green, blue, and purple; the fifth, purple plane, had to be added to the four unique hues because there are roughly twice as many discriminable hue steps between red and blue as between the other neighboring pairs of hue. Chroma is zero for colors on the gray scale and increases to different maximum values for different hues and lightnesses.

Correlates of Lightness *Brightness* is defined as an attribute of a visual sensation according to which an area appears to exhibit more or less light. (Adjectives: *bright* and *dim*.) *Lightness* is defined as the brightness of an area judged relative to the brightness of a similarly illuminated area that appears to be white or highly transmitting. (Adjectives: *light* and *dark*.)

Luminance factor, L/L_n, correlates with lightness but does not do so uniformly. Thus, for example, the apparent difference in lightness between samples having luminance factors of 80% and 90% is much less than that between samples of 20% and 30%. In the Munsell system, Munsell value is a function of luminance factor that correlates with lightness much more uniformly, but the function is complicated, and the CIE uses an approximation to it that is simpler:

$$L^* = 116(Y/Y_n)^{1/3} - 16$$

L^* correlates with lightness approximately uniformly.

Approximately Uniform Chromaticity Diagrams The distribution of colors in the x,y chromaticity diagram is quite nonuniform, and in 1976 the CIE standardized the u',v' diagram as an approximately uniform chromaticity diagram. (This diagram superseded the u,v diagram, which had been adopted in 1960). Each short line represents a color difference of the same magnitude for colors all having the same luminance and seen under the same conditions. For perfect uniformity, all the lines should be the same length; it is not possible to achieve this on a flat diagram, but clearly the variation in the length is much less in the u',v' diagram than in the x,y diagram. The following equations provide the means of calculating u',v' (and u,v).

Approximate uniform chromaticity diagram. The x,y chromaticity diagram with lines representing small color differences. Each line is three times the length of a distance representing a difference that is just noticeable in a 2 degree field for colors of equal luminance.

$$u' = 4X/(X + 15Y + 3Z)$$
$$v' = 9Y/(X + 15Y + 3Z)$$
$$u' = 4x/(-2x + 12y + 3)$$
$$v' = 9y/(-2x + 12y + 3)$$
$$w' = (-6x + 3y + 3)/(-2x + 12y + 3)$$
$$x = 9u'/(6u' - 16v' + 12)$$
$$y = 4v'/(6u' - 16v' + 12)$$
$$z = (-3u' - 20v' + 12)/(6u' - 16v' + 12)$$
$$u = u'$$
$$v = (2/3)v'$$

The approximately uniform CIE u',v' chromaticity diagram with a selection of the lines of the previous figure.

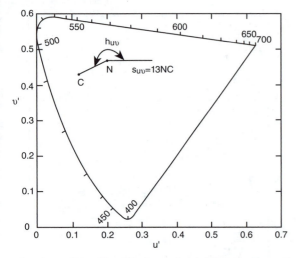

Correlates of Hue. The derivation on the u',v' diagram of h_{uv} and s_{uv}.

Correlates of Hue

Correlates of Hue *Hue* is defined as an attribute of a visual sensation according to which an area appears to be similar to one, or to proportions of two, of the perceived colors, red, yellow, green, and blue. Dominant wavelength correlates with hue but does so nonuniformly. To obtain a more uniform correlate of hue, the u',v' diagram is used to obtain CIE 1976 hue angle, h_{uv}:

$$h_{uv} = \arctan[(v' - v'_n)/(u' - u'_n)]$$

The subscript n indicates that the value is for the reference white.

Correlates of Saturation Saturation is defined in terms of colorfulness and brightness. *Colorfulness* is defined as an attribute of a visual sensation according to which an area appears to exhibit more or less of its hue. *Saturation* is defined as the colorfulness of an area judged in proportion to its brightness.

Excitation purity correlates with saturation but does so nonuniformly. To obtain a more uniform correlate of saturation the u',v' diagram is used to obtain CIE 1976 saturation, s_{uv}:

$$s_{uv} = 13[(u' - u'_n)^2 + (v' - v'_n)^2]^{1/2}$$

The subscript n indicates that the value is for the reference white.

Approximately Uniform Color Solids The CIELUV and CIELAB color solids were designed primarily to provide color difference formulas, but they were also formulated to make it possible to express color differences in terms of components that correlated with differences in hue, lightness, and chroma. This was achieved by making the solids approximately like the Munsell system.

The CIELUV and CIELAB color solids were adopted by the CIE in 1976 (superseding the CIE 1963 $U^*V^*W^*$ solid). These solids are obtained by plotting the three variables of each solid along axes at right angles to one another. The visual magnitudes of color differences are intended to be approximately proportional to distance in these spaces. The variables are defined as follows:

CIELUV Solid

$$u^* = 13L^*(u' - u'_n)$$
$$v^* = 13L^*(v' - v'_n)$$
$$L^* = 116(Y/Y_n)^{1/3} - 16$$

The L^* axis is regarded as vertical. The variables plotted in the horizontal plane are not u' and v', because as the luminance factor of colors decreases, differences in chromaticity become less and less apparent. It is therefore necessary to scale differences in chromaticity as a function of luminance factor, and this is achieved in the CIELUV system by multiplying the differences in chromaticity from the reference white in the u' and v' directions by L^*. The constant 13 is to equalize the u^*, v^*, and L^* scales.

CIELAB Solid

$$a^* = 500[(X/X_n)^{1/3} - (Y/Y_n)^{1/3}]$$
$$b^* = 200[(Y/Y_n)^{1/3} - (Z/Z_n)^{1/3}]$$
$$L^* = 116(Y/Y_n)^{1/3} - 16$$

In this solid the effect of falling luminance factor on chromaticity differences is incorporated by using not uniform chromaticities but cube root functions of the X, Y, Z tristimulus values. The presence of these cube roots means that there is no associated approximately uniform chromaticity diagram or correlate of saturation in the CIELAB system.

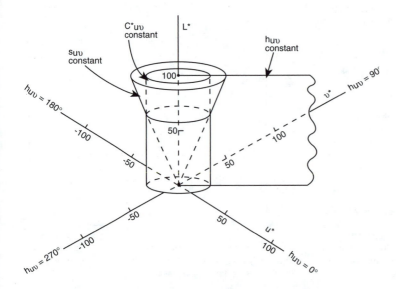

CIELUV solid. A three-dimensional representation of the CIELUV space. The CIELAB space is similar, except that there is no representation of saturation.

U*V*W* Solid

$$U^* = 13W^*(u - u_n)$$

$$V^* = 13W^*(v - v_n)$$

$$W^* = 25Y^{1/3} - 17$$

In all these solids, the subscript n indicates that the value is for the reference white. In the formula for W^* it is necessary to express Y as a percentage. If Y/Y_n is equal to or less than 0.008856, the expression for L^* is replaced by

$$L^* = 903.3(Y/Y_n).$$

If any of the ratios X/X_n, Y/Y_n, Z/Z_n, are equal to or less than 0.008856, they are replaced in the above formulas for a^* and b^* by

$$7.787F + 16/116$$

where F is X/X_n, Y/Y_n, Z/Z_n, as the case may be.

Correlates of Perceptual Attributes of Colors It is now possible to collect together correlates of lightness, hue, saturation, and chroma that are approximately perceptually uniform.

Lightness CIE 1976 lightness, $L^* = 116(Y/Y_n)^{1/3} - 16$. If Y/Y_n is equal to or less than 0.008856, the expression for L^* is replaced by $L^* = 903.3(Y/Y_n)$.

Hue CIE 1976 hue angle, h_{uv}, h_{ab}:

$$h_{uv} = \arctan[(v' - v'_n)/(u' - u'_n)]$$

$$h_{uv} = \arctan(v^*/u^*)$$

$$h_{ab} = \arctan(b^*/a^*)$$

Arctan means *the angle whose tangent is*; it is also sometimes denoted as \tan^{-1}. h_{uv} lies between 0 and 90 degrees if v^* and u^* are both positive; between 90 and 180 degrees if v^* is positive and u^* is negative; between 180 and 270 degrees if v^* and u^* are both negative; and between 270 and 360 degrees if v^* is negative and u^* is positive (and similarly for h_{ab} and a^* and b^*).

Saturation CIE 1976 saturation $s_{uv} = 13[(u' - u'_n)^2 + (v' - v'_n)^2]^{1/2}$.

Chroma *Chroma* is similar to saturation but with allowance made for the fact that, as luminance factor is reduced, differences in chromaticity become less apparent. CIE 1976 chroma, C^*_{uv}, C^*_{ab}:

$$C^*_{uv} = (u^{*2} + v^{*2})^{1/2} = L^* s_{uv}$$

$$C^*_{ab} = (a^{*2} + b^{*2})^{1/2}$$

In the Munsell system, on a page of constant hue, loci of constant chroma are vertical, and loci of constant saturation radiate from the black point.

Color Difference Formulas The color difference formulas provided by the CIELUV and CIELAB systems are as follows:

$$\Delta E^*_{uv} = [(\Delta L^*)^2 + (\Delta u^*)^2 + (\Delta v^*)^2]^{1/2}$$

$$\Delta E^*_{ab} = [(\Delta L^*)^2 + (\Delta a^*)^2 + (\Delta b^*)^2]^{1/2}$$

$$\Delta E^*_{uv} = [(\Delta L^*)^2 + (\Delta H^*_{uv})^2 + (\Delta C^*_{uv})^2]^{1/2}$$

$$\Delta E^*_{ab} = [(\Delta L^*)^2 + (\Delta H^*_{ab})^2 + (\Delta C^*_{ab})^2]^{1/2}$$

where

$$\Delta H^*_{uv} = [(\Delta E^*_{uv})^2 - (\Delta L^*)^2 - (\Delta C^*_{uv})^2]^{1/2}$$

$$\Delta H^*_{ab} = [(\Delta E^*_{ab})^2 - (\Delta L^*)^2 - (\Delta C^*_{ab})^2]^{1/2}$$

ΔH^* is known as the *CIE 1976 hue-difference* and is introduced so that a color difference, ΔE^*, can be broken up into components, ΔL^*, ΔH^*, and ΔC^*, which correlate with the perceptual attributes, lightness, hue, and chroma, and whose squares sum to the square of ΔE^*; Δh does not have this property.

ΔH^* is positive if indicating an increase in h and negative if indicating a decrease in h.

These measures only correlate approximately with the corresponding attributes, and the actual color perceived always depends on the viewing conditions, including the level and color of the illumination and the nature of the surround.

An improved version of the CIELAB color difference formula has been developed and is denoted as the CMC(1:c) formula. In this formula the color difference is evaluated as

$$[(\Delta L^*/lS_L)^2 + (\Delta C^*_{ab}/cS_c)^2 + (\Delta H^*_{ab}/S_H)^2]^{1/2}$$

where

$$S_L = 0.040975L^*/(1 + 0.01765L^*)$$
$$\text{unless } L^* < 16 \text{ when } S_L = 0.511$$

$$S_c = 0.0638C^*_{ab}/(1 + 0.0131C^*_{ab}) + 0.638$$

$$S_H = (fT + 1 - f)S_c$$

where

$$f = \{(C^*_{ab})^4/[(C^*_{ab})^4 = 1900]\}^{1/2}$$

and

$$T = 0.36 + |[0.4 \cos(h_{ab} + 35)]|$$

unless h_{ab} is between 164 and 345 degrees when

$$T = 0.56 + |[0.2 \cos(h_{ab} + 168)]|$$

The vertical lines enclosing some of the expressions indicate that, for these, the value is always to be taken as positive, whatever the numerical result obtained by the initial calculation.

It is clear that what this formula does is to vary the relative weightings of the contributions of the difference in L^*, C^*_{ab}, and H^*_{ab} according to the position of the color in the CIELAB space.

For characterizing the magnitudes of the *perceptibility* of color differences the factors l and c are set equal to unity.

For characterizing the magnitudes of the *acceptability* of color differences the factors l and c may be greater than unity.

CIE Index of Metamerism For two colors whose corresponding tristimulus values are identical with respect to a reference illuminant and reference observer, the CIE metamerism index is equal to the color difference, ΔE, between the two colors computed when either the reference illuminant is replaced by a test illuminant (illuminant metamerism index), or the reference observer is replaced by a different observer (observer metamerism index).

Color Perceptions and Their Correlates in the CIELUV and CIELAB Systems Of the six principal color perceptions, brightness, lightness, hue, colorfulness, chroma, and saturation, the CIELUV system provides approximately uniform correlates for four, and the CIELAB system for three.

Perception	Correlate
Brightness	No uniform correlate available yet
Lightness	CIE 1976 lightness, L^*
Hue	CIE 1976 hue angle, h_{uv}, h_{ab}
Colorfulness	No uniform correlate available yet
Chroma	CIE 1976 chroma, C^*_{uv}, C^*_{ab}
Saturation	CIE 1976 saturation, S_{uv}

There are at present no such correlates for brightness and colorfulness, but these are provided by some models of color vision that are being developed.

MODELS OF COLOR VISION Whereas lightness, hue, chroma, and saturation remain approximately constant when the level of illumination is varied, brightness and colorfulness vary considerably. To obtain satisfactory correlates of these perceptions it is therefore necessary to model the way in which the visual responses vary with changes in illumination level. It is also of interest in some applications to know how the appearance of colors varies with changes in the color of the illuminant. For instance, when tungsten light is used for viewing a picture of a scene lit by daylight, conventional colorimetry is of little help in evaluating the reproduction, because all its colors have to be physically yellower than in the original to suit the change in the sensitivity of the eye caused by its adaptation to the prevailing tungsten light. Furthermore, when pictures are viewed in dark surrounds, as in the case of projection in dark auditoriums, a subjective lowering of the apparent contrast takes place, and this affects the way in which the physical contrast of the picture has to be set.

These effects can be included in models of color vision, and they are beginning to be used to evaluate colors seen under different conditions of viewing.

Books: Billmeyer, F. W., Jr., and Saltzman, M., *Principles of Color Technology.* 2nd edition. New York: Wiley, 1981; Hunt, R. W. G., *Measuring Colour.* 2nd edition. New York: Ellis Horwood, 1991; Hunt, R. W. G., *The Reproduction of Colour.* 4th edition. New York: Van Nostrand Reinhold, and Surbiton, England: Fountain Press, 1987; Stroebel, L., et al., *Photographic Materials and Processes.* Boston: Focal Press, 1989.

R. W. G. Hunt

COLORING

A SHORT HISTORY From the beginning of photography through the invention of the first color film, hand coloring was used to improve the quality and to add color to original photographs. By the 1840s, just a few years after the invention of photography, people were looking for something beyond the black-and-white daguerreotype. Miniature portrait painters were hired to paint directly on the images, using fine-haired brushes to apply the powdered pigment. It was a difficult and tedious process to add the colors to the delicate surface, but the application proved quite lucrative. Portrait studios soon opened up in most cities in Europe and America.

Travel photographers hand tinted to enhance their photographs by coloring their slides for use in both lectures and books. By this time transparent oils or water-based paints were also in use. In the early 1900s hand-tinted photographs were made into postcards, with images ranging from landscapes to movie stars. People collected them and put them into albums to save on their shelves.

With the introduction of color film, hand tinting went out of fashion for a few decades. However, in the 1970s coloring saw a large resurgence. Rather than trying to imitate what was produced with color film, photographers began using hand tinting to enhance their images and to shift reality to influence the viewer's experience.

Today, coloring is not just used by the fine-art photographer but in magazine (print) advertisements, music videos, film advertisements (much like animated sequences), movie posters, postcards, notecards, and many other aspects of the art and commercial world.

MATERIALS USED Many different agents are being used, ranging from oil- or water-based colors to food dyes and markers. A darkroom is not needed, but instead a room with very good light is required.

Print selection is one of the most important choices, and because coloring will not improve a boring photograph, an interesting black-and-white image should be used. The print should have good tonal range, and it can be toned or bleached beforehand. Resin-coated or fiber-based papers can be colored, as can either matt or glossy surfaces.

Coloring agents can be applied in different ways, depending on the medium used and the effect desired. For example, when the artist is using oils and would like the image to show through, cotton swabs may be better to work with than brushes, because the swabs can be made to fit in smaller areas. Wiping an area with a larger piece of cotton will take off a lot of the paint and make the oils look transparent, almost like a wash. For a more painterly effect, a brush can be chosen to apply the oils in a thicker manner. Done in this fashion, the oils will not allow the image to show through the paint and can produce an end product much like a photorealist painting. Oils can be removed with distilled turpentine, which will not harm the print when used sparingly. Many beginning painters choose to use this medium for that specific reason. Colorists have several chances to make decisions on the same print when using oil colors, oil pencils, or pastel chalks. With acrylics, however, only one application is possible, because they dry quickly.

Oil pencils can be applied in many ways. Drawing on the print will allow the viewer to see every stroke and add texture to the image. Adding just a slight amount of turpentine to the pencil marks and then rubbing them in with cotton will make the pencil colors look so much like oil paints that people cannot tell the difference between them. The choice between oils and pencils is up to the personal preference of the artist. The results could conceivably look the same.

The drying time of oil-based colorants ranges from a couple of hours to a couple of days, depending on how thickly the paint is applied. Oil-based paints and pencils have the greatest permanence of all hand-coloring materials.

Pastel chalks and Cray-pas are used much the same as oils and pencils. They are easily manipulated and are quite easy to remove just by rubbing with a hand or with the help of a cotton ball. However, chalk colorings must be sprayed with a fixative when finished to prevent smudging or other damage. Any fixative will do, including hair spray. All fixatives will yellow a print within a few years, but it is the only way to hold the chalks to the photographic paper. Both chalks and Cray-pas do not adhere well to glossy surface fiber or resin-coated papers, but if a coat of oil paint is first applied, the chalks can then be used on top for a different effect.

Water colors from tubes, food coloring, felt tip pens, retouching colors, as well as something as unusual as gentian violet, can all be applied with cotton swabs or brushes. The drier the brush, the less likely that the print will buckle. The intensity of the colors can be controlled by diluting them with water or Photo-Flo. If a mistake is made, some of the color can be removed if the print is rewashed.

Acrylics can be applied with a brush and can be thinned down with water to help control the application. Water can also be used to remove excess paint or unwanted paint, up to a point.

Hand-tinted photography has gained acceptance in the arts, in the commercial world, and in historical record keeping. The work of hand colorists can be found in major museums around the world and throughout various media. The technique enables the artist to add personal interpretation beyond the specific results of the camera. *J. Enfield*

COLORING PHOTOGRAPHS Hand coloring or tinting of monochrome black-and-white photographs is sometimes a pleasing alternative to prints made by direct color photography. Dyes soluble in water may be applied to moistened prints, or colored oils may be applied to dry prints. The obsolete Flexichrome process made use of a gray dyed gelatin relief image similar to that of a dye-transfer matrix but on an opaque base. The controlled application of colored

dyes replaced the gray to produce an image not unlike that of a direct color photograph.

Most subjects are suitable for hand-coloring, but simple color schemes are often most desirable. It is best to work in soft daylight. It is more difficult to judge the effect of color under artificial illumination.

MAKING PRINTS FOR COLORING Photographs intended for coloring should be exposed using filters on the camera that will render dark colors lighter. Unless especially intended to be low-key or dark, prints should generally be of lower than normal density (lighter). For portrait work it may be desirable to use prints toned with one of the sulfide or selenium tones.

WATER COLORING Transparent water-soluble dyes are available in sets similar to those used by artists, but designed specifically for hand coloring of photographs. They are also available in the form of "stamps" of paper coated with the soluble dyes that are dissolved in suitable amounts of water. Being transparent they do not obscure the details of the photograph.

Care should be taken to avoid finger marks or other oily smudges on the surface of the prints. If they have been dried, the prints should be thoroughly resoaked in water. One of the wet prints is then placed face up in a smooth support such as a sheet of glass. Excess moisture is blotted off. Then large areas should be colored with diluted dye using a good quality brush, taking care to stay within the bounds of the image element being colored. Size O brushes are suitable for small details, while sizes 2 and 4 are suitable for larger areas. The dye should be applied in successive washes until the desired tint is reached. Care should be taken to avoid excess dye density. Some dye reductions can be achieved by soaking the print in water, or sometimes with water containing dilute sodium carbonate. However, it is best to avoid over coloring.

OIL COLORING The print, preferably on a semimatt paper, is prepared by applying the clear medium supplied by the maker of the colors. It should then be attached by its corners to a smooth board covered with blotting paper. Transparent oil colors are supplied in tubes. They must not be mixed with white or opaque color. A small tuft of cotton is wound around the tip of a small pointed wooden dowel. This is then placed in the color, which is then applied to the area being colored. The color is worked into the surface with another piece of clean cotton. Excessive color can be removed with cotton moistened with the thinning medium. When coloring is completed the print should be dried in a warm, dust-free atmosphere.

Heavy oil coloring involves the use of opaque colors much as those used by oil painters. Details and texture can be enhanced or added to the image. This is an advanced technique and requires more skill and artistry than when using transparent colors. *I. Current*

See also: *Coloring.*

COLOR INTERNEGATIVE A negative color film that is used to record images from other photographic records. For example, a transparency may be exposed on to an internegative film, to provide a negative image that is suitable for printing on to a nonreversal color print material. *R. W. G. Hunt*

COLORIZATION The process of electronically adding color to video versions of motion pictures originally produced in black and white. *H. Lester*

COLOR LOOK-UP TABLE (CLUT) CLUTs provide an algorithm that will allow for the translation of RGB color into some other color space, such as CMYK. If an area of the image that is displayed as red comprises 85% red, 10% green, and 10% blue, then a CLUT would be written to translate the RGB data into 5% cyan, 60% magenta, 35% yellow and 0%

black. The CLUT exists as a predetermined set of values in tabular form, thus making it unnecessary to calculate the appropriate values for each change in display color. *R. Kraus*

COLOR MAPPING Color mapping uses a color look-up table (CLUT) for monitor display purposes. *R. Kraus*

COLOR MASKING Procedure in which a photographic image is combined in register with another image to achieve color corrections or some other effect. For example, in graphic reproduction, a red separation negative may be combined with a low contrast green separation positive to correct for the unwanted green absorption of the cyan ink that is being used. *R. W. G. Hunt*

See also: *Color correction.*

COLOR MATCHING (1) Procedure in the colorant industries whereby a sample is adjusted to be the same color as a reference material. (2) In colorimetry, the processing of adjusting a mixture of colors until it matches a test color. *R. W. G. Hunt*

COLOR-MATCHING FUNCTIONS The amounts of three color-matching stimuli (tristimulus values) needed to match monochromatic stimuli of equal radiant power per small constant-width wavelength interval throughout the spectrum. These functions are important in color reproduction, because they define the theoretically correct camera sensitivities in color systems. *R. W. G. Hunt*

Syn.: *Color-mixture curves.*

See also: *Color photography; Colorimetry.*

COLOR MEASUREMENT Colors can be measured in various ways, the most important of which are (1) by comparison with calibrated samples on a color atlas; (2) by visual matching against calibrated amounts of red, green, and blue primaries in an additive mixture; (3) by computation from spectral power data using a set of color matching functions as weighting functions; and (4) by photoelectric measurement through filters that, with the spectral sensitivity of the photodetector being used, generate a set of sensitivities that closely match a set of color-matching functions.

For the calibrated atlas method, the atlas used could be, for instance, the *Munsell Book of Color* or the *Natural Color System Atlas*. This method is simple but is not very accurate. It requires interpolation and sometimes extrapolation, and it implies the use of an illuminating source that matches the illuminant used for calibrating the atlas, but such a source is not usually available.

The red, green, and blue color matching method is the one that was originally used for setting up standard colorimetric measures, but it is now only used for research work, because it is very slow and of limited precision.

The computation from spectral power data method is the one that is regarded as standard for practical applications. It requires the spectral power distributions of the samples, and these are usually derived by multiplying the spectral reflectance factor, or the spectral transmittance factor, of each sample by the spectral power distribution of a chosen illuminant, at regular wavelength intervals throughout the spectrum.

The method of measurement with filtered photodetectors is convenient in that the equipment required is relatively simple, but it is not possible to match the required color-matching functions exactly, so that accuracy is limited.

Books: Billmeyer, F. W., Jr., and Saltzman, M., *Principles of Color Technology*. 2nd edition. New York: Wiley, 1981; Hunt, R. W. G., *Measuring Colour*. New Jersey: Prentice and Schuster, and Hemel Hempstead, England: International Book Distributors, 1987. *R. W. G. Hunt*

See also: *Colorimetry.*

COLOR-MIXTURE CURVES See *Color-matching functions.*

COLOR NEGATIVE FILM A photographic film in which light and dark subject tones are reversed, and in which subject colors are represented as their complements, e.g., a blue object is recorded as yellow. This complementary color relationship is partly obscured in most color negative films by the presence of color masking dyes, which improve the color rendition of any print made from the negative. *M. Scott*

See also: *Ektacolor; Kodacolor.*

COLOR NOTATION Means of defining colors, for example, the CIE X, Y, Z system; the CIELAB and CIELUV systems; the Munsell system; the natural color system (NCS). *R. W. G. Hunt*

COLOR PAPER Photosensitive material on a paper (often resin-coated for rapid processing) base for making reflection prints from negative or positive color films. Negative-working paper and a color negative process are used with the former; positive-working paper and a color reversal process with the latter. Color paper processes are usually simpler and briefer than their film equivalents. As with most films, three layers on the papers receive red, green, and blue components of the exposure and render these in dye images of cyan, magenta, and yellow, respectively. *M. Scott*

COLOR PERSPECTIVE See *Advancing and receding colors.*

COLOR PHOTOGRAPHY The final form of a color photograph is normally either a reflection print on paper or a transparency; a transparency can be a slide film, a sheet film, or a motion-picture film. In all cases the original information from the scene is recorded in three photosensitive layers having different spectral sensitivities and coated on a convenient support. Reflection prints on paper are usually made by printing such records on to a paper having similar layers coated on it. In the case of transparencies, however, the film used in the camera may be used for displaying the final image directly or it may be used to take a print on to another suitable film. The requirements for accuracy of color rendering are physically different for transparencies and for reflection prints because of their different viewing conditions, and the design of photographic materials must allow for this fact, among many others.

COLOR VISION To produce the colors in a picture so that their relative distributions of light throughout the spectrum are the same as those for the colors in the original scene is not generally practicable. All modern systems of reproducing color pictures, whether in photography, printing, or television, therefore, depend on the trichromatic principle, whereby colors can be matched by the additive mixture of red, green, and blue lights. This is possible because human color vision depends initially on absorptions of light by photosensitive pigments having only three different types of spectral sensitivity; these pigments are situated in cells in the retina of the eye called cones. This makes it possible, in color photography, for all the different colors in the picture to be obtained by using dyes of only three different colors. Each of these dyes absorbs light mainly in a different band of the spectrum, and these three bands are those mainly absorbed by the three different pigments of the retina. One of these three pigments may be regarded as absorbing mainly reddish light, another mainly greenish light, and a third mainly bluish light.

THE SUBTRACTIVE PRINCIPLE When white light is used for purposes of illumination, it normally contains all the colors of the spectrum. Because of the nature of the retinal pigments, however, we may regard the spectrum as consisting of three main bands; first, that comprising light of wavelengths over about 580 nm, which contains all the reddish part; second, that comprising light of wavelengths between about 490 nm and about 580 nm, which contains all the greenish part; and third, that comprising light of wavelengths shorter than about 490 nm, which contains all the bluish part. If the blended light from each of these three bands of the spectrum is viewed, the three colors that are seen are red, green, and blue. It therefore follows that white light can be thought of as an additive mixture of red, green, and blue components. In order to produce a wide range of colors in a beam of white light, all that is required is some means of varying the amounts of the reddish, greenish, and bluish bands, independently of one another.

When the percentage transmission at each wavelength of a yellow dye, at four different concentrations, is plotted against wavelength, it can be seen that, for all the concentrations, the transmission in the reddish part of the spectrum is high, in fact nearly 100%. In the greenish part, the variation of transmission with concentration is not large; but, in the bluish part, the transmission depends markedly on the concentration of the dye. By varying the concentration of a yellow dye in a beam of light, its bluish content can be modulated nearly independently of its greenish and reddish contents.

Similar spectral-transmission curves for a magenta dye, at four different concentrations, show that the main effect of altering the concentration of the magenta dye is to modulate the transmission in the greenish part of the spectrum. It is true that the transmission in the bluish and reddish parts do alter also, but they do so to smaller extends. Similar curves for a cyan dye at four different concentrations show that the main effect of varying the concentration of the cyan dye is to modulate the transmission in the reddish part of the spectrum, and to a lesser extent, the transmission in the greenish and bluish parts.

If, therefore, the concentrations of a cyan, a magenta, and a yellow dye are varied in a beam of white light, a wide range of colors will be produced. This is the subtractive principle of color reproduction, because the dyes subtract from the white light those components that should not be there. It is clear that, although the colors of the dyes are cyan, magenta, and yellow, this is merely incidental to the fact that it is dyes of these colors that correspond, respectively to a red-absorbing, a green-absorbing, and a blue-absorbing colorant. (In the graphic reproduction industry the colors of the inks used are sometimes referred to as blue (or process blue), red (or process red), and yellow, but their functions are still to act as absorbers of reddish, greenish, and bluish light, respectively.)

To produce a subtractive color reproduction, all that is necessary is to be able to control the concentration of the three dyes independently, at each point in the picture, in suitable accordance with the absorptions in the three different types of pigments in the cones of the retina for the same point in the scene. Assuming that this can be done, the successive stages of subtractive color photography are as follows.

1. Records of the original scene are made by means of red, green, and blue light in order to record the pattern of absorption of light by the three types of retinal cones.
2. Dye-image positives are made from the records, the red record giving a cyan image, the green record a magenta image, and the blue record a yellow image.
3. When superimposed in register, the three dye images are viewed in white light.

FORMING DYE IMAGES To form a dye image, as distinct from a uniform layer of dye, it is necessary for the amount of dye present at each point to be suitably dependent on the red, green, or blue exposure at that point. The most widely used method of achieving this result is by means of color development. In color development, the exposed silver halide in the photographic emulsion is reduced to silver, as in

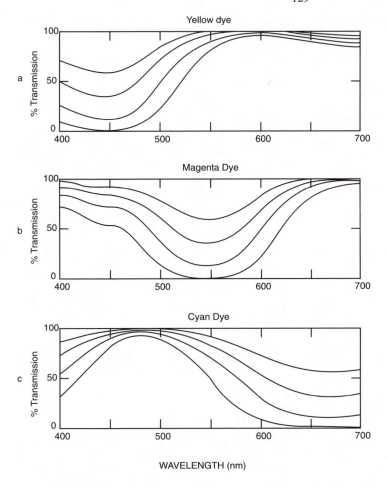

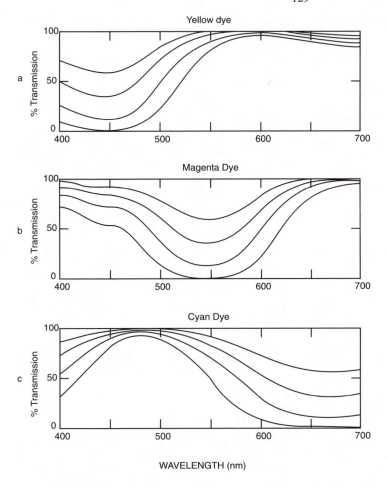

The subtractive principle. Spectral transmission curves for (a) yellow, (b) magenta, and (c) cyan, dyes at four different concentrations.

black-and-white development, but the developer, which becomes oxidized as a result, is then made to react with a coupler to produce an insoluble cyan, magenta, or yellow dye. This process can be represented as follows:

AgBr + developing agent, → Ag + oxidized developing agent

$$
\begin{array}{cc}
\downarrow & \downarrow \\
\downarrow & + \text{ coupler} \\
\downarrow & \downarrow \\
\text{Ag} & \text{insoluble dye}
\end{array}
$$

Most developing agents, when oxidized, will not combine with couplers to produce dyes. This reaction, therefore, only works satisfactorily with some developing agents, notably

para-phenylenediamine and some of its derivatives. It is clear that the dye is formed jointly from the coupler and the oxidized developing agent, and the color of the dye formed depends on both these constituents. The amount of dye formed depends on the amount of oxidized developer available, and this in turn depends on the amount of silver that has been developed. Thus, the amount of dye is related to the amount of exposure given at each point and is therefore laid down as an image and not as a uniform layer. The reaction of the oxidized developing agent is localized around the silver halide crystals (or grains, as they are usually called) containing the latent image, so that, on color development, blobs of insoluble dye are formed only around the silver grains developed; hence, the dye image obtained reproduces in a somewhat blurred manner the granular nature of the silver

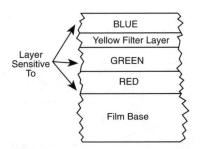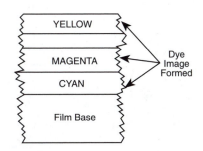

Integral tripacks. Structure of an integral tripack typical of those used for films of camera speed.

image from which it is derived. If three such dye images are produced, using couplers that produce cyan, magenta, and yellow dyes, and if the silver is removed by bleaching, a subtractive color photograph is obtained by superimposing the three images in register. Alternatively, the dye images can be transferred to another support, but color development is usually used to produce dye images of different colors in different layers of a single film.

INTEGRAL TRIPACKS If three pictures have to be exposed one after the other, only still life or very slow moving scenes can be recorded. In modern subtractive systems of color photography, the three records are taken on three emulsions coated on top of one another, an arrangement known as an integral tripack.

The natural sensitivity of photographic emulsions covers only the blue part of the visible spectrum. Their sensitivity to the green and red parts requires the addition of sensitizing dyes. An ordinary, unsensitized, emulsion usually constitutes the top layer in a tripack, and in it is produced a negative that provides the blue record of the scene, but in this case no blue filter is necessary because the emulsion itself responds only to blue light. The bottom layer of the film consists of an emulsion sensitized only to red light. It still has its natural sensitivity to blue light, but this is rendered inoperative by means of a yellow filter layer situated immediately below the top layer. In this bottom layer, therefore, is produced a negative providing the red record of the scene, but once again no red filter is needed, because the yellow filter together with the red-sensitizing of the emulsion make the layer sensitive only to red light. Between the yellow filter layer and the bottom layer is an emulsion sensitized to green light only. This sensitizing, together with the yellow filter layer, constitutes a layer sensitive to green light only, and therein is produced a negative providing the green record of the scene, but without using a green filter.

With such a three-layer film, a single exposure suffices to record the three images required, one being effectively taken through a red filter, another through a green, and a third through a blue. It remains to process the film in such a way that cyan, magenta, and yellow dye images are formed in these three layers, respectively. There are two main methods

of achieving this by color development. In one method, the couplers are incorporated in the film; in the other, they are in the three separate developers.

PROCESSING WITH COUPLERS INCORPORATED IN THE FILM The way in which an integral tripack material can be processed when the couplers are incorporated in the film can be shown diagrammatically. Each of four large circles depicts a highly magnified cross-section of the three emulsion layers and the yellow filter layer. Each small triangle represents a silver halide crystal, or grain, and the triangles with dots in them indicate grains that have been exposed and contain a latent image, while those without dots indicate grains that have not been exposed and do not contain a latent image. It is thus clear that in this example light has fallen on the right-hand part of the film but not on the left. The circles represent particles of couplers, those in the top (blue-sensitive) layer being capable of forming yellow dye, those in the bottom (red-sensitive) layer being capable of forming cyan dye, and those in the other (green-sensitive) emulsion layer being capable of forming magenta dye. The couplers are prevented from wandering away from their proper layers, either by attaching long molecular chains to them or by dissolving them in oily solvents and then dispersing them in the form of minute oil droplets; when oil droplets are used they are usually about one-tenth the diameter of the silver halide grains. On immersing the material into a solution containing a suitable developing agent, the developing agent converts the silver halide to silver wherever a latent image was present, and around each grain of silver thus formed, the oxidized developing agent reacts with coupler to produce dye: yellow (Y) in the top layer, cyan (C) in the bottom layer, and magenta (M) in the other emulsion layer. The dyes are deposited as very small clouds of molecules or droplets around each developed grain. It is now necessary to remove the unexposed silver halide from the film, for this has a milky appearance and would gradually darken as the film was viewed. This fixing is carried out as in black-and-white films by means of a hypo solution, but it is also necessary to remove the silver image that otherwise would darken the result, and this is conveniently done by converting the silver back to silver halide by means of a suitable

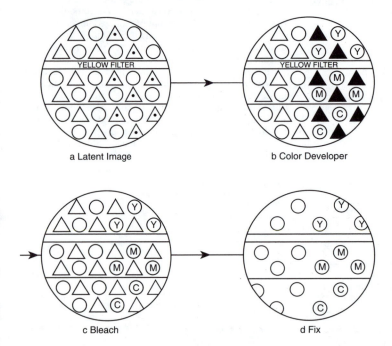

a Latent Image

b Color Developer

c Bleach

d Fix

Processing with incorporated couplers. Diagrammatic representation of highly magnified crosssections of an integral tripack material with incorporated couplers being processed to give a negative image. Open triangles, unexposed silver halide grains; triangles with dots, exposed silver halide grains; filled triangles, developed grains of silver; circles with Y, particles of yellow dye; circles with M, particle of magenta dye; circles with C, particle of cyan dye.

bleach, used before the fixing stage. In the remainder of the process, the bleach converts the silver to silver halide again and all the silver halide is removed by the fixer. (In some processes the bleaching and fixing steps are combined in a single solution known as a blix.) The yellow filter layer generally also disappears at the bleach stage. The unused coupler is harmless and is allowed to remain. In fact, in some color films the unused coupler is actually used to improve the accuracy of the final results, and in these cases it is usually colored yellow or pink, but otherwise it is colorless.

After the processing has been completed, the final result is that on the right-hand side of the film, where the light originally fell, all three dyes (cyan, magenta, and yellow) are produced (resulting in a dark area), whereas on the left-hand side, where no light fell, no dyes are produced (resulting in a light area). The result is thus a negative: light becoming dark and dark becoming light. In addition, colors will be reversed; red becoming cyan, green becoming magenta, and blue becoming yellow, and vice-versa. That this is so can be seen by considering the following example. If the light falling on the film had been red, only the bottom layer would have been exposed; hence only cyan dye would have been formed. Conversely, if the light falling on the film had been cyan (blue-green), only the blue- and green-sensitive layers would have been exposed, and hence only yellow and magenta dye would have been formed and the superimposition of these

two dyes would result in a red color. To produce a color positive from such a record, which is called a color negative, it is only necessary to rephotograph or print the processed negative onto a similar piece of film or paper. Once again, by the same arguments, both the tones and the colors will be reversed and the final result will be in its correct colors.

REVERSAL PROCESSING If a separate negative stage is not required, the film exposed in the camera can be reversal processed to give a positive image directly. The way in which this is done can be shown diagrammatically. When light has fallen on the right-hand part of the film but not on the left, the latent image is present only on the right. The film is then immersed in an ordinary black-and-white developer, which converts the exposed halide to silver, thereby oxidizing the developing agent. Being an ordinary black-and-white type developing agent, however, its oxidized form does not react with the couplers and, hence, no dye is formed at this stage. The next step is to reexpose the film to a strong white light, or to immerse it in a fogging agent, so that a latent image is formed in all the undeveloped silver halide. The film then enters a color developer that converts this silver halide to silver, and the oxidized developer formed in the vicinity of this silver reacts with the couplers to form cyan, magenta, and yellow dye images as before. The usual bleaching and fixing stages then remove all the silver to give, now, all three dyes (dark areas) on the left-hand part of the

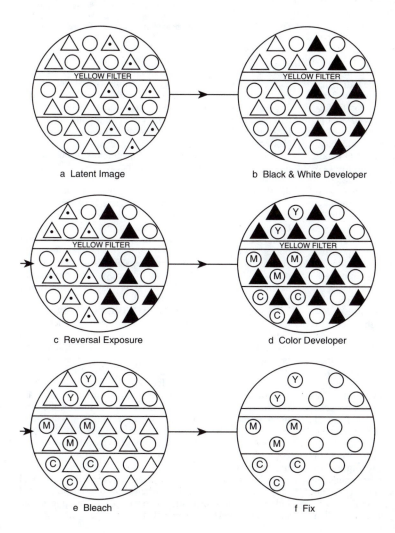

a Latent Image

b Black & White Developer

c Reversal Exposure

d Color Developer

e Bleach

f Fix

Reversal processing. The processing sequence necessary (reversal process) to obtain a positive image directly on the camera film.

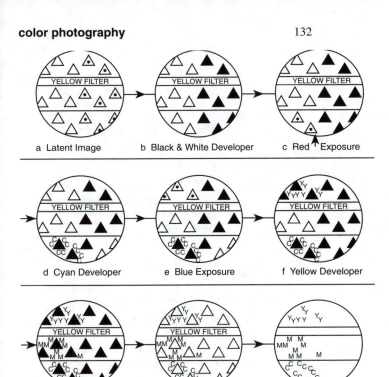

a Latent Image b Black & White Developer c Red ↑ Exposure

d Cyan Developer e Blue Exposure f Yellow Developer

g Magenta Fogging Developer h Bleach i Fix

Processing with developer couplers. Using the method where the three couplers are in three different developers instead of in the layers of the tripack. Y, particle of yellow dye; M, particle of magenta dye. C, particle of cyan dye.

film, where the light originally did not fall, and no dyes (light areas) on the right-hand part of the film, where the light originally did fall. The result is thus a positive, as required. That the colors are also rendered correctly can be seen by the following example. If the right-hand side was exposed only to red light, only the bottom layer would have been exposed so that, in the black-and-white developer, silver would have been produced only in the bottom layer. The reversal exposure would therefore produce latent images in the top two light-sensitive layers but not in the bottom layer. On color development, yellow and magenta dyes, but no cyan dye, would therefore be formed and hence a red color produced on the film in the area in which the red light originally exposed it.

PROCESSING WITH COUPLERS IN THE DEVELOPERS An example of one way in which direct-positive color images can be obtained using the other main method of color developing, that in which the couplers are in three separate developing solutions, can be visualized in the same way. Once again, light has fallen on the right-hand part of the film and not on the left. An ordinary black-and-white developer therefore produces silver images on the right-hand part as before. The film is then reexposed uniformly, not to white light but to red light from the bottom. Because only the bottom layer is sensitive to red light, a latent image is formed only in this layer, so that on immersing the film in a color developer containing cyan-forming coupler, cyan dye is formed on the left-hand part of the bottom layer only. The film is next exposed to blue light from the top, and, because the yellow filter layer protects the bottom two layers from all blue light, a latent image is, at this stage, formed only in the top layer, so that on immersing the film in a color developer containing yellow-forming coupler, yellow dye is formed in the left-hand part of the top layer only. It is now required to form magenta dye in the left-hand part of the other emulsion layer, and since it is only in this part of the entire film that there is any silver halide left, use is made of a color developer containing magenta-forming coupler and of such a

character that development takes place even when the silver halide has not been exposed. The final two stages are the usual bleaching and fixing steps. It will be seen that the final disposition of the dyes is the same as before so that a positive has been achieved, and by the same arguments as used previously, the colors as well as the tones are correctly reproduced.

Color negative images cannot conveniently be obtained by this method of color development because it is the reversal exposure step that provides the opportunity for the color developers to affect each layer in turn independently.

It can be seen that this type of process is of considerable complexity and is, for this reason, only operated at a few large processing stations. In return for this complexity, however, the process can yield an extremely high resolving power, so that it can be used satisfactorily even for 8-mm cinematography, where the frame size is only 3.68×4.88 mm (or 4.22×6.22 mm in Super 8). The outstanding example of this type of process is that used for Kodak Kodachrome film.

DEFECTS OF THE SUBTRACTIVE PRINCIPLE Subtractive color photographs produced by some modern commercial processes are often so pleasing to the eye that the impression is made that almost perfect color rendering has been achieved. In point of fact, however, as far as color rendering is concerned, all subtractive processes suffer from some important inherent defects.

Unwanted Stimulations We may regard it as necessary, for the moment, that the effective sensitivities of the three photographic emulsion layers used to record the three images should be the same as the probable sensitivity curves of the three types of cones, r, g, and b, used as the basis of color vision. This can be achieved, but it is further required that the cyan dye controls a band of wavelengths to which only the r cones respond, the magenta dye a band to which only the g cones respond, and the yellow dye a band to which only the b cones respond. When we look at the approximate bands of wavelength controlled by the cyan, magenta, and

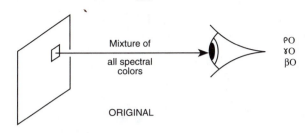

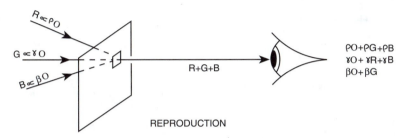

Unwanted stimulations. Diagrammatic representation of the effect of unwanted stimulations in a three-color reproduction.

yellow dyes, however, it is clear that the r, g, and b responses are not independently controlled by the three dyes; these unwanted stimulations can cause serious defects in the color reproduction.

If the r and b curves did not overlap in the blue-green part of the spectrum, then a band of green light could be found that stimulated the g cones on their own, but since the r and b curves do overlap appreciably, the g cones cannot be stimulated on their own, and hence simple trichromatic means cannot achieve correct color reproduction. This is not a difficulty peculiar to any particular method or process but one that underlines all modern methods of color reproduction, whether in photography, in graphic arts printing, or in the additive systems used in television. It cannot be avoided because it follows from the basic nature of human color vision.

If some particular part of the original gives rise to responses ro, go, and bo, and if the strengths R, G, and B of the reddish,

greenish, and bluish light composing this part of the reproduction are proportional to these responses, then the reproduction is spoiled because the reddish light gives rise to an unwanted g response, gR, the greenish light gives rise to unwanted r and b responses rG and bG, and the bluish light gives rise to unwanted r and g responses rB and gB.

The effect of this may be appreciated in the following way. The strengths, R, G, and B of the lights in the reproduction have to be reduced to renormalize them so that white is still reproduced correctly. This means that any differences between the r, g, and b responses then become smaller than the differences between ro, go, and bo, because of the addition of the unwanted stimulations. It may be assumed that, for whites and grays, the r, g, and b responses are equal; hence, reductions in differences between the responses result in the colors becoming less different from whites and grays. In others words, they become less colorful.

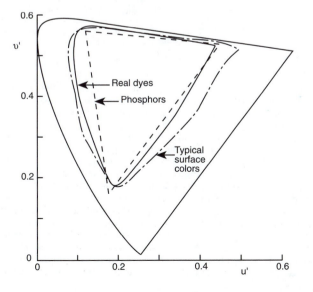

Color gamuts. Solid lines, the gamut of chromaticities that can be reproduced using, with Standard Illuminant DGS, the dyes of a typical color film, using combinations of concentrations of dye corresponding to densities in the main absorption band of 2.0. Broken lines, the gamut of chromaticities that can be reproduced by the phosphors of typical television receivers. Dot-dash line, the gamut of chromaticities typical of surface colors present in scenes.

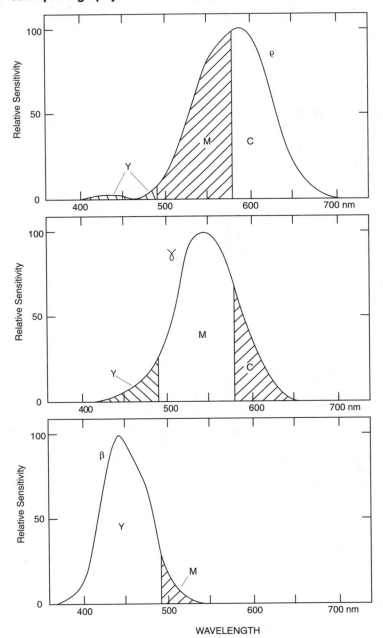

Unwanted absorptions. The areas labeled C, M, and Y, show the magnitudes of the retinal responses controlled by the absorptions of cyan, magenta, and yellow dyes, respectively. In an ideal system, the absorption of the yellow dye would control the response of the b cones only; the absorption of the magenta dye would control the response of the g cones only; and the absorption of the cyan dye would control the response of the r cones only.

The unwanted stimulations by the bands of light controlled by the cyan, magenta, and yellow dyes also limit the gamut of colors that can be reproduced. This is also the case with the red, green, and blue light produced by the phosphors in color television.

Unwanted Absorptions A further defect arises from the fact that the best cyan, magenta, and yellow dyes have appreciable absorptions in parts of the spectrum where they should have 100% transmittance. These unwanted absorptions result in colors being produced considerably darker than in the original scene unless corrections are made. These unwanted absorptions also reduce the gamut of colors that can be reproduced. Effective methods have been developed for correcting for the effects of unwanted absorptions. One method is to use interimage effects, whereby the amount of dye formed in a layer depends not only on the exposure in

that layer but also on the exposure in another layer in the opposite direction. Another method is to use couplers that are colored. These methods will be considered more fully later in this article.

Color Gamuts Obtainable The chromaticity gamut of colors obtainable with the dyes used in a typical color film can be compared with that obtainable with typical television phosphors and that covered by typical surface colors encountered in scenes. Both the film-dye and television-phosphor systems cover less than half the full area of chromaticity (enclosed by the spectral locus and the purple boundary); but the area for the typical surface colors is only slightly larger, and it is for this reason that the limited gamut of these reproduction systems is successful for most scenes. The film-dye and television-phosphor systems are remarkably similar in their gamuts. The unwanted absorptions of the film-dyes,

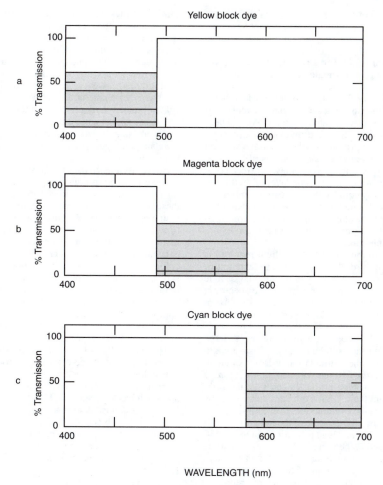

Block dyes. Spectral transmission curves of ideal subtractive dyes (block dyes) at four different concentrations.

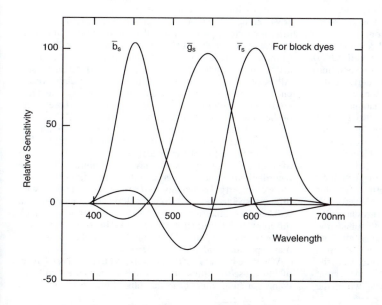

Block dyes. Color-matching functions for the primaries modulated by the block dyes.

however, have a darkening effect on the colors that causes further restrictions on their gamut, but these cannot be shown on chromaticity diagrams because the luminance factor is not shown.

SPECTRAL SENSITIVITIES FOR COLOR FILMS

The spectral sensitivities that should be used for film must now be considered.

Spectral Sensitivities for Block Dyes For the sake of simplicity, consider first the case of a set of cyan, magenta, and yellow dyes having spectral transmission curves. These block dyes control bands of the spectrum that constitute red, green, and blue lights, or primaries, whose relative spectral compositions are the same at all concentrations of the dyes, thus providing stable primaries. To achieve correct color reproduction, it is then necessary for one layer of the film to have a spectral sensitivity equal to the curve representing the amount of red primary needed to match each wavelength of the spectrum, another to be similarly related to the green primary, and the third to the blue primary. These curves are known as color-matching functions.

As is to be expected, the amount of red light required is greatest in the reddish third of the spectrum, the amount of green greatest in the greenish third, and the amount of blue greatest in the bluish third. In some parts of the spectrum, however, negative amounts of light are required. Thus, at around 510 nm an appreciable negative amount of red light is required. The reason for this is that the band of the spectrum modulated by the magenta dye produces a large unwanted r stimulation, and although light of wavelength 510 nm also results in some r stimulation, it is not so great. In attempting to match the 510 nm wavelength, therefore, a mixture of the green and blue primaries can give the right amount of g and b stimulation, but even zero amount of the red primary gives too much r stimulation. In colorimetry, this difficulty is overcome by adding some of the red primary, not to the mixture of the green and blue primaries, but to the 510 nm light being matched. When this is done a match can be obtained, and the amount of red light is then plotted as a negative amount. In some other regions of the spectrum, negative amounts of the green and blue primaries are required.

The implication for color film is that the red-sensitive layer should be such that light from the blue-green part of the spectrum should reduce the latent image formed by light from the reddish part of the spectrum; and similar reductions of exposure should occur in the other two layers of the film in accordance with the distribution of the positive and negative parts of the curves. Unfortunately, no accurate way of achieving these negative lobes of sensitivity has yet been found for color photography. In color television, where the same problem occurs because of unwanted stimulations caused by the phosphors, the negative lobes are realized by having an all-positive set of sensitivity curves corresponding to suitable combinations of the curves and then deriving the correct signals by suitable subtractions subsequently, a practice known as matrixing. Thus, if the red channel in the camera had a sensitivity curve corresponding to the red curve plus the green curve, the combined curve would not have any negative parts. Subtraction of the green signal from the combined signal would then give a red signal identical to that which would have been obtained from the red curve alone. Of course, negative light cannot be used in the picture, and so this procedure only gives correct colorimetric color reproduction when the true red signal is positive or zero. It is this effect that results in the limited gamut of chromaticities reproducible by color television. All colors lying outside the triangle representing the gamut for the television phosphors require either one or two of the three signals to be negative; such negative signals are usually taken as zero, and the reproductions then lie on the edge of the gamut triangle. With matrixing, however, all colors lying within the gamut triangles can have correct colorimetry, and fortunately this includes most of the range of chromaticities corresponding to surface colors normally found in scenes. Hence, in color television, the unwanted stimulations caused by the red, green, and blue phosphors result in a limited gamut, but within that gamut the colorimetry can be correct. In color photography, however, the unwanted stimulations caused by the bands of light modulated by the cyan, magenta, and yellow block dyes not only cause the gamut to be limited but also cause colorimetric errors because of the inability of film to incorporate negative lobes of spectral sensitivity or to have any analogue of matrixing (except in approximate and limited forms).

Spectral Sensitivities for Real Dyes The chromaticities of the effective reproduction primaries are easily calculated for the block dyes considered in the previous section, and these chromaticities define the appropriate set of color-matching functions. Because real dyes do not absorb uniformly in each third of the spectrum, however, the chromaticities of the corresponding primaries vary as the concentrations of the dyes are altered to produce the various colors. The use of these unstable primaries means that there is no unique set of theoretically correct color-matching functions and spectral sensitivity curves for color-reproduction systems using real dyes. Although this is an unwelcome complication, one small bonus is that the nonuniform spectral absorption of the dyes does extend the chromaticity gamut somewhat, especially in the blue-green direction.

The instability of the primaries in color photography means that accurate colorimetric reproduction of all matchable colors cannot be achieved by using a set of theoretically correct spectral sensitivity curves in the film. Instead, the approach has to be statistical, and the variables in the system have to be adjusted so that, if accurate colorimetric reproduction is the objective, the departures from it are minimized for ranges of colors typifying those most often encountered in practice and weighted according to their relative importance and the relative importance of different types of errors for them.

The spectral sensitivities that are optimum in practice depends on several requirements, some of which are conflicting. If possible, it is clearly desirable that the curves be a set of color-matching functions, because only then will colors that look alike in the original always look alike in the reproduction, and colors that look different in the original will always look different in the reproduction. Spectral sensitivities with accurate negative lobes are not yet possible, however, and the curves of all-positive sets of color matching functions require considerable subtraction of the three records from one another to obtain the correct result; moreover, this subtraction can normally be done, if at all, only to a limited and approximate extent by photographic means. All positive sets of color matching functions also overlap one another considerably along the wavelength axis, and this tends to use the light available for exposing the three layers of the film in a tripack rather inefficiently. For all these reasons, photographic systems are usually optimized with sensitivity curves that depart appreciably from any set of color-matching functions. By using all-positive sets of curves that overlap one another less, the levels of subtraction of the records required are reduced and the exposing light is used more efficiently. The penalty is that some pairs of colors with different spectral compositions that look alike in the original will not look alike in the reproduction, and some that look different in the original will look alike in the reproduction. Some colors with particularly unusual spectral compositions may reproduce with quite large errors.

When we look at a set of spectral-sensitivity curves typical of those used in films, it is clear that, compared with the color-matching functions, the blue film curve peaks at

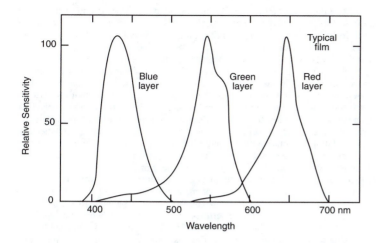

Spectral sensitivities for real dyes. Spectral sensitivity curves typical of those used in color films.

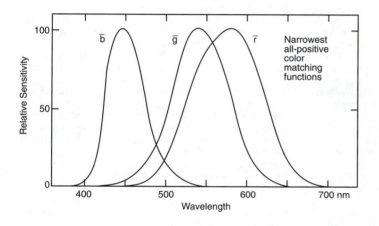

The narrowest possible set of all-positive color-matching functions.

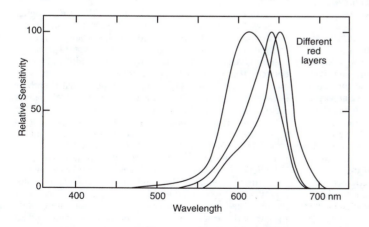

Various alternative spectral sensitivity curves for the red-sensitive layer of color films.

slightly shorter wavelengths, the green film curve is narrower, and the red film curve is narrower and peaks at considerably longer wavelengths. Although the film curves depart considerably in shape from either set of color-matching functions, it is found in practice that, for most colors, the colorimetric errors are not too large, even when no subtraction of the records from one another takes place. The shifting of the blue film peak to shorter, and of the red film peak to longer, wavelengths and the narrowing of the green and red film curves provides a crude substitute for the negative lobes that should really be incorporated. The small amount of overlapping of the curves also enables the exposing light to be used efficiently. The most serious problems can, in fact, all be traced to one cause: some colors, such as certain blue flowers and certain green fabrics dyed with particular synthetic colorants, exhibit high reflectances at the far red end of the spectrum, where the eye has very low sensitivity but the film has high sensitivity. These colors are

therefore reproduced too red in color photographs, so that the blue flowers can be rendered pink and the green fabrics may be rendered gray or even brown. Another effect is for reds of varying depths to be reproduced rather similar to one another. Attempts are made to reduce these effects by adjusting the position of the red film curve along the wavelength axis, but if the red curve is moved to short enough wavelengths to avoid the problems completely, then greens are reproduced too yellow, the colorfulness of reds is reduced quite severely, and the pink of Caucasian skin (which is an extremely important color in photography in the Western world) is rendered too ashen and gray. These latter problems could be overcome by using enough correction by subtraction of the records from one another, but the level of correction required is so high that it is difficult to incorporate accurately and would result in a film that was somewhat precariously balanced in its interactions.

An alternative approach, used in one type of commercially available film, is to move the red film curve to shorter wavelengths, restore the loss of colorfulness in reds by raising the contrast of the red layer, and then using an interimage effect from an additional blue-green sensitive layer to restore correct contrast in grays and pale colors. This type of approach reduces some errors usefully but falls short of providing sensitivities that are an accurate set of color-matching functions.

CORRECTION OF UNWANTED ABSORPTIONS
As already mentioned, the cyan, magenta, and yellow dyes used in color photography absorb not only the band of the spectrum that they are intended to modulate but also to a lesser extent the other bands. These unwanted absorptions result in the colors in pictures being darker than they should be, and the effect is particularly strong in the case of blue and green colors, because typical cyan and magenta dyes have appreciable unwanted blue absorptions, and typical cyan and yellow dyes have appreciable unwanted green absorptions. Such effects caused by unwanted absorptions can, however, be corrected in photographic systems, and two methods are important in practice.

Colored Couplers The first method of correction is to form dye images from couplers that are themselves colored. These colored couplers are widely used to correct unwanted absorptions in films that produce color negatives. If a magenta image is formed from a coupler that is itself yellow, then as more magenta dye is formed, more coupler will be used up and, consequently, the absorption of blue light will decrease because there will be less blue-absorbing yellow coupler present, but the increased amount of magenta dye will absorb more blue light. By balancing these two opposing effects, the layer can be made to have a blue absorption that is constant, whatever the amount of magenta dye present. The blue absorption is therefore uniform over the whole picture area and can be allowed for by a suitable increase in the overall blue content of the light used when printing the negative to form a positive. Similar correction for the unwanted green and blue absorptions of cyan dyes can be made by forming the cyan image from a coupler that is reddish, so that it absorbs the appropriate amount of green and blue light. The use of yellow magenta-forming and reddish cyan-forming couplers in color negatives gives them their familiar orange appearance. (Other unwanted absorptions could be similarly corrected, but those mentioned are the most significant.)

Interimage Effects The second method of correcting for unwanted absorptions in by means of interimage effects. Colored couplers can, unfortunately, only be used in materials designed to be printed or otherwise duplicated. For materials intended for direct viewing, the presence of the colored couplers in light areas gives a pronounced orange cast, and the eye is not able to adapt sufficiently to compensate for it. For this reason, colored couplers have no applica-

tion to reversal films intended for viewing, and the brilliance of the colors in some of these is caused, at least in part, by interimage effects that have beneficial consequences not unlike those produced by colored couplers.

In an interimage effect, the unwanted absorption of a dye is corrected by appropriately reducing the amount of dye in another layer. Thus, the unwanted blue absorption of a magenta dye can be corrected by arranging that increases in the amount of magenta-image dye formation are accompanied by suitable decreases in the amount of yellow-image dye formation, the two effects again being balanced to enable the magenta dye to be increased without any accompanying change in the absorption of the film to blue light. Of course, this is only possible if there is enough yellow-image dye present to allow the appropriate reduction to be made in its amount, but for most colors this is the case. Corrections for other unwanted absorptions can be made in a similar way.

Interimage effects may be present whenever different development rates occur in adjacent layers. This can happen in several ways. For instance, as a developer penetrates a multilayer material, it will normally be partially exhausted by the time it reaches the bottom layer. Hence, if the development is not carried out to completion in all layers, in order to achieve a matched gray scale, it may be necessary to make the bottom layer faster or of higher contrast. When only the bottom layer is exposed (in the case of a saturated red color for materials with the conventional layer order), however, the developer will not be partially exhausted on reaching the bottom layer because no development will have occurred in the upper two layers. Hence, the speed or contrast of the cyan image will be greater in reds than in grays, and this can be made to correct for the unwanted red absorption of magenta-image dyes, thus making reds lighter than they would otherwise be.

Interimage effects in a multilayer material can also be caused by the degree of development in one layer being affected by the release from a neighboring layer of development-inhibiting agents. These agents can be bromide or iodide ions or special inhibitors released by developer-inhibitor-releasing (DIR) couplers.

Interimage effects that affect color reproduction adversely can also occur. For instance, if some oxidized developing agent wandered from one layer to another in a coupler-incorporated material, dye of the wrong color would be formed and the color reproduction distorted. This type of contamination is usually minimized by having thin interlayers between the image-forming layers of multilayer materials, and these interlayers may contain chemicals that absorb or immobilize any oxidized developing agent that reaches them. Another adverse effect occurs if development in an unexposed layer occurs because an adjacent layer is very highly exposed. This type of effect has to be avoided by choosing emulsions that are as insensitive as possible to fogging as a result of vigorous development in an adjacent layer.

COLOR QUALITY Enough has been said to show that there are fundamental limitations to the fidelity of color reproduction by subtractive photographic means. Because of the unwanted retinal stimulations, some colors are outside the gamut that can be matched by the dyes available, and all colors, whether matchable or not, may be reproduced to some extent erroneously because of the impossibility of incorporating negative lobes in the spectral sensitivities of the three layers. Furthermore, the unwanted absorptions of the dyes reduce the reproducible color gamut and darken the colors unless corrections are made.

Real dyes have slightly larger chromaticity gamuts than block dyes, however. The shifting of the spectral sensitivities of the red and blue layers toward the ends of the spectrum, and narrowing that of the green layer, produces some compensation for the absence of the negative lobes for most

colors; the unwanted absorptions of the cyan, magenta, and yellow dyes can be corrected by using colored couplers and interimage effects. In consequence, the practical results achieved usually show errors in color reproduction that are fully tolerable except for a few special colors, and the pictorial effects obtainable can be, and often are, extremely pleasing.

Books: Hunt, R. W. G., *The Reproduction of Colour.* 4th edition. New York: Van Nostrand Reinhold, and Surbiton, England: Fountain Press, 1987. *R. W. G. Hunt*

COLOR PHOTOGRAPHY, HISTORY

The history of color photography follows three strands. The first concerns the attempts made to reproduce the same spectral distributions of light in the reproduction as in the original scene. The second concerns the synthesis of colors in pictures by means of additive mixtures of separate red, green, and blue beams of light. The third concerns the use of cyan, magenta, and yellow colorants in a single beam of white light, the so-called subtractive systems. The first strand had the earliest beginning and the third strand is of by far the greatest current interest, but there is a considerable overlap in the periods during which the three strands have been active.

SPECTRAL COLOR PHOTOGRAPHY To reproduce the same spectral distributions of light in the picture as in the original was an early goal in color photography. As long ago as 1810, Johann Seebeck and others knew that if a spectrum were allowed to fall on moist silver chloride paper some of its colors were recorded, although the images soon faded, so that no permanent record was achieved.

An explanation for this phenomenon was given by Wilhelm Zenker in 1868. He reasoned that when light was incident on the layer of silver chloride, it passed through the layer and was then reflected back by the white paper on which the light-sensitive material was coated. This caused the formation of standing waves. At the nodes, the forward and backward beams canceled each other, but at the antinodes they supplemented each other. At these points the light intensity became sufficient to cause photochemical decomposition of the silver chloride. Hence, through the depth of the layer, there were formed laminae of silver whose distances apart were half the wavelength of the incident light. The laminae served as interference gratings for any subsequent light incident upon them, and these gratings resulted in the wave pattern of the original being reproduced.

The Lippmann Method In 1890 Otto Werner pointed out that it should be possible to replace the silver chloride layer with a fine grain photographic emulsion. Gabriel Lippmann did this in 1891, using a layer of mercury in contact with the emulsion to provide the backward traveling beam of light. He also obtained permanent images by fixing them with hypo in the conventional way.

Many color photographs were produced by the Lippmann method in the following decade, and examples can be seen in photographic museums, testifying to the excellent permanence that was achieved. That the colors were indeed formed by interference has been demonstrated by cutting cross sections through the films and examining them under a microscope. In areas exposed by saturated light, distinct laminae were always present, but, in areas exposed by white light, the image was always more diffuse in depth. Where laminae were present, they were typically between four and eight in number.

Although quite elegant, the Lippmann method has not survived as a successful process for the following reasons. First, in order to resolve the laminae, which were only separated by half the wavelength of the exposing light, it was necessary to use extremely fine grain photographic emulsions, and these are of very low speed. Consequently, exposures of at least several minutes were necessary even in bright sunlight. Second, the use of mercury in the camera was a hazard both to the emulsion and to the photographer and it made the camera unwieldy. Third, because the picture had to be viewed by reflected light, it could not easily be projected, and it was too dark and too restricted in angle of view to be considered a reflection print.

The Micro-Dispersion Method An alternative method of reproducing the spectral distributions of the colors in the original is to disperse them through a prism. In this *micro-dispersion* method, the light from the lens in the camera is imaged on a coarse grating having about 300 slits per inch (12 per millimeter), separated by rather wider opaque interstices. The light that passes through the slits is then dispersed by a prism having a narrow angle of only 2 or 3 degrees. A lens then forms images of the slits on a suitable photographic material, but because of the prism, the light from each slit is spread out into a small spectrum. In this way recordings are made of the spectral composition of the light from each point along each slit. The photographic material is then processed to give a positive, repositioned in exactly the same place in the camera as when it was exposed, and white light is then passed back through the apparatus. Of the light that emanates from any point on the processed material, only that of the same wavelength as made the exposure at that point is able to retrace its path through the apparatus and emerge at the other end; all other light is blocked by the opaque interstices of the grating. In this way the spectral composition of the reproduction is the same as that of the original at each point in the picture. The method was developed by F. W. Lanchester in 1895.

The micro-dispersion method was not successful for the following reasons. First, very fine grain photographic material had to be used in order to record the very small spectra, and hence, as with the Lippmann method, long exposures were required even in strong lighting. Second, the grating reduced the resolution of the picture. Third, the photographic material had to be precisely registered in exactly the same position after processing. Fourth, the necessity for the prism and lens system, required to form the spectra, resulted in a very unwieldy camera.

ADDITIVE COLOR PHOTOGRAPHY The idea that color had some sort of a triple nature gradually became established in the eighteenth century, and by 1807 Thomas Young had correctly ascribed this to the light-sensitive properties of the eye. James Clerk Maxwell decided to use a photographic demonstration to illustrate the trichromacy of color vision in a Friday Evening Discourse at the Royal Institution, in London, in 1861. The experimental work was done by Thomas Sutton, a prominent photographer of that time.

Maxwell's Demonstration The subject matter of Maxwell's demonstration was a tartan ribbon. Three photographs were taken of the ribbon, one through a red filter, one through a green filter, and one through a blue filter (a fourth was also taken through a yellow filter but was not used in the demonstration). A positive was made from the picture taken through the red filter, and it was then projected through a red filter on to a white screen. Similarly, positives from the negatives taken through the green and blue filters were projected through green and blue filters, respectively. The three projected images were positioned in register, and the result was the first trichromatic color photograph.

Although the quality of the picture obtained was apparently not very good, the principle demonstrated was basic to all modern forms of color reproduction, whether in photography, television, or printing.

One of the strange things about Maxwell's demonstration is that it was done at a time when the photographic materials available were only sensitive to blue light. This apparent anomaly remained unexplained for a hundred years. In 1961 Ralph M. Evans reconstructed Maxwell's experiment and found that his green filter transmitted just enough blue-green

light to make an exposure possible, and that the red filter transmitted ultraviolet radiation to which the photographic material was also sensitive. The three negatives were therefore exposed not to red, green, and blue light, but to blue-green and blue light and to ultraviolet radiation. The use of blue-green instead of green would not have vitiated the demonstration entirely, but the use of ultraviolet instead of red would at first sight seem to be disastrous. Evans drew attention to the fact that many red fabrics also reflect light in the ultraviolet, so that, by using a tartan bow as the subject, a color reproduction was produced that was evidently sufficiently realistic to serve as a demonstration of the trichromacy of vision, which was Maxwell's objective.

Sensitizing Dyes It is clear from the above discussion that proper color photography requires photographic materials that are sensitive to the greenish and reddish parts of the spectrum. In addition to the bluish part to which they naturally respond. Sensitivity to parts of the spectrum in addition to blue is obtained by the use of *sensitizing dyes* discovered by Hermann Wilhelm Vogel in 1873 for green light and in 1884 for orange light; the extension of the sensitivity to red light was achieved in the early years of the twentieth century. (Materials sensitized to green and orange were used for the Lippmann and micro-dispersion methods of color photography described earlier.)

One-Shot Cameras Maxwell's method, involving three successive exposures through different filters and projection from three projectors in register, is inconvenient, and much ingenuity has been used to find better ways of carrying out additive trichromatic color photography. Many different workers were involved, among whom Louis Ducos du Hauron and Frederic E. Ives were particularly prominent.

One way of simplifying the exposing step was to use a one-shot camera. In this device, after passing through the lens, the light was divided into three beams by semireflecting mirrors and focused on to three different pieces of photographic material, a red filter being used in one beam, a green filter in another, and a blue filter in the third. Similar devices, sometimes known as *Kromskops,* were also made for viewing the three positive images, by superimposing their virtual images seen in the semireflecting mirrors.

Mosaic Processes An alternative method was to cover the photographic material with a fine mosaic of small areas of red, green, and blue filters. The red, green, and blue records were then made on neighboring areas of the same piece of photographic material, processed to a positive, and viewed at a sufficient distance for the red, green, and blue light from the small areas to blend together just as effectively as in triple projection. The success of this method depends on the fact that the eye has only a limited resolution, determined by the optical properties of its lens system and by the finite size of the cones in the retina. The majority of modern color television display devices depend on this same principle, the small areas in this case being occupied by phosphors that emit either red, green, or blue light when irradiated with electrons.

One of the earliest, and most successful, of the mosaic additive color photographic processes was developed by the brothers Auguste and Louis Lumière, and called Autochrome. It was introduced in 1907 and was still being sold in the early 1930s. It used a random mosaic of dyed starch grains to provide the filtration.

Another mosaic process that had a long life was the Dufay system, which was introduced in 1908 and was still being sold in the 1940s. It used a regular mosaic of rectangles of red, green, and blue areas.

The most recent examples of additive mosaic photographic processes are those introduced by Polaroid in 1977 (Polavision for movies) and 1983 (Polachrome for slides). These processes used a regular arrangement of red, green,

and blue stripes, there being the astonishingly high number of about 60 triads of stripes per millimeter.

Lenticular Processes Another system of additive color photography that met with some success, especially for cinematography, was the *lenticular process.* In this process the lens is covered by stripes of red, green, and blue filters. The film base has furrows, or lenticulations, embossed on one side, and the emulsion is coated on the other (smooth) side. The film is exposed in the camera through the base, and the lenticulations form, on the emulsion, images of the stripes of filter on the camera lens. The red, green, and blue records are therefore exposed on neighboring strips of the film. The film is processed to a positive and projected with its lenticulated base toward the lens, which has a similar set of stripes of filter over it; this ensures that light transmitted by the area of the film exposed originally to red light passes through the red filter on the projection lens, and similarly for green and blue.

The lenticular system was invented by R. Berthon in 1909, developed by A. Keller-Dorian, and demonstrated as the Keller-Dorian Berthon process in 1923. In 1928 Kodak introduced a lenticular process for 16-mm movies called Kodacolor, which lasted until 1937. It used 22 lenticulations per millimeter.

SUBTRACTIVE COLOR PHOTOGRAPHY The history of subtractive reproductions goes back to times before the invention of photography. For example, in 1722 Jakob Christoffel LeBlon was using a form of three-color printing. The main credit for introducing the idea of subtractive color photography, however, must go to Louis Ducos du Hauron, who described it in some detail in 1868. The principle, which du Hauron had clearly grasped, is to modulate the reddish, greenish, and bluish thirds of the spectrum in a beam of white light by varying the amounts of a cyan (red-absorbing) dye, a magenta (green-absorbing) dye, and a yellow (blue-absorbing) dye.

Assembly and Transfer Processes Initially the red, green, and blue records were still obtained by making successive exposures or by using a one-shot camera. From these records, images in cyan dye were made from the red record, in magenta dye from the green record, and in yellow dye from the blue record. These three dye images then had to be assembled in register to make the final picture. Many methods for forming the dye images and assembling them in register were tried, with varying degrees of merit, but only two achieved appreciable commercial success: Carbro and Technicolor. Both processes ran for many years and only became obsolete when integral tripack materials became available.

In the Carbro process, gelatin layers were used in which the hardness of the gelatin could be made to depend on exposure to light or on contact with a silver image. On washing such exposed gelatin layers with hot water, the unhardened gelatin was removed, leaving the hardened gelatin as a relief (in-depth) image that could be dyed cyan, magenta, or yellow. The gelatin layers were then assembled by superimposing them in succession on a suitable support.

In the Technicolor process, gelatin relief images were also made and dyed, but instead of assembling the gelatin images, the dyes were transferred in succession to a suitable receiving material. One important advantage of such a *dye transfer,* or *imbibition* process is that the gelatin images can be redyed and used to make further copies; this was the way in which many copies of films were made by the Technicolor process. The Technicolor process also used a rather unusual form of one-shot camera. After passing through the lens the light was split by a prism into a green beam and a red plus blue beam; a single film was used to record the green record from the green beam, but the red plus blue beam was imaged onto a sandwich of a blue-sensitive film and a red-sensitive film. The blue-sensitive film was exposed through its base

and incorporated a yellow filter to prevent blue light from exposing the other film in the sandwich. An imbibition process similar to Technicolor but for making reflection prints is the Kodak dye transfer process.

Integral Tripacks The Technicolor camera used a sandwich of two films, and attempts had also been made to use sandwiches of three films together. With three films, however, it is impossible to get all three emulsion layers in close proximity, and the presence of the thickness of a film base between some of the images made such tripacks impracticable because of the unsharpness of the resulting pictures.

The way to overcome this problem of getting three emulsion layers in intimate contact was foreseen by du Hauron as long ago as 1895; what was required was to coat at least two of the emulsions on top of one another on the same support. Karl Schinzel, in 1905, first proposed coating, on the same support, first a red-sensitive layer, then a green-sensitive layer, and then a blue-sensitive layer. It was in 1912, however, that the most complete description was first published of what has now become known as the *integral tripack,* which is used for the vast majority of all color photography today. It was given in a patent granted to Rudolph Fischer, which contained the following statement: "Three positives may be obtained in one operation by the use of three superposed emulsion layers sensitized for the particular colors, and in which the substances necessary for the formation of the colors are incorporated. Intermediate colorless insulating layers are preferably used to prevent diffusion of the colors, and a yellow filter layer is used to reduce the sensitiveness to blue of the red and green layers." Fischer thus gave a full description of the integral tripack, including the yellow filter layer and the incorporation of *couplers;* he also described how the couplers should form dye images by combining with oxidized developer in proportion to the amount of silver developed. Current practice uses one of the two types of developing agents, and two of the five types of image dyes, described by Fischer.

Kodachrome The stage was set in 1912 for the integral tripack as we know it today. More than 20 years were to pass, however, before a successful integral tripack was produced. Among the difficulties that prevented earlier success was the tendency for sensitizing dyes, couplers, and other components to wander from one layer to another, thus spoiling the results.

It was left to two professional musicians, the pianist Leopold Mannes and the violinist Leopold Godowsky, Jr., to lead the way in finding solutions to these problems. Working at first in New York City as amateur hobbyists, in 1922 they caught the attention of C. E. Kenneth Mees, the Director of Research of the Eastman Kodak Company, who provided experimental coatings for their work. In 1928 the Kodak Research Laboratories discovered sensitizing dyes that were less prone to wander from one layer to another, and in 1930 Mannes and Godowsky moved to the Kodak Research Laboratories in Rochester, New York.

The problem of finding couplers that would not wander from one layer to another had still not been solved, so the first commercially successful integral tripack, Kodachrome film, did not incorporate the couplers in the layers but used them in three separate color developers. The initial Kodachrome process was quite complicated. After developing negative images in all three layers, the remaining silver halide was developed in the presence of a cyan coupler in the developing solution to form cyan dye in all three image layers. The cyan images in the top two image layers were then bleached, and the silver halide in these top two layers was redeveloped to form magenta dye images. After bleaching the magenta image in the top layer, this was then redeveloped to form a yellow dye image.

By 1938 sensitizing dyes had been discovered that did not wander from one layer to another, even when the film was being processed in aqueous solutions. It then became possible to form the dye images separately in the three layers and avoid the difficult dye-bleaching steps. In the revised process, after developing the negative images in all three layers, the film was exposed to red light through the base and then developed in the presence of a cyan-forming coupler; the cyan image was thus formed in the bottom layer only. The film was then exposed to blue light from the top and redeveloped in the presence of a yellow-forming coupler; the yellow image was thus formed in the top layer only. Finally, the film was developed in a fogging developer in the presence of a magenta-forming coupler; the magenta image was thus formed in the other image layer only. The Kodachrome process has remained basically the same ever since. The new process was not only less complicated and less critical to operate but also resulted in dye images of good stability, the original dye images being rather fugitive.

Agfacolor Meanwhile, in Germany, the problem of finding couplers that did not wander from one layer to another was being solved by the Agfa Company. Research carried out by G. Williams resulted in the attachment to the coupler molecules of long molecular chains that acted as a ballast and prevented the couplers from wandering. The first film of this type, Agfacolor Neue film, was introduced in 1936. It was thus the first successful reduction to practice of Fischer's 1912 patent. The processing steps in a film with the couplers incorporated are simpler than those for a film in which the couplers are in the developers. With the couplers in the film, only one developer is required for a color negative image, or two for a reversal positive image.

Kodacolor A different solution to the problem of immobilizing the couplers was adopted by Kodak with the introduction of Kodacolor film, a negative film for making amateur reflection prints. The couplers in this product were dissolved in oily solvents and then dispersed in the form of tiny oily droplets in the emulsion layers. The oxidized developer was able to penetrate the droplets to form the image dyes, but the droplets were not able to move from one layer to another. The negatives obtained on the Kodacolor film were printed onto a similar integral tripack coated on paper to produce the final paper prints.

Ektachrome and Eastman Color Using the same principle of the oily droplets, a reversal film, called Ektachrome film, was introduced in 1946, and a negative camera film and positive print film, Eastman Color Negative Film and Eastman Color Print Film, for professional motion picture production, were introduced in 1950.

Colored Couplers The use of cyan, magenta, and yellow dyes twice in the negative–positive systems means that their unwanted absorptions take their toll twice, and the resulting colors can then be quite poor. In 1948 W. T. Hanson of the Eastman Kodak Research Laboratories introduced the concept of *colored couplers.* By making the magenta-forming coupler have a yellow color that was gradually reduced as it was used up during development, it was possible to correct for the unwanted absorption of the magenta dye; and by making the cyan-forming coupler have a pink color that was gradually reduced as it was used up during development, it was possible to correct for the unwanted green and blue absorptions of the cyan dye. The use of colored couplers was a very important advance in the technology of color photography, and they are now widely used in the products of many manufacturers.

Printing Color Negatives The appearance of color negatives is too unfamiliar for it to be possible to judge by inspection how they should be printed in terms of their density and color balance, but unless these variables are near optimum, the quality of the final pictures is considerably degraded. In professional work, whether for still photography or for

motion picture production, it is often feasible either to make test pictures before making the final print or to use sophisticated control equipment for maintaining good density and color balance. In the production of large numbers of reflection prints for the amateur market, however, some quick and reasonably reliable means of adjusting the printer setting is required for each negative.

Ralph M. Evans of the Eastman Kodak Company solved this problem in 1946 with the introduction of the principle of *integrating to gray*. In printers that use this principle, the transmittances of each negative to red, green, and blue light are measured, and then the exposures given to the red-, green-, and blue-sensitive layers of the paper are made inversely proportional to the appropriate one of the three transmittances. The effect of this is to make prints whose reflected light approximately integrates to gray. Although this is sometimes not the best thing to do (for instance, if the scene has a large area of blue sky in it, the print will tend to come out too yellow), it has been found that, for most scenes, the integrating to gray principle provides a simple, quick, and reasonably reliable method of making prints, and it has been an indispensable part of the technology that has made the mass production of prints for the amateur market so successful. The yield of good prints can be increased by introducing parameters that modify the integrating to gray principle, and these are used in many modern printers.

Coating Multilayers When integral tripacks were first manufactured, the three emulsion layers, the yellow filter layers, and any other layers required had to be applied one at a time in succession. This was a lengthy procedure that was not easy to control and was costly to operate. In 1955 T. A. Russell, of the Eastman Kodak Research Laboratories, was having difficulty in mixing together two different emulsions before coating. This gave him the idea that perhaps it might be possible to coat the two emulsions on top of one another by extruding them through a double hopper. The idea worked. In fact by incorporating appropriate surface agents, it was possible to coat four or even more layers at the same time. The component emulsions were extruded through hoppers and allowed to slide down a ramp on top of one another until they met the web on which they were to be coated, suction being applied at the coating bead to keep it on the web. It was then found that, using this technique, each emulsion layer could be much thinner than in the old one-at-a-time method, and this resulted in much thinner tripacks and hence considerably sharper pictures. The thinner layers also required less drying capacity in the coating machines, and faster coating was therefore possible. Finally, the application of the emulsions at the same time improved product consistency considerably.

Few inventions have incorporated so many advantages simultaneously as hopper coating did for the manufacture of photographic materials. The method gave pictures that were much sharper, manufacturing costs that were much lower, and products that were much more consistent.

The method was licensed to other photographic manufacturers all over the world, and it has undoubtedly been a major factor in the widespread use of integral tripacks in color photography.

Image Stability In some of the early systems of subtractive color photography, the stability of the images was only moderate. In recent years much effort has been spent on improving the stability of dye images for both dark keeping, and exposure to light. This has involved the synthesis of better couplers and the introduction into both the photographic materials and their processes of compounds that act as stabilizing agents. A dark life of 50 years or more and a room life of 10 years or more are now possible.

Dye-Bleach Systems Instead of forming the image dyes by color development, it is possible to start with the maximum amounts of cyan, magenta, and yellow dyes before the exposure is made and then to bleach away the unwanted dye in an image-wise way in each layer. Bela Gaspar developed this type of process in the 1930s. In 1953 Ilford Limited introduced its Ilford Color Print process, which was based on this principle, and it was a commercial success for several years. The CIBA company in Switzerland introduced another dye-bleach process in 1963, called Cibachrome (renamed Ilfochrome), which provides a reversal print system with good dye stability among its virtues.

Instant Color Photography In 1963 Polaroid introduced its Polacolor system. In this system, a special film is processed within the camera so that the result is available in situ shortly after the exposure has been made. The system is similar to the dye-bleach system, in that maximum levels of cyan, magenta, and yellow dyes are present before the exposure is made, but the exposure, instead of bleaching dye, results in a change in mobility so that the cyan, magenta, and yellow dye images can migrate from their tripack to a receiving sheet. In the original version of this system, the receiving sheet had to be peeled apart from the tripack to obtain the print. In a revised version, introduced in 1972, the receiving sheet is integral with the tripack so that it is not necessary to peel the receiving sheet apart; the image is laterally reversed, however, so that the camera has to have a mirror incorporated in it.

In 1976 Kodak introduced a different system of instant color photography, but it was withdrawn in 1986 because of patent litigation.

Photographic Speed A characteristic of the history of color photography has been the steady increase in the photographic speed of color systems. From the extremely slow Lippmann and micro-dispersion methods to the first integral tripack Kodachrome film, the speed had risen to the point where exposures of 1/50 second at an aperture of f/6.3 were recommended in sunlight. Today films having speeds more than 100 times as fast are available. This has come about as a result of improved methods of sensitizing photographic emulsions, both by means of better chemical sensitizers and also by the use of better sensitizing dyes. More sophisticated coating patterns made possible by the introduction of hopper coating have also played their part. For instance, by coating an emulsion in two parts, a fast layer on top of a slow layer, it has been possible to attain a higher speed for a given granularity than with a single layer. In some products, the fast red layer is coated on top of the slow green layer, and further speed increases can be obtained in this way. The use of tabular-shaped grains that have an increased surface-to-volume ratio has also resulted in increased speed.

There is an ultimate limit to the speed that can be attained in a color photographic film for a given resolving power, but studies have suggested that existing films are probably short of this limit by a factor of about ten. There should, therefore, be room for further increases in the speed of photographic color films in the future.

PHOTOGRAPHY AND ELECTRONICS The history of photography has been closely tied to silver halide products. The rise of television has introduced another principle of image capture, the all-electronic camera. Both systems are confined ultimately by the basic laws of physics that set upper limits for speed, noise or granularity, and resolution. In spite of some confident forecasts in the past that silver halide was doomed to be replaced by electronic cameras, photographic film continues to hold its own, not only in its own fields of amateur and professional still photography and in professional motion picture photography, but also in broadcast television, where film is widely used for program origination. Only in the field of amateur movies has there been a significant move away from silver halide films to electronic cameras.

Visual Resolution and Minimum Visible Detail at Different Magnifications

Viewing Situation	Magnification	High-Contrast Object		Low-Contrast Object		Structure Visible
		Cycles per mm[1]	μm[2]	Cycles per mm[1]	μm[2]	
Naked eye	1	5	100 (0.1 mm)	1	500 (0.5 mm)	None
Projected with 100 mm lens At projector	2½	12½	40	2½	200	None
Halfway from screen	5	25	20	5	100	Little or none
One-tenth distance from screen	25	125	4	25	20	Grain clumps
Microscope	250	1250	0.4	250	2	Single grains
Electron microscope	2500	12500	0.04	2500	0.2	Dye droplets

[1] Resolution
[2] Diameter of smallest visible detail

It seems that there is an inherent convenience and a superb information storage capacity in silver halide films that make it likely that it will still be around for many years to come. Hybrid systems, however, where both film and electronics are used together, can offer advantages over either system on its own, and it seems likely that, in the future, increasing use will be made of such cooperative technology.

Books: Coe, Brian, *Colour Photography*. London: Ash and Grant, 1978; Hunt, R. W. G. *The Reproduction of Colour*. 4th edition. New York: Van Nostrand Reinhold, and Surbiton, England: Fountain Press, 1987. *R. W. G. Hunt*

See also: *Color photography*.

COLOR PHOTOGRAPHY: IMAGE STRUCTURE

When a color photograph is viewed without any magnification, the only structure visible may be that of the subject matter of the picture. If increasing degrees of magnification are introduced, however, it becomes apparent that, just as in the case of black-and-white photography, the image is composed of a granular structure.

MAGNIFICATION If a 35-mm slide is held in the hand and viewed at about 250 mm (10 inches) distance, no granular structure will be visible. In this case, assuming a visual resolution of 20 cycles per degree (objects down to about 1½ minutes of arc in diameter visible), the eye cannot see detail finer than about 5 cycles per millimeter, so that the smallest object visible, which would be half of a light–dark cycle, would be about 1/10 mm in diameter. If, however, the slide is projected using a projection lens of 100-mm focal length, the magnification introduced will be 250/100, that is 2½ times, if the screen is viewed from near the projector, or twice this amount, that is 5 times, if the observer is half way between the projector and the screen; the limits of resolution on the slide then become 12½ or 25 cycles per millimeter, respectively. At these magnifications the picture is usually still largely free of granular appearance, but if the magnification is increased much further, some granular structure usually becomes apparent. If the screen is viewed from a distance equal to one-tenth the projector-to-screen distance, so that the magnification is 25 times, then areas that appeared uniform before will appear granular, much less sharp, and lacking in fine detail. Visual resolution is now down to about 125 cycles per millimeter (so that objects of about 0.004 mm, or 4 micrometers (μm), diameter are visible). If, by using a microscope, the magnification is increased by a further 10 times, to 250 times, the limit of visual resolution is now 1250 cycles per millimeter (0.4 μm objects visible), and the image will appear to consist of small blobs of different colors. A further increase of magnification to about 2500 times, using an electron microscope, so that the limit of resolution is about 12,500 cycles per millimeter (0.04 μm objects visible), might

reveal that the blobs themselves consist of clouds of small droplets of dye.

The granular structure of most color photographic images is caused by their derivation from silver halide photographic emulsions, which are themselves composed of discrete crystals, or *grains* as they are usually called. The average size of these grains varies from about 0.5 μm in diameter for slow emulsions such as are used in print films, up to about 1.5 μm in diameter for fast emulsions such as are used in x-ray films. In any one emulsion the grains usually cover quite a large range of sizes. Because the larger the grain the more light it can absorb in a given time, the range of sizes can be useful in providing grains having a range of sensitivities. This can result in an emulsion that can accommodate a wide range of exposures, that is, one that possesses good *exposure latitude*.

In emulsions used for camera films in color photography, the mean grain size can be regarded as about 1 μm in diameter. Hence, the 25 times magnification involved in the close inspection of the 35-mm projected slide, with its 4-μm limit in resolution, does not enable the grains to be seen. The reason that the image looks granular at this magnification is that the grains are not present in a regular array but are distributed more or less randomly, and this results in clumps of grains and grain-free areas of much more than 4-μm diameter being present. It is these areas, sometimes extending up to about 40 μm in diameter, that make the pictures appear granular.

The developed silver grains and the undeveloped silver halide grains in color images are usually all removed in the processing sequences, so that the blobs in the image are small volumes of cyan, magenta, and yellow dyes produced by the color development step. If the couplers forming these dyes are uniformly dispersed in the emulsion layers or are provided from color developing solutions, then the small volumes of dye formed around each developed silver grain have only molecular structure, but if the coupler is dispersed in small oil droplets, then the volumes of dye have a substructure of these droplets. These volumes of dye, which can be called *color grains,* may be similar in size to, or slightly larger than, those of the silver halide grains. Thus, the separate volumes may be about 1 μm in diameter (although they occur frequently merged together into larger volumes), but the individual droplets, when present, are usually about 0.1 to 0.2 μm in diameter. It is thus clear why magnifications of 250 times (giving resolution down to 0.4 μm) are necessary to see the color grains, and 2500 times (giving resolution down to 0.04 μm) are necessary to see the oil droplets. These figures are summarized in the table, where limits for visual resolution are given for high-contrast detail, and also for low-contrast detail for which the resolution is much reduced; the granular structure in film images is often of medium contrast

for which figures intermediate between the two sets given in the table will be applicable.

GRAININESS AND GRANULARITY The degree to which the granular structure of a photographic image is apparent to an observer is termed the *graininess;* the physical property of the photographic materials that causes graininess is termed the *granularity.* Graininess is thus a subjective term; granularity is an objective term. At a given magnification, a particular piece of film illuminated in a given manner has an invariant granularity, but its graininess at that magnification may vary according to the conditions of viewing. For example, if surrounded by an area of much higher luminance, the graininess may become imperceptible. Graininess is usually objectionable in pictures because it results in uniform areas being reproduced with spurious texture (or motion, in cinematography) and because it results in fine detail being broken up.

In color images, the total visual graininess is made up of superimposed cyan, magenta, and yellow grain patterns, and it might therefore be thought that the graininess would appear to consist of fluctuations in both brightness and color. For most applications, however, films are used near enough the threshold of perceptible graininess for the color fluctuations to be largely unnoticeable. To see color differences it is necessary for each of the three types of retinal cones to be represented in each elemental area. To see brightness differences it is only necessary for one of the three types of cones to be represented (or, more precisely, any one of two of the three types, since the blue-absorbing cones contribute negligibly to the perception of brightness). Bearing in mind the random distribution of the cones in the retina, this makes the magnification at which luminance differences are visible about four times less than that at which chromaticity differences are visible. It has therefore been found that the graininess of color films correlates well with just luminance fluctuations.

For black-and-white films, granularity increases with density. For color films this is not always so. At high densities the dye clouds may merge together so that the granularity decreases.

SHARPNESS The degree to which fine detail and edges in pictures are clearly displayed is referred to as *sharpness.* Loss of sharpness can occur as a result of various effects.

First, if the optical image that exposes the photographic material is blurred, then of course the resulting latent image will be unsharp. This blurring can be caused by incorrect focusing of the camera or printer, or by optical aberrations in the lens, or by movement of the image during the exposure, or by the inability of the camera lens to bring objects at different distances all into focus at the same time.

Second, because photographic emulsion layers diffuse the light as it passes through them, even if the optical image were perfectly sharp, the photographic latent image would be less sharp. In multilayer color films, diffusion of the light by the upper layers often causes the sharpness of the images in the lower layers to be appreciably reduced. Sharpness can be improved by using emulsion layers of low turbidity, especially in the upper layers. Because the magenta image usually affects sharpness most, and the yellow layer least, sharpness can be improved by coating the magenta layer on the top and the yellow layer at the bottom; this can only be done with emulsions with little natural blue sensitivity, such as chlorobromide emulsions, and these are of slower speed, so this layer order can usually only be used for films intended for printing, where high photographic speed is often not important. Diffusion of light in emulsion layers can also be reduced by incorporating absorbing dyes in the layers; as these dyes reduce the speeds of the layers, they too can usually only be used with print films.

Third, when color images are formed by chemical constituents, produced at the grains, and combining subsequently with couplers to form the dyes, then diffusion of these chemical constituents may result in the photographic image being only diffusely related to the latent image. These diffusion effects can be reduced by adding suitable scavenging compounds to the emulsions.

Fourth, the granular nature of photographic images can reduce their sharpness; however, this is usually only a minor factor compared with those described above.

Books: Hunt, R. W. G., *The Reproduction of Colour.* 4th edition. New York: Van Nostrand Reinhold, and Surbiton, England: Fountain Press, 1987. *R. W. G. Hunt*

See also: *Images; Vision.*

COLOR PHOTOGRAPHY: INSTANT By processing the photographic material in the camera, it is possible to have a finished picture available within a few minutes of making the exposure. In these *instant* systems, the dyes are not usually formed by color development but are present in the film as uniform layers before exposure. The result of exposure and processing is then to transfer to another layer different fractions of the dyes in order to form a dye image that is appropriately related to the exposure.

THE POLAROID SYSTEM In the Polaroid system, called *Polacolor* and introduced in 1963, the cyan, magenta, and yellow dye molecules are attached to hydroquinone molecules. After exposure, the material is passed through rollers that break pods of alkaline activator that enables the hydroquinone to develop the exposed silver. This development activity renders the hydroquinone insoluble so that the dyes in developed areas remain *in situ;* where development has not occurred, the dye–hydroquinone compounds can migrate to a receiving sheet where the dye is mordanted to form a permanent image. In the earlier version of the system, the receiving sheet was peeled away from the rest of the materials, but in 1972, a new, integral, version of Polacolor was introduced in which it was not necessary to peel apart the receiving sheet. Because the image in the Polacolor system is viewed from the lens side of the material, it is necessary for Polacolor cameras to incorporate a mirror to avoid lateral reversal of the image.

THE KODAK SYSTEM In the Kodak instant system, which was introduced in 1976, special emulsions are used that can be processed to give positive images by development of the unexposed areas instead of the exposed areas. In the unexposed areas the developing agent is oxidized, and this renders incorporated cyan, magenta, and yellow dyes diffusible; the dyes then diffuse to a receiving layer, where they are mordanted to give a permanent image. In the Kodak system the image is viewed from the nonlens side and, hence, no mirror is necessary to avoid lateral reversal (although some cameras using this system incorporated a pair of mirrors to make the cameras more compact). The Kodak system was withdrawn from the market in 1986 as a result of patent litigation.

ADDITIVE INSTANT SYSTEMS Rapid processing of black-and-white emulsions coated beneath a mosaic of red, green, and blue filter areas can also result in systems in which the final image is available a few minutes after exposure. Polaroid introduced such a system for instant movies in 1977 called *Polavision,* and a similar system for instant slides in 1983, called *Polachrome.* These systems use triads of red, green, and blue filter stripes, having the remarkably small size of 60 triads per millimeter.

CHARACTERISTICS OF INSTANT SYSTEMS To have the image available within a few minutes of the exposure is an important advantage in many applications, such as instrument recording, microscopy, and other scientific work. For more general applications, instant systems have several disadvantages. First, the instant picture is the same size as

the camera frame, so that the absence of an enlarging step results in a compromise between having either small prints or large cameras. Second, the technology needed to achieve the instant feature of the systems generally results in the photographic speed, sharpness, and color rendering being inferior to that obtainable in conventional color photography. Third, the cost per picture is generally higher than for conventional systems. Fourth, in amateur photography, the accumulation of prints while photographing can be inconvenient, and a delay before seeing the pictures can actually heighten the sense of reliving an occasion that is part of the fascination of photography. Fifth, conveniently located one-hour or less color processing labs are readily available. These disadvantages have resulted in only a limited use of the instant systems for amateur photography.

Books: Hunt, R. W. G., *The Reproduction of Colour.* 4th edition. New York: Van Nostrand Reinhold, and Surbiton, England: Fountain Press, 1987. *R. W. G. Hunt*

COLOR PHOTOGRAPHY: PRINTING

Although the word *printing* is widely used to mean the application of ink to paper, in photography it is used to mean the derivation of one photographic image from another. Thus, negatives are *printed* onto photographic paper or print films to obtain positive images. Positive images are also sometimes printed, for instance, when extra copies are required or when a change in the size or other characteristic of the image is needed. In color photography, it is often necessary at the printing stage to make adjustments for density and color balance. When the original is a positive it is not difficult to assess visually the types of correction that need to be made. When the original is a color negative, however, visual assessment is not possible, and other means have to be found, which vary according to the application.

PRINTING STUDIO NEGATIVES If studio lighting is carefully controlled, the single batches of film and paper or print film are being used, then, after establishing, by trial and error, the correct printing conditions for a typical negative, the same conditions can usually be used for other similar negatives.

If more variable lighting conditions occur and different batches of film are used, a gray card can be included near the edge of the scene, or in an exposure on an adjacent frame similarly illuminated, and densitometric readings on the area of the negative corresponding to this gray card can be measured and used to predict the required printing conditions.

Another method is to use a television tape of film scanner to display a positive image of each negative on a monitor; the monitor can then be adjusted to give a picture of the required density and color balance and its settings used to make the appropriate adjustments to the printer.

The actual adjustment of the color of the exposure can be made by inserting pale cyan, magenta, and yellow filters into the beam of light being used for the printing; density can be adjusted by controlling the exposure time, or the lens aperture, or by using neutral filters.

PRINTING AMATEURS' NEGATIVES When the color negative is used for amateur photography, a wider variety of lighting is encountered, and other factors also vary more, so that printing adjustments are even more necessary, but a reasonably low price is needed for their mass production. It is therefore essential to have a method of printing that is quick, does not require highly skilled operators, and yet gives a high yield of saleable prints at the first printing.

Printers used for printing amateurs' negatives usually depend on a principle first enunciated by Ralph M. Evans in 1946. According to this principle, prints are made so that the total light reflected from them integrates approximately to gray. Evans argued that this would enable the eye to adapt

to them more readily and, hence, make their color balance appear acceptable. The small visual fields usually subtended by typical prints limits this effect considerably, however, and the success of the principle depends more on the fact that the light from many actual scenes approximately integrates to gray.

The procedure usually adopted is to measure the integrated light transmitted by each negative through appropriately chosen red, green, and blue filters and then to expose the red-sensitive layer of the paper to an extent that is inversely proportional to the red transmittance of the negative and the green and blue layers of the paper for extends similarly related to the green and blue transmittances of the negative, respectively. When this is done, the light from each print obtained does not exactly integrate to gray because the measured transmittances of the negatives depend more on the dark parts of the scene (light on the negative) than on the light parts of the scene (dark on the negative).

This method of printing does result in errors in print color balance for some types of scene. Any scene that has a large area of a color of high saturation tends to be printed with a color bias of the opposite hue. For instance, if there is a large area of blue sky, the print tends to be somewhat yellowish. One of the worst cases is a scene in which a baby is photographed against a red carpet; the resulting cyan bias can have a disastrous effect on the color of the baby. Such cases are said to exhibit *color failure,* and when they occur the negatives have to be reprinted with deliberate corrections away from the integrating to gray balance. Similar errors can arise from unusual distributions of lightness in scenes. For instance, snow scenes tend to be printed too dark, and night scenes too light, a situation referred to as *density failure.* Again, deliberate corrections away from integrating to gray have to be made. For the majority of the scenes that occur in typical amateurs' pictures, however, the integrating to gray principle works surprisingly well.

The yield of saleable prints can be increased by making more sophisticated measurements on the negatives. For instance, separate measurements can be made in the center, in the top, and in the bottom of the picture; and the measurements in the center area can be made at as many as 100 different picture subareas. Computer programs have been devised to use this information to increase the yield of acceptable prints to the point where the incidence of color failure and density failure are much reduced.

Books: Hunt, R. W. G., *The Reproduction of Colour.* 4th edition. New York: Van Nostrand Reinhold, and Surbiton, England: Fountain Press, 1987. *R. W. G. Hunt*

See also: *Printing techniques (color).*

COLOR PHOTOGRAPHY: TONE REPRODUCTION

The way in which the lightnesses of colors are reproduced, called *tone reproduction,* can have a profound effect on the appearance and quality of color pictures.

Although absolute luminance levels have some effects on tone reproduction, they tend to be second-order effects, and it is possible, therefore, to a good approximation, to consider only relative luminances.

TONE REPRODUCTION FOR REFLECTION PRINTS The slopes of lines plotted in logarithmic graphs of density versus luminance are referred to as the *gammas,* and the lines themselves as *characteristic curves,* or *D-log H curves.*

When reflection prints are viewed in typical rooms, the topmost surfaces reflect some light from the ambient illumination that does not pass through the dye layers in the print. This *flare* light is usually added uniformly all over the surface of the print, but on a density scale, it makes a much larger difference at high densities than at low densities. To offset the effect of this viewing flare, and also typical effects

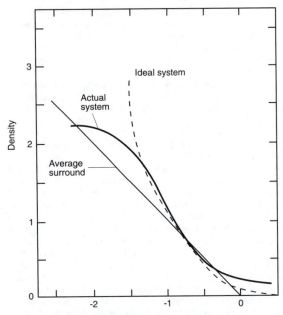

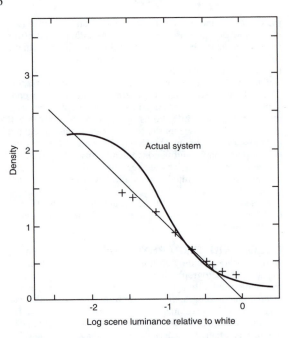

Tone reproduction for reflection prints. The straight line at 45 degrees represents tone reproduction in which the relative luminance in the reproduction are the same as those in the original. This is because density (which can be regarded as log reproduced luminance relative to a reference white) is plotted against log scene luminance relative to a reference white. This line is marked "Average surround" because it is an appropriate aim for the tone reproduction for pictures viewed in surrounds of approximately the same average luminance as that of the picture; this situation usually applies when reflection prints are viewed. The line marked "Ideal system" shows the relationship between density and log scene luminance relative to white that a photographic system must have in order to achieve correct tone reproduction in the presence of a surround of the same average luminance as that of the reproduction, as shown by the line marked "Average surround." The difference between these two lines is caused mainly by the presence of typical amounts of camera flare, printer flare, and viewing flare. The curve marked "Actual system" is the combined characteristic curve for a commercially successful system used for the production of color reflection prints.

Color reflection print. The densities seen by an observer (crosses) looking in an ordinary room at a color reflection print reproduction of a nine-step gray scale photographed in bright sunlight on a film–paper system having the characteristics of the "Actual system" line.

of camera flare, it is therefore necessary at high densities for the photographic system to result in much higher densities (as measured in a typical low-flare densitometer) than those given by the 45 degree line. Such densities are shown by a curve that has increasingly high gammas as the density increases. In deriving this curve the amount of camera flare is chosen to be representative of good quality cameras, and the amount of viewing flare typical of that occurring with the viewing of glossy photographic prints in typical room viewing situations. It will be noted that, at low densities, this curve also has lower densities than those of the 45 degree line, and this is to offset the flare in the printing step, it being assumed that the reflection print is made from a color negative in an optical enlarger or printer. The rounded toe of the curve at extremely low densities is to provide a gradual, instead of a sudden, reduction in density modulation as the scene luminance exceeds that of the reference white (as occurs in catchlights in the scene, for instance). The curve marked *Actual system* is the combined characteristic curve provided by a negative film and a printing paper without the effects of camera flare, printing flare, or viewing flare; such curves are sometimes referred to as *print-through curves*. It can be seen that the "Actual system" curve follows the "Ideal system" curve quite closely, except at the low-density end

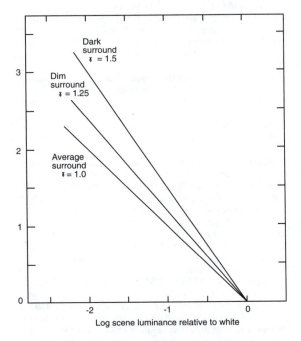

Print viewing surround. The relationship required between density seen in the reproduction, and log luminance in the scene relative to white when the reproduction has an average surround in which the luminance is similar to the average of that of the reproduction (as in the viewing of reflection prints); or a dim surround (as with cut-sheet transparencies viewed on a light-box in room light, or as in typical viewing of television displays); or a dark surround (as with film projected in a dark auditorium).

where it is slightly too high, because of the stain or fog of the paper; and at the high density end where it is too low, because of the impossibility of achieving the infinitely high gamma called for by the "Ideal system" curve.

The crosses show the densities actually seen by an observer in the presence of camera flare, printer flare, and viewing flare, using film and paper giving the "Actual system" curve. It is clear that, although the characteristic of the actual photographic system is very curved, with a maximum gamma well in excess of 1.0, the crosses still lie on the 45 degree line over most of their density range. (At the high-density end the viewing flare is the main factor in reducing the densities from the "Actual system" curve values to the values of the crosses.) Major deviations only occur below a density of about 0.4, where light grays and white are reproduced too dark, and above about 1.4, where dark grays and blacks are reproduced too light. Hence, good reproduction of relative luminances has been achieved over most of the density range.

TONE REPRODUCTION FOR TRANSPAREN-CIES When pictures are viewed on transparent film, the situation is rather different. Whether the transparency is of the cut-sheet type and is viewed on an illuminated light box or whether it is a slide or a motion-picture film and is viewed by projection, the average luminance of the surround is now appreciably less than that of the picture; and any effects of this may be enhanced by the fact that most such reproductions are viewed at reduced angular magnifications, and typically only occupy some 10 to 15 degrees of the visual field.

If the transparency is in the form of a film of cut-sheet size and is viewed on an illuminated light box that it completely covers, then the surround will consist of the rest of the room in which the viewing takes place. The luminance of objects in the room is usually lower than those in the transparency and we may call this a *dim surround*. If the film is projected in a dark room, the surround is normally of a very much lower luminance than that of the picture, and we may call this a *dark surround*. The effects of these dim and dark surrounds are to make the pictures appear lighter than would be the case with a surround of the same luminance, but such lightening occurs to a greater extent in dark areas than in light areas of the picture. Hence, a darker surround lowers the apparent contrast. With a dim surround, in order to produce tone reproduction that appears correct, it is necessary to increase the effective objective gamma of the photographic system to about 1.25. With a dark surround the apparent lightening of the dark areas of the picture is even more marked, so that to produce tone reproduction that appears correct now requires a gamma of about 1.5. Only if the reproduction is seen with a surround having the same average luminance (an average surround) will a gamma of 1.0 be appropriate, and this condition generally applies only when reflection prints are being viewed.

In order to achieve the gammas of 1.25 and 1.5, it is necessary for the photographic materials to have even higher gammas (as measured in typical low-flare densitometers) in order to overcome the effects of flare light in the camera and in the viewing situation (and in the printing step, if any). The amount of viewing flare depends very much on the projection conditions. Under the very best conditions, the flare light, when projecting film of normal density, is equal to about 0.1% of the open-gate screen luminance, but under average conditions, it might amount to about 0.6%. It is seen that the gamma of the film has to be increased at high densities by gradually increasing amounts so that the required relationship becomes curved. If the flare were greater than the value chosen, the curvature would be greater and would extend to lower density levels.

As in the case of reflection print systems, transparency systems must have gradually decreasing gammas at the light end

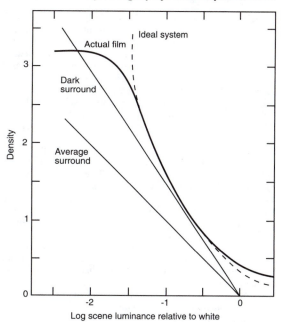

The line marked "Ideal system" shows the relationship between density and log scene luminance relative to white that a photographic system must have in order to achieve correct tone reproduction in the presence of a dark surround. The difference between the "Ideal system" and "Dark surround" lines is caused mainly by the presence of typical amounts of camera flare and viewing flare. The line marked "Actual film" is for a commercially successful system used for the production of color slides. (If printing flare had been included in calculating the curve, its main effect would have been to require further increases of gamma.)

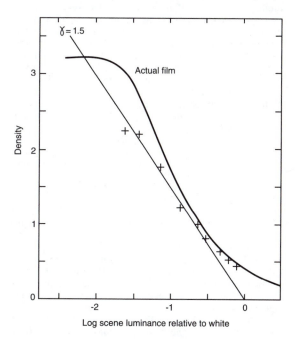

Tone reproduction for transparencies. The densities seen by an observer (crosses) looking in an ordinary room at a color reflection print reproduction of a nine-step gray scale photographed in bright sunlight on a film–paper system having the characteristics of the "Actual system" line.

of their scales as shown by the curve marked "Ideal system." Also shown is a curve marked "Actual film" and this is the characteristic curve of a commercially successful film used for the large-scale production of transparencies for the amateur market. It is seen to follow the ideal curve quite closely except at the low-density end where it is slightly too high because of the stain or fog of the film, and at the high-density end where it is too low because of the impossibility of achieving the infinitely high gamma called for by the ideal curve.

It is clear that, although the characteristic curve of the actual photographic system is very curved, with a maximum gamma well in excess of 1.5, the crosses still lie on the straight line of 1.5 gamma over most of their density range. (At the high-density end, the viewing flare is the main factor in reducing the densities from the "Actual film" curve values to the values of the crosses.) Appreciable deviations only occur below a density of about 0.7 where light grays and whites are reproduced too dark, and above about 2,2 where dark grays and blacks are reproduced too light. Hence, satisfactory tone reproduction is achieved for most density levels.

EXPOSURE LATITUDE If the viewing flare occurring in the projection of transparencies remains of constant magnitude in spite of changes in the density of the transparency, then the tone-reproduction curve effective on the screen will remain substantially constant with variations with exposure level of the film (because by far the greater part of the flare is viewing flare). Part of the viewing flare in projected transparencies, however, derives from light from the screen being reflected by the room, back to the screen. Hence, the viewing flare will decrease somewhat as transparencies become more dense, and the effective gamma will rise at high densities. Furthermore, light parts of the scene will be reproduced away from the low-gamma curved portion of the film characteristic; hence, dark transparencies will have higher effective gammas. Conversely, light transparencies will have lower effective gammas. It would therefore be expected that the exposure latitude of transparency materials would be limited by pictures of high average density resulting in excessive contrast and pictures of low average density in insufficient contrast. This is exactly what is found in practice. With high-density transparencies, however, insufficient maximum density in the film may result in insufficient contrast in the shadows, and this, when combined with excessive contrast in the rest of the scale, presents a particularly unpleasant appearance. High-density transparencies may also be unsatisfactory because of inadequate screen luminance, causing unacceptably large losses in the brightness and colorfulness of the displayed colors.

In reflection prints the exposure latitude at the camera will be limited by the film, and, in the case of color negative films, their long straight characteristic curves usually provide far more camera exposure latitude than is possible with the curved characteristics required for transparency films. When printing negatives, however, the latitude of the printing exposure is limited; in light prints it is limited by insufficient contrast (caused by the falling gamma of the system at low densities); in dark prints, it is limited by insufficient density range being available to depict an average scene adequately; and in general, it is limited by the need for objects to be reproduced with about the same luminance factor as they had in the scene, because reflection prints are seen in the presence of other natural objects with which their lightnesses can be compared.

TONE REPRODUCTION IN DUPLICATING The "Actual film" curve is now marked "Camera film." If a transparency, exposed on a film system having this characteristic curve, is duplicated by printing on to the same film, the resultant characteristic curve is as shown by the broken line. It is clear that the basic gamma of 1.5 of the film system (with even higher gammas at high densities to offset flare) have

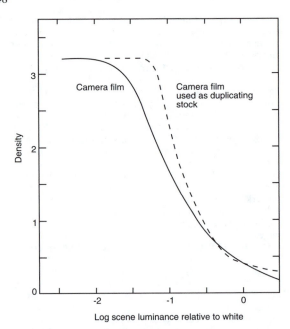

Tone reproduction in duplicating. The effect on the overall characteristic curve (broken line) of using, for duplicating, a film with the "Actual film" characteristic curve, shown here as "Camera film" curve.

resulted in a much higher gamma for the duplicate system than for the original transparency system. Duplicates made on such a system exhibit excessive middle-tone contrast, blocked-up shadows, and insufficient highlight contrast (burnt-out highlights).

The situation can be improved by adding extra printer flare, a technique known as *flashing*. The amount of correction that it is possible to introduce by flashing, however, is limited by the necessity of maintaining an adequate maximum density in the copy.

Ideally, from the point of view of tone reproduction, a duplicating film should be used that has a characteristic curve with a gamma of 1.0 at all densities. In practice it is impossible to avoid low gamma toes and shoulders at the ends of the characteristic curves of photographic films, but special duplicating films are manufactured with long straight characteristic curves of gamma 1.0 over most of their density range, and they can give satisfactory results for most scenes. A slight increase of gamma at high densities may be desirable to offset flare occurring at the printing stage.

Books: Hunt, R. W. G., *The Reproduction of Colour.* 4th edition. New York: Van Nostrand Reinhold, and Surbiton, England: Fountain Press, 1987. *R. W. G. Hunt*

COLOR POSITIVE A color image in which the tones and the colors are all reproduced naturally, as distinct from a color negative in which the tones and the colors are all reversed (whites becoming blacks, blacks becoming whites, yellows becoming blues, etc.). *R. W. G. Hunt*

COLOR PRINT FILM Photosensitive material on a flexible, transparent support for making color transparencies from color negatives by projection or contact printing. There are no masking dyes in color print films. *M. Scott*

COLOR PRINTING Most of the equipment needed for printing from color negatives or slides is the same as that used for black-and-white printing: an enlarger, film carrier, lens, timer, focusing magnifier, easel, blower brush or anti-

lens, timer, focusing magnifier, easel, blower brush or anti-static negative brush, and color printing filters. Other useful accessories are: a contact printer, masking easel, paper safe, dodging tools, and color safelight. Several safelights that are specifically designed for color printing, such as the Dukas 50 and the Jobo Maxilus, produce a relatively high level of illumination.

Either the additive or the subtractive method is used for color printing. The additive method uses red, green, and blue filters and the subtractive method uses cyan, magenta, yellow filters. Enlargers with color heads allow the user to dial the desired filtration. With conventional black-and-white enlargers, it is necessary to have a set of separate filters.

For additive printing, Kodak Wratten three-color filters number 29, (red), number 98 (blue), and number 99 (green) or the equivalent are required. The color printing paper is given three separate exposures, one with each filter. Each color affects one emulsion layer at a time, which minimizes color crossover.

Subtractive and additive systems for color printing.

Filters	Subtractive (Cyan, Magenta, Yellow filters)	
	Transmit	Absorb
Cyan	Green & Blue Light	Red Light
Magenta	Red & Blue Light	Green Light
Yellow	Red & Green Light	Blue Light
	Additive (Red, Green, Blue filters)	
Red	Red Light	Green & Blue Light
Green	Green Light	Reed & Blue Light
Blue	Blue Light	Red & Green Light

For subtractive printing, a single exposure is made through a combination of two filters, normally magenta and yellow. Using all three colors of subtractive filters produces neutral density, which increases the exposure time without affecting the color balance. If after making test prints and color-balance adjustments the filter pack includes all three filter colors, the smallest filter value should be subtracted from all three filter values. In the following example, all filter values should be decreased by 10. (Decimals are not used in the values of color compensating filters and color printing filters, but a value of 10 corresponds to a peak wavelength density of .10.)

10C	+	40M	+	50Y		Original filter pack
−10C	−	10M	−	10Y		
0		30M	+	40Y		New filter pack

Because this change is the equivalent of a decrease of .10 in neutral density, the exposure should be decreased either by stopping the enlarger lens down one-third stop or by dividing the exposure time by 1.26, the inverse log of .10.

Filters for subtractive color printing are supplied with either an acetate base or a gelatin base. Gelatin-base filters are identified as color compensating (CC) filters and acetate-base filters are identified as color printing (CP) filters. The major difference between the two types is in optical quality. CC filters are superior, and may be used in the imaging light path, either above or below the enlarger lens. CP filters should be placed between the light source and the film carrier. A typical set of CC or CP filters includes the values 025, 05, 10, 20, 30, 40, and 50 for each hue.

STANDARD NEGATIVE OR POSITIVE SLIDE Using a standard negative or slide to make the first print is helpful. Having used this image to help establish a *standard filter pack,* it can be used as a starting point for other images. A good standard negative or slide must have normal overall density and contrast, with detail in highlights, shadows and midtones. It should have some neutral grays, a range of

colors and good skin tones. It can be purchased, or you can produce your own, including a person with normal skin tone (no suntan) holding an 18% gray card and a color test chart like the Macbeth ColorChecker.

Creating your own standard negative by using the same film that you normally use, with your own equipment, helps reduce many variables that contribute to printing inconsistency. Most color negatives or slides of the same type of subject exposed under similar conditions will print similarly. Differences may result from variations in type of film, film emulsions, light sources, cameras, and lenses. Other factors involve type of enlarger, enlargering lens, type of paper, paper emulsion batch, chemicals, and film processing. Processing your own film, or using a professional lab for good processing and consistent results is very important. Poor processing can create a color cast and change the general contrast of the film. This makes color correction difficult. To help with consistency, purchase your film and printing paper in sufficient quantities and store as specified by the manufacturer.

A good printing negative should be slightly denser than normal (slightly overexposed). A good printing transparency should also be slightly dense (slightly underexposed). Printing from thin negatives or transparencies creates prints that are low in contrast.

PRINTING FROM A NEGATIVE (SUBTRACTIVE METHOD) Clean the negative, and place it in the enlarger with the emulsion side down (numbers and letters appear backwards when looking at the emulsion side). For subtractive printing, dial in the manufacturer's recommended starting filter pack or insert the necessary CC or PC filters, and a UV filter in the filter drawer. This information can be found in the enlarger manual, or in the literature accompanying the color printing paper. This is just a starting point.

Turn off the room lights. Color printing papers are preferably handled in absolute darkness from the time they are removed from the packaging until they are processed, a color safelight specifically designed for use with color materials can be used.

Keep the color printing paper package tightly sealed and refrigerated. Remove from the refrigerator at least two hours before printing to avoid condensation on the paper, and to let it reach room temperature.

MAKING A TEST PRINT Turn on the light in the enlarger, and adjust the enlarger to project an image. Compose and focus the image sharply. (The base side of a discarded print of the same thickness makes a good focus sheet.) Remove the focusing sheet and turn off the enlarger light. Place a new sheet of paper on the easel, with the emulsion side up. (You can tell the emulsion side of the paper in the dark by gently running your finger tip across the paper. There is a slight sound from the back side, none from the emulsion side, which is smoother.)

There are a number of ways to make a test print, one is to use a piece of black cardboard with one-quarter section cut out as a mask. Make four exposures by changing the position of the cardboard each time and vary the exposure each time by increments of one stop.

For the first test with additive printing, set the lens aperture at f/5.6. Expose the paper through the red filter for four seconds, the green filter for 10 seconds and the blue filter for 12 seconds. These are three separate exposures using each filter just below the lens. Repeat this procedure with the lens aperture set at f/8, f/11, and f/16 to produce four test prints.

Process the print and dry it thoroughly. Drying can be speeded by using a squeegee to remove the excess water and then a hair dryer. The print must be completely dry before any attempt at evaluation is made. A wet print will look darker and bluer than it will when dry.

DENSITY Analyze the print for proper density, first by

| f/5.6 | f/8 | f/11 | f/16 |

Making four test prints and changing exposures by one stop.

finding the test quadrant that is closest to the right density, and then make the necessary density correction. Look at highlights, shadows, and midtones for proper exposure. If the print is too light, increase the exposure time, if too dark, decrease exposure time. In making density corrections, remember that a one *f*-stop change is equivalent to doubling the exposure or cutting it in half. Make a new full size print, using the correction necessary.

COLOR Once the overall density of the print is correct, analyze the color balance. Examine the print with respect to the primary and secondary colors, to determine which color cast is too strong. After deciding which color needs to be reduced use viewing filters such as Kodak Color Print Viewing Filters to help judge the amount of correction necessary. Evaluate the color by looking through a filter of the complementary color held about twelve inches from the print.

For example: A print has the proper density but has a bluish cast. Viewing it through a CC20 yellow filter corrects for the bluish cast. To correct for the bluish cast during printing, add a CC20 yellow filter to the filter pack. (A slight increase in exposure will be necessary to compensate for the added filter.)

Color Correction Table for Printing Color Negatives

If overall color balance is:	Action with additive filters	Action with subtractive filters
Too Red	Increase red filter exposure	Increase magenta and yellow filtration or decrease cyan filtration
Too Green	Increase green filter exposure	Decrease magenta filtration
Too Blue	Increase blue filter exposure	Decrease yellow filtration
Too Cyan	Decrease red filter exposure	Decrease yellow and magenta filtration or increase cyan filtration
Too Magenta	Decrease green filter exposure	Increase magenta filtration
Too Yellow	Decrease blue filter exposure	Increase yellow filtration

The density of the viewing filter that makes the print appear the best is the correction that should be made in the filter pack. When changing the filtration, or the image magnification, exposure adjustment is necessary. Make as many test prints as needed until an excellent print is made. Make a record of the final filter pack, and all the settings used to obtain this print; the enlarger height, the lens aperture, the filter pack, the exposure time, and the paper used. These data

will now become your starting point for all subsequent printing, unless you make some major changes.

Trouble Shooting

Common Problems	Reason and Action
White spots or specks	Dust. Clean the negative to remove the dust.
Streaks, nonuniformity	Improper agitation during processing.
Print contrast too flat	Developer is exhausted or excessively diluted, the paper has been fogged. Check safelights.
High contrast with cyan stain	The developer is too concentrated.
Color stains in highlights	Contaminated developer, developer too warm, exhausted stop bath, or developer out of date.
Blue-green or reddish spots	Exhausted stop bath
Bluish black tones	Developer too dilute or developing time too short.
Prints too dark	Exposure time too long, developer too warm or too concentrated.
Prints too light	Exposure time too short or developer too cold or too dilute.
Low color saturation	Insufficient exposure time, or developer too cold or exhausted.
Pink streaks	Water condensation on the paper before processing.
White areas on print	Fixer contaminated when handling paper before developing.

With quantity printing, prints will have a tendency to become bluer as the developer becomes exhausted.

COLOR PRINTING FROM SLIDES OR TRANS-PARENCIES Clean the slide carefully, and place it in the slide carrier with the emulsion side down (numbers and letters appear backwards when looking at the emulsion side). If you are using a film carrier, you must first remove the slide from the slide mount. Place the carrier in the enlarger. For the first test print, follow the same steps as for printing from color negatives, but using a paper and chemistry specifically designed for printing from color slides.

After processing, dry thoroughly. (A wet print looks darker and slightly more magenta.) Keep in mind that this is a reversal process. Corrections are exactly the opposite to those when printing from color negatives. If the print is too light, for example, you need to decrease exposure time; if too dark, increase exposure time. Color corrections are also different but the procedure for judging the necessary color correction is the same as that for printing a color negative.

Color Correction Table for Printing Slides or Transparencies

If overall color balance is:	Action with additive filters	Action with subtractive filters
Too Red	Decrease red filter exposure	Increase cyan filtration or decrease yellow and magenta filtration
Too Green	Decrease green filter exposure	Increase magenta filtration or subtract cyan and yellow filtration
Too Blue	Decrease blue filter exposure	Increase yellow filtration or subtractive magenta and cyan filtration
Too Cyan	Increase red filter exposure	Decrease cyan filtration or increase magenta and yellow filtration
Too Magenta	Increase green filter exposure	Decrease magenta filtration or add yellow and cyan filtration
Too Yellow	Increase blue filter exposure	Decrease yellow filtration or add magenta and cyan filtration

Compare the test print with the original transparency to determine the color balance. Make new test prints until you have an excellent print. Make a record of the final filter pack, and all the settings used to obtain this print; the enlarger height, the lens aperture, the filter pack, the exposure time and the paper used. These data now become your starting point for all your printing from slides and transparencies unless you make major changes.

Books: Current, Ira, *Photographic Color Printing*. Boston: Focal Press, 1987. *F. NeJame*

See also: *Color photography, printing*.

COLOR PROCESSING Development of silver images is a common denominator in the production of color images by photographic means. In some cases, such as in additive systems, simple silver images modulate the red, green, and blue light reaching the viewer. Development of silver is also associated with color image formation with subtractive systems, even though very little is left after the process has been completed. In all of the processes, various secondary processing steps, such as stop baths, fixers, and bleaches, are involved.

ADDITIVE COLOR PROCESSES Additive color processes rely on one or more neutral images to control the red, green, and blue light that reaches the observer's vision. Hence, simple black-and-white processing is employed. This may involve a negative-positive system or reversal processing. A set of separation negatives exposed through red, green, and blue filters may be printed as positive transparencies that are then placed in three projectors fitted with red, green, and blue filters corresponding to those made to expose the original negatives. The three images are superimposed on a screen or other device, permitting them to be overlaid for viewing as a color image.

Autochrome, an obsolete additive system, consisted of a mixture of red, green, and blue dyed grains or other elements through which the image-forming light passed to expose a panchromatic emulsion. A simple reversal process would produce silver density behind each of the grains corresponding to the density required to modulate transmitted white light to reveal colors corresponding to those in the original object photographed.

Another additive color screen system made use of a separate taking screen having geometric red, green, and blue elements. This was placed over a panchromatic plate at the time of exposure. After negative processing the plate was contact printed to produce a positive that could then be registered with the original screen, or more likely with separate viewing screens. The colored positives could thus be mass produced. As with the integral screen systems, the original plate could be reversal processed to produce a single image for registering with the taking screen or another viewing screen.

SUBTRACTIVE COLOR PROCESSES

Dye Transfer The dye transfer printing process uses gelatin matrices produced by developing films coated with a simple emulsion in a tanning black-and-white developer such as pyro. After fixing, the undeveloped, untanned part of the emulsion is washed away with hot water, leaving a tanned relief positive that is immersed for a time in the appropriate dye solution. When rolled into contact with a paper receiver, the image is transferred. A complete subtractive color image results from the transfer in register of matrices dyed with cyan, magenta, and yellow dyes corresponding to negatives exposed with red, green, and blue filters.

Transparency subtractive color photography systems make use of an integral tripack of emulsions balanced to record the red, green, and blue images. A blue-absorbing filter layer beneath the blue-sensitive layer prevents the blue light from being recorded in the green- and red-recording layers which retain blue sensitivity. After exposure, simple negative development produces a silver image in each of the layers. A second color-forming development of the remaining undeveloped emulsions produces cyan, magenta, and yellow dye images that control the red, green, and blue light reaching the observer. A silver bleach then removes the silver in the original negative, as well as any formed with color development, leaving the positive dye images.

Kodachrome The Kodachrome process starts with a black-and-white negative first development of all three of the exposed emulsion layers. The bottom, red-sensitive layer is then exposed to red light, followed by a color-forming development that produces a cyan image. The top blue-sensitive layer is then exposed to blue light and the film is developed in a developer that produces a yellow dye image. The film is then processed in a fogging developer that forms a magenta image in the remaining green-sensitive layer. After bleaching to remove the silver, the yellow, magenta, and cyan dye images are left for viewing.

Negative Incorporated-Coupler Films Subtractive color negative processes use a developer that forms dyes corresponding to the three image layers, at the same time that silver images are formed. After the silver is removed by bleaching and fixing, the three integral dye images are available for printing on a positive three-color emulsion system. These negative films also incorporate preexisting colored masking dyes that are destroyed in proportion to the amount of negative development taking place. The parts that remain of these incorporated dye images produce dye masks that correct for the unwanted absorptions of the image dyes that are formed.

Reversal Incorporated Coupler Films Subtractive color reversal films that can be processed by the user, such as Kodak Ektachrome films, go through two development steps. The first development produces a negative silver image in each of the three emulsion layers. The remaining unexposed and undeveloped silver halide grains are then fogged and developed in a developer that forms a positive silver image and a positive dye image in each emulsion layer. The negative and positive silver images are removed by bleaching, leaving the cyan, magenta, and yellow dye images.

Color Printing Processes Reversal and negative color printing processes using red-, green-, and blue-sensitive layers are processed in a fashion similar to those used for color films. With print materials on an opaque base for viewing by reflected light, each layer absorbs light twice, once when light enters the image, and a second time when it exits after being reflected from the base. Thus, the emulsion layers need to be only half as thick as those on transparency films, permitting more efficient transfer of the processing solutions.

Dye-bleach reversal color printing materials such as Cibachrome (Ilfochrome) are made with emulsions containing cyan, magenta, and yellow dyes of a strength equal to or greater than that of the maximum density of the final image. Black-and-white development is employed to produce a negative silver image. This is then treated in a low pH bleach that destroys the dyes in proportion to the amount of silver that was formed and removed, thus leaving a positive image.

Dye Diffusion Processes Dye diffusion processes, such as the original Polacolor Film, consisted of red-, green-, and blue-sensitive emulsions, interspersed with dye developer layers containing developer linked to dye molecules. A viscous developer is squeegeed between this film and a receiving layer. Where development occurs in the exposed areas, yellow dye molecules are immobilized, but where no development occurs these dye molecules migrate to the receiving paper. A similar effect occurs with the magenta and cyan layers. The subtractive image exists on the paper when it is peeled away.

The Polaroid SX-70 system produces an image that is not separated during processing. It appears on the side of the pack that faces the camera lens and would thus be a mirror image of the original scene if the camera did not incorporate a mirror.

The Kodak Instant Color Film, now discontinued, employed direct reversal emulsions that produced a positive image on development. Dyes released as the result of development migrated to the image-receiving layer on the side opposite to that facing the camera lens.

Books: Current, Ira, *Photographic Color Printing, Theory and Technique*. Boston: Focal Press, 1987; Krause, Peter, and Shull, Henry, *Complete Guide to Cibachrome Printing*. Tucson: H. P. Books, 1982; Stroebel, Leslie, Compton, John, Current, Ira, and Zakia, Richard, *Basic Photographic Materials and Processes*. Boston: Focal Press, 1990; Stroebel, Leslie, Compton, John, Current, Ira, Zakia, Richard, *Photographic Materials and Processes*. Boston: Focal Press, 1986.

I. Current

COLOR PROOFING Color proofing is the process of making test color reproductions of color images to see how the final printed color reproduction will look.

COLOR PROOFS There are two main types of color proofs: press proofs and off-press proofs.

Press Proofs There are two types of press proofs: those made on special flat-bed proof presses and those made on rotary production-type presses. Most proofs made on flat-bed proof presses are made one color at a time. Most rotary-type proofing presses are multicolor lithographic or letterpress presses in which proofs are made with wet trapping of inks similar to that on production presses. Press speeds may be different. Gravure proofs are made on slow production-type presses in one color or multicolor. In lithography especially, speed differences are great, and this causes variations between proofs and press prints. The fact that proofs are made on presses with the same ink and paper as the printing press is no guarantee that the proof will match the print, as there are many variables in lithographic printing that can affect printing results.

Off-press Proofs There are two main types of off-press proofs: analog, which are made from separation films; and digital, which are made from digital data in computers or storage media. Analog proofs are of two types: overlay and single-sheet or laminated proofs. Digital proofs are also of two types: soft proofs, which are the color displays on video terminals; and hard proofs, which are made on paper or other substrates. Digital hard proofs are in turn of two types: continuous tone and halftone or screened.

PROOFING MATERIALS AND PROCESSES

Overlay Proofs There are three types of overlay proofs: (1) individual plastic foils with photosensitive coatings overcoated with a pigmented layer corresponding to the color of the separation or other printing color; (2) individual photosensitive foils overcoated with dyes corresponding to the printing colors; and (3) foils coated with a photosensitive peel-apart layer. Overlay proofs are less costly than other analog proofs. They are useful as progressive proofs to show what the single-, two- and three-color overprints look like in addition to the appearance of the four-color print. They have the disadvantage of high optical-dot gain in highlight and middletone areas because of the many reflective surfaces in the combined layers.

Single-sheet or Laminated Proofs There are six types of single-sheet or laminated proofs: (1) photosensitive ink layers; (2) laminated photoadhesive layers that change in adhesivity on exposure to light and absorb pigmented dry toners in proportion to the adhesivity of the image areas; (3) adhesive peel-apart images pigmented with dry toners, laminated onto a reflective base; (4) laminated pigmented photosensitive layers; (5) multiple liquid-dispersed toner images transferred to the printing substrate from an electrophotographic photoconductor; and (6) images exposed onto color photographic paper using multiple exposures to correct or contaminate the hues produced by the dye/emulsion layers in attempts to match the printing ink colors. Many of the single-sheet proofs are used as contract proofs which clients sign or approve as being representative of what the printed job should look like. The laminated adhesive toner and pigmented layer proofs suffer from excessive optical gain throughout the tone scale. The photographic proofs have difficulty matching the printing colors, especially the yellow, which is slightly orange in hue on the photographic proof.

Soft Digital Proofs Soft digital proofs have difficulty correlating the RGB (red, green, blue) phosphors of the video display terminal (VDT) to the CMYK (cyan, magenta, yellow, and black) of the printing colors. Also they cannot be used as contract or sign-off proofs.

Hard Digital Halftone Proofs There are two types of hard digital halftone proofs: electrophotographic and thermal dye sublimation transfer proofs. Both types produce good-quality proofs. They are, however, limited in size to two or four pages and are very expensive. Hard digital continuous tone proofs are of four types: (1) dye diffusion thermal transfer; (2) thermal dye sublimation transfer; (3) light valve technology; and (4) ink-jet. The main objections to these proofing systems are the inability to simulate image structure (halftones) in printing, and subject moiré effects caused by interference patterns between the halftone screen image and patterns in the subject such as herringbone weave and lace textiles.

M. Bruno

COLOR RENDERING INDEX A method of assessing the degree to which a test illuminant renders colors similar in appearance to their appearance under a reference illuminant. The CIE has defined a general color rendering index R_a for characterizing illuminants. Values of R_a range from about 50 for fluorescent lamps having relatively poor color rendering

to about 95 for those having very good color rendering; the maximum value possible for R_a is 100. *R. W. G. Hunt*

COLOR REPRODUCTION OBJECTIVES
The objective in a color reproduction may be any one of a number of alternatives. Six objectives have been defined for different circumstances.

Spectral color reproduction is defined as reproduction in which the colors are reproduced with the same spectral reflectance factors, or spectral transmittance factors, or relative spectral power distributions, as those of the colors in the original scene.

Spectral color reproduction is the ideal aim for commercial catalogs in which it is desired to depict the color of goods accurately. For accuracy to be achieved for viewing under a variety of light sources, spectral color reproduction is required but can usually only be achieved by supplying samples of the actual goods.

Colorimetric color reproduction is defined as reproduction in which the chromaticities and relative luminances are the same as those in the original scene. This is usually applicable to reflection prints.

Exact color reproduction is defined as reproduction in which the chromaticities, relative luminances, and absolute luminances, are the same as those in the original scene. This is applicable to cases where absolute luminance levels are important.

Equivalent color reproduction is defined as reproduction in which the chromaticities, relative luminances, and absolute luminances are such as to produce the same appearances of colors as in the original scene. This is applicable to cases where simulation of appearance is required.

Corresponding color reproduction is defined as reproduction in which the chromaticities and relative luminances are such as to produce the same appearances as the colors of the original scene would have had if they had had the same luminances as those of the reproduction. This is generally applicable to many reproduction situations.

Preferred color reproduction is defined as reproduction in which the colors depart from equality of appearance at equal or at different luminance levels in order to achieve a more pleasing result. This is applicable when departures from any of the other five objectives are required in order to achieve a more pleasant or more flattering result.

Books: Hunt, R.W. G., *The Reproduction of Colour*. 4th edition. New York: Van Nostrand Reinhold, and Surbiton, England: Fountain Press, 1987. *R. G. W. Hunt*

See also: *Color photography.*

COLOR REVERSAL FILM
Photosensitive material on a flexible, transparent support that reproduces the tones and colors of the original scene in their correct relationships. The term seems contradictory, however, in that nothing is reversed. All the early photographic processes were negative-working; thus, a process that "reversed" the negative to produce a positive was called a reversal process, and films specially designed for such came to be called reversal films. *M. Scott*

Syn.: *Color transparency film.*

COLOR SCIENCE
Systematic knowledge about color in all its aspects, including physics, chemistry, physiology, psychology, measurement, instrumentation, art, photography, television, printing, colorants, lighting, and displays. *R. W. G. Hunt*

COLOR SENSITIVITY
The measurement of the response of a color photographic material to the various wavelengths of energy in the visible part of the spectrum. One method of measurement involves the use of a wedge spectrograph. More reliable data can be obtained with a monochromatic sensitometer, which exposes the sample to carefully monitored amounts of narrow-band radiation and provides the data needed for constructing a characteristic (D-log H) curve for each tested wavelength.

The term *spectral sensitivity* involves similar measurements, including exposure to invisible radiation, such as ultraviolet and infrared. *M. Leary and H. Todd*

See also: *Sensitometry; Wedge spectrogram; Wedge spectrograph.*

COLOR SENSITOMETRY
Color sensitometry is the technology of measuring the response of color photographic materials to exposure and processing. The requirements for such a procedure are more severe than for black-and-white materials because color photography involves at least three emulsion layers and because the processing consists of several additional stages.

The aims of color sensitometry vary with the questions to be answered. In manufacturing, some of the questions are: Does this product meet specifications? Is a presumed better product indeed better? Questions for the processor are: Is the process stable? Does the system conform to specifications? Finally, the consumer of the color material is interested primarily in the appearance of the image and cares little about the process by which the image is generated. Sensitometric test methods will therefore vary with the data required to answer the appropriate questions.

EXPOSURE Sensitometers that are adequate for exposing black-and-white materials may need modification for use with color materials. The light-source–filter combination of a 2850 K tungsten lamp and a gelatin Wratten 78 AA filter, although a sufficient match for standard daylight for black-and-white film, is inadequate for testing color films. More appropriate filters for use with a tungsten lamp are (1) Corning glass 5900 and (2) Davis-Gibson liquid filters. These are more stable with use than gelatin filters but may show changes in absorption with temperature.

Practical tests are needed for color films that are to be used with fluorescent lamps or with speedflash, since the spectral characteristics of these sources can hardly be matched by any tungsten-lamp–filter combination.

If only a single emulsion layer of a color material is to be exposed, very narrow-band filters, such as interference filters, are needed. With their use, exposure times will be quite long and thus remote from practice.

Reciprocity effects are serious problems with color materials because the emulsion layers vary in their responses to changed exposure times. For this reason, the exposure time used in the sensitometer must closely correspond to that used in practice. For slow color materials, the illuminance at the test sample must be very high, and the light source in the sensitometer may need to be redesigned.

Testing a color film or paper only to white light exposures gives little information about the ability of the material to simulate the many different colors of a typical scene. One technique involves the use of a real subject as input, but visual examination of the resulting image is difficult to interpret. An alternative method uses a Macbeth ColorChecker, which approximates real colors, such as skin tones, blue sky, and foliage. The image may be measured under standard viewing conditions for fidelity to the original.

Filters used to adjust sensitometric light levels must be neutral in their absorption of different wavelengths. Gelatin filters absorb short wavelengths more than longer ones and therefore should be replaced by carbon or inconel filters. For the same reason, silver step tablets are reasonably satisfactory for producing different levels of exposure, but ones made of carbon are more nearly neutral.

PROCESSING Development of color images is complex, involving several stages. Development by-products

diffuse not only laterally but also from one emulsion layer to the others, giving rise to vertical adjacency effects that alter the image. Processing solutions need to be mixed with great care and stored under controlled conditions to avoid deterioration.

Agitation during processing presents particularly difficult problems. It is essential that sensitometric processing be checked to avoid even minor changes in the effectiveness of agitation and that the processing conform to practice at each stage of the process, not simply over all.

When exposed sensitometric strips are supplied by a manufacturer of color films to be used in monitoring processing, the strips must be stored in a frozen condition to avoid unwanted changes with time. When they are used to check a processing system, undesirable results merely indicate that a change has occurred in the process and do not indicate the nature of the change or the source of the error.

MEASUREMENT Densitometers suitable for measurement of color images must have a stable light source that produces sufficient energy in the blue, green, and red portions of the visible spectrum. Infrared radiation must be removed by an appropriate filter to avoid instrument instability.

Filters are used to isolate spectral regions. For many color measurements, Wratten 92, 93, and 94 filters are often used. Such filters need to be checked periodically because they may change in absorption characteristics with time.

Stable color check plaques should be used to determine densitometer error and instability. Twice-daily measurements of the plaques, plotted on a control chart, assist in identifying densitometer variability and error.

Color images, because they consist of dyes, scatter less light when they are measured than do particulate silver images. For this reason, optical problems typical of black-and-white samples are less severe for color dye images. Complications found in the measurement of dye images, however, arise from the spectral absorption of the dye layers. Every dye has significant unwanted absorption for wavelengths other than those it is intended to absorb. For this reason, every measurement of an area of a color film is affected simultaneously by all three dyes, as well as by fog or stain.

Color densities are basically of two types: (1) integral and (2) analytical. Integral densities are measures of the absorption of the three superimposed dye layers. Analytical densities are intended to estimate the effect of a single dye layer and are found by physically or optically separating the layers. Analytical densities are most often needed by the manufacturer of the material and are rarely needed by the user.

Integral densities are of several types: (1) spectral, which indicate the absorption of energy wavelength by wavelength; (2) printing, which indicate the effect of the sample when used with a specific printer and printing material; (3) visual, indicating the effect on a human observer; and (4) three-filter, used ordinarily to discover whether or not a sample matches a standard.

DATA ANALYSIS Because each patch of a processed sensitometric strip will have been measured separately with blue, green, and red light, the presentation of the results will involve three characteristic curves. Although the test samples may be visually neutral, the three curves will not exactly coincide, even for a correctly exposed and processed test sample.

If, however, for example, the blue-density curve has higher densities throughout than the green-density and the red-density curves, the inference is that the image is yellowish, indicating an excess of yellow dye—the one that is sensitive to blue light in the original exposure. Such an

excess could result from incorrect manufacturing or from a faulty light source.

Although the reproduction of neutrals by a color photographic material is important, no color material can reproduce all grays—including whites and blacks—perfectly. Furthermore, correct reproduction of neutrals does not ensure excellence of other colors. If departure from neutrality is consistent throughout the scale, correction is possible by the use of a corrective filter in future exposures of the material. If, however, the hue shifts with the color lightness, this is an indication of a crossover of the characteristic curves of the film or paper, and no exposure correction is possible.

M. Leary and H. Todd

See also: *Analytical density; Characteristic curve; Densitometry; Equivalent neutral density; Film speed; Integral density; Printing density; Sensitometry; Specular density; Visual density.*

COLOR SEPARATION (1) The process of obtaining three (or more) monochrome images from a color image or from a color scene. Such images are used to produce printing surfaces. (2) One of the monochrome images obtained in (1).

R. W. G. Hunt

See also: *Separation negatives.*

COLOR SLIDE FILM A color transparency roll film in a small format intended for projection, usually 35-mm or square 120 size.

M. Scott

COLOR SPACE Three-dimensional representation of colors.

R. W. G. Hunt

See also: *CIELAB system; CIELUV system.*

COLOR SYNTHESIS The process of producing a color image from red, green, and blue components in an additive system, or from cyan, magenta, and yellow components in a subtractive system.

R. W. G. Hunt

COLOR TEMPERATURE (1) All light sources emit electromagnetic radiation, some of which is in the visible region between 400 and 700 nm in wavelength. The amount of radiation emitted at each wavelength, and the total amount of radiation emitted, varies from source to source. The most exact way to describe the radiation emitted is with a spectral energy distribution diagram, which specifies the amount of energy emitted at each wavelength. The total amount of energy emitted can then also be determined by integrating or summing over all the wavelengths. The fact that many types of sources approximate a blackbody in their spectral energy distribution, however, provides for a simpler means of specifying, at least approximately, the output of a source.

The spectral energy distribution of the radiation emitted by any blackbody, or source approximating a blackbody, is a function only of the temperature of the blackbody. This means that all blackbody sources will have the same spectral energy distribution if they are at the same temperature. (Such curves are frequently called blackbody radiation curves.) It is therefore possible to completely specify the spectral energy distribution of a blackbody type source by specifying the temperature of the source. By convention, this temperature is specified using the absolute, or Kelvin, scale. (This convention also results in zero emittance at all wavelengths at 0 K.) Because the spectral energy distribution of a visible source describes the color of the source, the temperature of a blackbody light source is known as the color temperature. It is important to remember, however, that the total amount of energy emitted by a blackbody source is dependent on the area of the source as well as the temperature.

Strictly speaking, the color temperature of a real light source is defined to be the temperature (using the Kelvin scale) of the blackbody which most closely approximates the source. Color

temperatures for incandescent sources, however, do correlate fairly well with the actual temperature of the source. It is important to note that sources that do not approximately resemble a blackbody in output do not have color temperatures, although they can be assigned *correlated* color temperatures. The lower the color temperature of a source, the longer the mean wavelength of the radiation emitted and, therefore, the warmer the color of the light emitted. Lower color temperatures also result in smaller amounts of radiation and light being emitted.

Color temperature is particularly important in color photography because color films are designed to give optimal color rendition only when exposed using light of a specified color temperature. In particular, daylight color films are balanced for 5500 K, type A tungsten films are balanced for 3400 K, and type B tungsten films are balanced for 3200 K. Color temperature is also important in printing and projection systems because photographic materials are designed to be printed or viewed using specific types of illumination. Color temperature can also be important in black-and-white photography because the speeds of photographic materials are frequently dependent on the color temperature of the illumination.

Color Temperatures of Various Sources

Source	Approximate Color Temperature
Standard tungsten bulb (below 100 watts)	2600 K
Standard tungsten bulb (100 watts and above)	2800 K
Sensitometric lamp (standard)	2848 K
Projector lamps	3200 K
Photoflood lamps (several hour life)	3400 K
Flash bulbs	4000 K
Electronic flash	5000–6000 K
Sunlight	5000 K
Daylight	5500 K
Overcast daylight	7500 K
North sky, blue	10,000–20,000 K

Two relations that use (color) temperature describe two of the key characteristics of blackbody radiation curves. The first is the Stefan–Boltzmann law, which was determined experimentally by Josef Stefan and later derived theoretically by Ludwig Boltzmann. This law states that the amount of radiation emitted by a blackbody source is proportional to the fourth power of the color temperature: $E_{tot} = \sigma T^4$, where σ is the Stefan–Boltzmann constant equal to 5.67×10^{-8} W-m^{-2} – K^{-4}, and T is the temperature. The second is Wien's displacement law, which gives the wavelength of maximum emittance: $\lambda_{max} = 2.8978 \times 10^{-3}/T$. This law gives rise to an alternative way of expressing color temperatures: the MIRED (*micro-reciprocal-degrees*) scale. The MIRED value of a light source is its color temperature divided into 1,000,000. Thus a color temperature of 5000 K corresponds to a MIRED value of 200. Because the MIRED value, like the wavelength of peak emission, is inversely proportional to the temperature, MIRED values are directly related to the wavelength of peak emission (in fact, the wavelength of peak emission in nanometers is approximately 2.9 times the MIRED value). MIRED values are useful in assessing the effect of color temperature shifts and light balancing filters. When color temperature is expressed using the MIRED scale, the change in the MIRED values when going from one source to another (the MIRED shift) is independent of the initial color temperature. This is because the MIRED value is directly related to wavelength rather than to temperature. Color temperatures and MIRED values can be read out on most color temperature meters.

Of historical and physical significance is the absolute re-

lation between the spectral energy distribution of a blackbody source and its temperature, given by Planck's radiation law: $E_\lambda = (8\pi hc/\lambda^5) (1/(e^{hc/\lambda kT}-1))$, where E_λ is the energy emitted at wavelength λ, h is Planck's constant (6.626×10^{-34} joule-sec), c is the speed of light (2.9979×10^8 m/sec), and k is Boltzmann's constant (1.381×10^{-23} joule/K). This law is of particular interest since in its derivation Max Planck invented the idea of quantization of energy, which led to quantum theory and our idea of the universe today.

J. Holm

See also: *Absolute temperature; Blackbody radiation; Color temperature meter; Microreciprocal degree; Quantum theory.*

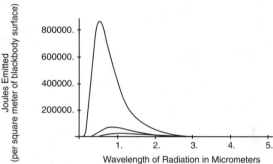

Color temperature. Plots of the spectral energy distribution as given by Planck's radiation law for various temperatures. *Top curve,* 5500 K; *middle curve,* 3400 K; *bottom curve,* 2800 K.

COLOR TEMPERATURE (2) In computer imaging, color temperature is supposedly a measure of the color quality of the monitor image. It assumes that the monitor adheres to a heat-to-light relationship as does a blackbody radiator. This is not the case for video monitors. A more accurate term would be correlated color temperature. Quality monitors generally allow for a 5000 K setting and higher. The purpose of such monitors is to approximate daylight viewing conditions for images so that matching can occur.

R. Kraus

COLOR-TEMPERATURE METER A photoelectric instrument that compares the relative spectral energy levels in two or three spectral regions, typically red and blue or red, green, and blue. The proper use of a color-temperature meter by photographers is an attempt to determine the photographic usefulness of the spectral-energy distribution (special quality), rather than the photometric quantity (intensity) of a particular light source, and then match the source (using various filter combinations) to the light-source standard for which color films are balanced. Subject color rendition accuracy will improve as this match between light source spectral quality and film spectral sensitivity is approached. Several convenient hand-held color-temperature meters are available to assist photographers in determining the relative spectral-energy ratios of light sources that are close in spectral-energy distribution of a theoretically perfect radiator of energy—namely the many phases of daylight and types of tungsten lamps.

The basic color temperature ratings of color film products are generally divided into those films balanced for daylight (5500 K) and tungsten (3200 K) light sources. Early color-temperature meters used two filters to determine the relative warm (red) – cool (blue) balance of light sources for photographic purposes. The addition of a green filter allows newer meters to also be sensitive to the spike emissions of the mercury-vapor gases in fluorescent and other noncontinuous spectrum light sources.

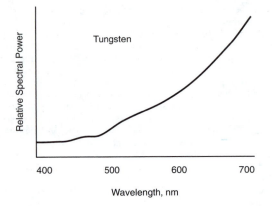

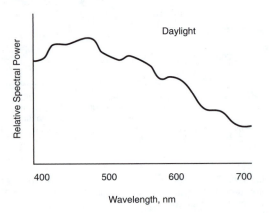

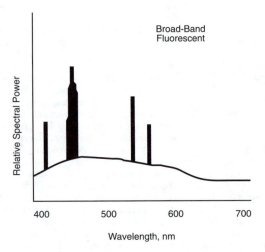

Color temperature meter. (Light sources.) Relative spectral power distribution for three common light sources.

A typical contemporary color temperature meter configuration consists of three filtered silicon photodiode detectors arranged under a diffusion material in the meter reading area. Although color-temperature meters do not have the ability to make narrow wavelength discriminations similar to a spectroradiometer, the addition of the third filter significantly increases the reliability of these devices in making blue/red

and green/red readings with fluorescent and other nonconventional photographic sources. Filter selection for the photodiodes is carefully matched to allow the filtered detector response to simulate the nominal color sensitivities of daylight- or tungsten-balanced reversal films.

DISCONTINUOUS LIGHT SOURCES The use of color-temperature meters to provide color information for the photographer can be misleading because the meters are often used with light sources that are improperly assigned color temperature ratings. Light sources that do not approximate blackbody sources in their spectral emissions cannot be assigned a true color temperature value and must be assigned a *correlated* or *equivalent* color temperature designation. Familiar nonconventional (discontinuous emission) sources typically consist of mercury, neon, or sodium vapors that emit light energy at only limited, narrow wavelength bands across the visible spectrum. The intended use of these sources is for economical, long-term illumination of large outdoor areas such as parking lots, sports arenas, display signs, and efficient illumination of retail store merchandise and office work spaces.

Fluorescent lamps that appear to be *white* sources are actually combinations of mercury vapor line spectra overlaid with a continuous spectrum provided by the fluorescent coating inside the glass lamp tube. Exacting photographic color rendering with these nonconventional light sources should not be attempted without prior film tests and client consultation. The use of a three-detector color-temperature meter in these critical color rendering situations is particularly valuable in assisting the photographer to make appropriate, although sometimes heavy filtration correction decisions for preshoot film tests. Photographers should also be aware that the 60-cycle electric current pulsations associated with many nonconventional sources could cause streaking or underexposure in situations where shutter speeds are faster than 1/60 or 1/125 second. Color-temperature meter reading times are not necessarily sensitive to these current pulses.

Different light sources with similar correlated color temperature ratings that match visually may not produce similar photographic color rendering effects. Given these differences, it has been suggested that a *photographic color-temperature* rating scale and related set of filter recommendations be developed to better identify and overcome trouble-some spectral light source deficiencies and related color rendition problems.

ELECTRONIC FLASH Electronic flash tubes contain vapors such as xenon, which, under pressure, tend to emit a

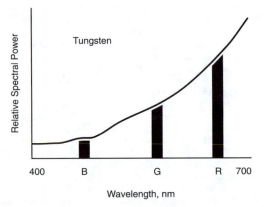

A color-temperature meter samples the relative amounts of red, green, and blue light in a light source and compares the red to blue and the red to green light energy.

more continuous spectrum that closely approximates the energy distribution and color temperature of standard photographic daylight (5500K). Flash manufacturers balance the spectral emission of flashtubes with a variety of tube coatings and/or flash unit protective lens colors. Some current color-temperature meters also have the ability to measure the red – green and red – blue spectral emission ratios of electronic flash units, providing the ability to color balance different flash sources in multiple lighting setups.

INCIDENT READINGS Color-temperature meter readings are correctly made in the incident mode so that the meter reads only the spectral emissions from the light source in question and not the spectral reflectances from colored subject object. Color-temperature readings can be taken from sources independent of their illumination level. Meter scales are calibrated in warming/cooling filter combinations in color compensation (CC) values or mireds (MIcro-REciprocal Degrees). Input scales can be adjusted for either daylight or tungsten balanced films.

MIXED LIGHT SOURCES Color-temperature meters should not be used to take simultaneous readings with mixed color sources because they do not have the ability to differentiate between individual source emissions of spectral energy in mixed lighting situations. Separate color-temperature meter readings of each source should be made.

THEATRICAL LIGHTING Manufacturers of theatrical-lighting filters make high quality light-balancing (moderate shifts in color temperature), color-conversion (large shifts in color temperature/balance), and color-compensating (relatively small changes in color balance) filters matched for use with color temperature in tungsten, electronic flash, fluorescent, and other spectrally different sources to obtain photographically appropriate color temperatures and color rendering in still and motion picture filming, television, and other imaging applications.

Other color-temperature meter features include the ability to make discrete or continuous color-temperature readings, liquid crystal multi-data displays, and filter correction data and tables for both color-compensation (CC) and light-balancing filters in magenta-green and warm-cool correction combinations, respectively.

Books: Eastman Kodak Company, *Color Photography Under Fluorescent and High-Energy Discharge Lamps.* Eastman Kodak Company, 1990. Rochester, New York: Publication E-104; Hunt, R. W. G., *Measuring Color.* Second Edition, Chapter 4-Light Sources. New York and London: Ellis Horwood, 1991. *G. Miller*

COLOR TEST CHART
A selection of colors assembled into a convenient array for testing the color reproduction characteristics of a color reproduction system. An example is the *Macbeth ColorChecker Color Rendition Chart* of painted paper chips, in which 6 neutral colors and 18 carefully selected chromatic colors are mounted together on a cardboard base. *R. W. G. Hunt*

COLOR TRANSPARENCY FILM
Synonym for color reversal film. Color transparency film is the preferred term, since it describes the item rather than merely the process by which it was made. *M. Scott*

COLOR VISION
See *Vision, color vision.*

COMA
Lens aberration involving oblique rays from an off-axis object point producing an asymmetrical image light patch directed away from the axis like the tail of a comet. Coma is reduced by stopping down the lens. *S. Ray*

See also: *Lenses.*

COMB FILTER
A filtering circuit on some color monitors designed to give a better color rendition and minimize distortion. *R. Kraus*

COMBINATION PRINT
See *Composite photograph.*

COMBINATION PRINTING
Combination printing and photomontage are used for making pictures from more than one negative or print. The first to exhibit photographs using this method was William Lake Price in 1855. Better known, however, is O. G. Rejlander's allegorical composition *The Two Ways of Life,* done in 1857, which was printed from more than 30 separate negatives. His technique, which was strictly photographic, was to mask all parts of the picture except the one area being printed. Henry Peach Robinson was also known for using combination printing is in his *Fading Away* composition in 1858 which used five negatives. Using scissors to cut, then paste to combine the photomontages, he then retouched and rephotographed the compositions. During the collodion period, the standard practice was the printing in of separate cloud negatives, first suggested by Hippolyte Bayard in 1852, owing to the insensitivity of the negative material which became overexposed in the sky when properly exposed for the landscape. Another way of working is to simultaneously print, or *sandwich* two or more negatives together, placed in the negative carrier of the enlarger and printed together. Eventually, photography's technical progress surpassed the limitations of early photographic materials. But in the 1920s and 1930s such European artists as John Heartfield, Raoul Haussman, and Herbert Bayer revived composite techniques that created fantastic images that the Surrealist and Dadaist art movements encouraged. The American photographer who reinvented and mastered combination printing in the 1960s through to the present day with enormous success has been Jerry N. Uelsmann, who has created an extensive body of work using this technique to create paradoxical, surreal landscapes of the mind with technical perfection. *J. Natal*

See also: *Photomontage.*

COMMAG
An abbreviation for *composite magnetic,* printed on the leader of motion-picture release prints with a magnetic, as opposed to an optical, sound track. *H. Lester*

COMMERCIAL PHOTOGRAPHY
Commercial photography is the branch of professional photography that is concerned primarily with supplying the photographic needs of the advertising, communication, display, and sales side of industry and the art departments of media involved with industry. Commercial photographers typically make photographs of products for reproduction in catalogs, brochures, instruction manuals, press releases, and advertisements in newspapers, magazines, and other media. Because commercial photographs commonly serve as a substitute for the objects photographed, they are expected to appear realistic, and because they should create a favorable impression on the viewer, especially when used for advertising purposes, they are expected to make the objects appear attractive and desirable. Commercial photographers do not have the freedom that illustrative photographers have to glorify products and to create an exaggerated aura of prestige and desirability, but they can make maximum use of the basic controls such as choice of background and props, arrangement, lighting, viewpoint, choice of lens, and photographic craftsmanship to make an attractive but also realistic photograph.

Whereas some commercial photographers will accept a wide range of assignments, such as photographing small manufactured products, automobiles, architectural interiors and exteriors, industrial locations and operations, food, and packaged materials, and making photographic copies of paintings and other images, other commercial photographers will specialize in a narrow area, such as making photographs only of furniture. Some large commercial photographic studios will cover a range of assignments by using a number of

photographers who specialize in different areas, such as glassware and polished metal or automobiles.

Commercial photographers generally prefer to work in a studio where they have control over lighting and the other elements involved in making photographs, but some will do both interior and exterior location work, including such things as making a sequence of photographs at a construction site for a progress report or for documentation purposes.

View cameras have been the camera of choice of commercial photographers because of the advantages of large-format film in recording detail and of being able to control image shape and the angle of the plane of sharp focus with the tilt and swing adjustments. Although 8×10-inch format view cameras were considered to be the standard size in earlier years, subsequent improvements in films and camera lenses have resulted in a strong movement to smaller 4×5-inch view cameras. Commercial photographers also use small- and medium-format roll-film cameras when they are appropriate for the assignment. *G. Cochran*

See also: *Advertising photography; Architectural photography; Catalog photography; Copying; Food photography; Illustrative photography; Professional photography.*

COMMERCIAL REGISTER
In photomechanical reproduction, a misregister tolerance of plus or minus one row of dots. *M. Bruno*

COMOPT
An abbreviation for *composite optical,* printed on the leader of motion-picture release prints to indicate an optical, as opposed to a magnetic, sound track. *H. Lester*

COMPACT CASSETTE
One specific audio cassette, which is the most widely used and familiar audio tape medium in the world. It uses a standardized outer cassette shell for protection of the tape and generally standardized record characteristics such as speed, track format, equalization, and noise-reducing companding for good interchangeability. *T. Holman*

See also: *Dolby.*

COMPACT DISC AUDIO (COMPACT DISC PHILIPS)
The popular standardized digital audio disc format using optical recording to encode two channels of 16-bit linear pulse code modulated audio information of up to approximately 72 minutes in length. *T. Holman*

COMPACT DISC-INTERACTIVE (CD-I)
A new standard for the use of CDs containing still images, moving image sequences, and audio tracks. A CD-I device will allow a user to *interact* with the program contained on the disc. It requires a CD-I player and appropriate monitor. the CD-I player has its own microprocessor and represents a higher-level of built-in intelligence than a standard CD or CD-ROM player. *R. Kraus*

COMPACT DISC READ-ONLY MEMORY (CD-ROM)
Discs that can hold text, images, and sound, and are a major means of data storage and distribution. Their storage capacity is in the region of 650 Mbytes of data. Since the throughput of CD-ROM players are standardized at 150 Kbytes per second, these devices are capable of playing audio CDs. *R. Kraus*

COMPANDING
A system of compressing a signal before recording and expanding it on playback in a precise complementary way. The object is to restore the signal exactly, but any noise that intervenes between encoding and decoding will be subject only to decoding: the tape noise will only be expanded downward and thus will be reduced. *T. Holman*

COMPARISON PHOTOMETER
See *Visual photometer.*

COMPETITIONS
A contest for photographs (or occasionally papers on photographic topics, etc.) in which the winners receive awards, often honorary.

Photographers evaluate their own performance by competing with others. Recognition is achieved by being among a few whose works are included in an exhibit. However, the term *competition* is most widely applied to contests where tangible prizes are given, the winners are selected by judges, and the work may be published in one of the popular media. They may be organized by various clubs, publications, commercial organizations, civic promotions, or other causes, and allow entries in specified classes of photographic subject matter. There are usually entry rules that must be complied with. Entry fees and return postage are commonly required, and winning photographs may become the property of the sponsor. *I. Current*

COMPILER
A software type program that converts high-level programming language into machine language in preparation for execution. Compiled languages run faster than interpreter languages and can be complied into executable programs. *R. Kraus*

COMPLEMENTARY AFTERIMAGE
A visual phenomenon whereby a person continues to see an image after the stimulus has been removed, with the hue of the afterimage being positioned approximately on the opposite side from the hue of the stimulus in a Maxwell triangle. *L. Stroebel and R. Zakia*

See also: *Afterimage; Maxwell triangle.*

COMPLEMENTARY COLORS
(1) In colorimetry, two color stimuli are complementary when it is possible to reproduce the tristimulus values of a specified achromatic stimulus by an additive mixture of these two stimuli. (2) Generally, complementary colors are those of the opposite hue: thus, red and cyan are complementary colors, as are green and magenta, and blue and yellow. *R. W. G. Hunt*

COMPLEMENTARY WAVELENGTH
Wavelength of the monochromatic stimulus that, when additively mixed in suitable proportions with the color stimulus considered, matches the specified achromatic stimulus. *R. W. G. Hunt*

COMPOSITE PHOTOGRAPH
A photograph on which two or more separate images have been combined by any camera, printing, or postprinting technique. *R. Zakia*

See also: *Photomontage.*

COMPOSITE PRINT
A motion-picture print containing both picture and sound track. *H. Lester*

Syn.: *Release print; Married print.*

COMPOSITION
Composition is the arrangement of visual elements in a picture or an image.

Two divergent strands dominate concepts of composition in photography: those that find photography among the two-dimensional arts as the inheritor of a long pictorial tradition subject to traditional concepts of composition, and those that believe there are unique problems of composition in photography due to the interface with reality of the photographic process and the capacity of the photographic process for mimetic veracity. The former may be described as previsualization; the latter as postvisualization.

Previsualization seems to be identified with the idea of a gestalt inherent in the human brain, and selection, arrangement, and organization of forms take place by moving the frame, or the viewfinder before the picture is even made. The ordering of the elements is produced by the artist/photographer. Principles of composition may be considered classical,

traditional, or universal to the human principles—the S curve, the golden section, ratios of organizational balance of 2:3, 3:4, or other arithmetic progressions, a rule of thirds, symmetrical or asymmetrical balance, anchor figures, a center of interest, a leading line, and other principles of compositional organization are all considered rooted in a relationship between the physical organism (the human being as spectator), and the world this spectator inhabits. Our vertical position subject to gravity, the human tendency to problem solving, and the imposition of visual order in gestalt theories of perception are all used as natural rationales for these principles of the imposition of formal or compositional order. Balance, rhythm, and unity are inherent in the physical and psychological patterning of the person who then imposes these patterns of order on the material world or on representations of the material world. Composition "grows," alters, changes, and emerges or develops under the guiding mind and hand of the artist, designer, or photographer, almost in terms of an organic metaphor. On this model, composition and layout, the altering of borders and frames by cropping and bleeding, the ordering of the relationship between figure and ground, object and space through careful selection, or altering of the focal lens, are all possibilities and/or rules of order in composition. The frame established by the view finder is seen as a limen, a border separating the image from the factual world.

In postvisualization, order is apparent in the visible world and the artist, designer, or photographer finds, selects, or chooses this order and reproduces it with as much verisimilitude as possible. The eye–brain–mind operates on this model as a process of recognition and selection of an order "out-there," an order that should be recapitulated with accuracy. In this approach to composition, the stopped moment, a particular portion of fleeting time is captured and held. Tilted picture planes, the angling of camera and lens angles to produce perspective views that move from a centering of the viewer to aerial views or bird's eye views, or from beneath, in a worm's eye view, are all part of the unique possibilities of the camera. In this view, the border acts as a frame, recapitulating the process of isolating a fragment of reality in the view finder. Snapshot-like compositions of tilted angles, fragmented figures, selective focus, partial blurs or the uncomposed pictures produced by moving cameras, or accidental discoveries are all part of this approach to photographic composition.

In discussing composition, or the organization of visual elements, Rudolph Arnheim argues that our sense of the world is based upon two spatial systems: one cosmic, the other parochial. Arnheim's systems, while not exactly replicating postvisualization and previsualization techniques of composition, lay out two compositional approaches that deal with an inherent order and an imposed order, and for this reason appear to bear some degree of similarity to the previsualization and postvisualization approaches to composition outlined above.

In the cosmic, or centered approach, matter, according to Arnheim, organizes around centers, generally marked by a dominant mass, whether microscopic systems in nature or macrosystems such as galaxies. Cosmic organization is symmetrical, like concentric shapes around a central point. The physical equivalent in the natural world is gravity, to which all weights and masses are subjected.

The parochial system is a planar organization—the simplest the mind can seek: a geometric organization of grids of verticals and horizontals. The grid has no center, and the concentric system hasn't sufficient organizing power, so a combination of both the centering system and the grid are necessary to order space. It is this combination that provides visual composition with organizing power with the means to make content readable as form.

To these ordering systems, Johannes Itten added the dimension of expression. Itten described the basis of composition in exercises in the theory and practice of forms by indicating that the three basic forms—square, triangle, and circle—are typical of the four different directions in space. Itten believed that the experience of these directional possibilities could be directly felt, that abstract form or the geometrical structure underlying natural form could generate emotional response. This was the hallmark of the teachings of the Bauhaus in Germany in the 1920's: essential forms could elicit emotional response in and of themselves, regardless of content. The Bauhaus developed the modern ideas regarding visual form, the language of vision, and ideas of formal organization, or composition.

In the dynamics of visual composition, the spectator, or the viewer is a center; so, too, is the imaginary axis or fulcrum around which shapes are arranged. This *center of interest* need not be directly in the middle; one of the continuing classical compositional devices is that to the *golden section,* or golden mean, which places objects in a mathematical relation to an imaginary middle and structures the picture plane, to the positive and negative areas, and to the figure–ground relationship in composition. Dynamic pictorial shapes are achieved by manipulations of the picture plane, of positive and negative space, and of the figure–ground relationship by ordering these relationships to the frame.

Striving for a photographic reality of cropped borders, angled picture planes, and an immediacy of vision similar to an unplanned snapshot and then reordering a visual balance in the darkroom is a complement of both modes of order. Isolation of forms, suppression of detail, selective focus, and depth of field are all possibilities for the ordering of composition, and they depend upon film, wide angle lenses, stopping-down apertures and the organization of variations in the tonal range of a photograph through burning in, dodging out, or other exposure controls. Here technical choices, selective ordering of figure–ground relationships, spatial illusions, and the control of the frame create a balance between pre- and post-visualization techniques of composition.

Books: Arnheim, Rudolph, *The Power of the Center: A Study of Composition in the Visual Arts* Rev. ed. Berkeley, Los Angeles, London: University of California Press, 1982; Berger, Arthur Asa, *Seeing Is Believing: An Introduction to Visual Communication.* Mountain View, California: Mayfield, 1989; Itten, Johannes, *Design and Form. The Basic Course at the Bauhaus and Later.* Revised Ed. New York: Van Nostrand Reinhold, 1975; Zakia, Richard D., *Perception and Photography.* Rochester, New York: Light Impressions, 1979. *R. Welsh*

COMPOUND See *Chemical compound.*

COMPOUND LENS A lens unit of two or more individual elements that may be cemented together. *S. Ray*

COMPOUND SHUTTER A central-opening between-the-lens type of shutter formed by a number of overlapping leaves mounted symmetrically around the optical axis of the lens. Invented by Friedrich Deckel of Munich in 1902.

L. Stroebel

COMPOUND TABLE The flat platform of an animation stand, capable of precise movements, on which the artwork is placed when being photographed. *H. Lester*
Syn.: *Compound.*

COMPRESSION In electronic imaging, image data are compressed in order to achieve smaller files for storage and/ or transmission. LZW and Huffman codes are two compression algorithms widely used on images. Video is often compressed using an interframe process whereby redundancy

shared by two frames is ignored. In transmission of image data under this scheme only the differences between the frames are transmitted, thus decreasing the time necessary to transmit the data. *R. Kraus*

COMPRESSOR A special kind of audio amplifier arranged so that equal level changes in the input result in smaller level changes at the output, often used to help fit a wide dynamic range program into a narrower dynamic range channel.

While there are a number of useful purposes for a compressor, there are also side effects that must be accounted for if they are to remain generally unperceived. Among the best uses of compressors is to control the dynamic range of individual elements during a mix. Let us say that there is music underscoring a dialogue scene. What is desired is that the music be at an unobtrusive but always audible level. Here the compressor is useful on the music track to keep it within prescribed limits so that, on the one hand, it does not intrude into the dialogue, and on the other, does not appear to drop out at any point.

Compressors applied to already mixed program material often show a number of undesirable side effects. *T. Holman*

See also: *Dynamic range.*

COMPUTER-AIDED DESIGN (CAD) The use of computers to assist in design activities such as graphics, architecture, engineering, and page layout. *R. Kraus*

COMPUTER-AIDED MANUFACTURING (CAM) The use of computers to assist in the design and monitoring of a manufacturing process. *R. Kraus*

COMPUTER ANIMATION See *Animation, animation techniques.*

COMPUTER-ASSISTED INSTRUCTION (CAI) The use of computers in the classroom to advance teaching and learning. Almost any involvement of computers in providing instruction, questioning, or feedback in the teaching-learning paradigm has been labeled CAI. Currently, CAI has come to mean the use of a computer in the control of multimedia for the purposes of instruction. *R. Kraus*

COMPUTER GRAPHICS When personal computers were first introduced, they were seen as a mere novelty. It wasn't until the introduction of word processing and spreadsheet software that their use as an integral tool for communications was recognized. Even though programs that could create graphic elements soon followed, words and numbers remain the mainstay of most computer-generated communications. This was due in large part to several factors including the fact that programs were not only difficult to use, they failed to provide the user with a real-time display of what was being created, there was no efficient, inexpensive way of obtaining hardcopy output of graphic information, and there was no way to easily integrate graphics and text elements.

In the mid-1980s, several technological developments occurred that changed all of that and launched the visual communications revolution known as desktop publishing. The introduction of a graphic user interface and a concept embodied in the acronym WYSIWYG (what you see is what you get) made it possible for anyone who could use a *mouse* (a point-and-select device) to draw with a computer. At the same time the introduction of inexpensive, high-resolution output from laser printers made it possible to get graphic designs off the computer's display screen and into the hands of intended viewers. Finally, page layout software made it

possible to integrate text, graphic elements, and photographs into a single document.

TEXT INFORMATION Today word processing programs not only allow users to enter and print out alphanumeric characters, they provide the writer with an opportunity to be a graphic designer as well. With thousands of type fonts available and the ability to apply any number of type styles to a document, designers can easily use text as a graphic design element. For many situations, a word processing program and a laser printer have totally replaced the need for typesetting.

GRAPHICS PROGRAMS There are two basic approaches that graphics programs take in representing information on screen and to output devices. These approaches give the programs two unique *feels* that not only affect how the artist creates elements but also what the final output looks like.

Bitmapped Programs Bitmapped graphics generated with *paint programs* use a work surface made from a grid of individual picture elements (pixels). Graphic line artwork is created by assigning black or white values to each pixel in the work area. Gray-scale artwork is possible if the program supports assigning gray levels to individual pixels. The number of pixels contained in the work area determine the resolution of the file regardless of the potential resolution of the output device. For example, even though a drawing can be printed on a laser printer having a potential resolution of 300 dots per inch, if the paint program used to create the file only uses 72 dots per inch, the final output will only have a resolution of 72 dots per inch. The visible effect of graphics created with low-pixel resolution will be that curved elements in the design will exhibit stair-stepped artifacts referred to as *jaggies* or *aliasing*.

Vector-Based Programs Vector-based (sometimes referred to as object-oriented) graphics created with *draw programs* use mathematical expression (like those used in coordinate geometry) to describe graphic shapes. Shapes are dealt with as individual objects that may be grouped, layered, and superimposed to create graphic designs. Because the location of pixels needed to render an object are defined by those points that make the mathematical definition true, the resolution of the graphic will be determined by the capabilities of the output device, not by the number of pixels the program can address. In the case of a graphic object rendered to a laser printer having a resolution of 300 dots per inch, the mathematical definition will identify which 300 pixels should be activated for any given inch. The file size of a vector-based graphic will be substantially smaller than the file size of a similar bitmapped graphic because the vector-based program does not have to store information about each and every pixel.

DESKTOP PUBLISHING Desktop publishing has given personal computer users, working under short deadlines, the ability to inexpensively generate documents that use graphic design, photography, and text to effectively communicate. Page layout programs make it possible for a designer to perform many of the tasks that previously required the services of specialists, including such things as typesetting, halftone separations, stripping, and printing. The page layout program brings computer data that may exist in a number of formats together as one file. The other significant function that page layout programs provide is that once the data have been edited and assembled into one file, they are translated into a format that can be universally understood by a wide range of output devices, independent of the computer system used to create it. This is accomplished through the use of a page description language. Like other programming languages, a page description language generates a list of instructions that tells an output device how to render all the visual elements contained on any given

page. The page description language that has essentially become an industry standard is called Postscript and many output devices will list one of their advantages as being Postscript compatible.

PRESENTATION PROGRAMS In addition to desktop publishing documents, computer graphics will be prominently featured in the production of images used to support presentations by live speakers. Generally distributed in the form of slides and overheads, these images represent a multibillion dollar segment of the communications industry. There are a number of software programs that, like page layout programs, help the designer organize, produce, and output the visuals that will be used in a presentation. In addition to a full range of graphic production tools, these programs also allow users to organize ideas with the use of an outlining feature, generate summary handouts, and produce scripts and storyboards for the speaker as well as import visual and text information from other programs.

MULTIMEDIA Depending on who you talk to, the term *multimedia* will be given a variety of definitions. A relatively new computer concept, multimedia uses the personal computer to bring together text, graphics, animation, photography, and sound. This digital information is organized into presentations that can exist as interactive packages delivered by the computer, self-contained programs presented on videotape, or visual support material used in live presentations. *T. Zignon*

COMPUTERS FOR PHOTOGRAPHERS In recent years there have been a number of developments and trends in computer technology that have important implications for the photographer. Computers have traditionally been large, centralized devices requiring technical specialists to operate them. Their primary function has been computation. Unprecedented improvements in technology, however, have resulted in system efficiencies that have reduced size, lowered costs, and greatly expanded capabilities. As a result, the form and function of today's computer have changed radically. The advent of the personal computer has resulted in a decentralization of computing. A computer at every desk has become the norm in many organizations. The primary function of the computer has changed from computation to communication. Word processing, databases, spreadsheets, electronic mail, and desktop publishing are all examples of this change. Until recently, the tangible output of a computer's communications function has taken the form of text-based documents and graphic representation of data. This is rapidly changing, with computers playing an ever increasing role in the creation and distribution of both halftone and continuous-tone photographic images. Today computer technology represents a tremendous opportunity for photographers, as visual communicators, to express themselves in new and exciting ways.

COMPUTER SYSTEMS In discussing computers, there are many systems to consider. These systems can be as simple as the hand-held calculators that have replaced the slide rule, or as sophisticated as the supercomputers used by scientists and engineers to solve complex theoretical problems. Photographers will most likely find themselves working with a microcomputer or perhaps a workstation. Accordingly, this discussion will focus on these computers.

Regardless of their sophistication, all computer systems are a combination of hardware and software components.

These components can be functionally grouped into the three broad areas of input, processing, and output. Hardware includes all the physical (mechanical, electronic, electrical, magnetic) parts of a computer, as well as a number of peripheral devices. Hardware components are useless without appropriate software. Operating system software gives a computer its functionality by providing a set of instructions that direct hardware components to perform specific tasks. Utilities and applications are software programs that work in concert with the computer's operating system to perform specialized jobs such as word processing.

The way in which the user interacts with the computer is referred to as *user interface*. In the past few years, this relationship has been the subject of much study and has resulting in new *user-friendly* environments, making computer use by neophytes much more common. There are currently two ways a user can interact with a microcomputer. The first is a command line, character-based interface, which requires the user to learn a set of commands (instructions) with very specific syntax. The computer waits for a command to be typed in with a keyboard and, if that command is in the software's vocabulary, tasks such as creating a file, saving a file, or printing a file are accomplished. Programs that use this type of interface can have a substantial learning curve associated with them because each new program may require learning a whole new set of commands. This is an example of a command line used in Microsoft's Disk Operating System (MS-DOS): C> Format/4 a:. It represents, for a novice user, a fairly cryptic way of communicating.

The other approach uses a graphic user interface. The Apple Macintosh and Microsoft Windows are examples. In these systems, icons graphically representing files, storage devices, and other program and system components are used to create a somewhat intuitive visual work environment. All commands and actions that can be taken by the user are listed under a set of menus. In addition to the keyboard, the user also uses a pointing device called a *mouse*. Unlike the command line interface, which simply waits for an appropriate instruction, the graphic user interface provides closed-loop communications. The computer is continually checking and updating mouse positions and displays that position on the screen. Users are able to select and move visual elements on the screen. The system provides feedback when inappropriate actions are taken.

INPUT Computer input refers to any component, function, or action that provides the system with information. Human beings live in an analog world. We receive information using the senses of sight and sound. Light energy and the mechanical energy that constitutes sound are converted by the eyes and ears into a constant flow of fluctuating electrical voltages. The brain processes these electrical currents and provides us with the sensations of sight and sound. Unlike humans, a computer, which is nothing more than a collection of circuits that can be turned either on or off, requires that the information it receives be presented in a digital form (a series of ones and zeros representing the on and off states the computer can understand). Input devices and software therefore serve as the interrupter between man and machine.

Analog to digital (A/D) conversion is the process by which a flow of infinitely varying electrical voltages (analog information) is sampled at a given rate and the discrete values that are obtained are expressed as a string of binary

Microcomputers / Calculators / Workstations / Minicomputers / Mainframes / Multi-Processor Super Computers / Simple — Sophisticated

Computer systems, from simple to sophisticated.

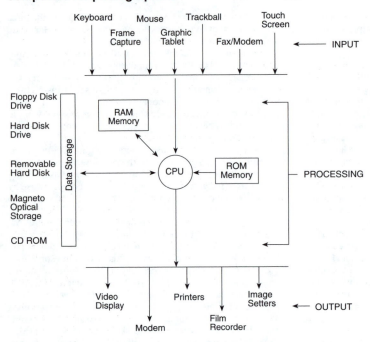

Keyboard Mouse Trackball Touch Screen

Frame Capture Graphic Tablet Fax/Modem

← INPUT

Floppy Disk Drive

Hard Disk Drive

Removable Hard Disk

Magneto Optical Storage

CD ROM

Data Storage

RAM Memory

CPU

ROM Memory

— PROCESSING

Video Display Printers Image Setters ← OUTPUT

Modem Film Recorder

Computer system components: input, processing, and output.

(ones and zeros) numbers (digital information). Once converted these values can be used by the computer, manipulated, stored, and retrieved for later use. Many input devices are used with today's microcomputers.

Keyboards Keyboards have provided the traditional way in which people interact with a computer and provide an efficient way of entering alphanumeric information. In addition to the keys found in standard typewriter layouts, most computer keyboards also contain a separate numeric keypad for easier number entry. Also, most computer keyboards contain a special set of *function keys* that provide shortcuts when using certain software programs. In some cases these keys can be programmed to perform special tasks.

Mouse While a keyboard is adequate for interacting with

text-based programs, it doesn't provide the kind of input necessary to take full advantage of a graphic user interface or to interact with many graphic drawing programs. A mouse is a hand-held device that is moved along any flat surface. A pointer (cursor) on the display screen indicates the relative position of the mouse as its position changes. Buttons on the mouse allow the user to select, grab, and move objects, as well as make selections from various menus. In some cases, these buttons can be made to operate like the function keys found on most keyboards.

The mouse's location is tracked in one of two ways. The most common method uses a rollerball located in the bottom. As the mouse moves, the ball rotates against two variable resistors, which make voltage adjustments to signals repre-

Input. Computer screen display for a graphic user interface.

senting x and y coordinates. While this design is adequate for most uses, it is somewhat inaccurate and susceptible to mechanical failures, dust, and dirt. The second method uses a special pad that has a very fine grid etched into its surface. The mouse shines a laser light source onto the grid. The reflected light is interpreted, providing very accurate mouse location information.

Trackball One of the drawbacks of a mouse is that it requires a minimum 8 × 9-inch area to operate. It also requires the user to develop a certain eye/hand coordination to use it efficiently. The trackball works on the same rollerball principle as the mouse. However, instead of being underneath, in a trackball the rollerball is located on top. Rather than dragging the ball around on a flat surface, users rotate the ball with their fingers. Many users find this gives them greater control and accuracy in moving the cursor on the screen. Also, the fact that the trackball remains stationary, requiring less space, makes this a popular alternative to the mouse.

Graphics Table While a mouse or trackball gives the user the ability to move a pointer (cursor) around on the screen and use the basic drawing tools found in many graphics programs, they are awkward to use for intricate drawings tasks. Most illustrations are created by artists who have developed their ability to render objects using pencils, brushes and similar hand-held tools. The digital graphics tablet provides the artist and designer with an input environment that closely replicates using such tools.

The graphics table is an electronic work surface containing a finely placed grid of sensors. A stylus, resembling a pencil or brush, is moved over the tablet's surface, activating the embedded sensors and causing the motion to be rendered on the screen as lines or brush strokes. The sensors will respond to either pressure or to magnetic flux being emitted by the stylus. In some graphics tablets the amount of pressure being applied to the stylus is also noted. This information, when presented to software programs designed to recognize it, provides the artist a realistic environment for working with tools such as air brush, pencils and charcoal.

Tablets are available in various sizes and can be programmed to respond as either absolute or relative devices. With absolute referencing, the tablet responds, point by point, to physical locations on the screen, (i.e. to a point 1 inch in from the left edge of the screen would correspond to a point 1 inch in from the left side of the graphics tablet. An 8 × 10-inch piece of artwork created on the screen would require and 8 × 10-inch graphics tablet.) In the relative mode, the distance moved is noted and rendered on the screen. In this way, a large piece of artwork can be manipulated using a relatively small graphics tablet. The stylus is simply picked up and repositioned on the tablet to continue drawing a line whose length exceeds the length of the tablet. (Most mice and trackballs use the same *relative distance* method being described here.)

Touch-Sensitive Screens Touch-sensitive screens are a type of interactive system in which the user is prompted to interact with the program by touching certain objects depicted on the screen. This system uses a pressure-sensitive film that is attached to the video display screen. These screens can eliminate the need for a keyboard or any other input device and are well suited for those situations in which a novice user must interact with a computer.

Scanners Scanners are computer input devices that can convert black-and-white or color line art, halftone, and continuous-tone photographic images, into digital information. Although image scanners have been available for some time, the cost of these systems, and the computers needed to support them, have kept them out of the reach of the average photographer. The three basic designs available for use with microcomputers include flatbed, hand-held, and desktop film scanners. In each case these devices make use of a photo-

sensitive integrated circuit chip called a charged-coupled device (CCD). A CCD contains thousands of transistors, made from light-sensitive semiconductors. When light energy strikes the CCD, it is converted to electrical current with voltages proportional to the illuminance of the light striking it. Analog-to-digital circuitry samples these voltages and converts them to binary numbers that can be used by the computer.

Flatbed scanners are designed for the reflective copy of print and photographic material as large as 11 × 17 inches. The original is placed face down on a glass platen, and, in much the same way as an electrostatic copy is made, an optical system focuses reflected light onto a CCD that is mechanically passed under the original in stepped increments. For colored originals, three passes (scans)—one each for red, green, and blue information—are made.

Hand-held scanners work on the same principle as the flatbed; however instead of the scanner mechanically moving the CCD past the original, the user rolls the scanner over the original material. This is very useful for those situations where the original cannot be placed on the glass platen of a flatbed, or where portability is a concern. Hand-held scanners are fairly inexpensive and work reasonably well with small images. Lager originals can be difficult to scan because of the need to roll the device consistently over larger areas.

Film scanners are used to convert photographic negatives and transparencies into digital information. Like flatbeds, film scanners contain an optical system that focuses an image on a CCD. The CCD will either be moved through the projected image, or, in the case of scanners that use an area array CCD, be exposed to the entire image for a fixed interval without moving the CCD. Color information will be scanned by making three passes (or exposures) through red, green, and blue filters. Film scanners are available for originals ranging in size from 35-mm to 4 × 5 inch. Some flatbed scanners can be fitted with a light source for transillumination and can be used to scan larger-sized negatives and transparencies. The overall image quality obtained from a scanner will depend on the scanner's spatial and brightness resolutions.

Frame Capture Cards Frame capture cards bridge the gap between electronic and digital image making. There are currently two options available to the photographer wishing to explore *filmless photography*—electronic (motion or still) and digital. Electronic photography includes camcorders, which use videotape to record motion imagery, as well as electronic still video cameras, which use a 2-inch magnetic floppy disc to record up to 25 frames of video information. In both cases visual information is stored as analog video signals.

Frame capture cards are integrated circuit boards that can be attached to an expansion slot on the computer's main circuit board. These cards are designed to accept the electrical voltages that constitute a video signal and convert those voltages to digital information. These boards typically can process a number of video signal formats including NTSC, PAL, SECAM, S-Video, and component RGB. As a rule, video images that have been digitized using a frame capture card will be of lesser quality then images made with a digital camera system using an area array CCD. This is due to the lack of spatial and brightness resolution inherent in analog video.

Modem A *modem* (short for modulate/demodulate) is a device that allows two computers to communicate with each other over ordinary telephone lines. The digital information from the originating (sending) computer is modulated as a series of pulses (similar to the early telegraph using Morse code). The receiving computer uses its modem to demodulate the incoming pulses back into digital information.

Large mainframe computers can be set up as clearing

houses of information that anyone with a microcomputer and a modem can access. Bulletin board services and information networks such as Compuserve, America On-Line, and Prodigy offer their subscribers far-reaching services that include such things as access to research libraries, electronic mail, public forums for the exchange of ideas, airline reservations, banking services, stock market quotes, and shopping. While a majority of this information is text-based, photographers, particularly photojournalists, are also making use of this technology. Digital images can be sent all over the world instantly, without the photo-processing delays associated with traditional wire services.

The speed at which information can be sent is referred to as the *baud rate*. Baud rates associated with microcomputer modems start at 300 bits per second (bps) and go as high as 9600 bps. Baud rates of 1200 or 2400 bps are acceptable for communicating text-based information. Visual information, particularly digital color photographs, contains significantly larger amounts of data and requires much higher baud rates in order to send this type of information in a reasonable amount of time. The current limits as to how fast computer data can be sent via modems is related to the bandwidth limits of present telephone systems.

PROCESSING Input devices provide the computer with raw material (data) that must be gathered, organized, and manipulated to create useful output. Computer processing is accomplished with software programs that provide a set of procedures and instructions that direct hardware components to gather raw data, structure it in ways that will allow the software to further manipulate and use the information, and finally save that information in formats that can be used later by a variety of output devices.

Central Processing Unit The central processing unit (CPU) is the heart of any computer. The term *CPU* is often used to describe the *black box* to which all input and output peripherals are connected. More accurately, the CPU is the microprocessor contained in a single integrated circuit chip. The vast majority of today's microcomputers use chips made by one of two manufacturers. IBM PCs and compatibles use one of the following Intel microprocessors: 8086, 80286, 80386, or 80486. The Apple Macintosh uses one of the following Motorola microprocessors: 68000, 68020, 68030, or 68040. These processors have been listed in order of technological advancement and performance with the 80486 and the 68040 representing the most advanced chip technology. The CPU is responsible for executing software instructions that manipulate computer data. The CPU's performance is given a rating based on the number of instructions it can execute in a given period of time. Ratings as high as 20 million instructions per second (mips) are possible on some systems using the "486" and "040" microprocessors.

Two factors that influence the CPUs mips rating are clock speed and data architecture. In order to coordinate all the discrete actions taken by the CPU, timing circuitry is used. Activities are timed and sequenced, creating a processing cycle. A computer's clock speed refers to the number of processing cycles per second that can be performed by the system. The frequency of CPU processing cycles (clock speed) can range anywhere from 8 to 50 megahertz (*MHz*). The other factor affecting the CPU's performance is the data architecture used by the system. Digital information is a string of ones and zeros. Each digit in the string is referred to as a *data bit*. Large strings of bits are grouped into manageable bundles or units called *bytes*. Eight bits make up a data byte. A system's data architecture refers to how the computer organizes and processes these bytes for any one processing cycle. Microcomputers use either an 8-bit (1 byte), 16-bit (2 byte) or 32-bit (4 byte) architecture. Obviously, the number of bits involved in any one processing cycle, combined with the number of cycles that can performed in a given time will determine the system's processing speed. Speed becomes an important consideration when a computer is used for image capture, manipulation, and output because of the huge amount of data needed to represent the image.

Data Bus A computer's data bus refers to the electrical connections and pathways between the CPU and all other system components. In most cases the data bus represents the primary bottleneck to data processing. The CPU can execute instructions much faster than the data can be moved between components and in most cases they must be programmed to wait for the data to catch up. The need for ever increasing processing speeds has led to the fact that future generations of computers will probably use light rather than electrical energy simply because electrons can't move fast enough to keep up with the anticipated capabilities of future CPUs.

Computer Memory Computer memory refers to those components that store data either temporarily, while being gathered, structured, and manipulated, or long term, once the data has been organized into its final form, ready for output. One of the specifications often cited is a computer's memory capacity and it is an important consideration for systems that will be used to manipulate visual information. Memory capacity is expressed in terms of the number of bytes of information it can store. Storage capacities are measured in kilobytes, megabytes, and gigabytes where 1 kilobyte equals a thousand bytes, 1 megabyte equals a million bytes, and 1 gigabyte equals a billion bytes.

Random-Access Memory *Random-access memory* (RAM) is used to temporally store data while it is being processed by the system. It represents the computer's work area and the storage capacity set aside for this function is an important factor in how efficiently the system works. The act of placing data in memory is referred to as *writing to memory*. Obtaining information from memory is known as *reading from memory*. RAM memory is said to be volatile. Volatile memory will store data only as long as there is current applied to the circuitry. When the system is turned off, this temporary memory is lost. A computer must be configured with enough RAM memory to store operating system instructions and application software instructions, as well as the input data that will be manipulated by the software. For text-based applications such as word processing, spreadsheets, and databases, a megabyte of RAM is usually adequate. For applications designed to work with graphic design and visual information, it is not uncommon to need 8 to 12 megabytes of RAM storage to efficiently gather and manipulate data.

Read-Only Memory As its name suggests, *read-only memory* (ROM) cannot have data written to it as part of normal system operation. Data that are stored in ROM are installed when the chip is manufactured. ROM memory chips typically contain frequently used instructions and subroutines related to the operating system. ROM is an example of nonvolatile memory storage. Data in nonvolatile memory are stored permanently and it does not require electrical current to maintain the data.

Storage Memory Storage memory is often confused with the RAM and ROM memory used to process data. Storage memory involves using a variety of digital recording techniques and media to store and distribute software programs and the files those programs create. There are currently two methods being used to record data for later playback—magnetic and optical.

Magnetic systems mechanically position a write/read (record/playback) head to specific locations over a spinning disk of magnetic recording medium. Magnetic patterns of changing polarity are captured in much the same way as information is captured when making a recording to magnetic audio or video tape. In playback, magnetic polar pat-

terns are read as the on/off patterns that represent the digital information presented during recording.

Optical systems use microscopic points of laser light to pit the surface of a reflective disk with burn marks that scatter rather than reflect light. To read back the information, the disk is spun in front of a laser light source. The pattern of burn marks breaks the beam of reflected light, causing it to pulse in a series of on-and-off patterns that the computer processes as binary data.

Important factors to consider in evaluating storage memory include total storage capacity, data access time, and data transfer rates. As a general rule, for photographers using a computer to manipulate visual information, the more storage capacity, the better. A single full-color image can require 20–30 megabytes of storage. Data access time, measured in milliseconds, refers to how long it takes the storage device to locate all the specific pieces of data needed for a particular file. Data transfer rate refers to how fast data can be read from the storage device and presented to the CPU for processing. This rate, expressed in kilobytes per second, is related to the data architecture of the system.

Floppy Disks Floppy disks are computer storage media made from flexible disks of magnetic recording material very similar to material used in audio and video recording tape. The disk is mounted in a cardboard or plastic housing that protects it from dust and dirt. Floppy disks are available in 5-1/4 and 3-1/2-inch sizes. Floppy disk drives often use a serial data exchange method and have relatively slow access times, making them a fairly slow storage and retrieval method. Depending on how the disk is manufactured and the type of magnetic recording material used, a disk will use either a double-sided, double-density or high-density design. To be used, the disk must first be formatted. Formatting establishes specific regions on the disk where magnetic information can be recorded and later played back. Depending on the drive mechanism and how system software formats the disk, a floppy disk may be able to store 400 Kbytes, 720 Kbytes, 800 Kbytes, 1.2 Mbytes, 1.4 Mbytes, or 2.8 Mbytes of data.

Hard Disk Hard disk drives use a series of rigid platters that can be recorded to (write) and played back from (read) in much the same way as a floppy disk. The plates used in these drives have a much greater capacity to store information than do floppy disks. Hard disks' storage capacities can range anywhere from 20 megabytes to 4 gigabytes. Hard disks use parallel data exchange methods and use drive mechanisms that have data access times as fast as 15 milliseconds. This makes the hard disk drive one of fastest storage and retrieval systems available.

Removable Hard Disk The removable hard disk is very similar in design to the fixed hard disk. The major difference is that the rigid magnetic platter is contained in a plastic housing that can be removed. This gives the user the ability to expand storage capacity by buying additional removable disks, using them the same way as floppy disks. Another difference is that the removable hard disk can store significantly more data. There are several removable disk designs that allow for storage capacities of 44, 88, or 90 megabytes. The access and read/write times for removable dries fall in the range of 50 to 100 milliseconds.

Compact Disk Read-Only Memory *Compact disk read-only memory* (CD-ROM) storage offers an alternative to the magnetic recording process used with floppy and hard disks. The same technology used to distribute audio recordings in the form of compact discs, is used to record and distribute computer data. This method allows data to be written only once but read back as often as needed. Thus, the acronym WORM (Write Once, Read Many) is frequently used to describe this technology. CD-ROM offers large storage capacity in an easily distributed format; typically 650

megabytes of data, equivalent to 300,000 typewritten pages of text information, can be stored on a 4 1/2-inch compact disk. Data stored on a CD-ROM is much less likely to be damaged because the storage medium is not susceptible to extraneous magnetic energies that can destroy data nor the mechanical actions of a magnetic read/write head moving over the surface of the recording medium. The one drawback to CD-ROM is that the inherent access time and data transfer rate makes it one of the slowest forms of data storage available.

Magneto-optical Magneto-optical (MO) storage utilizes a combination of magnetic and optical technology to produce a system that can provide 125 megabytes of read/write storage on a disk the size of a 3 1/2-inch floppy. Some MO disks can store in excess of 1 gigabyte of data and, even though they have slower data exchange rates, they offer the same utility as a removable hard drive with ten times the capacity.

OUTPUT Computer output reverses the analog-to-digital processes of input to display to output devices, in an analog form, the results of computer processing.

Digital-to-Analog Conversion Digital-to-analog (D/A) conversion is the process by which the string of binary numbers resulting from data processing operations is converted into electrical voltages. There are a variety of output devices that can respond to these voltages to present information in the form of sight and sound.

Monitors/Video Cards Video display monitors provide immediate feedback as the user interacts with the system and, in some cases, also provide the final output. Depending on the application being used, video display requirements can be as simple as a monochromatic cathode ray tube. The vast majority of today's computer systems use color video monitors to support programs designed to generate and display full-color graphic information. Some systems may limit the number of colors that can be displayed at any one time—typically 256 colors. This is more than adequate for most applications. Photographers, however, will often require video systems that can display full-color images containing millions of specific colors. The display capabilities of a computer monitor will be determined by special video interface circuitry, usually contained in an expansion card attached to the computer's main circuit board. Video display cards allow users to customize a system to their particular needs. The card will determine the number of colors that can be displayed, the type of video signal used (usually noninterlaced RGB), and the resolution characteristic of the display.

Printers The majority of tangible computer output will come from some form of printer. A variety of systems are used to apply ink, dye, and toner to paper including daisy wheel, dot matrix, ink-jet, and thermal dye sublimation. Few systems, however, have had as much impact on the use of computers for visual communications as the laser printer. Using the principles of an electrostatic copier, the laser printer uses a beam of laser light to electrostatically charge areas on a piece of paper that correspond to the image being rendered. Magnetically charged toner is attracted to these areas and heat-fused to the paper, producing a high-resolution line image. Laser printers typically have resolutions of 300 dots per inch or greater and can replicate limited gray scales using halftone dot patterns. This output technology has spawned the desktop publishing industry and, with the advent of color laser copiers, represents tremendous opportunity for photographers to become involved with using computers as a tool to create and display their work.

Halftone Output If photographers are going to have their work seen by the masses, they will, at some point, be involved with the halftone printing process. The computer is having a major impact on how images are published. Desktop publishing, electronic prepress, and proofing operations

have now made it possible to take a digital file containing photographic images and go directly to the printing press, bypassing traditional photographic processes.

While this technology has been available in the printing industry for some time, it is now becoming available to personal computer users. As a result, photographers will have significantly greater control in getting their work into print.

Contone Output Continuous-tone color output from a computer file is accomplished in one of two ways. The first uses a heat-transfer technology known as dye-sublimation printing. In this system, transparent yellow, magenta, and cyan dyes are transferred to special receiver paper creating 11×11-inch prints with a resolution of 300 dots per inch. In many cases these prints can rival the quality obtained using traditional photographic processes.The second method uses a film recorder to make a photograph of the image as it is formed on a high-resolution monochromatic cathode ray tube. Using additive color principles, the image is formed by making three exposures through red, green, and blue filters. Film recorders are capable of very high resolutions, offering one of the best methods for producing color negatives and transparencies from digital files. *T. Zignon*

See also: *Digital photography; Electronic still photography.*

COMPUTER-TO-PLATE SYSTEMS Photomechanical reproduction printing systems that use digital plates.
M. Bruno

See also: *Photomechanical and electronic reproduction.*

CONCAVE Optical term applied to lenses and mirrors indicating that the surface is curved to form a hollow and the center of curvature is in front of the surface. *S. Ray*

CONCENTRATION The concentration, or amount of a chemical dissolved in a liquid, can be expressed as grams of solid dissolved in a liter of liquid (weight per volume), as grams of solid in grams of liquid (weight per weight), as volume of liquid in a volume of liquid (volume per volume), or percentage solutions (parts per hundred). Avoirdupois measures may be used in place of the metric weights and volumes. *G. Haist*

CONDENSATION The process whereby water vapor from the air gives up its heat of vaporization and forms droplets of liquid water. This process occurs whenever air containing a sufficient amount of water vapor is cooled sufficiently (to a temperature below the dewpoint). Condensation can be very troublesome on film and photographic and electronic equipment that is brought from a cold environment into a relatively warm or humid environment. The liquid water that forms on surfaces can interfere with the operation of film, lenses, mechanical equipment, and electronic circuits. Condensation of this type can be avoided by warming the equipment to a temperature higher than the dewpoint of the environment the equipment is about to enter. If condensation occurs, it can be removed by gradually heating the equipment in a safe manner. It is important to remember that the liquid water will have to reabsorb its heat of vaporization to vaporize; moderate warmth over a period of time is more effective than strong heat. Dehumidifiers are effective at lowering the dewpoints of areas where condensation is a particular problem. Fog is a result of condensation occurring in the air. Condensation occurs on surfaces more easily, however, because of surface tension effects. *J. Holm*

CONDENSER (ELECTRICAL) See *Capacitor.*

CONDENSER ENLARGER An enlarger that has a positive lens positioned above the film carrier that focuses light from the source to a point in or near the enlarger lens. With more efficient use of the light, exposure times can be shorter with a condenser enlarger than with a diffusion enlarger using the same light source. The condenser lens must have a diameter at least as large as the diagonal of the negative or transparency being printed. Some condenser enlargers use variable focal length condenser lenses to compensate for changes in enlarger lens focal length with different film formats, and others use interchangeable condenser lenses. *L. Stroebel*

See also: *Enlargers.*

CONDENSER LENS See *Lens types.*

CONDENSER MICROPHONE See *Capacitor microphone.*

CONDUCTION BAND The lowest-energy band of a crystal that is either partially filled with electrons or is empty. Its degree of occupancy determines whether the material is an insulator or a conductor. Because it is only, at most, partially filled, the electrons in this band are free to move around the crystal and are able to "conduct" electrical current.
R. Hailstone

See also: *Photographic theory.*

CONES, RETINAL One of two basic types of light receptors in the retina, the other being rods. Cones are responsible for our perception of color, and they number about 7 million in each eye. Each cone contains one of three different photopigments, the basis for trichromatic vision.
L. Stroebel and R. Zakia

See also: *Vision, the human eye, color vision.*

CONFIGURATION The spatial arrangement of the various elements and components of an optical system. Conventionally, a vertical cross section is shown in diagrams with the incident light entering from the left. *S. Ray*

CONFORMING The process of matching original motion-picture film to the edited work print for the making of release prints. *H. Lester*

See also: *A & B roll; Checkerboard cutting.*

CONJUGATE Distance measured from the front or rear nodal point of a lens to the object or the image, respectively. The object conjugate (distance) and its corresponding image conjugate for a given focal length are related by the lens conjugate equation. *S. Ray*

See also: *Lenses; Optics.*

CONSERVATION See *Image permanence.*

CONSOLE (SOUND) A piece of audio equipment designed to amplify, combine, and otherwise process multiple inputs. *T. Holman*

See also: *Audio mixer.*

CONSTANCY Any of various phenomena whereby a person's perception of some aspect of a scene or object, such as brightness, color, or size, remains unchanged or resists change despite changes in the corresponding stimulus. As an object moves away from a viewer, for example, the object is normally perceived as remaining constant in size even though the retinal image of the object decreases in size. *L. Stroebel and R. Zakia*

See also: *Perspective; Visual perception, constancy.*

CONSTANT ANGULAR VELOCITY (CAV) A record/playback technique for the encoding and reading of data on a laser disc. CAV maintains constant disc rotational speed to enhance access time to randomly stored frames.
R. Kraus

CONSTANT LINEAR VELOCITY (CLV) A record/playback technique for the encoding and reading of data on a laser disc. In CLV-type disc players the speed for the disc changes so that the track velocity is constant, thus increasing storage capacity. Such a design is appropriate for motion picture storage and display. *R. Kraus*

CONSTRINGENCE See *Abbe number.*

CONTACT MICROPHONE A specialized microphone designed to pick up vibration directly from a solid body. Contact microphones have been used to record items as diverse as a violin and a bridge structure stimulated by traffic. *T. Holman*

CONTACT PRINTER An exposing device for making 1:1 scale reproductions from images on a transparent base, typically negatives, without the use of an optical system. In still photography, contact printers generally consist of a box containing one or more light sources, a red safelight bulb, a diffusing panel, a transparent support, and a platen to press the sensitized material against the image being printed and the transparent support. They sometimes include masking blades, an automatic timer, and individual switches for a grid network of light sources to control light distribution. Motion-picture contact printers have a mechanism for moving the processed film and the raw stock together in close contact as the exposure is being made. *L. Stroebel*

CONTACT PRINTER/PRINTING Light-sensitive printing materials may be exposed by projection or by contact. Projection permits enlargement or reduction of the size of the original image; contract printing produces same-size images.

Contact prints are made most simply in a contact printing frame consisting of a glass plate, a wooden or metal frame and back, and a spring or clamping mechanism that holds the negative in firm contact with the printing material. Exposure may be by daylight or by artificial light from an enlarger or a room lamp. Common printing techniques such as dodging, burning in, and masking can be applied.

More elaborate contact printing devices include printing boxes, the bright illumination of which may be diffused by ground or opal glass. Lab-grade units are designed for speedy film handling. Some are large enough to make offset lithographic masters from negatives or positives, or to print x-ray film. Reflex printers for copying documents handle sheets as large as 30 by 40 inches. Motion pictures are reproduced by contact printing processed film to raw stock. Step printers stop for the exposure of each frame; continuous printers move the film at a fixed rate.

Contact printing is used for a variety of reasons. Many historical and graphic arts materials are relatively insensitive to light, necessitating exposure to direct sunlight or high intensity artificial light for practical reasons. W. H. Fox Talbot's calotypes and the salted-paper processes that succeeded it were contact printed, as were albumen, gum, platinum, and palladium prints. When faster materials became available, many photographers continued to contact print their large format negatives for aesthetic reasons and because of the simplicity of the apparatus required. Roll films are contact printed to provide a reference record and to help decide what to print and how to print it.

A properly made contact sheet will demonstrate the correct printing exposure and contrast for a large-format negative or for individual images on a roll of film. Black must be printed through the edge of the negative, the area of least density, which consists of the film base plus any fog created during development. Once the shortest exposure necessary to produce maximum black through the edge is established, the printing contrast is adjusted so that the range of tones in the final print is appropriate to the literal or expressive intentions of the photographer. *H. Wallach*

CONTACT SCREEN A system of variable density dots used to produce halftones. *M. Bruno*

See also: *Photomechanical and electronic reproduction; Halftone photography.*

CONTAMINANTS Photographic processing materials must be guarded to prevent environmental contamination. Dust and other aerial pollution is a major photographic contaminant. Dust must be kept off the surface of films and papers from exposure through processing and drying, and even in storage. Water often contains particles, organic matter, and a variety of other contaminants that may embed in soft emulsion layers during processing and washing of films and papers. Poor laboratory technique in weighing and handling of photographic chemicals can cause insidious and persistent chemical effects, such as emulsion fogging, that can make darkrooms unsuitable for photographic processing. *G. Haist*

CONTAMINATION CONTROL The air and the water are two major sources of contaminants in photography. Filtration of the air and water, plus dust control in photographic work areas, will do much to control or avoid problems caused by physical contamination. Even so, filtering photographic solutions just before use will add an extra measure of prevention. Cleanliness in the darkroom is a necessary practice to prevent chemical contamination. Some chemicals are fogging agents and can easily be transferred by human hands to photographic emulsion layers. High humidities in work and storage areas should be avoided as moisture stimulates biological growth. *G. Haist*

CONTAMINATION, PHYSICAL Physical contamination results when some foreign material is allowed to collect on the surfaces of negatives or prints before, during, or after processing. These contaminants can include sludges and scum from wetting agents, aluminum or calcium precipitates, iron or rust, ink or paint, organic material such as biological growths, and dust. Filtering of water and processing solutions, replacement and maintenance of rinses, removal of excess water before drying, filtering of drying air, and care in handling material at all stages can generally prevent contamination. *I. Current*

CONTINUITY A quality of the scenes of a motion picture or the images in a photographic series, and so on, that tends to combine the individual parts into a unified whole. Used in reference to both the total effect and to factors such as lighting, action, mood, props, photographic quality, and written or spoken material accompanying the photographs.

STILL PHOTOGRAPHY Generally, a photograph describing an actual event or object in the real world does so using a single frame. Yet, within the stationary single frame, continuity or movement can be depicted by the composition, or arrangement, of shapes on a surface. Continuity can be progressive, as in the alignment of similar shapes in a single line that moves across a picture plane either on a single line resembling a narrative movement left to right, or by an alternating rhythm up and down as the similar shapes move across the picture surface. Continuity or movement back into space operates through perspective renderings where the eye level or camera angle can depict a direct movement into the picture, or through the use of alternate perspectives: oblique, bird's or worm's eye views. In designs based upon curves or spirals, continuity in space causes a series of movements and counter movements on the picture

plane around an imaginary fulcrum as the progression moves continuously into or onto the picture plane.

Patterns of continuity can be alternating movement and counter movement in the picture through disjunctions that emphasize a dominant movement, or one pattern of movement can counter a separate movement pattern. Something as simple as posing two figures in single directions with one small element in an alternate pattern of movement, can set up patterns of movement and counter movement. Posing a figure with the head turned at a three-quarter face view while the body sits straight to a camera angle creates this alternation of movement. A figure leaning forward as if moving off the picture surface, or a figure or object tilted back sets up alternating movements.

Strong diagonal compositions create illusions of motion within a picture plane. Alternating shapes at differing levels or distances around an imaginary axis or fulcrum on the picture plane causes the illusion of a rotating continuity of motion. Camera angles, changes in focus, blurs from camera movement and multiple stationary frames can convey the illusion of temporal continuity through changes in appearance or conjunctions of events. Pairs of photographs, sequences of images and a continuous mosaic of many frames of a single image or related images can create a tension between statis and the illusion of motion or continuity. The eye perceives illusions of motion through successive steps that alternate or displace forms in space, or through changes that suggest motion has taken place.

Some contemporary photographers often use the representation of process in a work to suggest the movement in time of the making of the image; the various aspects of process suggest the development in time of the image to indicate continuity. Others alter sequences that disturb expectations formed by conventional perspective and create discontinuous sequences that interfere with the "normal" flow of continuous time. Verbal narratives accompanying pictures convey succession in time, and foster illusions of temporal continuity. Words can interrupt pictorial continuity, and photographic images used as a rhebus can disturb verbal continuity.

MOTION PICTURE PHOTOGRAPHY Continuous sequences of still photographs moving rapidly create the illusion of continuous motion. This is due to a phenomenon known as *persistence of vision* (in which the image stimulation continues on the retina for a fraction of a second longer than the initial exposure to the stimulus) and the *phi phenomenon (a psychological effect)*. These effects cause the images to merge one with the other, creating the illusion of continuity or continuous motion. Persistence of vision was known as early as the first century B.C. and was discussed by Leonardo da Vinci. Early in the nineteenth century, a number of toys were manufactured based upon this phenomenon; by the end of the century, the motion picture camera was in use.

Closeups, which move the image directly to the front of a picture plane; medium shots, which represent an image at a mid-point between close up and distance; and a long shot, which places an object or an action at a distance from the viewer, are the essence of motion picture continuity. The arrangement of these shots into visual continuity sequences according to rhythms form the essence of style in motion pictures. Editing continuous film into these rhythms, or montage, creates these patterns of continuity in motion pictures.

Books: Bloomer, Carolyn M., *Principles of Visual Perception.* New York: Van Nostrand Reinhold, 1990. *R. Welsh*

CONTINUITY STILL A photograph of a motion-picture scene taken to record details of decoration, costumes, and props to ensure matching in subsequent shots. *H. Lester*

CONTINUOUS PROJECTOR (1) A motion picture projector designed to accept a film loop so that the film can be shown over and over without interruption. (2) A slide projector with a circular slide tray that automatically changes each slide at a specific time interval, will eventually reach the first projected image, and start the sequence over from the beginning. *M. Teres*

CONTINUOUS SPECTRUM A spectrum that indicates amounts of radiation of a relatively wide range of wavelengths in a relatively smooth functional relationship. A spectrum that is not continuous is called a discontinuous spectrum. *J. Holm*

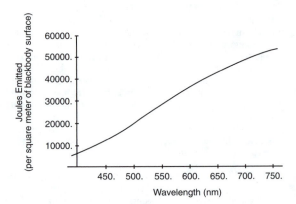

Continuous spectrum—the spectrum of a tungsten-halogen lamp (3200 K).

CONTINUOUS TONE (1) Identifying imaging processes that are capable of producing a smooth transition of density from light to dark, or images produced by such processes. Conventional photographic images are continuous tone as distinct from line images, which contain two discrete tones, and halftone images, where the perception of intermediate tones is created with arrays of dots that are uniform in density but vary in size. The fact that greatly magnified photographic images are not continuous tone is generally ignored. (2) In computer imaging, continuous tone refers to a minimum number of gray levels (256) representing the scene. For true color representation there would be 256 gray levels for each channel of color information.
L. Stroebel and R. Kraus

CONTOUR FILM Film with both positive and negative emulsions resulting in a summed response that records only a line representing levels of equal illumination. By making exposures at different exposure levels, *contour maps* representing iso-brightnesses could be produced. Agfacontour film was available in the 1960s. Today, digital imaging techniques would make such work much easier. *M. Scott*

CONTOURING In electronic imaging, an unwanted effect whereby smooth gradations of tone in the original are imaged as a series of stepped tones (similar to posterization) due to an insufficient number of quantizing levels or faulty information processing. *L. Stroebel*

CONTRACT PHOTOGRAPHER In photojournalism, a photographer who covers selected assignments for a publication and is paid on a per-assignment basis, as distinct from a staff photographer, who is a full-time employee. *B. Polowy*

CONTRAST

CONTRAST The variation between two or more parts of an object or image with respect to any of various attributes such as luminance, density, color, or size. Examples of subjective descriptions of contrast include low contrast (or flat), high contrast (or contrasty), and normal contrast, terms that are variously applied to photographic subjects, lighting, film, developer, printing paper, and prints. Examples of objective measurements of contrast include a 3:1 lighting ratio, a 160:1 scene luminance ratio, a 3.0 log exposure range, and a print density range of 2.0. Ratios with conventional numbers correspond to differences when the numbers are converted to logarithms, so that a luminous ratio of 100:1 corresponds to a log luminance range of 2.0 (2.0–0.0). Other measures of tonal contrast include gamma and contrast index, which are based on the slopes of straight lines on D-log H graphs, where a value of 1.0 represents the slope of a line at an angle of 45 degrees to a horizontal line.

We should make a distinction between local contrast and overall contrast in photographic images. In terms of the characteristic curve of a printing paper, the local contrast varies for subject tones represented on the straight line and on different parts of the toe and the shoulder, which correspond to the middle, highlight, and shadow subject tones, respectively. This difference is especially pronounced in prints that are commonly described as being too contrasty. In such a print the middle tones are contrasty but the lightest highlight and darkest shadow areas typically have no detail and therefore no local contrast.

The perceived contrast of a given photograph can change dramatically with changes in viewing conditions. It is well known that a print appears darker when it is viewed with a white surround than with a black surround, a perceptual effect known as *simultaneous contrast,* and also when it is viewed under a low level of illuminance, with corresponding changes in local or overall contrast. The contrast of a color transparency appears to be much higher when it is viewed by transmitted light in an otherwise darkened room than when the room lights are on or the area around the transparency on the illuminator is not masked off, due to simultaneous contrast and the effects of flare with a light surround. *R. Zakia*

See also: *Contrast index; Modulation transfer function.*

CONTRAST CONTROL

CONTRAST CONTROL There are a number of ways of altering tonal contrast when photographing a subject, including changing the lighting on the subject. In studio situations, a fill light is commonly used near the camera to lighten shadows created by a main light. A lighting ratio of 3:1 is considered appropriate for most formal portraits, for example, but higher and lower ratios are used for different effects. Outdoors there is less control, but electronic flash can be used to reduce the lighting ratio by filling in shadows created by direct sunlight for subjects that are relatively close. For more distant subjects, such as landscapes and buildings, it may be necessary to select a different time of the day, or a day on which the weather conditions are different to obtain a less contrasty lighting effect.

FILM AND PROCESSING The contrast of black-and-white negatives made on general-purpose film can be altered within limits by the choice of developer and the time, temperature, and agitation of development. The degree of development, which includes all of these factors, is commonly calculated from D-log H curves as contrast index or gamma. In the zone system, plus-1 development and minus-1 development are used to expand or contract the tonal range by the equivalent of one exposure zone.

Because of reciprocity effects, negative contrast tends to be higher with long exposure times and lower with short exposure times such as are encountered with electronic flash. Adjustments in the degree of development are recommended for film exposed under these conditions.

Some films, such as lith films, have inherently high contrast, and other films, such as extended-range films, have inherently low contrast. Changes in the degree of development is not a practical procedure for controlling contrast with color films. Color filters can be used on the camera lens to control local contrast with black-and-white films, such as using a yellow or red filter to increase the contrast between white clouds and blue sky. A polarizing filter can be used to produce a similar effect with color films.

PRINTING In black-and-white printing, print contrast can be controlled to compensate for variations in the contrast of negatives by the choice of paper contrast grade or the choice of color filter with variable-contrast paper. Condenser enlargers also produce slightly higher contrast prints than diffusion enlargers. Toning black-and-white prints can alter image density and contrast in addition to color, changes that vary with the choice of paper and toner. Selenium toner is sometimes used with cold-tone papers to increase image density and contrast with only a subtle change in image color. There is much less variation in contrast among color printing papers than black-and-white papers. Other methods of altering contrast in printing include binding a mask in register with a negative or transparency to either increase or decrease contrast, and the use of controlled flashing to reduce contrast. Some slide duplicators have built-in provisions for flashing to reduce the contrast with reversal color films, and some duplicating color films have inherently less contrast than conventional reversal films.

DISPLAY Viewing conditions can have a significant effect on the appearance of density and contrast of a photograph. Increasing the illumination level on a normal print tends to make the print appear to be too light overall with a decrease in detail and contrast in the highlights. A low level of illumination tends to make the print appear to be too dark overall with a decrease in detail and contrast in the shadows. However, a print that has been printed slightly darker displayed under a higher-than-normal level of illumination appears to have a greater range of tones than a print having normal density displayed under normal room illumination.

Slides and motion pictures projected on a screen in a darkened room appear more contrasty than when there is ambient light in the room, because the ambient light lightens the dark areas proportionally more than the light areas and because the dark surround in the darkened room produces a simultaneous contrast perceptual effect.

COLOR MATERIALS With color materials the best way to control contrast is to control both the lighting ratio and the color temperature. Little can be done during development without destroying the color balance of the print or transparency. Care in how the prints are mounted and displayed will have an effect on contrast; color temperature, light level, and surround are also important.

VIDEO INDOORS The first step in video contrast control is the same as that in photography: adjust the lighting of the scene to be videographed to match the recording system. In a studio situation, control is accomplished by adjusting the light level and adjusting the camera to a white level of 100% and a black level of 75%. A waveform monitor (a video lightmeter) that displays luminance values on an oscilloscope is used to make these adjustments. After adjustment is made for luminances, color balance is established by adjusting the gain for rgb (red, green, blue) phosphors to a black level and then to a white level, and usually balancing for a flesh tone.

VIDEO OUTDOORS Adjusting overall contrast when videographing outdoors can be done by using fill-in lighting in the shadow areas to reduce contrast. Additional limited control can be done in-camera by reducing the white level to compress contrast or by *white clipping* to eliminate whites that are beyond the camera's recordable range. At one time

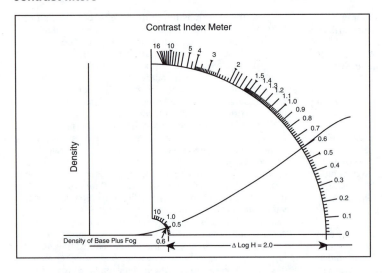

Contrast Index Meter

Density

Density of Base Plus Fog

Δ Log H = 2.0

Contrast index. The use of a contrast-index meter, showing a CI value of 0.60.

these adjustments had to be performed manually, but now they are done automatically. In situations where the light level is too low and there is a danger of severely underexposing, it is possible to *push* the sensitivity of the video camera system by boosting the gain to maximum. As in photography, when you push film speed the result is weak, muddy shadows and graininess (noise).

The videographer can also control contrast by using the gamma correction circuit and the edge enhancement circuit, both of which are built into the camera. The edge enhancer is an electronic device that sharpens the video image by exaggerating the luminance transition between light and dark areas in the picture. This is analogous to the so-called adjacency or border effect in photography that produces an increase in sharpness by exaggerating the density differences at the edges of an image.

Video Display Contrast, brightness, and color controls are also available on TV/video receivers and monitors. As with photographs, ambient light and lightness of the surround affect the appearance of contrast.

Electronic Still Photography The ultimate in contrast control of both tone and color can be achieved by combining photographic and electronic systems. The photograph (print, transparency, or negative) can be scanned, digitized, manipulated with a computer software program, and then printed out using any of a variety of printing systems, including photographic. Image definition in the print, depending upon the system used, can approach that of an original photograph.

Books: Mathias, Harry, and Patterson, Richard, *Electronic Cinematography*. Belmont, Calif.: Wadsworth, 1985. *R. Zakia*

See also: *Color contrast; Contrast; Simultaneous contrast; Visual perception.*

CONTRAST FILTERS See *Filter types.*

CONTRAST GRADES The numbering system relating to black-and-white photographic printing papers indicating (in inverse order) their exposure scales. The numbers are consecutive integers with 0 representing a high exposure scale (about 1.70) and 5 representing a low exposure scale (about 0.70). When printing a given negative, the higher the paper contrast grade number, the greater the contrast in the print. The ideal pictorial negative should make a pleasing print on a number 2 paper. Variable contrast papers use a similar numbering system for the filters that change their effective contrast. *M. Scott*

CONTRAST INDEX (CI) The preferred measure of development contrast in a negative film sample. It is the slope of a straight line drawn between two defined points on the film characteristic curve.

Contrast index may be found by either of two methods: (1) Place a transparent CI template so that the characteristic curve intersects the right and left arcs at the same numerical value—the CI; (2) locate a point on the toe of the curve at 0.10 above the base-plus-fog density, and from that point strike a circular arc with radius 2.0 in log-H units that intersects the upper portion of the curve; the slope of a straight line between the lower and upper points approximates the CI value.

Contrast index is preferred to gamma (the slope of the straight line of the D-log H curve) because some modern films do not have a single straight line and because subject shadow tones often fall in the toe of the curve.

Contrast index is often used in monitoring a development process for stability. A fixed contrast index, however, does not ensure that all processed negatives with the same CI value will have the same printing characteristics, because other factors (camera exposure level, camera flare, and scene contrast) will affect the resulting negatives.

M. Leary and H. Todd

See also: *Average gradient; Characteristic curve; Gamma.*

CONTRAST RESOLUTION In electronic imaging, the brightness range that the digitizer is capable of representing. This is also referred to as pixel depth, the number of bits that each pixel is capable of holding. The number of bits determines the number of gray levels that will represent the image. *R. Kraus*

CONTRE JOUR Term to describe a photograph taken with the camera pointed toward the light source.

F. Hunter and P. Fuqua

See also: *Back lighting.*

CONTROL CHART A graph showing the performance of a process, based on measurements over time, and intended to detect unwanted changes in the process. For example, in monitoring photographic processing systems, standardized exposed test strips are periodically sent through the system and measured and the results plotted. *H. Todd*

CONTROL LIMITS Lines on a control chart showing the highest and lowest test measurements to be expected of an

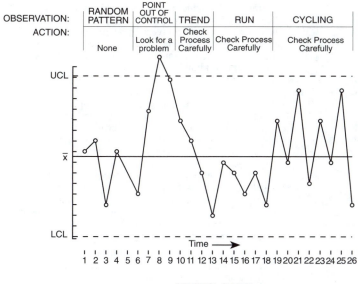

OBSERVATION:	RANDOM PATTERN	POINT OUT OF CONTROL	TREND	RUN	CYCLING
ACTION:	None	Look for a problem	Check Process Carefully	Check Process Carefully	Check Process Carefully

CONTROL CHART

Control chart. Horizontal lines show the expected process average and upper and lower control limits.

unchanged process. Data falling outside the limits are signs that action should be taken to restore the process to its normal characteristics. *H. Todd*

CONTROL STRIP A small piece of photographic film or paper, exposed in a standard manner (as in a sensitometer), that is sent through a chemical process and then measured. The results are often plotted on a control chart. *H. Todd*

CONTROL TRACK (SOUND) In any recording medium it is possible to control the level of recording on a track by means of a compressor, and then to also record the compression amount by a signal on a separate track. In playback, the process may be reversed by using the compression amount information to expand the audio back to full dynamic range. The separate track containing the compression information is known as a control track. Several commercial realizations of the control track principle have been used over the years on both optical (Fantasound) and magnetic (Dynatrack) analog recordings but have generally passed out of use in favor of signal-controlled companding noise reduction systems (such as the various Dolby Noise Reduction systems), which do not require use of a separate dedicated control track. *T. Holman*

CONVERGING LENS Lens that is thicker in the middle than at the edge and having at least one convex surface. Transmitted rays of light are refracted toward the optical axis. The lens can form a real image, i.e., one that can be focused on a screen. Converging lenses are also called *positive lenses*. *S. Ray*

CONVERGING LINES The image of parallel subject lines, such as railroad tracks, viewed obliquely. With a camera, this effect results whenever the film plane is not parallel to the parallel subject lines. *L. Stroebel*
 See also: *Perspective*.

CONVERSION FACTORS See *Appendix J*.

CONVERSION FILTERS See *Filter types*.

CONVERSION TABLES See *Appendices H, J, K, L*.

CONVERTER LENS See *Lenses, afocal lens*.

CONVERTIBLE LENS See *Lens types*.

CONVEX Optical term applied to lenses and mirrors having a surface that bulges outward at the center and having the center of curvature behind the surface. *S. Ray*

COOKIE/COOKALORIS/CUKALORIS/CUKE A thin, opaque sheet with a pattern of irregularly shaped and positioned holes. When held in front of a light source, a dappled highlight and shadow pattern is cast on a backdrop or other surface. Typically used so that light appears to have been filtered through trees outside a window. The edges of the cookie should be irregular, and not straight-edged, to avoid angular shadows that reveal the use of an effect tool. *R. Jegerings*

COOL COLOR Bluish color, as distinct from a yellowish or reddish (warm) color. *R. W. G. Hunt*
 See also: *Color circle*.

COPIER A device designed to make facsimile reproductions of documents and other two-dimensional originals, either in black-and-white or in color. Many types of imaging processes have been employed in the past, but the field is now dominated by the xerographic process. *L. Stroebel*

Syn.: *Copy machine, office copier, photocopier*.

COPPER SULFATE LIQUID FILTER See *Filter types*.

COPROCESSOR In computers, the use for a special chip on the motherboard or other special board to speed up graphics and mathematics-intensive applications. The use of coprocessors is extremely important in rendering two- and three-dimensional design work. *R. Kraus*
 See also: *Video accelerator*.

COPY (1) A reproduction of a two-dimensional image. (2) The act of making a reproduction of a two-dimensional image. (3) In the graphic arts, any image (including photographs, drawings, paintings, and text) that is to be reproduced. (4) With an analog image such as a photograph or

Cookie with a random pattern of irregularly shaped holes to cast a light-and-shade pattern onto set surfaces.

videograph, there is a loss of information when copies are made. Copies of digital images suffer essentially no loss (only 10^{-12}).

L. Stroebel

COPY CAMERA See *Camera types.*

COPYING, PHOTOGRAPHIC Photographic copying is the process of making photographic reproductions of two-dimensional subjects such as photographs, paintings, drawings, and printed matter. The broad field of copying also includes slide duplicating, microfilm information storage and retrieval systems, facsimile transmission, computer digitized imaging, common office copying, and copying for photomechanical reproduction with process cameras and color scanners. Cartoons (animated motion pictures) are produced with specialized copy cameras known as animation stands.

Conventional photographic copying is directed toward providing a high quality reproduction, either print or transparency, for any of a variety of reasons, including (1) the original is too precious, unstable, or fragile to be exposed to everyday handling; (2) the original is too large or too small to handle or use conveniently; (3) the original has a short-coming that can be eliminated in the reproduction; and (4) more than a single image is needed for distribution. Copying allows the producer to keep an inviolate archival file, while allowing others to have access to the information contained in the original image.

Photographic service departments offer career opportunities that require photographic copying expertise as part of an overall photographic education. Some photographers make their living exclusively by producing prints, slides, and overhead transparencies for visually augmented presentations. Facsimile office copying and storage and retrieval systems are designed to be operated by untrained personnel, but there are career opportunities in engineering, sales, and consumer relations in these areas.

Computerized digital imaging and videotape and laser disk imaging are relatively new career opportunity fields. Electronically stored images can be archivally stored in a small and remote space and then recalled in any order and displayed on a video monitor, with or without electronic manipulation. The graphic arts industry makes extensive use of process copy cameras and color scanners to convert continuous-tone originals to high contrast halftone dot images suitable for photomechanical reproduction on the printed page.

Copying using a copy stand and conventional photographic materials accounts for the vast majority of the work done in this field. The normal photographic copying technique requires that:

1. the material to be copied is evenly illuminated,
2. the lighting does not produce glare reflections,
3. the film plane of the camera is parallel to the subject,
4. the optical axis of the lens is perpendicular to the subject,
5. the subject is flat and centered with respect to the camera, and
6. the film and filters (if any) are appropriate for the light source.

Even illumination is usually accomplished by placing one or two lights of known color balance on each side of the copy camera. If the lights are at equal distances and angles, non-uniformity due to distance falloff by lights on one side is compensated for by the falloff of the lights on the other side. By measuring the illuminance with an incident light meter at each corner and at the center of the subject, the lights can be adjusted until the lighting is uniform over the entire subject area. The size of the uniform area can be increased by increasing the distance between the subject and the lights. The lights should be placed at an angle of approximately 45 degrees to the subject plane to avoid specular reflections and objectionable texture shadows.

Polarizing filters can be used to eliminate small specular reflections on textured originals, such as oil paintings. It is necessary to place a polarizing filter over each light source, with all such filters oriented in the same direction, and to place another polarizing filter over the camera lens with the orientation at a right angle to that of the filters on the lights. Sometimes the texture of a painting or the brush strokes are important characteristics with respect to the artist's technique. In such cases it is the use of specular reflections and small-scale shadows that reveal the texture. The proper amount of emphasis to be placed on texture should be determined in consultation with the client. In the vast majority of copy photographs, however, specular reflections and shadows are detrimental.

If the film plane of the camera is not parallel to the subject, the shape of the reproduction will be distorted. With 35-mm and other cameras that do not have swing and tilt backs, the camera must be positioned so that the back of the camera is parallel to the subject, which is not a simple task when the camera is mounted on a tripod. Copy stands, however, are designed to keep the camera film plane parallel to the subject plane as the camera is moved to change the scale of reproduction. Some copy cameras can project a grid image back through the camera lens onto the copyboard to assist in positioning the original, and in controlling cropping and focusing without using the camera viewfinder or ground glass.

The subject should be held as flat as is practicable to prevent image distortion and uneven lighting. If the photog-

rapher has input with regard to the format proportions of the final presentation image, as is often the case when slides, overhead transparencies, or images for presentation on television are being produced, the photographer should use the same aspect ratio for the camera-ready art. The film selected should be appropriate for the desired representation of the subject that is to be copied. When using color film, it is important to match the color balance of the film to the color temperature of the light source, and to use appropriate filters when necessary.

Although modern optics and films allow the use of 35-mm cameras equipped with macro lenses for copy work, there are retouching and other advantages with larger negatives and transparency sizes. Larger format films are often used when image manipulation techniques are required or when optimal image quality is essential. Professional photographers who specialize in copy work maintain a permanent copying workstation with fixed lighting and predetermined exposure data. Incident-light exposure meter readings and reflected-light exposure meter readings are more dependable than reflected-light readings of the subject due to the variation in the balance of light and dark tones among subjects. Compensation must be made for variations in lens-to-film distance with changes in the scale of reproduction unless using a camera equipped with through-the-lens metering.

Copying transparent materials presents additional problems. Most transparency and radiology viewers do not have sufficient light uniformity for copy photography, and the light sources do not match the color balance of color films. A uniform light source can be made by backlighting a piece of opal glass or by modifying a light box. A reflected-light exposure meter can be used to check uniformity of the lighting by making a series of closeup readings. Commercial slide-copying or duplicating devices are available that are equipped with color-compensating filters and uniform diffuse light sources. Slide duplicators require very little space, and some provide flashing capabilities to reduce image contrast with color films. Through-the-lens metering is more practical than attempting to use hand-held exposure meters because of the small size of the original slides, but allowances must be made for variations in the balance of light and dark tones and variations in density of the area of slides that the meter is measuring. *D. Page*

See also: *Audiovisual communication.*

COPYRIGHT

LEGAL CONCEPT A copyright is a bundle of rights that comes into being upon the creation of a work. In the United States, since January 1, 1978, those rights are almost exclusively defined by a federal statute known as the Copyright Law. The categories of work that may be the subject of a copyright are included in the Copyright Law. The following assumes that the work being discussed was created on or after January 1, 1978.

A statutory copyright comes into being at the moment the work is created in tangible form. The key word is *tangible*. The idea behind a unique photograph cannot be the subject of a copyright for the photograph. The photograph must first be created. The idea, however, may be the subject of a written article which is subject to copyright. The copyright on the article would, however, not prevent a photographer, other than the author, from creating a photograph based on the idea expressed in the article. "Ideas," as opposed to the writing encompassing the ideas, are not subject to copyright protection.

The statute specifically states that copyright protection for an original work of authorship does not extend to any idea, procedure, process, system, method of operation, concept, principle, or discovery, regardless of the form in which it is described, explained, illustrated, or embodied in such work.

There is no doubt, however, that once the photograph is created, a second photographer is prohibited from copying the photograph. The term *copying* includes creating a new setup and taking a new image, if indeed the basis of the new image is the copyright image.

In order to further understand the concept of copyright law, a comparison with patent law is helpful. Both copyright law and patent law deal with the protection of the end product of the creative process. The major difference is that patent law only protects the first inventor. Even if it can be demonstrated that the second inventor had no access to the ideas of the first inventor, the first inventor is the only person who obtains rights. Copyright law, however, permits a second creator to obtain rights, provided the second work has not resulted from the copying of the first work.

Thus, it is possible that Photographer A may create a photograph based on a unique lighting setup and find that independent of the work of A, Photographer B has created substantially the same photograph. Each photographer has a copyright.

WORK SUBJECT TO COPYRIGHT What may be the subject of a copyright is specifically defined in the statute. Of major importance to photographers and other visual artists is that pictorial, graphic, and sculptural works are copyrightable. Other works that may be the subject of a copyright include literary works, musical works, dramatic works, pantomimes and choreographic works, motion pictures and other audiovisual works, and recordings.

New and changing technology nevertheless has resulted in litigation over such issues as whether the "look" of screen interface between the user and a computer program may be the subject of a copyright. The ability of computers to manipulate all or a portion of a copyright photograph has already given rise to questions of copyright infringement for which there are no definitive answers. It may take until the end of the twentieth century before litigation resolves the issues.

RIGHTS OF THE COPYRIGHT HOLDER The holder of a copyright on a work has the exclusive rights to do and to authorize any of the following: (1) to reproduce the work; (2) to prepare derivative works based on the work; (3) to distribute copies of the work to the public by sale or other transfer of ownership, or by rental, lease, or lending; (4) to display the work publicly.

The bundle of rights arising from the copyright are not limited to the medium in which the copyright work was created. One court has held that a work of sculpture based on a photograph was an infringement of the copyright on the photograph.

The copyright on a photograph is separate from the ownership of the photograph. A photographer may make and sell an unlimited number of copies of a copyright photograph without transferring the copyright. Similarly, unless restricted by the terms of a prior license, a photographer may enter into an unlimited license agreement for the use of the same photograph. It is that fact that is the basis for the business of stock photography.

A transfer of a copyright, by statute, must be specific and in writing.

The provision of the Copyright Law relating to "work for hire" was, during the 1980s, a source of controversy. The relevant provision provided that, in the absence of a written agreement providing otherwise, the employer owned the copyright on the works of employees. The controversy arose because of the claim by many advertising agencies that when photographers were given assignments, the photographs produced were "work for hire." If correct, it would be the agency's client who owned the copyright. The Supreme Court removed most of the controversy by declaring that the governing rules were substantially the same as for determining whether any person was an employee or independent

contractor. Since most photographers are independent contractors, the controversy diminished in intensity.

Because the question of who owns the copyright can be determined by contract, it is important, even if the photographer is clearly an independent contractor, to read the terms of the assignment contract.

TERM OF A COPYRIGHT The term of a copyright, for works created after January 1, 1978, is the artist's life plus 50 years.

COPYRIGHT REGISTRATION All works may be registered with the Copyright Office, in the Library of Congress in Washington, D.C., whether or not they have been published. Photographs and other pictorial, graphic, and sculptural works are registered on Form VA. The 1993 filing fee is $20. Two copies of the work must be submitted with the form and filing fee.

Registration is not necessary to gain copyright protection. Registration does, however, have important advantages: (1) the certificate of registration, if issued either before or within five years of first publication, is presumptive proof of the validity of the copyright and the truth of the statements made in the copyright application; (2) if registration has been made prior to commencement of an infringement, the copyright holder may qualify to receive attorneys' fees and "statutory" damages (damages that a photographer can elect to receive if actual damages are hard to prove). A published work registered within three months of publication meets the "prior to commencement of infringement" qualification; (3) registration is necessary in order to commence a suit for infringement; and (4) by registering, certain defenses that an innocent infringer might be able to assert due to a defective copyright notice are eliminated. The effective date of registration is the day on which an acceptable application, deposit copies, and fee reach the Copyright Office.

Each photograph need not be the subject of a separate form and fee. An unpublished collection may be registered as a group under a single title. Even if the work has been previously published in periodicals, there is a provision and an additional form for group registration, Form GR/CP.

NOTICE OF COPYRIGHT Although under the 1978 statute, copyright notices are less important than under prior law, it is preferable to place a copyright notice on every copy of a work. Although there are exceptions in the statute, a notice form that is always correct includes: Copyright or Copr. or ©, the photographer's name, and the year of publication, or creation if placed on an unpublished work. The notice must be placed so as to give reasonable notice to an ordinary user of the work. So as not to impair the aesthetic qualities of photographs and other pictorial art, the notice may be placed on the front, back, backing, mounting, or framing.

Books: Crawford, Tad, *Legal Guide for the Visual Artist*. New York: Allworth Press, Inc., 1989; Feldman, Weil & Biederman, *Art Law*. Boston: Little, Brown, 1986; Lerner & Bresler, *Art Law: The Guide for Collectors, Investors, Dealers, and Artists*. New York: Practicing Law Institute, 1989. *R. Persky*

See also: *Agencies; Business practices.*

CORONA DISCHARGES Used to deposit a uniform charge on the surface of xerographic photoreceptors. Corona devices are comprised of a series of stainless steel or W wires strung between insulators in a semicylindrical shield. The corona wires are maintained at very high potentials. The fields in the vicinity of the corona wires are sufficiently high that any free electrons in the region of the wires will be accelerated to velocities such that ionization of the air molecules will occur. The concentrations of the ionized gas molecules are primarily determined by the corona polarity and the atmosphere. Corotrons are corona devices that contain an auxiliary electrode in close proximity to the corona wires. The purpose of the auxiliary electrode is to control the field

geometry such that the corona potentials are more uniform. Scorotrons contain a metal screen between the corona and the photoreceptor and set to a potential that closely approximates the potential to which the photoreceptor is to be charged. *P. Borsenberger*

CORPORATE PHOTOGRAPHY Corporate photography illustrates the most visible and important communications issued by any company. Corporate photographs represent the company and help to convey its image along with any particular content.

Because companies value corporate photography so highly, this specialty can earn high rates for photographers who make it their priority. Such photographers often have an inclination toward editorial photography and a willingness to do location work. They also have a personal and business attitude that, even if somewhat idiosyncratic, somehow jells with the corporate representatives with whom they must deal.

Corporate photography assignments emanate from company headquarters as well as advertising agencies and graphic designers. Executives with titles such as advertising manager, public relations director, and director of communications—as well as those who report to them—originate corporate photography assignments. So do the agency account executives and designers who have been assigned projects that require photographic illustration.

The most sought-after project in corporate photography is the annual report. It represents a visual image of the company executives, facilities, workers, products, etc. Depending on the style and length of the particular annual report, the photography may take a couple of days or several weeks. As many as 20 or more different subjects—everything from people to products, industrial plants to customer applications—may need to be photographed.

Other corporate photography assignments might require coverage of employees on and off the job for recruitment brochures; pictures of a company's facilities and services for a capabilities brochure; and photographs of just about anything related to the company, its employees, and its customers for its internal and external publications. Corporate publications reach as few as one hundred and as many as several million readers.

Although not as easy to enter as in years past, the realm of corporate photography welcomes the talented photographer who conducts business in a professional manner. Meeting deadlines and delivering what's expected—or something even better that meets client needs—are essential to success in corporate photography, as is an ability to work with all kinds of people and leave a positive impression, one that reflects well on the corporation.

Would-be corporate photographers should locate someone within the corporation who assigns photography projects and make an appointment to show their portfolio. Ideally, the portfolio should be a powerful presentation of the photographer's best work, with every marginal picture edited out.

Because corporate photographic needs are so diverse, a substantive portfolio may be appropriate. Such a portfolio might include a tray of 35-mm color slides, tearsheets of previously published photographs, and laminations. Personal publicity, including advertising, direct mail, and newspaper coverage may help a photographer gain serious consideration.

Newcomers to the field may offer a corporation some economy or flexibility they need in order to pursue a particular communications task. They also may offer the corporation access to special subject matter or certain techniques. One young photographer won a major assignment to photograph the alphabet for a large corporation because he had an extensive collection of old display type.

Books: Brackman, Henrietta, *The Perfect Portfolio*. New York: Amphoto, 1984. *K. Francis*

CORPUSCULAR THEORY A theory for the propagation of light in particle, or *corpuscular*, form advanced by Sir Isaac Newton. This theory stated basically that light rays were made up of many tiny corpuscles which traveled at very high speed and had characteristic colors. These corpuscles were thought to travel in straight lines unless reflected or refracted. The phenomenon of diffraction resulted in the abandonment of the corpuscular theory. *J. Holm*

See also: *Quantum theory; Wave theory.*

CORRECTION FILTER See *Filter types.*

CORRELATED COLOR TEMPERATURE A value assigned to a light source that does not approximate a blackbody source and therefore does not possess a color temperature. The correlated color temperature is the color temperature of the blackbody source that most closely approximates the color quality of the source in question. Correlated color temperatures are determined by illuminating selected color samples with the source in question and then determining the color temperature of the blackbody source that results in the color samples appearing the most similar to a standard observer. *J. Holm*

CORRESPONDING COLOR REPRODUCTION
Reproduction in which the chromaticities and relative luminances are such as to produce the same appearances that the colors of the original scene would have had if they had had the same luminances as those of the reproduction.

R. W. G. Hunt

See also: *Color reproduction objectives.*

CORRESPONDING COLOR STIMULI Pairs of color stimuli that look alike when one is seen in one set of adaptation conditions and the other is seen in a different set.

R. W. G. Hunt

COSINE LAWS (1) For a flat black radiating surface that is a perfect diffuser, the energy emitted in any direction is proportional to the cosine of the angle which that direction makes with a perpendicular to the surface. (2) For a flat surface receiving radiated energy, such as an illuminance meter (incident-light meter), the measurement varies as the cosine of the angle to a perpendicular at which the energy falls on the receptor. (3) Cosine3 law: When a plane is illuminated by a point source located on a line perpendicular to the plane at the center, the off-center illumination equals the center illumination times the cosine3 of the off-center angle. This law combines the effects of the cosine law (No. 2 above) and the inverse-square law. (4) Cosine4 law. In a photographic optical system using a lens or a pinhole, the light level on the film is reduced in proportion to the fourth power of the cosine of the angle to a perpendicular at which the light falls on the film. If the angle is 45 degrees for example, the cosine is about 0.7, and the light level at the center is changed by a factor of 0.7^4; it is thus about 25% of that at the center of the film, approximately a two-stop falloff. This law combines the effects of the cosine3 law (No. 3 above) and the reduced area of the lens aperture when seen at an angle. *H. Todd*

COSMIC RADIATION FOG Cosmic rays are mainly charged particles from outer space that can have a measurable effect on photographic materials even at considerable depths below ground or water. They are mostly composed of positively charged atomic nuclei, which on entering the atmosphere collide with other atomic nuclei to form nuclear fragments. The fogging effect is relatively insignificant during the useful life of most practical photographic films. However, the cumulative effect on high speed films, even at low temperatures, can be significant. This effect can be min-

imized by storage at depths well below the earth's surface.

I. Current

COSMIC RAYS Extremely high energy photons and subatomic particles that travel throughout the universe at speeds equal to or close to the speed of light. These particles are important because they have very high penetrating ability and can expose photographic grains or pixels in electronic detectors. They can also result in random, unpredictable events occurring in computers and magnetic storage media. These events, called *glitches,* occur when a cosmic ray strikes a particularly sensitive element in a computer, temporarily changing the output of the element. Very roughly speaking, approximately 100 cosmic rays per hour strike an average-sized person. Cosmic rays are not a significant problem in most systems because they strike such small areas. *J. Holm*

COULOMB (C) The basic unit of electrical charge equal to 6.25×10^{18} electrons. *W. Klein*

See also: *Charge.*

COUPLED DIAPHRAGM A camera diaphragm designed so that the opening is automatically determined or adjusted by some other camera operation, such as by the exposure meter reading in a shutter priority automatic-exposure camera, by tripping the shutter of a single-lens-reflex camera (where the diaphragm is stopped down to a preselected F-number while the film is being exposed), and by inserting and removing a film holder in a view camera that has this coupled feature. *P. Schranz*

COUPLED EXPOSURE METER A system of control between a camera exposure meter and the shutter speed and aperture controls on a camera. As the meter responds to light, an appropriate adjustment is automatically made in the shutter or aperture setting. Since the aperture and shutter work independently, various combinations of correct exposures are possible. *P. Schranz*

COUPLED RANGEFINDER A distance-calculating system that is connected directly to the focusing mechanism of the lens on rangefinder cameras. The rangefinder views a subject from two different positions several inches apart. One of the viewing points has a rotating mirror that projects the image to superimpose over the other or to align with the other in a split field. When the two images in the rangefinder coincide, the lens is simultaneously focused on that object.

P. Schranz

COVERING POWER See *Lenses, covering power of lenses.*

COVERING POWER (SENSITOMETRIC) A measure of the effectiveness with which silver in a photographic image attenuates light. It is the ratio of the measured density of a sample to the mass of silver per unit area.

Covering power changes with the density level and with the size of the individual silver grains. Large grains have low covering power because of their smaller ratio of area to volume. Very small grains, with diameter less than 0.05 micrometers, affect light as if their optical diameter were greater than their physical diameter and therefore have greater covering power.

Covering power is the reciprocal of the photometric equivalent. *M. Leary and H. Todd*

CRAB DOLLY A rolling platform used to support and move motion-picture and television cameras during shooting on which all wheels can be steered to provide maneuverability, including sideways movement. *L. Stroebel*

CRANE A large device with a boom arm that is used to support and raise a camera and camera operator above the level of the subject to provide an elevated viewpoint; used especially in professional motion-picture and television productions. *L. Stroebel*

CRASH In computers, a slang term meaning to bring the computer to a nonfunctional state. Typically, the computer is unable to recognize any event and it cannot respond in any way. The usual way out of this stalemate situation is to reboot the computer. *R. Kraus*

CRAWLING TITLE One or more lines of title or caption that move on a motion-picture screen. *H. Lester*

CREDIT LINE Printed acknowledgement of the source of an illustration reproduced in a publication, such as *Photograph by John Jones,* or *Photograph by Henri Cartier-Bresson, courtesy of the Museum of Modern Art.* The copyright holder is commonly allowed to specify the exact wording to be used. Credit lines are usually set in small type and typically are placed under or along one side of the illustration. *B. Polowy*

C.R.I. A common abbreviation for color reversal inter-negative—a single strip negative printing master made directly from a cut motion-picture-camera original negative. *H. Lester*
See also: *Sharpness.*

CRISPENER In electronic imaging, a feature that sharpens unsharp image edges. *L. Stroebel*
See also: *Sharpness.*

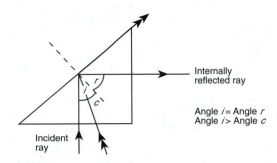

Angle *i* = Angle *r*
Angle *i* > Angle *c*

Critical angle. Total internal reflection in a right-angled prism with critical angle *c*.

CRITICAL ANGLE When a ray travels from a denser to a less dense medium it is refracted away from the normal. Refraction depends on the angle of incidence in the denser medium, and the value of this angle where the emergent ray just grazes the surface is the critical angle. For all greater angles of incidence, most of the light will be reflected at the interference, call *total internal reflection;* some is absorbed but none is transmitted. *S. Ray*
See also: *Total internal reflection.*

CRITICAL APERTURE The aperture or *f*-number at which a practical lens gives its optimum overall performance. It is usually about three stops closed down from maximum aperture and is the point at which the steadily increasing performance due to the reduction of residual aberrations by stopping down is just beginning to be affected by the increase in image degradation due to diffraction effects by using a progressively smaller aperture. The term is only applicable to an aberration limited lens. *S. Ray*
Syn.: *Optimum aperture; Limiting aperture.*
See also: *Diffraction-limited.*

CRITICAL FLICKER/FUSION FREQUENCY The minimum number of fluctuations per second in luminance that will be seen by a viewer as being continuous rather than flickering. The actual value depends on the level of luminance and other factors. An important concept in motion pictures and video. *L. Stroebel and R. Zakia*
See also: *Ferry–Porter Law; Flicker; Fusion.*

CRITICISM/CRITIQUE A philosophically based literary genre that offers a narrative accompaniment to the visual impact of an image. Systems and standards of criticism range from amateur, to journalistic, to pedagogical, educational, and philosophic. Each type is based upon a system of thought that attempts to explain the image, ranging from the simple category of personal taste to highly esoteric structures. Evaluation of photographs by authoritative persons or groups. Varying forms of criticism discuss technical aspects, formal aspects, psychological, and philosophical aspects of photography. *R. Welsh*
See also: *Aesthetics.*

CRONAR BASE Trade name of DuPont Corporation for polyester film base. *M. Scott*

CROPPING Altering the boundaries of an image. The trimming of a print or of an image to improve the composition. Usually applied to: (1) areas of a scene included by the camera; (2) area of a negative or transparency included on a print; (3) trimming or masking of a finished print or transparency; (4) the reproduction of a selected part of a photograph. *R. Welsh*

CROSS CUT In a motion picture, cutting back and forth between two apparently simultaneous scenes. *H. Lester*

CROSS FADE A transitional effect in motion pictures in which one shot fades out at the same time a second shot fades in. *H. Lester*
Syn.: *Dissolve.*

CROSSLINE SCREEN A glass halftone screen consisting of opaque lines at right angles to each other. *M. Bruno*
See also: *Halftone process; Ruled screen.*

CROSSMARKS Register marks used to position images and superimpose overlays for contact printing. *M. Bruno*

CROSSOVER An image that extends across the gutter onto both pages of a two-page spread. *M. Bruno*

CROSS TALK (SOUND) Undesired audio signals coming from adjacent sources or tracks. The sources of cross talk include inductive and capacitive coupling among, for example, the various channels of a tape head. *T. Holman*

CROWN GLASS Generic term for optical glass of low dispersion, having an Abbe number of 50 or more with a refractive index above 1.6, or above 55 with refractive index below 1.6. Principle types include fluor crowns (1.465–1.525 and 70–59) and barium crowns (1.552–1.657 and 63–51). Crown glass is one of the earliest forms of glass and is hard and weather resistant. In combination with flint glass it forms an achromatic combination. *S. Ray*
See also: *Achromatic; Lenses.*

CROW'S FOOT A device attached to tripod legs to hold them in position. *L. Stroebel*

CRT See *Cathode-ray tube.*

CRYSTAL A crystal is a solid form of a substance in which the atoms or molecules are arranged in a regular repeating three-dimensional structure, the size and shape of which may depend on the conditions during formation. Each substance develops a form with precise plane surfaces that result from their internal structure. Crystals form from a liquid as the saturation of the ions of a compound begins to exceed the solubility of the compound in the liquid. *G. Haist*

CRYSTAL SYNC The term is used generally to describe a method for synchronizing tape recordings with film cameras. A separate recording derived from an accurate quartz-crystal-based oscillator is made as a reference on conventional nonperforated tape simultaneously with audio recording. Crystal sync relies on accurate motor speed control of the camera and frequency accuracy of the reference oscillator in the recorder.

The need for recording a separate signal related to camera speed on production sound tapes arises because even the small tape speed variations between recording and playing on the very best analog recorders would cause noticeable lack of lip sync in long takes, since sync must be maintained to within better than one frame for sound and picture to appear to sync.

A newer method than those based on crystal sync is the use of SMPTE/EBU time code. In this system, the crystal oscillator is divided down and counted into a code based on hours, minutes, seconds, frames, and parts of a frame, and the result is recorded on two-channel stereo machines on an added center track, or on multitrack machines on one of the tracks. Time code has the advantage of containing a continuous reference position that may be used by devices for rapid locating and synchronizing to other units. *T. Holman*

CRYSTOLEUM An early color process made by combining a black-and-white transparency and a hand-colored image that gave the appearance of direct painting on glass. A photographic print (usually albumen) on very thin paper was placed face down on the inside of a curved glass, and the paper was then reduced by sandpapering until it was almost removed. The print was then rubbed with oil, wax, or varnish to make it translucent. Colors were placed on the back of the print and adhered to a white backing sheet paper. The effect was of a finely colored photograph without the appearance of paint on its surface or any of the photographic detail obscured by paint. This process was based on one used in the eighteenth century for hand-coloring engravings known as mezzotint painting. *J. Natal*

CT MERGE In electronic imaging, the function of combining the files of two continuous-tone images to provide a smooth transition between the images. *L. Stroebel*

CUBIC CENTIMETER (cc, cm³) In the metric system, a unit of volume equal to that of a cube 1 cm on a side. In practice, a cubic centimeter is equivalent to a milliliter, which is now preferred as a unit of liquid volume. *H. Todd*

CUE A signal to begin a specified activity such as an actor's speech or action or the next programmed event of a mechanical or electronic device. *H. Lester*

CUE DOTS Visible indicators warning a motion-picture projectionist or television broadcaster of the impending end of a program section. *H. Lester*

CUE TONE Any system in which a tone is used to cause an action. An example is a slide change system based on tones on one track of a tape recorder, while other tracks may contain program material intended to be heard. *T. Holman*

CUE TRACK The track of a multitrack recorder assigned to cue tones, or a track with incidental information, such as editing information. *T. Holman*

CUNNINGHAM, IMOGEN (1883–1976) American photographer. Learned platinum printing from Edward S. Curtis, continued her studies in Germany, then opened a portrait studio in Seattle (1910). Her first work was romantic, soft-focus portraits and nudes. After moving to San Francisco in 1917, she became active in the photographic community and her images came to reflect the straight tradition. Produced a beautiful botanical series between 1922 and 1929. A founder of Group *f*/64 (1932). Worked as a commercial photographer from the 1930s, including a series of portraits of movie stars for *Vanity Fair*. Her last book, *After Ninety* (1977), was a collection of sympathetic portraits of people beyond that age. Fondly remembered for her crusty and outspoken independence and irreverent sense of humor, she was a generous teacher of young students who flocked to her for counsel during the last 20 years of her long life.

Books: Dater, Judy, *Imogen Cunningham: A Portrait.* Boston: New York Graphic Society, 1979. *M. Alinder*

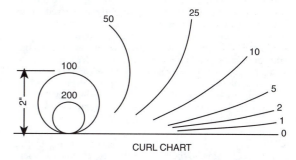

CURL CHART

Curl chart. Chart for measuring curl in values equal to those covered by American National Standard PH1.29 *Curl of Photographic Film, Methods of Determining.* The diameter of the circle representing a value of 100 should be drawn with a dimension of 2 inches. The formula for the curl values is 100/radius in inches.

CURL In the simple case of a gelatin emulsion coated on a flexible support, changes of temperature and (especially) humidity will cause the material to curl because of differential expansion of the base with respect to the emulsion. (Simple hygrometers work on this principle.) Manufacturers design their films and papers to minimize this effect. Polyester films and resin-coated papers have greatly reduced curl. Fiber base papers are perhaps the most troublesome contemporary materials in this regard. Low humidity in the workplace often causes *face curl*, i.e., emulsion concave. *Back curl* due to high humidity is less often encountered. Humectants added to the final rinse are useful in some cases.

Archivists working with prints and negatives made before the 1940s need to be especially careful in straightening curled pictures. *M. Scott*

CURL REDUCTION Because the gelatin-emulsion coating of films and papers tends to shrink to a greater extent than does the support, the material tends to curl toward this coating on drying. Manufacturers have traditionally compensated for this curl tendency of films by coating a gelatin layer on the reverse side of the material. This is not possible with conventional papers since the extra coating would inhibit the removal of water on drying. Resin-coated (RC) papers or papers with other treatments that prevent

absorption of water during processing can be back coated to compensate for any curl. Present-day materials are manufactured with much thinner coatings than in the past, so curl is now much less of a problem.

In critical applications, if curl of films is a problem the control of drying conditions may be of help. A low relative humidity and higher temperature can be employed while the material is still wet, since evaporation will tend to cool the emulsion. As drying progresses, higher relative humidity and lower temperatures will minimize excess hardening and shrinking of the emulsion and/or gelatin coatings. Long rolls of film should be wound emulsion facing out, if possible, to induce a set that would counteract curling.

In some instances the flatness of a film can be restored by rewetting, treating with a humectant rinse, and carefully drying. When the base of an old sheet film loses solvents near the cut edges, shrinkage causes a form of curl known as *cupping* that may interfere with good contact when printing. This is practically impossible to correct.

Fiber-based papers will generally tend to curl even with thin emulsion coatings due to the *baryta* or other rawstock coatings. Carefully pulling the backside of the curled dry sheet across a small diameter such as the rounded corner of a table can straighten dried prints. This should be done with caution since there is a risk of fracturing the gelatin emulsion or gelatin coating. Also placing recently processed prints back to back under a letter press (or unheated dry mounting press) for a day or more will also usually flatten them. If possible, prints should be stored with emulsions facing one another or back to back. Placing previously dried prints individually under a heated dry mounting press for a few seconds will also "iron" out curl of some papers. Prints dried on heated dryers generally do not curl, but instead have a tendency to buckle at the edges. Some of this is eliminated if 1/4 to 1/2 inch of paper can be trimmed off. *I. Current*

CURSOR A symbol, such as a cross or blinking line or block, that locates on the monitor the insertion point where an action, such as cutting and pasting or the input, is to begin or conclude. *R. Kraus*

CURTIS, EDWARD SHERIFF (1868–1952) American photographer. Beginning in 1896, photographed Native Americans, providing an extensive document of their life and customs. Not concerned with fact alone, Curtis, a prize-winning pictorialist, produced a romanticized record of the tribes from the Southwest, Great Plains, Pacific Northwest, and Alaska. Published 20 volumes of his photographically illustrated *The North American Indian,* between 1907 and 1930.

Books: *Portraits from North American Indian Life.* New York: Promontory Press, 1972. *M. Alinder*

CURVATURE OF FIELD A primary aberration of a simple lens where an off-axis object point is brought to a sharp focus on a curved surface, the Petzval surface, rather than the ideal Gaussian image plane. The curvature depends on the net powers of individual elements in a multielement lens and can be flattened suitably. A field flattener element may be place near the focal plane for this purpose. Occasionally a curved film gate may be used. The effects of the aberration may be reduced on stopping down, because of the increase in the depth of focus at the focal surface, reducing the unsharpness. *S. Ray*

Syn.: *Petzval curvature.*
See also: *Lenses; Petzval surface.*

CUSTOM FINISHING *Custom finishing* is a phrase that is typically used to describe the production of individualized photographic prints by hand. This is in contrast to amateur photofinishing, where prints are mechanically reproduced at a relatively high speed.

Prints that are custom finished, either black-and-white or color, are made to specific requirements provided by the photographer or client. They usually define the color balance, print density, and negative cropping that are needed to meet the final use of the photograph. To produce a custom print, the lab will enlarge the negative or transparency using a conventional enlarger and make modifications such as increasing the amount of exposure in particular areas, referred to as *burning,* or decreasing the amount of exposure in particular areas, referred to as *dodging,* to achieve the desired effect. The custom finishing of a print is very labor intensive and requires a skilled operator.

Custom prints are usually 8 × 10 inches in size or larger. They can be made up to 40 inches wide by 6 feet or even larger. The smaller prints are used for such applications as magazine reproduction or counter-top display, whereas the larger prints are commonly used for wall display. A photographer who desires a perfect rendition of the subject will choose this method of printing. If the photograph is to be made from a black-and-white negative, the photographer can choose from a variety of silver image tones and photographic paper surface textures. This is done to ensure that the final image is suitable for the intended use. An example of this would be a portrait, for display, being made on a soft looking matt-surface paper, versus a photograph of a building, for photomechanical reproduction, that is made on a glossy-surface paper.

Because of the variations and requirements of individual pictures, custom finishing labs produce prints in a much smaller number than the amateur labs, and great care is taken to ensure that the photographic image shows exactly what the photographer wants. These prints are typically processed

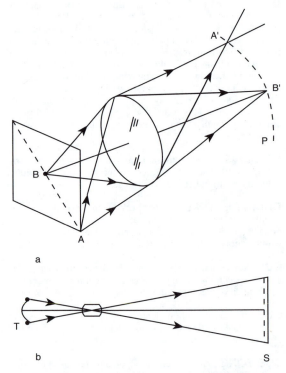

Curvature of field. (a) Curved field from a planar subject. P, Petzval surface. (b) Flat image S from a curved transparency T in a slide projector using a curved field lens.

one at a time, by the printer/operator. Often the printer will be the only person to work on the photograph.

The custom finisher no longer has to depend completely upon a hand production process. Recently, some custom finishing labs have turned to the computer to aid them in making the perfect print. To use the computer, the negative is scanned to convert the image into digital information that can be manipulated, stored, and displayed on a monitor much like a television screen. The operator will provide the computer with exact directions to modify the image on the screen, until it appears as desired. This modified computer information is then made into a new negative through a digital image writer. The new negative will now reflect the modified image that was displayed on the monitor. A print is then produced in an enlarger from this modified negative. While still a labor intensive process, it does provide the ability to view the finished image before the actual print is made. Sometimes, the photographer will be present as the image is modified, to provide direction, ensuring that the print will have the desired quality. This method of custom printing allows the custom finisher a way of making a perfect print without having to go through the difficult processes of hand retouching the negative and burning and dodging the print.

Since custom finishing sometimes involves making very large prints, the lab also may specialize in many other services, such as mounting the final photograph for display. As with the print, the lab will mount the photograph in a method that is requested by the photographer or client. Various methods are used for mounting the print, such as heat sensitive dry-mounting tissue, which looks like wax paper, or special glues that have been made for this purpose. The print, depending on size and final use, can be mounted on a stiff fiber board or on a special display board that has a foam core. Some professional photographers do their own custom finishing to ensure that they have control over the production of the print. Determining the most appropriate qualities of a final print is a subjective process, and this control allows them to make their own corrections to the photograph, resulting in a photographic print that has been made by them through all stages of the process. *T. Gorham*

See also: *Photofinishing.*

CUT (1) To trim and splice motion-picture film during the editing process. (2) The instantaneous change from one motion-picture scene to another. (3) The director's command to stop performance and filming on a motion-picture set.
 H. Lester

CUT-AND-PASTE A computer operation that is analogous to a scissors-and-glue operation with paper used on an image or text. More sophisticated programs are beginning to replace cut-and-paste with select-and-drag operations that perform the same function but more quickly and visibly.
 R. Kraus

CUTAWAY A shot inserted into a motion-picture scene that is not part of the principal action, such as a shot of birds flying overhead or a bystander's reaction. Often a noncritical shot used to adjust timing or to avoid having to cut directly between two shots that do not match in terms of movement or subject position.
 H. Lester

CUTTING The selection and assembly of the various shots of a motion picture. *H. Lester*

See also: *Film editing.*

CUTTING REDUCER See *Subtractive reducer.*

CYAN Color name given to colorants that absorb the reddish third of the spectrum. They usually look blue-green, but if they have high unwanted green absorptions they can look blue. In the graphic reproduction industries the red-absorbing ink was formerly called blue or process blue. *R. W. G. Hunt*

CYAN PRINTER The color separation produced by photographing the original with a red filter. *M. Bruno*

CYANOTYPE Invented by Sir John Herschel and presented in a paper to the Royal Society of London entitled "On the Action of the Rays of the Solar Spectrum on Vegetable Colours and on Some New Photographic Processes" in 1842. From the Greek word meaning dark blue impression, cyanotype is a simple process based on combining ferric ammonium citrate with potassium ferricyanide, resulting in a final image that combines ferrous ferricyanide and ferric ferrocyanide. Each chemical is mixed separately with water to form two working solutions, which in turn are mixed in equal parts to form the light-sensitive solution that is then coated on a paper or cloth support. Dried in the dark and then contact printed by exposure to ultraviolet radiation through either a negative, to make a print, or in direct contact with an object, to make a photogram. It is then washed in a bath of running water to permanently *fix* the image and develop its characteristic *cyan* blue color. The image is embedded in the fibers of the paper or cloth and accounts for its matt print surface. A very dilute solution of hydrogen peroxide can be added to the wash water to intensify the blue coloration. Also called blue-print process, or Prussian-blue process. The process was used to illustrate the three volumes of *British Algae: Cyanotype Impressions* in 1843 by Anna Atkins. This is considered to be the earliest example of a book illustrated by a purely photographic process. The process was little used after this until the 1880s.

Books: Schaaf, Larry J. *Sun Gardens: Victorian Photograms by Anna Atkins.* New York: Aperture, 1985. *J. Natal*

CYCLE (1) An interval of space or time in which is completed one round of events or phenomena that recur regularly and in the same sequence. In photography, the term *cycle* is most commonly applied to processes, spatial frequencies, and temporal frequencies of electromagnetic radiation. For example, a processing machine may take 5 minutes to complete a specific sequence of processing steps; a camera may be able to resolve 50 cycles (light/dark line pairs) per millimeter; or a photon may have a frequency of 10^{15} cycles per second (see *electromagnetic radiation; Hertz*). (2) In animation photography, a cycle is a series of drawings arranged so that the first drawing can be used after the last for a continuous repetition of the action as long as needed. *J. Holm*

D

D Density
D-1, D-2, D-3 Video formats
DA Digital-to-analog
DAC Digital-to-analog converter
DAD Digital audio disc
DAT Digital audio tape
dB Decibel
DC Direct current
DCS Digital camera system
DCT Discrete cosine transform (compression algorithm)
DDES Digital data exchange standard
DGPh Deutsch Gesellschaft für Photographie (Germany)
DIC Differential interference contrast
DIN Deutsche Industrie Norm (Germany)
DIP Dual in-line package
DIR Development-inhibitor-release
DL Difference limen (Also JND, just-noticeable difference)
D-line Radiation having a wavelength of 589.6 nm
D-log H Density-logarithm exposure
DM&E Dialog, music, and effects
Dmax Maximum density
Dmin Minimum density
DN Digital number
DNA Deutschen Normenausschuss (German standards organization)
DOF Depth of field
DOP Developing-out paper
DOS Disk operating system
DP Director of photography
DPCM Differential pulse code modulation
DPI Dots per inch
DPM Dots per millimeter
Dr Reflection density
DRAM Dynamic random access memory
DRAW Direct read after write
DSP Digital signal processing
DSU Digital storage unit
Dt Transmission density
DTC Dual time code
DTP Desktop publishing
DTR Diffusion transfer reversal
DTV Desktop video
D2T2 Dye diffusion thermal transfer
DU Dual (magnetic sound tracks)

dupe Duplicate
DVI Digital video interactive
DVR Digital video recording
DW Double weight
DX Photographic bar code; Double exposure

DAGUERRE, LOUIS-JACQUES-MANDÉ (1787–1851) French inventor of the daguerreotype, the first commonly used photographic process. A successful designer of theatrical sets and inventor of the Diorama (1822). In 1829, became partners with Niépce, who had been attempting for many years to permanently capture the image obtained in the camera obscura. Niépce died in 1833 and Daguerre continued the project based on Niépce's work. In 1831, Daguerre had found that iodized silver-coated copper plates were light sensitive. His decisive discovery in 1835 was that those plates, after exposure in a camera obscura, developed a direct positive image when subjected to the fumes of mercury. In 1837, Daguerre was able to fix the image with a salt solution, and in 1839, he applied Herschel's suggestion to use a solution of hyposulphite of soda (sodium thiosulfate). Dubbed "hypo," it is today still commonly used. The first official report of the daguerreotype was made by the French physicist Arago on January 7, 1839, to the French Academy of Sciences. The process was bought by the French government and was given "free to the world" on August 19, 1839—but had been patented in England and the United Stated five days earlier. The coming of the daguerreotype aroused keen interest worldwide and remained popular until 1860. It suffered from three grave defects: it produced only one, nonreproducible original; the image, though exquisitely detailed, was difficult to view due to its highly mirrored surface; and mercury fumes are highly toxic.

Books: Buerger, Janet E., *French Daguerreotypes*. Chicago and London: University of Chicago Press, 1989; Gernsheim, Helmut and Alison, *L.J.M. Daguerre*. Cleveland and New York: World, 1956; Newhall, Beaumont, *Latent Image*. New York: Doubleday, 1967. *M. Alinder*

DAGUERREOTYPE The daguerreotype was presented to the world in August, 1839. It was, without question, the first workable photographic system. Its progenitors lacked sharpness or tonal range or controllability. By comparison, within days of Arago's demonstration of the process, a legion of daguerreotypists was established. In the 1840s, the world generally understood photography to mean daguerreotype. The images were remarkably sharp and grainless, even when viewed with a magnifying glass. Their size was precious, as were their silvery sheen and the cases they came in. True, the images were laterally reversed, but that was, after all, what people saw in the mirror each morning. Yes, it was expensive and could not be duplicated, but the

daguerreotype established the mercantile aesthetic, and communicative foundations of photography.

In L.J.M. Daguerre's original iteration, a sheet of copper plated with silver was prepared by polishing it with pumice powder in a muslin bag, then with cotton balls and olive oil. Three times, nitric acid was spread on the plate and it was heated, cooled, and polished. The plate was then sensitized by placing it in a light-tight box containing iodine vapor until the plate turned a "fine golden yellow color" (a door was left ajar in the otherwise dark room), indicating the formation of silver iodide. As soon as possible, but within an hour at most, the plate was exposed in a camera obscura for between 3 and 30 minutes in daylight. It was then developed immediately in a box containing 2 pounds of mercury heated by a burner to 60° C. The mercury formed an amalgam with the silver, making the highlights and middle values visible. The unused silver iodide was then removed with a saturated solution of water and common salt, or, by the spring of 1839, "hyposulfite of pure soda." Washing was performed in a quart of distilled water. The positive image was now permanent but fragile. The highlights and middle values were creamy white but plainly visible; the shadows were plain polished silver, making the level of viewing light important. The plate was covered with glass immediately and placed in a case.

Soon, improvements to the process were made. A second electroplating of silver was added to the stock plate. Buffing procedures were enhanced. A second sensitization using bromine fumes made the plates much more responsive. Faster lenses also reduced exposure times. Gold chloride toner improved the appearance of the image and slowed the tarnishing or oxidation of the plate. Reversing mirrors were sometimes added outside the camera to make the image laterally correct.

A full plate measured 6.5 in. by 8.5 in. and sold for $30 or more. Quarter and sixth plate sizes were much more popular because they could cost as little as $2, still a substantial sum in the 1840s, and because the exposure times were much shorter, smaller plates meant shorter focal length lenses closer to the plate.

By the time the wet collodion plate, the ambrotype, and the tintype replaced it in the 1850s, the daguerreotype had caused the idea of photography to become fixed in the collective consciousness of Western society. *H. Wallach*

See also: *Daguerre, Louis Jacques Mandé; History of photography; Photographic processes, history.*

DAILIES Unedited motion-picture work prints, ideally delivered and evaluated on the day of shooting. *H. Lester*
Syn.: *Rushes.*

DAMPING A resistance to motion that is proportional to the speed of the motion, such as friction, particularly as applied to oscillators. A frictionless oscillator will continue to oscillate indefinitely. A damped oscillator will eventually come to rest in its equilibrium position. Classes of damped oscillators are: *underdamped,* where the oscillator oscillates for some time about the equilibrium position but the magnitude of the oscillation decreases with time; *critically damped,* where the oscillator returns as quickly as possible to the equilibrium position but does not overshoot; and *overdamped,* where the resistance to motion is so great that the oscillator slowly approaches the equilibrium position. In most cases involving the suppression of vibration or oscillation, critical damping is optimal but difficult to achieve. The concept of damping can also be applied to electronic circuits. Damping mechanisms are frequently installed on pointers, such as those found on meters and balances, to reduce the time required for the pointer to come to rest so a measurement can be taken. *J. Holm*

DANCE PHOTOGRAPHY Dance photography makes a still photograph of an art form defined as movement. Rather than simply stopping that movement, the best dance photographs somehow suggest movement through the position of the dancers' bodies, purposeful and artistic blur, or even multiple image techniques.

As with any kind of specialty photography, dance photography requires its practitioners to know dance terms, attitudes, and working methods. With classical ballet and other known dance works, photographers need to familiarize themselves in advance with the particular dance to be photographed. With new works, conscientious photographers will attend several rehearsals to choose the moments where they will trigger their prefocused cameras. Of course, permission always needs to be obtained before photography begins.

Dance photographs differ in content and style, depending on how they will be used. Those that publicize a specific dance event most often feature sharp, easily understood images of moments from the performance. Advertising and promotion photos take more liberties in an effort to suggest the scope and energy of the dance event. Artistic photographs, intended for exhibition or for publication in books, offer subjective interpretation, a photographer's own response to the dance.

Clive Barnes has written that "we remember dance in terms of pictures." Some of the early dance pictures were paintings and lithographs. The first dance photographs recorded such companies as the Ballet of the Second Empire, the Royal Danish Ballet, and the ballets of Imperial Russia. Dance-world luminaries such as Isador Duncan and Vaslav Nijinsky dance through time in the images of Arnold Genthe and Baron Adolf de Meyer.

Technological improvements in cameras and film gave birth to the mid-air, stop-action dance photograph. Gjon Mili is believed to have been the first photographer to use strobe lights to photograph dance. Experiments with slower shutter speeds suggested the possibilities of creative blur—when either the panning camera or the dancing subject moved during exposure.

Barbara Morgan, renowned photographer of Martha Graham, Merce Cunningham, and José Limón among others, used her spiritual oneness with the dancers to capture the

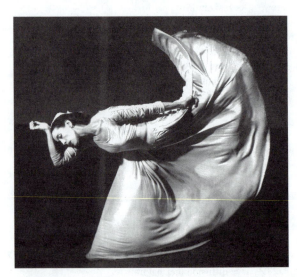

Martha Graham, "Letter to the World." Photo © Barbara Morgan, Willard and Barbara Morgan Archives.

gesture, the vitality, the moment of triumph. Her photographs of American modern dance in the 1930s and 1940s, "strike the viewer with the impact of live experience." (*Dance Magazine,* August 1991)

Since the 1970s, Lois Greenfield has photographed what she calls "experimental" or modern dancers defying gravity with their leaps. Annie Leibovitz has transferred the physicality and body consciousness of dance to photography of nondance celebrities as well as celebrated dancers such as Mikhail Baryshnikov.

The directness of dance makes it easily accessible to the photographer willing to become the audience for studio setups and on-stage photo calls. Because it is a visual art, dance ordinarily does not need translation, only sensitive recording. An ability to feel the music and the dance and, somehow, to channel that feeling to the camera trigger finger, underlies the best dance photographs. Some photographers, Edward Steichen and Cecil Beaton among them, actually tried dancing to give them better insights into their dance photography.

When shooting in the theater, dance photographers use performance lighting. In the studio, they often prefer the relatively shadowless lighting or bounced electronic flash. Medium- and large-format cameras offer the image quality expected when art records art. Film and lens choices depend on intention. Wide-angle lenses, however, provide desirable depth of field together with a feeling of spaciousness.

Anna Pavlova is quoted in *Opportunities in the Dance* as saying, "For the dancer must feel so perfectly at ease, so far as technique is concerned, that when on stage she needs devote to it not a single thought, and may concentrate upon expression, upon the feelings which must give life to the dance she is performing" (Denis). Similar words apply to the photographer of the dancer.

Books: Denis, Paul, *Opportunities in the Dance.* Lincolnwood, Ill.: VGM Career Horizons, 1985; Greenfield, Lois, *Breaking Bounds.* New York: Chronicle, 1992; Back issues of *Dance Magazine.* Morgan, Barbara, *Martha Graham: Sixteen Dances in Photographs.* New York: Duel, Sloan and Pearle, 1941. *K. Francis*

DARK ADAPTATION The process by which a person's visual perceptual system adjusts to a low level of illumination, producing an increase in sensitivity. For example, when first entering a darkroom, or a movie theater, everything appears dark and then gradually begins to lighten. In complete darkness, the maximum adjustment takes about forty minutes.
 L. Stroebel and R. Zakia

See also: *Adaptation; Light adaptation; Vision, adaptation.*

DARKFIELD ILLUMINATION In photomicrography, an illumination system used with transparent subjects whereby the angle at which the subject is back-illuminated is controlled so that only light refracted or reflected by the subject enters the microscope, thus producing a light image against a contrasting dark background. *R. Zakia*

DARK REACTION A progressive hardening of light-sensitive materials in the absence of light. *J. Natal*

DARKROOM A lightproof room for the handling of light-sensitive photographic materials. Throughout the history of photography, it has been necessary for the photographer to have access to a darkened space in which to prepare, handle, and process imaging materials. At one time, when photographers were using the collodion wet-plate process, it was necessary to coat the plate with an emulsion in the dark and, while it was still wet, load it into a holder, take the photograph, and process it. If the plate dried at any time, it would lose sensitivity. It was therefore necessary to have a dark

space at the actual site where the photograph was being taken. This seems an impossibly cumbersome method to us, with our handy enclosed film cartridges. However, the Crimean War, the Civil War, and the early scenic vistas of the West were all photographed with this process. Eventually, dry-plate processes were introduced, and the photographer was able to roam freely through the world without the burden of having a dark room for a companion.

Even with the convenience of dry plates there was, at first, no way to enlarge the camera image once it was recorded. If a large final image was desired, then a large plate had to be used. The first enlargers used the sun as a light source, directing its rays through a set of mirrors into the darkroom. It was said that cloudy days were actually the best for printing. With the advent of electricity enlargers could be powered by light that the photographer could call upon whenever needed. We now have the modern darkroom with provisions for developing film and making enlarged prints—both black and white and color. It is even possible to purchase processing equipment to assist in all these tasks that is reasonably priced and small enough to be used in a commercial photographer's in-house darkroom, or even a home darkroom.

DESIGN AND CONSTRUCTION Because of the variety of different operations that will be performed in the darkroom and because of its usually limited size, it is necessary to carefully look at work patterns to insure efficient layout of the space. Even though photographers may think they know which processes they will use the darkroom for, it seems that as soon as the photographer builds a darkroom without provisions for a certain process, that process becomes necessary.

Darkrooms are often perceived as small dim places that are squeezed into some corner unusable for anything else. This preconception results in darkrooms that are unpleasant and inefficient to use, making darkroom work—a wonderfully creative aspect of photography—unpleasant and inefficient. A darkroom is like any other work room. It should fit the needs of the work being performed and take into account the human needs of the worker.

Most darkrooms have a workbench, a sink, a lightproof entry, and perhaps film and print-drying facilities. The simplest design for a darkroom is a linear one, with a workbench for the enlargers and dry equipment on one side, and a sink and all the wet equipment on the other side. This *wet side, dry side* division is obviously necessary to keep dry equipment dry. Although with careful work habits this distinction may be violated, it is not a good idea.

A major consideration in darkroom design is the need to keep the darkroom clean and dust-free. All materials used in the darkroom should be nonabsorbent and easily cleaned. Spilled chemicals that are not quickly cleaned will dry to a powder that will settle on equipment and negatives causing their deterioration. It will also create an unhealthy situation since the powder will be breathed by any workers in the darkroom. Since dust is a great problem in printing, it is necessary to prevent dust buildup in the darkroom.

Photographers will have to make their own decision as to size and shape of the darkroom, often constrained by the location. The following sections will provide some guidelines as to possible size, location, and exterior space near the darkroom to be used for finishing work. The final design decisions can be greatly facilitated by making a scale drawing of the available space on grid or graph paper. Each square will represent a unit of length; for instance, one square might equal 6 inches. Then all the tables, workbenches, and sinks that are designed can also be drawn to scale on the same paper, cut out, and moved around in the drawing to see how they may best fit. If the placement of the darkroom walls is not fixed, that is, it is not an already existing room,

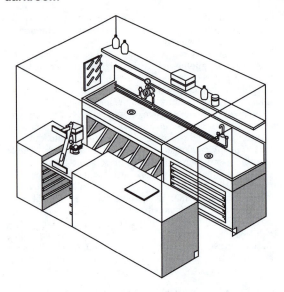

Typical linear darkroom design showing features discussed in this section.

their positions may be selected to accommodate the desired arrangement. In any event, a scale layout will give a much clearer idea of what the final result might be.

Size Darkrooms come in all sizes from large professional and photographic school darkrooms to the closet darkroom of the occasional amateur. The size of the darkroom will depend on how many different operations are to be performed in it, how many enlargers are needed, how large final prints will be, how many people are to use it, and how much time is to be spent in it. The size should allow easy performance of all necessary operations and enough free space to prevent a claustrophobic feeling. It should not be so large as to waste effort in moving from one operation to another. The decision about size must take into consideration the possibility of expansion of operations or the increase in size of enlarging or processing equipment. A darkroom as small as 10 × 12 × 9 feet high will provide ample room for color as well as black-and-white processing, several enlargers, prints as large as 16 x 20 inches, and two workers, and is comfortable enough to spend the long periods sometimes required.

Location Darkrooms are often hidden away in odd and dark corners that are not suited for any other purpose. This prejudice against darkrooms should be reconsidered. The professional photographer will want a darkroom that is accessible to other work areas. In this way the darkroom can be used at the same time as other areas. For instance, when printing with a processor there is a finite time when the photographer is not needed to oversee the activity. This allows other activities to be done at the same time. The darkroom is also used in conjunction with other kinds of activities. For instance, when photographing in a studio with sheet film, the darkroom should be close enough to allow for easy loading and unloading of film holders.

The other main consideration for locating a darkroom is accessibility to building services such as water, drainage, and electrical power. The choice of location should also take into consideration ease of ventilation.

For the professional photographer, a darkroom location is largely a matter of choice; for the amateur, it might be a matter of finance or availability of space at home.

Walls Darkroom walls are usually of standard construction. Sheetrock painted a light tone is most common. One of the great myths about darkrooms is that they should be painted black. Black paint on a wall that is behind an enlarger may be necessary if the enlarger leaks some light, since this will help prevent the light from scattering around the darkroom. It is convenient to have a wall or an area of a wall that material may be pinned to temporarily. Work in progress, chemical mixing information, material processing steps, or just fun images can be pinned to a piece of Homesote that is attached to a wall. Homesote is a pressed paper board that accepts push-pins. It is an excellent way to have a bulletin board in a darkroom. Materials, such as cork boards, that shred are unacceptable in the darkroom because of the possibility of particles on film. At least some walls will have to be strong enough to support shelves or perhaps wall-mounted enlargers. There is an interesting wall material called tile board, which is covered with a hard tile-like coating, that allows easy cleaning in those areas where chemicals may be inadvertently splashed.

If the darkroom is a temporary one or if a final decision on size or location cannot be made at once, then walls can be made out of light-tight plastic or other material that can be removed or altered at a later date.

Floor The type of floor the darkroom has will depend to some extent on where the darkroom is located. The existing floor in the space to be turned into a darkroom may be satisfactory, but there are basic considerations for a darkroom floor. The floor should be smooth and without any abrupt changes in height that might trip a person in the dark. The floor should also be of a nonabsorbent material since there is always the chance of a spillage of chemicals or a leak in the water or drain systems. The floor should also be of a softer material than concrete to help alleviate fatigue. Even though all floors seem hard, a wood or asphalt tile floor is softer and less tiring to stand on than a concrete floor. Wood, unfortunately, is not a good substance for a darkroom floor because it is too absorbent, and it stains, swells, and even splits if wet. Asphalt tile is a good floor covering if there is little or no spillage. Asphalt tile does stain from spilled chemicals, however, and the tiles warp and come away from the underflooring with excessive wetting. A continuous roll of linoleum fitted to the floor, if seams are kept to a minimum, is a good flooring material. No matter what is on the floor, the photographer may consider the installation of antifatigue mats. They come in several types, but have the problem of being higher than the existing floor, creating the possibility of tripping over the raised edges when working in the dark.

The floor should be as level as possible to help create the proper drainage in the sink and to facilitate leveling enlargers and workbenches.

Before laying any floor over an existing floor, one should make sure that there is no incompatibility between them that will cause problems, such as buckling or trapping of water and chemicals between them.

Ceiling The darkroom ceiling should be level and smooth to prevent dust from accumulating (as it would if there were exposed pipes or beams). The ceiling should also be strong enough to support safelights, and should be painted flat white.

If the existing ceiling over the space chosen for a darkroom is not smooth, a good solution is the installation of a drop ceiling. This gives the required smoothness and creates a space above the ceiling for running wires for safelights. Drop ceilings also provide sound-proofing, which helps to dampen the noise of processors and running water in the darkroom's confined space. Drop ceilings are normally strong enough to support safelights unless the lights are unusually heavy, and they allow the safelights to be positioned almost anywhere using clips that are designed for drop ceilings. Since most darkrooms are small, a drop ceiling can be installed by the photographer.

The ceiling should be high enough to allow the enlargers to be raised sufficiently to make the required size prints. In cases where the ceiling must be low, an enlarger table that can be raised and lowered is a possible solution. This requires the enlarger to be wall-mounted. (See the section on Dry-Side Workbenches.) The alternative is to buy specially designed wide-angle lenses for enlargers.

Power Requirements All electrical work done in the darkroom generally must be performed by a licensed electrician and must conform to local building codes. These codes are designed to insure that the installation of the electrical system is safe. It is not a good idea to try to circumvent these codes. This section should provide enough information to enable photographers to tell the electrician what is needed and to answer any questions the electrician may have.

The power requirements of a darkroom are relatively small. The only machines that draw significant power are dryers. The total power required for a darkroom is easily calculated using the formula:

$$Watts = volts \times amperes$$

where watts are the measure of electrical power, volts are the measure of electrical force, and amperes are the measure of electrical flow. Since these terms are often somewhat hard to understand, water can be used as an analogy. The volt is equivalent to water pressure, and the ampere is equivalent to

the flow rate of water. The amount of water flowing at a certain pressure gives the power of the water. Calculating the power requirement for the darkroom is done by adding up the wattages of all lights and heating elements and using the formula above to calculate the amperage. The amperage will determine what size wire is needed to carry the power (or load) safely. For example, if the total wattage of the lights and dryers in your darkroom is 700 watts and, using 110 volts (the usual voltage delivered by electrical companies), then:

$$700 \quad = 110 \times amps$$

$$amps \quad = 700 / 110$$

$$amps \quad = 6.36$$

When rounding to the nearest whole number, always round up for safety. This then is the minimum amperage the wires must be able to carry, but a safety factor should be added.

One of the main considerations in planning darkroom electrical layouts is the proximity of water to all areas of the darkroom. Electrical outlets must be placed in such a way that no water is likely to reach them. This is especially important on the wet side of the darkroom. There are usually few outlets necessary for use on the wet side, but, depending

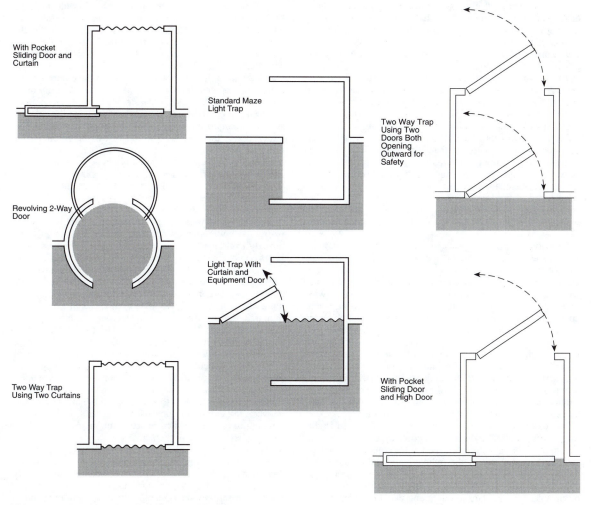

Light trap configurations (top views).

on the processes to be used, there may be some. Timers, rotating motor bases, constant temperature baths, and automated processors will all require access to electricity. This creates a necessary but dangerous electrical hazard. The best way to deal with this is by installing the electrical system with a fault interrupt circuit. This is a device that senses an open circuit, or grounding of the electrical system. An open circuit results from a sudden shorting of the electrical system to ground. This is typically caused by worn insulation or accidentally cutting through a wire. In the darkroom, it may be caused by water getting into an outlet or by wet hands touching an open circuit. The fault interrupt switch will automatically shut off the electricity before it can reach the outlet or hand that is causing the problem, which can save a life. These devices are commonly seen in modern bathrooms, and for the same reason they should be used in darkrooms.

A handy feature that can be designed into the electrical system and that may help prevent problems is to have a single switch at the outside of the darkroom that shuts off all power. By throwing this switch when leaving the darkroom, the photographer can be sure that no electrical device has been left on inadvertently. Since the amount of electricity in the darkroom is small, this can be a simple wall outlet switch.

Light Trap The entrance to the darkroom, when closed, must keep out all light. This can be achieved by installing a common household type door. The frame should be lined with weatherproofing material that compresses when the door is closed to prevent light from leaking around the edges of the door jam. A sliding door that hides in the wall is an alternative when space is at a premium, but it involves a more complicated installation.

The most convenient entry to a darkroom is through a light trap. This is an opening that is constructed to prevent light from entering the darkroom without preventing a person from entering. The basic principle is based on the fact that light travels in straight lines. An entry with flat black surfaces that leads around a corner can prevent light from entering without a door. Entry to the darkroom is then possible without disrupting darkroom operations. A light trap also allows for easy escape from the darkroom during an emergency, and it is a great help in ventilating the darkroom. This type of entry requires considerably more construction and space. The addition of curtains to block most of the light at each end of the trap will reduce the space required. The curtain material should be dark and heavy enough to hang properly. A material called black-out cloth, designed for this use, is available.

Other types of light traps use two doors with a small dead space between them. A person opens one door, steps into the enclosure, and closes the first door. Then the second door can be opened to enter the darkroom. Curtains instead of doors will work if the person entering is careful, and curtains will save money and time by eliminating the need to buy two doors and build two doorways. The curtains should be hung so they open in the middle with a generous overlap at the center and at all sides. A heavy dark cloth that will hang by its own weight works best. The use of a light trap labyrinth or curtains will also help alleviate any claustrophobic feelings that working behind closed doors in a small space may cause. The dead space between curtains or doors should be painted flat black to reduce light scattering. A white line can be painted on the walls to help people orient themselves.

There are commercially available prefabricated light traps. These are large cylinders that come in several sizes and fit into the doorway of the darkroom. One enters the cylinder through an open slot in the cylinder and then rotates the cylinder until the slot is facing into the darkroom. The cylinder portion is on wheels and is easy to turn. It is also removable, so that large equipment can be added to or removed from the darkroom conveniently, or for ease in

cleaning the darkroom. These units work very well and take up little space, but are quite expensive.

Windows A window in a darkroom may at first seem like a problem, but it is actually an asset. A window makes ventilation much simpler and can provide light for cleaning and other white-light activities. It also provides a more enjoyable atmosphere when not actually working with light-sensitive materials. The window can be darkened with opaque shutters or by hanging a dark cloth or black garden plastic over it. There are commercially available black-out curtains, but they are expensive.

Dry-side Workbenches The dry side of the darkroom is the side that the enlargers occupy, as well as any other equipment or materials that must be kept dry. This equipment generally requires countertops for its use. The size of the countertop depends on the equipment to be placed on it, but it must not be so deep that it is difficult to reach the back. Most standard size (ready-made) counters are 24 inches deep. However, even a small enlarger could easily have a baseboard deeper than that, and a 4 x 5 enlarger could have a baseboard as deep as 34 inches. This requires the photographer to build a custom-sized countertop. The countertop can be as deep as 30 inches and still allow the back to be easily reached. The baseboards of the enlargers may overlap the edge a bit, but this is better than making access to wall shelves inconvenient.

Enlargers may be wall-mounted to help alleviate this problem, and most enlarger manufacturers sell wall-mounting brackets. This type of enlarger mounting keeps the countertop clear and at one level. Care must be taken to insure that the negative stage of the enlarger is perfectly parallel to the countertop. Failure to do so will result in distorted images and prints that are sharper on one side than on another. When wall-mounting, it is a good idea to fasten the enlarger to the wall at the top and the bottom to increase the stability of the enlarger. If a cable is used for fastening the top, a turnbuckle can be installed in the line to assist with leveling the enlarger. A wall-mounted enlarger allows the photographer to construct a base that can be lowered below the countertop to obtain a wide range of print sizes, even in a room having a low ceiling. This can be as simple as a large version of a book shelf with adjustable brackets. Again, keeping the base level with the enlarger is most important. The movable baseboard must be strongly constructed to prevent any chance of warping.

Simple countertops may be constructed from plywood that is framed and mounted on legs. It can also be mounted directly to the wall or on commercial kitchen bases. These bases come in a variety of models and can provide such conveniences as a set of drawers under the counter. They will provide a standard counter height of 36 inches. If a different height is more convenient, then one of the other mounting methods must be used. No matter which way the counter is mounted, the construction must be strong enough to prevent the counter from having any give. The top of the counter should be smooth and easy to clean. Covering the counter with Formica or a similar plastic material is ideal, but a simpler and less expensive method that works well is to give the plywood several coats of a good floor paint. This paint is thick and will fill any small cracks in the wood and provide a hard, durable surface that is easy to clean. Any spaces between the countertop and the wall should be covered by molding to prevent dust from accumulating or objects from slipping behind the workbench.

Having a small light box in the darkroom is a great help in examining negatives and transparencies and positioning them in a negative carrier. The light box can be built into the counter so it is flush to the working surface. The bulbs and wiring can actually be mounted in one of the drawers under the bench for ease of maintenance. Open space under the

counter can be used for storage, a trash receptacle, or print-drying racks.

Wet-side Sink The wet side of the darkroom is usually occupied by a long sink in which materials are processed. The size of the sink depends on the type of work to be done in it. Making large black-and-white prints requires a large sink for the processing trays. (An automated print processor can be an alternative to a large sink.) If space allows, having the print washer in the sink is convenient. The sides of the sink are usually high enough to prevent chemicals from splashing outside the sink. The front side also provides the photographer with a convenient place to lean while processing. The back of the sink can also be made higher than the front to provide a splashboard. A small shelf on top of the splashboard is a convenient place to keep timers, thermometers, print tongs, etc. Before deciding on a sink size and depth, the photographer may want to try out the design on a mock-up or use an existing darkroom as a test.

Ready-made darkroom sinks are available from several manufacturers. Since they are designed primarily for commercial use they are usually constructed of stainless steel. This makes them very durable and easy to clean but they are also expensive and noisy when hit. There are also a variety of plastic sinks available. All of these sinks come in standard sizes. If cost is a factor, or if none of the standard sizes is correct, a custom darkroom sink can easily be constructed of wood and then waterproofed. Plywood is a good construction material for the bottom of the sink. The plywood does not have to be very thick since the sink does not have to support much weight, but the base should be well braced to prevent low spots and warping. Remember to build in ample slope towards the drain hole. The side can be built from one-inch planks of the correct height. Remember to give the front edge a thick top for resting on. To facilitate moving the sink to a new location, the basin should be separate from the legs. Underneath the basin and between the legs, a rack may be installed to store unused trays and film developing equipment. This rack can be made from thin slats of wood. Because of the availability of inexpensive processors, the wet side may also have one or more small countertops to set processors on. Most processors are "table top" and do not have to be set in a sink or even on a waterproof surface.

There are many types of waterproof coatings for wood on the market. Polyurethane is a plastic coating that is painted on the surface. It is not completely waterproof and must be reapplied at regular intervals. Fiberglass fabric and liquid coating gives a permanent and completely waterproof finish. There are industrial neoprene (rubber) coatings that provide a seal that is also slightly cushioned to help control the noise of trays. A marine supply store is a good resource for waterproofing materials. All of these materials give off very toxic fumes and must be applied outdoors or in a highly ventilated space.

Plumbing As with the electrical system, plumbing must conform to local building codes. This usually means that a licensed plumber must do the work. There are many technical details that must be considered—such as vents and vacuum breakers. A good home improvement book that features plumbing will be helpful. Many areas require the installation of a back flow prevention valve. (See the section on Environmental Consideration.)

The complexity of the plumbing depends on the processing operations that will be used. The size of the sink and the need for availability of water at different places in the sink are also factors. The addition of a temperature control valve to the plumbing system is not only a convenience, it is almost a necessity for the more exacting processes such as film developing and color processing. A filter on the outlet of the temperature control valve is also valuable, if not a necessity. If there is no temperature control valve, then two filters

are needed: one on the cold water inlet and one on the hot water inlet. The outlet from the temperature control valve is connected to a pipe that has a series of valves in it called a header. These valves are placed at intervals to allow film and print-washers and processors to be connected to them where needed. There should also be one or two uncommitted valves for use in supplying water for mixing chemicals and for washing equipment and hands. Flexible tubing is often attached to the supply valves in the sink to prevent splashing and to allow water to be directed where needed. Care must be taken that the tubes do not produce splashing. Tubing is also used to attach film and print-washers and processors to their respective valves.

The plumbing that contains the valves to control water in the sink can be attached to the splashboard. The sink plumbing can then be attached to the building plumbing through pipe unions. These are devices that allow the pipe to be disconnected without cutting it. In this way the entire sink, complete with plumbing, can be moved to a new location. Plumbing the darkroom in the new location is then simply a matter of attaching the built-in sink plumbing, through unions, to the building water supply.

As with all other aspects of darkroom design, considerable thought should be given to the plumbing. It is expensive to install and to alter.

Lighting The darkroom should have white lighting that will give overall illumination for activities that do not involve sensitized materials, including cleaning up. This can be any type of general lighting, such as fluorescent. It should have a separate switch in the darkroom that allows it to be shut off for the safelight and dark activities without affecting any of the other electrical circuits. The switch should be in an out-of-the-way place or covered to prevent it from being accidentally thrown when light-sensitive photographic materials are in use.

Safelights come in many styles and sizes. They should emit enough light to provide adequate visibility but not enough to fog light-sensitive emulsions. A simple test can be performed to see if the safelights provide safe illumination. Shut off any overhead lights and place a sheet of exposed but undeveloped photographic paper on the workbench. Cover the paper and turn on the safelights. Expose the paper to the safelights in teststrip fashion with the longest time longer than any that would be required by exposing and processing. Develop the paper in complete darkness and see if there is a density difference between any of the steps. If there is no difference, then the safelights truly are "safe." Safelights are usually used only for black-and-white printing, but there are some special uses such as film development by inspection. Special safelights should also be tested with the materials they are going to be used with to make sure they will cause no fogging to the exposed emulsions. All the safelights should be on the same circuit and attached to a switch that cannot be accidentally thrown.

The other kind of lighting that is used in a darkroom is for print-viewing. This is a light of the proper intensity to judge if the print is of the desired density. The white room lights can be used for this purpose if the illuminance at the print surface is approximately 800 LUX (74 foot candles). A stronger light is useful for checking prints for sharpness, defects, and the maximum density. This print-viewing light can be positioned in such a way as to shed light locally on the final print. It can be hung at the far end of the sink over the fixing or washing tray, or a spotlight can be aimed at the vertical backboard of the sink on which the wet print is placed. The print-viewing light can be attached to a footswitch so it can be turned on and off without touching a switch with wet hands.

Ventilation Proper ventilation is important in the darkroom for several reasons. Breathing concentrated chemical

fumes of any kind is unhealthy. Working in a humid, enclosed space is uncomfortable and counterproductive. Any equipment or materials kept in a space filled with fumes or humid air can be adversely affected.

Ideally, the air in the darkroom should be changed every 6 to 8 minutes. This can be accomplished with an exhaust fan of the correct size used in conjunction with inlet vents. Exhaust fans are rated in cubic feet per minute (CPM) of air that they can move. The cubic feet of the darkroom space is easily calculated by multiplying the height times the width times the length. Dividing the calculated cubic feet by 6 minutes (the suggested exchange rate for the air) gives the CPM required of the fan. Inlet vents must be placed in the walls to admit fresh air. Both the vents and the fan need to be light tight.

A circulation pattern that draws the air out over the sink is necessary to maintain the wet/dry integrity. This is accomplished by placing the fan above the sink and the vents as low as possible on the dry side.

Drying Facilities for drying both prints and negatives are commonly in the darkroom itself. This makes it unnecessary to carry wet materials out of the darkroom, lessening the chance of a wet floor hazard or of getting dust on wet materials.

An enclosed film-drying cabinet allows film to be hung to dry without risk of dust in the air settling on the film. Commercially made cabinets are available. They usually contain some facility for heating the air moderately to quicken the drying process. These are often quite expensive, and photographers may wish to build one for themselves. A 100-watt bulb can be placed near the bottom of the cabinet to safely dry the film when quick turnaround time is important.

Prints can be dried on a set of racks covered with plastic window screening. The screening can be stretched over painter's canvas stretchers. These will slide on runners attached to a frame. Depending on its size, the frame can go under the sink or under the dry-side workbench. An RC print dryer is handy for quick drying of rush-order prints or, when color printing, for the immediate evaluation of color. Again, such devices are commercially available at considerable expense or one can be constructed with a hairdryer and an enclosed screen-covered rack.

Color Darkroom Simplified color chemistry and the availability of various kinds of color print processing equipment have made it possible for any darkroom to be used as a color darkroom.

Color processors come in a variety of sizes and types from print drums with light traps for pouring chemicals in and out to fully automated machines that deliver a completely processed and dried print. Frequency of use, cost, and space are determining factors. An effective compromise between the labor-intensive drums and the fully automated processors are the "table top" machines. A print is placed in the machine, a light-tight lid is closed and nothing more needs to be done until the wet print drops out. It must then be washed and dried by hand. The processor can be placed on a workbench with the end of the machine slightly overhanging the sink. The print then drops into a waiting tray of water and the processing can be completed from there. Once the print color is corrected, all the copies can be washed and rack-dried at once. These machines do not require the high electrical input, the overhead storage tanks of chemistry, or the constantly running water of the fully automated machines. Models of the *table top* machines that make relatively large prints—up to 20 inches wide are available.

To help in judging the color of prints, a *daylight* print-viewing box can be constructed. This makes use of fluorescent tubes that are rated at 5000 K, the correlated color temperature of daylight. Judging the print under any other color light will give a cast to the print that makes it difficult to form a correct judgment of its color. If the overhead lights are fluorescent, these 5000 K tubes can replace the normal fluorescent tubes, which often have a greenish cast. Then the entire darkroom is illuminated with the recommended quality of light for viewing color prints. However, the overhead light may not have the proper intensity for judging the print's density. Also, it helps to judge final prints against a standard print and the previous test print. For these reasons a viewing box may be desirable. This is simply a box mounted on the wall large enough to hold the largest print to be made. The inside is surrounded by fluorescent fixtures that allow the print to be viewed with white light of the proper quality and intensity. A clip akin to the ones doctors use to hold X-rays can be installed so the print or a series of test strips can be viewed simultaneously. It also gives the photographer the opportunity to step back and view the print as a whole before making a final judgment.

Storage Because of its normally confined space, storage in the darkroom must be carefully planned. All equipment that is necessary to the various processes used in the darkroom, as well as all chemicals, is normally stored in the darkroom. They should be stored so that they are out of the way when not needed but easily accessible. Because of the humidity and chemical fumes, it is not advisable to store negatives in the darkroom.

Equipment Dry-side equipment consists of enlarger accessories—lenses, negative carriers, focusing magnifiers, as well as print trimmer, lupes, flashlight, sheet film holders, etc. The lenses should be stored where they cannot be broken and are shielded from any accidental spills. Drawers under the dry-side workbench are ideal for this. They can be cushioned so the lenses in their lens boards can rest in the drawer safely. The best place to store enlarger lenses is on a three-lens turret that is attached to the enlarger in place of a single lens board. Changing lenses is then a simple matter of rotating the turret to bring the desired lens into place. This system keeps lenses safe and accessible. Negative carriers can also be kept in drawers under the workbench but they tend to slide around and become a jumble. Hanging them on a peg board near the enlarger is very handy. Rubber-coated peg board hangers are available that will not scratch the negative cut-out. Most of the other smaller accessories are used so often that they are left out where they can be easily reached, but leaving them on the workbench surface can result in a cluttered work space. Small shelves near the enlarger can be constructed to hold these items and keep them out of the way until they are needed. Sheet film holders and the collection of film boxes needed to transport exposed film to the lab are also easy to store in drawers.

Wet-side accessories consist of developing trays of various sizes, film developing tanks and reels, thermometers, print tongs, etc. The equipment drying racks under the sink (see the section on Wet-Side Sink) are perfect for storing as well as drying items such as trays and tanks. Smaller, more delicate equipment such as film and thermometers are conveniently stored on a small shelf above the sink's splashboard. (See the section on Wet-Side Sink.)

Chemistry Because the darkroom is the place in which chemicals will be mixed and used, chemicals are often stored in the darkroom, but professional processing labs usually have separate chem-mix rooms.

Unmixed chemistry comes in all sizes and types, both liquid and powder, making standardizing storage difficult. Powders must be kept dry, of course. Shelving in out-of-the-way places works well. They can be under the processor bench, above the sink, even under the dry-side workbench.

Mixed chemistry can be kept under the sink, on shelves above the sink, or in the sink itself along the back edge.

Negatives See *Studio, archives.*

Print finishing See *Studio, finishing and shipping area.*

ENVIRONMENTAL CONSIDERATIONS Because darkroom work by its very nature produces waste products, the photographer should be aware of the nature of these products and what can be done to minimize their impact on the environment.

Waste Disposal The factors affecting waste management are volume of effluent (the waste flowing out of the darkroom), temperature of effluent, types of chemicals used, and the ratio of chemical waste to wash water. The effluent from personal darkrooms is within most established sewer codes. The pH (measure of relative acidity or alkalinity of a liquid) is between 6.5 and 9, the temperature is less than 90°, and there are very few suspended solids. Most commercially available processing solutions contain no grease or oils, nothing flammable or explosive, and they do not have much color or odor. Photographic chemicals are generally biodegradable and will not harm municipally run biological treatment systems. It is not advisable to discharge darkroom wastes directly into a septic tank and/or leach field unless the amount is small in comparison to domestic discharge volumes or has been greatly diluted.

Many states require the installation of a back-flow prevention valve in the inlet water supply of the darkroom. The valve prevents chemicals from being sucked back into the domestic water supply if a vacuum is accidentally created in the municipal system.

The silver in the waste water is in the form of soluble silver thiosulfate from the fixing bath. It is not in the form of toxic, free-ion silver. The thiosulfate is converted by municipal processing plants into insoluble silver sulfide and some metallic silver. These are removed with other solids during clarification.

Recycling Since the earth and its resources are finite, photographic chemicals should be conserved and recycled whenever possible. The use of replenishers instead of one-shot chemistry is advised where feasible. The main darkroom chemical that is recycled is silver. It can be removed from fixing baths by several methods—metallic replacement, electrolytic recovery, and ion exchange. For larger, commercial darkrooms with high flow rates, electrolytic or ion exchange are economically reasonable. For personal darkrooms with much lower flow rates, metallic exchange makes the most sense.

Metallic exchange is a very simple process in which a more active metal than silver (usually iron) replaces the silver and goes into solution. The insoluble silver metal settles out as a solid. There are several commercially available systems on the market. Photographers can make their own by placing steel wool in a drum and pouring the fixing bath into it. The silver will form a sludge in the bottom. This sludge is sold or given to a recycling company that recovers the silver. The silver content of the sludge is hard to determine so most companies will not pay for it. They pick it up for free and make what profit they can. Even though the photographer receives no monetary compensation, the feeling of having made an effort to help the environment is payment enough.

Publications: American National Standards Institute, *Viewing conditions—photographic prints, transparencies, and photomechanical reproductions* (ANSI PH2.30). New York: American National Standards Institute, 1985; American National Standards Institute, *Methods of determining safety times of darkroom illumination* (ANSI PH2.22). New York: American National Standards Institute, 1978. *J. De Maio*

DARKROOM CAMERA See *Camera types.*

DARK SLIDE The opaque sliding panel found on sheet film, film pack, or roll film holders that protects the film from light exposure. The slide is removed from the film path when the film is ready to be exposed in the camera. It is then replaced before the film holder is removed from the camera.
P. Schranz

DATABASE In computers, the holding of information in an electronic form in a cross-referenced structured format that allows for rapid retrieval and cross-referring. Large databases are used for a variety of data-intensive fields. Some multimedia applications use databases as the referencing tools to rapidly access and display visual data.
R. Kraus

DATA-RECORDING CAMERA See *Camera types.*

DAVIDSON, BRUCE (1933–) American photographer. A photojournalist who chooses not to work surreptitiously, his portraits bear witness to the trust between photographer and subject, unguarded and open to his camera. A Magnum photographer since 1958, has worked in advertising and for magazines such as *Life* and *Esquire.* Awarded the first photography grant by the National Endowment for the Arts (1967).

Books: *East 100th Street.* Cambridge, MA: Harvard University Press, 1970; *Subway.* New York: Aperture, 1986. *M. Alinder*

DAVIS GIBSON FILTER See *Filter types.*

DAY-FOR-NIGHT Filming a motion-picture scene in daylight so that it will appear to have occurred at night, using filters and/or underexposure. *H. Lester*

DAYLIGHT Daylight is the oldest and by far the most significant form of light. The sun is the source of all daylight. Even when it hides behind a cloud it provides the natural light by which we see and take pictures. Direct sunlight at noon in the summer provides an illuminance of approximately 100,000 lux—as much light as 400 photoflood damps at a distance of 2 meters.

Daylight is made up predominantly of sunlight, but with a mixture of skylight and reflected light, and is not constant. It varies because the sun's altitude angle changes throughout the year and from the beginning to the end of the day. In the northern hemisphere, the sun is highest in the sky in June and lowest in December; the months being reversed in the southern hemisphere. The sun angle is also the highest in the middle of the day (halfway between sunrise and sunset). The exact time of this occurrence varies with the longitude, time zone, and the type of time (daylight or standard), but is usually between 11 a.m. and 2 p.m. The sun angles are symmetric around both these maxima. If the midday time is 1 p.m. the sun angle will be approximately the same at 10 a.m. in April as at 4 p.m. in August. The amount of direct sunlight in daylight also varies with the position of the sun. Direct sunlight can only travel in straight lines from the sun. Skylight and reflected light can enter shadow areas. Since skylight is typically more blue than sunlight, the shadow areas of outdoor color photographs typically appear bluer than sunlit areas. Strong reflecting surfaces can also influence the color balance of a shadow area. One of the reasons that scenes appear different in color photographs than to the eye is because the eye has the ability to adapt to locally different qualities of illumination color, whereas the photographic process generally does not.

The directional quality of daylight depends on the sun angle and atmospheric conditions. If the sky is clear the sun will cast sharp, distinct shadows. These shadows are longer and therefore more evident when the sun angle is low. If the sky is hazy, shadows will still be cast, but they will be softer. Overcast skies gradually eliminate all but the most diffuse shadows as the cloud cover becomes thicker. Foggy conditions without cloud cover can result in a particularly soft light but with some shadows. Photography at high altitudes under clear conditions can result in exceptionally

sharp shadows and high rendition of detail, especially at a distance. This is because the color temperature and balance of the sunlight and skylight components of daylight change at high altitudes, and because there is generally less haze at high altitudes. Smaller amounts of atmospheric scattering (due to smaller amounts of atmosphere) result in more of the light arriving in the form of direct sunlight, and in higher color temperatures for both the sunlight and skylight. A somewhat opposite effect occurs at low sun angles because of the increase in the amount of atmosphere the sunlight must penetrate (although at very low sun angles the proportion of light from the sky may decrease because the sky becomes less well illuminated by the sun). Low sun angles are generally the most desirable for landscape photography, however, because of the pleasing effect produced by the long, distinct shadows and warm light. The warm light can also result in somewhat greater haze penetration in directions away from the sun due to its longer wavelength. The key to judging the quality of daylight lies in determining the quantity of direct sunlight as opposed to scattered light. If the solar disc is visible, some direct sunlight is getting through and there will be some amount of distinct shadow. The depth of the shadow will depend on the amount of scattered light present—the brightness of the sky. If the solar disc is not visible, shadows will not be distinct.

When the sun is at a high angle and the sky is relatively clear, daylight illumination is relatively consistent the world over. This consistency gives rise to the famous f/16 rule. This rule states that under the previously mentioned conditions, a good exposure of an average scene, illuminated by sunlight, can be obtained by exposing film at f/16 for an exposure time in seconds equal to the reciprocal of the arithmetic film speed. This rule is quite reliable assuming the conditions are appropriate, and can even be used for a quick check of the calibration of an unknown light meter. This rule, however, applies only to sunlit subjects; subjects that are in a shadow area will require more exposure. Other exposure values will also be required at low sun angles and if the sun is obscured, even partially, by clouds or fog. *J. Holm*

See also: *Moonlight; Skylight; Sunlight.*

DAYLIGHT ILLUMINANT Illuminant having the same, or nearly the same, relative spectral power distribution as a phase of daylight. *R. W. G. Hunt*

DAYLIGHT-LOADING (1) Identifying film or other sensitized material that is packaged so that it can be inserted into a camera, printer, etc. under normal white-light conditions. (2) Identifying processing equipment that can be loaded with exposed sensitized material under normal room illumination. *L. Stroebel*

DAYLIGHT LOCUS The locus of points in a chromaticity diagram that represent chromaticities of phases of daylight with different correlated color temperatures. *R. W. G. Hunt*

DAYLIGHT SCREEN (1) A highly directional, high-gain screen that can be used in an environment with a fair amount of ambient light. (2) A small shielded backlit projection system. These systems are often used for synchronized sound-slide programs and are ideal for education, training, point-of-purchase display, and other applications that require simplicity and portability. *M. Teres*

See also: *Beaded screen; Projection screen.*

DDL See *Digital delay line.*

DEBLURRING In computers, when an image is blurred from either linear motion in a specific direction or from a lack of depth of field, the image sharpness may be restored by deblurring techniques such as the use of a Wiener filter. *R. Kraus*

DEBOT EFFECT See *Appendix A.*

DECARAVA, ROY (1919–) American photographer and teacher. Studied painting and learned photography to document his work, switching completely to the new medium in 1947. Photographed Harlem, from tenement halls to life in the streets and portraits of jazz musicians. Received a Guggenheim Fellowship (1952), the first African-American thus honored. His photographs with text by Langston Hughes appeared to much acclaim in the 1955 book, *The Sweet Flypaper of Life.* Steichen selected a number of DeCarava's images for his hugely popular exhibition and book, *Family of Man* (1955). Since 1975, professor of art at Hunter College.

Books: Alinder, James, ed., *Roy DeCarava, Photographs.* Carmel, CA: The Friends of Photography, 1981. *M. Alinder*

DECENTRATION ABERRATIONS Aberrations caused by incorrect alignment (centration) of all the elements of a lens to the common optical axis. *S. Ray*

DECIBEL Abbreviated dB. Literally, one-tenth of a Bel. The use of the term decibel means that logarithmic scaling of the amplitude of a quantity divided by a reference amplitude has been employed. Such scaling is useful because the range of amplitudes encountered in sound is extremely large and because hearing judges relative loudness of two sounds by the ratio of their intensities, which is logarithmic behavior. Differing factors are used when applying decibels to various quantities so that the number of decibels remains constant; 3 dB is always 3dB, although it represents twice as much power, but only 1.414 times as much voltage.

For reference, 3 dB is twice as much power, 6 dB is twice as much voltage, and twice the perceived loudness is reached between 6 and 10 dB depending on the experiment used. Thus, as much as nine times the sound power is required to make a sound twice as loud.

Because the use of the term *decibel* implies a ratio, the reference quantity must be stated. Some typical ones are:

dB SPL	referred to threshold of hearing at 1 kHz
dBm	reference 1 milliwatt, usually in 600 ohms
dBV	reference 1 volt
dBu	reference 0.7746 volts

T. Holman

DECIMAL EQUIVALENTS See *Appendix F.*

DE CLERQ, LOUIS-CONSTANT-HENRI-FRANÇOIS (1836–1901) French photographer. Traveled to Egypt, Palestine, and Syria, as part of a French archaeological expedition, returning to France where *Voyage en Orient, 1859–1860,* was published with 222 salted paper prints made from waxed-paper negatives. De Clerq's photographs, beyond documentation, juxtapose shapes and texture in stark, geometric compositions.

Books: Mayer, Rolf, *Louis De Clerq.* Cologne, Germany: Edition Cantz, 1989. *M. Alinder*

DECODER A device that takes in composite video and decodes the signal information into separate signals for picture (RGB), sync, and timing. Decoders may be used to input video into a computer when sync signals are weak or when picture signals need boosting in a particular channel. *R. Kraus*

DECOMPOSITION Decomposition reactions involve the separation of a compound into simpler compounds or elements. Water, for example, can be decomposed into molecules of hydrogen and oxygen by a process called electrolyses, involving an electric current. Gallic acid, an early

developing agent, was heated to produce pyrogallol, a more active developing agent formed in the decomposition.

G. Haist

DECORATION PHOTOGRAPHY Decoration photography personalizes a room to reflect the taste and interests of the individual, family, or business. Decor use of photography emerged in the mid-1950s when improvements in film and paper enabled commercial photographers to make large prints suitable for framing.

Magazines of the time encouraged "home galleries" and "living walls" of family pictures. In 1956, the Eastman Kodak Company hung photographs in a Manhattan apartment to show how elegant decor photography could look.

Today, decoration photography includes everything from walls of traditional family portraits to single, spectacular enlargements—of a flower close-up, for instance, or a fine, old vase. Photographs may be framed to blend with the furniture, or they actually may be incorporated into an occasional table or a folding screen matched to room decor. Although most decor photographs continue to be rectangular in shape, any photograph may be affixed to a stiff backing and cut to the shape of the subject pictured.

Straightforward photographic prints, perhaps enhanced by special lighting, continue to dominate decoration photography, particularly in the home. In retail establishments and in some corporate environments, backlighted transparencies lend an extra measure of eye appeal. Some photographic materials allow a print to be viewed either by reflected or transmitted light—flexibility appreciated especially in industrial and commercial applications.

To be decoration photography, a print need not be large or expensive to install. At times, photographs have been mounted on placemats, cutting boards, even window shades turned into wall hangings. They have been made into mobiles, planters, and room dividers. Cork walls, bulletin boards, and pegboards permit print displays that change with the season or the whim of the decorator.

To bring the outdoors into a small, windowless room, a large photomural of natural rock formations might occupy one entire wall. The photomural usually consists of a series of floor-to-ceiling panels attached directly to the wall. A coating of special lacquer protects the photomural. Even more elaborate wall treatments transform company hallways into forests, and lobbies into tranquil waterside retreats.

Many decor applications of photography can be achieved by the amateur photographer capable of making a graphically interesting photograph that can withstand the rigors of enlargement. Old as well as new images can be turned into photographic art. Large photomurals generally require the expertise of the professional photographer experienced in decor photography.

Subject matter ranges from family portraits to high-impact, even photojournalistic photography. Nature subjects—animals in their natural environment; flowers, trees, and natural vegetation of all kinds; spectacular mountain, seaside, and desert views; slices of geological beauty; seasonal manifestations; fruits and vegetables in extreme closeup—tend to dominate decor intent on bringing the outdoors in. Special interest subjects such as sailing, horseback riding, bird-watching, and travel help reflect the personalities of the occupants. Corporate subjects include everything from employees to facilities and products—plus attention-getting images that somehow convey the corporate philosophy. Some professional photographers specialize in corporate decor photography.

Custom color labs can produce just about any print needed for home or business decor. They also will work with the photographer to make sure that every aspect of the decor piece—from cropping to color corrections and dodging/burning in—comes out exactly as expected. Some color labs even offer their own image libraries from which customers can select an image.

Once prints have been mounted or framed and hung on the wall, lighting fixtures can be installed to lend drama and set the proper mood. Both track and recessed lights can provide the desired spot or wash lighting. Recessed lighting lends a more finished look to photomural installations.

Books: Holland, John, *Photo Decor—A Guide to the Enjoyment of Photographic Art.* Rochester, N.Y.: Eastman Kodak Company, 1978.

K. Francis

DECOUPAGE The decorative process of bonding cutouts of paper or other thin material, including photographs, to an object such as a box, dish, or tabletop, and covering it with multiple coats of varnish or lacquer to obtain a smooth protective surface.

L. Stroebel

DEDICATED Identifying a device designed to be used for a specific purpose or in conjunction with another specified device. A dedicated flash unit, for example, may be designed to fit in the flash shoe of a camera and provide shutter synchronization and automatic exposure control by means of the camera's electronic circuitry.

L. Stroebel

DEDICATED FLASH An electronic-flash unit with a built-in sensor that is tied directly to the camera exposure controls. The flash units are designed to be used with matching camera bodies to enable communication of information between the two units, normally in a hot shoe, which eliminates the need for a sync cord. On cameras equipped to handle dedicated flash, the exposure-control indicator lights are visible in the camera viewfinder.

P. Schranz

DEFECTIVE COLOR VISION An abnormal physiological condition characterized by a chronic reduced ability to detect hue differences between certain colors.

L. Stroebel and R. Zakia

Syn: *Color blindness.*
See also: *Vision, color vision.*

DEFECTS Defects in photographs can have a wide variety of causes, and this can be multiplied by the diversity of formats and purposes of the work. Defects can include those that are physical in nature, such as curl and dimensioning, that might affect intermediate handling as well as final product performance. These physical attributes may also cause optical and imaging problems, such as excess density resulting from pressure, marks due to kinking of the film, etc. The defects can also be due to such causes as improper photographic processing, contamination of solutions, improper temperature, and inadvertent light fog, to name a few.

PHYSICAL DEFECTS Physical defects such as improper dimensioning, excessive curl, brittleness, or excessively high or low coefficient of friction can have a pronounced effect on processes depending on mechanical handling such as for motion pictures or other continuous processes. Dimensional failures can also be important in applications such as aerial photography for mapping.

Physical problems may also influence the image quality of photographs. Film that is buckled can yield incomplete contact with a printing material or variations in enlarger focus causing a loss in image quality. If dimensions are not properly maintained, loss of pictorial image quality or of optical sound quality can occur due to slippage when printing motion picture or other continuous films. Glossy surfaces of negatives in contact with pressure glass in enlargers, for example, can cause the interference effect known as *Newton's rings.*

Definition. Two photographs of a single test pattern made with types of spread function giving low sharpness and high resolution (left), and high sharpness and low resolution (right). Source: *Applied Optics*, vol. 3, no. 1, 1964).

Other physical defects in original images, such as scratches and abrasions, ferrotyping of the emulsion surface, frilling, and the presence of dirt, dust, or other unwanted material will have obvious deleterious effects on photographs printed from them.

PHOTOGRAPHIC DEFECTS Physical problems such as those mentioned above may result in photographic defects that would not in themselves be considered "physical." In addition, however, are defects that are photographic in nature from the beginning. These include image fog, either uniform or nonuniform. Nonuniform fog is more apt to be seen because of the localized changes in density, whereas uniform fog produces an overall reduction in contrast. Fog may be due to improper storage or excessive age of the sensitized material before use, improper processing, cosmic radiation, inadequate safelights, or stray light.

Other photographic defects include stains, areas of uneven density, streaks, and spots due to improper photographic processing. Changes in tone or density of prints, such as plumming, can result from improper drying.

The source of defects may be in the unexposed photographic material itself, although this is very rare. Defects can arise during any of the steps involved in making photographs, including exposure of the film in the camera, processing of the film, exposure or processing of the prints, or during handling, storage, or use of the final image. Care at all steps to prevent defects is usually less costly than later correction.

Defects in the crystal lattice of silver halide grains in emulsions are responsible for higher sensitivity, which is actually a beneficial characteristic. *I. Current*

DEFINITION A general term identifying the microcharcteristics of an image, as distinct from the characteristics of larger areas that are associated with tone reproduction—such as those presented in *D*-log *H* curves. Image definition of photographic images is a combination of the more specific subjective characteristics—sharpness, detail, and graininess— or the corresponding objective characteristics—accutance, resolving power, and granularity. These characteristics can be evaluated subjectively at different criteria levels by examining the image at a normal viewing distance, at close range, through a magnifier, and through a microscope. Objectively, resolving power is measured by examining the image of a test target consisting of parallel black bars on a white background and identifying the smallest set where the bars are still discernible. The results are recorded as lines/mm, for example, 100 lines/mm. Acutance and granularity are mea-

sured by scanning suitable test images with a mathematical interpretations to the resulting data. The highest definition results with a combination of low granularity and solving power and acutance. The separate characterisics are not completely independent, however. An increase in granule, tends to have an adverse effect on resolving power and acutance.

The concept of definition can be applied to other than photograph images, such as photomechanical and video images, although some of the terms and units of measurement are different. (Electronic enhancement to improve resolution in a hard copy can in some cases, reduce sharpness.)

L. Stroebel

See also: *Acutance; Detail; Graininess; Granularity; Modulation transfer; Resolving power; Sharpness.*

DEFOCUS Deliberate movement of the lens away from the focus position giving optimum sharpness to render all or part of the scene less sharp. *S. Ray*

DEFORMATION PROCESS See *Thermoplastic recording.*

DEGAUSS (1) To demagnetize. When done deliberately in a degausser, this means applying first a strong ac magnetic field that can reverse the state of all magnetic domains in the object being demagnetized, and then decreasing the field strength in an orderly way to zero. This process leaves the state of the various magnetic domains utterly random and thus demagnetized. (2) In computers, the act of demagnetizing the cathode-ray tube (CRT) in the monitor. The use of the CRT builds up a charge on the surface of the monitor. Degaussing the monitor prolongs monitor life and minimizes distortion. *T. Holman and R. Kraus*

DEGREE (°) (1) A unit on a scale of temperature. (2) A unit of angular measure, 1/360 of a full circle. The angle of view of a normal camera lens is about 50 degrees. (3) See *Photographic degree.* *H. Todd*

DEHUMIDIFIER A device that removes humidity from the air by first passing the air over refrigerated coils to condense out the water vapor, and then, in some units, over heated coils to warm it up again. The condensed water is channeled off into a reservoir that must be emptied periodically, or into a drain. Air conditioners also serve as dehumidifiers in warm climates, with the refrigerated coils removing the water vapor and the warm surroundings heating the air back up again. *J. Holm*

DEIONIZE Water is deionized by passing the hard water through separate columns that remove the detrimental metallic ions and the acidic ions. Deionized water can be as pure as distilled water, produced by vaporization and condensation of impure water. Water softeners, however, pass impure water over a resin, such as sodium aluminum silicate, that exchanges sodium ions for the calcium and magnesium ions of the hard water. *G. Haist*
See also: *Ion exchange.*

DELAYED ACTION The automatic release of the shutter at a specified time after the release is activated. *P. Schranz*
See also: *Self-timer.*

DEMACHY, ROBERT (1859–1936) French photographer. The leading pictorialist in France, member of the Linked Ring and exhibited at Stieglitz's "291" gallery in New York, Demachy insisted that a photograph must be manipulated before it could achieve the status of art. In 1894, mastered the gum bichromate printing process that became his chosen means of expression. Demachy applied the gum bichromate to textured paper with a thick brush that produced the painterly evidence of brushstrokes in the finished photograph. His images were highly impressionistic in appearance.
Books: Jay, Bill, *Robert Demachy, 1859–1936.* New York: St. Martin's Press, 1974. *M. Alinder*

DE MEYER, BARON ADOLF (1868–1946) American photographer. Born in Paris and with his wife, Olga, part of the European social set. A pictorialist and member of the Linked Ring (1903). His photographs were exhibited by Stieglitz at "291." In 1911, the de Meyers promoted Diaghilev's Ballet Russe in their first London appearance and de Meyer made his famous photographs of Nijinsky. From 1914 to 1935 he lived in America where he became the top fashion photographer. Also known for his portraits of celebrities for *Vanity Fair, Vogue,* and *Harper's Bazaar.*
Books: Brandau, Robert, ed., *De Meyer.* New York: Knopf, 1976. *M. Alinder*

DENSITOMETER An instrument used for the measurement of the extent to which an area of a photographic image absorbs light. Densitometers are of several types:
Visual, in which the eye compares a sample with a calibrated reference
Photoelectric, in which a photocell measure the amount of light from a standard source transmitted or reflected by the sample
Transmission, used for the assessment of a transparent material, such as a negative or positive film sample
White-light, whereby the sample is illuminated with the entire spectrum of light
Narrow-band, in which the sample is illuminated with various sections of the spectrum, used in the measurement of color photographic images
Automatic, which give a printout or a graphical plot of the data from a sample exposed in a sensitometer.
 M. Leary and H. Todd

See also: *Color densitometer; Color density; Densitometry; Density; Diffuse density; Doubly diffuse density; Exposure density; Specular density; Transmission density.*

DENSITOMETRY The measurement of the photographic effect in a processed sample. A known illuminance (light level) is caused to fall on the sample, and the transmitted illuminance (for a transparent image) or the reflected illuminance (for a print) is recorded. For a transparent image, photographic density is defined as the logarithm of the ratio of the initial light level to the light level after being affected by the sample: $D_t = \log I_o/I_t$. For a print, the reflection density is usually defined as the log of the ratio of the light reflected by the base to that reflected by the sample: $D_r = I_b/I_r$.

Theory and experiment have shown that such a definition of density provides numbers that are

1. approximately proportional to the concentration of silver or dye in the image;
2. for pictorial images, related to the visual response of the eye of the viewing person;
3. for negative images, approximately inversely related to the log exposure values they will produce in the printer;
4. additive, so that when a mask is added to a negative in a printer, the total density for each area is the sum of the individual densities.

The preceding statements are correct only if the sample is measured appropriately. The nature of the image strongly affects the effects it will have on received light or other energy, for two reasons: (1) silver images, and to a much smaller extent dye images, scatter light because of their microscopic structure; (2) silver images, and certainly dye images, differently affect energy of different wavelengths; a resulting change in the color of the original light must be taken into account. For these reasons, measurement of the light transmitted or reflected by the sample involves complex problems of optics and receptor spectral sensitivity.

OPTICAL CONSIDERATIONS An instrument for measuring density—a *densitometer*—consists of two basic parts: the source of energy and the receptor—the eye, or more commonly, a photoelectric cell and associated electrical apparatus.

If the source is, for example, a small lamp and the energy is focused on the sample, the illumination is called *specular.* The scattering effect of silver images causes the light to be dispersed over an angle of nearly half a hemisphere; some of the light is even returned toward the source. If the receptor is placed at an appreciable distance from the sample, only the directly transmitted light is recorded. Such a density is called *specular.* If, however, the receptor is placed in contact with the sample, almost all the transmitted light is recorded, giving what is called a *diffuse* density. Specular densities are larger, for a given sample, than diffuse densities, the difference being greater for high densities than for low ones.

Following the law of optical reversibility, an alternative method of finding diffuse densities involves providing the sample with diffuse light, as from a ground or opal glass in contact with the sample, and measuring only the directly transmitted light.

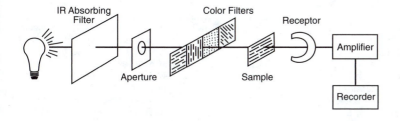

Densitometer. The sample is placed at the right of the aperture.

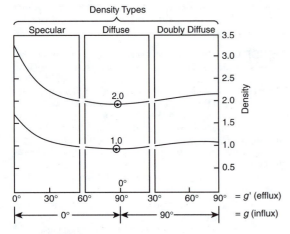

Density Types

Optical considerations. Variation in film density for a single film sample with angle of illumination and angle of collection. The specular density, at the left, is approximately 3, the diffuse density, at the center, is close to 2, and the doubly diffuse density, at the right, is more than 2.

A third type of optical system provides diffuse energy to the sample and records the diffusely transmitted energy, giving what is called a *doubly diffuse* density. For a given sample, such a density is intermediate in value between the specular and the diffuse measurement.

Given the variation in measured density with the optical system, the problem of the user is what type of density to measure. The answer is found in the phrase *conform to practice.* For predicting the printing behavior of a negative, the optical system of the densitometer must be similar to that of the printer. If a condenser-type of projection printer is to be used, the illumination is specular, the collection is also specular, and thus a specular density measurement method would be appropriate. Diffusion-type projection printers, however, provide diffuse light to the negative and collect mostly specular light; for these printers diffuse density measurements are apropos. For a contact printer, doubly diffuse densities would be the most useful predictors.

International standards define diffuse density, and commercially available densitometers provide such data. The predictive value of such measurements is clearly related to the manner in which the negative is to be printed. Practical testing will, to some extent, indicate the reliability of the measured values in determining contrast and exposure characteristics. Such testing may well give different results for negatives of different characteristics, since grain (fine or coarse) affects the amount of scattering.

A further optical consideration involves the size of the aperture in the densitometer. If a very small aperture is used, the sensitivity of the photoelectric system may be impaired. If a very large aperture is used instead, minor defects in the image area may give false readings. The optimum aperture size must be found by trial.

SPECTRAL CONSIDERATIONS A silver image, although nominally said to consist of a set of grays, is in fact rarely neutral in its absorption of radiation. Absorption is greater for short wavelengths (ultraviolet and blue) than for long ones (red and infrared.) The measured density of the sample therefore depends on the spectral characteristics of the radiation source and those of the receptor.

For density values that reliably predict the printing behavior of a negative, the spectral response of the densitometer must match that of the print material. Print emulsions usually have a greater response to short wavelengths than to long

ones. The mismatch between an unmodified densitometer response and that of the print material requires the use of a filter in the densitometer to provide a correlation between the measurement and the effect of the negative in the printer. A perfect match is hardly obtainable, because print materials differ in their response to different wavelengths. Careful testing is needed to assure the reliability of density measurements in predicting negative printing characteristics.

REFLECTION DENSITOMETRY Print samples present special difficulties in measurement because the appearance of a print depends on the nature of the illumination and the way in which the print is viewed. Print samples reflect light diffusely, the reflected light level varying with the angle of illumination, the angle at which it is viewed, and the nature of the surface, whether matt or glossy or textured.

The current standard for print density measurement specifies specular illumination at an angle of 45 degrees and specular collection at an angle of 0 degrees. This method eliminates the glare reflection from a glossy print. Furthermore, since most prints are viewed straight on, the collection method specified by the standard is appropriate. Prints, however, are illuminated in a variety of ways and rarely only at an angle of 45 degrees; thus, the standard may not invariably predict print appearance.

Prints are not often neutral spectrally. For this reason, cautions such as those mentioned previously for negative materials must be applied to print measurement.

An alternative method of estimating print density calls for the use of a calibrated reflection step tablet and a visual comparison of the print area with the tablet. Density values of the tablet are usually given in intervals of 0.10 in density, and careful comparison can estimate the density of a sample to within a few hundredths. An aperture should be made in a sheet of gray paper and placed so that only the image patch being measured and a single patch of the tablet are visible at one time.

COLOR DENSITOMETRY Each dye of a color transparency has some absorption for every wavelength of light; thus, every density measurement is affected by all three dyes, as well as by possible fog or stain. The situation is even more difficult for a color negative, which usually contains colored masks as well as the other dyes. Therefore, the spectral characteristics of the light source and the receptor used in the densitometer are especially important.

There are two basic types of color density:

1. Integral, in which the effects of all three dyes are measured simultaneously.
2. Analytical, obtained by estimating the spectral absorption of each of the dyes separately.

TYPES OF INTEGRAL DENSITY

1. Spectral densities are obtained by using an instrument that subjects the sample successively to narrow bands of wavelengths of light throughout the spectrum.
2. Printing densities are obtained with an instrument that is designed to measure the effect that a sample will have when it is used in a specific printer and with a specific print material. Such a densitometer must be carefully tested so that the results will have useful predictive value.
3. Visual densities indicate the effect that the image will have on a human observer. Again, the densitometer must match a typical viewer in spectral response.
4. Three-filter densities are made by successively introducing into the light path of the densitometer a blue, a green, and a red filter, usually Wratten 92, 93, and 94. Such measurements are often used in processing control to discover whether or not a processed sample duplicates a standard and therefore to detect a change in the processing system. Such measurements show that a change has occurred but do not identify the cause of the change. *M. Leary and H. Todd*

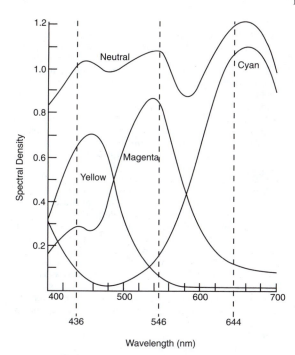

Spectral considerations. Spectral absorption of the dyes of a positive color film. The spectral absorptions of the three superimposed dyes and the absorption characteristics of the dyes are shown separately. The measured sample was visually neutral and had a net density of 1.0 when measured with a conventional densitometer and with white light.

See also: *Analytical density; Color densitometer; Color density; Equivalent neutral density; Exposure density; Integral density.*

DENSITY

A measure of the light-absorbing characteristics of an area of a photographic image, filter, etc. Density is defined as the common logarithm of the ratio of the light received by the sample to that transmitted or reflected by the sample. $D = \log (I_o/I)$, where D is the density, I_o is the illuminance (light level) on the sample, and I is the illuminance falling on the receptor after being affected by the sample.

There are very many types of photographic density, depending on the optical system used in the measuring instrument (the densitometer), the type of image (negative or positive, neutral or colored) and the color of light used in the measuring instrument (densitometer). *M. Leary and H. Todd*

See also: *Densitometer; Densitometry.*

DENSITY-LOG EXPOSURE CURVE

See *Characteristic curve.*

DENSITY RANGE

The difference between the densities of the lightest and darkest areas in a photographic image. For a negative, the density range is a measure of the total contrast of the image and is related to the scale index (tolerable log-H range) of the appropriate printing material. For a positive, the density range is a measure of the extent to which subject tones, from the darkest shadow to the lightest highlight, may be reasonably well recorded. *M. Leary and H. Todd*

See also: *Density scale.*

DENSITY SCALE

The range of transmission densities (in negatives and transparencies) or reflection densities (in prints) from unexposed areas to the maximum density (non-reversal materials) or the minimum density (reversal materials) the material can produce. That portion of the density scale that is of practical use in printmaking is called the *useful density scale.* *M. Leary and H. Todd*

See also: *Density range.*

DENSITY TABLET

See *Optical wedge.*

DENTAL PHOTOGRAPHY

Dental photography, as a subspecialty of clinical/medical photography, can include external facial views as well as intra-oral views for practitioners of all dental specialties including oral surgery. Photographs are typically taken of the teeth and/or oral environment to illustrate dental disease, malformations, soft tissue, the development of the oral cavity as well as aspects of jaw and facial formation.

Comparative pictures are often generated to illustrate the procedures over time. Also, portrayal of a condition using various parts of the radiation spectrum can illustrate aspects of a condition not visible by other means.

Dental pictures are currently used by dentists for monitoring treatment plans, teaching, publishing and/or research as it pertains to their work. Additionally, the overall healthcare environment has changed, and thus dental pictures are being used for other applications. Marketing of dental products and dental services are two of these newer applications, as well as documentation for legal (malpractice) cases.

CONSIDERATIONS Producing photographs for dentistry and its subspecialties requires no special equipment or techniques when producing external views of the face and jaws. Depending on the size of the dental facility, dental photography may be done by a trained dental photographer or by the dentist, assuming at least limited experience in photography.

Intra-oral procedures are a bit more complicated and require substantially more equipment and expertise. Because of the increased need for expertise, shooting protocols are often standardized by the dentist or photography department to ensure the highest quality and consistent results.

EQUIPMENT Because of the need for photography to be done on site, most camera systems are kept chairside or in close proximity to the clinic. Most dental photography is done with 35-mm single-lens-reflex (SLR) camera systems, although some work is also accomplished with instant-picture cameras. The camera can influence the ease with which good results of dental photography are obtained by offering features such as autoexposure and autoadvance. These features allow concentration to be placed on the patient rather than on the mechanics of photography.

Intra-oral views require much depth of field to ensure the entire dentition is maintained in sharp focus, and the camera lens should be capable of minimum apertures of at least *f*/22. Lenses also should be chosen for working distance considerations. Lenses of approximately 100 mm focal length provide a large enough image size without intrusion of the patient's space.

Special mirrors are needed for dental photography, and either polished metal or front surface glass mirrors will produce satisfactory results. Mirrors come in three shapes for various applications—palatal, buccal, and lingual—as well as in adult and pediatric sizes. To facilitate the recording of the appropriate field with mirrors, proper retraction of the lip must be accomplished with unobtrusive retractors.

LIGHTING To ensure maximum quality and fidelity in the recording of dental pictures, electronic flash is imperative. Use of ambient daylight or overhead fluorescent lights will produce less than satisfactory results, even with high speed emulsions because of the difficulty in directing light from these sources into the oral cavity. Electronic flash and through-the-lens (TTL) metering systems provide the easiest

system and most accurate images of intra-oral views when using automatic systems.

Electronic flash can be obtained in either ring light or point light configuration. The ring light, which encircles the lens, is easy to use and provides shadowless illumination for deep cavity views. Point lights, which may be small electronic flash units, typically having a guide number of approximately 80 with ISO 100-speed film, provide satisfactory results as well. Placement of this light must be considered so that no shadow produced from the lip interferes with visibility in the far regions of the mouth.

OTHER Still photography can also be supplemented with videotaping when motion is an important factor. For studies involving temporal mandibular jaw (TMJ) or mobility studies, videotaping the range of motion over the course of the treatment stages might be in order.

Many practitioners of dental photography are affiliated with one or more professional societies, such as the Biological Photographic Association.

Books: Vetter, John, editor, *Biomedical Photography*. Boston: Butterworth-Heinemann, 1992. *M. Peres*

DEPTH The subject dimension that corresponds to variations in distance from the viewer, or to the representation of that dimension in a photograph or other image. Texture, form, and distance represent depth at different scales of reproduction. *L. Stroebel*

See also: *Perspective.*

DEPTH OF FIELD Strict geometrical theory of image formation by a lens indicates that when a lens is sharply focused on a subject detail in order to satisfy the lens conjugate equation ($1/u + 1/v = 1/f$), only one plane can be in sharp focus and other regions are rendered unsharp. Inspection of a photograph of a subject of considerable depth shows image sharpness varying with depth, however. Detail both in front of and behind the point of optimum focus may be acceptable enough to give a zone of sharp focus termed the *depth of field*. This term applies only to the object space and should not be confused with *depth of focus.*

Manipulation of the position and extent of depth of field is an important creative control, and knowledge of the means of extending, restricting, or simply achieving depth of field is a vital skill in practical photography.

DEPTH OF FIELD PARAMETERS In practice, experiment shows depth of field can be controlled by the choice of the focal length and aperture of the lens and the focused subject distance, so can be quantified and calculated in terms of these three parameters. There is, however, a less obvious fourth parameter. Consideration must be given to what is an acceptable standard of sharpness of a photographic record such as a print viewed in the hand. Depth of field boundaries are not clearly defined. Usually there is a blending of acceptably sharp into less sharp detail. Much depends on the viewing conditions and visual factors such as acuity and the criteria of the viewer.

Visual Acuity Perception of detail and judgment of sharpness and depth of field in a photograph depend on visual acuity, viewing distance, image contrast, and ambient illumination. The muscular action to focus the eye sets a normal comfortable near distance of distinct vision D_v at some 250 mm (10 inches). The resolving power of the eye, or visual acuity, is the ability to discriminate fine details of objects in the visual field of view, and it decreases radially from the visual axis. Acuity may be defined as the width of the just resolved detail at D_v or as the angle subtended by the detail. At best, a single line with a contrasting background can be *detected* when the width of the line subtends an angle as small as 1/2 second, which corresponds to a width of 0.0006 mm (0.000024 inches) at the standardized viewing distance of 250 mm (10 inches). Because depth of field is based on the appearance of image sharpness rather than detection, resolving power is a more appropriate measure of visual acuity for depth-of-field purposes. In this context, an angle of 1 minute is considered to be an average value for subject lines and about double that value for points. An angle of 2 minutes corresponds to a width of 0.145 mm (1/170 inches) at D_v, which is close to the average value used for the diameter of the circle of confusion by camera manufacturers when calculating depth-of-field scales and tables.

Circle of Confusion *Circle of confusion* can be defined as the patch of light a lens produces when it images a point source. This patch, which is circular on the lens axis, is at a minimum size when the image of the object point is critically focused. Such a circle is identified as the circle of least confusion. The largest circle that is seen as a point rather than as a circle at a specified viewing distance is identified as the permissible circle of confusion (or the acceptable circle of confusion). Depth of field is the distance between the nearest object and the farthest object where points on the objects are imaged at the film plane as permissible circles of confusion.

Because people tend to view photographs at a distance that is about equal to the diagonal of the photograph, the appropriate size for a photograph that is to be viewed at the standardized viewing distance of 250 mm (10 inches) is approximately 6 × 8 inches. (Contact prints made form the formerly

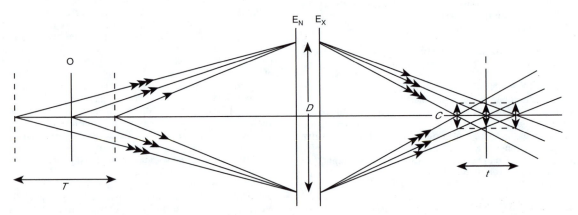

Depth of field. Conjugate relationship between depth of field (*T*) and depth of focus (*t*). *C*, circle of confusion; *D*, effective aperture of lens; EN, entrance pupil; EX, exit pupil; O, object plane; I, image plane.

popular 6.5 × 8.5-inches *whole-plate* and 5 × 7-inch view-camera format could be viewed comfortably at this distance.) If the permissible circle of confusion for a contact print that is properly viewed at D_v is 0.145 mm (1/170 inch), then the permissible circle of confusion for the negative will be the same size. If, however, a smaller negative must be enlarged to produce a 6 × 8-inch print, the permissible circle of confusion must be proportionally smaller on the negative. Since a 1 x 1.5-inch 35-mm negative must be enlarged 6 times, the diameter of the corresponding circle on the negative would be one-sixth that on the print, or 0.024 mm (1/1020 inch).

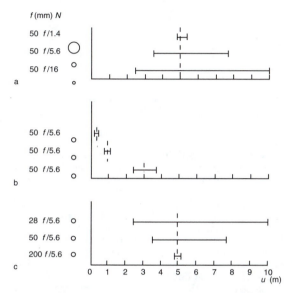

Depth of field parameters. Three variables in general determine depth of field T given a fixed value for the circle of confusion. (a) Lens aperture N, varying from f/1.4 to f/16 with a 50-mm lens focused at 5 m. (b) Focused distance u, varying from 0.3 to 3 m with a 50-mm lens at f/5.6. (c) Focal length f varying from 28 to 200 mm at f/5.6 focused on 5 m. (C, circle of confusion, is taken as 0.03 mm).

DEPTH OF FIELD EQUATIONS Practical equations to calculate depth of field are derived from the geometry of image formation. For a lens of focal length f, used at an f-number N and focused at a distance u (object conjugate) and using circle of confusion C, the far limit D_F and near limit D_N of the depth of field, respectively, are given by:

$$DF = uf2/(f2 - NCu), \text{ and } DN = uf2/(f2 + NCu).$$

These values may be tabulated in various ways, displayed in graphic form, available in a programmable calculator, or shown as the depth of field scales on the focusing mount of a lens.

If depth of field (DoF) is defined as $DoF = D_F - D_N$, then the previous equations may be combined and simplified to

$$DoF = 2u2NC/f2$$

Depth of field is directly proportional to the circle of confusion, the f-number, and the square of the focused distance and inversely proportional to the square of the focal length. Subject distance and focal length have the greatest influence; doubling the value of u increases DoF fourfold, while doubling focal length reduces DoF (at a fixed distance) by a factor of four. Extensive depth of field is given by the use of a wide-angle lens at a small aperture focused at medium distance.

Note that for all but closeup subjects the depth of field is asymmetrical about the focused distance, being larger behind than in front. As the distance focused on increases from close up to the hyperfocal distance, the ratio of depth in front of and behind the distance focused on gradually changed from 1:1 to 1:infinity. Although a ratio of 1:2 is obtained for only one intermediate object distance, the rule of thumb advice to focus one-third of the way into the range of distances desired sharp is useful in the absence of more specific information.

Minimum depth of field is achieved by a combination of long focal length, large aperture, and close focus to achieve differential focus to separate the subject from a distracting background.

HYPERFOCAL DISTANCE Maximum depth of field in any situation is given by use of the hyperfocal distance set as the focused distance on the focusing scale of the lens. The hyperfocal distance (h) is defined as the focus setting (u) that makes the far limit of sharp focus (D_F) equal to infinity or, alternatively, as the nearest distance in focus when the lens is set to infinity focus.

From the equation for D_F, the condition is

$$f^2 = NCu, \text{ and as } u = h, \text{ then } h = f2/NC.$$

The equations for D_F and D_N and DoF then simplify to

$$D_F = hu/(h - u), \text{ and } D_N = hu(h + u), \text{ and DoF} = 2hu^2/(h^2 - u^2).$$

The equation for D_N, the nearest distance in focus, shows that if u equals h then D_N is $h/2$; when u is infinity then D_N equals h. So if the lens is focused at a distance u so the u equals h, then the near limit of depth of field is $h/2$. This gives the maximum depth of field from infinity to $h/2$, for a given f-number N. Cameras with fixed focus (pan-focus) lenses are constructed with the focus set on the hyperfocal distance for the maximum aperture (if this is variable) to give the maximum depth of field.

CLOSEUP DEPTH OF FIELD Closeup photography is defined as situations in which the distance from the subject to the lens is such that the magnification (m) is in the range 0.1 to 1.0. At such close distances the depth of field (T) is effectively symmetrical about the plane of sharpest focus and for a given f-number (N) and circle of confusion (C) can be calculated from the equation:

$$T = 2CN(1 + m)/m2$$

This equation does not involve focal length directly, so for a given magnification a long focal length is preferred, as a longer working distance and better perspective are given by virtue of the more distant viewpoint, without any difference in depth of field for a given f-number.

DEPTH OF FOCUS The term *depth of focus* applied only to the image space in a camera and is the tolerance in the position of the film, which in turn depends on the acceptable diameter of the circle of confusion. Alternatively, it may be considered as the zone about the focal plane between the conjugate planes on either side of the sharp image plane that correspond to the subject planes at the extremities of the depth of field zone.

Depth of focus (t) for a lens of focal length f, set at f-number N and with the lens of film distance (image conjugate) v and a circle of confusion C, is given by the equation:

$$t = 2CNv/f$$

Or, for a magnification m, $T = 2CN(1 + m)$.

For general photography where m is small, these equations reduce to:

$$t = 2CN$$

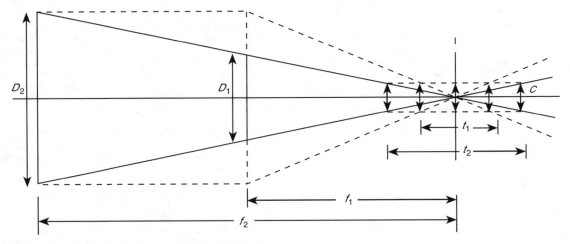

Depth of focus t is independent of f, provided that lenses are at the same value of $N = f/D$. Lenses f_1 and f_2 have entrance pupils D_1 and D_2, giving depth of focus t_2, but this reduces to t_1 if D_1 is increased to D_2.

Depth of focus is small in extent but important in that it allows some tolerance in the flatness of the film surface in the image plane, but for a large aperture lens the depth of focus is small and the film gate must be accurately perpendicular to the optical axis. When a lens is focused close up so that m has a significant value, the depth of focus increases, as it does when small apertures are used.

DEPTH-OF-FIELD CALCULATORS Dedicated calculator devices either of the circular annular rotating log scale variety or electronic digital hand calculators that are programmed to solve precisely values for the extent of the depth of field in given situations, are used particularly by cinematographers, who find that depth of field scales on lenses are not accurate enough, especially when using zoom lenses. Cinematographers also measure focused distance from the focal plane and not from the more difficult to determine position of the front node of the lens, usually approximated as the front rim.

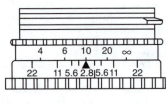

a

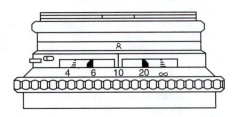

b

(a) Depth of field indicator scale; (b) coupled indicator.

DEPTH OF FIELD SCALES Depth of field scales are a symmetrical pair of aperture value scales set on either side of the focusing index mark on a lens barrel to give a quick visual indication of the approximate depth of field. Many lenses, especially autofocus zoom types, no longer have such scales or have only vestigial indicators. Some lenses have elegant mechanical arrangements using moving indicators linked to the aperture scale as well. Such scales are useful for the techniques of *zone focusing* and using the hyperfocal distance.

CAMERA MOVEMENTS A feature of many medium- and large-format cameras of the view camera, technical, and field types is that they have a range of camera movements that allow the lens panel and film plane to be shifted linearly and rotated about their axes, thereby giving precise control of the sharpness and shape of the image. A primary use is to control the location and extent of the depth of field zone other than by alteration of the usual parameters of focal length, aperture, and focused distance. Such sharpness control is primarily by rotation of the lens panel about vertical (swing movement) and horizontal axes (tilt movement). If sufficient depth of field cannot be obtained even with the lens stopped well down, with the risk of loss of sharpness due to diffraction from the lens at such settings and the need for long exposures or high lighting levels, then for an inclined subject the wedge-shaped depth of field zone obtained by tilt or swing movements can often be placed to coincide with the extent of the subject required in focus. As the ratio of image conjugate distances to object conjugate distances is unaffected by such rotation of the lens, there is no differential change in magnification to cause alteration of image shape. The camera lens must have sufficient covering power to allow such rotational movements. By fortunate coincidence, as a lens is focused closer, its covering power and the depth of focus both increase, which facilitates lens movements to distribute sharpness in the field of view. Camera movements are often used to satisfy the Scheimpflug condition. (Note that the camera back can also be used to alter the angle of the plane of sharp focus, but it will affect image shape.)

The Scheimpflug rule or condition is that an inclined subject plane is rendered sharp when the plane of the subject, the rear nodal (principal) plane of the lens, and the film plane, all extended into space as necessary, meet in a common line. The depth of field about the subject plane is inclined in the same direction as the plane.

Depth of field and camera movements. The inclined subject S is not fully within the depth of field T_1 until the lens L is rotated through angle Θ to satisfy the Scheimpflug condition, putting S within T_2.

Books: Ray, S. *Applied Photographic Optics.* London, Focal Press, 1988; Stroebel, L. *View Camera Technique,* 6th ed., Boston: Focal Press, 1993. *S. Ray*

DEPTH OF FOCUS See *Depth of field.*

DERIVATION Any of various special effects achieved by abstracting one or more attributes from an original photograph, thereby reducing realism. Example: making two reproductions from an original color photograph, one abstracting contour lines and the other abstracting color (but eliminating lightness differences), and then superimposing the two abstractions to form the final image. *R. Zakia*

DERMATITIS Inflammation of the skin that can include cracking of the surface and bleeding. Dermatitis can result when an individual becomes sensitized to a certain chemical or group of chemicals after repeated exposure, and the ailment is sometimes identified as contact dermatitis. In photography likely offenders include developing agents, solvents (that tend to remove protective oils), and several chemicals. Some people are more likely to become sensitized than others, but everyone should take care to prevent the problem by avoiding contact with suspect chemicals. If inflammation occurs, consult a doctor. *I. Current*
 Syn.: *Metal poisoning.*

DESATURATE Make a color, or colors, less saturated, that is, appear to be more like grays of the same lightness. *R. W. G. Hunt*

DESENSITIZATION Efforts to develop panchromatic film by inspection are inherently problematic: virtually any safelight bright enough to permit examination for a useful time will cause fogging. Desensitization uses dye to reduce the sensitivity to light of exposed films or plates without degrading the latent image.
 A partial explanation of the mechanism by which the dyes desensitize is that, as weak oxidants, the dyes trap in their unoccupied electron levels free electrons that were released within the silver halide crystals of the emulsion during exposure. The dyes also probably interfere with latent image formation. The roles of oxygen and water vapor in the desensitization process have not been fully explained. Interestingly, the dyes that cause desensitization also cause sensitization under different conditions.

The dyes used most commonly before development are pinacryptol green and pinacryptol yellow. Treatment is for two or three minutes in darkness, or in a normal safelight for orthochromatic materials, followed by rinsing and development. Slow orthochromatic materials may now be developed in subdued white light; fast orthochromatic materials may be developed in bright amber light, and fast panchromatic materials bright green light. Phenosafranin, which stains the emulsion red, may be added to developers other than paraphenylene diamine types, avoiding a separate step but changing the performance of the developer.
 Desensitization is a special aid to lab technicians who practice factorial development, measuring the time to the first appearance of the image and then multiplying by a factor which is a function of the developer used to determine the total development time. *H. Wallach*

DESENSITIZER (1) Some dyes act to desensitize or block the normal effect of light upon silver halide materials. After the exposed material is bathed in a dye solution, or the dye is added to the developer, visual inspection of a developing image may be made under dim lighting conditions. Desensitizing dyes must be nonstaining, must be stable in solution, must not attack the latent image, and must not interfere with the processing cycle. Pinakryptol green with low staining properties has been useful for desensitizing. (2) In platemaking, a chemical that makes the nonimage areas of the plate non-ink-receptive. *G. Haist and M. Bruno*

DESICCANT/DESICCATED Certain substances, called *desiccants,* have the capacity to absorb water or dehydrate photographic materials. A product called *silica gel,* for example, can absorb up to 50% of its weight in water from atmospheric humidity, then be regenerated by heating.
 Photographic chemicals may contain strongly held molecules of water that can be almost completely removed, producing compounds that are termed *desiccated.* *G. Haist*

DESIGN Design is the deliberate arrangement of the elements of vision in an image for the purposes of balance, rhythm, and unity.
 Design, as the arrangement of the elements of vision in general, is concerned with line, shape, space, pattern or texture, masses, volumes, color, and tonal ranges of light and dark. Variations exist in the identification of elements, but in general, these listed here constitute the elements of a language of vision, the elements of design, or the elements of art. Whether a painting, a photograph, or an advertising layout, these elements and their arrangement are organized or designed for visual effectiveness.
 Visual effectiveness is achieved by unity; unity through several modes of arranging the elements of vision. Dominance and its corollary, subordination, is achieved by the attention paid to the various elements. Location in the space of the picture, convergence of lines to a point or their radiation from a point, and a strong sense of dominant light at a single point in an image can all create illusions of dominance and subordination. A stress on an unusual element in a picture can produce a sense of dominance.
 Coherence, or a sense of almost organic unity is achieved by relating elements through similarity or symmetry, or by stressing analogies of tone or color ranges. A single tone ranging through a print or an image, a single color repeated throughout an image, or repetitions of shape can all advance the illusion of coherence. Coherence must be balanced by some degree of variety, or the result will be boredom.
 Balance, or the adjusting of the illusion of weights and stresses, operates through symmetry. Asymmetrical balance is achieved by distribution of shapes about a center of interest at varying distance illusions, and balance by weight.

Symmetrical balance is psychologically successful because of the inherent organic symmetry of the human body. Balance by the distribution of weight functions through distribution of interest. Rhythm is the regular or irregular repetition of one or more of the visual elements. It can alternate, flow, progress in the sense of accumulation of similar shapes, decrease in the sense of diminishing numbers of shapes in a series. Rhythm is often discussed as analogous to the distribution of sounds in time, like music. In the visual arts, it is the distribution of lines, shapes, volumes, masses, and colors in space.

Proportion deals with the size relationships of parts to each other. It can be a reference to objects in the actual world, illusionistic proportions or proportions based upon imaginary forms and relationships. A mathematical approach to illusions of proportion is possible through linear perspective, which operates to create the sense of diminishing forms in space. Both linear perspective and aerial perspective, in which forms diminish in clarity as they move off into a distance, are in proportion based upon natural phenomena and are psychologically successful because they closely approach the manner in which the eye sees. There is also the implication of time in the depiction of space through the momentary quality of illusionistic projection as opposed to the permanent or essential qualities known through observation of the object at different times or from various points of view. For example, a location in a clearly depicted depth suggests distant events that are still relevant and have a past orientation psychologically. A location in front of a vaguely recognized space indicates the importance of the present over the past, and suggests the present. No recognizable space at all suggests the absence of a temporal dimension, and hence unknown time, suggesting a point in the future.

The mathematical attempts to create interesting proportions based upon the golden section or a rule of thirds do so out of the conviction that perfectly symmetrical divisions of equal halves are not sufficiently interesting to hold the eye for any length of time. Unusual camera angles, unique perspective views, and oblique rather than head-on views all add interest to the composition and provide dissimilar proportional relationships.

Photography has specific aspects of design as well as the general ones outlined above. The choice of subject or image is primary for a photographer taking or making an image; the arrangement of that subject or image by considering angles, backgrounds, lighting, the altering of the distance from the object, the selection of the elements in the viewfinder, and the choice of horizontal or vertical format—square or rectangle for symmetrical or asymmetrical (occult) balance—are equally important and constitute design. The essential choice is that of framing, which is dependent upon the camera and lens, since different camera lenses have varying fields of vision and focal lengths. Shutter speeds, too, must be considered since they are relative to the distance from the object.

Many photographers, tied to the notion that a photograph is unique and apart from the artistic tradition that considers these principles of organization and arrangement, rely on the "aesthetics of the snapshot" and seek out formlessness, cluttered scenes, dissonance, and accidental properties of lighting and placement. They work not towards the imposition of a perceptual or visual order upon "reality," but, instead, they change any ordered reality into visual chaos. Discovering the darker side of human nature, proclaiming, by attending to the rawness of the instant view, that the eye views selectively is the approach most desirable because it maintains the spontaneity and most purely photographic use of the medium.

Books: Cheatham, Frank R., Jane Hart Cheatham, and Sheryl Haler Owens, *Design Concepts and Applications.* Englewood Cliffs, NJ: Prentice Hall, 1983; Ocvirk, Otto G., Robert O. Bone, Robert E. Stinson, and Philip R. Wigg., *Art Fundamentals: Theory and Practice.* 5th Ed. Dubuque, Iowa: Wm. C. Brown, 1985. *R. Welsh*

DESKTOP PUBLISHING In graphic arts reproduction, a compact publishing system that includes a personal computer, word processor, plate makeup, illustration and other software, PostScript page description language, and image-setter to produce halftone films. *M. Bruno*

See also: *Photomechanical and electronic reproduction.*

DESTRUCTIVE INTERFERENCE See *Optics, physical optics.*

DETAIL Relatively small-scale parts of a subject or the images of those parts in a photograph or other reproduction. In a portrait, detail may refer to the ability to see individual hairs or pores in the skin. In an aerial photograph, detail may rfer to the ability to see a person or an automobile.

L. Stroebel

DETECTION A visual response such that the subject is aware of the presence of a stimulus. Detection does not require any additional information concerning the stimulus, as distinct from recognition, resolution and localization.

L. Stroebel and R. Zakia

See also: *Visual acuity; Visual perception, perception of detail.*

DEUTERANOMALY Defective color vision in which a person, compared to one with normal color vision, requires more green in a red-green mixture of light to match a given yellow color. (A mixture of red and green light produces yellow.) *L. Stroebel and R. Zakia*

See also: *Defective color vision; Deuteranopia; Protamonaly; Tritanomaly; Vision, color vision.*

DEUTERANOPIA Defective color vision in which a person sees only blue and yellow in the spectrum. Lacking a red/green chromatic response system, reds and greens are seen as grays. The luminosity curve of deuteranopes is shifted to the right. *L. Stroebel and R. Zakia*

See also: *Defective color vision; Dichromatism; Protanopia; Vision, color vision.*

DEUTSCHES INSTITUTE FUER NORMUNG (DIN) The national standardizing organization of Germany.

P. Adelstein

DEVELOPERS The latent image of an exposed silver halide crystal consists of submicroscopic clusters of metallic silver, from a few atoms to a few hundred atoms, located at various sites that are not randomly distributed. Some silver specks are on the surface, some just under the surface, and others throughout the depths of the crystal. These metallic silver aggregates were formed when photoelectrons, released by light in a tidal flood during the instant of exposure, were trapped fleetingly on impurities or crystal defects. The negative charge of the electrons attracted mobile silver atoms of positive charge, forming neutral atoms of metallic silver. The latent image then grew by the atom-by-atom addition of metallic silver in the split second of light exposure.

The latent image is of no direct use, for it is far too minute. The exposing burst of light, unfortunately, generated only enough electrons to provide the centers of nuclei. More silver atoms are needed to make the nuclei visible and useful. If the light exposure could have been continued, a visible silver image would have resulted. When a silver halide photographic paper, rich in silver ions, is placed behind an

image, then given a massive exposure to light energy, a visible metallic silver image is produced on the paper. This is a printout image that strongly suggests that a latent image could be made visible if electrons could be supplied to the unseen silver nuclei.

Electrons cannot exist unbound but are contained in every atom or molecule on earth. Any potential source, however, must supply electrons only to those silver halide crystals that have a latent image. This eliminates all those substances that are too energetic in giving up electrons. Certain compounds are electron rich but less energetic in freeing their electrons. These compounds need the help of the catalytic effect of the silver of the latent image, as less energy is then required for an electron transfer. These compounds are suitable electron donors (in chemistry, reducing agents) to amplify the invisible light-formed image to a visible one. These image amplifiers are called *developing agents* because they grow or develop the latent image to a useful size, finishing the image formation started by the exposing light.

The exposed silver halide crystals receive the electrons first and grow larger first. Some molecules of the developing agent may possess sufficient energy to donate electrons to unexposed crystals. Once a nucleus of silver atoms is formed on the crystal, less energetic molecules can transfer electrons, and nonimage silver may be formed more quickly. The formation of nonimage silver, called *fog*, obscures image detail and limits the degree of image amplification that is possible.

Developers continue the series of events that occurred during the light exposure. After millions of silver atoms have been formed by development, the image becomes visible. If all the silver comes entirely from the silver crystal on which the latent image is located, the visible image is said to have been formed by *chemical development*.

The latent image can be amplified in another manner. After exposure, all of the unused silver halide in the crystal can be removed, leaving only the silver atoms of each latent image in place in the gelatin layer of the photographic material. A solution containing a developing agent and a soluble silver salt, such as silver nitrate, then is used to treat the gelatin layer. The developing agent donates its available electrons to the silver ions so that metallic silver is catalytically deposited from solution on the silver nuclei of the latent image. This slow form of image amplification is called *physical development* and the solution is a *physical developer*.

Silver salts are not present in the formulas of modern, practical developing solutions. Such solutions do contain, however, compounds that dissolve and etch the silver halide crystals during the initial period when chemical development occurs. The quantity of silver ions in the developing solution will increase with time. Some of the silver ions solubilized from any silver halide crystals, exposed to light or unexposed, will be deposited as metallic silver upon the silver formed by chemical development of the latent image. This combined chemical and physical development, which often occurs as a result of modern development, is called *solution-physical development*.

DEVELOPING AGENTS A wide range of substances have been reported to possess developing activity: polluted lake and river water, old red wine, citrus fruit juice, and even human urine. Thousands of compounds might serve as electron donors to convert exposed silver halide crystals to metallic silver. Metal ions, such as ferrous salts, give up or gain electrons easily in a reversible manner. Many organic molecules can be electron sources, but the reverse action is different. Most of today's developing agents were found between 1880 and 1900 by testing under practical developing conditions. Uncounted organic derivatives have been synthesized in this century, especially for use as color developing agents.

Most of these early practical developing agents were derivatives of benzene. Benzene itself does not have enough energy to transfer any of its electrons, although its unsaturated condition

makes some of its electrons more loosely held than others. The useful compounds had two or more hydrogens of the benzene ring replaced by –OH or –NH2, each or in combination. Two of these groups were usually adjacent on the ring carbons (*ortho,* or 1,2-configuration) or separated by two carbons of the benzene ring (*para,* or 1,4-configuration).

One substitution of only -OH or -NH2 on the benzene ring was not active as an electron donor. Benzene compounds with only –OCH3 and –N(CH3)2, that is, the active groups with their hydrogens replaced, were not developing agents. Substitution of three –OH and –NH2 on the benzene with one ring carbon between (the 1,3,5-configuration) yielded compounds that are not active as developing agents. Multiple group substitution on benzene, such as the 1,2,3-configuration, produced quite active developing compounds.

Substitution of the hydrogens of the benzene ring with -OH or -NH2 groups provides electron-rich substituents that increase the electron density of the molecule. Both oxygen and nitrogen have electron pairs that are loosely held and are not used for bonding. These mobile electrons convert benzene from a relatively inactive solvent to a molecule that is an active electron donor, a developing agent. This neat electronic explanation of the developing activity of compounds, however, fails to explain why at least two substitutions on the benzene ring are necessary or why the 1,3- or 1,3,5-configuration of groups is not active.

Factors other than electron release must be satisfied to characterize a practical developing agent. The active form of a primary developing agent must be able to adsorb strongly to the surface of the exposed crystal. Compounds with poor surfactant properties, either high water solubility or structural hindrances, are poor or slow developing agents. A stabilized intermediate after losing one electron must be formed; otherwise the free radical may attack the silver in the latent image. Partially oxidized intermediates that have two 1,2- or 1,4-substitutions have the desired stability. Unless the intermediate has sufficient stability, it may instantly reverse the reaction with no net effect. Some compounds that lose two electrons may form an oxidized molecule that can catalyze the development activity of the developing agent.

Many developing agents have been made, but only a very few are used today, ranging from pyrogallol (1850) to ascorbic acid, a sugar derivative (1930s), and Phenidone (1940s). The table gives more details of practical compounds but does not indicate the many derivatives of *p*-phenylenediamine made in this century that make color photography possible. After developing the latent image, the oxidized *p*-phenylenediamine is reacted further with color-forming compounds to produce the dyes of the color image. The structure of the developing agent thus affects the color and stability of the dye. The *p*-phenylenediamines are poisonous and cause contact dermatitis, so much effort has been made to modify structure to lessen these undesirable properties.

DEVELOPER CONSTITUENTS Developing agents supply the electrons to amplify the latent image, but, unfortunately, will give electrons to other than the latent image. Certain sites on the silver halide surface called fog centers compete for the electrons. Oxygen dissolved in the water avidly seeks electrons. Oxidized forms of the developed agent may interact or stain. Often a second source of electrons, or an electron transfer agent, may be needed to secure the desired developing action.

Developers are more than simple solutions of a developing agent but may also contain

- an alkali to activate the developing agent so that electron transfer is most efficient
- a preservative to protect the developing agent from losing electrons through undesired reactions
- a restrainer or antifoggant to limit image formation to the latent image of exposed silver halide crystals

Properties of the Major Developing Agents

Common Name	Hydroquinone	Chloro-hydro-quinone	Catechol	Pyrogallol	para-Aminophenol	Amidol
Scientific names	1,4-Dihydroxy-benzene; para-dihydroxy-benzene	2-Chloro- 1,4-di-hydroxyben-zene; 2-chloro-1,4 benzenediol	1,2-Dihydroxy-benzene; ortho-dihydroxy-benzene	Pyrogallic acid; 1,2,3-trihy-droxy-benzene; 1,2,3-benzene triol	4-Amino-1-hydroxy-benzene hydro-chloride; para-hydroxyaniline	2,4-Diaminophenol dihydrochloride
Commercial names	Quinol, Tecquinol, Hydroquinol	Adurol, Chloroquinol	Pyrocatechin	Piral, Pyro	Activol, Azol Kodelon, Para, Rhodinal	Acorl, Dianol
Form	Needle-shaped crystals	Needles or leaflets	Needles from water	White crystals	Free base: plates from water. Hydrochloride salt: crystalline.	Crystals
Molecular weight	110.11	144.56	110.11	126.11	Free base: 109.12. Hydrochloride salt: 145.5.	197.01
Melting point (°C)	170	103	105	131.133	Free base: 190. Hydro-chloride salt: decomposes about 306	205
Solubility in water (g in 100 ml at 20°C)	8	92	30	40	Free base: 1.2. Hydrochloride salt: 10.	25
Solubility in solvents	Soluble in alcohol and ether. Slightly soluble in benzene.	Soluble in alcohol. Slightly soluble in ether and chloroform.	Soluble in alcohol, benzene, chlorform, ether, pyridine.	Soluble in alcohol and ether. Slightly soluble in benzene and chloroform.	Free base soluble in alcohol and ethyl methyl ketone, slightly soluble in ether, almost insoluble in benzene and chloroform. Hydrochloride salt is soluble in alcohol and slightly soluble in ether.	Free base is slightly soluble in alcohol and acetone, very slightly soluble in ether and chloroform. Hydrochloride salt is soluble in alcohol.
Human toxicity	Relatively safe in very low con-centrations. Ingestion of 1 g or more may cause serious complications. Contact with skin may cause dermatitis.		Can cause eczematous dermatitis. Ingestion can cause very serious compli-cations. Avoid contact with large areas of skin.	Severe poison-ing may result from percuta-neous absorp-tion. Inhalation can cause asthma.	Can cause der-matitis and skin sensitization. Inhalation can cause asthma.	Pure compound or oxidation products may cause eczema-toid contact der-matitis or bronchial asthma.

Properties of the Major Developing Agents *(continued)*

Common Name	Metol	Glycin	para-Phenylene-diamine	$_L$-Ascorbic Acid	Phenidone
Scientific names	Monomethyl-para-aminophenol sulfate; para-methyl-amino-phenol sulfate	para-(Hydroxyphenyl) glycine; para-hydroxy-phenyl-amino acetic acid	para-Diamino-benzene; 1,4-diaminobenzene	$_L$-Xyloascorbic acid; hexuronic acid	1-Phenyl-3-pyrazolidone; 1-phenyl-3-pyrazlidi-none
Commercial names	Elon, Genol, Graphol, Pictol, Photol. Rhodol	Athenon, Glycin, Monazol, Iconyl	Free base: Diamine, Paramine, Metacarbol. Hydrochloride salt: Diamine H, P.D.H., p.p.d.	Vitamin C, many pharmaceutical names such as Ascorin, Cevitex, Cevimin	Phenidone, Graphidone
Form	Crystal	Leaflets from water	White crystals	Crystals (plates or needles)	Leaflets or needles from benzene
Molecular weight	344.38	167.16	108.14	176.12	162.19
Melting point (°C)	Free base: 87 Sulfate salt: 260 with decomposition	Browns at 200, begins to melt at 220, completely melted at 247 with decomposition	Freebase: 145-147. Hydrochloride salt: Decomposes without melting.	190-192 some decomposition	121
Solubility in water (g in 100 ml at 20°C)	4	0.02	1	30	2
Solubility in solvents	Freebase very soluble in alcohol, ether, and hot water. Sulfate salt slightly soluble in alcohol and ether, insoluble in benzene.	Low solubility in alcohol, acetone, ether, and benzene.	Freebase solution in alcohol, chloroform, ether. Hydrochloride salt soluble slightly in alcohol and ether.	Soluble in alcohol and propylene glycol. Insoluble in ether, chloroform, benzene.	Soluble in alcohol and benzene. Almost insoluble in ether.
Human toxicity	Can cause skin irritation or sensitization.		Pure compound or oxidation products may cause eczematoid contact dermatitis or bronchial asthma.	Essential vitamin in human nutrition.	Low oral toxicity. No reported cases of dermatitis.

- other chemicals, such as sequestering agents, to inhibit side reactions that might interfere
- special chemicals for specific purposes, such as color film processing

Preservatives Sodium sulfite is almost universally used to protect the developing agent from oxygen in water and for removing the oxidized forms of many developing agents. Sulfite has many other functions as well. It is mildly alkaline, sometimes serving as the sole alkali. It is a solvent for silver halide crystals, enhancing emulsion speed and promoting fine grain development. Ascorbic acid and sodium isoascorbate, sugars, mercaptoamino acids (cysteine), hydroxylamine, and small quantities of other developing agents have found some use for preserving developing solutions.

Alkalis Developing agents are acids because of the –OH group, bases because of the presence of –NH2, or amphoteric because both are present. The desired form in developers is the one that is most electron-rich. With the acidic group this is the negative charged ion, formed by the loss of the hydrogen ions. With the alkaline group, it is the uncharged –NH2OH form. Each of these forms is produced by making the solution alkaline. Suitable alkalis include sodium and potassium hydroxide, sodium or potassium carbonate, sodium metaborate, ammonia or ammonium salts, and organic amines.

Restrainers and Antifoggants Photographic materials may inherently contain centers (not formed by light) that are developable. Such centers may form during storage, or an active developing agent may in time reduce silver halide crystals

that have not had light exposure. Such developed silver is undesirable as it degrades sharpness or fogs the desired image. To prevent this, organic or inorganic antifogging compounds are added to the solution to form hard-to-develop silver compounds. Potassium bromide and iodide and organic compounds, such as benzotriazoles or mercaptotetrazoles, are often present in developers.

Sequestering Agents Calcium and magnesium salts in the water of the developer, or compounds contained in the photographic material itself, may precipitate a sludge from the solution. Sometimes the scum forms on the delicate surface of a photographic emulsion and is difficult to remove. Sequestering compounds combine with the calcium ions to form water-soluble ions to prevent any precipitation. Sodium hexametaphosphate, or ethylenediaminetetraacetic acid and its sodium salts, are two examples of compounds, often sold under trademarked names, that are effective in keeping a developing solution free of precipitates.

Special Compounds Color photography is essentially black-and-white photography using a carefully selected developing agent whose oxidized form reacts with a special compound, called a coupler, to form a colored dye. In the Kodachrome color reversal process, the film has three superposed silver halide emulsion layers, each sensitized to a different third of the spectrum. The film contains no color-forming components. The three developers, one for each layer, contain both the p-phenylenediamine derivative as developing agent and the color-forming coupler. In a color negative process, such as Kodacolor, the coupler is dispersed in the film emulsion layer and the developing agent is in the developer. The developing agents and the couplers are chosen as a pair with utmost care so that the optimum dyes are as stable as practical.

The formulas of developers list the chemicals to be added to water in order and the exact amount of each. Each compound should be added slowly and dissolved completely before the next one is added. If the total volume of water is only specified as the last item in the formula, about 3/4 of that amount should be used to dissolve the chemicals, then enough water added to make the final volume. The table gives a formula for Kodak developer D-76 with the order of addition and purpose of the chemical added for emphasis.

Kodak Developer D-76

Order of Addition	Name of Ingredient	Quantity	Purpose of Ingredient
1	Water, about 125°F (50°C)	750 ml	Solvent
2	Kodak Elon developing agent	2 grams	Developing agent
3	Sodium sulfite, desiccated	100 grams	Preservative
4	Hydroquinone	5 grams	Developing agent
5	Borax, granular	2 grams	Alkali
6	Water to make	1 liter	Solvent

TYPES OF BLACK-AND-WHITE FILM DEVELOPERS General-purpose photographic films are a compromise among speed, graininess, and sharpness. A high speed film will be grainier than a fine-grain film at the same contrast. A fine-grain film will have less speed and may have less sharpness than the high-speed film. A suitable developer maintains the inherent character of the film without destroying the built-in compromises. As Ansel Adams has noted, "Variations in developers are, in truth, so small that with certain adaptions of exposure and use, almost any developing formula can be used with almost any negative material." In fact, a formula such as Kodak developer

D-72 can be used as a paper print developer and as a rapid-acting or contrast film developer.

Standard or general-purpose developers maintain full emulsion speed, often at the expense of graininess and other image characteristics. These developers were a necessity in the past when photographic films and photographic lenses were slow in speed. Such formulations, such as Kodak developers DK-50 and D-23, are still popular with portrait, scenic, and art photographers who use large-format negatives. The modern approach, however, is to consider the film and the developer as parts of a single system in order to secure the maximum results with the fewest compromises.

Photographic films are designed for specific purposes. Developers are formulated to best achieve those purposes, usually fine grain or high definition or maximum film speed. Separate developers for each of these goals are needed, as one solution cannot satisfy all three at once to a maximum. Successful developers for these purposes optimize one goal by compromising with the other two. Besides the three major groups of developers—fine grain, high definition, and high energy—there are many specialized developers for specific purposes, such as high contrast, tanning, x-ray film, and photographic paper developers.

Fine-Grain Developers A fine-grain developed silver image is more than the result of using a special developing solution. The image formed by development is a nonhomogeneous dispersion of metallic silver filaments of varying size, the larger masses of silver being formed from the large crystals. Fine grain, therefore, starts with the emulsion maker, who must provide a very thin layer of small silver halide crystals with as high a sensitivity as can be obtained. The efficient fine grain developer seeks to maintain these desirable emulsion characteristics.

Graininess is that mottled or mealy appearance that is most evident in the middle densities of the developed silver image, caused by a lack of uniform distribution and size of the silver filaments. Thick emulsion layers increase the possibility of greater graininess because of the overlapping of the filaments in depth. Full or maximum exposure also causes the image to penetrate deeper into the layer. Developing an exposed image to high contrast, or trying to achieve maximum amplification, produces larger deposits of silver. Even high definition development has edge effects that increase the mass of silver in the image. Fine grain silver images are thus a result also of minimum exposure and moderate degrees of development by solutions of low alkalinity.

Most fine-grain developers are one of two general types: (a) Metol or Phenidone solutions of low alkalinity that produce low contrast images with near normal emulsion sensitivity, or (b) Metol solutions of low alkalinity containing a silver halide solvent that usually results in some loss of emulsion speed. Kodak developer D-76 is an example of (a) and Metol–sulfite formulas, such as Kodak developer D-23, are examples of (b). Early fine-grain physical developers based on the solvent effect of p-phenylenediamine are not used today because of the great loss in emulsion sensitivity.

The D-76 developer combines low alkalinity and high sulfite concentration to produce fine-grain images. No restrainer is present, so optimum emulsion speed is obtained. D-76 is actually the free base of Metol in 10% sodium sulfite, the borax being used to neutralize the acid that was part of the Metol salt. Hydroquinone is an ineffective developing agent at the pH of this developer solution. The formula of D-76 developer is given in the table on the left.

Phenidone (1-phenyl-3-pyrazolidone) has been used to replace Metol in fine-grain developers. Very small quantities are needed, as this developing agent is regenerated by the larger amounts of hydroquinone. Phenidone has low toxicity and low skin irritation. Ilford developer ID-68 is a buffered

borax Phenidone–hydroquinone solution that is said to give emulsion speed as good as D-76 with only a small increase in graininess.

Phenidone–Hydroquinone Fine-Grain Developer

	ID-68	ID-68R
Warm water (125°F [50°C])	750 ml	750 ml
Sodium sulfite (anhydrous of desiccated)	85 g	85 g
Hydroquinone	5 g	8 g
Borax	7 g	7 g
Boric acid	2 g	—
Phenidone	0.13 g	0.22 g
Potassium bromide	1 g	—
Cold water to make	1 liter	1 liter
Dilution	0	Add to ID-68 to maintain level
Time	8 to 10 min, 68°F	

The small contribution of hydroquinone in D-76 can be replaced by simply increasing the amount of Metol, thus eliminating the need for borax. Kodak developer D-23 is representative of the many formulations of Metol with high concentrations of sodium sulfite. The formula of D-23 is simplicity itself: 7.5 grams of Metol and 100 grams of desiccated sodium sulfite in a liter of water. Image graininess is slightly less than that given by developer D-76, but the film emulsion speed is 10 to 20% less. Some of the speed loss can be made up by adding small quantities of an alkali, such as sodium metaborate (Kodalk). One such variation is MCW Rapid Developer: 5.5 grams of Metol, 75 grams of anhydrous sodium sulfite, and 5 grams of sodium metaborate in 600 ml water. Development times at 77°F are about half those in D-76 at 68°F.

High-Definition Developers Clarity of detail is an impression of the human mind of the visual appearance of the photograph. Definition is a composite of many factors: graininess, resolving power, sharpness, and contrast being the most important. Sharpness is thought to be the major determinant, as this is the impression that a human being gets when viewing fine image detail. The final image of a sharp edge is also affected by the scatter of the exposing light in the emulsion depth as well as the graininess of the developed image. Objective methods of measuring sharpness, such as acutance or modulation transfer functions, have been used but are subject to some modification by development edge effects.

Definition is influenced by adjacency or edge effects that cause irregular changes in the density of the developed silver image. Such changes are most evident at the boundaries between high and low development. Active developing agents diffuse from areas of low exposure of the exposed material to areas of high exposure, producing increased contour silver at the interface. Development byproducts diffuse from areas of high to low exposure, inhibiting the developing activity.

Edge effects are caused by local chemical changes in the developing solution. Often there is an increase of the silver deposit on the dense side of an abrupt image edge (border effect) or a decrease on the less dense side (fringe effect). The density of the developed image may be related to its size (Eberhard effect). Small images have higher densities than images of larger size, even though both have had the same exposure and development times. In addition, in large areas of high exposure, the local exhaustion of the developing agent plus a drop in the alkalinity causes a decrease in the rate of developing action, a compensating effect that limits the total amount of developed silver in that area.

Fine-grain developers give finely divided silver with a loss of image sharpness; high-definition developers achieve their goal by some increase in graininess. This negative result can be offset by using fine-grain, thin-layer photographic films of low or moderate film speed. These develop image contrast easily, so soft-working developing agents, such as Metol or Phenidone, can be used in solutions of low or moderate alkalinity. Because the developer is used in dilute solution, the solution exhibits a compensating action to limit the amount of metallic silver in areas of high exposure.

High-definition developers are often concentrated solutions or consist of two solutions but are used in diluted form, then discarded after one use. A conventional fine grain developer, such as Kodak D-76, can be diluted with water to form the working solution. The two-solution developer of Willi Beutler is of the high-definition, one-use type. The formula is listed in the entry "Surface Development." See also the high-acutance formula for the POTA developer that is used for high-contrast, very fine-grain photographic films.

High-Energy Developers Fine-grain and high-definition developers are especially suited for processing small film sizes, such as the 35 mm format. Such developers may also be used for larger-sized films but are not really necessary. High-energy developers are formulated for large format photographic materials because such solutions are rapid acting and produce high emulsion speed. Some high-energy developers are made to yield desired high-image contrast, such as for copying or process work.

High-energy developers usually consist of a single or a superadditive pair of developing agents in highly alkaline solution. Hydroquinone produces high contrast in caustic solution. Two developing agents are combined in developers to yield a full range of image tones with good shadow detail. Maximum emulsion speed is obtained with high-energy Metol–hydroquinone or Phenidone–hydroquinone developers. Neither the Metol nor Phenidone in highly alkaline solutions is restrained by the bromide or iodide ions that are produced during development.

High-contrast developers normally use about 4–10 times as much hydroquinone as Metol or up to 2 grams per liter of Phenidone combined with high concentration of hydroquinone. Rapid acting developers also have high concentrations of developing agents in solution. Some of these formulas are listed in the table. Note that Kodak D-72 may be used as a rapid film developer but is used primarily (when diluted with two parts water) as a developer for black-and-white photographic papers. Kodak developer D-8 is a caustic solution of hydroquinone that yields high contrast but has a short life in solution.

For many years, photographic films did not have enough sensitivity to record images of low light scenes. Developers were often compounded to secure any image under dim illumination. Today, photographic films are available that have speed indexes in the thousands. The preferred route for maximum film speed is by using these films designed for recording the dimly lit scenes, not by using overactive developers to push slow speed films to higher sensitivity. Such attempts trade off desirable image characteristics for the higher speed and contrast.

Generally, as G.I.P. Levenson has stated, full development in D-23 or D-76 gives the highest emulsion speed that the emulsion can give. Levenson concluded, "In my experience, D-76 has always equalled, and has sometimes surpassed, the sensational proprietary super-speed developers, not only for speed but for fineness of grain."

Books: Haist, G., *Modern Photographic Processing.* Volumes 1 and 2. New York; John Wiley, 1979. *G. Haist*

See also: *Surface development; POTA developer.*

Contrast developers

Ingredient[a]	Kodak D-19	Kodak D-72	Kodak D-8	Ilford ID-13	Ilford ID-72	Wiedermann Document	Wiedermann PQ X-Ray	Willcock No. 2
Water (125°F[52°C])	500 ml	500 ml	750 ml	750 ml	750 ml	750 ml	750 ml	750 ml
Metol	2.0	3.0	—	—	—	—	—	—
Sodium silfite, desicated	90.0	45.0	90.9	—	72.0	120	150	100
Potassium metabisulfite	—	—	—	12.5	—	—	—	—
Hydroquinone	8.0	12.0	45.0	12.5	8.8	26	20	30
Phenidone	—	—	—	—	0.22	1.0	1.0	1.5
Sodium carbonate, monohydrate	52.5	80.0	—	—	48.0	—	—	—
Potassium carbonate	—	—	—	—	—	110	75	—
Sodium hydroxide	—	—	37.5	—	—	—	—	25
Potassium hydroxide	—	—	—	25	—	—	—	—
Potassium bromide	5.0	2.0	30.0	12.5	4.0	15.0	8.0	3.5
Benzotriazole	—	—	—	—	0.1	1.0	0.5	1.0
Cold water to make	1.0 liter	1.0 liter	1.0 liter	1.0 liter	1.0 liter	1.0 liter	1.0 liter	1.0 liter
Dilution	None	None	2:1	None	None	1:2	1:2	None
Time (min at 20°C)	5	1 to 3	2	3 to 5	5	2 to 4	5	1/2 to 1

[a]All quantities are in grams unless indicated otherwise.

DEVELOPERS, COMPENSATING A developing solution that has less than normal activity in high exposure image areas but normal activity in image areas of low exposure. Image contrast is reduced without appreciable loss of detail in the low density areas. Compensating developers are often very dilute solutions in which the developing agent is exhausted in the areas of high exposure. *G. Haist*

See also: *Developers, types of black-and-white developers.*

DEVELOPERS, FILM Chemical solutions containing suitable reducing agents and other compounds that convert the latent image of an exposed photographic material into a visible image. Film developers may be formulated for a specific purpose or may be of more general use. *G. Haist*

See also: *Developers, types of black-and-white developers.*

DEVELOPERS, FINE-GRAIN These chemical solutions are formulated to produce silver particles of minimum size from the latent image of exposed photographic films, especially the 35-mm size. Generally, such developers contain a weakly activated developing agent with considerable amounts of a silver halide solvent, such as sodium sulfite. Fine-grained photographic images are the result of using a fine-grain developer with a photographic film of inherently fine grain. *G. Haist*

See also: *Developers, types of black-and-white developers.*

DEVELOPERS, HIGH-ACTUANCE Chemical solutions can be compounded to secure developed photographic images of high acutance, the objective correlate of sharpness. High acutance images are secured when fine-grain photosensitive film is developed in solutions having a low concentration of a developing agent with a minimum of silver halide solvents. Edge effects are produced that enhance the edge sharpness between areas of different density. *G. Haist*

See also: *Developers, types of black-and-white developers.*

DEVELOPERS, HIGH-CONTRAST Developing solutions can be specially formulated to produce maximum density differentiation between areas of low and high exposure of exposed photographic films. Such energetic developers may consist of high concentrations of a developing agent or agents in highly alkaline solution. Hydroquinone solutions with very low free sulfite concentration also yield high-contrast silver images when used with lithographic films. Maximum contrast is obtained by using high-contrast developers with films designed to produce high-contrast images. *G. Haist*

See also: *Developers, types of black-and-white developers.*

DEVELOPERS, PAPER Chemical solutions that are carefully formulated to produce desirable tone scale, image contrast and color, and other image characteristics when used to develop paper prints. Paper developers are usually in concentrated form so the stock solution can be diluted with water for use. Paper developers have sometimes been used as film developers, especially for rapid development of larger-sized negatives. *G. Haist*

See also: *Developers, types of black-and-white developers.*

DEVELOPERS, RAPID Developing the latent image of a photographic material in the shortest possible time is the purpose of certain developing solutions. Such developers often contain high concentrations of superadditive developing agents in solutions of high alkalinity. *G. Haist*

See also: *Developers, types of black-and-white developers.*

DEVELOPERS, STAINING Certain low-sulfite developing solutions containing polyhydroxybenzenes (pyrogallol or pyrocatechol, for example) stain and harden (tan) the gelatin in areas of image development of exposed photographic materials. The oxidized forms of the developing agents crosslink the gelatin molecules, decreasing the solubility of the gelatin of the emulsion layer. A stain image also reinforces the silver image when low-sulfite pyrogallol developers are used. *G. Haist*

See also: *Developers, types of black-and-white developers.*

DEVELOPERS, TROPICAL Developers can be used at the higher temperatures of the tropics if formulated with a high salt content to minimize the swelling of the emulsion layer of the photographic films. An inert salt, such as sodium sulfate (not sulfite), may be added to the usual chemical ingredients, or the formulation may contain a high concentration of a normal compound, such as sodium sulfite. Hardening developers containing aldehydes or other hardeners allow high temperature development in the tropics but increased fog may be obtained. *G. Haist*

See also: *Developers, types of black-and-white developers.*

DEVELOPERS, UNIVERSAL Chemical solutions suitable for developing latent images on both photographic film and paper materials have been called universal developers. Most of these are Metol–hydroquinone formulations compounded for processing photographic prints, which can be diluted with water to make less concentrated solutions useful for film development. This compromise developer is less desirable than developer solutions compounded for specific purposes. *G. Haist*

See also: *Developers, types of black-and-white developers.*

DEVELOPING The term *developing* is frequently used as an informal designation for the procedure for the processing of photographic films and papers. More formally, development is the first processing step, which amplifies the latent image to make it visible.

THEORY Basically, photography consists of the exposure of some light-sensitive material to form a latent image and the subsequent processing of this image to form some type of reproduction of the image. In conventional photography, the processing of the image is accomplished through the use of a series of chemical baths. The most important of these is the developer, so the chemical processing of photographic film is sometimes referred to as developing. Typically, the other processing steps include fixing and washing, and sometimes a stop bath. Color processes also require a bleach and have two kinds of developers—silver and dye. (See also: *Stop bath; Fixing; Washing; Color processing.*)

The developer is the most important step in developing because developing is the step that converts the latent image formed by the exposure to a visible, useful image. The other processing steps ensure the permanence of this image; the fixer removes the undeveloped silver halides, and the wash removes residual chemicals from the emulsion. The final image in a black-and-white negative or print is made up of grains of metallic silver. These grains resemble steel wool when viewed with an electron microscope. The image appears black because of the scattering of light by the filamentary structure of the grains. Color films and papers work differently; the image is in the form of dyes that absorb the incident light as opposed to scattering it.

DEVELOPER FUNCTIONS When film is exposed to light (or other form of radiation to which it is sensitive) a chemical change occurs in the silver halide crystals in the emulsion—the silver ions in these crystals gradually begin to change to silver atoms. The amount of light (photons) required to change one ion to an atom varies with the sensitivity and efficiency of the emulsion but is generally quite small. Additional amounts of light convert more ions. After exposure, when the film is placed in the developer, the developer acts to convert the remaining silver ions in certain crystals to metallic silver atoms. The developer selects the crystals to convert by the number of silver atoms previously formed on each crystal by the exposure (latent image). It is said that the silver grains making up the latent image catalyze the development of the entire grain when it is placed in the developer. The rate of development is therefore dependent on the number of silver grains forming the latent image. It is also dependent on the arrangement of the atoms in the grain.

The amplification of the latent image accomplished by the developer is quite large. Typically, a latent image center on a crystal will contain between three and a few hundred silver atoms. The entire crystal, however, may contain trillions of silver ions. The amplification produced by the developer is the number of silver atoms in the final grain divided by the number of silver atoms in the latent image. As development is allowed to proceed, this amplification increases, initially because the proportion of silver ions converted increases, and subsequently because crystals with smaller and smaller latent image centers are developed to completion. The devel-

oper cannot distinguish between the grains perfectly, however, and if development is allowed to proceed too long, significant numbers of unexposed grains may begin to develop.

FACTORS AFFECTING DEVELOPMENT Factors (other than the latent image) that affect the rate of development are the developer composition, development time, developer temperature, and agitation. It is the control of these variables that is generally the major concern in development, the exposure having been determined previously.

Developer Composition Developers contain a variety of chemicals, but these chemicals can be grouped into the following functional types.

Developing Agents Developing agents are selective reducing compounds that are responsible for changing the silver ions to silver atoms in the presence of a latent image center. Different developing agents develop emulsions to different contrasts and at different speeds. Developing agents working in combination can also have a different effect than the additive effect of the agents used individually. The choice of developing agents has a great effect on the behavior of the developer. (See also: *Developer; Superadditivity.*)

Accelerators The higher the pH of a developer, the faster development occurs. Buffer systems, such as sodium borate or carbonate, are primarily used to raise the pH because they are able to maintain it at a certain value throughout development. The use of a strong alkali such as sodium hydroxide ensures fast development but decreases the useful life of a developer, as strong alkalis tend to oxidize in the presence of air. The choice of alkali is generally dependent on the desired developer activity level and the developing agents used. The pH of most developers is between 7.5 and 14. (See also: *Developers.*)

Restrainers Restrainers serve to limit the rate of reduction of the silver ions and prevent the spontaneous development of unexposed silver halide crystals. These somewhat different functions result in there being two classes of restrainers, general restrainers like potassium bromide and antifoggants such as benzotriazole. In both cases, the purpose of the restrainer is to ensure that the crystals containing a latent image are developed first and that the developed image is free of such artifacts as fog and bromide streaks. (See also: *Developers.*)

Preservatives Preservatives reduce the oxidation of the developing agents due to atmospheric oxygen. They have little effect on the developed image except for helping to ensure that the developer is active when it is used. The most common preservative is sodium sulfite, which also acts as a mild silver halide solvent, thereby reducing the appearance of graininess in the emulsion. (See also: *Developers.*)

Development Time The duration of development determines the degree of completion to which the development is carried out. Longer development times result in the more heavily exposed crystals being more fully developed, and the less heavily exposed crystals beginning to develop. As a result, longer development times result in an increase in speed, contrast, and graininess. Development times are generally chosen to give the most appropriate contrast, the film choice being a better way to balance speed and graininess.

Development Temperature The rate at which development occurs is highly dependent on temperature. Changes in temperature have much the same effect on the developed image as changes in development time. Different developing agents respond differently to changes in temperature, so it is necessary to know which developer is being used to precisely compensate for a change in temperature with a change in time. A general-purpose equation providing an approximate relationship between changes in development time and temperature is as follows:

$$t_2 = [0.7(T_1-T_2)] + t_1$$

where t_1 is the original development time; t_2 is the new development time; T_1 is the original temperature in degrees Celsius; and T_2 is the new temperature in degrees Celsius.

Development temperature also affects the developed image in other ways, so there are limits to the range of temperatures that can be used. Older film emulsions, for example, become soft at higher temperatures, resulting in an increase in grain size. At extreme temperatures the emulsion can wrinkle or crack or even peel off the base. Newer emulsions use harder gelatin and are more resistant to these effects, but extreme temperatures can still cause problems. The best results are obtained by adhering to the manufacturers' recommendations. (See also: *Reticulation; Tropical processing.*)

Agitation The type and amount of agitation used during development can have a significant effect on the developed image. (See also: Agitation.)

Film manufacturers generally provide guidelines for the development of their products. These guidelines are typically the result of extensive testing and, when followed, give good results for most conditions. There are, however, some general techniques for developing film, a knowledge of which may be assumed by the manufacturer. Also, special conditions may require the use of special techniques and some deviation from the manufacturers' recommendations. (See also: *Zone system; Push-processing.*)

DEVELOPING FILM EXPOSED FOR EXTREMELY LONG OR SHORT TIMES The duration of the exposure affects how the latent image forms in a silver halide crystal and subsequently how the crystal will develop. Long exposure times tend to form one large cluster of silver atoms per crystal. Short exposure times tend to form a number of small clusters on each crystal. It turns out that the size of the cluster is more important than the number of clusters, so films exposed for very long times develop faster than films exposed for very short times. As a result, development should be reduced for very long exposures and increased for very short exposures to produce normal contrast. The specific amount of change depends on the exposure time, film, and to some extent the developer, but a rule of thumb is to reduce the development time by 10% to 20% for exposures that require correction for low-intensity reciprocity law failure and increase development by the same percentages for exposures that require correction for high-intensity reciprocity law failure. (See also: *Photographic effects.*)

MAINTAINING PROCESSING SOLUTION ACTIVITY An important consideration in subsequent developing runs is the maintenance of processing solution activity. This can be accomplished in several ways.

One-Shot-Processing The simplest method for ensuring proper activity in processing solutions is to use them once and throw them away. The advantage of this method is its simplicity and reliability. Disadvantages include the cost of the chemicals and the environmental impact. A variation on complete one-shot-processing is to use fresh developer each time but to reuse the fixer. This reduces the cost and environmental impact somewhat while retaining most of the advantages. The fixer is tested for exhaustion and is discarded (preferably into a silver recovery system) when exhausted.

Compensating for Activity Changes with Time Changes The most economical way to deal with chemical activity changes in small scale processing is to compensate for the decrease in developer activity with use by increasing the development time accordingly. Most developers contain recommendations for development time increases based on the number of rolls processed. An additional advantage to this technique is that some developers produce slightly superior results when partially used. The disadvantages of this technique are the undesirable effects which may be obtained

with color processes, the slight change of developer characteristics with use, and the reduced shelf life of partially used developers.

Correcting for Activity Changes with Replenishment The most economical way to deal with chemical activity changes in larger scale processing is to correct for the decrease in developer activity with replenishment. Replenishment is accomplished by adding appropriate amounts of specially designed solutions called *replenishers* as film is run through the process. The replenishers compensate chemically for the effects of the use of the processing solutions. An appropriately controlled replenished system can be used indefinitely with good results. (See also: *Quality control.*)

DEVELOPING BLACK-AND-WHITE FILM Development by Inspection The oldest method of development is based on observing the growth of the image. Sheet films are placed in a tray or tank and developed until they have a suitable density range. The development is stopped when the highlights appear dark gray or black and the shadows light gray, judged by looking at the back of the emulsion. The darkroom has to be illuminated by a suitable safelight that will not further expose the films. To be able to judge the density and contrast of an image under these dim conditions requires considerable experience. Although development by inspection allows for a great amount of control over the development process and consequently the appearance of an image, it is rarely practiced with modern panchromatic films, which do not allow for even the smallest illumination in the darkroom.

Tray Development Sheet films are placed in a tray of developer, emulsion up. They should be immersed quickly, with the immersion followed by good agitation to ensure an even wetting of the surface. The films can also be presoaked in water to prevent air bubbles from being trapped on the emulsion surface, causing uneven development. A safelight may be used during development of blue-sensitive and orthochromatic emulsions, but panchromatic films require total darkness during most of the development step. The development time is predetermined according to the developer composition, temperature, agitation method, and desired development contrast. Two methods of agitation are commonly employed—shuffling and rocking. In tray shuffling, the sheets are removed one at a time from the bottom of the stack and immersed at the top. In tray rocking, the films lie at the bottom of the tray, and the tray is rocked in a somewhat irregular fashion (although some regularity in the rocking is generally necessary to ensure repeatability of the results). The result in both cases is a relatively continuous and random flow of developer across the emulsion surface. With tray shuffling, it is important to place the films in the developer separately to avoid sticking, to take care to avoid

Two methods of tray processing.

See-saw agitation method.

Small tank development. (Two methods of loading.)

scratching, to remove the films from the developer in the same order and at about the same rate they were immersed, and to always develop the same number of films each time for consistent results. With tray rocking, it is important to maintain even wetting and agitation of all the film surfaces, to prevent the films from overlapping or sticking to each other or the tray, and to agitate in a consistent manner from batch to batch. A flat plate that holds the films apart is quite useful with this type of developing, and temperature control is important as the solutions in trays are sensitive to changes in temperature of the external environment. In all types of processing, the best results are obtained if all of the processing steps are carried out at the same temperature.

By using a see-sawing agitation method, roll films can also be developed in a tray. The two ends of the film are alternately lowered and raised so that the bottom of the loop passes continuously through the solution.

As the end of the development step approaches, the film is drained and placed in a water rinse or stop bath so that immersion in the second solution coincides with the time designated as the end of the first step. The draining time should be regular, and should be determined according to the time necessary for the stream of developer running from the films (and their holder, if one is used) to turn into drops (typically about 10 seconds). Agitation in the subsequent processing steps should be carried out in the same fashion as in the developer. If tray shuffling is used, care should also be taken to prevent cross contamination of the chemicals, as it will be necessary to agitate films in more than one solution at the same time. After rinsing or stopping, the films are placed into a tray containing a fixing solution. The room light can be turned on after the films have been fixed for a few minutes. After fixing, the films should be washed for 30 minutes (or 5 minutes if they are first rinsed in a sodium sulfite solution) in running water at the same temperature as the processing solutions, then immersed in clean water that contains a wetting agent, and then hung up to dry. (See also: *Fixing; Washing; Drying.*)

Small Tank Development Small tanks for roll films usually consist of small, light-tight containers that hold up to eight spiral reels (although tanks that hold more than four or five reels tend to take a long time to fill and drain, thereby giving inferior results). The film is loaded onto spiral reels that hold it in a compact space but allow the developing solutions easy access to all the film surfaces. An older design of tank used aprons with corrugated edges rolled up with the film to accomplish a similar purpose. Many different tanks have been designed for small tank development. Some permit daylight loading although the majority require darkroom loading. The actual loading procedures vary depending on the type of tank used and may require some practice. The manufacturer's instructions should be consulted.

There are basically two different types of spiral reels available, self-loading and center-loading spirals. In case of the self-loading type, the reel consists of two disks connected by a spindle, with a spiral groove running on the inside faces of each disk until it reaches the spindle at the center. The separation of the disks is sometimes adjustable so that films of different widths can be processed. The film is pushed into the grooves just past a gripping mechanism. By rotating the disks back and forward, the film is drawn into the spiral. Center-loading spirals have fixed disks; the film is clipped to the central core. By rotating the entire spiral in one direction and holding the film in a curved position so that it clears the grooves, the film is loaded from the center toward the outside. These spirals are sometimes provided with a device that maintains the film in a curved position to facilitate loading.

After the film has been loaded onto the reels, the reels are placed into the tank, the tank is closed, and the room lights may be turned on. All processing steps can be carried out in white light, with the chemicals being poured into and out of the tank through a light-tight baffle (note: these baffles are not always completely light tight, and "daylight" processing tanks should not be used in extremely bright surroundings).

Before processing, the temperature of all the chemicals and the water for rinsing and washing should be adjusted to the desired value. The developing procedure is as follows:

1. Pour in the developer, and tap the tank on the counter several times to dislodge air bubbles.
2. Agitate by either tilting or inverting the tank, rolling the tank back and forth, shaking the tank up and down, or by twisting the reel (see the tank and film manufacturers' instructions). (See also: *Agitation.*)
3. Develop for the predetermined time, allowing for drain time.
4. Pour out the developer so that all the developer is out at the end of the development time.
5. Fill the tank with clean water or an acid stop bath, and agitate for 30 seconds. Repeat if water is used.
6. Pour out the rinse.
7. Pour in the fixer and fix for the required time with agitation. (See also: *Fixing.*)
8. Pour out the fixer. The fixer can be reused until exhausted.
9. Wash, either with running water or changes of water. (See also: *Washing.*)
10. Soak in clean water that contains a wetting agent for about 30 seconds.
11. Dry, preferably at room temperature, in a dust free place. (See also: *Drying.*)

Note: Some films require that the developing solution be placed in the tank and then the reels containing the film added in the dark. Specific agitation techniques may also be required for particular films and tanks. A prewetting step and solutions that allow for extended processing times may also be desirable. Development times of less than 5 minutes generally give inferior results with small tanks.

Film developing procedure.

Large tank development.

rials, the processing must occur in total darkness. (See also: *Agitation.*)

Large tank lines are the smallest scale processing setup where replenishment of the processing solutions is commonly used to maintain solution activity. This allows for more economical processing. To minimize atmospheric oxidation, the tanks are covered with lids, either by covering the top of the tank or floating the lid on the solution.

There are also a number of half or fully automated processing machines with various capacities available. (See also: *Agitation; Automatic processing.*)

DEVELOPING BLACK-AND-WHITE PAPER Experiments have shown that for good reproduction of an average scene in a photographic print, the nonspecular highlights should be reproduced at a density 0.04 above the base white of the paper and the shadow areas should be reproduced at 90% of the maximum density. Unlike negative films, however, the contrast of photographic papers is not readily controlled by development. Some resin-coated (RC) photographic papers, as well as some fiber-based papers, have developing agents incorporated into their emulsions that speed up development, thereby preventing the control of contrast through developer composition and dilution. Even in nondeveloper-incorporated papers, the limits imposed by the minimum and maximum density requirements prevent large amounts of contrast control from being achievable. (See also: *Developer; Tone reproduction.*)

To compensate for different negative contrasts and enlarger characteristics, photographic paper emulsions come in different contrast grades. A grade 0 emulsion, sometimes referred to as a very soft emulsion, can appropriately reproduce a larger negative density range than a grade 5 (extremely hard) emulsion. A grade 2 emulsion is usually referred to as a normal contrast or *medium* paper. These different contrast grades can either be bought separately or, in case of variable-contrast papers, be achieved by filtering the enlarger light. To obtain a good print reproduction with a correct contrast range depends primarily on the correct choice of paper grade and the correct exposure. To help determine the correct combination, paper control strips showing a representative part of the image should be exposed and developed. The goal in the developing of black-and-white paper is optimization of the density range and consistency.

Development Characteristics Most commonly used paper developers are Metol-hydroquinone (MQ) or phenidone-hydroquinone (PQ) developers. The normal development temperature for photographic paper is between 18° and 24°C (65° and 75°F) for manual processing. The normal development time at 20°C in a common paper developer is 30 to 90 seconds for RC paper and 90 seconds to 3 minutes for fiber-based paper. Dilution of the developer prolongs the development time accordingly. Excessively

Large Tank Development Tank, sink, or basket lines are processing arrangements where each tank is filled with a different processing solution, and the films are placed in holders or baskets and moved from tank to tank. These arrangements can be used for larger scale processing than small tanks or trays and are less expensive than processing machines. The tanks are set up in a temperature controlled environment (usually a water bath) to maintain the temperature of the processing solutions at the correct value. The most common size for large tank lines is $3^1/_2$ gallons or 15 liters, although larger and smaller size tanks are used. Sheet films are kept separated in sheet film hangers, and roll films are wound on spiral reels and placed into a basket. Agitation occurs by lifting the basket or sheet film holders out of the processing bath, letting them drain, and returning them to the tank, and through the use of nitrogen bursts. After the appropriate processing time, the films are transferred to the next tank for the next processing step. For most panchromatic film mate-

short development times should be avoided because the maximum image density cannot be achieved, the image color may be poor, and the development may not be uniform over the whole print. On the other hand, developing too long carries a risk of fog and staining.

Image Color The color of an untoned photographic print is dependent on the manufacturing of the emulsion and the choice of developer. The three components in a developer that affect the color the most are the developing agent, bromide restrainer, and any organic antifoggants. PQ developers tend to give a cold, bluish image, as they usually contain organic antifoggants. A high bromide content results in a warmer, reddish-brown image. By choosing the appropriate dilution of the developer and adding extra potassium bromide, this effect can be enhanced. (See also: *Developers.*)

Tray Development Most black-and-white photographic print materials are developed on the basis of the developer composition, temperature, and time method, and the inspection method. The correct exposure and paper grade should first be determined by using control strips that are developed with the appropriate time-temperature combination. By using the method of inspection, the development time can be adjusted to compensate for slight under- or overexposure. The type of safelight that can be used for processing is usually indicated in the paper manufacturer's data. Tray development for paper is basically the same as tray development for films. (See also: *Agitation.*)

The procedure for tray development of black-and-white papers is as follows:

1. Each print is immersed face down in the developer and submerged so that the solution flows rapidly over the surface, providing good agitation and preventing any air bubbles from being trapped on the emulsion surface. If more than one print is processed at one time, the prints should be shuffled from bottom to top to ensure even development. Prints can also be processed in pairs, back to back. Prints can be handled using gloved hands (processing chemicals can cause contact dermatitis) or tongs. If tongs are used, care should be taken to prevent scratching of the emulsion.

2. During the required developing time (the time necessary for a completely exposed sheet of the paper to reach its maximum density), the tray may be rocked gently by lifting one edge to ensure even development over the whole surface. Alternatively, the prints may be shuffled, or if there is only one print, it may be flipped over and over. Some local control over print density is also possible by increasing the agitation and development temperature by manually rubbing a particular area of a print. After the specified development time has elapsed, development may be extended if visual inspection reveals the print to be too light (note that the appearance of the print will be different under safelight illumination than under room light). The maximum development time is the maximum time an unexposed sheet of paper can remain in the developer without a significant increase in its base plus fog density.

3. After development, the prints are lifted out of the developer, drained, and placed in an acid stop bath for 10 to 30 seconds. A vigorous, one minute, running water rinse may be used if necessary in place of the stop bath, but this is not desirable as paper fog levels may be increased. The transfer can be done by hand or by using tongs. In any case, care should be taken that the developer is not contaminated by either acid stop bath or fix from a previous processing run.

4. The prints are then drained and transferred into the fixing bath and fixed for the appropriate time. The tray should be agitated regularly. White light can be turned on after this stage is halfway complete. (See also: *Fixing.*)

Tray development of black-and-white papers.

5. The prints must be washed in running water or changes of water. (See also: Washing).

6. The prints are dried by air or by using an appropriate dryer. RC and fiber-based papers usually require different types of dryers. (See also: *Drying, Dryers.*)

When prints are too large for normal developing trays, they may be developed by either see-sawing them through a tray, by processing them in one single large tray and draining the solutions after each step, or by applying the processing solutions with a swab or spray.

For large quantity print processing, various half and fully automated print processing machines are available. (See also: *Agitation; Machine processing.*) *S. Süsstrunk and J. Holm*

See also: *Agitation; Automatic processing; Color processing; Developers; Development theory; Dryers; Drying; Photographic effects; Fixing; Image permanence; Machine processing; Push-processing; Quality control; Reticulation; Stop bath; Superadditivity; Tone reproduction; Tropical processing; Washing; Zone system.*

DEVELOPMENT (1) In xerography, an electrostatic latent image is created on the surface of a photoconducting insulator. The latent image is made visible by bringing toner particles into contact with the photoreceptor surface. If the toner particles have the opposite polarity of the charged regions, they are attracted to the charged, or unexposed, regions, which correspond to the dark areas of the original image. This form of development is described as charged-area development and is used in most copiers. If the toner particles are of the same polarity, they are attracted to the discharged areas. This is described as discharged-area development and is widely used in printers. Toners contain a small concentration of a colorant in a resin binder. The particles are typically 5 to 20 mm in diameter and are usually charged by contact electrification with carrier particles. Early xerographic processes used gravity to cascade carrier and toner particles over the latent image. Cascade development was replaced by magnetic brush development in the mid 1970s and is used today in all high-speed copiers and printers. Other development techniques are based on electrophoretic, powder cloud, and thermal processes. In the final step of the development process, toner particles are separated from the carrier particles and transferred to the photoreceptor. Toner detachment will occur when the detachment forces due to the electrostatic image overcome the adhesion forces due to the carrier. (2) A process for producing a visible image from a latent image formed by radiation is called development. With photographic materials, electron donors called developing agents convert exposed silver halide grains to metallic silver. In electrophotography, toner particles are applied to a charged surface to form the visible image. *P. Borsenberger and G. Haist*

DEVELOPMENT EFFECTS See *Photographic effects.*

DEVELOPMENT THEORY There are many types of development, but they all rely on the detection by the developing agent of a small nucleus of silver. The agent transfers electrons to this silver nucleus. The electron-rich nucleus incorporates silver ions, causing additional silver metal atoms to form, thereby enlarging the nucleus. One way to classify development is by the source of these silver ions. If they are obtained from the silver halide grains in the coating, it is called chemical development. When they are obtained from a silver salt dissolved in the developer solution, it is called physical development. The latter can take place either while the silver halide grains are present, known as prefixation physical development, or after they have been removed, known as postfixation physical development. The silver solution transfer process is based on the principles of physical development.

CHEMICAL DEVELOPMENT Reducing agents in commercial developers are usually drawn from three classes of aromatic organic compounds: (1) polyphenols, (2) aminophenols, and (3) polyamines. In typical developer formations, these reducing agents will, given enough time, reduce all the silver halide grains to silver metal, whether they have been exposed or not. What makes discrimination between exposed and unexposed grains possible is the presence of the latent image. This center provides a lower-energy pathway for transfer of electrons from the developing agent to the grain, i.e., the latent image catalyzes the development process. Thus, development of exposed grains occurs at a much faster rate than the development of unexposed grains and, by proper choice of development time, good discrimination between image and fog is achieved.

Developer formulations usually are aqueous-based and include components other than the developing agent. The more-reducing forms of the developing agents are the ionized versions where one or more protons have been removed from the molecule. Thus, high pH (typically 9 to 12) is a characteristic of developer formulations and this is maintained by using buffering agents, such as metaborate/tetraborate, carbonate/bicarbonate, or phosphate/monohydrogen phosphate. The developing agents also can be oxidized by oxygen, so sulfite salts are usually included as a preservative, as well as a scavenger for oxidized developer, which could retard development. A third common ingredient is bromide ion. This species tends to slow down the development reaction, but it does so more for the unexposed than the exposed grain and thus decreases fog.

It is often convenient to view the development reaction as an electrochemical cell composed of two half cells. In one half cell the silver ions are being reduced to silver metal and in the other half cell reduced developer is being converted to its oxidized form. An electrochemical potential can be calculated for each half cell and the overall potential for the cell is just the difference of the two half cell potentials. If the potential is zero, the system is at equilibrium. If it is positive, then silver is reduced; if it is negative, then silver is oxidized. The latter condition is due to oxidized developer buildup. This can be prevented by incorporating an oxidized developer scavenger, such as sulfite.

The majority of commercial noncolor developing solutions actually contain two developing agents. It has been found that when two agents are present in the right proportion a synergistic effect often occurs. The exact mechanism of this effect is not easily discerned, but it does appear to be some sort of regeneration effect. One of the agents transfers an electron to the growing silver nuclei and is in turn oxidized. This oxidized form then interacts with the reduced form of the second agent and is converted back to the reduced form, ready for another electron transfer to the growing silver nuclei. The oxidized second agent is presumably removed in a sulfite reaction.

Commercial developers are almost exclusively capable of detecting only surface latent image. If the latent image forms more than a few atomic layers below the surface it will go undetected. This is usually not a problem since commercial emulsions are ordinarily made and sensitized so that the latent image forms at or very near the surface. In cases where the latent image, either unintentionally or by design, forms at a location that is unreachable by the developer, the developer formulation must be modified to include a silver halide solvent or recrystallization reagent. These compounds allow the slow dissolution of the silver halide or the disruption of the surface with inward-pointing channels that allow the developer access to internal latent image centers. The optimization of internal latent-image detection involves optimizing the level of these reagents. In favorable cases the efficiency

of internal latent-image detection can be as high as that for surface latent image.

PHYSICAL DEVELOPMENT In physical development, the dissolved silver salt is slowly reduced to form a supersaturated silver solution. The presence of the latent image nuclei causes the silver to be deposited from solution, so that the nuclei virtually become silver plated. In time the physical developer will plate silver at random onto the walls of the development chamber and over the surface of the emulsion coating. Thus, physical developers are inherently unstable and must be mixed just before use.

Chemical development includes to some extent physical development. Even though no silver salt is intentionally added to the developer formulation there are components in the typical developer formulation that can act as silver halide solvents, most notably sulfite because it is present in such large quantities. These solvents can transport silver ions to the site of development whereupon they are reduced to silver. These silver ions may originate elsewhere on the developing grain or form adjacent grains in the coating. This phenomenon is present to some extent in all developers and is known as solution physical development. The extent of solution physical development will depend on the region of the characteristic curve under examination. In the toe (shadows) many grains are undevelopable and they serve as a source for silver ions to take part in solution physical development. In the shoulder (highlights) most grains are developing and the supply of silver ions for solution physical development is low.

COLOR DEVELOPMENT In color development the final image is due to a colored image dye. This is produced by the interaction of the oxidized developer, usually from the paraphenylenediamine class, with a dye precursor to generate the final dye image. Except in the Kodachrome system where the precursor is in the processing solution, the precursors are in the film in the form of oil droplets in the aqueous coating. Each color record—blue, green, red—contains the precursor for the yellow, magenta, or cyan image dye, respectively. If the developed silver were retained in the coating it would cause unwanted hue shifts in the dye images. For this reason, it is bleached back to silver halide and fixed out along with the undeveloped silver halide. These are the essentials of the color negative system. Color reversal systems have a more complicated process, using two developers. The first developer is a noncolor developer—its oxidized form will not react with the image dye precursors. The remaining undeveloped grains are made developable with a fogging solution and then developed with a color developer to generate a positive dye image. As with color negative development, all the developed silver is bleached and fixed out.

Books: Haist, G., *Modern Photographic Processing.* New York: John Wiley, 1979; James, T. H., ed.; *The Theory of the Photographic Process,* 4th ed.; New York: Macmillan, 1977; Carroll, B. H., Higgins, G. C., and James, T. H., *Introduction to Photographic Theory.* New York: John Wiley, 1980; Jacobsen, C. I., and Jacobsen, R. E., *Developing,* 18th ed.; London: Focal Press, 1980; Cox, R. J., ed., *Photographic Processing.* London: Academic Press, 1973; Mason, L. F. A., *Photographic Processing Chemistry.* London: Focal Press, 1966. *R. Hailstone*

DEVICE INDEPENDENT COLOR A classification of PC-based electronic color imaging systems. *M. Bruno*

See also: *Photomechanical and electronic reproduction.*

DEWPOINT The temperature at which the water vapor in a particular volume of air or gas will begin to condense. Dewpoint is related to absolute and relative humidity in that it is a measure of the water vapor present in the air. It is dependent on barometric pressure but not on temperature. The

dewpoint predicts at what temperature condensation will begin to occur, and can be used to indicate the drying ability of the air when compared to the actual temperature. *J. Holm*

DIAPHRAGM One or more opaque plates that obstruct radiation in an optical system except through an opening that normally is centered on the optical axis. A variable diaphragm is typically a set of thin overlapping metal blades that may be adjusted to leave a symmetrical aperture of continuously changeable diameter. An early version (1858) of the diaphragm that was not continuously adjustable consisted of a series of holes in a strip of metal, known as *waterhouse stops* after its inventor John Waterhouse. Each larger hole allowed twice as much light to pass through as the next smaller opening, and the strip was slid sideways through the lens barrel for use. Later a circular stop plate that rotated the various sized openings into the lens path was created. The iris diaphragm appeared around 1900. *J. Johnson*

DIAPHRAGM OPENING See *Aperture.*

DIAPOSITIVE (1) A positive image on a transparent or translucent support that is used as an intermediate step in producing the final image. A diapositive made from an original negative, for example, might be used to make one or more duplicate negatives. Syn.: Interpositive. (2) A transparency that is intended to be viewed by transmitted light. *L. Stroebel*

DIASCOPE An overhead optical projector for showing enlarged screen images of transparencies or diapositives. Some overhead projectors have a scrollable plastic film roll onto which a lecturer can write notes, make diagrams and highlight information with special water-soluble markers. There are special video output cards in computers that send the computer screen image to a liquid-crystal display unit mounted on an overhead projector. This liquid-crystal display can then be projected onto a screen in order to show the computer screen image to an audience. *M. Teres*

Syn.: *Overhead projector.*

See also: *Liquid crystal display.*

DIATHERMIC MIRROR A mirror with a suitable combination of substrate and multilayer coating such that incident light is reflected but the infrared (thermal) radiation is transmitted and dispersed. The mirror may be flat or in concave ellipsoidal form suited to the reflector for a tungsten lamp. *S. Ray*

Syn.: *Cold mirror; Heat transmitting mirror; Heat filter.*

DIAZO PLATES A type of lithographic plate using diazonium salts as sensitizers. *M. Bruno*

See also: *Photomechanical and electronic reproduction.*

DIAZO PROCESSES/DIAZOTYPE Reproduction process in which diazonium compounds, when exposed to blue light or ultraviolet radiation, decompose, losing their ability to react with couplers to form azo dyes. The light sensitivity of diazo compounds was announced in France in 1881, and by 1885 diazo printing had been demonstrated. However, it was not until 1890 that the first practical printing process was announced in the United States. A. Green, C. F. Cross, and R. Bevan, used the dye primuline yellow on fabric that was then treated with nitrous acid, which converted the primuline to a diazo compound, and upon exposure under a line image to sunlight that destroyed the dye-forming potential in exposed areas. It was not until the 1920s that this process became commercially viable and began to compete with the blueprint process in the field of

commercial technical reproduction. Materials used in this system are also known as *dyeline* materials. The dyeline process, producing dark images on a white background of drawings, documents, and plans, has completely replaced the commercial blueprint. Ozalid and related copy materials are diazo-based, and diazo emulsions on transparent bases are used for color proofing systems in photomechanical reproduction. When diazo materials, which contain a light-sensitive diazonium salt and a coupler compound, are exposed to ultraviolet radiation, the salts in areas corresponding to the clear areas of the transparency are decomposed. If the paper is *developed* in ammonia fumes, it is called the vapor diazo process; if heat is used as the developing agent, it is referred to as the thermal development process. This makes the sensitive coating alkaline, which causes the coupler and the unexposed diazo crystals to link up, forming the dyeline image. Diazo-treated paper is an excellent surface on which to draw, paint, or hand color. It is very inexpensive, easy to use, and comes in red, blue, brown, and black. The major drawback of this process is that the diazo paper will eventually fade if exposed to ultraviolet radiation for prolonged periods of time. Diazo and dyeline products find their widest use in the commercial marketplace for direct copying of documents and architectural drawings on translucent paper, linen, or matt-surfaced plastic film. *J. Natal*

DICHROIC FILTER See *Filter types.*

DICHROIC FOG The nonimage-forming density produced when some of the silver halide in an emulsion is dissolved during the developing process, migrates to a different location, and is subsequently reduced. The resulting silver deposit often appears to change color with changes in viewing conditions. *L. Stroebel and R. Zakia*

DICHROIC HEAD An enlarger light source that uses dichroic (interference) filters to absorb unwanted light. A *subtractive* head has yellow, magenta, and cyan filters to absorb controlled amounts of blue, green, and red light. The light is then blended in a *mixing box* that produces diffused light. Dichroic condenser enlarger heads also are made. *Additive* dichroic heads use sharp-cutting red, green and blue filters. *R. Jegerings*

See also: *Enlargers; Interference filter; Projection printing.*

DICHROMATE PROCESS See *Gum bichromate printing process; Carbon process.*

DICHROMATISM A type of defective color vision whereby additive mixtures of only two components, rather than three, are necessary and sufficient to match all colors. *L. Stroebel and R. Zakia*

See also: *Defective color vision; Deuteranopia; Protanopia; Vision, color vision.*

DICHROMATISM (COLOR) A change in the color of transmitted light with the thickness of the layer through which it passes. A characteristic of dyes whose molecules aggregate to different extents in different concentrations of solutions. Dyes possessing two broad but not equally deep absorption bands in the visible spectrum appear one color (typically red) in a concentrated solution while changing to their characteristic colors when diluted. *R. W. G. Hunt*

DIELECTRIC An insulator used between the plates of a capacitor to increase the capacitor's ability to store an electrical charge. The increase in capacitance because of the addition of a dielectric material (other than air) is a measure of the relative dielectric constant of the insulator. *W. Klein*

DIFFERENTIAL FOCUS Technique of selection of camera settings of focus, aperture, and focal length to produce depth of field limited to a shallow zone to make a particular subject plane or detail stand out sharply against an unsharp background and/or foreground. *S. Ray*

See also: *Depth of field.*

DIFFERENTIAL HARDENING PROCESS Any process in which exposure causes a material to harden in proportion to the amount of radiation that strikes it. Niépce used bitumen of Judea for his 1820s heliographs. Gelatin hardens in the carbon and carbro processes. Photopolymerization is central to many photomechanical printing processes. *H. Wallach*

See also: *Carbon process; Carbro process; Heliography; Photopolymerization.*

DIFFERENTIAL REEXPOSURE In processing nonincorporated-coupler reversal color film, the procedure of making all remaining silver halides (after formation of the negative images) developable, one layer at a time, by fogging with light. For example, red light can be used to fog one layer because only one layer is sensitive to red light. After each of the two layers has been reexposed and developed in an appropriate coupler developer, the third layer can be fogged chemically. *L. Stroebel and R. Zakia*

See also: *Kodachrome.*

DIFFRACTION See *Optics, physical optics.*

DIFFRACTION GRATING An optical device using diffraction instead of dispersion to separate out an incident beam of white light into its component wavelengths (colors). Long wavelengths are diffracted more than shorter wavelengths, which is the opposite of the dispersion behavior of a prism, but the deviation is linear throughout the spectrum, again unlike the nonlinear behavior of a prism. The spectrum is less intense, however, than for a prism, and a series of progressively weaker spectra are given by the grating.

The grating may be of the reflection or transmission type but is basically a series of closely spaced parallel lines, alternately transmitting (or reflecting) and opaque on a suitable base. There may be several hundred lines per millimeter. Commercially produced gratings may be replicas of a master mechanically ruled grating or more usually of a master formed in photoresist material by holographic interference techniques. *S. Ray*

See also: *Dispersion; Abbe number.*

DIFFRACTION-LIMITED Imaging performance of a lens whose resolving power is limited only by the degrading effects of diffraction around the edges of the aperture stop; hence, performance is close to the theoretical maximum possible so that the image of a point source of light is symmetrical Airy pattern. Any degree of stopping down degrades performance. Such diffraction-limited lenses of large aperture corrected for use with monochromatic light are used in processes such as microimage work and microlithography for production of integrated circuits. *S. Ray*

Syn.: *Aperture-limited.*

See also: *Airy disk; Optics, physical optics.*

DIFFRACTION (SOUND) The property of sound that permits it to be heard around corners; sound encountering an edge will reradiate into a new space from the edge. *T. Holman*

DIFFUSE DENSITY The result of the measurement of the absorption of light by a film sample using either of the following two optical arrangements:

1. The sample is illuminated by specular (focused) light, and nearly all the light transmitted by the sample is recorded.
2. The sample is illuminated with light incident through nearly a hemisphere, and only the directly transmitted light is recorded.

Such a measurement is useful for predicting the printing characteristics of a negative in a diffusion enlarger and is the standard method for negative measurement.

M. Leary and H. Todd

See also: *Densitometry; Doubly diffuse density; Specular density.*

DIFFUSER Any light-scattering medium placed in the path of a beam of light. In the case of an illumination system, to soften its character. Examples are matt-white reflectors behind or frosted or opal glass or nets in front of a light source. In an imaging system the aerial image can be made visible at any point in the beam by scattering from a ground glass screen.

Diffusers in the form of clear glass or plastic engraved with concentric circles or as thin chiffon-type material may be used close to a camera or enlarger lens to soften the overall definition of a subject. *S. Ray*

Syn.: *Soft-focus attachment.*

DIFFUSE REFLECTANCE The ratio of the part of the radiant or luminous flux reflected by diffusion to the incident flux, under specified conditions of irradiance. Symbol, ρ_d.
R. W. G. Hunt

DIFFUSE REFLECTION Reflection of light in many directions. A subject producing a perfectly diffuse reflection would have the same luminance regardless of the angle from which it is viewed. Although no surfaces produce perfect diffuse reflections, matt white paper approximates the effect.
F. Hunter and P. Fuqua

DIFFUSE TRANSMITTANCE The ratio of the part of the radiant or luminous flux transmitted by diffusion to the incident flux, under specified conditions of irradiance. Symbol, τ_d. *R. W. G. Hunt*

DIFFUSION The scattering of a directional incident beam of light in most directions by reflection from a roughened surface or by passage through a translucent material. An opalescent diffusion screen such as in a light box helps produce an evenly illuminated surface. Both white paint and milk are diffusing media because microscopic particles in suspension give random reflections. A perfect diffuser or lambertian surface is one that is seen with uniform luminance irrespective of viewing direction. *S. Ray*

DIFFUSION ENLARGER An enlarger that provides uniform illumination by scattering the light from the source, either by transmitting it through a sheet of ground glass or other translucent material or by reflecting the light from a dull white surface. Distinguished from a condenser enlarger, which uses a lens between the light source and the negative carrier. *L. Stroebel*

See also: *Condenser enlarger; Enlargers.*

DIFFUSION PANEL Translucent material attached to a frame and positioned between the subject and a lighting fixture to diffuse the light. Panels do not trap stray light like enclosed diffusion sources (e.g., softboxes) do, but they are more versatile. Diffusion panels are also used outdoors to soften sunlight for close-up views. *R. Jegerings*

DIFFUSION (SOUND) The property of acoustical barriers to provide usually desirable scattering in reflected sound. An example of a lack of diffusion is the flutter echoes arising between two flat, parallel, hard walls. Good diffusion promotes smooth sounding reverberation, without discrete audible events such as echoes. *T. Holman*

DIFFUSION TRANSFER Diffusion transfer is a reversal process yielding positive prints or transparencies in black and white or color. There are three essential components: a silver halide emulsion with or without dyes, an image-receiving layer, and a processing solution. The emulsion is exposed; a negative image is developed; the remaining unsensitized positive image diffuses in the processing solution and transfers to the image-receiving layer where the positive image forms. The process takes as little as 15 seconds, or as much as a few minutes, depending upon the material employed and the conditions of use.

While the process has its roots in the nineteenth century, its development and application stand as a touchstone of innovation in photochemical imaging in the mid-twentieth century. In 1857, Belfield Lefevre moistened a processed daguerreotype plate with thiosulfate and pressed it against gelatin-coated paper, causing all the particles forming the image to transfer to the paper. In 1899, the German colloid chemist Raphael Eduard Liesegang caused diffusion transfer by coating a glass plate with a gelatin-gallic acid mixture and pressing it against a silver chloride print that contained silver nitrate. The silver nitrate diffused from the print to the plate where it was reduced by the gallic acid, forming a negative image.

The fundamentals of the diffusion-transfer process in use today were arrived at independently, and virtually simultaneously, by Andre Rott, working for Gevaert in Belgium, and Edith Weyde, of Agfa in Germany. In 1939, they took patents for silver diffusion-transfer copying systems, the first of which was marketed in 1940 by Gevaert as Transargo. Diffusion transfer was adapted to become a practical, in-camera photographic process by Edwin H. Land and his colleagues at Polaroid. They began the design of a one-step system in 1943, published their first photograph in 1946, gave their first public demonstration in February of 1947, and introduced the first one-step camera, the Model 95, in late 1948.

In black-and-white, peel-apart diffusion-transfer imaging, the negative material has a silver halide emulsion, the effective speed of which may be very slow for reflex copying, or as high as ISO 3000 for motion or low-light work. The

Diffusion panel.

gelatin has hardening agents added to limit swelling during processing and antifoggants to ensure that all unexposed silver is retained for the positive image. A highly alkaline developer is incorporated in the emulsion. Its components may include metol, hydroquinone, phenidone, gallic acid, or pyrogallol, selected to produce development fast enough to be complete before the solubilization of the silver halide begins.

The positive material is not light sensitive. Its functions are to receive diffused silver complexes as they transfer from the negative material and to provide the development nuclei around which silver will be deposited. Substances used to form these catalytic sites include several sulfides of metals, colloids of silver and some organic sulfur compounds. Additional developing agents to speed up the process may be incorporated in the receiving material.

The alkaline processing solution activates the developer and provides the silver complexing agent that separates the silver halides of the positive image from those that were developed to form the negative image, enabling the transfer by diffusion of the undeveloped positive to the receiver. Common complexing agents are sodium thiosulfate, ammonium thiosulfate, sodium thiocyanate, ammonia, and sodium cyanide. The processing solution usually contains viscosity enhancers to promote even spreading, and restraining agents to minimize fog. Additives also increase the rate of silver transfer, improving image density.

After exposure, the peel-apart process requires that the negative and receiver be pulled between rollers, forcing the sheets together and bursting a pod containing the processing solution. The solution activates the developer, wherever it is located. The negative image develops quickly; the remaining positive-forming silver halides form complexes that diffuse into the processing solution and migrate to the receiver where they are attracted by the development nuclei, forming the positive image. When the sheets are peeled apart, the negative sheet covered with processing solution is discarded and the print remains.

Some diffusion-transfer materials are one piece, integral picture units that do not require peeling. After exposure, the sealed assembly passes through rollers, bursting the pod. The light-sensitive emulsion must be protected from fogging by ambient light as it exits from the camera. An opacifying layer is incorporated in the processing solution; it protects the negative below and then reverses itself, becoming transparent by the conclusion of processing. Development and diffusion-transfer products must be concealed when processing is completed because they cannot be discarded. To separate the negative and consumed chemicals from the positive image, a white pigment interlayer forms beneath the image, becoming the reflective surface against which the image will be viewed.

Color prints are produced by the dye diffusion transfer process. The multilayer films have red, green, and blue sensitive layers interleaved with their respective metallized dye developers that form cyan, magenta, and yellow subtractive dyes. Development in exposed areas is begun as in black-and-white processing: the material passes through rollers that burst the pod containing the viscous processing reagent, spreading it across the negative. In color, there is a separate developer for each emulsion layer. Developed dye/developer molecules are immobilized; undeveloped molecules migrate through the emulsion to the mordanted receiver, forming the positive image.

In areas exposed to red light, cyan dye developer is concealed beneath the white pigment; the yellow and magenta dye developers transfer to the receiver where they absorb blue and green but reflect red, so that area appears red. In areas exposed to blue light, yellow dye developer is immobilized; magenta and cyan dye developers transfer to the receiver where they absorb green and red, making the area appear blue. Magenta dye developer is immobilized by exposure to green light; yellow and cyan dye developers transfer, absorbing blue and red, making the area appear green. Exposure to white light causes all the dye developers to be immobilized; no exposure causes all the dye developers to transfer, forming black.

Diffusion transfer is the basis of an interesting variety of materials. Polaroid makes an additive screen 35-mm color transparency film called Polachrome that is reminiscent of screen process and lenticular products of the 1920s. Exposure is through a screen consisting of 3000 parallel red, green, and blue lines to an emulsion that forms a black-and-white positive image by peel-apart diffusion transfer. White light projected through the back is modulated by the emulsion densities and broken into its primary color components by the screen to form an image that is positive and color correct. Polaroid also offered a color additive screen motion picture film called Polavision.

Kodak's Ektaflex system offered peel-apart diffusion transfer printing materials consisting of films for printing from positives or negatives, receiver paper, and alkaline activator solution. Agfachrome Speed was a single sheet, self-contained material, tray processed in activator, for printing from transparencies. Kodak Instant Print Color Film used fast, direct-reversal emulsions exposed from the base side. The oxidation of the processing chemicals caused dye releasers to release, rather than form, dyes which then diffused to the receiver.

Current diffusion-transfer materials include 35-mm peel-apart color, black-and-white and white-on-blue transparency films, color, and black-and-white pack films whose speeds reach 3000, sheet films that yield both a print and a negative, color and black-and-white integral films, sheet x-ray and radiographic films, and color print materials to 20 ¥ 24 inches and beyond. Large diffusion-transfer prints have been very popular with photographers who sell prints and with the people who collect them because each print is unique. *H. Wallach*

See also: *Additive color process; Lenticular color photography; Polaroid photography; Screen process.*

DIFFUSION TRANSFER REVERSAL See *Diffusion transfer.*

DIGESTION
In the manufacture of silver halide emulsions, after grain precipitation and growth followed by the removal of undesired chemicals, the emulsion is given a second heat treatment called *digestion*. During this afterripening period, the emulsion sensitivity is increased by the formation of more effective surface centers on the surface of the silver halide crystals. *G. Haist*

DIGITAL
In a measuring instrument (for example thermometer, densitometer), a display of the measured values as numbers, as distinct from the position of a pointer of a scale or a fluid level. The use of digital instruments reduces human error. Contrast with *analog.* *H. Todd*

DIGITAL AUDIO
A method of representing signals electronically and on various media that employs conversion from the analog domain into the digital one through the use of two processes: sampling and quantization. The forte of digital audio is replication—a copy is potentially not degraded in any way; rather, it can be considered to be a clone of the original source. Thus, mass production can be used to bring many users copies that are audibly indistinguishable from the original master. (Analog audio recording inevitably brings some degradation generation by generation because of imperfections in the analogy between the repre-

sentation of the audio on a medium and the actual audio, but analog audio still predominates in many areas.)

Sampling is the process of capturing the amplitude of the signal at regular intervals quickly enough so that the desired audio signal is completely represented. The sampling theorem states that this process must occur at least somewhat more frequently than twice each cycle of the audio to be represented, so popular sampling frequencies have become 32 kHz (some broadcast links, especially in Europe), 44.1 kHz (consumer audio, including compact disc), and 48 kHz (professional audio).

The heart of digital audio is quantization. This is a process of *binning,* or measuring the amplitude of each sample in order to represent it as a set of numbers. Then, the numbers are combined with additional numbers used to provide protection against errors and to tailor the stream of resulting numbers for a specific purpose such as for a medium before recording or transmission. Some issues relevant to this process are the basic method, the number of bins, the regularity of the bins, and the deliberate addition of small amounts of noise called *dither* that acts to smooth the transitions across the bin boundaries. *T. Holman*

See also: *Analog audio.*

DIGITAL DELAY LINE A method of producing a time delay of an audio or video signal, by converting from analog to digital representation at the input of the device, delaying by means of digital memory, and subsequent conversion from digital to analog representation at the output. Delay lines have many uses in both audio and video signal processing. In audio, the output of the delay is added together with the original signal to produce a range of effects from "thickening" of a voice to discrete echoes. In video, one-line delay lines are used for many purposes, including color decoding of composite video signals. *T. Holman*

DIGITAL EDITING See *Digital image.*

DIGITAL HALFTONE A halftone produced on a digital device such as a laser printer. Typically the dot size is fixed by the resolution of the printer (300 dpi). The digital halftoning creates the effect of variable size by the process of dithering. The dithering process creates a cluster of two or more dots and varies the percentage of black dots in order to achieve a gray tone. A typical 300 dpi laser printer can produce a dithered cluster of 4×4 cells and achieve a halftone resolution of 75 dpi. However, the number of gray levels is a product of the cluster. In this example, the number of gray tones is 16 (4×4). If the number of required tones is increased, then the resolution (dpi) decreases. *R. Kraus*

DIGITAL IMAGE An image that is represented by discrete numerical values organized in a two-dimensional array. The conversion of images into a digital form is known as digital imaging. Hence, manipulation of the image in digital form is called digital editing, retouching, enhancement, and so on. *R. Kraus*

DIGITAL IMAGE BACK See *Camera, digital types imaging camera, electronic still camera.*

DIGITAL-IMAGING CAMERA See *Camera types.*

DIGITAL PHOTOGRAPHY For the past decade, the goal of digital photography has been to develop affordable capture, edit, and display systems that will compete with the quality of traditional silver halide processes. Some would argue that in the past several years that goal has been met. Others will note that with every advancement made on the digital side, advancements with silver halides keep raising the stakes. In either case, the accomplishments in digital technology must be recognized. In many areas, the image quality issue has been addressed to the point that digital photography not only competes with silver-based imaging, but it offers advantages that surpass traditional techniques. The photographer needs to be aware of these advantages and applications where digital imaging offers a better alternative for a given project.

There are three basic avenues available to the photographer wishing to explore digital photography's creative potential. The first involves using one of several electronic still-video camera systems to make photographs as with any other camera. In this system the image is stored as a video signal recorded to a 2-inch still video floppy disc. Once captured, the video signal is converted to a digital format through the use of a frame capture card. Another option is the use of a digital camera system that retrofits standard 35-mm and medium-format cameras to convert light energy directly to digital information at the instant the shutter is released. These data are stored to a portable hard disk for later manipulation by the computer. Existing silver-based images can also be converted to digital form with a flat bed or film scanner. These devices make digital copies of prints, slides, or negatives, resulting in some of the highest-quality digital images currently available.

The image quality produced by these methods can be classified as:

Scans of silver halide images—best
Digital camera systems—good
Electronic still video—fair to poor

In each method the analog-to-digital conversion process is accomplished through the use of a charge-coupled device (CCD). A CCD is an integrated circuit chip made up of thousands of pieces of light-sensitive semiconductor material. The spatial resolution of the image is directly related to the number of individual semiconductors that can be placed on the CCD chip. The CCD chip converts light energy falling on the chip to electrical voltage that is then converted to digital information using A/D circuitry. Current manufacturing techniques makes it very difficult to produce CCD chips in large quantities with enough pixel density to match the detail produced by silver halide films.

Resolution When evaluating digital-imaging capabilities, there are several areas of image resolution that must be addressed. Spatial resolution refers to the number of discrete points of picture information contained in a given area. The *pixel,* short for picture element, is the unit used to describe the smallest discrete point used in constructing a digital image. The number of pixels in a given area will be used to describe a system's spatial resolution; usually expressed as PPI (pixels per inch). Because digital images have a two-dimensional aspect ratio of height and width, an image's spatial resolution will be expressed as a two-dimensional grid, for example, 2048×1365 PPI. In this case the image would consist of approximately 2.8 million points of picture information.

As a generalization, digital image files containing between 2.5 to 3.5 million pixels of visual information are thought to have a spatial resolution comparable to 35-mm negative film. It is difficult to make direct comparisons of equivalent resolutions between film and digital files. There are a number of variables that must be considered in measuring a system's resolving capability and in some instances, measurements can't be applied equally to both systems.

Brightness resolution refers to the number of gray levels that can be assigned to each pixel. Digital photography uses a binary numbering system to represent values (a string of digits made up of ones and zeros). Each digit in the binary string is referred to as a *bit.* The more digits contained in a binary

string, the greater the number of specific values that can be assigned using that string. For example, a binary string containing only one digit would only be able to express two values (1 and 0). Two digits in the string could represent four values and so on. It is common when describing a system's brightness resolution to express it in terms of the number of binary bits used to assign brightness values. Therefore, a system that has an 8-bit brightness resolution has the ability to assign one of 256 shades of gray for any one pixel in the scene. This is more than adequate in dealing with the gray scales associated with black-and-white images. In the case of full-color photographic images, a digital photography system will need a brightness resolution of 24 bits. This will allow any combination of 256 shades of red, green, and blue to be assigned to any one pixel in the scene, resulting in over 16 million pos-sible colors.

Photometric accuracy is a way of describing how accurately a digitally assigned gray level represents the actual brightness level in the scene at a given pixel location. This characteristic is primarily a function of how well a CCD chip converts light energy into electrical voltage and how accurately the analog-to-digital circuitry converts that voltage into a binary number.

Memory Requirements A high-resolution digital image will require a significant amount of memory for data capture, image processing, and file storage. A high-resolution digital image is considered to be any image with a horizontal resolution of 2,000 PPI or more. To figure the memory requirements needed to work with such an image, multiply the number of pixels times the image's brightness resolution (expressed in bytes where 8 bits = 1 byte). In the case of a full-color 35-mm image (24 bit brightness resolution) the file size would be calculated to be 2048×1365 pixels \times 3 bytes of brightness resolution which equals 8.4 megabytes. This would represent the minimum memory capacity needed to store the image. In addition, many image-processing programs will require that additional storage space be maintained on the system's hard disk for the purposes of temporarily storing data for computation and to store backup copies of information to allow the user to undo certain procedures. Free workspace requirements on the hard drive can be as high as three times the file size, which in our example would be 25 megabytes.

Photo CD Photo CD has the potential to have a profound effect on a photographer's introduction to digital image making and may be instrumental in the transition from silver halide to the digital technologies of the future. Photo CD allows the photographer to use traditional photographic materials, scan the resulting images to create digital photographs, and store up to 100 of these images on a compact disc. Although the technology is being marketed for consumer use, its first impact will be felt in the areas of professional design, photography, and desktop publishing. The proliferation of photographic images in desktop publishing documents could represent new markets for photographers. The ability to conveniently distribute portfolios, to organize, catalog, and market stock images, to organize and choreograph images to music, to create marketing and training material, and to allow viewers to interact with these images are just a few of the advantages this technology offers the photographer. *T. Zignon*

See also: *Electronic still photography.*

DIGITAL PLATES Printing plates made directly from digital data. *M. Bruno*

See also: *Photomechanical and electronic reproduction.*

DIGITAL PRINTING Printing from digitally produced printing plates. *M. Bruno*

See also: *Photomechanical and electronic reproduction.*

DIGITAL RECORDING Any method of recording, on tape, disc, or film, that uses digital audio. *T. Holman*

DIGITAL RETOUCHING See *Digital image.*

DIGITAL (SOUND) A signal that has been converted to numerical representation by means of quantizing the amplitude domain of the signal (putting amplitudes into bins, each bin called by a number). This means that for each amplitude a number is derived for storage or transmission. The advantage of digital is that to the extent the numbers are incorruptible by way of error-protecting coding, the signal will be recovered within the limits of the original quantizing process, despite how many generations or transmission paths are encountered by the signal. *T. Holman*

DIGITAL-TO-ANALOG CONVERTER (DAC) In computers, a component that converts digital data to analog information. Many cathode-ray tubes (CRTs) are analog-driven devices. For the computer to display the image, the data must be changed from the digital domain to voltage in the analog world. Many A/D boards are also D/A boards. Targa boards, among other capture/display boards, contain both an A/D circuit and a D/A circuit. *R. Kraus*

DIGITAL VIDEO The images displayed by the monitor are digital representations held by and displayed through the computer. Such an approach to video gives opportunity to the manufacturing of *intelligent* television at high-definition levels. *R. Kraus*

DIGITIZER The device that converts analog data into digital data. The analog data are sampled and quantized. The number of bits that the digitizer is capable of quantizing determines the number of gray levels captured by the digitizer. An 8-bit digitizer can digitize 256 levels of brightness.- *R. Kraus*

DIGS Digs are small scratches or imperfections generated in film emulsion surfaces as the result of being struck by sharp pointed objects such as clips, film hangers, dirt, or nicks on transport rollers. Since digs disrupt the emulsion surface, it is difficult to retouch or correct them except on the final paper print. If, for example, they occur on one of the sprockets or rollers of a motion picture camera, printer, processor, or projector, they may appear as a repeating flash, or spot on the screen when projected. *I. Current*

DILATE In morphological filtering of electronic images, the expanding of specific pixels and the filling of holes, which produces a larger, thicker image. The operation is binary and produces one image, although it requires two images to process. Sometimes it is referred to as growing an image. *R. Kraus*

D ILLUMINANTS CIE standard illuminants having defined relative spectral power distributions that represent phases of daylight with different color temperatures. *R. W. G. Hunt*

DILUTION (1) The act of adding water to a stock or other solution for use. (2) In adding water to weaken a solution, the volume ratio of stock solution to water, for example, 1:2 (1 part stock solution to 2 parts water). *L. Stroebel and R. Zakia*

DILUTION FORMULA See *Appendix M.*

DIMENSIONAL CORRECTION Expansion of fiber-based paper during the wet processing and washing stages tends to be largely permanent if the print is ferrotyped during drying and the material is thus not allowed to return to its

expected lower dimension as the result of drying. Similar failures in expected dimensional changes can occur with other materials if they are restrained during the drying process. In cases of this kind, the normal expected dimensions can be approached if the material is reprocessed, or resoaked in water followed by the corrected drying procedure. Complete correction is not usually achieved, however.

Permanent changes in dimension can result from losses in solvents or stabilizers, or to stress changes during drying or storage. Materials subjected to these kinds of conditions are not restored by reprocessing or reconditioning.

Shrinkage at the edges of sheet films due to greater loss of solvents than in the other areas may cause a *cupping* of the sheet that could prevent uniform contact when printing. This difference in dimension would also introduce problems where the image is used for making measurements. This type of defect is practically impossible to correct. *I. Current*

DIMENSIONAL STABILITY The ability of a material to resist changes in size or shape caused by changes in temperature, humidity, processing, or age. It is normally expressed as a percentage change in length or width of the material. (Even length and width stability can differ; fiber-base paper is notorious for shrinking more in width than in length.) The commonly available materials can be ranked in order of decreasing dimensional stability: glass plates, polyester film, acetate film, resin-coated paper, fiber-base paper. For most materials, wet chemical processing is the greatest influence on stability, but environmental influences cannot be ignored.

For work of the very high dimensional accuracy, glass plates are the outstanding choice. (Some ultra precise work has necessitated fused quartz, with its even lower index of thermal expansion.) Masks used in semiconductor manufacture and plates for positional astronomy (sky mapping) are always glass. Photogrammetric mapping from aerial surveys, formerly done on glass plates, now uses polyester film for both the original aerial photography and for the diapositives in the stereogrammetric plotters. Some manufacturers publish extensive data on the dimensional stability of their materials.

With the general availability of many emulsions on polyester support, most needs for metric accuracy are now easily met. For ordinary pictorial photography, acetate roll film is adequate, and the polyester base of many sheet films is far more stable than required. *M. Scott*

See also: *Photogrammetry; Support.*

DIMENSIONING Dimension is an important aspect of photography, and failure to meet dimensional standards can lead to a host of defects. Film sizes and formats are required to perform in a variety of cameras and other equipment produced by different manufacturers. In addition, some processes depend on proper interaction of precise dimensions. Failure to meet standards in any of these areas can lead to loss of quality or even complete failure of the system.

Oversized sheet film will buckle out of focus, while inadequate size may allow it to fall out of the film sheath. Paper that has been cut with its long dimension in the cross machine direction of the master roll may shrink differently from paper cut with the machine direction, and the final size of the two sheets will not match. Motion picture film that has been perforated with incorrect pitch dimensions may become distorted in a camera, printer, or projector, and the final image may be unsharp or unsteady. For example, the pitch of a negative must be a given amount less than that of the positive film on which it is printed to ensure that the two do not slip while being exposed. Dimensional stability is important in applications where precise photographic dimensions are critical, such as in aerial mapping.

The American National Standards Institute (ANSI) and the International Standards Organization (ISO) publish a wide variety of standards covering dimensions of films and papers for still photography, and for films used in motion picture photography. *I. Current*

See also: *Standards.*

DIMMER A name given to many devices used to control the intensity of lamps, either to adjust the illumination for photographic reasons or simply to reduce the voltage applied to the lamp to prolong its working life or to save energy. If two lamps are to be operated at light levels that are not critical, a double-pole, double-throw (DPDT) switch can be used to connect the lamps in parallel for bright operation or in series for dim operation. Smooth control of lamp intensity can be achieved by the use of a rheostat, a variable autotransformer, or a thyristor circuit. *W. Klein*

See also: *Rheostat; Thyristor.*

DIN FILM SPEED See *Film speed.*

DIODE A semiconductor or vacuum tube with two electrodes: an anode and a cathode. A diode permits electrons to flow through it in one direction only—from cathode to anode. Conventional current flows from anode to cathode. When diodes are used to convert ac power to direct current, they are referred to as *rectifiers*. *W. Klein*

See also: *Semiconductor diode.*

DIOPTER Unit expressing the refracting power of a lens, being the reciprocal of its focal length in meters. The accompanying sign plus or minus indicates a converging or diverging lens, respectively. A +2 diopter lens is a converging lens of focal length 500 mm. Principally used by optometrists, it is also used to specify closeup and other supplementary lenses for cameras. An alternative spelling is *dioptre*. *S. Ray*

DIOPTRICS The science of the refraction of light. Lenses that use only refractive elements are termed dioptric. *S. Ray*

See also: *Light refraction.*

DIORAMA A three-dimensional small scale representation of a scene made up of painted or photographic backgrounds with an assortment of objects as foreground: trees, bushes, animals, houses, storefronts, cars, and the like, depending upon the scene being depicted. Many displays in museums provide examples of dioramas. Originally dioramas were small scale models of entire sections of a city. (Early in his career Daguerre painted backgrounds for dioramas.) *R. Zakia*

DIP FILTER (SOUND) An electrical circuit having one, usually tunable, frequency that is suppressed, while passing audio at both lower and higher frequencies. A dip filter is most useful for removing tonal noise from recordings, such as hum or certain whistles. *T. Holman*

DIRECT CURRENT (DC, dc) Electrical current that flows in one direction only, as distinguished from alternating current, which periodically reverses direction. The abbreviation DC, or dc, is invariably used to describe a voltage whose polarity does not reverse, e.g., dc voltage. *W. Klein*

DIRECT DIGITAL COLOR PROOF Color proofs made directly from digital data. *M. Bruno*

See also: *Color proofing.*

DIRECTIONAL EFFECTS In the continuous processing of film or paper, changes in density due to a decrease in developer activity as related to the orientation of the material. The lead end of the film or paper receives more development than the tail. The effect occurs on a local basis and can be minimized with adequate agitation.

L. Stroebel and R. Zakia

See also: *Photographic effects.*

DIRECTIONAL MICROPHONE A microphone exhibiting any microphone polar pattern other than omnidirectional.

T. Holman

See also: *Microphone polar patterns.*

DIRECTIVITY (SOUND) The factor describing a preference for one direction of sound propagation over another; a highly directional sound source is said to have high directivity or high "Q."

T. Holman

DIRECTOR The person responsible for the communicative and expressive aspects of a motion-picture production. While the producer handles management and business aspects of the production, the director determines creative goals, supervising and coordinating the work of performers or subjects and all the people and crews involved in creating a motion picture.

H. Lester

DIRECTOR OF PHOTOGRAPHY (DP) The person responsible for the "look" of a motion-picture film, devising a camera and lighting plan consistent with the film director's vision, and supervising the work of the camera operator and gaffer and their crews. On many productions the DP may also be the camera operator and/or gaffer.

H. Lester

DIRECTORY A listing of the addresses of the files held on floppy and hard disks. The directory directs the computer to the file. Directories hold subdirectories and files. They are the basis for a hierarchical filing system for storing files.

R. Kraus

DIRECT POSITIVE (1) Applied to films and papers that yield a positive image of the subject following reversal processing. Typically the major processing steps are: image exposure (forms negative latent image), first developer (forms visible negative image), bleach (destroys visible negative image), general nonimage exposure (fogs remaining silver halide), second developer (forms visible positive image), fix, wash. (2) Identifying a photographic process that yields a positive image directly from a positive original without the intermediate formation of a negative image, for example, *Autopositive, dyeline, Thermofax,* and *xerographic* processes for document copying.

M. Scott

DIRECT REFLECTION See *Specular reflection; Diffuse reflection.*

DISC A thin, circular plate used to record information. Although disc and disk are sometimes treated as synonyms, disc is normally used for compact-disc (CD) audio recordings, electronic and film disc cameras, disc film, and the discs used in the Kodak Photo CD system, whereas disk is normally used in computer contexts such as floppy disk (or diskette), hard disk, and disk drive.

L. Stroebel

DISC CAMERA See *Camera type.*

DISCHARGE LAMP A light source that produces light by electricity flowing through as in a sealed translucent or clear envelope (a fluorescent lamp or electronic-flash tube) instead of by incandescence (a tungsten filament lamp) or combustion (a flashbulb).

R. Jegerings

DISCONTINUOUS SPECTRUM A spectral energy distribution that is not continuous across a range of warelengths. Gaseous sources of light are discontinuous.

J. Holm

See also: *Continuous spectrum.*

DISDÉRI, ANDRÉ-ADOLPHE- EUGÈNE (1819–1889) French photographer and inventor. In 1854 opened the largest studio in Paris and patented the *carte-de-visite,* which became a worldwide rage: a full-length photographic portrait pasted to the back of the person's calling card, to be traded with friends and family. The *carte-de-visite*s of the famous could be purchased to add to one's collection. In 1861 he was reputed to be the richest photographer in Europe, but the demand for *carte-de-visite*s disappeared and Disdéri died penniless, blind, and deaf.

Books: McCauley, Elizabeth A., *A.A.E. Disdéri and the Carte De Visite Portrait Photograph.* New Haven: Yale University Press, 1985.

M. Alinder

DISK Generically, the platter of magnetically coated material that stores data for the computer. These disks are interchangeable among computers of similar type. Software exists that allows for the reading of floppy disks across platforms. Data are recorded serially in concentric circles called tracks. Disks come in several sizes and density capacities. Originally, the flexible or floppy disk was 8 inches in diameter and held more than 360+ kilobytes of data on a single side. The current standard for most machines is 3 1/2 inches in diameter, double-sided, high-density with a capacity of 1.44 megabytes of data. Also available are 3 1/2-inch disks with capacities of 2.88 megabytes, but these are not widely used, and they require special drives. Specially manufactured 3 1/2-inch disks are entering the market that are capable of storing 21 Mb and more. These require special disk drives.

R. Kraus

See also: *Hard disk.*

DISK OPERATING SYSTEM (DOS) Personal computing is diskette-based and requires that system software, i.e., the instructions to the computer on what to do and how to operate stored in a form accessible to the computer. Early computers usually lacked hard drives and so a floppy diskette called the operating system diskette was used to store data, programs, and the computer operating system. Current usage has made the term DOS limited to describing the operating system of IBM-type platforms using Microsoft's operating system.

R. Kraus

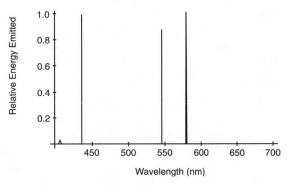

Discontinuous (line) spectrum—the spectrum of a mercury vapor lamp.

DISK SHUTTER A flat rotating opaque plate with one or more open segments. Disk shutters with one opening, sometimes adjustable, are used on motion-picture cameras, and shutters with two or three openings are used on motion-picture projectors. *L. Stroebel*

Syn.: *Sector-wheel shutter.*
See also: *Shutters.*

DISLOCATION A crystal defect in which part of a plane of ions is missing. *R. Hailstone*

DISPERSION The separation out by refraction at an interface between two transparent optical media and subsequent deviation of an incident beam of white or polychromatic light during its passage through the second medium. All transparent media show dispersion. A single lens of optical glass chosen to have a high refractive index, giving it a large optical power for a shallow surface curvatures to reduce spherical aberration, usually has a correspondingly large dispersion, the cause of chromatic aberrations. Glasses are available with a variety of dispersion for a given refractive index.

A triangular glass prism may be used to disperse an incident beam into its constituent wavelengths and the degree of dispersion for two chosen spectral or Fraunhofer lines. Because refraction increases as wavelength decreases, dispersion is greater for short wavelength light. Dispersion is also nonlinear with wavelength so that correction of chromatic aberration by using a pair of glasses in an achromatic combination with similar but opposite dispersion results in a residual dispersion or secondary spectrum. Mean dispersion is the difference in refractive indices $(n_F - n_C)$ for the F (cyan) and C (red) lines in the spectrum of hydrogen. Partial dispersion is the difference between two other chosen spectral lines. Dispersion is also quantified by the dispersive power, Abbe number, or v-number. *S. Ray*

See also: *Lenses, chromatic aberrations.*

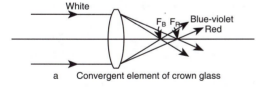

a　Convergent element of crown glass

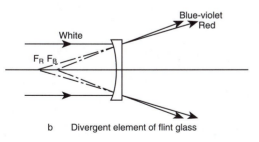

b　Divergent element of flint glass

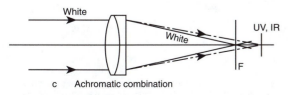

c　Achromatic combination

Dispersion. The principle of an achromatic lens combination.

DISPERSITY A distribution of properties or sizes. As applied to photographic emulsions, it can relate to its distribution of grain sizes. Emulsions possessing a broad range of sizes are said to be polydisperse, whereas those possessing a very narrow range of grain sizes are said to be monodisperse. With regard to latent-image formation, it refers to a distribution of silver photoproduct. The silver nuclei form at many sites on the grain surface, rather than at a single site. Depending on the minimum developable size of the latent image, the dispersity can be an inefficiency in the image-recording stage. *R. Hailstone*

DISPERSIVE POWER See *Abbe number.*

DISSOCIATION In water solution, compounds may come apart or dissociate into negatively and positively charged particles called *ions*. Ions, which may contain one or more elements, take part in chemical reactions, sometimes merely interchanging and in other cases undergoing electronic changes. Sometimes certain compounds form ions by a process called *ionization*. This is a type of dissociation in which the water separates and surrounds the ions of the solute. *G. Haist*

DISSOLVE A motion-picture optical effect involving one shot fading out at the same time a second shot is fading in. *H. Lester*

Syn.: *Cross fade, Lap dissolve.*

DISTANCE CONVERSION See *Appendix K.*

DISTILLED An adjective that describes a liquid that has been vaporized and then condensed to a liquid. Distillation purifies liquids by leaving the impurities behind or separates mixed liquids with different boiling points. Water, for example, is converted to steam by heating, then condensed by cooling to produce distilled water. This purified water is especially suitable for making photographic solutions because any interfering impurities have been removed. *G. Haist*

See also: *Deionize.*

DISTORTION Ideally, an image is formed by the photographic process that is a faithful representation in scale and perspective of the various elements of the scene or subject. In practice the image may be subject to alterations of the shape and proportions of the subject at various stages, and such variations are termed *distortion*.

Various forms of distortion may be identified.

CURVILINEAR DISTORTION A lens that give a distortion-free image is said to be *orthoscopic*. It is difficult to achieve such results, and many lenses have residual traces of the aberration of curvilinear distortion, where straight lines in the subject are rendered as curving outward (barrel distortion) or inward (pincushion distortion). This is a result of asymmetry of lens configuration and is most marked in zoom lenses.

GEOMETRIC DISTORTION With increasing obliquity of the angle of view as with a wide-angle lens, the peripheral detail of a subject with any depth suffers increasing elongation that is radial from the center of the image. This effect is not present for a two-dimensional or flat subject orthogonal to the optical axis. The elongation is proportional to the secant of the semifield angle to the subject. The effect is often confused with curvilinear distortion, but is due solely to the large angle of view.

Syn: *Wide-angle effect.*

ANAMORPHIC DISTORTION In order to compress a high aspect ratio subject field into a film format of lower aspect ratio, as in the case of wide-screen motion pictures, the camera lens uses cylindrical elements to provide two

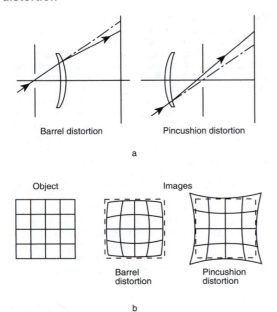

Barrel distortion Pincushion distortion

a

Object Images

Barrel Pincushion
distortion distortion

b

Curvilinear distortion. (a) The effects of selection of a geometrically incorrect ray bundle; (b) barrel and pincushion distortion.

different focal lengths in orthogonal vertical and horizontal directions. Consequently, the image is squeezed horizontally in the image format, termed *anamorphic distortion*. The process is reversible on projection.

Additionally, anamorphic distortion can arise in cameras of the panoramic, peripheral, or flow varieties, where the

film is moved across the focal plane at a velocity to match that of the image across the film surface. In the case of a mismatch of velocities, the resultant image will show a horizontal compression or expansion, or anamorphosis.

The use of a focal-plane shutter may also cause a form of distortion of the subject, depending on the orientation of the camera, the direction of travel of the slit in the shutter, and the direction of movement of the subject relative to the camera position.

PERSPECTIVE DISTORTION The viewing distance of a photograph for correct perspective is related to the focal length of the lens and the print magnification. In practice prints are viewed at a similar distance so that the relative proportions of subjects close to or distant from the camera may be exaggerated or reduced, respectively. The abrupt perspective due to a close viewpoint and use of a wide-angle lens is of course the true perspective from that viewpoint and may be used for effect.

DISTORTION CONTROL The camera movements provided in the rear standard near or in the film plane of a view camera offer a means of distorting the image deliberately. The normal perspective of the subject is obtained with the film plane orthogonal to the optical axis. By use of swing and tilt movements, the film plane is positioned askew or slanted to the optical axis and hence magnification of the image varies across the film plane by alteration of the image conjugates. This causes alterations in the vanishing points of perspective in image, and so such image distortion provides shape control of the subject.

The image may also be distorted by means of various forms of optical attachment to the camera lens, including the use of closeup lenses and prismatic devices.

IMAGE DISTORTION The image may be distorted at later stages in the photographic process after exposure, such as by differential expansion and contraction of the base

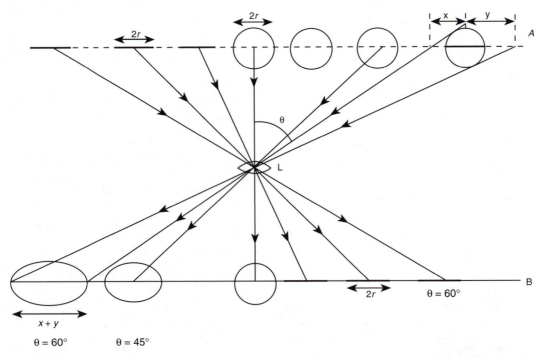

Geometric distortion. An array of spheres of radius r and lines of length 2r in the subject plane A are imaged by lens L in image plane B at unit magnification. The lines retain their length independent of the field angle, but the spheres are progressively distorted into ellipses with increases in the field angle.

of film and print material when processed and dried or mounted.

Books: Ray, S., *Camera Systems*. London: Focal Press, 1983; Ray, S., *Applied Photographic Optics*. London: Focal Press, 1988. *S. Ray*

See also: *Distortion; Strong perspective; Weak perspective; Wide-angle effect.*

DISTORTION (SOUND)
Any undesired alteration of the signal that is related to the signal (this definition excludes noise). Distortion is separable into two types: linear and non-linear. Linear distortions include frequency response and phase errors and are characterized by reversibility by equal and opposite signal processing. Nonlinear distortions involve the generation of new frequency components not present in the original and thus not generally reversible.
 T. Holman

DISTRIBUTION TEMPERATURE
Temperature of a Planckian radiator whose relative spectral power distribution is the same as that of the radiation considered. Symbol, T_d.
 R. W. G. Hunt

DITHERING
In electronic imaging, the variation in the number of ink dots to represent a tone of gray. Dithering requires that a physical area with a known matrix of dots called a cell be established. For example, a cell may contain an 8×8 matrix. If all 64 locations are filled with ink dots, then the area appears black; if all 64 locations contain nothing, then the area appears white. Varying the number of filled and unfilled cells can give the perception of a tone of gray. Electronically adjacent pixels are turned on or off or are assigned different colors, thus creating the appearance of a tone of gray or another shade or color. *R. Kraus*

DIVERGING LENS
A lens or optical system that spreads an incident parallel beam of light into a divergent emergent beam. A diverging lens forms a virtual image, the focal length is taken as having a negative sign, and the lens is also called a *negative lens*. A lens element of double concave or plano-concave configuration in air or medium of lower refractive index behaves in this way.
 S. Ray

See also: *Lenses.*

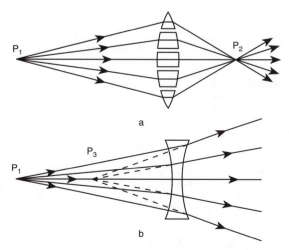

Negative and positive lenses. (a) Simple positive lens considered as a series of prisms; (b) formation of a virtual image of a point object by a negative lens.

D-LOG E CURVE
See *Characteristic curve.*

D-LOG H CURVE
See *Characteristic curve.*

D, M, AND E
Abbreviation for Dialog, Music, and Effects. Usually a monaural master that is intended to be used with the three elements summed 1:1:1 but kept separate in case the primary language or the balance must be changed.
 T. Holman

DOCTOR BLADE
That part of a coating machine that regulates the thickness of a liquid layer being spread on a support. In the printing process, the doctor blade on a printing press removes unwanted ink from the nonimage areas of gravure plates. *G. Haist*

DOCUMENTARY PHOTOGRAPHY
From its inception in 1839, photography was heralded as the epitome of realistic representation, in large part because of its unique ability to show things in literal, objective, and commonly understood visual terms. The medium's unsurpassed power of realistic representation rested on its precision, clarity, sharpness, impartiality, truth to nature, and compelling believability. Photography thus provided evidence of places and events in an accurate and truthful way, the cornerstone of factual documentary reporting.

Although it may be said that any photograph is documentary because it shows what actually occurs in front of the camera, the documentary genre in photography is more specifically based on the premise that the photograph is a transcription of reality that contains fact, evidence, and truth. Documentary photography therefore is expected to alter events as little as possible from reality, i.e., to show what would have occurred or existed had the photographer not been present, and to provide viewers with substantially the same experience as contained in the original event.

The basic form of pictorial documentary representation involves an emphatically unmanipulated approach that underscores the undisputed priority of subject over style. To this end documentary photographers use a wide variety of personal techniques that eschew transparent artistic and pictorial conventions and yet allow the photographer to remain as unobtrusive and candid as possible. Traditional ways of working include clear and direct framing of the subject, an overriding but not obtrusive narrative approach, freedom from pictorial distortion and bias, a clear and impartial display of fact that appeals to the denotative aspects of the medium, use of multiple station points in observation, and the use of the snapshot aesthetic.

Historically, documentary photography is a rich and diverse genre that has always had great popular appeal. From its inception in 1839, documentary photography has helped satisfy curiosity of the unknown by bringing impartial and accurate images of far-away places and events to the viewer. In the process, documentary photography has also created important visual records that provide tangible evidence supported by great visual detail, cast the compelling impression of truth, allow viewers to occupy the position of the photographer, serve as an impartial and faithful witness to life's events, freeze an instant of time so that places and events may be later studied and restudied.

Examples of early documentary photography include French photographer Maxime du Camp and his published views of the ancient Near East done in 1849–1850; the British photographer Roger Fenton and his popular and publicly sold images of the last phases of the Crimean War in 1855; the American Mathew Brady, who in 1861–1865 organized nearly 20 photographers to produce more than 10,000 negatives of the American Civil War; and then, after the

Civil War, photographers such as Carleton Watkins, Timothy O'Sullivan, and William Henry Jackson, who used the unwieldy wet-plate process to document the unexplored Western territories.

SOCIAL DOCUMENTARY PHOTOGRAPHY Social documentary photography uses an approach and style similar to that of pure documentary photography. However, the social document goes further than the simple recording of events and phenomena by highlighting their impact on the human condition. It is for this reason that the social documentary photographer often uses the persuasive power of the medium to influence viewer awareness and understanding and to elicit positive social change.

Social documentary photography also has a rich history. It has been used by such notable individuals and groups as Thomas Annan, in the published album *The Old Closes and Streets of Glasgow,* 1868, documenting the squalid conditions and dehumanizing effects of the slums in Glasgow, Scotland; John Thomson, in *Street Life in London,* 1877, which revealed the daily lives of London's street merchants and lower working class; Jacob Riis, in published books such as *The Children of the Poor,* 1898, and *How the Other Half Lives,* 1890, showing the sordid living conditions of America's urban poor; Lewis Hine and his powerful pictorial critique of the destitution endured by laboring classes and immigrants in early twentieth-century America; the Farm Security Administration, in response to the social and economic devastation wrought by the American Depression in the 1930s; New York's Photo League, in the 1930s to the 1950s, through which Aaron Siskind created *The Harlem Document,* 1938–1940; by the many photographers, such as W. Eugene Smith, David Seymour ("Chim"), and Robert Capa, who published in mass circulation picture magazines such as *Life* and *Look,* which were the main source of the documentary photography essay until the early 1970s; and by socially concerned practitioners such as Werner Bischof, Henri Cartier-Bresson, Dan Weiner, André Kertész, Leonard Freed, Donald McCullin, Gordon Parks, Marc Riboud, Ernst Haas, Bruce Davidson, Larry Burrows, Eddie Adams, Eugene Richards, Sebastiao Salgardo, and Milton Rogovin to name a few.

Today, the documentary approach appears in a multitude of contexts such as art, journalism, magazines, in scientific applications in space and undersea exploration, and in many other applications that require objective, straightforward, and truthful visual documents. *J. Fergus-Jean*

See also: *Candid photography.*

DOCUMENT COPYING See *Office copiers.*

DODGE Refers in darkroom printing to holding back exposure from an area of an image that would otherwise be too dark. By blocking the light with an opaque object (often cardboard cut to a specific shape and fastened to a wire) or, in multiple-light contact printing, by switching off one or more lights, the resultant print shows the area dodged to be lighter than if no action had been taken. Care must be exercised in dodging that the printing exposure time is long enough for careful placement of the dodging tool and for moving it in such a way that the dodging is not obvious in the final print. *J. Johnson*

Syn.: *Hold back.*

DoF See *Depth of field.*

DOISNEAU, ROBERT (1912–) French photographer. An industrial photographer during the 1930s, Doisneau used his skills as a photographer in the Resistance during the Second World War. Following the war he became a freelance photographer, working for *Life, Paris-Vogue,* and other periodicals. Doisneau is a gifted Parisian street photographer whose photographs show humanity with sweetness and humor.

Books: *Three Seconds from Eternity.* Boston: New York Graphic Society, 1980. *M. Alinder*

DOLBY A set of technologies introduced by Dolby Laboratories with applications in professional and consumer audio. In the area of reducing noise and improving the match of program material to the capabilities of analog sound systems, Dolby has introduced a number of systems labeled with letters having various applications:

A-type The first professional system using four frequency bands and a minimum processing of high-level signals, introduced in 1965.

B-type The first consumer system applied to compact cassette recordings for reducing noise using one sliding frequency band. It is the most widely used.

C-type The second consumer system used on compact cassettes employing two sliding frequency bands and other improvements in audio quality.

D-type The most recent addition to consumer noise reduction systems typically for use on compact cassettes, based on the principles used in Dolby's professional SR system.

SR (Spectral Recording) A professional signal processing system with noise reduction and other enhancements to recording, employed on open reel professional recording tape among other uses, introduced in 19876.

In addition, Dolby HX Pro is a system for dynamic bias for extending the high-frequency headroom for recordings on the compact cassette medium.

Dolby stereo and *Dolby surround* are terms applied to the use of amplitude and phase matrix encoding of four channels of information into the two tracks available on motion-picture film and various consumer media, with subsequent decoding in the theater or home to left, center, right, and surround channels. *T. Holman*

DOLLY A camera support mounted on wheels so that the camera can be moved more easily during shooting with motion-picture and video cameras and between shots with still cameras. A simple dolly may consist only of a set of three wheels in a triangular bracket to be used under a tripod. A professional motion-picture dolly may be a four-wheel vehicle that is large enough to accommodate a camera operator and an assistant in addition to a large camera. *L. Stroebel*

See also: *Crab dolly.*

DOLLY TRACKS Tracks or flat boards laid down to ensure the smooth movement of a motion-picture camera and operator on a dolly. *H. Lester*

DOMINANT EYE The eye that tends to determine the perception when images formed by both eyes fail to fuse. With prolonged viewing under such conditions, the perception may fluctuate from one eye to the other, a process known as retinal rivalry. *L. Stroebel and R. Zakia*

See also: *Retinal rivalary; Vision, binocular vision.*

DOMINANT WAVELENGTH Wavelength of the monochromatic stimulus that, when additively mixed in suitable proportion with the specified achromatic stimulus, matches the color stimulus considered. Symbol, λ_d. *R. W. G. Hunt*

See also: *Colorimetry.*

DOPE (FILM-BASE) Film base in liquid form before removal of solvents in the manufacturing process. Usually cellulose triacetate and plasticizers dissolved in a mixture of organic solvents to the consistency of a syrup. *M. Scott*

DOPE, RETOUCHING Retouching *dope, fluid,* or *lacquer,* is a commercially available *medium* in a spirit or essential oil solvent, which when applied to the surface of a negative imparts a "tooth" that accepts pencil retouching. A drop or so of the fluid is applied to the surface of the negative and rubbed with a tuft of cotton until dry. Most negative materials are manufactured with surfaces intended to accept retouching, but in some cases additional treatment is needed. The fluid can also be used to remove retouching marks if the first results are not correct. *I. Current*

DOPING (SEMICONDUCTORS) The addition of very small amounts of impurity to very pure semiconductor material, such as silicon or germanium, to change its electrical characteristics. The number of valence electrons of the impurity determines whether the semiconductor becomes a *p*-type or an *n*-type semiconductor. *W. Klein*

DOPPLER EFFECT (SOUND) The effect on frequency caused by the source or the receiver of sound moving, familiar from the pitch drop of a train whistle as it passes an observer. The Doppler effect is put to good advantage during postproduction of motion pictures by using a digital pitch shifter to simulate objects in motion.
 T. Holman

DOSIMETRY The use of photographic material to monitor exposure to ionizing radiation (e.g., gamma rays, x-rays). Subjects to be monitored wear a light-tight badge containing a piece of film sensitive to the radiation to be monitored. In order to deduce the type of radiation as well as the quantity, several types of metallic foils are placed above the film. Interpretation is based on the resultant density of each area of the developed badge and the relative spectral transmission characteristics of each foil type. Precise calibration of each emulsion batch to the different types of radiation is critical.

Analogous methods can be used to monitor exposure to electrons and neutrons by using indirect exposure techniques. Again, careful calibration is required to allow type and quantity of radiation to be determined. *J. Pelz*

DOT The individual element of a halftone. *M. Bruno*

DOT ETCHING A means of color correcting printing color separations. *M. Bruno*
See also: *Photomechanical and electronic reproduction.*

DOT FRINGE A small area of fog around the perimeter of a dot that can cause variable dot size according to the amount of exposure. *M. Bruno*
Syn. *Halo; Soft dot.*

DOT GAIN A printing defect in which dots print larger than they show—called mechanical or physical dot gain. Optical dot gain is caused by light absorption in the paper between the dots. Most noticeable in middletone areas.
 M. Bruno

DOT MATRIX PRINTER A printing device that uses pins to strike an inked ribbon against the paper to imprint a character. The characters are composed of tiny dots created by small pins mounted in the print head. The greater the number of points the finer the characters printed. Twenty-four pin dot matrix printers offer the highest, smoothest looking quality characters. These are often referred to as NLQ (near letter quality) printers. *R. Kraus*

DOTS PER INCH (DPI) A unit of measure of the resolution capability of an input device such as a scanner or an output device such as a laser printer. *R. Kraus*

DOUBLE BLACK PRINTING A means of extending the tone scale of a black-and-white reproduction by printing two black images, one with a normal scale and the other with a short scale from middletones to shadows to extend the density range and detail in the shadow areas. *M. Bruno*

DOUBLE-COATED In camera negative films, describes the coating of two emulsions on one side of general-purpose films, usually a fast component over a slower one, to extend tonal range and exposure latitude. Since this is now the usual practice, it does not often serve to differentiate one film from another. Seldom used.

In x-ray films, describes the coating of emulsion on both sides of the base, allowing extremely high amounts of silver halide to be carried. Putting such a large amount on one side would lead to coating and processing problems and to excessive curl. High silver content is necessary for efficient capture of x-ray energy.

In graphic arts films, describes films with two emulsions on one side of the base offering special scope for contrast control.

Not to be confused with bipack films (which see) at one time used for color motion picture photography. *M. Scott*
Syn.: *Duplitized.*
See also: *Duplitized film.*

DOUBLE DECOMPOSITION *Double replacement* and *metathesis* are other names for this reaction in which two reactive compounds interchange their negative ions. In order for the reaction to complete, one of the products must be a precipitate, a gas, or not an ionic compound. For example, during emulsion making, silver nitrate reacts with potassium bromide to form precipitated silver bromide crystals in gelain solution: $AgNO_3 + KBr \rightarrow AgBr \downarrow + KNO_3$. This double decomposition or replacement reaction completes, that is, removes all the silver ions to make silver bromide.
 G. Haist

DOUBLE EXPOSURE The recording of two superimposed images on the same piece of photosensitive material, either intentionally or by accident. Most 35-mm single-lens reflex cameras are designed to advance the film as the shutter is cocked to prevent accidental double exposures. With some such cameras the film advance can be deactivated with a separate control when double exposures are desired.
 J. Johnson

DOUBLE-EXTENSION A view camera or other bellows camera that allows the lens to be placed at a distance equal to two times the focal length of the (normal) lens from the film plane. The system allows for scales of reproduction up to 1:1. *P. Schranz*
See also: *Triple-extension bellows.*

DOUBLE-FRAME A still camera format that is referenced to a motion-picture standard. The image size of a motion-picture frame on 35-mm film is 18×24 mm. This is referred to as a single-frame. While the outside dimensions of 35-mm film are the same for still and motion cameras, still cameras usually have a format of 24×36 mm, which is twice the size of the motion-picture frame. Over the years, the double frame has become so accepted by still photographers using 35-mm film that the smaller 18×24 mm still-camera format is frequently referred to as a half-frame camera.
 P. Schranz

DOUBLE JET A method of formation of silver halide crystals for a photographic emulsion that consists of adding a solution of silver nitrate from one stream or jet and a solution of a halide compound from another jet into a stirred

gelatin solution. Many factors or variations in technique influence the nature of the crystals precipitated, such as rate of addition, the presence of excess halide, temperature and stirring variations, and the presence of other addenda.

G. Haist

DOUBLE SPREAD A reproduction of a photograph that is printed across two facing pages in a book or magazine.

M. Teres

DOUBLE SYSTEM The standard motion-picture production technique of handling sound and picture separately. While the film is exposed in the camera, the sound is recorded on a separate synchronized magnetic tape. Editing is also accomplished with sound and picture on separate strips of film. When all creative work is complete, release prints are made, finally combining sound and picture onto single film prints.

H. Lester

See also: *Single system.*

DOUBLE-WEIGHT (DW) Photographic printing paper thicker than medium-weight, single-weight, and lightweight papers, but thinner than premium weight. Paper thickness standards vary among manufacturers.

M. Scott

DOUBLY DIFFUSE DENSITY The result of the measurement of the absorption of light by a negative illuminated with scattered (diffused) light when all the transmitted light—direct and scattered—is recorded. Such a method usefully predicts the printing behavior of a negative in a contact printer, but no commercially available densitometer measures negatives in this manner.

M. Leary and H. Todd

See also: *Densitometry; Diffuse density; Specular density.*

Double-frame format (bottom).

DOWSER A shutter that is used to block the light path in a projector or film printer.

L. Stroebel

DRAW A computer function of many software art programs that allows one to literally draw in a freehand fashion using a mouse or other pointing device as one would use a pen. Draw programs will save its drawing in either vector or raster formats.

R. Kraus

DRIFFIELD, VERO CHARLES (1848–1915) English chemist. With Ferdinand Hurter, originated the study of sensitometry. In 1890, together they charted the H&D curve that traces the relationship between exposure and photographic

density, determining the speed, or sensitivity, of the emulsion and enabling the computation of correct exposure times.

M. Alinder

DROP BED A feature on some press and technical flatbed cameras whereby the hinged front part of the bed can be lowered beyond the normal horizontal position for the purpose of placing the lens in a lower position than can be obtained with the rising-falling front or to avoid intrusion into the angle of view of a wide-angle lens.

L. Stroebel

Drop bed.

DROP-IN LOADING A system that allows film or tape to be inserted in a compatible camera or other device so that it is ready for operation without threading or other manipulation.

L. Stroebel

DROPOUT (1) In printing, the loss of highlight dots or the elimination of highlight dots in halftone negatives using a supplementary exposure that results in highlights printing white without dots. (2) A momentary loss of signal, usually applied to audio or video signals recovered from a medium or transmission path. The signal loss may not be complete but may result only in a change in level.

M. Bruno and T. Holman

DROP SHADOW A graphic effect that attempts to suggest a three-dimensional quality to a image by placing a shadow (gray or subdued tone) under and offset to either the left or right of the object or characters displayed.

R. Kraus

DRTIKOL, FRANTISEK (1883–1961) Czechoslovakian photographer. Established photographic studio in Prague (1910) that he operated for 25 years. Early in the century, became his country's most famous photographer, known for soft-focus portraits. Later changed his style (1917) to reflect his commitment to the Art Deco movement, choosing the nude as his primary subject. His images were often concerned with the effect of shadow and light upon the model, often pushing the tonal values to extremes for abstract effect. Drtikol's work influenced the artists of the Bauhaus to explore photography. He quit photography in 1935, devoting himself to philosophical studies and painting.

Books: Farova, Anna, *Frantisek Drtikol*. Germany: Schirmer/Mosel, 1986.

M. Alinder

DRUM (AKA IMPEDANCE DRUM, INERTIAL ROLLER) A cylindrical rotating element in the path of a film or tape transport having substantial mass. The tape or film wraps around the element whose inertia helps to reduce

speed variations and thus improve wow and flutter performance. In the Davis loop drive design used on many film sound transports, the tape path through the head assembly is immediately preceded and followed by such drums.

T. Holman

DRUM CAMERA See *Camera types.*

DRUM PROCESSOR A device containing a rotating cylinder used for processing exposed photosensitive materials. With one type, the sensitized material and a small quantity of processing solution are placed inside the drum. The solution remains on the bottom and the sensitized material rotates through it. With another type, the sensitized material is attached to the outside of the drum, the bottom of which rotates through a shallow tray of processing solution.

L. Stroebel and R. Zakia

See also: *Agitation.*

DRUM SCANNER (1) An input scanner that produces spiral scanning patterns by rotating the original on a drum as the light source and sensor assembly moves horizontally. (2) A specific type of scanner that converts photographic images, reflection or transparency, to electronic signals. Unlike flatbed scanners, drum scanning systems contain a second drum that takes the electronic output of the first drum and produces color separations. Drum scanners are the nexus of prepress color separation activities. *L. Stroebel and R. Kraus*

See also: (1) *Flatbed scanner; Scanner.*

DRYING The final step of film or print processing is drying. Careful handling during this step will prevent any last-minute defects that can damage the work. With film or paper, a complete washing of the material must be performed just before drying. Drying should commence immediately; it is important to not prolong the wet time beyond what is required. This is especially true with resin-coated papers, as they will begin to swell and separate if overwashed. The use of excessive heat when drying any photographic material is not recommended because of the potential for cracking the emulsion.

Just before drying, film should be treated with a wetting agent such as Kodak Photo-Flo to prevent water spots. Water spots or streaks can cause uneven density that may be impossible to remove once dry. If a wetting agent is not used, the film must be gently wiped with a photo chamois or soft rubber squeegee. Extreme care must be used to prevent scratching the emulsion.

Film can be hung from a line in the darkroom or can be dried in a heated drying cabinet. In either case, a dust-free environment is essential. A weighted clip must be attached to the bottom of roll film to prevent curling. Sheet film is hung from one corner with a clothes pin or clip. Wooden clothes pins are recommended; they grip film better than plastic and are less likely than metal to damage the emulsion. Drying cabinets provide a faster and more controlled alternative to line drying. Heated air is forced through the cabinet with a small fan. The air can be filtered, preventing any dust from sticking to the film. Larger drying cabinets can be configured to hold several rolls of film and/or multiple sheets.

Print drying can be accomplished in several ways, depending on the type of paper and the surface finish desired. Resin-coated paper can be hung on a line, laid on racks, or run through an RC print dryer. Before drying, RC prints must be squeegeed on both sides to remove surface water. To line dry RC prints, one should hang them from one corner in the same fashion as sheet film. Drying racks made of nylon screen stretched across a frame are an alternative to line drying. RC prints should be placed face-up on the screens. Depending on temperature and relative humidity, these two

methods will result in a drying time of several minutes to an hour. Heated RC print driers will provide drying times of one to two minutes. These driers first press the print through rubber rollers, removing all surface water. A series of alternating racks or rollers will then move the prints through a stream of heated air. Regardless of the method used, RC prints will normally lie flat because of the dimensional stability of the material.

Fiber-based prints are generally air dried on screens or in heated print driers. To screen dry, excess water is squeegeed off and the prints are laid face-down on the screen. Depending on the weight of the paper, a certain amount of curling will occur. This method of drying is preferred for maximum archival stability, because the screens are easily cleaned and provide less chance of contamination.

Heated fiber-based driers are available in two configurations: flat-bed and rotary. Flat-bed driers consist of a heated, polished metal surface with a cloth apron that holds the prints in place. Rotary driers use a motorized, polished, circular drum with a continuous apron. Glossy or matt surface papers can be dried in both types. Glossy prints are soaked in a flattening/glossing solution and are then placed facing the metal surface. This solution helps reduce curl and produces a high gloss finish on the print. Matt-surface prints should be placed facing the cloth apron. Lower heat settings will reduce the amount of curl. *G. Barnett*

DRYING MARKS Marks left on the surface of film or paper as a result of uneven drying. The marks take the form of patches of plus, or more commonly, minus density. Drying marks can be prevented by adding a wetting agent to the final rinse or by carefully sponging all the water drops from the surface of the film or paper. *L. Stroebel and R. Zakia*

See also: *Drying.*

DRY-MOUNT ADHESIVES (COLD)

Sealeze Optimount—UV An optically clear, two-sided mounting adhesive designed for mounting photographic transparencies and other materials to clear, milky, or smoked acrylics and plastics. This material has built-in inhibitors for protection against the harmful effects of fluorescent light and ultraviolet radiation.

Sealeze Printmount An acid-free, two-sided, adhesive-coated film available for the general mounting of photographs onto foam boards, paper mount-board, wood, and plastic. It is applied with a roller laminator. It has a protective release liner on either one or both sides for easy handling.

Sealeze Printmount Ultra A surface smoothing, mounting adhesive designed for high-gloss photographs and laminates. The adhesive masks surface imperfections and irregularities of substrates such as plywood.

Sealeze Printmount USA An unsupported pressure-sensitive, self-trimming adhesive, designed for mounting a wide range of materials to most surfaces, including aluminum and plastic. *M. Teres*

DRY MOUNTING A process of attaching a photograph to mount board or other substrate using a sheet of dry-mount tissue or dry-mounting adhesive. The dry-mount tissue can be a thin glassine tissue coated on both sides with shellac or a similar permanent adhesive, or it can be a self trimming heat-activated adhesive sheet, or a sheet of porous tissue coated with a thermal adhesive that may or may not be heat activated. The purpose of mounting the photograph is to protect it, to keep it flat, and to display it. The mounted photograph and mount board can then be further protected or enhanced by window matting and framing.

Cold pressure-sensitive mounting adhesives may require a combination or cold mounting press to help strip a protective backing from the adhesive material while the adhesive

material is being attached to the back of the photograph and pressed against the substrate.

Heat-activated dry-mount tissues or dry-mounting adhesives require a dry-mount or combination press that applies heat and pressure to the photograph and the mount board during the mounting process. The heat-activated dry-mount materials are placed into either a vacuum or mechanical thermostatically controlled dry-mount press. The shellac type of dry-mount tissue melts at temperatures in the 185–225°F range, which is appropriate for fiber-based papers. Other dry-mounting adhesives are designed for use with color and resin-coated papers; these tissues have lower melting temperatures so there is less chance of damaging the print because the dry-mount press is too hot.

The mounting adhesive melts and is absorbed into the back of the print and into the surface of the mount board. As the adhesive cools (under weight or pressure) the bond sets. Some dry-mount adhesives can be reheated so that the print can be removed from the mount board; some mounting materials are permanent bonds and cannot be reversed.

The process of attaching the print to a mount board with dry-mount tissue is a simple one, but it is necessary to use a dry-mount press. First, preheat the print and the mount board, separately, to drive out any moisture. Then tack the dry-mount tissue to the back of the print with a tacking iron. The photograph and the dry-mount tissue are trimmed after they are tacked together so the dry-mount tissue and the photograph to which it is attached are the exact same size. It is important to maintain square edges and corners when preparing the print or it will appear crooked on the mount board.

After the print and mounting material are trimmed, the dry-mounting tissue (or mounting adhesive) is tacked down at each of the tissue's corners to the mount board surface with a tacking iron. (To prevent melting a hole through a sheet of the nontissue-type solid adhesive mounting material, a Teflon- or silicone-treated release paper should be used between the tacking iron and the adhesive surface.) Since the tissue is not tacked down to the print at the corners, they are free to expand over the dry-mount tissue when the two are heated together in the dry-mount press. This is done to ensure that the print will cover the tissue and that the tissue will not extend beyond the edges of the print during and after the mounting process.

The placement of the print and tissue on the mount board is determined by the mounting style selected: flush mount, border mount, or over-matted. For a flush or bleed mount, the print is mounted to the mount board and the two are trimmed square to the desired finished size. With hardboard or other hard surfaced mounting material, the board is first trimmed square to the finished size of the print. Then the print is mounted to the hardboard surface, and any over-hanging print area is trimmed off with a mat knife. The cut edges of the print and mount board can be finished off and sealed with tape or paint.

The bordered print can be positioned in several ways. Center-finding rulers and T-squares help align the print to the mount board; some of these devices even build a signature space into the lower portion of the mount. Another technique is to visually align the print on the mount board and make the final adjustments with a ruler to ensure squareness. Mea-

Dry mounting. Tacking down the dry-mounting tissue.

suring down from the mount board edge with a ruler and marking the mount board with a pencil dot at two points, which will be used to line up the corners of the print, will also provide correct print positioning.

The window mat mounting technique can be done in two ways. The reveal-matted method requires that the window opening is cut larger than the print size so that when the mat is placed over the mounted print, a small amount of the mount board around the print shows through the window opening. This method needs to be much more accurate than the overlap window method since the area around the print will accentuate any off-squareness.

For the overlap window method, it may be more convenient to tack the dry-mount tissue to the back of the print and trim the print to size first. Then position the print on the mount board to determine how much overlap is needed to just barely cover the edges of the print. Use a scribing tool, mark the mat board, and then cut the window mat opening using exactly the same size board as the print is mounted on. Position the print with the dry-mount tissue attached, so that it is positioned under the window opening with the *correct* amount of overlap. Then, carefully remove the window mat and tack the dry-mount tissue to the mount board and place the print into the dry-mount press for the required length of time. Remove and cool the print and attach the window mat with linen tape to the mount board.

Whichever method is used, after tacking the four corners of the dry-mount tissue (with the print tacked to it in the center) to the mounting surface, cover the face of the print with a sheet of Teflon or silicone release paper or a sheet of kraft paper. Then place the print and mount board into a hot dry-mounting press. Close the press for the desired length of time, approximately 10–15 seconds. The time that the print and mount board should remain in the press will depend upon the kind of dry-mounting adhesive used, the size of the print, the thickness of the mount board, and the temperature of the mounting press.

The mounted print is removed from the dry-mount press and immediately placed under some weight and allowed to cool; after it has cooled for a few minutes, the mounted print should be flexed (assuming that the mount board is a non-rigid board). If the print has not adhered properly to the mount board, it will pop and begin to separate. Should this happen, to properly readhere the print to the mount board place the *mounted print* back into the hot press and repeat the process, increasing the time in the press.

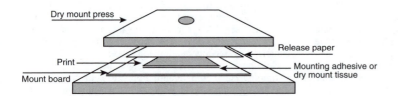

Mounting a print.

The type of mounting materials used will determine the degree of archival permanence of the photograph. Acid-free archival boards and archival dry-mount adhesives will provide the greatest print permanence. In general, dry-mounting adhesives will help protect the back of the print from chemical substances in the mount board.

Cold-mount adhesives require only pressure to attach the photographs to mount boards and other substrates. Although a hand burnisher will be useful in mounting small prints, a roller cold-mount press is highly desirable for larger-sized prints. Some cold-mount tissues are easily removable; some are designed to be repositionable for short periods of time, but most cold-mount adhesives bond permanently. It is important to know the tissue characteristics before the process begins. Some color prints should not be heat mounted, in which case cold-mount adhesives are the only choice. *M. Teres*

See also: *Tacking iron.*

DRY-MOUNT TISSUES/ADHESIVES (HOT) Dry-mount tissues and adhesives are available in sheets or rolls. Pre-coated mount and foam-core boards are also available. The tissues/adhesives are formulated for a variety of purposes. Depending on the type of print and the kind of substrate the photograph will be mounted on, there are several products to choose from, each having different characteristics:

Archivalmount Plus An archival quality dry-mounting tissue made from acid-free tissue coated on both sides with an acid-free adhesive. The tissue core is buffered to prevent an acid in the substrate from migrating to the photograph. This tissue is removable.

Canvasmount A high-density canvas woven mounting material available for attaching photographic emulsions that have been stripped from the photographic paper base to a canvas mounting fabric in order to impart the surface texture of the canvas to that print. The print then can be stretched on canvas stretcher frames and hung as a painting, or the photograph may be rolled up, emulsion side out, and transported, and unrolled as a temporary display, for example, at a trade show, lecture, or exhibition.

Chartex A white cotton fabric, coated with a low-temperature adhesive backing used to reinforce artworks. The fabric provides the added strength of cotton fiber to help support delicate artwork. This low-temperature adhesive backing can be removed when reheated.

Colormount A low-temperature, permanent dry-mounting porous tissue for color, RC photographs, and slick nonporous surfaces.

ColorMount Board A pre-coated mounting board convenient for mounting photographs quickly and easily. The mounting board has a low-temperature adhesive coating on one side. To mount with the pre-coated board, place a piece of release paper over the print surface and tack the print to the mounting surface with a tacking iron. Cover the print and mount board with several layers of release paper or a single release board, and place the mount board and print in the dry-mount press. This process is reversible.

Fotoflat A removable dry-mounting tissue developed for delicate and heat-sensitive materials. It is a glassine-cored tissue with a very low melting temperature (150°F). This dry-mount tissue is for general mounting and perfect for textured materials. It is removable.

Fusion 4000 Plus & Fusion Ultra A general-purpose dry-mounting adhesive for use with most materials including fabrics and other textured surfaces. The adhesive is solid and acid-free and melts completely when heated to 170°F. The bonding takes place as the adhesive cools. This liquefaction allows the adhesive to be pieced together, overlapped, and

self trimmed around irregularly cut photographs. This material is removable when reheated. This low-temperature adhesive is available in an opaque white version that allows the mounting of thin or translucent artworks. Because it is a solid adhesive film, this product must be treated differently than other dry-mounting materials. Do not touch this adhesive sheet directly with a tacking iron, as it will melt. Insert a piece of Teflon- or silicone-treated paper (Seal Release Paper) between the tacking iron and the adhesive sheet before attaching the adhesive to the back of a photograph or when attaching the adhesive to the mount board.

For self-trim mounting with this adhesive use the following procedure: Warm the press to 210°F (be careful—RC papers can melt at slightly higher temperatures). Place the photograph face down on kraft paper, and cover the photograph with a piece of the adhesive mounting material so that the adhesive extends slightly beyond the edges of the print. Place the kraft paper, adhesive, and the photograph between two pieces of release paper. Then place the entire sandwich into the dry-mount press. Close the press for 30 to 60 seconds. Open the press. Before the materials have a chance to cool, separate the top sheet of release paper from the kraft paper. The print will cling to the other piece of release paper; let it cool. The excess adhesive will be fused to the kraft paper. After the print cools, remove it from the release paper by lifting the print at an edge and peeling it away from the release paper. The adhesive is now self-trimmed and attached to the back of the print, and the print is ready for mounting.

MT5 A permanent thin glassine tissue coated on both sides with an adhesive that bonds as it heats up. This dry-mounting tissue is formulated for porous paper surfaces and is not recommended for smooth surfaces such as RC photographic papers and plastics.

Multimount An all-purpose dry-mounting tissue that is coated on both sides with a multitemperature adhesive that bonds as it cools. The wide range of usable temperatures (165–225°F) make this material useful for all kinds of artworks. This material can be reheated to remove and remount the print. *M. Teres*

DRY PROCESS In photography, a dry process is one that requires no water in any of its steps. Electrophotography copiers and laser printers are dry, as are diazonium salt, or diazo, processes. Several photothermographic processes are dry as well. Printing-out-paper (POP) produces an image by exposure alone, but the image is not permanent. No dry silver halide imaging process has been devised. *H. Wallach*

DRY-TO-DRY (1) Identifying a processor that automatically wet-processes exposed photographic material, including the removal of water. (2) Indicating a complete processing cycle with any of various wet processes, as, for example, in dry-to-dry time. *L. Stroebel and R. Zakia*

DUBBER A playback-equipped only motion-picture film transport designed to play various sound track formats as required. *T. Holman*

Syn.: *Dummy.*

DUBBING The process of rerecording sound tracks from the elements or units cut by sound editors to, first, *premixes* such as dialog, or *Foley* representing a particular kind of sound. Subsequently, a final mix is prepared by combining the various premixes to make the stems. Then the stems are used in preparation of the various print masters needed for all the release media. Dubbing uses a wide variety of processes, including equalization, filtering, dynamic range control such as expansion and limiting, noise-reduction devices such as

the CAT. 43, reverberation, pitch shifting, panning, and many others to produce a desired mix from the individual elements. *T. Holman*

See also: *Element; Foley; Premix; Print master; Stems.*

DUCOS DU HAURON, LOUIS (1837–1920)
French scientist, pioneer of color photography. In *Les Couleurs en Photographie* (1869), described a three-color photographic process and formulated the principles of the additive and most of the subtractive methods of color reproduction. His research provided much of the foundation of color theory.
M. Alinder

DUFAYCOLOR
Reversal positive mosaic additive system using a film support on which a geometrical three-color (red, green, blue) mosaic had been produced by a mechanical printing process (L. Dufay 1910). *M. Scott*

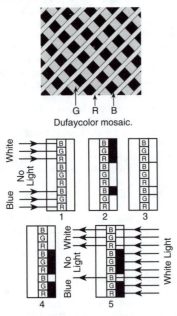

Dufaycolor mosaic.

Dufaycolor. (1) Light from subject passes through mosaic elements to panchromatic emulsion; (2) developer to negative; (3) silver image dissolved away; (4) reversal positive image which is viewed by transmitted light (S).

DULLING SPRAY
A liquid sprayed on polished metal and other glossy surfaces that dries to a matt finish and diffuses reflections from those surfaces. Commercially available dulling spray does not harden as it dries and is easily removable from most surfaces, but smears easily. Matt varnish produces a similar effect and is more easily handled, but permanent. *F. Hunter and P. Fuqua*

DUMMY
See *Dubber.*

DUOTONE
A halftone with a second accenting color made from one photograph. *M. Bruno*

DUPE NEGATIVE
A motion-picture duplicate negative made by printing from the original negative rolls, followed by reversal development, or printing with conventional development from a fine grain positive previously printed from the original negative. *H. Lester*

Syn.: *Dupe.*

DUPLEX
(1) Identifying a motion-picture photographic sound track having two symmetrical variable-area records. (2) A microfilm recording system whereby both sides of documents are recorded side-by-side on the film. (3) A method of using an incident-light exposure meter whereby an average of two readings is used, one with the meter aimed at the main light source and the other with it aimed at the camera. *L. Stroebel*

DUPLEX EXPOSURE SYSTEM
(1) A system of simultaneously recording microfilm images of opposite sides of a document, side by side on a roll of film. Compare with simplex. (2) A system of taking two incident-light exposure-meter readings with backlighted subjects, aiming the meter directly at the main light for one and at the camera for the other, and exposing for a value midway between the two. *J. Johnson*

See also: *Exposure; Exposure meters.*

DUPLICATE/DUPLICATING
Strictly speaking, the term duplicating refers to the processes by which color transparencies are replicated, including changes in size, density, and color balance. Dupes are duplicate color transparencies. Duplicating, however, is also understood to mean making copies to and from negative stock. Duplicates are made to keep originals out of harm's way, whether from dirt or scratching, the heat of projection, or loss in transit. Before the restoration of an original is attempted, a duplicate is always made as a precaution, and sometimes it is the duplicate that is then modified.

Black-and-white negatives are duplicated on black-and-white direct duplicating films such as Kodak Rapid Process Copy Film 2064 (35 mm), or Professional B/W Duplicating Film 4168 (sheets). These slow, orthochromatic, direct reversal materials are exposed by contact, in a camera, or by projection. They are designed for direct negative duplication of black-and-white negatives, and process conventionally, not by reversal. Contrast is controlled by development time.

A duplicate black-and-white negative may also be made by first creating an interpositive (or diapositive) on films such as Kodak Super XX Pan 4142, Commercial Film 4127, or Commercial Film 6127. A wide range of corrections, such as dodging, burning, retouching, and intensification, in addition to exposure and development controls, can be applied to the interpositive. The same film stock that was used in the first step is used to make the duplicate negative.

The interpositive technique is also useful in making black-and-white negatives from color negatives. If the interpositive is made on Kodak Separation Negative Film 4131, Type 1, the black-and-white negative is made on Technical Pan 2415; if the interpositive is made on Ektapan Film 4162, the black-and-white negative is made on Kodak Commercial Film 4127.

A variety of medium speed films, in addition to Super XX and Tech Pan, may be used to make black-and-white negatives from color transparencies.

Color negatives can be duplicated by printing on color reversal duplicating film. Correct color balance is determined with a densitometer using the density-difference or curve-plotting method. If contrast reduction is necessary, a neutral density, unsharp mask can be made and sandwiched with the original during printing.

Positive black-and-white transparencies can be made from black-and-white negatives with Kodak Translite 5561 (sheets, wide rolls), Eastman Fine Grain Release Positive Film 5302 (35 mm) and Kodak Fine Grain Release Positive Film 7302 (sheets), orthochromatic films that are exposed and processed like photographic paper. *H. Wallach*

See also: *Color duplicating; Copying.*

DUPLICATING FILM In still photography, a film designed to make an accurate copy of an existing negative or positive. Duplicate negatives are used to protect valuable original negatives when many prints are needed. Nitrate negatives in danger of deterioration and other archives in need of preservation are often duplicated. Duplicating collections of glass plates saves space and weight. Duplicating films are often special emulsions that give a positive from a positive or a negative from a negative in one step with only conventional processing. Alternatively, they may be regular emulsions used in a reversal process. In either case, a resultant gamma of minus one is needed to maintain the density range and contrast of the original unchanged. Color duplicating films are unlike regular transparency films in that they have spectral sensitivities tuned to the spectral transmittances of the dye set in the films they will be copying. They, too, have an effective gamma of minus one. *M. Scott*

DUPLITIZED FILM Film coated with emulsion on both sides of the support, such as x-ray film. Duplitized 35-mm positive film was used in early two-color subtractive motion-picture processes in which the front and back were toned in different colors. *M. Scott*

DU PONT Du Pont's participation in the photographic industry can be traced back to its work in the field of cellulose chemistry in the mid-nineteenth century. Cellulose nitrate, an extremely flammable material, was the key to diversification from the original Du Pont product—gunpowder. From it came lacquers, fabric coatings, rayon, and a clear, flexible film that proved suitable as a base on which to coat photographic emulsions. Motion picture film was chosen as the first application, and work began in 1912 to develop the film base. Finding a limited market for nitrocellulose solution, the company hired experts in 1915 to explore the manufacture of photographic film base and light-sensitive emulsions to go on it. Plans to build an experimental plant for motion-picture film manufacture at Parlin, New Jersey, were announced in 1919, and the first sensitized Du Pont photographic film was produced a year later.

In 1924 a joint venture with Pathé Cinema Societe Anonyme de Paris was formed, providing an immediate outlet for Du Pont's product. By 1931 Du Pont acquired Pathe's interest and established the Photo Products department in Parlin. In 1927 Photo Products introduced a high-speed, fine-grain panchromatic film that won immediate endorsement among professional motion-picture cameramen as the highest quality fast film available. Du Pont later won an Academy Award from the National Academy of Motion Picture Arts and Sciences for this product.

Photo Products expanded rapidly into x-ray film with a unique blue base that enhanced the diagnostic clarity of radiographs (1932). It entered the graphic arts market (1935) with Photolith film, precursor of a broad range of films and printing plates that began the printing industry's change from letterpress to offset reproduction. By 1945 Photo Products reached $10 million in annual sales, half in x-ray film and screens (the Patterson Screen Company, Towanda, Pennsylvania, was acquired in 1943). In 1945 Du Pont acquired the Defender Photo Supply Company of Rochester, New York, a manufacturer of printing papers.

After the Second World War, research for an improved photographic film base commenced based on Du Pont polyester technology. This led to the introduction of Cronar polyester film base in 1955 to replace the standard acetate base. Researchers at the Experimental Station demonstrated the application of photopolymerization for imaging in 1949 with the demonstration that a liquid polymer could be hardened into a plastic printing surface by ultraviolet exposure. This resulted in the introduction of Dycril photopolymer printing plates for the commercial printing market in 1957.

Throughout its rapid growth, Photo Products had concentrated on specific market areas and product lines in which Du Pont's traditional technical skills and competence could make the greatest contribution. But the competition from companies supported by income from a growing amateur photographic market was a threat to Photo Products' offerings, which were limited to the industrial market. In 1955 research expenditure was doubled and a fledgling amateur color film program was picked up from the corporate Chemical Department. A partnership with Bell and Howell to commercialize amateur color film was terminated unsuccessfully in 1965. In 1962 the acquisition of Adox Fotowerke in Neu Isenberg, Germany, was completed. Adox was a supplier of color and black-and-white photographic materials for the amateur and professional markets; over a period of years these products were replaced by graphic arts and x-ray films for the European market. Out of the increased research effort in the late 1950s came a steady stream of new products, including chromium dioxide magnetic material and Crolyn high-fidelity audio and video magnetic tapes (1967). From continuing advances in photopolymer technology came Riston, a dry film photopolymer resist film for printed-circuit manufacture (1968). Du Pont then pioneered the development of photographic (phototooling) films specifically designed to expose these resists. By 1970 Photo Products sales reached $200 million, resuscitated by polyester-based graphic arts and x-ray films.

Around 1970 Photo Products added the Instrument Products Division, maker of analytical, process control, and medical instrumentation, and the Electrochemicals Products Division, maker of precious metals and glass powder for microcircuits. With the acquisition of Berg Electronics (connectors), the Ivan Sorvall Company (centrifuges) and the analytical operations of Bell and Howell in the early 1970s, Photo Products was becoming too broadly based in the marketplace, and the Biomedical Department was split off in 1978. Again in 1983 it split into Photosystems and Electronic Products and the Medical Products Departments.

Important contributions to the printing and publishing industry continued to result from photopolymer technology with Cromalin custom color proofing films in 1972, Cyrel flexographic plates in 1973, and Cromacheck peel-apart color proofing films in 1984. Rapid access film processing chemistry for graphic arts was introduced in the early 1970s followed by Bright Light films in 1977 and X-Stat films in 1987. In 1986 Photosystems and Electronic Products split into Electronics and Imaging Systems Departments in order to better serve the needs of those rapidly expanding markets.

In the late 1980s, Imaging Systems began to organize its activities to address the growing impact of electronics on the printing and diagnostic imaging businesses. The formation of a separate Electronic Imaging business division and joint ventures with Xerox (for digital proofing equipment) and Fuji (for electronic prepress) were announced. There followed the acquisition of Howson Algraphy (printing plates), Imagitex (monochrome electronic image scanners), Camex (newspaper electronic systems), and, together with Fuji, Crosfield (color electronic prepress systems).

The development of photopolymer technology continued with new product and system developments to meet growing market needs in optical elements (Omnidex dry processing photopolymer holographic films in 1990) and stereolithography (SOMOS high performance liquids in 1991).

Today, Du Pont Imaging Systems serves the needs of printing and publishing, diagnostic imaging, and industrial photographic businesses (including architectural and engineering, nondestructive testing and specialty papers) with silver halide and photopolymer films, chemical processors and electronic

imaging systems all over the world. Throughout 80 years of contribution to the photographic industry, Du Pont has promoted healthy change by exploiting its core corporate competencies through vigorous research in a stream of innovative products and systems for the printing and diagnostic imaging markets. Out of these developments and technologies have also come products that have changed the electronics and medical markets where imaging is used in ways that sometimes extend the traditional photographic modality. Having led major changes in technology for the printing, diagnostic, and electronics industries, Du Pont is poised to contribute significantly to the increasing impact of digital electronic systems in these industries in the 1990s and to meet the demand for higher performance, continuing quality improvement, lower cost, and environmentally favorable materials and systems. *P. Walker*

DUSTING-ON PROCESS A printing process that uses a support coated with a layer of gum arabic and a hygroscopic substance like honey, glucose, or sugar sensitized with a bichromate. A coating of this nature becomes sticky with moisture that it absorbs from the atmosphere, but if light reaches any part of it, that part loses its stickiness. This is the effect that makes the imaging process possible. The sensitized surface is exposed to light under a positive transparency. It is then left in the air away from light to acquire a particular degree of stickiness. The surface is then brushed lightly with a selected color of powdered pigment. Where the positive image has masked the surface, it remains sticky and holds the pigment. In this way the printer is able to build up a positive image that can be *fixed* with a spray of fixative. This process has been used particularly for printing photographic images on glass or ceramic objects by replacing the pigment with a powder that can subsequently be burned in or vitrified. *J. Natal*

DX CODE A pattern printed on the outside of film manufacturers' film cassettes that can be read by an in-camera sensor. This sensor, found on automated cameras, reads the film speed and other pertinent information and sends it to the camera's program exposure system. It consists of a bar code plus a checkerboard pattern code of metal and black paint. Probes in the camera body read the checkerboard area for information. Where the black paint is located, the signal is prevented from passing through to the sensor probes. Information comes only from the silver areas. The patches give information about the film speed, film length, color, and contrast information needed to modify auto exposure programs. The bar code is also used by automated processors to identify film type. Another code printed near the edge of the film provides color balancing information to auto printers. DX is an arbitrary designation, not an abbreviation. *P. Schranz*

DYE BLEACHING Dye bleaching sometimes offers a method for lowering the dye strength of images. Formulas have been provided for selective bleaching of specific dyes in a subtractive color image in order to bring it into color balance. The bleach formula depends on the particular type of dye used to produce the image; thus there is no general information available. Nonselective dye bleach formulas have been used to remove black spots from prints, for example, then the resulting white spot can be retouched with dye to match the surrounding area. *I. Current*

DYE-BLEACH PROCESS See *Silver-dye bleach process.*

DYE COUPLING Almost all modern color films are *coupler incorporated*, meaning that part of the material that

forms dyes upon development is included in the emulsion when the film is manufactured. During development, oxidized developer components react with these couplers to form dyes in proportion to the amount of silver deposited at each development site. The silver is removed by bleach and fixer, leaving just the dye image. *H. Wallach*
See also: *Kodachrome.*

DYE DESENSITIZER Dyes can be used to decrease the light sensitivity of silver halide materials after exposure. The desensitizer is thought to act by displacing the sensitizing dye on the surface of the silver halide crystal or by competing for photoelectrons when light strikes the crystal. Phenosafranine and pinakryptol green, yellow, or white, are examples of dye desensitizers. *G. Haist*

DYE DESTRUCTION PROCESS Color system that depends upon the selective bleaching of dyes existing fully formed in a sensitized material rather than by forming dyes during processing. *H. Wallach*
See also: *Silver-dye bleach process.*

DYE IMBIBITION Assembly process for making color prints from matrices produced from three separation negatives. The matrices are gelatin relief images that are soaked in yellow, magenta, and cyan dyes and transferred in register to a support. A mordant on the support helps the dye to adhere. In the Technicolor process, the assembly is made on positive motion picture film. Jose Pé introduced a workable dye imbibition process in the 1920s, some forerunners of which were E. Edwards' system of 1875, the Tegeotype, Pinatype, and hydrotype. In the mid-1930s, Eastman Kodak developed a unified dye imbibition system called washoff relief, later changed to dye transfer. *H. Wallach*
See also: *Dye transfer process; Technicolor.*

DYEING Dyeing refers to the application of dye to an image, generally uniformly, but in some cases selectively. Dyeing is different from dye toning where the dye is taken up only in image areas that have been mordanted or otherwise treated. In its simplest form, the paper print or film transparency (as in early motion pictures) is dyed to the desired color. The black-and-white image is unchanged. Hand coloring is an example of selective dyeing of monochrome images.
Color photographs may be uniformly dyed to balance an unwanted stain or tint that is most evident in the highlights. Color prints or transparencies may also be selectively dyed to modify or correct specific areas of the image.
 I. Current

DYELINE A printing process based on the action of light on diazo compounds that is widely used in office copying and producing duplicates of maps, drawings, and plans. The primary advantage of the process is its relative cheapness.
 J. Natal

See also: *Diazo processes.*

DYE MORDANT Chemical substance that adsorbs dye to a support and reduces its solubility. It is often used in dye-imbibition and dye transfer processes. *H. Wallach*
See also: *Dye imbibition; Dye transfer; Mordant.*

DYE RETOUCHING Color negatives, transparencies, and prints can be retouched with dyes to correct or modify details. The dye solutions are applied to the areas to be treated by means of a small brush. The dye densities of the three images are adjusted to balance surrounding areas. Dry dyes can also be applied to prints until a desired result is

obtained, then fixed by applying moisture in the form of steam to the print. Black-and-white negatives and prints can also be retouched by means of dyes. Neococcine dye allows the corrected areas of negatives to be visually identified due to its pinkish color. *I. Current*

DYE REVERSAL See *Appendix A.*

DYES
Soluble colorant, as distinct from pigments, which are insoluble colorants (although the term *pigment* is used generally for colorants in the tissues or cells of animals and plants). *R. W. G. Hunt*

DYE SENSITIZER
Silver halide crystals are sensitive only to blue or more energetic radiation, but dyes can be added to the crystal surface to extend the sensitivity to radiation of less energy, such as green and red light. Dye sensitizers make possible orthochromatic (blue and green light response), panchromatic (sensitive to all colors), and infrared photographic materials. *G. Haist*

DYE TRANSFER
The dye transfer process is a subtractive imbibition assembly process for making color prints from color positives or negatives. Forerunners of the system date from 1875 and include dye imbibition materials first marketed in 1925. Eastman Kodak offered a process called wash-off relief in 1935, which was improved by photographers Louis Condax and Robert Speck and released by Kodak in 1946 as the dye transfer process. The many controls available in this process, combined with the beauty and permanence of the dyes employed, make dye transfer the finest of all color printing methods despite the care and effort it requires.

There are currently two kinds of matrix material available, Kodak Matrix Film 4150, which is orthochromatic, and Kodak Pan Matrix Film 4149, which is panchromatic. The first set of procedures in the dye transfer process is determined by the choice of matrix material. The panchromatic film is designed for making separations from color negatives directly onto the matrix, eliminating the need for making separation negatives first, and simplifying registration problems later because only one negative, fixed in place, is used. On the other hand, significant control over the final image can be exercised while making separation negatives, whereby red, green, and blue filters are used to expose suitable film stock, such as Kodak Super-XX 4142.

Neither matrix film has an antihalation backing, permitting exposure through the base. This procedure is necessitated by the dichromated gelatin of the matrix film emulsion that is subject to hardening when it is struck by light. After exposure in registration, development is accomplished in a tanning (hardening) developer that can be constituted to produce a wide range of contrast levels. The silver image produced and the degree of tanning are proportional to each other. The silver image is then fixed in a nonhardening fixer. As an alternative procedure, the silver image may be formed by a conventional reduction developer, rinsed, fixed, and then bleached in a sulfuric acid-ammonium bichromate solution. The silver is removed while the gelatin is tanned. Preparation of the matrix is completed by washing in hot water, which removes the soft surface gelatin and reveals the hardened relief of gelatin that was exposed through the base. Care must be exercised at every wetting and drying stage to avoid distortions that would cause a loss of registration.

Dye transfer prints are made on double-weight photographic paper that has been mordanted during manufacturing to make dyes adhere, or on regular photographic paper that has been fixed, washed, and treated in Kodak Mordanting

Solution M-1 containing aluminum sulfate and sodium carbonate. Both papers must be bathed in Dye Transfer Paper Conditioner, a 5% solution of sodium acetate, half an hour or more before transfer.

The sequence for applying the dyes in registration to the paper is cyan (red separation negative), magenta (green separation negative), and yellow (blue separation negative). Each matrix is soaked in dye for about 5 minutes and placed in a 1% acetic acid rinse to remove excess dye. This rinsing bath may be altered to control contrast. Sodium acetate will reduce contrast in the middle and shadow tones. Calgon will clear highlights by removing surplus dye. Reducing the strength of the acid rinse will reduce contrast, while more acid causes more dye to be carried from the dye bath, increasing highlight contrast. Other controls include the amount of added chemicals, the rinsing time, and the quantity of rinse used. Color intensity may be reduced by adding a 5% solution of sodium acetate to the acid rinse.

Dye baths may be checked by superimposing the three dye images; the result should be neutral gray. Dye contrast may be raised by adding acetic acid or lowered by adding triethanolamine. More than one transfer of a color may be applied to intensify that color.

As many as 100 prints can be made from one set of matrices. If the matrices were made from separation negatives, it is a simple matter to make a new set of matrices from which to continue printing. The subtle, lustrous appearance and near-archival durability of dye transfer prints continue to justify the effort required to make them, even in an age when remarkably good chromogenic prints pop out of the processor, washed and dried, in less than four minutes.
 H. Wallach

See also: *Dye imbibition; Mordant; Registration.*

DYNAMIC MICROPHONE
A transducer that changes acoustical energy into electrical energy by the motion of a conductor in the field of a magnet. A typical construction involves a rigid diaphragm exposed to a sound field and allowed to move in a plane perpendicular to the diaphragm by the action of a suspension. Attached to the diaphragm is a voice coil which in turn is suspended in the field of a magnet. Motion of the diaphragm moves the voice coil in and out of the field, thus cutting the lines of magnetic force with a conductor. Dynamic microphones have a reputation for high reliability and ruggedness and may be built using most of the common microphone polar patterns.

A case related to the dynamic microphone is the ribbon microphone, utilizing the same principle for electroacoustical conversion but with different construction.
 T. Holman

See also: *Microphone polar patterns; Ribbon microphone.*

Dynamic microphone with moving coil suspended in the field of a magnet.

DYNAMIC RANDOM-ACCESS MEMORY (DRAM)
The memory component of the computer. These chips hold data and instructions supplied by the software program in a quickly accessible state, thus reducing the need for the computer's central processing unit (CPU) to continually access the program disk. These chips hold data as long as there is power. Once the power is turned off the DRAM loses its contents. *R. Kraus*

DYNAMIC RANGE
The range stated in decibels from the background noise level to the overload level of a medium. Dynamic range may be stated in terms of audio-band-wide noise to midrange overload or in a variety of other manners. A complete description would include a graph of the headroom and of the noise versus frequency.
T. Holman

DYNAMIC RANGE (SCANNER)
The density range or output of electronic scanners. *M. Bruno*

See also: *Photomechanical and electronic reproduction, flat-bed scanners.*

aE Illuminance/irradiance (international standard); Exposure (nonstandard)

e Radiant energy; Base of natural logarithms

EAVA European Audio-Visual Association

EBR Electron beam recording

EBU European Broadcasting Unit

ECPS Effective candle power seconds

ECU Extreme closeup

EE Electric eye

EEPROM Electronically erasable programmable read-only memory

EFX Effects (motion-picture code)

EI Exposure index

EIA Electronics Industry Association

EM Electron microscope

EMF Electromotive force

EMR Electromagnetic radiation

EMU Electromagnetic unit

END Equivalent neutral density

ENG Electronic news gathering

EO Emulsion out

EO Electro-optics

EPIC Evidence Photographers International Council

EQE Equivalent quantum efficiency

EROS Earth resources observations systems

ERTS Earth resources technology satellite

ESCSC Electronic Still Camera Standardization Committee

ESU Electrostatic unit

E_v Exposure value (APEX) (Also EV)

eV Electron volt

EVGA Extended video graphic array

EVOP Evolutionary operations

EVR Electronic video recording

EXP Exposed

EARTH RESOURCES OBSERVATIONS SYSTEMS (EROS)
Systems for imaging, classifying, and assessing the various resources of the earth including geography, climate, vegetation, and minerals. An Earth Resources Technology Satellite (ERTS), for example, provides multispectral photographs of large sections of the earth on a regular cycle. Densitometric measurements of these photographs can then be translated into radiometric information on the areas covered. *I. Current*

EASEL
A device for holding photographic paper or other photosensitive material flat and in the desired position for projection printing or for holding pictures, printed matter, etc. flat and in the desired position for copying. *L. Stroebel*

EASTLAKE, LADY ELIZABETH RIGBY
(1809–1903) British art critic and model. One of the first serious writers on photography. In an unsigned article in Edinburgh's *Quarterly Review* in 1857, she argued that photography should express itself through its own strengths and resist imitation of painting or drawing, an early herald to be later taken up by Group *f*/64 in the 1930s. Before her 1849 marriage to Charles Eastlake, she sat frequently for Hill and Adamson and was the subject of 16 portraits. Sir Charles Eastlake (1793–1865) was elected the first president of the Photographic Society of London, the earliest group dedicated to the medium in that country. *M. Alinder*

EASTMAN, GEORGE
(1854–1932) American photographic inventor and manufacturer. His first products were gelatin dry plates for which he introduced machine coating in 1879. Invented first roll film in 1884 using paper negatives and, in 1888, roll film on a transparent base, still the universal standard. Introduced the "Kodak," also in 1888, the first roll-film camera. The incredibly popular Kodak box camera encouraged millions of hobbyists worldwide to become photographers. The camera's advertising slogan, "You press the button, we do the rest," proved true to great success. As a direct consequence, the Eastman Kodak Company, Rochester, New York, provided a dramatic, almost fantastic example of growth and development in industry, and it has founded and supported a unique chain of research laboratories. Eastman's commercial manufacture of roll film provided the basic material for cinematography. Eastman introduced 16-mm reversal film for amateur filmmaking (and the necessary camera and projector) in 1923 and developed various color photography processes to commercial application. Eastman died by his own hand ("My work is done—why wait?").

Books: Collins, Douglas, *The Story of Kodak.* New York: Abrams, 1990. *M. Alinder*

See also: *Kodak.*

EBERHARD EFFECT
See *Photographic effects.*

ECHO
A discrete repetition of a source signal, distinguished by its separation from reverberation by its greater level. To be defined as an echo, the repetition must be late enough to not be integrated into the source sound by the ear and high enough in level to be distinct from reverberation. A special case of echo is the flutter echo, occurring when two parallel surfaces reflect acoustical energy back and forth between them. The result is a characteristic patterned reflection. *T. Holman*

ECHO UNIT An older term generally used to describe what is thought of today as a reverberator. Echo means specifically what is heard as a discrete repetition of a sound, and that is not generally what is meant when the term *echo unit* is used. On the other hand, a digital delay line can be used to produce a discrete echo. *T. Holman*

See also: *Digital delay line.*

ED GLASS See *Optics, optical materials.*

EDER, JOSEF MARIA (1855–1944) Austrian photochemist, teacher, and photographic historian. Made outstanding contributions to photography, photographic chemistry, and photomechanical work so numerous that only a few highlights can be listed. In 1879 his thesis on *The Chemical Action of Colored Light* was published. In 1880 Eder became professor of chemistry at the Royal Technical School in Vienna. Determined in 1880 the suitability of pyrocatechin ("pyro") as a developer. With Pizzighelli, introduced gelatinsilver chloride paper in 1881. Produced his encyclopedic *Handbook of Photography* on the science and technique of photography in 1884, which remained in print through many editions for 50 years. In 1889 he was appointed director of Vienna's highly regarded Graphic Arts Institute, a position he held for 34 years. Finally, among other books, there is his respected *History of Photography,* the last edition (German) of which appeared in 1932. *M. Alinder*

EDGE-BEAM LIGHTING Turning a studio reflector light to make it effectively a thin source for the purpose of altering the shape of a shadow, or a reflection on a glossy surface, or to alter the distribution of light on a subject. *R. Jegerings*

See also: *Feather.*

EDGE DETECTION In electronic imaging, a convolution technique designed to determine local contrast (gray–level) differences across some measure of homogeneity. The zone of change between two different regions is processed by an operator so that the zone itself is obvious. *R. Kraus*

EDGE EFFECT See *Photographic effects.*

EDGE NUMBERS Sequential numbers exposed by the manufacturer as a latent image at the edge of motion picture film to identify scenes and frames in editing and for the production of special effects. They appear when the film is normally processed. Some still films also have edge numbers and other markings. *M. Scott*

Syn.: *Key numbers.*
See also: *Edge printing.*

EDGE PRINTING Information impressed as a latent image at the edges of various roll films. The marking becomes visible upon normal processing. Data imprinted includes some but not necessarily all of the following: manufacturer, film type, frame number, and manufacturing codes useful in tracing defects. *M. Scott*

See also: *Edge numbers.*

EDGERTON, HAROLD (1903–1990) American scientist, photographer, and teacher. Receiving a Ph.D. in science from the Massachusetts Institute of Technology in 1931, he taught there for much of the rest of his life. In 1938, developed the electronic flash tube that emitted a brilliant light lasting less than one-millionth of a second and was capable of being fired rapidly to obtain multiple-image stroboscopic effects. Electronic flash photography is based upon his discoveries. Using the stroboscope, he explored the field of high-speed photography, becoming the first to photograph many events imperceivable to the human eye, such as a bullet in flight. In addition to being scientific evidence, his photographs have been exhibited in museums of art.

Books: Jussim, Estelle, *Stopping Time, The Photographs of Harold Edgerton.* New York: Abrams, 1987. *M. Alinder*

EDGE STRIPE A band of magnetic material applied lengthwise to motion picture film outside the picture area for recording a sound track. *M. Scott*

See also: *Balance stripe.*

EDISON, THOMAS ALVA (1847–1931) American inventor. Earned a record 1033 patents for his inventions, including the telephone, automatic telegraph systems, the phonograph, the microphone, incandescent electric lamps, and, in 1891, the kinetoscope for taking and viewing serial pictures. Was probably the first to use film perforated at the sides on a practical scale, and was also the first to combine the projection of pictures with his phonograph to produce practicable, though far from perfect, sound motion pictures. *M. Alinder*

EDITING See *Motion-picture photography; Video.*

EDITORIAL CUT In motion-picture editing, a cut made on both picture and sound track on the corresponding frames relative to their sync relationship. *H. Lester*

Syn.: *Straight cut.*

EDITORIAL PHOTOGRAPHY The specialization of making nonadvertising photographs to be reproduced for mass viewing, usually in connection with an article or commentary. Photography in newspapers, magazines, and books, and stills on TV is being influenced by the country's economy, inventions, and scientific development. The 1990s recession undermined spending on photography. Many photographic staff positions were eliminated—photographers

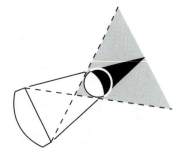

a

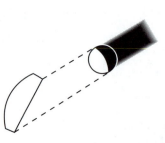

b

Edge-beam lighting. A reflector light (a) wraps light around the subject and casts dense umbra and lighter penumbra edge shadows; turning the light (b) causes it to cast a natural shadow.

and picture editors alike, and publications, magazines, and newspapers, continued to go out of business. Publishers ordered editors to save money and give fewer assignments, thus saving money on travel, hotels, and day rates. Photographic assignments became one of the highest costs in publishing—the most expensive single cost in producing visual products for the field.

Publications turned to buying pictures from stock picture agencies like The Image Bank, Comstock, and *Life* Picture Syndication, and photo reportage by-the-picture from Sygma, Gamma, and Black Star. Europe's strong editorial photography managed to continue on an assignment-oriented basis.

Even Eastman Kodak entered the market by purchasing The Image Bank agency as a money-making investment and as a place to try new electronic photography technology. Most stock picture agencies benefitted from the economic downslide because stock pictures are less expensive than assignment photography.

Kodak and Apple Computer established The Center for Creative Imaging in Camden, Maine, for teaching electronic imaging, where Greg Heisler created an electronic composite of still pictures featuring Ted Turner for a Man of the Year cover picture on *Time* magazine. Editors and executives from publishing are invited for hands-on seminars, learning how standard cameras and electronic imaging can work together to cut cost and make publishing competitive with other media. In 1993, the Center was sold to a management group in Camden, Maine.

To save on costs, many writers and reporters on newspapers have been encouraged to shoot their own photographs on assignments involving far-off travel and time-consuming reporting efforts.

The computer's power as a news gathering device has been accepted throughout journalism, and images appear on closed-circuit TV monitors and in editorial offices like *Time* magazine, the *New York Times,* the *Detroit Free Press,* and co-ops like Associated Press. Editorial design firms like New York's Hopkins/Bauman create entire magazines, including *Kids Discover,* and America Express's *Your Company* on a Macintosh system. The company also designs picture books by using the same computer and desktop publishing programs.

The Persian Gulf war brought both censorship and electronic imaging to the battlefield. Thousands of images were transmitted from the desert war via phone lines and satellite. Sygma sent editorial pictures without going through censorship. They brought in their own color processing machines and satellite transmission equipment to the front lines.

The collapse of the USSR sent shock waves through the country's editorial establishment and photographers' ranks. Editorial photographers scrambled for assignments and contracts from overseas. *Pravda* went out of business, at least temporarily. Film shortages, gas shortages, and cutbacks in spending staggered most editorial photographers in the country.

Still pictures on television gained a spotlight from the award-winning series on public television created by the Burns brothers, *"The Civil War."*

Photo CD was presented to the American public by Philips and Kodak. Fuji and several other major film corporations joined the ranks of those who will use the system. With the CD system, amateurs or professionals get processed film from local labs with prints and on a CD disc. Pictures can be played back through a TV CD disc player onto the home TV screen. Several thermal printers can be added to the TV photo circuit for making prints from the TV set image. The Photo CD disc could play a big role in desktop publishing. Major publishers talk about the possibility of creating CD picture books, and interactive photo CD children's picture books to be played on TV.

NASA, America's photographic team in space, continues to collect never-before-seen images, including environmental photographs of one of the earth's major dilemmas, the hole in the ozone.

Editorial photography is in the midst of change. Electronic imaging becomes an important money-saving ally and alternative. Publications challenge the immediacy of television by speedily moving and printing pictures.

Advances in science have produced a revolution in reproduction—pictures in publications now have better quality, contain finer detail, and are closer to the vision of the photographer. *J. Durniak*

See also: *Photojournalism.*

EDUCATION See *Photographic education.*

EFFECTIVE APERTURE The diameter of an entering collimated (parallel) beam of light that will just fill the opening in the diaphragm in an optical system such as a camera lens. The effective aperture is the same size as the diaphragm opening (or aperture) only when the diaphragm is located in front of the lens. *J. Johnson*

Syn.: *Entrance pupil.*
See also: *f-Number.*

EFFECTIVE CANDLEPOWER SECOND (ECPS)
A unit of light output for electronic flash that averages values over a given angle of light for a specific reflector.
R. Jegerings

See also: *Beam candlepower second; Joule; Watt-second.*

EFFECTIVE EXPOSURE TIME The time duration between the half-open position and the half-closed position of a leaf-type shutter. In this context, the shutter is considered to be open when any specified diaphragm opening is just completely uncovered, whereas the marked shutter speed is based on the maximum diaphragm opening. Therefore, the effective and marked shutter speeds (on a perfectly calibrated shutter) agree only when the diaphragm is set at the maximum opening. With the diaphragm stopped down, the film receives more exposure than is indicated by the marked shutter speed. *J. Johnson*

EFFECTIVE f-NUMBER A number obtained (a) by dividing the image distance (as distinct from focal length) for a lens in a specific situation by the effective aperture, or (b) by multiplying the f-number (relative aperture) by the ratio image distance/focal length. Used instead of f-number when photographing nearby objects to compensate for the loss of light as the lens-to-film distance increases. In closeup work, for most practical purposes, it can be assumed that, when the camera lens is set at infinity, the addition of a positive supplementary lens does not affect the f-number of the camera lens.
J. Johnson

Syn.: *Effective relative aperture.*

EFFECTIVE FOOTCANDLE See *Footlambert.*

EFFECTS (1) See *Optical effects; Photographic effects; Sound effects editing; Special effects.* (2) A motion-picture term, usually written as FX or EFX, broadly applied to the creation of events or imagery that could not or did not occur in reality, including optical effects created by manipulating the picture in a printing process, for example, a freeze frame, and special effects created in front of the camera, for example, making a building appear to collapse by shooting a miniature. Sound effects are considered to be all sounds other than speech or music and are often enhanced for dramatic impact, for example, making gunshots or punches sound louder than they would in reality. *H. Lester*

See also: *Motion-picture photography, special effects; Special effects.*

EFFECTS LIBRARY A cataloged collection of recordings of sounds other than voices or music (examples: thunder, wind, traffic, whistles, birds, wild animals, sea mammals). Such recordings are used in making soundtracks in motion pictures and television. *R. Zakia*
Syn.: *Sound effects library.*

EFFICIENCY (1) The comparison of the energy or power generated by a device to that supplied. For a lamp, the efficiency is the ratio of lumens emitted by the lamp to the power supplied to the lamp. Unit: lumens per watt. (2) For a shutter, the effective operating time divided by the total time the shutter works. The efficiency is 50% if the shutter, set on a very high speed, barely opens before it must close again. At very long times, shutter efficiency is close to 100%. *H. Todd*

EFFLUX Flowing out, identifying the energy coming from an irradiated sample. In a densitometer, the efflux energy involves that transmitted or reflected by the sample and the extent to which the receptor receives the scattered as well as the direct energy. Contrast with *influx.* *M. Leary and H. Todd*

EIDETIC IMAGERY A visual effect in which a relatively vivid and accurate image that is capable of being scanned persists after the physical removal of the stimulus. Such an image is different from an afterimage in that it may last for 40 seconds or more, the image is positive, it retains an approximation of colors of the original, and remains stable when the eyes are moved during the scanning process.
L. Stroebel and R. Zakia
See also: *Visual perception, poststimulus perceptions.*

800 NUMBERS See *Appendix O.*

EIGHT MILLIMETER See *Film formats.*

EIGHT TRACK See *Track forms (audio tape).*

EINSTEIN The number of photons that would cause a mole (one molecular weight of a material expressed in grams) of a photosensitive material to react if every photon were absorbed and caused one molecule to change. The number is 6.023×10^{23}. *J. Johnson*

E (IRRADIANCE, ILLUMINANCE) Symbol for irradiance and illuminance; the quotient of power incident at a surface and the surface area. The preferred units are watts per square meter (W/m^2) for irradiance and lux, or lumens per square meter (lm/m^2), for illuminance. *J. Pelz*
See also: *Irradiance; Illuminance; Photometry and light units.*

EISENSTAEDT, ALFRED (1898–) American photographer. German-born, he is acknowledged as one of the first photojournalists, his occupation since 1929 when, equipped with a Leica, he began work for the Associated Press in Berlin. Emigrated to the United States in 1935 where the next year he became one of the original four staff photographers for *Life,* joining Margaret Bourke-White, Peter Stackpole, and Thomas McAvoy. Eisenstaedt was the consummate *Life* photographer, contributing more than 2,000 photoessays and 90 cover images. He has described his job as a photojournalist, "to find and catch the storytelling moment."
Books: *Eisenstaedt: Remembrances.* Boston: Bulfinch, 1990; *Witness to Our Time,* rev. ed. New York: Viking, 1980; *People.* New York: Viking, 1973. *M. Alinder*

EKTACHROME Manufactured by Eastman Kodak Company, a range of integral tripack, substantive, color transparency films and color papers that can be processed by the user. Daylight and tungsten; roll, sheet, and motion picture;

original and duplicating types are offered. Ektachrome infrared film is a false color material for aerial, scientific, and special-effects purposes. *M. Scott*

EKTACOLOR A range of user-processable, integral tripack, substantive, color negative films and papers for professional use, introduced by Eastman Kodak Company in 1945. Roll and sheet formats are offered, as is an intermediate film for making negatives from transparencies.
M. Scott
See also: *Kodacolor.*

ELECTRET MICROPHONE A capacitor microphone type in which the insulator is made of a plastic material that can be permanently charged electrostatically so that the microphone needs no externally applied polarization voltage. Electret microphones are often less expensive than air-condenser microphones because of their greater simplicity.
T. Holman
See also: *Capacitor microphone.*

ELECTRICAL CONDUCTIVITY The ability of a material to conduct current. Metals have good conductivity, insulators have very poor conductivity, semiconductors are in-between. The influence of light on the conductivity of certain materials is important to the operation of photoconductive cells and to electrostatic photographic processes. Conductivity is the reciprocal of resistivity. *W. Klein*

ELECTRICAL CURRENT (I) The flow of electrons in a conductor. The direction of electron flow is from the negative terminal of a source through the external circuit and back to its positive terminal. In the eighteenth century, long before the nature of the electron was known, scientists thought electricity to be some kind of fluid and that it flowed downhill from the plus terminal of a source through the external circuit to the negative terminal. This is the direction of what is even now called *conventional current flow.* Current, however defined, is directly proportional to the applied voltage and inversely proportional to the resistance of the circuit (Ohm's law). The symbol of current is I. The basic unit of current is the ampere. *W. Klein*

ELECTRICAL ENERGY The capacity to do work by means of electricity. Electrical energy is equal to power multiplied by time. Common units of electrical energy are the watt-second and the kilowatt-hour. One watt-second is equal to 1 joule. Electric power companies bill their customers for the number of kilowatt-hours of energy they use. *W. Klein*
See also: *Watt-second.*

ELECTRICAL POWER (P) The time rate of the production or consumption electrical energy; 1 joule per second equals 1 watt. The symbol for power is P. In dc circuits

$$P \text{ (watts)} = V \text{ (volts)} \times I \text{ (amperes)}.$$

In single-phase ac circuits, however,

$$\text{True } P \text{ (watts)} = V \text{ (volts)} \times I \text{ (amperes)} \times PF$$

where PF is the power factor, the cosine of the phase angle.
W. Klein
See also: *Apparent power.*

ELECTRIC CELL A device that converts chemical energy into electrical energy. At minimum, a cell consists of an anode, a cathode, and an electrolyte. An assembly of two or more cells is a battery, although a single cell is commonly, but imprecisely, called a battery. *W. Klein*
See also: *Battery.*

A series circuit has the same current (*I*) flowing through each element. Shown is a series circuit of three resistors: R_1, R_2, R_3.

ELECTRIC EYE (1) A photocell. (2) Identifying an automatic exposure-meter system that directly controls the aperture or shutter speed in response to light falling on a photocell. *L. Stroebel*

ELECTRICITY A phenomenon occurring in nature based on the interaction of subatomic particles. In the Bohr model of the atom, electrons orbit around a nucleus consisting of protons and neutrons. The electrons carry a negative electrical charge, the protons carry an equal positive electrical charge, and the neutrons carry no charge. The number of protons in the nucleus is equal to the number of planetary electrons, rendering the atom itself neutral. The electrons are arranged in shells or energy levels; each level has a specific number of electrons it can accommodate. The outer, or valence, shell of an atom determines its electrical characteristics and how it will chemically react with other atoms. Electricity is generated when the electrons are separated from the protons by any of many means: chemical action (battery), moving magnetic field (generator), electromagnetic radiation (photovoltaic cell), heat (thermocouple), and, for static electricity, friction.

TYPES OF ELECTRICITY There are two types of electricity: static electricity and dynamic electricity. The effects of static electricity were studied in ancient times. A piece of amber rubbed with fur would acquire an electrical charge, but because amber is a good insulator, the charge remained stationary (static) on the surface of the amber. The charge could attract light objects and produce sparks. Little practical use was made of static electricity until the invention of the electrostatic printing process by Chester Carlson in 1938.

It is dynamic electricity that dominates the world of electricity and electronics today. In this form of electricity the electrical charges are in motion and called *electrical current*. It was only after 1800, with the invention of the voltaic pile, that scientists had a continuous source of current to work with.

For electrical current to flow there must be a complete path from one terminal of the source to the other terminal. This complete path is known as a *circuit*. The electromotive force, or voltage, of the source is the cause; the current that flows is the effect. Voltage sources are designated by the nature of the current they deliver: direct current or alternating current.

DIRECT CURRENT Direct current is the flow of electrical charges in one direction only. The current need not be of constant amplitude to be considered direct current. A thorough knowledge of dc theory is necessary to understand how electronic circuits operate. There are many sources of direct current. Those having applications in photography include dry cells and batteries to power portable equipment, the photovoltaic (solar) cells to measure light levels in light meters and automatic exposure controllers, and, most importantly, the rectifier power supplies that convert the ac voltage from the mains to a constant (and frequently very precise) direct voltage for electronic circuits.

Ohm's Law Ohm's law states that the current that flows in a circuit is directly proportional to the applied voltage and is inversely proportional to the resistance of the circuit.

$$I \text{ (amperes)} = V \text{ (volts)} / R \text{ (ohms)}$$

When a circuit consists of more than one resistor, the effective resistance of a circuit depends on the configuration of the interconnections among the various resistors. The resistors can be connected in series or in parallel or in some combination of the two.

Series Circuit The resistors in a series circuit are connected end-to-end so the current through each resistor is the same and is equal to the applied voltage divided by the sum of the individual resistors.

$$I \text{ (amperes)} = V \text{ (volts)} / R_1 + R_2 + R_3 \text{ (ohms)}$$

A series connection of resistors is frequently used as a voltage divider to obtain a voltage, or voltages, less than the voltage available from a power source. The voltage across each resistor is equal to the common current multiplied by the resistance of the resistor.

$$V_N \text{ (volts)} = I \text{ (amperes)} \times R_N \text{ (ohms)}$$

The sum of the voltages equals the applied voltage.

Parallel Circuit The resistors in a parallel circuit are connected across (or shunting) each other, thus providing as many paths for the current to flow through as there are resistors. The value of the voltage across each resistor is the same. The sum of the current through each of the resistors is equal to the current delivered by the source.

$$I_T = I_1 + I_2 + I_3 + \ldots$$

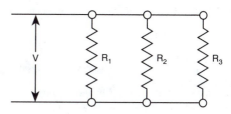

A parallel circuit has the same voltage (*V*) across each element. Shown is a parallel circuit of three resistors: R_1, R_2, R_3.

Power The power consumed in any component in a dc circuit is equal to the voltage across the component multiplied by the current through it.

$$P \text{ (watts)} = V \text{ (volts)} \times I \text{ (amperes)}$$

Substituting $V = I \times R$, it may be calculated as:

$$P \text{ (watts)} = I^2 \text{ (amperes}^2) \times R \text{ (ohms)}$$

The power consumed by the circuit is equal to the sum of the power consumed by each component in the circuit.

$$P_T = P_1 + P_2 + P_3 + \ldots$$

ALTERNATING CURRENT Voltages and currents associated with audio systems and radio and television signals are examples of ac voltage and current. Most electrical power generated throughout the world is generated as ac power because it is more economical to transmit and distribute than dc power. The instaneous amplitude of the voltage distributed by the power companies varies as a sine wave at a frequency of 60 hertz (cycles per second) in the United States, Canada, and a few other countries and 50 hertz in the rest of the world. Capacitors and inductors, as well as resistors, are widely used in ac circuits. Depending on the

component, the current through it may be in phase or 90 degrees out of phase with the voltage across it.

Resistive Circuits The current through a resistor is always in phase with the voltage across it. Ohm's law applies just as it does for a dc circuit. The calculations for series and parallel circuits and for power are valid.

Capacitive Circuits When a capacitor is connected across an ac voltage, current will flow. The amplitude of the current is directly proportional to the applied voltage and inversely proportional to the capacitive reactance of the capacitor.

$$I \text{ (amperes)} = V\text{(volts)} / X_c \text{ (ohms)}$$

Capacitive reactance is a function of the frequency, f, of the source and the value of capacitance, C.

$$X_C\text{(ohms)} = 1\sqrt{2\,pf\text{(hertz)}C\text{(farads)}}.$$

An important property of a capacitor is its ability to block a steady dc voltage while passing ac signals. The higher the frequency, the less the opposition to ac signals. This characteristic makes capacitors useful in the design of frequency-selective filters, tuners, and dc isolators. The ac current that flows through a capacitor leads the voltage across it by 90 degrees.

Inductive Circuits In an ac circuit, the current that flows through an inductor (coil) is directly proportional to the applied voltage and inversely proportional to the inductive reactance of the inductor.

$$I \text{ (amperes)} = V\text{(volts)} / X_L \text{ (ohms)}$$

Inductive reactance is a function of the frequency, f, of the source and the value of inductance, L.

$$X_L\text{(ohms)} = 2\,\pi f\text{ (hertz)} \times L \text{ (henries)}$$

The ac current that flows through an inductor lags the voltage across it by 90 degrees.

Impedance Impedance, Z, is the net opposition to the flow of current through a series ac circuit consisting of any combination of resistors, capacitors, and inductors. It is measured in ohms and is equal to

$$Z\text{(ohms)} = \sqrt{R^2 + (X_L - X_C)^2}$$

The current in such a series circuit is determined from Ohm's law for an ac circuit:

$$I \text{ (amperes)} = V \text{ (volts)} / Z \text{ (ohms)}$$

Power Power in a single-phase ac circuit is equal to the product of the voltage, the current, and the power factor, PF. The PF is equal to the cosine of the phase angle, θ

$$P \text{ (watts)} = V \text{ (volts)} \times I \text{ (amperes)} \times \cos\theta$$

If the circuit consists of only resistances, the voltage and current will be in phase and the phase angle is 0 degrees. Because the cosine of 0 degrees is 1.0, $P = V \times I$ (the same as for dc circuits). If the circuit includes inductors or capacitors, the PF will be less than 1.0 and must be included in the calculation of power.

Three-phase circuits. An alternator with three windings equally spaced will produce three voltages that are 120 degrees out of phase with each other. These windings can be connected in wye or in delta configuration. When connected in wye, the line-to-line voltage is equal to 1.732 times the phase voltage v_\varnothing.

$$V_{LL} = 1.732\ V\phi$$

Three-phase ac systems provide more efficient transmission and distribution of power and simpler starting of ac induction motors.

<div align="right"><i>W. Klein</i></div>

See also: *Electronics.*

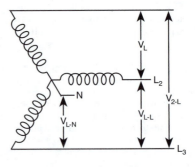

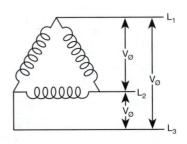

b

Three-phase circuits. (a) The wye connection generally has a fourth, neutral (N), wire connected to ground. The voltage from the neutral to any of the three lines, $V_{N\text{-}L}$, is equal to $0.577 \times V_{L\text{-}L}$. (b) With the delta connection the line-to-line voltage is the same as the phase voltage v_ϕ.

ELECTROACOUSTIC RESPONSE The frequency response of a complete sound system including loudspeakers and the effects of room acoustics measured with microphones. The electroacoustic response is usually measured with a real time analyzer (RTA) made much more reliable and repeatable by spatial averaging, and the output of an RTA is made more repeatable when used with computed temporal averaging.

<div align="right"><i>T. Holman</i></div>

See also: *Frequency response; Real-time spectrum analyzer; Spatial and temporal averaging.*

ELECTRODE A terminal through which current enters or leaves an electrical or electronic device.

<div align="right"><i>W. Klein</i></div>

ELECTROLUMINESCENCE The production of light by the flowing of an electric current through a medium, but not as a result of line emission or incandescence. Electroluminescence can only be produced using specific chemical compounds.

<div align="right"><i>J. Holm</i></div>

ELECTROLUMINESCENT LAMP A light panel that sandwiches phosphors between conductive layers, one of which is translucent and has a transparent protective surface. Alternating voltage applied to the conductive sheets excites the phosphors, which emit light. The efficiency of the panels is low, but since they use no evacuated bulbs or filaments, they have a long life, and they are thin and can be made in a

variety of shapes. If their light output can be increased closer to theoretical limits they may be widely used in photography in the future.
 R. Jegerings

ELECTROLYTIC DEVELOPMENT
Processes by which a photographic image is produced by applying an electric voltage or field. In conventional silver halide imaging, the latent image formed in the silver salts of the emulsion is reduced to metallic silver by a developer that donates an electron to each silver ion. The oxidation of the developer converts the organic compound to a more stable form. An electric current could therefore be used in place of a developer to perform the silver reduction. This process is called electrolysis.

As a practical matter, application of an electrode to each silver halide crystal is out of the question, so the exposed sensitized material is bathed in a reducing solution that is generated and then regenerated by electrolysis. The development of positive motion picture film may be performed in this fashion with a solution consisting of a vanadium salt in hydrobromic acid.

In a photoconductive electrolytic system, an electrical current is used to form a deposit on a latent image. For example, a zinc oxide photoconductive emulsion coated on a metallic support may be given a xerographic exposure causing a pattern of varying conductivity. The emulsion is then wiped with a silver-bearing solution, and a current is induced between the wiper and the metallic support. Local conductivity determines the intensity of the local current, and therefore the amount of silver deposited. Processes of this sort have applications in document copying. *H. Wallach*

ELECTROLYTIC PRINTING
System for producing an image on paper by application of an electric voltage or field. The paper is moistened in an aqueous solution, such as potassium nitrate, to facilitate electrical conduction. It is then treated with a marking compound; iron-catechol, iron-MDA, or a silver-formaldehyde complex. The paper is passed between an anode of steel or silver, and a cathode of a noble metal such as platinum. The electrodes and the paper must be in good electrical contact. When a voltage is applied, the anode is electrolyzed into the moistening solution and reduced by the marking compound.

The process is generally simple and inexpensive and the electrical requirements are not great, but the wet paper is a disadvantage in several respects. The most common applications have been in press wirephoto networks and in document, line-drawing, and weather chart transmission, all of which are subject to replacement by digital systems.
 H. Wallach

ELECTROLYTIC SHUTTER
High speed shutter based on liquids whose optical transmissions change under the influence of an electric field. The changes are due to birefringence, not electrolysis. *J. Johnson*

See also: *Electro-optics; Kerr cell.*

ELECTROLYTIC SILVER RECOVERY
A process used to recover silver from silver-bearing solutions by passing the solution between two electrodes through which dc current flows. The silver plates out on the cathode as almost pure silver. With careful monitoring, fixer can be reused for some processes. Silver recovered by the electrolytic method is easier to handle and less costly to refine than that recovered by other methods. *W. Klein*

ELECTROMAGNETIC RADIATION
The primary form of radiant energy. There are many categories of electromagnetic radiation: radio waves, microwaves, infrared radiation, light, ultraviolet radiation, rays, and gamma rays.

All of these types of radiation are electromagnetic (EM) radiation, and they are all propagated in the same manner: electromagnetic radiation is made up of photons (or quanta). The photons have energy, but no mass, and travel at the speed of light in a vacuum, and at the speed of light divided by the index of refraction of the material in other materials.

A photon is a quantized packet of energy. These packets are designated as being quantized because only discrete energy levels are possible. The energy of any photon is equal to Planck's constant times the frequency of the photon ($E = hn$) Therefore, every group of photons, or burst of EM radiation, must have an energy level equivalent to an integral multiple of the energies of the photons present. In this sense photons are similar to particles. On the other hand, the energy of a photon is contained in an oscillating, self-limiting combination of electric and magnetic fields. These fields oscillate in a transverse manner, perpendicular to the direction of propagation and each other. In this sense photons are similar to waves. It is convenient to look at electromagnetic radiation as being made up of independent wavelike energy packets, sometimes called *waveicles*. EM radiation can be analyzed as it actually exists using quantum electrodynamics, or only the wave aspects of the radiation can be analyzed using wave theory. The advantage of using wave theory is that it is much simpler than quantum theory, allowing for practical analysis of more complicated systems. If the amount of radiation present is large, the quantum effects may not be noticeable in some applications.

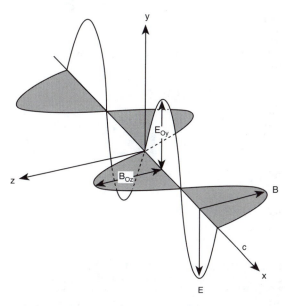

Electromagnetic radiation. A schematic drawing of a photon. The photon is traveling in the x direction. The electric field (E_{Oy}) is oscillating in the y direction, and the magnetic field (B_{Oz}) is oscillating in the z direction.

As with mechanical oscillators, higher energy levels result from more rapid oscillations of the electric and magnetic fields in photons (this also follows from Planck's expression for the energy of a photon, given previously). This means that as the frequency of a photon increases, so does the energy. Both the frequency and the energy of a photon contribute to its characteristics, and result in the subdivision of the broad range of electromagnetic radiation into the well-known categories listed here (in order of increasing frequency). Because of the law of conservation of energy, the frequency of a photon cannot change. Photons travel on

until they are absorbed by a substance, increasing the energy level of the substance. A minor exception to this is when two gamma ray photons combine to produce an electron-positron pair. In this case the energy is converted to mass according to Einstein's relation $E = mc2$. Only very high energy gamma rays have sufficient energy to form matter; the electron-positron pair being the smallest amount of matter that can be formed. *J. Holm*

See also: *Blackbody radiation; Color temperature; Infrared radiation; Light; Photon; Quantum theory; Ultraviolet radiation; Wave theory.*

ELECTROMAGNETIC SPECTRUM

The range of types of electromagnetic radiation presented according to category in order of decreasing wavelength, from long wavelength (and low frequency) radio waves to short wavelength (and high frequency) gamma rays. The visible part of the electromagnetic spectrum is generally considered to extend from 400 to 700 nanometers, although there is some variation in this range among individuals and also with the energy level and viewing conditions. *J. Holm*

The Electromagnetic Spectrum

Frequency (Hz)	Wavelength (nm)	Type of Radiation
10^2	10^{16}	Long radio waves
10^3 (kHz)	10^{15}	"
10^4	10^{14}	"
10^5	10^{13}	AM radio
10^6 (MHz)	10^{12} (1 km)	"
10^7	10^{11}	FM radio & television
10^8	10^{10}	"
10^9	10^9 (1 m)	Short radio waves
10^{10}	10^8	"
10^{11}	10^7 (1 cm)	Microwaves
10^{12}	10^6 (1 mm)	"
10^{13}	10^5	Infrared radiation
10^{14}	10^4	"
10^{15}	10^3 (1 μm)	"
10^{16}	10^2	Light (~400–700 nm)
10^{17}	10	Ultraviolet radiation
10^{18}	1 nm	Soft x rays
10^{19}	0.1 (1 Å)	Hard x rays
10^{20}	10^{-2}	Gamma rays
10^{21}	10^{-3}	"
10^{22}	10^{-4}	"
10^{23}	10^{-5}	"

ELECTROMECHANICAL ENGRAVING

Electromechanical engraving is a method of producing image carriers, or printing plates, by electromechanical means. Electromechanical engravers combine mechanical devices with electronic controls. These were first produced for making engravings for letterpress, but they are no longer used because of the decline in letterpress printing. Electromechanical engraving systems are used extensively for gravure. They consist of an input unit, an image recording and converting computer, and an output unit. The input unit consists of a rotating drum on which continuous tone or halftone positive or negative prints are mounted in position for reproduction with one or more reading heads that measure the scanned image densities and transmit them to the computer station. This station records the image densities and converts them to electrical impulses, which are transmitted to engraving heads equipped with diamond styli. These engrave gravure diamond-shaped image cells in the gravure printing cylinder corresponding in area and depth to the images measured on the input prints. The engraving

heads are mounted in the output unit adjacent to the printing cylinder, which is engraved as it rotates. The ability to use halftone prints on these systems has made possible the use of the same halftone films for making gravure cylinders as are used for making lithographic printing plates. The films are called generic films and the process is called halftone gravure. *M. Bruno*

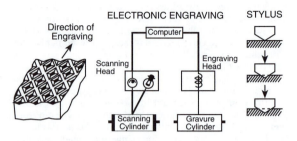

Electromechanical engraver for gravure.

ELECTROMECHANICAL SHUTTER

A mechanically powered shutter in which the duration of exposure is controlled electronically, rather than mechanically as with conventional shutters. *P. Schranz*

ELECTROMOTIVE FORCE (EMF, E, V)

The potential difference measured between two points in an electrical circuit. The term is often used interchangeably with voltage. When used, emf usually applies to the voltage generated by a source and has *E* for its symbol (instead of *V*). The unit of emf is the volt. *W. Klein*

Syn.: *Potential difference; Voltage.*

ELECTRON

A subatomic particle of unit negative charge of electricity. One electron carries a charge of 1.602×10^{-19} coulomb. *W. Klein*

ELECTRON BEAM RECORDING

A direct method for recording the signals carried by a modulated electron beam on photographic material. The film is placed in an evacuated cathode ray tube and is exposed directly by the electron beam, producing a high-resolution image. By comparison, indirect methods record the phosphor image on the face plate of the tube. *H. Wallach*

ELECTRON GUN

See *Cathode-ray tube.*

ELECTRONIC

Identifying devices and systems involving the flow of electrons in a vacuum, in gaseous media, and in semiconductors. *L. Stroebel*

ELECTRONIC DOT GENERATION

Use of screening algorithms to produce halftones on scanners, output recorders, or imagesetters. *M. Bruno*

See also: *Halftone process.*

ELECTRONIC ENLARGER

A projection printer that has a scanning light source. An incorporated monitoring control system varies the intensity of the light source during the scanning process to achieve dodging effects and overall contrast control. *L. Stroebel*

ELECTRONIC FLASH

See *Flash, electronic.*

ELECTRONIC-FLASH METER

Although conventional exposure meters cannot measure the short-duration

light from electronic flash units, specially designed flash meters can do so, and some meters can measure both flash and continuous light. An adjustable time gate feature on some flash meters provides for the measurement of the combined light from the flash and continuous light from other sources for different lengths of time, corresponding to shutter speed settings. Incident-light measurement has been the preferred mode for hand-held flash meters, but some can also measure reflected light. Through-the-lens flash metering is now commonly available in small-format cameras. All through-the-lens meters, whether flash or conventional, measure reflected light, or more accurately, *luminance.*

A more sophisticated approach to metering the light from electronic-flash units is to measure the light reflected from the subject as the film is being exposed and quenching the light at the source when the meter senses that the correct amount of light has been received. Because of the short duration of the flash with electronic-flash units, this technique requires a meter system that responds instantaneously. This system eliminates the need to fire the flash to obtain a meter reading before taking the picture. *J. Johnson*

See also: *Exposure meters.*

ELECTRONIC-IMAGE BACK　See *Camera back; Electronic imaging.*

ELECTRONIC PHOTOGRAPHY

Electronic photography is the electronic recording of optical images in analog or digital form. Image capture can be through the use of photo multiplier devices or linear or area charge-coupled devices (CCDs) with the recording on magnetic, optical, or solid-state media. Images may be made with a dedicated electronic still camera or video camera, or may be converted from silver halide originals into electronic form. The combining of silver halide and electronic technology is also known as hybrid technology. *J. Larish*

ELECTRONIC PUBLISHING

The production of printed material making use of a computer with an appropriate software program, which typically accommodates text and illustrations with layout control, and a peripheral printer. *L. Stroebel*

ELECTRONIC RETOUCHING　See *Digital image.*

ELECTRONICS

That branch of electrical science that deals specifically with the flow of electrons in a vacuum, a gaseous medium, or a semiconductor. The rapid advances in the field of electronics in recent years are largely a result of research in semiconductor materials and the invention of the transistor. Since the invention of transistors in 1948 at Bell Telephone Laboratories, solid-state devices have replaced vacuum tubes for almost all electronic applications. Some of the reasons for the widespread use of transistors and other solid-state devices are (1) unlike tubes they have no filaments to consume power, especially important when used in battery-operated equipment; (2) they are much smaller and much lighter than vacuum tubes, permitting high density mounting on printed circuit boards; (3) they are rugged and reliable and have extraordinary long life. By the early 1960s, designers were incorporating many transistors, diodes, resistors, and all the interconnections on a single piece of semiconductor and calling it an integrated circuit (IC). Compared to similar circuit using discrete devices, an IC requires much less power, is much smaller, and is more reliable.

The development of solid-state electronics has had a significant impact on the design of all kinds of photographic equipment—cameras with automatic exposure control, autofocusing, and motorized film advance; processors with precision temperature control; high-volume computer-controlled color printers; video color negative analyzers; and most recently, cameras and recording media for electronic imaging. (See illustrations, pages 244–245.) *W. Klein*

See also: *Electricity.*

ELECTRONIC SCANNER

An electronic scanner is a device used to convert black-and-white and color originals into images ready for reproduction. The black-and-white scanner can enhance tone reproduction and produce halftone films. Color scanners separate color originals into red, green, and blue records and perform color correction, retouching, and other modifications before outputting films for reproduction. There are two types of scanners: drum scanners using photomultiplier tubes (PMT) and red, green, and blue filters to produce the separations; and flat-bed scanners, which use charge-coupled devices (CCD) or linear arrays to record or separate the images. *M. Bruno*

See also: *Photomechanical and electronic reproduction.*

ELECTRONIC SHUTTER

The mechanics of opening and closing the shutter are based on electromagnets, and timing is based on electrical current passing through a resistor to a capacitor. The capacitor is connected to a solenoid that holds the shutter open until the charge reaches a predetermined level. Since only the shutter blades move, electromagnetic shutters are virtually vibration free. This system is more accurate than a timing mechanism using gears that can be affected by wear and severe temperature. This system also provides a greater variety of intermediate shutter speeds than those of conventional shutters. *P. Schranz*

Syn.: *Electromagnetic shutter.*

ELECTRONIC STILL CAMERA　See *Camera type.*

ELECTRONIC STILL PHOTOGRAPHY

Electronic still photography is the electronic recording of individual optical images in analog or digital form. Image capture can be through the use of photomultiplier devices or linear or area charge-coupled devices (CCDs) with the recording on magnetic, optical, or solid-state media. Images may be made with a dedicated electronic still camera or a motion video camera, or they may be converted from silver halide originals into electronic form using a variety of available monochrome or color scanners. The combining of silver halide and electronic technology is also called hybrid technology.

Electronic still photography began with the introduction of the Sony video still camera called MAVICA, an acronym for *magnetic video camera.* Announced on August 24, 1981, it was to be several years before Sony delivered a professional camera called the ProMavica.

ELECTRONIC ANALOG STILL VIDEO PHOTOGRAPHY

Photography, either with a conventional or electronic still video camera, is an analog process. Whether the photographic image is captured in a still video camera, a video camcorder, or a scanner associated with a computer, the first step with each of these devices is the production of an analog image recorded in analog waveform using a CCD that, when exposed to light, creates a pattern of charges that are recorded as analog waves. A principle component of the electronic still video camera is an optical system, which is the same as that of a conventional silver halide still camera. The still video camera depends on either a charge-coupled device (CCD) or metal-oxide semiconductor (MOS) as the initial image-capturing device.

The CCD is the equivalent of a piece of film with the ability to record electronically what the lens of the camera has seen. Only in the last few years have cost-effective imaging devices appeared. Patent literature is filled with new variations and modifications of basic sensors, using them for

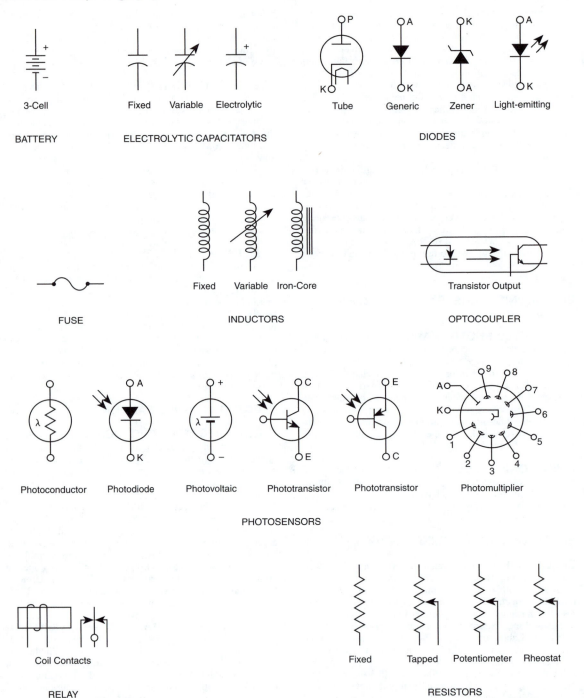

Electronics. Graphic symbols commonly used in electronic circuit diagrams. (See entry for specific components for electrode identification.)

camera focusing, for white light balancing, and for all of the various functions needed by the complete electronic still video camera.

Initial standards for electronic still video photography were established in 1982. A greatly improved standard, Hi-band, was announced in mid-1988. These standards fit the standard NTSC (National Television Standard Committee) format used for U.S. home video systems. More than 40 companies worldwide are part of the Electronic Still Standardization Committee in Japan.

With analog still video photography, the analog electronic signal that is recorded on the 2-inch magnetic floppy disk is similar to the signal recorded on conventional video tape. Because of the use of the floppy disk, many people think that the system is digital, but it is an analog system. The 2-inch floppy disk is one of the limitations still to be overcome for

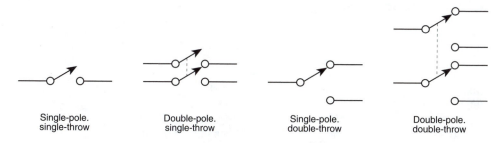

SWITCHES

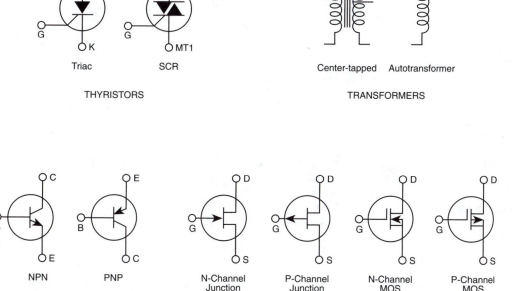

Electronics. Graphic symbols commonly used in electronic circuit diagrams. (See entry for specific components for electrode identification.)

higher-resolution electronic still systems. The 2-inch disk contains 52 tracks—50 for field recording and 2 for control. Provisions are also contained in the standard to use alternative field tracks to record 9.6 seconds of audio associated with an adjacent image field.

If the still video floppy disk were a computer disk (a 2-inch disk with a slightly different plastic shell is being used in laptop computers), the disk capacity would be between 740 kilobytes (KB) and 1 megabytes (MB), depending on the manufacturer. Some manufacturers are thinking of using the 2-inch floppy as an electronic photography digital medium, but in a double-sided format with 1.5 MB on a disk.

A basic limitation for still video cameras and camcorders is the resolution capability of CCD sensors, the medium that records the picture scene in an analog form. There is an inherent optical difference between conventional film cam-

eras and still video cameras. The sensors used to capture the electronic image are much smaller than the conventional 35-mm film so that a lens used on a interchangeable lens still video camera has actually four times the magnification of a lens used with 35-mm film. As an example, a 50-mm lens used with an electronic sensor would be the equivalent of a 200-mm lens used with a 35-mm camera. This means that the development of wide-angle lenses is a greater challenge for the still video camera designer, while long focal length lenses for sports use or law enforcement surveillance are already available and at lower prices than equal focal length lenses for 35-mm cameras. Optical design is a much easier task at the long focal length end of the range since a 1000-mm lens is equal to a 4000-mm lens in 35-mm photography, and the center portion of the lens is used that gives the greatest area of flat imaging and sharpness.

	Original	Hi-Band
1. Recording system		
Luminance	FM modulated recording system (*NTSC/PAL System*)	Same
White Peak	6.0MHz	9.7MHz
Synch. Peak	1.5MHz	7.7MHz
Frequency deviation	1.5MHz	2.0MHz
White Clipping	None	Less than 250%
Recording Current (Optimum)	7MHz	9MHz
Color Signal	R-Y, B-Y differential color lines. Subsequent FM-modulated recording in accordance with Still Video Floppy System.	Same
2. Disk Sheet	In accordance with Still Video Floppy System	Same
Thickness	40 μm	Same
Magnetic Sheet	Metal sheet or equivalent	Same
3. Disk Pack	In accordance with Still Video Floppy System	Same
Dimensions	60 × 54 × 3.6 mm (*W × H × D*)	Same
4. Track	In accordance with Still Video Floppy System	Same
For picture/sound	From track 1 to 50 digital data	Same
Cue Track	Track 52	Same
Track Pitch	100 Micron	Same

Analog still video photography standard, original and hi-band.

For the moment, all of the new still video cameras that have appeared are Hi-band cameras. Most manufacturers have chosen to go the route of field recording cameras that give 50 images per disk as opposed to frame-recording cameras that give only 25 images. There are some subjects that would be better reproduced if the frame option, with its greater information content, were available, but the field image is adequate for most amateur photography. Almost all of the new cameras have appeared with 380,000 or more pixel sensors that produce good-quality video images. Lenses for most prototype electronic still cameras are zoom lenses with macro focusing. This offers a great deal of creative opportunities for the person using the electronic still video camera.

There is still the problem of the video-look of still video pictures. The film-look that people have become used to through the proliferation of 35-mm film cameras has not been achieved by still video cameras. The inherent contrast of still video camera images combined with low exposure indexes limits the creative use of the still video camera. Some of the low light limitations have been overcome by providing $f/1.2$, $f/1.4$, or $f/1.8$ lenses on some prototype cameras. The real answer will be an improvement in the CCD sensors, but this may be a problem since most CCDs are used in the growing market of camcorders and the electronic manufacturers of camcorders are satisfied with current performance of CCDs for this use.

DIGITAL STILL VIDEO PHOTOGRAPHY An analog waveform continuously varies in value and time. To convert this to a digital signal, both the value and the time must be changed to noncontinuous values. The amplitude will be represented by a digital integer of a certain number of bits, and time will be represented as a series of those values taken at equal steps in time. The process of time determination is called sampling and the conversion of the amplitude is quantizing. Together these are called analog-to-digital conversion (A/D) or digitizing.

This conversion process is an approximation, but it has become much more refined with the improvement of A/D conversion devices and the use of higher rates. If the sampling rate is low, the result will be a very inaccurate representation of the signal. If the sampling rate is high, an almost exact copy of the original, both for color and density, can be achieved. A/D chips developed in 1991 have a rate of 300 million samples per second, and we can expect that figure to increase substantially.

In the case of color, the red, green, and blue information is handled as three complete, separate sets of data producing

Asahi Optical Co., Ltd.
BASF Aktiegesellschaft
Canon, Inc.
Casio Computer Co., Ltd.
Chinon Industrial, Inc.
Citizen Watch Co., Ltd.
Copal Co., Ltd.
Columbia Magnetic Products Co., Ltd.
Dai Nippon Printing Co., Ltd.
Eastman Kodak Company
Elmo Co., Ltd.
Fuji Photo Film Co., Ltd.
Hitachi, Ltd.
Hitachi Maxell, Ltd.
Kasei Verbatim Corporation
Keystone Camera of Japan, Ltd.
Konica Corporation
Kyocera Corporation
Mamiya Camera Co., Ltd.
Matsushita Electric Industrial Co., Ltd.
Minolta Camera Co., Ltd.
Mitsubishi Electric Corp

NEC Corporation
NEC Home Electronics, Ltd.
Nihon Polaroid Corporation
Nikon Corporation
Olympus Optical Co., Ltd.
Philips International B.V.
Ricoh Company, Ltd.
Samsung Japan Electronics Co., Ltd.
Sankyo Seiki Manufacturing Co., Ltd.
Sanyo Electric Co., Ltd.
Seiko Co.
Seiko Epson Co.
Sharp Corporation
Sony Corporation
Space-Wide Enterprises Co.
TDK Corporation
Thompson-Japan K K Co.
3M Company/Sumitomo 3M Ltd.
Toshiba Corporation
Victor Company of Japan, Ltd. (JVC)

Electronic still standardization committee members.

three complete sets of digital information. Three A/D circuits are used and the encoding is done simultaneously. As an image is digitized, a series of adjacent points in the image is created in the same pattern that the camera tube or solid-state imaging device originally scanned the image. These individual points are picture elements, or pixels. When reconstructing the image for display, each pixel is shown either as a small rectangle or square filled with color calculated from the number of color bits representing that pixel, or as a shade of gray if a black-and-white image is being recorded.

If the resolution of a system is low, it will result in a fuzzy picture showing the individual pixels; this is called pixelation. The degree of pixelation depends on how far you are away from the image and the corner-to-corner diagonal of the screen. A large viewing screen can appear sharp with a

Canon RC-570 still video camera. (Courtesy of Canon U.S.A., Inc.)

fewer number of total pixels, whereas a small viewing screen requires a large number of pixels to appear sharp.

Digital still video camera systems are beginning to appear. These systems begin with the same analog CCD, but the picture information is converted to a digital signal in the camera and stored in either a static random-access memory (SRAM) or electronically erasable programmable read-only memory (EEPROM). Digital still video camera systems have already been shown in prototype form by several different manufacturers with the first systems already available for sale. However, there are significant variations in the various systems. One prototype system was equipped with a 2 megabyte card—the camera produced 52 images through the use of a in-camera discrete cosine transform (DCT) compression algorithm. Another stored 10 images on a 16 megabit (Mbit) card, while a different system stored 20 pictures on an 8 Mbit memory card. Another system, jointly developed and marketed by Fuji Photo Film Co. Ltd. and Toshiba Corp., offers two different memory cards—a six- or twelve-image version in high-quality mode. This system will be one of the proposed standards. Sixteen Japanese manufacturers have begun to study a standard for digital still video photography imaging.

A digital camera has been developed that does not depend on the NTSC video standard, the current video standard for the United States and some other parts of the world. The Kodak Professional Digital Camera System (DCS) blends a conventional Nikon camera and digital imaging technologies. This system consists of two camera backs—one color and one monochrome—that replace the camera's standard back, a camera winder, and a Kodak digital storage unit (DSU) that stores up to 158 uncompressed, or 400 to 600 compressed images. The digital storage unit incorporates a 200-megabyte Winchester disk and Joint Photo Experts Group (JPEG)–compatible image compression capability. The imaging area of the DCS electronic digital camera back is only half that of a 35-mm film frame. So, the focal lengths

Fuji *FUJIX* digital still camera system. (Courtesy of Fuji Photo Film U.S.A., Inc.)

of the Nikon-mount lenses used are effectively doubled. For example, a conventional 200-mm lens becomes a 400-mm lens with the system. Both backs use a 1280 × 1024-pixel imager. The DCS produces color images equivalent to exposure indexes (EI) of 200, 400 (system nominal speed), 800, and 1600. Monochrome images are equivalent to EI 400, 800 (system nominal speed), 1600, and 3200.

In the United States it appears that the coming High Definition Television (HDTV) standard will be digital. The results of this digital approach will further enhance the field of electronic photo imaging in digital form at resolutions that begin to approach those of film, as perceived in the eyes of the viewer. The ultimate impact of these improvements will be the ability to greatly enhance the quality of the video pictures. Video images will rapidly approach the quality expected from conventional photographic material.

THE FUTURE At the same time that all of these changes are occurring, we should not forget the introduction of multimedia for the computer. While some see this only as an educational tool, it may ultimately be much more widespread. Multimedia brings interactive technology into the computer, combining video, sound, text, and photographs.

Standards are beginning to emerge for multimedia, and this may be a significant area of growth with the continued need for digital photographic images. This leads to the simple conclusion that the need for digital photographic images will continue to grow at a logarithmic rate far exceeding the recent significant advances in the development of conventional silver halide technology. A Fuji researcher, a number of years ago, said that the limits had been reached for silver halide technology. This may now be closer to reality since the cost of admission for companies entering the electronic digital photography area is much lower than the cost of entry into the silver halide area and therefore easier. The companies developing electronic photography products, in many cases, will be companies that in the past had not been in the photo-imaging marketplace.

Much work is being done on better and higher-resolution CCDs, particularly for use in HDTV systems. The result will be CCDs with an increase of five to ten times the resolution of the 1991 camcorder and still video sensors. These coupled

with improved memory chips will bring in a new era of electronic image capture both in the still and video areas.

OTHER MEANS OF ELECTRONIC DIGITAL CAPTURE Motion video camera or camcorders offer another means of capturing electronic photographs. Cameras using vacuum-tube technology have been mostly replaced by CCD-chip cameras. Chips are more stable and resist mechanical problems such as damage from being dropped. Video cameras usually operate at a total level of 8 bits of total red, green, blue (RGB) color because of the basic limitation of the color component of the NTSC color signal. Luminance or brightness has been enhanced, but the signal is limited by the NTSC bandwidth. Since video images are analog, they require the use of A/D conversion, usually done in a computer by using a plug-in board.

Another way of capturing photographs digitally is scanning. Scanners can range from large, high-resolution rotary scanners, which were first developed for image separation in printing, to flatbed or hand-held scanners that can have resolutions up to 1200 dots per inch (DPI). The flatbed or hand-held scanners use linear arrays that are like the CCDs found in camcorders or still video cameras but with the sensor elements located in a single line requiring three separate passes of the scanning head, one for each color. In 1990, tricolor arrays using three rows of elements became popular allowing full-color scanning in a single pass of the scanning head. Area arrays, much like those found in cameras but with higher resolution, have been used for new, faster scanners. For 35-mm film scanning, resolutions close to that of the Kodak Digital Camera System have been available.

The major limitation of scanners has been resolution. Normal desktop scanners operate in the 300 dpi range. Some high-resolution scanners offer resolutions from 1000 to 3000 dpi, but the cost jumps sharply for the higher resolutions, as do the scan time and the file size. Some of these higher-resolution scanners can take 10 minutes or more to scan and can reach file sizes of over 200 MB, not an easily handled data file. Another consideration in color scanning is the color depth of each scanned RGB pixel. Six bits or more per color are necessary to assure a natural-looking color without *banding,* a striping of color steps. This adds to the storage demands of a system as well as to the capabilities of the scanner.

Added together, the various forms of image capture provide the opportunity of increasing the use of electronic photography. Whether a still video camera, a scanner, or a motion video camera adapted to still work, these all open new ways of using electronically or digitally captured images.

IMAGE STORAGE Magnetic storage has been the most cost-effective way of image storage up to this time. The capacity of floppy disks has been increased as has the capacity of the Winchester hard disks. WORM (write once read many) optical disks have provided large-capacity storage media in a nonerasable form. In the late 1980s, the introduction of magneto-optical erasable disks have added additional capability for image storage. The high capacity of this medium has made it ideal for image storage of any size image, and newer technology has brought the record and playback speeds on a par with magnetic material.

Kodak's Photo CD provides an additional hybrid nonerasable digital storage product for industrial, commercial, and consumer use. The Photo CD is the same size as the popular audio CD or CD-ROM but its resemblance stops there. The Photo CD stores 100 color digital electronic images scanned from 35-mm film at about the same resolution as a 35-mm negative—18 million pixels. The Photo CD can be used on the CD-ROM HA and CD-I players. The transfer process includes a Kodak-developed scanner with a 2K RGB linear array sensor, a Sun SPARC workstation at the data

manager, a Kodak XL-7700 to produce 42-image proof cards for the Photo CD boxes, and a CD optical disc writer from Philips. Kodak will make the optical media and materials for the printer. The Photo CD discs can be used for NTSC, European PAL, and SECAM standard video playback and current Japanese Muse HDTV through internal electronic functions.

IMAGE TRANSMISSION Computers have been talking to each other via modems for a number of years. The digital transmission of data—be it information from stores, corporations, medical facilities, or even home computers and the vast computer network—is a service being offered. While initial modems in 1980 were slow, with ranges of 80 to 300 bits per second (bps), in 1991, through the use of special lines and equipment, it is actually possible to send almost 10,000 bps of information. This will continue to increase substantially as fiber optic transmission lines become available in the future. For data, the 1991 speed might be acceptable; for images, the cost of telephone time combined with the actual wait for images is, for the most part, unacceptable.

To overcome this, special transmitters have been designed by a number of companies for both transmission of still video electronic photographs and conventional film images in electronic form in 1 to 4 minutes. These images can be received, generally, as digital images suitable for digital processing or direct separation in systems used by many newspapers and magazines.

IMAGE PROCESSING High-resolution color imaging on personal computers was pioneered by an AT&T *intrapreneurial* venture, the Electronic and Photographic Imaging Center (EPICenter), Indianapolis, Indiana, founded in mid-1984, later becoming TrueVision, Inc. The company produces one of the most widely recognized of the high-end graphic boards available for the IBM PC/XT, AT, and compatibles. Several hundred third-party companies offer imaging software that utilizes Targa, and a number of video conversion boards (some with bundled software) are available. Competition has brought dramatic changes in the workstation market. These new platforms from more than a half dozen companies have brought greater performance and capability, all at reduced cost. The future will depend on digital technology. It has never been truer that digital technology is getting better and lower in price than ever, particularly with respect to electronic imaging.

A digital photographic image is a redundant image where the same information may appear more than once. Where the same color is at different pixels within the image, this may be one redundancy, either horizontal or vertical. If the image is moving, there may be a redundancy between succeeding images. If there are straight lines of information, this may create another redundancy. Compression of images depends on this redundancy of information in the image. Images may be compressed because of the dependence of each pixel value on the value of its neighbors. The larger this dependence, the more compression is achievable. The information content of images depends on the resolution, noise travel level, bit depth, and many other factors and is difficult to quantify, but three types of redundancies can be identified:

Spatial redundancy—due to the correlation (dependence) among neighboring pixel values.

Spectral redundancy—due to the correlation of color planes (RGB) or spectral bands.

Temporal redundancy—due to the correlation between different frames in a sequence of images.

Images are referred to as lossless when the reconstructed pixel values (compressed/decompressed) are identical to the original values. For lossless compression, the bit rates equal to the information content of an image can be obtained. Lossy compression has some discrepancies between the original and reconstructed pixel values. With lossy compression, lower bit rates can be achieved depending on how much distortion can be tolerated.

There are a number of different techniques for compressing images. One of the simplest techniques for image compression is truncation. With truncation, data are reduced by throwing away some parts of the bits for each pixel. These are usually the least significant bits for every pixel. Another simple preparation scheme is the use of a color look-up table (CLUT). This is usually not a satisfactory approach for photographs that usually will use a color look-up table of 30,000 or more colors. The CLUT approach is done at no more than 8 bits per pixel. For this application, color look-up tables have 256 colors or less. The third simple method is run-length (RL) coding where the same pixel is repeated, such as a solid color, and a single value is substituted—a count of how many times to repeat the value. This again is only possible when simple colors exits.

After some four years of work, JPEG has produced a color image data compression standard. Image compression has become easier with the advent of new discrete cosine transform (DCT) chips from several developers of microchips. These chips provide a dedicated means DCT computation. This means that image compression and decompression can be improved and the process made faster.

The evolution of compression technology for images is still continuing. The introduction of new still image and video fractal compression technology from Integrated Systems provides another approach to image compression. The P.OEM (pictures for original equipment manufacturers) software, a compression technology, has been demonstrated with software-based video, both color and gray scale, at frame rates of up to 30 frames per second using a 386–33 mHz machine with sight and sound from a floppy disk.

PROCESSING PLATFORMS Most common among the platforms used for retouching electronic still photographic images are the Apple Macintosh, IBM-PC and a variety of clones, and Sun SPARC platforms. Systems available range from sophisticated dedicated retouching systems using specially formatted platforms to a wide variety of PC- or Macintosh-based systems. A typical dedicated system might include a rotary scanner for image input, a Sun, Macintosh, or PC-based processing platform, with output to a film recorder or a rotary film writer. Images may be input and output on tape also.

SOFTWARE Image software development has concentrated primarily on software for the Apple Macintosh computer. There are several different categories of photo-imaging software that are now available. Retouching software, such as Adobe PhotoShop, allows an image to be scanned on a variety of platforms. The images can then be enhanced with contrast and color changes or a variety of pictorial effects that can improve or enhance the image. Page makeup software allows the combining of type and photographs into a final form for output to a film recorder or to an imagesetter for preparation of separations, or to magnetic tape or other digital form for printing. Picture filing software allows the filing and retrieval of digital photographs through assigned work descriptors used as search criteria.

IMAGE DISPLAY AND OUTPUT Viewing electronic still photographic images on a screen is referred to as a soft viewing. This is because no permanent copy is made of the screen image unless a film image or film capture device is used. The word hardcopy comes from the photocopy machine industry and the various aspects of creating a rigid or permanent copy of an image.

DISPLAY MONITORS The most common display monitor, whether it is contained in a home television set or a dedicated color display monitoring device for a video system or computer, is a cathode ray tube (CRT). The CRT uses a

viewing screen that is coated, in the case of a color tube, with either bands of phosphors that produce red, green, and blue or individual dots of phosphor. Electrons are emitted from a cathode in the narrow end of the tube and these are focused either magnetically or electrostatically into a small spot on the screen and positioned by either magnetic or electrostatic deflection. The cathode and electronic focusing lenses are part of the tube called the gun with the beam being accelerated towards the phosphor by high voltage at an anode.

The first CRTs appeared just before the turn of the century and remain a major display medium for both video and computer imaging. The CRT is an inexpensive device with many desirable features including the ability to produce tubes of 35- and even 45-inch diagonal proportions. The one problem of CRTs is the bulk that they represent. Even some of the newer designed tubes with their much shorter form still make it difficult to create wall displays or briefcase-sized devices. The CRT needs a considerable distance from the gun to the screen to focus and scan the image.

Because of some of the shortcomings of the CRT, much effort has been expended to develop a form of flat display device. Work on flat-panel displays has continued for some 20 years, and the best results have been shown by liquid crystal displays (LCDs). Liquid crystal compounds are assembled in a thin film (approximately 0.5 mil in thickness) between parallel transparent conductors. When the electronic field is applied, a scattering effect allows light to reflect or pass through the conductors. The most recent development of the active screen places a transistor at each pixel location to produce extremely high resolution results.

Liquid crystals range from unique 2000 × 2000-line liquid crystals produced by Hitachi and written with a laser to control a tungsten light source to color 14-inch LCD screens already suitable for computer graphic display. Color is obtained by using a dichroic dye in the crystal color materials that the light passes through.

Those who work with color imaging systems are concerned that the color you see is the color you get (CYSI/CYG). With increased use of color monitors as the viewing choice for electronic images, particularly in the graphics area, more efforts are being made to assure a match in color between the soft screen and the hardcopy images. While this concern was a key part of the printing industry's move to digital imaging, it is now reaching into the world of electronic photography also. The solutions offered include computer-controlled monitors and testing programs for monitor standardization. The important fact is that awareness of this problem should result in better viewing conditions, much like the standardization that occurred in the color transparency and print viewing standards work of several decades ago.

HARDCOPY PRINTERS It is important to have the ability to create a hardcopy of an electronic still photograph in a photorealistic form. Color printers are not new, but the most recent series of thermal dye-transfer printers have begun to approach the level of photorealism expected of good electronic still photographs.

For both the professional and general user, hardcopy prints are still a significant need. There are many approaches to creating prints from electronic images—some work very well, others adequately, and some leave much to be desired. Much is related to what the application for the prints will be. If prints are desired for publication, the resolution must match the resolution of silver halide prints, or otherwise moiré or wavelike patterns develop because of the inconsistencies between the graphic arts screening process and the pattern that already exists on the electronic prints.

There are some criteria that must be met to achieve good-quality hardcopy. (1) The resolution must be high enough to reproduce all the information contained in the electronic version of the picture. The increased resolution of the images with the continued development of true digital electronic still cameras and HDTV-based systems will become a major obstacle to some available systems. The minimum resolution acceptable to the eye must be at least 200 dpi. (2) Color reproduction must be accurate with good separation of tones. (3) The gray scale reproduction for each color must be a minimum of 6 bits per color with a scale approaching that of conventional silver halide photography. (4) The print time must be 1 to 2 minutes for a completed print. A short time would be even more advantageous. (5) The system must be easily coupled to existing computer or video systems. (6) The finished print must give the appearance of a conventional silver halide color photograph. In these criteria, some judgmental factors are certainly based on individual preferences, and other conditions could be added like storage life, and unexposed storage life, as well as environmental impact.

In discussing the various approaches to hard copies, two distinct forms of control over the scale of the images produced become apparent. In systems such as conventional silver halide photography or thermal dye-transfer printing, either light or heat will create a proportional value equal to the density of the pixel desired. In other systems such as ink-jet, ion deposition, or thermal wax transfer, this variation is created by the size of the ink drop or by breaking the single pixel down to the micropixels and increasing or decreasing their size. This variation of the two basic systems is one of the reasons why the thermal dye transfer process has won popular support.

As a color print output system, the thermal dye transfer print system, also referred to as dye sublimation or D2T2 (Dye Diffusion Thermal Transfer), uses a color ribbon that is the same size as the finished print with gravure-printed layers of cyan, magenta, and yellow dye, each the size of the finished print. Dyes are applied one at a time to high-gloss finish receiver paper, similar in characteristics to conventional photographic paper. Thermal dye transfer printers range in size up to 11 × 17 inches.

Ink-jet printers have also begun to serve the needs of quality photographic imaging. Ink-jet printers produce photorealistic results through the use of electrically charged particles that can be deposited in a series of micropixel portions to create shadings. While early ink-jet printers suffered from problems of clogged jets and lack of speed, contemporary ink-jets self-clear each time, use piezo or other electrical charge techniques to increase color fidelity, and are available with improved inks.

There are now several new approaches to color silver halide image printing. Ilford premiered a new liquid crystal light valve (LCLV) printer that produces continuous-tone color prints, transparencies, and 35-mm slides directly from computer-based digital input with true photo quality. Digital images are written by a laser onto three LCLV cells and then the image is projected by tungsten light on the photo medium and processed. The whole operation is done in white light. Both print and transparency materials are provided in daylight-load roll cassettes. The images have 256 levels of gray for each color. This is a palette of 16.7 million different colors. The resolution of each LCLV is 3500 × 2550 pixels. For 8 1/2 × 11-inch prints, that is 300 pixels per inch or 3500 lines for 35-mm slides. Writing to the cell takes less than 2 minutes with processing and drying takes 3 1/2 minutes. Once the image is written, multiple images may be made without rewriting. Images are written with a laser on the 3M Color Laser Imager. The system uses infrared-sensitive color print material. The resolution of the system is 300 dpi.

Fuji Pictrography 2000 is an LED-written product. The silver halide print materials (reflective and transmission) require no chemical processing, only water and heat. Each component color of the image is graded in 256 steps for

16.7 million shades of color at a resolution of 11.2 dots/mm (284 dpi).

FILM RECORDERS Film recorders use high resolution CRTs to produce an individual record of red, green, and blue images for transfer to color silver halide film. Film recorder outputs can range from 35 mm to 8 × 10 inches at resolutions of 1000 × 1000 to 16,000 × 16,000 pixels. The cost of higher-quality film recorders is much lower than the cost of graphic art image setters but they require long exposure times because of the amount of information written to the CRT.

Books: Larish, John J., *Understanding Electronic Photography.* Blue Ridge Summit, Penn. Tab Books, 1990. Larish, John J., *Digital Photography, Pictures for Tomorrow.* Torrance, Calif. Micro Publishing Press, 1991. Larish, John J. *Photo CD: Quality Photos At Your Fingertips.* Torrance Calif. Micro Publishing Press, 1993. *J. Larish*

ELECTRONIC TRICK PHOTOGRAPHY See *Special effects.*

ELECTRONIC TRIGGER

Any momentary pulse that initiates further circuit action. Examples include the signal that causes a silicon controlled rectifier (*SCR*) or triac to start to conduct and the signal that causes the horizontal sweep of an oscilloscope to start.

Also, the ionizing of gas in a flashtube by the momentary application of a very high voltage (2.5 to 15 kV) to a fine wire next to the flashtube. A transparent conductive coating on the flashtube is sometimes used instead of the wire electrode. *W. Klein*

ELECTRON IMAGING

The use of electron energy to produce images. A scanning electron beam excites phosphors, which in turn emit light, on the screen of a cathode ray tube. The image can be viewed directly as on a television screen, radar screen, or oscilloscope, or it can be photographed. If high resolution is required, then special electron-recording film and equipment are used to record the electron beam image directly. *R. Zakia*

See also: *Electron lens.*

ELECTRON LENS

An arrangement of magnetic coils and electrodes used to focus a beam of electrons in a manner similar to that of a conventional optical system focusing light. The focal length is defined in the same way as that of an optical lens. *R. Zakia*

See also: *Electron imaging.*

ELECTRON MICROGRAPHY

An electron microscope is an instrument for revealing fine detail through magnification by the use of electrons. Whereas the light microscope uses glass lenses to focus magnified images using photons of light, the electron microscope uses magnetic lenses to focus images using electrons. The limiting magnification of the light microscope is usually about 2000×, due to the wavelength of light. The much shorter wavelength of electrons gives usable magnifications over 1,000,000×. Electrons travel freely only in vacuum, so the electron source, lenses, specimen, and detector are all located in a column under high vacuum. There are two basic types: the transmission electron microscope (TEM) and the scanning electron microscope (SEM).

The TEM requires a specimen of exceeding thinness, cut on an ultramicrotome to a fraction of a micron. The TEM is best for revealing internal structure. The specimen must have areas differing in their abilities to absorb or scatter electrons. "Staining" biological tissues with heavy metals usually accomplishes this. In a manner similar to that of the compound light microscope, the TEM uses several cascaded stages of

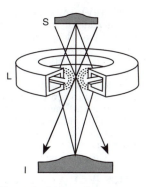

Electron lens. (S) sample, (L) lens, (I) image.

magnification. Images are composed and viewed on a screen that fluoresces when struck by electrons that have passed through the specimen and been magnified by the lenses. Silver halide films or plates put in place of the screen receive and are exposed by the electron image, and are then processed to a negative, as in conventional photography. Because the physics of latent image formation with electrons differs fundamentally from that with light photons, control of the process is different; exposure controls contrast while development controls speed and image structure.

The SEM uses its magnetic lenses to focus the electron beam to an exquisitely fine point. This point beam of electrons is scanned over the surface of the specimen in a raster pattern. The specimen needs to be electrically conducting: if it is not naturally so, it must be given a conducting coating. After striking the specimen, electrons are reflected or scattered, or secondary electrons are emitted. These electrons are picked up by a detector. The output of the detector is used to modulate the brightness of the beam of a video display tube that is being scanned synchronously with the specimen. This gives a highly magnified picture of the surface of the specimen.

The specimen in the SEM is scanned at video rates and in a course raster producing a real-time picture at low resolution. This visual image is used for instrument and specimen adjustment. To make a permanent record, the specimen is scanned slowly with a very fine raster. This image is displayed on a special high-resolution video tube that faces an ordinary camera with ordinary film. All viewing and recording are done outside the vacuum column. Polaroid films are predominantly used. The SEM excels at showing surface detail and texture.

If before examination the SEM specimen is bombarded in a vacuum coater with a stream of metal atoms coming from a fixed direction at a known angle, the metal film thus formed will appear to cast shadows over the specimen's rough topography. This will indeed show up as shadows in the final image. Since the angle of illumination is known, heights of surface detail can be measured in the image using simple trigonometry.

The energies of secondary electrons emitted by the specimen in the SEM depend on the chemical composition of the spot the scanning beam is resting on. By holding the beam on a spot of interest and diverting the secondary electrons to the electron equivalent of a spectrograph, the SEM can be used for chemical analysis of very small particles.

Both types of EM produce black-and-white images, since they examine the specimen in a region of the spectrum far removed from the realm of light and color. Color is sometimes introduced artificially into EM images, especially SEM when used in the analytical mode, where different chemical elements can be represented in different colors. *M. Scott*

ELECTRON VOLT (eV) An energy unit equivalent to the amount of energy imparted to an electron traveling across a potential difference of 1 volt in a vacuum, or 1.602×10^{-19} joules. Electron volts are commonly used to express the energy levels of particle radiation (such as beta particles) and higher energy photons. The energy of a photon is related to its wavelength by the following equation: $E = hc/\lambda$, where h, Planck's constant, is equal to 6.626×10^{-34} joule-sec and c is the speed of light (2.9979×10^8 m/sec). A blue light photon with a wavelength of 450 nm, therefore, has an energy of 2.76 eV. This energy is sufficient to promote an electron in a silver halide crystal to the conduction band of the crystal.

J. Holm

ELECTRO-OPTICS (EO) A rapidly growing branch of electronics related to such devices as lasers, fiber optic transmitters and receivers, bar code readers, optical character readers (OCR), optocouplers, and light emitting diode displays.

W. Klein

ELECTROPHORESIS The migration of charged particles in a fluid to a field. Photoelectrophoresis is the difference in electrophoresis in the presence and absence of radiation. In photoelectrophoresis, the charge on the particle is changed, or reversed, by charge transfer to an electrode, or the surrounding medium. Most photoconductive pigment imaging processes involve photoelectrophoresis.

P. Borsenberger

ELECTROPHOTOGRAPHY Schaffert (1975) defines electrophotography as image-forming processes that involve the interaction of light and electricity. Within the framework of Schaffert's definition, many different processes exist. Of these, processes that involve the development of electrostatic charge patterns on insulator surfaces, as originally described by Carlson (1942), are the most highly developed. Schaffert and Oughton (1948) described these as "xerography," derived from the Greek words *xeros* for dry and *graphein* for writing. The literal meaning of the word is thus "dry writing."

In the 50 years since the first xerographic copy was created, xerography has established itself as one of the leading technological innovations of this century. Today, more than 1 trillion documents are generated annually by this technology. Xerography is currently used in all commercial copiers. With the advent of semiconductor lasers and light-emitting diodes in the late 1970s, it has also been widely used for printing. This entry includes a review of the early development of electrophotography and then describes the xerographic process, followed by a review of alternative electrophotographic processes.

EARLY HISTORY Processes by which electrostatic charges are used for image reproduction can be traced to the formation of charge patterns by Lichtenberg (1777), which still bear his name. Lichtenberg images were prepared by scattering dust on the surface of resin insulators that had previously been sparked. A decade later, Villarsy (1788) was able to determine the polarity of Lichtenberg figures by using a mixture of red lead and sulfur powders. The first practical demonstration of electrostatic recording was by Ronalds in the early 1840s. The instrument produced by Ronalds was called an electrograph and involved the movement of a stylus contact, which was connected to a lightning rod, across an insulating resin surface. The charge pattern, induced by atmospheric electricity, was made visible by dusting the surface with charged powder particles.

During the latter part of the nineteenth and early part of the twentieth centuries, there were a number of observations in which electrostatic images were made visible. All had in common the displacement of powder, dust, or smoke to charged surfaces. The first sustained efforts for the reproduction of electrostatic images were in the 1920s and 1930s by Selenyi. The technique used by Selenyi involved the writing of electrostatic images on insulating surfaces by electrons or ion beams. The images were subsequently made visible by dusting the images with positively charged lycopodium powders. An important aspect of Selenyi's process involved the use of electrons or ions, rather than light, for writing of the images. As such, Selenyi's processes are more properly described as electrographic, rather than electrophotographic. Reviews of early work on electrostatic recording have been given by Carlson (1965) and more recently by Mort (1989).

Many of the early attempts to create electrostatic charge patterns were based on the photoelectric effect, the process by which electrons are ejected from a solid by the absorption of radiation. A fundamental limitation of processes based on the photoelectric effect is that they require very high exposures. In the 1920s and 1930s, several attempts were made to use photocurrents to control chemical changes in specially treated papers. From the results of these studies, Carlson concluded that chemically based phenomena of this nature were not feasible with the magnitude of photocurrents that could be produced under conditions of practical interest. As a result, Carlson and Kornei began to experiment with the creation of electrostatic latent images on the surface of photoconducting insulators. The results of these experiments led to the discovery of an image-forming process that Carlson later described as "electrophotography."

The date of reduction-to-practice of Carlson's discovery is October 22, 1938, and described by Dinsdale (1963). The discovery is best described in Carlson's own words: "October 22, 1938, was an historic occasion. I went to the lab that day and Otto had a freshly-prepared S coating on a Zn plate. We tried to see what we could do toward making a visible image. Otto took a glass microscope slide and printed on it in India ink the notation '10-22-38 ASTORIA.' We pulled down the shade to make the room as dark as possible, then he rubbed the S surface vigorously with a handkerchief to apply an electrostatic charge, laid the slide on the surface and placed the combination under a bright incandescent lamp for a few seconds. The slide was then removed and lycopodium powder was sprinkled on the sulfur surface. By gently blowing on the surface, all the loose powder was removed and there was left on the surface a near-perfect duplicate in powder of the notation which had been printed on the glass slide. Both of us repeated the experiment several times to convince ourselves that it was true, then we made some permanent copies by transferring the powder images to wax paper and heating the sheets to melt the wax. Then we went out to lunch to celebrate."

The first seminal patent on electrophotography was awarded to Carlson in 1942. In 1944, Carlson was awarded a patent on an automatic copying machine. In that same year, Carlson undertook an agreement with the Battelle Development Corporation, a subsidiary formed by the Battelle Memorial Institute for the purpose of sponsoring new inventions. Under the agreement, Battelle agreed to conduct further research in support of Carlson's invention. In 1947, the Haloid Corporation acquired a license to the process and began support of research at Battelle. At that time, the Haloid Corporation had a product line of photocopying machines based on wet chemical processes. During the late 1940s and 1950s, many significant improvements in the electrophotographic process were made. A major innovation was that amorphous Se, α-Se, layers were insulators with much higher photoconductivity than S or anthracene used in Carlson's original research. Other significant discoveries were screen-controlled corona charging devices, the development of two-component developer particles, and electrostatic transfer methods. The first public announcement of the

Oct. 6, 1942. C. F. CARLSON 2,297,691

ELECTROPHOTOGRAPHY

Filed April 4, 1939

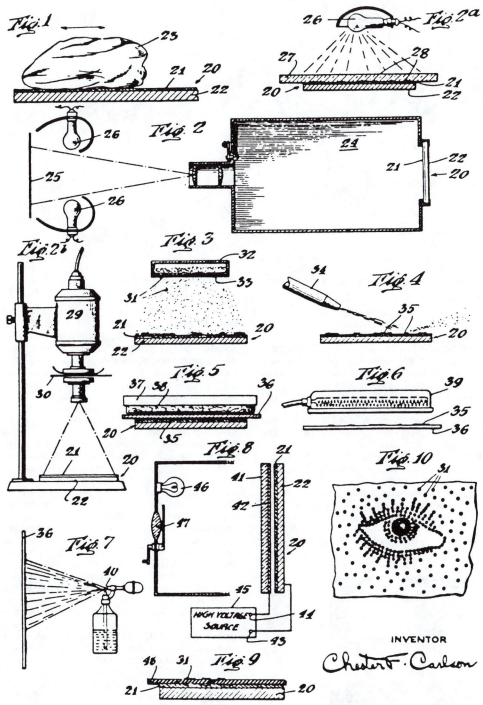

INVENTOR

Chester F. Carlson

The first page of Carlson's original patent on electrophotography, issued in 1942.

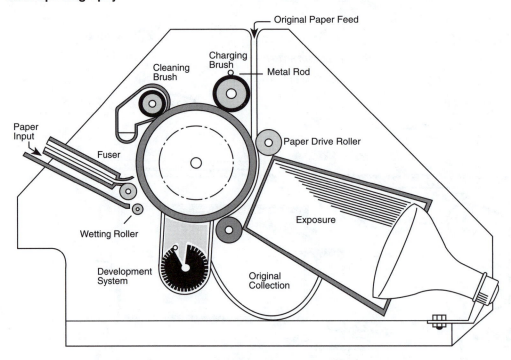

The first automatic electrophotographic copying machine, described in a 1944 patent issued to Carlson.

process was at the annual meeting of the Optical Society of America on October 22, 1948, the tenth anniversary of Carlson's discovery, by Schaffert and Oughton. At that time, the process was given the name of xerography. The first sale of commercial xerographic equipment was of Haloid's Xerox Copier Model A in 1949 and the Copyflow printer in 1955. Due to the commercial significance of xerography, the Haloid Corporation was renamed Haloid-Xerox in 1955 and the Xerox Corporation in 1961.

For reviews of early work, see Wilson (1948), Carlson (1948, 1949), Schaffert (1950), Oliphant (1953), and Dessauer, Mott, and Bogdonoff (1955).

XEROGRAPHY In xerography, the primary image-forming step involves the formation of an electrostatic latent image on the surface of a photoconducting insulator. The latent image is made visible by toner particles, transferred to a receiver, then made permanent by a fusing or fixing process. In a variant of this process, the photoconductor is coated on the receiver, thus eliminating the transfer process. This process is separately discussed in the following section.

This special commemorative stamp was issued in honor of Chester Carlson.

In conventional xerography, the overall process can involve as many as seven steps. In step 1, a uniform electrostatic charge is deposited on the photoreceptor surface. This is accomplished by a corona discharge. In the second step, the photoreceptor is exposed with an optical image of the object to be reproduced. This selectively dissipates the surface charge in the exposed regions and creates a latent image in the form of an electrostatic charge pattern. In step 3, electrostatically charged toner particles are brought into contact with the latent image. The toner particles are transferred to a receiver in step 4, then fused in step 5. In step 6, the remaining toner particles are removed from the photoreceptor surface. Finally, in step 7, the photoreceptor is uniformly exposed to remove any remaining surface charge. Following step 7, the process can be repeated. The various steps are carried out around the periphery of a photoreceptor drum or belt. Drums are commonly used for low-volume copiers and printers while belts are more common in high-volume copiers. Each of the various process steps is separately discussed in the following sections. For reviews of the xerographic process, see Schaffert (1975), Scharfe (1984), Williams (1984), and Schein (1988).

Corona Charging The initial step in the xerographic process is the deposition of a uniform charge on the photoreceptor surface. Xerographic photoreceptors are between 20 and 60 mm in thickness and prepared on electrically conducting substrates. The substrate electrode is maintained at ground potential. The photoreceptor is charged to potentials of several hundred volts in the dark by a corona discharge. Potentials in this range correspond to surface charge densities between 10^{11} and 10^{12} charges/cm^2. To prevent the dissipation of the surface charge in the time between the charge and development steps, it is necessary that the dark conductivity be extremely low. Further, the free surface and substrate electrode must form blocking junctions to the photoreceptor. The corona charging apparatus is usually comprised of a series of stainless steel or W wires, typically 100 mm in diameter, strung between insulators in a stainless channel. The corona wires are maintained at very high (5–15 kV)

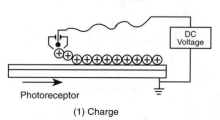

(1) Charge

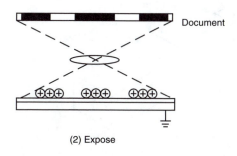

(2) Expose

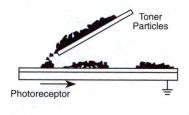

(3) Develop

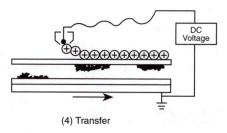

(4) Transfer

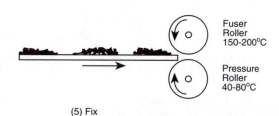

(5) Fix

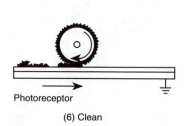

(6) Clean

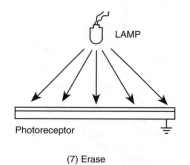

(7) Erase

A schematic of the various steps in the xerographic process.

potentials. The fields in the vicinity of the corona wires are sufficiently high that any free electrons in the region of the wires will be accelerated to velocities such that ionization of the gas molecules will occur. The concentrations of the ionized gas molecules are primarily determined by the corona polarity and the atmosphere (Shahin, 1969). For positive coronas, the dominant species are hydrated protons of the generalized formula $(H_2O)_nH^+$, where $n = 4–8$. For negative coronas, CO_3^- is the principal specie. Corona discharges from bare wires usually show significant nonuniformities in intensity. The corotron was invented to avoid problems associated with nonuniform charging. Corotrons are corona devices that contain an auxiliary electrode in close proximity to the corona wire. The purpose of the auxiliary electrode is to control the field geometry such that the corona potentials

are more uniform. Corotrons can have many different electrode arrangements. Usually the auxiliary electrode is at a very low, or ground, potential. The emission uniformity along a corona wire is strongly influenced by the polarity. Uniformity is good for positive coronas and poor for negative coronas. The scorotron was developed to resolve the problem of nonuniform charging with negative potentials. The scorotron contains a metal screen, or grid, between the corona wires and the photoreceptor and set to a potential that closely approximates the potential to which the photoreceptor is to be charged. The purpose of the scorotron screen is analogous to the control grid of a vacuum triode.

Latent-Image Formation In the second step, the photoreceptor is exposed with an imagewise pattern of radiation that corresponds to the image that is to be reproduced.

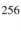

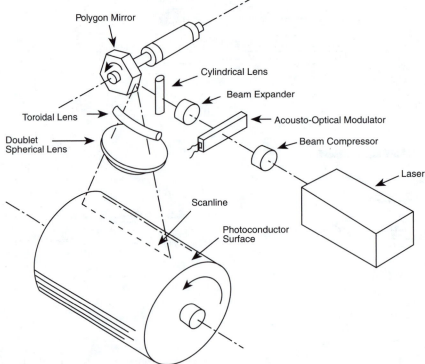

Polygon Mirror

Cylindrical Lens

Beam Expander

Toroidal Lens

Acousto-Optical Modulator

Doublet Spherical Lens

Beam Compressor

Laser

Scanline

Photoconductor Surface

A schematic of a printer in which the photoreceptor is in a drum configuration (after Fleischer, Latta, and Rabedeau). Reprinted with permission from *IBM J. Res. Dev.,* 1977, 479. Copyright 1977, the IBM Corporation.

Absorption of the image exposure creates bound electron-hole pairs. Under the influence of the corona-induced field, the pairs separate and are displaced to the free surface and the substrate electrode. As a result, the surface charge is dissipated in the exposed regions and an electrostatic latent image is created. For copiers, the image exposure is reflected from a document, then imaged onto the photoreceptor through a lens. The source of radiation is usually a xenon-filled lamp for flash exposures or a quartz-halogen or fluorescent lamp for scan or continuous exposures. To reproduce color originals, it is necessary that the photoreceptor have sensitivity throughout the visible region of the spectrum. For printers, exposures are derived from either a laser or an array of light-emitting diodes. In this case, the photoreceptor need be sensitive only at the emission wavelength of the laster or light-emitting diode. Laser exposures are usually scanned across the photoreceptor surface by a spinning polygon mirror. Most printers use either HeCd, Ar, HeNe, or GaAlAs lasers. For most applications, latent image formation requires exposures of approximately 10 ergs/cm². These correspond to an ASA rating of approximately unity.

In Carlson's original patent, anthracene, sulfur, and mixtures of sulfur and selenium were described as photoconducting insulators suitable for the creation of latent images. From the patent, it is clear that Carlson understood that latent image formation involved the selective dissipation of the corona-induced potential by the creation of free charges. The materials described by Carlson had very limited photoconductivity, however, particularly in the visible region of the spectrum. Further, these materials had very poor mechanical properties and could not be readily prepared in large areas. One of the initial responsibilities of the Battelle group was the development of materials with improved photoconductivity and mechanical properties that

could be readily prepared in a large-area configuration. A major accomplishment of the Battelle group was the development of α-Se as a xerographic photoreceptor. Photoconductivity in α-Se was discovered independently in the late 1940s by two laboratories searching for large-area photoconductors suitable for imaging application. One of these was the RCA Laboratories, which was investigating the use of photosensors in vidicon technology. The other was at Battelle where photoreceptors for xerography were pursued. Both applications require materials with very low dark conductivity and high photosensitivity. During the 1960s and 1970s, α-Se and alloys of α-Se with arsenic and tellurium were widely used as photoreceptors. Other materials that were used were dispersions of inorganic particles, mainly ZnO, CdS, and CdSe, in a polymer host. In the past decade, organic materials and α-Se have been increasingly employed. The use of ZnO, CdS, and CdSe has been largely discontinued.

While α-Se was widely used in the early development of xerography, it has several limitations. The first is that it is susceptible to crystallization to the more stable trigonal form. The dark conductivity of trigonal selenium is such that it is not usable for xerography. This was eventually solved by the addition of small amounts of As. Another limitation is that α-Se shows very little photoconductivity in the long-wavelength region of the visible spectrum. A solution to this problem involved the incorporation of either tellurium or arsenic, in relatively high concentrations. Films containing 40% arsenic (As_2Se_3) show comparable levels of photoconductivity in the blue, green, and red regions of the spectrum. The most significant limitation of α-Se and related alloys is that these materials cannot be prepared in a flexible belt configuration. This poses significant process limitations for color or high-volume applications. For a general review

of α-Se and related alloys for xerography, see Pfister (1979a, 1979b) and Kasap (1991).

The use of organic photoreceptors for xerography was first described in the late 1950s. Organic photoreceptors contain a strong electron donor or acceptor in a host polymer. Usually a pigment is added to impart the desired spectral sensitivity. Organic photoreceptors can be prepared in a belt or drum configuration. These are usually fabricated in a multilayer configuration by solvent coating methods. These materials are well-suited for xerography, particularly for high-volume applications, color applications, or applications that involve near-infrared exposures. Further, the fact that they can be readily prepared in large areas by solvent-coating processes introduces significant cost advantages. The basic limitations are that they are relatively soft and have low abrasion resistance. For these reasons, the process lifetime is substantially less than α-Se or α-Si. For reviews of organic photoreceptors for xerography, see Nguyen and Weiss (1988, 1989), Melnyk and Pai (1990), and Borsenberger and Weiss (1991).

Amorphous silicon is usually prepared by plasma-induced chemical vapor deposition. The preparation of α-Si by this technique was first reported in the 1960s. During the 1970s and 1980s, α-Si was widely studied for both photovoltaic and xerographic applications. For xerography, the basic advantage of α-Si is high hardness, which leads to a very long process lifetime. Other advantages include high mobilities and bipolar transport. The advantage of high mobilities is that they permit a reduction in the process time between exposure and development. Bipolar transport permits the use of either polarity of the corona-induced surface potential. This, in turn, permits the reproduction of positive or negative images and the same developer. The major limitations of α-Si are high dark conductivities, high capacitance, cost, and factors related to health and environmental considerations. For a general review of the use of α-Si for xerography, see Mort (1991).

Image Development In the development step, toner particles are transferred to the surface of the photoreceptor. If the toner particles have the opposite polarity of the charged regions, they are attracted to the charged, or unexposed, regions, which correspond to the dark areas of the original image. This form of development is described as charged-area development and widely used in copiers. If the toner particles are of the same polarity, they are attracted to the discharged areas. This method, which is described as discharged-area development, is frequently used in printers. Variations of the amount of toner deposited in the image areas are due to differences in the charge density of the latent image. Most organic photoreceptors are charged negatively, while α-Se and α-Si are usually charged positively. Toners contain a small concentration, 5–10%, of a colorant in a resin binder. The role of the resin is to bind the colorant to the receiver, thus creating a permanent image. For black-and-white reproduction, the most common colorant is carbon black. For color applications, phthalocyanines are usually used for cyans, azo compounds for yellows, and quinacridones for magentas. Toner particles are in the range of 5–20 mm, and usually charged by contact electrification with carrier particles. Carrier particles, or beads, are typically 100 mm in diameter. The beads may contain a thin polymer surface layer to control the toner charge. In magnetic development, a further requirement is that the beads be magnetic. Carrier particles serve several functions: (1) they provide a means for charging the toner, (2) they scavenger the toner from background areas of the photoreceptor, and

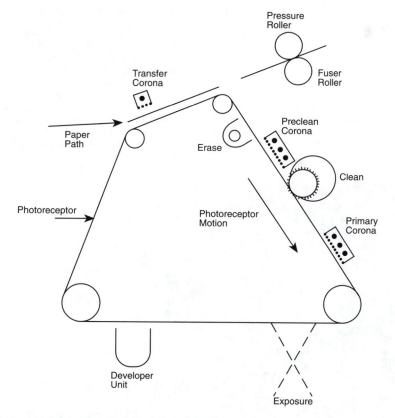

A schematic of a copier in which the photoreceptor is in a belt configuration.

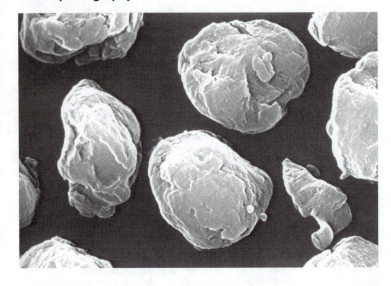

An example of typical toner particles used in a copier. The magnification is 2000X.

(3) in the case of magnetic carriers, they provide a means for transport of the toner particles to the latent image. For a review of carrier materials, see Jones (1991).

While most copiers and printers use dry development processes, liquid development is used in some applications. Liquid toners are comprised of a colloidal dispersion of pigmented particles in an insulating liquid. A charge-control agent is added to impart the desired charge on the pigment particles. Ionic surfactants or metal soaps are usually used as charge-control agents. Liquid toner particles can be charged positively or negatively. The particles are significantly smaller than dry toner particles. Due to their small size, liquid toners have much higher resolution capability. For this reason, liquid toners have been used in a wide range of high-quality color printing applications.

Early xerographic processes used gravity to cascade carrier and toner particles over the electrostatic image. Carriers for cascade development were usually glass or metal beads. Cascade development was used in all early Xerox copiers. The major limitations of cascade development are that the process is not amendable to high process speeds, the inability to reproduce solid areas, and the physical size of the devel-

opment system. For these reasons, cascade development was replaced by magnetic brush development in the mid-1970s. Magnetic brush development was invented in the 1950s. It is used today in almost all high-volume copiers and printers. In magnetic development, the carriers are usually iron, cobalt, or strontium ferrites. In this the magnets are stationary while the brush roll rotates, bringing the magnetic carrier beads and attached toner particles into contact with the electrostatic latent image. Key requirements of magnetic brush development are the need to monitor the toner concentration and the addition and mixing of fresh toner. In the final step in the development process, toner particles are separated from the carrier beads and transferred to the photoreceptor. Toner detachment from the carrier will occur when the detachment forces due to the electrostatic latent image overcome the adhesion forces due to the carrier.

Single-component developers do not contain a carrier. Usually these are transferred to the photoreceptor by a donor roller. Since it is not necessary to control the toner-to-carrier ratio of single-component developers, there are advantages of mechanical simplicity of the development apparatus. A further advantage is that abrasive wear of the photoreceptor is usually reduced. There are, however, several limitations.

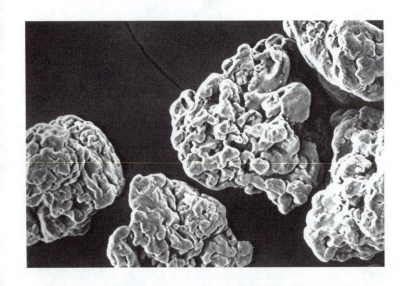

An example of a typical carrier bead. The magnification is 200X.

For process color applications, the developers must be non-magnetic. Depending on the charging method, another disadvantage may be low charging rates. A further problem is filming of the photoreceptor and the developer roller. Single-component developers can be charged by induction, injection, contact, or by corona charging. In single-component developers, the detachment forces due to the latent image must overcome the forces between the developer particles and the donor roller to transfer the particles to the photore-

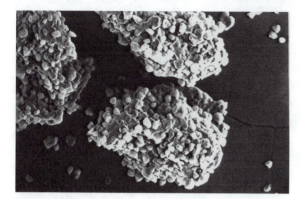

Attachment of the toner particles to the carrier bead. The magnification is 200X.

ceptor. While two component developers still dominate the industry, single-component developers have received increasing emphasis in recent years.

For reviews of image development, see Williams (1984), Schein (1988), and Hays (1991). For a discussion of dry toner technologies, see Gruber and Julien (1991). For liquid development, see Schaffert (1975), and Schmidt, Larson, and Bhattacharya (1991).

Toner Transfer In the transfer step, toner particles are transferred from the photoreceptor to the receiver. This is normally accomplished by electrostatic transfer. In electrostatic transfer, a receiver is placed in contact with the toned image, either a corona discharge or a roller with a polarity opposite to the toner particles is passed over the receiver; then the receiver is separated from the photoconductor. For efficient transfer, there must be intimate contact between the photoreceptor and the receiver. The density of the transferred image is usually slightly less than the original. Maximum toner transfer efficiencies are between 80 and 95%. Toner transfer occurs when the forces on the toner due to the fields from the charge on the receiver exceed the adhesion forces between the toner and the photoreceptor. For conventional-sized toners, adhesion is primarily due to image forces. Other techniques include roller transfer and techniques based on adhesive transfer. Adhesive processes have the advantage that they are more uniform than electrostatic process and much more efficient for small-sized particles. A limitation is the difficulty in transferring thick layers.

Image Fusing After the toner particles are transferred to the receiver, some form of fixing or fusing is required to render the image permanent. This can be accomplished by pressure, heat, radiation, or solvent fixing. Solvent fusing generally does not work well with a wide range of receivers and requires complex solvent entrapment equipment. Cold-pressure fusing processes are limited to low-volume applications and generally give lower image quality than hot-pressure processes. Further, cold-pressure fusing requires special toners. The advantage is the absence of standby power requirements. Radiant fusing is generally not amendable to high process speeds. For these reasons, processes that involve combinations of heat and pressure are the most widely used. This is normally accomplished by hot-roll pressure devices in which at least one roll is heated. Offset can be avoided by the use of special oils wicked onto the surface of the roll. Most rolls use either silicone rubber or poly(tetrafluoroethylene). For reasons of stability and durability, the latter is more common.

Photoreceptor Cleaning When toner particles are transferred from the photoreceptor to the receiver, some particles remain and must be removed before the subsequent image-

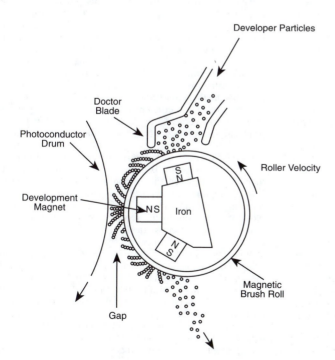

A schematic of a typical magnetic brush development system (after Schein). Reprinted with permission from *Electrophotography and Development Physics*, 1988, Springer-Verlag, Berlin, p. 27. Copyright 1988, Springer-Verlag.

forming process. Toner to photoreceptor adhesion results largely from electrostatic and dispersion forces, which must be broken to separate the toner particles from the photoreceptor. Schaffert (1975) mentions a number of techniques that can be used: rotating brushes, solvents, wiping the photoreceptor surface with disposable fiber webs, air blasts, skive blades, and abrading the surface with particles having a polarity opposite to the toner particles.

In most applications, toner removal is accomplished by either skive blades, magnetic brushes, or fiber brushes. Low-volume machines usually use metal or polymeric blades. For mid- and high-volume machines, mechanical magnetic or fiber brushes are widely used. Blade cleaning has advantages of mechanical simplicity and process compactness. The use of this technique on seamed photoreceptors requires provision such that the blade can be intermittently deactivated. In magnetic brush cleaning, the photoreceptor surface is abraded by carrier particles that are transported to the surface by rotating magnetic fields. Fiber brush cleaning is usually accomplished by a vacuum-assisted rotating brush. After the toner is separated from the photoreceptor surface, it is usually removed by air flow.

Cleaning is a major factor in determining the photoreceptor process lifetime. For conventional cleaning processes, lifetimes of chalcogenide glass and α-Si photoreceptors are in the range of 10^6 (1 million) impressions. For the same conditions, lifetimes of organic photoreceptors are typically 10^4 to 10^5 (10,000 to 100,000) impressions.

Photoreceptor Erase The purpose of the erase exposure is to remove any residual electrostatic charges so that prior to the subsequent process cycle the surface charge density is spatially uniform. If a residual electrostatic image is present prior to the subsequent corona charging step, the surface potential and photosensitivity will be different in areas corresponding to the preceding image and background. Erase exposures are frequently used in conjunction with a corona. Erase exposures are considerably more intense than image exposures and usually continuous. flash exposures are seldom used for erase purposes.

Summary The fundamental image-forming process in xerography is the creation of an electrostatic latent image on the surface of a photoconducting insulator. To create the latent image, the photoreceptor is charged by a corona discharge and then exposed to an imagewise pattern of radiation. The exposure creates free electron-hole pairs. Under the influence of the corona-induced field, the pairs are displaced to the free and substrate surfaces. Thus, the corona-deposited surface charge is dissipated in the exposed regions and a latent image is created that corresponds to the image that is to be reproduced. To develop the latent image, electrostatically charged toner particles are brought into the vicinity of the latent image. Due to the fields created by the charges on the photoreceptor surface, the toner adheres to the latent image, converting it to a visible image. The developed image is transferred to a receiver and rendered permanent by a fusing or fixing process. Finally, the photoreceptor is cleaned of any remaining toner particles and then erased to eliminate any residual surface charges. Following the erase step, the process can be repeated.

OTHER PROCESSES Within the framework of Schaffert's original definition of electrophotography, many different processes exist. Due to the very considerable process complexity of conventional xerography, there have been many attempts to develop alternative technologies. A discussion of early work has been given by Carlson (1965), Claus and Corrsin (1965), and Schaffert (1975). Recent work has been reviewed by Schein (1988). Prominent among the alternative technologies are the following:

Electrofax In Electrofax, a photoconductive layer is bonded to paper. The coated paper then serves as the medium for both the formation of the latent image and the final image, thus eliminating the transfer and cleaning processes. As such, the process offers significant cost advantages. As with conventional xerography, the process involves the creation of an electrostatic latent image that is subsequently developed by charged toner particles. Such a process was commercialized by RCA in the early 1950s. In the Electrofax process, the photoconductor contains a dispersion of ZnO particles in a low-molecular-weight silicone binder. The process was widely used for low-volume black-and-white applications during the 1950s and 1960s. For economic and aesthetic reasons largely related to the need for specially prepared paper, this process has declined steadily in recent years. For a description of the Electrofax process, see Young and Greig (1954) and Amick (1959a, 1959b).

Persistent Internal Polarization Certain photoconducting materials can be polarized by the simultaneous presence of radiation and a field. The resulting polarization persists after the field and radiation are removed. Persistent internal polarization is based on trapping. The polarization requires a very high concentration of trapping centers. This phenomenon was discovered independently in the United States and the Soviet Union in the late 1950s. In the United States, the phenomenon is described as persistent internal polarization. In the Soviet Union, such materials are described as photoelectrets. Latent images can be created by either the selective polarization in exposed regions or by first producing a uniform polarization of the photoconductor surface followed by a depolarizing image exposure. In principle, multiple copies can be made from a single exposure. The limitations of the process are very high exposures and latent image stability.

Photoconductive Pigment Electrophotography In photoconductive pigment electrophotography, the photosensitive material is incorporated in the toner particles. The particles are then dispersed in either an insulating liquid or softenable resin. Absorption of the image exposure creates a variable charge on the particles which are then displaced in a constant field. In conventional xerography, the photoinduced discharge modulates the field at the photoreceptor surface while the charge on the toner remains constant.

There are several variations of this process. Photoelectrophoresis uses toner particles dispersed in a liquid and is primarily used for color reproduction. Manifold imaging uses a receiver precoated with a thin toner layer. Migration imaging uses a thin layer of toner particles dispersed in a thermoplastic host. Migration imaging has potential for microimaging applications. For color reproduction, the fundamental limitations of photoconductive pigment electrophotography are that it is difficult to achieve high color densities, problems related to efficient color separation, and problems of liquid management. For black-and-white applications, the principal limitations are cost and problems related to output rates.

Other Processes of Interest In ion-flow electrophotography, a photoreceptor is coated onto a metal screen that is then placed between the corona and a dielectric receiver. Exposed regions of the screen then permit ions to pass to the receiver while nonexposed regions become charged and block the ion flow to the receiver. Processes that involve transfer of the electrostatic latent image, rather than the toner, have also been proposed. By this method, the electrostatic latent image is transferred to a dielectric-coated paper prior to development. Transfer is accomplished by placing the paper in contact with the photoreceptor in the presence of a field. As with Electrofax, the principal limitation of the process is the need for a special paper. Numerous other processes have been proposed. These include processes based on electrophotolysis, electrothermography, photoadhesion, and photoemission.

At present, none of these processes is competitive with the

quality, cost, and output rates of xerography for copier applications. For printers, the principal alternatives to xerography are ink jet and thermography. For a more detailed discussion of alternative technologies, see Schaffert (1975), Jaffe and Mills (1983), and Schein (1988).

SUMMARY *Electrophotography* is defined as image-forming processes that involve a combination of light and electricity. *Xerography* is a branch of electrophotography that involves the development of electrostatic charge patterns formed on insulating surfaces. Xerography is the most highly developed form of electrophotography at present.

Relative to other forms of electrophotography, xerography has many advantages. Of these, cost, image quality, and process speed are the most significant. Xerography is currently used in all commercial copiers. With the advent of semiconductor lasers and light-emitting diodes, xerography has also been widely used for printing. For office and desktop applications, xerography has become the dominant nonimpact printing technology.

References:

Amick, J. A. (1959a). *RCA Rev. 20:*753.

Amick, J. A. (1959b). *RCA Rev. 20:*770.

Borsenberger, P. M., and Weiss, D. S. (1991). In *Handbook of Imaging Materials,* A. S. Diamond (Ed.). New York; Marcel Dekker, p. 379.

Carlson C. F. (1942). U.S. Patent 2,297,691.

Carlson C. F. (1944). U.S. Patent 2,357,809.

Carlson C. F. (1948). *Engr. Sci. 12:*11.

Carlson C. F. (1949). *Photogr. Age,* Mar., p. 10.

Carlson C. F. (1965). In *Xerography and Related Processes,* J. H. Dessauer and H. E. Clark (Eds.). London: Focal Press, p. 15.

Claus, C. J., and Corrsin, L. (1965). In *Xerography and Related Processes,* J. H. Dessauer and H. E. Clark (Eds.). London: Focal Press, p. 451.

Dessauer, J. H., Mott, G. R., and Bogdonoff, H. (1955). *Photogr. Eng. 6:* 250.

Dinsdale, A. (1963). *Photogr. Sci. Eng. 7:*1.

Fleischer, J. M., Latta, M. R., and Rabedeau, M. E. (1977). *IBM J. Res. Dev.* 479.

Gruber, R. J., and Julien, P. C. (1991). In *Handbook of Imaging materials,* A. S. Diamond (Ed.). New York: Marcel Dekker, p. 159.

Hays, D. A. (1991). *J. Imag. Technol. 17:*252.

Jaffe, A. B., and Mills, R. N. (1983). *SID 24:*219.

Jones, L. O. (1991). In *Handbook of Imaging Materials,* A. S. Diamond (Ed.). New York: Marcel Dekker, p. 201.

Kasap, S. O. (1991). In *Handbook of Imaging Materials,* A. S. Diamond (Ed.). New York: Marcel Dekker, p. 329.

Lichtenberg, G. C. (1777). *Novi Comment, Gottingen 8:*168.

Melnyk, A. R., and Pai, D. M. (1990). *SPIE 1253:*141.

Mort, J. (1989). *The Anatomy of Xerography.* Jefferson, NC: McFarland and Company.

Mort, J. (1991). In *Handbook of Imaging Materials,* A. S. Diamond (Ed.). New York: Marcel Dekker, p. 447.

Nguyen, K. C., and Weiss, D. S. (1988). *Denshi Shashin Gakkai-shi (Electrophotography)* 27:1.

Nguyen, K. C., and Weiss, D. S. (1989). *J. Imag. Technol. 15:*158.

Oliphant, W. D. (1953). *Discovery 14:*175.

Pfister, G. (1979a). *Contemp. Phys. 20:*449.

Pfister, G. (1979b). *J. Elect. Mater. 8:*789.

Ronalds. (1842). In *Encyclopedia Britannica.* Edinburgh, Vol. 8, p. 661.

Schaffert, R. M. (1950). *The Penrose Annual 44:*96.

Schaffert, R. M. (1975). *Electrophotography.* London: Focal Press.

Schaffert, R. M., and Oughton, C. D. (1948). *J. Opt. Soc. Am. 38:*991.

Scharfe, M. E. (1984). *Electrophotography: Principles and Optimization.* Letchworth, England: Research Studies Press.

Schein, L. B. (1988). *Electrophotography and Development Physics.* Berlin: Springer-Verlag.

Schmidt, S. P., Larson, J. R., and Bhattacharya, R. (1991). In *Handbook of Imaging Materials,* A. S. Diamond (Ed.). New York: Marcel Dekker, p. 227.

Shahin, M. M. (1969). *Appl. Opt. Suppl. Electrophotogr.* 3:106.

Villarsy. (1788). *Voight's Mag. 5:*176.

Williams, E. M. (1984). *The Physics and Technology of the Xerographic Process.* New York: John Wiley and Sons.

Wilson, J. C. (1948). *U.S. Camera 11:*46.

Young, C. J., and Greig, H. G. (1954). *RCA Rev. 15:*469.

P. Borsenberger

ELECTROPLATING The use of electricity to deposit metal from a solution containing metallic ions onto a surface as in the electrolytic development of latent images. *W. Klein*

ELECTROSTATIC Pertains to static electricity; that is, electrical charges at rest as distinguished from current or dynamic electricity, which is electric charges in motion.

W. Klein

ELECTROSTATIC LATENT IMAGE Imagewise charge patterns used in xerography. The patterns are subsequently made visible by toner particles, transferred to a receiver, then made permanent by a fixing process. The latent image is created by uniformly charging a photoconducting insulator by a corona discharge, then exposing the photoreceptor to a light image. Absorption of the image exposure creates free electron hole pairs that dissipate the surface charge in the exposed regions, thus creating a latent electrostatic image that corresponds to the image to be reproduced.

P. Borsenberger

ELECTROSTATIC LENS See *Electron lens.*

ELECTROSTATIC PLATES Printing plates produced by electrostatic means. *M. Bruno*

See also: *Photomechanical and electronic reproduction; Plate/cylinder making.*

ELECTROSTATIC PRINTING See *Electrophotography.*

ELECTROTYPE Duplicate plate used in letterpress printing. *M. Bruno*

See also: *Letterpress; Photomechanical and electronic reproduction.*

ELEMENT An element consists of atoms that have a structure of electrons, protons, and neutrons that is distinct from the atoms of other elements. Each element is given a name and a symbol consisting of one or two letters. An atomic number for each element is derived from the number of protons in the nucleus (which also contains all of the neutrons). The electrons are visualized as being in rapid motion in a cloud surrounding the nucleus. *G. Haist*

ELEMENT (LENS) See *Lens element.*

ELEMENT (SOUND) A single strand of film cut by a sound editor to synchronize with the picture for use in rerecording. The original elements are broken down by discipline into dialog, music, and sound effects categories. Within each category there is further breakdown, particularly with sound effects, into, for example, *ambience, Foley,* and principal effects. The breakdown is done so that the process of premixing the elements can be accomplished readily. Many elements contain a large amount of fill leader used as spacing

between sounds just to maintain synchronization with the picture. *T. Holman*

ELEVATOR Identifying a tripod having a centerpost that allows a camera to be moved smoothly up and down.
L. Stroebel

ELLIPTICAL DOTS In photomechanical reproduction, elongated dots that give improved tone gradation, particularly in middletones and vignettes—also called chain dots.
M. Bruno

EMBOSSING Embossing a photograph is a method of recessing the image area of a print, which leaves the white border of the print raised to simulate the *plate-sunk* effect incidental to printing some types of line block. The print is made on a piece of photographic paper with a large white border around the print edge. A piece of card stock, about 1/16th inch thick, is cut to the exact image size. The card stock is then placed on top of the image and held in place with either a couple of dabs of rubber cement or double-sided low-tack tape. The stack is inverted so that the print (backside-up) is on top of the card stock.

The combination is placed on a flat, hard, level surface and the print is gradually pressed down over the edge of the card stock using a hard round-edged object like a bone burnisher, a brush handle, a pen or rounded dinner knife handle. The print is pressed over the edge of the card stock, gently at first, then more firmly, being careful not to crease or crack the emulsion of the photograph. The print and the card stock underneath will remain raised, while the border area of the print will flair out. When the print is turned over and the card stock removed, the image will appear to be sunk into the surface. This is the effect produced in printing engraved or etched plates on a print-maker's press. Embossing photographs in this manner adds rigidity to the photo paper and is an effective way to present small prints. *M. Teres*

EMERSON, PETER HENRY (1856–1936) British photographer. Champion for the recognition of creative photography as a fine art. Advocate of "naturalistic" photography, who believed that the photograph should reflect how the eye naturally sees: one area of sharp focus surrounded by soft-focus. Opposed to retouching and composite photographs made from multiple negatives. His theories were developed in reaction against the popular work of the time by photographers such as H.P. Robinson and Rejlander. In 1889 wrote influential textbook *Naturalistic Photography*. All original prints are platinum; in reproduction he favored photogravure. Published series of portfolios and books dealing with daily country life in England, including: *Life and Landscape on the Norfolk Broads* (1896, platinum prints), *Pictures of East Anglican Life* (1898, gravure) and *Marsh Leaves* (1895, gravure). In 1890, he renounced the beliefs for which he had fought since before 1880 and declared that "photography was not Art."

Books: Newhall, Nancy, *P.H. Emerson*. New York: Aperture, 1975. *M. Alinder*

EMISSIVITY (e) The ratio of a thermal source's output to that of a blackbody, that is:

$$\varepsilon = \text{Actual power output/Power of blackbody at same temperature}$$

The spectral distribution of a heated body is a function of the material and its temperature. A blackbody is a theoretical ideal radiator whose spectral output depends entirely on its temperature. The output of any real body is always less than that of the theoretical blackbody at the same temperature. By definition, the theoretical blackbody's emissivity is unity. All other radiators have emissivities below unity; a tungsten fil-

ament operating at 3000 K has an emissivity of approximately 0.33, while a laboratory standard "graybody" (such as that used for the standard candela) can reach values greater than 0.98. *J. Pelz*

EMITTANCE Obsolescent term for *exitance* (*M*); the quotient of flux output from a surface divided by the area of that surface. The preferred unit for radiant exitance is watts per square meter (W/m^2). The preferred unit for luminous exitance is lumens per square meter (lm/m^2). Note that while the dimensions are identical to those used for irradiance and illuminance, exitance refers to power *leaving* a surface.
J. Pelz

Syn.: *Exitance.*
See also: *Exitance; Photometry and light units.*

EMMERMANN PROCESS To reduce print contrast, unexposed photographic paper is soaked in developer. During exposure, partial development creates a mask that inhibits the formation of further print density. *H. Wallach*
See also: *Mask/masking.*

EMMERT'S LAW The perceived size of an afterimage is directly related to the distance of the surface on which it is projected. An afterimage projected on a surface 8 feet away will look larger than one projected on a surface 4 feet away.
L. Stroebel and R. Zakia
See also: *Visual perception, accuracy of visual perceptions, poststimulus perceptions.*

EMPTY MAGNIFICATION In photomicrography, the magnification of an image beyond the resolution limit of the optical system of the microscope. *R. Zakia*

EMULSIFICATION The first step in photographic emulsion making, called emulsification, consists of mixing a soluble silver salt, usually silver nitrate, with a soluble halide salt or salts in a water solution containing gelatin. Many procedural variations exist in this step of forming the nuclei for the light sensitive silver halide crystals. *G. Haist*
See also: *Double Jet; Single Jet.*

EMULSION NUMBER The designator on a package of light-sensitive material identifying the particular production batch. Sometimes this information is also edge printed as a latent image on the film itself. For critical work some photographers prefer to purchase a quantity of film all with the same emulsion number to assure uniformity of speed, color balance, and other characteristics. *M. Scott*

EMULSIONS Historically, the precipitation of silver halides to prepare a photographic emulsion has been a secret operation practiced in near darkness, figuratively and literally. Even in commercial practice today, skilled workers add numbered but unidentified chemicals in a prescribed order under specified conditions to continuous machines but do not know chemically what they are doing. The exasperating defects and variations of the resulting coated emulsions emphasize that emulsion making today is a scientific art, not a precise science. Quality aim points are more an average of variations, not an exact achievement every time. Published research results have helped reveal some of the basics involved in emulsion making, but secret commercial achievements often remain hidden behind a silver curtain.

Making and coating a photographic emulsion involves a progression of operations, some of which blend together:

1. Emulsification and crystal growth
2. Physical ripening
3. Separation and washing
4. Chemical sensitization
5. Finishing and coating the emulsion.

Ever since 1871 when R. L. Maddox mixed cadmium bromide with excess silver nitrate in gelatin solution, gelatin has been the preferred emulsifier, carrier, and binder for silver halide emulsions. The hardening and swelling characteristics of gelatin make photographic processing easily possible. Chemically modified gelatins and gelatin substitutes have found specific uses, but gelatin is still essential. An understanding of emulsion making and coating requires an understanding of this unique substance.

GELATIN Gelatin does not exist in nature, being derived from collagen, which is extracted from the skin, bones, and sinew of animals. Collagen is believed to consist of three chains, each a helical coil, wound tightly around one another to produce a triple helix structure. Gelatin consists of long-chain single molecules that result when the ropelike triple helix of collagen is cleaved by the harsh lime treatment of bone or acid treatment of hides. Each gelatin chain consists of amino and imino acids joined by

$$\begin{array}{c} -\overset{\displaystyle \|}{\underset{\displaystyle O}{C}}-\overset{\displaystyle |}{\underset{\displaystyle H}{N}}- \end{array}$$

linkages called peptide bonds. The general formula of the gelatin polypeptide molecule has been represented as

$$\left[-\overset{}{\underset{\displaystyle H}{N}}-\overset{\displaystyle R}{\underset{\displaystyle H}{C}}-\overset{\displaystyle \|}{\underset{\displaystyle O}{C}}- \right]_n$$

where n represents 500 to 1000 amino acid units or residues and R is a side chain or ring of the amino acid that contains functional groups that make the molecule reactive and soluble in water.

There are 18 amino acids in the polypeptide chain of gelatin, but 58% of the weight of gelatin is composed of 3 amino acids: glycine (27.5%), proline (16.4%), and hydroxyproline (14.1%), which make up almost two-thirds of the amino acids in gelatin. One preferred sequence of these amino acids in gelatin is

-glycine-proline-hydroxyproline-

Many of the other third of the amino acids are present as side chains that have terminal amino ($-NH_2$) or carboxyl ($-COOH$) groups.

Gelatin can act either as an acid or a base because of the many basic amino or acidic carboxyl groups. Except in highly acidic or alkaline solution, both $-N^+H_3$ and $-COO^-$ are present in the gelatin molecule. At a certain solution condition, the number of $-N^+H_3$ and $-COO^-$ are equal. This is the isoelectric point (IEP) of the gelatin, the pH value where the molecule has a net charge of zero. This effect of pH on the charge of the gelatin molecule might be shown as

The charge on the gelatin molecule is important because a positively charged silver halide crystal will repulse a positively charged gelatin molecule, allowing an increase in the growth rate of the crystal.

The IEP is characteristic of the kind of gelatin, its preparation, and impurities present. It is the point at which the molecule is most contracted and least soluble. For lime-processed gelatins, the IEP lies on the acid side; for acid-processed gelatins, the IEP occurs in slightly alkaline solution.

Gelatin is a natural polymer of variable composition and contains many impurities. The tedious procedure of preparing, purifying, and blending batches of gelatin from the bones of cattle from India, or the hides of Argentine cattle, or the skins of pigs from the United States, has spurred a search for a synthetic substitute that easily can be made and purified. Polyvinyl alcohol (PVA) has found some use but interferes with crystal growth. Polymers can be used as a partial replacement of gelatin. Gelatin, itself, has been modified chemically to permit easier flocculation during the washing step.

EMULSIFICATION AND CRYSTAL GROWTH Emulsification occurs immediately after a solution of a halide (such as alkali metal or ammonium salts) and a solution of a silver salt (often silver nitrate) are mixed in a solution of an emulsifying or protective colloid such as gelatin. Instantly, the solution of the silver halide or halides becomes highly supersaturated, forming a great number of nuclei or centers that are believed to be spherical at first. The nuclei grow in size until the solution is no longer supersaturated. Some of the smaller and more soluble particles dissolve and deposit silver halide on the larger particles, by a process called Ostwald ripening. As a result, the nuclei form cubic microcrystals or grains of various shapes with cubic and octahedral surfaces. The growth of the microcrystals, sometimes called first ripening, occurs during the holding of the initial solution from 10 to about 60 minutes at 40° to 70°C with continuous agitation. Coalescence and recrystallization decrease the total number of grains while the average size increases.

Two general methods of emulsion preparation are used: the single jet or double jet addition of the solutions. In the single jet method, the halide salt and gelatin are in the mix-

$$\underset{R}{\overset{+}{NH_3}}-\overset{|}{\underset{R}{CH}}-COOH \underset{H^+}{\overset{OH^-}{\rightleftharpoons}} \underset{R}{\overset{+}{NH_3}}-\overset{|}{\underset{R}{CH}}-COO^-$$

Positive charge
pH less than IEP

Neutral charge
pH equal to IEP
(isoelectric point
of gelatin)

$$NH_2-\overset{|}{\underset{R}{CH}}-COO^-$$

Negative charge
pH more than IEP

ing vessel, and the silver salt is slowly added by a pipe or jet. In the double jet method, the gelatin is in the mixing vessel, and the halide and the silver salt are added simultaneously through individual jets. These methods of crystal precipitation permit almost an infinite variety of the emulsion. Slow addition of the silver nitrate solution allows a smaller number of crystals to grow to a larger size. Rapid addition produces a greater number of small crystals of similar size that do not grow rapidly. Higher solution temperatures accelerate the growth in grain size. A high degree of agitation during the crystal precipitation favors the production of smaller grains.

Generally, photographic emulsions are prepared in neutral (acid) or ammoniacal solution, but many intermediate variations exist. During emulsification, the solid silver halide is precipitated by a double decomposition reaction between an alkali halide (potassium bromide) and silver nitrate (or silver ammoniate for the ammoniacal emulsions), as shown by the two equations that illustrate the two classes of emulsions.

$$AgNO_3 + KBr = AgBr + KNO_3$$

$$[Ag(NH_3)_2]NO_3 + KBr \rightarrow AgBr + KNO_3 + 2NH_3.$$

The precipitation of the silver halide is the most important stage in the making of a photographic emulsion, as the characteristics of the emulsion are largely determined at this point. It is also the most critical stage to control and to duplicate, requiring specialized equipment and automation in industrial practice.

Simple decomposition equations like those listed previously do not describe the reality of the structure of modern emulsion microcrystals. During precipitation, silver iodide may be incorporated in the core or throughout the crystal of silver bromide. Double-structure grains, called core-shell grains, may have cores with high iodide content (up to 35 mol%) covered by a shell of silver bromide. A sequential double precipitation has been reported to be the best method of preparation for monodisperse core-shell emulsions. Increasing iodide in the core up to 10 mol% was found to increase the absorption of light energy without loss of development activity.

The importance of gelatin is often overlooked during the study of the varied results of emulsification and crystal growth. Crystal formation may occur in solutions of natural gelatins blended with gelatin modified to decrease its acid solubility. A small proportion of the gelatin, a monolayer or less, is irreversibly adsorbed to the surface of the silver halide microcrystals and cannot be removed by hydrolysis in aqueous solutions. The protective action of gelatin keeps the microcrystals from coagulating during precipitation and protects the grain surface during chemical ripening. During crystal growth, the adsorbed gelatin envelope has been said to enlarge "like a growing cellular bag."

PHYSICAL RIPENING Excess silver halide solvents promote crystal growth during the period of the precipitation of the grains. The continued crystal growth after the precipitation stops might be considered merely an extension of the first process. The solution is held at 40° to 70°C in the same vessel. *Physical* or *first ripening* is the name given to this first holding period and provides an opportunity to add solvents or other grain modifiers to the solution.

Excess halide ions, either present from the precipitation of the microcrystals or added after, or ammonia or ammonium salts, or other silver halide solvents promote grain growth during the continued heat treatment of the solution. Grain growth increases by two mechanisms: Ostwald ripening and grain coalescence. Ostwald ripening involves the smaller grains, which are more soluble, dissolving and depositing on larger grains. Coalescence growth has been described as the union, in one body, of two or more intact crystals. Recrystal-

lization must occur at the point of junction, ranging from minimal to a complete loss of the original crystal form. Lattice defects, dislocations, and intercrystalline layers formed during this relocation of the silver halide largely determine the attainable sensitivity limit of the microcrystals. The illustration shows the two main mechanisms of grain growth during physical ripening. Another mechanism, recrystallization, occurs with mixed silver halides.

In the absence of ammonia, the increased solubility of silver bromide at high bromide concentrations is the result of the formation of complex ions such as $(AgBr_2)^-$ and $(AgBr_3)^=$. The presence of ammonia leads to an increase in the solubility of silver halide at low bromide concentrations. The solvent effect of ammonia is greatest in the absence of bromide ions. Ammonia increases the solubility of silver halide by forming soluble $[Ag(NH_3)_2]^+Br^-$ complexes. Ammonia also raises the alkalinity, which is thought to accelerate chemical sensitization during the physical ripening.

The size of the silver halide grains increases with time and temperature, with the concentration of the silver halide solvent, the dilution of the gelatin, and the degree of the agitation. The sensitivity of the emulsion increases with the time of ripening up to a limiting value. Gelatin inhibits crystal growth. Gelatin contains within its molecule amino acids such as cystine, cysteine, and methionine, which are natural retarders. Although retarders can be eliminated during the manufacture of gelatin, their presence is needed for certain types of emulsions (high contrast). Compounds such as cadmium or thorium salts, or benzotriazole or thioglycolic acid, may be added as retarders.

SEPARATION AND WASHING After physical ripening, the silver halide grains are in a gelatin solution that contains soluble halides and nitrites, acids and bases, as well as impurities and any other chemical addition. These compounds may fog, shorten the keeping life, or crystallize in the emulsion. The soluble salts must be removed as they interfere with the subsequent chemical and spectral treatments so necessary to produce the modern high-speed, panchromatic emulsions.

The classical method of removing the soluble salts involves adding dry gelatin to the solution after physical ripening. Sufficient gelatin should be added to make a concentration of 7–10% of the water in the emulsion before cooling. The added gelatin is necessary to minimize water absorption and swelling during the washing step. The emulsion is set to form a gel by cooling near 40°F. The solid emulsion is then shredded into fine noodles and washed in water, often from the public or special water supply. The length of the washing period depends on the concentration and kind of gelatin, the fineness of the shreds, the volume and agitation of water, the temperature, and the hardness (calcium and magnesium content) of the water.

The setting, shredding, and washing of an emulsion requires much time and handling. There are many other disadvantages of washing. Excessive swelling and dilution of the emulsion, bacterial and chemical contamination from the water, and continued crystal growth or loss of water-soluble components in the gelatin solution increase the uncertainties of emulsion making. These limitations have led to a number of methods for separating the solid part of the emulsion from the liquid after the first ripening step. These include salting out with double or triple-charged ions, coagulation by alcohol, centrifugation, sedimentation, dialysis, and flocculation.

One modern method involves the flocculation of the solids of the emulsion into curds with the use of acids. On the acid side of the isoelectric point the gelatin adsorbed to the grains will become insoluble if its free amino groups are no longer available to produce that solubility. Acids, such as trichloroacetic acid, will form a salt with the amino groups of gelatin,

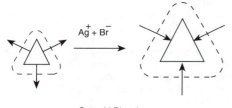

Ostwald Ripening

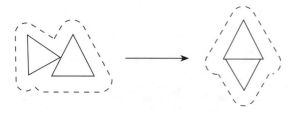

Coalescence

Physical ripening. Schematic representation of the two main mechanisms of grain growth during physical ripening. (Adapted from Sheppard and Lambert.)

producing flocculation of the gelatin–silver halide emulsion. Many flocculating agents, such as polymeric acids or anion soaps, have been proposed, as the precipitated curds are easily soluble when the alkalinity is increased above the iso-electric point.

A more elegant method of separating the solid and liquid parts of the emulsion involves a chemical modification of the gelatin. The amino groups of gelatin are reacted with suitable acids to make a permanent modification of the amino group. This gelatin is not soluble in acid, so lowering the emulsion to just below the isoelectric point causes a curd to separate easily. The adsorption of the modified gelatin still occurs on the surface of the silver halide grains. The gelatin can be present during the precipitation of the silver halide grains or added after grain growth. The flocculated material is usually larger in volume than coagulated sediments and is easier to disperse in gelatin.

CHEMICAL SENSITIZATION Physical ripening produces enlarged crystals of increased sensitivity to light, but the ripened crystals are still relatively inefficient in forming latent images and are blind to all radiation except blue, violet, and ultraviolet. Chemical sensitization is a part of the emulsion-making process that increases the response of the silver halide crystals by chemical means. This treatment, often called *second ripening* or *afterripening,* is not dependent on crystal growth but consists of adding chemical impurities to the surface of the crystals. The emulsion is heated for minutes to hours in the presence of the chemical ripeners. Although a vast number of chemicals are added to emulsions, the sensitizers are usually classed as (a) sulfur, (b) reduction, (c) gold, and (d) spectral dye.

Sulfur Sensitization Early emulsion makers often chose the gelatin on the basis of its activity, as some gelatins gave emulsions of increased sensitivity to light. In 1923 Sheppard and co-workers demonstrated that some gelatins acted as chemical sensitizers and that silver sulfide was formed by gelatin components containing sulfur. The silver sulfide is in intimate contact with the silver halide crystal, but the exact function is subject to dispute. The net effect seems to be an

increase in the efficiency of latent image formation, resulting in improved sensitivity to light.

Sodium thiosulfate is now known to act as does the natural sulfur sensitizer of gelatin. The thiosulfate may be formed by the degradation of a sulfur-containing amino acid during the treatment of the collagen. Sulfur sensitizers in gelatin are now removed to produce inert gelatin, then a few milligrams of sodium thiosulfate per kilogram of gelatin are added during the heat treatment of chemical sensitization. This produces a known and precise method of sulfur sensitization. The thiosulfate ion is believed to be adsorbed on the crystal surface of a silver halide such as silver bromide

$$S_2O_3{}^{2-} + 2AgBr \rightleftharpoons Ag_2S_2O_3 + 2Br^-$$

Thiosulfate ion	Silver bromide	Silver thiosulfate	Bromide ions

During the elevated temperatures of the second ripening, some silver thiosulfate, an unstable compound, is believed to decompose:

$$AgS_2O_3 + OH^- \rightarrow Ag_sS \downarrow + HSO_4{}^-$$

Silver thiosulfate	Hydroxyl ion	Silver sulfide	Hydrosulfate ion

Silver sulfide is deposited at discrete sites on the crystal surface, acting possibly as electron traps or reacting to remove freed halogen.

Reduction Sensitization Active photographic gelatin has been found to contain reducing substances, such as aldehydes, sugars, or sulfite. Such reducing compounds are believed to produce metallic silver in unexposed silver halide crystals of enhanced sensitivity. The silver atoms may be formed by reducing agents present even in inert gelatin or by adding a reducing compound to the emulsion during the chemical ripening holding period. *Reduction sensitizing* is the name given to the production of silver that increases emulsion sensitivity.

Silver atoms are thought to be formed by the reduction of silver ions from the crystal or from excess silver salts. The location has been claimed to be in the gelatin envelope surrounding the crystal, although many feel that the sensitizing substance is on the crystal surface. The function of the silver atoms is also obscure. The silver atoms may form a subdevelopable center. Another opinion holds that the silver atoms have the sole function of reacting with the halogen released during light exposure. Reduction sensitizing is often combined with sulfur sensitization.

Gold Sensitization After the Second World War it was revealed that R. Koslowsky had achieved two- to four-fold increases in the sensitivity of emulsions without increases in graininess by using certain complex gold salts. Koslowsky used ammonium aurothiocyanate, $NH_4Au(CNS)_2$. Gold treatment alone is of limited value but is quite effective when combined with sulfur sensitization. The aurothiocyanate is believed by some to replace the silver with gold in the surface development centers, either increasing the efficiency of the center or possibly its stability. Gold sulfide or silver–gold sulfide, AgAuS, may be formed during gold and sulfur sensitization, but the mechanism of such chemical sensitization may be more complex than is now understood.

The great disadvantage of gold sensitizing is an increase in fog. Gold is most effective with larger grain emulsions that have low fog. The choice of gelatin is also important, as reducing the substances in the gelatin, especially aldehydes, may react with the gold, producing fog centers. Sulfur- containing amino acids of the gelatin may react with the gold and interfere with the sensitization. Because of the fog problem, an antifoggant is necessary, but it must not be so powerful as to interfere with dye sensitization. Emulsion stabilizers such as

the azaindolizines are remarkably effective in preventing age fog in emulsions that have gold sensitizers. A suitable stabilizer is 4-hydroxy-6-methyl-1,3,3a,7-tetraazaindene.

Spectral Sensitization Extending the spectral response of primitive silver halide crystals by the adsorption of dyes might be considered a type of chemical sensitization. The mechanism of dye sensitization is discussed in the entry "Spectral Sensitization."

FINISHING

A number of additional compounds must be added to the chemically sensitized emulsion before it can be coated on a suitable base.

Stabilizers Chemical ripening may continue at a slow and persistent rate, changing the emulsion sensitivity and producing chemical fogging. Reducing the concentration of silver ions by adding halide ions, gelatin with restrainers, or silver complexing compounds helps to restrain fog but also may decrease emulsion sensitivity. Organic stabilizers, such as the tetraazaindenes or cadmium or mercury ions, are needed to prevent the coated emulsion from changing with time.

Antifoggants Nonimage silver (fog) may be produced when a coated emulsion is developed in a very active developer, such as one with high pH. Benzotriazole and other organic antifoggants may be added to the emulsion before coating. A loss in emulsion sensitivity may result from such developer restrainers, so such compounds are sometimes added in latent form. These are not reactive until the alkalinity of the developer releases the active form. Isothiuronium compounds are of this type.

Polyethylene Oxides Polyethylene oxides are long-chain, high molecular weight compounds that may double the normal sensitivity of high-speed bromoiodide emulsions without a serious increase in granularity. Certain polyethylene oxides are believed to be development accelerators, adsorbing strongly to the silver halide grain surface and facilitating the approach of negatively charged developing agents.

Hardening Agents Gelatin hardening compounds are added to the emulsion just before coating to minimize the extent of the gelatin swelling in processing solutions. Hardeners crosslink the gelatin chains to limit the extent of swelling of the coated layer. Aldehydes link the amino groups of two different gelatin chains. Metal ions such as chromium and aluminum form intermolecular links between the carboxyl groups of different gelatin molecules. Compounds containing vinylsulfonyl groups are said to be rapid hardeners without continued afterhardening.

Wetting Agents Because of the low water solubility of some of the hydrophobic groups of gelatin, surface active agents must be used to spread the emulsions to spread in thin layers without resist spots or streaks. One end of the molecule of the wetting agent is usually water soluble, the other end having lower water solubility. By acting in the interface between the emulsion and the base, or between layers being coated simultaneously, the wetting agent produces even spreading. Saponin, a naturally occurring substance, has been used for many years but long organic molecules (with trade names for identification), not unlike household detergents, are commonly found in emulsion formulations. The molecules of the wetting agents may be positively or negatively charged or uncharged.

Other Chemical Agents Numerous other compounds may be present to change the physical character of the emulsion or aid in the coating operation, including antiseptics, matting agents, pH buffers, antioxidants, plasticizers, filter dyes, image toners, antifrothing agents, solvents, and other special-purpose chemicals. A special-purpose chemical could be a developing agent so that the exposed coating could be developed by simply immersing in an alkaline solution. Another addition to an emulsion is an oil dispersion of a coupler, making color photography possible.

EMULSION COATING

Coating an emulsion is an unpublished science that is cloaked in commercial secrecy. The melted emulsion must be homogeneous and stay so throughout the coating period. Air bubbles and mechanical impurities must not be present. The viscosity must be of a required value for the coating conditions. The rheological properties of the emulsion also must be considered. The desired amount of silver halide per unit area of the support must be coated to obtain the desired characteristics of the coated product. The thickness of the coating is fixed by the viscosity of the emulsion at a given temperature and by the coating machine speed.

Many methods of applying the liquid emulsion to the support have been used, including doctor knives and jets of compressed air to limit the emulsion thickness that is coated. Dip coating involves a rotating roller that transfers the emulsion liquid from its bottom side to the support, often paper base, at the top of the roller. Modern photographic practice uses hoppers with narrow slits through which metering pumps feed the liquid emulsion of the correct viscosity. The emulsion is supplied as a continuous sheet as the support speeds by the hopper. Multiple slit hoppers, even up to six slits, are commonly used, requiring a careful selection of surfactants so that the multiple layers spread on each other. Surprisingly, the thin layers do not intermix.

Modern photographic products consist of many layers. Photographic paper is coated with a baryta layer to provide a smooth layer for the emulsion. Photographic film base resists the even spreading of aqueous layers, so a number of layers of differing hydrophilicity are coated on the plastic base. These sublayers allow the emulsion to spread and adhere to the film base. Some black-and-white films have two emulsion layers, a high speed layer coated over a slow speed layer. (The slow speed underlayer helps reduce halation and improves graininess in areas of high exposure.) Color films have many very thin layers, sometimes 10 or more. Most photographic products have a top layer (T-coat) that protects the emulsion layer. The top coat may contain the sensitizing dye, the hardener, matting agents, and other chemicals. Lubricants, especially for motion picture film, may be added to the top layer.

The coated emulsion on the support is quickly chilled to set the gelatin, then festooned through a tunnel-type dryer, the temperature rising through the succeeding zones. The finished photographic material is truly a marvel of photographic technology but with enough defects to spur continued efforts to improve the imperfect miracle.

Books: Carrol B.H., Higgins, G.C., and James, J.H., *Introduction to Photographic Theory.* New York: John Wiley, 1980; Haist, G., *Modern Photographic Processing,* Volume 1. New York: John Wiley, 1979. *G. Haist*

ENAMEL PROCESS

There are several processes for creating photographic images on enameled metal plates or forming the image in enamel on an uncoated plate. Invented in the 1860s, a collodion positive was removed from its glass support and transferred to the enameled surface. When fired, the silver fused to the enamel while the collodion burned away. Later developments included preparing a carbon print with enamel oxides instead of pigments in the emulsion that was transferred to the plate for firing. An early halftone engraving process invented in the late 1800s named the Enameline process, used a copper plate coated with bichromated gelatin/glue that was exposed under a halftone negative. In development, the unexposed emulsion was washed away, the resulting positive image was fired over a gas flame and etched in acid to enhance the image relief and contrast.

J. Natal

See also: *Ceramic process.*

ENCAPSULATION (1) A process of archivally preserving fragile images or documents. The item is placed between two pieces of transparent polyester film and the two film surfaces are sealed together at the edges with a special double-coated film tape. The polyester surface protects the artwork/document from moisture, fingerprints, and dirt. The process is reversible. If the material being encapsulated is likely to contain any acidic chemical substances that can deteriorate the artwork, deacidification solutions may be used to chemically deacidify the artwork. Although this process can be used to protect photographs, photographs are usually laminated, rather than encapsulated. (2) The process of enclosing minute quantities of chemicals in microscopic packets to prevent diffusion or unwanted reaction of the chemicals. Applications include incorporating developers within emulsions and the confinement of color couplers to specific layers. *M. Teres and M. Scott*

See also: *Lamination.*

ENCODER A device that takes a RGB picture signal and timing signals and composites these data into composite video. *R. Kraus*

ENDOSCOPIC CAMERA See *Camera types.*

ENDPOINT DENSITIES In photomechanical reproduction, the densities that produce the desired highlight and shadow dots in a reproduction. *M. Bruno*

ENERGY The work that a physical system is capable of doing in changing from its actual state to a specified reference state; the total includes, in general, components of potential energy, kinetic energy, and rest energy. As such, energy is a basic physical quantity like mass. The law of conservation of energy states that energy can be neither created or destroyed, although the theory of special relativity ($E = mc^2$) states that mass and energy are interchangeable. In photography, the primary forms of energy of interest are the energy carried by photons ($E = hn$), the energy levels (bands) in atomic and molecular arrangements, and the thermal (kinetic) energy present in substances. *J. Holm*

ENGLISH UNITS The foot-pound-second system of measurement. *L. Stroebel*

ENGRAVING Direct printing plate used for letterpress printing or making a mold for duplicate plates. *M. Bruno*

See also: *Photomechanical and electronic reproduction.*

ENHANCED GRAPHIC ADAPTERS (EGA) In computers, this cathode-ray tube (CRT) superseded color graphics adapter (CGA) and provided higher resolution and more color. Typically EGA could provide resolution of 640 × 350 and 16 colors from a palette of 64 colors. In text mode, one of twelve modes, characters are formed from an 8 × 14 matrix, thus giving higher text resolution. *R. Kraus*

ENHANCEMENT Any method by which an image may be improved, such as airbrushing or retouching with photo oils, but commonly understood to be a computer related process whereby an original is scanned and digitized, then manipulated with image management software. The image may be sharpened, its colors may be corrected, and inappropriate elements may be removed. Certain elements may be emphasized by changing their tonal value or the value of the surrounding areas. Rotation or combination with elements of other images are other possibilities. Output can be to a digital storage medium, a film recorder, or a prepress device. *H. Wallach*

See also: *Computers; Image enhancement; Scan/scanning.*

ENLARGER An enlarger is a precision optical device designed to project the image of a transparent medium at variable magnifications onto light-sensitive paper or film.

Early photographers did not need an enlarger. The only processes available produced the final image directly on whatever material was in the camera. Final image size was dependent on the format size of the camera.

As photographic technology improved, it became possible to make glass plate negatives. An exposed and processed glass negative was placed in contact with photosensitive paper to make each print (contact printing). The final image size was still limited by the camera format, but negatives were capable of producing multiple prints.

The desire for more convenient and portable camera systems, plus the introduction of film base in the late 1800s led to the development of smaller cameras. Unfortunately, fine details in the smaller negatives were not readily visible in a contact print. The solution was to project the smaller negative image onto photosensitive paper. Now, not only could all the details be enlarged, but the degree of magnification and final print size could be controlled.

Today, projection printing is standard practice and easily handled by the wide range of modern enlargers.

BASICS In its simplest form, an enlarger consists of a light source, a film carrier and a lens. During operation, the light illuminates a negative or transparency in the holder so that the lens can project an image. Because standard laws of optics apply, increasing the distance between the enlarger and the projected image increases the magnification.

The similarity between enlargers and cameras is not surprising. A camera typically records a miniaturized view of a subject on film and an enlarger works in reverse to project and enlarge this reduced image to a size that is suitable for direct viewing.

Just like a camera, the exposure time required is dependent on the illuminance of the light image and the sensitivity of the photosensitive material. Exposure control can be as sophisticated as integrated electronic timing circuitry or as simple as a hand covering the lens.

We typically refer to the image being enlarged as the negative. In actuality, this can be either a negative or positive image. While the material being exposed is most commonly negative-working paper, it can also be reversal, or positive-working paper. If required, one can also enlarge onto film.

In addition, enlargers don't always enlarge. Most systems also have the capability to provide image reduction.

DESIGN Two important considerations in the design of enlargers are the maximum film size that needs to be accommodated and the maximum magnification required. These factors are directly related to both the physical size of the enlarger and the space that must be provided for operation.

Today, more than a dozen film formats are commonly in use, ranging from smaller than 8 × 10 millimeters to larger than 8 × 10 inches (203 × 254 millimeters). To maximize the performance of an enlarger, it is usually best to limit the range of film formats that it will accept. It wouldn't be practical to expect one enlarger designed for 8 × 10-inch film to work efficiently with 8 × 10-millimeter film, which has an area 645 times smaller. The differences between the two are like comparing an image the size of your small fingernail to one almost as large as a sheet of typing paper.

The magnification requirements of different formats can also be quite demanding if one enlarger is used for all applications. Most enlargers are designed to operate in a vertical orientation, but ceiling height can limit the extension and restrict the maximum print size. For occasional use, some enlargers can be rotated to project a large image onto the wall. For professional labs, however, there are enlargers specifically designed for horizontal projection. These enlargers ride

Vertical enlarger. The optical system of the conventional vertical enlarger consists of a frosted lamp and condensers that spread the illumination evenly over the negative in the negative carrier. The negative is projected on the baseboard by the lens. Raising or lowering this entire unit alters the degree of enlargement; movement of the lens controls sharpness.

on tracks mounted on the floor and are capable of projecting 8 × 10-inch films up to wall-sized or mural prints.

CONSTRUCTION There are many differences in the way enlargers are constructed and operate, but most share the same basic components. We can organize the components into three subassemblies:

1. Column, the backbone of the enlarger, which links together all of the parts;
2. Base, which can function as the main support for the column as well as a place to position the holder for the photosensitive material;
3. Projection assembly, by far the most complex group of components, consisting of a lens and focusing unit, a film carrier, and an illumination system.

Column It is the job of the column to act as the backbone of the enlarger and provide a smooth track upon which the movable components can ride. The demands placed on the

column vary mainly in terms of strength. Vertical enlargers range in height from approximately 2 feet to 7 feet and in weight from a few pounds to several hundred pounds.

A small enlarger can have a simple column consisting of no more than a cylindrical or square tube. The weight and size of a big enlarger requires the column to be of heavy construction, often consisting of multiple complex metal extrusions bolted or welded together.

European and Asian enlargers have their columns in a straight upright vertical position. The logic to this design is that as components ride up and down the track, the optical centerline of the system is maintained. The image only changes size, not position. This means that the optical center must be located far away from the column, however, so the column must be heavier to offset and support the extra leveraged weight.

American enlargers in general have taken a different angle, both figuratively and literally. A 5- to 15- degree slope is incorporated in the orientation of the column. The resulting enlarger can be lighter and less costly. As the magnification changes, however, so does the position of the projected image. The enlarging paper holder must be repositioned with each magnification change, following the image as it moves backward for small prints and forward for large prints.

A third approach to this construction is the use of two pairs of pivoting parallel arms. This parallelogram arrangement usually provides minimal movement of the projected image with changes in print size. By design, however, this type of enlarger is limited in its range of magnification. Today this approach is only used in one enlarger model, primarily for the ability to provide direct linkage to a mechanical autofocus system.

Horizontal enlargers don't have a column in the strictest definition of the word. A column as long as a room would be costly to build and difficult to work with, so floor mounted tracks or rails serve the same purpose.

Base The base of the vertical enlarger can be thought of as providing two functions. It is (1) the main support of the enlarger column, and (2) a place to position the enlarging paper holder.

The most common configuration for an enlarger is with a half-height column mounted directly to a wooden board. This free-standing system is short enough to sit on a countertop yet permits an extensive range of magnifications. Because the board provides the base for support of the system, it is called a baseboard.

Typically the image is projected down toward the baseboard when enlarging. Photosensitive enlarging paper is held flat and in position in an accessory enlarging easel or printing frame, which sits on the baseboard.

Enlarger Size Categories

	Maximum Film Size[a]	Acceptable Smaller Film Formats[b]
Small format	35 mm (24 × 36 mm)	Subminiature (8 × 10 mm), 110 (13 × 17 mm), half frame 35 (18 × 24 mm), 126 (26.5 × 26.5 mm)
Medium format	6 × 9 (2^1/$_4$ × 3^1/$_4$ in.)	Full frame 35 (24 × 36 mm), 127 (4 × 4 cm), 645 (1^5/$_8$ × 2^1/$_4$ in.), 6 × 6 (2^1/$_4$ × 2^1/$_4$ in.), 6 × 7 (2^1/$_4$ × 2^3/$_4$ in.)
Large format	4 × 5 in. (10 × 13 cm)	All in medium format plus 6 × 12 (2^1/$_4$ × 4^1/$_2$ in.), 9 × 12 cm (3^1/$_2$ × 4^1/$_2$ in.)
Extra-large format	8 × 10 in. (20 × 25 cm)	4 × 5 in. (10 × 13 cm), 6 × 17 cm. (2^1/$_4$ × 6^5/$_8$ in.), 5 × 5 in. (13 × 13 cm), 5 × 7 in. (13 × 18 cm), 9 × 9 in. (23 × 23 cm)

[a]All sizes listed by most common designation followed by closest alternative dimensions in parenthesis.
[b]Other formats may be accommodated with accessories or with restrictions on system performance.

Horizontal 8 x 10-in. enlarger. For selection, enlargers can be grouped into different size categories as shown in the table.

Full-height enlargers stand taller than most people. Their long, heavy columns could not be attached securely to a normal wooden baseboard, so a large metal U-shaped foot provides the base for this system. The need to support an enlarging easel still exists. A separate baseboard is incorporated either at one or two fixed points near the bottom of the column, or as part of an assembly that can be positioned at any point along with length of the column.

For some applications it is preferable to mount the enlarger on the wall. In this case, a special base combined with a top bracket attaches the column securely to a wall. The easel support function is provided either by a table or a custom-built counter with a baseboard that can be positioned at various levels.

Because conventional enlarging easels work best when sitting flat, they are not the proper choice for horizontal enlargers. For this purpose, it is preferable to work with a special vacuum frame or magnetic easel mounted directly on the wall.

Projection Assembly The entire group of components that consists of the lens and focusing unit, film carrier, and illumination system is referred to as the projection assembly. On most enlargers the projection assembly is a complete module that is attached to the column by a component known as the carriage. The carriage moves along the length of the column (or on the rails of a horizontal enlarger) to whatever position or elevation is required for a desired print size.

Very small, lightweight enlargers require the operator to physically slide the projection assembly up or down to the proper elevation. Most enlargers, however, incorporate springs or weights that counterbalance the weight of the projection assembly to simplify movement. The actual mechanisms for movement vary and include friction drive, rack-and-pinion gearing, threaded-shaft drive, and electric motors. Some mechanisms automatically lock into position, while others require a manual operation.

Regardless of the method used, it is important that controls for this movement be easily accessible and operable at all elevations. Both coarse and fine elevation control is desirable, as is the inclusion of some scale of reference marker to indicate and permit precise repositioning of the carriage.

Lens The proper selection of an enlarging lens is a key factor in the total performance of the enlarging system. This selection is often made difficult because the lens is an accessory not usually supplied by the enlarger manufacturer.

As with cameras, each specific film format has an ideal *normal* lens. The focal length of choice is considered to be one that is approximately equal to the length of the diagonal of the film. Unlike a camera lens, the lens of an enlarger is not changed to give different perspective effects. The purpose of the lens is only to project an undistorted, flat-field view of the film at various magnifications. A long focal-length lens may result in insufficient print size, and a short focal-length lens may not have sufficient covering power. Different film formats require different *normal* focal length lenses. A lens selection chart for different film formats can be used. There are some exceptions to the guidelines given in the table. When making very small prints (reduction), a longer than normal lens may be used. When making extreme enlargements shorter than normal lenses are chosen.

Lens manufacturers may also *stretch* the capabilities of their lenses by recommending a shorter than normal focal length in anticipation of a limited range of enlargement. Wide-angle (WA) lenses are designed to offer greater magnifications for particular film formats. Specifically, these WA focal lengths of 40 mm, 60 mm, 80 mm, 120 mm, and 240 mm are intended to substitute for 50-mm, 80-mm, 100-mm, 150-mm, and 300-mm normal focal-length lenses, respectively. A slight loss in image quality may be the trade-off for this benefit.

Most enlarging lenses today offer certain operating con-

Primary enlarger components and controls.

trols which, although not essential, definitely are a convenience for darkroom work. These mechanical features include illuminated *f*-numbers, aperture adjustments with or without click-stops, and pre-set *f*-stop control.

The final criteria for lens selection are based on intended usage. One enlarging lens manufacturer lists five different 50-mm *f*/2.8 lenses, all designed to enlarge full frame 35-mm film. While price may seem to be a determining factor to measure some performance difference, upon closer examination specifications reveal more. One lens is designed to work best at 4× to make small prints (4 × 6 in.) while another is intended for 25× to make large prints (24 × 36 in.). The other three lenses are all optimized for a more typical print size at 10× (8 × 10 in. to 11 × 14 in.) but with varying degrees of optical quality. Of these three lenses, one needs to operate with the aperture closed down two stops and the other three stops to approximate the maximum aperture (wide open) performance of the most sophisticated lens in this group.

All enlarging lenses are equipped with a mounting thread so they can be attached easily to most enlargers. The universal or Leica thread M39 × 1/26 in. originated with the 35-mm Leica screw mount camera system and is the most common size mount today. Other sizes are used on long focal-length lenses, which have larger diameters and may be fitted with thread mounts up to M90 × 1. Enlargers often have some provision for holding filters for special effects, black and white, and color printing. One of the locations for a filter holder is directly below the lens. Because any filters used in the focused image path of the lens can affect image sharpness, it is preferable to reserve this position for optical effects filters. To change the color of the light, filtration should be inserted into the illumination system, where it won't influence image definition.

Focusing To permit image focusing with different lenses and degrees of magnification, enlargers, like cameras, must provide the ability to vary the lens-to-film spacing. A light-tight sleeve should prevent any non-image-forming light from escaping or interfering with the projection path between the lens and the film. In specialty-model enlargers or those with limited capabilities, this can be accomplished by a sliding or rotating tube-within-a-tube arrangement similar to focusing systems on modern 35-mm camera lenses. Enlargers that have multiple film format capabilities, however must provide more extensive adjustments.

It is not unreasonable to expect a 4 × 5-in. enlarger to have a lens-to-film spacing range from 1 to 12 in. The most convenient and common way to bridge this gap is to use a flexible bellows. Although bellows are quite simple and relatively inexpensive, they lack the rigidity of a telescoping tube. Therefore, standard practice is to attach the lens to a platform or lens stage and connect it to the enlarger carriage

Lens Selection Chart

Lens	Maximum Film Size[a]	Acceptable Smaller Film Formats[b]
28 mm	Half frame 35 mm	Subminiature, 110
50 mm	Full frame 35 mm	126
80 mm	6 × 6 cm	645,127
100 mm	6 × 9 cm	6 × 7 cm
135 mm	6 × 12 cm	6 × 9 cm
150 mm	4 × 5 in.	9 × 12 cm
180 mm	5 × 5 in.	6 × 17 cm
240 mm	5 × 7 in.	5 × 5 in.
300 mm	8 × 10 in.	9 × 9 in.

[a]Specific lens manufacturer's recommendations may vary.
[b]Other formats may be accommodated with magnification restrictions.

with a sliding post or rail. In this way the lens position can be varied relative to the film, which is held at a fixed location on the carriage.

The way in which the lens attaches to the lens stage depends on the complexity of the enlarger. On a simple single-format enlarger, the lens may just screw in, as it will not have to be changed. Multiple-format enlargers are often designed to accept a lens board or lens plate that has the lens mounted on it. These lens boards usually snap in place or are held with a thumb screw and permit lenses to be changed easily. As an alternative, some enlargers offer an optional lens turret. Once installed, the turret provides the convenience of having any one of three lenses available simply by rotating the lens plate. The mechanisms for focusing are as varied as those used for elevation control, although they must operate on a smaller scale. In addition, the same requirements apply. Controls should be easily accessible and operable at all elevations, and coarse and fine focus controls are desirable.

Film Carrier The image to be enlarged is generally a film original that needs careful treatment and handling. To facilitate this, the film is usually placed in a frame with a handle, which is commonly referred to as a negative carrier or film carrier. Because the enlargement is made on a piece of flat enlarging paper, it follows that the film or plate original needs to be held flat and parallel to the paper during projection. This helps to assure an image that is sharp from corner to corner and true in shape.

The dimensional stability of glass makes this an easy task, and glass plates are the preferred choice of sensitized material for some precise scientific applications. A carrier for plates is usually a simple frame with a recessed groove that holds the plate in position.

The task of holding film flat is much more demanding, as films can vary in thickness from 0.003 to 0.007 in. and have a tendency to curl. Most glassless film carriers are of a two part design and sandwich the film between upper and lower frames that hold the film around the edges of the picture area. Small formats have less area to hold flat and can often be accommodated by the simple sandwich design. Each glassless carrier has an opening that precisely matches the dimensions of a single frame of the film format being enlarged. Any light not blocked or masked off by the carrier would mix with the image-forming light to reduce image contrast.

With larger formats, clear glass plates are commonly used on both sides of the sandwich to hold the film flat. While glass is preferred from the standpoint of flatness, it introduces additional problems. Each side of glass is an extra surface to keep clean, and any dust or scratches will certainly be visible in the enlargement. In addition, when the smooth base side of the film comes in contact with the glass pressure plate, microscopic discrepancies between the flatness of the two show up. The phenomenon is known as *Newton's rings* and has the appearance of irregularly shaped concentric rainbow patterns. To minimize this effect, the glass surface that will be in contact with the film base should not have a high gloss. Glass is available that has been lightly etched with acid or otherwise treated just enough to break up the smooth surface without interfering with the imaging requirements (anti-Newton-ring glass).

Glass carriers are usually sized to match the maximum film format of the enlarger. To accommodate smaller formats, either separate masks snap into the carrier or sliding masking blades within the carrier can be positioned to eliminate non-image-forming light. Some enlargers also have masking blades built into the support stage just below the carrier.

For certain cases where Newton's rings can't be eliminated or the film original is damaged, a fluid immersion carrier offers the best solution. This special carrier has a glass pocket where the film is held flat in an optically clear oily fluid that suppresses surface scratches. Other specialty film

Film holders. (a) Glass plate holder; (b) full glass film carrier; (c) half glass film carrier; (d) glassless film carrier.

carriers are available to provide rapid film transport of roll films. Some have unique film stretchers to flatten the film without a glass sandwich. Pin registration carriers are useful when printing with photographic masks or for complex multiple exposures.

All carriers are positioned over an opening in the projection assembly known as the *film stage*. Certain carriers slide directly into place, while others require the stage first to be opened or unlocked with a lever. Some systems insert a base/adaptor assembly in place for carriers to slide through. For greatest convenience an enlarger should allow easy insertion of the carrier and a way to release pressure on the film while in place on the film stage for final positioning and changing images.

Illumination Systems The illumination system sits above the film carrier and provides light of appropriate intensity, color quality, and uniformity. There are two major components of the illumination system:

1. Light source—the lamp itself, a power supply or power converter, and some method of cooling the lamp.
2. Light source optics—the elements that spread and distribute the light across the entire dimension of the films to be enlarged.

An ideal illumination system should provide even, uniform lighting across the image plane. It should be bright enough to permit convenient exposure times, and the quality of the light should be compatible with color enlarging papers.

Light Source The most basic light source for enlarging consists of a frosted or white light bulb. The ones specifically designed for enlarging burn at a slightly higher color temperature (2900 K) than standard household bulbs (2600 K) and are more uniform in the way their frosting is applied. They often are powered directly on household line voltage and, depending on their size, can fit into a housing that will dissipate heat with the normal flow of air currents.

More power can be packaged into a smaller area with the use of a tungsten-halogen type bulb. These bulbs or lamps are clear glass with a special small filament that is designed to glow more brightly (3400 K) and burn more consistently than a standard enlarging bulb. Power requirements are often at voltages lower than that supplied from electrical outlets, so power converters or transferrers are a necessary part of the system. In addition, voltage regulators or stabilizers are typically incorporated to guarantee accuracy and repeatability of exposures in more critical applications. The energy in this system is so concentrated that fans are often used to provide cooling. In some cases so much cooling has to be provided that the fans are remotely mounted and attached by a hose to prevent vibrations from affecting the enlarger.

Both types of lamps provide a continuous spectrum output. This means that they emit light over the entire visible range and can provide energy from ultraviolet to infrared. Although photographic papers can be sensitive to all of these energies, the invisible radiation is normally filtered out.

Another type of light source used in enlargers is the fluorescent tube. Its radiation is composed of output at a number of narrow bands of wavelengths combined with a continuous spectrum from fluorescence, which, to human vision, averages out to give the appearance of a white (or slightly colored) light. Some photographic papers have high sensitivity to this quality of light. Other photographic papers, however, especially color papers, require unusual filtration to compensate for the missing colors of the spectrum. The fluorescent tube does not generate as much heat as a standard bulb and is often referred to as a *cold light*. This permits them to fit in a small housing, and although there are no cooling requirements, a heater is normally integrated to regulate the light and assure more consistent exposures. Special high-voltage transformers are necessary to power these systems.

Another noncontinuous spectrum light source is the pulsed-xenon flash tube. Flash tubes are sometimes used in high output systems matched to the printing requirements of specific papers. One computerized automatic light source incorporates a series of filtered tubes sequentially flashing at high rates. This effectively breaks up a single exposure into hundreds of small steps for precise manipulation and control. Customized power supplies and cooling configurations are required for these light sources.

Light Source Optics All things considered, illumination systems incorporate optics that give the best compromise of efficiency and performance for the most common working

Masking blades. Adjustable masking blades can be incorporated in (a) the film stage of the enlarger, or (b) a removable film carrier.

conditions. It is not an easy task to illuminate the negative or transparency evenly. The need to do this for a variety of film format dimensions makes the job much tougher. Further compounding the problem are the numerous possible operating magnifications. Two methods of optical construction offer quite different solutions to the problem:

1. Condenser—lens elements that provide concentrated, focused illumination;
2. Diffuser—translucent optical elements that provide scattered, nondirectional illumination.

Differences in the projected images with these two lighting systems can be dramatic.

Four different illumination systems that vary from most specular to most diffuse are:

1. Small filament clear bulb with condensers;
2. Frosted white bulb with condensers;
3. Frosted white bulb with diffuser;
4. Fluorescent tube grid positioned next to diffuser.

The major differences are in image sharpness and contrast. The effect on contrast is based on the amount of silver in a film image and is therefore only relative to black-and-white printing. Areas of opaque image silver block (and scatter) direct light from condensers more than indirect light from a diffusion system. Low density areas of film have little silver to block light and therefore transmit both types equally. Thus, the difference (or contrast) between high and low film densities is greater when illuminated by condensers than when illuminated with a diffusion system. This effect (Callier effect) was named after the man who discovered it (André Callier) and can be expressed in mathematical terms as the *Q factor,* or *Callier Coefficient,* which is the ratio of specular to diffuse density for a given sample.

Because of the nature of the illumination, diffusion systems tend to minimize image defects and dust better than condenser systems. When contrast differences are eliminated through printing techniques, however, sharpness differences are not as obvious. Proper film handling and cleaning techniques are the preferred route to good image quality.

Condenser Systems Condenser systems are composed of one or more lens elements that focus the light through the film and to a point near the enlarging lens, which in turn focuses the film image on the paper. In theoretically perfect systems, the point of condenser focus is precisely coincident with the center of the enlarging lens. Because of format changes, lens changes, and magnification changes, an exact match is seldom achieved. Some systems adjust condenser spacing or actually change condenser elements to shift focus and help compensate for some of these differences. In practice, for a given format, the point of condenser focus is usually designed to be slightly below the focus range of the format's corresponding enlarging lens. The converging rays from the condenser form a cone of light through which the enlarging lens travels. Therefore, regardless of the position the lens must be at for image focus, there is always light available within the cone to illuminate the entire image.

Improperly configured systems will have uneven illumination, most likely with a *hot* spot in the center. In the worst case situation the lens will project a circular vignetted (partial) view of the film image.

The size of the light source also influences this illumination condition. Large diameter bulbs project a larger area than small bulbs and are easier to work with. In the opposite direction, some systems designed for specialized high-resolution imaging only use the lamp filament of a clear glass lamp for illumination. Because the filament is extremely small, it seems like a point to the condenser system and is referred to as a *point light* source. To accommodate the extremely small point source, it is necessary to provide precise three-axis positioning control for the lamp filament relative to the condensers. In this way all ideal conditions of condenser and enlarging lens focus can be met. This system needs constant refocusing and realignment of all optical components, but it provides the most specular type of illumination system for the most demanding applications.

Most condenser systems have a filter drawer or some other provision that allows for the insertion of colored filters into the light path. This location, as opposed to below the lens, is the preferred position for filtration. Filtration in the non-image-forming light path will not affect the sharpness of the projected image.

Diffusion Systems Diffusion systems can be of the sim-

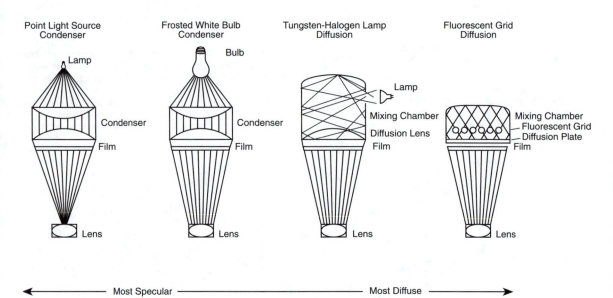

Four typical illumination systems. Point light source; frosted white bulb; tungsten-halogen bulb; fluorescent grid.

plest configuration, consisting of no more than a light bulb, a housing with reflective white walls, and a single translucent plastic or glass plate on the output end. Much of the light in this system bounces around without reaching the enlarger lens, so it is not as efficient as condenser systems. If light power can be sacrificed, however, relatively large areas can be illuminated easily, and, unlike the focusing requirements of condenser systems, the diffusion system remains in a fixed position with output directly above the film stage. Because of the extreme scattering of light, the enlarging lens focuses on a uniformly illuminated film at all magnifications and with all formats. The only adjustment that can be made to optimize illumination with format change is to modify the shape or size of the reflective walls of the internal *diffusion* chamber. In this way the same size lamp can concentrate its energy into more precise areas corresponding to smaller film formats.

Cold-light systems have a fluorescent grid in close proximity to the output diffusion plate. Because of this spacing and the design of the grid, the cold-light source is both highly efficient and the most diffuse of all illumination systems.

The most common diffusion configuration today is a system that deflects light projected at right angles to the optical output with either reflectors or mirrors. This light enters the diffusion, or *mixing,* chamber, where it blends into one consistency and is output through a molded or machined plastic diffusion lens that assures uniformity of illumination across the image plane.

One exception to the standard diffusion configuration uses a fiber optic light transfer system. A fiber optic cable transmits light from an external source to an expanded fiber optic bundle that corresponds in size to the maximum film format. A diffusion panel at the output end of the bundle is used to eliminate any imaging of the ends of the fiber optics and provide a final blending of light. By design, this is a relatively efficient system and is more specular in output than traditional diffusion illumination.

Because of the low efficiency of most diffusion sources, two or more lamps are sometimes used for greater brightness. In addition, the optical mixing of diffusion systems is ideal for integrating various colors from filters or filtered lamps as well as neutral-density control. Virtually all illumination systems with built-in filters operate on the diffusion principle.

Integrating color filters requires one of two types of control systems. Either the controls are on the illumination

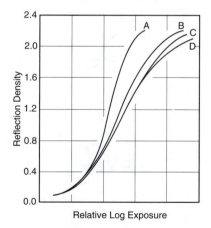

Contrast differences for different enlarger systems. (A) Point light source condenser enlarger; (B) frosted white bulb condenser enlarger; (C) tungsten-halogen bulb diffusion enlarger; (D) fluorescent grid (cold-light) diffusion enlarger.

system or they are attached to a console that is connected by a power cord. The units with controls on the illumination system generally have a series of knobs directly connected to filters. By varying the position of a calibrated knob, one can insert the specified density filter in the light path. On external control units this movement can be accomplished by small motors directly linked to the filters. An alternative system exists where two or more lamps are used, each one either colored or completely covered by a colored filter. In this case, the intensity of the lamps is varied and the resulting relationship between them gives the desired color balance. These systems are equally applicable in variable-contrast black-and-white and color printing.

System Alignment For optimum image quality, an enlarger needs to provide a strong rigid structure and maintain alignment among all the optical elements. The lens, film carrier, and illumination system components must be centered on the optical axis to assure uniform image illumination. For image sharpness the planes of the film carrier, lens board, and easel must be parallel. These requirements are very much the same as for process cameras.

Sometimes it is desirable to vary the relationship of the subject, lens, and film planes. As, for example, in an architectural setting where a conventional photograph shows converging vertical lines. A view camera offers image shape and sharpness control with tilt and swing adjustments. Some enlargers have similar adjustments.

As long as the enlarger lens plane and either the film plane or the easel plane can be tilted, it will be possible to correct converging lines on a negative or transparency and also obtain a sharp image on the print. The optical concept that permits this is named after Theodor Schiempflug, who first discussed the theory of the concept. The Schiempflug principal states that overall image focus will be achieved if the image plane, the lens plane, and the object plane are arranged so that they converge at a common line.

Equally important to the ability to provide this image control is the ability to return the enlarger, negative holder, and lens to zero settings precisely for normal operation.

COLOR ENLARGERS Considerable confusion exists concerning the differences between black-and-white and color enlargers. In truth, there is no such thing as either. By its simplest definition, an enlarger projects an image that exposes photographic materials. That is all a black-and-white system has to do. If you can modify the color of the light with filters, you can use it to expose color materials as well.

The reason for the nomenclature is simple. When enlargers first came into existence, there was no color photography. Obviously, there could only be black-and-white enlargers. As color materials became available, these black-and-white enlargers were modified to accept color filters and therefore were capable of color enlarging. Further refinements in design included actually building the filters into a diffusion illumination system, which became known as a *colorhead.*

Eventually, it was easier to refer to an enlarger with a traditional frosted bulb and condenser system as a black-and-white enlarger. Those that had the colorhead illumination system were called color enlargers. This is still a common practice, although it does nothing to indicate to the user that either system is capable of both color and black-and-white enlarging.

Black-and-White Exposure Requirements Standard black-and-white printing is possible with a variety of light sources. Graded paper is sensitive to wavelengths from long wavelength ultraviolet radiation to green light, with peak sensitivity in the blue. Most illumination system optics, enlarger lenses, and inexpensive filters absorb ultraviolet radiation so that all exposures are made with radiation in the visible spectrum.

Cold-light fluorescent systems have strong blue output, although they have almost no output in the green to red, so they appear visually dim. Because cold lights have strong output in the spectral regions where photographic emulsions have high sensitivity, such light sources are referred to as having a high *actinic* value. By comparison, tungsten light has a relatively low blue output but significantly higher output for the rest of the spectrum. It is visually much brighter but not relative to the sensitivity of the paper.

Panchromatic and variable-contrast papers have spectral sensitivities that extend into the green and red regions and are not normally exposed well by the standard fluorescent light source, which is deficient in these colors. To provide the variable aspect of variable-contrast black-and-white papers, the color of the light must be controlled. There are typically two color-sensitive emulsions that work together to form the basic shape (or contrast) of the variable-contrast paper curve. One emulsion is basically blue sensitive and the other is blue-green sensitive. These are selectively and proportionately exposed either by yellow-magenta filtration or green/blue filtration to yield the desired contrast.

The simplest variable-contrast filtration consists of a set of a dozen or more filters providing steps of contrast ranging from low contrast #00 (dark yellow) to high contrast #5 (dark magenta). As a convenience, a degree of neutral density is generally built into each filter to maintain a constant exposure value. This eliminates or minimizes exposure calculation when switching filters.

Illumination systems that have yellow and magenta filtration incorporated for color printing can also be used to control contrast with black-and-white variable-contrast papers. Although there is a benefit of continuously variable filtration in this system, the particular filters used for color printing are often not optimum for high contrast black-and-white values.

Certain illumination systems designed for variable contrast have more specifically selected filtration. One system uses a sliding composite filter arrangement. A yellow filter, exposure balanced with neutral density, is assembled next to a magenta filter. This pair of filters can be *dialed* into the light path to produce yellow light, magenta light, or a combination of the two. Contrast control is continuously variable over the whole range, and exposure is constant.

For higher output systems, two lamps are used, one for each color. A control system varies the intensity of the lamps to adjust the relationship of the two colors for contrast and exposure. Although magenta and yellow filters were once

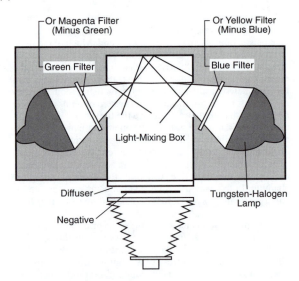

Illumination system with yellow and magenta filtration for color printing can also be used for printing with variable contrast paper.

used for this purpose, it is more common now to use green and blue. These filters are more selective in the way they exposure the specific emulsions. In addition, they're selective in what they don't expose. There is no output in the red region where unwanted heat is generated and must often be additionally filtered with heat absorbing glass and expensive infrared filters.

Color Exposure Requirements Full color photography requires a complex assembly of emulsions with sensitivity to the three primary wavelengths of light—red, green, and blue. All color films and papers have at least one emulsion layer dedicated to each of these colors. The actual dyes that form the final image are almost always the complement of these colors—cyan, magenta, and yellow. When the proper relationship and density of the three dyes exist, the print is color balanced. This balance is accomplished using filters to vary the relative levels of red, green, and blue light output by the illumination system.

The original method of exposing color was with the additive system of red, green, and blue filters. These primary color filters each absorb two-thirds of the visible spectrum

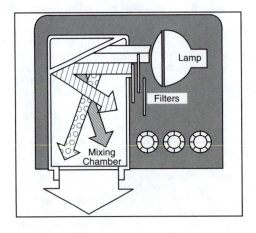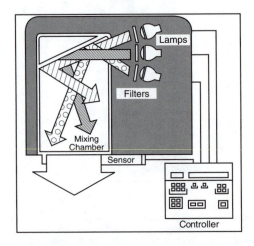

Diffuse illumination colorheads. (Left) With mechanical filter control; (Right) with electronic filter control.

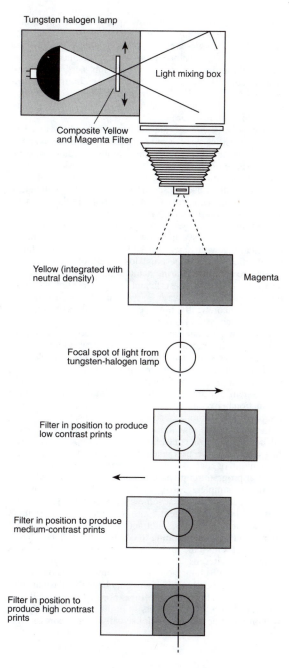

Tungsten halogen lamp

Light mixing box

Composite Yellow
and Magenta Filter

Yellow (integrated with
neutral density) Magenta

Focal spot of light from
tungsten-halogen lamp

Filter in position to produce
low contrast prints

Filter in position to produce
medium-contrast prints

Filter in position to
produce high contrast
prints

A composite yellow and magenta filter provide variable contrast control.

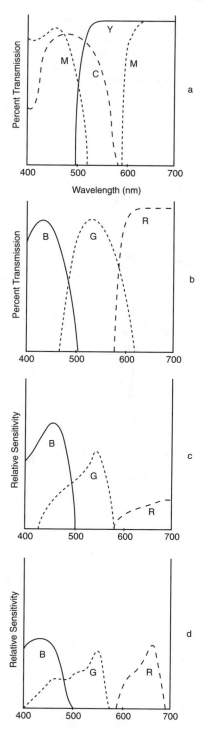

Additive and subtractive printing with color negatives and color reversal materials (slides and transparencies). (a) Transmission curves for a set of subtractive filters. *Dashed line,* cyan filter (minus red); *dotted line,* magenta filter (minus green); *solid line,* yellow filter (minus blue). (b) Transmission curves for a set of additive filters. *Dashed line,* red filter; *dotted line,* green filter; *solid line,* blue filter. (c) Spectral sensitivity curves for color negative print material. *Dashed line,* red sensitivity; *dotted line,* green sensitivity; *solid line,* blue sensitivity. (d) Spectral sensitivity for color reversal print material. *Dashed line,* red sensitivity; *dotted line,* green sensitivity; *solid line,* blue sensitivity.

and transmit their own color of light. If red, green, and blue light beams are overlapped, the three colors can be *added* together to recreate the original *white light* as well as virtually any other color. When making color prints, however, three separate filtered exposures may be made (tricolor exposure). By varying the time of each primary color exposure, the photographs can achieve the proper density and color balance. Still in use in automated machine printers, tricolor exposure is an appropriate practical process. In a manual enlarging system, however, it does not permit selective area exposure control (dodging and burning).

More recently, some additive systems have incorporated

three separate filtered lamps in a diffusion integrating illumination system. A control unit varies the intensity of the lamps to adjust the relationship of the three colors for balance and exposure. Although the efficiency of these systems is very poor (each filter absorbs two-thirds of the light), the output is integrated into a single exposure.

Because of the relatively slow speed of color materials, high-efficiency systems have always been desirable. The most efficient single-exposure color enlarging systems use *subtractive* primary color filters—cyan, magenta and yellow. Each of these three filters absorbs, or subtracts, an additive primary color of light and transmits the remaining two-thirds of the white light. Related to their additive counterparts, these filters are cyan (minus-red), magenta (minus-green), and yellow (minus-blue).

Originally, separate cyan, magenta, and yellow filters of various densities were inserted manually into the enlarger. Later, color enlargers incorporated graduated dichroic color filters. These filters are made by vacuum depositing specific compounds onto clear glass. The resulting filter is fade and heat resistant. In use, the desired color density is dialed in with a calibrated control to a specified point in the light path of a diffusion illumination system.

Separate cyan, magenta, and yellow filters are still in use and are the most cost efficient way of providing color control for enlarging with black-and-white enlargers. The relative sensitivities of the three emulsion layers of color printing papers are controlled during manufacture so that it is seldom necessary to use the less efficient cyan filter. Subtractive filtration systems will always be twice as efficient as additive systems. Theoretically, however, additive filters offer some benefits when speed is not an issue.

Comparing transmission curves and spectral-sensitivity data of printing papers, it's easy to see that additive filters selectively expose each individual color layer, while subtractive filters simultaneously expose two layers. Therefore, a color change is more directly implemented with the additive system. A subtractive filter adjustment results in some interaction between two colors (crosstalk) and often requires a second more minor adjustment to compensate.

In addition, the few additive enlarging systems that exist all have *intelligent* controllers. These computerized interfaces between the user and the illumination system offer more intuitive control and make learning color theory easier. Internal programming can eliminate calculations and make operation simpler. Most subtractive-based systems are mechanical and require a somewhat *backwards* logic to operate. Although intelligent controllers are available in more sophisticated electronic subtractive systems, they require more levels of programming to compensate for the different degrees of crosstalk and spectral sensitivities of various color print materials.

Many people claim better color accuracy for additive systems. While this is logical, it will only be realized when color dyes improve. However, all color exposure systems will benefit from future developments in emulsion technology that will provide fine tuning of color sensitivity and more discrete color separation.

Four curves illustrating the relationships of a light source, paper sensitivity, and safelight filters. The vertical axis is relative, representing the relative energy of the light source, relative sensitivity of the paper, and relative transmittance of the safelight filter. (a) Graded black-and-white paper spectral sensitivity with white light exposure. *Dashed line*, photographic paper; *solid line*, 3200 K lamp; *broken line*, light amber safelight. (b) Variable contrast black-and-white paper spectral sensitivity with subtractive filters. *Dashed line*, variable contrast paper; *broken line*, light amber safelight; M is a magenta filter (minus green light); Y is a yellow filter (minus blue light. (c) Variable contrast black-and-white paper spectral sensitivity with additive filter exposures. *Dashed line*, variable contrast paper; *broken line*, light amber safelight; B, blue filter; G, green filter. (d) Panchromatic black-and-white paper spectral sensitivity with white light exposure. *Dashed line*, panchromatic paper; *solid line*, light source; *broken line*, dark amber safelight.

Photomontage enlarging system.

SPECIALIZED APPLICATION ENLARGING SYSTEMS

Special imaging techniques often require an extremely complex operation or unique equipment. Some commercially available enlarging systems were created for specific tasks. Two of these systems are described here.

Photomontages and multiple exposures are relatively easy to accomplish with normal enlarging systems. A series of enlargers exist, however, that make this a standard operation. When two complete projection assemblies are joined together at right angles, two images can be projected simultaneously. The inclusion of a semisilvered mirror acting as a beam splitter allows the two individual images to be blended together and projected in register as one.

When detailed subject matter needs precise tonal modification in select areas of the image, pinpoint illumination control is essential. Photographic masks can be created through a number of steps and may, combined with the film original, produce the desired result. Fortunately, there is an easier and faster way through cathode-ray tube (CRT) exposure systems. A CRT is essentially the picture tube found in a high-resolution television set. The image is formed by an electron beam exposing phosphors spot by spot, rapidly across the width, and down the height of the CRT. The human visual system integrates these spots into a single image that is changed so rapidly that we perceive complete images and smooth motion in the television picture. As opposed to a conventional light source, which exposes the entire image in one shot, the CRT system uses its electron beam as the exposure source and allows us to have precise spot control of film illumination.

CRT exposure must be combined with a photomultiplier tube (PMT) measuring system that can follow the speedy little electron beam around the image and feed back the effect of the beam to a control system. On a spot-by-spot basis, the electron beam varies its intensity and the length of exposure time to produce the desired effect. The effect is regulated by preset (but adjustable) parameters input into the electronic feedback system. Dark areas of a negative will receive correspondingly more illumination and exposure than light areas of a negative. This dodging and burning system can automatically print the most complex low contrast and high contrast images on conventionally graded paper.

AUTOMATIC ENLARGING SYSTEMS

Over the past few years, various levels of automatic operation have been integrated into different components of enlarging systems. Automatic focus has been available for many years, mostly operating on a mechanical system. Lenses are calibrated to a special track attached to the enlarger column (or parallel arms). A roller riding on this track is directly linked to the focus mechanism. As the enlarger elevation changes, the roller follows and adjusts the focus for the corresponding new print size. This system performs well but offers limited magnification control and lens selection. More common today are electronic systems that provide motorized lens positioning at any magnification and with any lens, once they are calibrated at the highest and lowest points on the enlarger column.

There are a variety of different levels of automation of illumination systems. For black-and-white printing on graded papers, a simple exposure control device can read the light from the projected image and set a timer or shutter accordingly. Black-and-white printing on variable-contrast paper can be automated as well. Some systems measure the shadow and highlight density of the projected image and calculate the density range. Then they determine the proper contrast for printing and automatically expose the appropriate different contrast emulsions of variable contrast photographic paper.

Similar levels of sophistication have been added to color exposure systems. Reading the red, green, and blue compo-

CRT projection printer and schematic diagram.

Automatic enlarger network.

nents of a projected image, some metering systems will compare the values to previously memorized *correct* printing values. Once compared, the light source will automatically adjust itself to compensate for the difference between the two sets of values. The resulting print will be correct in both color and density.

While not inexpensive, today it is possible to have an enlarger that provides complete computer controlled *hands-off* operation. Films can be electronically analyzed. These data, plus printing size and quantity information, can be fed directly through to the enlarger. If required, the data can also be output in a bar code format and attached to the film for reading at the enlarger station. When the film reaches the enlarger for printing, all sizing, focusing, color balance, and exposure control are automatically set. In high volume labs such a system can be cost justified when the time (and money) savings are considered.

Looking forward to the future, computers will be an even more integral part of laboratory enlargers. Sophisticated image processing will be available before a final print is made.

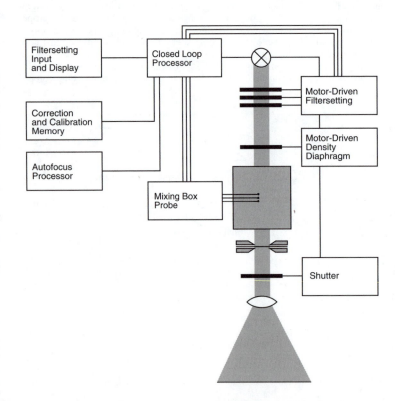

Schematic diagram of a fully automatic enlarging system.

Exposure systems will offer even greater amounts of control, and output will be available on a wider variety of materials.

Books: Coote, Jack H., *Ilford Monochrome Darkroom Practice: A Manual of Black-and-White Processing and Printing.* Boston: Focal Press, 1988; Current, Ira, *Photographic Color Printing: Theory and Technique.* Boston: Focal Press, 1987; Jacobson, Ralph; Sidney, Ray; and Geoffrey, Attridge, *The Manual of Photography,* 8th edition. London: Focal Press, 1988; Eastman Kodak, *Quality Enlarging with Kodak Black-and-White Papers.* Rochester, N.Y.: Eastman Kodak, 1985. *R. Rose*

ENLARGER LENS See *Lens types.*

ENLARGING See *Projection printing.*

ENLARGING METER
In its simplest form an enlarging meter is a light meter designed to be used to determine the correct exposure time for a selected *f*-number, or the correct *f*-number setting for a standard exposure time, for projection printing. Enlarging attachments are available for some hand-held exposure meters. Incident readings are normally made in a small area of the projected image close to the easel surface. Because conventional exposure meters are calibrated for film speeds rather than paper speeds, it is necessary when using such a meter to establish the relationship between a meter reading and the correct exposure time for a normal print of a test negative determined by the test strip method. When switching to a different negative, it is usually more convenient to adjust the aperture to obtain the same meter reading and keep the exposure time unchanged than to change the exposure time. With this method, it is necessary to standardize the area of the projected image that is measured—shadow, midtone, or highlight. Readings can also be made from highlight and the shadow areas to determine the appropriate contrast grade of printing paper to use for negatives that vary in contrast, although it is more convenient to use densitometer readings of the negative for this purpose.

Specialized meters called *color analyzers* are designed for the purpose of determining exposure time and color filtration for projection color prints. Color analyzers measure red, green, and blue light separately in addition to measuring white light. The red, green, and blue readings of the image of a neutral test card or other standard reference area can be used to determine appropriate densities for cyan, magenta, and yellow filters, and the white light reading is used to determine the exposure time or aperture setting.

Photofinishing printers contain sophisticated computerized metering systems that can obtain and integrate readings from a number of different areas of the image and control the color balance of the illumination and the exposure automatically and rapidly. *J. Johnson*

ENLARGING PAPER
Light-sensitive paper with speed and other characteristics suitable for projection printing, as distinct from the slower contact paper. Enlarging papers in general are much less sensitive than typical films. Although they are not rated in terms of film speed, an equivalent ISO speed would be about three. *M. Scott*

ENTE NAZIONALE ITALIANO DI UNIFICASZIONE (UNI)
The national standardizing organization of Italy. *P. Adelstein*

ENTRANCE PUPIL See *Pupil.*

ENYEART, JAMES L.
(1943–) American museum director and writer. Studied photography at Kansas City Art Institute and the University of Kansas. Professor of photography and photographic history, University of Kansas (1968–1976). Executive director of The Friends of Photography (1976–1977). Director of the Center for Creative Photography, University of Arizona (1977–1989). Director of the International Museum of Photography, Rochester, since 1989. He has authored books on Francis Bruguiere, Jerry N. Uelsmann, and Edward Weston. *M. Alinder*

EPIDIASCOPE
A projector that combines into one apparatus the functions of an episcope (an opaque projector) for showing opaque objects, pictures and photographs, and a diascope (an overhead projector) for showing enlarged images of transparencies or diapositives. *M. Teres*

See also: *Opaque projector; Diascope.*

EPISCOPE
An optical device for projecting images of opaque objects, pictures, and photographs onto a projection screen. *M. Teres*

Syn.: *Opaque projector.*

EQUALIZATION (SOUND)
Generally, equalization means to adjust the frequency response of audio by means of either fixed or adjustable devices. *T. Holman*

EQUALIZER
A device to produce equalization. The device may produce fixed equalization, as in compensating for deliberate response variations (such as Recording Industries Association of America (RIAA) equalization used on phonograph records), or it may be adjustable. Among adjustable types, some are designed as program equalizers for users to adjust by listening and others are designed to be set using the results of instrumented measurements, such as 1/3-octave equalization. *T. Holman*

EQUAL-LOUDNESS CONTOURS
A set of curves plotting amplitude versus frequency characterizing the sensitivity of human listeners across the audible frequency range at various levels. The lowest curve is the minimum audible sound field versus frequency, and it shows that human hearing is most sensitive to midrange frequencies centered around 2 kHz, with less sensitivity at lower and at higher frequency. The curves also show that at no sound pressure level does human hearing have a flat frequency response. While the best known of these curves are named after the original researchers who found the effect, Fletcher-Munson, more recent work is more widely accepted and has been standardized as an ISO standard. *T. Holman*

EQUIDENSITY FILM
A photographic copying material containing both positive and negative image-producing emulsion, designed to produce a line-drawing effect from a continuous-tone positive or negative original. The effect is controlled with variations in exposure and filtration. Used for both pictorial and scientific purposes where it is desirable to compress some tonal differences and to expand others, as in the enhancement of Schlieren patterns. *R. Zakia*

See also: *Contour film.*

EQUIENERGY SPECTRAL DISTRIBUTION
A spectral distribution with all wavelengths present at equal energy levels over a specified bandwidth. The spectral response of a system can be specified by plotting a spectral energy distribution of the output of a system assuming an equienergy input. It is sometimes significant to note that equal amounts of energy at different wavelengths do not mean equal numbers of quanta, as quanta of different wavelengths do not possess the same energy. Equienergy spectral distributions are rarely found in nature; they are created either in the laboratory, or more commonly theoretically, and are used to specify the performance of some element of a system assuming an equienergy input or output. *J. Holm*

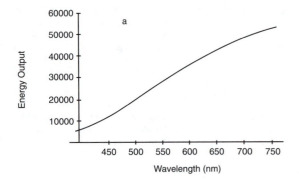

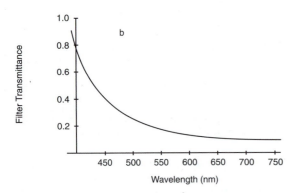

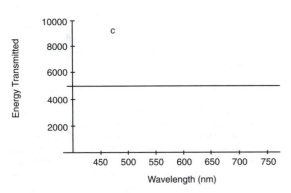

Equienergy spectral distribution. The combination of a source and a filter to produce an equienergy spectral distribution. (a) The energy output of a 3200 K blackbody source (in joules per square meter). (b) The transmittance curve for a filter that will transform this source into an equienergy source. (c) The energy from the source transmitted by the filter.

EQUIVALENCE/EQUIVALENT IMAGE The fact that a photograph can serve as a representation for something other than the object photographed. A cloud pattern in the sky, or a closeup of a pepper, for example, can serve as a visual metaphor for some other object, experience, or emotion held in memory. Equivalence, which may function as a psychological mirror, accounts for different responses by different people viewing the same photograph or motion-picture.　　　　*L. Stroebel and R. Zakia*

　See also: *Gestalt; Visual perception, gestalt.*

EQUIVALENCE FACTOR In industrial radiography, a measure used to describe the relative absorption of a material with respect to that of a standard. A material's absorption of x-rays cannot be simply scaled by the physical density of the material. For example, although lead is only 1.5 times the density of steel, 1 mm of lead absorbs the same fraction of incident x-rays as 12 mm of steel (200 kV source), giving it an equivalence factor of 12 for x-rays at 200 kV. A material's equivalence factor varies with the exposing source's voltage; greater voltages tend to reduce the difference between materials. For example, lead's equivalence factor falls from 12 (at 200 kV) to 5 for 1000 kV x-rays. In order to calculate the correct exposure, the thickness of a metal sample is multiplied by the equivalence factor to obtain the equivalent thickness of the standard metal. Equivalence factors are often given with respect to the absorption of aluminum and steel for low- and high-energy x-rays, respectively.　　*J. Pelz*

　See also: *Radiography.*

EQUIVALENT COLOR REPRODUCTION Reproduction in which the chromaticities, relative luminances, and absolute luminances are such as to produce the same appearances of colors as in the original scene.　　*R. W. G. Hunt*

　See also: *Color photography; Color reproduction objectives.*

EQUIVALENT COLOR TEMPERATURE A value assigned to a light source that cannot have a true color temperature, such as one having a discontinuous spectrum, that is the same as the color temperature of light source having a continuous spectrum that produces the same effect on a specified receptor (color film, color-temperature meter, etc.).　　*L. Stroebel*

　See also: *Correlated color temperature.*

EQUIVALENT DYE In negative color films containing color couplers (masks), the spectral density distribution of the combination of dye layers and masking layers that results from varying exposures. Depending on the color of the light reaching the film, various amounts of dyes are formed and various amounts of the masks are reduced.

　　　　M. Leary and H. Todd

EQUIVALENT FOCAL LENGTH The common value of the front and rear focal lengths of a lens and the net focal length of all the individual optical elements forming the lens. Usually just referred to as *focal length*.

　If the media in the object and image spaces are different, as in the case of an oil-immersion microscope objective or an underwater lens, then the front and rear focal lengths differ.

　　　　S. Ray

EQUIVALENT LUMINANCE The CIE $V(\lambda)$ relative luminous efficiency function used to determine the physical luminance properties of a surface is accurate only for the light-adapted eye (i.e., scenes within the *photopic* range). If a visual measurement is attempted below that range, it will not correlate with the physical photometric values based on the $V(\lambda)$ function, and visual matches made between surfaces with different spectral composition will vary with the brightness at which those matches are made. While the $V'(\lambda)$ (dark-adapted, or *scotopic*) luminosity function has also been defined, there is a broad luminance range over which both systems are active; the *mesopic* range. When objects of different colors are viewed under such conditions, the relative brightness of the two varies and can reverse; a red object that

appears lighter than a blue object under photopic illumination may appear darker as the illumination is reduced as a result of the *Purkinje shift*. Consequently, a single photometric value assigned to a surface in the mesopic range cannot accurately predict visual perception at other luminance levels.

In order to allow luminance values to be assigned to surfaces under such conditions, the equivalent luminance of a source or surface at mesopic levels is defined as the luminance of a blackbody radiator at 2045 K with the same subjective brightness as the unknown surface. *J. Pelz*

See also: *Luminance; Photometry and light units; Photopic; Purkinje shift*.

EQUIVALENT NEUTRAL DENSITY (END) A measure of the amount of dye in a color photographic image. It is the density of the visual neutral that the dye would produce if combined with appropriate amounts of the other two dyes of the process. For a sensitometric test sample consisting of a set of visually neutral patches, the three characteristic curves formed when END values are plotted against log H would coincide.

Equivalent neutral printing density is a similar concept, except that it applies to a negative and is that sample density that produces a neutral in the print with a specific processing system and correct exposure. *M. Leary and H. Todd*

EQUIVALENT PHOT See *Lambert*.

EQUIVALENT REFRACTING SURFACE The locus of all the points at which the paths of conjugate rays of light intersect within a compound lens. Its position depends on the conjugate distances. For a subject at infinity, the equivalent refracting surface is at the second principal (nodal) point. This surface may replace the lens for calculation purposes.
 S. Ray

EQUIVALENT WEIGHT Alternative method of expressing chemical concentrations that may be used for neutralization reactions. For an acid, the equivalent weight is the weight in grams that provides one mole of hydrogen ions (H^+); for a base, it is the weight in grams that provides one mole of hydroxyl ions (OH^-). Determination of an equivalent weight is useful because an acid or base may have more than one hydrogen or hydroxyl ion that must be considered in the neutralization. *G. Haist*

ERASE HEAD A tape head, addressing one or more tracks at a time, that subjects the magnetic domains on the tape to a strong magnetic field adequate to saturate them. As the oxide moves away from the gap in the direction of travel, the gradually diminishing field leaves the oxide with no net magnetization and thus no signal. The source of high-frequency ac current for the erase head is usually the bias oscillator. *T. Holman*

ERECT Term describing the image formed by a lens or optical system that has not been inverted and so appears the correct way up. *S. Ray*

ERG In the metric system, the basic unit of energy. 1 erg = 10^{-7} watt-second. *H. Todd*

ERGONOMIC Identifying cameras or other equipment designed with the operator's comfort, ease of operation, safety, etc. in mind, such as contours and controls on a camera that conform to a natural position of the operator's hands.
 L. Stroebel

EROTIC PHOTOGRAPHY Erotic photographs are those that display the human form, either directly or indi-

rectly, in a way that tends to produce sexual arousal in the viewer. The nudes of Edward Weston and of Ruth Bernhard, who studied with Weston, are examples of direct representation of the human form. The vegetable series (peppers, etc.) by Edward Weston and the flower series by Imogen Cunningham are more subtle and indirectly display "structural equivalents" of the human form. The distinction between erotic photography and pornographic photography can be a difficult one, depending on who authored the work, the audience, and the context and culture in which the work is shown. In general, erotic photographs tend to be artistic, subtle, and suggestive, whereas pornographic photographs tend to be direct, explicit, and blatant. In simple terms, one could consider pornographic photography as hard core and erotic photography as soft core.

Erotic photographs can be seen as an extension of the erotic drawings and paintings that preceded them. In fact, most of the early nude photographs mimicked nude paintings. The first erotic photographs were daguerreotypes, many of which are now highly valued as collectibles. As early as the 1850s, a market for erotic photographs began quietly to take hold and flourish. The market became more open about 15 years later, as society became more accepting of the nude form in photographs. The era of the French postcards, showing photographs of women in sexually suggestive and provocative poses, became popular in the 1880s in the United States as well as in Europe. At the turn of the century, Pictorialist photographers began to idealize the human form in a manner similar to that of classical painting and sculpture. The work of William Mortensen depicting female nudes in classical poses with classical lighting, heavy retouching, and no pubic hair exemplifies such photography. Some of his photographs in his book, *Monsters and Modonnas*, are so posed and so heavily retouched that they begin to look like the erotic airbrush images of Alberto Vargas, who created the ongoing series of "Varga Girls" that were displayed in early issues of *Esquire* from the 1920s to the 1950s. Mortensen even went so far as to have his nude female forms look like sculpture by airbrushing out the head and arms and airbrushing in dents and cracks. He was heavily criticized by many of his contemporaries, but now much of his work is valued by collectors.

Photographers of the same era who were noted for their erotic photography include Man Ray, with the many photographs of his favorite model Kiki; Brassai, who photographed night life in Paris; and Paul Outerbridge, Jr., who created a provocative series of fetishized nudes.

In more recent years the list of photographers who have attracted widespread attention for their erotic photographs has grown, among them Ralph Gibson, Robert Heinecken, George Kraus, Sally Mann, Bettina Rheims, Herb Ritts, Victor Skrebneski, and Jack Sturges. Male as well as female nudes can now be seen in photographs, including some used in advertisements. Helmut Newton and Guy Bourdin are well known for their erotic photographs that have appeared in advertisements. Calvin Klein and Guess? Jeans thrive on the use of suggestive and erotic photographs in their ad campaigns. Calvin Klein has shown nude men and women in the same ad.

Photographs dealing with homosexual themes have become more open, although still somewhat controversial. The homosexual erotic work of Robert Mapplethorpe caused quite a furor when it was first exhibited.

Minor White's work dealing with a similar theme was more subtle and did not create controversy. The display of nude children and teenagers in a photograph continues to cause controversy but is not a new phenomenon, as can be seen by reviewing earlier photographs in museum archives and in early publications.

The growing availability of computer imaging, with the

ability to scan photographs into a computer and to interact with the images, is giving a new twist to erotic photography.

R. Zakia

See also: *Pornographic photography.*

ESTABLISHING SHOT In motion-picture photography, the first shot of a new scene, used to orient the audience. Often this is a long shot, providing a general or distant view of the new location. *H. Lester*

ESTAR BASE A film support of polyethylene terephthalate having very high dimensional stability, very high tensile strength, and high stiffness. (Eastman Kodak Company, 1960). *M. Scott*

ESTIMATED MIDTONE A method of exposure determination whereby a reflected-light meter reading is taken from a subject area that appears to be midway in lightness between the darkest and lightest areas in the subject. *J. Johnson*

See also: *Artificial midtone; Brightness-Range method.*

ETCH (1) In platemaking, the electrolytic action of an acidified chemical on metal surfaces that produces relief images on letterpress plates and intaglio cells on gravure cylinders. It is also used to describe an acidified natural or synthetic gum solution used to desensitize (make water-receptive) the nonprinting areas of the plate, and similar solutions added to fountain solutions in printing. (2) To remove physically, as in the removal of silver from a print or a negative by scraping with a sharp tool. (3) To remove chemically, as in the removal of a material not protected by a photoresist in the manufacture of printed circuits and photoengraving plates. (4) To remove unhardened material in a differential hardening process, such as gelatin in the carbon and carbro processes. (5) To reduce the size of halftone dots with a chemical solvent, altering tonal rendition in photomechanical reproduction. *M. Bruno and H. Wallach*

ETCH-BLEACH PROCESS A solution of 1% citric acid and 1% cupric chloride in water, combined with an equal volume of 3% hydrogen peroxide just prior to use, can remove both silver and gelatin from a fully developed, fixed, and washed image. The 5-minute treatment leaves a high contrast representation that seems to be a photo drawing in relief. Lith film, processed as a positive or a negative, works well in this application. Resin-coated paper is more effective than fiber. Selected areas of the negative or print may be protected from the action of the solution with frisket, a type of rubber cement used by graphic designers. After processing, a brief soak in plain acetic acid stop bath makes the remaining gelatin more receptive to the variety of dyes that may be used. *H. Wallach*

ETCHING (PHYSICAL) Removal of defects and local reduction of density on black-and-white negatives by scraping with a hardened knife sharpened to a wide angle. Etching knives are commercially available. Held at an angle approaching 90 degrees to the surface of the emulsion, the knife is used to *carefully* scrape away silver until the desired silver reduction has been reached. Chemical reduction is preferred to etching with prints since the surface abrasion is difficult to conceal. *I. Current*

EVANS, FREDERICK HENRY (1853–1943) English photographer. Best known for his delicately toned and unmanipulated platinum photographs of English cathedrals. Also took many fine portraits of his artistic and literary friends. Promoted by Stieglitz, who devoted an entire issue of *Camerawork* to Evans in 1903 as, "the greatest exponent of architectural photography." Active member of the Linked Ring, a British group of photographers working for the full recognition of their medium as an independent art form. Gave up photography when platinum paper became unobtainable during the First World War.

Books: Newhall, Beaumont, *Frederick H. Evans.* Millerton, NY: Aperture, 1973. *M. Alinder*

EVANS, WALKER (1903–1975) American photographer. Began serious photography in 1928 and had first solo show in 1932 at the Julien Levy Gallery, New York. Committed to straightly seen, unadorned documentation where the photographer's personality does not intrude upon the image. Opposed to the noted examples of the times, Stieglitz and Steichen, whom he perceived as personifying artiness, the former, and commercialism, the latter. A photographer for the Farm Security Administration (1935–1938). Two books cemented his reputation: *American Photographs* (1938), and, with James Agee, *Let Us Now Praise Famous Men* (1941), illustrated with Evans's sad and disturbing portraits of southern sharecroppers. From 1945 to 1965 he was a staff writer and the staff photographer for *Fortune.* From 1965 until his death he was professor of graphic design, Yale University.

Books: *First and Last.* New York: Harper & Row, 1978; Szarkowski, John, *Walker Evans.* New York: Museum of Modern Art, 1971. *M. Alinder*

EVAPOROGRAPHY A technique for recording images based on the differential evaporation of a thin layer of a volatile liquid in relation to variations in temperature of the image areas. *L. Stroebel*

EVGA In electronic imaging, an abbreviation for extended video graphics array (VGA), meaning a display that can

Etching knife blade. The blade of the etching knife is ground and honed to a narrow angle, then held nearly vertically while removing thin depths of emulsion layer with a scraping action.

achieve a resolution of 1024×768. This high resolution is usually noninterlaced, although it may be found interlaced.

R. Kraus

EVOLUTIONARY OPERATIONS (EVOP)
A statistical method of improving a process (such as photographic development) by making a systematic series of changes about the usual levels. Only small changes are made, too small to produce defects in the output, and the results tested. Only if a favorable outcome is assured is the process changed in the appropriate way.

H. Todd

EXACT COLOR REPRODUCTION
Reproduction in which the chromaticities, relative luminances, and absolute luminance are the same as those in the original scene.

R. W. G. Hunt

See also: *Color reproduction objectives.*

EXCITATION PURITY
Quantity defined by the ratio NC/ND of two collinear distances on the *x, y,* or on the x_{10}, y_{10}, chromaticity diagram. NC is the distance between the point C representing the color stimulus considered and the point N representing the specified achromatic stimulus; ND is the distance between the point N and the point D on the spectral locus at the dominant wavelength of the color stimulus considered. In the case of purple stimuli, the point on the spectral locus is replaced by a point on the purple boundary. Symbol, ρ_ε.

R. W. G. Hunt

See also: *Colorimetry.*

EXCITER FILTER
See *Filter types.*

EXCITER LAMP
The light bulb, which together with optics, provides the illumination for playing optical sound tracks.

T. Holman

EXCITON
If the absorbed photon energy is just slightly below the threshold for creation of a free electron in the conduction band and a free hole in the valence band, a bound electron-hole pair called an exciton results. At room temperature the electron-hole pair quickly dissociates to a free electron and hole because the binding energy is very small.

R. Hailstone

EXHAUSTION OF SOLUTIONS
The useful life of photographic solutions such as developers, fixers, bleaches, etc., is limited by a number of factors: the active ingredients become used up or they automatically decompose in the working solution; the solution becomes contaminated with impurities produced by the decomposition of the active ingredients; and certain solutions such as developers are oxidized by contact with the atmosphere or air dissolved in the water.

L. Stroebel and R. Zakia

See also: *Processing; Replenisher/replenishment.*

EXISTING LIGHT
See *Available light.*

EXISTING-LIGHT PHOTOGRAPHY
Existing light photography refers to photographs taken by the natural light present on the scene. Also called *available light,* this photography precludes the use of photographic lighting equipment such as electronic flash. It makes full use of everyday light sources such as lamps and other lighting fixtures, fireplaces, candles, windows, and skylights. Neon signs and theatrical spotlights, even overhead fluorescent school or office lighting can provide the necessary illumination for an existing-light shot.

Outdoor daylight pictures, which fit the technical definition of this category, normally are not considered to be existing-light photographs. Pictures taken near dawn or at sunset, during twilight or after dark, however, not only belong to existing-light photography but suggest its actual bias toward lower light levels.

HISTORY
Today's existing-light photography might be traced back to England's Peter Henry Emerson. Put off by the artificiality of much of the pictorial art photography of the late 1870s, he suggested that only natural subjects in natural surroundings could be turned into beautiful photographs.

Alfred Stieglitz in the United States pressed for well-composed photographs of natural beauty. "Every phase of light and atmosphere is studied from its artistic point of view," he wrote in *Scribner's Magazine* (1899), "and as a result we have the beautiful night pictures, actually taken at the time depicted, storm scenes, approaching storms, marvellous sunset-skies."

Ansel Adams liked the way *natural* light, as he called it, helped to simplify photography and to reveal the simple truths of the natural world. "With natural light only minor controls are possible—by use of screens and reflectors, and by the selection of viewpoint," he wrote in the foreword to *Natural-Light Photography* (1952). "To utilize it fully you must know how to evaluate its intensities and qualities, not only in their effect on sensitive emulsions but also in relation to the intangible elements of insight and emotion that are expressed in a good photograph."

Deeming available light photography "a higher level of photography," John Lewis Stage, in his foreword to *Available Light Photography* (1980), writes: "Under conditions of low light, the photographer is operating at the extreme limits of sensitivity of film and of lens. It is not an area for the safe, the timid, or the impatient photographer. In this subtle and shadowy world you risk possible failure in an effort to gain visual rewards that are far beyond the triteness of 'perfect sharpness and even lighting.'"

Today's existing-light photographer could be the mother with the simple snapshot camera taking a series of pictures of her two-year-old daughter in the slanted golden light of late afternoon. On the other hand, and perhaps more typically, it might be the 35-mm SLR photographer using 400-speed film, carefully composing a silhouette of a barn at sunset.

The equipment of choice for existing-light photography is an adjustable 35-mm camera with a large maximum aperture ($f/2.8$, $f/2$, or $f/1.4$ are variously recommended). A 50-mm $f/1.4$ lens in combination with a fast film permits picture taking in extremely low light levels. For versatility, some professional photographers, who need to rely on existing-light, add an extra camera body to their equipment so they can mount two fast lenses, a medium telephoto and a moderate wide-angle lens.

Although medium-speed film may be fast enough for picture taking near daylight windows or skylights, most lower-light situations require fast 400-speed film. A tabletop tripod or other method of firm support helps guard against camera shake at slow shutter speeds. A good in-camera or hand-held exposure meter needs to be balanced by an understanding of light, constant experimentation (with note taking), and bracketing of exposures.

Reflectors sometimes help fill in the shaded side of a subject. Gobos or light-blocking screens remove or direct light in complex, existing-light shots. Simplicity and mobility, however, remain at the heart of this naturalistic photography intent on capturing the mood of the moment.

Books: Trachtenberg, Alan (ed.), *Classic Essays on Photography.* New Haven, Conn.: Leete's Island Books, 1980; Thorpe, Don O. *Available Light Photography.* New York: Amphoto, 1980.

K. Francis

EXITANCE (*M*)
Power output (emitted or reflected) per unit surface area. The preferred unit for radiant exitance is

watts per square meter (W/m^2). The preferred unit for luminous exitance is lumens per square meter (lm/m^2). Unlike luminance and radiance, which are measures of the power output into a given solid angle per unit surface area, exitance measures the total power emitted in all directions. Note that while the dimensions used to define exitance are identical to those used for irradiance and illuminance (i.e. power/area), exitance refers to the power *leaving* a surface, while irradiance and illuminance refer to power *incident* on a surface. The former term *emittance* has been abandoned. (2) At a point on a surface, the flux leaving the surface per unit area.

J. Pelz and R. W. G. Hunt

Syn.: *Emittance* (obsolete).

See also: *Luminance; Photometry and light units; Radiance.*

EXIT PUPIL See *Pupil*.

EXPANSION (SOUND) The opposite of compression; any device or process that increases dynamic range. An expander is an amplifier whose gain is deliberately controlled by the signal, effectively turning the volume down in low-level passages and up in high ones. A special case of the expander is a downward expander that expands the signal only below a threshold, usually adjustable. The purpose of a downward expander is to reduce noise by adjusting the threshold level to be set between the level of the desired program material and the level of the noise. Then only passages where the only content is the noise will be subject to downward expansion, and a useful noise reduction occurs.

T. Holman

EXPECTANCY A condition whereby people are more receptive to seeing what they expect or want to see than to alternative responses. *L. Stroebel and R. Zakia*

See also: *Set (Perceptual).*

EXPIRATION DATE The year and month stamped on the external package of films, plates, and some papers after which aging effects may be significant. The prudent user should test expired material before committing it to an important use. *M. Scott*

See also: *Outdated.*

EXPLODED VIEW A photograph of the component parts of an object separated so that each part is visible and correctly oriented in space in relation to its position in the assembled object. Exploded-view photographs are commonly used in repair instruction manuals, in catalogs of equipment parts, and in medical illustrations. *R. Zakia*

EXPONENTIAL MOVEMENTS The movement of object or camera in motion-picture animation, where the speed of movement is relative to the size of the field, for example, when filming a scene of miniatures to be cut into a sequence of normal live action. *H. Lester*

EXPONENTS See *Appendix G.*

EXPOSURE In the field of photography the term *exposure* can have a number of different meanings, including the process of allowing light to fall on a photosensitive material and the amount of light received by a photosensitive material.

CORRECT EXPOSURE The correct exposure for a photograph can be defined as an exposure that produces an image with the tonalities and colors the photographer desires, or at least more nearly so than would result with either an increase or a decrease of the exposure. In some situations, however, a range of exposures may produce equally acceptable results. With negative materials, the least exposure that produces adequate shadow detail, plus a safety factor, is considered to be the correct exposure. With reversal camera films and with printing materials, the correctness of the exposure is judged on the basis of the appearance of the overall density of the positive image. Such criteria are used as guidelines for establishing speed rating systems for photographic materials.

EXPOSURE AND IMAGE DENSITY Photographic scientists have devised a graphical system to represent the response of photographic materials to different amounts of light; it is known as the characteristic curve, or D-log H curve, where D is density and H is exposure. In earlier times the characteristic curve was known as the H & D curve, in honor of Ferdinand Hurter and Vero Charles Driffield, who first described the concept in late 1800s. The relationship between the two variables that determine exposure is expressed by the formula $H = E \times t$ (formerly $E = I \times t$), or exposure equals illuminance times time. The term *photographic exposure* is sometimes used to identify the total amount of light that falls on a photosensitive material to avoid confusion with *camera exposure* and *print exposure*, which refer to the exposure time and the *f*-number used for exposing film or printing material. All three terms are commonly shortened to *exposure* when the context makes the intended meaning clear.

The vertical axis of characteristic curves represents different densities (*D*), which increase from bottom to top. The horizontal axis represents different amounts of light as exposure (*H*), which increase from left to right. Since density values are logarithms (found by taking the log of the opacity), a more useful curve is produced by using log exposures, rather than exposures, on the horizontal axis. Basically, the D-log H curve illustrates (for nonreversal materials) that as the log exposure increases, the density increases—but not in a consistent manner except for the central straight-line portion.

What does the characteristic curve mean to photographers? It shows that exposure is a measurable property, which, once quantified, can be controlled to obtain consistent results, and it provides information about the effects that changes in exposure have on the image.

FILM SPEED In the early years of photography, when photographers made their own light-sensitive materials, there were only crude guidelines as to the sensitivity of the materials, and these were based on the trial-and-error exposure times required to produce satisfactory images. With the introduction of factory production of large quantities of uniformly sensitized materials and an understanding of the principles of sensitometry, it became possible to assign film speed numbers to camera films to assist photographers in obtaining correctly exposed images.

Many different film speed systems have been proposed over the years, but only recently has one system been accepted as an international standard. There has been general agreement for some time, however, that the film speed of negative films should be based on the *minimum useful density* concept, and experimental studies revealed that a minimum density of 0.1 above base plus fog density is required for the darkest subject area where detail is desired. This criterion, which is incorporated in the ISO film-speed standard for black-and-white pictorial films, also provides the photographer with a useful guide for evaluating the correctness of exposure of negatives by measuring, or even estimating, shadow densities.

EFFECTS OF UNDEREXPOSURE AND OVEREXPOSURE When photographic materials have been given less or more than the ideal exposure, the images produced exhibit certain undesirable characteristics. When camera films are underexposed, there is a loss of contrast and detail in the darker subject areas. Because the loss of contrast

occurs in the toe portion of the characteristic curve with negative films, printing an underexposed negative on a higher contrast grade of paper may improve the overall appearance of the image but will not fully compensate for the underexposure. Any shadow detail lost through underexposure, of course, cannot be restored.

Overexposure of negative films moves the shadow areas from the toe of the characteristic curve to the steeper straight-line portion, thereby increasing shadow contrast and the total density range. There is no change in contrast for the midtone areas or for the highlight areas unless the overexposure moves them up onto the shoulder part of the curve, where they suffer a loss of contrast, an effect referred to as being *blocked up*. Dense negatives require longer printing exposure times and the enlarged images will tend to appear grainier.

Whereas underexposure results in a loss of density with negative films, with reversal color films it produces an increase in density, but the loss of contrast and detail still occurs first in the darker areas of the subject. Slight underexposure is sometimes used intentionally to increase color saturation or to increase highlight detail, especially with transparencies that are to be reproduced for mass viewing, where the overall density can be optimized in the final image.

EXPOSURE LATITUDE With negative materials, both color and black-and-white, optimum exposure is important but not critical, because negatives are meant to be printed rather than being viewed as the final image. Exposure latitude is larger on the overexposed side of normal than on the underexposed side, and the total exposure latitude varies with the luminance range of the scene, the exposure latitude of the film, the amount of camera flare, and the amount of image degradation that is acceptable to the viewer. There is seldom more than a one-stop exposure latitude on the underexposed side, but several stops of overexposure may be acceptable for noncritical applications. Because shadow detail is so important, the general rule with negative materials is, if in doubt, overexpose rather than underexpose.

Exposure latitude is much smaller for reversal color films and for printing materials. Plus-or-minus one-half stop is commonly considered to be the maximum exposure latitude for color films. Slightly larger deviations may be acceptable for images viewed in isolation, such as slides projected in a darkened room, providing that all of the slides in a sequence are uniformly underexposed or overexposed. Either side-by-side or sequential comparisons of images make variations in density less acceptable.

The exposure latitude when making quality prints is very small, sometimes less than plus-or-minus 10%, since prints are normally viewed with general room lighting and are seen in comparison with other objects in the environment. The perceived darkness of a print, however, does depend upon the localized level of illumination on the print. A print that appears normal under a bright inspection light in the printing darkroom may appear too dark when viewed with normal room illumination, and a print that appears correct in density with normal room illumination may appear too light when displayed under a higher level of illumination. For this reason, ANSI and ISO standards have been established that specify light levels and color quality of light sources for various viewing conditions. An illuminance level of approximately 800 lux (74 footcandles) and a color temperature of 5000 K have been recommended for judging and exhibiting prints.

CAMERA EXPOSURE CONTROLS There are two adjustments on cameras for controlling the amount of exposure the film receives—the size of the diaphragm opening, or *aperture,* which is calibrated in *f*-numbers, and the shutter speed, which is calibrated in fractions of a second and seconds. The aperture controls the illuminance of the light falling on the film and the shutter controls the exposure time, the same variables that appear in the definition of photographic exposure—exposure (H) equals illuminance (E) times time (t). It should be noted that when the shutter is tripped to make a photograph, the film actually receives a whole range of different exposures because of the variations in the amount of light reflected from different parts of the subject, and when the aperture or shutter setting is changed, it increases or decreases the exposures for all parts of the image by the same factor.

f-numbers *f*-numbers are calculated by lens manufacturers by dividing the focal length of the lens by the diameter of the effective aperture, where effective aperture is defined as the diameter of the entering beam of light that just fills the diaphragm opening, not the diameter of the diaphragm opening itself. As the opening becomes smaller, therefore, the *f*-number becomes larger. Lenses are normally calibrated with *f*-numbers that represent whole stops, where a change of one stop doubles or halves the amount of light transmitted. The following *f*-numbers represent a series of consecutive whole stops: 0.7, 1.0, 1.4, 2.0, 2.8, 4.0, 5.6, 8, 11, 16, 22, 32, 45, 64, 90, 128. The series can be extended in either direction by noting that adjacent numbers vary by a factor of the square root of 2 (approximately 1.4), and that alternate numbers vary by a factor of 2, with an occasional adjustment for the truncating of decimals, as occurs with *f*/22 and *f*/45. Few lenses have a range of more than eight stops, with the numbers on lenses for small-format cameras tending to occupy more of the left side of the above series and lenses for large-format cameras tending to occupy more of the right side. Intermediate *f*-numbers are not marked on lenses except when the *f*-number for the maximum diaphragm opening is not one of the series of whole stop numbers, such as *f*/2.2. Some lenses do, however, have intermediate markings or click stops representing halves or thirds of a stop. Thirds of a stop are more useful since (1) they offer more precise control over exposure; (2) the scale of ISO film speed numbers is based on thirds of a stop; and (3) the intermediate markings on the scales of many exposure meters represent thirds of a stop—although some electronic exposure meters provide digital decimal readouts to a tenth of a stop.

Shutter Speeds Camera shutter speed settings have traditionally conformed to the following sequence of numbers: 1, 1/2, 1/4, 1/8, 1/15, 1/30, 1/60, 1/125, 1/250, 1/500, 1/1000. The range has been extended on some newer shutters to 30 seconds or longer on the long-exposure end and 1/8000 second on the short-exposure end. Whereas intermediate settings cannot be depended upon to provide proportional intermediate exposure times with conventional shutters, some camera automatic-exposure system electronic shutters will provide appropriate intermediate exposure times for selected *f*-number settings.

Because adjacent shutter speed settings and whole-stop *f*-number settings both change the exposure by a factor of two, photographers have a choice of many different combinations of shutter speeds and *f*-numbers that produce the same exposure, the choice depending upon depth-of-field and motion-stopping requirements.

METHODS OF DETERMINING CAMERA EXPOSURE Although exposure meters are the most commonly used method of determing camera shutter and aperture settings, other methods are available to photographers. The original method was that of estimating exposures on a trial-and-error basis. Once a correct exposure has been determined experimentally, it can be standardized as long as conditions remain the same, such as when photographing subjects in sunlight on a clear day. A refinement of this approach is to make an exposure table that covers a range of daylight lighting conditions, and such tables have been provided by film manufacturers for many years. The *f*/16 rule is a simpli-

fication of this approach, whereby the recommended exposure time at $f/16$ is the reciprocal of the film speed, such as 1/125 second for a film having an ISO speed of 125, for subjects in sunlight. An extension of the $f/16$ rule is the key f-number rule, whereby $f/11$ is used for hazy sun conditions, $f/8$ for cloudy bright, and $f/5.6$ for open shade or heavy overcast. Comprehensive exposure and nomographs, such as those provided in the ANSI standard *Photographic Exposure Guide,* provide exposure data for a wide range of day and night natural light conditions including sunsets, moonlit landscapes, and lightning, plus typical indoor and outdoor artificial lighting situations.

Other methods that are used in place of exposure meter readings or in combination with them include making extra exposures, bracketing the assumed correct exposure, and making test exposures with instant-picture film. With negative materials, exposures are commonly bracketed at full stop intervals from two stops under to two stops over. With reversal color films, smaller intervals are generally used, such as one-half or one-third stop, because of the smaller exposure latitude of these films. When using instant picture film for an exposure check, some photographers use neutral density filters on the camera lens to compensate for any difference in the film speeds of the instant picture film and the conventional film so that the same f-numbers and shutter speed settings can be used with both films to eliminate the possibility of introducing another exposure variable.

Metering Methods The most widely used methods of determining camera exposure settings are to measure the light falling on the subject and the light reflected by the subject with an exposure meter. Whereas light meters that are designed for use by scientists and engineers are calibrated in photometric units, such as footcandles and candelas per square foot, exposure meters are designed to convert the input into f-number and shutter speed data for a range of film speeds, or in the case of automatic-exposure cameras, to adjust the aperture or shutter speed.

Even though film speeds for black-and-white pictorial films are based on the exposure required to produce a density of 0.1 above base plus fog density for the darkest area in the subject where detail is desired, exposure meters are calibrated to produce the optimum exposure when reflected-light measurements are made from a medium tone. With subjects having a normal luminance range, exposing for a midtone will produce adequate detail in the darker subject areas.

Reflected-Light Readings Because reflected-light exposure meters are calibrated for midtone readings, any area used for a reflected-light reading will be reproduced as a midtone on the film, even if the area is the darkest or lightest area in the subject. Thus, exposing a film as indicated by a reading of the darkest area will record that area as a medium tone rather than as the desired 0.1 above base-plus-fog density, and the negative image overall will be much too dense. Conversely, exposing according to a reading from the lightest tone in the subject will record it as a medium tone, and the negative image overall will be much too thin.

Midtone Readings A problem with midtone reflected-light readings is the difficulty of selecting an appropriate area for the reading, and some subjects may not even contain a suitable medium tone. Because of these problems, it is common practice to place an artificial midtone, in the form of a standard gray card having a reflectance of 18%, in front of the subject for the meter reading. For copying situations, the gray card should be placed directly in front of the original, facing the camera. With three-dimensional subjects, the card should be aimed at a position midway between camera and the key light source.

An alternative method of exposing for a midtone that may not even exist is to take separate readings from the lightest and darkest areas where detail is desired and then to select a middle value. The scales on most hand meters are arranged so that the major markings represent a doubling of the luminance, the equivalent of one-stop changes. If the meter has an interval scale of numbers for the light values, such as 1, 2, 3, 4, 5, 6, 7, and the shadow reading is 1 and the highlight reading is 7, the middle number, 4, would be the appropriate midtone value. The same could be done by determining the f-numbers for the highlight and shadow readings at a given shutter speed and selecting the f-number midway between the two on the meter scale or the camera lens, or by determining the shutter speeds for the highlight and shadow readings at a given f-number and selecting the shutter speed midway between the two on the meter or camera shutter-speed scales.

Camera-Position Readings Aiming a reflected-light meter at the subject from the camera position is the most convenient method of using an exposure meter. To produce acceptable results, the subject area being photographed must be composed of an appropriate balance of tones. A scene dominated by light tones produces a false high meter reading and an underexposed image, and a scene dominated by dark tones produces a false low reading and an overexposed image. Camera-position readings produce a high proportion of acceptable images with negative films, which have considerable exposure latitude, when precautions are taken to avoid including such items as light sources, bright skies, and other subject areas that would distort the balance of tones.

It is possible to make reflected-light readings of midtone or other selected areas from the camera position using an exposure meter that has a narrow angle of acceptance. Whereas conventional hand-held reflected-light exposure meters have angles of acceptance approaching the angle of view of normal focal-length lenses, spot attachments and spot meters have smaller angles, such as 15 degrees, 7.5 degrees, and even as small as 1 degree.

Small-format cameras that have built-in exposure meters also use camera position reflected-light type readings. Different cameras use different systems of sampling the light that is transmitted by the camera lens with through-the-lens (TTL) exposure meters, including integrating the light over a large area, measuring the light in a small area in the manner of a spot meter, measuring the light over a large area but giving greater emphasis to a reading in the center, and averaging the readings from two or more small areas.

Zone System Readings Correct exposure can be obtained by taking a reflected-light reading from a darker or lighter area than a midtone if an appropriate adjustment is made to compensate for the difference in luminance. If it is known, for example, that a white card reflects 90% of the incident light, five times as much as the standard 18% gray card, the camera exposures and the negative densities would be the same for a normal reading from the gray card and a reading from the white card with the indicated exposure time multiplied by five or by dividing the film speed by five for the white-card reading.

The early Weston exposure meter had four positions marked on the meter dial in addition to the normal arrow, which was calibrated for use with midtone or integrated reflected-light readings. A U position, located four stops below the normal arrow, represented the darkest subject area where satisfactory detail would be recorded in the negative. Thus, exposing film with the U position aligned with a reading from the darkest area could be expected to record the appropriate density to hold detail in that area. The exposure would be one-sixteenth, or four stops, less than the exposure that would have resulted from setting the normal arrow opposite the shadow-area reading.

An O position, located three stops above the normal arrow, was designed to be used with readings from the lightest subject area where detail was desired. The resulting exposure

would be eight times, or three stops, more than the exposure that would have resulted from setting the normal arrow opposite the highlight reading. A and C positions were located one stop below and one stop above the normal arrow, respectively, and were designed to be used with appropriate darker and light subject tones such as green foliage and caucasian skin.

The subject tone range represented by the U and O positions was seven stops, or a luminance ratio of 1 to 128. Readings made from a large number of scenes have established that average outdoor and indoor scenes have a luminance ratio of approximately 1 to 160, which is only a fraction of a stop higher than the specified seven-stop range.

The zone system, originated by Ansel Adams, associates a gray scale of print tones with the full-stop positions on the meter dial, with a slightly lighter than black dark tone at the U position (subject value I), an 18% reflectance gray tone at the normal arrow (subject value V), and a slightly darker than white tone at the O position (subject value VIII). Thus, the photographer can record a subject area as any tone of gray (or print value) by aligning the selected patch with the meter reading from that area. With negative films, an objective is to obtain negatives having appropriate densities so that print exposure times can be standardized, in addition to obtaining the desired tone reproduction. With instant picture materials and reversal color films, this procedure should produce images with the desired density in the selected areas.

Incident-Light Meter Readings Incident-light exposure meters are designed to measure the light falling on the subject (the illuminance), as distinct from the light reflected or emitted by the subject (the luminance). If the same meter is to be used for both reflected-light and incident-light readings, it is necessary to add a diffusor over the photocell, both to increase the angle of acceptance for incident-light readings and to absorb an appropriate fraction of the light to produce the same incident-light reading as would be obtained with a reflected-light reading of an 18% reflectance gray card in the same situation.

Incident-light meter readings have been popular with professional motion-picture and still photographers because of the ease with which the readings can be made and the consistency of the results. The diffusor that covers the photocell is typically hemispherical in shape and designed to make an appropriate adjustment in the meter reading as the dominant light source is moved from directly in front of the subject through an arc of 180 degrees around the subject to the rear, with the meter remaining aimed directly at the camera. Because the illuminance decreases so rapidly with distance from a light source, it is important to hold incident-light meters very close to the subject with studio lighting situations. Outdoors, the meter reading can be made at the camera whenever it is evident that the illuminance is the same at the subject and the camera. Some incident-light meters are provided with a flat (cosine-corrected) diffusor in addition to a hemispherical diffusor. Flat diffusors are recommended when making photographic copies, since changes in the angles of the lights affect the meter reading in the same way they change the luminance of the flat surface of the material being copied.

Reflected Versus Incident Most hand-held exposure meters can be used for both reflected-light and incident-light readings. With normal subjects the two types of readings should agree. It is a useful practice to compare the two types of readings with a variety of subjects and when they do not agree to try to find an explanation for the difference. If a logical explanation cannot be found, exposing a film as indicated for each type of reading will provide evidence as to which was more dependable in that situation.

There are picture-making situations in which the photographer has little or no choice whether to make a reflected-light or incident-light reading, and where one or the other

clearly has an advantage. Incident-light readings are inappropriate with objects that emit light, such as fires, molten metal, and night signs, and with transparent and translucent objects that are photographed with transmitted light, such as stained-glass windows and color transparencies placed on illuminators for copying. Incident readings are also inappropriate when the lighting is different at the camera and a distant or unapproachable subject, such as a sunlit scene photographed from the shadow side of a city street, and a stage play photographed from the darkened theater. When incident meters can measure the light falling on the subject, they normally produce dependable results, but a small adjustment, typically one-half to one stop, is recommended when photographing predominately dark or predominately light subjects.

Reflected-light readings are also undependable or difficult to make in certain situations. Conventional reflected-light exposure meters cannot accurately measure the light from small subject areas, or even from larger subject areas that cannot be approached, although this problem is less severe with spot meters. Some subjects do not contain a suitable midtone area for a reading, where an adjustment must be made for a reading from a lighter or darker area, or an artificial midtone must be inserted into the scene for the reading—and a reflected-light reading from an 18% reflectance gray card offers no advantage over an incident-light reading and is generally less convenient. With small-format cameras having through-the-lens (reflected-light) metering, the photographer is often unaware of the subject area or areas that the meter is measuring, which makes it difficult to compensate for abnormal situations. In such a situation it is best to bracket.

EXPOSURE ERRORS Consistent exposure errors are easier to deal with than erratic ones. Consistent underexposure, for example, can be compensated for by setting the meter for a lower film speed. Photographers, however, usually want to know the cause of exposure errors.

Exposure Meter Accuracy Comparison tests in which meter readings are made of a standard light source reveal that there are variations of response of new exposure meters and more serious variations among older meters. Testing the entire system by exposing reversal color film, which has a small exposure latitude, with a normal subject and bracketing the indicated exposure can be reassuring when the normally exposed photograph turns out to be the best one of the series, but it doesn't identify where the fault lies when that photograph is too thin or too dense. Comparing a meter of questionable accuracy against several other meters under the same conditions can provide useful information, or the meter can be returned to the manufacturer for testing against a calibrated standard light source. It would also be appropriate to ask the manufacturer to specify its acceptable range of variability.

Method of Using the Meter Greater care is required when using reflected-light meters than incident-light meters to avoid errors, including selecting an appropriate midtone, holding the meter close enough to exclude a contrasting surround but not close enough to cast a shadow, avoiding glare reflections on the area being measured (including the standard gray card), and shading the meter from a backlighting light source. With incident-light meters, care is required to hold the meter close to the main subject, aim it directly at the camera, and make an adjustment for dark or light subjects. The instruction manuals provided with exposure meters usually provide a helpful list of suggestions.

Closeup Exposure Factor A rule of thumb is that an exposure adjustment should be made to compensate for the increased lens-to-film distance (image distance) when photographing objects that are closer to the camera (object distance) than 10 times the focal length of the lens, such as

20 inches for a 50-mm (2 inch) lens on a 35-mm camera, and 80 inches for a 203-mm (8 inch) lens on a 4 × 5-inch view camera. No exposure compensation is required, however, with cameras having through-the-lens metering, including exposure meters with probes that can be inserted in place of a film holder to make readings at the film plane of large-format cameras.

There are various methods of calculating the closeup exposure factor, including

Exposure factor = (Image distance/focal length)2

Exposure factor = (Scale of reproduction + 1)2

Shutter Accuracy Shutter speeds can deviate from the indicated speed even on new cameras, but they do so more commonly on older cameras that have had considerable use or abuse, and a given shutter can be fast at one setting and slow at another setting. The newer electronic shutters tend to be more accurate than mechanical shutters. With between-the-lens shutters, as distinct from focal-plane shutters, the *effective* exposure time gradually increases as the diaphragm is stopped down at the faster shutter-speed settings because the smaller diaphragm opening is completely uncovered sooner and remains uncovered longer than occurs with a larger diaphragm opening. The overexposure resulting from this effect approaches a factor of two, or one stop, with a combination of a small diaphragm opening and a high shutter speed setting.

Lens Transmittance The *f*-number markings on new lenses can be expected to be within acceptable tolerances of accuracy. Inaccuracies can occur with use due to wear and physical damage. Two lenses set at the same (accurate) *f*-number can produce different exposure, however, due to differences in transmittance of the glass elements. Lenses having a large number of elements can, especially if they have not been treated with an antireflection coating, absorb a significant proportion of the entering light. Some lenses, especially motion-picture camera lenses, are calibrated in *T*-numbers on the basis of the proportion of light transmitted, which eliminates variations in transmittance as an exposure problem.

Film Development Published film speeds for black-and-white films are based on a specified degree of development. Photographers who use condenser enlargers, as distinct from diffusion enlargers, tend to develop their film to a lower contrast index, which results in a small decrease in the effective film speed.

Illumination Color Balance Film manufacturers at one time published daylight and tungsten film speeds for black-and-white films, with tungsten speeds being lower. As the differences between the two speeds decreased with improvements in panchromatic films, they changed to a single film speed. The difference in the effective film speeds for panchromatic films with daylight and tungsten illumination can still be as large as a third of a stop. With color films that can be used with both types of illumination by adding a filter for one or the other, two different film speeds are commonly published, rather than one film speed and an exposure filter factor.

Filters Because filters absorb some fraction of the incident light, an exposure adjustment is required when a filter is added to a camera lens. Some cameras that have through-the-lens metering claim that the meter will automatically compensate for the addition of a filter, but differences in spectral sensitivity of the meter sensor and the film tend to cause exposure errors. Even filter factors that are published by film manufacturers usually carry a cautionary note that they should be tested.

Reciprocity Effects Effective film speeds depend to some extent on the values of illuminance and time in the equation *exposure = illuminance × time*. Extremes of low illuminance and long time and high illuminance and short time both result in a decrease in effective film speed. Typically, exposure times longer than 1 second require an increase in the exposure. Reciprocity effects with high illuminance and short exposure times occur mostly with electronic flash illumination. Image contrast and color balance can also be affected with both long and short exposure times.

Other Factors Exposure errors can be caused by a variety of factors other than those previously mentioned. Increases of camera flare light, caused by such things as a light background or a dirty or uncoated camera lens, create the effect of an increase in exposure, although the effect is most noticeable in the darker subject areas.

Fogging caused by light, x-rays, or chemicals can produce changes in image density similar to those caused by flare light.

Effective film speeds can be different from the published values because of variations in manufacturing, where plus or minus one-sixth of a stop is acceptable, and the effects of storing film before it is used, especially under unfavorable conditions.

Adding a positive or negative supplementary lens to a camera lens changes the effective focal length and *f*-numbers of the lens. Decreasing the lens-to-film distance by refocusing after adding a positive supplementary lens results in an increase in image illuminance and exposure. Adding a negative supplementary lens produces the opposite effect, a decrease in exposure. If the image is brought into focus by changing the object distance rather than the lens-to-film distance after adding a supplementary lens, no change in exposure occurs.

Changes can occur in latent images when films are not processed within a reasonable time following exposure.

Abnormal viewing conditions can cause normally exposed photographs to appear to have been underexposed or overexposed, especially with prints, slides, and transparencies viewed with very high or very low levels of illumination.

Books: Adams, A., The New Ansel Adams Photography Series: *The Negative.* Boston: Little, Brown, 1981. Stroebel, L., Compton, J., Current, I., and Zakia, R. *Photographic Materials and Processes.* Stoneham, MA: Focal Press, 1986. White, M., Zakia, R., and Lorenz, P. *The New Zone System Manual.* Dobbs Ferry, NY: Morgan & Morgan, 1989. *J. Johnson*

See also: *Additive system of photographic exposure; Exposure meters; Photographic effects; Reciprocity effects; T-number; Zone system.*

EXPOSURE AUTOMATION See *Automatic exposure.*

EXPOSURE CALCULATOR A device that contains exposure information for the photographer in a handy form. Older calculators might incorporate tables and a sliding or rotating scale. Newer versions convert exposure data into usable combinations of *f*-numbers and shutter speeds. Such a calculator is on the dial on some hand-held meters.

J. Johnson

See also: *Exposure meters.*

EXPOSURE CONTROL Identifying a neutral density filter, which absorbs equal amounts of all wavelengths of light and therefore reduces exposure. *J. Johnson*

See also: *Exposure; Filters.*

EXPOSURE COUNTER A number readout found on most roll-film camera bodies and film holders that indicates the number of frames of film remaining or already exposed.

P. Schranz

EXPOSURE CRITERIA The standard used for determining the optimum exposure of photosensitive materials may vary depending on the type of material and the desired outcome. For black-and-white negative materials, tests have revealed that a minimum density of 0.1 above base-plus-fog density is an appropriate criterion. With reversal color films, some photographers prefer a slightly darker image for reproduction than for direct viewing. The light level under which prints are displayed affects the choice of the optimum print density and, therefore, the exposure. With the zone system, a decision to produce a silhouette or semisilhouette profile portrait of a person, for example, rather than conforming to realistic tone reproduction, would alter the optimum exposure. *J. Johnson*

See also: *Zone system.*

EXPOSURE DATA (1) Quantitative information concerning illuminance and exposure time, used, for example, for the determination of photographic exposure for sensitometric purposes. (2) A combination of *f*-number and shutter speed, used, for example, as a record of camera exposure settings for a specific photograph. *J. Johnson*

See also: *Camera exposure; Photographic exposure.*

EXPOSURE DENSITY The logarithm of the ratio of the exposure produced by an ideal white surface (one that reflects 100% of all wavelengths of light) to that produced by a specific subject area. When color film is involved, a subject area will have three exposure densities, one each for the blue light, green light, and red light exposures. In this context, the term *exposure* includes the effects of the color of the light source and the film sensitivity. *M. Leary and H. Todd*

EXPOSURE EFFECTS Exposure effects are a group of phenomena associated with the complex response of a photographic material to absorbed light or other radiation. Typically, photographic materials (especially silver halide emulsions) exhibit nonadditivity and nonlinearity. *H. Todd*

See also: *Photographic effects.*

EXPOSURE FACTOR (1) In radiography, a numerical quantity equal to milliamperes times time divided by distance squared (for x-rays) and millicuries times time divided by distance squared (for gamma rays). The exposure is used, for example, to determine the exposure time required to produce a satisfactory image. (2) Figure by which the exposure indicated for an average subject and/or processing should be multiplied to allow for nonaverage conditions. Commonly used to compensate for increased image distance in closeup photography and for the addition of a filter to a camera lens. *J. Johnson*

EXPOSURE INDEX (EI) A value, analogous to a film speed number, used with an exposure meter to find the camera settings that will produce an image of satisfactory quality. The necessary EI will vary with the subject, the light source, and the effect desired, whereas film speed values are determined in a standard manner. *M. Leary and H. Todd*

EXPOSURE LATITUDE The range of exposure levels that will produce an acceptable image on a photographic material. Exposure latitude is usually expressed in terms of *f*-stops but may be stated as an exposure ratio or a log-exposure range.

Exposure latitude decreases as subject contrast, film contrast, or development contrast increases. For negative materials, exposure latitude is greater in the overexposure direction than in the underexposure direction. Reversal films

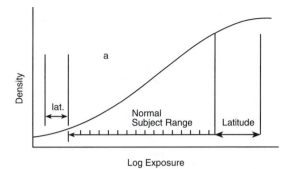

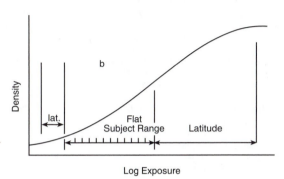

Exposure latitude varies inversely with subject contrast.

and positive printing materials have little latitude in either direction. *M. Leary and H. Todd*

EXPOSURE METER An exposure meter is a light-measuring instrument that is designed to provide appropriate time and aperture settings on a camera for a desired exposure effect. A photometer is a light-measuring instrument that is calibrated in photometric units, such as footcandles (illuminance) or candelas per square foot (luminance). A few exposure meters have been designed to provide photometric measurements in addition to indicating camera exposure settings, either with a scale calibrated in such units or by way of a conversion table. Exposure meters are also commonly referred to as *light meters*.

 BEFORE EXPOSURE METERS Because early photographers did not have exposure meters, they used other means of obtaining correctly exposed negatives, such as trial-and-error exposures. Once correct camera exposure settings were established for a given lighting condition, the data could be noted and used again in the future. This led to the establishment of exposure tables, which have long been provided by film manufacturers. Although black-and-white negative films have considerable exposure latitude, the estimated correct exposure was commonly bracketed when it was important to obtain an image of the highest quality.

 EARLY EXPOSURE METERS The actinometer was an early form of exposure meter in which paper coated with silver bromide or iodide and a chemical sensitizer was exposed to the light falling on the subject until it darkened to match a comparison tone. A calculator converted the time taken to do this to an approximation of the time required for the correct exposure of camera materials, which in those days had low sensitivity and required long exposure times.

 Extinction exposure meters were also used before the introduction of photoelectric exposure meters. The extinction meter was a visual device for viewing the scene through a graduated neutral-density filter, each step of which

contained an opaque number or letter. The last legible figure was used with a conversion table to determine the camera exposure settings. Because of brightness adaptation of the visual system, the results changed progressively with the viewing time, so that decisions either had to be made promptly or after a standard viewing time.

PHOTOELECTRIC EXPOSURE METERS The Weston Universal 617 photoelectric exposure meter was introduced in 1932. This meter and all other photoelectric exposure meters for many years consisted of a simple electrical circuit containing a selenium photocell and an ammeter. Light falling on the photoelectric cell creates an electrical current that causes a pointer on the ammeter to rotate over a calibrated scale. The indicated number on the scale is converted to combinations of shutter speeds and *f*-numbers for a range of film speeds by means of a calculator dial. Photoelectric cells that generate an electrical current when exposed to light are more specifically identified as photovoltaic cells. Exposure meters having selenium photovoltaic cells do not require a battery, but their sensitivity to light is relatively low compared with contemporary exposure meters, even when the size of the photocell is as large as $1\frac{1}{2}$ inches in diameter. The spectral response of selenium photocells, however, is reasonably close to that of panchromatic photographic films, so that measuring reflected light from subject areas containing saturated colors does not cause significant exposure errors. Prolonged exposure of selenium photocells to strong light does result in a fatigue effect whereby the reading slowly drifts to a lower value.

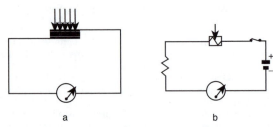

(a) Light falling on a selenium photovoltaic cell generates an electrical current that is measured by an ammeter. (b) Light falling on a cadmium sulfide cell reduces the resistance in a circuit containing a battery. A switch prevents the battery from being drained when the meter is not being used.

Around 1960, cadmium sulfide (CdS) photoelectric cells were introduced. Whereas selenium photovoltaic cells generate an electrical current, CdS photoelectric cells operate on the principle that light falling on the cell reduces the electrical resistance in a circuit containing a battery, a classification identified as photoconductive. A major advantage of photoconductive cells is that they have much higher sensitivity to light, even with smaller cell sizes. The ratio of sensitivities of selenium and CdS exposure meters is more than 1:200. The high sensitivity of relatively small CdS cells made it practical to use through-the-lens (TTL) metering to measure the light falling on the film in the camera rather than the light falling on the subject or the light reflected by the subject. Early TTL metering systems typically involved adjusting the *f*-number or shutter-speed setting to match two pointers in the viewfinder. Problems that had to be solved with TTL meters in single-lens-reflex cameras included (1) designing the system so that the reading made at the maximum aperture would be correct when the lens was stopped down to a preset *f*-number; (2) preventing light entering the viewfinder from inflating the reading; and (3) avoiding false readings when polarizing filters were used on the camera lens or measurements were made of polarized light. TTL

metering with motion-picture cameras faced the problem of having to continually monitor the light and adjust the exposure to changing lighting conditions as the film was being exposed. Early solutions to the meter reading problem included a beam splitter that diverted a fraction of the image light to the exposure meter, and an angled mirror on the rotating shutter that reflected all of the image light to the exposure meter while the shutter was in the closed position and the film was being moved to the next frame. An early solution to adjustment of the exposure consisted of an elongated tapered opening in an opaque material that was attached to the exposure meter pointer so that it moved in front of a fixed diaphragm in the lens as the light level changed.

Disadvantages of CdS exposure meters included an effect known as memory, whereby after exposing the photocell to a high level of illumination the meter reading will only gradually drift down to the correct value for a reading where the light level is much lower, sometimes requiring as long as 30 seconds or a minute to completely stabilize. Also, CdS photocells have a spectral response that deviates more from that of panchromatic films than selenium cells, tending to have higher sensitivity to red light and lower sensitivity to blue light. This color imbalance can introduce exposure errors when making reflected-light readings from strongly colored

Distributions of exposure-meter sensitivity within the picture area in 35-mm single-lens reflex cameras are averaging (*top*), spot (*middle*), and center-weighted (*bottom*).

subject areas and when making TTL readings with colored filters on the camera lens.

Small silicon photoconductive cells have high sensitivity without the disadvantage of memory, but they have an even greater imbalance of color response than CdS cells, having a peak sensitivity in the infrared region. Blue filters are placed over the silicon cells to improve the color response balance in silicon blue cell (SBC) exposure meters, but effective filtration considerably lowers the overall sensitivity of the meter.

Research continues in efforts to develop light metering

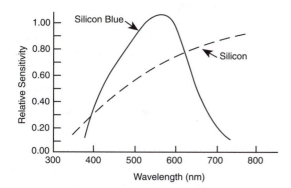

Silicon cells have high red sensitivity and low blue sensitivity, but the spectral sensitivity balance is improved in silicon blue cells through the use of filters.

systems with smaller sensors, higher sensitivity, faster response times, and better spectral response balances. Newer sensors include silicon photodiodes and gallium arsenide phosphide photodiodes. Extremely fast response times are required for sensors used in automatic-exposure electronic-flash systems, where the sensing unit quenches the light output of the flash when the indicated desired amount has been received. Whereas early handheld exposure meters used a pointer that moved over a calibrated scale, newer electronic meters use liquid crystal digital displays.

Reflected-Light Meters Because exposure meters can only respond to the light that falls on the photoelectric cell, consideration must be given in designing a meter to such factors as the angle of acceptance and the calibration in relation to the way in which the meter will be used. Even though the same meter can be used for both reflected-light and incident-light readings, some adjustment is necessary to compensate for the differences between these two types of readings.

For reflected-light readings, the meter is aimed at the subject so that light reflected from the subject falls on the photocell. The term *luminance* would be more appropriate than *reflected light* for such meters since they measure light emitted by luminous objects and light transmitted by transparent and translucent objects in addition to reflected light, but reflected light is the term that is more generally used.

Reflected-light exposure meters are calibrated to produce the best exposures when readings are taken from medium-tone areas. Because it is not always easy to identify an appropriate midtone area in scenes having a large range of tones—and some scenes may not contain a suitable midtone area—an artificial midtone in the form of a gray card having a reflectance of 18% is commonly inserted in the scene for the meter reading. Although 18% reflectance may not be thought of as being midway between white and black, it does appear to be equally positioned between the two to the eye, and it does function as a suitable midtone photographically. Also, when the light from all parts of typical scenes is inte-

grated, the average luminance is close to that of an 18% gray card.

It is not essential, however, for photographers to make all reflected-light exposure meter readings from a medium tone area or from a position that includes the entire scene. Measurements can be made in the lightest area and the darkest area where detail is desired in a scene to obtain an average by selecting the *f*-number that is midway between the *f*-numbers indicated by the meter for the separate readings at a selected shutter speed, or by selecting the shutter speed that is midway between the shutter speeds indicated for the separate readings at a selected *f*-number. Some electronic exposure meters are capable of automatically averaging two or more separate readings. A single closeup reflected-light reading can also be made from an area that is lighter or darker than a midtone, as long as a suitable adjustment is made in the indicated exposure. The zone system makes it possible to reproduce any selected subject area as any tone from white to black in the photograph with such a procedure.

The angle of view of a normal focal length lens on a camera is approximately 50 degrees. To obtain an integrated reading from the camera position that represents an average of the different luminances in a scene that is to be photographed, a reflected-light exposure meter should have an angle of acceptance of 30 degrees or larger, which is representative of hand-held meters. Such meters can also be used to measure the luminance of a relatively small area by holding the meter close enough to the area to avoid including any surrounding area having a lighter or darker tone but not so close that a shadow of the meter is cast on the subject. Some reflected-light exposure meters will accept spot attachments that restrict the angle of acceptance and include a viewfinder to identify the area being measured so that readings can be made of local subject areas from a distance. Even smaller areas can be measured with meters specifically designed as spot meters, and some have an angle of acceptance as small as 1 degree.

Spot meters have a lens to focus an image of the area being measured on the meter photoelectric cell. It has been claimed that while this optical system also adds a small amount of flare light to the image, it duplicates the flare effect of the camera optical system and therefore provides a more realistic reading. An inaccurate reading can result with a spot meter, however, if it is used close to the subject to measure a very small area since this reduction in the object distance causes the image to be out of focus at the plane of the photocell. This will produce a false high reading if the surround is lighter than the area of interest and a false low reading if the surround is darker. A positive supplementary lens can be placed in front of the meter lens to bring the image into focus on the photocell, in the same way that closeup supplementary lenses are used on camera lenses. The focal length of the supplementary lens for both applications should be approximately equal to the distance from the meter or camera to the subject.

Various angles of coverage are also used for TTL camera meters, including large-angle integrated readings, center weighted readings, and spot readings. Some models offer a choice of systems, while others offer only a single system. There are also TTL metering systems that measure the light in two or more different areas and average the readings. It is important for the photographer to know the sensitivity pattern of the exposure meter with cameras having TTL meters to avoid inadvertent readings of light or dark subject areas that could result in under- or overexposure. When the pattern is not clearly indicated in the camera viewfinder or the instruction manual, the photographer can determine it by placing a clear light bulb in front of a dark background, scanning the bulb with the camera with the meter activated, and making a sketch of the responses.

TTL meters are also available for use with view cameras. In one type, the photocell is located at the end of a probe that can be inserted in front of the ground glass and moved around to take a reading in any desired location of the image, or readings can be taken in multiple locations to obtain an average value. Another type uses a pattern of very small light sensors attached to the camera ground glass. The meter control allows readings to be taken in any one position or in a combination of positions. Electronic exposure meter controls are available that perform a number of functions such as integrate multiple readings, calculate the exposures for a mixture of electronic flash and continuous light, automatically compensate for a decrease in effective film speed as a result of reciprocity failure, and automatically adjust the lens *f*-number and shutter speed settings.

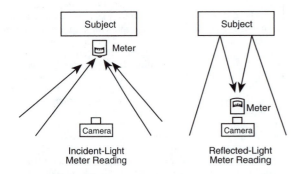

Incident-Light
Meter Reading

Reflected-Light
Meter Reading

With incident-light readings the meter is pointed at the camera from the subject position. With reflected-light readings the meter is pointed at the subject from the camera position.

Incident-Light Meters Incident-light exposure meters are designed to measure the light falling on a subject rather than the light reflected, transmitted, or emitted by the subject. Some meters can be used for both incident-light and reflected-light readings, but this requires a change in the meter as well as in the way the meter is used. If a reflected-light meter is turned around and used as an incident-light meter without modification, it would measure 100% of the incident light rather than the 18% of the light that is reflected from the standard midtone. Thus, it is necessary to cover the photocell with a material that transmits only 18% of the light. Whereas neutral-density filters for lenses must be clear in order not to scatter the image-forming light, translucent material is more suitable for incident-light meters to obtain uniform illumination on the photocell.

The shape of the diffuser also affects the reading, and there is no single shape that is ideal for all picture-making situations. When photographing a flat subject, as when making photographic copies, a flat diffuser provides more reliable exposure information since changes in the angles of the light sources will affect the luminance of the subject and the meter reading in the same way. An incident-light meter equipped with a flat diffuser is known as a *cosine-corrected meter* because it responds according to the cosine law of illumination.

Flat diffusers are not as well suited to photographing three-dimensional subjects, but if an incident-light meter equipped with a flat diffuser is used with such a subject, the recommendation would be to aim the meter midway between the camera and the main light source, the same advice given to positioning a standard gray card for reflected-light readings. Such readings, both incident and reflected, become less reliable as the position of the main light moves to the side and behind the subject. Don Norwood theorized, in 1940,

that a diffuser in the shape of a hemisphere would produce appropriate incident-light meter readings with changes in the angle of the main light, and the Norwood meter, featuring a hemispherical diffuser, appeared on the market. Both hemispherical and flat diffusers are provided for some incident-light meters. *J. Johnson*

See also: *Exposure.*

EXPOSURE RANGE See *Log exposure range.*

EXPOSURE SETTINGS The *f*-number and the exposure time used on a camera for a film exposure or with an enlarger for a print exposure. *J. Johnson*

EXPOSURE SHEET The frame-by-frame instructions provided by an animator for the animation camera operator, accompanying the artwork when it is ready to be photographed. *H. Lester*

EXPOSURE TABLE A systematic arrangement of data that enables a photographer to determine appropriate *f*-number and shutter speed settings for exposing film in a camera without using an exposure meter. *J. Johnson*

EXPOSURE TIME The period, measured in fractions of a second, seconds, and, rarely, minutes, that light or other radient energy is allowed to fall on a photosensitive material in controlled-exposure situations. With between-the-lens camera shutters, the exposure times marked on the shutter by the manufacturer are measured from the half-open to the half-closed positions of the shutter blades, based on the amount of light transmitted with the shutter and the diaphragm in fully open positions. *J. Johnson*

See also: *Effective exposure time; Photographic exposure.*

EXPOSURE VALUE (E_V) An integer obtained by adding the light value and the speed value in the additive system of photographic exposure (APEX). Expressed in symbol form as $E_v = B_v + S_v$. Because the exposure value also equals the sum of the aperture value and the time value, it is used to determine an appropriate combination of camera aperture and shutter settings. On some older cameras the controls are sometimes marked in a whole number scale of exposure values, where each number setting permits twice as much light to pass through to expose the film as with the next higher number. With these cameras, shutter and aperture settings can be interlocked so adjustment of one setting automatically adjusts the other as well. To a large extent E_v settings have been superseded by new electronic exposure systems, many of which feature shutter or aperture priority. *J. Johnson*

See also: *Additive system of photographic exposure; Automatic exposure; Exposure.*

EXPRESSIVE PHOTOGRAPHY The making of photographs that are intended to reveal the photographer's feelings or thoughts about some subject. The primary motivation of the photographer for making expressive photographs is to communicate an internalized message to others, as distinct from making photographs for profit or even because it is thought that others will admire the photographs. Expressive photographs may make a profit for the photographer, but the main reward is the making of the photograph and having it communicate what was intended to others.

The expressive photographer may desire that viewers not only understand the intended message, but that they are motivated to action, as in an effort to move others to do something about a deteriorating environment that the photographer feels strongly about. The fact that we have many

beautiful national parks in America is the direct result of the majestic photographs made in the late 1800s by Henry Jackson and others. These photographs strongly influenced the Congress to pass laws setting aside large areas of land for the enjoyment of future generations. The child labor laws passed in the early 1900s were a direct result of the photographs made by Lewis Hine, photographs that forcefully expressed the shameful manner in which industry was exploiting youth.

An expressive approach may also be applied to various fields of photography including photojournalism, and portrait, glamour, landscape, and documentary photography. Such expressive applications are commonly characterized as a "photographic style" that becomes recognizable and is associated with the photographer, including photographers such as Ansel Adams, Eugène Atget, Henri Cartier-Bresson, Robert Frank, Yousuf Karsh, and Eugene Smith. *R. Zakia*

See also: *Abstract photography; Fine art photography; Surrealistic photography.*

EXTENDED MEMORY A de facto requirement in the processing of images or the using of multimedia on DOS-based platforms. Extended memory occurs above 1 megabyte. Four to eight megabytes has become standard RAM in multimedia machines. *R. Kraus*

EXTENDED-RANGE FILM Film with an extremely large exposure range, which can be used to provide great exposure latitude with conventional subjects, or to image subjects that in themselves have an extremely large luminance range. One type has two identical sets of color transparency emulsion layers coated one on top of the other. The lower set begins to record only after the upper set has recorded its maximum response. *M. Scott*

EXTENSION TUBES A hollow cylinder that fits between the lens and the camera body that increases the lens-to-film distance and therefore the closeup range of the lens. The tube usually has a mechanical system to couple the lens diaphragm to the controls on the camera. The longer the tube, the closer the lens will focus. Extension tubes typically come in sets of three different lengths so that they can be used individually or in tandem, depending on the degree of closeness required. They work similarly to closeup bellows, but do have continuously adjustable lengths. *P. Schranz*
See also: *Closeup bellows/tube.*

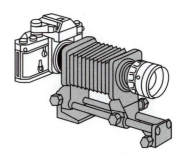

Extension bellows for 35-mm camera.

EXTINCTION Identifying the point on a stimulus luminance scale below which changes in luminance produce no change in appearance. Shadow detail that is visible when a print is viewed under standard gallery light, for example, will not be visible when viewed in dim light if the luminances are below the extinction point. The extinction point will vary with the adaptation level. *L. Stroebel and R. Zakia*
See also: *Adaptation.*

EXTRAORDINARY RAY See *Birefringence.*

EYE See *Vision, the human eye.*

EYE CAMERA See *Camera types, eye camera.*

EYE CUP A flexible cup used on viewfinders to shield the eye from extraneous sidelight. For camera operators with eyeglasses, the cup protects the glasses from scratching, but also impedes full image viewing. *P. Schranz*

EYEPIECE See *Ocular.*

EYE RELIEF The distance from the eyepiece lens of an optical instrument or camera viewfinder to the exit pupil or Ramsden circle. The eye is ideally located at this point where all light rays leave the system. For the convenience of spectacle wearers the eye relief should be 10 to 25 mm. If this distance is not sufficiently large, difficulty will be encountered in attempting to use the viewfinder while wearing eyeglasses. *L. Stroebel and R. Zakia*

F Fahrenheit; Farad; Fast (type of flashbulbs)

f Focal length

f- f-number (word)

fl f-number (number, such as f/16)

FAP Front axial projection

fax Facsimile

fc Footcandle

FET Field effect transistor

FF Flare factor

FI Fade in

FIAF Fédération Internationale des Archives du Film

FIAP Fédération Internationale de l'Art Photographique

FKGT Fernseh-und Kinotechnischen Gesellschaft (German film and television technical society)

fL Footlambert (luminance)

F-line Radiation having a wavelength of 486.1 nm

fl oz Fluid ounce

FM Frequency modulation

FO Fade out

FOP Friends of Photography

FOV Field of view

FP Focal plane; Front projection

FPE Fellowship of Photographic Educators

fpm Feet per minute; Frames per minute

fps Feet per second; Foot-pound-second; Frames per second

FPSA Fellowship of the Photographic Society of America

FRPS Fellow of the Royal Photographic Society of Great Britain

FSAP Farm Security Administration Photography

f/64 f/64 Group

ft Foot

FX Effects (motion picture)

FABRIC PHOTOGRAPHIC PRINTS Photographic images utilizing a variety of printing processes that use fabric as the image support instead of the more traditional paper support. Linen, silk, canvas, and muslin are some examples of the kind of fabrics used since the invention of photography. There are historic as well as contemporary examples on fabric using the platinum, cyanotype, and salted paper processes in the form of photo quilts and family album quilts, as well as travel souvenirs in the form of handkerchiefs, particularly from around the turn of the century. Photogravure prints were also made on fabric particularly during the early 1900s. Electrostatic imaging has been done on fabric by means of a transfer process similar to the one used to produce images on T-shirts. Commercially coated photo-linen is still manufactured today and commercially available through the Luminos Company. *J. Natal*

FABRIC PRINTING Photographic prints can be made on fabric by dyeing the fibers of the fabric or by using the fabric as a support for the image. Ink or dye can be applied through a stencil or a screen; an emulsion can be coated on fabric, or the fabric can be soaked in a sensitizing bath.

Transparent dyes are available in solutions that are ultraviolet sensitive. They are applied to untreated natural fabrics by brushing or spraying in safe illumination and exposed in contact with a negative by a UV source or sunlight. Development is in cold running water and then warm soapy water. An iron is used to set the dyes permanently.

Printing-out fabric sensitizer that contains silver nitrate is commercially available. The fabric is treated in a sizing bath of tannic acid, sodium chloride, and arrowroot, then soaked in a 10% solution of silver nitrate. Exposure by contact causes the black-and-white image in silver to print out.

Diazotype images are formed by the light-induced decomposition of dye-forming compounds. In diazo printing, the final dye image is lightest where the most exposure has taken place; therefore, printing is by contact through a positive original. The fabric is treated in primuline, then sensitized in a solution of sodium nitrite and oxalic acid. After exposure, the developer selected determines the color produced. For example, 1% phenol makes yellow and .8% sodium hydroxide forms red.

Iron-silver fabric printing employs the action of light to reduce ferric salts to the ferrous state in which they will react with silver nitrate to form silver images. In darkness or red safelight, the fabric is soaked in a solution of ferric oxalate, oxalic acid, and silver nitrate. The fabric is dried, flattened, and printed out by contact exposure. The solutions used for the cyanotype, kallitype, and Vandyke processes function similarly.

A photographic image may act as a mordant for dye. After washing, the fabric is sensitized in a solution of potassium or ammonium bichromate and then dried. Exposure is by contact in sunlight until a faint image consisting of chromium hydroxide, a mordant for dyes such as alizarine and anthracine, appears. The fabric is then boiled in a solution of the appropriate dye, cleared in sodium hypochlorite, washed in soap and water, and dried.

A silkscreen, which can be produced in many ways, makes it possible to record an image by forcing dye or ink through the screen onto fabric. *H. Wallach*

See also: *Nonsilver processes; Silkscreen printing.*

FACSIMILE (1) An exact copy or a copy that closely resembles the original. (2) A scanning copying system that forms electrical signals that can be transmitted to another

location where the scanning process is reversed to recreate the image on photographic paper. *L. Stroebel*

FACTORIAL DEVELOPMENT Method of developing by inspection in which the time to the first appearance of the image is multiplied by a factor to give the total development time. The method was first suggested by A. Watkins in 1893 and is sometimes referred to as the Watkins Factor.

L. Stroebel and R. Zakia

FACTORS See *Appendix G.*

FADE (1) A motion-picture optical effect in which the shot gradually appears from black or disappears to black. (2) A sound effect in which a sound gradually dims below audible levels, or gradually increases to audible levels. *H. Lester*

FADEOMETER Registered trademark for a device that allows photographs (in particular those in color) to be illuminated by radiation of predetermined wavelength and intensity under controlled temperature and humidity conditions in order to determine their lightfastness. *K. B. Hendriks*

FADER (SOUND) A level control, also known as a *pot* (for potentiometer), a gain control, or a volume control.
T. Holman

FADING The term *fading* describes a weakening of the image tones in either black-and-white or color photographs. It is concurrent with a loss of contrast and image sharpness. Fading can be expressed quantitatively as a loss in image density. It is a result of chemical reactions of the image-forming substance with chemically aggressive materials, which may originate either from the environment or from the photograph itself. In black-and-white photographs, such chemical degradation is caused primarily by substances that oxidize the image silver. Among those originating from the environment are hydrogen peroxide, nitrogen oxides, sulfur dioxide, and compounds present in sleeves or envelopes with which the photograph is in close contact. Examples of reactive materials emanating from the photograph itself include residual processing chemicals such as sodium thiosulfate, and degradation products from inherently unstable components of the photograph. Deteriorating cellulose nitrate film is a case of a source of degradation products that in turn catalyzes further destruction of the photographic image. In color photographs, density can be lost through chemical reactions of image-forming dyes involving pathways such as oxidation or hydrolysis. Since these are temperature-dependent reactions, they occur even in the dark, but in the presence of oxygen and humidity, both coming from the surrounding air. This process is known as *dark fading*. Dyes in color photographs can further be destroyed slowly by exposure to light, again in the presence of moisture and oxygen. Their behavior under these conditions is described as *light fading*. *K. B. Hendriks*

See also: *Image permanence.*

FAHRENHEIT (°F) The name of a temperature scale, now used only in the United States, on which pure water freezes at 32°F and boils at 212°F. *H. Todd*

FAKE COLOR A multicolor image made from a monochromatic original. Many methods exist for achieving this end, including hand coloring and computer enhancement.
H. Wallach

See also: *False color; Multispectral imaging.*

FALLING FRONT/BACK See *Rising-falling back/front.*

FALLOFF (1) The dark area in a scene illuminated by a light source with an angle of illumination too narrow to light the scene evenly. Falloff may be a defect, as when a flash with a normal angle of illumination is used on a camera equipped with a wide-angle lens. It is also used to aesthetic advantage, often by turning the light away from part of the scene to deliberately darken that area. (2) The decrease in image illuminance toward the corners of the film in a camera and off-axis with some other optical instruments, such as projectors. *F. Hunter and P. Fuqua*

See also: (1) *Feather;* (2) *Cosine laws.*

FALSE COLOR Distinguished from fake color, which adds color to a monochromatic image, false color is the unrealistic representation of the colors in a subject. Most commonly, it is achieved by using integral tripack films that have emulsion layers sensitive to invisible radiation, such as infrared, or that have emulsion layers that produce dyes that are not complementary to the colors to which they were exposed.

Infrared transparency film's top emulsion layer is sensitive to infrared, rather than the blue of conventional film, and produces cyan dye rather than yellow. The middle layer sees green, as does conventional film, but yellow dye is produced here rather than magenta. The inner layer sees red but produces magenta dye. Green objects are rendered as blue, red as green, and infrared as red. Most subjects reflect a complex mixture of wavelengths, so these films yield fascinating results.

Multilayer color masking materials also have altered spectral response dye-generation relationships, and tripack monochrome films with scientific applications for recording extended brightness ranges have widely varying effective speeds that can produce false color.

Applications for these products include detecting plant disease, detecting camouflage, examining buildings for heat loss, masking, scientific recording including ultra-violet microscopy, and differential autoradiography, and, of course, unusual pictorial effects. *H. Wallach*

See also: *Extended range film; Infrared color film; Mask/Masking; Radiography.*

FAN REFLECTOR A set of flexible metal blades that open to form a circular reflector for a flashlamp. When the blades are folded, the holder has a compact size for transport and storage. No longer produced. *R. Jegerings*

FARAD (F) The unit of capacitance of a capacitor. A 1 farad capacitor will store 1 coulomb of charge when 1 volt is applied to its terminals.

$$C \text{ (farads)} = Q \text{ (coulombs)} / V \text{ (volts)}$$

A farad is a very large unit. Practical units are the microfarad (10^{-6}F) and the picofarad (10^{-12}F). *W. Klein*

FARADAY EFFECT The rotation of the plane of polarization of a beam of plane polarized light (or other electromagnetic radiation) when it passes through an isotropic transparent medium such as quartz, water, or carbon disulfide solution placed in a strong magnetic field. Rotation is in the direction of the lines of force of the magnetic field. (Michael Faraday, 1845). This effect has been used in a shutter device for high speed photography to give short exposure durations. *S. Ray*

FARMER, ERNEST HOWARD (1860–1944) English scientist. Inventor in 1883 of the reducer formula, which lowers densities in negatives and prints. Still widely used

and known as Farmer's Reducer, it contains hypo to which is added potassium ferricyanide. Described in 1894 the interaction between a silver-bromide print, potassium bichromate, and gelatin, the basis of the bromoil process. *M. Alinder*

FARM SECURITY ADMINISTRATION (FSA) The FSA was formed during the depression years of the 1930s to document the plight of U.S. farmers during that period. Roy Stryker, a professor of economics at Columbia University in New York City who had used photography to record information for his sociological studies, was called to Washington in 1935 to head up the Historical Section of the FSA. His charge was to photograph the activities of the government in helping destitute farmers and their families. Stryker hired a number of young photographers, later to become famous, to assist him in this undertaking: Walker Evans, Jack Delano, Dorothea Lange, Russell Lee, Arthur Rothstein, and Ben Shahn, a painter. Several other photographers were hired later including such notables as Gordon Parks and Marion Post Wolcott. This small group of photographers created about 250,000 negatives, many of which have become recognized works of art and photographic icons of the depression years, most notably Dorothea Lange's "Migrant Mother, Nidoma, California, 1936" and Arthur Rothstein's "Dust Storm, Cimarron County, 1937."

The monumental photographic efforts of the FSA Historical Section suffered severe budget cuts in 1938 and many of their photographers were let go. In 1942 the agency was transferred to the Office of War Information. The unique collection of negatives and photographs, thanks to the efforts of Roy Stryker, is housed and preserved in the Library of Congress.

Books: Newhall, Beaumont, *The History of Photography.* New York: Museum of Modern Art, 1982. *R. Zakia*

FARMER'S REDUCER Named after its inventor, Ernest Howard Farmer, this chemical reducer consists of sodium thiosulfate (hypo) and potassium ferricyanide in water. When combined in a single solution it acts as a subtractive reducer, but when used with two steps, bathing in potassium ferricyanide followed by treatment in a separate hypo bath, it acts as a proportional reducer. A typical *single bath* formula is:

Solution 1		
Potassium ferricyanide	37.5	grams
Water to make	500	ml
Solution 2		
Sodium thiosulfate	480	grams
Water to make	2	liters

Just before use, 30 ml of solution 1 and 120 ml of solution 2 are combined and diluted with water to make 1 liter of reducing solution. The negative is immersed in this working solution until the desired reduction has taken place, after which the negative is washed and dried. Local areas can be reduced by applying the reducer to the wet but squeegeed surface with a cotton swab or brush. The reducer can also be used with black-and-white prints. *I. Current*

See also: *Intensification; Reduction.*

FASHION PHOTOGRAPHY Fashions in fashion photography change almost as rapidly as they do in clothes. When the glossy fashion magazines started, their market and that of the couture houses that produced fashion was the rich, sophisticated, middle-aged woman. Her tastes and habits dictated the style of fashion photographs and fashion magazines until just after the Second World War. The photographs were expected to show the texture of the fabric, the design, drape, and decoration of the clothing, and the background setting.

In more recent years increased attention has been given to designing clothes for working women. Although fashion photography includes clothing for men and children, the emphasis continues to be on clothing for glamorous women—for social occasions, the office, and leisure activities. With the change in fashions has come a change in fashion photography in that the fashion photographer's function is not so much to create an accurate and attractive visual record of the garment that can be appraised by critical and well-informed buyers, but to project romance and excitement. Wit and artistic sensitivity have become more important in fashion photography than the traditional expertise of the photographer.

Fashion photography divides broadly into two aspects—editorial and advertising.

EDITORIAL The editorial branch of fashion photography began in the glossy fashion magazines. Basically, the editorial purposes of fashion photographs are (1) to inform the reader that a garment exists, (2) to express a preference—this dress, of the many available, has been chosen because the editors feel it embodies an important fashion point, (3) to contribute to the excitement of the magazine, and (4) to stimulate the garment's manufacturer or seller to buy advertising space in the publication.

All serious fashion magazines create their own illustrations. Fashion editors make the important decisions concerning the choice of clothes, accessories, and so on. The art director assigns a photographer, who, with the fashion editor, engages models. The photographer may work full time for the magazine, or may be a freelance photographer, or may be under contract to produce so many pages a year. Fashion photographers are generally young enough so that they are in touch with the all-important youth market, and they must know how young women want to look. Fashion photographers must also be able to function as stage directors; they must be able to make contact with their models and put them at their ease; they must be able to dissect the fashion qualities of garments and be able to devise poses to reveal desirable features; they must have a feeling for pictorial composition; they must be able to put some new quality into every picture; and they must be competent photographic technicians.

Although large-format cameras are suitable for photographing carefully arranged scenes with static poses, most fashion photographers now use 35-mm and medium-format roll-film cameras so that they can record a large number of different poses. Electronic flash and a combination of a fast camera lens and high-speed film make it possible to allow the model to move about while the pictures are being taken, which tends to produce a more natural and interesting appearance.

ADVERTISING Fashion photographs made for advertising purposes have traditionally been more conservative than those made for fashion magazines, with greater emphasis placed on showing the garment clearly. Less emphasis is placed on creating a mood or a startling effect, and the models tend to look more like ordinary people. Larger cameras are more commonly used for advertising fashion photographs, and since the photographs may be used for reproduction in a variety of ways, including newspapers and glossy magazines, the quality of the photographs must be appropriate for the intended use. In general, less freedom is allowed photographers in choosing models, poses, and lighting, and they are often required to work from a sketch prepared by the advertising agency. Occasional examples of advertising fashion photographs that display characteristics of editorial fashion photographs can be found, however,

even in some catalogs that feature relatively inexpensive clothing. *G. Cochran*

FAST MOTION A motion-picture technique of creating abnormally fast motion by filming at slow frame rates and projecting back at the standard 24 frames per second. *H. Lester*

FAX Slang for facsimile. *L. Stroebel*

FEATHER To take advantage of the unequal distribution of light by most lighting equipment. In particular, to aim a light in front of the subject so the light falls off toward the side of the head. Also, to achieve even illumination by directing the brighter center portion of the beam of light at the more distant part of a scene while the less intense edge of the beam illuminates the closer part. *F. Hunter and P. Fuqua*
See also: *Falloff.*

FEATURE In electronic imaging, an area defined by a mark, or the name given to any shape or to an entire page. *L. Stroebel*

FECHNER'S COLORS See *Subjective colors.*

FECHNER'S FRACTION The ratio of $\Delta B/B$, where B is the luminance and ΔB is the smallest increase in luminance that is detectable. This ratio remains approximately constant at relatively high values of luminance, but increases for small values of luminance and for small-field angles. *L. Stroebel and R. Zakia*
See also: *Constancy; Fechner's law; Weber's law.*

FECHNER'S LAW An arithmetic increase in a sensation requires a logarithmic increase in the stimulus. A gray scale having equal density decrements (log luminance increments) between steps should, according to Fechner's law, be perceived as having equal increments of lightness. It has long been known, however, that there is a departure from linearity at high and low light levels. *L. Stroebel and R. Zakia*
See also: *Fechner's fraction; Weber–Fechner law.*

FEEDBACK A component of the output of a system that is *fed back* into the input of the system. Feedback can be intentionally introduced into a system for a desired effect or signal processing purpose, or can be an unwanted effect (such as the squeal in public address systems). Feed-back is most commonly associated with audio systems, but is gaining importance in electronic imaging systems. *J. Holm*

FEEDBACK, ACOUSTIC The familiar public address system ringing or oscillation occurring when an open microphone output is amplified and applied to a loudspeaker with sufficient gain. *T. Holman*
Syn.: *Howl round.*

FEEDBACK (SOUND) Any process that takes a signal from a later stage and applies it to an earlier one, whether deliberately or accidentally. In audio amplifiers, feedback is used beneficially to stabilize such characteristics as gain, to reduce distortion, and to set input and output impedances. Feedback may be local, applied to one stage only, or more global, up to and including all stages within an amplifier. It may also be used to sustain oscillation in an oscillator, among many other purposes. *T. Holman*

FEEDFORWARD (SOUND) An amplifier design technique that uses more than one path between the input and output of the amplifier. The main amplifier is supplemented by one or more added amplifiers, which act to correct the errors generated in the main amplifier, especially at high frequencies. *T. Holman*

FENTON, ROGER (1819–1869) English photographer. Studied painting in England from 1838 until he left to study with Paul Delaroche in Paris (1841–1843), where he met fellow students Le Gray, Nègre, and Le Secq. Upon seeing his first daguerreotype, Delaroche is reported to have proclaimed, "From today painting is dead." Fenton is credited with being the first war photographer, making over 350 photographs in the Crimea during the spring of 1855. Though extensive in vision, Fenton's images do not show actual death or devastation, but record, instead, formally posed soldiers and general views of battlefields. Founding member of the Photographic Club of London in 1847, which became the Royal Photographic Society in 1853.
Books: Hannavy, John, *Roger Fenton of Crimble Hall.* London: Gordon Fraser, 1975; Gernsheim, Helmut and Alison, *Roger Fenton, Photographer of the Crimean War.* London and New York: Thames & Hudson, 1973. *M. Alinder*

FERRIC AMMONIUM CITRATE Used in certain sensitizers and toners, mostly for the blueprint process. Characteristics: Brown or green crystals of slightly variable composition. Solubility: 20–30 parts in 100 parts of water at room temperature. *J. Natal*

FERRIC CUPRIC PROCESS An iron salt process that results in a range of red and purple tones. J. B. Obernetter published his iron process results in 1864. It has also been known as *cuprotype.* It is based on the light sensitivity of a mixture of ferrous and copper chlorides, which results in cuprous chloride being formed upon exposure to ultraviolet radiation. *J. Natal*

FERRIC GALLIC PROCESS An iron salt process that produces a direct-positive image of black lines on a white ground, which has been used as a substitute for the blueprint process. The paper is coated with a gelatin or gum arabic solution of ferric chloride and ferric sulfate and then developed in water if the print has been dusted with gallic or tannic acid, or developed without dusting in an acid solution. Gallic acid produced purple-black lines; tannic acid produced brown lines. A successor to the gallate of iron process, the black line process, also called the ferriogallic or Colas process for the German who invented it. *J. Natal*

FERROPRUSSIATE See *Cyanotype.*

FERROTYPE/TINTYPE PROCESS The ferrotype was first described by Frenchman A.A. Martin in 1853. Its wet collodion emulsion was coated on a thin, black lacquered iron plate. Like the daguerreotype, its image is laterally reversed, but it has a duller appearance more typical of the ambrotype. The process was patented in 1856 in Amer-ica by Hamilton L. Smith, and in England by William Kloen and Daniel Jones. Smith assigned his patent to William and Peter Neff, who called the plates they manufactured melainotypes. Victor Griswold named his plates ferrotypes. The public soon came to know them as tintypes. In the 1880s, the wet collodion was replaced by dry gelatin emulsions.
Because they were cheap, easy to produce, and fast, the ferrotype brought to photography a universality it had not yet enjoyed: People could have casual portraits made on the spur of the moment. The images were rugged. Itinerant photographers could develop the plates in trays inside the bellows of the camera or in containers suspended beneath slots in the

bottom of the camera. Drying of the metal plate was very quick. *H. Wallach*

See also: *Ambrotype process; Collodion process; Daguerreotype, melainotype.*

FERROTYPING

FERROTYPING (1) A defect called ferrotyping occurs when the emulsion side of film is held in contact with the base side of another sheet of film (or convolution of roll film) for some time. This is aggravated by higher than normal moisture content, high temperatures, abnormal pressure, or extended time. The gelatin emulsion surface pressed against the more glossy base surface produces a variation in sheen that is visible by reflected light. Sometimes this defect is also seen on a print made from the film or when the film is projected, particularly as a motion picture. It is less likely to occur with films that have some matting agent in the emulsion surface and noncurl (NC) layer. (2) A technique of producing a high gloss surface on so-called glossy papers by squeegeeing the washed print on a polished enamel or chrome surface to dry. With this procedure a defect consisting of small unglossed areas can occur because of inadequate contact of these areas with the polished surface. (3) The process of producing a glossy image by squeegeeing a washed print on a japanned metal or chrome plated metal sheet for drying. Care must be taken to insure that the plate is cleaned and polished, and that the water between the paper and plate surface is removed without leaving airbells. The process is becoming obsolete with the increasing ability of paper manufacturers to produce papers having a high gloss without ferrotyping. *I. Current*

FERRY–PORTER LAW

FERRY–PORTER LAW The minimum frequency at which intermittent visual images fuse is approximately proportional to the logarithm of the area times the luminance. *L. Stroebel and R. Zakia*

See also: *Critical flicker/fusion frequency; Flicker.*

F FLASH SYNCHRONIZATION

F FLASH SYNCHRONIZATION F, for fast, represents a class of flashlamps that reach peak light output approximately 5 milliseconds after the electrical circuit is closed, and also the shutter synchronization for this class of flashlamps. Designations for other classes of flashlamps are M and S, and for electronic flash, X. *P. Schranz*

FIBER OPTICS

FIBER OPTICS Light may be conducted along a thin, rigid, transparent rod or flexible fiber by a process of successive reflections given by total internal reflection at the glass–air interface to emerge at the exit face. This property has numerous applications in imaging and illumination systems. The flexible thin fiber arrangement is generally more useful and adaptable than a rigid rod system.

LIGHT GUIDES A simple fiber in air conducts light by numerous internal reflections. Depending on the refractive index (n) of the material, the maximum value of the apex semiangle (i) of the acceptance and emittance cones of light at each end is measured as the numerical aperture (NA) of the system. So $NA = n \cdot \sin i$ and i has a typical value of some 30 degrees.

When used as a light guide in instruments such as endoscopes, the emitted light forms a cone of illumination of some 60 degrees. The glass or polymer fibers of a light guide are typically some 25 μm in diameter and form an incoherent bundle.

CLADDING Unfortunately, for bundles of fibers in loose contact, light is lost by leakage and tunnelling by crosstalk to adjacent fibers, which is acceptable for illumination systems but not for imaging systems. By *cladding* each fiber with a thin coating of material of lower refractive index, crosstalk is much reduced and transmission improved.

The cladded fiber has a step-index refraction profile. Note that a fiber 1 meter long, 10 μm in diameter gives some 10,000 internal reflections. For general use the refractive indices of core and cladding are 1.62 and 1.52, respectively.

APPLICATIONS An assembly of fibers kept in a fixed array and which retains spatial information is termed a *coherent bundle*, not to be confused with *coherent light*. A coherent bundle may also be used to give a flat image plane from a curved one, as in the transfer process from a phosphor to photocathode in an image intensifier. An image may be inverted, minified, magnified, made linear, or even encoded by scrambling, all by suitably shaped coherent bundles.

A fiberscope device may typically use 17,000 fibers 10–20 μm in diameter. The image on the end surface is recorded on film via a relay lens.

Large coherent arrays of short fibers are used to give fiber optic focusing screens for cameras, and a similar vacuum-tight fiber optic plate is used for image transfer in electron microscopy. Fiber optic light guides are used extensively in color negative analyzers and scanning printers for sampling light beams.

A Polaroid film back may be adapted to a single-lens reflex (SLR) camera by using a thin fiber optic plate to transfer the image from the focal plane to the Polaroid film surface if the film cannot physically be positioned at the focal plane because of mechanical restrictions.

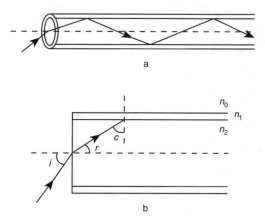

Fiber optics. (a) General path of incident ray along a clad fiber; (b) condition for maximum value of angle of incidence i. r, angle of refraction; c, critical angle; n_0, n_1, n_2 are refractive indices of air, cladding, and glass, respectively.

GRADED INDEX FIBERS An improvement on the step index fiber is to treat the fiber to give the core material a parabolic index profile, or graded index, reducing the peripheral index by about 1%. The transmitted ray then follows a curved path, termed *self-focusing,* and the fiber behaves like a lens, called a *graded refractive index,* or GRIN lens. The fibers are used as thick as 1 mm and termed a *rod lens,* with the property that focal length depends on the length of the rod. Values as low as 1 mm are possible. An erect, real image is given behind the lens or, by choice of rod length, actually on the rear exit surface. Arrays of GRIN, lenses are used in office copiers to replace the usual lens and mirror relay systems, giving a compact machine. *S. Ray*

FIDUCIAL MARKS

FIDUCIAL MARKS Reference marks located in a camera and imprinted onto the recorded image. In photogrammetry such marks in the form of arrays of small

crosses may be carried on a reseau plate in the focal plane and help determine any distortions in the image.　　*S. Ray*

FIELD (1) The entire subject area imaged within a specific format of a camera, viewfinder, or other optical device, also known as the *field of view.* (2) The entire subject area that is imaged within the circle of good definition of a lens. (3) The imaginary surface that represents the best focus for each point of a flat object perpendicular to the lens axis. (4) In television, one of the two scans of the scene that are interlaced on the viewing screen. (5) In video, the scanning of an image in interlaced mode is done in two passes. Each pass contains one-half the data or resolution. Each one of these passes is known as a field. The field is scanned every 60th of a second (NTSC).　　*S. Ray and R. Kraus*

FIELD CAMERA See *Camera types.*

FIELD CHART A sheet of heavy acetate, punched with registration holes and printed to indicate the size of standard fields, used in motion-picture animation to provide a reference for aligning and photographing artwork.　　*H. Lester*
Syn.: *Field guide.*

FIELD CURVATURE See *Curvature of field.*

FIELD-EFFECT TRANSISTOR (FET) A three-terminal semiconductor device in which a voltage applied to the input terminal controls the current through the device. It differs from a bipolar junction transistor (BJT), which uses input current to control the current through it. The input terminal of an FET is known as the *gate* and corresponds to the base of a BJT. Voltage applied to the high-impedance gate controls the flow of current through a thin bar of semiconductor material called a *channel.* Connections made to the ends of the channel are called the source and the drain and correspond to the emitter and collector of a BJT, respectively. There are two types of FETs: the junction FET (JFET) and the metal-oxide semiconductor FET (MOSFET). Large-scale integrated circuits are built primarily using MOSFET devices because they consume little power to operate. Both types are available as *P*-channel and *N*-channel FETs, according to the type of semiconductor used in their fabrication.　　*W. Klein*
See also: *Bipolar junction transistor.*

FIELD FLATTENER A lens element incorporated specifically to correct or reduce curvature of field in an image as an alternative to curving the film surface or projection screen or stopping down the lens to increase depth of focus. First devised by Charles Piazzi Smyth in 1875, it is often a large negative element place near the focal plane.
　　S. Ray

See also: *Petzval sum.*

FIELD LENS See *Lens types.*

FIELD OF COVERAGE See *Angle of coverage.*

FIELD OF VIEW See *Angle of view.*

FIELD STOP The physical diaphragm or stop in an optical system that determines the extent of the subject recorded or that will be represented in the image. In the case of cameras it is the film gate that determines the dimensions of the format in use.　　*S. Ray*

FIFTH-ORDER ABERRATIONS See *Lenses, lens aberrations.*

FIGURE See *Figure-ground.*

FIGURE-GROUND What is attended to at any moment within a perceptual field is called figure and it is always against some (back)ground. If, in turn, one looks at the background then it is seen as figure. In a photograph, the subject is figure and the ground (background and foreground) is the surround.　　*L. Stroebel and R. Zakia*
See also: *Gestalt; Visual perception, gestalt.*

FILAMENTARY Identifying developed silver that appears threadlike when greatly magnified.　　*L. Stroebel*

FILAMENT LAMP Incandescent lamp with a thread-like conductor, commonly a coiled tungsten wire, as part of its circuit. When an electrical current passes through the filament, it produces light and heat. The hotter the filament, the more efficiently it converts electricity to light but the shorter its life. Therefore, lamps of equal wattage may have different intensity ratings, and one may burn out sooner. Many different types of filament lamps are used in photography, including with clear and frosted bulbs (for optical and diffusion qualities) and with built-in reflectors. A filament lamp may have a *prefocus base* so it only fits in the reflector one way and the filament is always correctly oriented for optical purposes. When the burn position of the lamp is known—for example, in a projector—a specific design may be used for the filament's supporting grid and the ideal burn position (e.g., base down) noted.　　*R. Jegerings*
See also: *Light sources.*

FILE (1) In computers, the file is the basic structure for saving or storing data. Images, spreadsheets, and text documents are stored as files to be retrieved later by the programs (applications) that created or can operate on the file. (2) In electronic imaging, the digital database that represents a picture or a line image, or a set of instructions.
　　R. Kraus and L. Stroebel

FILING A system for retaining negative, prints, and transparencies along with relevant data. Filing makes it possible to find any image when needed, in addition to protecting the images. The system should be established early, allow for indefinite expansion, and be dutifully maintained.
　　STORING IMAGES The basis of filing is the safe and orderly storage of the photographic images in filing cabinets, boxes, or albums, whichever is found to be most appropriate for the given situation. Supplementing this should be a file of proof sheets. Valuable images should be stored in archival containers and be properly identified.
　　NUMBERING IMAGES A simple sequential numbering system may be used with one series for negatives and another for transparencies. Frame numbers of negatives can be taken as the final two digits of a number following a serial precursor, e.g., 51, 2xx where xx is the frame number. This can be made more elaborate by classifying the images into categories with a separate number series along with a designator for each category. Slides, for example, may be more appropriately handled in this way. In some situations the proof sheets in albums can be maintained in a chronological order since they can be found readily in the appropriate time frame along with visual scanning of the images. All prints should be numbered according to their negatives and also show the date to make searching files easier.
　　NEGATIVE DATA Exposure and processing data for small format negatives along with other details can be recorded in loose-leaf or bound notebooks or on separate file cards or data sheets. This information can be recorded directly on the filing envelopes for larger sizes. For selected

or key negatives, a separate card file can maintain a record of each print, its technical data, its sale or exhibition performance, location, and disposition. A file of captions for the photographs may be maintained for copying as required when prints are made.

INDEXING Images or their data sheets can be filed under appropriate categories such as Family, Children, Portraits, Travel, Industrial, Flowers, or chronologically. If the data are maintained with cards, additional ones for cross-referencing can be included. A computer can simplify the task of filing and cross-referencing. *I. Current*

FILL CARD See *Reflector.*

FILL FLASH The use of flash or electronic flash as a fill light to illuminate shadows created on a subject by sunlight. *F. Hunter and P. Fuqua*
See also: *Lighting; Sunlight.*

FILL LIGHT Any light source used to illuminate shadows produced by the main light. It is less intense than the main light, but how much less intense depends on aesthetic preference. Usually the fill light should not produce visible shadows of its own. This is accomplished by keeping it near the camera, by greatly diffusing it, or both. *F. Hunter and P. Fuqua*
See also: *Lighting; Lighting ratio.*

FILM A photosensitive material on a flexible, transparent support. *M. Scott*
See also: *Motion-picture photography; Photographic film.*

FILM APERTURE An opening, normally rectangular, in an opaque plate that is located close to the film plane of a camera or projector to restrict the area of illumination. *L. Stroebel*

FILM BADGE A device to be worn on the person to detect and quantify any ionizing radiation the individual may have been exposed to. Badges pinned to the clothing or finger rings are the usual forms. They contain one or more chips of very sensitive film in a light-tight housing, often with various filter materials to selectively measure different types of radiation. *M. Scott*

FILM BASE The flexible, transparent, or translucent support on which the photosensitive emulsions of sheet and roll films are coated. Cellulose triacetate and polyester are the most common materials. *M. Scott*

FILM CEMENT A solvent used to make permanent overlap splices on motion-picture film by dissolving part of the film base and binding the two strips together as the cement dries. *H. Lester*

FILM CHAMBER The interior compartment of a motion-picture camera that contains the film, gate, and pulldown mechanism. *H. Lester*

FILM CLEANERS Film cleaners consist of one or more of several solvents, preferably low in toxicity, non-flammable, and noncorrosive. They are normally applied with soft fabric or cotton to dissolve any oil or grease and to remove any dirt particles from film. They are marketed in proprietary form. Because the cleaner will remove lubricating waxes or oils, they will have to be restored if low film friction characteristics are important. Motion-picture film cleaners incorporate a lubricant so that adequately low film friction is achieved after cleaning. It is important

that the cleaning area be well ventilated. Highly toxic solvents such as carbon tetrachloride should never be used. *I. Current*

FILM CLIP Any short length of processed motion-picture film. *H. Lester*

FILM CODING The process of printing numbers with ink on the edge of both motion-picture work print and separate sound track to provide convenient reference points for maintaining a synchronous relationship between picture and sound. *H. Lester*

FILM COUNTER See *Exposure counter.*

FILM EDITING The final creative phase of a motion-picture production, where sections of picture and sound are selected and sequenced to create a comprehensive whole. The film editor is responsible for the overall structure of the film as well as the matching of one shot to another. Because the collaborative creative work of writers, directors, performers, and production crews all winds up in the hands of the editor for final interpretation and unification, creative editing is one of the most significant factors contributing to the success of a film.

A great many considerations are involved in making editorial decisions, such as the creation of subtle or overt visual and aural rhythms; the matching of action and position from one shot to another; the creation of an editorial style consistent with the style of performance, camera work, and directorial vision; the maintenance of a consistent editorial style from scene to scene; dramatic pacing; the effect of a smooth or abrupt cut; the need to maintain or disrupt the audience's suspension of disbelief; and the problem of missing or inadequate footage. Because many of these considerations might result in conflicting decisions, creative problem solving is an essential part of the editing process. *H. Lester*
Syn.: *Film cutting.*

FILM FESTIVAL An organized series of motion-picture screenings, usually focusing on recent work, often competitive in nature, offering awards in one or more categories, providing filmmakers with showcase opportunities for new work and film enthusiasts an opportunity to view and discuss current or past aesthetic and technological trends. *H. Lester*

FILM FORMATS Film formats can be broken into four general categories: Miniature films, 35-mm films, roll films, and sheet films.

Miniature films: 16 mm, Minox, 110.

35-mm films: 24×36 mm perforated, and half-frame 18×24 mm perforated. Film lengths are available for 8, 12, 24, and 36 exposures for full frame, and double that for half frame. Longer rolls are available but must be used with specially designed backs.

Roll films: 120 and 220 size films. These films give a negative with at least one side being 6/cm (2 1/4 inches). The number of images on a roll of film is determined by the other dimension of the format. Roll film formats generally come in 6×4.5 cm, 6×6 cm, 6×7 cm, and 6×9 cm. 220 film is the same width but longer thereby doubling the number of frames on a roll.

Sheet films: 2 1/4 inch \times 3 1/4 inch, 4×5 inch, 8×10 inch, 11×14 inch, and 16×20 inch. Larger sizes are available for special uses. *P. Schranz*

FILM FORMATS (MOTION PICTURE) Motion-picture formats are identified by the width of the film or the aspect ratio of the camera or projected image. The most

8x10 inches

5x7 inches

4x5 inches

2¼ x 2¾ inches

35 mm

Film formats.

common motion picture formats are 35 mm, 16 mm, super 16 mm, regular 8 mm, super-8, 9.5 mm, and 65 and 70 mm.

35 MM Used for most feature films and other situations where quality of imagery is more important than cost, 35-mm film has 16 frames per foot and is sprocketed on both sides, each frame being four sprocket holes high. It is shot with an aspect ratio of 1.33:1, although it is often masked to 1.85:1 in projection. The 35-mm frame is approximately four times larger than a 16-mm frame and therefore requires one-quarter the enlargement in projection. Its large number of sprocket holes contributes to an extremely steady projected image. On release prints, both sound track and picture are placed between the sprocket holes.

16 MM A professional format that might be preferred to 35 mm because of the ease in handling smaller equipment or because of economic considerations. There are 40 frames per foot, with a sprocket hole at each frame line. Camera original film is usually double perforated while releasing prints are always single perforated since the sound track is placed where sprocket perforations would be.

SUPER 16 MM Shot on single perforated 16-mm film in cameras with specially modified gates, extending the image area horizontally on one side into that part of the film usually reserved for sprocket holes, this format has an aspect ratio of 1.66:1. It is most often used when it is to be later blown up to 35 mm for release.

REGULAR 8 MM An obsolete home movie format shot on 16-mm film with twice as many sprocket holes, one side at a time, and then split and spliced into a long strip 8 mm wide.

SUPER-8 A home-movie format 8 mm wide, packaged in plastic cartridges. Using narrow sprocket holes, it has an image area 50% larger than regular 8 and an aspect ratio of 1.33:1.

9.5 MM An obsolete home-movie format developed in France, with the sprocket holes uniquely placed in the middle of the film in between the frames.

65 AND 70 MM These formats are usually used for spe-

cial wide-screen presentations or for filming high quality optical effects later to be reduced to 35 mm. *H. Lester*

See also: *Photosensitive materials, motion-picture film.*

FILM FRICTION Excessively high or low film friction (or coefficient of friction) between surfaces of a film and its contact during transport through cameras, projectors, or other equipment can lead to problems with performance such as unsteadiness, poor registration, and incorrect velocity. In some cases high film friction can cause defects in the film such as scratches, distortion, or fractures. Motion picture films with high film friction, for example, can be distorted because of the excessive pressure required to advance the film. Perforations are sometimes damaged, and the film can even tear or break. On the other hand, excessively low film friction can cause poor registration or unsteadiness because of insufficient drag, allowing variation in stopping position after each advancement. Since this characteristic of motion picture films is often controlled by lubrication at the laboratory, excessive cleaning afterward without relubricating can result in these kinds of failures.

Film can be damaged in still 35-mm cameras because of excessively high film friction, although this rarely occurs with modern films and cameras. *I. Current*

FILM GATE The part of a motion-picture camera, printer, or projector, that contains the pressure and aperture plates that hold the film in its proper plane for exposure and projection and defining the exposed area of the film. *H. Lester*

Syn.: *Gate.*

FILM HANGER A device, such as a grooved metal frame, designed to hold a sheet of film for processing in a tank, as distinct from holders for processing roll films in tanks, which are called reels. *L. Stroebel*

FILM HOLDER Light-tight container that allows for the transportation and in-camera exposure of light-sensitive materials. Two common types are sheet film holders and 35-mm roll film cassettes. Film holders may also be thought of in reference to interchangeable backs on medium-format

Film holder, double sheet-film.

roll-film cameras and specialized backs, such as those used for Polaroid sheet-film and film-pack, and for ready-load sheet films in light-tight paper envelopes.

The conventional sheet-film holder usually has two sides for two separate sheets of film. The film is loaded emulsion side out in complete darkness. An opaque dark slide covers the film for transportation to the camera back. Once secured in the camera, the slide is removed for exposure and then replaced. The holder can then be turned around for the same sequence for the second sheet.

The 35-mm cassette has the film spooled around the center, with one end exiting through a slit with cloth edges. The cloth slit prevents light from entering. Only the film outside of the cassette is exposed during the loading operation. After placing the cassette in the camera and slotting the film tongue on the take-up spool, the camera back is shut. Film is then transported frame by frame as it is exposed. When the roll is completely exposed, it is rewound into the original cassette and removed from the camera for processing. Empty reusable 35-mm cassettes are available for bulk loading from 50 to 100-foot long rolls to reduce film costs.

Many medium format cameras have interchangeable backs for 120/220 roll film. This film is wound on the spool with an opaque paper backing strip, for daylight loading. Each back has a separate dark slide, similar to those on sheet-film holders. In this manner, the backs may be interchanged from the camera body in mid-roll.

Specialized film holders include the Polaroid and Kodak Readyload backs.

The Polaroid holder uses print film that is individually packaged in light-tight envelopes. The holder is inserted in the camera in the same way as a sheet-film holder. The film packet is placed in the holder and the surrounding envelope is pulled out to uncover the film during exposure and then replaced. A roller squeeze mechanism is then implemented that breaks a processing pod contained in the envelope when the packet is removed from the holder. The pod's developing agent is spread across the emulsion for processing. After a short interval, the envelope is totally removed, leaving the fully processed image.

The Kodak Readyload is similar in operation but it contains a sheet of conventional color film and does not have a processing pod. The film is placed in the light-tight envelope at the factory, protecting it from dust, which sometimes permeates conventional film holders. The exposed film and envelope are taken to the lab and the film is removed in darkness for processing. *P. Schranz*

FILM LEADER See *Leader.*

Film notches (1).

FILM NOTCHES (1) On sheet films, indentations cut into one edge, which, when felt with the finger, allow the emulsion side, the type, and the manufacturer of the film to be identified in the dark. When the film is oriented vertically and the notch is in the upper right corner, the emulsion faces the operator. (2) On motion-picture films, indentations at appropriate locations along an edge for any of a variety of purposes, including providing cues or instructions for editing or printing, and locating damage. *M. Scott*

Syn.: *Edge notches.*

FILM PACK (1) A standard form, now seldom used, of black-and-white negative sheet film in which usually 16 sheets of thin-base film are glued to sheets of opaque paper having extended tabs. The tabs project outside the pack and the holder in which the pack must be placed to adapt it to a view or similar camera. Pulling the tabs in sequence uncovers fresh film in the exposure plane and draws the exposed films into a storage space. The advantage of this format is that 16 films can be carried in a space not much bigger than a conventional film holder containing two films. The disadvantages are that the films are on a much thinner, more flimsy support than conventional sheet films, and they are slightly longer. These hinder their processing in many standard processing holders. (2) A package of black-and-white or color Polaroid instant-picture films that can be inserted into an instant-picture camera or into an adaptor for use with some conventional cameras, such as view cameras. *M. Scott*

FILM PLANE The correct position for the emulsion side of the film in a camera. It is also a reference plane for the emulsion side of a negative or transparency in an enlarger, motion-picture projector, or slide projector. The exact placement is critical, particularly for correct focus, and when measuring film-to-subject distance in closeup photography Some cameras have a circular mark with a line through it on the top of the camera, indicating the location of the film plane. The front surface of the ground glass of a view camera must be in the film plane when the photographer focuses the camera. *P. Schranz*

Film-plane marker on a 35-mm camera.

FILM RECORDER A device to reproduce an electronic analog or digital image on conventional color or monochrome silver halide film using a monochrome high-resolution cathode-ray tube (CRT). For color imaging, individual exposures are made through red, green, and blue filters to provide records of the analog or digital color image information in raster or bitmap form. Monochrome exposures can be made without a filter or through the same filter set with individual exposures. *J. Larish*

FILM SPEED The film speed number was intended originally to measure the fundamental sensitivity of a negative or positive semitransparent photographic material. Now, film

speed is an index value on a scale for use by photographers in determining the camera settings that will yield a satisfactory image.

Therefore, film speed is part of a system that includes the color and intensity of the light on the subject, the subject itself, the type of light meter and the method of use, the film processing, the printing, technique, and the criteria of image quality.

HISTORY In 1890, Ferdinand Hurter and Vero Charles Driffield, British amateur photographers, published an account of their methods of testing photographic negative materials. Their aim was to assess the claims of the many manufacturers of films concerning the sensitivity of their products.

They believed that only the straight line part of the characteristic curve they invented was useful, and they therefore devised a speed measurement based on the exposure needed to initiate the straight line. This exposure level they called the *inertia*. Because of their difficulty in locating the exact point where the toe of the curve becomes the straight line, they extended the straight line to the base plus fog level and called that point the inertia. The H & D speed was calculated with the formula $\text{Speed}_{H\&D} = 34/\text{inertia}$.

Weston speeds invented later also were based on a straight-line exposure. Such speed numbers were intended to take varying film development into account and were defined as $4/H$, where H was the exposure needed to give a density equal to gamma (the straight-line slope) of the developed film.

The assumption behind the Weston speed system was that straight-line exposures were essential to image quality and in this respect followed Hurter and Driffield's belief. In addition, the use of Weston speeds implied that placing the exposures of the subject tones around the center of the straight line of the characteristic curve would yield negatives of optimum quality.

In the 1930s and 1940s, Loyd Jones and his co-workers at the Kodak Research Laboratories carried out an extensive set of experiments on image quality and its relationship to negative characteristics. This work involved three carefully selected and measured outdoor scenes, more than a dozen films, several processing methods, and hundreds of prints and viewers. Their results contradicted the straight-line hypotheses.

It was found that the least film exposure that would produce a print considered excellent by the audience had to meet these criteria: The minimum exposure fell in the toe of the D-log H curve; there the slope was 0.30 times the average slope from that point over a log-H range of 1.3, the range of log exposures from the average outdoor scene. A speed based on these criteria was adopted by the American Standards Association. Because of the difficulty in finding this speed value in manufacturing and process control, a revision of the ASA speed method was adopted in 1960.

ISO (ASA) SPEED Pictorial negative film speeds are now based on the following requirements: The characteristic curve is plotted for a film exposed and processed in a standard manner; the exposure is found that produces a density of 0.10 over base plus fog only for that D-log H curve that has a density difference of 0.80 ± 0.05 over a log H range of 1.3 from the first point. The formula for arithmetic speed based on these criteria is $S_x = 0.80/H$, where H is the exposure at the minimum point on the curve. This method is accepted almost worldwide.

An alternative expression of speed is based on a logarithmic scale, first used in Europe and then accepted internationally. The characteristic curve of the film must meet the requirements stated above. The speed value is found by the formula $S_v = \log(0.24H_m)0.30$, where H_m again is the minimum exposure. Logarithmic film speeds are convenient in use with the APEX method of determining camera settings.

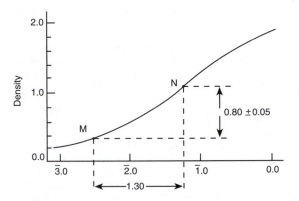

ISO speed. Method of determining ISO arithmetic speed of negative black-and-white pictorial films.

Negative pictorial film speeds found as above are accepted by BSI (for British Standards Institute) and DIN (for Deutsche Industrial Norm). The Russian Standards Association (GOST) specifies a similar method but with a basis of a density of 0.20 over base plus fog.

OTHER FILM SPEEDS For reversal positive films, the net density (i.e., a density over base plus fog) is specified as 0.20, and the formula is $8/H_m$, where H_m produces the stated density.

For microfilms, the speed is found from the exposure giving a net density of 1.20, and the formula is $45/H_m$.

For industrial x-ray films, the net density is 1.5, and the formula is $1/H_m$. *M. Leary and H. Todd*

See also: *Color sensitometry.*

FILM SPLICER A device for joining two pieces of motion picture film into a single strip, holding the film in proper alignment including sprocket and frame line placement during the splicing operation. Hot or cement splicers are used for making permanent overlapped splices of original film, while tape splicers, using preperforated tape or cutting their own sprocket holes into nonperforated tape, are used during the editing of work prints when nonpermanent changeable splices are preferred. *H. Lester*

See also: *Splicing.*

FILMSTRIP Short rolls or lengths of 35-mm film on which there are a series of color or black-and-white transparencies. The strips may be viewed in a hand-held viewer or projected with a filmstrip projector. They are often accompanied by records, audio tapes or written scripts for classroom use. Because the strip is continuous, it is a convenient way to arrange a lecture, demonstration, or "slide show" to be sent out and viewed by anyone with the proper equipment. The order is set so that the viewer can only display the images as programmed, unlike 35-mm slide transparencies in 2×2-inch mounts, which can be rearranged, replaced individually, and edited by the viewer. Recently, trade show presentation and general usage of the filmstrip has diminished because filmstrips are often replaced with videotape, 35-mm 2×2-inch slides, or multimedia microcomputer presentations. *M. Teres*

FILM TRANSPORT SYSTEMS In cameras, various film transport systems are used to move film into and out of the exposure position behind the film aperture.

ROLL FILM TRANSPORTS Earlier film transport systems on roll film cameras used a winding knob and a small red viewing window on the back of the camera to read

the frame numbers located on the outside of the backing paper. The film was advanced from a supply spool of unexposed film, with light-protecting paper cover to a take-up spool following exposure. Shutter-cocking mechanisms were independent of the film advance. Later versions of the system used a pressure-sensitive measuring device that locked the frame advance to one frame by measuring the amount of film rolled onto the take-up spool, replacing the red viewing window. Still later versions replaced the winding knob with a cranking device that allowed for faster film advance. In later versions, the shutter mechanism was readied for exposure (cocked) with the same movement that advanced the film. More contemporary professional cameras offer an automated film advance system. This battery-powered system advances the film and cocks the shutter automatically after each exposure. Due to the design of moving one frame to another by the pulling operations of a take-up spool, most roll film devices are not designed for shooting rapid sequences. For high-speed recording of multiple exposures, 70-mm perforated roll film can be used with a sprocket transport system and for a continuous advance of several frames per second.

35-MM FILM TRANSPORTS 35-mm film transport systems evolved in a similar fashion to those of roll films. Because the 35-mm cameras first used motion-picture film, the sprocket hole/gear system used in continuous frame advance of cinema was already in place in the 35-mm camera. With the ability to move an exact distance on a strip of film measured by the number of sprocket holes moving over a geared wheel, the 35-mm camera usually had an independent frame counter. The early winding knob mechanism was soon replaced with a self-cocking shutter/film advance combination and a one or two-stroke film advance lever. Automated film transport systems for 35-mm include both an auto-winder that advances one frame, to motor drives that automatically advance and expose a number of consecutive frames in a given time such as three frames per second. In an automated system, the mirror will not return for focus and composition until the sequence is completed. Since 35-mm film is meant to be rewound into the original cassette, a button located somewhere on the camera body acts like a clutch when depressed. This allows for the forward geared assembly to be placed in a neutral position. The film is then rewound into the cassette by a crank or rewound using an electric take-up motor.

SHEET-FILM TRANSPORT SYSTEM Sheet film is usually used in double film holders that hold one sheet of film on each side and that must be inserted in and removed from the camera for each exposure. A black-and-white film pack is a daylight-loading assembly that typically contains 16 pieces of thin-base film with paper tabs attached to one end, arranged so that pulling the protruding tabs in sequence first moves the opaque paper cover and then each film, following exposure, from the front exposure position to the back of the unit. These film packs were used in 4 × 5 press cameras by newspaper photographers in past years, but are no longer manufactured. The Graflex Grafmatic film holder contains six thin metal sheaths that are loaded with conventional sheet film in a darkroom. The six sheets of film can be exposed in rapid sequence without removing the holder from the camera.

POLAROID FILM TRANSPORT Early Polaroid Instant films, other than sheet film, also used a film transport system with a stack of unexposed plates attached to interleaved paper tabs. Prior to exposure, the photographer pulled out one of the tabs that would advance the plate for exposure. After exposure, another tabbed interleaf was pulled transporting the film between two rollers and breaking the developing agent pod, thus processing the print. Later versions in the genre of the SX-70 replaced the tabs with an automated discharge system that ejected the exposed film through the developing rollers and out the front of the camera where development continued in daylight.

SPECIAL FILM TRANSPORT SYSTEMS Special film transport systems are frequently devised for scientific research. Large film canisters can be attached to 35-mm cameras, allowing the use of a 250-exposure strip of film. Still other film advance systems like those used in streak cameras, require extremely high speed and continuous transport of the film past an aperture, because no shutter mechanism is used. *P. Schranz*

See also: *Camera back.*

FILTER BANDWIDTH The range of wavelengths transmitted by an optical filter. The unwanted wavelengths are absorbed in the case of a passive absorption filter. A dichroic (interference) filter has both transmission and reflection wavebands. *S. Ray*

FILTER FACTOR A multiplying number used to compensate for the absorption of light (and other radiant energy) when exposing photosensitive materials, especially in a camera. The factor is normally applied to the exposure time without the filter, although a corresponding adjustment of the *f*-number can be made, with the exposure time remaining constant. The absorption of filters is sometimes indicated in other ways such as the density of neutral-density (ND) filters and color-compensating (CC) filters. The filter factor for ND filters corresponds to the antilog of the density—for example, a factor of 2 for a density of 0.3. *J. Johnson*

FILTER HOLDER A device used for holding glass, plastic, or gelatin filters perpendicular to the optical path of a camera or enlarger. Some of these devices are independent and attach to the front of the lens. Most compendium lens hoods have a filter holder built in. Color enlargers have built-in cyan, magenta, and yellow color wheels that provide a wide range of superimposed filter densities. *P. Schranz*

FILTERING The removal of particles from a liquid or gas by passing it through a porous material. Filters are commonly installed in water lines and recirculating processing systems in photographic labs. Small quantities of photographic solutions can be filtered by gravity with a funnel and filter paper. *L. Stroebel and R. Zakia*

FILTERING (SOUND) Removing a part of the frequency spectrum, usually performed to reduce the effect of undesired sound lying within the rejected frequency range in favor of the desired sound lying within the passband of the filter. Categorized by high-pass, low-pass, band-pass, band-stop, or notch filters, depending on shape and what range is rejected. Note that a high-pass filter is one that *passes* highs; it rejects lows. The term *high filter* usually means, in contrast, that it is the highs that are being filtered, so a high filter is really a low-pass filter. *T. Holman*

FILTERS An optical color filter is a transparent flat sheet of colored material that is placed in a light path so that exposure takes place through it. It is a passive absorption filter or

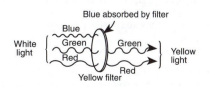

Filters.

frequency filter that removes or reduces particular spectral bands normally transmitted by the lens. The color of the filter depends upon the transmitted wavelengths and is independent of orientation. The main reasons for using a filter are to correct for the imperfect spectral sensitivity of the film, to modify the tone reproduction of chosen colors, to change color temperature, to use near monochromatic light, to modify polarized light, and to produce special effects.

SPECTRAL PROPERTIES Filters are usually characterized by their spectral transmission properties shown as a curve of spectral transmission against wavelength. Transmittance may be normalized or expressed as a percentage. Both arithmetic and logarithmic scales are used. The preferred method is to plot optical transmission density against wavelength, giving a spectral absorption curve as produced by an instrument such as a recording spectrophotometer.

FILTER FACTOR The number by which an exposure must be multiplied to compensate for the loss of light by absorption by a filter. The ratio of the necessary filtered exposure to the corresponding unfiltered exposure. It may be quoted as a multiplying factor such as X4 or as a negative EV correction such as − 2 EV. The filter factor depends mainly on the spectral absorption, the spectral emission of the illuminant, the spectral response of the film, and the exposure duration if reciprocity law failure effects are significant. Cameras incorporating TTL exposure metering may give the correct compensation for certain filters such as neutral density and pale ones, but with some filters errors may arise because of the differing spectral responses of the photocell and the film in use.

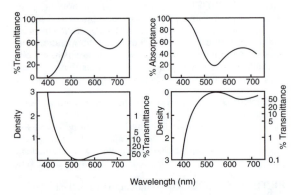

Spectral properties. Some methods of illustrating spectral absorption data for a color filter. The four graphs show the same data for a pale green filter plotted in different ways to show the variations in curve shape given.

OPTICAL QUALITY Refers to the possible effects the use of a filter may have upon optical performance. A camera filter is part of the image-forming system, and the optical quality must be of the highest in terms of the flatness and plane parallelism of the filter surfaces. Filters used in illumination systems such as over lamps or in enlargers can be of a lower quality. Filters are available in various forms such as gelatin, cellulose acetate, polyester and other optical plastics or resins, solid glass, gelatin cemented between glass, gelatin on glass, and interference types. Where possible, antireflection coatings reduce the possibility of lens flare.

S. Ray

See also: *Filter types.*

FILTER TYPES Filters are available in many types for a wide range of general and specialist purposes, principally for use with a camera or light source or enlarger.

BARRIER FILTER Used over the camera lens in ultraviolet fluorescence photography to absorb completely all direct and scattered UV radiation so that only the fluorescent wavelengths are recorded. A haze filter or conventional ultraviolet filter would not be adequate in this case. Also used in fluorescence microscopy.

COLLOIDAL CARBON FILTER A filter made of a suspension of very small particles of carbon in gelatin to provide a neutral-density filter for the visible spectrum. Used also to make continuous and step filters for sensitometry.

COLLOIDAL SILVER FILTER A yellow filter in a tripack color film located between the blue and green sensitive layers and composed of small particles of silver suspended in gelatin that strongly absorb blue light. The filter is removed in the bleach stage. Also called Carey-Lea layer.

COLOR FILTER Description of a filter that has some selective spectral absorption and hence appears colored by transmitted light as a result of the addictive mixture of the transmitted wavelengths.

COLOR COMPENSATING (CC) FILTERS Pale color filters used to produce small but significant color shifts in the rendering given by color film, especially reversal types. These CC filters are available in blue, green, red, yellow, magenta, and cyan colors of various strengths denoted by their optical density to light of the complementary color for example a CC20M filter is magenta in color and has an optical density of 0.2 to green light. Their uses are for alteration of color balance when exposing color prints, correction of processing shifts, local color effects, reciprocity failure effects, batch differences, and special effects.

COLOR SEPARATION FILTERS A set of three filters, red, green and blue, each transmitting approximately one-third of the visible spectrum and used when making color separation negatives directly from the subject or from a color transparency.

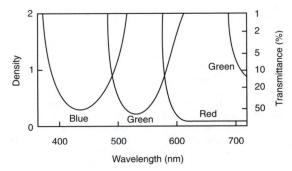

Color separation filters. Spectral absorption curves of standard tricolor filters.

CONTRAST FILTERS Filters used in black-and-white photography to alter the tonal record of selected colors in a scene relative to their surroundings. The tone may be darkened or lightened by using a contrast filter of the complementary or same color, respectively. Thus, for a red subject on a green background, a red filter would lighten red and darken green, while a green filter would have the reverse effect.

CONVERSION FILTERS Blue and orange filters used with color film (especially reversal types) to allow them to be used with a light source for which the film is not balanced. For example, to use daylight type color film balanced for 5500 K with studio lamps of color temperature 3200 K, a deep blue color conversion filter is required. To use artificial

light film balanced for 3200 K in daylight (5500 K) an orange conversion filter is required.

CORRECTION FILTERS Colored filters used with panchromatic black-and-white film to correct for the non-ideal spectral sensitivity of the film with various light sources. The aim is to reproduce colors in their true relative luminosities. Panchromatic materials tend to have reduced sensitivity to green light compared to blue and red, while some have enhanced red sensitivity. Full or partial correction is possible with the penalty of significant filter factors.

DAVIS GIBSON FILTER A liquid filter made using two separate cells containing solutions of copper and cobalt salts with other colorless constituents. (Davis, R., and Gibson, K. *Trans. Soc. Motion Picture Engrs.* 12 (May 1928).) Specified versions of the filter were adopted in 1931 to convert CIE illuminant A (2848 K) to an approximation of sunlight (illuminant B) or north skylight (illuminant C).

DIATHERMIC FILTER See *Heat filter.*

DICHROIC FILTER Literally, a filter having two colors, one as seen by transmission, the other by reflection, which is the complement of the first. The filter is not an absorption type but operates by interference effects between multiple layers of thin refractive material coated on its surface. As many as 25 layers may be used, and accurate and narrow spectral band widths can be transmitted or reflected, depending on the design of the *stack* of layers. Also called interference filter.

EXCITER FILTER Filter used to isolate and transmit a range of spectral wavelengths to induce fluorescence in a suitable specimen, particularly in ultraviolet fluorescence photography but also in fluorescence microscopy.

FOG FILTER A colorless camera filter with a treated surface used to produce diffusion in the image to simulate the effect of atmospheric fog in the subject. Various strengths can be used for special effects.

GELATIN FILTERS Camera filters made from very thin sheets of gelatin dyed to suitable colors by imbibition of a dye or mixture of dyes. The gelatin is only some 0.1 mm thick and has very little effect on the image definition. A wide range of filter types and colors is available. The filters are not robust and are easily marked and damaged in use. They can be supplied cemented between glasses of suitable grades for protection.

GLASS FILTERS Many filters are available in the form of *dyed-in-the-mass* glass, where the colorants are added to the glass melt to give a uniform color. The glass filters can be finished to the desired optical quality. A more limited range of colors is available than for gelatin filters, but certain types, such as UV transmitting, heat filters, and haze filters, are available only in glass form.

GRADUATED FILTER A filter that does not have a uniform color or density (ND filters) but instead part is tinted, with an unsharp demarcation zone between the different areas. The filter is positioned some little distance in front of the lens and by inspection is slid laterally to have its effect on a chosen zone of the scene. For example, the background may be filtered but not the foreground. Two separated colors may be used in one filter for differential filtering of a scene.

One special form of graduated filter is the radially graduated neutral density type of *spot filter,* which has a central density diffusely reducing to a zero at the periphery; its use is to even out the exposure level given to an image by an extreme wide-angle lens that otherwise gives unavoidable vignetting.

HAZE FILTER A colorless or very pale yellow filter used to absorb almost all of the scattered UV and extreme blue light produced by atmospheric haze but requiring no exposure compensation. Used with outdoor scenes it can improve contrast and remove an objectionable blue cast on color transparencies. Most color films now incorporate some

form of UV absorption layer and the glasses of modern lenses also absorb UV, but the filter is still useful as a mechanical protection to the front element of the lens.

HEAT FILTERS Filters used primarily in illumination systems to remove the near infrared wavelengths, which are manifested as heat. Various forms of filters are used. Colorless glass filters can transmit the visible but absorb the infrared region. This is not highly efficient, however, and interference types are preferred in some instances. A *cold* mirror will reflect the visible and transmit the heat energy to a heat sink, while a *hot* or diathermic mirror will reflect heat and transmit the visible.

INFRARED FILTER A visually opaque filter that transmits only a very small percentage of the far red wavelengths but that freely transmits the near infrared region up to some 900 nm. The designation of the filter such as 87 or 88 may indicate the peak wavelength transmitted, such as 870 or 880 nm. The filters may be of gelatin and are primarily used with infrared film either over the lens or over the light source such as a flashgun. For discrete or narrow infrared wavebands, interference filters are required.

INTERFERENCE FILTERS Also known as *dichroic* filters, these look like a mirror with an intense color reflection and the complementary color transmitted. They work not by absorption of selected wavelengths from white light but by carefully engineered constructive and destructive interference of light in the stack of multiple layers of thin coatings of refractive material on the substrate. The transmission band depends on the number of layers, their thicknesses, and chemical composition. They are expensive to make in large sizes and are primarily used in apparatuses such as color enlargers and printers.

LIGHT-BALANCING FILTERS Pale filters of yellow or blue color used to give small corrective shifts of color temperature to the light transmitted by a lens when used with color film, especially reversal types. The filters are also available in nonoptical quality as large sheets that can be used directly with the illumination such as over a flash head or a window. Typical uses are for reducing the blue cast given in open shade on a sunny day or for the variations in color temperature with the season or time of day.

NEUTRAL-DENSITY FILTER A filter that does not selectively absorb wavelengths in the visible region but absorbs all to about the same degree, giving a gray appearance to the filter. It is usually classified in terms of the EV or aperture stops increase required as a filter factor, e.g., a X4 or − 2 EV type, or as the optical density. Such filters can be used with any type of film and have uses in allowing large apertures to be used in bright conditions, especially with fast film types or to allow long exposure times to be given when the lens cannot be stopped down enough. A special variety is the *graduated neutral density filter.*

Neutral-density filter. The spectral absorption curve of a neutral density filter of density 1.0 and of a nonscattering type.

PC FILTERS Plastic coated glass plates, commonly used as safelight filters. The colored plastic filter coating typically overcoated with clear plastic for protection.

PLASTIC FILTERS Filters made from suitable polymers such as polyester, acetate, butyrate, and optical resin. For camera use the filters are usually in semirigid sheet form 2 mm thick. Optical quality can be good, especially when new, but the surface does become marked with use. The material can be dyed to almost any color for a variety of corrective and effects purposes. A lower optical grade can be used for filters for illumination systems such as enlargers for use with color materials or variable contrast paper.

POLARIZING FILTERS A linear polarizing filter is one of neutral density appearance but that consists of a layer of suitably aligned polymer molecules made optically active so that only light waves vibrating in one plane are transmitted and those at a right angle to this plane are blocked. Light at intermediate angles is partially transmitted. Such a linearly polarizing filter may be used to select light for transmission to the image if some of it is polarized. The light coming from the scene may be in various states of partial or complete polarization. The filter can be used with color or black-and-white film. Its principal functions are to subdue reflection from materials that are nonconductors of electricity such as glass, wood, and plastics; darken a blue sky by removing the light polarized by scattering; and increase contrast in a scene by removal of surface reflections.

Another form of polarizing filter, the *circular* type is made by adding a thin layer of suitable material, called a quarter-wave plate, behind a linear polarizing filter. The emergent light is not then linearly polarized but circularly polarized and has the useful property that, with beam-splitter devices such

as used in exposure determination and autofocus systems, the direction of the polarizing axis of the filter has no effect upon the ratio of splitting of the incident light by the beam-splitter.

PV FILTER See *Viewing filter*.

SAFELIGHT FILTERS Colored filters meant for darkroom work, being positioned over the light source in use to filter out all the emitted wavelengths to which photographic material is sensitive and transmit those with little or no effect. No safelight filter can be regarded as truly safe and must be tested at intervals by the exposure of materials to ensure that the fading of any dyes used in the filter do not allow actinic radiation to pass. Most printing materials other than color materials are not fully panchromatic and so blue-sensitive types can be used with a yellow or red filter, while orthochromatic types can be handled by red light.

SKY FILTERS Filters used to control the tonal rendering of the sky, especially in the presence of clouds. The contrast between blue sky and white cloud can be progressively increased by the use of yellow, orange, and red filters, which in turn transmit less blue light to which panchromatic film is especially sensitive. Graduated filters can be used to selectively filter the sky and leave foreground unfiltered or filtered by a different color such as green. Polarizing filters also have a useful darkening effect on a blue sky given by scattered blue light, especially with color film.

SKYLIGHT FILTER A very pale pink filter that requires no exposure compensation, used particularly with color reversal film to remove blue color casts in dull weather or subjects in open shade that are illuminated only by blue skylight.

SPATIAL FILTER A mechanical device used principally to improve the quality of a laser beam. Essentially, it consists of an opaque plate with a suitable shaped pinhole of suitable diameter upon which the laser beam is focused by means of a short focus lens such as a microscope objective. Only the undisturbed primary beam with a true spherical wavefront emerges free of unwanted modes and stray reflections. The beam has a lateral intensity distribution of Gaussian profile and is suitable for such applications as holography.

SPATIAL FREQUENCY FILTERS A mechanical device used in the process of image processing by coherent light, where the image is illuminated by coherent light from a laser and the far-field diffraction pattern produced is reimaged to form the final result. Filters in the shape of patch stops or annuli or other shapes can be placed in this Fourier transform plane to selectively remove spatial frequencies by simply blocking their path to the imaging lens. An annulus will remove high frequencies (fine detail), a patch stop, low frequencies (coarse detail).

STAR FILTER A clear glass or plastic filter bearing closely engraved lines in a regular pattern, which by scattering and diffraction cause the directional spreading of small intense highlights in the subject to give a star-burst effect to these regions without seriously affecting overall definition. Sometimes these filters are made from holographically produced diffraction grating patterns to produce intense spectra alone or in tandem from every small light source or highlight in the scene.

STATUS FILTERS Densitometer filters that are designed to produce appropriate spectral responses for various applications.

Status A: Color transparencies intended for direct viewing.
Status D: Color prints.
Status G: Inks used in photomechanical reproduction.
Status M: Color negatives and transparencies that are to be printed.
Status V: Visual densitometry.

ULTRAVIOLET FILTERS Usually refers to a colorless glass filter that serves to remove ultraviolet radiation below

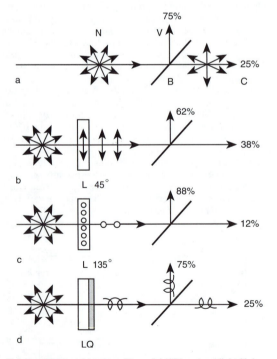

Polarized light and beam splitters. (a) With natural light N, beam splitter B reflects light to viewfinder V and transmits to photocell or autofocus module C in ratio 3:1. (b) With linear polarizing filter L in 45 degree position, ratio is 62:38. (c) With linear polarizing filter in 135° degree position, ratio is 88:12. (d) With circular polarizing filter made by addition of quarter-wave plate Q, the ratio is constant at 3:1 for all positions.

some 400 nm from the light entering the lens and also as a protective transparent lens cap for the lens. The filter has no exposure increase factor and can be left permanently in place. One of good optical quality is essential. Gelatin types have a pale yellow color and are used as a barrier filter to remove unwanted UV during fluorescence photography.

Another form of ultraviolet filter is the UV transmitting type that is of glass only and is visually opaque as it does not transmit light, only UV radiation below some 400 nm. It is used for ultraviolet reflectance photography.

VARIABLE-COLOR FILTER A filter whose color may be varied by polarization means. It uses two linear polarizing filters in tandem, one being rotatable. Between them is a sandwich of dichroic plastic material that selectively retards the various wavelengths, and this is followed by a color filter to absorb one waveband, such as green. The analyser then transmits different amounts of the remaining red and blue bands, giving a red to blue transition. Other variations are possible or only one color may be selectively introduced.

VARIABLE-CONTRAST FILTERS A set of filters used with variable-contrast black-and-white printing paper to vary the contrast grade given by altering the color of the exposing light to selectively expose the two different emulsions of the paper.

VIEWING FILTER A pale purple visual filter used to show the subject in term of its approximate brightness values as would be recorded with a panchromatic black-and-white film. Also called panchromatic vision filter, or PV filter. A Wratten 90 dark grayish-amber filter is recommended for zone system visualization of a scene in terms of lightnesses.

Books: Eastman Kodak, *Kodak Filters*. Rochester, NY: Eastman Kodak, 1989; Jacobson, R., et al., *The Manual of Photography*, 8th ed. London: Focal Press, 1988. *S. Ray*

FINAL (SOUND) See *Final mix.*

FINAL MIX (SOUND) The outcome of premixing together the various component parts of a sound mix. In a preceding stage, individual sound elements, cut by sound editors, were rerecorded to form premixes such as dialog, music, ambience effects, Foley effects, and principal on-screen sound effects. In final mixing, these premixes are combined to produce the final mix stems, which are the number of tracks and strands of film needed to completely represent the mix, while still keeping various kinds of sound separate so that they can be replaced for specific purposes, such as for foreign language mixes.

The final mix thus represents everything that is intended to be heard, mixed in proper proportion but separated enough among multiple channels so that it is easy to prepare alternative versions. *T. Holman*

Syn.: *Final*
See also: *Element, sound; Premix; Stems.*

FINE ART PHOTOGRAPHY The most fundamental activity of the artist is to apprehend personal experience and to express that content in a form that is compelling and appreciable. The artist in any medium is moved from personal impression to a desire for active expression. The mimetic power of photographs to represent visual experience in a unique format, to imitate but not duplicate, to give perceptible form to personally understood content, and to make private pictures publicly available made photography an ideal medium for fine art expression. Photography from its earliest days has provided an obvious means for rendering or drawing what the outer and inner eye perceives, as well as of transforming what the artistic spirit imagines.

Fine art photography, the art of mark-making or rendering with light, enjoys a rich and varied historical development.

Particularly in England, following the early lead of W.H. Fox Talbot and later H.P. Robinson, Oscar Rejlander, Julia Cameron, and P.H. Emerson, the camera was respected as a tool for creating artistic effect and unique artifacts. *Pictorialism* became identified as an informal aesthetic movement representing photographers who pursued artistic purposes from the 1850s to the 1920s. Their photographic aim was to communicate *artistic sensibility* in subject matter and manner of execution. The Golden Age of Pictorialism (1890–1910) was characterized by exhibitions and salons of amateur societies, as well as the better known and more elite Brotherhood of the Linked Ring in England and the Photo Secession in New York. During this period, which lasted until the First World War, galleries, museums, and fine art publications opened their doors and pages to photographic art for the first time and excited large and enthusiastic audiences.

The time between the two world wars was one of exceptional ferment in the mixture of photography with graphic arts, design, and the more traditional visual arts. Surrealism, Vorticism, Cubism, Constructivism, Dadaism, Expressionism, and the German Bauhaus all gave prominent position to photography as an artistic tool for committing the imagination to the ambiguity of dreams, subconscious symbols, autobiographical reenactment, irrational thought, and poetic abstraction. Aesthetic directions after the mid-twentieth century have continued in a myriad of directions that include Objective Precisionism and straight photography, personally concerned photojournalism, Postmodern political dialectic, spiritualism, allegory, and neo-Pictorialism.

One of the characteristics that distinguishes fine art photography from scientific, commercial, and literal purposes is the importance of the photographic outcome as an object in its own right, to be seen and appreciated as a product or end in itself. The photographic art object results from a limitless variety of processes and techniques that may be playful or scientifically exacting, inventive or slavishly formulaic, predictable or accidental. At the heart of the process is the intention of the artist to create and the willingness to make the art object with the materials of choice. These may include a variety of light-sensitive metals and salts; paper, glass, or film supports; light exposure techniques; developing or printing-out procedures; manners of format, presentation, exhibition, or reproduction.

Fine art photography is also distinguished by its origins in creative self-expression from more literal and commercial applications of picture making. In aesthetic principle, personal expression takes precedence over the usages of client, art director, or editorial agent. In practice, however, artistically moving photographs more than occasionally find their way into advertising, photojournalism, promotional enterprises, and thematic illustrations.

Since the 1960s the fine art photograph has become a commodity, subject to the fluctuations of the collecting market. Remarkable sums of money have been paid for vintage as well as contemporary photographs, and the business of valuation of art photographs is not unlike that of soybeans or pork futures. Photographs are purchased or traded by private collectors, museums, and galleries. They appear in finely produced publications, limited edition portfolios, and monographs. Profits from the sale of photographs have supported some individual photographers and their agents quite handsomely, but private and public funding for fine art photography is unfortunately quite limited for the number capable artists committed to the field. Nevertheless, opportunities do exist for the sale and distribution of original fine art photographs, as well as for feature layouts of artistic images in discriminating magazines and publications.

Photography has taken its place as a visual arts discipline

alongside the more conventional fine arts fields of drawing, painting, sculpture, and printmaking; and in practice, these media are frequently combined. Studio programs at many colleges and universities have been developed since the 1960s on both the undergraduate and graduate levels, as well as workshops and artists' apprenticeship programs. And the history and criticism of fine art photography has developed into a strong academic field in its own right.

Characteristically willing to respond to new technologies, as well as to the wealth of the photographic tradition, contemporary photographers currently respond to the image-making potential of video cameras, computer digitizing and manipulation, electronic transmission, and desk-top printing, at the same time as they work with vintage processes such as platinum, gum, or gravure printing in the service of fine art.

M. Flecky

FINE CUT The final edited version of a motion-picture scene.

H. Lester

FINE-GRAIN Applied to films and developers that tend to produce images of low granularity and to images made with such materials.

M. Scott

FINGERPRINT CAMERA See *Camera types.*

FINGERPRINTS Fingerprints are caused by touching the surface of a photographic emulsion with the fingers. Before development, oil-like substances transferred from the fingers to the film or print surface will protect the areas contacted from the developer, leading to light marks with negative materials and dark marks with reversal materials. Chemical contamination such as developer or fixer transferred from the fingers can also lead to light or dark marks. Even moisture from pure water can produce a fingerprint. Some darkroom workers have dry skin and seldom experience problems of this kind. On the other hand, some workers with oily skin or careless work habits continually have trouble. Hands should always be rinsed and dried before handling sensitized products, and contact with emulsion surfaces should be avoided as much as possible. Thin gloves should be worn when handling dry photographs or sensitized materials. Contaminants from fingers during handling of processed photographs can cause marks to be generated after long-term storage.

I. Current

FINISH Surface characteristics of photographic paper affecting appearance, specifically texture, sheen, and gloss.

M. Scott

FINLAY COLOR An obsolete additive color process in which the ruled mosaic screen was separate from the monochrome positive. It had the advantage that copies could be made by normal black-and-white technique and then turned into color transparencies by binding each copy with its own color mosaic screen.

M. Scott

See also: *Dufaycolor.*

FIRELIGHT EFFECT For film and video, a flickering firelight shadow effect is created by dangling strips of silk ahead of two or more lights. The strips are then moved with a small fan.

R. Jegerings

FIRMWARE In computers, an instruction set or program that is stored and retrieved from programmable ROM or plug-in modules that are self-initiating and do not typically require software. Firmware differs from software in that the application exist as a program on a floppy disk or in a hard drive, while firmware is built into a chip or PROM.

R. Kraus

FIRST-GENERATION Identifying an image that is one step away from the original. The original may be a subject or, in copying contexts, a photograph. Thus, a first-generation copy would be a reproduction of the original photograph.

L. Stroebel

FIRST-ORDER ABERRATIONS See *Lens aberrations.*

FIRST UNIT The motion-picture production group responsible for primary picture and sound recording. For the sake of production expediency, a second unit might be formed to shoot backgrounds, material for special effects, or location scenes while the first unit continues with its assignment.

H. Lester

FISCHER, RUDOLPH (1881–1957) German chemist. Granted a patent in 1912 for dye-coupling development, which served as a base for the invention of Kodachrome film by Leopold Mannes and Leopold Godowsky in 1937.

L. Stroebel

FISHEYE LENS See *Lens types.*

FISHPOLE A lightweight, hand-held microphone pole widely used to get a microphone close to actors but out of the shot being filmed.

T. Holman

FIXATION TEST A means of determining the extent to which the silver halides remaining in a photographic emulsion following exposure and development were removed in the fixing and washing steps. A drop of 0.2% sodium sulfide solution applied to the clear margin of a negative or print will combine with remaining silver salts to form brownish silver sulfide. The depth of the color, which should be compared with a standard, is an indication of the amount of silver salts in the emulsion. Incomplete washing with thorough fixation can also produce a positive result.

L. Stroebel and R. Zakia

FIXED-FOCUS CAMERA See *Camera types.*

FIXING The primary function of a fixing bath is to remove unexposed silver halides from a photographic emulsion.

THEORY After a photographic emulsion has been developed and rinsed in water or a stop bath, it has to be fixed in order to remove all residual, unreduced silver halides and become stable to white light. In theory, any soluble compound capable of forming stable and soluble complexes with silver halides could be used as a fixing agent. In practice, only a small number of compounds are used, the rest being unsuitable for various reasons such as expense, toxicity, and attack on the silver image. The most widely used fixing agents today are sodium thiosulfate (hypo) ($Na_2S_2O_3$) and ammonium thiosulfate ($NH_4S_2O_3$).

The fixing bath removes the residual silver halides by forming soluble argentothiosulfate complexes. The general equation can be written as:

$$m\ Ag^+ + n\ S_2O_3^{2-} \leftrightarrow [Ag_m(S_2O_3)_n]^{(2n-m)-}$$

where the values of m and n can vary. The halogen ion passes into the solution unchanged. These complexes are not particularly stable and have to be removed from the emulsion through washing. If left in the emulsion, they can break down in time to form yellowish-brown silver sulfide stains.

As a fixing bath is exhausted, i.e., if the silver content becomes too high, there is evidence that one of the argentothiosulfate complexes formed has a tendency to adsorb to the

emulsion. Its removal in the washing becomes difficult and the risk of staining increases.

CONSTITUTION OF A FIXING BATH Although a plain fixing bath containing only sodium or ammonium thiosulfate would be sufficient, a *weak acid* is usually added for most black-and-white processing. A neutral fixing bath containing only hypo is used when an acid fixer would affect the

developed image, such as after color processing. The presence of an acid in the fixing bath ends the process of development immediately on immersion by neutralizing any alkali carried over. This prevents the developer from forming stains on the emulsion during fixation and allows white light to be switched on during fixation, providing the emulsion has been immersed completely and agitated for a few seconds. An acid condition also improves the effectiveness of some hardening agents.

Most acids cause thiosulfate to decompose with the deposition of colloidal sulfur, which may contaminate the emulsion and reduce the activity of the bath. This decomposition can be avoided by using bisulfite, either sodium bisulfite ($NaHSO_3$) or potassium metabisulfite ($K_2S_2O_5$) to lower the pH.

Simple Acid Fixer

Sodium thiosulfate	8–10	ounces	200–300	grams
Sodium bisulfite or				
potassium metabisulfite	1	ounce	25	grams
Water to make	40	fluid ounces	1	liter

Although this is a cheap and easy way to obtain an acid fixer, the buffer capacity is not very great. If the pH has to be controlled within close limits over a long period of time, a sodium acetate/acetic acid buffer is most commonly added after adding sulfite or bisulfite.

To reduce possible mechanical damage during the washing and drying stage, *hardening agents* can be added to the fixing bath. Hardeners reduce the swelling and consequent softening of the emulsion layer. The amount of water an emulsion absorbs is dependent on the pH, increasing with alkalinity and contact time. Swelling occurs in the developer but it is limited because of the hardening agents in the emulsion. Considerable swelling would occur during the final washing without additional hardening. In practice, it is convenient to combine the hardening process with fixation. If less water is taken up by the emulsion during washing, the drying will be accelerated. As hardeners also raise the softening temperature of the emulsion, higher drying temperatures can be used.

The degree of swelling of an emulsion increases with temperature. Under tropical conditions the partial swelling during development can be significant. It is therefore common to harden films before development under these circumstances. Processing at elevated temperatures is sometimes used to reduce contact time, especially with color materials.

The two most commonly used hardening agents are *potassium alum* (aluminum potassium sulfate) and *chrome alum* (chromic potassium sulfate). Chromium or aluminum ions combine with the gelatin to form cross-links that make the emulsion more resistant to water, heat, and abrasion. Both chrome and potassium alum require a pH range of about 4 to 6.5 to work properly and are therefore only used in acid fixing baths with good buffering properties.

Although both chrome alum and potassium alum are widely used, there are some differences in their properties. Chrome alum allows for a higher concentration of sodium thiosulfate (up to 40%) than potassium alum fixing baths (maximum of 30%). Chrome alum fixing baths are capable of a greater degree of hardening, important for high-temperature pro-

cessing, but they may produce excessive hardening at normal temperatures. They are also more susceptible to changes of hardening ability and color with small changes in pH.

Chrome Alum Fixer

Chrome alum	12.5 grams
Sodium metabisulfite	12.5 grams
Sodium sulfite, anhydrous	6.25 grams
Sodium thiosulfate (5 H_2O)	400 grams
Water to make	1 liter

Potassium Alum Fixer

Sodium thiosulfate (5 H_2O)	240	grams
Sodium sulfite, anhydrous	15	grams
Boric acid	7.5	grams
Acetic acid, 28%	48	ml
Potassium alum	15	grams
Water to make	1	liter

RAPID FIXER Although sodium thiosulfate is the most common fixing agent, ammonium thiosulfate is used in most rapid fixers on the market today. Its fixing rate is from two to four times faster than the rate of sodium thiosulfate, mainly because the ammonium ion also contributes to the formation of complexes. The usual concentration is about 10-20%, compared to 20-40% used in sodium thiosulfate fixing baths. However, there are some limitations to the use of ammonium thiosulfate as a fixing agent. It is less stable than the sodium compound and thus usually sold as a concentrated solution, which has to be diluted before use. Exhausted ammonium thiosulfate fixing bath can cause more staining, as the breakdown of the silver complexes is more rapid. Overfixation of prints can also have a bleaching effect on the silver image.

Rapid Fixer

Ammonium thiosulfate	135	grams
Boric acid	7	grams
Sodium acetate, anhydrous	10	grams
Sodium metabisulfite	5	grams
Sodium sulfite, anhydrous	6	grams
Water to make	1	liter

Potassium cyanide is another chemical with rapid fixing properties but is rarely used because of its toxicity.

STABILIZATION Stabilization is a process where the residual silver halides are converted into more stable complexes that are not subsequently washed out of the emulsion but are left in the final image. Stabilization is commonly used today in rapid processing systems and where image permanence is not a major issue. Stabilization allows one to forgo the final wash, one of the longest steps in processing, especially with fiber-base printing papers. The material must be dried directly after the stabilization bath.

Certain thiosulfates, thiocyanates, thiourea and allied compounds are used for stabilization baths. However, the image stability is never as good as after proper fixation and washing. When a stabilized image deteriorates, two reactions can occur. The highlights first turn yellow, and finally brown, or the image silver is bleached away. Depending on the circumstances (type of compound used, illumination, temperature, and humidity), either one may dominate. However, if a stabilized image is refixed in a normal fixing bath, it can be made permanent.

RATE OF FIXING The rate of fixing depends primarily on the following factors: type and thickness of the emulsion,

degree of exposure and development, type and concentration of fixing agent, temperature, agitation, and exhaustion of the solution.

Type of the Emulsion Fine grain emulsions fix more rapidly than coarse ones. As there is some correlation between film speed and graininess, higher speed films generally take longer to fix. Silver chloride emulsions fix more rapidly than silver bromide emulsions, and silver iodide emulsions take even longer. If silver bromide is converted to silver iodide as in physical development, fixing takes longer than usual. Chloride or chloro-bromide papers take less time to fix.

Thickness of Emulsion Thin emulsions fix more rapidly than thick ones. As a consequence, photographic papers fix more rapidly than film, since their emulsion layer is thinner.

Degree of Exposure and Development The amount of unused silver halides that have to be converted into argentothiosulfate complexes depends on the amount of exposure and development. The smaller the amount of silver halide remaining in the emulsion, the faster the rate of fixation. As a general rule, a material may be considered fixed after approximately twice the clearing time. Photographic emulsions appear opalescent because of the silver halides dispersed in them. As the fixer dissolves the silver halides, the emulsion becomes clear. The time required for this process is known as *time to clear* or *clearing time* and provides the basis of most recommended fixing times.

Type and Concentration of Fixing Agent Ammonium thiosulfate fixing baths have a faster rate of fixation than sodium thiosulfate fixing bath. The increase of thiosulfate concentration increases the fixing process, with a maximum concentration of about 20% for ammonium thiosulfate and 30–40% for sodium thiosulfate. Fixers for photographic print material contain usually only half the concentration of thiosulfate used in negative fixers. A stronger bath can lead to bleaching of the silver image during prolonged fixation and may aggravate the problem of removing the excess chemicals absorbed in the paper base during washing. Resin-coated photographic papers have little or no absorption of acids and thiosulfates in the paper base, which allows for a shorter washing time. In any case, the fixing time for photographic print material should not be prolonged unnecessarily.

As the composition of commercially available fixing baths varies, it is difficult to give accurate fixing times. The following figures are therefore only approximations, as all the other factors also influence the fixing time.

Sodium Thiosulfate Fixers

Films	7–10	minutes
Fiber-base papers	3–5	minutes
RC papers	2	minutes maximum

Ammonium Thiosulfate Fixers

Films	2–5	minutes
Fiber-base papers	1/2–5	minutes
RC papers	2	minutes maximum

Temperature of the Fixing Bath An increase in temperature results in an increase of the rate of fixation. It should be noted, however, that the temperature of film fixing baths should not exceed a ±5°C limit compared to the other processing baths to avoid possible reticulation, and ±1°C is desirable for optimum results. High temperatures also encourage swelling of the emulsion. It is advisable to use a prehardener before development when processing at high temperatures.

Agitation As fixation is basically a diffusion process, the amount of agitation influences the fixing rate. The more a photographic material is agitated, the shorter the fixing time becomes. In any case, the material should always be agitated to allow for complete fixing.

Exhaustion of the Solution The composition of fixing baths, like that of developers, changes with use. The area of negative or print material that can be fixed in one bath is limited. The life of a fixer depends on the concentration of silver complexes in the solution and the dilution of the fixing bath. The increasing concentration of silver compounds in a solution makes fixing progressively more difficult, until a point is reached when the material cannot be completely fixed, even if the bath is replenished by adding thiosulfate. For film emulsions, the maximum concentration of silver in a sodium thiosulfate fixing bath is about 6.0 grams per liter, in an ammonium thiosulfate fixing bath it is about 13.0 grams per liter. The concentration of silver in a fixing bath used for print material has to be considerably lower; the fixing bath should be replaced if the concentration reaches 2.0 grams per liter. It is therefore not advisable to fix print and film material in the same fixer. A fixer that will still work satisfactorily for film may contain too high a concentration of silver for paper. There is also a danger that dissolved antihalation dye from film material may stain prints.

The fixing time will also be prolonged by dilution of the fixing bath. Carry-over from either the development or the stop bath can lower the concentration of the chemicals, and the buffer capacity may be affected. If the pH of the solution rises over 6.0, the fixing bath will not stop the development, and there is a high risk of staining. Manufacturers usually state the life of a fixing bath in terms of sheets or rolls per gallon or liter. These figures are only approximations, as it is impossible to predict the amount of silver halides remaining in a specific emulsion, given a certain exposure and development, and the amount of dilution through carry-over. The following figures, however, can be taken as a rough guide:

Film Material	Number per Liter of 25% Sodium Thiosulfate Solution
135–20 film	60
135–36 film	30
120 film	30
4x5 inch film	100
8x10 inch film	30

The number of prints that 1 liter of 20–25% sodium thiosulfate solution will fix is about the same as for negatives. Although printing paper contains less silver than negative materials, the actual amount of dissolved silver a fixing bath can contain and still work satisfactorily is also lower.

Testing for Exhaustion A good indication as to when a fixing bath is exhausted is the time to clear for a known material. When the clearing time doubles, the fixing bath should be replaced. More accurately, silver concentration and acidity can be tested with indicator test papers. Silver indicator papers are calibrated so that the amount of coloration depends on the silver concentration. Another test is to add about 1 ml of 5% potassium iodide solution to 25 ml of the fixing bath. If the solution becomes cloudy and does not clear with shaking, the fixer is exhausted. Indicator papers for testing the acidity change color depending on the pH of the solution.

Testing for exhaustion of print material fixing baths by watching the clearing time is difficult, as clearing is not readily observable. A better method is to count the number of sheets processed or to test the fixing bath at frequent intervals.

Two-Bath Fixing The best and most economical way of ensuring complete fixing is the use of two fixing baths. In practice, the film or print material is placed in the first fixing bath for the recommended amount of time. In the second bath, any residual silver compounds are removed. When the first bath is exhausted, it is discarded. The second bath is then used as the first one, and it is replaced by a fresh bath.

Replenishing Fixing Solutions In a fixing bath, where no stop bath is used, the first properties to fall off are the acidity and the hardening power. By adding an appropriate acid mixture, which may contain a hardener, the life of a fixing bath can be prolonged. This process cannot be repeated indefinitely though, as the accumulation of silver ions in the fixer also determines its lifetime. It is therefore not advisable to replenish with thiosulfate unless some way of removing the silver is available.

SHELF-LIFE OF FIXING SOLUTIONS Freshly mixed fixing solutions, with the exception of chrome alum fixer, will keep almost indefinitely; they are not exhausted by storage as are developers. In a partly used fixer, especially if it is exposed to light, the silver complex gradually decomposes and forms a blackish sludge. If potassium alum is present, a white deposit of aluminum hydroxide may also form, especially when the acidity is low. If these precipitates are filtered out, the fixing bath can be used to full exhaustion. If fixing solutions are kept over an extremely long period of time, i.e., one year and longer, the thiosulfates may decompose to form colloidal sulfur. *S. Süsstrunk*

See also: *Image permanence.*

FIXING BATH Only a small amount of the silver salts in the emulsion layer of a photographic film or paper is needed to produce the silver of the developed image. The unused, unwanted silver halide of the emulsion layer will darken upon exposure to light if it isn't removed in a short time, obscuring the silver image. The process of removing the undesirable silver halides from the photographic material is called *fixation*; the solution that dissolves the silver halides is the *fixing bath*, or more simply, the *fixer.*

The chloride, bromide, and iodide salts of silver are almost insoluble in water and thus cannot be washed from the emulsion layer. A considerable number of compounds, however, adsorb to the crystal surface of the silver halides and react with silver ions to form water soluble compounds, which then diffuse with an equal number of halide ions into the solution. The silver crystals are etched away, leaving a metallic silver image in the otherwise transparent emulsion layer. The developed image has been *fixed,* that is, protected from continuing change by the removal of the unwanted silver salts.

Many compounds in solution possess the ability to etch the crystal surface of the silver halides. Certain developer constituents actually begin the etching process during the development treatment. Silver halide solvents in developers include ammonia or ammonium salts, potassium or sodium thiocyanate, sodium sulfite, sodium thiosulfate, and chloride, bromide, or iodide ions. Any of these silver halide solubilizing compounds, as well as nitrogen (amine) or sulfur (mercapto) organic compounds, might be used in separate baths to complete the removal of the unused silver salts.

In actual practice, however, the choice is quite limited. Ammonia and sodium sulfite solubilize silver chloride but are slow to attack silver bromide. Potassium cyanide easily dissolves all the silver salts, even silver sulfide, but is highly poisonous. Even this did not stop cyanide from being used as a fixing bath for the early high-iodide wet plate or ambrotype processes. Organic fixing agents are costly and often toxic.

When chemical activity, solubility, stability, toxicity, and cost are all considered, today's universal choices have been sodium thiosulfate ($Na_2S_2O_3$) and ammonium thiosulfate [$(NH_4)_2S_2O_3$].

The thiosulfate ion dissolves the insoluble silver halide crystal by combining at the surface with a silver ion, forming a complex ion. A second thiosulfate is thought to be necessary before the complex silver ion can be carried into the solution. The reactions of thiosulfate fixation may be written Note that a bromide ion (Br^-) is also released with each silver ion solubilized. Eventually an excess of bromide ions in the fixing solution will effectively compete with the thiosulfate for the silver ions. At this point the fixing bath is said to be exhausted.

$AgBr$	+	$S_2O_3^{2-}$	\rightarrow	$[AgS_2O_3]^-$	+	Br^-
(Solid)		(Solution)		(Adsorbed complex of low solubility and low stability)		(From solid into solution)

$(AgS_2O_3)^-$	+	$S_2O_3^{2-}$	\rightarrow	$[Ag(S_2O_3)_2]^{3-}$
(Adsorption complex)		(Solution)		(Leaving crystal surface and passing into solution)

$[Ag(S_2O_3)_2]^{3-}$	+	$S_2O_3^{2-}$	\rightarrow	$[Ag(S_2O_3)_3]^{5-}$
(Solution)		(Solution)		(Solution)

Fixing baths are not simple water solutions of the thiosulfate salts. Because developing solutions are alkaline, the fixing solutions need to be acid to inhibit further image formation. The presence of a gelatin-hardening compound in the fixing bath is desirable, but hardening agents, such as the alums, are effective only in moderate acidity. These factors dictate that the fixing solution be acidic, but such a need greatly complicates the composition of the bath.

Because thiosulfate ions are unstable in low pH solutions, the solution must be maintained so that the solution does not become highly acidic. Alum, usually potassium alum, requires a narrow range of acidity, usually that given by a buffered acetic acid solution. Sodium sulfite is needed as a preservative as well as an inhibitor of the precipitation of sulfur from the thiosulfate ions in the fixing bath. Boric acid is added to acid fixers as an antisludging agent and helps the buffering of the solution. *G. Haist*

FIXING BATH TEST A means of determining when a used fixing bath should be replaced with a fresh bath. Depletion of sodium thiosulfate in the bath can be detected by an increase in the clearing time for a strip of unprocessed black-and-white film. Accumulation of silver salts in the bath can be determined with a potassium iodide test solution, which when added to a small sample of the bath will combine with silver salts to form a yellowish silver iodide precipitate.

L. Stroebel and R. Zakia

FLAG An oblong opaque light-blocking device that shades a subject area or the camera lens. When attached to an articulated arm for ease of positioning, it is sometimes called a *French flag.* *R. Jegerings*

Syn.: *Flag, Gobo, Headscreen.*

FLANGE FOCAL DISTANCE The distance from the front locating surface of the lens mount throat in an SLR camera body to the principal focal plane. Ideally this should be less than the back focal distance of the lens when fitted to allow maximum clearance for a reflex mirror. A low value

may allow lenses of one camera system to be adapted parfocally to another using a short intermediate ring. *S. Ray*

FLARE Non-image-forming light in a camera or other optical system due to the reflection of light from any of a variety of surfaces, such as those of the lens, the lens mount, and the interior of a camera or enlarger. When the flare is uniform over the image area, it produces a reduction of image contrast and an increase in image illuminance and exposure. The loss of contrast is largest in the image areas that receive the least exposure—the subject shadow areas for negative and reversal film exposed in a camera and prints on reversal color paper exposed with a transparency in an enlarger, and the subject highlights for prints made with a negative in an enlarger. Also, flare in the human eye causes a loss of contrast of the visual image. When the flare is gradually more concentrated in a local area, it is referred to as a *flare spot.* When the outline shape of localized flare resembles the shape of the limiting aperture, it is identified as a *ghost image.* Including the sun or other strong light source in the field of view and bright backgrounds increase the amount of flare. *L. Stroebel*

See also: *Flare factor; Ghost image (video); Tone reproduction.*

FLARE FACTOR Flare is nonimage-forming, stray light in an optical system due to internal reflections at air–glass interfaces and reflections from interior surfaces of, for example, the camera (camera flare). A flare factor of 2 would represent a reduction of a 160:1 luminance ratio scene to an 80:1 ratio illuminance image. *S. Ray*

Syn.: *Glare index.*

See also: *Flare; Tone reproduction.*

FLASH (1) A brief, intense burst of light used to illuminate photographic subjects. (2) Part of a compound construction (flashbulb, flashtube). (3) An adjective (flash gun, flash reflector, flash photography), or made clear by an adjective (electronic flash, studio flash). (4) A *flash exposure* (or *flashing*) refers to a low-level exposure to nonimage-forming light that lowers film or paper contrast (e.g., when making duplicate slides or enlarging). Flashing is a standard procedure in photomechanical reproduction. *R. Jegerings*

FLASHBACK In a motion picture, a scene from the past relative to the story's main line of action, or the act of cutting to such a scene. *H. Lester*

FLASHBULB Also known as *flashlamp* or *photo flashlamp,* a sealed glass housing containing a combustible material in an atmosphere of oxygen that is ignited by an electrical current through a filament to produce a single flash of light of high intensity. It replaced flash powder and is itself being rapidly replaced by electronic flash. *R. Jegerings*

See also: *Light sources.*

FLASH, CHEMICAL Brief duration, high-intensity light from a single-use light bulb containing combustible material in an atmosphere of oxygen, as distinguished from electronic flash. *R. Jegerings*

Syn.: *Flashbulb, flashlamp.*

FLASHED OPAL Clear sheet glass that is coated with a white diffusion material. It can be used as a light diffuser in contact printers, viewing boxes, and so on, but has been largely replaced by translucent opal plastics. *R. Jegerings*

FLASH, ELECTRONIC A lighting system that produces a brief, intense burst of light by electrical discharge through an atmosphere of xenon or other inert gas in a sealed trans-

parent or translucent envelope called a *flashtube,* which can be used repeatedly. *R. Jegerings*

See also: *Flashtube; Light sources.*

FLASH EXPOSURE The supplementary overall exposure in halftone photography used to strengthen the dots in the shadow areas of the negative. *M. Bruno*

FLASH FILL See *Fill flash.*

FLASH GUIDE NUMBER See *Guide number.*

FLASH GUN A device for holding and firing a flashbulb for the purpose of illuminating a subject for a photograph. Flash guns typically have a reflector to direct the light and are powered by one or more enclosed batteries. *L. Stroebel*

FLASHING The controlled exposure of a sensitized material to uniform non-image-forming light, commonly in combination with an image exposure, for the purpose of modifying tone-reproduction characteristics, to modify density in a local area (to add a black border, for example), or to increase the effective speed of a sensitized material. Overall flashing can be used to lower print contrast with a given contrast grade of paper, but excessive flashing produces dark and flat highlight areas. Flashing is commonly used when making halftone negatives for photomechanical reproduction. Flashing with the halftone screen in place is referred to as a *highlight* exposure and with the screen removed as a *bump* exposure. *L. Stroebel*

See also: *Latensification.*

FLASH-PAN A very fast panning move by a motion-picture camera, resulting in a blurred or indistinct image. Often used as a transition from one scene to another. *H. Lester*

Syn.: *Swish pan; Whip pan.*

FLASH POWDER An explosive mixture of magnesium powder and an oxidizing agent used for illumination in low light. Long discontinued, it was normally used in a tray and ignited in open air by touch paper, a gunpowder cap, or an electrically heated element. As a portable light source, it was replaced by the safer flashbulb. *R. Jegerings*

FLASH READYLIGHT A light on an electronic-flash unit that indicates when the capacitor has built a full charge. If an exposure is made before a full readylight indication, underexposure will occur. On many automatic cameras with dedicated flash capabilities, the readylight is also shown in the camera viewfinder. *P. Schranz*

FLASH SEQUENCER An electronic-flash synchronizing device that fires two or more separate flash heads, one after the other, allowing stroboscopic effects. *R. Jegerings*

See also: *Stroboscope/stroboscopic flash.*

FLASH SYNCHRONIZATION The coordination of timing of the opening of a camera shutter and the peak output of light by a (chemical) flashbulb or (electronic) flashtube so that flash photographs can be made at instantaneous shutter speeds, as distinct from the manual *open flash* procedure where the shutter is opened on the B or T setting, the flash is fired, and the shutter is closed. With electronic flash, the electrical circuit for the flash can be closed when the shutter reaches the fully open position. With flashbulbs, it was necessary to close the flash circuit before the shutter blades opened, and the delay to peak light output varied with different types of flashbulbs.

Some camera shutters offer the photographer the option of synchronizing electronic flash at the end of the exposure, so that in photographs of rapidly moving objects made with a

combination of flash and existing light, the streak produced by the existing light will appear behind the subject rather than in front. 　　　　　　　　　　　　　　　*J. Johnson*

See also: *Tailflash synchronization.*

FLASHTUBE The light source in electronic flash units that produces flashes of light by electrical discharges through an atmosphere of xenon or other inert gas. 　　*R. Jegerings*

FLAT (1) Lower-than-normal contrast. The term is variously applied to the tonal range of a subject, lighting contrast, and photographic images. (2) A panel used in studios and elsewhere as a background, reflector, wall, etc. (3) In photomechanical reproduction, a sheet of paper or other material used to hold halftone and line negatives in position during exposure of printing plates. 　　*L. Stroebel*

FLATBED CAMERA See *Camera types*

FLATBED EDITING MACHINE A motion-picture editing machine on which the film and sound move horizontally through the picture gate, or across the sound heads, on a table-like platform, as opposed to upright editors, where the film moves vertically. Flatbed editors, because of their layout as well as a more sophisticated technology used in their design, often provide the editor with greater convenience and efficiency during various editing procedures.
　　　　　　　　　　　　　　　　　　　H. Lester

FLATBED SCANNER A type of scanner that scans flat art that is placed on a flat surface similar to the image capture area of a photocopier and renders an image of the scanned object via a charge-coupled device (CCD) array that converts the optical density differences into electronic signals that are quantized into whatever gray levels are supported by the scanner. 　　　　　　　　　　*R. Kraus*

FLAT-FIELD LENS See *Lens types.*

FLAT LIGHTING Lighting that comes primarily from the direction of the camera, often used synonymously with *front lighting.* Flat lighting completely illuminates the front of the subject. Pictures lit in this manner show little, if any, depth because the entire visible part of the subject is uniformly illuminated, and few if any shadows exist to delineate surface detail and form. 　　　　*F. Hunter and P. Fuqua*

See also: *Front lighting.*

FLETCHER-MUNSON CURVES (SOUND) The first measured equal loudness contours, now generally superseded by later work. 　　　　　　　*T. Holman*

See also: *Equal-loudness curves.*

FLEXOGRAPHY Flexography is a relief printing process like letterpress except that the plates are resilient, requiring much less makeready on the press, and solvent inks are used for printing. Both molded rubber and special resilient photopolymer plates are used, as well as laser-etched rubber plates and cylinders. The process is used extensively in packaging, where it competes with gravure in the flexible film printing market, and for book and newspaper printing, where it is replacing letterpress. 　　　*M. Bruno*

FLICKER The perception of a rapid variation in brightness when viewing a rapidly flashing light or series of intermittent images that alternate with darkness as with motion picture and video images. Persistence of vision prevents flicker with appropriate values of image frequency and luminance. 　　　　　　*L. Stroebel and R. Zakia*

See also: *Critical flicker/fusion frequency; Ferry-Porter law; Flicker; Persistence of vision.*

FLICKER BLADE An extra blade on the shutter of a motion picture projector that interrupts the light during the projection of a frame, designed to minimize the audience's perception of flicker. A normal projector shutter is closed only during the movement of film from one frame to the next.
　　　　　　　　　　　　　　　　　　　H. Lester

See also: *Chopper; Persistence of vision.*

FLICKER PHOTOMETER A device that allows visual luminance matches between fields with different spectral distributions (heterochromatic photometry). Bipartite field photometers are subject to large errors when fields of different colors are matched because of the difficulty in distinguishing differences in luminance from those as a result of hue and saturation differences. Flicker photometry allows heterochromatic luminance matching by taking advantage of the fact that color differences fuse at lower temporal frequencies than do luminance differences, presumably because of the different neural pathways responsible for color and luminance perception. Rather than the simultaneous comparison used in bipartite field photometers, flicker photometers rapidly alternate the test and standard fields in the same location. There is a range of flicker rates (typically 10–20 Hz) over which color differences fuse, resulting in the perception of a single color. A luminance match is achieved by reducing the remaining flicker to luminance differences. 　　　　　　　　*J. Pelz*

See also: *Bipartite field photometer; Heterochromatic photometry; Visual photometer.*

FLINT GLASS An optical glass with an Abbe number below 50 for a refractive index above 1.6 or an Abbe number below 55 for a refractive index below 1.6. A soft glass much used for decorative glassware, it was one of the two early forms of optical glass and formed a simple achromatic combination with crown glass for imaging lenses. 　　*S. Ray*

FLIP In electronic imaging, a computer function for rotating an image 180° about a horizontal axis, thus reversing the image from top to bottom. 　　　*L. Stroebel*

FLOAT The unsteady positioning of the image in motion-picture projection, usually caused by inconsistent positioning of the film in the camera, printer, or projector gate.
　　　　　　　　　　　　　　　　　　　H. Lester

FLOATING LID A processing-tank cover that fits inside the tank and rests on the surface of the contained liquid, thereby reducing evaporation and oxidation.
　　　　　　　　　　　　　　　L. Stroebel and R. Zakia

FLOATING MARK A visible pointer, usually in the form of a movable spot of light, given by the stereoscopic fusion of two separate light sources (mark halves) of variable horizontal separation viewed independently through the dual optical systems of a measuring stereoscope. Alteration of separation gives the visual illusion that the mark moves (floats) vertically through the stereomodel seen in the viewer. Its displacement can be related to dimensions in the subject. 　　　　　　　　*S. Ray*

FLOODLAMP A light bulb with a built-in reflector that distributes the reflected light over a moderately large angle. Those intended for photographic use have high wattage and an appropriate color temperature for use with color films.
　　　　　　　　　　　　　　　　　　R. Jegerings

FLOODLIGHT A studio-type lighting unit having a relatively large reflector that produces moderately diffuse light and normally used on a light stand. Additional diffusion can be obtained with some floodlights that can be equipped with a metal cap over the front of the bulb to prevent direct light from reaching the subject. *R. Jegerings*

FLOP In electronic imaging, a computer function for rotating an image 180° about a vertical axis, thus reversing the image from left to right. *L. Stroebel*

FLOPPY DISK See *Disk.*

FLORENCE, HERCULES (1804–1879) French-born draftsman who emigrated to Brazil in 1824. Recent investigations indicate the Florence independently discovered photography in 1833 using paper bathed in silver-nitrate and fixed with urine. Florence kept meticulous journals that also state he coined the term "photographie" on August 15, 1832. His discovery met with general disinterest in Brazil and after he first viewed daguerreotypes, he decided that he could not attain such sharp prints and moved on to other work.

Books: Kossoy, Boris, *Hercules Florence: The Isolated Discovery of Photography in Brazil.* Sao Paulo, Brazil: Livraria Duas Cidades, 1980. *M. Alinder*

FLOW CAMERA See *Camera types.*

FLUORESCENCE Electromagnetic radiation emitted from a substance as a result of the absorption of radiation incident on the substance. Instead of being converted entirely into thermal energy, the absorbed radiation is reemitted as electromagnetic radiation. Fluorescence is distinguished from phosphorescence in that fluorescence occurs almost immediately (within a few nanoseconds) after the absorption of the incident radiation. *J. Holm*

FLUORESCENCE PHOTOGRAPHY (1) The recording of visible radiation (i.e., light) produced by fluorescence when certain substances are exposed to invisible ultraviolet radiation. An ultraviolet-absorbing *barrier* filter is usually used on the camera lens to prevent ultraviolet radiation from reaching the film and obscuring the fluorescence effect. (2) The recording of ultraviolet-radiation images, usually using an *exciter* filter that transmits ultraviolet radiation and absorbs visible radiation on the camera lens. Fluorescence photography is used especially in the fields of medical photography and forensic photography.
L. Stroebel

FLUORESCENCE PHOTOMICROGRAPHY Fluorescence photomicrography is the photography of fluorescing microscopic specimens, using a microscope equipped with appropriate light sources and filters.

BASIC PRINCIPLES Photoluminescence of microscopic specimens is light emitted as the result of excitation by light of the same or shorter wavelength. The energy of the exciting illumination is taken up by the electrons, which jump to higher energy levels. After removal of the exciting illumination, the electrons return to lower energy levels, and in the process give off light of a wavelength that is of the same or, more usually, longer wavelength. The average order of magnitude of the lifetime of the electron in the excited state is of the order of 10^{-8} seconds. The emission that occurs after the excitation is removed is called *afterglow.* If the afterglow ceases within the 10^{-8} seconds, the luminescence is called *fluorescence*; if the afterglow persists longer than 10^{-8} seconds of the removal of the excitation, the lumi-

nescence is called *phosphorescence.* Phosphorescence may persist for seconds, hours, or days.

There are two principal types of fluorescence: *primary,* or *autofluorescence,* in which a specimen fluoresces in and of itself without prior treatment, and *secondary* fluorescence, in which fluorescence occurs as the direct result of the pretreatment of the sample with a fluorescing substance (flurochrome).

EQUIPMENT Fluorescence photomicrography may be conducted with transmitted light, epi illumination (top light; vertical illumination), or both simultaneously. In any case, the ordinary microscope needs to be modified for fluorescence work. The first consideration is the choice of *exciting* filters. Specific fluorochromes are excited to fluoresce by specific wavelengths, which may be below the visible usually 365 nm—or somewhere in the visible—usually 400 nm, 430 nm, or 546 nm. The choice of exciting wavelength, which depends on the fluorochrome selected, will determine the light source needed. For 365 nm excitation, a high-pressure mercury vapor lamp is needed—these are commonly supplied as 50W, 100W, or 200W HBO types. For blue-violet fluorescence (e.g., 400 nm) or green fluorescence (546 nm) a quartz halogen lamp is sufficient.

Next, excitation filters are needed to isolate specific portions of the emitted spectrum. In the case of ultraviolet fluorescence, UG-type filters are required to isolate the 365-nm wavelength—these are often supplied in two thicknesses for a choice of spectral purity and intensity. For blue-violet fluorescence, the BG-type filters are needed; and for green fluorescence, the 546-nm green filter is needed. These filters may be placed anywhere in the light path before the specimen. The ultraviolet filters allow residual red to pass in addition to the UV, so that a red-suppression (e.g., BG38-type) filter is added to the UV filter pack. Additionally, a heat filter is needed in the path ahead of any of these other filters, as the exciting filters will, otherwise, crack. Since heat-absorbing filters themselves often crack from the heat, it is better to substitute the more effective, but more expensive, interference type, heat-reflection filters. A filter pack then for UV fluorescence would consist of a heat filter, a UG1 or UG5, and a BG38 (or equivalent).

The exciting wavelength, once isolated, is impinged on the specimen, which causes it to fluoresce. The light from the sample field of view now consists of the exciting illumination and the fluorescence. The exciting illumination must now be suppressed so that only the fluorescence is visible. This is done through the use of *barrier* filters placed anywhere after the specimen in the light path. Barrier filters suppress all—or nearly all—wavelengths at and below that of the exciter, but pass all wavelengths longer. These barrier filters are colorless to various shades of yellow, and are matched to specific exciter filters. In microscopes made specifically for fluorescence microscopy, the exciter and barrier filters are conveniently introduced and removed from the light path through the use of incorporated sliders, cubes, and trays.

In the past, more use was made of transmitted fluorescence, but the trend today is almost exclusively epi-fluorescence utilizing sliding or rotating cubes or carousels that incorporate both exciter and barrier in the same module. Furthermore, the technology is such that the sophisticated coatings favor maximum specific excitation reflection to the specimen and maximum specific fluorescence transmission to the eyepiece and camera.

PHOTOMICROGRAPHY The same photomicrographic cameras used with ordinary light are used for fluorescence photomicrography, but there are several specific considerations for successful fluorescence photomicrography. For color fluorescence photomicrography, color films balanced for daylight are used. The film speed depends on several factors, not the least of which is the fluorochrome. The biggest problem in biomedical fluorescence photo-

micrography is quenching of the fluorochrome. That is, there is a strong tendency for commonly used fluorochromes to fade rapidly when illuminated by the exciting radiation—not leaving sufficient time for a successful exposure. Therefore, very fast films are usually selected and, where possible, very long exposure times are used. Actually, these problems can be minimized by first making sure that Köhler illumination is set up to ensure maximum, even illumination. Second, the numerical aperture and magnification of the microscope objective selected is of paramount importance. The lowest magnification but highest possible numerical aperture should be chosen. For strictly fluorescence work, special very high numerical aperture objectives are available from some manufacturers. Finally, use neutral density filters and diffusers while setting up, arranging, and focusing the specimen, and remove these only when the exposure is to be made.

In much industrial fluorescence photomicrography, quenching is not a concern, but with weakly fluorescing specimens, long exposure times are needed. The usual reciprocity failure filter corrections and speed changes need to be applied; additionally, a common error is to leave the shutter open for long periods in a well-lighted laboratory. Under these circumstances, light from the room enters the side telescope, reflects down the beam-splitter, is reflected from the top of the eyepiece, and records on the film along with the specimen. For this reason, room lights need to be lowered and/or the side telescope needs to be capped (some manufacturers supply a blackout slider for this purpose).

Common resinous mounting media for micro specimens, such as Canada balsam, fluoresce, so that special mountants must be used; glycerin or glycerin-water mixtures are often used for temporary mounts. Oil for oil-immersion objectives also fluoresces so that again special *low-fluorescence* oil must be used. The cements used between the objective lenses may also fluoresce, so that objectives made with non-fluorescing cements are used for fluorescence microscopy. The glass used for microscope slides and coverglasses is weakly fluorescing. This problem is evident only when dealing with weakly fluorescing specimens, but can be minimized by illuminating with darkfield techniques. Alternatively, quartz slides and coverglasses can be used.

Because the fluorescence is so narrow-banded, many exposure meters may give incorrect readings in different spectral regions, so that exposure compensation factors often have to be determined and applied.

Multiple exposures utilizing different exciting wavelengths and/or mixed lighting techniques are especially effective in fluorescence photomicrography.　　　*J. Delly*

See also: *Photomacrography.*

FLUORESCENT LAMP
A light source, typically in the form of a cylindrical glass tube, in which light and ultraviolet radiation are produced by electricity flowing through mercury vapor. Phosphors on the inside surface of the tube convert the ultraviolet radiation to light. Fluorescent lamps are economical to operate, emit relatively little heat, and produce uniform diffused light that makes them well suited for use in light boxes and transparency illuminators. The color quality of the light varies with the types of phosphors used, but none are balanced for use with reversal-type color films without filtration.　　　*R. Jegerings*

See also: *Light sources.*

FLUORIDE LENS　See *Lens types.*

FLUOROGRAPHY
The process of recording by photography fluorescent images, however, produced. The term usually refers to the technique of photographing—typically on a reduced scale—the visible images produced on a fluorescent screen by x-rays.　　　*L. Stroebel*

FLUTTER　See *Wow and flutter.*

FLUX (ϕ)
The time rate of flow of energy (i.e., power) emitted by a source or passing through a defined aperture. Radiant flux (ϕ_e) is a measure of electromagnetic energy at all wavelengths and is measured in watts (W). Luminous flux (ϕ_v) measures power scaled by the relative luminous efficiency function [V(λ)], and is measured in lumens (lm). One lumen is the power falling on (or passing through) a unit area that is everywhere unit distance from a 1 candela source.　　　*J. Pelz*

See also: *Lumen; Luminous flux; Photometry and light units; Radiant flux.*

FLUX DENSITY
Flux per unit area; the quotient of time rate of flow of energy emitted from (or flowing through) a small area, divided by that area, that is dΦ/dA. The preferred unit of measurement for radiant flux density is watts per square meter (W/m2); for luminous flux density it is lumens per square meter (lm/m2). When the term is applied to flux leaving a surface (radiant or luminous exitance), dA is the area emitting the flux; when applied to flux incident on a surface (irradiance or illuminance), dA is the area receiving the flux. In the case of illuminance, the preferred unit is the lux (lx), equal to 1 lumen per square meter.　　　*J. Pelz*

See also: *Exitance; Illuminance; Irradiance; Photometry and light units.*

FLUXIVITY
The strength of a magnetic field stored on a tape or film, usually given in units nW/m. Reference fluxivity is the level recorded on a calibration tape used in aligning tape and film recorders.　　　*T. Holman*

See also: *Calibration tape or film.*

FLYING-SPOT SCANNER
An image-forming device employing a beam of electrons (cathode-ray tube) or light (electronic printer) that moves systematically over an area and varies in intensity to form an image. In cathode-ray tubes the beam of electrons produces fluorescence on the screen. In electronic printers, the light beam exposes a photosensitive material.　　　*L. Stroebel*

See also: *Cathode-ray tube; Electronic enlarger/printer.*

FM SYNC TONE
A synchronization method used with stereo 1/4-inch tape recording. A narrow track is added between the two audio tracks carrying 60 Hz tone frequency modulated on a 13.5 kHz carrier. The use of the high frequency carrier to carry the tone is helpful in preventing cross talk from the 60 Hz signal.　　　*T. Holman*

See also: *Crystal sync.*

f-NUMBER
Numerical expression of the relative aperture of a lens at a specific diaphragm opening. A number (*f*/16, for example) obtained by dividing the focal length of a lens by the effective aperture and used to control the amount of light transmitted by a lens. (The image illuminance is inversely proportional to the square of the *f*-number. The required exposure time is directly proportional to the square of the *f*-number.) Selected *f*-numbers, usually representing the maximum aperture and consecutive whole stops, are normally printed on the lens mount.

The *f*-number is written in various forms, e.g., *f*8, *f*/8, 1:8, but the preferred form is *f*/8. When focused on infinity, all lenses stopped down to the same *f*-number produce images of equal illumination (apart from differences due to varying reflection losses, a situation that is handled by *T*-numbers).

The following numbers represent *whole stops* in the standard series of *f*-numbers: *f*/0.7, 1.0, 1.4, 2.0, 2.8, 4, 5.6, 8, 11, 16, 22, 32, 45, 64, 90, 128. A typical professional quality lens will have considerably fewer than the 16 stops listed

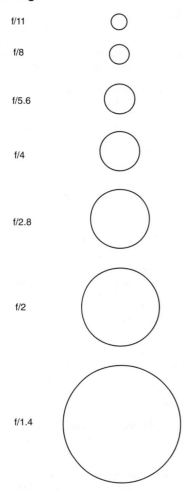

f/11

f/8

f/5.6

f/4

f/2.8

f/2

f/1.4

f-number and aperture size relationship.

sure by 8 times. Because the *f*-number is calculated by dividing the focal length of the lens by the diameter of the effective aperture, there is an inverse relationship between the *f*-number and the amount of light transmitted by the lens, so that a large *f*-number represents a small diaphragm opening.

Occasionally more precise control of exposure is needed than is permitted with whole stops. Exposure meter scales and dials are normally subdivided into one-third stops, this being the smallest practical increment for bracketing and other purposes. Intermediate *f*-stops are not marked on the *f*-number scales of lenses, but one-third or one-half stops may be indicated by dots, lines, or click stops. In the absence of intermediate markings on the scale, the photographer must estimate the settings. Most shutters, however, are not designed to be used at intermediate settings, so that small changes in exposure must be made by changing the *f*-number setting.

Books: Stroebel, Leslie, *View Camera Technique*, 6th ed. Boston: Focal Press, 1993. *J. Johnson*

See also: *Aperture; Diaphragm; Relative aperture; T-Number.*

FOCAL LENGTH The distance from the rear principal or nodal point of a lens to the rear principal focus, that is, when the lens is focused on infinity so that parallel light is entering the lens. Image size is directly proportional to focal length. Focal length is a primary property of an imaging lens. The term *focus* is a common synonym when describing long- or short-focus lenses. The reciprocal of focal length is the *power* of a lens. *S. Ray*

Syn.: *Focus.*

See also: *Power focus.*

FOCAL LENGTH, CALIBRATED A calculated value for the distance from the best focus of an infinitely distant object plane to the rear nodal plane, adjusted so that the extreme positive and negative values over the useful field are equal in magnitude.

For purposes of photogrammetry, the performance of a suitable lens is evaluated by measurement of residual curvilinear image distortion across the image circle for a given focused distance. By selection of a calibrated focal length with a value close to the true focal length, the distortion errors may be redistributed more symmetrically in the image, assisting computations from image measurements. This calibration process determines the *inner orientation* of the photogrammetric camera. *S. Ray*

FOCAL LENGTH, EQUIVALENT A complex lens with numerous individual refracting and/or reflecting elements with positive and negative powers has a resultant net power. The lens may be replaced theoretically by an *equivalent refracting surface* in space of identical power. For incident parallel light the distance from this surface to the rear principal focus is the equivalent focal length. In practice the term is shortened to *focal length*. *S. Ray*

FOCAL PLANE A surface in space defined by a real image formed of an array of image points of maximum sharpness corresponding to conjugate subject points in a plane through the subject. Usually this plane is perpendicular to the optical axis in most cameras but may be inclined to the axis in the case of a camera with swing and/or tilt movements applied. The image may not be truly planar but a shallow complex best surface of sharpness due to residual curvature of field. *S. Ray*

Syn.: *Image plane.*

FOCAL PLANE, PRINCIPAL A plane through the rear principal focus of a lens perpendicular to the optical axis

above, usually in the proximity of seven stops. The area of the diaphragm opening and, therefore, the amount of light transmitted both change by a factor of 2 with each whole stop, decreasing as the *f*-number increases. *Opening up* one stop, for instance from *f*/5.6 to *f*/4, doubles the amount of light transmitted. Two stops either *opened* or *closed* changes the exposure by 4 times, while three stops changes the exposure by 8 times.

f-Number	Diameter	Area	Exposure time
	(Relative Values)		
f/11	1	1	1
f/8	1.4	2	1/2
f/5.6	2	4	1/4
f/4	2.8	8	1/8
f/7.8	4	16	1/16
f/2	5.6	32	1/32
f/1.4	8	64	1/64
f/1	11.3	128	1/128

f-number. Interrelationship of *f*-number, effective aperture, and corresponding exposure time.

when focused on infinity. The sharp image points in this plane are conjugate to corresponding image points in a similar plane at infinity. The focal length is measured from the rear principal (nodal) plane to the principal focal plane.

<div align="right">S. Ray</div>

FOCAL-PLANE SHUTTER A camera shutter located in front of and close to the film aperture and focal plane, typically consisting of two opaque curtains or blades that form a variable-width slit between them as they move across the film aperture to expose the film, but that overlap during the shutter-cocking operation to prevent unwanted exposure of the film during movement in the opposite direction. Advantages over lens shutters include the need for only one shutter with interchangeable-lens cameras, higher maximum shutter speeds, and essentially no change in the effective exposure time as the lens diaphragm is stopped down. Top speeds have increased over the years from 1/1,000 to 1/4,000 sec. Disadvantages include image distortion with rapidly moving objects at slower shutter speeds, due to the time differential of exposure as the slit moves across the film, and difficulty of synchronizing the shutter with electronic flash at high shutter speeds, since the film must be completely uncovered when the flash is fired. The top sync speed has increased over the years from 1/60 to 1/250 sec. The accuracy of the shutters has also increased with the transition from mechanical to electronic control of the speeds. Focal-plane shutters are most commonly used on 35-mm cameras, but they have been used on larger-format cameras, including the early 4×5 Graflex single-lens-reflex camera. The focal-plane shutter was invented by William England in 1861.

<div align="right">P. Schranz</div>

FOCAL POINT Point of intersection of all rays of light transmitted by a theoretically perfect lens from a given object point. When the object is at infinity and the incident rays are parallel to the axis, the focal point becomes the principal focal point on the axis.

<div align="right">S. Ray</div>

FOCAL POINT, PRINCIPAL The point behind the lens on the axis where parallel light incident on the lens is converged to a common focus.

<div align="right">S. Ray</div>

FOCUS/FOCUSING

SHARP FOCUS The setting of the lens-to-image distance (v) in order to satisfy the lens conjugate equation $1/u + 1/v = 1/f$, given the lens to subject distance (u). The film plane is then conjugate to a plane in the subject, but additional detail is rendered sharp because of the circle of confusion standard adopted, giving depth of field in the subject and depth of focus about the image plane. (Diffraction limited lenses require much more precise focusing to within 1/4,

the Rayleigh limit.) As the subject conjugate distance decreases, the lens has to be moved farther from the film plane until at unit magnification the two distances are equal and of length twice the focal length, and this is the closest approach of the film plane and subject. The necessary extension is usually referred to as the *focusing extension* or *bellows extension*. There are various visual focusing arrangements used. Autofocus systems are dealt with separately.

FOCUSING ARRANGEMENTS

Fixed Focus Some cameras simplify focusing by having the lens set to its hyperfocal distance and relying upon small apertures and short focal length to give the necessary depth of field. Sometimes called a *pan focus* arrangement.

Focusing Scales Most lenses are in a focusing mount with a distance setting scale. These may seldom be used if a coupled rangefinder, reflex, or autofocus system is provided, but

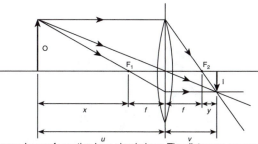

Focus. Image formation by a simple lens. The distances are measured from the center of the lens; distance *y* is the focusing extension.

Focusing arrangements. (a) Unit focusing distance *x*. (b) Front cell movement distance *y*. (c) Supplementary lens L. (d) Internal focusing. (e) Comparison of movements *x* and *y* required for methods (a) and (b) over a range of object distances (u).

otherwise a visual estimate or measurement is made of the subject distance and this set to be within the depth of field available as indicated by the adjacent depth of field scale on the mount. Such a scale is also useful for exposure determination with on-camera flash. As an alternative to distances, simple symbols may be provided for zone focus settings.

Front Cell Focusing An early popular arrangement that involved moving the front element of the lens a short distance to alter focal length, hence change the subject conjugate to a shorter value. The image conjugate remained constant. Near focus was limited to about 1 meter before aberrations became a problem. The movement of the element could be coupled to a rangefinder.

Unit Focusing Unit focusing refers to moving the whole of the lens unit for focusing, and better performance is given compared with front cell focusing over a similar focusing range. The lens doesn't rotate on most 35-mm cameras that have rotating helical focusing sleeves on the lens barrel. Macro lenses are corrected for close distances. Two varieties of unit focusing are used: (1) *helical* where the lens rotates as it moves forward, which can be a problem with direction sensitive attachments such as polarizing and graduated filters; and (2) *rectilinear* movement, which does not involve rotation and is preferred.

Internal Focusing A more recent form of focusing comes from development work with zoom lenses in that by the limited axial movement (floating) of an internal element or group, a full focusing range is obtained. There are many advantages. The lens can be sealed against ingress of dust or rain and does not increase in length in its mount so can be encapsulated in a blimp more easily. The focusing control needs only a small rotational movement for the whole range so can be light and swift in action. The floating action can require low torque suited to control by a micromotor for autofocus operation. A combination of unit and internal focusing is sometimes used where the floating element is linked to the focus control to minimize aberrations as the lens is focused closer.

Supplementary Lenses A fixed-focus or long-focus lens may have a closest focus setting that is inconveniently distant. This compromise can save the cost of an expensive focusing mount. Attachment of positive meniscus or achromatic supplementary lenses can give sharp focus on near distances. If the lens is set to infinity focus, then it will be in focus on a distance equal to the focal length of the supplementary lens, so a +1 diopter lens of focal length 1000 mm will give a close focus of 1000 mm.

CLOSE FOCUSING The closeup range of distances gives a magnification range from about 0.1 to 1.0 (unit or life-size reproduction). Greater magnification takes the lens into the region of photomacrography, and performance may be poor unless the lens is reversed in its mount to keep the longer conjugate to the rear element or a special macro lens is used.

Technical or view cameras have extendable bellows that may allow as much as *triple extension* with the standard lens, i.e., 450 mm with a 150-mm lens, giving continuous focusing from infinity to twice life size on the film. Shorter focal lengths give even larger magnifications. Other cameras have lenses with more limited focusing mounts unless of macro design with a double helicoid arrangement, giving extension to provide 0.5 or 1.0 magnification. Otherwise, extension tubes or bellows may be fitted between lens and camera body to provide additional extension in discrete or continuous form.

FOCUSING AIDS Focusing on a ground glass screen is assisted considerably by the use of a focusing aid such as a hood or cloth to exclude ambient light and a focusing magnifier to inspect the image.

VIEWFINDER FOCUSING Various means of focusing a lens may be incorporated into the viewfinder of the camera as an additional function, with the feature of visual confirmation of focus.

FOCUS ERROR Visual indication of sharp focus is not always reliable. The image as recorded may not be critically in focus. There are various reasons. The system used may not be accurate enough for the lens or aperture in use, such as by using a split-image rangefinder. There may be incorrect register of a reflex mirror with respect to the focusing screen. The subject may move significantly during the lag before the shutter operates. The lens will normally be corrected for visible radiation and use for infrared or ultraviolet photography will give a *focus shift* because of chromatic aberration. Often a focusing scale carries a supplementary index in red for infrared work, and the visually focused distance is transferred to this index. To confirm sharp focus or to recalibrate, a focusing test is necessary where the results of careful focusing upon specific distances is evaluated in terms of the focus shift given.

FOCUS SHIFT With soft-focus lenses, because of the residual uncorrected spherical aberration in the lens that is responsible for the effect, there is a shift in the point of sharpest focus when the lens is used stopped down from its maximum aperture.

Books: Ray, S., *Applied Photographic Optics*. London & Boston: Focal Press, 1988. *S. Ray*

See also: *Autofocus; Lenses; Magnifier; Viewfinder.*

FOCUSING CLOTH/HOOD Focusing accessories that block out extraneous light from falling on the ground glass viewing system, used especially with view cameras. The focusing cloth is usually a black cloth large enough to fit over the camera back and extending over the head and shoulders of the camera operator. Some focusing cloths have an additional layer of white cloth on the outside to reflect heat when working in the field.

A focusing hood offers similar advantages, but is smaller and can be either rigid or folding. The folding hoods open

(Top) Focusing cloth being used on a view camera. (Bottom) Binocular reflex focusing hood.

quickly for viewing and fold compactly against the camera body. Most hoods can be fully removed to view the entire focusing screen more easily. Some focusing hoods, primarily those found on medium-format cameras, have a small magnifying glass that can be swung out for critical focusing.

P. Schranz

FOCUSING LIGHT A continuous light source that is used for preparatory operations before making an exposure with electronic flash, such as composing and focusing the image with a slide duplicator. With studio-type electronic flash units, such a light is commonly identified as a modeling light. *R. Jegerings*

FOCUSING MAGNIFIER A low-magnification accessory found on medium-format reflex cameras with waist-level finders. The magnifier swings out from the focusing hood and magnifies a small section of the ground glass. The lower magnification power of built-in hoods has a tendency to vignette the corners of the ground glass but a Fresnel lens in front of the focusing screen minimizes this effect. Hand-held focusing magnifiers, typically 8x, are commonly used to focus view cameras, but lower-power binocular focusing hoods are also available. *P. Schranz*

FOCUSING SCALE A calibrated set of lines on some camera lenses or bodies indicating object distances. When the camera is visually focused, the point of critical focus is indicated on the scale by a reference mark. Also, the reference mark can be aligned with a measured or estimated distance as an alternative method of focusing the camera, as in dim light and with rapidly moving objects. In addition, the focusing scale will show pairs of lines on either side of the reference mark that indicate the depth of field at different *f*-numbers. *P. Schranz*

FOCUSING SCREEN A piece of ground glass on the back of a view camera and on the inside top of reflex cameras that shows the projected image from the viewing lens. On reflex cameras, the distance from the lens to mirror to focusing screen is the same as from the lens to the film plane. Focusing screens can be interchanged on some cameras. They can be plain or have a 45-degree split rangefinder, a microprism, an imprinted scale or grid markings, or some combination. *P. Schranz*

FOCUS PRIORITY An override option on some auto-focus cameras of the autofocus mechanism that allows for manual or power-assisted focusing. It is used where a scene prevents the autofocus function from being able to target one specific point or where the photographer desires to manually focus on a specific section of the image. *P. Schranz*

See also: *Power focus.*

FOG Fog is unwanted density in nonreversal photographic materials, or a corresponding loss of density in reversal materials—density that is not attributable to the action of image-forming radiation. It may be caused by unintentional exposure to light or other radiation, exposure to chemicals or gases, aging, or excessive or unwanted reactions in processing. Some fog can occur in the preparation of the emulsion, but this is minimal today. Aging, especially beyond the expiration date or with poor storage conditions, contributes to an increase in fog, and this occurs to a greater extent with higher speed emulsions. In the latter case, cosmic radiation can make a contribution.

OPTICAL FOG Unwanted light can reach the sensitized surface of film in cameras through careless handling while loading or unloading, leaks in the camera through poorly fitted or improperly closed doors, pinholes in bellows,

leaks in film holder light traps, incompletely closed shutters, lens flare, etc. Light generated by a static electricity discharge over the film can cause characteristic fog markings. Exposure to x-rays can cause markings as a result of the shadows of adjacent convolutions of film or metal parts of cassettes or magazines. These effects are most often nonuniform over the surface of the film. Fog can also result from incorrect or excessive darkroom illumination, insufficient light trapping in construction, leaks in safelamps or use of incorrect filters, and, in the case of papers, light escaping from printer boxes, poorly seated enlarger heads, etc.

DEVELOPMENT FOG Fog not due to exposure to light can be caused by the effects of development or of chemicals on the sensitized material. Excessive development during processing, improper choice or mixing of developer, or contamination can contribute to this type of fog, which tends to be uniform throughout the film area.

Dichroic fog has one color when viewed by transmitted light and another when viewed by reflected light. It is due to the presence of colloidal silver resulting from a variety of causes involving physical development. These include developers with excessive sulfite, hypo contamination in the developer, exhausted stop bath, and presence of developer in a nearly exhausted fixer. These kinds of fog may often be removed by means of a weak chemical reducer such as Farmer's Reducer.

ATMOSPHERIC FOG While not falling in the categories mentioned previously, the presence of mist or fog in the atmosphere lowers the contrast of the photographic image, although in some pictorial work the effect is considered to be an enhancement. Since fog particles are relatively large, they tend to absorb all wavelengths of light equally, and the use of filters makes little improvement, as distinct from using filters with aerial haze.

FOG MEASUREMENT Processing fog of unexposed photographic material can be measured with a densitometer after subtracting the density of a piece of the same material that has been fixed only. The gray base for antihalation or light piping protection is not considered to be fog. Less energy is required to produce detectable fog in exposed image areas than in the unexposed borders, an effect that should be taken into consideration when conducting darkroom safelight fog tests. *I. Current*

FOG FILTER See *Filter types.*

FOLDED OPTICS See *Cassegrain; Lenses, catadioptric lens.*

FOLDING CAMERA See *Camera types.*

FOLEY (SOUND) A kind of sound effect that is made in a sound studio while watching a picture. The most well-known Foley effect is footsteps, but many other sounds are also recorded in this manner. The use of Foley effects started with the need for such sounds in pictures that were dubbed into foreign languages and lacked any of the other sound picked up on the set during production sound recording. The need grew as the field became more specialized and production sound mixers concentrated more on recording dialog; in these cases it has been found expeditious to add many low-level kinds of sounds with the Foley process in order to make the sound seem more real. *T. Holman*

See also: *Production sound.*

FOLLOW FOCUS Changing the focus setting of a lens during the filming of a motion picture shot, to keep a moving subject in sharp focus, or to redirect the audience's attention to another part of the image. *H. Lester*

FOOD PHOTOGRAPHY More and more there is a strong need for photographs of food. Much of this need is due to a wide interest in nutrition and health and the public's desire to explore the tastes of different cultures.

The food photographer's studio is designed with the kitchen as a main ingredient, and it can be as fully equipped as a professional chef's kitchen. Shooting food in the studio for an advertisement or a magazine editorial usually follows a certain pattern. Prop styling, the gathering of an assortment of dishes and table linens, of silverware and glassware, and materials needed for backgrounds, is done a day or two before the actual shoot day. Although a number of photographers are accomplished chefs, one usually works with a home economist or food stylist, as this leaves the photographer free to concentrate on the photographic part of an assignment. Food shopping is done the day before or even the morning of the shoot to ensure that all food needed will be fresh and appealing. At times foods that are out of season may be flown in from other parts of the world where they are available.

Usually working from a layout, the photographer and art director or designer select the props, background, and setting for the photograph. Meanwhile the food stylist prepares a stand-in dish, which the photographer uses to refine the lighting and to determine proper exposure. Generally, electronic flash is used so the food will not be affected by the heat from tungsten lights. Although more photographers are experimenting with using hot lights, electronic flash is still needed to freeze a pour at the high point of the action.

Appetite appeal is the primary reason to shoot food, and large format cameras, 8×10-inch and 4×5-inch, allow for texture and color to be rendered in great detail in reproductions. Most food being photographed today is shot on color transparency film. Because of the importance of color for an appetizing look, there is less and less black-and-white food shooting being done. One may see it on occasion in newspapers, but they too are turning to color.

Teamwork and timing between the photographer and the food stylist are very important. Food must be photographed at its peak in order to take advantage of its color and its "moment of serving" appearance. A timing sequence must be worked out so that the most perishable of the dishes is the last to reach the set and will be fresh while the more durable dishes still have their fresh look. Just before the exposures are made, the photographer or stylist performs the last minute touches that enhance the food's appearance, such as brushing certain items with a thin coating of vegetable oil to give them an attractive shine, spraying fresh vegetables and fruit with a mixture of glycerine and water to make them appear fresher and more appetizing; adding the little pools of gravy with a syringe; spooning on the sauce and dressings; or adding the important dessert toppings of powdered sugar or whipped cream or whatever is necessary to finish off the photograph and make it appear mouth-watering and desirable.

Photographing liquids presents other special problems. A can of soda must appear cold and perhaps frosty. A glass or mug of beer must have a full and appetizing collar of foam, and a bottle must pour smoothly without "burping" as it pours. To frost a can, a stylist may first spray it with a glycerine and water mix, and then sprinkle it with salt, which will appear as frost on the can. To achieve the same effect on a beer glass, it is first sprayed with a thin coat of clear lacquer so the glycerine mixture will adhere to its surface. Room temperature beer is used and the head is spooned on later and gently coaxed over the glass's rim. To make a bottle or can pour without gulping for air, a photographer or stylist drills a hole in or near the bottom. The can or bottle is then rigged on a stand, out of frame, and a small hose or funnel is used to allow the liquid to pour freely through. All of these tech-

niques and methods take a great deal of patient practice before expertise can be achieved. *A. Vogel*

See also: *Commercial photography; Professional photography.*

FOOTAGE Common term for any processed motion-picture film. A piece of motion-picture film is usually described in terms of physical length in feet, rather than, for instance, time, since such description also implies screen time and number of frames and is directly relevant to all film handling procedures as well as the procedures for making aesthetic decisions. *H. Lester*

FOOTAGE COUNTER A device for measuring the length of a piece of motion-picture film. *H. Lester*

FOOTCANDLE (fc) A unit of illuminance; the quotient of luminous power received over a surface divided by the area of that surface. One footcandle is equal to 1 lumen per square foot, the illuminance at a point 1 ft from a point source with a luminous intensity of 1 candela. The preferred unit is the International System (SI) lux (lumens per square meter) (1 fc = 10.764 lx). *J. Pelz*

Syn.: *Lumen per square foot.*
See also: *Illuminance; Photometry and light units.*

FOOTLAMBERT (fL) A unit of luminance; the quotient of luminous intensity of a surface per unit projected area. A surface whose luminance is 1 footlambert radiates or reflects 1 lumen per square foot into a hemisphere, and $1/\pi$ lumens per square foot per steradian $[(lm)/(ft2 \cdot sr)]$. The preferred unit is the International System (SI) candela per square meter (1 fL = 3.426 cd/m2). *J. Pelz*

Syn.: Effective footcandle (obsolete).
See also: *Luminance; Photometry and light units.*

FOOTSWITCH A device for closing and opening an electrical circuit that can be placed on the floor and operated by foot, commonly used in darkrooms to free the hands for other operations such as dodging during projection printing or handling film or paper during processing. *L. Stroebel*

FORCED PERSPECTIVE See *Strong perspective.*

FOREGROUND The part of a scene that is visible in front of the subject as viewed from the camera position or in a photograph. Foregrounds are often kept clear of large objects that would cover up the main subject, but appropriately placed objects in the foreground can increase the appearance of depth in the photograph and can serve as framing devices for the main subject. *L. Stroebel*

See also: *Background.*

FORENSIC PHOTOGRAPHY A broad category of photographs made to provide documentation and proof of physical facts and to act as supportive evidence in litigation proceedings and public hearings. In cases involving criminal activities, *law enforcement photography* describes the field; in noncriminal situations, it is *civil evidence photography.* Medical and scientific photography that documents or examines specimens for purposes of scientific proof falls into this broad category.

Law Enforcement Photography This subcategory includes crime and accident scene coverage, surveillance photographs, documentation and recording of confessions and depositions, identification photos ("mug shots"), evidence photography, documentation of medical evidence at autopsies, and questioned document examinations. Technicians trained in each of these specialties are either sworn peace officers or civilian technicians, depending upon the practices of the community. Some smaller townships call

upon local professional photographers when special photography is needed.

Making photographs for law enforcement purposes calls for knowledge of crime scene investigative methods, the rules of evidence gathering and handling, procedures for maintaining and preserving the chain of evidence, local requirements for courtroom admissibility of photography, preparation and presentation of courtroom visuals, and knowledge of departmental practices and procedures.

Photographic needs—on location at crime or accident scenes—are usually met with the use of small (35-mm) and medium-format cameras, portable flash equipment, and color negative or black-and-white films. While color transparencies (slides) might be made for unique purposes, enlarged prints are usually required as the end product. At such scenes, the objective is to document and record all physical evidence related to the event before it is disturbed and collected. All photographs made at a crime scene are considered physical evidence and must be maintained and handled in accordance with the rules of evidence.

More elaborate methods are used in the crime or evidence laboratory to further document and examine evidence for physical facts. Some larger-format (4×5-inch) equipment, mounted on elaborate vertical copystand hardware, is often used in such examinations. Sophisticated evidence photography techniques can include use of ultraviolet long- and short-wave fluorescence and reflection methods, infrared reflected and luminescent photographs, use of high-contrast materials and sharp-cutting filtration, special narrow-band light sources, documentations of DNA matched images, laser-energy sources, spectrophotography, photogrammetric studies, comparative photographs for ballistic markings and fingerprint matching, photomicrography and photomacrography techniques, and images produced with hard and soft x-rays. Electronic imaging systems, often in combination with chemical-imaging methods, are used by most metropolitan law enforcement agencies when conducting in-depth analysis of evidence. Fingerprints are routinely scanned and classified by computer-assisted systems and can be transmitted globally by dedicated telephone lines. Identification photographs (mug shots) can be circulated in the same manner. Considerable use is made of instant-imaging film and print materials (Polaroid) for identification photographs and for specialized laboratory procedures.

Civil Evidence Photography This subcategory requires skills and knowledge similar to that of photographers in the law enforcement field; however, civil evidence photographers are usually independent business persons, hired by attorneys or independent investigators to photographically document physical facts associated with civil litigation proceedings. In this role, their objective is to function on behalf of their client's interests. If their client is involved as the defendant in a criminal proceeding, their photographs must comply with the local rules of evidence and legal practices to be admissible in the courtroom. Videotaped depositions and presentations have become standard devices for use in civil litigation proceedings.

Photographic experts, from both the law enforcement and civil evidence fields, are often called upon to testify in the courtroom, relative to the accuracy of a photograph or to interpret the elements within a photograph. Such experts must be qualified as such by the court, based on local jurisdictional methods.

All qualified forensic photographers are knowledgeable in and concerned with perspective and the effects of lenses, accurate interpretations of spatial elements, magnification rates and image sizes, accurate color renderings, the effects of light quality and direction, proper viewing distances for photographic visuals, and the differences between human vision and the photographic image. All emphasis is placed on the making of accurate, undistorted images of physical evidence situations. Unusual enhancements, embellishments, or retouching methods can be construed as elements that tamper with the evidence, thus making it inadmissible in the courtroom.

In criminal cases involving extreme carnage, repetitive and excessive presentation of harsh realities, can make photographs unacceptable to the courts. Those responsible for presenting photographic evidence must exercise considerable discretion when selecting images for the courtroom. In some cases, black-and-white photographs have been found more acceptable than color—in spite of their abstract, interpretive nature. *J. McDonald*

See also: *Documentary photography.*

FORESHORTENING A perspective effect whereby an object dimension or the distance between objects appears unrealistically small. Usually the result of viewing that part of the scene obliquely, using a long focal-length lens on a camera at a relatively large distance from the subject, or viewing the image at a shorter than normal distance. *L. Stroebel*

See also: *Perspective.*

FORM (1) The surface configuration of an object or its representation in an image. Although form and shape are sometimes used interchangeably, form refers to the three-dimensional nature of the subject and shape refers to the outline. (2) In photomechanical reproduction, the assembly of pages and other images for printing on a lithographic plate. In letterpress, it refers to type, line cuts, etc. locked in a chase for printing. *L. Stroebel and M. Bruno*

FORMALDEHYDE An irritating and flammable gas (HCHO, molecular weight 30.03) that is usually supplied as a clear, colorless solution in water that gives off poisonous vapors. *G. Haist*

See also: *Formalin.*

FORMALIN A water solution containing about 37% formaldehyde gas by weight, usually with 10 to 15% methanol as an inhibitor of polymerization. Escaping gases from the liquid irritate and attack the eyes and respiratory system.

Formaldehyde hardens gelatin, either in coated emulsion layers or in a processing bath. Used to lower free sulfite in hydroquinone developers to produce high image contrast (lith effect). *G. Haist*

FORMAT The actual or relative dimensions of negatives, prints, transparencies, films, papers, mount boards, etc., and also identifying associated photographic equipment—for example, 4 × 5-inch film, 35-mm enlarger, square-format camera. *P. Schranz*

FORMULAS, CHEMICAL A notation, called a chemical formula, lists the symbols of the elements and their number in a chemical compound. The three elements in silver nitrate are shown as $AgNO^3$. The formula for an organic compound may show groups separately. *N,N*-Diethyl-*p*-phenylenediamine monohydrochloride, a developing agent, may be shown as $(C_2H_5)_2NC_6H_4NH_2 \cdot HCl$. *G. Haist*

See also: *Structural Formula.*

FORMULAS, PROCESSING A photographic recipe that lists the order and quantities of chemical ingredients to be added as well as other information needed to prepare a processing solution. Published formulas are often designated by a letter/number, such as D-76, a developer, or F-5, a fixing bath. *G. Haist*

FOUR-COLOR PROCESS PRINTING Color reproduction using cyan, magenta, yellow, and black printers.
M. Bruno

See also: *Photomechanical and electronic reproduction.*

FOURIER TRANSFORM A mathematical operation whereby a function (such as a two-dimensional image) is broken up into sine and cosine wave components. The image is then completely represented by coefficients indicating the magnitude and phase of each of these components. Such a representation is called a *frequency domain* representation. A wide variety of mathematical techniques are based on the Fourier transform—it is the foundation for most modern image evaluation techniques and a significant percentage of the more powerful digital image processing techniques. A common example of a Fourier transform is the modulation transfer function, which is the Fourier transform of the point spread function for an image.
J. Holm

See also: *Modulation transfer function.*

FOVEA *(FOVEA CENTRALIS)* The part of the retina used when we look directly at an object point, which means that the fovea is located on the visual axis. The fovea contains a large proportion of the approximately seven million retinal cones, but no rods, and is the area of the retina having the highest acuity.
L. Stroebel and R. Zakia

See also: *Vision, the human eye.*

FOXING The formation of brown, feathery spots on paper. These spots are characterized by the presence of minute iron particles and bacterial growth. The formation of foxing is aided by high humidity. It has never been reported to occur on photographic prints that were machine-made since the 1860s for use as photographic paper base.
K. B. Hendriks

FPS An acronym for foot-pound-second, implying the U.S. customary system of measurements.
H. Todd

FRACTIONAL EQUIVALENTS See *Appendix F.*

FRAME (1) A single photograph in a motion picture, filmstrip, microfilm, computer animation field, or similar sequence of photographs. (2) The area within the film aperture in a camera or projector. (3) An enclosed border made of wood, metal, plastic, or other material used to enhance and protect a photograph. (4) The limiting border in a viewfinder. (5) In television, two interlaced fields. (6) To set up a camera to include only the desired subject area of the photograph. (7) To adjust the motion-picture projector so that the frame line does not show on the screen. (8) A box, drawn with a computer, around a text or picture block. (9) An area of a computer image page activated or set aside to create or import a graphic image. (10) A set of 525 individual scan lines on a television screen. The screen generates (draws) 30 separate frames each second. (11) A collapsible or permanently constructed rectangle, usually of plastic or aluminum, to support a stretched-out projection screen, reflector, diffuser, etc. for photographic presentation or lighting control.
M. Teres

FRAME CAPTURE In video, the act of freezing one frame's worth of data (1/30 of a second) and flash converting that analog data into digital form.
R. Kraus

Syn.: *Frame grab.*

FRAME COUNTER Indicator on a motion-picture camera that shows the number of film frames that have been exposed. The term is also used synonymously in still photography with the terms *film counter* or *exposure counter.*
P. Schranz

FRAME (FILM) (1) Each photograph in a motion picture, filmstrip, microfilm strip, or similar sequence of photographs. (2) The area within the film aperture of a camera or projector or the corresponding area of a viewfinder.
L. Stroebel

FRAME GRAB See *Frame capture.*

FRAME LINE (1) The nonimage area that separates individual photographs in a motion picture or other series of pictures on a strip of film. (2) A boundary marker in some viewfinders to indicate the subject area that will be recorded on the film.
L. Stroebel

FRAME RATE In video, the speed at which a frame is displayed (1/30 of a second, NTSC); also known as *real time.*
R. Kraus

FRAMES PER SECOND (FPS) The number of individual images, filmed or projected, per second. The normal frame rate for motion pictures is 24 frames per second.
H. Lester

FRAME STORE A device for the storage of still video frames for subsequent insertion into future video.
R. Kraus

FRAME STRETCH An optical printer technique for increasing the frame rate of motion-picture films by printing selected frames more than once.
H. Lester

FRAMING (1) The act of composing a motion-picture image. (2) Adjusting the film, or aperture plate, in a projector to properly center the screen image. (3) The process of placing a picture frame around a photograph in order to display and/or protect the photograph.

KINDS OF FRAMES Aluminum Aluminum section frames are archival in that they contain no impurities that will leach out and contaminate mount-boards or photographs. They are available in a variety of anodized or oven-baked color finishes in addition to the classic brushed finish. These frames come in a variety of styles to accommodate the standard photographic paper sizes and are easily custom cut to the user's specifications. They are simple to assemble and hang with the standard hardware kits available for aluminum section frames. Spring tension clips are provided in the hardware kit, or are available separately, to provide firm contact between the glass or Plexiglas that is slid into place with the matted print.

Acrylic Boxes Acrylic boxes are a convenient method of displaying photographs. Some boxes are about 1 inch deep and include a paper box insert or foam pad to firmly hold the photograph and mat firmly against the acrylic surface. Small acrylic cubes are also available. These boxes are designed to accept several small photographs that are held against the five plastic surfaces by a small foam cube. Acrylic boxes are not archival.

Plexiglas Frames Plexiglas, unlike the acrylic display boxes or frames, is an archival material. Plexiglas is available in sheets, like glass, and is cut to size for use. Plexiglas is available in a variety of types and thicknesses and can be assembled into boxes or used as a substitute for glass in framing photographs. UF-3 Plexiglas is a lightweight variety of Plexiglas that screens out about 92% of ultraviolet radiation. Because ultraviolet radiation is most harmful to resin-coated black-and-white photographic papers and to color photographic images, the use of UF-3 Plexiglas will retard the damaging effects of both natural and artificial light sources.

Ready-made Frames Ready-made frames may be made of any material. These frames are preassembled, usually in

standard mat or photographic print sizes and simply accept these standard-size prints and/or mats. The print/mat may be slid into a groove and held in place by a clip or tape, or simply by friction. Some frames have backs that pop out and snap in to hold the print in place.

Wood Frames Wood frames are available in a great variety of woods and styles. The cost, which is directly proportional to the style and type of wood, ranges from inexpensive, narrowly cut strips of soft pine, to more expensive, elegant, and intricately carved hardwoods. In addition to the natural wood finishes, velvet, linen, and suede liners and metal insets adorn some frames. High-gloss laminated colors, silver and antique gold finishes, and gold leaf are but a few of the other styles available in standard mount sizes. Some of the frames contain multiple openings for clustering several photographs within a single frame and are available in a variety of molding shapes and widths with either rectangular, oval, beveled, or rounded corners. Most frames come ready to hang or are available in kits that require some assembling. Some frame kits use wooden splines for constructing the frame without nails. There are, of course, photographers who enjoy building their own frames from scratch.

The photograph should be mounted and matted before it is inserted into a frame so the print does not touch the glazing surface. For flush-mounted prints, which have no mats, an Innerspace plastic strip provides the necessary air space between the photograph and the glass surface. Most frames use spring clips to hold the mat firmly against the glass. There are also *frameless* frames, a bracket that holds the glass or Plexiglas, mat, photograph, and backing material together while providing some kind of clip to which a hanging wire can be attached.

Custom Frames Custom frames may be simply a plain or fancy frame cut to the size of a print or mat. Some custom frames may offer very elaborate and/or exotic ways to display photographs. There are times when the frame may be so "attractive" that it interferes with the artwork that is framed. Mirrored, chromed, hand-painted, and ceramic frames are available from specialty frame suppliers or may be designed and constructed at home. Custom-framed photographs may be overmatted, sub-mounted, grouped with several other photographs, and/or placed onto laminated wooden plaques. The range of available frames is limited only by taste and budget. *H. Lester and M. Teres*

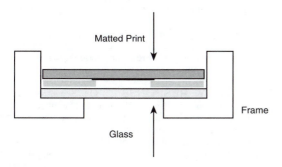

Framing.

FRAMING CAMERAS See *Camera types.*

FRANK, ROBERT (1924–) American photographer and filmmaker. Born in Switzerland where he apprenticed as a photographer. Emigrated to the United States (1947), where, guided by Brodovitch, he became a successful freelance photographer for magazines such as *Harper's Bazaar.*

Awarded a Guggenheim Fellowship in 1955, Frank took off on a two-year road trip to see America, photographing with his 35-mm camera. The resulting photographs were published in *The Americans* (1959). On the basis of this one book, Frank became the most influential photographer of the mid-twentieth century. Szarkowski wrote, "*The Americans* subverted the comfortable assumption of a fundamentally progressive and happy America, and replaced it with the image of one that seemed not vicious but empty." From 1966 concentrated on making his highly personal movies and videos. Returned to still photography during the late 1980s.

Books: *The Americans,* rev. ed. Millerton: Aperture, 1978; *The Lines of My Hand.* Los Angeles: Lustrum, 1972. *M. Alinder*

FREE-FIELD MICROPHONE A measurement microphone calibrated for use with sound fields where one principal direction of the field is predominant, such as in an anechoic chamber. Usually such microphones are used with the diaphragm perpendicular to the incident sound field.
T. Holman

FREELANCE PHOTOGRAPHY Freelance photography is the work done by a photographer who runs his or her own business rather than working for someone else. Generally speaking, freelance photographers own their equipment and take photographs for more than one client. If a so-called freelance photographer ends up working exclusively for one client and even uses the client's equipment and darkroom, that photographer may be deemed an employee of the client—not a freelance photographer.

Making a living as a freelance photographer is not easy. In fact, many of those willing to be called freelance photographers actually pay their bills by holding other jobs in photo-oriented concerns (i.e., studios, camera stores, newspapers) or even in such seemingly unrelated fields as computers and security.

The newcomer to freelance photography might start out assisting a more well-established photographer with some mundane aspects of client photography. At the same time, the person might build a portfolio by completing speculative assignments and, perhaps, shooting some pictures on the side for local publications and small businesses.

Freelance photographers also emerge from the ranks of photographers employed by larger corporations, daily newspapers, and educational institutions. For photographers who retire early or simply want more freedom in their work, freelance photography holds genuine appeal. Often doing work from the outside can provide needed income supplement as well as creative reward.

Not that freelance photographers cannot enjoy major, full-time, career-long success. The best have taken a wide variety of photographs while becoming known for a specialty. The specialty gives a client a specific reason to call; the flexibility enables the photographer to say yes to a client challenge and, at the same time, to enhance the all-important portfolio.

Just about any publication that prints photographs—from big consumer magazines to local weekly newspapers—is a possible outlet for freelance photography. So are businesses of virtually any size, along with their advertising and public relations agencies.

One classic freelance market—the stock picture agency, or stock house—may undergo some change with the advent of easy electronic manipulation of images. For years, these picture agencies have accepted freelance photographers' images on consignment and then retained part of the fees they charge clients to use the pictures.

U.S. syndication agencies place feature stories, personality profiles, and news stories within the United States first. Then they resell the material in other countries. Freelance photographers whose work translates well to the world

market eventually may be asked to cover a major story anywhere in the world.

For all freelance photography markets, photographers need to show a portfolio of their best work. Such a portfolio might include a tray of color slides and either a box of tearsheets and laminations or a book-type binder with acetate sleeve protectors for photographs and tearsheets. Contents should include strong samples plus a photographic essay and some personal photography. Advertising portfolios more often take the form of a dozen or so laminated tearsheets in a box-type portfolio—although some well-known advertising specialists show color slides.

A freelance photographer, no matter how talented, must address the legal and business implications of self-employment in photography, including model releases and other required permissions—to shoot in a historic house, for example, or to borrow certain necessary props. They also include establishing ownership of photographs and usage rights before accepting assignments from new clients. Certain organizations that count freelance photographers among their members offer insurance for everything from a photographer's health to photographic equipment, props, and film. Such organizations also publish price guidelines for various types of freelance photography, although actual fees vary widely.
K. Francis

FREEZE (1) To obtain a sharp image of a rapidly moving object, typically by the use of a high shutter speed or electronic flash of short duration. (2) To stop the motion during the viewing of a motion picture or video by using a single frame for prolonged viewing.
L. Stroebel

FREEZE FRAME (1) See *Frame capture.* (2) A motion-picture optical effect in which a single image is repeated in order to appear frozen in place, that is, stationary, when projected.
H. Lester

Syn.: *Hold frame; Stop frame.*

FRENKEL DEFECT A crystal lattice defect in which one of the ions moves into one of the voids or interstices of the crystal from which it can migrate to other regions of the crystal. The resulting species is known as an interstitial ion and the vacant lattice position left behind is called a vacancy. In silver halides it is the silver ions that migrate as interstitial ions, the halide ions being too large to partake in such a process.
R. Hailstone

FREQUENCY (V) The number of complete events of a regular cyclic sequence, usually counted out over 1 second. The term is especially applied to the wave propagations of various forms of energy such as electromagnetic radiation and acoustic energy, as well as regular mechanical movement. The frequency of an oscillation is inversely proportional to the wavelength and directly proportional to the velocity of a wave, as given by the equation $v = v/\lambda$. The velocity v and the wavelength λ must both be measured using appropriate units, i.e., meters per second and meters.

As described, frequency is another means (along with wavelength and energy) for specifying the exact nature of a photon of electromagnetic radiation. The frequency of a photon is equal to the speed of light in a vacuum divided by its wavelength. For example, a photon with a wavelength of 600 nm has a frequency of 5×10^{14} hertz. Since frequency is related to energy, by the law of conservation of energy the frequency of a photon cannot change. Changes in the speed of a photon as it passes through materials with different indexes of refraction result in changes in its wavelength. Most commonly, longer wavelength electromagnetic radiation (such as radio frequency radiation) is expressed in

terms of frequency and shorter wavelength radiation is expressed in terms of wavelength (when propagating through a vacuum).

Electrical energy is also generally distributed as alternating current (sinusoidal voltage) and therefore has a frequency. This frequency varies around the world, usually being either 50 or 60 hertz. Purely resistive loads, such as light bulbs or heaters, function equally well at either frequency (providing the voltage, which also differs, is correct), but other devices may function incorrectly, or even be harmed, by operating them at the wrong frequency.
J. Holm

FREQUENCY DISTRIBUTION A display, usually in the form of a graph, of the results obtained from the repeated examination of a process, showing the number of occurrences of different outcomes. Such a graph permits the identification of the process as caused by chance, if a near-Gaussian (bell-shaped) pattern appears. Otherwise, one can detect the influence of nonchance effects if, for example, the pattern is skewed.
H. Todd

See also: *Gaussian distribution; Random variability; Skewed distribution.*

Frequency distribution.

FREQUENCY MODULATION (FM) A means of transmitting a signal by combining the signal with a constant frequency *carrier wave* so that the frequency of the carrier wave is changed by the signal. The receiver then decodes the fluctuations in the frequency of the carrier wave to reconstruct the original signal. Frequency modulation is a common means for radio and television transmission.
J. Holm

FREQUENCY RESPONSE (1) See *Modulation transfer function.* (2) The amplitude output with respect to frequency characteristic of a system under test. One method of measurement is to drive the system with a sine wave that sweeps from one end of the desired frequency range to the other while measuring the amplitude of the output. The resulting curve of amplitude versus frequency, usually plotted in decibels of amplitude versus logarithmic frequency, is a frequency response curve.
T. Holman

FRESNEL LENS See *Lens types.*

FRESSON PRINTING PROCESS Early carbon printing process in which no transfer to a final support is necessary. It is similar to the Artique process but uses a different type of paper. Invented by Theodore-Henri Fresson in France

around 1900. It is still used by the Fresson family in France and by Luis Nadeau in Canada, who acquired the process in 1979. Belonging to the dichromated colloid group, a mixture of a colloid, pigment, and a dichromate compound creates a light-sensitive emulsion. After exposure to a negative image, the unexposed parts of the emulsion are relatively soluble and can be removed with a slight abrasive, usually by pouring a mixture of sawdust and water over the print until the desired density is achieved. The Fresson process has attracted considerable attention in both commercial and artistic photography, despite the jealously guarded secrecy that surrounds the process, due to the work produced by contemporary photographers Sheila Metzner and Bernard Faucon.

Books: Nadeau, Luis, *History and Practice of Carbon Processes*. Fredericton, New Brunswick: *Atelier* Luis Nadeau, 1982. *J. Natal*

FREUND, GISELE (1912–) French photographer. Born in Berlin. Earned a Ph.D. from the Sorbonne; her dissertation was on nineteenth-century French photography. Became a freelance photojournalist, first photo essay published in *Life* (1936). Freund's portraits are important documents of a generation of writers and artists, including, Andrè Malraux, Andrè Gide, Virginia Woolf, and Marcel Duchamp.

Books: *Gisele Freund, Photographer.* New York: Abrams, 1985. *M. Alinder*

FRIEDLANDER, LEE (1934–) American photographer. His photographs record the American urbanized landscape, confronting the mundane chaos of the everyday scene. Also known for his self-portraits. First photographer to receive a MacArthur Fellowship (1990).

Books: Slemmons, Rod, *Like a One-Eyed Cat, Lee Friedlander, Photographs 1956–87.* New York: Abrams. *M. Alinder*

FRILLING Frilling is a crinkle-like defect caused when an emulsion layer expands and separates from the support at the edges. It is generally caused by high temperatures in processing, sudden changes in temperature during processing, excessive processing times, rinses or washes in excessively soft water, or extremes in pH such as going from a highly alkaline developer to a strongly acid stop bath or fixer. The problem occurs less when rinses and washes are carried out with hard water. Modern thin emulsion products seldom exhibit this problem. *I. Current*

FRINGE A defect in color photography resulting from imperfect registration of the component images. It may be caused by optical parallax such as when the three records are made through different lenses, the result of printing one of the images in an incorrect location with respect to the others, differential shrinkage of the three records before printing, or by image shifts when the three exposures are made in succession. *I. Current*

FRINGE EFFECT See *Photographic effects.*

FRITH, FRANCIS (1822–1898) English photographer. One of the first of the hearty brigade of British expeditionary photographers. Established his reputation by publishing a large number of photographically illustrated books with views taken on his three extensive tours of Egypt and the Holy Lands (1856–1860). Returned home to photograph England and western Europe. His printing firm, Frith & Co., flourished and became the largest photographic publisher of English and foreign views in the world, their catalogs listing several hundred thousand pictures.

Books: Talbot, Joanna, *Francis Frith.* London: MacDonald, 1985. *M. Alinder*

FRONT END In motion-picture productions, those operations concerned with initial photography, sound recording, and preparation for screening of rushes. *H. Lester*

FRONT FOCAL DISTANCE/LENGTH See *Principal focal points/planes.*

FRONT LIGHTING Illumination coming from near the camera, referring to the main light when more than one light is used. *F. Hunter and P. Fuqua*

See also: *Flat lighting.*

FRONT PORCH That part of the image in composite video broadcasting between the front edge of the horizontal blanking and front of the horizontal sync signal. *R. Kraus*

FRONT PROJECTION (1) Front projection is the most common type of image projecting system in use. In its simplest form, it consists of projecting a photographic or video image with a suitable projector onto a wall or projection screen. There are a great variety of projection screens available for front projection. The type and quality of projection screen surface is selected for the specific characteristics necessary for the audience and the screening area. Front-projected images are brighter, have more contrast, and are sharper than images produced with rear-screen projection systems because the projected image is not diffused by traveling through the screen material. The major disadvantage with front projection occurs when the projector has to be placed within the audience so that the noise, projectionist distractions, and blocked viewing interfere with the presentation. On the other hand, if the projector is placed at the back of the auditorium the image brightness may suffer and a longer focal-length lens will be required to obtain the same image size on the screen.

(2) Another form of front projection takes place in the photographer's studio. In this instance an image is projected onto the subject and high-gain screen behind the subject. The purpose of this type of front projection is to enhance the subject by creating a background scene that provides the illusion

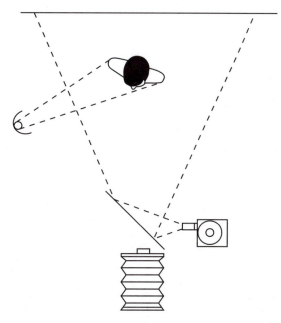

Front projection.

that the subject is photographed somewhere other than in a studio. To avoid having a visible shadow of the subject on the background, the projected image must come from the direction of the camera lens. this is done with commercial systems using beam splitters that allow a projected image to line up exactly with the camera lens. A front-projection beam splitter is a semisilvered mirror set at a 45° angle to the camera and projector lenses so that the image from the slide projector is reflected onto the subject and background directly in line with the axis of the camera lens. Because the directional high-gain screen reflects so much more light than the subject, the projected image will not be visible on the subject. Some care is required in controlling the studio lighting on the primary subject to avoid excessive stray light from falling on the background, which would reduce the contrast of the projected background image. *M. Teres*

See also: *Projection; Rear projection.*

FRONT-SURFACE MIRROR

Mirror in which light is reflected directly from a thin coating on a glass (or metal) support. This avoids refraction problems caused if the light has to pass through a glass substrate before reflection, as in a conventional back-surface mirror. *S. Ray*

FROST DEFORMATION IMAGE

A process employing a photoconducting thermoplastic film on which an electrostatic image is produced and which upon heating is deformed by the electrostatic change in the corresponding image areas to form a light scattering image. *J. Natal*

See also: *Thermoplastic recording.*

f-SIXTEEN RULE

A rule of thumb for determining the shutter-speed setting to use with a relative-aperture setting of *f*/16 to obtain a normally exposed negative or transparency with frontlit subjects on clear days when the sun is well above the horizon. The procedure is to set the aperture at *f*/16 and the shutter at a setting of 1/(the ISO film speed). For example, with a film rated at ISO 64, the correct settings are *f*/16 and 1/60 second.

The *f*/16 rule can be extended for use with other weather conditions by substituting the following *f*-numbers for *f*/16:

f/11 heavy haze or thin cloud layer
f/8 cloudy bright
f/5.6 heavy overcast, or subject in open shade on a clear day

Alternatively, one can simply open up 1, 2, and 3 stops, respectively, for these conditions after applying the *f*/16 rule. *J. Johnson*

F/64 GROUP See *Group f/64.*

f-STOPS See *Appendix G.*

F SYNCHRONIZATION

F represents *fast,* referring in flash photography to a system whereby the shutter is in the fully open position at the proper time to fully utilize light from flashlamps requiring 5 milliseconds to reach peak light output. *J. Johnson*

See also: *Flash synchronization.*

FUGITIVE DYE

Trivial term for unstable dye. It is generally not used in serious deliberations on dye stability. *K. B. Hendriks*

FUJI

Fuji Photo Film Co., Ltd., headquartered in Tokyo, Japan, is a leading manufacturer and marketer of imaging and information products. The company is the world's second largest and Japan's largest producer of photosensitized materials. In 1990, Fuji ranked number 183 by sales in the Fortune Global 500 directory.

In 1974, Fuji opened its first overseas manufacturing operation in Brazil. Initially built to produce photographic color paper, the plant now manufactures photographic color film and processing chemicals as well. In 1984, Fuji opened a fully integrated production facility for photosensitized materials in the Netherlands. Since then, a facility has been opened in Kleve, Germany, to manufacture videotape and floppy disks. In 1989, the company opened a facility in Greenwood, South Carolina, to manufacture presensitized plates and related products used to manufacture videotapes. The company also operates Fuji Hunt Photographic Chemicals factories in the United States, Canada, Belgium, and Singapore.

HISTORY Fuji Photo Film Co., Ltd., began operations in 1934, with the production of a professional 35-mm motion-picture film. In November, 1936, Fuji brought its first amateur still film to market. The opening of the Ashigara Research Laboratory in 1939 paved the way for the introduction of Fuji's first color film in 1948. In 1954, Fuji established a magnetic tape research laboratory and in 1960 produced its first magnetic tape products. In 1963, the company introduced the first 2-inch broadcast videotape to the domestic television industry. In 1977, Fuji developed Japan's first 8-inch floppy disk.

The company entered the North American market in 1955 and culminated a decade of growth with the establishment of its Fuji Photo Film U.S.A., Inc., subsidiary in 1965.

Fuji has twice introduced the world's fastest color print still film: in 1976, a 400 ISO speed film; in 1984, a 1600 ISO speed film. The company also twice introduced the world's fastest color motion picture film: in 1978, an EI 250 speed film; in 1984, an EI 500 speed film. In 1987, Fuji introduced the world's first 35-mm one-time use camera, Fujicolor QuickSnap, and in 1988 introduced the QuickSnap Flash, the first 35-mm one-time use camera with a built-in flash. Fujicolor Reala, advertised as the first film to reproduce colors as they are seen by the human eye, was introduced in 1989.

Fuji's technological advances in imaging products have led to numerous citations and awards, including the 1982 Academy Award (the Oscar) and two Emmys for Technical Merit, one in 1982 for Fujicolor A-250 high-speed color negative motion picture film and one in 1990 for developments in metal particle tape technology. In 1991, Fuji received the Scientific and Engineering Award for its F-series of color negative motion picture films from the national Academy of Motion Picture Arts and Sciences.

Fuji products available in the United States include amateur and professional color photographic film, photographic paper, cameras, black-and-white film, color copiers, and minilab photofinishing equipment; 8-mm camcorders; electronic imaging products; professional broadcast and consumer videotape; audiocassette tapes; floppy disks and computer cartridge tape; professional motion picture film; microfilm, microfilm camera/processors, reader/printers and chemicals; graphic arts film and chemistry, presensitized offset plates and chemistry, phototypesetting paper, film and plate processors, a color proofing system, and a monotone scanner system; reprographic films for engineering, architectural, electronics, photogrammetry, and seismic recording reproduction applications; medical and industrial x-ray films, processors, and multiformat cameras and film-loaders.

(Courtesy of T. Shay, Corporate Communications, Fuji Photo Film U.S.A., Inc.)

FULL APERTURE

The maximum diaphragm opening or aperture (smallest *f*-number) of a lens. Its use gives reduced depth of field, a bright image for viewing or focusing, and most likely the poorest performance because of residual aberrations. *S. Ray*

FULL BLEED A spreading beyond an original or a desired position of all four sides of the image, or to mount an image without a border on all four sides. The easiest approach to a full bleed is through trimming the borders after a print has been mounted. *R. Welsh*

See also: *Bleed.*

FULL COAT (SOUND) 35-mm perforated film coated with magnetic oxide across at least the full area between the perforations. It may be recorded in track formats accommodating three, four, or six tracks. (Nothing prevents recording just one track, but these recordings are generally made on stripe coat film.) *T. Holman*

See also: *Stripe coat.*

FULL-FRAME APERTURE The aperture of a motion-picture camera, normally having an aspect ratio of 1.33:1, in contrast to altered apertures in projectors or printers creating a different aspect ratio for the projected image by masking off the top and bottom of the frame. *H. Lester*

FULL STOP A change in a lenses aperture setting that corresponds to multiplying or dividing the lens transmittance by 2, or the *f*-number by the square root of 2. The conventional series of *f*-numbers, in which adjacent numbers represent full stops, is: $f/0.7$, 1.0, 1.4, 2, 2.8, 4, 5.6, 8, 11, 16, 22, 32, 45, 64, 90, 128. *J. Johnson*

See also: *f-Number.*

FUNGUS There are a wide variety of fungi whose spores exist everywhere. These may attach themselves to the gelatin surfaces of photographic materials, grow, and cause damage when the relative humidity is above 60%. Temperature has little effect. If the damage occurs on the film before processing, it causes density changes in black-and-white materials and color changes in color materials. It is not possible to correct for this damage. The damage to materials that have been processed is not immediate, so that if it is detected early, corrective action can be taken before the damage is excessive. Since the effect of the fungus growth is to solubilize the gelatin, it should not be removed with water, but instead with a film cleaner. Films can be lacquered to retard the fungus from attacking the gelatin. When damage is detected, the lacquer can be removed and the film recoated with lacquer.

Fungus growth does not occur at a relative humidity below 50%. This can be maintained by burning an electric bulb in the film cabinet to keep the temperature about 10°F above the outside temperature. Dessicants can be used for smaller containers, but care should be taken to use adequate quantities and maintain them properly. Unexposed film should be kept in sealed, unopened packages.

Similar precautions should be taken with paper prints, and they present a greater problem due to the larger sizes and volume of material being stored. Fungi also attract insects.

I. Current

See also: *Image permanence.*

FUSE A protective device consisting of a wire or thin strip of a metal that has a low melting point. When current passing through the wire exceeds a prescribed level, the wire melts and opens the circuit. Fuses are used primarily to reduce the danger of fire or damage to wiring or to equipment. They are rated in voltage as well as current. Fuses are also available in different physical sizes and shapes and with different speeds of response: quick-blow, slow-blow, etc. It is important to always replace a fuse with the same rating and type as was originally used in the device. Never replace with a coin or a piece of wire. *W. Klein*

See also: *Circuit breaker.*

FUSION The perceptual blending of images or other visual stimuli that are separated in time or space, such as motion picture images presented at a rate above the critical flicker frequency. *L. Stroebel and R. Zakia*

See also: *Binocular fusion; Critical flicker/fusion frequency; Flicker; Temporal fusion.*

FUTZ (SOUND) To deliberately distort for a desired effect. *T. Holman*

FX See *Effects.*

G Gradient; Selwyn granularity; Gauss

Ḡ G bar, average gradient

g Gram (also gm)

gal Gallon

GATF Graphic Arts Technical Foundation

gel Gelatin

GFCI Ground fault circuit interrupter

GG Ground glass

GHz Gigahertz (one billion cycles per second)

gm Gram

GN Guide number

G-N G-Number, or photometric aperture

GOST Gosudarstvenny Obshchesoyuzny Standart (USSR, now CIS, standards organization)

gr Grain

GRIN Graded refractive index

GUI Graphical users interface

G/V General view

GAFFER The person in charge of a motion-picture lighting crew, responsible for setting lights in accordance with the plan of the director of photography. *H. Lester*

GAFFER TAPE An all-purpose strong pressure-sensitive tape (such as duct tape) used by stage hands to repair or secure parts of stage settings, fixed properties, flats, etc. Now widely used to secure photographic setups, displays, cables, light fixtures, film containers, camera stands, tripods, etc., especially when other stands or fixtures might be in the way. *I. Current*

GAIN For a process or system, the ratio of the output to the input. For sound reproduction, the ratio of output power from an amplifier system to the input power. For a projection screen, the luminance in a given direction divided by the luminance from a perfect diffuser in the same direction. The gain is thought to be in the billions for the development of photographic images since the initial latent image is submicroscopic. *H. Todd*

GAIN SCREEN A surface for projection that produces, in a given direction, a luminance greater than that from a perfect diffuser. The gain of a screen is found by comparing the luminance reading of a standard (often magnesium oxide) to a reading of a screen from the same position. One type of gain screen is the highly reflective glass-beaded screen, which reflects, back toward the source, a high portion of the light striking its surface. Newer hi-tech high-gain screens made of a highly reflective Scotchlite material (high-gain

sheeting) are capable of reflecting back anywhere from 600 to 1600 times more light than conventional matt-surface white screens. *M. Teres*

GALLATE OF IRON PROCESS Iron salt sensitive process that produces a black ink-line image. Not to be confused with Poitevin's pigment process of the same name. *J. Natal*

GALLERY An exhibition space for artwork. Some exhibition spaces may be operated by nonprofit organizations, such as colleges, local government agencies, or churches. These organizations often use the galleries to enhance community activities, and/or educational programs, and may or may not offer the displayed works for sale. Commercial galleries, on the other hand, are supported by the commissions earned on the sale of the exhibited artwork, and they promote sales. Most commercial galleries tend to be selective or focused in the type of photography they show. Some galleries specialize in vintage photography, others in contemporary work, and still other galleries may focus more narrowly, showing only documentary work. Photographers may need to search for a particular gallery that shares their artistic style and subject matter. Commercial galleries may also pass some of the operating costs on to the exhibiting artists, such as the cost of the opening reception and mailing of announcements, but the galleries are generally responsible for hanging the exhibition, maintaining the facility, and for the promotion and publicity for the exhibitions.

Some commercial galleries are also co-op galleries that require the co-op members to participate in the daily running of the gallery by helping to keep the gallery open during the exhibition days and/or contributing monetarily to the gallery maintenance. The exhibitor usually pays for all the related exhibition expenses. Some galleries are rental spaces and the exhibitor contracts out the space and the services necessary for an exhibition. Photographic resource centers, photo groups and camera clubs, rental darkroom facilities, and photographic workshops all usually maintain gallery spaces. Some of these facilities are funded by private donations, and some by corporate gifts, while others are funded from public arts endowment grants, membership dues, and/or admission fees. *M. Teres*

GALLERY CAMERA See *Camera types.*

GALLON A unit of measurement of liquid volume in the American system, equivalent to 4 quarts, or 128 fluid ounces, and to 3.7853 liters in the metric system. *H. Todd*

GALVANOMETER RECORDING (SOUND) Refers to one of the methods of producing a variable area optical image to represent sound. The galvanometer is a voltage-

sensitive coil of wire placed in a magnetic field and connected to a mirror. Current through the coil moves the coil and thus the mirror which, with a light source and appropriate lenses and masks, produces the varying area needed to expose the sound negative. *T. Holman*

GAMMA The slope (steepness) of the straight line of a characteristic (D-log H) curve. Formerly used as a measure of basic film and development contrast, gamma has for most purposes been replaced by *contrast index*.
M. Leary and H. Todd

See also: *Contrast index.*

GAMMA INFINITY The maximum straight-line slope of a D-log H curve obtainable with a specified film and processing chemistry. Gamma increases with development time, but after the maximum is reached it may fall because of increased development fog. *M. Leary and H. Todd*

GAMMA-LAMBDA EFFECT For specific film and processing conditions, the change in gamma (a measure of the steepness of the straight line of the characteristic curve) with the wavelength of the exposing radiation. Gamma is relatively small for short wavelengths (ultraviolet radiation and blue light) and at a maximum for wavelengths near the center of the visual spectrum, that is, in the green region. For this reason, an increase from normal development time is ordinarily needed when the film is exposed with a blue filter.
M. Leary and H. Todd

GAMMA RADIOGRAPHY The use of gamma rays to form an image of a substance. The gamma rays are produced by radioactive isotopes and can be passed through the substance or localized at specific sites in the substance, such as in biological materials. *J. Holm*

GAMMA RAYS Very high energy photons with wavelengths shorter than x-rays. Gamma rays are a natural part of cosmic radiation, and are produced by the decay of some radioactive materials. Gamma rays have even greater penetrating ability than x-rays, and can similarly be used to form an image on photographic film. Gamma radiography using isotopes is used in science and industry. *J. Holm*

GAMMA-TIME CURVE See *Time-gamma curve.*

GAMMETER A transparent template containing a scale that when placed on the straight line of a characteristic curve shows gamma (the slope) directly. *M. Leary and H. Todd*

GAMUT See *Color gamut.*

GARDNER, ALEXANDER (1821–1882) American photographer. Employed by Mathew Brady, first in his New York studio and from 1858 as manager of his new Washington studio. During the American Civil War, worked on Brady's staff of war photographers then resigned in 1862, protesting Brady's practice of taking credit (and copyright) for all photographs made by photographers under his employ. In 1863, Gardner opened his own studio in Washington. Some of Brady's best photographers, including O'Sullivan, joined with Gardner in competition with Brady to photograph the Civil War, producing many unforgettable images. In 1866, Gardner published the remarkable *Sketch Book of the War,* a two-volume set illustrated with 100 albumen prints carefully credited to each photographer. In 1867, he became official photographer to the Union Pacific Railroad Company, photographing the people and landscape along the railroad's route all the way to California. *M. Alinder*

GAS-BURST AGITATION See *Nitrogen-burst agitation.*

GAS DISCHARGE LAMP See *Discharge lamp.*

GASEOUS DEVELOPMENT The process of converting a latent image to a visible image by the action of an agent in vapor form, such as the processing of exposed diazo materials with ammonia fumes. *L. Stroebel*

GAS HYPERSENSITIZATION/GAS HYPERING Although the American chemist John William Draper successfully photographed the moon in 1840, and W.H. Fox Talbot magnified an insect's wing 17 times in 1835, the application of photography to scientific investigation continues to present particular difficulties. In astronomy and in photomicrography, high resolution images must be made of low luminance subjects. The requisite lengthy exposures result in reciprocity failure, particularly in the low illuminance areas of the image. Spectroscopic plates, introduced by Kodak in 1931, address these problems, but all manufactured light sensitive materials must take into account considerations such as shelf life, handling convenience, and latent image keeping. Scientists willing to sacrifice these traits can achieve higher effective film speed and reduced reciprocity effects. Hypersensitization increases effective film speed after manufacture and before exposure. Chemical baths, flashing (preexposure), and gas treatment are the most common methods. Latensification, on the other hand, intensifies the latent image after exposure and before development.

Forming gas is a nonhazardous mixture of hydrogen and nitrogen. An 8% mixture (8% H_2, 92% N_2) in a gas-tight aluminum box at temperatures around 66° C for several hours, can produce one to three stops increase in sensitivity and a substantial reduction of low intensity reciprocity failure. Pure hydrogen may also be used in this procedure. Potassium metabisulfite fumes may be utilized at lower temperature, but mercury vapor and sulfur dioxide, formerly used, are unsafe. Gains are greatest for long exposures, and insignificant for exposures shorter than one second. Care must be taken to select a material whose spectral response matches the predominant wavelengths of the subject. Exposed film or plates must be processed immediately or frozen at very low temperatures (-25° C). An additional attraction of hypersensitized film is its lower cost compared to spectroscopic plates. *H. Wallach*

See also: *Exposure effects; Hypersensitization; Latensification.*

GAS LASER A laser in which the resonating cavity is filled with a gas, the resonant wavelength therefore being determined by the band structure of the gas. Gases commonly used are helium-neon, which produces a red light (632.8 nm); argon, which produces a cyan light (514.5 nm); neon, which produces ultraviolet radiation (333.4 nm); and carbon dioxide, which produces infrared radiation (10,600 nm). *J. Holm*

GATE The part of a motion-picture camera, printer, or projector, containing the aperture and pressure plate, that holds the film in place for exposure and projection and defines the image area. *H. Lester*

Syn.: *Film gate.*

GATE FLOAT Unsteadiness in a projected motion-picture image caused by inconsistent positioning of the individual frames in the projector gate. *H. Lester*

GAUSS, KARL FRIEDRICH (1777–1855) German mathematician, physicist, and astronomer. His pioneering research in the field of optics made possible the design of precision lenses. Discovered the nodal points (Gauss points) of a lens. *M. Alinder*

GAUSS　A unit of magnetic induction (magnetic field strength) such that a charge of 1 coulomb moving with a velocity of 1 meter per second perpendicular to a magnetic field of 1 gauss experiences a force of 10^{-4} newtons. One gauss is equal to 10^{-4} tesla, the standard unit of magnetic field strength. Gauss units are more common than tesla units, however, because they tend to be of a more appropriate order of magnitude. The magnetic field strength of the earth is approximately 0.6 gauss.

J. Holm

GAUSSIAN DISTRIBUTION　For a set of numbers, a pattern of variation about a central value caused by change. The plot of such a pattern, often called, from its shape, the *bell* curve, is completely defined by the arithmetic average and the standard deviation.

H. Todd

Syn.: *Normal distribution.*

See also: *Normal distribution; Standard deviation.*

GAUSSIAN OPTICS　See *Optics, optical calculations.*

GAUSS POINTS　Points of an optical system such as a camera lens used for measurement and calculation. There are six Gauss points (Karl Friedrich Gauss, 1777-1855). They are the object and image principal focal points, object and image principal points, and the object and image nodal points.

S. Ray

Syn.: *Cardinal points.*

See also: *Focal planes/focal points; Nodal points/planes; Optics, optical calculations; Principal points/planes.*

G-BAR (AVERAGE SLOPE)　A measure of development contrast similar to that of contrast index.

M. Leary and H. Todd

See also: *Contrast index.*

GEAR TRAIN　A system of interlocking gears in mechanical shutters that control the timing of the opening and closing of the shutter blades.

L. Stroebel

GEIGER COUNTER　An instrument based on the Geiger-Müller counting tube that allows high energy radiation such as x-rays, gamma rays, and cosmic rays to be detected and counted. Because it is difficult to monitor such radiation directly in real time, the Geiger-Müller tube detects the radiation indirectly; a quantum of ionizing radiation enters a tube filled with rarified gas, freeing an electron through a process known as *impact ionization*. The freed electron accelerates toward a charged wire running through the center of the tube, attaining enough kinetic energy to ionize other atoms of gas, initiating a cascade of further ionizations. Each event results in a voltage spike large enough to be detected and counted by an electrical circuit in the Geiger counter. The energy of the absorbed quanta are not known because each event initiates a cascade whose output voltage pulse is constant regardless of the absorbed quantum's energy.

J. Pelz

See also: *Dosimetry.*

GEL　(1) The jelly produced when a emulsoid sol coagulates or sets. (2) A filter made from a thin dyed sheet of gelatin.

S. Ray

GELATIN　A naturally occurring protein having many uses in photography, most importantly as a binding medium for photosensitive compounds and other emulsion ingredients. It is extracted from animal hides, bones, and connective tissues by various processes, which influence its properties. Different types of gelatin are used for different purposes. It is insoluble in cold water, but will absorb about 10% of its weight in water. (This is mainly what must be driven off in drying films after processing.) Hot solutions of gelatin will set to a rigid gel when chilled, a property useful in photographic emulsion manufacture. Gelatin is not a definite chemical compound, and a given sample may contain molecules of various molecular weights, ranging from about 20,000 to more than 100,000, and of various amino acid compositions.

An important property of gelatin is its protective colloid action towards silver halide crystals during emulsion preparation. (A photographic *emulsion* is not an emulsion in the modern usage of physical chemists, but rather, a suspension. The term, however, is too well established to displace.) The gelatin present during the precipitation reaction of silver nitrate with potassium halide influences the rate and nature of crystal growth of the resulting silver halide. In the absence of gelatin the silver halide is precipitated as crystals too large for photographic purposes. Sometimes the best type of gelatin for precipitation does not have the ideal properties for coating or for some desired property in the finished film. In such cases the first gelatin can be removed by *isoing*, that is, adjusting the pH of the emulsion to the isoelectric point of the gelatin, the pH at which it loses its colloidal protective power. The crystals precipitate, and the gelatin solution is drawn off and discarded. The crystals are then resuspended in a solution of the desired gelatin.

A property of gelatin directly connected with the actual photographic process is its role as a halogen receptor. During exposure the action of light on a silver halide leads to the formation of atoms of silver and of the halogen. If the very reactive halogen is not immediately trapped by some other substance, it may recombine with newly formed silver, thus nullifying the effect of the light. Gelatin is such a substance, although other halogen receptors are also added to emulsions.

One of the earliest materials used as a binder for silver halide was collodion, or cellulose nitrate, on which the *wet collodion process* was based. In 1871, however, gelatin was found to be a good binding medium, and had the advantage over collodion that emulsions made with it were much more sensitive, and were also sensitive when dry. Not all gelatins gave equally sensitive emulsions, and the "good" photographic gelatins were found to contain a few parts per million of certain sulfur compounds. The addition of such compounds, for example, allyl thiourea, to "poor" photographic gelatins enabled good emulsions to be made. Today, photographic gelatins are of high purity and the sensitizing compounds are added in controlled amounts.

A coating of gelatin on the back of a film acts to balance the tendency of the film to curl under extremes of temperature and humidity. A thin coating of gelatin over the emulsion protects it from abrasion.

Thick, unsupported castings of gelatin emulsion were used briefly in the 1880s in place of plates for pictorial photography (Cristoid film, Fandell), and also in the 1950s (Ilford, Kodak) in stacks of such *pellicles* for recording the trajectories of energetic particles in space.

Synthetic polymers, such as polyvinyl alcohol and polyamides, have been tried as substitutes for gelatin, but none has proven completely satisfactory as yet. Where wet processing is not required, as for some direct-writing (print-out) papers for instrumentation recording, polystyrene and similar materials have been used as the binding medium.

Aside from the silver halide process, gelatin itself plays a major role in many imaging processes where its physical properties are somehow changed by the action of light. On exposure it can combine with heavy metal ions to form insoluble products. Some photomechanical processes are based on this light-induced hardening of gelatin. For example, the action of light on gelatin containing potassium dichromate (formerly called bichromate) forms an insoluble compound. Washing with warm water removes the unexposed areas,

leaving a relief image. Gelatin is also hardened by other agents including formaldehyde and the oxidation products of some developers, for example, pyrogallol.

Thin, cast gelatin films containing organic dyes of various colors and intensities are widely used as light filters in photography. *M. Scott*

See also: *Bichromate process.*

GELATIN FILTERS
Thin sheets of dyed gelatin that are available in a wide range of colors and densities including neutral densities. They are used for controlled absorption of light, especially on cameras, enlargers, and light sources. Gelatin filters are of high optical quality but are fragile, and must be handled only at the edges. They must be kept dry and never placed in areas of extreme heat and should be stored flat. *P. Schranz*

See also: *Filters; Filter types.*

GENERATION
One of a sequence of images of the same subject in which each image is made from the next lower-generation image except for the first, which is made directly from the subject. Each generation normally consists of a negative image and a positive image, or a reversal image. It should be noted that if a first-generation copy is a reproduction of an original photograph, it is a second-generation image. Second- and higher-generation images are made for any of various reasons, including to alter the size or tone-reproduction characteristics of an image and to obtain multiple copies. *L. Stroebel*

GENERIC FILMS
Halftone films that can be used for making lithographic plates and prints for electromechanical engravers for making gravure cylinders. *M. Bruno*

GENEVA MOVEMENT
A mechanical device producing intermittent film movement in a motion-picture projector, based on a four-slotted star wheel, called a Geneva cross or Maltese cross, interacting with a pin rotating on a disc. *H. Lester*

GEOLOGICAL PHOTOGRAPHY
Geological photography records rocks that make up the earth's crust. Photography of such seemingly unrock-like substances as coal and peat belongs to this category because these subjects, along with the more easily linked mineral masses and aggregates, fit the geologist's definition of rock.

All geological photography can be divided into field work and specimen work. Field work takes place anywhere natural rock is exposed. Specimen work occurs in the laboratory where geological specimens, collected in the field and specially prepared, become the subject of photomacrography and photomicrography.

One advantage in geological photography is that rock, in its various forms, does not move. This static subject challenges the photographer to show it exactly as it is. In the field, that means photographing both the rock and its immediate environment. In the lab, it means choosing the background and lighting that properly showcases the colors, textures, edges, and other details of the individual specimen.

No matter where such closeup photography takes place, the geologist also needs record shots that describe the locality and site where the specimen was discovered. These photographs generally include views that show the topography of the terrain, the general configuration (bedding, for instance), and the direction and angle of dip, if any, of the exposed rocks. Additional photography of noteworthy features, together with a map, offer interested parties some idea of what they could expect to find at the site.

FIELD WORK Because the geologist must carry other equipment (hammer, etc.) related to rock study, cameras for field work need to be as small and light as possible. The 35-mm single-lens-reflex camera, with its ability to accept close-up attachments as well as macro lenses and filters, suits the situation. Not only will such a camera give the geologist flexibility in terms of camera-to-subject distance, but it also permits the use of such accessories as polarizing filters to help control reflections from surfaces.

Wide-angle lenses permit fairly closeup photography of an interesting specimen in its natural environment. Macro lenses of 50-mm to 100-mm focal lengths permit life size images of gems and other small geological subjects. The 100-mm macro lens allows the photographer to move back a bit to reduce the risk of casting shadows on the subject. Photographers who want to obtain panoramic views of a locality can supplement their 35-mm SLR camera with one of the new single-use panoramic cameras. These new 24-exposure cameras meet the need for a small, lightweight camera with an extremely wide field of view.

In an attempt to make true and accurate records of geological finds, photographers typically shoot pictures at times when natural shadows help show formations. Ideally, a hammer, a specially painted walking stick, or other familiar object of known size appears in the picture to suggest the size of the rock exposure. Several shots from different angles offer the best coverage.

SPECIMENS In the lab, geological specimens can be treated much like any three-dimensional object. Lighting usually should be fairly diffuse. The background should be white unless the specimen is very light in color; then, a black background works better.

A single flood lamp or spotlight also can be positioned at an angle to graze the surface of the rock and show its texture. (Lighting from anywhere above center should provide accurate relief.) Reflectors also can be used to lighten shadow areas.

In photographing crystals, Alfred A. Blaker, author of *Handbook for Scientific Photography,* recommends "working in a semidarkened room and using a small pen flashlight to test for the correct lamp position," that is, "an angle that gives a good average reflection from most or all of the planes."

Thin sections of rock can be prepared and illuminated by transmitted light through a microscope. Lighting technique depends on the kind of rock and what aspects need to be shown in a photograph. Thin mineral sections that have banded granular material, for example, require low-power, directional Rheinberg photomacrographic lighting.

Books: *Handbook for Scientific Photography,* by Alfred A. Blaker. Stoneham, Massachusetts: Focal Press, 1989.
 K. Francis

GEOMETRICAL OPTICS
See *Optics.*

GERMANIUM
A crystalline, semiconducting optical material grown synthetically. It is visually opaque, of metallic appearance, and has a high transmittance in the far infrared, with a refractive index of approximately 4 for radiation of wavelength 10.6 μm. It is used for lenses in thermal imaging cameras. *S. Ray*

GERNSHEIM, HELMUT ERICH ROBERT (1913–)
British historian and collector. Born in Germany, where he studied art history and photography, emigrating to England in 1937 to escape Nazi Germany. Became a freelance photographer. Married Alison Eames (1911–1969) in 1942, who became his collaborator a on a number of books. With encouragement from Beaumont Newhall, began research into the history of photography and also started to collect photographs. Key rediscoveries made by Gernsheim include the photography of Lewis Carroll and the identity of the ear-

liest existing photograph, Nièpce's view of his house's courtyard from 1826. Published biographies of Cameron (1948), Carroll (1949), and Daguerre (1956). With Alison, wrote *The History of Photography* (1955) and biographies of Fenton (1954) and Coburn (1966). The Gernsheim Collection, a rich assemblage of prints from throughout photography's history, is housed at the University of Texas, Austin.

Books: *The Origins of Photography*. New York: Thames & Hudson, 1982; *The Rise of Photography*. New York: Thames & Hudson, 1988. *M. Alinder*

GESTALT The perception of images as organized configurations rather than as a collection of independent parts, as when a mosaic is seen as a whole rather than as discrete tiles. *L. Stroebel and R. Zakia*

See also: *Visual perception, gestalt.*

GESTALT LAWS See *Visual perception, gestalt.*

GHOST IMAGE (1) A superfluous and undesirable image typically of the diaphragm opening, which can appear in photographs taken under high flare conditions. It is a form of flare spot and may be removed or reduced by use of an efficient lens hood. Multicoated lenses are less prone to such defects. (2) An image of an opaque object that appears to be transparent, an effect that can be produced in various ways including double exposure and the use of a partially transmitting mirror. Jacques Henri Lartigue began taking photographs in 1901 at the age of seven and accidentally produced a ghost-like image. He wrote in his diary, "Sometimes when I am taking a photo, I can, if I hurry, go and stand in front of the camera after taking the cover off the lens and in that way make a photo of myself—I have to race back and put the cork back on. The idea is not bad, I think, but the result . . . I'm half transparent, like a ghost." Lartigue, Jacques Henri, *Diary of A Century*. Penguin, New York: 1970, p. 5. *S. Ray and R. Zakia*

See also: *Spirit photography.*

GHOSTING In photomechanical reproduction, selectively reducing the contrast of part of an image in order to emphasize the areas of interest, which are reproduced with a normal range of tones. *R. Zakia*

GHOST PHOTOGRAPHY See *Spirit photography.*

GIGABYTE One billion bytes or 1024 megabytes. *R. Kraus*

GIGAHERTZ (GHz) A measure of wave frequency, equal to 10^9 cycles per second. *H. Todd*

GILPIN, LAURA (1891–1979) American photographer. Student at the Clarence H. White School (1916–1917). Opened a portrait studio (1918). Her many photographic jobs included chief photographer for Boeing Aircraft (1942–1945). Best known for her command of platinum printing used in the service of her sympathetic portraits of the Navajo (1946–1968), and her dramatic landscapes of New Mexico and Arizona, especially her Canyon de Chelly project (1968–1979).

Books: *The Enduring Navajo*. Austin: University of Texas Press, 1968; Sandweiss, Martha A., *Laura Gilpin, An Enduring Grace*. Fort Worth: Amon Carter Museum, 1986.

M. Alinder

GIMBAL HEAD A device for holding a camera or other instrument so that it can be tilted and swung in any direction freely and smoothly. *L. Stroebel*

GLARE Direct reflection from a highly reflective surface such as polished metal, water, or glass. The term often, but not necessarily, implies a direct reflection that is aesthetically displeasing. Since glare always depends on the angle of illumination and the angle of view, it can be controlled by manipulation of those angles. If the glare is polarized, it can also be controlled by a polarizing filter on the camera lens. *F. Hunter and P. Fuqua*

See also: *Polarization; Specular reflection.*

GLASS (1) See *Optics; optical materials.* (2) A hard, brittle substance, usually transparent, made from fusing silicates with potash and soda. Used as a support for film emulsions, making lenses, trays, graduates, and framing and protecting photographs. The basic physical characteristics of glass make it a desirable protective cover for a photograph because it is transparent, smooth and highly polished, reasonably inexpensive, easily cut to size, and chemically inert and static free. Nonglare glass is an abraded glass and has a matt texture on one surface that reduces specular reflections on that side, but also reduces the contrast, color saturation, and sharpness of the photograph below the glass. Denglas is a multilayer optically coated (on both sides) glare-reducing glass that does not diffuse the image or desaturate the color or contrast as much as with standard abraded nonglare glass. *M. Teres*

GLASS FILTERS (1) Filters made from *dyed in the mass* glass, where the color is distributed uniformly throughout the single sheet of glass. The optical quality is high if the surfaces are optically flat, but may cause a small shift in focus if added to a camera or enlarger after focusing the image. More expensive and available in a smaller range of colors and densities than gelatin filters, but much more durable. (2) Layered filters made with a gelatin filter sandwiched between two sheets of clear glass. More durable than gelatin filters but not as durable as dyed glass filters. The optical quality varies with the precision of manufacture, but layered filters are thicker and cause more focus shift than other filters. (3) Glass interference filters are made by vacuum-depositing extremely thin layers of certain metals or other suitable materials on glass plates and sealing them in a sandwich with epoxy. Interference filters provide greater precision in absorbing or transmitting narrow bands of wavelengths than other types of filters. *P. Schranz*

See also: *Filters; Filter types.*

GLASSINE A thin, translucent, glazed paper widely used for the storage of negatives. Because it is not a stable material itself, it may affect the quality of the image. Its use is not recommended. *K. B. Hendriks*

GLASS SHOT A special effect, used especially in motion-picture photography, whereby an image on a transparent support is placed a short distance in front of the camera lens so that on the processed film it appears to be part of the scene being photographed. For example, a tree painted on a glass plate could be used to hide an incongruous modern building in a historical film. *R. Zakia*

See also: *Schufftan process.*

GLASSWARE PHOTOGRAPHY The specialization of making photographs of transparent or translucent objects, including glass and plastic objects. *L. Stroebel*

See also: *Lighting; Surface .*

GLITCH In the vernacular of electronic imaging, an error, bug, or problem that unexpectedly occurs. *R. Kraus*

GLOBAL CHANGE An overall color change in electronic image correction or processing. *M. Bruno*

GLOSS See *Sheen*.

GLOSSMETER An instrument designed to measure the specular reflectance of a flat surface. A light source is directed toward the surface at a fixed angle; the reflected light is measured by a detector placed at an equal but opposite angle with respect to the surface. *J. Pelz*

GLOSS TRAP Device used in spectrophotometry to eliminate specular components from measurements. *R. W. G. Hunt*

GLOSSY A surface finish available on certain printing papers characterized by the complete absence of texture. The surface then is mirror-like, smooth, and shiny. The finish is produced on fiber-base papers by ferrotyping, also called glazing (U.K.). Resin-coated papers produce their glossy finish merely by air drying, although the gloss is not as perfect as that obtainable by ferrotyping fiber-base paper.

The highest range of tones is possible on a glossy paper. The viewer instinctively tips the print so that some dark object is reflected in its mirror-like surface. Glossy prints are preferred for photomechanical reproduction and for all technical and scientific images. Disadvantages of a glossy surface include the more distinct appearance of grain from the negative, the greater visibility of scratches and blemishes, and the difficulty of retouching. *M. Scott*

See also: *Ferrotyping.*

GLUE STICK Glue sticks are neat and convenient ways of applying adhesives and are similar in appearance to a tube of lipstick. The glue adhesive is water soluble, nontoxic, nonacidic, and washable. Some brands of glue sticks color their adhesives so that they are easier to see on the back of the material being mounted. A wheat paste-like adhesive in stick form is applied by simply rubbing it on the back of whatever light-weight material is to be mounted. *M. Teres*

GLYCERIN The clear, colorless, sweet-tasting, syrupy liquid of this polyalcohol ($CH_2OHCHOHCH_2OH$, molecular weight 92.09; also called glycerine, glycerol, or 1,2,3-propanetriol) is very soluble in water or alcohol.

Used as a humectant to maintain flexibility of photographic papers and films or to thicken water solutions as a means to control diffusion rates. *G. Haist*

See also: *Humectant.*

GLYCERIN DEVELOPMENT A modification of the platinum process that allows very selective control of specific areas to be developed. After exposure, the print is covered with a layer of pure glycerin and the image is then developed area by area using a brush dipped in developer. The glycerin retards the rate of development so that the photographer can slowly bring an area up to a desired tonality without allowing the developer to flow into adjacent areas. Careful brushwork is necessary to blend the various areas together for a visually cohesive result. Variations of image color can be produced by adding mercuric chloride to the developer. Alfred Steiglitz and Hoseph T. Keiley successfully utilized this technique in the early 1900s. *J. Natal*

GLYCIN The common name of *para*-(hydroxyphenyl)-glycine or *para*-hydroxyphenylaminoacetic acid and should not be confused with glycine (CH_2NH_2COOH, molecular weight 75.07; also called aminoacetic acid). The developing agent glycin ($HOC_6H_4NHCH_2COOH$, molecular weight 167.16) forms white leaflets from water, the water solubility being only 0.02 gram per 100 ml at 20°C, with low solubility in acetone, alcohol, or ether. Glycin is soluble in alkaline solutions, so this compound is usually added after the sodium sulfite has been dissolved in a developing solution.

Glycin developing solutions are resistant to aerial oxidation, nonstaining, but slow acting. Because of the low activity, glycin is often combined with other developing agents to produce fine grain developers. *G. Haist*

See also: *Developers.*

G-NUMBER The photometric transfer function of an optical system, describing the ratio of object luminance to image illuminance, i.e., $G = L/E$. The G-number is given approximately by $G \cong 4 \cdot T^2 = (4 \cdot F^2)/t$, where G is the G-number of lens; T is the T-number of lens; F is the F-number of lens; and, t is the transmittance of lens. *J. Pelz*

Syn.: *Photometric aperture.*

See also: *F-number; T-number; Transmittance.*

GOBO A small opaque panel, typically mounted on a boom stand, that is used to shade the light from an area of a subject or to shade a camera lens from direct light that could cause undesirable flare. *L. Stroebel*

GODOWSKY, LEOPOLD JR., (1902–1983) and **MANNES, LEOPOLD DAMROSCH** (1899–1964) American scientists. While employed at Eastman Kodak's Rochester laboratories, and working under Mees, Godowsky and Mannes invented Kodachrome, a color positive transparency material, released as movie film in 1935 and 35-mm roll film in 1937. Kodachrome was the first color process to require only one exposure and has been called, "the greatest improvement in the history of color photography."

Book: Mees, C.E.K., *From Dry Plates to Ektachrome Film.* New York: Ziff-Davis, 1961. *M. Alinder*

GOERZ, CARL PAUL (1854–1923) German optician. Founder of the C.P. Goerz Optical Works in 1886 in Berlin-Friedenau. Known for highest quality camera lenses. Emil von Hoegh, a Goerz designer, introduced the famous Dagor double anastigmat lens in 1893 and the wide-angle Hypergon in 1900. Goerz also produced cameras, motion-picture apparatus, optical instruments, and telescopes. Introduced photo-finish equipment (1922) to determine race winners. Goerz was bought out by Zeiss-Ikon in 1928. *M. Alinder*

GOLDBERG A technique of animation cinematography where the artwork involves a component that can be moved into several positions, thus avoiding the need for individual drawings in those positions. Named for cartoonist Rube Goldberg, famous for inventing complicated procedures for simple tasks. *H. Lester*

GOLDBERG CONDITION For mathematically correct tone reproduction, the product of the gamma values for the negative and positive should be 1.0. This requires long straight lines for both photographic materials and ignores the effects of flare in the camera and in the printer. For these reasons, the Goldberg condition is rarely met. *M. Leary and H. Todd*

GOLDBERG WEDGE A device sometimes used in a sensitometer (an apparatus for exposing test samples of photographic material) that produces a continuous, rather than stepwise, change in illuminance and therefore exposure. It is a dyed gelatin layer of varying thickness and therefore varying absorption of the exposing light. *M. Leary and H. Todd*

GOLDENROD Yellow or orange paper or film on which films are assembled for platemaking. *M. Bruno*

See also: Flat.

The relationship between the golden mean and logarithmic spirals common in nature.

GOLDEN SECTION/GOLDEN MEAN A proportional relationship obtained by dividing a line so that the shorter part is to the longer part as the longer is to the whole. These proportions seem to have a universal aesthetic appeal that has led artists of varying periods and cultures to employ them in determining basic dimensions in the visual arts, architecture, and music. This relationship is approximately 3 to 5. However, the classical, historical preference, which comes close to the golden section, is based on a ratio of 3 to 4. The ancient Egyptians were aware of the golden section and the planar understanding of the golden section was laid out by Pythagoras, the Greek mathematician. The mathematics for the golden section were discovered by Leonardo Fibonacci of Pisa in the thirteenth century. The Fibonacci number series 1, 2, 3, 5, 8, 13, 21, 34, 55, 89, etc., is generated by adding the sum of the two previous numbers to find the next in the sequence. This sequence represents a mathematical equivalent of many of the shapes found in nature, such as the curves of seashells, or the design of galaxies and plants. These proportions are evident in photographic usage. Negatives of 4×5 inches, 8×10-inch prints, and 16×20 mount boards have the same 4×5 ratio. Photographic slides conform to the 3:5 ratio of the golden mean. *R. Welsh*

GOLD PROTECTIVE SOLUTION Commercial term for a toning solution containing gold salts that can be used for enhancing the permanence of processed black-and-white photographs, microfilm in particular. *K. B. Hendriks*
See also: *Image permanence.*

GOLD SENSITIZATION The addition of complex gold salts, such as aurothiocyanate, to the emulsion during the afterripening period to increase the light sensitivity of the silver halide crystals. Gold sensitization is usually combined with other kinds of chemical sensitization, such as with sulfur, to produce modern high-speed photographic materials. *G. Haist*

See also: *Emulsions.*

GOLD TONER A process for converting part of the silver of a black-and-white print to gold, which produces a blue color. If the print is first toned to a sepia color by one of the sulfide methods, then gold toned, the result is a brilliant red. When gold is added to a sulfur toning bath such as hypo-alum (containing free sulfur) the color of the sepia image is enhanced. A typical gold toning formula is as follows:

Water	1 liter
Ammonium thiocyanate	100 grams
1% gold chloride solution	60 ml

The well washed prints are toned in this solution, followed by fixing for several minutes, and washing before drying. *I. Current*

GONIOPHOTOMETER An instrument for measuring the angular reflectance characteristics of materials. The angle of incidence and the angle at which reflected readings are made can be adjusted independently. *J. Pelz*

GOST FILM SPEED See *Film speed.*

GRADATION A more or less gradual change of tone, color, texture, etc. between adjacent areas of an object or the corresponding image. Gradation provides the viewer with information concerning the three-dimensional attributes of the subject, such as the facial features of a portrait subject as revealed by the variation of tones produced by the lighting. *L. Stroebel*

Syn.: *Local contrast.*

GRADED INDEX FIBER See *Fiber optics.*

GRADES See *Contrast grades.*

GRADIENT The slope of a curve at a given point. It expresses the relationship between the rate of change of the dependent variable with respect to the rate of change of the independent variable. For a D-log H curve, the gradient measures the relationship between the image contrast and the subject contrast. *M. Leary and H. Todd*

GRADIENT SPEED Any of several methods, mostly obsolete, for estimating the sensitivity of a photographic material based on the slopes of defined portions of the D-log H curve. The ASA speed, for example, was based on the

exposure needed to produce in the toe of the curve a slope equal to 0.3 times the average slope. *M. Leary and H. Todd*

GRADING The selection of color and printing exposure values for each shot in an assembled roll of motion-picture original film. In video production, the matching of color balance between shots. *H. Lester*

GRADUATE (1) See *Photographic graduate*. (2) A shortened form of *graduated cylinder*. A transparent tubular vessel marked at different levels with appropriate measures of liquid volume. A graduate is used, for example, in the careful preparation of photographic processing solutions. *H. Todd*

GRADUATED FILTER See *Filter types*.

GRAFLEX The following represents a brief chronological history of Graflex.

1887 Partnership formed between William F. Folmer and William E. Schwing to manufacture Crown gas lighting fixtures and Sterling bicycles.

1887–1889 "Bargain Price List" penny postcards listing many cameras, old and new, and supplies sent out over the name of Folmer and Schwing Manufacturing Co.

1890 The Folmer and Schwing Manufacturing Co. was incorporated, with "Capital Stock $50,000 paid in" (as printed on the inside cover of the 1898 catalog).

1898 The catalog listed a number of models of Graphic cameras in the 4 × 5, 6-1/2 × 8-1/2, and 8 × 10 sizes, along with many commercial and studio cameras, and a multitude of supplies for producing the final prints. It also included a listing for a twin-lens Graphic.

1902 The Graflex camera was patented and introduced in the 4 × 5 size only. The original Graflex had the already familiar single-lens reflex feature of the moving mirror and focal-plane shutter; but in this camera, the mirror automatically released the shutter. The shutter consisted of two curtains with variable spacing of the size of the opening and also variable speed control—very complicated. Interestingly enough, the patent also included a device for closing and reopening the lens diaphragm, all by action of the mirror.

1905 The Folmer and Schwing Manufacturing Company was purportedly purchased by George Eastman.

1906 A catalog bears the identification "Folmer and Schwing Division, Eastman Kodak Co., Rochester, NY." This catalog shows that the variable aperture, variable speed curtain had been replaced with the fixed aperture multi-slit curtain used thereafter in all Graflex and Graphic cameras.

1912 The Speed Graphic camera was introduced in the 4 × 5, 3-1/4 × 5-1/2, and 5 × 7 sizes.

1917 The name was changed to "Folmer and Schwing Department of Eastman Kodak Co."

1926 The company became "The Folmer Graflex Corporation, an independent company."

1939 The very popular 2-1/4 × 3-1/4 Miniature Speed Graphic appeared.

1940 The Anniversary Speed Graphic model was introduced in 3-1/4 × 4-1/4 and 4 × 5. (The name was given because it was believed at the time that 1890 was the founding date of the Folmer and Schwing Mfg. Co.) Also in 1940, Graflex made its own flash (bulb) equipment, but because of military contracts, none was made available to the civilian market until after the Second World War.

1941 The 4 × 5 Speed Graphic had become the standard camera for all branches of the armed forces of the United States and also all of the Allied Forces. From December, 1941, through March, 1945, 330,000 cameras were produced for this use.

1946 The company's name was changed to Graflex, Inc.

1947 The Pacemaker Crown and Speed Graphic models were introduced in the 2-1/4 × 3-1/4, 3-1/4 × 4-1/4, and 4 × 5 sizes. The Crown Graphics did not have the focal plane shutter and were a little thinner and lighter than the Speed Graphics.

1949 The 2-1/4 × 3-1/4 Century Graphic appeared, with molded plastic body replacing the wood.

1951 Graflex purchased the tools and rights to make the Ciro 35-mm and Ciroflex twin-lens reflex cameras.

1955 Graflex purchased Strobo Research, manufacturers of professional quality electronic flash equipment.

1956 Graflex, Inc., was purchased by and became a division of General Precision Equipment Co. At that time production of Ampro 16-mm projectors and SVE slide and stripfilm projectors, both for the audiovisual market, was consolidated and moved from Chicago to the Graflex plant in Rochester.

1968 General Precision Equipment Co. was purchased by the Singer Company.

1970s The name Graflite was sold to a firm in Florida, which later purchased the name Graflex. This firm sold it to an Australian firm that had the intention of using it on some inexpensive 35-mm cameras to be made in the Far East. However, nothing has appeared on the U.S. market.

1973 In June, Graflex was dissolved and became the Singer Education Systems.

1982 After other parts of the company had been dissolved or sold off, the remaining AV product lines were purchased by Telex. *T. Holden*

GRAIN A silver halide crystal in a photographic emulsion or the silver particle resulting from the development of the crystal. Graininess, or grain, is a subjective impression of the distribution of the many silver particles or dye clouds of the developed photographic image.

Grain is an attribute of photographic paper describing the orientation of the fibers or descriptive of the making of the textured surface of a photomechanical printing plate, ground glass, and other materials.

Grain is a small unit of weight. There are about 16 grains in a gram, or 7,000 grains in a pound. *G. Haist*

See also: *Graininess; Granularity*.

GRAININESS The appearance of nonuniformity of density in more or less uniformly exposed and processed areas of photographic images. Graininess is a subjective characteristic that corresponds with objective granularity. Measures of graininess are the viewing distance or the magnification at which the appearance of nonuniformity just disappears. *L. Stroebel*

GRAM A unit of mass (approximately, weight) in the metric system. One pound of weight is equal to 454 grams. *H. Todd*

GRANULARITY The objective measure of nonuniformity of density in a uniformly exposed and processed area of photographic material. Specifically, the standard deviation of density values with respect to the average density, based on a microdensitometer trace at a fixed aperture. In a given silver image, the granularity varies with the density of the area measured. *L. Stroebel*

Syn.: *RMS granularity; Selwyn granularity*.

GRAPHIC ARTS Another name for graphic communications and printing. It encompasses all the operations of image processing in the reproduction of text and illustration copy in quantity. *M. Bruno*

GRAPHIC ARTS IMAGING For over 400 years after the invention of printing by Gutenberg, illustrations were produced manually by hand retouching, copperplate intaglio engraving, woodcuts, steel engraving, and hand-drawn lithographic stones. The invention of photography in 1839 revolutionized imaging and created new printing processes for graphic arts. Lithography became photolithography, engraving became photoengraving, intaglio engraving became photogravure, collotype was called photogelatin, and platemaking for printing was called photomechanics. Graphic arts photography was the means for imaging and producing illustrations for all graphic arts processes for more than 100 years until electronics and computers revolutionized graphic arts imaging in the 1980s.

GRAPHIC ARTS PHOTOGRAPHY The processes, equipment, and materials used in graphic arts photography are described in this encyclopedia under the entry *Photomechanical and Electronic Reproduction*. Most images for reproductions originate as photographic prints or color transparencies. All printing processes with the exception of some conventional gravure, collotype, and screenless lithography are binary processes that cannot print gradient tones of ink. All intermediate tones for these processes must be converted to halftones. Also, because color reproduction is based on the three-color theory of light, all color originals must be divided into four separate photographic records, or separations, that represent the cyan (C), magenta (M), and yellow (Y) components of the color images plus black (K). Because printing inks do not have correct color absorptions, color separation films must be corrected to compensate for these absorption errors. This is usually done manually by dot etching using silver solvents or photographically by controlled exposures to adjust dot sizes to correct the colors.

The purpose of graphic arts photography is to convert line images such as text and line illustrations into high contrast images on photographic films and continuous-tone photographs into halftone images; to photograph color images through red, green, and blue filters, and a contact screen to produce halftone separations of the three printing colors, CMY and black (K); and to correct the images for reproduction. After photography and correction, the films are used to make color proofs of the images for approval by the customer. After approval, the films are assembled into page layouts that are combined by contact exposures onto single films for each color separation. The single films for the individual pages are proofed again and composed into signature layouts for the press by mounting them in imposition order on orange or red plastic layout sheets that are used for making the printing plates. These are all labor-, skill-, and cost-intensive operations.

Electronic Imaging The trend to electronic imaging was generated by the need to shorten deadlines for printing by time-sensitive publications like weekly newsmagazines. This was accomplished by electronic imaging that reduced and/or eliminated the labor- and skill-intensive operations of graphic arts photography and conventional prepress functions. The systems of electronic imaging used for these purposes are described in the section entitled "Electronic Prepress" in the article *Photomechanical and Electronic Reproduction*.

Electronic scanners are used to make color-corrected halftone color separations for reproduction. Special scanners are used to convert black-and-white or color images to single or duotone (two-color) halftone images. Even original photography is being replaced by electronic cameras using sensors like CCDs (charge coupled devices) for recording the images that are converted to digital data for image processing. Color electronic prepress systems are used to enhance color correction, perform airbrushing, retouching, pixel editing, cloning, and other image manipulation, compose type and pages, and output high quality halftone images. Electronic layout and stripping systems assemble images into page layouts and pages into plate impositions.

These high-end electronic systems are expensive and device dependent as they use dedicated hardware with proprietary formats that make interfacing between systems by different manufacturers difficult. New device-independent systems using off-the-shelf components and universal standard page description languages are completely interfaceable, have most of the features of the high-end systems, are much less expensive, have various levels of sophistication, and provide links with existing high-end proprietary systems. *M. Bruno*

See also: *Halftone process; Photomechanical and electronic reproduction.*

GRAPHIC ARTS PHOTOGRAPHY Production of photographic films for graphic arts uses. *M. Bruno*

See also: *Photomechanical and electronic reproduction.*

GRAPHIC EQUALIZER An audio equalizer having a multiplicity of controls arranged so that in use they draw out the frequency response in use. *T. Holman*

GRAPHICS TABLET An interactive device for inputting data into a computer graphics program. These devices locate positions on a tablet (grid) that correspond to locations on the monitor. A stylus or pointing device can cause a voltage difference at any position on the tablet. These voltages are converted to coordinates and stored. Sonic graphics tablets use sound to locate position. The time it takes to note the sound by sensors at the edge of the tablet is employed to determine location. The stylus is used as a pen would be used on a sheet of paper (tablet). *R. Kraus*

GRAPHIC USER INTERFACE (GUI) The GUI is intended to utilize graphic elements such as symbols, menus, and icons to assist the computer operator interacting with the computer's operating system. The graphic objects are accessed via a mouse or other pointing device. *R. Kraus*

GRAPHS Lines or surfaces that show the relationship between two or more variable quantities. Typically, one of these is called the *independent* (or input) *variable,* the values of which may be chosen, and the other is called the *dependent* (for output) *variable,* the values of which are determined by the process being examined.

For example, if incident-light measurements are made at an outdoor location every hour from dawn to dusk on a clear day, the light measurements (dependent variable) would be plotted on the vertical scale (y axis) of the graph versus the corresponding times (independent variable) on the horizontal scale (x axis). When the points are connected with a smooth line, the line would rise during the morning hours and fall during the afternoon hours.

Trilinear plots are two-dimensional graphs that have three axes representing the three additive and the three subtractive primary colors. When required, a three-dimensional rectangular coordinate system can be used, in which the third, or z, axis is considered to be perpendicular to the x-y plane.

FORMATS *Rectilinear,* the most common graphical layout, is based on a plan whereby two straight lines intersect at right angles to form four contiguous rectangular areas. The intersection of the lines is called the *origin* and is the location of zero value for both variables. The input variable is plotted according to a scale on the horizontal (x) axis, the dependent variable on the vertical (y) axis. Positive values are to the right of and above the origin, negative values are to the left of and below the origin. Often only positive numbers are of interest and therefore only one of the four quadrants is used.

Circular, or *polar,* formats are used when the input variable consists of various angles. The basis of the plot resembles a protractor covering, in principle, 360 degrees. The output variable is positioned according to a scale involving a set of circular arcs at different distances from the center. Such a graph is useful when, for example, the data come from measurements of the light emitted by a lamp in different directions or from readings of a light meter when the energy falls on the sensitive surface at different angles.

SCALING The two most common scales of numbers used on graphs are interval scales, where the numbers increase by equal amounts as on rulers and thermometers, and ratio scales, where the numbers increase by a constant factor, for example, 1, 2, 4, 8, 16. When the range of numbers to be plotted is very large, it is usually more appropriate to use a ratio scale, but it should be noted that differently shaped graph lines will be produced using interval and ratio scales with the same data. The inconvenience of the very large numbers that may be encountered with ratio scales can be avoided by substituting logarithms for the numbers, which also converts the ratio scale of numbers to an interval scale. Thus, a ratio scale of 1, 2, 4, 8, 16 becomes the interval scale of 0.0, 0.3, 0.6, 0.9, 1.2, and the large number 1,000,000 becomes 6.0.

Even though the word *log* appears only once in "D-log H graph," the numbers on both axes are indeed logs because density by definition is the log of the ratio of the light falling on a sample and the light transmitted (or reflected) by the sample. In addition to the graphing advantages noted, logarithms are used for plotting the characteristic curves of photographic films and papers because these materials (and the human visual system) respond more nearly uniformly to logarithmic changes in light level than they do to arithmetic changes.

INTERPRETATION One of the most important advantages of presenting data in graph form, in comparison with columns of numbers, is that the shape of the curve provides an overall picture of the interrelationship of the input and output variables. This is especially useful when the relationship changes with different levels of input as with D-log H graphs for photographic film where the level base-plus-fog, toe, straight line, shoulder, and reversal sections represent different responses of the film to uniform increases in log exposure.

For graphs plotted on rectilinear coordinates, direct proportionality between input and output values is shown by a straight line that passes (actually or by extension) through the origin, as would be produced, for example, by plotting the photographic exposure (illuminance × time) against increasing units of time with constant illuminance.

The straight line on a film D-log H curve indicates that uniform increases in *log* exposure produce uniform increases in density or, in other words, that local image contrast is related in a direct fashion to the local contrast of the subject, but the limited length of the straight line indicates that the relationship breaks down beyond a limited range of log exposures.

A reverse relationship between input and output produces a downward sloping line. This occurs in the reversal region of a film *D*-log *H* curve, where each increase in log exposure produces a decrease rather than an increase in density. The shape of this downward sloping line will be straight only where uniform increases in log exposure produce uniform decreases in density.

Plotting the illuminances at different distances from a point light source will produce a downward sloping curved line as a result of the inverse-square relationship between distance and illuminance.

The ratio of the output change to the input change is called the *slope,* or *gradient,* where slope is equal to output change divided by input change. If the slope in any region of a graph is 1.0, as would occur with a straight line at an angle of 45 degrees, the output change is equal to the input change. If the slope is 2.0, the output change is double the input change. The slope of a curved line constantly changes, but the slope can be determined for a selected position on the line by finding the slope of a straight line drawn tangent to the curved line at that point.

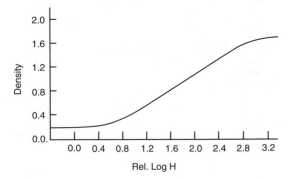

Graphs. D-Log H graph.

Another important advantage of line graphs over the lists of input and output numbers is that the graphs make it possible to interpolate between the given data. To prepare a time-temperature film developing graph, it is necessary only to determine by experiment the corresponding developing times for three different temperatures, covering the range of temperatures of interest. When these three points are plotted and connected with a smooth line, the correct developing times can be determined for any temperature between the upper and lower limits.

Graphs identified as control charts are especially useful in monitoring ongoing processes such as the manufacture of photographic films and papers, and the processing of films and prints in photofinishing labs. Control charts enable the operator of the process to determine, for example, whether variations of selected attributes such as density, contrast, and color balance of uniformly exposed test areas represent only the random variability expected of a stable process or represent changes due to an assignable cause that require compensation. *H. Todd*

See also: *Control charts; Quality control; Tone reproduction; Trilinear plot.*

GRASSMAN'S LAWS Three empirical laws that describe the color-matching properties of additive mixtures of color stimuli:

1. To specify a color match, three independent variables are necessary and sufficient.
2. For an additive mixture of color stimuli, only their tristimulus values are relevant, not their spectral compositions.
3. In additive mixtures of color stimuli, if one or more components of the mixture are gradually changed, the resulting tristimulus values also change gradually.

R. W. G. Hunt

GRATICLE A device such as a piece of glass carrying a pattern of fine lines that can be superimposed on the visible image in an optical instrument to facilitate aligning, measuring, or sighting. *S. Ray*

Syn.: *Graticule; Reticle; Reticule.*

GRAVURE Gravure (a generic term that includes rotogravure and photogravure) is a photomechanical printing process that uses the intaglio principle in which the image areas are depressed below the surface of the image carrier. These depressed areas carry the ink, and the nonimage areas are kept clean by a doctor blade that wipes or scrapes the unwanted ink from the surface of the image carrier. Solvent inks are used that have low viscosity, with a consistency like light cream, a heating station or dryer sets the ink on the image between each printing unit by evaporating most of the solvent. Most gravure is printed on fast (up to 3000 feet per minute) multicolor web presses in which the paper is fed from a roll. After printing is complete, the printed impositions are folded into signatures and delivered from the press. The signatures are folded so that the pages (from 32 to 64 in number) are in consecutive order. Gravure presses for publication printing are very large with image cylinders from 80 inches (2 meters) to 120 inches (3 meters) wide. Presses for packaging and specialty gravure are smaller (30–60 inches wide) and run slower. Some specialty gravure printing, for example, wood grains and wall and floor coverings, are printed on very large special flat-bed presses.

Most gravure cylinders are made on electromechanical engraving machines, and many are made using halftone prints. Some are made using photopolymer gravure plates on steel-based plates that are mounted on magnetic cylinders. *M. Bruno*

See also: *Electromechanical engraving; Photomechanical and electronic reproduction.*

GRAY Name given to colors that do not exhibit a hue and that are intermediate in lightness between white and black. *R. W. G. Hunt*

GRAY BALANCE The dot values of densities of yellow, magenta, and cyan inks that produce a neutral gray without a dominant hue. *M. Bruno*

GRAY CARD A piece of cardboard having a neutral-color reflectance of 18% that is used as a standard artificial medium tone for reflected-light exposure meter readings. It can also be included in a scene, either in a position where it can be cropped out or on an extra frame of film, for use in determining print exposure and printer filtration for controlling color balance when making color prints.

The gray-card tone corresponds to subject value V (or zone V) in the zone system and the middle value of 5 on the Munsell system of color notation value scale.

A 90%-reflectance white surface is commonly used on the reverse side of gray cards. This side can be used for reflected-light meter readings in low-light-level situations by either dividing the ISO film speed by 5 or multiplying the indicated exposure time by 5 to compensate for the higher reflectance. *J. Johnson*

Syn.: *Neutral test card.*

GRAY COMPONENT REPLACEMENT (GCR) A technique used by scanners to remove the least process color (graying component) where the three colors yellow, magenta, and cyan overprint and replace it with the proper amount of black. It is an advanced case of undercolor removal (UCR). *M. Bruno*

GRAY CONTACT SCREEN A contact screen composed of gradient dots of developed silver used to produce halftone negatives from continuous-tone copy. *M. Bruno*

See also: *Halftone process.*

GRAY SCALE (1) In electronic imaging, the range of brightnesses available to a digital system based on the power of 2. Each bit can represent a brightness. In a 2-bit gray scale (2^1) there are two gray tones available. In a 4-bit gray scale (2^2) there are four gray tones available. In a 7-bit scale (2^7) there are 128 gray tones available. (2) A set of neutral patches arranged in order from light to dark used for producing on a test sample a set of different exposures. The patches are identified with numbers related to the resulting relative log exposure values. Reflection gray scales may be placed in the scene; ignoring the effects of surface reflections and camera flare, the log exposure change from one patch to the next is equal to the density change, typically 0.10. Transmission gray scales are used in some types of sensitometers and for checking the performance of a printer, as well as for other uses in testing. *R. Kraus, M. Leary, H. Todd*

See also: *Optical wedge; Step (area); Step tablet.*

GREEK LETTER SYMBOLS See *Appendix B.*

GREEN One of the four visually unique hues, the others being red (to which green is opponent), yellow, and blue. A hue that corresponds to the 500–600 nm wavelength region of the spectrum. *R. W. G. Hunt*

GREEN BLIND See *Deuteranopia.*

GREENE, JOHN BEASLY (1832–1856) American archeologist and photographer. Born and raised in France to American parents. Believed to be the first American to photograph Egypt (1853–1854). Blanquart-Evrard published 200 calotypes by Greene in 1854, *Le Nil, monuments, paysages photographiques.* Though little is known of Greene, who died so young, his hauntingly modern photographs speak across the centuries. His images are simply composed of essential elements, with each monument but an island isolated by the overwhelming sky and desert.

Book: Jammes, Andre and Janis, Eugenia Parry, *The Art of French Calotype.* Princeton: Princeton University Press, 1983. *M. Alinder*

GRENZ RAYS Soft x-rays used for the industrial radiography of textiles and materials that produce too little contrast to give a usable image using normal x-rays. *J. Holm*

GRID SPOT Restricts lateral light spread like a honeycomb grid but is round so it can also produce a circular light patch for spotlight effects without the harshness of a spotlight. *R. Jegerings*

Syn.: *Honeycomb grid.*

GRIP A member of a motion-picture production crew responsible for transporting, setting up, operating, and removing equipment used for camera and lighting support and control (such as dolly tracks and dolly). *H. Lester*

GROUND See *Figure-ground.*

GROUND (ELECTRICAL) A connection to earth for ac power lines. For safety reasons, ground must be connected to the metal enclosure of equipment supplied by mains of 120 (nominal) volts or higher. In electronic equipment, ground is usually connected to the metal chassis and to one side of the internal dc power supply and becomes the reference for all voltage measurements. *W. Klein*

Syn.: *Earth (United Kingdom).*

GROUND FAULT CIRCUIT INTERRUPTER (GFCI) A device used to protect people from electric shock. A GFCI opens a circuit when the current in the neutral wire is not equal to the current in the hot, or live, wire. Such inequality would occur when current flows through the body of a

person directly to ground rather than returning to the power source via the neutral wire. Local electrical codes usually require a GFCI to be installed in wiring going to electrical outlets located in kitchens, bathrooms, near swimming pools, or any place near water. Even if not required, GFCI should be installed in all circuits in darkrooms, near photo processing machines, and other wet locations. *W. Klein*

GROUND GLASS A sheet of glass with a fine-grain texture surface on one side that provides a translucent surface capable of showing a projected image and that is used as a focusing screen for view, studio, and all reflex cameras, including 35-mm. The surface is prepared by an abrasion or etching process. The ground glass may also have surface grid marking or may incorporate a fine-focusing device, such as a split image or microprism, in the center. *P. Schranz*

Ground glass for a view camera.

GROUND NOISE See *Noise*.

GROUND RESOLUTION A number that is based on the width of the smallest object on the earth or another planet that can be identified in a photographic or other image made from a high altitude, as from a satellite or airplane, obtained by converting the lines resolved in the image into lines per unit length on the ground. *H. Todd*

GROUP DELAY (SOUND) The difference in time that it takes for one part of the spectrum, say bass frequencies, to propagate through a system under test, compared to a reference part of the spectrum, say mid-range frequencies, mathematically related to the phase response. *T. Holman*

GROUP f/64 A small informal gathering of California photographers who, influenced by the work of Edward Weston, shared a common vision of how photography should be practiced. The group functioned from 1932 to 1935 and consisted of photographers such as Ansel Adams, Imogen Cunningham, Willard Van Dyke, and Edward Weston. They advocated an aesthetic based on *straight* (unmanipulated) photography. Their style of photographic realism in American photography became known as the West Coast School. (During this same period the photographer/film maker and sometimes humorist and critic, Ralph Steiner, used a pinhole in front of his camera lens and claimed to be the originator of the f/180 East Coast School.)

There was strong opposition to the proclaimed aesthetic of the f/64 group by the Pictorialist photographers of that time led by William Mortensen, a leading West Coast pictorialist well known (and criticized) for his extensively manipulated photographs.

Books: Newhall, Beaumont. *The History of Photography.* New York: Museum of Modern Art, 1982. *R. Zakia*

GROUP OPERATORS In electronic imaging, an image-processing operation that takes into account the gray level of neighboring pixels surrounding the pixel of interest. A scalable odd number array (3×3, 5×5, 9×9) or mask is often used to do the filtering. *R. Kraus*

GROWTH This term has at least two similar applications in photography. In emulsion precipitation, it refers to that part of the precipitation in which no further formation of nuclei takes place and only the existing emulsion grains are growing. In latent-image formation as viewed by the nucleation-and-growth model, it refers to formation of metal nuclei possessing more than two atoms. *R. Hailstone*

See also: *Photographic theory.*

GRUBER, FRITZ (1908–) German exhibition director and writer. Founder and organizer (1950–1980) of Photokina, the largest photographic trade fair and festival in the world, held biennially. Founder of the German Society for Photography. *M. Alinder*

GUIDE NUMBER A numerical value that can be used to determine an appropriate aperture setting when making a photograph with a flash or electronic-flash light source as an alternative to other methods such as using a flash meter, an automatic exposure system, or an exposure table. The guide number is typically divided by the distance from the light source to the subject in feet to determine the *f*-number. Guide numbers are based on certain conditions, such as the reflectance from the ceiling and walls in an average-sized room, so that compensation may be required when conditions are different, as when making flash photographs outdoors at night. *J. Johnson*

GUIDE TRACK A motion-picture sound track, not to be used in the finished film but valuable as a reference for the creation of the final sound track or animation and editorial planning. *H. Lester*

GUM ARABIC A sticky substance obtained from the stem of the acacia and the fruits of certain other plants. It is soluble in water, but becomes insoluble when combined with certain bichromates and exposed to light. Also used for sizing paper before sensitizing for certain processes. *J. Natal*

See also: *Gum bichromate printing process; Carbon process.*

GUM BICHROMATE PRINTING PROCESS One of three processes that are based on the selective solubility of bichromated colloid resulting from the action of light (the other two are carbon and carbro printing), discovered by Alphonse Louis Poitevin (1819–1892) in 1855. The gum bichromate process, also referred to as the photo-aquatint process, was first exhibited in 1894 by A. Rouillé-Ladevèze in Paris and London. The process enjoyed immense popularity among pictorial photographers and was adopted as the process of choice in the fine art photography movement between 1890 and 1900. Popular again in the 1920s, and still used occasionally today, it is valued for the high degree of artistic control in the printmaking process. A print is made by brushing onto a sheet of heavily sized paper a sensitizing solution that combines gum arabic, pigment (usually in the form of watercolor pigment), and potassium bichromate. Upon drying, it is exposed to ultraviolet radiation in direct contact with a negative the desired size of the final image.

Gum bichromate printing.

After exposure, the print is placed in a tray of water, and the gum solution that was not exposed to light and therefore has remained soluble is slowly dissolved and washed away. The process lends itself to a great deal of hand alteration and manipulation by brushing selected areas of the surface of the print to dissolve greater amounts of the pigmented gum, thereby controlling the density of the deposits of pigment.

Once dry, the print can either be recoated with the same color gum solution, for a richer print, or other color gum solutions can be built up layer upon layer with careful registration of the negative image to alter, deepen, or enrich the print overall or in selective areas. It was not uncommon to combine a platinotype image with the gum process. The process does not contain silver, and the image is permanent.

Books: Scopick, David, *The Gum Bichromate Book, Non-Silver Methods for Photographic Printmaking.* 2nd ed. Boston: Focal Press, 1991. *J. Natal*

GUM-OIL PRINTING PROCESS

An oil-based pigment can also be used in the gum bichromate printing process to produce images that more closely resemble etchings. Coat a piece of paper with an unpigmented bichromate gum solution. Dry, contact expose, and develop normally as with a gum bichromate print. Once the image is completely dry, there will be areas of insoluble gum where the image areas have been exposed to light. Work an oil-based paint into the surface of the print. The hardened gum will repel the paint (highlight areas), but the paper fibers will accept it (shadow areas). Continue to rub surface of the print until no more paint can be wiped away. Soak the print in an alum bath to remove dichromate stain and dry. *J. Natal*

GUM PLATINUM PRINTING PROCESS

This process combines the gum bichromate and the platinotype processes. A slightly underexposed print is made on paper coated with a platinum-sensitizing solution, developed, and dried. The print is then sensitized with a gum solution that combines potassium bichromate and a watercolor pigment. The print is then registered under the negative. The gum coating is then exposed and developed in the usual manner.

J. Natal

See also: *Gum bichromate printing process; Carbon process; Platinotype.*

GUN CAMERA See *Camera types.*

GUNPOD

A device for holding a camera steady by bracing the butt end of the gunpod against a shoulder in the same way that a rifle or shotgun is held. A cable-release connection makes it possible to trip the camera shutter by squeezing a trigger on the gunpod. *L. Stroebel*

GURNEY-MOTT THEORY

A theory of the way in which a latent image is formed in a sensitized silver bromide emulsion by the action of light, proposed by R. W. Gurney and N. F. Mott in 1938. The theory suggests that electrons liberated by absorbed light concentrate at one or a few active sites and that these electrons are then neutralized by the movement of an equivalent number of interstitial silver ions to form the latent image. *R. Hailstone*

See also: *Photographic theory.*

GYRO STABILIZER

A camera-steadying device in which a rapidly spinning wheel produces resistance to sudden changes in orientation, used especially with hand-held motion-picture and video cameras, and also with hand-held still cameras operated at slow shutter speeds or on moving vehicles. *L. Stroebel*

H

H Photographic exposure (international); Hue (Munsell); Henry (inductance)

H&D Hurter and Driffield

HARP High-gain, avalanch-rushing amorphous photoconductor

HD High density

HDTV High-definition television

HE Head end (motion picture)

HI High intensity (arc lamp)

HICON High contrast

HID High-intensity discharge

HI8 Video format

HIRF High-irradiance reciprocity failure

HI VF (High-band still video)

HMI H (Hg/mercury), M (medium arc), I (iodide)—(metal halide lamp)

HP High pressure (mercury vapor lamp)

HR High resolution

HSSV High-speed shuttered video

Hz Hertz, or cycles per second

HAAS, ERNST (1921–1987) Austrian photographer. A native of Vienna, Haas photographed the grim return of Austrian prisoners of war in 1947. Joined Magnum (1949–1962), moving to the United States in 1951. Produced photo essays for *Life* and *National Geographic*. Still photographer for many motion pictures, including *West Side Story* and *The Misfits*. An early convert to color photography, he is known for his innovative, and sometimes impressionistic, use of color.

Books: *The Creation.* New York: Viking, 1971. Haas, Ernst, *Color Photography.* New York: Harry N. Abrams, 1989.

M. Alinder

HAIR LIGHT A light used to produce a highlight that separates dark hair from a dark background. With blonds, a hair light can brighten up a picture and make it less somber. Hair lights are often placed behind the subject on the side opposite the main light.

F. Hunter and P. Fuqua

HALATION Bright light sources in photographs are often surrounded by a luminous halo with a diffuse outer edge. A night photograph with street lamps against a dark sky is a typical occasion for such halation. The sources could be several. If mist or smoke is in the air, it will scatter the light and be seen by the photographer and the camera. In clear air the picture may show halation the eye did not see. If the camera lens and body are not treated to eliminate internal reflections, they could contribute to this condition. This is called *flare*.

The film itself can be responsible, however. Light is scattered by the particles in the emulsion and is further spread every time it passes from one transparent medium into another. This means air to gelatin to film base to air to camera pressure plate and all the way back again. Manufacturers try to minimize this by various antihalation features built into films. Overexposure aggravates this effect. *M. Scott*

See also: *Antihalation coating; Flare.*

HALF-FRAME CAMERA See *Camera types.*

HALF OPEN The position of a leaf-type shutter where it transmits 50% as much light as it does at the fully open position. The time interval between the two half-open positions as the shutter blades open and close is the standard measure of the *effective* exposure time. With leaf-type between-the-lens shutters, the effective exposure time for a given shutter-speed setting changes as the diaphragm is stopped down.

J. Johnson

See also: *Effective exposure time.*

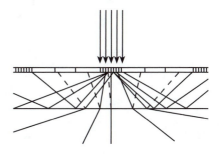

Halation. Light scattered in the emulsion is reflected from the bottom of the support and at a certain angle forms a halo around bright image points (e.g., light sources in the picture).

HALF-PEAK A point on a time-light curve for flashbulbs or electronic flash that represents 50% of the maximum light output. The time interval between the two half peaks is the effective duration of the flash. *R. Jegerings*

HALF-SILVERED MIRROR A mirror with a metallic coating that splits incident light into a 50:50 ratio of transmitted to reflected light. The mirror material may be glass, plastic, or nitrocellulose (pellicle type). The surface coating is of aluminium or chromium, which tarnish less than silver.

S. Ray

See also: *Beam splitter.*

HALFTONE GRAVURE The process of using halftone prints on electromechanical engraving machines to produce gravure printing cylinders. *M. Bruno*

See also: *Gravure; Photomechanical and electronic reproduction.*

HALFTONE PROCESS The halftone process is used to represent continuous tone images, such as photographs, with binary printing processes; that is, processes that can print either solids of the ink on the press or no ink. (This use of the word *halftone* should not be confused with *halbton* which is the German word for continuous tone.) The halftone principle is based on an optical illusion in which tones are represented by a large number of small dots of different sizes with equal optical density and equal spacing between their centers.

The halftone principle is possible because of the limited visual acuity of the human eye. The eye cannot distinguish two points separated by less than one minute of arc. At a normal reading distance of 10–12 inches, this corresponds to two dots separated by about 1/250th of an inch. This is equivalent to a screen ruling of 125 lines per inch (lpi). Halftones with screen rulings higher than 125 lpi have dots indistinguishable to the normal eye. Newspapers have pictures with screen rulings from 60 to 100 lpi; low-budget magazines, newsletters, and other publications use illustrations with screen rulings from 100 to 120 lpi; magazines, catalogs, and other medium-quality publications use screen rulings from 133 to 150 lpi; high-quality printing uses screen rulings of 175 to 250 lpi.

Screen rulings are oriented at different screen angles. Since most screen rulings use a square matrix, screen angles repeat every 90 degrees. Dots oriented at 0 degrees or 90 degrees form rows that the eye can see as disturbing patterns with a screen ruling of 133 lpi and higher, even though the eye cannot resolve the individual dots. Therefore, single-color (black-and-white) halftones are almost always placed with the screen angle at 45 degrees. In color printing it has been found that dot images separated by exactly 30 degrees produce minimum moiré effects, or interference patterns. Since there are only three 30-degrees in 90 degrees, there are problems in four-color printing with regard to the placement of the fourth color. Conventional angles are usually black 45 degrees, magenta 75 degrees, yellow 0 degrees or 90 degrees, and cyan 15 degrees or 105 degrees. To eliminate the moiré pattern caused by the spacing of yellow between magenta and cyan, the yellow is sometimes printed in a coarser or finer screen ruling.

The original halftone screen consisted of a grid of straight lines ruled and inked on two sheets of optically flat glass cemented together at right angles. The lines were the same width as the spaces between them. Glass screen photography requires (1) precision equipment in the camera back to mount the screen and maintain accurate screen distance, and (2) experienced craftsmen with expert skills to produce satisfactory halftones. Because of these constraints, glass screens are now practically obsolete, having been replaced by either contact screens or electronic dot generation. Contact screens are made on film and are used on camera backs, enlarger platforms, or vacuum frames. They are usually made from glass screens. The dots are vignetted with variable density across each dot. There are gray screens with dots consisting of deposits of silver in the film and dyed screens—usually magenta—with dots in which the silver has been replaced by a dye. There are square, round, and elliptical dot screens for special effects, especially in the middletones, double-dot (Respi), and triple-dot screens for special effects in the highlights.

Electronic dot generation (EDG) is performed by special computer programs on electronic scanners, and on prepress and desktop publishing systems. They combine the picture elements, or pixels, of digitized images into data that simulate dot sizes, shapes, screen rulings, and angles of conventional halftone screened images. Special films and processing are used to produce high-contrast images for reproduction. *M. Bruno*

See also: *Photomechanical and electronic reproduction.*

HALIDE A compound of bromine, chlorine, fluorine, or iodine, such as sodium chloride or silver iodide. The photosensitive element is not the metal but the halide ion. *G. Haist*

HALOGEN The name of a family of elements comprising fluorine, chlorine, bromine, and iodine, originally derived from and named after sea salt. The light-sensitive silver salts of chlorine, bromine, and iodine have proved to be the most useful for making photographic emulsions. *G. Haist*

HALOGEN ACCEPTOR Halogens (chlorine, bromine, and iodine) may be released in the emulsion layer during exposure of silver halide materials. To minimize the attack of these active halogens on the silver of the latent image, halogen acceptors, such as gelatin, sulfides, and other compounds, must be present in the emulsion layer. *G. Haist*

HALOGEN LAMP See *Quartz-halogen lamp.*

HALOGEN REGENERATION The greater utility of quartz-halogen lamps, compared to tungsten-filament lamps, is due to the *tungsten-halogen cycle.* Evaporated or sublimated tungsten from the filament combines with halogen gas

Halftone process. Moiré patterns in printing due to improper screen angles.

in the bulb to form tungsten halide. A small bulb and hot wall maintain the halide in a gaseous phase at any point in the bulb. The tungsten halide is recirculated and comes in contact with the hot filament, disassociates into tungsten and halogen gas, and the tungsten redeposits on the filament instead of blackening the bulb wall. Lamp life is longer since the filament is not thinned by vaporization, but tungsten does not always redeposit on the part of the filament from which it vaporized, and the lamp eventually fails. *R. Jegerings*

See also: *Light sources.*

HALSMAN, PHILIPPE (1901–1979) American photographer. Born in Latvia and worked as a freelance photographer in Paris from 1930 to 1940. Moved to New York and joined the Black Star Agency. Photographed over 100 covers for *Life*. In addition to more conventional portraits, he photographed the rich, famous, and powerful captured in mid-jump, which he believed broke through barriers to better reveal the personality.

Books: *Jump Book.* New York: Simon & Schuster, 1959.
M. Alinder

HAND COLORING See *Coloring.*

H AND D CURVE See *Characteristic curve.*

H AND D FILM SPEED See *Film speed.*

HANGER MARKS Uneven density near the edges of a negative or transparency processed in a film hanger, typically due to nonuniform movement of developer over the entire film surface. *L. Stroebel and R. Zakia*

See also: *Tanks and tank processing.*

HANSON, WESLEY T., JR. (1912–1987) American scientist. Inventor of Kodacolor negative type color film (1941) that became the universal standard in color print photography.

Books: Mees, C.E.K., *From Dry Plates to Ektachrome Film.* New York: Ziff-Davis, 1961. *M. Alinder*

HARD See *High-contrast.*

HARD COPY (1) A computer-screen image printed out on paper or film. (2) A photographic print from a microfilm or other image projection, as distinct from an image projected only for visual inspection. *M. Teres*

HARD DISK A magnetic storage device that is capable of holding thousands of megabytes, in contrast to floppy disks that hold approximately 3 MB. Hard disks are also referred to as fixed disks. These disks contain a platter that is spun at a high speed and a read/write head that accesses data. The hard disk maintains its integrity (data) when the power is off. Density of these disks is measured in hundreds of millions of bytes. *R. Kraus*

HARDENER This chemical crosslinks gelatin molecules to make them less soluble in water, less susceptible to swelling in water, and thus more resistant to abrasion. Hardening agents are added to the emulsion layer during manufacture and have been included in separate baths or prebaths or in stop baths or fixing baths. Hardeners for emulsion incorporation are often organic molecules, such as aldehydes or vinylsulfonyl compounds, while those for processing solutions include dialdehydes and multivalent metal ions, such as chromium or aluminum. *G. Haist*

HARDENER FIXER Acid gelatin-hardening fixing baths may contain salts of aluminum, chromium, iron, or zirconium to form intermolecular linkages that lower the solubility of gelatin and toughen the gelatin of processed emulsion layers. The double salt of aluminum sulfate with sodium or potassium sulfate, especially potassium alum, $K_2SO_4 \cdot Al_2(SO_4)_3 \cdot 24H_2O$, is commonly used as the hardener in buffered acid thiosulfate fixers. *G. Haist*

HARD PROOF A proof (test image) on paper as opposed to a soft proof, which is a corresponding image on a video display terminal. *M. Bruno*

HARD SHADOW A shadow with a clearly defined edge, lacking intermediate tones in the boundary between the highlight and shadow area. Such shadows are produced by small and by highly focused light sources. *F. Hunter and P. Fuqua*

See also: *Soft shadow.*

HARDWARE All the components of a computer system except the programmed instructions, that is, except the software. *R. Kraus*

HARD WATER Water hardness is the result of dissolved salts in the water supply but primarily due to the calcium and magnesium ions of the soluble bicarbonates and sulfate salts. Calcium and magnesium bicarbonates can be decomposed by boiling the water, resulting in the deposition of a hard, insoluble scale (carbonates) inside the vessel, pipes, or processing tank. This is temporary hardness. Boiling sulfate salts does not decompose them, so this type of hardness is termed permanent. Calcium or magnesium in the water of developing solutions may result in the precipitation of carbonates or sulfites. *G. Haist*

See also: *Calgon.*

HARMONIC A sine wave having a frequency that is an integral multiple (greater than one) of the frequency of some fundamental wave. In sound, the correctness of reproduction of harmonics determines to some extent the quality of the reproduction of the sound. In photography, interference filters may transmit, in addition to a desired wavelength, one or more harmonics that must be removed by a supplementary filter. *J. Holm*

HARMONIC DISTORTION When a pure sine wave is applied to a system, the output of the system may contain the original sine wave accompanied by sine waves at harmonic frequencies $2 \times f$, $3 \times f$, etc. Harmonic distortion is caused by a lack of perfect replication of the original sine wave.
T. Holman

HASSELBLAD, VICTOR (1902–1978) Swedish photographic inventor and manufacturer. Invented the Hasselblad single-lens reflex, modular camera with interchangeable lenses, viewfinders and film backs, that produced 2-$1/_4$-inch square negatives (1948). Hasselblad continued to design improved models until his death. Acknowledged as one of the finest cameras in history, it was taken to the moon by the first astronauts in 1969. *M. Alinder*

HAWARDEN, LADY CLEMENTINA ELPHINSTONE (1822–1865) British photographer. A pioneer woman of photography, whose work precedes Cameron's. Hawarden was self-taught. Photographed her daughters elaborately dressed and lit by angled sunlight, creating elegant, idealized portraits.

Books: Ovenden, Graham, ed., *Clementina Lady Hawarden.* New York: St. Martin's Press, 1974. *M. Alinder*

HAZE Loss of general contrast in the image due to scattering of light by fine particles in the air. The appearance of haze differs from that of fogged film in that the degree of

contrast reduction is not uniform, but increases in the more distant parts of the scene. Even clean air produces significant haze in scenes viewed over great distances.

Because shorter wavelengths are scattered more than the longer ones, ultraviolet absorbing filters reduce haze in landscape photographs. In studio scenes, photographers sometimes add a small amount of smoke to the air to deliberately produce haze to simulate distance or to influence the mood of the scene. *F. Hunter and P. Fuqua*

HAZE FILTER See *Filter types.*

HEAD (1) An electromagnetic subdevice in a floppy disk drive or hard disk drive that reads and writes data to the disk. The head provides directed current that affects the magnetic property of the media, causing data to be written to, read, or erased from the magnetic disk or tape. (2) The top or the principal functioning part of certain devices such as a tripod head, the part of a tripod that holds the camera and commonly provides for controlled tilting and panning of the camera. *R. Kraus and L. Stroebel*

HEAD ALIGNMENT A term applied to film and tape recording of analog or digital, and to audio, video, or other signals, meaning the correct positioning of the head with respect to the tape or film. Important considerations include the need for continuous intimate contact between the tape or film and the head or else severe spacing loss will occur. *T. Holman*

HEAD LEADER Leader placed on the front end of a motion-picture roll, not intended for projection, containing labeling and cueing information and providing some protection for the film from physical damage. *H. Lester*

HEADPHONES Small electroacoustic transducers meant to be worn by individual users and classified according to whether they are worn with contact around the outer ear, sit on the outer ear, or are inserted in the ear canal. *T. Holman*
Syn.: *Cans* (slang).

HEADROOM The amount of signal handling capacity above a reference level before reaching a specified distortion. For example, "the headroom of magnetic film at 90 feet per minute is +16 dB for 3% total harmonic distortion above a reference level of 185 nW/m." *T. Holman*

HEADSCREEN An opaque or translucent panel, usually attached to the end of a rod on a stand, used to shade a limited area from direct light, such as to deemphasize a person's ear or bald head for a portrait, and to shield a camera lens from direct light that could cause camera or lens flare. *R. Jegerings*
See also: *Barndoors; Feather; Flag; Gobo.*

HEADSET See *Headphones.*

HEADS OUT A roll of motion-picture film wound so the first shot is at the beginning of the roll, as opposed to being wound tails out. *H. Lester*

HEAD SYNC In motion-picture production, cue marks placed on the head leader of picture and sound tracks to ensure proper synchronization. *H. Lester*

HEAT DEVELOPMENT See *Thermography.*

HEAT FILTER See *Filter types.*

HEAT RECORDING A variety of systems exists for the recording of temperature variations in a subject or the detection of objects in the absence of visible radiation.

Headscreen used to shade the ear and side of the head.

Detectors convert radiation into electrical or photographic information. Some detectors respond to photons, or light energy, either in the visible or infrared range. The photon effect is converted by a cell into a flow of electrons that can be used to generate an image by devices such as a metascope, used by the military for night driving, or an intensified image dissector, which has detected the satellites of Jupiter during daylight.

Other detectors respond to thermal energy. The evaporograph camera consists of a membrane that separates two evacuated chambers, one of which contains oil vapor. When an infrared image is focused on the front of the membrane, the oil film deposited on its rear evaporates to form a picture that can be photographed with color-sensitive film through a glass window at the end of the oil chamber. The absorption edge image converter uses a selenium film that changes its absorption characteristics and its transmission of light when it is heated locally. Any object that is even slightly warm will, when focused on the selenium film, cause the film to transmit less light. It may be possible to photograph a teapot in the dark at a considerable distance when the pot is just 10°C warmer than ambient temperatures.

Hot objects in the dark whose surface temperatures range from 250°C to 500°C can be photographed with infrared film. Temperature variations can be measured by comparing densitometer readings of the negatives, with increased density corresponding to higher temperatures, a process called photographic thermometry.

Temperature-sensitive paints that change to a range of colors may be applied to an object which is then photographed. Phosphor may be coated directly on a heated object or an image of the hot object may be focused on a phosphor-coated screen. Heat causes the brightness of the phosphor to drop by about 10% per degree Fahrenheit, providing both a thermal map and quantitative data derived from densitometric readings.

A scanning thermograph concentrates infrared radiation from an object on a pyroelectric detector. The electronic output of the detector can be converted to light for imaging on

film, converted to a video image, computer analyzed, transmitted, or stored. The device can be used in scientific, industrial, and medical applications. *H. Wallach*

See also: *Infrared photography; Thermography.*

HEAVY OIL (1) An opaque oil paint that is sometimes used in coloring black-and-white photographs, either in combination with transparent oil colors to accent certain areas such as highlights, or to convert the photograph into an oil painting. (2) A hand-coloring procedure that uses opaque colors in a thick oil base. The colors are applied with brushes, and when the colors are applied to the entire surface of a photograph, the photograph is converted to an oil painting. Greater skill is required for coloring with heavy oils than with transparent colorants. Heavy oils can also be used locally, to accentuate highlights and shadows for example, on photographs that have been colored with transparent colorants or even on color photographs.

L. Stroebel and I. Current

See also: *Coloring.*

HEINECKEN, ROBERT (1931–) American photographer and teacher. Leader of the American photographic avant-garde during the 1960s through the 1970s, extending the limits of what we call photography by using collage, lithography, photocopies, liquid photographic emulsions, and light-sensitized linen. Subject matter most usually is appropriated and concerned with the female figure, sometimes combined with graphic elements. Began photography program in the department of art, University of California Los Angeles (1960).

Books: James Enyeart, ed., *Heinecken.* Carmel, CA: The Friends of Photography, 1980. *M. Alinder*

HELICAL MOUNT A type of lens mount where the image is focused by rotating the lens barrel, thereby moving the lens forward or backward on matching spiral threads on the barrel and the mount. *L. Stroebel*

HELIOGRAPHY Heliography, sun writing, is the name given to the asphaltic compound system of imaging invented by Joseph-Nicéphore Niépce in 1822. Interested in the new lithographic printing process, Niépce was seeking a simplified way to print multiple impressions from a single master. He knew that bitumen of Judea, used as a resist in engraving, became insoluble in oil of lavender after exposure to light. He coated the bitumen on a glass plate and contact printed an engraving of Pope Pius VII on paper that he had oiled to enhance its translucency. After washing in oil of lavender, the high spots consisted of the areas where the engraving had been less dense, and the low spots corresponded to the areas that were dark in the engraving.

In 1824, Niépce used a camera to record an image on lithographic stone and began coating the bitumen on pewter and silver-surfaced copper plates. Two years later, he succeeded in making what is now generally accepted to be the first permanent, camera-made image. He took one of his plates, about 6.5 by 8 inches, and placed it in a camera that he pointed out a second story window of his estate, Le Gras, near Chalon-sur-Saône in central France. The exposure lasted eight hours. After the oil solvent treatment, a direct positive image was visible against the dark metal background of the plate.

Niépce later experimented with fuming his plates with iodine crystals, but saw that he needed assistance in the development of his invention. He formed a partnership with L. J. M. Daguerre in 1829, but passed away in 1833, six years before the grand introduction of the daguerreotype, a process closer in nature to Niépce's failed experiments of 1793 and 1813–1817 than to the success that made him the first photographer. *H. Wallach*

See also: *Niépce, J. N.*

HELMHOLTZ, HERMANN VON (1821–1894) German physicist and physiologist. Developed the science of physiological optics. Author of the influential *Handbook of Physiological Optics* published in 1867. Contributed notably to the theory of color and shared responsibility for the Young-Helmholtz theory that the eye is sensitive to three colors—red, blue, green. Invented the opthalmoscope.

M. Alinder

HELMHOLTZ–KOHLRAUSCH EFFECT Change in brightness of perceived colors produced by increasing the purity of a color stimulus while keeping its luminance constant (within the range of photopic vision). *R. W. G. Hunt*

HELSON–JUDD EFFECT Tendency, in colored illumination, for light colors to be tinged with the hue of the illuminant and for dark colors to be tinged with the complementary hue. *R. W. G. Hunt*

HENRY (H) The basic unit of inductance of an inductor. A 1 henry inductor will develop 1 volt of counter-electromotive force when the current though it changes at a rate of 1 ampere per second. *W. Klein*

See also: *Inductance.*

HERSCHEL EFFECT See *Photographic effects.*

HERSCHEL, SIR JOHN FREDERICK WILLIAM (1792–1871) English astronomer and pioneer photographic chemist. In 1819, discovered thiosulfates and that their properties included the ability to completely dissolve silver salts. Upon learning in 1839 that both Talbot and Daguerre claimed to have discovered photography, independently invented a photographic negative process on glass (1839). Generously suggested to both men, and others, the use of sodium thiosulfate, "hypo," as a photographic fixing agent. This proved to be important, since hypo more effectively eliminated unexposed silver salts, than the common table salt then used. Though widely credited with coining the word *photography,* that was actually done by the Frenchman Hercules Florence in Brazil in 1834. Introduced terms *negative* and *positive* as well as *emulsion* and *snapshot.* Investigated the photochemical action of the solar spectrum. Discovered the different spectral sensitivities of the silver halides, chloride and bromide, and of silver nitrate, and described the light sensitivity of the citrates and tartrates of iron and of the double iron-ammonium citrates. Discovered the Herschel effect, the name given to the fading caused by infrared radiation falling on an exposed image, that has been the starting point for much modern research on the nature of the photographic latent image. Invented the cyanotype, the first blueprint in 1842. Suggested microfilm documentation.

Books: Newhall, Beaumont, *Latent Image.* New York: Doubleday, 1967. *M. Alinder*

HERTZ The unit of frequency; 1 hertz being 1 cycle per second. Used for sound, electromagnetic radiation, and other wave motions. *J. Holm*

HETEROCHROMATIC PHOTOMETRY The luminance of two fields can be visually matched with great accuracy if the colors of the fields are identical, or nearly so. However, in the case where the fields are of different colors (heterochromatic), accuracy suffers. While brightness judgments of differently colored fields can still be made in cases where there are large luminance differences between the two

fields, great uncertainty exists in matches performed with large color differences because hue and saturation differences are confounded with luminance differences, making heterochromatic matches difficult and unreliable. While matches made under scotopic (dark adapted) conditions would eliminate color differences, they would not correlate with photopic perception because of the different spectral sensitivity.

Several reliable heterochromatic methods have been developed. In the *cascade* or *step-by-step* method, a large color difference is broken up into a series of smaller steps. These smaller steps can be made with nearly the same precision as with homochromatic fields. Another method places colored filters over one or both fields to minimize the color difference. The spectral transmittance of the filters is then taken into account in determining the result. Perhaps the most successful method is flicker photography, in which the two fields are viewed in rapid succession. This method takes advantages of the fact that perceived color differences fuse at lower flicker rates than do brightness differences. A match is achieved by adjusting the test field to minimize the flicker due to the luminance difference.

Physical heterochromatic photometric measurements are made by scaling the power in each wavelength region by the CIE $V(\lambda)$ function analytically or by filtering the detector.
J. Pelz

See also: *Critical flicker/fusion frequency; Equivalent luminance; Flicker photometer; Photometry and light units; Purkinje effect/Purkinje shift.*

HIDDEN LINES/SIDES In computer graphics, the modeling of a three-dimensional object in wire frame mode will display all the necessary lines to fully visualize the object. When the object is displayed as a solid, not all of the lines are visible. Those lines that are hidden by a surface are not visible, hence they are called hidden lines. These lines remain a mathematical formula and are only displayed if the object is viewed from another vantage point.
R. Kraus

HI-FI TRACKS Audio recording made a part of the video signal and recorded to and replayed from the tape by heads on the video scanning drum. Kept separate from the video by the use of a different carrier frequency rather like tuning in a different station on a radio and other tricks. Better quality than longitudinal recording because the relative tape-to-head speed is much higher (the heads are rotating).
T. Holman

HIGH COLOR A general-purpose PC graphics board that is capable of surpassing VGA specifications. High color graphics boards can display 32,768 (15-bits) colors at a spatial resolution of 800 × 600 pixels. Fifteen-bit displays allow for the representation of 32 shades of red, × 32 shades of green × 32 shades of blue. High color display is not photographic quality, but it does render color at NTSC levels.
R. Kraus

HIGH-CONTRAST Identifying a lighting, film, developer, printing material, etc. used to increase tonal separation, either to achieve a high-contrast effect or to compensate for a low-contrast effect elsewhere in the system.
L. Stroebel

HIGH-CONTRAST FILM/PAPER Photosensitive materials of higher contrast than is normal for pictorial photography. They may be used pictorially for special stark effects, or in scientific and technical photography to enhance subtleties. These materials are often used with high contrast development and perhaps with special high-contrast lighting of the subject.
M. Scott

See also: *Lith/Litho/Lithographic.*

HIGH DENSITY (HD) HD floppy disks can hold between 1.2 Mbytes and 2.88 Mbytes. Floppy disks are marked HD (high-density), DD (double-density, ≈ 720 Kbytes) or SD (single-density, ≈ 360 Kbytes).
R. Kraus

HIGHER-ORDER ABERRATIONS See *Lenses, lens aberrations.*

HIGH FILTER A source of unending confusion, this is a term used in consumer audio for a filter that rolls off high frequencies. The corresponding professional term is low-pass filter, since the definition used by engineers is to define what is passed rather than what is rejected in the name of the filter.
T. Holman

HIGH-INTENSITY DISCHARGE LAMP (HID) Group name for industrial sodium, metal halide, and mercury high-pressure arc-discharge lamps that are encountered by location photographers, for example, in stores, sports arenas, and parking lots. HID lamps emit only certain wavelengths, or have a spectrum in which some wavelengths predominate. Some lamps may have a phosphor coating on the interior of the bulb and be described as *color improved*.
R. Jegerings

See also: *Light sources.*

HIGH KEY Describes an image composed of mainly light tones. Although exposure and lighting influence the effect, an inherently light-toned subject is almost essential.

High-key photographs usually have pure or nearly pure white backgrounds. In the studio this usually requires more light on the background than is common for moods other than high key.

The high-key effect requires tonal gradation or shadows for modeling, but precludes extremely dark shadows. Unless the main light is very close to the camera, enough fill to maintain a lighting ratio no greater than 3:1 is usually necessary to maintain the high-key mood.
F. Hunter and P. Fuqua

See also: *Low key.*

HIGHLIGHT A light area in a scene, photograph, or other image, especially one where the lighting has contributed to the effect, such as a highlight produced by the main light on the cheek, nose, or forehead of a person in a portrait. Highlights may be identified more specifically as specular (a mirror-like reflection on a polished surface) or diffuse (a reflection on a dull surface).
L. Stroebel

HIGHLIGHT MASKING To facilitate the reproduction of color positives, it is sometimes necessary to reduce the difference in density between highlight and shadow areas. An unsharp mask of low density is made and sandwiched in registration with the original positive. Substantial increases in highlight detail may be obtained. This technique can be applied to the printing of negatives as well.
H. Wallach

See also: *Mask/Masking; Masking, unsharp.*

HIGH-LOW CIRCUIT (1) A switching method by which an even number of floodlamps with equal wattages can be operated at full intensity or at a reduced intensity to extend the life of the bulbs and conserve energy. A double-pole, double-throw switch is used to switch the lamps from parallel (full intensity) to series (reduced intensity) operation. (2) A switching method that permits use of all or only part of the storage capacitors in an electronic flash power pack in order to control its light output.
W. Klein

HIGH OBLIQUE An aerial photograph made with the camera inclined at an angle from the perpendicular that places the horizon near the top of the photograph, in contrast to low oblique, vertical, and horizontal positions.
L. Stroebel

HIGH-PASS FILTER (1) An electrical filter that passes frequencies above a defined and usually adjustable one, while rejecting frequencies below the cutoff frequency. High-pass filters are most often used to reduce the effects of background noise, which often has predominant low-frequency content, while minimally disturbing the desired signal, such as voice. (2) The attenuation of low frequency data in an image. This operation enhances high-frequency data such as the transition from low-contrast data to high-contrast data (edge). Detail is generally enhanced.

T. Holman and R. Kraus

HIGH-PRESSURE LAMP General classification for arc lamps that produce light from an arc in a pressurized gas or vapor.

R. Jegerings

Syn.: *Arc lamp.*

HIGH-RESOLUTION Applied to lenses and sensitive materials capable of imaging exceedingly fine details.

M. Scott

See also: *Resolution; Resolving power.*

HIGH-SPEED CAMERA See *Camera types.*

HIGH-SPEED CINEMATOGRAPHY Motion picture recording at rates exceeding about 50 pictures (frames) per second, to photograph movement and events too fast to be perceived by visual or straightforward photographic methods. Such recording requires special means of operation, and high-speed cinematography is accordingly classified as follows:

1. High speed, at 50 to 500 frames per second (fps), using intermittent film motion and mechanical shuttering;
2. Very high speed, at 500 to 100,000 fps, using moving film and image compensation;
3. Ultra high speed, at 100,000 to 10 million fps, using a stationary film with moving image systems;
4. Super high speed, in excess of 10 million fps.

The boundaries between systems are not precise, as some cameras employ combinations of techniques. This arrangement fits in with common practice in the main and also the terms used follow the same pattern as those used in the classification of radio frequencies although, of course, frames and cycles do not agree. It is unfortunate that superlatives were used too readily, that is, before the cameras in the last two groups became possible.

High-speed cameras of group 1 are specially developed versions of normal cine cameras, being limited in speed by the physical strength of the film, for the stresses imposed by starting and stopping between exposures can exceed the breaking point of the film base, causing tears first at the sprocket holes. The fastest cameras operate at up to 300 fps on 35-mm film and 1000 fps on 16-mm film.

In the cameras of group 2 the film is moved smoothly and continuously and some form of compensation is required to avoid image blue during the exposure.

In cameras of groups 3 and 4 the film is stationary and the image only moves.

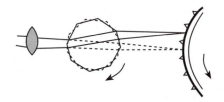

Rotating prism. Rotation of the compensating prism keeps the image stationary on the moving film as it passes over the sprocket. Successive frames are exposed as each prism surface faces the lens in turn. Prism and film movement are synchronized. Maximum camera speed is 10,000 frames per second on 8-mm film.

Rotating Prism Compensation Between the lens and the film is placed a rotating prism of regular form (parallel sided block, cube, or octagon). By refraction or reflection, the light forming the image is moved during the exposure in the same direction and at the same speed as the film by various optical and mechanical schemes. Thus, during exposure, there is no relative motion between the image and the film. Suitable masks are fitted to the prism to limit the exposure time to the period during which compensation is possible. Masks with smaller apertures are also used when still shorter exposure times are required.

The physical strength of the film base again sets the limit and the maximum rates achieved are 20,000 fps with 8-mm frames and 10,000 fps with 16-mm frames.

Rotating Drum Systems Some improvement in speed can be made at the expense of total recording time by attaching a length of film to a rotating drum so that the film now has support and the limit is set by the strength of the film.

Using a rotating mirror for image compensation, a commercially available camera gives 224 frames of 7.5 × 10.2 mm at 35,000 fps.

Using two concentric drums, one carrying the film and the other a number of lenses, frames of 5 x 8 mm have been recorded at 40,000 fps.

With a single objective lens and a rotating drum, it is also possible to synchronize a series of very short duration light flashes to the drum motion, so that the brief exposure of each flash is so short as to give no appreciable image movement. This permits framing rates up to about 100,000 fps.

A complex installation of five drums and 50 spark gaps, all synchronized, produced 2,500 frames 25 x 200 mm at 250,000 fps, and 5,000 frames 25 x 10 mm at 500,000 fps.

Multiple-lens Cameras To exceed the framing rates possible with moving film, various methods exist in which the image is moved along a stationary film.

The subject is imaged very near the surface of a rotating mirror (commonly about 25-mm width). This image can then be re-imaged on to the film by an arc of lenses. A relay lens between the objective lens and the mirror images the stop of the objective on to the stops of the lenses on the arc. As the mirror rotates, the image-forming light beam moves from lens to lens on the arc producing a series of images on the

Rotating prism acts as shutter and keeps the image sharply in position on the moving film. (1) End piece of prism cuts off light. (2) Prism opens light path; image is displaced upwards by refraction. (3) The image follows the moving film. (4) After maximum downward displacement, the prism cuts off the light again.

Rotating drum camera. The film is fastened to the inside of a drum that further carries a ring of lenses, so that each lens covers one frame on the film. The image of the subject is projected into the center of the drum and from there directed to the circumference. As the drum rotates at a high speed, each moving lens picks up the image and keeps it stationary on the individual film frame behind the lens until the next lens moves into position. A stationary between-lens shutter cuts off the light after one revolution of the drum. A, stationary focal plane shutter (slit through which image is projected). B, final image, moves with film. C, Stationary diaphragm shutter. D, moving lenses in drum. E, moving film in drum. F, intermediate image projected into center of drum.

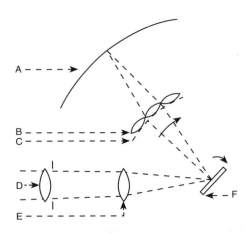

Rotating mirror camera. The objective lens images the subject via a relay lens on the surface of the rotating mirror. The image of the subject, therefore, is relatively stationary. The relay lens images the aperture of the objective lens successively on to miniature lenses which form further images of the subject on the film. Owing to the rotation of the mirror the reflected beam travels in the direction shown by the arrow, exposing successive frames. With two rotating mirrors the travel speed of the beam can be very greatly increased. A, film. B, miniature lenses forming final images. C, lens stops. D, objective lens with lens stop. E, relay lens. F, rotating mirror.

film, with negligible image-to-film motion during each exposure. Exposure time of individual frames can be varied by changing the aperture stops.

Suitable mirrors can be rotated up to 80% of their burst in velocity due to centrifugal forces and when made of suitable materials, e.g., high-tensile steel, rotation speeds of 500,000 rpm have been achieved.

With individual frame sizes of 8 x 8 mm, speeds up to 10,000,000 fps are possible. Buy changing the lenses used,

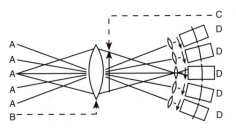

Multiple drum multiple spark cameras. Each drum has its own lens and spark series. As each spark is imaged on the aperture of only one camera lens, it cannot affect the other four cameras. A, sparks. B, field lens. C, subject. D, drum cameras.

larger frames at lower rates can be recorded using the same camera and mirror. The number of frames recorded is commonly between 30 and 200.

Use of two rotating mirrors and multiple reflections can produce still higher rates.

To increase the number of frames in a sequence and to reduce synchronization problems, it is sometimes advantageous to keep the camera continuously recording. Thus irrespective of mirror position, an exposure is being made at all times somewhere on the film track. This can be accomplished by using multiple optical paths in one camera or by synchronizing two or more cameras together.

Adding a rotating drum mechanism to a rotating mirror system can increase the number of frames recorded without reducing frame rate excessively but the camera becomes more complex and expensive.

Many of these cameras do not produce records which can readily be projected as cine-films, although skillful printing can make this possible. However when the number of frames is not large analysis is normally done frame by frame.

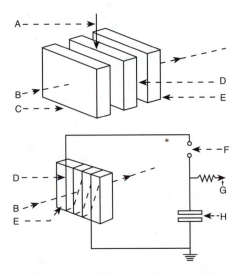

Capping shutters. Top: In the shatter shutter a glass block is sandwiched between two Plexiglass plates. At the end of the exposure an explosive charge shatters the glass and so obstructs the light. In the spattered wire shutter (bottom on the left), a high-tension current pulse fuses a lead wire wrapped around a glass block in the light path. This spatters lead all over the glass, so obstructing the light. A, explosive force. B, light path. C, Perspex plates. D, glass block. E, lead wire. F, trigger. G, high-tension supply. H, high-tension capacitor.

Capping Shutters When photographing self-luminous subjects with high-speed cameras that depend on polarized light (Faraday or Kerr effects) or on rotating drums or mirrors, a capping shutter is necessary if the luminosity continues after the camera exposure. Otherwise the image can record by light leakage through the polarizers or on the next camera revolution. Such capping shutters normally have to move from open-to-shut only, in periods around 10 microseconds. Less frequently, a shut-to-open system is required went the exposure is to be made after a period of luminosity or when the background lighting is high enough to record, say on a drum camera, by the additive exposure of many revolutions.

The methods used are numerous. They include the sputtering of lead wire on to a glass window by passing a high current through the wire; explosively spraying a black mixture (lamp black, say, plus a greasy binder) on to a window; explosively shattering a glass window sandwiched between two sheets of plexiglass such that it becomes relatively opaque by multiple scattering. Various tricks with very thin metal foils have been proposed that give opening or closing shutters depending on arrangement—all involve some electrical discharge circuit to produce the necessary energy, usually demanding many thousands of volts and large capacitors.

Passing a discharge through a thin metal layer forming a mirror, so removing the metal layer can also be used as wither type of shutter.

Multiple Cameras A series of pictures taken in sequence by a number of single-shot cameras constitutes a form of cinephotography. The advantages lie in the increased information per frame, flexibility in frame interval and exposure time, shorter exposure times and reduction of image movement.

An assembly of 12 Kerr cell cameras has been so used, each at 0.1 microsecond exposure. When triggered in immediate succession, this set-up can give a rate of 10,000,000 fps. Kerr cell shutters have been operated at still shorter exposures down to 5 nanoseconds 5/1,000,000,000 of a second). Similarly Faraday shutters and image tubes can be used.

For nonluminous events, events, a battery of cameras each with its own spark light source has been used at up to 100,000 fps.

Some difficulty in analysis occurs in that these cameras all have slightly different viewpoints. to some extent this is overcome by using mirrors to bring the viewpoints closer. An alternative method is to make one camera with a sectional lens, that is, the lens is divided into segments that are then displaced a little from each other. Arranging a rotating disc with a single aperture causes each lenslet to be exposed in turn, giving a series equal in number to the number of lenslets. Such camera, which is simple and relatively cheap, takes eight frames at 6,000 fps.

Image dissection is also a kind of multiple exposure system, but with more complex recording and analysis requirements.

Optical Delay Camera The extremely short exposures possible with a Kerr cell permit a further technique. The light from the subject is relayed to the camera via a system of mirrors such that six possible paths exist, all of different lengths. Light only travels 1 foot in 1 nanosecond. Thus, if the path length difference between adjacent cameras is 5 feet, then at exposures of 5 nanoseconds, the light for one exposure is different from the light used in the next exposure. All six paths can be made to pass through the same Kerr cell, so that one shutter action produces six separate images corresponding to six separate time periods in the subject. Such pictures of exploding wires have been made at 5 nanosecond exposures and with frame intervals of 15 nanoseconds, equivalent to 66,000,000 fps.

Image Tube Framing Cameras The shuttering and

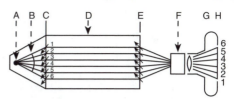

Optical delay camera. The light from the even (from the subject) passes through a series of field lenses into an optical time-delay tank. There it is reflected between a series of mirrors in the first and second mirror plane. It thus reaches the film plane of the camera at different instants separated by the time taken by the light to traverse different lengths of the optical path. This yields a series of successive images 1 to 6 on the film. A subject. B, field lenses. C, first mirror plant. D, optical time delay tank. E, second mirror plan. F, Kerr-cell shutter. G, 35-mm miniature camera. H, film plane.

deflection properties of image tubes can be used to produce a short sequence of pictures on one tube. Image tubes can already be used to produce shorter exposures and higher deflection rates than other techniques and also can even intensify the light available making it possible to record events previously not sufficiently bright. A commercially available camera gives three frames,. each 17 x 25 mm, with exposures as short as 5 nanoseconds at intervals of 50 nanoseconds or 20,000,000 fps. Other cameras give six or eight pictures at up to 1,000,000 fps.

Timing Cameras with moving film require timing marks on the film to assist in interpretation. In many applications the film never achieves a steady velocity and is often still accelerating when the magazine is exhausted, so small marks recorded at regular time intervals along the film edge indicate the film velocity (more precisely, the time resolution) at any point of the film. These timing marks can be reproduced by a variety of techniques which depend on some independent stable frequency source.

A tuning fork is such a source and its vibrations can be maintained by an electromagnet powered by, say, a 12-volt battery. A ray of light shines vie a slot mounted on the fork, the fork's vibrations causing the slot to interrupt the beam regularly, thus a 500 cycles per second fork produces 1,000 marks per second on the film; the camera rate is readily computed, e.g., 4 marks per frame—260 fps, 4 frames per mark—4,000 fps.

With continuing advances in electronics, compact timing units using crystal oscillators to drive argon, neon, or xenon lamps recording on film through narrow slits, or to drive light emitting diodes, have been made. These devices have the advantage that the duration of the timing mark and its rate can be adjusted to suit requirements.

Particularly with cameras at rates below 1,000 fps, a neat method is to include a clock (dial or digital) in the field of view so that, during projection, it can be observed at the same time as the record.

In the ultra-high-speed class with rotating mirrors, it is customary to direct a beam of light via the mirror to a path alongside the film where it can, by suitable masks, make marks on the film. Simultaneously the beam is received by a photoelectric tube that can then send out electrical pulses suitable for triggering events or light sources and for making measurements of the camera speed via electronic equipment.

Illumination Up to 50,000 fps, a variety of lighting systems are used including tungsten lamps, photofloods, flash bulbs and electronic flash tubes. A more sophisticated source is the pulsed xenon arc lamp, which can be driven for short periods into peak power of 10 kilowatts and produces

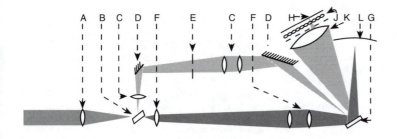

Streak and framing camera. A beam splitter divides the image rays from the objective lens along two paths to a rotating mirror. This in turn projects the images on the one hand through the imaging lenses of a framing camera, and on the other on to the film plane of a streak camera. A, objective lens. B, slit and beam-splitting relay mirror. C, framing field and relay lenses. D, fixed relay mirror. E, primary framing stop. F, streak camera field and relay lenses. G, rotating mirror. H, framing camera field plane. J. Imaging lenses and secondary stops. K, framing camera projection lens. L, streak camera film plane.

enough light over an area of 1 square foot for photography at 20,000 fps on black-and-white film.

For higher framing speeds, many events are self-luminous but when subject lighting is required then either electronic flash tubes or argon flash bombs are used, which an be synchronized to the camera and the event.

Streak Cameras In this special type of high-speed camera, a very narrow segment of the subject is selected for analysis and continuously successive exposures of this segment are made so that all visual changes during the recording period are observed. Thus the final photograph has exchanged one of its two space dimensions for a dimension in time.

In its simples form, the subject is imaged by the objective lens on to a narrow slit, thus selecting the portion to be analyzed. This slit-image is then re-imaged onto the film. The film may be attached to a rotating drum so that the slit-image is then streaked or smeared along the film at right angles to the long axis of the slit-image. The film could be moved past the slit-image by a camera such as a rotating prism camera, so giving a much longer record. Or again, the slit image could be moved along a stationary film by means of a rotating mirror to give higher writing speeds.

The writing speed of these cameras may be quoted in two ways, either the speed of the relative motion of the slit-image and film or by the item it takes for the slit-image to be moved by an amount equal to its own width. One is usually given in mm per microseconds and the other in seconds or fractions of seconds. The latter is a better indication of performance and is the time resolution of the camera.

The fastest rotating mirror cameras give writing speeds up to 40 mm per microsecond (equivalent to 100,000 fps or nearly 100 times the speed of sound—Mach 100) with resolution times as short as 2.5×10^{-9} seconds (or 2.5 divided by 1,000,000,000). Rotating drums are unlikely to exceed supersonic peripheral speeds and so are at least 100 times slower.

Many streak cameras are not continuously viewing; hence it is necessary to synchronize the event to the period during which a record can be taken. By use of multiple optical paths within the camera, or multiple cameras, this can be overcome. A rotating element designed to achieve this with fewer components uses both refraction and reflection within a rotating element of two prisms. As these must be transparent, only lower speeds can be used as the prism material will not have as high a tensile strength a metal mirrors.

Image tubes can also be sued as streak cameras with relatively shorter recording periods. A slit-image of the subject is imaged on the photocathode. By electronic deflection within the tube, a steak image then appears on the screen. Such tubes have achieved time resolution on the order of a few femoseconds ($n \times 10^{-15}$).

The time for light to travel one wave-length is only about 10^{-15} seconds, so it is apparent that absolute physical limits are being approached.

Synchroballistic Cameras One technique has been used that does not fit into either streak or framing categories but is somewhere between the two. If a streak camera is used to photograph a missile whose image velocity is equal to the streak speed, each portion of the missile will be photographed in turn and the film will show a still picture of the whole of the missile. This is a streak image of the changes in a given slit in space but is also equivalent to a very short exposure with a focal plan shutter. The technique is also known by the more generic term of strip photography.

It is also a high-speed version of the racetrack photo-finish camera. It is very useful in missile studies, as it can give a high-resolution picture of a missile in flight whose length is so much greater than its girth, that a more normal optical system could not provide an adequately sharp record.

Multiple-Slit Streak Cameras If instead of a single slit, an array of parallel slits is used, a record sampling more portions of the event is obtained. The recording period is, of course, very much reduced, as the streak image of one slit should not overlap that of the next slit. Such a system, when the number of slits is large, becomes an image dissection system and operates as a form of framing or cine camera.

Streak versus Framing Cameras These cameras are not so much comparable as complementary. A framing camera records two spatial dimensions but only samples in time, thus it is possible for a change to occur between two frames that is not evident in either frame. A streak camera records one spatial dimension (i.e., a sample of space) continuously in time, such that no change in time within the space sample is missed. The streak camera is ideal for studying events of uniform growth or decay, an expanding sphere or cylindrical discharge, when only the rate of growth is to be measured. But its results can easily be misinterpreted. Streak cameras are also known as velocity recording cameras.

Combinations of framing cameras and streak cameras or streak cameras with a number of single-shot cameras produce the maximum amount of information with the minimum possible errors and the minimum of equipment. (One combined camera is commercially available giving up to 23 frames, 6 x 12 mm, at 8,000,000 fps and a streak record for 4.5 microseconds at 27.6 mm per microsecond with a possible resolution time of 7.7 milli-microseconds.

Applications Up to 20,000 fps, the subjects for high-speed cinematography cover a wide variety of fields in both industry and research including motors, relays, switches, textile machinery, internal combustion studies, rockets, biology, and medicine.

At higher speeds, the uses are more likely to be in scientific research on explosive (both conventional and nuclear) plasma studies particularly for atomic energy fusion reactors, supersonic research for aircraft and missiles and studies of the fracture of materials, e.g., shattering of glass in car windshields.

Books: Proceedings of the International Congresses on High Speed Photography held in Washington and other major cities

worldwide every two years (1952–1992); Saxe, F.R. *High Speed Photography*. London: Focal Press 1966; Arnold, C.R., Rolls, P. J., and Stewart, J. C. *Applied Photography*. London: Focal Press, 1971, *High Speed Photography*. Rochester, New York, 1981.

See also: *Ballistic photography; Schlieren photography; Image dissection; High-speed photography.*

HIGH-SPEED LIGHTING

Typically lighting of short duration and high intensity that is used to obtain a sharp image of a rapidly moving object, such as a bullet in flight. When a sequence of photographs is required, the light source can be a strobe, which produces a rapid series of flashes, or a high-intensity continuous light that provides sufficient illumination for operation of a high-speed camera. *R. Jegerings*

See also: *High-speed photography; Shadograph.*

HIGH-SPEED PHOTOGRAPHY

The realm of high-speed still photography is generally determined by the exposure times used or the picture repetition rate. Exposure times of leaf or diaphragm mechanical shutters in still cameras generally have a minimum time limit of around 1/500 second, while modern focal plane shutters have achieved exposure times as short as 1/8,000 second. Generally, when photography with exposure times shorter than about 1/1000 second is contemplated, it is classed as high-speed work and nearly always requires special techniques.

To arrest motion in a picture, either the shortest exposure possible is used or the camera is moved in synchronism with the subject (permitting the background to blur).

A formula for the maximum permissible exposure time is

$$T = L/500 \times V \text{ seconds}$$

where L is the largest subject dimension to be recorded and V is the subject speed in the same units as L per second. For example, for a car moving at 68 mph, 100 feet per second (fps), the longest frame dimension, L, might be 50 feet. Thus,

$$T = 50/ (500 \times 100) \text{ or } T = 1/1000 \text{ second}$$

This is just on the limit for a normal shutter and no camera motion.

It should be noted that both V and L determine the exposure time—increasing V or decreasing L both demand shorter exposures. Many research subjects are both faster and smaller than a car.

Another method for determining exposure time is based on the concept of maximum allowable blur based on subject dimensions. A decision on what this dimension is at the subject may be influenced by several factors, each depending on user-defined criteria. These may include such items as total absence of blur at a given degree of magnification of the reproduction, size of smallest object within the subject of which useful detail needs to be recorded, etc. The formula, which also takes into account the direction of subject motion, is

$$T = \text{size of smallest detail within subject} / (K \times \text{velocity of subject} \times \cos A)$$

where K is a quality constant, generally a number from 2–4, and A is the angle between film plane and subject direction.

Even an air rifle dart with a relative slow speed (100 fps) but only an inch or so long, within which it is desired to perceive detail as small as 1/200 inch, according to formula and practice, requires an exposure as short as 4 microseconds (μsec) (1/250,000 second).

The two main methods of taking high-speed still photographs are the use of a suitable high-speed shutter system and the use of a short-duration flash while the shutter is open.

High-speed shutter systems may be magneto-optical, elec-tro-optical, or electronic units using image-converter tubes. High-speed flash systems may use electronic flash discharges or sparks, or special discharges such as x-ray flashes for high-speed radiography.

MAGNETO-OPTICAL SHUTTER A magneto-optical shutter uses the Faraday effect, that is, the rotation of the plane of polarization of light passing through a transparent medium in a magnetic field. To use the Faraday effect, a suitable medium in a magnetic coil is placed between crossed polarizers. Dense flint glass is generally used, since it shows considerable rotation of the plane of polarization for a given magnetic field and is convenient to handle. With no current in the coil, there is no magnetic field, no rotation of the plane of polarization occurs, and therefore no light is transmitted. When a suitable current is applied (often 1,000 amperes needing 10,000 volts) the plane of polarization is rotated until it agrees with the second polarizer, and the maximum light is transmitted. This current can be supplied by discharging a capacitor through the coil using a spark gap as a switch. The time of the discharge depends on the capacitor size, the voltage, and the number of turns in the coil. Exposure times down to 1 μsec have been achieved.

In practice, a cylinder of the glass is placed in front of the lens and coaxially with it, together with the crossed polarizers, while the coil surrounds the cylinder. The capacitor discharge may be controlled by a spark gap, the spark in turn is

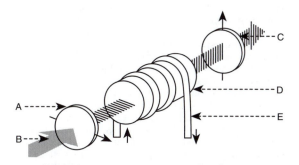

Magneto-optical (Faraday) shutter. A, first polarizer; B, light ray from subject; C, second polarizer; D, glass cylinder; E, coil. The second polarizer passes light only when the glass cylinder rotates the plane of polarization under the influence of the magnetic field. This is created by a high-voltage pulse passed through the coil.

actuated by the subject itself (i.e., the shock wave or the flash from an explosion under examination).

ELECTRO-OPTICAL SHUTTER (KERR CELL SHUTTER) Kerr discovered that certain media in the presence of an electric field become birefringent, that is, light polarized in one plane has a different velocity in the medium to light polarized in a plane at right angles. The usual Kerr cell shutter consists of a glass cell fitted with electrodes and filled with nitrobenzene and placed between two polarizers. The whole assembly may be mounted in front of the camera lens or within the optical system. The first polarizer is set such that its polarizing plane is at 45 degrees to the cell plates and the electric field. Plane-polarized light entering the cell becomes circularly polarized, that is, it has two equal components, each at 45 degrees to the original plane of polarization, 90 degrees to each other.

If a suitable voltage is applied to the plates (commonly near 20,000 volts), the phase difference produced by the differing velocities is such that on recombining at the second polarizer, the resultant plane-polarized beam is in agreement with this polarizer. With no voltage applied, no phase change

Electro-optical shutter (Kerr cell). A, first polarizer; B, light beam from subject; C, second polarizer; D, electrodes in liquid cell. The liquid becomes birefringent on application of a high-voltage pulse to the electrodes.

Image converter setup. This system is used for single photographs of nonluminous objects that are illuminated by a flashtube. The image converter shutter is synchronized with the peak of the flash. A, electronic flashtube powered in the usual way; B, trigger circuit; C and E, variable delay circuits; D and F, thyratron switches; G, lens; H, image converter.

occurs and the resultant beam is polarized such that no light is transmitted. Thus, by switching the voltage on and off, a shutter is produced, and exposure times down to a few thousandths of a microsecond (1/200,000,000 second) are possible.

IMAGE TUBES A variety of image tubes exist, including image converters, orthicons, image-orthicons, and image-intensifiers. Some of these image tubes can act as high-speed shutters. Metals, particularly cesium, have the property that, in a suitable electric field, they emit electrons when irradiated with light. Also, certain materials exist that emit light when bombarded by electrons (e.g., a television screen).

A combination of such materials in one evacuated tube can produce an image converter. The light receiver is called a photocathode, and the light emitter is the screen. An image is focused on the photocathode by a lens. By applying suitable electric and magnetic fields the image can be faithfully reproduced on the screen, which in turn can be photographed by a recording camera. With no voltage applied to the tube, no picture is produced. Thus, by turning the electric field on and off, the tube acts as a shutter. The voltages used are usually between 6,000 and 25,000 volts. In some tubes, other electrodes (grid electrodes) are inserted that can control the tube with lower voltages (e.g., about 300 volts). Additionally, by suitable electrodes or magnetic coils, the image on the screen can be deflected, permitting other techniques.

The orthicon or iconoscope uses as the light receiving element a mosaic of photoemissive elements. These store an image that is later scanned off by an electron beam. The image-orthicon has a photocathode, similar to the image converter. The electrons from the cathode strike a storage plate, which is again scanned later. An image-intensifier has a photocathode and a number of secondary emissive sur-

faces, the electron beam passing from one to another in turn and being amplified before reaching either a screen or a storage plate. The gains possible to intensifiers, to date, are several thousandfold. An image converter can give some light intensification, e.g., at 25,000 volts, the light gain in a simple tube can be ten times.

Using image converters, exposure as short as fractions of 1 nanosecond (nsec) have been achieved, and it is in these devices, particularly, that further advances will be made.

FLASH PHOTOGRAPHY Electronic flash is now standard photographic equipment and is used not only when the available light is too weak but, with an open shutter, to arrest motion as a result of the shortness of the flash. Normal photographic electronic flashes have durations in the region of 100 to 1,000 μsec (1/1000 to 1/10,000 second), which is too long for most high-speed subjects. With special control circuits and capacitors, however, durations of a few microseconds or so are possible at photographically practical intensities.

As the exposure time gets shorter, the intensity of the light source must increase. The threshold of fast films has been measured at very short exposures to be 10^{-3} (1/1000) meter-candle-second. This means, allowing for all the likely losses, that the subject illumination needs about 1 meter-candle-second or 1,000,000 lumens per square meter if it is to last for 1 μsec. This would be the equivalent to a source of 1,000,000 candles at a distance of 1 meter.

The light sources capable of producing the high levels normally used in high-speed photography include special electronic flash tubes, sparks, and flash bombs. Sparks are produced by capacitor discharges across tungsten, steel, or copper electrodes. They have been made with durations as short as a few nanoseconds. In the microsecond region, an improved spark gap has argon gas blown into it via a hole drilled along the axis of one electrode, giving a longer gap for the same voltage and thus more light output and a repeatable line source particularly suitable for schlieren photography.

A special type of spark is obtained by the explosion of thin metal wires. The wire is connected in series with a spark gap, wired in parallel with a bank of capacitors. The capacitors are charged to 15,000 to 60,000 volts. As the voltage rises, the spark gap breaks down, and the wire explosively vaporizes with a brilliant flash. Generally, however, explosions are more likely to be the events studied by high-speed photography rather than light sources for other subjects.

High-speed radiography units capable of submicrosecond exposure times are also available. A high vacuum x-ray tube is used for the purpose and is fed by 500,000–2,000,000 volt pulses at several thousand amps.

Flash bombs are tubes containing argon with a transparent end window and a small explosive charge at the opposite

Image tubes. Holst image converter. A, subject; B, lens; C, semi-transparent photocathode; D, electron stream; E, viewing screen observed by eye. As the image of the subject is formed on the photocathode, the photocathode emits electrons, which travel through the evacuated tube and excite the fluorescent screen to produce an image.

end. The explosive, when detonated, produces a luminous shock wave in the gas, which produces a high light level for periods from fractions of a microsecond up to many microseconds, depending on the geometrical structure.

The latest light source is the giant pulsed laser, giving extremely energetic flashes as short as 30 nsec, concentrated in a narrow spectral band and in a parallel beam. It allows photography of the surfaces of other highly luminous surfaces as the subject light can be ignored by a narrow-band filter set to accept the laser light only.

With these various devices, high-speed still pictures can be taken, using normal cameras with open shutters, always assuming that the background light level is not excessive.

STROBOSCOPIC OPERATION Using a still camera and a flashing light source (stroboscope), a subject can be photographed in a series of positions in one picture. Alternatively, by synchronizing the flashes with a subject with a repetitive motion, a succession of exposures can be superimposed of the subject in the same position.

The first method, with the flashes at regular intervals, is useful in studying movement sequences (e.g., athletes, dancers). The second method serves to study mechanical motion when it is not possible to produce enough light to take a single short-duration exposure or when it is desirable to check that the subject is truly repetitive. Stroboscopic flash units are available that operate at speeds up to many thousand flashes per second in some special cases but more commonly operate at around 100 per second.

LIGHTING TECHNIQUE High-speed photographs taken with electronic or optical shutters need a high level of illumination. Self-luminous subjects, such as flash discharges and explosions, usually themselves provide sufficient illumination for high-speed photographs. Nonluminous subjects, as well as those where the self-illumination is not to be recorded, must be lit separately. There the light source may be either a constant-intensity lamp or a flash unit synchronized with the shutter.

Suitable constant-intensity sources are high-pressure mercury vapor lamps. They are available in units up to 1,000 watts, with an arc length of about 1/2 inch. With an appropriate reflector, lighting levels up to 50,000 foot-candles can be achieved over an area 5 inches in diameter, 8 inches from the lamp.

Pulsed xenon arc lamps can reach light intensities ten times as high. The lamp usually burns at 50 watts and is pulsed up to 10,000 watts for periods of 2–3 seconds.

In many cases the high instantaneous intensity of electronic flash or spark units makes them more suitable as high-speed light sources, even when an electronic or optical shutter is used. The light usually still lasts longer than the effective shutter opening, so that the latter controls the exposure time.

The light may be synchronized to provide the whole of the illumination or merely the shadow illumination for self-luminous phenomena such as explosions. Alternatively, the synchronization may be timed in such a way as to exclude the light generated by the subject itself (e.g., explosion flash) and record only the movement of, for instance, the shock wave. This procedure is possible only with the aid of a high-speed shutter. Such a shutter is also useful for eliminating other extraneous light. This may include the tail, or afterglow, of the high-speed flash discharge itself; even a 2-μsec discharge may take about 10 or more microseconds to die away completely. Such a comparatively low intensity light may, without a Kerr cell or similar shutter, record on the film owing to its duration and blur or obscure the main subject.

Under certain conditions, quenching circuits may be used to shorten the duration of otherwise conventional flashes to generate durations as short as 20 μsec (1/50,000 second) or less.

Flash high-speed photography. (Photograph by Andrew Davidhazy.)

SYNCHRONIZATION It is equally important not only to select the correct exposure time but also the correct exposure instant. Various techniques are possible and each new experiment may suggest or demand a new method.

When the event is self-luminous, a photoelectric trigger is most commonly used. It has the particular advantage that the trigger sensitivity level can be so adjusted that the exposure is not made until the subject is sufficiently bright to be recordable. For exposures at later instants, the same trigger may be used and electronic delay circuits inserted before a start signal is passed to the shutter.

Should the event and the camera both be capable of precise triggering, suitable signals can be generated from a common source, thus allowing any possible time arrangement to be selected. An important factor is to know the response time of all components. This becomes increasingly important as time intervals become shorter, reaching, eventually, conditions in which it is essential to make due allowance for the transit time of light. In 1 nsec (1/1,000,000,000 second) light only travels approximately 1 foot.

When the event is nonluminous, some light source is necessary. Especially at the shorter exposure times, this is some form of electrical discharge started by an electrical signal. The event must then be made to activate some electrical circuit and in a sense be made to take its own picture. For example, it can be arranged that a light beam to a photocell is interrupted or a projectile can break a wire or pierce a screen to give a signal. At lower speeds, relays can be used. Each subject usually suggests its own solution.

On supersonic projectiles or events initiated with a bang, an acoustic pickup can be an elegant device. For example, when photographing the action of guns and their projectiles, a pickup to detect the initiating explosion or the projectile's shock wave can be used to trigger or start the light source and, when necessary, the shutter. Merely moving the pickup along and below the line of flight can trigger exposures at different instants, by knowing the distance the pickup was moved and comparing it with the change in the projectile's position in the pictures, the projectile's velocity can be readily given as a multiple of the speed of sound.

More elaborate arrangements are sometimes required, including, for example, coincidence circuits when two parts of an experiment are not precisely controllable. Normally, how-

ever, relatively straightforward optical, acoustic, or mechanical synchronization devices will most often suffice.

APPLICATIONS High-speed still cameras have been used in almost every field of scientific and industrial research, permitting the study of subjects whose changes are far too rapid for the unaided human eye to perceive. It is true that it is in weapon research that most advances have been made, but it is one of the bonuses of warlike activities that high-speed photography has been developed to its currently high capability and that it is now available for more peaceful applications. High-speed photography has been a valuable tool in the studies of motors, complex mechanical processes, medicine, and the peaceful uses of atomic energy.

EXPOSURE EFFECTS Exposures of short duration at high light intensities are subject to reciprocity failure. The effective sensitivity and contrast of most materials reaches a minimum with exposure times of about 10 μsec. Below that the reciprocity law is usually valid, and the sensitivity of blue-sensitive emulsions remains independent of the exposure time. With optically (dye-) sensitized emulsions, a further loss of speed occurs around 1 μsec exposure and is believed to be due to the sensitizing dyes. Above 10 μsec the speed and contrast increase, showing a maximum at 10,000 μsec (1/100 second). This is generally the optimum exposure time from the point of view of speed for most materials.

With all short-duration exposures, the photographer must consider the effects of such short exposures, particularly with respect to proper color reproduction when using color films. Incorrect color reproduction may be caused by differences in the reciprocity characteristics of the color layers or a change in the overall color output of the flash tube at different durations and/or illumination intensities.

STROBOSCOPIC FLASH Electronic flashes can be fired repeatedly at high frequencies of hundreds to thousands of flashes per second. This method has various applications in high-speed photography and motion study. Technically, a stroboscopic flash unit is based on an electronic flash discharge circuit, with certain modifications to permit a high flashing rate.

Historically, electronic flash lighting is almost as old as the negative-positive photographic process, since W.H. Fox Talbot used both about 150 years ago. True, he covered only a small subject with his flash, but his writings prophetically describe the modern electrical equipment as used in photography today.

Theory of the Single Flash Light is produced when electrical energy stored in a charged condenser is discharged into the flash tube. During the discharge, the instantaneous power is quite large (it may be as much as several million watts). However, the practical criterion is the light energy or exposure—i.e., the integral of the candlepower in candlas during the flash time in seconds.

Possibly the most important component in a flash unit, other than the flash lamp, is the condenser (or capacitor). The condenser accounts for most of the weight, volume, and cost of the typical flash equipment. The capacitor is the energy storage component of the circuit. It can take in energy at a slow rate over a period of seconds or even minutes and then discharge it into the lamp in a fraction of a second at the required megawatt rate. Many of the advances in modern electronic flash equipment design have been concerned with improved capacitors, and further improvements are expected.

Electronic flash tubes are made in many sizes and forms, such as straight, U, or spiral shapes, as required for different applications. The gas pressure and electrode spacing are arranged so that the tube will not flash by itself in most applications. When a triggering pulse is applied to an external electrode, however, internal ionization results, and the tube flashes.

Most flash tubes used today are filled with xenon gas at a pressure of a fraction of an atmosphere. A series of 1 μsec exposures of the arc in a typical tube made with a magneto-optic shutter shows that the arc starts as a narrow filament adjacent to the flashtube wall on the side of the external triggering electrode. Soon, if the energy is sufficiently large, the arc filament enlarges to fill the entire flashtube.

Flash duration for a specific flashtube and circuit is best defined by plotting the light as a function of time. This shows the initial delay, the initial rise, the peak, and the decay of the light. From a practical standpoint, the actual duration is negligible, if the motion of the subject is effectively stopped. One common way to indicate duration is to define it as the time between the initial and final instants when the light is 1/2 of the peak intensity. This is the method in widest use, but it also may be misleading in terms of actual action-stopping ability of the flash, because of the fact that the light emitted by the flash at intensities below the 1/2 peak intensity actually is image-forming light and is only one stop away from maximum exposure. A duration criterion based on 1/8 peak to peak intensity would be more appropriate for high-speed photography but is not generally accepted.

The output of a flashtube is the integral of the light against time. An approximate value can be obtained by taking the product of duration and peak light. If the candlepower of peak light is measured in candlas and time in seconds, then the output will be in units of candle-power-seconds. The lumen-second output is greater by a factor of 4 pi, or about 2.5, when the angular asymmetries of the flashtube are considered.

The electronic flashtube has a most unusual volt-ampere characteristic. At the start of the discharge, the resistance is infinite, since no current is flowing. Then, as current starts to flow, the resistance drops rapidly to a value of a few ohms for the main portion of the discharge. Finally, the current again becomes zero and the resistance infinite. During most of the flash, the volt-ampere curve is similar to that of a resistor and the circuit transients can be calculated approximately. Extrapolations to other lengths and diameters of flashtubes can be made as though the tube were a resistor of uniform conductivity. Then flash duration can be estimated from the equation

$$\text{Flash duration} = RC/2 \text{ seconds}$$

where C is capacitance in farads, and R is resistance.

A large variety of electronic flashtubes is available for the equipment designer to consider. For any specific case, important factors are the following.

1. The shape of the tube—linear, spiral, U-shaped, etc. A concentrated lamp is more effective in a reflector, where control of the light is required.
2. The efficiency at the required energy input. Each lamp has its maximum efficiency for a particular input. The designer should attempt to use the lamp at or near this maximum efficiency point, although in practice it is generally necessary to work at a lower value of efficiency to prevent the tube from overheating and to prolong its life.
3. The flash duration is a function of the tube and the circuit. If a specific duration is required, the design is usually fixed.
4. The voltage at which the flash is desired. Item 2 above needs to be reconsidered in terms of voltage, since the efficiency usually drops when the tube is used at low voltage.

Many times the most efficient flashtube cannot be used—particularly in stroboscopic work, at high frequency and high power—because of heat storage and heat conductivity problems.

Stroboscopic Photography The term *stroboscopic* photography has come to mean multiple-flash exposed photographs. Among the earliest exploiters of this general sys-

tem were Eadweard Muybridge and Etienne Marey, whose excellent pictures of horses, people, and bullets are still used as examples today. The first multiexposure photographs were made on a single, moving plate using a slotted disc as a shutter or on separate plates with a series of cameras. The modern method is to use a succession of electronically produced flashes of light separated by accurately controlled intervals of time.

Two practical problems arise when an electronic flashtube is required to run as a stroboscopic source:

1. The flashtube becomes so hot that it does not function properly—for example, it may miss occasional flashes as a result of not starting properly.
2. The flashtube fails to deionize, thus preventing the capacitor from building up a charge for the subsequent flash. A low value continuous current flows in the flashtube. This condition is called *holdover.*

A hot tube may fail for several reasons, such as, puncture of the glass by the external sparking circuit, short circuiting of the triggering spark by the conduction of the hot glass, or actual collapse of the glass wall of the tube. Failure of a tube to deionize results in the continuous arc holdover condition, where the capacitor charging current flows continuously into the lamp. A further difficulty may result when the tube self-flashes, as the capacitor recharges, because of the lowering of the holdoff voltage by residual ionization or temperature.

Any or several of the difficulties mentioned are soon experienced when a flashtube is operated at a fast rate of flashing with high energy per flash. Tubes of quartz are better than glass tubes at high power rate, because quartz has a higher melting temperature. Several special circuits have been used

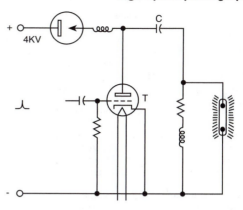

Hydrogen thyratron pulsing circuit. The quick deionization time of the thyratron tube permits higher flashing frequencies. C, main capacitor; T, thyratron tube.

the mercury cathode goes directly between the two main electrodes. This circuit makes it possible to start flashtubes at very low voltages on the flash capacitor. Operation at several thousand flashes per second with an input of 1 kilowatt is practical with the mercury-connectron tube.

Hydrogen-thyratron tube The thyratron serves as a switch to discharge the capacitor energy into the flash tube. This thyratron has a very quick deionization time, thus enabling the starting of the flashtube to be controlled at high frequency, far above rates where the frequency is limited by the slowly deionized high-pressure gas in the flashtube. High pressure (10 to 70 cm) of xenon gas is required for efficient light production in the xenon flash tube.

The circuit with the hydrogen thyratron is similar to that used in radar transmitters, except that the flash is replaced by a magnetron. In either application, the function is the same, namely, to pulse the lamp or magnetron with high-voltage and high-power energy. One of the properties of the hydrogen thyratron is the ability to supply large peak currents without change to the thyratron cathode.

A typical commercial high speed stroboscope using a hydrogen thyratron control tube operates at the following elec-

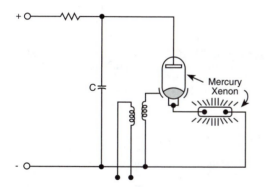

Mercury pool control circuit. The mercury tube in series with the main flashtube sharply starts and interrupts the current for the flash and handles high power rates. Permits several thousand flashes per second. C, main capacitor.

to operate flashtubes at high rates. Examples are the mercury-arc rectifier of the pool type, and the hydrogen thyratron, as used in radar modulators.

Mercury-pool Control Tube Circuit The only new element added to the conventional electronic flash operating circuit is the mercury tube. The mercury tube is connected directly in series with the main discharge current path of the capacitor to the flashtube. Thus, the mercury tube must be designed to handle adequately these high-valued peak currents. Immediately after a discharge, the mercury tube deionizes quickly, because of its low pressure and thereby prevents the previously mentioned holdover current from flowing in the flashtube.

The mercury tube connected in series is also beneficial in starting a flashtube, because the igniting spark circuit from

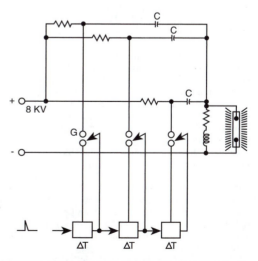

Multicapacitor circuit. A series of separate capacitors is discharged in turn into the same flashtube. Unit is flexible but bulky. C, power capacitors; G, controls gaps; T, time delay units for triggering the successive flashes.

trical conditions: lamp voltage, 8,000 volts; capacity, 0.01, 0.02, or 0.04 microfarads; frequency, 6,000 maximum per second (0.01 microfarads); flash duration 1 to 3 μsec; energy per burst, 1,500 watt seconds (limit set by lamp heating).

The flashtube in such equipment must be designed with high resistance to reduce the peak-current requirement of the hydrogen thyratron. This is accomplished by the use of a small diameter (on the order of 1 mm) and a long arc length (up to 4 inches). A small percentage of hydrogen gas is mixed with the xenon to reduce the afterglow in the discharge.

The stroboscopic light can also be synchronized with the motion of the film to produce framed pictures for projection. This is commonly done with 16-mm high-speed cameras. Magnetic pickups are used to trigger the flash lamp at the correct instants of time.

Multi-capacitor Circuits There is another general type of multiflash equipment that is capable of great speed and flexibility and which has utility when a limited number of photographs can be used. Each flash for this method is powered by a separate capacitor into either separate lamps or a common lamp. This circuit becomes bulky when a large number of flashes are desired, since each flash requires a separate storage system, as contrasted with a single storage capacitor discussed in the previous method. There is a frequency limit set by trigger-tube deionization for these last two circuits, even if one operation is used. Control air-gaps with three electrodes triggered by a time-delay element can be used.

Applications Stroboscopic flash has two main applications: analyzing a rapid movement by photographing successive phases on one film or plate and arresting a rapid cyclic or other periodic movement for visual observation and photography. Examples of the first application are multiple photographs of dancers, hurdlers, etc.; the classic one was a shot of a golfer teeing off. For this, two flashtubes were used, each driven by a mercury pool tube. Each flashtube was operated from a 10 watt-second charge at 100 flashes per second. The power into each lamp was about 1 kilowatt. Normally, such a lamp will soon overheat unless it is artificially cooled, but this tube did not overheat since the operation time was only half a second.

The photograph of the bullet in flight was taken by multiflash photography with a xenon tube operated at 6,000 flashes per second, with about a half watt second per flash for a brief period. The bullet was photographed against a background of reflecting material to reflect the light of the lamp, which was mounted directly above the camera lens. A strip of 35-mm film was used. The flashing frequency was controlled by an electronic oscillator. There was no blur on the continuously moving film, since the exposure was only about 1 μsec in which time neither the bullet nor the film had moved appreciably. In this method there is no need for synchronization between the film motion and the frequency of flash; it is only necessary to move the film so fast that the photographs do not pile up on top of each other.

For the second type of application, the flashing frequency is matched to the frequency of the cycle of the movement. As a simple instance, a machine component rotating at 5000 revolutions per minute may be illuminated by one or more stroboscopic flashes flashing at 5000 flashes per minute. If both rates are accurately matched, the flash will illuminate the same phase of the movement every time and the component will appear stationary. It can then be observed or photographed in that way—a useful procedure in industrial photography where it is not practical to stop a machine for picture taking.

By slightly shifting the phase of the flash between successive exposures, a whole picture series of complicated movement cycles is obtained, permitting the study of motion that would be impossible to observe in any other way.

A. Davidhazy, G. Lunn, and L. Mannheim
See also: *High-speed cinematography; High-speed lighting.*

HIGH-SPEED PROCESSING A variety of techniques that permit the rapid processing of film and prints. They may employ the roller application of hot or high-energy developers, or alkaline activators, followed by stabilization rather than fixing and washing. Race tracks, hospitals, and dental facilities, instrument-recording cameras, police stations, and newspaper offices all use these processes to produce x-rays, negatives, and prints within a minute or two. *H. Wallach*

HIGH-SPEED VIDEO CAMERA See *Camera types.*

HIGH-TEMPERATURE PROCESSING The processing of photosensitive materials at temperatures well above the traditional 68°F (20°C), which is usually done because (1) it is difficult or impossible to lower the temperature of the processing solutions and wash water, or (2) processing times can be shortened by raising the temperature. The speed with which development takes place is substantially influenced by temperature. The thermal performance of a developer is represented by a temperature coefficient, with numbers ranging from about 1.2 to 3, the factor by which developing time must be multiplied to compensate for a decrease in temperature of 10° C. Increased velocity of development to a specific gamma, or contrast index, may be achieved by using the temperature coefficient to compute the new processing temperature. Racetrack photofinish labs use 110° F developer to develop prehardened film in 12 seconds. Industrial rapid access systems use developer temperatures as high as 170° F to achieve process times as short as several seconds. *H. Wallach*
See also: *Rapid access; Temperature coefficient; Tropical processing.*

HILL CLOUD LENS See *Lens types.*

HILL, DAVID OCTAVIUS (1802–1870) Scottish painter and photographer, and **ADAMSON, ROBERT** (1821–1848) Scottish photographer. In 1843, Hill was commissioned to paint the first General Assembly of the Free Church of Scotland, that involved a total of some 470 portraits of delegates. To assist him in this task he decided to make a calotype of each delegate. He established a studio and hired the young photographer Robert Adamson, who was recommended to him by Sir David Brewster. Their collaboration produced the most important, extensive photographic study accomplished during photography's first decade. More than 1000 portraits and landscapes were made before Adamson's death in 1848. Hill finally finished the massive painting of the delegates in 1866, though it pales in comparison to the lovely calotype portraits made by both men. Hill was the subject of the first serious monograph on a photographer: *David Octavius Hill, Master of Photography* by Heinrich Schwarz, published by Knopf in 1931.

Books: Stevenson, Sara, *David Octavius Hill and Robert Adamson, Catalogue of their Calotypes.* Edinburgh: National Galleries of Scotland, 1981; Ford, Colin, *An Early Victorian Album.* New York: Knopf, 1976. *M. Alinder*

HILLER, LEJAREN À (1880–1969) American. Influenced the direction of advertising art by incorporating photography with painting as early as 1906. Hiller used his experience as a painter and magazine illustrator, and his flare for the dramatic to create an original series of powerful photographic images depicting the history of surgery. His images were photographic collages created by manipulating and adding color directly to a print, by adding related or contrasting visual elements, and by changing size, shape and position of elements. His pioneering work stands as a prede-

cessor to todays electronic manipulation of photographs.

R. Zakia

HINE, LEWIS WICKES (1874–1940) American photographer. Hine was a sociologist who began photography in 1904 while teaching at New York's Ethical Cultural School. Documented immigrants upon arrival at Ellis Island, then followed them in their harsh new lives in the slums of America. In 1907, Hine photographed the Pittsburgh iron and steel workers, revealing employment of children under grueling, torturous conditions. As staff photographer to the National Child Labor Committee from 1911 to 1917, Hine's photographs contributed to the passing of child labor laws. During the 1920s, he committed himself to "positive documentation," embarking on portraits of the working man. His landmark book, *Men at Work,* was published in 1932.

Books: Rosenblum, Walter and Naomi, and Trachtenberg, Alan, *America & Lewis Hine: Photographs, 1904–1940.* Millerton: Aperture, 1977; Gutman, Judith Mara, *Lewis W. Hine and the American Social Conscience.* New York: Walker, 1967.

M. Alinder

HISTOGRAM In computers, a description of a continuous-tone image through the tabulation of the number of pixels for each gray level extant. The tabulation is displayed as a bar graph or histogram with the vertical axis as the number of pixels and the horizontal axis being the number of gray levels.

R. Kraus

HISTORICAL PHOTOGRAPHY The compilation of a body of important photographic work that traces the progression of photography from its early beginnings to the present. Knowledge and study in the history of photography is essential for those interested in museum work, writing about photography, and teaching photographic courses. College programs and degrees are available in this subject, but few schools deal with the important technical and scientific side of photographic history.

R. Zakia

See also: *Archival; Biographies; History of photography; Photographic education.*

HISTORY OF PHOTOGRAPHY A chronological list of advances in photographic technology can be found under the heading *Advances in Photographic Technology.* In addition, historical information is provided in major articles throughout this encyclopedia, including the articles on cameras, color photography, electrophotography, lenses, motion-picture photography, nonsilver processes, photographic education, photographic processes, photographic publications, photomechanical reproduction, sensitized materials, and video.

L. Stroebel

HOCKNEY, DAVID (1937–) British painter and photographer. Has frequently incorporated photographs into his paintings through photomontage, as well as working more directly in photography. Used multiple small photographs in collage to construct multiperceptual portraits.

Books: *David Hockney, A Retrospective.* Los Angeles: Los Angeles County Museum of Art, 1988; Joyce, Paul, *Hockney on Photography.* New York: Harmony Books, 1988.

M. Alinder

HOFMEISTER SERIES F. Hofmeister studied the effect of a number of substances on the swelling of gelatin and listed the following in order of decreasing effectiveness in suppressing gelatin swelling: sulfates, citrates, tartrates, acetates, alcohol, sugar, distilled water, chlorides, nitrates, bromides, acids, and alkalis. The most effective salt ions

were said to attract the molecules of water, thus salting out the gelatin molecules from the solvent.

G. Haist

HOLD FRAME See *Freeze frame.*

HOLE Refers to the vacant position left in the valence band after light absorption has promoted an electron to the conduction band. Because other electrons in the valence band can move and occupy this vacant position and thereby cause the vacant position to appear to move, the hole can be treated as a pseudo particle having mass and mobility just like the electron. In order to conserve charge, the hole is assigned a position charge.

R. Hailstone

See also: *Photographic theory.*

HOLOGRAM A three-dimensional picture recorded on photographic material as an interference pattern between a direct (reference) coherent light beam and one reflected or transmitted by the subject. When viewed under the proper conditions, appropriately different reconstructed images are presented to the left and right eyes, producing the appearance of three dimensions.

L. Stroebel

See also: *Holography.*

HOLOGRAPHIC INTERFEROMETRY Also called double exposure holography, holographic interferometry is a technique for examining the effect of mechanical stress on small components. Two holograms are made of the object under examination, one before loading and one during the stress application or immediately afterwards. When the holograms are combined, interference fringes are visible where dimensional changes occurred. Quantitative data may be obtained. The technique has controllable sensitivity and is useful in the design and manufacturing processes for predicting and avoiding component failure.

H. Wallach

HOLOGRAPHY Holography, from the Greek words for *whole* and *write,* is a two-step form of three-dimensional imaging using laser illumination. Invented in 1947 by Dr. Dennis Gabor for improving the resolution of electron microscopes, holography was merely a laboratory curiosity until the invention of the laser in 1960. Its subsequent application to holography by Emmett Leith and Juris Upatnieks created a path for practical holographic imaging. Holography has since grown into a powerful tool used in both artistic and technical pursuits.

THEORY The initial step is to record the hologram. Holograms (or holographs as they are sometimes called) are recorded by the process of interference of light waves. A wavefront that represents light reflected or transmitted by the subject of the hologram (subject beam) is made to interfere with a pure background wavefront (reference beam) that is derived from the same coherent source. Lasers are used as a source of coherent light for this since laser light acts most closely as a single wavelength and therefore preserves the phase (timing) between the subject and the reference beams when they are split apart. The second step is called reconstruction, where the hologram is illuminated with a light source at the same angle as the original reference beam. Depending on the type of hologram, this reconstruction source may be a spread-out laser beam or even light from an ordinary tungsten light bulb.

Holography captures complete wavefront information from the subject being recorded, which includes phase as well as intensity information. A macroscopic examination of the surface of a hologram reveals little information about the subject. Only density, or evidence of a general fogging exposure, is apparent. Under microscopic examination many small marks, which are actually the interference fringes, can be observed. Again, this bears little resemblance to the sub-

ject of the hologram. Photography only captures the intensity of the light that is focused by a lens to distinct parts of the recording plane, whereas each point on the holography subject is recorded over a large portion of the entire hologram.

In effect, a hologram captures a very large number of stereo pairs. This accounts for the true three-dimensional character of the holographic image and the ability of the viewer to change the viewing angle and see the subject from different perspectives. This also accounts for the unique ability of a small portion of the hologram to reconstruct the entire image. For example, if a hologram recorded on a glass plate is broken into many pieces, each piece may reconstruct the entire scene when a laser beam is passed through it.

TYPES OF HOLOGRAMS Holograms can be classified in several different manners. They may be in-line or off-axis, according to how they are recorded. They may be either transmission or reflection, according to how they are viewed. They may be laser transmission, white light reflection, or white light transmission, according to the type of source used for reconstruction. They may also be classified according to the type of medium on which they are recorded and as to how many beams are used to record them. Typical media include silver halide, dichromated gelatin, photoresist, thermoplastic, and embossed plastic. The media generally have ultra-high resolution. Other important general types of holograms are the rainbow hologram and the integral stereogram.

TECHNIQUE To record a transmission hologram of a three-dimensional subject, laser light is split into two beams. The first illuminates the subject and an unexposed piece of recording material. No lens is necessary to focus the light onto the material as in conventional photography. During the exposure period the reference wave and subject wave interfere to form a pattern of bright and dark bands called fringes. The intensity and position of each fringe relies on the distance that each interfering wave travels and its relative intensity. If beams travel a whole number of wavelengths, they interfere constructively and produce a bright fringe. If they travel an odd number or half wavelengths, they interfere destructively and cancel each other out, forming a dark fringe. The angle between the beams is also important in that it controls the fringe period. The beam paths must not change by more than 1/4 wavelength during the exposure. Therefore, vibration must be kept to a minimum. After the exposure is completed, the material is developed and replaced in the film folder. This is called the reconstructive step. Illuminating the hologram with just the reference beam will now cause a virtual image of the original subject to appear in the original subject's exact same location. This reconstruction step relies on diffraction of the laser light by the hologram. Holograms are actually complex diffraction gratings that bend and focus light in much the same way that prisms and lenses do in conventional refractive optics.

To record a reflection hologram, both beams come from opposite sides of the medium. These holograms have the advantage of being able to reconstruct using white light (such as from a normal tungsten lamp). Their disadvantage is limited depth and greater susceptibility to vibration during recording.

Many variations on these two basic types have been created. Often auxiliary optics are used to enable the use of white light in reconstruction and to increase image depth and clarity.

PRESENT STATUS Currently, holography is being applied in a number of interesting technical areas. Holographic techniques are being used to direct laser beams in optical computers and bar-code scanners. Optical engineers are combining holographic optics with conventional optics to create improved lenses for special application. Holograms are used to study mechanical properties of engines and other machinery. Futuristic "heads-up" displays for advanced jet aircraft as well as some automobiles are created using holo-

graphic optics. Computer-generated holograms are used for lens testing and character recognition. The Society of Photo-Optical Instrumentation Engineers conducts annual seminars on holographic topics.

Display type holograms can be seen on diverse objects such as book covers and cereal boxes because of relatively new mass hologram printing techniques such as embossing and hot stamping. Display holograms for artistic and viewing pleasure have been growing in number as a result of interest in this new medium by artists. Several traveling exhibits have toured internationally. The Museum of Holography in New York City has been operating for nearly 20 years, showing both historical images and current work by holographic artists. *A. Lungershausen*

HOME In some computer applications, *home* is used as a synonym for the main menu. Home is the starting place from which to launch subapplications from the main program. In HyperCard, a relational database, home is the launching pad for stacks. *R. Kraus*

HONEYCOMB GRID A panel of hexagonal cells used to restrict lateral light spreading when placed over a light source and reflector. The degree of restriction depends on the size and depth of the cells, on their color from white to black, and on the type of fixture over which they are used. Photographers often select them according to the type of edge shadow they wish to produce, hard-edged or graduated. A black grid over a small open-faced fixture will project a harder edge shadow than a white grid over a large fixture with a front diffuser. Honeycomb grids do not increase contrast since they do not change the size of the source, but limiting light spread can effectively increase contrast and color saturation by removing fill light and reducing flare.

R. Jegerings

See also: *Grid spot.*

HOOKUP In animation photography, the last drawing of a series that leads back to the first drawing, so that the sequence can be filmed repeatedly, producing continuous action of a cyclic nature. *H. Lester*

HORIZON The apparent boundary between the earth and sky. The horizon is a major compositional element in outdoor photography and is used as an orienting reference in some aerial photography. Generally, the horizon line is placed in a position other than that of dividing the picture plane in half. There are three different ways of adjusting the position of the horizon: by tilting the camera up or down, by keeping the camera level and raising or lowering the front, and by keeping the camera level and later cropping part of the top or bottom of the negative during printing or enlarging. There is a relationship between the illusion of distance and the camera viewpoint. A low viewpoint is suitable for near objects, a high viewpoint for distance. *R. Welsh*

HORIZON CAMERA See *Camera types.*

HORIZONTAL CANDLEPOWER Often used to refer to the mean horizontal candlepower of a source, that is, the average of luminous intensity measurements made at fixed intervals in a horizontal plane around the source. It is also used to describe the distribution of intensities in several directions in a horizontal plane about the source. The values are tabulated and/or presented in graphical form in polar coordinates. *J. Pelz*

See also: *Luminous intensity; Mean horizontal intensity; Mean spherical intensity; Photometry and light units.*

HORIZONTAL ENLARGER An enlarger designed to

project the image onto a vertical surface, whereas a vertical enlarger projects the image onto a horizontal surface. Some enlargers can be tilted on a horizontal pivot so that they can be used either way. *L. Stroebel*

HORIZONTAL SYNC When a line of video scan is complete, a signal is issued indicating the end of the line and the need to shut off the electron beam so that a new line of scan may begin. The horizontal sync signal lasts for ≈ 10.9 microseconds and separates each horizontal line of scan.

R. Kraus

HORN An acoustical amplifying device known since antiquity (the megaphone is an example, or even cupping one's hands to shout) whose principal purpose is to provide better coupling between an acoustical source and air. The basic configuration of a horn is to control the expansion of sound waves from a small source at the throat of the horn to a larger end radiating to the air, called the mouth. Horns come in many different shapes as progress over half a century has dictated even higher levels of performance, particularly with respect to uniformity of output coverage over differing output angles. The most recent development of horns are the constant directivity types, which are nontraditional in shape, but better performing than earlier types for most purposes. The drivers coupled to the throat of a horn are called compression drivers. *T. Holman*

HOSOE, EIKOH (1933–) Japanese photographer and teacher. Graduate of Tokyo School of Photography (1954). Professor of photography at Tokyo Institute of Polytechnics since 1975. Internationally published and exhibited, Hosoe's black-and-white photographs describe an interior world of surreal dreams. His work with the nude is both sensual and disturbing. Came to world notice with the publication of *Barakei (Killed by Roses)* (1963), his highly personal and complex visualization of the cycle of life with text by Yukio Mishima, who was also a central model. *M. Alinder*

HOT (ELECTRICAL) · Refers to any wire, terminal, or uninsulated metal part that is connected to the "live" terminal of a power source as distinct from those parts that are grounded or at ground potential. *W. Klein*

HOT MIRROR The converse of a diathermic, or cold, mirror. The infrared (thermal) component of the incident radiation is reflected out of an optical system or to a heat sink, but the visible radiation is transmitted. *S. Ray*

HOT SHOE The flash unit mounting device on the top or side of a camera body. This is the same as an accessory shoe except the flash is connected electronically to the camera's synchronization system at the base, eliminating the need for a PC sync cord. *P. Schranz*

HOT SPLICER A device for making permanent motion-picture cement splices, containing a heating element to help dry the cement quickly. *H. Lester*

See also: *Film cement; Splicing.*

HOT SPOT A local area in a scene or on a projection or focusing screen that is inappropriately brighter than the remaining area. The term is used to describe faults caused both by uneven illumination and by specular reflection.

F. Hunter and P. Fuqua

HOWL ROUND See *Feedback, acoustic.*

HUE Attribute of a visual sensation according to which an area appears to be similar to one, or to proportions of two, of

the perceived colors, red, yellow, green, and blue. Hue varies with the wavelength composition of the light. The other two attributes of light are lightness (or brightness) and saturation (or chroma). *R. W. G. Hunt*

See also: *Color.*

HUMAN EYE See *Vision, the human eye.*

HUMECTANT A substance that absorbs water from the air. A humectant, such as glycerol, may be added to gelatin emulsion layers of photographic materials to maintain flexibility by preventing dehydration of the gelatin. *G. Haist*

HUMIDIFY To increase the humidity, usually by means of a humidifier—a device that expels water vapor. Dehumidifiers, which decrease the humidity, are also required in some environments. *J. Holm*

HUMIDITY The amount of water vapor contained in the air. Typically measured using three scales: relative humidity, dewpoint, absolute humidity. *J. Holm*

HUNTER LAB SYSTEM System of expressing color measurements in terms of three variables L, a, and b:

$$L = 10Y^{1/2}$$
$$a = [17.5(1.02X - Y)]/Y^{1/2}$$
$$b = [7.0(Y - 0.847Z)]/Y^{1/2}$$

Photoelectric colorimeters that express their results in these variables are used in some applications. *R. W. G. Hunt*

HURTER, FERDINAND (1844–1898) Swiss chemist. Worked in an English chemical factory and was a colleague of V.C. Driffield. These two scientists and amateur photographers established the first reliable approach to accurate sensitometry, including the H&D curve, now known as the D-log H curve. They published a full description of their apparatus and methods in 1890, and they were granted the Progress Medal by the Royal Photographic Society in 1898.

L. Stroebel

HYALOGRAPHIC PROCESS The process by which a photographic image is etched on glass. Paper is coated with a gum bichromate emulsion of which a sticky substance such as honey, maple syrup, or a sugar solution has been added. Exposure hardens the highlights and leaves the shadows tacky and able to hold a powdered resist. When the emulsion is pressed against a heated glass plate, the resist adheres to the plate. After removal of the paper and the emulsion, the plate can be etched by hydrofluoric acid fumes, provided that appropriate safety precautions are taken. *H. Wallach*

HYALOTYPE (1) Albumen-on-glass positive transparency produced c. 1849 by F. and W. Langenheim, (2) Cliché-verre technique of F.A.W. Netto c. 1840 in Germany.

H. Wallach

HYBRID IMAGING The use of two or more imaging technologies to produce an image. For example, Photo CD is a hybrid imaging system. An image is captured on 35-mm film, scanned, digitized, and recorded on a special compact disc (CD). Up to 100 color and black-and-white images can be recorded on the disc. The disc can then be used to display soft copy on a video or computer screen, or, a thermal printer can be used to make hard-copy quality prints or slides. *R. Zakia*

See also: *Photo CD.*

HYDRATE A compound containing one or more chemi-

The pH and pOH Scales

Hydrogen Ions (moles per liter)		pH Scale			pOH Scale		Hydroxyl Ions (moles per liter)	
1.0	or	10^{-0}	0	Highly acid	14	10^{-14}	or	0.00000000000001
0.1		10^{-1}	1		13	10^{-13}		0.0000000000001
0.01		10^{-2}	2		12	10^{-12}		0.000000000001
0.001		10^{-3}	3		11	10^{-11}		0.00000000001
0.0001		10^{-4}	4		10	10^{-10}		0.0000000001
0.00001		10^{-5}	5		9	10^{-9}		0.000000001
0.000001		10^{-6}	6		8	10^{-8}		0.00000001
0.0000001		10^{-7}	7	Neutral	7	10^{-7}		0.0000001
0.00000001		10^{-8}	8		6	10^{-6}		0.000001
0.000000001		10^{-9}	9		5	10^{-5}		0.00001
0.0000000001		10^{-10}	10		4	10^{-4}		0.0001
0.00000000001		10^{-11}	11		3	10^{-3}		0.001
0.000000000001		10^{-12}	12		2	10^{-2}		0.01
0.0000000000001		10^{-13}	13		1	10^{-1}		0.1
0.00000000000001		10^{-14}	14	Highly alkaline	0	10^{-0}		1.0

cally bound molecules of water, called water of crystallization.

G. Haist

See also: *Chemicals.*

HYDROGEN ION CONCENTRATION/pH

In water an acid readily gives up a hydrogen ion (proton). The hydrogen ion (H^+) cannot exist alone in solution. Water molecules (H_2O) act as hydrogen ion acceptors; that is, water acts as a base to form hydronium ions, H_3O^+. When hydrogen chloride dissolves in water, the chlorine takes the electron from the hydrogen and exists in the solution as the negatively charged ion, Cl^-. The freed hydrogen ion then combines with a molecule of water, as shown by the equation $HCl + H_2O \rightleftharpoons Cl^- + H_3O^+$ the longer arrow pointing to the right indicating that most of the hydrogen chloride is in the form of the ions on the right of the equation.

A strong base, such as sodium hydroxide (NaOH), ionizes almost completely in water: $NaOH \rightarrow Na^+ + OH^-$. The hydroxyl ion ($OH^-$) is a strong base, accepting a hydrogen ion to form a molecule of water. The sodium ion could have been replaced by other metal ions and the compound would still act as a base, because it is the hydroxyl ion that is the hydrogen ion acceptor.

When a strong acid reacts with a strong base in water, neutralization occurs, destroying the acidic and basic properties of the reactants, forming a salt and water. The reaction of hydrochloric acid and sodium hydroxide may be written $H_3O^+ + Cl^- + Na^+ + OH^- \rightarrow 2H_2O + Na^+ + Cl^-$. In water solutions sodium and chloride ions occur in both the reactants and products, having played no part in the overall reaction. Thus, the neutralization reaction consists of the interaction of hydrogen ions with hydroxyl ions, as shown by $H_3O^+ + OH^- \rightarrow 2H_2O$. The uncharged water molecule is neither acidic nor basic and is said to be *neutral.* When the water is removed, sodium chloride (NaCl) can be isolated as a crystalline solid.

The water molecule consists of a hydrogen ion (an acid) and a hydroxyl ion (a base). The reaction between two molecules of water may be written $H_2O + H_2O \rightleftharpoons H_3O^+ + OH^-$ The large arrow pointing to the left indicates that most of the water molecules are nonionized. The number and concentration of acid (H_3O^+, or simply H^+) and basic (OH^-) ions are equal, so that pure water is neither acidic nor basic. Natural water, however, may be acidic from absorption of acidic aerial gases or may be basic from dissolution of alkalis.

Water is more than an inert solvent but plays a part in the reaction. Acidity consists of an excess of hydrogen ions in the form of H_3O^+; basicity involves an excess of hydroxyl ions. Chemical reactions are greatly influenced by the hydrogen ion concentration. A quantitative measure was long needed to describe the condition of water that contains extra hydrogen or hydroxyl ions.

In 1909, S. P. Sorenson originated the symbol pH to express hydrogen ion concentration in water solutions, as

$$pH = \log_{10} \frac{1}{\text{concentration of } H^+ \text{ in moles per liter}}$$

The value of pH is equal to the logarithm (base 10) of the reciprocal of the concentration of hydrogen ions in moles per liter of the aqueous solution.

In a liter of water at 25°C there is 0.0000001 mole of hydrogen ions; there is also 0.0000001 mole of hydroxyl ions. At 25°C the pH of water is given by

$$pH = \log_{10} \frac{1}{0.0000001} = 7$$

The pH = 7, but the pOH = 7 as well, and pH + pOH = 14. Increasing the number of hydrogen ions in solution produces a decrease in an identical number of hydroxyl ions, as the product of the concentrations of the two ions is a constant. The relationship of the pH scale (acidity) and the pOH scale (alkalinity) is shown in the table.

In practice only the pH values are used as a measure of acidity or alkalinity. Acidity increases (alkalinity decreases) by a factor of 10 for each pH unit less than 7, the neutral point; alkalinity increases (acidity decreases) by a factor of 10 for each pH unit above 7. A pH 6 solution is 10 times as acid as a pH 7 solution; a pH 5 solution 100 times as acid as a pH 7 solution. A pH 8 solution is 1/10 as acid or 10 times as alkaline as a pH 7 solution.

G. Haist

HYDROPHILIC

Water receptive.

M. Bruno

HYDROPHOBIC

Water repellent.

M. Bruno

HYDROQUINONE

The white or off-white crystals or crystalline powder of this developing agent (C_6H_4-1,4-$(OH)_2$, molecular weight 110.11; also called quinol or 1,4-benzenediol) are soluble in water, alcohol, or ether but more soluble in hot water. Photographic grade is 99% minimum. The compound oxidizes as a solid or in solution. Human exposure may result in eye injury or dermatitis.

Hydroquinone in strongly alkaline solutions produces high image contrast but when combined with Metol or Phenidone,

improves image formation in areas of minimum exposure.

G. Haist

See also: *Developers; MQ developers; PQ developer.*

HYDROXIDE A chemical compound containing a hydroxyl group, which when ionized in water provides an alkaline or basic condition, readily accepting protons. *G. Haist*

See also: *Chemicals.*

HYGROSCOPIC This adjective describes the absorption or attraction of water from the air, a property possessed by many substances. The holding of a small amount of water by a humectant can be useful but the liquefaction of an alkali, such as sodium hydroxide, can result in its degradation.

G. Haist

HYPERFOCAL DISTANCE See *Depth of field.*

HYPERSENSITIZATION EFFECT See *Photographic effects.*

HYPERSTEREOSCOPY A modification of stereoscopy whereby the distance separating the viewpoints for the two images is increased beyond that of the eyes for the purpose of increasing the appearance of depth. *L. Stroebel*

See also: *Hypostereoscopy; Perspective; Stereoscopy.*

HYPO A common term for ammonium or sodium thiosulfate salts or the fixing baths made with these compounds. The term is derived from the early but incorrect name, hyposulfite of soda, given to sodium thiosulfate. *G. Haist*

See also: *Ammonium thiosulfate; Sodium thiosulfate.*

HYPO-ALUM TONER A direct sepia toner utilizing free sulfur in a suspension that results when potassium alum is added to a hypo solution. A silver nitrate *ripener* is sometimes added. The prints are toned in this heated bath, with occasional agitation, for 20 minutes to 1 hour, or until toning is complete. Toning can be accomplished at room temperature overnight (12 to 14 hours). Toned prints should be brought to room temperature and any sulfur remaining on them sponged off before washing for 15 to 20 minutes in running water. *I. Current*

HYPO ELIMINATOR A dilute aqueous solution containing hydrogen peroxide and ammonia that was previously recommended for the removal of residual fixing salts such as sodium or ammonium thiosulfate, which are oxidized by this solution to harmless sodium or ammonium sulfate salts. Since the hydrogen peroxide can also affect the image silver itself, it is no longer recommended for the processing of contemporary materials. *K. B. Hendriks*

HYPOSTEREOSCOPY A modification of stereoscopy whereby the distance separating the viewpoints for the two images is less than that of the eyes. This procedure is used in closeup stereophotography where the normal separation would be large in comparison with the object distance.

L. Stroebel

See also: *Hypostereoscopy; Perspective; Stereoscopy.*

HYPO TEST The stability of photographic silver images is largely determined by the residual thiosulfates or other fixing compounds. Various test solutions have been proposed to detect the remaining concentration of hypo and to estimate the effect on the long-term stability of the image. Hypo test methods often involve turbidity or stain measurements. *G. Haist*

HYPOTHESIS TEST A statistical method of using experimental data to see whether or not there is a difference between two populations, as between two lots of photographic material, or between an assumed and an actual result. For example, in film production, a set of samples is taken from a large roll of film, and the sample average speed is compared with the desired value to see whether or not the product meets specifications. *H. Todd*

HYPOTHETICAL PRIMARIES A set of three primaries that do not exist in practice but that are useful for expressing colorimetric measurements or for characterizing reproduction systems. An example is the set of CIE primaries X, Y, Z used for the X, Y, Z tristimulus values; another example is the set of primaries that correspond to pairs of a set of subtractive colorants, such a set of block dyes.

R. W. G. Hunt

HYPSOCHROMIC SHIFT Movement of an absorption band to shorter wavelengths. *R. W. G. Hunt*

I Electrical current; Radiant intensity (I_e) or luminous intensity (I_v); Instantaneous (shutter speed); (formerly Illuminance)

IBN Institute Belge de Normalisation (Belgium standards institute)

IC Integrated circuit

ICHSPP International Congress on High-Speed Photography & Photonics

ICI International Commission of Illumination

ICIA International Communications Industries Association

ICO International Commission for Optics

ICP International Center of Photography

ICR International Council for Reprography

IDF Intermediate donor film

IEC International Electrotechnical Commission

IEEE Institute of Electrical & Electronic Engineers

IFPA International Fire Photographers Association

IIP Institute of Incorporated Photographers

IIPC India International Photographic Council

IMBI Institute of Medical and Biological Illustration

IMC Image-motion compensation

IMLA International Minilab Association

IMPA International Museum Photographers Association

IMP/GEH International Museum of Photography/George Eastman House

inf Infinity

I/O Input/output

IPC International Photographic Council

IPI Image Permanence Institute

IPOSA International Photo Optical Show Association

ips Inches per second

IR Infrared

IRE (Formerly) Institute of Radio Engineers, (now) a measurement unit

IS&T Society for Imaging Science and Technology/SPSE

ISCC Intersociety Color Council

ISDN Integrated Services Digital Network

ISO International Organization for Standardization (International Standards Organization)

ISP International Society for Photogrammetry

ITVA International Television Association

IU International unit

IVLA International Visual Literacy Association

ICON A primary graphical object in a graphical user interface. The icon may represent a device such as a drive or scanner. It may also represent a file, message, or application. Icons may change their appearance when an event occurs. An open file may be represented by a differently appearing icon than when the same file is unopened. *R. Kraus*

IDEAL PRINTING COLORS See *Block dyes.*

IDEAL RADIATOR A theoretical substance or device that radiates all energy input to it with perfect efficiency and therefore remains the same temperature as its surroundings. An ideal radiator will not heat up when exposed to electromagnetic radiation, but will reflect or re-radiate the radiation. A hot liquid passing through an ideal radiator would be cooled to the temperature of the surroundings of the radiator at a speed determined by the radiator's ability to absorb heat from the liquid. *J. Holm*

IDEAL TONE-REPRODUCTION CURVE A 45-degree straight-line relationship in a graph of the tonal relationship between an original subject and a photographic reproduction where the line represents facsimile tone reproduction, an effect that cannot be achieved with conventional photographic materials and procedures. *L. Stroebel*

See also: *Preferred tone-reproduction curve.*

IDENTIFICATION PHOTOGRAPHY Identification photography involves quickly making a portrait of a person for a passport, security pass, license, or permit. The college ID and the photographic driver's license are two widely seen uses of identification photography. Photography has become the preferred method of identification because a quick visual comparison is all that is required for verification.

HISTORY A French photographer, Louis Dodero, originated the idea of using photographs to establish identity or rights in 1851. A year later, Switzerland began to photograph all vagrants and beggars, and France started to circulate its first photographic "wanted" posters. In 1865, *cartes de visite* of John Wilkes Booth and his accomplices were glued onto the first U.S. "wanted" posters prompted by the assassination of President Abraham Lincoln.

By 1860, both England and the United States made photographic records of those arrested and/or imprisoned. Alphonse M. Bertillon, appointed head of the Paris police ID section in 1882, devised the Bertillon system. The widely adopted system required three basic components: full and profile photographs; extended and precise written description, and body measurements or anthropometry. In a famous 1903 case involving two nearly identical prisoners—Will West and William West—at the Federal Prison at Leavenworth, Kansas, fingerprints were found superior to body measurements for absolute identification.

Identification photographs were first used publicly in the United States by the Chicago & Milwaukee Railway Company for the season ticket holders in 1861. Since then, countries, states, companies, universities, and just about any other large entity interested in confirming identity has turned to photography.

In recent years, personal identification photography has proliferated throughout the world. While a person in the United States might need a photo ID to cash a check or to gain admission to a place where alcohol is served, a person in a Third World country might be required to show a photo ID simply to walk down a street or to drive along a country road.

EQUIPMENT AND FILM A small number of identification photographs can be made with a 35-mm single-lens-reflex camera, a medium telephoto lens, and a 24- or 36-exposure roll of color negative film. For larger volumes, a camera designed specifically for ID photography can be used with 100-foot or longer rolls. Both instant and traditional film systems exist.

Features of a successful photo identification system might include the ability to photograph a person and printed information on the same piece of film; the ability to photograph a special symbol over both areas of the photo; lamination to prevent alteration; and even additional heat sealing and a validation stamp to permit annual review.

One of the newest photo ID card systems uses electronic imaging to generate photographs and other information by computer. The subject and other information are captured on a single piece of film and laminated in less than a minute. The photo ID, then, can be encoded with a magnetic stripe, a bar code, or Hollerith perforations. Primers, masks, holograms, and other security features can lend additional tamper resistance.

Still another novel photo ID system, invented by Kodak engineer Joe Rice, uses infrared radiation to make the veins in a person's hand visible to an electronic camera. The tree-like pattern of veins is converted into digital information to be stored on the magnetic stripe of an ID card. The hand, then, can be scanned at point of card use to confirm identification through Veincheck technology. *K. Francis*

IGNITION TIME The number of milliseconds a flashbulb takes to begin burning after electrical current is applied. Also, the number of seconds a film requires to begin burning under standard test conditions. *R. Jegerings*

See also: *Time-light curve.*

IKONOGRAPH A motion picture made up of still photos or drawings, where the impression of movement is dependent on movement of the camera or zooming the lens.

H. Lester

Syn.: *Filmograph.*

ILFOCHROME See *Cibachrome.*

ILFORD Ilford's history modestly began in 1879 when Alfred H. Harman started manufacturing glass dry plates for photographers in the basement of his home located in the small village of Ilford in Essex County, England. Mr. Harman chose to locate his enterprise there because of its nearness to London's market and because of its "clean, dust free environment." His original factory staff included two men and three boys, who sometimes, when busy, were assisted by Mr. Harman's wife and housekeeper. The formation of his business, The Britannia Works, was one of the essential actions that took photography from amateur hands and set it securely on the way to becoming a significant, highly skilled, and professional industry.

In 1886, after selling through a distributor for 6 years and

expanding production to the point of building a special plate manufacturing factory, the Brittania Works Company, Mr. Harman began selling his products, now called Ilford Dry Plates, directly to his customers. Ilford Dry Plates' popularity, gained through its performance in the marketplace, provided the foundation for the modern, international company that Ilford was to become. Alfred Harman's insistence on quality and innovation led him to hire a quality supervisor in 1889 and in the same year to publish the first edition of the Ilford Manual of Photography, together with other useful publications that promoted Ilford products.

In 1898, the company went public and in 1900 changed its name to Ilford Limited. Although Mr. Harman discontinued active involvement in the day-to-day operations of Ilford Ltd., he maintained a consultant's activity and was a board member and a director until 1904, when ill health forced him to retire. By 1906 Ilford was a relatively small but successful company, employing about 300 workers. Alfred Harman died in 1913 at the age of 72.

Between 1906 and 1939, Ilford's expansion increased through the gradual acquisition of other old, established photographic companies. This consolidation included names well recognized in the photographic business world: Selo Limited, Imperial Dry Plate Co., Rajar Ltd., and the Thomas Illingsworth Company Ltd., to name a few. These and other companies lost their separate identities in 1930–1931 when they came under the Ilford name and organization.

After the Second World War and starting in 1946, a whole new program of expansion and reconstruction of war-damaged factories occurred. In the 1950s Ilford and BX Plastics formed Bexford Ltd., which then produced all of the film base used in Ilford film products. Later Bexford became a part of Imperial Chemical Industries (I.C.I.). Subsequently, through an exchange of technology with I.C.I., Ilford developed and introduced a line of color film products.

With time, I.C.I. accumulated all the outstanding shares of Ilford Ltd. stock and then sold 40% to CIBA, the Swiss dyestuffs and pharmaceutical company. CIBA and Ilford had independently developed color printing materials based on the silver dye-bleach process.

In 1970, CIBA merged with J.R. Geigy, another Swiss chemical company. Geigy and Ilford were not strangers. Since the 1950s, Geigy, with facilities in Manchester, England, had produced the dyes for Ilford's silver dye-bleach products and also manufactured Phenidone, the revolutionary new developing agent invented by Ilford chemists.

In 1972 Ciba-Geigy decided to operate Ilford as a part of its photographic group. Ilford Limited was declared not only a part of Ciba-Geigy's photographic division but also part of the newly formed Ilford Group, responsible for the worldwide operation of the parent company's interests through its own factories and selling companies. The Ilford Group would also include Ciba-Geigy Photochemie AG at Fribourg, Marly, Switzerland, and Lumière SA at Lyon, France.

During the period 1972 through 1989, many significant products were introduced. Cibachrome, a high quality direct positive product line using silver dye-bleach technology was marketed. Cibachrome A was introduced to the amateur hobbyist market and became popular in the United States and Europe. In addition, new black-and-white products that included HP5 film and Galerie and Multigrade fiber-base papers were marketed. New production facilities were constructed in England, France, and Switzerland to supply the world market that the Ilford Group had developed.

In 1976 after 97 years' occupancy, Ilford left the original Essex site, the last glass plates having been coated there on November 11, 1975. Other sites at Brentwood and Basildon in the south of England were closed and sold. The U.K. production of film and paper was consolidated at the former Rajar Works in Mobberley, Cheshire, near Manchester in the

north of England. This period was highlighted through the introduction of the Ilfospeed and Multigrade resin-coated paper product lines, the XP-1 400 chromogenic black-and-white film, Ilfospeed 2000, 2150, and 2240 paper processors, and the Multigrade 500 Enlarger Head exposure system. Ilford also entered the high-quality color copy market with the introduction of the Cibacopy product line, which is based on silver dye-bleach technology.

In 1989 International Paper, an American company with international markets, purchased the Ilford Group from Ciba-Geigy. Ilford is now a part of the Imaging Products Division of International Paper, which comprises several formerly independent manufacturers of supplies for the printing, photographic, and graphic arts markets with worldwide sales of nearly $1 billion.

Throughout its long history, Ilford's contributions to photographic technology have continued to be numerous and significant. Most recent examples include the Digital Photo Imager, which combines electronic imaging technology with high-quality color photography, and the Omnipro Processing System, which processes black-and-white paper and the world's fastest color print paper. *W. L. Mauzy*

ILLUMINANCE (E)

A measure of luminous power per unit area incident on a surface ($d\Phi/dA$). The preferred unit is the International System (SI) unit lux, equal to lumens per square meter. A point 1 m from a 1 candela source receives 1 lux of illuminance. Other common units are the footcandle (fc), equal to 1 lumen per square foot, and the phot (ph), equal to 1 lumen per square centimeter. (1 footcandle = 0.76 lux, 1 phot = 10^4 lux) The analogous measure of radiant power per unit area incident on a surface is irradiance.

Note that while the dimensions of illuminance are the same as those for luminous exitance (luminous power per area), they refer to different processes. The area in the definition of illuminance is that area *receiving* power while in exitance, it refers the area *emitting* power.

Surface illuminance is a function of source intensity, the distance from source to surface, and the angle at which the light strikes the surface. Surface illuminance from a point source falls off as the square of the distance to the source; $E \propto I/d^2$. Illuminance from a point source at angle θ from surface normal is reduced further because the power is spread over a larger area. The falloff obeys the cosine law, $I_\theta = I_0 \cdot \cos(\theta)$, where I_0 is the normal illuminance. Combining losses due inverse-square falloff and the variation due to illuminance angle, $E(\theta) = I/d^2\cos(\theta)$. *J. Pelz*

See also: *Irradiance; Photometry and light units.*

ILLUMINANCE METER See *Incident-light meter*

ILLUMINANT

A light source, especially one with a specified color temperature such as the CIE standard illuminants.- *R. Jegerings*

See also: *Standard illuminants.*

ILLUMINANT POINT

Point on a chromaticity diagram, or in a color space, representing an illuminant used for a real scene or for a reproduction. *R. W. G. Hunt*

ILLUMINATION

Illumination refers to the process of luminous flux falling on a surface. The term is sometimes used to refer to the measure of that power, which is more properly labeled illuminance. *J. Pelz*

See also: *Illuminance; Photometry and light units.*

ILLUMINATOR

A light box for viewing transparencies and negatives. *R. Jegerings*

Syn.: *Transparency illuminator/viewer.*

ILLUSIONS See *Optical illusion.*

ILLUSTRATION

A photographic image, drawing, graph, etc., that supplements text, as in books and magazines, commonly for the purpose of explaining or clarifying something related to the text or to add visual impact. *B. Polowy*

ILLUSTRATION PHOTOGRAPHY

According to dictionary definitions of *illustration,* the term can be applied to all pictures, including drawings, paintings, and photographs. The term *illustration photography* and *photographic illustration,* as used in reference to a field of photography, however, suggest a more limited meaning, namely, that photographs in this category are more than faithful images of objects. In addition to representing objects, such photographs are expected to communicate something less tangible to the viewer, such as a concept or a mood.

The field of photographic illustration can be subdivided based on the objective of the photographer in making a photograph or on the use that is made of the photograph. A photograph made for the purpose of selling a product, by means of a magazine ad, for example, is identified as an advertising illustration; a photograph used to attract the reader's attention and provide a clue concerning the contents or to establish a mood for a magazine article or other publication, for example, is identified as an editorial illustration; and a photograph made for the purpose of communicating the photographer's opinions or emotions concerning a subject can be identified as an expressive illustration.

With respect to advertising illustrations, the photographer typically works closely with an advertising agency art director. The art director commonly provides the photographer with a layout, which may vary from a rough sketch to a detailed drawing, which the photographer is expected to place on the camera ground glass and conform to exactly. Some art directors like to be in the studio when the photograph is being made or to be provided with a proof print or a finished transparency or print before the set is dismantled. Electronic cameras are now available that allow the ground-glass image to be displayed on a video monitor, which permits an art director to inspect the image and suggest changes before the film is exposed. It is also possible to digitize electronic images, which may then be transmitted by telephone with a computer modem to another location such as an art director's office, where it is displayed on a video monitor, or the digitized image can be electronically retouched or modified and stored before being reproduced.

Photographers commonly become more involved in the planning and modification of layouts as they gain experience and the trust of the art director. Some photographers like to photograph a variation that incorporates their own ideas, after making a photograph that conforms to a specified layout, to be offered to the art director for consideration. Also, photographers who have gained a reputation of generating creative ideas may be given complete freedom to execute an assignment as they see fit.

Most advertising illustrations involve the efforts of other people in addition to an art director and a photographer, possibly including the photographer's representative, a prop manager, a carpenter, a set designer, a location scout, a hair and makeup stylist, a studio manager, a wardrobe supervisor, a camera or darkroom assistant, and one or more models. *G. Cochran*

See also: *Photographic education.*

IMAGE

A representation of an object or other stimulus. With respect to photography and other light-sensitive systems, the word *image* is applied to the optical images formed by a camera, enlarger, and projector lenses, the latent images resulting from exposure of light-sensitive materials, the

negative and positive black-and-white and color images resulting from processing exposed sensitized materials, the ink images produced by photomechanical reproduction of photographs, the light images displayed on video and other cathode-ray tubes, and the visual images perceived when viewing original subjects or reproduction images.

A great amount of research effort has been expanded on the analysis of images both at the macro level (for example, tone reproduction and color quality) and at the micro level (for example, image definition). With respect to the images formed by lenses, all optical systems introduce some image degradation, but research has resulted in dramatic improvements in lenses. Modulation transfer function (MTF) curves provide valuable information concerning image definition while other optical procedures provide more detailed information about such factors as specific aberrations, flare, transmittance, and the effect the lens has on image color quality. Lens speed, as calibrated in f-numbers and t-numbers, is an important factor for some photographic purposes because faster lenses produce higher-illuminance images and shorter exposure time, but with the disadvantages of a shallower depth of field and the need for more elements to control aberrations.

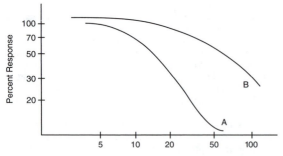

Image Modulation transfer function (MTF) for a television (CRT) (A), and for a moderate-speed black-and-white film (B). (Adjacency effects during chemical development account for the over 100% response of the film at low frequencies.)

Even more dramatic improvements have been made in image recording and reproduction with silver halide materials and with alternative imaging systems. The microimage definition of silver halide images has traditionally been measured in terms of resolving power (detail), granularity (graininess), and acutance (sharpness), or, more recently, modulation transfer function. Macroimage characteristics such as tone and color reproduction have commonly been presented in the form of D-log H or characteristic curves for specific sensitized materials and four-quadrant tone-reproduction curves for entire systems. The same or analogous methods are used to evaluate images produced by alternative systems to silver halide photography, including nonsilver chemical processes, photomechanical reproduction, video, and electronic still photography. Limitations on recording detail with photomechanical-reproduction processes are commonly specified in terms of lines or dots per inch, and in terms of pixels with electronic imaging. Many factors in addition to image quality need to be taken into consideration when comparing imaging systems, including sensitivity, cost, permanence, convenience, and ease of manipulation.

The human visual system is an important factor in any study of imaging. Variations in individual eyesight are taken into consideration by identifying an average or normal specification for various measurements, such as 20-20 for resolution with a Snellen eye chart, normal color vision for the

absence of identifiable defective color vision, and 10 inches as the average minimum distance for comfortable accommodation. Examples of applications of this type of information include determining the maximum acceptable circle of confusion for camera depth of field scales, determining the minimum resolving power needed for a specified imaging system or application such as microfilming, and establishing standards for the spectral quality and light level to be used for transparency and print viewers.

IMAGING TECHNOLOGIES The following table lists the imaging systems and applications for five major imaging technologies:

1. silver halide photography
2. nonsilver chemical photography
3. graphic arts and mechanical imaging
4. electrophotographic imaging
5. electronic imaging *L. Stroebel and R. Zakia*

COMPARISON OF IMAGING MODALITIES In the past several decades there has been an astonishing emergence of various imaging modalities that have offered the user alternative choices to traditional silver halide technology, including video, direct thermal printing, and electrophotography, which have often competed directly with conventional photography. The following table lists a number of imaging systems and selected characteristics of each technology, with a qualitative description and comparison of characteristics, strengths, and weaknesses of selected imaging systems.

ELECTROPHOTOGRAPHIC IMAGING Electrophotography has undergone dramatic evolution and development since it was invented by Chester F. Carlson in 1938. Today electrophotography is a multibillion dollar industry that has provided monochrome and full-color hardcopy output not only for business but for the individual end user. Advantages of electrophotography include plain-paper copying and printing, high-speed output, dry processing that eliminates wet solutions and chemicals, low cost per copy for black/white output, and near-photographic quality for full-process color output.

Electrophotography enjoys a large amplification factor of 10^6–10^7, modest exposure energy requirements, or high speed, which enable high throughput rates of up to 120 copies per minute. The spectral response range for electrophotography is from about 280–400 nm for amorphous selenium photoconductors, and up to 830 nm for bilayer organic photoconductors. This enables the use of solid state gallium, aluminum, arsenic (GaAlAs) semiconducting lasers as exposure sources, and today's desktop printers use these light sources together with organic photoconductors (OPCs). The resolution capability of conventional electrophotographic copiers and printers is about 12–20 lines/mm. This is enabled by the use of conventional optics for analog copying, or by the use of laser spot rasterized scanning or light-emitting diode (LED) array light sources for digital copying. Printing is achieved by the use of LED arrays, laser raster output scanners, or liquid crystal shutter arrays. Higher resolution is possible using nonconventional electrophotographic technology. Stork Bedford B. V. Corporation has developed a color-proofing system using a crystalline cadmium sulfide photoconductor and liquid toning that is capable of resolutions exceeding 1000 lines/mm. This yields full-process color hard-copy output that approaches silver halide photographic quality. A recent trend in increasing imaging resolution involves software algorithms that improve the apparent resolution possible with hardware implementations. For example, an electrophotographic engine with mechanical hardware design capable of a resolution of 300 lines per inch (\approx 12 lines/mm) may be enhanced to 1200 lines per inch (\approx 48 lines/mm) by use of software to modulate laser intensity.

Imaging Technologies, Systems, and Applications

Technologies	Systems	Applications
1. Silver halide photography	A. Monochrome (black and white)	• Black-and-white negatives, prints, transparencies • Instant black-and-white prints, negatives, slides • Instant additive color slides • Dry silver—hard copy, overheads
	B. Color chromogenic systems	• Photofinished color prints, slides, transparencies • Color output from electronic imagery
	C. Color nonchromogenic systems	• Instant color prints, transparencies • Dye bleach color prints, transparencies
2. Nonsilver chemical photography	A. Photopolymer and resist systems	• Plates, proofs, resists—circuit boards and chips
	B. Diazo and vesicular systems	• Plates, proofs, resists—circuit boards and chips, overheads, microfilms
	C. Dye imaging—photochromics, leucodye systems	• Proofs, duplications
	D. Thermal systems	• Nonimpact printing, overheads
3. Graphic arts and mechanical imaging	A. Press printing systems • Lithography • Gravure • Letterpress—flexography • Screens	• Press printing • Circuit board printing
	B. Automated typing systems	• Impact printing
	C. Ink-jet systems	• Nonimpact printing
4. Electrophotographic imaging	A. Xerographic systems	• Plain paper offset
	B. Electrofaxic systems	• Office copy, proofing systems, litho plates for G/A, slide copiers
	C. Laser scanning xerography	• Nonimpact printing
	D. Electrostatic, dielectric, and magnetostatic systems	• Nonimpact printing
5. Electronic imaging	A. Television	• Television, home video • Taped playbacks—broadcast and VCR
	B. Electronic taking imagery	• Graphic arts prepress systems • Medical CRT applications • Remote sensing, infrared, radar • Airport x-radiograph devices
	C. Computer generated imagery	• Word processors, phototypesetters • CAD/CAM • Facsimile • Computer output microfilm

Source: Allan Shepp, "Introduction to Images and Imaging," John Sturge et al. *Image Processing and Materials.* New York: Van Nostrand Reinhold, 1989, p. 3. Courtesy Van Nostrand Reinhold.

ELECTRONIC IMAGING SYSTEMS

Television and HDTV There are today three worldwide television standards: the National Television System Committee (NTSC) standard used in the United States and Japan; the phase alternating line (PAL) used in the United Kingdom, South America, Africa, and parts of Europe; and Sequential couleur a Memoire (SECAM) used in France, the former Soviet Union, and Eastern Europe.

In the last decade, television has undergone significant advances in technology, driven principally by work in Japan.

Comparison of Imaging Modalities

Imaging System	Amplification Factor	Exposure Energy (μJ–cm^{-2})	Resolving Power (l-mm^{-1})	Unsensitized Sensitivity Range (nm)	Sensitized Sensitivity Range (nm)
Silver halide—fast	10^9	5×10^{-4}	50	<200–500	Up to 1300
Silver halide—medium	0.2×10^9	10^{-2}	150	<200–500	Up to 1300
Dry silver (3M)	10^6	10^{-1}–20	100–400	<200–500	
Vidicon tube	10^{10}	10^{-5}	5	<400–800	
Charge-coupled device		10^{-3}	600	400–1000	Up to 9 μm
Electrophotography	10^6–10^7	10^{-1}	20–>1000	280–400	Up to 830
Photopolymerization	>10^6	10^2–10^5	500	280–400	Up to 600
Photoresist	>10^3	4×10^3–10^5	>1000	<200–500	ion beam, x-ray electron beam
Diazo	1	3×10^4–10^7	>1000	350–450	
Photochromism	1	10^4–10^5	1000	uv–vis, narrow bands	
Thermal transfer dye diffusion trans.	—	—	20	—	—
Ink Jet	—	—	4–12	—	—

Television recording utilizes a television camera tube in an electronic device that converts an optical image into an electrical signal. The vidicon is the most widely used camera tube today, and its small size and simplicity permit its use by inexperienced users. Charge-coupled device (CCD) technology has begun to replace the use of camera tubes; however, recent technological developments in Japan have resulted in the *high gain avalanche rushing amorphous photoconductor* (HARP), and *amplified MOS intelligent imager* (AMI) camera tubes that are from 10 to 100 times as sensitive as CCD camera tubes. CCD technology will be discussed later.

Japan embarked on HDTV (high definition television) research more than 20 years ago and has invested an estimated $1 billion. HDTV offers improved resolution capability with 1125 scanning lines (versus 525 for NTSC), and an aspect ratio of 16:9 which is 25% wider than conventional television. The picture spans a horizontal visual angle of 30° at the specified viewing distance, which has been verified in experiments to be large enough to induce a sensation of reality. Proposed technical standards for HDTV are:

Number of scanning lines	1125
Aspect ratio	16:9
Interlace ratio	2:1
Field frequency	60 Hz
Bandwidth of video signal	
Luminance (Y)	20 MHz
Chrominance (Cw)	7.0 MHz
Chrominance (Cn)	5.5 MHz
Viewing distance	$3 \times$ H (screen height)
Angular width of screen	30 degree

Japan has introduced satellite broadcasting of HDTV programming on selected channels in Japan. HDTV is planned for introduction into Europe by 1993, and it is uncertain when HDTV or some subset of HDTV will be introduced in the United States.

CHARGE-COUPLED DEVICES CCD technology has largely replaced the use of vidicon and saticon camera tubes in television today. Present requirements to support aerospace as well as HDTV specifications call for high overall resolution of 1000 TV lines or more, a large field of view, and large dynamic range. The CCD detector used in cameras is typically 18-mm format, but the future will require 25-mm format, with associated higher costs for the devices. CCD arrays are monolithic devices composed of photosites (sensors), analog shift registers, and a charge-sensing output amplifier. CCDs do not employ *scanning* techniques as do traditional camera tubes, and although they are slower (less sensitive) than vidicon devices, they offer higher resolution. Modern device arrays of 2K × 2K photosites are capable of ≈600–700 lines/mm after proper consideration is given to Nyquist sampling to eliminate aliasing. The spectral response depends upon the materials and sensor structures employed. For conventional silicon, the range of sensitivity is 400–1000 nm. The spectral sensitivity may be extended into the infrared, for example, platinum silicide sensors are responsive to 4–5 μm, indium antinomide to 5 μm, and iridium silicide to 9 μm. CCD camera tubes have replaced conventional photographic media in all of the modern astronomical observatories in the world due to their far infrared sensitivity and digitized imagery capabilities. Improved solid-state sensor designs including large-area CCD sensors, higher-resolution arrays, together with improved optics and electronics will accelerate the replacement of tube camera with CCDs.

CHEMICAL IMAGING SYSTEMS

Photopolymer Imaging The term *photopolymer* is considered to include photo-crosslinkable polymers, photodimerizable polymers, photosensitive polymers, photoconductive polymers, and the more recent areas of photopolymerizable systems that involve the formation of polymer from monomer precursors. Many light-induced reactions of photopolymers involve a change in molecular weight with corresponding changes in solubility properties. Thus photoreactions that yield higher molecular weight materials result in decreased solubility for these regions and enable negative-working imaging processes. Not all photopolymer imaging systems involve changes in molecular weight, but may depend on other physical property changes, including enhanced solubility properties (positive working systems), changes in polymer crystallinity with corresponding light-scattering imaging, photo-induced changes in tackiness with corresponding changes in adhesion or toning, changes in viscosity, etc. The wide interest in photopolymer materials comes from their ability to produce quality images with short access times and convenient dry processing.

Sensitivity The sensitivity range associated with a number of photopolymer systems is up to 600 nm. Although the relative speed of photopolymer systems is orders of magnitude slower than the speeds of silver halide, there is also the promise of amplification in the chain reactions of polymerization (and depolymerization) that in some cases leads to camera speed photographic systems without silver.

Spectral Response Photopolymer systems with a range of spectral response from the ultraviolet to infrared have

been reported; however, practical applications generally involve ultraviolet exposures.

Photographic Characteristics Resolution, D_{max}, D_{min}, and contrast comparable to silver halide systems have been reported. The conversion of monomer to polymer is a low-contrast process, which may be converted to high contrast by the readout systems. Readout methods include solvent development, thermal transfer of image regions to a support, thermal de-lamination, peel-apart of film layers, modulation of diffusion of chemicals through a film layer, and differences in light scattering. Continuous-tone response results from some readout methods, but most photopolymer systems are high contrast.

Photomicrolithography/Photoresist Photoresist materials lie at the heart of the microelectronics industry. Microlithography is the leading process by which imagewise patterns are defined and generated on or in semiconducting material substrates via the imaging vehicle of photoresist systems.

Photoresist Formulations A positive photoresist is one in which developability is increased by light exposure, whereas a negative resist is one whose developability is decreased by light exposure. A photoresist is a system with many components, including binder, photoactive compound (PAC), casting solvent, adhesion promoters, and other miscellaneous additives, such as absorbing dyes, surfactants, inhibitors, and stabilizers.

Resist Systems A photoresist coated on a silicon wafer is normally not a simple single layer. On the contrary, depending upon the particular application involved, resist systems often employ multiple layers applied one on top of another.

Resolution Positive photoresist systems have the highest resolution capabilities, and device features below one-quarter micrometer range (4000 lines/mm) are now being attained using a 193 nm ArF excimer laser exposure source. In photopolymer resists, the ultimate resolution is determined by the optical systems used. The resolving power may be approximated by:

$$W = \lambda/2NA$$

The minimum line width *(W)* is proportional to wavelength, and inversely proportional to numerical aperture of the lens system. Deep UV exposure enables the minimum device features (resolution) required by the microelectronics industry.

Optical and Exotic Exposure Tools In addition to optical exposures, resist systems have been developed that may be exposed by ion beam, electron beam, and x-ray sources. These techniques are employed in direct-write mask making, as well as microlithographic applications.

Thermal Systems

Direct Thermal Printing Direct thermal printing has applications in FAX and bar-code printing. This technology uses thermal papers that are coated with heat-sensitive dyes. Advantages of direct thermal printing include small size, odorlessness, quietness, no ink or ribbons, moderate operational costs, excellent reliability, and low power consumption. On the negative side, the output-paper hard copies exhibit low resolution, are subject to fading, and have poor archival properties, and many papers have an objectionable appearance.

Thermal Dye Transfer Printing Recently direct thermal paper technology has been surpassed by thermal dye transfer imaging. In this technology, an intermediate sheet coated with pigmented waxes, known as an intermediate donor film (IDF), is used to transfer an image to a receiver sheet by heat. This technology has established applications in word processing, FAX, computer printing, graphics, pictorial color,

and labels. Thermal dye transfer may also be used for full color processing, using three or four colors (CMYK), and is capable of approximately 20 lines/mm resolution. The strengths of thermal dye transfer are saturated colors, high resolution, high quality text and graphics, ideal for computer-aided design (CAD), and availability of supporting software. The weaknesses of this technology include slower printing, no gray scale (continuous tone), special ribbons, and the requirement of very smooth receiver paper. Because this technology offers the advantages of relatively simple color implementation, plain paper, image stability, and high quality, thermal dye transfer processes are gaining ground over the direct thermal processes.

Dye Diffusion Thermal Transfer (D2T2) This most recent thermal printing technology has the great advantage of continuous-tone reproduction. This is made possible by the fact that the amount of dye transferred by sublimation (diffusion) varies in proportion to the amount of heat provided to the IDF by the thermal printhead. In this process, a thermal printhead causes subtractive image dyes to transfer in the vapor phase to the receiver paper. The materials media delivers near photographic quality prints from digital signals. The process provides 8 bit (256) hues, high resolution, and optical density range equal to photography. Applications include photographic proof printing, electronic prepress, full-color facsimile, home video, and others.

PHOTOCHROMIC IMAGING Many organic and inorganic compounds show a change of color when exposed to light but return to their original state in the dark. The reversible color change is called photochromism. The *reversibility* distinguishes it from all conventional photosensitive image-forming reactions. This reversibility precludes amplification in this process. Photochromic systems cannot compete in certain respects with silver halide, but they do offer an image that is formed directly without processing steps. Another advantage is that the materials are reusable. Unlike silver halide films, photochromic materials are completely grain-free and have very high resolution of approximately 1000 lines/mm. This technology is well suited to microfiche, images can be reduced by 150:1, and a very high density of information storage is achieved. Other imaging applications include mask making, use in holographic recording, and information display systems with writing and erasing capability.

Diazo Imaging Systems Diazo systems are one of the oldest nonsilver processes and are still widely used. Diazo systems generally refer to systems based on diazonium compounds ($ArN_2^+Cl^-$) and (Ar-N = n-SO_3Na), as well as diazomethanes and organic 2-diazophenols. Diazonium compounds decompose when exposed and couple with a color former to produce a stable image. Diazonium compounds can form images in a variety of ways and may be divided into positive-working and negative-working processes. Diazo processes are economical, easy to handle, and are mainly used for copying engineering drawings and in microfilm. Although they exhibit low photosensitivity, their high contrast and capability of producing a direct positive copy are advantageous. Diazo images have no granularity and the resolution capabilities are reported to exceed 1000 lines/mm.

GRAPHIC ARTS IMAGING SYSTEMS

Ink-Jet Printing Ink-jet printing is rapidly becoming a leading method for generation of monochrome or full-color images on paper. In this process, a stream of ink droplets is emitted under pressure from a nozzle with an orifice from 10 µm to 100 µm and deposited onto paper or other receiver material to form an image. The high quality of the prints, easy adaptation to full color, silent operation, low cost of consumables, and wide range of applications make this technology very attractive. There are three basic types of ink jet printing, *drop-on-demand or impulse,* in which a drop is

emitted in response to an applied signal; *continuous jet*, in which drops are continuously generated and deflected to produce an image; and *phase change*, in which a physical change of state occurs in the ink. Ink jet is the only raster-based system capable of printing color in a single pass. This is because ink jets have multiple ink nozzles, with at least one nozzle for each subtractive color. Recently Stork Bedford B.V. has introduced an ink jet color proofing system that produces full-color proofs with quality rivaling silver halide color photography.

Books: Diamond, Art (ed). *Handbook of Imaging Materials.* New York: Marcel Dekker, 1991; Stroebel, Leslie, et al. *Photographic Materials and Processes.* Boston: Focal Press, 1986; Sturge, John, Walworth, Vivian, and Shepp, Allan, (ed.) *Imaging Processes and Materials.* New York: Van Nostrand Reinhold, 1989. *D. Marsh*

See also: *Definition, photographic; Electronic still photography; Electrophotography; Nonsilver processes; Photographic processes; Photomechanical and electronic reproduction; Tone reproduction; Video; Vision; Visual perception.*

IMAGE AMPLIFICATION Electronic system for intensifying an optical image as much as 15,000 times by conversion into electron streams, amplification, and reconversion into light. The optical lens of an image-amplification device focuses the low-intensity source image on a collector screen consisting of multiple CCDs (charge-coupled devices) or an electron-emissive photocathode. The electron stream produced by the CCDs is amplified by a multiplier circuit; the stream from the photo-cathode is amplified by an accelerating voltage. The output from the amplification stage is focused on a luminescent screen, at which point the image may be viewed or recorded by traditional photographic techniques.

Image amplification may be applied profitably to infrared recording where direct imaging with low sensitivity emulsions would require long exposures. Amplification can reduce the exposure time by 1000 × or more. The process may be used to photograph starlit subjects at night with exposures of less than one second, study high-speed phenomena, perform astronomical observations, and conduct surveillance.

The term image amplification is also applied in silver halide imaging to the amplification of the latent image by several orders of magnitude during development. *H. Wallach*
See also: *Electronic photography.*

IMAGE ASSEMBLY The positioning of negatives (or positives) on a flat to compose a page or layout for platemaking. *M. Bruno*
Syn.: *Stripping.*

IMAGE CAPTURE See *Frame capture.*

IMAGE CARRIER A printing plate or cylinder ready to be printed on a press. *M. Bruno*

IMAGE-CONVERTER CAMERA See *Camera types.*

IMAGE DEGRADATION The slow destruction of image-forming substances, or of the image layer itself by chemically aggressive reactants or biological contaminants. *K. B. Hendriks*

See also: *Image permanence.*

IMAGE DISSECTION In a conventional high-speed camera, film must move across the image field very rapidly. Practical limitations are imposed by the distance the film must travel and the length of film required to make a substantial number of images. Image-dissection cameras solve these problems by limiting the movement of the film or keeping it stationary, and by making many images on one plate.

In image dissection cameras, the incoming light passes through an objective lens and is divided into as many as 80,000 elements. If a multiple-lens screen is used for dissection, the division is made by a lenticular plate, a crossed pair of lenticular plates, or a fly's-eye array of spherical lenses. A Nipkow disc with a spiral pattern of scanning holes rotating behind the objective lens can be used to achieve image deflection. In place of a screen, a fiber optical bundle can be shaped so that the bundle is tightly grouped on the input end to accept as much of the image as possible, and spread out on the film end to form advantageous array configurations.

The many image points of the dissected image are evenly separated from each other by spaces that can be measured in point widths. The image needs to be moved only one image point to record the next image in the sequence. If the separation between points is ten times the point width and the tracking motion is parallel to the array, then at least ten frames in sequence are possible; if points have this separation in both directions, there can be up to 100 frames in a sequence. If the tracking motion is at a slight angle to the array, 50 frames may be recorded without overlap. This procedure can be repeated until the entire sheet of film is covered with scrambled images. The film is then processed, placed back in the camera, and the original images are reconstituted from the separated elements.

In high-speed applications, image-dissection cameras give relatively long recording times and miss very little action because imaging is virtually continuous. Processing is simplified because each sheet of film contains many images, an advantage that makes image dissection attractive for document recording as well. The process has been used for studying projectiles and explosions. In cine-microscopy, it has been employed to examine liquids and particles such as coal dust.

Image dissection may be accomplished by scanners or charge-coupled devices (CCDs) whose digital or electronic outputs may be stored, transmitted, or processed by computers. These systems are inherently faster than photochemical systems. *H. Wallach*

See also: *Fiber optics; Halftone process; High-speed photography; Lenticular screen.*

IMAGE DISTANCE The distance between the rear nodal (principal) plane of a lens and the plane of maximum sharpness of the image. When the lens is focused on infinity, this distance has its minimum value and corresponds to the focal length of the lens. For unit focusing of a lens the image distance increases. Associated with the image distance is a conjugate object (subject) distance. *S. Ray*
Syn.: *Bellows extension.*

IMAGE ENHANCEMENT Generally, the term image enhancement refers to any method by which an image may be improved, but it has come to be understood specifically as denoting the digitization and manipulation of an image to produce an extensive array of effects. Images on film or paper are translated from analog dye or silver to digital data by a scanner.

Sharpness may be enhanced by digitally examining transfer edges. The rate of change of tone at these boundaries indicates the degree of sharpness. Sharpening is achieved by comparing maximum and minimum values on either side of the edge and accelerating the rate of transition between them.

The slope of the dye density curve of the red, green, blue, and black components, or of the yellow, magenta, cyan, and black components, may each be controlled separately. This procedure effects an overall change in color or tonal contrast, a change of the contrast of one color relative to the others

present, or a change of local contrast in a selected area. Individual pixels can have their color or density changed, restoring fading, repairing damage, improving reproduction characteristics, improving the overall impression of an image, or reinterpreting the original input entirely. *H. Wallach*

See also: *Computers for photographers; Scanning.*

IMAGE MOTION See *Image movement.*

IMAGE MOTION COMPENSATION (IMC) (1) A method of moving a projected image in synchronization with a continuously moving recording film for high-speed motion picture photography, such as by the use of a rotating mirror. (2) A system used in photo-finish and some other cameras where the film moves past a narrow slit at a rate that matches the movement of the image of a moving object. *L. Stroebel*

See also: *Stabilization, image.*

IMAGE MOVEMENT If the subject of a photograph is moving as the shutter is released, its image will move over the surface of the film in the camera, no matter how slowly the subject is traveling or how quickly the shutter opens and closes. Because of this movement the negative and any prints made from it will show blur, and if the negative is enlarged, the blur will be increased in proportion. Even so, the blur is not bound to be visible in the finished print. In fact, if it is less than 1/100 inch wide the average human eye will not be able to detect it under normal viewing conditions. With this as a starting point it is possible to lay down conditions for

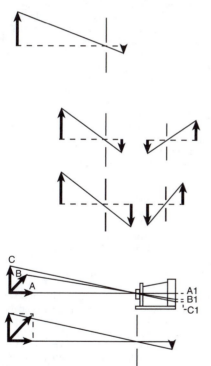

Image movement. Top: The image movement is smallest for a distant moving object. Center left: At a given distance a short focal-length lens gives a smaller image (with less movement) than a longer focal-length lens. Center right: If, however, both negatives are enlarged to the same image size, the blur through image movement will be the same. Bottom: Object movement along the camera axis causes the smallest image movement, across the axis the greatest. Movement at an angle is intermediate in effect, as it can be resolved into a movement along the camera axis and one at right angles.

photographing moving subjects in such a way that the final picture will appear to be perfectly sharp, that is, so the actual blur will not be greater than 1/100 inch on the print.

Slowest Shutter Speed If the negative is to be used for making contact prints that will be viewed at the normal distance of 10 inches with the unaided eye, the condition to be fulfilled is simple: the image must not move more than 1/100 inch while the shutter is open. In this case it is only necessary to calculate the time the image takes to move 1/100 inch on the film, and the answer will be the slowest shutter speed that will arrest the movement of the subject.

For example, a racing car is to be photographed passing across the field of view 300 feet away at 120 miles per hour (176 feet per second), the negative is to be exposed with a 10 inch lens, printed by contact, and viewed from 10 inches (these conditions produce normal perspective). As the car (300 feet away from the lens) moves 176 feet in 1 second, the image (10 inches away from the lens) moves (by simple proportion) $(176/300) \times 10$ inches = 5.86 inches. It moves this distance in 1 second, so that it will move 1/100 inch in $1/(5.86 \times 100)$ or, roughly, 1/600 second.

This is the lowest permissible shutter speed (lps) that will arrest the movement of the subject at that particular speed, distance, and direction of movement. For other shutter speeds, distances, and directions, the corresponding lowest permissible shutter speed follows by simple calculation.

If the racing car is traveling at 240 instead of 120 miles per hour, the slowest permissible shutter speed would be $1/600 \div 2 = 1/1200$ second. If the racing car is being photographed at 100 feet instead of 300 feet, the slowest permissible shutter speed would be $1/600 \div 3 = 1/1800$ second.

Movement across the field is most marked; movement towards the camera becomes only a relatively slow change in size. So, if the car moves towards or away from the camera instead of across the field of view, the lps can be three times as long—$1/600 \times 3 = 1/200$ second. And if the car moves obliquely, at 45 degrees to the camera-subject line, the lps can be twice as long—$1/600 \times 2 = 1/300$ second.

Effect of Focal Length The theory holds good for contact prints from negatives made with a 10-inch lens and viewed at a distance of 10 inches. But if the negative is enlarged, then the blur is enlarged with it, and blur that was not noticeable in a contact print might become visible in an enlargement viewed at the same distance. For every diameter the negative is enlarged, the lps must be made shorter in proportion. That is, if the negative is to be enlarged four times, the lps must be divided by four.

Generally, the magnification required to produce a natural-looking print is found by dividing the focal length of the taking lens (in inches) into the focal length of the lens that gives a natural print by contact—10 inches.

A negative taken through a 2-inch lens must be enlarged $10/2 = 5$ times to give a natural print. But the amount of blur in the negative is smaller in the same proportion because the film is 2 inches away from the lens instead of 10. So that the lps for any particular moving subject is the same irrespective of the focal length of the taking lens.

But this is true only as long as the negative is enlarged to make a print in which the perspective appears normal when viewed at the standardized viewing distance of 10 inches (or proportionally greater or lesser magnifications for larger or smaller viewing distances.) Because all of the negatives on a roll of film are usually enlarged to the same size prints regardless of the focal lengths of the lenses used to expose the individual negatives, however, the lowest permissible shutter speed decreases in proportion to the lens focal length. Thus, if the lps for a 50-mm focal-length lens on a 35-mm camera is 1/60 second, it would be 1/30 second for a 25-mm wide-angle lens and 1/125 second for a 100-mm telephoto lens. A convenient rule of thumb for 35-mm cameras is that

Practical Shutter Speeds for Moving Objects

Distance		Exposure Time (seconds) for Object Speed of								
ft	m	2	4	8	16	30	60	120	250	500 mph
		3.2	6.4	13	25	50	100	200	400	800 kmph
1	0.3	1/30000	—	—	—	—	—	—	—	—
2	0.6	1/1500	1/3000	—	—	—	—	—	—	—
4	1.2	1/750	1/1500	1/3000	—	—	—	—	—	—
8	2.4	1/400	1/750	1/1500	1/3000	—	—	—	—	—
16	4.8	1/200	1/400	1/750	1/1500	1/300	—	—	—	—
32	10	1/100	1/200	1/400	1/750	1/1500	1/3000	—	—	—
64	20	1/50	1/100	1/200	1/400	1/750	1/1500	1/3000	—	—
125	40	1/25	1/50	1/100	1/200	1/400	1/750	1/1500	1/3000	—
250	80	1/10	1/25	1/50	1/100	1/200	1/400	1/750	1/1500	1/3000
500	150	1/5	1/10	1/25	1/50	1/100	1/200	1/400	1/750	1/1500
miles	km									
	0.4	1/2	1/5	1/10	1/25	1/50	1/100	1/200	1/400	1/750
	0.8	1	1/2	1/5	1/10	1/25	1/50	1/100	1/200	1/400
	1.6	2	1	1/2	1/5	1/10	1/25	1/50	1/100	1/200

These shutter speeds apply for objects moving across the line of sight of the camera. For movement diagonally towards or away from the camera, the exposures may be 1-1/2 times as long (e.g., 1/500 second instead of 1/750). For movement directly towards or away from the camera 3 times as long exposures may be given (e.g., 1/250 second instead of 1/750). The standard of definition is 1/1000 of the focal length of the normal camera lens. With long focus or telephoto lenses the speeds must be multiplied (or the exposure time must be divided) by the power of the telephoto lens, e.g., 1/100 second becomes 1/200 with a 2× telephoto lens.

the slowest safe shutter speed for hand-holding the camera is the reciprocal of the lens focal length in millimeters—for example, 1/50 second with a 50-mm lens.

Complex Motion What has been said about simple motion can rarely be applied in practice because so many subjects involve more than one kind of motion. If a man is being photographed walking past the camera, a fairly slow shutter speed will arrest the movement of his body, but something very much faster would have to be used to give a sharp image of his hands and feet in the middle of their swing. The shutter speed that would arrest the movement of a railway engine would still leave the spokes of the wheels blurred.

In fact, almost every form of movement met with in practice is complex, and no photographer could hope to work out the exact minimum shutter speed necessary to arrest the movement of a given subject in time for the answer to be of any use. But a knowledge of the theory is a useful guide when adopting the more practical approach described below.

Focal Plane Shutter Distortion In a camera with a focal plane shutter, movement of the subject (or the camera) may distort the image on the negative even at shutter speeds fast enough to prevent blur. This is because the moving slit of the shutter exposes the negative piecemeal and not simultaneously all over. The speed of the shutter is the time taken to uncover and cover a single point on the surface. This may be so short that the image does not move enough to show blur in the print. But the total time taken by the shutter to expose the whole surface in this way is much longer and the image may also be moving as the slit moves across the focal plane. In that case each successive image strip exposed through the slit will be displaced farther in the direction of the image movement, and the subject will appear to be sloping in that direction in the finished print. The wheels of a car traveling past the camera will appear to be sloping either forwards or backwards if the camera is held so that the shutter travels from bottom to top or top to bottom, respectively. If it travels from side to side, the image will be either compressed or elongated in the direction of movement (that is, round wheels appear oval).

The extent of the distortion depends on the time it takes for the slit to traverse the image. So the closer the subject to the camera—the larger the image—the worse the distortion. And the longer it takes the slit to complete its travel—the slower the speed of the blind or the farther it has to go—the

greater the distortion. This explains why, under similar conditions, there is less distortion with a miniature focal plane shutter than with a larger type where the slit has a greater distance to travel.

This discussion relates only to the image distortion produced by movement. The blur is controlled independently and in exactly the same way as with a between-lens shutter.

The Practical Approach In practice the whole problem of photographing moving subjects is very much simpler than the theory suggests. The experienced photographer avoids movement blur in one or more of four ways: (1) by shooting from a distance and angle that will minimize blur; (2) by using the fastest shutter speed possible, irrespective of the theoretical lps; (3) by making the exposure at a *dead* point in the motion; and (4) by panning the camera to keep pace with the movement of the subject.

Distance and Angle The closer the camera is to the subject, the greater the blur on the negative, and at any distance, the blur is worst when the subject is moving across the field of view and least noticeable when the subject is moving towards or away from the camera. If conditions preclude the use of fast shutter speeds, the photographer should not work close to a moving subject and should choose a position where the direction of movement is not directly across the field of view, but at about 45 degrees to the line of sight. (A head-on photograph would show even less blur, but the three-quarter view gives a better impression.)

Shutter Speed From actual experience it is possible to make a list of the lps values that apply to a number of representative subjects, moving at various distances and direction. These values take into account any secondary movement of the subject (for example, the arms and legs of a walking person, which move faster than the body) as well as its speed so they are more reliable than a theoretical list based on speed alone. At the same time, the photographer cannot carry such a list in mind and will rarely have time to refer to it. In practice simply use the fastest shutter speed that the circumstances—lighting, lens aperture, and film speed—will permit. In fact, within limits, the actual shutter speed used is less important than the other practical considerations governing the amount of blur.

The following table provides a set of suitable exposure times.

The Dead Point A swinging pendulum comes to a stop at

each end of its swing; an athlete or a horse and rider at the highest point of a jump are moving neither up nor down; there is an instant in walking and running when the hands and feet are stationary. In almost every form of complex movement, there are *dead* points where the movement halts. These are the instants that the practiced photographer looks for to avoid blur in pictures. It is not enough merely to be able to recognize the dead point; the photographer must learn to allow for the time lag in both the human and the camera mechanism.

Panning the Camera One of the most effective ways of minimizing the blur caused by straightforward movement is called *panning the camera.* This simply means that the camera is kept pointing at the subject as it moves past, the image of the subject being held in the center of the viewfinder up to and during the instant of exposure.

When the camera pans with the subject in this way, the subject will be sharp on the negative, and the background will be blurred. But as a rule the blur, far from being objectionable, helps to separate the subject from the background and actually increases the impression of speed. Panning the camera will render completely sharp only those objects that are solid units, such as cars, trains, etc., but there will still be evident a blurring in arms and legs of subjects such as human beings, as well as the limbs of animals.

Deliberate Blur Blur in a photograph of a moving subject is not always objectionable; there are times when a certain amount actually improves the picture. In fact, the only photographs in which blur is completely out of place are scientific records of movements too fast for the eye to follow. In pictorial work it is rarely advisable to show both moving subject and its background perfectly sharp even when it is possible. If both are sharp, the photograph simply looks as though the subject were stationary. *F. Purves*

See also: *Chronophotography; High-speed cinematography; High-speed photography; Sports photography; Stroboscopic photography; Time-lapse photography.*

IMAGE PERMANENCE

IMAGE PERMANENCE The permanence of an image or other document defined by the dictionary as lasting or intended to last indefinitely is a somewhat elusive quality unless it is given a practical meaning. Because no object can truly be said to last indefinitely, the requirement for, or designation of, an image to be permanent seems unrealistic. In practical terms, permanence indicates a record "having permanent value," for example, a motion-picture film, or a historical still photograph. This qualification indicates the need that it be preserved, either in its original form or by copying or duplicating its contents. Another term widely used to suggest long-lasting properties is *archival,* in such expressions as archival storage conditions, archival processing of photographs, or an image having archival quality. The word *archival* is a nonscientific term that is meant to imply permanence but is unsuitable for material specifications since it does not describe a measurable property.

Life Expectancy In order to alleviate the careless use of such words as *archival* and *permanent* for attributing a certain quality to photographic images, the American National Standards Institute (ANSI) has introduced the concept of life expectancy (LE) rating for photographic records. An LE_{100} rating for an image on film, for example, indicates that it is expected to be usable for one hundred years. Specific LE ratings have been assigned to certain materials, which makes this concept practical and useful.

In general terms, permanence indicates the resistance of a material to chemical action that may result from impurities in that material itself or agents from the surrounding air. This definition is essentially one given by the U.S. Technical Association for the Pulp and Paper Industry (TAPPI) for the permanence of paper. For chemical elements and well-defined compounds, such resistance to react chemically can

be expressed quantitatively. For example, the series of standard electrode potentials of metals precisely defines the energy required to oxidize elemental metals to the ionic state. For pure chemical compounds, the reaction enthalpy for a specific reaction indicates its reactivity. It has been determined for many compounds. However, neither paper nor photographic records consist of pure chemical compounds, but are mixtures of many ingredients, as in paper, or possess an intricate layer structure of components with different properties, which characterizes photographic materials. While the stability of pure chemical elements and compounds can be determined quantitatively, more empirical approaches have to be taken with composite materials. Thus, permanence can indicate the ability of a material to remain usable for its intended purpose for a specified number of years. This is the purpose of the LE rating. The resistance of a photographic image to chemical action, a definition that will be adhered to throughout the following discussion, can be determined by measuring its ability to maintain measurable *mechanical* and *optical* properties, either during natural aging or after exposure to accelerated aging conditions. Tests for these properties are an integral part of many standards published by ANSI that deal with photographic records.

Besides observing the properties of photographic images throughout their history and so drawing conclusions about their stability, one can prepare such images, or other records, from known ingredients and observe their ability to maintain mechanical and optical properties under forced conditions. Such experiments allow one to draw conclusions with respect to the suitability of materials for the long-term retention of information. It can be shown that some materials are clearly superior to others with regard to their stability. This knowledge is essential in writing *contents-based* standards with material specifications for the preservation of records having permanent value.

Photographic Records So far this discussion of permanence has used the general terms *record,* or *document,* rather than focusing on photographic images. There are good reasons for this: first, it is not practical to have several definitions for permanence for different kinds of records. Keepers of col-

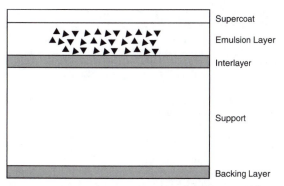

(not drawn to scale)

Photographic record cross-section. While nearly all photographs have a distinct emulsion layer (exceptions: daguerreotypes, salted paper prints) the antiabrasion layer, or supercoat, is found mostly on twentieth-century materials. An interlayer, which is located between the emulsion and the support, can be found either in films as subbing layer, where it is transparent, or in fiber-base prints as a gelatin layer filled with the white pigment barium sulfate. There it is called a baryta layer. In resin-coated papers (RC papers), the interlayer consists of polyethylene that contains a white pigment, typically titanium dioxide. In both types of prints, the interlayer is opaque. The backing layer can function as an anticurl and as an antihalation layer.

lections in archives are likely to have more than photographic images to care for, for example, paper records. Secondly, photographs can have a variety of support materials, the principal ones being paper, plastic film, and glass plates. Paper is a generic term that indicates that different kinds are made from similar materials using similar technologies. A definition of permanence for newsprint should also be applicable to a photographic print. It should be applicable to plastic films as well, made of either cellulose acetate or polyester, that are used as a support for both photographic films and sound tapes.

Defining permanence as the resistance of records to chemical action means that it is not solely a property that is either built-in or lacking in the product, but also a property that is determined by its subsequent use and storage. In addition, photographic records are distinguished from other recording media by their need for chemical processing. This requirement places a burden on users of photographic films and papers that does not exist for paper or magnetically recorded media. With a specific focus on photographic images, three factors determine their permanence:

- the manufacture, from raw materials to technology used;
- the processing, in particular, sufficient fixing and washing;
- the subsequent storage conditions and use of photographs.

Each of these factors can contribute to an increase in the resistance of photographic images to chemical action.

All contemporary photographic records have three principal components: a support, a binding agent coated on top of the support, and an image-forming substance held in place by the binding agent. While the most common support materials are paper, film, and glass in contemporary photographic records, gelatin has been used almost exclusively for the past 100 years as the binding agent in black-and-white and in color photographs. Both the support and binding agent contribute to the stability, or lack of it in some cases, of a photographic record. The principal component, however, that determines the longevity of a photographic image is the image forming substance. In *black-and-white* photographs it consists of finely divided elemental silver. The wide range of hues in a *color* photograph are formed by organic dyes. Since the stability of these two principal image-forming substances varies widely according to their chemical nature, they are discussed separately.

BLACK-AND-WHITE IMAGES The chemical stability of image silver in *black-and-white* photographs is lower than could be expected from its position in the series of standard electrode potentials that classifies it as noble metal. In order to understand the mechanism of image degradation in a *black-and-white* photograph that manifests itself as discoloration or fading of the image, a brief introduction into the formation of a photographic image may be useful. The elemental silver present in these images is generated by two fundamentally different pathways. The first occurs by direct and sufficient exposure of a silver halide to light. The silver halide can be a chloride or bromide, or a combination of these, with small amounts of silver iodide sometimes present. It is evenly distributed throughout the image layer in the form of fine particles. Upon exposure to light elementary silver is formed, which is termed photolytic silver. Exposure times are long, typically from 30 to 60 minutes at about 300 footcandles. In practical photography the process of making photographs just described is known as the printing-out process, and photographic papers operating on the principle of producing an image by exposure alone are called *printing-out papers* (POP). After the image has been printed out upon exposure under a negative, prints are treated in a fixing bath to remove unexposed silver halide, washed, and dried. The printing-out process was the first by which photographic prints were made, and it was the predominant, although not the only, process of making photographic prints in the nine-

teenth century. Examples include the earliest positive photographs on paper, called salt-prints, or salted paper prints, which were in use from the late 1830s to the mid-1860s. They are characterized by the lack of a distinct image layer; the image silver particles are largely drawn into the fibers of the paper, but lie partially on the paper surface. The most widely occurring photographic print material of the nineteenth century were albumen prints. Other photographs made by the printing-out process are collodio-chloride papers and silver gelatin printing-out papers. The recently discontinued Studio Proof Paper by the Eastman Kodak Company is a prominent example.

The second pathway takes place by the chemical reduction of a silver halide crystal that has been exposed to light for a period sufficiently long to create latent image specks of elemental silver on that crystal. Chemical reducing agents dissolved in water, known in photographers' language as developers, act upon these elemental silver specks so as to reduce the entire crystal to elementary silver. The exposure times that are necessary to form the developable silver nucleus range from fractions of a second for camera films, to a few seconds for photographic papers, at the same intensity as above. The chemical reaction that converts a briefly exposed silver halide to elemental silver is called development in normal photographic practice. Photographs made by this process are termed *developed-out prints* (DOP). Obviously, a photograph so produced also needs to be fixed, washed, and dried in order to become a stable image. Photographic prints made by the printing-out process have conventionally been divided into bromide papers, first manufactured in the early 1880s; chloride papers, characterized by relatively low sensitivity, a cold-black image tone, a higher maximum density than other developed papers, fine grain, and good contrast; and chlorobromide papers, which are used in many commercial applications as projection-speed enlarging papers. In chlorobromide papers, silver bromide is predominant over silver chloride in the unexposed and unprocessed material.

The elemental silver grains present in each of the two groups of photographic prints differ from each other in their respective size and morphology. Silver particles present in printed-out photographic prints are smaller by a factor of almost two orders of magnitude than those formed by chemical development. Although the size of silver particles in either printed-out or developed photographic prints fluctuate widely, the former average around 0.02 micrometers in diameter. They are approximately spherical in shape. By comparison, the dimension of a developed-out silver grain can vary around a value of 0.5 micrometers. Developed-out silver grains can be cubic shaped, or irregularly formed grains with numerous edges and corners. Many consist of filamentary silver, which may be likened in appearance to steel wool. This variation in the morphology is built into the raw stock by the manufacturer in order to achieve specific photographic and sensitometric properties in a given film or paper. Silver gelatin photographic technology allows the manufacturer to tailor photographic images to specific applications, such as studio work, motion pictures, microfilming, x-ray films, and many others. In processed photographic films, silver grains are generally larger than in paper prints, because larger silver halide particles provide greater sensitivity to light, a desired property for negative films to be used in cameras. Experience has shown that the image-forming silver in photographic prints made by the printing-out process are more reactive towards aggressive chemicals than those in developed-out photographs. This knowledge will be useful in understanding various observations made throughout the history of photography on the stability of black-and-white photographs.

Environmental Reactants A wide-ranging body of

experimental evidence and practical experience indicates that the image silver in black-and-white photographs can be oxidized by aggressive chemical compounds. Numerous reagents have been found capable of reacting with the image silver to produce silver ions. The most notorious are peroxides. In the form of hydrogen peroxide, they are also the most common reactants used in laboratory tests designed to study the resistance of black-and-white photographs to oxidizing agents. Research performed about thirty years ago at the Eastman Kodak Company showed that peroxides could oxidize individual silver particles in processed microfilms with the concurrent formation of microscopically small orange-color spots known as *redox blemishes, red spots,* or *microspots.* The term redox is derived from the abbreviation for *red*uction-*ox*idation, the chemical mechanism by which they are formed. Redox blemishes consist of circular spots of colloidal silver. The studies indicated that elemental silver had been oxidized to silver ions which could diffuse outward in a radial fashion before being redeposited as colloidal silver. This process could repeat itself so that circular zones of high silver concentration were followed by silver-free rings, giving rise to the visible appearance of concentric rings. They usually occur on negative films, especially camera original microfilm, because of the relatively high silver content in these images.

Environmental reactants. Redox blemishes on processed microfilm, magnification 50X.

Since redox blemishes were found on microfilm that had been stored in cardboard boxes, the source of the peroxides was traced to the groundwood present in the cardboard. Peroxides, which can emanate from groundwood during natural aging, are gaseous compounds that can be envisaged as reactive forms of oxygen. They are, as noted, capable of chemi-

cally attacking image silver in processed films. The formation of redox blemishes is not restricted to microfilm, as they have been observed on contemporary black-and-white resin-coated (RC) prints as well.

Another source of peroxides that may cause the discoloration of black-and-white photographic prints are alkyd-based paints when drying. Extensive experiments that investigated the effects of different types of house paints on the discoloration of photographic prints showed that latex-based paints were harmless, but that during drying, alkyd-based paints produce peroxides that can react with the image of silver photographs.

Investigations carried out by the Agfa Corporation showed that certain phenol-formaldehyde resins, upon aging, can cause image degradation. Other damaging materials included ozone produced by electrostatic office copiers, exhaust gases from automobiles, and other industrial gases. Recent studies have explained the appearance of edge-fading on mounted photographic prints dating from the first ten years or so of photography. Commercially available animal glue caused severe fading of an image area when applied to the back of sample prints that were prepared for experimental purposes. The chemical compound *thiourea,* present in minor amounts in animal glue, was found to be the active ingredient capable of reacting with both photolytic silver, as in images on printing-out papers, and developed-out silver grains. The occurrence of serious edge-fading in photographic prints decreased after the first decade following the medium's invention, suggesting that photographers had developed an understanding of the danger of using animal glue for the mounting of photographs. Similar studies on the effect of fingerprints on black-and-white images revealed that the principal component of sweat produced by glands in the human skin is sodium chloride, present at a concentration of about 0.03%. A conversion of image silver to silver chloride is the most likely reaction to happen as a result of a fingerprint. The silver chloride so formed may print out when exposed to light, giving rise to the discoloration lines in the form of the ridges and valleys on the surface of the human skin. This example illustrates well that only very small amounts of aggressive chemicals are necessary to cause visible discoloration in black-and-white photographic images. The amount of image silver, while varying throughout the technological history of photography and from one type of record to another, is in the range of $50–60 \mu g/cm^2$. It is finely divided, finely distributed, and has a large surface-to-volume ratio, making it a reactive material. Degradation reactions of the image silver are fascinating because the amazingly small amount of silver present in a photograph requires only equally minute amounts of reactants to cause striking visual changes in the image that are described as fading or discoloration.

Other chemically reactive gases capable of oxidizing silver image particles in black-and-white photographs include hydrogen sulfide and nitrogen oxides. The latter are particularly insidious. As a reaction product of degrading cellulose nitrate film base, they can react with the image silver of other black-and-white films and papers stored in the vicinity; they can also attack the gelatin layer of these photographs, destroying its chemical structure and turning it weak and unable to perform its function.

Numerous observations and experiments have demonstrated that the presence of moisture is necessary for reactions of the image silver with aggressive chemical reagents to occur. It also accelerates most of these reactions. Since the moisture is supplied in most cases from the relative humidity in the surrounding air, the environmental conditions during experimental work, as well as in keeping photographic collections, must be controlled.

This discussion has focused so far on the nature of impurities from the surrounding air that may precipitate chemical

action in a photograph. Included here are also impurities which can produce discoloration that originate from filing enclosures, envelopes, or any other materials with which a photograph may be in close contact. Prominent examples are newsprint (newspaper clippings!), the transfer of ink from inscriptions on the back of a print to the surface of an adjacent photograph; and adhesives used in the seam of filing enclosures. The exact identity of the offending substance is not known in any of these cases.

Residual Processing Chemicals Besides the possible degradation of image silver resulting from aggressive chemicals in the vicinity of a black-and-white photograph, there are other causes resulting from impurities in the photograph itself. The most notorious of these are residual processing chemicals. During processing, the unexposed and undeveloped silver halides are removed from the image layer by dissolving them in a silver halide solvent. The most effective solvent, used almost since the beginning of photography, is an aqueous solution of sodium thiosulfate, or its faster working relative, ammonium thiosulfate. The former is known in photographers' language as fixer, or fixing solution, the latter as rapid fixer. The fixing process may be regarded as proceeding in three phases. During the first step of the fixing reaction, silver halides form a complex salt with the thiosulfate anions of the fixing solution. In the second step, the silver-thiosulfate complex is washed out of the image layer by fresh fixing solution. This is achieved by using two fixing baths in sequence, the second of which must be a freshly prepared solution. In the last step, the pure fixing solution is removed from the photograph by washing with copious amounts of water.

The fixing reactions and the washing step must be carried to completion in order to obtain a stable silver image. If a photograph is *underfixed,* complex residual silver salts may form silver sulfide stains that are visible as yellow or brown discoloration. If a photograph is *underwashed,* residual thiosulfate anions may react with image silver to form similar sulfide stains. Both reactions are generally slow. Since the potentially reactive compounds do not necessarily react with image silver at once, the results may not become visible for several years after a photograph has been processed. Experience has shown that residual silver-thiosulfate complexes and pure fixing salts can be present either in the paper base or in the image layer in a semi-stable state. For example, an insufficiently washed photographic print or fiber-base paper may show no visible discoloration when kept in controlled conditions; a change in the environment is needed to provoke a reaction. If exposed to high relative humidity coupled with elevated temperature, a reaction of the sulfur-containing residual processing compounds is triggered to produce discoloration.

Chemical Tests Since visual examination of a processed photograph alone cannot determine whether it was correctly fixed and washed, chemical tests in the form of spot tests that produce the same stains on insufficiently processed images as those that would occur over the long term in normal keeping conditions can be performed. These tests are generally done on a second sample that is processed along with the final image in order to avoid test stains on it. The test solution for residual silver salts, that is for *underfixing,* is a 0.2% sodium sulfide solution, which forms yellow to brown silver sulfide stains if the test is positive. To detect residual fixing salts, sodium or ammonium thiosulfate, a drop of an approximate 1% acidic silver nitrate solution, which forms the same silver sulfide stains, is applied to the photograph. Such tests are mandatory for fiber-base prints for two reasons: first, conventional fiber-base papers have the ability to absorb and retain processing chemicals not only in the emulsion layer, but also in the paper base itself. By contrast, glass plates and plastic film support materials do not absorb chemical processing solutions that can penetrate only into the image layer. A second reason is the smaller grain size of image silver particles in prints in comparison to those present in negatives, which makes them chemically more reactive. Correct fixing and washing eliminates a potential reactant from the print. The foregoing illustrates the need for careful processing of black-and-white photographs, a subject that has been treated exhaustively in various photographic publications. Insufficient fixing and washing has sometimes been represented as the *only* serious threat to the permanence of photographic images. However, factors arising from the immediate environment are of equal significance.

Protective Toning In order to protect photographs from such impurities in the surroundings, their treatment in a toner solution is often advised. The purpose of treating photographs in a toner solution is two-fold: to change the neutral tone of an image to one desired by the photographer, for example to a sepia color or to a cold blue tone; and simultaneously, to increase the permanence of the image. The principal idea behind such treatment is either to convert the image silver to a silver compound or to modify the morphology of silver particles, both of which would increase the chemical stability of the image-forming substance. Typical examples are treatment in a solution of gold salts—commercially called gold protective solution—and in selenium salt and sulfur-containing solutions. Recent studies have shown that toner treatments should be considered mandatory for contemporary films and papers if permanent photographic images that are resistant to chemical changes are to be obtained. Some manufacturers have offered commercial toning solutions, or image protective solutions, to enhance the stability of black-and-white photographs. Examples include the Sistan solution by the Agfa Corporation, Silverguard by Fuji Photo Film Co. Ltd., and Silverlock by the Image Permanence Institute.

HISTORICAL OBSERVATIONS Many of the properties related here have been observed empirically since the beginning of photography by its practitioners. Descriptions of image stability are scattered throughout the various photographic journals. It is only during the past twenty years that studies on the permanence of photographic images have assumed a more systematic role. One of the earliest, albeit rather crude, attempts to test the stability of photographs was carried out in 1843 by a pharmacist in Hamburg, Germany, who exposed daguerreotypes, introduced just four years earlier, to hydrogen sulfide gas. The images disappeared within a few hours. Prominent among the early reports is an account of studies by a committee that had been appointed by the Royal Photographic Society (R.P.S.) in London, England, in the mid-1850s. Its full name indicated its purpose: Committee Appointed to Take into Consideration the Question of the Fading of Positive Photographic Prints upon Paper. In its first report, published in 1855, it correctly cited "the presence of hyposulphite of soda" (sodium thiosulfate in contemporary terminology) in photographic prints *and* "the continued action of sulphuretted hydrogen and water" as predominant causes of discoloration and fading. Sulphuretted hydrogen is termed today hydrogen sulfide. The fading committee noted that "there are traces of this gas at all times present in the atmosphere," and predicted that "pictures will not remain unaltered under the continued action of moisture and the atmosphere in London." The fading committee's findings indicate that careless processing and small amounts of aggressive oxidizing chemicals in the presence of moisture are the principal reasons for the discoloration of black-and-white photographs.

The effect of relative humidity in assisting such discoloration reactions was demonstrated in 1892 in a report by a photographer working in India. The disappearance of images on bromide prints, a common photographic enlarging paper

by the developing-out process, was traced to "the instigation by humidity of chemical action in the material or the paper, which converts the silver into a compound that diffuses and disappears in the support." The author interpreted his observations correctly: elemental image silver is converted into a silver salt, a process that is aided by humidity. The disappearance of the silver salt into the support is probably the first observation of the migration of image silver in the process of image degradation.

Yet another empirical report from a practicing photographer emphasized the devastating effect of persistently high relative humidity on the permanence of photographic prints. Working in the Solomon Islands, that is, in a "climate of the warmth and dampness of that of the South Pacific Islands," this author in 1929 described humid conditions as a very good test of the permanence of photographic prints—quite in keeping with contemporary views. The "fading to a sickly yellow in a year or so" of bromide prints was attributed "to retained sulphur or sulphur compounds in the print, which in the presence of moist heat reacts on the silver image." The source of the sulphur compounds no doubt is to be found in the fixing salts that have been left inadvertently in the print. Photographic reflection prints, made traditionally from fiber-base paper, are capable of retaining residual processing chemicals more effectively than supports made of glass or plastic film, as noted. The felted sheet of fibers that defines paper readily absorbs liquids and gases, retains them under some circumstances and allows them to migrate through the sheet in others. For example, it has been observed that cardboard mounted with a black-and-white print absorbed hydrogen peroxide, retained it for a while, then released it to migrate farther into the image layer of the photograph. The result is visible discoloration of the image. Similarly, residual silver-thiosulfate complexes or pure fixing salts can be retained by the paper base, unless washed out carefully.

Image Degradation The mechanism of image silver degradation is now well established. The first step is the oxidation of elemental silver to silver ions. This first oxidation step is more easily achieved than the classification of silver as a noble metal would indicate. The reaction is facilitated by the extremely small size of the individual processed silver grain (as small as 5 to 35 µm in printing-out papers) as well as by its accessible surface area, which is large relative to its size. The second step is either an immediate reaction with an available anion to form a stable silver salt or a migration of silver ions away from the original silver nucleus. The water content of the gelatin—which may vary from about 4 to 9% depending on the relative humidity of the surrounding air—while possibly playing a role in the ionization step, is definitely responsible for the ability of the silver ions, once formed, to migrate away from the original silver grain.

This migration can be seen by studying silver grains using electron microscopy. This process can be repeated under laboratory conditions, using, for example, hydrogen peroxide as the oxidizing agent in the presence of humidity. The destruction of the integrity of the original developed silver grain can be driven to completion. The result is a complete loss of sharpness of the image to the eye, a phenomenon that may rarely be seen in naturally aged photographs. The migration of silver ions just described is characteristic of all degradation mechanisms in black-and-white silver gelatin images involving oxidation reactions.

The foregoing observations serve to demonstrate that the structure of photographic materials and the morphology of their respective image silver grains allow us to arrange their *inherent permanence* relative to each other. The resistance of photographic films and prints towards the effect of oxidizing chemicals *increases* in the following order: salted paper prints < albumen prints < chloride paper < bromide paper < negative films. The image silver in salted paper prints is the

Image degradation. Naturally aged processed silver grain from a negative. The nucleus is surrounded by numerous small particles that have migrated away from it, as a result of image silver degradation. Transmission electron micrograph at a magnification of 60,000X.

most reactive: image-forming silver grains in these prints are smaller than in developed-out papers by a factor of about 100. Therefore they are much more sensitive towards reactive materials in comparison to developed-out prints. The lack of a separate binding layer (termed the baryta layer in contemporary print materials) only reinforces this sensitivity, since the paper support is quite permeable for many oxidizing gases, such as hydrogen peroxide. The absence of such a protective layer further increases the danger of mechanical damage by abrasion. Consequently, modern films and papers carry a separate layer as protection against abrasion coated on top of the image layer. And finally, early photographs on salted paper were generally made using support materials of unknown quality with the concurrent uncertainty regarding their stability.

Albumen prints, as the name indicates, carry the image particles inside a protective layer derived from the white of eggs. Chloride papers and bromide papers are both developed-out prints with silver particles embedded in a gelatin layer, which are larger than in salt prints and albumen prints. They enjoy the additional benefit of a baryta layer, sandwiched between the paper support and the image layer, that protects the image from impurities migrating through the paper support. Photographic films have traditionally had a requirement for high light sensitivity, which results in a comparatively coarse image structure and increased resistance to chemical attack.

Increasing Image Longevity Referring to the definition stated earlier that permanence of a document is not only determined by its own inherent material properties but also by subsequent processing and keeping conditions, an understanding of these characteristics points directly to specific recommendations for black-and-white photographs. *Preventing damage* to them means ensuring and maintaining their permanence. At the record creating stage, correct fixing procedures must be introduced by using two fixing baths, of which the second consists of freshly prepared solution, followed by sufficient washing. Simple chemical tests must be performed to verify both.

The longevity of the well-processed black-and-white image depends now on subsequent storage, handling, and use conditions. Keep photographic negatives and prints away from aggressive, oxidizing chemicals, as they are present in rooms freshly painted with alkyd-based paints, or around

electrostatic office copy machines, which produce ozone. Use filing enclosures that are stable themselves and do not give off materials upon aging that may be harmful to the photograph inside. While sleeves and envelopes may be made of either plastic sheeting or paper, their properties should match the requirements of the American National Standards Institute (ANSI), published in document IT 9.2. Do not wrap photographs in newsprint, and do not keep newspaper clippings in an envelope that also contains original photographs.

Store processed microfilm in boxes of inert plastic or metal. A material notorious for producing chemically reactive gaseous products that attack the image silver of other photographs stored nearby is aging cellulose nitrate film base. Consequently, store all photographs in an area segregated from the storage area used for cellulose nitrate film. When mounting photographic prints, use pastes of plant origin or dry mounting tissue. Handle photographs only when wearing lintless cotton or nylon gloves in order to avoid fingerprints. Avoid attaching photographs to other documents using paper clips or staples. Do not roll up large film negatives (panorama negatives) but store them flat in map cabinets. Do not tolerate food and drinks in the vicinity of original photographs.

Well-processed silver gelatin photographic prints on fiber-base paper are essentially stable to light of normal illuminance levels, i.e., 100 to 200 footcandles, as found in homes and offices. Direct sunlight—which easily reaches levels of above 10,000 footcandles—is extremely damaging to all photographs. Keep them out of direct sunlight. Dry heat alone is not considered to be a serious threat to the stability of well-processed black-and-white photographs. Rather, any combination of the three principal factors, i.e., the presence of oxidizing substances, high relative humidity, and heat, produces a synergistic effect that will seriously affect their longevity.

It follows that a storage area for photographs should have an air-conditioning system that removes harmful polluting gases that may originate from industrial activity or automobile exhaust gases from its environment and provides stable temperature and relative humidity levels. Since temperature is not too crucial, normal comfort levels are adequate, for example 20°C (68°F), but it may well be a few degrees below or above that. It should not, however, fluctuate more than 4°C (7°F) daily. Relative humidity has been shown by numerous studies and practical experience to be of overriding importance. A level of 25 or 30%, with a variation not exceeding ±3%, is considered optimum.

These recommendations are the result of the collective knowledge and experience of photographic manufacturers and users of photographic imagery alike. Such expertise is reflected in recommendations for the preservation and storage of photographic images published by the American National Standards Institute (ANSI). Published standard specifications for photography, originally designated PH followed by a number and year of publication, are now labeled IT, for imaging technology. Several ANSI standards are pertinent to the permanence and preservation of black-and-white and color photographic images.

In the foregoing, the term black-and-white photograph has been used synonymously with an image that has silver as the image forming substance. Since these pictures are rarely of a neutral black-and-white image tone, but are more often variations of this ideal with the appearance of cold-blue or warm-brown tones, the term *monochrome* is also applicable, especially in order to distinguish them from color photographs.

Nonsilver Images During the second half of the nineteenth century, when the potential instability of silver prints became apparent, many attempts were made to replace the silver with a more stable material, such as printer's ink or suspensions of carbon particles (lampblack) in gelatin. Several of these nonsilver processes were solely developed because the resultant images had a stability superior to those made by conventional silver processes. While numerous processes were in use at one time or another, only a few have gained high rank and recognition for their superior rendering of tones and their permanence. These are the Woodburytypes, carbon prints, collotypes, and photogravures, as well as modifications of these processes. Other processes that must be mentioned here are handmade, nonsilver pigment printing processes such as cyanotypes (blue prints), gum bichromate prints, bromoil prints, and photographs that have nonsilver metals as an image-forming substance, such as platinum prints (platinotypes) and palladium prints. Since elemental carbon (lampblack) in Woodburytypes and carbon prints is chemically nonreactive, these photographs are virtually fade resistant. Since they are not susceptible to any of the oxidation reactions that black-and-white image silver may undergo, they come close to the distinction of being permanent monochrome images with truly continuous-tone characteristics, except for the potentially limiting stability of the gelatin layer into which the carbon particles are embedded.

COLOR IMAGES The image in *color photographs* consists for the most part of organic dyes with properties that differ in their chemical properties in several ways from the image-forming elemental silver present in black-and-white photographs. Contemporary color photographs are produced by one of four processes with organic dyes as the image-forming substance. In addition, some individual photographers and printmakers still make color photographs that contain pigments not unlike those found in oil paintings. There are also color photographs in collections that were made by now obsolete additive processes of color formation, which will be reviewed briefly below.

The different structural and chemical properties of black-and-white and color photographs is reflected in the kind of information that is available about them. While black-and-white photographic images are fairly similar as a generic group—distinguished in their respective permanence characteristics mainly by the different size of image silver particles and by the presence and kind of a separate image layer—the stability of color photographs is generally directly determined by the type of image-forming dyes. They may vary from one generic group to another and, within one group, may differ from one manufacturer to another. For example, factors detrimental to microfilm, such as hydrogen peroxide, are equally damaging to other silver gelatin photographs. Treatments to enhance the stability of black-and-white images, such as toning, are applicable to all black-and-white records. By contrast, color photographic materials require detailed consideration according to the process by which they were made. Because of this variation between generic groups and manufacturers, stability characteristics of color slides, negatives, and prints have indeed become significant factors in publicity campaigns for certain products.

By far the largest number of color photographs today are made by the *chromogenic development process*. All photographic color negatives, slides, motion picture films, and the great majority of color prints are made by this process. It is therefore the most common and economically important process. The dyes that form the final image are chemically synthesized during development from colorless precursors initially present in the film layers. These precursors are known as *dye couplers*. The principle of color formation is described as follows. An unexposed color film or paper contains silver halides as the light sensitive agent. During development the silver halides that have been exposed to light, as in the formation of black-and-white images, are reduced to elemental silver, with the concurrent formation of oxidized developer. The oxidized developer now reacts with dye cou-

plers to form simultaneously the three subtractive dyes: cyan, magenta, and yellow. This describes the simple processes as they were practiced 50 years ago. In contemporary color films, additional chemical reactions occur to provide sharp images and color balance. Such films may contain as many as 15 or more different layers with dyes and filter layers.

A second method of making color photographs is known as the *silver dye bleach process*. In these materials preformed dyes are incorporated into the emulsion during manufacture. After exposure, the dyes are partially destroyed imagewise during processing under the catalytic action of developed silver. The only materials of this kind manufactured at present are Ilford Professional Color Products, such as Ilfochrome Classic, Ilfochrome Rapid, or Ilfocolor Deluxe, made by Ilford A.G., a division of International Paper Company. These materials were made between 1963 and 1991 by Ciba-Geigy A.G. of Switzerland, and were known as Cibachrome Color Print Materials. Silver dye bleach materials are positive working; a slide, that is, a positive transparency, exposed to a sheet of Ilfochrome Classic produces a positive color print. This material has low light sensitivity, but is used for identification photographs and in color microfilm. It is also suitable for the preparation of color prints and positive transparencies in color.

Widely used in amateur and specialized professional applications are photographs made by *dye diffusion transfer processes*. They are also known as instant color photographic processes, or one-step photography. In an intricate series of chemical reactions following exposure in a camera, dye developer molecules incorporated in these images react with the developer moiety to form the three subtractive image dyes. Such materials were first produced by the Polaroid Corporation (Polarcolor; Polacolor 2; SX-70; Spectra Film; Spectra HD, etc.). Eastman Kodak Co. produced its instant color prints under the names of PR-10, Kodamatic, Trim Print, etc., from 1976 to 1986, and Fuji Photo Film Company marketed its FI-10 system in 1981 and its Fuji 800 Instant Color Film in 1984.

In another process known as *dye imbibition process*, preformed dyes are successively built up in the gelatin mordant layer coated on a stable paper support from a printing matrix film to produce dye imbibition prints. The only such process in use in North America is Eastman Kodak's Dye Transfer Process. In Japan, Fuji Photo Film Co. provides color prints made by a similar process known as Fuji Dyecolor. The Technicolor motion picture process, still in use today in the People's Republic of China, but abandoned everywhere else, also works on the dye imbibition principle. Finally, developments are underway to produce color images from digitally encoded data or from display monitors. North American and Japanese companies have succeeded in perfecting *thermal dye transfer* processes with excellent image quality. Their image stability is the subject of current tests. Color prints have also been made since the late nineteenth century, and are still made today, by printing processes that use pigments of mineral origin. Examples are tricolor carbo prints, gum bichromate prints, and Fresson Quadrichrome prints.

Fading and Stains A wealth of knowledge on the permanence of color photographs made by chromogenic development processes has been accumulated during the past four decades. Since color photographs are produced annually in truly staggering numbers, their stability has become a matter of economic importance. The permanence of color photographs, analogous to that of black-and-white images, is a function of their inherent properties, and of storage and display conditions. Dyes in color films and prints can fade under the effect of light as well as in the dark. Since fading occurs in the two circumstances at different rates and by different mechanisms, the terms *light fading* and *dark fading* are used to distinguish between them. The dyes present in color photographs made by the process of chromogenic development are the only dyes known to fade in the dark. There are no other colored documents that behave similarly. This fading in the dark is largely dependent upon the temperature and relative humidity at which the materials are kept. An increase in the storage temperature will accelerate the fading rate. Researchers take advantage of this effect with so-called accelerated aging tests which allow them to observe changes in a relatively short time that might otherwise require many years to occur. The opposite is true for keeping color films at low temperature: the rate of dye degradation is greatly reduced.

Color photographs may also build up stain when stored in the dark; this is visually apparent in low density areas. For example, a white area may change to yellow. Dyes in color photographs will also fade when exposed to light, as noted, as do textile dyes, watercolors, and printing inks. In addition, build-up of stains can also occur in photographs exposed to light. Consequently, the photographic industry monitors the stability of its products under dark storage conditions as well as under light fading conditions. Dark storage stability is assessed under the influence of heat and high relative humidity alone, whereas light fading and staining are monitored during constant temperature and relative humidity concurrent with exposure to light sources of known intensity and spectral distribution. The longevity of a color photograph is defined, for experimental purposes, as the time elapsed before the limiting dye—i.e., the weakest dye—has lost 10% of its dye density. Destruction of organic dyes through chemical reactions, such as oxidation or hydrolysis, is considered irreversible. A restoration of faded color photographs by chemical means is not, at present, believed possible. For this reason, prevention of dye fading is essential.

Three variations of chromogenic development processes were developed by manufacturers in the period from the early 1930s to the end of the 1940s. The first commercially available color slide film was Eastman Kodak's Kodachrome films, put on the market in 1935. It was followed closely by Agfa's Agfacolor film in 1936 and Eastman Kodak's Ektachrome films in 1940. The three systems differ in the provenance of the dye coupler. In the Kodachrome process, the dye couplers are introduced from an external source, along with the developer. Consequently, no residual couplers remain in the finished picture, a property that contributes to the image's long-term permanence. In the Agfacolor transparency films, the three different dye couplers—one each for yellow, cyan, and magenta dye images—were incorporated for the first time into three gelatin images in a multilayer structure. This incorporation was achieved by attaching long-chain molecules to the couplers, thus making them immobile, or *nondiffusing*, without affecting their photographic properties. In a single development step, which could be performed by the user, all three dye images were formed simultaneously. Eastman Kodak's Kodacolor introduced the principle of dispersing dye couplers in microscopically small droplets of an oily substance, hence the term *oil-protected coupler*. Such dispersion turned out to be the more enduring system, as it has been used worldwide by all major manufacturers. With the notable exception of Kodachrome, dye couplers not used in the formation of dyes during processing remain in the image layer after processing, which has significant consequences for the stability of the image.

The difference in the behavior of color photographs kept in the dark and those exposed to light can be recognized visually. It was observed early that cyan generally is the least stable dye in the dark—or after exposure to accelerated aging conditions at elevated temperature and relative humidity in the dark—and assumes a reddish overall cast. Under the influence of light, however, cyan dyes are generally the most stable, while magenta is weakest. Photographs

faded by exposure to light therefore show a blue-green overall tone, which is caused by the predominance of the surviving cyan plus yellow dye.

Changes in the visual appearance of color photographs are measured by monitoring their dye density. It has always been assumed that the recorded changes in physical properties, i.e., density, occur as a consequence of chemical changes. While the actual measurements can in principle be carried out quickly and easily, the necessity of performing very large numbers of density determinations make this a time-consuming task. Additional factors must be considered when recording dye density changes. Results will be different whether they are taken from a pure (single) dye patch or from a neutral density patch that contains roughly equal amounts of all three dyes. Stain formation in a minimum density area must also be determined as an important criterion of image stability. In order to predict the long term stability of dyes in color films and papers in the dark, the materials can be subjected to accelerated aging conditions at a minimum of four, preferably five, different temperatures. From results obtained at elevated temperatures it is possible to estimate the longevity of a dye at room temperature. Such estimates are based on the Arrhenius equation, which relates chemical rate changes to temperature. The Arrhenius equation states that the logarithm of the rate constant of a first order chemical reaction is inversely proportional to the temperature in degrees Kelvin. Research performed in the photographic industry and published in 1980 showed that the dark fading of dyes follows first order chemical kinetics and that the rate of dye fading at room temperature can indeed be predicted from results obtained in incubation tests. Fortunately, the American National Standards Institute has published a standard procedure for predicting the long-term dark storage stability of color photographic images and for measuring their color stability when subjected to certain illuminants at specified temperatures and humidities. Light exposure tests are not predictive; they can be used to compare the effect of different light sources or to examine the effect of a certain light source on different color images. The document is entitled *Methods for Measuring the Stability of Color Photographic Images,* ANSI IT 9.9-1990. The study of this document is highly recommended for everyone wishing to appreciate the complexities of determining the permanence of color materials.

Chemical Mechanisms of Deterioration Several chemical mechanisms have been found to contribute to the degradation in the dark of dyes made by *chromogenic development* process. E. Bancroft stated as early as 1813: "If a dye fades, it sometimes becomes oxidized, and sometimes reduced." Adding that sometimes a dye may become hydrolized summarizes the principal pathways of dye destruction. For example, the instability in the dark of azomethine and indoaniline dyes in early chromogenic color photographs was shown to be caused by their susceptibility to *acid* hydrolysis. Reaction occurs at the azomethine bond. *Alkaline* hydrolysis can also destroy yellow azomethine dyes, the nucleophilic reactant attacking, in this case, the keto bond. Nucleophilic reagents such as hydroxyl, sulfite, cyanide, or thiosulfate anions can react with naphthoquinone-imine dyes, which leads to a loss in dye density. A very fast reaction of the addition of an oxygen to the azomethine bond occurs when a pyrazolone-azomethine dye is exposed to ozone.

A further mechanism, unrelated to the above but recognized already in the early 1950s, involves the reaction of residual pyrazolone couplers with the magenta dye formed by them. Individual reactions of this type cannot be described in detail within the scope of this entry. Their nature and mechanism have been studied extensively, and the results of such studies are published in the technical literature. It may be noted that residual thiosulfate anions can, here as in black-and-white photographs, affect the permanence of the image.

Correct processing according to the instructions given by various manufacturers is therefore necessary.

During the past decade, photographic manufacturers have published image stability data about their products. The reader will find a selection from these publications in the Books list following this entry. Typical contemporary chromogenic color prints will survive in the dark for approximately 120 years before losing 20 percent dye density of the limiting dye, usually cyan, from an initial density of 1.0, but some recent products claim an even higher stability. Exposure to tungsten light at 100 lux will allow contemporary chromogenic color prints to be exhibited for 10 hours per day, 6 days per week, for 75 to 100 years before a 10% loss of the limiting dye is achieved. Instant color prints are also very stable when kept in the dark. Prints made by the dye imbibition process, and color prints made by silver dye bleach processes, such as Ilfochrome Classic, have the highest dark storage stability of all color print materials containing dyes: approximately 800 years before loss of 0.2 density units of the limiting dye from an initial density of 1.0.

Cold Storage Since all principal pathways of dye degradation during dark keeping of chromogenic color photographs were recognized within a couple of decades after the development and commercial introduction of these materials, manufacturers have succeeded in improving the stability of color photographic images by a factor of two or three magnitudes. Since dark stability is essentially determined by temperature, and to some degree by humidity, the two factors must be controlled for long-term keeping. Motion picture studios in Hollywood began storing color negative films in the mid-1950s at temperatures between 45 and 50°F (7 to 10°C) and 40 to 50% relative humidity. Fifteen years later, researchers from the Eastman Kodak Company proposed cold storage of color films as a long-term preservation measure, including storage in hermetically sealed containers (such as foil bags) at 0°F (−18°C) or below, or in taped cases at 0°F or below. Relative humidity was recommended to be between 15 and 30%. Another decade later, Eastman Kodak published actual figures indicating the increase in longevity, or increase in storage time to reach specified dye density losses, for a color if it is kept at low temperatures. The time at 40% RH for a 0.1 density loss to occur from an original density of 1.0 increases by a factor of 16 if the storage temperature is lowered to 39°F (4°C) from 75°F (24°C), and by a factor of 340 if the storage temperature is 0°F (−18°C). It is necessary to control strictly the relative humidity at low temperature. It is the *relative* humidity that affects longevity. While it is not easy to control relative humidity at temperatures below 32°F, i.e., the freezing point of water, where the *absolute* humidity (the ability of air to hold a certain amount of water vapor) is limited, there are nevertheless technologies available to achieve this, and there are companies that supply this technology. A level of 30% RH is recommended. Cold storage of chromogenic color photographic films, slides, negatives, and prints at 30 to 35% RH is accepted today as the most efficient and cost-effective measure for the long term preservation of large amounts of color materials. Such facilities are now available in many collections in North America, Europe, and Japan.

DETERIORATION OF SUPPORT MATERIALS
The permanence of photographic images is not only a function of the inherent stability of image-forming substances, but also of the properties of the materials that support the image. Many different materials have been used throughout the history of photography, including such unusual examples as leather, cloth, wood, or ivory. Photographs made by two processes in the beginning of photography have a metal support. Daguerreotypes, one of the earliest types of photographs, were made on copper plates. They are named after their inventor, L. J. M. Daguerre, who introduced them in

1839. Copper plates have been proven to be a stable support during the past 150 years, as no observations exist that demonstrate a detrimental effect of the support on daguerreotype stability. Another type of photograph made by the wet collodion process during the second half of the nineteenth century also used a metal support, in this case a flexible sheet of iron. They are known as tintypes. The most common base materials, however, are plastic film, paper, and glass plates; the following remarks focus on these supports.

It is no accident that the first photographic images dating from the mid-1830s by W. H. Fox Talbot were made on paper. Talbot himself had mentioned that he was in search of a method for producing mechanical drawings of landscapes or persons, without the aid of a pencil. In the instructions dating from the first decades of photography, the use of "good quality" writing paper is advised, although this latter condition is nowhere clearly specified. It had been observed early on that the raw stock for producing salted paper prints should be devoid of chemically aggressive substances, should have a certain wet strength, and must remain flat. Industrial manufacture of papers as photographic base materials began in the 1860s in Europe. Photo papers have been made since that time in high purity and with excellent strength properties. While details of their manufacture and composition remain proprietary knowledge of the industry, experience in handling and studying photographs in historical collections has shown them to be among the most permanent papers made industrially. They generally do not exhibit the normal symptoms of poor quality papers upon aging, such as yellowing, foxing (the development of brown feathery spots), or brittleness. This is achieved by a high alpha-cellulose content, the use of special sizing agents, the absence of metal ions or particles, and by appropriate manufacturing procedures.

In the 1960s, the photographic industry developed resin-coated (or RC) papers, in which the paper sheet is coated on both sides with a layer of polyethylene. The polyethylene layer on the image side, that is the one below the emulsion layer, contains a white pigment, usually titanium dioxide. RC papers have many technical advantages: dramatically reduced processing times, less tendency to curl, and improved wet strength. Early versions of this paper could develop cracks in the polyethylene that would propagate into the image layer and so become visible. This cracking appeared to be catalyzed by the presence of titanium dioxide. Numerous successful efforts by the manufacturing industry have overcome these initial drawbacks. Chromogenic color papers by all manufacturers have been produced for the past twenty years or so exclusively on resin-coated paper stock.

While the first photographic negatives were prepared on paper, glass plates became the predominant negative support in the nineteenth century. First used in the glass plate negatives made by the wet collodion process, they became the first supports coated with a gelatin layer containing a light sensitive silver halide. Glass's weight and fragility make it an inconvenient material. Well-known is its susceptibility to chemical attack by alkaline materials. It is otherwise a stable material; witness the large number of glass plate negatives surviving in historical collections.

Plastic film supports, first manufactured in the 1890s, rapidly superseded glass as the principal emulsion support for negatives. These first materials were made of cellulose nitrate, which has a number of properties that make it suitable for use as a photographic film base. It is now well established that cellulose nitrate is also inherently unstable, becoming weak and brittle during natural aging. Its major drawback is high flammability. Several fires have been reported that were caused by spontaneous self-combustion of cellulose nitrate film, usually in motion picture film exchanges. An additional feature of aging cellulose nitrate is the detrimental effect of gases emanating from it on processed acetate films stored in its vicinity. The gases are mainly oxides of nitrogen, which affect first the processed image silver, next the gelatin binder, and finally the safety film base itself. In the 1930s, cellulose nitrate film was gradually replaced by cellulose ester films (diacetate, triacetate, acetate propionate, acetate butyrate). While cellulose nitrate is thermodynamically the least stable of all film bases, the cellulose ester films, usually labeled "safety film" along with polyester films, have also been shown to be subject to shrinkage, loss of plasticizer, and plastic flow leading to distortion. Notorious is their low resistance to moisture. Some contemporary views hold that the instability of cellulose ester film is of the same order as that of cellulose nitrate. The latter has been studied more extensively; its tendency to degrade suddenly, to self-ignite spontaneously under specific circumstances, and the devastating effect of the by-products of its own degradation on other photographs have given it the notoriety of being the largest source of problems in photograph collections.

By contrast, the widely accepted and confirmed stability of polyester film [poly(ethylene-terephthalate)] is the result of decades of determined effort by the photographic manufacturing industry. Current polyester films, also used in the manufacture of magnetic tape, have been shown to be chemically inert and of good dimensional stability. They have a high wear and tear resistance and low moisture sensitivity. Estimates by various sources for the longevity of polyester films under controlled conditions of 20–25°C and 50% RH range from 900 to several thousand years. Such predictions were made after Arrhenius-type testing, i.e., after aging the materials at several different temperature levels.

Other synthetic plastic materials either proposed or actually used as film bases include polystyrene supports or polycarbonates. Little is known about their stability.

DETERIORATION OF GELATIN Gelatin, a complex natural polymer of animal origin, has been used almost exclusively as the binding agent in photographic records for more than a hundred years. It has numerous properties that make it uniquely suitable as a binder for light-sensitive silver halide crystals and a host of other ingredients in the raw stock. After exposure and processing, the gelatin lends protection to the elemental silver grains and to the dyes in color photographs. Its permanence is a function of keeping conditions. If kept dry at normal room conditions, the stability of gelatin layers is estimated to be unaffected for several hundred years. It is sensitive to alkaline environments. Its resistance to processing solutions, some of which are alkaline, may be controlled through the use of hardeners. Hardeners reduce the swelling of gelatin layers in aqueous solutions and increase its melting point, defined as the temperature at which the layer dissolves, or breaks up, in a specified alkaline salt solution. Conventional hardeners are trivalent salts of chromium and aluminum, and formaldehyde or other aldehyde derivatives. When processed correctly and kept in suitable conditions, gelatin layers do not limit the stability of photographic materials.

SUMMARY Photographic images have existed for more than 150 years. Observations made by practitioners of the art and collectors alike, scientific investigations by the manufacturing industry as well as photograph historians and conservators have collectively contributed to a firm body of knowledge on the permanence of photographs. Several processes provide stable, permanent images in both black-and-white and color. To remain permanent, keepers of collections, in turn, must provide storage conditions conducive to longevity. For example, well-processed silver gelatin images on microfilm can confidently be expected to survive many centuries, making them an ideal copying medium to preserve information that is printed on less stable materials, such as newsprint.

The majority of photographs in historical collections, such as museums and archives, are in excellent shape. There are

exceptions, notably images on cellulose nitrate film, or those in color made by the very early chromogenic development processes. The technical history of photography is also a history of continuous manufacturing improvements to the permanence characteristics of photographic images. Knowledge on how to handle, display, and keep photographs has increased concurrently. Amateur and professional users alike have reasons to appreciate and to trust the permanence qualities of photographic images

Books: Agfa-Gevaert, *Agfacolor Type 8 Paper.* Technical Data A 81. Leverkusen, Germany: Agfa-Gevaert AG, 1984; Agfa-Gevaert, *Agfachrome Umkehrpapier.* Technische Daten A 82. Leverkusen, Germany: Agfa-Gevaert AG, 1986; American National Standards Institute, *American National Standard for Photography (Film), Processed Safety Film, Storage.* ANSI IT9.11-1992. New York, NY: ANSI, 1985; American National Standards Institute, *American National Standard for Photography (Film and Slides), Black-and-White Photographic Paper Prints, Practice for Storage.* ANSI PH1.48-1982 (R 1987). New York, NY: ANSI, 1987; American National Standards Institute, *American National Standard for Imaging Media, Stability of Color Photographic Images, Methods for Measuring.* ANSI IT9.9-1990. New York, NY: ANSI, 1990; American National Standards Institute, *American National Standard for Photography, Film, Plates, and Papers, Filing Enclosures and Storage Containers.* ANSI IT9.2-1991. New York, NY: ANSI, 1991; American National Standards Institute, *American National Standard for Photography (Plates), Processed Photographic Plates, Practice for Storage.* ANSI IT9.6-1991. New York, NY: ANSI, 1991; Eastman Kodak, *The Book of Film Care.* Kodak Publication H-23. Rochester, NY: Eastman Kodak Company, 1983; Eastman Kodak, *Conservation of Photographs.* Kodak Publication F-40. Rochester, NY: Eastman Kodak Company, 1985; Eastman Kodak, *Kodak Ektacolor Plus and Professional Papers for the Professional Finisher.* Kodak Publication E-18. Rochester, NY: Eastman Kodak Company, 1986; Eaton, G. T., *Photographic Chemistry in Black-and-White and Color Photography.* Third revised edition. Dobbs Ferry, New York, NY: Morgan & Morgan, 1980; Fuji Photo Film, *Fujicolor Paper Super FA Type 3.* Fuji Film Data Sheet Ref. No. AF3-723E (92.1-OB-5-1). Tokyo: Fuji Photo Film Co. Ltd., 1992; Ilford Photo Corporation, *Mounting and Laminating Cibachrome Display Print Materials and Films.* Paramus, NJ: Ilford Photo Corporation, 1988; Polaroid, *Storing, Handling, and Preserving Polaroid Photographs: A Guide.* Toronto, Canada: Focal Press, 1983; Reilly, J. M., *Care and Identification of 19th Century Photographic Prints.* Kodak Publication G-2S. Rochester, NY: Eastman Kodak Company, 1986; Sturge, J. M., Walworth, V., and Shepp, A., *Imaging Processes and Materials: Neblette's Eighth Edition.* New York, NY: Van Nostrand Reinhold, 1989.

K. B. Hendriks

See also: *Color photography.*

IMAGE PERMANENCE INSTITUTE (IPI) A research laboratory working in the field of the permanence of imaging materials and located in Rochester, New York at the Rochester Institute of Technology. *P. Adelstein*

IMAGE PLANE The surface of a real image in space, where all the image points are located of maximum sharpness and conjugate to the corresponding points of a plane of the subject. In Gaussian optics this surface is assumed to be a plane, but in practice residual curvature of field may give instead a shallow dished surface. For infinity focus the image plane corresponds to the (principal) focal plane. *S. Ray*

IMAGE PROCESSING The alteration, enhancement, and analysis of images for the purpose of improving the pictorial representation or extracting data from the image. Image processing relies on a number of well-tried algorithms

that simplify and speed the process. While image processing is applicable to optical and analog approaches, the term's use is mostly limited to digital imagery. *R. Kraus*

IMAGE RECONSTRUCTION The assembly of an easily interpreted image from a set of fragmentary or dissected records. These components may be matrices from an assembly process, such as dye transfer, or streak camera records, or the products of wavelength interference, as in the Lippmann or holographic processes. *H. Wallach*

See also: *Dye-imbibition; Dye transfer; Holography; Lippmann process.*

IMAGESETTER A device that outputs text, line art, and tonal pictures in position. *M. Bruno*

IMAGE SPREAD The increase in the size of a small optical or photographic image over that to be expected from geometrical considerations. *L. Stroebel*

See also: *Spread function.*

IMAGE STABILIZATION See *Stabilization, image.*

IMAGINARY PRIMARIES A set of three primaries that do not exist in practice but that are useful for expressing colorimetric measurements. An example is the set of CIE primaries X, Y, Z used for the *X, Y, Z* tristimulus values. *R. W. G. Hunt*

See also: *Hypothetical primaries.*

IMAGING SCIENCE Imaging science is a new scientific specialty that brings together a broad variety of disciplines to study how images of all types are formed, recorded, transmitted, analyzed, and perceived. An *image* until recently has generally referred to a two-dimensional, silver-halide-based photograph. In the context of imaging science, an image may refer to any multidimensional representation, and is often based on a variety of new technologies, such as ultrasound systems using acoustic energy, satellites transmitting digital images, and electron microscopy.

While moving beyond silver halide technology, imaging science grew out of the science of photography, and includes optics, the science of light. It also brings together the divergent disciplines of chemistry, physics, computer science, mathematics, statistics, digital image processing, and color science, among others.

Because it is a new science, only a few academic programs offering imaging science as an integrated discipline are available at the undergraduate and graduate level. Areas of research within the broad umbrella of imaging science include the following:

- remote sensing, involving the capture and analysis of aerial and satellite photography
- medical diagnostic imaging, including ultrasound and magnetic resonance imaging
- graphic arts, including electronic prepress systems
- robotic and machine vision and artificial intelligence
- digital image processing, in which images are captured in digitized form for ease in analysis, compression, and transmission
- morphological image processing, concerned with computer algorithms designed to recognize shapes and textures
- color science, including standardization, nomenclature, and specification of color
- optical and electron microscope imaging, including fault detection and metrology, beam propagation phenomena, atomic force microscopy, and scanning tunnel microscopy
- silver halide technology, including chemical and spectral sensitization, and latent image stability and processing

- human visual perception, studying the links between a physical image and how is it perceived, including the use of psychophysics
- optics; design, astronomical systems

Applications of these emerging technologies in business, industry, government, and the military have been growing rapidly. They include medicine (medical diagnostic imaging), agriculture and environmental studies (remote sensing), military reconnaissance, printing and publishing (color measurement, digital graphics, electronic imaging and printing), and computer science industries (digital image processing, artificial intelligence, and robotic vision).

While imaging science is relatively young as a distinct discipline, it is in fact the combination of its separate components under a single umbrella that is new. In the past, scientists and engineers could only specialize in individual disciplines. As the relationship among these disciplines grew along with their application to emerging imaging technologies, the need for individuals trained across these areas has become clear. Today, imaging scientists are able to bring this interdisciplinary approach to the design and analysis of complex imaging systems. *J. Pelz*

IMBIBITION PROCESS Any process for making prints by the selective absorption of dyes on a gelatin or similar surface. Typically, a hardened gelatin relief matrix is used to transfer the dye by contact. Color prints can be made from a set of three separation positives. *H. Wallach*

See also: *Dye imbibition; Dye transfer; Technicolor.*

IMMERSION OBJECTIVE Microscope objective lens whose bottom surface can be immersed below the surface of a small pool of cedar wood oil situated on the top cover glass of the slide. This eliminates the air gap, interposing a medium of higher refractive index between the lens and the specimen with consequent increase in numerical aperture and hence resolving power while eliminating spherical aberration. *D. A. Spencer*

IMPEDANCE (Z) Net opposition to the flow of current through a series ac circuit consisting of any combination of resistors, capacitors, and inductors. The symbol for impedance is Z. It is measured in ohms and is equal to:

$$Z(\text{ohms}) = \sqrt{R^2 + (X_L - X_C)^2}$$

W. Klein

See also: *Electricity.*

IMPOSITION The arranging of pages in a press form so that the pages will be in the correct order after the printed sheet is folded and cut. *M. Bruno*

IMPRESSION For photomechanical reproduction, the pressure of type, plate, or blanket as it comes in contact with the paper feeding over the impression cylinder. Also used to indicate revolutions of the press. *M. Bruno*

IMPRESSIONISTIC PHOTOGRAPHY A photographic style that emphasizes light and color as interpreted subjectively by the photographer, as distinct from a realistic style. By extension, any photographic style that produces nonrealistic images. *L. Stroebel*

See also: *Abstract photography.*

IN-BETWEENER The assistant animator who creates the drawings that fall between the extreme points of a movement. *H. Lester*

INCANDESCENCE The emission of electromagnetic radiation by an object as a result of its temperature. The distribution of wavelengths of incandescent radiation is called a blackbody curve and is dependent on temperature. Temperatures above approximately 1000 K are required to produce photons with sufficient energy (short enough wavelengths) to be visible. *J. Holm*

INCANDESCENT LAMP General classification for lamps that produce light by the passage of electric current through a filament, heating it to a temperature that produces light of the desired color quality and intensity. *R. Jegerings*

Syn.: *Filament lamp.*

INCH A measure of linear dimension, equal to 2.54 centimeters. A common sheet-film size is 4×5 inches. *H. Todd*

INCIDENT LIGHT Light that is falling on a subject, particularly as applied to exposure-meter readings. An incident-light exposure meter determines exposure by measuring the illuminance or light falling on the subject and assuming average reflectivity. *J. Holm*

INCIDENT-LIGHT METER An exposure meter designed to measure the light falling on the subject (illuminance) rather than the light reflected, transmitted, or emitted by the subject (luminance). Calibration of the meter is based on the assumption that the subject reflects 18% of the incident light. Most incident-light exposure meters are equipped with a hemispherical diffuser over the photocell, which, when the meter is place close to the subject and aimed at the camera, produces an appropriate change in the reading as the main light position changes from front lighting to side lighting to back lighting with three-dimensional subjects. Some incident-light meters are also provided with a flat *cosine-corrected* diffuser, which is recommended for use when making copies of photographs, paintings, and other two-dimensional subjects, also with the meter aimed at the camera. If a flat diffuser is used with three-dimensional subjects, the meter should be aimed midway between the main light and the camera, the same as the recommendation for positioning a gray card for reflected-light meter readings. *J. Johnson*

See also: *Exposure; Exposure meter.*

INCOHERENT RADIATION Electromagnetic radiation in which the electric and magnetic field oscillations of the photons are not all in phase. Monochromatic light can be coherent (such as the light emitted by a laser) or incoherent. Light that is made up of photons of different wavelengths must be incoherent. Destructive interference between photons in incoherent light greatly diminishes the power delivered by the light. *J. Holm*

See also: *Coherent light.*

INCORPORATED COUPLER Rather than add color couplers during processing, incorporated couplers are included in the emulsion during the manufacture of many films and printing papers. *H. Wallach*

See also: *Color processing.*

INDEXED COLOR In electronic imaging, a look-up table containing color information that facilitates displaying 24-bit color on an 8-bit driven monitor. *R. Kraus*

INDEX OF REFRACTION Also known as refractive index, this number indicates the extent of deviation due to refraction when a ray of light passes through the interface of two transparent optical media of different density. Refraction is due to a decrease in velocity in the denser medium, and

refractive index is defined as the ratio of velocities in vacuum (in practice, air) and the medium.

Alternatively, refractive index (n) is defined by $n = \sin i/\sin r$ where i and r are the angels of incidence and refraction, respectively, as measured from the normal to the surface at the point of incidence. Refractive index varies nonlinearly with wavelength, causing chromatic aberration in optical systems. Its symbol n usually has a subscript (F, C, D, or d) referring to wavelengths of Fraunhofer lines in the spectra of light sources. *S. Ray*

Syn.: *Refractive index.*

See also: *Light refraction; Snell's law.*

INDICATORS A chemical, usually a dye, that indicates by its color the condition of a solution. Many dyes that change color at definite values of acidity or alkalinity can be used to measure pH. Comparison to known color standards for the dye can be made for solutions or for indicator dyes impregnated in paper strips. By mixing indicator dyes, a universal indicator paper will give a number of colors over a wide pH range. *G. Haist*

INDIRECT LIGHTING See *Bounce lighting.*

INDUCED MOVEMENT A visual effect whereby a stationary object appears to move in the presence of a moving object. At night the moon sometimes appears to move past apparently stationary cloud formations. *L. Stroebel and R. Zakia*

See also: *Optical illusion; Visual perception, accuracy of visual perceptions.*

INDUCTANCE (L) The property of an inductor to oppose a change in the current through it. The change in the magnetic field caused by the change in current induces in the inductor a counter-electromotive force that opposes the original change of current. The symbol for inductance is L. The basic unit of inductance is the henry (H). *W. Klein*

INDUCTION PERIOD The interval elapsing between the immersion of a negative in the developer and the appearance of the first sign of an image. Important for factorial development. *L. Stroebel and R. Zakia*

INDUCTOR A coil of wire having the property of inductance. The inductance of an inductor is determined by four factors: the number of turns, the area enclosed by the coil, its length, and the material the coil is wound on. Coils are wound on ferromagnetic cores to increase their inductance and are used in power supplies to reduce the ripple in the output voltage. Such inductors are called *chokes*. Inductors are extensively used with capacitors to form resonant circuits. *W. Klein*

INDUSTRIAL PHOTOGRAPHY Industrial photography encompasses the broad range of photography in any organization dedicated to the commercial production and sale of goods and services. Although traditionally associated with manufacturing, industrial photography also applies to photographic work in nonmanufacturing companies.

The industrial photographer usually works directly for a specific company; freelance photographers often supplement the work of the so-called in-house or in-plant photographer. The inside photographer frequently exhibits expertise in technical photographic areas necessary to photograph the company's operations, products, and services. Ideally, the photographer also may have studied engineering, design, chemistry, physics, or some other field related to the particular industry.

Not only does the industrial photographer need to be aware of just about every facet of still photography but also the many ways in which cinematography and videography may play roles in testing, documentation, advertising, or any other aspect of the job. With increasing interaction between computers and photographic images, industrial photographers must learn enough about electronic imaging to keep their company space. Considering the breadth and depth of the field, the industrial photographer can never stop learning.

Career possibilities include positions as a scientific or technical specialist, a general-purpose photographer, or an administrator of a photographic department. In some companies, all photographic services are centralized. In others, individual departments support specialized photographic services such as identification photography (security) or photojournalism (publications).

Usually, in-department photography supplements centralized photography. Pictures for a beta manual for trade trial, for instance, might be taken by the engineers working on the new product while the photography for the finished, printed manual might be taken by a specialist from the company photographic department.

Centralized processing facilities handle everything from slide duplication to print enlargements for company displays and exhibits. Some processing services, like some photography, may be purchased from the outside. Cost and time factors influence such buying decisions.

In an era of downsizing, the industrial photographic department, like every other department, needs to accomplish more work with a smaller staff. Industrial photographers need to be flexible specialists with an understanding of company direction and policies. They need to be able to schedule and manage the work of outside photographers as well as their own photography in order to meet the demands of the changing industrial environment.

The industrial photography department itself remains an unlikely candidate for outsourcing. Its advantages include familiarity with the company and its products, easy and immediate access, security, economy, and fast turnaround.

Depending on the scope of the particular industrial photography department, it may provide and/or coordinate any of the following types of photography:

- Service-related photography of construction, inventory, maintenance, research, training, production, engineering, and other subjects.
- Sales-related photography, including advertising and publication illustrations as well as public relations and publicity photographs.
- Reproduction-related photography, including engineering drawings, microfilming, and photocopying.
- Technical-oriented photography, including all kinds of scientific photography from x-ray diffraction to nuclear photography.

K. Francis

INERT GASES Strictly speaking, the noble gases from the eighth column of the periodic table, i.e., helium, neon, argon, krypton, xenon, radon. These gases possess an atomic structure that makes them extremely resistant to chemical bonding, and exist almost exclusively in a gaseous, monatomic state. This is because they all have a completely filled outer shell of electron orbitals. Other gases may also be designated as inert gases for a particular purpose, such as the use of nitrogen for agitation during development, but such designations are not strictly correct. *J. Holm*

INERT GELATIN Gelatin, a commercial product derived from the skin, bones, and sinew of animals, is normally an impure, variable product containing both sensitizers and restrainers. Gelatin that has been chemically treated to remove these impurities that influence silver halide sensitivity is said to be *inert*. During emulsion making, known

amounts of impurities can then be introduced, a process called *chemical sensitization*. *G. Haist*

INERTIA The exposure at the approximate start of the straight line of a negative D-log H curve, found at the intersection of the extended straight line and the base plus fog level. It was the basis for the first sensitometrically determined film speed, devised by Hurter and Driffield—the H & D speed. *M. Leary and H. Todd*

INFECTIOUS DEVELOPMENT A type of photographic development during which the developing rate of silver halide grains is greatly accelerated by the partially oxidized form of the developing agent. Low-sulfite lithographic film developers containing hydroquinone exhibit this type of developing activity.

Some persons restrict infectious development to the reduction of unexposed grains in the vicinity of developing exposed grains. Developers containing hydrazine form products that are fogging agents and develop grains without regard to exposure. This type of fogging developer does not show the discrimination of the hydroquinone lith developer. *G. Haist*

INFINITY (∞) (1) In photographic optics, an object distance so great that the sharpest image is formed at a distance from the lens (or mirror) equal to the focal length of the system. (2) Identifying a mark on the focusing scale of some cameras used to obtain optimum image focus for very distant objects. *H. Todd*
See also: *Gamma infinity.*

INFINITY STOP A mechanical limitation on a camera focusing mechanism that prevents the lens from moving closer to the film than the position where a star or other distant object would be in focus—that is, the position where the image distance equals the focal length of the lens. *L. Stroebel*

INFLUX Flowing in, identifying the energy falling on a sample. In a densitometer, the influx energy involves the energy source and the optics that cause the energy to fall on the sample being measured. Contrast with *efflux*. *M. Leary and H. Todd*

INFORMATION (IMAGE) The actual or potential maximum data contained in an image, commonly specified in terms of the binary digit or bit, the amount of information that is conveyed by a *yes* or *no* answer when both are equally probable. The information storage capacity of different sensitized materials or imaging systems can be expressed as bits per unit area, such as 1 million bits per square cm. *L. Stroebel*
See also: *Binary; Pixel.*

INFORMATION THEORY General name given to theorems relating to the transmission and recording of information and which permit the evaluation of the efficiency of recording and reproducing systems, and the choice of systems for particular purposes. The basis of these theorems is that quantity of information can be given a precise scientific definition that is in keeping with intuitive ideas. The natural units of information fall on a binary scale, and the ability of a system to transmit or store information is sometimes termed the information capacity. *L. Stroebel*

INFRARED CAMERA See *Camera types.*

INFRARED COLOR FILM A false-color (or color-translating) positive transparency film with its three emulsions sensitized to the green, red, and near infrared. A yellow filter is required over the lens to absorb blue light. The film displays infrared as red, red as green, green as blue, and blue

as black. Major uses have been for camouflage detection, agricultural crop disease detection, forest management, and medical photography. *M. Scott*
See also: *Infrared photography.*

INFRARED DETECTOR (1) Thermal radiation detectors in which some physical character of the material changes with temperature; for example, platinum thermometers' electrical resistance changes with temperature *(Golay cell).* (2) Quantum detectors that release electrons upon absorption of quanta of appropriate frequency *(photoconductive* or *photoemissive* devices). Appropriate *doping* of the absorbing surface will modify the wavelength response relation. (3) Infrared was first recorded by J. F. W. Herschel (1800) who exposed black paper soaked in alcohol to a spectrum. The alcohol evaporated more rapidly in the region beyond the red end *(evaporography).* (4) Silver halide emulsions can be sensitized to record infrared directly up to 1200 nm. *L. Stroebel and M. Scott*
See also: *Image conversion; Sensitizing dyes.*

INFRARED FILM Silver halide emulsion film that has been sensitized to radiation in the 700–1200-nm wavelength range. Because such emulsions are also sensitive to radiation in the ultraviolet and blue regions, appropriate filtration is needed to record only infrared radiation. *L. Stroebel*
See also: *Infrared color film.*

INFRARED FILTER See *Filter types.*

INFRARED MARK The compensating mark on a camera lens that indicates the focus difference between white light and infrared radiation. It is a separate mark, usually identified with a red color or the letter "R," on the far-distance side of the center focusing mark. Using infrared emulsions, the photographer should first focus visually, note the distance mark on the lens focus scale, and move that distance setting from the white-light focus mark to the infrared mark to compensate for the focusing difference by increasing the lens-to-film distance. *P. Schranz*

Infrared mark (R) on the focusing scale of a 35-mm camera lens.

INFRARED MIRROR A mirror that reflects the heat associated with the infrared emission of light sources while transmitting most of the light, used in some projectors to remove heat from the system or to divert it to a location where dissipation is more convenient, as distinct from heat-absorbing filters. Infrared mirrors typically consist of multilayer dielectric coatings on a glass base. *L. Stroebel*
Syn.: Heat-reflecting mirror, hot mirror.
See also: *Diathermic mirror.*

INFRARED PHOTOGRAPHY Infrared photography is of interest to the amateur and commercial photographer and to scientists and technologists because it produces

images that are not possible with conventional photographic films. In its practice there is not much difference between infrared and normal photography. The same cameras and light sources can usually be used, together with the same processing solutions. Infrared photography, however, is usually only attempted by skilled photographers, scientists, and technicians with a particular purpose in mind.

TECHNIQUE The peculiarities of infrared photography lie in the ability of the film to record what the eye cannot see (permitting, for instance, photography in the dark); in the fact that many materials reflect and transmit infrared radiation in a different manner than visible radiation (light); in the ability of infrared radiation to penetrate certain kinds of haze in the air so that photographs can be taken of distant objects that cannot be seen or photographed on normal films; and in the ability to photograph hot objects by the long-wavelength radiation that they emit. These properties permit infrared photography by normal light.

The infrared range of the electromagnetic spectrum lies beyond the red. This portion of the spectrum is invisible to human eyes. Infrared includes all radiations between wave-

A photograph taken using infrared radiation. (Photograph by Leslie Stroebel.)

lengths just beyond those of the deepest reds of the visible spectrum (700 nm) and microwaves (100,000+ nm), which are used for cooking in microwave ovens. Although infrared covers a vast part of the spectrum, the portion of it that can be used to expose photographic emulsions is actually quite small. The area extends from about 700 nm to about 1200 nm, but most amateur and commercial infrared films are only sensitized to about 900 nm.

Photographs by infrared radiation were already made in

the nineteenth century, but it was not until the early 1930s that it became possible to carry out infrared photography with the ease and certainty of ordinary photography. Just as orthochromatic and panchromatic films owe their response to the inclusion of certain sensitizing dyes, infrared-sensitive materials owe their response to special infrared dye sensitizers. The earlier infrared-sensitive materials were quite low in speed, but with improvements in the methods of making photographic emulsions and the discovery of new dyes, it has been possible to make available for general use infrared films that are sufficiently sensitive that they can be used under average daylight conditions with unsophisticated cameras at fairly small apertures and reasonably fast shutter speeds, such as 1/125 second at f/11 for distant scenes to 1/30 second at f/11 for nearby subjects.

Infrared photographs are indispensable to astronomers, physicists and other scientists and have permitted many important discoveries to be made. It was, in fact, with these applications in mind that most of the developments related to infrared films originated. The need to develop films for specialized scientific applications eventually resulted in the availability of infrared films that could be put to more practical uses in a large number of other applications and fields, from medicine and law enforcement to aerial photography and fine art.

The visible spectrum ends for all practical purposes at a wavelength of 700 nm, but films have been made, and are used by scientists, that respond to radiations up to about 1200 nm. Films that are used for general infrared photography, however, must have good speed, and in practice they respond up to about 900 nm.

Infrared-sensitive materials require the user to observe certain safeguards. Refrigeration is often advised during storage because the sensitizing dyes used tend to be less

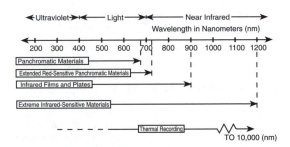

Infrared photography. The spectral ranges of panchromatic materials, extended red-sensitive panchromatic materials, infrared films and places, extreme infrared-sensitive materials, and thermal recording. (Reprinted courtesy of Eastman Kodak Company.)

stable than in other films, and exposed film should be processed promptly to prevent loss of image quality. Because antihalation backing is not always added to infrared film, the images may be adversely affected by halation. In 35-mm cameras, film pressure plates sometimes impress an overall pattern of small dots of density on the film. This is caused by a regular pattern of dimples on the plate that focus the infrared energy that passes through the film back onto the film emulsion.

Infrared Sources The light sources commonly used in photography are also suitable for use with infrared materials. Most of them depend for their visible radiation on heating certain materials to incandescence, but a great part of their radiation is nevertheless in the invisible infrared region. The

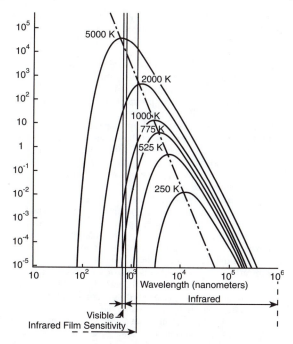

Infrared sources. Blackbody emissions at different temperatures, measured on the Kelvin scale. K = degrees Celsius (°C) + 273. (Reprinted courtesy of Eastman Kodak Company.)

tungsten filaments in standard household incandescent lamps as well as in photoflood lamps and the foil or wire-filled flash lamps are especially suitable, because they have the peak of their emission in the part of the infrared where the films have their maximum sensitivity. A natural incandescent light source is the sun.

In addition to the sources that depend on the heating of materials, some depend on an electric discharge through gases in a tube. There are many such sources, but some, like the fluorescent tubes used for room lighting, are not suitable for infrared work because they emit relatively little infrared energy. Electronic flash tubes, on the other hand, are usually good sources of near-infrared energy and make good sources for infrared photography.

Unless one photographs a subject that emits only infrared radiation or is irradiated only with infrared radiation, it is always necessary to use a filter, because all normal films are sensitive to light as well as to infrared. If no filter were used, the infrared effect would be largely masked by the exposure to light.

In typical photographic situations one would use a deep red filter such that when it is placed over a single-lens reflex camera lens, the photographer can still see a dim image on the ground glass of the camera. More pronounced infrared effects may be obtained by using visually opaque but infrared-transmitting filters. In this case, since it is impossible to view through them, it is common practice to fit the infrared filter to the lens of a rangefinder or a twin-lens reflex camera. In single-lens reflex cameras it may be possible to install visually opaque filters just in front of the shutter but behind the mirror in order to retain the ability to compose the image on the ground glass. When photographing unobtrusively, in dimly lit situations or in the dark, the filter is placed over the light source instead of over the camera lens.

Equipment Normal cameras can be used for infrared photography, but two possible sources of problems should be

checked: (1) the camera body itself, bellows, film holders, and dark slides, should be tested to ensure that they do not transmit infrared radiation, and (2) the focus of the lens in the infrared region is usually different than it is for the visible spectrum. An adjustment needs to be made after the lens has been focused visually in order to achieve the best focus for the infrared images.

Because most lenses do not have their best focus for infrared radiation when they are focused for light, it is usually necessary to rack the lens *forward* slightly after achieving visual focus, as if focusing on a nearer object. The exact distance to give a sharp image can be determined by testing or by moving the distance focused upon visually opposite a special infrared focusing mark provided by the lens manufacturer on the focusing scale of some lenses. To some extent, the focus problem can be minimized by using small apertures and relying on depth of field to take care of the discrepancy.

The camera and its attachments can be tested by loading film in the camera or in the film holder, exposing it to bright incandescent or sunlight illumination from all sides, and developing the film. Absence of fog indicates safety. The presence of fog means that the camera or other piece of equipment (it could even be the developing tank) is not suitable for use with infrared materials. Some of the newer plastic-body cameras should be carefully checked. Most commercially manufactured film holders have a mark placed on them if they are guaranteed to be safe for infrared use.

The instructions accompanying 35-mm black-and-white infrared film warn the user that the film should be loaded into the camera in complete darkness, even though the cassette is a conventional daylight-loading type.

Standard developers may be used with infrared film, but more vigorous development is usually recommended than for standard films. Fixing, washing, and drying are the same as for normal photographic materials.

Lighting Outdoor photography is done with the sun and skylight as the natural sources of infrared, and a filter is used over the camera lens to confine the exposure to the longer wavelengths. The normal rules for subject lighting are followed.

With artificial lighting in the studio, normal tungsten filament lamps, photoflood-type lamps, and electronic flash sources are all satisfactory. Front lighting is generally recommended when detail is desired.

Filters must be used on the lens, or, to make pictures in the dark, on the light source. It should be noted that most polarizing filters are manufactured for use with visible radiation and that they will have very little, if any, effect on infrared rays. Special infrared polarizing filters are available. As in the case of all filters, those used over the lens must be chosen so that they will not impair the definition of the lens.

Exposure and Light Meters The proper exposure of infrared is usually determined on the basis of charts provided by the manufacturer since standard light meters are designed to measure light and not infrared. Further, standard photographic speed systems are based on exposing films to light and not infrared, and therefore infrared film cannot be assigned a conventional film speed index.

Most charts are based on the assumption that the ratio of infrared present in a light source and the amount of light emitted by the source have some constant relationship. This essentially permits the assignments of a filter factor to the various filters that a photographer may use for infrared photography. It should be noted that the filter factors assigned for infrared film are smaller when tungsten illumination is used as opposed to daylight.

The application of filter factors based on exposure recommendations provided by reflected light meters may be in error because these meters are influenced by the color, tone, or visual appearance of a given subject. Incident meters, on

the other hand, may also indicate erroneous exposure compensation factors because they do not take the subject itself into account.

Photographers have calibrated meters whose cells approximately match the infrared sensitivity limit of the film by covering the meter cell with the same type of infrared filter that is used over the camera lens. These meters should always be used in the reflected mode to assure the photographer that a particular density will be achieved on the film. Because infrared tonal relationships are usually invisible, this ensures that infrared information is recorded, albeit possibly at an incorrect level of density.

Proper exposure for color infrared materials can be determined with standard light meters as long as the photograph is not made strictly by infrared since two of the film's three color layers are sensitive to light. If the record is to be made by infrared alone, it is usually best to use black-and-white infrared film.

Infrared Fluorescence Certain materials spontaneously emit infrared radiation when shorter visible radiation or ultraviolet radiation falls on them. This property, then taking place in the infrared, is sometimes called *luminescence* but is actually a special form of *fluorescence,* an effect more commonly seen when a subject emits light upon being exposed to ultraviolet radiation. In both situations the incident radiation is converted to longer wavelength radiation.

Usually two filters are required to accomplish infrared fluorescence photography. An *exciter filter,* typically a pale blue-green filter, is placed over the light source to limit the incident radiation to the shorter wavelengths of light. It is basically an infrared blocking filter. Its function is to prevent any infrared emitted by the source from reaching the subject. Some of the light falling on the subject is changed to longer, invisible infrared radiation. A second filter that only allows these newly formed rays to pass is placed over the camera lens. This filter is called a *barrier filter.* It is usually a visually opaque infrared filter. Its function is to block all visible rays with which the subject is illuminated from reaching the film.

The exciter filter can be omitted if the incident radiation can be limited to visible wavelengths by using a source that emits only wavelengths shorter than infrared ones. Wavelength tunable lasers provide such a source, and they have the added advantage of being able to easily select from a wide range of wavelengths for exciting fluorescence in the infrared or other areas of the spectrum.

APPLICATIONS For many years, the popular conception of infrared photography was that it was a way of seeing through fog. This was largely the result of the sensational handling of the subject by the press. In fact, infrared photography does not provide a way of seeing through fog, which consists of water droplets, although it can improve visibility through certain kinds of haze where the light scattering is produced by much smaller particles.

Long-Distance Photography The property of improved visibility through haze is particularly important for long-distance photography on the ground, where the detail of distant objects is often obscured by haze, and for high altitude, and especially oblique photography from the air. Actually, infrared photography does not always result in a marked increase in the range of vision, but it generally increases the contrast of the distant subjects and thus the amount of detail that can be seen. This produces the effect of greater penetration.

For long-distance infrared photography, the modern fast infrared film is used with a red filter equivalent to a Wratten #25 or tricolor red. Along with improved detail in distant subjects, the general effect is one of an abnormal rendering of subject colors. Grass and leaves of deciduous trees appear white, as if covered with snow, although coniferous trees

generally appear dark. Clear sky is reproduced very dark, particularly away from the horizon and away from the sun. Clouds appear white and, in the case of heavy cumulus clouds, they stand out strikingly against the dark sky. High, wispy clouds, which may be invisible in an ordinary photograph, may show up clearly. Water generally appears black, unless it is turbid with suspended matter.

Portraiture Infrared portraits, outdoors or indoors, appear unusual because infrared radiation causes skin to have a chalky appearance, red lips appear pale, and eyes to appear as dark spots. Doctors, however, use infrared photographs for diagnostic purposes. Infrared radiation tends to penetrate turbid skin and show up the veins lying close to the surface, and from their appearance certain medical conclusions can be drawn.

Survey and Reconnaissance In infrared photographs made outdoors from the ground or from the air, grasses and the foliage of deciduous trees appear white because of the high near-infrared transmission characteristics of green chlorophyll and the high infrared reflectance of the underlying cellulosic structure of these subjects. The result is that the infrared contrast of a landscape or an aerial terrain may be quite different from the visual contrast, and this, over and above enhanced penetration resulting from use of the longer wavelengths, may help to increase the visibility of distant objects. Further, it helps in aerial survey and reconnaissance to distinguish deciduous trees and grass from coniferous, diseased, and dead trees and burned grass, which tend to appear dark in an infrared photograph.

A common misconception is that infrared is used as a means of camouflage detection in wartime. While this may have been the case in the early days of infrared photography, the application of infrared for this purpose is no longer generally practiced. On the other hand, it is possible to distinguish living plants and foliage from green paints if no special precautions are taken with the paints. Most normal green paints that match green foliage visually are strong absorbers in the infrared and appear dark in an infrared picture, while natural green foliage photographs as white.

In practice, infrared photography has been used in forest survey to distinguish between stands of coniferous and deciduous trees. It is also possible to detect the presence of disease in plants and pollution in rivers and other bodies of water.

An important application of infrared aerial photography in war is its use for determining the depth of water and detecting underwater obstacles off potential landing places on enemy coastlines. It has been claimed that by comparing infrared and conventional photographs of average coastal water, depths to 20 feet can be determined to an accuracy of 10%. Infrared photographs have been used for the construction of charts, the study of sandbars and silting of navigable channels, the control of erosion and pollution, the charting of currents, and the study of marine life. Seaweed surveys have also been made by infrared photography.

In the Dark Because infrared radiation is invisible, photography in total darkness can be readily carried out if infrared film is used and the light source is covered with a light-absorbing but infrared-transmitting filter.

Infrared flash photography has been used in this way for many special purposes, such as press photography outdoors in the blackout during war, for photographing during nighttime landing operations on an aircraft carrier, and in other situations where a bright flash would be disturbing (or betray the photographer), such as for detection of intruders and criminals in the dark; audience-reaction studies in lectures, training-film projection, and motion-picture theaters; unobtrusive instrument recording in aircraft; dark adaption studies of the eye; photography of wildlife in darkness; and

photography of industrial operations that are carried out in the dark, as in the photographic industry.

Usually, filters that permit the passage of the minimum of visible radiation are used, but it must be recognized that deep red light can be quite visible in the dark. The filters may be placed over the front of the flash unit or the flash bulb, or the jackets of electronic discharge tubes may be dipped in a dark, infrared-transmitting lacquer. Normal safelight lamps provide a good lamphouse if an infrared filter is used in place of the safelight glass. Suitably dyed plastic bags have also been used as covers for flash bulbs.

In audience-reaction studies by flash, it is usually sufficient to cover flash lamps and reflectors with an infrared filter and point them to the ceiling as for bounce-flash to produce radiation that is invisible to the audience. Members of the audience who are looking in the direction of a flash unit covered with a deep infrared filter will probably be conscious of a red flash. A few deep ruby bulbs among the cove lights or in the exit signs of rooms can often provide enough unobtrusive illumination for infrared photography.

Document Inspection Infrared photography, particularly infrared fluorescence photography, has found several applications in criminological investigations, and it is a standard tool in many laboratories for the study of faded, burned, worn, dirty, or altered documents; the differentiation among pigments, dyes, and inks that may appear indistinguishable to the eye; examination and identification of cloth, fibers, and hair; detection of secret writing; and a variety of other special applications.

In the study of documents, infrared photography was dramatically used in the early 1930s for showing up printing underlying the obliterating ink of censors, which although black to the eye, happened to be transparent to infrared. In this respect, infrared photography is an important adjunct to ultraviolet photography in document examination. Printed matter, engravings, and photographs that have become undecipherable through dirt or age can frequently be revealed. Mechanical or chemical erasure can often be determined, even if overwritten, provided, of course, the overwriting is in an ink transparent to infrared, and even writing on documents charred in fires has been made readable, provided the charring has not gone too far. Infrared photography has taken

a place with chemical, ultraviolet and x-ray study in determining the authenticity of works of art.

Scientific and Industrial Applications Infrared photography is one of the accepted tools of the applied photographer, and the imaginative worker should have little difficulty in recognizing its possibilities and enlarging its field. Among its special uses are plant pathology, in the study of plant diseases where there is change in pigment or cellular material; paleobotany, particularly in coal petrology; in the textile field for detection of irregularities to the fibers, particularly where the material is dyed a dark tone and visual examination is difficult; in photomicrography of deeply pigmented tissues and thick sections, to show enhanced details of internal structure; and in the study of furnaces while they are operating.

Because heated objects emit infrared radiation, in some circumstances they may be photographed on infrared films by the infrared rays they themselves emit. The surface temperatures of hot objects such as hotplates, engine parts, stoves, cooling ingots, and castings have been studied in this way. The useful range is limited, however, because at temperatures below about 400°C exposure times become impractically long.

Infrared photography is a tool of great importance in astronomy and spectrography. Through its means, hundreds of new lines have been recorded in the spectra of the elements, much has been recorded in the spectra of the elements, much has been learned of the composition of the stars and the atmospheres of the planets, new stars have been discovered, and the haze of nebulae has been penetrated to bring us a fuller knowledge of the universe.

While direct infrared photography is limited to a maximum wavelength of about 1200 nm, the recording of longer wave radiations is possible by certain other methods. For instance, the latent photographic image can be partially destroyed by long wave red and infrared radiation (the Herschel effect) with photographic emulsions that are otherwise not sensitive to red light. This effect has been used to make direct-positive copies of documents by making prints on fogged bromide paper using long wavelength radiation for the image exposure.

COLOR INFRARED PHOTOGRAPHY Multilayer

Infrared photography. (Left) Copy of oil painting made with panchromatic film. (Middle) Copy made with black-and-white infrared film and a filter that absorbs light and ultraviolet radiation but transmits infrared radiation. (Right) Sketch showing the visible image with dotted lines and the hidden image revealed by the infrared with solid lines. (Photographs by Andrew Davidhazy.)

color films are also available and used in which one layer responds mostly to blue and infrared while the other two respond to green and blue, and red and blue, respectively. This film is designed for use with a yellow filter that eliminates from a scene the blue light to which all layers are sensitive. The film will reproduce a neutral as neutral when it reflects approximately equal amount red, green, and infrared radiation. Other colors assume a distorted character and a false color picture is produced in which everything shows up with an abnormal color. The yellow-dye layer responds to green light, the magenta-dye layer to red light, and the cyan-dye layer to infrared radiation.

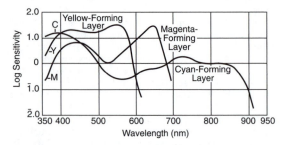

Color infrared photography. Spectral sensitivity curves for the three emulsion layers of Kodak Ektachrome infrared film. (Reprinted courtesy of Eastman Kodak Company.)

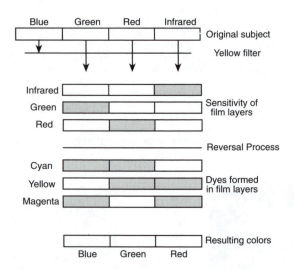

Color infrared photography. Color imaging on Kodak Ektachrome infrared film with green, red, and infrared subject areas, which are represented as blue, green, and red colors, respectively in the image. (Reprinted courtesy of Eastman Kodak Company.)

Thus, it is possible to identify areas where there is a little or much infrared present by the amount of cyan dye formed in the film. In addition, because the other dye layers are not complementary to the colors they respond to, most colors in the final transparency generally bear little resemblance to the colors of the original scene. This can be used to aesthetic advantage as well as to make the differentiation between subjects of similar color or tone more obvious. The method is particularly applicable when the objective is to detect small differences in the infrared reflectance of visually similar subjects.

Assuming that the subject is yellow and reflects approximately equal amounts of red and green, exposure to yellow alone will produce similar amounts of magenta and yellow dye in the film, giving the appearance of red for these two layers only. If, in addition, the subject is made up of a great deal of infrared radiation, exposure to infrared will not produce much dye in the cyan layer and the subject will look very red. On the other hand, if the subject contains little infrared, the cyan layer will be unexposed and full cyan density will remain in the film, making the subject appear cyanish. A similar approach can be taken to predict other colors that the film will produce under specific conditions.

Color infrared film has widespread applications in military aerial photography, remote sensing, and environmental impact studies. At one time standard color films and infrared films could be processed in the same solutions, but current color infrared emulsions require solution formulations that are not the same as those used for most other coupler-incorporated emulsions.

INFRARED IMAGE CONVERTERS Special devices are available that convert infrared radiation to light. The most common of these is the image converter. The infrared radiation collected by a lens is focused on an electrically charged surface called a *photocathode*. The infrared radiation causes electrons to leave the photocathode, and these electrons are focused by a magnetic lens on a screen coated with a fluorescing material. In this fashion the invisible infrared image formed on the photocathode surface is made visible as a fluorescent image that can be seen or recorded with a camera loaded with conventional film.

Infrared image converters are used in photofinishing laboratories and photosensitive materials manufacturing plants to monitor procedures that do not involve handling infrared sensitive products. They also are used to gain a visible appreciation of the infrared appearance of a subject before photography with infrared film.

THERMOGRAPHY While normal infrared photographic techniques use radiation reflected from the subject to form images, thermography uses infrared radiation naturally emitted by objects at all temperatures above absolute zero. Further, it works with infrared receptors other than photographic emulsions, such as certain types of photoelectric and transistor cells. Thermography extends the sensitivity range to wavelengths of approximately 10,000 nm and is suitable even for recording heat radiations emitted by objects at 0°C.

A thermographic recording camera, which includes a lens and moving mirrors or prisms that scan the image, focuses the heat rays on an infrared detector. The scan moves over the subject area in a television-like pattern. Radiation from

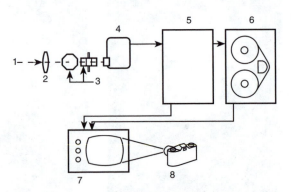

Thermography. A schematic diagram of electronic thermography. (1) Infrared energy; (2) lens; (3) scanning mirrors or prisms; (4) cooled infrared detector; (5) amplifier and control circuits; (6) tape recorder; (7) television monitors; (8) camera. (Reprinted courtesy of Eastman Kodak Company.)

successive small scanned areas is converted into electric signals that are amplified and used to modulate an electron beam scanned over the surface of a cathode-ray tube (CRT) is synchronization with the movements of the scanning system in the camera. In this fashion a television-like picture is seen on the CRT in real time. A thermogram is made by simply photographing the image on the CRT tube.

Applications of such thermographic scanning techniques include the detection of heat loss in buildings, the analysis of military targets and backgrounds (the presence of vehicles on the ground can, for instance, be detected by the higher temperature of their engines), monitoring industrial process installations, testing heating and cooling systems, investigating the degree of heating up of engines, electrical components, and other machinery in use, as well as medical and biological investigations. In the last case slight variations in the skin temperatures of a subject may reveal hidden tumors and other clinical conditions. *A. Davidhazy*

INFRARED (IR) RADIATION

Electromagnetic radiation with wavelengths between 700 and 15,000 nm. Infrared radiation is made up of photons with wavelengths longer than those of light, but shorter than those of microwaves. Infrared radiation is perceived as heat, and is of particular interest to photographers because photographic emulsions can be sensitized to radiation with wavelengths as long as 1200 nm (although normal IR film is only sensitive to about 900 nm). Electronic detectors can be constructed that are sensitive to the entire IR range. Infrared radiation has the ability to penetrate fog and haze to some extent, and is not scattered by the atmosphere as much as light. Healthy plants also reflect infrared radiation strongly. These characteristics combine to give dramatic effects in monochrome infrared photography—black skies and white foliage. Infrared photography can also be used to determine the health of plants in aerial photography, for biomedical, scientific, and industrial photography, for photography in the dark (only under infrared illumination), and for the examination of documents and artwork. *J. Holm*

See also: *Infrared photography.*

INFRARED SLAVE

A remote trigger for electronic-flash units. An infrared emitter and receiver are used. An advantage of the infrared slave is that it not only eliminates trailing synchronizing cords from the camera to flash fixtures, but also that the light from another photographer's flash cannot inadvertently activate an infrared trigger. They may also be part of a system for remote camera release, and for triggering electronic flash or a camera when a subject breaks the beam. *R. Jegerings*

See also: *Slave unit.*

INFRASONIC FREQUENCY RANGE

The region below the audible frequency range, from extremely low frequencies associated with slow changes in air pressure, up to 20 Hz. Very high levels of infrasonic acoustic energy, especially around 12 Hz, can lead to discomfort and nausea. *T. Holman*

INITIALIZE

In computers, the starting for the first time of a component, such as initializing a video board. In order to write to a disk, it must be initialized (formatted) so that it is prepared to receive data. This initialization organizes the sectors and tracks appropriately. *R. Kraus*

INK-JET PRINTER

A computer-controlled output device that sprays ink through very fine nozzles. The fineness of the nozzle determines the dot size of the ink spray. Usually, the water-based ink will be sprayed in liquid form or it may be heated and sprayed as a bubble. Ink-jet printers can resolve between 150 dpi to 360 dpi. Color output is possible. *R. Kraus*

INK-JET PRINTING

See *Photomechanical and electronic reproduction, digital printing systems.*

INORGANIC

A term that is descriptive of any chemical compound that is not classed as organic. Derived from mineral sources, inorganic compounds usually do not contain carbon. *G. Haist*

INPUT

Something that is put into a device, process, etc., such as the light that falls on the photoelectric cell of an exposure meter as it is being used to make a measurement, the electric current that powers an electronic flash unit, two known values entered in the equation 1/focal length = 1/object distance + 1/image distance to determine the unknown third value, and information entered into a computer program that is being used for film processing quality control.

INPUT/OUTPUT The terms *input* and *output* are interdependent, and they are commonly combined in the form of input/output to represent the beginning and end of a process. In the process of making a photograph, for example, the subject is generally considered to be the input and the photographic image the output. The photographic process, however, can be broken down into a series of steps that can be considered as microprocesses. The light falling on the subject, for example, represents the input for the smaller process whereby the subject modulates the light by means of variations of absorption and the output is represented by the resulting luminances. These output luminances for the various subject areas in turn represent the input for the formation of the optical image by the camera lens, which in turn serves as the input for the formation of the latent image in the film emulsion, which then serves as the input for the development of a negative image, and so on through the printing process. Thus, certain items can be classified as input or output only in the context of a specific process.

Whereas the photographic image was considered above to be the final output, photographs are normally made to be viewed, so that the photographic image can be considered to be the input for the process of visual perception, but of course the visual process can be subdivided into a series of microprocesses also. In the literature on visual perception, input is commonly referred to as stimulus and output as response. Stimulus-response psychology represents the point of view that the task of the psychologist is to discover the functional relationships that exist between stimuli and responses.

Evaluation of photographic materials or a photographic process commonly involves comparing the output (the image) with the input (the subject). In practice, this is not always convenient or even possible, so we often compare the photographic image with a memory of the appearance of an object or scene at the time the film was exposed, a subjective and undependable method of evaluation.

TEST TARGETS One way to avoid the errors introduced by the vagaries of memory concerning the appearance of the original scene is to use an appropriate test object that can be saved and compared with the photographic image, or that can provide an objective measurement of some aspect of the imaging process. Some of the items that are commonly used as artificial subjects for testing purposes are listed below. The choice of test target depends on which attributes of the subject or the imaging process are to be compared or measured.

Neutral Test Card A gray card having a reflectance of approximately 18% is referred to as a neutral test card, a gray card, or an artificial midtone since it has been determined

that this tone appears to be midway in lightness between white and black. This tone corresponds to a middle value of 5 in the Munsell system of color notation and to Zone V in the Zone System. It is an appropriate tone to use for re-flected-light exposure meter readings and should produce approximately the same results as an incident-light exposure meter reading. As an artificial subject, it can be used in the darkroom when making prints to assist in determining the proper density of a print. Actually, however, it has been found in tone-reproduction studies that viewers tend to prefer prints in which the midtones are a little lighter than the corresponding tones in the original scene.

Gray cards are also useful when making color photographs. Including a gray card in the original scene can assist the color printer in determining the proper color filtration by means of red, green, and blue density readings of the color negative, or similar readings made with a darkroom color analyzer light meter. Neutral subject areas are also useful in color photographs for judging the color balance of the photographic image subjectively since variations of color balance are easier to detect in neutral areas than in areas having highly saturated hues such as a red apple or a blue sky.

Gray Scale A series of neutral tones, usually in the form of discrete calibrated steps that are arranged in sequence from light to dark with a typical density range of approximately 0.0 to 2.0. Gray scales having uniform density increments between steps tend to be more useful, but some gray scales have modified increments that provide the appearance of more nearly equal increments in lightness, which requires larger density increments on the dark end. Although gray scales can be used alone as an artificial subject, they are often included with other subjects but in a position where the image appears near the edge of the photograph where it can be eliminated by cropping or trimming.

Gray scales offer the advantage over gray cards of providing information about the local and overall contrast of the image in addition to the density of any tone of interest. Evaluation of image density and contrast can be done subjectively by visually comparing the image of the gray scale with the original gray scale, or objectively by comparing measured densities of the image steps with the corresponding marked densities on the original gray scale.

Step Tablet Transmission gray scales are commonly referred to as step tablets. Typical step tablets have a density range of approximately 0.0 to 3.0 with either 20 increments of 0.15 or 10 increments of 0.30. A step tablet can be used, for example, on an illuminator along the edge of a transparency that is being copied or along the edge of a negative or transparency in an enlarger. Step tablets are also used in sensitometers to provide a series of known exposures to sensitized materials for the purpose of determining the tone reproduction characteristics of the material or of determining the effects of changes made in processing conditions. The input and output data of such tests are commonly presented in the form of density versus log exposure graphs where the relationship between input and output is revealed in the form of a characteristic curve.

Transmission tablets that have a continuous change in density from light to dark rather than discrete steps are referred to as continuous-tone tablets or wedges. Such tablets are used with automatic equipment that measures the densities by scanning the image from one end to the other and simultaneously plots a characteristic curve.

Color Chart A panel containing patches of selected colors that is designed to be photographed, with or without other objects, for the purpose of evaluating color reproduction quality. Such charts are sometimes identified as color rendition charts or color control charts. The colors selected typically include the additive primary colors (red, green, and blue), the subtractive primary colors (cyan, magenta, and yellow), white, and black. The Macbeth ColorChecker has 24 patches that include typical subject colors such as light skin, dark skin, blue sky, and foliage, and a six-step gray scale in addition to the additive and subtractive primary colors, and it was designed to be used with photomechanical and television reproduction systems in addition to photographic systems. The colors are also identified with ISCC/NBS names, and specifications are provided for both the CIE system of color measurement and the Munsell system of color notation.

A bar type resolving power test target. The resolving power is based on the smallest set of bars that can be resolved when the image of the test target is examined with a microscope.

Resolving Power Target A pattern of alternating dark and light bars that decrease systematically in width, that is used to measure the resolving power of a photographic system or component. The resolving power is determined by the narrowest set of target bars that can be distinguished as being separate in the image and is expressed in terms of lines per millimeter, where a line is a dark-light pair of bars. To determine the resolving power of a lens, the aerial image formed by the lens is examined with a microscope. When a photograph is made of the target, the resolving power determined from the image is that of the system, which includes all of the components such as camera lens and film for a negative or transparency, and camera lens, film, enlarger lens, and paper for a print. Targets having bars with sharp edges are sometimes referred to as square-wave targets, as distinct from sine-wave targets. Reflection-resolving power targets are provided in both high-contrast and low-contrast versions, and transmission targets, which are capable of providing higher density ranges than reflection targets, are also available.

Alphanumeric Target With conventional resolving power targets, the observer selects the smallest set of bars where the correct number of bars, commonly three dark bars on a light background, can be identified, a process that results in variability, especially with inexperienced observers. Alphanumeric resolving power targets contain block letters and numbers, each of which contains three parallel bars that are similar to the bars on the conventionally resolving power targets. With alphanumeric targets the observer selects the smallest set of characters on the basis of recognition of the letters and numbers. Since the accuracy of the identifications can be checked, and incorrect selections are

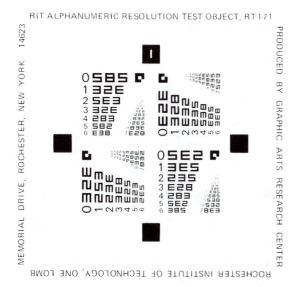

Alphanumeric resolving power test target. Since the accuracy of the tester's choice of the smallest resolved set of characters can be checked, variability is lower than with conventional resolving power test targets.

rejected, variability with repeated observations made by one person and observations made by different people is low.

Sine-Wave Target Sine-wave targets, like conventional resolving power targets, have alternating light and dark bands of varying widths, but the transition between adjacent bands is gradual rather than abrupt. Even though resolving-power data are valuable in evaluating optical systems and photographic materials and processes, it has long been known that the observed sharpnesses of two images sometimes vary *inversely* with their resolving powers. Modulation transfer function curves based on the relative contrast of the light and dark bands in the image of a sine-wave target reveal how an imaging system that produces high contrast in large image areas and low contrast in small image areas can appear sharper and yet reveal less fine detail and therefore have a lower resolving power than another imaging system having the reverse contrast relationships.

Lens Aberration Test Targets The simplest of all the different test targets is undoubtedly the artificial star target produced by making a pinpoint opening in a thin piece of opaque material and placing a light source behind the opening. Examination through a microscope of the image formed by a lens with the point source of light in various positions on and off axis and with modifications of the spectral quality light can reveal considerable information about the shortcomings of the lens.

There are other specialized test targets designed to reveal specific lens aberrations such as distortion and chromatic aberrations. Although sophisticated lens testing is done by specialists in an optics lab equipped with a precision lens bench, simple charts containing a variety of targets are available for photographers who want to test their own lenses.

Vision Test Targets Two widely used targets for testing visual acuity are the Snellen chart containing letters of progressively decreasing size, and a geometrical design used to detect astigmatism. Pseudoisochromatic test targets for detecting defective color vision consist of patterns of neutral and colored dots such that figures that are visible to persons with normal color vision cannot be seen by those with defective color vision.

Numerical Input Whereas subjective evaluation of input

factors or input/output relationships are commonly expressed in general terms such as light, dark, flat, and contrasty, objective measurements normally involve numbers. Examples of useful measurement data at the input stage of picture making include the color temperature of the light source for color photography, incident-light measurements at the subject to determine the lighting ratio, reflected-light measurements of a scene to determine camera exposure settings and scene contrast, and the measurement of a dimension of an object or scene when information about size or distance is required.

Quantitative input information is commonly required in order to determine precise input-output relationships. These relationships can be presented in a variety of forms including as a ratio (such as a scale of reproduction of 1:1), a table (such as a depth-of-field table that lists f-numbers and corresponding depth-of-field distances), a graph (such as a film characteristic curve), and miscellaneous forms (such as dial and slide-rule devices and nomographs).

Graphs are an especially efficient method of presenting input-output relationships, since by plotting a limited number of points and connecting them with a smooth line, it is possible to interpolate to determine the output for any input value that falls between the limits. A time-contrast index graph for the development of black-and-white film can be prepared with data for only three different developing times, for example, and a film characteristic curve, which has a more complex shape, can be prepared by using a step tablet that produces only 11 different exposures on the film.

The input for graphs, or for any input-output relationship, is referred to as the independent variable and the output as the dependent variable. *L. Stroebel*

See also: *Alphanumeric target; Gray card; Lenses; Recognition; Resolving power; Sine-wave target; Vision.*

INPUT/OUTPUT (I/O) A device that allows data to be entered into the computer (mouse, graphics tablet) or a device that accepts data for review (monitor, printer). I/O may also refer to the controller of these devices. I/O compatibility is a major consideration in the fabrication of an imaging or graphics computer workstation. *R. Kraus*

INPUT SCANNER Any advice that can capture an electronic representation of reflection or transmission of original material and convert it into a digital representation of the original. *J. Larish*

INSPECTION DEVELOPMENT The use of the appearance of the image with safelight illumination as a guide to the completion of development. Contrast with time-temperature development. *L. Stroebel and R. Zakia*

See also: *Pinacryptol.*

INSTANT PHOTOGRAPHY Any photochemical photographic system that yields a positive print moments after the exposure is made. In the 1850s, the five-minute wait for a tintype seemed nearly instantaneous. Now, a variety of Polaroid materials can produce a finished print in a minute or less using the diffusion transfer process. The photo booths common in amusement parks produce prints on direct positive paper in about five minutes. Various digital imaging systems hold the promise of truly instantaneous photography. *H. Wallach*

See also: *Electronic photography; Polaroid photography.*

INSTANT-RETURN MIRROR The mirror on a single-lens reflex camera that swings up and out of the light path during exposure and immediately swings back when the exposure is completed. *P. Schranz*

INSTITUTE BELGE DE NORMALISATIONE (IBN)
The national standardizing organization of Belgium.

P. Adelstein

INSTRUCTIONAL PHOTOGRAPHY See *Audiovisual communication.*

INSTRUMENTATION CAMERA See *Camera types.*

INTAGLIO PROCESS A term used to describe the gravure process.

M. Bruno

See also: *Gravure.*

INTEGRAL DENSITY For a tripack color photographic image, a measurement of the absorption of light by a sample in which all three layers affect the result. Integral densities are useful for predicting the printing characteristics of a color negative and the appearance of a color positive. Contrast with *analytical density.*

M. Leary and H. Todd

See also: *Color densitometry.*

INTEGRAL TRIPACK Photographic material for color photography consisting of three differently sensitized layers on the same support. Since virtually all color materials now used in the motion picture industry are of this type, these terms have fallen into disuse.

M. Scott

Syn.: *Monopack.*

INTEGRATED CIRCUIT (IC) Microminiature circuit containing many transistors, diodes, resistors, capacitors, and connecting wiring on a single semiconductor chip. Integrated circuits are the building blocks of modern electronic circuits. Thousands of different IC circuits are commercially available. They can be divided according to their use: linear, digital, and hybrid. Linear ICs are used to amplify audio, video, radiofrequency, and other analog signals. An operational amplifier used extensively in analog computers is a linear IC. Digital ICs are used to perform a variety of functions in digital computers, such as logic gates, flip-flops, registers, accumulators, and the central processing unit (CPU). Digital ICs are also used in the long-distance transmission of intelligence by telephone lines and radio and in the storage of data, including photographic images, on floppy and hard discs, on magnetic tape, and on compact discs. Hybrid ICs contain on a single chip both linear and digital circuits, for example, the digital-to-analog converter and the analog switch. ICs are fabricated using bipolar or metal-oxide semiconductor (MOS) technology. They are available in dual in-line packages (DIP) or as surface mounting devices to facilitate automatic assembly on printed circuit boards.

W. Klein

INTEGRATING METER (1) An exposure meter that measures the total amount of light falling on the photocell over a certain period of time rather than recording the light level at a given moment. Such meters are used with process cameras in the graphic arts where exposure times tend to be relatively long, and some can be set to terminate the exposure when the total amount of light reaches a specified value. (2) An exposure meter that measures the total amount of light falling on the photocell for relatively short periods of time, designed to be used to measure combinations of short-duration light from an electronic flash source and continuous light from other sources. The time gate on some such meters can be adjusted to correspond to a range of shutter speeds. (3) A reflected-light exposure meter that measures light over a relatively large angle, producing a reading that corresponds to an average luminance. This type of meter integrates light over area rather than over time and is sometimes identified as having an averaging sensitivity pattern, as distinct from spot and center-weighted patterns.

J. Johnson

See also: *Exposure meter.*

INTENSIFICATION Intensification is a postprocessing chemical procedure used with black-and-white negatives to increase density. The formulas and procedures for intensification are varied, but they can be divided into four general categories: (1) addition of silver to the existing image, along with sometimes changing the form and structure of the silver; (2) addition of another metal to the silver image; (3) converting the silver image to a compound of another metal; and (4) incorporating or substituting a colored compound or dye that has a greater light-absorbing effect in the spectral sensitivity range of the printing paper.

PROPORTIONAL INTENSIFICATION The increase in density is most commonly *proportional* to the amount of silver that existed in the negative prior to treatment, thus producing an increase in contrast, or an effect similar to that which would have been attained with a longer developing time.

SUPERPROPORTIONAL INTENSIFICATION The percentage of increase in density is greater for the higher densities than for the lower densities of the original image. There is a considerable increase in highlight density with little increase in shadow density. The overall contrast tends to be higher than that achieved with a proportional intensifier.

SUBPROPORTIONAL INTENSIFICATION A third alternative is a percentage increase that is greater for the lower densities of the original than for the higher densities to produce a *subproportional* effect. The contrast is lower than that obtained with a proportional intensifier but is higher than that of the original negative, with better enhancement of shadow detail.

ADDITION OF SILVER One proportional intensification method is accomplished by what in effect is *physical development,* that is the depositing of additional silver on the existing image. The intensified image has the same color as the untreated image, and thus is easy to judge when printing. The technique is somewhat critical, requiring considerable skill and care. Some treatment may be required to avoid addition of silver to the nonimage gelatin areas, and the life of the solution is relatively short.

ADDITION OF OTHER METALS Another method consists of converting the silver image to a halide or combination of halide and another metal followed by redevelopment to produce an image having greater opacity. One of the most reliable of these intensifiers is that utilizing chromium, which produces a proportional result. Other metal intensifiers make use of lead, copper, tin, and uranium. Modifications of some of these procedures can be made to give superproportional or subproportional effects.

Another technique makes use of uranium to convert the silver image to a warm colored image that has a strong intensifying effect due to its absorption of blue light to which most printing papers are highly sensitive. It is difficult to judge due to the difference between the visual appearance and the photographic result.

DYE INTENSIFICATION When a metal-hydroquinone developed silver image is converted to a halide by bleaching, then redeveloped in a low-sulfite pyro developer, the dye-silver image has a greater light absorbing effect due to the added pyro stain. A silver image can also be mordanted (made to attract dye) then dyed to produce an image that has an intensified photographic effect.

FLUORESCENT IMAGE ENHANCEMENT When a developed negative is soaked in a fluorescing dye, such as Rhodamine B, the dye is absorbed strongly even in areas with minute silver. This dye negative is then subject to

ultraviolet radiation to produce a fluorescent image that is then rephotographed. *I. Current*

INTENSIFYING SCREEN
A sheet coated with a substance that fluoresces when struck by x-rays and used to reinforce x-ray images. The x-ray film is placed in close contact between two sheets coated with the fluorescing material and the effect of the excited fluorescence on the silver halide particles is greater than from direct absorption of x-ray energy. Large exposure reductions are therefore possible. *R. Jegerings*

See also: *X-ray photography.*

INTENSITY
(1) (I_v) A measure of the rate of emission of light from a source in a specified direction. Unit: candela (standard candle and candlepower are obsolescent); lumens per steradian. By the definition of a lumen, a source with an intensity of 1 candela also has an intensity of 1 lumen per steradian. (2) (I_e) Similar to definition (1), but as applied to radiometry (without consideration of the visual response). Unit: watts per steradian. (3) Loosely, the amount or strength of light or radiation. (4) As applied to color, vividness; saturation. *J. Holm*

INTENSITY-SCALE SENSITOMETER
An instrument for producing a set of different exposures on a sample of photographic material for which the time is constant and the light level varies on different parts of the sample. The device uses a step tablet or other means of changing the illuminance. Such a device is to be preferred to a time-scale sensitometer, since it exposes the material in a manner conforming to practice. *M. Leary and H. Todd*

See also: *Sensitometer; Sensitometry.*

INTENSITY (SOUND)
Among acousticians, used precisely, the complex characteristics of sound propagation, quantifying both amplitude and direction of sound. Slang, used interchangeably with amplitude, but applied usually to sound pressure. Street slang, loudness. *T. Holman*

INTERACTIVE
Communication between the computer and the user. There are several levels of interactivity. The highest level occurs in a time span that is real or near real time. *R. Kraus*

INTERAXIAL DISTANCE
The horizontal distance between the axes of the two lenses of a stereoscopic camera or between two viewpoints for stereo purposes. Normally set at 63-65 mm, the average value of the human interocular distance. *S. Ray*

INTERCHANGEABLE LENS
A lens with an attachment system that matches the one on a camera so that any of a variety of lenses can be used on the same camera. Bayonet mounts, consisting of matched flanges that require only a small rotation of the lens, are commonly used on 35-mm cameras. Alternative methods include lenses with a threaded barrel that is screwed into a matching part on the camera, and lenses that are permanently mounted on a lensboard, which in turn can be easily attached to the camera, a system normally used on view cameras. Lens turrets that hold two or three lenses are sometimes used on motion-picture cameras and enlargers, thereby allowing lenses to be changed by simply rotating the turret. *P. Schranz*

INTERCUTTING
In motion-picture editing, cutting back and forth between two or more different scenes. *H. Lester*

INTERFACE
A means of connection between two independent devices with different connectors, formats, data storing or protocols. Sometimes called a black box. *M. Bruno*

INTERFERENCE
See *Optics, physical optics.*

INTERFERENCE COLORS
Spectral colors resulting from destructive and constructive interference effects in a composite beam of light. Examples are the colors of very thin films and of birefringent crystals viewed in a polariscope. *S. Ray*

INTERFERENCE FILTERS
See *Filter types.*

INTERFERENCE MICROSCOPE
As a general term, any microscope that uses interference phenomena to produce a distinct image, often of an otherwise low-contrast or invisible object. Interference is produced by dividing a light beam from one point in the source into two identical beams, passing one of those beams through the specimen, and recombining it with the other (the reference) beam. Differences in optical path length through the specimen retard the phase of light with respect to the reference beam. Constructive and destructive interferences take place in the combined beams, resulting in parts of the specimen appearing brighter or darker than the background.

Phase-contrast and differential-interference-contrast (DIC) microscopes depend on interference phenomena. These are primarily qualitative instruments, providing images of greatly enhanced contrast. In phase microscopes objects usually appear surrounded by bright halos, an optical artifact. In DIC microscopes optical path differences appear in pseudo-relief or in false colors. Knowledge of these phenomena are essential to prevent misinterpretation of the images.

As a specific term, an interference microscope is a quantitative instrument that displays an image overlaid with a fringe pattern. The fringes represent differences in specimen thickness or height in terms of wavelengths of light. Adjustable optical components (compensators) in the microscope are calibrated to very small fractions of a wavelength of light. Extremely small measurements may be made. For highest accuracy measurements are made with monochromatic light. *M. Scott*

INTERFERENCE PHOTOGRAPHY
See *Holography; Lippmann process.*

INTERFEROGRAM
A photogrammetric-quality photographic recording of the high-definition interference fringe patterns used in the study of the microstructure of the surfaces of crystals, glasses, metals, etc. *L. Stroebel*

INTERFEROGRAPHY
The technique of photographing interference fringe patterns to produce *interferograms*. *L. Stroebel*

See also: *Holography.*

INTERFEROMETRY
The specialization of the precise measurement of distances from the pattern produced when two beams of light or similar radiation superimpose. The difference in path length of the two beams can be accurately inferred from the interference pattern. *L. Stroebel*

INTERIMAGE EFFECTS
A change of the image in one emulsion layer caused by chemical effects from an adjacent layer during the development of a multilayer photographic material, such as a color film. Interimage effects can be beneficial as well as detrimental. *G. Haist*

INTERLACE
The scanning method of displaying images on the cathode-ray tube (CRT) whereby each of two fields is displayed every 60th of a second. The "a" field is composed

of every odd line and the "b" field is composed of every even line. The two are interlaced together to represent one frame.

R. Kraus

INTERLOCK A device or procedure for maintaining a desired relationship between two variables. A shutter-diaphragm interlock on a camera enables the operator to obtain different combinations of shutter speed and *f*-number, all of which produce the same exposure, by making a single adjustment. An interlock is also used to maintain synchronization of picture and sound when they are recorded separately and synchronization of the separate projectors in multiple-projector presentations.

L. Stroebel

INTERMEDIATE IMAGE A second-generation image that is then used to produce the final image, such as a color negative made from a positive color transparency for the purpose of making a display print on nonreversal color printing paper. Such a negative may be more specifically identified as an *internegative*. A positive transparency made from a negative for the purpose of making one or more duplicate negatives can be identified as an *interpositive* or a *diapositive*.

L. Stroebel

INTERMITTENCY EFFECT See *Photographic effects*.

INTERMITTENT AGITATION Periodic movement of solutions rather than continuous. Often used in tank processing of roll and sheet film.

L. Stroebel and R. Zakia

INTERMITTENT MOVEMENT (1) The stop-and-go movement of motion-picture film through a camera or projector that holds a frame in place for exposure or projection and then advances the film on to the next frame. (2) The mechanism that produces such movement in a projector or camera.

H. Lester

INTERMODULATION DISTORTION The generation of waveforms (by an amplifier or photographic system) other than those that are fed into the system. These extraneous waveforms distort the reproduction of the original waveform. Intermodulation distortion is a problem in audio and image reproduction systems.

J. Holm

INTERMODULATION DISTORTION (SOUND) A type of distortion occurring when sine waves of more than one frequency are used to stimulate a system under test. A distorting system will generate added sine waves at new frequencies related to the applied ones by being at sum and difference frequencies compared to the original ones. A measurement of the level of such components compared to the level of a composite of the applied sine waves is a measure of intermodulation distortion of the system under test.

T. Holman

INTERNAL DEVELOPMENT After the removal of the surface latent image by oxidizing agents, such as chromic acid, the latent image in the interior of a silver halide grain can be made accessible by using a developer containing mild silver halide solvents. These latent image centers can then be developed, showing the presence of an internal latent image.

G. Haist

INTERNAL LATENT IMAGE Most of the latent image formed by light exposure of silver halide grains is situated on the surface of the crystal, possibly at centers formed during the chemical sensitization step of emulsion making. It has been shown, however, that latent images also exist internally through the depth of the grain. It is possible that the internal latent image forms along boundaries and along dislocation lines in the strained regions of the crystal, but it has been difficult to obtain proof of the nature of the latent image in the interior of actual emulsion grains.

G. Haist

INTERNATIONAL CANDLE A historical, but not obsolete, standard for the measurement of photometric intensity: the light output of a spermaceti wax candle burning at the rate of 120 grains of wax per hour.

J. Holm

See also: *Candela*.

INTERNATIONAL ELECTROTECHNICAL COMMISSION (IEC) An international standards-making body located in Geneva, Switzerland, with activity in audio, electroacoustics, video, television, and photography, among many other fields. It is probably best known to the lay public as the organization that standardized the categorization of Compact Cassette tape types in four types numbered I, II, III, and IV and film speeds. Its standards are generally available within each country from the local standards-making body, such as ANSI in the United States and B.S. in England.

T. Holman

See also: *Compact cassette*.

INTERNATIONAL STANDARDS ORGANIZATION (ISO) A worldwide federation of national standards bodies.

P. Adelstein

INTERNATIONAL SYSTEM OF UNITS See *Système International d'Unités (SI)*.

INTERNATIONAL UNIT A basis for measurement agreed upon by scientific experts of various countries. The International System of units (SI—an acronym from the French *Système International*) includes seven base units: the meter (length), the kilogram (mass), the second (time), the kelvin (temperature), the ampere (electrical current), the candela (luminous intensity), and the mole (amount of a substance). Two supplementary units are the radian (plane angle) and the steradian (solid angle). Hundreds of other units are derived from these nine.

H. Todd

See also: *Metric system; Système International d'Unités; Weights and measures*.

INTERNEGATIVE A negative image that is produced from a positive transparency for the purpose of producing one or more positive images, such as a color negative made from a positive color transparency for the purpose of making a display print on nonreversal color printing paper. *L. Stroebel*

See also: *Intermediate image*.

INTERPOLATION A method of image processing whereby one pixel, block, or frame is displayed or stored based on the differences between the previous and subsequent pixel, block, or frame of information. Using such a technique allows for the magnification of a section of the image without blocking.

R. Kraus

INTERPOSITIVE A positive transparency that is made from a negative for the purpose of producing one or more duplicate negatives.

L. Stroebel

Syn: *Diapositive*.

See also: *Intermediate image*.

INTERPRETATION One of the most important advantages of presenting data in graph form, in comparison with columns of numbers, is that the shape of the curve provides an overall picture of the interrelationship of the input and output variables. This is especially useful when the relationship changes with different levels of input as with D-log H graphs for photographic film where the level base-plus-

fog, toe, straight line, should, and reversal sections represent different responses of the film to uniform increases in log exposure.

For graphs plotted on the rectilinear coordinates, direct proportionality between input and output values is shown by a straight line that passes (actually or by extension) through the origin, as would be produced, for example, by plotting the photographic exposure (illuminance x time) against increasing units of time with constant illuminance.

The straight line on a film D-log H curve indicates that uniform increases in log exposure produce uniform increases in density or, in other words, that local image contrast is related in direct fashion to the local contrast of the subject, but the limited length of the straight line indicates that the relationship breaks down beyond a limited range of log exposures.

A reverse relationship between input and output produces a downward sloping line. This occurs in the reversal region of a film D-log H curve, where each increase in log exposure produces a decrease rather than an increase in density. The shape of this downward sloping line will be straight only where uniform increases in log exposure produce uniform decreases in density.

Plotting the illuminances at different distances from a point light source will produce a downward sloping curve line as a result of the inverse-square relationship between distance and illuminance.

The ratio of the output change to the input change is called the slope, or gradient, where slope is equal to output change divided by input change. If the slope in any region of a graph is 1.0, as would occur with a straight line at an angle of 45 degrees, the output change is equal to the input change. If the slope is 2.0, the output change is double the input change. The slope of a curved line constantly changes, but the slope can be determined for a selected position on the line by finding the slope of a straight line drawn tangent to the curved line at that point.

Another important advantage of line graphs over the lists of input and output numbers is that the graphs make it possible to interpolate between the given data. To prepare a time-temperature film developing graph, it is necessary only to determine by experiment the corresponding developing times for three different temperatures, covering the range of temperatures of interest. When these three points are plotted and connected with a smooth line, the correct developing times can be determined for any temperature between the upper and lower limits.

Graphs identified as control charts are especially useful in monitoring ongoing processes such as the manufacturer of photographic films and papers, and the processing of films and prints in photofinishing labs. Control charts enable the operator of the process to determine, for example, whether variations of selected attributes such as density, contrast, and color balance of uniformly exposed test areas represent only the random variability expected of a stable process or represent changes due to an assignable cause that require compensation. *H. Todd*

See also: *Control charts; Quality control; Tone reproduction; Trilinear plot.*

INTERSTITIAL IONS Some silver ions in a silver halide crystal are located in the interstices between the other ions of the crystal lattice structure. The ability of these displaced ions to move is thought to take part in the formation of the latent image and the development of the silver image. *G. Haist*

INTERVALOMETER A device used to achieve the desired length of time between exposures for series of photographs made, for example, for aerial mapping, time lapse, and surveillance purposes. *L. Stroebel*

INTERVAL SCALE As used in sensory and other measurements, a refinement of the ordinal scale involving equality of the intervals between adjacent levels, similar to those on a thermometer. For example, the Munsell system of perceptual color measurement is based on a set of color patches that are equally spaced from each other. *H. Todd*

See also: *Ordinal scale.*

IN THE CAN A motion-picture term indicating a shot or scene has been filmed and is ready to go to the laboratory for processing. *H. Lester*

INVERSE LOG See *Logarithms.*

INVERSE SQUARE LAW A statement of the fact that the illuminance, irradiance, or flux density produced by a point source is inversely proportional to the square of the distance from the source. This law is easily rationalized by imagining the total instantaneous output of photons from a point source as being a sphere with a radius equal to the speed of light multiplied by the elapsed time since the emission of the photons. Since the number of photons remains constant while the area of the sphere increases as the square of its radius (area of a sphere = $4\pi r^2$), the density of the photons decreases as the square of the distance or radius. For example, if the illuminance falling on a surface 1 meter from a 32 candela source is 32 lux, the illuminance from the same source at 4 meters will be 2 lux. This law can be expressed mathematically by the equation: $E = I/d^2$ where E is the illuminance produced by a point source with intensity I at a distance d. It is important to note that the inverse square law applies only to sources that approximate point sources. Other relations exist for other source distributions. For example, for an infinite linear source $E = I/d$, and for an infinite planar source, E is invariant with d. *J. Holm*

distance X distance X

Inverse Square Law. Light originates from an approximate point source. If the distance from the light source is doubled, the area illuminated by the same amount of light from the source is two squared, or four times the original area. This means that the illuminance produced by a point source goes as the inverse of the square of the distance of the surface.

INVERSE SQUARE LAW (SOUND) The property of sound waves to spread out as a function of distance away from a point source leads to a decreasing intensity of sound with distance. The law, or rule that the fall-off follows is a square-law, i.e., for twice the distance the amplitude is reduced to one-quarter. *T. Holman*

INVERTED TELEPHOTO LENS See *Lens types, wide-angle lens.*

INVERTER (1) An electronic device that converts dc voltage to ac voltage through the use of an oscillator. Some electronic flash attachments use an inverter to derive high-

voltage dc by stepping up the oscillator output voltage with a transformer and rectifying its output. The frequency of the ac is in the tens of thousands of hertz, thus enabling the use of a smaller transformer and filter. (2) An electronic circuit that provides an output signal that is the negative of the input signal. *W. Klein*

IODIDE A salt containing the element iodine. An iodide salt of silver was the light sensitive part of the early daguerreotype and wet plate processes and remains today part of photographic emulsions. *G. Haist*

See also: *Iodine.*

IODINE Violet-gray crystals (I_2, molecular weight 253.81) with a vapor that is extremely irritating to the eyes, stains skin, and attacks the respiratory tract. Slightly soluble in water but more so in aqueous solutions of potassium iodide or in alcohol, chloroform, or ether. Used as an oxidant to reduce or remove silver images, as in bleaches, reducers, or solutions for removing silver stains. *G. Haist*

ION When a neutral atom of a metal loses one or more electrons, a positively charged ion, called a *cation*, is formed. The cation is smaller than the neutral metal atom because a smaller number of electrons is being attracted by the same positive nuclear charge. When a neutral atom of a nonmetal gains one or more electrons, a negatively charged ion, called an *anion*, is produced. The anion is larger in size than the neutral atom of the nonmetal because of the extra electrons that are being held by less than an equal number of protons in the nucleus. The attraction of opposite charges on ions increases their chemical activity and makes possible the formation of ionic crystal structures, such as the cubic form of sodium chloride. *G. Haist*

ION EXCHANGE Calcium and magnesium ions can be removed from hard water by passing the water over complex sodium aluminum silicates (zeolites). The complex silicate exchanges its sodium ions for the calcium and magnesium ions of the water. Water-soluble sodium sulfate and water-insoluble calcium aluminum silicate are formed. By flushing with a solution of sodium chloride, the sodium salt of the silicate can be regenerated for further use. *G. Haist*

See also: *Deonize.*

IONIC CONDUCTIVITY The conductivity caused by the movement of ions in an electrical field. In silver halides this conductivity is due to the movement of interstitial silver ions. *R. Hailstone*

IONIZATION Ionization is a type of dissociation or separation of a compound when water causes the compound to form ions that are hydrated. For example, hydrogen chloride, a gas, dissolves in water, forming hydrogen ions, H^+, and chloride ions, Cl^-, that are surrounded by water molecules. Atoms of a gas can be ionized under the influence of an electrical discharge or radiation energy. *G. Haist*

IRIS The structure of the eye that adjusts the size of the pupil over about a 1 to 4 ratio of diameters or 1 to 16 ratio areas, in rough accordance inversely with the luminance of the stimulus. In terms of *f*-numbers, the human eye has a range of approximately *f*/2 to *f*/8. *L. Stroebel and R. Zakia*

See also: *Vision, the human eye.*

IRIS DIAPHRAGM Standard form of adjustable aperture stop for a lens. Consists of a number of thin metal or plastic leaves arranged to form a roughly circular aperture. The aperture size can be varied by the radial movement of a coupled lever. This action can be automated for viewfinding, focusing, and exposure purposes. *S. Ray*

IRIS WIPE A motion-picture transitional effect with an expanding or contracting circular boundary between the two scenes. *H. Lester*

IRON OXIDE The active ingredient in a magnetic coating for audio and video tape or film. *T. Holman*

IRON PROCESSES See *Iron salt processes.*

IRON SALT PROCESSES Photographic processes utilizing the action of light on ferric salts that are reduced to the corresponding ferrous salts. The latter act as an intermediary in forming a visible image. Thus it can be converted into Prussian blue (blueprint process) or used to reduce silver salts in the emulsion to silver (Kallitype and other iron-silver processes) or to reduce palladium or platinum salts (palladiotype and platinotype). In the Pellet process, a variation of the blueprint process, the *un*exposed iron salts are converted into Prussian blue, rather than the exposed salts, to form the image. Yet another type of iron salt process is based on insoluble colored compounds formed by ferric salts with gallic or tannic acid (ferro-gallic and ferro-tannic processes). *J. Natal*

IRRADIANCE (E) A measure of radiant power per unit area incident on a surface $d\Phi/dA$. The preferred unit is the watt per square meter (W/m2). The analogous measure of luminous power per unit area incident on a surface is illuminance.

Note that while the dimensions of irradiance are the same as those for radiant exitance (radiant power per area), they refer to different processes. The area in the definition of irradiance is that *receiving* power, while in exitance, it refers to the area *emitting* power. *J. Pelz*

See also: *Photometry and light units; Radiometry.*

IRRADIATION The process of radiant flux falling on a surface, analogous to illumination for luminous flux. In photography, the term also refers to the spread of light within the emulsion layer of film or paper. The spreading is caused by scattering and absorption of the crystals within the suspension, resulting in lowered contrast and resolution. The image quality degradation due to irradiation is a function of many factors, including emulsion thickness, special-purpose emulsion additives, and choice of silver halide. Irradiation is reduced in thin emulsion coatings, though sensitivity is reduced. Dyes or particles added to the emulsion absorb scattered light to reduce lateral image spread, again at the cost of reduced sensitivity. Conversely, light-scattering particles can be incorporated in the emulsion to increase the probability that a photon will strike a silver halide crystal at the expense of reduced resolution and contrast. Because scatter is a function of refractive dispersion in particulate systems, silver chloride emulsions suffer less from irradiation effects than do silver iodide and silver bromide emulsions. *J. Pelz*

See also: *Halation.*

ISOCHROMATIC LINES Term used in photoelastic stress analysis for the colored interference fringes produced in birefringent materials under load. Their direction indicates the loci of zones of equal strain and the number and color of the relative strains in different parts of the specimen. *S. Ray*

See also: *Photoelastic stress analysis.*

ISOCLINIC LINES Term used in photoelastic stress analysis for the dark interference fringes produced in birefringent materials under load. They show the direction of the stress and can be subdued by use of circularly polarized light and quarter wave plates in the polariscope for improved analysis of the isochromatic lines. *S. Ray*

See also: *Photoelastic stress analysis.*

ISODENSITOMETRY The measurement of a photographic image with a recording microdensitometer that provides a display of contours of equal density in the image. It detects very small differences in the photographic record and assists in the recovery of information. A line of uniform density is called an isohelie or an isophote. *M. Leary and H. Todd*

ISOELECTRIC POINT The isoelectric point (IEP) occurs at a certain solution condition at which a molecule or crystal has a net charge of zero. With gelatin in water, the isoelectric point is the pH value when the negative and positive charges on the molecule are equal in number. The molecule is then in a condition of lowest solubility and greatest compactness. The IEP of a silver halide crystal is the silver ion activity (pAg) when the net electrical charge on the crystal is zero. *G. Haist*

ISO FILM SPEED See *Film speed*.

ISOHELIE See *Isodensitometry*.

ISOING In emulsion making, adjusting the pH of the emulsion to its isoelectric point so that the silver halide grains can be separated from the gelatin.

ISOMERIC PAIR Two colored samples that have identical spectral reflectance or transmittance distributions, so that they match under all conditions of viewing. *R. W. G. Hunt*
See also: *Metamerism*.

ISOPHOTE See *Isodensitometry*.

ISO STANDARDS See *Appendix X*.

ISOTOPES Isotopes are atoms of a chemically inseparable element varying slightly in weight because of different numbers of neutrons in the nucleus of the atom. All natural elements are a mixture of two or more isotopes derived by different routs of radioactive decay, resulting in an automatic weight that is an irregular number. *G. Haist*

IVES, FREDERIC EUGENE (1856–1937) American photographic inventor. Among his 70 U.S. patents are many concerning improvements in the halftone process, the most important being the cross-line screen introduced in 1886. Also a pioneer in color photography. Invented a series of cameras, beginning in 1892, that produced a color image via three transparencies viewed all together with the assistance of a special viewer or projector. Performed basic research in the field of subtractive color during the 1920s that was essential to the development of Kodachrome film in 1935.
 M. Alinder

IVORYTYPE Frederick Wenderoth introduced the ivorytype in the United States in 1855. A photographic image was transferred to imitation ivory or to a sheet of glass backed with ivory-colored paper in an attempt to duplicate paintings done on ivory. *J. Natal*

J Joule
JISC Japanese Industrial Standards Committee
JND Just-noticeable difference
JPEG Joint Photo Experts Group

JACKSON, WILLIAM HENRY (1843–1942) American photographer. In a long and very productive life, Jackson, a western landscape photographer, produced many thousands of stereotypes and small album-sized prints as well as mammoth plates. Appointed the Hayden Survey's official photographer (1870–1878), making the first photographs of the Yellowstone area (1871), which, when shown to Congress, proved important to the establishment of Yellowstone as the first national park (1872). Produced an impressive document of Native Americans, their portraits and dwellings, and also photographed for the railroads.

Books: Newhall, Beaumont, and Edkins, Diana E., *William H. Jackson.* Fort Worth: Amon Carter Museum, 1974; Hales, Peter B., *William Henry Jackson and the Transformation of the American Landscape.* Philadelphia: Temple University Press, 1988.
M. Alinder

JACOBI, LOTTE (1896–1990) American photographer. Born into a family of photographers, Jacobi escaped Nazi Germany in 1935. From 1927 to 1935, she established herself as a preeminent portrait photographer in Berlin, sought after by artists, dancers and theater people. With her sister, opened a studio in New York (1935–1955). Admired for her portraits of Einstein made between 1927 and 1938.

Books: *Lotte Jacobi.* Danbury, NH: Addison House, 1978.
M. Alinder

JAMMING Jamming occurs when film fails to transport in a camera or projector and may result in a pile-up or damage. Sometimes damage is also inflicted on the camera or projector. It can be caused by poor film friction, excessive brittleness, improper splices, or improper dimensioning. These conditions, in turn, can be aggravated by low temperature, low or high relative humidity, or improper maintenance of equipment.
I. Current

JAPANESE INDUSTRIAL STANDARDS COMMITTEE (JISC) The national standardizing organization of Japan.
P. Adelstein

JELLY See *Gel.*

JENA GLASS Optical glasses of low dispersion relative to their refractive indices, first introduced by Carl Zeiss in Jena, Germany, as manufactured by Schott after research by Ernst Abbe. The first anastigmatic lenses were then possible.
S. Ray

JET SPRAY Agitation in which the processing solutions are forced against the film through a nozzle in a forceful stream.
L. Stroebel and R. Zakia
See also: *Spray processing.*

JITTER Irregular unsteadiness of the film in a motion-picture camera or projector, or jerky movement due to faulty animation or camera work.
H. Lester

JOHNSTON, FRANCES BENJAMIN (1864–1952) American photographer. Often called the first woman press photographer. Gifted with a Kodak Box Brownie by Eastman (1880). Studied photography with T. W. Smillie at the Smithsonian Institution. Opened a portrait studio in Washington, D.C., in the early 1890s. Became the unofficial presidential photographer during the Cleveland, Harrison, McKinley, Roosevelt, and Taft administrations. Commissioned to produce such photo-essays as her straightforward and appealing presentation of the Hampton Institute, Virginia (1900).

Books: Daniel and Smock, *A Talent for Detail, The Photographs of Miss Frances Benjamin Johnston.* New York: Harmony Books, 1974.
M. Alinder

JOLY, JOHN (1857–1933) Irish physicist and inventor. Beginning in 1894, developed the first color photographic process that produced an actual color print without the need for viewers or projection. Though of limited success, this line-screen process was the forerunner of many other additive color processes, such as Dufaycolor.
M. Alinder

JONES DIAGRAM See *Quadrant diagram.*

JOYSTICK A vertical shaft that directs the cursor on a computer monitor. A sophisticated joystick may also contain buttons for the activation of special features, and some joysticks are pressure sensitive. Joysticks for the most part are attached to game ports and are most useful in the playing of computer games.
R. Kraus

JUDD CORRECTION Modification of the $V(\lambda)$ function to correct the low values at wavelengths below 460 nm. The CIE has standardized this corrected function as the *CIE 1988 2° Spectral Luminous Efficiency Function for Photopic Vision,* with the symbol $V_m(\lambda)$. This modification is a supplement to, not a replacement of, the 1924 CIE $V(\lambda)$ function to which the $\bar{y}(\lambda)$ function is still identical.
R. W. G. Hunt

JUDGE/JUDGING A photography judge is a person who evaluates photographs, especially in connection with the showing of prints and transparencies. Generally, it is assumed that the judge is qualified by experience and education to make a judgment, and has no direct or personal

interest in the exhibition. The responsibility of the judge is to fairly consider the entries submitted, and to select those that possess the highest merit.

Generally, merit is determined by established criteria and standards of excellence. Obviously there is some degree of latitude among the various types of exhibits: from the large-scale museum exhibitions, to commercial galleries, to local camera clubs, but whatever the constituency of the group, some criteria of merit are required in order to establish objectivity. *R. Welsh*

See also: *Jury.*

JUICER Motion-picture production slang term for an electrician. *H. Lester*

JUMBO SLIDE Jumbo or superslides offer more image area than standard 35-mm slides. The standard 35-mm slide frame opening is 23×34 mm, while that of a standard superslide is 38×38 mm. Both superslide and standard 23×34 mm transparencies are encased in 2×2-inch slide mounts and will fit into standard 35-mm projectors. The surface area of a superslide is almost 85% larger than the standard slide. The major advantage of the larger slide is the image size. Because less magnification is required, image brightness increases, which is especially important in high ambient light situations, and the images are sharper.

Using $2\frac{1}{4} \times 2\frac{1}{4}$ (6×6 cm) or $2\frac{3}{4} \times 2\frac{3}{4}$ (7×7 cm)

transparencies provide still greater increases in surface area, but these transparencies require medium-format projectors.
M. Teres

JUMP Extreme unsteadiness of a motion-picture projection. *H. Lester*

JUMP CUT In motion-picture editing, a cut that breaks continuity by jumping forward from one part of an action to another that is obviously separated from the first by an interval of time. *H. Lester*

JURY A group of judges—persons who make judgments on photographic quality. The persons may be experts who choose prints for hanging in a salon, an exhibition, or a museum, or may be selected as typical of a group of potential customers. *R. Welsh*

JUST-NOTICEABLE DIFFERENCE (JND) The smallest difference between two stimuli that an observer can detect. As applied to vision, the smallest detectable change in luminance, hue, size, shape, or other attribute of the stimuli. In terms of density, a difference in density of about 0.004 is detectable at the optimum light level.
L. Stroebel and R. Zakia

See also: *Detection; Subliminal; Visual acuity; Visual perception, perceptual discrimination.*

K Kelvin
k Kilo
kb Kilobit
kB Kilobyte
kg Kilogram
kHz Kilohertz
kW Kilowatt

KALVAR PROCESS Proprietary name of a low-speed, heat-developable, light-scattering photographic system. The image is produced by the decomposition of diazo compound in a plastic layer, liberating nitrogen. On heating, the nitrogen forms minute bubbles in the plastic layer, producing a vesicular light-scattering image. *J. Natal*

See also: *Diazo processes; Vesicular process.*

KARSH, YOUSUF (1908–) Canadian photographer. Born in Armenia, he escaped the Turkish persecution, emigrating to Canada in 1924. Apprenticed to a photographer in Boston, he returned to Ottawa in 1932 where he opened his portrait studio that remains his home base. Known for his portraits of the powerful and famous, including his 1941 *Life* cover of the imposing and bulldog-faced Winston Churchill.

Books: *Karsh, A Fifty-Year Retrospective.* Boston: Little, Brown, 1983. *M. Alinder*

KASEBIER, GERTRUDE (1852–1934) American photographer. After raising a family, began the study of art (1888). Within five years focused on photography, opening a New York portrait studio (1897). Known for her sympathetic portraits of women with children. Produced platinum, gum-bichromate, bromoil, and silver prints. Founding member with Stieglitz and others of the Photo-Secession in 1902. Stieglitz promoted her work, reproducing it in *Camera Work.* Eventually, in reaction against Stieglitz's definition of straight photography, formed the Pictorial Photographers of America in 1916 with Coburn and C. White.

Books: Caffin, Charles H., *Photography as a Fine Art.* New York: Doubleday, 1901 and 1972; Michaels, Barbara L., *Gertrude Kasebier, The Photographer and Her Photographs.* New York: Harry N. Abrams, 1992. *M. Alinder*

KEEPING QUALITY The stability of photographic chemicals, processing solutions, or sensitized materials with time. *K. B. Hendriks*

KELVIN (K) A temperature scale having its zero at –273.16°C, and scale intervals equal to those of the Celsius scale. The color temperature of light sources is given in kelvins, for example 3200 K. *H. Todd*

See also: *Color temperature.*

KERNEL A targeted group of pixels in a closely defined array that can be convolved, i.e., evaluated with weighted coefficients. The value of each pixel in the kernel is dependent upon its neighbors. The array of weighted coefficients is called a mask. The size of the mask is the same as the kernel. In many texts the terms *kernel* and *mask* have become interchangeable. *R. Kraus*

KERNING The adjustment of the space between type characters to improve their visual appeal. Certain page layout programs, including QuarkXPress, and languages such as PostScript allow desk-top publishing to adjust spacing. *R. Kraus*

KERR CELL A non-mechanical shutter that consists of a glass cell filled with nitrobenzene of undecyl alcohol and placed between a pair of crossed polarizing filters. No light is transmitted until a high voltage pulse is applied to electrodes in the cell. This causes the liquid to become birefringent, whereby the plane-polarized light entering the cell becomes circularly polarized (the Kerr effect), enabling it to pass through the second polarizer and into the camera lens. Exposure times as short as 1/200,000,000 second are possible. A Kerr cell activated by a high frequency oscillating circuit can be used in ultra-high-speed cinematography as an intermittent shutter operating at up to 10^9 times per second. *J. Johnson*

KERTÉSZ, ANDRÉ (1894–1985) American photographer. Began photographing the daily life about him in 1911 in his hometown, Budapest, Hungary. Worked in Paris (1925–1935) as a freelance photojournalist. Kertész chose to use small-format cameras and make black-and-white prints, his camera always at the ready to catch the chances and happenings of everyday life. His photographs, though, do not have a snapshot quality, but are formal compositions. Subject matter included nude distortions, portraits, still lifes, and street scenes. As a friend of such artists as Chagall and Mondrian, he was able to photograph them and their studios, producing many unforgettable images, including *Chez Mondrian* (1926) and *Chagall in His Studio* (1933). His work inspired Cartier-Bresson and Brassai. Traveled to the United States in 1936, becoming a U.S. citizen (1944). Signed an exclusive contract with Condé Naste Publications (1949–1962). From that time until his death, he returned to his own creative work, publishing many books and portfolios.

Books: *André Kertész, Diary of Light, 1912–1985.* Millerton, NY: Aperture, 1987. *M. Alinder*

KEY (1) The dominant balance of tones in a photograph, such as high key and low key, which see. (2) The light source that dominates the lighting of a subject or scene and determines the shape and location of the major shadows and

highlights. Typically the light source that produces the highest level of illumination on the subject, as distinct from fill light, background light, etc. *L. Stroebel*

KEYING Keying is the act of combining pictures from one signal source into a picture sourced from a different signal. Keying can be controlled by frames or by color, such as chromakeying. *R. Kraus*

KEY LIGHT The dominant light in a lighting setup, as distinct from fill light, background light, hair light, etc.
F. Hunter and P. Fuqua
Syn.: *Main light*.

KEYLINE In photomechanical reproduction, an outline drawing, usually on a tissue overlay, indicating shape, position, and size of image elements and instructions for special handling or operations. *M. Bruno*

KEYPLATE The plate in printing, usually with the most detail, with which the other color plates are registered.
M. Bruno

KEYSTONE EFFECT A convergence of parallel subject lines in the image when a camera or projector is tilted up or down. Elimination of convergence in a camera requires the film plane to be parallel to the subject, and elimination in a projected image requires the transparency to be parallel to the projection screen. *L. Stroebel*
See also: *Perspective-control lens*.

KEY TRIANGLE An inverted triangular highlight falling on a model's eye and cheek, the key triangle provides guidance as to where to place the main light when taking portraits. Its analysis reveals several common portrait lighting problems. *F. Hunter and P. Fuqua*

KICKER A light source used to produce a highlight in addition to that caused by the main light. Highlights produced by kickers are usually small. If the kicker highlight occurs inside the larger main-light highlight, there is an illusion of brilliance that could not be produced by the main light alone without overexposure of the subject.

Placement of the kicker is usually to the rear of the subject. This is partly to keep the kicker from illuminating too large an area of the subject. Such an angle is also likely to produce some direct reflection that, because of its brightness, makes a kicker of greater intensity unnecessary.
F. Hunter and P. Fuqua

KILL A slang term used as an order to turn a light off in a lighting setup. *F. Hunter and P. Fuqua*

KINK MARKS A kink mark is produced when a film or paper is locally stressed before processing. The strength and polarity (dark or light compared to the surrounding area) of the mark is affected by the relative humidity at the time of the stress, and by whether it was made before or after exposure to light. Kink marks commonly occur when roll film is improperly loaded on a processing reel, or when film or paper is bent sharply in a local area because of careless handling. *I. Current*

KINK SITE A site on the (100) surface of an ionic crystal in which three of its neighbors are missing relative to the same ion located inside the crystal. Because of the missing neighbors which would be oppositely charged, it has a net charge of ±1/2, depending on the ion at the kink site. On silver bromide surfaces the positive kinks are silver ions and the negative kinks are bromide ions. The excess charge allows the kink sites to attract electronic carriers, electrons, or holes of the opposite sign and act as shallow trapping sites. *R. Hailstone*

KIRCHOFF'S LAW Consists of two rules that may be applied to analyze any simple circuit consisting only of batteries and resistors (no AC capacitances or inductances):

1. The sum of the potential drops around any circuit loop must equal the sum of the potential increases.
2. At a junction point in a circuit where the current can divide, the sum of the currents into the junction must equal the sum of the currents out of the junction.

J. Holm

KIRILIAN PHOTOGRAPHY In Kirilian photography, a high-frequency voltage is used to create images in silver halide photographic film. The process does not involve an exposure of the object. In the usual arrangement, one of the electrodes is the object which is at ground potential. The second electrode is a metal layer on a glass plate. Between the electrodes, a photographic emulsion lies on the glass plate. A high voltage pulse is then applied to a metal electrode that lies under the glass plate. This kind of experimental apparatus is usually described as a Kirilian generator. Kirilian photographs of objects surrounded by air show blue and white auras analogous to Lichtenberg figures. While all objects give a Kirilian aura, the aura of nonliving objects is constant over time while that of living creatures is time-dependent. The aura from humans appears to be related to the mental, emotional, and physical health of the subject being photographed. It has been claimed that these auras can be used as a means to detect illness in living substances before other symptoms are visible. Kirilian photographs may be of potential interest as a diagnostic tool for medical purposes as well as nondestructive testing of other materials. While not completely understood, it is generally accepted that the images created in Kirilian photographs are due to light produced by electrical discharges in air and a flow of charged particles from the charged object to the photosensitive layer. The radiation produced by the discharge is usually described as the primary radiation while the flow of charged particles is described as the secondary radiation. The secondary radiation is believed to occur only from the surface of biological objects subject to stress. Kirilian photography has also been described as corona-discharge photography, plasma photography, Kirilian electrophotography, and Kirilian electrography. *P. Borsenberger*

KLEIN, WILLIAM (1928-) American photographer, filmmaker, and painter. Has lived in Paris since 1948. Klein has published a series of photographic books of cities—New York (1956), Rome (1959), Moscow, and Tokyo (both 1964), though far from the usual guidebook vision. His grainy, black-and-white photographs are aggressively abrasive, with nothing to soften the realities of urban life except for the spirit of the people portrayed. *M. Alinder*

K MOUNT See *Bayonet mount*.

KODACHROME (1) Pioneer color transparency film of the integral-tripack, nonsubstantive, subtractive color type. Invented by two musicians, Leopold Mannes and Leopold Godowsky of New York City in 1933, and introduced by Kodak in 1935. It quickly became the standard of comparison for transparency materials. It was eventually offered as 8-mm and 16-mm motion picture film, in short 35-mm rolls for miniature cameras, and in sheet sizes to 11 × 14 inches. Sheets were discontinued in 1955. Kodachrome film has a simple three-layer structure, each layer merely recording one

of the three additive primaries, blue, green, or red. The processing, however, is very lengthy and complex. An initial black-and-white development of all three layers to separation negatives is followed, along with other steps, by individual color development of each layer in the sequential presence of yellow, magenta, and cyan color couplers in the solutions. The process has varied over the years, but always involves over a dozen baths and multiple re-exposure steps; hence, very few laboratories are equipped to process Kodachrome films. (2) An obsolete two-color process intended for portraiture. Bipack negatives were made in a conventional camera, or in a special beam-splitting camera with separation filters. Primaries used were a brick-red and a blue-green. Flesh tones were remarkably good, but the process was never commercialized (Capstaff, 1915, Eastman Kodak Company). *M. Scott*

See also: *Transparency materials.*

KODACOLOR

(1) The name for integral tripack, substantive, films and papers in a negative-positive color process primarily for making subtractive color prints. They are the basis of a snapshot color system. (Other similar, but not identical, materials for professional use are called Ektacolor.) Both Kodacolor and Ektacolor negatives are, like all negatives, reversed in tones: bright objects appear dark and vice-versa. Colors appear as their complements, but not exactly. The color couplers in the film are themselves colored in such a way as to mask unwanted absorptions by the dyes themselves. This makes the negatives difficult to interpret visually, but renders any prints made from them much truer in color reproduction (Eastman Kodak Company, 1949). (2) An obsolete additive color process on 16-mm lenticular motion picture film, first sold in 1928, based on the Keller-Dorian patents. Special tricolor filters in the additive primaries were placed over the camera and projector lenses. The effective ISO speed was about 0.5, and the projected image on the screen was not very bright. The colors, however, were amazingly good. There was little interest in it after the introduction of Kodachrome film in 1935. *M. Scott*

KODAK

About 1877, George Eastman, a young bank clerk in Rochester, New York, began to plan for a vacation in the Caribbean. A friend suggested that he take along a photographic outfit and record his travels. The "outfit," Eastman discovered, was really a cartload of equipment that included a light-tight tent, among many other items. Indeed, field photography required an individual who was part chemist, part tradesman, and part contortionist, for with *wet* plates there was preparation immediately before exposure and development immediately thereafter—wherever one might be.

Eastman decided there was something very inadequate about this system. Giving up his proposed trip, he began to study photography. At that juncture, a fascinating sequence of events began that led to the formation of the Eastman Kodak Company.

Before long, Eastman read of a new kind of photographic plate that had appeared in Europe and England. This was the dry plate—a plate that could be prepared and put aside for later use, thereby eliminating the necessity for tents and field-processing paraphernalia. The idea appealed to him. Working at night in his mother's kitchen, he began to experiment with the making of dry plates. He had no scientific training, but he was methodical, precise, and ingenious.

Out of his experiments came a successful series of dry plates and, more important, an idea for a machine to make them uniformly and in quantity.

Because London was the center of the photographic and business world, Eastman went there in 1879 to obtain a patent on his plate-coating machine. An American patent on it was granted the following year.

In 1880, George Eastman rented a third-floor loft in Rochester and began to manufacture dry plates commercially. The success of this venture so impressed Henry A. Strong, a hard-headed businessman who roomed with the Eastmans, that Strong invested some money in the infant concern. On January 1, 1881, Eastman, together with Strong, formed a partnership called the Eastman Dry Plate Company.

In 1884, Eastman startled the trade with the announcement of film in rolls, with a roll holder adaptable to nearly every plate camera on the market. He dreamed of making photography available to everyone. With the No. 1 Kodak camera in 1888, he laid the foundation for fulfilling his goal.

The Kodak camera was a light, portable instrument that could be easily carried and hand held during operation. It was priced at $25 and loaded with enough film for 100 exposures. After exposure, the camera and film were returned to Rochester. There the film was developed, prints were made, and new film was inserted—all for $10.

In 1884, the Eastman–Strong partnership had given way to a new firm—the Eastman Dry Plate and Film Company—with 14 shareowners. A successive concern—the Eastman Company—was formed in 1889.

The company has been called Eastman Kodak Company since 1892, when Eastman Kodak Company of New York was organized. In 1901, the present firm—Eastman Kodak Company of New Jersey—was formed under the laws of the State of New Jersey.

Eastman had four basic principles for the business: mass production at low cost; international distribution; extensive advertising; and finding and meeting the needs of customers.

Today, these principles are generally understood and accepted, but in 1880 they were novel. Eastman saw them as closely related, for mass production could not be justified without wide distribution, which in turn, needed the support of strong advertising. From the beginning, he imbued the company with the conviction that fulfilling customer needs and desires is the only road to corporate success.

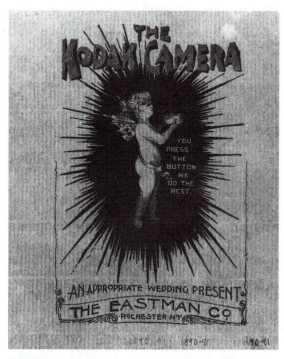

Kodak ad, 1890. (Courtesy of Eastman Kodak Company.)

To Eastman's basic principles of business, he added these policies: foster growth and development through continuing research; treat employees in a fair, self-respecting way; and reinvest profits to build and extend the business. The history of Eastman Kodak Company is, indeed, one of progress in development of these basic principles.

From the nineteenth century on, some great photographic discoveries occurred in Europe. Niépce and Daguerre in France, Talbot in England, and others laid the foundations for the techniques leading to present-day photography. By the time George Eastman launched his dry-plate business in 1880, European interest in photography was keen, but its practice was limited to professionals.

Eastman early recognized the potentialities of the world market. Only 5 years after the company was established in the United States, a sales office was opened in London. Within the next few years, particularly after the introduction of the Kodak camera and Eastman's simplified methods, picture-taking became popular with hundreds of thousands of amateurs.

By 1900, distribution outlets had been established in France, Germany, Italy, and other European countries. A Japanese outlet was under consideration, and construction of a factory in Canada was under way with the organization of Canadian Kodak Co., Ltd.

The Rochester Export Territory was established in the early 1900s for the distribution of Kodak materials to South America and to the Far East. Service to the Orient was broadened in 1907 when a small photographic-plate manufacturer in Australia joined Kodak to form Kodak (Australasia) Pty. Limited.

Kodak Pathe of France was added in 1927 and today has factories at Vincennes, Sevran, and Chalon-sur-Saone occupied with the manufacture of Kodak photographic products. The formation in Stuttgart, Germany, of Kodak A.G. also occurred in 1927.

These are highlights of the growth that has contributed to the effective distribution in domestic and world markets. Today, Kodak products are marketed by Kodak companies in 40 countries and by distributors in almost every nation and territory in the free world.

George Eastman's faith in the importance of advertising, both to the company and to the public, was unbounded. The very first Kodak products were advertised in leading papers and periodicals of the day—with ads written by Eastman himself.

By 1889, the slogan "You Press the Button, We Do the Rest," coined by Eastman with the introduction of the No. 1 Kodak camera, was becoming well known. Later, with advertising managers and agencies carrying out his ideas, magazines, newspapers, displays, and billboards bore the Kodak banner. Space was taken at world expositions, and the "Kodak Girl," with the style of her clothes and the camera she carried changing every year, smiled engagingly at photographers everywhere. In 1897, the word *Kodak* sparkled from an electric sign on London's Trafalgar Square—one of the first such signs to be used for advertising. By 1899, Eastman was spending three-quarters of a million dollars a year for advertising.

Today, the trademark *Kodak*, coined by George Eastman in 1888, is advertised in more than 50 countries. George Eastman invented the name *Kodak*; he explained: "I devised the name myself . . . The letter K had been a favorite with me—it seems a strong, incisive sort of letter. . . . It became a question of trying out a great number of combinations of letters that made words starting and ending with K. The word *Kodak* is the result."

The distinctive Kodak yellow for packages of most company products is widely known throughout the world and is one of the company's most valued assets.

Official portrait of George Eastman, 1921. (Courtesy of Eastman Kodak Company.)

The wide variety of photographic products that Kodak markets stems directly from productive research. After the introduction of the first Eastman photographic dry plate in 1880, each successive year brought the presentation of new Kodak products; photography and the company's business forged ahead.

The year 1889 saw the introduction of the first commercial roll film of transparent nitrocellulose support; this was the film that Thomas Edison used to make his first motion picture. In 1896, Kodak perfected the first positive motion-picture film, a great boon to the emerging motion-picture industry. In 1908, the company manufactured its first nonflammable film using safety cellulose-acetate base. With continued research, this improved base became the standard for a wide variety of film products. Gradually, it replaced the highly inflammable cellulose-nitrate type.

In 1923, Kodak made amateur motion pictures practical with the production of 16-mm reversal film on safety base. Since 1928, experiments in the field of color photography have led to the continuous introduction of many new films and processes. The introduction of Kodachrome film in 1935 revitalized the world of photography. Further improvements in the first safety-base film enabled the company to switch the production of professional movie film wholly to safety base in 1951. More recently, Kodak films and equipment have found wide acceptance in the television industry, the data-processing field, and for missile and space projects.

In 1963 the company introduced Kodak Instamatic cameras and four cartridge-loading films designed to operate interchangeably. The cartridge-film pack eliminated the amateur snapshooter's perplexing problem—the difficulty of loading a roll of film.

In 1965, the instant-load idea was applied to home movies. The company introduced super 8 films in cartridges and a new family of Instamatic cameras. In the same year, the introduction of flashcubes further stimulated indoor picture-taking. Indoor color movies without movie lights became

practical in 1971. The next year marked the introduction of the popular Kodak Pocket Instamatic cameras.

In 1975, Kodak announced the introduction of the Ektaprint copier/duplicator, a plain paper copier that combined easy operation with speed and outstanding quality.

Kodak has made its facilities for research and production available to the government during war and peacetime. Kodak designed and built a special camera-and-film system used by the National Aeronautics and Space Administration in the Lunar Orbiter program to determine favorable sites for moon landings by American astronauts. The brilliant flight of Apollo II and the historic pictures of man's first steps on the moon were recorded on Kodak film. A camera designed and built by Kodak specifically for the Apollo mission was used to take closeup photographs of the lunar surface—in stereo and color—for scientific study.

Other significant developments in Kodak history include the following:

1923 Kodak made amateur motion pictures practical with the introduction of 16-mm reversal film on cellulose acetate (safety) base, the first 16-mm Cine-Kodak Motion Picture Camera, and the Kodascope Projector.

1929 The company introduced its first motion picture film designed especially for making the then-new sound motion pictures.

1932 The first 8-mm amateur motion-picture film, cameras, and projectors were introduced. That same year, George Eastman died, leaving his entire residual estate to the University of Rochester. In 1949, his Rochester home was opened as an independent public museum—the International Museum of Photography at George Eastman House.

1935 Kodachrome film was introduced and became the first commercially successful amateur color film, initially in 16-mm for motion pictures. Then 35-mm slides and 8-mm home movies followed in 1936.

1938 The first camera with built-in photoelectric exposure control was developed—the Super Kodak Six-20 Camera.

1942 Kodacolor Film for prints, the world's first true color negative film, was announced. Kodak's Rochester plants were awarded the Army-Navy "E" for high achievement in the production of equipment and films for the war effort.

1946 Kodak marked Kodak Ektachrome Transparency Sheet film, the company's first color film that could be processed by the photographer with newly marketed chemical kits.

1948 Kodak announced a 35-mm triacetate safety base film for the motion picture industry to replace the flammable cellulose nitrate base—and the industry rewarded the company with an Oscar for it two years later.

1952 Kodak received an Oscar for the development of Eastman Color Negative and Color Print films, introduced in 1950.

1958 The Kodak Cavalcade Projector, the company's first fully automatic color slide projector, was introduced. The Kodak X-Omat Processor reduced the processing time for x-ray films from one hour to six minutes. The company's first single-lens reflex camera, the Kodak Retina Reflex Camera, was manufactured by Kodak A.G. in Stuttgart, Germany. Kodak Polyester Textile Fiber, developed by Tennessee Eastman, was made available for use in clothing.

1960 Estar Base (a polyester film base) was introduced to give improved dimensional stability to Kodalith Graphic Arts Films. The Recordak Reliant 500 Microfilmer was introduced and was capable of photographing up to 500 checks or 185 letters in one minute.

1961 The company introduced the first in its very successful line of Kodak Carousel Projectors, which featured a round tray holding 80 slides.

1962 The company's U.S. consolidated sales exceeded $1 billion for the first time and worldwide employment passed the 75,000 mark. John Glenn became the first American astronaut to orbit the earth, and Kodak film recorded his reactions to traveling through space at 17,400 miles per hour.

1963 The line of Kodak Instamatic Cameras was introduced, featuring easy-to-use cartridge-loading film, which eventually brought amateur photography to new heights of popularity—more than 50 million Instamatic Cameras were produced by 1970.

1973 The company unveiled sound home movies with the introduction of two super 8 sound movie cameras and cartridge-loading super 8 film, magnetically striped for sound recording. Sales surpassed $4 billion.

1981 Company sales surpassed the $10 billion mark.

1982 Kodak launched "disc photography" with a line of compact, "decision-free" cameras built around a rotating disc of film. Kodacolor VR 1000 Film was introduced, utilizing a new T-Grain Emulsion technology that represented a major breakthrough in silver-halide emulsions.

1987 The company entered the electronic still-video market with seven products for recording, storing, manipulating, transmitting, and printing electronic still video images.

1990 The Kodak Photo CD system was announced as a consumer bridge between three very familiar—but formerly incompatible—systems: camera, computer, and television. Film images are transferred to a photo CD, allowing photographs to be viewed and manipulated on TV screens and computer monitors.

Over the years, Kodak has diversified beyond the conventional photographic field, expanding to office copiers, medical technology, chemicals, batteries, magnetic tapes and disks, and polyester textile fiber.

(Information taken from "Eastman Kodak Company: A Brief History" [October, 1983, Eastman Kodak Company] and "Journey Into Imagination: The Kodak Story" [© 1988, Eastman Kodak Company], provided courtesy of M. More, Eastman Kodak Company.)

KÖHLER ILLUMINATION In making photographs with a microscope, a lighting technique that produces a uniformly bright field with a light source of almost any type. A lens is used to focus the light on the substage condenser, which in turn focuses an image at the field (limiting) aperture on the specimen. *R. Zakia*

KOSTINSKY EFFECT See *Photographic effects.*

KRASZNA-KRAUSZ, ANDOR (1904–1989) British publisher and editor. Hungarian-born, he studied photography in Munich, entering publishing in 1925 in Berlin. Kraszna-Krausz began the professional film journal *Filmkunst* and also *Film fur Alle,* Europe's first magazine for the amateur filmmaker. Arrived in London in 1937, soon establishing Focal Press (1938), dedicated to publishing technical and scientific photographic and film books, including the *Focal Encyclopedia of Photography.* Focal Press has been one of the world's most active publishing houses, releasing well over 1200 titles, most by the acknowledged experts in each field. *M. Alinder*

KRON EFFECT See *Appendix A; Photographic effects.*

KWIK PRINT PROCESS A commercial color proofing system called Kwik Proof developed by Samuel Sacks in 1941 for commercial printers as a method to proof color reproductions. The same product was modified slightly for use by artists and released under the name of Kwik Print. The process uses the same principle as other pigment processes,

using a pigment suspended in a bichromated colloid, but
vinyl is the standard support, which allows short drying
times between each color application, and durability, which
facilitates numerous layers of color and multiple printings. A
broad range of pigments are available from which almost
any color can be derived. *J. Natal*

See also: *Pigment process.*

L Inductance; Luminance (L_v) or Radiance (L_e); Lambert; Long-exposure color film

l liter(s)

lab Laboratory

LATD Large area transmission density

lb Pound

LCD Liquid crystal display

LCL Lower control limit

LCLV Liquid crystal light value

LE Life expectancy

LED Light emitting diode

LIRF Low-irradiance reciprocity failure

lith Lithographic

LLL Low light level

lm Lumen

l/mm Lines per millimeter

lm-s Lumen-second

ln Natural logarithm

log Logarithm

lpi Lines per inch

lpm Lines pairs per millimeter

LS Long shot; Loudspeaker

LSF Line spread function

LUT Look-up table

Lvr Longitudinal video recording

LW Line work (file)

lx Lux (meter-candle)

lx-sec lux-second (meter-candle-second)

LACQUER See *Protective coatings.*

LAINER EFFECT The action of small amounts of alkali iodides in accelerating development by low-potential developers, such as hydroquinone, apparently by partially converting the surface of silver bromide grains to silver iodide.
R. Zakia

LAMBERT (L) A unit of luminance; the luminous intensity emitted or reflected from a surface per unit projected area. A surface whose luminance is 1 lambert emits (or reflects) 1 lumen per square centimeter into a hemisphere, and $1/\pi$ lumens per square centimeter per steradian [(lm)/cm$^2 \cdot$ sr)]. The preferred unit is the candela per square meter (cd/m^2, or nit). (1 L = $1/\pi \cdot 10^4$ cd/m^2). *J. Pelz*
Syn.: *Equivalent phot (obsolete).*
See also: *Luminance; Photometry and light units.*

LAMBERT-BOUGUER LAW See *Lambert's laws.*

LAMBERTIAN SURFACE A Lambertian surface or source provides uniform diffusion and exhibits constant luminance (and radiance) at any viewing angle. While there is no true Lambertian surface, some materials, such as pressed barium sulfate (BaSO$_4$), closely approximate the ideal surface. Because viewing a finite surface from a non-perpendicular angle reduces its projected area, the luminous intensity of a truly Lambertian surface must fall off at exactly the same rate as the projected area, that is, by the cosine of the angle of view. *J. Pelz*
See also: *Lambert's laws (2); Luminance; Photometry and light units.*

LAMBERT'S LAWS (1) The fraction of light absorbed by (and therefore the density of) a filter or other absorbing material is independent of the incident power and is directly proportional to the thickness of that material. The law predicts that densities of similarly colored filters are additive; for example, if three neutral density filters of d = 0.1, 0.3, and 0.6, were used in series, the total density would equal the sum: d = 1.0. If the materials have different spectral transmission characteristics, the law can be applied by adding the spectral densities. The law does not hold if there are multiple reflections between filters or if the material scatters or fluoresces. (2) The luminance (and radiance) of a Lambertian surface is constant, regardless of the angle from which it is viewed. While the luminous intensity per unit area of a Lambertian surface falls off as the cosine of the angle from which it is viewed, that is, $I_\theta = I_0\cos(\theta)$, the change in the surface's projected area cancels that loss. Surfaces with specular components do not obey this law. *J. Pelz*
Syn.: *(1) Lambert-Bouguer law; Bouguer's law.*
See also: *Lambertian surface; Luminance.*

LAMINAR LAYER A very thin layer, especially of a developing solution in contact with a photographic material being processed. The thickness of such a laminar layer affects the rate of penetration of developing chemicals into and out of the emulsion and thus affects the rate of development. Laminar flow involves the movement of a thin sheet of a fluid, as distinct from a turbulent motion.
L. Stroebel and R. Zakia
See also: *Agitation.*

LAMINATION Lamination is a process by which a photograph is bound between two layers, usually clear plastic, to protect it from dirt, fingerprints, and moisture. In the case of ID cards, the lamination process also inhibits changing or altering the photograph. Several different product lines are available for laminating photographs, and, as with dry-mounting materials, laminating materials come in both cold and hot mounting press varieties. Some laminating films, in addition to physically protecting the photograph, also provide ultraviolet radiation protection. In addition to protecting photographs from ultraviolet radiation, moisture, dirt, and

fingerprints, heavily textured laminating materials may also be used to enhance the aesthetic nature of a photographic image by providing a texture pattern that may enhance the mood of the photograph.

Cold laminating films are either clear or textured plastic materials with an adhesive coating on one side. These laminating materials must be applied with a professional laminating press unless the print is very small. Other types of laminating materials are designed to encase the print between two layers of the plastic laminate, one on the front of the print and one on the back of the print, which provide a better moisture-proof seal than single surface lamination. A greater degree of waterproofing and moisture protection is afforded if the laminate overlaps the print edge.

Heat-activated laminating materials are available in a variety of thicknesses and types of plastics. The type of laminating material selected determines the strength and rigidity of the photograph. The type of plastic used for laminating will affect the permanence or archival quality of the print; polyester and polypropylene films are best. Acrylic and polyvinyl chloride laminates will not last as long. The substrate to which the print is mounted will also provide additional rigidity, moisture protection, and strength. Nontextured aluminum or Lexan plastic sheets are smooth-surfaced rigid materials that are dimensionally stable and will not harm the print chemically, and they offer complete moisture protection. Some laminating services provide a felt or velvet backing to the laminate to prevent several stacked laminated prints from rubbing against each other and scratching the laminate surface.

Exhibitex A texturizing film material that allows the photographer custom surface finishing of the photograph. Textures such as linen, lace, or sand, can be imprinted onto the film during the processing, producing a one-of-a-kind surface. The surface can, however, be changed afterwards.

Print Guard—UV A vinyl laminating material available for surface and moisture protection for photographs. Laminates are also used for enhancing the photograph's surface texture.

Sealeze ThermaShield A clear polyester film with an optically clear, permanent adhesive that is designed for encapsulating photographic artwork such as transparencies, Cibachromes, Duratrans, and resin-coated prints. The material should be applied with a laminating press.

Seal-Lamin Pouches that are offered in pre-cut sizes of sturdy polyester films with a permanent, heat-activated adhesive coating on one side. These pouches provide an airtight and waterproof seal that can be written on with special water-soluble markers and then cleaned off. Because the materials are sealed permanently, the contents are tamperproof. These pouches are sealed with adhesives that bond at high temperatures, 260°F to 275°F and therefore are not recommended for photographs. *M. Teres*

See also: *Encapsulation.*

LAMP A source of artificial light, such as incandescent lamp. *R. Jegerings*

See also: *Light sources; Artificial sources.*

LAMPHOUSE Typically a light-tight and ventilated enclosure for the light source on an enlarger or projector. *L. Stroebel*

LAND, EDWIN HERBERT (1909–1991) American inventor and founder of Polaroid Corporation. Concentrated his research in the fields of vision, light, and optics. Held well over 500 patents, second only to Edison. Developed first light polarizer (1929) that was applied to sunglasses, windows, dyes, camera filters, and gunsights. Founded the Polaroid Corporation in a Cambridge, Massachusetts, garage

(1935) and built it into a $1.4 billion business by 1980. Best known for inventing instant photography, the Polaroid-Land process, introduced in 1948, in which a negative/positive sandwich was exposed in the camera, then extracted, automatically activating a chemical pod that developed the print. Within eight years, 1 million of these cameras were sold. Polaroid research brought out instant transparencies (1957), large-format Polaroid film packs (1958), Type 55 P/N film, which produced both a finished negative and print (1961), Polaroid Polacolor film (1963), and instant X-rays (1966). In 1973, Land introduced the simple-to-operate SX-70 camera system, that produced dry color prints. Land presented his ill-timed Polavision, instant silent motion pictures, in 1977, which was quickly eclipsed by the universal popularity of the video cassette recorder. Admired for his effective management style, Land created a model corporation, known for its high expectations of employee dedication and performance, as well as its responsibility and concern in return. Employed Ansel Adams as photographic consultant from 1948 until his death in 1984. Appointed by President Eisenhower to develop a high-altitude surveillance system (1954) that was used by the U-2 spy plane and by satellites. Known for his aphorisms, including, "Don't do anything that someone else can do" and "The bottom line is in heaven." Retired from Polaroid in 1982 to devote himself to pure research at the Rowland Institute for Science, which he had founded in 1980.

Books: Wensberg, Peter C., *Land's Polaroid.* Boston: Houghton Mifflin, 1987. *M. Alinder*

LANDOLT C A visual test target consisting of c-shaped figures of decreasing size rotated to place the openings in different positions. The visual ability measured with this test is that of localization, the ability to correctly identify the position of the opening. Other visual abilities that are related to visual acuity are detection, resolution, and recognition.

L. Stroebel

LANDSCAPE ORIENTATION In computers, a page format with the horizontal axis being the longer dimension, in contrast to portrait orientation. *R. Kraus*

LANDSCAPE PHOTOGRAPHY The landscape photograph is a pictorial representation of our natural and man-made environment, and landscape photographs are as diverse as the land itself. While landscape is generally recognized as being natural in character, landscape photographs often include people, buildings, and other man-made objects that lend interest to the composition.

Landscape photography has a long and noble history. One of the first photographs taken by Louis Daguerre is a daguerreotype made in 1839 of a Parisian view of *The Seine and the Tuileries.* This is possibly the beginning of urban landscape photography. The early exploratory photographers, such as Francis Frith, the Bisson brothers, Timothy O'Sullivan, and William Henry Jackson, created pictures of strange romantic lands that were new to the people of Europe and the United States. Jackson's photographs of Yellowstone were so impressive that they influenced Congress to create Yellowstone Park in 1872. These and many other photographers have helped to increase the public awareness of the beauty, wealth, and frailty of our environment.

LIGHTING The action of light on the landscape and the atmospheric conditions affecting that light are of paramount importance to the character of the photograph. To capture the decisive presence of light on the land is the challenge of the landscape photographer. The mood of the image is controlled by the direction, color, and quality of light. The direction of light might be front light, side light, or back light. Side lighting produces a three-dimensional quality by

enhancing shadows, form, and texture. The rich luminescence of front lighting (lighting from behind the photographer) emphasizes shapes and produces a more two-dimensional view of the land. Back lighting (lighting from behind the scene) increases the perception of contrast, depth, and texture. The quality of light is described in terms of soft and hard light. Hard light is usually strong directional sunlight that creates contrast and texture. Overcast skies produce soft nondirectional light that is excellent for photographing delicate texture and soft shadow detail, as is the soft light produced just before sunrise and shortly after sunset.

Many landscape photographers shoot during the morning or late afternoon when the sun is close to the horizon. This lighting creates long dramatic shadows and produces a warm red-orange glow that adds color and interest to scenes that might otherwise appear monochromatic. In comparison, the cooler colors of the midday sun and the sky introduce more blue light to the scene, especially in the shadows. The French Impressionist painter Claude Monet was so intrigued by the action of light and its color that he produced a study of light in a series of paintings titled *Haystacks.* These paintings expressed the different moods of light at midday, morning, and evening in sunlight, overcast lighting, and fog.

CAMERAS AND LENSES Any camera may be used for landscape photography. Although 120-mm and 35-mm formats are popular choices today, photographers in the second half of the nineteenth century used cameras as large as 20×24 inches. Following this tradition, photographers continue to work with large-format view cameras such as 8×10 and 4×5-inch formats. The larger size image provided by view cameras is excellent for recording fine subject detail and producing large prints, and the camera adjustments provide control over the plane of sharp focus and image shape to obtain desired effects.

A camera with interchangeable lenses is desirable because of the option of using different focal length lenses to obtain different sized images and angles of view from a given location. The normal focal length lens renders perspective of the scene similar to that experienced by a person standing in the same location. Wide-angle lenses are used to accentuate space and distance between objects, emphasizing the foreground. The larger angle of view of wide-angle lenses produces a broad panoramic view. Panoramic cameras that cover an even larger angle are sometimes used. The long focal length lens is used to bring distant objects closer and to eliminate unwanted areas of the composition. Its graphic compression of space has the opposite effect of the wide-angle lens.

FILTERS A variety of filters are used for landscape photography to control tonal values of a scene. When using black-and-white films, filters are used to lighten their own color and darken their opposite color. A green filter can be used on the camera to lighten green leaves that would normally appear dark in a print. Panchromatic films, which are highly sensitive to blue light, render blue sky lighter than normal. A yellow filter will darken the sky to its normal tonality. To further increase the contrast between blue sky and clouds, a red filter is used. Another filter that effectively darkens blue sky is a polarizing filter. This filter is used in color photography, where red and yellow filters cannot be used, not only to darken blue sky but to increase color saturation. Black-and-white and color infrared films, used with appropriate filters, can produce unnatural appearing but interesting landscape photographs.

Landscape photographers select the desired elusive qualities of light to define their subject, and their vision isolates the select portion of the landscape to be recorded. Ansel Adams framed the grandeur and beauty of wilderness areas of the American West, Minor White explored the mystical realm of nature, Edward Weston searched for truth and the essence of things in his natural surroundings, while Robert Adams revealed the intrusion of people into the landscape. It seems a very natural pursuit that photographers have recorded images of the land from the beginning of photography. *D. Defibaugh*

See also: *Nature photography.*

LANGE, DOROTHEA (1895–1965) American photographer. Studied photography with Arnold Genthe (1915) and Clarence White (1917–1918). Opened a portrait studio in San Francisco (1919–1934). In 1932, as the Great Depression deepened, Lange felt she must take her camera from her studio into the streets where she recorded strikes, demonstrations, and lines of the unemployed, such as *White Angel Breadline* (1933). A woman of great commitment, she dedicated her photography to social reform. Employed by the Farm Security Administration (FSA) from 1935 to 1942, establishing her reputation as one of America's most gifted photographers. On assignment, she photographed the entire United States excepting New England, producing a rich portrait of a poor America. Best known for her gripping images of migrant workers, including the iconic, *Migrant Mother* (1936). Tacked to her darkroom door was this quote by Francis Bacon, "The contemplation of things as they are, without error or confusion, without substitution or imposture, is in itself a nobler thing than a whole harvest of invention." During her remaining years, though slowed by illness, she traveled, taught, and worked freelance for *Life* and other publications.

Books: *Dorothea Lange, Photographs of a Lifetime.* Millerton, NY: Aperture, 1982; *An American Exodus,* with Paul Taylor. New York: Reynal & Hitchcock, 1939. *M. Alinder*

LAP DISSOLVE See *Dissolve.*

LARGE FORMAT A commonly accepted term for all still cameras using a film format of 4×5 inches or larger.
P. Schranz

LARTIGUE, JACQUES-HENRI (1894–1989) French photographer and painter. Raised in a wealthy French family, Lartigue was given a camera as a young child. Though his life as a photographer and a painter scanned many years, he is most fondly remembered for his charming childhood photographs, made between the ages of seven and twelve. Living a privileged life, he humorously recorded the astounding events as the century turned—the first motorcars and hot-air balloons—and the everyday quirks of life—his cousin skipping downstairs and a family friend plunging backwards into a lake.

Books: *Boyhood Photos of J.H. Lartigue, the Family Album of a Gilded Age.* Switzerland: Ami Guichard, 1966; *Diary of a Century.* New York: Viking, 1970. *M. Alinder*

LASER (light amplification by stimulated emission of radiation) A device that emits a beam of coherent, monochromatic, electromagnetic radiation in the visible or near-visible region of the spectrum. Lasers work because of the phenomenon of stimulated emission, whereby an atom in an excited state is triggered into emitting a photon by the incidence of a similar photon. With stimulated emission, the emitted photon has the same phase as the incident photon, i.e., the two photons are coherent. The laser concept is based on a large number of stimulated emissions occurring simultaneously.

The first operating laser was constructed by Theodore Maiman in 1960. It is interesting to note that the announcement of this invention was at a news conference; the paper that was to have announced the invention in a more conventional form having been rejected by the journal *Physical*

Review Letters. Maiman's device consisted of a small, cylindrical, synthetic, pale pink ruby rod containing a small amount of chromium oxide. The rod's end faces were polished flat, parallel, and normal to the axis. Then both were silvered (one only partially) to form a resonant cavity. The rod was then surrounded by a helical electronic flashtube. When the flashtube is flashed, a large number of the ruby molecules are forced into an excited state. Under normal conditions these spontaneously and randomly decay, producing monochromatic (694.3 nm) but incoherent light. In the laser, however, such large numbers of molecules are in an excited state that the first to decay stimulate emission of coherent light in the rest. The continuous beam of the laser is produced by repeatedly flashing the flashtube to pump the molecules back to the excited state as soon as they decay, thereby allowing for continuous stimulated emission.

J. Holm

See also: *Coherent light; Gas laser; Optical pumping.*

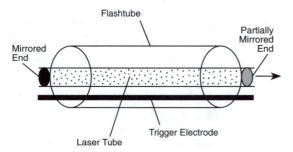

Laser. The flashtube keeps all the atoms or molecules in the laser tube at an excited state. The laser beam emerges from the partially mirrored end.

LASER POINTER A device, usually about the size of a large fountain pen, that is used to project a highly visible red dot onto an image or an object. The laser diode emits a beam of highly coherent and intense red light that is easily visible in either a daylight environment or in a darkened theater or lecture hall. This laser light beam can travel more than 200 feet with little dispersion or softening of the dot. The beam is so intense that the dot shows up easily on any surface, whether it is a flat two-dimensional object, a three-dimensional object, or an image that is projected onto a projection screen or wall. The laser pointer is battery powered, light in weight, and easily handled by a lecturer giving a presentation.

M. Teres

LASER PRINTER An output device that prints text and dithers images through the use of a laser light source and electrostatic imaging techniques. The RAMs in these printers process font data, the text itself, and direct the laser activity. The spot size of the laser will determine the resolution of the printer. Current printer standards are between 300 and 400 dpi.

R. Kraus

LATENSIFICATION Latensification, latent image intensification, and hypersensitization have as their objective the amplification of an image produced from a low luminance subject during an extended exposure. Hypersensitization is applied before exposure, and latensification is applied, as its name suggests, after exposure but before development. The techniques are similar, relying on exposure or chemical treatment. Outlined here are procedures that yield an increase in effective film speed of one to two stops.

A very low level uniform exposure to white light works selectively on the latent image. While an exposure slightly below the threshold of the film or plate does not create many new, developable points, it amplifies those parts of the emulsion that have already received an exposure above the threshold. Further, effective film speed is increased because some areas that received exposure below the threshold are raised by the intensifying exposure to measurable density. While fog level necessarily increases, an exposure determined by test to fall just below the toe of the characteristic curve will intensify appreciably more than it fogs.

Chemical latensification is more convenient than chemical hypersensitization because the film or plates need not be dried after the treatment. The effective sensitivity increase may be greater if drying follows the treatment, however. Triethanolamine is an effective latensifier. Film may be soaked in 1.5% hydrogen peroxide and washed thoroughly before development. A solution consisting of .5% each of sodium bisulfite and sodium sulfite may be used for up to five minutes, as may .5% solutions of potassium metabisulphite or sodium bisulphite with lessened effect.

Chemical vapors were used in the past for latensification, but the customary mercury vapor and sulfur dioxide present health hazards. Potassium metabisulfite fumes, also used for hypersensitization, may be effective, as may forming gas.

H. Wallach

See also: *Flashing; Gas hypersensitization/gas hypering.*

LATENSIFICATION EFFECT See *Photographic effects.*

LATENT IMAGE The latent image represents a recording of a scene by the photographic emulsion coating. It has the unique ability to cause an entire emulsion grain to develop when the exposed coating is placed in a photographic developer. This remarkable ability to induce a large discrimination between exposed and unexposed grains is what makes photography possible. Forming the latent image requires the absorption of photons, and this process ultimately leads to the conversion of a few silver ions of the emulsion grain into silver metal atoms. Upon development the entire grain can be converted into metallic silver, resulting in a large amplification factor of about 10^9.

Because of its relatively small size, determining the properties of the latent image with conventional analytical techniques is quite difficult. The latent image is too small to be observed by optical absorption or even in a transmission electron microscope. Elemental analysis is confounded by the large background signal of the lattice silver ions. Although some signals observed in electron spin resonance spectra of exposed silver halides have been attributed to silver formation, they cannot be related to a specific size. Thus, the most common way to detect the latent image is by photographic development, both conventional and unconventional. This is unfortunate since much of what we know comes from indirect evidence. Nevertheless, it will have to suffice until improved direct observational techniques become available.

PROPERTIES OF THE LATENT IMAGE

Composition The composition of the latent image is usually that of metallic silver atoms, but in some cases it consists of a mixture of silver and gold atoms. These metal atoms are bonded to each other, much the same as they would be in a chunk of silver metal or silver/gold alloy. They form small molecules or clusters. Evidence to support these statements comes from the strong catalytic nature of the latent image when it comes into contact with solutions containing reducing molecules such as those that act as development agents. Elemental analysis indicates that these agents reduce suitably exposed grains to silver metal. Whereas these agents are very ineffective at reducing photographic grains that do

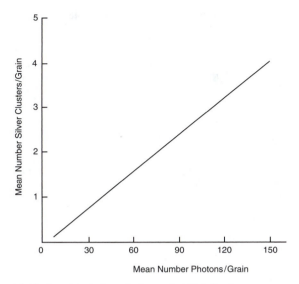

Distribution. A typical result observed at high illuminance exposures for chemically sensitized emulsions.

lates the exposing illuminance and produces a D-log H curve. Before development, however, the film is given an additional exposure without the step tablet. This second exposure is of very low illuminance and its main effect is to add electrons to the latent subimage and, with addition of silver ions to form silver atoms, enlarge the latent subimage to a size that will trigger development. This process is called light latensification and is a very important tool in understanding the properties of the latent image and latent subimage.

The extent of latent subimage formation is a function of several system variables—the type and level of chemical sensitization, the exposure illuminance, and the development conditions that influence the minimum developable size. Regardless of the cause, the presence of these latent subimages represent an inefficiency in the detection of recorded images. They represent information that is recorded, but not detected under normal exposure and development conditions.

Distribution Ideally, the photographic grain stores all the recorded information of the incoming photons in one site on the grain. For low levels of exposure this site may be a latent subimage. The grain simply has not received enough photons to lead to a latent image—a site that will trigger development. With additional exposure, this site is able to grow to a size that will trigger development. This ideal situation is, in fact, approximately realized for many conditions of exposure. When one considers that there are a large number of equivalent sites on a photographic grain where silver clusters can form, it is surprising that latent image formation is often restricted to a single site. Nevertheless, the mechanism by which these clusters form acts to limit their formation to one or at most a few sites when the exposing illuminance is low or intermediate, i.e., requiring exposures times of about 0.1 second or longer.

The main exception to this ideal situation is one in which a high-intensity light source, such as an electronic flash, is used. Then, depending upon how the emulsion grain was chemically sensitized after preparation, a number of metallic clusters can form. Many of these are of the latent subimage size, whereas others are of the latent image size. Thus, the recorded information is dispersed over a number of sites, and this represents an inefficiency. If a grain contains a number of latent subimages, but no latent image, then the grain has what is called a *dispersity inefficiency*. If those latent subimages could be collected in one site, they would become a latent image and the grain would be developable.

In summary, the size and distribution of photoproduced silver clusters depend strongly on the exposure intensity. In chemically sensitized emulsions, they vary from relatively large single developable clusters at low light levels to a multiplicity of small and sometimes developable clusters at high light levels. In unsensitized emulsions the variation in size and number with change in exposure illuminance is much smaller. This effect of chemical sensitization is due to its effect on the efficiency of latent image formation.

The effect of exposure level on the mean number of latent images per grain in chemically sensitized emulsions has been studied. At high light levels, a general trend is that the mean number increases linearly with increasing exposure level. This means that all the latent images form with equal efficiency. If it requires x photons to form one latent image, it will require $2x$ photons to form two latent images, etc. Evidently, the efficiency of formation of these latent images is not influenced by their number. The trends would be quite different of course at low light levels. Here there would be primarily one center per grain, as discussed.

Development The variation of silver cluster size with exposure illuminance produces some dramatic differences in development rates. Because the centers are large at low light

not have latent images—unexposed or subdevelopable grains—they easily reduce photographic grains that have latent images on them. Such a strong discrimination effect is most likely caused by small metal clusters acting as the catalytic sites for transfer of electron from the developer to the grain.

Further evidence that the latent image is composed of metallic silver comes from its reactivity to certain reagents known to oxidize metallic silver, such as dichromate bleaches. Although the quantitative aspects of the response to such reagents may be different for bulk silver and latent image silver, due to differences in the number of silver atoms present, the qualitative aspects are quite similar. Furthermore, when gold is a part of the latent image, as it appears to be when gold ions are included in the chemical sensitization of the emulsion, the bleaching solution must be of higher strength to accomplish a similar bleaching observed with a silver-only latent image. This is precisely the trend expected as gold is more resistant to oxidation than silver.

Although in the usual method of photographic development both the emulsion grain and its latent image are present, it is not a necessary requirement. The silver halide grain can be dissolved away with a fixing agent, and, if done carefully, the latent image remains in the coating. If such a coating is placed in a developer solution that contains silver ions, an image will be formed having characteristics very similar to those obtained with normal development. This is further evidence that the latent image is composed of silver atoms, as these would not be readily removed in the fixing step.

Size There is a threshold size of the latent image that is necessary to trigger the development reaction. The number of silver or silver/gold atoms that constitutes this minimum developable size cannot be given a definite value. It depends on how the photographic emulsion was chemically sensitized and on the nature of the development conditions—time, temperature, developing agent, pH, etc. However, selecting a range of three to six atoms will probably encompass most emulsion/developer situations.

Experiments involving double exposures have indicated that there are stable but undevelopable metal clusters. These are called the latent subimage. The experiment involves exposing the film coating through a step tablet that modu-

levels, the initiation of development is very rapid and a visible image appears relatively quickly. Conversely, at high illuminances the centers are small and near the threshold size for triggering development. The visible image appears rather slowly, but, given enough time, it will look similar to that observed at low illuminances. This means the photographic response will be a strong function of development time at high exposure intensities, but it will show little sensitivity to development time at low illuminances.

Occasionally photographic films are subjected to what is called *pushed development*. This just means that the development is extended to longer times than what would normally be used for a particular film/developer combination. The purpose of the pushed development is to induce a higher speed in the photographic response. Although such techniques are ultimately limited by an increase in fog, they can reveal additional image that was not detected at the normal development time. The basis for this effect lies in the development rate differences just discussed. By allowing the exposed film to remain in the developer longer, more time is available for the small cluster to trigger development. It also follows from our previous discussion that pushed development will have its greatest effect for high illuminance exposures and will be virtually useless for low illuminance exposures. Thus, the definition of the latent image as a size that will cause development becomes somewhat ill defined. It will strongly depend on the development time. What might be classified as a latent subimage at short development times may become a latent image at sufficiently long development times.

Location The location of the latent image can be either on the surface of the grain or somewhere in its interior. In some cases, where multiple latent images and latent subimages form, some could be at the surface, some in the interior. In general, internal latent image formation represents an inefficiency since virtually all commercial developers are only able to detect latent images located either at the surface of the grain or at most within a few atomic layers of the surface. As with the latent subimage, internal latent image represents information that is recorded but not detected. Internal latent image formation is promoted by the presence of internal lattice defects or impurities.

The only case where internal latent image is desirable is in direct reversal emulsions. In one example the image is formed by using the photoholes created upon exposure to oxidize surface fog centers so that a positive image is generated upon increasing exposure. In this case, the electrons are an unwanted by-product of exposure and are disposed of by allowing them to form internal latent image. In another example, the internal latent image is used to modify the electronic properties of the grain so that upon subsequent treatment in a reversal developer the unexposed grains will develop, but the exposed ones will not.

Stability The stability of the latent image is of importance in making silver halide photography practical. It is often desirable and necessary that development be delayed after exposure for days, weeks, months, or in some cases years. Any substantial loss of latent image by processes that effectively reverse the formation stage will result in significant degradation of the image. Fortunately, latent images are fairly stable with only modest precautions. A major reason for this property is that the gelatin plays a very important role as a protective colloid. The reverse of the formation step is essentially an oxidation process, so that the presence of oxidants must be avoided. The oxidation pathway is most likely enhanced by elevated temperature as is thermally induced ionization of the latent image site. Thus, the exposed film must not be subjected to elevated temperatures.

Much of the stability of latent images has to do with their energy levels. Silver halides are crystalline solids and therefore have energy bands. The import bands are the valence band, in which all the available electronic levels are filled, and the conduction band, in which all the available electronic levels are empty in the silver halides. Between these two bands lies an energy gap; electrons are not allowed to have energies within this range. However, it is permissible for localized sites, such as latent images, to have energies within the bandgap. Thus, latent images provide sites of reduced energy for the electrons.

Energy Levels vs. Size A long-standing question is: How do the energy levels of these latent images and latent subimages vary with the number of silver atoms in the cluster? Earlier researchers had suggested that the energy level decreases with increasing number of atoms and this would account for the increasing stability. At some point in the size series an energy would be reached at which electron transfer from developer molecules would occur readily. This would be the characteristic of the latent image.

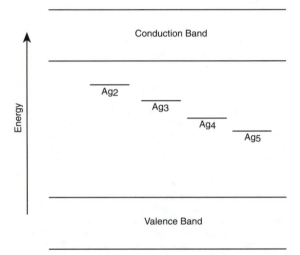

Energy levels vs. size. The variation of energy level with silver cluster size according to earlier researchers.

More recently researchers have realized this problem of energy levels should be treated by use of molecular orbital theory. This theory provides a way of relating the electron orbitals in the atoms to the newly formed electron orbitals in a molecule. Since the latent image can be viewed as a molecule composed of several silver atoms bonded together, this theory seems to be appropriate. When allowances are made for the interaction of the latent image with the underlying silver bromide crystal, the theory leads to a quite different picture of the energy levels showing that they oscillate in energy as the size is increased. This sort of behavior has been seen in silver clusters created in vacuum, but evidence for such an oscillation is inconclusive for photographically produced silver clusters.

MECHANISM OF FORMATION The key question to be addressed in understanding how the latent image forms is: How do the atoms of silver collect at one or perhaps a few sites? In other words, what is the aggregation mechanism at work? The details of this aggregation are controversial. Some researchers believe that silver atoms produced in different parts of the grain are able to diffuse to *special* sites where they form the latent image. However, this proposal is at odds with the general belief that single silver atoms are unstable. Evidence for the instability of silver atoms comes from the response of emulsion coatings to low illuminance

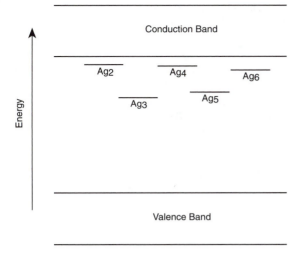

The variation of energy level with silver cluster size according to molecular orbital theory.

exposure. Under these conditions the sensitivity is reduced from that at higher illuminance, shorter time exposures and the loss of sensitivity increases with decreasing illuminance. This phenomenon is most easily explained by assuming some photoproduct is fading. Quantitative analysis of the phenomenon leads to the conclusion that the fading species is the silver atom. A corollary is that the next larger photoproduct, the two-atom silver center, is stable.

The more generally believed mechanism of aggregation is the collection of photogenerated electrons and silver ions at certain sites on or within the silver halide crystal. This was proposed by Gurney and Mott in the 1930s. Their view was that several electrons would be captured, and then an equivalent number of silver ions would be captured to form the silver atoms. The silver ions are obtained from ions that would usually be in lattice positions of the crystal but have left these sites and are diffusing through the crystal via interstitial positions—hence the name interstitial silver ions. Subsequently, Berg and Seitz modified this picture such that electrons and interstitial silver ions take turns being captured at the sites, which are now identified as surface defects with a partial positive charge.

The Gurney-Mott proposal with its subsequent modifications has become the basis of the nucleation-and-growth model of latent-image formation proposed by Hamilton. In this model the initial electron trapping and silver atom formation are considered reversible. The critical stage is the formation of the two-atom silver cluster, which is the smallest stable cluster. This step is called the nucleation step and is generally the major bottleneck in forming the latent image. Under virtually any reasonable development condition, this two-atom center is not developable. Thus, additional silver atoms must be added to the site and this occurs by alternate addition of electrons and interstitial silver ions. These events are collectively called the growth stage, which continues until there are no remaining electrons.

Double exposure experiments of the type discussed earlier have clearly shown that there are two distinct stages in latent-image formation and each stage has its own peculiar inefficiency. The nucleation-and-growth model is designed to account for this experimental result. Computer simulations based on this model have been very successful in explaining a wide variety of photographic properties of the silver halides. Although other models have been proposed, they have not undergone the extensive quantitative compar-

ison with experimental data that the nucleation-and-growth model has been subjected to. Until such comparisons are made, the nucleation-and-growth model will have to be considered the best model available.

EFFICIENCY OF FORMATION The efficiency of latent-image formation is a very important parameter in the photographic performance of silver halides. By efficiency we mean how many of the absorbed incoming photons actually contribute to forming the latent image. When the efficiency is measured for silver halide emulsions without any chemical sensitization, only a few percent of the absorbed photons contribute to the latent image. Since the efficiency is one of the primary controlling factors in determining photographic speed, emulsions without any chemical sensitization are not very useful for building camera-speed films.

We have previously mentioned some inefficiencies in latent-image formation—internal latent image and dispersity of the latent image at the surface. Another major inefficiency is recombination. The electrons and photoholes produced upon light absorption are able to recombine before the electron is able to participate in latent-image formation. This is a major inefficiency that must be minimized before practical photographic systems can be built. This has been accomplished by the process known as chemical sensitization. By adding certain reagents to the emulsion and heating for a period of time, sites are created at the grain surface at which latent-image formation becomes more efficient. Commercial emulsions have been optimally sensitized. They have a photon efficiency of about 20%, much better than the unsensitized emulsions. Nevertheless, they do waste about eight out of every ten photons they absorb. This means that the efficiency of the photographic process can be improved by a factor of five, resulting in even more sensitive film coatings. Such an improvement has been achieved in laboratory situations, but has not been converted to commercial use because of current practical limitations.

Another inefficiency is caused by the environment. Film coatings that have been placed in a vacuum for a period of time are more sensitive than those exposed to ambient conditions, particularly for long-time, low-illuminance exposures. Research has indicated that the O_2 and H_2O removed by the vacuum treatment are desensitizing the photographic emulsion. The mechanism proposed to explain this effect is that the O_2 may scavenge electrons trapped at surface sites on the grain. The role of water seems to be that of swelling the gelatin layer and thus providing a higher diffusion coefficient for the O_2. This type of desensitization is not usually important for camera-type exposures, but it is a severe problem for astronomers, who routinely work with limited illuminance.

Books: Carroll, B. H., Higgins, G. C., and James, T. H., *Introduction to Photographic Theory.* New York: Wiley, 1980; James, T. H., (ed), *The Theory of the Photographic Process,* 4th Ed. New York: Macmillan, 1977; Sturge, J., (ed), *Neblette's Handbook of Photography and Reprography,* 7th Ed. New York: Van Nostrand Reinhold, 1977; Sturge, J., Walworth, V., and Shepp, A., (eds), *Imaging Processes and Materials,* 8th Ed. New York: Van Nostrand Reinhold, 1989. *R. Hailstone*

See also: *Photographic theory; Development theory.*

LATENT-IMAGE FORMATION See *Photographic theory.*

LATENT-IMAGE STABILITY See *Photographic theory.*

LATENT SUBIMAGE Those stable metal nuclei created upon exposure of silver halides that are too small to catalyze development. A distinct size in terms of the number of atoms cannot be given because the boundary between latent

subimage and latent image is a function of the minimum developable size of the latent image, which will depend on the development condition. *R. Hailstone*

LATERAL ADAPTATION A process by which a surrounding area, or an adjacent area, affects the perception of a given patch. Tones in a print will look darker when displayed on a white mount board than a black one because the eye adapts to a luminance level that is intermediate between the average print luminance and the surround luminance. A yellow looks lighter and more saturated (vivid) next to a blue patch than next to a white one. *L. Stroebel and R. Zakia*
See also: *Lateral inhibition/excitation; Simultaneous contrast.*

LATERAL CHROMATIC ABERRATION See *Lenses, chromatic aberrations.*

LATERAL INHIBITION/EXCITATION In visual perception, modification of the electrochemical signals in neurons representing adjacent subject areas that differ in lightness, such as two steps in a gray scale, so that the weaker signal from the darker area is further weakened along the border by the nearby stronger signal, and the stronger signal from the lighter area is further strengthened along the border by the nearby weaker signal. The visual effect is an increase in contrast at the border between the two areas.
L. Stroebel and R. Zakia
See also: *Lateral adaptation; Mach band; Simultaneous contrast.*

LATERAL OBLIQUE An aerial photograph made with the camera tilted between the perpendicular and horizontal positions at right angles to the line of flight. *L. Stroebel*
See also: *High oblique; Low oblique.*

LATERAL REVERSAL An altered image of the type seen in a mirror whereby a person's left hand appears as the right hand of the reflected image, and vice versa. Since camera lenses produce images that are reversed both left-to-right and top-to-bottom, printed words in a scene are correct reading but upside down on the ground glass of a view camera when viewed from behind the camera. Thus, negatives and transparencies appear correct when viewed from the base side but laterally reversed when viewed from the emulsion side. Since Daguerreotypes were viewed from the sensitized side by reflected light, the images were laterally reversed unless a reversing mirror or prism was used in front of the camera lens. *L. Stroebel*

LATERAL SHIFT One of the movements on a view camera that allows for changes in horizontal image placement without changing the camera position or angle. This is accomplished by moving the film standard or lens standard sideways. *P. Schranz*

LATITUDE See *Exposure latitude.*

LAVENSON, ALMA (1897–1989) American photographer. Self-taught, she was introduced to the photographers Imogen Cunningham and Consuela Kanaga in 1930. A pictorialist using soft-focus, her work soon reflected their influence and a commitment to straight photography. One of four photographers invited to exhibit with the seven members of Group *f*/64 in their ground-breaking exhibition at San Francisco's de Young Museum (1932). Lavenson remained active in photography throughout her long life.
Books: Ehrens, Susan, *Alma Lavenson: Photographs.* Berkeley: Wildwood Arts, 1990. *M. Alinder*

LAW OF REFLECTION Fundamental law of optics in that the incident ray to a surface, the normal at that point and the reflected ray are all in the same plane and the angles of incidence and reflection are equal. *S. Ray*

LAYBACK (SOUND) The process of copying audio from a sound-only master back to a video master tape. The processes of laydown and layback together permit sound postproduction to be done on media especially well suited for audio. *T. Holman*

LAYDOWN (SOUND) The process of copying audio from the sound tracks of an original video tape onto the postproduction audio recording medium. *T. Holman*
See also: *Layback.*

LAYOUT An arrangement of photographs, prints, or typographic material used as a guide for those engaged in preparing copy to be readied for printing, for example, advertisements, or for other types of display such as books and magazines. (2) In animation, a careful plan of the action as a guide for the animator. *R. Welsh*

LEADER A strip of film or other flexible material used to thread a camera, processor, printer, projector, etc. Opaque leaders spliced to the sensitive film are used as protective light seals on unprocessed film. Integral leaders are extra lengths of film beyond the nominal for light protection and threading; for example, a nominal 100-foot roll of 16-mm motion picture film is actually 107 feet long, the extra 7 feet being considered leader and trailer. The trailer serves to protect the exposed film from light when it is wound onto the take-up spool.

The leader for 35-mm film supplied in magazines for still cameras requires the first several inches to be shaped to properly engage the loading mechanism. The standard used from the 1920s for a long tongue (about 100-mm) was shortened in the 1980s to the current length. Some older cameras, notably screw-mount Leicas, require the current short tongues to be recut to the old standard if loading difficulty or film damage is to be avoided. *M. Scott*
See also: *Tongue; Trailer.*

Leader. Template for film leader. Some miniature cameras need specially shaped film leaders for loading; these may be cut accurately with the aid of a suitable template.

LEADING LINE In pictorial composition, a linear element that is thought to direct the eye of the viewer into the composition, or in a specific direction on the picture surface. (Studies of the eye motion of observers suggest, however, that they actually look at different picture areas in a less predictable way.) *R. Welsh*

LEAF SHUTTER A shutter with a thin ring of overlapping blades pivoted at the edge to open outward from the center to uncover the diaphragm opening and then reverse direction to terminate the exposure. The shutter blades are

usually located between the lens elements and close to the diaphragm to insure better shutter efficiency. Leaf shutters can also be synchronized with electronic flash at all speed settings. *P. Schranz*

See also: *Between-the-lens shutter; Shutter efficiency.*

LE GRAY, GUSTAVE (1820–1882) French photographer, inventor, and teacher. A student (c. 1839–1843), along with Fenton, Le Secq, and Nègre, of painter Paul Delaroche. After first experimenting with the daguerreotype process (1847), learned Talbot's calotype process, becoming its leading proponent in France. Working to improve the calotype, he invented the Le Gray waxed-paper process, which provided the photographer with a dry, presensitized paper negative of increased transparency, important advances for the traveling photographer. An ever-generous teacher, Le Gray taught his new method to many, including Le Secq and Maxime Du Camp. Hired by the French government to photograph historical monuments (1851). All five photographers chosen for this project used Le Gray's waxed-paper process. Cofounder in 1851 of the first serious photographic society in the world, Société Héliographique, with Le Secq and Nègre. Highly regarded as one of photography's greatest artists, Le Gray is admired for his beautifully detailed images of the forest at Fontainebleau, begun c. 1849, and his seascapes, spectacular visions of the sky and ocean printed from multiple negatives (1855–1860).

Books: Janis, Eugenia Parry, *The Photography of Gustave Le Gray.* Chicago: University of Chicago Press, 1987. *M. Alinder*

LEICA/LEITZ In his article "Leica: An Enviable History" (*Photo-Source,* July/August 1989), Michael Disney says: "Leica has occasionally claimed in its advertising that the Leica was the first 35-mm still camera, much to the indignation of photographic historians and collectors. Although this claim is not literally true . . . it is in a sense justified. As a design the first Leica owed almost nothing to the predecessors. In contrast, almost every subsequent 35-mm camera has owed something to the Leica." His tribute to Leica concluded: "One can say without exaggeration that the history of the 35-mm camera as it has developed in this century would be inconceivable without the Leica, and whatever course it might otherwise have taken would probably have been very different."

Dr. Ernst Leitz II, who was responsible for the introduction of the Leica, was the son of the founder of Leitz/Wetzlar. Since its founding in 1849 the company's only concern has been the design and manufacture of precision optical equipment. This focus on optical precision is the base on which the Leica reputation has been built. Today Leitz manufactures instruments for scientific research, industry, and amateur and professional photography.

A brief chronological history of significant contributions to photographic technology includes the following:

In 1913, Barnack designed the first operational prototype of the Leica for 35-mm cine film. It had an all-metal housing, a collapsible lens, and a focal-plane shutter. A screwed-on lenscap, which was closed during shutter rewind, prevented fogging of the film. This camera is known as the original Leica.

The A-series model, introduced in 1923, was the first commercial Leica to be manufactured. Before its introduction, 31 prototypes were made by hand to test public reaction. The lens was a five-element 50-mm anastigmat *f*/3.5 designed by Professor Max Berek. Its focal-plane shutter was self-capping with automatic compensation for acceleration. Film advance coupled with shutter retensioning and a frame counter prevented double exposures for the first time in photographic history. Although the hand-made samples were greeted with considerable skepticism both inside and outside

the organization, Dr. Ernst Leitz made the fateful decision to "build Barnack's camera." The Model A with a 50-mm Elmax (later Elmar) *f*/3.5 went into production in 1925, and before the year was out, 1,000 cameras were produced.

The year 1930 saw the introduction of the Model C, the first Leica with interchangeable lenses. Three screw-mounted Elmar lenses were available: 35-mm wide-angle, 50-mm *f*/3.5 normal focal length, and 135-mm *f*/4.5 long focal length. For focusing accuracy, a vertical longbase accessory rangefinder was part of the package.

Known as the Autofocal Leica, the Model II was introduced in 1932 and simultaneously established two significant firsts. It was the first camera with built-in coupled rangefinder and the first camera with rangefinder coupling for a whole family of interchangeable lenses.

The new Leica III appeared in 1933 with speeds from 1 to 1/500 second. Slow speeds between 1 and 1/20 second were arranged on a front-mounted selector dial. Also in 1933, Leica introduced the first telephoto lens, the 200-mm Telyt *f*/4.5, for which the world's first accessory reflex housing was provided.

In 1934, a *Reporter* Leica was produced with spool-chambers holding approximately 33 feet of film. The new model took 250 exposures without reloading. Fewer than 1,000 Reporters were made in a number of small series between 1934 and 1942.

With the introduction of the Model IIIa in 1935, Leica's top speed jumped from 1/500 to 1/1000 second. For fast shooting with the IIIa, Leica also introduced a new baseplate trigger-advance unit. The new ultra-wide-angle 28-mm Hektor *f*/6.3 expanded the optical lineup to 12 lenses in nine focal lengths from 28-mm through 400-mm, giving angular fields of 6 to 76 degrees.

In the United States in 1935, Eastman Kodak introduced 35-mm Kodachrome film. Leica saluted the two co-inventors, Leopold D. Mannes and Leo Godowsky, Jr., by presenting them with Leica Nos. 150,000 and 175,000 respectively.

The first postwar camera design was the Model IIIf, introduced in 1950. Up until the introduction of the IIIf, Leica flash synchronization was by means of external devices which either replaced the camera baseplate or made connection with its spinning shutter-speed selector dial. The new Model IIIf, however, provided full internal synchronization for all types of expendable flashbulbs as well as for the new electronic flash units that were beginning to gain popularity. Also introduced in 1950 was the 85-mm Summarex *f*/1.5, the fastest lens of its focal length to date.

In addition to being the world's first 35-mm camera to feature a built-in universal rangeviewfinder for four different lenses, the M3, introduced in 1954, scored another significant advance: its illuminated lens viewfinder frames were automatically compensated for parallax over the full focusing range of each lens. Other advances included an automatically resetting frame-counter, an exclusive rapid-advance lever, and a quick-change bayonet lensmount of unusual precision and rigidity.

In the decade preceding 1967, Leica introduced many new lenses. Notable among these: 21-mm Super-Angulon *f*/4 ultra-wide-angle lens with a coverage of 92 degrees; *f*/2 Summicron lenses of 35-and 90-mm; and the ultra-fast Noctilux *f*/1.2, the world's first lens for 35-mm cameras using series-produced aspheric lens elements.

With the introduction of selective through-the-lens light measurement in 1968, the Leicaflex SL is the camera that brought Leica precision and the famous *Leica feel* to single-lens-reflex photography. A precision microprism central focusing field facilitates snap-in focusing for even short focal length lenses. The meter reads a central, circular area, equal to one-sixth the acceptance angle of whatever lens is

attached to the camera. The area measured is sufficiently large to integrate typical scene brightness. However, it is selective enough to permit quick, accurate spot readings for difficult, high contrast scenes. The meter needle, direction of diaphragm adjustment, and shutter speed are displayed in the viewfinder for easy reading without removing the eye from the camera. Inside the SL, the focal-plane shutter traverses the film aperture in approximately 9 milliseconds, permitting flash synchronization up to 1/100 second and precise shutter speeds to 1/2000 second.

Introduced in 1971, the M5 combines Leica's half century of development in rangefinder optics with an accurate through-the-lens metering system.

(Courtesy R. Horn, Leica Camera Inc.)

LEITZ, ERNST (1871–1956) German photographic manufacturer. Succeeded his father, of the same name, as head of the Leitz optical works in Wetzlar, Germany, in 1920. Admired for the manufacture of precision microscopes, telescopes, and binoculars. Expanded production lines to include industrial optical measuring instruments and photographic equipment. Supported research by Oskar Barnack, who invented the Leica camera in 1913, which Leitz subsequently manufactured with great success from 1924.

M. Alinder

LENS ABERRATIONS See *Lenses*.

LENS AXIS A straight line of symmetry joining all the centers of curvature of the individual surfaces of the elements of the lens. *S. Ray*

LENS BOARD A detachable panel that serves as the lens support for a view-type camera or an enlarger. *P. Schranz*

LENS CAP A protective cover for a lens that can be a separate item or can be built into a camera. *P. Schranz*

LENS CENTERING Adjustment of the individual elements of a lens so that the centers of curvature of all the spherical surfaces of the elements lie on a single straight line, the optical axis. If an element is decentered, the image moves around as the lens is rotated and is subject to severe decentration aberrations. *S. Ray*

LENS COATING See *Lenses*.

LENS ELEMENT The single refracting components of a lens system, which may have surfaces that are flat, concave, or convex, giving the alternative configurations; biconvex, biconcave, plano-convex, plano-concave, positive meniscus, and negative meniscus. *S. Ray*

LENS EQUATION See *Optics, optical calculations*.

LENSES
COVERING POWER OF LENSES
Image Circle A positive lens forms a real image of a distant subject in space behind the lens. If this image is intercepted by placing a screen at right angles to the optical axis and at a suitable distance to provide a sharp image, then the whole extent of the image formed will be seen to be circular. This is termed the *image circle* and this shape is given irrespective of the shape of the aperture stop.

The illumination of this circle falls off toward the edges, gradually at first and then rapidly. The limit to this *circle of illumination* is set by vignetting, both natural and mechanical.

Circle of Good Definition In the image circle, because of the presence of residual uncorrected aberrations of the lens, the definition of the image within this disk deteriorates

from the center of the field outward, at first gradually and then more rapidly at the edges. By defining an acceptable standard of image quality, it is possible to locate an outer boundary within the image circle that in turn defines a circle of good definition. The negative format should be located within this circle. The extent of this circle of good definition also determines the practical performance of the lens regarding the covering power relative to a given film format. The covering power may be expressed as an angle of coverage which may be the same or greater than the angle of view of the format in use.

Extra Covering Power A lens with a greater angle of coverage than set by the format has extra covering power. This feature is essential for a lens fitted to a view camera for the use of camera movements and also in a perspective control (PC) lens or *shift* lens when lens displacement movements are to be used. The extra covering power allows displacement or swing of the lens or film within the circle of good definition. Eventually vignetting occurs, shown by a perceptible decrease in image luminance at the edges of the format. This is often referred to as *cutoff*.

Covering power is increased by closing down the aperture diaphragm of the lens. Both mechanical vignetting and off-axis aberrations are decreased by this action. The covering power of lenses for view cameras is usually quoted for *f/22* with the lens focused on infinity. Covering power also increases as the lens is focused closer; for closeup work a lens intended for a smaller format may be suitable to cover a larger format, with the advantage of a shorter bellows extension giving the same magnification as a longer focal length lens normally used to cover the format.

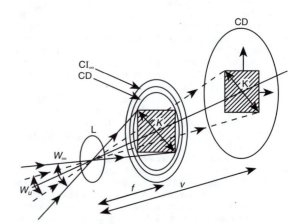

Covering power of a lens L, showing the image circles, fields of view, and format displacements possible at infinity focus and at close focus. K, format diagonal; CD, circle of good definition; CI, image circle for infinity focus; W, field angle; f, focal length; v, image conjugate.

Natural Vignetting The image circle of a lens has a clearly defined diameter as determined by the falloff of light at the perimeter. This reduction in image illuminance and consequent darkening of the image is termed *vignetting* and was a feature of early photographs taken with inadequate lenses. Natural vignetting is due to the combined behavior of light forming the image and the geometry of image formation by the lens. Consider a beam of light forming a small portion of the image. An angle θ is subtended at the lens between this ray and the optical axis, forming the semifield angle when the former is at the edge of the image circle. The image patch has reduced illuminance due to the multiplying factors of (1) the inverse square law of illumination, as the

ray has farther to travel; (2) Lambert's cosine law of illumination, as the light illuminates the image obliquely. Both introduce an image illuminance reduction factor proportional to the square of the cosine of θ, which rapidly becomes less than unity as the angle increases.

Cos⁴θ Law It can be derived mathematically that image illuminance E is proportional to $\cos^4\theta$. This relationship is usually referred to as the *cos⁴θ law of illumination*. It can be shown that even a standard lens with a semiangle of view of 26 degrees has an edge illuminance of only two-thirds that on axis. For an extreme wide-angle lens where θ is 60 degrees, peripheral illuminance is only some 0.06 of its axial value. Wide-angle lenses need corrective measures to obtain more uniform illumination and reduction in vignetting.

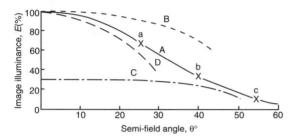

Cos⁴θ law. Variation in image illumination with semifield angle (θ). A, natural vignetting due to the cos⁴θ law. B, improvements by lens design. C, use of a graduated neutral density antivignetting filter. D, effect of optical vignetting. a, standard lens; b, wide-angle lens; c, extreme wide-angle lens.

Reduction of Vignetting At full aperture, the image circle usually just circumscribes the format, and vignetting may even be detectable in the image formed by large aperture (speed) lenses used fully open. There are various means of reducing the effects of vignetting. As the projected area of the aperture stop is smaller for rays passing through it at an angle, if this angle is reduced by using larger front and rear elements that are negative, then vignetting can be reduced to a level within the exposure latitude of color reversal film. Lens designs such as quasi-symmetrical types with short back focal distances and retrofocus lenses both benefit from this technique. Vignetting considerations apply only to orthoscopic lenses that endeavor to give a distortion-free image. If distortion is ignored and a large amount of barrel distortion allowed, as in a fisheye lens, then image illumination can be near uniform over a large field angle.

Mechanical Vignetting Mechanical vignetting arises through such causes as the type and design of the lens, its axial length and the position of the axial stop, and the mechanical construction of the lens barrel. The effect is to reduce the diameter of off-axis beams of light that can pass unobstructed through the lens. This effect can be reduced by oversize front and rear elements and careful mechanical design. Another cause is the use of a lens shade that is too long or a filter mount that is too thick, especially with wide-angle lenses. The remedy is to use attachments suited to the lens that do not intrude into the field of view.

Sometimes mechanical vignetting in the form of a radially graduated neutral density filter, or *spot* filter, is used deliberately to even out the image illumination of very wide-angle lenses, where the central darkening introduced balances the peripheral vignetting. The penalty is the loss of the lens speed on the order of two stops.

Camera Movements A lens for use with camera movements has extra covering power and a circle of good definition the diameter of which is much greater than the diagonal of the format in use. The film area should remain within this

circle when the lens or camera back is shifted laterally or swung. Commonly, an angle of coverage of 70 to 80 degrees is provided in a standard lens, allowing some 10 to 15 degrees of swing. Wide-angle lenses have greater angular covering power, but not necessarily a larger circle of good definition if the focal length of the wide-angle lens is shorter. For extreme covering power and movements, where the field angle is less important, the standard lens for a larger format can be used. Lenses of telephoto construction have adequate but not generous covering power. Covering power increases with close focus, allowing additional movement for studio work.

LENS ABERRATIONS A perfect lens would show the image of a point as a point and a straight line as a straight line, but in practice lenses, especially simple lenses, are never perfect. A point is reproduced as a patch and a straight line as slightly curved. Such imperfections and others are called *lens aberrations,* and even in a well corrected lens there are residues of such imperfections.

Cause and Effects The causes of aberrations are the use of lens surfaces that are spherical in shape, the dispersion of light by optical materials, and light behaving as a wave motion and suffering diffraction.

The effects of aberrations usually increase with an increase in angle of view so that light enters the lens more obliquely. A ray trace through a lens surface-by-surface depends on repeated applications of Snell's law, given here as $n_1\sin\theta_1 = n_2\sin\theta_2$.

Now sin θ can be expanded in a power series:

$$\sin\theta = \theta - \theta^3/3! + \theta^5/5! \; -............$$

Taking sin θ as θ gives the first order or paraxial approximation for Gaussian optics where θ is 10 degrees or less. For more accurate calculations for larger apertures and wider fields of view, sin θ is taken as $[\theta - (\theta^3/3!)]$, giving third order theory and better realization of image topography. Associated with this are five recognizable aberrations for monochromatic light, usually called the (von) Seidel aberrations, and two chromatic aberrations.

Necessary levels of correction in modern lenses may demand consideration of fifth and even seventh order theory.

Monochromatic Types The Seidel aberrations caused by spherical surfaces and the variation of refraction in each concentric annular zone of a surface are spherical aberration (SA), coma, astigmatism, curvature of field, and distortion. They can be grouped in various ways. Spherical aberration is a direct aberration affecting all the image, while the other four are indirect and their effects increase with field angle. Fortunately, aberrations depend on curvatures, thicknesses, refractive index, spacing of elements, and stop position, so it is possible to use *downstream* correction. Aberrations in one element or group are removed or reduced by equal and opposite aberrations in a subsequent group, so a compound lens is needed for most practical purposes. Note that SA, coma, and astigmatism do not give stigmatic imagery, so that a blue patch is given instead of a point. Curvature of field and distortion give curved and nonidentical images, respectively, violating the requirement for an orthoscopic lens. A lens corrected for SA and coma is an aplanat, and an anastigmat is corrected for astigmatism.

Spherical aberration is due to parallel incident rays being progressively brought to a focus closer to the lens as they are refracted by zones farther from the axis. The effect increases with lens aperture. A lens suffering from SA will be overall degraded and show a focus shift as it is stopped down. Certain soft focus lenses, however, deliberately retain a controllable amount of residual uncorrected SA to give their characteristic effects. The effects of SA also increase at close focus and may be offset by use of a *floating element.* An

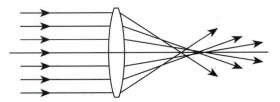

Spherical aberration in a simple lens.

aspheric element in a lens design can reduce SA considerably and require fewer elements.

Coma is often considered the most troublesome aberration, as it is asymmetrical in its effect. Its name is derived from the comet-like shape of the image patch from an off-axis object point as a result of different refraction at different lens zones as the angle of incidence changes. Like SA, coma of a thin lens is shape-dependent and worsens with increase in aperture. Coma may be reduced by using an aperture stop at an appropriate position. Spherical mirrors suffer from severe coma unless a very small field angle is used; hence, they are limited to long focus designs.

Astigmatism, if the only aberration present, is shown as the image of an off-axis object point being two short lines occupying different positions in space. The one nearer the lens is tangential to the image circle, and the other one farther from the lens is radial (sagittal) to the optical axis. Their separation is a measure of astigmatism, and the position of best focus where the image degrades to the circle of least confusion lies between them. Such a lens is an *astigmat,* i.e., not a point. Astigmatism is cured by suitable manipulation of the combined astigmatic image surfaces of several elements. If the image is used beyond its circle of good definition, astigmatism becomes severe. All modern lenses are *anastigmats,* literally *not a point.*

Curvature of field is where the image is formed as a curved surface, dished, or concave, toward the lens for a lens of positive power. This image topography of a paraboloid shell is called *Petzval curvature.* It is unaffected by changes in the positions or shapes of elements or by the stop position but is controlled by the net power and refractive indices of the elements. Field curvature is not tolerable in cameras that use a flat film gate. Sometimes a field flattener element is placed close to the film gate. An enlarging lens must also give a flat image surface to coincide with the paper plane. Lenses well corrected for astigmatism will also in general have a flat field.

Curvilinear distortion does not affect the sharpness of an image, only its shape. It is unaffected by altering the aperture size. It is caused by a variation in image magnification radially from the optical axis. It is especially found in lenses of asymmetrical configuration, so that retrofocus designs tend to give outwardly curving distortion (pincushion type) rather than straight lines. The remedy is to use symmetrical configuration in a design, especially for copying and architectural photography. A fisheye lens has a deliberate large amount of uncontrolled barrel distortion, which gives it a large angle of coverage without vignetting.

Lens design to correct for these monochromatic aberrations involves the suitable choice of the number of elements, surface curvatures, thicknesses, and separations as well as the position of the aperture stop. The lens is then further corrected for chromatic aberrations.

CHROMATIC ABERRATIONS
Longitudinal Chromatic Aberration Shorter wavelengths of light are refracted more than longer ones by a transparent medium, so the focal length of a simple lens increases with wavelength. This is shown as a separation of

focus along the axis for a positive lens, termed *axial* or *longitudinal* chromatic aberration. Early lenses with this defect gave a different focus for the blue (actinic) rays and the visual yellow-green rays, necessitating a small focus correction or the use of a small aperture to increase the depth of focus. The latter technique allows such lenses to be used in simple cameras.

John Dollond in 1757 demonstrated an achromatic lens that was a combination of a negative lens and a positive lens of flint and crown glass, respectively so that the near equal and opposite color aberrations cancelled out sufficiently for most purposes, with the achromatic combination having a net positive power. This form of doublet lens could also be highly corrected for spherical aberration and coma and give excellent performance over a narrow field. Usually the elements were cemented together.

The chromatic performance of a lens is shown by a graph of wavelength against focal length. A chromatic lens has a linear variation, and an achromatic has a parabolic curve through the two wavelengths chosen to be coincident. The curve shows the residual and uncorrected secondary spectrum. For color separation work, the use of a third type of glass may give correction for three wavelengths to bring three foci into coincidence so that separation negatives are identical in size. This level of correction is often called *apochromatic.* This term is also used to describe lenses that are fully corrected for two wavelengths but use special low and anomalous dispersion glass (ED glass) to give a much reduced secondary spectrum. In exceptional cases, four wavelengths to include the infrared region may be corrected; such a lens is called a *superapochromat.* No focus correction is then needed between 400 and 1000 nm.

For infrared or ultraviolet photography with conventional lenses, a focus correction is needed after visual focusing as the focal length for these regions is longer than for the visible. Many lenses carry an additional focus index mark colored red on their focusing scales for this purpose. A photographic test is always sensible to confirm that this is accurate.

The use of reflecting surfaces that do not disperse light, in the form of *mirror lenses,* offers another solution; but most mirror designs are for long focus lenses only. Most too are catadioptric, which include one or more glass elements, and, therefore, still require some color correction.

Lateral Chromatic or Transverse Aberration This is an off-axis aberration, the effect of which increases with field angle. It is manifest as colored fringes at the edges of an image point, blue toward the axis and red toward the periphery. Whereas axial chromatic aberration affects the distance from the lens where the image is formed, this lateral

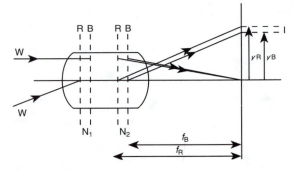

Lateral (or transverse) chromatic aberration for off-axis points in a lens that has been corrected for longitudinal chromatic aberration only. The effect is a variation in image height *y* for red and blue light.

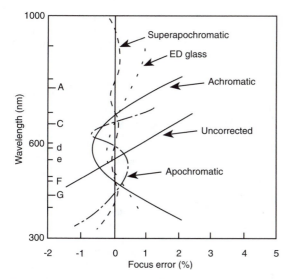

Types of color correction for lenses. The letters on the vertical axis represent the wavelengths of the spectral (Fraunhofer) lines used for standardization purposes.

chromatic aberration concerns the size of the image. It is also known variously as *transverse chromatic aberration* (TCA), *lateral color,* or *chromatic difference of magnification.*

It is not easy to correct. Its effects worsen with increase in focal length and are not reduced by a smaller aperture. It effectively sets a limit on the performance of long focus lenses. It can be minimized by a symmetrical lens construction and the use of three types of glass at least. The most effective cure is to use special optical materials such as fluorite (calcium fluoride) or ED glass. The cost of such a corrected lens is significantly higher than one of equivalent conventional design.

LENS DESIGN

Optical Engineering A highly corrected lens is one of the most accurately made items that it is possible to buy at modest cost, but before a lens is made is must be designed, which is the job of a lens designer or an optical engineer. The first stage is receipt of a specification giving properties such as focal length, aperture, field of view, level of correction, and back focal length. To work with, the designer has the variables of kinds of glass, number of elements, thicknesses, curvatures and separations, and position of the aperture stop.

Predesign Experience may suggest a suitable configuration of elements as a starting point, and a predesign stage involves simple calculations on the layout with sensible ideas as to the width, thicknesses, and separations of the elements. Also considered are boundary conditions concerning choice of glass types, rim thicknesses, curvature limits, and manufacturing economics, which include use of readily available glasses of low cost, minimum numbers of elements, as many flat surfaces or those of identical curvature as possible, the possibility of cemented surfaces and ease of assembly. Design trade-offs include choice between a mirror or lens, replacing a high-refractive-index singlet with two low-index elements or replacing three spherical surfaces by one aspheric surface.

For simple systems such as condenser lenses, graphical construction may be adequate for design, but otherwise ray tracing is needed.

Ray Tracing By repeated application of Snell's law of refraction at each interface, the passage of a ray of light can be traced through a lens design and its position in the focal plane determined and evaluated. Such ray traces are diag-

nostic for the various aberrations and confirmation of focal length. The initial design usually needs some 40 ray traces, and a programmable pocket calculator may be used.

Computer-Aided Design After a promising predesign, much more detailed analysis is needed. The advent of digital computers to perform the drudgery of tracing rays has freed the designer to consider alternative designs for similar purposes. Lens design packages for such computer-aided design may be capable of tracing several thousand rays per second and handle designs with a large number and variety of surfaces, evaluate the predicted image in various ways including modulation transfer function (MTF), spread functions and aberration curves, and contain libraries of glass types or useful designs for commencement. Interactive optical displays show configurations in perspective and the effects of altering a surface shown rapidly in terms of effects on the image.

Optimization Computer-aided design is useful not only for the ability to handle, say, 50 variables simultaneously and increase speed in ray tracing but also in the ability to optimize a design, using as criteria user-created merit functions and boundary conditions such as element thicknesses and curvatures as chosen by the designer.

The computer compares its calculated image with the requirements. In effect, it is looking for a suitable minimum in a multidimensional surface, but when it has found one the possibility of an even lower one still exists. Existing designs may be reworked in circumstances such as availability of a new glass to see if a cost-effective improvement can be made. Often the designer is presented with a number of possible solutions of apparently equal merit but then relies on workshop experience to make a final choice of a lens that can be made at reasonable cost. Considerable effort goes into fine-tuning a suitable design to make is as insensitive as possible to the inevitable and sensible tolerances on the properties of glass, fabricated elements, and mechanical assembly. Such desensitization gives a more uniform product with lower reject rates and contributes to the modest cost of photographic lenses.

Special Designs If cost is not a limitation, an optical system with almost any desired specification can be produced, and many such one-offs or special designs have been made. Inevitably, progress in production techniques allows special features such as aspheric surfaces, floating elements, multilayer coating hybrid glass-polymer elements, and ED glass to be used in series-produced lenses. Lens design must also be considered in conjunction with the possibilities allowed by the use of robot assembly lines, molded polymer for assembly purposes, and the numerically controlled production of cams and control surfaces. Compactness and low weight as well as the electronic enrichment of lenses with devices to focus the lens and transduce lens data to the camera control system are also design priorities.

LENS HISTORY

Prephotography Photographic lenses have common origins with other types of lenses. The thirteenth century Arabian scholar Alhazen knew the elementary properties of biconvex lenses, and convex spectacles were in use at that time. A biconvex lens was first used in a camera obscura in the middle of the sixteenth century. Newton in 1666 gave the cause of chromatic aberration in such lenses and, believing the problem insoluble, turned his attention to catoptric systems. The first achromatic lens was produced in 1757 by John Dollond. In 1812 William Wollaston devised the meniscus lens. By suitable choice of radii of curvature it gave a reasonably flat field and the stop position in front of the lens reduced coma. A field of 50 degrees could be covered at *f*/14 or smaller. This was the first landscape lens.

In 1839, the official birthday of photography with the daguerreotype process, the extant lenses were meniscus

and simple achromat types. Louis-Jacques-Mandé Daguerre specified an achromatic landscape lens for his camera made by Chevalier of Paris, the best of its time.

Astigmatic Lenses Early lenses were astigmatic designs, uncorrected for astigmatism and field curvature. The simplest lens for photography, an equibiconvex landscape lens with its limited parameters, has limited correction. The meniscus configuration with a stop in front corrects for coma and tangential field curvature, while spherical and longitudinal aberrations are acceptable at *f*/16. Distortion, Petzval curvature, and transverse chromatic aberration are uncorrectable.

Such designs were used on early cameras and later box cameras where the shutter at the stop position protected the lens. The pronounced spherical aberration (SA) can be reduced by reducing surface curvatures, but the field then curves inward, requiring a curved film gate, as used on some cameras. Used with focus fixed at the hyperfocal distance, acceptable sharpness is given.

Various forms of improvement are possible to this simple lens. The achromatic doublet version include several distinct types. The Chevalier type, specified by Daguerre, used the two available glasses, crown and flint, with the softer flint in front with a concave surface. Excessive astigmatism remained. The Grubb version of 1857 used a front meniscus crown, reducing SA but giving either heavy coma or astigmatism. The astigmatism die to the glass interfaces could be reduced by using a crown glass of greater index that the flint, and such glasses became available after about 1886. These new achromat types had less field curvature but more SA. The design did lead to the Protar of 1890, the first anastigmatic lens.

Petzval Lens The simple lens was inconveniently slow for portraiture with the insensitive plates of the period, and efforts were made to design a lens of large aperture. The principles were understood, but lack of suitable glasses hampered development. In 1840, Josef Max Petzval designed a lens of aperture *f*/3.7, using two separated. dissimilar achromatic doublet groups. This was the first lens to computed mathematically specifically for photography. It had roughly fifteen times the transmittance of contemporary designs. The inevitable uncorrected aberrations, particularly astigmatism, gave poor peripheral definition, but this was found pleasing for portraiture, giving a characteristic softness. Its restricted field of good central definition demanded a longer focal length than normal to cover a given plate size; the consequent need for a fairly distant viewpoint was a factor con-

Lens history. Relationships of some basic lens configurations and designs. (a) Achromatic doublet; (b) triplet; (c) symmetrical (periscopic); (d) Petzval; (e) tessar; (f) zoom variator; (g) telephoto; (h) retrofocus; (i) double gauss; (j) rapid rectilinear; (k) fisheye; (l) double anastigmat; (m) celor (process); (n) plasmat; (o) quasi-symmetrical.

tributing to improved perspective in portraiture. The design is still the basis of many long-focus, large aperture lenses.

Symmetrical Doublets Landscape lenses improved little until the 1860s, when designs of good performance, flatter field, and moderate aperture became available. The Steinheil Periskop lens of 1865 used two meniscus components placed symmetrically about a central stop. The importance of symmetrical or near-symmetrical construction is that it permits almost complete correction is that it permits almost complete correction of the oblique errors of coma, lateral chromatic aberration, and distortion. This nonachromatic (chromatic) lens was superseded in 1866 by the simultaneous introduction of two independent designs: the Rapid Rectilinear by T. Dallmeyer and the Aplanat of Steinheil, in which the meniscus lenses were replaced by achromatic combinations, retaining symmetry. Maximum aperture was around $f/8$, but astigmatism was still uncorrected.

Anastigmats Astigmatism and field curvature could not at this time be corrected together with the other aberrations, since the dispersion of available glasses increased proportionally with refractive index. Pioneer work by Abbe, Zeiss, and Schott in the 1880s, however, resulted in new types of optical glasses with the desired properties. Anastigmatic lenses with flattened field became possible. Early examples were the Ross Concentric (1888), Zeiss Protar (1890), Goerz Dagor (1892), and Zeiss Double Protar (1894). Lenses became increasingly complex: although the principle of symmetry was followed, both components became a multiple cemented combination of old and new glass types. Maximum apertures were limited to about $f/6.8$ by uncorrectable SA.

Triplets The increasing complexity of anastigmat lenses led to high manufacturing costs. In 1893 the Cooke Triplet lens designed by H. Dennis Taylor was introduced. This departed from symmetry as it used only three single separated elements; two were biconvex of high-index crown glass of low dispersion and separated by a biconcave element of light flint glass of high dispersion, serving to flatten the field. The outstanding feature of this design is its simplicity of construction while having sufficient parameters for full correction. The original aperture was $f/4.5$, later increased to $f/2.8$. Subsequent development was by splitting and/or compounding the elements to give numerous derivaties, e.g., the Zeiss Tessar lens designed independently in 1902 by Rudolph, which has been in production ever since.

Double-Gauss Lenses Symmetrical lenses have great advantages but cannot easily be corrected for higher order SA, which limits the maximum aperture to about $f/5.6$. Triplet construction is limited to about $f/2.8$. To obtain useful apertures of $f/2$ or better with some semblance of symmetry, a derivative of symmetrical design based on a telescope doublet lens designed by astronomer Carl Gauss was found suitable. This doublet was air-spaced, with deeply curved surfaces concave to the subject. Two such doublets, both concave to a central stop, are the basis of the Double-Gauss form of lens. Derivatives with up to seven elements have useful apertures to $f/1.2$.

Modern Lenses The highly corrected lenses in use today still use triplet, symmetrical, and Double-Gauss configurations, with the advantages given by improved glasses of high refractive index, computer aided lens design, multi-layer coatings, aspheric surfaces, floating elements, electronic evaluation, and automated assembly.

LENS MANUFACTURE Historically, lenses have been made by grinding opposing surfaces of a slab of glass to be flat, convex, or concave, using an abrasive such as jewelers' rouge (ferric oxide). Flat or spherical surfaces are comparatively easy to make with the surface pressed against a suitable former to give the desired radius of curvature. Modern production methods are automated but have changed little in principle. Several stages are involved.

Stages of Production Rough shaping is molding, pressing, or cutting out of a glass blank slightly larger than the finished size. *Blocking* is attachment of blanks to a rigid surface for grinding and polishing. *Generating* is grinding away excess glass to give a spherical surface of correct radius and thickness. Generating on the reverse side establishes the central thickness of the element and second radius. A cup-shaped diamond wheel is used for grinding and a spherometer is used to check the radius.

Next, *lapping* removes surface damage due to generating to give a true spherical surface and final thickness. Iron tools with diamond pellets or grades of abrasive may be used. *Polishing* removes damage from lapping and gives a smooth specular surface. A shaped pitch lap with cerium oxide abrasive is commonly use. A test plate using interference fringes (Newton's rings formed in the air film between a reference surface and the polished surface) checks results and departures from sphericity. *Figuring* is a hand-controlled polishing operation to correct for undesirable local variations due to lapping. It may also be used to produce aspherical surfaces by trial and error.

A vital final stage is *centering,* where the optical and mechanical axes are brought into coincidence. The element is aligned on a centering device and then edge-ground to a specific diameter. Alignment aids for later assembly, such as bevels or flats on the rim, can also be added.

The *cementing* of elements to matching flat or spherical surfaces is by use of epoxy cements or traditional Canada balsam. Most cements now contain UV absorbers to minimize UV transmission variance between lenses.

Finished elements or cemented components are then coated with thin layers as required to reduce surface reflection losses. Up to seven layers may be coated in one cycle.

While flat and spherical surfaces are generally easy to make, some arrangements are best avoided, such as glasses that stain, thick elements, thin meniscus elements, and small air gaps between highly curved surfaces.

A photographic lens is an assembly of single and cemented elements held in a lens barrel in a particular spatial relationship. Exact centering of all elements is vital to achieve design performance, especially in zoom lenses.

Additional Techniques Depending on cost factors and quantity and quality desired, optical surfaces may be generated in other ways.

In *diamond machining,* the surface is generated directly by machining a blank on a lathe with a diamond cutting tool under computer control. Such micromachining gives a finish suitable for infrared optics, and various materials such as plastics, semiconductors, and nonferrous metals can be machined. Aspheric and faceted surfaces can be made at modest cost.

In *electroforming,* reflective metal optical surfaces are made by electrodeposition of nickel or copper on to a precisely made mandrel immersed in an electrolyte. The fresh surface of the mirror is protected by a coating of rhodium or aluminium. Structural features can be grown-in for ease of assembly.

In *replication,* particularly difficult surfaces such as faceted mirrors may be made using thin, precise replicas cemented to an approximate substrate. An accurate mandrel of opposite shape is coated with a parting layer and protective coating for the mirror before the reflective layer is coated. The mirror and coating are separated and cemented to the substrate. Aspheric elements are routinely produced in this way.

Aspherics The type of aspheric surface determines its production method. Those that differ only very little from a sphere can be made by hand figuring. Computer control of

special laps is better for volume production. High volumes are possible by replication, injection molding, and pressing techniques, normally for polymer materials, but glass can be molded in small diameters. Electroforming is used for large elements and also replication by an add-on technique where a small amount of resin added to a spherical surface is molded to an aspheric contour.

Lens Mount The assembled lens or *optical unit* is of little practical use until it is encased in a *lens barrel,* commonly with a focusing mount incorporated for attachment to a camera. The barrel also contains items such as an automatic iris mechanism and electronic devices to interface with the camera. Design of a mount is a complex task involving precision molded components of industrial plastic and precisely machined control cams for the moving groups of a zoom lens.

LENS COATING

Light Losses and Effects Not all the light incident on the surface of a lens is transmitted. A significant amount, some 4 to 6%, is lost at each interface and proceeds as non-image-forming or flare light to cause problems such as lens flare and loss of contrast in the image. Given a transmittance T for each surface, a lens of n surfaces has a total transmittance $(T)^n$, so for 8 surfaces of average transmittance 0.95, overall transmittance is $(0.95)^8$ or 65%. A zoom lens with 20 surfaces would have a transmittance of only some 36%. An increase to 0.99 for each surface would increase transmittance to 0.92 and 0.82, respectively. Flare is significantly reduced to improve image contrast. This can be achieved by thin coatings on each surface using the phenomenon of the destructive interference of light.

Theory of Thin Films It was observed by Harold Taylor in 1892 that transmission of a lens increased with age and surface tarnishing. In 1935 artificial tarnishing using thin transparent films deposited in a vacuum became possible and *bloomed* lenses with characteristic purplish appearance by reflected light first appeared.

Fresnel's equations give the surface reflectance (R_1) between two media of refractive indices n_1 and n_2 as

$$R_1 = (n_2 - n_1)^2/(n_2 + n_1)^2$$

Likewise, if a thin coating of material $n3$ is deposited between $n1$ and $n2$, reflectance $R2$ at the coating is

$$R_2 = (n_2 - n_3)^2/(n_2 + n_3)^2$$

If destructive interference occurs between R_1 and R_2, they may be equated equal, and if n_1 is air then $n_1 = 1$, so $n_3 = (n_2)^{1/2}$. So the coating should have an index equal to the square root of the index of the glass. For a glass of index 1.51, a suitable material is magnesium fluoride with index 1.38, near to the ideal value of 1.23.

The necessary thickness (t) of the coating is given by the condition for R_1 to equal R_2 and cancel out, which for normal incidence of light with wavelength λ is $2n_3t = \lambda/2$.

Hence, the *optical thickness,* the product of refractive index and physical thickness, is equal to 1/2, termed a *quarter-wave coating.* The thickness can only be correct for one wavelength and is usually optimized for the middle of the spectrum (green) and hence looks magenta in appearance.

Coating Methods Several methods are used to apply coatings. Vacuum deposition is the most common. The lens is placed in a vacuum chamber with a container of the coating material. This is heated and evaporates, being deposited on the lens surface to the required thickness. This technique is limited to materials of low melting point. For materials of high melting point, an electron beam directed at the substance will cause evaporation and deposition, termed *electron beam coating.* Silicon dioxide ($n = 1.46$) and aluminium oxide ($n = 1.62$) may be deposited in this way and give very hard coatings suited to protect aluminized and soft optical glass.

Lens coating. An antireflection coating on glass using the principle of the destructive interference of light. I, incident ray; R1, R2, reflected rays from interfaces; t, thickness of coating; n, refractive index.

Multilayer Coatings Modern coating machinery, techniques, and materials, plus digital computers to perform the necessary complex calculations, allow extension of single coatings to *stacks* of separate coatings. Up to some 25 in number may be used to give the necessary spectral properties in interference filters.

By suitable choice of the number, order, thickness, and refractive indexes of individual coatings, the spectral transmittance of an optical component may be selectively enhanced to a value greater than 0.99 for any chosen region of the visible spectrum. Modern lenses now almost all use double and triple coatings, and as many as 7 or 11 are used occasionally. Many advanced lens designs are possible by the aid of coatings to remove the otherwise unacceptable flare. A balanced set of coatings applied to their surfaces allows a range of lenses to have a standardized color rendering, important for use with color reversal film.

Multilayer coatings. The effects of various types of antireflection treatment compared with uncoated glass for a single lens surface at normal incidence.

LENS TESTING

Need for Testing A lens is subject to various tests during manufacture, but it is prudent for the purchaser or user to have available some means of testing a lens. Specific reasons include the need to see that it conforms to specifications and is suitable for its intended purpose and also to confirm its performance when it is a mass-produced item subject

only a batch testing. Testing also allows a new lens to be compared with existing apparatus and graded accordingly. The specific performance over the field and at various apertures can be determined for optimum conditions of use. Lenses should be retested periodically, especially if they have been subject to accidental knocks or repairs or abuse. Ideally, testing facilities must be of modest cost and readily available and take up little space or even be packed for use on location.

Tests During Manufacture The individual elements of a lens are tested to check that diameter, axial thickness, centering, and surface curvatures are correct within tolerances. Groups of elements may be tested, especially if containing a cemented pair. The completed lens may also be fully tested if produced in limited numbers, but more often batch tests are carried out where, depending on batch size, a small number of lenses are selected for testing and, dependent on those results, the whole batch is accepted or rejected. Consequently, lenses may be found to vary in performance depending on the rigor of examination after production. A series of tests is done including resolution testing and MTF testing.

Test charts. An array of lens test targets for resolution testing.

Methods of Testing

Infinity Test Most photographic lenses are aberration corrected for a large object conjugate and normally used focused on distant subjects. It is necessary to find some laboratory substitute for a large field at infinity focus. Various optical systems can be used.

The Collimator The collimator is a highly corrected lens of high *f*-number and small field with an illuminated test target or reticle at the rear principal focus. When viewed from the image space, the emergent parallel or collimated rays simulate a distance or pseudo-infinity for the target, which is physically only a short distance away. The camera lens may then look into the collimator to focus on the target to check on infinity performance. The target only subtends a small angle in the field, so a fan of several collimators may be used or a single collimator moved to various positions.

The Reflex Autocollimator The reflex autocollimator is a refinement of the simple collimator by the addition of a beam splitter placed adjacent to the target and a reticle in an equivalent focal plane, viewed by an eyepiece. The emergent collimator beam is reflected back into the instrument, and any displacement of the target image with respect to the reticle indicates deviation due to the system under test. Angles and flatness of surfaces can be measured. The image of the target can be observed on the film plane of a camera and collimation of the lens checked as well as the accuracy of focusing mounts.

Star Testing Star testing involves the visual inspection under high power of the image formed by the lens under test of a point source subject, such as a distant illuminated pinhole. The test has its origins in astronomy, when stars and double stars were used as test subjects and the Airy patterns observed from the near diffraction-limited telescopes. If the lens is positioned on a nodal slide on an optical bench, then various tests are possible, including measurement of focal length, chromatic aberration, the effect of filters, axial symmetry, and the topography of the image surface.

Test Charts A lens-testing chart is an array of test targets filling the field of view of a lens under test at a conjugate distance that is a convenient multiple of focal length (*f*) to give a magnification related to the resolving power figures indicated on the targets. Typically a magnification (*m*) of 1/50 is used, or reproduction ratio of 1:50. The distance (*D*) from target plane to film plane may be calculated from $D = f(2 + m + 1/m)$. Alternatively, a datum line may be attached to the test chart and its image measured to give the exact value of magnification.

Various designs of targets are in use, depending on the use for the lens under test, but the pattern known as USAF 1951 is widely used. Carefully positioned lines can indicate the fields of view of different formats at various distances to provide a check on viewfinder accuracy, assist alignment, and provide a means of measuring curvilinear distortion in the lens if present. The test target is photographed at a finite distance rather than infinity, but this is unavoidable for a compact, convenient system. The target must be evenly illuminated as exposure level affects resolving power and so falloff of image illumination can be detected. The optical axis of the lens must be accurately perpendicular to the plane of the target and intersect the central target. A series of exposures is made with the lens set slightly to either side of best visual focus to obtain a through-focus series. After exposure and processing under standardized conditions, the target images are examined under ×50 magnification to find the limiting resolution of the system. A single figure of merit cannot be given for system performance, but useful comparisons can be made such as aperture related performance or between lenses.

MTF Testing Lenses may be routinely tested by electronic means where the image contrast is evaluated by use of modulation transfer function (MTF) apparatus. Essentially, a target located at the focus of a collimator generates a range

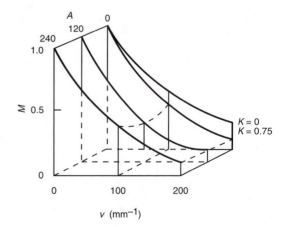

MTF testing. Basic set of MTF data plotting modulation transfer factor *M* against spatial frequency *v*. The lens is evaluated at optimum focus, with white light, at full aperture and infinity object conjugate. MTF traces are made at three azimuth (*A*) orientations, on-axis *K* = 0, and three-quarter field *K* = 0.75.

of spatial frequencies and the change in modulation of these measured at the focus of the lens under test then displayed graphically. This method requires a range of such measurements to be made at different apertures, wavelengths, and image field positions. A through-focus series determines the focal length of the lens precisely. The procedures can be automated.

GENERAL PROPERTIES OF LENSES The general properties of a lens that are of interest to the photographer may be provided on the lens itself or in a separate data sheet provided by the manufacturer. These may include focal length, usually a nominal value, e.g. 50 mm; maximum aperture and aperture range expressed as *f*-numbers, or for cine lenses as *T*-numbers; focusing range to closest unaided distance; and exposure correction factors or magnification in the case of macro lenses.

The covering power related to format and any permissible camera movements is provided in tabular form.

Less frequently needed are details of back focal distance and flange focal distance, or the spectral correction range of the lens.

Lens Attachments and Accessories A variety of optical and mechanical attachments can be affixed to the camera lens. Principally they are attached to the front of the lens by a variety of push-on, screw, and bayonet methods. The inside rim of the front of the lens may have a standardized screw fitting such as 52 mm to take such accessories as closeup lenses, image modification or degradation devices, filters, filter holders, optical devices, lens hoods, and matte boxes. A requirement may be the ability to rotate or shift an attachment such as polarizing filters or graduated filters, respectively. Other front-attached devices include stereoscopic beam splitters, afocal converters, telescopes, and fisheye attachments.

Attachments to the rear of the lens usually require that they have male and female mounts to locate them between lens and camera body. Optical devices include teleconverters, image intensifiers, and relay systems. Other devices are extension tubes and bellows to allow close focusing. Sometimes filters are attached to the rear element of a lens or even inserted between elements in a suitable holder. Front or rear groups of elements may be removable and interchangeable to provide alternative configurations.

Books: Horne, D. *Optical Production Technology.* Bristol: Adam Hilger, 1972; Kingslake, Rudolph, *A History of the Photographic Lens.* London: Academic Press, 1989; Kingslake, Rudolph, *Lens Design Fundamentals.* London: Academic Press, 1983; Kingslake, Rudolph, *Optics and Photography.* Bellingham, WA: SPIE Optical Engineering Press, 1992; *Optics and Refraction: the User-Friendly Guide.* Miller, David, editor, New York: Gower Medical Publishing, 1992; Malacara, D., *Optical Shop Testing.* Chichester: Wiley, 1978; Ray, S., *Applied Photographic Optics.* London and Boston: Focal Press, 1988; Stroebel, Leslie, *View Camera Technique.* 6th ed. Boston: Focal Press, 1993. *S. Ray*

See also: *Lens types.*

LENS FLARE Nonimage-forming stray light in an optical system. The effect is to degrade the contrast of the image. This is quantified by the flare factor, which is the ratio of image illuminance range to subject luminance range, sometimes expressed as a percentage. Camera flare factors of 2 to 3 are typical for a coated lens. *S. Ray*

See also: *Flare factor.*

LENS HISTORY See *Lenses.*

LENS HOOD A device that fits on the front of a camera or lens to exclude extraneous light and thereby reduce lens flare and camera flare. The interior surface of lens hoods should be flat black. Lens hoods come in various sizes, shapes (round or square), and materials (metal, rubber, plastic). A hood that is too deep for a particular focal length lens will cause vignetting on the film. Lens hoods can also be in the form of an adjustable bellows so that a single hood can be used with different focal-length lenses. Bellows hoods for view cameras may also include adjustable masking blades for more precise control over the size and shape of the opening.

Some lenses have built-in lens hoods such as a telescoping hood on the lens barrel, or a barrel that extends well beyond the front of the lens. *P. Schranz*

Syn.: *Lens shade.*

LENSMAKERS' FORMULA For a thin lens in air, an equation that determines the focal length of the lens from (1) the index of refraction (*n*) of the material composing the lens, and (2) the radii of curvature (R_1 and R_2) of the two lens surfaces. The equation is

$$\frac{1}{f} = (n-1)\left[\frac{1}{R_1} - \frac{1}{R_2}\right]$$

H. Todd

LENS MANUFACTURE See *Lenses.*

LENS RESOLUTION The ability of a lens to resolve fine detail in the subject. In photography this depends principally on the correction of the lens and the conditions of the test such as the type and contrast of the test target. *S. Ray*

See also: *Lenses, lens testing; Resolution; Resolving power.*

LENS SPEED Measure of the maximum light-transmitting power of a lens, usually taken as the *f*-number of the largest aperture (smallest *f*-number). This is a geometrical measure and takes no account of light losses by absorption and reflection in the lens. If this is important, the speed may be expressed as a *T*-number. *S. Ray*

See also: *T-number.*

LENS TESTING See *Lenses.*

LENS-TESTING CHART A test target that contains designs for detecting various lens shortcomings, such as barrel or pincushion distortion, coma, low resolving power, and chromatic aberrations. *L. Stroebel*

See also: *Input, test targets.*

LENS TYPES The majority of cameras are purchased with a normal or standard lens for the format, especially if the lens is not interchangeable, but fixed lenses that are wide angle or zoom or have dual focal lengths are also available. For cameras with interchangeable lenses, there is a very wide choice of alternative focal lengths and specialized types that use particular forms of design or construction to obtain the desired properties. A comprehensive selection of lens types is discussed in the following sections.

AFOCAL LENS An afocal lens is one whose two elements are separated by the sum of their focal lengths, giving the principal (nodal) plane at infinity. Parallel light incident emerges still parallel, i.e., not focused, but the diameter of the beam is changed. The magnifying power of the system is given by the ratio of the focal lengths of the two components. Astronomical telescopes and Galilean telescopes are examples of afocal systems. Such devices can be used in conjunction with a conventional prime lens or projector lens to change focal length and are usually

called *afocal converters.* For example, Galilean telescope devices used normally and in reverse may give magnifying powers of ×1.5 and ×0.7, respectively. Variable-power attachments are available also. The geometric maximum aperture of the prime lens is unchanged, but transmission losses occur. Medium apertures are best to avoid additional aberrations.

ANAMORPHIC LENS In cameras, especially cine cameras, the format aspect ratio of height to width is limited by the film aperture and the width of the film stock used, typically 35 mm or 16 mm. To obtain aspect ratios from 2:1 to 3:1 instead of the usual 1.33:1 to 1.5:1, an anamorphic lens system will compress, or *squeeze,* the image laterally to retain the film aperture ratio, so the image is distorted when recorded. Upon projection, a similar system will *unsqueeze* the image to give a widescreen presentation. The anamorphic ratio or compression (squeeze) factor is the ratio of undistorted to distorted image widths. An anamorphic lens is a conventional lens used with an afocal reversed Galilean telescope attachment using cylindrical instead of spherical lens elements. First demonstrated in 1927 by H. Chrétien and later developed into the Cinemascope process.

ASPHERIC LENS An aspheric lens has one or more of its refracting (or reflecting) surfaces that are not spherical but instead may be a conic surface, such as an ellipsoid, paraboloid, or hyperboloid, or of complex curvature. The refraction errors of a surface, such as spherical aberration, are much reduced, and fewer elements may be needed in a design for similar performance. Aspheric single-element lenses may be used in simple cameras and for specialist work such as thermal imaging. Such surfaces are still difficult and costly to make, reflected in the price of the lens. For illumination systems, however, condenser lenses with molded aspheric surfaces are cost effective. An aspheric surface is usually a small, internal one in a lens configuration.

CAMERA LENSES Imaging lenses of usefully large aperture and usable at this aperture to provide a reasonably uniform level of illumination and resolving power appropriate to the film format in use. Performance improves with stopping down, typically to be optimum when closed down some three full stops. The lens is usually optimized for aberration correction assuming a distant subject. Designs are characterized by multielement construction and multilayer coatings and may include automation of functions such as iris diaphragm and focusing.

CATADIOPTRIC LENS An imaging system of long focal length using a combination of mirrors and refracting elements. Commonly called a *mirror lens,* the configuration is usually Cassegrain to give a compact design by virtue of the folded optical path. The refractive elements are necessary to correct the spherical aberration and field curvature given by a low-cost spherical mirror. There are three major systems in use. The Schmidt corrector plate is an aspheric element located at the center of curvature of the mirror and is normally used for large aperture, wide-field astrotelescopes. The cheaper Mangin mirror is a back-silvered meniscus lens through which light passes twice to provide corrections. The Bouwers–Maksutov solution is to use thick meniscus lenses concentric with the mirror. Maximum apertures are moderate, and apertures are usually not adjustable. Internal focusing by movement of the secondary mirror gives close focus capability. Catadioptric lenses are quite prone to flare, and alignment during assembly is critical.

CATOPTRIC LENS An optical system that uses only mirrors as imaging elements. The advantage of surface silvered mirrors is that there is no dispersion of light, large diameter optics are possible, and infrared and ultraviolet photography need no focus correction. A Cassegrain configuration is popular for the compactness of design. A spherical mirror is cheap but suffers from spherical aberration and field curvature. A paraboloid mirror is expensive and has severe off-axis coma. Ellipsoidal mirrors have two foci and are best used in illumination systems such as diathermal mirrors for light sources for enlargers.

CONDENSER LENS An optical system that concentrates the light from a source into a beam forming an evenly illuminated image of the source and which may be directed into the entrance pupil of a lens. Condensers are used in

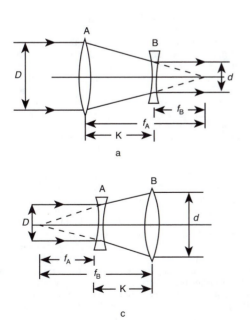

a

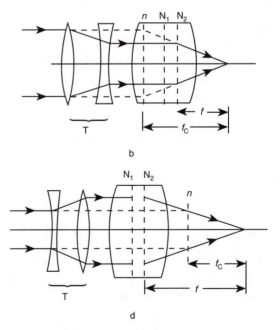

b

c

d

Afocal attachments for prime lenses. (a) The Galilean telescope: power = f_A/f_B = D/d. (b) Telephoto attachment T gives a new nodal plane at n. f_C, focal length of combination. (c) Reversed Galilean telescope. (d) Wide-angle attachment T.

enlargers, projectors, camera viewfinders, and microscopes. The simplest form is a large-diameter plano-convex lens. Optical quality need not be perfect, as condensers are used in illumination systems and not imaging systems. The subject, such as a negative or slide, is placed between the condenser and the image-forming lens, close to the condenser. Better results and smaller systems are given by use of two such lenses positioned convex sides innermost. In an enlarger the lenses are interchangeable for different formats, as in many slide projectors. Because optical quality can be lower, condensers for projectors can be molded to shape and have an aspheric surface to reduce spherical aberration and increase efficiency. Where space is important, the plano-convex lens can be replaced by a flat Fresnel lens with the same effect. This is the arrangement when used to even out the illumination of the focusing screen of a camera. The substage condenser of a microscope is usually color corrected and of large numerical aperture. Large mirrors, often aspheric and diathermal, may be used in cine projector illumination systems.

CONVERTIBLE LENS An obsolescent lens feature, usually in one of near symmetrical configuration, particularly those for large format cameras, which by unscrewing the rear group may be converted into one of considerably longer focal length with loss of maximum aperture. For example, 150 mm $f/5.6$ convertible to 450 mm $f/16$. Acceptable results are possible but aberrations such as distortion remain.

ENLARGER LENS A lens used to produce images in projection printing. A large aperture or $f/5.6$ to $f/2$ is used for focusing and the lens used two or three stops closed down. Depending on maximum aperture, three, four, or six elements designs are used in triplet, reversed Tessar, or symmetrical configurations. Aberration correction is for short object conjugates, a flat image field, and freedom from distortion. Performance is optimized for a given magnification. The lenses may successfully be used on cameras for closeup work and copying when used in reverse.

FIELD LENS Usually a single-element lens that is located at or near the focal plane of another lens. Field lenses have no effect on the focal length of the prime lens in this position. Their functions include flattening the field (image surface) of the prime lens (Piazzi Smyth Field Flattener, especially with Petzval lenses); redirecting peripheral rays in the image plane to avoid darkening in the corners as in viewfinder focusing screens, and in lens endoscope systems.

FISHEYE LENS A lens with extreme angle of coverage. The geometry of orthoscopic image formation and image illumination limit the angle of coverage of a distortion-free lens to about 120 degrees. If barrel distortion is permissible, then the angle can be increased to 180 degrees or more. Extreme retrofocus configuration allows use in a single-lens reflex (SLR) camera. There are two versions of such fisheye lenses. The quasi-fisheye has a circle of illumination that circumscribes the film format and gives 180 degrees angle of view across the diagonal. The true fisheye has a circular image area wholly within the format, thus including more of the scene. The diameter of the image circle depends on the focal length (f). Image formation uses equidistant projection by the lens where the image height Y from the optical axis is given by $Y = f \cdot \theta$, where θ is the semi-field angle measured in radians. Conventional lenses use central projection with the relationship $Y = f \cdot \tan \theta$.

FLAT-FIELD LENS A lens that is highly corrected for astigmatism and Petzval curvature to give a nearly flat image surface to match accurately the film surface at the focal plane. Copying, enlarger, and process lenses must have flat fields.

FLUORIDE LENS Also known as Fluorite, Fluorspar, a lens using one or more elements of calcium fluoride (CaF_2) made from synthetic crystals. This material gives possibili-

ties of very high color correction, especially of transverse chromatic aberration. Now largely replaced by Fluoro-Crown (ED) glasses for most purposes but still used to give an achromatic combination with fused quartz material in lenses for ultraviolet photography, because of their high UV transmission. No focus correction is needed for UV use after visual focusing.

FRESNEL LENS A converging lens in the form of a thin panel of plastic or glass with a series of concentric stepped grooves or rings produced by molding or replication processes. Each groove face is tilted at a different angle to correspond to the zone of a condenser lens it replaces. Used with the grooves facing the longer conjugate, the facets refract light to a common focus and the lens is corrected for spherical aberration. Two to eight grooves per millimeter are possible, and the large diameter and short focus allow effective apertures up to $f/0.6$. Uses include focusing spotlights, field lenses for focusing screens, the overhead projector, and zoom lenses for electronic flash units.

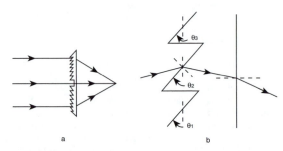

Fresnel lens: (a) in use as a collimator; (b) configuration of grooves $\theta_1 < \theta_2 < \theta_3$.

HILL CLOUD LENS A precursor of the modern fisheye lens designed by Robin Hill in 1924 for meteorological photography of clouds. It was a three element design of 21-mm focal length and $f/8$ aperture and not corrected chromatically, as it was used with a red filter. The image circle diameter was 63 mm.

LONG-FOCUS LENS A lens with a focal length markedly longer than the diagonal of the format in use. As image size is proportional to focal length, an increase in focal length gives a larger image. Depending on the focal length and maximum aperture required, lens configurations such as achromatic doublet, Petzval, symmetrical, and Double-Gauss have all been used. Very long focus types can be of very simple construction. Transverse chromatic aberration and flare set a limit to imaging abilities. Telephoto and catadioptric designs are more compact.

MACRO LENS General term for a lens designed for closeup photography but capable of good results at unit magnification (life-size). Good aberration correction in a lens requires the object distance to be specified; normally this is taken as infinity, so closeup performance suffers. Macro lenses are optimized for shorter conjugates or a magnification such as 0.1. Maximum aperture tends to be modest, such as $f/2.8$ to $f/4$. A feature is the considerably extended double helical focusing mount that allows continuous focus to half- or same-size. For magnifications greater than 1.0, the lens is best used in reverse to retain corrections, but automatic features are then lost. Triplet or Gauss derivative designs are used to give flat fields and distortion-free results desirable in copy work. Additional aberration correction may be achieved by floating elements within the configuration, coupled to the focusing control. Focal length then varies with focused distance.

MACRO-ZOOM LENS A type of zoom or varifocal lens that offers an additional feature of a close-focus capa-

Long-focus lens. Lens configurations for long focal length designs. (a) Long focus; (b) telephoto; (c) two mirror catoptric. N_2, rear nodal plane; f, focal length; BFD, back focal distance.

bility but almost never approaching same-size imagery that would truly qualify it for the *macro* title. Close focusing may be continuous in the focus control or at a separate setting, but normally a fixed focal length is selected, usually the shortest in the range, and a zoom group then doubles as a variable closeup lens to provide a closeup focusing zone. There may be a focus gap between the normal near focus point and the start of the ancillary range.

MENISCUS LENS Single element, simple thin lens with both surfaces curved in the same direction, i.e., one is concave and the other convex. Depending on the relative radii of curvatures, the net power of the lens will be either positive or negative. If the convex surface radius is smaller, the lens is thicker in the center and is positive, and vice versa. Used for closeup supplementary lenses and simple cameras.

MICRO-IMAGING LENS Lens of diffraction limited performance capable of approaching the theoretical limit of resolving power. Used to produce microimages and masks for the production of integrated circuitry by microlithography. Performance is achieved by placing restraints on the lens such as chromatic and aberration correction for one spectral line, a fixed reproduction ratio, a fixed large aperture, symmetrical configuration, and very small field.

MIRROR LENS An image-forming system using flat and curved mirrors instead of refractive elements. An advantage is freedom from chromatic aberration and visual focusing for use in the infrared and ultraviolet regions. Very large apertures, up to $f/0.6$ are possible at modest cost even with spherical surfaces, used for recording fluorescent screen im-

ages in fluorography. Astronomical telescopes use all mirror designs of Cassegrain configuration with aspheric mirror surfaces. The wide-field Schmidt telescope uses a spherical mirror with an aspheric glass corrector to reduce spherical aberration and flatten the field for photographic recording.

MULTIPLE LENS An array of lenses as used in certain cameras and printers. An ultra-high-speed camera of the Miller or rotating mirror type projects an image onto an arc of identical lenses, which in turn reimage the subject in a framed sequence onto a length of film. Some designs of stereo cameras use two, three, or four identical lenses in a horizontal row to provide a multiplicity of viewpoints. A printer may use a cluster of lenses in multiples of several focal lengths to provide a set of identical prints of different sizes as a package deal.

NEGATIVE LENS An alternative name for a diverging lens, which is of negative refracting power. In the case of a simple lens, it has one or more concave surfaces so that it is thinner in the middle. It forms a virtual image of the subject.

ORTHOSCOPIC LENS Term to describe a lens that apart from other features gives an image free from curvilinear distortion, i.e., gives correct drawing. An essential requirement is near symmetrical configuration. Such lenses are essential in such applications as copying, architectural photography, aerial survey, and photogrammetry.

PERSPECTIVE-CONTROL/PC LENS Wide-angle lens of retrofocus construction that has extra covering power so that the image circle exceeds the diameter of the film format. These lenses are fitted in mounts that allow lateral displacement movements without vignetting the image and are used on small and medium format cameras that lack any movements otherwise. Both rising/falling and lateral cross movements are possible. Occasionally a tilt movement is provided too.

See also: *Depth of field, camera movements.*

PORTRAIT-ATTACHMENT LENS (1) Supplementary negative lens attached to the fixed prime lens on a camera to increase its focal length and hence be more suited for portrait photography. (2) A positive supplementary lens used to reduce the effective focal length of the lens on a camera having a limited focusing range, thus allowing the camera to be moved closer to a portrait subject to obtain a larger image (with the disadvantage of an accompanying stronger perspective). The preferred term is *closeup attachment*.

PORTRAIT LENS A general term to cover lenses found preferable for portraiture, being of long focus to provide an improved perspective of the face due to a more distant viewpoint to give the necessary field of view. Lenses of lower aberration correction standards are often preferred, and special soft-focus types are widely used too. The Petzval lens was a precursor of portrait lenses.

POSITIVE LENS Alternative name for converging lens. In the case of a simple lens it is thicker in the middle and has one or both surfaces convex. For a distant subject, light is focused to a real image on the opposite side of the lens.

PROCESS LENS Lens for process cameras used for precision copying and color separation work for photomechanical reproduction purposes. The lens must be corrected for near unit magnification and for three spectral colors (apochromatic) and essentially distortion free. The usual configuration is a four to six element symmetrical system. The iris diaphragm may also be calibrated in millimeters. Long focal lengths are needed to cover large size film formats. Near diffraction-limited performance is given on-axis.

PROJECTOR LENS Lens used for the projection of magnified images on a screen for general viewing as in the cinema or for viewing small format color transparencies. Traditionally the focal length is twice the diagonal of the format, but wide-angle and long focus versions are used

also, depending on the projector-to-screen distance. Designs without cemented elements are preferred to avoid heat problems. Triplet, Petzval, and double Gauss derivative designs are used, depending on the performance required. Zoom or varifocal lenses are popular because of the convenience in setting up, but some curvilinear distortion is inevitable.

REDUCTION LENS Lens used in a system such as an optical printer to give an image in a smaller format by optical reduction. A high-quality copying lens free from distortion is desirable.

REFLECTING LENS An alternative term for lens of catoptric or catadioptric construction, which uses one or more mirror surfaces for image formation.

RELAY LENS A lens or group of lenses used to transfer an intermediate real image formed in one region of an optical system to another part by optical projection. A change of magnification may be involved, an image inversion or reversal or the lengthening of the optical path in an imaging system or viewfinder. Also used to form the image of a phosphor screen onto film for recording, as in an image intensifier system.

SOFT-FOCUS LENS Lens designed primarily for portrait purposes that by use of deliberate introduction of residual uncorrected spherical aberration can give an image that is diffused and unsharp but color corrected, characterized by a sharp core with halo. Stopping down reduces the unsharp halo effect. Alternative optical arrangements include the use of a special perforated diaphragm stop to blend central and uncorrected peripheral rays or the controlled separation of elements to reduce corrections.

SPLIT-DIOPTER LENS Supplementary closeup lens in the form of a semicircle to cover only half of the front element of the prime lens and used to enable two subjects at different distances to be recorded in sharp focus. Light rays from the nearer subject pass through the half lens, and those from the farther subject do not.

SUPPLEMENTARY LENS Lens or optical system added to the front of an existing prime lens, usually to change focal length. Complex afocal attachments are used with fixed lenses, which retain aperture and focusing range. The term *supplementary* is usually used just for positive and negative simple lenses. A negative meniscus lens will increase focal length, but the focusing system must allow the additional extension needed. Much more popular is the positive meniscus or achromatic doublet supplementary lens used for close-up photography. The effect is to shorten focal length, so with a given lens to image distance the near focusing limit is reduced. With the prime lens set at infinity focus, the combination is focused at a distance equal to the focal length of the supplementary lens.

TELECONVERTER LENS Optical attachment that is placed between the camera lens and body to increase the focal length of the prime lens. It is not strictly a lens but a group of elements of net negative power and operates on the principle of the telephoto lens. First suggested by the astronomer Barlow in 1834, modern versions use four to eight elements with multicoating housed in a short extension tube, retaining automatic functions of the prime lens. The optical effect is to double or triple the focal length of the prime lens, forming a telephoto of short physical length. As the entrance pupil is unaffected, this doubling or tripling means that maximum aperture is decreased by two or three stops respectively, e.g., a 100 mm $f/2.8$ lens with a X2 converter becomes a 200 mm $f/5.6$ telephoto. The minimum focusing distance is retained. The results are best with long focus lenses, and they are not suitable for wide-angle types. Many super telephoto lenses are supplied with matching teleconverters of power X1.4.

TELEPHOTO LENS Long focus lens relative to the format but distinguished by a different optical construction

Teleconverter principle. (a) Camera lens C of focal length f in body B focuses light onto film F; (b) addition of teleconverter T of thickness d gives rear nodal plane N and combined focal length 2f.

that gives a more compact design. A negative component is placed behind a front positive component of long focal length, which displaces the nodal planes in front of the lens. The length of the lens barrel is much less than for a conventional lens of similar focal length. Telephoto lenses are well corrected, possibly with some residual pincushion distortion due to the asymmetry of configuration. Use of ED glass and internal focusing have given a class of lenses called *super telephotos,* which have focal lengths from 200 to 800 mm and maximum apertures $f/2$ to $f/5.6$, depending on focal length. Use of a teleconverter increases their focal length.

VARIABLE-FOCAL-LENGTH LENS Term used to describe a zoom lens but usually taken to mean a varifocal lens where sharp focus drifts as the focal length is changed, necessitating a focus check each time. The slight inconvenience is offset by the simpler optical design possible or the higher correction available. This system is much used in cine and slide projector zoom lenses. The f-number and image illuminance also change as the focal length is changed.

WIDE-ANGLE LENS Lens having significantly greater covering power than a normal lens of equal focal length, thereby permitting the use of shorter focal length lenses to obtain a larger angle of view. Early versions suffered from poor covering power and falloff in marginal resolution, limiting the maximum useful aperture to about $f/22$. Two forms of optical design are now used, giving greatly improved results and larger apertures. Quasi-symmetrical derivative designs allow apertures up to $f/2.8$. The symmetry means correction for distortion is particularly good. The design uses very large negative meniscus lenses on either side of the small central positive group, giving the lens a characteristic wasp-waisted appearance and increasing bulk. Such lenses have extra covering power, allowing their use with camera movements on large format cameras, but have a small back focal distance so that reflex viewing and focusing are not possible. When these are necessary, retrofocus construction is needed instead.

Retrofocus of inverted/reversed telephoto configuration is a departure from symmetry using a front divergent (nega-

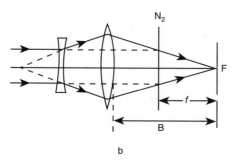

Wide-angle lens. The retrofocus principle: (a) short focus lens where back focal distance B is approximately equal to focal length f; (b) retrofocus equivalent with $B > f$, N_2, rear nodal plane; F, film surface.

tive) group with a rear convergent (positive) group. This gives a short focal length with a long back focal distance by shifting the nodal planes. The asymmetry can cause some residual barrel distortion, but reflex mirrors or beam splitters can be inserted between lens and film. Such lenses have increased complexity, bulk, and cost, but they provide less falloff of light toward the corners of the film than conventional wide-angle lenses of the same focal length.

ZOOM LENS Lens with a focal length that can be varied continuously between fixed limits while the image stays in acceptably sharp focus. The visual effect in the viewfinder is that of a smaller or larger image as the focal length is decreased or increased, respectively. Zoom ratios of 2:1 to 6:1 are available for 35-mm still photography, 10:1 to 20:1 for cine and video. The basic optical design uses the axial movement of one element to change focal length by altering separation of the elements. For example, a front negative lens plus a rear positive lens arrangement with reduced separation has an increase in focal length. This simple system

would be severely aberrated, and the image would change focus with focal length. Both defects require extra elements; in practice, any number between 6 and 20. Sharp focus is retained by compensation, such as another element moving in conjunction with the zoom element. Optical compensation is where the moving elements are coupled together, while mechanical compensation has two or more groups moving at different rates and in different directions. The latter is preferred, as better compensation is obtained, but high mechanical precision is needed for the control cams. Up to four moving groups are used.

The classical configuration of a zoom lens uses four groups of elements. The two linked movable zoom groups are located between a movable front group used for focusing and a fixed rear group, which also contains the iris diaphragm. This rear group is positive and acts as a relay lens to produce an image in the film plane via the zoom groups, which act as an afocal telescope system of variable power. This arrangement keeps the f-number constant as focal length is altered by controlling the size and location of the exit pupil of the system. The elements may also be separately adjusted to provide a *macrozoom* feature, and the f-number may remain constant over a closeup focusing range. Newer lenses provide continuous close focusing by movement of all or part of the lens groups, making separate macro mode obsolescent. The internal focusing may be under the control of an in-camera autofocus system, and the lens will contain suitable electronics to interface with the autoexposure system of the camera. A penalty of mechanical compensation is that the f-number changes with focal length, giving a loss of one-half to one full stop from minimum to maximum focal length. This penalty is accepted to keep zoom lenses small and light. Exposure variations are monitored by the in-camera through-the-lens (TTL) metering system. Early zoom lenses tended to suffer from variable distortion as zooming progressed, but modern designs give much improved image quality, approaching that of a fixed focal length lens. Unfortunately, the maximum apertures available are still modest in comparison to a prime lens.

Books: Ray, S., *Applied Photographic Optics*. London & Boston: Focal Press, 1988. S. Ray

See also: *Lenses; Optics*.

LENTICULAR COLOR PHOTOGRAPHY Lenticular systems use embossed screens on transparent supports. The screens consist of 1600 or more parallel, semicylindrical columns per inch that break an image into components that are subsequently recombined. If a second set of linear elements is added at right angles to the first set, the spherical lenticules formed will produce finer resolution. In addition to

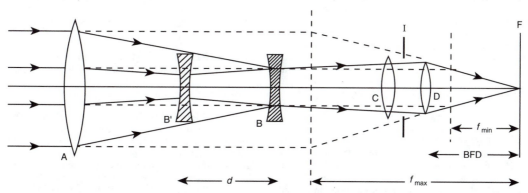

Zoom lens. Basic zoom lens system: Elements A, B, and C form the zoom variator system; D is the relay lens and I is the iris diaphragm.

color photography, lenticular systems are used in image dissection and stereo photography.

In the late nineteenth and early twentieth centuries, before the perfection of dye-based color materials, the best hope for a workable system of color photography seemed to lie in the optical division of white light into its components. In 1908, the French physicist and Nobel laureate Gabriel Lippmann proposed an additive color film with an integral lenticular screen. The following year, Rodolphe Berthon, a French engineer and astronomical optician, described the use of a cylindrical lens behind which there was a red, green, and blue striped filter. His film was coated with a black-and-white panchromatic emulsion on the side away from the lens and embossed with a lenticular screen on the side facing the lens. Interlaced three-color separation records were formed on the film. After reversal processing, a full color image was generated by projecting white light back through the film, screen filters, and lens.

In 1914, the French photoengraver Albert Keller-Dorian received a patent for a working lenticular cinematographic system, which he marketed briefly. The Keller-Dorian-Berthon process formed the basis for many subsequent patents and for a 16-mm amateur color motion picture film released in 1928. It was called Kodacolor, a name later given to a series of subtractive color materials. The Siemens-Berthon lenticular process produced the Agfacolor amateur color film of 1931. *H. Wallach*

See also: *Image dissection; Lenticular screen.*

LE SECQ, HENRI (1818–1882) French painter and photographer. A student of the painter Paul Delaroche (1840–1843). Fellow students included Fenton, Le Gray, and Nègre. Learned Le Gray's waxed-paper process, a variation of Talbot's calotype, directly from Le Gray, (c. 1848). Cofounder in 1851 of the first photographic society in the world, Société Héliographique, with Le Gray and Nègre. Hired by the French government as one of five to photograph historical monuments (1851), producing graceful compositions, full views and details of the great cathedrals of Amiens, Reims, Chartres, and Strasbourg. Le Secq showed an unusual concern for shadows in his photographs, which he included with deliberation. Also documented his home city, Paris, to preserve important buildings and monuments before they were destroyed by the wrecking ball of progress. Though he abandoned photography in 1856, he is now more highly regarded as a photographer than painter, though he devoted much more time to the latter.

Books: Jammes, Andre, and Janis, Eugenia Parry, *The Art of French Calotype*. Princeton: Princeton University Press, 1983; Janis, Eugenia Parry and Sartre, *Henri Le Secq, Photographe de 1850 a 1860*. Paris: Flammarion, 1986. *M. Alinder*

LETTERPRESS Letterpress is the oldest printing process; it was invented and used by Johann Gutenberg about 1440 A.D. Letterpress is a relief process using cast metal type and engravings or photopolymer plates, and it is printed on sheet-fed or web (roll-fed) presses with oil-base inks. The process has declined in use because of the time and difficulty in makeready on the press because of differential pressures exerted by different size image elements (highlight dots and shadow dots, type of solids) during printing.
 M. Bruno

See also: *Photomechanical and electronic reproduction.*

LEVEL BUBBLE A sealed transparent container nearly filled with liquid, leaving a small air bubble. The bubble rests in the middle of the container when it is perfectly horizontal. Level bubbles are used, for example, on view camera beds and front and back standards, panoramic cameras, and tripod heads. *P. Schranz*

LEVEL CORRECTED In animation, the adjustment of colored inks used when preparing a sequence to be filmed with several acetate cel overlays, to maintain color consistency while compensating for the effect of filming through several sheets of acetate. *H. Lester*

LEVELING/SHARPENING The visual process by which the structural features in an image are simplified or exaggerated. For example, imagine a small circle within a square where the circle is slightly off center. If it is seen and remembered as centered, the lack of symmetry is being leveled. If, however, it is seen as greatly off center, it is being exaggerated and therefore sharpened. The tendency is to make perceptual structures as clear-cut as possible. Leveling enhances symmetry and unification, while sharpening enhances differences. *L. Stroebel and R. Zakia*

See also: *Visual perception, gestalt.*

LEVEL SYNC In motion-picture production, the alignment of picture and sound tracks so that corresponding points coincide, as opposed to projector or printer sync, where the sound is placed ahead of the corresponding image.
 H. Lester

Syn.: *Dead sync; Editorial sync.*

LEVITT, HELEN (1918–) American photographer. Influenced by Walker Evans, with whom she studied (1938–1939) and by the work of Cartier-Bresson. Levitt, with her surreptitious Leica camera, has captured the parade of human comedy on the streets of New York, especially children at play. Her images, though at first glance informal, are fully seen and composed.

Books: *A Way of Seeing,* with James Agee. New York: Viking, 1965; *In the Street.* Durham, NC: Duke University Press, 1987; Phillips, Sandra S. and Hambourg, Maria Morris, *Helen Levitt.* San Francisco: San Francisco Museum of Modern Art, and New York: The Metropolitan Museum of Art, 1991. *M. Alinder*

LEVOROTARY Optically active, birefringent substances that rotate the plane of polarization of transmitted plane polarized light. When looking into the incident light, if the rotation is anticlockwise, the substance is termed *levorotary.*
 S. Ray

LIBRARY In computer parlance the library is a repository of a file from which the software may make calls. The calling of subroutines or procedures from the library can speed software development and provide for standardized approaches to the writing of code. *R. Kraus*

LICENSING See *Business practices, legal issues.*

LIFE That time during which photographic materials and equipment remain useful, such as the shelf life of films and papers, the storage life of processing solutions, and the lamp life of projector and studio lamps. *L. Stroebel*

LIFE EXPECTANCY (LE) The time expressed in years during which a photograph is expected to remain usable.
 K. B. Hendriks

See also: *Image permanence.*

LIGHT Light is fundamental to *photography*. The word *photography* literally means drawing with light. The function of photographic materials is to record patterns of light, and the function of the photographic equipment used for taking pictures is to produce, measure, and control light. Few things are more valuable to the photographer than an understanding of light. To be complete, this understanding must be made up of both aesthetic and physical components. The aes-

thetic component is the artistic side of photography. In using photography as a medium for artistic expression, the photographer is painting with light, or recording a naturally occurring arrangement of aesthetically significant light values. In either case, the ability to aesthetically evaluate and control light is essential. This ability is the base for creative image making, and is discussed and exemplified throughout countless books related to the field of photography.

In the physical sense, light is defined as electromagnetic radiation to which our eyes are sensitive and depend upon for the sensation of vision (with wavelengths between approximately 400 and 700 nm). The obvious importance of light has resulted in it being the object of an enormous amount of experimentation and study over many centuries. The first person to make significant headway in understanding the nature of light was Isaac Newton (1642–1727). He performed a series of experiments, and proposed that light is emitted from a source in straight lines as a stream of particles. This theory was called the *corpuscular theory*. It proposed that white light is composed of a range of independent colors, and that the corpuscles of light associated with the different colors vibrated at different frequencies; red light having the lowest frequency and blue light the highest. At about the same time, many attempts were made to determine the speed at which these corpuscles traveled. The most successful of these experiments was conducted by Römer, who arrived at a value of 48,000 leagues (214,000,000 meters) per second by timing the eclipses of Jupiter's moons. Today we know that the photons which make up light travel at a speed of approximately 299,790,000 meters (186,000 miles) per second.

Considering the experimental methods and techniques available, and the general level of physical understanding during Newton's time, his corpuscular theory is actually surprisingly close to the truth. The particulate, or more precisely the quantum nature of light, is now well established. Light, however, also has wave characteristics—light bends when it passes from one medium to another, and light passing through a very small aperture tends to spread out. These characteristics are not easily explained by Newton's corpuscular theory. As a result, Christian Huygens (1629–1695) proposed another theory called the *wave theory*. This theory holds that light and similar forms of radiation (called electromagnetic radiation) are transmitted as a waveform in some medium. The basis of Huygens' theory is that each point on a wavefront acts as a point source; the next wavefront being the mathematical sum of the wavefronts from these individual point sources. This concept is called Huygens principle, and can be used to mathematically explain a great deal of the behavior of light. Because of the significant power of the wave theory, a number of scientists continued to experiment and elaborate on it, some of the most notable being Young (1773–1829) and Fresnel (1788–1827). Wave theory is still used extensively today in optics, where the electromagnetic and quantum characteristics of light are not significant.

The next development in the theory of light was made by James Clerk Maxwell (1831–1979). He established that light (and other electromagnetic radiation) is a combination of electric and magnetic fields. Maxwell's *electromagnetic theory* first explained the nature of the propagation of light. It had been previously thought that light must propagate through a medium in a manner similar to a sound wave. Maxwell established a theoretical base proposing that electromagnetic radiation consisted of transverse electric and magnetic field waves. It is interesting to note that Maxwell established his theory entirely from the mathematical viewpoint; it is unfortunate that he died before it was confirmed experimentally by H.R. Hertz (1857–1894).

Unfortunately, the electromagnetic and wave theories still did not explain all of the observed behavior of light. One of the more notable of these unexplained effects was the behavior of blackbody radiation. (Blackbody radiation is radiation produced by an object that absorbs all the radiation that strikes it, and emits radiation by incandescence depending on its temperature.) In 1900 Max Planck (1858–1947) suggested the hypothesis of the *quantization of energy* to explain the behavior of blackbody radiation. This theory states that the only possible energies that can be possessed by a ray of light are integral multiples of a quantum of energy. Another unexplained characteristic was the apparent lack of an *ether*, a supporting medium for the propagation of light. In 1905 Albert Einstein (1879–1955) proposed a return to the particle theory of light with light consisting of photons, each photon containing a quantum of energy. (The word *photon* was first used by G. N. Lewis in *Nature*, December 18, 1926.) Einstein further proposed, in his theory of special relativity, "The introduction of a 'luminiferous ether' will prove to be superfluous inasmuch as the view here to be developed will not require an 'absolutely stationary space' . . . light is always propagated in empty space with a definite velocity c which is independent of the state of motion of the emitting body." These suggestions, along with others, gradually developed into what is known today as *quantum theory* or *quantum electrodynamics*. This theory combines aspects of the corpuscular and wave theories, and, when combined with Einstein's special and general relativity theories, satisfactorily explains all of the known behavior of light. Unfortunately, these theories are difficult to conceptualize and can be rigorously explained only by the use of sophisticated mathematics. As a result, the corpuscular and, in particular, the wave theory are still used to some extent where more simple explanations of the behavior of light are desired.

J. Holm

LIGHT ABSORPTION Processes whereby light energy is lost by reflection from a surface or during transmission through a medium. Absorbed light may be converted into heat or produce chemical or electrical changes in the absorbing molecules. Selective absorption from the range of wavelengths making up white light produces colored light. This term should not be confused with *adsorption*. Losses are quantified by the *reflection factor* or *absorptance*, respectively.

S. Ray

LIGHT-ACTIVATED Identifying a switch, typically on an electronic-flash unit that is separated from the camera, that momentarily closes a triggering circuit when exposed to a flash of light such as that produced by an electronic-flash unit on the camera. This eliminates the need for a connecting electrical cord between the two flash units to obtain synchronization with the camera shutter.

R. Jegerings

See also: *Infrared slave.*

LIGHT ADAPTATION A decrease in the sensitivity of the eye as the level of illumination is raised.

L. Stroebel and R. Zakia

See also: *Adaptation; Brightness adaptation; Color adaptation; Dark adaptation.*

LIGHT-BALANCING FILTERS See *Filter types.*

LIGHTBANK An arrangement of light bulbs in a row or in tiers, usually in a single large reflector, used when a high-intensity source of moderately diffuse light is required.

R. Jegerings

LIGHT BEAM A bundle of light rays emanating from a finite area of a light-emitting or illuminated surface. The rays may be parallel, diverging, or converging.

S. Ray

LIGHT BOX A box-shaped object that contains a light source and is covered on one side with a diffusing panel, typically opal glass or plastic. Commonly used as a background for objects when a white background and shadowless lighting are desired, as in some catalog and medical photographs. When used for color photographs, the spectral quality of the light source is a consideration. Light boxes are also used as transparency viewers. *R. Jegerings*

LIGHT-EMITTING DIODE (LED) A semiconductor diode that emits light or infrared radiation when current passes through it. The color emitted is red, green, or orange depending on the type of semiconductor used and the color of the plastic housing or lens. LEDs are used extensively in alphanumeric display panels and as a pilot light or a warning indicator. For example, some cameras use an LED to alert the photographer that the scene is not bright enough and that a flash exposure is required. *W. Klein*

LIGHTFAST Permanence of a photograph, or any colored material, under the influence of light. *K. B. Hendriks*
 See also: *Image permanence.*

LIGHT FOG Light fog is the result of unwanted exposure of the sensitized material. Overall exposure, such as when the film or paper is used under unsafe lighting conditions, may extend uniformly over the sheet, producing a uniform fog that may not be obvious. Such fog reduces the overall contrast of the image, but in many cases it can be compensated for by adjusting exposure and contrast of the printing material.
 Nonuniform exposure such as from camera leaks, faulty plate holder light traps, situations where shadows can fall on the sensitized material exposed to ambient light, and light produced by static discharges often renders the image useless. *I. Current*

LIGHT GATE Alternative term for a light valve consisting of two contra-rotating polarizing filters. *S. Ray*

LIGHT GUIDE See *Fiber optics.*

LIGHTING Light is the raw material of photography. Photography begins the moment light is emitted from a source. It climaxes with still more light reflecting from a print, passing through a transparency, or beaming from a TV picture tube and striking a human eye. All the steps between, manipulate light in one way or another—to control it, record it, and present it to a viewer. Whether those manipulations serve artistic or technical purposes hardly matters; the two are often synonymous. Whether the manipulations are physical, chemical, electrical, or electronic is of no concern, for they are all guided by the same understanding of how light behaves. Such an understanding allows photographers to realize the objectives of good lighting: the proper delineation of form and shape, the faithful recording of detail, color, texture, and distance and the successful execution of the composition, mood, and other desired effects.

 HISTORY OF LIGHTING In the early years of photography, daylight was the only light intense enough to provide feasible exposure time with the slow sensitized materials then available. Photographers had no other choice. If they wanted to make a picture, the sun was all they had to work with.
 Some enterprising photographers went to great lengths to build their studios with glass walls and ceilings to let as much light into their studios as possible, and subjects who sat for their portraits were often held still for the long exposures required by the complex arrangements of props and supports.

Photography by artificial light was possible but impractical because of the less sensitive emulsions. Although photographers experimented with artificial light almost from the birth of photography, widespread application came with later improvements in materials. The most significant such advance was the evolution of highly light-sensitive gelatin-based emulsions during the 1870s. Ongoing improvements in the resolution of film in the twentieth century have made progressively smaller film sizes practical. Because smaller images have acceptable depth of field at wider apertures, photography is possible with less light.
 The First Artificial Light Artificial lighting appeared on the scene during the 1840s, when two American photographers used a carbon arc light to make daguerreotypes. The first portrait of which we know shot with such a light source was made in Russia in 1857.
 During the same period experiments were also tried in which lime was heated by a hydrogen flame to produce a bright light. The technique proved, however, more useful for making enlargements and illuminating magic lanterns than for taking pictures.
 Magnesium Flames and Flashes The 1860s saw the introduction of burning magnesium wires and ribbons as artificial light sources. In one form or another they continued to be used until the 1930s.
 The first use of powdered magnesium as a light source occurred in 1886. When ignited, it produced a bright flash. Flash powder was used with a number of different firing devices. Among the most common were troughs that were filled with flash powder and then fired by a sparking device similar to that used in cigarette lighters. Flash powder was also used in fuse-ignited *bombs* and in cartridges fired from pistols made specially for the purpose. Flash powder produced adequate illumination, but it clouded the air with smoke and it was a fire hazard.
 Incandescent Lights and Flash Bulbs The widespread availability of electric power and incandescent light bulbs provided photographers with a previously unimaginable access to artificial light in the 1890s.
 Incandescent lamps greatly extended the capability of practical photography but had, and still have, drawbacks. Lamps bright enough to allow fast shutter speeds and small apertures can cause human subjects to perspire and squint. Placed too close to the subject, such lamps were sometimes a fire hazard. Increases in the efficiency of modern incandescent lamps have reduced the problem of excess heat but not eliminated it.
 Gas-filled bulbs containing combustible filaments were introduced in 1926, the first generation of modern flashbulbs. The brevity of the flash permitted much higher intensity illumination without the heat and discomfort associated with continuous lights. Not needing to keep the light turned on continuously provided still another bonus—battery power was adequate and portability became easy.
 Electronic Flash In 1936 Harold Edgerton revolutionized artificial light photography when he introduced his electronic flash tube, the first dependable, intense, reusable, short-duration light source available to photographers. With a flash duration still shorter than that of flash bulbs, subjects moving too fast for the eye to see could be photographed clearly. Human subjects ceased to be bothered by the light almost entirely. Today the electronic flash is preferred by most still photographers for artificial-light photography.
 HOW PHOTOGRAPHERS DESCRIBE A LIGHT SOURCE Photographers evaluating a single light source are primarily interested in intensity, color, direction, distribution, and diffusion of that source.
 Intensity From a purely technical standpoint, a brighter light is usually a better light. At the most basic level, if the light available to us is not bright enough, we cannot record

the picture. If, on the other hand, the available light is brighter than the minimum we must have, then we can obtain a technically superior picture.

For example, photographers who use film can use a smaller aperture or a faster shutter speed if they have more light. If they do not need, or want, a smaller lens opening or a shorter exposure time, then more light allows using a slower, finer grain film. In either case, the image quality improves.

Technical qualities alone, however, do not determine the merit of a photograph. Photographers may very well prefer a dimmer light *if* that particular source offers an aesthetic improvement in one of the other qualities of light.

Color We consider light to be white when it contains an approximately even mix of the three primary colors red, blue, and green. Human beings perceive this combination of light colors to be colorless, or white.

The proportions of the primary colors in white light may vary greatly and still be perceived as white because of adaptations of the visual system. Humans can perceive only major differences in the color of two sources, unless they have both available for a side-by-side comparison.

Film, on the other hand, cannot make the automatic adjustment to color that the brain does. It faithfully records even slight shifts in color. Photographers must therefore pay attention to the differences between various white light sources.

In order to classify variations in the color of white light, photographers use the *color temperature* scale, based on the fact that heated materials glow. The color of this glow depends on how much the material is heated. Color temperature is measured on the Kelvin temperature scale. The measurement unit kelvin is abbreviated K.

Interestingly, light with a high color temperature is composed of a disproportionate amount of those colors artists call *cool*. For example, 10,000 K light has a great deal of blue in it. Similarly, what physicists tell us is a low temperature source has much of those colors artists call *warm*. Thus, a 2000 K light tends toward the red to yellow family of colors.

Photographers use three different light color temperatures as standards. The first of these, 5500 K, is called photographic daylight. There are two tungsten color temperature standards: 3200 K and 3400 K. Photographers can buy film that is *color balanced* for any of these three light color standards.

Tungsten film reproduces the colors of a scene most accurately if it is illuminated by tungsten bulbs. Tungsten light tends to be relatively orange. Tungsten film compensates for this orange and produces picture colors that are close to the way we see them.

Daylight film is manufactured to produce standard picture colors in scenes lit by daylight. Such light has a better balance of the red, green, and blue primary colors. Daylight films are designed for this, and they give the most accurate color reproduction when they are used with either daylight or electronic flash.

Video cameras have color filters, usually inside the camera. Selecting the appropriate one balances either daylight or tungsten illumination to the optimum color for the camera video tube. Still and motion-picture photographers may use similar filters to correct color balance if they need to expose film by a light source other than the one for which it is balanced.

Direction The main light can be located anywhere in an imaginary sphere surrounding the subject (or a hemisphere, assuming the subject is on the ground). Where the source is located in that space influences both the aesthetics and the technical accuracy of the rendition of the subject. The direction of the main light source determines where highlights and shadows occur. Such tonal variation is one of the strongest factors in creating the illusion of depth and texture in a two-dimensional image.

Light coming from the direction of the camera is called *front lighting* because primarily the front of the subject is illuminated. Front lighting shows the least possible depth because the visible parts of the subject are illuminated uniformly. The shadow falls behind the subject where the camera cannot see it. The camera sees little tonal variation. For this reason, front lighting is often called *flat lighting*. This lack of tonal variation makes front lighting effective for purposes such as reducing skin texture in a portrait subject.

Back lighting reveals little detail but sometimes produces a great deal of drama. Coming from behind the subject, back lighting puts the visible part of the subject in shadow. In the most extreme form, back lighting produces only a silhouette. For this reason, back lighting is seldom used without other lighting.

Since the perception of depth requires both highlights and shadows, a lighting direction between front and back lighting maximizes that perception. Such lighting is called *side lighting*. Most photographic lighting is, at least to some extent, side lighting.

Still-life photographers usually use *top lighting* for table top subjects. Top lighting represents depth to the same extent as side lighting, because it gives the subject the same proportion of highlight and shadow.

Because light directly from the side or the top often conceals too much of the subject detail in shadow, photographers may place the light in an intermediate position between those of side lighting, top lighting, and front lighting. This compromise is called *three-quarter lighting*.

Distribution Most photographic lights have metal or metallic cloth reflectors to confine the light and partly focus the beam. Additional manipulation by snoots, grids, barndoors, and lenses, may further restrict or focus the rays. These increase the intensity of the light where it is needed and reduce problems otherwise caused by lighting the camera and surrounding areas. Manufacturers of equipment often specify this as angle of illumination or a similar measure. However, the edge of the beam of most equipment is too ill-defined to allow more than rough measurement. Even within this vaguely specified angle, the distribution of rays is uneven for most lighting equipment. All of this presents hazards and opportunities.

An unevenly illuminated scene will show *falloff*. As a defect, one common example of this is the use of a flash with a normal reflector and a camera with a wide-angle lens. Controlled falloff, however, can darken part of a scene for emphasis of another or increase the illusion of depth.

Uneven distribution of rays also enables *feathering* the light—directing the brighter central portion of the beam at a more distant part of the scene while the weaker fringe of the beam lights closer areas. Feathered carefully, a source with uneven distribution may illuminate a scene more evenly than a source with even distribution of rays.

Diffusion Another important characteristic of a single source is its degree of diffusion. A light source is said to be highly diffused if its rays strike the subject from many different angles. Conversely, light rays from an undiffused source all strike the subject from approximately the same angle.

If there is only one light source, the degree of diffusion determines the range of tones at the boundary between the highlight and the shadow. A completely undiffused light, a point source, produces only bright highlight and deep shadow. Rays from a highly diffused source illuminate the subject from directions other than the principle one, partly filling some of the shadow area to produce a more gradual transition of tones.

Direct rays from the sun on a clear day is a common example of a light source with little diffusion. The light rays coming from the sun all strike the subject from nearly the

Diffusion. The light rays coming from a small, undiffused light source in A all strike the subject from nearly the same angle. Light rays coming from a diffused source—such as the sun on a cloudy day shown in B—strike the subject from many different angles.

A.

B.

same angle. The easiest way to recognize such sources is by the sharpness of the edge of the shadow. Undiffused sources cause the edge of the shadow to be sharp and clearly defined.

On an overcast day, sunlight becomes a highly diffused light source. Clouds scatter the rays, causing them to illuminate the subject from many different angles. Again, the type of lighting is distinguished by the appearance of the shadow. Some of the rays of a low-contrast light partly illuminate the shadow, especially at its edge, causing it to loose its sharp edge. The viewer cannot decide exactly which part of the scene is in shadow and which is not.

Notice that the words *sharp* and *diffused* only describe the shadow edge definition, not how light or dark the shadow is.

The *effective size* of a source is the principle influence on its degree of diffusion. A small light source is never highly diffused, because it is not large enough to illuminate the subject from many angles. A small light projected through a large translucent sheet or bounced from a large reflector is no longer a small source; the translucent sheet or the reflector is the source, not the lamp. Large light sources are always diffuse, unless they have been further manipulated by grids or focusing devices.

It is important to note, however, that the physical size of a light does not completely determine its effective size. If the distance of a light source causes it to appear small to the subject, then its photographic effect is like that of a small source, regardless of its actual physical size. The sun, for example, is more than a million kilometers in diameter, but it is far enough away to act as a small source for a photographic subject on earth.

The degree of diffusion does not directly affect the *total contrast* between the brightest highlight and the deepest shadow. However, for a single source, diffusion is one of the principle influences upon the *local contrast,* the range of tones between the extremes. Assuming the subject has a uniform tone, a single point source often produces a photograph with only two tones: absolutely black shadow, plus a highlight value determined by the tone of the subject and by exposure. Greatly diffusing the source can transform the same scene into one composed mostly of middle grays. Notice that diffusing the source does not affect the luminance ratio; the values of the brightest and darkest points in the scene remain unchanged. However, diffusion greatly affects how much of the scene will be rendered as extreme values and how much will be rendered as intermediate values.

Because of this relationship between diffusion and local contrast, photographers usually use the word *soft* to describe large, diffuse light sources and the shadows they produce. Similarly, small lights, as well as sharply defined shadows, are frequently described as *hard.*

HOW THE SUBJECT AFFECTS THE LIGHTING

Lighting effects are influenced by the intensity, the color, and the diffusion of that light source, but these are not the only factors involved. All lighting is also strongly influenced by the subject characteristics. A full appreciation of this is needed to perceive and control light accurately.

When light strikes a subject, three basic things can happen to it. It can be transmitted, absorbed, or reflected.

Transmission Light that passes through the subject is said to be transmitted. Clean air and clear glass are examples of common materials that transmit light. A subject that transmits light freely and does not alter the light in some way is invisible. Nevertheless, we *can* photograph subjects such as glass. This is because nearly all subjects refract and reflect some of the incident light.

Refraction is the bending of rays of light as they are transmitted, or pass, from one transparent material to another. Refraction occurs whenever the two materials have different densities and the path of the ray is not perpendicular to the boundary between the two materials. Some materials refract light more than others. Air, for example, normally refracts light very little, while the glass used in a camera lens refracts it a great deal.

Direct transmission allows light to pass through a material in a single path. Some materials, however, scatter the light rays into many paths as they pass through. This is called *diffuse transmission.* White glass and thin paper show this effect. Such materials are called *translucent* to distinguish them from *transparent* materials such as clear glass.

Diffuse transmission is more important to light *sources* than photographic *subjects.* Covering a small light with a large translucent material is one way to increase its size and, hence, to soften it. Translucent subjects usually require no special lighting considerations because they scatter transmitted light the same as most opaque objects scatter reflected light.

Absorption Light that is absorbed by the subject is never again seen as light. The absorbed energy still exists but in a different form, usually heat. Highly light-absorbing subjects, such as black velvet or black fur, are sometimes difficult to photograph because they absorb such a large proportion of the incident light.

Most subjects absorb part, but not all, of the light striking them. The degree of partial absorption is one of the factors determining whether we see a given subject as dark, light, or some intermediate tone. Most subjects also absorb some frequencies of light more than others. This is one of the factors determining the subject color.

Reflection Light that bounces off a surface rather than being absorbed or transmitted is identified as being reflected. Reflection makes surfaces visible. Since most objects produce no light, their visibility depends on light reflected from them.

REFLECTION A subject can transmit, absorb, or reflect the light that strikes it. Of these, reflection is the most visible. Photographic lighting is, therefore, primarily an exercise in reflection management. Understanding reflected light and then managing it to produce desirable results is essential to good lighting. In this section we will examine how different

surfaces reflect light and some of the techniques used to manage reflection.

Types of Reflections Light can reflect from a subject as a *diffuse reflection, direct reflection,* or *polarized reflection.* Most surfaces produce some of each of these three types. The proportions vary with the subject, and it is the proportions of the reflections in the mix that make one surface look different from another.

As we examine each of these types of reflections, we will assume that the reflection is a perfect example, uncontaminated by either of the other two. This will make it easier to analyze each of them. (Subjects in nature only approximate such perfect examples.)

For now, it is unimportant what type of light source might be producing any of the following examples. Only the reflecting surface will be considered.

Diffuse Reflection A perfect diffuse reflection would be the same brightness regardless of the angle from which we view it. This is because the light from the source is reflected equally in all directions by the surface it strikes.

If light falls on a small white card, and if three cameras placed at three different angles photograph the white card, each picture will record the subject as the same brightness. The image of the card will have the same density in each negative. Neither the angle of illumination nor the camera angle influences the intensity of the reflection. Although no surfaces reflect light in a perfectly diffuse manner, white paper approximates the effect.

Note that diffuse reflection does not require a diffuse light source. Highlights produced by diffuse reflection appear identical regardless of the size of the light source. Also notice that every white subject produces a great deal of diffuse reflection. This is why every white subject appears white, regardless of the angle from which we view it.

Although the angle of illumination does not affect the intensity of a diffuse reflection, the distance from the light to the surface of the subject does. A diffuse reflection gets brighter if we move the light source closer to the subject. Intuitively, we might expect this to be true of any reflection. However, we will next look at one case where this is not so.

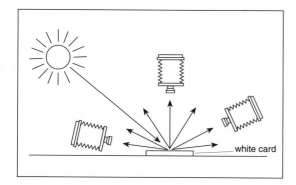

Diffuse reflection. A white card produces mostly diffuse reflection. The light source is reflected in all directions by the card's surface. If perfect diffuse reflection were possible, the reflections would be equally bright in all directions.

Direct Reflection A *direct* reflection is a mirror image of the light source that produces it. It is also called *specular* reflection. We commonly see nearly perfect direct reflection produced by bright metal, including the metallic backing of a glass mirror.

Suppose we replace our white card with a small mirror. Both the light source and the observers are in the same posi-

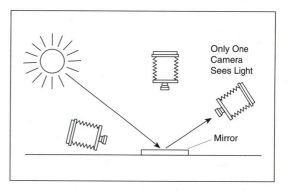

Direct reflection. This time a small mirror replaces the white paper. Since almost all reflection produced by the mirror is direct reflection, one camera sees a glare reflection of the light source while the others see no reflection at all.

tions as they were earlier. Now, however, one camera sees a bright reflection, as bright as the light source itself, while the others see no reflection at all in the mirror.

The Law of Reflection Direct reflection strictly obeys the Law of Reflection, which states that *the angle of incidence equals the angle of reflectance.* This means that the visibility of direct reflection is exactly determined by the angles between the light source, the subject surface, and the camera viewpoint.

A camera positioned to see a perfect direct reflection records an *image* of that reflection that is exactly as bright as an image recorded by a camera looking at the light source itself, regardless of the distance to the light source. You can prove this to yourself by positioning a mirror so that you can see a lamp reflected in it. If you move the mirror closer to the lamp, it is apparent to your eye that the intensity of the lamp remains constant.

At a glance, this experiment seems to defy the *inverse square law.* Notice, however, that the size of the reflection of the lamp does change. This change in size keeps the inverse square law from being violated. If we move the lamp to half the distance, the mirror will reflect four times as much light, just as the inverse square law predicts. But the image of the reflection covers four times the film area, so that image still has the same density on the negative.

The Family of Angles The white card and mirror examples of reflection have been concerned with only a single point on the surface. The surface of a photographic subject, however, is made up of an infinite number of points. A viewer looking at that surface sees each of these many different points at a slightly different angle. Taken together, these different angles make up the family of angles that cause direct reflection. (In theory, we could also talk about the family of angles that produce diffuse reflection. Such an idea would be meaningless, however, because diffuse reflection can come from a light source at any angle.)

Photographers may prefer to maximize or to minimize direct reflection, depending on the subject and on taste. In either case, the preference is likely to be a strong one. This often makes the family of angles the overriding consideration in the placement of photographic lights. Any light positioned within the family of angles will produce a direct reflection. A light placed anywhere else will not.

Similarly, the family of angles can determine the ideal size of the light source. Unlike a diffuse reflection, the appearance of a direct reflection is greatly influenced by the size of the light source. Seeing a direct reflection from most of the surface of a mirror-like subject requires using (or finding in nature) a light source large enough to fill the family of

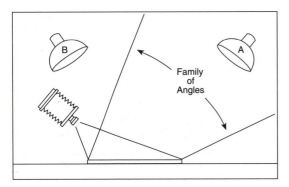

Family of angles. Light A is positioned within the family of angles and will produce a direct reflection. Light B is outside the family of angles, so it will not.

angles. Avoiding a direct reflection from the same subject means placing both the camera and the light so that the light source is outside the family of angles. If the family of angles is large, keeping the entire light source outside those angles can necessitate using a small source.

The size of the family of angles depends on both the subject and the camera viewpoint. Larger surfaces and convex surfaces have larger families of angles than small, flat surfaces. A flat surface viewed perpendicularly has a larger family of angles than one viewed nearly on edge to the camera.

Notice that the size of the family of angles also depends on the distance between the camera and the subject. The farther away the subject is, the smaller the family of angles becomes. Moving the camera farther from the subject (and using a correspondingly longer lens to maintain image size) makes a highly reflective subject easier to light. If the photographer wants the light source to fill the family of angles, a smaller one will suffice; or, if the source must not enter the family of angles, having a smaller family of angles allows greater freedom of position.

Polarized Reflection A *polarized* reflection is a special type of direct reflection with special characteristics that merit separate attention. Like simple direct reflection, polarized direct reflection obeys the reflection law. Similarly, the brightness of polarized direct reflection in the photograph is not affected by the distance to the source. Unlike simple direct reflection, an image of a polarized reflection tends to be dimmer than a photograph of the light source itself. This is because some of the light energy is absorbed by the reflecting surface as it polarizes the rays.

Polarized reflection is so similar to simple direct reflection that we often treat both the same. Polarization, however, also gives photographers several specialized techniques and tools for dealing with it.

Photographers are familiar with filters placed over the camera lens or the light source to polarize the light transmitted through the filter. The molecular structure of some materials can polarize light reflected from them in the same manner that the polarizing filter polarizes transmitted light. Water, painted surfaces, glossy wood and plastic are examples of such materials. As a general rule, direct reflection is likely to be polarized if the reflective surface is not an electrical conductor and if the surface is lit and viewed at the *Brewster angle*. The Brewster angle, determined by the molecular arrangement in the surface, is about 55 degrees (measured to a line perpendicular to the surface) for most materials.

Glossy subjects are more likely to polarize the light they reflect, and that reflection is more likely to be visible if the

subject is black or transparent. Black and transparent subjects do not produce stronger direct reflections. Instead, they produce weaker diffuse reflection and this makes it easier to see the direct reflection. This is why changing viewpoints tends to change the apparent brightness of black objects more than white ones.

Crossing the axes of two polarizing filters blocks the transmission of light. Similarly, a single polarizing filter can block reflection that has been polarized by the surface. When almost all reflected light is polarized, and the polarizing filter blocks it, little of the light reaches the film.

The neutral density of the polarizing filter is sometimes used to effectively increase a polarized reflection. Rotating the polarizing filter 90 degrees from the orientation that blocks polarized light allows the polarized reflection to pass through easily.

Turning Simple Direct Reflection into Polarized Reflection We often prefer that a reflection be polarized so that we can manage it with a polarizing filter on the camera lens. If the reflection is not polarized, the polarizer on the lens will have no effect except to add neutral density. In those cases, a polarizing filter over the light source will cause the direct reflection also to be polarized. A lens polarizer can then either enhance or decrease the reflection effectively. This is why polarizing filters are sometimes useful for subjects such as bright metal, even though conventional wisdom says that polarizes have no effect on electrically conductive materials. In those cases, the subject is reflecting a polarized source.

Outdoors, the open sky often makes a good polarized light source. Facing the subject away from the most polarized part of the sky can make the lens polarizing filter effective in darkening blue sky.

SURFACE APPEARANCE The subject and the light have a relationship with each other. In a good photograph the light is appropriate to the subject. *Appropriate* is a creative decision, not a technical one, but it is based on a technical understanding of how the subject and the light together produce an image.

Good lighting means deciding what type of reflection is important to the subject and then capitalizing on it. In the studio this often means manipulating the light. Outside the studio it often means getting the camera positioned, anticipating the movement of the sun and clouds, waiting for the right time of day, or otherwise finding the light that works.

Let us look at how this applies to some particular photographic subjects.

Using Diffuse Reflection and Shadow to Reveal Texture Any discussion of surface definition needs to consider texture. A textured white cloth lighted at a shallow angle to the surface allows the light to skim across the surface. The angle of illumination gives each particle of texture a highlight side and a shadow side. A small light source produces sharply defined shadows.

Lighting Polished Metal In some photographs polished metal is attractive if reproduced absolutely white. On other occasions it might be preferable to render the metal black. More often we like to see something between these extremes.

If we assume that we want the entire surface of the metal to photograph brightly, we then need a light source that at least fills the family of angles that produce direct reflection. When we use a light this size it will produce direct reflections over the entire surface of the subject. These reflections make the subject bright in the picture.

What happens when we place the light source outside the family of angles that produces direct reflections? This lighting arrangement can cause only diffuse reflection. Since polished metal cannot produce much diffuse reflection, it appears black. White paper in the same situation can produce

Lighting polished metal. The light used here was barely big enough to fill the family of angles defined by the spatula. Because almost all reflection from the metal is direct reflection, the metal has approximately the same brightness as the light source. A reasonable exposure for the metal renders the white paper background as dark gray.

This shot was made with the light outside the family of angles defined by the spatula. With no direct reflection, the metal now appears black, and the paper on which it is placed, white.

diffuse reflection from a light from any direction, so it is rendered white.

Photographers generally prefer a compromise between the two extremes: light filling the family of angles that produces direct reflection plus illumination from other angles to produce diffuse reflection from the background. This approach fully controls the tone of the metal independently of the rest of the scene, and it can be any step between black and white that is desired.

Curved metal surfaces require more work because they reflect so much more of the environment. One solution is to use a *tent*. A tent is a white enclosure that serves as both the environment and the light source for the subject. The subject goes inside the tent, and the camera is almost always outside, looking in through a small opening. Usually used for subjects such as metal that produce a great deal of direct reflection, tents are sometimes used simply to produce very soft light for such subjects as scientific specimens and for fashion and beauty.

Lighting Glass Like metal, almost all reflection produced by glass is direct reflection. Unlike metal, this direct reflection is often polarized, but polarization does not make much difference to the appearance of direct reflection. We might, therefore, expect the techniques for lighting glass to be similar to those for metal; but this is not so. When we light metal we are primarily interested in the surfaces facing the camera. Lighting glass, on the other hand, requires attention to the edges. Without good edge definition, transparent subjects tend to blend with the background.

A family of angles can produce direct reflection on a single round glass. For now, we only care about the extreme limits of the family of angles. These limits tell us where the light must be if the edges of the glass are to be bright in the picture or, conversely, where it must not be if the edges are to remain dark.

Excellent edge definition can be obtained by either of two basic lighting arrangements: the *bright-field* and the *dark-field* methods. We could also call them dark on light and light on dark approaches. The appearances of the results of these two are as opposite as the terms imply, but the guiding principles are identical. The background dictates how we must treat any glass subject. On a bright background we have to keep the glass dark if it is to remain visible.

In the bright-field approach to lighting glass, we do not want the edge of the glass to be bright in the photograph, so there must be no light along the lines marked **L** in the diagram.

The dark-field method produces the opposite result. Since we now want the edge of the glass to be bright, there must be light at the far limits of the family of angles.

The effective size of the background is the single most important consideration when using either technique. The background must, of course, be large enough to fill the field of view. But if it is too large, it will extend into the family of angles that produce direct reflection on the edge of the glass. That will eliminate the dark outline needed for bright-field illumination or prevent the edge highlight necessary in dark-field illumination. Ideally, the background should exactly fill the field of view of the camera, no more and no less. Fortunately, this ideal is not strictly necessary in practice.

Most failures in photographing glass result from mixing the bright-field and dark-field techniques. Using the two simultaneously requires keeping them separate even in a single picture. We make a mental division of the scene and decide that one part of the glass is to be bright-field while the other is dark-field.

Frequently, the photograph must also clearly show the glass surface in addition to the outline edges. Large highlights are essential to glass surface definition. The family of angles described by any round object is quite large. For this reason lighting for surface definition can sometimes require surprisingly large light sources.

LIGHTING FOR SHADOW AND FORM Lighting a

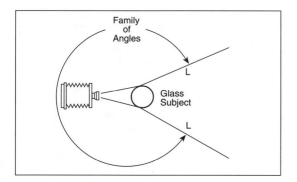

Lighting glass. The limits of the family of angles marked L. Light from these two angles will produce edge highlights.

An example of bright-field lighting. Glass against a bright background must be kept dark to be visible.

In dark-field illumination the shape and form of the subject are delineated by bright lines against a dark background.

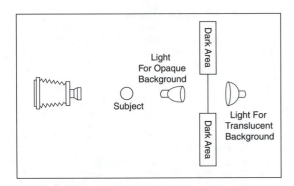

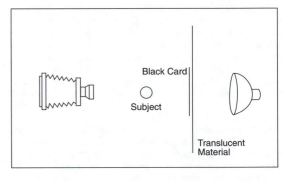

Bright-field illumination. This diagram shows one way to produce bright-field lighting. Notice, it keeps nearly all the light off of the subject, thus making it visible against the light background.

Dark-field illumination. This diagram shows one way to produce dark-field lighting.

three-dimensional subject well requires more than revealing surface detail. A box with each of its surfaces lit identically appears dimensionless, even if each visible surface is, by itself, well represented.

Creating the illusion of three dimensions in two-dimensional photographs requires highlight and shadow areas. Very pronounced highlights and shadows may increase the illusion of depth, but if they are too pronounced they become subjects in their own right and compete with the principle subject.

Beyond these generalities, applications depend on the subject and the specific lighting objectives. The way most photographers apply the controls to portrait lighting, however, provides some examples of worthwhile considerations for many subjects.

The Main Light The size and placement of the main, or

key, light determine where the highlights and shadows will fall and how sharply defined they will be. Once it is properly managed, other lighting may be unnecessary. More often, other sources are needed, but the effect of the main light determines what other kind of lighting is needed. Either way, the size and position of the main light are the first considerations of successful lighting.

Choosing the Size of the Light The size of the portrait main light emphasizes shadow definition and texture. Small lights produce hard shadows and apparent skin texture. In portraiture, both of these can emphasize character at the expense of beauty. Large lights, on the other hand, give soft shadows, reduce skin texture, and make irregularities less noticeable.

Placing the Main Light Most portrait lighting is three-quarter lighting. As we have seen, this offers a good compro-

mise between the more extreme dimensionality of side or top lighting and the full illumination of features of front lighting. Fine-tuning the position of the main light requires attention to the features of the individual.

One good way of deciding where to put the main light is to study the *key triangle.* This is an inverted triangular highlight on the model's eye and cheek. It provides one good lighting standard upon which any variations can be built. Analyzing the key triangle helps to reveal several common lighting problems. If, for example, the key triangle is too broad, the main light is too close to the camera. The result is uniform, flat lighting that shows little or no contour in the subject's face. If the key triangle is too narrow, or cannot be seen at all, the main light is too far to the side. The result of this positioning of the light source is that the model's nose casts a shadow across his or her face, blocking the key triangle highlight. If the key triangle is too low, the main light is too high. The result is dark shadows in the eye sockets.

The *catchlight* is a reflection of the light source on the surface of the subject's eye. Often the brightest point in the portrait, the catchlight gives a feeling of life to the subject. Since catchlights are usually produced by both the key light and the fill light, it is common practice to remove one of them by etching the negative or spotting the print.

If the portrait is to be taken with the subject's head turned to one side or the other, the photographer must decide on which side to place the main light. When the light source is on the same side as the subject's visible ear, the picture is said to be lit with *broad* lighting. Broad lighting produces a broad sweeping highlight running from the back of the subject's hair all the way across the face to the bridge of the nose.

Positioning the main light on the side opposite the visible ear results in *narrow,* or *short,* lighting. The highlight produced with this lighting is quite narrow, its brightest part extending only from the subject's cheek to the nose.

The choice of whether to use broad or short lighting is sometimes based on the shape of the subject's face. Narrow lighting tends to make a full face appear thinner. If the subject is wearing eyeglasses, however, narrow lighting is more likely to produce a pronounced direct reflection upon them. In such cases broad lighting may be the better choice.

In deciding which side of the face to light, remember that most people have a dominant eye—one that appears more open than the other. If this difference is pronounced, it is usually better to put the main light on the same side as the dominant eye.

MULTIPLE LIGHTS The main light is the most important but seldom the only source of illumination. Fill light will improve most pictures, even if it is only the fill light reflected from the surrounding walls of a small studio, although a strategically placed white reflector is more commonly used. Other possible lights include background, hair, and rim lights, and kickers.

Fill Lights Having darker areas in a photograph contributes to the illusion of depth, or three-dimensions. Those areas also have less detail, however. Shadow areas that are too dark may have so little detail that they disturb the viewer. Such a picture ceases to be believable because a human viewer standing in place of the camera would see detail where the film does not.

The fill light is usually placed near the camera to illuminate everything the camera sees. The illumination it adds to the highlights is unimportant, except for minor exposure considerations. Its whole purpose is to add enough detail to the shadow areas to make them pleasing to the viewer.

The amount of fill required is partly a matter of personal preference, such as a desire to create a certain mood effect, but it also depends on the subject. A black area with no detail in the subject itself may require no fill; the viewer is less

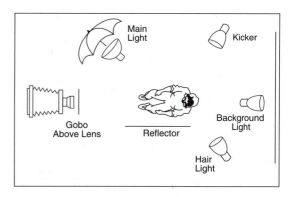

Multiple lights. Main and additional lights. Here we see how a main and several supplemental light sources can be used together.

likely to be bothered by being unable to see detail that does not exist. A similar black area, but with essential detail, may require a great deal of fill to photograph acceptably.

The intensity of the highlight illumination (main light plus fill light) compared to that of the shadow (fill light) is called the light ratio. In portraiture, lighting ratios between 2:1 and 4:1 are common.

Any shadows cast by the fill light, even minor ones, are likely to compete with the main light. Depending on the form of the subject, keeping the fill light as close to the camera lens as possible, preferably just above the lens, avoids placing additional shadows where the camera can see them. Alternatively, the fill light may be almost anywhere if it is large enough to produce shadows too indistinct to be detectable. One of the best ways of doing this is to bounce the fill from a large reflecting surface near the camera. If the subject is capable of direct reflection, highlights produced by the fill light may also distract from the main lighting.

Background Lights Unlike the lights we have mentioned so far, all of which are aimed at the subject, background lights are pointed at the background. They surround subjects with a pleasing glow and help to set them apart from the backgrounds against which they are shown.

Hair Lights Hair lights are often used to produce a separate highlight that sets dark hair apart from the background. With blonds, a hair light can help to brighten up a picture and make it less somber. Hair lights are often placed behind the subject on the side opposite the main light.

Kickers Kickers add illumination to a small part of the scene. In portraiture they are often used slightly behind the subject to add a brighter highlight within the principle one. This produces increased modeling and an illusion of brightness that would be impossible without overexposure if the main light were used at the intensity required to illuminate the entire highlight to the same brightness.

Rim Lights Rim lights illuminate the edges of the subject. Rim lighting is often achieved by using a combination of hair lights and kickers. Some photographers like to use a single light placed behind and aimed at the subject's head. The result is a halo of rim light that sets it clearly apart from the background.

MOOD AND KEY Photographers speak of the mood, or *key* of a photograph. Subject matter, setting, and exposure all influence the key, but lighting may be the single most important factor in establishing it.

Low-Key Lighting Low-key pictures tend to be dark and somber. Side lighting and sometimes back lighting puts much of the subject in its own shadow. Background, and, in portraits, costume and hair, are usually dark. The result

calls up such adjectives as serious, formal, dignified, and melancholy.

High-Key Lighting High-key lighting is the reverse of low-key lighting. It is light, bright, youthful, and cheery in mood. High-key pictures are filled with whites and other light tones and often a pure white background. High-key portraiture generally uses front lighting and a low lighting ratio.

When Lighting Is Part of the Story A child blowing out birthday candles, a firefighter lit by the harsh red light on the engine, and an orchestra conductor in stage lighting are the worst possible examples of good portrait lighting. In none of these cases, however, would we improve the portrait with standard studio lighting. When the lighting is part of the story we gain more by capitalizing on it than by tampering with it. We may, however, decide to use additional light to minimize unpleasant effects.

If the illumination comes from an unorthodox direction or if the light source is visible in the scene, fill light almost always improves the photograph. Too much fill light, however, overpowers the effect of the principle illumination. Deciding how much fill can be difficult. Instead of a conventional exposure bracket, consider exposing several frames at the same aperture and shutter speed but altering the fill by adjusting the distance of the fill light, or the power on a variable power electronic flash.

If the illumination has an extremely unorthodox color, position the fill to illuminate from an entirely different direction from the main light. This prevents the fill light from diluting the color. It also produces some neutral tones in areas that would otherwise be in dark shadow, reveals the true color of the subject, and emphasizes that the unorthodox color comes from a strongly colored source.

USING DAYLIGHT Daylight is composed of sunlight plus sky light. Additional light reflected from surroundings may also fall on the subject. On a clear day, the principle fill light is light reflected from the sky, which produces a ratio of about 8:1. Light-toned surfaces such as sandy ground sometimes provide additional fill. On a cloudy day, the cloud cover provides diffusion and increases the effective size of the light source, just as translucent diffusion materials do in the studio. Geographical location, season, and time of day determine the direction of the main light.

Conceptually, then, using daylight is no different from using any other photographic light source. The principle manipulations—direction, diffusion, and fill—are all available. Convenient application is another matter. We have to wait for appropriate lighting conditions. If we want diffused illumination over a large area, we have to wait for cloud cover and hope it is not more or less dense than we want. Practical considerations often make it impossible to use daylight to duplicate lighting we might prefer in the studio.

Choosing Sunlight Direction Sometimes pleasing studio lighting resembles noon sunlight, but such images are

exceptions. Most of the time sunlight has the wrong direction, too little diffusion, and too little fill.

During the middle of the day, sunlight resembles top lighting. Even when it is not directly above the subject, it is commonly higher than we would place the main light in the studio. The only studio subjects that routinely receive top lighting are still life scenes, especially product photography, where the camera looks down on the scene. Such subjects and viewpoints make up a minority of outdoor scenes.

If the scene must be lit with direct sunlight, working early or late in the day often provides better lighting. Flat landscapes have more texture, mountains have more dimension, and architectural overhangs cast smaller shadows.

If the site has tall trees or buildings, the sun may be hidden early or late in the day. Then the open sky becomes the principle source and eliminates the problems of too little fill and too little diffusion. If the sun is just barely above the tree line, the sun can serve as a hair light or kicker instead of a main light, setting the subject apart from the dark tree background.

Notice that each of these remedies also changes the color balance of the light. Earlier and later in the day, daylight is warmer than standard daylight. If the sun is not the main light, the lighting assumes the color of whatever is reflecting the sunlight: blue sky and green foliage are the most common examples. If the direction of the color shift is displeasing or if accurate color rendition is important, correction by filtration is essential.

Diffusing Sunlight Almost no studio light is as small as the effective diameter of the sun. The consequence is very sharply defined shadows. This sometimes makes undiffused sunlight a superior source if a shadow pattern is a principle subject. If the shadow serves simply to give dimension to the primary subject, however, sharp definition is likely to be a distraction.

Cloud cover provides excellent diffusion, but getting the right amount of it takes luck. Complete cloud cover may diffuse the sunlight too much. Furthermore, the sky is an important element in many outdoor photographs, and proper exposure of the principle subject usually renders an overcast sky as a displeasingly light gray. Spotty cloud cover is often better, especially if there is enough high altitude wind to keep the clouds moving. The wind guarantees that ideal lighting will not last more than a few minutes at a time, but as long as the conditions keep changing, just the right amount of diffusion is likely to occur at some point. Watch the sky, the subject, and your light meter, and be ready to shoot.

Adding Fill Light Light reflected from the sky, plus the rest of the environment, adds fill to a sunlit scene but usually not enough. In the middle of the day undiffused sunlight has a lighting ratio higher than any likely to be used in the studio.

The spotty cloud cover in the preceding example can also provide effective fill. A cloud over the sun reduces its intensity. If most of the rest of the sky is clear, the fill it provides is almost as great as if there were no cloud cover. The combination means a reduced lighting ratio.

Reflector cards can provide fill for smaller subjects in sunlight as well as in the studio. Beware of mirror-like cards in direct sun, however. Silver card reflections from a large studio softbox may be too soft to cast competing shadows, but in sunlight, shadows from that reflector will be sharp enough to be detectable. Matt white and textured silver cards are more likely to be effective.

Flash Fill If the principle subject is close enough to the camera to allow illumination by electronic flash, using the sunlight and the flash together allows good control of the lighting ratio. This technique usually uses the sunlight as the main light and the electronic flash as the fill. Since most of the exposure by the flash occurs during an interval much

Using daylight. The direct sunlight entering the house from the left is warm colored and noticeably biased toward yellow. On the other hand, light reaching the house on the right comes from the open sky. It will have a much cooler, blue biased, color.

shorter than the shutter opening duration, careful selection of the shutter speed and aperture combination can provide whatever ratio the photographer is likely to want.

Thus, a photographer might select an aperture one stop smaller than what would be required for the flash alone, then select a shutter speed of half that required for proper sunlight exposure at that aperture. Ignoring the effect of skylight and environmentally reflected light, the result of this combination is a 2:1 lighting ratio. Highlights are normally exposed, half by sunlight and half by the flash, while the shadows receive one stop less than normal exposure, from the flash alone.

This example is only one possible ratio. Ambient fill or personal taste may require adjusting the ratio. Changing the aperture, with an equivalent but opposite adjustment of shutter speed, modifies the flash exposure without affecting that of the daylight. Changing just the shutter speed modifies the daylight exposure without significant effect on the amount of flash exposure.

The distance to the background and its importance to the scene limit the amount of control this technique permits. Outdoor scenes typically include background subjects too far away to receive significant flash illumination. The ratio used in the example produces up to one stop underexposure of the background. If realistic representation of the background is essential to the picture, higher ratios of sunlight to flash illumination are necessary.

Cameras with focal plane shutters also limit the degree of possible control, because, with some exceptions, these shutters will not synchronize with the flash at faster speeds. Slower films allow more control by permitting slower shutter speeds at whatever aperture suits the power of the flash. Similarly, more powerful flash units regain some degree of control because they permit using smaller apertures and, hence, slower shutter speeds.

The power of the flash also limits the practical distance from the camera to the subject. Assuming the flash is near the camera, even a very powerful flash is too weak to compete with direct sunlight for far away subjects. Using the most powerful flash unit permitted by weight and bulk restrictions partly overcomes this limitation. Notice, however, that very powerful flash units may provide too much fill at close working distances, unless they have controls to allow reduction of their power below the maximum.

If the perspective is not critical, lens selection also offers increased control over the sunlight to flash ratio, especially if the lens is a zoom lens. Again assuming the flash is near the camera, moving farther from the subject, and using a longer lens focal length to maintain image size, reduces the intensity of a flash that is too powerful.

Sometimes using a shorter focal length lens allows getting close enough to increase the intensity of a flash that is too weak. However, a flash unit with a normal angle of coverage underexposes the edges of the scene visible to a wide angle lens. If the composition places an important subject at the edge of the frame, the defect may be unacceptable. Compensating for this with a wide angle reflector or lens on the flash reduces the flash intensity and may undo the very advantage the photographer is seeking.

Using Multiple Exposure to Control Lighting Ratios
Midday daylight on a cloudless day has a high lighting ratio, but just before sunrise and just after sunset all of the light comes from the sky and the ratio resembles that on a cloudy day. If the subject is static, such as a building, multiple exposures can combine the two to produce whatever lighting ratio we want.

The procedure for balancing the two exposures resembles that for flash fill. If, for example, we want a 2:1 ratio, we might use a sunlight exposure of one stop less than normal. Then, immediately after sunset, make another exposure of

one stop less than normally required for those lighting conditions. Together, these add up to normal exposure in the sunlit highlight and, ignoring daytime sky fill, one stop less than normal in the shadow.

Because so much of the exposure is by dusk or dawn sky, the color balance is not likely to be accurate, especially in the shadows. Furthermore, the color shift is unpredictable because dusk and dawn sky color varies randomly from one day to the next and because the orientation of landscapes and buildings to the compass directions also varies randomly. Unless true color is a primary objective of the photograph, however, the shift is usually not displeasing and may be more attractive than accurate color balance.

Notice that this multiple exposure technique is potentially useful for recording any light that is too dim to compete with the sun. Examples include lit interiors visible through the windows of buildings, lighted signs, and street lights.

STUDIO LIGHTING OUTSIDE THE STUDIO
Improvements in film continue to make indoor available light photography practical in more situations. Reduction in grain size makes the use of faster films and smaller formats increasingly acceptable. Furthermore, the smaller formats allow acceptable depth of field at wider apertures. This trend is especially evident in photography for newspapers, where deficiencies in reproduction camouflage minor deficiencies in the photograph, and in magazine photography, where the typical page size makes extreme enlargement of the image less likely.

Sometimes, however, photographers find the existing light to be unattractive. On other occasions, an indoor location does not have enough available light for a high quality photograph, especially of a live subject. In these cases it is necessary to carry lighting, usually electronic flash, to the scene.

The choice of type of flash unit depends on how much light is needed and time constraints. If it is practical to move heavy equipment to the location, studio equipment provides the power and the versatility to handle almost any photographic situation, but the nature of most nonstudio assignments requires the portability of smaller flash units. These tend to have diameters too small and power supplies too weak to easily duplicate the effect of studio lighting. Furthermore, the same constraints that demand using smaller flash units also preclude using a large number of them. Fortunately, there are techniques that minimize, if not overcome, these deficiencies.

Improving the Quality of Light Lighting by portable electronic flash tends to suffer from two basic defects in appearance, namely, sharp-edged shadows and uneven illumination. The sharp shadows are caused by the need to use small, portable flash units. Uneven lighting is the result of needing to illuminate large areas with a few lights. Fortunately, *bouncing* and *feathering* produce a quite acceptable quality of light with many portable flash units.

Bounce Flash Portable flash units produce hard-edged, unattractive, shadows. Bouncing the light from an umbrella solves this problem. One way to obtain a similar effect without additional equipment is to bounce the light from a ceiling or wall. The ceiling then becomes the effective light source, and since it is much larger, it makes the shadows in the scene far softer and less noticeable.

While bounced light is far more attractive than direct flash, it does have the drawback of being far less efficient. This is because the rays must travel farther and because some of the light is absorbed by the ceiling.

Compensating for the increased distance simply requires basing guide number calculations on the distance from the light to the ceiling and back down again to the subject, instead of just the distance from the flash to the subject. The amount of light lost by ceiling absorption and scattering varies with paint and texture of the ceiling. Opening the lens

by two stops is a rough rule of thumb, but more dependable results can be obtained by using a flash meter or a flash unit or camera with built-in automatic flash exposure control.

If the ceiling is very high, or if the subject is close to the camera, a ceiling bounce will cause dark shadows in the eye sockets. This defect can be reduced by using tape or rubber bands to attach a small bounce card to the flash head. The card bounces some of the light directly onto the subject's face. The rest is bounced from the ceiling resulting in a relatively evenly lit picture. This fill-light feature is incorporated in some electronic flash units.

Feathering Light Feathering a light means aiming it so that part of the beam (the edge) illuminates the foreground and another part (the more intense center) lights the background, rather than aiming the light directly at the foreground.

How well feathering works, or whether it will work at all, depends on how the flash head is constructed. Some of the larger portable flash units are made with large, circular reflectors that often scatter a great deal of light in many directions. Such units can usually be feathered well. On the other hand, many light-weight flash units with very efficiently focused reflectors are far less suited to feathering.

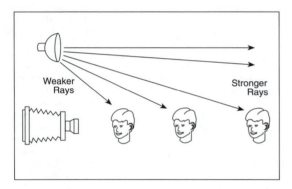

Feathering light. Feathering allows the dimmer part of the light beam to illuminate the foreground while the brighter part lights the background. The success of this technique depends greatly on the reflector design.

LIGHTS OF NONSTANDARD COLOR Photographers shooting color film in the studio carefully control the color temperature of their light. When working on location, however, it may be impossible to control the color temperature of the light being used. Frequently, the existing light does not match any standardized photographic color balance. Such nonstandard color can have unpredictable and troublesome consequences if it is not anticipated.

The general remedy is filtration, either on the light source or, more commonly, on the camera lens. Appropriate theatrical gels on the lights sometimes approximate a standard color balance. Color compensating filters on the lens allow balancing the color of the scene with great precision.

Examples of Nonstandard Light Sources Photographers consider daylight and two slightly different colors of tungsten light (3200 K and 3400 K) to be standard. They consider all other light sources as nonstandard. Such nonstandard lights are common, and they cause a number of problems when shooting on location.

Fluorescent tubes are the nonstandard light source photographers encounter most frequently indoors. The light produced by fluorescent tubes presents photographers with a special problem. Not only is it nonstandard, it also comes in many different colors. Film makers publish tables of recommended filtration for each of their films exposed under each common type of fluorescent tube.

Unfortunately, age changes the color of fluorescent tubes. Furthermore, people replace burned out tubes with new ones of a different type. Filtration that is good for any particular type of tube may not be as good for the mix, thus it is all but impossible to predict the color of a picture lit by a mixture of fluorescent tubes.

Fortunately, when time allows, it is almost always possible to find an acceptable combination of color-compensating filters through text exposures. Use a color temperature meter or use the film manufacturer's recommended filtration for the test, modify that filtration based on evaluation of the test, and reshoot.

High-intensity discharge lamps, used to light many industrial and outdoor locations, are deficient in certain wavelengths. The degree of this problem varies greatly with the type, the wattage, and the manufacturer of the lamp. The color of those used in areas such as sports arenas, where the builders anticipated the need for photography, may be correctable by lens filtration. Those used in factories and parking lots, however, often lack certain colors entirely and no filtration can produce an acceptable color balance. If accurate color is important, test and retest to get the best balance possible, then attempt further correction in printing, duping, or color separation.

Nonstandard tungsten light is more common than either of the photographic standard tungsten color temperatures. Ordinary tungsten bulbs are significantly more orange than photographic bulbs, and they get more so as they age. The difference is enough to matter whenever color balance is critical.

Nonstandard daylight does not surprise most people. We all know that sunlight is much more red at dawn and dusk. What does surprise most of us is learning that daylight can be quite nonstandard even in the middle of a bright day.

Two different kinds of daylight are light from the sun and light from the sky. Sunlight coming through a window onto a subject will be quite warm and have a noticeable red to yellow color bias. If the subject is lit by light that comes from the blue sky—rather than from the direct sunlight—the light is decidedly cool with good deal of blue in it.

Both of the subjects are illuminated by what is called daylight. The only problem is that the daylight is very different for each of them and will produce very different pictures. *Daylight* means light that is made up of a combination of rays coming directly from the sun and those that come from the sky around it.

The color, as well as the contrast, of daylight may also be influenced by atmospheric haze, especially if distances in the scene are great.

Lights of Different Color in a Single Scene In many locations we encounter different types of lighting with different color balances in a single scene. The best photographic strategy depends on whether the color is mixed color or unmixed color.

Mixed color situations are easy to handle because the improper illumination is uniform throughout the scene. The color balance of the whole picture will be wrong, but it will all be wrong in the same way throughout. This uniformity makes the problem simple to correct. All we have to do is to use the proper filter over the lens. The result will have the correct color balance and colors within the scene reproduce in a standard, or realistic, way.

Knowing what filter to use may be difficult. A color meter will do the job, if used with two continuous-duration sources such as fluorescent and tungsten, but it will not tell you the combined color of fluorescent and electronic flash. The only accurate way to select the proper filter is by test exposures.

If the light from nonstandard sources is mixed, and if the sources are not visible in the scene, the degree of correction

in shooting is less critical. Because color balance problems are uniform when colors of light mix, it is possible for labs to make color adjustments.

No filter on the lens can correct unmixed colors. Whatever correction is right for one area is wrong for another. For the same reason, such scenes are difficult to correct in reproduction. Instead, the best way to cope with unmixed color sources is to filter the lights so that they match each other as closely as possible. The objective of this is to get all of the light sources to be a single color, but not necessarily the right color. Then a filter over the camera lens can correct the color reaching the film.

Books: Feininger, A., *Light and Lighting in Photography*. New York: Amphoto, 1976; Hattersley, R., *Photographic Lighting*. Englewood Cliffs, NJ: Prentice-Hall, 1979; Hunter, F. and Fuqua, P., *Light: Science & Magic*. Boston: Focal Press, 1990; Kerr, N., *Technique of Photographic Lighting*. New York: Amphoto, 1979. *F. Hunter and P. Fuqua*

See also: *Electronic flash; Filters; Filter types, color correction, conversion, light balancing, polarizing; Light sources; Polarized light.*

LIGHTING CONTRAST The relative amounts of light received by the highlight and shadow areas of a subject or scene. When evaluated subjectively, lighting contrast is identified in general terms such as high, normal, and low. When measurements are made, lighting contrast is typically expressed as a ratio, such as 4:1, although it can also be expressed as a difference in light-value numbers (in the APEX system) or equivalent exposure stops—where the difference would be 2 in both units for a 4:1 lighting ratio.
F. Hunter and P. Fuqua

See also: *Lighting ratio.*

LIGHTING RATIO The ratio of the incident light received by the highlight and shadow areas of a scene. Thus, lighting by a main light and a fill light of equal intensity is expressed as a 2:1 ratio, assuming both sources illuminate the highlight area, but only the fill illuminates the shadow area. Lighting ratio depends on the relative distances of the lights to the subject, as well as on their intensities. Therefore, a photographer can achieve a high lighting ratio using two lights of equal intensity.

The ideal ratio depends on both subject and aesthetic judgment. Ratios lower than 2:1 and higher than 6:1 are seldom used in controlled lighting situations.
F. Hunter and P. Fuqua

See also: *Lighting contrast; Luminance ratio.*

LIGHTING TENT An enclosure designed to provide diffuse illumination from all directions for an object placed inside and photographed through a small opening. Typically

Lighting tent removes unwanted reflections from glossy subject surfaces and replaces them with smooth reflections of the tent interior.

made of translucent material so that the light sources can be placed outside the tent, and constructed as a cone to eliminate corners that might be distracting in reflections on polished metal and plastic surfaces. For very large objects, an entire room having white walls and ceiling can serve as a lighting tent. *R. Jegerings*

LIGHTING UMBRELLA An umbrella designed to diffuse and in some cases modify the color quality of light from a light source.

Lighting umbrellas fold up like conventional umbrellas for convenient transport or storage. Light is normally bounced off the interior surface of the opened umbrella, but a translucent-surface white umbrella can also be used for transmitted and bounce light. Bounce light is generally softer, and since light distance is measured up the shaft and back to the subject, there is a small but often useful distance increase for more even lighting in confined areas.

A variety of umbrellas are made for location and studio photography. Surfaces can vary in specularity to alter effects and can be tinted different colors, for example, to convert tungsten light for use with daylight film or to lower color temperature for warm fill. *Zebra* umbrellas have alternating specular and diffused panels between the ribs. Shape is normally approximately circular to put *sun* catchlights in subject eyes, but square umbrellas are made for *window* catchlights and to allow the umbrella to be used closer to ceilings. Square umbrellas can sometimes be opened in various amounts to control the angle of coverage. Some can be opened flat to do double duty as reflector panels. A round umbrella with a silver fabric and steep inner curves can reflect light to a focal point and should be tested for even light coverage at various distances.

Reflections on highly polished objects can show the umbrella ribs, and the lighting unit head and wires, which look unnatural. Umbrellas also have a reputation for scattering flare-causing light around rooms because of their open design and because some light shoots through the surface. A black opaque cover can be used to block transmitted light when the umbrella is used for bounce lighting. For transmitted diffused lighting, an umbrella with opaque sides traps stray light. *R. Jegerings*

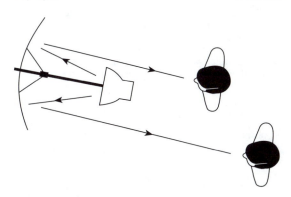

Lighting umbrella.

LIGHTLINE A style of glassware lighting in which the edges of the glass object appear lighter than the background.
F. Hunter and P. Fuqua

Syn.: *Dark field.*
See also: *Bright field.*

LIGHTNESS The aspect of color that applies to reflecting surfaces and that relates the appearance of such surfaces to a scale of grays. Whites are grays of high lightness and blacks

are grays of low lightness. In a print, highlights are tones of high lightness and shadows are tones of low lightness. Brightness is similar to lightness but differs in that brightness is applied to surfaces seen as sources of light, rather than as reflecting surfaces. *L. Stroebel and R. Zakia*

See also: *Brightness; Brilliance; Luminance; Value (Munsell).*

LIGHTNESS CONSTANCY
A process whereby the lightness of a surface is perceived as remaining unchanged when viewed under different levels of illumination. A white card, for example, continues to be seen as white even when the light source is moved closer or farther away. *L. Stroebel and R. Zakia*

See also: *Brightness constancy; Color constancy; Constancy.*

LIGHTNING
A large-scale electrical discharge caused by high potential differences naturally created between different regions of the atmosphere or between the atmosphere and ground objects during a thunderstorm. Flashes of lightning are not difficult to photograph. The light of the flash is bright enough to give a good image on a relatively slow-speed film with an aperture of *f*/11. The camera is supported on a tripod and aimed at a part of the horizon where the flashes are most frequent. The shutter is set on "B" and held open until a flash occurs, and then released. It may also be left open long enough to record a number of flashes, providing ambient light levels are sufficiently low. A light meter and reciprocity failure tables should be used to determine the longest exposure time that can be used without overexposing the scene. Lighting ratios between the scene and the lightning can also be approximately determined by using a light meter and treating the lightning as a more conventional photographic flash. *J. Holm*

LIGHT PEN
An input device that detects light emitted from the cathode-ray tube (CRT) and locks onto the cursor of a computer screen. The movement of the pen across the screen is automatically tracked, allowing the user to modify images directly, as a pen does on paper. *R. Kraus*

LIGHT PIPE
See *Fiber optics.*

LIGHT RAY
Huygens theory of light postulates each point on a subject emits expanding spherical wave fronts. A ray of light is a straight line normal to this wave front and defines a direction of travel of natural light energy as an oscillating electromagnetic waveform with random polarization about the ray direction. Light velocity depends on the density of the medium. *S. Ray*

LIGHT REFLECTION
Redirection of light or other radiation by a surface. Reflection may be specular if the surface is polished. If the surface is matt, reflection becomes more or less diffuse, the light being scattered in all forward directions. *S. Ray*

LIGHT REFRACTION
Change of direction or deviation of a ray of light passing obliquely from one transparent medium into another of a different density, e.g., from air into glass. Refraction takes place because the velocity of light varies according to the density of the medium through which it is passing. Refraction is toward the normal to the surface when rays enter a denser medium. Refraction is wavelength dependent, shorter wavelengths being refracted more but in a nonlinear manner. Refraction of materials is quantified by refractive index. The action of prisms and lenses depends on refraction. *S. Ray*

Syn.: *Refringence.*
See also: *Achromatic; Index of refraction; Snell's law.*

LIGHT SCATTER
Scatter in general is the deflection of incident radiation by inelastic collision with matter with a transfer of energy. One consequence is the decrease in velocity of light when it enters a denser medium. Light is scattered in various distinct ways, depending on particle size. Nonselective scattering is independent of wavelength and is by relatively large particles such as in a photographic emulsion, a rough surface, or mist and fog. Visibility is reduced and infrared photography is of no help. Even smaller particles give *Mie* scattering that reduces visibility in clear air. When particle size approximates molecular level or the wavelength of light, selective *Rayleigh* scattering occurs, which is wavelength dependent, being proportional to the inverse fourth power of wavelength ($1/\lambda^4$). Scattering here is a special case of diffraction. The sky appears blue as short wavelengths are scattered more than longer ones. Visibility in clear air is some 50 miles and is increased by infrared photography. The scattered light is also polarized. *S. Ray*

LIGHT SENSITIVE
See *Photosensitive.*

LIGHT SOURCES
Light is an essential component of the photographic process, as indicated by the prefix *photo* in the word *photography*. Photographers now have available a wide variety of artificial, continuous, and flash light sources in addition to daylight, but it should be noted that Edison's first practical carbon filament electric light bulb was not invented until 40 years after the birth of photography with the introduction of the Daguerreotype process in 1839.

Photographic materials are inherently sensitive to ultraviolet radiation and they can be sensitized to infrared radiation. Although both types of radiation lie outside the visible region of the spectrum that is identified as light, there is no need to exclude them from the discussion of light for photographic applications.

NATURAL LIGHT Light from the sun, sky, moon, and stars can be used for photography. For the most part, light from these sources is under the control of nature rather than the photographer—who may have no choice but to wait for a desired lighting condition.

Daylight Artificial light was initially too weak for photography or was not available in rural areas. Indoor portraits were made by window or skylight, contact prints were exposed by sunlight, and an enlarger light source was often a hole in the roof connected to the enlarger. Daylight varies widely in color balance, intensity, and contrast, which can change between the time a meter reading is taken and the time the film is exposed. Flare is a problem since the camera often faces a large, bright sky. Atmospheric effects and wind can make high resolution impossible. Daylight has a continuous spectrum and can be assigned color temperatures. Though they vary from approximately 200 K at sunset to

Daylight. Color-temperature changes. At sunrise and sunset, light travels a longer distance through the earth's atmosphere than at noon.

12,000 to 18,000 K from a blue sky, the range can be controlled with bluish cooling and amber warming filters.

A large number of filters would appear to be necessary to balance the wide color-temperature variation for general color photography. Few pictures, however, are compared to original colors, and incorrect balance often creates appropriate coolness and warmth, for instance at twilight and sunset. Most color pictures are made from color negatives, and color-balance corrections can be made when printing. The film becomes the finished image when using color transparency film, and photographers have to be more concerned about daylight variations when the original subject will be compared to the transparency in fashion or product photography. The rule of color filtration that a warm color cast is more acceptable than a cold one simplifies color corrections: a photographer who uses a pale warming filter to guard against bluish casts will do no harm by slightly warming the image when film and light are color balanced.

Warm–cold contrast has been used to express contradictory moods since the beginning of color photography. Daylight color film, used outdoors at twilight, records a house as cold but its windows as warm and inviting if the interior is illuminated with tungsten lighting. Electronic flash at sunset contrasts cold foreground subjects against a warm background for a surrealistic effect.

The red-orange color cast at sunrise and sunset is from light traveling a greater distance through the atmosphere than it does near noon. Short wavelength bluish light is scattered more than longer wavelength reddish light. The warm light is normally considered appropriate, so less corrective filtration may be used to improve skin tones without eliminating the sunset effect. At high altitudes, the reverse effect occurs and ultraviolet-absorbing filtration is needed to prevent bluish color casts.

The majority of color films are balanced for average daylight of about 5500 K, adapting them to good weather conditions with sun and a blue sky during approximately the middle two-thirds of the day. Split color balance that is different in shadows and highlights occurs when highlights are illuminated by the combination of sun and sky and the shadows by the sky alone. Blue shadows may add appropriate coldness to snow and other scenes. When not acceptable, an amber filter that removes some of the cast from the shadows without overly warming the highlights is used. In open shade, blue sky may be the only source of illumination and more warming filtration will be needed. Hazy skylight and white clouds reduce the blue-tinting effect of the sky.

Shadow formation in daylight is natural due to the great distance of the sun. Subjects may cast shadows that are shorter or longer than their dimensions, but the shadows are not unnaturally tapered, and shadows from multiple subjects are parallel. Also, there is only one set of shadows since the sun is a single source.

Light ratios in daylight vary from absolutely flat in a blizzard to about 8:1 in bright sunlight. Sunlight with a thin cloud cover or white clouds is ideal for color photography, having nearly correct color temperature and a ratio of about 3:1 that prevents loss of shadow and highlights detail and color.

Though sunlight is often thought to be the most contrasty light source, there is always some fill from surroundings and sky to lower contrast. Outdoor lighting changes dramatically with time and climatic conditions. Lighting ratios decrease with clouds in front of the sun, but even on an overcast day the light still has a directional quality. Outdoor lighting varies, therefore, from a small to a large main source, but the fill is always from a large source. Studio photographers commonly try to duplicate natural daylight.

A large diffused main source, such as skylight, reflects less light from underlying color pigments, especially with glossy

7:1 7:1+1:=8:2=4:1

Daylight. Fill light adds an equal amount but a higher percentage of illumination to the shadows than to the highlights. High ratio of 7:1 is lowered to 4:1 *(right)* by adding one part fill to both the shadows and the highlights. Shadows can therefore be selectively tinted by changing the color of the fill light.

subjects, and more from the overlaid surface, decreasing color saturation. Color saturation tends to be higher on clear sunny days.

Haze is created by moisture and particles in the air scattering light passing through the atmosphere. Useful *aerial perspective* is created as more particles are encountered with increasing distances, but haze can be detrimental to applications such as oblique aerial photography. The blue portion of the spectrum is affected most by haze, and red filters for black-and-white photography and ultraviolet filters for color photography can reduce its effects. Conversely, blue filters can increase haze effects in black-and-white photography. Backlighting also increases haze effects. Smoke, fog, and smog effects cannot be lessened by filters.

Window Light Window light is a daylight variation and a useful source of indoor illumination for portraits and interiors. Since a window acts like an aperture or secondary light source, illumination decreases with increasing distance. Supplementary light from fill cards or other sources may be required to lighten shadows. If fill sources such as tungsten or fluorescent lamps are used, color balances will be different in the shadows and the highlights and the sources may have to be filtered. A large north skylight was a standard light source for early studio photographers. North skylight is too bluish for color photography, however, without a filter on the camera, and window light from any direction can be bluish when the illumination is from a blue sky.

Careful light balancing allows outdoor scenes to be seen through windows. Standard practice is to slightly overexpose the outdoor scene so it does not look unnaturally like a large photo mural on a wall. If tungsten film and light are used for the interior, the outdoor scene illuminated by daylight will have a cold bluish tint and interior warmth will be suggested. Slight underexposure of the outdoor scene can then suggest twilight.

Night Light Night photography normally uses artificial light from street lights, windows, automobile lights, and signs. The multiple colors add vibrancy, and lack of neutral balance is not a serious problem for photographers, who are divided on whether to use film with tungsten or daylight balance. Shadow detail can be increased if a tripod is used and a brief preexposure given just before dark, which may also add natural blue to the sky. The main exposure then records the night cityscape.

In rural areas, moonlight on snow or sand may provide

enough light for photography. The exposure differential between the moon and landscape will be high and a graduated neutral-density filter is required to record the moon's surface if it is included in the picture. A multiple exposure is often the easiest way to include a detailed moon in a landscape picture.

A night sky is not a technically useful light source. Extremely long exposure times make bracketing exposures difficult or impossible. Reciprocity failure causes color shifts that are different in shadows than highlights, and stars are recorded as streaks from the earth's rotation. Star trails are used as special effects, with or without the inclusion of the earth's surface, but reflected urban lighting ("light pollution") can reduce contrast between the sky and star trails.

Night photography can be imitated in daylight with filtration and underexposure that produces a monochromatic image of lower resolution. Colors are not anticipated at night since color adaptation of the eye changes with light intensity and the retina's color-insensitive rods are utilized more than the cones. The iris of the eye is also wide open and resolution diminished. For these reasons, cinematographers often create *day-for-night effects* with blue filters and underexposure for a monochromatic rendering that is more acceptable to viewers. A mild diffusion filter may be added to imitate the lower resolution of the eye.

ARTIFICIAL LIGHT SOURCES As color photography increasingly displaced black-and-white photography, it became necessary to have compatibility between light sources and color films, and film manufacturers were reluctant to make color films for more than two or three different color temperatures of light. Lamps that were color consistent through their useful lives were also required.

Filament Lamps Practical filament lamps date to the last quarter of the nineteenth century. Filaments were straight, made of carbon, and operated in a vacuum since any oxygen in a bulb causes the filament to burn. When tungsten, which would withstand more heat and produce more light, could be softened and formed into various shapes, it replaced carbon. Inert gases were introduced and it was discovered that coiling the filament decreased the area exposed to the circulating gas, heat loss was reduced, and the light intensity was increased. In 1934 the *double-coiled* or *coiled-coiled* filament (a coiled filament coiled a second time) again increased light output. Current lamp filaments are predominantly tungsten (coiled or double-coiled), which has created the convention of calling light produced by heating filaments *tungsten light* or *tungsten lighting.*

Producing light by heating filaments to glow brightly is inefficient since only 10 to 12% of the power input is converted to light and the rest is wasted as heat. Electricity costs in studios tend to be high, especially if air-conditioning is required to keep sets comfortable. Despite this, tungsten-filament lamps create fewer color-balance problems than discharge sources and are widely used by photographers. It is also a convenient continuous-light source for video and cinematography, especially since heat retention by the filament prevents flicker from AC cycling.

Tungsten filaments evaporate with use, causing the light intensity to decrease. The vaporized tungsten coats the interior of the bulb, again reducing intensity and also altering color balance. A thinner deposit results with a large interior area, but there is a practical limit to bulb size. Photography is better served by small bulbs with correspondingly small fixtures and efficient, compact reflectors. A wider range of effects is possible since a light source can be enlarged by diffusion but reducing its effective size is impractical.

A collector screen used above the filament in a gas-filled general-service or projection lamp to collect the blackening carried upwards by gas currents can allow more consistent brightness and a smaller bulb, but it must be used base down.

Another type of bulb that is used base up causes the blackening to collect at the base where the light is already partly blocked. Low-wattage household tungsten lamps (e.g., 40 watt) are vacuum filled and blackening is deposited evenly over the surface with all burning positions. The burn position of many electric lamps is specified for a variety of reasons, such as safety and lamp life, and should be followed. A few high-wattage, high-intensity lamps have a small amount of tungsten powder in the bulb; shaking the bulb can scour the blackening from the inside of the bulb and increase efficiency. Tungsten-filament lamps have clear and frosted envelopes. A clear envelope is used for optical reasons, for example, in a focusing spotlight or projector. A *prefocus* base is used when the filament has to be precisely located in an optical system.

Tungsten lighting has a continuous spectrum with a high predominance of red. The cell sensitivity of some exposure meters may require a small ISO adjustment. Lamps made especially for photography are made "whiter" by heating filaments to higher color temperatures of 3200 K and 3400 K, for which there are tungsten-balanced color films. The closer a filament is heated to its melting point, the shorter the lamp life; a 3400 K photoflood lamp of 250 watts is *overrun* (e.g., applying normal domestic line voltage to a lamp that should normally be run at lower voltage) and has an average life of 3 hours. The advantage is a high light output of about 32 lumens per watt compared to about 28 lumens per watt for a typical 600-watt quartz-halogen lamp with a 75-hour life. Blue-coated photoflood lamps have an approximate color temperature of about 4800 K but reduced intensity since the coating acts like a filter.

A line-voltage fluctuation of 1 volt at about 3200 K can cause a color-temperature change of about 10 K. Lower voltage reduces the color temperature, while higher voltage increases it. At 3200 K, a change of about 75 K will cause a noticeable color cast in a transparency. Highly saturated colors will absorb greater variations, but with neutral and delicate colors of low saturation a 50 K shift may be unacceptable. Voltage stabilization may be needed for critical color balance. Since tungsten light approximates light from a blackbody source, a relatively economical *two-color* color-temperature meter that has red- and blue-filtered cells is reasonably accurate. High current draws may require that tungsten lighting be plugged into different circuits to prevent overloading.

Household and commercial tungsten lamps have lower color temperatures of about 2760 K for a 40-watt lamp and about 2860 K for a 100-watt lamp. Bluish filtration can produce a neutral color balance on color films. Under-correction is sometimes preferred for the warm glow it gives to human skin in portraits. Retrofit fluorescent lamps that screw into standard household sockets are becoming increasingly popular and can fool photographers. Replacing general-service lamps with photo lamps is dangerous since sockets, fixtures, diffusers, and reflectors are not made to withstand the heat these higher wattage lamps produce, which can increase even more in enclosed spaces.

Tungsten light sources eliminate the previewing and focusing problems that can occur with electronic flash, although some flash units have built-in tungsten modelling lights. When small apertures are used, there may be reciprocity and resolution problems with long exposures. Even if the camera is used on a heavy tripod or stand to prevent blur from camera vibrations, heat can create thermal effects that can cause movement within the set, for instance, with curtains.

The life of all tungsten-filament lamps can be extended by running them at reduced voltage with dimming controls, turning them up to full power only for exposure. Slide projectors may have a half-power switch that can be used to

warm up the bulb, since failure often occurs with the initial rush of current, or when projecting onto a small screen. Dimming a lamp does not provide a convenient method of ratio control for color photography since color temperature is reduced as voltage is lowered. However, dimming can be a convenient way to slightly warm color balance.

The quick-start characteristic of tungsten-filament lamps allows them to be switched on and off with automatic exposure timers for printing. High-volume printing may use appropriate cooling; leave the lamp switched on, and control the exposure with a shutter, which also prevents color shifts when the burn-up and burn-down time of a lamp occupies a larger portion of the short exposure times used for high production. Quartz-halogen filament lamps are normally used for critical color printing.

Quartz-Halogen Lamps The quartz-iodine lamp, introduced in 1959, was a major advance in filament lamps. Currently called quartz-halogen, or tungsten-halogen lamps, they overcome some of the shortcomings of standard tungsten lamps by recirculating vaporized tungsten back to the filament to eliminate bulb blackening and increase the filament life. The high heat required for recirculation requires smaller bulbs, which allows a corresponding reduction in fixture sizes. The bulb, which must be hard to withstand the heat, is usually made of quartz, and may be subject to shattering. Fixtures are often fitted with clear safety covers that may also be necessary to block harmful ultraviolet radiation. Quartz-halogen lamps have displaced standard tungsten for critical color balance and have a life of about 75 to 100 hours.

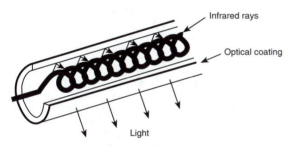

Quartz halogen. Applying a multilayer interference film coating to the outside of a quartz-halogen lamp's envelope allows light to pass freely but reflects infrared energy back to the filament.

Many types of quartz-halogen lamps are made for photography, including retrofit screw-in ones to modernize older fixtures and lamps with built-in reflectors for enlargers and projectors. The reflector may be a cold-mirror type that reflects visible radiation to the film but passes infrared radiation through the back of the reflector to keep heat from buckling the film during printing or projection. Reverse technology keeps more heat in a stage or studio quartz-halogen lamp's envelope for greater efficiency: multilayer interference film coating on the outside of the bulb transmits visible radiation but reflects infrared energy back to the filament. The power needed to reach the required filament temperature is reduced, and about 29 to 37 lumens per watt are possible without reducing lamp life. Utility costs are lowered, more lower-wattage fixtures can be used on given circuits to produce more light, and less radiant heat is transmitted to the set.

Tungsten-halogen lamps for enlargers and projectors may run at reduced voltages and subsequently have thicker and more rugged filaments. Low-voltage lamps with rugged filaments may be battery powered for video cameras, but long extension cords cause a drop in intensity and color temperature.

Fluorescent Lamps Fluorescent lighting has been a commercial success since the introduction of the first practical hot-cathode, low-voltage lamp in 1938. Fluorescent lamps are used commercially for their energy efficiency, which can be over 80 lumens per watt while producing little heat, and for their long life. Photographers have to use fluorescent lighting when photographing interior building spaces because such areas are too large to light with photographic light sources.

The fluorescent lamp is an electric discharge source that produces high light output with little heat. The tube contains mercury vapor at low pressure and a small quantity of inert gas for starting. Electrodes sealed into each end are coiled tungsten wires coated with an emission material that gives off electrons when heated; the electrons travel at high speed between the electrodes and collide with mercury atoms to cause a state of excitation and the emission of mainly short-wave ultraviolet radiation. Bulb blackening is a minor problem compared to tungsten lamps and occurs at the ends of tubes where filaments are located.

The inner walls of a fluorescent lamp are coated with fluorescent powders and the fluorescence of the phosphor crystals by the ultraviolet radiation produces approximately 90% of the light; the remaining 10% is from the mercury-arc line spectrum. The color of the light depends on the type of phosphor or mix of phosphors; a decorative color lamp may have a color coating in addition to the phosphor. *Black lights* have phosphors that are efficient sources of near ultraviolet radiation; the tube may be made of filter glass that absorbs most visible radiation and makes external filters unnecessary.

Spectral energy distribution charts for fluorescent lamps show a continuous spectrum with peaks and *spikes* at specific wavelengths. They impart a color cast to film that must be corrected with filters in color photography. Typically, the spikes impart a bluish or greenish color cast. Perfect color correction may not be possible since correcting one spectral deficiency with a filter may adversely affect another color. Filtration charts from different sources may therefore not agree with each other. If two or more different types of tubes are intermixed, or if other light sources contribute to illumination, normal color balance cannot be achieved with camera filters. A fluorescent lamp may be assigned a *correlated color temperature,* which is the blackbody temperature that produces the closest (but not necessarily close) visual match. Filtration should be based on tests, or guided by the use of a three-color meter that reads the relative red, blue, and green content of light.

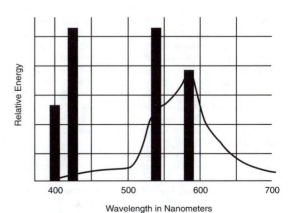

Fluorescent lamps. Spectral-energy distribution for a typical cool white fluorescent lamp. It has a line spectrum with spikes at specific wavelengths and an overlaid continuous spectrum.

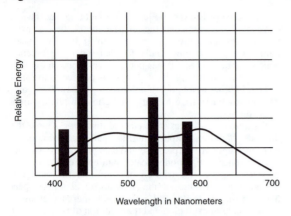

Spectral-energy distribution for a color-improved fluorescent lamp. Lamp has a correlated color temperature of 6000 K and a color rendering index of 93.

Fluorescent lamp utility for photography: (a) in a transparency viewer; (b) in an enlarger head; (c) an array of tubes in a lighting fixture; (d) as copy-stand lighting.

Photographers filtering for fluorescent lighting may be limited by not being able to correct for all of the irregularities in the spectral distribution of the fluorescent light with one filter or even with a combination of filters.

Correcting color negatives when printing is more expedient. Some photographers use the best possible filtration on the camera lens (e.g., magenta) and complementary filtration (e.g., green) on an electronic flash (or other source) since good main-subject illumination compensates for background color deficiencies. Special color-correcting filter sleeves are available for fluorescent tubes and rolls of color-conversion sheeting are available to cover windows.

The larger the share of continuous spectrum in a lamp's energy distribution, the better the light is for color photography, and for color print or color transparency evaluation. Lamps with a high *color rendering index* that require minimum filtration are available. Since they have a lower light output, more efficient lamps with a more pronounced discontinuous spectrum are commonly used in commercial buildings. In addition, lamps that have spectral deficiencies for photography may be deliberately chosen to enhance certain colors. Manufacturers provide charts of recommended enhancement tubes for florists, shoe stores, supermarkets, etc. The effects of artificial lighting on health, learning ability, and work efficiency are being studied, and, as the database of information increases, there may or may not be a trend to using lamps with a more natural spectrum.

Despite the problems fluorescent lamps can cause location photographers, fluorescent lamps with a high color rendering index and correlated color temperature of about 5000 K are often chosen for photography. The cool operating characteristics of fluorescent lamps allows them to be used in enclosed transparency illuminators and enlarger heads for black-and-white printing, and for copy-stand lighting where the heat of tungsten lights might be unacceptable. A set-lighting fixture may have a series of fluorescent lamps in a reflector and be used as a primary light source, or with tested filtration to illuminate main subjects when location fluorescent lamps provide background lighting.

When fluorescent lamps are chosen for subject lighting, photographers should recognize that they are low brightness sources but the length and diameter of tubes can produce a high total light output. These size considerations make them primarily large diffused light sources, and, since illumination is from excitation of internal phosphors that produce smooth, even illumination over the bulb surface, they can be used in open fixtures without diffusing screens.

Alternating current causes fluorescent lamps to pulse rapidly in brightness. With incandescent lamps heat retention of the filament compensates for cycle variations, but with fluorescent lamps light carry-over depends on the persistence of the tube coating, which can vary. Shutter speeds of longer than 1/60 of a second may be required for even exposure across the film format with focal-plane shutters and for avoiding underexposure with leaf shutters. In cinematography, exposure differences from frame to frame will register as *flicker* on the screen. Corrections include using appropriate shutter speeds and three-phase operation of adjacent lamps (or pairs of lamps) so two of the three are always "lit." It is advisable to allow fluorescent lamps to warm up before making meter readings or exposing film.

Metal Halide Lamps Metal halide gas-discharge arc lamps for photography are usually called HMI lamps (H for the mercury symbol HG, M for medium arc, and I for iodides). They have similarities to mercury-vapor high-intensity discharge lamps, but modifications include the addition of metal oxides to emit a closely spaced multiline spectrum that is effectively continuous. Adding these oxides in different proportions allows the spectral response to be varied, and lamps are made with correlated color temperatures of about 6000 K, 5600 K, and 3200 K. The lamps produce about 80 to 100 lumens per watt and emit less heat than tungsten lights. The relatively short arc allows the lamps to be used in focusing fixtures. During the initial burning time of about 200 hours, ultraviolet filtration may be needed on the camera lens even though fixtures are fitted with safety ultraviolet-absorbing glass. The color rendering index may change with lamp age. Infrared emission is low and the emitted light is comparatively cool.

Metal halide lamps operate on AC current and are subject to flicker, but control gear is required and newer fixtures tend to be supplied with *flicker-free* ballasts. Equipment expense has limited its use to high-budget applications, such as cinematography, but metal-halide lighting is making inroads into still photography. Industrial metal-halide lamps have a less closely spaced line spectrum and are normally grouped with industrial *high-intensity discharge* lamps.

Carbon-Arc Lamps Carbon-arc lamps differ from other arc lamps since the arc burns in air rather than in a mixture of gases. The arc is a flame in a space between positive and negative carbon electrodes. As the electrodes burn away, a motor feeds them towards each other and the feed speed must be controlled to prevent flicker. Electrodes of different composition produce a *white flame* or *yellow flame* for use with daylight or tungsten color films. The lamps have a continuous spectrum with peaks and high ultraviolet content, which can be controlled with filters. Carbon-arc lamps are used in cinematography where their intense illumination makes up for their problems: size and weight, the need for DC generators, and potential safety problems such as high amperage, high ultraviolet content, and heat.

High-Intensity Discharge (HID) Lamps Industrial HID lamps are high-pressure sodium, metal halide, and mercury arc lamps characterized by high intensity for their energy consumption and long life for low maintenance. Low-pressure sodium lamps are included in the category because they have similar utility characteristics. Matching ballasts and starting equipment are required but some mercury-vapor lamps are self-ballasted. Slow-start and reignition characteristics for most limit their use to street, stadium, factory, and other commercial lighting.

The lamps have line spectrums with disproportionate energy at different wavelengths in the visible spectrum, and often no wavelength in some portions. Objects may not appear in true colors, and color meters may not give accurate readings. Phosphor coatings partially correct color deficiencies, but unlike in a fluorescent lamp the phosphor does not add a useful overlaid spectrum. It only adds a missing color. When lamps are mixed with other sources in a city street scene at night, the lamp colors and their object rendering can add vibrancy. Accurate interior recording can be difficult, and indoors or outdoors it may be necessary to light closeup subjects separately. Some lamps have higher color-rendering indexes, but a high CRI has more to do with how colors appear to the eye than how they will be recorded on color film or color video. Camera filters will still be required, but, as with fluorescent lamps, a high CRI may make filtration easier. As the CRI rises, efficiency (lumens per watt) is reduced, and efficient lamps that feature poor color-rendering qualities are often encountered in location photography. Lamp and film manufacturers often provide starting-point filter-pack recommendations. Using color negative film and making corrections when printing can solve these problems.

Sodium lamps use sodium as the main light-producing gas in an arc tube. At low pressure, sodium vapor produces a single yellow color close to the peak sensitivity of the eye, and efficiency is the highest of all lamps. They emit primarily a single spike of high-energy radiation, which makes them useful as safelights in darkrooms. At high pressure, the spectrum of a sodium lamp is broadened to include the entire visible spectrum, but yellow still dominates and subject colors may not be accurately observed. The *whiter* light of a high-pressure sodium lamp is preferred for many applications. The color rendering of HID lamps is being improved, and a high-pressure sodium lamp with a CRI of 80 is available, but the CRI can be as low as 21 for a more efficient lamp.

Clear mercury-vapor HID lamps are deficient in red and the light appears bluish-white without eye adaptation. Red and orange objects may appear brownish under them, while blue, green, and yellow ones will be enhanced. The outer bulb of some may have an interior phosphor to add red and compensate for the lamp's deficiency in that color. Even these *improved* lamps may require corrective red filtration. Safety HID mercury lamps extinguish in about 15 minutes after the UV-absorbing outer envelope is broken or punc-

tured in order to give protection from shortwave ultraviolet radiation. Deep red-purple glass is sometimes used to pass only near ultraviolet for fluorescent effects.

Metal-halide HID lamps produce energy through the visible spectrum and may have fluorescent phosphors added to the inside of the outer bulb to improve color rendering. High-wattage metal-halide lamps are widely used for sports lighting and *broadcast* illumination levels for television.

Other A variety of other continuous-light sources may be encountered or used by photographers. They include xenon and zirconium lamps, computer screens (e.g., copying to produce lecture slides), and electroluminescent lamps. Lasers are used to produce holograms, and laser pointers used by slide-show lecturers project a collimated beam of light that is in focus at all distances.

ELECTRONIC FLASH Electronic flash was developed before World War II and has become increasingly popular over the intervening years. Though the historical picture of subjects such as the frozen splash of water created by a car driving through a puddle seem mundane by current standards, they were sensational for their time. The extremely brief duration of electronic flash was compared to the comparatively slow burning of the flashbulb. Flashbulbs remained popular throughout the early evolution of electronic flash: they were more powerful and were made smaller to meet the competition. Electronic flash was less intense, required a bulky and heavy over-the-shoulder power supply, and recharging took longer than changing a flashbulb.

Improved electronic flash has now displaced flashbulbs as the main source of portable and studio light for still photography. The brief burst of intense light stops action, allows a camera to be used without a tripod to quickly take pictures from a variety of angles, produces little heat, and has a spectrum matched to daylight-balanced color films. It can be conveniently mixed with daylight for fill. Like tungsten light, electronic flash can be used to manipulate cold and warm color balance, or contrast them for effect. The flash tube can be triggered thousands of times with little change in color balance or intensity.

Electronic flash is mainly used for still photography. It can be synchronized with a movie camera's framing speed for a more realistic rendering of moving subjects such as cereal flakes being poured into a dish. To compensate for the required recharging time, several units may have to be synchronized to flash sequentially. Specially designed rapid-firing electronic flash units are also used for stroboscopic effects, and some enlargers use flash tubes that fire rapidly enough to effectively produce continuous light. Low-volume slide duplicating is often done with electronic flash. The long life and color consistency of a flash tube eliminates the need to do color-balance tests to compensate for lamp replacement and aging.

Color temperature in degrees Kelvin is applied to electronic flash. While electronic flash has a line spectrum, the lines are so closely spaced that emission nearly duplicates that of a blackbody. Most contemporary electronic flash units can be used with daylight color films without filtration, where photographic daylight is identified as having a color temperature of 5500 K. The color temperature does vary somewhat among flash units, however, and even for a given unit at different power settings and flash durations. The adverse effects of ultraviolet radiation, which is produced by all flash tubes, are controlled in many units by UV-absorbing coatings on the tubes. As with tungsten light, color-balance tolerance depends on whether color negative or color transparency film is being used, on the use of the final image, and on the color saturation of the subject. Color temperature is lowered by diffusing screens and raised by metallic reflectors and long flash durations. Typically, a flash duration

change from 1/3000 to 1/1000 second will increase the color temperature by the equivalent of a CC10 filter. Manufacturers sometimes provide a variety of protective tube covers that alter color temperature for precise balance or aesthetic reasons. A given protective shell for a studio flash head might raise the color temperature on the assumption that diffusion with soft boxes, umbrellas, etc. will lower color temperature. Small on-camera guns often have warming reflector covers or coated tubes. Some color-temperature meters are capable of measuring the color temperature of electronic flash.

The flash tube is usually made of quartz glass and filled with xenon gas. Tungsten or molybdenum electrodes are fused into the ends to seal in the gas. The gas in the tube does not conduct electricity, so a triggering electrode (which may be seen as a wire wrapped around the tube in studio flash or may be a transparent coating with small flash units) is used. A high-tension pulse through the triggering electrode temporarily ionizes the gas and makes it conducting so that the flash discharges. The camera shutter is normally isolated from the high current of the trigger circuit for safety and to prevent damage to the shutter contacts. Flash tubes can be straight or coiled for various applications, for example, as a ringlight, to wrap around a modeling lamp, or for optical qualities with a given reflector.

A basic electronic flash circuit series for a portable battery-powered flash has a power supply from rechargeable or disposable batteries, a transistor oscillator circuit that converts the low-voltage DC current from the batteries to pulsed current that simulates AC current and is then stepped-up to high-voltage AC, and a rectifier circuit for changing high-voltage AC to high-voltage DC current to charge the capacitor or bank of capacitors. Capacitor energy is discharged through the flashtube to produce the brief flash of light. A flash-ready indicator light normally switches on when the flash capacitors are recharged, and it may be accompanied by an audible signal. The characteristic high-pitched whine of the oscillator circuit during recharging also gives a clue to the charge and battery condition. The time the *ready light* takes to illuminate can vary from a fraction of a second to 15 seconds or more, depending on capacitor size and on the incoming voltage. Weak batteries take longer to recharge the capacitor.

An alternative power supply may be a high-voltage battery pack that only has to be converted to AC and eliminates part of the circuit. It is possible for a portable flash unit to have multiple power supplies: from small low-voltage batteries inside the unit, from a separate low-voltage pack connected to a simulated battery cluster that is inserted in place of the normal batteries, from a high-voltage pack that plugs into a separate socket, and from AC. A given battery pack may have outlets for two flash units, which doubles the amount of power available but halves the number of flashes from a set of batteries and increases recharging time. Since high-voltage batteries are expensive, have a limited shelf life, and are not rechargeable, an alternative is a pack with low-voltage rechargeable batteries: the voltage is then stepped-up so the pack can be used as a high-voltage pack for quicker recharging and a large number of flashes.

Using Electronic Flash A flash burst that occurs within a longer shutter speed has advantages and disadvantages. For fill flash, the flash portion can be controlled with the aperture, the continuous light portion with the shutter speed. A slow shutter speed and flash burst can be used for motion effects with sharp and blurred elements, to lower shadow density, to give backgrounds and continuous lights time to register on the film, and to add the warm glow of tungsten light to faces. The use of a high shutter speed in daylight can produce dark backgrounds for evening and night effects, or simply darken the background, for example, for better color

saturation in a hazy blue sky. Disadvantages occur when a slow synchronizing shutter speed is not selected by choice but used because a focal-plane shutter will not synchronize at higher shutter speeds.

Electronic flash is normally synchronized to fire immediately after the shutter is completely open. Leaf shutters synchronize at all shutter speeds. A focal-plane shutter exposes the film with a slit at higher speeds and part of the film will be unexposed if the flash fires before the shutter fully opens. Focal-plane shutters vary widely in maximum synchronizing speeds, from 1/20 second with a large cloth shutter for medium-format cameras to 1/250 second with a vertically running lightweight metal shutter in some 35-mm cameras.

Slow synchronizing speeds cause several problems. Fill flash is difficult with slow shutter speeds: an intense flash may be required to compensate for the small aperture forced by the slow shutter speed, and a tripod may be required to prevent blur from the slow speed. Even if flash is the only intended source of light, ambient light may contribute too much to the exposure and create color casts and ghost images as subjects move after the flash. Optional leaf-shutter lenses are available for some focal-plane shutter medium-format cameras.

Photographers sometimes desire a motion effect, using a long shutter speed and flash bursts to freeze a moving subject ahead of motion streaks. Flash synchronization normally triggers the flash at the start of the shutter cycle and the resulting streaks are unnaturally ahead of the subject since the subject normally moves forward after the flash fires. Some 35-mm SLR cameras with focal-plane shutters have optional *rear-curtain synchronization* that fires the flash at the end of the shutter-speed cycle for natural motion effects. An alternative is to use a synchronizing system that delays the flash triggering until the end of the shutter speed, which allows all cameras to be used, including those with leaf shutters.

Most studio and many battery-powered electronic-flash units allow power reductions with a subsequent shortening of recharge time. The flash duration is also shortened to freeze rapid subject movement. Varying the intensities of main and fill lights by simply *dialing in* the required intensity gives convenient light-ratio control, especially when the photographer does not wish to change the source-subject size relationship by moving a diffused source like a soft box.

Though many different on-camera portable electronic flash units are available, professional photographers often require more light than they provide to illuminate large areas, to use small apertures for increased depth of field, and to compensate for diffusing the light. The number of models of 200 to 400 watt-second battery-portable units on the market is small. Since some are sold on the basis of power and reliability, they may not have an autoexposure light-quenching system.

Exposure Control Automatic-exposure control is standard for portable on-camera electronic flash units, but is usually not available for studio electronic flash systems. Constantly changing light distances make automatic exposure control more desirable for an on-camera flash than for a studio flash system. Repeated guide-number calculations or calculator-dial checks are detrimental to quick photography and inevitably cause a larger percentage of exposure errors than an automatic-exposure system. Reflected-light flash-meter readings are difficult to take with on-camera flash, and incident readings may require asking a subject to hold the meter. For these reasons, automatic-exposure control for flash is a useful feature.

Focusing-distance and *quenching* systems are used for automatic exposure control. A system based on the focusing distance alters the aperture size as the focusing distance is changed. It allows the full power of the flash to be used for the smallest possible apertures and is used in some amateur

Exposure control. Simplified circuit steps for a sensor-eye, automatic-exposure electronic flash system. While capacitor energy (C) is discharged through the flash tube (F), light reflected from the subject onto the light sensor (S) is measured by an analog control chip (A); when enough has been received for correct exposure, the thyristor (T) terminates the capacitor discharge, and unused energy is saved for future exposures. A range of autoexposure apertures may be provided by sliding degrees of neutral-density filtration (W) in front of the sensor (S); one portion of the neutral density strip is opaque, so the capacitor is fully discharged with manual-exposure control.

Closeup photography with through-the-lens automatic flash. (Photograph by Ron Jegerings.)

snapshot cameras that have small low-powered flash units built in and require full flash intensity at moderate distances. *Guide-number* lenses were once made for interchangeable-lens cameras. They could not be fooled by background variations and the numerous nonautomatic electronic flash and flashbulb fixtures available at the time could be used. They were displaced by a small lens selection, the inability to change camera and flash distances, and they became unusable when bounce flash, diffusion, and closeup photography make guide numbers invalid.

Quenching systems sense light reflected from the subject and terminate the flash duration when enough has been received for correct exposure. Energy-saving circuitry terminates the capacitor discharge so that the flash can be rapidly recharged when shooting at near distances or with wide apertures. The sensor eye is located on the flash fixture, and a tilting and swivelling head may be included to bounce light off a wall or ceiling while the eye remains aimed at the subject.

Since bounce light can cast detail-hiding shadows, a second mini flash may be provided on the main body to fill in the shadows. It remains aimed at the subject while the main head is pointed at the bounce surface. A *bounce panel* attached to the back of a flash head redirects spill light into the shadows. When bounce panels are not available, some photographers make their own. A cord connection mounts the sensor eye on the camera while the flash is aimed at a bounce surface, or aimed at the subject but used away from the camera for better light modeling.

Sensor-eye electronic flash units are popular and have the advantage of being adaptable to any camera with an adjustable diaphragm and f-number markings and X-synchronization. An *auto aperture* is set on the flash to terminate the duration for a matching aperture on the camera lens. Normally, a range of apertures can be used for shooting at different distances, to vary depth of field, or to shorten the recharge time. A test preflash system may be built in. Typically, a light on the back of the flash illuminates briefly if there was enough flash light for correct exposure. The system may not warn of overexposure if there is too much light but exposure problems are usually from insufficient light. There is usually an auto-distance scale on the flash, with near and far limits for given apertures, but it is not operational for bounce flash or other diffusion techniques.

Quenching systems sometimes compensate for exposures made before the unit is fully recharged. A flaw of quenching is that it must keep some capacitor energy in reserve to function and the full power of the flash unit cannot be used. Increased flash intensity is usually more desirable than less.

Dedicated systems that use mating contacts in a camera flash shoe and the flash foot were first available for sensor-eye flash. Camera and flash had to be compatible, but the systems set the correct synchronizing speed for focal-plane shutters, eliminating a major cause of failed flash pictures. In the programmed automatic-exposure mode, a few dedicated systems automatically set the correct flash aperture to eliminate another potential cause of exposure error. A full-charge indicator light can usually be seen in the viewfinder, so there is no need to lower the camera for repeat flash shots. Dedication increases complexity and cost, and may not allow mixing cameras and flash units.

TTL-OTF (through-the-lens and off-the-film) automatic flash is an improved and now dominant dedicated flash system. It is also a quenching system. However, the sensor (or sensors) is in the camera body and aimed at the film instead of at the subject. When enough light has been reflected off the film for correct exposure, the flash duration is terminated. Again, camera and flash have mating electrical contacts. Dedicated systems are available for 35-mm and medium-format cameras.

Since quenching decisions are made after light has passed through the lens with a TTL system, any aperture can be selected within intensity and quenching limitations. Allowances do not have to be made for color filters that are pale and do not alter the meter's spectral sensitivity. Lens extension calculations are not required, making the system especially useful for closeup photography. Fiber-optic sensing guides that were clipped to the lens rim and aimed at the subject were once made for sensor-eye flash heads but were displaced by the greater utility of TTL flash for closeup photography.

With a TTL system there may not be enough light for long-range or small-aperture exposures. A viewfinder indicator light flashing pattern warns if flash illumination was insufficient but may not warn of overexposure if the flash duration is not terminated quickly enough. Unlike sensor-eye flash, many TTL systems do not allow a test preflash and an exposure may have to be wasted to find out if exposure was correct. When TTL systems do allow a test preflash,

they may be quite sophisticated, for example, allowing spot readings or allowing aperture readings for nondedicated electronic flash.

Dedicated TTL flash may be coupled to the segmented metering pattern of a 35-mm autofocus SLR. When contrasty continuous light is sensed, the required amount of fill flash is used. The photographer may be able to control the light ratio for more or less fill light.

Most pictorial films have reasonably equivalent reflection factors and work well with TTL-OTF electronic flash. Otherwise, an ISO adjustment is needed. If TTL flash functions while allowing the photographer independent control of the shutter speed and aperture, a higher ISO number can be used to control the light ratio for fill flash.

Automatic flash is rarely used to control multiple heads. After positioning lights on stands, there is almost always time to use a flash meter, which is more accurate and allows full power to be used for small apertures. However, different auto-apertures settings can be used to control the light ratio with sensor-eye units. The degree of success is variable as light from one flash may strike another sensor and terminate the duration too soon.

When setting up multiple dedicated TTL flash heads, system dedicated connecting cords and multiple connectors are required since there is only one control sensor in the camera body. All flash durations in the chain may be terminated at the same time and ratio control becomes semiautomatic since light intensity control is by changing light distances or by changing the intensity of different units with diffusers, zoom heads, or filters. A recent innovation is cordless TTL automatic flash. Stroboscopic control bursts from a flash built into the prism of a 35-mm SLR camera signal the off-camera unit to start and terminate the flash duration.

An electronic flash may have a Fresnel lens zoom head that can be adjusted to change the angle of illumination for different focal-length camera lenses. Dedicated 35-mm SLR autofocus systems improve on the feature with a central processing unit that recognizes the focal length on the camera lens and automatically adjusts a motorized-driven zoom flash head. Other dedicated features for autofocus 35-mm SLR cameras include automatic aperture setting according to the focal length, infrared preflash to project a target pattern on the subject for the autofocus system for correctly focused

Multiple TTL flash. One light sensor, in the camera body, terminates the light emission of both flash units simultaneously.

flash shots in low light, a red-eye reduction flash with a series of preflashes before the main burst to narrow pupils, automatic selection of a slow shutter speed to balance flash and ambient light, and coupling an automatic exposure-bracketing system to flash or fill flash.

Many photographers still calculate the flash aperture according to the light distance. Distance calculations can be more reliable than auto exposure when using a single on-camera flash and allow the full power of the flash to be used. Calculator dials and panels on flash units eliminate the need for guide-number calculations, but exposure tests are needed since manufacturers frequently overrate flash intensity. Professional photographers often relate aperture numbers to distances in feet. If, for example, the aperture for a distance of 11 feet is found by trial and is thought of as $f/11$, moving to 8 feet ($f/8$) requires closing the aperture one stop, and backing to 22 feet ($f/22$) requires opening the lens two stops.

Flash meters are normally used to set light ratios and calculate exposures for studio electronic flash. Meter readings are frequently supported with instant-film test shots. Multiple heads set at various distances and angles, diffusion, and overlapping beams make distance calculations excessively complex. Incident and narrow-angle reflected flash meters are preferred. Spot probes allow film-plane readings with view cameras. Economical flash meters may be of marginal value since they may only read a narrow range of flash durations from about 1/1000 to about 1/2000 or 1/3000 second. Studio flash may have durations longer than 1/250 second, and flash durations shorter than 1/3000 second may be required to stop action. An advanced flash meter will combine continuous and ambient light in readings with a full range of shutter speeds, may indicate the differences between flash and continuous contributions, and have an optional incident-light reading flat diffuser to set light ratios.

An exposure advantage for electronic flash is that the exposure is largely independent of the shutter speed. Shutter-speed inaccuracies therefore normally cause no exposure problems. Studio photographers sometimes use a series of flashes with an open shutter in low ambient light. The camera is mounted on a sturdy tripod or stand and two or more flash bursts are triggered to increase the exposure or the depth of field. Two bursts allow closing down one stop, four bursts allow closing down two. This doubling of the previous number of bursts for each additional smaller aperture puts practical limits on intensity increases. Testing is required since intermittency effects can cause underexposure and color shifts.

Studio Electronic Flash High intensity is the main requirement of studio flash. Power may be from about 250 to 6000 watt-seconds, depending on whether the system is to be used for location portraiture or lighting large sets. This can be compared to about 100 watt-seconds for a typical on-camera portable flash. AC line outlets are the primary source of power, which is stepped up with a transformer.

As well as providing an economical power source, AC supplies allow continuous tungsten-filament modeling lamps to be used, overcoming the previewing and focusing problems of brief flash durations. Manufacturers usually try to position modeling lamp and flash tube close together, but the slightly different positions may still create different effects unless a diffuser blends the two beams.

Despite the value of modeling lamps, their intensity is rarely as high as continuous studio lighting, and there can be focusing problems and scene previewing problems when the intensity of existing light changes the effects of light from modeling lamps. Proportional modeling lights dim as flash intensity is reduced so the light ratio with the modeling lamps is the same as with flash, but modeling lamps of low initial intensity may be unusable when dimmed. Some modeling lamps switch off after the flash fires to indicate if each

head in the set actually fired and may switch on to indicate recharging is complete. Modeling lamps usually have a color temperature of about 3200 K and can be used for occasional assignments that require continuous light, especially if they are quartz-halogen lamps. Location photography away from convenient AC outlets may be possible with a generator or automobile battery but modeling lamps may not be usable.

There are two basic studio electronic-flash systems, self-contained (monoblock) and power-pack systems. A self-contained system has all circuitry in the flash-tube head, while a power-pack system basically has a trigger circuit in the head and the capacitor(s) discharges through a heavy-duty cable from a *floor* power pack to the head. Two or more heads can normally be connected to a single power pack. A few professional on-camera electronic flash systems also house the capacitors and related circuitry in a separate over-the-shoulder or belt power pack that may have outlets to power two lightweight flash heads.

There are practical limits to how large a monoblock unit can be made, and they are not as powerful as many power-pack systems. They are more convenient for location photography, and when using several units the photographer can continue working if one fails. Additional weight can make using them high on stands risky, and when out of reach the power reduction controls cannot be used. Some monoblocks have optional remote control.

As well as often being more powerful, power-pack systems are also more versatile. Their lighter heads are easier to use on stands and can be more easily hidden and placed in awkward positions. A wider variety of heads is available; a typical studio system may have ringlight, strip, fiber-optic and other special-purpose heads.

Though a power pack usually allows multiple heads to be attached, power is not increased since capacitor capacity remains the same. If four heads are cabled to a 1000 watt-second power supply, the power is divided between them. Power division may be symmetrical for 250 watt-seconds into each head, or asymmetrical so more power can be directed to some heads for better lighting control. Plugging additional heads into a power pack discharges the capacitors quickly for shorter flash durations, which can be useful for stopping motion in studio photography since flash durations are routinely 1/500 and 1/250 second and slower for studio systems. Y-cables may be available to run two heads from a single outlet, and some heads can be powered by more than one power pack to increase intensity. For example, a head might have more than one flash tube to allow multiple power packs to be used.

While adjustments, such as modeling lamp intensity and flash power reductions, can be conveniently made with a floor power pack, a relatively short low-resistance cable between the flash and power pack increases efficiency. Long cables, especially when coiled, decrease efficiency and lengthen flash durations. Some remote heads may therefore be best mounted close to their power supplies and remote control adjustment is available for some power packs.

FLASHBULBS A flashbulb produces a single intense flash of light by means of electrical ignition of a highly combustible material in an enclosed atmosphere of oxygen. It has been largely displaced by electronic flash, which is reusable, allows quicker repeat exposures, is more economical for numerous exposures, and has a shorter duration to prevent blur from subject or camera movement. Flashbulbs are coated with lacquer to prevent shattering when the bulb is fired. The light source is typically zirconium in smaller bulbs such as AG (all-glass) types and aluminum in larger bulbs. Electrical current, usually from a dry battery source, is passed through a filament that burns and ignites a primer and the aluminum or zirconium. The metal burns at a relatively predictable rate once ignited, and since it produces most of

the light, accurate guide numbers are possible. However, filament burning can be delayed by current that is lower than about 3 amperes, causing synchronization problems at higher shutter speeds, and erratic exposures. Nearly discharged batteries and resistance from corroded contacts often cause amperage reductions. To compensate, most flashbulb fixtures have a BC (battery-capacitor) circuit in which the capacitor stores a sufficient charge and releases it when required.

Numerous types and shapes of flashbulbs have been made and are categorized by the time in milliseconds they take to reach peak intensity. While X-synchronization for electronic flash can be used with flashbulbs at slow shutter speeds (generally up to 1/30 second) that allow time for ignition and burning, synchronization is required at higher shutter speeds. Shutter opening must be delayed slightly to allow the bulb to begin burning and then remain open to include most of the light output. Class M (Medium) bulbs have a peak delay of about 18 to 22 milliseconds and can generally be used with X-synchronization at 1/30 and slower speeds, and with M-synchronization with leaf shutters at all shutter speeds. Class S (Slow) bulbs had the advantage of high light output, but a long firing delay of about 30 milliseconds made them unsuitable for synchronization at speeds faster than about 1/8 to 1/15 second; they were often used with an open shutter and manual triggering. Class F (Fast) bulbs reach peak brilliance in about 5 to 6 milliseconds and fade out at about 11 milliseconds. Class FP (Focal Plane) bulbs synchronize with focal-plane shutters at all speeds. Since a focal-plane shutter exposes with a moving slit at higher shutter speeds, the flash must remain at peak intensity for a longer period of time.

While correct matching of bulb, shutter and synchronization allows high shutter speeds to be used, high speeds cut off part of the bulb's light output, which results in a lower guide number. Many cameras and shutters are still synchronized for bulb flash and if bulb synchronization is accidentally used with electronic flash, the flash will fire before the shutter opens and the film will not be exposed.

The spectrum of flashbulbs is continuous with a color temperature of abut 3200 K, but some bulbs have a bluish coating that converts the color temperature to about 5500 K for use with daylight color films.

Numerous flashbulb systems have been designed for snapshot cameras. The *flashcube* contains four small bulbs with reflectors and is rotated for each subsequent exposure; a variation is the *Magicube* in which an external torsion spring for each bulb ignites the primer and eliminates the need for electrical current. With *FlipFlash* arrays of eight bulbs, the array is flipped after four bulbs are fired and then the remaining four are fired. Power is supplied by a *Piezo-electric* ceramic inside the camera: a tiny hammer strikes the ceramic to release a brief pulse of electricity to fire the flash, again eliminating the need for batteries to fire the flash. *Flashbars* are used with cameras that use Polaroid self-ejecting films and allow ten exposures (e.g., a pack of SX-70 film) in two sequences of five flashes.

REFLECTED LIGHT In some indoor situations, the main light for a photograph is directed not at the subject but away from the subject, with the understanding that the diffused light reflected from large surfaces will produce a more attractive result than direct light. Even when direct lighting is used, intentional or incidental reflected light commonly alters the lighting effect. In direct sunlight, reflected light from the sky and the surroundings reduces what would otherwise be an infinitely high lighting ratio to a ratio of approximately 8 to 1. As conditions change to a hazy sun, light overcast, and cloudy, or as the reflecting surfaces become lighter and closer to the subject, the lighting ratio decreases.

In the studio, diffuse light reflected from a white panel functions well to lighten shadows cast by a direct light

because it does not create conflicting shadows. Although such fill light adds equal amounts to shadow and highlight areas, proportionally more is added to the shadows. By changing the color of the reflecting surface, the color of the shadows can be altered. Outdoors, the reflected fill light from blue sky produces bluish shadows that are more obvious when they appear on a white or light-colored surface.

LIGHT SOURCES IN PHOTOGRAPHS Occasionally a light source can serve as an interesting subject or compositional element in addition to or instead of serving to illuminate a scene. Campfires, fireplace fires, closeup candle-lit scenes, building fires, night signs, fireworks, and lightning are common examples, and the sun itself can add a dramatic impact to an outdoor photograph.

INFRARED AND ULTRAVIOLET Infrared and ultraviolet radiation are on opposite sides of the visible spectrum but can be used as light sources for photographs. They are often used in scientific photography to reveal details not visible to the eye, and for special effects in pictorial photography.

Infrared black-and-white film is used with filters that restrict or eliminate visible radiation so infrared radiation dominates the picture. A deep red filter passes enough light for composition with a reflex camera, or a visually opaque filter may be used for a more pronounced effect. In pictorial photography, distant haze is penetrated, foliage turns white in prints, and blue skies turn black. The effect is often used to produce dream images, and day-for-night moonlight effects. An infrared filter that blocks light is sometimes taped over an electronic-flash reflector to take discreet candid pictures without a visible flash of light. Flashbulbs with a coating that blocked light were once available for infrared photography. Infrared slaves allow triggering flash heads (or cameras) without trailing synchronizing cords. Infrared focusing systems in autofocus cameras project a target pattern on the subject, allowing the camera to focus accurately in low light.

Light sources that emit ultraviolet radiation, such as some fluorescent lamps and some electronic-flash tubes, are used for two types of ultraviolet photography with most conventional films. *Reflected-ultraviolet photography* is used in scientific photography with a camera-lens filter that blocks light and passes ultraviolet radiation (an exciter filter) to reveal what is invisible to the eye. Objects that fluoresce under ultraviolet radiation are commonly photographed in a darkened room with a camera-lens filter that blocks ultraviolet radiation but passes visible radiation (a barrier filter) to dramatize the fluorescence. Color pictures made by *fluorescence* or *black-light photography* have brilliant fluorescent colors, but some objects fluoresce more than others; fluorescent coloring materials from art-supply stores can be used for enhancement. Ultraviolet radiation, especially short and medium-wave ultraviolet, can cause eye injury and sunburn; therefore, the lamp manufacturer's instructions should be followed.

That color films are sensitive to ultraviolet and infrared radiation can cause problems in conventional photography. Fabrics that reflect ultraviolet energy record as bluish, especially if they are neutral or have low color saturation. An ultraviolet filter over the camera lens, or over the light source, will reduce the effect.

As in black-light photography, with normal light sources some fabrics absorb ultraviolet and emit it in the near blue portion of the visible spectrum. Though the results are not as dramatic, some fabrics will have an unexpected and unwanted bluish tint. Ultraviolet filters can be used over the light source *and* the lens to correct the problem. Viewing a fabric under ultraviolet radiation may show if it is likely to fluoresce.

Anomalous reflectance occurs from high reflectance at the far red and infrared end of the spectrum where the eye has little or no sensitivity but color film does. Some flowers in nature do not reproduce as seen by the eye, and some organic dyes used in fabric manufacture have high far-red reflectance. The effect is most obvious with green fabrics since red reflectance neutralizes the green and the fabric reproduces as neutral or warm-colored. Illuminating green fabrics with *reddish* tungsten lighting and viewing them through a deep red filter may warn of potential poor color reproduction. If the fabric viewed in this manner appears lighter than a green fabric known to reproduce well, there will be reproduction problems. Since anomalous reflectance has a warming effect, it may not be as unacceptable as bluish tints from a film's ultraviolet sensitivity.

POLARIZED LIGHT *Cross polarization,* with polarizing filters used over the light source and over the camera lens, eliminates reflections. The most common application is for copying flat art. Polarizers over the lights cause light rays to vibrate in one direction so they, and their reflections in glossy surfaces, can be blocked by a similar linear polarizer rotated at a right angle to the light polarizer over the camera. Cross polarization with an on-camera flash allows quick copying with a hand-held camera, but a powerful flash may be required to compensate for the large light loss. A cross

Infrared. Moonlight effect in sunlight with black-and-white infrared film. (Photograph by Ron Jegerings.)

polarizer set is made for a ringlight for close-up photography. In still-life photography, a polarizer over a light causing the problem reflection and one over the camera lens may eliminate a glare spot. Heat can damage a polarizing filter and sheet polarizers should be used at recommended distances from hot light fixtures.

Cross polarization and transmitted light can reveal stress patterns in clear plastics, and distinguish crystals that look similar, but are different, in photomicrography. The subject is placed between polarizers, which are then rotated to reveal a multicolored pattern *(birefringence)* that can be used for pictorial or scientific purposes.

Books: *Philips Lighting Handbook.* North American Philips Lighting Corporation, 1984; Kerr, R., *Technique of Photographic Lighting.* New York: Amphoto, 1982; Hunter, F. and Fuqua, P., *Light—Science & Magic.* Boston: Focal Press, 1990; Carlson, V. and E., *Professional Lighting Handbook,* 2d ed. Boston: Focal Press, 1991; Marchesi, J., *Professional Lighting Technique.* Switzerland: Verlag Photographie, 1988.

R. Jegerings

LIGHT SUPPORTS Light supports or stands are the workhorses of studio and location photographers. They can be used to support lighting equipment, props, reflectors, and diffusers. Available in assorted designs and sizes, supports or stands can range from simple spring-loaded clamps to elaborate motorized ceiling rail systems.

Spring-loaded clamps can be used to support reflector

Light supports. Examples of light supports and stands. (a) Spring-loaded, clamp-on light. (b) Collapsible lightweight Pic stand. (c) Heavy-duty studio stand with casters. (d) Counter weighted boom arm mounted on a heavy-duty stand.

floodlights or lightweight electronic-flash heads. They are popular with location photographers and can be attached to just about anything, fitting in places that would make stand placement difficult.

Collapsible Pic-type stands are lightweight, basic, and available in several heights. Knurled thumb knobs are used to tighten each section and the legs. Stops on the post sections prevent the stand from coming apart. The legs and post sections are collapsible, making these stands quite compact.

Heavy-duty stands are normally used in studios, where they support larger, more powerful lighting sources. These stands are available with fixed or folding legs, casters, and multiple sections. Oversize knobs provide positive locking of the post sections. Grip heads and clamps are used with these stands to support scrims, flags, cutters, and reflectors. Boom arms are normally mounted on this type of stand. Booms are counter-balanced support arms that attach to the top of light stands. They provide a method of suspending a light source or other lighting accessory out over a subject, giving the photographer precise, and in some situations, otherwise unobtainable control of the lighting. In the motion picture and video industry, booms are also used to suspend microphones over the actors just above the active frame area. When used with heavy lights or long extension, sand bags are placed on the stand legs to keep the boom from tipping over.

Ceiling-mounted rails or tracks represent the ultimate in state-of-the-art support systems for large commercial studios. These systems can be fairly simple, using scissor action or fixed height supports. Motorized systems operated by remote control provide unequaled flexibility and ease of use for the photographer who can afford them. Light banks or individual heads can be rotated, raised, lowered, or moved in any direction.

G. Barnett

LIGHT TABLE A stand-alone transparency viewer, with legs, or a viewer built into the top of a bench or cabinet, usually at table height.

R. Jegerings

See also: *Light box; Transparency viewer/illuminator.*

LIGHT-TIGHT Identifying holders, containers, devices, etc. designed to protect enclosed film or other sensitized material from being fogged by external light sources.

L. Stroebel

LIGHT TRANSMISSION The propagation of light energy through a medium permitting the passage of light. The medium may be transparent or translucent, but emergent light is diffused by scattering in the case of the latter. The emergent light or transmitted light may be changed in various ways, including intensity, spectral composition and polarization. Spectrally selective absorption changes white light to colored light. Transmission is quantified by the *transmittance* or *transmission number* of the medium, which is the ratio of emergent to incident light. The inverse is the *opacity* of the medium, and *optical density* is the logarithm of opacity.

S. Ray

See also: *Sensitometry.*

LIGHT TRAP In a darkroom, an arrangement of walls and openings that excludes undesired light yet permits easy entrance to or exit from the room. The walls should be painted flat black to absorb light. On film holders, magazines, or cassettes, a light trap, lined with a material like black velvet, permits passage of film or dark slides but no light. Camera doors or covers are also light trapped by means of stepped-down grooves. (See illustration, page 462.)

I. Current

See also: *Darkrooms, light trap.*

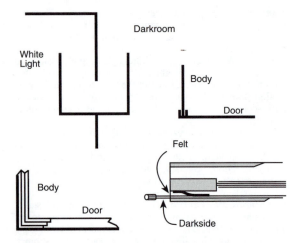

Light trap. The various light traps shown are (upper left) typical darkroom maze, (upper right and lower left) camera or magazine doors, (lower right) sheet-film holder darkslide trap.

LIGHT UNITS See *Photometry and light units.*

LIGHT VALUE (B_v) In the additive system of photographic exposure (APEX), a number represented by the symbol B_v that equals the logarithm to the base 2 of the light level in footcandles divided by 6. The exposure value (E_v) equals the light value (B_v) plus the film-speed value (S_v).
<div align="right">J. Johnson</div>

See also: *Additive system of photographic exposure.*

LIGHT VALVE An optical or mechanical device used to control the transmission of light. Various forms are in use, such as a pair of contrarotating linear polarizing filters whose transmission varies nonlinearly with their relative angle. A pair of louvre shutters opened and closed very rapidly modulate light in cine film printers.
<div align="right">S. Ray</div>

LIGHTWEIGHT Characterizing photographic printing papers on a support thinner than single-weight.
<div align="right">M. Scott</div>

LIMEN (1) The minimum stimulus that elicits a response on 50% of the presentations. In vision for example, a light level that is barely detectable. (2) The minimum stimulus difference that elicits a correct response on 75% of the presentations. In vision, for example, a difference in density that is barely detectable.
<div align="right">L. Stroebel and R. Zakia</div>

Syn.: (1) *Absolute limen; Absolute threshold; Threshold.* (2) *Differential limen; Differential threshold.*

See also: Just-*noticeable difference; Subliminal.*

LIMITER (SOUND) An electronic device that acts to keep the amplitude of signals from exceeding a usually adjustable maximum amount. The limiter turns down the signal by the amount by which it exceeds the maximum as required so that the output contains no higher level than the set maximum.
<div align="right">T. Holman</div>

LINEAR (1) Specifying a scale of numbers in which arithmetic values are equally spaced. A thermometer scale is linear. Contrast with *ratio scale.* (2) As applied to a function, one that plots as a straight-line graph. The general formula is $y = a + bx$, where a is the intercept and b is the slope (steepness) of the line. (3) As applied to a system, one in which the output is directly proportional to the input. Most photographic systems are not linear. (4) As applied to perspective in a photograph, depth perception for the viewer arising from

the convergence of parallel lines or the reduction in image size with increased object distance. (5) Identifying a magnification value that is the ratio of length of the image to the length of the object, as distinct from a ratio of areas. A linear magnification of 5× is equivalent to an area magnification of 25×.
<div align="right">H. Todd</div>

LINEARIZATION A form of electronic imaging system calibration to control image quality by adjusting all the output optical, physical, and electrical elements of an imaging system.
<div align="right">M. Bruno</div>

LINEAR MOVEMENT In animation, movement at a constant rate, the same distance being moved between each photographed frame.
<div align="right">H. Lester</div>

LINEAR OUTPUT Output that varies proportionally to the input. Video displays are linear with respect to the accuracy of the tone reproduction.
<div align="right">R. Kraus</div>

LINEAR PERSPECTIVE The appearance of depth in an image due to the convergence of parallel subject lines or diminishing image size of objects with increasing object distance.
<div align="right">L. Stroebel</div>

See also: *Perspective.*

LINE COPY In photomechanical reproduction, all copy that can be reproduced without the need for a halftone screen such as black type or drawings on a white background.
<div align="right">M. Bruno</div>

LINE EMISSION Emission of electromagnetic radiation by a substance as a result of the relaxation of electrons in the atomic orbitals of the substance. For line emission to occur, the electrons must have been previously raised to excited orbital levels. This is most frequently accomplished by electron bombardment, as in a gas discharge lamp. The quantum nature of the electron orbital levels results in photons emitted by this process having wavelengths grouped into very narrow regions, or *lines.*
<div align="right">J. Holm</div>

LINE IMAGE A drawing, type, or other image consisting of a single tone on a background of a contrasting tone, such as a black ink drawing on a white background. When a line original is to be reproduced, photographically or photomechanically, for example, it is identified as a line copy.
<div align="right">L. Stroebel</div>

LINE OF BEAUTY Term originally used by the English artist William Hogarth (1697–1764) to relate elegance and gracefulness, hence beauty, to a curved S-shaped line. Hogarth discussed this line in his essay Analysis of Beauty, and employed this sinuous, curving form in many of his paintings. The Line of Beauty or S curved line is one of the elements of pictorial composition sometimes used by photographers who try to compose their work in the manner of academic painters.
<div align="right">R. Welsh</div>

Syn.: *S-curve.*

LINE PAIR In a resolving power test target consisting of alternating light and dark bars of equal width, a line pair consists of one light bar and one dark bar. When resolving power is specified in terms of lines per millimeter, the numbers are based on line pairs. To avoid confusion, the term *line pairs* is sometimes used.
<div align="right">L. Stroebel</div>

LINE SPECTRUM A discontinuous spectrum that results from line emission, or from the absorption by a substance of narrow wavelength regions of a continuous spectrum (line absorption).
<div align="right">J. Holm</div>

LINES PER INCH (LPI) A measure used by printers to determine the resolution of the line screen for the image. Newspaper images are typically 65 lpi while magazines are commonly 133 lpi. These resolutions also depend upon the type of imager being used and the quality of the substrate upon which the image is being printed. *R. Kraus*

See also: *Halftone process.*

LINE-SPREAD FUNCTION See *Spread function.*

LINE WORK FILE An electronic image file, typically for a light image against a dark background without intermediate gray tones, formed either by scanning a line image into the system or by forming the image in the system.
L. Stroebel

LINKING In computers, the connecting of code to a library that supports the calls made by the code. Linking will allow the code when compiled to become executable, i.e., stand by itself for running. *R. Kraus*

LIPPMANN EMULSION A silver bromide emulsion of surpassingly fine grain and extreme contrast formulated by Gabriel Lippmann for use in the color process that bears his name, a process at once simple and elegant in concept, but very difficult in practice. The size of the photosensitive crystals is so small that there is virtually no scattering of light. Resolving powers beyond 5000 line-pairs per millimeter are estimated. Emulsions of this type have also found use in some forms of holography and special scientific applications
M. Scott

See also: *Lippmann, Gabriel.*

LIPPMANN, GABRIEL (1845–1921) French physicist and teacher. Professor at the Sorbonne, in 1891 he originated the interference method of direct color photography that produced the first excellent and fixable color photographs, but the process was difficult to carry out and is now obsolete. Received the Nobel Prize in physics in 1908 for this invention. Suggested lenticular film in 1908, used for additive color photography and for the production of stereoscopic images. *M. Alinder*

LIPPMANN PROCESS French physicist Gabriel Lippmann devised a system for color photography in 1891 that relied on wavelength interference, rather than dyes or pigments. His panchromatic glass plate was coated with an almost clear emulsion of very small silver halide crystals. In the camera, the plate faced away from the lens, in contact with a nearly perfect mirror of liquid mercury. Light passed through the plate and was reflected by the mercury. Phase difference caused the reflected rays to interfere with light coming through the plate. Varying degrees of cancellation and reinforcement occurred, producing a latent image of the interference pattern on the plate. After development, the faint but natural color image was viewed by placing the plate against a mirror and shining a light through it. Examined at a carefully determined angle, only the original wavelengths could pass through the interference pattern. The process has proven to be too difficult for any application beyond the scientific investigation for which it was originally conceived.
H. Wallach

See also: *Lenticular color photography; Lippmann, Gabriel.*

LIP SYNC In motion-picture production, the simultaneous recording of picture and sound such that the sound appears to accurately coincide with the picture. In animation, the creation of mouth movement matching the previously recorded dialogue on the sound track. *H. Lester*

LIQUID CRYSTAL DISPLAY (LCD) A readout device commonly used on digital meters, digital clocks, and calculators. Two types of units are available: field-effect and dynamic-scattering. Both types use an organic material that will flow like a liquid but has a molecular structure similar to that of a crystal. The liquid crystal is sealed in a thin glass enclosure with transparent electrodes on the front and back surfaces. Typically, on each side of the liquid crystal there are seven electrodes in the form of a figure eight. An electrostatic field resulting from a voltage applied across opposite electrodes will cause the crystal between the electrodes to reflect or transmit light, depending on the type. By applying voltage to two or more pairs of electrodes any digit from 0 to 9 can be displayed. LCDs require much less power to operate than light-emitting diode displays but do require an external source of light, usually ambient light, for display.-
W. Klein

LIQUID CRYSTAL DISPLAY PROJECTOR Liquid crystal display (LCD) technology was developed in 1973 and was most commonly used in digital watches and handheld calculators, where light weight, low power, and high resolution made it the ideal presentation medium. Liquid display material is activated electrically and is now also used to form images for laptop computers and word processors. These items use a *duty-type* LCD, where the individual pixels are controlled by a liquid crystal matrix. These *duty type* LCDs can be used to display color and video images, but they have slow response times that make them impractical for rapidly changing images. On the other hand, *active matrix* LCDs have a transistor at each pixel point that controls only that pixel and can respond much more rapidly to image changes. This new generation of *active matrix* LCDs is competitive with conventional CRT displays (TV monitors). Because these new LCDs provide a quick change response time, high resolution, impressive picture quality, and excellent color reproduction, they are being used for the video market and high-speed computer-aided design displays. LCDs consume very little power and are extremely light weight compared with conventional CRT displays, which make them ideal for use as very large, flat-screen, wall-mounted video image displays. This technology also provides for convergence-free color video projection systems. *M. Teres*

LIQUID GATE Identifying an enlarger or optical printer film holder that sandwiches the film in a layer of glycerine or other suitable liquid between two glass plates, used to reduce the visibility of surface scratches and abrasions. *L. Stroebel*

LIQUID MEASURE CONVERSION See *Appendix J.*

LITER In the metric system (SI), a unit of volume, equal to 1000 milliliters (ml) and to 1.06 quarts. *H. Todd*

LITHIUM BATTERY/CELL See *Batteries.*

LITH/LITHO/LITHOGRAPHIC The first two names are familiar terms for the last, here referring not to the lithographic method of planographic printing itself, but to special films of extreme contrast and density range used in exposing lithographic printing plates. These films find many other uses in photography where high contrast, high density and high resolution are needed. To achieve maximum contrast and density, a special lith developer is necessary—often supplied as two solutions to be combined just before use. It is formulated to encourage infectious development, leading to the highest possible contrast. Gammas of 25 to 50 are produced with maximum densities beyond 7.0. For high but not extreme contrasts, ordinary developers can be used.

In the graphic arts, special developers and techniques, such as still development, are used for the reproduction of very fine lines without loss or breaking. Development by inspection is sometimes used, with critical examination of the dot and line images as they develop. Most lith film is orthosensitive for handling under a bright red safelight, but panchromatic versions are also supplied, permitting direct screened color-separation negatives to be made. *M. Scott*

LITHOGRAPHY Lithography (a generic term that includes offset, lithography and planography) is a planographic printing process in which the image and nonimage areas are essentially on the same plane of a thin metal-, plastic-, or paper-based plate, and the difference between them is maintained by the physicochemical principle that grease and water don't mix. Offset lithography differs from the other printing processes in that an intermediate blanket (offset) cylinder is interposed between the plate and the impression cylinder. The inked image is offset from the plate cylinder to the blanket-covered cylinder from which it is transferred to the paper as it feeds over the impression cylinder. Practically all lithography is done by the offset principle. As a result the term *offset* has become synonymous with lithography.

The light-sensitive coatings on lithographic plates are selected so that the image area after exposure and processing is ink- (grease) receptive and water-repellent, and the non-image areas are treated to render them water-receptive and ink-repellent. When the plates are run on the press, in every revolution water is transferred from the dampening system rollers to the nonprinting areas of the plate and ink is transferred from the inking rollers to the image areas. A delicate balance, known as the ink–water balance, must be maintained between the ink receptivity of the images, the water receptivity of the nonimage areas, and the ink and dampening solution amounts and properties.

The ink–water balance is not a constant property. It varies according to many conditions of the inks, dampening solutions, paper, temperatures, etc. Establishing a proper balance is a big part of the makeready operations to produce an OK sheet and is the hallmark of experienced pressmen. Once established, it remains reasonably constant as long as the press is running. As soon as the press is stopped, the ink–water balance is destroyed and must be reestablished when the press is restarted. This takes time and causes paper waste until the new balance is established, and often it is not the same as it was before the press stopped, which causes variations in the color balance and consistency of the printing. *M. Bruno*

See also: *Photomechanical and electronic reproduction.*

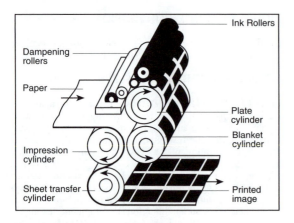

Lithography. Diagram of offset lithographic press.

LITMUS An indicator dye derived from a lichen that changes color from blue to red under acid conditions and red to blue under alkaline conditions. The dye is available as a solid, in water solution, or impregnated in paper test strips. *G. Haist*

LIVE ACTION Action recorded by a motion-picture camera, as opposed to action created through animation techniques. *H. Lester*

LOAD The transfer of data or the application from storage (hard or floppy disk) to the memory (RAM) of the computer. *R. Kraus*

LOCAL CONTROL Any method by which the tones in limited areas of a photographic image are managed or manipulated. These may include dodging, burning, spotting, etching, or masking. Such techniques may be applied manually with conventional darkroom tools, or digitally, by scanning the original image and manipulating with a computer and image processing software. *H. Wallach*

LOCALIZATION The ability of a person to detect a small displacement of one part of a test object, such as a broken part of a straight line. Localization is one aspect of visual acuity. *L. Stroebel and R. Zakia*

See also: *Detection; Recognition; Resolution; Visual Acuity; Visual perception, perception of detail.*

LOCATION In motion-picture production, filming that is done in a real environment, as opposed to that done in the artificially created environment of a studio or lot. *H. Lester*

LOCK-UP A glitch that prevents a computer from accepting instructions from an input device. In effect, the user is locked out and the keyboard is locked up. In MS-DOS systems, holding down the control, alternate, and delete keys at the same time will undo a lock-up by warm booting the system. Other computers require a different sequence of keys to escape from a lock-up. *R. Kraus*

LOG See *Logarithm.*

LOGARITHM If the series of numbers 100, 1000, 10,000 is rewritten as 10^2, 10^3, 10^4, the values 2, 3, and 4 are logarithms of the original numbers to the base 10. Thus, a logarithm, often shortened to *log*, is an exponent, or power, that generates a plain number when used with the base.

An increase of 1 in the log implies a multiplication by 10 of the corresponding arithmetic value, which is called the *antilog*. Also, a division of the antilog by 10 is equivalent to a decrease of 1 in the log. Therefore, the log of 10 is 1, and the log of 1 is 0.

The series can be expanded indefinitely, as in the following table:

Number	0.0001	0.001	0.01	0.1	1	10	100	1000	10,000
Logarithm	-4	-3	-2	-1	0	1	2	3	4

An interval scale (equal increments) of logs corresponds to a ratio scale (change by a constant factor) of numbers. Because zero is never reached in a ratio scale, there is no log for the number zero or for a negative number.

Numbers between 1 and 10 necessarily have logs between 0 and 1, i.e., decimal values. The log of 2, for example, is 0.30. Multiplying a number by 2 increases the log by 0.30. Thus the log of 4 is 0.30 + 0.30, or 0.60, and the log of 8 is 0.90. By the same process, the log of 200 is the sum of the logs of 100 and 2, i.e., 2.30. The whole number part of the

log is called the *characteristic,* and the decimal part is called the *mantissa.* The log of 4000 is 3.60; the characteristic is 4, and the mantissa is 0.60.

The logs of numbers less than 1 have negative characteristics. For example, the log of 0.02 is the log of 0.01 plus the log of 2, or -2 + 0.30. This log can be written in several ways: 0.30 -2, or more often [2].30, where the characteristic (-2) is transferred to the front of the log, and the minus sign placed over it, to indicate that only the characteristic is negative. An obsolescent way of writing such a log is 8.30 – 10, where the 8 and the -10 are equivalent to the -2.

The log of 0.02 can also be expressed as -1.70, where the entire log is negative, as distinct from the bar-notation [2].30 expression, where only the characteristic is negative. Electronic calculators are based on the negative log system, whereas the bar-notation system is used more commonly in photography.

Logarithms have many applications in photography. There are two major reasons for this fact:

1. The human visual system responds nearly uniformly to uniform logarithmic changes in the light stimulus, if the range of light levels is not excessive. Equal multiplications of the light level produce nearly equal changes in the response. If, for example, a person is asked to choose, from a large number of patches ranging from white to black, a set of those patches that are equally spaced, that person's choices, when measured with a meter, are separated by approximately equal logarithmic intervals.

2. Photographic films and papers also respond more evenly to logarithmic changes in the energy they receive than to arithmetic changes. For example, an increase of 1 second in exposure time is a large change if the original time is also 1 second but has little significance if the first time is 10 seconds. Therefore, it is the factor by which the time changes ($2 \times$ in the first case but only $1.1 \times$ in the second) that is meaningful. When it is the factor that counts, logs are appropriately used.

A few of the numerous examples of the use of logarithms in photography are as follows:

1. Density, the measure of the photographic response of films and papers, is a logarithm. It is approximately proportional to the silver (or dye) content of the finished image, if properly measured.

2. The *characteristic curve* showing the response of photographic materials to received exposure is plotted with log scales on both axes.

3. A one-stop exposure change implies a change by a factor of 2 and thus a logarithmic change of 0.30. Thus, camera settings are spaced logarithmically.

4. Speed values for films and papers are similarly spaced, although this fact may be obscured by the actual numbers used.

5. The APEX system for computing camera settings from light values and speed values is based on logs.

H. Todd

See also: *Appendix F and G.*

LOGARITHMIC FILM SPEED See *Film speed.*

LOG EXPOSURE The logarithm to the base 10 of the exposure (quantity of light per unit area) received by a photographic material. Characteristic curves of photographic films and papers are plots of log exposure as input (independent variable) on the horizontal axis versus density as output (dependent variable) on the vertical axis. *J. Johnson*

LOG-EXPOSURE RANGE The difference between the log-H values for the minimum and maximum useful points on the D-log H curve. The range varies with emulsion characteristics, with processing, and with the definition of *useful.* For negative and reversal films, the log-H range limits the scene contrast that the material can accommodate and the allowable variation in camera exposure settings. For printing papers, the log-H range (formerly scale index) varies with the paper grade and is approximately equal to the total negative contrast that the paper can record.

M. Leary and H. Todd

LOG H See *Log exposure.*

LOGIC BOARD The primary circuit board in a computer that holds the CPU, ALU, RAM, ROM, and the bus network for the various peripherals. *R. Kraus*

LOGO/LOGOTYPE A printing term for a unit of type bearing two or more single letters. A definitive design may be proprietary and used as a trademark for an artist, firm, product, etc. In motion pictures and television, the element of motion or animation is commonly added. *I. Current*

LOG SHEET In motion pictures, a written record of camera filming and sound recording activities. *H. Lester*

LOGS (SOUND) See *Production sound logs.*

LONG FOCUS Term used to describe a lens whose focal length is greater than the diagonal of the image format in use. The assumption is that the corresponding standard lens has a focal length equal to the diagonal, but this may not be the case in cinematography and video. A standard lens for a large format can be used as long focus for a smaller format. *S. Ray*

LONGITUDINAL CHROMATIC ABERRATION See *Lenses, chromatic aberrations.*

LONGITUDINAL (SOUND) (1) Generally, any recording that occurs along the length of a piece of tape, used with video recording to describe recordings made with other than the rotating head assembly. (2) An audio recording made along the edge of a piece of video tape by conventional direct analog magnetic recording methods. Limited in quality by the nature of the tape (optimized for video recording) and by the low tape speed. *T. Holman*

LONGITUDINAL WAVE A wave in which the medium oscillates in a direction parallel to the direction of travel of the wave. Sound waves are longitudinal waves. *J. Holm*

See also: *Transverse wave.*

LONG-PULSE FLASH/LONG-PEAK FLASH Electronic flash with an extended peak duration created by firing the flash as a series of extremely short pulses that are effectively a longer flash duration of about 40 milliseconds (1/25 second). It allows a focal-plane shutter to synchronize up to the shutter's maximum speed since the flash intensity is constant as the shutter slit moves across the film. The guide number is reduced as higher shutter speeds use less of the total light output. Camera and electronic flash must be dedicated to each other for correct synchronization, so the flash emission starts before the shutter slit starts to scan the film. *R. Jegerings*

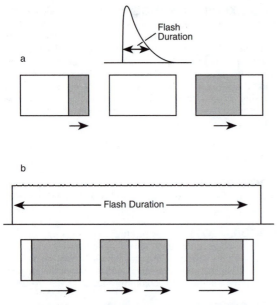

Long-pulse flash. A normal electronic-flash burst (a) rises quickly to peak intensity and decays rapidly; a focal-plane shutter must be fully open (center) during the total flash duration or the shutter will block part of the film from flash illumination. A long-pulse flash (b) has an extended duration that allows the film to be exposed with the scanning slit of high shutter speeds.

LOOK-UP TABLE (LUT) An image-processing operation that accepts input and maps it via a table based on some point processing algorithm to specific output. The conversion of RGB to CMYK (input to output) relies heavily on a color look-up table (CLUT). *R. Kraus*

LOOP (1) A length of free film in a motion-picture camera or projector, on both sides of the gate, creating some slack to allow for the intermittent movement of the film traveling through the gate. (2) A length of film or tape spliced end-to-end to form an unbroken band, allowing continuous repetitive projection or sound playback. (3) In computer programming, a loop is a structured set of instructions that are repeatedly executed until some condition is satisfied. *H. Lester and R. Kraus*

LOOPING A technique of motion-picture sound dubbing where loops of picture and sound are continuously projected, giving actors and sound technicians many chances at matching the lip sync relationship between picture and sound. *H. Lester*

LOOSE REGISTER A variation in register of more than plus or minus one row of dots. *M. Bruno*

LOUDNESS The subjective strength of a sound field, a complex function of sound pressure level, spectrum, duration, and other factors. *T. Holman*

LOUDSPEAKER An electroacoustic transducer that takes an electrical input and converts it to sound meant to be heard. *T. Holman*

LOUPE See *Magnifier.*

LOUVERS A series of long, thin flaps, imitating those used in window shutters, that restrict light spread when used over a light fixture. Louvers are useful to keep light from shining into the camera lens or falling on the background when large lights are ahead of the camera. *R. Jegerings*

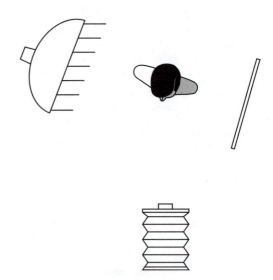

Louvers limit spill light from a large light source.

LOW-CONTRAST Identifying a lighting, film, developer, printing material, etc. used to decrease tonal separation, either to achieve a low-contrast effect or to compensate for a high-contrast effect elsewhere in the system. Also, identifying an image having less than normal contrast. Film resolving powers, for example, are determined using both high-contrast and low-contrast test targets. *L. Stroebel*

LOW FILTER See *High-pass filter.*

LOW KEY Describes an image composed mostly of dark tones. Subject matter, exposure, and lighting contribute to the effect. Of these, lighting deserves more attention. A dark-toned subject in a dark-toned environment will not necessarily produce a low-key mood if the lighting does not produce large areas of shadow. Reduced exposure of the negative or increased exposure of the print can, by itself, produce a low-key photograph, but not necessarily a good one if too much shadow detail is lost.

Low-key lighting always requires placing the main light far enough to one side to cause much of the subject to be in shadow. Gobos, barndoors, or focusing devices may be used to confine the illumination to the important part of the subject. The result is often a single highlight area surrounded by darkness and the placement of that highlight in the image area influences the compositional effect.

Although good low-key photographs may be made by a single light source, additional sources such as hair lights, kickers, and background lights are usually used to add detail to areas of significant but secondary importance.

The relative intensity of the fill light is critical to the success of a low-key photograph. If the subject is composed entirely of light tones (generally considered unsuitable for a low-key photograph), it may be necessary to eliminate the fill light altogether to preserve the low-key mood. But if the subject is inherently dark, a bright fill light can add shadow detail without destroying the effect. *F. Hunter and P. Fuqua*

See also: *High key.*

LOW OBLIQUE An aerial photograph made with the camera tilted from the perpendicular, but not enough to include the horizon. *L. Stroebel*

See also: *High oblique; Lateral oblique.*

LOW-PASS FILTER (1) An electrical filter that passes signals at frequencies below a cutoff frequency, while attenuating frequencies above cutoff. The term is used by electrical engineers and by professional audio personnel, but note that the term used for the same thing in the consumer marketplace is a high filter. (2) In electronic imaging, the attenuation of high-frequency data in an image. This operation enhances low-frequency data. The low-pass filter will smooth the appearance of the image, and it is useful for eliminating noise in the image. *T. Holman and R. Kraus*

LOW-PRESSURE LAMP An arc lamp with a small quantity of vapor in the envelope producing high-intensity illumination in isolated wavelengths, unlike high-pressure lamps, which have a fuller spectrum. *R. Jegerings*

LUMEN (lm) A unit of luminous flux (power); the time rate of flow of visible energy emitted by a source or passing through a defined aperture. One lumen is the luminous power falling on (or passing through) a unit area that is everywhere unit distance from a 1 candela source, that is, into 1 steradian (unit solid angle). Because a sphere of unit radius has an area of 4π, the total luminous flux emitted by a 1 candela point source is 4π lumens.

The analogous measure of radiant flux is the watt (W). The conversion from radiant flux to luminous flux is a function of the relative spectral response of the human visual system. The CIE standard $V(\lambda)$ relative luminous efficiency function describes the relationship for the standard observer. At the peak of the standard observer curve (555 nm), 1 W of radiant power is equivalent to 683 lm. The conversion of any single wavelength (i.e., for a monochromatic source) is given by:

$$\Phi_v = k \cdot \Phi_r \cdot V(\lambda)$$

where Φ_v is the luminous flux, in lumens; k is the maximum luminous efficacy (683 lm/W); Φ_r is the power (in watts) of the source, and $V(\lambda)$ is the relative luminous efficiency function of the standard observer.

For a source containing more than one wavelength, the power in each wavelength band is scaled by the $V(\lambda)$ function, and the results at all wavelengths are summed:

$$\Phi_v = k\Sigma_{360}^{780}\Phi_r(\lambda)V(\lambda)\Delta\lambda$$

where $\Phi_r(\lambda)$ is the spectral power (in watts per nanometer) at wavelength λ; k is the maximum luminous efficacy (683 lm/W); $V(\lambda)$ is the relative luminous efficiency function of the standard observer; and $\Delta\lambda$ is the wavelength interval (in nanometers) used in the summation. *J. Pelz*

See also: *Luminous efficacy; luminous flux.*

LUMEN PER SQUARE FOOT (lm/ft²) A unit of illuminance; the quotient of luminous power incident on a surface divided by the area of that surface. One lumen per square foot is equal to 1 footcandle (fc), the illuminance at a point 1 ft from a point source with a luminous intensity of 1 candela. The International System (SI) unit lux (lumens per square meter) is preferred (1 lm/ft² = 10.764 lux). *J. Pelz*

Syn.: *Footcandle.*

See also: *Illuminance; Photometry and light units.*

LUMEN PER SQUARE METER (lm/m²) The unit lumen per square meter is used in two contexts: (1) It is the International Systems (SI) unit for luminous exitance, the total luminous power *emitted* or *reflected* in all directions per unit surface area. (2) The same unit is used as a measure of illuminance, the luminous power *incident* per unit surface area. When used as a measure of illuminance, the SI term lux (lx) is preferred (1 lux = 1 lumen per square meter). *J. Pelz*

Syn.: *Lux (for illuminance measure).*

See also: *Exitance; Illuminance; Lux; Photometry and light units.*

LUMEN SECOND The International System (SI) unit used to measure luminous energy emitted by a source, analogous to the erg for radiant energy. It can be used to measure the total light output for a pulsed source, such as a flashlamp, or the total energy given off by a bulb over its lifetime. A source's energy, in lumen seconds, is the product of the luminous flux (measured in lumens) and the time, in seconds. Light energy ratings of standard bulbs are sometimes reported in lumen hours. (1 lumen hour = 3600 lumen seconds). Distinguished from the lux second, a unit of exposure at a surface, defined as the product of surface illuminance and time. *J. Pelz*

Syn.: *Talbot.*

See also: *Photometry and light units; Talbot.*

LUMIÈRE, AUGUSTE (1862–1954), and **LUMIÈRE, LOUIS** (1864–1948) French scientists, filmmakers, and photographic manufacturers. Their father, Antoine, founded a photographic dry-plate factory in Lyon in 1882. The two brothers continued the manufacture of dry plates and expanded to the production of roll films and printing papers in 1887. Together and separately, they carried out and published important scientific and technical work on a variety of photographic subjects. In 1904 they invented the first widely used color process, the autochrome. Publicly demonstrated their cinematographe motion picture camera and projector in 1895, using perforated, celluloid 35-mm film; the design continues to be used in nearly all modern filmmaking apparatus. Acknowledged in that same year for making the first movie to be publicly exhibited.

Books: Rosenblum, Naomi, *A World History of Photography.* New York: Abbeville Press, 1984. *M. Alinder*

LUMINANCE The quotient of luminous intensity of an extended surface in a specified direction by the projected area in that direction (i.e., candelas per square meter). The luminance of an extended source or surface is invariant with viewing distance. Luminance is also invariant within a lossless optical system because changes in image size are balanced by inverse changes in solid angle. The luminance of a Lambertian (ideal) diffuser is invariant with viewing angle because the reduced power reflected off-axis is balanced by a reduction in projected area.

Luminance is the property of a source or surface that most closely correlates with the subjective perception of brightness, which, because of adaptation and contrast effects of the visual system, cannot be used as a reliable measure.

A confusing array of units have been used to specify luminance. One group of units was derived in terms of intensity per unit projected area, with *area* specified in several units, i.e., candela per square meter (nit), candela per square centimeter (stilb), candela per square foot, and candela per square inch. In addition, a second group of luminance units were derived for a Lambertian (ideal) surface receiving a given level of illumination. For example, one apostilb (asb) is defined as the luminance of a Lambertian surface illuminated at 1 lux (lumen per square meter). The reradiation characteristics of the energy into a hemisphere introduces a $1/\pi$ factor, so 1 apostilb = $1/\pi$ cd/m². Similarly, 1 lambert = $1/\pi$ cd/cm², and 1 footlambert = $1/\pi$ cd/ft². Many of these units were derived independently, so multiple names for the

same units also exist; that is, 1 apostilb = 1 equivalent lux = 1 blondel. The preferred International System (SI) luminance unit is the candela per square meter (nit). (See *Photometry and light units* for conversion chart). *J. Pelz*

Syn.: *Photometric brightness (obsolete).*
See also: *Photometry and light units.*

LUMINANCE FACTOR Ratio of the luminance to that of the perfect diffuser identically illuminated. Symbol, β.
R. W. G. Hunt

LUMINANCE GAIN A measure of the directional reflectance characteristics of a projection screen. It is defined as the ratio of screen luminance in a given direction to that of a lambertian reflector receiving the same illumination. While an ideal lambertian reflector would provide a wide viewing angle, screens can be designed to increase the luminance across expected viewing angles by redirecting the power that would otherwise be directed above, below, or to the sides of viewers. *J. Pelz*

LUMINANCE MEASUREMENT Luminance can be measured in two ways: (1) physical measurements made by photoelectric meters designed to accept luminous power over a limited angle, and (2) visual measurements in which an observer matches the perceived brightness of the test field to that of a reference field.

Photoelectric detectors respond to the power incident on the surface per unit area, that is, illumination. In order to measure luminance, the detector must be made to respond to power emitted from or reflected off of a distal surface. In its simplest form a luminance meter can be made by restricting the angle over which light is collected on the detector surface and pointing the meter at the surface to be measured. Adequate shielding ensures that only light from the surface is allowed to fall on the detector. Measured luminance doesn't change with distance; as the meter is moved farther from the surface, inverse-square losses are exactly canceled by the increased area within the meter's view. More advanced designs incorporate optical systems to form a real image of the surface. Luminance is constant throughout a lossless optical system, so luminance measures of an image represent the luminance of the distal surface. In both cases, the photodetectors must be filtered to approximate the spectral sensitivity of the human visual system.

Visual luminance measurements can be made with great precision by matching the brightness of the test field with an adjacent reference surface of known luminance. Such measures are valid only if the colors of the test and reference fields are similar. Attempts to match fields with significant color differences increases the variability of such measurements. Flicker photometry, in which the fields are rapidly alternated in the same location instead of viewed side by side, should be used when the test and reference fields have different spectral distributions. *J. Pelz*

See also: *Luminance; Luminance meter; Photometry and light units.*

LUMINANCE METER A light meter that is designed to measure the light reflected, transmitted, or emitted by the subject, better known as a reflected-light meter, as distinguished from an illuminance (incident-light) meter.
J. Johnson

See also: *Exposure meter; Luminance; Luminance measurement.*

LUMINANCE-RANGE METHOD A procedure for obtaining a midtone value from reflected-light exposure meter readings of the lightest and darkest areas in a scene by selecting a position midway between the two (for the purpose of determining an appropriate combination of *f*-number and shutter speed). The two readings can also be used as a guide to whether the developing time should be increased or decreased from normal to compensate for low-contrast and high-contrast scenes. In the zone system, this procedure is referred to as N+ and N– development. *J. Johnson*

Syn.: *Brightness-range method; Calculated midtone.*

LUMINANCE RATIO The ratio of the amount of light reflected, transmitted, or emitted by the lightest and darkest areas in a scene. The average luminance ratio for outdoor and indoor scenes is approximately 160:1. Scenes are rarely lower than 27:1 or higher than 760:1 when light sources and specular reflections are excluded from the measurements. Luminance ratio should not be confused with lighting ratio, which is based on light falling on the subject.
F. Hunter and P. Fuqua

See also: *Lighting ratio; Luminance.*

LUMINESCENCE The emission of light by a substance as a result of bioluminescence, chemiluminescence, electroluminescence, fluorescence, phosphorescence, radioluminescence, or triboluminscence. *J. Holm*

LUMINOSITY (1) The appearance of the amount of light per unit area being emitted by a source. Since the responses to changes in the amount of light are subjective, there are no physical units of measurement. (2) In electronic imaging, a measure of brightness of a color based on the average of a pixel's RGB values.
L. Stroebel, R. Zakia, and R. Kraus

Syn.: (1) *Brightness*
See also: (1) *Lightness; Luminance.*

LUMINOSITY CURVE See *Luminosity function.*

LUMINOSITY FACTOR The ratio of energy required to produce a fixed brightness at the wavelength of maximum eye sensitivity of approximately 555 nm to that at any other specified wavelength. *L. Stroebel and R. Zakia*

See also: *Luminosity; Luminosity function.*

LUMINOSITY FUNCTION The relative sensitivity of the human eye to different wavelengths of light. The sensitivity is the reciprocal of the energy (in physical units) needed to produce a fixed response. The eye is most sensitive to the middle (green) wavelengths under normal (photopic) lighting conditions. *L. Stroebel and R. Zakia*

Syn.: *Luminosity curve.*
See also: *Brightness; Photometry and light units.*

LUMINOUS (1) Emitting light. (2) Specifying the evaluation of radiation according to its capacity to evoke a visual response, as luminous intensity; luminous flux. *J. Holm*

LUMINOUS EFFICACY (1) Of a source: ratio of luminous flux emitted to power consumed. Unit: $lm \cdot W^{-1}$. (2) Of a radiation: ratio of luminous flux to radiant flux. Unit: $lm \cdot W^{-1}$. (3) The conversion factor that describes the light-producing capability of a source of radiant energy, i.e., the ratio of luminous flux at a given wavelength (or range of wavelengths) to the radiant flux at the same wavelength (or range of wavelengths). The International System (SI) unit of luminous efficacy is lumens per watt (lm/W). Monochromatic radiation at a wavelength of 555 nm produces the maximum visual effect; 1 watt of power at that wavelength produces 683 lumens of luminous power for the CIE standard observer. Hence, the maximum efficacy for any monochromatic source is 683 lm/W. A theoretical broadband source containing equal energies at all wavelengths between

400 and 740 nm would have an efficacy of 215 lm/W. Some typical values of real broadband sources are as follows:

15 W tungsten bulb	10 lm/W
100 W tungsten bulb	20 lm/W
Fluorescent bulb	75 lm/W
High pressure sodium	120 lm/W

R.W.G. Hunt and J. Pelz

See also: *Photometry.*

LUMINOUS EFFICIENCY

(1) Ratio of radiant flux weighted according to the $V(\lambda)$ function, to the radiant flux. (2) The ratio of luminous efficacy at a given wavelength to the maximum efficacy (683 lm/W). Luminous efficiency represents the relative spectral response of the CIE standard observer.

$$\text{Luminous efficiency} = \text{Efficacy}(\lambda)/\text{Efficacy}_{max} = \text{Efficacy}(\lambda)/683$$

Because the value represents a ratio of efficacies, it is dimensionless. Luminous efficiencies are often stated as percentages.

For example, the luminous efficiency of a helium neon laser is

$$\text{Efficacy}(632.8 \text{ nm})/\text{Efficacy}_{max} = 169.4/683 = 0.2480, \text{ or}$$
24.8%. *R. W. G. Hunt and J. Pelz*

See also: *Luminous efficacy.*

LUMINOUS EXITANCE

At a point on a surface, the luminous flux leaving the surface per unit area. Symbol, *M*. Unit: $\text{lm} \cdot \text{m}^{-2}$. *R. W. G. Hunt*

LUMINOUS FLUX (Φ_v)

The time rate of flow of light (i.e., visual power) emitted by a source or passing through a defined aperture. Luminous flux is a measure of radiant power scaled with respect to the CIE standard observer's spectral sensitivity and is measured in lumens (lm; the flux flowing into 1 steradian from a 1 candela source). The luminous flux of a source is calculated by scaling the spectral power distribution of that source by the standard observer's relative photopic sensitivity:

$$\text{Luminous flux} = \Phi_v = k\Sigma_{360}^{780}\Phi_r(\lambda)V(\lambda)\Delta\lambda$$

where k is the maximum luminous efficacy (683 lm/W); $\Phi_r(\lambda)$ is the spectral power (in watts per nanometer) at wavelength λ; $V(\lambda)$ is the relative luminous efficiency function of the standard observer; and $\Delta\lambda$ is the wavelength interval (in nanometers) used in the summation.

Because the luminous flux of a source measures light emitted in all directions, it may be a misleading measure of the source's useful power. Luminous intensity, a measure of power flowing in a given direction, is frequently a more practical measure of a lamp's output. *J. Pelz*

See also: *Luminous intensity; Photometry and light units.*

LUMINOUS INTENSITY (I_v)

The time rate of flow of light (i.e., visual power) emitted by a point source in a given direction. The SI unit luminous intensity is the candela (cd). A point source whose luminous intensity is 1 candela emits 1 lumen into 1 steradian of solid angle (1 lm/sr). Early luminous intensity standards included candles, flame lamps, and carbon filament incandescent lamps. While intensity is strictly defined only for point sources, the measure is often applied to sources whose maximum dimension is much less than the distance from which they are viewed. (Luminance is the appropriate measure for sources whose maximum dimension is >1/10 the viewing distance.)

By definition, the intensity of a source is invariant with distance, but the intensity of any real source varies with direction, so a single intensity value may be of little use in determining the effectiveness of a source in illuminating a scene. For example, a reflector can direct the power of a small bulb into a narrow solid angle, greatly increasing the intensity in that direction. The increase in one direction is balanced by a loss in other directions, leaving the total power constant. *J. Pelz*

See also: *Candela; Horizontal candlepower; Photometry and light units; Radiant intensity.*

LUSTER

Describes the surface finish of photographic papers between semimatt and glossy. *M. Scott*

LUX (lx)

The International System (SI) unit of illuminance; the luminous power per unit area incident on a surface. One lux is equivalent to 1 lumen per square meter and to 1 meter-candle. A point 1 m from a 1 candela source receives 1 lux of illuminance. Other illuminance units in common use are the footcandle (fc; 1 lumen per square foot) and the phot (ph; 1 lumen per square centimeter) (1 lx = 0.0929 fc = 10-4 ph). *J. Pelz*

Syn.: *Lumen per square meter; Meter-candle.*

See also: *Illuminance; Meter-candle; Photometry and light units.*

LUX SECOND

The preferred unit of exposure, equivalent to 1 lumen-second per square meter and to 1 meter-candle-second. Used, for example, for the log exposure values on the horizontal axis of D-log H graphs. *J. Johnson*

See also: *Exposure.*

LYONS, NATHAN

(1930–) American teacher, writer, and photographer. From 1957 to 1969 a key figure at George Eastman House serving in many roles from publishing to curator and associate director. Assembled such important exhibitions as "Toward a Social Landscape" (1966), "Persistence of Vision" (1967), and "Vision and Expression" (1966). Founder and first chairperson (1963) of the Society for Photographic Education. Founder and director of the Visual Studies Workshop, Rochester, from 1969.

Books: *Photographers on Photography.* Englewood Cliffs, NJ: Prentice-Hall, 1966; *Notations in Passing.* Cambridge, MA: MIT Press, 1974. *M. Alinder*

M Magnification (Also R, reproduction ratio); Medium (speed flashbulbs); Radiant exitance (M_e) or luminous exitance (M_v); Exitance; Mega- (1,000,000)

m Meter; Milli- (1/1,000th)

mag Magnetic

MAGB Microfilm Association of Great Britain

M&E Music and effect track

mat Matrix

Mavica Magnetic Video Camera (Trademark)

Mb Megabit

MB Megabyte

MBPS Megabytes per second/megabits per second

mc meter-candle

mcs meter-candle-second

MCU Medium closeup

mg Milligram

MHCP Mean horizontal candlepower

MHZ Megahertz

mike Microphone

mil One-thousandth of an inch

milli- One-thousandth

min Minute

MIPS Million instructions per second

mired Micro-reciprocal-degree

mks Meter, kilogram, second

mL Millilambert

ml Milliliter

MLS Medium long shot

mm Millimeter

MOD Minimum operating distance

MOS Mit out sound; Metal-oxide semiconductor

MPAA Motion Picture Association of America

MPC Multimedia personal computer

MPCD Minimum perceptible color difference

MPDFA Master Photo Dealers and Finishers Association

MPEG Motion Picture Experts Group

MQ Metol-hydroquinone (developer)

MRI Magnetic resonance imaging

MS Medium shot

ms Millisecond (1/1000th)

MSCP Mean spherical candlepower

MSDS Material safety data sheet

MTF Modulation transfer function

MUM Maximum useful magnification

MUTE Silent film

mV Millivolt

MACADAM ELLIPSES Ellipses on chromaticity diagrams representing colors that are perceptually equally different from the color at the center of each ellipse, all the colors having the same luminance. *R. W. G. Hunt*

MACBETH COLORCHECKER A checkerboard array of 24 color squares, including the additive primary colors (red, green, and blue), subtractive primary colors (cyan, magenta, and yellow), colors of objects of special interest such as human skin, foliage, and blue sky, and six neutral colors that range from white to black. *L. Stroebel*
See also: *Input; Test targets.*

MACH BAND Originally, an optical illusion produced when a subject area having a lighter uniform tone gradually blends into an area having a darker uniform tone whereby a dark band is seen near the edge of the darker area and a light band is seen near the edge of the lighter area. The term now is also applied to the effect seen when viewing adjacent areas that have abrupt rather than gradual changes in tone, such as the steps in a gray scale. *L. Stroebel and R. Zakia*
See also: *Lateral inhibition/excitation.*

MACH, ERNST (1838–1916) Austrian physicist. Pioneer in the use of electric flash, the stroboscope, and time-lapse photography. Photographically captured a bullet in flight using an electric-flash light source (c. 1886). The invention of stereo x-rays is attributed to him, pictures of which were produced in 1896. Mach's name is used to describe measurement of the speed of an object in relation to speed of sound. *M. Alinder*

MACHINE CODE The binary language that the computer understands and into which higher-level languages are translated. *R. Kraus*

MACHINE PROCESSING Machine processors are the workhorses of the professional photofinishing industry. They offer a variety of advantages to the user, ranging from precise temperature control to high speed and consistent processing. Except for simple table-top models, these machines are complex and expensive—a large start-up investment is required along with continuous maintenance and supply costs.

Machine processors come in a wide variety of configurations from several manufacturers. There are five basic styles of machine processors: roller transport, dip and dunk, continuous strand, rotary, and drum. Each has its own merits as well as drawbacks, but they share common features such as automatic replenishment, speed and temperature control, and user serviceability.

With the exceptions of the rotary and drum processors, replenishment of the chemistry is automatic. External tanks of the various replenishers are connected to the processor's tanks with hoses and pumps that send measured amounts based on sensor readings or preestablished settings. Temperature probes monitor each tank, turning on heaters when the temperature falls below set points. Automatic wash water and drying are also controlled by sensors. Current processors are controlled by microprocessor computers, providing a wide variety of programmable options.

Modern legislation regarding environmental issues has forced manufacturers of photographic materials to create processes that produce little or no effluent and use less toxic chemicals. This has kept machine processor manufacturers busy designing new systems that are compatible with the ever-changing market. An additional by-product of this evolution is higher speed processes. Current color print processes have been reduced to less than half of the dry-to-dry time seen only a few years ago. Typically, a Type "C" color print will take approximately 4 minutes dry-to-dry, and the very latest Type "R" materials are now running in the 4 to 10 minute range.

Roller-transport machines are widely used for almost every photographic process. Color, black-and-white, x-ray, graphic-arts films, and enlarging papers can all be processed in this type of processor. The machine contains a series of tanks with one or more racks filled with rollers. Motors drive the rollers, propelling the material through the machine. Heaters, replenishment and recirculating pumps, sensors, and sophisticated controls are all required components. The processor is usually partially enclosed by a light-tight loading booth or darkroom. Film and paper are loaded on a feed tray and exit from the dryer stage. Constant monitoring is required to ensure that the rollers and rack crossovers are clean; otherwise, scratching can occur.

Dip and dunk processors are popular today for large-batch film processing. Roll and sheet film can be processed together by using the appropriate racks. The machine is essentially a series of large tanks with a transport mechanism for dunking and advancing racks of film. This offers the advantage of multiple film formats and all but eliminates the chance of scratching. In this type of machine the film never comes into contact with anything except the solutions and bubbles. Dip and dunk processors require a large space with high clearance for the racks as they are removed from the tanks for agitation and advancement. One additional drawback is that film at the bottom of the roll or rack receives more contact time with the chemistry. They must also be operated in total darkness because of the open tanks.

Continuous-strand processors are used for aero and cine films as well as roll paper. These machines can be roller transport or leader belt with a feed and take-up spool at both ends. Several rolls of material can be spliced together, thus giving the name *continuous strand*. The leader belt design used mostly for paper processors, employs a continuous belt that pulls the material through tanks with guide rollers at the top and bottom. Cine processors use a similar technique but with offset rollers that spiral the film through the tanks. Some older designs of cine film processors are made up of a series of long tubes and tanks that contain the chemicals. A leader is used to begin the process and the film is then drawn through. The speed of continuous strand processors is measured in feet per minute, and most are capable of processing hundreds of feet per day.

Rotary processors are quite different from the other designs. They usually have one large chamber with a shaft that circular frames are mounted on. These frames come in different sizes to hold roll and/or sheet film and prints. Once the machine is loaded, the lid is closed and the processing can be performed in daylight. Temperature-controlled tanks contain the various chemicals. The machine is run by a preloaded program, either stored on plastic cards or in computer memory. A major disadvantage of this type of processor is that the film or paper must be removed wet and dried externally. Additionally, some models dump the chemicals, allowing only one-time use, which can be costly and raises environmental concerns.

Drum processors represent the most basic type of machine processor. Most of these machines are small enough for table-top use. The processor consists of a motor with rollers or a spindle to rotate the tank. Tempered water baths for the tank and the chemical storage area are common in all but the most basic models. Most drum processors discard each chemical after a single use. Based on the size of tanks available, multiple film formats and print sizes can be processed.

G. Barnett

See also: *Agitation; Processing.*

MACROGRAPH See *Photomacrography*.

MACRO LENS See *Lens types*.

MACULA In the human retina, a yellowish area 1 mm in diameter, within which lies the fovea, the spot of highest visual acuity. *L. Stroebel and R. Zakia*

See also: *Fovea; Retina; Vision, the human eye.*

MADDOX, RICHARD LEACH (1816–1902) English physician, inventor, and photographer. Described the first workable dry-plate process in 1871 that unshackled photographers from their darkrooms. Maddox coated silver-bromide gelatin emulsion on glass plates that, with improvements by others such as the replacement of glass by celluloid in 1883, laid the foundation of the future film industry. He made his ideas public "to point the way," without patenting this revolutionary process and spent his last years in straitened circumstances. *M. Alinder*

MAGAZINE A light-tight, rigid, sometimes reloadable container for holding lengths of film or paper or stacks of cut film or plates. It is designed so that it can be attached to or inserted in a still or cine camera or printer, and after exposure of the sensitized material, removed in a lighted area. A magazine thus allows a camera to be operated continuously without the need of a darkroom for reloading. Magazine printers can be operated under white light conditions, the sensitized material being transferred to and from the darkroom in the magazine, which provides complete protection to the sensitized material before and after exposure.

Thirty-five-mm magazines (covered in American National Standard PH1.14-1983 [or latest revision thereof] *135-Size Film Magazines and Film for 135-Size Still Picture Cameras, Dimensions for*) are used universally in modern 35-mm still picture cameras. These are loaded by the film manufacturer, and carry a conductive "DX code" on their outer surface that tells modern cameras the speed of the sensitive material when loaded. Manufacturer-loaded magazines are most often destroyed on removing the film for processing. Some types of magazines, however, permit user loading, and reuse. Thirty-five-mm magazines are sometimes referred to as *cassettes* or *cartridges*.

Professional motion-picture cameras rely on magazines with two parts—a supply spool for the unexposed film, and a take-up spool for the film after exposure. The entire magazine can be removed from or fitted to the camera with the light fogging of no more than a few frames of film. For several years motion-picture cameras for amateur use used daylight loading magazines that were simply inserted into the

camera for use and then removed after exposure for forwarding to the processing laboratory. These cameras have now largely been replaced by electronic video cameras using magnetic tape cassettes.

Cameras for aerial photography make use of larger magazines with cavities on either side, one for supply of unexposed film and the other for take-up after exposure. These are manufactured in a variety of configurations, some of them being quite large.

Printers for making paper prints may make use of darkroom-loading magazines that permit operation of the printers in white light. The supply magazine may be separate from that used for take-up of the exposed paper.

Motion-picture or recording-machine processors for small volume or field use may accept magazines loaded with exposed film taken directly from the camera.

Film magazines have also been made for still cameras that use sheet film (and even glass plates), which permitted as many as 18 exposures. The exposed film was pushed from the front of the stack to the back in a light-tight magazine. An integral film pack (magazine) could also be used with sheet-film cameras. The sheets of film were attached to black paper tabs, permitting them to be pulled from the face of the pack around the end of the pack to the rear. *I. Current*

See also: *Camera magazine.*

MAGAZINE PHOTOGRAPHY "The art of taking photographs in color requires the technique of an engineer, the artistic ability of a great painter, and the news interest of a daily news photographer." So wrote Gilbert Hovey Grosvenor, long-time (1899–1954) editor of the *National Geographic* magazine, in a 1926 letter to a photographer in the field.

Since then, the challenge of magazine photography—in black-and-white and color—has remained much the same. Technological advances in equipment, film, and pre-press image manipulation have turned one-time editorial dreams into magazine-page realities. Complex graphic treatments combine more than one picture to create an elaborate illustration for an article. More traditional layouts simply showcase the optimally printed photograph at its best.

The magazine photograph *comes to life* on the printed page. As the first link in the chain of magazine photography reproduction, the original photograph most often is a sharp transparency with as little grain as possible. Editors appreciate bracketed exposures and sharp images. The original needs to be as good as possible to compensate for the inherent limitations of the halftone reproduction process.

The assignment for a magazine photograph usually starts with the magazine's editorial staff. Editors represent such departments as health, art, fashion, environment, entertainment, etc.

The department editor develops a script for the shoot. It includes plenty of specifics—from why the story is being written and what angles should be emphasized to what individual pictures need to be taken. Still, the script is considered to be more advisory and helpful than compulsory. Except where certain copy points must be illustrated in a certain way, the script is very much a *working* document. Even precisely predetermined guidelines for some fashion and science assignments allow the photographer to come up with a better or more creative way of fulfilling editorial expectations.

Departmental scripts go to the picture editor, who holds meetings with his assignment staff to evaluate them. Once a script has been approved, the picture editor and staff work together to select the photographer best suited to the assignment. Both staff and freelance photographers are considered;

the photographer's areas of specialization and photographic *style* come into play. Choosing a photographer for a magazine assignment might be compared to casting an actor in a play. Some photographers complain about *typecasting,* but picture editors may choose to go *against type* in their quest for a fresh photograph.

Freelance magazine photographers work independently or through a picture agency. They usually charge on the basis of a day rate, which may be supplemented by a space rate. Some magazines simply offer a space rate for number of pages filled. Expenses related to a shoot usually, but not always, are paid by the magazine; receipts are required. The American Society of Magazine Photographers (ASMP) helps magazine photographers track the going rate and resolve such issues as what rights to sell for how much.

In addition to assignment work, freelance magazine photographers often license the use of photographs from their own stock files or from a stock agency. Using stock photographs can save a magazine time (on short deadlines) and money (on travel expenses). The manipulative power of the computer makes stock photographs even more versatile but also complicates copyright, licensing, credit line, and rates. The photographer may want to determine, in advance, just how much a particular image may be altered digitally.

Any photographer interested in taking pictures for magazines needs to learn about the business side of magazine photography, including contracts, model releases, and special permissions. The growing number of special-interest magazines expands the market for photographs and provides more points of entry. At best, however, the highly visible market is extremely competitive. To sell to this buyer's market, a photographer needs to produce pictures that meet magazine editorial needs. Local magazines and magazines serving a field in which the photographer has special access or knowledge make good starting points.

Books: Jacobs, Lou Jr., *Selling Photographs.* New York: Amphoto, 1988. *K. Francis*

MAGENTA Color name given to colorants that absorb the greenish third of the spectrum. They usually look a bluish red, but if they have high unwanted blue absorptions they can look predominantly red. In the graphic reproduction industries the green-absorbing ink was formerly called red.

R. W. G. Hunt

MAGENTA PRINTER In photomechanical reproduction, the plate that prints the magenta image—also used to refer to the magenta color separation from which the magenta plate is made. *M. Bruno*

MAGENTA SCREEN A dyed contact screen used for black-and-white halftones. *M. Bruno*

See also: *Halftone process.*

MAGIC LANTERN An early type of still-picture projector of transparent slides. *L. Stroebel*

MAGNESIUM A metal that burns with a dazzling white light when ignited. Magnesium has been used in photography as a light source, producing a flash in powder form (mixed with potassium chlorate and manganese dioxide) and limited continuous light in ribbon and wire form. *R. Jegerings*

MAGNESIUM FLUORIDE A colorless crystalline compound with formula MgF_2 and low refractive index of 1.38. It is used to give robust thin-layer coatings on lens surfaces by vacuum thermal deposition to reduce surface reflection. A lens having the characteristic purple coloration is sometimes called a *bloomed* lens. *S. Ray*

MAGNESIUM OXIDE A substance that reflects diffusely nearly 100% of the light falling on the surface. It is often used as a standard for checking the performance of reflection densitometers. *M. Leary and H. Todd*

MAGNETIC FILM A magnetic recording medium consisting of a base film coated with an oxide and binder, and optionally coated on the opposite side with a conductive backing. The base is perforated according to the standard in use and made of tricellulose acetate or polyester. The oxide is a magnetically "hard" material, designed to be relatively difficult to magnetize and then to hold the magnetic field for a very long time for future reproduction. *T. Holman*

MAGNETIC FLUX The strength of the magnetic field in an area, as determined by the field intensity and the magnetic permeability of the medium. Magnetic flux is expressed as a concentration of field lines in diagrams of magnetic fields (such as a diagram of a bar magnet), and is measured in webers. Magnetic flux density is a significant consideration in the recording and storage of magnetic recording media. *J. Holm*

MAGNETIC HEAD An electromagnetic device designed to erase, record, or reproduce magnetic film or tape. It is made of a magnetically "soft" core material on which is wound a coil of wire. (Magnetically soft material inherently does not retain a magnetic field; one of the greatest difficulties in head design is finding magnetically soft materials that are also mechanically hard for long wear.) The core is gapped so that magnetic flux may leak out in the case of erasure and recording, and be received by the core material in the case of playback. A current through the coil of wire sets up a magnetic field in the core, which then leaks out to the tape or film by way of the tap in order to record; for reproduction the process is reversed. *T. Holman*

MAGNETIC IMAGE RECORDING Images may be recorded on magnetically sensitive material in a process similar to the way audio is recorded, whereby sound pressure is converted into a series of electrical impulses by a diaphragm connected to a magnet. When the diaphragm moves, a current is produced. A charge-coupled device (CCD) can convert a still image into a pattern of electrical impulses as well. In either case, the signal is amplified and recorded on a metallic oxide-coated tape by applying the signal to an electromagnetic head that magnetizes the particles on the tape, storing the information. The signal may also be digitized by an analog-digital converter before storage on the magnetic medium. Playback induces magnetic impulses in the head that are converted to an electrical signal and amplified. Digitized signals are reconverted by a digital-analog converter before amplification. Digitized images can also be stored on a fixed magnetic card.

Other magnetic imaging systems exist. Messages, computer output, and cathode-ray tube (CRT) hard copy can be recorded as a latent image on an endless magnetic belt that is then dusted with toner. The image is transferred by contact to plain paper and fused; the belt is cleaned and degaussed. In another system, a magnetic field may cause chemical reactions in liquid droplets containing color-forming chemicals, creating an additive three-color display. *H. Wallach*

MAGNETIC LENS See *Electron lens.*

MAGNETIC SOUND RECORDING Recording of signals on magnetic tape or film generally by means of magnetic heads. *T. Holman*

See also: *Magnetic head.*

MAGNETIC STRIPE A magnetic oxide coating in a stripe along the length of a piece of film. The film may contain a picture in the case of magnetic release prints, widely used for 70-mm prints, and historically used for 35-mm and 16-mm prints. Super 8 also used a magnetic stripe for audio recording. *T. Holman*

MAGNETIC STORAGE Any disk, film, tape, drum, or core that is used to store electronic information. *M. Bruno*

MAGNETIC TAPE A strand of material intended for magnetic recording that contains two essential ingredients—a base and a magnetically responsive coating. Tape is distinguished from film by the lack of perforations on tape; the base material is also generally less thick. The base consists of acetate (historically) or of polyester, usually between 0.5 and 1.5 mils thick. The coating consists of a magnetic oxide, along with binders, lubricants, and antistatic agents. Optionally, the tape may be back coated with an antistatic backing intended to also improve winding characteristics. Note that with back-coated tapes, the oxide side may not be immediately obvious because both sides contain coatings. *T. Holman*

MAGNIFICATION (1) A scale of reproduction that is larger than 1.0, that is, the image is larger than the object. (2) In optics, a scale of reproduction regardless of the value. Thus, a scale of 1/5 is called magnification even though the image is only one-fifth the size of the object. *S. Ray*

Syn.: *Scale; Scale of reproduction.*

MAGNIFIER A lens system of high power that allows close and detailed inspection of a subject or image, especially for purposes of accurate focusing. The simplest type is an equibiconvex positive lens, but achromatic doublet, triplet, and even aspheric designs are available. With an object at the front principal focal point, the rays of light leave the magnifier and enter the eye traveling parallel, and an enlarged erect and correct virtual image is seen without accommodation strain. The power is commonly given in terms of the size of the image viewed through the magnifier from a distance of 250 mm (10 inches), such as 5X, and can be determined by dividing 250 mm by the focal length of the magnifier in millimeters. For example, 250 mm/50 mm = 5X. If the eye is placed close to the lens and the subject positioned close to but inside the front focus, a magnified, erect, and correct virtual image is seen. If the image is located at the near distance of distinct vision (250 mm), then the magnification is numerically one-quarter of the power of the lens in diopters. *S. Ray*

Syn.: *Loupe; Simple microscope.*

MAGOPTICAL Refers to motion picture prints containing both a magnetic sound track and an optical sound track. Magoptical printing was used historically for some 35-mm prints and some 16-mm ones. *T. Holman*

MAG TRACK Motion-picture term for sound tracks made on magnetic sprocketed film that is the same width as the picture film and moves at the same speed, used for editing, sound mixing, and printmaking. Also, a sound track coexisting with picture on the same release print when it is recorded on a magnetic stripe along the edge of the film. *H. Lester*

MAIN EXPOSURE The primary exposure with a halftone screen, usually supplemented by additional bump and flash exposures. *M. Bruno*

MAIN-FRAME COMPUTER A large multitasking computer that may support a number of dumb terminals through

Makeup chart. (a) Foundation; determines the general tint of the complexion. This is also applied to all visible body portions such as the neck and shoulders. (b) Eyelash makeup; usually black for dark faces, left untouched for light faces. (c) Pencil for eyebrows and eyes. (d) Eye shadow. (e) Highlights (under eyes, also around mouth and nose; generally applied with a wet brush and blended into the foundation with a dry brush. (f) Shading often applied initially underneath foundation, the latter then being rubbed away to bring up the shadows. (g) Lipstick or lip paint; may be applied with a brush.

sophisticated time-sharing software. This host processor operates at high speed and serves a large group of users via a local area network (LAN). *R. Kraus*

MAKEOVER In photomechanical reproduction, a plate or film that has to be remade. *M. Bruno*

MAKEREADY The set of operations performed to prepare a press for printing. *M. Bruno*
 See also: *Photomechanical and electronic reproduction.*

MAKEUP Cosmetics used to cover blemishes on the face or body of a model, to cover shiny surfaces, or to otherwise change the appearance of the entire face or of individual features. Example: to narrow a too-broad nose or jaw, or to remove a double chin. This can be done by applying suitable highlights and shadows with makeup of the right color. It is important to use makeup colors that record correctly on film or video. Colors that look correct to the eye may not appear the same when photographed or videotaped. *R. Zakia*

MALTESE CROSS A four-slotted star wheel used in the intermittent drive mechanism of a motion-picture projector.
 H. Lester

 See also: *Geneva movement.*

MANNES, LEOPOLD DAMROSCH (1899–1964)
See *Godowsky and Mannes.* *M. Alinder*

MANTISSA The decimal part of a logarithm, which specifies the digits in the corresponding number. For example, in the logarithm 1.301, the mantissa is 0.301, implying the digit 2 in the plain number which is 20. *H. Todd*
 See also: *Logarithms; Characteristic.*

MAPPING In electronic imaging, the process of transforming input brightness to output brightness. *R. Kraus*

MAPPLETHORPE, ROBERT (1946–1989) American photographer. Achieved popularity for his elegant photographic still lifes, portraits, and nudes, before dying tragically of AIDS. Also produced highly controversial photographs of homosexual life that became a symbol for proponents of censorship and the removal of public funding for the arts.

Books: Marshall, Richard, *Robert Mapplethorpe*. Boston: Little, Brown, 1988. *M. Alinder*

MAREY, ÉTIENNE-JULES (1830–1904) French physiologist. After meeting Muybridge in 1881 and viewing his photographic motion studies, he began to use photography to analyze animal and human movements. Invented methods and instruments for registering complicated and fleeting physiological actions; notably, a camera capable of making a series of images on a single plate, the ophygmograph for heart action, and a photographic gun in 1882 for taking serial pictures of birds in flight. In 1887, introduced an early movie camera, the "chronophotograph"; the second model, designed by Marey and George Demeny in 1890, used flexible film. Marey also invented slow-motion cameras (700 images per second in the 1894 model). *M. Alinder*

MARGINAL RAYS Rays of light that enter the peripheral or outer zone of an optical element and usually undergo different refraction or reflection than that of axial rays from the same object point, so that the two do not meet in a common image point. This causes forms of lens aberrations, particularly spherical aberration and coma. *S. Ray*
 See also: *Lenses.*

MARINE PHOTOGRAPHY The specialization of photographing subjects related to seas, such as boats and harbors, including seascapes. *L. Stroebel*
 See also: *Underwater photography.*

MARKING UP In photomechanical reproduction, the operation of indicating corrections on proofs. *M. Bruno*

MARRIED PRINT A motion-picture print containing both picture and sound on the same strip of film. *H. Lester*
 Syn.: *Composite print; Release print.*

MARTENS PHOTOMETER A bipartite field photometer used to measure the luminance of a source or surface. Unlike other visual photometers based on the reduction of illuminance with distance (the inverse-square-law), the Martens photometer makes use of polarization phenomena to measure the luminance of a test surface. The unknown and reference surfaces are polarized in perpendicular directions and viewed side by side. The bipartite field is viewed through an analyzing polarizer, which is rotated until the

brightness difference between the two fields is minimized. The luminance of the test surface is then a function of the analyzer's angle. Care must be taken that the test and reference surfaces are randomly polarized. *J. Pelz*

See also: *Photometry and light units.*

MARVILLE, CHARLES (1816–1879)
French photographer. Began as a painter and engraver. By the early 1850s was working intensively with the calotype process, changing to collodion wet plate by the end of the decade. Photographs extensively published by Blanquart-Evrard. Employed by the French Commission for Monumental Historical Monuments. In the 1860s, in hundreds of images that foreshadow the work of Atget, Marville made a sweeping photographic document of the streets, alleys, and details of Paris, including the sections scheduled to be destroyed to make way for the boulevards of Haussmann.

Books: Szarkowski, John, *Photography Until Now.* New York: Museum of Modern Art, 1989; Jammes, Andre, and Janis, Eugenia Parry, *The Art of French Calotype.* Princeton: Princeton University Press, 1983. *M. Alinder*

MASER See *Laser.*

MASK/MASKING
Masks are supplementary neutral density images used in register with an original image to modify or adjust the characteristics of the original. The purpose may be the reduction of overall or local contrast to enhance highlight or shadow detail, correction of tone reproduction, correction of color separations to allow for variations in the performance of dyes or inks, or the removal of yellow, magenta, or cyan ink, and the proportional substitution of black ink to get clean dark tones in photomechanical reproduction.

Masks may consist of silver or dye images, and may be gray or colored. They may be purely electronic. They may be made on a single emulsion film, or on a film having three or more layers, producing the equivalent of five or more masks. They may be on wet process or vesicular film, sharp or unsharp, of limited or full tonal range, positive or negative. They may be made by contact printing, by a process camera, or by computer processing of a scanned and digitized input. *H. Wallach*

MASKING, DYE
(1) Grainless masking image consisting of dye, rather than silver. Several dye masks may be superimposed, allowing for integral tripack applications and use with multiple masking films. A single magenta dye mask is used when color corrected separation negatives are made from a reflection copy or a color transparency. (2) Early form of contrast control in which black-and-white negatives were stained selectively, usually with blue dye, and printed with light filtered with complementary colors. Variable contrast papers provide a more effective alternative. *H. Wallach*

MASKING, ELECTRONIC
Color corrected separations may be produced by scanning a continuous tone image and then selecting from a set of programmed masks or generating a custom mask. The masking process may be completed in the computer, eliminating the need for separate photochemical masks. *H. Wallach*

See also: *Computers for photographs; Scan/scanning.*

MASKING EQUATIONS
In photomechanical reproduction, sets of equations that relate dot sizes to the amounts of inks printed in color reproduction, e.g., Neugebauer equations. *M. Bruno*

MASKING, FLUORESCENT
The production of a contrast reducing mask by means of contact printing. Ultraviolet radiation is made to pass through a transparent panel that has a phosphor coating, exciting the phosphors and causing visible wavelengths to be emitted. This light passes through a UV filter and exposes a negative and then printing paper, all sandwiched in contact with each other. The mask is made by projecting infrared radiation from the opposite side, through the paper, the negative, and the filter, quenching the fluorescence of the panel in proportion to the amount of infrared that passes through the negative. This mask may be used to enhance shadow detail without altering the rest of the tonal scale of the print. *H. Wallach*

MASKING, FREQUENCY
The property of hearing that makes one frequency cause another to be inaudible to human listeners. Masking is more effective close to the masker tone or noise than farther away in frequency, is more effective towards high frequencies than low, and is more effective at higher levels than at lower ones. *T. Holman*

MASKING, TEMPORAL
The property of hearing that causes one sound to suppress another despite their not being precisely simultaneous in time. Divided into premasking, where the sound covered up occurs very slightly before the masking sound; and postmasking, where the sound covered up occurs after the masking sound. A use by filmmakers of premasking is in close cutting of dialogue in which an editor will cut a plosive "p" with a butt splice to make it produce premasking, which will tend to hide the edit. *T. Holman*

MASKING, UNSHARP
An unsharp mask is a tool for the reduction of contrast or the correction of color in the reproduction of transparencies or negatives. The addition of uniform density to thin areas of the original enhances the rendering of fine detail.

Printed by contact, the mask is rendered unsharp by a spacer approximately .01 inch thick that is interposed between the original and the masking film. The spacer may be a diffusion material, clear plastic or glass, or a combination of diffusion material with plastic or glass. The light source must be large enough to create the soft edges that are much easier to keep in registration than hard edges. *H. Wallach*

See also: *Mask/Masking.*

MASKING (VISUAL)
When pictures or other images are presented in quick succession, the result is an alteration or even elimination of the perception of the first image by the second image. *L. Stroebel and R. Zakia*

MASTER
(1) In motion-picture production, a printing negative made from the camera original and used for making subsequent release prints. (2) In photomechanical reproduction, an original or duplicating paper or plastic plate from which copies are made. *H. Lester and M. Bruno*

MASTER SHOT
A motion-picture shot during which all action of a scene takes place. Usually a long shot, showing all details of the scene, into which closeups and medium shots can later be cut. *H. Lester*

MAT/MATRIX
A relief image for making dye or pigment prints by transferring color from the raised parts of the relief to a receiver that is usually paper or plastic. Mat is commonly an abbreviation of matrix. Gelatin matrices are employed in the dye transfer printing process. After exposure, bleaching or tanning development yields selective hardening, which allows the removal of unhardened areas by washing; the gelatin relief image remains.

In photomechanical reproduction, a matrix is made of cellulose pulp impregnated with thermosetting resin, or of damp pulp. The image is cast in the surface of the matrix by

pressing against a relief and heating. For rotary presses, the mats are curved before the images are set. *H. Wallach*

MATRIX PRINTER A printer of text and graphic images that uses an electromagnetically operated array of needles that produce dot images. *L. Stroebel*

Syn.: *Dot-matrix printer.*

MATTE An opaque mask used for motion-picture special effects, limiting the area of picture that is exposed. Depending on the effect desired, matting may be done on the camera or during a printing process. *H. Lester*

See also: *Traveling matte.*

MATTE BOX A support system, usually a bellows, placed in front of a lens, that is used for holding cut-out masks for special effects, filters, or diffusion screens, and that can be used as a lens hood. Also called a *compendium hood.*

P. Schranz

MAXWELL DISK Disk on which different colors are mounted in various segments. On rapid rotation, the individual colors merge into a uniform additive mixture of the components. The device is so named because Maxwell used it to determine properties of color vision. *R. W. G. Hunt*

MAXWELL, JAMES CLERK (1831–1879) Scottish physicist. Established that light is an electromagnetic wave. Author of valuable investigations on color perception. Began making some of the earliest color photographs in 1855. Formally demonstrated the fundamental basis of three-color photography in 1861. *M. Alinder*

MAXWELL TRIANGLE Chromaticity diagram, originated by Maxwell, in which the three matching primaries are represented by the points of an equilateral triangle. Chromaticity diagrams are now based on triangles whose angles are 90 degrees, 45 degrees, and 45 degrees. *R. W. G. Hunt*

MEAN In statistics, an average, i.e., a measure of the central tendency of a set of data. Two kinds of means are often used. (1) The arithmetic average, found by dividing the sum of the group of values by the number of items in the set. Such an average is used for numbers on an interval scale, such as weights, temperatures, and photographic densities, and is used as the central line in a process control chart. (2) The geometric average, which is the square root of the product of two numbers. This average is used to find the middle value for numbers on a ratio scale, such as shutter speeds, *f*-numbers, luminances, and ISO arithmetic film speeds. *H. Todd*

See also: *Median; Mode.*

MEAN HORIZONTAL CANDLEPOWER See *Mean horizontal intensity.*

MEAN HORIZONTAL INTENSITY The average of luminous intensity measurements made at fixed intervals in the horizontal plane passing through a source. Because the intensity of all real sources varies with direction (e.g., dropping to zero at the base), the mean horizontal intensity is often an appropriate measure of a source's intensity. The preferred unit is the candela (cd), equal to 1 lumen per steradian (lm/sr). *J. Pelz*

Syn.: *Mean horizontal candlepower.*
See also: *Luminous intensity; Photometry and light units.*

MEAN NOON SUNLIGHT For sensitometric purposes, the light at a color temperature of 5400 K obtained by screening a tungsten lamp with a Davis-Gibson liquid filter. This color temperature was the average of readings taken in

Washington, D.C., by the U.S. National Bureau of Standards of sunlight excluding skylight at noon on specific dates over a number of years. *J. Holm*

MEAN SPHERICAL CANDLEPOWER See *Mean spherical intensity.*

MEAN SPHERICAL INTENSITY The average of luminous intensity measurements made in all directions about the source. The measurements may be made by taking readings at several positions at a fixed distance from the source or by placing the source in the center of an integrating sphere whose interior surface is covered with a diffuse reflective coating. The luminance of any point on the interior, if shielded from direct illumination, can be scaled to provide the mean spherical intensity of the source.

The preferred unit is the candela (cd), which is equal to 1 lumen per steradian (lm/sr). Because the mean spherical intensity is a measure of the average number of lumens emitted per steradian into a sphere, the total luminous flux of a source may be found by multiplying the mean spherical intensity by 4π sr (the solid angle of a sphere):

Total flux (lm) = mean spherical intensity (lm/sr) \cdot 4π (sr)

J. Pelz

Syn.: *Mean spherical candlepower.*
See also: *Luminous intensity; Photometry and light units.*

MEASURE, UNITS OF See *Appendix I.*

MEASUREMENT Photography is unique among the creative arts because it is the only one in which science and technology play major roles. From the transformation of raw materials into optical devices and photographic materials, through their application in the field, and to the viewing process, physics, chemistry, mathematics, and psychology are all important.

In each of these fields, securing data by means of reliable measurements is essential. In addition, everything must work together: one error in the entire process, such as an incorrect camera exposure, can be disastrous.

Even in an area as seemingly simple as temperature measurement, a long chain of data collection goes back from the user checking the developer temperature to thermometer manufacturer to the reference instruments at the bureaus of standards in various countries, and, finally, to the International Bureau near Paris.

In the United States, photographic measurements, such as the calculation of emulsion speed, are based on standards set up by the American National Standards Institute (ANSI), formerly called the American Standards Association (ASA). Similar organizations exist in other countries. All are related to the International Organization for Standardization (ISO) and to the Système Internationale d'Unitéd (SI). *H. Todd*

See also: *Color measurement; Color sensitometry; Color temperature; Densitometry; Exposure meter; Lenses; Munsell system; Natural color system; Optics; Photochemistry; Photographic chemistry; Photometry and light units; Radiometry; Rangefinder; Shutter testing; Statistics; Tone reproduction; Weights and measures; Zone system.*

MECHANICAL A camera-ready pasteup of artwork and text for reproduction. *M. Bruno*

MECHANICAL SHUTTER An exposure-control device using spring tension to open a light barrier for a specified time interval that is controlled by a mechanical gear train, similar to a watch mechanism. A separate return spring closes the shutter. The springs are placed under tension, usually through a separate cocking device. This can be a separate lever, such as those found on a view camera lens, or it can be part of the film transport system. As the film is

Areas of Measurement

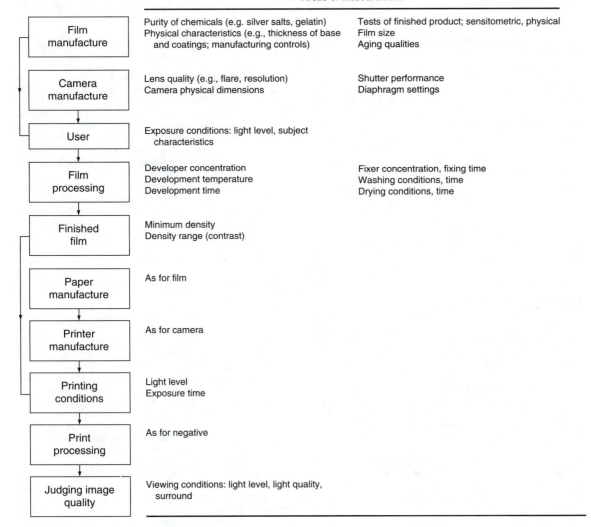

Film manufacture	Purity of chemicals (e.g. silver salts, gelatin) Physical characteristics (e.g., thickness of base and coatings; manufacturing controls)	Tests of finished product; sensitometric, physical Film size Aging qualities
Camera manufacture	Lens quality (e.g., flare, resolution) Camera physical dimensions	Shutter performance Diaphragm settings
User	Exposure conditions: light level, subject characteristics	
Film processing	Developer concentration Development temperature Development time	Fixer concentration, fixing time Washing conditions, time Drying conditions, time
Finished film	Minimum density Density range (contrast)	
Paper manufacture	As for film	
Printer manufacture	As for camera	
Printing conditions	Light level Exposure time	
Print processing	As for negative	
Judging image quality	Viewing conditions: light level, light quality, surround	

Measurements for a black-and-white photographic process.

advanced in many single-lens-reflex cameras, the shutter is cocked.

Mechanical shutters have their timing increments based on a factor of two. *P. Schranz*

See also: *Electromechanical shutter; Electronic shutter.*

MECHANOMORPHIC Having the form or qualities of a machine or mechanism. The representation of human figures as though they were parts of a machine. Thus, an elbow or knee can be represented as a mechanical hinge. Cubist, Surrealists, and Dada artists painted human figures in a metamorphic guise. John Heartfield did the same in Germany using collages in the 1930s to create political satire. In the 1500s the Italian painter Arcimboldo created interesting and fascinating portraits using machine parts, armor and artillery. Television and print commercials for antacids draw an analogy between the internal workings of the digestive system and a mechanical plumbing system.

Books: Mandiargues, Andre Pieyre de, *Arcimboldo the Marvelous*. Abrams, New York: 1978. *R. Zakia*

See also: *Anthropomorphic.*

MEDIAN A measure of central tendency used in statistics—the middle value when a series of numbers is arranged in order of size. In the set 10, 11, 11, 12, 15, 17, 90, the median is 12. Unlike the mean, the median is unaffected by extreme values. *H. Todd*

See also: *Mean; Mode.*

MEDICAL PHOTOGRAPHY Medical photography is the specialized profession of producing photographic records of human or veterinary subjects or their diagnostic materials for the practitioners of medicine. The photographs are made to document all of the prominent features of a subject without exaggeration, enhancement, distortion, deliberate obliteration, or the addition of details that might lead to misinterpretation by the viewer. These subjects may include clinical photographs, surgical procedures, surgical specimens, autopsy and forensic material, tissue slides, bacterial specimens, laboratory preparations, CAT scans, magnetic resonance imaging (MRI), ultrasound, x-rays, electronic images, graphic and fine art renditions, medical equipment, and public relations features.

The medical photographer must have a broad knowledge of the photographic process, with special emphasis on optics, perspective, and lighting techniques to ensure that the image is a factual representation of the subject. The photographer is expected to have a basic and working knowledge of computers and electronic imaging systems as well as unconventional imaging techniques such as ultraviolet and infrared recording.

The image may be recorded on conventional silver halide based films, on video tape, on digital imaging media, or other contemporary recording material.

The medical photographer must posses a general knowledge of anatomy and an elementary knowledge of physiology and histology and be familiar with the common everyday terms used in pathology, bacteriology, radiology, and surgical procedures. In addition, the photographer should possess a reasonable knowledge of medical prefixes, suffixes, and abbreviations frequently used in medicine, and be familiar with all hospital protocol, particularly regarding obtaining informed-consent patient releases for all visual or audio recording and reproduction purposes.

The photographer needs to have an understanding of and sensitivity to a patient's condition and provide for the patient's safety during the photographic procedure. As a compassionate individual, the photographer must be concerned about the patient's illness but avoid all personal comments as to the prognosis of the disease. The photographer needs to be aware of the infectious nature of certain diseases and take precautions to avoid contact and to protect fellow employees from hazardous procedures.

Photography in the operating room (theater) requires the utmost attention to the emotional and physical environment in the room; the photographer must strictly observe sterile protocol and remain unruffled during any emergency. It frequently occurs that the photographer becomes part of the surgical team and confers with the team in the placement of the camera, lights, and recording equipment. Before entering the theater, the photographer must discuss with the surgeon the procedure, from what position and angle to photograph the operative field, and the period in the procedure that photographs are to be made.

The range of equipment employed in medical photography will vary with the application. The standard setup includes the popular 35-mm single-lens reflex (SLR) camera with a comprehensive range of lenses, lighting equipment, and accessories. Other equipment, depending on the application, may include large format cameras, motion picture and video cameras, digital imaging systems, and related computer processing apparatus, photomicrography setups including time-lapse configurations, photomacrography setups including vertical scanners, endoscopic and ophthalmic cameras, and a host of other specialized equipment designed for specific imaging techniques.

The photographic department must be equipped with sufficient related reference material to investigate and resolve unusual photographic problems and to assist the research efforts of medical workers.

One of the prime requisites of a medical image is that it be permanent, properly classified, recorded, and filed for easy retrieval. Medical photographers are expected to create and maintain this service as one of the primary functions of the department. They are also expected to have a working knowledge of computer application software principles such as databases, graphics, and spreadsheets to facilitate this function, as well as to produce common clerical and financial records of the department's operation.

Medical photographers must understand the basic principles of audiovisual presentations such as the characteristics of microphones, sound amplification, audio recording, and projector equipment, and screen requirements, as they are frequently called upon to provide complete audiovisual services for medical conferences.

Many formerly named medical photography departments are now given the title of medical media departments because of the extensive range of services they offer. It is not uncommon to find such departments offering desktop publishing and typographic services, print-shop services, and community television productions on health matters, including institutional commercials.

Education and training in medical photography are available at several institutions and from professional organizations. The School of Photographic Arts and Sciences at the Rochester Institute of Technology, Rochester, New York; Bellevue Community College, Bellevue, Washington; Brooks Institute of Photography, Santa Barbara, California; Center for Creative Studies, Detroit, Michigan; Ohio Institute of Photography, Dayton, Ohio; Randolf Technical College, Asheboro, North Carolina; and the University of Illinois at Chicago, Department of Biocommunication Arts, Chicago, Illinois offer two- and four-year degree programs in biomedical photography. Several hospitals throughout North America and the United Kingdom have on-the-job training programs. Information on workshop courses, regional conferences, publications, and certification programs in biomedical photography can be obtained from the Biological Photographic Association (United States) and the Institute of Medical Illustrators (United Kingdom).

HISTORY OF MEDICAL PHOTOGRAPHY The alliance of photography and medicine has been quite productive and fortunate for humankind. The ability of the camera to record accurately and permanently the details of medical phenomena has been vital in the dissemination of medical information. Numerous medical discoveries have been made through techniques exclusive to photography. The ability of the motion-picture camera to compress and expand time sequences has resulted in the knowledge of tumor cell growth, development of bacteria colonies, and other phenomena not observable by any means until recently.

The first application of photography to medicine occurred when Alfred Donné of Paris photographed sections of bones, teeth, and red blood cells using an instrument constructed by Soliel called the *microscope-daguerreotype* in February 1840. Conventional medical photography apparently began in France when Dr. Baillarger photographed cretins (1851), which was followed by Dr. Behrendt photographing his orthopedic cases in Berlin, Germany (1852), and in the same year by H.W. Diamond photographing mental patients at the Surrey County Asylum in England.

During the American Civil War (1861–1865), countless photographs were made of wounds; these photographs are preserved at the National Library of Medicine, Washington, D.C. In 1861 J. Gantz made stereoscopic photographs for T. Billroth at the Chirurgical Clinic in Zurich. J.N. Germack made photographs through the endoscope (1862), and the human retina was photographed by William Thomas Jackman and J.D. Webster in 1885. The first gastroscope fitted with a camera was constructed by the German doctors Lange and Meltzing, and Max Nitze, inventor of the photographic cystoscope, made photographs of the interior of the bladder in 1894.

A new era in medical photography occurred when E.J. Muybridge synthesized motion studies (chronophotography) of humans and animals (1877-1893), which greatly stimulated other investigators in medical photography, and the French physician E.J. Marey endeavored to analyze human and animal motion by serial photographic studies (1882) and devised a chronophotographic apparatus and projector (1890) that was the forerunner of the modern motion-picture camera. In 1927 R.P. Loveland made a medical teaching film using cinephotomicrography, demonstrating the life history

of the yellow fever mosquito, and in 1929 F. Neumann in Germany made a time-lapse film of living bacteria.

Published engravings, copied from photographs of medical specimens, appeared in the atlas accompanying Donné's *Cours de Microscopie* (1845). After the introduction of the wet collodion process, invented by F. Scott Archer in 1848, books on photomicrography, including medical subjects, were published by Lionel. S. Beale (1857), J.W. Draper (1858), and Joseph Gerlach (1863). The first medical publications illustrated with photographs were *Album de Photographies Pathologiques et Mecanisme de la Physiologie Humaine* (1862) by G.B. Duchenne, the founder of electrotherapy. *The Photographic Review of Medicine and Surgery* (1870), by F.F. Muary and L.A. Duhring, was the first medical journal illustrated with photographs. Albert Londe in 1888 published a book, *La Photographie Moderne*, containing information on medical photography and also the first book specifically devoted to medical photography, *La Photographie Medicale* in 1893. *J. P. Vetter*

See also: *Audiovisual communication; Biomedical photography; Biological photography; Communications; Dental photography; Forensic photography; Infrared photography; Ophthalmic photography; Photomacrography; Photomicrography; Radiography.*

MEDIUM See *Optics, optical materials.*

MEDIUM FORMAT Contemporary reference to still cameras using 120 roll-film formats from 6×4.5 to 6×12 cm. *P. Schranz*

MEDIUM SHOT In cinematography, a scene in a cinema production that is the intermediate between a long shot and a closeup. The action appears to be at an intermediate distance from the camera, between a long shot and a closeup of the same scene, and as such, is used as a transitional device. A medium shot covers a limited area of a scene, usually a section of the whole setting of a sequence. When a medium shot involves people, it usually corresponds to a view taking in a small group or single figures shown in full length. Medium shots can be subclassified into medium long shots—taking in a larger view but not large enough for a long shot proper—and medium closeups. *R. Welsh*

MEES, CHARLES EDWARD KENNETH (1882–1960) English-born photographic chemist and physicist. In 1903, in collaboration with Samuel E. Sheppard, amplified Hurter and Driffield's work on sensitometry. Published the authoritative *Investigations in the Theory of the Photographic Process,* with Sheppard (1907). In 1908, Mees joined the English photographic manufacturing firm of Wratten and Wainright, and in 1912 established at Eastman's request the Kodak Research Laboratory in Rochester, New York, which he directed for 43 years. Under his leadership, both the first color reversal and negative films were developed, Kodachrome and Kodacolor. Scientist from the Kodak laboratories have been responsible for much of the photographic research during the twentieth century. Author of the standard reference *The Theory of the Photographic Process* (1942). Mees was central to the establishment of the International Museum of Photography at George Eastman House, Rochester, in 1947.

Books: *From Dry Plates to Ektachrome Film.* New York: Ziff-Davis, 1961. *M. Alinder*

MEGA- (M) A prefix denoting one million (10^6), as in megajoule (MJ, 1,000,000 joules) or megahertz (MHz, 1,000,000 hertz). *J. Holm*

MEGABYTES (MB) Loosely, one million bytes. More precisely, 1,048,576 (2^{20}) bytes. *R. Kraus*

MELTING Melting of the emulsion layer occurs when the temperature of the developer or wash water is excessive. In an extreme situation the emulsion can even run off the base. In most cases, however, damage occurs only in those areas that are touched by the fingers. The problem is aggravated with high pH developers. It seldom occurs with modern thin and highly hardened film emulsions. *I. Current*

MEMORY The active memory, or core memory, of the computer in which all data and instruction reside before and during processing. Data in memory is existent only as long as the system is operating. Once powered down, the memory becomes empty. *R. Kraus*

MEMORY COLOR A recalled color perception, which is usually different from the original perception. In general, light colors tend to be remembered as lighter, dark colors as darker, and hues as more saturated. In addition, the hues of memory colors tend to differ somewhat from the original hues. *L. Stroebel and R. Zakia*

See also: *Visual perception, perception of hue and saturation, poststimulus perceptions.*

MENISCUS LENS See *Lens types.*

MENU A group of computer program alternatives from which one of the alternatives is to be selected to implement a command. Some menus are designed to be pulled down from a menu bar at the top of the display screen. Other menus are designed to pop up upon the stroke of a key or click of a mouse button. Menus are evoked by events and are a basic part of Graphic User Interfaces (GUI). *R. Kraus*

MERCURY This poisonous element (Hg, molecular weight 200.59) exists at room temperatures as a silvery gray liquid with an insidious, penetrating vapor that can make a darkroom unsuitable for photography and affect the health of anyone who uses it. Mercury clings to surfaces and is a long-lasting contaminant that causes mottled or spotted development. For this reason, glass thermometers containing mercury should be banished from processing areas.

Mercury fumes made possible the image development of the daguerreotype process and have been used to increase the sensitivity of silver halide materials either before or after light exposure (hypersensitization). *G. Haist*

MERCURY LAMP An arc lamp that produces light (having a greenish line spectrum and a high ultraviolet content) by electrical discharge through mercury vapor. Indus-

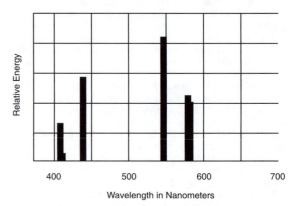

Mercury lamp. Spectral energy distribution for a typical clear mercury-vapor lamp

trial lamps may have an outer bulb to absorb ultraviolet radiation and a safety interface to extinguish the lamp after the outer bulb is broken or punctured to prevent harmful UV exposure. The addition of a phosphor coating improves color rendering but the spectrum is generally still too discontinuous for exacting color photography. *R. Jegerings*

Syn.: *High intensity discharge lamp: Mercury-vapor lamp.*
See also: *Light sources.*

MERCURY SALTS Salts of mercury, especially the chloride and iodide, even though very poisonous, have long been used in photography as intensifiers of the silver image. Mercuric chloride ($HgCl_2$, molecular weight 271.5, also called corrosive mercuric chloride, corrosive sublimate, mercury bichloride, or mercury perchloride) is available as a whitish powder or crystals that are soluble in water, alcohol, or ether. Mercuric iodide (HgI_2, molecular weight 454.47, also called red iodide of mercury, mercury biniodide) is a scarlet red powder that is slightly soluble in water but very soluble in potassium iodide, sodium sulfite, or sodium thiosulfate solutions. Both mercury compounds are poisonous and should be avoided. *G. Haist*

MERGE In electronic imaging, a function for overlaying two continuous-tone images so that both images are visible. *L. Stroebel*

See also *CT Merge.*

MERIDIONAL LINE/RAY See *Tangential line/ray.*

MESOPIC Specifying a light level that is intermediate between photopic and scotopic vision, that is, a level at which both retinal rods and cones function to some degree. *L. Stroebel and R. Zakia*

See also: *Photopic; Scotopic; Vision, the human eye.*

METACHROMASY/METACHROMATISM The process in which a single dye, usually blue or violet, produces two or more stain colors in a sample; the mechanism involved may be a hypsochromic shift caused by a specific reaction with the substrate or a substrate-induced aggregation of the dye molecules. *R. W. G. Hunt*

METAL HALIDE LAMP Industrial metal halide lamps are in the mercury vapor family of high-intensity discharge lamps but produce different radiation characteristics and a fuller spectrum because of the addition of other metals in the arc stream. Lamps made for photography have a closely spaced line spectrum that can be considered continuous and are used for high light output in cinematography. *R. Jegerings*

Syn.: *High-intensity discharge lamps.*
See also: *Light sources.*

METAL OXIDE SEMICONDUCTORS (MOS) Efficient but costly photon detectors that can be used in place of charge-coupled devices (CCD). *R. Kraus*

METAMERISM Situation in which spectrally different color stimuli look alike, or nearly alike. In color reproduction, because only three primaries or colorants are normally used, metamerism occurs between the original scene and the picture for virtually all colors. An important characteristic of metamerism is that, if a change is made to a different illuminant or to a different observer, the matches can be appreciably upset. *R. W. G. Hunt*

See also: *Isomeric pair; Metamerism index; Observer metamerism.*

METAMERISM INDEX Measure of the extent to which two stimuli that match one another become different when the illuminant or the observer is changed. *R. W. G. Hunt*

METAMERS Spectrally different color stimuli that have the same tristimulus values. *R. W. G. Hunt*

METASCOPE A viewing device that uses near infrared radiation. An infrared emitting lamp irradiates the target. Focus is achieved on a phosphor screen by means of a mirror system and an image converter. *H. Wallach*

METER (m) (1) In the metric system (SI), the basic unit of length, equal to 100 cm, and approximately equal to 39.37 inches. (2) A general term for a measuring instrument—for example, light meter, exposure meter, color-temperature meter, thermometer, voltmeter. *H. Todd and L. Stroebel*

See also: *(1) Metric system; (2) Light meter.*

METER-CANDLE (mc) A unit of illuminance; the luminous power per unit area incident on a surface. One meter-candle is equivalent to 1 lumen per square meter and to 1 lux, the preferred SI unit. A point 1 m from a 1 cd source receives 1 meter-candle of illuminance. Other units in common use are the footcandle (fc; 1 lumen per square foot), and the phot (ph; 1 lumen per square centimeter). (1 mc = 0.0929 fc = 10^{-4}ph.) *J. Pelz*

Syn.: *Lumen per square meter; Lux.*
See also: *Illuminance; Lux; Photometry, and light units.*

METERCANDLE SECOND (mcs) The quantity of light received by a unit area of photosensitive material in 1 second, a unit of exposure. *J. Johnson*

Syn.: *Lumen-second per square meter; Lux second.*

METER MEMORY The tendency of some photoelectric exposure meters, especially those with cadmium sulfide (CdS) cells, to be slow in responding accurately when changing from reading a light area to reading a dark area. This produces a false high reading for the dark area unless sufficient time is allowed for the reading to stabilize. *J. Johnson*

METOL A common name (others are Elon, Graphol, Pictol, and Verol) for *para*-methylaminophenol sulfate [$(CH_3NHC_6H_4OH)_2 \cdot H_2SO_4$, molecular weight 344.38]. The white, crystalline powder is soluble in water, alcohol, and ether. Metol should be added to water before sodium sulfite during preparation of developing solutions. Metol is toxic and an irritant.

Metol forms soft-working developers that are nonstaining and keep well but is often combined with a contrast-building developing agent, such as hydroquinone, to obtain developing solutions that produce images having good shadow detail and contrast. *G. Haist*

See also: *Developers.*

METOL POISONING Some persons develop skin irritation and blistering, called contact dermatitis, from continued exposure of the skin to photographic solutions, particularly Metol and other aminobenzene developing agents. Once sensitized, an individual's skin may swell or redden after even the slightest exposure to the chemical. The allergenic effect of amino-containing developing agents can be reduced by altering the molecular structure to increase the water solubility of the compound. *G. Haist*

See also: *Chemical safety.*

METRIC PHOTOGRAPHY The specialization of photographing subjects or events under conditions where accurate quantitative information about the subject or event can be obtained from the photograph, as in surveying or determining the trajectory of missiles. *L. Stroebel*

METRIC SYSTEM A system of weights and measures that originated in France and was adopted there in 1799, now used worldwide for scientific and technological applications and (except in the United States) for other uses as well. Multiples and fractions of metric units are related to each other by factors of 10, allowing conversions to be made by moving the decimal point; thus, 1 m equals 100 cm and 1,000 mm, for example. *H. Todd*

See also: *Système International d'Unités; Weights and measures.*

MEZZOTINT An engraving produced on a roughened copper plate to produce a hand-drawn stippled effect. *M. Bruno*

M-FLASH SYNCHRONIZATION A shutter timing device designed so that the opening of the shutter coincides with the output of light from an M-type flashbulb, which reaches peak output 20 milliseconds after the electrical circuit is closed. *P. Schranz*

MICHALS, DUANE (1932–) American photographer. Successful as a commercial photographer, New Yorker Michals has also staked out personal territory for his creative photography: sequences of images that tell a story, most often fantastical, and embellished with a handwritten narrative. Strongly influenced by the artist Rene Magritte.

Books: *Now Becoming Then.* Altadena, CA: Twin Palms, 1990. *M. Alinder*

MICRO- (1) Prefix used in the metric system, meaning one-millionth. A microsecond is one millionth of a second. (2) Prefix meaning *small*, as in *microphotography*, which is the production of very small images, for example, in the manufacture of chips used in computers. (3) Also in the manufacture of chips, a term (without the hyphen) involving a dimension of less than 0.002 inches. (4) A prefix denoting the utilization of a microscope or the application of a technique on a very small scale. *H. Todd and J. Holm*

MICROCOMPUTER A computer whose basic operating capabilities are on one chip. Using CISC technology, microcomputers are compact and powerful. The microcomputer has become known as a personal computer (PC). *R. Kraus*

See also: *Minicomputer.*

MICROELECTRONICS That branch of electronics dealing with microscopic-sized components and circuits fabricated on a semiconductor chip. Microphotography is extensively used in the fabrication of these chips. *W. Klein*

See also: *Photofabrication.*

MICROFICHE A sheet of film that typically carries from 30 to 100 extremely small images and is in the size range of 3 × 5 inches to 6 × 9 inches. The individual micro images can be viewed and printed at an enlarged size on a reader-printer. *L. Stroebel*

See also: *Microfilming.*

MICROFILM Photographic material, usually 16-mm or 35-mm in width, for recording images of documents at small scales of reproduction. Positive and negative forms, usually unperforated, are in use. The materials are characterized by contrast higher than normal for pictorial films and by resolving power three to six times that of conventional pictorial films. At common commercial reduction ratios, a regular office file drawer of documents can easily be stored on one 100-foot roll of 16-mm microfilm. *M. Scott*

MICROFILMING Microfilming refers to the technique of copying documents in greatly reduced size on 16-mm, 35-

mm, or sometimes wider film for compact filing and storage. Microimages exposed in a microfilmer can be viewed on microform readers or printed on a microfilm printer when documents need to be retrieved.

Most people first encounter microfilm in libraries, where past issues of periodicals normally are stored on microfilm. Microfiche, 3 × 5 to 4 × 6-inch film transparencies with rows of images in a grid pattern, show up more in business and industry where they serve as catalogs, research reports, training materials, parts lists, and other reference tools. Microcards, similar in size and arrangement to microfiche, substitute positive images on opaque sheets.

Business, industry,and government use microfilm because it secures vital information while offering savings in storage space, labor, and equipment. Microfilm's ability photographically to show content enhances its documentary usefulness. So do its proven archival and legal qualities.

HISTORY In the late 1920s in the United States, microfilm evolved out of the motion-picture industry where 35 mm and 16 mm were standard film sizes. The 100-foot roll that held thousands of images remained the microfilm medium of choice for several decades. Recordak Corporation developed the first internal format for microimages; the variable-length frame format on 16 mm initially was devised to record bank checks. Later, Eastman Kodak Company introduced the most lasting format for 35-mm film with its C, D, and E microfilm cameras. The popular cameras, which used nonperforated 35-mm film, could produce document images from 1-1/4 × 3/8 inches to 1-1/4 × 1-/34 inches. Large-scale commercial use developed in tandem with the industry.

In Europe, experiments with microimages on small sheets of film led to microfiche. Fiche is the French word for card. Dr. Joseph Goebel in 1935 invented the first *step-and-repeat* camera for recording microimages in a series of rows on a sheet of film. Microfiche, which did not catch on in the United States until the early 1960s, proceeded to become the most widespread microform in the world.

With the 1960s, computer output microfilm (COM) arrived. Reduction ratios, which had been improving gradually, doubled to 48 times. Computer users could output data directly onto microfilm or microfiche, thus making report duplication and distribution easier and more efficient. New reduction ratios allowed 200 standard-sized documents to be recorded on one microfiche.

In 1962, the National Cash Register Company (NCR) ushered in the era of ultramicrofiche or ultrafiche with photochromic coatings that had extremely high resolving power. Reduction ratios of 150 to more than 200 times meant that 3,200 microimages could be recorded on a 4 × 6-inch microfiche.

Kodak introduced Recordak Color film, later Kodak Color Microfilm, on July 25, 1975. Although original microfilm systems reproduced text materials in black-and-white only, color microfilm emerged in a publishing world increasingly dependent on color—from scientific journals and textbooks to consumer magazines and newspapers.

Today, 200,000 standard pages, the equivalent of 100 file drawers, can be stored in one color or panchromatic microfiche file that takes up no more space than a loaf of bread (12 × 4 × 6 inches). Bar-coding on microfiche permits hands-off management of COM. Film chips incorporate coded microimages onto microfilm for use in automatic retrieval systems. Robotic arms aid rapid retrieval of randomly filmed records in some computer-assisted retrieval (CAR) systems.

CAR systems, which have come into their own since 1985, together with integrated CAR/optical disk systems, usually handle information that needs to be retrieved frequently over a short period of time as well as information

that serves as a reference tool. Systems that integrate micro-forms with other information management media such as optical disk and magnetic materials appear to be the future of the industry. Already, special scanners make it possible to digitize images stored on microfilm. The digitized images, then, can be manipulated, transmitted, enlarged, rotated, and scrolled like images on magnetic or optical disks.

For those who never could quite figure out how to thread and view microfilm, so-called *jukeboxes* enable microfilm users to enjoy the benefits of microfilm without the hassle. These automated microfilm readers find rolls, thread them into the view, and replace them when the user completes a task.

Even if, in an emergency, there were no viewers available or no electricity to operate them, microforms still could be read by eye using a magnifier. This human-readable attribute, along with low cost and speedy input, especially when dealing with a great number of documents, has helped microforms maintain a role in the ever-changing information management field. *K. Francis*

MICROFILM READER/PRINTER A compact enclosed projection system that enlarges microfilm to produce an image on a translucent screen by means of a 45-degree mirror and back-projection or on sensitized paper by direct projection. *L. Stroebel*

MICROFLASH Electronic flash with a duration measured in millionths of a second, for example, to obtain sharp images of bullets in flight. *R. Jegerings*

See also: *Electronic flash.*

MICROFORM A general term for any very small recorded photographic image, typically of a document or drawing, made for the purpose of compact storage, including microfiche, microfilm, microopaques, and film strips.
 L. Stroebel

MICROMETER (µm) (1) In the metric system (SI), a unit of measurement equal to one-millionth of a meter. Formerly *micron*. (2) A device for measuring small distances to great precision, as to millionths of an inch. *H. Todd*

MICRON (µm) Obsolete measurement of length in the metric system, now replaced by *micrometer.* *H. Todd*

MICROPHONE An electroacoustic transducer responsive to sound pressure, velocity, or intensity, producing an electrical output. *T. Holman*

MICROPHONE MULTIPLEXER An electronic device that switches among a plurality of microphones continuously; a necessary device for spatial averaging of sound fields. An ordinary mixer does not accomplish the same effect because of the potential for cancellations when the output of multiple spaced microphones are summed.
 T. Holman

See also: *Spatial and temporal averaging.*

MICROPHONE POLAR PATTERNS
OMNIDIRECTIONAL MICROPHONE A microphone directivity pattern that responds to sound energy nearly equally well from all directions. Omnidirectional microphones are most likely to be dynamic or condenser types. Sound reaches the responsive diaphragm even from the direction of the microphone body by way of diffraction about the case of the microphone.
BIDIRECTIONAL MICROPHONE A microphone directivity pattern that responds to sound energy from two

sides, in a figure-8 shaped pattern. Bidirectional microphones are most likely to be ribbon or condenser types.
 CARDIOID MICROPHONE A microphone directivity pattern that responds to sound energy in a generally heart-shaped pattern, with a null point located to the back of the microphone. Useful because by aiming the microphone at a source, the relative pickup of the source compared to noise and reverberation in the room is enhanced over omnidirectional microphones. In addition to pointing the sensitive side of the microphone at the desired source of sound, it is also a useful property of the cardioid that one can point the null point at the rear of the microphone at an offending noise source.
 HYPERCARDIOID MICROPHONE Similar to the cardioid microphone, but having a narrower front angle of acceptance, two symmetrical nulls rather than one straight to

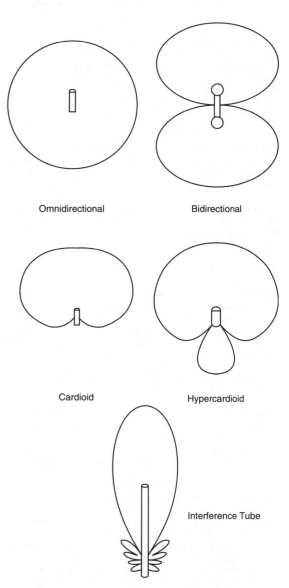

Omnidirectional Bidirectional

Cardioid Hypercardioid

Interference Tube

Microphone polar patterns. Bird's-eye view of polar patterns of microphones that are aimed at the top of the page. Complete polar patterns are three-dimensional, rotated about the body of the microphone.

the rear, and a small lobe showing sensitivity to sounds from the rear of the microphone.

INTERFERENCE TUBE (SHOTGUN OR RIFLE) MICROPHONE A microphone with a strong frontal sensitivity and with all other directions deemphasized. It has the highest ratio of direct to reverberant sound energy of all normally used microphones but suffers from changing directivity with frequency when used in any practical length. Also, most models show strong off-axis frequency response coloration. Still, probably the most often used production sound microphone. *T. Holman*

MICROPRISM See *Viewfinder, focusing.*

MICRORADIOGRAPHY See *X-ray micrography.*

MICRORECIPROCAL-DEGREE (MIRED) A designation of a light source, derived from its color temperature by multiplying the reciprocal of the color temperature by one million: MIRED = 1,000,000/color temperature. The advantage of using MIRED values lies in the fact that a change of a given amount has the same value over the entire range. For example, The color shift resulting from going from a light source with a MIRED value of 200 to a light source with a MIRED value of 275 is the same as the shift when going from a light source with a MIRED value of 325 to a MIRED value of 400. In both cases the shift in the light source is +75. The color temperatures corresponding to these mired values are 5000 K for MIRED 200, 3640 K for MIRED 275, 3080 K for MIRED 325, and 2500 K for MIRED 400. Note that even though the color shifts are equal in the two cases, the color temperature shift in the first case is -1360 and in the second case is -580.

Filters for modifing color temperatures are given in MIREDS. A nomograph relating color temperatures and MIRED shifts can be found in the Kodak data book on filters.

Books: Eastman Kodak, *Kodak Filters.* Rochester, New York: Eastman Kodak, 1989; Stroebel, L. et al., *Basic Photographic Materials and Processes.* Boston: Focal Press, 1990. *J. Holm*
See also: *Mired shift.*

MICROSCOPE An instrument used to magnify objects and specimens too small to be seen by the unaided eye. Optical microscopes use a combination of lenses for magnification; electronic microscopes use lens systems consisting of magnetic coils and electrodes. *R. Zakia*
See also: *Photomicroscope; Photomicrography; Solar microscope.*

MICROSENSITOMETRY/MICRODENSITOMETRY
Microsensitometry deals with the assessment of small-scale image quality, as of points, edges, and lines, useful in judging photographic images used in microfilms, photoreconnaisance, etc., when the smallest significant image is on the order of a millimeter or less in dimension.

Severe problems exist in all aspects of microsensitometry. For example, to determine the reproduction capability of a system to record points, a pinhole may be used as the exposing element. Even such a simple device involves scattering of light by the edges of the aperture. If a microscope is used to generate a point image as the test object, the characteristics of the optical system cause diffusion, and the object is no longer a point.

An alternative exposure method uses an illuminated slit and light from the slit focused on the test material. Again, the characteristics of the focusing lens are superimposed on the result.

For studying edges, the test object may be a razor blade, carefully prepared and darkened so that little light will be inappropriately reflected from the test object. Good contact between the blade edge and the material being tested is diffi-

cult. For this reason, the edge is often optically imaged on the sample, causing problems similar to those mentioned previously.

MICRODENSITOMETRY Density measurements of a microimage involve problems similar to those in conventional (large-area) densitometry. Microdensitometers include the following components:

1. A stable light source, usually a small-filament lamp
2. An adjustable aperture that restricts light on the sample to avoid excessive stray light
3. An optical system, such as a microscope, to image the aperture on the sample
4. A holder that can move the sample past the aperture
5. A second microscope to receive the light from the sample
6. A second aperture to restrict the size of the area being measured
7. A photocell and associated electronic equipment
8. A chart recorder to plot density (or transmittance) versus sample position

MICRODENSITOMETER CALIBRATION Density values from microdensitometry lie between specular and diffuse densities. The type of density that is recorded varies with the cone angles of illumination and pickup, which in turn vary with the magnification. At high magnification, the microscopes are close to the sample, giving large effective cone angles and diffuse light. At low magnification the cone angle is smaller, and therefore illumination and collection are more nearly specular. Therefore, each microdensitometer must be calibrated at the magnifications to be used. In addition, calibration is required for differing sizes of sample areas.

The calibration process is usually carried out by measuring a given sample on a microdensitometer and also on a large-area densitometer. From these data, the microdensitometer values can be converted to standard diffuse densities.

Microdensitometer data are dependent on many factors in addition to those mentioned, including sample preparation, spectral energy distribution of the light source, spectral response of the photocell, sample stage speed, and chart speed.

Too small an aperture or too high a magnification will give a noise trace, i.e., one difficult to interpret. Too large an aperture or too low a magnification will cause loss of information. Misalignment of a slit aperture used in tracing edges will greatly distort the record. For all these reasons, test traces made with slight modifications of the densitometer characteristics are almost always necessary.

M. Leary and H. Todd
See also: *Acutance; Edge gradient; Granularity; Information theory; Spread function.*

MIDTONE An area of an original scene or a reproduction that is intermediate in lightness between that of the highlights and the shadows—gray, for example, as distinct from white and black. *L. Stroebel*
See also: *Artificial midtone.*

MIGRATION Movement or diffusion of chemicals or particles in their supporting medium. *L. Stroebel and R. Zakia*

MIKE Slang for *microphone.* *T. Holman*

MILITARY PHOTOGRAPHY Military photography embraces the whole spectrum of photographic activity sanctioned by the armed forces of any country. Secondarily, it may refer to off-duty picture taking by military personnel.

Compare a military organization to an industrial operation, and the military photographer begins to look a lot like an industrial photographer. Such photographic needs as identification, security, documentation, and advertising and

promotion are not unique to military organizations, but they are necessary in any industry, military organizations included.

Traditionally, military photography has earned its stripes in time of war. In fact, the first known military photographs—landscapes of battlefields—were taken by the English photographer Roger Fenton in 1855 during the Crimean War. Ten years later, Irish-born American photographer Mathew Brady obtained the necessary permits to photograph at the front, gained the protection of the secret service, and paid all his own and his associates' expenses in order to photograph the U.S. Civil War. At the same time, A.D. Lytle, of Baton Rouge, Louisiana, became the first known *camera spy* while photographing a series of views of Northern forces for the use of the Confederate Secret Service.

French photographer Paul Nadar, who took the first successful aerial photographs from a balloon near Paris in the spring of 1856, passed up an invitation (1859) from the French Minister of War to apply his technique to military purposes. Instead, the first known military use of aerial photography occurred in 1862 during the U.S. Civil War.

General George McLennan, who led the Northern Army in its siege of Richmond, Virginia, ordered a photographer to use a tethered balloon to take a picture of Confederate troops and batteries. Two prints were made of the aerial photograph; each was divided into 64 numbered squares. Using a telegraph and referring to one marked photograph, the balloonist communicated exact troop movements so the general knew where to place reinforcements. By the 1880s, balloon units for photo reconnaissance existed in Europe as well as the United States.

Military photographs were first taken from airplanes during the First World War. Sir Douglas Haig successfully used a trench map prepared mostly from aerial photographs in a British attack on Neuve Chappelle—establishing photography's value for mapping and checking enemy activity. By 1918, improvements in camera equipment, photographic technique, and ways of gleaning information from photographs (photo interpretation) meant photography had become an important, if tactical, arm of military intelligence.

By 1938, surreptitious photography from British airplanes kept track of German preparations for the Second World War. Photography, whether from aircraft, agents, or submarines, not only helped the U.S. Air Force plan and assess its bombing missions but it also enabled Air Force senior officers to work with something *real* in an effort to grasp a situation or evaluate an operation. As much as 80% of crucial wartime intelligence has been attributed to photography.

During the war in Vietnam, photo reconnaissance was hampered by jungle cover, bad weather, and Viet Cong night activity. Longer focal-length lenses were required for day missions over North Vietnam at 12,000 feet. Technicians had to wrap ice in plastic to lower processing solutions to proper temperatures. By 1967, Tropic Moon units fitted with television capable of viewing the enemy at night or in other low-light situations welcomed electronic photography to the battlefront. In the War in the Persian Gulf, photography became especially important when bad weather and smoke from burning oil wells prevented military reconnaissance satellites equipped with visual sensors from being used. A long-range oblique photography (Lorop) camera mounted in an RF-4 pictured the area of a monumental oil leak while staying out of the range of the surface-to-air missiles.

Books: Francis Trevelyan Miller, ed., *The Photographic History of the Civil War.* Springfield, Mass.: Patriot Publishing, 1911; Babington-Smith, Constance, *Air Spy.* New York: Harper & Brothers, 1957; Stanley II, Col. Roy M. *World War II Photo Intelligence.* New York: Charles Scribner's Sons, 1981.
K. Francis

MILLER, LEE (1907–1978) American photographer and model. After modeling for Steichen and others, moved to Paris to become a model and assistant to Man Ray (1929–1932), where she became known as an accomplished photographer of the avant-garde. Opened her own New York studio in 1932 and was successful in the commercial field of advertising, fashion, and portraits, eventually working solely for *Vogue.* During the Second World War served as U.S. Army war correspondent. Miller was one of the first to enter and photograph the German concentration camps of Buchenwald and Dachau.

Book: Livingston, Jane, *Lee Miller Photographer.* New York: Thames & Hudson, 1989.
M. Alinder

MILLI- In the metric system (SI), a prefix meaning one-thousandth. One milligram is a thousandth of a gram.
H. Todd

MILLILAMBERT (mL) Unit of luminance equal to 3.183 cd/m^2.
R. W. G. Hunt

MILLILITER (ml) In the metric system (SI), a measure of volume equal to one-thousandth of a liter. Preferred to the nearly equivalent cubic centimeter.
H. Todd

MILLIMETER (mm) In the metric system (SI), one-thousandth of a meter, a unit of length used to specify film size (as 16 mm) and lens focal length (as 50 mm). One inch equals 25.4 mm.
H. Todd

MILLIMICRON See *Nanometer.*

MINIATURE CAMERAS See *Camera types.*

MINICOMPUTER A mid-size computer having processing power close to that of a mainframe, but at a lesser price while surrendering some of the mainframes key attributes, for example, supporting fewer terminals. Minicomputers have evolved into workstations optimized for specific applications. As processing power, RAM size, CPU speed, and bus speed/width increase for minicomputers and for microcomputers, the distinction among the three levels of computers is difficult to characterize.
R. Kraus

MINIMUM DEVELOPABLE SIZE The minimum number of metal atoms that will cause development of an exposed silver halide grain to occur, typically three to six atoms. An exact number cannot be given because the minimum developable size depends upon the type of chemical sensitization and the development conditions, including development time.
R. Hailstone

See also: *Photographic theory.*

MINUS COLOR Description of a color in terms of the part of the spectrum that its colorant absorbs. For example, minus red indicates the absorption of the red part of the spectrum, so that the color is cyan. Similarly, minus green is magenta, and minus blue is yellow.
R. W. G. Hunt

MIRED See *Microreciprocal-degree.*

MIRED SHIFT The color shift associated with changing MIRED values, given by the difference between the values. A MIRED shift of a certain value always represents the same amount of color shift, regardless of the color temperatures involved. When using the MIRED system to correct color balances, remember to shift the light source to match the film. For example, if 3400 K (type A) tungsten film (MIRED value 294) is to be shot under tungsten lighting with a color temperature of 2800 K (MIRED value 357), a MIRED filter

with a value of -63 (approximately -60) should be used. Consequently, MIRED filters with positive values have a warm-yellow color, and MIRED filters with negative values have a cool-blue color, with the intensity of the color depending on the value of the filter. *J. Holm*

MIRROR BOX A box-shaped optical device having reflecting interior walls and entrance and exit apertures that is placed between the light source and the negative or transparency in some color printers. Filtration is adjusted by inserting color filters over the entrance aperture, and the box functions like an integrating sphere. *L. Stroebel*

MIRROR CAMERAS See *Camera types.*

MIRROR IMAGE An image that is reversed either from left to right or from top to bottom, such as a reflected image seen in a vertical mirror or a horizontal mirror. Since the inverted image on the ground glass of a view camera is reversed both vertically and laterally, it is not a mirror image. *L. Stroebel*

MIRROR LENS See *Lens types.*

MIRROR LOCKUP A device on a single-lens reflex camera that allows for the reflex mirror to be temporarily removed from the light path. While this prevents viewing the image up to the moment of exposure, mirror lockup eliminates the chance of any camera vibration from mirror movement. Some ultra-wide-angle lenses protrude so far into the camera body that they interfere with the mirror reflex action. In this case, the mirror must be locked up, and a separate viewfinder and means of focusing must be used. Mirror lockup is also necessary on motor drives to attain a 4–6 frames-per-second rate. *P. Schranz*

MIRRORS See *Optics.*

MIRROR SHOT See *Schufftan process.*

MIRROR SHUTTER A type of motion-picture camera shutter with a mirrorized surface that reflects light into the viewing system during the closed part of the shutter cycle. *H. Lester*

MISSILE PHOTOGRAPHY Missiles and rockets, both guided and ballistic, are photographed during launch and in flight to obtain metric data to evaluate flight performance and impact accuracy.

 TRAJECTORY DATA Film or video cameras are integrated into or mounted onto tracking mounts to record missile flights. Film format, camera type, lens focal length, and framing rates are dictated by mission requirements. Tracking mounts can be manually operated, slaved to tracking radars, or instrumented with electro-optical automatic tracking devices. Azimuth and elevation encoder data from the mount are recorded on the film or video tape, along with missile imagery to determine angular position from the mount. Triangulation from three tracking sites determines missile position in space, or tracking mounts instrumented with laser or microwave ranging radars can provide a single station solution.

 EVENT DATA Launch sequences, control surface function, guidance maneuvers, and other missile flight parameters are typically photographed with high-speed pin-registered cameras up to 1000 pictures per second, or prism film cameras, achieving framing rates up to 20,000 pictures per second. Cameras are located on surveyed points along the missile flight path or can be put onto tracking mounts to

record events at high altitudes, such as the dispensing of submunitions or target intercept. *W. Vining*

MIX Used both as a noun and as a verb to describe the activity required to produce a complete sound track from the various different sources required. Mixing activities may be further broken down into premixing, final mixing, and print mastering. In premixing, the original cut sound units or elements are hung on dubbers, which run many strands of film in synchronization. Each of the outputs of the dubbers forms an input to the console. The output of the console is recorded on a new piece of film, called a premix. Sound editors and sound designers usually break down the premixes first into dialog, music, and sound effects one, and often further, into the type of, in particular, sound effects such as Foley, ambience, and conventional cut effects. After premixing, the various premixes are hung on dubbers and the console is used to produce a final mix. The final mix may still be recorded on many tracks, and even across multiple strands of film, forming the final mix stems. *T. Holman*

 Syn.: *Mixdown.*

MIXDOWN See *Mix.*

MIXED COLOR LIGHTING Occurs when light from different sources blend together to produce a color balance different from that of any of the light sources used, but a color balance that is uniform throughout the scene. In most scenes, mixed color lighting can be corrected to a photographic standard color balance by filters over the lens. *F. Hunter and P. Fuqua*

 See also: *Unmixed color lighting.*

MIXED MEDIA A collection or exhibition made up of images produced with a variety of materials such as silver, pigment, or dye. May also refer to a presentation, with or without audio or text accompaniment, consisting of any variety of the following media: photographs or other art viewed by reflected light (opaque), by projection as still photographs on a screen, projection as motion pictures, digitized computer images, or in the form of television or other electronic image. *I. Current*

MIXING SOLUTIONS Photographic solutions are mixtures of one or more solids, liquids, or gases in a liquid. Each ingredient must be carefully measured, then dissolved in the solvent. Premeasured packaged formulations, either solids or concentrated liquids, provide convenience and simplify the preparation of processing solutions. *G. Haist*

MODE For a set of numbers, the most frequently occurring value, a measure of central tendency in statistics. In a graph of a frequency distribution, the mode is the value associated with the peak of the curve. *H. Todd*

 See also: *Mean; Median.*

MODEL The term *model* is applied in several ways. (1) A scaled-down scene or object for display or photography that would otherwise be inconvenient or too expensive to achieve in full scale. (2) A person or persons included in a photograph to display fashions, represent a character, to complement a scene, etc. (3) A nonworking mock-up of a product or article to represent its appearance. (4) Designation given to a particular piece of equipment such as a camera to distinguish it from other variations. *I. Current*

MODELING Tonal variation in a three-dimensional subject, determined mostly by the position and size of the light source. Since conventional photography is a two-dimen-

sional medium, good modeling is usually essential to the effective representation of the subject. A ball lit directly from the front may have little gradation and appear to be a disk. Moving the light to one side produces highlight and shadow areas on the subject, which reveal its true form.

F. Hunter and P. Fuqua

MODELING LIGHT An incandescent lamp mounted in an electronic flash head, which allows the photographer to anticipate the effect of the flash. The modeling light can never perfectly duplicate the pattern of illumination of the flash tube, but placing the modeling light in the center of a doughnut-shaped flash tube usually provides a close approximation.

Less frequently, the term also describes the light source that produces *modeling* in the subject, usually the main light.

F. Hunter and P. Fuqua

See also: *Modeling.*

MODEL, LISETTE (1906–1983) American photographer and teacher. Studied music and painting, learning photography as a job to fall back on. Moved to New York (1937) where her work was encouraged by Brodovitch, garnering her commercial assignments as well as museum exhibitions. Known for her candid portraits, the often unsuspecting subject captured in a revealing pose and attitude. Taught photography at New School for Social Research, New York, from 1950 until her death.

Books: *Lisette Model.* Millerton, NY: Aperture, 1979; Thomas, Ann, *Lisette Model.* Ottawa: National Gallery of Canada, 1990. *M. Alinder*

MODEL RELEASE A legal document, to be signed by the subject of a photograph, giving permission for its commercial or editorial use in exchange for a payment. When the subject is a minor, the release is signed by a parent or guardian. When the subject is an animal, the release is signed by the owner. *L. Stroebel*

See also: *Business practices, legal issues, releases and permissions.*

MODEM A modem (modulator/demodulator) is a device that converts digital data from a computer via a communications port into analog data for transmission via telephone lines. Modems also receive analog data and demodulate analog data into digital data for processing by the computer. A modem will convert binary data, 1's and 0's into two different harmonic frequencies or tones. In simultaneous transmission and reception, full-duplexing, modems use four tones, two tones assigned to incoming data and two tones to output. *R. Kraus*

MODE (PERCEPTUAL) The manner in which a perception is identified as belonging to an object or surface (object mode), a liquid (volume mode), an illuminated opening (aperture or film mode), to a light source (illuminant mode, a TV screen, for example) or to light falling on objects (illumination mode). *L. Stroebel and R. Zakia*

See also: *Color.*

MODOTTI, TINA (1896–1942) Photographer and model. Italian-born, emigrated to the United States in 1913. Met Edward Weston (1921), moving with him to Mexico (1922), where she modeled for him and the painters Rivera and Orozco. Learned photography from Weston in 1922 and most of her work—straightly seen, simply composed portraits and still lifes—was made between then and 1929. When Weston returned to the United States in 1926, Modotti chose to stay, joining the Communist party and becoming active in the revolutionary movement. Deported from Mexico in 1929, she became a print reporter in Europe, returning to Mexico illegally in 1939. Until recently the quality of her photographs was eclipsed by the heavy shadow of her relationship to Weston. In 1991, Modotti's platinum print, *Roses, Mexico, 1925,* brought the highest amount of money to date for a photograph at auction—$165,000.

Books: Constantine, Mildred, *Tina Modotti, A Fragile Life.* New York: Rizzoli, 1983. *M. Alinder*

MODULAR CAMERA See *Camera types.*

MODULATION (1) The changing of the amplitude or power of an electronic signal of a beam of electromagnetic radiation. The change can be constant, such as with a neutral density or other lossy filter which decreases the amplitude or power of the incident radiation. The change can be a function of the wavelength or frequency of the incident radiation, such as with a bandpass or colored filter. Or the change can vary over time, as with the modulation of the carrier wave in a radio or television broadcast. Modulation that varies as a function of time is usually a result of the combination of a carrier wave and a signal. Amplitude modulation and frequency modulation are the most common examples of this type of modulation. The extraction of the signal from the carrier wave by a receiver is called demodulation. A distinguishing characteristic of modulation is that it is concerned only with the amplitude or power (which is the amplitude squared). Changes in phase alone are not generally considered modulation. (2) For a waveform, the ratio of the AC to the DC component, or the amplitude or power of the wave as compared to the maximum amplitude or power obtainable, usually expressed as percent modulation. (3) The ratio of the amplitude or power of a signal input to a system to the amplitude or power of the signal output, expressed as percent modulation. (4) The amplitude or power of a sine wave at a specific frequency. *J. Holm*

MODULATION TRANSFER FACTOR The ratio of the output modulation to the input modulation for a system at a specific frequency, especially as related to the modulation transfer function, where the modulation transfer factor is just the value of the modulation transfer function (MTF) at a specific frequency. As such, the modulation transfer factor is a measure of the fidelity with which a system reproduces a given input. A modulation transfer factor of 1.0 means correct reproduction; a factor of 0.0 indicates a complete failure of the recording or transmitting system. *J. Holm*

MODULATION TRANSFER FUNCTION (MTF) The ratio of the output amplitude or power to the input amplitude or power for a system as a function of frequency. In photography, the input is a test target of known fixed contrast and increasing spatial frequency; the MTF is a plot of the contrast of the output versus the frequency. In optics, the MTF is the magnitude of the optical transfer function, a function that completely describes the output of an optical system as a function of the position and frequency of the input. The MTF is the Fourier transform of the point spread function (or impulse response). As such, it describes the ability of a system to reproduce high frequency components or small details. A broad, flat MTF corresponds to a narrow, tall point spread function, indicating that the system is capable of reproducing a wide range of frequencies with good fidelity. An MTF can be flat over some limited bandwidth, but must at some point go to zero due to the physical impossibility of reproducing signals of infinite frequency. The components and materials used in a very high quality audio systems are capable of producing MTFs that are relatively flat over the audio spectrum (20–20,000 Hz). In photography, the frequencies of interest are spatial. Whereas resolving power test targets use square wave (sharp edge) spatial patterns that

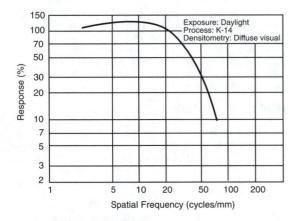

Diffuse rms Granularity Value*:9
Resolving Power Values
Test-Object Contrast 1.6:1 63 lines/mm
Test-Object Contrast 1000:1 100 lines/mm
*Read at a gross diffuse density of 1.0, using a 48-micromete
aperture, 12X magnification.

Modulation transfer function plot for Kodachrome 25 Film (from Kodak Publication P3-2E).

have only two tones and measure only the limiting frequency of the image, modulation transfer function targets change gradually in tone according to a sine wave pattern and evaluate the image contrast over a wide range of frequencies. Separate MTF curves for individual components in an imaging system can be combined to produce an MTF curve for the system. *J. Holm*

See also: *Image; Modulation; Resolution.*

MODULATOR That element of a physical system (light, sound, radio frequencies, etc.) that alters its strength in accordance with another signal. In a photographic sensitometer, for example, the other signal is a step tablet or optical device that acts as the modulator to produce a series of light intensities. *I. Current*

See also: *Attenuator.*

MOHOLY-NAGY, LÀSZLÒ (1895–1946) Hungarian photographer, filmmaker, teacher, and painter. Professor from 1923 to 1928 at the Bauhaus, the highly influential German school of art and design founded in 1919 by Walter Gropius. Director of the New Bauhaus in Chicago in 1937, that closed the next year. Founder in 1938 of the Institute of Design in Chicago, with photography central to the curriculum, teaching there until his death. Pioneer in abstract photography and photomontage. Often photographed from unusual viewpoints. Created camera-less photographs, "photograms," by placing three-dimensional objects on light-sensitive paper and so produced contours, shadows, and, in the case of translucent objects, texture. Author of significant books on theories of art, including *Malerei, Fotografie, Film* (*Painting, Photography, Film*) (1927) and *Vision and Motion* (1947).

Books: Passuth, Krisztina, *Moholy-Nagy.* New York: Thames & Hudson, 1985; High, Eleanor M., *Moholy-Nagy: Photography and Film in Weimar Germany.* Wellesley: Wellesley College Museum, 1985; Kostelanetz, Richard, *Moholy-Nagy,* New York and Washington: Praeger, 1970. *M. Alinder*

MOIRÉ An artifact of an imaging system resulting from interference between two regularly spaced sets of lines. In printing, moiré occurs because of incorrect printing angles for lines screens; in video, moiré occurs when strong verticals are scanned. *R. Kraus*

MONAURAL (SOUND) Having only one audio channel.
 T. Holman

Syn.: *Monophonic.*

MONITOR The video display terminal or monitor generally referred to as a cathode-ray tube (CRT) device, but the term is also used for other display technology such as liquid crystal displays (LCDs) and plasma screens. *R. Kraus*

MONOBATH Single solution process for the developing and fixing of silver halide images. It relies on different rates of developing and fixing to be effective. Concentrated phenidone and hydroquinone work quickly. Restrainers reduce the tendency of developers to interact with fixers to produce fog. The fixer is usually sodium thiosulfate or thiocyanate, with potassium alum added as a hardening agent.

A loss of effective film speed, increased fog levels, and enlarged grain all reduce the attractiveness of the idea of the monobath for general photographic applications. It is used in rapid access systems, x-ray, microfilm, and certain motion picture film and diffusion transfer processes. *H. Wallach*

MONOCHROMATIC LIGHT OR RADIATION Light or radiation made up of photons or particles of a single wavelength, frequency, or energy level. If the radiation is light, it will appear to be one pure, saturated spectral color. Lasers are currently the most common source of very pure monochromatic radiation that also happens to be coherent. Somewhat less pure, incoherent monochromatic radiation can be obtained by using filters to select off emission lines from a gas discharge lamp. The yellow doublet line of sodium is used in sodium vapor safelights, the infrared line of sodium is used for infrared photography, and the green and blue lines of mercury are used for microscopy. Objects viewed using monochromatic light can only reflect the wavelengths incident, and will therefore appear to be all the same color (although with different reflectances at the illumination wavelength). An exception to this is fluorescence, where monochromatic light is absorbed by a substance and the energy reemitted at a different wavelength.

Monochromatic illumination is useful in image formation because the performance of optical systems varies with the wavelength of the incident radiation. Simple optical systems can only be optimized for one wavelength. Achromatic systems are optimized for blue and red wavelengths. Apochromatic systems are optimized for blue, green, and red wavelengths. In all cases, there are some wavelengths present in white light for which the system is not optimized. The use of monochromatic light, especially at a wavelength used for optimization, can result in somewhat greater definition (although with apochromatic systems the improvement is usually marginal). In microscopy, the resolving power of a good objective is usually limited by diffraction and therefore related to wavelength. The use of monochromatic blue, or even green light in this case can significantly improve definition. Monochromaticity is also important in electron optics, where very short wavelengths allow for very high resolution (such as in electron beam microlithography and electron microscopy), because there is no way to correct for chromatic aberration. *J. Holm*

MONOCHROMATISM A rare type of color-vision defect in which hue discrimination is totally absent. A person with such a defect sees only in black and white and tones of gray. *L. Stroebel and R. Zakia*

See also: *Vision, color vision.*

MONOCHROMATOR A device used to isolate a chosen single wavelength from the spectrum of a light source using a prism or diffraction grating system to disperse the incident light. The selected wavelength emerges through a variable slit. *S. Ray*

MONOCHROME Identifying an image that consists of tones of a single hue, such as blue, or of a neutral hue (gray), or a process that produces such images. *L. Stroebel*

MONOCHROME MONITOR A video display device that is only capable of black-and-white rastering. Monochrome monitors are not capable of continuous-tone display. Those black-and-white monitors that can display continuous tones are known as gray-scale monitors. *R. Kraus*

MONOCULAR Relating to viewing with one eye, as in many optical instruments, but also used for one-half of a prismatic binocular system, especially one that can be adapted for camera use. *S. Ray*

MONOPACK See *Integral tripack.*

MONOPHONIC See *Monaural.*

MONOPOD A single, usually telescoping, leg that is used as a vertical support for a hand-held camera. *L. Stroebel*
See also: *Gunpod; Shoulderpod.*

MONORAIL CAMERAS See *Camera types.*

MONTAGE See *Photomontage.*

MOOD General emotional reaction associated with a photograph, such as melancholy, sadness, joy, and excitement. It usually differs from *atmosphere,* which is a term used to identify a natural quality. Mood is generally the result of a personal interpretation of a subject by a photographer, intending to elicit a particular emotional response. In motion pictures, mood music is intended to enhance the emotional quality of a scene. *R. Welsh*

MOON ILLUSION The moon (and the sun) appear to be larger near the horizon of the earth than when elevated in the sky. The illusion is most easily explained in terms of size/distance dependency. Although the distance from earth to moon remains the same, the moon is subconsciously thought of as being farther away when it is near the horizon, as an airplane flying at a constant altitude would be. To reconcile this error in judgment, the viewer perceives the moon as being larger. *L. Stroebel and R. Zakia*
See also: *Emmert's law; Optical illusion; Overconstancy; Visual perception, accuracy of visual perceptions.*

MOONLIGHT Moonlight is sunlight reflected by the moon, but is very much dimmer than sunlight primarily because the moon catches only a small fraction of the light emitted by the sun and also because of the darkness of the material on the surface of the moon. The moon is at approximately the same distance from the sun as the earth, so the $f/16$ rule applies on the moon also, but the reflectance of lunar material ranges only from about 4% to about 12% (this can be verified by examining moon rocks). When the moon is near full (this corresponds to a high sun angle on earth), the exposure required to render the surface a middle gray is therefore about $1/$(film speed) at $f/8$–11. The apparent bluish color of moonlight is a result of the fact that in dim light the peak sensitivity of the eye is at a slightly different point of the spectrum. Lunar material, while dark, is quite neutral in color. It is in fact possible to test the color balance of daylight color films at long exposures (1–20 minutes) by photographing typical scenes under the light of the full moon and comparing the results to the same scene photographed under sunlight. Not allowing for reciprocity failure, the exposure is 10,000/(film speed) second at $f/1.8$. The major differences should be the absence of shadow detail due to reciprocity law failure, slight blurring of the shadows, and the presence of star trails (and the trail of the moon if it is in the picture). This experiment will work only in the complete absence of artificial light, however, and therefore is becoming increasingly difficult to conduct.

Including the moon in landscapes is also frequently desirable. This can be accomplished using double exposures, or by shooting at dawn or dusk when the light level on the landscape is appropriate in comparison to the luminance of the moon. Typically, it is desirable to have the moon reproduce at about a zone VI or VII to make it look realistic. This requires an exposure of $1/$(film speed) at $f/5.6$ for a full moon, or $f/4$ for a quarter phase. The camera should be set up and the image composed while the scene is relatively bright. As the sun goes down, a light meter can be used to determine the moment when the best balance is achieved between the brightness of the moon and the surrounding landscape. *J. Holm*

MORAL RIGHTS The bundle of rights that artists have, other than those arising from copyright law, relating to such issues as changes made in their art work, mutilation of the work, the destruction of the work, and profits on resale. Moral rights are well developed in western Europe. In the United States, the federal Visual Artists Rights Act of 1990 and a few state statutes provide statutory moral rights. The federal law prohibits the destruction, distortion, or modification of art by persons other than the artist. The prohibitions apply only if the artist has retained the copyright. The work of printmakers and photographers is only protected if it has been produced in limited editions of 200 or fewer copies. Similar, but not identical, statutes exist in California, Connecticut, Louisiana, Maine, Massachusetts, New Jersey, New York, Pennsylvania, and Rhode Island. *R. Persky*
See also: *Rights, photographers'.*

MORDANT Substances that cause dye to adhere to a surface have been known since the neolithic revolution, and have been used particularly in the dyeing of fabrics. Mordants combine with dye to fix it in place. Some dyes are colorless in their unmordanted states; mordants then cause color to precipitate, forming permanent, insoluble lakes. Mordants are often the weakly basic hydroxides of aluminum, chromium, or iron. In imbibition processes, mordants are in the receiving surface. The silver metal of a photographic image can be replaced by a colored dye that is permanently attached to a metal salt, such as copper thiocyanate or ferrocyanide, which may replace all or part of the silver image.

May also refer to the etching solutions, such as ferric chloride or dilute acid, used to make letterpress or line block relief printing plates. *H. Wallach, R. W. G. Hunt, and G. Haist*
See also: *Dye imbibition; Dye transfer.*

MORGAN, BARBARA BROOKS (1900–1992) American photographer. Admired as a portraitist, Morgan specialized in black-and-white photography of dance, which she defined as "the life force in action." For ten years (1935–1945), Morgan documented the genesis of modern dance in America, dramatically capturing for posterity the graceful and athletic movements of Martha Graham, Doris Humphrey, Erick Hawkins, Merce Cunningham, Charles Weidman, and Josè Limòn. Morgan was also a pioneer in her use of photomontage. Founding member of the Photo League (1937) and *Aperture* (1952). Coowner, with her

husband Willard, of the photographic publishing house Morgan & Morgan (1935–1972).

Books: *Barbara Morgan*. Dobbs Ferry, NY: Morgan & Morgan, 1988; *Martha Graham: Sixteen Dances in Photographs*. Dobbs Ferry, NY: Morgan & Morgan, 1980; *Summer's Children*. Dobbs Ferry, NY: Morgan & Morgan, 1951.

M. Alinder

MORGAN, WILLARD (1900–1967)
American editor, publisher, writer. Morgan was photo editor of *Life* (1936), first director of photography at the Museum of Modern Art (1943), and a director at *Look* (1945). Introduced and promoted the Leica camera in America. Morgan was responsible for the first showing of Farm Security Administration photographs. With his wife, Barbara Morgan, he founded the Photo League (1937). Publisher of photographic books and technical manuals, and editor of *The Complete Photographer,* a ten-volume encyclopedia of photography.

R. Zakia

MORPHING
In computer animation, the transforming of one shape into another in a set number of frames. The number of frames determines the speed and smoothness of the transformation. A number of motion picture special effects are achieved through this animation technique. Morphing is used interchangeably with *tweening,* an abbreviation for inbetweening. Tweening is vector-based approach to transforming one object into another; however, the two objects must share some common polymorphic similarities.

R. Kraus

MORPHOLOGICAL FILTERING
In electronic imaging, an image-processing approach based on the form and texture of the image and employing highly rigorous algebraic topology and geometry.

R. Kraus

MORRIS, WRIGHT (1910–)
American writer, photographer, and teacher. An acclaimed author of some 40 books. Twice recipient of the National Book Award and three Guggenheim Fellowships, Morris was the first photographer to combine his fiction with his photographs, both at a high level of achievement. His work is based on the people and land of his boyhood home on the plains of Nebraska. People, however, rarely appear in his photographs; rather, their presence is felt by the structures and artifacts they leave behind.

Books: *The Inhabitants*. New York: Scribner's, 1946; Alinder, James, *Wright Morris: Photographs & Words*. Carmel, CA: The Friends of Photography, 1982.

M. Alinder

MORTENSEN, WILLIAM (1897–1965)
American photographer, teacher, and writer. Outspoken leader of the pictorialist movement in the United Sates from 1930 onward. Perfected the abrasive-tone method of modifying print images by hand, creating an effect that was suggestive of airbrushed and charcoal-drawn images. Founded the William Mortensen School of Photography, Laguna Beach, California in 1930. Wrote many books and articles on photographic craft.

M. Alinder

MOS
A motion-picture term identifying camera shots made without recording corresponding sound. MOS stands for "mit out sound," a phrase supposedly popularized in Hollywood as a quote from a visiting German director. *H. Lester*

MOSAIC
See *Photomosaic*.

MOSAIC COLOR SYSTEM
Color system in which the colors are formed by the additive mixture of light from adjacent areas that are too small to be resolved by the eye.

Mosaic systems were used in early color photography, but their main use now is in color television display devices.

R. W. G. Hunt

See also: *Color photography, history.*

MOTHERBOARD
In computers, the same as a logic board. In Microsoft MS-DOS systems the motherboard holds all the processing chips and circuitry necessary for the computer to function. The circuitry of the motherboard integrates all the bus slots, hard drives, display boards, and their controllers.

R. Kraus

MOTION CONTROL (ANIMATION)
A system of animation photography involving computer control of an animation crane so that a series of small camera and artwork movements can be precisely duplicated for several film passes. This process simplifies a variety of special-effect procedures such as the making of extremely precise traveling mattes.

H. Lester

MOTION PARALLAX
The apparent shift or change in position of objects at different distances when an observer, a motion picture camera, or a video camera moves laterally.

L. Stroebel

See also: *Parallax; Perspective.*

MOTION-PICTURE CAMERAS
See *Camera types*.

MOTION-PICTURE EDITING
See *Motion-picture photography*.

MOTION-PICTURE FILMS
Edge-perforated films supplied in lengths from 25 to 2000 feet on spools or cores in standard widths of 8, 16, 35, 65, and 70 millimeters. Amateurs use 8-mm almost exclusively, when they use film at all since most have turned to videotape. (Another gauge, 9.5-mm, was formerly popular among European amateurs.) Professional television is sometimes produced in 16-mm, as are documentaries and nature films. Most theatrical films are produced on 35-mm stock, except those in the special widescreen processes, which use 65- and 70-mm. Amateurs use color reversal films almost exclusively. The camera original is projected, and copies are rarely made. Professionals use negative films, color and black-and-white, for the flexibility the negative-positive process offers in making multiple prints and for special effects.

Dimensions for regular 8-mm film are: camera aperture 3.51×4.80-mm, projector 3.28×4.37-mm, 80 frames per foot. It is usually supplied 16-mm wide, double-perforated, on spools, and slit in half after processing. Super-8 with smaller perforations and 72 frames per foot has these larger apertures: camera 4.22×5.58-mm and projector 4.01×5.36-mm. It is supplied at 8-mm width, single-perforated, in cassettes. The 16-mm gauge is supplied on spools, single- (for sound) and double-perforated at 40 frames per foot. The apertures are: camera 7.47×10.41-mm and projector 7.21×9.65-mm. The single-perforated films exhibit "handedness" when supplied on the usual spools. The diagram shows the two different windings. The 35-mm gauge is supplied on spools or cores, always double-perforated at 16 frames per foot, 4 perforations per side per frame. Silent films had larger apertures than the modern sound film. The dimensions for sound film are: camera 16×22-mm and projector 15.29×21-mm for the conventional 4:3 aspect ratio. Other ratios are sometimes used.

Because of the enormous degree of enlargement—several hundred times—motion picture films need high resolving power and very fine grain. The grain problem is somewhat mitigated by the fact that each frame is shown but briefly and that the eye and mind seem to average the granularity of

many frames together, producing a smoothing effect. Resolving power lost in granularity, though, is lost forever. The good image structure must stand up through many steps of the production process: the making of intermediate positives and negatives, masks, printing masters, to the final release print itself. Recent developments in emulsion technology have led to an improvement of the speed-grain ratio by a factor of two to four. Trends in filming techniques depending on low levels of natural (or natural-appearing) lighting rely on these advances. *M. Scott*

MOTION-PICTURE PHOTOGRAPHY

Motion-picture photography, commonly referred to as *cinematography,* is an art based on illusion. It is the art of creating pictorial material for use in motion-picture presentations by recording moving events as a series of still photographs exposed rapidly one after the other. When these still images, called *frames,* are properly projected back, they appear to the audience, thanks to the human perceptual mechanisms identified as persistence of vision and the phi phenomenon, to be a continuous moving image. A picture flashed before our eyes is retained for a fraction of a second longer than its actual duration. If a second image is flashed before the persistence of the first has decayed, we do not see the intervening black screen, and if the pictures are a sequence showing the appropriate incremental changes in position of the subject, we perceive what we are seeing as smooth uninterrupted movement.

Illusion is also key to understanding the power of filmic communication, since the creation of a successful screen reality, whether in a fiction or nonfiction film, is often dependent on the audience perceiving meanings, events, and relationships from a sequence of shots, that are not inherent in the individual shots or even related to their actual filming. While it is impossible for motion pictures to duplicate a real experience, since motion pictures record only one element of a complex reality, it is possible to have the audience perceive added layers of meaning and feeling and to cinematically duplicate the truth of an experience (or to create a convincing lie about the experience). By controlling the length and sequence of shots and sound, the audience may believe they have actually seen a nonexistent event, for instance a car exploding, when what they have actually seen is the reaction of witnesses and quick glimpses of smoke, flame, and automobile parts. Motion pictures are normally shot and projected at 24 frames (still images) per second. The film editor therefore has complete control over what the audience sees up to a 24th of a second, as well as having control over how individual shots are juxtaposed. Cutting a scene together with smooth unnoticeable transitions or with abrupt jumps, may also add considerably to the audience's perceptions beyond the actual content of the shots.

Filming an event as a series of different shots is also important to the cinematographer since it allows for efficient production procedures, the maintenance of visual variety and vitality as a long scene progresses, the removal of sections without leaving a noticeable gap, and ease in editorial restructuring. A cinematographer's creative decisions are

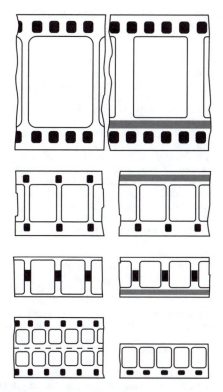

Motion picture film gauges. Approximately natural size. *Top left:* 35-mm silent. *Top right:* 35-mm sound. *Upper center left:* 16-mm silent. *Upper center right:* 16-mm sound. *Lower center left:* 9.5-mm silent. *Lower center right:* 9.5-mm sound. *Bottom left:* Double-run 8-mm. *Bottom right:* Super-8-mm.

Winding of 16-mm single perforated film. There are two ways of spooling up the film, known as type A and type B winding, for camera feed spools. They differ in the disposition of the perforations; in both cases the film is wound emulsion in. Type B is more common; if this is spooled onto another spool, it becomes type A winding with respect to the second spool.

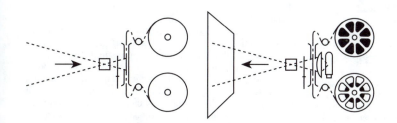

Intermittent movement and shutter. Motion-picture camera and projector. *Left,* camera with a continuous strip of film being moved from feed to take-up reels with sprocket drive wheels, a loop above and below the gate, and being pulled past the lens at an intermittent rate by a suitable mechanism engaging the perforation holes of the film. A shutter covers the lens while the film is actually in motion. *Right,* projector, using the same intermittent movement principle on the processed film.

therefore not only influenced by the graphic quality of the individual shot but by consideration of how that shot will match with others, and its potential function as part of a sequence.

BASIC FEATURES OF MOTION-PICTURE PHOTOGRAPHY On a technical level, still photography and motion-picture photography share a great deal in common. Considerations relative to optics, lens design, film emulsions, exposure, and photographic chemistry are basically the same for both media. There are, however, a variety of considerations that are unique to cinematography, the most significant of which are discussed in the following paragraphs.

Intermittent Movement and Shutters Motion-picture cameras are designed to transport long lengths of film continuously while rapidly exposing one still frame after another. The standard design uses a rotating semicircular disc shutter coordinated with an intermittent drive mechanism in the camera gate. The shutter rotates once per frame. When it is closed, the film is moved through the gate into position for exposure by a pull-down claw inserted into a sprocket hole along the edge of the film. Once in position, a registration pin might also be inserted to hold the film steady. The shutter opens, the frame is exposed and the cycle begins again as the shutter closes and the next frame is brought into place. The film is moved through the camera from feed to take-up spool by sprocket wheels and is loaded with a short loop of slack film above and below the gate, which serves to absorb the movement difference between the continuously

Intermittent movement and shutter. Top left, frame "A" in gate, shutter open. Top right, claw engages film perforation as shutter closes. Bottom left, shutter covers gate as claw pulls down film. Bottom right, shutter uncovers film with frame "B" in gate as claw withdraws from perforation.

rotating sprocket wheels and the jerky intermittent movement in the gate. With 35-mm film at the normal rate of 24 frames per second, a foot and a half of film will travel through the gate every second.

The front surface of shutters in most professional motion picture cameras is mirrorized, providing for a simple reflex viewing system. When the shutter is closed, the light from the lens is reflected from the shutter into the viewfinder system. When the shutter is open, the light from the lens exposes the film and the viewfinder is dark.

Some professional cameras also allow for changing the shape of the shutter from a 180-degree semicircle to a 270-degree three-quarter circle. This is not commonly done, however, except in certain high-speed photographic situations, or as an emergency light control option, since a 270 degree shutter cuts the exposure time for each frame in half. It also increases the amount of time between exposure of each frame and eliminates blur from some movements, which may alter the audience's perception of smooth continuous movement.

While motion-picture projectors may be built more sturdily than cameras, they share the same basic design for film transport, intermittent movement, and shutter. The shutter for theatrical projectors may also be two-bladed, with one blade masking the pull-down movement and the other causing an additional light interruption of the projected image, increasing the flicker frequency to 48 cycles per second and maximizing the persistence of vision effect.

Frame Rate and Exposure Time The standard frame rate in the United States is 24 frames per second (25 fps in some other parts of the world), which is considered the minimum rate for both maintaining the illusion of smooth movement and adequate fidelity in sound reproduction. Before the advent of sound motion pictures, the standard frame rate for silent films was 16 fps, which explains why old silent films often appear to us as having speeded up jerky movements, since they are being projected with modern projectors at 24 fps. It is a fundamental rule that the camera must run at the same speed as the projector for action on the screen to take place at the same speed at which it was performed. The standard rate for Super-8 and regular 8-mm home movie systems is 18 fps.

Unlike the still photographer, who has a wide range of shutter speeds to work with, the cinematographer does not, since exposure time is directly tied to frame rate. At 24 fps, each frame has available to it 1/24th of a second. Half this time the shutter is closed and the film is being moved. The other half of this time the shutter is open and the film is exposed. Therefore, the shutter speed is 1/48th of a second, which is usually rounded off to 1/50th for the sake of ease in calculation. Except for special-purpose cameras and some amateur cameras that might have shutters other than 180 degrees, the shutter speed is always one over twice the frames per second rate. When shooting at 100 fps for a slow-motion effect when projected at 24 fps, the shutter speed will be 1/200th of a second. When filming at 12 fps the shutter speed will be 1/24th of a second.

Motion-Picture Film Motion picture films are available with a range of exposure sensitivities similar to those available for still photography, in both negative and reversal (which yields a positive image on the camera original). Reversal stocks are most common for home movie use or nonproduction applications such as sports analysis or television news (although for these applications videotape is becoming much more common than film). Sprocket holes (perforations) must be precisely cut and placed to maintain proper image registration and smooth film transport. Print stocks have a slightly longer distance between perforations to allow for accurate image registration in the standard motion-picture contact printers. While Super-8 film is pack-

aged in 50-foot easy to load cartridges, professional stocks, in 100, 400, or 1000-foot rolls are packaged on daylight load spools. which may be loaded in subdued light, or wound on standard camera cores, which must be loaded in a changing bag or darkroom. Except for 100-foot rolls, daylight load spools are generally avoided since they add weight and noise, and increase the strain on the film transport system.

Motion-picture films are also available in several formats—35 mm, 16 mm, Super-8, etc.

Coordination with Sound Recording Most film production is with sound, which means the cinematographer must work collaboratively with the sound crew to allow for maximum quality in sound recording. Microphones must be placed properly but not seen in the picture. Camera and subject movement must be planned with sound recording in mind. Actual filming may be delayed or otherwise limited by special sound requirements, particularly the need to avoid extraneous environmental noise, such as that from airplanes flying overhead. Camera crews must work silently during filming, and the mechanical noise of cameras must be minimized. Even modern "noiseless" cameras might require a padded sound-absorbing jacket, called a *barney,* under some circumstances, and special-purpose cameras or older cameras might require a heavy, unwieldy rigid housing called a *blimp.*

Most film production is double system, which means the sound is recorded on a machine separate from the camera (usually on 1/4 inch magnetic tape) and is dealt with as a separate track until the making of the composite release prints, when picture and sound are combined on one print. The most common method of synchronizing picture and sound recorded on independent machines is to record a separate sync track on the mag tape with a signal sent from the camera or electronic unit matched to the camera. The 1/4-inch tape is then transferred (rerecorded) onto mag films (sprocketed motion picture film coated with magnetic oxide instead of emulsion) of the same gauge as the picture moving at 24 frames per second, and the speed of the 1/4-inch tape is varied according to the sync signal. The resultant sound track, when properly aligned with its matching picture, will be in frame-for-frame correspondence with that picture. Because small variations in this synchronous relationship would be noticeable, particularly with words and lip movements, the establishment and maintenance of picture and sound synchronization is an important consideration in the design and operation of motion-picture equipment.

There are many good reasons for double system production techniques, including quality, procedural efficiency, and the ability to independently cut the picture and sound, but they also add to the technical and organizational complexity of the cinematographer's job, and every shot must include a visible and audible slate and clap (reference mark for aligning picture and sound, such as the hinged sticks of a traditional wooden slate-board being clapped together).

Editorial Considerations Most films, whether documentary or theatrical, cover an event or theatrical scene as a series of shots that will be integrated into a continuous whole in the editing room. The cinematographer is therefore concerned not only with the function of each shot within the sequence but with the need to match shots as they can be edited together without appearing discontinuous. For instance, if we cut together two shots from the same camera point of view, minor differences that are impossible to avoid in the position of actors or props, or the speed of movements, would be immediately noticeable, and the cut would appear to *jump.* If we move the camera position between these shots, however, minor differences will not be noticed, and a smooth transition is possible. We will have also provided the scene with visual variety and forward-moving energy. It is also possible to make a change in camera point of view or an abrupt cut that is so extreme that the audience would be disoriented.

Another basic consideration is that of maintaining screen direction between shots. If a character were moving from screen left to screen right in shot No. 1, it would be extremely confusing to cut to a shot of the character moving from screen right to screen left. Avoiding this problem seems particularly troubling to beginners and is often described as the 180-degree rule. If we imagine a line drawn between two actors talking to each other, or in the direction of subject movement, we can move the camera anywhere within the 180-degree arc on one side of the line and still maintain the proper screen direction relationships, but if we cross this line we would be filming the back side of the action from the screen point of view, and screen direction will be reversed. Because in many situations staying on one side of this imaginary line might eliminate interesting visual possibilities, we can also avoid screen direction confusion by leading the audience across the line with a moving camera shot, or a series of shots that serve to gradually redefine the line from the audience's point of view.

Since the editor is juggling a variety of variables other than basic narrative logic, the cinematographer will also try to provide the editor with as many editing options as possible. For instance, action at the end of shot No. 1 will be repeated at the beginning of shot No. 2, allowing the editor the choice of any frame within the duplicated action as a cutting point. The concept of filming cutaways is also important, particularly in documentary situations where the cinematographer might be unable to provide the editor with appropriately timed matched editing points. Cutaways are shots related to, but not part of the main action, such as reaction shots or details of the environment, which can be used to cover moments of visual discontinuity. They can also provide enriching information and can be used in the creation and maintenance of visual rhythms. The documentary camera person will also try to move the camera, get close-ups, and change the field of view as often as possible, to allow the editor as many cutting options as possible for condensing the event without resort to jump cuts.

The cinematographer also keeps in mind that moving camera shots, while being powerful cinematic elements, are also difficult to cut into or away from during a continuous sequence and often must be used in their entirety or not at all. Subject movements however are an ideal place to cut. If the subject begins the movement in shot No. 1 and finishes it in shot No. 2, a smooth transition may be perceived even when the shots may also include other continuity flaws.

While these rules of shot relationship and selection are common to most filmmaking, it is also true that wonderful films have been made with alternative approaches to sequencing and unique criteria for shot relationship. Even without taking a special stylistic approach, the basic rules discussed here can be broken with dramatic and positive impact on the audience, although as with all such rules, to do so without thoroughly understanding them is likely to result in confusion for the audience or disastrous production complexities.

Lens Choice An interesting lens characteristic relevant to motion pictures and not to still photography is the effect of focal length on the perception of motion toward and away from the camera. This is most easily seen in extreme examples. If we film with an extremely long tele-lens a distant person running toward the camera, the runner will appear to be making very little, if any, progress, even though we see the obvious effort and dust being kicked up. This can be seen as the compression of space—the runner has actually moved many feet, but we perceive a movement of only a few inches—or the slowing of movement—we perceive the runner to have taken all that time to move only a short distance.

With an extreme wide-angle lens close to the subject, we get the reverse effects—expansion of space and speeding up of movement. With the subject only a few feet away, he will appear as an element in a larger set and to be farther away than he is. One step forward, however, and the face will fill the frame, giving the impression of having moved the distance of several steps at an accelerated rate, while having only moved the distance of one step at a normal speed.

Of course, these effects become less noticeable as the focal length of the lens approaches normal for the film format and under typical shooting conditions might be so subtle that they would not be noticed.

Wide-angle lenses also minimize the appearance of extraneous camera movement, while long lenses will accentuate such distractive movement. Wide-angle lenses are therefore the normal choice for hand-held filming. Their extreme depth of field also allows the camera operator to walk through a complex environment without having to make constant focus adjustments.

Camera Stabilization Because extraneous camera movement during a shot would be noticeable and would distract from the impact of the shot, keeping the camera steady is of prime importance to the cinematographer. Tripods are the most common and easiest to use camera supports. Hand-holding the camera is generally chosen only when no other support is available or practical and requires both practice and physical strength. Various shoulder pods and body braces are available as rigid support arms that rest against or strap to the operator's body and help steady the image and free the hands. Some operators, however, find these advantages outweighed by the restrictions to natural movement that result from their use. Dollies are wheeled platforms for camera and operator that allow horizontal camera travel as they are pushed or pulled across a smooth floor or along specially laid railroad-type tracks. Cranes move the camera and operator vertically. Special mounts can be attached to trucks and cars for high-speed or long distance tracking shots. Some camera mounts use a gyroscope to help keep the camera steady and are particularly useful for filming from helicopters and in other high vibration situations.

Steadicams and similar systems are an important and relatively recent development that provide very smooth camera movements while allowing the flexibility and convenience of hand-held operation. The camera rides on a floating platform attached to a heavily spring damped stabilizing arm attached to the vest of a weight distribution suit worn by the operator. Within the range of the support arm, the camera moves independently of the operator's body. Because the operator could not keep an eye to the eyepiece, viewing is accomplished with a video pick-up in the viewfinder system and a small video monitor mounted on the camera support. These systems allow very stable camera operation in formerly difficult situations, such as running on rough ground or up and down stairs, and provide an efficient alternative to traditional dolly shot methods.

FILM PRODUCTION Motion-picture photography is one of several factors contributing to the success of a film, which is also dependent on the quality of the contributions from actors, writers, sound crews, production managers, the director, the editor, set designers, carpenters, prop masters, stunt crews, special effects crews, costumers, make-up artists, processing labs and practical support crews of all types. The director determines the aesthetic approach and sets creative goals and limits while being responsible for coordinating all the various creative efforts to be in the service of a unified expressive goal. Production economics and the practical problems involved with organizing and communicating with large groups of people, whose work is dependent on the operation of delicate specialized equipment and the availability of a variety of resources, also

clearly requires considerable planning. The camera crew begins developing a shooting plan by analyzing the written script, with the director or in accordance with the director's instructions, and breaking down each scene into a series of planned shots. This plan may be modified by consideration of the technical and aesthetic needs of other departments and the practical limitations relative to actual locations or set design. A shooting schedule designed to be as efficient as possible is then developed. Shots are filmed in the order of greatest production efficiency, rather than in their story order. For instance, all scenes at a given location, or shots from a given camera position, are done at the same time since there would be considerable redundancy of effort in packing up at one location, moving to another and then returning to the first to again set up the equipment, lights, set dressings, and so on.

Preparation is also key to nonscripted situations and situations using relatively simple to organize small crews. For instance, a two-person documentary crew covering an actual event will try to become familiar with the location ahead of time, measure available light, plan for any additional lighting and power needs, study past similar events, learn the schedule and placement of planned activities and as much as possible about the participants, and might even rehearse by filming similar events. With the quality of a motion picture shot being dependent on so many variables, the odds of something going wrong are always high, and being prepared is always the best defense.

As soon as possible after shooting a scene, the camera film is processed, used to make a workprint, and then safely stored away. The prints, at this stage called *rushes* or *dailies,* are immediately viewed and evaluated. Subsequent shooting plans may be changed, and the editing process begins. When all editorial work is completed, the camera original is retrieved and cut to match the fine cut workprint for the making of printing masters or release prints.

With many thousands of feet of film involved, and the need to be able to identify any given frame and quickly find its counterpart on sound track and original roll, organization, accurate labeling, and the keeping of thorough camera and sound logs are also important characteristics of production technique.

SPECIAL EFFECTS A variety of techniques are used for creating motion-picture images of events that could not naturally exist or would be difficult or impossible to film because of practical production problems. Some effects can be achieved in the camera, such as slow motion by filming at a frame rate faster than 24 fps, or fast motion, or reverse motion, or unrealistically enhancing the image with filters or special lenses. Events can be produced in miniature and filmed to appear on screen as normal sized. Stop-motion techniques are used to animate models of all sizes, and of course great effects can be achieved by altering the reality in front of the camera with make-up, rigged props, and mechanical, explosive, or robotic devices of all kinds. Most often special effects are achieved with a combination of these techniques, and as with any cinematic scene, the audience's perception of the intended reality may be dependent on the relationship between the images and appropriate sounds and the scene's editorial structure.

HISTORY OF MOTION-PICTURE PHOTOGRAPHY In 1824, at the same time work was being done that led to the creation of the first photographs, Peter Roget published his *Persistence of Vision with Regard to Moving Objects.* The popularization of this concept led to the development of a variety of popular toys and novelty devices that successfully created one or two seconds of the illusion of movement with sequences of drawings. Experiments were also made in an effort to create sequences of photographs that could be animated with such devices, by posing subjects in successively altered positions, or by using a battery of

cameras designed to expose their films one after the other. Cameras were also designed that could take several successive images with a rotating film disc, or by using a stationary film plate with multiple lenses and a rotating slot shutter.

While these efforts were limited in many ways, including presenting little variety in one- or two-second segments of simple action and depending for popularity on the novelty of seeing such movement, they were an important part of the chain of experimentation and commercialization that led to the development of motion pictures. In 1888 George Eastman made roll film available through his patented process of applying a light-sensitive emulsion to a flexible celluloid strip. In contrast to the previous techniques of using glass or metal plates for the emulsion, roll film allowed the photography of a rapid sequence of images over an extended period of time. Motion-picture cameras and projectors were quickly developed to exploit this new possibility, with the contributions of many people working in the United States, England, France, and Germany, although exactly who invented which feature and when can be debated by historians, as it was debated in the patent courts of the day. By 1889 the Edison laboratories had developed a working camera called the Kinetograph, and by 1893 Edison was distributing short one-shot films for viewing in coin-operated peepshow machines called *Kinestoscopes*. In 1895 the Lumiére brothers presented in Paris the first theatrical projection of movies for a large audience, and by the end of 1896 cinematography was a recognized and profitable business.

Filmmakers also began to discover the cinematic importance of editing and special effects, with the most notable early examples being the films of Georges Méliés working in France and Edwin S. Porter working for Edison in the United States.

Since those early days, the history of motion-picture photography has been one of continual advance and improvement, consistent with general twentieth-century technological development, as cameras, lenses, lights, film stocks, laboratory processes, sound recorders, and support equipment continually became easier and more flexible to use while yielding higher quality results. The basic features of this technology, however, including the use of perforated film, sprocket drive wheels, intermittent movement in the gate, and film loop above and below the gate, are the same today as they were when first developed.

THE FUTURE Motion-picture production is entering an exciting new era of expressive possibility as computer and video technologies are making various production procedures simpler and more efficient, as well as providing alternatives to traditional techniques that allow the manipulation of complex imagery in the service of cinematic illusion. The business of motion-picture production is also, however, beginning an era of uncertain economic opportunity, since videotape is also providing an alternative to film as a motion media for both production and distribution. The use of video has already almost completely replaced the use of film in situations where instant viewing and cost are more important than quality of image, such as news gathering, recording of family events, sales demos, sports analysis, and some types of television shows. Film is still the medium of choice where image quality is a prime concern and in many instances might also have an advantage in terms of production convenience and cost.

It is, of course, impossible to predict the future, but it is not likely that video will replace film in the foreseeable future or even ever. What is likely is that more and more productions will involve both film and video, that video will continue to replace film for many applications, and that motion-picture production will become more expensive, with diminished availability of production and laboratory services.

Books: Detmers, F. (Ed.), *American Cinematographer Manual*, 6th ed. Hollywood, Calif.: The ASC Press, 1986; Rabiger, M., *Directing: Film Techniques and Aesthetics*. Boston, Mass.: Focal Press, 1989.　　　　　　　　　　　　　　　*H. Lester*

See also: *A & B roll; Animation; CinemaScope; Film editing; Film formats (motion picture); High-speed cinematography; Optical effects; Optical printer; Parallel action; Process shot; Sound recording; Sound synchronization (sync); Splicing; Stop motion; Vision; Visual perception; Wide-screen.*

MOTION STUDY　An analysis of movement of all or part of a subject, commonly by means of photographic or video images, including high-speed motion pictures or video, stroboscopic flash photography, and time exposures with pilot lights attached to key moving parts.　　*L. Stroebel*

MOTOR　A device that converts electrical energy into mechanical energy. A variety of motors are used in photography, from the miniature film drive motors used in cameras to large integral-horsepower motors used in photofinishing equipment.　　*W. Klein*

MOTOR DRIVE　A battery-powered film transport. The motor drive advances the film one frame and recocks the shutter after each exposure. Most motor drives have a

Motor. Characteristics of Small Motors.

Motor Type	Permanent Magnet (PM)	Coreless Rotor (PM)	Stepper	Synchronous Timer	Shaded Pole	Capacitor Start and Run
Voltage	DC	DC	Pulsed DC	AC	AC	AC
Reversible on start	Yes	Yes	Yes	No	No	Yes
Reversible during run	Yes	Yes	Yes	No	No	Yes
Special characteristics	Energy efficient	Low inertia rotor; fast response	Shaft turns a precise angle for each pulse	Constant speed	Lowest cost	High torque, reversible
Best suited for	Film advance and rewind in cameras	Film advance and rewind in cameras	Metering of film and paper in photofinishing equipment	Timers and clocks	Fans and blowers	Applications requiring frequent cycling
Limitations	Brushes may need replacement	Expensive, brushes may need replacement	Requires expensive electronic controller	Low torque, low speed	Inefficient, low starting torque	

single-frame advance or a continuous advance option. The continuous advance option will automatically expose and advance film at a specified rate, such as three frames per second. A number of automatic cameras have a motor drive built into the camera body.

Another form of automatic advance is an *autowinder* that simply advances the film and cocks the shutter automatically after each exposure, but will not expose a rapid sequence.

P. Schranz

MOUNTING A process of attaching a photograph or other material to a surface with any number of different methods and materials. These materials may include wet mounting procedures that use glues and liquid adhesives, hot or cold dry mounting materials, taping and hinging, laminating, and various other encapsulating procedures. *M. Teres*

See also: *Dry mounting.*

MOUNTING PRESS An electrical device for applying heat and/or pressure to a photograph while the photograph is in the process of being attached to a mounting surface. Although a small photograph can be mounted successfully by hand with cold-mounting adhesives, a household steam iron does not work well enough to be considered a reliable mounting tool for any of the heat-activated dry-mount materials. Therefore, a dry-mount or a combination press must be considered necessary for dry mounting photographic prints with any of the heat-activated materials.

The mechanical dry-mounting press consists of a heating element within a flat metallic platen that is suspended on a system of bars and free-moving hinges. This allows the heated platen to firmly squeeze down upon the photograph during the mounting process. The press firmly holds the dry-mount tissue and mount board sandwich together, under pressure, until the adhesive melts. The adhesion becomes permanent after the print and mount-board cool under pressure. Dry-mounting presses are thermostatically controlled and allow the pressure to be adjusted in order to accommodate different types and thicknesses of materials.

Dry-mounting presses come in a variety of sizes, and they are open on three sides so that photographs can be mounted in sections. By simply moving the print along the press after each section is heated, a print of any length but only twice the press depth can be mounted. The use of a special silicone release board when mounting large prints in sections will help to prevent platen lines from creasing the print where sections overlap.

It is important to accurately control the temperature and pressure of the press. Several models of dry-mounting presses can be purchased with built-in thermometers so that the temperature can be monitored throughout the mounting process. Although all presses have a thermostat to maintain the "correct" temperature, as a press ages, there may be some fluctuation in the heating elements or in the thermostat that may cause the actual temperature to deviate from the indicated temperature. Temperature indicator strips may be used to test the temperature accuracy of the dry-mounting press; these strips have two colored adhesive areas: one melts at 200°F; the other melts at 210°F. This temperature test allows adjustment of the thermostat dial to obtain the desired temperature. *M. Teres*

MOUNTING TAPE Acid-free linen tape is a very strong high-quality, tightly-woven linen with a water-activated adhesive. The tape comes in a standard size and an extra wide version. The extra wide style is designed for attaching hinges on mats and supporting very large window mats on backing boards.

Acid-free paper tape is a light-weight paper tape that has a water-activated adhesive. It is used to attach paper hinges and photo corners or to seal the back of frames against dust. The tape is removable when moistened with water. The tape is not strong enough to be used to hinge window mats to backing boards.

Adhesive transfer tape provides an instant bonding. It is a permanent synthetic acrylic adhesive on a roll. This adhesive material is temporarily attached to a removable siliconized paper liner that is separated from the adhesive when applied with a dispenser-type gun. It is similar to double-sided adhesive tape in the way it is used. The difference is that instead of the adhesive being attached to a support material, as is the case with double-sided tape, the adhesive is applied directly to the back of the print to be mounted and has no backing at all. Because this thin film of adhesive has no supporting layer, it is easiest to use when loaded into a gun-like dispenser. The adhesive bond is high tack. While ideal for paper, cardboard, textiles, plastics, leather, wood, and even glass, it is not designed for supporting heavy loads. Adhesive transfer tape softens at very warm temperatures so it should not be used for materials that will be exposed to heat. The heat from high-intensity art gallery lighting may be considered an unsafe environment.

Double-coated film tape has easy-release paper liner on each side, ideal for sealing polyester film sheets together for encapsulating fragile documents.

Hook and loop fasteners are pressure-sensitive adhesive-backed *Velcro-like* long-roll tapes or small pre-cut squares that attach to glass, metal, most wood, fabrics, and plastics. Strips of hook and loop fasteners are strong enough to exhibit framed and mounted photographs by attaching them directly to walls. Since the hook and loop strips pull apart, print exhibitions can be changed very quickly.

Filmoplast is an acid-free, neutral pH-balanced repair tape with a nonyellowing pressure-sensitive adhesive. Filmoplast is available in a variety of types and sizes. These tapes can be paper or linen, transparent or white opaque, and have low-tack adhesive so that the tape can be repositioned during the initial application. Some have water-soluble adhesives so that the tape can be removed with water, and some are permanent. These tapes are ideal for mending torn pages, reinforcing folders, and hinging window mats to backing boards. Some varieties of filmoplast tape make ideal *passe-partout* material.

Tyvek tape is a tear-resistant, white, nonwoven polyethylene material with a pressure-sensitive acrylic adhesive backing. This self-sticking pressure-sensitive tape eliminates the need for water to activate the adhesive and therefore ensures a dry working area for mounting delicate materials. Because this material is very strong, it is ideal for mat hinges, folder spines, portfolio construction, and book repairs. It is available in a variety of widths suitable for a number of different uses. *M. Teres*

MOUSE In computers, a hand-held input device that controls the cursor when moved about. The mouse has become the most popular pointing device for graphic user interface environments. *R. Kraus*

MOVEMENT See *Image movement.*

MOVEMENT ADAPTATION The process by which a person visually adjusts to a steady movement of a stimulus so that when the movement is stopped a reverse movement is experienced. For example, a spinning spiral that appears to be expanding is seen as shrinking when its motion is stopped.

L. Stroebel and R. Zakia

See also: *Adaptation; Optical illusion; Waterfall effect.*

MOVIOLA The trademarked name of a motion-picture upright style editing machine. Commonly used as a term for

any upright editing machine. The interlock between sound and picture and transport control is of a basic mechanical nature, with the picture moving vertically through its gate and picture and sound moving from the front to the back of the machine, in contrast to the more modern flatbed editing machines, where the film moves horizontally in front of the editor and transport and interlock functions are controlled electronically. *H. Lester*

MQ DEVELOPERS Metol is often combined with hydroquinone to make energetic developers that act more rapidly than either developing agent alone; that is, they show superadditive developing activity when used together. Metol and hydroquinone have been used in a great variety of developers for many years, and such solutions are often called MQ (*Metol–Quinol*) developers (Quinol was an early name for hydroquinone). *G. Haist*

MULTI-IMAGE The superimposition of several images on the same sheet of film in a camera or on printing paper using an enlarger. The images can be of the same subject or of combinations. *R. Zakia*

See also: *Photomontage; Stroboscopic photography.*

MULTI-IMAGE CAMERA See *Camera types.*

MULTILAYER FILM Consisting of two or more superimposed sensitive coatings on a support. In black-and-white films the layers may be of differing speeds, resulting in extended latitude and tonal range. Color films and papers are of different spectral sensitivities and different color-forming abilities. Some modern films have 16 or more layers performing various functions. *M. Scott*

MULTIMEDIA Originally, *multimedia* referred to the presentation of information using large projected images that combined a series of projected pictorial or graphic slides along with motion pictures and sound. From the presentation of individual sequential images, the development of electronic control equipment for projection systems allows the simultaneous presentation of multiple images. The number of individual images that make up a composite large screen display can be two, three, or a dozen or more. Often printed information, relating to the projected images, is used to reinforce or add to the depth of displayed visual information.

The development of large-screen projection television systems added the video medium to multimedia presentations. Educators, industrial trainers, and presentation specialists were eagerly looking for a more interactive form of presentation. The computer, as evidenced by the success of video games in the 1980s, provided an effective tool for interactive participation by the user.

Digital multimedia is now considered to consist of a single color monitor display screen with interactive information that may include single pictorial or graphic images along with video images and sound. A valuable attribute of multimedia is the ability to create an interactive program—people learn more easily when they are part of the learning experience.

Multimedia, with its combination of technologies, offers great communication opportunities to industry, government, education, and the home. It offers the opportunity for computer software to easily use words, graphs, digital photographs, live video, and sound in a user-friendly way and present them within the spatial limitations of the personal computer environment.

Computer users have a variety of choices of computer systems for multimedia applications. The Apple Macintosh favors desktop presentation applications, while the IBM computer offers processing and storage power, and the Commodore Amiga is designed to input and output images that can be viewed using existing home television screens. Now, plug-in computer boards for sound, animation, and video enhance computer systems for use in multimedia applications.

Multimedia software has been developed for use with MS-DOS (Microsoft Disk Operating System) and OS/2, both standard operating systems for IBM PC and compatible computers. For these same systems using the Windows graphic interface, multimedia extensions are available.

System 7.0, Apple's operating system, introduced a software architecture that allows the seamless integration of dynamic media such as sound, video, and animation.

A number of other software programs exist for multimedia—some can produce complete multimedia programs while other programs produce the pictorial, graphic, or motion images or audio components of multimedia programs.

The Joint Photo Expert Group (JPEG) compression standard made it possible to use digital photographs and store and retrieve these images efficiently from mass computer storage media or transmit them more rapidly over existing communication facilities. Work by the Motion Picture Experts Group (MPEG) will soon complete a motion image standard.

Digital video interactive (DVI) technology for motion image compression is already available. DVI is based on proprietary compression/decompression algorithms and a video/graphics chip set that performs the decompression processing and display capabilities that result in real-time video images with sound.

Impressive interactive multimedia programs have already been created for industrial, medical, and educational applications. Future advances are expected to result in lower costs for the hardware, software, and storage media needed for the advancement of multimedia. Future multimedia offerings will be easier to use, while there will be more capabilities in both diversity of media elements and the methods used for presentation. *J. Larish*

MULTIPLE EXPOSURE The act of recording two or more images, usually superimposed on the same sheet or frame of photographic material. Sometimes accidental, as when the photographer fails to change the film in the camera or puts in an exposed sheet or roll of film, but often deliberate, to serve an aesthetic or informational purpose. *R. Zakia*

MULTIPLE FLASH (1) Two or more flash heads may be strategically placed for various lighting effects, or may be close to each other to increase light intensity. (2) Successive bursts from one or more heads may be used to build up the light intensity on a single frame; the shutter is generally held open in low light, but may also be reset for each burst with the risk of camera movement. *R. Jegerings*

MULTIPLE LENS See *Lens types.*

MULTIPLE TONING Different areas of a print may be toned by protecting one area with rubber cement or with maskoid liquid frisket while the unprotected area is toned. Rubber cement, diluted with an equal part of thinner is carefully applied to the area to be protected. The print is then immersed in the toner until the desired color is achieved. The cement can be removed by rubbing with the balls of the fingers while the print is in the wash water. After the print is dry the process can be repeated with other toners if desired. The colored frisket makes it easier to see the areas that have been covered. It is removed while dry by pulling it off with masking tape. *I. Current*

MULTIPLEX Process of transferring numerous related images from various imaging systems via optical systems to a common recording medium, e.g., the transfer of a multi-image slide-tape program onto videotape with retention of all visual effects. *S. Ray*

MULTIPLIER PHOTOTUBE See *Photomultiplier tube*.

MULTISPECTRAL IMAGING Photographic recording of an object or terrain utilizing two or more wavelength regions of the visible and nonvisible (infrared and ultraviolet) spectrum with either monochrome film or color film, or both. This may be accomplished simultaneously with two or more cameras or optical systems, or with a single camera and multilayer film. For example, a reversal processed camouflage detection film has a green-sensitive layer that produces blue in the image (absence of yellow), a red-sensitive layer that produces green in the image (absence of magenta), and an infrared-sensitive layer that produces red (absence of cyan) in the image. Green foliage reflects infrared, but painted foliage does not; therefore, the camouflage would not be seen as red in the image. Likewise, diseased or dead trees would not reflect infrared. *I. Current*

See also: *False color*.

MULTITRACK Pertaining to audio formats using more channels than the release format, used for flexibility in mixing. The usual professional multitrack analog recorders have 4 tracks on 1/2-inch tape, 8 tracks on 1-inch tape, 16 or, more commonly, 24 tracks on 2-inch tape. Digital multitrack recorders usually use 24 or 32 tracks on 1-inch tape. *T. Holman*

MUNSELL SYSTEM A color order system in which the colors are arranged with as nearly as possible perceptually uniform spacing. Colors are specified in terms of their Munsell hues, values, and chromas. There are five principle hues—red, yellow, green, blue, and purple—with intermediate hues in between. The value correlates with the lightness of the colors, value 10 being for the perfect diffuser, and value 0 for a black having zero reflectance factor. Chroma is 0 for achromatic colors (whites, grays, and blacks) and increases to values of about 16 for very strong colors. Munsell specifications are always given in the order hue, value, chroma; thus, 5G 6/10 indicates that the hue is 5 green (a pure green), the value is 6 (a gray slightly lighter than a medium gray), and the chroma is 10 (a fairly strong color). *R. W. G. Hunt*

See also: *Colorimetry; Natural color system*.

MURAL A very large photograph mounted on a wall. When the mural exceeds the size of the largest printing material available, it becomes necessary to combine separate sections of the image in a procedure similar to that of applying wallpaper to a wall. *L. Stroebel*

See also: *Decoration photography*.

MUSEUMS AND COLLECTIONS The history of photography has been recorded in literature and collected by museums from the moment of its inception and announcement to the world in England and France in 1839. Within months of the public's awareness of both the daguerreotype and calotype, books and essays were being published on the processes and their respective histories. The first major treatise on the daguerreotype in America was published by Henry H. Snelling in 1849. And in France, the Musée Du Conservatoire Des Arts Et Metiers records its earliest gift of a daguerreotype in 1855. The first museum to collect photography, however, was the Bibliothèque Nationale in Paris, which continues to collect today. The majority of distinguished photographic libraries and collections existed in England and continental Europe for most of the medium's history. But beginning in the late 1960s the United States experienced a dramatic expansion of both public and private support for collections of photography. By the end of the 1980s, the United States emerged as the major public collection resource for photography worldwide.

Educational programs for photography in American universities and colleges expanded with equal intensity during this period. Concurrently, the commercial collecting world of galleries and auctions grew into a multi-million dollar business that produced the largest and broadest audience for photography in its history.

In 1853 the Société Française de la Photographie was founded in Paris by a group of photographers, and in 1855 the Société became an official museum. Today it houses over 15,000 prints that represent both historical subjects and the visions of individual photographers. The founding photographers were among the most entrepreneurial of their day and have over the course of history also come to be recognized as major artists of the medium. They included Hippolyte Bayard, Bission Freres, Louis Desire Blanquart Evrard, Gustave Le Gray, and Charles Nègre.

The role of photographers in the creation and development of public collections has been dramatic in both Europe and America. Their contributions, in addition to their own photography, have been largely as curators, writers, and organizers of support mechanisms for public collections. Traditional art history, for example, largely ignored photography until the 1970s and so, consequently, had art museums with one or two exceptions. In the absence of traditional academic training in the history of photography, many of the medium's historians were also photographers themselves. Given their devotion to photography as practitioners, these self-trained museologists and historians, provided a unique perspective on both technical and aesthetic matters in the formation of collections.

There were earlier museums than the Société Française de la Photographie that collected photographs. The Cabinet des Estampes of the Bibliothèque Nationale in Paris began collecting photographs in 1851 and its American counterpoint, the Library of Congress, began collecting the results of the new invention with the advent of the copyright deposit law in 1846. Today the American national library houses more than ten million photographs in 800 different collections. But neither of these museums nor any of the hundreds of historical societies, libraries, or science, history, and art museums that followed, assembled their collections of photography with an interest in the history of photography. Rather, the majority of these collections were brought into existence for the sake of recording historical evidence and creating archives of subject matter, the content of which was deemed more important than the photographic means or intent.

This collection perspective changed with the explosion of interest in photography as an art form beginning in the 1960s. A number of collections around the world were subsequently moved from libraries and other institutional resources to national and regional art museums.

When we compare the preceding edition of this encyclopedia's entry for museums, written in the late 1960s, with the current edition, we find a number of glaring differences. Among them was the reference that at that time there was no "public museum in Europe devoted to the permanent display of photographs. . . ." By 1991, there were over 125 museums in Europe and Asia that collected and exhibited photography.

In 1990, the newest photography museum was Japan's Tokyo Metropolitan Museum of Photography. It is one of the half-dozen museums worldwide devoted exclusively to photography. Its collections are intended to be international

in scope and to include nineteenth- and twentieth-century masterworks, numbering 10,000 by 1994. Collection goals include a major library. In addition to traditional programming, the museum plans an experimental visual space, which will provide exhibition and program access to a range of imaging devices from the Zoetrope to video and computer graphics.

Other important differences in photography museums in the ensuing period of more than two decades since the preceding edition of this encyclopedia include the increase in the number of museums in the United States solely devoted to photography. By 1991, there were four, and one of the original two—the American Museum of Photography in Philadelphia—had been dissolved and its collections absorbed by the International Museum of Photography at George Eastman House, the other of the two original museums. The three new museums include the Center for Creative Photography at the University of Arizona, the California Museum of Photography at the University of California, Riverside, and the Museum of Photographic Arts in San Diego.

Some collections were absorbed by other museums, e.g., the Kodak Museum in England, now a part of the National Museum of Photography, Film, and Television in Bradford, England. Also, the collection of Dr. Erich Stenger, which constituted the majority of the Agfa Corporation collection in Leverkusen, Germany, was absorbed by the Ludwig Museum of Art in Cologne.

The previous edition also mentioned that in U.S. collections "a few art museums have collected examples of artistic photography. . . ." By 1991, virtually every major art museum had a department of photography.

In 1973, there were 117 public collections in the United States, and by 1991 there were 535, which represents an increase of 450%. The implication of such enormous and rapid growth is that the economic base for all photographic activity was equally affected during this period, not the least of which were the greatly increased number of photographers who sought recognition in the art world.

As is now realized, photography as a technology was not thrust wholly, completely, and suddenly upon the world. Optical and chemical aspects of its imaging capability were in the inventory of ideas proffered by humankind for a number of centuries before its final resolution as photography when it appeared a mere 150 years ago. It is not its history or invention that amazes the world, but its use and incorporation into nearly all aspects of society. Once again its technology is evolving, and electronic, video, and computer imaging are changing the nature of ordinary communications. Where photographic technology once demanded the presence of the photographer to make patient choices of vision and to record select moments of observation, transmission technology suggests that editing and selection from abundant remote *electronic* possibilities may become the essential criterion for creative choice-making.

Among the nearly 700 museums and photographic collections worldwide, the International Museum of Photography at George Eastman House in Rochester, New York, is the most comprehensive in its collections, which include nineteenth- and twentieth-century photographs, films, rare books, and photographic equipment and technology. Although its 500,000 prints do not approach the number of prints in the collections of the Library of Congress or the Bibliothèque Nationale, they do represent one of the single most important concentrations of historical landmarks and masterworks. The film collection, which is the third largest private collection in the world, is also known for the finest collection of silent film. The technology collection of over 10,000 objects ranges from the only complete Gerioux

daguerreotype camera and outfit signed by Daguerre to the first lunar probe camera prototype.

Founded in 1947, the museum is devoted to the complete history of photography and film, which means that it functions as both an art and a science museum. In 1989 the Museum added to its complex of facilities a new 73,000 square foot building for exhibition, storage, and research. In 1990 the elegant mansion of George Eastman, which served for 40 years as the museum itself, was restored as a period museum including Eastman's original furniture and personal artifacts. The museum complex is situated on 13 acres, which includes three restored formal gardens, all according to their original design in 1905.

The combination of collections and an historic site make the International Museum of Photography at George Eastman House unique among all the photography museums worldwide. Two important European museums share the quality of being housed in or on historic sites. The Fox Talbot Museum of Lacock, Abbey in Wiltshire, England, is located in a building on the Talbot estate. The museum is devoted to the collections of Talbot's cameras and artifacts used in his experiments. The Musée Nicéphore Niépce is located in the village of Chalon-Sur-Saone, France, near the canal and location where Niépce conducted his experiments. It contains the Niépce collection of artifacts and technology, as well as other collections pertaining to the invention of photography.

Today, the state of collecting and collections is so prolific that it is beyond the scope of this essay to provide even a select list of private collectors. It is especially in this area that the word *major* carries less significance than ever before. In the past, names like Jammes, Cromer, Boyer, and Barthelemy stood out among the majority of private collections, but today there are so many with such a great variety of specializations that to mention even one private collection is to demand equal mention of another.

Although museum collections are also numerous, they can be more easily represented by a select list; they can be distinguished by the content of their collections; and they are generally recognized for their impact on scholars and the public.

In the United States, the International Museum of Photography at George Eastman House has already been described as the most comprehensive institutional collection of photography. The next largest collection is the Center of Creative Photography at the University of Arizona with over 50,000 prints and hundreds of thousands of negatives by twentieth-century American photographers. It also contains substantial correspondence and manuscript collections, as well as related artifacts, of several dozen major photographers including Ansel Adams, Richard Avedon, Wynn Bullock, Harry Callahan, Andreas Feininger, Robert Heinecken, Marion Palfi, Aaron Siskind, Frederick Sommer, W. Eugene Smith, Paul Strand, and Edward Weston. These individual collections are intended to represent the life work of those selected.

The photography collection of the Museum of Modern Art in New York City requires little description. Established in 1930, it is one of the great collections of the world with substantial holdings of nineteenth- and twentieth-century photography. Its nineteenth-century collection is small in comparison to the great European collections, but it is distinguished by unique features like the Eugene Atget collection and a broad selection of individual masterworks.

The Metropolitan Museum of Art in New York City maintains a small distinguished collection of photographs. In 1928 its collections were inaugurated with a gift from Alfred Stieglitz of his own photographs. In 1933 he gave another gift of 500 Photo-Secessionists' works. The museum has continued to collect since that time. In the early 1970s a

curatorial position was created for the photography collection and its acquisition, and exhibition programs became a major component of the scholarly tradition in the United States

The International Center for Photography in New York City houses a collection of 10,000 prints. The collection is largely devoted to the work of journalists and documentary photographers. The center is predominantly an exhibition, publishing, and education center with its collection serving as a study collection.

New York City also hosts three other important photography collections. The New York Public Library has a substantial collection that includes significant treasures from both centuries of the medium's history. The New York State Historical Society houses more than 500,000 prints, almost all documentary and relating to the history of New York State. Newest among the collections is that of the Schomberg Center for Research in African-American culture. All together, the New York institutions are among the major collection resources for photography of all kinds and styles. All are open for research purposes and to the general public.

In Washington, D.C., the collections are the largest in the United States, including the Library of Congress, the National Archive, and NASA. In Washington the National Gallery and the National Museum of American Art joined the National Portrait Gallery in the 1980s in establishing departments of photography and photography collections. The National Museum of American History, a division of the Smithsonian Institution, also has one of the oldest collections of apparatus and rare classical prints.

The next most significant collection in the United States (five million prints) is that of the Harry Ransom Research Center at the University of Texas, Austin, which houses the original Helmut and Alison Gernsheim collection. The collection is renowned for containing the famous Niépce photographic image made in Gras in 1826.

Moving around the United States, the following museums (listed in no order of preference) maintain a strong commitment to collecting, and most have generally done so for two decades or more. These collections represent important areas of research potential even though substantial areas of duplication will be found among most of them. Among the most notable are the San Francisco Museum of Modern Art, the Los Angeles County Museum of Art, the J. Paul Getty Museum of Art, the Art Institute of Chicago, the Chicago Historical Society, the Minneapolis Institute of Arts, the New Orleans Museum of Art, the Amon Carter Museum of Western Art, the Museum of Fine Arts, Houston, the Oakland Museum, the Philadelphia Museum of Art, The Boston Museum of Fine Arts, the Cleveland Museum of Art, the Seattle Museum of Art, the Baltimore Museum of Art, the Worcester Art Museum, the Norton Simon Museum, and the Denver Art Museum. The Visual Studies Workshop in Rochester, New York, houses an extensive collection of contemporary photography and an unusual concentration of thousands of photographs of a vernacular nature from both the nineteenth and twentieth centuries.

University art museum collections are best represented by Princeton University, the University of New Mexico, the Sheldon Memorial Gallery of the University of Nebraska, the California Museum of Photography at the University of California, Riverside, the Fogg Museum at Harvard, the University of California, Los Angeles, Research Library, the University of California Bancroft Library, Stanford University, Yale University, University of Louisville, and the Rhode Island School of Design.

International museums of distinction include the National Museum of Photography, Film, and Television in Bradford, England, which is a general museum of photography. (Its collections are largely the result of being the beneficiary of the English Kodak Museum when it closed and the collections of the National Science Museum); the Musée d'Orsay with collections concentrating on the period 1840–1918; the Musée Carnavalet devoted to the history of Paris; the Beaubourg and its contemporary concentration; the National Archive and the National Gallery in Ottawa; the Folkwang Museum in Essen, Germany; the Alinari Museum in Florence, Italy; the National Museum of Photography (the Royal Photographic Society) in Bath, England, with its distinguished collection of nineteenth-century masterworks: the Canadian Centre for Architecture in Montreal, with collections specializing in the history of architecture and the history of photography; and the Israel Museum, Jerusalem.

The most notable characteristic of all international collections is that the majority are housed within departments of art museums. Even so, the largest collections are not in art museums but in government institutions and a handful of photography museums.

There is also a special category of photography collections that pertain to technology. Collections of cameras, processing equipment, and accessories account for a surprising number of museums worldwide. In Austria there is the Photomuseum des Landes Oberosterreich, which is a general collection of cameras and paraphernalia, with a heavy emphasis on Austrian material. The collection was a private one that was made public when it was installed in the former tea house of the Austrian Emperor in Bad Ischl.

Belgium has the Provinciaal Museum voor Fotografie in Antwerp, which houses a fine collection of cameras and accessories. It is the result of the acquisition of several private collections and a continuing acquisitions program.

In Czechoslovakia there exists one of the best kept secrets in the world of photography. The Narodni Technicke Museum v. Praze has more than 10,000 square feet of permanent display space and one of the largest collection exhibits in the world. The collection is rich in film equipment, cameras, and accessories.

France, a country rich in photography collections, has the Musée Du Conservatoire National Des Arts Et Metiers. It is one of the most extraordinary collections of photographic memorabilia, technology, and apparatus. Its collections range from early lithographs of Daguerre's dioramas to examples of the first color experiments and the history of the invention of cinema. Its collections are second only to that of the International Museum of Photography at George Eastman House in terms of the breadth of its technological objects. It contains by far the greatest number of objects owned by the great French inventors of photography including Daguerre, the Lumière Brothers, and Ducos du Hauron.

In Germany the Munchner Stadtmuseum, although small in size, represents one of the highest quality collections of ciné equipment and traditional cameras. Similarly small in size but housing a great collection of still cameras is the Museo Nazionale del Cinema in Turin, Italy.

The new JCII Museum of Technology is owned by the corporation of the same name in Tokyo. Large by local standards, this museum is one of the best-designed museum spaces for exhibition and preservation of technology collections. Its collection program is international, and it has some of the highest quality and rarest objects in existence.

Finally, the newest museum to join the international scene of major museums of technology is the Museum of Imaging Technology, which opened its doors in 1991. Located on the grounds of Chulalongkorn University in Bangkok, Thailand, it contains an international collection of cameras and technology as well as several galleries of interactive exhibits ranging from photographic printing technology to scientific experiments and contemporary photography.

At this writing, two new museums plan to open their doors in 1992. The Fotomuseum Winterthur near Zurich, Switzer-

land, plans initially to program exhibitions of contemporary photography and facets of production techniques. If history repeats itself, however, collections will follow closely behind. Also opening at about the same time will be a new International Olympic Museum in Zurich dedicated to the history of the Olympics along with an extensive photography collection representing the history of the Olympic games.

At the beginning of this article it was mentioned that private collections had so grown in number that they could not be considered in the context of public museums and collections. It is also true that private collections no longer have the position of importance that they once did in terms of being a dominate means of preserving the history of photography.

Today, museums and public collections exist in sufficient number to allow for planned preservation of the extraordinarily broad applications of photography. However, for more than a decade now, museums have not been able to financially keep pace with the market value of historical and artistic objects; private collections, therefore, continue to be crucial havens for some of the most important and finest quality objects of history. The nature of the relationship between public and private collections is one of symbiosis. Many of the great public collections, if not most, were once the private passions and obsessions of individual collectors. The greatly expanded arena in both collection areas promises an ever greater future for the history of photography.

J. Enyeart

MUTE Silent, especially a control to turn off an audio signal.

T. Holman

MUYBRIDGE, EADWEARD JAMES (1830–1904) English photographer. Journeyed to United States in early 1850s. Gained fame with spectacular photographs of Yosemite from his trips in 1867 and in 1872, when he used 20×24 inch collodion mammoth glass plates to great effect. Hired in 1872 by Leland Stanford to prove with photographs that at some time a galloping horse has all four feet off the ground. Successfully captured this circumstance in 1877 by assembling a string of cameras that made consecutive exposures at regular intervals. In 1879, synthesized motion with his Zoogyroscope, using drawings from serial photographs, producing the first animated movie. Published eleven volumes in 1887 containing 780 plates of the first serial photographs of humans and animals in motion. His work greatly influenced painters and stimulated other investigators in photographic analysis, synthesis of motion, and early cinematography.

Books: Mosely, Anita Ventura, ed., *Eadweard Muybridge: The Stanford Years, 1872–1882*. Stanford: Stanford University Press, 1972; Naef, Weston J. and Wood, James N., *Era of Exploration*. Buffalo and New York: Albright-Knox Art Gallery and Metropolitan Museum of Art, 1975.

M. Alinder

MYLAR A tough plastic material used for the backing for magnetic films and tapes.

T. Holman

MYOPIA An optical defect in which rays of light come to focus in front of the retina instead of on the retina.

L. Stroebel and R. Zakia

Syn.: *Nearsightedness.*

See also: *Vision, the human eye, testing for vision defects.*

n Nano (1/1,000,000,000th)

n Index of refraction

NA Numerical aperture

NAB National Association of Broadcasters

NAF Numerical aperture of fiber optics bundle

NAPET National Association of Photo Equipment Technicians

NAPhA North American Photonics Association

NAPM National Association of Photographic Manufacturers

NAPP National Aerial Photography Program

NBS National Bureau of Standards

NC Nocurl coating

NCS Natural color system

ND Neutral density

NEP Noise-equivalent power

NFS Not for sale

NG No good

NHAP National High Altitude Photography

nicad Nickel-cadmium cell

nm Nanometer

NPIA National Photographic Instructors Association

NPN One of two types of bipolar junction transistors

NPPA National Press Photographers Association

ns Nanosecond

NSA National Stereoscopic Association

NTSC National Television Standards Committee

nu(ν)-number Index of refraction (Greek letter) (Syn.: ν-*number*)

NADAR (Gaspard Fèlix Tournachon) (1820–1910) French portrait photographer, writer, and balloonist. First achieved fame as a satirical cartoonist. Opened a successful photographic portrait studio in Paris in 1853; for over 30 years his subjects were the city's rich and famous. Pioneered many fields in photography. In 1858, he made the first aerial photograph from a balloon, which he soon used for surveying, mapmaking, and even postal delivery. His balloon, "Le Geant," lofted a two-story gondola, capable of transporting 49 men, complete with darkroom essential for his collodion wet plates. Among the earliest to try electric light for portraiture, in 1861–1862 he used magnesium light to become the first to photograph underground with the catacombs and sewers of Paris as his subjects. He produced the first photointerview in 1886: his subject—the centenarian chemist M. E. Chevreul. Always closely involved with the arts and artists, in 1874 Nadar lent his studio for the first exhibition of the Impressionist painters. Author of a number of books, including *Quand j'étais photographe* (1899).

Books: *After Daguerre.* New York: Metropolitan Museum of Art, 1980; Gosling, Nigel, *Nadar.* New York: Knopf, 1976.

M. Alinder

NANO- (n) A prefix denoting one one-billionth (10^{-9}), as in nanosecond (ns, one-billionth of a second) or nanometer (nm, one-billionth of a meter). *J. Holm*

NANOMETER (nm) In the metric system (SI), a unit of length equal to one-billionth of a meter, i.e., 10^{-9} m. This unit is used for specifying the wavelength of light and other radiation. The wavelength of light extends approximately from 400 to 700 nm. The nanometer is preferred to the equivalent but obsolescent *millimicron*. *H. Todd*

NANOSECOND (nsec) In the metric system (SI), a unit of time equal to one-billionth of a second, which may be expressed as 10^{-9} second. *H. Todd*

NARRATION In motion pictures and video, a spoken commentary accompanying the picture, usually by someone unseen, as distinct from an actor's dialog. *H. Lester*

See also: *Voice-over.*

NARROW-ANGLE Term referring to lenses having a lesser angle of view than the standard lens for the image recording format in use. *S. Ray*

Syn.: *Long-focus; Telephoto.*

NARROW-BAND Refers to the spectral passband width of a filter, particularly of the interference type whose stack of thin layer coatings can be used to limit the spectral transmission to a spectral wavelength band of as little as 10 nanometers. An absorption filter may be used in series to narrow the shortwave side transmission even further. *S. Ray*

NARROW LIGHTING A portrait lighting style whereby the main light is located on the opposite side of the subject from the subject's visible ear, that is, on the narrow side of the subject's face. It is generally considered that this lighting makes a full face appear narrower. *F. Hunter and P. Fuqua*

Syn.: *Short lighting.*

See also: *Broad lighting.*

NATIONAL BUREAU OF STANDARDS (NBS) A branch of the federal government that is devoted to the improvement of quality of measurement in many fields. The photographic section is concerned with the measurement of characteristics such the edge sharpness and resolution of images and light intensity. *L. Stroebel*

See also: *Standards, photographic.*

NATIONAL TELEVISION STANDARDS COMMITTEE (NTSC)

The standards committee for color television broadcasting for the United States, Mexico, Canada, and Japan. The standard is a composite luminance/chrominance system that allows for monochrome monitors to receive luminance information of a color broadcast. Since computers are used to create video, any electronic imaging that will be passed through an NTSC system, such as video tape, must conform to NTSC standards. *R. Kraus*

NATURAL COLOR SYSTEM (NCS)

A color order system in which the colors are arranged in accordance with their perceptual proportions of whiteness, blackness, chromaticness, and unique hues (red, yellow, green, and blue). The whiteness ranges from 0 for colors that have no white content to 100 for pure whites. The blackness ranges from 0 for colors that have no black content to 100 for pure blacks. The chromaticness ranges from 0 for achromatic colors (whites, grays, and blacks) to 100 for colors that have no white content and no black content. The whiteness, the blackness, and the chromaticness always sum to 100, so that it is not necessary to quote all three, and the whiteness is usually omitted from the specification. The hue is quoted in terms of the percentages of the two unique hues involved. For example, Y80R means that the color is a yellow-red with 20% yellow and 80% red; the hues are always quoted in the order yellow, red, blue, green, yellow. NCS specifications are always given in the order blackness, chromaticness, hue. Thus, 20, 50, B20G indicates that the color has 20% blackness, 50% chromaticness (and hence 30% whiteness) and that the hue is 80% blue and 20% green. *R. W. G. Hunt*

See also: *Colorimetry; Munsell system.*

NATURAL LIGHT

Usually the sun and sky, but broadly any light source not of human manufacture.

F. Hunter and P. Fuqua

NATURE PHOTOGRAPHY

Since the invention of photography, the camera has been trained on the natural world as a source of inspiration, wonder, and fantasy. Today increasing numbers of people are turning to nature photography for these same reasons and for relief from the stresses of modern living. The past decade has witnessed an explosion of nature photography workshops, camera clubs, books, and magazine articles. Almost entire issues of magazines may be devoted to nature photography.

In general, nature photography encompasses everything from the largest of natural subjects to the smallest, everything from astronomical photography to images produced by scanning-tunneling microscopes. While the main body of nature photography includes the natural world from mountain landscapes down to lifesize and closeup photography, people and evidence of the hands of humans are generally excluded. One might include scenic and horticultural/garden photography in the nature photography category as they utilize similar photographic equipment and techniques.

Images made with either 4 × 5-inch or 35-mm cameras make up the bulk of nature photography. However, the use of medium formats such as 6 × 4.5 cm, 2-1/4 × 2-1/4 inches, 6 × 7 cm, and 6 × 9 cm, has increased with the availability of high quality black-and-white and color films as well as the incorporation of automatic exposure features. Yet large-format cameras, especially 4 × 5-inch view cameras, remain the camera of choice for many professionals. The 4 × 5-inch view camera offers perspective and plane-of-sharp-focus controls unavailable on most 35-mm and medium-format cameras. Negatives or transparencies made with 4 × 5-inch cameras have the potential for exceptionally high quality because of their large film size. Also, each sheet of film can be custom developed independently of other exposed sheets, allowing for *push* or *pull* development of transparencies and expansion or contraction development for black-and-white zone system applications. Lightweight field versions of view cameras are available, but extra sturdy tripod heads are required for professional results.

Most amateur nature photographers and a significant portion of professionals work with 35-mm cameras. While spontaneous wildlife photography demands the use of small- or medium-format cameras, advances in optical and film quality allow 35-mm cameras to be used with a wide range of subjects, including landscapes, which have been dominated by large format photography in the past. Superior 35-mm nature images can be made using high quality yet simple equipment. Devoted amateurs and professionals rely on gear that is dependable in climatic extremes. Cameras need to be tightly sealed against moisture and, in cases of electrical failure, have manual back-up functions. While numerous automatic exposure and focus options are featured on many camera systems, they are not essential and can impede serious photography. Most nature photography is greatly improved by the use of a sturdy field tripod and tripod head sized for the equipment used. Cable releases reduce vibrations caused by manually pressing on shutter release buttons. Lens hoods physically protect lenses as well as reduce flare (nonimaging-forming light).

Film choices vary depending on specific needs. Amateurs tend to prefer the exposure latitude of color negative films and the availability of negative film processing and printing labs. Most professionals work with high quality ISO 50 to ISO 100 speed transparency films because slides and transparencies are preferred by publications and audiovisual producers. Quality custom prints can be made directly from transparencies, however, onto color reversal printing papers.

Exciting nature images can be produced in all but the most inclement weather and climatic conditions. Many professionals and advanced amateurs actively seek fog, light rain, snow, wind, early morning, late afternoon, or overcast day lighting and avoid bright sunny days. Wildlife photographers not only must endure days or weeks of waiting in concealment, they have little choice of weather and lighting conditions (the availability of subject matter takes priority over weather and lighting). On the other hand, still life photographs from great landscapes down to the intimate world of closeups are held to much higher standards of composition and quality of illumination.

Effective wildlife photographers know the habits of their subjects in order not to cause them injury or stress while stalking or photographing them. So, too, the still-life nature photographers must realize that through study and understanding of the environment in which they work, appropriate precautions can be exercised to minimize or eliminate the potential to harm the very subjects so treasured by nature photographers and their audiences.

S. Diehl and V. Zaremba

See also: *Landscape photography.*

NC-CURVES

A set of curves used to rate the background noise of spaces in terms of human perception of noise. The NC-curves permit a higher measured sound pressure level of low-frequency noise than of high-frequency noise because human hearing is less sensitive to low-frequency noise than high. Some typical ratings are:

Recording studios	NC-10
Dubbing stages	NC-20
High-quality theaters	NC-25
Maximum permissible in theaters	NC-30

In particular, the NC-10 rating for studios appears lower

than historical ratings given for these spaces, but the wider dynamic range of the digital recording era has made lower acoustical noise levels desirable in recording spaces.

T. Holman

NCS See *Natural color system.*

NEAR DISTANCE Referring to normal human vision, this is the average value of the closest distance an object can still clearly be focused upon with the unaided eye. This value is usually assumed to be 250 mm (10 inches).

In the case of cameras, it is the closest unaided focusing distance of the camera lens without accessory items.

In the case of depth of field, the distance from the camera to the closest object plane that is imaged with acceptable sharpness.

S. Ray

NEAR POINT The closest distance a person can focus on so that printed material appears sharp. This distance normally increases with age.

L. Stroebel and R. Zakia

See also: *Accommodation; Vision, the human eye.*

NEBLETTE, CARROLL B. (1902–1974) American Author and photographic educator. Six editions of his first book, *Photography, Its Materials and Processes,* were published from 1927 to 1962 in addition to numerous other photographic publications. He became known as the "father of photographic education" for his successful efforts to promote photography as a legitimate field of study at the college level on an equal footing with established programs in the arts and sciences at the Rochester Athenaeum and Mechanics Institute (later renamed the Rochester Institute of Technology), where he served as a school director and a college dean. He was an honorary fellow of the Royal Photographic Society of Great Britain, and honorary member and a fellow of the Photographic Society of America, and vice president for education with the Society of Photographic Scientists and Engineers.

L. Stroebel

NEGATIVE An image in which tonal relationships are such that light subject tones are dark and dark subject tones are light. Films that produce negative images are sometimes referred to as negative films, negative-acting films, or nonreversal films to distinguish them from reversal films that produce positive images.

Negative color films not only invert the light-to-dark tonal relationship of the subject but also represent subject colors as complementary colors, so that a blue area in the subject is yellow in the image. The complementary nature of the image colors may not be obvious with color films that have dye masking layers to improve the quality of the final positive print image.

L. Stroebel

NEGATIVE CARRIER (1) See *Enlarger, film carrier.* (2) A device that holds a negative or transparency in an enlarger. Glass carriers hold the film between two panels of glass. Glassless carriers hold the film by the edges between two frames, a system that provides fewer surfaces for dust to gather on but that allows the film to buckle.

L. Stroebel

NEGATIVE LENS A lens that is thinner in the center than at the edges and which forms a virtual image of the subject.

S. Ray

See also: *Lens types.*

NEGATIVE LOGARITHMS See *Appendix F.*

NEGATIVE MATERIAL A photosensitive material for the production of negative images, usually in a camera. Negative images are tonally reversed with respect to the subject,

bright parts are dark and vice-versa. Color negative materials also render colors as their complements.

M. Scott

NEGATIVE-POSITIVE PROCESS Distinguished from a reversal process, a negative-positive process uses separate materials for the camera image (negative) and the final image (positive).

H. Wallach

See also: *Nonreversal; Reversal process/materials.*

NEGATIVE-POSITIVE VIEWER A viewer that permits a negative to be seen as a positive or vice versa. With one system, the image is projected by infrared radiation onto a fluorescent screen that is excited by ultraviolet radiation where the infrared proportionally quenches the fluorescence. Alternatively, the image is reproduced by closed-circuit television where the positive-negative polarity can be altered.

L. Stroebel

See also: *Video color-negative analyzer (VCNA).*

NEGATIVE-WORKING In photomechanical reproduction processes, identifying a plate (made from a negative) in which the areas receiving the exposure are rendered receptive to ink.

M. Bruno

NÈGRE, CHARLES (1820–1879) French painter and photographer. Studied with Delaroche and Ingres. Learned daguerreotype process in 1844, changing to the calotype in 1847. At first, used photography to aid his painting. A successful architectural photographer by 1851, between 1850 and 1854 took his camera into the streets of Paris, capturing people in their daily activities. Cofounder of the world's first photographic society, Société Héliographique (1851). Concerned with image permanence, he investigated various photomechanical processes, inventing a photogravure process by which he obtained excellent halftone pictures in 1856.

Books: Borcoman, James, *Charles Nègre, 1820–1880.* Ottawa: National Gallery of Canada, 1976; Jammes, Andre, and Janis, Eugenia Parry, *The Art of French Calotype.* Princeton: Princeton University Press, 1983.

M. Alinder

NEIGHBORHOOD PROCESS In electronic imaging, a filtering process that takes into account the neighboring pixels of the pixel to be filtered. The group of pixels is called a kernel. The spatial dimension of the kernel is a square composed of an odd number of pixels, 3×3, 5×5, 7×7, etc. Almost all electronic imaging manipulation programs use this filter for smoothing or sharpening an image.

R. Kraus

NEOCOCCINE A red dye that is applied to areas of a negative to absorb part of the actinic light, thus making them appear less dense on the print. The application of the dye can be controlled by dilution and control with the brush. Since the photographic effect may be different from the visual effect, prints should be made from time to time to gauge progress. This frequent proofing is needed less as experience is gained.

I. Current

Syn.: *New coccine.*

See also: *Opaqueing.*

NEO-PILOTTONE A synchronization method for 1/4-inch magnetic tape. Using neo-pilottone, a precise 60 Hz tone (in the United States) is recorded to correspond to 24 frames per second (fps). The recording is made with two small gaps out of phase with one another, so that the net sum of the two at a full-track playback head is zero, but a head having matching gaps can play back the tone.

T. Holman

See also: *Crystal sync.*

NETWORK In computers, a group of connected computers sharing a common protocol for communications. These networks can be local or wide in area and can connect several to many thousands of terminals. *R. Kraus*

NEUTRAL (1) Color name given to pure achromatic colors, that is, whites, grays, and blacks that are not tinged with any hue. (2) Color name given to pure achromatic color stimuli, that is, stimuli whose chromaticity coordinates are the same as those of the illuminant. *R. W. G. Hunt*

NEUTRAL DENSITY As applied to a photographic image or a filter, a term implying equal absorption of light at all wavelengths. In fact, typical neutral-density filters have higher absorption of blue light than green or red.
M. Leary and H. Todd

NEUTRAL-DENSITY FILTER See *Filter types.*

NEUTRAL TEST CARD See: *Input, test targets.*

NEWHALL, BEAUMONT (1908–1993) American historian, curator, and teacher. Acknowledged as the foremost historian in the history of photography. His wife, Nancy, was also a leading historian and writer. Educated at Harvard, Newhall was hired by New York's Museum of Modern Art (MOMA) as librarian in 1935. Creative photography became his passion and he curated the important historical survey *Photography: 1839–1937* for MOMA in 1937. Newhall was central to the establishment of the first department of photography in a major museum, at MOMA, in 1940, and served as its curator (1940–1945). In 1948, he became the first curator at George Eastman House, the International Museum of Photography, until appointed its director (1958–1971). Moved to New Mexico in 1971 where he taught at the University of New Mexico. Author of many seminal books, including his famous history of photography, first published in 1937. Cofounder of *Aperture* (1952), and founding member and trustee of The Friends of Photography from 1967. Recipient of the prestigious MacArthur Fellowship (1989). In the mid-1980s, he began writing his memoirs with the same scrupulous research and care that were his hallmark.

Books: *The Daguerreotype in America.* New York: Duell, Sloan & Pearce, 1961; *Latent Image.* New York: Doubleday, 1967; *Airborne Camera.* New York: Hastings House, 1969; With Nancy Newhall, *Masters of Photography.* Braziller, 1969; *Photography: Essays & Images.* New York, Museum of Modern Art, 1980; *The History of Photography,* revised and enlarged. New York: Museum of Modern Art, 1982. *M. Alinder*

NEWHALL, NANCY PARKER (1908–1974) American historian. Studied art and writing at Smith College. Married Beaumont Newhall (1933), who introduced her to creative photography. Appointed acting curator of photography at the Museum of Modern Art (1942–1945) while the curator, her husband, served in the armed forces. A prolific writer, she collaborated with Ansel Adams on many projects, including eight books from the early 1950s until her death, most notably *This Is the American Earth* (1960) and her biography of Adams, *The Eloquent Light* (1963). She contributed the poetic text for Strand's *Time in New England* (1950). Newhall authored or edited *The Daybooks of Edward Weston,* 2 vols. (1957 and 1961), *Masters of Photography,* with Newhall (1958), and *P.H. Emerson: The Fight for Photography as a Fine Art* (1975). Cofounder *Aperture* (1952). Founding member and trustee of The Friends of Photography (1967).

Book: *From Adams to Stieglitz.* Millerton, NY: Aperture, 1989. *M. Alinder*

NEWMAN, ARNOLD (1918–) American photographer. Established his New York studio in 1946, quickly becoming a popular commercial photographer with his first of many covers for *Life* in 1947. Best known for his strongly composed black-and-white environmental portraits of artists.

Books: *One Mind's Eye, The Portraits and Other Photographs of Arnold Newman.* Boston: Godine, 1974; *Arnold Newman's Americans.* Boston National Portrait Gallery, Smithsonian Institution, in association with Bullfinch Press/Little, Brown, 1992. *M. Alinder*

NEWS PHOTOGRAPHY The specialization of making photographs dealing with current events for use in newspapers, news magazines, or other publications or in television.
L. Stroebel

See also: *Photojournalism.*

NEWTON'S RINGS The colored zones (fringes) seen when a thin film of material on a substrate causes interference effects between reflections from it and the substrate. Examples are those of an oil film on a wet road and fringes seen in a color transparency in a glass mount. *S. Ray*

See also: *Antinewton.*

Newton's rings.

NICKEL-CADMIUM (NICAD) BATTERY See *Battery.*

NIÉPCE, JOSEPH NICÉPHORE (1765–1833) French inventor of photography, which he called *heliography.* In 1816, using a camera obscura, obtained negatives by the action of light on paper sensitized with silver chloride, but could only partially fix them. By 1822, succeeded in making a permanent image by coating a pewter plate with bitumen of Judea, exposing it for many hours by direct contact, washing away with lavender oil the shadow portions that had not been hardened by light and thus obtaining the first permanent, direct-positive picture. The earliest surviving photograph from nature, taken in a camera, dates probably from 1826 and is now in the Gernsheim Collection at the University of Texas, Austin. Niépce was the first to use an iris diaphragm and bellows in his cameras. In 1829, substituting silvered metal plates for pewter, he found he could darken shadows (bare silver) by iodine fumes. He described that in detail in his supplement to the partnership agreement that he concluded with Daguerre in 1829, and doubtless contributed to Daguerre's discovery of the light sensitivity of iodized silver plates in 1831. Niépce died in 1833, leaving the completion of their work to Daguerre.

The subsequent history of the Niépce-Daguerre invention will be found in the biographical entry on Daguerre.

Books: Buerger, Janet E., *French Daguerreotypes.* Chicago and London: University of Chicago Press, 1989; Gernsheim, Helmut, *The Origins of Photography.* London and New York: Thames & Hudson, 1982; Jay, Paul, *Niépce, Genesis of an*

Invention. Chalon-sur-Saone, France: Society des Amis du Musee Nicephore Niépce. 1988. Newhall, Beaumont, *Latent Image*. New York: Doubleday, 1967. *M. Alinder*

NILSSON, LENNART (1922–) Swedish photographer. Pioneer medical photographer, who, using fiber optics, was the first to photograph the growth of a fetus inside the womb, published in his landmark book *A Child Is Born* (1965). Produced many photo essays on the human body for *Life*.
M. Alinder

NIMSLO 3-D CAMERA A 4-lens stereo camera that records four images at slightly different angles on half-frame 35-mm color negative film. The four negatives are then printed on a color print material having a lenticular surface. The prints can be viewed without any special stereo viewing device since the lenticular surface on the prints serves that purpose. The Nimslo camera was manufactured by the Scotland branch of the Timex watch company and introduced in Florida in 1982. The name Nimslo is taken after its inventors who worked for 12 years perfecting the camera, Jerry Nims and Allen Lo.

The print material was made of plastic scribed so that it had a lenticular surface of 200 lines/inch and coated on the non-scribed surface with a color print emulsion by the 3M corporation. To print the color negatives required a printing system with four lenses pointing at slightly different angles. Although the camera was a well designed high quality instrument with excellent lenses the ability to print the four color negatives in perfect alignment on a print material having a lenticular surface and to do it in a productive manner and with a reasonable turn-around time created major problems that led to the demise of the camera.

In 1989 the Nimslo camera was resurrected, modified slightly, and renamed Nishika N8000. To give the camera a sophisticated look, the Nishika N8000 sports a dummy pentaprism, fake liquid crystal display (LCD) panel and a simulated power-winder grip. It listed for about $200 in 1989 and is not of the quality of the original Nimslo that listed for about $250 in 1982. The exposed film is sent to Nishika's Nevada processing plant that claims to have corrected the complexity of printing with new high-tech computerized printers. *R. Zakia*

See also: *Cameras, stereoscopic.*

NIT See *Candela per square meter.*

NITRATE FILM Photographic film coated on a cellulose nitrate (celluloid, celloidin, collodion) support. Nitrate was the earliest type of flexible, transparent support. While it had many desirable properties as a support, it is no longer used because of its extreme flammability and its eventual self-destruction. It has not been manufactured since 1950.
M. Scott

NITROGEN-BURST AGITATION A method of agitation during processing using nitrogen gas bubbles that are emitted from an array of perforated pipes at the bottom of the processing tank. Release of the gas at appropriate intervals causes mixing of the processing bath, and the rising bubbles agitate the solution near the material being processed. Gaseous-burst is a more general term, including agitation by bubbles of air or other gas as well as nitrogen.
L. Stroebel and R. Zakia

See also: *Agitation; Processing.*

NO-BREAK A power supply system that automatically switches to an alternative source in the event of a supply failure, for example, a battery or a generator as a backup for the building electrical line current. *L. Stroebel*

NODAL HEAD A design of support for a camera on a tripod that allows horizontal panning movement to be centered on a vertical axis through the rear nodal point of the lens in use. The viewpoint stays constant as the camera is moved. Used in some designs of panoramic cameras. *S. Ray*

NODAL POINTS/PLANES Two of the six cardinal or Gauss points/planes used to define the parameters of a lens. Nodal points are two points on a lens axis such that a ray of light directed toward one appears to leave from the other. Although the ray of light can actually change direction only at the lens surfaces, it is here assumed to travel in a straight line to the object nodal point and to leave in a straight line from the image nodal point. The entering and departing rays will be parallel but displaced. The nodal planes are perpendicular to and intersect the lens axis at the nodal points. When there is the same medium such as air in both the object and image spaces, then the nodal and principal planes coincide. Focal length and image conjugate distances are measured from the rear nodal point, and object distances are measured from the front nodal point. Rotating a lens about a vertical axis through the rear nodal point keeps the image of a distant object stationary, a property used in determining the location of the nodal points of a lens and also in determining the correct location of the pivot point for panoramic cameras.
S. Ray

NODAL SLIDE A device used with an optical bench to determine the focal length of a lens. It has a variable vertical pivot point to locate the rear nodal point when there is no image movement of the reticle in a collimator. Focal length is the node to image distance. *S. Ray*

See also: *Lenses.*

NODE One computer or terminal on a network. *R. Kraus*

NOISE (1) Noise refers to random variations, associated with detection and reproduction systems, that limit the sensitivity of detectors and the fidelity of reproductions, such as an unwanted humming sound in an audio system. By analogy, the same term is applied to nonaudio systems, such as the granularity of photographic images. (2) In electronic imaging, the presence of unwanted energy in the signal. This energy will degrade the image. This is comparable to photographic flare, i.e., nonimage-carrying energy.
I. Current and R. Kraus

See also: (1) *Signal-to-noise ratio.*

NOISE (SOUND) Technically a sound is said to be noise-like when the signal cannot be distinguished as having tonal properties. Examples: waterfall, most jet engine noise, most air conditioning background noise. In more common usage, *noise* is any undesired signal. *T. Holman*

NOISE FILTER (1) Usually a low-pass filter, sometimes made dynamic responding to the high-frequency content of program material. The idea is that if there is high-frequency program material it will mask high-frequency noise, so that there should be no filtering, but in the absence of high-frequency program, then the filter should be applied to attenuate noise that often takes on the audible character of hiss. (2) In electronic imaging, the degrading effects of noise can be removed by the application of a noise filter, for example, a Weiner filter or a fast Fourier transform.
T. Holman and R. Kraus

NOISE METER An electrical meter equipped with frequency weighting filters, the sensitivity of which is made to simulate human perception so that comparative results correspond better to perceived noise. Noise meters also may use

more than one ac-to-dc converter so that various problems may be diagnosed; in particular, the ac-to-dc converter may have switchable time constants so that short bursts of noise like clicks can be recognized and measured appropriately.

T. Holman

Syn.: *Phosphometer (European use typically).*

NOISE POWER SPECTRUM See *Wiener spectrum.*

NOJIMA, YASUZO (1889–1964) Japanese photographer and publisher. Acknowledged for introducing and nurturing creative photography in Japan. A highly respected photographer, he made gum-bichromate prints in service to a pictorialist vision that matured as the century progressed to one dedicated to purely photographic means. Began the first Japanese journal devoted to modern photography, *Koga*, in 1932. A man of independent wealth, Nojima financially supported the work of other artists and opened some of the first art galleries in Japan to exhibit photographs. *M. Alinder*

NOMINAL SCALE A set of categories that are identified by names. In assessing the quality of photographic prints, for example, viewers might identify individual prints as being simply acceptable or unacceptable, a two-category nominal scale. An expansion of such a scale might include such labels as excellent, good, fair, and poor. *H. Todd*

See also: *Interval scale; Ordinal scale; Ratio scale.*

NOMOGRAM/NOMOGRAPH A graphical display of two or more scales, which when crossed by a straight line gives the numerical (or other) solution to an otherwise difficult computation. *H. Todd*

NONACTINIC An adjective that describes light or other radiation that does not possess sufficient energy to cause chemical change. Silver halide crystals are sensitive to violet and blue light but do not respond to the rest of the light of the spectrum, which could be identified as nonactinic light. This makes red safelights usable in darkrooms for unsensitized photographic materials, such as photographic paper for black-and-white prints. Most photographic emulsions are now spectrally sensitized by dyes to make panchromatic materials that respond to all colors of the visible spectrum. *G. Haist*

NONCURLING Describes film with a balancing coating of gelatin on the side opposite the emulsion which causes it to resist the tendency to curl, especially in extremes of temperature and humidity. *M. Scott*

NONIMPACT PRINTER An electronic printing device such as a copier, laser, or ink-jet printer, that creates images on a surface without contacting it. *M. Bruno*

Syn.: *Pressureless printing.*

NONINTERLACED In electronic imaging, the cathode-ray tube (CRT) may be interlaced or noninterlaced. An unwanted effect of an interlaced scanning display is annoying and distracting flicker. Noninterlace monitors write every video line in sequence. The result is the disappearance of flicker. *R. Kraus*

NONLINEAR PERSPECTIVE The appearance of depth in an image due to factors other than the convergence of parallel subject lines or diminishing image size of objects with increasing object distance. The factors include overlapping objects, depth of field, lighting, aerial haze, color, stereoscopy, and holography. *L. Stroebel*

See also: *Perspective.*

NONLOSSY In electronic imaging, an image compression technique that is designed to save storage space and not lose any image data. *R. Kraus*

NONRANDOM Characterizing a type of variability in which differences in observed results are caused by factors other than chance. Camera shutter times at a fixed setting vary slightly by chance; a time change caused by very cold weather would be a nonrandom effect. *H. Todd*

NONREVERSAL The term *nonreversal* may refer to a process or to a light sensitive material, either film or paper. It indicates that a positive is produced from a negative, or that a negative is produced from a positive. It is distinguished from a reversal film, paper, or process in which film from the camera produces a positive image after processing, or when a positive print is made directly from a positive original. Nonreversal applies most appropriately to intermediate steps in an extended process in which it is inaccurate to say *negative* or *positive*. *H. Wallach*

NONSILVER PROCESSES For the purpose of this article, nonsilver processes refers to a broad range of diverse photographic processes that do not use silver salts for light sensitivity and that do not result in a final image consisting of silver. Besides this literal definition, since the 1960s the term *nonsilver photography* has become synonymous with *alternative photographic processes*. This implies that all processes other than silver become incidental and are grouped together without individuation. The result of this is an assumption of an ideal photographic convention being a straight or unmanipulated photographic print. It is not the purpose of this article to debate the art/photography issue or to explain the historical implications of these arguments. It is important to understand the relationship of art photography to nonsilver processes because these processes are an important vehicle by which art photography breaks photographic conventions. Certain qualities of photographic processes are generally perceived as being inherently photographic. It was common, historically, that the commercially available support materials of the day defined the convention. The gelatin silver print holds that position today and, consequently, photography questions the inclusion of other kinds of imaging processes. It is particularly interesting to pinpoint exactly where in its history photography splintered the idea of process from that of aesthetic since photography owes it existence to the natural inclination—rooted in the nine-teenth–century traditions of art, science, chemistry, optics and philosophy—of creating an environment of experimentation and invention. So, historically, the photographic ideal was continually evolving and being rapidly redefined, predicted on each new invention and each new discovery. It was not until debates pertaining to the nature of art and photography and the examination of the expressive qualities of the medium after the beginning of the twentieth century, that the Pictorialists challenged the supremacy of painting over photography as art. The point of departure became the print itself, whether it extended the expressive potential of the medium by interpreting the negative through manipulation or remained faithful to the record. This controversy weaves a complex web around the very nature of the relationship of photography to art that centers the debate on the intrusion of the artist's hand upon the unrelenting mechanical eye of the camera, that influences the choice of process and the way the image is interpreted through the use of specific materials.

HISTORY OF NONSILVER PROCESSES It is necessary to examine the early history of photography in order to understand how the evolving technology that brought the photograph into existence blazed a trail of immense explo-

ORIGINAL SOURCE IN K

T_1

FILTER
REQUIRED

CONVERTED SOURCE IN K

T_2

Nomograph for light source conversion.

ration and experimentation using nonsilver processes. There were literally hundreds of processes invented between 1839 and 1885. Each practicioner of photography was required to learn how to manipulate chemicals and chemical apparatus, and the photographic journals of the day were filled with descriptions of new techniques and improvements developed by energetic amateurs. The development of nonsilver photographic processes is the very history of photography itself. The birth of photography is marked in history books by Daguerre's dramatic announcement in 1839 of his invention of the daguerreotype. However, the earliest photograph was created in 1826 in France by Joseph-Nicéphore Niépce. *View*

from the Window at Gras was the first permanent photograph based on his experiments that started in 1822. It was made of a layer of bitumen of Judea, a type of asphalt that becomes insoluble when exposed to light, thinned with oil of lavender, then coated on a polished pewter plate. After exposure, the plate was washed with oil of lavender and turpentine. The areas of bitumen that had not hardened by exposure to light were dissolved. This process became known as heliography, the first nonsilver process. What is interesting to note about this process is that it came out of Niépce's desire to duplicate visual information. Once having adhered the photographic image onto a plate, he experimented with etching and inking it like an intaglio printing plate. In 1829, Niépce and Daguerre formed a partnership and in 1839 the heliographic process and the daguerreotype were announced to the public by Daguerre and Niépce's son. Niépce died four years after the partnership was formed, and both the heliograph and Niépce contributions were overshadowed by the uproar over the invention of the daguerreotype. The hand of the artist immediately applied itself to the daguerreotype. It was commonplace to draw, retouch, remove, and hand color a daguerreotype to contribute or alter the mechanical eye of the camera.

Cliche-verre, literally meaning "drawing on glass," is a cameraless process invented by three English engravers shortly after William Henry Fox Talbot introduced his negative-positive process in 1839. Materials such as varnish, asphalt, and carbon from the smoke of candle, were applied to make a sheet of glass opaque. Once dry, an etching needle was used to draw, paint, or scratch away an image through the applied surface. This was then used as a *negative* to make numerous impressions that were contact-printed onto light-sensitive materials. In the 1850s, Adalbert Cuvelier updated the process by incorporating the recent photographic discovery of the collodion glass plate process with cliche-verre. Artists from the French Barbizon school, particularly Jean-Baptiste Corbot, used this process as a means to produce quick and inexpensive editions of monoprints. Although this marked the heyday of cliche-verre, such notable later artists as Man Ray, Brassai, Max Ernst, Picasso, Paul Klee, Fredrick Sommer, Henry Holmes Smith, and Joel-Peter Witkin revived interest in the process in the 1960s. The number of ways that cliche-verre can be used in conjunction with other processes is limitless.

Iron Salt Process What proceeded Niépce's early experiments in France was an era of exploration of light-sensitive materials that is unprecedented throughout the history of photography. Many different metallic salts were investigated in regard to their light-sensitive properties. None, however, yielded as many successful possibilities as the ferric salts. When combined with other chemicals and exposed to strong ultraviolet radiation these salts produce a reaction in three primary ways. The first is when there is a light-hardening effect of ferric salts on a colloidal compound. The second is the ability of ferric salts to react chemically with certain metallic compounds to form images of metallic precipitate. The third relies on the reaction of iron salts with chemical compounds to form a colored by-product that creates an image. Some of these processes, now obsolete and anticipated, were important stepping stones to the processes that followed. Catalsotype, chromatype, chrysotype, amphitype, anthotype, energiatype, and fluorotype were just some of the processes developed in the 1840s that did not survive. However, the one process that has survived from this period of time, leaving a rich body of work behind, is the cyanotype process.

Sir John Herschel, a famous English scientist, astronomer, inventor, and friend of William Henry Fox Talbot, made numerous achievements and contributions to the field of photography and photochemistry including the discovery of a method of permanently *fixing* an image by the use of sodium thiosulfate (hyposulfite of soda) in 1819. He is also credited with coining the terms *photography,* and *negative* and *positive* for the image made in the camera and the print resulting from it, in reversed tonalities. In 1842, in a paper to the Royal Society of London entitled "On the Action of the Rays of the Solar Spectrum on Vegetable Colours and on Some New Photographic Processes," Herschel described for the first time the discovery of the printing process that used the sensitivity of iron salts to light. He also invented the chrysotype process, which depended on the exposure to light of ferric salts and the development of the ferro-image with gold and silver solutions. The cyanotype process, from the Greek meaning *dark blue impression,* also known as the blueprint of ferroprussiate process, is an exceedingly simple process based on the reactions of two chemical compounds, ferric ammonium citrate and potassium ferricyanide. The resulting image is a combination of ferrous ferricyanide and ferric ferrocyanide. The two compounds are each separately mixed with water to form two solutions that in turn are mixed in equal parts to form the light-sensitive solution that is then coated on paper or cloth. The support is dried in the dark and is contact-printed by exposure to light through either a negative, to make a print, or an object, to make a photogram. It is then simply washed in a bath of running water to permanently *fix* the image and develop its characteristic *cyan* blue color and matt print surface. Out of the many photo discoveries Sir John Herschel made, the cyanotype process became the most commercially successful.

The major user of the cyanotype process during Herschel's lifetime was one of the earliest woman photographers known, Anna Atkins. Her remarkable *British Algae: Cyanotype Impressions* was the first book to use photography for scientific illustration. Predating William Henry Fox Talbot's *The Pencil of Nature,* the first of her three volumes was published in 1843. These volumes combined scientific accuracy with the cyanotype process to document Atkin's, extensive research on her vast seaweed collection using actual specimens. The cyanotype process was particularly suited due to its low cost, permanence, simplicity of process, and freedom from any patent restrictions. However, its unchangeable blue image color, particularly suitable for illustrations of seaweed, kept the cyanotype from entering the mainstream of photographic practice.

The cyanotype process became popular again at the turn of the century but was used mostly by amateur photographers. Family album quilts, using cyanotype on satin, are but one unique example of the work produced at this time. It was also at this time that architects, shipbuilders, and draftsman, began to use commercially prepared cyanotype paper to generate fast, inexpensive copies of line drawings and architectural renderings. But the blueprints of today are actually produced using the diazo process. Paper treated with diazonium salt and a coupler compound is exposed to ultraviolet radiation, which decomposes the salts in areas corresponding to the clear areas of the transparency. The paper is processed in ammonia fumes, which makes the sensitized coating alkaline. This causes the coupler and the unexposed diazo crystals to link up forming the dyeline image. This paper may be purchased very inexpensively and is still used by architectural and engineering firms to reproduce large-scale plans and drawings cheaply and quickly, and it is available in red, brown, blue, and black.

Another process, patented in 1878, with very similar qualities to the cyanotype process, and occasionally referred to as the positive cyanotype, is the Pellet process. This more obscure process, which produced a positive image from an original positive (the reverse of the cyanotype), used gum arabic as a collodial body to suspend the sensitizer consisting of ferric ammonium citrate and ferric chloride. The ex-

posed material was developed in a bath of potassium ferrocyanide, which produces the characteristic blue of the print. This process eliminates the additional step of making a negative from a film positive to achieve a positive-reading print.

Herschel's idea, to precipitate precious metals by exposing ferric salts on those parts of the image where ferrosalts form, was dramatically improved when platinum salts were introduced to this process. Herschel gave an account of the reductive action of light on a salt of platinum at a meeting of the British Association of Oxford. In 1844 Robert Hunt published his own experiments with platinum in his book *Researches on Light*. But not until Englishman William Willis, on June 5, 1873, patented his new photographic printing process that was based on the use of combining ferric oxalate with platinum salts was the platinum process of printing perfected. Willis, realizing the instability of silver images, set out to develop a more permanent alternative called the platinotype and billed the process as "Perfection in the Photomechical Process." The exquisite quality of the image, matt surface, neutral black tone, and the extraordinary permanence of the image ensured wide acceptability of the process.

Monochromatic Pigment Processes Between 1860 and 1910, there was an explosion of photographic printing processes that were invented to produce photographic images in pigment rather than silver or other metals. Some of these processes never died out altogether and are still a viable form of image making today. These processes are still taught, and prints utilizing them are supported and encouraged through the art market and within the gallery/museum structure. They were created for several reasons that addressed specific needs:

1. In early photographic processes, silver images were not completely stable. Images in pigment, however, are very stable and permanent. They are not susceptible to the fading and discoloration that have plagued the development of the silver processes.
2. The pigment processes particularly, through the various steps, allowed and encouraged at times dramatic alteration and manipulation of the image. At this time photography was trying to emerge as a fine art so that imitations of paintings, etchings, drawings, pastels, and other fine-art mediums were in vogue. This went, sometimes, so far as to completely conceal the photographic origins of the image.
3. Pigment process materials were much less costly and therefore commercially more viable that other metal-imaging materials, like platinum and gold, that could equal the pigment processes permanence.
4. The pigment processes offered some of the first feasible color processes, because pigments, watercolors usually, were offered in a wide variety of colors. Ranging anywhere from the more neutral colors of the lamp blacks to the sepias and warm reddish browns to the realization of a polychrome image. It was also a way to introduce color without having to have the artistic skill and control necessary to hand apply the paint.

Almost all the pigment processes utilize one of two basic methods of working. The first is where pigment is literally part of the emulsion of the print material. The process of exposure fixes or hardens the pigmented gelatin in direct proportion to the negative, and development washes away any of the unexposed pigment, which results in a positive image. The carbon and gum bichromate processes work in this way. The other method relies on exposure to make an unpigmented emulsion or surface receptive so that it will retain pigment either dusted on it or transferred by pressure to it, or attached by either a chemical reaction or an electrostatic charge. Examples of this are the bromoil process and xerographic printing.

Color Techniques Predating the invention of photography, in 1807 Thomas Young revealed that our perception of color is based on only three basic colors: red, green, and blue. These he called the *additive* primaries because when added together in varying amounts they can produce all the other colors found in the real world. In 1839 Daguerre announced his astounding invention—the daguerreotype—to the world in Paris. Even before the photographic process was perfected, attempts to incorporate and reproduce color photographically were made. In 1859 and again in 1861 in London, James Clerk Maxwell gave a three-color photographic slide presentation in which he projected images from film positives that he prepared by exposing film through a red filter, a green filter, and a blue filter, which when superimposed in register on the screen produced what appeared to be fairly realistic color pictures.

The second system of color is called the *subtractive* system of color that relies on using colorants that are complementary in color to the additive primaries, namely cyan, magenta, and yellow. Even though the Lumière brothers devised the first practical color system in 1907 called the Autochrome process, the color print had to wait until the 1920s, when José Pe invented the dye-imbibition process. Color separations were made by exposing three separate negatives of the subject, one through a red filter, one through a green filter, and one through a blue filter. From these separation negatives, film positives, called matrices, were made and developed in a gelatin tanning solution that hardened the gelatin in direct proportion to the light exposure received. After conventional development and fixing to removed the unexposed silver halides, the unexposed gelatin was washed away with hot water. The matrices were each soaked in a dye bath, drained and transferred sequentially in register onto a photographic paper coated with gelatin (an emulsion without silver compounds). The paper is prepared in a buffer solution so that the dye will migrate quickly from the matrix to the gelatin paper. The red-filter negative produces a cyan matrix, the green-filter negative a magenta matrix, and the blue-filter negative a yellow matrix. This became the basis of the dye transfer process that is still being commercially used today.

The carbon process predated the dye-imbibition process. Initially it was a monochromatic process, invented in 1855 by Poitevin, that used the photosensitive qualities of potassium bichromate to sensitize gelatin. This process became popular and practical in the late 1890s, using carbon black as the pigment of choice for the print, hence the name of the process. The logical development of this process was to substitute cyan, magenta, and yellow colorants for the black pigment, to make three separation negatives, and produce three pigmented gelatin positives which, when transferred in register, yielded a full-color photographic carbon print. The carbro printing process further improved on this by utilizing a silver bromide print immersed in a bath of potassium ferricyanide to change the metallic silver to silver ferricyanide. When the print is placed in contact with a sheet of bichromated gelatin, the silver ferrocyanide image tans or hardens the gelatin as if it had been exposed to light. The print is then removed, washed and reused to make another color print, and the gelatin sheet is developed in hot water and transferred to a final support in register with the other primary colored images to complete the color print.

Kwik Print, a more contemporary form of the gum-bichromate process, found a commercial market as a quick, inexpensive color-proofing system used by commercial printers to check the accuracy of their color separations. It also found an artistic market promoted by the photographic artist Bea Nettles in her publications *Flamingoes in the Dark* and

Breaking the Rules, A Photo Media Cookbook, in which she demonstrates ways the process can be artistically manipulated.

CONTEMPORARY TRENDS AND NEW TECHNOLOGIES The technological changes that have brought photography out of the darkroom and into the light via the computer and electronic imaging have not occurred suddenly or unexpectedly. These changes, in fact, continue the journey established early in the nineteenth century with the camera lucida, the camera obscura, and the camera. What started out based on the blending of light, alchemy, and paper to record, store, and transmit visual images is evolving into an electronic imaging system. Developing tanks, enlargers, and chemicals are being replaced by copiers, computers, software programs, and laser printers with an infinite range of possible manipulations that are based on nonsilver technology.

In their search to modulate the camera's precise and mechanical record, and in their struggle to glorify photography to the status of fine art where artistic influence was the ultimate creator of the image, the Pictorialists, which included Edward Steichen, Gertrude Kaesebier, Robert Demachy, Frank Eugene, Annie Brigman, and J. Craig Annan (to name but a few), reached its peak of popularity in 1910. The hand-manipulated printing processes that were the signature style of the Pictorialists continued to be used into the 1930s but with less and less frequency. Photographers began to respond, in Europe, and America through Alfred Steiglitz's 291 Gallery, to the abstract forms of cubism and the chaotic challenges of the surrealists, leaving the manipulative processes behind in an attempt to serve this new vision directly through the camera lens.

The straight, unmanipulated image printed on a commercially available photographic paper prevailed from the 1930s until the early 1960s. Ansel Adams, Edward Weston, Paul Strand, Imogen Cunningham—all became a part of a enduring movement in photographic history that has become the photographic convention even today, that touted the clarity of the photographic lens even and the objectivity of the *photographic eye.* The 1960s was a time of great social upheaval in the United States initiated by the Vietnam War. Photography in the 1960s was also defined by a rebellion against the traditional, dominant form of photography that generated a revival of the historic nonsilver photographic processes. This renaissance of print manipulation grew out of a desire to redefine parameters and blur the boundaries of photography and art. Based on their willingness to embrace popular culture, the Conceptual art and Pop art movements, which included artists like John Baldessari, Robert Rauschenberg, and Andy Warhol, used the photographic medium because of photography's powerful ability to define and perpetuate cultural myths and exploit the mass media. At the same time, influenced by these artists but interested in maintaining the inherent reality of the photographic image as a starting point, were photographic artists Betty Hahn, Bea Nettles, Robert Fichter, and Robert Heinecken, to name a few. Photography in the 1960s could be characterized by a radical transformation that was manifested by the willingness and insistence of artists to challenge and somehow interrupt or interfere with the accepted conventions of the medium. This period was one of great exploration that echoed the climate of diversity that had surrounded the discovery of photography itself. It differed, however, in that the struggle for recognition of photography as a fine-art form was no longer an issue. The relationship of painting and photography, specifically, and the relationship of photography to the plastic arts, in general, was less an adversarial role and more an interdisciplinary one than it was at the turn of the century.

Also at this time, a group of image makers began to explore the *new technologies* in an on-going attempt to broaden and expand the definition of photography. The straight photographer's acceptance of the limitations imposed by the mechanical nature of the camera came to be what defined the medium in its pure form, and their exploration of the expressive and metaphorical aspects is what helped establish photography's credibility as an art despite its dependency on a machine. By employing electronic-imaging systems and other commercially used processes, contemporary photographers like Sonia Sheridan, William Larson, Joan Lyons, and Sheila Pinkel continued to challenge photography's relationship to the machine through the use of nontraditional photographic materials. This reliance on the machine was no longer considered limiting or distasteful in the post-industrial society. Instead, it was seen as something with enormous potential for artistic expression. This mirrors the nineteenth-century distrust of machines vs. the twentieth-century embracing of them.

The office copier was invented to generate fast, inexpensive, and accurate reproductions of documents used in business. It is also a process that is available to almost everyone and is capable of transforming and manipulating images that can generate new visions. The use of these machines immediately brought into question the validity of photography to accurately describe what the world looks like. Copy machines for the most part act like a simple camera without a bellows adjustment. Therefore it produces a very flat, very limited depth of field that extends approximately one-quarter of an inch above the copier plane or copier glass. Black-and-white copiers use an electrostatically charged monochromatic toner that forms an image on paper and that is then fused or melted onto the paper support. The more recent development of the color copier forms an image using the subtractive system (cyan, magenta, and yellow), with each color made up of a thermoplastic powder, called a toner or pigment, that is electronically fused onto the paper. Laser copiers are the latest and most technologically advanced development in the history of electrostatic processes. This machine relies on a scanner that reads the image and converts it to digital signals which are then transmitted to a laser printer capable of subtle color/tonal distinctions. This machine also uses the subtractive color system with the addition of black, which creates a more accurate sense of color and depth of field in image reproduction.

Chester F. Carlson, in the late 1930s, invented this new technology, called *electrophotography,* then sold the patent to the Haloid Corporation in Rochester, New York. Calling the new process *xerography,* it was put into practice in 1948. It did not, however, really become practically and commercially viable until 1960 with the introduction of the Xerox Copier #914 that remedied the early models' problems of being cumbersome, messy, expensive, and slow. The advantages of the present day machines are many, including:

1. Rapid, consistent, and relatively inexpensive duplication and production.
2. The ability to make a color copy from a 35-mm slide or a 35-mm negative.
3. An amazing amount of color control and manipulation, overall or specified areas only, of the color reproduction, which includes a color balance memory that can be programmed.
4. Contrast adjustment and control of reproduction.
5. Image size easily scaled up or down, including framing devices that allow the operator to frame, compose, obliterate, or segment the image and/or text, if desired, into as many as 16 segments.

Artists using copier machines to create art shattered the preconception that the copy machine's single function was to produce a facsimile of the original image. In 1979, a seminal exhibition of art created on copy machines entitled "Electroworks," curated by Marilyn McCray at the International Museum of Photography at George Eastman House in

Rochester, New York, cinched the marriage of art and technology. The exhibition embodied work that combined *copier aesthetics* with every possible artistic medium including painting, sculpture, ceramics, printmaking, photography, video, film, animation, design, conceptual art, performance art, artists' books, mail art, and poetry. Installed along with the works of art were the machines themselves, with artists scheduled to generate art on them throughout the duration of the exhibition.

Due to the immovable nature of the copy machines, the photographic artist was once again relegated to the studio as the arena for the picture and art making. As in the nineteenth century when the subject was brought to the photographic artist who confined to the studio by slow film emulsions, bulky equipment, and process limitations, so the subject was brought to the machine in the twentieth century. Printing photographs on material other than sensitized photographic paper can also be traced to the second half of the nineteenth century when it was common for photographs to appear on glass, porcelain, tile, leather, and fabric.

Although called copies, the prints generated by the machines were considered original works of art conceived as unique objects, but due to the very nature of the machine art could be generated quickly, cheaply, and efficiently. This called into question the sacred artistic concept of the *original*. Artists had embraced a process that challenged the concept of creativity and brought into focus one of contemporary art's most curious paradoxes—technological processes designed for mass production but used to create singular works of art. The ability of the machine to rapidly generate images, however, is paralleled only by the use of electronic media such as electronic still photography and video.

Electronic Imaging: Present and Future Since the 1960s, computer technology has dramatically changed our understanding of photography. The way we read and process visual information has been challenged not unlike how copy machines altered our perceptions of *real* and *original*. Bridging the gap between technology and art, computer graphics offers a broad spectrum of manipulations and controls over the creation of visual images that dissolve the boundaries between real and fabricated. Computers have also dissolved the boundaries between one medium and another. The computer's astounding ability to assimilate or appropriate information seamlessly from one medium to another, disguising the origins of information, is unsurpassed in the history of image making. It destroys the idea of photographic truth. The implications of this are profound, affecting how pictures are made, stored, and disseminated. Our ability to detect image manipulation lessens as the sophistication of computer technology grows, the quality of image resolution improves, and accessibility to equipment expands. Photography, since its invention, has struggled with the mechanical nature of the medium. The nineteenth-century photographer's insistence of challenging this inherent quality of photography with the physical alteration of the image by the hand of the artist has become obsolete. Now, on the brink of the twenty-first century, artists have turned to embrace the mechanization that was once so abhorrent.

Electronic images are, for the most part, nonsilver imaging systems that artists can use to manipulate and reassemble images. Many of the artists who have used the historic nonsilver processes to alter color, tonality, and print support material have turned to electronic imaging as a visual synthesizer that is simply another tool for artistic expression. The images achieved in this way are all but unattainable any other way. Images can be generated on overhead transparent projection material that is computer printed, and this piece of acetate is then used as the image support that is transferred to a final support material using a variety of alternative photographic processes.

Books: Bunnell, Peter C., *Nonsilver Printing Processes: Four Selections;* 1886–1927. Salem, New Hampshire: Ayer Company, 1984; Crawford, William, *The Keepers of Light: A History and Working Guide to Early Photographic Processes.* Dobbs Ferry, NY: Morgan & Morgan, 1979; Eder, Josef Maria, *History of Photography.* New York: Dover, 1945; Nadeau, Luis, *Gum Bichromate and Other Direct Carbon Processes from Artique to Zimmerman.* Fredericton, New Brunswick: Atelier Luis Nadeau, 1987; Nadeau, Luis, *History of Practice of Carbon Printing.* Fredericton, New Brunswick: Atelier Luis Nadeau, 1982; Nadeau, Luis, *History and Practice of Platinum Printing.* 2nd rev. ed. Fredericton, New Brunswick: Atelier Luis Nadeau, 1986; Nadeau, Luis, *History and Practice of Oil and Bromoil Printing.* Fredericton, New Brunswick: Atelier Luis Nadeau, 1985; Reilly, James, *Care and Identification of 19th Century Photographic Prints.* Rochester, NY: Eastman Kodak Company Publication No. G-2S, 1986. *J. Natal*

See also: *Electronic still photography; Image; Photographic processes.*

NONSUBSTANTIVE COLOR FILM A color film having no color-forming substances within it; those being supplied in the color developer baths. *M. Scott*

See also: *Kodachrome.*

NONTHEATRICAL Motion-picture productions, such as educational and industrial films, not intended for exhibition in commercial theaters. *H. Lester*

NO-PARALLAX FOCUSING See *Aerial image.*

NORMAL An imaginary line perpendicular to the interface (surface) between two optical media and usually constructed at the point of incidence or emergence of a ray of light. Angles used in optical calculations may be referred to the normal. *S. Ray*

NORMAL DISTRIBUTION (1) See *Gaussian distribution.* (2) For a set of numbers, a pattern of variation about a central value caused by chance. The plot of such a pattern, often called, from its shape, the *bell* curve, is completely defined by the arithmetic average and the standard deviation. *H. Todd*

See also: *Standard deviation.*

Normal distribution illustrating areas contained under the curve for ± 1, 2, and 3 standard deviations.

NORMAL LENS Defined for photography as one whose focal length is equal to the diagonal length of the film format in use. This gives a diagonal field of view of some 52 degrees. Many cameras ignore this convention. To provide a preferred perspective and greater working distance, cine and video cameras have "normal" lenses whose focal length is twice the format diagonal. *S. Ray*

Syn.: *Standard lens.*

NORMAL SOLUTION A designation descriptive of a solution containing a dissolved substance that is chemically equivalent to 1 gram atom of hydrogen in a liter of solution. A 1 normal (1 N) solution of sodium hydroxide (NaOH) will neutralize a molar solution of hydrochloric acid (HCl) because the acid has only 1 gram atom of hydrogen. *G. Haist*

See also: *Equivalent weight.*

NOTCH A cue mark punched along the edge of motion-picture negatives, indicating exposure adjustments during the printing process. *H. Lester*

NOTCH CODE See *Film notches.*

NOTCH FILTER (SOUND) An electrical filter arranged to produce generally sharp attenuation in a fairly narrow frequency band, passing frequencies both lower and higher than the notch one unattenuated. Notch filters are particularly useful in attenuating tonal noise such as hum or whistles while having minimum audible effect on the program material. *T. Holman*

NUCLEAR-TRACK PHOTOGRAPHY The specialization of recording with a camera the tracks left by a charged subatomic particle (electron, proton, alpha particle, meson, etc.) using a cloud chamber, bubble chamber, or spark chamber—all of which make the normally invisible trail of ions left by the particular visible and photographable. *L. Stroebel*

NUCLEATION This term has at least two similar applications in photography. In emulsion precipitation, it refers to that part of the precipitation in which the formation of nuclei takes place. The number of nuclei formed during this part of the precipitation will have a large influence on the final grain size. In latent-image formation as viewed by the nucleation-and-growth model, it refers to formation of metal nuclei possessing two atoms. This is the smallest stable size and its formation is a highly critical step in the formation of the latent image. *R. Hailstone*

NUDE PHOTOGRAPHY The specialization of photographing unclothed human figures. *L. Stroebel*

See also: *Erotic photography.*

NULL (1) Identifying a measuring instrument in which a balance is found between a known quantity and an unknown. In a null densitometer, for example, a calibrated wedge may be moved to bring the light level to a fixed value when the test sample is inserted. (2) Identifying a lens of known curvature used in testing a manufactured lens. A null lens surface is used especially when the surface of importance is not spherical. *H. Todd*

NUMBERS, 800 See *Appendix O.*

NUMERICAL APERTURE Alternative method of specifying the relative aperture of a lens and preferred in microscopy. Numerical aperture (NA) is defined as NA = $n \cdot \sin \alpha$, where n is the refractive index of the medium in the object space (air, oil, water, etc.) and α is the angle of incidence of the most oblique ray entering the lens. Resolving power increases with NA for diffraction-limited lenses. To relate to relative aperture, for f-number (N) of $f/4$ or smaller, $N = \frac{1}{2}$ NA. *S. Ray*

NU (ν)-NUMBER See *Abbe number.*

NUBUS A special high-speed bus found in Macintosh computers. The Nubus is distinguished from other bus designs by its protocol for moving data within the computer. *R. Kraus*

NUTTING'S LAW The transmission density of a processed photographic silver image varies in proportion to the mass of silver per unit area. The validity of the law varies with the grain size distribution in the image and fails at very high densities. *M. Leary and H. Todd*

See also: *Covering power, sensitometric.*

NYQUIST CRITERION Specification of discrete sampling requirements of a continuous waveform; the minimum frequency with which a continuous waveform must be sampled in order for it to be accurately reconstructed from discrete sampling data. This frequency is greater than twice the maximum frequency present in the analog waveform. If the waveform is sampled at a frequency lower than that specified by the Nyquist criterion, the undersampled frequencies will be aliased and the lower frequencies will be distorted. *R. Zakia*

NYSTAGMUS The involuntary rapid tremor of the eye. Even though the movement is too small to be apparent to the viewer, it is the basis of the scanning process that is essential to vision. *L. Stroebel and R. Zakia*

See also: *Saccadic; Vision, the human eye, eye movements.*

O Opacity

OCR Optical character reader/recognition

ON Original negative

op Optical (op art)

OPT FX Optical effects

ortho Orthochromatic

OS Operating system

OTF Optical transfer function; Off the film

oz Ounce

OBJECT COLORS Colors attributable to reflecting or transmitting objects, as distinct from colors attributable to light sources. *R. W. G. Hunt*

OBJECT DISTANCE The distance from a subject point or plane to the front principal (nodal) point of the lens. In practice, it is often measured less precisely to the front rim of the lens, to the physical center of the lens, or even to the focal plane. *S. Ray*

Syn.: *Object conjugate (distance).*

OBJECTIVE The foremost lens in an optical instrument, that is, the lens closest to the subject. Usually applied more to telescopes and microscopes than cameras. *S. Ray*

OBLIQUE ILLUMINATION (1) Lighting that places the source at a low angle to a surface to reveal texture. The technique is particularly effective for light-to-medium-toned surfaces and surfaces that produce diffuse reflection. (2) In photomicrography, a lighting effect obtained by reflecting light onto an opaque object from an annular mirror surrounding the objective. *F. Hunter and P. Fuqua*

OBLIQUE PHOTOGRAPH An aerial photograph make with the camera tilted from the perpendicular. *L. Stroebel*

See also: *High oblique; Lateral oblique; Low oblique.*

OBLIQUE RAY Any ray of light entering or leaving an optical system at an angle to the optical axis. *S. Ray*

OBSERVER METAMERISM Variations of color matches (of spectrally different stimuli) among different observers. *R. W. G. Hunt*

OCULAR The lens or optical system by which the image formed by an optical instrument such as a microscope is viewed with the eye. *S. Ray*

Syn.: *Eyepiece.*

See also: *Microscope.*

OCULOMETER An instrument for producing a record of the movement of the eyes while a person is viewing a photograph, painting, text, and so on. *L. Stroebel and R. Zakia*

See also: *Vision, the human eye, eye movements.*

OFF-CAMERA In motion-picture and video production, a designation for a speech or event related to the action that happens outside the camera's field of view. *H. Lester*

OFFICE COPIERS Early office copiers were designed primarily to make same-sized copies of printed materials. A number of different imaging processes have been used over the years, but the field is now dominated by the xerographic electrophotography system. Some of the improvements that have been made in office copiers, in addition to dramatic increases in the speed of reproduction, include the ability to (1) produce high-quality reproductions of continuous-tone originals, (2) alter the scale of reproduction, (3) copy on transparent projection materials, (4) control the density of the image, (5) copy both sides of a document, (6) collate and staple copies, and (7) make realistic color copies. *J. Natal*

See also: *Electrophotography.*

OFF LINE In monitoring a process, a separation of the data analysis from the collection of data, which necessarily involves a significant time lag in finding and correcting an error. *H. Todd*

See also: *On line.*

OFF-PRESS PROOF A color proof made by photomechanical or digital means that is intended to match the print off the press using the same image data or information. *M. Bruno*

OFFSET LENS A lens that is designed to control perspective, such as *keystoning* of projected images. If a projector is not aligned properly with the projection screen, parallel lines in the transparency image will converge on the screen image. There are two types of offset lenses. One has concentric rings that allow the lens to shift relative to its mount; the other uses two knobs to loosen the lens in its mount, allowing the lens to shift within the lens mount. Offset projection lenses make it possible to adjust the position of the image on the screen without tilting the projector. (See illustration, following page.) *M. Teres*

See also: *Center of projection; Lens types, perspective-control/PC; Offset mounts.*

OFFSET LITHOGRAPHY See *Lithography; Photomechanical and electronic reproduction.*

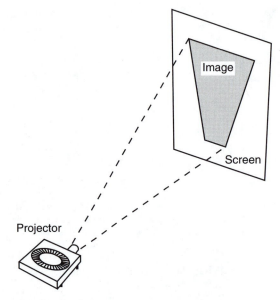

Offset lens. Keystone effect.

OFFSET MOUNTS (1) When projecting transparencies with multiple slide projectors in multimedia slide shows, occasionally two image are designed to butt up against each other in order to create the illusion of a single image, or three images may be combined to produce a panoramic scene. Special offset slide mounts (mounts that have the image area shifted off center) are used to place the projected image at the screen location that most appropriately conforms to the image being blended. (2) Mounts in which the image area is deliberately offset to compensate for the keystoning effect caused when two or more projectors are stacked one on top of another. This keystone distortion can be eliminated with a perspective control (PC) or offset lens. Since such lenses are expensive, an inexpensive alternative is to use an offset mount. These mounts reduce the need to shift the angle of the slide projector to the projection screen to position an image.
M. Teres

OHM (Ω) The basic unit of resistance. In an ac circuit it is also a unit of reactance and impedance. The amount of resistance that allows 1 ampere of current to flow when a potential difference of 1 volt is across the resistor. The symbol for ohm is the Greek letter omega, Ω. *W. Klein*
See also: *Electricity.*

OIL COLORING Transparent oil colors are applied to black-and-white (or toned) photographs by daubing and smoothing them out with a tuft of cotton. The cotton is twisted into a swab on the end of a pointed stick for coloring small areas, and control at the edges of large areas. Unwanted color beyond the desired boundaries can be removed with a swab moistened with a small amount of cleaning fluid. *I. Current*
See also: *Heavy oil.*

OIL-IMMERSION See *Immersion objective.*

OIL-PIGMENT PROCESS A pigment process using an oil-based pigment that is brushed, rolled, or dabbed on a gelatin relief image. The image can be transferred under pressure to another paper support, which is known as the oil transfer process. Oil prints, popular with the Pictorialists around 1900, are characteristically granular and slightly un-even in tone. G. E. H. Rawlins is credited with the revival of this process in 1904. The bromoil process was an improved and more widely used method of oil printing. *J. Natal*
See also: *Bichromate process; Bromoil process.*

OLEOBROME Derivitive of the bromoil process that was created by F. F. Renwick and F. J. Shepherd in 1930. Prints were inked with rollers instead of brushes. When it became available commercially, special papers and inks were required.
J. Natal
See also: *Bromoil process.*

OLEOPHILIC Oil or ink receptive. *M. Bruno*

OLEOPHOBIC Oil or ink repellent. *M. Bruno*

OMNIDIRECTIONAL See *Microphone polar patterns.*

ON-CAMERA In motion-picture and video production, a designation for a speech or event that happens within the camera's field of view, that is, that which can be seen by the audience. *H. Lester*

(100) A crystallographic designation of a plane of ions in a silver bromide crystal in which the silver and bromide ions alternate in both the x and y directions. This designation is sometimes applied to the surface of an emulsion grain. Such surfaces would define a cubic morphology for the emulsion grain and are therefore referred to as cubic surfaces.
R. Hailstone

(111) A crystallographic designation of a plane of ions in a silver bromide crystal in which all the ions are either silver or bromide. This designation is sometimes applied to the surface of an emulsion grain. Such surfaces would define an octahedral morphology for the emulsion grain and are therefore referred to as octahedral surfaces. *R. Hailstone*

ONE-LIGHT PRINT A motion-picture print made without printer adjustments to compensate for differences in exposure and color between shots. Used for work prints and those release prints made from printing masters already incorporating necessary adjustments. *H. Lester*
See also: *Timed print.*

ONE-SHOT CAMERA See *Camera types.*

ONE-TIME USE One-time use describes the limited right given by a photographer to a client who has contracted for permission to reproduce a photograph, for example, for use as the cover of a book or in connecon with an advertisement. The one-time use may be as restrictive as "one-time use" only for the first edition of a book. *R. Persky*
See also: *Business practices; Copyright.*

ONE-TO-ONE A scale of reproduction that produces an image the same size as the subject. This occurs when the image distance equals the object distance, and in this situation both distances will be equal to two times the focal length, and the effective *f*-number will be equal to two times the marked *f*-number. *L. Stroebel*

ON LINE (1) In monitoring a process, an almost immediate analysis of the data collected, thus reducing the time lag between the discovery of an error and the correction of the process. (2) In computers, the term simply means that the computer is functioning. Sometimes *on line* is used to mean that the computer terminal is in communication with a host computer operating system. *H. Todd and R. Kraus*
See also: *(1) Off line.*

OPACITY The ratio of the light falling on a processed film sample to that transmitted by the sample. Opacity is the reciprocal of the transmittance and the antilog of the density.
M. Leary and H. Todd

See also: *Density.*

OPAL GLASS Glass that has a translucent white tint throughout its thickness, as opposed to flashed opal, which has one treated opal surface only. Used as a diffusing medium in optical systems including enlargers, photometers, and transparency viewers.
S. Ray

OPAL LAMP A tungsten-filament lamp with an opal-glass envelope that diffuses the light more effectively than frosted glass.
R. Jegerings

OPAQUEING The selective application of a red, gray or black pigmented material, opaque, to areas of a negative to block transmission of light. This may be done to cover pin holes in a negative that would otherwise print as black spots. With continuous tone prints, the white spots are easier to fill in with spotting dye or pigment. It may also be used to block out material surrounding the image of an object, allowing it to be printed on a white background.
I. Current

See also: *Neococcine.*

OPAQUE PROJECTOR A fan-cooled optical device, with an extremely bright light source, that is used to project a reflected image from an opaque artwork, photograph, or printed reproduction. Portrait photographers sometimes use a small opaque projector for showing proof prints to their customers to indicate how an enlarged portrait will look. An opaque projector can be used to project an image from a book, a thumbnail sketch, etc., in order to trace the image for rendering, to make a composite manipulation, or to provide a quick and accurate template for enlarging or reducing a source image. An opaque projector can be used for presenting images from opaque documents at business meetings and lectures.
M. Teres

OPEN FLASH The procedure of opening a camera shutter on the bulb or time setting, firing one or more flash units, and closing the shutter, as distinct from using synchronized flash with an instantaneous shutter setting. This was a necessary procedure when flash powder was used as a light source. Sometimes used when multiple flashes are to be recorded on the same photograph, especially sequential flashes for a stroboscopic effect, and to combine flash and ambient light in a dimly lit environment.
J. Johnson

OPEN REEL Any tape recording format that does not use a cassette, which generally implies that it must be threaded by the user. The tape may be supplied either on reels or on a pancake.
T. Holman

OPERATING SYSTEMS (OS) In computers, a software program that supports the basic operations of the computer.
R. Kraus

See also: *Disk operating system.*

OPHTHALMIC CAMERA See *Camera types.*

OPHTHALMIC PHOTOGRAPHY Ophthalmic photography is a specialized form of biomedical photography that combines anatomical and medical knowledge of the eye with photographic artistry and state-of-the art technology in the diagnosis and treatment of eye-related disorders.

The profession is represented by the Ophthalmic Photographers' Society, an international nonprofit educational organization with the purpose of encouraging, facilitating, and recognizing excellence in ophthalmic imaging. A background in photography is important but is not a prerequisite for choosing this occupation. The society's more than 1200 members include ophthalmic photographers, ophthalmic technicians, nurses, ophthalmologists, basic researchers, optometrists, and others interested in this speciality. While acquiring the technical skills to perform ophthalmic photography, a photographer involved in this profession must also develop familiarity with the clinical pathology of the eye. The level of a photographer's competence in this field relates directly to an understanding of the pathology examined and the ways in which their special characteristics can be shown photographically.

Since its founding in 1969, the Ophthalmic Photographers' Society has continually provided the focal point for the profession through comprehensive programs of education, publication, and certification.

A full spectrum educational program is provided at the society's annual meeting held in conjunction with the national meeting of the American Academy of Ophthalmology. Regional educational programs are held yearly, and the quadrennial International Congress in Ophthalmic Photography, held in conjunction with the International Congress of Ophthalmology, provides a forum for the interchange of information with fellow professionals around the world.

The society's certification program recognizes two levels of proficiency: the core level of Certified Retinal Angiographer (C.R.A.) and the comprehensive level of Certified Ophthalmic Photographer and Retinal Angiographer (C.O.P.R.A.) These two levels of certification are routinely used as a standard hiring requirements or as a measure of accomplishment for promotion within the profession.

The *Journal of Ophthalmic Photography*, the society's biannual publication, presents tutorials and articles on photographic techniques, instrumentation, and related topics in ophthalmology.

For each structure of the eye—cornea, lens, retina, and optic nerve—there are ophthalmologists who specialize in diagnosis and treatment of that area. The eye is the only organ in the body that may be precisely examined in situ. The eye is living tissue that is both accessible and transparent; therefore, pathological processes as well as normal physiology can be observed with the use of specialized photographic instruments. Such specialized photographic techniques include the following.

External photography consists of photographs using a 35-mm camera to record the full face, both eyes together, or one eye at either high or low magnification.

Retinal fundus photography uses a camera (fundus camera), designed after the indirect ophthalmoscope. The image of the retina is recorded on 35-mm color transparency film, usually in three dimensions as a stereoscopic pair.

Retinal fluorescein angiography is a diagnostic test using a fundus camera, 35-mm black-and-white film, and special filters, where rapid sequence photography is performed of the retina after an intravenous injection of sodium fluorescein. The photographs are then used as maps in the performance of laser surgery.

In *Slit lamp photography* a biomicroscope is used to examine the anterior structures of the eye (cornea, lens, and iris), adapted to photographically record vision-altering changes to these areas.

In *Specular microscopic photography* a special biomicroscope with a magnification range of $25\times$ to $400\times$ is used with the specular reflection lighting technique to image and record the back layer of the cornea (endothelium) on 35-mm black-and-white film.

Recent advances in the field include digital electronic imaging. Primarily used in retinal fluorescein angiography,

photocomputer systems now provide instant digital information to facilitate same-day diagnosis of eye disorders and allow immediate treatment.

For more information contact: Ophthalmic Photographers' Society, 3632 Blaine Avenue, St. Louis, Missouri 63110. *M. Maio*

OPPONENT THEORY A theory of color vision proposed by Hering in the late nineteenth century and extensively developed by Hurvich and Jameson that assumes the existence of three pairs of processes, one each for white-black, blue-yellow, and red-green. The processes are now thought of as excitation-inhibition of neural firings above and below the spontaneous rate. *L. Stroebel and R. Zakia*

See also: *Retinex theory; Vision; Visual perception; Young–Helmholtz theory; Young theory.*

OPTICAL Term used in motion picture technology for a special effect such as a fade dissolve, superimposition, or wipe, as made by projection printing in an optical printer from otherwise normal scenes. *S. Ray*

OPTICAL ALIGNMENT Processss of arranging optical elements and components on a common axis, as when assembling a lens or illumination system. *S. Ray*

OPTICAL ATTACHMENTS See *Lenses.*

OPTICAL AXIS See *Lens axis.*

OPTICAL BENCH A rigid track along which the components of an optical system such as a light source, lens elements, and screen can be moved to vary their relative distances while staying in common optical axial alignment. Used to determine lens parameters and performance as well as photometry. *S. Ray*

OPTICAL BRIGHTENER A fluorescent substance added to paper during manufacture that converts invisible incident ultraviolet radiation to light, thereby increasing the apparent reflectance or whiteness of the paper. In imaging, optical brighteners make the highlights lighter, increasing the maximum tonal range of the image. *J. Holm*

OPTICAL CALCULATIONS See *Optics.*

OPTICAL CAVITY Term used in laser technology for the region between two plane mirrors spaced an exact number of wavelengths apart. Repeated to and from reflection of the photons liberated by laser action results in the production of standing waves of coherent light in the resonant cavity. *S. Ray*

OPTICAL CENTER Point on the axis of a lens through which any ray passes if it enters and leaves on parallel paths. It is not necessarily physically inside the lens, depending on configuration. *S. Ray*

OPTICAL CHARACTER RECOGNITION (OCR) In computers, a software program that reads scanned text into a format that can be entered into a word processing or spreadsheet program for alteration. *R. Kraus*

OPTICAL CONTACT Contact between two surfaces such that there is no space left between them, and the interface between behaves as though a single surface separates the two components. Ideal matching surfaces may not require adhesive. *S. Ray*

OPTICAL DENSITY See *Density.*

OPTICAL DESIGN See *Lenses, lens design.*

OPTICAL DISTANCE The length of a path of a light ray multiplied by the index of refraction of the material in which the ray travels. A thickness of 12 cm of water (of index 1.33) is optically equivalent to 15.96 cm of air (index 1.00). *S. Ray*

OPTICAL EFFECTS Motion-picture special effects that are created by manipulating and/or combining images during the printing process. While some basic optical effects can be achieved in the camera or on a contact printer, the primary tool for making such effects is the optical printer, which is, in its simplest form, a motion-picture projector aimed into a synchronized camera, and to some extent can be thought of as a motion-picture version of a darkroom enlarger. Advances in video and computer technology are continually enhancing traditional optical printer procedures, allowing for greater efficiency and the ability to handle more complex imagery, as well as creating electronic alternatives to the optical printer.

TRANSITIONAL EFFECTS Often used when changing from one scene to another, to enhance visual vitality, to smooth over abrupt changes, or to indicate a change in time, location, or point of view. These effects include fades, lap dissolves, wipes, ripple dissolves, out-of-focus or diffusion dissolves, spin-in and out, zoom-in and out, and an unlimited variety of matted wipe shots. These effects can also be used to compensate for a variety of problems with the original footage.

FRAME SEQUENCE ALTERATION By eliminating or repeating selected frames from the original sequence, a variety of effects can be achieved, such as slow or fast motion, or the subtle altering of the speed of an action to enhance the sense of realism or visual vitality. Repeating a single frame over and over results in a freeze frame. Repeating a series of frames back and forth results in the creation of cyclic repetitive movements. Creatively applied, this technique can transform a shot of a cat walking, into a shot of a cat doing a series of dance steps, or allow a man falling off a roof to bounce back up again. Altering the original frame sequence can also create numerous expressionistic effects in terms of movement rhythm and visual complexity.

COMBINING IMAGES Images can be combined in innumerable ways, including superimposition, bi-packing (sandwiching of two film strips in the projector stage of the printer), split-screen, where several independent images are printed within the frame area, and through the use of traveling matte procedures. Traveling mattes are made on motion-picture film and bi-packed with original footage during the printing process, blocking selected areas of the frame from exposure. For instance, the appearance of a monster walking down a city street can be achieved by making a traveling matte that in each frame exactly matches the changing silhouette of a moving monster model shot in miniature. The matte is next bi-packed with the background footage and printed. The recording film is rewound and a second printing pass is made with the monster footage, in some instances using a reverse matte, combining the images into a new, seemingly realistic, film event.

CHANGE OF IMAGE SIZE OR POSITION Unwanted areas of the image can be cropped out. Closeups can be created for extra editorial cuts. Camera moves such as zooms and tracking shots can be imitated and action can be repositioned for dramatic effect or for use in further multiple exposure procedures. *H. Lester*

OPTICAL FILTERS See *Filters.*

OPTICAL FLAT An optical element of finite thickness with both sides accurately plane-parallel and highly polished

to a flatness of within λ/4 to λ/10 as measured by interference fringes. The flatness and parallelism ensure minimum effects on image formation. High grade filters are optically flat. *S. Ray*

OPTICAL GLASS See *Optics, optical materials.*

OPTICAL HEAD The part of a motion-picture projector, or similar device, that "reads" an optical (photographic) sound track. Consisting of an exciter lamp and photocell, the optical head translates variations in the optical track into electrical variations, which are then, through an amplifier and speaker, converted into sound. *H. Lester*

OPTICAL ILLUSION A visual perception different from the physical reality of one or more stimulus attributes such as size, shape, form, distance, color, and motion. The moon, for example, tends to appear larger when it is near the horizon than when it is overhead. *L. Stroebel and R. Zakia*
See also: *Visual perception, accuracy of visual perceptions.*

OPTICAL MATERIALS See *Optics.*

OPTICAL MEDIA In electronic imaging, optical media are being used to store large image files that may exceed 20 MB. Unlike typical hard disks that are coated in a magnetically addressable medium, optical media are addressed by laser. *R. Kraus*

OPTICAL MEDIUM Transparent substance through which light can propagate. Velocity is maximum in a vacuum and slower in other more dense media. *S. Ray*
See also: *Index of refraction.*

OPTICAL PLASTICS See *Optics, optical materials.*

OPTICAL PRINTER The basic tool used for the creation of motion-picture optical effects, this device reproduces motion-picture film by exposing the raw stock through a system of lenses, in contrast to a contact printer, which exposes the raw stock while it is in physical contact with the original. Optical printers allow a great deal of control and variation in the printing process, exposing one frame at a time, while all film is registered and at rest, with independent control of both original film and raw print stock. In addition to optical-effect production, optical printers are used for making prints whenever it is not possible to do so on a contact printer, such as when making blow-up or reduction prints where the print stock is a different format from that of the original. These printers are also useful for *doctoring*—modifying original footage to compensate for a variety of problems. *H. Lester*
See also: *Optical effects.*

OPTICAL PUMPING the use of light (or electromagnetic radiation) to elevate the atoms or molecules of a substance to an excited state. Laser light is emitted from lasers as a result of optical pumping of the laser tube. Extremely powerful lasers can also be constructed by using a less powerful laser to pump the main tube. The concept of optical pumping also applies to some extent to the formation of the latent image in photography, although the term is not used because the result of the pumping is a chemical change rather than the emission of more light. *J. Holm*
See also: *Lasers.*

OPTICAL RESINS See *Optics, optical materials.*

OPTICAL SCANNER See *Scanner.*

OPTICAL SENSITIZATION See *Dye sensitizer; Spectral sensitization.*

OPTICAL SOUND RECORDING The process of recording sound photographically by means of an optical camera recording a sound negative, usually using variable area to represent the waveform of the sound, and subsequent development of the negative, printing, and print developing. The result is an economical means of supplying large quantities of release prints with sound that can be printed in the same printer as the picture negative. Thus, its costs are much lower than magnetic sound recording and its use predominates on the 35-mm and 16-mm formats. *T. Holman*

OPTICAL SPREAD FUNCTION The distribution of the light in an image formed by a lens or mirror system when the object is a point or a line. Although ideally the image would be similar to the object, in fact, light is spread out in the image because of diffraction and aberrations. *H. Todd*

OPTICAL SYSTEMS An assembly of optical components such as lens elements, mirrors, prisms, and filters, suitably aligned and tested, for acquisition of an image for recording and evaluation. *S. Ray*

OPTICAL TRANSFER FUNCTION (OTF) A mathematical expression of the extent to which an image-forming system conveys information. The OTF includes the modulation transfer function and the wave-phase shift, i.e., any change in position of the peaks of the waves. *H. Todd*
See also: *Modulation transfer function.*

OPTICAL WEDGE A semitransparent device used in a sensitometric exposure test for varying the light level received at different positions on the sample. It may be made to cause a continuous change in received illuminance at the sample or made with a series of patches of different absorption of light—a step tablet, the preferred term, or step wedge. *M. Leary and H. Todd*
See also: *Goldberg wedge.*

OPTICS Optics is the study of the behavior of light and its interactions with materials.
OPTICAL THEORY
 The Electromagnetic Spectrum Energy in the form of electromagnetic radiation is produced by a variety of thermal and other sources. It travels as rays in straight lines, termed rectilinear propagation, at a constant velocity in a homogeneous medium and can be considered behaving either as a sinusoidal wave phenomenon or as separate quanta of energy. In the visible spectrum, which the eye perceives, such quanta are called photons. Deviation of the ray path is caused by reflection, refraction, diffraction, and scattering.

Light velocity in a vacuum, irrespective of wavelength, is approximately 299,793 kilometers per second, taken conveniently as 3×10^{10} centimeters per second or 186,000 miles per second. A reduced velocity is given in other media, dependent on their density.

As a waveform, light intensity is the square of the amplitude, while wavelength is the peak-to-peak distance in nanometers (nm). One nanometer is 10^{-9} meter. The visible spectrum extends from some 400 to 700 nm.

Light (or radiation) may also be characterized by its frequency, given by dividing the distance traveled in 1 second by the wavelength. Light of wavelength 600 nm and velocity 3×10^{17} nm /second has a frequency of 5×10^{14} cycles per second, or Hertz (Hz).

 Reflection Light interacts with materials in various ways. When light encounters an opaque surface, specular or diffuse reflections occur.

A perfectly diffuse surface reflects the incident light equally in all directions so that its brightness is seen as constant, irrespective of viewpoint. Few surfaces have such properties, and there is usually a slight sheen, depending on the degree of gloss. Most surfaces have a reflectance in the range 2 to 90%, represented by matt black paint and white paper, respectively.

A glossy surface gives little scattering, and a specular reflection of the light source is seen. The incident light is reflected at an angle equal to the angle of incidence, both measured from the normal to the surface. Suppression of reflections may be possible using the properties of polarized light.

Refraction Light meeting a transparent surface is partially reflected at the surface, but otherwise transmitted, usually undergoing refraction at this interface between two optical media. The transmitted ray in the second medium has altered velocity, being slower in a denser medium. The ratio of velocities in a vacuum and the medium give the refractive index of the medium.

A decrease in velocity causes the ray to be deviated toward the normal and vice versa. This deviation is termed refraction. The relationship between the angle of incidence (i), angle of refraction (r), and the refractive indices n_1 and n_2 of the two media is given by Snell's law

$$n_1 \cdot \sin i = n_2 \cdot \sin r$$

The refractive index of materials varies with wavelength, producing chromatic aberrations. The usual value is quoted

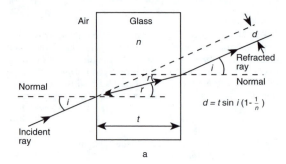

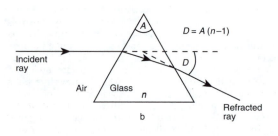

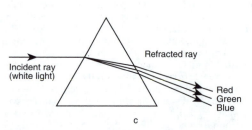

Refraction of light by glass prisms. (a) Light passing obliquely through a parallel-sided glass block, and resultant displacement d; (b) refraction of light caused by its passage through a prism, and resultant deviation D; (c) dispersion of white light by a prism.

for the d-line in the helium spectrum, at 587 nm and denoted n_d. Gases and liquids change in density with variations in temperature or pressure-causing refraction changes.

A plane parallel sided block of glass does not deviate an incident oblique ray, but the emergent ray is laterally displaced. This can cause image aberrations or a focus shift in the case of glass filters.

Refraction of a ray emerging from a dense medium increases as i increases until a critical value is reached when the ray does not emerge, as it has undergone total internal reflection. This property is used in reflector prisms and fiber optic devices.

Absorption and Transmission The energy budget of light transmission by a lens is $R + A + T = 1$, where R, A, and T are surface reflectance, absorption by the medium, and transmittance, respectively. To maximize T, R and A must be minimized.

Surface reflectance can be reduced by very thin coatings of material applied by vacuum deposition and electron beam methods. The principle of a single thin layer is that reflections from the air–layer and layer–medium interfaces interfere destructively to enhance transmission. The condition is that the coating has thickness of one-quarter wavelength ($\lambda/4$) and index $n^{1/2}$.

In practice, magnesium fluoride is used to give a single hard coating, giving a characteristic purple appearance to the surface by reflected light. Reflectance is reduced to less than 2%. A double layer gives less than 1%, while progression to multiple layer stacks of coatings in layers of differing thicknesses and refractive indices can reduce values to much less than 1%. Some 7 to 15 layers may be used as needed.

Multiple coatings can also be used to enhance reflectance as in mirrors for SLR cameras or can be spectrally selective and reflect (or transmit) very narrow spectral bands with sharp cutoff. These are termed interference filters and find use in such applications as multispectral photography and color printing.

Multilayer coatings can also be used to make infrared transmitting or reflecting filters, often called *cold* or *hot* mirrors, respectively.

Optical glass should ideally be spectrally nonselective with regard to absorption, but lower grade glass sometimes used for condenser lenses absorbs slightly in the red and blue, giving a greenish tinge to the element.

By addition of certain minerals to the glass melt, *dyed-in-the-mass* glass is obtained and used for absorption filters.

The transmittance (T) of a lens is of considerable importance when precise exposures must be determined, as in cinematography. Light transmittance is usually measured as the f-number (N) or aperture stop, which is defined geometrically. The true f-number may be significantly different, so a photometrically determined value, the T-stop or T-number is preferred instead, defined as

$$T\text{–number} = \frac{N}{(T)^{1/2}}$$

An $f/2$ lens with transmittance 0.85 has a T-number of $T/2.2$.

Dispersion Refraction of light is wavelength dependent in that shorter wavelengths are refracted more than longer ones but occurring in a nonlinear manner. A variety of glasses are needed for lens design correction techniques.

Dispersion by simple glass lenses causes two distinct forms of chromatic or color aberrations. Because of axial chromatic aberration the lens changes focal length with wavelength, increasing with wavelength. Correction is by a combination of suitable positive and negative lenses of different glasses, so equalizing focal length for two wavelengths such as the F and C lines spanning the visible spec-

trum, when the lens is said to be achromatic. This achromatic doublet has an uncorrected secondary spectrum, further corrected by using three glasses optimized for three wavelengths, termed apochromatic, although this may just mean a reduced secondary spectrum by the use of special low dispersion glasses, often termed ED glasses.

A lens is not normally corrected for the infrared and ultraviolet regions, and a focus correction must be made after visual focusing to allow for the different focal lengths of the lens in these regions. The focusing scale may have an infrared focusing index. A special form of correction, superapochromatic, extends correction from 400 to 1000 nm.

By contrast, transverse chromatic aberration, or lateral color, is dispersion of obliquely incident rays and the color fringing effect observed worsen rapidly as the image point moves off axis. It is a difficult aberration to correct, but for general-purpose lenses, symmetrical construction is effective. Lateral color sets the performance limits to long-focus refracting lenses, but fluorite and ED glass elements have proved very effective for correction.

Reflecting elements such as full or partial mirrors do not disperse light, and mirror lenses can be used for long-focus lenses as well as for ultraviolet and infrared work and microscopy. Pure mirror designs are called catoptric and are not suitable for photography. Additional refracting elements are needed for full aberration correction, giving catadioptric lenses.

PHYSICAL OPTICS

Interference Certain properties of light are explained only by considering light as a wave motion. Under certain conditions, two monochromatic waves may undergo interference, and the resultant intensity may vary between zero for complete destructive interference, when the two waves are exactly 180 degrees out of phase, to a doubling of intensity by constructive interference when they are exactly in phase. One condition is that the waves are coherent, usually given by means which will split a wavefront in two, such as two closely spaced slits or pinholes. Another method, such as a thin film, will produce interfering waves by division of the amplitude of an incident beam.

Destructive interference for a particular wavelength removes that wavelength from a beam. Interference effects are usually seen as light or dark or colored bands, called fringes.

Note that photography records only the amplitude of light waves as their intensity, but holography records both phase and intensity information about the subject in the form of fine interference fringes derived from two coherent beams of light, one being a reference beam and the other reflected from the subject.

Interference finds practical applications in single or multilayer antireflection coatings on lenses and as interference or dichroic filters for selective filtration of broad or narrow spectral bands.

Interference effects also limit the performance of an otherwise perfect lens by the effects of diffraction.

Diffraction Diffraction may be considered simply as the tendency for light to spread around the edge of an opaque obstruction. For example, a diffraction grating gives a regular array of closely spaced obstructions, and transmitted light is spread into a spectrum, as diffraction is wavelength dependent.

The aperture stop of a photographic lens is variable in size, and at the smaller diameters or large f-numbers, diffraction may occur at the perimeter of the iris diaphragm, giving an image of lesser resolving power than expected. For this reason, many lenses have minimum values of $f/16$ or $f/22$, as performance could be degraded progressively beyond this limit. A lens without residual aberrations under specific conditions such as monochromatic light and at a fixed magnification is said to be diffraction-limited in performance. Most

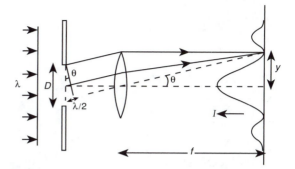

Diffraction. Fraunhofer diffraction of light at a slit of width D.

nonspecialist lenses are aberration-limited, as residual aberrations are greater than the diffraction effects, certainly at larger apertures.

Physics of the Image A perfect, aberration-free lens still suffers from diffraction, which causes the image of a subject point to be given as the Airy pattern of alternating dark and light rings from interference effects. The Airy disk is the diameter (D) of the first dark ring of the pattern given by

$$D = 2.44\lambda N$$

where N is the f-number.

For light of wavelength (λ) 400 nm, D is approximately $N/1000$, i.e., 0.008 mm for an $f/8$ lens.

The resolving power (RP) of a lens is its ability to resolve fine detail and is quantified by the Rayleigh criterion, where two adjacent point sources are just resolved if their Airy disk images overlap to the extent of their radii, hence

$$RP = 1/1.22\lambda N$$

expressed as units of line pairs per millimeter (lpm). An Airy disk of 0.008 mm gives an RP of 250 lpm, but few practical lenses achieve this figure.

It is seen that RP increases as wavelength (λ) decreases and f-number decreases, properties also made use of in microscopy.

Resolving power is greatly influenced by subject contrast and shape and special test targets can be used to estimate its value in fixed circumstances. A different idea of lens behavior is given from consideration of its response to the spatial frequencies in the subject, fine detail having a high spatial frequency.

Modulation Transfer Function An image formed by a lens can be considered as a convolution (summation) of all the Airy patterns from each subject point. The Airy pattern is also called the point spread function. It is found that when regular subject intensity patterns such as a rectangular (crenelate) variation undergo convolution, as the subject spatial frequency increases (fineness of pattern), the image pattern contrast degrades to vanish finally as a uniform intensity. This change in contrast or modulation provides a basis of image evaluation.

The spatial frequency (V) of a test pattern is the number of complete intensity cycles per millimeter (mm–1). The modulation (m) of a pattern is given by

$$m = (I_{max} - I_{min})/(I_{max} + I_{min})$$

The change in modulation (contrast) after imaging, is given by the modulation transfer factor (M) where

$$M = m_I/m_O$$

where I and O denote image and object, respectively.

A graph of M against V gives a curve called the modula-

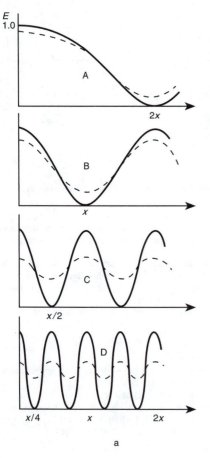

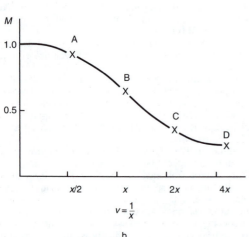

Modulation transfer function. Variation of modulation transfer factor *M* with spatial frequency. (a) Object modulation (solid line) and image modulation (dashed line) for sinusoidal intensity periods (*x*). (b) Corresponding MTF graph.

tion transfer function (MTF) used to evaluate imaging behavior of a lens.

If the object intensity pattern is sinusoidal, the pattern after imaging is still sinusoidal but with a reduction in amplitude. Changes in the image positions of the peaks are due to lens aberrations and are given by the phase transfer function

(PTF). The composite of the MTF and PTF is the optical transfer function (OTF).

MTF data can be useful. A direct use is the determination of best focus setting by the maximum response obtained. MTF theory is applicable to every component in an incoherent imaging chain, and their individual responses can be cascaded together by simple arithmetic to give the overall response of the system.

A single MTF curve does not fully describe lens performance, and many curves have to be generated at different apertures, in monochromatic and white light, at different focus settings, conjugates, and orientations for a better understanding. Lenses may be compared directly under similar conditions and often may be characterized by inspection of their MTF data as being, say, high image contrast but limited RP or moderate contrast but high RP. Both types give distinctive images and are preferred for specific types of practical work, typically general purpose recording by the former and copying by the latter. Separate assessments must be made of other image characteristics such as distortion and flare.

Polarization A monochromatic beam of natural light consists of a series of wavetrains of equal amplitude, identical wavelength, and random phase relationships. A cross section of the beam shows component waves to be vibrating in all possible directions, termed an unpolarized beam. By passing this beam through a linear polarizing filter, only the waves and components of other waves vibrating in a particular direction are transmitted. Light intensity is reduced as well.

A beam of linear or plane-polarized light can be converted into circularly polarized light by means of a quarter wave plate, which is a birefringent material of specific thickness that splits the plane-polarized light into two equal perpendicular components with a phase difference of a quarter of a wavelength. The emergent beam proceeds with a circular helical motion. Left- and right-handed circular polarization is possible. Circular-polarized light is a special form of elliptically polarized light, where the two perpendicular components are of unequal amplitude. Circularly polarizing filters have a specialized photographic application with some SLR cameras that use metal film beam splitters to sample the light from the lens for exposure determination or for an autofocus system. The beam splitter varies its percentage split of an incident beam depending on its amount of linear polarization that in turn can affect exposure determination or light reaching the autofocus module. Circularly polarized light is unaffected.

A linear-polarizing filter is quite useful in controlling surface reflections from dielectric materials, that is, most materials except metals, which become partly or wholly polarized. Color saturation can be improved. Blue skies may be darkened, as scattered light is polarized relative to the sun's position.

GEOMETRICAL OPTICS

Image Formation by Simple Lenses A simple lens consists of a single element with two surfaces. One surface may be flat. A curved surface may be concave or convex. The focal length (f) and power (P) are given by the lens makers' formula

$$P = 1/f = (n_d - 1)(1/R_1 - 1/R_2)$$

where R_1 and R_2 are the radii of curvature of the surfaces, being positive measured to the right of the vertex of the surface and negative measured to the left. Depending on the values for R_1 and R_2, f can be positive or negative. In terms of image formation, a positive or converging lens refracts parallel incident light to deviate it from its original path and direct it toward the optical axis and form a real image that can be focused or projected on a screen. The location, size, and orientation of the image may be determined by simple calculations. The object and image distances from the lens are termed conjugate distances and commonly denoted by the letters u and v, respectively.

Compound Lenses and Cardinal Planes A simple thin lens is normally unsuitable as a photographic lens because of aberrations. A practical lens consists of a number of separated elements or groups of elements, the physical length of which is a significant fraction of its focal length. This is a compound, thick, or complex lens. The term equivalent focal length (EFL) is often used to denote the composite focal length of such a system. For two thin lenses of focal lengths $f1$ and $f2$ in contact, the EFL (f) is given by

$$1/f = 1/f1 + 1/f2 - d/f1f2$$

where d is their axial separation.

Thin lens formulas can be used with thick lenses if conjugate measurements are made from two specific planes perpendicular to the optical axis. These are the first and second principal planes that are planes of unit transverse magnification. For thin lenses in air the two planes are coincident. For thick lenses in air the principal planes are separated and coincident with two other planes, the first and second nodal planes. An oblique undeviated ray directed at the first nodal plane appears to emerge on a parallel path from the second nodal plane. The two terms *principal* and *nodal* are used interchangeably, but when the surrounding optical medium is different for object and image spaces such as an underwater lens with water in contact with its front element or an immersed microscope objective, then the two pairs of planes are not coincident. For a symmetrical lens, the nodal planes are located approximately one-third of the way in from the front and rear surfaces. Depending on lens design they may or may not be crossed over or even located in front of or behind the lens.

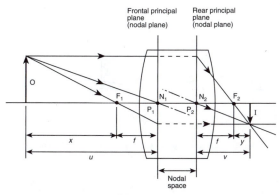

Compound lens. Image formation by a compound lens where distances are measured from the principal or nodal planes (P and N).

The third pair of these cardinal or Gaussian planes are the front and rear focal planes through the front and rear principal foci on the axis.

Gaussian or paraxial optics are calculations involving subjects located close to the optical axis and small angles of incidence. Detailed information about the image and its aberrations is not given; instead, ray path traces using Snell's law at each surface are necessary.

The focal plane is curved slightly even in highly corrected lenses, and only approximates to a plane close to the optical axis.

Focal Length A thin, positive lens converges parallel incident light to the rear principal focus on axis. The distance from this point to the optical center of the lens is the focal

length (f). For a thick lens, focal length is measured from the second principal or nodal plane. Parallel light from off-axis μpoints is also brought to an off-axis focus to form the rear principal focal plane. As light is reversible in an optical system, there is also a front principal focus.

The rear principal focus is the closest to a lens an image can be formed. An object inside the front principal focus will give a virtual image, as formed by a simple magnifier or loupe. As the object distance decreases from infinity, the principal focus recedes from the lens, so in practical terms, the lens is shifted away from the film plane or focal plane to focus on close objects.

The conjugate distances and focal length are related by the lens conjugate equation

$$1/u + 1/v = 1/f$$

The Cartesian sign convention is suitable and the lens taken as the origin, so distances measured to the right are positive and those measured to the left are negative.

Useful derived equations are

$$u = vf/(v - f); \qquad v = uf/(u - f);$$

$$u = f(1 + 1/m); \qquad v = f(1 + m);$$

where the image magnification (m) is defined as $m = v/u$. For large values of u, $v \approx f$, hence, $m \approx f/u$. Focal length in relation to a film format, therefore, determines the size of the image.

Focal length can be specified also as dioptric power (P) of the lens, where, for f in millimeters

$$P = 1000/f \text{ diopters (D)}$$

Normal sign convention is applicable. A photographic lens of focal length 100 mm has a power of +10 D and one of 50 mm a power of +20 D. This term is used in optometry and is also used to specify closeup lens, although other numbering systems may be used by some makers.

An advantage of powers is that they are additive; two thin lenses of powers +1 and +2 diopters placed in contact give a combined power of +3 D.

Magnification Image magnification, or the magnifying power of an optical system, is the size of the image relative to the size of the object. Because in most practical photography the image is very much smaller than the subject, the magnification is less than unity, and the term magnification is reserved for photomacrography, where the image is unity or greater. The term scale of reproduction is often preferred, giving a quantity such as 1:50 instead of magnification 1/50 or 0.02.

Related to the imaging geometry, three types of magnification are definable: lateral or transverse (m), longitudinal (L) and angular (A) with the relationship $AL = m$. As defined, $m = I/O = v/u$, and $L = m^2$.

Transverse magnification (m) is most useful in photography, but for afocal visual instruments such as telescopes, angular magnification is used. Note that for a lateral magnification of 0.02, longitudinal magnification is 0.0002, so that if depth of field is 3 meters, depth of focus will be 1.2 mm.

An ideal lens gives a constant magnification in a given perpendicular image plane, but radial variations cause both barrel and pincushion distortion, while a variation with wavelength as well causes the aberration of lateral color.

Magnification can be determined by direct measurement of object and image dimensions or by use of a scaled focusing screen or a scale on the focusing mount of the lens. Measurement derived from conjugates are more difficult, as the exact location of the nodal planes may not be known.

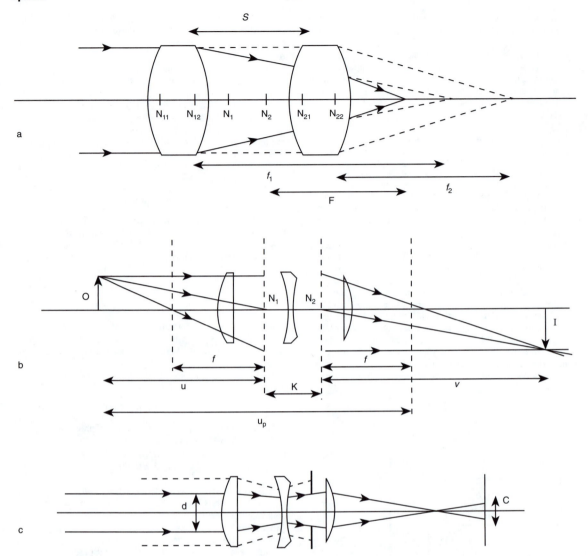

Optical calculations. Terminology for optical calculations. (a) Combination of two lenses 1 and 2 separated by a distance S; (b) image formation using concept of nodal planes; (c) the effective aperture of a lens.

Alternatively, if m is known, the values of u and v can be calculated from derived equations.

At magnifications greater than about 0.1, exposure corrections are usually necessary to the values indicated by hand-held light meters.

Mirrors A variety of mirrors find use as optical elements in both imaging and illumination systems. The mirror can be plane, spherical, aspherical, faceted, or compound.

A plane mirror gives an image that is virtual, upright, diminished, and laterally reversed, located at the same distance behind the mirror as the subject is in front. Plane mirrors deviate the direction of the incident light and have a refractive index of -2 for optical calculations. A series of angled mirrors can be used to invert or laterally correct an image. Mirrors can be surface silvered or immersed, as with the surface of a prism. Rotation of a mirror through an angle K rotates an incident beam through an angle $2K$.

Spherical mirrors may be concave or convex and have different imaging properties. Convex mirrors have a negative power and give an erect, minified, virtual image. Paraxial imaging behavior is given by the mirror formula

$$F = 1/f = 1/u + 1/v = -2/R$$

where R is the radius of curvature and $f = 2R$.

Aspherical mirrors with ellipsoidal or paraboloidal shapes are useful in imaging systems by virtue of the way they focus light. For large radii of curvatures, a spherical mirror approximates well to a paraboloid for paraxial imagery.

OPTICAL CALCULATIONS Information about an image or optical parameters may be calculated using a series of simple equations derived from Gaussian or paraxial optics. It is assumed that no aberrations are present. Conjugate distances are measured from the first and second principal or nodal planes (points) as appropriate.

Terminology The symbols used are defined as follows.

f = focal length

f_1 = focal length of component 1 in a multielement system, etc.

F = equivalent focal length of a system with several components

S = axial separation of two optical components in a system

P = power of a lens in diopters

u = object conjugate distance

u_p = object distance measured from the focal plane instead of the node

u_s = object distance for lens focused at distance u, used with a supplementary lens

v = image conjugate distance

D = separation between object and image, i.e., sum of conjugates ($u + v$), ignoring nodal space K

K = nodal space

O = linear size of object

I = linear size of image

m = optical (image) magnification = $I/O = v/u = 1/R$

M = print magnification, i.e., degree of enlargement

R = reduction ratio = $1/m = O/I = u/v$

d = effective clear diameter of a lens

N = relative aperture or f-number

N' = effective aperture or effective f-number

C = diameter of circle of confusion

H = hyperfocal distance

e = movement of lens along axis, i.e., focusing extension

t = depth of focus

T = total depth of field ($T = S' - R'$)

S' = far limit of depth of field

R' = near limit of depth of field

Equations The fundamental equation is the lens conjugate equation

$$1/u + 1/v = 1/f$$

assuming real is positive, virtual is negative.

Various rearrangements are often more convenient to use.

1. Focal length can be calculated from a knowledge of any two of u, v, m, R, and D defined above.

$$f = uv/(u + v) = u/(1 + R) = Rv/(1 + R) = mu/(1 + m) = v/(1 + m)$$
$$= DR/(1 + R)^2 = Dm/(1 + m)^2$$

2. Object distance can be calculated knowing any two of the following: f, v, m or R, and D.

$$u = vf/(v - f) = f(1 + R) = f(1 + m)/m = DR/(1 + R) = D/(1 + m).$$

3. Image distance can be calculated knowing any two of the following: f, u, m or R, and D.

$$v = uf/(u - f) = f(1 + R)/R = f(1 + m) = D/(1 + R) = Dm/(1 + m).$$

4. Magnification or reduction can be calculated knowing any two of the following: u or O, v or I, f or D.

$$m = I/O = v/u = (v - f)/f = v/(D - v) = f/(u - f) = (D - u)/u.$$

$$R = O/I = u/v = f/(v - f) = (D - v)/v = (u - f)/f = u/(D - u)$$

5. Conjugate sum requires knowledge of two of the following: f, u, v, m, or R.

$$D = f(1 + m)^2/m = f(1 + R)^2/R = v(1 + m)/m = v(1 + R) =$$
$$u(1 + m) = u(1 + R)/R = (u + v).$$

6. Object size can be determined from m or R plus image size (I), or from the latter with two of the following: u, v, D, and f.

$$O = IR = I/m = If/(v - f) = I(D - v)/v = I(u - f)/f = Iu/(d - u) =$$
$$Iu/v$$

7. Image size can be determined from m or R and the object size, or the latter with two of the following: u, v, D, and f.

$$I = O/R = Om = Ov/u = O(v - f)/f = Ov/(D - v) = Of/(u - f) =$$
$$O(D - u)/u$$

Combinations of Lenses Total focal length (effective focal length) of a combination of two lens components depends on the individual focal lengths and their separation.

$$F = f_1 f_2/(f_1 + f_2 - S)$$

Given a fixed focal length of one component, such as a camera lens, the focal length of a supplementary lens required to give a desired focal length for a combination is given by

$$f_1 = F(f_2 - S)/(f_2 - F)$$

$$f_2 = F(f_1 - S)/(f_1 - F)$$

These focal lengths are positive when the lens is collective, and negative when dispersive.

If the focal length of one component (e.g., the supplementary lens) is known in diopters, the equations change to

$$f_1 = F(1000/P - S)/(1000/P - F) \text{ (unit, mm)}$$

Axial separation, the separation between two lens components of given focal length that will provide a given total focal length for the combination, is given by

$$S = f_1 + f_2 - f_1 f_2/F$$

If only approximate focal lengths are required and the two components can be placed close together, then S can be ignored and the previous equations become

$$F = f_1 f_2/(f_1 + f_2)$$

$$f_1 = F f_2/(f_2 - F)$$

When the camera lens is focused on infinity, and a supplementary lens f_2 is added, the object distance for a sharp image becomes

$$u = f_2.$$

The distance is independent of f_1 or F or S. If the camera is focused on nearer objects, this does not apply and the combination has to be calculated.

Focusing Movements The forward movement of a lens to focus sharply a near object can be defined in terms of u and f. This distance e is measured from the infinity focus position. Object distance can be determined from f and e. Different formulas apply when object distance is measured from the focal plane and not the front node.

1. For u measured from front node:

$$e = f^2/(u - f) = fI/O = fv/u$$

$$u = f(f + e)/e$$

2. For u measured from the focal plane:

$$e = [u_p - 2f - (u_p^2 - 4fu_p)^{1/2}]/2$$

$$u_p = (f + e)^2/e$$

3. Magnification and camera extension

$$m = e/f$$

$$e = fm$$

4. Focusing movement with supplementary lenses. If F is computed as above, then this can substitute for f in the equations listed.

For a camera lens fitted with supplementary lens f_2, and focused not on infinity but a near distance u, then the object distance u_s is given by the approximate formula

$$u_s = uf_2/(u + f_2)$$

Depth of Focus and Depth of Field Relevant equations are based on the premise that some degradation of the image is permissible for objects not sharply in focus. The criterion of permissible unsharpness is the diameter of the circle of confusion.

Depth of focus is the permissible tolerance in the distance between a lens and the sensitized material:

$$T = 2CN$$

For near objects, this becomes

$$T = 2CN' = 2Cf/v.$$

Depth of field is given as the distance between the near and far points in acceptably sharp focus when the lens is focused on a subject distance that is not infinity.

$$S' = uf^2/(f^2 - NCu)$$

$$R' = uf^2/(f^2 + NCu)$$

$$T = S' - R' = 2f^2u^2NC/(f4 - N^2C^2u^2)$$

For practical purposes with distant scenes the second term in the denominator may be disregarded, so to a first approximation

$$T = 2u^2NC/f^2.$$

Hyperfocal distance is defined as the value of a particular focus setting (u) of the lens that makes the far distance in focus to be infinity. Use of this value considerably simplifies depth of field equations:

$$H = f^2/NC$$

$$R' = Hu/(H + u)$$

$$S' = Hu/(H - u)$$

$$T = 2Hu^2/(H^2 - u^2)$$

When the lens is focused at close distances, the depth of field is small, and it is sufficient to calculate the total depth of field between the near and far limits rather than each separately. $T = 2CN(1 + m)/m^2 = 2CNR'(1 + R')$

OPTICAL MATERIALS A variety of transparent and reflective materials are used to make optical elements, particularly glasses, plastics, and crystals.

Glasses Optical glass is the predominant material for photographic lenses, being highly transparent with suitable refractive properties. Early glasses were of the crown and flint varieties, but pioneering work by Abbe, Schott, and Zeiss in the 1880s gave many additional types with the addition of other compounds such as barium, boron, phosphorus, lanthanum, and tantalum. The lens designer needs glasses of both low and high refractive index and low and high dispersion. Glasses are characterized by their refractive index and dispersion measured as the Abbe number, giving each one a position on a *glass map* when the former is plotted against the latter. Additional properties are also important, such as resistance to staining and density. Glass is manufactured by melting the raw materials in platinum crucibles to avoid contamination, then casting or pressing in molds to approximate shapes or *blanks*. It is essential that glass is homogeneous in its properties.

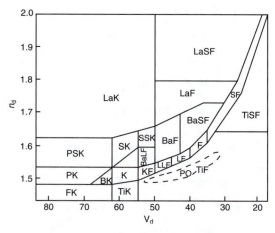

Optical materials. Regions of the optical glass chart. The code letters refer to glass types as listed in a catalog. The region PO is optical polymers (plastics). The graph is of refractive index (n_d) against Abbe number (V_d).

Plastics Many types of plastics (polymers) are used in optics, including transparent types for imaging systems, translucent and colored plastics for filters and diffusers, and opaque varieties for constructional purposes. The first plastic lens (1934) was of thermoplastic polymethylmethacrylate (PMMA) and shaped by molding. A small number of other materials are now used to provide chromatic correction (PMMA and polystyrene) and to replace glass with cost advantages. Plastics can be molded and extruded in complex shapes, including fibers and aspheric surfaces, and they can be made in large sizes. They can be surface coated and used in hybrid glass–plastic lenses. Disadvantages include low refractive index, birefringence, poor scratch resistance, and a focus shift due to thermal effects. One material, allyl diglycol carbonate, is particularly used as an optical resin for such accessories as filters and may be dyed to produce uniform or graduated colors. Constructional plastics have properties of low friction and dimensional accuracy suitable for molded devices such as lens barrels, focusing mounts, and camera bodies. Materials such as polycarbonate may be made opaque by the addition of graphite. Thin films of gelatin, collodion, and nitrocellulose are used for filters and pellicle beam splitters.

Other Materials A variety of crystalline materials have been used for optical purposes. Iceland spar and herepathite were used for polarizing optics until they were replaced by polymeric colloids. Natural mica is used for quarter-wave plates. Natural and synthetic quartz are useful for heat-resistant elements such as condensers and for UV optics. Fluorite or calcium fluoride grown as large crystals has useful properties for chromatic correction and UV lenses.

Books: Dainty, C., and Shaw, R., *Image Science*. London: Academic Press, 1974; Jenkins, F., and White, H., *Fundamentals of Optics*, 4th ed. London: McGraw-Hill, 1981; Kingslake, R., *Optics in Photography*. Bellingham, WA: SPIE Optical Engineering Press, 1992; Ray, S., *Applied Photographic Optics*. London and Boston: Focal Press, 1988. S. Ray

See also: *Abbe number; Crown glass; Filters; Flint glass; Index of refraction; Lenses.*

OPTIMAL COLOR STIMULI Color stimuli whose luminance factors have maximum possible values for each chromaticity when their spectral radiance factors do not exceed unity for any wavelength. Such color stimuli have spectral radiance factors that are either unity or zero at all

wavelengths and have only either one or two transitions between these two values. They represent the boundary of the gamut of all object colors that do not fluoresce.

R. W. G. Hunt

OPTIMIZE In computers, the optimization of the hard drive causes contiguous sectors on the block to be available for storage, thus achieving faster reads and writes to and from the hard drive. *R. Kraus*

OPTIMUM APERTURE See *Critical aperture.*

OPTOCOUPLER An electronic device consisting of a light source and a photosensor that uses light (or infrared) to couple two circuits without making an electrical connection between them. Optocouplers are useful in providing isolation between sensitive low-level circuits and noisy power circuits or between dc circuits and ac circuits. The light source is a light-emitting diode (LED); the photosensor can be either a photodiode or a phototransistor, with or without a transistor output amplifier. Input current through the LED causes it to irradiate the photosensor, which, in turn, causes output current to flow. The ratio of output current to input current, called the *current transfer ratio,* varies greatly from device to device. It can range from less than 1 to more than 100. The maximum voltage that can be applied between the input and output circuits without breakdown is usually 1000 volts or more. *W. Klein*

Syn.: *Optoisolator.*

ORANGE Color name used for hues consisting of mixtures of red and yellow. *R. W. G. Hunt*

ORDINAL SCALE A classification of objects according to some characteristic that changes progressively. For example, a set of prints made from the same negative at different exposure levels could be arranged in order from lightest to darkest for evaluation. There is no indication of the relative magnitude of the changes between members of the set with ordinal scales as there is with interval and ratio scales. *H. Todd*

See also: *Interval scale; Nominal scale; Ratio scale.*

ORDINARY RAY See *Birefringence.*

ORDINATE On a rectangular graph, the value plotted according to the vertical (*y*) scale; the output. Density is so plotted on the characteristic curve—the D-log H curve.

H. Todd

See also: *Graphs.*

ORGANIC Descriptive of substances derived from animal or vegetable matter, based on the early belief that such substances could be produced only by living organisms. Almost all organic compounds are now known to be made up of chains or rings of carbon atoms, usually prepared synthetically. Today, organic refers to compounds containing carbon and their study. Simple carbon compounds, such as carbon dioxide, are considered inorganic, however. *G. Haist*

ORGANIZATIONS, PHOTOGRAPHIC Photography is a large conglomerate activity incorporating major elements of science, technology, communications, creative artistry, social interests, and commercial activities. It has substantial business and commercial applications as well as a very large hobby-interest following. Many surveys have found it to be the number one listed hobby-interest among citizens in the developed nations. Organizations have, over the years, been formed to serve various communities of common interest in one or more elements of these fields.

These organizations have contributed greatly to the advancement of photography in all of its manifestations.

HISTORY OF PHOTOGRAPHIC ORGANIZATIONS In the earliest days of photography, lone experimenters and inventors tended to be isolated and secretive. Their work, when reported at all, found its way into learned scientific or academic societies, often of the national academy or royal sponsorship type. As photographic systems evolved that could produce marketable products, the protection of the secrecy of the technology led to guildlike organizations. In these, members paid their membership fees and were made privy to the secrets of the process, which they were sworn not to reveal to anyone outside the organization but which they could use to establish their own businesses. Some of these guilds established schools for the teaching of their proprietary processes to their members and as such may be considered the first photographic schools.

In the beginning, photography was largely the province of scientists, inventors, and experimenters. As it developed and became less difficult to practice, interest grew among people with more interest in photography as a means of creative expression and less interest in the technology necessary to produce photographs. As a result, early photographic organizations grew out of technological beginnings, and with the increase in the number of members who were more interested in the photographs themselves than in the process, it was natural that organizational stresses developed. Almost all of the earliest photographic organizations encountered schisms between technologists and artists, or "pictorialists," as they came to be called in the United States. As an example, the *Photographic Society of London* was renamed the *Royal Photographic Society* in 1894 and continued its strong process interests while a dissident group calling itself *The Linked Ring* was formed with an avowed interest in photography as an art form. "The Link," as it came to be known colloquially, supported the position that: "A work of art ends with itself; there should be no ulterior motive beyond the giving of aesthetic pleasure." This excluded practitioners who made photographs for commercial purposes.

In the same year, the *Photo-Club de Paris* was formed in France as an artistic alternative to the more professionally oriented *Sociétié Français de Photographie.* In the United States, all walks of life took to photographic pursuits, as opposed to Europe, where photography was practiced mostly by artists and men of means. Also, more women were notable in early American photography than in European. The *Photographic Society of Philadelphia*, founded in 1862, was credited as the first U.S. organization to promote artistic photography actively. However, the *Buffalo Camera Club,* founded in 1888, and the *California Camera Club* in San Francisco were other influential early pictorialist clubs.

Probably the most famous of the early U.S. pictorialist clubs was known as *The Photo-Secession* organized by Alfred Stieglitz, whose objective was to establish recognition for photography as a legitimate additional medium for pictorial expression. (Apparently the term *secession* was chosen to indicate the group's departure from the technologically dominated organizations in favor of artistic interests.) It was organized as a national association, but was centered in New York City, and its membership was only about 100 members. The group published a journal, *Camera Work,* and operated a facility in New York that came to be known simply as "291" from its street address. Edward Steichen later founded and installed exhibition space at "291" and designed the cover for the journal. This organization came to represent the elite wing of American pictorialism. Although the organization has been defunct since the First World War, the name 291 is often referred to in artistic circles as synonymous with the ultimate in artistic interest in fine art photography.

Debate about photography as an art form or as fine art continues to this day, and there are more recent examples of organizations having to accommodate splits among their membership with diverging views on this subject. It even rears its head as a problem from time to time with most local camera clubs where the members can't agree on the division of program schedules and activities between pictorial and technical subjects.

Photographic organizations that operate predominately in pictorial areas are usually associated with educational art institutions and museums. They are frequently associated in cooperative activities with practitioners of other forms of fine arts, i.e., manual art in various media such as painting, drawing, sculpture, and the like.

INFLUENTIAL PHOTOGRAPHIC ORGANIZATIONS OF THE PAST There have been some organizations that have profoundly affected photography and the way that it was practiced at some period in the past. While most have long since expired, their contributions deserve mention in any treatment of the role of organizations in the development of photography.

The Linked Ring, a pictorialist group growing out of the *Photographic Society of London* at the time that the *Royal Photographic Society* was formed in Great Britain, has been mentioned above as among several that marked the separation of technical interest groups from artistic groups. *The Photo-Secession*, a group with similar motivations in the United States, has also been described in the previous section.

A group known as the *Photo League* was founded around the beginning of the Great Depression as a political organization that used photography as its prime tool in its pursuit of the class struggle. Their films were largely related to social injustices, such as in poor working and living conditions; and since there was no appreciable commercial market for their films, they were shown largely at workers' meetings in union halls. In 1936, the organization split, with part of the group continuing with the social-struggle films and another part moving toward a more serious study of motion picture film communications techniques. Still photographers in this group came to the fore at this time and established the *Photo League* in facilities in New York City, which were used as a combination photo-gallery, photo-school, and photo-club. Many photographers who later came to be highly acclaimed in the world of photography were active in this group. After some involvement in the communist witch-hunts of the late-1940s, the *Photo League*, which by this time had apparently become essentially nonpolitical in its activities, disbanded in 1951 due to declining membership support, which probably resulted from the adverse publicity.

While definitely not a membership organization, the *Farm Security Administration, Historic Section*, under the management of Roy Stryker was an influential photographic organization formed with a relatively small group of dedicated photographers most of whom, after the FSA episode, went on to widespread recognition in the world of photography. Their objective at FSA was to record the problems and conditions of farmers and farms in the prevailing economic hard times as the U.S. economy emerged from the protracted Depression and moved toward the Second World War. In the eight years of its existence, this small group left in the files a record of this period of over 250,000 negatives. Their photographs had a profound effect on the nation's understanding of the period, and demonstrated the effectiveness of well-managed photojournalism in addressing social problems. The FSA Section was greatly cut back in 1938 and by mid-1942 it was virtually inactive as the farms and farmers were called upon to produce to meet the needs of the war, and the poverty conditions were reversed. The agency was closed in 1943, and its photographic activities were merged into the Office of War Information.

Another relatively small informal group that had considerable influence on the course of photography in the United States was known as the *f/64 Group*. This was a loosely organized body of California photographers who coalesced in 1932 and included such well-known names as Ansel Adams, Edward Weston, Willard van Dyke, Imogen Cunningham, Sonya Noskowiak, Henry P. Swift, and John Paul Edwards. Their principal common interest was in the production of pictures made with precise unmanipulated photographic technique, as opposed to the pictorialists and their many manual manipulation techniques. The *f/64 Group* was characterized by sharpness of image, maximum depth of field, and accurate tone scale reproduction, all produced by careful planning and photographic skill. This expression of photorealism was sometimes called *The West Coast School*. The loosely knit *f/64 Group* broke up in 1935.

MODERN MEMBERSHIP ORGANIZATIONS Membership organizations, in general, serve a fundamental human need to implement associations with people of common interests in a subject while serving as a reliable continuing source of information on the technology and its practice. Almost universally, the satisfactory enjoyment of photographic interests, either professional or amateur, is enhanced by active membership in one or more complementary organizations.

Types of Membership Organizations Photographic organizations range from the highly scientific, concentrating on chemistry, physics, and optics, at research and design levels, through applications organizations, such as various kinds of professional photographers and hobby groups, to commercial interests such as photographic dealers, volume photofinishers, professional laboratories, and picture agencies that concern themselves with marketing applications matters.

At the technical end of the organization spectrum are such societies as the *Society of Motion Picture and Television Engineers,* the *Society for Imaging Technology*, and the *Royal Photographic Society of Great Britain*. In the applications area there are broad organizations, such as the *Professional Photographers of America,* which include more specific interests in their suborganizations and divisions including portrait photographers, commercial photographers, industrial photographers, and photographic educators as subdivisions.

Also in this applications area, there are a number of stand-alone organizations serving specific photographic applications whose chosen field of coverage is usually evident from their names. For example: The *Association for Information and Image Management* (microforms), the *American Society for Photogrammetry and Remote Sensing, American Society of Cinematographers,* the *American Society of Magazine Photographers,* the *National Press Photographers Association,* the *Biological Photographic Association* (medical/biological photography), *Society of Photo-Optical Instrumentation Engineers* and the like, to name a few of the larger ones with national activities. These organizations tend to be largely technical in their undertakings, which include meetings, symposia and seminars dealing with various equipment, techniques and practices of photographers in the applications field of their interest, usually with one or more organization journals or periodical publications covering the field. Many of them hold meetings, regional or national/international in scope, that include trade shows where vendors of products used in the field exhibit, demonstrate, and promote their wares.

Some of these technical applications organizations also serve to contribute some social interest and structure to their fields. They provide leading practitioners a forum for their ideas and practices in their journals and at the podium in their meetings. Most of them provide individual activity recogni-

tions in the forms of citations, titles, or degrees that are conferred with considerable formal flourish upon their members who are found worthy. Additionally, the general membership has ample opportunity to form individual friendships and useful technical contacts at a personal level.

Moving from the technical applications organizations to those with less specific technical coverage and larger social intent, there are camera clubs at the local level; and in the national arena is the *Photographic Society of America,* which serves as something of an umbrella organization, with many local camera clubs affiliated with the national organization. However, the PSA also can serve equally well as a "camera club by mail" to individual, isolated amateur photographers.

Interestingly, more deeply technical expertise will be found frequently among photographers who pursue the subject as a hobby interest than among professional practitioners. This is probably because the hobbyists' interests are frequently driven by intellectual curiosity with little restraint on time, study, and experimentation. On the other hand, professional photographers are constrained by the need to produce their living income by doing work to conform to their clients' requirements, time schedules, and budgets. Hence, their approach to photography tends to be pragmatic, with emphasis on efficiency of production, rather than academic and searching in quest of knowledge, as is the case with the dedicated amateurs.

The *Professional Photographers of America,* mentioned previously, is an association for all types of professional photographers in this category. (See specific organization listings at the end of this article.)

Camera Clubs As photography advanced and became sufficiently easy for the public to undertake as a personal activity, camera clubs evolved to serve large communities of interest in the subject. Many large cities developed city-club types of photography clubs with permanent facilities available to the membership and with monthly as well as annual salons for the showing of members' work. Many companies sponsored camera clubs as a form of employee activity, as they do to this day. The largest camera club in the world is the Kodak Camera Club, which, for obvious reasons, is amply supported by the Eastman Kodak Company and has its own full-time staff and facilities, including multiple darkrooms, meeting rooms, projection facilities, and equipment loans. The facilities are located at Eastman Kodak Company's principal manufacturing facility, known as Kodak Park, in Rochester, New York.

Camera clubs have for many decades been associated with many institutions such as churches, youth social organizations, and high schools and colleges where students and faculty meet to enjoy their mutual interests in photography in its various forms.

Applications Organizations Especially in the applications area, many photographers join selected organizations solely to obtain their periodicals, which bring a continuing flow of the latest information on technical developments and practices. Modern membership organizations are basically communications activities. Other important functions of photographic organizations are for their educational activities and their collective promotional efforts on behalf of the general welfare and public regard of the group they represent.

Among broad-interest professional-photography applications organizations, *The Professional Photographers of America (PP of A)* is the largest and one of the oldest photographic organizations. In addition, it is one of the oldest trade associations of any type with a history of continuous activity until the present time. It traces its beginning to 1868, when a group of concerned photographers united to form the *National Photographic Association (NPA)* to oppose ambro-

type patent restrictions on the practice of photography. Their efforts were successful, and they disbanded in 1876.

According to PP of A historical information: "In 1880, members of the *Chicago Photographic Association,* and past members of *NPA* sounded an appeal to all photographers to form a new and better society. In April 1880, the group met and named the new society: *Photographers Association of America.* The PAA later changed its name to *Professional Photographers of America, Inc.,* in 1958 to distinguish itself from other emerging amateur photographic groups."

Commercial and Trade Organizations Beyond the wide world of amateur or consumer photography and professional photography of all types lie some organizations with commercial or business interests in serving the photography industry itself. The largest of these is undoubtedly the *Photographic Marketing Association International* (PMAI, originally established under the name of the *Master Photo Dealers and Finishers Association*), whose membership includes photographic dealers, photofinishers, distributors, and manufacturers. PMAI, often referred to as PMA, produces the largest annual photographic trade show in the United States, second only in size to *Photokina,* which is an every-other-year world photo trade show in Cologne, Germany. PMAI activities cover the distribution, marketing, promotion, sales, and customer service and information functions in the photographic industry from the suppliers' standpoint at the wholesale and retail levels.

In the commercial organization category there is also the *National Association of Photographic Manufacturers,* which is an influential, although numerically small, organization whose membership consists only of representatives of manufacturers of photographic materials and equipment. They concern themselves with subjects of common interest to manufacturers and the photographic industry as a whole. Matters such as product compatibility, technical standards, and industry-wide promotions are continuing interests, and the organization and its members are well represented on committees of the *American National Standards Institute (ANSI)* and the *International Organization for Standardization (ISO).* The membership tends to be largely North American companies. A similar organization is the *Photographic Manufacturers and Distributors Association,* whose activities are generally centered around New York City and which includes more distributors in the United States of products of European and Asian manufacture than does NAPM. PMDA holds regular meetings in New York City and sponsors a banquet and formal presentation ceremony at the PMAI annual convention at which it awards a photographic industry Man-of-the-Year Award.

In the matter of exhibiting, promoting, and selling photographs, efforts are concentrated on the types of photographs made by portrait photographers, commercial illustrators, school photographers, and to a certain extent some kinds of photojournalists. A relatively new category has appeared in recent years in this type of commissioned photography, which has become known as promotional photography. This is picture taking, mostly of children or family groups, by photographers usually at large chain general merchandise establishments that are frequently located in shopping malls. The name derives from the fact that the sponsoring stores promote and provide housing for the photography service as a way of building customer traffic in the stores. The needs of stores using this type of promotion are served by national companies with traveling crews of photographers who make the pictures and handle the processing in their own central laboratory facilities. Sometimes extended services by these photographers are sold under the name of "album plans," or "family portrait plans," or "clubs," which contract for family pictures to be made over a period of time, often years.

Picture Selling Organizations The market for photographs for journalistic, illustrative and advertising uses has spawned the establishment of picture agencies, or, as they are sometimes called, stock picture agencies. In general, these organizations are commercial business entities, although a few operate as a cooperative-style business. They stock, catalog, and merchandise the photographs of many photographers. In some instances, well-known photographers work solely with one agency. In others, the agency acquires its inventory from many photographers who offer photographs to suit the agencies' interests, requirements, and standards. As a rule, agencies provide photographs in response to their clients' specifications for one-time use for a fixed fee or for sale of all rights at negotiated prices for more extended uses. The photographers who supply the pictures are paid for each use of their pictures, after the agency's standard commission is deducted. Agencies and photographers enjoy a symbiotic relationship. The agencies obtain their product from the photographers, and the photographers are freed from the task of marketing their work individually and thus are able to concentrate better on producing their pictures.

When photographs are sold as art, their sale is most commonly through organizations known as *galleries*. Such sales are usually of large prints mounted and framed in an attractive fashion suitable for wall display. Some galleries maintain their picture inventory tastefully displayed in urban facilities, largely for a walk-in trade. Others periodically hold receptions, open-houses, or showings, either publicly announced or by invitation, for potential purchasers to see collections of work by fine-art photographers, with the intention of selling as many of them as possible. Galleries frequently specialize in pictures of a certain type or the works of a few well-known photographers.

Photographic Collections Collections of photographs are commonly found in many museums. There are some private collections owned by individuals, however, and a limited number of corporations maintain collections that are used to decorate the interiors of prestigious company facilities; or the corporate collections are circulated on a loan basis for promotional and corporate image-building purposes.

Collections may center around the works of a single photographer, or they may focus on a subject area (for example, railroads, the American Civil War, automobiles, landscapes, fashions, aircraft). Or, they may simply contain pictures depicting the history of a locality, or an industry, or some famous personality, collected from all possible sources.

Museums Museums in discharge of their primary function of tracing the development of important technical, artistic, or social trends frequently have collections of photographs or collections of pictures and artifacts. In some instances there are collections that delineate various facets of the development of photography itself.

Probably the world's largest exclusively photographic museum is the *International Museum of Photography at George Eastman House* in Rochester, New York. This institution, which was established in the palatial home of Kodak founder, George Eastman, has been considerably expanded in recent years and provides scholarly residence to large collections of historic photographs, motion pictures, and photographic equipment of historical interest.

Another excellent general photographic collection is to be found at the *Smithsonian Institution* in Washington, D.C., which has had a dedicated photographic curator for many years and has built collections, in addition to historic photographs, of photographic memorabilia and technically significant photographic apparatus.

ORGANIZATION ADMINISTRATION Organizations, in general, generate revenues to support their activities through the membership dues, advertising revenues from their periodicals, sale of publications (frequently originating from their technical meeting programs), rental of exhibition space at their trade shows, and contributions from interested parties, including product manufacturers as associate members, among other fund-raising activities. The magnitude and balance of these elements vary greatly in the mix of support for various organizations. Some organizations rely almost entirely on membership dues and meeting-registration fees; others depend most heavily on advertising revenues, trade-show exhibit space rentals, and publications sales, for example.

Most national organizations provide a full-time executive director, or secretary, or manager, and support staff at a permanent headquarters office. Some have substantial permanent central office operations including editorial, production, and even in-house printing facilities for their publications. Most operate some elements of a customer information system to service their area of responsibility. These usually include a public relations activity supporting their members' public image and sometimes even advancing their political and legal interests.

Membership organizations usually operate with an elected cadre of officers and a board of directors. These are largely unpaid positions. The board meets only a few times a year and establishes policy and direction. Typically, the officers oversee the administration of these policies through the permanent (paid) executive and staff at the headquarters office.

PSEUDO-ORGANIZATIONS Some commercial photographic organizations choose to operate under the name, and frequently the guise, of being membership organizations, but they are really for-profit businesses. These include catalog buyers' clubs, album plans, film clubs, family portrait clubs, book clubs, travel clubs, and processing clubs. Such organizations have in common the profit motive, the selling of some photographic product or service, or capitalizing on interest in photography to sell a product. In spite of their names, these are not really membership organizations and should be accepted for what they are, that is, specialized marketing operations. In some instances, they offer excellent pricing and service and convenient delivery of their products, but they are not really membership clubs or societies in the full sense of the word. Good indicators for this kind of organization are that they do not provide for the periodic election of the officers by the members, nor are their financial records open and reported regularly to the members.

SPECIFIC MODERN PHOTOGRAPHY ORGANIZATIONS The organizations in the list in this section are known to have a declared interest in some phase or phases of photography, whether technical, artistic, social, commercial, or some mixture thereof. Many are fairly narrow in the scope of their photographic interests as a legitimate part of a larger subject dedication. For example, the Institute of Electrical and Electronics Engineers (the world's largest engineering organization) has several subgroups with photographic interests such as electronic imaging, computer graphics, facsimile, and video. IEEE is, however, an engineering society, not primarily a photographic organization. As another example, the Technical Association for the Graphic Arts (TAGA) is concerned with reproduction by photomechanical means of original text and artwork, including among other forms, photographs, but they are also not primarily a photographic organization.

This list of organizations is all-inclusive among those known to have been active in photographically related fields in the recent past. Some may now be inactive or even defunct. The major organizations described in the expanded data listings are known at the time of publication to be active and fully operational in their defined sectors of interest in photography.

All listed organizations with descriptive paragraphs in the listing are believed to be nonprofit or not-for-profit member-

ship organizations with member-elected officers. Most of them sponsor national meetings, some including trade shows, and most publish one or more periodicals in their field. Some have more diversified publications programs, including proceedings of technical meetings, monographs, and technical books in the field. Some of the organizations have local chapters that maintain a schedule of local meetings in addition to the regional or national, even international, meetings organized by the parent organizations.

For the purposes of this listing, membership organizations are defined as those meeting the following criteria:

They are a democratic organization with a table of officers regularly elected in organization-wide polling.

They have as a stated principal objective the serving of one or more areas of photographic technology, business, or artistic interest.

They have a provision for membership qualification either by evaluated direct application or member nomination, or by appointment as a representative of some other group, or by invitation from the organization itself or nomination by members.

They serve a wide geographic area of national or international scope (as opposed to a restricted localized area).

They have a relatively permanent headquarters business address.

Fiscally they are either nonprofit or not-for-profit operations.

They have a record of active programs in the defined fields on a dependable, continuing basis.

They are *principally* concerned with chemical photography and/or electronic imaging, and/or the practice thereof as a business, profession, or hobby (or have an organization subdivision with such interests).

They publish and distribute one or more dedicated organization periodicals.

The financial operations are independently audited and regularly reported to the members.

In the section that follows, all known organizations are listed that qualify generally as specified above. If their address is known, it is listed (as of 1991). In the cases of those entries that do not include an address, the omission merely connotes that they have not responded to mailed queries to their last known address or that they are believed by the editors to be currently inactive. At least, after appropriate effort, they could not be reached and their business addresses confirmed. Apologies are offered to those qualified organizations that are not listed or whose addresses are not included.

Several of the listed organizations are described in a paragraph of detailed data in the list. These are the largest and most active nationally recognized broad-interest organizations. Most of the others not so treated are narrower in coverage or smaller in size or activities. No inference should be drawn from this selection that there is any quality difference implied between the programs of one type as opposed to the other.

Some otherwise fully qualified organizations may be missing from the list. These omissions are the result of the organization having escaped the editor's attention in a search of photographic literature, and apologies are offered for the oversight.

LIST OF PHOTOGRAPHIC MEMBERSHIP ORGANIZATIONS

Advertising Photographers of America (APA)
 45 East 20 Street, New York, NY 10003
American Institute of Graphic Arts (AIGA)
 1059 Third Avenue, New York, NY 10021. This group represents graphic designers.

American National Standards Institute (ANSI)
 655 15th St. NW, Suite 30, Washington, DC 20005. This is the U.S. standards coordinating group. Photographic standards are handled through committees assigned according to subject matter.
 See also: *Standards.*
American Photographic Artisans Guild (APAG)
 524 W. Shore Drive, Madison, WI 53715
American Society for Photogrammetry and Remote Sensing (ASPRS).
 The society's headquarters, under the direction of a full-time executive director and staff is located at 5410 Grosvenor Lane, Suite 210, Bethesda, MD 20814-2160 (301-493-0290). The ASPRS was founded in 1934 as the *American Society of Photogrammetry (ASP)* to give service to the scientific community and the nation through development of the art and science of photogrammetry which was then largely photographic mapping and interpretation. In 1987 the name was changed to broaden the society to include coverage of the emerging remote sensing technology. This society of more than 8,000 members has 19 regional organizations, some with more than one chapter. Both individual and corporate memberships are provided. Two national meetings are held each year—one called the Annual Conference and the other the multisociety GIS/LLS/Fall Conference and Exposition. These meetings are accompanied by trade shows. *Photogrammetry* is defined by ASPRS as "the art, science, and technology of obtaining reliable information about physical objects and the environment, through the process of recording, measuring and interpreting imagery and digital representations of energy patterns derived from non-contact sensor systems." Within this definition, photogrammetry includes the acquisition of imagery from conventional photographic systems, as well as from sensors utilizing other portions of the energy spectrum. Modern photogrammetry is considered to embrace all the elements of image acquisition, mensuration, and interpretation that are called *remote sensing.* A new area of interest is Geographic Information Systems (GIS), which marries traditional photogrammetry to computers to form very large databases of information about land in all its aspects. ASPRS publishes the monthly technical journal *Photogrammetric Engineering & Remote Sensing,* and also basic manuals of the science, as well as technical papers from meetings, and other reference material. The ASPRS is the U.S. national member of the *International Society For Photogrammetry and Remote Sensing* and is an active participant in the international organization.
American Society for Testing Materials (ASTM)
 1916 Race Street, Philadelphia, PA 19103
American Society of Cinematographers (ASC)
 1782 N. Orange Drive, Hollywood, CA 90028. The society for professional motion picture directors of photography. Membership is by invitation only.
American Society of Magazine Photographers (ASMP)
 The executive director and the headquarters are located at: 419 Park Avenue South, New York, NY 10016 (212-889-9144). This Society's stated purpose is to protect and promote the interests of photographers whose work is for publication. Photographers of all disciplines are represented in their work for publication. (During 1944–1946, ASMP changed its name to the *Society of Magazine Photographers* and then changed back to the current name.) ASMP has approximately 5,000 members and 33 chapters across the United States. There are also some affiliated sustaining organization memberships. Society activities tend to center around

the business of photography for publications. They publish a membership directory as an assistance to location and selection of members for assignments. Monographs and books are published on business practices, stock photography operations, etc. Seminars are held at a major meeting every year, and at local chapters throughout the year.

American Society of Photogrammetry and Remote Sensing (ASPRS)

American Society of Photographers (ASP)
P. O. Box 52836, Tulsa, OK 74152. This society is a subdivision of the *Professional Photographers of America*. Its membership is by invitation and consists of past recipients of PP of A Degrees.

American Society of Picture Professionals (ASPP)

Architectural Photographers of America (APA)
Box 35203, Charlotte, NC 28235.

Associated Photographers International (API)
21822 Sherman Way, Canoga Park, CA 91270.

Association for Educational Communications & Technology (AECT)

Association for Information and Image Management (AIIM) 1100 Wayne Avenue, Silver Spring, MD 20910. This group was originally known as the *National Microfilm Association* and as photographic information handling has grown into other forms, the association changed its name and broadened its activities.

Association for Multi-Image International (AMII)

Association Français de Normalisation (AFN)

Association of Audio-Visual Technicians (AAVT)

Association of Cinema & Video Laboratories (ACVL)
In care of Forde MP Lab, 306 Fairview Ave. N., Seattle, WA 98109.

Association of Federal Photographers (AFP)
P. O. Box 46097, Washington, DC 20050. This Association represents the interests of photographers who work for U.S. federal agencies.

Association of International Photography Art Dealers (AIPAD)
60 E. 42 St., Rm. 718, New York, NY 10165.

Association of Photographic Laboratories (APL)
9 Warwick Court London, England WC1 R5DJ.

Association of Professional Color Laboratories (APCL)
3000 Picture Place, Jackson, MI (49201). This trade association provides both individual and company memberships in the interest of technical and business operations of professional photographic materials processing laboratories. APCL is one of several divisions of the *Photo Marketing Association International*. APCL maintains its own set of officers and its own schedule of activities somewhat independent of PMAI.

Audio Visual Management Association (AVMA)

Biological Photographic Association (BPA)
115 Stoneridge Drive, Chapel Hill, NC 27514. The activities of this association are concerned with all forms of biological photography including medical photography as a major interest. There are about 3000 members involved in an active schedule of programs including chapters and regional meetings.

Commission Internationale de L'Eclairage (CIE)
Central Bureau, Kegelgasse 27, A-1030 Wien, Austria.

Deutsch Gesellschaft fur Photographie (DGPh)
Neumarkt 49, Cologne, Germany.

Electronic Still Camera Standardization Committee (ESCSC)

Electronics Industry Association (EIA)
2101 Eye Street N.W., Washington, DC 20006.

Evidence Photographers International Council (EPIC)
600 Main Street, Honesdale, PA 18431. This organization serves the interests of forensic photographers who work in police, insurance, legal, and fire investigatory work.

Farm Security Administration Photography—See "Influential Photographic Organizations of the Past" earlier in this article.

Fellowship of Photographic Educators (FPE)

Friends of Photography (FOP)
250 Fourth Street, San Francisco, CA 94103. This is a fine art photography group which supports a photographic center known as *The Ansel Adams Center* at their address in San Francisco. Membership is approximately 7000. The organization is operated by an appointed board.

f/64 Group
See "Influential Photographic Organizations of the Past" earlier in this article.

India International Photographic Council (IIPC)
12, Modern School, Barakhamba Road, New Delhi-110001, India. Founded in 1985 and modeled after the Royal Photographic Society and the Photographic Society of America, it now has more than 5,000 members, including both amateur and professional photographers. It is the only such photographic organization in the eastern hemisphere, but its founders and members represent many countries from around the world.

Institute of Electrical & Electronic Engineers (IEEE)
345 E. 47 Street, New York, NY 10017. Said to be the world's largest engineering association, the IEEE has some subgroups with interests in imaging subjects such as facsimile, video, computer graphics, etc. They are very active in standards work including computers and computer graphics.

International Communications Industry Association (ICIA) 3150 Spring Street, Fairfax, VA 22031.

International Congress on High-Speed Photography & Photonics (ICHSPP)
136 S. Garfield Ave., Janesville, WI 53545.

International Fire Photographers Association (IFPA)
P. O. Box 8337, Rolling Meadows, IL 60008.

International MiniLab Association (IMLA)
102 N. Elm St., Suite 33, Greensboro, NC 27410. This trade association caters to the marketing and technical interests of owners and operators of minilabs, i.e., stand-alone processing labs, which are frequently located in retail locations and offer expedited processing services.

International Museum Photographers Association (IMPA)
5613 Johnson Ave., Bethesda, MD 20817.

International Organization for Standardization (ISO)
Case Postale 56; 1, rue de Varembé; CH-1211; Genève 20, Suisse.

International Photographic Council (IPC)
In care of FUJI Photo Film, 555 Taxter Road, Elmsford, NY 10523. This council is a small group concerned with coordinating photographic industry promotional activities in general.

International Photo Optical Show Association (IPOSA)

International Radio Consultative Committee (CCIR)

International Society for Photogrammetry (ISP)
Leonardo di Vinci 32 20133, Milan, Italy. This is the international organization of which the ASPRS is the cooperating U.S. counterpart.

International Television Association (ITVA)
6311 N. O'Connor Road, LB51, Irving, TX 75039.

International Visual Literacy Association (IVLA)
c/o Dr. L. W. Miller, Montgomery College, Takoma Park, MD 20912. This is an academic group concerned with educational aspects of using and understanding graphic images.

Intersociety Color Council (ISCC)
In care of Applied Color Systems, Inc., PO Box 5800, Princeton, NJ 08540.

National Association of Broadcasters (NAB)
1771 North Street, NW., Washington, DC 20036-2898.

National Association of Photo Equipment Technicians (NAPET)
3000 Picture Place, Jackson, MI 49201. This division of PMAI serves the operating and servicing technicians who work with photographic equipment including cameras, processing equipment, projecting equipment, etc.

National Association of Photographic Manufacturers (NAPM)
600 Mamaroneck Avenue, Harrison, NY 10528 (914-698-7603). This association represents the companies that manufacture most of the photographic equipment and supplies sold in the U.S. Membership is confined to companies. Individual memberships are not available. Representatives from the member companies are involved in activities that tend to be working groups and committees addressing industry needs such as product standards, industry-wide promotions, consumer concerns, legislation, environmental matters, and public relations as they apply to the photographic industry.

National Photographic Instructors Association (NPIA)

National Press Photographers Association (NPPA)
3200 Croasdaile Dr., Suite 30, Durham, NC 27705. NPPA is the trade association of photojournalists, largely newspaper and magazine, but with a growing membership among television news photographers.

National Stereoscopic Association (NSA)

North American Photonics Association (NAPhA)

Ophthalmic Photographers' Society (OPS)
3632 Blaine Avenue, St. Louis, MO 63110

Photographic Administrators Inc. (PAI)
1150 Avenue of Americas, New York, NY 10036. PAI is a New York City group that manages a schedule of luncheon meetings of interest to people who manage or administer photographic operations of all types.

Photographic Art and Science Foundation (PASF)
111 Statford Road, Des Plaines, IL 60016. An outgrowth of the *Professional Photographers of America,* this foundation operates the Photography Hall of Fame in Oklahoma City.

Photographic Historical Society (PHS)
P.O. Box 9563, Rochester, NY 14604.

Photographic Industry Council (PIC)
3000 Picture Place, Jackson, MI 49201. This group consists of appointed representatives of photographic membership organizations and is concerned with communications, coordination, and cooperation among such groups with regard to meetings, conferences, tradeshows, etc.

Photographic Manufacturers and Distributors Association (PMDA)
The Executive Manager's office address is 866 United Nations Plaza, Suite 436, New York, NY 10017 (212-688-3520). PMDA is a very active organization that produces a schedule of seven or eight meetings through the year in New York City. Its membership consists of companies that participate in the photographic industry as manufacturers and/or distributors. About a hundred company memberships support the organization, but many individuals from the member companies participate in association activities. There are no chapters. One monthly meeting per year is devoted to a presentation by a prominent invited personality from outside the photographic industry. There is also an annual Photographic Industry Man-of-the-Year Award dinner in mid-winter. As an association activity, PMDA sponsors an

ongoing program of generic photography exhibits at leading public expositions relating to sporting and marine activities to stimulate interest in picture taking.

Photographic Society of America (PSA)
3000 United Founders Boulevard, Oklahoma City, OK 73112. This organization is the oldest and largest national society representing the interests of serious amateur photographers. For many years, the technical division of PSA was the primary forum where still photography research and development was reported in the photographic community. In the early 1960s, the technical division merged with the *Society of Photographic Engineers* to form the *Society of Photographic Scientists and Engineers,* combining the scientific coverage of the technical division with the engineering interests of SPE into one program. PSA continues its activities in creative and practical photographic matters of interest to serious amateur photographers. PSA offers many services to local camera clubs that are members. They sponsor print and slide competitions and assist in salon activities throughout the year. They hold one annual convention which moves among large cities in the U.S. Convention activities are oriented toward creative and technique subjects with a good mixture of social activities. PSA publishes the *PSA Journal.* Individual memberships, camera club affiliations, and commercial sponsor memberships are available.

Photokina
Bi-annual international photographic trade show in Cologne, Germany.

Photo League (PL)
See "Influential Photographic Organizations of the Past" earlier in this article.

Photo Marketing Association International (PMA or PMAI) 3000 Picture Place, Jackson, MI 49201 (517-788-8100). PMAI is the largest trade association in the photo industry, and the parent organization represents primarily the interests of photographic retailers and photographic processors of all types. In addition, PMA has sections of the organization that service specialized scopes of interests. These are: Association of Professional Color Labs (APCL); Professional School Photographers Association (PSPA); National Association of Photo Equipment Technicians (NAPET); Society of Photographic Counselors (SPC); Society of Photo-Finishing Engineers (SPFE). The membership is approximately 16,500 of which company memberships predominate, although individual memberships are available. Members reside about 75% in the United States and 25% outside the U.S. A number of periodicals are published among which *Photo Marketing Magazine* is principal. Others are: *MiniLab Focus, Specialty Lab Update, The School Photographer, Sales Counter, Colorgram* (APCL), and *SPFE* and several other newsletters. The PMAI sponsors the largest U.S. photographic trade show in connection with its annual convention in late winter or early spring of each year. About 50 meetings of various kinds are held throughout the year in Canada, Australia, New Zealand, and the U.K. There are localized chapters that also hold meetings.

Photo-Secession
See "Influential Photographic Organizations of the Past" earlier in this article.

Pictorial Photographers of America (PPA)
299 W. 12th Street, New York, NY 10014. This is a Photographic Society of America subdivision concerned largely with salon photography.

Picture Agency Council of America (PACA)

Professional Photographers of America (PPofA)
1090 Executive Way, Des Plains, IL 60018 (708-298-8161). Founded in 1880, and laying claim to being the

oldest trade association in the United States, PPofA is the largest trade association broadly representing professional photographers with a membership of approximately 17,000. Individual memberships as well as company affiliations are provided. There are more than 200 state, regional, and international affiliated organizations. PPofA sponsors two annual national meetings, its annual convention and an annual Marketing and management conference, each with an accompanying trade-show. Tracing its roots to the days when the first commercial products of photography were portraits, over the years PPofA has expanded its purview to include commercial photography, and after the Second World War, industrial or corporate photography. The organization tends to concentrate on marketing, promotion, management, and business aspects of professional photography in addition to its coverage of practical technical aspects of picture-making. They operate the *Winona International School of Professional Photography* in Mount Prospect, Illinois. This school provides a year-round schedule of 3 to 5-day intensive hands-on short courses in various professional photographic subjects. PPofA publishes two monthly periodicals: *Professional Photographer* and *PHOTO>Electronic Imaging* (formerly *PhotoMethods*). An honorary society within PPofA, *The American Society of Photographers (ASP)* has membership by invitation only. The PPofA provides opportunity for considerable social interaction among its members, and there is a formal system for the awarding of recognition of the achievements of outstanding members in the form of "degrees" and other citations that are presented each year at ceremonies during the annual convention.

Professional School Photographers Association (PSPA)
 3000 Picture Place, Jackson, MI 49201. This is the trade association for companies that supply picture-taking services to schools, usually with traveling camera teams and using a central processing laboratory facility.

Professional Women Photographers (PWP)

Royal Photographic Society of Great Britain (RPS)
 The Octagon, Milsom St. Bath, Avon, United Kingdom BA1 1DN. This venerable group services both technical and artistic areas of photographic interest. It enjoys a large worldwide membership of both professional and amateur photographers.

Societe Français de Photographie et de Cinematographie (SFPC)
 9 rue Montalembert, Paris VIIe France.

Society for Imaging Science and Technology (IS&T)
 7003 Kilworth Lane, Springfield, VA 22151 (703-642-9090). Founded in Washington, D.C. during the Second World War as the *Society of Photographic Engineers,* SPE later joined with the technical division of the *Photographic Society of America* to form the *Society of Photographic Scientists and Engineers,* and in 1987 changed to the present name but retained the SPSE acronym until late 1990. Chapters are located in 14 cities mostly in the Eastern U.S. with two in California and one in Japan. Individual memberships total around 3000. It publishes two highly technical journals: *Journal of Imaging Technology* and *Journal of Imaging Science* consisting mainly of formal refereed technical papers reporting research and design work. (There is discussion of merging these journals.) IS&T holds one annual conference and several single-subject seminars or symposia each year at various locations around the United States and abroad. Individual memberships and corporate sponsorships are available. Activities tend to be of interest to scientists and engineers in various technical imaging areas—photographic, optical, and electronic—especially research and design activities. SPSE and the Rochester Institute of Technology established at RIT the Image Permanence Institute, which is devoted to the study of image permanence issues and technology. This laboratory was funded by subscription to an industry fund by the photographic manufacturers through the efforts of SPSE in 1980.

Society for Photographic Education (SPE)
 University of Colorado, Campus Box 31, Boulder, CO 80309. SPE is the society for teachers of photography, largely at a college level. It was founded in 1962 in Rochester, New York, "to establish a formal organization whose primary interest is in the teaching of photography." The society publishes a periodical called *Exposure.*

Society of Motion Picture and Television Engineers (SMPTE)
 595 W. Hartsdale Avenue, White Plains, NY 10607. An engineering technical society devoted originally to the particular technology of cameras, processing, and projection of motion pictures; SMPTE expanded its coverage in the 1950s to television production and distribution. Chapters are located in many cities where there is sufficient motion picture/television production work to support such activities. The *SMPTE Journal* is published monthly and has a long distinguished history of covering motion picture and television technology. The society has about 10,000 individual members, and company sponsor memberships are also available. There is an annual conference, where technical papers are presented, a TV conference, and there are local 1- and 2-day meetings on various subjects.

Society of Photo-Finishing Engineers (SPFE)
 3000 Picture Place, Jackson, MI 49201. This Society is a subdivision of PMAI and is concerned with the interests of engineers who design, manufacture, service, and operate photofinishing laboratory equipment.

Society of Photographers in Communications (SPC)

Society of Photographic Counselors (SPC)
 3000 Picture Place, Jackson, MI 49201. This society is a subdivision of PMAI and serves the needs of training and qualifying retail sales personnel in photographic concerns.

Society of Photographic Scientists and Engineers (SPSE)
 See *Society for Imaging Science & Technology (IS&T)*

Society of Photo-Optical Instrumentation Engineers (SPIE)
 P.O. Box 10, 1000 20th Street, Bellingham, WA 98227-0010. This technical society has a membership of about 3000. It has a very active meeting and publications program oriented heavily to optical and electronic instrumentation engineering growing out of the military, space, and satellite industries.

Society of Photo-Technologists (SPT)
 P.O. Box 9634, Denver, CO 80209.

Society of Professional Videographers (SPV)

Society of Teachers of Professional Photography (STOPP)
 1090 Executive Way, Des Plaines, IL 60018. This group is affiliated with *Professional Photographers of America* and is concerned with activities of teachers of professional photography subjects.

Studio Suppliers Association (SSA)
 548 Goffel Road, Hawthorne, NJ 07506. Dormant.

Technical Association for the Graphic Arts (TAGA)
 In care of RST, P.O. Box 9887, Rochester, NY 14623 (716-275-0557). This is a graphic arts technical association that has considerable activity in matters of reproduction of photographic illustrations by photo-mechanical means, i.e., printing presses.

University Photographers Association of America (UPAA)

607 Cohodas, Marquette, MS 49855. This association concerned with photographers whose work is involved with and in support of institutions of higher learning.

White House News Photographers Association (WHNPA) Box 7119, Ben Franklin Station, Washington, DC 20044. This association is for the large group of photographers who are accredited to the White House. They operate an annual seminar for high school students who are interested in photojournalism.

Books: Rosenblum, N., *A World History of Photography,* Revised Edition. New York: Abbeville Press, 1989; Pollack, Peter, *The Picture History of Photography to the Present Day.* New York: Harry N. Abrams, Inc.; *International Center of Photography Encyclopedia of Photography.* New York: Crown Publishers, Inc., 1984. *A. Peed*

ORIENTATION The relationship of an image to the viewer or to the image environment, for example, the position of an image (or a mount) according to its longer axis, i.e., *vertical* (long dimension perpendicular to the horizon) or *horizontal* (long axis parallel to the horizon). The vertical orientation is sometimes referred to as *portrait,* and the horizontal as *landscape.* The portrait and landscape designations are also used to define orientation of text on a page; landscape lines running across the length of the page, portrait across the width.

The term also applies to placing a negative or other image in a printer, enlarger, or projector with respect to the emulsion facing toward or away from the light source, the top of the image being positioned upward or downward, etc. It might refer to the axis or other reference of a photograph, such as the north–south axis of an aerial image.

Orientation might also refer to *right-reading* or *wrong-reading* of text or image material, that is, whether it is a correct-reading image or a mirror image. *I. Current*

ORIGINAL The term *original* refers to the negative (or positive if reversal processed) that was in the camera when the object was photographed. It also applies to sound recordings on film, or video recordings. Originals are also materials from which copies are made, such as handwritten or typed documents, printed material, tracings, drawings, etc. The term might also apply to an original work of art. *I. Current*

ORTHO/ORTHOCHROMATIC The first term is the familiar form for the second term. Orthochromatic films are sensitive to all colors except deep orange and red. *M. Scott*
See also: *Blue-sensitive; Pan/panchromatic.*

ORTHOSCOPIC IMAGE (1) An image that is completely free from any form of distortion. This theoretical ideal cannot be achieved, but distortion can be so small as to be undetectable except by laboratory methods. A symmetrical arrangement of the front and rear components of a lens about a central stop reduces distortion to a minimum, and such lenses are sometimes identified as orthoscopic lenses. (2) An image that is characteristic of normal vision.
L. Stroebel

ORTHOSCOPIC LENS See *Lens types.*

OSCILLOSCOPE A useful test instrument that displays on a cathode-ray tube the variation of applied voltage with respect to time. The waveform is displayed on the screen of the CRT by moving a spot of light resulting from an electron beam (the cathode ray) striking the phosphors on the face of the tube. The spot can be deflected both vertically and hori-

zontally. The vertical axis of the display represents the amplitude of the voltage applied to the vertical input terminals. The horizontal axis is linear with respect to time. The pattern on the screen, therefore, displays a graph of the variation of applied voltage as a function of time. The oscilloscope is generally used to observe two types of voltages: (1) those that are repetitive or cyclic in nature and whose trace is continuously displayed, and (2) those that are transient, where the trace appears on the screen only once (until triggered again). Some oscilloscopes can display two or more waveforms simultaneously. Although basically a voltmeter, the oscilloscope can also be used to measure current, phase difference, and frequency of cyclic waveforms. Certain physical quantities such as light, force, temperature, and distance can be converted to their electrical analog and can be displayed. One such photographic application is the shutter tester, where the relative amount of light passing through the shutter is represented by the vertical displacement of the CRT spot and time by its horizontal displacement. Oscilloscopes are capable of displaying exceedingly fast transient phenomena.

Photographing oscilloscope waveforms, cyclic as well as transient, provides a permanent record of the behavior of the equipment under test and can be useful for later evaluation of the waveform, especially in the case of transients. *W. Klein*
See also: *Cathode-ray tube.*

OSCILLOSCOPE CAMERA See *Camera types.*

OSTWALD COLOR SYSTEM Color order system in which the arrangement of the colors is similar to that of the Natural Color System; the Ostwald system is no longer available commercially. *R. W. G. Hunt*
See also: *Munsell system; Natural color system.*

OSTWALD RIPENING A stage in the manufacture of silver halide emulsions in which the fine crystals dissolve and reprecipitate on the larger, less soluble crystals. This process of physical ripening was named for W. Ostwald, who in 1900 studied the crystal growth of mercuric oxide and iodide. Ostwald ripening is usually carried out in the presence of silver halide solvents, such as excess bromide ions or ammonia. *G. Haist*
See also: *Emulsions.*

OSTWALD, WILHELM (1853–1932) German professor of physical chemistry at Leipzig University for 20 years, establishing his independent laboratory nearby in 1907. Received the Nobel Prize for chemistry in 1909. Between 1892 and 1900, proposed theories on the chemical development of the latent image and on the ripening and growth of the grains in an emulsion. In 1914, introduced a new theory of color and published his *Color Atlas,* which described the Ostwald System of color tabulation that used pure hues to which were added varying proportions of black and white.
M. Alinder

O'SULLIVAN, TIMOTHY (c. 1840–1882) American photographer. A gifted photographer of the Civil War, working first for Brady and then for Gardner. Of the 100 photographs included in Gardner's *Photographic Sketch Book of the War,* 45 were by O'Sullivan. Following the war, became one of the greatest photographers of the American West, while working as official photographer for the U.S. Geological Survey, as they explored along the 40th parallel (1867–1869) and for the various Wheeler expeditions (1870–1875), including its survey of the 100th meridian and the first voyage up the Colorado River. Used collodion wet plates producing albumen prints. Died of tuberculosis.

Books: Dingus, Rick, *The Photographic Artifacts of Timothy O'Sullivan.* Albuquerque: University of New Mexico Press,

1982; Naef, Weston J. and Wood, James N., *Era of Exploration.* Boston: New York Graphic Society, 1975. *M. Alinder*

OUNCE In the U.S. system of measurements, (1) a measurement of weight, equal to 1/16 lb and to 28.3 grams; (2) a measurement of volume, equal to 1/32 quart and to 29.6 ml.
H. Todd

OUTDATED Photographic materials for which their effective usage is now past the expiration date on the package, a date beyond which full performance cannot be counted on. With black-and-white films and papers, speed and contrast may be reduced, and fog may be increased. To some extent these can be overcome by adjusting exposure and development and by the use of antifoggants added to the developer. Color negative materials may show the same troubles and also shifts in color balance; processing changes probably will not help. Color transparency materials also lose speed and contrast, but because of their reversal nature, they manifest fog as a loss of maximum density, which is seen as smoky shadows. *M. Scott*
See also: *Expiration date.*

OUTERBRIDGE, PAUL, JR. (1896–1958) American photographer. Studied with Clarence White (1921). While in Paris (1925–1929) as art director of Paris *Vogue,* was accepted into the group of avant-garde artists that included Duchamp and Man Ray. Returned to the United States and became a popular commercial color photographer for such magazines as *Harper's Bazaar, House Beautiful,* and *Vogue.* Admired for his technical command of the craft from his early platinum prints to three-color carbro prints.
Books: Howe, Graham, *Paul Outerbridge, Jr., Photographs.* New York: Rizzoli, 1980. *M. Alinder*

OUTPUT The terms *input* and *output* are interdependent, and they are commonly combined in the form of input/output to represent the beginning and end of a process. In the process of making a photograph, for example, the subject is generally considered to be the input and the photographic image the output. *L. Stroebel*
See also: *Input.*

OUTTAKE A motion-picture shot not selected for use in the final film. *H. Lester*

OVERCOAT A thin usually colorless gelatin layer coated over an emulsion to protect it from abrasion. Sometimes a dye is added to provide color correction to a color emulsion.
M. Scott
Syn.: *Topcoat; Supercoat.*

OVERCONSTANCY Any of various phenomena whereby a person's perception of some aspect of a scene or object, such as brightness, color, or size, displays overcompensation in the attempt to remain constant as the stimulus changes. With two objects of equal size but at different distances from the viewer, for example, the farther object will be perceived as being larger even though the retinal image of that object is smaller. This is a perceptual effect commonly experienced when viewing photographs made with long focal length telephoto lenses.
L. Stroebel and R. Zakia
See also: *Perspective; Visual perception; Weak perspective.*

OVERCRANKING Operating a motion-picture camera at a faster frame-per-second rate than that intended for projection, resulting in the effect of slow-motion movement on the screen. Movement is slowed in proportion to the differences in frame rate; for instance, because the normal projec-

tion rate is 24 frames per second, filming at 58 frames per second would convert motion into half speed, while filming at 240 frames per second would slow the motion by a factor of 10. *H. Lester*

OVERDEVELOPMENT Processing in a developer for too long a time, in an excessively active bath, or at too high a temperature or agitation rate. The result may be excessive image density (especially in the highlight areas of the negative), excessive image contrast, high graininess, and fog.
L. Stroebel and R. Zakia

OVERDUB The process of using a multitrack recorder for recording different parts at different times, using playback from the recording head of already recorded sounds as a synchronization reference. In this way, a prerecorded click track, for instance, can be played into headphones on musicians who then play their parts for recording on other tracks. Synchronization in time is assured by playing from the same head that is recording on separate tracks. *T. Holman*
See also: *Selsyn.*

OVEREXPOSURE In general, giving photosensitive materials more than the optimum amount of exposure, producing dense images on nonreversal materials and light images on reversal materials. The highlights are the first areas to lose contrast and detail with overexposure on both types of materials. The shoulder of the characteristic curve for negative films is sometimes identified as the overexposure region, although adverse effects, such as increased graininess and print exposure time, can occur before reaching the shoulder. *J. Johnson*

OVERLAP In motion-picture production, the duplication of action at the end of one shot and the beginning of another, allowing for editorial flexibility in selecting a matching point between the two shots. *H. Lester*

OVERLAPPING OBJECTS Arrangement in a scene whereby a closer object obscures part of a more distant object, providing the viewer with a strong clue as to the relative distances of the objects. *L. Stroebel*
See also: *Nonlinear perspective; Perspective.*

OVERLAY (1) An assembly of transparent or translucent prints placed one over the other to form a composite image. (2) A drawing, tracing, or other transparent medium superimposed on another record or image to delineate areas or correlate them with other information. (3) In electronic imaging, the use of several images as pieces in the composing of a new image. The images are seamlessly pasted, and the resulting image is displayed without evidence of its being a composite. *I. Current and R. Kraus*

OVERLAY PROOF A type of color proof consisting of separate colored foils. *M. Bruno*
See also: *Color proofing.*

OVERLOAD (1) Any load that exceeds the rated output of a component or machine. (2) Any input that exceeds the ability of a component or machine to accept input. *W. Klein*

OVERRIDE A control on a camera that cuts out automatic operation. The override is necessary where a camera battery is weak or the photographer desires a different exposure than the automatic control would produce. *P. Schranz*

OXIDATION Originally, the name given to the effect of oxygen on other substances, such as forming rust (Fe_2O_3) or in the combustion of carbon to form carbon dioxide (CO_2).

Deterioration of photographic solutions, such as developers, may be the result of the effect of aerial oxygen. A more general definition now recognizes oxidation as the process by which electrons are removed from atoms or ions, even though oxygen itself may not be involved. *G. Haist*

See also: *Reduction, chemical.*

OZALID PROCESS

A commercial diazo process introduced in 1922, commonly called brownline or blackline process, that produced dark lines on a light background. The Ozalid paper contains diazo and dye-coupling compounds. Exposure under a negative destroys the dye-forming capabilities in the exposed areas. Ammonia fumes cause the positive line image to form. *J. Natal*

See also: *Diazo process.*

OZOBROME PRINTING PROCESS

Forerunner of the carbro process. In common with carbro, the process produces pigment prints direct from bromide contact prints or enlargements without the action of light. Invented by Thomas Manly in 1905 and marketed in 1907 as the carbro process. *J. Natal*

See also: *Carbro process.*

OZOTYPE

Method of pigment printing invented by Thomas Manly in 1899, which was later replaced by the ozobrome process. A form of carbon printing. A sheet with bichromated gelatin was contact exposed to a negative. It was then placed in contact with a pigmented carbon tissue soaked in a dilute solution of acetic acid and hydroquinone, and squeegeed together. A chemical reaction took place that hardened the carbon emulsion in direct proportion to the degree of exposure. The sheets were separated and the unexposed and therefore unhardened pigment was washed away, leaving the hardened areas to form the image. One of the many processes that finally led to present-day carbro printing. *J. Natal*

See also: *Carbro process.*

P

P Power (radiant flux other than light); Power (electrical)

p *para* (organic chemistry)

PA Public address

PACA Picture Agency Council of America

pAg Silver ion concentration

PAI Photographic Administrators, Inc.

PAL Phase alternative line, European color television coding system

pan Panchromatic

PASF Photographic Art and Science Foundation

PC Personal computer; Pin-cylinder (connector); Phase change (disk); Plastic-coated

PCB Printed circuit board

PCM Pulse code modulation

PCMI Photochromic microimage process

PD Physical development; Potential difference

PE Polyester; Photoelectric (cell)

Pe Excitation purity (colorimetry)

PEC Photoelectric cell

PEP Photoelectrophoresis

PF Power factor

pH Hydrogen ion concentration

phi(ø) Radiant flux or luminous flux (Greek letter)

photo Photograph; Photography

PHS Photographic Historical Society

PIC Photographic Industry Council

pico 10^{-12}

PIP Persistent internal polarization

pix Picture (slang)

pixel Picture element

PL Photo League

PMA Photographic Manufacturers Association

PMAI Photo Marketing Association International

PMDA Photographic Manufacturers and Distributors Association

PMS Pantone matching system

PMT Photomultiplier tube

PNP One of two types of bipolar junction transistors

POP Printing-out paper

POTA Photo Optics Technical Area (POTA developer)

POV Point of view

PPA Pictorial Photographers of America

PPM Pulses per minute

PPofA Professional Photographers of America

pps Pictures per second

PQ Phenidone-hydroquinone (developer)

pro Professional

ps Picosecond (10^{-12} second)

PSA Photographic Society of America

PSC Portable single camera

PSF Point spread function

PSPA Professional School Photographers Association

pt Pint

PTF Phase transfer function

PV Panchromatic viewing (filter)

PVC Polyvinyl chloride

PWP Professional Women Photographers

PACKAGE PRINTER A type of projection printer that exposes several images of different sizes simultaneously from a negative. Commonly used for school portraits.

L. Stroebel

PACKET EMULSIONS Photosensitive materials consisting of discrete small globules of different emulsions separated by immiscible binders. Variable-contrast papers often use such emulsions for the high- and low-contrast components.

M. Scott

pAg pAg represents a measurement of silver ion concentration in a solution and is defined as the negative logarithm (base 10) of the silver ion concentration in moles per liter. At the point of neutrality, the silver ion concentration [Ag$^+$] equals the halide concentration [halide$^-$]. Below the point of neutrality there is an excess of silver ions; above the neutrality point there is an excess of halide ions. pAg values are of vital importance in the manufacture of silver halide emulsions.

G. Haist

PAINT In electronic imaging, the process of creating images of a specific color, size, and shape, analogous to painting manually with a brush.

L. Stroebel

See also: *Brush.*

PAINTINGS (PHOTOGRAPHING) See *Copying.*

PAINTING WITH LIGHT Moving the light source during a long exposure. This technique can achieve effects difficult or impossible with a fixed source. Moving the source over a wide area enables a small light source to produce a shadow pattern similar to that of a large soft source.

Some fiber optic light sources are designed specifically for painting with light. These confine the beam well enough to allow placing the light within a couple of centimeters of the

subject without recording the hand of the photographer or the source itself on film. This permits creating highlights similar to those of a larger source farther from the subject, but from angles of illumination impossible for the larger source. Such highlights may have the brightness of those produced by direct reflection, but with the color saturation of those produced by diffuse reflection.

The disadvantage of painting with light is the impossibility of seeing the effect before processing the film. Polaroid testing and experience are essential; conveniently available conventional film processing is highly desirable.

F. Hunter and P. Fuqua

PAIRED COMPARISON (1) A method used in statistical testing when the measured values vary because of factors that are not under consideration. For example, in checking the performance of two densitometers, the recorded values will change markedly with the level of the sample density, and a comparison of the average readings over a range of densities would be ineffective. Therefore, the density readings from the two instruments are paired, and the differences in the pairs of readings are examined to detect a difference in the two densitometers. (2) A method used in statistical testing in which a set of items (for example, prints A, B, and C) are compared in all possible combinations of two (A and B, B and C, A and C) to determine if the results are consistent. If a person judged print A to be lighter than print B, print B to be lighter than print C, and print C to be lighter than print A, the responses would not be consistent, indicating that the person was guessing or influenced by some factor other than the actual tones of the prints. *H. Todd*

PALETTE In computing, the possible number of colors displayed is a selection of colors from a larger possible group known as the palette. Thus a computer that can display 16 colors at any one time typically will select a group of 16 colors from a palette of 256 colors.

PALLADIUM PRINTING PROCESS/PALLADIOTYPE Printing process introduced around 1916 capable of very delicate tone rendering. Special paper was used and the final image consisted of palladium. The process was very similar to platinotype. *J. Natal*

See also: *Platinotype.*

PAN Familiar form for *panchromatic.* Panchromatic photosensitive materials respond to the whole visible spectrum in much the way the human eye does. Red, green, and blue regions are recorded, but also recorded are the ultraviolet that all silver halide films respond to, unless this is blocked by a UV-absorbing overcoat. *M. Scott*

PAN-AND-TILT HEAD A tripod attachment that permits a camera to be rotated horizontally about a vertical axis (pan) or vertically about a horizontal axis (tilt). Some have a separate locking mechanism for each movement. *L. Stroebel*

PANAVISION Trade name for a motion picture widescreen process. Using Panavision anamorphic lenses, the negative camera image is horizontally compressed by 50%. When projected, the image is horizontally expanded proportionally by projecting through an appropriate anamorphic projection lens. *H. Lester*

See also: *Lens types, anamorphic.*

PANCAKE (SOUND) Audio magnetic tape wound on a core without flanges. *T. Holman*

PANCHROMATIC VISION (PV) FILTER See *Filters, viewing.*

See also: *Blue-sensitive; Ortho/orthochromatic.*

PANNING A term used to describe the technique of following the action of a subject with the camera, or moving the camera across relatively stationary objects, or moving objects, in order to record a sharp image. *R. Welsh*

PANORAMIC CAMERAS See *Camera types.*

PANORAMIC PHOTOGRAPHY The term *panoramic* is applied to photographs that include a large horizontal angle of view. It is not normally used with photographs made with conventional cameras and wide-angle lenses unless the image is cropped at the top and bottom to increase the width-to-height proportions.

Panoramic photographs can be produced in various ways. In motion-picture photography, the camera can be panned to increase the horizontal coverage on a sequential basis. Panning too rapidly produces an annoying jumpy effect, while covering a large angle with a slow pan requires considerable time. Sophisticated multiple camera systems have been devised whereby the separate films are projected side by side with synchronized projectors to produce a composite image having a wide angle of view. Another system makes use of an anamorphic lens on the motion-picture camera that squeezes the horizontal dimension of the scene with another anamorphic lens on the projector that unsqueezes the image to produce a screen image having a high aspect ratio. This is usually referred to as a wide-screen system since it requires a screen having greater width than is required for conventional motion pictures. Complications occur when such films are shown on television screens, however, where the aspect ratio of the screen is much lower.

Still photographers have also made panoramic photographs by panning the camera, in this case to produce a set of overlapping images that could be combined into a single composite image, but it is a difficult and time-consuming process, especially if the work must be done so skillfully that the final image appears to have been made as a single photograph. Most panoramic photographs are now made with panoramic cameras.

PANORAMIC CAMERA At this time the term *panoramic camera* applies to any camera that is able to make a photograph whose aspect ratio is greater than 1:3. Many cur-

Diameter of outer drum is 4x focal length of lens.
Diameter of film bearing drum is 2x focal length of lens.
Camera can cover almost 360° sequentially.

An early type of panoramic camera.

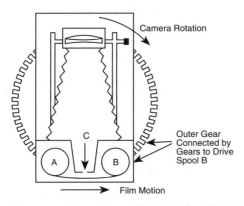

A circuit-type panoramic camera capable of more than 360-degree sequential coverage. The film moves from spool A to spool B driven by gears or pulleys connected to the turning motion of the camera such that the image motion past slit C is equal to the film motion.

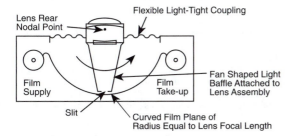

Panoram-type panoramic camera capable of about 150-degree sequential coverage. The lens pivots about its rear nodal point, effectively keeping the image stationary as it scans the scene. The exposure time is usually controlled by the rate at which the lens scans the scene.

rent cameras classified as panoramic types are simply conventional cameras fitted with a rectilinear wide-angle lens and an internal mask, which may indeed be the camera body itself, to achieve such aspect ratios. Typically these cameras do not exceed a horizontal angle of view much greater than 100 degrees. Their distinct advantage is simplicity of operation and rectilinear perspective.

On the other hand, to include greater angles of view there are special camera designs that expose scenes sequentially and are able to cover horizontal angles of about 150 to close to 360 degrees on stationary film, to over 360 degrees when the film is placed in motion.

In every one of these designs the lens scans the scene from side to side and exposes the film by scanning the image onto the film through a narrow slit. Thus, the camera has an instantaneously narrow horizontal angle of view and a vertical angle of view that depends on the focal length of the lens in use.

There are many variations on the same general theme, but only three will be described here.

The first scheme is characterized by the very successful Panoram cameras manufactured by Eastman Kodak and, more recently, the Widelux. In these cameras, which have a limited angle of view, the film is held in a circular arc whose radius is the focal length of the lens. The lens is attached to top and bottom shafts whose axes run through its rear nodal point and is connected to the camera front by a flexible light-tight baffle. During exposure the lens pivots about its rear nodal point, scanning the horizon from side to side while the

image-forming light passes onto the film by way of a funnel-shaped fan with a slit near the film surface.

Under these conditions the lens produces a stationary image, and the exposure time is governed by controlling the rate at which the lens is allowed to scan from one side to the other. Because of mechanical factors, these cameras can only cover angles of about 150 degrees. They are, however, among the simplest of the true panoramic camera types.

A second design never achieved commercial success, but many amateur photographers have made prototypes that work quite successfully. In this approach the film is held around the outside surface of a drum of radius equal to the lens focal length and within which the film supply and take-up spool are usually also stored. An outer drum, of $2\times$ lens focal length radius, carries the lens and a light baffle that has a slit near the film surface and rotates around the inner drum. The lens has a mirror mounted in front of it to reverse image motion direction such that the image appears to stand still as far as the film is concerned.

The third type of panoramic camera is the one based on the Cirkut cameras also made by Eastman Kodak and currently exemplified by such cameras as the Alpa Technorama, the Hulcherama, the Roundshot, and the Globuscope.

In these designs the film and the lens both move. The lens rotates about its rear nodal point while a slit moves along a circle determined by the focal length of the lens. Simultaneously, film is transported past the slit at a speed that just matches the apparent velocity of the slit past the image, which actually is stationary. In a way this type is nothing more than an extension of the first type, but instead of having the film set in an arc about the lens as it pivots, the arc is built up behind the lens as the lens scans the scene. In this way, horizontal (or vertical, for that matter) angles of coverage exceeding 360 degrees are possible.

Cameras of this latter type, in particular, are often used for taking pictures of large groups of people. Because they are scanning cameras, the total time that it takes to make an exposure may be as long as a few seconds to more than 30 seconds, although the effective exposure time of each point in the picture may be as short as 1/10 second. Local exposure time is adjusted by varying the width of the exposing slit or the panning rate of the camera.

In the case of a group shot, the subjects would remain quite still during the exposure, as any movement will lead to blurring and a compression or expansion-type distortion of a subject, depending on its direction of motion relative to the scanning direction of the camera. Double exposure stunts are, however, possible, by one or two members located at the first extreme edge running behind the group, or around the camera, to the other edge and reaching it before the scanning shutter slit of the camera gets there.

Special panoramic cameras have also been developed for aerial purposes in which an arrangement of prisms and mirrors is used to scan from one horizon to the other while the film is continuously moving in the camera. Other designs exist that cover angles of view of almost 360 degrees in a single simultaneous exposure on a curved strip of film with a special optical system. *A. Davidhazy*

See also: *Lens types, fish-eye lens, Hill cloud lens; Streak and strip photography.*

PANTOGRAPH A drawing copying device consisting of a parallelogram arrangement of bars that can be altered to provide different scales of reproduction, used, for example, on some motion-picture animation stands. *L. Stroebel*

PANTONE MATCHING SYSTEM (PMS) A commonly used ink mixing and color matching system. *M. Bruno*

PAPER See *Photographic paper.*

PAPER BASE The support for photographic paper emulsions. Two types are current—fiber and resin-coated. The latter absorbs almost no water during processing, greatly speeding washing and drying. An older version of water resistant paper not made since the 1950s was resin-impregnated. Fiber-base papers are the classical type and may be either direct-sensitized (emulsion spread directly on sized paper, giving a dull surface) or baryta-coated (clay-coated). Most fiber papers are of the latter type, making them smoother and giving a longer tonal scale. Fiber papers absorb processing chemicals within their fibers, making them difficult to wash. They imbibe a great deal of water in the sponge of their fibers, making them hard to dry. These factors militate against rapid machine processing. Resin-coated (RC) papers were designed to overcome these troubles. RC papers are a web of conventional fiber paper coated front and back with a thin skin of polyethylene or similar plastic. The emulsion is then coated on one side of that. Such papers absorb virtually no chemicals or water except those in the emulsion itself, making them ideal for rapid machine processing. Extensive washing of resin-coated papers is detrimental, since water and chemicals eventually penetrate at the edges. Fiber-base papers are declining in use as mechanized processing becomes more widespread, but are still preferred for serious exhibition work and by the fine-art photography market. *M. Scott*

PAPER CONTRAST GRADES Numerical designations of photographic printing papers on a scale from 0 (very low contrast) to 5 (very high contrast). What are called *soft* papers have grades of 0 and 1; *normal* contrast is designated as 2; *hard* papers have grades above 2.

The grade numbers are approximately inversely related to the scale index, which is the range of log H values over which the paper responds effectively. The scale index, in turn, is nearly equal to the density range of the negative that will print well on the paper if the exposure level is appropriate.

The experimentation that gave rise to the ASA method (now ISO) of determining film speed also involved decisions of observers about print quality. Best-liked prints almost uniformly contained as the darkest tone one well below the maximum black the paper could produce and at a point on the curve where the slope was equal to the average slope of the curve. Thus, it was clear from the experiments that perceptible shadow detail was important for high print quality. Although the preferred minimum density was more variable, it averaged out at a point only slightly above the base plus fog density.

Paper contrast. Characteristic curves of photographic papers of six different grades. Each of the papers can produce the same range of tones, from the basic white to the maximum black. They differ in their average slopes and, more important, in the range of log exposure values required to give the minimum and maximum tones.

These results were the basis for defining the useful part of the curve on which present standards are founded:

1. The minimum useful density is 0.04 above base plus fog.
2. The maximum useful density is 0.9 times the density at the highest part of the curve.
3. The log-H range, formerly known as the scale index, is the difference between the log-H values for the two points defined above.

The table shows the log H ranges and the appropriate density ranges of the negatives that fit the various paper grades. The values for the negatives differ for the two types of projection printers because of the different optical systems for diffusion and condenser enlargers.

Other printing systems, such as contact printers, may require adjustments in the paper selection process. One test method available to the practicing photographer involves the use of a calibrated transparent step tablet. When an exposure is made with the tablet in the printer, visual examination of the image can identify the desired minimum and maximum print densities, and therefore the density range of the tablet steps that correspond to the print tones. *M. Leary and H. Todd*

PAPER GRADE Photographic paper for pictorial and most technical photography is made in a range of different contrasts. A few manufacturers use names alone—extra soft, soft, normal, hard, extra hard, ultra hard—but most use numbers zero through five for these, with two corresponding to normal. The majority of negatives should print best on a number two paper. A soft negative, or one with less contrast, would need a higher grade; a hard negative, or one with more

Paper grades. *Top:* A, negative with long scale of tones from black to transparent; B, printed on hard paper; C, on medium paper; D, on soft paper. These papers reproduce, respectively, a short, medium, and full range of the negative tones, spreading them from black to white. *Center:* E, negative of short scale of tones; F, printed on hard paper; G, on medium paper, H, on soft paper. The negative tones are increased in contrast, reproduced correctly, or flattened, respectively. *Bottom:* I, negative with long scale of tones; J, printed on hard paper to secure tone separation and highlight detail at the expense of shadows; K, exposed to secure shadow detail at the expense of highlights.

Relationship between Paper Grade, Paper Log Exposure Range, and Density Range of Negatives for Diffusion and Condenser Enlargers

Contrast Grade Number of Paper	ANSI Descriptive Term	Log Exposure Range of Paper	Density Range of Negative UsuallySuitable for Each Log Exposure Range or Grade Number (Diffusion Enlarger)	Density Range of Negative UsuallySuitable for Each Log Exposure Range or Grade Number (Condenser Enlarger)
0	Very soft	1.40 to 1.70	1.41 and higher	1.06 and higher
1	Soft	1.15 to 1.40	1.15 to 1.40	0.86 to 1.05
2	Medium	0.95 to 1.14	0.95 to 1.14	0.71 to 0.85
3	Hard	0.80 to 0.94	0.80 to 0.94	0.60 to 0.70
4	Very hard	0.65 to 0.79	0.65 to 0.79	0.49 to 0.59
5	Extra hard	0.50 to 0.64	0.64 and lower	0.48 and lower

contrast, a lower one. Although international standards define the degree of contrast by grade number, there is no general adherence to their specifications. An alternative to graded papers is variable contrast paper. *M. Scott*

See also: *Contact printer/printing; Contrast; Photographic paper; Projection printing; Variable contrast paper.*

PAPER HOLDER See *Printing easel.*

PAPER-NEGATIVE PROCESS The use of sensitized paper in a camera to obtain a negative that is then contact printed, usually by transmitted light, onto another sheet of sensitized paper to obtain a positive image. Talbot's calotype process, the first viable negative-positive process, was a paper-negative process. The fibers in the negative base produced a graininess in the positive image that was generally considered to be unattractive, although some expressive photographers in later years used the process, partly for the ease with which major retouching could be done on the back of the negative, but also because they considered the graininess to be a desirable artistic effect. The early calotype prints were usually waxed on the back to enhance translucency. *H. Wallach*

PAPER SPEED A numerical value inversely related to the exposure needed to produce an excellent print. The extensive experimentation that led to the present standard for film speeds demonstrated the great importance of shadow detail reproduction in observers' judgment of print quality. For this reason, paper speeds based on the maximum useful point on the paper characteristic curve (at 90% of the maximum density) are appropriate. The formula for such shadow speed values is $1/H_{max} \times 10,000$.

The present ISO standard for paper speeds is, however, based on the exposure needed to yield a midtone value, i.e., a density of 0.60 over base plus fog. The formula for midtone speeds is $1/H = 1000$. This definition of paper speed assumes that correct reproduction of midtones is essential. Also, it eases the comparison of prints made in tests of different paper grades printed with the same negative.

Soft papers (grades 0 and 1) ordinarily have greater speeds than do hard papers (grades 3 and above). It is not unusual for a family of paper grades from the same manufacturer to have a greater change in midtone speeds than in shadow speeds. The reason is that a set of characteristic curves from each of the paper grades may nearly intersect near the shadow region but lie farther apart in the midtone region. For other papers, the contrary may be true. *M. Leary and H. Todd*

PAPER SURFACE See *Photographic paper; Surface.*

PAPER WEIGHT The thickness of a photographic paper support. The usual range is light, single, medium, double, and sometimes premium weights. There is no standardization on

exact thicknesses corresponding to these names among manufacturers. A given photographic paper may be made in more than one of these weights. *M. Scott*

PARA- This is one of three structural configurations of a naming system for locating two substituents on a benzene ring. *Para-* (or *p-*) locates the substituents at the 1 and 4 positions of the ring. The relationship of *para* with the other structural arrangements is shown by *G. Haist*

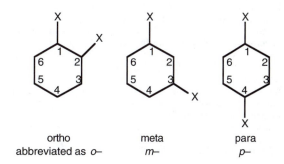

| ortho | meta | para |
| abbreviated as *o–* | *m–* | *p–* |

PARA-AMINOPHENOL This developing agent (other names: Activol, Azol, PAP, Kodelon) is available as a free base ($NH_2C_6H_4$, molecular weight 109.13) or a white to tan crystalline salt ($NH_2C_6H_4OH \cdot HC1$, molecular weight 145.59). The free base is soluble in alcohol but not easily so in water; the hydrochloride salt is more soluble in water. The salt is toxic, an allergen, and a skin irritant.

Developers with *para*-aminophenol produce images free from stain with very low fog, even with strongly alkaline solution or at high temperatures. The free base is very soluble in strong alkali, making possible highly concentrated developers. *G. Haist*

See also: *Developers.*

PARABOLIC MIRROR A concave silvered reflector whose shape is a paraboloid of revolution about the axis or cross section of a parabola. A point source of light placed at the geometrical focus is reflected as an emergent parallel beam. Used in illumination systems such as spotlights and film projectors using carbon arcs. *S. Ray*

See also: *Optics, geometrical optics.*

PARALLAX A change in position, shape, or rotational view of one or more objects when viewed from different positions, such as the change in position of background objects when an object in the foreground is viewed first with one eye and then with the other. Parallax occurs with cameras having a viewfinder that is displaced from the camera

lens. The change in position of objects in pictures from that seen in the viewfinder is referred to as parallax error.

L. Stroebel

See also: *Motion parallax; Perspective.*

PARALLEL ACTION In a motion picture, a method of representing two or more events as happening at the same time by cutting back and forth between them. *H. Lester*
Syn.: *Cross cutting.*

PARALLEL CIRCUIT See *Electricity.*

PARALLEL PORT In computing, one of the two standard input/output means used by the computer to control external peripherals such as a printer. Parallel ports send data in groups, 16 or 32 bits at a time, thus allowing for a faster transfer. *R. Kraus*
See also: *Serial port.*

PARA-PHENYLENEDIAMINE The white to tan-gray crystals of this dihydrochloride salt ($C_6H_4(NH_2)_2 \cdot 2HCl$, molecular weight 181.07; other names: Diamine H, P.D.H., and PPD) are soluble in water but only slightly so in alcohol. The white to yellowish white crystals of the free base ($C_6H_4(NH_2)_2$, molecular weight 108.14, other names: Diamine or Paramine) have low solubility in water (about 1 gram per 100 ml at 20°C) but are soluble in alcohol, chloroform, and ether. Both compounds or oxidation products may cause dermatitis or bronchial asthma.

Para-phenylenediamine is a low energy, slow acting developing agent producing fine grain silver images but is often combined with other developing agents to form more energetic developers. Today, derivatives of *para*-phenylenediamine are the primary developing agents in color photography. After developing the silver image, the oxidized form reacts with color-forming compounds to yield the dye images of color materials. *G. Haist*
See also: *Developers.*

PARAPHOTOGRAPHY See *Nonsilver processes.*

PARAXIAL Term used to describe rays passing through the central zone of a lens at small enough angles of incidence (in practice some 10 degrees or less) so that the sines and tangents of the angles are taken as equal to the angles in optical calculations. Gaussian optics apply in this region. *S. Ray*

PARFOCAL A group of lenses, such as those fitted to a turret on a microscope, that have been mechanically set or collimated such that they have an identical flange focal distance, and they replace each other so that the image is sharp at a constant distance. For a camera lens adapted to a body of another system, it means that the lens has been collimated to give sharp focus on infinity when that distance is set on the focusing scale. *S. Ray*

PARKS, GORDON (1912–) American photographer, writer, and film director. A self-taught photographer who purchased his first camera in 1937, Parks was one of the earliest internationally recognized African-American photographers. Photographed for the Farm Security Administration (FSA) (1942–1943), and was a staff photographer for *Life* (1948–1972), producing such major photographic essays as "The Death of Malcom X," "On the Death of Martin Luther King, Jr.," and the poignant story of a Brazilian child, "Flavio da Silva." Has also been successful as an author and Hollywood director.

Books: *The Learning Tree.* New York: Harper & Row, 1963; *Voices in the Mirror, An Autobiography.* New York: Doubleday, 1990. *M. Alinder*

PASCAL LANGUAGE A high-level programming language that is highly structured, that is, it requires that certain steps be followed absolutely and that certain lines of code be placed in specified locations within the program. Next to C, Pascal is the most commonly used language in computer imaging/graphics. *R. Kraus*

PASSBAND The region of the spectrum in which a filter has low absorption (high transmittance). *L. Stroebel*

PASSE-PARTOUT Passe-partout is a gummed taping material for framing pictures. The process of passe-partout framing seals a matted photograph between a sheet of glass and backing board by taping around the outer edge of the print, mat, glass, and backing board sandwich. The mat prevents the photograph from coming into contact with and sticking to the glass, and the backing board protects the back of the photograph and provides a place to attach passe-partout rings or hanging hoops. In addition to the traditional passe-partout gummed tapes, there are a variety of self-adhesive fabric, polyester, and foil tapes available in different colors and styles. Passe-partout provides inexpensive artistic-looking framing that has the benefit of sealing the image and protecting it from dust and moisture. *M. Teres*

PASSPORT PHOTOGRAPH A small photographic portrait to be attached to a passport or other identification document, typically a full front view without a hat and unretouched. In the United States, passport photographs must be square and from 2.5 to 3 inches in size, and may be in color. *L. Stroebel*

PASTEL (1) Adjective used to indicate that a color is pale or desaturated. (2) Art work produced by crayons composed of chalk with other materials. *R. W. G. Hunt*

PASTE-UP See *Mechanical.*

PASTEUP PROCESS A combination of two or more images, usually prints, on a single support, normally by the use of adhesives. Typically used to prepare material for publication in print. Distinguish from *collage,* which involves different media, and from *mosaic,* which involves the assembly of images of adjacent areas of a scene to form a continuous whole. In photomechanical reproduction, the assembly of text and graphics on a single support in preparation for reproduction. *H. Wallach*

PATTERN MASK Used with spotlights and spotlight attachments, or projectors, to cast a shadow design onto set surfaces. Shadow patterns imitate the presence of an object outside the set, such as a window frame, but can also be used to project special-effects patterns and colors, and to restrict light spread. *R. Jegerings*
See also: *Cookie.*

PC CONNECTOR The connecting port on a camera for a PC (Pin Cylinder) flash synch cord. The port consists of a circular hole with a center post. The cord is held in place by contact tension. Older cameras had M and FP terminals for flashbulbs. Most contemporary cameras have only X synchronization for electronic flash units. Synchronization may be marked with a letter (F, FP, M, or X) or with a jagged lightening bolt. *P. Schranz*

PC LENS See *Lens types.*

PEAK WHITE In electronic imaging, the setting of useful highlight detail at 100 IRE units is called peak white. The difference between peak white and the pedestal is the contrast range of the system. *R. Kraus*

PEARLESCENT Adjective used to denote reflecting colors that contain metallic or other particles that impart reflective properties similar to those of pearls. *R. W. G. Hunt*

PEDESTAL In electronic imaging, the video signal that reproduces black at 7.5 IRE units. This black is elevated just above no signal black. Useful shadow detail is set at this level. *R. Kraus*

PEG BARS In motion-picture animation, registration pins used for aligning artwork during all stages of production, corresponding to holes punched in paper, cels, or background artwork. *H. Lester*

PELLET PROCESS An obsolete iron salt process that yields a positive blue image. Used predominantly for rendering copies of engineering drawings and architectural plans. *J. Natal*

PELLICLE/PELLICLE MIRROR See *Beam splitter.*

PENCIL TEST In animation production, a film or video made from preliminary pencil sketches to check for timing and smoothness of movement before creating the final artwork to be filmed. *H. Lester*
 Syn.: *Line test.*

PENN, IRVING (1917–) American photographer. Studied with Brodovitch in the mid-1930s. Though best known for his work in fashion photography, Penn has developed a varied body of creative work, including photographs of ethnic peoples isolated from their environment, whether in New Guinea, Morocco, or Peru, by placing them on plain backdrop paper; using precious platinum printing paper for softly lit, large photographs of discarded cigarette butts and other detritus.
 Books: Szarkowski, John, *Irving Penn.* New York: Museum of Modern Art, 1984. Penn, Irving, *Passage.* New York: Alfred A. Knopf and Callaway, 1991. *M. Alinder*

PENTAPRISM See *Prism; Viewfinder.*

PERCENT SOLUTION In photography, the percentage quantity of a chemical is dissolved in a quantity of water less than 100 ml, then the volume made up to 100 ml to give a weight/volume (W/V) percentage solution, such as a 10 percent solution. A percentage quantity of a liquid may be added to a quantity of water less than 100 ml, then sufficient water added to make 100 ml of a volume/volume (V/V) percentage solution. Another percentage solution, not used in photography, involves adding the percentage number of grams to 100 ml of water. *G. Haist*
 See also: *Appendix M.*

PERCEPTION See *Visual perception.*

PERF Familiar form for *perforation.* Many strip film formats are perforated along one or both edges (or, rarely, down the middle) to engage with mechanisms that (1) move them from one frame to the next, or (2) stabilize their position during exposure or projection. The holes are very precisely shaped and spaced to mate with sprocket wheels, pull-down claws, and register pins in cameras, processors, editors, viewers, and projectors. In 35-mm and wider motion picture films, different shapes of perforations are used for negative and print materials: the Bell and Howell (BH) barrel-shaped perforation for negative films and the Kodak Standard (KS) rectangular perforation for print films. Different pitches, that is, spacings between adjacent perforations, are used for these two classes of films as well. In printing machines, first the negative and then the print material are wrapped around the

Perforation types and sizes. (1) Super-8-mm; (2) standard double-8-mm film; (3) standard 16-mm film; (4) negative perforation of standard 35-mm film; (5) positive perforation of standard 35-mm film. All dimensions are in inches.

sprocketed printing drum. For perfect registration without *creep,* the outer (print) film needs to have its perforations slightly farther apart than the inner (negative) film, because of the larger effective diameter on which it is wound. *Long pitch* and *short pitch* perforation standards exist for such films. International standards exist for virtually all film perforation schemes. The negative perforation can be traced to Edison's and Dickson's work and became an industry standard around 1910. The positive perforation was adopted in 1925. Some photographic papers are perforated, especially for accurate movement in phototypesetting machines. *M. Scott*

PERFECT DIFFUSER In colorimetry, an ideal isotropic diffuser with a reflectance (or transmittance) equal to unity.
 R. W. G. Hunt

PERFORATED SCREEN When sound equipment is placed behind the projection screen, the screen absorbs and blocks some of the sound from reaching the audience. In order to allow as much of the sound as possible to reach the audience, the projection screen is perforated. Whereas more and larger perforations will allow a greater proportion of the sound to pass through the screen, the greater the number of holes in the screen, the less there is of the screen's reflective surface. There is a limit to the size and number of perforations possible before the projected image becomes noticeably reduced. *M. Teres*

PERIODIC TABLE A systematic arrangement of the elements in a table that is based on the electronic configurations of the atoms and in order of increasing atomic mass. All

elements in the horizontal line of the periodic table are called a *period*. All elements in a vertical column are termed a *family* or *group*. Elements in a family have similar characteristics.

G. Haist

PERIPHERAL PHOTOGRAPHY

Technique for making a 360-degree view of an object in order to reproduce in a flat photograph all the surface details around the object's external or internal surfaces. Three common methods exist for making such photographs: The object is rotated in front of a camera containing a moving film system, the object is rotated and moved across the field of view of a standard camera, and a standard camera is used, but the photograph is made by way of mirrors.

Peripheral and panoramic cameras have similar design and operating features. While one looks inward and toward the center of a subject, the other looks outward and away from the subject's center. The principles on which they operate are identical.

Peripheral photography. A slit is located either close to the film in the camera or approximately one focal length in front of the camera lens. The film moves at the same speed and in the same direction as the image of the rotating subject. The camera shutter remains open while the subject makes one full revolution.

PERIPHERAL CAMERA SYSTEMS

Moving Film In the first method the subject is placed and centered on a turntable. A strip camera, one in which the film can be moved past a narrow slit, is aligned so that the slit covers the center of rotation of the turntable. Two basic designs of strip cameras are used. One draws roll film past the slit and the other moves a sheet film back past the slit. In the latter the length of the photograph is limited to the length of the sheet film, while the former typically does not have length limits because the film can be obtained in long rolls.

The camera only records a narrow portion of the object's surface at any given time, but since the object turns, the film moving behind the slit is eventually able to make a record of the whole 360 degrees of the object's circumference.

Various methods are used to make sure that the rate of motion of the film is equal to the rate of motion of the surface features of the cylindrical object. If the object is not cylindrical, those areas whose image is moving faster than the film will appear compressed in the final record, and the opposite is true for surface features whose image is moving slower than the film.

The same system is used to deal with internal surfaces of cylindrical objects by placing a mirror within the cylinder at

With the camera shutter open, the carriage moves across the field of view. Because the subject counterrotates on rollers, the film records a stationary image even though the subject is moving. The effect is that the surface of the cylindrical subject has been unrolled onto the film.

an angle of 45 degrees to the camera's lens axis. Typically the object is made to rotate, but in certain cases the mirror and the camera are turned while the object remains stationary. In either of these cases the technique might more properly be called a panoramic photography since the camera records a subject that surrounds the point of view of the camera.

Stationary Film In the second approach the film remains stationary, but the object is placed on a set of rollers and rolled across the field of view of the camera while in contact with the rollers. For this approach the object must generally be cylindrical or at least have ends that are circular and have no surface areas that protrude beyond the cylindrical surface defined by the ends.

The reason that the subject must be driven by the rollers is that the rotation direction must be opposite to the translational direction in order for the image of the surface to appear stationary as it "unrolls" onto the film. In effect the principle can be described as optical printing.

If the object is irregular it can be held between two plates or surfaces, each fitted with a wheel chosen to equal the average diameter of the subject clamped between these inner surfaces. The wheels, in turn, roll on two other wheels along tracks or on a smooth, level surface.

In both cases the camera's field of view is restricted by the installation of a large black mask containing a narrow slit above the subject's surface. The slit is parallel to the rotation axis of the object. The top of the mask must be black and must be made as nonreflective as possible, perhaps by covering it with black velvet, because it remains exposed for the whole time that the carriage bearing the subject is drawn across the field of view of the camera. If the top of the mask is not completely light absorbing, there will be a lack of contrast in the final image.

As the subject is moved across the field of view of the camera, it also rotates, and the camera records different portions of the surface sequentially. The magnification of the camera is adjusted to include along the chosen film dimension the distance that the object moves during one revolution.

There are lighting problems with this type of peripheral equipment because not only does the subject move but the lights may also be carried along, although it is possible to work with fixed lights. Various schemes for dealing with lighting the exposed area of the rotating subject have been proposed, including use of broad sources lighting through

Peripheral photography. (Photograph by Andrew Davidhazy.)

the slit from above and various approaches for lighting from below the mask.

A small error is introduced with this approach to peripheral photography because the lens records the subject's surface at a slight angle at either side of the optical axis. As with the first type of peripheral camera, if the object is not cylindrical, deviations from the cylindrical surface that the system is adjusted for will distort the size of features and introduce unsharpness in areas that are larger or smaller than the chosen one. Unsharpness can be minimized by reducing the width of the exposing slit, but distortion cannot be corrected.

PERIPHERAL MIRROR SYSTEMS Instruments that provide a simultaneous all-around view of the circumference of an object are based on the use of a segmented or continuous peripheral mirror system surrounding the object itself. The mirror system surrounds the object, which is placed in the center of the mirror or mirrors. The mirror or mirror array is then recorded with a camera that shows an end view of the subject surrounded by a circular peripheral view of its surface features. This method does not require moving parts but is limited to rather small subjects.

The image consists of a flat ring, the inner and outer boundaries of which define the upper and lower limits of view of the subject's surface along the lens axis. Because the image itself is stationary, an added dimension can be achieved by moving the object through the mirror assembly and recording with a motion picture camera or moving the mirror and camera assembly past a stationary object. In this application, a small portion of the surface is generally obscured by connecting rods.

The circular image produced by a mirror-based peripheral system can be converted into a final flat one by projecting the circular peripheral negative onto a reversing mirror system that projects the image into a cylindrical surface surrounding the optical system. If photographic paper surrounds the reversing mirror, then a flat 360-degree record can be obtained.

Interior view of objects can be obtained using a panoramic mirror system. Conical mirrors are generally used for this purpose. These images also are circular in nature and can be made to approximately reconstitute the original's surface details by projecting the negative onto the same mirror while surrounding it with photosensitive material. *A. Davidhazy*
See also: *Panoramic photography; Streak and strip photography.*

PERIPHERALS In computers, attachments that are connected through a variety of data input/output channels, for example, printers, scanners, and plotters. *R. Kraus*

PERMEABLE An adjective describing the capability of being penetrated, especially of a fluid through a porous substance. A processing solution must be able to permeate through a swollen gelatin layer of the photographic emulsion. *G. Haist*

PERSISTENCE In electronics, the tendency of certain phosphors to glow after the excitation has been removed. After the electron beam in a cathode-ray tube has passed over the fluorescent screen, the phosphor on the screen along the path traced by the beam may continue to glow for a certain time. Some phosphors, such as those used on high-speed oscilloscopes, have virtually no persistence, whereas other phosphors have long persistence to meet special requirements. *W. Klein*
See also: *Cathode-ray tube; Persistence.*

PERSISTENCE OF VISION The fusion of successive images, as in motion pictures, animation, and television, into an apparently continuous image without flicker. The duration of each persistent image is usually about 1/25th of a second, but it varies depending upon the luminance level and other factors. *L. Stroebel and R. Zakia*
See also: *Critical flicker/fusion frequency; Fusion.*

PERSISTENT INTERNAL POLARIZATION Certain types of photoconductors can be polarized by the simultaneous presence of radiation and an electric field. Under some conditions, the polarization may remain after the field and radiation are removed. The phenomenon was discovered independently by Kallmann and Fridkin in the late 1950s. Kallmann described the process as persistent internal polarization, while in the Soviet Union such materials were described as photoelectrets. The polarization results from carriers that are deeply trapped in the vicinity of the electrodes. Depolarization involves the release of carriers from traps by the absorption of radiation. Persistent internal polarization can be used as a means for latent image formation. By this method, latent images can be created by either selective polarization in exposed regions or by first producing a uniform polarization followed by a depolarizing image exposure. In principle, multiple copies can be made from a single image exposure. Relative to conventional latent image formation, the limitations of processes based on persistent internal polarization are the high exposures required and poor latent-image stability. *P. Borsenberger*

PERSONAL SPACE
The private space around each individual within which the person generally feels at ease except when it is violated by another person. It is an imaginary bubble of space surrounding a person, the size of which will vary depending on the situation, the culture, and the senses involved. For the visual sense, a space within 1-1/2 feet is considered to be intimate space, from 1-1/2 feet to 4 feet personal space, 4 to 12 feet social space, and beyond 12 feet public space.

In making photographs one should consider the intent and where and how the photograph will be displayed. In a magazine, space is fixed at less than 1 foot viewing distance for most people (intimate space), in a gallery usually less than 4 feet (personal space). Similar considerations exist for film and television. The size of the image and the viewing distance affect perception. *L. Stroebel and R. Zakia*

PERSPECTIVE
Perspective refers to the appearance of depth when a three-dimensional object or scene is represented in a two-dimensional image, such as a photograph, or when the subject is viewed directly.

TYPES OF PERSPECTIVE The fact that we humans have two eyes is often credited for our ability to perceive depth and judge relative distances in the three-dimensional world with such accuracy. If we close one eye, however, the world does not suddenly appear two dimensional because there are other depth cues, cues that photographers can use to represent the three-dimensional world in two-dimensional photographs.

Linear Perspective Linear perspective is exemplified by the convergence of parallel subject lines in images and by the decrease in image size as the object distance increases. Linear perspective is so effective in representing depth in two-dimensional images that it is often the only type of depth cue provided by artists when making simple line drawings.

Early Egyptian artists drew pictures without linear perspective, where a boat in the foreground and a boat on the horizon were drawn the same size. Brunelleschi, an Italian architect, is credited with devising a mathematically proportional system, which he used in architectural drawings in 1420. In 1435 Alberti, another Italian architect, originated the concept of thinking of the picture plane as a window through which he looked at the visible world, which enabled him to record the images of objects with the correct size-distance relationships. Alberti is also credited for the concept of vanishing points, where parallel subject lines that recede from the viewer meet in the image.

Linear perspective is represented by the convergence of the parallel subject lines toward a vanishing point on the horizon and by the decreasing image size of the poles and the track ties with increasing object distance.

Overlap If a subject is arranged so that a nearby object obscures part of a more distant object, the viewer is provided with a powerful cue as to which object is closer. Overlap by itself, however, does not provide any information concerning

The increasing distance of the cats from right to left is evidenced by the fact that the closer objects obscure detail in the overlap areas of the more distant objects.

the actual distances or even relative distances of the near and far objects.

Depth of Field Depth of field refers to the range of object distances within which objects are imaged with acceptable sharpness. When a camera is focused on an object at a certain distance and closer and more distant objects appear unsharp in the photograph, the viewer is made aware that the objects are at different distances. When the depth of field is very large and objects at all distances appear sharp in the photograph, the viewer may become confused about relative distances unless there are other depth cues such as relative sizes. Photographs in which a pole in the background appears to be growing out of the head of a person in the foreground is an example of confusion resulting from a large depth of field.

When objects in the foreground and the background are equally sharp, it is easy to perceive the background object as resting on the foreground object.

Lighting Depth can be emphasized with lighting that reveals the shape, form, and position of objects. A lack of tonal separation between the dark hair of a model and a dark background, for example, destroys the appearance of distance between the model and the background. Uniform front lighting on a white cube with three visible planes can make it appear two dimensional, whereas lighting that produces a different luminance on each plane will reveal the cube's true form. With curved surfaces, as on the human face, form and depth are revealed with lighting that produces gradations of tone on the curved surfaces. Shadows on objects on the opposite side from the main light and shadows of objects cast onto other surfaces can emphasize both the form of the objects and their locations.

The three-dimensional attribute of objects can be represented in two-dimensional images with lighting that produces gradations of tone and shadows.

Aerial Haze The scattering of light by small particles in the atmosphere makes distant objects appear lighter and with less contrast than nearby objects. With a series of mountain ridges that increase in distance, each more distant ridge appears lighter than the one in front of it. Heavy fog is a more dramatic example of the same effect, where a person walking away from the camera can appear to fade and then disappear in a short distance. The appearance of aerial haze, and therefore the apparent distance, can be altered considerably by the choice of film and filter. Since the haze consists of scattered light that is bluish in color, use of a red filter with panchromatic film will decrease the appearance of haze and a blue filter will increase it. Black-and-white infrared film used with a red or infrared filter will decrease the appearance of haze and depth and increase the detail that is visible in the more distant objects. Smoke in a smoke-filled room creates the similar effect of increasing the appearance of depth in interior photographs. Fog machines are used by some photographers and cinematographers to achieve a haze effect.

Haze produces a progressive lightening of image tone with increasing object distance.

Color As applied to perspective, red is identified as an advancing color and blue as a receding color. The terms indicate that if a red card and a blue card are placed side by side and there are no other cues as to their distance from the viewer, the red card will tend to appear nearer. If the explanation for this effect is that it is due to association, it can be noted that with aerial haze, the haze becomes more bluish with increasing distance. Also, blue sky is thought of as being at a great distance. Researchers in visual perception have considered the possibility of a physiological explanation based on a difference in focus on the retina in the eye for red light and blue light. It is not uncommon for artists to use red and blue colors to achieve perspective effects in their paintings.

Stereophotography Attempts have been made since the early days of photography to make photographs more realistic through the use of stereoscopic vision. All such attempts involve two (or more) photographic images made from slightly different positions, each of which is then presented to the appropriate eye of the viewer. The stereoscope is an individual viewing device that holds the pictures side by side with a separate viewing lens for each eye. The first stereoscope, designed by Wheatstone in 1832, before the invention of the daguerreotype process, made use of multiple mirrors and pairs of stereoscopic drawings. It is possible, with practice, to fuse the two images of a stereograph without a viewing device. The centers of the two images must not be farther apart than the pupils of the eyes, which varies among individuals but is about 64 mm (2.5 inches) average, since the axes of the two eyes cannot normally be made to diverge. Wedge-shaped lenses in the improved stereoscope introduced by Sir David Brewster in 1849 eliminated eyestrain and made stereophotography practical. With contact-size stereographs, it is recommended that the lenses in the stereoscope have approximately the same focal length as the lenses in the camera, but most were somewhat longer. The imposed limitation on the size of the stereograph images in the viewer is not a problem since the viewer perceives an image projected into space similar to the effect of looking at the original scene. During the years following the introduction of the Brewster stereoscope, many photographers, including the famed landscape photographer William Henry Jackson, made stereoscopic photographs in addition to conventional photographs. By 1900 stereoscopes were common parlor room fixtures and photographic stereographs were being sold by the millions.

A limitation of the stereoscope is that it is an individual viewing device. Various processes have been developed to produce stereoscopic images that could be viewed by more than one person, and even large groups in theaters. The anaglyph consists of superimposed red and green images. By looking through a red filter with one eye and a green filter with the other, viewers see the appropriate image with each eye and perceive a three-dimensional image.

Superimposed images that are polarized at right angles produce depth perception when viewed through polarizing filters that are also rotated at right angles to each other. By using polarizing filters in front of two projectors, color stereographic slides or motion pictures can be viewed by groups of people wearing polarized glasses. It is necessary for the screen to have a metallic surface, such as aluminum paint, to prevent the reflected images from being depolarized.

Viewing devices can be eliminated by using a system that combines the two photographs as very narrow alternating vertical strips over which is placed a plastic layer containing

 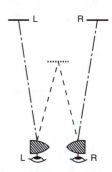

Left, Elliot's stereoscope, a viewing device that contains no optical elements. The openings allow each eye to see only its corresponding image when the positions of the left and right images are exchanged. Right, Brewster's stereoscope. Two prisms or half lenses allow the eyes to converge naturally even though the separation of the pictures is greater than that of the eyes.

Motion perspective. To a person driving down the road, the speed of the apparent motion of objects on or near the road varies inversely with distance.

a lenticular pattern that refracts the light from each set of strips to the appropriate eye. Stereoscopic cameras with four lenses have been manufactured, a design that represents a refinement of the lenticular stereoscopic process.

Three-dimensional images have been presented on conventional television receivers with a process that requires the viewer to wear glasses that place a neutral density filter over one eye. The filter causes that eye to adapt to a lower light level, which reduces the time resolution and produces a delay in the perception of the image in that eye.

Motion perspective The term motion perspective identifies a changing image pattern with respect to the angular size and separation of objects in a three-dimensional scene as the distance between the scene and the viewer or camera changes.

Linear perspective in a static situation refers to a fixed point of view. A change in distance between a scene and the viewer may be due to movement of the viewer, the subject, or both. It is more convenient, however, to think of the observer as a fixed reference point around which there is a continuous flow of objects, even when it is the viewer who is moving.

When a distant point is selected as representing the direction of movement of the viewer, the parts of the scene appear to move away from this point in all directions. For example, when driving through a tunnel, the opening at the far end expands away from the center at an increasing rate and the edge of the opening passes around the car on all sides as the car emerges from the tunnel. The flow of objects away from the distant vanishing point is most rapid closest to the viewer since the rate of movement is inversely proportional to the distance between the object and the viewer.

When one approaches a photograph of a three-dimensional scene rather than the scene itself, the effect is entirely different. Now, the images of objects at different distances do not change in relative sizes and the rate of movement of the parts away from the center of the photograph is unrelated to the distance of the objects from the camera. The illusion of depth in two-dimensional photographs is therefore less realistic when the viewer alters the viewing distance (or horizontal position) than when the viewing position remains constant. This is one factor that contributes to the realism of depth in slides and motion pictures that are projected on a large screen where the viewing position remains constant.

The consequences of motion perspective can be seen in motion-picture and television pictures when the camera moves directly into or away from a scene in comparison to using a zoom lens from a fixed position. The use of the zoom lens has an obvious advantage in convenience, and in many situations, the difference in effect is unimportant, but zooming in on a scene tends to reduce the illusion of depth in a manner similar to that of moving in relation to a still photo-

tograph because the images of near and far objects increase in size at the same rate.

Also, using a long, fixed focal-length lens decreases motion perspective because the image of an object moving toward the camera increases in size more slowly. This technique was used effectively in the motion picture *Lawrence of Arabia,* where the viewer is kept in suspense when the image of a distant horseman (friend or enemy?) very slowly increases in size, even though he is obviously riding rapidly toward the camera. Conversely, use of a short focal-length lens for a car race seems to exaggerate speed due to motion perspective.

Motion Parallax When a person moves sideways, whether just moving one's head a few inches or looking out the side window of a moving vehicle, the relative positions of near and far objects change. The basic concept is the same as for stereoscopic vision where the two eyes view an object from slightly different angles and the relative position of the background is different for the two eyes, but with continuous lateral movement the foreground-background changes are also continuous. If one fixates a foreground object, the background appears to move in the same direction the person is moving. If one fixates a background object, the foreground appears to move in the opposite direction. During the movement, the person has a strong impression of the distance between foreground and background objects. A similar perception results when viewing moving images produced with a motion-picture or video camera that was moving laterally.

Motion parallax. When a person who is moving from left to right fixates the middle (black) tree, more distant objects appear to move in the same direction (left to right) and closer objects appear to move in the opposite direction (right to left).

Holography Holographic images also present different viewpoints to the two eyes, and, within limits, the viewer experiences motion parallax with lateral movement. A hologram is made by recording on a photographic material the interference pattern between a direct coherent light beam and light from another beam from the same source after it is reflected or transmitted by the subject. By viewing the hologram with a beam of coherent light, positioned the same as the direct beam used to expose the hologram, an image is produced that has the same three-dimensional appearance as the original subject.

LINEAR PERSPECTIVE VARIABLES The relative sizes of the images of objects at different distances is determined by the position of the eye when we look at the objects directly and the position of the camera lens when we photograph the objects. Although lenses of different focal lengths change the size of the entire image rather than the relative sizes of parts of the image, strong perspective is associated with short focal-length wide-angle lenses and weak perspective with long focal-length telephoto lenses. This is in part due to the fact that the focal length of the camera lens determines the camera-to-object distance required to obtain an image of the desired size—small for short focal-length wide-angle lenses and large for long focal-length telephoto lenses. In addition to the relative image sizes, which largely determine the viewer's impression of the perspective in pho-

tographs, psychological factors involved in changes in viewing distance also influence the perception.

Object Distance and Image Size Two objects of equal size placed at distances of 1 foot and 2 feet from a camera lens produce images having a ratio of sizes of 2 to 1. If the ratio of the object distances is 1 to 3, the ratio of image sizes will be 3 to 1. The relationship between image size and object distance is that image size is inversely proportional to object distance. Linear perspective is based on the relative size of the images of objects at different distances. With movable objects, the image sizes and linear perspective can be controlled by moving the objects. In situations where the subject matter cannot be moved easily, it is necessary to move the camera and/or change the focal length of the camera lens to alter image sizes.

With two objects at a ratio of distances of 1 to 2 from the camera, moving the camera farther away to double the distance from the closer object does not double the distance to the farther object, and therefore the ratio of the image sizes will not remain the same. If the ratio of object distances changes from 1:2 to 2:3 by moving the camera, the ratio of image sizes will change from 2:1 to 3:2 (or 1.5:1). Moving the camera farther away not only reduces the size of both images, but it also makes them more nearly equal in size. The two images can never be made exactly equal in size no matter how far the camera is moved away, but with very large object distances the differences in size can become insignificant.

The linear perspective produced by moving the camera farther from the objects is referred to as a weak perspective. Thus, weak perspective can be attributed to a picture in which image size decreases more slowly with increasing object distance than expected. The images of parallel subject lines also converge less than expected, with weak perspective. Another aspect of weak perspective is that space appears to be compressed, as though there were less distance between nearer and farther objects than actually exists.

Conversely, moving a camera closer to two objects increases the image size of the nearer object more rapidly than that of the farther object, producing a stronger perspective. For example, with objects at a distance ratio of 1:2, moving the camera in to one-half the original distance to the closer object doubles its image size but reduces the distance to the farther object from 2 to 1.5, therefore increasing the image size of the farther object to only 1.33 times its original size. Moving the camera closer to the subject produces a

stronger linear perspective whereby image size decreases more rapidly with increasing object distance, and the space between the closer and farther objects appears to increase. Strong perspective is especially flattering in architectural photographs of small rooms because it makes the rooms appear to be more spacious, and it permits the building of relatively shallow motion-picture and television sets that appear to have normal depth when viewed by the audience. Strong perspective is inappropriate, however, for certain other subjects where the photograph is expected to closely resemble the subject.

Changing Object Distance and Focal Length In many picture-making situations it is appropriate to change lens focal length and object distance simultaneously to control linear perspective and overall image size. For example, if the perspective appears too strong and unflattering in a portrait made with a normal focal-length lens, the photographer could substitute a longer focal-length lens and move the camera farther from the subject to obtain the same size image but one with weaker perspective. Since short focal-length wide-angle lenses tend to be used with the camera relatively close to the subject and long focal-length telephoto lenses tend to be used with the camera at relatively large distances, strong perspective is often associated with wide-angle lenses and weak perspective is similarly associated with telephoto lenses, but it is the camera position and not the focal length or type of lens that produces the abnormal linear perspective.

The change in linear perspective with a change in object distance is more apparent when an important part of the subject is kept the same size by simultaneously changing the lens focal length.

In situations where a certain linear perspective contributes significantly to the effectiveness of a photograph, the correct procedure is to select the camera position that produces the desired perspective first, and then select the focal-length lens that produces the desired image size. For example, if the photographer wants to frame a building with a tree branch in the foreground, the camera must be placed in the position that produces the desired relationship between the branch and the building. The lens is then selected that produces the desired image size. A zoom lens offers the advantage of providing any focal length and image size between the limits. With fixed focal-length lenses, if the desired focal length is not available, and changing the camera position would reduce the effectiveness due to the change in perspective, the

3:1 2:1 1.5:1

Image Sizes

3:1 2:1 1.5:1

Object Distances

With two objects of equal size, the ratio of the image sizes will be the same as the ratio of the object distances, illustrated here with the camera in three different positions.

The difference in perspective produced by using a short focal-length lens with the camera close to the subject (left) and a long focal-length lens at a correspondingly larger object distance (right).

best procedure is to use the next shorter focal-length lens available and then enlarge and crop the image.

Cameras cannot always be placed at the distance selected on the basis of linear perspective. Whenever photographs are made indoors, there are physical limitations on how far away the camera can be placed from the subject. Fortunately, the strong perspective that results from using short focal-length wide-angle lenses at the necessarily close camera positions enhances rather than detracts from the appearance of many architectural and other subjects.There are also many situations where the camera must be placed at a grater distance from the subject than would be desired. This, of course, applies to certain sports activities where cameras cannot be located so close that they interfere with the sporting event, block the view of spectators, or endanger the photographer.

Not all subjects are such that the perspective changes with object distance. Since two-dimensional objects have no depth, photographs of such objects reveal no change in the relative size of different parts of the image with changes in camera distance. Also, photographic copies of paintings, photographs, printed matter, etc., made from a close position with a short focal-length wide-angle lens, and from a distant position with a long focal-length telephoto lens, should be identical.

Viewing Distance Although it might seem that the distance at which we view photographs would have no effect on linear perspective, since a 2:1 ratio of image sizes for two objects at different distances will remain constant regardless of the viewing distance, changes in viewing distance can alter the perception of depth providing that the photograph contains good depth cues. Photographs of two-dimensional objects or subjects that have little depth appear to change little with respect to linear perspective when the viewing distance is changed, whereas those that contain dominant objects in the foreground and background or receding parallel lines that converge in the image can change dramatically.

Seldom do we encounter unnatural-appearing linear perspective when we look at the real world. Such effects tend to occur only when we look at photographs or other two-dimensional representations of three-dimensional objects or scenes. The reason perspective appears normal when we view three-dimensional scenes directly at different distances is that as we change the viewing distance, the perspective and the image size change simultaneously in an appropriate manner. Because we normally know whether we are close to or far away from the scene we are viewing, the corresponding large or small differences in apparent size of objects at different distances seems normal for the viewing distance.

To illustrate how the situation changes when we view photographs rather than actual three-dimensional scenes, assume that two photographs are made of the same scene, one with a normal focal-length lens and the other with a short focal-length lens with the camera moved closer to match the image size of a foreground object. When viewers look at the two photographs, they assume that the two photographs were taken from the same position because the foreground objects are the same size, but if the perspective appears normal in the first photograph, the stronger perspective in the second photograph will appear abnormal for what is assumed to be the same object distance.

Viewers can make the perspective appear normal in the second (strong perspective) photograph, however, by reducing the viewing distance. The so-called *correct* viewing distance is equal to the focal length of the camera lens (or, more precisely, the image distance) for contact prints, and the focal length multiplied by the magnification for enlarged prints. This position is identified as the *center of perspective.*

The correct viewing distance for a contact print of an 8 × 10-inch negative exposed with a 12-inch focal-length lens is 12 inches. Since we tend to view photographs from a distance about equal to the diagonal of the photograph, the perspective would appear normal to most viewers. If the 12-inch focal-length lens is replaced with a 6-inch focal length wide-angle lens, the print would have to be viewed from a distance of 6 inches for the perspective to appear normal. When the print is viewed from a comfortable distance of 12 inches, the perspective will appear too strong. Conversely, the perspec-

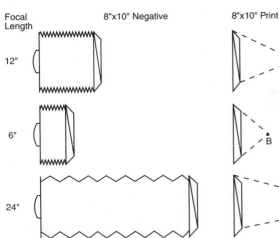

Focal Length / 8"x10" Negative / 8"x10" Print

12"

6"

24"

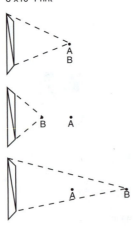

The correct viewing positions for normal-appearing perspective with 8 × 10-inch photographs made with three different focal-length lenses are indicated with the letter B. Since people would tend to view all three photographs from the same distance, position A, the perspective tends to appear too strong in the second photograph and too weak in the third.

The wide-angle effect. The image of a ball-shaped object will be circular only when the object and image are on the lens axis (and the film is perpendicular to the lens axis). The amount of stretching of the image in a direction away from the center of the photograph increases with the off-axis angle. The effect is therefore more obvious in photographs made with short focal-length wide-angle lenses.

tive of a photograph made with a 24-inch focal-length lens will appear too weak when viewed from a distance of 12 inches. It is fortunate that people do tend to view photographs from standardized distances based on their size rather than adjusting the viewing distance to make the perspective appear normal, for that would deprive photographers of one of their more useful techniques for making interesting and effective photographs.

The Wide-Angle Effect In addition to the association of short focal-length wide-angle lenses with strong perspective, they are also associated with the wide-angle effect. The wide-angle effect is characterized by what appear to be distorted image shapes of three-dimensional objects near the edges of photographs. This effect is especially noticeable in group portraits where the heads near the sides seem to be too wide, those near the top and bottom seem to be too long, and those near the corners appear to be stretched diagonally away from the center.

The image stretching occurs because rays of light from off-axis objects reach the film at oblique angles rather than at a right angle as occurs in the center of the film. If the subject consists of balls or other spherical objects, the amount of stretching can be calculated in relation to the angle formed by the light rays that form the image and the lens axis. Thus, at an off-axis angle of 25 degrees, the image is stretched about 10%, and at 45 degrees the image is stretched about 42%. (The image size of off-axis objects changes in proportion to the secant of the angle formed by the central image-forming ray of light and the lens axis. The reciprocal of the cosine of the angle may be substituted for the secant.) Normal focal-length lenses, where the focal length is about equal to the diagonal of the film, have an angle of view of approximately 50 degrees, or a half angle of 25 degrees.

Why don't we notice the 10% stretching that occurs with normal focal-length lenses? It is not because a 10% change in the shape of a circle is too small to be noticed, but rather that when the photograph is placed at the correct viewing distance, the eye is looking at the edges at the same off-axis angle as the angle of the light rays that formed the image in the camera. Thus, the elliptical image of the spherical object is seen as a circle when the ellipse is viewed obliquely. The

image would also appear normal even with the more extreme stretching produced with short focal-length wide-angle lenses as long as the photographs were viewed at the so-called correct viewing distance. Since the correct viewing distance is uncomfortably close for photographs made with short focal-length lenses, people tend to view them from too great a distance, where the stretching is obvious.

If two-dimensional circles drawn on paper are substituted for the three-dimensional balls, the circles will be imaged as circles in the photograph, and there will be no evidence of a wide-angle effect. The distinction is that when one looks at a row of balls from the position of the camera lens, the outline shape of all of the balls will appear circular, whether they are on or off-axis, but off-axis circles drawn on paper will appear elliptical in shape because they are viewed obliquely. The compression that produces the ellipse when the circle is viewed from the lens position is exactly compensated for by stretching when the image is formed because the light falls on the film at the same oblique angle at which it leaves the drawing.

Viewing Angle As was noted above, even when viewers are directly in front of photographs they look obliquely at the edges of the picture, which alters the shape of images near the edges. There are situations where it is necessary to view the entire picture at an angle, as when sitting near the sides or the front of a motion picture theater. At moderate angles, viewers tend to compensate mentally for the angle so that they perceive a circle in the picture as a circle even though the shape is an ellipse at the oblique viewing angle, a phenomenon known as shape constancy. At extreme viewing angles, viewers may have difficulty even identifying the subject of the photograph. Some early artists were fascinated with slant perspective, where the image had to be viewed at an extreme angle to appear realistic. Oblique aerial photographs also display slant perspective, which must be rectified if the photographs are to be used for mapping purposes.

View Camera Perspective Controls In addition to accommodating lenses of varying focal lengths, which allows the camera to be placed at different distances from the subject with corresponding variations of linear perspective, view cameras have tilt and swing adjustments on the front and back of the camera that provide considerable control over the shape and sharpness of the image. Tilt refers to a vertical rotation around a horizontal axis and swing refers to a horizontal rotation around a vertical axis. The tilt and swing adjustments on the lensboard control the angle of the plane of sharp focus vertically and horizontally, but do not alter the shape of the image. The same adjustments on the back of the camera are normally used to control the shape of the image, although they can be used to control the angle of the plane of sharp focus also if they are not needed to control image shape. It is the change in image shape, such as the convergence of the image of parallel subject lines or the relative sizes of the images of objects on opposite sides of the photograph, that represents a change in linear perspective.

To illustrate how changing the angle of the film plane in a view camera affects the linear perspective, assume that the camera is set up to copy a subject consisting of a grid of parallel vertical and horizontal lines. With the back of the camera parallel to the subject, the vertical and horizontal subject lines will be parallel in the image. Tilting with top of the camera ground glass (or film) away from the subject will cause the vertical subject lines to converge toward the bottom of the ground glass, or the top of the picture since the image is inverted on the ground glass. Tilting the ground glass will have no effect on the shape of the horizontal lines, however. When the camera back is tilted in this way, it is in a similar position to the back of a conventional camera that has been tilted up to photograph a tall building, where the

Vertical subject lines will be parallel in a photograph only when the film plane is also vertical. Tilting the back of a view camera as shown in the center diagram (or tilting any camera upward from a low position) will cause the vertical lines to converge toward the top of the photograph. Tilting the back in the opposite direction will cause the lines to converge toward the bottom of the photograph.

vertical building lines converge toward the top of the picture. Thus, it is the angle of the film plane that controls convergence of vertical subject lines, not the angle of the body and lens of the camera. If a view camera is tilted up to photograph a tall building, it is only necessary to tilt the back of the camera perpendicular to the ground and parallel to the vertical lines of the building to prevent convergence of those lines in the photograph. If the photographer wanted to exaggerate the convergence of the vertical lines, perhaps to make the building appear taller, the camera back would be tilted in the opposite direction, increasing the angle between the building lines and the film plane.

Although this explanation has been written in terms of the convergence of parallel subject lines, it could just as well have been in terms of the relative size of objects at different distances from the camera. With the same subject, we can think of the width of the building at the top and the bottom. If a camera is tilted up and no adjustment is made in the angle of the back, the top of the building, which is farther from the camera than the bottom, will be narrower than the bottom in the photograph. With the back of the camera tilted so that it is perpendicular to the ground, the top and bottom of the building will have the same width in the image.

The same principle applies to the control of the convergence of horizontal subject lines by swinging the back of the view camera. The only time horizontal subject lines will be parallel in a photograph is when the film plane is parallel to the horizontal subject lines. When photographing a box-shaped object, such as a building, it is common practice to show two sides of the object. If the back of the camera is swung parallel to the horizontal lines on one side of the object to prevent convergence of those lines, the angle between the camera back and the other side of the object will be increased, which will exaggerate the convergence of the horizontal lines on that side of the object. Even though converging vertical lines are just as natural as converging horizontal lines when we look at objects directly, professional photographers consider converging vertical lines to be less acceptable than converging horizontal lines in photographs.

TRICK PERSPECTIVE Because the three-dimensional world is represented with two dimensions in photographs, it is possible to fool the viewer concerning the perspective of the subject of the photograph. One of the most common accidental illusions occurs when the main subject

and the background are equally sharp in the photograph, and an object in the background appears to be sitting on or to be a part of the object in the foreground. Motion-picture photographers make use of the same concept in the glass shot, where part of a scene, which is commonly an imaginary and dramatic large expanse, is painted on glass. The painting is then photographed in combination with action, which is seen through clear areas on the glass. When skillfully done, the painting is accepted by the viewer as part of the three-dimensional world.

Projected backgrounds and traveling mattes are also used so that actors can be photographed under controlled conditions, usually in a studio, commonly on a mockup of a supposedly moving vehicle such as a car, train, plane, or ship, with a projected image of a distant scene appearing in the background.

A trick perspective effect is achieved in the famous Ames room whereby objects appear twice as tall when placed in the right-hand corner as when placed in the left-hand corner even though both corners appear to be at the same distance. The left-hand corner is actually twice as far away. The effect is achieved with a ceiling that slopes down and a floor that slopes up from left to right so that, due to linear perspective, the room appears to be rectangular in shape from one position. From any other position the illusion is destroyed.

Scale models have been used by architects to show what a proposed building will look like, and when photographed skillfully, the model can appear to be a full-size

A trick perspective effect obtained in the distorted Ames room. The height of a person appears to double when moved from the left side to the right because the distances to the camera are in a ratio of 2 to 1, as shown in the overhead view on the bottom left. The actual shape of the back wall and the slopes of the ceiling and floor are shown in the diagram on the bottom right.

building. Motion-picture photographers commonly make use of scale models to depict disaster events, such as a large ship being capsized in a storm, where the actual event would be prohibitively expensive or impossible to photograph.

Still photographers have long combined parts of different photographs, such as the image of a clothing model with a photograph of the Egyptian pyramids, to save travel time and money and to produce dramatic effects. With computer software programs that are now available, sophisticated and undetectable special effects can be achieved easily with video and still video images.

Books: Lipton, L., *Foundations of the Stereoscopic Cinema*. New York: Van Nostrand Reinhold, 1982; Fielding, R., *Technique of Special Effects Cinematography*. London: Focal Press, 1985. *L. Stroebel*

See also: *Holography; Nimslo 3-D camera.*

PERSPECTIVE-CONTROL LENS See *Lens types.*

PERSSON PROCESS A multiple masking technique used as a tone-control mechanism when more than one mask is required to modify both high and low values in one print. In this case, the masks are sharp and must be registered with care. *H. Wallach*

See also: *Mask/masking.*

PETZVAL, JOSEF MAX (1807–1891) Hungarian mathematician. Invented the first purposely intended photographic lens in 1840, which reduced exposure time by 90%, allowing the rapid development of the daguerreotype's use for portraiture. Manufactured by Voigtlander, later copied by others, the Petzval lens marked a great advance on previous lenses and was widely used for half a century. *M. Alinder*

PETZVAL LENS See *Lenses, lens history.*

PETZVAL SUM A numerical value derived from the number, power, and refractive indices of the individual elements forming a lens and whose reciprocal is the radius of curvature of the best fitting sphere to the Petzval surface given by residual curvature of field. A high value indicates a strongly curved surface, and a positive value means curvature concave to the lens. Deliberate addition of a negative element to a lens design can flatten the field. *S. Ray*

PETZVAL SURFACE The curved surface on which a sharp image is formed by a lens otherwise free of primary monochromatic aberrations. The surface can be concave or convex and its curvature is the reciprocal of the Petzval sum. *S. Ray*

See also: *Curvature of field; lenses, lens aberrations.*

PHANTOM POWER See *Apparent power.*

PHANTOM VIEW (1) In an illustration, a subdued, ghostlike image, as of a background, to provide emphasis to other portions of the image. (2) An image through which the background or other image can be seen. This effect can be produced deliberately or inadvertently, as by double exposure. *R. Zakia*

PHASE (ϕ) The position of a periodic waveform with respect to time and space, frequently with respect to the distance or time by which one periodic waveform must be moved so that it will coincide with another identical waveform.

Phase analysis is usually applied to sine waveforms, but can be applied to any periodic waveform. For example, if

waveform A at time one (t_1) matches waveform B at time two (t_2), the phase difference between the two waveforms ϕ = $t_2 - t_1$. Similarly, if waveform A will coincide with waveform B if it is shifted in position by a distance x, the phase difference is $x = \phi$. Phase is usually expressed in terms of an angle between 0 and 2π radians or between $-\pi$ and π radians (relative phase). This is because the sine of a number is the same as the sine of the same number plus or minus 2π. Therefore, with a sine waveform, a phase shift of 2π produces exactly the same waveform as before the shift, except for the length of the waveform in the two directions (if it is not infinite). With light waves, wavelengths are very small so the length of the waveform is frequently of little importance. This leads to the common use of relative phase in optics.

Phase analysis is applied to waveforms that are not sinusoidal by breaking the waveform up into a linear combination of the fundamental sine wave, which has the same period as the waveform, and its harmonics. In this case the phase of each component is usually different; the phase of the fundamental component being the phase of the waveform. Phase is expressed in the general form for traveling sine wave, $A(x,t) = \sin(kx - wt + \phi)$, as an additive factor at the end (see *sine wave*). For nonsinusoidal waveforms this equation becomes a possibly infinite sum of sine waves: $F(x,t) = \sum[\sin(kx - nwt + \phi_n)]$.

The primary importance of phase lies in the interference effects produced by different phases of light waves. The amplitudes of the electric and magnetic field components of two photons which have the same phase will add together, while the amplitudes of two photons that have the same wavelength but are out of phase by π will exactly cancel. *J. Holm*

See also: *Absolute phase; Phase shift; Relative phase.*

PHASE CONTRAST MICROSCOPY Technique for revealing the structural features of microscopic transparent objects whose varying but invisible differences in thickness result in varying differences in the phase of the transmitted light. These are converted to visible intensity differences by the use of an objective having a thin annular deposit of a material that increases the optical path by about a quarter of a wavelength. When the unaffected image light passing through the center of the lens combines in the eyepiece with the retarded diffraction spectrum the diffraction pattern is augmented so that regions differing in optical path but not in visible density become visible. *D. A. Spencer*

PHASE CONTROL A method to control the operation of a thyristor circuit by shifting the phase of the gate voltage with respect to the applied voltage. Shifting the phase of the gate voltage changes the firing angle, which is the time conduction through the thyristor starts in each half cycle. Without phase shifting, the firing angle cannot be increased beyond 90 degrees. Typical application for phase control of thyristors include lamp dimmers and motor speed controls. *W. Klein*

See also: *Thyristor.*

PHASE HOLOGRAM A hologram in which the silver image has been removed by bleaching, leaving a corresponding gelatin relief pattern in its place. Diffraction by this pattern yields a brighter image than that of the silver image in the conventional amplitude hologram. *L. Stroebel*

See also: *Holography.*

PHASE SHIFT The displacement of an electromagnetic waveform in time or space. Displacement of a sinusoidal wave by one complete wavelength is a phase shift of 360 degrees. Displacement by half a wavelength gives a shift of

180 degrees and peaks replace troughs of the waveform, and vice versa. The resultant addition of two coherent waveforms depends on interference and the relative phase. Two identical waveforms 180 degrees out of phase will cancel out if combined. At other phase angles partial cancellation occurs.

The optical transfer function of a lens is the composite modulation transfer function and the accompanying phase shift due to residual aberrations. *S. Ray*

See also: *Quarter-wave plate.*

PHASING (SOUND) The process of making certain that the various paths in a sound system have identical polarity; that is, if presented with a positive-going increase at the input of the system, a positive-going signal will appear at all accessible points within the system. If sound systems are not phased correctly, undesirable cancellations of sound may occur. *T. Holman*

PHENIDONE The trade name for a developing agent, 1-*phenyl-3-pyrazolidone* ($C_9H_{10}ON_2$, molecular weight 162.19; other names: 1-phenyl-3-pyrazolidinone, Phenidone A, and Graphidone) with a low solubility in water but soluble in alcohol. The photographic grade of the white crystals or crystalline powder assays 98.5% minimum by weight. Reported to act as an allergen and skin irritant.

Phenidone is a slow acting, nonstaining developing agent, giving good image detail in areas of low exposure. Often combined with hydroquinone to produce solutions that are similar to Metol-hydroquinone developers but less Phenidone than Metol is needed to secure equal activity. *G. Haist*

See also: *Developers; PQ developers.*

PHI (φ) Symbol for flux, the time rate of flow of energy emitted by a source or passing through a defined aperture. Radiant flux (I_e) is a measure of electromagnetic energy at all wavelengths and is measured in watts (W). Luminous flux (I_v) measures power scaled with respect to its visibility and is measured in lumens (lm). *J. Pelz*

See also: *Flux; Luminous flux; Photometry and light units; Radiant flux.*

PHI PHENOMENON The appearance of motion when a sequence of still pictures containing image elements that are systematically displaced in position are observed in rapid sequence, as with animated cartoons, motion pictures, and video. *L. Stroebel and R. Zakia*

See also: *Visual perception, perception of motion.*

PHON A unit of subjective loudness. Plotting a point at a frequency and sound pressure level on an equal-loudness contour graph, one can determine where such a point lies with respect to the equal-loudness contour curves. The loudness in phons for such a tone is the nearest loudness contour that can be drawn through the point. The reference for phons, which are given in decibels, is a sinusoidal tone at 1 kHz and 40 dB sound pressure level. *T. Holman*

PHOSPHOR A substance that emits light as a result of fluorescence or phosphorescence. *J. Holm*

PHOSPHORESCENCE Electromagnetic radiation emitted from a substance as a result of the absorption of radiation incident on the substance. Phosphorescence is distinguished from fluorescence in that phosphorescence can continue long after exposure to incident radiation ceases. *J. Holm*

PHOSPHOROPHOTOGRAPHY An indirect infrared photographic system based on the ability of infrared radiation to proportionally reduce phosphorescence of a uniform phosphorescent surface, producing a negative image that can be viewed or photographed. *L. Stroebel*

PHOSPHOR PERSISTENCE In computing, the length of time that a phosphor within a cathode-ray tube (CRT) emits energy is determined by the chemical composition of the phosphor. There are various phosphor decay times. The selection of a particular monitor's phosphor decay rate depends upon the particular use that the computer operator has in mind. Monitors with long phosphor decay times would not be appropriate for an application that updates the CRT screen with new information with each refresh. *R. Kraus*

PHOT (ph) A unit of illuminance; the luminous power per unit area incident on a surface. One phot is equivalent to 1 lumen per square centimeter. A point 1 cm from a 1 candela source receives 1 phot of illuminance. The SI unit lux (1 lumen per square meter, lm/m²) is preferred. Another unit in common use is the footcandle (fc; 1 lumen per square foot) (1 ph = 10,000 lux = 929 fc). *J. Pelz*

Syn.: *Lumen per square centimeter.*

See also: *Illuminance; Photometry and light units.*

PHOTO See *Photograph.*

PHOTO- (prefix) (1) Associated with light, as in photography, photometry, photocell, etc. (2) By extension from (1), associated with electromagnetic radiation, as in photochemistry, photoelectric, etc. (3) Associated with a photographic process, as with photomechanical, photoengraving, etc. *J. Holm*

PHOTOBASE A computer network devoted to information about photographic education. *R. Zakia*

See also: *Photographic education.*

PHOTOCELL A solid-state electronic device that converts light into electrical energy or that uses light to regulate the flow of an electrical current. *L. Stroebel*

Syn.: *Photoelectric cell.*

PHOTOCERAMIC DECAL A technique involving a transfer process for reproducing photographic images on ceramic objects. The image is silkscreened, using a finely ground china paint or overglaze pigment, onto a decal transfer paper. The decal is then positioned on a ceramic piece that has been glazed and fired. After the decal is applied, the piece is refired. *J. Natal*

See also: *Ceramic processes.*

PHOTOCHEMISTRY Through the ages light has been observed to cause chemical changes. The dyes in some flowers and textiles fade. Light is required for green plants to produce organic substances, such as sugars, from carbon dioxide and water. Photochemistry is the study of the chemical reactions caused by the energy of light and other radiation. Absorbed radiant energy can cause a compound to be decomposed (photolysis) or substances to be combined (photosynthesis). Oxidation, reduction, hydrolysis, and polymerization are some chemical reactions that are promoted by light of suitable energy.

Only light that is absorbed can be effective in causing chemical change. All the energy may not be effective chemically. Some may be converted to heat and some may be reemitted as light of the same or another frequency (fluorescence). Mere absorption of light may not be sufficient to cause change. The light also must possess at least enough energy to promote reaction. The shorter wavelengths of radiation are the most energetic, so ultraviolet may cause

chemical changes that red light or infrared radiation cannot initiate.

For each actinic photon there should be produced one decomposed or one synthesized molecule; that is, one quantum of energy causes one chemical change. The quantum yield is one. This relationship applies only to the primary photochemical reaction. The resulting activated molecule may have secondary thermal or other reactions that may obscure the quantum efficiency of the primary process. The quantum efficiency of a photochemical reaction may range from a value of less than 1 to a large number. The union of hydrogen with chlorine is said to have a quantum efficiency as high as 100,000 under the influence of light with a trace of water vapor present.

The action of light upon silver halides is the fundamental photochemical reaction making photography possible. Pure silver halide crystals are thought to be insensitive to light. Impurities and crystal imperfections are believed to make the formation of a latent image possible by providing a suitable site for the deposition of metallic silver atoms. Chemical sensitization of photographic materials is simply a way to introduce impurities to make the formation of the latent image more efficient, thus increasing the sensitivity of the material to light.

In a silver bromide crystal the silver and bromide atoms exist as alternating charged ions in a cubic lattice. The primary photochemical process involves the absorption of a quantum of actinic light energy to remove an electron from a bromide ion. This reaction might be summarized by the equation

$$Ag^+Br^- + \text{light energy} \rightarrow Ag^+ + Br^o + e^-$$

where e^- is a photoelectron. Electrons cannot exist in a free state so a secondary reaction occurs:

$$Ag^+ + e^- \rightarrow Ag^o \text{ (metal)}$$

The combination of the electron and the silver ion may occur at some distance, not necessarily at the release point of the electron. The combination of the photoelectron and an interstitial silver ion occurs at a preferred site, where the impurities or crystal defects momentarily trap the electron and attract the silver ion. Latent image formation requires that this reaction occur at least four times, and actually many more times, at the same site before the silver atoms are stable enough to persist with time. The necessary multiple reactions mean that photoelectron losses reduce the efficiency of the overall process. *G. Haist*

See also: *Reciprocity law.*

PHOTOCHROMATIC INTERVAL
The difference between the minimum intensity of a light stimulus at which hue becomes apparent (chromatic threshold) and the minimum intensity that can be detected (absolute threshold).

L. Stroebel and R. Zakia

Syn.: *Colorless interval.*
See also: *Just-noticeable difference.*

PHOTOCHROMISM
Photochromism is a particular kind of phototropy, a reversible change of a material between two states having different electromagnetic radiation absorption spectra. In photochromism, a reversible change of color takes place when certain organic or inorganic compounds are exposed by short wavelength radiation. For example, transparent calcium fluoride crystals doped with lanthanum or cerium become optically dense when exposed to ultraviolet radiation. They become transparent again when exposed to infrared radiation. Reversion may also be achieved with heat, photoreversal (longer but visible wavelengths), or phosphorescence.

The process has applications in variable transmittance filters (including sunglasses), information storage, negative proofing, masking, displays, and ultraviolet dosimetry (dosage measurement). These applications are limited by photochromic materials' low sensitivity, narrow spectral response, fatigue with repeated reversal, partial memory, and relative impermanence. *H. Wallach*

PHOTOCOMPOSITION
The process of setting type photographically. *M. Bruno*

PHOTOCONDUCTIVE CELL
A photosensor, the electrical resistance of which decreases as light on it increases. The value of resistance at a specific light level is determined by the area of the cell, the configuration of the electrodes, and the type of photoresistive material used—most frequently cadmium sulfide (CdS) and cadmium selenide (CdSe). The spectral response of these cells is quite narrow. Cadmium sulfide cells have a maximum sensitivity at about 515 nm (blue-green) and cadmium selenide from 615 to 735 nm (near infrared). Because of their spectral response, cadmium sulfide cells have been widely used in light meters and in cameras with automatic exposure control. At light levels of less than 1 footcandle these cells are exceptionally linear; that is, the current is directly proportional to the incident light. Disadvantages of photoconductive cells are that they need an external source of voltage to operate, unlike a photovoltaic cell, and their relatively slow response to changes in light level compared to the fast response of phototransistors and photodiodes. *W. Klein*

Syn.: *Photoresistor.*
See also: *Photoconductivity.*

PHOTOCONDUCTIVE PIGMENT ELECTROPHOTOGRAPHY
In photoconductive pigment electrophotography, light-sensitive material is incorporated into toner particles. The particles are then dispersed in an insulating liquid or softenable resin. On exposure, a variable charge is created on the particles, which are then displaced in a field. The more common variants of this process are photoelectrophoresis and migration imaging. In photoelectrophoresis, the particles are suspended in a liquid that is placed between a metal and transparent electrodes. On exposure, the charge is transferred from the particles to the electrode in such a way that the charge-reversed particles are attracted to the metal electrode. As a result, a positive image is created at the transparent electrode and a negative image at the metal electrode. Photoelectrophoresis is of interest as a potential technique for color reproduction. In migration imaging, the photosensitive material is in the form of a thin layer of Se particles embedded in the surface of a resin layer. The layer is charged by a corona discharge and exposed. The exposed particles then migrate to an imagewise depth in the resin host. Migration imaging is of interest for microimaging applications. *P. Borsenberger*

PHOTOCONDUCTIVITY
The property of certain materials such as cadmium sulfide and cadmium selenide to change electrical resistance when exposed to light or infrared radiation. The resistance changes inversely with the incident light over a range of five decades or more. *W. Klein*

See also: *Photoconductive cell.*

PHOTOCOPYING
The process of making a reproduction of a document or other original based on the principle of light sensitivity, typically with an office xerographic photocopying machine. *L. Stroebel*

PHOTODEVELOPMENT
The production of a visible image from a latent image without chemical processing. Dry process printout emulsions are exposed to high intensity

radiation and then dry developed by subsequent exposure to low intensity radiation, often ultraviolet. *H. Wallach*

PHOTODIODE A semiconductor *p-n* junction device whose reverse (leakage) current is proportional to incident radiant energy. Unlike the photoconductive cell, the photodiode is polarized and must be connected only in the reverse bias mode. The photodiode has a faster speed of response to a change in radiant energy than a photoconductive cell.
W. Klein

PHOTOELASTIC STRESS ANALYSIS Optical technique for revealing stress distribution by passing polarized light through transparent plastic models in a polariscope with applied loads proportional to those on the real subject. The stressed regions become birefringent, and retardation of the transmitted light produces interference patterns of dark and colored fringes called isoclinic and isochromatic lines. By using certain polymers, such as epoxy resins, and by heating and cooling under load, the stress patterns can be retained for detailed analysis. Alternatively, the actual subject can be coated with a polymer and viewed through a reflecting polariscope. *S. Ray*

PHOTOELECTRIC CELL See *Photocell; Photoconductive cell; Photovoltaic cell.*

PHOTOELECTRON (1) An elementary particle bearing a negative charge. In photography, an electron freed from its normal position in a crystal such as silver halide by the absorption of radiant energy. Such electrons participate in the formation of the latent image. (2) An electron that is emitted from the surface of a phototube cathode when a photon strikes the cathode. The photoelectrons are attracted to a positively charged anode. The flow of electrons is frequently referred to as *photocurrent*. There is a linear relationship between the magnitude of photocurrent and the level of incident light. *W. Klein*

PHOTOELECTROPHORESIS (PEP) In the electrophoretic process, ionically charged dyes in an insulating liquid can be made to travel a short distance (0.005 inch, for example), usually transferring from a ribbon to a receiver sheet, when a strong, pulsed, unidirectional charge is applied. In photoelectrophoresis, pigment particles with controlled spectral response characteristics are dispersed in the insulating liquid. Exposure enhances the charge-exchange properties of these dyes. The image is produced by the pulsed field. *H. Wallach*

PHOTOENGRAVING The process of producing printing plates for letterpress. *M. Bruno*
See also: *Photomechanical and electronic reproduction.*

PHOTO ESSAY In photojournalism, a series of photographs that tell a story, typically in a subjective manner as distinct from straightforward documentary or factual reporting. *L. Stroebel*
See also: *Visual literacy.*

PHOTOFABRICATION The manufacture of a variety of small metal, plastic, or electronic parts using a photographic process. A light-sensitive organic resin resist is coated on a plate. The pattern used to expose it is drawn very large and then reduced to its typical micro size whereupon it is used to form an image in the resist. The unhardened areas are removed leaving a stencil pattern that permits the etching, plating, electroforming, or chemical milling of selected areas of the underlying plate. A similar procedure may be performed on the back of the plate. Greater accuracy

is achieved when a laser is used to etch or expose the plate directly. *H. Wallach*

PHOTOFINISHING *Photofinishing* is a word used to describe automated processing or printing of photographic film. It is typically designated to the processing and printing of film used by amateur photographers. Today's photofinishing is designed for two groups of photographers: those who require their film returned in less than two hours, and those who are less concerned about the length of time for processing.
HISTORY Photofinishing first brought photography to the public in 1888 when roll film was manufactured to be sold to the public in a camera by the Eastman Company, of Rochester, New York, now known as the Eastman Kodak Company. This film was long enough to take 100 pictures, after which the exposed film and the camera were sent to the factory for photofinishing. Prints were made by first processing the film and then making a contact print of each negative on light-sensitive photographic paper. The camera was then reloaded and sent back to the photographer, with the 100 processed pictures ready for display. In those early days of photography, when photofinishing became an industry, it could take many hours to process the film and make the 100 prints. Modern photofinishing plants can make hundreds of thousands of prints a day. Automated printers use computers to help operators to examine and analyze each negative and expose it onto a long roll of photographic paper. The long roll of paper is processed and cut into single prints while automatically being matched with the negatives from the roll of film.
TYPES OF PHOTOFINISHING
Minilabs In the 1970s a new photofinishing service was provided for the picture-taking public. The facility offering this service was to become known as the *minilab*. These labs can handle approximately 200 rolls of film per day, are often located in retail stores, and occupy a relatively small space. Minilabs generally provide 1-hour service, typically for a surcharge. The film is processed and then printed in an optical printer, with the assistance of an operator, onto a long roll of photographic paper. The prints are processed automatically and come out of the printer sorted for each roll of film. The negatives are matched to the prints by the operator, and packaged ready for pickup by the photographer. Minilabs have gained a wide acceptance for photofinishing. They can be found in most of the larger shopping centers or malls and in many camera stores.
Photofinishers Simultaneously, the high-volume photofinishing industry has developed many computerized pieces of equipment that allow stores that do not have minilabs to offer a convenient photofinishing service. When a roll of film is left for photofinishing by a photographer, it is sent to a centrally located laboratory. The film is first identified with the envelope in which it is received, so it can be matched to the print and order envelope when the order is completed. The film is spliced onto a long roll of film made up of rolls of film from other photographers. This bulk roll of film can be more than 100 rolls long. It is then processed in a high-speed processor to produce negatives, which are put onto a computerized printer that can make up to 27,000 prints per hour. The computer will scan each negative in the bulk roll to determine the correct amount and color of light needed to make a quality print. The negative is exposed onto a long roll of photographic paper. As both the negative and the print are in continuous form, they can be cut and matched together after the processing. The negatives and prints are then packaged by envelope order and sent back to the stores to be picked up by the customers.
Photofinishing is now convenient and accessible to all photographers. Although only black-and-white films were available in the early days of photofinishing, the industry has now

been almost completely converted to the processing and printing of color films. Photofinishing has truly brought a new meaning to the original 1888 slogan of the Eastman Company: "You press the button, and we do the rest." *T. Gorham*

PHOTO-FINISH PHOTOGRAPHY
The specialization of photographing the finish line at a race track to determine the winner in a close race, normally with a streak or strip camera. *L. Stroebel*

See also: *Camera types, streak; Strip; Streak and strip photography.*

PHOTOFLASH LAMP
See *Flashbulb.*

PHOTOFLOOD LAMP
Tungsten-filament lamp with a diffused bulb. Since they operate at 3400 K, they have a short life of about 4 to 6 hours but produce more light for their wattage than 3200 K lamps. *Tungsten* (or type B) color films are balanced for use with 3200 K light and require mild amber filtration when used with photofloods. Type A color films are balanced for 3400 K light. Blue-coated photoflood lamps have a color temperature of about 4800 K and reduced intensity since the coating functions like a conversion filter. *R. Jegerings*

Syn.: *Floodlight/floodlamp.*

PHOTOGENIC
(1) *Photogenic drawing* was a term used by W. H. Fox Talbot to describe his earliest photographic process "by which natural objects may be made to delineate themselves without the aid of the artist's pencil (brush)." (2) In contemporary usage, photogenic is an adjective borrowed from the French, indicating subjects, generally people, who are particularly easy to photograph well, possibly because they combine ease in front of the camera with well-proportioned or expressive features. (3) Producing light, applied to biological sources such as fireflies, luminescent bacteria, or fungi. *R. Welsh*

PHOTOGRAM
An image produced without camera or optics by interposing a transparent, translucent, or opaque object in a beam of light falling on photographic paper or other sensitized material. Opaque objects in full contact with the sensitized material will block all light and no exposure will result. Transparent objects will permit exposure as a function of their base densities. Objects that are shiny, translucent, or not in full contact can produce a complex series of reflections, shadows, and patterns that are capable of eliciting surprise.

Many early experiments in photography employed this technique. Thomas Wedgwood and (later) Sir Humphry Davy attempted to record leaves and insect wings on paper and leather. They called their images *profiles* and published their findings in 1802. By 1835 W. H. Fox Talbot had made a series of photograms of lace and botanical specimens that he called *photogenic drawings*. In Zurich in 1918, Dadais Christian Schad used pieces of books and newspaper to make *Schadographs*, arguably the earliest application of the photogram to abstraction, freeing the process of image generation from camera-imposed limitations of perspective. In the 1920s, Man Ray called the same product a *Rayograph*, and Laszlo Moholy-Nagy made both printed-out and developed-out photograms.

An earlier meaning of *photogram* distinguished a deliberately artistic image from a purely mechanical one, called a *photograph*. An effort was also made to designate *photograph* as a verb meaning to make images, and *photogram* as a noun indicating the thing one made while photographing. *H. Wallach*

PHOTOGRAMMETRY
The science of photogrammetry involves the methods, techniques, and analytical procedures used to make accurate measurements of distances and/or heights of objects from photographic images. In the broadest sense, photogrammetric techniques can be applied to any subject matter, but by far the most common application is for the creation of maps and land surveys using aerial imagery. Accurate geodetic maps can be produced using metrically calibrated aerial cameras and knowledge of aircraft position and altitude information. Topologic maps can also be produced when stereo imagery (two overlapping views of the same ground area taken from two accurately know camera locations) is available. Map scales from 1:1,000,000 to 1:100 or larger can be created by appropriate selection of camera altitude, lens focal length, and film format.

The aerial cameras used on photogrammetric applications must be specifically designed to minimize optical distortions, and their focal length, nodal point locations, and focal plane flatness must be precisely known in order to obtain accurate distance measurements from the resulting photographs. These *metric* cameras commonly use 4- to 9-inch-wide, high-resolution aerial film. Depending on the application, black-and-white (B-W), color, or color infrared (CIR) films can be used.

Although aerial mapping applications account for the major portion of photogrammetric engineering, other uses include architectural design and construction, archeological and geological surveys, medical research, biology, and even microscopic analysis. Every application relies on the same mathematical principles that use the known imaging geometry of the photograph to calculate the position of objects relative to known reference points or other objects within the scene.

For mapping applications, a single vertical photograph can provide distance information if the camera altitude and optical parameters are well known. The approximate image reduction can be determined by aircraft altitude divided by focal length. Then, if the distance between two points on the photographic image is accurately measured and multiplied by the image scale, the actual distance on the ground can be determined. This method relies on accurate knowledge of aircraft altitude, which is often difficult to measure. If greater accuracy is desired, known distances on the ground (reference points) can be compared with the image distance between the same points to arrive at a better estimate of the image reduction.

In order to determine height information (e.g., for topographic maps), two vertical photographs are required with sufficient overlap (usually 55% or more) to allow height calculations using the known parallax between the two images. In this application, accurate knowledge of the separation between the two images (referred to as the stereo base) as well as the aircraft altitude and camera focal length must be known. Stereoplotters are often used to assist with the measurement and determination of ground topology.

Several sources for calibrated aerial imagery are available for use in mapping and survey applications. The National Aerial Photography Program (NAPP) and its predecessor, the National High Altitude Photography (NHAP) program, collect both B-W and CIR imagery of the United States. NAPP imagery is available at a 1:40,000 scale covering approximately 5.25 miles on a side. Stereo coverage is available with a 60% overlap. These 9-inch frames are available to the public and are suitable for land use analysis and photogrammetric measurements. Space-based metrically calibrated stereo imagery has also been collected using NASA's Large Format Camera from the space shuttle. This imagery is available at a 1:900,000 scale covering approximately 260×130 miles on a 9×18-inch film format. The U.S. Landsat and French SPOT multispectral satellites also provide metrically calibrated imagery from 1:1,000,000 to 1:100,000 scale. Landsat scene coverage is approximately 115×105 miles, and SPOT covers approximately 37×37

miles. The American Society of Photogrammetry and Remote Sensing (ASPRS) is the major technical society that addresses many aspects and applications for photogrammetry. *L. Scarff*

See also: *Photometrology.*

PHOTOGRAPH An image of one or more objects produced by the chemical action of light or other forms of radiant energy (gamma rays, x-rays, ultraviolet radiation, infrared radiation) on sensitized materials. By extension, an image formed by an electronic imaging system (electronic photography). *L. Stroebel*

PHOTOGRAPHIC APPRENTICESHIP *Apprenticeship* is a term not frequently used today. The original meaning implied that a novice could work in the studio of a master photographer and learn the skills of the trade. The apprentice would start at a very low salary, which would increase with additional skills. *Assistant* is now a more widely accepted label for a person who has the responsibilities formerly assigned to the photographic apprentice. *R. Malone*

PHOTOGRAPHIC BOOKS See *Publications, photographic.*

PHOTOGRAPHIC CHEMISTRY The photographic image begins with exposure, a photochemical reaction that releases photoelectrons from the halide ions of the silver halide in the emulsion layer. A photoelectron combines with a silver ion to start the formation of a small nucleus of metallic silver, the latent image. Chemistry then amplifies the unseen image to a useful size by deposition of metallic silver on the nucleus. The branch of chemical science and technology that deals with the formation and treatment of the silver or dye image, especially the nature of processing solutions, is the field of *photographic chemistry.*

The critical part of photographic processing is development because the characteristics of the final image are determined during this chemical treatment. Much effort has been devoted to the choice, activation, and maintenance of the developing agents. After the image is formed, the rest of the chemical treatment is secondary but is ever so necessary to ensure the permanence of the developed image.

DEVELOPMENT Amplification of the latent image is accomplished by a developer, a water solution of several chemicals. Many thousands of varied formulations have been devised. Each contains essentially the same constituents: a developing agent or agents, alkali, preservative, antifoggant, and special purpose compounds.

Developing Agents Being a chemical electron donor is not sufficient to make a compound a developing agent. The critical complex for photographic development, using a Phenidone ion as the developing agent, might be shown as

Developing agent Latent image Silver ions
 silver from crystal

The developing agent must contact or be adsorbed to the metallic silver of the latent image. The molecule should have one end that is attracted to the metallic silver of the latent image (argentophilic); the other end should have low water solubility (hydrophobic). Once the argentophilic group is adsorbed to the silver, the rest of the molecule is water insoluble, thus forcing the molecule to adhere to the latent

image. This condition greatly promotes the ease of electron transfer. Not all developing agents have this surfactant character. Hydroquinone, for example, in alkaline solution, often exists as the doubly charged ion, $^-$O–C6H4–O$^-$. Both ends of the molecule are argentophilic. When one end is adsorbed, the other end still has high water solubility. If conditions permit, the molecule may be adsorbed flat on the surface. This orientation is different from the strongly adsorbed developing agents that are adsorbed from the argentophilic end, much like a deck of cards on end. The surfactant differences between developing agents has led to their classification based on their adsorption to catalytic sites, as shown at right.

Hydroquinone is an excellent electron donor but is a slow-acting developing agent because it is not strongly adsorbed. Developing agents with good surfactant properties, such as Metol or Phenidone, transfer electrons efficiently, but the oxidized forms then take time to move aside for unused molecules. This has led to the use of two developing agents, one of each type, such as Phenidone and hydroquinone, in developing solutions. In this case, one developing agent (Phenidone) stays adsorbed and the other (hydroquinone) provides electrons to it, thus regenerating the adsorbed molecule. The Phenidone acts as an electron transfer agent, with hydroquinone from solution providing the electrons. The Phenidone is not exhausted and need not leave the surface on or near the latent image. Only a very small quantity is needed of the strongly adsorbed developing agent.

The cooperative developing activity of two developing agents of differing surfactant properties is called *superadditive development.* Because of the increased efficiency of the electron transfer, the amount of developed silver is greater for the two cooperating compounds than the sum of the individual actions of each alone, all used under the same conditions.

Catechol

Metol

N,N-Diethyl-*p*-phenylene diamine

Hydroquinone
Not hydrophobic

1-Phenyl-3-pyrazolidone

Hydrophobic Argentophilic

Many of today's developing agents are related to three benzene compounds found before the turn of the century:

Hydroquinone p-Phenylenediamine p-Aminophenol

and

Phenidone Methyl Phenidone Dimezone

The hydroquinone molecule is still used in its original form and Metol, the *N*-monomethyl derivative of *p*-aminophenol, is a widely used developing agent. But *p*-phenylenediamine has undergone what might be called chemistry engineering.

p-Phenylenediamine is a slow, physical developing agent because it is much too water soluble. This deficiency has been modified by adding hydrophobic methyl and ethyl groups to the molecule. Although improving the surfactant properties of *p*-phenylenediamine, the change also addsto the oil solubility of the compound, making more severe the skin irritation and systemic poisoning properties. To lessen this, the ethyl group was changed to a long water-solubilizing chain (lessened skin absorption), making an important color developing agent:

has become

p-Phenylenediamine

Chemical names: *N*-ethyl- *N*(β-methylsulfon-amindoethyl)-3-methyl- *p*-phenylenediamine sesquisulfate monohydrate; or 4-amino- *N*-ethyl- *N*(β-methanesulfonamidoethyl)- *m*-toluidine sesquisulfate monohydrate.

Trade name Kodak Color Developing Agent, CD-3

In this century two important developing agents, and modifications, have been found that are not benzene derivatives:

L-Ascorbic acid Isoascorbic acid

Ascorbic acid (Vitamin C) is a sugar derivative that is a good antioxidant. Isoascorbic acid has only about one-twentieth of the antiscorbutic properties of Vitamin C. Phenidone is a 3-pyrazolidone (sometimes called 3-pyrazolidinone) that has had methyl groups added to the molecule to improve the stability in alkaline solution.

Of the many thousands manufactured, only about 10 developing agents are needed to compound the immense variety of black-and-white or color developers in use today.

Developer Alkalis Organic developing agents are weak acids because of the OH⁻ groups, which ionize to give off protons ($-OH \rightarrow -O^- + H^+$), or weak bases because of the $-NH_2$ groups, which accept protons. If both $-OH$ and $-NH_2$ are present in the same molecule, the developing compound is amphoteric, that is, has both acidic and basic properties. For -OH groups, the form that has the greatest electron availability is when it is ionized ($-O^-$); for molecules with $-NH_2$, the uncharged form ($-NH_2$) is most electron rich. The purpose of the developer alkali is to convert the molecule of the developing agent to a form with the highest electron density and suitably charged condition so that electron transfer to the latent image can be most rapidly achieved. Alkalis have sometimes been called activators because of their acceleration of chemical reactivity.

Some developing agents, such as hydroquinone, are weak acids. Alkalis supply hydroxyl ions (OH⁻) in water solution. The caustic alkalis (sodium or potassium hydroxide, for example) have all their hydroxyl ions available. One molecule of sodium hydroxide acts first to ionize one hydrogen of the hydroquinone:

Another hydroxyl ion will then remove the second hydrogen:

The hydroquinone has been converted by the alkali from an unreactive, nonionized molecule to the fully ionized form that is most capable of transferring electrons.

Some developing agents with –NH$_2$ groups are weak bases that can transfer electrons, though very slowly, without the need of an alkali in solution. These developing agents also have their developing activity increased by alkali. *p*-Phenylenediamine combines with water to give

Uncharged –NH$_3$OH groups are formed but these give off hydroxyl ions, as shown by

The doubly charged positive ion is a poor electron transfer agent, being very water soluble and possessing a positive charge that might repel positive charged silver ions at the latent image site. If hydroxyl ions from an alkali are added, the neutral molecule is formed. This is the active form for electron donation.

An alkali supplies hydroxyl ions. Almost all alkalis have essentially similar effects if compared at the same pH value. The concentration of the hydroxyl ions, not the compound that is the source, is the important condition. In practice, however, the choice may be dictated by many factors. Only caustic alkalis supply enough hydroxyl ions for high–pH developing solutions. Retention of sodium carbonate in the emulsion layer may cause damaging release of carbon dioxide gas if the layer is immersed in a strongly acid stop bath. Ammonia and ammonia salts are unstable in high temperature solutions. The nature and concentration of the developing agents and other compounds in the developer often determine a specific choice of the alkaline substance.

A summary of practical alkalis is given with the equation showing the condition of the compound in water. In parenthesis following the kind of alkali is the name of the compound used as an example in the equation.

Caustic alkali (sodium hydroxide)
$$NaOH \rightarrow Na^+ + OH^-$$

Carbonate alkali (sodium carbonate)
$$Na_2CO_3 + H_2O \rightarrow Na^+ + OH^- + Na^+ + HCO_3^-$$

Borate alkali (borax)
$$Na_2B_4O_7 + 3H_2O \rightarrow 2NaBO_2 + 2H_3BO_3$$
$$NaBO_2 + 2H_2O \rightarrow Na^+ + OH^- + H_3BO_3$$
Sodium metaborate (Kodalk), $NaBO_2 \cdot 4H_2O$, is the fused product of borax and sodium hydroxide.

Phosphate alkali (trisodium phosphate)
$$Na_3PO_4 + H_2O \rightarrow Na^+ + OH^- + Na_2HPO_4$$

Sulfite alkali (sodium sulfite)
$$Na_2SO_3 + H_2O \rightarrow Na^+ + OH^- + Na^+ + HSO_3^-$$

Ammonia alkali (ammonia and ammonium hydroxide)
$$NH_3 + H_2O \rightleftharpoons NH_4OH \rightleftharpoons NH_4^+ + OH^-$$

Organic amine alkali (trimethylamine)
$$(CH_3)_3N + H_2O \rightarrow (CH_3)_3NH^+ + OH^-$$

Developer Preservatives An alkaline solution of a developing agent is unstable, deteriorating rapidly because of the presence of the degraded products. In a hydroquinone developer, for example, the hydroquinone molecule can lose one electron to form a semiquinone, or two electrons to form quinone. The loss of one electron is a slow step, the loss of the second electron is more rapid. The quinone then can react with hydroquinone, forming two semiquinones, thus bypassing the slow step in the degradation of hydroquinone. The catalytic chain reaction then accelerates to degrade the unprotected developing agent.

To prevent the autocatalytic destruction of the developing agent, a chemical compound called a preservative is added to the developer. Ever since 1882, when it was proposed by H. B. Berkeley, sodium sulfite has been nearly the universal choice for developer preservative. When sodium sulfite reacts with the oxidized forms of a developing agent such as those from hydroquinone, the sulfite adds to the oxidized molecule to form a new compound. Quinone combines with sodium sulfite to produce sodium hydroquinone monosulfonate.

Sodium hydroquinone monosulfonate is a weaker electron donor whose oxidized form, quinone monosulfonate, may also react with sodium sulfite.

The disulfonate of hydroquinone is not very reactive.

The reactive oxidation products of a developing agent are removed by sodium sulfite. This action prevents the auto-oxidation of the electron donor but also keeps the developing solution clear and colorless. The formation of

dark, staining reaction products, called humic acids, is prevented. The oxidized form of *p*-aminophenol (quinoneimine) and the oxidized form of *p*-phenylenediamine (quinonediimine) are also reactive with sulfite, as are other benzene derivatives that are developing agents. Ascorbic acid and Phenidone do not form sulfonates with sodium sulfite.

The reaction of silver bromide at the latent image site with an alkaline solution of hydroquinone containing sodium sulfite may be described by the equations that follow. (The oxygens of the doubly ionized hydroquinone ion have been depicted with dots to represent the reactive electrons of each atom.)

$$\text{(hydroquinone dianion)} + AgBr \longrightarrow Ag^0 + Br^- + \text{(semiquinone)}$$

The hydroquinone transfers one electron to the silver ion of silver bromide, forming metallic silver, a bromide ion, and an intermediate form of hydroquinone that has lost one electron (semiquinone).

$$\text{(semiquinone)} \rightleftharpoons \text{(quinone radical)} + Na_2SO_3 \longrightarrow \text{(sulfonate)} + H + Na^+$$

In the presence of sodium sulfite the intermediate form of hydroquinone reacts to form a sulfonate

$$AgBr + \text{(sulfonated intermediate, } SO_3Na) \longrightarrow \text{(hydroquinone monosulfonate, } SO_3Na) + Ag + Br^-$$

The intermediate sulfonated form then loses another electron to the silver bromide, yielding metallic silver and hydroquinone monosulfonate. In the course of the reaction, bromide and hydrogen ions are produced. The hydrogen ions, both from the ionization of the hydroquinone and from the reaction, are neutralized by the hydroxyl ions of the alkali.

Compounds other than sulfite, or those yielding sulfite ions, act as preservatives in developers. Certain organic compounds having a mercapto group (–SH), such as thioglycolic acid, $HSCH_2COOH$, or cysteine, $HSCH_2CH(NH_2)COOH$, react in a manner analogous to sodium sulfite, preventing the coloration, staining and accelerated degradation caused by the oxidized forms of the substituted benzene developing agents. Reducing compounds such as ascorbic acid exert an antioxidant action on developer solutions.

Developer Antifoggants *Fog* is the name given to unde-sired silver density formed during development. The veiling effect of fog lowers image contrast and obscures image fine detail. Fog is a general term given to nonimage silver of different types resulting from a variety of mechanisms. Such image degradation may arise from the nature of the photographic material, the developer composition, and the conditions of processing, including the effect of oxygen from the air (aerial fog).

Photographic emulsions that have been too fully sensitized chemically, or become so upon aging, often show fog after development (emulsion fog). High energy developers of high alkalinity or developers with high concentrations of silver halide solvents have a tendency to produce fog (oxidative or development fog). Impurities in Phenidone and other developing agents also produce this kind of fog. Some fogs may occur at a distance from silver halide crystals, or even as a two-color layer of metallic silver on the surface of the developed emulsion layer (dichroic fog).

The requirements are the same for the chemical development of the latent image and fog: a suitable source of electrons, a nucleated center of metallic silver, and a source of silver ions. The development of latent image centers and the development of fog centers have the same two-step mechanism:

$$Red_{dev} \xrightarrow{Ag_n} Ox_{dev} + 2e^-$$

$$2Ag_i + 2e^- + Ag_n \longrightarrow Ag_n + 2$$

In the first step, the reduced form of the developing agent in the presence of the silver (Ag_n) of the latent or fog image transfers two electrons, leaving the oxidized form of the developing agent. In the second step, two interstitual silver ions (Ag_i) combine with the two electrons at the silver center of *n* atoms to form a new silver center that has grown by two silver atoms ($n + 2$).

Preferential destruction of the silver of fog centers is not possible because of their similarity to the latent image centers. The modification of the source of the electrons, the developing agent, is also not a possibility. That leaves two possibilities: modifying either the source of silver ions or changing the surface characteristics of the silver of the catalytic nucleus. The mechanism of the preferential inhibition of the development of fog centers is not known with any certainty but may well involve either or both of these possibilities.

One of the practical solutions for inhibiting fog formation is to decrease the supply of silver ions. For many years this has been accomplished by the use of inorganic compounds in the developer called *restrainers,* such as potassium bromide or potassium iodide. These compounds adsorb to the silver halide crystal and form compounds of low solubility. Potassium bromide, for example, would form silver bromide having the same low solubility as the silver bromide of the emulsion layer. Although this would slow the supply of silver ions to both fog and latent image centers, the restrainer is relatively more effective on the smaller fog centers than on the latent image.

A developing agent, such as Phenidone, is more strongly adsorbed than potassium bromide, thus making the restraining action of the bromide ineffective. Organic compounds, called *antifoggants,* are therefore necessary. Benzotriazole and its derivatives, or 1-phenyl-5-mercaptotetrazole, are examples. Such agents combine with silver ions to form compounds of extremely low solubility. But the exact mechanism of their action is still being researched. 1-Phenyl-5-mercaptotetrazole may act by poisoning the surface of the silver centers. Effective inhibitors are said to destroy the surface of the silver or "form by flat-on adsorption a network of

pseudo-polymeric bands," thus screening the silver from further activity. Such action would be more effective on the smaller, slower-developing silver centers of fog.

Special Purpose Developer Compounds Various chemicals have been added to developing solutions to improve the activity or modify the fundamental process. Sequestering agents are added to the water to prevent precipitation of calcium and magnesium compounds of low solubility. Solubilizing agents for silver halide may be added in such concentration as to fix the silver halide at the same time it is being developed. Such solvent developers, called monobaths, feature a chemical competition between developing and fixing agents as well as the competitive results of the competition between chemical and physical development.

Undoubtedly, the most important special-purpose developer addendum is the one that converts *p*-phenylenediamine developers into solutions that form the silver image first and then, after a secondary reaction, yield a dye image. After the silver image is removed (bleached and fixed), only the dye image remains, making modern color photography possible. The special purpose compound added to the developer is called a *coupler*, a color-forming compound that adds to the oxidized form of the developing agent. The coupler may be contained in the developing solution but, for convenience, is often dispersed in the emulsion layers of the photographic material. Three couplers are needed, either in three developers or in three superposed emulsion layers, each resulting dye covering about one-third of the spectrum.

A molecule of a *p*-phenylenediamine developing agent, such as the *N,N*-diethyl derivative, can supply two electrons to the latent image to form two atoms of metallic silver, producing quinonediimine, the oxidized form of the developing agent. The positively charged quinonediimine and the negatively charged coupler ion may unite to form a molecular structure that is similar to a dye, called the *leuco dye*. The leuco dye may be colorless or weakly colored. It is believed that leuco dye then reacts with another quinonediimine to form the dye, regenerating a molecule of the developing agent in the reaction. These reactions are summarized by the following equations:

Quinonediimine α-Naphthol ion

Leuco dye ion Hydrogen ion

Leuco dye ion Quinonediimine

Cyan indoaniline dye *N,N*-Diethyl-*p*-phenylene diamine

Two quinonediimines, one to react with the coupler and one to convert the leuco dye to the dye, are needed to produce one molecule of dye. Four silver ions were required to produce the two quinonediimines, so that the coupler is called a four-equivalent coupler.

AFTERTREATMENT OF THE DEVELOPED IMAGE Developers determine the quality of the developed image, but the image continues to form when the film or paper is removed from the developing solution. Neutralizing the alkalinity of the developer with immersion in an acid solution stops image formation. A weak acetic acid solution (1–3%), called a *stop bath*, is often used. The acid bath also conditions the processed film so it does not neutralize the acidity of the next bath, the fixing solution. Acid hardening fixing baths must be maintained in an acid condition.

The fixing bath contains sodium or ammonium thiosulfate to combine with the unused, unwanted silver halide crystals that are opaque and still light sensitive. The chemistry of complex ion formation is discussed in the entry "Fixing Bath." The silver thiosulfates formed are water soluble, thus allowing the removal of the insoluble silver halides.

When the photographic material is removed from the fixing bath, the emulsion layer may still retain some developer or stop bath chemicals as well as the chemicals from the fixing bath. Most of these chemicals are readily soluble in water, but thiosulfate or silver thiosulfate ions may interact with the gelatin or the silver image. Retention of these ions after washing in water may result in their degradation in time and an attack on the image. Washing aids are sometimes used immediately after fixation to displace the thiosulfates. Bathing in 1% sodium sulfite causes the sulfite ion to displace the thiosulfate ions, thus ensuring their removal from the emulsion layer. Dilute alkali, such as 2% sodium metaborate (Kodalk), as a washing aid is also effective but may remove gelatin hardening or cause serious swelling of the gelatin layer. A thorough washing in running water, following by drying, completes the processing of the photographic image.

Even the best washing techniques have difficulty removing all of the processing chemicals from the matted cellulose fibers that make up the paper base of photographic prints. Thiosulfates and silver thiosulfates are held by powerful capillary action in the tiny channels of the paper fibers. Originally, to facilitate rapid processing, fiber paper bases were coated with a water-resistant barrier layer, usually cellulose acetate or other cellulose ester. The baryta and emulsion layers were then coated on this water-repellent base. Recently, to reduce the volume of water needed for washing, resins have been used to coat the sides of the fiber paper base.

Although chemical retention is less, requiring much less water to wash photographic prints on a resin-coated base, the prints may not necessarily provide a longer lasting photograph. Tiny cracks may form in the coated layers from the tensions created as the paper fibers expand and contract with the daily cycles of temperature and humidity. For this reason, many prefer two-bath fixation, washing aids, and very thorough washing of fiber-based photographic prints when archival keeping is a requirement.

Books: Haist, G., *Modern Photographic Processing*, Volume 1. New York: John Wiley, 1979. *G. Haist*

See also: *Image permanence.*

PHOTOGRAPHIC CONFERENCE A number of people meeting for discussion and consultation with a broad format and selection of topics within a specified subject area. Typically, the program of a conference will include a number of meetings, with guest speakers, panel discussions, audiovisual presentations, and technical productions. Conferences are commonly sponsored by professional societies and may be organized on a local, regional, national, or international basis. A photographic conference can also be a formal gathering of a few professionals discussing a specific issue or assignment. *R. Malone*

PHOTOGRAPHIC CRITIQUE

Photographic critiques are designed to provide an analysis and an assessment of photographic works. Critiques are commonly used in graduate, undergraduate, workshop, and seminar programs for instructional purposes. Critiques are usually conducted by teachers, recognized experts, and professionals in the field. Occasionally, photographic critiques are conducted by a panel, such as the judges who select photographs for an exhibition. A photographic critique may also be a written opinion of the merits of a photograph or collection of photographs.

R. Malone

PHOTOGRAPHIC DAYLIGHT

A standard quality of light used for testing (especially color) films that has a spectral energy distribution approximately equal to the light encountered in typical good weather conditions during the middle of the day outdoors. The color temperature is 5500 K.

J. Holm

PHOTOGRAPHIC DEFINITION See *Definition*.

PHOTOGRAPHIC DEGREE

An academic title that is granted to a student after completing a program of study in photography in an accredited college or university, such as an associate degree (A.A.S.), bachelor of fine arts (B.F.A.), bachelor of science (B.S.), master of fine arts (M.F.A.), or master of science (M.S.) degree. Photographic trade schools award diplomas upon completion of a program. Certificates are sometimes presented to participants in workshops and other specialized programs.

R. Malone

PHOTOGRAPHIC EDUCATION

HISTORY The historical tradition of teaching photography began with the first inventors demonstrating their new equipment and processes. L. J. Mandé Daguerre published detailed instructions for each new camera that he sold. The first edition appeared in August, 1839, soon after the announcement of the daguerreotype process to the French Academy of Sciences. By 1856 the University of London was offering a course in photographic chemistry. In Berlin, in the 1880s, there were classes in photographic chemistry taught by Hermann Vogel. Alfred Stieglitz was a student of Dr. Vogel while in Germany.

Courses taught in Berlin, Dresden, and Munich between 1863 and 1888 ranged in attendance from 2 to 150 students. Initially such courses were largely technical, but the programs also required some education in liberal arts and scientific studies. The curriculum consisted of course offerings in dosimetry for penetrating radiation, solid-state dosimetry, colorimetry of color pictures, photo-optics, cinematography, graphic arts, latent-image theory, development and materials testing measurement for cartographers.

The Photographic Society of London was founded in 1853. Members learned much from each other and published their own journal. Queen Victoria, by decree in 1894, inaugurated the Royal Photographic Society, which replaced all previously existing photographic societies in England. Josef Maria Eder, in 1888, founded the Graphic Arts Institute in Austria. This university institution taught photographic chemistry, photographic reproduction, and scientific research in photography. Eder, in his *History of Photography,* included technical information as well as a chapter on "Photography as Art."

By the end of the nineteenth century it was possible for students to obtain a formal education in the technical aspects of photographic chemistry, the physical properties of the developed image, and some photographic services. Lab assistants in the classroom were an early academic practice that is still used in photographic education. Professors of science who also had a personal interest in photography were the first teachers of photography.

By 1900, instruction in the new medium had begun to spread, and photographers were conducting group and private photography classes to interested persons in the United States. The availability of smaller and less complicated equipment plus simplified chemical processing attracted an ever growing number of people from a broader range in society.

One of the earliest institutions established in the United States with the specific intention of training professional photographers was the California College of Photography at Palo Alto, California. It was founded in the early 1900s and structured its first year's curriculum on art, chemistry, and optics, followed by studies in photographic theory and practice.

Clarence H. White, a founding member of Photo-Secession, began teaching photography at Columbia University, New York City, in 1907. In 1908 he taught at Brooklyn Institute of Arts and Sciences, as well. Two years later White helped found a summer school of photography in Maine, and in 1914 he opened his famous Clarence H. White School of Photography in New York City. White died in 1925 while teaching students on a photography trip to Mexico. In most cases photography was taught by individuals working within the framework of larger programs and academic institutions during the first one hundred years after the announcement of the daguerreotype process in Paris in 1839. Persons desiring to learn photographic skills were necessarily self-taught or learned from a friend or relative if they did not live near one of the photographic programs.

In 1919 Walter Gropius, architect, founded the Bauhaus in Weimer, Germany. The Bauhaus was a university-accredited school with innovative concepts in teaching and learning. Photography was introduced into its curriculum for use in design, applied technology, and experimentation by way of the photograms of Moholy-Nagy. After the Bauhaus was closed in 1933, Moholy-Nagy opened the New Bauhaus in Chicago in 1937, which was later to become the Institute of Design at the Illinois Institute of Technology. This private school produced a new generation of photographic teachers in America, who in turn started new teaching programs in colleges and universities across the country.

By the early twentieth century, photographic training in technical and academic institutions was also available in major cities around the world including Berlin, Geneva, Dresden, Stockholm, Wroclaw, Darmstadt, Tokyo, Frankfurt, Prague, Vienna, Zurich, London, Leeds, Manchester, Paris, Brussels, Milan, Santiago, Barcelona, Ontario, Montreal, and Sidney. Photographic instruction also found strong roots in Russia. In 1929, 4500 photography groups were under the umbrella of the Friends of Soviet Cinema and Photography.

In 1930, a department of photography was established at the Rochester Institute of Technology (then named the Rochester Athenaeum and Mechanics Institute). Although photography courses were offered at a few other colleges, typically in art or journalism departments, the R.I.T. program was the first college program to be treated as the equivalent of programs in the established disciplines. Originally a three-year diploma program with majors in professional photography and photographic technology, it expanded following the Second World War to eventually include majors in applied photography, biomedical photography, film and video, fine art photography, imaging and photographic technology, and photographic processing and finishing management. The country's first doctorate in imaging science is now offered in the Center for Imaging Science, which evolved from the long-established photographic science major.

The New York Film and Photo League, a politically motivated organization, began teaching film in the early 1930s.

By 1936 a split in the organization created The Photo League. This provided a gallery, darkrooms, a meeting room, and classroom spaces. The Photo League contributed not only teaching opportunities, but some of the best learning opportunities for photographers anywhere in the United States during the 1930s. Upon its opening in 1934, Stoneleigh College, a small women's liberal arts college in New England, offered beginning and advanced courses in photography.

During the 1950s in the United States, photography classes were taught at state universities and private art institutions. Nationally, the number of students studying photography grew to 800 by 1967, 4,000 by 1970 and over 80,000 in the 1980s. The increase was due largely to the growth in the number of photography courses offered in departments of art, design, commercial art, illustration, and photojournalism.

In November, 1962, an invitational conference on photography and general education took place at the George Eastman House in Rochester, New York. This conference, which promoted ideas about teaching photography, developed into the Society for Photographic Education (SPE). Founded in 1963, SPE is the largest association of college-level photography teachers, and it emphasizes photographic history, aesthetics, and, more recently, political theory.

Currently, photography, in all its various scientific, commercial, and artistic forms, is being taught at colleges and universities throughout the world. Most academic programs are designed for two to four years and grant certificates and degrees. Graduate studies are also offered in select areas. These programs usually require from one to three years of study beyond a bachelor's degree, depending upon a student's background and the specific curriculum. Although an academic or professional education will provide students with knowledge and expertise in various photographic technologies, applications, and procedures, a great deal of initiative and creativity are required to attain what has become one of the world's most competitive careers.

Information on photographic educational programs is available from various photographic professional and technical periodicals, books, and journals, which list and describe the many programs offered in schools, museums, and workshops. In 1983, the Eastman Kodak Company published a list of over 1000 colleges and universities in the United States and Canada that teach photography. This information is currently being transferred to a data base and is available through a computer modem system. The Rochester Institute of Technology distributes the data base program.

In addition to college and university photographic courses and programs, trade schools have long offered courses in photography, either in a school or by means of home-study correspondence courses. Some photographic manufacturers offer in-house courses for their own employees, and sometimes for selected customers. Professional photographic organizations offer a variety of educational workshops, seminars, and conferences, and the Professional Photographers of America operates a photographic school where it offers short courses in a range of photographic topics for its members.

Photography began as a technically innovative professional activity in 1839. Through the years it has expanded so that virtually all cultures worldwide experience some form of photographic activity. The twenty-first century will witness an even broader scope and influence of this unique medium. Computer imaging is being utilized at an increasingly rapid rate, and academic institutions are adapting their curriculums to address these changes.

Faculty In the early days of photographic education many of the teachers did not have a college degree, much less a degree in photography, but they were employed because of their professional credentials as photographers and their interest in education. Many of their students were granted either certificates or degrees, most of which were 2-year degrees. Because of the lack of qualified teachers with degrees in photography, many graduating students were hired by their own institutions as teachers. As the field grew, however, this changed, and graduates were hired by other institutions that were installing photographic programs. As the number of institutions offering photographic programs expanded, as it did beginning around 1950, graduate degrees leading to an M.F.A. in photography grew to fulfill the requirements for teaching photography at the college level. Many of these graduates found that they were best prepared to teach in fine art photography programs rather than in the technical or applied areas of photography. As any M.F.A. curriculum will reveal, most M.F.A. photography programs are designed to prepare students to be artists, not teachers of photography. Unlike art education programs leading to a graduate degree in teaching, there are, as of 1993, no photographic education programs. This is true even though, since 1963, there has been a Society for Photographic Education.

PHOTOGRAPHIC AREAS OF STUDY There are many educational programs in photography that lead to degrees, including 2-year associate degrees (A.A.S.), 4-year bachelor degrees (B.A., B.F.A., B.S.), and graduate degrees (M.A., M.F.A., M.S.). Although there are no doctoral programs in photography, there are doctoral programs in related fields, such as art history and imaging science, that include photographic components.

Listed below are some of the photographic subject areas that are included in formal programs of study in educational institutions. The emphasis placed on the various topics varies from a single course offered as an elective, to a required course, to a cluster of courses offered as a minor or major area of concentration, to a complete degree program.

Advertising photography
Aerial photography
Airbrushing
Animation
Architectural photography
Archaeological photography
Audiovisual production
Ballistic photography
Biomedical photography
Botanical photography
Careers in photography
Catalog photography
Corporate photography
Color photography
Color printing
Computer animation
Dental photography
Digital photography
Documentary photography
Documentary film production
Editorial photography
Electronic still photography
Experimental film production
Fashion photography
Fine art photography
Food photography
Forensic photography
High speed photography
History of photography
History and aesthetics of film
Holography
Illustration photography
Industrial photography
Landscape photography

Materials and processes of photography
Materials and processes of film
Missile photography
Motion-picture editing
Motion-picture photography
Multimedia production
Museum studies
Nature photography
Nonsilver photography
Ophthalmic photography
Photographic conservation
Photographic criticism
Photographic laboratory management
Photographic restoration
Photojournalism
Photomacrography
Photomicrography
Picture editing
Picture researching
Portable video
Portrait photography
Professional photography
Retouching
Sensitometry
Semiotics and advertising photography
Surrealism in photography
Technical photography
Technical writing for photographers
Travel photography
Underwater photography
Video
Visual perception and photography
Writing for film and video
Zone system

Most degree programs in photography devote a significant proportion of the credit hours to nonphotographic liberal arts and/or science courses. In addition, depending upon the photographic major, certain other nonphotographic courses may be included in the program with the rationale that knowledge in that area is considered to be important, if not a prerequisite, to a successful career in the student's chosen photographic field. For example, business knowledge is essential for anyone planning on owning or managing a photographic business, and important for other photographers who must interact with the business world.

PHOTOGRAPHIC DEGREE PROGRAMS There are more than 300 schools in the United States offering degree programs in photography with studies in a wide range of photographic subjects. Over 60 schools offer graduate degrees, most leading to an M.F.A. degree in photography. A few schools offer Ph.D. degrees with a major in art history and the history of photography. The Rochester Institute of Technology (R.I.T.) offers the most comprehensive range of degree programs in photographic studies.

The R.I.T. degree programs include:

Biomedical photographic communications (A.A.S., B.S.)
Computer animation (M.F.A.)
Film/Video (B.F.A.)
Fine art photography (A.A.S., B.F.A., M.F.A.)
Imaging and photographic technology (A.A.S., B.S.)
Imaging science (B.S., M.S., Ph.D.)
Photographic processing and finishing (B.S.)
Photograph preservation and archival practice (M.S.)
Professional photography (A.A.S., B.F.A.)

Biomedical Photographic Communications This program is designed to prepare students for a photographic career that supports allied health teams in hospitals and other medical facilities such as ophthalmic clinics, medical research centers, veterinary medicine, and other health science situations. The biomedical photographer works with both still and moving images, including black-and-white and color photography, motion pictures, video, and computer imaging. A typical 4-year program leading to a B.S. degree would include the following:

Biomedical photography I and II
Materials and processing of photography
Medical terminology
Human biology
Color photography and design
Color printing and theory
Advanced photography
Photomacrography/photomicrography
Preparation of visuals
Audiovisual production
Electronic still photography
Introduction to film/video
Business electives
Professional electives
Science electives
Liberal arts

Fine Art Photography For much of this century in the United States a formal education in fine arts photography was only available at professional schools, in design departments at art institutes, or at university schools of journalism.

But from the late 1950s onwards, fine art photography evolved into a major area of instruction. The fine arts degree prepares a student to develop individual artistic visions, for a teaching career, or for a variety of positions with museums, commercial galleries, and corporate and private photography collections. As new departments of photography grew during the 1970s and 1980s, the need for teachers increased. Those faculty positions have been mostly filled and new teaching positions are now less numerous.

Teaching photography as a fine art has always been dedicated to a greater appreciation of its aesthetic values and to communicate a heightened sense of personal expression. But as we near the end of the twentieth century this attitude has expanded to include social consciousness, the influence of the media upon personal and commercial work, and an expanded knowledge of personal fame and financial success.

A well-rounded program in the fine arts provides a student with both aesthetic and social concerns while providing technical and professional skills necessary for all forms of photographic communication.

A variety of courses can be found in undergraduate and graduate fine art photography curriculums, depending upon the particular school:

Introduction to fine art photography
Photography as a fine art I and II
Introduction to color photography
Color photography I and II
Experiments in color
Photo media survey
Alternative photographic processes
Archival photography: processing, display, and storage
Zone system photography
The fine print
Portfolio seminar
Electronic still photography
Drawing for photographic majors
Design elements and processes
The moving image: film/video
History and aesthetics of photography I and II
Contemporary issues in photography
Survey of critical theory
Bauhaus photography

Influence of surrealism and dadaism on photography
Photographic criticism
Film history and aesthetics
The landscape as photograph
Photographic extensions
Preservation issues
Photography core
Special topics workshop
Independent study
Research seminar
Research and thesis
Visual imaging electives
Liberal arts courses

Imaging and Photographic Technology This is an applied program that blends technical, industrial, and scientific imaging. Image-making aspects of photography are covered through courses in basic photography, color studio photography, color printing, audiovisual presentation, and film/video productions. Technical courses include sensitometry, chemistry, optics, colorimetric measurement, photomacrography, photomicrography, infrared and ultraviolet photography, high speed photography, holography, digital imaging processing, scanning electronic microscopy, photoinstrumentation, graphic arts printing, and photographic process control.

Graduates find employment with photographic companies, research organizations, government agencies including NASA and the CIA, the military, and graphic arts printing companies. A typical 4-year program leading to a B.S. degree includes the following required and elective courses:

Photography I
Materials and processes of photography
Survey of imaging and photographic technology
Photography as an analytical tool
Photographic instrumentation
Photographic sensitometry
Technical photographic chemistry
Photographic optics
Color photography/design
Color printing methods
Color measurement
Applied computing
College physics
College algebra and calculus
Audiovisual production and presentation
Photomacrography/photomicrography
Materials and processes of the moving image
Introduction to portable video
Introduction to computer programming
Technical writing
High-speed/time-lapse photography
Introduction to research
Survey of nonconventional imaging
Technical concentration electives
Senior research project
Organizational business behavior
Business elective
Liberal arts courses

Imaging Science The Imaging Science program at R.I.T. is an outgrowth of the photographic science degree program begun in 1956, and it includes both a B.S. degree and an M.S. degree. In 1992 the program was extended to include a Ph.D. degree. The program is centered around the applications of physics, computer science, chemistry, optics, and mathematics to the formation, recording, and perception of images. Also included is the design of imaging systems, evaluation of the images they produce, and the application of those systems to a broad range of careers in industry, business, medicine, and government. Concentrations include digital image processing, remote sensing, photographic chemistry, optics, image evaluation, color science, color appearance, and color technology. Career opportunities exist in such areas as microelectronics, aerospace technology, graphic arts, medical research centers, government agencies, marketing, and technical representation.

The course content for a B.S. or M.S. in imaging science is typical of science and engineering programs with the added feature of applications to imaging.

Imaging science: introduction, survey, and seminar
Introduction to computers
Chemical principles and laboratory
Chemical foundations of imaging
Organic chemistry and laboratory
General university physics and modern physics
Geometric and physical optics
Calculus I, II, III, and IV
Statistics I and II
Mathematics and computation for imaging science I and II
Interaction between light and matter
Radiometry
Vision, color, and psychophysics
Macroscopic imaging systems analysis
Electronics
Research practices and technical communications
Senior research project
Imaging systems analysis
Advanced imaging systems analysis
Quantum limitations of imaging processes
Professional electives
Liberal arts courses

Photographic Processing and Finishing Photofinishing establishments, including the 1-hour minilabs located in some supermarkets and malls, process and print hundreds of millions of color prints each year. Some labs also process and print work for professional photographers. People who operate and manage the labs must know more than just the photographic process. They must also be knowledgeable in the areas of statistics, quality control, process control, electronic imaging, and running a business. Students typically receive hands-on experience by actually operating and managing a school photofinishing laboratory and/or by serving as an intern with a professional establishment. Part of this experience includes concern for the environment, pollution abatement, minimum effluent discharge, and recycling procedures.

There are 2-year programs that prepare students to work in a photofinishing lab and 2-year upper level programs that prepare them to manage such an operation. One can receive either a 2-year A.A.S. degree or a 4-year B.S. degree.

A typical 4-year program leading to a B.S. degree includes the following:

Materials and processes of photography
Color photography/design
Color printing theory
Orientation to photofinishing production
Technical writing
College algebra and trigonometry
Survey of computer science
Electricity and electronics
Film processing
Automated printing
Custom and professional finishing
Finishing lab operations management
Operation, care, and maintenance of equipment
Photographic process control
Applied statistical quality control
Data analysis

Training and supervision
Organizational behavior
Principles of marketing
Financial and managerial accounting
Professional electives
Liberal arts courses

Photographic Preservation and Archival Practice

In September, 1992, a new graduate program leading to an M.S. degree in photographic preservation and archival practice was introduced as a joint venture between the Rochester Institute of Technology and the International Museum of Photography at the George Eastman House. The purpose of the program is to provide students with the technical and managerial skills necessary to preserve photographic collections in museums, galleries, archives, libraries, universities, government agencies, corporations, and private collections.

The program is designed with working professionals in mind—people who are already employed or working with institutional photographic collections and who seek specialized graduate training in preservation. Course work is supplemented with guided experience in working with the extensive collection at the museum and on research projects at the Image Permanence Institute at R.I.T. The program can be completed in one year, including a summer.

Fall Quarter
Photographic preservation I
Chemistry of photographic deterioration
Photographic archive administration
Practicum

Winter Quarter
Photographic preservation II
Photographic process identification methods
Photographic archive administration II
Practicum

Spring Quarter
Preservation of photographic albums and books
Exhibition preparation and installation
Cataloging and registration methods
Practicum

Summer Quarter
Historic process workshop
Copying and duplication
Preservation project
Practicum

Professional Photography

There are many specializations in photography that can be pursued in a professional photography program such as advertising photography, fashion photography, commercial photography, photographic illustration, portraiture, and photojournalism. One distinction between professional photography and fine art photography is that in the former, the photographer performs some service for a client, whereas in the latter, the photographer is the client. Both fields can be creative, productive, challenging, and at times frustrating. A variety of courses are included in the curriculum depending upon which major is chosen and the school selected. A number of foundation courses are required, regardless of the professional major chosen, such as the following:

Photographic orientation
Photography fundamentals
Photographic practice I and II
Lighting theory and practice
Color photography I and II
Photo design and layout
Materials and processes of photography
Chemistry
Large format photography
History of photography
Audio visual production
Electronic imaging
Moving image: film/video
Liberal arts courses

Advertising Major:
Advertising photography I and II
Advertising, corporate and commercial fundamentals
Semiotics and advertising photography
Advertising concepts
Advertising and editorial photography

Portraiture Major:
Portraiture fundamentals
Lighting people
Intermediate portrait methods
Advanced portrait methods
Advanced color portraiture

Illustration/Fashion Major:
Illustration photography I and II
Advanced lighting techniques
Modeling techniques
Introduction to fashion photography
Fashion and beauty workshop
Photographing the nude
Directorial photography

Documentary Studies and Photojournalism

From the very beginning of photography, all photographs have been, before all else, some means of documentation. The calotype, daguerreotype, and albumen print were all different attempts to improve the quality of the documentary process. Digital imaging is one more technology reforming our current concept of what constitutes a documentary photograph. This documentary tradition greatly preceded the discipline of photojournalism, which did not exist until the late nineteenth century.

Photographers are carrying on the documentary tradition in long-term projects that require great commitment and a passion for a particular subject. The Center for Documentary Studies at Duke University has both a graduate and undergraduate program and is expanding into film and video documentation. The International Center of Photography in New York City conducts a photojournalism and documentary photography program in collaboration with New York University consisting of a one-year certificate program or a graduate studies degree.

Photojournalism often includes documentary projects, but more often it is involved with the news media and magazine publishing. Instant digital imagery and televised satellite communications have revolutionized this world and are changing the guidelines and definitions of journalism itself.

Since photojournalism includes an integrated use of text, photojournalists are required to have a sensitivity to the relationship between the two disciplines. The knowledge and awareness to combine these two very different forms of communication, words and images, represent a major challenge to academic programs. Schools of photojournalism contribute to the field by developing the experience, technical know-how and feedback that editors rarely have time to provide. Most such schools have formal relationships and connections with professional publications and photographic manufacturers. Training in photojournalism can lead to careers in magazine, newspaper, and other feature publications. Additional related areas of opportunity include public relations firms and corporations.

Courses will vary depending upon the particular school and the emphasis of the program. Some programs concentrate more on photography while others place the emphasis

on journalism. Some of the courses in a typical photojournalism curriculum are:

Photography I and II
Introduction to color
Color photography
Electronic photography
Photojournalism I and II
Photojournalism workshop
Documentary photography
Magazine photography
Newswriting and editing
Mass media seminar
Communication law & ethics
Philosophy of journalism
History of photography
History of mass media
Picture researching
Graphic desk management
Layout and design
Professional electives
Liberal arts courses

Some of the better known schools teaching photojournalism are:

Arizona State University
Walter Cronkite School of Journalism and Telecommunications
Tempe, AZ 85287

Boston University School of Public Communication
640 Commonwealth Ave.
Boston, MA 02215

California State University at Long Beach
Photojournalism Program
1250 Bellflower Boulevard
Long Beach, CA 90840

Kent State University
School of Journalism and Mass Communication
Kent, OH 44242

San Jose State University
Department of Journalism and Mass Communications
San Jose, CA 95192

University of Montana
School of Journalism
Missoula, MT 59812

Indiana University School of Journalism
Ernie Pyle Hall
Bloomington, IN 47401

University of Kansas
William Allen White School of Journalism
Lawrence, KS 66045

University of Minnesota School of Journalism
111 Murphy Hall
Minneapolis, MN 55455

Syracuse University
Photography Department
School of Public Communications
Syracuse, NY 13210

University of Missouri, Columbia
200 Swallow
Columbia, MO 65201

Western Kentucky University
Bowling Green, KY 42101

Ohio State University
Columbus, OH 43210

California State University at Fullerton
Fullerton, CA 92634

Ohio University
Athens, OH 45701

California State University at Fresno
Fresno, CA 93740

San Francisco State University
San Francisco, CA 94132

North Illinois University
DeKalb, IL 60115

University of Texas at Austin
Austin, TX 78712

University of Texas at Arlington
Arlington, TX 76019

University of Wisconsin at Madison
Madison, WI 53706

History of Photography Studies in the history of photography are indispensable to the entire field of photography. It is through history that one can more objectively evaluate the significance and meaning of events. And, the present is always better served when the past is accurately revealed. Photography's history has been incorporated as part of the formal study of the medium from the beginning of its inclusion in academia and its literature. For example, Josef Maria Eder's *History of Photography* clearly presented the relationship between social and technical histories. By the mid-1950s in the United States, many photography teachers included history as a regular part of their courses. Academically accredited courses in the history of photography, however, were not available to most students until the late 1960s. The history of photography reveals that the medium is not only an art but also a technology unto itself, a science, a commerce, and a means of social communication. By the mid-1970s scholarly programs in universities offered advanced degrees within art history departments. A degree in art history that includes the history of photography prepares students to teach, write, and curate shows, all of which are career areas in academia, museums, and related arts organizations.

Some of the photographic courses included in art history are:

Survey nineteenth-century photography
Survey twentieth-century photography
Advanced history of photography
Social and cultural history
Technical and scientific history of photography
Historiography of the history of photography
Painting and photography
Early photographic processes
Contemporary issues in photography
The fabricated photograph, past and present
FSA and documentary photography
Propaganda and photography
Stieglitz and the Photo-Secession
Aesthetics and criticism of photographs
Dada, surrealism, and photography
Landscape as photographs
Modernism and postmodernism in photography
Exhibition design
Cataloging procedures
Conservation
Museum practice
Research seminar and thesis

Following are some of the higher education institutions in the United States offering graduate programs that include the history of photography:

University of New Mexico
Albuquerque, NM 87131

Ohio State University
Columbus, OH 43210

Arizona State University
Tempe, AZ 85287

University of California
Riverside, CA 92521

California State College
Fullerton, CA 92634

University of Arizona
Tucson, AZ 85721

Princeton University
Princeton, NJ 08540

University of Rochester
Rochester, NY 14627

(For detailed information consult *PhotoBase*)

REASONS FOR STUDYING PHOTOGRAPHY

The study of photography, whether in a formal setting such as an educational institution or an informal one such as photographic workshops, provides opportunities for both career development (or change) and for personal development. Listed in the article on Photographic Fields and Careers and throughout this book are a large number of photographic fields that offer employment opportunities. Competencies in photography can lead to employment in which photography is either the major component or a complementary component.

In terms of personal development, photography offers wonderful opportunities, as do music, dance, art, and other expressive disciplines. Photography can be a socializing activity, involving making photographs, sharing them with others informally, or exhibiting them formally with an opening reception. Early photographers formed clubs such as the famous f/64 Group in California and The Circle of Confusion Group in New York. Today there are hundreds of camera clubs and other photography organizations that provide opportunities for formal and informal classes in photography and for competitions and exhibitions. Photography can be a competitive sport in which photographs are submitted for judging, exhibition, and awards. Photography has been used by psychologists as a means for therapy in the same manner that art has been used by some therapists.

In a formal school setting, photography provides an opportunity to study in a field that is of great interest and includes a number of other courses in the sciences, arts, and liberal arts. Although one does not have to go to school to become a photographer, there are many advantages to doing so, including obtaining a well-rounded education while majoring in a field that many find to be stimulating and rewarding.

PROPRIETARY SCHOOLS

Some proprietary schools offering concentrated courses in photography of short or long duration are:

Rhode Island School of Photography
241 Webster Avenue
Providence, RI 02909

New England School of Photography
537 Commonwealth Avenue
Boston, MA 02215

Germain School of Photography
225 Broadway
New York, NY 10007

New York Institute of Photography
880 3rd Avenue
New York, NY 10017

The Art Institutes
526 Penn Avenue

Pittsburgh, PA 15222
(Schools in Atlanta, Dallas, Houston, Denver, Fort Lauderdale, Philadelphia, Pittsburgh, Seattle)

Winona School of Photography
350 N. Wolf Road
Mt. Prospect, IL 60056
(The Winona School of Photography is a subsidiary of the Professional Photographers of America)

Hawkeye Institute
1501 E. Orange Rd.
Waterloo, Iowa 50704

Hallmark Institute in Massachusetts
at the Airport
Turner Falls, MA 01376

Ohio Institute of Photography
2029 Edgefield Rd.
Dayton, OH 45439

PHOTOGRAPHIC WORKSHOPS

A photographic workshop is an intensive learning program of limited duration with a strong singular perspective conducted by an expert in the field.

Photographic workshops, as opposed to formal classroom instruction, enable the participants to explore and expand their own photographic knowledge and creative potential while working in close contact with experienced photographers. Since there are a significant number of photographers interested in improving their knowledge, workshops have become a natural resource for learning advanced photographic skills.

One of the objectives of workshops is to make it an inspirational event. It is a "hands-on" educational experience where students can acquire technical knowledge, develop new skills, and achieve new ways of thinking, seeing, and photographing.

Since those attending photographic workshops are committed to photography, it is the commitment of those involved that makes a workshop a valuable learning experience for the students, instructors, and organizers. The togetherness of attending demonstrations, classes, and lectures unites the workshop leader with a group of total strangers of varying ages, with different temperaments and personalities, providing them with a spirit that is conducive to hard work, concentration, and great personal growth. Workshops commonly foster long-lasting friendships.

There are many kinds of photographic workshops throughout the country. Workshops should be selected according to personal or professional needs, course content, the location of the workshop, the facilities, the instructor teaching the course, and most important, the quality of the program itself.

Most workshops are structured to improve a particular photographic skill or set of skills. Students can pick a workshop according to their level of experience and their personal or professional needs. Additionally, many photographers choose workshops outside of their area of expertise to broaden their base of knowledge.

Workshop instructors are typically chosen from the most talented professionals working in the photographic field. A vibrant and energetic approach combined with a willingness to share knowledge can stimulate and inspire the participants.

Workshops range in length from a day to a week or even a month for trips to exotic locations. Most workshops are interactive. Classes are usually small, ranging from eight to fifteen students. Portfolios are usually reviewed at the beginning of each workshop, which allows the teacher to structure the workshops according to the experience and needs of the entire class. Some workshops, in cooperation with a local college, offer college credit.

The better workshops are geared toward a specific level of

student knowledge and offer a combination of lectures and slide presentations, daily field trips to locations typical of the area, and critiques of work produced the previous day. Some workshops also include darkroom work where students learn advanced developing and printing techniques.

Workshops also commonly include social interactive events and provide an opportunity to spend an extended period of time with people who share the same passion.

One of the earliest photographic workshops in America, then called a photographic forum, was conducted by Ansel Adams and Edward Weston in the summer of 1940 at the request of Tom Maloney, editor of *US Camera.* The popularity of photographic workshops as a learning experience has grown throughout the years. Today there are over 500 in existence. Although most workshops concentrate on a single topic, there are coordinated workshop programs that encompass many areas of photography as well as all levels of expertise: advertising photography, architectural photography, black-and-white techniques, color printing, documentary photography, electronic photography, glamour photography, hand coloring, infrared photography, editorial photography, fine art photography, flash photography, landscape and environmental photography, sports photography, stock photography, slide duplicating, studio photography, underwater photography, view camera photography, and the zone system.

Some workshops run only in the summer months while others, especially in warmer climates, run during the winter months, and most of the year.

Two annually published guides list all the workshops that are available in the United States: *Photographers' Forum,* "Photography and Travel Workshop Directory," which is sponsored by Eastman Kodak Company, Professional Products Division; and "The Guide to Photography Workshops" by Shaw Associates.

TRENDS IN PHOTOGRAPHIC EDUCATION

Photographic education began gaining momentum in the early 1950s, and the changes in photography since then have been profound. Programs evolved from nondegree certificates to associate degrees, to baccalaureate degrees, to graduate degrees including a Ph.D. degree in imaging science in 1992.

Emphasis has shifted from black-and-white photography to color photography and to electronic still photography. Hand processing of film and paper has given way to automatic machine processing. Printing of color materials in photofinishing laboratories has accelerated from about 500 prints per hour to about 10,000 prints per hour. The turnaround time for processing and printing has been reduced from days to less than an hour. Cameras have become more automated with automatic focus and exposure, electronic shutters, and automatic setting of film speeds in the camera based on DX bar codes. Enlargers too have become more sophisticated with a variety of controls including computer controls. Because of the increasing trend to automatic controls, electronic imaging, and computers, there is less emphasis on the manual and mechanical aspects of photography and more on other areas such as design, visual concepts, problem solving, creativity, history, and communications.

Changes are also occurring in the teaching of photography that now extend outside the traditional classroom. Advances in technology are making photographic education available off-campus and out-of-city. Distance Learning, modeled somewhat after the techniques pioneered and used so successfully by the Open University of Great Britain for over 20 years, allows delivery of instruction via television, videocassette, videodiscs, CD-ROM, teleconferencing, computer, and fax machines. Not only does the technology facilitate delivery of photographic instruction, but the instruction can be designed to be interactive.

As we approach the twenty-first century, we witness photography going through a transition and marriage between conventional silver halide chemistry-based photography and electronic-based photography. The introduction of Kodak's Photo CD (compact disc) in 1991 allows the photographer to produce digital images for display on a video monitor or a personal computer. The system, a joint effort between Kodak and Phillips, is capable of storing and displaying not only digital records of photographs but also graphics, text, and sound. Photo CD is compatible with 35-mm slides and negatives.

There are a growing number of courses in electronic imaging and computers emerging in many of the schools. In 1991 the Eastman Kodak Company and Apple Computer Company established a joint proprietary school in Camden, Maine, exclusively for electronic still photography using the latest equipment available. "The Center for Creative Imaging" offers introductory and advanced courses in electronic imaging. An array of new technologies is used including scanners, film-recorders, high resolution electronic cameras, high performance computer workstations, and electrostatic, thermal, and film printers. (For more information contact the Center at 91 Mechanic Street, Camden ME 04843.)

PHOTOBASE In 1991 the Rochester Institute of Technology and the Eastman Kodak Company established a computerized network of photographic information called *PhotoBase.* It is international in scope and as of 1992 it provides four distinct functions for photographic educators and career counselors:

1. Access to up-to-date information on photography courses and programs available in the United States and worldwide through Ian Smith's *PHOTOLINK* project in England.
2. A Message Center that allows participating schools to leave messages for the Systems Operator in Rochester, New York, to keep PhotoBase information current.
3. A Bulletin Board that lists current shows, lectures, trips, special events, courses, and so on available to students and faculty members at participating schools.
4. A Job Mart that lists current faculty positions at subscribing schools and provides faculty members and administrators the options of presenting their resumes.

For more information write:

PhotoBase
American Video Institute
Rochester Institute of Technology
P.O. Box 9887
Rochester, New York 14623-0887
Fax: (716) 475-5804
Phone: (716) 475-6625

DEPARTMENTS OFFERING COURSES IN PHOTOGRAPHY Most courses in photography are not taught in departments of photography but rather as an integral component of a curriculum. Photography courses are found most often in art departments and least often in departments of technology and science. A little over one-third of all the photography courses taught, based on a sampling of 414 degree-granting institutions, are in art departments. Most of the departments of photography are found in community colleges.

Few colleges offer degrees in photography; most schools offer photography courses as a major or minor in another discipline such as art. Colleges such as Brooks in California and R.I.T. in Rochester, New York, however, offer degrees in photography. The following is a listing of colleges that offer various courses in photography. (For specific course offerings, degrees, etc., contact the college or consult the computerized *PhotoBase* network.)

Departments Teaching Photography

- 5% Other
- 3% Technology/Science
- 4% Audio Visual/Media
- 5% Graphics
- 5% Liberal Arts
- 9% Communications
- 9% Journalism
- 9% Photography (Colleges & Universities)
- 20% Photography (Community Colleges)
- 31% Art Departments

Percent of all Courses Taught
1991-1992

Nearly one-third of all the courses in photography at the college level are taught in art departments. (Based on a survey of colleges and universities.)

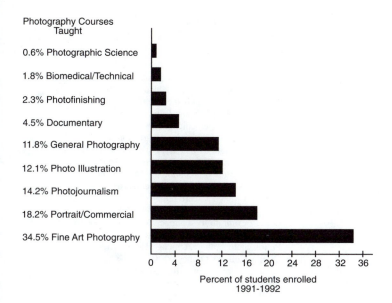

Photography Courses Taught

- 0.6% Photographic Science
- 1.8% Biomedical/Technical
- 2.3% Photofinishing
- 4.5% Documentary
- 11.8% General Photography
- 12.1% Photo Illustration
- 14.2% Photojournalism
- 18.2% Portrait/Commercial
- 34.5% Fine Art Photography

Percent of students enrolled
1991-1992

A little more than one-third of all photography courses taught at the college level are within an art curriculum. (Based on a survey of colleges and universities.)

COLLEGES OFFERING COURSES IN PHOTOGRAPHY

Alabama
Alabama A&M, Normal 35762
John C. Calhoun Community College, Montevallo 35115
University of North Alabama, Florence 35632
University of South Alabama, Mobile 36688

Alaska
University of Alaska, Anchorage 99508
University of Alaska, Fairbanks 99775

Arizona
Arizona State University, Tempe 85287
Cochise College, Douglas 85607

Mesa Community College, Mesa 85281
Navajo Community College, Tsaile 86556
Northern Arizona University, Flagstaff 86011
Northland Pioneer College, Holbrook 86025
Phoenix College, Phoenix 85035
University of Arizona, Tucson 85721

Arkansas
Arkansas State University, State University 72467
Southern Arkansas University, Magnolia 71753
University of Arkansas at Little Rock, Little Rock 72204

California
Academy of Art College, San Francisco 94102
Antelope Valley College, Lancaster 93534
Art Center College of Design, Pasadena 91103

Brooks Institute, Santa Barbara 93108
California College of Arts & Crafts, Oakland 94618
California Institute of the Arts, Valencia 91355
California Polytechnic State University, San Luis
 Obispo 93407
California State University, Fullerton 92634
California State University, Fresno 93740
California State University, Long Beach 90840
California State University, Los Angeles 90032
Chaffey Community College, Alta Loma 91701
Citrus Community College, Azusa 91702
City College of San Francisco, San Francisco 94112
College of the Desert, Palm Desert 92260
Compton College, Compton 90221
Cosumnes River College, Sacramento 95823
Cypress College, Cypress 92806
DeAnza College, Cupertino 95014
East Los Angeles College, Los Angeles 91754
El Camino College, Torrance 90506
Foothill College, Los Altos 94022
Grossmont College, El Cajon 92020
Long Beach City College, Long Beach 90806
Los Angeles City College, Los Angeles 90029
Monterey Peninsula College, Monterey 93950
Mount San Jacinto College, San Jacinto 92383
Ohlone College, Freemont 94539
Orange Coast College, Costa Mesa 92628
Palomar College, San Marcos 92069
Pasadena City College, Pasadena 91106
Pepperdine University, Malibu 90265
Riverside City College, Riverside 92506
Sacramento City College, Sacramento 95822
San Diego City College, San Diego 92101
San Diego State University, San Diego 92182
San Francisco Art Institute, San Francisco 94133
San Jose State University, San Jose 95192
Santa Ana College, Santa Ana 92706
Santa Monica College, Santa Monica 90405
Santa Rosa Junior College, Santa Rosa 95401
Solano Community College, Suisun City 94585
Taft College, Taft 93268
University of California, Berkeley 94720
University of California, Riverside 92521
University of California, Santa Barbara 93106
University of San Francisco, San Francisco 94117
Victor Valley College, Victorville 92392
West Valley College, Saratoga 95070
Yuba College, Marysville 95901

Colorado
Adams State College, Alamosa 81102
Colorado Institute of Art, Denver 80203
Colorado Mountain College, Glenwood Springs 81601
Colorado Mountain College, Leadville 80461
Colorado State University, Fort Collins 80526
Community College of Denver, Denver 80204

Connecticut
Central Connecticut State University, New Britain 06050
Connecticut College, New London 06320
Manchester Community College, Manchester 06040
Northern Connecticut Community College, Winsted 06098
Paier College of Art, Hamden 06511
Southern Connecticut State University, New Haven 06515
University of Bridgeport, Bridgeport 06602
University of Connecticut, Storrs 06268

Delaware
University of Delaware, Newark 09711

District of Columbia
George Washington University, Washington DC 20025

The American University, Washington DC 20016
The Corcoran School of Art, Washington DC 20006
Mount Vernon College, Washington DC 20007
Trinity College, Washington DC 20017

Florida
Art Institute of Fort Lauderdale, Ft. Lauderdale 33316
Barry University, Miami 33161
Brevard Community College, Cocoa 32922
Broward Community College, Ft. Lauderdale 33314
Daytona Beach Community College, Daytona Beach 32015
Florida Institute of Technology, Jensen Beach 23457
Florida School of the Arts, Palatka 32077
Florida State University, Tallahassee 32306
Gulf Coast Community College, Panama City 32405
Lake-Sumter Community College, Leesburg 32748
Miami-Dade Community College, North Miami 33167
Palm Beach Junior College, Lake Worth 33463
University of Florida, Gainsville 32605

Georgia
Art Institute of Atlanta, Atlanta 30326
Georgia Southern College, Statesboro 30460
North Georgia College, Dahlonega 30597
South Georgia Technical, Americus 31709
Savannah College of Art and Design, Savannah 31401
West Georgia College, Carrollton 30118

Hawaii
Honolulu Community College, Honolulu 96817

Idaho
Ricks College, Rexburg 83440
University of Idaho, Moscow 83843

Illinois
Belleville Area College, Belleville 62221
Bradley University, Peoria 61625
Chicago State University, Chicago 60628
College of DuPage, Glen Ellyn 60137
College of Saint Francis, Joliet 60435
Columbia College, Chicago 60605
Eastern Illinois University, Charleston 61920
Governors State University, Park Forest South 60466
Illinois Central College, East Peoria 61635
Illinois Institute of Technology, Chicago 60616
Illinois State University, Normal 61761
Morton College, Cicero 60650
Northern Illinois University, DeKalb 60115
Oakton Community College, Des Plaines 60016
Olive-Harvey College, Chicago 60628
Prairie State College, Chicago Heights 60411
Quincy College, Quincy 62301
Saint Xavier College, Chicago 60655
School of The Art Institute, Chicago 60603
Southern Illinois University, Carbondale 62901
State Community College, East St. Louis 62201
University of Illinois, Champaign 61820
University of Illinois, Chicago 60680
University of Illinois, Urbana 61801
Western Illinois University, Macomb 61455

Indiana
Ball State University, Muncie 47306
Franklin College of Indiana, Franklin 46131
Hanover College, Hanover 47243
Herron School of Art, IUPUI, Indianapolis 46204
Indiana State University, Terre Haute 47809
Indiana University, Bloomington 47405
Indiana Vocational Technical College, Columbus 47203
Indiana Vocational Technical College, Evansville 47710
Indiana Vocational Technical College Northcentral,
 South Bend 46619

Ivy Technical South Central, Sellersburg 47172
Purdue University, West Lafayette 47907
Saint Francis College, Fort Wayne 46808
Saint Mary's College, Notre Dame 46556
Vincennes University Junior College, Vincennes 47591

Iowa
Briar Cliff College, Sioux City 51104
Grand View College, Des Moines 50316
Hawkeye Institute of Technology, Waterloo 50704
Kirkwood Community College, Cedar Rapids 52406
Mount Mercy College, Cedar Rapids 52402
Southwestern Community College, Creston 50801
University of Iowa, Iowa City 52240

Kansas
Barton County Community College, Great Bend 67530
Cowley County Community College, Arkansas City 67005
Emporia State University, Emporia 66801
Fort Hays State University, Hays 67401
Fort Scott Community College, Fort Scott 66701
Garden City Community College, Garden City 67846
Highland Community College, Highland 66035
Pittsburgh State University, Pittsburgh 66762
University of Kansas, Lawrence 66045

Kentucky
Brescia College, Owensboro 42301
Henderson Community College, Henderson 42420
Jefferson Community College, Louisville 40202
Murray State University, Murray 42071
Northern Kentucky University, Highland Heights 41076
University of Kentucky, Lexington 40506
University of Louisville, Louisville 40292
Western Kentucky University, Bowling Green 42101

Louisiana
Louisiana Technical University, Ruston 71272
Northeast Louisiana University, Monroe 71209
Northwestern State University, Natchitoches 71457
Southern University, Baton Rouge 70813
University of New Orleans, New Orleans 70148
University of Southern Louisiana, Lafayette 70504

Maine
Portland School of Art, Portland 04101
University of Southern Maine, Gorham 04038

Maryland
Allegany Community College, Cumberland 21502
Ann Arundel Community College, Arnold 21012
Cecil Community College, Northeast 21901
Community College of Baltimore, Baltimore 21215
Dundalk Community College, Dundalk 21222
Hood College, Frederick 21701
Loyola College, Baltimore 21210
Maryland Institute College of Art, Baltimore 21217
Montgomery College, Rockville 20850
Salisbury State College, Salisbury 21801
St. Mary's College of Maryland, St. Mary's City 20686
Towson State University, Baltimore 21204
University of Maryland Baltimore County, Catonsville 21228

Massachusetts
Boston University, Boston 02215
Bridgewater State College, Bridgewater 02324
Curry College, Milton 02186
Endicott College, Beverly 01915
Fitchburg State College, Fitchburg 01420
Massachusetts College of Art, Boston 02215
Northeastern University, Boston 02115
School of the Museum Fine Arts, Boston 02115

Southeastern Massachusetts University, North Dartmouth 02747
Worcester State College, Worcester 01602

Michigan
Center for Creative Studies, Detroit 48202
Central Michigan State University, Mount Pleasant 48859
Charles Stuart Mott Community College, Flint 48503
Cranbrook Academy of Art, Bloomfield Hills 48013
Eastern Michigan University, Ypsilanti 48197
Grand Rapids Junior College, Grand Rapids 49503
Kellogg Community College, Battle Creek 49017
Grand Valley State College, Allendale 49404
Lansing Community College, Lansing 48901
Northern Michigan University, Marquette 49855
Oakland Community College, Farmington Hills 48018
University of Michigan, Ann Arbor 48109
Washtenaw Community College, Ann Arbor 48106
Western Michigan University, Kalamazoo 49008

Minnesota
Bethel College, St. Paul 55112
College of Associated Arts, St. Paul 55102
Film in the Cities, St. Paul 55114
Hennepin Technical College, Eden Prairie 55347
Lakewood Community College, White Bear Lake 55110
Minneapolis College of Art and Design, Minneapolis 55404
Minneapolis Community College, Minneapolis 55403
Moorhead State University, Moorhead 56560
St. Cloud State University, St. Cloud 56301
University of Minnesota, Minneapolis 55435
University of Minnesota, Duluth 55812
Willmar Technical College, Willmar 56201
Winona State University, Winona 55487

Mississippi
Hinds Junior College, Utica 39175
Mississippi College for Women, Columbus 39701
Mississippi State University, State University 39762
University of Southern Mississippi, Hattiesburg 39406

Missouri
Central Missouri State University, Warrensburg 64093
Columbia College, Columbia 65201
Evangel College, Springfield 65802
Northeast Missouri State University, Kirksville 63501
Northwest Missouri State University, Maryville 64468
Park College, Parkville 64152
School of the Ozarks, Point Lookout 65726
St. Louis Community College, Florissant Valley, Ferguson 63135
University of Missouri, Columbia 65201
University of Missouri, Rolla 65401
Webster University, St. Louis 63119

Montana
Miles Community College, Miles City 59301
Montana State University, Bozeman 59717

Nebraska
Creighton University, Omaha 68178
Southeast Community College, Beatrice 68310
The University of Nebraska-Lincoln, Lincoln 68588
Wayne State College, Wayne 68787

Nevada
Clark County Community College, North Las Vegas 89030
University of Nevada, Las Vegas 89154

New Hampshire
Plymouth State College, Plymouth 03264
University of New Hampshire, Durham 03824
White Pines College, Chester 03036

New Jersey
Brookdale Community College, Lincroft 07738
Burlington County College, Pemberton 08068
County College of Morris, Randolph 07801
Gloucester County College, Sewell 08080
Jersey City State College, Jersey City 07305
Kean College of New Jersey, Union 07083
Mercer County Community College, Trenton 08690
Rutgers University, Newark 07102
Somerset County College, Somerville 08877
Stockton State College, Pomona 08240
Trenton State College, Trenton 08625
William Paterson College, Wayne 07470

New Mexico
San Juan College, Farmington 87401
The University of New Mexico, Albuquerque 87131

New York
Adirondack Community College, Queensbury 12804
C.W. Post College, Greenvale 11548
Baruch College, CUNY, New York City 10010
Cayuga Community College, Auburn 13021
Corning Community College, Corning 14830
Cornell University, Ithaca 14850
D'Youville College, Buffalo 14201
Fashion Institute of Technology, New York City 10001
Fulton-Montgomery Community College, Johnstown 12095
Genesee Community College, Batavia 14020
Hartwick College, Oneota 13820
Hudson Valley Community College, Troy 12180
International Center of Photography, New York City 10128
Ithaca College, Ithaca 14850
Kingsborough Community College, Brooklyn 11204
LaGuardia Community College, Long Island City 11101
Long Island University, The Brooklyn Center, Brooklyn 11201
Mercy College, Dobbs Ferry 10522
Mohawk Valley Community College, Utica 13501
Monroe Community College, Rochester 14623
Nassau Community College, Garden City 11530
New York Institute of Tech./Metro Campus, New York City 10023
New York University, New York City 10003
Onondaga Community College, Syracuse 13215
Pace University, New York City 10038
Parsons School of Design, New York City 10011
Pratt Institute, Brooklyn 11205
Queensborough Community College, Bayside 11364
Roberts Wesleyan College, Rochester 14624
Rochester Institute of Technology, Rochester 14623
School of the Visual Arts, New York City 10010
State University of New York at Albany, Albany 12222
State University of New York at Brockport, Brockport 14420
State University of New York at Buffalo, Buffalo 14215
State University of New York at Geneseo, Geneseo 14454
State University of New York at New Paltz, New Paltz 12561
State University of New York at Morrisville, Morrisville 13408
State University of New York at Oswego, Oswego 13126
State University of New York at Plattsburgh, Plattsburgh 12901
State University of New York at Potsdam, Potsdam 13676
Sullivan County Community College, Loch Sheldrake 12759
Syracuse University, Syracuse 13210
The College of Staten Island, Staten Island 10301
The Cooper Union School of Art, New York City 10003
The New School for Social Research, New York City 10011
University of Rochester, Rochester 14627

North Carolina
Appalachian State University, Boone 28608
Campbell University, Buies Creek 27506
Carteret Technical College, Morehead City 28550
Chowan College, Murfreesboro 27855
Coastal Carolina Community College, Jacksonville 28540
Elon College, Elon College 27244
Guilford Technical Institute, Jamestown 27282
Randolph Technical College, Asheboro 27203
Southwestern Technical College, Sylva 28779
University of North Carolina, Chapel Hill 27599
Western Carolina University, Cullowhee 28723

North Dakota
Dickinson State College, Dickinson 58601

Ohio
Art Academy of Cincinnati, Cincinnati 45206
Bowling Green State University, Bowling Green 43403
Clark Community College, Springfield 45501
Cleveland State University, Cleveland 44115
College of Mount St. Joseph, Mount St. Joseph 44505
Hiram College, Hiram 44234
Kent State University, Kent 44242
Lakeland Community College, Mentor 44060
Ohio Institute of Photography, Dayton 45439
Ohio University, Athens 45701
Otterbein College, Westerville 43081
University of Akron, Akron 44325
University of Cincinnati, Cincinnati 45221
University of Dayton, Dayton 45469
University of Toledo, Toledo 43606
Wright State University, Dayton 45435
Youngstown State University, Youngstown 44555

Oklahoma
Northern Oklahoma College, Tonkawa 74653
Oklahoma City Community College, Oklahoma City 73159
Oklahoma State University, Stillwater 74078
Saint Gregory's College, Shawnee 74801
South Oklahoma City Junior College, Oklahoma City 73159
Southern Oklahoma State University, Durant 74701

Oregon
Linfield College, McMinnville 97128
Oregon State University, Corvallis 97331
Portland Community College, Portland 97219
University of Oregon, Eugene 97405

Pennsylvania
Alvernia College, Reading 19607
Art Institute of Philadelphia, Philadelphia 19103
Art Institute of Pittsburg, Pittsburg 15222
Bucks County Community College, 18940
Community College of Philadelphia, Philadelphia 19081
Drexel University, Philadelphia 19104
Edinboro State College, Edinboro 16444
Indiana University of Pennsylvania, Indiana 15705
Lycoming College, Williamsport 17701
Pennsylvania School of Art and Design, Lancaster 17603
Philadelphia College of Art and Design, Philadelphia 19102
Tyler School Temple University, Elkins Park 19126
Villanova University, Villanova 19085
Wilkes College, Wilkes-Barre 18766

Rhode Island
Rhode Island College, Providence 02906
Rhode Island School of Design, Providence 02903
University of Rhode Island, Kingston 02881

South Carolina
Clemson University, Columbia 29631
USC/Coastal Carolina College, Conway 29526

South Dakota
University of South Dakota, Vermillion 57069

Tennessee
Cleveland State Community College, Cleveland 37311
East Tennessee State University, Johnson City 37614
Lincoln Memorial University, Harrogate 37752
Memphis State University, Memphis 38152
Nashville State Technical Institute, Nashville 37209
Shelby State Community College, Memphis 38107
The Memphis Academy of Art, Memphis 38112

Texas
Amarillo College, Amarillo 79178
Austin Community College, Austin 78768
Collin County Community College, Plano 75074
East Texas State University, Commerce 75428
Eastfield College, Mesquite 75150
Houston Community College Systems, Houston 77004
Kilgore College, Kilgore 75662
Laredo Junior College, Laredo 78040
North Harris County College, Kingwood 77339
North Texas State University, Denton 76203
Odessa College, Odessa 79762
Sam Houston State University, Huntsville 77341
San Antonio State University, San Antonio 78212
San Jacinto College Central Campus, Pasadena 77505
Southern Methodist University, Dallas 75275
Stephen F. Austin State University, Nacogdoches 75962
Tarrant County Junior College, Hurst 76054
Texas A&M University, College Station 77843
Texas Christian University, Fort Worth 76129
Texas Southern University, Houston 77004
Texas State Technical Institute, Waco 76705
Texas Tech University, Lubbock 79409
Texas Woman's University, Denton 76204
The Art Institute of Dallas, Dallas 75231
University of Texas at Arlington, Arlington 76019
The University of Texas at Austin, Austin 78712
University of Houston, Houston 77004
University of Houston at Houston, Houston 77025
University of Texas at San Antonio, San Antonio 78285
University of Texas, Odessa 79762
University of Texas at Tyler, Tyler 75701
Western Texas College, Snyder 79549

Utah
Brigham Young University, Provo 84602
Southern Utah University, Cedar City 84720
University of Utah, Salt Lake City 84112
Utah State University, Logan 84322
Weber State College, Ogden 84408

Vermont
Goddard College, Plainfield 05667
Middlebury College, Middlebury 05753

Virginia
George Mason University, Fairfax 22030
James Madison University, Harrisonburg 22807
John Tyler Community College, Chester 23831
Northern Virginia Community College, Alexandria 22311
Northern Virginia Community College, Sterling 22170
Thomas Nelson Community College, Hampton 23670
Virginia Commonwealth University, Richmond 23235
Virginia Intermont College, Bristol 24201
Virginia Military Institute, Lexington 24450
Virginia Polytechnic Institute, Blacksburg 24061

Washington
Art Institute Seattle, Seattle 98034
Bellevue Community College, Bellevue 98004
Columbia Basin College, Pasco 99301

Eastern Washington University, Cheney 99004
Everett Community College, Everett 98201
Evergreen State College, Olympia 98505
Shoreline Community College, Seattle 98108
University of Washington, Seattle 98195
Washington State University, Pullman 99164

West Virginia
West Virginia University, Morgantown 26506

Wisconsin
Beloit College, Beloit 53511
Gateway Technical College, Racine 53403
Madison Area Technical College, Madison 53703
Milwaukee Area Technical College, Milwaukee 53203
University of Wisconsin, Milwaukee 53201
University of Wisconsin, La Crosse 54601
University of Wisconsin, Oshkosh 54901
University of Wisconsin, Platteville 53818
University of Wisconsin, Superior 54880
Viterbo College, La Crosse 54601
Western Wisconsin Technical Institute, La Crosse 54601

Wyoming
Casper College, Casper 82601
Northwest Community College, Powell 82435
Western Wyoming College, Rock Springs 82435

COLLEGES AND UNIVERSITIES OFFERING GRADUATE PROGRAMS THAT INCLUDE PHOTOGRAPHY Listed are some of the colleges and universities that offer graduate degree courses in which photography is a major or a service course. Unless otherwise noted, the degrees offered are from art departments within the colleges. For additional information, contact the college or consult PhotoBase.

Arizona
University of Arizona, Tucson 85721 M.F.A.

Arkansas
University of Arkansas, Fayetteville 72701 M.F.A.

California
California College of Arts and Crafts, Oakland
 94618 M.F.A.
California Institute of the Arts, Valencia 91355 M.F.A.
San Francisco Art Institute, San Francisco 94133 M.F.A.
University of California, Davis M.F.A.
University of California, Los Angeles 90024 M.F.A.
University of California, Riverside 92521 M.A.

Colorado
University of Colorado, Boulder 80309 M.A., M.F.A.

Delaware
University of Delaware, Newark 19711 M.F.A.

District of Columbia
George Washington University, Washington,
 D.C. 20052 M.F.A.

Florida
Florida State University, Tallahassee 32306 M.F.A.
University of Florida, Gainesville 32611 M.F.A.
University of South Florida, Tampa 33620 M.F.A.

Georgia
Georgia Southern College, Statesboro 30460 M.F.A.
Georgia State, Atlanta 30303 M.F.A.
Savannah College of Art and Design,
 (Photo Department), Savannah 31401 M.F.A.
University of Georgia, Athens 30602 M.F.A.

Hawaii
University of Hawaii, Honolulu 96822 M.F.A.

Idaho

University of Idaho, (Photojournalism
 Department), Moscow 83843 M.F.A.

Illinois

Bradley University, (Communications
 Department), Peoria 61606 M.F.A.
Columbia College, (Photo Dept.), Chicago 60605 M.F.A.
Governors State University 60466 M.A.
Illinois Institute of Technology, Chicago 60616 M.S.
Illinois State University, (Photo Depart.), Normal
 61761 M.F.A.
Northern Illinois University, (Photojournalism
 Dept.), DeKalb 60115 M.A.
School of the Art Institute of Chicago, (Photo
 Dept.), Chicago 60603 M.F.A.
University of Illinois, Champaign 61820 M.F.A.
University of Illinois, (Photojournalism Dept.),
 Urbana 61801 M.S.

Indiana

Indiana State University, Terre Haute 47809 M.F.A.
Indiana University, Bloomington 47405 M.F.A.
Purdue University, West Lafayette 47907 M.F.A.

Iowa

University of Iowa, Iowa City 52240 M.F.A.

Kentucky

Murray State University, Murray 42070 M.A.
University of Kentucky, Lexington 40506 M.F.A.

Louisiana

Louisiana Tech University, Ruston 71272 M.F.A.
University of New Orleans, New Orleans 70148 M.F.A.

Maryland

Maryland Institute of Art (Photo Dept.), Baltimore
 21217 M.F.A.

Massachusetts

Art Institute of Boston, (Photo Dept.), Boston
 02215 M.F.A.
Massachusetts College of Art, Boston 02138 M.F.A.
University of Massachusetts Amherst, Amherst
 01003 M.F.A.

Michigan

Central Michigan University, Mount Pleasant
 48859 M.A., M.F.A.
University of Michigan, Ann Arbor 48109 M.A., M.F.A.
Western Michigan University, Kalamazoo
 49008 M.A., M.F.A.

Minnesota

University of Minnesota, Duluth (Photojournalism
 Dept.), Duluth 58812 M.A.

North Carolina

University of North Carolina, (Visual Communication
 Dept.), Chapel Hill 27599 M.A.

Nebraska

University of Nebraska, Lincoln 68588 M.F.A.

New Jersey

Montclair State College, Upper Montclair 07143 M.A.
Princeton University, Princeton 08544 Ph.D. Art History

New Mexico

University of New Mexico, Albuquerque 87131
 M.A., M.F.A., Ph.D. Art History

New York

C.W. Post, Greenvale 11548 M.A., M.F.A.
Cornell University, Ithaca 14850 M.F.A.
Hunter College, New York City 10021 M.F.A.

International Center of Photography, (Education
 Dept.), New York City 10128 M.F.A.
Pratt Institute, Brooklyn 11205 M.F.A.
Rochester Institute of Technology, Rochester 14623
 (School of Photographic Arts and Sciences) M.F.A.
 (Imaging Science) Ph.D.
(with the International Museum of Photography, GEH)
 M.S.
Parsons School of Design, (Photography Dept.),
 New York City 10011 M.A.
School of Visual Arts, (Photography Dept.),
 New York City 10010 M.F.A.
State University of New York, Buffalo 14215 M.F.A.
State University of New York, New Paltz 12561 M.F.A.
State University of New York, Brockport 14410
 (with Visual Studies Workshop, Rochester 14607) M.F.A.
Syracuse University, Syracuse 13244 (Newhouse
 School of Public Communication) M.A., M.S.
University of Rochester, Rochester 14627 Ph.D. Art History

Ohio

Bowling Green University, Bowling Green 43403 M.F.A.
Ohio University, Athens 45701 M.A., M.F.A.
University of Cincinnati, Cincinnati 45221 M.F.A.

Oregon

University of Oregon, Eugene 97403 M.F.A.

Pennsylvania

East Stroudsburg University, (Media Dept.), East
 Stroudsburg 18301 M.S.
Tyler School Temple University, Elkins Park 19126 M.F.A.

Rhode Island

Rhode Island School of Design, (Photo Dept.),
 Providence 02903 M.F.A.

South Carolina

Clemson University, (Visual Arts Depart.),
 Clemson 29634 M.F.A.
Winthrop College, Rock Hill 29733 M.F.A.

Tennessee

East Tennessee State University, Johnson City
 37604 M.F.A.

Texas

East Texas State University, (Journalism Dept.),
 Commerce 75428 M.F.A.
North Texas University, Denton 76203 M.F.A.
Southern Methodist, Dallas 75275 M.F.A.
Southern Methodist University, Dallas 75275 M.F.A.
Texas Tech University, Lubbock 79409 M.F.A.
University of Texas, Austin 78712
 M.F.A., Ph.D. Photojournalism
University of Houston, Houston 77004 M.F.A.

Utah

Utah State University, Logan 84322 M.A., M.F.A.

Vermont

Goddard College, Plainfield 05667 (Photo Dept.) M.A.

Virginia

George Mason University, Fairfax 22030 M.F.A.
James Madison University, Harrisburg 22807 M.F.A.
Old Dominion University, Norfolk 23529 M.F.A.
Regent University (Journalism Depart.),
 Virginia Beach 23464 M.A.
Virginia Commonwealth University, (Photo
 Dept.), Richmond 23284 M.A.

Washington

Central Washington University, Ellensburg 98926
 M.A., M.F.A.
University of Washington, Seattle 98195 M.F.A.

Wisconsin
University of Wisconsin, Milwaukee 53205 M.A., M.F.A.

SUMMARY:
COLLEGES, FACULTY, STUDENTS, STATES

The following data are based on a sampling of 414 degree-granting institutions in the United States that offer photography as a major or as a service course for related disciplines.

Number of Colleges Surveyed 1991–1992	*414*	
Colleges and Universities	258	(62.3%)
Junior and Community Colleges	156	(37.7%)

Total Faculty	*2140*	
Full-time	941	(43%)
Part-time	1199	(57%)

Total Students Taking Photography Courses 29,046		
As majors	10,457	(36%)
As service courses	18,589	(64%)

Top Five States Having Colleges Teaching Photography
1. California 69
2. New York 42
3. Texas 27
4. Illinois 23
5. Florida 22

R. Zakia, R. Malone, and F. NeJame

PHOTOGRAPHIC EFFECTS The term *photographic effect* refers to any of a number of results where some aspect of a photographic image is different from the image anticipated or produced under normal conditions. It is assumed, for example, that an image of the sun included in a photograph will be dark on the negative and light on a print made from the negative, but under some conditions the opposite occurs. It might also be assumed that all parts of an area of a negative or print that received a uniform exposure will have the same density, but multiple measurements made across such an area with a small-aperture densitometer reveal that complete uniformity from edge to edge would be unusual.

Photographic effects are usually brought about by changes in the light sensitivity of the photographic material or the nature of the final image as a result of either changing the conditions of exposure or processing, or the introduction of additional physical or chemical steps during processing. Although photographic effects might be subdivided into exposure effects and processing effects, both factors are involved in some photographic effects.

Basic causes for photographic effects include (1) the size of latent-image specks, where a certain minimum size is required for development to occur; (2) length of time and temperature between exposure and development, where regression of the latent image can occur; (3) the distribution of the latent image between the interior and surface of the silver halide grains; and (4) development factors, such as local exhaustion of developer at the surface of the silver halide grain.

Some of the following effects, such as adjacency or edge effects, are not unique to silver halide photography. They manifest themselves in other imaging systems such as nonsilver imaging, electronic imaging, and human vision.

ADJACENCY EFFECTS Nonuniform densities in image areas when a region of great exposure lies next to one of low exposure. The cause is diffusion of fresh developer from a low-density area into one of high density, and the reverse—diffusion of exhausted developer from the high-density area into the low-density area.

Proper agitation during development plays only an indirect role, since the adjacency effects are associated with movement of chemicals from the thin layer of developer that adheres to the emulsion (the laminar layer) and diffusion within the emulsion itself.

See also: Border effect; Eberhard effect; Edge effects; Fringe effect; Ross effect.

ALBERT EFFECT The production of a reversal image by the following steps: (1) give the emulsion a high level of exposure to image light; (2) bleach, as with an acid bichromate solution; (3) clear with a sodium sulfite solution; (4) reexpose to diffuse light; (5) develop; (6) fix and wash. The result has sometimes been found to give better image quality than conventional two-stage duplication processes.

BORDER EFFECT At a boundary between a region of high exposure and one of low exposure where there is a greater density of the dense area immediately next to the thin area, as compared with that farther from the boundary. The cause is the difference in developer activity, which is greater at the edge than farther away where more exhaustion of the developer occurs.

See also: Edge effects.

BROMIDE-STREAK EFFECT Areas of underdevelopment in a film when, because of inadequate agitation, exhausted developer flows in a nonturbulent manner over the film. The effect is often seen in tank processing of sheet film.

CLAYDEN EFFECT The reversal of an image made with a short-time, high-intensity exposure when it is followed by a long-time, low-intensity exposure. This effect, sometimes called *black lightning,* may be produced when the camera lens is left open after the lightning flash.

EBERHARD EFFECT For small-image areas, less than about 4 mm in diameter, increasing image density as the size of the patch decreases, with constant exposure. The cause is greater developer exhaustion at larger image areas.

EDGE EFFECTS At a boundary between a region of low exposure and one of high exposure, enhancement of the high-exposure level next to the low-exposure level (the border effect) and a reduction of the low-density level next to the high-density area (the fringe effect). The combination of these two nonlinear effects is often called the *Mackie line.*

FRINGE EFFECT At an edge between a region of high exposure and a region of low exposure, a reduction in the density of the thin area immediately next to the dense area. The cause is weakness in the developer that is partially exhausted by action in the dense part of the image. The fringe effect is one of the edge effects.

HERSCHEL EFFECT The partial destruction of a latent image formed with exposure to short wavelengths when the material receives a second exposure to red or infrared radiation. This effect appears only with photographic materials that are initially insensitive to long radiation wavelengths. This effect may be used to change the tone reproduction characteristics of a photographic paper.

HYPERSENSITIZATION EFFECT A process intended to increase the effective speed of a photographic material by treatment before the image exposure. Various methods have been used, such as preexposure to weak, uniform light; treatment with mercury vapor; and bathing in solutions of ammonia, organic acids, etc. Recent tests have shown a tripling of the usual speed of films used in astronomy by heating the films in an atmosphere of hydrogen and nitrogen gases.

Hypersensitization is distinguished from latensification, which involves treatment after the image exposure.

INTERMITTENCY EFFECT If a continuous exposure time is divided into a successive number of exposures, the photographic effect is reduced, even though the total energy received by the photographic material is unchanged. A series of short exposures may be used, for example, to photograph a street scene without recording the presence of interfering objects such as automobiles or pedestrians.

The cause of this effect is similar to that which produces

reciprocity effects, and the effect is reduced if the separate exposure times are very short and very close together.

KOSTINSKY EFFECT When two or more very small adjacent images of high exposure, such as those of stars, lie within an area of low exposure, the shape and separation of the images will change with increased development. The developing agent is somewhat exhausted in the narrow space between the images and more effective outside them. The Kostinsky effect causes problems in the measurement of astronomical images, among others.

KRON EFFECT A decrease in reciprocity with increasing time of development when the photographic material is exposed at short times and with high intensities of illumination.

See also: *Reciprocity effects.*

LATENSIFICATION EFFECT Treatment of a photosensitive material after an initial exposure with the aim of increasing image density and contrast, and therefore effective speed. Various methods are used, among them a second exposure to weak, uniform light, and bathing with mercury vapor or with other chemicals, e.g., hydrogen peroxide. The effect is small or absent for very fast modern emulsions.

PRESSURE-MARK EFFECT A local area of higher density or lower density on processed film or paper due to the application of pressure to that area prior to processing. Such marks can result from bending film, such as can occur accidentally while loading roll film on a processing reel, as well as by applying pressure with a hard object. Whether the pressure has a sensitizing or desensitizing effect is influenced by whether the pressure is applied before or after the exposure and by the amount of exposure.

RECIPROCITY EFFECTS Changes in the response of a photographic material when the exposure is fixed but the components of exposure (illuminance and time) are altered. The term *reciprocity* arises from the reciprocal relationship between illuminance (light level) and exposure time for a given exposure, as shown by the definition of exposure as $H = E \times t$.

The reciprocity "law" states that the photographic effect is unchanged with changed exposure time, if the total exposure as defined by the above equation is fixed. In fact, most photographic materials show significant changes in the image at very short and very long exposure times, so that compensation must be made in exposure and processing for the emulsion to produce an acceptable image. The phrase *reciprocity law failure* was formerly used. Since the "law" rarely holds, the term *reciprocity effects* is now preferred.

There are several reciprocity effects:

1. There is an optimum time (and corresponding optimum illuminance) for which a given density will be produced with minimum exposure. For extreme departures from the optimum, the necessary exposure may more than double.
2. As a consequence, the measured speed of a photographic material varies with the chosen exposure time. For this reason, standard exposure time is selected at near the mean value of usual practice.
3. Unless an adjustment is made in development time, there is often a change in the slope of the characteristic curve and therefore in the image contrast. For low light levels, and therefore long exposure times, a reduction in development time from normal is usually required to generate normal contrast. The converse is usually true for images made with very short exposure times.

Reciprocity effects are seen in the response of photographic papers, especially when dense negatives and enlargements require the use of unusually long printing times. The results are loss in speed and reduction in image contrast.

For color films and papers, reciprocity effects often vary in significance among the three emulsion layers. As a result, not only speed and contrast but also color balance may be affected when the exposure conditions are unusual. In these situations the user must compensate not only for a loss in speed but also for a change in color balance.

Photographic manufacturers often include information about reciprocity effects in the data sheets that accompany the product. Otherwise, only practical tests can indicate the presence of reciprocity problems if they exist.

See also: *Appendix O–V.*

ROSS EFFECT Changes in the size and location of small adjacent images caused by the strains produced by the tanning (hardening) of gelatin during development.

SABATTIER EFFECT Partial image reversal associated with the following sequence: (1) less-than-normal first exposure to a scene, (2) less-than-normal first development, (3) a diffuse second exposure, (4) a second period of development, and (5) conventional completion of processing. The result is a change in the characteristic curve, and the pictorial effect is a reversal of some of the image tones and enhance-

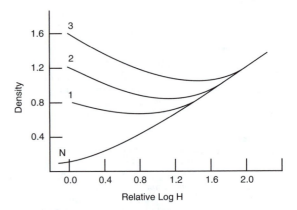

D-log H curves showing the Sabattier effect. N is the usual curve, and curves 1–3 show the results when the film received progressively less first development time.

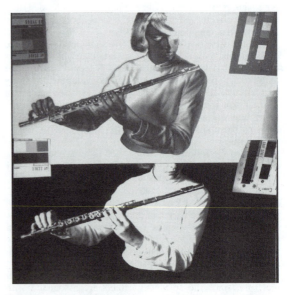

Sabattier effect: pictorial effect.

ment of lines. The line effect has been used in practice to increase the sharpness of spectrographic images.

The Sabattier effect is probably caused by the presence of silver formed in the first development covering the silver halide grains and shielding them from the second exposure. The effect sometimes appears when unsafe "safe" lights are used in the darkroom.

The Sabattier effect should be distinguished from solarization, which is image reversal caused by abnormally large exposure levels.

SOLARIZATION EFFECT With gross overexposure of a photographic material, a reduction in density with increasing exposure. The effect is shown in a characteristic curve that has a negative slope beyond the shoulder. The effect is small with most modern photographic emulsions, although the effect is sometimes observed in photographic papers and x-ray films. Solarization should be distinguished from the Sabattier effect.

SPROCKET-HOLE EFFECT Uneven development caused by the movement of developer in patterned flow associated with the holes in the margins of motion picture and other films.

STERRY EFFECT The reduction in contrast that results when exposed photographic material is treated with a weak (less than 1%) solution of potassium dichromate before development.

TEMPERATURE EXPOSURE EFFECT The extent of latent image formation in a photographic material as affected by the temperature at which the exposure occurs. Sensitivity is reduced at very low temperatures but may increase at high temperatures, especially for exposures to strong light for short times.

VILLARD EFFECT A partial reversal of an image formed in a photographic material when it is first exposed to x-rays and then exposed a second time to light. *H. Todd*

PHOTOGRAPHIC EQUIPMENT Photography, whether viewed as a form of artistic expression or technical discipline, is equipment dependent. From a photograph's initial inception to its final form, equipment is used extensively in each step. Although the word *equipment* is often used in an all-encompassing way, there are many types of photographic equipment.

The evolution of photographic equipment has paralleled technological developments in many fields. Improvements or breakthroughs in mechanics, optics, and chemistry have all contributed to the rapid growth of photographic equipment and processes. Later developments in electronics and computers have brought photography to today's highly sophisticated levels. In our world of computer-driven technology, many people feel that equipment has become so advanced that it takes away from the photographer's creativity. This could not be further from the truth. A camera or any other piece of equipment is just a tool that must be directed by the photographer. Rather than becoming distracted by, or even despairing over, advanced features, they should be seen as a way to free the photographer from mundane concerns. Technology will continue to advance whether greeted with open arms or fought tooth and nail.

Photographic equipment can be broken down into five basic groups: Cameras and accessories, camera supports, lighting, darkroom and processing equipment, and electronic imaging. Within each of these groups there are several subgroups. Camera equipment includes the various types and formats of cameras, lenses, and exposure meters. Camera supports refers to tripods, tripod heads, monopods, studio stands, dollies, and motion-compensation devices. Lighting equipment covers tungsten studio and location lights, electronic flash, reflectors and diffusers, and stands and booms. Darkroom and processing equipment covers a wide array of

items including sinks, processing tanks, thermometers, enlargers, safelights, driers, contact printers, and machine processors. Electronic imaging equipment includes computers, scanners, printers, software, and optical storage systems. This is by no means a complete list of every piece of photographic equipment but rather a simple overview.

Cameras are often what most people think of when the word *equipment* is used in photography. The earliest cameras were simple boxes with a pinhole opening; today this type of camera is known as a *camera obscura.* Because sensitized materials were not available to record images, the camera projected an image onto a surface so that tracings could be made. The development of light-sensitive plates in the mid-1800s led to the creation of what we would call true photographic cameras.

Improvements in lens manufacturing and timing mechanisms for shutters provided early photographers with more control for recording images. With the advent of roll film, photography became available to the masses. Multiexposure cameras were available to anyone who could afford them. Improvements in films eventually created a demand for different size roll-film formats. Over the years, many formats have come and gone. Some of the sizes that are now disappearing are 110 mm, 126 mm, 626 mm, and disc film. Thanks to modern film emulsions, 35 mm is the format most widely used today. Medium and large formats are used extensively by professional and advanced amateur photographers. Current medium formats include 6×4.5, 6×6, 6×7, 6×9, 6×12, 6×17 cm. The film used in cameras of these formats are commonly called 120 or 220 rolls, depending on the length. Large-format cameras use individual sheets of film. The sizes most commonly used are 4×5, 5×7, 8×10, 11×14 in.

Advances in the design of cameras over the years have truly been revolutionary. Photographers can choose from a wide selection of cameras in each format. Interchangeable lenses, motor drives, special-purpose finders, removable film magazines, and many other accessories are available for most popular camera systems. Shutters are available with either mechanical or electronically controlled timing. Modern optical engineering has produced lenses with resolving power exceeding what can normally be detected by the human eye. Combined with advanced multicoating and low dispersion glass, today's lenses offer outstanding performance.

Modern exposure meters, whether built in or external, offer superb accuracy. In the early days of photography, failed attempts at determining exposure were often the cause for poor image quality. Today, digital technology provides features that would astound early photographers. A typical professional meter will take incident, reflected, spot, flash, or combination readings. Many meters can store multiple readings to assist with averaging or zone system calculations. Built-in camera meters offer the ability to take basic readings that allow the photographer to choose lens and shutter settings or perform sophisticated, fully automatic exposure control. Many of these in-camera meters also have selectable metering fields or patterns.

Camera support equipment serves a valuable role in producing quality images, regardless of the type of camera the photographer uses. In the case of view cameras and other large-format cameras, there really is no choice but to use some kind of support system. The basic design of tripods has not changed very much in recent times. Lighter weight metal alloys and more ergonomic features typify modern tripods. Most manufacturers offer several types and sizes of pan and tilt heads for their tripods. This provides the photographer with the flexibility of using one set of legs with several different heads. Monopods are a lighter weight alterative to tripods when stand-alone stability is not required.

Studio photographers often require a more substantial

support system beyond what a tripod can offer. Studio stands are designed to meet this need. Typically, these stands use a heavy base with retractable wheels and a counter-balanced arm that can be moved with little effort on a tall center column. Studio stands are capable of supporting heavy, large-format cameras without vibration or the possibility of tipping over.

Other devices are available for special support needs. Camera dollies are basically mobile shooting platforms. They are primarily used for professional motion-picture and video cameras. The camera is attached to a mount and the operator sits in an adjustable seat. A crew is usually needed to push and or steer the dolly. Larger and more elaborate dollies used in the motion-picture industry are sometimes called *cranes*. These are equipped with a boom arm that can lift the camera and the photographer into the air while the dolly is in motion. For situations where the camera is subjected to constant motion such as aerial photography, gyro stabilized mounts are available. These devices use gimbal mounted gyroscopes to absorb vibration and sudden movements.

Photographers have long relied on artificial light sources to fill in or entirely illuminate a subject. The earliest form of artificial lighting was provided by *flash powder*. This explosive, gunpowder-like mixture was set off just as the shutter was opened. While it did provide a nice burst of light, a little too much could result in singed patrons. Fortunately, today's photographers do not have to resort to such extreme measures. A wide array of tungsten and electronic flash equipment is available. Basic studio tungsten or *hot lights* have remained unchanged for many years. Mini-spotlights, focusable spots, spots with fresnel lenses, and soft lights are all still widely used today. Scoop lights and simple flood lights are also found in many studios.

Small but powerful quartz lights are popular with photographers who specialize in location and architectural interiors. Diffusers or reflector panels are used to soften the hard light that is produced by these units. When using any tungsten light source with color film, tungsten balanced film should be used. Tungsten light is generally rated at 3200 Kelvin. Daylight film must be filtered when used with tungsten lights; otherwise a red to orange cast will result. Daylight film is balanced for approximately 5500 Kelvin.

Electronic flash has become the mainstay of many location and studio photographers. On-camera flash units are also widely used by photojournalists, wedding photographers, and amateur photographers. Most of the popular point-and-shoot cameras produced today are equipped with built-in flash units. Some of the main advantages to using electronic flash over tungsten lights include less heat and the ability to stop action and to use the wide array of daylight films. Studio flash units offer flexible output of light with a high degree of control. Many systems allow for individual flash heads to be rationed at the power pack. Infrared remote control units and triggering are some of the features offered on sophisticated studio flash systems. On-camera flash units also offer advanced features. Several manufacturers have dedicated through-the-lens (TTL) flash units for 35-mm and medium-format cameras that can provide accurate flash exposures. *Red-eye* reduction is a recent innovation in on-camera strobes. One method used is a short burst of low power flashes that go off just before the actual exposure. This is supposed to make the subject's pupils contract, reducing the reflection of light from the rear of the eye.

Many accessories are available for lighting equipment, including various types of stands, boom arms, clamps, diffusers, reflectors, and umbrellas. Some of these items bear unusual names such as *cookie cutters, flags,* and *gobos*. They are all designed to aid in the placement of, or control over, the lighting. Collapsible reflector panels made of fabric have become popular because of their light weight and portability.

Plastic tubing, fiberglass wands, or spring steel bands are used in the reflectors for support. They are available in a variety of reflective surfaces and colors.

Darkroom and processing equipment have come a long way from the early days of developing daguerreotype plates over mercury vapors. Professional labs and home darkroom enthusiasts have a wide array of equipment to choose from. While most large-scale labs have switched over to automated machine processing, smaller custom labs and home darkrooms still use many of the traditional tools. A large, well-built sink of stainless steel or plastic is the best place to start. Both of these materials are resistant to corrosion from photographic chemicals. Plastic or stainless steel trays of various sizes are required for processing prints and sheet film. Roll-film tanks made of plastic or stainless steel come in sizes that will hold from one to ten rolls. Reels made of the same materials are available for 35-mm, 120/220, and 4×5-in. films. Hard-rubber deep tanks are also still in use for processing multiple pieces of sheet film. A well-equipped darkroom will also include a good assortment of measuring beakers, storage containers, and funnels.

An accurate thermometer is an essential item for monitoring chemical and wash water temperatures. Mercury-filled thermometers were always considered the most accurate until digital electronic models became available. Darkroom timers have also undergone the transformation to digital technology. Many models are now available with accuracy to one-tenth of a second. Other features have been incorporated such as numeric light-emitting diode (LED) readouts, audible count-down beeps, and programmability for several different processes. The Gralab timer, an old standby, is still popular with its large glow-in-the-dark dial and easy to set hands. Other items found in a typical darkroom will include contact print frames, adjustable masking easels, print trimmers, film and print washers, and driers. Depending on the water quality, in-line filters may be needed to remove particles and other impurities. Light-baffled fans are available to provide darkrooms with proper ventilation. This is an often overlooked feature that is essential to the health of those who work in the darkroom.

The primary piece of equipment in a darkroom is the enlarger. For many years, the Omega "D" series of enlargers dominated the professional and advanced amateur market. These sturdy, fully adjustable 4×5, 5×7, and 8×10-in. enlargers had many advanced features for their time. Still available, they continue to be popular with professionals because of their durability. Other manufacturers were not idle during these years, and subsequently, many other designs have appeared and become popular. Today, there is a wide variety of both color and black-and-white enlargers to choose from. New designs allow for interchangeability from color to black and white, while others are specific to only one or the other.

Depending on the illumination system, enlargers are classified as either condenser or diffusion. Until recently, only tungsten, quartz, or fluorescent lamps were used as light sources. A recent, innovative enlarger system uses an electronic-flash light source. This system uses a probe to measure the light level and color balance. The information is fed back into a computer controller, which, with user input, sets the correct values. A unique advantage to this system is that it compensates for color balance shifts in the flash tubes, providing a high level of repeatability over the course of time. Dichroic color heads cannot offer this precise repeatability because the filters change density and the quartz lamp will change in color balance with age. Other modern innovations include multicontrast, diffusion-source black-and-white enlarger systems. These enlargers are used with multigraded papers, allowing for instant adjustment of contrast levels.

Machine processors and automated printers are the backbone of the professional photofinishing industry. Until the

development of these machines, all film and print processing had to be performed by hand. The mass appeal of photography on the amateur level is in part a result of the ability of these machines to put out high volumes of quality processing quickly. Today, one-hour minilabs can be found almost everywhere. Modern machine processors offer computer-controlled accuracy and high-speed throughput. The most common design used in machine processors is roller transport. These processors are made up of a series of chemical tanks containing racks of gear-driven rollers. Drive speed, replenishment, solution heating, and drying are all monitored and controlled by computer. Current color processes have reduced the dry-to-dry time of these processors to less than 5 minutes.

Electronic-imaging equipment is at the top of the list for the most modern technology. The debate over whether electronic imaging will ultimately take over photography is hotly contested in many circles. Needless to say, these new technologies will forever alter the photographic equipment world. Central to electronic imaging is the personal computer, or PC. The Apple Macintosh system took the early lead as the premier imaging platform. Recently, however, the IBM-compatible world has pulled into line with the Apple systems. The fast pace of development work on these imaging systems has brought prices down to a level that a typical professional photographer can afford. Electronic imaging is still closely linked with traditional photography. Current electronic-imaging cameras are not capable of producing the high resolution that is possible with silver-based film. Digital cameras offer the possibility of much higher resolutions in the future.

Scanners are the tools that allow photographers to import silver-based images into a computer imaging system. Transparencies, prints, and even negatives can be scanned and transformed into digital images that can be directly manipulated by software programs. High-quality scanners are able to resolve the image at near original levels. The ability to maintain the original resolution, color, and density values of the image then becomes dependent on the hardware and software being used. The high-end standard for color imaging is called 24-bit RGB color. To achieve this level, each pixel is assigned twenty-four bits of color information. A pixel is the smallest individual picture element that the system is able to resolve, and a bit is the smallest individual piece of computer information that can be assigned. In a 24-bit RGB color image, each pixel is assigned 8 bits of information for Red, Green, and Blue. This combination allows for 16.8 million colors in an image.

Software packages for imaging offer an incredible number of features, allowing images to be manipulated in just about any fashion imaginable. Color, density, and contrast can be altered or adjusted, and special effects such as posterization and image reversal are available. Sophisticated editing tools allow for cutting and pasting segments of images together. Other tools can take samples of colors or textures from one area of an image and reproduce them elsewhere. High-end imaging software can produce color separations that can be electronically transferred to prepress for reproduction in the printing process. Once an image has been manipulated, it can be printed out directly by the computer or sent to a film recorder. Color thermal printers are available that can produce near photographic quality prints.

Image storage technology and equipment are advancing rapidly toward mass availability. Eastman Kodak is pioneering the Photo CD system. This is a technology that allows photofinishing labs to place photographic images on a compact laser disc. The images can then be viewed with a Photo CD compliant disc player. Some see this as an answer to archival stability problems, laser discs are not subject to the same image degradation as silver based film and paper. Others may view this as the first step toward the eventual replacement of all silver-based products, but there is little doubt that photographic equipment as we know it today will continue to serve photographers for many years to come. *G. Barnett*

See also: *Camera accessories; Camera support; Camera types; Color-temperature meter; Computers for photographers; Electronic flash; Electronic still photography; Enlarger; Exposure meter; Light sources; Printer; Processor; Projector; Scanner; Stand; Timer; Trimmer; Tripod.*

PHOTOGRAPHIC EXPOSURE

The amount of light that falls on a photosensitive material, the product of the illuminance and the time, or $H = E \times t$. The preferred unit of measurement is lux second, which is equivalent to meter-candle-second and lumen-second per square meter.

J. Johnson

See also: *Exposure.*

PHOTOGRAPHIC FIELDS

Although some photographers consider themselves generalists to the extent that they are willing to make almost any type of photograph requested of them by a customer, there are many recognized areas of specialization within the broad field of photography. There are also many different ways of subdividing photography into areas of specialization, such as according to the subject (architectural photography, food photography, portrait photography), according to the intended use for the photographs (advertising photography, communications photography, forensic photography), and according to a photographic process or procedure (infrared photography, holography, underwater photography).

Listed below are 100+ generally recognized areas of photographic specialization for which there are articles, arranged alphabetically, in this encyclopedia. The list by no means includes all possible areas of specialization, and some of the areas could be subdivided into narrower categories, such as studio portraits, environmental portraits, portraits of children, and portraits of animals as more highly specialized subdivisions of the field of portrait photography.

A number of degree-granting educational institutions and proprietary schools have courses in many of these areas of specialization in their photographic programs. (See *Photographic education.*) In addition, over 500 photographic workshops offer concentrated study in some of these subjects in various locations in the United States for periods ranging from a few days to a few weeks. Advertisements for the larger workshops can be found in photographic magazines, and a comprehensive list is included in a special annual issue of *Photographers' Forum.*

Abstract photography
Advertising photography
Aerial photography
Allegorical photography
Amateur photography
Anthropological photography
Archaeological photography
Architectural photography
Astrophotography
Audiovisual communications
Ballistics photography/videography
Biological photography
Botanical photography
Camera repair
Candid photography
Catalog photography
Closeup photography
Coloring
Commercial photography
Communications photography
Copying, photographic

Corporate photography
Custom finishing
Dance photography
Decoration photography
Dental photography
Documentary photography
Electronic editing
Electronic still photography
Erotic photography
Existing-light photography
Expressive photography
Fashion photography
Fine-art photography
Flash photography
Food photography
Forensic photography
Freelance photography
Geological photography
Graphic-arts photography
High-speed photography
Historical photography
Holography
Identification photography
Illustration photography
Imaging science
Industrial photography
Infrared photography
Landscape photography
Magazine photography
Medical photography
Microfilming
Military photography
Missile photography
Motion-picture editing
Motion-picture photography
Multimedia
Nature photography
Ophthalmic photography
Panoramic photography
Photofinishing
Photogrammetry
Photographic education
Photographic science (See *Photographic research; Photographic theory*)
Photographic workshops
Photoinstrumentation
Photointerpretation
Photojournalism
Photomacrography
Photometrology
Photomicrography
Photomurals
Pictorial photography
Picture editing
Pornographic photography
Portrait photography
Postcard photography
Professional photography
Radiography
Remote sensing
Repeat photography
Research photography
Restoration photography
Retouching
School photography
Scientific photography
Snapshot photography
Space photography
Spirit photography
Sports photography

Stereo photography
Still-life photography
Streak photography
Surrealistic photography
Surveillance photography
Technical photography
Theatrical photography
Travel photography
Underwater photography
Video
Wedding photography
Yearbook photography

Books: Evans, A., *Careers in Photography*. Redondo Beach, CA: Photo Data Research, 1992; Johnson, B., Mayer, R., Schmidt, F., Evans, A., *Photo Business Careers*. Redondo Beach, CA: Photo Data Research, 1992; *Opportunities in Photographic Careers*. Chicago: National Textbook, 1985; Gilbert, G., *Photography Careers Handbook*. 2nd ed. New York: Photographic Arts Center, 1992. *L. Stroebel*

PHOTOGRAPHIC FILM Photosensitive material consisting of an emulsion coated on a flexible, transparent base. Films for still photography can be grouped according to their formats as follows: roll films, perforated films, and sheet films (including packs). Motion-picture films are perforated materials supplied in long rolls. Other formats outside the mainstream are the specialty materials such as panoramic and subminiature. The commercially important materials are almost exclusively silver halide, but a few other materials have their special uses.

STILL FILMS

Roll Films A design that permits daylight loading of medium-format cameras. The usual form is a strip of film laid on a longer strip of opaque backing paper, which extends beyond it at both ends, and the pair are wound on a spool. The flanges of a metal spool make a light-tight seal with the paper. The leading end of the film is fixed to the backing paper with a piece of adhesive tape. The backing paper is printed in the area over the film with one or more series of numbers, which align windows in some camera backs to indicate the frame in the exposure plane, and in nonautomatic cameras to guide the photographer in accurately spacing exposures along the roll. Advanced cameras automatically space the exposures. The common 120-size film is numbered 1–8 for pictures 2–1/4 × 3–1/4 in., 1–12 for pictures 2–1/4 in. square, and 1–16 for pictures 1–5/8 × 2–1/4 in., according to the camera used. The demand for more exposures led to 220-size film. It is supplied on the same size spool as 120, but provides twice as many exposures. Backing paper does not extend the whole length of the film but is merely the leader and trailer lengths spliced onto a double length of film. (The numbers 120 and 220 are in no sense a measurement of size: they are part of a series of arbitrary numbers designating various roll film sizes.) Many other roll film sizes once popular for snapshot photography are now discontinued or are obsolescent.

Perforated Films The original film used in the first 35-mm still cameras was merely short lengths of standard motion-picture negative stock, but now films are made specially for this field. The perforation standard of the motion picture field has been taken over into still photography with the common format being a frame eight perforations long, double the motion standard. The exposure area is nominally 24 × 36-mm, usually called full-frame. A few amateur cameras use the 18 × 24 half-frame still format, which is the same as the motion picture full frame.

The usual format is a metal magazine for daylight loading holding 36 exposures. Other lengths of normal film are 20 or 24 exposures, although lengths of 8, 12, 15, and 18 are sometimes seen. For photojournalists, film on a very thin base has

been supplied in 72-exposure lengths in the regular magazines. Latent image frame numbers and identifying data are exposed by the manufacturer at the very edge of the film in the perforation area. A shaped tongue at the start of commercially packaged film aids in camera loading. Long rolls, usually 100 feet, are supplied for those who load their own magazines.

In the majority of cameras, film is exposed as it is withdrawn from the magazine and wound onto the take-up spool. It must then be rewound into is original magazine before the camera back can be opened to change films. Failure to rewind before opening the camera leads to the ruining of some or all of the film. A few automatic snapshot cameras upon loading immediately run all film onto the take-up spool, then rewind exposure by exposure back into the original magazine, protecting exposures already made.

Although most perforated still film is 35-mm wide, a few other gauges are also seen. For commercially produced slides, 46-mm is sometimes used. Some technical and micro-film applications use 105-mm stock. For mass portraiture 90-mm stock is used, often unperforated. The most important size, other than 35-mm, is 70-mm.

Seventy millimeter film has much to recommend it for scientific and technical photography. Many high-quality 120 cameras also have alternative interchangeable backs for 70-mm film. Image size is usually 2–1/4 by 2–1/4 to 2–7/8 inches. The usual load consists of a magazine looking like an overgrown 35-mm magazine and containing 15 feet of 70-mm film. The film is threaded from the supply magazine, across the focal plane, and into an identical but empty take-up magazine. Unlike 35-mm, the film is not rewound in the camera after exposure.

The 70-mm format may be thought of as both the largest of the small formats and the smallest of the large formats. Because of this, a great variety of emulsions are available in it, usually in long rolls. Aerial, instrumentation, scientific, portrait, microfilm, copying, duplicating, and general-purpose emulsions are supplied in black-and-white and in color.

Sheet Films These, also called *cut* films or *flat* films, are made in sizes to fit the popular view, press, and technical cameras. The usual packaging is in boxes of 10 to 100 sheets, which must be loaded into light-tight holders in the darkroom. To solve the problem of locating the emulsion side in total darkness, sheet films have notches along one edge. When the film is oriented vertically and the notch is in the upper right corner, the emulsion faces the operator.

A few manufacturers are offering another way of handling sheet film. Single or double sheets are supplied in light-tight paper sleeves to fit special holders. No darkroom is needed until time for processing.

Film packs, although the base material is as thin and flexible as roll film, can be considered as sheets because they are used in cameras designed primarily for sheet films. In this format 16 films fit in a special holder not much thicker than a normal holder containing two films. The film-pack format has fallen out of favor for conventional films but is now widely used for black-and-white and color instant-picture films.

MOTION-PICTURE FILMS The common professional gauges are 16-mm, now diminishing due to video, and 35-mm, still the professional standard. Wide-screen processes use 65 and 70-mm stock. Amateur 8-mm and 9.5-mm gauges are obsolescent, and super-8 is also waning due to home video systems.

Motion picture film is perforated down one or both edges to engage with mechanisms to transport it between exposures and to stabilize its position during exposure or projection. The perforations are made to exacting international standards, and they engage with sprocket wheels, pull-down claws, and register pins in cameras, processors, editing equipment, and projectors.

Professional films are supplied on cores or on spools and sealed in metal cans. The spools may be loaded directly into cameras in subdued light. Film on cores must be loaded into cameras or magazines in the darkroom. Super-8 films are supplied in cassettes for drop-in loading into the amateur camera. *M. Scott*

See also: *Acetate film base; Film base; Film pack; Motion-picture films; Nitrate film; Nonsilver processes; Perforation; Tongue.*

PHOTOGRAPHIC GRADUATE A student who has completed all requirements of a photographic program and received a degree representing this completion. An associate degree typically requires two years of study. The bachelor's degree requires four years, and a master's a minimum of five years. A person who is enrolled in a master's degree program is identified as a *graduate student.* *R. Malone*

PHOTOGRAPHIC INTERNSHIP A person who works as a trainee or assistant for the purposes of gaining professional photographic experience. Photographic internships are usually granted through an academic or professional institution. Internships are for a specific length of time, which gives the intern the opportunity to gain experience and learn from an accomplished photographer or professional. The internship may provide a nominal salary, no salary, or college credits in addition to the invaluable experience of working with a highly knowledgeable and respected person in the field. *R. Malone*

PHOTOGRAPHIC JOURNALS See *Publications, photographic.*

PHOTOGRAPHIC LOGARITHMIC NOTATION See *Appendix F.*

PHOTOGRAPHIC MAGAZINES See *Publications, photographic.*

PHOTOGRAPHIC MONITORING The use of photographic images for purposes such as security and detecting changes in a process or environment. Photographic badges, for example, can measure cumulative exposure of a worker to dangerous radiation. *L. Stroebel*

See also: *Camera types, surveillance camera; Surveillance photography.*

PHOTOGRAPHIC PAPER Several physical aspects of photographic paper apply to all kinds alike. They will be discussed first. The distinct aspects of color and black-and-white will then be taken up separately.

COMMON PROPERTIES

Base The base of support has considerable bearing on the ease, speed, and cost of paper processing. The old standard fiber base requires conventional three-bath tray processing, and extended washing and drying. It offers the greatest flexibility in process variation to alter density, contrast, and image tone. The greatest variety of textures, tints, and finishes is also available in fiber papers. RC (resin-coated) papers begin with a conventional fiber support onto which a pigmented polyethylene is extruded. The emulsion is then coated on one side of that. The support of RC papers does not absorb chemicals or water, so they are quick to wash and dry.

Weight The thickness of a photographic paper support. The usual range is light, single, medium, double, and sometimes premium weights. There is no standardization on exact thicknesses corresponding to these names among manufacturers. A given paper may be made in more than one of these weights.

BLACK-AND-WHITE PAPERS The term *black-and-white photographic paper* has become almost synonymous with silver halide enlarging paper, but even in this restricted sense there is considerable variation—fiber vs. RC, graded vs. variable contrast, tray vs. machine processable, single vs. double weight, glossy vs. matt surface. These and the alternatives—contact, printing-out, nonsilver—will be discussed.

Processing Method Papers may be grouped according to the processing method for which they are intended: manual processing in trays or mechanized processing. Any paper may be processed manually, including those with incorporated chemicals intended for mechanized processing, although only the ordinary papers without incorporated chemicals will respond to the manipulations often required in manual processing. To speed up mechanized processing, all the ingredients for a developer, except the alkali, are built into the emulsion. The first bath in the processing machine is a strong alkali, so development starts instantly and is complete in seconds. The second bath is a fixer, followed by a washing and drying, only 60 seconds elapsing from dry to dry. Only RC papers are used in these machines. A sometimes overlooked advantage of fully mechanized processing is that prints need not be sorted out from an entire day's production. Each job is separate.

A step between manual and fully mechanized processing is stabilization processing, which uses a small machine with two baths, no wash and no dryer. Here again incorporated-developer paper is used, but this time it is fiber base in most cases. The first bath is an alkaline activator, but this time followed by a stabilizer, not a fixer. The stabilizer converts undeveloped silver halide into a relatively light-stable complex salt, which remains in the paper. Prints issuing from the machine are damp, limp, and odoriferous, requiring air drying. The images have moderate stability under office conditions. To render these prints as stable as any other black-and-white prints, they should be fixed in hypo, washed, and dried.

Contrast Grade Photographic paper for pictorial and most technical photography is made in a range of different contrasts using names such as—extra soft, soft, normal, hard, extra hard, ultra hard—or numbers zero through five, with two corresponding to normal. The majority of negatives should print best on a number two paper. A soft negative, or one with less contrast, would need a higher grade; a hard negative, or one with more contrast, a grade lower. Although international standards define the degree of contrast by grade number, there is no general adherence to their specifications.

An alternative to graded papers is variable-contrast paper. These papers have two emulsion components, one of high contrast, one of low contrast. In the usual scheme the high contrast component is sensitive to blue light, and the low to green. By changing the color of the exposing light with filters one can have any desired contrast between maximum and minimum.

Surface The surface of a photographic paper is a combination of its texture and its finish. Its texture may range from smooth to rough in several steps. It may also have a discernible pattern impressed to resemble fabrics, such as silk, linen, or canvas. (As paper manufacturers supply fewer of these, other methods of achieving such surfaces on a smooth print are offered by firms making embossing equipment.) Finish may range from glossy to matt in several steps.

Tone and Tint Papers vary in image tone, the color of the image itself, not that of the paper base. To a large extent this is built in at manufacture, but it can be influenced by the choice of developer. Further major changes can be made after conventional processing by various chemical toners. Tint is the color of the base itself, independent of image tone. White and various creams are the usual tints. In former times deeper tones, such as old ivory, were used for portraiture.

Speed Most papers today are of projection speed for enlargement, although some slower contact papers still exist. Other than their level of light sensitivity, there is little to distinguish one from the other. Although papers are not rated in the same speed system as film, it may be of interest to know where they stand with respect to each other. The equivalent speed of a typical enlarging paper might be equivalent to ISO 3; contact paper is about a tenth to a hundredth of that.

SPECIALTY PAPERS With the continuing trend to smaller negatives, the demand for printing-out papers as proofing materials has fallen greatly, but they are still available from some manufacturers. Most current uses would be in fine-arts applications and in the printing of antique negatives.

A small but lively interest remains for esoteric printing processes using nonsilver materials and nongelatin silver materials. A few of these are made by very small manufacturers, but most are prepared by individual photographers with chemicals and instructions from firms catering to the fine-arts trade.

Recording papers for various technical instruments form images by the direct action of light; first the intense exposure of a xenon arc-lamp spot swept at high speed over the paper to impress the data trace, then photolytic development as the paper prints out under ordinary roomlight conditions. The record is a bluish trace on a tan background.

COLOR PAPERS

Materials Negative- and positive-working chromogenic papers, dye-destruction (silver-dye-bleach) materials, and dye-transfer materials provide a wide variety of routes to the final image. The great flexibility of dye transfer, with all of its possibilities of masking for color correction and contrast control, along with all of the other systems previously mentioned, offer a rich palate of printing possibilities.

Prints from color transparencies Reversal papers can produce prints directly from transparencies. Some of these materials are of high contrast, and since many transparencies are also of high contrast, the cascaded result is sometimes a print with too much contrast. The method does, though, have the advantages of simplicity and economy, with no intermediate needed. For technical and scientific subjects the gain in contrast is often a boon.

A route that offers control over contrast and better color reproduction is a print on negative-working paper via an intermediate negative. When making a large print from a small transparency, obtaining some of the enlargement in the intermediate negative will optimize image quality in the final print, e.g., a 35-mm slide to a 4×5-in. interneg to a 16×20-in. print.

Prints from color negatives Negative-working chromogenic papers are supplied in at least two grades of contrast. Dye-transfer prints can also be made. *M. Scott*

See also: *Cibachrome; Ektacolor; Kodacolor; Tint; Toner/Toning; Variable-contrast paper; Warm-tone.*

PHOTOGRAPHIC PHYSICS Areas in the general field of physics that are related to photography. To some extent this means that all physics is photographic physics, especially with the advent of electronic imaging. A more limited definition would involve the application of physics to photographic systems and problem solving. *J. Holm*

PHOTOGRAPHIC PROCESSES Classification of photographic processes may be made according to the chemical components and their functions, the method of obtaining a final copy, or the intended application.

Since 1800, salts of silver formed with members of the halogen family, chlorine, bromine, and iodine, have constituted the basis of most photochemical imaging. Exposure causes these salts to form a latent image that can be devel-

oped out or, with sufficient exposure, printed out. Fixing in sodium thiosulfate or ammonium thiosulfate removes unexposed and undeveloped salts, rendering the image safe in light. Silver halides are used in most color imaging as well; they are used to form the image and are removed after dye formation in chromogenic processes, or after dye destruction in dye-bleach processes.

Some iron slats are also sensitive to light. The reduction of iron from its ferric (3+) to its ferrous (2+) state is the basis of the chrysotype, cyanotype, kallitype, platinotype, and Vandyke processes. The ferro-cupric and ferro-gallic high-contrast processes are also iron-based.

When a colloid such as gelatin, casein, albumen, shellac, or gum arabic is sensitized with potassium, sodium, or ammonium bichromate, the emulsion changes upon exposure to light. The colloid may become insoluble if previously soluble; it may no longer absorb water and swell up, or it may lose its surface tackiness. For example, powder processes are based on loss of tackiness, creating ceramic and photomechanical applications. The carbon, carbro, gum bichromate, bromoil and dye transfer processes also employ bichromates, as do some silkscreening techniques.

Diazo copying processes employ diazonium salts that are destroyed when they are exposed by ultraviolet, violet, or blue light. The salts can couple with aniline to form colored compounds.

Another way of classifying photographic processes is according to the way they arrive at a final product. Of the three viable photographic systems published in 1839, W. H. Fox Talbot's was a negative-positive process, and L. J. M. Daguerre and Hyppolyte Bayard made direct positives. Reversal processing was first achieved by C. Russell in 1862. Transfer of a chemical image, a physical image or an emulsion from one support to another is the basis of dye transfer, carbro, bromoil, and diffusion transfer processes.

Color processes may be additive, combining red, green, and blue elements, or subtractive, combining yellow, magenta, and cyan. Some record images on panchromatic black-and-white emulsions by employing linear or lenticular screens to separate white light into its primary components. Some color processes, such as tri-color carbro and dye transfer, rely on the assembly of a color image from separate matrices.

Development of an image may be physical or chemical. In physical development, the silver forming the image is supplied by the developer rather than by the emulsion, essentially silver plating the latent image specks. In chemical development, the developer reduces exposed silver halides to form metallic silver and halogen ions. Tanning developers that harden the gelatin of the emulsion must first operate chemically; it is the developer oxidation products that harden the gelatin.

Photomechanical reproduction is a distinct branch of photography that employs many of the processes described in conjunction with general purpose photography.

Letterpress line blocks are made by making a negative on lithographic film from a line drawing and exposing it by contact onto a zinc plate with a dichromated albumen coating after which the plate is etched.

Halftone blocks begin with a litho film negative made through a halftone screen. The negative is contact printed on a zinc or copper plate coated with a light-sensitive fish glue-ammonium dichromate solution; the plate is then etched.

Offset lithography also uses halftone images produced from continuous tone images by means of a halftone screen, and a plate coated with dichromated colloid, but here the hardened colloid may be used directly for printing.

Photogravure etches the image into a printing cylinder. Carbon tissue bathed in potassium dichromate is exposed through a photogravure screen and transferred to a copper cylinder where the soluble, unexposed gelatin is washed away. The tissue forms a resist that determines where the cylinder will be etched with ferric chloride.

Color printing processes use photographically made separations to prepare plates that print yellow, magenta, cyan, and sometimes black. Specialized presses can print six or more impressions in one pass through the press, and offer the option of finish coatings over color.

COLOR PROCESSES

Chromogenic Development Today, most negative and reversal color photochemical imaging systems employ chromogenic development to form dye images. The technology has its roots in the textile industry of the nineteenth century in which dye-coupling was used to form colors in the fibers of fabrics. In 1873, H. W. Vogel used dyes to extend the spectral response of silver halides, making orthochromatic collodion plates. Research by R. E. Liesegang, H. Luppo-Cramer, B. Homolka and others into dye characteristics, oxidation, and development enabled R. Fischer and H. Siegrist to patent a practical system of chromogenic development in 1912.

Negative films with conventional integral tripack emulsions form silver and dye images during the single development step. Reduction of the silver image from silver halides produces oxidation products that then react with dye couplers in each emulsion layer to form subtractive dyes. To keep the couplers from migrating into other layers, forming inappropriate colors, they may be encapsulated in shells of colloids that are permeable but not soluble in the processing solution, or they may be anchored in place by attaching them to long, inert hydrocarbon chains that make the couplers too heavy to move or too large to slip through gelatin. Yellow dye is formed in the blue-sensitive layer; magenta dye is formed in the green-sensitive layer, and cyan dye is formed in the red-sensitive layer.

Color negatives have a characteristic orange cast, which is a mask that compensates for unwanted absorptions by the cyan and magenta dye layers. One method of generating the mask incorporates yellow couplers in the magenta layer, and orange or red couplers in the cyan layer. Oxidation products form dyes that are visible in the unexposed areas of the negative.

Because developer oxidation products join with color formers to produce dye, customary antioxidants such as sodium sulfite would inhibit dye formation. Antioxidant concentrations are necessarily kept very low, with the consequence that color developers have very short working lives.

Bleaching and fixing remove the silver image, leaving the dye. The bleach is a complex mixture that forms silver bromide from the silver in the image, enabling an ammonium thiosulfate-based fixer to complete the task of silver removal. The bleach and fixer are often combined in one step, called blix. After washing, a stabilizer with little or no formaldehyde is used to preserve the dyes.

Chromogenic integral tripack color reversal materials are similar in many respects to their negative counterparts. A latent image is first formed in silver halides, but the first development is black and white only, forming a silver negative image. The remaining unexposed or undeveloped areas of the emulsion are then either re-exposed to light or sensitized in a fogging bath, forming a positive latent image. The second development works like the developer in negative processing. Color couplers in each emulsion layer react with oxidation products in the developer, forming subtractive dyes, as well as a positive silver image. Bleach then converts the silver of both images to soluble compounds that are removed by the fixer. Washing and stabilization follow.

Prints can be made chromogenically from either negatives or positives. Negatives are printed on integral tripack papers and display materials that are like negatives without the compensating mask. Development follows the same steps.

Positives are printed on integral tripack materials that mirror positives, requiring re-exposure to light or a reversal bath.

Modern formulations of processing solutions are made with concern for safety and environmental considerations. Because photochemical systems are in use throughout the world, manufacturers must maintain compliance with a maze of often-contradictory regulations. There is also a need to avoid infringing on industrial patents, necessitating the search for new ways to perform old tasks.

Differential Dye Diffusion Kodachrome was invented in the 1930s by Mannes, Godowsky, and a research team at Eastman Kodak. They solved the problem of making the dyes stay in their respective emulsion layers by adding the dyes during processing. The film has three silver halide emulsion layers without color couplers. In a highly sophisticated processor, the antihalation backing is removed; silver negative images are developed; the film is exposed to red light through the back and developed with cyan-forming developer yielding a cyan and silver positive; the film is exposed to blue light from the top and developed in yellow-forming developer, yielding a yellow and silver positive; a fogging developer forms a positive magenta dye and silver image. Bleach then converts all the silver to soluble compounds that are removed by fixer, leaving a dye image.

The skilled personnel required for the performance of these tasks, the expense and relative scarcity of the equipment involved, and the dramatic improvements in chromogenically processed reversal materials that can be processed quickly and successfully almost anywhere all call the long-term future of Kodachrome process materials into question.

Dye Diffusion Transfer The formation of color images by means of the diffusion transfer process is, currently, the sole province of Polaroid. In the 1980s, Agfa marketed a dye-diffusion-transfer integral-color printing material called Agfachrome Speed, and Kodak offered a line of peel-apart printing materials called Ektaflex, as well as instant color print films. Now, Polaroid has peel-apart and integral diffusion transfer materials. They have red, green, and blue sensitive layers interleaved with metallized dye developers that form cyan, magenta, and yellow dyes. The material is exposed and passed through rollers that break the pods containing separate processing solutions for each emulsion layer. The developed dye/developer molecules are immobilized while the undeveloped molecules can migrate through the emulsion to the mordanted receiver where the positive dye image is formed.

Peel-apart materials protect the light-sensitive components until processing is complete, and facilitate the disposal of all substances consumed and no longer necessary. Integral materials enjoy no such luxuries. They protect the emulsion after exposure by generating an opacifying layer that reverses itself at the conclusion of processing. They form a pigment barrier layer between the image and the negative to conceal and isolate processing byproducts and provide a background for viewing.

Screen Processes Before effective chromogenic materials were available, systems by Joly, the Lumière Brothers, Dufay, and Finlay, as well as Kodak and Agfa, all used screens to divide light into its primary components. Some screens were lenticular, some were colored lines, and some were mosaic or reseau. All split the light on its way to a panchromatic black-and-white emulsion, usually reversal processed. While the details varied, most used white light projected through the back to modulate the intensity of the light reaching the screen. As the light passed through, a color image was constructed. Currently, Polaroid Polachrome 35-mm film employs a screen in conjunction with a peel-apart diffusion transfer emulsion to produce an additive three-color positive image.

Dye Transfer The dye transfer process is an assembly process for making color prints from color positives or negatives. Two kinds of matrix film are used—orthochromatic and panchromatic. The panchromatic film is used when separations are to be made directly from color negatives or internegatives onto the matrix film, eliminating the need to make separation negatives. However, significant control over the final image can be exercised while making separation negatives.

In either case, the separations are made in registration through red, green, and blue filters, eventually producing the matrices that will print cyan, magenta, and yellow dyes. The matrix film is exposed through the back because its dichromated gelatin emulsion is subject to hardening in a tanning developer where the emulsion has been exposed. The unexposed and unhardened parts of the emulsion are on the top and can then be washed away in warm water, leaving a relief image in gelatin.

The matrices are soaked in their respective dyes and applied to the print, cyan first, then magenta and yellow, in register. Multiple applications, changes in soaking and rinsing procedures, and modifications of the dye baths all provide additional controls. The intricacy of the process is a function of the degree of control it offers to the skilled practitioner. The dye transfer process is generally regarded as the foremost system of color printing because of that control, the durability of the prints and the subtlety of the dyes that form the image.

Silver-Dye-Bleach Process The silver-dye-bleach process is an integral tripack system with yellow, magenta, and cyan azo dyes incorporated into the blue-green-, and red-sensitive emulsion layers, respectively, during manufacture. After exposure from a color positive, the material is processed in black-and-white developer to produce a silver image. A strongly acidic dye bleach with an added accelerator causes the destruction of the dyes adjacent to the silver image grains in proportion to the amount of silver bleached. Fixer removes the bleached negative silver image and the unexposed, undeveloped silver halide components of the positive image. The stable, luminous azo dyes that remain correspond to the original positive image.

HISTORY OF PHOTOGRAPHIC PROCESSES

Before the nineteenth century, photography existed as a phantom. Its components had been known for hundreds of years. The Greeks and Egyptians knew substances whose nature was altered by exposure to sunlight. Renaissance painters knew how to project an image onto canvas in a darkened chamber. The growing middle class wanted images of their travels and of family members, and there were scientific and industrial applications waiting eagerly for someone to figure out how to write with light.

Experimentation, discovery, and development in photographic processes in the nineteenth century were concerned first with finding workable materials that would record an image in a reasonable time. Early in the century, exposures lasted 8 hours. Before the end of the century, birds' wings and horses' hooves could be frozen in mid-action.

The impermanence of their work plagued early experimenters. In 1800, Wedgwood and Davy could not prevent their photograms from turning black in light, and the salt used by Talbot and Daguerre in the 1830s was of limited effectiveness. The "hyposulfite of soda" method for making silver halide images permanent was discovered by Sir John Herschel in 1819 and shared generally in 1839. Washing of film and paper were reasonably well understood by the turn of the century.

For daguerreotypists and ferrotypists, the lack of a sufficiently clear base on which to coat emulsions was of little concern; their work couldn't be duplicated anyway. For those who employed negative-positive processes to get

multiple prints from individual negatives, paper negatives lacked sufficient translucency for successful printing, even if the paper was waxed. Glass was the next solution, and it was an admirable one except for its weight, fragility, and rigidity. By the end of the century, celluloid roll films could be loaded in daylight.

Early in the century, photographic emulsions had no shelf life at all; they were exposed wet shortly after sensitization, and their effective speed varied with a multitude of factors. Dry plates, sheet film, and roll film were manufactured to standardized sensitometric standards by century's end.

Blue skies and red clothing rendered respectively as white and black were artifacts of silver halide emulsions that were most sensitive at the blue-violet end of the spectrum and saw nothing of the red end. Vogel's discovery of dye-sensitization in 1873 laid the groundwork for orthochromatic and then panchromatic light-sensitive materials, as well as the attainment of the great goal—workable color photographic systems.

In sum, one might argue that the thrust of photography in the nineteenth century was democratization. It started in the labs of scientists, inventors, and tinkerers, and was sold prepackaged on street corners by the end of the century. The huge—and growing—market for photographic materials provided the profits to fuel the research projects of the twentieth century that gave us faster and more universal processing, dramatically increased film speed, reduced grain size, provided more accurate and more saturated color, increased convenience in packaging and one-step materials, and a vast range of specialized products for medical, scientific, business, industrial, and military applications.

At the close of the twentieth century, the two principal thrusts in photographic processes are, first, reduced toxicity of the chemicals used in processing and reduced discharge of all contaminants that are produced by photographic processes, and second, a steady movement toward electronics and microprocessors in the management of photographic imaging and processing equipment, and in the acquisition, storage, and manipulation of the images themselves.

Despite the extraordinary quality of current photochemical imaging systems, their continued success depends upon the development of processes that work successfully within the confines of environmental protection. Digital imaging needs to solve storage, cost, and resolution problems, but the market is in place. The rate of transition from photochemical to digital imaging is what remains to be determined.

PHOTOGRAPHIC PROCESSES: OUTLINE HISTORY

1727	J. H. Schulze, sensitivity to light of silver nitrate with chalk
1772	J. Priestley, *History and Present State of Discoveries Relating to Vision, Light and Colours*
1777	C. W. Scheele, silver reduced by light from silver chloride; silver chloride more sensitive to some colors of light (violet, blue) than others; ammonia destroys light sensitivity of silver chloride
1800	Sir W. Herschel, discovery of infrared
1800	T. Wedgwood and H. Davy, unfixed silver nitrate and silver chloride photograms
1819	Sir J. F. W. Herschel, discovery of thiosulfates and the solution of silver halides by "hypo"
1826	J. N. Niépce, Heliography, exposed areas of bitumen of asphalt became insoluble in lavender oil, a photopolymerization process
1835	W. H. F. Talbot, photogenic drawing, printing-out negative and paper sensitized with salt and silver nitrate
1839	L. J. M. Daguerre, daguerreotype process published
1839	H. Bayard, direct-positive paper process
1840	W. H. F. Talbot, calotype, developed-out negative, printed-out positive
1840	N. de St. Victor and R. Hunt, thermography

1842	Sir J. F. W. Herschel, cyanotype, ferroprussiate paper
1844	R. Hunt, ferrous oxalate process, ferrous sulfate development
1847	N. de St. Victor, albumen glass plates
1850	L. D. Blanquart-Evrard, albumen paper
1851	G. Le Gray, waxed-paper process
1851	F. S. Archer, collodion binder, wet-collodion process
1851	Regnault and Liebig, independently, pyrogallol developer
1852	W. H. F. Talbot, photoglyphic engraving
1853	A. A. Martin, tintype, ferrotype, melainotype
1854	J. A. Cutting, ambrotype
1855	J. C. Maxwell, isolation of primary colors
1855	Poitevin, carbon-potassium bichromate print process (later Pouncy, Swan, Du Hauron)
1858	H. Anthony, ammonia-fumed albumen paper
1860	Collodion dry plate
1862	L. Ducos du Hauron, beam splitter camera for color images
1865	Woodburytype photomechanical printing process
1868	Photolithography/collotype
1868	L. Ducos du Hauron, *Les Couleurs en Photographie*
1871	Liverpool Dry Plate Co., gelatin coated silver bromide printing paper
1873	H. W. Vogel, dye-sensitized orthochromatic collodion plates
1873	W. Willis, platinotype
1878	Gelatin silver bromide glass dry plate
1879	Photogravure
1880	W. de W. Abney, hydroquinone developer
1880	J. Eder and Toth, pyrocatechin developer
1882	H. B. Berkeley, use of sodium sulfite as a preservative for organic developing agents
1881	Halftone screen
1883	J. Eder, developing-out chlorobromide paper
1884	Eastman, roll film system and machine coated printing paper
1884	Vogel-Obernetter, orthochromatic dry plate
1886	W. de W. Abney and P. E. Liesegang, aristotype gelatin silver chloride paper
1887	H. Goodwin, patent application for celluloid roll film
1887	G. Pizzighelli, platinum printing-out process
1888	Emulsion stripping paper roll film
1888	J. Carbutt, emulsion coated on celluloid sheets
1888	Developing-out paper, gelatin silver bromide
1888	Kodak camera, "You press the button—We do the rest."
1888	F. Hurter and V. C. Driffield, actinograph
1888	M. Andresen, *p*-phenylenediamine developer
1889	H. Shawcross, Vandyke brown print process
1889	Eastman nitrocellulose roll film base
1890	Printing-out paper, gelatin silver chloride
1890	F. Hurter and V. C. Driffield, *Photographic Researches*
1890	Gelatin silver chloride gas light paper
1890	Platinum chloride paper
1891	L. Ducos du Hauron, Anaglyphs, 3-D photographs using red-green discrimination for separation
1891	M. Andresen, use of para-aminophenol, Rodinal, as developer
1891	A. Bogisch, metol developer
1891	F. Ives, Kromskop "one-shot" three-color separation camera
1891	S. N. Turner, Kodak daylight loading film rolls
1891	G. Lippmann, wavelength interference color system
1893	Baekeland, Velox silver chloride ammonia gaslight paper
1894	J. Joly, line screen additive color images
1895	R. E. J. Liesegang, silver bleached away, dye image remains

1895	W. C. Roentgen, discovery of x-rays and radiography	1976	Kodak Instant Print film
1896	R. E. J. Liesegang, lenticular screen color process	1978	Polavision Self-Processing diffusion-transfer 8-mm additive (screen) movie film
1899	T. Manly, ozotype carbon	1979	Ilford Galerie paper
1901	A. Eichengrun, cellulose acetate film base	1979	Cibachrome "A" Pearl surface resin coated paper
1902	H. Luppo-Cramer, metol-hydroquinone developer	1979	Olympus OM-2 Camera, which reads subject illumination on the film and controls exposure at the time it is made
1902	Kodak gelatin anti-curl backing for film		
1903	Agfa, panchromatic film		
1905	K. Schinzel, dye destruction		
1906	Finlaycolor additive screen plate	1981	Ilford XP-400 black-and-white film makes use of color technology and can be processed in proprietary XP1 chemistry or C-41
1906	F. C. L. Wratten and Wainwright, commercial panchromatic plates		
1907	Lumière Brothers. Autochrome plate (1904 patents)	1981	Kodak Ektachrome 160 movie film introduced in 8-mm and 16-mm formats, requires new EM-26 process
1907	B. Homolka, leuco dye color development		
1907	C. W. Piper and E. J. Wall, bromoil process		
1908	Dufay, poured color	1981	3M high-speed artificial-light tungsten color film having an ASA rating of 640
1912	R. Fischer and H. Siegrist, color couplers for dye formation		
1914	A. Keller-Dorian, lenticular cinematographic system	1981	Kodak Ektaflex PCT one-solution color print making system for both color negatives and transparencies
1915	Technicolor dye imbibition motion picture film		
1915	Kodachrome, subtractive 2-color process, black-and-white separation negatives.	1981	Improved Cibachrome A-II material utilizing a P-30 chemistry makes home processing easier
1916	Agfacolor dyed vanish screen plate film	1982	Kodak Disc-Film camera, film, and processing system
1919	Autotype Co., carbro print process	1982	Sony Mavigraphy, a new electronic photographic system
1920	H. Luppo-Cramer, desensitization		
1921	Pako automated processing machine	1983	A revolutionary T-grain emulsion system makes it possible to introduce a new Kodak 1000-speed color film
1921	A. Bocage, x-ray tomographs of living subjects		
1923	J. G. Capstaff, Cine-Kodak reversal process motion picture film	1983	Polaroid Autoprocess 35-mm Transparency system consisting of one color and two black-and-white films, along with a compact low-contrast manual processor, slide mounter, and mounts
1925	Dye imbibition		
1928	Kodacolor lenticular color motion picture film		
1929	K. Jacobsohn, hypersensitization with ammonia and ammoniacal silver chloride	1983	Polaroid Polaprinter capable of making instant full-color prints in about one minute
1930	Three-color carbro print process	1982	Technidol developer for use with Kodak Technical Pan 2415 film
1932	Agfa lenticulated film		
1933	B. Gaspar, Gasparcolor dye bleach motion picture film	1984	Kodak Camcorder (camera-recorder) 8-mm cassette video system
1935	L. Mannes and L. Godowsky, Kodachrome 16-mm movie film, three-color subtractive reversal film, color couplers added to developers (1936—35 mm, 1938—sheets)	1984	Vivitar Autofocus 200 AF lens, which works by comparing the images formed by light passing through the lens, measuring displacement of different clusters of light
1935	Gasparcolor opaque dye-bleach printing material	1984	Kodak Elite Fine-Art Paper, a premium black-and-white enlarging paper
1936	Agfacolor Neu, tripack coupler incorporated		
1938	N. F. Mott and R. W. Gurney, theory of the latent image	1986	Video cameras (camcorders) by RCA, GE, Chinon, and others
1938	C. Carlson and O. Kornei, dry powder pigment image-transfer copy system	1987	Kodak T-Max developer for use with T-Max (T-grain) and other black-and-white films
1939	A. Rott and E. Weyde, diffusion-transfer copying systems	1989	Kodak Ektapress 1600 color negative film capable of exposure indexes up to 3200 with normal processing, and 6400 with modified processing
1939	Agfacolor negative-positive color printing process		
1940	Ilford multigrade variable contrast paper	1991	Kodak Photo CD
1941	Kodacolor dispersed-coupler color negative film		
1942	Ilford, phenidone developing agent		
1943	Kodacolor Aero dispersed-coupler color reversal film		
1946	Ektachrome reversal sheet film, user processed		
1946	Kodak Dye Transfer print process		
1947	D. Gabor, theory of holography		
1948	E. H. Land, Polaroid black-and-white peel-apart diffusion-transfer material		
1948	Kodak cellulose triacetate safety film, nonnitrate base		
1948	W. T. Hanson, Kodak integral mask color negative film		
1950	Eastman color negative and print motion picture films		
1950	DuPont polyethylene terephthalate (PET) film support		
1955	Kodak Type C Ektacolor paper		
1955	Kodak Type R Ektachrome paper		
1963	Polacolor peel-apart color diffusion transfer		
1972	Polaroid SX-70 integral diffusion transfer color material		

H. Wallach

See also: *Carbro process; Diffusion transfer; Dye transfer; History; Advances in photographic technology; Lenticular color photography; Nonsilver processes; Polaroid photography; Screen color processes; Silver-dye-bleach process.*

PHOTOGRAPHIC RESEARCH Scientific research can be defined as the investigation or experimentation aimed at the discovery and interpretation of new facts, or the understanding of existing facts. The scientific process can be carried out in five basic steps—identify the problem, formulate a hypothesis, collect and analyze data, formulate a conclusion, and verify, reject, or modify the hypothesis. The process can be divided into a theoretical part—hypothesis building and prediction—and an experimental part—collecting and analyzing data. In recent years a third part, computer simulation, has become important because both theory and experiment have become too complex to compare easily. Photographic research is just a special case of scientific research and, thus, bears all these attributes.

Photographic research has been primarily carried out in industry. Because of its special requirements, it is a costly and difficult activity to carry out in an academic environment. For example, high-quality emulsion coatings for research require reasonably sophisticated coating machines that are beyond the financial capabilities of most academic researchers. Academic studies have been primarily focused at small pieces of the overall system and use model settings to help elucidate the underlying principles. Research designed to relate more to the application of silver halide materials has been carried out in industrial environments where the generation of the required materials is most easily done.

EXPERIMENTAL TECHNIQUES Photographic research involves a wide variety of experimental techniques. Emulsion preparation involves crystal-growing techniques to achieve desired crystal morphology and composition. Recent years have seen the incorporation of process-control methodology to achieve uniformity and reproducibility. Characterizing the emulsion grains involves measurement of the distributions of grain volume and area, observation of crystal morphology by either optical or electron microscopy, bulk compositional analysis using neutron activation analysis or x-ray diffraction, localized compositional analysis by analytical electron microscopy, and surface analysis by ion-scattering spectrometry or secondary ion mass spectrometry. Characterizing the products of chemical sensitization, on the other hand, is extremely difficult because of their minute size. Thus, this part of the photographic process is one of the least understood.

Spectral sensitization studies require a supply of organic dyes. This involves highly specialized organic synthesis techniques and clever purification schemes. The mechanisms are elucidated by combinations of photographic techniques, spectroscopy, and electrochemistry. The latter is used to determine energy levels of dyes adsorbed to the silver halide grain, and spectroscopy is used to measure electron-transfer rates. Photographic techniques include measuring the effect of the sensitizing dye on speed and reciprocity failure and rates of development. Developing agents are studied by classical chemical and electrochemical techniques. Development is studied by analyzing the rates of silver formation and the morphology of the developed silver. Because of its small size, the initial detection of the latent image can only be inferred by extrapolation of studies of larger silver centers. Thus, the details concerning this part of the process remain obscure.

THEORETICAL TECHNIQUES The theory of the photographic process encompasses the whole range from exposure to development, but it can be divided into the four components—light absorption, image formation, image detection, and image amplification. There is no single theory encompassing all of these. In light absorption studies, an attempt is made to understand how light is distributed and absorbed in a photographic layer. A common way to treat the problem is to use Monte Carlo computer techniques to trace the path of individual photons through a photographic layer. The Monte Carlo technique merely assumes that events occur in a probabilistic way and by following a large number of events a researcher obtains information about the statistics of light absorption, scattering, and reflection.

There are many diverse theories concerning latent-image formation. They all seek to explain photographic phenomena. Because of the complexity of both theories and experimental results, it is usually difficult to compare them quantitatively. Researchers must resort to building a computer model based on the theory that will predict or simulate the photographic experiment. In this way consistency is established between theory and experiment. Because the number of possible comparisons with experiment can be extremely large, theories can only be disproved. As long as

consistency is maintained, the theory can be considered a plausible explanation of the real world. Only one theory has been extensively tested in this way and that is the nucleation-and-growth model. Its consistency with experimental results has been repeatedly shown. Lacking similar testing for other theories, we cannot make comparative evaluations of consistency with the photographic process.

Theories concerning development focus on the electron-transfer step and how it is influenced by various factors, such as developer potential, developer composition, pH, and temperature. One of the most successful theories is the electrochemical theory in which the small silver nuclei are treated as electrodes. Another theory called the adsorption catalysis theory views the developer molecule and silver ion as forming a complex. Adsorption of the complex on the silver nuclei lowers the energy barrier for electron transfer from the developer to the silver ion. Computer models based on the electrochemical theory can explain the major features of the development process. *R. Hailstone*

PHOTOGRAPHIC SCIENCE The application of physics, optics, chemistry, statistics, and mathematics to the study of image formation by the interaction of radiant energy and matter. *L. Stroebel*

See also: *Imaging science; Photographic research; Photographic theory.*

PHOTOGRAPHIC SOUND A system of recording and reproducing sound on motion-picture film in which the optical (photographic) sound track is scanned by a beam of light that modulates a photoelectric cell. The sound record may take the form of variations in density or width of a photographic image. *H. Lester*

Syn.: *Optical sound.*

See also: *Optical head; Sound, sound recording.*

PHOTOGRAPHIC THEORY The theory of the photographic process attempts to explain how images are recorded in silver halide materials. Since the latent image is composed of several silver atoms forming a cluster big enough to cause development in a photographic developer, we must somehow explain how silver cations and free electrons combine to yield this developable silver cluster. The silver cations are available as part of the crystal lattice and the free electrons are made available through the light-absorption process. Models of latent-image formation try to explain how these two species come together to form the latent image.

Silver halides belong to a class of materials known as *insulators* because all their electrons are attached to individual ions in the crystal lattice. In metals, on the other hand, some electrons are free to move around the crystal and conduct electricity. This difference in electrical properties is due to their different electronic-band structure. In analogy with individual atoms, the electrons in crystals are constrained to certain energies. But unlike atoms where distinct energy levels exist, the electrons in crystals reside in energy bands. The two important bands in a crystal are the *valence* band and the *conduction* band. The energy region between these two bands is called the *bandgap,* and electrons are forbidden to have energies in this region. The valence band is the highest energy band that is filled with electrons. The next highest energy band is the conduction band, which is partially filled with electrons in the case of a metal but is empty in the case of an insulator. Thus, the different occupancy of the conduction band determines whether a crystal will be an insulator or conductor. It is convenient to depict only the top of the valence band and the bottom of the conduction band in energy-band schemes as these are the important energies. We will adopt this convention in the remainder of this article.

Because only electrons in the conduction band are free to

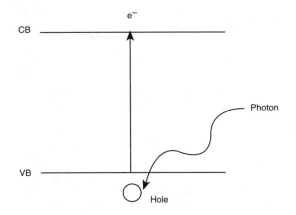

Schematic of the light-absorption event. The energy of the photon is given off to a valence band electron so that it may jump to the conduction band. It leaves behind a "hole."

move around the crystal and combine with silver cations to form a latent image, the electrons must somehow acquire enough energy to move from the valence band (VB) to the conduction band (CB). This additional energy is supplied to the crystal by absorption of *photons*. Photons are quantized particles of light and they have a characteristic energy determined by their wavelength. We can divide the visible part of the electromagnetic spectrum into three regions—blue, green, and red. The wavelength decreases in going from red to green to blue, and the photon energy therefore increases in going from red to green to blue. The photon must have enough energy to raise an electron from the valence band to the conduction band. In silver halides this energy corresponds to that of a blue photon. Green and red photons lack the necessary energy and they pass through the crystal without being absorbed. Thus, silver halides can record images only in the blue region of the spectrum. In order to record images in the green and red region it is necessary to use spectral sensitizing dyes that we will discuss later.

The promotion of the electron to the conduction band leaves behind a vacant position in the valence band. This vacant position is called a *hole*. When other electrons move in the valence band so as to occupy this vacant position,

they leave behind a vacant position. Thus the hole appears to move in the valence band just as the electron moves through the conduction band. It is easier to consider this hole as a pseudo particle with a defined mobility rather than consider the motion of the other valence-band electrons. Because the hole is the absence of the negatively charged electron, it has a positive charge. In this way charge is conserved.

Silver halide emulsion crystals contain millions of silver ions. However, most of these silver ions are locked into crystal lattice positions and are not available to move through the crystal to combine with electrons to form silver metal atoms. Fortunately, a small but significant fraction of the silver ions are able to leave their lattice position and migrate through the crystal in the voids or interstices between the lattice ions. These are known as *interstitial silver ions,* and their existence makes latent-image formation possible.

LATENT-IMAGE FORMATION Many models regarding image recording in silver halide materials have been advanced. One of the first was proposed by Gurney and Mott and is often referred to as the Gurney-Mott theory. In order to provide a pathway whereby the electron and interstitial silver ion could combine, they proposed that there were sites at the crystal surface that could localize electrons for a period of time during which the interstitial silver ions could migrate to the site and combine with the electrons to form silver atoms. These proposed sites are known as *traps* for the electron and represent a localized region of the crystal with energies somewhat lower than the bottom of the conduction band. The time that the electron spends in the trap is determined by how much it lowers the electron energy relative to that which it had in the conduction band. This energy lowering is known as the trap depth—deeper traps confer longer residence time on the electrons.

Gurney and Mott proposed that several electrons would be trapped at the site and then several interstitial silver ions would join the electrons to form the latent image. Berg soon realized that this picture represented a problem in efficient formation of the latent image. Each electron carries one unit of negative electrostatic charge so that after capturing the first electron there would be an electrostatic repulsion for capturing the second electron. Berg suggested that it would seem intuitively more efficient if the electrons and interstitial silver ions would take turns arriving at the trapping site. In

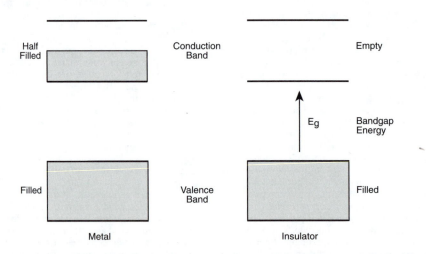

Photographic theory. Energy-band diagram for a metal and an insulator. Crosshatched areas indicate regions occupied by electrons.

this way the trapped electron would provide a negative charge to attract the positively charged interstitial silver ion.

Somewhat later Sietz considered the charge on the trap before the capture of the first electron. Surfaces of ionic crystals are not expected to be smooth atomic planes, but rather contain terraces, steps, and jogs along the steps. Because the ions in the defect regions of the surface lack the full charge compensation by their oppositely charged neighbors that they would have if they resided inside the crystal, they have a net fractional unit charge that could attract an electron or interstitial silver ion of opposite sign. He suggested a partially positively charged defect would capture an electron and yield a partially negatively charged site that would attract an interstitial silver ion to yield a partially positively charged site set to capture another electron. Thus each step in the process is electrostatically driven, providing an intuitively satisfying picture of latent-image formation.

Probably the most extensively tested model is the nucleation-and-growth model proposed by Bayer and Hamilton. In this model latent-image formation is divided into two stages—a nucleation stage and a growth stage. The inefficiencies are different in the two stages. The model incorporates the features introduced by Berg and Sietz into the Gurney-Mott picture. The initial trapping of the electron is considered to be a reversible process as is the formation of silver atoms. This leads to the concept of the three-way cycle. The electron is assumed to spend a certain fraction of its time in the free state, a certain fraction in the trapped state, and a certain fraction in the atom state. Only when latent-image formation reaches the two-atom stage does the process become irreversible.

In the nucleation stage the formation of the two-atom center occurs. An electron is captured at a silver atom site, followed by capture of an interstitial silver ion, Ag_i^+, to form the two-atom center. The electron is first captured in a relatively shallow level provided by the defect site where the silver atom formed. The electron then has two choices—it can either fall into the deeper trap provided by the silver atom or it can reenter the conduction band and continue its excursion through the crystal. To the extent that the latter event occurs,

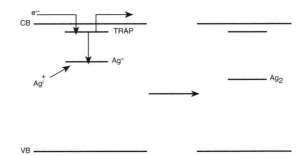

Nucleation. A representation of the nucleation event showing electron capture at the atom site (left), followed by silver ion movement to the site to create a two-atom center (right). Note that electron capture is a two-step process involving first a capture in the shallow level provided by the trap and then a transition to the deeper level of the atom state. The competing event of electron escape from the trap level is also shown.

the efficiency of the nucleation stage is reduced proportionately. The nucleation stage represents the bottleneck in latent-image formation and the efficiency of this stage has a large impact on the overall efficiency of latent-image formation.

Two-atom silver centers will not cause development under most conditions. Therefore additional events are needed to build the center up to a larger size. These are the growth events. An electron is captured by an n-atom silver center, when n is some integer greater than one. Following electron capture, an interstitial silver ion is added to give a silver center one atom larger. The main distinction between this event and that of growth is that the electron is captured with unit efficiency at the n-atom center. This difference in electron capture at a silver atom and at centers possessing two or more silver atoms is due to the electronic properties of these different sites. Thus, the efficiency of the growth events is usually taken as unity, and it is the efficiency of the nucleation event that is of greatest importance. Note that the number of growth events is not specified. The process continues until all electrons have been consumed. The minimum number of growth events to make a crystal developable will be determined by the minimum developable size of the latent image.

In analogy with the electron, the hole can also be trapped, although on our energy band scheme the hole moves upward and is trapped at levels above the valence band. Remembering that the movement of a hole is just the movement in the opposite direction of an electron, we see that the capture of a hole is the movement of an electron from an energy level above the valence band into the valence band itself. Thus, the

Latent-image formation. Three-way cycle for the electron showing free, trapped, and atom states. Arrows indicate the reversible transitions between these states.

Growth. A representation of the growth event showing electron capture at a site where $n > 1$. Electron release from the trap level is not shown because it is considered to be a highly unlikely event when $n > 1$. As a result of a growth event the n value is increased by 1.

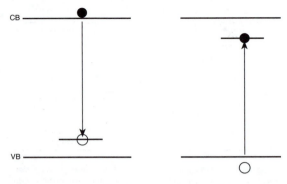

Recombination. A representation of the two possible modes of recombination—free electron/trapped hole (left) and trapped electron/free hole (right).

concept of hole capture is completely consistent with that of electron capture from the conduction band.

Under practical conditions the efficiency of latent-image formation is significantly less than unity. The predominant inefficiency is recombination of the electron and hole. This is an irreversible event and destroys any memory of the photon absorption event that led to the creation of the electron. Recombination of a free electron and a free hole is an unlikely process; it is more likely when one of the particles is localized at a trap. This results in two possibilities—either a free electron recombines with a trapped hole or a free hole recombines with a trapped electron. The trapped species provides a charged site for capture of the oppositely charged free particle. Therefore, just as with the nucleation and growth events, the recombination event is electrostatically driven.

Development Photographic developers contain molecules that can donate electrons to the silver halide grains. The initial stages of photographic development can be viewed as an extension of the growth event with the elec-

trons now being supplied by the developer molecule rather than by light absorption. The latent image introduces a new level within the bandgap that allows electron transfer from these developer molecules. Electron transfer from the developer molecule to the latent image involves a horizontal transfer, i.e., no additional energy is needed. On the other hand, the electron transfer to an unexposed grain must occur through the conduction band, requiring considerable additional energy. Thus, the latent image provides a way for the photographic developer to distinguish between exposed and unexposed grains.

A further refinement would place the different size silver centers at somewhat different positions within the bandgap. The most simple picture places these centers at monotonically decreasing energy levels so that at a certain size the energy level of the silver center matches that of the developer molecule. This is defined as the *minimum developable size* of the latent image. The situation is somewhat more complicated than this simple picture when different developers are compared or the development conditions are modified, but for our purposes the simple picture will suffice.

Efficiency The efficiency of latent-image formation is of great importance. It plays a major role in determining the sensitivity of the coated silver halide material. Ideally, the efficiency should be as high as possible so that sensitivity is maximized. A convenient way to determine this efficiency is by measuring the quantum sensitivity. This is defined as the mean number of absorbed photons per grain to make half the grains developable. Note that a *lower* number for the quantum sensitivity means a *higher* efficiency. If the minimum developable size is known, then a comparison with the quantum sensitivity will indicate how many photons are contributing to latent-image formation and how many are being wasted through loss processes. For example, if the minimum developable size is 5 atoms and the quantum sensitivity is 20 photons, then 5 photons are used to make the latent image and 15 photons are wasted through loss processes. For this particular example only 25% of the absorbed photons are used in image recording.

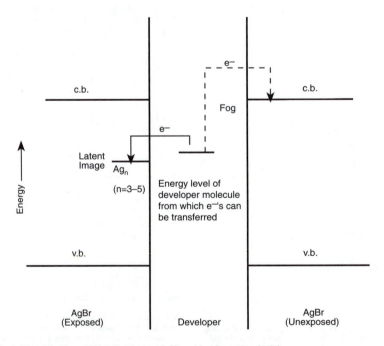

Development. Illustration of the detection of the latent image (left) and fog formation (right).

The nucleation-and-growth model gives a concise way to calculate what the quantum sensitivity should be for certain assumptions. The following equation expresses this in words:

$$\text{Quantum Sensitivity} = \begin{array}{c}\text{Number of}\\\text{atoms to}\\\text{make the}\\\text{latent image}\end{array} + \begin{array}{c}\text{Number of electrons}\\\text{lost to recombination}\\\text{during nucleation}\end{array} + \begin{array}{c}\text{Number of}\\\text{electrons lost to}\\\text{recombination}\\\text{during growth}\end{array}$$

In this equation we have divided the efficiency into three terms. The first term deals with the use of the photons to form the silver atom cluster, i.e., the desired effect. The second and third terms deal with the loss processes, and it is useful to divide the recombination losses between the nucleation and growth steps. As discussed previously, the nucleation stage represents the bottleneck of the process and as the efficiency of this stage is improved the second term gets smaller. The third term is related to the first term in that the larger the minimum size the more growth events are needed and the greater the chance of recombination.

Model Analysis How do we know this model really represents what is happening during image recording in silver halide materials? We try to establish consistency between the predictions of the model and what happens in the real world. The concepts we have been discussing can be reduced to mathematical equations. Under certain conditions the equations can be solved algebraically and the result compared with photographic behavior. More generally, however, it is necessary to resort to computer simulation to get quantitative predictions to compare with experimental results. This has been done and the consistency between the predictions of the nucleation-and-growth (N&G) model and experimental results has been repeatedly shown.

Stability It is desired that the latent image be stable over long periods of time so that images recorded at different periods of time may all be faithfully reproduced upon development. Processes that can interfere with this goal cause latent-image *keeping* problems that photographic manufacturers must constantly strive to overcome. Such processes as thermal dissociation, oxidation, and regression of the latent image can lead to instability of the latent image. These processes can cause a speed loss with delay time between exposure and development, and may also depend on the exposure level causing a decrease in contrast as well.

Thermal dissociation of the latent image produces smaller silver aggregates by the following reaction:

$$Ag_n \rightarrow Ag^+ + e^- + Ag_{n-1}$$

The rate of this process will increase with increasing temperature. Unless the electrons are permanently removed by some process, this reaction will not lead to latent-image *keeping* problems. The electrons will simply return to the original site of the latent image or participate in latent-image formation elsewhere on the emulsion grain. One permanent loss pathway would involve recombination with trapped holes, of which there will be one for every atom of silver formed. Oxidation of the latent image can be represented by the following reaction:

$$4\,Ag + O_2 + 2\,H_2O \rightarrow 4\,Ag^+ + 4\,OH^-$$

Finally, regression of the latent image can occur by the following process:

$$Ag_n + hole \rightarrow Ag_{n-1}$$

This reaction is similar to the thermal dissociation reaction and involves the recombination of a free hole with an electron residing in the latent image. By considering these various reactions it is possible to rationalize why latent-image keeping is poor at high temperatures and humidity and why it is better at low temperatures under a vacuum.

RECIPROCITY LAW FAILURE Exposure can be defined as the product of irradiance and exposure time. If the irradiance and the exposure time are varied reciprocally to the same degree, the value of the exposure remains the same. The reciprocity law is a general law of photochemistry and states that as long as the exposure is kept constant the amount of photoproduct will be the same. As applied to photography, the law says that a constant exposure should produce a constant photographic density. That is, a long-time, low-irradiance exposure should produce the same density as a short-time, high-irradiance exposure. When this fails to happen, we have what is called reciprocity law failure or, more tersely, reciprocity failure. In photography reciprocity failure is more the rule than the exception.

Reciprocity law studies are done by carrying out exposures in which the exposure time and irradiance are varied reciprocally. Upon measuring speed at a certain reference density on the characteristic curve, the results can be plotted on a speed vs. log time plot. A failure at both high and low irradiance are termed low-irradiance reciprocity failure (LIRF) and high-irradiance reciprocity failure (HIRF). All silver halide materials will show LIRF, given a low enough irradiance. The observation of HIRF will depend on development conditions and the type of chemical sensitization.

The principles of the nucleation-and-growth (N&G) model can be used to explain these instances of reciprocity failure. At high irradiances many photons are absorbed within a very short time period. This enhances the probability of nucleation relative to growth because nucleation requires two electrons whereas growth requires one electron. Thus, after the formation of the first two-atom center, there are several electrons left to participate in latent-image formation, and it is just as likely that these electrons will participate in another nucleation event as their participation in the growth of the first two-atom center. This situation leads to more than one stable silver center on the grain and they compete with each other for the formation of a developable center. The occurrence of multiple competing centers on a grain is termed the dispersity inefficiency. A simple definition of the dispersity inefficiency is: *that fraction of grains that is not developable, but that would be developable if the silver atoms they contain could be concentrated into a single center per grain.* The dispersity inefficiency is synonymous with HIRF.

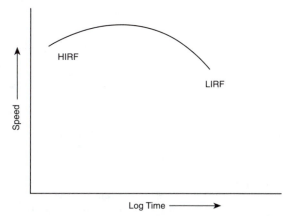

Reciprocity law failure. An example of a reciprocity-failure curve showing regions of high-irradiance reciprocity failure (HIRF) and low-irradiance reciprocity failure (LIRF). If there were no reciprocity failure, the line would be horizontal.

At low irradiances the conduction band electrons are created at widely spaced time intervals. Under these conditions the first electron will most likely recombine with a hole before the second electron becomes available and nucleation becomes possible. At some point two electrons are made available within a short time period by chance and nucleation becomes possible. But many electrons have been wasted prior to this chance event and a lower speed and LIRF result. LIRF becomes progressively greater as the irradiance is lowered because the probability of the chance event of closely spaced electron creations becomes increasingly less likely. Note that the phenomenon of low-irradiance reciprocity failure is due to the instability of the silver atom. If silver atoms were permanently stable there would be no LIRF because the first electron would form a silver atom and would simply wait there until the second electron arrived.

CHEMICAL SENSITIZATION As made, silver halide materials form latent images very inefficiently; electrons are much more likely to undergo recombination than latent-image formation. This is primarily due to the inefficiency of the nucleation stage. The main purpose of chemical sensitization is to improve the efficiency of latent-image formation and thereby increase the sensitivity of the silver halide material. Other desirable secondary effects of chemical sensitization include an altered shape of the characteristic curve, minimization of reciprocity failure, and lowered sensitivity to time of development.

Chemical sensitization can be defined as the reaction of low levels of chemical reagents with a photographic emulsion after precipitation. Elevated temperatures are often required to encourage the reaction to occur within a reasonable time period. Optimization of the level of reagent used is an important part of the chemical sensitization procedure. This is because too much reagent or too long a reaction time can lead to less than the maximum speed gain seen with lower reagent levels or shorter reaction times.

Sulfur Sensitization One of the first types of sensitization was that due to silver sulfide. Early workers found that just heating the photographic emulsion would improve sensitivity considerably. It was later discovered that gelatin contained active sites that contributed sulfur to the emulsion grain. Current practice is to use inert gelatin and add the sensitizing reagent in a controlled and deliberate way. A common reagent for sulfur sensitization is sodium thiosulfate, $Na_2S_2O_3$. One of the sulfur ions in this compound can be removed by heating and leads to the formation of Ag_2S. Actually, there appear to be three steps in the sulfur sensitization: (1) adsorption of the thiosulfate anion to the grain surface; (2) formation of Ag_2S; (3)aggregation of the silver sulfide molecules to form clusters of silver sulfide [for example, $(Ag_2S)_2$ and $(Ag_2S)_3$]. This last step appears to be critical; if it is omitted there is essentially no sensitivity increase.

The sensitometric results of sulfur sensitization are many. It moves the onset of LIRF to longer exposure time, but introduces HIRF. The speed for high-irradiance exposures is very dependent on development time. The optimum speed/fog is obtained at a certain sensitization level. If higher levels or longer sensitization times are used, then a lower speed is obtained. Much of the work in preparing photographic emulsions for imaging applications involves establishing this optimum sensitization.

The N&G model explains the effects of sulfur sensitization by assuming that the sensitizer centers provide deeper traps for electrons than the intrinsic defect traps. These deeper traps improve the efficiency of the nucleation stage by allowing more time for the electron to make the transition to the deeper atom state level. Referring to our quantum sensitivity expression, it is the second term that is decreased by sulfur sensitization and this improves the quantum sensitivity of the emulsion.

Sulfur sensitization moves the onset of LIRF to longer exposure times because it improves the nucleation efficiency and thereby allows nucleation to better compete with recombination. The explanation for the onset of HIRF follows similar reasoning. In the unsensitized emulsion the nucleation efficiency is low, nucleation cannot compete with growth at any irradiance, and only one silver center per grain forms. With their improved nucleation efficiency, the nucleation stage in sulfur-sensitized emulsions is better able to compete with the growth step and multiple silver centers form at high irradiance. The resulting dispersity of these centers causes HIRF. The sensitivity to time of development is a natural consequence of this dispersity. At a given development time, a threshold developable size exists and those clusters smaller than this will not develop. At longer development times small clusters will cause development because there is more time for electron transfer, even through the electron must go uphill energetically.

Sulfur-Plus-Gold Sensitization In 1936 Koslowsky discovered the beneficial effects of gold salts, and this became known to the rest of the world after World War II. By combining sulfur and gold sensitization the highest sensitivities are achieved. The source of the gold is usually obtained from the ion $AuCl_4^-$. Both the sulfur and gold reagents are added to the liquid emulsion before the heat cycle. The gold ions appear to be incorporated into the sensitizer center. In addition, because the latent image in sulfur-plus-gold sensitized emulsions is more stable, it is generally believed that the latent image is partly composed of gold metal atoms. This would be consistent with the fact that gold is a more noble metal than silver, that is, it is more difficult to oxidize.

The sensitometric effects of sulfur-plus-gold sensitization are similar to those for sulfur sensitization in two very important ways. There is often little or no HIRF and there is much less sensitivity to time of development at high irradiances. These sensitometric effects are explained by the N&G model by assuming that sulfur-plus-gold sensitization improves the nucleation efficiency over that of sulfur alone. The physical basis for this assumption remains obscure; there appears to be no further trap deepening than that induced by sulfur alone. One speculation is that the atom state in the case of sulfur-plus-gold sensitization is a gold atom and that this produces the change in the nucleation efficiency. This causes a further decrease in the second term of our quantum sensitivity expression over that with sulfur alone. However, this hypothesis can only account for part of the increased sensitivity. A further requirement is that the minimum developable size is decreased to about three atoms. This will decrease the first and third terms in our quantum sensitivity expression and lead to an even higher quantum sensitivity.

The assumption of a minimum developable size of three atoms also accounts for the lack of HIRF in sulfur-plus-gold sensitized emulsions. The degree of dispersity at high irradiances depends strongly on the minimum developable size because the number of possible configurations of the silver atoms into clusters increases with the minimum size. For the case of a three-atom size the number of possible configurations is low and HIRF is negligible. This also explains why the sensitivity to time of development is low—only the two-atom clusters can be detected by extended development.

Given this conclusion we must now explain how incorporating gold into the sensitization reduces the minimum developable size. As mentioned, gold is a more noble metal than silver, i.e., it is more difficult to oxidize. This would cause a three-atom cluster composed partly of gold atoms to lie lower on our energy band scheme than a similar sized cluster composed of only silver atoms. Thus, for a given developer

energy level a smaller minimum developable size should be the case for the sulfur-plus-gold sensitized emulsion.

Reduction Sensitization Reduction sensitization was discovered in 1951 by Lowe, J. Jones, and Roberts. As the name implies, this type of sensitization involves the formation of small silver clusters on the grain surface by the action of chemical reducing agents, such as $SnCl_2$, at an elevated temperature. These clusters are too small to cause development of the grain. Reduction sensitization finds its use in direct positive materials.

Reduction sensitization produces a speed increase comparable to sulfur sensitization. It decreases LIRF, but does not cause HIRF. Speed usually increases monotonically with increasing sensitizer level, the optimum level being determined by fog considerations. In order to explain these effects it is necessary to conclude the reduction sensitization operates by a fundamentally different mechanism than sulfur or sulfur-plus-gold sensitization. There is good evidence that the sensitizing centers created by reduction sensitization capture holes and are destroyed. In this way recombination is reduced and both the second and third terms of quantum sensitivity expression are reduced. The LIRF is likewise decreased by lower recombination. Reduction sensitization does not cause HIRF because the nucleation efficiency is unaffected.

Silver nuclei created by reduction sensitization are given an entirely different role than in the case of latent-image nuclei. This leads to an apparent paradox. Why don't the nuclei created by reduction sensitization act as latent-image precursors? The explanation lies in their location on the grain surface. Latent-image nuclei are thought to form at sites of positive charge where they can be electron traps, whereas reduction sensitization causes the silver nuclei to be located at sites of negative or neutral charge where they would be hole traps, or at least not good electron traps. Thus, the charge determines the ability of the nuclei to be electron or hole traps.

It is interesting to now think about the ultimate efficiency of silver halide materials. If reduction sensitization could remove all holes before any recombination could occur, then latent images would form with unit efficiency and the quantum sensitivity would be determined by the minimum developable size. Such results have been achieved in laboratory settings, but practical limitations have so far prevented its commercial use.

SPECTRAL SENSITIZATION Spectral sensitization involves the addition of colored organic dyes to the silver halide emulsion, making the grains sensitive to wavelengths of light they do not normally absorb, that is, in the green and red regions of the spectrum. The process was discovered by Vogel in 1873. In this way silver halide materials can give appropriate monochromatic tone reproduction with black-and-white films and faithful color reproduction with color films. The dye must be adsorbed to the surface of the grain in order to function. Spectral sensitization makes it possible for the subtractive color-recording system to work because separate emulsion layers can be selectively sensitized to the different regions of the visible spectrum.

Cyanine dyes are the dyes of choice in spectral sensitization. These dyes (1) absorb light very strongly, (2) adsorb well to the silver halide surface, (3) are very efficient in transmitting the energy from the light they absorb to the silver halide grain, and (4) the wavelength of light absorption can be tuned by changes in chain length or ring substitution.

Mechanisms of spectral sensitization must explain how light of energy less than the silver halide bandgap is able to accomplish what bandgap illumination does. For some time there was consideration given to the idea that the dye could somehow transmit the energy of the photon it absorbs to some acceptor center in or on the silver halide grain. This idea has been convincingly discredited and most photographic scientists believe the dye transfers an electron to the silver halide conduction band whereupon it proceeds to form a latent image just as if it were put into the conduction band by a photon absorbed by the grain.

The energy band picture indicates that sensitizing dyes have ground and excited state levels. The excited state is created by absorbing a photon and using its energy to move an electron from the ground to the excited state. The photon energy must match the energy difference between the ground and the excited states. Photons of higher and lower energies will not be absorbed. Once in the excited state the electron has two choices: (1) it dissipates its excess energy to the surrounding medium or as a photon, i.e., as fluorescence; or (2) it jumps to the conduction band of the silver halide. The latter process is favored if the excited-state energy level is at or above that of the conduction band. Thus, a great deal of research has gone into understanding how dye structure affects the position of the excited-state energy level of the adsorbed dye.

Dyes also have the ability to influence the processes within or on the silver halide grain. The dye ground state can act as a trap for holes from the valence band of the grain. These dye-trapped holes act as recombination centers and remove electrons from the conduction band. A further problem appears at high dye coverages because the dyes can act to shuttle the dye holes around the surface. During this excursion they may encounter latent-image centers and take part in a bleaching reaction of these centers. Some dyes can also trap electrons from the conduction band and these can recombine with holes in the valence band. These processes are collectively known as dye desensitization, and photographic scientists search for ways to minimize them.

OTHER MODELS

Phase Formation Model Both Moisar and Malinowski have proposed models that take a more macroscopic view of latent-image formation. In these models the formation of silver clusters is considered to be a formation of a new phase. The formation of this new phase is driven by a supersaturation of electrons and holes upon exposure. The electrons lead to the formation of silver clusters of varying size. There is a critical size below which the clusters are unstable; these decay under the attack of holes.

The critical size for suitability is a function of the supersaturation conditions, which will in turn depend upon the exposure irradiance, because this will determine the concentration of electrons available at any instant of time. Thus, smaller clusters are able to grow at high irradiances, whereas they will decay at low irradiances. Chemical sensitization centers, such as Ag_2S, have a twofold function. They reduce the barrier to formation of centers having sizes larger than the critical size. They also trap holes, giving those clusters that are smaller than the critical size a chance to grow.

Mitchell Model By virtue of the high degree of covalent bonding in silver halides, Mitchell asserts that the intrinsic defects are too shallow to act as a trap for electrons. He proposes that silver atoms form by the simultaneous trapping of the electron and an interstitial silver ion at the trap. The silver atom is thermally unstable and cannot trap an electron, according to its classical electron affinity. The two-atom silver center forms by the same mechanism as the single-atom center and again cannot trap electrons using electron affinity data. The three-atom center forms also by the simultaneous trapping of an electron and an interstitial silver ion. Again, this center cannot trap an electron, but it is of sufficient size to extract a Ag^+ from the lattice to form a Ag_4^+. This center is now stable and by virtue of its positive charge is a good trap for electrons. Mitchell calls it a "concentration speck."

The formation of the latent image now proceeds by the alternate addition of the electron and an interstitial silver ion,

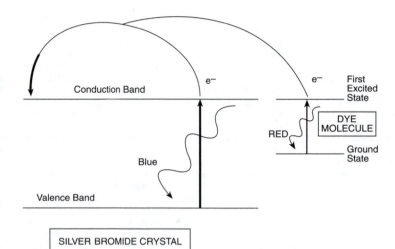

Spectral sensitization. A representative cyanine dye structure. The region of alternating single and double bonds in the center of the molecule is known as the chromophore. The length of this unit and any substituents on it play a strong role in determining the wavelength at which the molecule absorbs light.

Spectral sensitization. A comparison of light absorption by the silver bromide crystal and an adsorbed dye indicating how the dye allows the recording of images at longer wavelengths than that of blue light.

but the ionic event precedes the electronic event. The Ag_4^+ center looses a Ag^+ when in contact with the aqueous developer and cannot accept an electron from the developer molecule because its energy level lies too high on the energy band scheme. The Ag_5^+ center, however, does not loose a silver ion. It is the concentration speck of minimum developable size. The concentration speck is considered to have a very long-range effect on the electron and provides a deep trap. Its formation is the critical step in making a grain developable and is analogous to the nucleation step in the N&G model.

The inefficiency in the Mitchell model is the attack of holes on the Ag, Ag_2 Ag_3 centers. That is, the bleaching reaction discussed earlier in connection with spectral sensitization. Recombination between electrons and holes is deemed unimportant. The positive charge on the concentration specks repels holes and prevents this regression.

Sulfur sensitization produces monolayer islands of Ag_2S around which are adsorbed Ag_2 molecules which are produced by the natural reducing properties of gelatin under the usual sensitization conditions. The adsorbed Ag_2 have no net charge but can, nevertheless, trap holes. If for some reason the Ag_2 molecules do not exist, then the Ag_2S islands trap holes. The electron and interstitial silver ion move together to a trapping site, which could be an Ag_2 molecule at the edge of the sulfide island. The result would be an Ag_3 center, which would convert to an Ag_4^+ by extracting a silver ion from the lattice. The sensitization center and associated Ag_2 molecules provide a shorter and more efficient pathway to the concentration speck.

Books: Carroll, B. H., Higgins, G. C., and James, T. H., *Introduction to Photographic Theory.* New York: John Wiley, 1980; James, T. H., *The Theory of the Photographic Process,* 4th ed. New York: Macmillan, 1977; Sturge, J., (ed.), *Neblette's Handbook of Photography and Reprography,* 7th ed. New York: Van Nostrand Reinhold, 1977; Sturge, J., Walworth, V., and Shepp, A., (eds.), *Imaging Processes and Materials,* 8th ed. New York: Van Nostrand Reinhold, 1990. *R. Hailstone*

See also: *Development theory.*

PHOTOGRAPHY The age of the word *photography* is a good deal more certain than the age of the idea it represents. It has long been known that Sir John Herschel and the German astronomer Johann von Maeder used it in their mutual correspondence early in 1839, and Herschel used it in a letter to W. H. Fox Talbot dated February 28, 1839. Documentation that Hercules Florence had used the word *photography* in Brazil in 1833 was not discovered until 1973. The word *photography* was derived from the Greek roots meaning to write with light, and it immediately replaced Niépce's word, *heliography* (sun writing), and Talbot's phrase, *photogenic drawing.*

For 150 years, there was little question that the word *photography* referred to a variety of photochemical systems in which the agency of light alters sensitized materials in a camera. The materials are chemically treated to produce a visible image. Without a camera, these processes would produce photograms (which we do not alternatively call photographs) of the sort made by Talbot in the 1830s or Man Ray in the 1920s.

If the idea of photography is inextricably bound to the camera, then the idea can be traced back at least to the painters of the Italian Renaissance, who used lenses to project images in correct perspective on their canvases in darkened chambers. The images were made permanent in paint. If the idea of photography is fundamentally photochemical, then it is at least as old as the efforts of Wedgwood and Davy in about 1800 to record leaves and insect wings on paper, glass, and leather.

What, then, can we say about the systems of producing photographs that wed photochemical and electronic or digital processes, or that are purely digital? In all cases, light-sensitive receptors in electronic still video or digital cameras switch or produce currents that are electronically or digitally processed and stored. The pictures can be made visible by conversion from digital to analog for viewing on a monitor, or imaging to output devices such as a film recorder, a laser printer, or a thermal printer. The criteria of light-sensitive materials exposed in a camera, processed to produce a vis-

ible image are still met. These *imaging systems* are clearly, then, still doing photography and are properly referred to as photographic systems.

On the other hand, the lesson of modern lexicography is that usage determines meaning. It is pointless to try to legislate the continued use of the word *photography* if it is generally concluded that digital imaging systems are so radically different that they require a new name. For the foreseeable future, the word *photography* will appear both by itself and in hyphenated agglomerations and the hyperbolic phrases of advertising executives wishing to convince the world that what they offer is new, new, new, even as it follows the form and function of the tried and true. *H. Wallach*

PHOTOGRAVURE See *Gravure*.

PHOTOINSTRUMENTATION Photoinstrumentation is a field of photographic specialization that developed out of the military weapons and ballistic test ranges during the late 1940s and 1950s. The term was closely linked to the establishment of a technical group called the Society of Photographic Instru-mentation Engineers, or SPIE, that developed around the activities associated with these ranges. This society thrives today, and while it kept its initials, it is now known as the International Society for Optical Engineering.

Eventually the subject matter that concerned this society, and indeed photoinstrumentation in general, expanded and eventually evolved to include a wide range of sophisticated applications of photographic- and electronics-based imaging techniques.

The field now encompasses any application of image-making instrumentation that is used to visualize events that are generally invisible to the naked eye or to standard cameras or photosensitive materials, the design and use of specialized photographic or electronic image-making devices, the making of records whose primary purpose is to serve as the basis on which measurements of an event under study are made, the use of cameras and image-recording materials in hostile environments, or any combination or extension of these factors.

Individuals who are able to operate successfully as photoinstrumentation engineers or technologists must posses a high degree of skill and knowledge obtained through on-the-job experiences and university-level education.
 A. Davidhazy

PHOTOINTERPRETATION The process by which information or intelligence is derived from a photographic image. It is usually associated with aerial photography and remote sensing. Photographs serve as a permanent record in a readily interpretable form that can be stored for future comparison. Accurate information can be extracted for use in a variety of disciplines that include military reconnaissance, botany, hydrology, ecology, geology, urban and city planning, coastal zone management, and archaeology.

In the collection of data for object recognition, trained photointerpreters use subjective judgment with deductive reasoning in evaluating elements of an image. Primary factors that are used in object recognition include photographic tones and colors, patterns, shadows, textures, areas, and shapes. Photointerpreters benefit by using interpretation keys to assist in the recognition of features.

A number of influencing factors can enhance the process of photointerpretation. Knowing the focal length of the lens and the altitude allows a photointerpreter to calculate the scale of reproduction. In aerial photography, sun angle, scale, and season affect the photointerpretation process. Vertical aerial photographs are taken with a camera pointed straight down at the earth's surface, which produces a nearly uniform scale over the entire picture area. Oblique aerial

photographs shows special features at particular altitudes, or can be used as supplements to vertical aerial photographs. Aerial stereo pairs should overlap at lest 60 percent in the flight path and 30 percent on the side for best results. The resulting aerial photographs can be viewed as a three-dimensional image using an optical device known as a stereoscope. To avoid an illusion of depth reversal, these stereo pairs should be oriented so that the shadows fall toward the observer. The stereo pairs can be used to produce topographic measurements in the map-making process.

Photographic film has been the traditional image-recording medium for subjective photointerpretation. There are two basic types of film—black-and-white (panchromatic and infrared) and color (normal color and color infrared). Film characteristics can influence the ability of photointerpreters in distinguishing elements that lead to object recognition. The spectral sensitivity of a film describes its photographic response to radiation of various wavelengths. False-color films (color infrared film) can be used to emphasize differences between objects that are visually quite similar. The ability to produce photographs that have good definition is one of the most important properties of a film emulsion. Resolving power refers to the ability of an emulsion to record fine detail distinguishably. Experience also plays an important role in accurately interpreting photographic images.

There are other sensing devices that can be used to capture nonvisible portions of the spectrum. Thermal infrared sensors are used to image emissivity differences, converting signals on a recorder or display device for interpretation. Radar imagery is used for comparative measure of reflection and is generally converted to a hard copy for photointerpretation.

The introduction of automatic image interpretation is made possible with the aid of computers and software specifically designed to assist in object recognition. These systems increase a photointerpreter's capabilities. The element of subjective evaluation is greatly reduced. *L. LaFeir*

See also: *Aerial photography; Astrophotography; Geological photography; Military photography; Photogrammetry; Photometrology; Remote sensing; Space photography; Surveillance photography.*

PHOTOJOURNALISM The word *photojournalism* was coined in 1924 by Frank Luther Mott, dean of the University of Missouri School of Journalism. He used it to designate a newly established photography sequence that emphasized photographic reportage. The combined words connote the integration of words and pictures to communicate effectively. Thus, photojournalists need more than just camera skills. They should have the talents of a reporter as well as the special skills of a visual communicator. This is the distinction between photojournalism and the labels *press photography* and *news photography*. Photojournalism is the visual reporting of news for publication in newspapers and magazines.

Few photographs taken for publication are so self-explanatory that they don't need words to accompany them. Of the basic five W's of journalism, a photograph may only partially answer *who, where, when*. It is even more ambiguous in answering *what* and *why*. The point is that in journalism a photograph needs words as an equal partner to confirm or correct viewers' first impressions as well as to communicate what a photograph cannot. *Life* magazine former picture editor Wilson Hicks said words and pictures should complement each other to "create a unity of effect." He also pointed out, "In traditional journalism words are produced first and the picture is used to illustrate them. . . . In photojournalism there is an exact reversal of that order."

Present-day photojournalism has its roots in documentary photography—the kind done during the Great Depression of the 1930s by Roy Stryker's Farm Security Administration

(FSA) photographers. They tried to record life in America accurately, honestly, and without intrusion. Stryker placed great emphasis on realism and maintained that "truth is the objective of the documentary attitude."

Photojournalism should reflect reality without distortion. There should be no room on the printed page for a deliberately dishonest picture.

In the era of the 4×5-inch press camera and flashbulbs, most newspaper photographs were posed setups. "Hold it" and "Just one more" were the clichés of that period. The gradual acceptance of 35-mm cameras with fast lenses and fast film enabled photographers to shoot more candidly, using available light.

Before the Second World War, one became a newspaper photographer by first paying one's dues as a darkroom worker. News photographers generally did not have a college education. They were considered a service group that took orders from college-educated reporters and editors.

Photographers on visually oriented newspapers who attended week-long Missouri Photo Workshops began to emulate the documentary approach of Stryker's FSA group. The Workshop's creed was "to show *truth* with a camera. Truth is a matter of personal integrity. Ideally, truth is achieved with no manipulation or suggestion. Under no circumstance will the Workshop staff tolerate contrived pictures."

In the postwar years, journalism schools expanded their photojournalism programs. Photography majors now have essentially the same educational background as their word-oriented counterparts in the newsroom.

When these graduates entered newspaper photographic departments, they began to impact not only what they photographed but how their images were edited and displayed.

During the decade of the 1950s, photojournalism flourished in magazines such as *Life, Look, Colliers,* and *The Saturday Evening Post.* Newspaper photographers were often recruited for their photographic staffs because, as generalists rather than specialists, they could cover all types of assignments.

Magazine photographers generally have less control over their work than do newspaper staffers. They have little influence on the selection of photographs, story direction, or layout, and no say about text or headlines. Editors, writers, and art directors shape the meaning and appearance of the photographer's work in print.

The rapid growth in photographic education has trained more people than there are openings for them. Magazines have used the many available freelancers, and therefore no longer employ staff photographers. By relying on contract photographers and freelancers, magazines avoid the high costs of health and retirement benefits as well as photographic equipment. The result is that the status of photojournalism in magazines has declined.

The status of photojournalism in newspapers, however, continues to improve. Photographers have heeded Bob Gilka's admonition to "get out of the darkroom and into the newsroom." They have become initiators of story ideas and respected participants in the editing and layout of their work.

Although the photojournalism field is crowded, opportunities await the person who is curious, competitive, and committed. To achieve success and satisfaction requires a genuine interest in people, curiosity about all aspects of society and the environment, strong motivation to communicate, and skills in editing and layout.

Books: Hicks, Wilson, *Words and Pictures.* Facsimile edition (1952) New York: Arno Press, 1973; Evans, Harold, *Pictures on a Page.* New York: Holt, Rinehart and Winston, 1978; Edom, Clifton C., *Photojournalism Principles and Practices,* Second Edition. Dubuque, Iowa: Wm. C. Brown, 1976, 1980; Kobre, Kenneth, *Photojournalism: The Professionals' Approach,* Second Edition. Boston: Focal Press, 1991; McDougall, Angus, and Hampton, Veita Jo, *Picture Editing and Layout: A Guide to*

Better Visual Communication. Columbia, Missouri: Viscom Press, 1990. *A. McDougall*

PHOTOKINA An international photographic exhibition and trade fair, usually held every two years in Cologne, Germany. The first was in 1950. *L. Stroebel*

PHOTO LINEN A commercially available fabric that resembles canvas, is precoated with a gelatin silver emulsion, and is processed in regular black-and-white photographic printing chemicals. *J. Natal*

PHOTOLITHOGRAPHY See *Lithography; Photomechanical and electronic reproduction.*

PHOTOLOFTING The production of a photographic image of an engineering drawing on the raw material from which a template or a part is to be made. Used in the aircraft and motor industries and for marking out patterns on plywood, plastic sheets, etc. *L. Stroebel*

PHOTOLUMINESCENCE Light or ultraviolet radiation emitted when appropriate phosphors are irradiated with shortwave electromagnetic radiation. If reradiation lasts only a fraction of a second after excitation stops, it is termed *fluorescence,* as distinct from *phosphorescence,* which lasts from minutes to days. *R. W. G. Hunt*

See also: *Luminescence.*

PHOTOLYSIS The chemical decomposition of a substance by the energetic action of radiation, expecially by light. Photons of light, also called *quanta,* produce the latent images in silver halide crystals of the emulsion of photographic materials. *G. Haist*

PHOTOLYTIC SILVER Photolytic silver is the name given to atoms of metallic silver produced in silver halide crystals by the energy of incident radiation, especially photons of light.. A small number of accreted silver atoms, called a *latent image,* serve as a center for the development of the photographic image. *G. Haist*

PHOTOMACROGRAPHY Photomacrography has been defined in terms of both magnification and equipment used; there is no standard, universally accepted definition. Generally, photomacrography is the practice of photography at magnification between that which can be done with an ordinary camera and lens, and that which requires a compound microscope that is between life-size and $40 \times - 50 \times$ magnification.

For example, the typical 35-mm camera, with normal lens (~50 mm) can be focused for subject distances from infinity down to 0.4-1 meter (~18-39 inches), where the image size on the film is about 1/10th of the subject (reproduction ratio 1:10). There are several ways to extend the reproduction ratio down to life-size (1:1), including the use of supplementary closeup lenses, extension tubes or bellows, or *macro* lenses; this is the area of closeup photography. Magnification at or greater than life size achieved with ordinary lenses corrected for subjects at infinity will generally result in lower-quality images.

At the other end of the scale, the lowest power microscope objective normally used for photomicrography is about $4\times$, which, with the commonly used $10\times$ eyepiece, results in a $40\times$ final magnification. Today, there are $2.5\times$, and even $1\times$ microscope objectives made, but these do not yield the highest quality images.

Yet, there is considerable magnification overlap, with some camera systems achieving up to $24\times$ magnification using a reversed 20-mm lens with bellows, and some micro-

scope setups achieving less than 10× magnification with 1× objectives and reducing lenses. One commercially available photomacrographic stand permits magnification to 95×. Thus, the magnification range between life-size and about 50× is the province of photomacrography. There is a tendency for photographs in this magnification range to be made with the common low-power stereomicroscope but because of the relatively low numerical aperture of the objectives—necessary in order to achieve the long working distances—and because of the tilted lens axis, the resulting photographs are not of the highest quality.

Either normal camera and enlarging lenses, used reversed, or low-power stereomicroscope can be used for the occasional photomacrograph; however, the highest quality images are most easily made by employing lenses designed specifically for use within narrow magnification ranges between about 0.8× and 95×, or by using one of the commercially available macroscopes designed expressly for low-magnification photography.

The history of photomacrography parallels that of photomicrography, and that entry should be consulted for the historical discussion.

BASIC SETUP Photomacrographic lenses may be used with bellows made for 35-mm cameras mounted on a copy stand or tripod with head turned downward, but because vibration problems are so critical at elevated magnifications, special apparatus is more commonly employed. A typical, basic photomacrographic setup consists, first of all, of a sturdy stand, consisting of a large, cast-metal base, with large

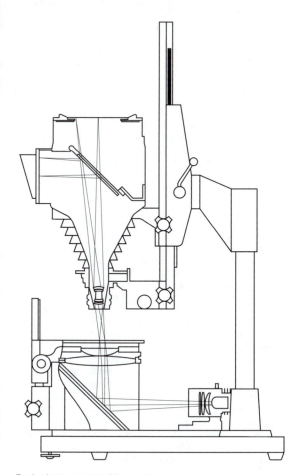

Basic photomacrographic setup.

diameter uprights and crossbeam that support a vertical dovetail slide. On the dovetail slide, there is mounted a floating shutter assembly at the lower end, followed by bellows, and finally a camera on slider at the upper end. Both short and long bellows are used with a 35-mm camera, and for large-format there is supplied a large bellows surmounted by a reflex housing for lateral viewing via a mirror, and a film holder. Lathe-bed type stands are particularly effective for photomacrography.

Additionally, a transillumination (diascopic) base is available for photographing transparent objects. Condenser lenses of different focal lengths are supplied to match each photomacrographic lens. Nesting field stops and a large iris diaphragm are provided with the apparatus. The stage unit of the transillumination base is vertically adjustable to aid focusing, and the entire dovetail assembly supporting the camera system may also be movable in the vertical axis. Knuckle joints allow some camera units to be tilted, as well.

Several commercial units made specifically for photomacrography incorporate stepped magnification changes or zoom systems. They may also be provided with binocular viewing, or side-telescope viewing. Apochromatic lenses for these new photomacrographic systems are supplanting the former setups, and the entire field is thus in transition with respect to equipment.

LENSES The lenses are the optical heart of any photomacrographic setup. Photomacrographic lenses are more like camera lenses than microscope objectives, although many photomacrographic lenses have the same Royal Microscopical Society (RMS) thread size as microscope objectives. The lenses have adjustable iris diaphragms, and are designated by focal length, but they seldom indicate the iris settings by conventional f-numbers. The f-numbers on ordinary camera lenses are defined in terms of an object at infinity, which is never the case with photomacrographic lenses. The lens-to-subject distance is usually very short compared to the lens-to-film distance in photomacrography, and the effective f-number of the lenses is, therefore, much increased (representing a decrease in lens speed), and because of the bellows, continuously variable. For this reason, some photomacrographic diaphragm settings are designated by a straight numerical sequence, for example, 1, 2, 3, 4, 5, 6 while others are designated by Stolze numbers, for example, 1, 2, 4, 8, 15, 30 related to exposure increases relative to the wide open position, "1."

For lenses calibrated in numerical sequence, that is 1, 2, 3, 4, 5, 6, each step indicates one f-stop, or factor of two exposure increase, over the next smaller number. The maximum aperture, or smallest f-number, is designated on the lens by the manufacturer; this maximum aperture is given the value "1." To determine the f-number for the other numerical designations, the maximum lens aperture in f-number as given by the manufacturer is multiplied by $2^{(n-1)/2}$. For example, for a 65-mm f/4.5 lens used at the "5" aperture number, the f-number will be $4.5 \times 2^{(5-1)/2} = 4.5 \times 2^2 = 18$.

For lenses calibrated by exposure increase factor relative to their maximum aperture, that is, 1, 2, 4, 8, 15, 30, the f-number can be found by multiplying the maximum lens aperture in f-number engraved on the lens by $\sqrt{}$ of exposure factor. For example, for a 25-mm f/3.5 lens used at the "8" exposure factor setting, the f-number will be $3.5 \times \sqrt{8} = 3.5 \times 2.8 = 9.8$.

Table I lists the characteristics of photomacrographic lenses made by three different manufacturers, from which a comparison can be made as to typical focal lengths, maximum aperture, aperture number, magnification range for best performance, and mounting thread. The corrections for each lens are computed for optimizing image quality within the stated magnification range. It will be noticed that the magnification ranges overlap somewhat and an entire series covers

Table I. Lenses For Photomacrography

Manufacturer	Focal length (mm)	Maximum aperture	Aperture numbers	Magnification range (best performance)	Mounting thread
A	16	f/2.5	1,2,4,8,15,30	10× – 40×	RMS
	25	f/3.5	1,2,4,8,15,30	6.3× – 25×	RMS
	40	f/4.5	1,2,4,8,15,30	4× – 16×	RMS
	63	f/4.5	1,2,4,8,15,30	2× – 10×	RMS
	100	f/6.3	1,2,4,8,15,30	0.8× – 8×	M35 × 0.75
B	12.5	f/1.9	1.9, 2.8, 3.5, 4, 5.6, 8	15× – 30×	RMS
	25	f/2.5	2.5, 3.5, 4, 5.6, 8, 11, 16	7× – 16×	RMS
	50	f/4.0	4, 5.6, 8, 11, 16, 22, 32	3× – 8×	RMS
	50	f/2.8	2.8, 3.5, 4, 5.6, 8, 11, 16, 22	3× – 8×	M40 × 0.75
	80	f/4.5	4.5, 5.6, 8, 11, 16, 22, 32	1× – 4×	M40 × 0.75
	120	f/5.6	5.6, 8, 11, 16, 22, 32	0.5× – 2×	M40 × 0.75
C	19	f/2.8	1, 2, 3, 4, 5, 6	15× – 40×	RMS
	35	f/4.5	1, 2, 3, 4, 5, 6	8× – 20×	RMS
	65	f/4.5	1, 2, 3, 4, 5, 6	3.5× – 10×	M39 × 1.0
	120	f/6.3	1, 2, 3, 4, 5, 6, 7	0.3× – 4×	M39 × 1.0

the magnification range from just below life size up to the compound microscope range.

LIGHTING Lighting for photomacrography ranges from simple to quite complex; from transmitted, to epi (vertical, incident) to combinations.

For transparent specimens, transmitted light (diascopic illumination) is used. A condenser is selected to match the photomacrographic lens, for example, both 65-mm, and is installed in the transillumination base beneath the specimen. After the bellows extension is set for the desired magnification, and the specimen is focused, the lamp-condenser lens is adjusted until the image of the filament is formed in the plane of the diaphragm of the photomacrographic lens. This step, which is vital if even illumination is to be achieved, is most easily done by temporarily detaching the bellows at its lower end, and raising it; a piece of paper aids in the focus of the

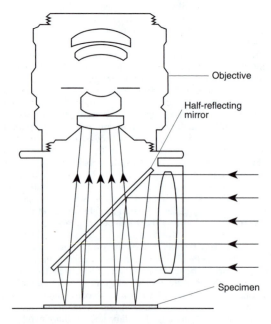

Lighting. Half-mirror illumination system.

lamp filament on the diaphragm. The mirror in the transillumination base may have to be tilted and the filament centering screws adjusted to achieve a centered filament image at the lens diaphragm.

For opaque specimens, several illumination options are available, including (1) the use of one, two, or more auxiliary illuminators on separate stands directed toward the specimen; (2) fiber optics, with the single or multiple units variously positioned; (3) a ring light—incandescent or fluorescent; (4) a half-mirror attachment, together with field lens, on the front of the lens; or, the use of a very thin piece of glass supported at a 45° angle above the specimen—both require the illuminator to be directed into the attachment from the side; (5) a Lieberkuhn mirror—a type of mirror with a concave surface, which reflects light coming from below; the mirror surrounds the lens, which protrudes from a hole in the mirror's center. The transillumination base is used to direct the light upward around the opaque specimen to the Lieberkuhn mirror; (6) various cone-shaped diffuser tents placed over the specimen, with light directed to the tents; and (7) ordinary flood lamps, or quartz halogen lamps in reflectors, or electronic flash. Fiber optics and electronic flash are popular ways of lighting specimens in photomacrography because they do not subject the specimen to heat, which is an important consideration for many kinds of specimens, including living things. The nature of the specimen will dictate which illumination method(s) will be used.

EXPOSURE DETERMINATION Going from long-distance photography to closeup photography and photomacrography requires an increase in the lens-to-film distance. In ordinary photography with normal lenses, the aperture ratio holds; that is, the f-numbers are still determined by the ratio of lens diameter to focal length. With the increased extension used in photomacrography, the aperture ratios are no longer valid; the lens diameter is now divided not into the focal length, but into the focal length plus any extension. In the case of life-size (1:1) photography, the lens is extended by one full focal length, making the lens-to-film distance now two focal lengths, thereby doubling the original distance. Because the aperture represents an area, this number is now squared to get the exposure increase necessary. The equation for the exposure increase factor in terms of magnification or reproduction ratio is:

$$\text{Exposure increase factor} = (M + 1)^2.$$

The "1" represents one focal length of any lens used; M is the magnification or reproduction scale; but since the reproduction scale always corresponds to the increase in extension, the M may be thought of as this increase. At 1:1 the extension required is one focal length; therefore, the exposure-increase factor is $(1 + 1)^2 = 2^2 = 4$. At 4:1, the magnification 4×, and the exposure-increase factor is $(4 + 1)^2 = 5^2 = 25$.

Exposure times increase rapidly with increased magnification. For example, Table II shows the exposure factor from 1:20 reduction, through life-size (1:1), to 20:1, or 20× magnification. At 1/10th life-size, the exposure factor of 1.2× is hardly significant; at life-size, the exposure factor is 4×; and at 10× lifesize, the exposure factor has increased to 121×. It will be apparent why photomacrography above 80× is rarely attempted.

In actual practice, there are several ways of determining the correct exposure time. One way, still practiced often, is the test strip or test roll, in which a series of exposures are made on one sheet, or over several frames, and the results evaluated to determine the final exposure. This method is particularly popular with instant film users.

Light meters are used in several ways. For 35-mm work, many photographers rely on the camera's automatic exposure determination feature, usually with bracketing. For large format, some photomacrographic apparatus incorporates—as an option—a built-in photocell that is temporarily introduced into the light path for reading, and an outboard, attached analog meter. A probe-type meter is often used to take readings in front of or off of the ground glass focusing screen. The reference point on the meter f-number scale is initially determined through an exposure series test. Still another method of obtaining correct exposure is to determine the light value at the specimen, using an incident-light exposure meter, measure the bellows extension, and then make

use of one of the many circular slide rules or tables available in various photoguides and professional handbooks. All of the newest photomacrographic systems, of course, incorporate automatic exposure.

MAGNIFICATION The size of the image in photomacrography depends on the focal length of the lens used and the lens-to film distance. The focal length of the lens is engraved somewhere on the lens barrel, and the lens-to-film distance, or bellows extension, is normally measured directly by extending a retractable rule found near the lens mounting plate. The end of the rule is simply pulled up to the film plane, and the lens-to-film distance is read at the witness mark. Magnification can be computed from the formula:

$$M = \frac{d - f}{f}$$

where d is the lens-to-film distance, and f is the focal length of the lens in use. For rough determination the focal length is simply divided into the bellows extension. Of course, all values must be in the same units. If possible, however, it is best to substitute a ruler for the specimen, and then measure the image of the ruler on the ground glass focusing screen using a second ruler.

If a particular magnification is wanted, the lens-to-film distance, or bellows draw, can be calculated by transposition of the above formula to read

$$d = f(M - 1).$$

Magnification is set by bellows draw for any particular focal length. Focusing is then accomplished either by moving the specimen vertically or by moving the complete camera lens combination; focusing by adjusting the lens vertically changes the magnification.

Still another way of determining magnification is by comparing the size of the specimen image directly with scales engraved on the focusing screens incorporated in large format reflex attachments.

NUMERICAL APERTURE The resolving power of a photomacrographic lens system depends on its numerical aperture. The numerical aperture of a lens system of f-value, f, is expressed as:

$$NA = \frac{M}{\sqrt{4f^2(M + 1)^2 + M^2}}$$

where NA is the numerical aperture, M is the magnification, and f is the f-value. This equation expresses the relationship between numerical aperture and the f-value, and reveals that the numerical aperture of a photomacrographic objective depends only on its f-value and the magnification of the image formed by it; it does not depend on the focal length.

It is interesting here to compare low-power microscope objectives used for photomacrography with true photomacrographic lenses. Ten times magnification, for example, can be achieved with a 1× microscope objective combined with an 8× eyepiece, and a bellows extension of about 12.5 inches. The numerical aperture of the 1× planachromat is 0.04. The same magnification is obtained with a 25-mm photomacrographic lens and a bellows extension of 11 inches. At 10×, the numerical aperture of the 25-mm ($f/3.5$) lens is 0.128, or more than three times as high.

DEPTH OF FIELD The depth of field is the vertical distance in the object plane that is in acceptable focus. The depth of field increases as the lens is stopped down, but unfortunately there is a limit to how far a lens can be stopped down without degrading the image, even in the plane of sharpest focus. That limiting point is called the diffraction limit.

Table II. Exposure Compensation
Compensation factor = $(M + 1)^2$

Image to subject ratio	Compensation factor	Image to subject ratio	Compensation factor
1:20	1.10	1:1	4
1:19	1.11	1.25:1	5
1:18	1.11	1.50:1	6
1:17	1.12	1.75:1	7.5
1:16	1.13	2:1	9
1:15	1.14	2.25:1	10.5
1:14	1.15	2.5:1	12
1:13	1.16	2.75:1	14
1:12	1.17	3:1	16
1:11	1.19	3.5:1	20
1:10	1.21	4:1	25
1:9	1.24	4.5:1	30
1:8	1.27	5:1	36
1:7	1.31	6:1	49
1:6	1.36	7:1	64
1:5	1.44	8:1	81
1:4.5	1.50	9:1	100
1:4	1.56	10:1	121
1:3	1.78	12:1	169
1:2.75	1.86	13:1	196
1.2.5	1.96	14:1	225
1:2.25	2.09	15:1	256
1:2	2.25	16:1	289
1:75	2.47	17:1	324
1:5	2.78	18:1	361
1:25	3.24	19:1	400
1:1	4.00	20:1	441

The equation for depth of field, d, is :

$$d = \frac{2fc(M+1)}{M^2}$$

where f is the f-number to which the lens is stopped down, c is the diameter of the circle of confusion, and M is the reproduction ratio. The circle of confusion is often taken as 1/30 mm (0.033 mm) but can range from 0.025 to 0.075 for negatives to be enlarged. For all practical purposes, at normal print-viewing distances of 10 inches (250 mm), images formed of circles of confusion of these diameters are acceptably sharp to the unaided eye. Resolution of the image is assumed to be diffraction limited, and points above and below the specimen focal plane will be blurred by the combined effects of geometric and diffraction blur.

Both camera magnifications and subsequent enlarger magnifications affect the final results. Recommended minimum f-values for optimum depth of field with resolution of seven line pairs per millimeter has been proposed as:

$$\text{Optimum } f\text{-number} = \frac{220}{M_e(M_c+1)}$$

where M_e is the enlarger magnification, and M_c is the camera magnification.

The depth of field (in millimeters) for a resolution of 6 line-pairs/mm print resolution, using the suggested optimum aperture, is:

$$\text{Depth of field} = \frac{70}{(M_e \times M_c)^2}$$

For 3 line-pairs/mm print resolution, the numerator increases to 260.

The optimum-aperture concept is most easily applied when the data are plotted in graphical form.

For very thick specimens, one can get around the depth of field limitations by resorting to what was originally called *deep-field microscopy* and is now called *scanning light photomacrography*. With this technique, the photomacrographic camera is set up in the normal manner, but the lights are arranged perpendicular to the camera axis in the form of a thin sheet, achieved through the use of narrow slits in front of two or three light sources. The thin sheet of light is positioned to lie in the plane of best focus. The specimen is located beneath the sheet of light. The room lights are turned off, and the shutter is opened. As there is no specimen in the narrow beam of light, no light reaches the film. The specimen is then elevated at a controlled rate, mechanically, hydraulically, or more commonly, electrically. Only that portion of the specimen that lies in the narrow light beam is illuminated, and, as the shutter is open, a continuous image composite is built up, and quite thick specimens can thus be photographed.

Stereo photomacrography and stereo scanning-light photomacrography are accomplished through the use of a tilting specimen holder, and paired exposures.

TECHNIQUE The following is a summary of the procedure for making a 4 × 5-inch photomacrograph of a transparent specimen at, for example, 12×:

1. Select an appropriate lens. Reference to Table I shows that the lens will have a focal length of 25-35 mm. If a 35-mm photomacrographic lens is chosen, install the 35-mm condenser lens in the transillumination base. Make sure the darkslide is in, the mirror reflecting the light to the focusing screen is swung into the light path, and the shutter is open.
2. Place the specimen in position on the glass stage-plate; a mechanical stage or stage clips may be used if the specimen is mounted on a microscope slide.
3. Center the lamp with respect to the condenser and camera.
4. Arrange the bellows length for the desired magnification. This setting is facilitated by scales normally found on the equipment or the projected image of a ruler can be measured on the ground glass.
5. Focus the specimen either by moving the specimen vertically via the stage focus control, or by moving the entire camera assembly vertically. Critical focus is best done with the aid of a focusing magnifier.
6. Detach the bellows from the shutter.
7. Using a piece of paper, if necessary, adjust the lamp condenser so as to focus the lamp filament on the lens diaphragm. The filament should be centered and should cover the entire aperture.
8. Reattach the lower end of the bellows to the shutter.
9. Open the lens diaphragm, recheck the focus with a magnifier, and then close the lens diaphragm for the desired depth of field. The exact setting is determined visually, or through the use of depth-of-field nomographs, or is calculated. The lamp diaphragm can be opened, as it is not used as a field diaphragm, as in photomicrography.
10. Make minor adjustments, read the light values on the focusing screen, determine the correct exposure, close the shutter, swing the mirror out of the light path, remove the darkslide, and make the exposure at the calculated speed.

The references expand on the mathematical treatment of photomacrography, and contain tables and graphs that relate magnification, f-number, resolution, depth of field, lens-to-subject distance, lens-to-film distance, and so on, all of which are practical aids for successful photomacrography.

References:

Clarke, T., "Method for Calculating Relative Apertures for Optimizing Diffraction-Limited Depth of Field in Photomacrography." *The Microscope* 32 219-258 (1984); "Photography of Fractured Parts and Fracture Surfaces," pgs. 78–90 in Vol. 12 *Fractography, Metals Handbook* Ninth Edition. ASM, Metlas Park, Ohio

Gibson, H.L., *Close-up Photography and Photomacrography.* Rochester, N.Y.: Kodak, 1970; "Depth and Enlarging Factors in Ultra-Close-up and Photomacrographic Prints and Slides." *Journal of Biological Photography* 54 127-142 (1986)

White, W., ed., *Photomacrography.* Boston: Focal Press, 1987. *J. Delly*

See also: *Closeup photography; Photomicrography.*

PHOTOMECHANICAL AND ELECTRONIC REPRODUCTION

In the strictest sense, *photomechanics* is the term that applies to the operations of producing printing plates or image carriers. In the more general sense, the meaning of the term has been expanded to include as well all the photographic, color correction, and image assembly operations before platemaking. It includes continuous tone, line, and halftone photography for the particular printing process; film processing; single and two-stage masking for color separation; manual retouching with pencils, dyes, and airbrushing; manual color correction with chemicals (wet dot etching); photographic masks for dry dot etching; opaquing; layout; stripping; plate exposure; and processing.

PRINTING PROCESSES In the latest sense, the concept of photomechanics has been further expanded to include electronic reproduction. Ever since electronics and computers invaded printing, they modified and replaced many of the functions traditionally considered photomechanics. The impact of electronic reproduction has been so pervasive that the two technologies must be considered together to understand how images are prepared for reproduction.

Each printing process has proprietary characteristics that impose specific requirements and limitations on the types of images used for reproduction. Letterpress and flexography

are relief processes that use halftone negatives to make original engravings and photopolymer printing plates. Gravure is an intaglio process that prints from cells in cylinders, mainly on roll-fed web presses. These have been made traditionally using positive continuous-tone images and chemical etching. Lithography is a planographic process with ink-receptive image areas and water-receptive nonimage areas. The printing plates are made from negatives or positives, depending on the platemaking system. Screen printing is a porous printing process in which the image carrier is produced on the fine screen either by manual or photomechanical means.

COPY PREPARATION *Copy* is the name given to text, line, and tone illustrations to be reproduced. The line and tone illustrations include diagrams, drawings, photographic prints, color transparencies, and original art. They can be in single, spot, multi- or process color. Copy preparation includes all the operations involved in getting the copy ready for reproduction. There are two basic steps: (1) the design or layout of the printed product; and (2) sorting, preparation, and assembly of the various job elements or components for reproduction. The layout is necessary before any of the other operations are performed. It can be a rough sketch, a loose comprehensive, or a tightly rendered comprehensive that looks like the finished product in all details.

For the text to be prepared for reproduction it must be typeset on a word processor or typesetting machine in the proper typeface or style and with the proper point size, letter and line spacing, column width, indention with hyphenation or justified; it must be set ragged right, ragged left, or as a runaround around an illustration, and proofread before photography or entry into a desktop publishing or prepress system. Line illustrations must be checked for size and examined for sharpness and density of lines. Photographs and color transparencies must be checked for size and cropping and segregated according to type of reproduction, such as single color, spot color, or process color, and tone reproduction such as normal, light, dark, high-key, and low-key originals. Photographs and color transparencies are continuous tone and must be converted to halftone images for reproduction.

GRAPHIC ARTS PHOTOGRAPHY

Cameras Since graphic arts can involve the photography of large subjects or layouts with two or four pages, large darkroom process cameras are used. These are mounted on precision beds with spring supports to dampen vibration effects. The copyboard and lens board travel on precision tracks; the image back is stationary behind the darkroom wall and is connected to the lens board with a bellows. The image back is equipped with a ground glass for focusing and a hinged vacuum back on which the film is mounted for exposure. Vertical cameras that look like enlargers but are much larger are used for smaller images (up to 20×20 inches). These are usually used in a darkroom.

Lenses Lenses are coated to reduce internal surface reflections, thereby increasing image sharpness and resolution. Process lenses are usually of symmetrical design to decrease image distortion and produce a flat field for image sharpness over an image field of about 50 degrees. All process color lenses are apochromatic, or fully corrected for the visible and near infrared spectrum. They have fairly small maximum apertures from $f/8$ to $f/11$ and have optimum apertures from $f/16$ to $f/22$ for best average sharpness over a wide field. Focal lengths range from 8 inches for wide angle lenses for 20 inch (vertical) cameras to as long as 48 inches for 40 inch cameras.

Lights and Exposure Controls High-intensity lights such as quartz iodine, pulsed xenon, or photoflood lamps are used to expose the slow-speed, high-resolution films used for graphic arts. Special point source lights are used for contact printing. Computerized light integrators are used to control exposures in photography and platemaking. These integrate the total quantity of light received by the film by varying the exposure time inversely with the illuminance.

Graphic Arts Films Special high-contrast, high-resolution, slow-speed emulsions of silver halides in gelatin, coated on stable base polyester films, known as lith films, are used for line and halftone photography. Continuous-tone films are used for color separations, masks, contact films, and gravure printing. Graphic arts films are color blind (blue sensitive), orthochromatic (blue and green sensitive), or panchromatic. Special films are made for scanners, and they are films that can be handled in controlled daylight or yellow-filtered light made for stripping or image assembly.

Film Processing Special chemistries consisting of high-contrast developing solutions followed by a stop bath, sodium or ammonium thiosulfate fixing solution, and washing are used for processing lith films. The operation is usually carried out in an automatic processing machine that can also be used for processing continuous-tone films by changing the chemistry. Stabilization processing, used extensively for phototypesetting resin coated (RC) and film prints, speeds processing by eliminating washing through converting the unexposed silver halide to a moderately stable complex (that eventually stains after exposure to enough light). Rapid access processing uses continuous-tone type developers to process lith films exposed by electronically generated (laser) images.

Line Photography Line copy, including text matter, lines, figures, sketches, and drawings, that are to be reproduced, is placed on the copyboard of the camera. The image is projected at the correct size by adjusting the bellows extension and copyboard position, and the focus is checked on the ground glass that is on the image plane of the camera. High contrast lith film is mounted on the vacuum back positioned in the image plane. The lens aperture is set, the copy is illuminated by the high-intensity lights, and the exposure is made through the shutter, which is operated manually with a stopwatch or automatically by an electric timer or a computerized light integrator. The lith film is processed in a high-contrast developer in an automatic processing machine. The final product is a high-contrast negative image of the subject on the copyboard; i.e., the white areas on the original are reproduced by black and the black areas on the original are clear on the negative.

Contact Printing Contact prints, used extensively in graphic arts, especially for image assembly operations, are made by placing a negative or positive continuous-tone or lith film over an unexposed film of similar type but usually color-blind in color sensitivity, preferably emulsion-to-emulsion, on the blanket of a vacuum frame. The frame is closed and locked, the vacuum pump is turned on, the exposure is made to a point light, and the film is processed in the appropriate chemistry to minimize undercutting of the image by the light source. The product is usually a positive from a negative, or vice versa. Special duplicating film can be used to make negatives from negatives or positives from positives. Contact prints are also made on photographic papers, and contact or duplicate prints are made of color transparencies.

Continuous-Tone Photography This includes photography on continuous-tone black-and-white and color photographic films and papers. These are used as original or duplicate copies for reproduction. The photographic operations are similar to those used for line photography and contact printing except for the photographic materials and the processing chemistries used.

Halftone Photography Halftone photography is done through the grid pattern of a halftone screen. In photography with a contact screen, the screen is used in direct contact with the film, with the emulsion side of the screen in contact with

the emulsion side of the unexposed film. The variable density of the vignetted dots in the screen produces a wide range of dot sizes on the film, corresponding to the amount of light reflected or transmitted from the copy. The contrast of reproduction can be varied within limits by techniques known as flashing and no-screen or bump exposures. Flash exposures are used to reduce the contrast of reproduction, especially in the shadows, by producing a dot pattern over the whole film, and they are made by exposing the film to a yellow bulb or light. The bump exposure is used for increasing the contrast in the highlights and is done by removing the screen during a short part of the exposure. Contrast can also be increased by turning the screen over so the back side of the screen is in contact with the emulsion side of the film. Additional control of contrast is achieved by the use of magenta–dyed screens and colored filters during part of the exposure—yellow filter to reduce contrast and magenta filter to increase contrast.

Halftones can also be produced by the use of prescreened film. This consists of high-contrast photographic film that has been preexposed to a 133-line screen and packaged. During photography, the light areas in the original that reflect high levels of light produce large dots in the film, and darker areas that reflect lesser amounts of light produce smaller dots, so that when the exposed film is processed a halftone negative of the image is produced that contains dot sizes corresponding to the amounts of light reflected from the original. Halftones are made on electronic scanners by electronic dot generation. This is described in the section of this article on *electronic scanning*.

COLOR REPRODUCTION Color printing consists of the use of spot color to emphasize or differentiate information or subjects; block color as in cartoons, bar or pie charts, or other means of printing differentiating information; and four-color process reproduction that produces quantities of prints that simulate color photographs or paintings, or other color images. Spot and block color printing are like single color except that a separate film and plate are needed for each color, and reasonable care must be used to obtain fair register between the black text and spot or block color images. Four-color process printing, on the other hand, is critical; it is dependent on the three-color theory of light, which requires special color separation techniques and inks with special colors and other printing characteristics; it demands very close register of images in platemaking and printing; and in lithography, it requires critical adjustment of ink and water in printing. Four-color process printing involves three related processes: color separation using the principles of the three-color theory of light; color correction and manipulation; and color printing using transparent pigmented inks with colors complementary to the separation colors. The third process, printing, is not a part of the photomechanical process but will be described briefly since the printing materials and characteristics have an effect on the prepress and platemaking photomechanical operations.

Three-Color Theory of Light Color process reproduction is based on the three-color theory of light and vision. It consists of three primary colors of light: blue, green, and red. In the physical sense, each wavelength of light differs in color from every other wavelength. The human eye has two types of visual receptors: rods, which sense luminances, but not hues, and cones, which sense luminances and hues, but not at low light levels. There are three types of cones: those sensitive to a broad band of blue wavelengths of light; those sensitive to a broad band of green wavelengths of light; and those sensitive to a broad band of red wavelengths of light. This is the basis of the three-color theory of light, which determines how colors are perceived. The three colors, red, green and blue (RGB) are called additive primaries because when lights of these three colors are added together in dif-

ferent proportions they produce an entire gamut of colors, including white light.

What a person sees depends on the health and condition of the cones and the experience of the viewer in addition to the nature of the stimulus and the viewing conditions. If the cones are abnormal, the viewer has a form of color blindness that distorts the appearance of the subject colors. The appraisal of color, therefore, is an individual, subjective experience. Difficult to measure in absolute terms, it is a comparative phenomenon that depends on the comparison of the reproduction to the original. This is why color proofing is such an important part of color reproduction.

Color Separation The process of color separation in color reproduction is similar to the way the eye sees color. The original photograph or artwork is separated into three records by photographing the subject through filters with light transmissions each corresponding to one of the additive primary colors—red, green, or blue.

Photographing the original with a red separation filter over the lens produces a negative record of all the red light reflected by or transmitted through the original. This is known as the red separation negative. A positive made from this negative is a record of the absence of red and its presence of blue and green in the subject. The combination of light blue and green light produces the color called cyan. The positive made from the red separation negative is the cyan printer.

Similarly, photographing a color subject through the green filter produces a record of the green in the subject. The positive made from the green separation is a record of the red and blue in the subject, which is called magenta. The positive made from the green separation negative is the magenta printer.

Photographing through the blue filter produces a negative record of the blue in the subject. The positive made from the blue separation is a record of the red and green in the subject. Red light and green light combine to form yellow. The positive made from the blue separation negative is the yellow printer.

The three colors cyan, magenta, and yellow (CMY) are called subtractive primaries because colorants of these colors absorb red light, green light and blue light, respectively. Cyan, magenta, and yellow are the colors of the printing inks used for process color reproductions.

When the three positives made from the three separation negatives are combined or printed, the result is not a reasonable reproduction of the original. The colors other than the yellows and reds are dirty or muddy. There is too much magenta in the blues, greens, and cyans and too much yellow in the blues, magentas, and purples. The poor color reproduction is not a fault of the theory but is caused by deficiencies in the colors and transparencies of the inks. To compensate for the deficiencies in the inks, corrections are made in the separation negatives and positives. Even with these corrections the printed result lacks saturation and contrast.

To overcome the lack of image strength or saturation and contrast, a fourth printer, black, is added to the three colors, making color reproduction a four-color process. The black separation can be made using a special yellow filter or split exposures through the three filters successively. The black printer improves the contrast of the grays and increases the saturation of the shadows. It is used in a range of tone reproductions from a skeleton black to a full black. The trend is toward the use of full blacks, especially in high-speed magazine printing. The other colors are reduced proportionately so that inks transfer, or trap, properly. The operation of reducing colors and printing a full black in shadow areas is called undercolor removal. Gray component replacement is an extended form of undercolor removal in which black is

used to replace the graying component, or the minimum third-color combinations throughout the tone scale.

Color Correction Corrections for the spectral errors in the inks are made by manual dot etching, photographic masking, or electronic scanning (described in the section on Electronic Prepress). These are also used to correct faulty tone reproduction caused by exposure errors in photography.

Manual Dot-Etching Manuel dot-etching is used to increase or reduce color in local areas, using chemical reducers such as potassium ferrocyanide to dissolve silver on the periphery of halftone dots to reduce their size. This is called wet or chemical dot etching. It is a delicate operation requiring very high manual skills. When the dot-etching is done on positives, it reduces color by reducing the size of the image dots. When done on negatives, it increases color by reducing the size of the nonprinting areas (black areas in the negative). *Dry dot-etching* is a method of color correction in which dot sizes are changed by the use of computerized exposures and development.

Photographic Masking Photographic masking is the method of color correction using low-density range continuous-tone negatives of the original made through special filters. The low-density range negatives are called masks and are placed in contact with the original, if it is a color transparency, or in the back of the camera in contact with the unexposed film in the case of separating a reflection color subject. The mask corrects color in the separation negative according to the colors of the filter(s) used to make the mask and the filter used for the separation, and in proportion to the strength of the mask. Masks are also used to correct tone reproduction.

Image Assembly Image assembly is also called stripping. Before films can be assembled into page layouts they must be trimmed, checked for size, register, margins, bleeds, register marks, trim marks, etc., and touched up with special preparation, called opaque, to remove pinholes and other flaws or image defects in the films. This is where the page layout produced in copy preparation is implemented. This layout indicates the size and color of each copy element and its exact orientation and position on the page. In addition, a plate layout is provided (by the press department or bindery) that indicates the exact position of each page on the printing plate to assure that pages after printing and finishing tasks such as folding will be in the correct or consecutive order. Also, fronts and backs of pages printed from separate plates must register so that heads, side and bottom margins, and page numbers (folios) line up. In label or forms printing, the labels or forms must be laid out so that they can be cut on a guillotine cutter without cutting through or destroying other labels or forms.

The stripper assembles all the films of the copy elements that print in the same color on a goldenrod or red base sheet, called a *flat*, and cuts out windows for exposing images onto plates. A separate flat must be prepared for each color. These are all manual operations that are very time-consuming and cost-intensive, as they require extensive and precise skills. This is an area where computer aided design (CAD) has been quite successful in reducing the time and cost and increasing the productivity of prepress operations (see the section on Electronic Prepress).

Color Proofing The main purposes of color proofing are to determine if all the image elements fit and are in the right colors and how the job will look when it is printed on the press. Color proofs are usually made after color separation, color correction, page assembly, and sometimes after page imposition. They can be (1) press proofs, printed on production presses, which makes them slow and expensive to reproduce, (2) off-press proofs, which are made from color separation films and are faster to make and less expensive than press proofs, but usually cannot be made on the actual printing paper or match the printing inks, and (3) digital proofs, which are made from digital information from electronic prepress systems.

Electronic Prepress The main objective of electronic prepress systems is to increase productivity by eliminating as many manual operations as possible by reducing the time required to process color images. The first applications of electronics and computers in photomechanics were electrophototypesetting in the period from 1949 to 1954 and color separation by electronic scanning in 1950. Neither technology was successful until 1970, when the introduction of the video display terminal (VDT) and optical character recognition (OCR) made electrophototypesetting correctable and editable, and electronic dot generation and digital magnification made electronic scanners cost efficient and productive.

Practically all typesetting is done on electronic typesetting systems, which are so efficient they are called imagesetting systems, or more popularly, desktop publishing systems, using personal computers and software. These systems handle both text and graphics and have expanded their capability to color reproduction.

Electronic Scanning Electronic scanning is the system of choice for color separation and correction. The two types of color scanners used are drum-type and flat-bed. The *drum-type scanner* uses a process similar to photographic color separation. The original, mounted on a rotating drum, is scanned with light beam that is split into three beams after being transmitted by or reflected from the original, depending on whether it is a color transparency or an opaque subject. Each beam is deflected to a photomultiplier tube or cell (PMT) covered by a filter corresponding to one of the additive primary colors, red, green, or blue, thereby separating each area of the original into its three color components (RGB). Older scanners use analog computers to convert the voltages corresponding to the intensities of R, G, and B light to compute the amounts of yellow (Y), magenta (M), and cyan (C) in the separation films. A fourth computer is used to compute the black (K) from the RGB data. Also, color correction is done by modifying the currents for each color, depending on the effects of inks, papers, and other printing conditions on the reproduction of the printing colors.

An analog-to-digital (A/D) converter is used to convert the analog RGB data to digital CMY data needed for enlargement and reduction of images and converting the continuous-tone color levels to halftone dot sizes by systems of electronic dot generation, which produce the correct dot size, screen ruling, and screen angles. Most newer digital scanners use digital computers, and these computations are assisted by the use of look-up tables (LUT) on computer boards. Also, they are modular so that input and output are in separate units and can be addressed by networks over a wide range of distances.

Flat-Bed Scanners Flat-bed scanners are less expensive electronic color separation devices than drum scanners. They use special light and color-sensitive electronic arrays like charge-coupled devices (CCD) to scan the image on a flat plane and record it as red, green, and blue separations. The main limitations of flat-bed scanners are size, resolution, which is dependent on the number of elements in the array, and dynamic range, which is equivalent to the density range of the reproduction. Most flat-bed scanners have dynamic ranges of about 2.0, while drum scanners have typical dynamic ranges of 3.0–3.8. The higher the dynamic range, the longer the scale of reproduction and therefore the more detail in the highlights and shadows. Several manufacturers have introduced flat-bed scanners for the conversion and reproduction of color originals in single color or duotone (usually black with an accenting color).

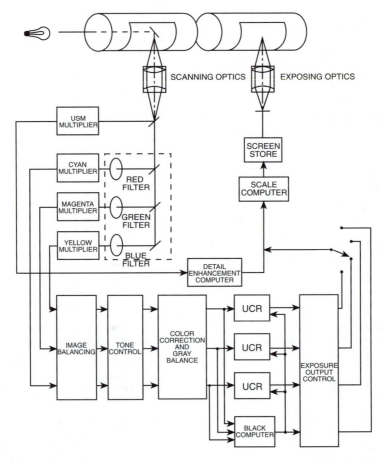

SCANNING OPTICS EXPOSING OPTICS

USM MULTIPLIER

CYAN MULTIPLIER — RED FILTER

MAGENTA MULTIPLIER — GREEN FILTER

YELLOW MULTIPLIER — BLUE FILTER

SCREEN STORE

SCALE COMPUTER

DETAIL ENHANCEMENT COMPUTER

IMAGE BALANCING

TONE CONTROL

COLOR CORRECTION AND GRAY BALANCE

UCR

UCR

UCR

BLACK COMPUTER

EXPOSURE OUTPUT CONTROL

Electronic scanning. Schematic of an analog electronic color scanner.

Prepress Systems Prepress systems were designed to process the information from scanners, retouch the image and combine it with other color, text, and linework elements, and produce complete pages for combining into assemblies or flats for platemaking. These systems consist of a scanner or scanner interface, digitizing tablet with cursor, mouse or light pen, computer storage, software, high resolution monitor, and an output device. These systems can input text, black-and-white and color illustrations, page layout, and other image processing instructions; perform the functions of color correction, airbrushing, retouching, pixel editing, cloning, type composition, page makeup with all elements in correct position, soft proofing on VDT terminals, and hard proofing on direct digital color proofing (DDCP) systems; and output the digital information with electronic dot generation into digital data storage or into film recorders using lasers to produce color separation films, and/or imagesetters to expose high speed printing plates.

Electronic Stripping Systems Electronic stripping systems use computer aided design (CAD) technology to perform the prepress image assembly (stripping) functions of producing layouts, shaping masks, dropouts, and undercuts for text, halftone, and screen tint images. After the mask films are cut, all the craftsman (stripper) has to do is crop the text, halftones, and screen tint films, and attach or strip them on the mask. These systems have enabled strippers to save more than 50% of total image assembly time. These systems have also been cost effective by providing new levels of mechanical accuracy for complex magazine and catalog

pages with multicolor halftone images, screen tint backgrounds, and images that cross over on two facing pages.

Desktop Publishing Systems Although color electronic prepress systems (CEPS) have been successful in minimizing and almost completely eliminating all manual operations and intermediate films and processing, they have been very expensive. They are all device-dependent systems with proprietary formats, or protocols, and interfacing between systems by different manufacturers is difficult, even with digital data exchange standards (DDES) approved by ANSI (American National Standards Institute).

Device-independent systems using personal computers (PC) and off-the-shelf software programs have increased in capability since they were introduced for typesetting in 1985. Called desktop publishing systems, their use for typesetting resulted from the introduction of the Macintosh computer, the Apple LaserWriter and Adobe's PostScript software program. PostScript is a universal standard page description language that enables typesetters or imagesetters by different manufacturers to interpret files from personal computers using available software programs.

Desktop color prepress systems consist of a scanner to input color transparency or reflection color print images; a platform or workstation on which to view and manipulate the images as well as integrate them into pages, with the proper software for each function; storage capacity to store the pages electronically; a proof printer to see the pages as hard copy; and an imagesetter or other film recorder to output film negatives. All the components must be networked, or con-

Color Publishing Systems

Features	Density/Creative	Desktop System	Mid-range System	High-end Prepress
Skill Levels	Low-moderate	Moderate	Moderate-high	High Proprietary
Hardware	Standard	Standard	Blend	Proprietary
Software	Standard	Standard	Blend	Proprietary
Productivity	Low	Low-moderate	Moderate	High
Quality	Low	Low-moderate	Moderate	High
Proofing	B/W laser	Color thermal	Color thermal	Traditional/DDCP
Storage Capacity	80 MB+	100 MB+	200 MB+	1 gigabyte+
Output	Proof printer	Imagesetter	Imagesetter	Film recorder
Cost	X	2X	4X	8X

nected, together. Some systems have multiple workstations for different tasks such as scanning and retouching on one and page assembly on another. Also, the workstation requires a monitor and some type of calibration.

The four levels of color electronic publishing systems are shown in the table.

Design/creative and desktop systems use similar equipment and software with the exceptions that design systems use lower cost proofers and output since they produce mainly comprehensive layouts. Mid-range systems use the same software as desktop systems but they use drum scanners in place of flat-bed, UNIX-based workstations instead of Macintosh or IBM compatible computers, and more sophisticated imagesetters. High-end systems are the expensive prepress systems with sophisticated drum scanners and film recorders. Many of the high-end systems have links to desktop or mid-range systems mainly to take advantage of the lower cost page assembly software. The most productive and cost effective use for desktop color systems is for page assembly.

PLATE/CYLINDER MAKING The image processing operations for all the printing processes are essentially the same. The differences among the processes is in the making of the printing plates, cylinders, or image carriers and in how they are printed. Letterpress and flexography are relief processes that print directly from the plate to paper (or other substrate). Gravure is an intaglio process that uses cylinders almost exclusively and prints from cells, or wells, in the cylinder, using a fluid solvent ink and a doctor blade to scrape the ink off the nonprinting areas. It, too, prints directly from the ink-filled wells in the cylinder to the paper (or other substrate). Lithography is a planographic process that uses an ink–water balance to print viscous inks by the offset principle from the plate to an intermediate blanket-covered cylinder and then to the paper (or other substrate).

Letterpress Letterpress photomechanical plates can be made of three types: original photoengravings, molded duplicate plates, and photopolymer plates. Original photoengravings can be either line or halftone. In the United States, line and coarse screen engravings are made on zinc or magnesium, and fine screen engravings are made on copper. In Europe, zinc is used for all types of engravings. Original photoengravings are made by coating the metal plates with special light-sensitive coatings, exposing the coated plates to negatives and developing the images. The plates are then processed in etching machines using special powderless etching chemicals.

The original photoengravings can be used for printing, but most generally are used to make molds from which duplicate plates are made. The duplicate plates are (1) stereotypes, which have been used extensively for newspaper printing; (2) electrotypes, which are used for letterpress commercial and magazine printing; and (3) plastic and rubber plates, which are used for some commercial printing, books, and flexography for printing on rough surfaces such as en-

velopes, bags, tags, wrapping papers, corrugated boxes, and milk cartons.

Photopolymer plates are precoated and are used as original (or direct) pattern and wraparound plates. Plates coated on steel and mounted on magnetic cylinders are used for long-run magazine printing. Photopolymer plates are also used for newspaper printing.

Letterpress has been declining in use because of the excessive time required for making the plates ready for printing (called makeready). The problem is caused by the variable pressure required by different size image elements (dots) to print properly. Highlight dots require less pressure or squeeze to print or transfer ink properly (without positioning the paper) than shadow dots, type, or solids. Evening out the pressure is a time-consuming manual task that has made letterpress too expensive for most printing markets.

Flexography Flexography, which is a relief process like letterpress, has avoided the makeready problem by the use of resilient plates that compress or distort during the impression. In addition, it uses solvent inks and a special inking system (anilox) that simplify ink transfer and eliminate the tack forces of viscous inks. Flexography uses rubber duplicate plates made with molds from metal original photoengravings, or special resilient photopolymer plates. Flexographic rubber plates and/or cylinders can be made by laser etching. Flexography has replaced letterpress in many of its applications, particularly newspaper, book, forms, and packaging printing.

Gravure Gravure is an intaglio process in which the image consists of wells or cells in the surface of a copper-plated steel cylinder that is chromium plated after imaging. The nonimage areas are kept from printing by a doctor blade that scrapes any excess ink off the smooth nonimage areas of the cylinder surface. Chemically etched gravure cylinders are almost obsolete because of the difficulty in controlling the etching process as a result of impurities in the copper, concentration of copper salts in the etch, local temperature effects, and other uncontrollable factors. Powderless etching, as used for letterpress engravings, has been used with variable results.

Practically all the gravure cylinders are produced by electromechanical engraving (EME). This process produces diamond-shaped cells in the copper-plated cylinder that vary in size and depth (volume) corresponding to the density of the prints scanned. The original prints can be continuous-tone or halftone negative or positive prints. A special reading head is used for halftone prints to defocus the halftone dots. The use of halftone prints makes it possible to use the same halftones for lithographic and gravure printing. After imaging, the cylinders are chromium-plated to increase image life on the press. When the chromium wears, because of abrasion of the doctor blade, the cylinders are removed from the press and rechromed. Gravure cylinders have been used for up to 100 million impressions.

Gravure is the first printing process to produce image

carriers from digital information by going directly from the original copy to the press cylinder. Instead of using continuous-tone or halftone prints on electromechanical engravers, digital information is fed directly from the prepress system through an interface to the EME computer, which activates the diamond styli that engrave the copperplated cylinder.

Gravure is a long-run process capable of millions of impressions. It is also a very expensive process that requires large plating and polishing equipment to prepare the cylinders, expensive electromechanical engraving machines, and large expensive handling equipment to transport the cylinders between processing steps and mounting on the press. The plating chemicals and solvent inks are pollutants and require expensive anti-pollution controls and devices.

Gravure has been used to print large editions of mail order catalogs and long-run magazines for which it has been admirably suited. Changes in market conditions, however, are decreasing the need for long-run printing processes. Large mail order catalogs have been replaced by smaller specialty catalogs requiring shorter runs. Magazine runs have also been shortened by the trends toward demographic editions and target marketing. The new run lengths are within the range of lithographic print runs, which have encroached on gravure markets.

Photopolymer image carriers have been developed for gravure that make it a viable competitive process for shorter runs for publication and packaging printing. Precoated photopolymer plates on a steel base that can be mounted on magnetic cylinders after processing have been one approach. Another has been thin metal sleeves precoated with polymers or photopolymer coatings. The photopolymer coatings are exposed to films and developed in automatic processors similar to the way letterpress and flexographic plates are made. The polymer coatings can be imaged on electromechanical engravers.

Lithography Lithography is the leading printing process, accounting for almost 50% of all printing done in the United States. It represents about 75% of all commercial printing, which consists of advertising and direct mail printing, magazine and catalog printing, labels and wrappers, financial, legal and miscellaneous publishing, and general printing. It is a planographic process based on the principle that water and oil (grease) do not mix. Image and nonimage areas are essentially on the same plane with image areas that are ink receptive and water repellent, and nonimage areas that are water receptive and ink repellent.

Lithographic printing plates are relatively simple to make compared with plates or image carriers for letterpress, flexography, and gravure. Most lithographic plates have an aluminum base, usually anodized and sealed with a silicate solution to provide the plates with good water receptivity. They are all presensitized with diazo coatings for short to medium-long runs (over 100,000), or photopolymer coatings for very long runs (over 1 million). There are plates made for use with negative films, plates made for use with positive films, and a few plate types that can be used with either positive or negative films. Several plate types with silicone overcoatings can be run on the press without water. Most plate types use coatings that can be processed with water-based solutions, to avoid water pollution problems.

There are also four types of high-speed digital printing plates that can be imaged directly by digital data from electronic prepress systems, or desktop publishing systems without using intermediate films. These plates are: (1) silver halide based; (2) electrophotographic; (3) high-speed plates using special dye sensitized photopolymer coatings; and (4) nonphotosensitive, dry processed waterless plates. The first three types are exposed by lasers; the fourth is imaged by spark discharge. The spark discharge plate can be produced directly on the press since it does not require any processing

except removing the debris from the discharge with a brush or cloth. While the plates are being produced, the press computer controlling the operation also computes the ink demands of each plate, by counting the printing dots, and automatically presets the ink fountains for each color on the press. This reduces the makeready time appreciably and makes the plate profitable for short-run color printing, a new market created by the availability of digital printing plates.

DIGITAL PRINTING SYSTEMS Besides digital plates, a number of other digital imaging processes can produce prints directly from digital data without the use of intermediate films or plates. These include high-speed copiers, electrophotographic, magnetographic, and ion-deposition printers, and ink-jet printing.

High-speed digital office copiers use electrophotographic-toner technology to produce imaging systems with speeds up to 135 pages per minute (ppm) for black-and-white prints.

High-speed color copiers have been modified by the addition of intelligent processing unit interfaces with digital data from desktop color systems to output digitally composed color pages at the rate of 5 ppm. These systems are being used to produce short-run color printing in runs up to 200 prints.

Electrophotographic printing is similar to high-speed office copier systems. It is a pressureless system that uses an electrostatic photoconductor that is charged by a corona discharge, imaged by lasers, driven by digital signals from a front-end system (DTP), developed by dry or liquid toners, and a system for transferring the toned images to a substrate. The system is used commercially on a special web press for printing business forms, checks, personalized advertising, forms, and other types of variable printing. The press is linked to an electronic page layout system and a data base of variable information. Speeds are slow—about 300 feet per minute (fpm)—resolution of images is about 300 dots per inch (dpi), and it can print two colors on one side of the paper, or one color on each side.

Magnetographic printing is similar in principle to electrophotographic printing, except the photoconductor and toners are magnetic. It is a short-run process with a breakeven point with lithography of about 1500 copies. Its limitations are slow speeds (300 fpm), toner cost, as thick layers of toner are needed (up to 30 micrometers—compared with 2 micrometers for conventional printing), and no light colored or transparent toners, so it will not be suitable for process color printing until such transparent toners are available.

Ion-deposition printing is similar to other electronic printing systems. It consists of four simple steps: (1) a charged image is generated by directing an array of charged particles (ions) from a patented ion cartridge toward a rotating drum, which consists of hard anodized aluminum maintained at a temperature of about 54°C (130°F); (2) as the drum rotates, a single-component magnetic toner is attracted to the latent charged image on the drum; (3) the toned image is transferred to plain paper and fixed on it by high pressure without heat (cold pressure fusing); and (4) most of the toner (99.7%) is transferred to the paper and the drum is readied for reimaging by removing the remaining toner with a reverse angle doctor blade.

Thousands of ion-deposition systems are in use for volume and variable printing of invoices, forms, tags, tickets, checks, letters, proposals, reports, and manuals. The system has not been used for color printing because of the distortion in the paper that can be caused by the cold pressure fusing. A modified ion-deposition system for color printing is in development. The process uses two unique materials that eliminate the deficiencies of previous processes. Among other features, the process will print continuous-tone images by varying ink densities on the image rather than by varying

the size of image elements as in halftone printing. It will also have no image moiré, 100% ink transfer, and instant setting and drying of the ink on contact with the substrate. Such a process could have print on demand capability as well as use for short- and long-run color printing.

Ink-jet printing is a nonphotosensitive printing system. Images are produced by fine droplets of aqueous dye solutions that are controlled by digital information from imaging systems. Two main types of ink-jet printers are in use: continuous drops and drops-on-demand. There are also single and multiple jet systems. Ink-jet printing is used mainly for variable printing such as addressing, coding, computer letters, sweepstakes forms, and other personalized direct mail advertising. New applications are short-run color printing and the production of color digital hard-copy position and verification proofs for color reproduction. Multiple jet continuous drop ink-jet color proofing and printing systems have been developed that produce images with improved color quality, saturated colors, and image smoothness without graininess. *M. Bruno*

See also: *Color proofing; Electronic scanner; Flexography; Gravure; Halftone process; Letterpress; Lithography; Photomechanical and electronic reproduction history.*

PHOTOMECHANICAL AND ELECTRONIC REPRODUCTION HISTORY
The first illustrations in books were made with woodcuts. They were tooled out of wood blocks by hand, engraving with the grain and leaving raised surfaces that were hand-inked like type. Albrecht Pfister of Bamberg, Germany, first used woodcuts to illustrate books in about 1460, approximately 20 years after Gutenberg invented printing. Manual copperplate intaglio engravings, forerunners of steel die engravings and gravure, were used to illustrate books printed between 1570 and 1770. Woodcuts had a revival in 1770 when Thomas Berwick of England developed a new special engraving tool for cutting across the grain instead of with the grain. Illustrations in the 1800s before the introduction of photomechanical methods were made by hand-drawn lithographs on stone.

Graphic arts photography involves line, halftone, and color separation photography used to reproduce illustrations and art subjects. Photomechanics combines photography with the mechanical operations for platemaking, for example, photoengraving, photolithography, photogelatin, and photogravure. The invention and use of photography and photomechanics completed the mechanization of the printing process begun in the Industrial Revolution in the early 1800s. These inventions made illustrations practical and economical and fostered the phenomenal growth of advertising, periodical, book, and commercial printing. More recently, electronic reproduction has created another revolution in imaging technologies and processes.

The blackening effect of light on silver salts had been known by alchemists for years, but it was not until 1839 that Daguerre demonstrated methods to produce permanent images. It was in the same year that the astronomer Herschel, who had discovered the fixing properties of sodium thiosulfate (hypo) in 1819, gave *photography* its name, and W. H. Fox Talbot invented the first negative-positive process called calotype, that eventually proved more practical than Daguerre's process. In 1851, F. Scott Archer invented the wet collodion process of photography, which remained in use until the middle of the twentieth century. Many other significant improvements were made in the 50 years between Talbot's calotype process and George Eastman's introduction of the first flexible film base and the Kodak camera in 1888. Other highlights in the history of graphic arts photography were the introduction of the first high-contrast lithfilm, Kodalith, in 1929 and Kodachrome—the first multilayer color film—in 1935.

Photomechanical developments closely paralleled advances in photography. In 1826 Daguerre's partner, Joseph Niépce, made the first metal engraving by light using a bitumen-coated metal plate that was etched after exposure and development. Potassium bichromate was first used as a sensitizer in 1839 by Ponton, and W. H. Fox Talbot used it in 1852 to sensitize gelatin and produced the first halftone engraving by laying a fine gauze screen between the coated metal and a negative of the original. In 1855 Poitevin invented photolithography based on the use of bichromated albumin. Photoengraving advanced rapidly and was in commercial use by 1871, and by 1880 photoengraved prints were replacing woodcuts in books and magazines. In 1880 the first halftone engraving for printing was made by Stephen Horgan and was printed by lithography in the *Daily Graphic of New York*, the first picture newspaper.

In 1883 Max and Louis Levy of Philadelphia produced the first commercial halftone screen. In 1885 Frederick Ives improved on the Levy technique and developed the first version of the glass crossline screen. It wasn't long before halftones were used for color reproduction. The first color process engraving was printed in 1893 and displayed at the U.S. Columbian Exposition.

Electronics and computers started to impact photomechanical reproduction with the introduction of phototypesetting in 1949. Electronic scanners were introduced in 1950 by PDI, a subsidiary of *Time* Magazine. By 1975 scanners produced more than 25% of all color separations in the United States and by 1990 they produced almost 95% of all separations in North America, Europe, Japan, the Pacific Rim countries, and Australia. By 1985 color electronic prepress systems (CEPS) were producing completely composed pages, and by 1991 many of these systems were being replaced by PostScript-based desktop publishing systems at less than half the cost of the prepress systems. *M. Bruno*

PHOTOMETER
An instrument used to measure luminous quantities such as luminous intensity, luminance, and illuminance. There are two classes of such instruments: (1) visual photometers, in which the measurements are based on visual comparison between the unknown field and a reference field, and (2) physical photometers, in which a photoelectric detector (filtered to match the photopic relative luminous efficiency function of the standard observer) is used to measure the desired quantity. While physical photometers must be calibrated frequently, they are capable of more repeatable results because variations in individuals' spectral sensitivity can affect visual measurements. *J. Pelz*

See also: *Photometry and light units.*

PHOTOMETRIC APERTURE See *G-Number.*

PHOTOMETRIC BRIGHTNESS See *Luminance.*

PHOTOMETRIC EQUIVALENT
The ratio of the mass of silver per unit area to the diffuse density of the sample. It is the reciprocal of the covering power. *M. Leary and H. Todd*

See also: *Covering power.*

PHOTOMETROLOGY
The field of photometrology encompasses the derivation of metric information via measurements made from a photographic image of an object or event. Perhaps the most common form of photographic mensuration is the creation of topographic and geodetic maps from aerial imagery. This application has become so well studied that the field of photogrammetry has evolved to specialize in technologies specifically related to making highly

accurate terrain measurements from aerial images. Many other ground-based applications require measurements to be made from images, however, and it is to these nonaerial mensuration applications that the term *photometrology* has most recently been applied.

Photometrology is most often used when direct measurement is either uneconomical or impractical. Any type of imaging sensor can be used, but accurate reference information must be available for the camera system, and for some applications a standard of reference must be present in the scene as well. When height information is to be derived from photographs, two pictures are required (stereo), and the separation between the camera positions for each image must be either accurately known or calculated. Other necessary information includes knowledge of the camera's focal length and the distance from the camera to the object. If the dimensions of an object are to be accurately determined from a single photograph, a method for calculating image and print magnification must be available or a reference object included in the same plane as the subject to be measured.

Some applications require an accurate measurement of the time dimension created in multiple-frame photography (high-speed, time-lapse, or real-time electronic or film recording techniques). The accuracy of these measurements requires that timing information (light pulses or electronic timing information) be present during imaging in order to derive the time interval between frames. Examples of time dimension measurements include aerodynamic analysis (high-speed recording), vegetation growth and development (time-lapse recording), and automated manufacturing and product assembly analysis (real-time recording).

The research and scientific fields making use of these photomensuration techniques are quite diverse. Examples of medical applications include the location of artifacts using x-rays or other medical imaging modalities. Fetal development is now routinely monitored using measurements made from ultrasound images. Estimates of tumor growth, cosmetic surgery documentation, and orthopedic reconstructions are also common medical applications of photometrology. Common industrial and commercial applications include architectural measurements, traffic accidents, forensic photography, and nondestructive testing. Further examples of use can be found in many diverse fields, such as paleontology (fossil dimensions of fragile specimens), biology (light- and electron-microscope measurements), ecology (pollution monitoring), and astronomy (lunar surface topology). Some of the more unusual applications of photometrology have included such diverse fields as meteorology and computer-assisted design (CAD). Cloud development has been analyzed by meteorologists using both aircraft photography and imagery acquired from space. Expert systems are currently being developed to analyze site photographs of existing equipment, automatically determine dimensional information, and develop a database to provide engineering drawings or to be used as a front-end input to a CAD system for further manipulation and design.

The principles of photometrology rely on a complete knowledge of the camera geometry of images being analyzed as well as the need to understand the characteristics and limitations of the imaging sensor and image display medium. For example, video cameras and images photographed from CRT displays can be used in some applications, but dimensional inaccuracies and distortion can be introduced if the system has not been carefully calibrated. Optical distortion, output medium dimensional stability, and errors in direct measurement of distances, heights of reference objects, and other on-site dimensions will all contribute to error in the resulting measurements made from the image.

L. Scarff

See also: *Forensic photography; Photogrammetry; Photoinstrumentation.*

PHOTOMETRY AND LIGHT UNITS Photometry is
the science of measuring light (from the Greek *photo,* of light, and *metron,* to measure). Although the word *light* is sometimes used to refer to infrared and ultraviolet energy, it is defined strictly as only that region of the electromagnetic spectrum that stimulates the rods and cones of the human eye. Formally, measurements of energy beyond the visual range fall within the field of *radiometry,* the science of measuring any form of electromagnetic energy.

Because photometry deals with the measurement of light and its effect on the human visual system, its origins were necessarily in psychophysics, and all units are therefore based on psychophysical measures.

ELECTROMAGNETIC RADIATION Electromagnetic radiation is carried in traveling waves made up of electric and magnetic fields that vary periodically in time and position. The spectrum of electromagnetic radiation spans more than 20 orders of magnitude, from gamma rays to electric power transmissions. Electromagnetic radiation can be described by its *wavelength* (λ), the distance over which the wave completes one full cycle. Electromagnetic radiation can also be described by its frequency, the number of cycles the wave undergoes per unit time. The common unit of measure for frequency is the Hertz (Hz), the number of cycles per second. The frequency is equal to 1/period, where period is the length of time it takes for the wave to go through one complete cycle. Since all electromagnetic radiation travels through a vacuum at 3×10^8 meters/second, its wavelength (measured in meters) and frequency (measured in cycles per second) are related by

$$c = \lambda \cdot \nu$$

where c is the speed of electromagnetic radiation in a vacuum; λ is the wavelength; and ν is the frequency.

The spectrum of electromagnetic radiation spans a huge range of wavelengths and frequencies. Long wavelength radiation (long radio waves) measure more than a kilometer,

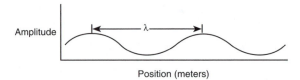

Electromagnetic radiation. The wavelength of electromagnetic radiation (λ) is the distance between peaks of the periodic wave.

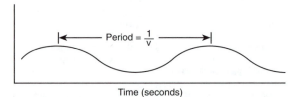

The frequency of electromagnetic radiation (ν) is the number of cycles the periodic wave undergoes per second. It is equal to 1/period, where period is the length of time it takes for the wave to complete one full cycle.

while gamma rays, at the other extreme, have wavelengths of only 10^{-12} meter—1/100 the diameter of an atom.

LIGHT The human visual system is not sensitive to the vast majority of the electromagnetic spectrum. The human eye contains two classes of photoreceptors, the rods and cones, which together are sensitive only to electromagnetic radiation in the relatively narrow band of wavelengths from ~400 nm (blue light) to ~700 nm (red light). (The nanometer is equal to 1/1,000,000,000 meter.) The frequency of light varies from ~7.5×10^{14} Hz (blue) to ~4×10^{14} Hz (red). The visual system is not uniformly sensitive within this region; the CIE $V(\lambda)$ function describes the average relative sensitivity from 350 to 750 nm under daylight conditions. The human visual system's peak sensitivity in daylight is ~555 nm and 5.4×10^{14} Hz.

Point source. The luminous intensity of any real source varies as a function of viewing angle. The distribution can be displayed on a polar graph, where the intensity is plotted as a function of angle.

Light. The CIE $V(\lambda)$ function describes the relative sensitivity of the average light-adapted human visual system to electromagnetic radiation.

SOURCE VS. SURFACE MEASUREMENTS Photometry includes two broad categories of measurement: (1) measures of light emitted (or reflected) from point or extended sources, and (2) measures of light falling onto surfaces. While fundamental physical differences exist between the two cases, it is important to note that many of the characteristics of both measures are common (i.e., the spectral composition of the light) and that a surface upon which light falls reflects some fraction of the incident light and may be considered an extended source itself.

SOURCE MEASUREMENTS The simplest case is that of a theoretical point source of light, defined as an infinitely small source of light, emitting energy equally in all directions. Such a source can never actually exist, but small sources at a sufficient distance from the measuring device often approximate the theoretical point source. Even very large sources, such as the sun, can be considered point sources because of its distance. Sources are often treated as point sources if they are viewed from a distance greater than ten times their largest dimension. The rate at which a point source emits light in a specified direction is known as its *intensity*. The standard photometric measure of intensity is the *candela*.

Larger sources with significant area are measured in terms of their *luminance*, the rate at which they emit light in a specific direction from each unit area of its surface.

Point Sources: Luminous Intensity (*I*), the Candela (SI unit) The luminous intensity (I_v) of a point source is defined as the time rate of flow of light (i.e., visual power) emitted by the point source in a given direction. The SI unit for luminous intensity is the candela (cd). A point source whose luminous intensity is 1 candela emits 1 lumen into 1 steradian of solid angle (1 lm/sr). Early luminous intensity

standards included candles, flame lamps, and carbon filament incandescent lamps. The original standard candles were superseded in 1948 by the new candle, which was renamed the *candela* in 1963. The standard candela is now defined as the luminous intensity of 1/60 cm^2 of platinum at its solidification temperature, viewed through a narrow tunnel made of thorium dioxide. The old candle was equal to 1.02 times the current standard candela. Tungsten filament lamps are used for secondary standards after calibrating them to a standard source of luminous intensity.

While the theoretical point source emits energy equally in all directions, real sources do not. The shape of the filament, the location and size of the lamp base, and other variables cause irregularities in directional intensity. Several methods can be used to specify the varying intensity of such real sources. Measurements can be taken at many points around the source, either in a plane about its midline, or covering a full sphere. Polar plots are used to display the output in a single plane.

Mean Horizontal Intensity Alternatively, the luminous intensity measurements made at fixed intervals in the horizontal plane passing through a source can be averaged, yielding a single value rather than a function of horizontal viewing angle. Such measurements are termed *mean horizontal intensity*, or *mean horizontal candlepower*. The measure can be made by sampling the source's output at several radial positions, or by integrating over time as the bulb is rotated.

Mean Spherical Intensity The intensity of real sources does not vary only in the horizontal plane. The mean spherical intensity represents the average in three dimensions of luminous intensity measurements made about the source. The measurements may be made by taking readings at several positions a fixed distance from the source or by placing the source in the center of an integrating sphere whose interior surface is covered with a diffuse reflective coating. The luminance of any point on the interior (shielded from direct illumination) can be scaled to provide the mean spherical intensity of the source.

In order to describe the distribution in three dimensions, it is necessary to define a measure for a three-dimensional (or

solid) angle. Analogous to an angular measure in two dimensions, the solid angle is a measure of a three-dimensional cone-angle, such as that contained within the cone defined by a point light source and a circular aperture some distance from the source. The unit of measure is the steradian (sr), defined as the solid angle that subtends on the surface of a sphere an area equal to the square of its radius, such that $A/r^2 = 1$. A sphere of radius r has an area of $4\pi r^2$, so there are 4π steradians in a sphere.

Because the mean spherical intensity is a measure of the average power emitted into a sphere, the total luminous flux of a source may be found by multiplying the mean spherical intensity by 4π steradians (the solid angle of a sphere):

$$\text{Total flux (lumens)} = \text{mean spherical intensity} \cdot 4\pi$$

Luminous Flux (Φ), the Lumen (SI unit) The luminous flux (Φ_v) of a surface is a measure of the visual power emitted in all directions into space. If a source emitted uniformly in all directions, its luminous flux would be equal to the product of the source's intensity (in candelas) and 4π, the number of steradians in a sphere:

$$\text{luminous flux (lumens)} = \text{luminous intensity (cd)} \cdot 4\pi$$

Because the luminous flux of a source measures light emitted in all directions, it may be a misleading measure of the source's useful power. Luminous intensity, the measure of power flowing in a given direction, is frequently a more practical measure of a lamp's output.

EXTENDED SOURCES While distant sources can sometimes be treated as point sources, the photometry of real sources with measurable area is important. In addition to conventional light sources such as frosted tungsten and fluorescent bulbs, note that any surface receiving light scatters and/or reflects some portion of that light and serves as a secondary source. The walls and floor of a room serve as significant sources, as does the day sky. For all extended sources, the visual energy from the source as well as the projected area of the source are significant. Note that two sources with identical intensities may vary in luminance. While a bare tungsten filament and a fluorescent bulb may have the same intensity in a given direction, the visual power is spread over a much larger area in the fluorescent bulb.

Luminance (L), Nit (SI unit) The luminance of a source is defined as the quotient of luminous intensity of source in a specified direction divided by the projected area in that direction (e.g., candelas per square meter). The luminance of an extended source or surface is invariant with viewing distance because the change in luminous energy arriving from each point is exactly balanced by the change in angular size of the surface.

Luminance is the property of a source or surface that most closely correlates with the subjective percept of brightness, which, because of adaptation and contrast effects of the visual system is not a reliable measure.

Typical Luminance Values (in stilb)

Clear sky	0.4
Candle flame	0.5
Fluorescent tube	1
Frosted bulb	30
Tungsten filament	500
Carbon arc	10,000
Sun	150,000

A number of units have been used to specify luminance. Many units are defined in terms of luminous intensity per unit projected area; the preferred International System (SI) unit, the nit, is equal to 1 candela per square meter. Another group of units is based on the luminance reading when an ideal lambertian surface receives a given illuminance.

Luminance can be measured in two ways: (1) physical measurements made by photoelectric meters designed to accept luminous power over a limited angle, and (2) visual measurements in which an observer matches the perceived brightness of the test field to that of a reference field.

Photoelectric detectors respond to the power incident on the surface per unit area, that is, illuminance. In order to measure luminance, the detector must be made to respond to power emitted from, or reflected off a distal surface. In its simplest form a luminance meter can be made by restricting the angle over which light is collected on the detector surface and pointing the meter at the surface to be measured. Adequate shielding ensures that only light from the surface is allowed to fall on the detector. Measured luminance doesn't change with distance; as the meter is moved farther from the surface, inverse-square losses are exactly canceled by the increased area within the meter's view. More advanced designs incorporate optical systems to form a real image of the surface. Luminance is constant throughout a lossless optical system, so luminance measures of an image represent the luminance of the distal surface. In both cases, the photodetectors must be filtered to approximate the spectral sensitivity of the human visual system.

While it is true that absolute luminance judgments cannot be made visually, visual luminance measurements can be made with great precision by matching the brightness of the test field with an adjacent reference surface of known luminance. Such measures are valid only if the colors of the test and reference fields are similar. Attempts to match fields with significant color differences increase the variability of such measurements. Flicker photometry, in which the fields are rapidly alternated in the same location instead of viewed side by side, are used when the test and reference fields have different spectral distributions.

Lambert's Law The luminance of some surfaces is constant, regardless of the angle from which it is viewed. Such surfaces are known as lambertian surfaces. While the luminous intensity per unit area of a lambertian surface falls off as the cosine of the angle from which it is viewed, that is, $I_\Phi = I_o \cos(\Phi)$, the change in the surface's projected area cancels that loss. All real surfaces exhibit some specular component and cannot be truly lambertian, though some materials, such as pressed barium sulfate ($BaSO_4$) approximate an ideal lambertian surface.

Reflected-Light Meters While the light source is often considered an external component in a photographic scene, every point in the scene that emits, scatters, or reflects light is a source and has an associated luminance. Reflected-light meters measure the luminance of a scene. Averaging reflected-light meters respond to the average luminance, while spot meters allow the measurement of small areas within the scene. Some meters use a combination of the two; center-weighted meters respond to a large scene, but the reading is influenced more strongly by the luminance in the center of the field.

The measured luminance is invariant with distance between the meter and a uniform surface as long as the surface being measured fills the meter's field. Although the light reaching the meter from a given position is reduced with increased distance, the field of view from the new position increases at the same rate, resulting in distance invariance.

Reflected-light photographic exposure meters do not read out luminance values. The measured luminance is used to predict the correct exposure settings for a given film speed, assuming that the scene is of average reflectance, usually taken to be 18%. If the scene does not have average reflectance, the indicated settings will produce incorrect exposure. For example, the average luminance of a highly

reflective scene lit with a given source could be identical to that of a dark scene lit with 10 times the light. Since the luminance is identical in both cases, the exposure meter would indicate the same exposure for both scenes. The photographer's knowledge of scene reflectance is necessary to arrive at correct exposure settings in each case.

SURFACE MEASUREMENTS The other major class of photometry is the measurement of *illuminance,* the measure of light energy incident on a surface. The source of the incident light may be point or extended sources, as well as reflections from other surfaces. Unlike luminance measures, surface characteristics and reflectance have no effect on illuminance.

Illuminance (E), Lux (SI unit) The illuminance incident on a surface is a measure of the luminous power per unit area incident on a surface. Surface illuminance is a function of source intensity, the distance from source to surface, and the angle at which the light strikes the surface. Illuminance from a point source falls off at a rate proportional to the square of the distance to the source: $E \propto I/d^2$. Illuminance from a point source at an angle Φ from surface normal is reduced further because the power is spread over a larger area. The falloff obeys the cosine law, $E_\theta = E_0 \cdot \cos(\theta)$, where E_0 is the normal illuminance.

Typical Illuminance Values (in lux)

Full moon	0.2
Dim hallway	25
Well-lit street	50
Comfortable reading	500
Workshop	1,000
Precise work	2,000
Under clear blue sky	20,000
Direct sunlight	100,000

Illuminance is specified in units with lumen per area measures; the lux (the preferred SI unit) is the number of lumens incident on a 1 m^2 surface. A point 1 m from a 1 candela source receives 1 lux of illuminance. Other common units include the footcandle (fc) and the phot (ph).

Photographic exposure is defined as the product of image-plane illuminance and exposure duration, $H = E \cdot t,$ and is usually given in units of lux seconds.

So called incident-light meters measure the power per unit area falling on a surface and are therefore a type of illuminance meter. Note, however, that many meters designed for use in determining photographic exposure are not filtered to match the spectral sensitivity of the standard photopic observer [the CIE $V(\lambda)$ function]. Consequently, they may not indicate true illuminance as defined.

PHOTOMETERS Instruments used to measure luminous quantities are known as photometers. Before the advent of photoelectric detectors, the only method available to make source or surface light measurements was the use of visual instruments based on subjective matching. Because of adaptation and contrast effects of the visual system, it is impossible to make reliable absolute measures. While the visual system cannot make absolute measurements, it is exquisitely sensitive to small changes between adjacent regions of the visual field. The earliest photometers took advantage of this ability, measuring photometric quantities by matching the brightness of an unknown surface to that of a standard.

Because of the advent of reliable photoelectric detectors, there are now two broad classes of photometers: (1) visual photometers, in which the measurements are based on visual comparison between the unknown field and a reference field,

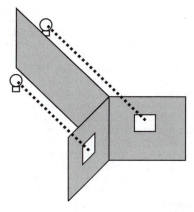

Visual photometer. The first reported device designed to evaluate photometric quantities was the Bouguer photometer, designed in the early 1700s. The relative intensity of two sources was determined by adjusting the distance between each source and a translucent window until their apparent brightnesses were equal.

and (2) photoelectric photometers, in which a photoelectric detector (filtered to match the photopic relative luminous efficiency function of the standard observer) is used to measure the desired quantity. While photoelectric photometers must be calibrated frequently, they are capable of more consistent results with different operators because variation in individuals' spectral sensitivities can affect measurements based on visual matching.

Visual photometers Visual photometers are used to measure luminous quantities such as luminous intensity, luminance, and illuminance based on visual comparison of two fields. The operator views an unknown source (or surface) along with a reference field. While absolute brightness judgments are impossible, this class of photometers takes advantage of the visual system's sensitivity to differences in brightness between two fields, i.e., contrast. The two fields

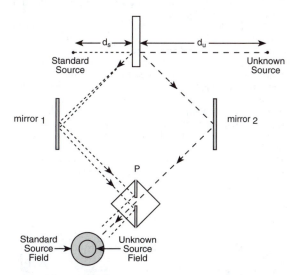

The Lummer–Brodhun photometer uses a special prism to allow the standard reference and unknown fields to be viewed in close proximity. Light from the standard source is reflected inside the prism, forming the peripheral annulus, while light from the unknown source is transmitted through the center of the prism, forming the central disc. The distances d_s and d_u are adjusted to minimize the contrast between the two fields.

are made to match by adjusting the brightness of one or both fields, and the unknown quantity is inferred from those adjustments and knowledge of the reference source's characteristics. The first reported design for such a device was the Bouguer photometer, named after its designer, Pierre Bouguer (1698–1758). The photometer held two sources, each illuminating a waxed paper window, and baffling to separate the two light sources. The distance from each source to its translucent window was adjusted until the brightness of the two fields matched. Based on the relative distances of the two sources when the match was achieved, one could find the relative intensity of the unknown source with respect to the known by applying the inverse square law.

The precision of Bouguer's design was limited because the reference and unknown fields were separated, making equality of brightness judgments unreliable. The Lummer–Brodhun photometer is one of a class of photometers known as bipartite field photometers. It contains a specially designed prism that displays the reference and unknown fields in close proximity, allowing the operator to reliably minimize the difference between the fields. In most bipartite field photometers the total field is circular and subtends approximately 2 degrees to ensure foveal vision. In addition to the disc-annulus field type, many bipartite field photometers have vertical or horizontal midline divisions.

Bipartite field photometers are capable of providing very accurate measurements if the reference and test fields have the same spectral content. The accuracy and repeatability of measurements fall quickly when the colors of the two fields differ because hue and saturation differences are confounded with luminance differences in the visual system.

Heterochromatic Photometers While brightness judgments of differently colored fields can still be made in cases where there are large luminance differences between the two fields, great uncertainty exists in matches performed with large color differences because hue and saturation differences are confounded with luminance differences, making heterochromatic matches difficult and unreliable. While matches made under scotopic (dark-adapted) conditions would eliminate color differences, they would not correlate with photopic perception because of the different spectral sensitivity at those light levels.

Several reliable heterochromatic methods have been developed. In the *cascade* or *step-by-step* method, a large color difference is broken up into a series of smaller steps. Measurements of these smaller steps can be made with nearly the same precision as with homochromatic fields. Another method places colored filters over one or both fields to minimize the color difference. The spectral transmittance of the filters is then taken into account in determining the result. Perhaps the most successful method is flicker photometry, in which test and reference fields are viewed in rapid succession. When the two fields are alternated slowly, any difference in luminance or color results in perceived flickering. Flicker photometry takes advantage of the fact

that perceived color differences fuse at lower temporal frequencies (typically 10–20 Hz) than do luminance differences. By selecting the appropriate rate, a match can be achieved by adjusting the test field to minimize the flicker due only to the luminance difference.

Heterochromatic photometric measurements can also be made with photoelectric photometers by scaling the power in each wavelength region by the CIE $V(\lambda)$ function. Such scaling can be accomplished analytically or by filtering the detector to match the $V(\lambda)$ function.

Photoelectric Photometers The advent of photoelectric detectors has allowed the design of photometers based on physical measures of light in place of earlier visual comparison photometers. While photoelectric photometers must be calibrated frequently, they are capable of more repeatable results because significant variation in individuals' spectral sensitivities can affect visual measurements.

Current photoelectric photometers are designed around several different classes of photodetectors: *Photoemissive* detectors make use of the phenomenon that some metals release electrons when they are struck by light. The photomultiplier tube is an example of such a device. In order to detect very low light levels, its output is increased by secondary emission; the electrons released by the incident light create an even larger current by releasing still more electrons at intermediate surfaces in the photomultiplier tube. *Photovoltaic* detectors (solar cells) are semiconductor devices in which incident light creates a potential difference across a boundary layer, converting the incident light to an electrical voltage. Selenium cells are one example of such photodetectors. *Photoconductive* detectors are not a source of electric current; rather their conductance is increased as a function of illumination incident on the cell. Cadmium sulfide cells (CdS) are an example of photoconductive cells.

Photoelectric photometers can be calibrated to read photometric values directly. All photometric units are based on the original visual definitions, so photoelectric photometers must be designed to respond as though they had the same spectral sensitivity as the visual system, as specified by the CIE $V(\lambda)$ function. This can be accomplished by filtering the light that reaches the photoelectric cell or by correcting the cell's response in each wavelength region analytically.

Photoelectric photometers. The CIE $V(\lambda)$ function describes the relative sensitivity of the average light-adapted human visual system to electromagnetic radiation, but there is significant variation in individuals' responses. These differences increase the variability in all visual photometric measures of polychromatic sources. Photoelectric photometers eliminate this variability but must be carefully calibrated and monitored to ensure reliable results.

PHOTOMETRIC UNITS The International System of units (SI) for all measurements is based on just seven fundamental dimensions: length, time, mass, temperature, electric current, amount of substance, and luminous intensity. All other units are derived from these fundamental units.

The visual fields in bipartite field photometers place the unknown and reference fields side by side. Shown are a vertical-midline field, *left,* and a disc-annulus field, *right.*

Luminous intensity (I_v) is the time rate of flow of light (i.e., visual power) emitted by a point source in a given direction. The SI unit for luminous intensity is the candela (cd). A point source whose luminous intensity is 1 candela emits 1 lumen into 1 steradian of solid angle (1 lm/sr). Early luminous intensity standards included candles, flame lamps, and carbon filament incandescent lamps. While intensity is strictly defined only for point sources, the measure is often applied to sources whose maximum dimension is much less than the distance from which they are viewed. (Luminance is the appropriate measure for sources whose maximum dimension is >1/10 the viewing distance.)

By definition, the intensity of a source is invariant with distance, but the intensity of any real source varies with direction, so a single intensity value may be of little use in determining the effectiveness of a source in illuminating a scene. For example, a reflector can direct the power of a small bulb into a narrow solid angle, greatly increasing the intensity in that direction. The increase in one direction is balanced by a loss in other directions, leaving the total power constant. Luminous flux (F_v) is the time rate of flow of light (i.e., visual power) emitted by a source or passing through a defined aperture. Luminous flux is a measure of radiant power scaled with respect to the CIE standard observer's spectral sensitivity and is measured in lumens (lm; the flux flowing into 1 steradian from a 1 candela source). The luminous flux of a source is calculated by scaling the spectral power distribution of that source by the standard observer's relative photopic sensitivity:

$$\text{Luminous flux} = \Phi_v = k\Sigma_{360}^{780}\Phi_r(\lambda)V(\lambda)\Delta\lambda$$

where k is the maximum luminous efficacy (683 lm/W); $F_r(\lambda)$ is the spectral power (in watts per nanometer) at wavelength l; $V(\lambda)$ is the relative luminous efficiency function of the standard observer; and $\Delta\lambda$ is the wavelength interval (in nanometers) used in the summation.

Because the luminous flux of a source measures light emitted in all directions, it may be a misleading measure of the source's useful power. Luminous intensity, a measure of power flowing in a given direction, is frequently a more practical measure of a lamp's output.

Luminous exitance (M_v) is the power output (emitted or reflected) per unit surface area. The preferred unit is lumens per square meter (lm/m²). Unlike luminance, which is a measure of the power output into a given solid angle per unit surface area, exitance measures the total power emitted in all directions. Note that while the dimensions used to define exitance are identical to those used for illuminance (i.e., power/area), exitance refers to the power *leaving* a surface, while illuminance refers to luminous power *incident* on a surface. The former term *emittance* has been abandoned.

Illuminance (E_v) is a measure of luminous power per unit area incident on a surface (dF/dA). The preferred unit is the International System (SI) unit lux, equal to lumens per square meter. A point 1 m from a 1 candela source receives 1 lux of illuminance. Other common units are the footcandle (fc), equal to 1 lumen per square foot, and the phot (ph), equal to 1 lumen per square centimeter.

Conversion Factors for Illuminance Units

	Lux	Footcandle	Phot
Lux	1.0	$9.29 \cdot 10^{-2}$	$1.0 \cdot 10^{-4}$
Footcandle	$1.08 \cdot 10^{1}$	1.0	$1.08 \cdot 10^{-3}$
Phot	$1.0 \cdot 10^{4}$	$9.29 \cdot 10^{2}$	1.0

Note that while the dimensions of illuminance are the same as those for luminous exitance (luminous power per

area), they refer to different processes. The area in the definition of illuminance is that area *receiving* power, while in exitance, it refers to the area *emitting* power.

Surface illuminance is a function of source intensity, the distance from source to surface, and the angle at which the light strikes the surface. Surface illuminance from a point source falls off as the square of the distance to the source, $E \mu I/d^2$. Illuminance from a point source an angle q from surface normal is reduced further because the power is spread over a larger area. The falloff obeys the cosine law, $E_q = E_0 \cdot \cos(q)$, where E_0 is the normal illuminance.

The units used to specify illuminance have dimensions of *lumen per area*. The lux (the preferred SI unit) is the number of lumens incident on a 1 m² surface. A surface 1 m from a 1 candela source receives 1 lux of illuminance. Other common units include the footcandle (fc), the number of lumens incident on a 1 square foot surface, and the phot (ph), the number of lumens incident on a 1 cm² surface.

Luminance (L_v), formerly photometric brightness, is the quotient of the luminous intensity of an extended surface in a specified direction divided by the projected area in that direction (i.e., candelas per square meter). The luminance of an extended source or surface is invariant with viewing distance. Luminance is also invariant within a lossless optical system because changes in image size are balanced by inverse changes in solid angle. The luminance of a lambertian (ideal) diffuser is invariant with viewing angle because the reduced power reflected off-axis is balanced by a reduction in projected area.

Luminance is the property of a source or surface that most closely correlates with the subjective percept of brightness, which, due to adaptation and contrast effects of the visual system, cannot be used as a reliable measure.

Photometry has been plagued with a confusing array of units because of its origins in psychophysical measures, the changing standards as technology moved forward, and its concurrent growth in many places around the world. The specification of luminance values is perhaps the most confusing. One group of units was derived in terms of intensity per unit projected area, with *area* specified in several units, for example, candela per square meter (nit), candela per square centimeter (stilb), candela per square foot, and candela per square inch. A second group of luminance units was derived for lambertian (ideal) surfaces receiving a given level of illumination. For example, 1 apostilb (asb) is defined as the luminance of a lambertian surface illuminated at 1 lux (lumen/m²). The reradiation characteristics of the energy into a hemisphere introduces a 1/π factor, so 1 apostilb = 1/π cd/m². Similarly, 1 lambert = 1/π cd/cm², and 1 foot-lambert = 1/π cd/ft².

Many of these units were derived independently, so there are multiple names for the same units, (e.g., 1 apostilb = 1 equivalent lux = 1 blondel) and different units with the same name (e.g., the Hefner apostilb = 0.9 apostilb). The preferred International System (SI) luminance unit is the candela per square meter (nit).

Although this table includes most of the units that one is likely to encounter in current literature, it is not exhaustive; units such as the skot (equal to 10^{-3} asb) and the meter-lambert (equal to 1/π cd/m²) are found in older literature.

While these photometric variables are capable of fully specifying the visual effect of any source, other measures are required to gauge a light source's conversion of electric current into light. Luminous efficacy (K) is the conversion factor that describes the light-producing capability of a source of radiant energy, that is the radio of luminous flux at a given wavelength (or range of wavelengths) to the radiant flux at the same wavelength (or range of wavelengths). The International System (SI) unit of luminous efficacy is lumens per watt (lm/W). Monochromatic radiation at a wavelength of 555 nm produces the maximum visual effect; 1 W of power at that wavelength produces 683 lumens of luminous power for the

Conversion Factors for Luminance Units

	Nit	Stilb	Apostilb	Lambert	Millilambert	Footlambert	Candela/ft²
1 nit	1.0	$1.0 \cdot 10^{-4}$	π	$\pi \cdot 10^{-4}$	$\pi \cdot 10^{-1}$	$2.92 \cdot 10^{-1}$	$9.29 \cdot 10^{-2}$
1 stilb	$1.0 \cdot 10^4$	1.0	$\pi \cdot 10^4$	π	$\pi \cdot 10^3$	$2.92 \cdot 10^3$	$9.29 \cdot 10^2$
1 apostilb	$1/\pi$	$1/\pi \cdot 10^{-4}$	1.0	$1.0 \cdot 10^4$	$1.0 \cdot 10^{-1}$	$9.29 \cdot 10^{-2}$	$2.96 \cdot 10^{-2}$
1 lambert	$1/\pi \cdot 10^4$	$1/\pi$	$1.0 \cdot 10^4$	1.0	$1.0 \cdot 10^3$	$9.29 \cdot 10^2$	$2.96 \cdot 10^2$
1 millilambert	$1/\pi \cdot 10^1$	$1/\pi \cdot 10^{-3}$	$1.0 \cdot 10^1$	$1.0 \cdot 10^{-3}$	1.0	$9.29 \cdot 10^{-1}$	$2.96 \cdot 10^{-1}$
1 foot lambert	3.43	$3.43 \cdot 10^{-4}$	$1.08 \cdot 10^1$	$1.08 \cdot 10^{-3}$	1.08	1.0	$1/\pi$
1 candela/ft²	$1.08 \cdot 10^1$	$1.08 \cdot 10^{-3}$	$3.38 \cdot 10^1$	$3.38 \cdot 10^{-3}$	3.38	π	1.0

Photometric Quantities: Symbols, Defining Equations, Units, and Abbreviations

Quantity	Symbol	Defining Equations	SI Unit	Abbreviation
Luminous flux	Φ_v	$\Phi = dQ/dt$	Lumen	lm
Luminous exitance	M_v	$M = d\Phi/dA$	Lumen per square meter	lm/m²
Illuminance	E_v	$E = d\Phi/dA$	Lux (lumen per square meter)	lx
Luminous intensity (formerly candlepower)	I_v	$I = d\Phi/d\omega$	Candela (lumen per steradian)	cd
Luminance (formerly photometric brightness)	L_v	$L = dI/d(A\cos q)$	Nit (lumen per steradian square meter)	
Source efficacy and efficiency definitions:				
Luminous efficacy	K	$K = \Phi_v/\Phi_e$	Lumen per watt	lm/W
Luminous efficiency	η	$\eta = K/K_{max}$	[ratio]	

CIE standard observer. Hence the maximum efficacy for any monochromatic source is 683 lm/W. A theoretical broadband source containing equal energies at all wavelengths between 400 and 740 nm would have an efficacy of 215 lm/W.

Luminous Efficacy of Typical Broadband Sources

15 W Tungsten bulb	10 lm/W
100 W Tungsten bulb	20 lm/W
Fluorescent bulb	75 lm/W
High pressure sodium	120 lm/W

Luminous efficiency (h) is the ratio of a given source's efficacy to the maximum (683 lm/W):

$$\text{Luminous efficiency} = \text{Efficacy}(\lambda)/\text{Efficacy}_{max} = \text{Efficacy}(\lambda)/683$$

Because the value represents a ratio of efficacies, it is dimensionless. Luminous efficiencies are often stated as percentages. For example, the luminous efficiency of a helium neon laser is

$$\text{Efficacy}(632.8 \text{ nm})/\text{Efficacy}_{max} = 169.4/683 = 0.2480,$$
or 24.8%

<div align="right">J. Pelz</div>

See also: *Bouguer photometer; Equivalent luminance; Inverse square law; Luminous intensity; Mean horizontal intensity; Mean spherical intensity; Purkinje effect/Purkinje shift; Solid angle; Steradian; Vision, the human eye.*

PHOTOMICROGRAPHY Photomicrography is a special form of microprojection by which photographs of minute objects are made with a camera and microscope. It should not be confused with microphotography, which is the process by which minute photographs are made of large objects.

HISTORY The historical development of photomicrography parallels that of enlarging—both produce enlarged images by projection. Henry Baker, an English microscopist described a projecting solar microscope in his 1743 publication, *The Microscope Made Easy,* based on a camera obscura microscope shown to him by Lieberkuhn in 1740. George Adams in a 1771 publication illustrated one of the earliest projecting microscopes using artificial illumination (a four-wick oil lamp). In 1784, his son, George Adams Jr., described an improved version using the Argand lamp. But these and later projection microscopes had to await a means of recording the projected images. In 1802, Thomas Wedgwood described his success using a solar microscope to make photomicrographs on paper prepared with a sensitized coating of silver chloride; his images unfortunately, were not permanent.

It was not until 1835 that William Henry Fox Talbot would find a way to preserve the photographic images. By applying his experimental process of photogenic drawing to the solar microscope, Fox Talbot obtained photomicrographs of such objects as a slice of wood and an insect's wing, magnified 17×, using exposures of about 15 minutes. Freidrich Gerber of Berne made enlarged photographic images of microscopic objects on paper sensitized by his independently devised method, before February 1839. The Reverend Joseph B. Reade made his earliest photomicrographs of a flea on March 26, 1839. Alfred Donné made photomicrographs on daguerreotype plates of sections of bones and teeth in February 1840, and subsequently he and others made photomicrographs of medical specimens. In July 1840, John Benjamin Dancer used a gas microscope to photograph a flea magnified large enough to fill a 5 × 7-in. daguerreotype plate. J. Delves, a member of the then newly founded Microscopical Society, successfully made photomicrographs by the wet collodion process in 1852. Thereafter, photomicrography was extensively practiced. In the United States during the latter half of the nineteenth century, Col. Dr. J. J. Woodward of the U.S. Army Medical Museum was a prominent and prolific photomicrographer.

BASIC SETUP In its simplest form, photomicrography does not require a camera—only a microscope and light

source. With this arrangement, the real image from the microscope is projected directly onto photographic film or paper mounted on a wall in a darkened room—a right-angle prism, silvered on the hypotenuse, being used to bend the light path in the case of a vertically positioned microscope. This simple, although somewhat inconvenient arrangement, is used by both amateurs who cannot afford photomicrographic cameras and by seasoned professionals who wish to eliminate the effects of multiple optical components.

In the more conventional arrangement, there are always three main units in any photomicrographic setup; a lamp system for illuminating he specimen, a compound microscope, and a light-tight extension to hold the sensitized material. These three components, rigidly fixed together, make up a photomicrographic optical bench.

This optical bench may be arranged vertically or horizontally. The horizontal bench is found primarily in metallographs—photomicrographic setups for metals or other opaque specimens. It can be made absolutely rigid and presents fewer construction problems, especially for handling larger metal specimens. Biomedical specimens, on the other hand, frequently require liquid preparations, where a vertical arrangement is more convenient. A vertical instrument also takes up less bench space and, if it is rigidly constructed, is capable of just as fine work as the horizontal type. To assure rigidity for large-format photomicrography, some photomicrographers build their instruments on lathe beds and anchor them to floors, wall studs, or ceilings. For large-format photomicrography it is best to support the camera unit separately on a rigid stand, rather than have it simply attached to the top of the microscope.

The Camera The camera is no more than a light-tight box fitted with a focusing screen and a film holder, capable of light-tight connection with the microscope eyepiece.

Optical bench arrangement. *Top*, horizontal, which is easy to construct but requires considerable bench space. The microscope lamp directly illuminates the condenser. *Bottom*, vertical, which is compact but difficult for the amateur to construct in a sufficiently rigid form. A mirror directs light from the lamp to the condenser. The camera and bellows are usually part of the unit.

Basic setup. Uses a normal camera, focused on infinity. The microscope is focused visually and the exposure is found by trial and error. A table lamp serves as the light source for the substage condenser. Such an arrangement is suitable only for low-power work.

In its simplest form, the camera can be homemade from a beverage can, round cereal box, coffee can, etc., depending on the film format. Or, more commonly, any kind of camera of any format can be used if its lens is first set to infinity and it is supported close against the eyepiece of the microscope, after the specimen has first been focused visually in the ordinary way. The resulting image, however, is likely to be vignetted, because the exit pupil of the eyepiece is too far away from the camera lens diaphragm.

Single-lens reflex cameras can be used for photomicrography, usually by removing the lens and using a light-tight coupling adapter between the microscope and eyepiece. There are two main types of adapters for use with single-lens reflex cameras: (1) those that are simply single or ganged extension tubes with no lens incorporated, and (2) those that incorporate a lens. Those that incorporate a lens are more desirable for this reason: the microscope is, by design, a visual

Photomicrographic attachment. *Top left*, complete optical system of microscope, photomicrographic attachment, and small-format camera with lens removed. A movable prism permits observation of the image. *Top right*, the photomicrographic attachment. *Bottom left*, the attachment (with its own shutter) mounted on the microscope.

instrument, and as such the image-forming rays exit the eye-piece parallel, and enter the eyelens where they are then focused onto the retina. Therefore, when the microscope is focused visually, and then a camera without lens is attached, the image will not be in focus in the camera viewfinder—the rays from the eyepiece are still parallel. At this point, the microscope needs to be refocused; but refocusing to convert the microscope into a projector introduces spherical aberration in the final image. Photomicrography is still possible, but the image will be somewhat degraded.

Adapter tubes that incorporate a lens provide superior images because the adapter lens substitutes for the eyelens; the film lies one focal length away from this lens, and the image will be in focus without having to refocus the microscope from its visually set position.

If a single-lens reflex camera is used for photomicrography, it should be one that has interchangeable focusing screens. The regular focusing screen will only be suitable for relatively low magnifications (~30×); for higher magnifications, the aerial image must be focused on a screen that has a clear area with crosshairs, or other reference lines that indicate the proper focal plane. Changing focusing screens may affect the automatic exposure feature of some cameras.

Apart from these homemade or single-lens reflex camera adaptation methods, there are special eyepiece cameras for 35-mm films made specifically for making photographs through a microscope. They typically fit directly on the microscope eyetube and require no external support. They incorporate an eyepiece, a beam splitter, an intermediate lens, and a film transport mechanism. The beam splitter divides the light between a focusing side telescope (20–30%)

and the film (70–80%); in some instruments, the beam splitter may be removed from the light path before the exposure is made. In those units without a built-in light meter, the light value is read at the side focusing telescope with a separate light meter. Film transport in these special cameras may be manual or automatic.

Special photomicrographic cameras for large format film come in two main configurations–fixed length and variable length. The fixed-length adapters usually also have a side focusing telescope and attach directly to the microscope eyetube. These units tend to be less stable and produce more stress at the attachment point, especially for the 4 × 5-in. units.

The variable-length units incorporate a reflex-viewing film holder mounted on a separate stand, with a variable-length bellows being the only attachment to the microscope eyetube. Photomicrographic cameras of this type are extremely versatile instruments, as the magnifications are continuously variable, and the apparatus is invariably quite rigid.

The most modern and expensive instruments are the large research-type photomicroscopes with several, interchangeable light sources, and built-in photomicrographic capabilities including up to two 35-mm cameras, and 4 × 5 in., together with built-in spot and integrated light meter, and automatic exposure. Instruments of this type, however, are neither necessary for, nor do they guarantee, successful photomicrographs.

The Microscope Practically any good compound microscope can be used for photomicrography, even instruments 50–100 years old—the age does not matter. The main things to look for are rigidity of all parts and freedom from backlash

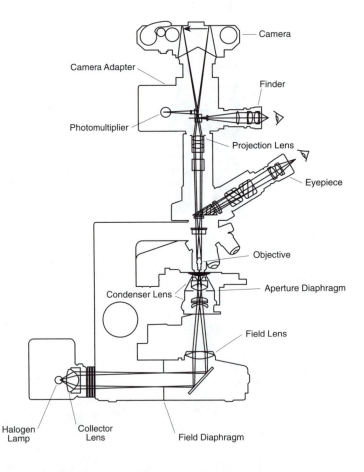

Professional photomicrographic system.

or seizing in the focus controls—all mechanical considerations. Of course, since the excellence of the resulting photographs depends on the optical equipment, all of the lenses should be of the best quality that one can afford.

Objectives are the principal image-forming components. They are available in three degrees of correction: achromatic, fluorite (semiapochromatic), and apochromatic. Achromats are corrected for two wavelengths for chromatic aberration and one wavelength for spherical aberration; fluorites are corrected for two wavelengths of chromatic aberration and two wavelengths of spherical aberration; apochromats are corrected for three wavelengths of chromatic aberration, and two wavelengths of spherical aberration. Each of the three degrees of correction is additionally available either as flatfield (plan) or nonflatfield. Nonflatfield achromats are by far the most commonly available but have the least corrected objectives; whereas the planapochromats are the least common and most expensive but have the most highly corrected objectives.

There are, with a couple of notable exceptions, residual aberrations remaining in the objective so that the eyepieces used should be matched to their respective objectives. In general, compensating eyepieces are best with apochromatic objectives and high numerical aperture achromatic objectives, but achromatic objectives and Huyghenian eyepieces will give excellent results in black-and-white photomicrography with monochromatic light produced by interposing a suitable filter (generally green) between the light source and the microscope.

The substage condenser is an often overlooked optical component in photomicrography. The substage condenser may be absent from some simple student-grade microscopes, or consist of a single lens fixed in the stage, or may be a focusable one- or two-lens unit, or a seven- to nine-lens achromat. The quality of the final photomicrograph depends on matching the condenser to the objectives, especially with regard to correction and numerical aperture.

Many critical photomicrographers prefer older microscopes because of the versatility of their drawtubes, centerable aperture diaphragms, separate light sources, and other mechanical features not found on modern instruments.

In photomicrography, the resolving power—or the ability to separate the images of two points lying very close together—is more important than mere magnification. There is no upper limit to the magnifying power of the light microscope (in 1834, a hydro-oxygen microscope was magnifying living creatures in a drop of water 500,000×). The angular aperture, or ability to capture diffracted rays of large angle, is the key to resolving power. The ability of an objective to resolve detail is indicated not by the magnification engraved on its barrel, but on its numerical aperture. In transmitted-light photomicrography, the numerical aperture of the substage condenser should be equal to or greater than the numerical aperture of the objective it is to be used with. Objectives and condensers for photomicrography should be selected for the highest numerical aperture that one can afford.

Illumination　As the name *photomicrography* implies—and in common with all forms of photography—the lighting, or illumination of the specimen, is critical for successful photomicrography. Improper illumination results in a *hotspot* (fall-off at the edges) or an image of the filament superimposed on that of the specimen.

For very simple subjects, an opal filament lamp of 60–100 W will suffice, and may be positioned so that the light falls directly onto the specimen. For many amateur photomicrographs, this form of illumination may be sufficient, but for serious photomicrography, more specialized lamps are required.

In the distant past, the ideal light source was regarded as "a white cloud in the North sky," but modern photomicrographers use artificial light because of the complete control that

is possible with it. Light sources today range from simple low-voltage (6–12 V) lamps of 5–60 W, with or without built-in diffusers, to 100 W projection lamps, cesium iodide burners, and high-pressure mercury vapor lamps. The most common, however, are the 12 V quartz halogen lamps of 20–100 W, which have a color temperature of 3200 K. Electronic flash is used for moving specimens.

The light source will be fitted into a well-ventilated housing, which may be on a separate stand to be used with horseshoe-base microscopes, or may be built in and attached to the rear or side of the microscope base. In either case, there are three main components to all professional microscope illuminators: the filament, the lamp condenser, and the field (or lamp) diaphragm. Optimally, the distance between the filament and the lamp condenser should be adjustable, so that the filament can be focused. This can be done through adjustments for the positioning of the filament with respect to a fixer condenser or through a focusing lamp condenser and a centerable filament. Less versatile and efficient illuminators incorporate a diffuser and no adjustable parts.

Good illumination also requires a microscope with focusing substage condenser, incorporating an adjustable aperture diaphragm.

Köhler Illumination　The form of illumination introduced by August Köhler about 100 years ago is still the most usual method of critical illumination; it provides the maximum intensity of even illumination from nonhomogeneous light sources. This method of illumination requires a lamp condenser and field diaphragm in the illuminating apparatus and a focusable substage condenser with aperture diaphragm in the microscope.

The specimen is first brought into good focus with the coarse and fine focus controls, and any centerable components, such as a centerable rotating stage, or centerable objectives are adjusted to be mechanically aligned on the optical axis.

The first step in setting up Köhler illumination is to close the field diaphragm and focus on the iris leaves using the substage condenser focus control. This results in a sharply focused field diaphragm in the plane of the specimen. The field diaphragm is then opened until it is just outside of the field of view.

The second step in setting up Köhler illumination is to focus the filament in the plane of the substage condenser's aperture diaphragm, using the lamp condenser. This can be done by actually observing the filament image on the partly closed aperture diaphragm while looking up into the condenser via the mirror or, more commonly, by removing the eyepiece and looking down the microscope at the objective back focal plane (the second conjugate image of the filament). The filament is adjusted to be centered in the objective back focal plane, and the lamp condenser is focused to just fill the entire objective back focal plane. These steps are best done initially with a *high-dry* objective, that is, 40–63×. Then, while looking down the tube with the eyepiece removed, the aperture diaphragm is closed until it is just inside the objective exit pupil. If there is a diffuser anywhere in the light path, this step cannot be accomplished as described, and the goal then will be to arrange the bulb or any adjustable parts so that the objective back focal plane is fully and evenly illuminated.

When the microscope illumination is adjusted in this way, the specimen field of view will be evenly illuminated. The field diaphragm's function is to illuminate only that part of the specimen that is under direct view of the objective and no more. It is adjusted until it is just barely outside the field of view. This prevents light from striking specimen structures outside the field of view and then being reflected into the objective, which results in glare and reduced contrast. The field diaphragm setting must be

readjusted whenever the objective magnification is changed—opening for the lower magnifications and closing for the higher magnifications.

In critical photomicrography, the focus of the field diaphragm in the plane of the specimen is checked between specimens, because different slide thickness and different amounts of mounting medium beneath the specimen will require refocusing the field diaphragm with the substage condenser.

At the same time, the aperture diaphragm in the substage condenser controls the numerical aperture of the system; that is, it controls the angle of the illuminating cone of light from the condenser. Ideally, the angle of this illuminating cone exactly matches the angular aperture of the objective. In practice, the aperture diaphragm is closed down somewhat. This reduces glare and other image aberrations resulting from using the margins of the lenses. In this regard, the aperture diaphragm acts like the diaphragm in an ordinary camera lens or enlarging lens—closing down one or two stops from wide open. The aperture diaphragm must be readjusted whenever the numerical aperture of the objective is changed, that is, usually whenever the objective magnification is changed. As the numerical aperture of the objective is increased (usually with increase of magnification), the aperture diaphragm must be opened; as the numerical aperture of the objective is decreased (usually lower magnification), the aperture diaphragm must be closed. Note that this is opposite to the field diaphragm settings.

In Köhler illumination, there are actually two separate ray paths occurring simultaneously, the image-forming ray path and the illuminating ray path. The image-forming ray path traces the image of the field diaphragm and specimen through the optical system. Starting at the field diaphragm on the illuminator, note that the first real image of this diaphragm is in the plane of the specimen; this is achieved by the user focusing the substage condenser until the field diaphragm image is seen sharply focused on the specimen. From there, an enlarged image of the specimen and field diaphragm image are focused in the intermediate image plane by the objective. Then the eyepiece, being focused on the intermediate image plane, results in the final real image of the specimen and field diaphragm on the retina. There are thus three conjugate foci of the field diaphragm: the specimen, the intermediate image plane, and the retina. The sharp focus of the field diaphragm is accomplished with the substage condenser focus control.

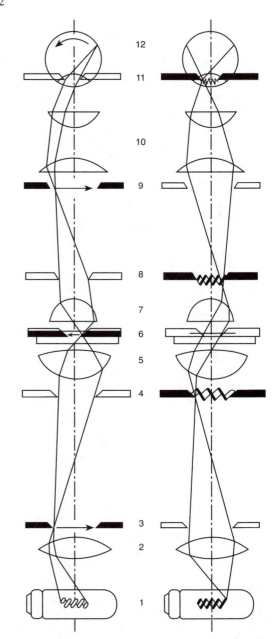

1 Lamp Filament
2 Lamp Condenser
3 Field Diaphragm
4 Substage aperture diaphragm
5 Substage condenser
6 Preparation
7 Objective
8 Objective back focal plane
9 Intermediate image plane
10 Eyepiece
11 Eyepoint
12 Retina/Film plane

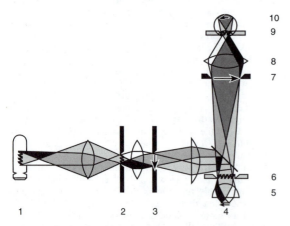

Köhler illumination for vertical (epi) illumination of opaque samples. (1) Filament, (2) aperture diaphragm, (3) field diaphragm, (4) specimen, (5) objective, (6) objective back focal plane, (7) intermediate image, (8) eyepiece, (9) eyepoint, and (10) retina.

Köhler illumination. *Left,* the field diaphragm (3) is focused in the plane of the specimen (6) using the substage condenser (5). *Right,* the filament (1) is focused in the plane of the aperture diaphragm (4) using the lamp condenser (2), or by moving the filament (1) closer to or farther from the lamp condenser (2).

At the same time, the illuminating ray path traces the image of the filament throughout the system. The first real image of the filament appears in the plane of the aperture diaphragm. This is achieved by the user focusing the lamp condenser (or by moving the filament with respect to a fixed lamp condenser). Then the substage condenser and objective together relay this image into the objective back focal plane, where the filament and aperture diaphragm are seen when looking down the eyetube with the eyepiece removed. The eyepiece next images the filament and aperture diaphragm at the eyepoint (the plane where the lens of the eye is placed). There are thus three conjugate foci of the filament: the aperture diaphragm, the objective back focal plane, and the eyepoint. The sharp focus of the filament is accomplished with the lamp condenser focus control (or by moving the lamp with its filament closer to or away from the fixed lamp condenser).

It is important to notice that the field diaphragm is focused with the substage condenser first. This puts the aperture diaphragm of the substage condenser at the correct position to receive the focused filament. The key to the Köhler illumination principle lies in the specimen plane. Note that the light rays from the filament are parallel through the specimen plane. This ensures that the filament will not be in focus anywhere near the specimen, and the specimen background will then be evenly illuminated at the retina.

When the microscope has been set up for Köhler illumination and the best possible visual image has been attained, the photomicrographic camera replaces the eyepiece, and the image can be focused in the side telescope or the ground glass. The image of the field diaphragm should be checked for sharp focus in the specimen plane and then opened to just outside the field of view. The aperture diaphragm is adjusted for optimum image quality—contrast, depth of field, and resolving power. The aperture diaphragm should never be used to adjust brightness. The light intensity should only be adjusted with the rheostat setting or, in the case of color photomicrography, with neutral density filters.

TECHNIQUE Once the microscope has been set up for optimum visual image, the photographic side of micro-technique is comparatively straightforward. Certain points do, however, differ from standard practice.

FOCUSING With side-telescope viewing, one must look through rather than at the reference cross hairs, while adjusting the focusing eyelens, i.e., the eye must be relaxed as much as possible, focused at infinity. Both eyes should be open. The room lights should be subdued, and the microscope should not face a window. After the telescope is focused on the format-indicating reference lines or cross hairs, the specimen is brought into focus, preferably by adjusting the focusable eyelens of the microscope eyepiece, or by adjusting the microscope focus if the eyepiece does not have a focusable eyelens.

If a ground glass is used, it will be found too coarse for accurate focusing; the aerial image must be used. Most modern ground glass screens have a clear center spot with reference lines for this purpose. If it does not, crosslines can be ruled on the ground side with India ink, and then a coverglass is cemented over the lines using Canada balsam. The specimen image is then examined by means of a magnifying glass focused on the cross in the clear spot. The specimen should be seen in sharp focus in the same plane as the sharply focused cross. This can be checked by the parallax method in which the head is moved up and down, or from side to side. If the image is not in focus in the correct plane, it will appear to move with respect to the crosslines, but when they lie in the same plane, the specimen image and the cross will move together.

Filters Color filters are used in black-and-white photomicrography to control the contrast of stained specimens. To decrease contrast, a color filter of the same color as the spec-

FILTER EFFECTS

Color of Filter	Gives Contrast with	Gives Detail with	Approx. Factor (Tungsten Light)
Deep magenta or purple	Chitin, diatoms orange, green	Blue	x10-x15
Deep blue (tricolor blue)	Chitin, diatoms, red, orange, yellow	Blue	x15-x35
Blue-green	Diatoms, yellow (compensates achromatic objectives)	Green	x10
Tricolor green	Red, orange (compensates achromatic objectives)	Green	x6-x9
Yellow green	Compensating filter to absorb U.V. and excess red		x 1½
Pale yellow	Compensating filter to absorb U.V.		x 1½
Deep yellow	Blue, violet	Yellow	x1½-x2
Orange	Blue, violet	Red, orange	x2-x4
Tricolor red	Green, blue violet	Red, orange	x2-x5
Deep red	Green, blue	Red, infra-red	x8-x25
Magenta	Green	Blue, red	x2-x3

imen is placed in the light path; to increase contrast, a filter of complementary color is used (see Filter Effects Table).

A green filter used with achromatic objectives will hold back out-of-focus wavelengths and result in sharper photomicrographs.

Blue-green, blue, or violet filters are used for photographing fine detail, or whenever one wishes to increase resolution. For even greater resolving power, the wavelength can be extended down into the ultraviolet, in which case, a mercury-vapor lamp must be used, together with a filter for isolating specific wavelengths. If below about 300 nm, objectives, condensers, slides, and coverslips must be made out of quartz.

For color photomicrography, color-balance filters must be placed in the light path in order to match the color temperature of the light source to that of the film. With modern quartz-halogen lamps operated at the manufacturer's recommended voltage, the color temperature will be 3200 K, and tungsten-balanced film can be used directly. With daylight-balanced film (5500 K), an 80 A filter must be inserted in the light path. With older light sources using conventional incandescent lamps, the color temperature of a new lamp might be around 2800–2900 K, and an 82 B should be added to the light path.

Didymium filters are used to enhance eosin-hematoxylin stained specimens. Heat absorbing or reflecting filters are used to prevent heating of delicate specimens. Neutral-density filters are used to control intensity in color photomicrography. Whenever filters are used in photomicrography, they should be placed in the light path away from the heat of the filament and away from the field diaphragm where any flaws, scratches, etc., will be imaged in the specimen plane; the best place for filters is as close to the aperture diaphragm as possible (usually just beneath the substage condenser).

Film Selection Photomicrography calls for negative materials with fine grain and high resolution. There are a number of suitable emulsions now available coated on cut film and 35-mm film; the use of glass plates has declined to

certain specialized uses only. Instant films are very popular in general photomicrography, especially in industry.

Whether for black-and-white or color photomicrography, films of the highest resolution and finest grain should be selected. These are apt to be slow; faster emulsions are only used when the subject is likely to move and electronic flash is not available or when photographing fluorescent specimens in which the fluorochrome quenches rapidly.

Infrared film is selected when it is necessary to photograph insect chitin or to penetrate brown, red, or amber minerals that are nearly opaque to ordinary light but transparent in the infrared.

Exposure The correct exposure is found initially by making a test roll, or by making test strips, and critically evaluating the results relative to the light meter readings. The f-stop reference point on the light meter from which subsequent readings will be made is determined by finding, through inspection, the best negative for that light reading. Even automatic exposure meters are fooled by many microscopical specimen illumination methods because the light meter readings do not equate to conventional reflected-light readings.

Many photomicrographic units are only capable of full-stop shutter speed intervals—there being only one equivalent f-stop of the system. Therefore, a 0.15 neutral density filter can be introduced in the light path to achieve half-stop results; 0.10 and 0.20 neutral density filters are used for third-stop and two-third stop intervals.

Theoretical Considerations Whenever light impinges on a microspecimen, it is diffracted in passing through the spaces between the structural elements. the angle of diffraction; θ, depends on the wavelength, λ, of the light and the spacing, d, between the structures:

$$\sin \theta = \frac{\lambda}{d}$$

Note that the smaller the spacing, the greater the angle of diffraction.

According to Abbe's theory of microscopical image formation, in order to resolve a microspecimen, all of the diffracted rays from the specimen must be captured by the objective, because the intermediate image is produced by the constructive and destructive interference of these diffracted rays. It is vital, therefore, that the objective have a large angular aperture. The objective's ability to capture diffracted rays is expressed in its numerical aperture, NA, engraved on the barrel:

$$NA = n \sin \frac{AA}{2}$$

where n is the refractive index of the medium between the preparation and the objective, and AA is the angular aperture of the objective. The value of n will be 1.00 for air, i.e., dry objectives; for immersion objectives, n may be 1.33 (water), 1.47 (glycerin), 1.52 (immersion oil). The angular aperture is the diameter of the front lens, in angular terms, when the objective is in focus on a specimen.

The resolving power, r, depends on the wavelength, λ, of the light used, and the numerical aperture, NA:

$$r = \frac{\lambda}{2NA}$$

For photomicrography, therefore, one should choose the highest numerical aperture objective that one can afford. This equation also demonstrates why blue or violet light aids in resolution. The theoretical maximum useful magnification, MUM, is limited by the numerical aperture:

$$MUM = 1000NA$$

Today, the highest NA obtainable is 1.4, and the maximum useful magnification is 1400×; magnification beyond this is *empty,* resulting in larger images, but no further detail. In practice, one aims for a figure close to 600NA. Any subsequent enlargement of the negative must take this into account. Magnification produced by the eyepiece does not increase resolution; it merely increases the size of the image.

To achieve the highest numerical apertures with immersion objectives, immersion condensers must be used. That is, a high numerical aperture (1.3–1.4) immersion condenser must be used and oiled to the bottom of the slide when using a high numerical aperture objective oiled to the specimen coverglass.

The condenser aperture diaphragm controls the numerical aperture of the condenser and, therefore, the illuminating cone to the specimen and objective. This is a critical and delicate setting that must compromise among resolving power, contrast, and depth of field.

The total visual magnification of the microscope is the product of the magnification of the objective, eyepiece, and any intermediate lens system. In photomicrography, the projection distance must also be taken into account. In practice, it is best to determine final magnification on the negative by measuring the focused image of a stage micrometer directly. At stage micrometer is a microscope slide containing a diamond-ruled scale, or a much-reduced photographic scale, 1 or 2 mm long, with each millimeter divided into 100 parts, i.e., 10 mm per division. The magnification is then given directly by measuring the length of the image with a millimeter rule laid on the focusing screen or at the film plane.

The upper limit of magnification for a 35-mm camera negative is usually reached by enlarging to between 4×5 in. and 5×7 in. The advantage of large-format negatives in photomicrography is especially evident when preparing large prints.

Opaque Specimens Opaque specimens, such as those found in metallurgy and in the production of integrated circuits, are illuminated by using a special type of vertical illuminator in which light from the filament is received through the side, above the objective, and is then reflected downward, through (brightfield) or around (darkfield) the objective via a prism or semireflecting glass plate onto the specimen. The image-forming rays then reflect back into the objective, through the semireflecting glass plate, and to the intermediate image plane.

Special Methods One of the oldest, and still most useful, techniques used especially for transparent objects, is darkfield, or darkground, illumination. The technique makes use of commercially available condensers, or one can make opaque stops that are usually placed just below the condenser, and that just block out the axial light rays. The aperture diaphragm is opened, and the marginal light illuminates the specimen, which is then seen lighted against a dark background. Exposure times are longer with this technique than with conventional brightfield with the same illuminator.

There are many specialized microscopes made for both qualitative and quantitative imagery, including phase contrast, differential interference contrast (DIC), Jamin-Lebedeff transmission interference, and fluorescence. Photomicrography is practiced with all of these specialized techniques.

Books: Bergner, J., Gelbke, E., and Mehliss, W., *Practical Photomicrography*. London and New York: Focal Press, 1966; Delly, J. G., *Photography Through the Microscope*. Rochester, NY: Kodak, 1988; Loveland, R.P., *Photomicrography; A Comprehensive Treatise*. New York: Wiley, 1970; Shillaber, C.P., *Photomicrography in Theory and Practice*. New York: Wiley, 1944.

J. Delly

See also: *Photomacrography.*

PHOTOMICROSCOPES Microscopes with a built-in camera-recording system made specifically for photomicrography or for microscopical work that requires frequent photomicrographic documentation.

Books: *Photomicrography Through the Microscope.* Rochester, NY: Eastman Kodak Company, 1988. (Kodak Publication P-2). *R. Zakia*

See also: *Photomicrography; Solar microscope.*

PHOTOMICROSCOPY See *Photomicrography.*

PHOTOMILLING See *Photofabrication.*

PHOTOMONTAGE (1) A composite image, made by cutting and pasting or by projecting several images in sequence on different parts of the receiving photographic material, such as photographic paper on onto a video screen using cameras scanners and computers. (2) Any technique of making composite or multiple photographic images, such as multiple exposures in a camera or with an enlarger. *R. Zakia*

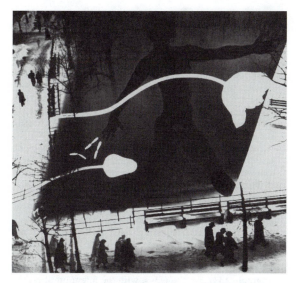

Photomontage. *Spring on Madison Square,* 1940. (Photograph by Barbara Morgan. ©Willard and Barbara Morgan Archives.)

PHOTOMOSAIC A set of overlapping aerial photographs usually used for map making. A controlled photomosaic is made by correcting perspective to eliminate distortions created when surveillance aircraft tilt in flight or when vertical movement results in change of scale.

H. Wallach

PHOTO MOUNTING CORNERS Paper mounting corners slip over the edges of a photograph in order to attach it to a backing board. The photo corners are attached to the supporting material with acid-free paper tape, linen tape, or filmoplast tape so that no adhesive ever comes into contact with the photograph. Because the photograph is supported only by the firmly positioned triangular corners, it is free to expand and contract with atmospheric changes. This mounting process is completely reversible.

Clear mounting corners are similar to paper photo corners except that they are smaller and made from transparent polyester film. These corners are prescored and are easily folded into small triangles. Each corner has a self-sticking adhesive-tape backing, so they can be easily attached to the

mounting surface. The photograph floats on the mount board surface in this mounting procedure the same way photographs are held in place with the paper corners—the print is free to expand and contract with atmospheric changes. This mounting process is completely reversible since the adhesive never touches the print. *M. Teres*

PHOTOMULTIPLIER TUBE A phototube capable of detecting and measuring extremely low levels of light. It is a transparent glass bulb containing a light-sensitive cathode, a series of electrodes called dynodes, and an anode. A resistance voltage-divider provides voltage for each dynode so that, proceeding from cathode to anode, each dynode is more positive than the adjacent dynode. A photoelectron emitted from the cathode is attracted to the first dynode with such energy that it causes more than one electron to be emitted from the dynode in a process called secondary emission. These electrons are attracted to the more positive second dynode, where they cause even more electrons to be emitted. This multiplication process is repeated through nine or ten dynode stages before the electrons are collected by the most positive electrode, the anode. Photomultipliers are used extensively in photographic scanners and in some densitometers. *W. Klein*

Syn.: *Multiplier phototube.*

PHOTOMURALS Photomurals are large, multisection, photographic prints spliced together to decorate walls or ceilings. Their width is greater than the width of the widest roll of photographic paper currently available. Their intent may be to bring the outdoors into a windowless area, to bring any kind of beauty into a plain interior, even to bring company products or accomplishments to the attention of visitors.

In most instances, photomurals are glued directly to the wall. Often they occupy the entire wall and make the room look considerably bigger. Sometimes, when the installation is temporary, the mural may be mounted on panels for easy removal and reinstallation in another location.

Because each photomural (unlike a wallpaper mural) is unique, proper installation is especially important. Installation often will be handled by the custom color lab that makes the photomural. If not, the lab should be able to recommend a reputable installer. Installation charges usually are billed separately from charges for the photomural itself.

At installation, the need for extremely high standards of production becomes obvious. The lab must use great care to make sure all the strips match. Strips usually need to be retouched along their edges to approximate a seamless blend.

Certain subjects such as a forest alive with undergrowth and brimming with foliage could make the production and installation tasks easier, the busy background serving to fool the eye. Other subjects such as a black-and-white view of an old-time amusement park might be printed in nine 3 x 3-foot panels and installed to look like the view through a giant window.

Although photomurals need not be panoramas, they often offer wide, inviting views of anything from recognizable coastlines and mountain ranges to beautifully landscaped company facilities. Other times they dramatize the special interests of the inhabitants or the products or services of a company. Always, they infuse an interior space with an eye-catching, noteworthy expanse of photographic art.

In consultation with a client, an interior designer can plan a photomural to fill just about any wall. Actual images can be selected from image banks or can be custom-made by professional photographers who specialize in photomurals and photo decoration. The negative for a photomural needs to be as well exposed and as sharp as possible, because any flaw

will be magnified many times in the enlarging. The best negative tends to be rather thin but full of detail.

An image can, however, be altered in the printing and one image can be combined with another image to create a photomural with greater impact or images can be posterized, that is, changed to achieve a poster-like effect, and toned to match interior colors. Images can be altered with chemicals or laser beams, even treated to a texture screen that lends a certain mood.

Any retouching generally should be done on the negative before the photomural is made. Sometimes, however, the small negative size makes it necessary to retouch and correct the photomural itself. Any pinholes, scratches, or other minus-density areas should be opaqued in the negative because they result in difficult-to-remove, plus-density areas on the print.

After installation, photomurals should be coated with one of the special lacquers designed to protect photographic prints. A variety of finishes including glossy, matt, stipple, and brush are available from photographic dealers. Such finishes allow a photomural to be wiped with a damp cloth. They also protect the surface of the photomural from atmospheric contaminates, dirt, fingerprints, abrasions, and graffiti. Small marks made by a ballpoint pen, for example, often can be removed with a bit of lacquer thinner.

Recessed lighting provides a more finished look in a room that features a photomural. Track lighting also may be used to flood the entire photomural or to lend a few dramatic spots of light. Ideally, lighting should enhance the mood of the mural and, in turn, the overall effect of the interior.

Books: Holland, John, *Photo Decor–A Guide to the Enjoyment of Photographic Art*. Rochester, NY: Eastman Kodak Company, 1978. *K. Francis*

PHOTON (*h*v) The fundamental quantity of electromagnetic radiation (see electromagnetic radiation, light). Photons are self-contained packets of energy that possess both wave-like and particle-like characteristics. As fundamental particles, they represent the minimum indivisible amount of energy that can be transferred in the form of electromagnetic radiation, the energy of an individual photon being represented by Planck's equation: $E = hn$. They are unlike other particles, however, in that they have no mass (although they do have momentum E/c). Photons travel at the speed of light ($c = 2.9979 \times 10^8$ m/sec) in a vacuum and at a speed equal to c/n in other materials, where n is the index of refraction of the material. are most precisely described as wave packets that solve Schrödinger's wave equation: $(ih/2\pi)(\delta\psi/\delta t) = -(h^2/8\pi^2 m)(\delta^2\psi/\delta x^2) + U\psi$. *J. Holm*

PHOTOPHORESIS The movement of fine particles of a solid in an evacuated vessel toward, away from, or in orbit around a beam of light due to changes in the charge-exchange properties of the particles produced by the light. *H. Wallach*

PHOTOPIC Identifying vision at normal levels of illumination. At this level the cones in the retina, necessary for color perception, are activated. At lower scotopic levels, only the rods are activated. *L. Stroebel and R. Zakia*

See also: *Mesopic; Retina; Scotopic; Visual perception, perception of lightness/brightness.*

PHOTOPIGMENTS Light sensitive substances in the receptors of the retina of the eye. Rhodopsin (visual purple) is found in the rods; red-sensitive erythrolabe, green-sensitive chlorolabe, and blue-sensitive cyanolabe are found in the cones. *L. Stroebel and R. Zakia*

See also: *Color vision; Vision, color vision, the human eye; Young–Helmholtz theory.*

PHOTOPLASTIC RECORDING Grainless, reusable electrophotographic process similar to xerography using a thermoplastic photoconductive polymeric layer. The film is corona charged, making it sensitive to light, and then exposed to produce a molten plastic surface layer. Electrostatic forces cause deformations in the plastic, which are rendered permanent by rapid cooling. Reheating erases the image, making the material reusable. Applications are predominantly in microfiche and compact image storage systems. *H. Wallach*

PHOTOPOLYMERIZATION A light-induced process that forms large molecules of high molecular weight from small molecules. The small molecules, called *monomers,* containing double or triple bonds, join together to form chains and cross-linked molecules of very large size and weight. *G. Haist*

PHOTOREALISM A style of painting whereby the resulting images have many of the characteristics of photographs, and sometimes are mistaken for photographs. *L. Stroebel*

PHOTORECEPTORS Used in xerography for the creation of electrostatic latent images. Photoreceptors can be prepared in a drum or flexible belt configuration. Drums are widely used for printers and low-volume copiers, while belts are commonly used for high-volume applications. The requirements include (1) very low dark conductivity (2) photoconductivity throughout most of the visible region of the spectrum, and (3) transport processes that occur over a wide range of fields in the absence of trapping. Further, the preparation of these materials must be amendable to large-area, low-cost manufacturing processes. In the early development of xerography, α-Se and alloys of α-Se with arsenic and tellurium were widely used as photoreceptors. Other materials used during that period were dispersions of inorganic particle, mainly ZnO, CdS, and CdSe, in a polymer host. In the past decade, organic materials and α-Si have also been employed. Most current applications use either α-Se alloys or organic materials. The use of ZnO, CdS, and CdSe has been largely discontinued. *P. Borsenberger*

PHOTOREPORTAGE In photojournalism, the use of photographs to report the news, with the intention of representing situations and events truthfully and without bias. *L. Stroebel*

PHOTORESIST A photosensitive coating uniformly applied to a substrate being prepared for chemical etching or a similar process. Exposure of the coating to a pattern of light and dark results in some areas becoming soluble, others insoluble. After the soluble areas are washed away, the chemical etching or other processes may proceed. Both negative- and positive-working photoresists are made. Positive resists may be successively reimaged and redeveloped. Uses include microelectronics, photomechanical printing, and small parts manufacture. *M. Scott*

PHOTORESISTOR See *Photoconductive cell.*

PHOTOSCULPTURE The production of a three-dimensional object from a series of two-dimensional photographs. The first such system was patented in 1860 by the French sculptor and painter, François Willème. He arranged 24 cameras around a portrait sitter with a silver ball over the sitter's head to provide negative registration. The images were made simultaneously in about 10 seconds. The negatives were projection printed and templates were made for each of the 24 different angles. A pantograph was used to trace the shapes

in clay, after which a considerable amount of hand work was required before a mold could be made.

In 1921, M. H. Edmunds published a process using a spiral light trace projected onto the subject from a point close to the camera lens. Distortions of the spirals in the photographs indicated the shape of the surface. In the carving process, the distorted image was scanned by a low-powered microscope linked to a pantograph with a power-driven engraving tool. This method reproduced cavities better than the systems that lit their subjects from the side.

Givaudan called his 1926 process *photostereotomy* because it used light shining through narrow slits to produce a series of perhaps 60 sections from the front to the back of the subject. The negative images were printed and the profiles cut out. A true-size figure could be produced by inserting spacers between the profiles.

In a modern photosculpture system, the subject is surrounded by cameras and lit from four sides by a stripe and shadow pattern, possibly laser-generated. The film is scanned and computer analyzed to determine the exact location of each subject point in space. This information generates instructions for automatic milling machines that reproduce the original in enlarged, reduced, or true size.

Current applications include the creation of industrial master molds, scale models of living organs, three-dimensional models from two-dimensional drawings, and operating systems for industrial robots.

The term *photosculpture* is also used by artist and photographer Robert Heinecken to describe his three-dimensional experimental work involving collage and manipulation.

H. Wallach

PHOTOSENSITIVE Capable of undergoing a physical or chemical change as a result of the action of radiation, especially light. The term embraces latent-image formation, bleaching of dyes, change in solubility (as in photoresists), and change in electrical properties (as in photocells, TV image tubes, and charge-coupled devices.) *M. Scott*

PHOTOSENSITIVE GLASS See *Photochromism*.

PHOTOSENSITIVE MATERIALS General term for all types of photographic material—films, papers, plates, etc.—that have been rendered sensitive to light and related radiation by being coated with an emulsion of silver salts or by impregnation with a chemical sensitizer. *M. Scott*

See also: *Photographic film; Photographic paper; Plate.*

PHOTOSENSITIVE MATERIALS HISTORY General term for all types of photographic material—plates, films and papers, etc.—that have been rendered light sensitive either by coating with an emulsion containing light sensitive silver salts, or by impregnation with a chemical sensitizer. The types of sensitized material vary considerably, from normal negative materials for use in a camera to special emulsions for scientific work.

For about the first 40 years of the photographic process photographers had to prepare their own sensitive material just before making the exposure. The division of labor between photographer and sensitive material manufacturer did not become general until about 1880, although dry-collodion plates had been put on the market as early as 1856.

EARLY PROCESSES Workable photographic processes were made public in 1839, almost simultaneously by Louis Jacques Mandé Daguerre in France and William Henry Fox Talbot in England. It is correct to honor Fox Talbot as the inventor of photography as the modern processes stem in a direct line from his work. Daguerre's process, although it enjoyed considerable popularity, did not prove capable of further development. Both the calotype, as

Talbot called his improved process of 1841, and the daguerreotype are real picture-making media and in skilled hands are capable of good results, though the nature of the processes limits their applications. Professional photography was founded on the daguerreotype, while the calotype was originally preferred by amateurs who were attracted by the lower cost of the materials.

In the daguerreotype process a highly polished silver plate, or silver-faced copper plate, was sensitized by exposing it in the dark to the action of iodine vapor or, in a later method, to bromine and iodine. After exposure in the camera, which might take several minutes in a good light, it was developed by the action of mercury vapor, which was allowed to condense on the surface of the plate and delineated the image. After fixation in a solution of common salt, or later hypo, the image was toned in gold chloride. Fine detail was well reproduced, and the daguerreotype had an attractive, jewel-like quality. The process, however, was expensive and not well adapted for the production of copies—an essential for a popular process.

In Talbot's calotype process, paper was coated with silver iodide by successive immersions in solutions of potassium iodide and silver nitrate, and exposed in the camera while wet. After exposure it was developed in a physical developer containing gallic acid and silver nitrate, and fixed in hypo. The vitally important step of using a developer was due to a suggestion from the Rev. J. B. Reade. The negative so obtained was printed onto similar paper so that multiple copies could be obtained and in this respect it was a great advance on the daguerreotype. The process was better for showing broad effects than for fine detail, but could be used in portraiture. The series of portraits made by D. O. Hill and R. Adamson of Edinburgh in the 1840s was particularly famous.

WET PLATES The next important step was the introduction of the wet-collodion process by Frederick Scott Archer in 1851. This process consists of coating a sheet of glass with a solution of nitrocellulose containing a soluble iodide, and sensitizing the plate by immersion in a solution of silver nitrate. While wet, the plate is exposed in the camera and is physically developed in pyrogallol or a ferrous salt. As the collodion layer must not be allowed to dry, it is a most inconvenient process to use but the results are excellent. Wet collodion has survived to this day for certain applications in the graphic arts field.

With the introduction of the wet plate a sensitive material suitable for topical photographs had arrived, for although the manipulation is exacting, failures are few and for small pictures the speed is adequate for snapshots in good light. News photography dates from the wet plate, notable early examples being Roger Fenton's photographs of the Crimean War and Mathew Brady's pictures of the American Civil War. It was also the medium for a great expansion in portrait photography; compared with the daguerreotype it was cheap and copies were easily made. Dagron's greatly reduced copies, used in the pigeon post that was operated from Paris during the siege in the Franco-Prussian War, were made by means of the wet plate.

Numerous attempts were made to modify the wet-plate process so that the sensitized plates would keep. The introduction of collodion emulsion by Sayce & Bolton in 1864 was one of the more successful, but the sensitivity was low, and the method was not popular.

DRY PLATES In 1871 Richard Leach Maddox, an English physician, produced the first workable, though slow, plate using gelatin as the medium to hold the silver bromide. The discovery, after improvement by others, proved outstanding, gelatin dry plates having a great advantage over wet collodion. The plates can be prepared weeks or months before exposure; the sensitivity is far higher, the processing

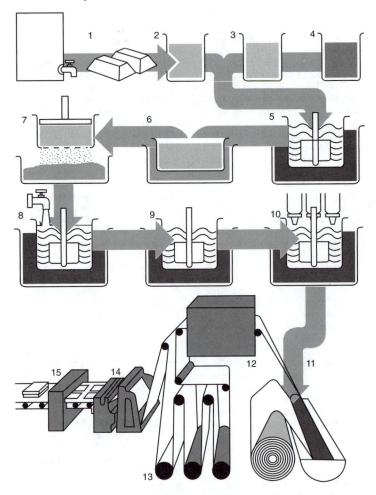

Photosensitive materials. Manufacture of sensitized materials. While production details depend on the particular manufacturer as well as on the product, this flow chart gives a simplified idea of the stages by which, for example, sheet film is produced. (1) Essential raw materials: silver and nitric acid. (2) These are used to make silver nitrate. (3) and (4) Further raw materials; gelatin and sodium or potassium bromide and iodide. (5) Mixing of the emulsion under carefully controlled conditions. (6) Cooling to jellify the emulsion. (7) Shredding the jelly. (8) Washing of the shredded jelly to remove unwanted salts (mainly sodium and potassium nitrate) resulting from the formation of silver halide. (9) Melting of the jelly and digestion (ripening) of the molten emulsion to build up speed and contrast. (10) Addition of color sensitizers, stabilizers, plasticizers, hardeners, spreading agents, etc. (11) Coating on the film base. (12) Chilling to set the emulsion. (13) Drying. (14) Cutting of the continuous roll of film into required sheet film sizes. (15) Final inspection and packaging. Various intermediate stages are not shown, including backing of the film base to provide antihalo protection and counteract curling, and application of supercoat.

is simple, and there is no need to develop the plate immediately after exposure.

It was no longer necessary for the photographer to make his own plates—very soon after Maddox's discovery he could buy them boxed and labeled ready for use. In 1873 gelatin emulsion was being offered for sale by Burgess. In 1867 the Liverpool Dry Plate Company was making plates in England, this being the second factory making sensitive material. By 1878 there were four dry plate manufacturers in England. Johann Sachs of Berlin is reputed to be the earliest manufacturer in Germany, and Carbutt of Philadelphia, 1879, the first maker in the United States. He was soon followed by Eastman, who founded in Rochester the enterprise now known as the Eastman Kodak Company. By the end of the century sensitive material manufacture had been established on a considerable scale in most advanced countries.

COLOR-SENSITIZED PLATES In 1873 a discovery of the greatest importance was made by H. W. Vogel in Berlin. While testing some plates which had been dyed to

reduce halation he found that they were sensitive to green light. He concluded correctly that this property was due to the dye, which was probably corallin, and set to work to examine a number of dyes. As a result he found several which could act as sensitizers, and predicted that it would in time become possible to photograph even by infrared rays, with dye-sensitized plates.

In 1884 the first color-sensitive plates were offered for sale. In the same year, Eder discovered the sensitizing properties of erythrosin, which was used in the manufacture of orthochromatic plates for many years. In 1906 the first satisfactory red sensitizing dye was discovered by Homolka working at Hoechst, and was sold as pinacyanol. This dye was used in the first panchromatic plates manufactured in England by Wratten & Wainwright, and continued in use for many years.

The discovery of a great number of new types of cyanine dyes from 1926 onwards led to the introduction of the supersensitive type of panchromatic materials that of recent years

have displaced color blind emulsions almost completely for ordinary photography and have made possible the production of fine-grained color-sensitive emulsions, which are essential for miniature camera work.

Plates were used for radiography in the year of Roentgen's discovery of x-rays. In 1920 the plate was replaced by double-coated film, and x-ray films are now made in great quantity and variety.

In the early years of the twentieth century slow process plates were produced for use in the photomechanical production of pictures. A range of special sensitive materials is currently made for the graphic arts industry, an important item being the *lith* type emulsion introduced about 1938, which gives negatives of remarkably high contrast when used with a suitable developer containing formaldehyde.

FILMS Fox Talbot used paper as a support for his negative material, but later glass became universal. Warnerke introduced a stripping film for hand cameras in 1875, and in 1889 Eastman started making films on a nitro-cellulose base. The flexible film base was a great advance as it made possible the construction of light daylight-loading cameras and led to the development of cinematography—1895 onwards. Nitrocellulose or celluloid was widely used until about 1930, when the much less flammable cellulose acetate began to displace it. On account of its good mechanical properties, however, nitrocellulose remained in use for 35-mm cine film as late as 1947, when it was replaced by cellulose triacetate base.

PRINTING PAPERS The development of sensitive material for making prints proceeded on similar lines to negative materials. The plain paper impregnated with silver chloride introduced by Talbot was replaced about 1850 by albumenized paper, which remained in use for over 30 years. It was inconvenient to use as it had to be immersed in a bath of silver nitrate and dried before being printed in daylight. Used with a strong negative, such as is obtained with the wet plate process, it gives good prints when gold toned.

Collodion chloride paper was introduced in 1868 and gelatin chloride printing-out paper was manufactured commercially in 1885. The first bromide paper was introduced by the Liverpool Dry Plate Company as early as 1873 and also by the firms of Morgan & Kidd and Mawson & Swan in 1880. Silver chloride and chlorobromide development papers date from 1883. In the years 1880 to 1914 the platinum process (which depends on the sensitivity of ferric salts, though the image is formed in platinum), and from 1866 on the carbon process (which depends on the sensitivity of chromate) were used to a great extent but are now obsolete. Silver halide development papers, particularly those based on silver chloride or chlorobromide and often dye-sensitized to increase the speed, are now the only important papers in photography.

Sensitized paper coated with diazonium salts, which is produced in great quantities for printing engineers' drawings and similar applications, derives from the discovery of light-sensitive diazo compounds by Green, Cross & Bevan in 1890, although the first practical application was by Koegel in 1923.

In recent years various special papers have been introduced. Among them variable-contrast papers dating from 1940, direct-positive (Herschel effect) papers dating from 1947, papers for the image-transfer process dating from 1950, and papers such as those introduced in 1952 that yield a direct positive by chemical fogging when used with a special developer.

Hybrids between color and black-and-white negative films were introduced in the 1980s by Agfa and Ilford. These are for monochrome photography, printing on conventional black-and-white paper, but the negatives are to be processed through the same steps used for color negative films, a convenience to many, since one-hour labs are ubiquitous in many countries. Extended exposure latitude and variable speed/grain ratio are claimed.

Advances continue to be made in speed/grain ratio. Tabular silver halide grains have long been known, but practical application to commercial products proved elusive. In the mid-1980s this was overcome by several manufacturers, resulting in about a two-stop increase over the previous speed-grain ratio, e.g., a new film of ISO 400 speed could be made with the image structure—resolving power, granularity—of a previous ISO 100 film. Photographers could choose among several new films, selecting either the same speed they previously had, but with finer grain, or they could select the same grain they previously had, but enjoy higher speed. Compared to cubic grains, tabular grains present more surface area for a given volume, providing more area for the absorption of sensitizing dyes, and thus being more effective targets for photons. T-Max films use this technology. (Eastman Kodak Company, mid-1980s).

The gap in quality between substantive and nonsubstantive color slide films was considerably narrowed in the late 1980s with the introduction of new films by Fuji for the E-6 process. The use of development-inhibitor-release (DIR) couplers by several manufacturers allowed color enhancement without upsetting the film's neutral balance. DIR couplers in the emulsion release chemicals during development that migrate vertically to other color-forming layers to inhibit dye production in those layers.

The former rich variety of photographic printing papers—both enlarging and contact—with their various stock tints, image tones, surface textures, and surface finishes, has shrunk considerably. With the continuing trend to the smaller film formats, the term photographic paper has become virtually synonymous with enlarging paper.

Various new formats for snapshot photography were aimed at extending the times and places where an unsophisticated camera user can get satisfactory snapshots, and at simplifying the film loading procedure. Two popular systems using drop-in cassettes were introduced by Kodak in the 1960s (26-mm square, size 126) and 1970s (13 × 17-mm, size 110) using film with backing paper in plastic cartridges. Another system introduced by Kodak in the 1980s using a disc of film and taking negatives only 8 × 10-mm produced pictures too grainy for many customers. The coming of the drop-in loading, fully automatic 35-mm cameras from many Japanese manufacturers quickly retired most of the 25 million disc cameras that had been sold.

Snapshot cameras are no longer the simple devices limited to sunlight conditions; they are quite sophisticated in their automatic mechanisms for focus, aperture/shutter control, and flash illumination. Aiding this is the DX coding system for 35-mm film magazines. It is used by most manufacturers and consists of a pattern of electrically conducting and insulating patches on the metal wall of the magazine itself. Contact points in the camera body read these patches to learn film speed, type, and exposure latitude. These are automatically fed to the control circuits of the camera.

Snapshot photography has gone dramatically from color slides to color prints made from color negatives. Small, one-hour processing labs for color negative films and prints are numerous in many parts of the world. The distinction between film and camera is somewhat blurred by the increasingly popular film-with-camera, or throw-away camera. This is a simple fixed-focus snapshot camera loaded with one roll of film. It must be damaged to some extent to remove the film for processing and cannot be reloaded by the purchaser. Regular, wide-view, and water-immersible models are made, some with electronic flash. Devoted amateurs still use color slides, but they now tend to be color negative users also. Color negative film in 35-mm format now offers image quality formerly found only in larger formats.

Amateur home movies have almost totally been displaced by home video. It remains to be seen if electronics will have a similar effect on still snapshot photography.

Along with the increasing awareness of the effect of industrial chemicals on the environment and on human health during the 1980s came increased attention to the effluents of photographic processing and manufacturing. Restrictions on organic solvents, heavy metals (especially silver, cadmium, and chromium), oxidants, aldehydes, and other chemicals were imposed by government bodies in many countries. Chemical safety in the workplace has taken on new importance. With these in mind, one shudders to think of photography's early days in the 1800s with their fumes of mercury and bromine, their potassium cyanide, gun-cotton, and explosive solvents.

Books: Boni, A., *Photographic Literature* (2 volumes). Dobbs Ferry, New York: Morgan and Morgan, 1962, 1972; Bunnell, P. and Sobieszek, R., *The Literature of Photography.* New York: Arno Press, 1973; Eder, J.M., *History of Photography.* New York: Columbia University Press, 1945 (reprint edition, Dover Publications, NY, 1978); Gernsheim, H. and A., *The History of Photography: From the Camera Obscura to the Beginning of the Modern Era.* New York: McGraw-Hill, 1969; Jenkins, R., *Images and Enterprise: Technology and the American Photographic Industry, 1839-1925.* Baltimore, Maryland: John Hopkins, 1975; Mees, C.E.K., *From Dry Plates to Ektachrome Film.* New York: Ziff Davis, 1961; Newhall, B., *The History of Photography from 1839 to the Present.* New York, Museum of Modern Art, 1982; *Pioneers of Photography: Their Achievements in Science and Technology.* Springfield, Virginia: Society of Imaging Science and Technology, 1987; Roosen, L. and Salu, L., *History of Photography: A Bibliography of Books.* London: Mansell, 1989; Rosenblum, N., *A World History of Photography.* New York: Abrams, 1989. M. Scott

See also: *Cameras; Development; History of photography.*

PHOTOSENSITIVE MATERIALS MANUFACTURE

Early photographers made their own photosensitive materials not just because there was as yet no industry to supply them, but because the nature of those early processes demanded that the sensitive materials be made within minutes of use. When first the manufacture and use could be separated by a reasonable length of time, an industry for supply developed, with sensitized plates becoming commercially available in 1874.

Today's photosensitive materials consist of suspensions of microcrystals of silver halides coated on film, paper, or glass. The long-established term for these suspensions is *emulsions* although in the current vocabulary of physical chemistry this is not correct. *Emulsion* is ingrained by more than a century of usage and will persist. (Incorporated-coupler materials actually depend in part on true emulsions, but to avoid confusion, these are called dispersions.)

SAFELIGHTING Light sensitivity begins the moment silver nitrate solution reacts with an alkali halide solution, requiring special measures to ensure that the newly formed emulsion is not fogged in manufacture. Any illumination used in the manufacturing areas must be weak and of such a color as not to affect the emulsion, while providing maximum visual brightness. This is the science of safelighting. In general, the same principles apply to manufacturing areas and processing darkrooms.

While emulsions have some degree of light sensitivity beginning with their initial reaction, it is relatively slight and limited to the blue and ultraviolet spectral regions. Bright red or even yellow light could be used in some cases. (All emulsions are less sensitive when they are wet.) In later steps of emulsion making, after sensitivity has been heightened and extended to the full visible spectrum, much less light can be tolerated. At this point advantage is taken of the shift of human vision under very dim lighting conditions to the scotopic mode, with its peak of sensitivity near 520 nm. Dense green filters passing a narrow band centered on this wavelength are used in safelights for the most sensitive panchromatic materials. Orthochromatic materials, being insensitive to red light, may be handled under dim red light.

In manufacturing rooms light is allowed to fall on the sensitive material only where it is absolutely necessary to control the operations. Lights at foot level are frequently used to guide workers through the rooms; if the sensitive material is carefully shielded, the lights can be relatively bright.

Another approach to safelighting is to use special electro-optical viewing devices (somewhat like a bulky pair of binoculars) and lamps that emit infrared radiation only. These devices are related to the military "snooperscopes," used at one time as night vision devices.

EMULSION MAKING A sequence of chemical and physical processes is involved in making an emulsion ready for coating on a support. Intensive research over the years has changed what was once an art into a science.

Precipitation Ingredients of high chemical purity are essential for the preparation of photographic emulsions, since trace amounts of certain impurities have large sensitometric effects. The silver nitrate and the alkali halides (salts of potassium, sodium, lithium, and ammonium) used are among the purest chemicals commercially available. Inert reaction vessels are needed, special stainless steel is now used, but old emulsion makers nostalgically remember solid silver kettles.

The other most important raw material, gelatin, is in many respects considerably purer than that used as food. Gelatin is an animal protein derived from the bones, hides, and connective tissue of such animals as cows, water buffaloes, and pigs. These are extracted by acids or alkalis for periods up to 18 months. Different processes produce gelatins with differing properties. The solution resulting after prolonged cooking is concentrated by vacuum evaporation and chilled to *set*. This, when evaporated still further, is reduced to flakes or powder containing about 15% water. The type of gelatin that may be ideal for the emulsion precipitation reaction may not be best for coating or for some other part of the manufacturing process. Gelatins in emulsions may be exchanged by *isoing,* that is, by adjusting the pH of the emulsion to its isoelectric point, the pH at which the gelatin can no longer protect the crystals from settling out. After filtration, they may then be resuspended in a solution of another gelatin.

The various silver halides have differing sensitivities, and they are selected individually or in combinations for the type of material being manufactured. Silver bromide with a few percent of iodide serves for the faster films and plates, silver chloride for slow contact papers, and silver chlorobromide or straight bromide for enlarging papers. These are formed in the presence of about one percent gelatin in water by the reaction of, typically, silver nitrate and potassium bromide to yield insoluble silver bromide and soluble potassium nitrate. It is the presence of the gelatin, a protective colloid, that prevents the insoluble silver bromide crystals from settling out or clumping together, keeping them in suspension.

Ripening The emulsion crystals, or grains, are then grown in size to increase their sensitivity. The process is known as ripening or cooking, and consists of prolonged heating in the presence of a mild solvent for silver halide. The substance of the smaller grains is in effect dissolved and redeposited on the larger grains. When this is optimum, the temperature is reduced and more gelatin is added to about seven percent.

Chilling, Shredding, and Washing The ripened emulsion is chilled, whereupon it *sets up*, into a condition familiar to anyone who has ever made gelatin dessert. This is then forced through a perforated plate to produce *noodles,* or oth-

erwise subdivided to expose a great amount of surface area. The noodles are then washed in cold water to dissolve out the potassium nitrate, from the precipitation reaction, and other unwanted substances. Gelatin swells but does not dissolve in cold water, becoming permeable to soluble substances. This same phenomenon is used to advantage during processing.

Digestion The washed noodles are then melted and the emulsion heated again, in a treatment known as digestion or afterripening. No appreciable grain growth takes place now, because no silver halide solvent is present, but sensitivity increases because of the addition of sensitizers, particularly gold and sulfur compounds. Extending the digestion process for high sensitivity also tends to increase fog, so compromises must be made for an optimum balance between building speed and keeping fog to a reasonable level.

The emulsion is *finished* by the addition of various chemicals; spectral sensitizing dyes to extend the native UV-blue sensitivity to the green, red, or infrared regions as desired; stabilizers to impart good keeping properties; hardeners to improve abrasion resistance; plasticizers to keep the coated emulsion supple; spreading agents for uniformity of coating; antistatic agents to prevent sparking as film is unwound; biostatic agents to prevent growth of fungus and mold, etc. The emulsion is now ready for test coating. If all is satisfactory, the production coating is scheduled; if not, further changes are made.

Color Emulsions The foregoing sequences traces the making of a black-and-white emulsion, but with one major addition it stands for a color emulsion also. That addition, used in both negative and positive substantive color emulsions, is a dispersion of a color-forming coupler. In the case of positive transparency emulsions, the coupler itself is colorless, but capable of reacting with oxidized color developer to form a colored dye. Each coupler chemical itself is specific to a particular emulsion layer. The coupler that will produce a dye to modulate the amount of red light must be placed in and remain in the red-sensitive layer and the same with the green- and blue-modulating couplers. These chemicals by themselves are prone to diffusing to other layers, muddying the colors in the developed picture. Ways are needed to anchor them in their assigned layers. Chemical *ballast* groups attached to the couplers provide one way. Entrapment of minute amounts of an aqueous solution containing the coupler in microscopic oil droplets is a common way. (Such dispersions are true emulsions, as the term is used by physical chemists.) The dispersions are mixed with the sensitive emulsions before coating. A water-miscible organic solvent in color developers opens the oil droplets when the couplers are needed for color forming. The color couplers of most camera negative color materials are themselves colored. Although these impede visual assessment of color negatives, they provide a valuable masking effect that increases the color quality of the final print.

Since all silver halide emulsions have a native sensitivity to blue light, the green- and red-sensitive emulsions of color films must not be allowed to see blue light. This is often done by coating them below a yellow filter layer, which absorbs blue. The yellow layer must be decolorized during processing for the image to be seen in its true colors. This is often achieved by making the filter of minute particles of silver which are of a size to absorb blue light exclusively, after the formula of the English chemist Carey-Lea. Such layers, called Carey-Lea silver or CLS layers, are automatically decolorized in the bleach step of color processing, and removed in the fix and wash baths.

EMULSION COATING Most bases must be prepared to receive the photographic emulsion by the application of a *subbing* (short for *substratum)* layer to provide good adhesion.

Films and papers are coated by moving a wide, continuous web of film or paper base past a coating head where the warm, melted emulsion flows in a thin layer of precise thickness. Modern coating heads are capable of laying down several layers of different emulsions at one time, expediting the production of color films, which may have 15 or more different layers. The moving web next passes over a chilled roller or under a current of cold air, which causes it to set. If more layers are required, a second coating head is next. Over the topmost sensitive layer an overcoat (topcoat, supercoat) of clear, hardened gelatin serves as a protection against abrasion, or it may contain a pale dye to make a subtle adjustment to the color balance of a film. The film or paper next passes into a chamber flowing with dry air, which removes most residual water from the emulsion. The film or paper is rolled up, ready for finishing into various shapes and sizes. The dried thickness of an emulsion is about 10% of the wet thickness as coated.

Glass plates are coated by running the melted emulsion through a slit onto a slowly moving procession of plates butted one against the next, riding on a continuous web of carpet. Chill-setting is done in line, but then the plates are removed individually and stacked in racks for drying in a room filled with clean, warm air.

SUPPORTS FOR PHOTOSENSITIVE MATERIALS

Film Base Flexibility and transparency are the chief characteristics of a film base, but other properties—static electricity production, halation protection, resistance to light piping, performance at high and low temperatures, tensile strength, absorption of water and chemicals, dimensional stability, resistance to changes upon aging—are also important.

The two important film bases in current use are cellulose triacetate, usually called acetate, and polyethylene terephthalate, also called polyester. There are no trade-names in popular use for acetate, but Estar (Kodak) and Cronar (DuPont) are in use for their polyester films. (In the 1930s cellulose diacetate base was briefly used, but it proved to be chemically and dimensionally unstable.)

Cellulose triacetate is made in huge quantities for film, rayon, and other plastics by the esterification of cellulose derived from wood or cotton. For film making it is dissolved in a mixture or organic solvents—alcohols, esters, ketones, chlorohydrocarbons. Plasticizers are added, and the viscous "dope" is extruded through a slit onto the surface of a very large, polished, chromium-plated wheel. The slow-turning wheel is heated to drive off the solvents, leaving the cast film ready to be stripped from the wheel in a continuous operation. Different thicknesses are made: about 0.0035 in. for roll film with backing paper and for pack film, 0.0055 in. for motion picture film and 35-mm film in magazines, and 0.009 in. for sheet films. Acetate base absorbs some water during film processing. The tendency to curl with changes in temperature and humidity is controlled to some extent with a balancing coat of gelatin on the side opposite the emulsion. Acetate is optically isotropic, thus films on acetate support can be used in projection systems using plane polarized light. Acetate films out-gas considerably in vacuum, loosing water and residual solvents. Scrap acetate is more easily recycled than polyester.

Polyethylene terephthalate is synthesized from petroleum stocks. For film manufacture it is extruded from the melt and stretched laterally and longitudinally while being cooled. The thicknesses most often found are 0.004 inch for roll films and 0.007 inch for sheet films. Where great lengths of film must be contained in little space, thicknesses (or thinnesses) of only 0.0025 and 0.0015 inch are used. No solvents are used in the manufacture of polyester film, which recommends it for instruments requiring high vacuum, such as transmission electron microscopes. It is optically anisotropic, which may interfere in illumination systems using

polarized light. It absorbs virtually no water during processing, which hastens drying.

A strand or ribbon of polyester plastic conducts light as does a fiber-optic light guide. When this is used for photosensitive film base, there is danger of fogging a considerable length of film if the end is exposed to light. This danger may be eliminated by incorporating a small amount of a light-absorbing material in the plastic itself. This amount is scarcely visible when the film is viewed perpendicular to its surface, but the attenuation quickly becomes enormous when measured along the length of a roll of film. For example, a film 0.004 inch thick having a perpendicular optical density of 0.1 will have a longitudinal density of 25 after 1 inch, indistinguishable from total opacity. Such film is often labeled AH, for antihalation.

Paper Base Impatience with the protracted processing (especially washing) time of classic fiber-base photographic paper led to the development of its rival, resin-coated (RC) paper.

Photographic fiber-base paper is usually manufactured in mills devoted to that purpose. Softwood pulps high in alpha-cellulose are desirable. Freedom from chemical contamination is of highest priority. Iron and copper are particularly injurious to emulsions. In addition to high whiteness, photographic paper stock should have high wet strength. Few papers now are direct sensitized, that is, have their emulsion coated directly on the sized paper itself. Most fiber papers have a baryta (or clay) coating under the emulsion for brilliance and texture. This is somewhat of a misnomer, since the mineralogist thinks of barium oxide as baryta. In photographic parlance, though, the baryta layer is a suspension of barium sulfate crystals in a little gelatin, providing a highly reflective surface to support the emulsion. A small amount of bluish dye overcomes any slight yellowness. Fluorescent brighteners are often added for extra apparent reflectance. The baryta layer can be made extremely smooth or a texture can be added by passing the baryta paper through textured rollers. Conventional fiber-base papers—baryta coated or not—have a vast amount of surface area in their mat of tangled fibers. This provides an unwanted sump for the absorption of water and chemicals. Most of the hour spent in washing double-weight papers is not to free the emulsion, but to free the base of chemicals.

Resin-coated papers are a good alternative to fiber where mechanized processing and rapid access to a fully processed and dried image is wanted. Some processing machines do this whole cycle from dry to dry in one minute. RC base is made by extruding thin membranes of polyethylene onto both sides of a conventional fiber paper. The resin on one or both sides may be somewhat opacified and whitened by incorporation of a white pigment such as titanium dioxide. The oleophilic nature of ordinary polyethylene resin is repellent to an aqueous emulsion. For better bonding, the terminal methyl groups on the surface are oxidized to the more hydrophilic aldehyde and carboxylic acid groups.

Plate Supports Plates provide the ultimate in flatness and dimensional stability. Ordinary soda-lime glass is by far the most common support for plates. Glass is selected for freedom from seeds and blisters. The degree of flatness and surface parallelism may be specified by the customer for exacting applications. Thicknesses from 0.030 to 0.250 inch are usual, with thickness being somewhat proportional to the overall plate size. Large plates, though, are sometimes coated on very thin glass when they must be bent, as in some spectrographs and astronomical instruments. Where an even-lower coefficient of thermal expansion than glass is required, or where UV transmission is needed, fused quartz plates are used. Emulsions coated on plastic plates, sheets of methyl methacrylate resin (Lucite, Perspex), can be cut and machined with ordinary tools. Because of the relative ease

and economy with which small batches can be produced, plates are the format of choice for exotic emulsions and special imaging applications.

FINISHING AND PACKAGING The long rolls of coated film and paper must be finished into sizes to fit exposing equipment and packed into convenient quantities. Slitting and chopping machines reduce the master rolls to usable sizes. Other devices measure length, count sheets, perforate, code notch, edge mark, spool, wrap, seal, box, and label. The high speed and panchromatic sensitivity of so many films makes the doing and inspection of these tasks increasingly difficult. The lower sensitivity of most papers eases this somewhat. Open or coded information on labels or as latent image edge marking identify emulsion batch, mast roll, slit, and date an shift of manufacture to aid in the tracing of complaints of defective performance.

Most photosensitive materials are packaged in equilibrium with 50% relative humidity, and sealed in packaging materials that provide a vapor barrier. The packaging material, like everything else the sensitive material comes in contact with, must be photographically inert. The effective equivalent of the former *tropical packaging* is now provided by the use of sealed plastic packaging for almost all goods, no matter what the sales destination. Many manufacturers have discontinued expiration dates on papers, but retain them for most films and plates. *M. Scott*

See also: *Expiration date; Gelatin; Safelight.*

PHOTOSENSITIVE POLYMERS Upon exposure to light, photosensitive polymers undergo a change in their physical properties and molecular weight. They may become insoluble in some solvents, undergo a change in their adhesiveness, viscosity, or photoconductivity, or change the way they scatter light. Although these materials may be synthetic or naturally occurring, they share certain properties. They tend to have lower effective sensitivity than silver halide imaging systems, with predominant spectral response in the ultraviolet region, and they are prone to high and low level reciprocity failure.

Readout techniques rely on discerning the physical differences between exposed and unexposed areas. When changes in solubility occur, unexposed areas can be washed away. In the 1820s, Joseph-Nicéphore Niépce used light-sensitized bitumen of asphalt's insolubility in lavender oil to produce his heliographs. Areas that soften on exposure are subject to thermal transfer to a support. Areas that become tacky on exposure may have pigment dusted on them.

Photosensitive polymers are used in preparing printing plates and manufacturing electrical components. They are common in information storage and holographic systems, photosensitive resists, and the image transfer and dye imbibition printing processes. They are available as prepared film stock or as liquid to be applied before use. *H. Wallach*

PHOTOSILKSCREEN See *Silkscreen.*

PHOTOTHERMOGRAPHY Thermal development of materials whose latent images were formed by exposure to light, infrared, or other radiation. Photothermographic materials are decomposed by heat in exposed areas. These processes have applications in office copying, the production of projection transparencies, and medical imaging.

H. Wallach

PHOTOTRANSISTOR A transistor responsive to radiant energy, used frequently as a light-operated switch. Unlike an ordinary bipolar junction transistor, the current through the phototransistor depends on the amount of light falling on the base electrode rather than on the amount of current flowing through the base-emitter junction. A photo-

transistor has a spectral response that peaks at about 800 nm but has some response in the visible range. Like the photo-diode, the phototransistor has a very fast response to changes in light level. It is available in PNP and NPN configurations. Some phototransistors have an external connection to the base to supply bias current. *W. Klein*

PHOTOTUBE A glass bulb containing a cathode coated with a light-sensitive metal, such as cesium oxide, and an anode to collect the electrons emitted from the cathode. The bulb may be evacuated or may be filled with an inert gas such as argon. With a dc voltage of 90 to 300 volts applied, the current through the tube is proportional to the light falling on the cathode. Phototubes are available with many different spectral characteristics, depending on the composition of the cathode coating. Phototubes have now been largely replaced by more rugged low-voltage semiconductor photocells. *W. Klein*

See also: *Photomultiplier tube.*

PHOTOVOLTAIC CELL A light-sensitive device that converts light energy to electrical energy. The output current is proportional to the incident light when the cell is connected to a low-resistance load. Photovoltaic cells have an advantage over other photosensors in that they do not require an external source of power. Common photovoltaic materials include selenium and silicon.

The selenium cell consists of an iron disc coated with selenium, which in turn has applied to it a film of gold or platinum thin enough to allow light to pass through. In a light meter, the leads from the selenium and from the gold or platinum film are connected to a microammeter. The current generated by light falling on the cell causes the needle of the meter to deflect an amount dependent on the incident light. Even though the spectral sensitivity of selenium cells approximates that of visible light, a color-correction filter is commonly used in light meters.

Typical silicon photovoltaic cells, also known as solar cells, have a peak response in the near infrared and are used primarily where efficiency of energy conversion is important. Special blue-enhanced silicon cells that have more sensitivity to blue light are commercially available. *W. Klein*

Syn.: *Barrier-layer cell.*

PHYSICAL DEVELOPMENT The process of developing a visible image by silver intensification of either a faint image formed by chemical development or a latent image consisting of silver specks—which can remain following fixation of an exposed emulsion in a nonacid fixing bath. The silver that forms the image is supplied by the developer, not by the silver halide grains in the emulsion as in normal (chemical) development. Advantages of physical development are fine grain and high resolution but at the expense of a considerable loss of film speed.

Physical developers that selectively deposit conducting or magnetic metals such as copper, iron, nickel, and cobalt on latent images formed on photosensitive resist coatings can be employed as an alternative to selective etching techniques in the production of printed circuits. The physically developed images are built up to the required thickness by electroplating. *L. Stroebel and R. Zakia*

See also: *Solution physical development.*

PHYSICAL OPTICS See *Optics.*

PHYSICAL PROPERTIES Those properties of a photographic material other than chemical and sensitometric. Among these are dimensional changes with temperature, humidity, and age; curl; electrification; abrasion resistance; and surface characteristics, such as sheen and texture. *M. Scott*

PHYSICAL REDUCTION Reduction in density of a silver image by rubbing a fine abrasive over the surface with a tuft of cotton, or by scraping the surface with a sharp knife, taking care to blend with the surrounding detail. *I. Current*

See also: *Abrasive reducers; Etching; Reduction.*

PHYSICAL RIPENING See *Ripening.*

PHYSIOGRAM A pattern recorded photographically by a point of light attached to a swinging pendulum. The pattern has an unusual and delicate beauty and is capable of endless variations. A variation of this is the recording of a point of light on a moving person such as a dancer or athlete. *R. Zakia*

See also: *Special effects, light drawings.*

PICA A unit of measure used by printers to measure lines. One pica is equal to 1/6th of an inch; 6 picas equal 1 inch.
Books: *Pocket Pal: A Graphic Arts Production Handbook.* New York: International Paper Company, 1976. *R. Zakia*

PICO- In the metric system (SI), a prefix meaning a trillionth, or 10^{-12}, as in *picosecond.* *H. Todd*

PICTORIALISM The term *pictorialism* came to be used generally by photographers in the late nineteenth and early twentieth centuries to describe an artistic approach to the making of photographs as well as to define a number of specific groups organized to promote art photographers and their work.

The question of artistic intent in photography had been discussed widely in Europe, particularly in England, beginning as early as the 1850s. Speaking on behalf of the artistic purposes of photography were critics and journalists such as Lady Elizabeth Eastlake, Oscar Rejlander, and Peter Henry Emerson. In 1869, Henry Peach Robinson published his *Pictorial Effect in Photography,* giving weight to the notion of photography as a self-conscious art form and popularizing the critical concept of pictorialism.

Pictorialism served historically as a reaction against the flood of unexceptional and easy photographs enabled by the technical advances of the 1880s. Convenient innovations such as the dry-plate hand-held camera, and flexible roll film, as well as improved camera design and optical sharpness, made camera work available to a larger group of amateurs whose primary concern was the graphic recording of information. Without attention to or regard for notions of aesthetic merit, the work of amateur photographers was seen by some to be artless and hopelessly devoid of personal sensibility.

Contemptuous of the literal representation of subjects and scientific and commercial applications of the medium, groups of photographers spontaneously organized under the banner of pictorialism to promote expressive feeling in their pictures by application of the principles, styles, and subject matter of the *high art* tradition. They turned away from what had been the primary photographic concern for accuracy in portraiture, architecture, and landscape to a concern for the picturesque: idealized and personalized views that showed conscious and careful attention to pictorial composition, broad delineation and tonality, symbolic and allegorical allusion, and signs of the careful hand of the artist.

Much the same as the academic painters and printmakers they emulated, pictorialists favored the classification of subject matter in such categories as landscape, portraiture, figure, still life, genre, and allegorical scenarios. In seeking to connect with the high art tradition of the nineteenth century, pictorialists sought to give pedestrian photography a look of

aesthetic respectability, to elevate the photograph to the status of rare and collectible art object, and to include amateur photographers in the dedicated service of art for its own sake.

Not only subject matter, but also manner of execution was important in the pictorialist salon. Pictorial photographers took great pains to attempt to see a picture where an ordinary person would not and to invest that image with spiritual significance. There followed the challenge to execute the making of the photograph in such a way that the creative intentions of the maker were unmistakable. In striving to create unique art objects and to suppress the mechanical and reproducible origins of the photograph, pictorialists resorted to nonstandard and inventive processes that relied on hand work and manipulation. Much as painters or watercolorists, photographers used techniques that lent a unique signature to their work and obscured the literal photographic information of the image. Photographic detail was suppressed by the use of a variety of textured and hand-made papers on which the photographic original might be rubbed, erased, or otherwise worked by hand. Hand-applied emulsions of gum bichromate and pigment; platinum, palladium, and iron sales; and multiple applications of toners and dyes not only were capable of exploiting the exquisite tonal range prized by pictorialists, but also gave each photograph standing as a unique and singular artifact. Pictorialist prints are frequently characterized by their fine observance of the quality of light—attention to atmospheric effects of haze and fog and rain made possible by printing-out carefully exposed negatives in direct sunlight. The striking effects of light were also exaggerated or distorted by the use of soft-focus lenses specifically designed to imitate the diffuse effect of impressionistic paintings and watercolors.

Although pictorialism was a widely dispersed movement, it was most carefully followed in England and the United States. The development of a clear pictorialist tradition may have its roots as early as 1887 in the organization of amateur camera clubs in the eastern United States, devoted to the international presentation of artistic photographs in an annual series of joint exhibitions that continued until 1894. These popular camera club salons, with their broad base of amateur membership, attempted to elucidate the notion of artistic feeling in subject matter and developed canons of practice based on the teachings of the fine-art academy. More importantly, they mounted well attended juried exhibitions that traveled to city art museums and galleries and were influential in promoting a popular understanding of the pictorialist aesthetic.

In 1891 a group of English pictorial photographers took on the name The Brotherhood of the Linked Ring and seceded from The Photographic Society of London in order to dedicate themselves to photography in the service of aesthetic pleasure. They initiated the first London Salon of Photography in 1894. In 1902, Alfred Stieglitz formed a group called The Photo-Secession, following his involvement with the New York Camera Club. Exhibitions at the Little Galleries of the Photo-Secession in New York, as well as critical articles and gravure reproductions in the periodical *Camera Work,* became the focal point for the pictorialist movement and modern art until 1917, when the effects of war devastated the dialogue of the artistic community worldwide. In the 1920s, pictorialism gave way to a new aesthetic of sharp optical rendering and realistic objectivity exemplified in the work of photographers like Edward Weston and the Group *f*/64 in California. As late as the 1930s, pictorialist theory was still argued in journal debates by William Mortenson, but the structure of the camera club salons and the pictorialist movement had become a thing of the past. Nevertheless, interest in pictorialism continues today among contemporary fine-art photographers, particularly evidenced in the interest

for reviving vintage processes such as the platinotype, cyanotype, and gum print to render stylized and singular art images of the picturesque. *M. Flecky*

PICTURE A visual representation of an object or scene, such as a photograph, painting, or drawing. *L. Stroebel*

PICTURE AGENCY An entity that serves as a representative, that is, agent, of photographers in accepting assignments, usually news. The term is sometimes used interchangeably with stock agency and, in fact, some picture agencies act as stock sources. *R. Persky*

See also: *Agencies; Business practices.*

PICTURE EDITING Picture editing involves assigning and selecting photographs for publication in newspapers and magazines. An understanding of the editorial goal and the parameters of reproduction are more important than any technical knowledge of picture taking.

In fact, some well-regarded picture editors never even learned to use a camera. Wilson Hicks, executive editor of *Life* magazine, reportedly "sent photographers to every point on the globe; he hired and fired the best photojournalists, and set the direction of the [picture editing] field for years to come. Yet he never took a picture that was published in his own magazine." (Kobre)

Rather than being able to take a picture with great visual impact, the picture editor needs to recognize such an image, even if it is only part of a film frame. Viewing contact sheets with as many as 36 images per sheet, the picture editor circles the best images with grease pencil. These images are enlarged for further consideration by the picture editor and other appropriate members of the editorial staff.

While the word *edit* often is equated with *eliminate* or *delete,* picture editing incorporates a strong proactive element. The picture editor on a newspaper decides daily what stories need pictures; the picture editor on a magazine works regularly with department editors to determine photographic needs. Each then assigns work to staff and freelance photographers who have the technical ability to meet standards, the creative ability to work with concepts, and the personal responsibility to meet deadlines.

In addition to responding to editorial needs, the savvy picture editor tries to anticipate future photographic needs. That way, excellent images will be available when news breaks or the time is right for a particular feature. Picture editors also develop and assign photo essays intended to run in picture spreads.

Whatever the assignment, the picture editor attempts to provide as much information to the photographer as possible. Clippings of related stories and names of people who can provide additional background establish a context within which the photographer can create and, ultimately, succeed.

When in doubt, especially in fast-breaking news situations, the photographer usually is told to shoot first. Then, it's up to the picture editor to decide if a photograph meets the criteria for publication. Some traditional guidelines include newsworthiness, human or community interest, and action or eye appeal. Here, the picture editor's judgment and understanding of the publication's readers come into play.

Just how much autonomy the picture editor enjoys depends on the publication. Just how much interaction the picture editor has with the photographer—after the shoot is completed—depends on the working style of the publication. Some picture editors feel that the images, beyond a certain amount of captioning information, should essentially speak for themselves.

In situations where no picture editor is involved, someone else—often the photographer—must do the picture editing. Then, the photographer must strive to forget inside knowl-

edge of the shoot and to choose the best images for the editorial purpose. Such objectivity can be difficult to summon. The problems inherent in editing yourself contribute to the importance of the picture editor.

Books: Kobre, Kenneth, *Photojournalism: The Professional's Approach,* Second Edition. Boston: Focal Press, 1991.

K. Francis

PICTURE ELEMENT See *Pixel.*

PICTURE SERIES A set of photographs dealing with a single concept or with related concepts, but without the progressional narrative qualities of a picture story. *L. Stroebel*
 See also: *Visual literacy.*

PICTURE STORY In photojournalism, a set of photographs related to a single theme, usually incorporating a transition analogous to a plot in literature and accompanied by text and captions. *L. Stroebel*

PIEZOELECTRICITY Electricity generated by squeezing, bending, or twisting certain crystalline substances such as quartz, tourmaline, and Rochelle salt. Piezoelectric crystals are used in oscillators to maintain the precise frequency required for clocks, timers, and radio transmitters and receivers. The piezoelectric effect is also used in crystal microphones, strain gages, and as the energy source for specially designed flash bulbs. A piezoelectrical crystal will distort when a voltage is applied across it and can be used for micropositioning of photosensors, etc. *W. Klein*

PIGMENT PROCESS When organic colloids such as albumen, casein, gelatin, gum arabic, or shellac, and some cellulose and polyvinyl esters are sensitized by the addition of potassium, ammonium, or pyridine bichromate, three kinds of physical changes may take place in the colloid upon exposure to light. It may become insoluble in a liquid that previously dissolved it; it may cease to absorb water and swell; it may lose its surface tackiness.

In the first instance, a pigmented layer may be incorporated into a bichromated colloid. After exposure, hot water dissolves the soluble, unexposed areas, forming a positive image in the insoluble, exposed colloid. The carbon, carbro, and gum bichromate processes, with the many variations on each are common examples of this procedure.

In the second case, some sensitized colloids will swell in their unexposed areas after exposure and bathing in water. Inks and dyes will be rejected by the swollen areas and accepted by the exposed areas, facilitating such processes as bromoil, oil printing, and dye imbibition.

In the last case, bichromated gum arabic loses its tackiness in exposed areas, permitting finely powdered pigment to be dusted onto the sticky, unexposed areas.

Xerography is similar to the second and third instances in that the pigment is added after exposure rather than being part of the emulsion. Exposure causes a discharge that permits the remaining, unexposed, charged areas to attract oppositely charged pigment particles. The pigment image is transferred to a paper support.

All these processes are relatively inexpensive, permanent, and flexible, lending themselves to combination and alteration. Early systems appeared in the 1850s and 1860s and have maintained their attractiveness to the present. *H. Wallach*
 See also: *Bichromate process; Bromoil process; Carbon process; Carbro process; Dye imbibition; Gum bichromate process; Xerography.*

PIGMENTS (1) Insoluble colorants. (2) Colorants in the tissues or cells of animals and plants. *R. W. G. Hunt*

PILOT (1) A small-scale manufacturing operation, inter-

mediate between a laboratory process and full commercial production. (2) A lamp providing supplementary illumination or indicating the status of a light source or piece of apparatus. (3) With *pin,* an element on a motion-picture camera or printer that aids in proper film placement. (4) Specifying a film or tape of a sample program, made as an example of a series with the intent of selling the series. *I. Current*
 Syn.: (3) *Register pin.*

PINACRYPTOL A dye powder that can be put into solution and used to desensitize panchromatic film before processing so that it can be developed by inspection. Pinacryptol green and pinacryptol yellow dye powders are soluble in alcohol and slightly soluble in water.

L. Stroebel and R. Zakia

PINCH ROLLER In tape transports, a disc of elastomeric material such as rubber that pushes the tape against the capstan so that the tape takes on the speed imparted by the capstan. *T. Holman*
 See also: *Capstan.*

PINHOLE Pinholes are very small spots on processed negatives, most often produced by the shadows of particles on the emulsion surface at the time of exposure. Although less likely, they may also be produced by chemical contamination by small particles on the emulsion surface, or by the formation of small blisters of gas due to improper processing. They may be corrected by jabbing the base side of the negative with a needle point, then retouching the lighter area produced on the finished print. *I. Current*

PINHOLE CAMERA See *Camera types.*

PINK NOISE A test noise signal whereby the noise power varies inversely with the frequency. *T. Holman*
 See also: *White noise.*

PINNAE The external ear parts. The important role of the pinnae in localization came to be understood just since the 1980s: sound fields approaching the ear from different angles encounter various reflections and shadowing provided by the head and outer ear. The resulting frequency response changes can be detected as location and movement information. *T. Holman*

PIN REGISTER A system of ensuring accurate positioning of film or other material by means of protruding pins that fit into matching punch holes in the material, such as the pins that engage the sprocket holes in motion-picture film to position each frame in the projector gate. Also used to obtain accurate registration of the cyan, magenta, and yellow matrices in the dye transfer color printing process. *L. Stroebel*

PINT In the U.S. measurement system, a measure of fluid volume equal to 16 fluid ounces and to 1/2 quart, and equivalent to 473 ml. *H. Todd*

PINUP A large photograph or photomechanical reproduction of a photograph of a sexually attractive person, such as a glamorized photograph of a young woman or man in a bathing suit, that is intended to be displayed on a wall.

L. Stroebel

 Syn.: *Cheesecake.*

PIPED LIGHT See *Fiber optics.*

PIPE PROCESSING A procedure for processing 35-mm film in which the container is a long narrow cylinder having an inside diameter slightly less than the film width,

such as a suitable length of plastic pipe or a golf-club tube, with a rubber stopper for each end. After inserting the film, developer is added to within about 2 inches of the top. Agitation consists of tilting the stoppered tube so that the bubble of air moves from end to end in alternating directions, with the developer flowing in the opposite direction to produce uniform agitation. *L. Stroebel and R. Zakia*

Syn.: *Tube processing.*

See also: *Agitation.*

PITCH (1) In films and equipment used in motion pictures, the distance between corresponding points on two adjacent film perforations or sprocket teeth. (2) In photofabrication, the distance between corresponding points on adjacent images. (3) In aerial photography, the tilt of the camera optical axis from horizontal. *H. Todd*

PITCH (SOUND) The sensation of a tonal sound ascribed as lower or higher; affected mostly by frequency of the sound but also by sound pressure level and timbre. *T. Holman*

PITMARKS Pitmarks are characterized as small deformities in the emulsion or base surface of photographic materials, often the result of a processing failure that is chemical or physical in nature. While related to small blisters, pitmarks have a more amorphous appearance. They may also be the result of some mechanical action on the material, and may be repetitive in nature, such as when film passes over a sprocket or roller having a burr. *I. Current*

PIX Slang for *picture.* *L. Stroebel*

PIXEL Picture element, the smallest component of a piture that can be individually processed in an electronic imaging system. *L. Stroebel*

See also: *Information (Image).*

PIXEL CLONING In electronic imaging, copying a pixel or group of pixels from an area of an image for the purpose of adding them to another area, in order to remove unwanted detail, for example. *L. Stroebel*

PIXELLATION When the spatial resolution of an electronic, computerized image is low, the individual pixels or groups of pixels become visible. This *blockiness* is known as pixellation. The degree of visibility of these blocky pixels depends upon the viewing distance from the cathode-ray tube (CRT). *R. Kraus*

PLANCKIAN LOCUS The locus of points in a chromaticity diagram that represent the chromaticities of the Planckian radiators at different temperatures. *R. W. G. Hunt*

PLANCKIAN RADIATOR See *Blackbody.*

PLANCK'S CONSTANT (h) The constant relating the frequency of a photon to its energy, equal to 6.626×10^{-34} joule-sec. *J. Holm*

PLANCK'S LAW A law of physics that states that heated enclosures with small apertures emit radiation whose spectral concentration of radiant exitance, M_e, in watts per square meter per wavelength interval, as a function of wavelength, λ, in meters, and temperature, T, in kelvins, is given by the formula

$$M_e = c_1\lambda^{-5}(ec_2{}^{\lambda T} - 1)^{-1}$$

in watts per square meter, where $c_1 = 3.74183 \times 10^{-16}$ W/m^2, $c_2 = 1.4388 \times 10^{-2}$ m \times K, and $e = 2.718282$. *R. W. G. Hunt*

PLANCK'S RADIATION LAW Relates the absolute (Kelvin) temperature of a blackbody radiator to the amount of electromagnetic radiation emitted as a function of wavelength. *J. Holm*

See also: *Color temperature.*

PLANE POLARIZED LIGHT Light in which the vibrations are restricted to a single plane, transverse and orthogonal to the direction of travel. Light reflected from a glossy electrically nonconducting (dielectric) material, such as glass, wood, and plastics, is plane polarized to some extent, the vibrations being parallel to the surface. Such reflections can be subdued or removed by use of a polarizing filter over the camera lens. *S. Ray*

Syn.: *Linearly polarized light.*

PLANO- Prefix meaning *flat,* used, for example, to specify one surface of a lens. A planoconvex lens has one flat surface; and the other is outwardly curved so that the lens is thicker in the center than at the edges. *H. Todd*

PLASMA DISPLAY In computers, cathode-ray tubes (CRTs) are only one form of display technology. As computers become smaller and more portable a limiting factor in achieving still smaller computers is the display. Plasma displays are flat-screen displays in which a wire mesh sits sandwiched between two sheets of glass in an environment of inert gas. Each crosspoint of the mesh represents a pixel that can be addressed by the computer. *R. Kraus*

PLASTIC DEFORMATION See *Deformation process.*

PLASTICIZER A substance added to a film base or other plastic material to increase its flexibility and its resistance to cracking when bent. *M. Scott*

PLASTICS Plastics are very long chain molecules made up of smaller molecules joined end to end. If there is no cross linkage between the molecules, the resin is said to be *thermoplastic,* that is, it will soften and flow when heated, then harden when cooled to a solid with essentially the same physical properties. If there is cross linkage between the long chain molecules, the resin is said to be *thermosetting,* giving a hard solid that may not soften with heat. Thermosetting plastics are preferred over thermoplastics where greater strength, higher heat resistance, and greater inertness are required.

Thermoplastic materials contain organic substances, called *plasticizers,* that modify physical characteristics, such as flexibility, hardness, strength, and water absorption. Plasticizers are often lost with time and may leach out to influence the results of photographic processing. Antioxidants, called *stabilizers,* are added as preservatives to maintain the plastic.

Glass resembles a plastic material but actually represents a vitreous condition that lies between the solid and liquid states. Glasses are composed of silica and boron trioxides combined with the oxides of metals. When heated, glass has some of the properties of a liquid, but when cooled quickly, the melt does not crystallize and the increasing viscosity traps a random arrangement of the molecules. Transparency and hardness are properties that have made glass a longtime choice for the lenses of photographic as well as other optical equipment. Plastic lenses, which can be molded and are less expensive to make, are replacing glass lenses in a steadily increasing number of uses.

Glass also gained acceptance in the early days of photography as the support for the wet plate collodion emul-

sions. Collodion is cellulose, a long, chain of glucose units that has been treated with nitric and sulfuric acids to give cellulose nitrate or pyroxylin (gun cotton). Just over two of the three hydroxyl groups per glucose unit of cellulose have been nitrated. Dissolved in organic solvents (ether and alcohol, 3:1) the solubilized pyroxylin, now called collodion, served as the liquid carrier of the light-sensitive silver salts to coat the glass plate. The image had to be developed as soon as possible after coating and exposure as the solvents evaporated quickly, leaving a thin, tough layer that water could not penetrate. Rigid nitrocellulose products were made of this plastic for the home and elsewhere, often sold under the Celluloid trademark.

Adding plasticizers, such as camphor, to the nitrocellulose made possible thin films of suitable flexibility as a plastic support for photographic emulsions. In 1889 Kodak introduced nitrocellulose as the transparent base for its first roll films. This film base had good dimensional stability and was water resistant, but the base had a tendency to decompose spontaneously and burn ferociously.

Cellulose was treated with acetic anhydride, glacial acetic acid, and sulfuric acid, then hydrolyzed so that each glucose unit had about $2\,^{1}/_{2}$ acetyl groups (38 to 40%). The cellulose diacetate, dissolved in acetone and with a plasticizer present, formed transparent, flexible films when coated on a heated surface to drive off the solvent. This plastic base made possible the slow-burning safety film needed to introduce amateur home motion pictures in 1923.

The diacetate film base was inferior to the nitrocellulose film in toughness and dimensional stability. Cellulose triacetate, with acetyl content slightly reduced for manufacturing purposes, had improved physical properties over the diacetate. Cellulose triacetate has found general use as a plastic film base from after the Second World War until the present time.

Acetyl esters of cellulose absorb moisture, swell, then do not return to the original dimension. Other materials were studied. Polyvinyl chloride–polyvinyl acetate (90%–10%) were tried but still had deficiencies. A film base, polyethylene terephthalate, was made by polymerizing ethylene glycol and dimethylterephthalate and then biaxially orienting the molecules by stretching the film in both directions under high temperature conditions. Polyethylene terephthalate film base has excellent dimensional stability and toughness, making it a premier film support since 1955 (Du Pont Cronar and Kodak Estar are examples).

Film base is probably the most important use of plastics in photography. The use of plastic for other purposes, from camera bodies to stirring rods, is increasing. Acrylics, polyesters, polyethylenes and polypropylenes, polystyrenes, and vinyls are a few of the types that have been studied. Plastic materials should be carefully tested, especially for processing equipment, as chemical resistance and chemical absorption vary greatly with plastic composition.

G. Haist

PLATE (1) Among photosensitive materials, a relatively thick, rigid, transparent support for a photosensitive coating. Glass is the most common material, ranging in thickness from 0.030 to 0.250 inch. Glass plates are chosen where extreme flatness or dimensional stability are needed. Some very specialized photographic emulsions are available only on plates. Methyl methacrylate sheets are sometimes used, and, rarely, fused quartz. (2) In camera technology, a flat member for locating the film in the image plane; also pressure-plate. (3) In photomechanical reproduction, a sheet of metal, plastic, or paper bearing an image for printing with ink.

M. Scott

See also: *Photosensitive materials manufacture.*

PLATE PRINTING In photomechanical reproduction, a thin metal, plastic film, or paper sheet that is converted to an image carrier in the printing processes.

M. Bruno

PLATFORM In computer parlance, the term has come to mean a specific type of computer system. The type of platform will determine what software will operate on the system.

R. Kraus

PLATINOTYPE By 1832 Sir John Herschel knew that some platinum salts were sensitive to light. Robert Hunt discussed the effect in 1844, but it was not until 1880 that a platinum-based printing material was marketed. William Willis took a patent on his process in 1873 and formed the Willis Platinotype Company in 1879. Three years later, the formulas were made public and enthusiasts could coat their own paper. The process was embraced by a large group of fine art photographers including Pictorialists and Photo-Secessionists for the delicacy of its tones, its permanence, and its print surfaces, which suggest that the image is part of the paper.

Platinotype (like its less expensive relative, palladiotype) is a ferric process. Fine-textured rag paper is sensitized with ferric oxalate, potassium chloroplatinite, oxalic acid, and, perhaps, potassium chlorate. The mixture is brushed on and dried. During contact printing with sunlight or UV source, the image prints out partially, creating a self-masking effect. Early production of shadow density retards the rate at which low print values darken, allowing highlights to receive more exposure than is possible in a purely developing-out process and facilitating the printing of negatives that have long tonal scales. Full development of the image is performed in potassium oxalate. Clearing and fixing are in dilute hydrochloric acid, followed by washing and drying.

H. Wallach

PLAYBACK EQUALIZATION The frequency response correction applied upon playback of a medium.

T. Holman

See also: *Equalization.*

PLAY HEAD In sound, a tape head intended to recover recorded flux available from a magnetic oxide, and convert it into an electrical signal. Mechanically it is similar to a record head, although there are differences that optimize heads for either record or play use. Still, some machines are produced that have only two heads: an erase head and a combination record and play head.

T. Holman

PLOTTER In computers, an electromechanical device that literally draws with pens, charts, and graphics as determined by the software. Plotters are often used to provide high-resolution line drawings as required by computer-assisted design (CAD) systems.

R. Kraus

PLUMBICON In electronic imaging, video tube–type cameras use various types of pickup tubes to image a subject. The plumbicon tube is particularly noted for its ability to image under low lighting conditions. It has been used widely in the area of video surveillance.

R. Kraus

PLUMMING Plumming refers to the change of color and density produced when some photographic papers are dried by means of high temperatures that cause a deterioration of the image whereby the maximum density is lowered and the high densities take on a purplish, plum, or bronze color. The effect is sometimes referred to as *bronzing*. The filamentary silver particles are transformed into more rounded particles having lower covering power. Appropriate chemicals are added to paper emulsions to minimize this defect, and further control may be achieved with a stabilizing bath before drying.

I. Current

POINT BRILLIANCE The illuminance produced by a source on a plane at the observer's eye, when the apparent diameter of the source is inappreciable. Unit: lux, lx.

R. W. G. Hunt

POINTING DEVICE In computers, the graphic user interface (GUI) functions most efficiently through the use of a pointing device that locates functions, addresses menus, or launches events. *R. Kraus*

See also: *Graphics tablet; Joystick; Light pen; Mouse.*

POINT PROCESSING In electronic imaging, a point process such as a histogram equalization is used to correct the brightness levels in an image in order to achieve a contrast change. *R. Kraus*

POINT-SPREAD FUNCTION See *Spread function.*

POISONS Poisonous substances have always been a peril to the health and even the life of human beings. Photographic processing, like daily living, involves hazards. Some photographic chemicals are poisonous to all; other chemicals may be injurious only to susceptible persons. Safe handling of acids, bases, and heavy metal salts involves only careful laboratory practices, but special care is needed for substances that are poisonous gases or are liquids or solids that emit gases, fumes, or vapors.

Identification and knowledge of specific poisons is necessary. The following substances are of a dangerous nature.

MERCURY The element mercury occurs in nature as a pure metal and as natural compounds, such as cinnabar. The liquid metal, called *quicksilver,* describes how it looks and acts, especially if spilled on a hard surface. Even at room temperature, the liquid metal gives off vapor into the atmosphere. Mercury poisoning is insidious; the effect of minute amounts may take months to show up, usually as damage to the human brain and kidneys. Continued exposure causes insanity, unconsciousness, paralysis, and death. "Mad as a hatter" is an old saying that refers to hat makers who had been poisoned by the mercury in felt used to make hats.

Mercuric chloride and mercuric bromide (corrosive sublimate) have been widely used in intensifying solutions for the silver image, as the insoluble mercurous salt reinforces the image. Mercury vapor has been used to increase the sensitivity of film materials (hypersensitization). Mercury occurs in batteries, thermometers, dyes and inks, fluorescent lights, plastics, and many other materials encountered in photography.

Avoid the chemical use of mercury metal or its compounds. If mercury metal is spilled, vacuum it up immediately and dispose of at once, calling a poison control center for details. Do not discard in landfills. Mercury poisoning should be treated by a physician. If mercury is ingested, giving egg whites may help. The compound BAL (2,3-dimercapto-1-propanol) is the antidote for mercury poisoning.

CYANIDE Cyanide is a white granular powder or pieces having a faint odor of almonds that dissolves in water to produce a very alkaline solution (around pH 11). On exposure to humid air, cyanide solid reacts with carbon dioxide, liberating a gas. Both the solid and the solution may give off hydrogen cyanide, a colorless gas that is intensely poisonous. Exposure to hydrogen cyanide at 150 parts per million in air for 1/2 to 1 hour has been reported to endanger human life. The average fatal dose of the solid is said to be 50-60 mg.

A solution of potassium cyanide is an excellent solvent for silver salts of low solubility, such as for the removal of silver sulfide stains. Cyanide was the preferred fixing agent for the silver iodide of the early wet plate process. It is used as an ingredient (as sodium cyanide) in the blackening solution for silver image mercury intensifiers (as in Kodak mercury intensifier In-1).

Do not use cyanides if possible. Do not add acids or acidic solutions, metallic salts, or oxidizing compounds to solid cyanide or its solutions, even during disposal, as the poisonous hydrogen cyanide gas may be liberated. Sodium nitrite or sodium thiosulfate have been used as antidotes.

POISONOUS GASES Special attention should be given to substances that may exist in gaseous form. Solids and liquids containing such gases are often unstable, easily releasing the gases, fumes, or vapors. Some of these potential poisons are discussed in the following sections.

Ammonia, Ammonium Hydroxide, and Ammonium Salts Ammonia is a colorless and pungent gas that can irritate and burn. Do not mix ammonia with chlorine bleach. If taken internally, give lemon juice or diluted vinegar.

Formaldehyde and Formalin (37% in water) A colorless, irritating gas that attacks the eyes, skin, and respiratory system and can cause coma and death. If swallowed, induce vomiting with a glass of water containing 1 tablespoon of ipecac syrup.

Acid Gases Hydrogen bromide, hydrogen iodide and iodine, hydrogen chloride, hydrogen sulfide, and nitric acid are either poisonous gases or water solutions that give off irritating and corrosive fumes that are dangerous to the skin or eyes or if inhaled or swallowed. Hydrofluoric acid is especially insidious as it does not burn when contacting the skin, only becoming painful after some hours. Glacial acetic acid, a liquid with a pungent odor, can cause severe burns.

ORGANIC SOLVENTS Acetone, amyl acetate, benzene and xylene, carbon tetrachloride, ether, methyl, and ethyl alcohol, various amines, and other solvents are often volatile, flammable, and poisonous. Avoid their use if possible, but they may be needed for their unique solubilizing properties for photographic chemicals. Carbon tetrachloride and other chlorinated solvents may be carcinogenic. Methyl alcohol is flammable and a poison; ethyl alcohol causes human impairment and inebriation. Benzene and xylene are flammable liquids that have acute and chronic poisoning effects. The volatile organic amines are often flammable.

HANDLING POISONS Avoiding the use of poisonous substances is to be preferred. If such substances must be handled, protection against contact with the skin or eyes, breathing gases or vapors, or ingestion is necessary. Be certain to read the referenced entries listed below, especially the one dealing with chemical safety. *G. Haist*

See also: *Chemical disposal; Chemical safety; Chemicals.*

POLACOLOR Proprietary diffusion transfer system of photography. A positive dye image is obtained about a minute after the material is exposed in a Polaroid camera or a dedicated camera back. *H. Wallach*

See also: *Polaroid photography.*

POLAR GRAPH A plot of data on a chart that resembles a map of the earth as seen from above one of the poles. Such a graph is often used when an angular measurement is

Polar graph.

involved, to show, for example, the pattern of light emitted in different directions from a light source. *H. Todd*

See also: *Graphs*

POLARITY (1) A property of electric charges, either negative or positive. A terminal or electrode is said to be *negative* if it has an excess of electrons; *positive,* if it has a deficiency of electrons. (2) A property of a magnetic field, either north pole or south pole. *W. Klein*

POLARIZATION As applied to objects that have two distinct and opposite ends; the arrangement of a group of such objects so that all the ends of one type face one direction, and all the ends of the other type face the opposite direction. The most frequent application of the term polarization in photography is in the polarization of light. *J. Holm*

See also: *Polarized light.*

POLARIZED LIGHT Light in which the orientation of the electric, and therefore the magnetic field oscillations are specified. Ordinary light is not polarized, i.e., the directions of oscillation of the electric and magnetic fields are randomly distributed among the photons. Light can be polarized by reflection off a nonconducting surface at the Brewster angle; by birefringence, where it is split into two polarized components; or by selective absorption, where one component is absorbed. In polarization by reflection, only electric field oscillations parallel to the surface of the reflecting material will be reflected. In polarization by birefringence, the nonpolarized incident light beam is broken into two components: one component with the electric field oscillations parallel to one axis of the material and the other component with the electric field oscillations parallel to a second axis of the material. The orientation of the axes of the material depends on the material. In polarization by absorption, electric field oscillations parallel to the polarization axis of the material are passed, and those perpendicular to this axis are absorbed; the light transmitted is polarized.

Polarizing filters are filters that transmit only polarized light. They are generally made by stretching certain organic materials to align the molecules. When aligned, these molecules absorb light that is polarized (has electric field oscillations) in one direction, and transmit light polarized in a direction perpendicular to that of the light absorbed. Circular polarizing filters transmit only light in which the direction of polarization is rotating in a helical fashion around the direction of propagation of the light. Circular polarizers are increasing in popularity because of the incompatibility of linear polarizers with certain auto-focus camera systems. Polarizing filters are useful for removing reflections when photographing through glass and for increasing color saturation (surface reflections frequently reduce the apparent color saturation of objects). Polarizing filters also increase the saturation of a blue sky (but not in the direction of the sun) for similar reasons.

Cross-polarization is also a useful technique in scientific photography where two linear polarizers are rotated so their polarization axes are perpendicular. (A crude variable neutral density filter can also be made by using two polarizers that are partially crossed; the density will be approximately equal to the negative log of one-half of the cosine of the angle between the axes of the polarizers.) Theoretically speaking, crossed polarizers will not transmit any light. (This is actually not the case, however, because polarizers are not perfectly efficient.) If a transparent material that changes the polarization of light is placed between two crossed polarizers, however, some light will get through. This light is frequently colored because the change in polarization in the sample material is frequently a function of wavelength. The colored image formed using crossed polarizers gives infor-

mation about the internal structure and the strains and stresses present in the sample. Cross polarization is particularly useful in microscopy for identifying substances and for artistic photography. A final use of cross polarization is in the Kerr cell, where the polarizing effect of a special liquid is controlled by a strong electrical field. With such a cell, it is possible to construct very high speed electronically controlled shutters. *J. Holm*

POLARIZER In photography, a filter that transmits only light that is polarized in a particular direction, depending on the type and orientation of the filter. for example, if nonpolarized light is incident on a linear polarizer, only light polarized parallel to the polarization axis of the filter will be transmitted. *J. Holm*

See also: *Polarized light.*

POLARIZING FILTER See *Filter types.*

POLAROID The Polaroid Corporation celebrated its 50th anniversary in 1987. The following chronological history constitutes a brief look at some of the significant events in Polaroid's history.

1926 Edwin H. Land leaves Harvard after his freshman year to pursue his own work on light polarization.

1928 Land creates the first synthetic sheet polarizer.

1929 Land files the patent for the first synthetic polarizer on April 26. He returns to Harvard to further his studies and continue polarizer research.

1932 Edwin Land leaves Harvard and with Harvard physics section leader George Wheelwright, II, establishes the Land-Wheelwright Laboratories to continue research and to manufacture polarizers.

1933 Land-Wheelwright Laboratories is incorporated to manufacture polarizers and to continue research into applications of polarizers in sunglasses, photographic and microscopic filters, and automobile headlights. Land is issued the patent covering synthetic sheet polarizers formed of parallel-oriented submicroscopic crystals embedded in plastic film. The product is known as J-sheet.

1934 Eastman Kodak signs a contract with Sheet Polarizer Co., Inc., to purchase light polarizers for the manufacture of photographic filters.

1935 Land displays his invention to a representative of the American Optical Company. The American Optical Company signs a license agreement to use the polarizers for the manufacture of sunglasses. At the end of 1935, the first polarizer advertisement appears in a scientific journal, and Land receives the Hood Medal from the Royal Photographic Society. Land and Wheelwright develop the Polariscope, which is used to detect strains in transparent materials like glass and certain plastics.

1937 The Polaroid Corporation is organized under the laws of Delaware on September 13, 1937. Land and Wheelwright receive the entire issue of 2,500 shares of Class B stock and approximately 60% of the common stock.

1938 Polaroid produces drafting table lamps, desk lamps, dermatology lamps, and polariscopes. Utilizing polarizing sheets, the company introduces variable density windows. The first installation is made on the club car of a Union Pacific streamliner.

1939 Curved lenses for prescription polarized sunglasses are developed using the glass/polarizer/glass laminates, making it possible to manufacture ground-and-polished prescription spectacles. Polaroid's stereoscopic motion picture, *In Tune with Tomorrow,* is shown at the New York World's Fair as part of the Chrysler exhibit. The first year's film is in black and white; the second year's is in color.

1940 Polaroid announces Vectograph 3-D pictures. The Vectograph represents the fusion of the company's original

technology, the polarizer, with photography. Among other applications, Vectographs will be used for aerial reconnaissance surveys during the Second World War. Other products include optical goods, lighting equipment, 3-D picture viewer, polarized sheeting, variable density day glasses, study lamp, 3-D motion pictures and polarizers.

1941 The ability to produce stereoscopic motion pictures is adapted for the three-dimensional sound movies and optical bullets.

1942 Most of Polaroid's products are for the war effort. With the invasion of Guadacanal, aerial vectographs are used extensively for military reconnaissance.

1943 Polaroid produces variable-density goggles, dark-adaptor goggles, aviation goggles for Army and Navy flying personnel, and fog-free goggles, polarizing filters and non-polarizing colored filters for use in gunsights, rangefinders, periscopes, binoculars, and other military instruments.

1944 Land conceives of the one-step photographic system. Only after three years of intensive work will Land and a group of Polaroid scientists and engineers produce the complete photographic system.

1945 A polarized, daylight driving visor is developed as a result of research into a polarizing system to eliminate glare from oncoming headlights.

1946 Research continues on one-step photography: a new method of color motion picture processing (called Polacolor), and Vectography.

1947 Land announces the one-step process for producing finished photographs within one minute.

1948 The first Land camera, the Model 95, is sold in Boston at Jordan Marsh department store on November 26 for $89.50.

1949 Photographic sales of the Polaroid Land camera Model 95 for the first year exceed $5 million. Land hires Ansel Adams as a consultant.

1950 By 1950 more than 4,000 dealers throughout the United States sell Polaroid cameras, film, and accessories. A contract from the Signal Corps results in the Tell-tale, a film badge that records radiation over a period of time. The resulting radiation record is developed in 60 seconds.

1951 A print coater is added to black-and-white film. The print coater is a simple treatment for long-term image stability. The chemical components of the coater liquid neutralize any alkalinity and remove any residual processing reagent left on the sheet. The coater solution then dries to a hard coating that protects the print from atmospheric contaminants. Type 1001 Land film for radiography is introduced and becomes the first in a continuing series of Polaroid instant x-ray products. Type 1001 produces a 10 × 12-inch x-ray print in 60 seconds. The Land Roll Film Back adapts professional cameras and various types of industrial and scientific instruments for use with Polaroid roll films.

1952 Polaroid introduces the Model 110 land camera, called the Pathfinder. This camera is designed for professional use and is equipped with an *f*/4.5 lens and provides shutter speeds to 1/400 of a second.

1953 Polaroid begins to develop x-ray film for the civilian market.

1954 The Model 100 debuts. It features special long-life roller bearings and a heavy-duty shutter. The camera is for use in business and industrial applications.

1955 PolaPan 200 Land picture rolls are introduced to the public.

1956 The one-millionth camera, a Model 95A, comes off the assembly line in September.

1957 Polaroid markets several new cameras, and the Polaroid Transparency System is introduced.

1958 One-step photography is extended to conventional studio and press cameras. The 50 Series of Land films (Types 52 and 53) and the 4 × 5 film holder become almost indispensable proofing tools for the professional photographer.

1959 Polaroid markets the Wink Light Model 250 and Model 252. Type 47 Land film, rated at 3000 ASA, becomes the fastest film available.

1960 Polaroid introduces its first automatic exposure camera: Model 900 with Electronic Eye.

1961 Polaroid releases two electric-eye cameras, the Model J66 and Model J33 in the $75 to $100 range. Type 55 P/N Land film is introduced. Polaroid continues to commission artists as consultants during the early 1960s.

1962 The Polaroid MP-3 Land camera is introduced.

1963 Polaroid debuts Polacolor. Products released this year include the CU-5 Closeup camera, type 510 Land film, featuring high-contrast reproduction for industrial applications and Type 413 Infrared Land film for use in laser research, military surveillance, and document analysis. The 5 millionth Polaroid Land camera, an Automatic 100, comes off the assembly line in Little Rock, Arkansas.

1965 The inexpensive Polaroid Swinger is introduced.

1966 CU-5 closeup framing kits are introduced to the industry. The ID-2 Land Identification System premieres. The ID-2 is the first in a series of self-contained identification systems using Polaroid instant photography. Among its applications, the system will be used for driver's license photos.

1967 Five Electric-eye 200 Series cameras are introduced worldwide. Type 51 film is marketed for high-contrast reproduction of line art work. Speed of Type 1461 Land film is increased to 320 under daylight/electronic flash illumination, 125 under tungsten. Polaroid releases an Instant Halftone System for the MP-3 camera.

1968 Polaroid introduces a number of additional new products: the M-10 camera, for low-level aerial reconnaissance pictures; the Special Events Land camera Model 228, for producing pictures on a high-volume, continuous basis; a new Polaroid 4 × 5 film holder (Model 545).

1969 The Polaroid Model ED-10 Land Instrument camera is introduced for educational institutions and research labs. A special adapter enables it to fit over the eyepiece of a microscope to provide a simple method of making photomicrographs. The Polaroid 300 Series pack cameras are introduced. The top-of-the-line Model 360 Land camera represents the first incorporation of integrated circuits into a consumer product and includes an electronic flash.

1970 Coaterless black-and-white film Type 20C for the Swinger camera goes on sale.

1971 The ID-3 Land Identification System is introduced.

1972 The revolutionary SX-70 system realizes Dr. Land's concept of absolute one-step photography: new concepts in camera and film interaction lead to the design of the first fully automatic, motorized folding single lens reflex camera that ejects self-developing, self-timing color prints.

1973 The Clarence Kennedy Gallery is established. The gallery serves as a showcase for the work of emerging and professional photographers using Polaroid products. The MP-4 technical camera replaces the older MP-3.

1974 Polaroid estimates that well over a billion instant prints will be made this year, about 65% of them being made in color.

1975 Polaroid begins marketing Polacolor 2 film (Type 108). It is the first peel-apart color film that uses a color negative manufactured by Polaroid (Polaroid has made color negatives for integral X-70 film since its introduction in 1972).

1976 The inexpensive Pronto! camera is introduced. The Pronto! uses SX-70 film and features a distance scale on the lens ring and an automatic electronic exposure setting.

1977 The OneStep Land camera is introduced. Polaroid introduces the 20 × 24-inch camera; the prototype camera

weighs 800 pounds. The camera produces color 20 × 24-inch photographs in 60 seconds. By the 1980s improvements to the camera reduce its weight to 200 pounds and add swings, tilts, and rising fronts.

1978 Research into sonar technology, initiated in 1963, results in the Sonar Autofocus system for the SX-70 and Pronto! cameras. Polavision, a new instant color motion picture system, makes 2-1/2-minute films in self-developing cassettes. The system includes a camera, a self-developing film called Phototape, and a player.

1979 Polaroid Type 611 video image recording film is introduced for use with medical diagnostic systems. Dr. Land demonstrates Time-Zero film. It is a brilliantly colored film for the SX-70 that produces an image visible in seconds and a developed print in 1-1/2 minutes.

1980 The Polapulse P100 battery, first developed for SX-70 film, is introduced for commercial applications. New products include Polaroid Colorgraph film Type 891, the Polaprinter, and a new 4 × 5 professional pack film system.

1981 The Polaroid Sun System brings the domain of automatic light mixing to amateur picture taking. Polaroid Colorgraph 8 × 10 Land film (Type 891) becomes the first instant color transparency film for overhead projection. Polaroid also releases a new 4 × 5 eight-exposure pack film system, which includes the Model 550 4 × 5 film holder, PolaPan Type 552 black-and-white film and Polacolor 2 Type 558 color film.

1982 Ultrasonic Ranging Systems are introduced. They are used in areas from instrumentation testing and hospital use to robotics. The company also introduces the SLR 680, a folding single lens reflex camera using 600 ASA instant color film. The camera has a built-in strobe that uses sonar to precisely determine the distance to the subject.

1983 The introduction of the 35-mm Autoprocess System makes Polaroid's instant photography products compatible with standard 35-mm cameras and equipment. Autoprocess produces rapid-access color or black-and-white transparencies without the use of a darkroom. Polaroid enters the computer and video industries. Supercolor video cassettes are premiered abroad with plans for national distribution in 1984. Polaroid introduces Palette, a low-cost computer image recorder that is supplied with Polaroid graphics software.

1984 Technical improvements in existing cameras lead to the Sun 660 Autofocus and Sun 600 LMS. Both include integrated circuitry called SPARR (Strobe Preferred Automatic Rapid Recharge), which allows one to take pictures in rapid succession without recharging the strobe.

1985 Recent developments result in the perfection of a continuous embossing process that makes low-cost, mass-produced holograms for commercial applications. The company announces the Polaform Process, a new custom service for the creation and mass production of embossed surface relief holograms, which can be viewed in ordinary light. The first conventional color transparency films, Polaroid Professional Chrome films, are distributed on a limited basis for commercial and industrial photographers.

1986 The Spectra camera debuts at Jordan Marsh department store in Boston, thirty-eight years after the Polaroid Land camera Model 95 was introduced.

1987 PolaBlue 35-mm instant slide film produces white-on-blue images from text, line art, graphs, and charts. A four-minute processing time in a Polaroid processor yields a high-quality presentation slide.

1989 The Polaroid 600 series camera is restyled and called *Impulse*. A conventional, non-instant photographic film called *OneFilm* is introduced.

1990 Polaroid expands its range of computer peripherals with photographic scanners and computer color image recorders for PCs and Macintosh environments.

1991 A new Spectra film having high definition becomes available.

1992 Introduction in Europe of a new format film and compact instant camera called *Vision.*

1993 The *Vision* camera becomes available in North America. Introduction of a professional rugged camera called *ProCam* for use in high volume photographic documentation of events occurring in difficult work areas such as construction sites. Polocolor Pro 100, a peel-apart high definition color film, based on hybrid chemistry becomes available.

(Information taken from *Polaroid: ACCESS Fifty Years* by Richard Saul Wurman, © 1989 Access Press, Ltd., provided through the courtesy of A. Verch, International Press and Publicity, Polaroid Corporation.)

POLAROID PHOTOGRAPHY The idea of Polaroid photography has two interlinked strands. One is the development of light-sensitive materials, almost all of which are based on the diffusion transfer process, giving a finished product in an uncommonly short time. The other is the development of hardware such as cameras, camera backs, film holders, and processors that facilitate the use of the imaging materials.

The first public demonstrations of the Polaroid diffusion-transfer photographic process were made in 1947 with a conventional 8 × 10 view camera modified by Otto Wolf and Bill McCune to accept their back with motorized processing rollers and a dark chamber. The first Polaroid Land camera, the Model 95, was brought to market in 1948 when it could satisfy Polaroid founder E. H. Land's requirements: exposures brief enough with moderate aperture lenses for hand holding in daylight without blur, processing incorporated into a camera and giving the impression of being dry, system-functional in a wide range of temperatures, and pictures large enough to be viewed without magnification at a reasonable distance. Color was added with the introduction of Polacolor, a peel-apart diffusion transfer film, in 1963.

The SX-70 system featured a built-in mirror that reversed the image laterally because its film was exposed and viewed through the front. (Films exposed through the back and viewed through the front do not need such a reversal.) The thin, flat shape was achieved by integrating an electro-mechanical control system with novel shutter, lens, diaphragm, and focusing designs. Polaroid continues to offer a range of amateur and professional integral films and cameras.

Holders for Polaroid sheet film use individually packed sheets or film packs. The sheet film holders can be inserted into a conventional view camera back to make a test that can be evaluated almost immediately. P/N materials furnish both a print and a negative that may be printed from later. The single-sheet holder has proven so convenient, and its use by professional photographers has become so widespread, that Polaroid now offers individually wrapped sheets of conventional chromogenic films for use in the holder.

Polaroid has designed camera and film combinations for scientific and industrial applications, including the MP-3 and MP-4 industrial view cameras, the CU-5 closeup camera, the ID-2 identification camera, and the ED-10 instrument camera. The CR-9 oscilloscope camera uses an ultra-high-speed, high-contrast film called Polascope whose ISO of 10,000 permits the recording of cathode-ray tube transients too brief to be discerned by the eye. Other combinations facilitate the direct recording of visible signals from interferometers, spectrographs, keratoscopes, endoscopes, and photomicrographic and immunodiffusion cameras. Polaroid materials can record nonvisible signals that have been converted to light by scanning electron microscopes,

thermographic scanning units, ultrasonic scanners, and an extensive range of medical imaging devices as well as the direct recording of x-rays.

Several Polaroid studio cameras that use 20 × 24-inch Polacolor film have become popular with photographers whose work is destined for collections because each image is inherently unique; its value can never be compromised by the availability, or the potential availability, of additional prints made from the same original.

A range of Polaroid materials are available for use in conventional 35-mm cameras. There are black-and-white and color transparency films with normal and high contrast, and a white-on-blue transparency film. All can be processed without power or water in a small, manually operated processor, although a powered, automatic processing unit is also available. *H. Wallach*

See also: *Diffusion transfer.*

POLECAT A pole of adjustable length that can be positioned vertically between the floor and ceiling as a support for a background, light source, etc. Two polecats with appropriate brackets are commonly used to support a roll of seamless paper as a photographic background. *L. Stroebel*

POLYESTER A plastic film base material, usually polyethylene terephthalate, of high dimensional stability and stiffness, which has replaced acetate film base and even glass plates in some graphic arts and photogrammetric applications. *M. Scott*

POLYGONAL WINDING Polygonal winding refers to the form that some motion picture film rolls (and sometimes other formats in long rolls) take when wound loosely with the emulsion side facing inward whereby the film roll assumes the shape of a many-sided polygon. If left uncorrected the deformity becomes set in the film and leads to problems on projection (or printing). The degree of curl of the film and low relative humidity tend to amplify the problem. Winding the film with the emulsion facing outward eliminates the problem. This would involve reverse winding of the film if the print is made to have the emulsion facing the light source on projection. *I. Current*

Polygonal winding.

POLYMER A *polymer* is a gigantic molecule formed by the bonding together of many small molecules called *monomers,* either of the same or different kinds. Polymers are either naturally occurring, such as cellulose, starch, and proteins, or produced synthetically, such as many kinds of plastics. Radiative energy promotes the formation of these macromolecules, so photographic processes can be based on the polymerization of monomeric substances. *G. Haist*

POLYMER IMAGING See *Photosensitive polymers.*

POLYPROPYLENE A stable synthetic polymer used, among many other things, in the production of slide storage

pages, which are preferable to those made of plastic materials containing chlorine, such as PVC. *K. B. Hendriks*

POP/PRINTING-OUT PAPER Photosensitive paper intended for prolonged exposure to intense light. The image is produced entirely by photolysis; no development is used, although some wet processing may be involved to render the image stable. *M. Scott*

See also: *Developing-out materials.*

POPULATION In statistics, the set of all possible measurements of a specified kind; for example, the set of temperatures measurable everywhere in a development tank at a given time. Most populations have a very large set of numbers, as distinct from samples, which are limited to the data actually collected. *H. Todd*

Syn.: *Universe.*

PORNOGRAPHIC PHOTOGRAPHY The production of photographs intended to sexually arouse the viewer, often by portraying sexual activity. The line between pornographic photography and erotic photography is not well defined and can shift back and forth depending upon the cultural norms and legal status at the particular time and place. Those charged with violating antipornography laws in the United States in recent years have usually been given the benefit of the doubt by the courts, either on the basis that the work has some redeeming artistic or social value or that to prohibit the work from being shown would in itself be a violation of the right of free speech, which is guaranteed by the constitution.

There are ways of preventing work judged by some to be pornographic from being displayed or distributed through the normal channels of communication other than by legal challenges. Those individuals or groups responsible for selecting images for display in galleries or for illustrations in publications, for example, are constantly forced to select only a portion of the images submitted, and the choices are commonly made on subjective basis rather than on whether they satisfy an objective set of pornographic, artistic, or other criteria.

The possibility of incurring a financial penalty for the display of pornographic or otherwise offensive material is often more effective as a deterrent than legal action. Consumers may threaten to boycott the products of advertisers who use or support images they find objectionable, and even educational institutions and museums that oppose any and all restriction on self-expression may find that the donations they depend upon are affected if they offend their patrons. Taking legal action against work considered to be pornographic is often self-defeating because of the free publicity provided the work by the media in reporting the action.

The motion-picture and television industries are especially sensitive to the financial penalty suffered when local censorship boards have the power to ban a movie or program from their area, as has occurred in a number of cities in the past. In an effort to prevent such bans, the motion-picture industry resorted to self-censorship by establishing the Will Hayes Code of Conduct. In order to satisfy the Code of Conduct, editing was required of a number of films produced in the United States and, especially, films produced in foreign countries with more liberal moral standards.

The Hayes Code was discounted in the 1960s but was later replaced by a panel of people considered to be representative of the general public. The panel reviews new films and publishes ratings, so that individuals can determine for themselves whether they think the film will be appropriate for them or for their children. The television industry has its own way of monitoring programs.

Much of what was considered pornographic in the past is not now, and what is considered pornographic now may not

be in the future. At one time it was forbidden to show photographs displaying pubic hair in a major museum in New York City. A photograph by Edward Weston, part of his retrospective, was returned by the museum for this reason. In a letter explaining why, the secretary made a typographical error and indicated that the photograph was being returned because it showed "public" hair, which was against the museum's rules. Weston had much fun with the letter, revealing to all his friends that the museum in New York refused to exhibit his nude photograph because it showed public hair. The pubic hair issue is no longer controversial in some countries but remains so in others. In the United States, at one time it was against the law to send pictures through the mail that showed pubic hair. A mail order company successfully avoided prosecution by selling exposed film (that could be developed by the customer) having a latent image of nude models displaying pubic hair. *R. Zakia*

See also: *Erotic photography.*

PORRO PRISM A glass prism of triangular cross section with angles of 45 degrees and 90 degrees. By total internal reflection from two faces, light entering normal to the hypoteneuse face is reflected back parallel to the original direction, and the image is inverted but not reversed. Devised by I. Porro (1801–1875). Used in pairs in prism binoculars and in process cameras for making laterally reversed negatives. *S. Ray*

Syn.: *Reversing prism.*

PORTER, ELIOT FURNESS (1901–1990) American photographer. Brother of the painter Fairfield Porter. Graduated from Harvard Medical School (1929). Continued work in medicine only for the next ten years. Began photographing in Maine at his family's summer home at the age of 13. Introduced to Ansel Adams in the early 1930s, who encouraged Porter and suggested he switch to a large-format camera. Porter's devotion to photography slowly escalated and in 1938–1939 Stieglitz exhibited his photographs at An American Place, the last solo exhibition by a photographer there excepting Stieglitz himself. Most of his work focused on wildlife, especially birds and the natural landscape. At first making black-and-white gelatin-silver prints, he became an early practitioner of color printing using the dye transfer process. An ardent conservationist, many of his books were published by the Sierra Club, including the final document of the Glen Canyon on the Colorado River before it was dammed and flooded.

Books: *Eliot Porter.* Boston: Little, Brown, 1987.

M. Alinder

PORTFOLIO (1) A group of photographs or collected artworks that are currently being shown to demonstrate a photographer's proficiency. (2) A limited edition of a group of selected photographs, as a rule in a container, case, or folder, and usually offered for sale to collectors. (3) Any type of closable folder, box, case, or quite often a leather-zippered briefcase, used to store or transport a collection of photographs. (4) A "red-rope envelope" for carrying and/or storing artworks; frequently used by students enrolled in art classes. *M. Teres*

PORTRAIT ATTACHMENT See *Lens types.*

PORTRAIT LENS See *Lens types.*

PORTRAIT ORIENTATION In computers, a page format with the vertical axis being the longer dimension, in contrast to landscape orientation, in which the longer dimension is the horizontal. *R. Kraus*

PORTRAIT PHOTOGRAPHY Portrait photography attempts to show the individuality of a subject. A portrait might be taken for its artistic merit or as part of a study. More often, it is commissioned by the subject, often for a special occasion or purpose.

Today, the same person might be seen in an executive portrait in the office, in an informal portrait relaxing with a favorite pet at home, even in a fantasy portrait at the wheel of a racing car. Couples and groups as well as children and pets and classic cars can have their portrait taken.

HISTORY Before the first photographic portraits, the *camera obscura* helped artists paint a mirror-likeness of a subject. With the advent of daguerreotypes and calotypes (1839) and improvements in their initially long exposure times, photographic portrait studios emerged throughout Europe and the United States by the mid-1840s.

The daguerreotype's highly reflective surface and precise detail prevailed over the calotype's graininess and diffusion. Still, the calotype was the medium of choice for a famous portrait series by David Octavius Hill and Robert Adamson in Scotland in the mid-1840s. Intended as an aid in rendering a large-group portrait painting, these calotypes used lighting effects and naturalistic poses that placed them among the most successful early attempts at portrait photography.

With the 1850s came portrait prints made from wet collodion-on-glass negatives. For two decades, the preeminent portrait photographer was Félix Nadar. His successful commercial studio in Paris became known for sensitive portraits of prominent writers, artists, and musicians.

The invention of the *carte-de-visite* in 1854 by the French photographer André Disdéri made portraits small enough to paste on calling cards. Because more exposures could be made on a standard glass negative, the price of portraiture went down and its popularity when up, especially among the middle and upper classes.

Disdéri photographed such well-known personalities as Emperor Napoleon III. He then prepared huge editions of his celebrity portraits for a public that treasured them like family photographs and even pasted them into albums. He also popularized the use of such studio props as pillars, draperies, and items indicative of a subject's profession.

Of the artistic amateur portrait photographers working near the end of the twentieth century, Julia Margaret Cameron ranks as one of the most original. Her soft-focus, intimate portraiture featured notable scientists and literati of Victorian England. Her work influenced the pictorialist and Photo-Secession movements around 1900.

Celebrity portraiture continued to charm the public in the early 1900s. Edward Steichen's views dramatized such luminaries as the sculptor Rodin and playwright George Bernard Shaw; Alvin Langdon Coburn's soft-focus portraits captured creative personalities like novelist Henry James and poet W. B. Yeats. After the First World War, magazines such as *Vanity Fair* and *Vogue* welcomed the portraiture of Steichen, Cecil Beaton, Horton P. Horst, and others.

With the 1940s came Philippe Halsman (1906–1979) of New York and Yousuf Karsh (1908–) of Canada, who supplemented their celebrity portraiture with private portraiture. Each strove to bring out the inner spirit and power of the individual.

About the same time, American portraitist Michael Disfarmer cataloged the uncertainty of the pre-Second World War years in the body language of those who came to his studio (1939–1946). His German predecessor August Sander recorded the social history of his country (1918–1934) in portraits of people from every level of society.

So-called environmental portraiture, that is, portraiture that shows a person in surroundings that reflect occupation or interest, developed before the Second World War. After the war, Arnold Newman perfected a large-format version of

this essentially small-format art. His views of artists include a portrait of abstract painter Piet Mondrian posed in what looks like one of his own paintings.

Antiglamour portraiture came into vogue in the 1960s with former fashion photographer Diane Arbus (1923–1971) focusing on society's fringe element of misfits and outlaws. During the same years, fashion and celebrity photographer Richard Avedon (1923–) shot unconventional portraits in which he revealed some of the less appealing aspects of America's cultural and political elite.

Today, just about anyone who can aim a camera and squeeze a shutter release can make a portrait. Still, mass market portrait photographers do a thriving business in schools and department stores. The portrait studio continues to offer professional quality and new approaches to attract customers. New electronic previewing systems allow portrait subjects to see *proofs* before the film has been processed and printed.
K. Francis

POSING Technique of arranging people to be photographed in characteristic, pleasing, or unusual attitudes.
R. Welsh

See also: *Portrait photography.*

POSITION PROOF In photomechanical reproduction, a color proof used to check the position, color breakout, and registration of image elements before platemaking.
M. Bruno

POSITIVE (IMAGE) An image in which the tonal relationships are such that light subject tones are light and dark subject tones are dark. Positive photographic images are commonly produced by printing camera negatives onto negative-acting (nonreversal, positive) printing materials. Positive images can be obtained without the printing process by using reversal-type film in the camera. *L. Stroebel*

See also: *Negative.*

POSITIVE LENS A lens that is thicker in the center than at the edges and that forms a real image. *S. Ray*

See also: *Converging lens.*

POSITIVE-WORKING In photomechanical reproduction processes, identifying a plate made from a positive in which the areas receiving exposure are rendered not receptive to ink, so that the resulting print corresponds to the positive original. *M. Bruno*

POSTCARD PHOTOGRAPHY Postcard photography most often celebrates the unique aspects of a tourist destination. It accentuates the positive attributes of a location and lends itself to succinct correspondence: "Wish you were here!"

The picture postcard debuted in 1870 when a French stationer published one to commemorate the visit of a popular regiment to his city. Brisk sales inspired entrepreneurs in Germany and Austria to put out picture postcards on a commercial basis. By the 1880s, such specialty items as French postcards showing attractive women in suggestive outfits and alluring poses sold well and relatively openly in many countries, including the United States.

By October 1908, when *The Photo Miniature* devoted an entire issue to photographic postcards, Germany continued to be the center of postcard manufacturing. Germans reportedly had sent 1.5 million postcards in 1907. Continental Europe led the rest of the world in this "friendly communication among nations" as the magazine called it. The picture postcard industry also flourished in Great Britain and the United States, where subject matter included, according to the magazine, "the whole range of human interests appropriate for all seasons and places with uses as widely varied as are human needs."

At that time, the magazine called postcard photography "a new field of pleasure and profit for the photographer." Even those with limited photographic facilities were encouraged to take photographs of special or local interest that commercial postcard makers might miss or overlook.

Today, postcard photography continues to be an area of opportunity for the enterprising photographer. Tourist areas that draw large crowds offer the best chance of selling the thousands of postcards necessary for a profitable line of picture postcards. Businesses and organizations that use postcards to promote their products and services may hire a photographer to take an attention-getting photograph or to see a chosen photograph through the production process that turns picture into a postcard.

Just about any entity that needs to present its best side to the public could become a postcard photography customer, including everything from political parties and individual campaigns to restaurants, hotels, motels, resorts, camps, amusement parks, art galleries, museums, athletic facilities, hospitals, universities, and sport teams and the complexes where they play.

Ideally, the client pays for the photographer's time plus expenses to make the postcard picture. Sometimes, the client provides the photograph to be used. By handling the postcard order, the photographer may qualify for a commission from the postcard manufacturer.

When photographers want to develop their own postcards, plenty of market research and personal contact with retail postcard outlets should precede any investment. Distributors, who take a commission, can broaden a photographer's marketing reach. Postcard manufacturers, in some cases, may purchase photographs for use in their own postcard lines.

Picture postcards have been used by amateur travel photographers as a guide to where—but not necessarily how—to take their pictures. Some postcard photography has earned the label cliché, French for an image repeated over and over again. To break through such stereotypes, the 35-mm photographer might use lenses of different focal lengths, an eye for the unusual angle or opportunity, and creative ability to make the most of what exists.

Books: Werner, Mike and Carol, *How to Create and Sell Photo Products.* Cincinnati: Writer's Digest Books, 1982.
K. Francis

POSTERIZATION A photographic printing method by which details of the image are suppressed and tonal separation of large areas is exaggerated. The final image consists of a limited number of discrete tones, usually three to five. Separation negatives are made on high-contrast material, each negative recording a narrow range of tones, and are successively printed on the same sheet of positive material. A similar effect is accomplished electronically and almost instantly in a video system or with a scanned and digitized photographic image displayed on a video screen through a computer system. *R. Zakia*

POST-FIXATION DEVELOPMENT See *Physical development.*

POSTPROCESSING Postprocessing refers to manipulation of the negative or print after the normal steps of the process have been completed. In the case of ordinary monochrome photography, these normal steps refer to developing, fixing, washing and, sometimes, drying. The unmanipulated image has often been referred to as *straight,* while the treated one is called *manipulated, modified,* or *retouched.* Such steps as mounting, framing, packaging, display, and so forth are not generally referred to as postprocessing.

TYPES OF MODIFICATION The postprocessing treatments may modify or enhance the image or preserve the image without modification. They may, for example, change the physical characteristics of the article, thus making it more attractive to display, or to perform better in display equipment, projectors, and printers. The treatment may be such as to make the image more stable to the ravages of environment or time.

On the other hand, these treatments may be applied to the negative or print to modify the tonal nature of the image itself. Modifications of the negative will be translated to subsequent prints, while those made in the print affect that image alone (unless the print is copied to make a new negative for subsequent prints).

Physical characteristics may be changed by chemical or physical treatment. Image characteristics may be changed by optical, as well as by chemical and other physical methods.

MODIFICATION OF PHYSICAL CHARACTERISTICS The value of a photograph is affected by its physical characteristics such as curl, brittleness, friction, hardness, and abrasion sensitivity; therefore, postprocessing techniques are used to enhance performance in these areas. Many of these techniques involve the final rinse after the wash that follows processing, and thus this bath may include a variety of components to serve a variety of purposes.

Curl One important physical characteristic of photographs is absence of curl. Curl can vary on a single sheet due to uneven drying resulting in *buckle*. Excessive curl can be annoying in single sheets but becomes a catastrophe when dealing with a stack of prints. This is less of a problem with modern materials made with thin emulsion coatings and resin-coated bases, but the problem still exists with fiber-based papers. One solution is to stack prints that have been faced, and place them under pressure such as that in a letter press, for from several hours to days. Treatment with humectants (hygroscopic materials like glycerin that attract and retain moisture) in the final rinse after washing may also be of some help.

See also: *Curl reduction.*

Brittleness Another problem is a tendency for cracking of the emulsion, referred to as brittleness, which in extreme cases can cause shattering of the film base as well. Again, this is less of a problem with modern thin emulsion coatings. A final rinse with a humectant solution, for example glycerin, may help. Also, control of drying conditions, such as lowering temperatures after the cooling effect of evaporation has ceased, can minimize the problem.

Film Friction The coefficient of friction of the film surface(s) affects mechanical performance in equipment such as high-speed cameras, VCRs, and motion-picture projectors. A high coefficient of friction can affect the steadiness of the projected image, can influence the occurrence of scratches and abrasions, and can be mistaken for brittleness when the film is damaged in cameras or projectors because of excessive resistance to transport. Waxes and lubricants can be used to control film coefficient of friction.

Hardening Another contributor to minimizing abrasions is hardness of the surfaces. Fixing baths that incorporate hardening agents are usually sufficient in most instances. In some circumstances, however, where the film or paper is subjected to repeated handling or passage through printers, projectors, or other machines, additional hardening treatments may be required.

Dimensions Dimension is a physical characteristic that may affect registration of images during printing, performance in projectors or other equipment, and the fit in storage devices. Control of temperature and relative humidity may be essential to maintenance of the desired dimensional stability of films. Since excessive stress can permanently deform sprocket holes used to transport film, control of film friction may be important.

Water Spots When droplets of water cling to the surface of film after washing, they may cause water-spot blemishes due to the stress of uneven drying and shrinkage of the gelatin resulting from the extended drying time in the area of the droplet. These droplets can be eliminated by using a final rinse containing a wetting-agent surfactant that reduces the surface tension of the water so that it is spread evenly over the surface.

Static When relative humidity is low, an electrostatic charge can be induced in films, thus making them susceptible to attracting dust, hair, and other particles from the atmosphere. This can occur even as the films are drying in a current of air, particularly those made with bases having low conductivity or a high dielectric constant. A final rinse after washing, in a bath containing a conductive agent that is adsorbed on the surfaces or absorbed in the surface layers helps to alleviate this problem. An antistatic agent may (1) lower the coefficient of friction, (2) increase surface conductivity, or (3) increase the dielectric constant of the system, or a combination of all three.

Ferrotyping The process of squeegeeing glossy gelatin-coated papers to a japanned metal or chrome plated surface for drying to achieve a high gloss surface is no longer necessary. Resin-coated papers are now available that give a high gloss with normal air drying. A spotty ferrotyping of a film emulsion surface due to prolonged and intimate contact with the base side of an adjacent convolution in a roll is sometimes a problem. Manufacturers may prevent this by means of a coating containing fine mineral or other particles on the base side. A posttreatment with a lacquer or other coating containing fine particles may solve a problem with existing materials.

Embossing The surface texture of paper prints can be changed by means of embossing rollers engraved with a variety of patterns such as "silk," "linen," "tapestry," and others less representative of familiar materials. During manufacture of the paper rawstock, embossing is sometimes accomplished before it is coated with sensitized emulsion. Photographers sometimes use embossing rollers to impart a pattern of this type on the surface of prints after they have been processed and dried.

PHYSICAL MODIFICATION OF THE IMAGE The negative or print *image* may be modified by physical methods, as distinct from those accomplished by chemical means. Typical procedures include the abrasive reducers, airbrushing, coloring, dyeing, neococcine, retouching, and spotting.

Abrasive Reducers Abrasives retained by a tuft of cotton are used to reduce the printing density of local areas of negatives, thus rendering them darker in the print. The abrasive material must be finely divided and free from any coarse material that would result in scratches or blemishes. This type of reduction is often supplemented by controlled etching of areas by scraping with a sharp knife. This procedure can be used to accentuate shadows, eliminate some kinds of blemishes, and so on.

Airbrushing Prints are airbrushed with colorant or opaque material to cover unwanted detail, alter colors, or to enhance details or contrast. This technique requires considerable artistic capability and manual skill.

Coloring Monochrome prints are colored by hand with dyes or oils to produce a color image. Prints colored in this way are not like those from direct photography since the monochrome image desaturates the colors applied over them. Oil coloring usually requires treatment of the print with a special medium before applying the colors. While not difficult, good oil coloring technique requires some experience.

A heavy oil technique makes use of more opaque colors

much like those used for oil painting and may considerably modify the image. They are commonly applied with brushing techniques that are allowed to show. While somewhat transparent, opacity can be increased by adding white pigment, which is sometimes used to enhance highlights or other details.

Black-and-white motion-picture films are sometimes colored by electronic video methods that allow specific contiguous density areas to be treated individually.

Dyeing The whole image may be dyed to suggest a mood or have some other aesthetic effect. Before the advent of sound motion pictures (where the dyes would attenuate the light actuating the photoelectric cell), fire scenes in black-and-white motion pictures were dyed red, moonlight was represented by blue or cyan, interior fireside scenes by amber or yellow, and so on. Similar colors have been used with prints for reflection viewing and with transparencies.

Neococcine Neococcine dye can be applied to local areas of a negative to absorb light and make these areas appear relatively lighter in the print. Some experience is required to judge the appropriate dye density because of its pink color, and the beginner is advised to practice with old or spare negatives that can be sacrificed.

Syn.: New coccine.

Retouching Negatives of portrait or other subjects are retouched with a sharp pencil or pointed brush and liquid dye to modify features or reduce blemishes. While some films are manufactured with a *tooth* on the emulsion or base side, or both, to accept the pencil lead, it is often necessary to apply a special retouching fluid to impart a surface that accepts the retouching. Intermediate tones of gray are obtained by making a pattern of small figures that blend at a normal viewing distance, somewhat like the dots in a halftone reproduction.

Spotting Prints are spotted by means of local application of dye or pigment to obliterate light spots caused by dust, dirt, hairs, etc. that may have been on the negative when the print exposure was made. Etching (or chemical reduction) techniques are required to remove dark spots on prints as the result of clear spots on negatives. When the offending density is removed by etching, however, the etched area can be seen by reflected light. It is usually better to apply opaque to clear spots in the negative before printing so that normal spotting techniques can be used.

Color prints are spotted with subtractive color dyes whose absorption characteristics are close to the dyes making up the image. It is important that the work be done under illumination having a high color-rendering index. One advantage of dye transfer is that prints can be spotted with the same dyes as those used for printing.

See also: *Abrasive reducers; Airbrushing; Coloring; Dope; Dyeing; Dye retouching; Etching; Heavy oil; Neococcine; Oil coloring; Opaqueing; Painting on photographs; Retouching; Spotting.*

CHEMICAL MODIFICATION OF THE IMAGE

Reduction and Intensification Chemical treatment of negatives includes *reduction* and *intensification* of the image. These may involve changes in contrast or gradient as well as of density. If the negative has been dried, it is necessary to make sure it is thoroughly rewet and that no finger marks or other spots that would interfere with penetration of the chemicals are present. Local application of chemicals can sometimes be used, but this requires skill and if incorrectly done may ruin the negative. Local reduction is best done by abrasive reduction, and the local intensification by application of neococcine. Prints can also be treated by total reduction, or by local reduction of specific areas, usually with no significant change in image tone. On the other hand, intensification of prints may result in stain, unsatisfactory

image color, or variation in image color between treated and untreated areas.

See also: *Farmer's reducer; intensification; Proportional intensification; Reduction, chemical; Subproportional; Subtractive reducer; Superproportional\intensification; Superproportional reduction.*

Toning Toning methods that change the color of the silver deposit are used to enhance the visual images of prints and transparencies. If it has been dried, the print should be rewet to obtain uniform toning. Any of a wide range of toning formulas can be used. *Direct* toning solutions act on the silver deposit to produce colored compounds such as brown or sepia, blue, green, and red. For *indirect toning,* the image is first reconverted to silver halide in one bath, then redeveloped in a chemical solution that forms a colored compound. *Dye* toning techniques involve treating the silver image with a bath that forms a mordant at the same time the image is bleached. This is then bathed in a dye solution that is mordanted to the image.

Color Images Photographic color images may be modified by means of dye bleaches or the application of dye. Bleaching can be applied to the whole area or to selected areas of the image. Likewise, dye can be applied to the whole area or to selected areas. Dry dyes can be applied to selected areas until the desired effect is achieved, then fixed by exposure to water vapor (steam). Depending on the method used, the bleached dyes may have a tendency to regenerate in a relatively short time. This may not be important if the image is used as an intermediate image from which plates for publication are made.

COPYING AND DUPLICATING

Retention of Print Modifications Once an image has been modified, it may be copied photographically to produce a negative or transparency from which multiple prints can be produced without repeating time consuming and variable print modification techniques such as dodging and burning, use of texture screens, diffusion screens, and the use of masks. Because copying on reversal transparency materials tends to increase contrast, especially in the mid-tones, masking techniques may be required, or unmodulated lights can be introduced optically to desaturate and reduce contrast. Duplicating color films are now available that have a gamma of approximately one and thus do not increase contrast. The color balance of color images can also be adjusted at the time copies or duplicates are exposed. Copying may also be required of images before being digitized for electronic manipulation, and required of images that have been processed in this manner.

Restoration of Photographs Copying may also be necessary where the original negative is no longer available, such as old family, historical, or record photographs that need restoration work such as physical repair, retouching, and air-brushing.

Electronic Manipulation Black-and-white and color photographic images may also be manipulated and/or retouched using electronic imaging methods. Photographic images can be entered into a computer using a video-type camera or scanner, where the image is digitized. It can then be manipulated by various methods that are available while reviewing the result on a computer monitor. When the desired result has been achieved, a hard copy can be produced by one of several printing methods. *I. Current*

See also: *Blue toners; Dye retouching; Electronic still photography; Friction adjustment; Gold toner; Hypo-alum toner; Multiple toning; Selenium toner; Split toner; Sulfide toners; Toners/toning.*

POSTPRODUCTION All the work of a motion-picture production that follows the completion of filming, such as editing, laboratory work, sound replacement, and sound mixing. *H. Lester*

POSTPRODUCTION (SOUND) The phase in the making of motion pictures and television programs that occurs after shooting of the production sound, including editing, mixing, and print mastering. The outcome of the process is a set of print masters that represent the sound track formats needed to produce all of the various release formats desired. *T. Holman*

POSTSYNCHRONIZATION In motion-picture production, the adding of sound to shots already filmed, so that the sound appears synchronized with the action and lip movements. *H. Lester*

POSTVISUALIZATION Photographic expression in which the image is manipulated in the conventional darkroom or an electronic darkroom as, for example, by combining photographs, parts of photographs, or other graphic material until a stimulating, unreal result is achieved, unlike that of a straight photograph. *I. Current*
See also: *Previsualization.*

POT Diminutive form of potentiometer. *T. Holman*
See also: *Fader.*

POTA DEVELOPER A developing solution, formulated by Marilyn Levy, consisting of 1.5 grams of Phenidone and 30 grams of sodium sulfite in a liter of water, that had given silver images of superior grain and sharpness when used to develop very high contrast, fine grain films. POTA is an acronym of Photo Optics Technical Area (U.S. Army Electronics Command). *G. Haist*
See also: *Phenidone.*

POTASSIUM BROMIDE A white crystalline solid (KBr, molecular weight 119.00) that is readily soluble in water but only slightly so in alcohol. Used as a restrainer to suppress fog during development with polyhydroxy developing agents, as a major constituent in the making of photographic emulsions, and as a rehalogenizing agent for bleached silver. *G. Haist*

POTASSIUM DICHROMATE Potassium dichromate, also called potassium bichromate ($K_2Cr_2O_7$, molecular weight 294.19), is available as orange-red crystals, granules, or powder that is readily soluble in water. This strong oxidizer causes skin and eye burns and is harmful if absorbed through the skin or swallowed (30 grams have been reported to be fatal).
 It can be used as a light sensitizer to selectively harden colloid binders, such as in screen printing or making resist for etching metal or other surfaces. Potassium dichromate makes both reducing and bleach baths or intensifying solutions for silver images. It insolubilizes gelatin so dichromate solutions are used for hardening solutions and hardening fixing baths. *G. Haist*
See also: *Gum bichromate process.*

POTASSIUM FERRICYANIDE The bright red crystals or powder ($K_3Fe(CN)_6 \times 3H_2O$, molecular weight 329.26), freely soluble in water to produce a yellow solution, should not be confused with the yellow crystals of potassium ferrocyanide ($K_4Fe(CN)_6 \times 3H_2O$, molecular weight 422.39). Used in bleach baths, toning, and dye toning solutions and combined with sodium thiosulfate to form Farmer's reducer. *G. Haist*

POTENTIOMETER A three-terminal variable resistor used primarily as an adjustable voltage divider. The output voltage is adjusted by rotating a shaft to which is attached a wiper that makes contact with a resistive element connected between two end terminals. The wiper is the third contact. The volume control on a radio or TV is a potentiometer. Potentiometers are used on analog-type color printers to adjust the exposure times for red, green, and blue for a standard negative or transparency. Most potentiometers exhibit a linear relationship between the shaft angle and the resistance from the wiper to one of the end terminals. Some units, known as tapered potentiometers, are designed to be nonlinear. Potentiometers are familiarly known as *pots*. *W. Klein*
See also: *Resistor; Rheostat.*

POUND A unit of weight in the U.S. customary system, equal to 16 ounces of weight, and to 453.6 grams. *H. Todd*

POWDERLESS ETCHING A process for making original photoengraving plates by processing the exposed plates in an etching machine using special powderless etching chemicals. *M. Bruno*
See also: *Photomechanical and electronic reproduction, plate/cylinder making.*

POWER FACTOR (PF) The ratio of true, or real, power to apparent power in ac circuits. The power factor, *PF,* is the cosine of the phase angle (the angle between the current and the applied voltage) and can have a value from 1 to 0.
 W. Klein
See also: *Electricity.*

POWER FOCUS An override available on some autofocus cameras that switch from autofocus to an electronically powered focus-by-choice system. *P. Schranz*

POWER (OPTICS) In optics, the reciprocal of the focal length of a lens in meters, also known as the dioptric power. Powers of lenses are additive if used in combination to give the resultant power. *S. Ray*
See also: *Diopter; Optics, optical calculations.*

POWER SPECTRUM See *Wiener spectrum.*

PQ DEVELOPER The combination of *P*henidone and hydroquinone (*Q*uinol, an early name for hydroquinone) developing agents to form PQ developers has provided formulations that meet almost every photographic need. Together, the two developing agents in PQ solutions give a rate of development that is greater than the sum of the rates of the two developing agents alone, that is, they exhibit superadditive development. *G. Haist*
See also: *Developers; MQ developers.*

PRECEDENCE EFFECT Also known as the law of the first wavefront, and the Haas effect. The property of hearing to localize on the direction of the first arriving sound, despite later reflections. It can be overcome if the later reflections are of sufficient amplitude. *T. Holman*

PRECIPITATION Exceeding the solubility of a substance in a liquid results in the separation of a solid substance from the solution. Precipitation is the first stage in the manufacture of a photographic emulsion, forming insoluble silver halide crystals in the presence of gelatin. Unwanted precipitations may occur from photographic processing solutions from the presence of ions that form compounds of low solubility.
 G. Haist

PREEXPOSING/PREFLASHING A light sensitive material may be given brief, uniform exposure before the image-generating exposure is made. This procedure can reduce contrast because the threshold of response is approached by the preexposure. Further exposure will yield

enhanced tonal separation in shadow areas. In low light situations characteristic of some scientific observation, pre-exposure, called hypersensitization in this application, can increase the effective speed of film and plates. When the initial exposure is very intense and of short duration, a subsequent lower intensity exposure of longer duration may produce a local desensitization resulting in partial or total image reversal called the Clayden effect. *H. Wallach*

See also: *Clayden effect; Hypersensitization effect; Photographic effects.*

PREFERRED COLOR REPRODUCTION

Reproduction in which the colors depart from equality of appearance at equal or at different luminance levels in order to achieve a more pleasing result. *R. W. G. Hunt*

See also: *Color reproduction objectives.*

PREFERRED TONE-REPRODUCTION CURVE

An s-shaped line on a graph of the tonal relationship between an original subject and a photographic reproduction where the line represents a photograph that would be judged to be of excellent quality even though it would not be a facsimile reproduction, which would be represented by a 45-degree straight line. *L. Stroebel*

See also: *Ideal tone-reproduction curve.*

PREFOCUS BASE

Used with a tungsten-filament lamp with a clear bulb, it locates the filament so it is correctly aligned in an optical system. *R. Jegerings*

PREMIERE

The first public screening of a completed motion picture, video, or similar production. *H. Lester*

PREMIUM WEIGHT

Used by some photographic manufacturers to designate a thickness of paper base heavier than double weight. *M. Scott*

PREMIX (SOUND)

One of the stages of preparation of sound tracks for film and television programs during which individual edited units of like kind are mixed together to form one complete component part of a final mix. Examples of premixes are dialog, Foley, and ambience ones. *T. Holman*

PRESBYOPIA

The decrease with advancing age in the ability of a person's eyes to focus on different distances.
L. Stroebel and R. Zakia

See also: *Accommodation; Vision, the human eye, testing for vision defects.*

PRESCREENED FILM

A high contrast film that has an overall latent image of halftone dots that produces halftone images after exposure and processing. *M. Bruno*

PRESENCE

(1) An extraordinary sense of being there; of a direct, unmediated perception. A materiality, the *hier und jetzt* (here and now) of an object, place, or thing. A feeling of placement at the scene created in the viewer by a very strong illusion of verisimilitude in the photograph. A strong sense of presence diminishes the realization that this is a photograph made by a photographer with a camera, and causes the spectator to imagine that he or she is a direct witness to the scene or action presented. Witness to a stopped moment, believing because seeing, is the hallmark of a classic approach to photography. (2) In sound, intercut background noise, usually recorded on location, also called *room tone*. (3) The frequency range from about 1 to 5 kHz in which boost equalization applied results in the sound source seeming closer, thus more present. *R. Welsh and T. Holman*

PRESENSITIZED PLATE

A printing plate that is pre-coated with a light-sensitive coating. *M. Bruno*

See also: *Photomechanical and electronic reproduction.*

PRESENTATION

Photographic presentation, broadly defined, is the acquisition, preparation, exhibition, and/or publication of photographic imagery. Presentation can take the form of hard copy, such as a photographic print exhibition, portfolio, family or wedding album, snapshot, newspaper, book, magazine, or hologram. Soft copy photographic presentation includes the slide-show, film, video, computer-generated (created, manipulated, captured or stored) photographic imagery, and some forms of holography. Soft copy photographic imagery requires equipment and specialized conditions, such as an area set aside for the particular kind of presentation.

A medium interchange, a process by which soft copy becomes hard copy and hard copy becomes soft copy, allows for one form of photographic production to metamorphose into another. The presentation modes of the photograph change with the medium of production, a process often driven by audience and budget. What we can afford usually dictates what we do, or how we do it.

Well cared for, personal photographic imagery, such as an important family portrait, may be properly matted and framed, but most family snapshots and photographic prints accumulate in closets, attics, and basements. Photographs are often stored improperly, in plastic cubes, rotary plastic page displays, shoe boxes, magnetic albums, or just stuffed into wallets and pocketbooks.

We have only recently become aware of the delicate nature of the photograph. How we prepare a photograph for presentation will always affect the useful life of that photograph. It is not necessarily the value that we place on the photographs, but our knowledge about the photographs that determine how we present and care for them.

INTRODUCTION Photographs have come full circle. From the silvery surface of the daguerreotype, enclosed, protected, and preserved in a delicate plastic case lined with fabric, to the computer-generated (or copied) photographic image(s) recorded onto the silvery rainbow surface of the CD video or Photo CD, also preserved in a plastic case. We have gone from an age of invention, to an age of technology, to an age of information. How we look at, process, and display photographic imagery has changed. The speed of this change has accelerated almost daily; things that were not thought possible last week are being tested the next. It appears that the look ahead is more a realization of science fiction than of industrial long-range planning. It is certain that computer imaging is the new imaging technology. What will happen to hard copy and the conventional silver gelatin print as we investigate virtual reality? What was a child's video game last year is rapidly becoming a new mode of presentation. At what point does virtual reality become visual reality? A child, or for that matter an adult, armed with a video game power glove and visor can be in the middle of the game's playing field. Tron! With the help of a computer, visor, and power glove, we will be able to enter a virtual reality field; and for a moment, we may not be able to, or want to, distinguish the image world from the real one.

EXHIBITIONS The search for validation and recognition as a photographer seems to be more intense than similar quests for artists in other mediums. Perhaps it is because of the great number of photographers or people taking pictures. Perhaps because the history of photography is so short, or the expansion of the medium so intense, photographers need to make their mark before the dust settles.

In the 1960s and 1970s the photographer's drive to distinction in the fine art of photography came about partly because of the rise in popularity of the medium and partly because of

the identification of the photographer/artist as "hero," as portrayed in the motion picture *Blow Up*. If it was not for the fame, it was for the money.

Photographers working for advertising agencies and/or doing commercial work could charge more money for their work, and their work was more sought after, if they had the recognition of the critics of the photo art world. Teachers of photography at the college level were rewarded with promotions, salary increases, and tenure. The amateur photographer found an additional source of income or encouragement in becoming a professional photographer. The entrepreneur found an insatiable demand for photography, any kind, and promoted in any way. For that matter, not only was the photograph sought after, but so was the paraphernalia of photography, photography books and magazines. Collecting and investing in photography became a sure thing. The value of "photographic" escalated beyond expectation.

The collecting of photographs and photography books was a mushrooming industry. Not only was there a desire for photographs, there was a need for the accoutrements of photography by the photograph collector. Many vintage photographic prints were found in bags and boxes in attics, barns, and basements. The haphazard and improper storage of these prints had taken its toll on the quality of what were fast becoming valuable assets. Photographs began to sell for high prices, and if one invested, it was essential to care for this investment properly.

Preservation and presentation had to go hand in hand. The birth of the photographic archival industry began. Many of the "presumed to be safe" methods of storage and presentation were investigated. The evidence of damage to photographic prints from improper storage, mounting, and display techniques became painfully evident. The investigation by museums of their exhibition and storage spaces found that the level and kind of lighting was as important as the temperature and humidity. The kind of mounting boards and adhesives used to bind the photographs to the mount boards needed to be reconsidered.

The photograph buyer became aware that photographs don't last forever; however, they will last longer if cared for properly. This proper care went beyond the mount and frame. Photographers had to archivally print their work and process carefully; still, some photographic media are unstable and fade. A popular anecdote is often repeated about a couple purchasing a contemporary color photograph at a prominent New York commercial photography gallery. They asked, "How long do color photographs last?" The response was, "Longer than most marriages."

Commercial photography galleries, or salons have existed since the birth of photography. Within a few months of Daguerre's announcement of his photographic process, there was a demand for photographs. The early demand for photographic portraits was met by a newly developing industry of commercial portrait photographers. As early as 1850 photography portrait studios began exhibiting and selling portraits of famous clients as well as taking portraits. The portrait gallery was a way of getting potential customers into the studio. *Brady of Broadway* was Mathew Brady's portrait studio and photography exhibition gallery where people came to see the portraits of the celebrities that Brady photographed. In addition to the demand for one's own likeness, there was a developing market for marketing celebrity portraits, travel photographs, stereo views, and visual imagery for publication.

In the 1850s the paper print began to replace the daguerreotype. Paper reprints from collodion plates were easier and cheaper to make than were reprints from daguerreotypes; this reduced cost and increased the number of available commercial photographs that were for sale. Dealers of photographic prints, stereographs, and *carte-de-visite* portraits increased outside of the photography studio gallery to book and print dealers. *Cartes* were sold and collected by the thousands. Even the Great Exhibition, in the Crystal Palace, in London in 1851 showed and sold photography.

Alfred Stieglitz established *The Little Galleries of the Photo-Secession* in 1905. The gallery was the first independent photography gallery dedicated to promoting the acceptance of photography as a fine art, and after 1908 the gallery became known as *291* and, eventually, *291* was replaced by *The Intimate Gallery* and that, in turn, evolved to *An American Place*. The galleries promoted high artistic merit for photography and, eventually, the other art media shown there.

There were several photography galleries that came and went between the 1940s and 1950s, but the greatest expansion of the photography galleries took place in the late 1960s and early 1970s. A 1989 survey of photography exhibition and sales spaces indicated that there were almost 1000 photography galleries and dealers worldwide. The main mission of the commercial photography galleries was to satisfy the demands of the public for photography. The galleries were for-profit businesses that promoted photography as a less expensive art alternative to painting. The public was encouraged to invest in photography and/or to collect it; even major art auction houses sold photographs.

Photography collections by photographic archives and government offices began in the 1840s and 1850s. The United States government was the earliest collector of images under the Copyright Deposit Law. In France it was the *Départment des Estampes et de la Photographic* that was required to have a copy of prints offered for sale. In England, it was the Royal Photographic Society that became a photographic archive and museum. The history of the photograph is so varied and diverse that many museums and archives began to specialize and narrow the focus of their collections.

Museums were slow to provide the imprimatur establishing photography as a fine art. The earliest museum commitment to a photographic exhibition was the 1910 *Photo-Secession International Exhibition* in the Albright (Knox) Art Gallery, in Buffalo, New York. Many years later, in 1926, the Metropolitan Museum of Art in New York City accepted Alfred Stieglitz's personal photographic collection as its first collection of photographs, and it was not until 1937 that the Museum of Modern Art in New York City opened its first photographic survey exhibition, *Photography, 1839–1937*. This exhibition was accompanied by an exhibition catalog written by Beaumont Newhall, who in 1940 was appointed the curator of the newly established Department of Photography at the Museum of Modern Art. In 1949 The International Museum of Photography (IMP) at George Eastman House was established in Rochester, New York. In addition to being a museum of photography (showing all aspects of photography), IMP is also a major photographic research center and an archive for motion-picture film and photographic equipment. It houses one of the finest collections of nineteenth-century photography in the world.

In 1974 the International Center of Photography (ICP) opened in New York City. Initially, ICP's interest was primarily concerned with photojournalism; however, now the museum has broadened its focus to all styles of twentieth-century photography. In addition to the conventional type of photography exhibitions, ICP also hosts workshops, classes, and a film series. ICP/Midtown is a satellite gallery in midtown Manhattan that provides a public space in among its exhibition galleries and screening room for showing film and video. These museums provided the recognition that was so important for the establishment of photography's place among the fine arts. Today there are more than 800 museums

that collect photography, non-profit photography galleries, and public exhibition spaces for photography.

In the 1960s and 1970s there was a tremendous expansion of photography courses into the academic curriculum of the colleges and universities in the United States. With this rapid expansion of photographic study into the collegiate setting, colleges and universities began to open small galleries and exhibition spaces on the campuses to provide places for many young emerging photographers to present their work. The art museums responded to the emerging interest in photography by providing a greater number of photography exhibitions that helped to create *photography superstars* and *photo heroes,* which in turn, generated further interest in the study of photography. The number of photography students and photography programs grew; however, this growth was not confined only to the universities.

Summer workshop programs, camera clubs, continuing education classes, professional photography associations, and regional photography centers added to this voluminous interest in photography, which in turn, had a direct effect upon both the size and degree of sophistication of the audience looking at photography. All of these programs added to the creation of photographic exhibition spaces and the showing of more and more photography. In addition to the more than 800 museums that collect and exhibit photography, there are photographic archives such as the Canadian Centre for Architecture, the Center for Creative Photography, the Library of Congress, the National Archive, and the Smithsonian Institution. Additional archives include NASA, The National Portrait Gallery, and many educational institutions such as, the Visual Studies Workshop, Rochester, New York; the Center for Creative Photography at the University of Arizona, Tucson; the universities of Texas at Austin, California at Santa Barbara, Louisville at Kentucky, and Oregon at Eugene.

Eventually the number of photographers who wanted to show their work exceeded the amount of exhibition space available, and the audience for photography remained committed to participate in additional opportunities to view photographs. The colleges, universities, public schools and other community spaces exhibited photographs, while photography contests, workshops, lectures, camera club events and photo group programs maintained the exhilaration and the interest in participating either as audience for or exhibitor of photography.

Many talented photographers are looking for places to exhibit their photographs. For little or no cost to the exhibitors, many show photographs in malls, shopping plazas, store windows, movie theater lobbies, banks, and restaurants. Excellent opportunities for hanging photographs are also found in industrial plant cafeterias, hallways, and offices. Photography is a relatively inexpensive art, an art form that is produced in every community and capable of fitting into any environment.

Many Chambers of Commerce exhibit community-oriented photographs to provide visitors with a preview of what is available and/or going on in the community. Video, an electronic form of photographic presentation, extends an additional link to the community, via cable TV or by video cassette tapes. Photographic exhibitions, as a form of community service, have become a regular attraction in hospitals, nursing homes, and community office buildings.

RETRIEVAL/STORAGE Proper storage methods and the use of archival materials will preserve photographic prints and make them accessible to photographers and their clients. Storage without the capability of retrieval is a problem. The photographer requires a filing system that not only allows prints, negatives, and transparencies to be identified and stored, but provides for the retrieval of these images. The storage conditions and the nature of the materials that the photographs are stored in or attached to are paramount in the preservation of photographic materials.

Polyethylene slide holders and negative sleeves, stored in baked enamel file cabinets or special archival loose-leaf binders, are ideal storage places for transparencies and negatives. Proper storage conditions include temperature and humidity control and should provide dark storage since prints are also vulnerable to fading when exposed to ultraviolet radiation. Print storage boxes made of heavy-duty acid-free paper are good places to store photographic prints. Acid-free tissue paper, cellulose acetate interleaving sheets, polyethylene storage bags, and mylar sheet protectors provide surface protection for prints stored in boxes.

All photographic materials are susceptible to damage from heat, moisture, and light. Transparencies are especially prone to damage from high humidity, which promotes fungal growth. Ideally, slide storage containers should provide an air circulation space around the transparencies and a light-proof environment. Carousel and rectangular slide trays with dust covers provide excellent storage in a dark room or closed, vented storage box.

The filing system can be as simple as a contact sheet. Give the contact sheet a number, a name, or a date, and you have an entry point to the photographs on a particular roll of film. Roll film has edge numbers that are preexposed by the manufacturer. These numbers along with the contact sheet name or number form an easy retrieval system for general work. Portraits, commercial works, and photojournalistic work may be better served by client names, dates, and places. This system, however, is on one level only. If multiple subjects are photographed or the subject matter changes on the roll of film, there is no cross reference with a single contact sheet filing system. A cross-indexing system is a better system for more varied and complex subject matter or with contact sheets that contain more than one kind of subject matter. The negatives do not have to be stored with the contact sheets, so long as you can locate the negative you want when you want it.

A card catalog styled after a library index card catalog system may be in order for cross referencing. A cross-cataloging system might have links to a visual notation system that uses a single contact sheet frame. This system may be very helpful to find important, perhaps previously published, photographs, but the cost and effort of such a system can be considerable for general filing.

A personal computer with any database software will prove to be an invaluable method of filing. The categories can be set up as a single word, date, and number and then searched for by a single category and/or multiple categories. For example, a search can be initiated for a photograph of a tree (under the category Trees), taken between May 1, 1991, and December 31, 1992 (under the category of Date), photographed in New York (under the category Place); the search will list *all* the photographs that match *all* of those categories. In addition to the category names, a file number can be assigned to the photograph or slide so that the search can be completed just by looking for a single number. This category find can yield a location number in a cross-file system. When a selected item is found, all the other information in the data base file for the selected item is also immediately accessible, so that captions, client names, and prices programmed into the database file will also appear on the screen or the print out. An added advantage to using a computer and database software is that the computer program can also print out an identification label, an index card for a hard copy index card file, and prepare and print a mailing list and set of labels for any photograph in the database.

A word of caution about computers: they are wonderful,

but you must invest the time to learn how to use them. Disks crash or can be damaged, so always make at least one back-up disk; two would be better. Power systems fail and computers break down, so you may need a manual card system as an emergency back-up. Computers are expensive, and as with any hi-tech product, computers become obsolete and dated. This is not to say that you can't use an old computer, but you may not be able to use some of the new technology and newer software on it.

With the proper software and hardware, the imaging capabilities of the computer can be used to create picture identification and filing systems. Negatives can be brought into commercial labs and printed onto a Photo CD, and the images can then be displayed on a regular TV screen or on a computer monitor. The cost of transforming your own photographs to a Photo CD as of 1992 is beyond the reach of many individual photographers, but if you arrange the images and have the lab "print" them, you can set-up the images to function as a visual filing system. Alternatives to Photo-CD imaging are the lower cost flatbed, 35-mm, and 3D scanners that work with personal computers. These scanners can convert 35-mm transparencies or photographic prints to computer images that can be transferred to databases to be incorporated with text and/or other visual references.

The still-video camera can be used to provide a similar visual record database. Copying photographs onto a video disc provides a search by numbered video frame, which, coordinated with a written record, furnishes a visual display to supplement the written record. Two-inch still-video discs can hold fifty images; these images can be displayed on a home TV receiver or converted by computer imaging software to computer image files that can in turn be placed into database files. Each computer database entry can be viewed on the monitor or printed out as hard copy.

Books: Horenstein, Henry, *The Photographer's Source.* New York: Simon & Schuster, 1989; Keefe, Laurence E., Inch, Dennis, *The Life of a Photograph.* Boston: Focal Press, 1990; Robl, Ernest H., *Organizing Your Photographs.* New York: Amphoto, 1986; Whipple, A.B.C. (Executive Ed.), *Caring for Photographs.* New York: Time-Life Books, 1972; Witkin, Lee D., London, Barbara, *The Photograph Collector's Guide.* Boston: New York Graphic Society (Little, Brown), 1980.

M. Teres

Polyethylene slide holder.

PRESENTATION FOLDERS Photo Mounts, Easy-Mounts, Multi-Vue folders, Folios and pre-cut mats are an alternative to framing photographs or putting them into albums. These mats are usually self-supporting and stand on tables or other flat surfaces. Mounts provide a pre-cut mat area so that the photographs are protected, firmly backed,

and can be handled without touching the print surface. Most mounts have a scored and folded flap that adds additional protection for the prints when stacked, or provides additional protection to the photograph when sending it through the mail. The mat openings and overall size and design vary. Several smaller prints can be grouped together or a single larger print can be displayed singly or simultaneously grouped with smaller prints.

M. Teres

PRESERVATION See *Image permanence.*

PRESERVATIVES Developing agents in alkaline solution are unstable, often degrading into colored, staining substances that are useless. A compound called a preservative is added to a developing solution to inhibit undesired chemical interactions. Sodium sulfite has gained universal use as the preservative ever since 1882 when H. B. Berkeley used it to reduce the staining by the oxidation products of a pyrogallol developer.

ANTIOXIDANT Oxygen from the air is readily absorbed into the water used to make developing solutions and will take electrons from (oxidize) the developing agent. Sulfite, often present in large amounts, effectively competes for the absorbed oxygen, forming colorless, harmless sulfate. If possible, the sulfite is added to the water before the developing agents are added. Some developing agents, such as Metol, must be added to the water first, as they are not soluble in large concentrations of sulfite ions. In this case, a pinch of sodium sulfite can be added first and the remaining quantity added after the Metol has dissolved.

INHIBITION OF SELF-OXIDATION Once started, the destruction of a developing agent may accelerate because of the presence of the oxidized forms of the developing compound. Sulfite ions remove these catalytic compounds, thus decreasing the rate of the degradation. This chain-breaking action is effective with the benzene derivatives that are developing agents but not with ascorbic acid or Phenidone, which do not react with sulfite ions.

STAIN PREVENTION Oxidized developing agents may be still chemically reactive, staining and/or hardening the gelatin layer of the photographic material. Sulfite interacts with these to form colorless, water-soluble products that still may possess some developing activity. The decolorizing action of sulfite also helps to protect the hands of photographers from discoloration.

OTHER SULFITE EFFECTS Sulfite ions act as silver halide solvents, promoting fine-grain development. Physical development, that is, the formation of image silver from silver ions from the developing solution, also occurs. The etching action on the silver halide crystals raises the effective emulsion speed of the material by increasing the rate of development in areas of low exposure of the silver halide crystals. Sodium sulfite is mildly alkaline, sometimes sufficiently so that it can be used as the sole alkali in gently acting developing solutions.

Many compounds can act as preservatives but may not be as versatile as sodium sulfite. In some cases, even moderate concentrations of sodium sulfite are objectionable, such as in lithographic, tanning, or color developers. In these developers, the oxidized form of the developing agent is necessary for a further chemical reaction. Hydroxylamines, hydrazines, and ascorbic acid exhibit preservative action in color developers. In low sulfite solutions, developing agents or related compounds often find use when present in small quantities compared with the primary developing agent. Hydroquinone or related polyhydroxybenzenes can help protect active developers containing agents such as amidol.

Lithographic developers produce high contrast images by allowing the intermediate oxidation product of hydroquinone to accelerate the development rate. The free sulfite

ion concentration must be kept very low. Certain aldehydes or ketones react with sulfite ions, forming complexes that act as sulfite buffers, maintaining the low concentration of sulfite ions in the solution. This provides some preservative action to protect the hydroquinone in the solution. Sodium formaldehyde bisulfite, for example, is a water-soluble, colorless compound that has found wide usage as a preservative for special purpose developers. *G. Haist*

PRESET DIAPHRAGM An automatic feature, especially on single-lens reflex cameras, whereby the lens diaphragm remains open to its fullest aperture for focusing, but when the shutter is released the lens closes down to the set aperture for correct exposure and then immediately returns to the full aperture. *P. Schranz*

PRESET SHUTTER A type of shutter the requires two separate actions. The first movement cocks the shutter and the second movement releases it. A preset shutter requires little pressure to release and therefore reduces chances of camera movement. *P. Schranz*

PRESS CAMERA See *Camera types.*

PRESS-FOCUS A feature on lens shutters that allows the shutter to be opened for composing and focusing on a ground glass without changing the speed setting from the desired instantaneous speed to the time (T) setting. *P. Schranz*

PRESSURE-MARK EFFECT See *Photographic effects.*

PRESSURE MARKS Pressure marks are a form of physical stress produced mainly by pressure applied over a small area of film or paper. Extreme pressure is required to produce even a minimal effect if applied over a large area. The mark may or may not produce an actual abrasion of the surface and may appear as a form of local fog or as a decrease in density in an area of an existing latent image. Even though no external pressure is applied to the surface, distorting film or paper can cause internal pressure that produces such effects as kink marks. *I. Current*

PRESSURE MICROPHONE A microphone the output of which is proportional to varying air pressure as a result of a sound field. Pressure microphones generally consist of a diaphragm enclosing a sealed chamber: it is changes between the externally applied varying sound pressure and the fixed internal air pressure that the microphone converts into electrical energy. *T. Holman*

PRESSURE PLATE A smooth panel that holds a photographic emulsion in the correct plane for exposure while not preventing or interfering with the advancement of roll film or paper between exposures. *P. Schranz*

PREVIEW A special presentation of a motion-picture production before its release for exhibition to the general public, allowing for audience feedback to influence possible final changes in the production or ad campaign. *H. Lester*

PREVIEW BUTTON A button found on single-lens-reflex cameras and some lenses that allows for a momentary closing down of the lens to a specified *f*-number for the purposes of checking depth of field. *P. Schranz*

PRICING The calculations used to determine the dollar amount charged for photographic services. The calculations involve the application of objective criteria, for example,

studio rental, studio overhead, film, processing, and travel together with subjective criteria, for example, the daily or hourly rate the photographer desires to receive, which in turn may be based on the photographer's reputation, the use to which the photographs will be put, and the perceived long-term benefits to the client and/or photographer. *R. Persky*

See also: Business practices, selling and licensing images.

PRIMARY CELL/BATTERY Any of a number of electrochemical sources of voltage that cannot be recharged. *W. Klein*

See also: Battery.

PRIMARY COLORS Sets of three colors that are used in color matching or in color reproduction. In additive systems, such as may be used in visual colorimeters and in color television, the primary colors of light are red, green, and blue, in order to excite each of the three different types of cones in the eye as separately as possible. In subtractive systems, such as may be used in color photography and in color printing, the primary colors are red-absorbing (cyan), green-absorbing (magenta), and blue-absorbing (yellow) colorants; in the past, in the printing industry, the cyan primary was sometimes called blue or process blue and the magenta primary was sometimes called red or process red. *R. W. G. Hunt*

PRIME LENS Term used to describe a camera lens that is attached to an accessory device such as an afocal converter, teleconverter, or anamorphic system. *S. Ray*

PRIMITIVES In computer graphics, a set of instructions that allows the user to draw simple and complex shapes on the screen, such as circles, squares, and polygons. *R. Kraus*

PRINCIPAL FOCAL POINTS/PLANES A pair of the cardinal or Gaussian points/planes used in paraxial optics and calculations. Parallel light from a subject at infinity converges to an image point in the rear principal focal plane, which itself cuts the optical axis at the rear principal focal point. The focal length of the lens is measured from the rear nodal point to the rear principal focal point (focus). There is a corresponding front principal focus and focal length, and normally they are identical to the rear values. *S. Ray*

Syn: *Principal focus.*

See also: *Cardinal points/planes; Focal point, principal; Nodal points/planes; Principal points/planes.*

PRINCIPAL POINTS/PLANES Important concept of Gaussian (paraxial) optics to define and calculate the parameters of a lens and its imagery. Principle points are two points where planes of unit magnification cross the optical axis perpendicularly. A ray of light entering the first plane emerges from the second at the same height above the axis. Conjugate distances in the object and image spaces are measured from the front and rear principal points, respectively. For the same medium, such as air in both spaces, then the corresponding principal and nodal planes coincide. This is not the case with an underwater lens. *S. Ray*

See also: *Cardinal points/planes; Nodal points/planes; Principal focal points/planes.*

PRINCIPAL RAY Ray of light from an object point that passes through the center of the aperture stop in an optical system. It has importance in lens design calculations. *S. Ray*

PRINT A photographic image, usually made from a negative or positive image rather than directly from an original scene or the process of making such an image. Prints are made to be viewed or reproduced, and are typically positive images on printing paper for still photography and positive

images on transparent film for motion pictures—or to produce such images. *L. Stroebel*

PRINT DISPLAY The physical space, kind of institution, and the type of photography exhibited will often determine the nature of a print display. The basic, traditional, methods of displaying photographs are mounting, matting, and framing. These materials are used to enhance and protect the photograph. Care in choosing the style of frame, the size and color of the mount-board, and whether or not to use a submount all affect the way the print looks and help to create or enhance the mood expressed in the photograph.

The size of the exhibition area, the purpose of the exhibition, and the number of prints being shown will often dictate the size of the display image. Fine-art photography is most often hung to accentuate the single image, isolated from the next, and usually hung in straight lines. Occasionally the prints are clustered into minithemes or isolated as a set or a series of related images. Journalistic photography is often clustered in groups or themes, printed in various sizes, flush mounted, and hung on several levels interspersed with captions.

Advertising, commercial, and portrait photography are used more decoratively and an effort is made to harmonize the display with the decor of the exhibition space, especially if the exhibition space is the interior of a home. It is advisable to use frames and mounting techniques that enhance the print and at the same time suit the decor and ambience of the display space. Large floor-to-ceiling wall murals are often used as decorative prints in commercial office space and in the lobbies of public buildings. These large prints are often used to convey something about the nature of the business of the places in which they hang. Amateur photography exhibitions, especially in small physical spaces, may be stacked almost floor to ceiling. Summer fairs, and outdoor photography art and craft exhibitions are often hung on snow fences at multiple levels.

Prints that are displayed for judging for the Professional Photographers of America and similar photographic organizations follow a very specific set of rules. Camera clubs and other photographic organizations try to approximate these regulations if possible. The rules are as follows: The photograph is lit by two 150 watt minispot lamps. The distance from the center of the print to the floor is 49 inches. The distance from the floor to the center of the spotlight is 83 inches. The distance from the center of the lens of the spotlight to the print is 65 inches. Using these measurements with the two 150 watt minispot lamps should yield a reading of 75 footcandles on a light meter that reads footcandles. If a footcandle meter is not available, the reading for an incident light meter reading should be 1 second at $f/16$ with the ISO film speed set at 100. The area surrounding the print should be covered with a matt gray cloth, the cloth should have a 60-degree reflectance. The print should be supported on a stand so that the top of the print is tipped forward and is closer to the viewer. If the print is supported on a stand that is on a table, the distance of the back of the table to the print should be 6 feet. To facilitate the judging by reducing the pauses for print changes, a pyramid-like turntable allows three prints to be placed in the judging area. The pyramid design allows only the print being judged to be seen; when a new print is to be judged the turntable is rotated. *M. Teres*

PRINT DRYER Any of various types of devices designed to accelerate the removal of water from prints after processing, commonly with a means of preventing the prints from curling while being dried. Drum dryers hold the prints against the curved surface of a rotating heated drum with a porous fabric cover, with the emulsion side toward the polished surface for a ferrotype finish with glossy papers, otherwise reversed. Automatic roller-transport type print proces-

sors commonly have a built-in dryer based on circulating warm air. Since resin-coated (RC) papers absorb little water and have little tendency to curl, they can be dried satisfactorily in a simple dryer that moves the prints through a flow of warm air on a porous belt. Small quantities of prints can be dried satisfactorily, but slowly, in a blotter roll, a system that puts a reverse curl on prints to counteract their tendency, especially with fiber-base papers, to curl toward the emulsion side. *L. Stroebel*

PRINTED CIRCUIT Electric wiring layout that is no longer produced by printing but by photofabrication techniques. A large scale drawing of the circuit is made and reduced to its true, miniature size. This image is projected on a blank laminated circuit board coated with a light-sensitive resin resist. The exposed areas are hardened, the unexposed areas are removed, and the copper circuit paths remain. Interestingly, the process is a relative of Niépce's heliography, introduced in 1822. *H. Wallach*

See also: *Heliography; Photofabrication.*

PRINTER (1) A device for exposing sensitized material to a negative or positive image on a transparent base, either by contact or projection, for example, contact printer, projection printer, optical printer, automatic printer. (2) A person whose function is to make photographic prints or photomechanical reproductions. (3) In photomechanical reproduction, an image-bearing plate that is used to make the final reproduction, such as the cyan, magenta, yellow, or black printer. *L. Stroebel*

PRINTER LIGHTS In motion-picture printing, a system for describing the proper exposure level for printing, in numbers from 1 to 50, relating to the intensity of light the printer will shine through the original footage. One camera f-stop is approximately equivalent to 8 printer lights. *H. Lester*

Syn.: *Printer points.*

PRINTER POINT In motion-picture printing, an increment of light intensity, on a scale of 1 to 50, used to describe printing exposure. Approximately 8 printer points represent one f-stop of color negative exposure. *H. Lester*

Syn.: *Printer lights.*

PRINT FINISHING Category of nonphotographic procedures applied to a photographic print to improve or alter its appearance:

Drying A wet fiber-base print may be ferrotyped, emulsion side toward a heated drum, to produce a high gloss finish, or air dried to give a low gloss surface. Curling may have to be removed. Resin-coated papers dry essentially flat as manufactured.

Spotting Dyes or opaque pigments may be applied to a print with a fine brush to hide the white spots caused by dust and scratches on the negative.

Etching A small, sharp knife or razor can be used to break the gelatin surface of the print and remove the silver black spots caused by pinholes in the negative.

Retouching Pointed pencils and brushes may be used to apply graphite, pigments, and dyes, usually to negatives, to correct small defects.

Texturing Lacquers, waxes, or other materials may be applied to the print to change its surface or form a protective coating or texture may be embossed on a print with a roller under pressure.

Hand coloring A wide variety of materials may be employed to color a black-and-white image realistically or with expressive intent.

Trimming The edges of the print may be removed to eliminate distracting elements and tighten composition.

Mounting A print may be dry mounted by using a heat-sensitive tissue or peelable adhesive sheet to fix it permanently to a mat board. Wet mounting employs liquid or spray adhesives for permanent mounting. Archival procedures use acid-free tape to fasten a print to a board impermanently. If the board is damaged, the print may be saved.

Framing A window overmat is prepared and the assembly is placed in a frame for formal display. *H. Wallach*

PRINT IN To give additional exposure to selected areas of an image, usually when making projection prints. *J. Johnson*
Syn: *Burn in.*

PRINTING In photography, any process by which a positive print is made from an original image on film. Either the original or the print may be color or black-and-white, positive, or negative. The print may be made by contact, using daylight or an artificial light source, or it may be made by projection, using an enlarger. The light source passes through the film to the sensitized printing material.
H. Wallach

See also: *Photographic paper; Printing techniques; Print judging.*

PRINTING DENSITY A measure of the absorption of light by a negative or other transparency evaluated in terms of the spectral response of the material on which the image will be printed. For example, if a negative has a yellowish stain, it will have a high printing density if it is printed onto a blue-sensitive paper because the stain absorbs more blue light than red or green light. For the same negative the visual density will be relatively small because the human eye responds well to yellow light. *M. Leary and H. Todd*

PRINTING EASEL A device that holds sensitized material flat and in position for exposure to a projected image, commonly with overlapping masking blades that hold the material along the edges and provide a border on the print. Borderless prints can be obtained either with an easel having only slightly angled channels that hold the sensitized material at the extreme edges or with a vacuum easel that holds the sensitized material in contact with the base with air pressure. Roll-paper easels allow the paper to be moved from the supply roll to the takeup roll between exposures for quantity printing. *L. Stroebel*

PRINTING FRAME A device that consists of a plate of glass in a frame with a removable back that holds sensitized material in contact with a negative or transparency while being exposed to light from an enlarger or other light source. The pressure back typically consists of two parts connected with a hinge so that one part can be lifted to check the image density on printout materials without disturbing the registration when additional exposure is required. *L. Stroebel*

PRINTING-OUT PAPER See *POP.*

PRINTING SYNCHRONIZATION In motion-picture production, the aligning of the sound track and picture to match their relative placements on a composite release print, with the sound placed ahead of the picture. *H. Lester*
Syn.: *Projection synchronism.*

PRINTING TECHNIQUES, BLACK-AND-WHITE
Master printers have often been celebrated for their idiosyncratic printing techniques. Still, there are requirements for successful printing that are broadly accepted, and procedures common to virtually all darkroom practice.

The work space should be dust-free and well lit. Enlargers should be optically clean, vibration-free, and well aligned.

There should be a reasonably consistent supply of power, effective ventilation, and fresh chemicals and paper.

Good printing begins with good negatives: properly exposed and developed, appropriately sharp, and free of damage. Much effort in the darkroom is devoted to compensating for negatives that are too dense or too thin, too flat or too contrasty.

A properly made contact sheet shows maximum black produced in minimum exposure time through the film base, detail in the highlights and shadows, and a correct range of tones in the image. From the contact sheet, one can determine what to print and how to print it in terms of cropping, exposure, and contrast.

Usually, the contrast of the printing material is selected to complement the negative being printed, but some photographers prefer to expose and develop their film to match a particular paper. A graduated test or a set of test strips is then made by varying exposure, and a work print is made. If this print seems close to a final product, local adjustments can be effected by dodging (holding back light to lighten an area), or burning in (adding light to darken an area). This lightening or darkening may be for corrective or interpretive purposes.

If indicated by the work print, more extensive measures may be undertaken to control contrast. Increasing exposure and reducing development will lower contrast, as will a greater dilution of developer concentrate. Increasing developer concentration, or adding potassium bromide, benzotriazole, hydroquinone, or sodium thiocyanate will increase contrast.

Two developer baths, one contrasty and one soft working, such as Beers #1 or #2 or Dektol and Selectol-Soft, may be used for precise control of print contrast by splitting development between the two baths. One developer and water bath, or one developer and an alkaline bath, 1% borax or sodium hydroxide, can achieve a substantial contrast reduction.

During the exposure process, contrast may be controlled in a variety of ways. If variable-contrast paper is used, it can be exposed with split filtration. Separate exposures are made with high and low contrast filters, affording combinations not available from the standard filter set. Color and variable-contrast heads permit the same procedure. Contrast can be lowered by flashing the print briefly with nonimage light, coming close to but not exceeding the threshold of exposure. Highlight areas that would have been blank will now have detail, while low values are essentially unchanged. A positive mask lowers contrast by adding density to thin parts of the negative, reducing the difference in densities to a more printable range.

Some printers prefer to print darker than normal, then immerse their prints briefly in Farmer's Reducer, plain fixer with potassium ferricyanide. Silver is removed until the highlights are bright and detailed. The benefits of this procedure are greatest where highlight exposure has been sufficient to exceed the toe of the characteristic curve of the paper, yielding good tonal separation.

Several procedures that involve soaking the print paper also reduce contrast. If the paper is soaked in developer and squeegeed before exposure, print density will emerge during the exposure in the fashion of printing-out paper. The shadows become self-masking; the existing silver blocks further exposure there, giving highlights time to emerge. A thorium nitrate forebath extends the tonal range of shadows without changing the rest of the print. After an exposure of two to three times normal, the print is soaked in a 10% solution for two or three minutes, rinsed, and developed normally. The Sterry process, in which the exposed print is soaked in a 1% solution of potassium bichromate or potassium ferricyanide for a minute and rinsed before normal

development, reduces overall contrast but turns print color slightly greenish and is inclined to cause stains. *H. Wallach*

See also: *Bleach; Burn in; Color printing; Contact printer/printing; Contrast; Contrast control; Developers; Developing; Dodge; Enlarger; Farmer's reducer; Filters, contrast; Fixing; Fixing bath; Flash; Intensification; Masking, unsharp; Photographic paper; Print quality; Print washing; Redevelopment; Reduction; Sterry process; Test strip.*

PRINT JUDGING Many professional photographic organizations and camera clubs have print competitions and judgings. More often than not, these organizations use the rules of the Professional Photographers of America. These rules change periodically, but the following are more or less standard guides for print judging.

IMPACT This is determined by what the viewer sees first upon looking at a photograph. Questions that determine impact follow this line of investigation: What creates the viewer's first impression? Does the image create a strong feeling? What entices the viewer to look? What holds the viewer's eye? Impact can be created by any of the following elements:

CREATIVITY Creativity is generally associated with imagination and originality. Invention, abstraction, and interesting design are assumed to add to the creative impact of a photograph. Some factors considered here (again, put into the form of questions) are: Does the viewer have the sense that the image mirrors the maker's imagination? Does the image spur the viewer's imagination? Is the photograph original and fresh in the approach to the subject? Does the image reveal creative cropping? Is the subject matter shown creatively?

Questions concerning style might be stated as: Does the photograph stand out from others in the group? Does it reveal a unique way of seeing? Does it reveal a different way of approaching the subject? Is the subject not too contrived? Does the photograph demonstrate experimentation and individuality?

COMPOSITION In deciding upon style, creativity, and impact, composition involves several important criteria: Are the primary and secondary subjects successfully arranged? Does the composition produce harmonious proportions? Does the image capitalize upon dynamic symmetry in the positions of important objects? Does the photograph create the sense of good repetition, a broad range of color, space, mood, or spatial divisions within the photograph?

PRINT PRESENTATION Creative and careful mounting can affect a viewer's first impression of a photograph. Criteria for presentation are: Does the presentation enhance the photograph? Does cropping add to the composition? Was a good color selected for the matting? Does the presentation dare to be dynamic and different, or is it traditional?

COLOR HARMONY Color harmony means the coordination of color between the subject photographed and the background. Questions on color harmony involve the use of interpretive color, creative color, a good color scheme, and abstract color.

LIGHTING Judges are invited to look for statements made with light, since lighting, according to these standards, is the art of reproducing the characteristics of the subject or object. In portraiture, look for successful execution of any of several standard lighting arrangements—Rembrandt, short, split, broad, butterfly, light-line profile, or dark-line profile. Questions judges are asked to consider concerning light might be: Is the lighting dynamic? Do patterns of light enhance the image? Does the lighting create a strong mood?

CENTER OF INTEREST Secondary points of interest are important to a successfully executed photograph. But they must not be so strong that they prevent the viewer from returning easily to the primary point of interest. Questions to be considered concerning center of interest in a photograph include: Does one object or subject dominate? Does the dominant subject create mood? Does it create strength and definition?

SUBJECT MATTER Contrasts are considered creative in these criteria—binary contrasts such as youth with age, warmth with cold, etc. Interpretation of the subject is a large question here. Does the image give an outstanding interpretation of the subject? Is the camera angle appropriate for the subject? Does it emphasize strengths of the subject or reduce its weaknesses? Is the model or object selected photogenic? Questions such as these are the sort of criteria by which subject matter is judged.

PRINT QUALITY Tonal range and simplicity of subject matter in determining quality. Does the print have strong tonal contrast with a good range of middle tones? Does it have good color balance? Does the background enhance the subject, without detracting from or overpowering it?

TECHNIQUE Application of art principles must be combined with technique, since design brings abstract ideas into concrete form. Appropriate questions include: Does photographic technique suit the subject? If warranted, is abstraction employed?

STORYTELLING OR NARRATIVE Questions asked of judges on narrative in the photograph include: Does the image make a statement? Does it present a complete story? Can the viewer grasp the complete meaning of the image at first glance? Does the image portray a strong emotion or mood in the subject, or elicit emotion from the viewer? Does the photograph challenge the viewer's imagination? *M. Teres*

PRINT MASTER (SOUND) A complete sound track containing all sound elements such as dialog, music, and sound effects, recorded in a format compatible with the needs of mass production of prints or video discs or tapes. *T. Holman*

PRINTOUT (1) The production of a visible image on a sensitized photographic material such as printing-out paper by exposure alone. (2) A computer-produced image recorded on paper or other material. (3) An enlarged reproduction of a microfilm image. *L. Stroebel*

PRINT QUALITY Attributes of a photographic print, such as density and contrast, that influence the appearance of the print with respect to the degree of technical excellence. Print quality is generally evaluated subjectively, but to the extent that subjective and objective measurements can be correlated, certain objective criteria can be established, such as appropriate minimum and maximum densities. Although the term may suggest that print quality depends entirely on the choice of materials and craftsmanship at the printing stage, it also depends on the quality of the negative being used and sometimes even such factors as the subject and the lighting. *L. Stroebel*

PRINT-THROUGH (SOUND) A defect of analog magnetic tape recording wherein a recording made and wound into a reel affects the adjacent layers, causing noticeable pre- and post-echoes. Print-through is exacerbated by time and by increasing temperature. *T. Holman*

PRISM A solid of transparent optical material bounded by plane polished surfaces inclined to one another. A refracting prism needs only two polished surfaces, but a reflecting prism using total internal reflection requires three. A refracting prism may be used to disperse white light into its component wavelengths. Reflecting prisms are superior in most instances to surface-silvered mirrors, being less delicate and permanently aligned, and they do not tarnish. They can also

be used to reverse and invert images. More complex prisms of the roof type are used in reflex cameras to provide correctly orientated images. S. Ray

See also: *Porro prism.*

PROCESS CAMERA See *Camera types.*

PROCESS CONTROL See *Quality control.*

PROCESS FILM Photosensitive film with special characteristics for making line and half-tone negatives and positives for photomechanical reproduction. M. Scott

See also: *Lith/Litho/Lithographic.*

PROCESSING Processing can be broadly defined as performing a systematic series of actions to achieve some end. In photography, processing refers to the actions taken after exposure of sensitized material to produce a visible, stable, and usable image. Processing of black-and-white films and papers normally consists of developing, rinsing, fixing, and washing, but may include additional steps such as presoaking film before development, using a washing aid between fixing and washing, and intensifying, reducing, or toning the image.

Because stabilization printing papers contain a developing agent in the emulsion, processing is reduced to two steps—treating the paper with an activator to develop the image and applying a stabilizer as a substitute for fixing and washing. Greater permanence can be obtained with stabilization prints, when desired, by fixing and washing them in the usual way anytime before evidence of deterioration appears. With silver-halide printing-out paper, the visible image is produced by exposure, but prints that are to be preserved may be treated with a toning solution to alter image color and a sodium thiosulfate solution to remove remaining silver halides before washing the prints to remove processing chemicals.

Processing of *nonreversal* chromogenic color films and papers includes development in a developer that produces both a silver image and a dye image. The silver image is then converted to a silver halide by a bleach, and all remaining silver halides are dissolved by a fixing bath, which may be combined with the bleach as a blix bath, and the dissolved chemicals are removed by washing. *Reversal* chromogenic color materials are processed in two separate developing solutions, the first to produce a negative silver image and the second, following fogging of the remaining silver halides, to produce positive silver and dye images. The negative and positive silver images are bleached and removed in the same manner as with the nonreversal color materials, leaving the positive dye image. Processing with dye-bleach (chromolytic) color printing processes, which produce positive images from positive transparencies, consists of (1) developing a negative silver image in each of the three emulsion-dye layers, (2) bleaching the silver images (which also bleaches the dyes in areas that are in contact with the silver grains, leaving positive dye images), and (3) removing remaining silver compounds and unwanted by-products with fixing and washing.

Monobath processing of black-and-white films involves the use of a single solution that contains both developing and fixing agents. Because development and fixation occur simultaneously, the process is carried to completion, and contrast is controlled by the composition of the monobath rather than by developing time.

With the diffusion-transfer process, a monobath-type processing solution is sandwiched between the exposed sensitized material and a receiving sheet that contains a nucleating agent. As a negative silver image is being developed in the exposed sensitized material, the unexposed silver-halide grains are being dissolved. The dissolved silver halides move to the receiving sheet by diffusion, where the nucleating agent causes them to become developable, and produce a positive silver image.

The procedures for processing nonsilver materials vary considerably, depending on the material. Water is all that is required to remove unexposed sensitized material with the blueprint process, where exposure produces an insoluble printout image, and the gum bichromate process, where exposure hardens the sensitized material containing a colorant. Dry processing is used with some nonsilver processes. With the diazo process, ammonia fumes react with diazonium salts in unexposed areas to produce a positive dye image. No fixing is required because sensitivity is destroyed by the exposing radiation in the exposed areas. Heat, usually from an infrared lamp, is used to form the image with thermographic materials, where decomposition or softening occurs in the heated areas. Dry processing is also used with the xerographic process, where dry toner particles temporarily adhere to the unexposed areas of an electrostatically charged surface and are then transferred to a sheet of paper and fused with heat.

Processing was more of a challenge for early photographers than it is today. With the daguerreotype process, the exposed plate was developed by placing it in a box with a dish of heated mercury, where the mercury fumes adhered only to the exposed areas. The developed plate was then fixed, washed, and dried. It has been reported that the health of some of these photographers was adversely affected by the mercury fumes. With the wet-collodion process, it was necessary to sensitize the plate immediately before it was exposed, to expose the plate while still wet, and to process it before it dried, which required taking a portable darkroom along when photographing on location.

Dramatic progress has been made over the intervening years to shorten processing times, reducing processing costs, and improve the quality of the results. The use of resin-coated printing papers, for example, has reduced the time required for fixing, washing, and drying to a fraction of that required for fiber-base papers. Roller-transport and other automatic processing machines for films and papers that provide dry-to-dry processing in a few minutes have revolutionized large-volume processing as required in photofinishing and custom-finishing labs and other large photographic organizations. Instant-picture materials produce finished pictures in seconds, and video and still electronic photography provide immediate viewing following exposure, without chemical processing.

In electronic imaging, processing refers to the electronic execution of programmed instructions as when digitizing, manipulating, storing, or retrieving an image or compressing image data.

Although contemporary processing materials do not present the same type of health hazard that mercury fumes did to early photographers working with the daguerreotype process, photographers are advised to provide adequate ventilation in areas where processing solutions are prepared, stored, and used and to avoid direct contact with the solutions. Safety goggles and rubber gloves are recommended when mixing or pouring photographic solutions. L. Stroebel

See also: *Agitation; Color processing; Machine processing; Nitrogen-burst agitation; Pipe processing; Rapid processing; Roller transport; Tanks and tank processing; Tray processing; Web processing.*

PROCESSING DEFECTS See *Defects.*

PROCESSING EFFECTS (1) See *Photographic effects.* (2) Processing effects are errors in development of exposed images caused by inappropriate local concentrations of developing agents. The chemical changes in the

development process result in reaction products that diffuse only slowly out of the emulsion. Movement of fresh developing agents into the exposed areas is similarly limited. The results are failure of highly exposed areas to be fully developed and nonuniformity of development in uniformly exposed areas.　　　*H. Todd*

PROCESSING TESTS　See *Fixation test; Fixing bath test; Hypo test; Stop bath test; Washing test.*

PROCESS LENS　See *Lens types.*

PROCESSOR　Typically an automatic or semiautomatic device that contains processing solutions in the appropriate order for the production of finished images from exposed sensitized materials, often including a final wash and drying.　　　*L. Stroebel*

PROCESS SHOT　A motion-picture shot in which live foreground action is filmed against specially photographed background action, rear projected onto a translucent screen or front projected and filmed through a beam splitting mirror, as for example, a dialogue scene between actors in the front seat of a car performed while appropriate street scenes are projected and seen through the rear window, creating the impression that the action was performed in a car driving through a real environment.

Process projectors have camera-type shutters, as opposed to flicker-blade shutters used for theatrical projection, and are operated in interlock with the recording camera so that their shutters open and close in unison. In order to successfully create the impression that all picture elements were filmed at the same time, a great many variables must be considered in matching the foreground action to the background *plate* (projected image), including exposure levels, apparent light sources, color balance, movement coordination, the speed of movements, and the grain and other projection characteristics of the plate.

Historically an important and common technique, its use today has in many instances been replaced by more efficient optical printing techniques or by the ability to shoot original action in its appropriate location in situations that previously would have presented insurmountable practical problems.　　　*H. Lester*

PRODUCTION SOUND　Sound recorded at the time of principle photography or production.　　　*T. Holman*

PRODUCTION SOUND LOGS　Written notes in prescribed form recording the content of each production sound tape. Usually included are scene and take information, printed take information through the convention of circling the printed take numbers, and other production and technical information needed to locate information and play back the tape correctly.　　　*T. Holman*

PRODUCTION SOUND MIXER　The person in charge of recording on the set, who generally controls the microphone technique, operates the audio mixer, often in portable form, and the recorder.　　　*T. Holman*

PRODUCT PHOTOGRAPHY　See *Catalog photography.*

PROFESSIONAL ASSOCIATIONS　See *Business practices, selling and licensing images; Organizations.*

PROFESSIONAL PHOTOGRAPHY　*Professional photography* is a term that encompasses many areas of photography having one common factor, the making of pho-

tographs for a living, as distinguished from photographs made by amateurs for their own satisfaction. Professional photography includes many branches of photography, such as advertising, catalog, commercial, illustration, industrial, medical, photojournalism, portraiture, wedding, and yearbook photography. The Professional Photographers of America (PPofA), which was founded in 1880, originally included and served mostly portrait photographers but later expanded its scope to include commercial photographers and still later industrial and corporate photographers. Some photographers prefer to identify themselves with their field of specialization rather than with the more generic term *professional* photography, and a number of organizations and publications are designed to serve photographers in these areas of specialization.

The size and structure of businesses in which professional photographers work vary over a wide range, including staff photographers in photographic departments in nonphotographic organizations such as newspapers and product manufacturers, staff photographers in large photographic organizations that employ specialists for different types of activities within those organizations, professional photographers who are the proprietors of their own business, with or without other employees, and freelance professional photographers.

Freelance photographers are independent photographers who produce photographs for sale either on assignment or on speculation. They may offer photographs for sale through a stock house, which is responsible for marketing activities, with a contract under which it retains a percentage of the income from sales. Some freelance photographers have agents who are responsible for promoting the photographer and locating assignments, again for a percentage of the resulting income.

Professional photographers who are proprietors of one-person studios, in addition to making photographs, must serve as receptionist, darkroom technician, bookkeeper, problem solver, travel agent, and any other type of specialist that the business requires and also possess knowledge about a variety of subjects, including copyright laws, registration of business names, liability for property of their clients, insurance, and ethical practices.

In the United States, a license is not required to practice professional photography, which is not the case in some European countries. Professional photographers must, however, work within the framework of state and local ordinances. When professional photographers work for or with government agencies they may be required to obtain some sort of certification, which is possible through training or examination.

There are various routes available for becoming a successful professional photographer. In the early days of photography the only choices were to teach oneself or to serve an apprenticeship with an experienced photographer. Today the choices include on-the-job training, trade schools, and college degree programs. Applicants for positions in the field of professional photography provide evidence of their qualifications with educational diplomas and degrees, portfolios of their work, awards, records of publication, and of course an impressive résumé. Even students who have graduated from intensive trade-school courses or college programs in photography, however, often find it necessary, and desirable, to work as an assistant to an experienced photographer before accepting the full responsibility of being a professional photographer.　　　*G. Cochran*

See also: *Photographic education.*

PROGRAM　(1) (verb) To write or specify a sequence of steps or commands that must be followed to achieve a particular result. This may apply to the programming of a

computer or to the operation of processing equipment (2) (noun) The steps produced by this process (3) (noun) In education, an instructional sequence designed to create the conditions necessary and appropriate for students to acquire a specific body of knowledge. *H. Wallach*

PROGRAMMABLE READ-ONLY MEMORY (PROM)
In computers, a chip that can be addressed to read a program and load it into memory so that accessing the program is quick because neither a hard drive nor floppy disk needs to be accessed. *R. Kraus*

PROGRAMMED CAMERAS See *Camera types*.

PROGRAMMED DATA BACK See *Camera back*.

PROGRESSIVE PROOFS
Sets of press, or off-press, proofs containing prints of each individual color, overprints of two-color combinations, three colors, and the final four-color reproduction. These were very important when four-color reproductions were printed on single and two-color presses. Since four-color presses have come into universal use, progressive proofs are seldom needed. *M. Bruno*

PROJECTED BACKGROUND
A scene imaged on a screen, in front of which actors or actresses perform, and thus appear to be on location. The technique is used in motion pictures, television, and also in still photography, especially for advertising purposes. The same effect can be produced electronically in video post-production techniques.
R. Zakia

See also: *Front projection; Process shot; Rear projection.*

PROJECTION
Ever since humans first looked at and recognized shadows, we have been interested in projected images. Early in the prehistory of moving-image photography, there was a fascination with the process of image projection. The magic lantern was invented by Athanasius Kircher in about 1640. In his book *Ars Magna Lucis et Umbrae,* first published in 1645, Kircher outlines the principles of the magic lantern. His magic lantern was a rear-screen projection show, images projected against translucent fabrics. The projected images were transparent figures that were hand-painted on glass strips. The areas around the transparent figures were heavily painted and appeared opaque. By changing the glass strips, Kircher figures appeared and disappeared. When the lanternist moved the lantern closer to and farther from the projection screen, the images seemed to change their size and form, and when the lantern was dimmed or partially covered, the figures would seem to fade away. The exhibition/performance of magic lantern shows was considered entertainment, not much different than the motion picture today.

The phantasmagoria evolved from the magic lantern show. It too was a rear-screen projection entertainment event, with sound effects, fade-in, and dissolves. There were even *X-rated* striptease phantasmagoria. The use of concave mirrors and projected aerial images added to the idea of the fantastic and magical adventure. Peepshows, panoramas, and dioramas were extensions of the phantasmagoria and a fascination with perspective, lenses, light and projection. Some of the dioramas were elaborate room-sized camera obscuras displaying painted canvases manipulated with light projected on the canvas or through translucent painted images on translucent fabric. Unfortunately, the light effects were not always manageable or consistent because of natural ambient light. The attempt to mirror reality turned some of the exhibitions into "performance art." In Daguerre's *View of Mont Blanc* a real chalet and barn were introduced into the diorama, and for an added touch of reality a goat eat-

ing hay was included. This innovation was not an overwhelming success; it was perhaps a bit too soon for audience participation.

The magic lantern slide show evolved into a form of traveling entertainment, where an itinerant magic lanternist carried a hand organ and a magic lantern with slides and went door to door soliciting for places to arrange a private magic lantern show. In the early 1800s the Galantee show became a popular form of entertainment, an amusement similar to hiring a performer for a private party. The entertainment was provided by a team of two, one playing music on an organ while the other projected slides.

Long strips of hand-painted slides were passed slowly in front of the magic lantern lens and gave the viewer a sense of motion. Panoramic *comic strip* slides added to the levity of the entertainment, while slipping slides and lever slides continued the progress toward the development of a moving image. Rack-work slide projection could simulate movement and rotation and even simulate continuous movement, such as smoke rising from a chimney.

The magic lantern slide images were not always hand-drawn and hand-painted images. By the late 1850s magic lantern slides were also photographically produced and then often, but not always, hand colored. The photographic process was becoming increasingly popular as a means of producing images for the magic lanterns. Drawings and engravings were also photographically reproduced as slides for the magic lanterns. The amateur photographers were encouraged to make their own photographic slides. So popular was the interest and production of slides and slide shows that the Crystal Palace presented slide shows daily throughout the 1880s and 1890s.

Two major slide publishers in London ran exhibition galleries where thousands of slides were available for viewing. Most slide publishers manufactured and sold hand viewers, usually constructed of mahogany with adjustable eyepieces, for looking at the transparencies so that they could be evaluated without the need to project them. The dealers sold the magic lantern slides either plain or colored, and if the customer wanted to personally paint the slides, a set of transparent slide painting pigments could also be purchased.

The original, single-candle japanned tin lanterns gave way to more ornate models. The drawing-room version was made of mahogany with brass fittings on the highly polished lacquered doors. Some magic lanterns had multiple chimney arrangements. The single candle was replaced by oil lanterns, then by gas, and finally by electricity.

There were a variety of slide-changing mechanisms. The *Metamorphoser* allowed one slide to be withdrawn as another slide replaced it. Another device had a descending curtain-like object lower between the changing slides and an endless loop device projected rapidly changing panoramas. Stacked or multiple lens magic lantern projectors provided an early multimedia-style slide show. This was possible by turning up the flame of one lantern (brightness control) while lowering the flame of another; the images appeared to fade in and out from one to the other. A day scene turned into a night scene was the most common change. Second in frequency of occurrence was a black-and-white image dissolving into a full color version of the same image. Live models were photographed in the real world or against a painted background scene, not unlike a Hollywood movie today. The use of photographic superimposition created a new visual vocabulary for the slide show, showing the audience a thought, an idea, either by projecting one image onto another or producing a multiple combination print and then converting it into a slide for projection.

The motion-picture projector came about through the evolution of image-projecting toys coupled with the magic lantern. The Projecting Phenakistoscope used a disk of

images that revolved across a shutter-like device in front of a magic lantern, projecting a smooth moving sequence. This shutter-like device was a key to the smoothing of action in projected imagery and lead to the development of contemporary motion-picture projectors. The Thaumatrope, a disk containing two or more images placed around the center that is twirled by two attached strings. The result is a single image that combines the separate images into one. By adjusting the tension on the string while the disks are spinning, the speed of rotation and the visual effect could be changed. The Zoetrope was another persistence-of-vision toy, capable of depicting the illusion of motion. A large, thin-walled metal drum with slits in the sides, capable of revolving easily around a pivot point at its base axis, is spun around very quickly. Inside the drum is mounted a long, narrow strip of photographic images or drawings that simulate a sequence of some simple action. The viewer, looking through one of the slits in the revolving drum, sees a moving image.

Other devices somewhat similar to the Zoetrope added to the numbers of toys that projected or displayed moving images. The Praxinoscope Theatre is a toy with two concentric rotating drums and a strip of images rotating on the inside of the outer drum. These rotating images were reflected on pieces of glass in the center drum, which also contained a stationary section that held little pieces of scenery. To the eye, the stationary scenery became the background over which the reflected moving images of the large drum danced. The Viviscope, and the Tachyscope were also based upon the Zoetrope. The use of instantaneous photography, when combined with the principles learned from the magic lantern projection devices and coupled with the persistence-of-vision toys, led to the development of the motion picture.

The projected image is a performance activity that is intended to communicate with an involve the audience. Unlike the single photograph, slide shows and motion picture provide, if viewing conditions are ideal, an intense, fully saturated color image far superior to that of a photographic print. Coupled with sound, scale, and a visually captured audience (since there is nothing else to look at) projected images are an especially effective communication medium. But all projected images are not equal, nor are they necessarily works of art. An overhead projected image may assist in lectures and demonstrations, but it is not as compelling as a slide show or film. Projection in this instance is for presenting information in visual form, the sole purpose of the projected image is to reach a larger audience with less effort and at the least possible cost for the desired effect.

The sequential still image slide show and filmstrip had been the industrial and educational standard for many years, and although the multimedia slide show had been around, in one form or another, since before the turn of the century, it wasn't until the development of the sound tape/slide synchronizer that the multiimage slide show became popular. The early 1970s saw the introduction of the slide programmer, with the ability to do quick cuts and varied dissolves. The late 1970s produced the electronic programmer, which permitted more sophisticated effects, with easier and faster programming and with the ability to control several projectors at once with a single control.

As the programming became easier to control, the photographic and projection techniques became more complex. The electronic programmer gave way to the microcomputer, which made it possible to control several banks of slide projectors, motion-picture projectors, lighting, and sound effects. These new more sophisticated multi-image shows with multiscreen projection began to take advantage of varied perspectives, closeup and panoramic vistas of the same subject side by side, essentially a multiviewpoint show.

Unlike filmstrips, video, and motion pictures, single-

image and multimedia slideshows can be edited instantly. For educational and commercial use, if something changes, a quick edit and the show is current at very little additional expense. In contrast, an entirely new motion picture, filmstrip, or video must be generated to include such updating. There are advantages and disadvantages of the various projection systems. The self-contained audio slide viewer permits the presenter to hand carry a slide tray, the projector, which has a built-in (usually 9×9-inch) rear-projection viewing screen and synchronized cassette tape player. These projection viewers make excellent point-of-purchase displays, sales promotion programs, and teaching tools, and, unlike most other projection presentations, the audio slide viewer does not need a darkened environment. Overhead projectors are useful for group presentation such as classroom lectures and business presentations, and are a necessary component for a personal computer LCD projection panel. These fan-cooled projectors can show large photographic transparencies (with subdued room illumination), standard overhead transparencies, and write-on projection films.

Computers are well on their way to becoming the major image-making, manipulating, and storage instrument. Interactive media puts the computer at the controls for bringing together video, film, videodisc, electronic still video, and, of course, computer-generated imagery. Animation, paint, presentation, and hyper-card type programs allow images to be arranged, cut and pasted or sequenced, and shown on the computer screen, (a cathode-ray tube or color monitor display), or sent directly to a LCD panel/overhead projector unit to be projected on a projection screen or sent to a video projection system for presentation on either a rear-projection screen or front-projection screen, or sent to a printer for a hard copy print.

The new Photo CD, a compact disc that contains photographic imagery as well as sound, text, and graphics, is bound to become a major force in multimedia presentations. Each disc can hold up to 100 images. Each image is represented in five different formats ranging from a thumbnail image for previewing, to a high-quality detail image file for photographic printing or TV viewing.

The laser disc or videodisc is another source of projectable imagery. Each disc can hold about 54,000 tracks, or frames, per side. This means that about a half hour of visual images can be stored and recalled. The recorded images can be played on a videodisc player and can contain sound as well as pictures. Coupled to a computer, with the proper software, the computer disk and player can become a random-access generator for high-quality color video, still photography, or motion-picture film. The images can be projected onto large rear- or front-projection screens with a video projection system.

The more traditional computer-ware has evolved to encompass a virtual reality simulation system. Armed with a DataGlove and EyePhones, the viewer/user/player can now interact with computer-generated imagery by moving around in simulated worlds, complete with 3-D sound.

To ensure an ideal presentation, the projection equipment should be set up before the audience arrives, the sound tested, and the projectors focused and aligned, especially if more than one projector is to be used. Extra projection lamps, extension cords, flashlight, and gaffer tape should be part of the equipment carried to any projection location. If possible, the projectors should be isolated from the audience with a soundproof booth. If that is not possible, then the projectors should be as far behind the audience as is physically possible. With noisy equipment in the room with the audience, sound-absorbing partitions or screens should surround the equipment. For informational presentations that contain text and numbers, the audience should be no farther away

than 8 times the screen height. If the text is larger than standard size or the program content is entirely pictorial, the screen-to-audience distance can be increased to 14 times the screen height. *M. Teres*

PROJECTION PRINTER See *Enlarger; Optical printer.*

PROJECTION PRINTING Exposure of light-sensitive printing material by projecting the image with an enlarger. The original may be a positive or a negative; the enlarger may be vertical or horizontal; the resulting print may be larger, smaller, or the same size as the original image. *H. Wallach*

PROJECTION SCREEN The most important characteristic of the projection screen is the reflective front surface. Projection screens are made from fabrics or plastics coated with substances that have highly reflective properties. Permanently installed theater screens are stretched tightly over a frame in order to keep the screen surface as flat and wrinkle-free as possible. Projection screens that roll up like a window shade provide portability, and also flexibility in the use of wall space with installed screens. Many projection screens are custom fabricated to the individual needs of the user. Specifications such as the kind of coatings, that is, aluminized, pearlescent, smooth, embossed, lenticulated and nonlenticular, matt, and textured will affect the reflectivity of the screen, the angle within which the audience can be seated, and how the ambient light affects the screen image. Manufactured reflective coatings produce brighter images (within a limited angle) than painted surfaces. Heavy gauge vinyl film screens are flameproof, mildew resistant, and in some cases washable.

There are several basic types of projection screens. *Beaded* screens reflect light back toward the source over a narrow angle, so that these screens are best suited for long, narrow rooms or rooms where the seating is within a 20- to 30-degree angle on either side of the projection beam. Because beaded screens concentrate light and produce very bright images, they are useful in rooms where there is a high level of ambient light. *Lenticular* screens have a regular or irregular raised pattern that act like tiny reflecting mirrors. These patterns are not noticeable from normal viewing distances and help to intensify the projected image by reflecting the projected image back to its source, the projector, which is in the direction of the audience. This same pattern helps to reduce image degradation from ambient lighting that falls on the projection screen from above or from the sides by reflecting the ambient light back to its source, which is away from the direction of the audience. Lenticular screens should be flat or slightly concave. The angle at which the projected image strikes the screen surface is important in that it controls the angle of reflection, and it may be necessary to aim the angle of the screen for the best results. *Matt* screens, also known as surface diffusers, reflect the incident light evenly in all directions. Regardless of where the viewer sits, the projected image appears equally bright. Unfortunately, this equally bright image is not as bright (for those sitting within a certain angle) as other, more directional types of screens. The matt screen is best suited for large widely spread out audiences. Matt screens can be inexpensive, since any dull-surfaced, white-painted wall can be used. *M. Teres*

See also: *Front projection; Rear projection.*

PROJECTION SYNCHRONISM In motion-picture production, the alignment of the sound track and picture in order to match their placement on a composite release print, with the sound track placed ahead of its corresponding picture. Because the optical or magnetic sound head on a pro-

jector is placed along the film path ahead of the projection lens, this alignment provides for synchronization between picture and sound. *H. Lester*

Syn.: *Printer synchronization.*

PROJECTIVE TRANSFORMATIONS In geometry, a transformation of data plotted in one plane by projecting it onto another plane by means of lines emanating from a point suitably situated outside of both planes. Such transformations can be defined by sets of simultaneous linear equations. For any given colorimetric observer, all chromaticity diagrams are linear transformations of all others; hence, a straight line in any one such diagram will be a straight line in all other such diagrams. *R. W. G. Hunt*

PROMPT In a nongraphical interface environment, the graphical cursor is replaced by the prompt that simply locates the position of the text about to be entered or just entered. The prompt may be as simple as the sign ">" or as complicated as statement of disk drive and directory in use, "C:\HG>." *R. Kraus*

PROOF PRINT (1) A test print made to determine if anything needs to be changed in a picture setup or the procedure for making a photograph. (2) A print of a negative or set of negatives to serve as a file copy of the pictures and to facilitate selecting negatives to be used for quality printing. *L. Stroebel*

PROPAGATION (SOUND) The process by which sound is distributed through a medium, by molecules nearer the source progressively imparting energy to ones farther away through mechanical vibration. *T. Holman*

PROPORTIONAL (1) In image intensification and reduction, specifying a change in density equal to a fixed percentage of the original density in each area of the image. Such a change is equivalent to that caused by an increase or decrease in the original time of development. (2) In mathematics, a relationship whereby doubling the value of the input variable doubles the value of the output variable. Such a relationship plots as a straight-line graph passing through the origin (the 0,0 point). Distinguished from a linear relationship, which plots as a straight line passing through a point other than the origin. *H. Todd*

PROPORTIONAL INTENSIFICATION Intensification in which the percentage of density increases is constant at each density level in the original negative. Most common intensifier formulas produce a proportional effect. Exceptions are those intended to enhance high contrast negatives and positives such as in graphic arts work (superproportional), and those that add a larger percentage (but not a larger amount) to the thinner areas than to the denser areas (subproportional). *I. Current*

See also: *Subproportional; Superproportional intensification.*

PROPORTIONAL MODELING LAMP Continuous previewing lamp used in an electronic-flash head. It dims in proportion to reductions in flash intensity (e.g., half- and quarter-power settings) so that shadow and contrast changes can be seen before taking the picture. *R. Jegerings*

See also: *Focusing light; Light sources.*

PROPORTIONAL REDUCERS Proportional reducers remove a given percent of image silver at each density level, thus lowering the contrast of the negative. It is thus the choice for correcting negatives that have been overdeveloped, and where it is desirable to reduce contrast as well as density. *I. Current*

PROTAN Adjective denoting protanopia or protanomaly, types of defective color vision. *R. W. G. Hunt*
See also: *Color deficiency.*

PROTANOMALY Defective color vision in which a person, compared to one with normal color vision, requires more red in a red-green mixture of light to match a given yellow color. *L. Stroebel and R. Zakia*
See also: *Defective color vision; Deuteranomaly; Deuteranopia; Protanopia.*

PROTANOPIA Defective color vision in which a person sees only blue and yellow in the spectrum. Lacking a red/green chromatic response system, reds and greens are seen as gray. The luminosity curve of protanopes is shifted to the left. *L. Stroebel and R. Zakia*
See also: *Defective color vision; Deuteranomaly; Deuteranopia; Dichromatism; Protanomaly.*

PROTECTED COUPLER A color former (coupler) in chromogenic films and papers immobilized in its proper layer through some method such as dispersion of its solution in a water-immiscible liquid or as an insoluble salt. Protected couplers reduce color contamination in images. *M. Scott*

PROTECTIVE COATINGS
FIXATIVE A protective spray used to protect pencil and pastel artwork from smudging. Various manufacturers use different chemicals as fixative, so care should be exercised in choosing one for photographs. Chemicals used include plastic, varnish, shellac, and lacquer. Be attentive to where you use them since they are usually volatile and toxic. Fixatives are available in bulk or in convenient spray cans. The artwork should be held vertically (straight up) when the fixative is sprayed on the surface of a print. Stand about 12 to 18 inches away from the print and spray at right angles, covering the entire surface as quickly as possible. Two light coats of fixative are better than one coat that is applied too heavily.
LACQUER Lacquer retouching sprays are available in a variety of types for initially preparing the surface of a photograph for retouching or to protect photographs that have been retouched. Dull or matt sprays provide a retouching tooth for protecting both glossy photographic papers and/or pencil, pastel, and paint retouching media while working on the print. In addition to surface preparation for retouching photographs, lacquers provide scuff protection, moisture and dirt protection, and ultraviolet radiation protection. Print lacquers are also used to embellish photographs with a variety of different surfaces such as, matt, semimatt, heavy texture, and high-gloss coatings. Brush or spray textures are companion retouching compounds that are formulated to show brush marks, which gives a photograph a hand-painted appearance. Other varieties of texture compound emulate linen, leather, weave, and pebble, and may be applied over retouching lacquers. *M. Teres*

PROTON A proton is a positively charged particle found in the nucleus of all atoms, having a mass of 1836 times that of the electron. Protos and electrons are equal in numbers in the atom but are opposite in charge. The third particle of the atom, the neutron, is found only in the atomic nucleus, being essentially the same mass as the proton. *G. Haist*

PSEUDO-COLORING In electronic imaging, black-and-white images captured by video or scanned into the computer may be displayed in color. The color displayed will not have any relationship to the actual image, but rather will be colored according to a look-up table that assigns colors according to group brightness levels within the image. For example, a pseudo-coloring program may divide the range of

brightnesses within an image into eight levels each containing 32 brightness levels and then assign a color to each level. The original black-and-white image will then be displayed in eight colors. In scientific imaging, pseudo-coloring is used to make subtle features of the image more visible, such as in radioangiography. The corresponding photographic technique of pseudo-coloring is posterization. *R. Kraus*
See also: *False color.*

PSEUDOISOCHROMATRIC A test for defective color vision in which a display of color dots, to be seen as figure, are placed against a similar background of gray dots. Some of the figures cannot be seen by persons with defective color vision. *L. Stroebel and R. Zakia*
See also: *Defective color vision.*

PSEUDOSCOPIC PAIR A pair of stereoscopic images that have been switched in a viewer, or a pair of identical photographs used in a stereoscope. *L. Stroebel*
See also: *Perspective.*

PSEUDOSTEREOSCOPY (1) An enhanced appearance of depth in two-dimensional images made with a single lens achieved by using factors such as overlapping objects, appropriate lighting, a shallow depth of field, aerial haze, a wide-angle lens, and wide-screen photography. (2) The use of two identical images in a stereoscopic viewing device. *L. Stroebel*
See also: *Perspective.*

PSOPHOMETER See *Noise meter.*

PSYCHIC PHOTOGRAPHY See *Spirit photography.*

PSYCHOLOGICAL EFFECTS See *Visual perception, physical, physiological, and psychological factors.*

PSYCHOLOGICAL PRIMARY COLORS Colors that do not appear to be mixtures of other colors, which include the hues red, green, blue, and yellow and the neutral colors black and white. *L. Stroebel*
See also: *Primary colors.*

PSYCHOPHYSICS The scientific study of the relationship between the physical attributes of a stimulus and the perceptual response of the viewer. A goal of psychophysics is to be able to predict the appearance of a stimulus on the basis of physical measurements of the stimulus. For example, sodium vapor emits a narrow wavelength band of radiation at approximately 590 nm, and it can be predicted that viewers generally will identify the color of the light as being yellow. *L. Stroebel and R. Zakia*
See also: *Photometry and light units.*

PUBLICATIONS, PHOTOGRAPHIC Although the literature of photography has a relatively brief history, it is rich and varied. Photographic publishing has grown steadily over the past 40 years as scholars have been drawn to the history of photography as a new field of cultural inquiry, the public has responded to photography's increasingly accessible technology, and society has become ever more image-hungry.
This essay has a twofold purpose: to provide a basic reading list of publications on a wide range of photographic topics and to help readers pursue specific topics in greater depth. The books and periodicals it lists provide sound information and are readily available from book dealers or libraries; nearly all are recent publications. Works that include bibliographies or other references have been given

preference over those that do not, and works in English have been favored over those in other languages. Basic reference tools for popular areas of photographic research have been described in detail. The information in each citation meets standard interlibrary loan requirements.

Because photography has only recently been accepted as a distinct field of historical inquiry, its bibliographic systems are still being developed and are primitive compared with those for well-established related disciplines in the physical sciences and fine arts. Although much progress has been made in the past ten years, photographic research requires persistence and ingenuity from students and scholars alike. This poses a challenge but also provides opportunities to break new ground.

HISTORICAL BACKGROUND *The Truthful Lens: A Survey of the Photographically Illustrated Book, 1844–1914* by Weston J. Naef and Lucien Goldschmidt (New York: The Grolier Club, 1980, 241 pages) is the most thorough history of its subject. The authors estimate that as many as 4000 books illustrated with original photographs were published between the appearance of Talbot's *Pencil of Nature* in 1844 and the ascendency of halftone reproductions in the 1880s. Julia Van Haaften, in her essay and catalog "Original Sun Pictures: A Check List of the New York Public Library's Holdings of Early Works Illustrated with Photographs, 1844–1900," (*Bulletin of the New York Public Library* (80 Spring 1977): 355–415), describes the early emergence of basic genres that still define photographically illustrated publications: travel, anthropology, art, history, and physical science. Helmut Gernsheim's *Incunabula of British Photographic Literature: 1839–1875,* and *British Books Illustrated with Original Photographs* (London: Scholar Press in association with Derbyshire College of Higher Education, 1982, 159 pages) is a catalogue raisonnée of British books illustrated with photographs and is based on Gernsheim's own collection. Beaumont Newhall's *Photography and the Book* (Boston: Trustees of the Public Library of the City of Boston, 1983, 52 pages) discusses the use of photographic illustrations from the mid-nineteenth century through the 1950s.

The basic categories of literature about photography were also quick to emerge. Carol J. Fruchter explains in "Photographic Literature of the Nineteenth Century" (*AB Bookman's Weekly* 78, November 3, 1986, 1737–1754) that the technical treatise or manual was one of the first and most important genres to develop: "It was the publication of such information that taught many early photographers the procedural and chemical aspects of the science-based art. . . . Many of the discoveries made and processes and apparatus invented relied upon previously published information. It was the publication of photo-technical books and pamphlets that allowed for the cross-germination of ideas that accelerated progress" (Fruchter, "Photographic Literature," 1746). Daguerre's *Historique et description des procedes du daguerreotype et du diorama* (Paris: Susse Frères, 1839) appeared the very year he announced his discovery, but treatises on the scientific principles upon which photography is based had begun appearing more than a century before.

Trade catalogs were also among the earliest photographic publications. Catalogs issued by companies such as E. and H.T. Anthony, Scovill and Adams, and others provided descriptions and illustrations of materials and products offered for sale, often through mail-order service. Other types of manufacturer's literature can also be traced back to the first years of photography. A manufacturer's instruction booklet, *Ackermann's Photogenic Drawing Apparatus* (number 639 in Gernsheim's *Incunabula of British Photographic Literature, 1839–1875*), survives from 1839. *The Scovill's Photographic Series* included both instructional and educational titles.

Treatises on purely aesthetic aspects of the discipline followed somewhat later, becoming a well-defined genre only at the end of the century, after the technical problems of making permanent images had been solved. Henry Peach Robinson's *Pictorial Effect in Photography, Being Hints on Composition and Chiaroscuro for Photographers* (London: Piper and Carter, 1869, 199 pages), one of the first and most popular treatises, was reprinted many times and translated into several languages. The prevailing taste of the period is documented in catalogs of photographic exhibitions and salons, the often ephemeral records of events sponsored by photographic societies and clubs. Most nineteenth- and early twentieth-century international expositions included photographic as well as art exhibitions, many of which were commemorated with substantial catalogs.

Photographs were first used to illustrate a periodical in 1846. William Henry Fox Talbot demonstrated his new "Talbotype" process by producing 7000 calotypes, which were hand-mounted in the June 1, 1846, issues of *The Art-Union*. William Owen's *Modern Magazine Design* (New York: Rizzoli, 1991, 240 pages) traces the development of the magazine illustrated with photomechanical reproductions, beginning with the universal adoption of the halftone screen process in the 1890s, continuing with the rise of the picture magazines in the 1920s and 1930s, and culminating in the *great age* of magazine design from the mid-1940s through the 1960s. The history of the illustrated periodical is also chronicled in Naomi Rosenblum's "Words and Pictures: Photographs in Print Media 1920–1980," the tenth chapter of her *A World History of Photography* (2nd ed. New York: Abrams, 1989. 460–513).

Early experiments with photography were documented in the science, art, and general interest press throughout the nineteenth century. In the 1969 edition of *The History of Photography: From the Camera Obscura to the Beginning of the Modern Era* (New York: McGraw-Hill Book Co., 1969), Helmut Gernsheim lists photographic journals and annuals first published between 1850 and 1861 (Gernsheim, *History of Photography.* 586–588). The first, *The Daguerrian Journal Devoted to Daguerrian and Photogenic Art,* was published in New York by S.D. Humphrey on November 1, 1850, and continued under the title *Humphrey's Journal of Photography* until July 1870. The longest-running photography periodicals, *The Photographic Journal* and *The British Journal of Photography,* began publication (both under different titles) in 1853 and 1854, respectively, and continue to this day.

Contemporary Reprint Series Their scarcity and value keep most original copies of early books, periodicals, catalogs, and pamphlets on photography in special libraries or private collections, off-limits to the average researcher. Many significant early publications have become much more widely available, however, thanks to several series of reprint editions. The most extensive of these, *The History of Photography* (Woodbridge, Conn.: Research Publications, 1979–1982), provides microfilm copies of 2195 books and 100 periodicals published in the United States and Western Europe from 1839 through the early years of the twentieth century. The series represents all aspects of photographic publishing: significant photographically illustrated books, trade catalogs, reference books, and treatises on the aesthetics, history, science, and methods of photography. *Early Rare Photographic Books* (London: World Microfilms, 1979) reprints on microfilm 62 titles, most of which were originally published in the United States or the United Kingdom. The series is strongest on technical treatises and instructional manuals, but includes a few works on aesthetics.

Peter Bunnell and Robert A. Sobieszek edited two hardcopy reprint series for Arno Press (New York). *The Literature of Photography,* issued in 1973, includes 62 volumes on

aesthetic, technical, scientific, and historical aspects of photography, books, and a few anthologies of shorter pieces published in the United States and the United Kingdom from 1840 to 1939. *Sources of Modern Photography*, a series of 51 volumes published in 1979, includes several anthologies of short pieces and complete reprints of works published between 1796 and 1949. The scope of the second series is broader than the first, and includes works on history and aesthetics, reference sources, technical and scientific treatises, and even patents. Materials were drawn from the United States, the United Kingdom, Germany, France, and the Soviet Union.

Dover Publications (New York) continues to add to its list of early titles reprinted in inexpensive but well-made paperbacks. Titles include the 1959 edition of *Gardner's Photographic Sketchbook of the Civil War* (first published as *Gardner's Photographic Sketch Book of the War*. 2 vols. Washington, D.C.: Philip and Solomons, 1866) and *Muybridge's Complete Human and Animal Locomotion* (1979, 1597 pages) which reproduces the 781 plates from the photographer's *Animal Locomotion: An Electro-photographic Investigation of Consecutive Phases of Animal Movements* (11 vols. Philadelphia: University of Pennsylvania, 1887).

GENERAL REFERENCE SOURCES
Bibliographies and Library Catalogs The first significant published bibliographies of photography were the library catalogs of the Royal Photographic Society of Great Britain (*Library Catalogue*. London: Royal Photographic Society of Great Britain, 1939; supplements issued in 1952 and 1953) and the Epstean Collection at Columbia University (*A Catalogue of the Epstean Collection on the History and Science of Photography and its Applications, Especially to the Graphic Arts*. New York: Columbia University Press, 1937, and its supplement, *Authors and Short Title Index, Epstean Collection*. New York: Columbia University Library, 1938. Reprint. Pawlet, Vt.: Helios, 1972). Both catalogs include books and periodicals. The Epstean Collection is especially rich in materials on the technical aspects of photography. The Royal Photographic Society collection has a somewhat broader scope.

Library catalogs continue to serve as excellent bibliographic sources. Photographica: A Subject Catalog of Books on Photography Drawn from the Holdings of the New York Public Library, Astor, Lenox and Tilden Foundations (New York: G.K. Hall, 1984, 380 pages) provides access to 8000 books and periodicals in the collection through 1971. With author, title, and subject listings for approximately 30,000 books on the history, aesthetics, technology, and science of still and motion-picture photography, the Library Catalog of the International Museum of Photography at George Eastman House (4 vols. Boston: G.K. Hall, 1982) is the most comprehensive published bibliographical source. Also useful are published library catalogs of other institutions with significant collections on photography, among them the Museum of Modern Art (14 vols. Catalog of the Library of the Museum of Modern Art, New York. Boston: G.K. Hall, 1976).

Albert Boni's landmark *Photographic Literature* (2 vols. New York: Morgan and Morgan, 1962, 1972) was for many years the only substantial published bibliography of photography. Its two volumes, the first covering 1727 to 1960 and the second 1960 to 1970, include listings for over 12,000 monographs, periodical articles, and pamphlets. They provide the best coverage for photographic science and technology and are also a good source of basic writings on the history of photography. Boni's work has been supplemented in recent years by several ambitious bibliographies of photography. *History of Photography: A Bibliography of Books* by Laurent Roosens and Luc Salu (London: Mansell, 1989, 446 pages) includes citations to more than 11,000

books, exhibition catalogs, dissertations, offprints, and other published sources. Its scope is international, although strongest for European sources. The authors claim comprehensive coverage of publications prior to 1914 and provide selective coverage thereafter.

Frank Heidtman's *Bibliographie der Photographie deutschsprachige Publikationen der Jahre 1839–1984: Technik, Theorie, Bild* (2nd rev. and enl. ed. 2 vols. Munich: K.G. Saur, 1989) is limited in geographic scope, but its 24,000 citations provide nearly comprehensive coverage of nonperiodical German-language publications on the history, aesthetics, sociology, and technology of photography. *Nineteenth-Century Photography: An Annotated Bibliography, 1839–1879*, compiled by William Johnson (Boston: G.K. Hall, 1990, 962 pages) draws many of its 21,000 citations from periodicals, and in fact provides the only systematic subject access to more than 50 important nineteenth-century photography journals and general-interest magazines. Although it includes a wide range of topics on the history and applications of photography, it is strongest on material about individual photographers. As scholarship in the history of photography develops, many useful reference works on specialized topics are being published. Penelope Dixon's *Photographers of the Farm Security Administration: An Annotated Bibliography, 1930–1980* (New York: Garland, 1983, 265 pages), for example, is a comprehensive compilation of books, periodicals, theses, and nonbook media on the FSA and the 13 photographers most closely associated with it.

Encyclopedias and Dictionaries Very few truly encyclopedic reference works have been published in recent years. *The Encyclopedia of Photography*, edited by Willard D. Morgan (20 vols. New York: Greystone Press, 1963), along with its earlier edition, *The Complete Photographer* (11 vols. New York: National Educational Alliance, 1942–1949), remains the most comprehensive title covering all aspects of still and motion-picture photography. The work is now very dated, although both editions continue to have invaluable historical significance and much of their material on basic principles and methods of photography remains valid. *The Encyclopedia of Practical Photography* (14 vols. Garden City, N.Y.: Amphoto, 1977–1979) edited by Eastman Kodak Company, is a guide to the materials, processes, and techniques of modern still and motion-picture photography. It includes substantial instructional articles and briefer definitions written in clear, direct prose. The encyclopedia has only limited historical information, most of it technical, and a small selection of biographical entries. It is illustrated throughout with diagrams, charts, graphs, and color and black-and-white photographs in the characteristic Kodak style. Each volume of the *Life Library of Photography* (Rev. ed. 16 vols. Alexandria, Va.: Time-Life Books, 1981–1983,) is devoted to a theme, such as *The Camera*, *Photojournalism*, and *The Art of Photography*. The series emphasizes the expressive and communicative aspects of the medium but also includes clear technical explanations of materials and processes. It is illustrated with well-selected photographs, some historical and some commissioned for the series.

The *International Center of Photography Encyclopedia of Photography* (New York: Crown Publishers, 1984, 607 pages) is the most substantial of several one-volume general reference works published in recent years. It covers technical, scientific, aesthetic, and commercial aspects of still and motion-picture photography. Topics are well chosen and entries range from brief definitions to substantial articles. The encyclopedia includes biographical entries for 250 photographers, scientists, and inventors, and it is liberally illustrated with color and black-and-white photographs, diagrams, charts, and graphs. *Dictionary of Contemporary Photography* by Leslie Stroebel and Hollis N. Todd (Dobbs

Ferry, N.Y.: Morgan and Morgan, 1974, 217 pages) is intended to be "a record of current usage in professional and illustrative photography, cinematography (including animation), and photographic engineering and science." It also includes terms from related disciplines relevant to photography—fine arts, graphic arts, physics, psychology, and so on. The definitions are brief but informative, and the book is illustrated with numerous diagrams, line drawings, and black-and-white photographs. *The Focal Dictionary of Photographic Technologies* by D.A. Spencer (London: Focal Press, 1973, 725 pages) covers scientific and technical aspects of still and motion-picture photography, drawing terms from related disciplines as well. It emphasizes contemporary technology, but includes key historical terms. Its definitions are succinct, and some entries include diagrams, graphs, or charts. Luis Nadeau's *Encyclopedia of Printing, Photographic, and Photomechanical Processes: A Comprehensive Reference to Reproduction Technologies* (2 vols. Fredericton, New Brunswick: Atelier Luis Nadeau, 1989) gives definitions for 1500 terms related to historical and contemporary processes. Many entries include references, and an extensive list of sources is given. *Cassell's Cyclopaedia of Photography* edited by Bernard E. Jones (London: Cassell and Company, 1911. Reprint. *Encyclopedia of Photography.* New York: Arno Press, 1974, 572 pages) covers the universe of photography as defined at the turn of the century. It provides invaluable, easily accessible documentation of early processes and techniques that are often omitted from later reference works. Detailed descriptions and recipes are given for all major nineteenth-century processes, and photographs, diagrams, line drawings, tables, and charts illustrate the text.

HISTORY AND CRITICISM

General Surveys In his introduction to *A History of Photography: Social and Cultural Perspectives* (Cambridge, England: Cambridge University Press, 1986), Jean-Claude Lemagny reflects upon the historiography of photography: "The first historians of photography were collectors (Gernsheim, for example). . . . Then professors and scholars such as Beaumont Newhall were drawn to the subject. Now theses on specific areas are beginning to appear, with all that that implies in terms of specialization and—as the word 'theses' itself suggest[s]—subjective views." Lemagny's analysis provides a convenient framework to discuss contemporary literature on the history of photography. The first two general histories remain important, but have been joined by a host of works on special genres or written from special perspectives.

Beaumont Newhall's *The History of Photography: From 1839 to the Present* was first published as the illustrated catalog for the exhibition, "Photography 1839–1937," which Newhall organized at the Museum of Modern Art in 1937. Now in its fifth edition (5th rev. and enl. ed. New York: Museum of Modern Art, 1982, 320 pages), it is the standard history—readable, well-illustrated, carefully documented, and authoritative. Helmut Gernsheim's *The History of Photography* first published in 1955, has in its third edition expanded beyond the confines of a single volume. Two of the three volumes projected have been published as of this writing: *The Origins of Photography* (New York: Thames and Hudson, 1982, 280 pages) and *The Rise of Photography, 1850–1880: The Age of Collodion* (New York: Thames and Hudson, 1988, 285 pages). As were the earlier editions, they are organized according to the major technical developments in photography. The books are based on original sources and are exhaustively documented. The work has superior illustrations; the reproductions of daguerreotypes are especially well done, using a process that mimics the reflective quality of the originals.

Newhall's and Gernsheim's histories have recently been joined by the equally comprehensive *A World History of Photography* by Naomi Rosenblum (2nd ed. New York:

Abrams, 1989, 672 pages). Rosenblum attempted to broaden her eminent predecessors' somewhat Eurocentric views of the history of photography by presenting a truly global cultural and technical perspective. She organized her history by themes—portraiture, advertising and photojournalism, documentation, and the camera as a medium of personal expression—and provides a chronological narrative for each. Rosenblum intersperses throughout the book chapters devoted exclusively to photography's technical development and provides a good bibliography on the aesthetic and cultural history of photography.

Surveys that focus on the aesthetic development of photography (that is, its history as an art form) include *The Art of Photography 1839–1989,* a collection of essays edited by Mike Weaver and Daniel Wolf (New Haven: Yale University Press, 1989, 472 pages) and Volker Kahmen's *Art History of Photography* (New York: The Viking Press, 1974, 232 pages. Originally published as *Fotografie als Kunst.* Tübingen: Verlag Ernst Wasmuth, 1973). Contributors to *The Art of Photography,* among them Beaumont Newhall, Peter C. Bunnell, and Anne Tucker, trace "iconographic and technical developments that have rendered the medium an art form in its own right" through the work of a very select group of practitioners including Julia Margaret Cameron, Francis Frith, László Moholy-Nagy, and Helmut Newton. Volker Kahmen's essay on the nature of photography draws upon the ideas of Walter Benjamin. His work is illustrated with an extensive selection of photographs from the nineteenth century through the 1970s.

The social significance of photography is the subject of Michel F. Braive's *The Photograph: A Social History* (New York: McGraw-Hill Book Co., 1966, 367 pages.) Braive explores the impact of photography on culture, and how the culture shaped the development of photography from the origins of the medium through the 1950s. Gisèle Freund's landmark work, *Photography and Society* (Boston: David R. Godine, 1980, 231 pages), originally published as *Photographie et société* (S.I.: Editions du Seuil, 1974), explores the interaction of "artistic expression" and "social forms" from the invention of photography through the 1970s. She devotes much of her discussion to the use of photography in the mass media.

Josef Maria Eder's *History of photography* (New York: Columbia University Press, 1945, 860 pages, originally published as *Geschichte der Photographie* (4th ed. Halle: Knapp, 1932), was first published in 1905 and is considered the first modern history of photography. Eder's work is almost exclusively devoted to the technical history of the medium, and continues to provide a valuable record of the discovery of the principles of photography and the development of photographic processes and materials from the eighteenth through the end of the nineteenth century. It is exhaustively documented and based on original sources. *Pioneers of Photography: Their Achievements in Science and Technology* (Springfield, Va.: The Society for Imaging Science and Technology, 1987, 285 pages) is the symposium proceedings and papers of the "First International Congress: Pioneer of Photographic Science and Technology." It includes essays by twenty-six well-known scientists and scholars (Edwin H. Land, T.H. James, George Eaton, and Harold Edgerton among them) on the development of photographic technology and the rise of the photographic industry. Industrial history is the subject of *Images and Enterprise: Technology and the American Photographic Industry, 1839–1925* by Reese V. Jenkins (Baltimore: Johns Hopkins University Press, 1975, 371 pages). Jenkins explores the "role played by technology in the formulation of business strategy, the organization of enterprise, and the structure of the industry," shaping his narrative around the role of Scovill and Anthony before 1880 and Eastman Kodak after 1890.

History of Special Subjects and Genres of Photography
Research on special aspects of the history of photography
has proved a rich source of publications, many of them tied
to museum exhibitions. Studies of the development of
national and local schools of photography—perhaps the
most popular approach to the history of photography—are
too extensive to be fairly represented in this essay. A good
guide to this topic is provided by Julia Van Haaften in *Guide
to the Literature of Art History* by Etta Arntzen and Robert
Rainwater (Chicago: American Library Association, 1980.
379–383). The following is a highly selective list of material
on other important genres and subjects.

Ben Maddow's *Faces: A Narrative History of the Portrait
in Photography* (Boston: New York Graphic Society, 1977,
540 pages) and the more recent *Lichtbildnisse: Das Porträt
in der Fotografie* edited by Klaus Honnef (Köln: Rheinland-
Verlag, 1982, 744 pages) are comprehensive, profusely illus-
trated surveys of portraiture in Europe and the United States
from the daguerrean era through the present. A variety of
portrait genres (individual and group portraits, formal and
informal approaches) are explored in both works. Honnef
includes extensive biographical notes on photographers. *The
Naked and the Nude: A History of the Nude in Photographs,
1839 to the Present* by Jorge Lewinski (New York: Harmony
Books, 1987, 223 pages) covers fine art, scientific, and erotic
approaches to female and male figure photography. Con-
stance Sullivan presents a personal selection of photographs,
most of female subjects, in her *Nude: Photographs
1850–1980* (New York: Harper and Row, 1980, 203 pages).
The large and beautifully reproduced illustrations are sup-
ported with essays by Robert A. Sobieszek and Ben
Maddow.

*Era of Exploration: The Rise of Landscape Photography
in the American West, 1860–1885* by Weston J. Naef and
James N. Wood (Buffalo, N.Y.: Albright-Knox Art Gallery,
1975, 260 pages) and *Landscape as Photograph* by Estelle
Jussim (New Haven, Conn.: Yale University Press, 1985,
168 pages) have become the standard studies of this genre
which is so closely identified with the expansion of the
United States. *Architecture Transformed: A History of the
Photography of Buildings from 1839 to the Present* (Cam-
bridge, Mass.: MIT Press, 1987, 203 pages) by Cervin
Robinson and Joel Herschman traces the history of style in
Western European and American architectural photography,
as defined by two extremes, factual record and personal
expression. Richard Pare's *Photography and Architecture:
1839–1939* (Montreal: Centre Canadien d'Architecture,
1982, 282 pages) presents works from the Centre Canadien
d'Architecture collection, introduced by a brief essay and
documented by extensive notes.

Marianne Fulton's *Eyes of Time: Photojournalism in
America* (Boston: Little, Brown and Co., 1988, 326 pages)
traces the development of documentary photography from
the Civil War through the 1980s. Although concerned pri-
marily with the United States, Fulton discusses important
European trends such as the picture magazines of the 1930s.
James Guimond's more theoretical work, *American Photog-
raphy and the American Dream* (Chapel Hill: University of
North Carolina Press, 1991, 341 pages), is a thematic rather
than chronological study of documentary photography and
its impact on the American culture from the 1930s through
the present.

Robert A. Sobieszek's *The Art of Persuasion: A History of
Advertising Photography* (New York: Harry N. Abrams,
1988, 208 pages) traces its subject from 1865 to 1987,
emphasizing modern and contemporary work. Sobieszek
makes a case for the intrinsic value of these photographs, and
in most cases presents them as freestanding works of art
rather than in their original contexts. Martin Harrison's
Appearances: Fashion Photography Since 1945 (New York:

Rizzoli, 1991, 312 pages) is a chronological treatment of the
subject, and is strongest after the 1940s. The book has excep-
tionally good illustrations, most originally published in the
fashion press, but as in *The Art of Persuasion,* few are shown
in their intended contexts.

Criticism Over the past 20 years, critical writing about
photography has evolved from the general and observational
to the specific and analytical, paralleling the development of
historical writing about photography. The works listed in this
section include those frequently cited as important to the
development of contemporary critical discourse on photog-
raphy; a selection of more recent titles; and, as befits an
emerging discipline, anthologies of short pieces gathered
from the periodical press.

Walter Benjamin's *Illuminations* (New York: Harcourt,
Brace and World, 1968, 280 pages), includes "The Work of
Art in the Age of Mechanical Reproduction," his essay that
inspired much current critical writing. Susan Sontag's *On
Photography* (New York: Farrar, Straus and Giroux, 1973,
207 pages) presents six essays first published in *The New York
Review of Books.* The emergence of contemporary criticism
can be traced through the work of A.D. Coleman, whose
*Light Readings: A Photography Critic's Writings; 1968–
1978* (New York: Oxford University Press, 1979, 283 pages)
is a collection of pieces on photographers including Robert
Heinecken, Les Krims, Larry Clark, Bea Nettles, and Michael
Martone. *Camera Lucida: Reflections on Photography* by
Roland Barthes (New York: Hill and Wang, 1981, 119 pages.
Originally published as *La Chambre Claire.* Paris: Editions
du Seuil, 1980) is an unconventional, but important contribu-
tion to the critical literature of photography. Photographer
Robert Adams's *Beauty in Photography: Essays in Defense
of Traditional Values* (Millerton, N.Y.: Aperture, 1981, 108
pages) presents nine essays, some first given as lectures, some
previously published in nine periodicals. Max Kozloff's *The
Privileged Eye: Essays on Photography* (Albuquerque: Uni-
versity of New Mexico Press, 1987, 307 pages) collects 19
essays originally published in a variety of American art and
photography periodicals. Two British critics, Peter Turner
and Gerry Badger, have gathered selections of their work
from 1974 to 1987 in *Photo Texts* (London: Traveling Light,
1988, 180 pages). Aperture's *Writers and Artists on Photog-
raphy* series promises to provide a forum for contemporary
critical writing. Works in the series include Andy Grund-
berg's *Crisis of the Real: Writings on Photography,
1974–1989* (1990, 258 pages), a collection of 40 essays first
published in *The New York Times;* Estelle Jussim's *The
Eternal Moment: Essays on the Photographic Image* (1989,
277 pages), 22 essays grouped in three sections: "Visual
Communications," "Genres," and "Bio-History"); and
Wright Morris's *Time Pieces: Photographs, Writing, and
Memory* (1989, 154 pages), 15 selections that "investigate the
elusive synergy between text and photography" and are
reprinted from books, exhibition catalogs, and periodicals
such as *Critical Inquiry.*

Two recent anthologies draw from journals that serve as
important forums for contemporary photographic criticism,
most notably *Afterimage, Artforum,* and *October.* Douglas
Crimp, Martha Rosler, Rosalind Kraus are among the 15
contributors exploring the relationship of photography to the
broader culture in *The Contest of Meaning: Critical Histo-
ries of Photography,* edited by Richard Bolton (Cambridge,
Mass.: MIT Press, 1989, 407 pages). *The Critical Image:
Essays on Contemporary Photography* edited by Carol
Squiers (Seattle: Bay Press, 1990, 240 pages) also includes
15 essays by writers such as Abigail Solomon-Godeau,
Victor Burgin, and Griselda Pollack.

With 75 selections ranging from writers as diverse as
William Henry Fox Talbot and Allan Sekula, Vicki Gold-
berg's *Photography in Print: Writings from 1816 to the*

Present (New York: Simon and Schuster, 1981, 570 pages) has the broadest scope of any critical anthology. *Classic Essays on Photography* edited by Alan Trachtenberg (New Haven: Leete's Island Books, 1980, 300 pages) covers the period from the pre-history of photography through the 1970s in 30 selections by Oliver Wendell Holmes, Baudelaire, Alfred Stieglitz, Walter Benjamin, and others. Each section is introduced by the editor, who also provides a cogent overview of the history of photographic criticism. *Photography in the Modern Era: European Documents and Critical Writings, 1913–1940* (New York: Aperture, 1989, 350 pages) was published on the occasion of the exhibition, "The New Vision: Photography Between the World Wars, Ford Motor Company Collection at The Metropolitan Museum of Art," and documents photography from this period in selections drawn from the work of Jean Cocteau, El Lissitzky, Franz Roh, F.T. Marinetti, Man Ray, and over 60 other European and Soviet modernists. Two anthologies, Nathan Lyons's *Photographers on Photography: A Critical Anthology* (Englewood Cliffs, N.J.: Prentice-Hall, 1966, 190 pages) and Beaumont Newhall's *Photography: Essays and Images: Illustrated Readings in the History of Photography* (New York: The Museum of Modern Art, 1980, 327 pages) present the special view of photographers themselves. Lyons's collection has essays by 23 nineteenth- and twentieth-century photographers, including Henry Peach Robinson, Minor White, and Dorothea Lange, and provides biographical notes and an excellent bibliography of other writings by the contributors. Newhall's work is "a chronological presentation of points of view" ranging from 1760 to 1971, and has 54 contributions, including selections by Frederick Evans, Moholy-Nagy, and Aaron Siskind.

BIOGRAPHY Biography is one of the most popular areas of scholarly interest in photographic research. Biographical dictionaries are the best place to begin researching the life and work of photographers because they help establish basic facts about the subject's life and work. Most of the titles cited here also include references to other sources of information about the subject—books and periodical articles, exhibitions, and museum collections in which the subject's work is represented. Although coverage is far from comprehensive, the discipline is well served by several excellent general biographical dictionaries and many specialized sources, most of which have been published since 1980.

Biographical Dictionaries *Contemporary Photographers* (2nd ed. Chicago: St. James Press, 1988, 1145 pages) is the most informative of the biographical sources available to the researcher, and provides the fullest and most consistently reliable information. It includes profiles of 750 late nineteenth- and twentieth-century photographers and is international in scope. Each entry includes extensive biographical information, lists of exhibitions and collections in which the subject's work has been represented, a statement by the subject or by a critic about the subject's work, a black-and-white reproduction of a representative photograph, and a list of publications by and about the subject. *Macmillan Biographical Encyclopedia of Photographic Artists and Innovators* by Turner Brown and Elaine Partnow (New York: Macmillan, 1983, 722 pages) covers a broader range of photographic professionals, with listings for approximately 2000 nineteenth- and twentieth-century photographers, photoscientists, critics, teachers, and museum and gallery professionals. Entries are briefer than those in *Contemporary Photographers,* but give basic biographical and directory information and selected lists of publications and collections in which the subject's work is included. Michèle and Michel Auer's *Encyclopedie International des Photographes de 1839 a nos Jours: Photographers Encyclopedia International* (2 vols. Hermance: Editions Camera Obscura, 1985) provides basic biographical data, lists of

exhibitions, bibliographical citations, portraits, and illustrations of typical work for 1600 photographers working in all genres. The encyclopedia is international in scope and has parallel texts in French and English. *The Photograph Collector's Guide* by Lee D. Witkin and Barbara London (Boston: New York Graphic Society, 1979, 438 pages) includes biographies for 234 nineteenth- and twentieth-century photographers, and includes supplementary lists with dates and nationalities of 1000 daguerreotypists and 6000 photographers working in other media. The most extensive biographical reference source available is the *George Eastman House Photographers Biography File* (1990/91 ed. Rochester, N.Y.: International Museum of Photography at George Eastman House; distributed by Light Impressions, 1990). Updated regularly, the *Biography File* is issued on microfiche and lists almost 35,000 nineteenth- and twentieth-century photographers practicing in all genres. Entries are for the most part quite brief, citing life dates and nationalities. Selected lists of bibliographic citations, collections, and exhibitions are included for major figures. Carole Naggar's *Dictionnaire des Photographes* (Paris: Editions du Sevil, 1982, 443 pages) provides substantial entries that list exhibitions, collections, and publications by and about 420 nineteenth- and twentieth-century photographers and photography critics from around the world. Black-and-white photographs are given for many entries. At the time of writing, the newest general biographical source is *Who's Who in Photography* (Plymouth, Vt.: Five Corners Publications, 1991, 250 pages). Its compilers plan biennial updates of the work, which lists over 1500 living American professionals and *accomplished amateurs* active in advertising and editorial illustration, photojournalism, and portrait and wedding photography. Each entry includes directory and brief biographical information (birth, education, marital status), a selected listing of published work, exhibitions, and professional affiliations. Many entries also include small color illustrations.

Several biographical dictionaries provide extensive coverage of nineteenth-century photography. Gary Edwards's *International Guide to Nineteenth-Century Photographers and Their Works* (Boston: G.K. Hall, 1988, 591 pages) includes over 4000 photographers. It was compiled from auction catalogs published between 1903 and 1986 and thus, in addition to basic biographical data, provides descriptions of works sold (dates, processes, formats, general subject matter, and locations) and works illustrated in the source catalogs. Oliver Mathews's *Early Photographs and Early Photographers: A Survey in Dictionary Form* (New York: Pitman, 1972, 198 pages) gives brief biographical entries and bibliographies for some 300 photographers and photographic firms active through 1910. William S. Johnson's *Nineteenth-Century Photography: An Annotated Bibliography, 1839–1879,* although technically a bibliography, is primarily devoted to material about approximately 3600 individual photographers. In many cases, the author has provided biographical statements, some quite substantial.

Biographical sources are beginning to document specialized populations and their contributions to photography. Some reflect ethnic parameter, such as Deborah Willis-Thomas's *Black Photographers, 1840–1940: A Bio-Bibliography* (New York: Garland, 1985, 141 pages) and *An Illustrated Bio-Bibliography of Black Photographers, 1940–1988* (New York: Garland, 1989, 483 pages). Others, like Michael Pritchard's *A Directory of London Photographers 1841–1908* (Bushey: ALLM Books, 1986, 106 pages), are regional. Some even reflect dual specializations, as in Peter E. Palmquist's *Shadowcatchers: A Directory of Women in California Photography Before 1901* (Arcata, Calif.: P.E. Palmquist, 1990, 272 pages).

Several excellent specialized biographical directories are

included in or appended to surveys and histories. André Jammes and Eugenia Parry Janis's *The Art of French Calotype: with a Critical Dictionary of Photographers, 1845–1870* (Princeton: Princeton University Press, 1983, 284 pages) includes entries for approximately 150 "photographers who used the paper negative, not professional calotypists." The entries vary from brief lists of extant work to full biographies with critical descriptions of work, lists of exhibitions, bibliographies, and illustrations. The "Biographies" section of *The American Daguerreotype* by Floyd and Marion Rinhart (Athens: University of Georgia Press, 1981, 446 pages) provides dates, place of residence, and a brief description of activity for 1800 daguerreotypists and related artists.

Biographical Directories Directories facilitate personal contact between individuals sharing common interests, such as members of an organization, or sharing common needs, such as service providers and service users. Directories are updated frequently but rarely provide more information than current addresses and phone numbers (although most offer alphabetical and geographical indexes).

Useful membership directories providing access to a variety of groups within the photographic community include the *ASMP Membership Directory* (New York: American Society of Magazine Photographers, Annual), the British Institute of Photography's *Directory of Professional Photography* (Cheshire: McMillan Group. annual), the *Directory of Professional Photography* (Des Plaines, Ill.: Professional Photographers of America. Annual), the Society for Photographic Education's *Membership Directory and Resource Guide* (New York: SPE. Annual), Photographic Society of America's *PSA Membership Directory* (Philadelphia: PSA. Irregular), and *Who's Who in Photographic Management* (Jackson, Mich.: Photo Marketing Association International. Annual).

Creative directories are used by advertising, public relations, and other creative industry professionals to locate talent and support services—designers, illustrators, photographers, production facilities, labs, model agencies, and so on. They provide brief contact information, and most feature self-promotional advertisements showing work samples and providing other information (clients, publication credits, areas of specialization). Many creative directories are restricted to specific geographic areas, some to particular media, others to particular products. General titles that provide extensive coverage for American photographers include *Adweek Portfolio* (New York A/S/M/ Communications. Annual), *A.R.: The Complete Annual Report and Corporate Image Planning Book* (Chicago: Alexander Communications. Annual), *Corporate Showcase* (New York: American Showcase, Annual), *The Creative Black Book* (2 vols. New York: Friendly Publications. Annual), *N.Y. Gold* (New York: New York Gold Annual), *Chicago Talent Sourcebook* (Chicago: Chicago Talent, Inc. Annual), and *The Workbook, California Edition* (4 vols. Los Angeles: Scott and Daughters. Annual). Coverage for Canada is provided by *Creative Source* (Toronto: Wilcord Publications. Annual) and coverage of Great Britain by *The Creative Handbook* (West Sussex: British Media Publications. Biennial). *American Showcase of Photography* (New York: American Showcase. Annual), *Art Directors' Index to Photographers* (Geneva: Rotovision. Annual), and *Stock Workbook* (Los Angeles: Scott and Daughters. Annual), are creative directories limited to photographers.

Other special directories of professional photographers are *Green Book: The Directory of Natural History and General Stock Photography* (New York: AG Editions. Biennial) and "Feature Writer and Photographer Directory," Volume 4 of *Working Press of the Nation* (4 vols. Chicago: National

Research Bureau. Annual) both of which provide access by name and subject specialties.

Monographic Series One of most popular genres of photographic publishing is books about individual photographers' lives and work, ranging from picture collections to fully realized critical studies that make major contributions to scholarship beyond the purely biographical. Space limitations prevent the listing of titles on specific photographers here, but several outstanding monographic series are described below. In addition, Beaumont Newhall's "Photography," Section N of *Arts in America: A Bibliography* (4 vols. Washington, D.C.: Smithsonian Institution Press, 1979) provides a choice selection of books and exhibition catalogs for nearly 200 photographers, and works on more than 100 photographers are listed in the bibliography of Naomi Rosenblum's *A World History of Photography* (2nd ed. New York: Abbeville Press, 1989).

Aperture has published two excellent series on the work of individual photographers. The first, the *Aperture History of Photography* series, began publication in 1976. Fifteen photographers, among them Wynn Bullock, André Kertész, and Erich Salomon, were featured. Each volume has 96 pages and, like all Aperture publications, is well designed and has excellent reproductions. The *Aperture Masters of Photography* series, begun in 1988, profiles an international selection of photographers, including Paul Strand, Manuel Alvarez Bravo, and Berenice Abbott. Each modestly priced volume features a respected scholar or critic's essay about the photographer's life and place in the history of photography, 42 full-page black-and-white reproductions of the photographer's best-known work, a brief chronology, and a selected bibliography.

The *Photo Poche* series was produced and published by the Centre National de la Photographie in Paris beginning in 1983. Most titles in the series are devoted to the work of a single photographer. The series' "classic and contemporary photographers" include Robert Capa, Lee Friedlander, J.H. Lartigue, and Man Ray. The books are pocket-size paperbacks, with photos printed one to a page. A brief essay about the photographer, a bibliography, and a list of exhibitions are included. Many titles in the series were issued with English text as *The Pantheon Photo Library*.

Smithsonian Institution Press (Washington, D.C.) began publishing the *Photographers at Work* series in 1990. The series presents genre-related profiles of well-known contemporary practitioners, including Mary Ellen Mark (*The Photo Essay*, 1990) and Jan Groover (*Pure Invention—The Tabletop Still Life*, 1990). The books run to about 60 pages with full-page color reproductions. Each volume includes a brief biographical essay and an interview with the photographer.

Though technically a periodical, *The Archive* (Tucson: Center for Creative Photography, 1976–date) provides excellent information about individuals documented by the photographic and manuscript collections at the Center for Creative Photography at the University of Arizona. Two numbers of the research series are issued per year, and most are devoted to the work of a single photographer. Issues of *The Archive* usually feature one or more essays about a photographer and his or her work, a selection of photographs, and excerpts from archival materials in the center's collection. Begun in 1976 under the title *Center for Creative Photography Series,* its subjects have included Garry Winogrand, Laura Gilpin, and W. Eugene Smith.

PHOTOGRAPHIC SCIENCE AND TECHNOLOGY

Theory The *SPSE [Society of Photographic Scientists and Engineers] Handbook of Photographic Science and Engineering,* edited by Woodlief Thomas, Jr. (New York: John Wiley and Sons, 1973, 1416 pages), is a comprehensive reference work on the scientific and technical aspects of

traditional silver halide photography and related technologies. With chapters devoted to such topics as photographic optics, the physical properties of photographic materials, and photographic chemistry, it is liberally illustrated with photographs, charts, diagrams, and graphs. The final section, "Guide to Photographic Information," edited by Elizabeth W. Kraus and Clare E. Freund, is an extensive, carefully selected bibliography of books, periodicals, and other sources on these topics. *The Theory of the Photographic Process* edited by T.H. James (4th ed. New York: Macmillan, 1977), a comprehensive scientific study of silver halide photographic processes, is the most recent edition of a work first published in 1942. C.B. Neblette's *Photography: Its Principles and Practice* (New York: D. Van Nostrand Co., 1927), a work that has served as the standard textbook on photographic science for more than 60 years, traces the progression of photographic materials and processes. Its eighth edition, edited by John Sturge, Vivian Walworth, and Allan Shepp and retitled *Imaging Processes and Materials: Neblette's Eight Edition* (New York: Van Nostrand Reinhold, 1989, 712 pages), has been expanded to include chapters on imaging systems and applications that have evolved since the late 1970s. *Handbook of Imaging Materials,* edited by Arthur S. Diamond (New York: Marcel Dekker, 1991, 625 pages), is somewhat more limited in scope, covering both traditional and recently developed materials and processes for photographic and graphic arts applications. Both works have extensive lists of references for every chapter.

Many outstanding theoretical works on special aspects of photographic science are included in the extensive Focal Library series published by Focal Press (London and Boston). Among them are several English translations of important works first published in Russian and other languages. The topics addressed in the series include photographic optics (G. Franke's *Physical Optics in Photography,* 1966, 218 pages), photographic chemistry (K.S. Lyalikov's *The Chemistry of Photographic Mechanisms,* 1967, 355 pages), photographic emulsions (V.L. Zelikman and S.M. Levi's *Making and Coating Photographic Emulsions,* 1964, 312 pages), image evaluation (E.H. Linfoot's *Fourier Methods in Optical Image Evaluation,* 1964, 90 pages), and sensitometry (I.U.N. Gorokhovskii's *General Sensitometry,* 1965, 303 pages). Current topics in photographic science, imaging science, and related disciplines are addressed in the *Proceedings of SPIE,* the published record of papers presented at conferences sponsored by the International Society for Optical Engineering (Bellingham, Washington).

Several recent textbooks provide excellent coverage of the general principles of photographic science and technology and their practical applications. Foremost among these is *Photographic Materials and Processes* by Leslie Stroebel, John Compton, Ira Current, and Richard Zakia (Boston: Focal Press, 1986, 585 pages). Other clear introductions to the scientific foundations of the medium are provided in Michael J. Langford's *Basic Photography: A Primer for Professionals* (5th ed. London: Focal Press, 1986, 320 pages) and *Advanced Photography: A Grammar of Techniques* (5th ed. London: Focal Press, 1989, 320 pages); *Introduction to Photographic Theory: The Silver Halide Process* by B.H. Carroll, G.C. Higgins, and T.H. James (New York: John Wiley and Sons, 1980, 355 pages); and *The Manual of Photography* by Ralph E. Jacobson (8th ed. London: Focal Press, 1988, 394 pages).

A wealth of material deals with practical applications of major aspects of photographic science. *Photographic Optics: A Modern Approach to the Technique of Definition* by Arthur Cox (15th rev. ed. London: Focal Press, 1974) is a detailed explanation of photographic lenses. Written specifically for photographers, it includes a lengthy section of lens

tables and diagrams. Other useful works on photographic optics include *Applied Photographic Optics: Imaging Systems for Photography, Film, and Video* by Sidney F. Ray (Boston: Focal Press, 1988, 526 pages) and *Photographic Lenses* by C.B. Neblette and Allen E. Murray (Rev. ed., Dobbs Ferry, N.Y.: Morgan and Morgan, 1973, 131 pages). Roger K. Bunting's *The Chemistry of Photography* (Normal, Ill.: Photoglass Press, 1987, 168 pages) is an elementary text on the chemistry of black-and-white and color photographic materials and processes. *Photographic Chemistry* by D.H.O. John and G.T.J. Field (New York: Reinhold, 1963, 330 pages), while somewhat more advanced, is still intended for the photographer rather than the photoscientist. R.W.G. Hunt's *The Reproduction of Colour in Photography, Printing, and Television* (4th ed. Tolworth, England: Fountain Press, 1987, 640 pages) presents the fundamental principles of color reproduction and their application in those media. *Photographic Sensitometry: The Study of Tone Reproduction* by Hollis N. Todd and Richard D. Zakia (2nd ed. Dobbs Ferry, N.Y.: Morgan and Morgan, 1974, 312 pages) teaches serious practitioners how to use sensitometry to gain greater technical control in their work, as does the more basic *Beyond the Zone System* by Phil Davis (2nd ed. Boston: Focal Press, 1988, 219 pages).

Practice The techniques of picture-making—the application of photographic theory—are a popular subject area of photographic publishing. In the following section, general works dealing with many aspects of practice are followed by a representative group of special studies of materials and processes, cameras and their operation, lighting, and special techniques of photography.

One of the best of the numerous popular introductions to the general practice of photography is *Photography* by Barbara London Upton and John Upton (4th ed. Glenview, Ill.: Scott, Foresman, 1989, 426 pages). Adapted from *The Life Library of Photography,* it provides an elementary examination of the theoretical issues involved in the operation of cameras, film developing, and printing for black-and-white and color photography. It also addresses the aesthetic aspects of photography and includes a brief overview of the history of the medium. Other good instructional works for the beginning student are Henry Horenstein's *Black and White Photography: A Basic Manual* (2nd ed., rev. Boston: Little, Brown, 1983, 229 pages) and *Beyond Basic Photography: A Technical Manual* (Boston: Little, Brown, 1977, 242 pages), and Ralph Hattersley's *Beginning Photography* (Garden City, N.Y.: Doubleday, 1981, 462). The three-volume *New Ansel Adams Photography Series (The Camera, The Negative,* and *The Print)* by Adams and Robert Baker was published by Little, Brown between 1980 and 1983. It updates the still-useful, five-volume *Basic Photo* series *(Camera and Lens, The Negative, The Print, Natural Light Photography,* and *Artificial Light Photography)* first published by Morgan and Morgan from 1948 to 1956 and reprinted by the New York Graphic Society in 1976. Both series provide practical guidance for serious students of photography and excellent introductions to the technique of photography, with ancillary discussions of photographic theory.

Photo Lab Index: The Cumulative Formulary of Standard Recommended Photographic Procedures (41st ed. Dobbs Ferry, N.Y.: Morgan and Morgan, 1990) provides descriptions, instructions for use, and other technical data for photographic films, processing materials, and printing and print finishing materials from every major manufacturer throughout the world. It also includes reference information about photographic lenses, lighting, photographic chemicals, and other topics useful to the working photographer. First published in 1939, it is issued in a looseleaf format and regularly updated. *Ilford Monochrome Darkroom Practice: A Manual of Black-and-White Processing and Printing* by

Jack H. Coote (2nd ed. London: Focal Press, 1988, 336 pages) is a thorough technical introduction to contemporary black-and-white materials, processing, and printing. The complex subject of color photography is addressed in two works for advanced students, Ira Current's *Photographic Color Printing: Theory and Technique* (Boston: Focal Press, 1987, 282 pages) and *D.A. Spencer's Colour Photography in Practice* by L. Andrew Mannheim and Viscount Hanworth (rev. ed. London: Focal Press, 1975). Both works provide an introduction to color theory and color vision and describe historical and contemporary materials and systems of color photography. A more basic treatment of this subject is Bob Nadler's *The Basic Illustrated Color Darkroom Book* (Englewood Cliffs, N.J.: Prentice-Hall, 1982, unpaged). Nadler provides clear instructions for processing color film and making color prints, and illustrates each step with a photograph. *Instant Film Photography: A Creative Handbook for Polaroid, Instant Film and Convertible Cameras* by Michael Freeman (Salem, N.H.: Salem House, 1986, 159 pages) is one of the few works available on this topic. It provides a brief introduction to the technology of instant film systems, describes the major instant film products and their standard use, and provides well-illustrated instructions for creating photographs, multiple exposures, and other experimental prints. A wide selection of contemporary and historical techniques are explained in Robert Hirsch's *Photographic Possibilities: The Expressive Use of Ideas, Materials, and Processes* (Boston: Focal Press, 1990, 242 pages). Hirsch covers special films and developing techniques, *alternative processes* such as cyanotypes, and the altering of negatives and prints with techniques such as hand-coloring. He also provides a good general introduction to digital photography.

Information on older processes and techniques is well documented in original treatises (many of which are available in the reprint series cited above in the "Historical Background" section of this essay). A series of works written by Luis Nadeau and published by Atelier Luis Nadeau (Fredericton, New Brunswick, Canada) documents nineteenth- and early twentieth-century processes and provides clear instructions on replicating those processes with modern materials and equipment. Nadeau's books include *Gum Dichromate and Other Direct Carbon Processes, from Artigue to Zimmerman* (1987, 95 pages), *History and Practice of Carbon Processes* (1982, 99 pages), *History and Practice of Oil and Bromoil Printing* (1985, 94 pages), *History and Practice of Platinum Printing* (2nd rev. ed. 1986, 96 pages), and *Modern Carbon Printing: A Practical Guide to the Ultimate in Permanent Photographic Printing: Monochrome Carbon Transfer and Carbro* (1986, 76 pages). Jan Arnow's *Handbook of Alternative Photographic Processes* (New York: Van Nostrand Reinhold, 1982, 238 pages) presents detailed, illustrated instructions for making prints using a broad range of older processes (albumen prints, platinum and palladium prints, Fresson prints) and newer techniques (inkodye and copyart prints). *New Dimensions in Photo Imaging: A Step-by-Step Manual* by Laura Blacklow (Boston: Focal Press, 1989, 137 pages) and *Breaking the Rules: A Photo Media Cookbook* by Bea Nettles (2nd ed. Urbana, Ill.: Inky Press Productions, 1987, 55 pages) provide clear, step-by-step instructions and list supply sources for older methods such as Van Dyke Brown and gum bichromate printing, as well as contemporary alternative processes such as magazine lifts and Kwik Prints.

The principles and applications of emerging digital technology as it is being applied to image making are explained by John J. Larish in *Understanding Electronic Photography* (Blue Ridge Summit, Pa.: TAB Professional and Reference Books, 1990, 271 pages), which covers electronic still photography, the capture, storage, and display of images, and current uses of this technology, including the electronic darkroom. In his *Beyond Photography: The Digital Darkroom* (Englewood Cliffs, N.J.: Prentice-Hall, 1988, 120 pages), Gerard J. Holzmann explains the basics of creating and modifying digitized images. He describes scanning, digitizing, and output equipment and discusses how to modify images using a personal computer. Norman Breslow's *Basic Digital Photography* (Boston: Focal Press, 1991, 193 pages) provides a lucid introduction to the technology of digital photography and covers hardware (basic home computers, graphics boards, video input devices, scanners), programs, and how to record the final image. Breslow includes a useful glossary and a directory of products and sources of information about digital photography.

The literature on cameras and related equipment is vast and grows constantly as new products are introduced and collectors and scholars continue to explore and document the technological history of photography. Michel Auer's *The Collector's Guide to Antique Cameras* (Monceaux-le-Comte, France: Editions Camera Obscura, 1981, unpaged) lists almost 3000 items. James L. Lager has written the more specialized *Leica: Illustrated Guide* series (3 vols. Dobbs Ferry: Morgan and Morgan, 1975–1979). In addition to the manuals and guides issued by equipment manufacturers, other publishers provide excellent instructional material for major camera systems. These include titles such as *The Hasselblad Manual: A Comprehensive Guide to the System* by Ernst Wildi (4th ed. London: Focal Press, 1986, 342 pages) and a series issued by Focal Press that covers almost every major manufacturer, among them *Leica Rangefinder Way* by Andrew Matheson (1984, 264 pages), *Nikon Way* by Herbert Keppler (3rd ed. 1982, 434 pages), and *The Minolta SLR Way* by Clyde Reynolds (1979, 365 pages).

Most introductory books on photographic technique, such as those by Upton and Upton and Horenstein cited above, provide a grounding in the basic operation of 35-mm camera systems. Leslie Stroebel's *View Camera Technique* (6th ed. Boston: Focal Press, 1993, 305 pages) is the most thorough study on the use of large format cameras and related equipment. The technical discussion is illustrated with hundreds of photographs and diagrams, and the work also offers detailed comparisons of over 75 cameras, traces the history of view cameras, and discusses applications of large format photography. Harvey Shaman's *The View Camera* (Rev. ed. New York: Amphoto, 1991, 144 pages) and Steve Simmons's *Using the View Camera* (New York: Amphoto, 1989, 144 pages) provide clear, well-illustrated explanations of the basic operation of large format cameras. Both works are primarily instructional, with little theoretical discussion.

Ernst Wildi's *Medium Format Photography* (Boston: Focal Press, 1987, 349 pages) is a technical guide to medium format equipment and materials. The author discusses major types of medium format equipment, special considerations for exposure and lighting, and common applications of the format. Lief Ericksenn's *Medium Format Photography* (New York: Amphoto, 1991, 144 pages) is a more popular treatment of the topic, covering selection of equipment and picture-making techniques. Unlike Wildi, Ericksenn frequently refers to specific products and makes comparative evaluations of current medium format systems.

The construction and use of pinhole cameras is discussed in two modest works for students, *Minimal Aperture Photography Using Pinhole Cameras* by John Warren Oakes (Lanham, MD.: University Press of America, 1986, 125 pages) and *The Hole Thing: A Manual of Pinhole Fotografy* by Jim Shull (Dobbs Ferry, N.Y.: Morgan and Morgan, 1974, 64 pages). Oakes is more thorough throughout, but both books include clear directions for fabricating pinhole cameras, exposing photographic film, and processing and printing negatives.

Light: Working with Available and Photographic Lighting by Michael Freeman (New York: Amphoto, 1988, 192 pages) is a brief introduction to the properties of light and color and the methods of measuring light. Freeman tells how to make photographs with natural light under various conditions and with different types of available artificial light, and offers more detail on photographic lighting systems. Using clear diagrams and photographs, he explains how appropriate lighting for a variety of situations and subjects can reveal weight, texture, translucency, and so on. Norman Kerr's *The Technique of Photographic Lighting* (New York: Amphoto, 1979, 192 pages) presents a more detailed theoretical explanation of light than Freeman's, but in clear, nontechnical language. He also discusses techniques for controlling light in both color and black-and-white photography. Concepts are illustrated with clear examples either created for the text or drawn from the history of photography.

Electronic Flash, Strobe (2nd ed. Cambridge, Mass.: MIT Press, 1979, 366 pages) by Harold E. Edgerton, a pioneer in electronic flash photography, remains the standard work on this topic and covers both theoretical aspects and practical application. *Photomacrography: An Introduction* edited by William White (Boston: Focal Press, 1987, 221 pages) is a thorough treatment of basic and specialized photomacrography techniques, including high-speed and instant photomacrography and their applications. It includes a brief historical and theoretical introduction to the topic. *The World of 3-D: A Practical Guide to Stereo Photography* by Jacobus G. Ferwerda (2nd ed. Barger, The Netherlands: 3-D Book Productions, 1987, 300 pages) is a comprehensive guide to creating Stereo images using either ordinary or stereo cameras. It also tells how to mount images and view stereo photographs. Joseph Paduano's *The Art of Infrared Photography: A Comprehensive Guide to the Use of Black-and-White Infrared Film* (2nd ed. Amherst, N.Y.: Amherst Media, 1991, 76 pages) is a basic instructional manual for infrared photography covering film speed, filters, printing, and toning prints. It includes a portfolio of fine art infrared photographs. More advanced treatment of the topic, including color infrared photography and techniques for special applications for science and industry is provided in *Applied Infrared Photography* (Rochester, N.Y.: Eastman Kodak Co., 1977, 84 pages).

Among instructional works on common technical applications of photography, *Manual of Aerial Photography* by Ron Graham and Roger E. Read (London: Focal Press, 1986, 346 pages) emphasizes survey applications including "military reconnaissance, aerial archaeology, remote-sensing multispectral photography (MSP), surveillance and commercial industrial applications." *Underwater Photography: Scientific and Engineering Applications* compiled by Paul Ferris Smith (New York: Van Nostrand Reinhold, 1984, 421 pages) presents techniques for still and motion-picture photography in a variety of underwater situations. It covers towed systems, *in situ* operations, submersibles, new imaging methods, and special treatment of photographic materials in the field. Alfred A. Blaker's *Handbook for Scientific Photography* (2nd ed. Boston: Focal Press, 1989, 287 pages) is a comprehensive survey of photographic methods useful to scientists. It presents instructions on specific techniques such as photomicrography, photomacrography, and stereo photography. It also includes suggestions for effective presentation through proper lighting, filters, and backgrounds, and advice on working with specific materials (insect materials, dish cultures, and plant parts, for example). Charles Lee Tucker's *Industrial and Technical Photography* (Englewood Cliffs, N.J.: Prentice-Hall, 1989) provides a practical introduction to the great range of photographic subjects encountered by the industrial photographer, among them construction, architecture and interiors, portraiture, and advertising.

Architectural Photography: Techniques for Architects, Preservationists, Historians, Photographers, and Urban Planners by Jeff Dean (Nashville, Tenn.: The American Association for State and Local History, 1981, 132 pages) provides a thorough foundation in the techniques for photographing building exteriors and interiors with 35-mm and large format cameras. Dean also provides excellent advice on presenting the subject. Paul Lester's *Photojournalism: An Ethical Approach* (Hillsdale, N.J.: Lawrence Erlbaum Associates, 1991, 202 pages) presents technical information about materials and equipment for a variety of situations encountered by photojournalists, and explores issues such as subjects' rights to privacy, manipulation of images, and other ethical concerns.

Manufacturers and distributors of photographic equipment and supplies publish descriptive and instructional information about their products. These publications have lasting importance as documentation of the technological history of the medium. Eastman Kodak in Rochester, New York, maintains the most ambitious publishing program of any photographic manufacturer. In addition to product documentation, the company issues so extensive a selection of books, pamphlets, periodicals, and other materials that it is an important force in instructional and technical photographic publishing. Its titles cover all aspects of photography and the graphic arts for those at all levels of expertise—amateurs, beginning students, professionals, instructors, and photographic industry personnel. The annual *Index to Kodak Publications* lists all available titles. The publications can be ordered directly from the company, are stocked by many photography dealers, or, in some cases, are carried by general bookstores.

PERIODICAL LITERATURE

Indexing and Abstracting Services Gaining access to periodical literature, both historical and contemporary, is perhaps the most frustrating aspect of research in photography. Success is dependent in equal measure on the researcher's luck, tenacity, and memory. The indexing of scientific and technical material is somewhat better than that for fine art and applied photography material, but systematic, comprehensive bibliographic control is lacking in all areas. Many important periodical publications are not indexed anywhere. References must be gleaned serendipitously from books, catalogs, and periodicals. The few retrospective photography bibliographies that include periodical literature, notably William Johnson's *Nineteenth-Century Photography: An Annotated Bibliography, 1839–1879* and Albert Boni's *Photographic Literature,* provide important, though very selective access, especially for nineteenth-century titles.

The Royal Photographic Society of Great Britain has provided unbroken coverage of still and motion-photography and other imaging systems in major scientific and technical periodicals, conference proceedings, and patents published throughout the world from 1921 to the present through *Photographic Abstracts* (London: Royal Photographic Society of Great Britain, 1921–1987) and its successor, *Imaging Abstracts* (Elmsford, N.Y.: Pergamon Press, 1988 to date. Bi-monthly). *Imaging Abstracts* is the only indexing service devoted exclusively to the discipline that is commercially accessible in electronic form (through Pergamon Publishing's Orbit Search Service, McLean, Va.) *Eastman Kodak Monthly Abstract Bulletin* (Rochester, N.Y.: Eastman Kodak, 1915–1961) and *Ansco Abstracts* (Binghamton, N.Y.: Ansco, 19??–1961) which merged to form *Abstracts of Photographic Science and Engineering Literature* (Albion, N.Y.: Rochester Institute of Technology for the Society of Photographic Scientists and Engineers, 1962–1972) also provided subject and author access to an international selec-

tion of scientific and technical photography publications and patents.

Approximately 75 titles are indexed by *Photohistorica: Literature Index of the European Society for the History of Photography* (Antwerp: The Society, 1978 to date. Semi-annual). Coverage is international, and although the subject scope is broad, fine art photography is emphasized. A variety of other photography periodical indexes have appeared over the past two decades, most ceasing publication within a few years. Most were limited in scope, covering ten or fifteen popular titles. The best of these, *International Photography Index* (Boston: G.K. Hall, 1983–1984; The first two issues were published by the Visual Studies Workshop, Rochester N.Y. from 1978 to 1980 as *An Index to Articles on Photography), provided through coverage of about 110 photography and art journals and a few general-interest magazines.

Better-developed bibliographic control systems for periodical literature dealing with various related disciplines (physical sciences, engineering, and the fine arts, for example) provide essential coverage for both current and older material. Among the most useful services are *Chemical Abstracts* (Columbus, Ohio; American Chemical Society, 1907 to date. Weekly; Available electronically through STN International, Columbus, Ohio, and through Pergamon Publishing's Orbit Search Service, McLean, Va.); *Art Index* (New York: H.W. Wilson, 1929 to date. Quarterly; Available electronically through H.W. Wilson's Wilsonline, New York, N.Y., and its Wilsondisc CD-ROM products); and *ARTbibliographies Modern* (Santa Barbara, Calif.: ABC-Clio Press, 1969 to date. Semi-annual; Available electronically through Lockheed Information Systems' Dialog Information Retrieval Service, Palo Alto, Calif.).

Current Periodicals Photography periodical publishing is a volatile area, marked by an endless series of introductions and inevitable cessations. The following list is drawn from the hundreds of titles in print at the time of compilation. It represents major categories of photography serials and includes examples from throughout the world, although it favors titles published in the United States and Western Europe. More complete listings are available in *Ulrich's International Periodicals Dictionary* (3 vols. New Providence, N.J.: R.R. Bowker, Biennial) and *The Standard Periodical Directory* (New York: Oxbridge Communications, Inc. Annual).

General Coverage

American Photo. New York: Diamandis Communications. Bi-monthly.
Asahi Camera. Tokyo: Asahi Shimbun. Monthly.
British Journal of Photography. London: Henry Greenwood and Co. Weekly.
Focus. Amsterdam: Focus. Quarterly.
Fotografia. Bucharest: Associatia Artistilor Fotografi din Romania. Quarterly.
Fotografisk Tidskrift. Stockholm: Göstaflemming. Bi-monthly.
Fotomagazin. Munich: Ringier Verlag. Monthly.
IrisFoto. São Paulo: Editoria Iris. Monthly.
Photo. Paris: Editions des Savanes. 10 issues/year.
Photo Life. Markham, Ontario: Camar Publications. 10 issues/year.
Der Photograph. Vienna: Verlag für Photographische Literatur. Monthly.
PhotoMagazine. Paris: Editions Paul Montel. Monthly.
Photo Reporter. Paris: Société Photovision, 1907 to date, monthly.
Photographers Forum. Santa Barbara: Serbin Communications. Quarterly.
Photographic Journal. Bath: The Royal Photographic Society. Monthly.

Photographie. Schaffhausen: Novapress. Monthly.
Photography. London: Argus Specialist Publications. Monthly.
Progresso Fotografico. Milan: Editrice Progresso. Monthly.
PSA Journal. Oklahoma City: Photographic Society of America. Monthly.
Valokuva. Helsinki: Suomen Valokuvajärjestöjen Keskusliitto Finnfoto. Monthly.
Sovetskoye Foto. Moscow: Soyuz Zhurnalistov U.S.S.R. Monthly.
View Camera. Sacramento: Steve Simmons Photography. Bi-monthly.
Zoom. Paris: Editions Zoom. Bi-monthly.

Fine-Art Photography, Photographic History, and Criticism

AFT: Rivista di Storia e Fotografia. Prato: Archivo Fotografico Toscano. Semi-annual.
Afterimage. Rochester, N.Y.: Visual Studies Workshop. 10 issues/year.
Aperture. New York: Aperture Foundation. Quarterly.
Les Cahiers de la Photographie. Paris: L'Association de Critique Contemporaine en Photographie. 3 issues/year.
Camera Austria. Graz: Camera Austria. Quarterly.
Camera Canada. Scarborough, Ontario: National Association for Photographic Art. Quarterly.
Camera International. Paris: Camera International. Quarterly.
Cliches. Bruxelles: Editions du Stratege. Monthly.
Creative Camera. London: CC Publishing. Bi-monthly.
Déjà-vu. Tokyo: Photo-Planète Co. Quarterly.
Edice RF. Prague: Orbis. Quarterly.
European Photography. Göttingen: Andreas Müller-Pohle. Quarterly.
Foto. Leusden: Foto. 10 issues/year.
Fotogeschichte. Marburg: Jonas Verlag für Kunst und Literatur. Quarterly.
Fotologia. Florence: Fratelli Alinari Editrice. Irregular.
History of Photography. London: Taylor and Francis. Quarterly.
Madame De Vue. Amsterdam: Madame De Vue. Quarterly.
October. Cambridge, Mass.: MIT Press. Quarterly.
Perspektief. Rotterdam: Perspektief Centrum voor Fotografie. Quarterly.
Photo Review. Langhorne, Pa.: The Photo Review. Quarterly.
Photographic Collector. New York: Consultant Press. Monthly.
Photographica. New York: American Photographic Historical Society. Quarterly.
Photographies Magazine. Paris PME SARL. 10 issues/year.
Photoresearcher. Croydon, Surrey, England: European Society for the History of Photography. Semi-annual.
Photovision. Madrid PhotoVision. Quarterly.
Pinhole Journal. San Lorenzo, N.M.: Pinhole Resource. 3 issues/year.
Portfolio Magazine. Edinburgh: Photography Workshop. Quarterly.
La Recherche Photographique. Paris: Paris Audiovisuel, Maison Europeenne de la Photographie, Université Paris. Semi-annual.
Revista de la Historia de la Fotografía Española. Seville: Sociedad de Historia de la Fotografia Español. Semi-annual.
SF Camerawork Quarterly. San Francisco: San Francisco Camerawork. Quarterly.
Stereo World. Columbis, Ohio: National Stereoscopic Association. Bi-monthly.
Ten.8. Birmingham, England: Ten.8 Ltd. Quarterly.

Museum, Gallery, and Art Center Publications

Archive. Tucson: Center for Creative Photography. Semi-annual.

Blackflash. Saskatoon, Saskatchewan: The Photography Gallery. Quarterly.

Center Quarterly. Woodstock, N.Y.: Center for Photography at Woodstock. Quarterly.

C.E.P.A. Quarterly. Buffalo, N.Y.: Center for Exploratory and Perceptual Art. Quarterly.

Contact Sheet. Syracuse, N.Y.: Light Work. 5 issues/year.

Frame-work. Los Angeles: Los Angeles Center for Photographic Studies. 3 issues/year.

Image. Rochester, N.Y.: International Museum of Photography at George Eastman House. Quarterly.

Katalog. Odense, Denmark: Museet for Fotokunst. Quarterly.

MOPA. San Diego: Museum of Photographic Arts. Quarterly.

Nueva Luz. New York: En Foco. Quarterly.

Photo Paper. Pittsburgh: Blatent Image/Silver Eye. Quarterly.

Photofile. Paddington, NSW: Australian Centre for Photography. Quarterly.

Photographie Ouverte. Brussels: Echevinat de la Culture de la Ville de Charleroi et de la Communaute Francaise de Belgique. Bi-monthly.

Spot. Houston: Houston Center for photography. 3 issues/year.

Untitled. San Francisco: Friends of Photography. Irregular.

Views. Boston: Photographic Resource Center at Boston University. 3 issues/year.

Applied Photography

Applied Arts Quarterly. Dons Mills, Ontario: Applied Arts. Quarterly.

Art Direction. New York: Advertising Trade Publications. Monthly.

Communication Arts. Palo Alto, Calif.: Coyne and Blanchard. 8 issues/year.

Graphis. Zurich: Graphis Press. Bi-monthly.

Industrial Photography. Melville, N.Y.: PTN Publishing. Monthly.

Journal of Biological Photography. Chapel Hill, N.C.: Biological Photographic Association. Quarterly.

Journal of Audio-Visual Media in Medicine. London: Butterworth-Heinemann for the Institute of Medical Illustrators. Quarterly.

Lürzer's Int'l Archive. New York: American Showcase. Bi-monthly.

News Photographer. Durham, N.C.: National Press Photographers Association. Monthly.

Photo/Design. New York: BPI Communications. Bi-monthly.

Select. Düsseldorf: Moser and Colby. 3 issues/year.

Career and Professional Information

ASMP Bulletin. New York: American Society of Magazine Photographers. Monthly.

Entry: A Guide to Photographic Competitions and Juried Exhibitions. Ann Arbor, Mich.: Entry. 10 issues/year.

Guilfoyle Report. New York: AG Editions. Quarterly.

Kodak Studio Light. Rochester, N.Y.: Eastman Kodak. Semi-annual.

Photo District News. New York: Photo District News. Monthly.

Photoletter. Osceola, Wis.: PhotoSource International. Monthly.

Picture Professional. New York: American Society of Picture Professionals. Quarterly.

Profession Photographe. Paris: Profession Photographe. Bi-monthly.

Professional Photographer. Essex, England: Market Link Publishing. Monthly.

Professional Photographer. Des Plaines, Ill.: Professional Photographers of America Publications and Events. Monthly.

Rangefinder. Santa Monica, Calif.: The Rangefinder Publishing Co. Monthly.

Studio Photography. Melville, N.Y.: PTN Publishing. Monthly.

Education

Exposure. Boulder, Colo.: Society for Photographic Education. Quarterly.

Ilford Photo Instructor Newsletter. Paramus, N.J.: Ilford Photo. Irregular.

Photo Educator. Rochester, N.Y.: Eastman Kodak. Irregular.

Photoeducation. Cambridge, Mass.: Polaroid Corporation. Quarterly.

Photographic Industry

International Contact. Ratingen: C.A.T. Verlag Blömer. 6 issues/year.

Japan Camera Trade News: JCTN. Tokyo: Genyosha Publications. Monthly.

Mini Lab Focus. Jackson, Mich.: Photo Marketing Association International. Monthly.

Photo Business. New York: Billboard Publications. Monthly.

Photo Lab Management. Santa Monica, Calif.: PLM Publishing. Monthly.

Photo Made in Italy. Milan: Mediaspazio. Quarterly.

Photo Marketing. Jackson, Mich.: Photo Marketing Association International. Monthly.

Photo Marketing Newsline. Jackson, Mich.: Photo Marketing Association International. Semi-monthly.

Photographic Processing. Melville, N.Y.: PTN Publishing. Monthly.

PhotoVideo. Toronto: AVS Publishing. 9 issues/year.

Photographic science

Image Technology: Journal of the BKSTS. London: British Kinematograph, Sound, and Television Society. Monthly.

Journal of Imaging Science and Technology. Springfield, Va.: The Society for Imaging Science and Technology. Bi-monthly.

Journal of Information Recording Materials. Berlin: Akademie Verlag. Bi-monthly.

Journal of Photographic Science. Bath: Royal Photographic Society of Great Britain. Bi-monthly.

Photographic Science and Photochemistry. Beijing: Science Press. Quarterly.

Scientific and Applied Photography and Cinematography (cover-to-cover English translation of Zhurnal Nauchnoi i Prikladnoi Fotografii i Kinematografii). New York: Gordon and Breach. Bi-monthly.

SMPTE Journal. White Plains, N.Y.: Society of Motion Picture and Television Engineers. Monthly.

Photographic Methods and Techniques

Camera and Darkroom Photography. Beverly Hills, Calif.: L.F.P. Monthly.

CamerArt. Tokyo: CamerArt. Monthly.

Darkroom and Creative Camera Techniques. Niles, Ill.: Preston Publications. Bi-monthly.

Outdoor Photographer. Los Angeles: Werner Publishing. Monthly.

Petersen's Photographic. Los Angeles: Petersen Publishing. Monthly.

Photo Answers. Peterborough, England: EMAP Pub. Monthly.

Photo Pro. Titusville, Fla.: PhotoPro of Titusville. Bi-monthly.

Photo Technique International. English ed. Munich: Verlag Photo Technik International. Quarterly; German ed. Munich: Verlag Photo Technik International. Bi-monthly.

Photomethods. Des Plaines, Ill.: PPA Publications and Events. Monthly.

Popular Photography. New York: Hachette Magazines. Monthly.

Shutterbug. Titusville, Fla.: Patch Publishing. Monthly.

Manufacturers' Periodicals

Hasselblad Forum. English, German, and Swedish editions. Göteborg: Victor Hasselblad Aktiebolag. Quarterly.

International Photography. Rochester, N.Y.: Eastman Kodak. Semi-annual.

Kodak Studio Light. Rochester, N.Y.: Eastman Kodak. Semi-annual.

Kodak Tech Bits. Rochester, N.Y.: Eastman Kodak Co. Irregular.

Leica Fotografie International. English, French, and German editions. Frankfurt am Main: Umschau Verlag. 8 issues/year.

Nikon Salon. Tokyo: Nikon Optical Company. Quarterly.

Pentax Life. Englewood, Colo.: Pentax Corporation. 3 issues/year.

Annuals and Yearbooks

American Photography. New York: American Photography.

Advertising Photography in Japan. Tokyo: Kodansha.

Communication Arts Photography Annual (August issue of *Communication Arts*). Palo Alto, Calif.: Coyne and Blanchard.

Graphis Photo. Zurich: Graphis Press.

Photography Yearbook. Surbiton, Surrey, England: Fountain Press. *B. Polowy*

PULFRICH PENDULUM EFFECT A visual illusion of the direction of movement when two eyes are stimulated by light of different intensities from a pendulum that is swung from side to side, achieved by placing a neutral density filter over one eye. The effect is that the pendulum appears to move toward and away from the viewer as well as from side to side. *L. Stroebel and R. Zakia*

See also: *Optical illusion.*

PULLDOWN In the gate of a motion-picture camera or projector, the advance movement of the film as a result of the action of the intermittent sprocket (pulldown claw). *H. Lester*

PULLDOWN CLAW In the gate of a motion-picture camera or projector, a metal tooth that intermittently engages the film perforation and advances (pulls down) the film one frame at a time, positioning the new frame for exposure or projection. *H. Lester*

PULL DOWN/POP UP In computers, methods of displaying a menu. *R. Kraus*

See also: *Menu.*

PULSE CAMERA See *Camera types.*

PULSED LAMP An intermittent light source (e.g., high-pressure xenon arc). The pulses can be used for stroboscopic photography, synchronized for motion-picture projection, or for high-speed photography. *R. Jegerings*

PULSED XENON LAMP Uses the basic electronic flashtube principle of generating light. Light flashes at each half cycle from an AC supply so it is in effect continuous. Desirable characteristics are instant starting, high intensity, long life, and an effective continuous spectrum with a color temperature of about 5600 K, plus infrared and ultraviolet radiation. They are typically used in the graphic arts with wattages from 600 to 8000 producing about 30 lumens per watt. *R. Jegerings*

PULSE SYNC See *Sync pulse.*

PUPIL Referring to a lens, it is the virtual image of the aperture stop. When viewing from the front of the lens the entrance pupil is seen, and from the rear the exit pupil is seen. These two pupils are not necessarily of the same diameter. The center of the entrance pupil is the viewpoint of the lens or center of perspective, and for a lens using central projection, all the rays enter here to emerge displaced but undeviated from the center of the exit pupil or center of projection of the lens. *S. Ray*

PUPILLOMETRICS The measurement of pupil size as related to mental and emotional states. The size of the pupil not only varies automatically with light intensity but also when one's emotional state changes. Portraits of people with large pupil openings are perceived as being more interesting and exciting than those with small pupils. *L. Stroebel and R. Zakia*

PUPIL MAGNIFICATION The ratio of the diameter of the exit pupil to the diameter of the entrance pupil of a lens. A symmetrical lens has unit value, a telephoto lens less than one, and a retrofocus lens greater than one. The value has to be incorporated into exposure correction calculations for closeup photography or photomacrography using the latter lenses. *S. Ray*

PURITY (1) In colorimetry, a measure of the proportions of the amounts of the monochromatic stimulus and of the specified achromatic stimulus that, when additively mixed, match the color stimulus considered. (In the case of purple stimuli, the monochromatic stimulus is replaced by a stimulus whose chromaticity is represented by a point on the purple boundary.) (2) In chemistry, the extent to which a chemical is free of other substances. *R. W. G. Hunt*

PURKINJE EFFECT/PHENOMENON/SHIFT (Also spelled Purkyne, pronounced Pur-kin-ye) At low energy levels, the sensitivity of the eye shifts from a peak at about 555 nm (green) toward shorter wavelengths (blue). In dim light, for example, blue objects look relatively lighter than they do in strong light, and red objects relatively darker. This is something to be considered when, for archival reasons, color photographs are exhibited with a low level of illumination. *L. Stroebel and R. Zakia*

See also: *Mesopic; Photopic; Scotopic; Vision, the human eye.*

PURPLE BOUNDARY In colorimetry, the line in a chromaticity diagram, or the surface in a color space, that represents additive mixtures of monochromatic stimuli of wavelengths of approximately 380 and 780 nm. *R. W. G. Hunt*

PURPLE STIMULUS In colorimetry, a stimulus that is represented in any chromaticity diagram by a point lying within the triangle defined by the point representing the specified achromatic stimulus and the two ends of the spectral locus, which correspond approximately to the wavelengths 380 and 780 nm. *R. W. G. Hunt*

PVA GLUE PVA (Polyvinyl Acetate) glue is a strong, nonvolatile, thick liquid adhesive that bonds to paper and other porous materials. PVA glues can also bond to some plastics. Testing will provide the most practical and reliable

information about specific plastic materials. This adhesive is white in the bottle but dries clear and remains flexible, unlike "all purpose" white glues, which are hard and brittle when dry. PVA glue won't deteriorate or contaminate paper. Because PVA glue is adversely affected by cold temperatures, it must not be subjected to freezing temperatures.

M. Teres

PV FILTER/PANCHROMATIC VISION FILTER See *Filter types, viewing filter.*

PYROMETRY, PHOTOGRAPHIC The temperature of objects such as furnace walls and ingots may be measured by photographing them by the light they emit and comparing the density of the images they record on film to the densities in a calibrated step wedge. The master wedge is made by photographing tungsten strip lights at controlled temperature increments. The process has scientific and industrial applications.

H. Wallach

PYRO-PHOTOGRAPHY Process by which ceramic photographs are made on glass surfaces using the dusting-on process. The dust consists of a fusible pigment that is baked on to the support by heat.

H. Wallach

PYRO/PYROGALLOL/PYROGALLIC ACID Pyrogallol, originally called pyrogallic acid and now often referred to as pyro [C_6H_3-1,2,3-$(OH)_3$, molecular weight 126.11)], is available as a white crystalline solid soluble in water, alcohol, and ether. Severe poisoning may result from absorption through the skin or if swallowed or inhaled.

Pyro forms active but unstable developers, producing a residual yellow-brown stain image and hardening (tanning) the gelatin. Used as a tanning developer for dye transfer matrices.

G. Haist

See also: *Developers.*

Q Quantity of energy (Q_e) or light (Q_v); Quality (electrical circuits); Q-factor (Callier coefficient); Q-switch (lasers)

QA Quality assurance

QC Quality control

QI Quartz-iodine (lamp)

qt Quart

Q-FACTOR See *Callier coefficient.*

QUADRANT DIAGRAM A graphical display of the relationship between the input and output for each step in a photographic process. The most common type of quadrant diagram is the *four-quadrant tone reproduction diagram.* In this diagram the subject log-luminance values are placed on the right side of the horizontal axis and the image log-illuminance values are placed on the right side of the lower half of the vertical axis. The curve in the first or lower-right quadrant represents the relationship between these values and is called the flare curve. The second or lower-left quadrant contains the film/development characteristic curve, with the film log exposures on the left side of the lower-half of the vertical axis and the negative densities on the bottom of the left side of the horizontal axis. The film log exposures equal the film

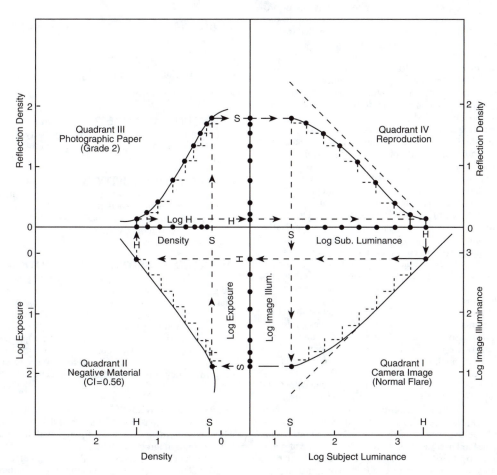

Quadrant diagram. Complete objective tone-reproduction diagram for a pictorial system.

log illuminances plus the log of the exposure time. The third (upper-left) quadrant contains the printer/paper/development curve and includes the effects of flare in the printing system (if any). The paper log exposures, which relate to the negative densities through the printer log illuminance and exposure time, are placed on the top of the left side of the horizontal axis, and the reproduction densities are placed on the top half of the vertical axis. The fourth (top-right) quadrant contains the reproduction curve, which displays the relationship between the log luminances of the subject and the densities of the reproduction.

Quadrant diagrams are used to study the objective tone reproduction of photographic processes. The effect on the tones of changing almost any of the factors in a process can be simulated using these diagrams. *J. Holm*

See also: *Tone reproduction.*

QUADRAPHONY Four-channel sound, usually used to describe the sound-only formats that used two front and two rear channels, now generally considered obsolete. *T. Holman*

QUALITY See *Print quality.*

QUALITY CONTROL A set of procedures used to monitor a process to detect departures from the desired result. Statistical techniques are often used, such as those involved in control charts. The phrase *quality control* is in fact a misnomer, because a process cannot be controlled in the ordinary sense.

Variability always exists, even in a manufacturing or processing system using the most reliable and up-to-date technology. Methods of quality control are intended to identify changes in the system that lie beyond those that are inherent. So-called assignable causes produce errors in the output that are correctable. Random, or chance, causes must be accepted, or the process must be redesigned.

Accurate test methods are essential to quality control. Calibration and routine testing of thermometers, densitometers, and so on, must be carried out.

The first stage of quality control requires extensive testing of a newly established process. A rule of thumb is that a large sample size must be initially obtained, *large* meaning 30 or more measurements. A plot of the frequency distribution will indicate whether or not the data probably come from a population having a normal distribution, i.e., one controlled by chance. The computed mean of the data will show whether or not the process average is sufficiently close to the desired result; the sample standard deviation is a powerful indication of the variation in the process, and thus the extent to which it meets specifications. Such a costly and time-consuming test procedure is reliable only if the process has operated normally, without detectable errors. If something has gone awry, the system must be corrected and the test procedure redone on the modified system.

Once the data indicate that the information has been obtained from a stable, correctly operating process, information is periodically obtained in order to detect future errors. Control charts are customarily used for this purpose. Usually, samples of small size are used, and the sample averages and ranges (differences between largest and smallest values) or standard deviations are plotted in sequence. Upper and lower control limits show the region within which plotted data will fall with high probability if the process continues to operate in an unchanged manner. Points lying outside the limits indicate the need to correct the process. Other indications of a needed process change are: (1) a sequence of points all lying above or below the process average (five or more such points are usually considered evidence sufficient to cause an examination of the process); and (2) a sequence of points all rising or falling, even though none of the points is outside the limits. *H. Todd*

See also: *Standard deviation; Statistics; Frequency distribution.*

QUANTIZING In electronic imaging, the converting of analog data into the digital domain. The continuous-tone information of the analog image is converted into a discrete number of bits, most typically into eight bits. *R. Kraus*

QUANTIZING (SOUND) See *Digital audio.*

QUANTUM The smallest and basic indivisible unit of radiant energy; the amount of energy making up a quantum being dependent on frequency. The term *quantum* is used primarily where the basic concern is a transfer of energy. For example, exposure quanta are absorbed by a silver halide crystal; photons refract and interfere in an optical system to form an image. *J. Holm*

Syn: *Photon.*

QUANTUM EXITANCE At a point on a surface, the quantum flux leaving the surface per unit area. Symbol, M_q.
 R. W. G. Hunt

QUANTUM EXPOSURE Number of quanta received. Symbol, H_q. *R. W. G. Hunt*

QUANTUM FLUX Number of quanta emitted, transferred, or received per unit of time. Symbol, F_q.
 R. W. G. Hunt

QUANTUM INTENSITY Quantum flux per unit solid angle. Symbol, I_q. *R. W. G. Hunt*

QUANTUM IRRADIANCE Quantum flux per unit area incident on a surface. Symbol, E_q. *R. W. G. Hunt*

QUANTUM OPTICS See *Optics, physical optics.*

QUANTUM RADIANCE In a given direction, at a point in the path of a beam, the quantum intensity per unit projected area (the projected area being at right angles to the given direction). Symbol, L_q. *R. W. G. Hunt*

QUANTUM SENSITIVITY A quantity that measures the efficiency of latent-image formation. It is defined as the mean number of absorbed photons per grain required to make a certain percentage, usually 50%, of the grains developable, after correction for fog. *R. Hailstone*

See also: *Photographic theory*

QUANTUM SENSITIVITY DISTRIBUTION A quantity that indicates how the quantum sensitivity varies among the grains of a photographic emulsion. It is derived from the shape of the characteristic curve when the log exposure axis has been converted into absolute units, i.e., mean number of absorbed photon per grain. It is most easily applied to monodisperse emulsions, although it can be applied to polydisperse emulsions. The quantum sensitivity distribution will indicate the most sensitive fraction of grains and can be very important in determining the mechanism of latent-image formation. *R. Hailstone*

QUANTUM THEORY A currently accepted theory explaining the behavior of matter and energy, especially when measurements are made of very small quantities or to a very high degree of precision. The basic premise of quantum theory is that energy, like matter, comes in small, individual units, and is not continuous. Quantum theory arose out of the study of electron orbitals in atoms and gen-

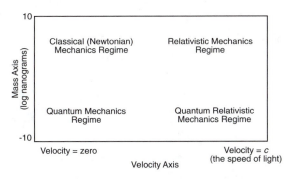

Quantum theory. The classical, quantum, relativistic, and quantum relativistic regimes. The appropriate branch of physics is determined by mass and velocity of the substances of interest. The areas overlap; the amount of overlap depends on the degree of accuracy required. (Note: Quantum Relativistic Mechanics are never wrong, just too complicated for calculations not requiring such sophistication.)

erally developed along two related lines: quantum mechanics, which is the study of the quantum behavior at the atomic level; and quantum electrodynamics, which is the study of the quantum nature of electromagnetic radiation. Einstein's theory of relativity must also be considered if the behavior of matter moving at high speeds (a reasonable fraction of the speed of light) is to be explained. Quantum theory and relativity theory can both be simplified using approximations if the quantities of matter and energy studied are not too small and velocities are not too high. Using these approximations, both theories give the same results as Newtonian or classical physics. *J. Holm*

QUANTUM YIELD A photochemical quantity that measures the amount of photoproduct relative to the amount of photons absorbed. A value of one would mean that every photon is used in making photoproduct. The photoproduct is not necessarily useful. For example, if it is used to measure the fluorescence of a spectral sensitizing dye the *desired* quantum yield would be zero because fluorescence is not a useful product in conventional photographic systems. A quantum yield greater than unity indicates a chain reaction as in photopolymerization. *R. Hailstone*

QUARTER-WAVE PLATE Optical device for converting plane polarized light into circularly polarized light. It is a thin sheet of a birefringent material of suitable thickness to give a retardation or phase shift of 90 degrees between the transmitted ordinary ray and the extraordinary ray at a given wavelength. If the plane of the incident polarized light is at 45 degrees to the optical axis of the crystalline material, circularly polarized light emerges; otherwise, it is elliptically polarized. Used to make circular polarizing filters for camera use, a circular polariscope for photoelastic stress analysis, and for phase-contrast microscopy. *S. Ray*

See also: *Filters; Photoelastic stress analysis.*

QUARTZ A transparent optcial material of chemical formula SiO_2. Desirable optical properties are high transmittance of ultraviolet and infrared and resistance to thermal and mechanical shock. Natural crystalline quartz is birefringent, but crushing and melting selected crystals gives fused quartz (silica), free of birefringence. Synthetic fused silica is made by chemical combination of oxygen and silicon. *S. Ray*

Syn.: *Fused quarts; Fused silica; Silica.*

See also: *Optics, optical materials; Ultraviolet photography.*

QUARTZ CRYSTAL In computer imaging, a device for locking onto an analog video signal for the purpose of converting it to digital. *R. Kraus*

QUARTZ-HALOGEN LAMP A compact tungsten-filament lamp that recycles vaporized tungsten back to the filament to prevent bulb blackening for more consistent light intensity and color balance through the lamp's life. Iodine added for the regeneration cycle created the once-popular name *quartz-iodine lamp.* *R. Jegerings*

Syn.: *Tungsten-halogen lamp.*

See also: *Light sources, quartz-halogen lamps.*

QUARTZ OSCILLATOR See *Piezoelectricity.*

QUENCHING In some electronic flash units, the termination of capacitor discharge to the flash tube, allowing automatic-exposure control by sensing light reflected from the subject. Also a reduction of phosphorescence or fluorescence by exposure to infrared energy, a process that has been used in masking methods. *R. Jegerings*

See also: *Light sources; Thyristor; Quenching tube.*

QUENCHING TUBE Part of an electronic flash unit circuit that provides automatic exposure. When enough light has been reflected from the subject for correct exposure, a thyristor is made conducting to divert capacitor energy to the lower-resistance quenching tube that absorbs the energy but emits no light. The flash duration is terminated or *quenched* and may range in duration from 1/1000 to 1/30,000 second.

Historically, the quenching tube gave birth to the first practical automatic-exposure system for electronic flash but had the disadvantage of using all the capacitor energy for each flash burst, no matter how little light was required. A thyristor can be more easily made conducting than nonconducting and therefore could not simply be placed between the flash tube and capacitor to terminate capacitor discharge and save its energy for future exposures. Later technology used reverse high voltage to make a thyristor positioned between the capacitor and flash tube nonconductive to terminate the flash burst and the flow of capacitor energy. Flash recharging was quicker and battery life longer. *R. Jegerings*

See also: *Light sources.*

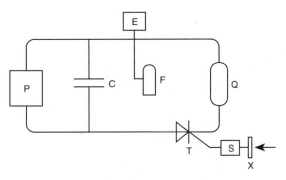

Quenching tube used for automatic exposure control. After power from the supply (P) is stepped-up, converted, and fed into the capacitor (C), the trigger circuit (E) allows it to discharge through the flash tube (F) and produce light. The sensor (X) reads light reflected from the subject and when enough has been received for correct exposure, the computer circuit (S) sends a current pulse to the thyristor (T); the thyristor becomes conductive and energy naturally flows to the quenching tube (Q) because of its lower resistance, terminating the flash exposure.

QUINOL See *Hydroquinone.*

R Reproduction ratio/Scale of reproduction (Also magnification); Resistance; Roentgen

rad Radian (unit of absorbed radiation)

RAM Random access memory

R&D Research and development

RAR Rapid access recording

RAT Reflected, absorbed, transmitted

RC Resin coated

RD Reconstructed distribution (colorimetry)

rep Representative

RF Roll film; Rangefinder; Radio frequency; Reciprocity failure

RGB Red, green, blue (video)

RH Relative humidity

RIAA Recording Industries Association of America

RIFF Raster image file format

RIP Raster image processor

RISC Reduced instruction set

RLF Reciprocity law failure

RMS Root mean square

ROM Read-only memory

ROP Run of press

RP Resolving power

rpm Revolutions per minute

rps Revolutions per second

RPSGB Royal Photographic Society of Great Britain

RTA Real time analyzer

RTS Royal Television Society

RACK AND PINION A two-part device commonly used for focusing view cameras, consisting of a notched bar attached to the camera bed and a wheel with matching notches attached to the lens and/or back standard. *L. Stroebel*

RACK AND TANK A processing method in which films are attached to a support that is immersed sequentially in a series of containers holding processing baths.

L. Stroebel and R. Zakia

See also: *Tanks and tank processing.*

RACK-OVER VIEWFINDER A device used when a camera must be precisely aligned before making the exposure. The camera body is mounted on a carrier that can be slid sideways, bringing a viewfinder behind the camera lens.

L. Stroebel

RAD A unit of radiant energy absorbed per unit mass of the irradiated material. One rad equals 100 ergs per gram. Rads

are normally used when the energy is of very short wavelength, such as x rays or subatomic particles. *H. Todd*

RADIAL LINE/RAY Description of the direction of a line image (as may be produced from an object point) that is along the radius of a circle perpendicular to and centered on the optical axis. Particularly used in connection with astigmatism and curvilinear distortion of lenses. *S. Ray*

Syn.: *Sagittal.*

See also: *Astigmatism; Tangential line/ray.*

RADIAN A unit of angular measure, commonly used for phase, equal to the distance around a unit circle. Since the circumference of a unit circle is 2π, 2π radians equals 360 degrees. *J. Holm*

See also: *Phase; Relative phase; Absolute phase; Phase shift.*

RADIANCE The quotient of radiant intensity of an extended surface in a specified direction and the projected area in that direction [i.e., watts per steradian per square meter; $W/(sr \cdot m^2)$]. The radiance of an extended source or surface is invariant with viewing distance. Radiance is also invariant within a lossless optical system because any change in image size is accompanied by an inverse change in solid angle. The radiance of a lambertian (ideal) diffuser is invariant with viewing angle because the reduced power reflected off-axis is balanced by a reduction in projected area. *J. Pelz*

See also: *Radiometry.*

RADIANCE FACTOR Ratio of the radiance to that of the perfect diffuser identically irradiated. Symbol, β_e.

R. W. G. Hunt

RADIANT Adjective denoting measures evaluated in terms of power. *R. W. G. Hunt*

RADIANT EFFICIENCY Ratio of the radiant flux emitted to the power consumed by a source. *R. W. G. Hunt*

RADIANT ENERGY Electromagnetic radiation emitted or reflected by a substance. *J. Holm*

RADIANT EXITANCE At a point on a surface, the radiant flux leaving the surface per unit area. Symbol, M_e. Unit: $W \cdot m^{-2}$ (watts per square meter). *R. W. G. Hunt*

RADIANT EXPOSURE Quantity of radiant energy received per unit area. Symbol, H_e. Unit: $J \cdot m^{-2}$ (joules per square meter). *R. W. G. Hunt*

RADIANT FLUX (Φ_e) The time rate of flow of radiant energy at all wavelengths (i.e., radiant power) emitted by a

source or passing through a defined aperture. The preferred unit of measure is the watt (W), equal to 1 joule per second.

Because the flux of a source measures power emitted in all directions, it may be a misleading measure of the source's useful power. Radiant intensity, which is a measure of power flowing in a specific direction, is frequently a more practical measure of a source's output. For example, a small infrared source may provide little total power (flux), but a well-designed reflector can produce a large intensity within a narrow cone. *J. Pelz*

See also: *Radiometry; Watt.*

RADIANT INTENSITY (*I_e*)
The time rate of flow of radiant energy (i.e., radiant power) emitted by a point source in a given direction. The unit of measurement is the watt per steradian (W/sr). While intensity is strictly defined only for point sources, the measure is often applied to sources whose maximum dimension is much less than the distance from which they are viewed. (Radiance is the appropriate measure for sources whose maximum dimension is >1/10 the viewing distance.)

By definition the intensity of a source is invariant with distance, but the intensity of any real source varies with direction, so a single intensity value may be of little use in determining the effectiveness of a source in illuminating a scene. For example, a reflector can direct the power of a small source into a narrow solid angle, greatly increasing the intensity in that direction. The increase in one direction is balanced by a loss in other directions, leaving the total power constant. *J. Pelz*

See also: *Radiometry.*

RADIATION
(1) Energy emitted by an object, either in the form of electromagnetic radiation or subatomic particles. It is important to note that radiation can be beneficial, as with the radiation from the sun that keeps us alive; neutral; or harmful, as is the case with most subatomic particle radiation and high-energy photons. (2) The emission of radiation.
 J. Holm

RADIATOR
An object that emits radiation, particularly electromagnetic radiation. *J. Holm*

RADICAL
A radical is a group of two or more atoms that react as a unit, often being incapable of a separate existence. When hydrogen, with its electron, is removed from a hydrocarbon compound, a hydrocarbon radical is formed, as when methane, CH_4, is converted into a methyl radical, CH_3.
 G. Haist

RADIOACTIVE ISOTOPE
An isotope is one of two or more forms of an element having the same or nearly the same chemical properties. The atoms in the different forms have the same number of protons but differ in atomic weight. Radioactive isotopes contain atoms formed by differing routes of nuclear disintegration that give off quantum or particle emission. Even certain stable elements, such as potassium, may have naturally occuring radioactive isotopes. *G. Haist*

RADIOACTIVITY
A phenomenon of spontaneous nuclear disintegration of an atom that results in the emission of alpha (helium nuclei), beta (electrons), and gamma (quanta of energy) radiation. An unstable, radioactive nucleus decays in steps, called a radioactive disintegration series, until a stable nucleus is formed. *G. Haist*

RADIOGRAPHY
Radiography is a specialized area of photography that utilizes x-radiation or gamma radiation, which can penetrate objects that are opaque to light. Typically films are used that are coated on both sides to increase

sensitivity. Radiography is used in a variety of industries, including health care as a diagnostic tool to investigative internal structure that otherwise would not be observable.

Various methods for exposure have evolved for radiographic materials. X-radiation is emitted naturally from the sun and other sources but also can be generated by a tungsten source. A system can be established to pass two levels of current, one low amperage and one high amperage, through a tungsten source. These currents are then directed by a focusing cup, made up of a high-potential field of high voltage. This focused beam is accelerated through an additional electric field and directed at a tungsten, platinum, or other heavy-metal plate. When the plate is hit by the electrons, they are absorbed and x-radiation is emitted. Although this is a common radiation source for imaging, radioactive isotopes cause spontaneous exposure, as with autoradiography.

There are two types of radiologic films—direct exposure and cassette exposure types. Direct exposure products are films that use exposure directly from the radiation source. These films require more radiation than cassette-type exposure products. An example of a direct exposure film would be dental films, which are held in a dark envelope and exposed directly to radiation. Cassette-type films are held in a holder that is coated with fluorescent materials. These coatings are referred to as intensifying screens. The exposure to cassette films is achieved by the fluorescence from the screen after bombardment/excitation from the radiation, producing blue or blue-green light. This process is referred to as *fluorography*. Cassette-type films require less radiation than direct exposure materials as a result of the film's sensitivity to the visible spectrum.

Radiography is a large field, with practitioners working in a variety of roles and related job classifications. Within a hospital, for example, entire departments perform radiography for diagnostic purposes and are staffed with technicians, engineers, equipment specialists, and doctors or radiologists.

At one time, radiography was limited to using sensitized films and plates; however, as technology has continued to evolve, radiographic images are being produced and captured by other means, such as video. These captured images are displayed on black-and-white monitors and often used for on-line inspection devices used in manufacturing. Manufacturing is not the only arena where this technology is being used. Airports use the same technology to examine the contents of carry-on luggage.

Another method of radiographic image production is *xeroradiography*. Xeroradiography, or *radioxerography*, is an electrostatic process using x-rays or gamma radiation, producing a dusted image on plate or paper of a photoconductive surface.

In addition to still cathode-ray tube (CRT) display of x-ray images, real-time x-ray images can also be produced. When a subject is placed between a radiation source and a piece of film, the subject blocks varying degrees of energy from reaching the negative film. Thus, bones, for example, image as light structures on the film, while less dense areas of tissue will be imaged with more density as a result of more exposure. Because many procedures involve investigating real-time procedures such as manufacturing or on-line inspection, real-time radiography provides a valuable diagnostic and quality-control tool. If subjects being investigated are not dense enough to short wavelength radiation, they can be treated with opaque materials to produce adequate density for examination. After this treatment, the subject can be evaluated for important investigations, such as fluid flow. Industrial applications include welding and other stress point analyses using film or video output such as is used for evaluating airplanes for hairline cracks. Similarly, many valued pieces of art are routinely x-rayed for authenticity or flaws.

Two advanced technologies that employ modified radiographic approaches are computerized axial tomography (CAT) scans and magnetic resonance imaging (MRI). In cat scans, cross-sectional images of the subject are generated using radiation, and these images are reconstructed using computers. In MRI, magnetism is used to produce a highly resolved image of soft tissue. *M. Peres*

See also: *Xeroradiography; Stereoradiography.*

RADIOISOTOPE CAMERA See *Camera types.*

RADIOLUMINESCENCE The production of light by a substance as a result of its radioactivity. *J. Holm*

RADIOMETRY Radiometry is the science of measuring radiant energy and power within the electromagnetic spectrum. It is a superset of photometry, which deals only with the measurement of visible radiation, or light. Radiometric measurements can be made at all wavelengths, from gamma rays to radio transmissions. Even measurements made within the region of the spectrum to which the human visual system is sensitive are distinct from photometric measures; radiometric measures represent absolute power and are not scaled by the spectral sensitivity function of the eye [$V(\lambda)$] as they are in photometric measurements.

ELECTROMAGNETIC RADIATION Electromagnetic radiation is carried in traveling waves made up of orthogonal electric and magnetic fields that vary periodically in time and position. The spectrum of electromagnetic radiation spans more than 20 orders of magnitude, from gamma rays to electric power transmissions. Electromagnetic radiation can be described by its *wavelength* (λ), the distance over which the wave completes one full cycle, and by its frequency, the number of cycles the wave undergoes per unit time.

BLACKBODY RADIATION There are many sources of electromagnetic radiation, among them electric discharge, fluorescence, and bioluminescence. Perhaps the most important class of sources in this context is incandescence. Any material at a temperature above absolute zero (–273.2° C) is a source of electromagnetic radiation. The radiation is a result of thermal agitation of the material's molecules and atoms and varies with the material's temperature.

The spectral content of the power emitted by a theoretical blackbody is described by Planck's equation. As the temperature is increased, the peak of the emitted radiation shifts from the infrared, through the visible spectrum from red to blue, then into the ultraviolet region of the spectrum. Wien's law describes the inverse relationship between peak wavelength and temperature. The total power emitted increases as the fourth power of the temperature, and is described by the Stefan-Boltzmann law.

The exact spectral distribution emitted by typical materials varies to some degree from that of the theoretical blackbody. Thermal sources of radiation are important and common. The majority of the energy emitted by a carbon arc source is due to the thermal radiation from the hot tips heated by the arc, and the sun's radiation is a result of the extreme temperature on the sun's surface.

RADIANT FLUX (POWER) All radiometric measurements are based on radiant flux (Φ_e), defined as the time rate of flow of radiant energy at all wavelengths. The preferred (SI) unit is the watt (W), equal to 1 joule per second. While the value of a source's radiant flux can be measured, values such as flux per solid angle (radiant intensity), or flux per unit area per solid angle (radiance) for sources, and incident flux per unit area (irradiance) usually represent better the characteristics of practical interest.

SOURCE VS. SURFACE MEASUREMENTS
Radiometry includes two broad categories of measurement:

(1) measures of radiant power emitted (or reflected) from point or extended sources, and (2) measures of radiant power falling onto surfaces. While fundamental physical differences exist between the two cases, it is important to note that many of the characteristics of both measures are common, and any surface that reflects some fraction of the incident energy may be considered an extended source itself.

SOURCE MEASUREMENTS The simplest case to consider is that of a theoretical point source of radiant energy, defined as an infinitely small source, emitting energy equally in all directions. Such a source can never actually exist, but small sources at a sufficient distance from the measuring device often approximate the theoretical point source.

An important measure of a point source's output is its *radiant intensity* (I_e), the rate at which radiant energy is emitted into a solid angle in a given direction.

The standard (SI) unit of radiant intensity is the watt per steradian (W/sr). While intensity is strictly defined only for point sources, the measure is often applied to sources whose maximum dimension is much less than the distance from which they are viewed. (Radiance is an appropriate measure for sources whose maximum dimension is >1/10 the viewing distance.)

By definition, the intensity of a source is invariant with distance, but the intensity of any real source varies with direction, so a single intensity value may be of little use in determining the effectiveness of a source in illuminating a scene. For example, a reflector can direct the power of a small source into a narrow solid angle, greatly increasing the intensity in that direction. The increase in one direction is balanced by a loss in other directions, leaving the total power constant. Because the theoretical point source emits equally in all directions, its total power (radiant flux) is equal to (intensity · 4πsr), because there are 4π steradians in a sphere.

EXTENDED SOURCES Radiant intensity is defined only for point sources. The radiant output from an extended source is described in terms of the rate at which energy is emitted into a solid angle in a given direction per unit area of the source, its *radiance* (I_e). The SI unit is the watt per steradian per square meter W/(sr · m²).

The radiance of an extended source is invariant with viewing distance because the loss of energy from each point because of increasing the viewing distance is exactly balanced by an increase in the surface visible within a given solid angle as the distance increases. Radiance is also invariant within a lossless optical system because changes in image size are accompanied by an inverse change in solid angle.

Note that any surface reflecting radiant energy serves as a secondary source with a measurable radiance.

SURFACE MEASUREMENTS The other major class of radiometric measurements describes the radiant power arriving at a surface, rather than that emitted from a point or extended surface. Irradiance (E_e) is a measure of radiant power per unit area incident on a surface. The SI unit is the watt per square meter (W/m²).

The irradiance at a surface is a function of source intensity (or radiance for an extended source), the distance from source to surface, and the angle at which the light strikes the surface. Irradiance varies linearly with source intensity (or radiance) because the power flowing into a given solid angle is increased.

Irradiance varies with the distance between the surface and any finite source. For a point source, the irradiance falls as the square of the distance to the source.

Surface irradiance is also a function of illumination angle. As the angle between the surface normal and light source increases, the power within a given solid angle falls on a larger area. The angle may be due to moving the source lat-

Surface measurement. The irradiance at a surface falls as the square of the distance, because constant power from a point source is spread over a larger area. At some distance d, area A subtends a given solid angle. At twice the distance ($2d$), each side of the subtended area doubles, so the area increases as the square of the distance. Because a constant power (in watts) is spread over a larger area ($4A$) as the distance doubles, the irradiance falls as the square of the distance.

Irradiance (radiant power/area) is a function of illumination angle; as the angle between surface normal and source increases, the area increases as the cosine of θ.

erally, tilting the surface, or both. The increase in area (and decrease in irradiance) is proportional to the cosine of θ, the angle between the normal and the point source: $E_\theta = E_0 \cdot \cos(\theta)$, where E_0 is the normal illuminance.

RADIOMETERS Instruments used to measure radiant quantities are known as radiometers. Any measurement technique that makes use of the human visual system as a detector measures photometric values; all measurements are weighted by $V(\lambda)$, the visibility function. Consequently, radiometers must rely on detectors whose response covers the range of the electromagnetic spectrum of interest. One class of radiometers measure radiant power indirectly by monitoring the secondary effects of the incident electromagnetic radiation. The bolometer can be used to measure incident electromagnetic

radiation at all wavelengths. Thermal variations caused by incident power alter the electrical resistance of the detector. Incident radiation is calculated by comparing that resistance to the resistance in the absence of the radiant energy.

Another class of radiometers is based on photoelectric detectors made from materials whose electronic characteristics change as a function of incident radiant power. Several types of photodetectors are used in such radiometers. *Photoemissive* detectors make use of the phenomenon that some metals release electrons when they are struck by radiant energy. The photomultiplier tube is an example of such a device. *Photovoltaic* detectors (solar cells) are semiconductor devices in which incident energy creates a potential difference across a boundary layer, converting the incident energy to an electrical voltage. Selenium cells are one example of such photodetectors. *Photoconductive* detectors are not a source of electric current, rather their conductance is increased as a function of irradiation incident on the cell. Cadmium sulfide cells (CdS) are an example of photoconductive cells. None of the detectors' responses is equal across the electromagnetic spectrum, so radiometric quantities are found by correcting the cell's response in each wavelength region based on its known spectral response.

SPECTRORADIOMETRY/
SPECTROPHOTOMETRY It is often desirable to describe the radiant power from a source or at a surface as a distribution of radiant power as a function of wavelength rather than as a single quantity, i.e., as $\Phi(\lambda)$ (watts per meter) rather than Φ (watts). Some method must be used to allow such measurements over narrow wavelength regions. The incident radiation can be selectively filtered with interference filters or spread into a spectrum with a prism or diffraction grating. The total radiant power (Φ_r) can be found by integrating $\Phi_r(\lambda)$ over λ, and the distribution contains useful information about the radiant power. For example, the luminous flux of a source can be calculated from its spectral distribution. The conversion from radiant flux to luminous flux is a function of the relative spectral response of the human visual system. The CIE standard $V(\lambda)$ relative luminous efficiency function describes the relationship for the standard observer. At the peak of the standard observer curve (555 nm), 1 watt of radiant power is equivalent to 683 lumens. The conversion at any single wavelength (i.e., for a monochromatic source) is given by:

$$\Phi_v = k \cdot \Phi_r \cdot V(\lambda)$$

where Φ_v is the luminous flux, in lumens; k is the maximum luminous efficacy (683 lm/W); Φ_r is the power (in watts); and $V(\lambda)$ is the relative luminous efficiency function of the standard observer.

For a distribution containing more than one wavelength, the power in each wavelength band is scaled by the $V(\lambda)$ function, and the results at all wavelength regions are summed:

$$\Phi_v = k \sum_{360}^{780} \Phi_r(\lambda) V(\lambda) \Delta\lambda$$

where $\Phi_r(\lambda)$ is the spectral power (in watts per nanometer) at wavelength λ; k is the maximum luminous efficacy (683

Radiometric Quantities, Defining Equations, and SI Units

Quantity	Symbol	Defining Equation	SI Unit	Abbreviation
Radiant flux	Φ_e	$\Phi = dQ/dt$	Watt	W
Radiant exitance (radiant emittance)	M_e	$M = d\Phi/dA$	Watt per square meter	W/m²
Irradiance	E_e	$E = d\Phi/dA$	Watt per square meter	W/m²
Radiant intensity	I_e	$I = d\Phi/d\omega$	Watt per steradian	W/sr
Luminance	L_e	$L = dI/d(A\cos\theta)$	Watt per steradian square meter	W/sr m²

lm/W); $V(\lambda)$ is the relative luminous efficiency function of the standard observer; and $\Delta\lambda$ is the wavelength interval (in nanometers) used in the summation. *J. Pelz*

See also: *Blackbody; Bolometer; Electromagnetic radiation; Inverse square law; Photometry and light units; Spectrophotometry; Stefan-Boltzmann law; Wien's law.*

RADIOPAQUE A material that has a high density to x-rays and gamma rays, designed to block high-energy particles. Uses of radiopaque materials include x-ray film packaging, carriers designed to protect photographic film from x-ray exposure, and protective smocks worn by those exposed to high-energy radiation. *J. Pelz*

RADIOPHOTOGRAPHY The production of images by projecting x-rays through a subject to materials sensitive to those wavelengths. *H. Wallach*

RADIO SLAVE A triggering system that uses radio frequencies and consists of a transmitter and one or more receivers to fire a remote electronic flash unit, or trip the shutter on a remote camera. Depending on conditions, ranges of 150 to 200 feet are possible, and the frequency may be adjustable to prevent interference. *R. Jegerings*

See also: *Infrared slave; Slave unit.*

RADIO-XEROGRAPHY Method of recording x-ray or gamma ray images xerographically on a corona charged selenium plate. The dry process forms an image in black powder. An outline effect yielding increased resolution is caused by voltage gradients along the transfer edges. In continuous-tone xerography, this effect is eliminated by a development electrode. *H. Wallach*

RAIL A metal rod, in any of numerous shapes and configurations, that forms the operating base for a monorail view camera. The rail can be extended on some camera systems to allow for extreme closeup and for long focal length lenses. *P. Schranz*

RAINBOW HOLOGRAM A hologram that can be viewed with white light rather than monochromatic laser light. Because of the different wavelengths contained in white light, bands of different colors can be seen. *L. Stroebel*

RAMSDEN CIRCLE The circular extent of the exit pupil of an eyepiece of an optical instrument such as a microscope. All the emergent rays pass through this zone, which ideally is of large diameter and some distance from the eye lens. *S. Ray*

Syn.: *Exit pupil; Eyering.*
See also: *Eye relief.*

RANDOM ACCESS The ability to select any item or to select multiple items in any order as distinct from accessing them sequentially in the order in which they have been arranged, such as the projection of slides in a different order than they appear in a slide tray or going directly to a desired page in a manuscript in computer memory. *L. Stroebel*

RANDOM-ACCESS MEMORY (RAM) In computing, the central processing unit (CPU) of the computer will access data and program instructions from an area of the computer called RAM. Any set of instructions or data can be very quickly accessed by the CPU. Data and instructions can be entered into RAM as needed and instructed by the computer. As long as the computer is on-line, data will remain in RAM. Once the computer is turned off, all data in the computer will be erased. *R. Kraus*

RANDOM-ACCESS PROJECTOR A projector that allows the operator to locate and project any slide in the slide tray in a very short time. *M. Teres*

RANDOM PROOF See: *Scatter proofs.*

RANDOM VARIABILITY Chance-caused differences in observed data. Grains in a photographic image are normally randomly distributed. The separation of limit lines on a process control chart should be determined by random effects. *H. Todd*

RANGE (1) The arithmetic difference between the largest and smallest numbers in a set of data, often used as a measure of variability in setting limit lines on process control charts. (2) The quotient found by dividing the largest number in a set of two by the smallest. The range of luminances in an outdoor scene may, for example, be 150 to 1. (3) The distance to an object in a scene, often measured with a rangefinder in order to ensure proper focus. *H. Todd*

Syn.: *Ratio, the preferred term.*

RANGEFINDER An optical device that assesses object distance based on comparing images from two different view points. *P. Schranz*

See also: *Coupled rangefinder.*

Rangefinder. Split-image (top) and superimposed-image (bottom).

RANGEFINDER CAMERA See *Camera types.*

RANGELIGHT A focusing aid on coupled rangefinders for use in the dark or in dim light. Rangelight projects two spots of light on the subject. Aligning the two spots also focuses the camera. On some automatic SLR cameras with auto-focus capabilities, a single red light is projected onto the subject and picked up by the infrared sensor for focusing. *P. Schranz*

RAPID ACCESS When substantially increased speed in the processing of black-and-white film or paper is required, elevated temperatures, concentrated solutions, and eliminated steps can reduce dry-to-dry times by as much as 75%. These procedures fall into the general category of rapid processing. When even more speed is required, a group of mechanized industrial processes, generally described as rapid access systems, can provide dry-to-dry times of less than one second per frame.

Cell and chamber processors permit the contact of small amounts of processing liquid with the emulsion side of the film. The film is located one frame at a time over a sealing

frame and is held tightly in place by a pressure plate. Small metered volumes of solutions, less than 0.5 ml, are used. They are selected on the basis of the emulsion used and the image characteristics desired, and are forced into the chamber. Development takes 1.5 seconds. Fixer pushes the developer into the waste container and completes its task in 0.5 second. Washing takes 1 second, and a hot, high-velocity air stream dries the film in 2 seconds. Process temperatures may range up to 130°F.

Viscous-layer applicators are used to process 16-mm black-and-white positive films at 36 feet per minute with a dry-to-dry time of 1 minute at 125°F. A coating hopper applies a viscous developer to the emulsion for 2.5 to 7 seconds, depending upon contrast requirements. A high-velocity water spray jet removes the developer; a coater applies fixer for 12 seconds; a 15 second spray wash removes the fixer, and an air dryer finishes the job in 20 seconds.

Porous rollers or plates made of sintered stainless steel granules can be used to apply thin layers of solution to the emulsion. The solutions are pumped through a series of plates as the film moves past. Jet-spray processors use compressed air forced through venturis to atomize solutions. In aircraft, slot processors produce images with an access time of 5 seconds at 40°C by drawing film past three narrow slots: developer, pressure barrier, and fixer. Nonporous roller applicators feeding solutions from a tank process cine film at 100 feet per minute. Saturated web applicators absorb chemicals and process film as it comes in contact with the web.

A typical highly active developer for the processors described might contain sodium sulfite, potassium carbonate, hydroquinone, phenidone, sodium hydroxide, benzotriazole, and water. The fixer is usually ammonium thiosulfate.

The diffusion-transfer and stabilization processes are capable of providing processing times near the speed of some rapid access systems and might be considered before examining more elaborate machinery.

Although no color film processing equipment is as fast as the black-and-white units mentioned here, a color print processing system widely marketed as *rapid access* produces washed and dry conventional prints in less than 4 minutes.

H. Wallach

See also: *Diffusion transfer; Rapid processing; Stabilization process.*

RAPID PROCESSING Methods of processing that enable exposed photosensitive materials to be processed in considerably less time than is normally required. Rapid processing may include the use of special developers, elevated temperatures, and other deviations from normal processing conditions. *L. Stroebel and R. Zakia*

RARE-EARTH GLASS See *Optics, optical materials.*

RASTER In electronic imaging, the scanning pattern of the electron gun across and down the cathode-ray tube (CRT) as it paints or refreshes the image. In computer graphics, a rectangular matrix of pixels. *R. Kraus*

RASTER GRAPHICS In computers, screen graphics are displayed by the cathode-ray tube (CRT) according to a raster pattern that is controlled by the deflection circuit of the electron gun and the circuit of the metal grid inside the picture tube. Graphic characters are created according to which pixels are excited by the electrons. Characters are composed of groups of pixels. The main drawback to raster-drawn graphics is the jagged appearance of text. *R. Kraus*

RASTER IMAGE PROCESSOR In electronic imaging, used to convert vector images to raster images in computers that use both kinds of image files. *L. Stroebel*

RASTER UNIT In electronic imaging, the distance between the midpoints of two adjacent pixels. *L. Stroebel*

RAT FORMULA All energy incident on a surface must be reflected, absorbed, or transmitted, so the sum of these fractions must equal unity, that is,

$$R + A + T = 1$$

where R is the fraction of incident energy reflected from the material; A is the fraction of incident energy absorbed by the material; and T is the fraction of incident energy transmitted by the material. *J. Pelz*

RATIO The result of dividing the larger number of a pair of data by the smaller. For example, the lighting ratio on the face of a person sitting for a portrait may be 3 to 1, meaning that one side of the face receives three times as much light as the other. *H. Todd*

RATIO SCALE A series of numbers in which adjacent values increase or decrease by a constant factor. For example, in the series of f-numbers representing whole stops, such as $f/4$, $f/5.6$, $f/8$, $f/11$, and $f/16$, the values increase by a factor of the square root of 2. *H. Todd*

See also: *Interval scale; Ordinal scale.*

RAUSCHENBERG, ROBERT (1925–) American painter, printmaker, and photographer. An innovative and influential artist who creates complex montages combining photographs as equal elements with painting, graphics, and lithography.

Books: *Robert Rauschenberg.* Washington, DC: Smithsonian Institution, 1976; *Robert Rauschenberg Photographs.* New York: Pantheon, 1981. *M. Alinder*

RAW STOCK Unexposed film, especially motion-picture film. *M. Scott*

RAY See *Light ray.*

RAYLEIGH CONDITION/RAYLEIGH'S CRITERION
Specification of the visual resolution limit or performance of a diffraction-limited optical instrument in terms of physical optics. An instrument fitted with a circular aperture images a point source as an Airy pattern. The Rayleigh condition or criterion is that the limit is reached when two closely adjacent point sources are separated such that their coalescing Airy patterns are arranged to give the central peak of one superimposed on the first dark ring (minimum) of the other. *S. Ray*

RAYLEIGH'S RADIATION LAW The scattered flux density (as a result of Rayleigh's scattering) is proportional to the fourth power of the driving frequency (of the incident radiation). This means that higher frequencies (blue light) will be scattered much more strongly than lower frequencies (red light). *J. Holm*

RAYLEIGH'S SCATTERING The scattering of light by small particles, such as those in the atmosphere. Short wavelengths are affected more than long ones; thus the sky is bluish and the direct light from the sun yellowish. *J. Holm*

RAYLEIGH TOLERANCE A severe focusing tolerance for diffraction-limited optical systems, such as telescopes and microscopes, which allows $\lambda/4$ of defocusing, which spreads 17% of the light from the central Airy disk into the surrounding rings without changing the size of the disk. This does not cause a reduction in resolving power when the sub-

ject is two closely adjacent point sources of light but does result in detectable loss of contrast in the fine detail of an image of an extended subject. *S. Ray*

RAY, MAN (EMMANUEL RUDNITSKY) (1890–1976)

American photographer, painter, sculptor, and filmmaker. Frequented Stieglitz's "291" New York gallery beginning in 1911. First a painter, began photography in 1915 to record his paintings, but soon adding it to his expressive media. Moved to Paris in 1921, joining his good friend Marcel Duchamp. Worked as a freelance commercial photographer and painter, opening a photographic portrait studio in Paris (1921–1939) and then in Hollywood during the Second World War, returning to Paris in 1950 to concentrate on his creative art. At first a devoted Dadaist, he became the only American member of the surrealist movement. Known for innovation, he sometimes mixed photography and painting, creating assemblages. Man Ray often manipulated his prints outside of the camera producing photograms (naming his "Rayographs") and employing the Sabattier effect. He stated, "I paint what cannot be photographed, I photograph the things that I don't want to paint."

Books: *Self Portrait.* Boston: Little, Brown, 1963; *Man Ray, Photographs.* New York: Thames & Hudson, 1982; Baldwin, Neil, *Man Ray, American Artist.* New York: Clarkson N. Potter, 1988. *M. Alinder*

RAYOGRAPH See *Photogram.*

RC See *Resin-coated.*

READ

In computers, the accessing of data or instructions from either a floppy disk or hard disk. *R. Kraus*

READER

A rear-projection optical device that enlarges microfilm images for inspection. *L. Stroebel*

See also: *Microfilm printer/reader.*

READ-ONLY MEMORY (ROM)

In computers, a reserved location of chips that contain a set of instructions, usually a part of the operating system that cannot be altered or written to. ROM chips retain their instructions/data when the computer is off, unlike random-access memory (RAM). *R. Kraus*

READOUT

The recall of stored information, from microfilm or a computer file, for example, in more usable form such as a print or a display on a monitor. *L. Stroebel*

READYLIGHT

A signal light that indicates when a flash unit is charged and ready for firing. Though commonly found on the flash unit itself, cameras with auto-coupled flash systems may also have a readylight display in the viewfinder. *P. Schranz*

READY MOUNT

A Kodak slide mount that comes in two styles: (A) folded, like a matchbook, with the folded edge serving as a hinge. The slide is placed into a recess area, closed, and heat sealed with a hot iron. (B) A closed slide mount, sealed on three sides; the transparency is slid into the open side and sealed with a hot iron. *M. Teres*

REAGENT

A reagent is a chemical substance that interacts with another substance because of its reactive capability. In the classification of the purity of chemicals, a reagent grade chemical is one of high purity, sometimes called an analytical reagent. *G. Haist*

REAL IMAGE

Representation of the subject where divergent rays from each subject point following reflection or refraction by optical elements meet again in a corresponding conjugate point. The pattern of points formed constitutes a real image in space, which can be made visible by a viewing device focused on a planar section of these image points or by a diffusing surface or screen placed in this plane. Likewise the real image may fall directly on the surface of photographic film or other recording surface. *S. Ray*

See also: *Aerial image; Virtual image.*

REAL TIME

The representation of an event or sequence of events that takes essentially the same amount of time as the original event. It is particularly distinguished from a frame-by-frame representation. Film and video are real-time media. In computer managed imaging, enhanced microprocessor performance is bringing increasingly complex tasks into the real-time domain. *H. Wallach*

REAL-TIME SPECTRUM ANALYZER

A device for measuring the amplitude versus frequency response characteristic of a device or system under test and that gathers information about all parts of the desired frequency range simultaneously. Real-time analyzers generally use a bank of frequency selective filters and a means of measuring the output levels from the bank of filters that is displayed as a graph of amplitude versus frequency. *T. Holman*

REAR NODAL POINT/PLANE See *Nodal points/planes.*

REAR PROJECTION

Rear projection uses a translucent screen onto which an image is projected from the back side. This allows the projection equipment to be placed out of sight of the audience. Because the images are shown through the screen from the back, the slides must be placed in the slide tray in a reverse manner or the images will appear reversed from left to right. Special lenses, which are designed for rear-screen projection, may be use instead of reversing the slides. These lenses utilize a prism to laterally reverse the image to achieve correct image orientation. A less expensive alternative is to attach a front surface mirror at a 45-degree angle just in front of the projector lens. Rear-screen lenses are usually designed to have a very short focal length in order to reduce the screen-to-projector distance. If there is not enough room between the projector and the screen to produce the necessary image size, it is possible to use a system of mirrors to zigzag or "fold" the image back and forth in order to increase the size of the projected image on the screen. Depending on the quality of the screen, rear projection may reduce to some extent the contrast and sharpness of the projected image. Lower quality systems may also produce a hot spot on the screen. Black nylon screens are recommended when front lighting on a subject can also fall on the screen. In motion pictures, rear projection is the basis

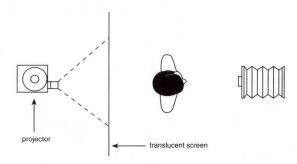

projector ← translucent screen

Rear projection.

of process photography, a method of combining live action with filmed scenes. *M. Teres*

See also: *Front projection.*

REAR SHUTTER A shutter found in motion-picture projectors. It is located behind the lens and film and in front of the projector light source. *P. Schranz*

REBUS LAYOUT An arrangement of photographs, images, designs, or typographical material in which the photographs are placed within the body of typographic copy, sometimes substituting for omitted words. Use of photographic image for narrative copy. *R. Welsh*

RECEDING COLOR A hue that is in the same physical plane as another but appears to be farther away. Bluish hues are sometimes seen as being more distant than reddish hues at the same distance. Blues are therefore identified as receding colors and reds as advancing colors. *L. Stroebel and R. Zakia*

See also: *Optical illusions; Perspective, types of perspective.*

RECEPTOR General term for any surface on which radiation falls and which responds to that radiation, e.g. photoreceptor, photocell, photographic emulsion, photoresist, retina. *M. Scott*

Syn.: *Photoreceptor.*

RECIPROCAL (1) The result of dividing a number into 1. Opacity is one measure of the absorption of light by a part of a silver image; it is the reciprocal of the transmittance. If the transmittance is 0.5, the opacity is 1/0.5, or 2. (2) Identifying a relationship between two variables by which as one increases the other decreases in proportion. To keep the exposure (H) constant, the needed light level (E) and exposure time (t) are reciprocally related, since $E = H/t$. *H. Todd*

RECIPROCITY DATA ON FILMS AND PAPERS See *Appendix O–V.*

RECIPROCITY EFFECTS (1) See *Photographic effects.* (2) Reciprocity effects are the experimental observation that equal exposures do not produce equal photographic images (density and contrast) if the time of exposure is unusually long or short (and the light level is correspondingly weak or strong). *H. Todd*

RECIRCULATION The forced movement of a processing solution through a tank, for example, to provide agitation, replenishment, temperature control, etc. *L. Stroebel and R. Zakia*

RECOGNITION The ability of a person to identify the stimulus. The person must be able to see characteristics that distinguish one object from another, such as the size and shape of a light meter and a 35-mm camera. The more similar the stimuli, the more difficult the task. The Snellen eye chart, composed of letters of the alphabet, is one visual test involving recognition. *L. Stroebel and R. Zakia*

See also: *Detection; Localization; Resolution; Visual perception, perceptual discrimination.*

RECOMBINATION Refers to the process in which electrons and holes recombine. This is an inefficiency of the photographic process and photographic scientists continually strive to minimize it. *R. Hailstone*

RECORD (1) A photographic image, especially one intended for use in data analysis, as compared with a pictorial image. (2) In color photography, a separation negative or positive representing a primary color. *L. Stroebel*

See also: *Sound recording.*

RECORD EQUALIZATION An equalization applied before recording to be complemented with a playback equalization. The purpose of the record and playback equalization cycle is to produce the best trade-off of headroom versus signal-to-noise ratio of a medium for its intended use. *T. Holman*

RECORD HEAD A tape head intended to leave a magnetic recording on a tape. It consists of metal laminations around which an electrical coil is wound—electrical current injected into the coil then produces a corresponding magnetic field in the laminations. The laminations are gapped at least on one end, and at such a gap a magnetic field extends out from the head able to record on oxide. *T. Holman*

RECORDING GALVANOMETER See *Galvanometer.*

RECORDING PAPER Photographic paper used in rolls to record the trace of a moving spot of light from a mirror galvanometer or other modulating device. The paper is moved continuously past the line in which the spot is focused. In some cases a direct print-out is obtained, amplified by controlled exposure to light of lower intensity. Color recording papers in recorders with filtered, multiple writing beams can write several variables at once. *M. Scott*

RECOVERY TIME The time required for the restoration of the ability of a device to function after performing an operational cycle. In a slide projector, for example, recovery time is the interval that passes between the advancing of one slide and the display of the next. *H. Wallach*

RECTIFICATION Term used principally in photogrammetry to describe the process of correction for nonparallelism between the subject plane and the film plane which results in, for example, rectangles being recorded as trapezia and convergence of vertical or horizontal parallel lines. Correction can be obtained from camera orientation data at the time of exposure or from reference points in the field of view. Rectification of negatives that have convergent verticals may be attempted during printing, using an enlarger with suitable movements of the lens panel and negative carrier. *S. Ray*

RECTIFIER A diode vacuum tube or a solid-state diode used specifically to convert alternating current to direct current. The term *rectifier* is also used to describe an assemblage of diodes, such as the bridge rectifier, which consists of four diodes. *W. Klein*

RECTILINEAR Term used to describe an early design of a symmetriacl lens that gave an essentially undistorted image, i.e., straight lines were not curved in the image. It is also used to describe the normal form of imagery by central projection through a camera lens. Additionally, it describes the motion of the focusing mount of a camera lens that does not rotate as the lens is focused, thereby facilitating the use of direction-sensitive attachments such as polarizing filters and effects filters. *S. Ray*

RECYCLE (1) To reuse, as in the recycling of wash water or heated air during photographic processing. (2) To return to a state of readiness, as in the recycling of an electronic flash after it has been fired. *H. Wallach*

RED (1) One of the four unique visual hues, the others being green (to which red is opponent), yellow, and blue. A hue that corresponds to the part of the visible spectrum having wavelengths longer than 650 nm. (2) Name sometimes given to the green-absorbing (magenta) colorant used

in a subtractive process, particularly in the past in the printing industry. *R. W. G. Hunt*

See also: *Unique hue; Magenta.*

RED BLINDNESS See *Defective color vision; Vision, color vision.*

RED DOT See *Infrared mark.*

REDEVELOPMENT Applies specifically to the process of converting the silver salts of a bleached negative or print image back into metallic silver by a second development. The term is commonly, but inappropriately, used to describe the second development in reversal processing in which silver halides that were chemically fogged or re-exposed to light are developed for the first time.

Negatives may be bleached and redeveloped in white light to alter density, graininess, or contrast. Observation of the process permits close control of final negative density. Graininess is reduced by redevelopment in a paraphenylene diamine developer instead of a metol-based one. Contrast is reduced by bleaching and redeveloping to a lower contrast index.

Prints are bleached and redeveloped to improve print color. In the carbro process, the matrix print may be used five or six times if it is redeveloped after each impression.

H. Wallach

RED-EYE REDUCTION FLASH An electronic-flash unit that fires a series of low-intensity flash bursts before the main full-intensity burst. The stroboscopic series reduces pupil diameter to reduce the risk of red-eye effects, with the risk of losing control over the moment of exposure. An alternative system turns on a continuous light for a brief period before the flash burst. Red-eye reduction systems are typically used on amateur cameras that have built-in flash tubes close to the camera lens. Narrow pupils are unnatural indoors but are less objectionable than the red-eye effect. *R. Jegerings*

See also: *Red-eye.*

Red-eye reduction flash. A pulsating series of low-intensity flash bursts before the main flash reduces pupil diameter, represented by the dashed line, to reduce the possibility of red-eye effects.

RED-GREEN BLINDNESS See *Defective color vision; Vision, color vision.*

RED, GREEN, BLUE (RGB) In computers, a tri-stimulus color system that displays color as a spatially additive

amount of red, green, and blue. Also, an acronym for the components of a color video signal. *R. Kraus*

See also: *Additive color process.*

REDOX POTENTIAL Reduction-oxidation potential (redox potential) is the measure of potential of the electric current flowing between two electrodes placed in a solution in which electron transfer can occur. By using a hydrogen half-cell (assigned zero potential), half-cell potentials can be determined for many elements and compounds, permitting a prediction of whether electrons will flow from reducing agent to oxidizing agent. *G. Haist*

RED SPOTS Red spots (also yellow or orange in color) sometimes seen on microfilms and motion picture films are often colloidal silver resulting from the oxidation of the silver in the vicinity of contamination particles after periods of storage in the presence of moisture. The contamination is most often seen at the beginning and ends of rolls and is probably due to handling contamination, not the manufacture of the film stock or its processing. Important records should be carefully inspected at regular intervals and rewashed at the first signs of defects. *I. Current*

See also: *Image permanence.*

REDUCING AGENT A reducing agent transfers one or more of its electrons to another atom, thus reducing that atom. The reducing agent itself is oxidized when it gives up its electrons. The compound receiving the electrons is called the *oxidizing agent* and is itself reduced. Both reducing and oxidizing agents are necessary if a reaction is to occur. The latent image of an exposed silver halide crystal is the site for a developing agent (the reducing agent) to transfer electrons to silver ions (the oxidizing agent), forming metallic silver of the photographic image. The silver ions have been reduced (gained electrons); the developing agent has been oxidized (lost electrons). *G. Haist*

REDUCTION Reduction is the lowering of densities in a negative or positive, usually by chemical methods. Reduction is used to lower densities of an overexposed image to reduce printing time, modify negatives that have been overdeveloped to reduce contrast, and remove fog from thinner areas of a negative or positive. The treatment is generally applied by immersing the whole negative or print after it has been thoroughly rewet, but some formulas allow local reduction of specific areas of the image. Reducing techniques are less used today because the photographer has better control of exposure and processing than in the past.

The chemistry of reduction generally involves converting part of the silver to a soluble compound that is washed away. In the case of Farmer's reducer, the silver is first converted to silver ferrocyanide, which is then made soluble by the presence of sodium thiosulfate (hypo). Other reducers such as those made with manganese, chromium, or copper salts convert the silver directly to a soluble compound that can be washed away.

The action of the reducer throughout the density range of the image depends on its formulation and concentration as well as on the kind of emulsion used to make the negative and the size distribution of the silver grains making up the image. For a given density, small grains present a greater surface area for chemical reaction than do large ones. The reducing action can be characterized as *subproportional,* (which includes *subtractive* or *cutting*); *proportional;* or *superproportional.*

SUBPROPORTIONAL REDUCERS Subproportional reducers remove a smaller percentage (but not a smaller amount) of silver from dense areas than from thin areas. A

subtractive or cutting reducer, one type of subproportional reducer, removes equal densities at all density levels, and thus does not change contrast. It is appropriate for some types of overexposure where lowering of density without change of contrast is desired. Farmer's reducer is typical, but when diluted produces some loss of contrast.

PROPORTIONAL REDUCERS A proportional reducer removes a given percentage at each density level, thus lowering the contrast of the negative. It is used to correct for overdevelopment where it is desirable to lower the contrast as well as density.

SUPERPROPORTIONAL REDUCERS A superproportional reducer has a greater percentage effect at high densities than at lower densities, and is used where the desired contrast reduction is greater than that achieved with a proportional reducer.

An important consideration in selecting a reducing method is the capability of assessing the degree of reduction. Some formulas continue to cause a reducing action even after the negative has been removed from the bath and washing has started. It is thus better to halt the treatment before the anticipated result. If further treatment is required, it can then be resumed. *I. Current*

See also: *Abrasion reduction; Etching (physical).*

REDUCTION, CHEMICAL Chemical reduction is the name of the process by which electrons are added to ions or atoms. Chemical reduction is part of the reduction and oxidation processes, which occur simultaneously in a reaction. The reducing agent supplies the electrons and is oxidized. The oxidizing agent acquires the electrons and is reduced. *G. Haist*

See also: *Oxidation; Reducing agent.*

REDUCTION LENS See *Lens types.*

REDUCTION, OPTICAL Process of making an image of reduced size relative to the subject by means of an optical system or lens. The image given by a camera for general use is an optical reduction of the scene for convenience of using a small format. Numerically, a scale of reproduction or an (optical) magnification of less than one means optical reduction. *S. Ray*

REDUCTION PRINT A motion-picture print made on a smaller film stock than the original, for example, a 16-mm print made from a 35-mm original. *H. Lester*

REED RELAY A very fast acting electromagnetic switch consisting of two thin strips of magnetic material within a glass envelope and a coil of wire wrapped around the envelope. When current flows through the coil, the magnetic field produced causes the thin strips to attract each other and complete the electrical circuit through the strips. Reed relays differ from ordinary relays in that they do not have a high-inductance iron-coil or a massive moving armature. Reed relays typically operate in less than a millisecond. *W. Klein*

See also: *Relay.*

REEL (1) A spiral device for holding roll film for processing in a tank. (2) A spool-type holder for processed motion-picture film, typically having calibrated open flanges so that the amount of film on supply and takeup reels can be easily determined. *L. Stroebel*

RE-ETCH A chemical or physical method used for correcting printing defects in letterpress engravings and gravure cylinders. *M. Bruno*

REEXPOSURE Applies particularly to the reversal processing of positive materials, such as color transparency films and printing papers designed to make prints directly from color transparencies. To reverse the tones in exposed reversal film to obtain a positive image, they are reexposed to light after the first development. This reversal exposure creates new developable areas in the emulsion that, upon second development, will yield a positive image. Current reversal processing systems substitute chemical reversal, called fogging, for reexposure. *H. Wallach*

REFERENCE Something used as a standard for comparison, such as a color print that is used to assist in judging the color balance of production prints. *L. Stroebel*

REFERENCE BEAM Term used in holography to describe the undisturbed wave front that is superposed at the recording film surface with another coherent wave front that has been modulated by reflection and interaction with the subject. *S. Ray*

REFERENCE FLUXIVITY A standardized level of magnetic flux, measured in nanoWebers/meter (nW/m) recorded on a tape or film, for use in calibrating tape and film recorders. Common reference fluxivity values include 100, 185, 200, 250, and 320 nW/m. *T. Holman*

REFERENCE PRINT A motion-picture print, approved by the director and producer, used as a quality standard for subsequent prints. *H. Lester*

REFLECTANCE See *Reflection factor.*

REFLECTED-LIGHT METER A light meter that is designed to measure the light reflected, transmitted, or emitted by the subject, more accurately but less commonly identified as a luminance meter. *J. Johnson*

See also: *Exposure meter; Incident-light meter.*

REFLECTING LENSES See *Lens types.*

REFLECTION See *Light reflection.*

REFLECTION COPY Photographs and other images that must be viewed and copied with reflected light as distinct from transparencies. The term is used primarily in the graphic arts for images that are to be reproduced. *L. Stroebel*

REFLECTION DENSITY The logarithm of the reciprocal of the reflectance of a print sample area. For example, if the sample receives 100 units of light and reflects 50 units, the reflectance is 50/100, or 0.50; the reciprocal is 1/0.50 or 2.0, and the density is the log of 2.0 or 0.30. Often the computation is performed with reference to the reflectance of the base taken as 1.0. *M. Leary and H. Todd*

See also: *Transmission density.*

REFLECTION (SOUND) Sound encountering a barrier may be reflected off it. A flat barrier will reflect sound with a specular reflection, just like a billiard ball encountering a bumper at the edge of a pool table. A shaped barrier can concentrate or diffuse sound, depending on its shape. One example of a deliberately shaped barrier to capture sound energy is a whispering gallery, which has two points of focus, many feet apart, that conduct sound between them very well. *T. Holman*

REFLECTIVITY Reflectivity is the limiting reflection factor of a given material, such that further increasing the thickness of the material does not increase its reflection

factor. The reflection factor of thin materials may increase with thickness because the total reflection is a result of both surface and complex internal reflections. *J. Pelz*

See also: *Reflection factor.*

REFLECTOR Two basic types of reflectors are used by photographers to redirect light, those curved around lamps in lighting fixtures and those that can be positioned independently. An independent reflector is used to redirect all or a portion of the light from a source for purposes such as illuminating shadows to lower contrast, or to effectively increase the size of a small source by *bouncing* the light off a large surface.

Reflectors used close to lamps in lighting fixtures have three principal curvatures. A *spherical* reflector spreads light over a relatively large area; a *parabolic* reflector emits a parallel beam to illuminate a smaller area; an *elliptical* reflector produces a converging beam to illuminate an even smaller area. In practice, light patches from different reflectors are less well defined than many drawings indicate. The relative positions of the lamp and the reflector are important to beam control. Moving the lamp backward or forward in a *focusing fixture* provides control over the angular distribution of the light. Seen from the front, fixture reflectors generally duplicate bulb shape. Round lamps have circular reflectors; linear quartz-halogen lamps and linear flash tubes for on-camera flash units have rectangular reflectors.

The interior surface of a fixture reflector affects light intensity and the uniformity of the illumination patch. A highly polished reflector produces brilliant but uneven illumination and may be used to compensate for a loss of intensity when the light is bounced or directed through a diffusion screen. Illumination with a polished reflector can be made more even with a patterned surface, or with a roughly polished surface. A brighter central area in the illumination patch is a problem with direct light, but it allows the light to be more easily feathered, and polished reflectors can produce more-specular highlights on subjects. Polished reflectors produce cooler color balance than white matt reflectors. A white matt reflector interior produces the most even illumination patch and reduces specular reflections. *R. Jegerings*

See also: *Lighting umbrella; Light sources; Reflector lamp.*

REFLECTOR FACTOR The ratio of the illumination falling on the subject from a light source in a reflector to that provided by the source without the reflector. Factors vary widely, for example from 2 for a matt-surface reflector to 6 for a highly polished reflector. Reflector factor should not be confused with the *reflection factor,* which is the ratio of reflected light to incident light and which has a theoretical maximum value of 1.0. *R. Jegerings*

REFLECTOR LAMP A lamp that controls light distribution with a built-in rear reflector, eliminating the need for a separate reflector. The lamp may be open-faced or have a protective or diffusing front cover. Lamps with rear-mounted reflectors are often quartz-halogen types for specialized applications: for use with a condenser system in a slide projector; or to provide a collimated light beam for use with dichroic (interference) filters in an enlarger head. Tungsten-halogen lamps may have a cold-mirror reflector that passes infrared radiation to reduce heat transfer to film or a projection system and reduce color-balance problems in printing. *R. Jegerings*

REFLEX AUTOCOLLIMATOR See *Autocollimator.*

REFLEX CAMERA See *Camera types.*

REFLEX COPYING Method for contact copying documents, especially those that are opaque or have two sides, by exposure through the back of the sensitive material. The light passes through the copying material and strikes the original. The dark parts of the original reflect little light; the light background reflects more. Because the copy material is both low in sensitivity and high in contrast, an image is recorded only in those areas that receive a double, or reflex (reflected) exposure.

Ordinarily, this procedure yields a reversed image requiring either a repetition of the process or a contact print through the back of the negative. The second step is avoided in office reflex copying machines that use diffusion transfer copying materials. The original is exposed in contact with the diffusion transfer negative which is then sandwiched with the receiver sheet. Activator causes the negative to develop on one sheet while the unexposed silver transfers to the receiver sheet and forms a positive image. The sheets are peeled apart in about a minute.

A system of reflex copying was proposed by A. Breyer in 1839. The first practical two-step system was J. H. Player's Playertype of 1896. *H. Wallach*

See also: *Diffusion transfer.*

REFLEX PROJECTION See *Front projection.*

REFRACTION See *Light refraction.*

REFRACTIVE INDEX See *Index of refraction.*

REFRESH RATE The speed at which the cathode-ray tube (CRT) updates the information displayed on the screen. The faster the refresh rate the steadier the picture appears. *R. Kraus*

See also: *Static memory.*

REGENERATION Procedure for restoring a processing bath to fitness for continued use. As fixer is used, the concentration of free thiosulfate ions decreases, the concentration of silver increases, the acidity may decrease, and the concentration of iodide increases. Regeneration must address each of these factors. Fixing baths may be electrolytically regenerated, removing accumulated silver and reconverting complex silver salts to thiosulfate. The silver may be precipitated by the addition of sodium sulfide or sodium hydrosulfite. Iodide may be removed by adding a thallous sulfate solution that precipitates thallous iodide. The thiosulfate concentration may then be restored by adding sodium thiosulfate, and reacidification achieved by adding sodium bisulfite, sodium metabisulfite, potassium metabisulfite, or acetic acid.

In metol-hydroquinone developers, metol becomes oxidized during the reduction of the silver halide image. Hydroquinone regenerates some of the oxidized metol to metol. In phenidone-hydroquinone developers, all the oxidized phenidone is regenerated, yielding a longer working life. The practice of replenishing developers by adding compounds to replace exhausted components is not regeneration because it does not remove accumulated contaminants.

In color processing, partially exhausted bleach solutions may be regenerated by oxygenation. Air is bubbled through the solution, returning the ferrous iron ions (Fe^{2+}) produced in the conversion of metallic silver to silver bromide, back to the ferric state (Fe^{3+}). *H. Wallach*

REGISTRATION The process of precise image alignment required for photographic masking, dye transfer printing, photomechanical reproduction, and other special effects. Registration can be accomplished by several methods: visual alignment, pin registration, edge guides, or sprocket-hole alignment. Registration by visual alignment can be used to produce contrast-reduction masks or separation negatives. This is a rather simple technique where the

original is sandwiched with the masking or separation film and exposed. The processed mask or separation is visually aligned with the original and then they are taped together. Use of multiple masks or separations with one original is more suited to pin-registered negative carriers. The use of visual registration marks is routinely employed in the photomechanical printing process. Typically, a circle with cross hairs is used in several locations outside of the text or image margins. By closely monitoring these marks, the printer can detect a loss of registration by looking for color or image bleed. To produce multiple exposures from the negative stage of an enlarger, pin-registered negative carriers are used. Typically these carriers are designed for 4×5 or 8×10 sheet film. A set of pins along the leading edge of the carrier registers the film, which is sandwiched between anti-Newton-ring glass. These carriers are supplied with a matched punch to place registration holes in the film. Positioning the carrier in exactly the same location each time is accomplished with a spring-loaded locking lever. The easel for holding the film or paper to be exposed must be secured to the work surface to prevent any movement.

Registration of dye transfer matrices during the printing process is achieved by using a pin-register board or easel. These easels use a flat metal base with two large registration pins. A spring-loaded clip is used on some easels to help secure the matrix film to the paper. After visually aligning the matrices, they are all punched to match the easel. Once the paper has been punched and presoaked, it is placed on the register board. One at a time, each of the three dye-impregnated matrices is registered on the paper and rolled to transfer the dye.

Edge guides are used in a fashion similar to pin-register easels. Rather than punching holes in the films or matrices, a common edge is trimmed after visual alignment. The edge guide and the trimmed edge of the material are butted together to perform the registration. This technique is not as precise as using punched holes and pins but is easier to set up if pin-registration equipment is not available.

Sprocket holes in motion picture film serve as a registration guide to maintain synchronization with the projector. Pins located in the film gate of motion-picture cameras maintain the registration of image frames to sprocket holes as the film is exposed. A loss of image registration when projecting films is quite apparent as the picture will blur and stutter.

Registration. Pin-registration easel. Used for situations requiring exact alignment at the enlarger baseboard level. A matching punch is used to place registration holes in the film or paper. The material can then be precisely aligned for multiple exposures.

To produce high quality multi-image slide presentations, pin-register cameras and slide mounts can be used. This will allow a multi-image progression projected onto one location to flow smoothly. Without this type of registration, the illusion of fluid motion can be interrupted by slight image position shifts. *G. Barnett*

REGISTRATION PINS A device in the gate of a motion-picture camera that engages the film perforations, ensuring that each frame of film is in exactly the same position as preceding and following frames and thus ensuring maximum steadiness of the image. *H. Lester*

REGRESSION The atoms of metallic silver i the latent image of an exposed photographic material are susceptible to chemical attack. Loss or regression may occur during latent image formation, and an oxidative attack during keeping after exposure can result in a loss of silver atoms. *G. Haist*
 See also *Halogen acceptor.*

REHALOGENATION A developed metallic silver image can be converted to a silver halide, that is *rehalogenated,* by treating the metallic silver with an oxidizing agent and a halide salt. Potassium ferricyanide and a soluble halide (usually bromide or chloride) will change the metalic silver to silver halide. this technique can be used to reduce negatives taht have been correctly exposed but overdeveloped. *G. Haist*
 See also: *Reducers; Reducing agent.*

REJLANDER, OSCAR GUSTAV (1813–1875) Swedish-born photographer. Trained as a painter. Worked in England from 1853 as portrait and genre photographer. A notable exponent of combination printing, his most famous photograph was *The Two Ways of Life,* made in 1857 from over 30 negatives. Composed nude and other studies for artists to paint from. Provided photographs to illustrate Charles Darwin's *Expressions of the Emotions in Man and Animals* published in 1872.
 Book: Jones, Edgar Yoxall, *Father of Art Photography: O.G. Rejlander, 1813–1875.* Greenwich, CT: New York Graphic Society, 1973. *M. Alinder*

RELATIVE APERTURE Basic parameter of a lens usually defined as the ratio of the focal length of the lens to the diameter of the effective aperture, expressed as the f-number. For optical purposes, the diameter of the entrance pupil is divided into the focal length. Given that the aperture diameter is $1/n$ of the focal length f, the relative aperture of the setting in question is f/n, usually written in such forms as $f/4$, $f/2$, $f{:}4$, and $1{:}4$. The effective light transmittance is inversely proportional to the square of this f-number. Camera lenses usually are calibrated with a scale marked in f-number steps that double or halve the transmittance, so that the scale numbers (rounded off for convenience) increase by a factor of the square root of two, e.g., $f/1.4$, $f/2$, $f/2.8$, $f/4$, $f/5.6$. The maximum aperture may not be in this series but have an intermediate value such as $f/3.5$ or $f/1.8$. *S. Ray*
 Syn.: *f-Number.*

RELATIVE HUMIDITY (RH) The amount of water vapor present in a gas (especially air) expressed as a percentage relative to the maximum amount of water vapor the gas could contain. Relative humidity is dependent on the barometric pressure and temperature of the gas. As a gas gets warmer or denser, the amount of water it is capable of containing in vapor form increases. For example, if a gas with 50% RH is warmed, the relative humidity decreases even though the amount of water vapor present remains constant. Relative humidity is most useful for determining the equilibrium water content that will remain in a substance (such as a photograph) when exposed to the air. Low relative humidities tend to be drying, and may improve the keeping properties of photographs but may also cause curling. *J. Holm*

RELATIVE LOG EXPOSURE For sensitometric tests, a situation in which the actual log exposure values are not known but the relationship between the various log H values

is known. Relative log H information can be obtained by the use of a gray scale (transmission or reflection) or from measurements of the luminance values for different subject areas. If one subject tone gives a luminance reading twice that of a second, the log exposure values for the two tones differ by the log of 2, or 0.30. In practice, camera flare somewhat lessens the computed value.　　　*M. Leary and H. Todd*

See also: *Gray scale.*

RELATIVE PHASE
The phase of a waveform relative to another identical waveform, but disregarding the phase of either waveform with respect to the origin. The difference in relative phase between two waveforms must be between -π and π, or 0 and 2π radians.　　　*J. Holm*

RELAY
An electromagnetically operated switch. Current through a coil on the relay produces a magnetic field that moves an armature to simultaneously actuate one or more sets of electrical contacts. The contacts open (break) and close (make) circuits with currents ranging from milliamperes to thousands of amperes, depending on the relay type. Heavy-duty relays are known as *contactors*. Relays are available with coils designed to operate with a wide range of dc or ac voltages. Typically, the power that a relay can switch far exceeds the power necessary to actuate it. Relays are used in electronic circuits primarily because they provide electrical isolation between the coil (the input) and the contacts (the output). In photofinishing equipment relays are frequently used to switch one or more analog signals with a digital (on-off) input signal.　　　*W. Klein*

See also: *Reed relay; Solenoid; Solid-state relay.*

RELAY LENS
See *Lens types.*

RELEASE
See *Cable release; Model release.*

RELEASE PRINT
A composite motion-picture print (including both picture and sound) made for general distribution and exhibition.　　　*H. Lester*

RELIEF IMAGE
A three-dimensional image produced by any of various methods including differential hardening of gelatin and removal of the unhardened gelatin with hot water, and the selective etching of a metal surface on the basis of variations of exposure. Letterpress printing plates have relief images.　　　*L. Stroebel*

RELIEF PRINTING
Letterpress and flexographic printing.　　　*M. Bruno*

See also: *Flexography; Letterpress.*

REMBRANDT LIGHTING
Illumination like that represented in paintings by the Dutch painter Rembrandt (1606–1669), having both brightly and dimly lit areas. Generally applicable to portraiture, the term is also used to describe both broad and narrow lighting with minimal, but adequate, fill light.　　　*F. Hunter and P. Fuqua*

See also: *Broad lighting; Narrow lighting.*

REM-JET
Shortened from removable jet, a type of antihalation coating containing carbon particles in an alkaline-softenable organic binder. It requires scrubbing for removal. It is remarkable for its efficiency in preventing reflection, and is effective even in the infrared.　　　*M. Scott*

REMOTE CONTROL
Control of the operation or performance of a device by an operator positioned remotely from the device. Photographic equipment can be operated remotely directly and indirectly. Direct control involves a physical connection between the operator and the device such as the long cable release on a camera or the controller at the end of the cord to a slide projector. Indirect control methods use light, infrared, or radio waves to transmit control signals.

LIGHT The triggering of slave electronic flash units is an example of remote control by means of light or infrared radiation. Photosensors in one or more remote units detect the master flash and trigger their own flashtubes.

INFRARED Transistorized battery-operated remote control units using coded pulses of infrared energy enjoy widespread use to control the operation of videotape recorders and television sets.

RADIO Controllers that transmit radio frequency energy range from the simple garage door opener to the sophisticated telemetering systems required for attitude control of orbiting satellite and for the operation of on-board instrumentation, including cameras and processing equipment.　　　*W. Klein*

REMOTE SENSING
Remote sensing is a broad discipline that encompasses the specialized instrumentation and analytical techniques for observing and measuring an object or process without coming into physical contact with it. Thus, concepts as different as an explorer getting the lay of the land from a hilltop, observations of the Martian surface by space probes, and nondestructive testing of machine parts using video cameras (close range remote sensing) are included in the general definition. When most people talk about remote sensing, however, they are referring to that subset of the discipline that involves studying and measuring the earth using airborne or space-based sensors. In particular, a large component of the remote sensing field involves the development and use of aerial and satellite imaging systems.

Conventional photographic imaging systems (cameras) ranging from standard 35-mm cameras to exotic large-format cameras (9×18 inches) using a variety of film types are commonly used. These cameras collect image data, which are then analyzed using remote sensing techniques to study many phenomena, including crop type and health for agricultural and forestry studies, water quality and extent for environmental and hydrological studies, land cover and elevation changes for transportation and engineering studies, as well as a host of other applications, including detailed mapping of topography and land cover features.

The large area coverage that can be obtained using images from airborne systems offers a perspective that often allows scientists an opportunity to study patterns and relationships that are not obvious in more localized studies. This was made dramatically clear when the first images from space began to show global cloud patterns as well as land cover and environmental conditions on national and even continental scales. The images from these early satellite systems were typically taken with the same film type cameras that were used for aerial photography. This approach is still the most common means of imaging on manned space missions. Over time, electro-optical imaging systems were also used for both aerial and satellite imaging. These systems have an advantage, particularly for satellites, because the image data can be sent down to earth where they can be processed on computers and printed out as photographs or displayed on computer monitors. The electro-optical systems have another advantage in that they can collect data at wavelengths where film is not sensitive. For example, many of the space-based systems collect data in the 8–14 μm (8000–14000 nm) region of the electromagnetic spectrum. In this region the energy that forms the image is largely caused by the temperature of the object viewed. As a result, the images carry information about the temperature of the earth. This temperature information can be used to study such phenomena as water circulation patterns and cloud heights. In addition, sensors using this wavelength region (for infrared) do not require reflected sunlight to form the image, and as a result they can image

day and night. The low resolution version of some of these images are processed to form the moving cloud images shown with television weather forecasts. Higher resolution images from these same sensors are analyzed on computers and printed out as photographs for more detailed analysis.

By combining images from many spectral bands (e.g., red, green, blue, near infrared), it is possible, using computer analysis, to identify land cover types and the condition of certain land cover features such as the amount of vegetation or biomass in a region. By combining satellite images of the same area taken over many days or seasons, it is possible to monitor very large scale processes such as the growth of the desert in central Africa or the deforestation in the Amazon basin.

Since the 1970s, advances in digital computing have enabled the remote-sensing field to draw heavily on digital-image processing to increase the amount of data that can be extracted from imagery. This has included development of digital enhancement techniques to sharpen images for subsequent photo interpretation (e.g., to make the pyramids stand out in an image of the Nile valley from space), development of geometric correction methods so that images distorted by such effects as earth curvature can be removed, and development of methods to mathematically merge many different images together so that spectral or radiometric analysis can be performed to extract information that is often difficult for human analysts to see.

Increasingly, remote sensing has focused on developing improved ways to quantify the data extracted from imagery. As a result, more and more work is being done to directly measure environmental factors. This involves correcting for atmospheric degradation of these images and removing their effects on the final image brightness. Between dealing with the collection and correction of remote sensing images and the display and application of the data, a broad range of scientific disciplines are involved. Among the individuals developing or using remote sensing techniques are optical, imaging, and photographic scientists, as well as geographers, geologists, agronomists, foresters, environmental scientists, and archaeologists. *J. Schott*

RENDERING In electronic imaging, the application of a textured surface to a wire frame object in a computer graphic. Rendering can be accomplished in two- and three-dimensional animation programs. In either case the computer power required to do rendering quickly and accurately is substantial. *R. Kraus*

REPAIR See *Camera repair.*

REPEAT In animation, a cyclic series of drawings or movements made so that the last leads smoothly back to the first. The action created can be prolonged indefinitely by shooting the series over and over. *H. Lester*

REPEATING BACK Special form of sheet film back that allows independent multiple imagery on a single sheet of film. A half or quarter cut-out is placed in a special film holder so only a section of the sheet of film is exposed at any one time. *P. Schranz*

See also: *Sliding back.*

REPEAT PHOTOGRAPHY The making of photographs that duplicate the subject and the camera position used for photographs made at an earlier time with the objective of revealing changes that have taken place or revealing similarities and the absence of change. In a city, for example, a comparison of a historical photograph and a repeat photograph made from the same location would show which of the early buildings remain and which have been destroyed or replaced and, possibly, changes in the modes of transporta-

tion, clothing worn by pedestrians, and so on. In a scenic area, such a comparison of early and recent photographs might show little change except for the growth of trees, or it might show effects of logging or the construction of housing, a dam, or a military installation.

Repeat photographs tend to be most effective when they duplicate the photographic procedure used by the earlier photographer as closely as possible. Factors to be considered include the camera location, film format and type of film, lens focal length, picture composition and cropping, weather conditions, time of year and time of day, and depth of field. Pairs of photographs made by the same photographer or for the same client to show the effects of a specific project, such as to dramatize the results of remodeling a room or constructing a building, for example, are commonly identified as before-and-after pictures. In the field of medicine, especially cosmetic medicine, repeat photographs of the patient are very helpful in showing the change as a result of the treatment. Such photographs can be useful also as evidence in legal disputes. The monitoring of earth from outer space by orbiting space vehicles is a prime example of the importance of repeat photography. Multiple repeat photographs made at specified intervals over long period of time provide valuable information on everything from changing weather conditions and environmental conditions to military deployment. In animation, repeat photography refers to the production of a series of images made so that the last joins with the first. By photographing the series over and over, an action can be extended to any desired footage. *R. Zakia*

REPLENISHER A solution that is added to a photographic developer, fixer, or other processing bath to stabilize the activity of the bath as it is used. During development, soluble bromide accumulates in the developer and the replenisher formula typically differs from the developer formula primarily in having little or no bromide restrainer. Fresh fixer can be added to a used fixing bath to replenish it, but the extent to which this can be done is limited by the accumulation of silver compounds unless these are periodically removed by an appropriate form of regeneration.

L. Stroebel and R. Zakia

REPLENISHMENT The process of adding replenisher to a processing solution to replace the active chemicals that are used up during processing and to replace solution carried out of the bath by the film or paper being processed. Processing machines, such as roller-transport processors, are commonly programmed to add the correct amount of replenisher according to the surface area of the film or paper that has been processed. *L. Stroebel and R. Zakia*

REPLICATION (1) In electron micrography, a technique used to avoid the problems caused by a subject whose surface would absorb or scatter electrons. A coating of resin or evaporated metal forms a replica that is then examined after stripping or destruction of the specimen. (2) The process of repeating an experiment to determine the magnitude of variability of the results. *H. Wallach*

REPRESENTATIVE/REP A photographer's agent ("rep") who serves as the contact with the client or the client's agent, usually an advertising agency. The rep is responsible for obtaining new business, maintaining relationships with existing clients, and relieving the photographer of the chores associated with marketing. A rep may serve more than one photographer. A photographer, in turn, may have more than one rep. The purpose of having more than one rep is usually to permit coverage of the same market in different geographic locations, or different markets in the same geographic location. Thus a photographer may have one rep for commercial

work and another rep for the fine art market. Reps usually work on a commission, that is, a percentage of the payment received by the photographer. *R. Persky*

See also: *Business practices.*

REPRODUCING HEAD A tape head designed for playback of a signal stored on tape or other magnetic media.
 T. Holman

REPRODUCTION An image that represents a copy of an object, scene, etc., such as a photograph, video image, drawing, painting, or photomechanical copy of an image.
 L. Stroebel

REPRODUCTION GAMMA (1) See *Tone Reproduction.* (2) The slope of the straight line of a graph in which the densities of the final image are plotted against the log luminances of the original subject. Reproduction gamma provides information about the contrast of the midtones of the image in relation to the corresponding subject tones, but not about the shadow and highlight subject areas, which are represented on the nonlinear shoulder and toe portions of the graph, or the total contrast. Reproduction gamma can also be calculated by multiplying the straight-line slopes of the factors that determine the final image such as camera flare, negative material, printer flare, and printing material. *L. Stroebel*

REPRODUCTION RATIO See *Scale of reproduction.*

REPRODUCTION RIGHTS The right, arising from ownership of a copyright for a photograph, that permits the making of copies, in any medium. The owner of the copyright, usually a photographer, may license others to reproduce the photograph. The license is usually limited as to the medium and time. What the licensee receives is reproduction rights, not ownership of the photograph or the copyright. The licensee pays a fee to the photographer for the defined reproduction rights. *R. Persky*

See also: *Business practices; Copyright.*

REPROGRAPHY A general term applied to photographic techniques of reproducing flat originals such as documents, drawings, photographs, and printed matter. Its scope includes silver halide and nonsilver copying processes such as microfilming and xerographic office copies, and photomechanical reproduction. *L. Stroebel*

RERECORDING The process of sound postproduction in which sound elements are combined into premixes, then again into final mix stems, then finally into print masters. Because these processes do not involve live recording, typically, the process became known as rerecording, to distinguish it from original recording. *T. Holman*

RESAMPLING In computer imaging, the resizing of an image to either larger or smaller dimensions. If the image is resampled to a smaller space, data are discarded. If the image is resized to a larger image, the data are either duplicated (pixel duplication) or interpolated. *R. Kraus*

RESCREENING Making a halftone negative or positive from a printed halftone, usually by placing a diffusion filter in front of the camera lens to eliminate moiré effects.
 M. Bruno

RESEARCH FILE See *Swipe file.*

RESEARCH PHOTOGRAPHY The field of research photography includes all forms of photography and imaging techniques that are used to assist with the collection, analy-

sis, discovery, and documentation of experimental research. The fields of research that rely on photographic analysis are numerous and include aerodynamics, astronomy, biology, ecology, environmental science, geology, medical research, oceanography, paleontology, and zoology, to list only a few. Professional photographic associations specializing in research photography include the Biological Photographic Association (BPA), the society for Imaging Science and Technology (IS&T), and the Professional Photographers of America (PPofA).

Each field has its own unique requirements and uses for photography, and thus a variety of illumination sources, imaging sensors, and exposure and processing techniques are used by the research photographer to address the specialized needs of the scientist or experimenter. Although the specific imaging components will depend on the type of research and information needed, the imaging environment can be divided into four fundamental areas: camera characteristics, lighting requirements, sensor properties, and analytical methods. These areas are interrelated, and the components from each area must be selected to provide the most appropriate and accurate representation of the information sought by the researcher.

CAMERA CHARACTERISTICS Still-frame cameras are used to capture information for laboratory documentation, accurate photomensuration, or analysis of single events that may be remotely located, dangerous, or difficult to analyze via direct visual observation. Astrophotography, photomicrography, specimen photography, and on-site documentation are examples of this type of application. Elapsed time is often an important element in experimental research; time-lapse, high-speed, or real-time imaging systems are used. High-speed motion analysis is used in such fields as nondestructive testing and aerodynamics, while time-lapse or slow-motion imaging can help to visualize changes over time that are too slow for direct observation or measurement (used in medical research and ecological and environmental studies).

LIGHTING REQUIREMENTS The spectral content, required power, and time duration of the illumination source will depend on the information being obtained. Fluorescence photography uses ultraviolent radiation, while vegetation analysis is enhanced using the near-infrared region of the spectrum. Monochromatic lasers are often used in specialized applications, as well as high-powered electronic flash and stroboscopic units with ultra-fast (1 millionth second) flash times to freeze subject motion. Objects that emit their own energy (thermal, visible, or high energy) can also be imaged using specialized sensors.

The optical geometry of the illumination and imaging systems can also be controlled to record otherwise invisible information, such as thermal gradients, shock waves, or phase changes. Holography, Schlieren photography, and interference microscopy are examples of this type of imaging.

SENSOR PROPERTIES Before the 1980s, photographic film was the primary medium used for imaging. With the growth of digital and electronic systems, a much wider array of radiation-sensitive devices became available to the research photographer. Charge-coupled devises (CCDs), video systems, thermal sensors, and multispectral cameras all extend the range of photographic systems for research applications. Lower light levels can be used, images can be obtained and analyzed without the need for chemical processing, and the region of the spectrum that can be used for imaging has been expanded via thermal and multispectral systems. Environmental researchers can now analyze residential heat loss using a thermal imaging sensor, while new information on ocean pollution, defoliation, crop vigor, etc. can be derived from simultaneous imaging in the ultraviolet,

blue, and near- and shortwave infrared spectral regions using airborne multispectral cameras.

ANALYTICAL METHODS Imagery acquired for the purpose of documenting or publishing scientific results often does not require further analysis. If the image is obtained to discover new concepts or collect information, however, the resulting photographic product will require analysis to discover or document the information contained in the image. Accurate motion analysis of high-speed images, dimensional measurements on still-frame photographs, and densitometric analysis to determine exposure from self-luminous objects are examples of analytical techniques. Digital image processing and enhancement capabilities have also added to the researcher's abilities for rapid and accurate analysis of photographic information. *L. Scarff*

See also: *Biomedical photography; Industrial photography; Scientific photography.*

RESIDUAL-HYPO TEST See *Washing test.*

RESIDUAL-SILVER TEST See *Fixation test.*

RESIN-COATED (RC) Identifying a paper fiber support with pigmented polyethylene resin extruded onto both sides. Since such support does not absorb water or chemicals, RC papers can be processed and dried quickly. *M. Scott*

RESIST See *Photoresist.*

RESISTANCE (R) The opposition to the flow of current by a resistor. Its symbol is *R*. The basic unit of resistance is the ohm (Ω). *W. Klein*

See also: *Resistor.*

RESISTOR An electrical component made of resistive materials used to control the flow of electrical current. Resistors are fabricated from carbon-composition material, resistance wire, or metallized film, and in integrated circuits by the appropriate doping of a semiconductor channel. Unless specified otherwise, a resistor is linear; that is, the current through it is directly proportional to the voltage applied across it. Resistors are available in a multitude of combinations of resistance values, power dissipation ratings, and manufacturing tolerances. Unlike inductors and capacitors, resistors cannot store energy. *W. Klein*

RESOLUTION The act, process, or capability of distinguishing between two separate but adjacent parts or stimuli, such as elements of detail in an image, or similar colors.

L. Stroebel

See also: *Resolving power.*

RESOLUTION (DIGITAL IMAGES) In electronic imaging, the number of horizontal and vertical pixels that comprise the image. The minimum resolution acceptable for scientific image processing is 512×512 pixels. If the term is used to describe brightness levels (contrast resolution), then the minimum levels of brightness are 256. *R. Kraus*

RESOLVING POWER The ability of an imaging system or any of its component parts (optical system, photographic material, etc.) to retain separation between close subject elements, such as lines, in the image. Resolving power is measured in lines per millimeter, and is determined using a test target consisting of alternating parallel light and dark bars as an artificial subject. The width of a light-dark pair of bars in the smallest set of bars that can be distinguished in the image is used to calculate the number of lines per millimeter.

The resolving power of an imaging system is always less than the resolving power of any of the components. Thus, it is more accurate to determine the resolving power of a lens by examining an aerial image of the test target formed by the lens than to examine an image formed by the lens that has been recorded on film. Since it is necessary to use an optical system to form an image of the test target on film when testing the resolving power of the film, the optical system must have a much higher resolving power than that of the film to minimize distortion of the true value.

Two different mathematical formulas have been used in photographic references to represent the relationship of the resolving powers of the components of an imaging system to that of the entire system:

$$1/R = 1/R_1 + 1/R_2$$

and

$$1/R^2 = 1/R_1^2 + 1/R_2^2$$

Both formulas can be expanded to include additional components in an imaging system, such as an enlarging lens and printing paper. Substituting 100 for the resolving powers of a lens and a film in the two formulas produces a calculated resolving power for the system of 50 with the first formula and 71 with the second formula.

The resolving power of pictorial films tends to vary inversely with the film speed, and the resolving power of a given film tends to vary with the type of developer used and the degree of development. The resolving power also varies with the contrast between the light and dark bars in the test target, typically being between two and three times as high with high-contrast targets as with low-contrast targets.

It has long been known that whereas resolving power values for different images correlate well with perceived detail in a side-by-side comparison, the correlation is much lower with perceived sharpness of the images. Modulation transfer function (MTF) curves provide more information about image quality when both detail and sharpness are considerations, but sophisticated laboratory equipment and skills are required to produce MTF curves. Resolution with electronic imaging is sometimes expressed as dots per inch (DPI), spots per inch (SPI) or pixels. *L. Stroebel*

See also: *Modulation transfer function.*

RESOLVING POWER TARGET A set of patterns that normally consists of dark bars on a light background such that there are alternating dark and light areas of equal width. The targets are used to determine the resolving power of a lens or film or of an imaging system by determining the smallest set of bars that can be distinguished as being separate under the specified conditions. The measured resolving power varies with the contrast of the target and typically is two to three times as high with a 1000:1 luminance ratio high-contrast target as with a 1.6:1 low-contrast target.

L. Stroebel

See also: *Input, test targets.*

RESONANCE The phenomenon that occurs when one oscillator oscillates with a frequency matching a natural oscillation frequency of another oscillator, causing a transfer of energy. Resonance is important in chemistry, optics, acoustics, and engineering. In chemistry and optics, when a photon of a particular frequency is incident on a substance resulting in transitions in the energy levels of the molecules of the substance, resonance absorption is said to be occurring. In acoustics and engineering, sound waves or wind patterns can actually cause resonance oscillations in physical structures, which may be damaging to the structures. *J. Holm*

RESPI SCREEN A contact screen with 110-line screen ruling in the highlight areas and 220-line screen in the

middletone and shadow areas to produce a longer scale of reproduction and smoother gradation of tones in the light areas. *M. Bruno*

RESPONSE See *Stimulus-response*.

RESPONSIVITY For a cyclic (wave-form) signal, the output power for unit input power. Applied to radiation detectors, including photographic materials. *H. Todd*

RESTITUTION In photogrammetry, the determination of the location of object points from the photographic record. *L. Stroebel*

RESTORATION Restoration is the activity of bringing back works of art, documents, or photographs to their original state once they have suffered damage. In its strictest sense, such activity is performed on the original work only and so does not include the preparation of any kind of copy. The restoration of photographs is also restricted to the damage that occurred since the time an image was created, as a result, for example, of inadequate storage and faulty handling and use. Its intent is not to correct faults that were incorporated into the image during exposure and processing. The latter point is noteworthy since some techniques used in restoration of photographs have been adopted for repair work from the photographer's arsenal of skills, of which retouching is the most prominent example.

The two fields—restoration (work on the original) and correcting an image during its creation—are no doubt related since they have a common origin: the desire to produce as perfect an image as possible. From the beginning of photography, attempts have been made to improve the image that was obtained merely by exposure of a light-sensitive support and subsequent processing. The hand-tinting of daguerreotypes practiced in the 1850s is a good example. A few years later the retouching of glass plate negatives was introduced, the first of those made by the wet collodion process, then of dry plates that were manufactured by gelatin silver halide technology. Hand-coloring of black-and-white prints and negative retouching are practiced to this day. Another technique used by photographers to improve the quality of their images is aimed at reducing the overall density of a negative or print or doing so on selected parts of the image. Conversely, low density in underexposed photographs can be built up by adding silver to the existing amount of image silver or by modifying the morphology of silver grains. The two procedures are called *reduction* (of density) and *intensification*. Because they change the amount of image-forming substance by either reducing or increasing it, neither of them is a method for restoring faint or weak images. They are considered appropriate tools of photographers to correct faults in their process of picture-taking.

In the following discussion of restoration of photographs, the subject is divided into five categories.

1. Conventional methods for the improvement or reconstruction of damaged and faded photographs, largely used by commercial establishments, consisting essentially of a combination of *copying* and *retouching* techniques.
2. The application of *mechanical* treatments in order to correct for physical damage in photographs, While some of these are derived from techniques developed in the conservation of works of art on paper, others are specific to photographs, taking into account their particular structure.
3. *Chemical* treatments of faded or discolored black-and-white negatives and prints that provide a true restoration to the original state of the image.
4. Specialized procedures for the preparation of reconstituted color photographs from faded images by purely *photographic* means, or by using *electronic imaging* techniques.
5. Miscellaneous techniques to reconstitute or reproduce a faded image; they are, for the most part, modification of copying methods.

Commercial procedures on how to cope with photographs that are physically damaged (parts of the image abraded; corners missing; photographs torn or creased by being folded or curled up tightly) have been described in the literature. These procedures originate from practicing photographers. They usually involve as a first step the preparation of a copy negative from which further work proceeds. This action distinguishes them from a true restoration effort, in which all work is performed on the original. After a copy negative has been prepared, a commercial operator can continue in one of two ways: (a) retouch the copy negative with pencil, ink, or airbrush to reduce or eliminate evidence of the damage, with the result that a print from the retouched negative will show a vastly improved image; (b) make a print from the unretouched negative, and all further retouching work is performed on this copy print. In either case, a copy of the cosmetically improved photograph *and* the original are returned to the customer. While such procedures may satisfy the modest needs of an inexperienced clientele, there are serious reservations about them. Generally accepted ethical principles that guide the work of a restorer demand respect for the creator of a work of art, nourished by an understanding of the original artist's intentions. The principal goal of any restoration effort is to *maintain* the work of art, that is, to preserve it and increase its stability. Cosmetic improvements, while almost always done, are mostly restricted to various cleaning operations. If the restorer judges that they are necessary, only such materials should be used that are compatible with those present in the original.

As photographic images have come to be recognized as works of art, restoration efforts performed on those that have suffered damage have adopted conventional techniques applied to works of art on paper, such as prints, drawings, and watercolors. A curled-up print can be flattened by placing it inside a sealed chamber of high relative humidity. Curl is a consequence of the layer structure of photographic materials. Image layer and base support possess different rates of expansion and contraction in an environment of changing relative humidity. The gelatin layer that carries the image has a high affinity for water, which it absorbs readily when available. Conversely, in dry conditions, the gelatin layer dries out faster than the support (either plastic film or paper) and contract at a rate that forces the photograph to curl up. A change in high humidity will quickly relax and flatten such a photograph. The foregoing presents a fine example of benefitting from the natural, inherent properties of photographic images to restore them to their original state.

Other treatments, still in the second category of prints and drawing techniques developed for original works of art, include dry and wet cleaning methods, using either special erasers and dry cleaning powders to remove accumulated surface dirt or aqueous solutions to loosen and remove grime. Most photographs can be immersed in water, having undergone an arduous processing sequence through a series of alkaline and acidic aqueous solutions in their creation. Notable exceptions are hand-tinted daguerreotypes and some hand-colored prints. At any rate, restorers are trained to perform extensive tests on expendable samples before applying an aqueous cleaning treatment to a photograph of unknown properties (or a doubtful cleaning solution to a photograph of well known structure and condition). Nonaqueous organic solvents can also be used to clean the surface of photographs. For example, anhydrous ethanol or acetone will not penetrate into the hydrophilic gelatin layer and so may advantageously

be used, with the aid of a cotton swab, to remove fatty or greasy deposits from the surface of photograph without affecting the image-forming substance.

Another widely practiced treatment is the repair of tears and the filling of holes or missing parts in photographic prints. Large tears are repaired by laying down the entire print onto a new, stable support, taking care to ensure that the torn ends fit perfectly back into each other. Missing parts can be added by chamfering on opposite sides the edges of the two papers that are to be joined together so that a good fit is obtained. Another technique consists of feathering the two joining edges to obtain a close overlap and interweaving of fibers that will add strength to the repair. In all cases of laying down an image onto a new support or repairing tears and holes, adhesives of plant origin are generally used. Termed *pastes,* as opposed to glues of animal origin, they are derived from natural polymers such as wheat starch or rice starch. One advantage of their use is that their applications are reversible. The longstanding principle of reversibility of restoration treatments, while not a universal one, applies particularly to methods of physically strengthening a document, be it a manuscript, a watercolor, or photograph, by adhering it to a new support. It cannot apply to certain treatments in chemical solutions or to retouching or imprinting.

The final step in the sequence of cleaning and repairing photographic prints is their mounting and matting for both storage and display purposes. The print is attached to a board of two-ply or four-ply thickness made of chemically inert material, for example, one of high alpha-cellulose content that is free of lignin, alum rosin size, metal ions, or sulfur-containing compounds. Such material is often referred to as museum-quality board. The print can be held in place by a variety of techniques, such as the use of T-hinges or photo corners. Applying animal glues, rubber cement, or even pastes to the *entire* back of the print or along the edges is generally avoided today. The reason for this is the notion that the print must be able to breathe, i.e., to equilibrate itself to the existing, and changing, temperature and relative humidity conditions of its surroundings, and that it must be able to move slightly inside its mount as a result of changing conditions. An exception is the use of dry-mounting tissue. Many fine-art photographers have dry-mounted their prints in the past and continue to do so. There is no evidence that dry-mounting photographic prints causes degradation of either a silver image or a dye image. Although it produces well mounted, perfectly flat prints, dry-mounting has the disadvantage of being, practically speaking, irreversible. While manufacturers of dry-mounting tissue claim that dry-mounted prints can be dismounted by reheating them in a press, this procedure is neither practical nor safe for the print, especially for large-format prints.

After the photographic print has been loosely attached to a sheet of mount board, it is held down by a window mat, usually cut from the same material as the board. The window opening is cut slightly smaller than the format of the print and so overlaps the print along its edges. The window mat acts as a spacer to prevent direct contact of the print surface with the final cover glass, which could lead to adherence of the two surfaces. This point deserves attention, because the appearance and integrity of the surface of a photographic print are principal factors in its aesthetic value. Such surface properties are described in terms of sheen and texture. Since they define, in combination with the image tone, the inherent characteristics of a photographic print, the destruction of delicate surface properties changes the aesthetic value of the print. Furthermore, experience shows that separating a photographic print whose surface is stuck to a glass sheet is a commonly requested restoration procedure. A photographic print prepared as described is ready for display under glass in a wood or metal frame, or for long-term storage in print boxes manufactured and sold for that purpose, after frame and cover glass have been removed.

The restoration of albums containing photographs has attracted attention in recent years. Because each album is generally an item of particular, individual properties, characterized by different formats, the presence of written or printed inscriptions, different mounting and binding techniques, and, at times, the presence of nonphotographic documents, the decision on how to proceed must be made from case to case. Treatment options include the removal and reattachment of individual photographs, cleaning and repair of images and album pages, rebuilding of the album, even the design and construction of a new album to accommodate the original prints.

Among mechanical treatments specific to photographs, two deserve to be mentioned: the repair of broken glass-plate negatives and the transfer of a negative emulsion from an unstable or broken support to a new, permanent support. Requiring manual skill, two broken parts from a glass negative can be joined together and held in place on a specially constructed stand using clamps, after an epoxy adhesive (for example, Epoxyglass Resin) has been applied along the line of fracture with special devices such as a wood applicator stock, a syringe, or specially made glass tips. A thin layer of gelatin, prepared from solutions ranging from 1.5 to 6% of gelatin, can be coated on top of the original fracture line in order to prevent its showing on a print from the repaired negative. The transfer of a negative emulsion layer has been practiced in photography for well over a hundred years, usually for purposes other than restoration. It is widely used to this day for publication and commercial ends. Gelatin emulsion layers can be removed from glass or film supports by a variety of methods. All methods aim to dissolve or loosen the bonding between the emulsion layer and the support. For glass plates, a 5% sodium fluoride solution in the presence of sulfuric acid works well. Another treatment uses a solution of sodium carbonate and formaldehyde in the presence of glycerine. Removal of a gelatin layer from films can be accomplished by dissolving the adhesion between image layer and support with a ketone, such as acetone or methyl ethylketone. In all cases, the liberated gelatin layer, which is surprisingly strong, is placed immediately on a new, clean polyester support, which has been shown to be the most suitable choice. Some practice and skill is required to stretch out the image layer gently over the new support and to arrange it to its original dimensions. The transferred emulsion layer can be attached permanently to the new support or, more practically, can be duplicated at once using a negative duplicating film on a stable support with a long straight-line section on the characteristic curve. Such work is currently offered commercially in the United States.

The most exciting aspect of restoring faded or discolored black-and-white photographs is provided by the application of chemical treatments. Such treatments can essentially reverse the chemical degradation of the image silver. A black-and-white photograph begins to discolor because oxidizing agents, aided by the presence of moisture, oxidize image silver to silver ions that eventually form either silver salts or fine particles of colloidal silver. This chemical reaction, if allowed to proceed far enough, destroys the integrity of the image structure. It is, however, a reversible reaction up to a certain point. If a chemical treatment can reverse that original degradation reaction, then a true restoration to the pristine state is achieved.

The treatment that attempts to achieve this reversion has been known for many years as *bleach and redevelopment.* It has often been proposed as a chemical restoration technique. Until recently, however, precise descriptions and data showing results of this treatment had not been published. In the first step, called the bleaching step, all image silver and

silver salts that are present as a result of chemical degradation reactions are uniformly converted into a silver halide. In photographic technology, the term *bleach* always refers to this conversion of image silver into a silver salt, usually a halide. Chemically speaking, this is an oxidation reaction that requires powerful oxidizing agents. In the restoration of works of art on paper, the term *bleaching* indicates a treatment that aims at turning a yellowed or darkened paper sheet brighter. To this end, mild oxidizing chemicals are used, such as hydrogen peroxide, sodium hypochlorite and derivatives, chlorine dioxide, and light of a certain wavelength and intensity. The silver halide, in the second development step, is then converted into elemental silver to reconstitute the original image. This is summarized in the following scheme:

$$\text{Mixture of image silver and silver salts} \xrightarrow[\text{Halide scource}]{\text{Bleaching agent}} \text{Silver Halide}$$

$$\text{Silver halide} \xrightarrow{\text{Developer}} \text{Elemental silver}$$

This simple scheme evolves into more thana dozen single experimental steps, including hardening, fixing, and washing. Since neither elemental silver particles nor the silver halide migrate during the reaction, the properties of the original image are not affected: resolution, sharpness, and density range are usually improved when converting a yellowed, or faded, image into one of the neutral gray tones. This treatment must be clearly distinguished from commonly used reduction and intensification treatments during which image silver is removed, added, or otherwise modified, as noted. No image silver is removed, and none is added in the restoration treatment. Since it literally recreated the photographic process by which it was made initially, it is a true restoration treatment that respects the intentions of the original photographer.

The suitability of this method has been examined closely for silver gelatin prints made by the developing-out process. It cannot be used for restoring faded prints made on printing-out papers, because of different morphology of their image silver particles. The image to be treated must have been developed out initially. Useful oxidizing agents for the bleaching step are acidic solutions of potassium permanganate, potassium dichromate, cupric chloride, and others, all in the presence of a halide ion source. The oxidation of image silver proceeds rapidly, i.e., within a few minutes, under normal daylight conditions. Care must be taken to remove residual oxidizing agents as well as the reaction products such as chromium or manganese salts. After several minutes of washing in running water, a fast working metol-hydroquinone developer brings about the restored image.

The weak link within the structure of a photographic print that may possibly limit the application of this treatment is the gelatin layer. In the experiments described above, test prints were made for the purpose of monitoring the behavior of the gelatin layer during chemical treatments. The swelling and deswelling of the gelatin layer was recorded as prints passed through the series of chemical solutions that constitute the treatment sequence (bleach baths, hardening baths, developer solution, fixing baths, rinsing steps, etc.). A gelatin layer in aqueous solutions readily absorbs water by swelling to a thickness several times that of the original. Because increased swelling indicates increased weakness, excessive swelling must be controlled at strategic intervals along the restoration procedure by using a prehardening bath, such as formaldehyde, and a hardening fixer after the development step. These experiments also demonstrated that for photographic *prints*, potassium dichromate, in the presence of a halide source, and cupric chloride are the most suitable

bleaching agents. Potassium permanganate, while rather effective in its oxidizing power, also appears to weaken the structure of the gelatin restored by the bleach-and-redevelopment process will continue to be subject to chemical attack by oxidizing agents unless the image silver is protected. Treatment of such prints in a commercial selenium toning solution enhances their permanence.

Similar treatments have been reported for stained and yellowed historical silver gelatin glass plate negatives. J.S. Johnsen has published the excellent results obtained in the restoration of discolored silver gelatin dry plates using cupric chloride as the bleaching agent with subsequent development in an amidol developer. B. Lavédrine and F. Flieder have succeeded in treating historical black-and-white silver gelatin negatives, dating from around 1900, that had turned yellow. A rather common observation for keepers of photograph collections, this yellowing was determined to be a result of intensification work by the photographer using mercuric iodide. This type of intensification allows the density of an underexposed negative to be intensified proportionally. The yellow appearance is caused by the formation of silver iodide over time, which can be restored by judicious treatment with a photographic developer. Another chemical treatment, proposed by E. Weyde, aims at removing the blue metallic sheen from the surface of silver-gelatine glass-plate negatives. Often referred to as a *silver mirror*, it is formed by silver ions that have migrated to the surface. They originate from oxidized image silver. A solution of 0.5 to 1% iodine in *absolute*, i.e., *anhydrous* ethanol can react only with the surface silver by converting it into silver iodide. Since anhydrous alcohol does not penetrate into the gelatin layer, the image silver inside the emulsion layer is not affected by this treatment. This procedure largely replaced one proposed by J. I. Crabtree that uses a solution of thiourea in the presence of varying amounts of citric acid. During the past few years, treatments in chemical solutions for the restoration of discolored and faded black-and-white photographic images have been developed to a high degree of excellence. They quite generally apply to silver gelatin photographic negatives of prints that were developed. No reliable data exist that would suggest treatments of this kind are possible for photographs made on printing-out papers, such as album prints, salted paper prints, collodio-chloride prints, and silver gelatin printing-out papers.

Because the degradation of organic dyes in color photographic images is considered to be irreversible, no chemical treatments have been reported to restore dyes that have faded. One manufacturer suggested a remedy several years ago for photographs in which the fading of one particular dye has caused a noticeable color shift. It was proposed to bleach the remaining two dyes to the same lower density of the faded dye to reconstitute the color balance. The suggestion does not seem to have enjoyed wide application.

Among the numerous attempts to restore disappearing photographic images, the conversion of image silver or silver compounds to a radioactive form of silver was hailed widely as a promising method a couple of decades ago. The photograph so treated could be placed in close contact with a sheet of radiographic film, as in contact printing of normal photographic practice. Radioactivity being stronger in high density areas, i.e., areas of high silver content, and correspondingly weaker in lower density areas, the x-ray film is exposed imagewise by the radioactive silver to yield an autoradiograph. Because the result is a radiograph, this procedure should correctly be classified as a copying technique. The crucial step is the creation of a radioactive silver, or silver compound, image. This can be done by neutron irradiation in a nuclear reactor, as initially done, or by converting the image silver into radioactive silver sulfide or selenide

according to conventional toning procedures. The method does not appear to have found wide acceptance in practice.

The reconstruction of faded or stained color photographs is pursued—apart from traditional retouching methods with pen and airbrush—apart from traditional retouching methods with pen and airbrush—essentially by copying techniques. Prominent among them are the corrective duplication of dark-faded color slides, proposed by the Eastman Kodak Company in the early 1980s and the newly emerging technique of preparing reconstituted copies of degraded color images by electronic means. Several techniques have been described for the preparation and use of contrast-increasing contact masks. When printed in register with the faded slide, a color-corrected duplicate slide is produced. This method has also been used to restore motion-picture films faded in the dark.

Restoring faded or discolored hues in color photographs is based on the capability of scanned and digitized information of being manipulated. Widely practiced in the graphic arts and printing industry, this method, which requires extensive technical equipment, has been described in the recent technical literature and shown to be useful for restoring contrast and color balance in photographs that have suffered in those areas. Commercially available devices now perform a variety of manipulations of color images, such as cropping, changing format, and electronic retouching.

Experience in working with photographs has demonstrated that a large majority have survived in fine shape. Photographic prints in fine-art collections are commonly acquired in excellent condition and in small numbers. It is likely that chemical restoration of such images will not be necessary in most cases. Work on fine-art prints is therefore generally restricted to some cleaning and matting, mounting, and preparation for display. Photographs in museum and archive collections, often consisting of large numbers and in a variety of types, including negatives and slides on glass and film, are more likely to have suffered physical or chemical damage, caused by a combination of neglect and heavy use. They are, consequently, more likely to be in need of restoration treatments.

Documentary photographic images of historical value are as likely to be put on display or used in publications as photographs from fine-art collections. For those photographs that have suffered damage, a wide spectrum of safe and effective treatments is available. While the practice of photograph restoration is not common, new methods of treating damaged and faded photographs are being developed and applied successfully.

Books: Stenger, E, *Wiederherstellung alter photographischer Bilder und Reproduction derselben im ursprunglichen und im neuzeitlechen Verfahren* ["The Restoration of Old Photographic Pictures and the Reproduction of Same in Old and New Ways"]. Enzyklpadie der Photographie, Heft 97. Verlag von Wilhelm Knapp, Halle (Saale), 1920; American Photograph Corporation, *Any Old Pictures to Mend?* New York: American Photograph Corporation, 1944; Fritsche, K., *Faults in Photography.* English edition, translated by L.A. Mannheim. London, New York; Focal Press, 1974; Eastman Kodak Company, *Restoring Faded Color Transparencies by Duplication (White-Light Printing Method).* Current Information Summary No. 22. Rochester, New York: Eastman Kodak Company, 1981; Eastman Kodak Company, *Restoring Faded Color Transparencies by Duplication (Tricolor Printing Method).* Current Information Summary No. 23. Rochester, New York: Eastman Kodak Company, 1981; Reed, Vilia, *Photographic Retouching.* Kodak Publication No. E-97. Rochester, New York: Eastman Kodak Company, 1987; Hendriks, K.B., Thurgood, B., Iraci, J., Lesser, B., Hill, G., *Fundamentals of Photograph Conservation: A Study Guide.* Toronto: Lungus Publications, 1991; Sturge, J.M., Walworth, V., and Shepp, A., *Imaging Processes and Materials:* Neblette's Eighth Edition. New York: Van Nostrand Reinhold, 1989. *K. B. Hendriks*

See also: *Image permanence.*

RESTRAINERS Chemical restrainers or antifoggants are added to the photographic emulsion or to the developing solution to restrain or minimize the formation of nonimage silver (fog). Potassium bromide and iodide are typical inorganic restrainers added to developers. Organic compounds, called antifoggants, are fog restrainers also and may be present in the emulsion or in the developing solution. All of these compounds are thought to work by reducing the availability of silver ions or by adsorption of the surface of the silver halide crystal or the latent image. *G. Haist*

See also: *Antifoggant; Photographic chemistry.*

RETICLE See *Graticle.*

RETICULATION Small-scale random wrinkling of the emulsion, usually caused by abrupt changes of temperature during processing. Reticulation is sometimes introduced deliberately for pictorial effect, but is rare with modern well-hardened emulsions. *L. Stroebel and R. Zakia*

RETINA The internal lining on the back of the eye that contains light-sensitive rod and cone receptors and a network of nerve cells. *L. Stroebel and R. Zakia*

See also: *Vision, the human eye.*

RETINAL A substance, formerly known as vitamin A, that combines with a protein to form rhodopsin (visual purple), the photopigment in the rods of the retina.

L. Stroebel and R. Zakia

See also: *Vision, the human eye.*

RETINAL RIVALRY The alternation of the dominance of one eye over the other, typically occurring at a relatively constant frequency. For most persons, one eye generally dominates the other, but nevertheless occasional shifts can occur. *L. Stroebel and R. Zakia*

See also: *Vision, binocular vision.*

RETINEX THEORY A theory of color vision proposed by Edwin Land based on experiments in which viewers reported seeing a range of colors in superimposed projected images of two black-and-white slides with a color filter on the lens of one projector and no filter on the other projector. In one experiment, one slide was made with a red filter on the camera, and the slide was projected with a red filter on the projector, while the second slide was made with a green filter on the camera, and the slide was projected with white light. Land maintained that information about the relationship between long and short wavelengths is sufficient to produce the sensation of a range of colors, in contrast to associating specific hues with specific wavelengths. It has been suggested that the Retinex theory is not incompatible with widely accepted opponent theory of color vision.

L. Stroebel and R. Zakia

See also: *Opponent theory; Vision; Visual perception; Young–Helmholtz theory; Young theory.*

RETOUCHING Photographic retouching is the process of applying transparent or opaque materials to local areas of negatives, transparencies, or prints, or removing density locally by physical or chemical means. The purpose of retouching is to correct flaws or to otherwise enhance the image. Skillful retouching can greatly improve a photograph, but clumsy retouching can destroy a photograph.

From the earliest days of photography, however, there have been purists who have objected—some vehemently—to any type of modification of the photographic image. Beaumont Newhall notes in *The History of Photography* (NY: Museum of Modern Art, 1982, p. 70), that despite these protestations and a lack of interest in retouching by most

of the early photographers, "retouching became routine because sitters now demanded that the often harsh, direct camera records of their features be softened, facial blemishes removed, and the wrinkles of age smoothed away." Heavy retouching became the norm for still publicity photographs of Hollywood motion-picture stars during the 1940s and beyond, a practice also followed by many professional portrait photographers. Now the practice is to soften lines and blemishes rather than remove them.

Black-and-White Negatives Negatives are retouched on a transparency illuminator (retouching desk) that provides uniform illumination of appropriate color quality. A color temperature of 5000°K is specified for retouching color images. The traditional method of retouching portraits with a needle-sharp pencil is giving way to the use of a pointed brush and liquid dyes. Considerable practice is required with pencil retouching in making a pattern of fine marks, in the form of the letter "c" or "s", for example, that blend in smoothly so they are not evident on enlarged prints. For professional production work, retouching machines are available that produce an appropriate small-scale vibrational movement of the negative to simplify the retouching task.

Brush retouching consists of using a properly diluted liquid dye with a sable brush that has been blotted to remove excess dye, and pointed. Advantages over pencil retouching include the ability to use different concentrations of dye to obtain the desired density on the negative, and the greater ease of developing the necessary skill.

Density can be removed from local areas of black-and-white negatives by physically shaving away the silver on the emulsion side using a razor-sharp etching knife. Abrasive reduction can be used on larger, less well-defined areas by applying a reducing paste with an artist's stump, Q-Tip, or wad of cotton, although retouchers now prefer to use a liquid reducer, such as Farmer's reducer, to remove silver density evenly, though the negative must then be washed and dried following this treatment.

Color Negatives Color negatives are more difficult to retouch since the altered area must match the surround in color as well as density. Dyes (and pencils) are provided in a range of basic colors including skin tones and primary and secondary colors. To remove a minus-density cyan spot on a negative, for example, requires the addition of a red colorant. Visibility of the retouching colorant can be increased by viewing it through a contrast or separation filter of the complementary color.

Color Transparencies Retouching color transparencies is more difficult than retouching color negatives even though the image is positive; there are no masking dyes as there are on color negatives, and the choice of retouching dye color is more obvious.

Removing density physically from color negatives and transparencies is impossible due to the layered positions of the cyan, magenta, and yellow dye images. Dye reducers that selectively bleach the colors are used, however, in transparency retouching.

Black-and-White Prints The most common retouching of prints consists of adding density to small light areas by applying a liquid colorant with a pointed brush. Density can be controlled by diluting the retouching color as well as by making repeated applications. Different retouching colors are required for warm-tone and cold-tone papers to obtain a close match with the surrounding areas. Etching and abrasive reduction are seldom used on prints due to the effect they have on the surface sheen, but chemical reduction can be effective. In some situations it is easier to completely remove a dark defect and then add retouching dye to match the surrounding area than it is to stop the bleaching action at the proper time.

Color Prints Cyan, magenta, and yellow spotting colors can be mixed in different proportions to match any print color, although it is sometimes more convenient to use certain other standard retouching colors such as neutral and skin color. Accidental excess application can be removed with clear household ammonia followed by swabbing with distilled water.

Cake-type dyes are available for application of colors to larger areas with a dry cotton swab. These colors are *set* by applying steam, but they should not be used with water.

Opaque colorants can also be used on color prints by first spraying the print with a retouching lacquer (with adequate ventilation and use of a respiratory mask as health and safety precautions). Opaque retouching media include color pencils, chalks, oil colors, and opaque colorants applied with an airbrush.

Most professional photographers possess some basic retouching skills, such as retouching dust spots on prints, but the more difficult retouching tasks and large-volume production retouching are usually delegated to a retouching specialist.

Electronic digital imaging has raised retouching to a new level, where images can be altered on a pixel-by-pixel basis to produce undetectable retouching, in addition to making it possible to completely alter images, for example, by adding and removing objects and changing the colors of objects and backgrounds. *J. Steele*

RETROFOCUS LENS See *Lens types, wide-angle lens.*

REVERBERATION Acoustic reflections from the environment occurring so frequently at such close spacing in time that the individual reflections making up the ensemble can no longer be distinguished. Reverberation time is the amount of time for an interrupted steady-state sound field to decay away to 60 dB below its original sound pressure level.
 T. Holman

REVERBERATOR A device that by mechanical or by computer-calculated means supplies the effect of reverberation. *T. Holman*
See also: *Reverberation.*

REVERSAL PROCESS/MATERIALS The reversal process produces a black-and-white positive by developing a negative image on exposed sensitized material, then removing the negative image and developing a positive one. Direct positive processes achieve a similar result by other means.

After black-and-white film is exposed, development forms a negative silver image that is removed by bleaching. The remaining silver halides in the emulsion, constituting a positive image, are then sensitized and developed. Once color film is exposed, the first developer forms a negative silver image. Chemical fogging or reexposure forms a positive latent image that is chromogenically developed, yielding both silver and dye images. Bleach and fixer remove the first and second silver images; the positive dye record remains.

The earliest successful reversal of an image in processing was achieved in 1862 by C. Russell. In 1899, R. Namias removed the negative image formed in first development with an acid solution of potassium permanganate, re-exposed his plate, and developed the positive. The Lumière brothers applied this strategy to the processing of the panchromatic emulsion layer of their Autochrome screen film of 1907. Louis Dufay used Namias' system for his printed tri-color screen film of the 1920s Dufaycolor. Cine-Kodak, an amateur 16-mm motion picture film requiring volume reversal processing, was introduced in 1923. Kodachrome, a complex integral tripack subtractive color reversal material, was introduced as a 16-mm motion picture film in 1935. The following year, Agfa released the first coupler-incorporated

reversal film, Agfacolor Neu. Kodak's first user-processible reversal film was Ektachrome, introduced in 1946.

In black-and-white reversal processing, relatively contrasty materials with thin emulsions and an even distribution of large and small silver halide grains give the best results. The larger, more sensitive and developable grains form the first silver image, which is removed. The second, positive image then consists of finer grains. Thicker emulsions may not permit exposure and development to go all the way through to the base; very thin emulsions may not have enough silver left for second development.

First developers for black-and-white reversal processing must be caustic and energetic to produce clean highlights. A rinse prevents the staining and sludge formation that results from contact of developer with bleach. While fixers remove silver halides without harming metallic silver images, bleach must remove silver without changing silver halides. Bleach employs an oxidizing agent such as potassium permanganate or potassium dichromate with sulfuric acid to convert metallic silver to silver ions for removal. Reexposure to light is difficult to achieve with many configurations of processing equipment, so chemical fogging combined with second development has become standard procedure. In color reversal processing, sequestering agents, preservatives, buffering compounds, restrainers, antifoggants, and accelerators all contribute to the formation of clean dyes during second development. Bleach and fix are often combined as *blix* to save a step and some time.

Reversal materials have very limited exposure latitude, especially when compared to negative-positive materials. Too much exposure causes too much of the emulsion to be used by the first image; the positive image will be too thin without remedy. Too little exposure results in excessively dense positive images. Reversal materials are therefore exposed for highlights, the limit being the sensitization of almost the entire coating of silver halide in a given area. *H. Wallach*

See also: *Albert effect; Clayden effect; Color processing; Diffusion transfer; Direct positive; Etch-bleach process; Herschel effect; Polaroid photography; Sabattier effect; Slides.*

REVERSE ACTION A motion-picture special effect in which the action appears to be happening in reverse. Reverse action can be achieved by optical printing or in the camera by shooting with the film moving backwards. It can also be achieved by shooting with the camera upside down and the film moving normally forward. Such shots are then reversed head-to-tail when used in the final film and require camera original film that is perforated on both sides. *H. Lester*

REVERSE ANGLE/SHOT In motion pictures and video, a shot in which the camera's viewpoint is almost opposite to that of the previous or following shot, switching the audience's view from one side of the action to the other, as for instance a shot of B talking to A after a shot of A addressing B. In order to maintain proper screen direction relationships, the camera must in both shots remain on the same side of the axis formed by the two subjects. *H. Lester*

REVERSED-TELEPHOTO LENS See *Lens types, wide-angle.*

REVERSE POLARITY The result of the interchange of electrical terminals. In television, the use of reverse polarity can make a negative produce a positive image, and conversely. *W. Klein*

REVERSIBILITY PRINCIPLE See *Optics, geometrical optics.*

REVERSIBLE BACK A type of film back on view cameras that allows for horizontal or vertical placement of a rectangular format film. *P. Schranz*
See also: *Revolving back.*

Reversible back.

REVERSIBLE FIGURE A special case of ambiguous figure in which the perspective of an image is seen to readily reverse itself. The familiar Necker cube being an example, whereby the cube can be perceived as being either higher or lower than the viewer, with a corresponding switch in the positions of the near and far corners of the cube.
 L. Stroebel and R. Zakia
See also: *Ambiguous figure; Figure-ground; Optical illusion; Visual perception, accuracy of visual perceptions.*

REVERSING PRISM See *Porro prism.*

REVOLVING BACK A camera back where the ground glass and/or film holder can be rotated without being detached from the camera to obtain either a horizontal or a vertical format. Backs that can be used in any intermediate position without vignetting may be identified as a 360° or fully-revolving back. Revolving backs are used on some view cameras and some medium format roll-film cameras.
 P. Schranz
See also: *Reversible back.*

REWIND In motion-picture photography a pair of supports, each having a spindle geared to a crank, to receive a reel of film, and used to wind film from one of the reels to the other. In some instances the crank is replaced by a motor drive. The term also applies to a device for rewinding video

Revolving back.

reels, or one to rewind the tape in video cassettes. These rewind functions are also a part of the video recorder capability. The knob or crank on 35-mm cameras using magazines is also referred to as a rewind.

Rewinding is also the transfer of film or tape from one reel to another after screening or playing or to change the orientation of the film. *I. Current*

RHEOSTAT An adjustable resistor used primarily to control the amount of current in an electrical circuit. The change in resistance is achieved by rotating a shaft to which is attached a wiper that makes contact with the resistance element. A rheostat has only two terminals, one connected to the wiper and the other to one end of the resistance element. A potentiometer has three terminals: the wiper and both ends of the resistance element. The use of rheostats for lamp intensity control has largely been replaced by more efficient and less expensive solid-state controllers using thyristors.
 W. Klein

RHODOPSIN/VISUAL PURPLE A reddish-blue pigment found in the rods of the retina. It is bleached by the action of light to produce electrochemical neural signals and is thus one of the chemical substances required for vision.
 L. Stroebel and R. Zakia

See also: *Vision, the human eye.*

RHYTHM The ordered recurrence in space of one or more of the visual elements. Usually, it is the repetition of the same shape that sets up a rhythm. Related to beats and measures of time in poetry, dance, and music, rhythm in visual arts is a function of repetitive, alternating, flowing, or progressive repetitions of elements in space. *R. Welsh*

RIBBON MICROPHONE A microphone type that converts acoustical energy into electrical energy by means of a fine, lightweight metal ribbon suspended in the field of a magnet. The ribbon moves in the magnetic field corresponding to the sound energy, and a voltage is obtained between the ends. *T. Holman*

RICCO'S LAW For small angles of view, the stimulus luminance for threshold perception is inversely proportional to the area of the stimulus. The law applies to areas of the retina outside the fovea and to the dark-adapted eye.
 L. Stroebel and R. Zakia

See also: *Adaptation.*

RIFLE MICROPHONE A slang term for an interference tube microphone having a club-shaped microphone polar pattern. *T. Holman*

See also: *Microphone polar patterns.*

RIGHT-ANGLE ATTACHMENT An ancillary optical system attached to the eyepiece of a prism reflex camera to provide a viewing direction at right angles to the optical axis of the lens for operational convenience. A simple prism system gives an upright but reversed image; a roof prism system gives a correct image and the attachment may be rotated to other orientations. The term also refers to a prism or 45-degree mirror used in front of the camera lens to provide reversal of the image. *S. Ray*

See also: *Viewfinder.*

RIGHT READING Identifying an image that corresponds to the orientation of the subject so that signs and printing in the original scene appear correct, in contrast to being laterally reversed. A negative exposed in a camera is right reading when viewed from the base side but wrong reading when viewed from the emulsion side. *L. Stroebel*

RIGHTS, PHOTOGRAPHERS' Photographers' rights are the aggregate of the rights granted photographers by the Copyright Law, the First Amendment, other statutes, and the common law. A 1990 amendment to the United States Copyright Law provides certain "moral rights" to photographers and other artists. They include the rights of photographers to prevent the use of their names as authors of works that they did not create or as authors of works that have been distorted, mutilated, or otherwise modified in a manner that would be prejudicial to their honor or reputations. The prohibited acts generally refer to intentional acts and are not prohibited as to all works of art. A few states have similar legislation that was derived from the tradition of moral rights for artists under French law. Other photographers' rights are derived from the First Amendment to the United States Consittution, that is, freedom of speech, and similar provisions in state constitutions. The freedom of speech rights may be limited, under some circumstances, by laws against pornography and obscenity.
 R. Persky

See also: *Copyright.*

RIIS, JACOB, A. (1849–1914) American photographer and writer. Emigrated from Denmark in 1870 and became a police reporter for the *New York Tribune.* A crusader for social change, began taking photographs in 1887 in New York City's slums to illustrate his stories. Was one of the first to use magnesium flash powder in order to reveal the dark tenements and dimly lit sweatshops. Published the influential *How the Other Half Lives* in 1890, a graphic testimony in words and photographs of the human misery he found in America's largest city. His pictures convinced Theodore Roosevelt to undertake social reform measures, and today the Jacob A. Riis Neighborhood Settlement stands on the site of once notorious tenements.

Books: *How the Other Half Lives.* New York: Dover, 1971.
 M. Alinder

RIM LIGHTING A specialized form of back lighting in which the source is more or less behind the subject and aimed directly at the subject. The bright edge of light that surrounds the subjects separates the subject from a darker background. Rim lighting is used particularly in portraiture but is not limited to portrait subjects.

Rim lighting is commonly used along with other lighting techniques. The rim lighting effect may be either pronounced or subtle, depending on the lighting ratio.
 F. Hunter and P. Fuqua

RINGAROUND A set of controlled, repeatable tests designed to explore the possibilities obtainable by varying selected factors. For example, in color printing, a ringaround would have the anticipated normal exposure and filtration in the middle, and an incremental set of exposures surrounding it in a circle or a box in which exposure or filtration, or both, are varied. A similar test can be made for black-and-white or color film in which exposure and development are varied, or for a black-and-white print, in which paper grades and exposures may be varied. Effective procedures for handling new chemicals or materials may be discovered by devising an appropriate ringaround. *H. Wallach*

RINSE A brief treatment of photographic material in a liquid during processing. A water rinse may be used to reduce contamination of a following bath, or as a substitute for a thorough wash in rapid processing. An acid rinse (stop bath) may be used to stop the action of a developer preceding a chemical treatment (typically, fixing).
 L. Stroebel and R. Zakia

RIPENING Ripening is an essential stage in emulsion making in which precipitated silver halides are heated and stirred in gelatin solution. Silver halide solvents, such as ammonia or excess bromide ions, are usually present during the long holding period. During the ripening, silver halide grains increase in size whereby smaller cyrstals dissolve and desposit on the larger crystals, and individual crystals coalesce. *G. Haist*

See also: *Emulsions; Ostwald ripening.*

RISING-FALLING FRONT/BACK An adjustment on cameras with separate lens and film standards, such as a view camera that allows for recomposing of the image vertically without having to change the tilt of the camera. *P. Schranz*

See also: *View camera.*

Rising-falling front and back on a view camera.

ROBINSON, HENRY PEACH (1830–1901) English photographer and writer. Acclaimed for his elaborate compositions by photomontage, including the famous *Fading Away* made from five separate negatives in 1858. Well known as a pictorialist spokesman, Robinson was a prolific and influential writer on the art of photography, his books serving as standard reference for photographers during the late nineteenth century. Founding member of the Linked Ring (1892).

Books: Harker, Margaret F., *Henry Peach Robinson: Master of Photographic Art.* Oxford and New York: Oxford University Press, 1988. *M. Alinder*

RODCHENKO, ALEXANDER MIKHAILOVICH (1891–1956) Russian painter, photographer, teacher, and graphic designer. One of the most significant artists in the post–Russian Revolution period with his goal in the synthesis of art into everyday life. Added photography to his skills in 1924. Explored the uses of photomontage for aesthetic, political, and design purposes. Experimented outside of traditional photographic framing, producing images seen from unusual, titled perspectives. Worked also as photojournalist and filmmaker.

Books: Noever, Peter, ed., *Aleksandr M. Rodchenko and Varvara F. Stepanova.* Munich, Germany: Prestel, 1991; Elliott, David, *Alexander Rodchenko.* New York: Pantheon, 1979.
 M. Alinder

RODS (RETINAL) Light-sensitive elements in the retina responsive especially to low light levels but without any hue discrimination. Hues such as red, green, yellow, and blue, are seen as shades of gray. There are about 120 million rods in the retina compared to only 7 million cones.
 L. Stroebel and R. Zakia

See also: *Dark adaptation; Scotopic.*

ROD VISION See *Scotopic.*

ROENTGEN RAYS See *X-rays.*

ROLLEIFLEX A twin-lens reflex camera designed by Dr. Reinhold Heidecke in 1929. The concept of a twin-lens reflex had been around for some time, but the Rollei was the first to put the concept into an all-metal precision camera. It used roll film and created 6 × 6-cm images. The camera had a built-in folding viewing hood. The 1932 version had a coupled film advance/film counter system, but the shutter mechanism was still cocked and fired separately. The camera changed little over the decades beyond additions of better Zeiss lenses and metering systems. While virtually replaced on the contemporary market by the medium format single-lens reflex, the twin-lens Rollei is still widely used and one version remains in production today.
 P. Schranz

ROLLER TRANSPORT/ROLLER PROCESSOR In automatic processing, the use of rotating cylinders to move film or paper through the process, simultaneously providing agitation. *L. Stroebel and R. Zakia*

Syn.: *Friction drive.*
See also: *Agitation.*

ROLL FILM A strip of photosensitive film protected by a strip of opaque paper and wound on a spool for daylight loading of medium-format cameras. *M. Scott*

See also: *Photographic film.*

ROOF PRISM See *Prism; Viewfinder.*

ROOM MODES (EIGENTONES, STANDING WAVES) Standing waves occur when sound is enclosed in a space reflective enough so that sound waves can "encounter themselves" coming and going. When the dimensions of the wave are related integrally with the dimensions of the space, the sound field is very nonuniform, with pressure maxima in one place at the same time that pressure minima occur in another. Standing waves are used to good advantage in musical instruments: organs, clarinets, and other tuned tubes make use of standing waves to produce specific pitches. *T. Holman*

ROOM SYNTHESIZER A specialized digital audio reverberator especially designed to simulate room acoustics. Room synthesizers are often used in postproduction to add the feeling of spaciousness. *T. Holman*

ROOM TONE See *Presence* (definition 1).

ROOT-MEAN-SQUARE (rms) A geometric average of a set of numbers, found by squaring them, finding the average of the squares, and then taking the square root of the average. Such a calculation is used to find the standard deviation of a set of measurements, which is a useful indication of variability. *H. Todd*

ROOT-MEAN-SQUARE GRANULARITY The standard deviation of measurements, made with a microdensitometer, of a uniformly exposed and processed film or paper sample. Such an objective value is well correlated with the visual judgment of graininess. *H. Todd*

ROSS EFFECT See *Appendix A; Photographic effects.*

ROTARY PRINTER A motion-picture contact printer in which both the original and the print stock are carried on a rotating sprocket wheel during exposure. *H. Lester*

ROTATING MIRROR/PRISM CAMERA See *Camera types.*

ROTOGRAVURE See *Photomechanical and electronic reproduction.*

ROTOSCOPE Trade name for an animation production device, originally developed and patented by the Max Fleischer studios in 1917, that is used to project live-action images, one frame at a time, onto a screen, where they can then be traced by an animator, facilitating the reproduction of complicated movements, the making of traveling mattes, or the creation of a realistic cartoon style. A common term for any system or technique of using live-action footage as a guide in animation. *H. Lester*

ROUGH CUT In motion pictures and video, a preliminary, trial stage of editing, in which shots, scenes, and sequences are cut together in approximate relationship, usually without detailed consideration of individual cutting points, allowing for convenient testing of editorial concepts before final decisions as to shot placement and specific cutting points are made. *H. Lester*

ROYALTY In book publication, a percentage of the sales receipts from books sold paid to the author, who is typically responsible for providing text and illustrations. *R. Persky*

RUBBER CEMENT A liquified rubber adhesive that can be used either for temporary or permanent bonding of materials. It is nonstaining and is easily removable when used as a single-coat adhesive. There is also a one-coat rubber cement that requires only one of the bonding surfaces be coated. For permanent bonding of two items, such as a photograph to a mount board, each surface is coated with rubber cement and allowed to dry. To allow for accurate positioning of the print, a slip sheet (any piece of smooth paper) is inserted between the print and mount board surface. The print is brought into contact with a small area of the mount board, and when the print is positioned accurately, the slip sheet is withdrawn slowly. This allows the two rubber-cemented surfaces to come into contact with each other; the resulting bond is "permanent." Permanence for rubber cement is only a year or two, after which the bond weakens. The two surfaces will eventually separate; heat and chemical residues will speed up the drying-out and decay process.

Keep in mind that rubber cement yellows as it ages. It will eventually damage photographs and is not archival. *M. Teres*

RUBY LASER A laser that uses a ruby rod containing a small amount of chromium oxide as the resonant cavity. The ruby laser was the first laser invented. *J. Holm*
 See also: *Laser.*

RUBYLITH A trademark name for thin red or amber film used in stripping images and cutting masks on electronic layout systems. *M. Bruno*

RULED SCREEN Another name for the obsolescent glass halftone screen. *M. Bruno*
 See also: *Crossline screen; Halftone process.*

RULE OF THIRDS In composition, the principle that the most effective division is in a 1 to 2 proportion. For example, according to the rule, the best placement of a horizon line in a photograph is one-third of the distance from the bottom or top. *R. Welsh*

RUN In computers, the instruction to begin execution of a programmed task. *R. Kraus*

RUNAROUND Setting type in a shape to fit around illustrations or figures. *M. Bruno*

RUNNING TIME In motion pictures and video, the number of minutes a given production takes when projected or played back at normal speed. *H. Lester*

RUN TIME ERROR In computers, a program error that is other than syntax that causes the computer to crash. The error is not identified during compiling and manifests itself only at the time the program runs. *R. Kraus*

RUSHES Unedited motion-picture work prints, ideally delivered on the day of shooting and immediately viewed and evaluated as to possible modifications in subsequent shooting plans and for making preliminary editorial decisions. *H. Lester*
 Syn.: *Dailies.*

S

S Short (exposure color film); Slow (type of flashbulb); CIE standard illuminants (Subscripts A, B, C, E)

s second (also sec)

SA Spherical aberration

SBC Silicon blue cell

SCR Silicon controlled rectifier

SCSI Small computer systems interface

SDT Silver diffusion transfer

sec Second

SECAM Sequential Couleur A Mémoire (French television system)

SED Spectral energy distribution

SEM Scanning electron microscope

SEPMAG Separate Magnetic (sound track)

SF Sheet film

SFPC Société Francais de Photographie et de Cinematography

SFX Sound effects

SGO Second generation original

SHSV Shuttered high speed video

SI Systéme International d'Unités (System of international units of measurement)

SIC Semiconductor integrated circuit

SLR Single-lens reflex (camera); Subject luminance range

SM Speed midget (flashlamp)

SMPTE Society of Motion Picture and Television Engineers

SMT System modulation transfer (acutance)

S/N Signal-to-noise ratio

SNR Signal-to-noise ratio

SOP Standard operating procedure

SPC Society of Photographers in Communications

SPC Society of Photographic Counselors

SPE Society for Photographic Education

SPFE Society of Photo-Finishing Engineers

SPG Sync-pulse generator

sp gr Specific gravity

SPIE Society of Photo-optical Instrumentation Engineers

SPL Sound pressure level

SPSE See *Society for Imaging Science and Technology, IS&T*

SPT Society of Photo-technologists

SPV Society of Professional Videographers

SR Society of Radiographers

sr Steradian

SRAM Static random access memory

SS Stainless steel

S/S Same size

SSA Studio Suppliers Association

SSR Solid-state relay

SSVR Solid state video recorder

STC Single time code

STPP Society of Teachers of Professional Photography

S$_v$ Speed value (APEX)

SV Still video

SVA Stereo variable area

S-VHS Super-VHS

SW Single weight

sync Synchronized, synchronization

SABATTIER EFFECT See *Appendix A; Photographic effects*.

SACCADIC Describing relatively large and rapid motions of the eye, associated with different points of fixations when reading, looking at a scene or a picture, etc.

L. Stroebel and R. Zakia

See also: *Nystagmus; Vision, the human eye, eye movements.*

SAFELIGHT FILTER See *Filter types*.

SAFELIGHTS Light-sensitive materials, when removed from their protective packaging, must be handled in darkness, or under a *safelight* that emits a color of light to which the photographic paper or film has little or no sensitivity. Extended exposure to safelight illumination will generally produce objectionable fog. Most darkroom safelights are therefore of relatively low intensity, or must be used at a suitable distances to reduce the illuminance to an acceptable level.

TUNGSTEN SAFELIGHTS A low-wattage tungsten-filament bulb behind a filter that absorbs the colors of light that the specified material is most sensitive to is the oldest and most popular safelight configuration. The normal practice is to use interchangeable filters, but safelights have been made with a filter turret that allows the desired filtration to be conveniently dialed in. In either case, most filters eventually fade and safelights should be periodically tested.

Conventional black-and-white enlarging papers are sensitive to blue light, and therefore require a yellow, orange, or red filter (which absorbs blue light). Variable-contrast black-and-white papers are sensitive to blue and green and require a different safelight filter. Orthochromatic film materials are also sensitive to blue and green light. Color

enlarging papers, and panchromatic black-and-white papers, can be handled safely only for a limited time under a dim amber safelight. Panchromatic films are too sensitive for continued safelight exposure, but a very dim green safelight can be briefly used after development is half completed to see if more or less than normal development is needed to compensate for inaccurate camera exposure. This is not because the film is insensitive to green but because the eye is more sensitive to it.

With black-and-white materials, photographers are often unaware of safelight fog since it lowers image contrast before it becomes evident in the unexposed margins. In color printing, safelight fog produces different color balances in the highlight and shadow areas of the print, which cannot be corrected by adjusting the enlarger filtration. Tungsten lamps have instant-start characteristics and can be plugged into darkroom timers that switch off the safelight during the enlarging exposure, reducing safelight exposure and making dodging and burning-in easier.

LINE-SPECTRUM SAFELIGHTS　　Sodium vapor lamps in safelights provide a considerably brighter darkroom for black-and-white print processing, and a somewhat brighter darkroom for color-print processing. Their main disadvantage is that they do not have instant-start characteristics and require a warm-up period before use. A typical low-pressure sodium vapor lamp's spectral energy distribution chart will show a main spike of high intensity at about 589 nanometers, near the peak sensitivity of the eye. A filter can remove low-energy spikes at different wavelengths. An electroluminescent lamp can be made to emit a line spectrum by phosphor selection. One for black-and-white enlarging has a single 585 nanometer line-spectrum band, adjustable intensity, and instant-start characteristics.

Light-emitting diodes (LEDs) manufactured in various colors also emit radiation in narrow bands, for example, at 590 nanometers for color enlarging. Individually, they do not produce much light but can be mounted in arrays to produce a broad, brighter illumination source. A removable filter allows bright light for black-and-white processing. The light output is generally proportional to current, so LEDs can be easily dimmed for use at various distances and to adjust the brightness control when testing for fog. LEDs have a very long life, can be switched rapidly on and off, and use little electricity. However, like other line-spectrum safelights they are expensive when compared to incandescent types.

FLUORESCENT SAFELIGHTS　　Fluorescent tubes are often used in darkrooms with fixture filters, or the lamp is inserted into a *tube* filter. Some nonsilver contact-printing materials can be handled in normal room light since their low sensitivity is limited mostly to ultraviolet radiation. UV-absorbing filter sleeves can be used with fluorescent tubes to decrease the danger of fog.

PORTABLE SAFELIGHTS　　Since safelighting may be restricted to key working areas, a portable safelight is useful. A filter over a flashlight is an economical solution, and several commercial pocket safelights can be used with some black-and-white and color materials. Infrared viewers are expensive but provide a bright greenish image. They are worthwhile in photofinishing operations where they can solve problems such as jammed processors without using normal lighting, or to monitor the safety habits of new employees. They come in two main types, hand-held units that look like small video cameras and those worn on the head to allow freedom to use both hands. Both consist of an infrared transmitter and viewing portion; the combination may be called an *infrared scope*.　　*R. Jegerings*

See also: *Electroluminescent lamp.*

SAFETY　　See *Chemical safety.*

SAFETY COATING　　A covering of lacquer or other transparent material on a flashbulb to eliminate the possibility of an explosive shattering of the glass when fired.
R. Jegerings

SAFETY FILM　　Film support not readily flammable. Contrast with highly flammable cellulose nitrate base, made for some purposes until 1950. Safety film is virtually synonymous with cellulose triacetate, although polyester base is also safe.　　*M. Scott*

SAGITTAL LINE/RAY　　See *Radial line/ray.*

SALGADO, SEBASTIAO (1944–　)　　Brazilian photographer. Educated as an economist, became intrigued with photography, accepting his first freelance assignment in 1973. His powerful photographs reveal a world of human despair, from the unspeakable conditions suffered by gold miners in Brazil, to famine victims in the Sahel of Africa, to the nightmare of Kuwaiti oil wells run amuck.

Books: *An Uncertain Grace.* New York: Aperture, 1990.
M. Alinder

SALOMON, ERICH (1886–1944)　　German photojournalist. Became a photographer in 1928. Using available light and small cameras, first the Ermanox and then the Leica, he pioneered the candid photograph, successfully capturing unaware and unposed politicians, diplomats, business magnates, and royalty. Interned by Nazis and killed, with his wife and a son, at Auschwitz concentration camp.

Books: *Erich Salomon.* Millerton, NY: Aperture, 1978.
M. Alinder

SALON　　See *Exhibitions.*

SALTED PAPER　　The earliest form of silver halide contact printing paper, dating to the mid-1830s. Artists' paper was imbibed with a solution of common salt and dried. This paper was sensitized under candlelight by floating it on a solution of silver nitrate and dried in the dark. Sunlight exposure behind a negative produced a strong visible image, which was toned in gold or platinum before fixation in hypo.
M. Scott

See also: *Calotype.*

SALT EFFECT　　An increase in developed density when unreactive chemical substances, such as sodium sulfate, are added to the developing bath. The cause of the density increases is thought to be a change in the electrical charges on the gelatin of the emulsion.　　*L. Stroebel and R. Zakia*

SALZMANN, AUGUSTE (1824–1872)　　French archeologist, photographer, and painter. Photographed the Holy Lands for approximately 20 years, beginning in the early 1850s. Though his assignments were to record specific sites for archeological evaluation, Salzmann added his own expressive vision to his hundreds of calotypes.　　*M. Alinder*

SAMPLE　　**(**1) In statistics, a part of a lot (the population) selected for study. In film manufacture, for example, from a very large roll of film (the population), a small amount of film (the sample) is tested. Similarly, in testing a 50-liter tank of developing solution for quality, only a few milliliters will be withdrawn for examination. Samples should usually be selected on a random basis.　　(2) In motion-picture production, a print made for quick examination for quality. *H. Todd*

SAMPLER (SOUND)　　A device that can store audio by means of sampling a waveform, basically digitizing it, and storing it away using a variety of means.　　*T. Holman*

SAMPLING In electronic imaging, the analog image signal is sampled at given points in time prior to the actual quantizing. *R. Kraus*

Also see: *Nyquist criterion.*

SANDER, AUGUST (1876–1964) German photographer. Began photography in 1892, opening his own studio in 1901, which he eventually named the August Sander Studio for Pictorial Arts of Photography and Painting. In 1910, launched his grand, personal project to photographically document the German people, "Man in the Twentieth Century," producing a vast portrait composed of every social strata and occupation, from formally posed industrialists to cooks in their kitchens and circus performers. Eschewing the use of a painted backdrop traditional at that time, he photographed many of his subjects outdoors. The first volume of this project, *Face of Our Time,* was published in 1929, but Sander's work was banned and all existing books were seized and destroyed by the Nazis. His son, Erich, died in a concentration camp. Sander's studio was devastated by bombing during the Second World War and negatives that survived that disaster were ruined by looters in 1946. Sanders continued his photographic work until shortly before his death.

Books: *August Sander, Photographs of an Epoch.* Millerton, NY: Aperture, 1980. *M. Alinder*

SATELLITE PHOTOGRAPHY See *Missile photography.*

SATICON In electronic imaging, video tube–type cameras use various types of pickup tubes to image a subject. The saticon tube is particularly noted for its ability to image at high resolution. *R. Kraus*

SATURATED SOLUTION A solution is said to be *saturated* when the rate at which a solid substance dissolves in a liquid equals the rate at which the dissolved substance returns from the solution to solid form. A saturated solution contains the maximum amount of the solid substance that will dissolve at that temperature and other conditions.

 Grant Haist

SATURATION The extent to which a color deviates from neutral, corresponding to chroma in the Munsell color system and purity in colorimetry. *R. W. G. Hunt*

Syn.: *Chroma.*

SAVE A computer instruction to store information on a magnetic disk or tape. *R. Kraus*

SCALE See *Scale of reproduction.*

SCALE OF REDUCTION In image formation, especially in the copying and optical reduction of large originals, the linear ratio of object size to image size. An object reduced to a scale of 10:1 is recorded as an image of one-tenth original size. It is the reciprocal of the scale of reproduction. The alternative use of scale of reproduction as the ratio of image size to object size is preferable and unambiguous. In optical work the preferred term is (optical) *magnification.* *S. Ray*

See also: *Scale of reproduction.*

SCALE OF REPRODUCTION In image formation by a lens, the linear ratio of image size to object size. For general camera work, this ratio is less than one as the image is a small reproduction of the scene. When subject and image are the same size, the scale is 1:1, also denoted S/S (same size). A larger ratio means the image is greater than the subject.

Because the scale is linear, it must be squared to give the area reproduction. A linear scale reproduction of 4:1 is an area reproduction of 16:1. In optical work, the term (optical) *magnificaion* is preferred. *S. Ray*

See also: *Optics, geometrical optics, optical calculations; Reduction, optical.*

SCALES Measurement systems used (1) to place items in separate categories (nominal scales), (2) to arrange categories of items in order on the basis of some characteristic (ordinal scales), and (3) to represent both the order of the categories of items and the magnitude of the differences between categories on a graduated basis (interval and ratio scales). *H. Todd*

See also: *Interval scale; Nominal scale; Ordinal scale; Ratio scale.*

SCALES (LABORATORY) See *Balance.*

SCALING (1) The process of comparing the dimensions of a photograph or other image that is to be reproduced to the dimensions of the space allotted to the reproduction, including determining whether cropping will be required because of a difference in the height-to-width proportions of the original and the reproduced images. One method is to make a rectangular outline the same size as the original on paper, draw a straight line through two opposite corners, and add lines corresponding to the dimensions of the space available for the reproduction. (2) In photomechanical reproduction, determining the correct dimensions of an image to be reduced or enlarged to fit an area. (3) In electronic imaging, images are resized by percentage where 100 percent is the original input image. *L. Stroebel, M. Bruno, and R. Kraus*

See also: (3) *Resampling.*

SCANNER (1) A scanner is a device that can translate a transmitted or reflected light image into a digital form. Scanners include rotary drum scanners, flatbed scanners, hand-held scanners, and dedicated film scanners. (2) In electronic imaging, a peripheral device that allows for the conversion of flat art, photographic prints, and transparencies into digital data that can be accessed by photographic imaging software. *J. Larish and R. Kraus*

See also: *Drum scanner.*

SCANNING ELECTRON MICROSCOPE (1) See *Electron micrography.* (2) Instrument capable of magnifying microscopically small, solid objects up to 200,000 times. A beam of electrons focused to a point spot by *electron lenses* is converted by a deflecting electrical field into a tiny *raster* falling on the subject matter at an angle of 45°. The secondary electrons emitted by the subject as the micro spot scans its surface are used to modulate the input to a television tube whose scanning frequency is synchronized with that of the micro-raster. The depth of field is some 300 times greater than that of an optical microscope and stereoscopic records are obtainable by changing the orientation of the subject to the electron beam between making successive photographs of the images of the video screen.

 D. A. Spencer

SCANNING PHOTOMACROGRAPHY A method of making enlarged images of small, three-dimensional objects that provides both fine detail and great depth of field. Those two desirable qualities have long been considered mutually exclusive in photomacrography's realm of life-size to 50×. In photomacrography one can set the lens at or near maximum aperture for greatest resolution of fine detail, and suffer the very shallow depth of field that comes naturally with it. Or one can stop the lens down to a small aperture to improve depth but suffer greatly degraded resolution brought on by

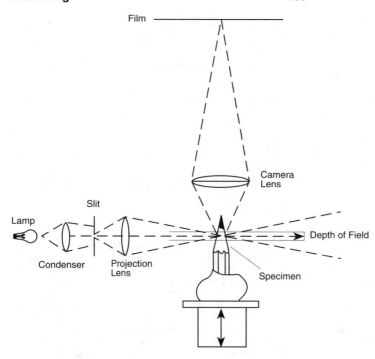

Film

Camera
Lens

Slit

Lamp

Condenser

Projection
Lens

Specimen

Depth of Field

Scanning photomacrography setup.

diffraction effects. Scanning photomacrography maximizes both depth and detail.

In practice the camera is arranged with the appropriate bellows extension for the magnification desired and mounted with its optical axis accurately vertical. Its lens should be wide open. At least two, preferably three, identical special illuminators are arranged around the vertical axis. Each of these illuminators can be considered a miniature slide projector, having a horizontal, adjustable slit in place of a slide. These project very thin, horizontal sheets of light in specimen space. All illuminators are adjusted into the same horizontal plane, the same plane as that focused on by the camera. The slits are narrowed so that the sheet of light in specimen space is thinner than the depth of field of the camera lens when used wide open. Thus, only in-focus parts of the specimen are illuminated. This includes only a thin slice of the specimen at any one time.

The specimen is mounted on a motorized platform capable of slow, controlled, vertical movement. Beginning with the entire specimen below the illuminated plane, this device slowly elevates the specimen until the entire specimen has passed through it. Exposure is controlled mainly by varying the speed of scanning, although slit width can also be varied somewhat. The duration of the entire procedure may be several minutes, depending on scanning speed and specimen height. Reciprocity correction, if any, should be based only on the several seconds any given area is illuminated. This can be calculated from the scan speed and the thickness of the illuminated plane.

At any moment in time an observer at one side would see a brightly lit contour of that part of the specimen then in the focused plane. Observing on the ground glass of the camera during a scan, one would see contour rings constantly changing shape until the whole specimen has passed. The final image is the film's summation of all of these changing patterns. The photographer's eye and mind cannot sum these up as film can. Only on seeing the processed film can the effect of the process be known.

The procedure works best with objects having no concave surfaces. Specimens that *pipe* light, such as certain fibers and

crystals, are not suitable for this technique. They conduct light to planes other than the focused plane, resulting in out-of-focus images. *M. Scott*

SCATTERING See *Light scatter.*

SCATTER PROOFS Unrelated or ganged proofs placed randomly on a proof sheet to fill the area of the sheet.
M. Bruno

SCENE (1) The subject matter of a photograph, implying but not necessarily limited to a broad expanse, as distinct from a single object. (2) In motion pictures, a single run of the camera, which is also called a shot. *L. Stroebel*
See also: *Subject.*

SCENE TESTER A motion-picture printing apparatus used to make sample test prints under different exposure conditions, to help determine final exposure levels and color corrections. *H. Lester*

SCHEELE, CARL WILHELM (1742–1786) Swedish chemist. Building on Johann Schultze's discovery of the light sensitivity of silver compounds, in 1777 Scheele determined that the silver in silver chloride would turn black when exposed to light and that the unexposed silver chloride could be washed away with ammonia. He also found that silver chloride blackened more quickly in the violet end of the spectrum than in other colors and deduced the existence of the unseen radiation band that we call ultraviolet rays. Among his many other significant discoveries, he is credited with first identifying elemental oxygen, before Joseph Priestly. *M. Alinder*

SCHEIMPFLUG RULE An inclined subject plane is rendered sharp when the plane of the subject, the rear nodal (principal) plane of the lens and the film plane, all extended into space as necessary, meet in a common line. The depth of field about the subject plane is inclined in the same direction as the plane. (Theodor Scheimpflug, 1904) *S. Ray*
See also: *Camera types, view camera; Depth of field.*

SCHLIEREN PHOTOGRAPHY A method of recording local changes in the refractive index of a transparent medium. (1) In its original form, of which there are now many variations, the image of a light source is focused on a knife edge placed in front of the medium and imaged alongside a second knife edge behind the medium to form a slit on which the camera is focused. Any local change in the refractive index of the medium due to local changes in its density results in deflection of the image of the source and therefore changes in the amount of light passing through the slit to form the camera image of that area (A. Toepler, 1866). (2) If the knife edge slit is replaced by a graded color filter, the deviated rays can be recorded in different colors that depend on the degree of refraction. Used in the study of air flow around shapes in wind tunnels, shock waves in ballistics, and gas from nozzles, for example. Schlieren projection systems are also used to reproduce images made by thermoplastic recording systems. Schlieren is German for streaks or striations. *L. Stroebel*

SCHMIDT CAMERA See *Camera types.*

SCHMITT TRIGGER An electronic circuit used to change random-amplitude signals with relatively slow rise and fall times into uniform-amplitude pulses with fast rise and fall times. Typical applications for a Schmitt trigger include improving the waveform of degraded digital signals in a digital computer and generating a square wave from a sine wave. *W. Klein*

SCHOOL PHOTOGRAPHY
HISTORY Since the beginning of professional photography as a trade, one of the greatest photographic opportunities has been to record school children. This originally was done to provide the school with a pictorial history of the students and their activities. The photographs were typically made by the local professional photographer, and the prints were sold to the school for use in their archives.

As photography became a part of everyday life, photographers recognized this class of trade could be expanded to taking individual portraits and class pictures, which would then be sold to the students. This introduced the students, and families, to the idea of having a professional portrait made for them at an early stage of family life. The families gain from the programs by having portraits of their children throughout the school years, and the photographers also benefit by having a larger number of subjects at a single location.

From the days of black-and-white photography, with individual photographers working for the local schools, school photography has grown into a major industry for specialized companies, maintaining their own photographers on contract. The photographs supplied in school photography now range from wallet-sized pictures to large, framed portraits. The work is now primarily done in color. The specialized companies have their own programs and marketing divisions to determine the offering best suiting their clients' needs. This often can lead to future visits to the school for special occasions.

CAREERS With companies specializing in school photography, a new opportunity for photographers has opened up. Such firms hire a number of photographers, usually under contract for each school season, to shoot for them. The photographers selected are either practicing professionals, using the jobs to fill in for slow times in their studios, or recent graduates having completed a recognized, postsecondary school education in photography. In addition, a self-taught photographer with a good portfolio will sometimes be considered. The locations are contracted by a sales division and scheduled for the photographer.

The photographer is responsible for setting up a portable studio at the school, with equipment usually provided by the company. The shooting of the portraits and class pictures will be done as previously contracted by the sales division. When completed, the exposed film is sent to the photofinishing firm for developing and printing. The photographs are then forwarded back to the school for distribution. Sometimes, the photographer will take the prints back and distribute them, while trying to secure future portrait sittings for special occasions such as graduation.

Although the programs vary company to company, they typically provide the student with a number of packages of different sized prints to choose from. Such packages are predetermined by the photofinisher based on the design of the printing equipment.

In a large school this work can be repetitive, as little time is allowed to take each portrait. To photograph a large number of students, capturing the best possible portrait requires both the skills of proper camera use and the ability to manipulate the subject to the right pose quickly. A common background is selected to help reduce the length of time needed to take the portrait. Attention is also given to placing the lights, posing chair, and the camera in fixed positions that are suitable for most subjects. Sufficient lighting is used to allow the photographer to focus on the initial subject only. When the proper setup has been completed, the photographer will have no need to readjust the equipment during the shooting session. During the shoot the photographer will reconfirm the focus and lighting, usually at the beginning of each class.

To vary the programs, while keeping the lights and posing chair in the same position, some school photographers make use of a special camera, called a rear projection camera, manufactured to insert a chosen background into the picture. This allows the student to select the background desired from a preselected list. A slide of the desired background is inserted into the camera before the photograph is taken, and it is photographed simultaneously with the student on the same frame of film. Once again, lights, posing chair, and camera remain in the same position. The set is designed to avoid the practice of having to come back to the school to reshoot out-of-focus or poorly-lit photographs.

In some rural locations, the local professional photographer maintains the school business and will do the selling as well. The photographer selects a photofinisher offering the packages that best suit the clients.

In either case, the competency of the photographers to provide acceptable portraits for the subjects determines their success in the trade. *T. Gorham*

See also: *Yearbook photography.*

SCHOTTKY DEFECTS A crystal imperfection in ionic crystals that involves pairs of ions missing from their lattice positions. In contrast to Frenkel defects, the missing ions are not in interstitial positions, but actually missing from the crystal itself. *R. Hailstone*

SCHUFFTAN PROCESS A method of making a composite motion picture. A mirror is used to reflect portions of the set; in places the silver is removed from the mirror to allow other parts of the scene to be photographed directly. *R. Zakia*

See also: *Glass shot.*

SCHULZE, JOHANN HEINRICH (1687–1744) German chemist. In 1725, made landmark discovery that light darkens silver nitrate, also proving that heat did not have this effect. Photography was eventually built upon Schulze's discovery. *M. Alinder*

SCHUMANN EMULSION Photosensitive emulsion characterized by silver halide crystals held to the substrate with minimal gelatin (by crude analogy, likened to sandpaper.) Invented by V. Schumann in 1892 for spectrography in the deep ultraviolet, it denudes the grains of gelatin that would otherwise absorb the shortwave radiation. *M. Scott*

SCHWARZSCHILD, KARL (1873–1916) German astronomer. Working with extremely long exposure times essential in astronomical photography, in 1899 he devised a formula to determine reciprocity failure. His assistant, E. Kron, gave this theory a stricter mathematical formulation in 1913, though it is still applicable only under limited conditions. *M. Alinder*

SCIENTIFIC PHOTOGRAPHY Scientific photography documents scientific investigation in pictures that are easy to study and share. Often, scientific photographs simply make a permanent record of what the scientist's eye sees. Other times they capture on film scientific subjects that normally would be too small, too fast, or too dark for any human to observe. In these ways and others, scientific photography actually extends the scientist's powers of observation.

Closeup photography, photomacrography, and photomicrography are three mainstays of scientific photography. They allow the scientist to record, for example, an insect in its natural habitat, that same insect closer up against a plain background for better body-part identification, and a cross section of some body part such as an eye.

The sensitivity of photographic emulsions to a wide range of light permits such applications as ultraspectrography (to detect very small quantities of metal in an alloy, for instance) and telephotography (to glimpse stars that even the eye aided by the same telescope cannot see). Photo sensitivity to charged particles such as electrons enable scientists to study the greatly magnified subjects of the electron microscope and to determine the charge, mass, and velocity of the particles themselves.

The ability of the camera to work outside of real time, even in badly lighted situations the human eye cannot penetrate, makes photography more than a recorder. Where there isn't enough light to see a scientific subject, the camera can gather light through long exposure or some alternative such as infrared film. When a lightning bolt or bullet defies human comprehension, high-speed photography can freeze the fast-moving subject for study.

Most scientists are more interested in the results of their photography than in the equipment and materials used to obtain them. Still, they need to be concerned with the sensitometric and image-structure characteristics of the plate or film they use to make a photograph. Such characteristics help determine the appearance and utility of the scientific photograph. They also need to establish standard processing techniques so that important, possibly irreplaceable, images will not be lost in the final step.

To select the appropriate photographic material for a specific scientific application, the scientist needs to determine what type of image is needed and what spectral sensitivity, emulsion speed, image structure, and physical characteristics will be needed to get that image. Time constraints, equipment requirements, and product availability also need to be considered.

Other specific examples of scientific photography include the following.

Photogrammetry uses photography to measure precisely in such well known applications as aerial photographs for topological mapping and in newer biomedical applications such as measurement of a facial pattern before orthodontic treatment.

Infrared photography records electromagnetic radiation with wavelengths greater than visible light and less than microwaves. It includes remote sensing from the air or from orbit.

Ultraviolet radiation helps the scientific photographer make a visible picture of an invisible subject or, by including fluorescence, increases visual contrast. Applications include diagnosis of skin and eye diseases as well as detection of forged or altered documents and paintings.

More than a century ago photographic film was called "the true retina of the scientist" by the French astronomer P.J.C. Janssen. "Whereas our retina erases all impressions more than a tenth of a second old," he went on to tell the Société Francaise de la Photographie in June 1888, "the photographic retina preserves them and accumulates them over a practically limitless time" (Darius, 1984).

Books: Blaker, Alfred A., *Handbook of Scientific Photography.* Boston: Focal Press, 1989; *Photography for the Scientist*, edited by Richard A. Morton. London: Academic Press, 1986; Darius, Jon., *Beyond Vision.* London: Oxford University Press, 1984. *K. Francis*

SCOTOPIC Specifying a very low light level to which the cones in the retina are insensitive and only the rods function. At such a low light level, the ability to distinguish hues (reds, greens, blues, etc.) is lost or greatly diminished. Only brightness/lightness discrimination remains. *L. Stroebel and R. Zakia*
See also: *Photopic; Purkinje effect; Mesopic; Visual perception, perception of lightness/brightness.*

SCRATCHBACK An animation technique in which portions of completed artwork on a cel are scratched off or erased during photography. Often filmed in reverse, so that rather than seeming to disappear, the material appears to be growing into a finished image. *H. Lester*
Syn.: *Scratch-off.*

SCRATCH DISK In electronic imaging, many image manipulation programs require that a copy of the image being processed be held in storage so that operator errors can be undone. Because of the size of images, the copy image is usually held in a reserved area of the hard disk called a scratch disk. After the image manipulation is complete, the copy image is removed from the hard disk and that area is no longer reserved. *R. Kraus*

SCRATCHES See *Abrasions.*

SCREEN ANGLE The orientation of screen images with respect to each other. For minimum moiré, angles of 30 degrees between colors are recommended. *M. Bruno*
See also: *Photomechanical and electronic reproduction.*

SCREEN COLOR PROCESS A method of producing a positive color image by coating a random or ordered array of extremely small filters on a plate above or below a panchromatic emulsion. Exposure is arranged so that light must pass through the screen and be filtered before it exposes the emulsion. Reversal processing yields a positive color image when viewed from the emulsion side. *H. Wallach*
See also: *Autochrome process; Dufaycolor; Finlaycolor; Joly, John.*

SCREEN DUMP In computers, when the data displayed on the cathode-ray tube (CRT) are sent to a file on a disk or are sent to a printing device. *R. Kraus*

SCREENLESS LITHOGRAPHY The printing of illustrations without regular halftone patterns using continuous-tone negatives or positives and special plates. *M. Bruno*
See also: *Collotype.*

SCREEN PRINTING A method of printing using the porous screen principle. *M. Bruno*
See also: *Silkscreen printing.*

SCREEN RULING In photomechanical reproduction, equivalent to the number of dot elements per inch or centimeter, usually expressed as lines per inch or lines per centimeter. *M. Bruno*

SCRIM A sheet of gauze or other translucent material that is used between a light source and a subject to diffuse the light, as for a closeup shot of a person's face in sunlight.
 R. Jegerings
Syn.: *Net.*

SCRIPT In motion pictures and video, the written guide for production including dialogue, narration, and descriptions of locations, action, staging, and when appropriate, camera moves and positions. *H. Lester*

SCROLLING (1) To move lines of text up or down on a computer monitor or a motion-picture screen. The credits at the end of motion pictures are commonly scrolled. (2) Using cranking handles at the side of an overhead projector with plastic film roll allows a lecturer to present information for on-screen projection as it is written and then scroll to a clear part of the film to write additional information. Some lecturers write the notes ahead of time and scroll through them as they talk. (3) Using a microfilm reader, rolling the film to locate the desired frames. Using a microfiche reader, moving the flat plate card holder over the reading window. (4) In computers, the movement of text or graphics or images through a portion of the display screen called a window. Scrolling may occur in either a horizontal or vertical direction. *M. Teres and R. Kraus*

SCULPTOGRAPHY The production or sculpting of solid objects by projecting a thin vertical line on a subject, rotating the subject, and photographing the effect of the light with a cine camera held at a 30-degree angle to the axis of the projector. When the recorded profile records are enlarged and cut out, the pieces may be assembled to form an object mathematically similar to the original. *H. Wallach*

SCUM In a processed image or on processing tanks, etc., a whitish deposit, typically associated with incomplete washing or incomplete compounded (or overworked) solutions. The problem often arises with hard water.
 L. Stroebel and R. Zakia

S CURVE An arrangement of the visual elements of a photograph or other image that resembles the shape of the letter "S." A traditional belief about composition is that such a curve conveys the impression of grace and beauty. *R. Welsh*
See also: *Line of Beauty.*

SEASCAPE A general marine view, analogous to landscape. *L. Stroebel*

SECOND (1) A unit of time (1/60 minute) used, for example to identify a camera shutter setting. Exposure time is distinguished from exposure. (2) A unit of angular measurement (1/60 degree). (3) (adj.) Applied to an image made from an original camera image; commonly *second-generation.* (4) (adj.) Identifying a usable, but not first-class, photographic product or image. *H. Todd*
See also: *Exposure; Exposure time.*

SECONDARY ABERRATIONS See *Lenses, lens aberrations.*

SECONDARY CELL Any of a class of electrochemical sources, the energy of which can be restored by recharging it with electricity. *W. Klein*
Syn.: *Accumulator (British).*
See also: *Batteries.*

SECONDARY COLORS Name sometimes given to the cyan, magenta, and yellow colors used in subtractive systems. *R. W. G. Hunt*
See also: *Primary colors; Subtractive color process.*

SECONDARY EMISSION The emission of electrons from a surface caused by the impact of incoming (primary) electrons. This phenomenon is used in a photomultiplier tube. Photoelectrons emitted from the cathode of the tube caused by impinging photons are attracted to a more positive electrode with such energy that they cause even more electrons (secondary electrons) to be emitted from the electrode. *W. Klein*
See also: *Photomultiplier tube.*

SECONDARY STANDARD A standard that is derived from a primary standard. Primary standards commonly cannot be made available in quantity and are difficult to use in nonlaboratory situations. *L. Stroebel*
See also: *Standards.*

SECOND-GENERATION With negative-positive processes, an original camera negative and a print made from the negative represent first-generation images. With reversal processes, an original camera transparency is a first-generation image. In other words, positive original to positive reproduction represents one generation or cycle. A second-generation image is a copy or duplicate of a first-generation image, such as a duplicate negative, a reversal print made from a transparency, a duplicate transparency, or a copy negative made from a first-generation print or a print made from the copy negative. *L. Stroebel*
See also: *Copy.*

SECOND-GENERATION ORIGINAL (1) In electronic imaging, typically a film output made from a computer data file of an original camera transparency or negative. (2) A second generation original results from the output of a digital image to a film recorder or imagesetter of such quality that the new image shows no apparent differences from the original image outside of image enhancement, image merging, or other electronic processing or manipulation.
 L. Stroebel and J. Larish

SECOND UNIT In motion pictures and video, a production crew set up to film or record scenes or events at the same time the principal crew is already engaged. Usually such scenes would not be considered to need the on-site supervision of the production's director or director of photography.
 H. Lester

SECTOR DISK An opaque circular plate containing a series of slots that increase geometrically in length; used in time-scale sensitometers to produce a precise series of exposures of increasing duration on sensitized materials as the disk makes one complete revolution. Most sensitometers now vary the illuminance received by the sensitized material rather than the exposure time. *L. Stroebel*
See also: *Intensity-scale sensitometer.*

SECTOR-WHEEL SHUTTER An opaque rotating disc in which an aperture has been cut, allowing for exposure, projection, or measurement once each rotational cycle, when the aperture lines up with lens and film. *H. Lester*
Syn.: *Sector disk.*

SELECTIVE FOCUS An effect obtained by using a chosen image distance or object distance in relation to a controlled shallow depth of field, so that some parts of the subject are sharp in the image and other parts obviously unsharp. Selective focus is used to emphasize part of a scene, to increase the appearance of depth, etc. *R. Welsh*

Syn.: *Differential focus.*

SELENIUM An element (Se, molecular weight 78.96) that is available as dark red crystals or powder insoluble in water but soluble in hot solutions of sodium sulfide or sodium sulfite. Selenium compounds are toxic and may irritate eyes, skin, or the respiratory tract.

Selenium is used as a toning bath to convert silver images into reddish tones. Slight treatment may improve the resistance of silver images to attack and degradation. Selenium acts as the light sensitive element in photoelectric cells, such as exposure meters, and electrostatic devices. *G. Haist*

SELENIUM TONER Selenium toners convert the silver image to silver selenide, which has a more reddish brown color than does the silver sulfide image formed by sulfur toners. Selenium is difficult to get into solution, but the metal can be dissolved in hot solutions of sodium sulfite, sodium sulfide, or both. Selenium toners work best on warm-toned chloride or chloro-bromide papers, but a modification in which the image is first converted to a halide before toning makes it possible to tone some papers that are otherwise difficult to tone. Proprietary liquid selenium toners are available, which simplify the process for most photographers. Avoid skin contact, due to toxicity.

Like sulfide images, selenide images have good permanence, and even partial toning with selenium renders an image more stable. With some papers, selenium toning increases the maximum density with only a small change in image color. *I. Current*

SELF-COCKING SHUTTER A single motion release and cocking shutter mechanism. This system is found in some older view camera lenses. Most contemporary shutters have the exposure and cocking of the shutter as separate functions, but self-cocking shutters are reappearing on some new lenses. *P. Schranz*

SELF-PORTRAIT In photography, a portrait in which the subject also serves as the photographer, which is possible with procedures such as using a remote control to trip the shutter, using a delayed-action shutter to provide time to move to a desired position after tripping the shutter, or photographing one's own reflection in a mirror. *L. Stroebel*

See also: *Portrait photography.*

SELF-TIMER A type of shutter release delay built into some cameras, and also sold as a separate attachment, that allows for the photographer to start the timing sequence and enter the scene before the shutter is released. *P. Schranz*

SEL-REP OR SEL-SYNC (SOUND) A mode of multitrack tape recorders that permits using the record head for listening purposes rather than the playback head. Use of the record head for playback ensures synchronization when sound is not all recorded at the same time but instead is built up in layers. As a time reference for recordings to be added after the initial one, performers can listen to reference channels off the record head in headphones, while recording to other channels simultaneously. The entire process is called *overdubbing,* invented by guitarist Les Paul so that he could play multiple parts on a recording. *T. Holman*

See also: *Overdub.*

SELSYN A motion-picture term for motors that are electronically linked to run in unison. Short for *self-synchronized,* such motors would be required for double system projection, where the picture and sound tracks are run on separate machines, or for camera and projector, when doing process cinematography. *H. Lester*

Syn.: *Interlock.*

SELWYN GRANULARITY An objective correlate of graininess, found from density variations in a magnified small image area. The value is found from the standard deviation of density measurements multiplied by the square root of the aperture used in the scanning microdensitometer. *H. Todd*

SEMICONDUCTOR A crystalline material, the resistivity of which is between that of an insulator and a conductor. It was the development of semiconductors that made possible the invention of the transistor, integrated circuits, and the entire field of microelectronics. Semiconductors most commonly used are made from very pure silicon and germanium. To utilize the unique properties of silicon and germanium, however, trace impurities must be added to make *p*-type or *n*-type semiconductors in a process called doping. Semiconductors are also used in light-sensitive and heat-sensitive devices. *W. Klein*

See also: *Doping (Semiconductor).*

SEMICONDUCTOR CHIP An integrated circuit fabricated on a small semiconductor wafer that contains anywhere from 100 to more than a million circuit elements. Typically, the chips measure from 0.05 inches square to 0.50 inches square. They are called *chips* because they are broken off a much larger wafer that contains many identical chips. *W. Klein*

SEMICONDUCTOR DIODE Any of a number of two-terminal semiconductor devices that consist of one junction of *p*-type and *n*-type semiconductor materials. Like its vacuum tube counterpart, it allows electrons to pass through it in only one direction—from cathode to anode. The cathode end is usually identified by a band painted around the diode. Sometimes the diode symbol is painted on the unit to identify the terminals. Diodes may be specified according to their usage. A large diode might be referred to as a *rectifier* because it is designed to convert ac power to dc power. A small diode might be called a *signal diode* because it is used to process weak signals in electronic equipment. *W. Klein*

See also: *Photodiode; Zener diode.*

SENSATION Direct response of a person to a stimulus; e.g., visual sensation is a response to light. Distinguished from perception, which involves memory and thought as well as sensation and which results in recognition, understanding and so on. *L. Stroebel and R. Zakia*

See also: *Visual perception, sensation and perception.*

SENSITIVE In photography, capable of responding to radiation, such as the reaction of photographic materials to light, or to other forms of energy, such as heat, pressure or atomic particles. *G. Haist*

SENSITIVITY A general term for the extent to which a photographic material, or other photosensitive element (such as a photocell), responds to light or other radiation. Historically, film speed was at first intended to be a measure of sensitivity; now speed numbers are considered to be index values useful in determining the camera settings that will yield an acceptable result. *M. Leary and H. Todd*

See also: *Film speed; Paper speed; Quantum efficiency; Quantum sensitivity; Spectral sensitization.*

SENSITIVITY GUIDE A gray scale, with numbered steps and a square root of 2 (1.414) density difference between steps, used to measure and control exposures in platemaking and lith-film photography. *M. Bruno*

SENSITIVITY SPECK A term used in early studies of the photographic process to refer to active sites on the emulsion grain surface where a latent image forms. We now refer to these sites as sensitizer centers because they form during the act of chemical sensitization. But early studies used materials that were simply heated to improve their sensitivity and the mechanism was unclear. We now know that the gelatin used was capable itself of sensitizing the grain. *R. Hailstone*

SENSITIZE Sensitize refers to the act of making a material respond to radiation, or extending the range of radiation to which a material is sensitive, or increasing its sensitivity. Chemical sensitization increases the light response of silver halide emulsions by treating the crystals to the action of sulfur, gold, or metal salts during the afterripening period of emulsion making. Spectral response can be expanded by adding sensitizing dyes to the silver halide crystals, increasing the response of the emulsions to all wavelengths of light. *G. Haist*

SENSITIZED MATERIALS See *Photosensitive materials*.

SENSITIZERS In photomechanical reproduction, chemical compounds such as salts of iron, silver, and chromium, dyes, and diazo and acrylic compounds that are used to make organic photographic and photomechanical coatings light sensitive. *M. Bruno*

SENSITIZING DYES Untreated silver halide crystals of photographic emulsions are sensitive only to the ultraviolet, violet, and blue regions of the spectrum. Sensitizing dyes adsorbed to the surfaces of the crystals can extend the sensitivity throughout the visible spectrum and into the infrared. Some of the more important sensitizing dyes, such as the various cyanines, are long carbon chains that exist as absorbed, aggregated resonance hybrids. These aggregates absorb light energy and transfer it to the silver halide crystal, forming a latent image. *G. Haist*

SENSITOMETER An apparatus used in testing photographic materials that produces a series of known exposures on a sample. Since exposure equals the light level multiplied by the exposure time ($H = I \times t$), a sensitometer may be either of two types:

1. The instrument produces a series of different light levels at a fixed time—an intensity-scale sensitometer.
2. The instrument produces a series of different exposure times at a fixed light level—a time-scale sensitometer.

Intensity-scale sensitometers expose the sample in a manner conforming to practice and therefore are more suitable for test purposes. *M. Leary and H. Todd*

See also: *Sensitometry*.

SENSITOMETRIC CURVE See *Characteristic curve*.

SENSITOMETRIC TABLET See *Optical wedge*.

SENSITOMETRY The complex process of determining the response of photographic materials to light (and other radiation) and processing. Begun in the late nineteenth century by Vero Driffield and Ferdinand Hurter, the initial aim was to develop test methods that would enable comparison of different films with respect to their sensitivity as expressed by emulsion speed values. During the past century, methods have been developed for emulsion testing that are essential to the operations of manufacturing and processing of photosensitive materials and that are useful to consumers of photographic products as well.

Sensitometry involves (1) the selection of samples to be tested; (2) proper storage of samples; (3) exposure to suitable radiation; (4) development and other processing; (5) image measurement; (6) data analysis.

SAMPLE SELECTION Samples of photographic materials to be tested for quality must be representative of the entire set (the population) from which the samples are chosen. For example, in manufacturing, rolls of film coming from the coating apparatus are normally several feet wide and many feet long. It is tempting to take samples that are conveniently located, as from the ends or the sides of the roll. It is necessary, however, to assure by extensive sampling that easily secured samples are indeed characteristic of the entire product. If they are not, other steps must be taken to obtain suitable test samples.

SAMPLE STORAGE Environmental conditions may alter sample characteristics. For processing control, samples of an especially selected test material may be kept for extended periods of time. High temperature and humidity are damaging. Therefore samples should be well wrapped and refrigerated, then removed from storage so that they come to reasonable temperature before use.

EXPOSURE In the exposing device—a sensitometer—choice of the correct energy source is essential. It must supply an appropriate spectral energy distribution. For much testing, the rule *conform to practice* must be obeyed. If the photographic material is to be used in a normal outdoor environment, then the sensitometric light source should be that of the present standard, i.e., having a continuous spectrum equivalent to that of standard daylight at a color temperature of 5500 K.

Other standards exist for the exposure of medical x-ray films to fluorescent screens and for films used in studios and exposed to tungsten lamps. No standards exist for such sources as flashlamps and fluorescent lamps used for general illumination. The same is true for photographic papers as exposed in most printers. For such uses, the consumers of the product must establish their own test procedures.

A set of different exposures is produced at the sample in the sensitometer by the use of a step tablet, i.e., a semitransparent strip consisting of a series of patches that absorb different amounts of energy from the source. Step tablets must be nearly neutral in their absorption of energy of different wavelengths.

Radiation (light source) Exposure Attenuator (optical wedge or step tablet)

Filter Shutter Film

Sensitometer. Schematic of an intensity-scale sensitometer.

A typical sensitometric step tablet consists of 21 patches that give a total ratio of exposures of 1000 to 1, or a log exposure change of 3.0. From one patch to the next the exposure changes by a factor of 1.4, a log change of 0.15, equivalent to one-half stop in camera exposure settings.

To avoid reciprocity effects (changes in the response of a photographic material with fixed exposure but changed exposure time and illuminance), the time of exposure needs to be close to that expected in practice. A typical time for available sensitometers is 0.1 second, selected to be neither exceptionally short nor long.

PROCESSING Development conditions must be carefully controlled. Of the major factors in development—time, temperature, developer composition, and agitation—the first two are easily monitored.

Effective agitation is needed to supply fresh developer to every area of the sample and to remove reaction products that would interfere with proper development. What is needed is turbulent movement over the film or paper surface to remove the laminar layer of developer, i.e., that solution that adheres to the emulsion surface, and it must be removed as effectively as possible. There are many methods of agitation, including rocking or shuffling one or a few sheets of film or paper in a tray; spinning the reel in a tank holding a roll of film or inverting and swirling the tank; lifting and draining sheet film holders in a tank; introducing bursts of nitrogen gas into a large tank; and squeezing the film by the use of rollers. All these methods need to be checked for uniformity of agitation using test samples sensitometrically exposed and measured.

The developer used for sensitometric purposes should have the following characteristics: (1) stability—freedom from deterioration with storage; (2) selectivity, which is freedom from the production of development fog; and (3) freedom from staining, so that the image will be as nearly neutral as possible. For most applications, the developer formula must follow the conform-to-practice rule, although there are international standards for some uses.

MEASUREMENT Processed sensitometric samples are measured with an instrument called a *densitometer,* which causes a known light level to fall upon the sample and records the light transmitted or reflected from the sample.

DATA ANALYSIS A sensitometric test sample usually consists of 21 areas that have received different levels of exposure. Analysis of the results is usually made by plotting a graph of the density values against the corresponding log exposure data. The result is the characteristic curve, also called the D-log H (formerly D-log E) curve.

From such a curve, the following information is obtainable:

1. The base plus fog density found from an unexposed area of the sample. This value is a measure of the selectivity of the developer.
2. An estimate of the speed of the material, usually based on a density slightly above the base plus fog level.
3. A measure of development contrast, found from the slope (steepness) of the curve well above the minimum point. In process control, development contrast is often found from the difference in density between two selected patches near the center of the sensitometric strip.

ALTERNATIVES TO SENSITOMETERS When a sensitometer is not available, or when precision data are not required, transmission or reflection gray scales may be used as substitutes with a camera or a printer. Calibrated gray scales usually supply only relative log exposure information, but they satisfy many aims.

Reflection gray scales are useful in practical tests of camera performance. Such a scale may be placed in the scene being photographed and illuminated carefully to avoid glare

reflection. Camera flare to some extent changes the log H values assigned to the steps of the tablet, which therefore gives only approximate exposure data. The use of this tablet, however, gives useful information about the performance of the system.

Transmission gray scales or step tablets may be used in a printer to give a set of light levels of known increments on the print material. If the printer illuminance is measured without the step tablet in place, actual, rather than relative, log H data can be obtained. Uniformity of light without the step tablet is essential. When such a step tablet is used in a projection printer, flare becomes a problem as it does in a camera. Masking down the area to be exposed is important. The effects of the optical system can be eliminated by placing the step tablet in contact with the print material.

In the absence of even these aids to testing, subject luminance data may be used as the input. Log luminance ratios are equivalent to relative log exposure intervals. For example, if different areas of the subject give luminances of 6.5, 13, 25, 100, and 400, they form in effect a five-point gray scale. The four successive luminance ratios are 2, 2, 4, and 4. The logs of these ratios are 0.3, 0.3, 0.6, and 0.6. These numbers can be used as relative log H intervals and will yield an approximate five-point characteristic curve when the image densities are measured. *M. Leary and H. Todd*

See also: *Agitation; Densitometer; Densitometry; Film speed; Gray scale; Sensitometer; Standards, photographic; Tone reproduction; Zone system.*

SEPARATION NEGATIVES Both color photographs and graphic arts color reproductions are generally derived from exposures of the subject matter using red light, green light, and blue light. In the integral tripacks widely used in color photography, these exposures occur in the differently sensitized layers of the materials. In graphic reproductions, the three exposures are commonly made using red, green, and blue filters. In both cases, the initial stage is usually to produce negatives, and the three negatives are called *separation negatives.* Because in integral tripacks the negatives are not available as separate entities, however, the term separation negatives is generally applied only to photographic systems in which the three images are assembled, such as dye transfer processes, and to the graphic reproduction industry.

In photographic dye transfer processes, negatives of the scene, or more usually of a color photograph of the scene, are exposed through red, green, and blue filters, and these are then used to produce positive images of hardened gelatin of varying thickness (the unhardened gelatin being removed by washing in warm water). The positive images are dyed with cyan, magenta, or yellow dye, as appropriate, and the dyes are then transferred in succession to a suitable support. For paper prints, a paper support is used; for motion picture films, a film support is used. This was the method used in the *Technicolor* motion-picture system. Before the availability of integral tripack color negative film, the Technicolor system used a special beam-splitting camera in which the separation negatives were exposed on three separate films.

The major interest in separation negatives now is in the graphic reproduction industry. Although the original scene is occasionally used, as in the reproduction of artists' paintings, most separation negatives are made from color photographs, and these are referred to as the *originals.* The filters used for making the exposures are typically similar to Wratten filter numbers 25 for the red, 58 for the green, and 47B for the blue.

MASKING Because the cyan, magenta, and yellow dyes or inks used to make the final positive image always have unwanted absorptions, good color reproduction can normally be obtained only if corrections are made to the separa-

tion negatives. This can be done by *masking,* by which is meant binding up in register with a separation negative a low contrast positive made from one of the other two separation negatives. For instance, if a low contrast positive is made from the red separation negative and bound up in register with the green separation negative, the effect in the final images will be to reduce the amount of magenta in areas where cyan dye or ink is present; this reduction in magenta can then compensate for the unwanted green absorption of the cyan dye. Similar procedures can be used to correct for the unwanted blue absorption of the cyan, for the unwanted red and blue absorptions of the magenta, and for the unwanted green absorption of the yellow (the unwanted red absorption of the yellow is usually negligible). By making these masks slightly unsharp, useful improvements in the apparent sharpness of the final image can be obtained.

SCANNERS In the graphic arts industry, separation negatives are now usually made on *scanners.* In a typical scanner the procedure is as follows. The original typically consists of a photographic color transparency. This is wrapped around a transparent drum on which a very small spot of white light is focused. The drum is rotated and advanced on a lead screw so that the spot of light scans the whole area of the picture in a series of parallel lines. The light is then split into three beams, one incorporating a red filter, another a green filter, and a third a blue filter. The three beams then excite three photodetectors, and the resulting electronic signals are used to control the intensities of three beams of light focused on three unexposed pieces of film or other photosensitive material, wrapped round further sections of the same drum. As the original transparency is scanned, the three pieces of film are exposed, and after processing, the separation negatives are obtained. Because of the difficulty of producing good blacks from cyan, magenta, and yellow inks alone, a black image is usually printed as well in dark and black areas of the picture, and another section of the drum can be used to expose a fourth negative from which the black ink printing can be derived.

In scanners, the information corresponding to the separation negatives is available in the form of electronic signals, and these can be manipulated to introduce various forms of correction corresponding to the older masking procedures; thus, corrections can be made for the unwanted absorptions of the cyan, magenta, and yellow inks, and the unsharp masking can also be achieved to improve the sharpness. Another useful procedure is known as *under color removal* or *gray component replacement* (GCR); in this procedure, wherever all three colored inks are present, the resulting gray color can be replaced by the corresponding amount of black ink, and this can reduce ink costs, facilitate the drying of the inks, and improve sharpness.

Books: Hunt, R. W. G., *The Reproduction of Colour.* 4th edition. New York: Van Nostrand Reinhold, and Surbiton, England: Fountain Press, 1987. *R. W. G. Hunt*

See also: *Color photography; Color photography, history; Color correction; Photomechanical and electronic reproduction.*

SEPARATIONS In electronic imaging, the creation of four separate files one for each of the four process colors, cyan, magenta, yellow, and black. The software for separations may be machine specific or may have various look-up tables to maximize color appearance for specific output devices. *R. Kraus*

SEPDUMAG A designation for a motion picture or video distributed with two magnetic sound tracks on a separate tape. Derived from *separate dual magnetic,* and most commonly used in international television distribution.

H. Lester

SEPIA TONER Generally applies to the color produced by a wide variety of methods in which the metallic silver image is converted to silver sulfide. The actual color depends on the nature of the emulsion used to manufacture the paper, the processing of the image, and the chemical formulation of the toning bath. The color can range from a yellowish brown to a reddish brown. Historically, portrait photographers have utilized a combination of paper emulsion and toning technique to produce a proprietary tone they advertised as distinctive. Gold has been included in some of the formulas. Sepia toned images are generally more stable than silver alone. Selenium toned images are sometimes included in the sepia category. *I. Current*

SEPMAG A designation for a motion-picture film or video distributed with a sound track on a separate magnetic tape. Derived from *separate magnetic.* *H. Lester*

SEPOPT A designation for a motion-picture film distributed with an optical sound track on a separate roll of film. Derived from *separate optical.* *H. Lester*

SEQUENCE CAMERA See *Camera types.*

SEQUENTIEL COULEUR A MEMOIRE (SECAM)
One of two European television broadcast standards. The chrominance signal is transmitted differently than either PAL or NTSC systems. The system is in use in France, the former Soviet Union, and in Eastern Europe. *R. Kraus*

SEQUESTERING AGENT An organic or inorganic compound that when added to a photographic developer removes the harmful ions in the solution, especially calcium, by forming stable, soluble complex ions. Polyphosphates, such as the polymeric form of sodium hexametaphosphate sold as Calgon, or nitrogen-containing tetraacids, such as ethylenediaminetetraacetic acid (EDTA) and its salts, are examples of sequestering agents that remove ions before insoluble compounds are precipitated. *G. Haist*

SERIAL PORT In computing, one of the two standard input/output means used by the computer to control external peripherals such as a modem. Serial ports send data one bit at a time in a sequential string. It is a slower transfer than a parallel process. *R. Kraus*

See also: *Parallel port.*

SERIES CIRCUIT See *Electricity.*

SERVO- Identifying a motor or mechanism that adjusts a process on the basis of feedback, such as an automatic focus mechanism, voltage regulator, and temperature control.

L. Stroebel

SET An area in a photographic studio or elsewhere that has been prepared to serve as the site, or setting, for a subject that is to be photographed. *L. Stroebel*

SET (PERCEPTUAL) A state of readiness to respond in a specific manner that is associated with expectation. Visual perceptions, for example, are affected by the perceptual set, as when one expects to recognize the face of a friend in a crowd at an airport. *L. Stroebel and R. Zakia*

See also: *Expectancy.*

SEVENTY MILLIMETER See *Film formats.*

SHADE (1) A dark and unsaturated color, as is produced by adding black to a more saturated color. Maroon, a dark red of low saturation, is a shade. (2) An area that is protected from direct light from a source. *R. W. G. Hunt*

SHADOW An area that is shielded from direct light from a source. The shadow can be on the object that is blocking the light, such as the shadow side of a building, or it can be on another surface, such as the shadow of a building on the ground on the side opposite the sun. *L. Stroebel*

See also: *Cast shadow.*

SHADOWBOARD A black card or other screening device with a hole in the center for the camera lens. Shadowboards are used in copy photography to remove camera and copy-stand reflections from flat art. Lightweight boards may be held in place by a lens hood. *R. Jegerings*

Shadowboard reduces reflections of camera in copy photographs.

SHADOWGRAPH A silhouette image, made without a camera by placing an object between the light source and the film. Often used in high-speed spark photography since a spark burst is too weak for conventional photography. *R. Jegerings*

See also: *Photogram.*

SHADOWLESS LIGHTING Any lighting technique that produces no shadow that is visible to the camera. Such lighting tends to reveal detail in complexly shaped subjects whose own shadows obscure other parts of the subject. It may also be used to conceal detail in such subjects as human skin, where shadows define texture.

Techniques for shadowless lighting can be classified into three broad groups:

1. Placing the light source as close to the camera viewpoint as possible so that shadows fall behind the subject where the camera cannot see them. The best example of this is the use of a *ringlight,* a circular flash tube that surrounds the lens.
2. Using a light source so large that its shadow edge is too softly defined to be apparent. Daylight on a very overcast day and *tent lighting* are examples.
3. Placing the subject in front of a background that can be illuminated independently of the subject. Translucent plastic lit from below is a common method of doing this. Some subjects may also be supported invisibly by a rod through the background, by gluing them to clear glass, or by attaching them to a thin line. Then an opaque background can be used far enough from the subject to be illuminated without the background lighting interfering with the subject lighting.

Any of these general groups of techniques may be combined with others. *F. Hunter and P. Fuqua*

See also: *Flat lighting; Tent lighting.*

SHADOW MASK (1) A perforated metal screen that is separated from the geometrical mosaic of red, green, and blue phosphor dots on the inner face of a color television tube and so positioned that it confines the passage of the beams from the R, G, and B electron guns to their corresponding color emitting phosphor dots. (2) A mask used when the full shadow detail in a four-color reproduction is desirably carried by the black printer. It is made from the black printer separation negative on a high-contrast emulsion and registered with the black printer positive when making the half-tone screen negative. *L. Stroebel*

SHADOW SERIES A series of colors of constant chromaticity but of varying luminance factors. *R. W. G. Hunt*

SHAPE The two-dimensional outline of an object or part of an object, as distinct from form, which implies a three-dimensional quality. *L. Stroebel*

SHAPE CONSTANCY The tendency to see objects as having the same configuration regardless of the variation in the viewing conditions. A coin is recognized as a circular-shaped object, even when it is observed obliquely so that the image on the retina is an ellipse. *L. Stroebel and R. Zakia*

See also: *Constancy.*

SHARPENING See *Leveling/sharpening.*

SHARPNESS A perceived quality of an image that is associated with the abruptness of change of tone at the edge of an object or tonal area. The purpose of focusing a camera is to adjust the lens-to-film distance to obtain the sharpest image. Acutance is an objective measure of edge quality that is related to sharpness. *L. Stroebel*

SHEELER, CHARLES (1883–1965) American painter and photographer. Both his paintings and photographs reflect a precisionist vision. Photographed primarily from 1912 until the early 1930s when he became successful as a painter. Employed as a freelance photographer from 1919, accepting assignments from *Fortune* and *Vogue.* His primary photographic subjects were industry, architecture, and works of art. Best known for three series of photographs: Chartres cathedral, Shaker architecture, and Ford Motor Company's River Rouge factory.

Books: Stebbins, Theodore E., Jr., and Keyes, Norman, Jr., *Charles Sheeler: The Photographs.* Boston: Little, Brown, 1987. *M. Alinder*

SHEEN Glossiness, as of a photographic paper. *M. Scott*

SHEET FILM Also *cut* or *flat* film. Photographic material on a stiff but flexible transparent support, cut into individual rectangular pieces. For use it is loaded into light-tight holders in the dark or under a safelight. Each sheet is normally used to make a single exposure. A notch in the edge in a conventional position locates the emulsion side. *M. Scott*

See also: *Notch code.*

SHEET-FILM HANGER Typically a grooved rectangular frame with a hinged edge designed to hold one or more sheets of film vertically in a series of tanks of processing solutions. A long top bar rests on opposite edges of the tanks, and the bars serve as handles so that the hangers can be lifted at intervals to drain the film as a means of providing agitation. *L. Stroebel*

See also: *Processing, agitation.*

SHELF LIFE The time during which a sensitized material, chemical, or chemical solution, can be used effectively and

safely before it begins to break down. It usually applies to darkroom chemicals. When used with reference to sensitized materials, the term *expiry* or *expiration date* is preferred.

K. B. Hendriks

SHOOT To expose film, tape, disc, etc. in a camera. To take a picture or a number of pictures. A photographic effort involving multiple photographs of a product, activity, theme, etc. *I. Current*

Syn.: *To photograph.*

SHOOTING RATIO In motion-picture photography and videography, a comparison of the amount of footage exposed in the camera to that used in the final edited picture, such as 10:1. *I. Current*

SHOOTING SCRIPT A motion-picture screenplay that includes details of the shooting and lighting plan, used as a guide for planning, shooting, and editing the film. *H. Lester*

Syn.: *Camera script.*

SHORT LIGHTING In portraiture, placing the main light on the side opposite the subject's visible ear.

F. Hunter and P. Fuqua

Syn.: *Narrow lighting.*
See also: *Broad lighting.*

SHOT (1) A photograph. (2) In motion-picture photography, a single run of the camera or the strip of film resulting from such a run. *L. Stroebel*

SHOTGUN MICROPHONE See *Microphone polar patterns.*

SHOULDER The high-density region of the characteristic curve where the curve diminishes in slope, becoming more nearly horizontal. This area is reached with increasing exposure for negative materials and with decreasing exposure for reversal materials. Subject tones exposed in the shoulder will have little or no detail in the image. *M. Leary and H. Todd*

SHOULDERPOD A camera support device that steadies the camera by resting against the operator's shoulder, thus permitting the use of slower shutter speeds with still cameras and providing smoother movement of motion-picture and video cameras. *L. Stroebel*

See also: *Gunpod; Gyro stabilizer; Monopod.*

SHRINKAGE A reduction in dimensions of photographic materials associated with drying, or, in films, with loss of residual solvent. Fiber-base papers shrink less in the *machine* direction (the direction of paper motion in the paper-making machine) than in the *cross* direction. Shrinkage of resin-coated (RC) papers is very small. Shrinkage of motion picture films could result in mechanical difficulty or damage to printing and projection equipment. Shrinkage of photogrammetric films would result in inaccurate maps and misregister of color would be the result of shrinkage in graphic arts films, both of which have been greatly reduced by the introduction of polyester base and are virtually eliminated by glass plates. *M. Scott*

SHUFFLE AGITATION In tray processing of sheet film, continuous agitation involving carefully bringing the bottom sheet in the stack of film to the top, and then the next one, and so on, typically throughout the process. *L. Stroebel and R. Zakia*

See also: *Agitation.*

SHUTTER The mechanism on a camera or lens that controls the duration of exposure of the film. The shutter and diaphragm together control the total amount of exposure. In addition, the shutter speed determines the amount of image blur with moving objects. Shutters also control the synchronization between film exposure and the triggering of electronic flash units. Traditional shutters have timing increments based closely on a factor of two. *P. Schranz*

See also: *Between-the-lens shutter; Electromechanical shutter; Electronic shutter; Focal-plane shutter; Leaf shutter; Mechanical shutter.*

SHUTTER ANGLE In motion pictures, the opening of the sector aperture in the rotating shutter, measured in degrees, such as 120 degrees. *P. Schranz*

Syn.: *Shutter opening.*

Shutter angle of 180 degrees on a motion-picture camera shutter.

SHUTTER EFFICIENCY The ratio of the amount of light actually transmitted by a shutter to the amount it would transmit if the shutter were fully open for the entire time between when it starts to open and when it returns to the completely closed position. With lens shutters, the efficiency is reduced by the time the blades take to completely uncover the diaphragm opening at the beginning of the exposure and to completely cover the opening at the end of the exposure. Because of this loss of light during the opening and closing phases, lens shutters approach 100% efficiency only with slow shutter speeds and/or when the diaphragm is stopped down to a small opening, where the light lost is a small fraction of the total amount of light transmitted. With focal plane shutters, the efficiency is reduced by the time required for the leading and trailing curtain edges to pass through the cone of light from an object point. With the shutter close to the film, the cone is approaching a point and the time is relatively short. *P. Schranz*

See also: *Effective exposure time.*

SHUTTER PRIORITY A mode in automatic exposure cameras where the photographer determines the shutter speed, and the camera automatically sets the aperture for proper exposure. *P. Schranz*

SHUTTER RELEASE A physical or electronically activated mechanism that opens the shutter at a specific time chosen by the photographer. The shutter release system is usually on the camera body along with a variety of accessories that allow for remote activation. Some cameras have more than one shutter release mechanism, depending on whether the camera is held vertically or horizontally. More modern cameras have electronic shutter releases ergonomically built into the contours of the camera body to reduce camera shake when depressed. *P. Schranz*

SHUTTER SPEED The marked exposure time on a shutter. Manufacturers calibrate shutters from the half-open to the half-closed positions on a time–transmittance curve, with the lens diaphragm set at the maximum opening. Due to limited space on lens and camera shutter scales, it is common practice to print only the denominator of fractions, such as 125 for 1/125 second. With exposure meters that list times longer and shorter than one second and cam-

era shutters capable of making measured time exposures, fractions are commonly represented with a short slash, similar to an apostrophe, before the denominator, such as '125 for 1/125.

Traditionally, adjacent shutter speeds vary by a factor of 2, such as 1, 1/2, 1/4. With electronically controlled aperture-priority cameras, shutter speeds normally vary on a continuous scale rather than a stepped scale, and the exact shutter speed is displayed in the viewfinder. *P. Schranz*

See also: *Effective exposure time.*

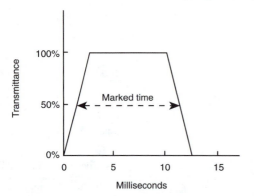

Shutter speeds are calibrated on the basis of the time interval between the half-open and the half-closed positions of the shutter.

SHUTTER TESTING Professional shutter testing is available at camera manufacturers' repair facilities, many camera stores, and at camera clinics. However, personal shutter testers have become quite inexpensive. They have a precalibrated memory based on the light distance to the probe on the tester. The shutter is placed along the optical beam and the results are displayed digitally. Because shutter efficiency falls off more rapidly with higher speeds and increases in efficiency with smaller apertures, every speed should be tested at each full aperture. Consistent errors can be compensated for by altering the aperture or film-speed setting, but erratic errors require repair work. *P. Schranz*

SHUTTLE A type of sliding intermittent drive device used in some motion-picture cameras and projectors to advance the film one frame at a time. *H. Lester*

SIDE LIGHTING Placing the main light at approximately 90° to the camera axis on either side of the subject. If the subject is three dimensional, one side of the subject is fully illuminated while the other is in shadow.
F. Hunter and P. Fuqua

SIGMA (σ) Greek letter signifying standard deviation.
H. Todd

See also: *Standard deviation.*

SIGNAL A general term for any desired input into a transmission, imaging, or other system that causes appropriate action with respect to the output. The term is commonly used in electrical, electronic, and electromagnetic contexts, such as the variation with time of a wave train by means of which information is conveyed in a transmission system. The simplest signal is a single pulse. Complex signals can carry sufficient information to build up a television image as a result of modulation. *L. Stroebel*

See also: *Input; Noise; Signal-to-noise ratio.*

SIGNAL-TO-NOISE RATIO (SNR) The quotient obtained by dividing the power associated with the desired input by the power associated with the random disturbance that may interfere with the desired record. In sound reproduction, the ratio of the loudness of the desired signal to the loudness of any unwanted sound signal. In a photographic image, for example, the signal is the mean average density of an image (D_I) less the mean background density (D_B), and the noise is the extraneous degradation introduced by granularity, normally expressed by σ. The signal-to-noise ratio is then ($D_I–D_B$)/σ. The typical SNR of photographic materials is about 4:1, but values ranging from 2:1 to 40:1 have been measured. In microcopying, a value of 11:1 is the minimum for a barely decipherable image. *L. Stroebel*

See also: *RMS; Granularity.*

SIGNAL-TO-NOISE RATIO (SOUND) The amount that noise of a medium or transmission path lies below the reference level in the medium. "The signal-to-noise ratio is 65 dB re 185 nW/m" is an incomplete specification because many conditions affect the measurement of signal to noise, including whether the measurement is weighted for human perception or measured flat. *T. Holman*

SIGNATURE A section of a book that is formed by folding one or more printed sheets, each of which contains more than four pages. *M. Bruno*

SIGN (PERCEPTUAL) A mark that serves as a substitute for the thing represented and typically has a visual similarity to the object. For example, a road sign may indicate a curve in the road by the use of a curved arrow.
L. Stroebel and R. Zakia

See also: *Visual perception, gestalt.*

SILENT In motion-picture production, a term describing a film without an accompanying sound track or a camera not intended for filming when recording sound because the camera design does not allow convenient synchronization with the sound recording or because the camera makes so much mechanical noise that it would interfere with the sound recording. Motion-picture cameras used for sound production must be blimped (encased in a sound absorbing box) or, more commonly, be specially designed and built to be noiseless (self-blimped). *H. Lester*

SILENT SPEED In motion-picture photography, the frame per second (fps) rate used for filming when no sound track is intended. For home movies the standard rate is 18 fps. The professional standard is 24 fps—the same as is used for sound production. In the past, 16 fps was used as an amateur standard as well as a professional one before the addition of sound to motion pictures. *H. Lester*

SILHOUETTE A photograph in which the subject is completely black, and the background is white or colored; named after Étienne de Silhouette, whose hobby was cutting profile portraits from black paper.

For a complete silhouette effect, the illumination of the subject must be too dim to record detail on film. This is most easily accomplished in the studio, with the subject in front of an illuminated background. To keep as much light off the subject as possible, the subject needs to be as far from the background as space allows and the light sources may need barndoors or gobos to confine their illumination to the background. In a small studio it may also be necessary to cover walls other than the background with black paper to reduce illumination reflected to the subject by them. The use of high-contrast film and/or printing material will facilitate in suppressing unwanted detail.

Commercial photographers also use the term to describe a graphic arts technique only slightly related to the classic usage. In this case a mask, photomechanically produced or hand cut, eliminates the background of a conventionally lit subject before making a printing plate. The mask, not the printed image, resembles a classic silhouette. Nevertheless, the word is used to describe the finished result. *F. Hunter and P. Fuqua*

See also: *Mask/masking.*

SILICA GEL A modification of silicic acid that, in granular form, is capable of absorbing various vapors. It is used as a drying agent in desiccators and for moisture control in storage boxes and compartments. *K. B. Hendriks*

SILICON-BLUE CELL (SBC) Identifying exposure meters that have a silicon photoelectric cell that is covered by a bluish filter to bring the spectral response of the meter into closer agreement with the spectral sensitivity of panchromatic films. *J. Johnson*

See also: *Exposure meter.*

SILICON CONTROLLED RECTIFIER (SCR) Silicon controlled rectifiers are in a class of semiconductor devices known as *thyristors.* The operation of an SCR differs from that of an ordinary rectifier in that a third terminal, called a *gate* (G), determines when the rectifier switches from an open-circuit to a closed-circuit state. In order to establish conduction through the SCR, the anode (A) must be positive with respect to the cathode (K) and a pulse of sufficient magnitude must be applied to the gate. Once conduction starts, removal of the gate pulse will not stop current flow. The usual methods of turning off an SCR are to momentarily short-circuit it or to remove the anode voltage. In automatic electronic flash units or cameras, an SCR is used to shorten (quench) the flash duration according to the light reflected from the scene. It does so by short-circuiting the capacitor that supplies energy to the flash lamp. SCRs are also used in solid-state relays, dc motor controls, various protective circuits, etc. *W. Klein*

See also: *Thyristor.*

SILKSCREEN PRINTING Silkscreen printing, sometimes called *serigraphy* or *retigraphy,* is a versatile and varied process by which paint is forced through a fine screen to record an image on almost any material. *Paint* is the general silkscreen term for any printing medium and may include dye, water color, paint, printing ink, cellulose, fluorescent pigments, and chlorinated rubber.

Originally, the screens employed in the process were silk, but while some woven natural fibers are still in use (for direct drawing with tusche or crayon), nylon, polyester, and metal screens are more popular. Printing can be on flat or cylindrical paper, plastics, textiles, wood, or metal. The process is used in the production of art prints, posters, signs, printed circuits, clothing, home furnishings, packaged goods, and beverage containers.

In the basic application of the process, the screen is stretched tightly in a frame and the areas that will not be printed are covered with a substance that will block paint: shellac, glue, gum, gelatin, or cellulose. The paint is squeegeed across the screen and forced through onto the material beneath. A hand-cut stencil may be used when coating the blocking compound on the screen.

A photosilkscreen can be made with the direct-screen-emulsion technique by coating the screen with several layers of a diazo-based direct emulsion or a light-sensitive colloid such as dichromated glue, gum, or gelatin. Exposure is by contact through a positive with a pulsed xenon, carbon arc, mercury vapor, or metal halide source. Exposure hardens the dichromated emulsion or destroys the diazonium salts. The shadows, receiving less light, can be washed away from exposure, while the highlights, receiving more light, will remain to block paint when the screen is printed.

Commercially available products produce photo stencils indirectly with a version of the carbon process. The carbon tissue is dichromate sensitized, exposed by contact and transferred to the screen after development. Another variation on the photosilkscreen uses a silver halide emulsion coated on the screen.

In those cases in which the original image is smaller than the desired final print, an enlarged positive is made on litho film, either directly or by making a negative and then contact printing it to get a positive. If continuous-tone effect is desired in the print, a full-size halftone positive is made by contact printing a negative through a halftone screen. Auto-dot film, with a pre-exposed dot pattern, may substitute for the continuous-tone positive and the halftone screen.

Once the stencil has been produced, it is touched up to repair imperfections and fastened to the receiving material. Paint is applied to the screen starting outside the image area, squeegeed or rolled across the unblocked areas, and forced through the screen to make the print. After each impression dries, further applications of paint can be made. *H. Wallach*

See also: *Bichromate process; Carbon process; Diazo process.*

SILVER A lustrous metal (Ag, molecular weight 107.87) that forms light-sensitive salts, making photography possible. Latent images in light-exposed silver halides consist of aggregates of silver atoms. After development, the photographic image consists of metallic silver, whose color is dependent on its size, shape, aggregation, and the condition of its surface. The silver is removed in color photography to leave a dye image. *G. Haist*

SILVER HALIDES A family of elements called halogens (fluorine, chlorine, bromine, and iodine) combine with silver to produce silver halides, the most light-sensitive salts of silver. Silver chloride, silver bromide, and silver iodide are the most useful of the silver halides and are often present in mixed combinations in photographic materials. *G. Haist*

SILVER HALIDE SOLVENT A chemical that converts water-insoluble silver halides into water-soluble compounds. Such solvents are used during the manufacture of the photographic emulsion or in processing solutions to form or treat the silver image. Sodium or ammonium thiosulfates are the common silver halide solubilizing compounds for processing solutions. Thiosulfates are found in fixing baths, reducers, toning solutions, bleach-fixing baths, monobaths, and many other solutions. A great number of other chemicals can act as solvents for the insoluble silver halides, including ammonia and ammonium salts, halide salts, and many organic sulfur-containing compunds. *G. Haist*

SILVER NITRATE Dissolving metallic silver (98-99% pure) in nitric acid and then purifying by electrolysis and recrystallization gives silver nitrate that is better than 99.9% pure. The white crystals ($AgNO_3$, molecular weight 169.87) are soluble in water and slightly so in alcohol and ether. Avoid contact with the solid or solutions as eye or skin burns may result. Do not get on clothing. Swallowing can cause death.

Highly purified salt is used to prepare photographic emulsions; less purified salt is used for silver intensifiers and other solutions, such as physical developers. *G. Haist*

SILVER RECOVERY Less than 25% of the coated silver of light-sensitive photomaterials is used to form the developed silver image, and all the silver is removed from color films and papers. This valuable metal can be recovered by a number of reclamation techniques: precipitated by chem-

Sine Wave

Cosine Wave

Sine wave in two dimensions (rectangular coordinates).

A radial sine wave in two dimensions.

The same sine wave, with the amplitude indicated by the lightness, as in an image.

Image of a radial sine wave

ical agents (such as sodium sulfide), precipitated by a non-selective compound (such as sodium hydrosulfite), displaced by less noble metals (such as zinc, copper, or iron), deposited by electrolysis or galvanic silver recovery units, or separated by ion-exchange methods.　　　　　　　　*G. Haist*

SILVER SULFIDE　A metallic silver image can be converted into silver sulfide (Ag_2S, molecular weight 247.8), producing a brownish image of great stability. Various sulfide toning baths have been formulated for this purpose. Silver sulfide is also formed during the chemical sensitization of silver halide emulsions before coating.　　*G. Haist*

SILVER-DYE BLEACH PROCESS　Instead of relying on the reaction of oxidized developer components with color couplers to form dye images as in chromogenic development, the silver-dye bleach process, also called dye bleach or dye destruction, is an integral tripack system with yellow, magenta, and cyan azo dyes incorporated into the blue-, green-, and red-sensitive emulsion layers during manufacture. The resulting image dyes are more stable in light and in acidic gases than the dyes formed in chromogenic development.

The process is based on the 1897 research of R. E. Liesegang into the softening of the gelatin around a silver image, and the 1899 research of E. H. Farmer into the tanning of that gelatin. In 1905, Karl Schinzel proposed an integral tripack color print process that used hydrogen peroxide to destroy unwanted dyes near silver image components by oxidation. Utocolor, introduced in 1910, used light to bleach dyes exposed under a color transparency. The destruction of the dyes by reduction with sodium hydrosulfite or stannous chloride was proposed by J. H. Christensen in 1918.

The principal proponent of dye bleach in the 1930s and 1940s was Béla Gaspar. Gasparcolor, a dye destruction motion picture film, was introduced in 1933, and his first material for making prints was shown in 1935 and was used until 1952. The idea was revived by Ciba-Geigy in 1963 with Cibachrome, for prints from transparencies, and Cibacolor, for prints from negatives. They were renamed Cilchrome and Cilcolor, then reverted to their original names. The negative printing material was discontinued, and Cibachrome has become Ilfochrome.

Cibachrome's three silver halide emulsion layers contain complementary color azo dyes, formed before being added to the emulsion and carefully selected for spectral absorption properties. After exposure, the material is developed in black-and-white developer to produce a silver image. A strongly acidic dye bleach with an added accelerator causes the destruction of adjacent dye molecules in proportion to the amount of negative silver image formed in that area. The dyes that remain correspond to the original positive image. The negative silver image is bleached and removed, as are the unexposed, undeveloped silver halide components of the positive image. The print is washed and dried.

　　　　　　　　　　　　　　　　　H. Wallach

SIMULTANEOUS CONTRAST　Enhancement of visual differences between areas of different luminance or color as seen at the same time in the same visual field. Within a photograph, for example, a dark object will look darker next to a light area than next to a dark area; a red object in a field of green grass will look more saturated than it would against a brown wall.　　　*L. Stroebel and R. Zakia*

See also: *Color contrast.*

SINE WAVE　A waveform, the amplitude of which is a sine (or cosine) function. The most common physical form for a sine wave is $A(x,t) = \sin(kx - \omega t + \phi)$, where $A(x,t)$ is the amplitude of the wave at position x and time t, k is the

angular velocity of the wave, ω is the angular frequency of the wave, and ϕ is the phase. Angular velocity and frequency are equal to the velocity (v) and frequency (ν) multiplied by 2π: $k = 2\pi v$, $w = 2\pi\nu$. They are used so that the angle of which the sine is taken will be in radians, a common unit. A cosine wave is a sine wave with a phase of π radians.

Sine waveforms pervade imaging—any image can be considered to be made up of a sum of sine waveforms with different frequencies and phases. Sine and cosine waves can also be subject to a wide variety of mathematical analyses. Most modern image evaluation techniques and a great deal of the more powerful image processing techniques rely on this fact.　　　　　　　　　　　*J. Holm*

See also: *Fourier transform.*

SINE-WAVE TARGET　An optical test pattern in which the luminance varies gradually and periodically between maximum and minimum values, as distinct from a square-wave target where the luminance changes abruptly between high and low values, as in a bar resolving-power target.

　　　　　　　　　　　　　　　　　L. Stroebel

See also: *Input.*

SINGLE-FRAME CAMERA　See *Camera types.*

SINGLE-FRAME EXPOSURES　A motion-picture camera technique where film, intended to be finally projected at 24 frames per second, is exposed one frame at a time, allowing for the subject to be moved before exposing the next frame. The basic filming technique used for animation.　　　　　　　　　　　　*H. Lester*

SINGLE JET　One variation of making a photographic emulsion that involves the introduction of a silver nitrate solution as a stream through a single tube (single jet) into a large volume of gelatin solution containing potassium bromide or mixed halies. If mixed halies are present, silver iodide is believed to precipitate first. Grain growth is accelerated by the excess halide in the gelatin solution. The rate of the addition of the silver nitrate, degree of stirring, temperature, and many other variables influence the nature of the crystals during the emulsification and crystal growth.　　　　　*G. Haist*

See also: *Double jet; Emulsions.*

SINGLE-LENS REFLEX　See *Camera types.*

SINGLE SYSTEM　(1) A motion-picture term for filming with a camera in which the sound is recorded simultaneously with the picture on the same strip of film on an optical or magnetic sound track running along side the images. Film used for single system cinematography, in 16 mm and Super-8, must be perforated only on one side and for magnetic recording must be prestripped with a magnetic track. Because of limitations in sound quality and difficulty in editing, single system production was commonly used only for news gathering or other situations in which little editing was intended and immediate viewing with synchronized sound was a requirement. In most instances today, single system cinematography has been replaced by video. (2) A method of recording both picture and sound on one piece of film; the sound recording may be by either photographic or magnetic means, used to describe the type of sound camera often used, for example, for newsreel shooting where simplicity of setup is paramount in use.

　　　　　　　　　　　　H. Lester and T. Holman

SINGLE WEIGHT (SW)　A thickness of photographic printing paper between lightweight and double weight.

　　　　　　　　　　　　　　　　　M. Scott

SISKIND, AARON (1903–1991) American photographer and teacher. During the 1930s, produced a photographic document of Harlem. His vision changed in the early 1940s. Close friend of the painter Franz Kline, both men produced abstract-expressionist work with strong visual links: insistently two-dimensional and graphically abstract black-and-white images. Professor of photography at Chicago's Institute of Design (1951–1971) and Rhode Island School of Design (1971–1976). A founder of the Society for Photographic Education.

Books: Chiarenza, Carl, *Aaron Siskind: Pleasures and Terrors.* Boston: Little, Brown, 1982; Featherstone, David, ed., *Road Trip.* San Francisco: The Friends of Photography, 1990. *M. Alinder*

SITTER A person who poses for a portrait, especially a formal studio portrait. *L. Stroebel*

SIXTEEN MILLIMETER See *Film formats.*

SIZE CONSTANCY The tendency for familiar objects to be seen as being correct in size despite differences in distance from the viewer. A person is perceived as being the same size at distances of 25 feet and 100 feet, even though the retinal images are in ratio of four to one. Size constancy holds only over a limited distance, which is greater horizontally than vertically. *L. Stroebel and R. Zakia*

See also: *Constancy.*

SIZE/SIZING A colloidal substance, perhaps with filler, for coating the surface of photographic or photomechanical paper to provide smoothness. *M. Scott*

SKELETON BLACK A black printer in a four-color reproduction that adds detail and contrast to the darker tones. *M. Bruno*

SKEWED DISTRIBUTION In a graph showing the number of occurrences of different values in a set of measurements, the nonsymmetry whereby one tail of the graph extends farther along the horizontal axis than does the other tail. An example of a nonnormal distribution. Such a pattern usually appears in the graph of emulsion grain sizes. *H. Todd*

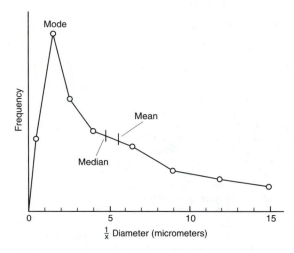

Skewed distribution.

SKIN TONE The appearance of an area of the face or other part of the body that is illuminated by the main light but does not include a specular highlight. When used as a stan-dard for quality control purposes, it is assumed, unless stated otherwise, that the typical subject is Caucasian with a skin reflectance of approximately 36%, one stop or zone higher than the standard 18% reflectance gray test card, which corresponds to subject value or Zone V in the Zone System. Skin tone is sometimes used as a reference instead of a gray card when an accurate reproduction of the gray card does not produce an accurate or pleasing reproduction of the skin, or when a gray card has not been included in the scene. *L. Stroebel*

Syn.: *Flesh tone.*

SKIP FRAME A motion-picture optical printing technique in which selected frames of the original scene are eliminated, resulting in speeded up action. For example, printing only every second frame would result in action appearing to be twice as fast as that of the original. *H. Lester*

SKIVINGS Fine threadlike slivers of film created in motion-picture cameras and projectors when the film edge rubs against an abrading surface of a film-path component, usually caused by a misalignment or a nick or burr on a film-path component. *H. Lester*

Syn.: *Angel hair.*

SKY FILTER See *Filter types.*

SKYLIGHT (1) Radiation reflected and scattered by the atmosphere, which together with sunlight (direct light from the sun) makes up daylight. Skylight is generally bluish on clear days, and thus causes outdoor shadow areas to reproduce as bluish in color photographs. (2) A window in the ceiling which allows skylight as defined in (1) (sometimes along with sunlight) to enter a room; used as a source of light in some photographers' and artists' studios. *J. Holm*

SKYLIGHT FILTER See *Filter types.*

SLATE In motion pictures, a data board with production information and shot identification numbers filmed at the beginning of each shot, most commonly with a mechanical or electronic clapper that provides both a visual and aural reference point for aligning the sound with the picture in the editing room. Traditional clapboards are made of wood with a hinged bar that is slapped against it for slating. Sound tracks are *slated* by speaking and recording the production information. A variety of modern clapping systems are in common use, involving electronic signals and the recording of lights and beeps or flashing time-code numbers. *H. Lester*

See also: *Clapboard.*

SLAVE UNIT A triggering system used to obtain flash synchronization with electronic (or other) flash units without using a connecting sync cord. Typically, a photoelectric sensor, or light switch, on a remote flash unit is activated by light from a flash unit on the camera. Some slave units are activated by infrared radiation or radio waves in order to prevent accidental firing by a flash on another photographer's camera and to fire remote flash units when a flash source is not needed at the camera. *R. Jegerings*

See also: *Infrared slave; Radio slave.*

SLIDE MOUNTING The process of placing a transparency into a frame of cardboard, plastic, or glass, usually 2×2 inches. The reasons for mounting transparencies are (1) to hold them flat while projecting them, (2) to allow the viewer to handle them without touching the film surface, (3) to protect the transparency from dirt and finger prints, (4) to provide a surface on which to add a caption or label, (5) to use shaped or masked slide mounts to project only part of an

image, (6) to combine two or more pieces of different transparencies in the same mount, and (7) to provide special pin registration pegs to hold the transparencies so that exact registration can be maintained for multiple slide projector presentations. *M. Teres*

SLIDE MOUNTS The frame that holds slides or transparencies flat and provides protection for the film. Three dimensions need to be considered when choosing a slide mount. First, the outside measurement, for example 2×2 inches, determines the size of the projector that is necessary to project the slide. The thickness of the slide is important in that slide trays that hold 80 images can accept thicker slide mounts than trays that hold 140 images. Second, the slide mount aperture or window area to be projected can be full frame, which allows the entire slide picture to be projected, or masked, which crops the image to a smaller size and possibly a different shape. Third, consider the film size and format, such as standard 35-mm, superslide, or in some cases the format required for image transfer, such as slide to video, slide to motion-picture film, or panorama-masked split images.

Slide mounts are available in a variety of types and styles. They range from inexpensive cardboard mounts with a heat activated adhesive to pin registration anti-newton ring glass mounts. Plastic mounts may vary in style and sophistication from simple drop-in or slide-in types to those that are hinged with glass covers. The aperture openings may vary in size or in the placement of the openings within the mount to accommodate several film formats or image placement on the screen, especially when presenting multiple projector slide shows. Glass covers are generally incased in plastic, but can simply be two 2×2-inch pieces of glass bound together with tape. The advantages of glass are that it holds the slide absolutely flat, which prevents *popping* out of focus, and protects the film surface from fingerprints and dirt. Anti-newton ring glass is a very finely textured glass that prevents patterned rainbow areas from forming when two very smooth surfaces (glass and film) are pressed tightly together.

Pin-registered slide mounts have plastic pins that correspond to the sprocket holes of the film, or new registration holes can be punched into the film edge with a special variable registration punch. These mounts hold transparencies in exact registration. This is especially helpful for sequenced images that need to appear exactly in the same place in each slide mount. The pins allow the film to expand when heated but does not allow the slide to shift in the mount. Archival mounts allow the transparencies to be encapsulated between anti-newton ring glass and taped with a metallic tape to seal out moisture and dust.

Perspective-control offset slide mounts are used to reduce or eliminate keystone distortion, which is caused when the lens axis of the projector and projection screen are not perpendicular. These mounts shift the image slightly off center in the projection gate to compensate for the displacement of multiple projectors. *M. Teres*

See also: *Ready mount*

SLIDES Slides are transparencies that have been mounted for projection. The mount normally consists of a frame that holds the transparency around the edges and restricts the passage of light to the picture area, or, a glass sandwich with a mask to restrict the passage of light. The mounts also serve to protect the film image and to facilitate handling and storage. Slide transparencies are normally positive images and may be either color or black-and-white. The most common professional use for slides is for projection in audiovisual presentations. Reversal 35-mm color films, which produce positive camera images, are sometimes iden-

tified as color *slide* films to distinguish them from color negative, or color *print,* films—but it should be noted that color prints can also be made from positive color slide images with either dye-bleach or reversal chromogenic color printing papers. Large-format transparencies can also be mounted in frames for handling, storing, and display purposes, but since they are not projected for viewing they are not identified as slides. Also, unmounted images on uncut 35-mm film, even though projected in a filmstrip projector, are not identified as slides. The most widely used film sizes and picture formats for slide projection are 35-mm film (24×36 mm) and 120 roll film (60×60 mm). The outside mount dimensions for 35-mm slides, which are commonly called 2×2 slides, are 50×50 mm, or approximately 2×2 in. Superslides are slides that have a 40×40-mm image area in a 50×50-mm outside dimension mount.

A wide variety of films are available to the photographer for slide production. Currently, color slide films are based on chromogenic processes. Kodak Ecktachrome and similar E-6 process films from other manufacturers incorporate dye couplers in the emulsion layers and can be processed by the photographer. Kodak Kodachrome Films require a more sophisticated processing that can be done only in specially equipped labs. Polaroid Polachrome, an additive type color slide film, can be processed by the user in a few minutes. Color slide films have a much smaller exposure latitude than negative color or black-and-white films, and there are differences in image contrast and color balance, image definition, and the hue and saturation with which certain subject colors are reproduced among the many brands and speeds of reversal color films. Slides can also be made from certain black-and-white films exposed in a camera by using reversal processing to obtain positive images.

Glass mounts, which were once widely used and are still used for audiovisual productions, have been largely replaced by cardboard and plastic glassless mounts. Plastic mounts are widely used by photofinishing labs in high-speed mounting machines. Hinged plastic mounts that snap together are convenient for remounting images after they have been removed for printing. Exposure to heat in slide projectors can cause glassless slides to warp and pop out of focus. Some projectors preheat each slide before it is projected to eliminate this problem, and automatic-focus projectors make it unnecessary for the operator to constantly monitor image focus. Some projector lenses are designed to compensate for the slight film curvature that is normal with glassless slide mounts to obtain simultaneous focus at the center and edges of the projected image.

Slides and transparencies offer distinct advantages over prints in the area of photomechanical reproduction since they typically represent first-generation images. Each time an image passes through another optical system or is recorded on another material between the original camera image and the final reproduction, degradation of image definition and tonal quality occurs. There are situations, however, when it is necessary or desirable to make slides from other than original subject material, such as photographic prints and published illustrations, or to duplicate existing slides. Slide copiers make it possible to conveniently produce multiple sets of slides from a single set of original slides and to introduce changes such as improvements in cropping, color balance, and density, the addition of titles, and the creation of special effects. Some slide copiers provide controlled flashing to prevent excessive contrast in duplicate slides, and slide-duplicating color films that are designed for this use are also available. Slides can also be made from color negatives by using a color negative slide film designed for this purpose. Although 35-mm color slides are commonly used for photomechanical reproduction, to make viewing and editing easier enlarged duplicate transparencies are commonly made. The

stock photography industry has also adopted this practice since the enlarged dupes can be viewed more easily than the original 35-mm slides.

Electronic imaging makes use of slides for both input and output. Scanners are used to digitize the slide image and import it to image-manipulating software. High-resolution film printers are used to output computer-generated or manipulated images to slides. Color laser copiers can also be used to scan and print slides. *G. Barnett*

SLIDE (TRANSPARENCY) SCANNER See *Scanner.*

SLIDING BACK A device used with large-format cameras that allows for two or more different exposures on one piece of sheet film, for example, two 5×8-inch images on an 8×10-inch sheet of film. This is accomplished by shifting the film behind a 5×8-inch film aperture on an 8×10 camera. Advantages are the economical use of film and the time saved in processing. *P. Schranz*

Syn.: *Divided back; Split back.*

SLIPPAGE A term often used to describe the antifriction characteristics of surfaces or materials. High slippage means a low coefficient of friction, or low film friction. Slippage is sometimes important in the printing of motion picture films or other continuous media since low definition results if the negative slips relative to the positive being printed. High slippage can also cause poor registration of successive frames in motion picture projectors as well as other handling problems such as telescoping of rolls of film or paper. *I. Current*

SLIT CAMERA See *Camera types.*

SLOPE The steepness of a line graph over a given region or at a point. It is mathematically equal to the tangent of the angle between a straight-line graph and a horizontal line.

For two points on a straight line, the slope is $\Delta y/\Delta x$, that is, the ratio of the change in the output values to the change in the input values. For a point on a curve that is not straight, a tangent is drawn to the curve at the point and the slope of the tangent found.

For a characteristic curve of a photographic material, the slope is a measure of the relationship of the image contrast to the subject contrast. *M. Leary and H. Todd*

See also: *Characteristic curve.*

SLOW MOTION A motion-picture effect created by filming the original action at a higher frame rate than 24 frames per second, the standard projection speed. When projected, the movement within such shots appears to be slowed down in proportion to the relative camera and projector speeds; for instance, action shot at 48 frames per second would take twice as long to project and would appear to be slowed down by a factor of two. *H. Lester*

Syn.: *Slo mo.*

SLOW SCAN In electronic imaging, the transmitting of video signals at a rate slower than real time is called slow scan. This is generally done because of bandwidth limitations. Slow scan video can be sent over radio frequencies other than those allocated for broadcast and over standard telephone lines. *R. Kraus*

SLUR A print defect in lithographic printing that results in directionally blurred dots in the middletone-to-shadow dot areas that is caused by slight slippage of the blanket during printing. *M. Bruno*

SMALL COMPUTER SYSTEMS INTERFACE (SCSI) In computers, there are several means of accessing

peripherals through a port that conforms to a particular protocol for data transfer. SCSI is one protocol that has become a de facto standard for data input/output in the Macintosh platform. Scanners and film recorders connected to a Macintosh exclusively use SCSI. Other peripherals such as removable cartridges and optical drives also employ SCSI. *R. Kraus*

SMALL-FORMAT CAMERAS See *Camera types.*

SMITH, W. EUGENE (1918–1978) American photographer. Famed photojournalist for *Life* magazine (1939–1955). During the Second World War, Smith photographed the Pacific theater with an unflinching vision, depicting the war in all its deadly, horrible reality. Produced definitive photo essays on a great variety of subjects, including Albert Schweitzer, and during just three years (1948–1951) published "Country Doctor," "Spanish Village," and "Nurse Midwife." Known for his integrity, Smith believed that the photographer was ethically responsible to each story that he was assigned, including its final presentation, and resigned at least twice from *Life* in protest over how the magazine used his work. After living with his wife in the small Japanese fishing village of Minimata for three years, published *Minamata* (1975), an extended essay in photographs and words of the tragic effect of mercury pollution that they found there. Awarded three Guggenheim Fellowships (1956, 1958, 1969).

Books: Hughes, Jim, *W., Eugene Smith, Shadow & Substance.* New York: McGraw-Hill, 1989; Madow, Ben, *Let Truth Be the Prejudice, W. Eugene Smith, His Life and Photographs.* Millerton, NY: Aperture, 1985. *M. Alinder*

SMOOTHING FILTER In electronic imaging, an electronic filter used to reduce the cross-hatch noise pattern that can appear with the use of charge-coupled devices. *R. Kraus*

See also: *Neighborhood process.*

SNAKE TRACK A special analog optical sound track recording used for testing the uniformity of illumination across the sound track area. The film consists of a small tone signal riding slowly back and forth across the sound track area. Uniformity of illumination is important in analog optical sound tracks since a fall off of illumination to one side, for example, will cause that side to be underrepresented in the output, which leads to distortion. *T. Holman*

Snake track. An optical snake track used to measure the uniformity of illumination across the area of a motion-picture sound track.

SNAP (1) To trip a camera shutter to make a picture, especially a snapshot. (2) An informal term used to describe an image having above average but pleasing local or overall contrast. *L. Stroebel*

See also: *Snapshot.*

SNAPSHOT PHOTOGRAPHY

Casual pictures made with hand-held cameras by amateurs. Most of the billions of photographs made each year by other than professional photographers are snapshots. In the hands of artists, a snapshot style has developed that mimics such things as careless framing, harsh flash lighting, tilted horizons, and fuzziness.

The term *snapshot* was coined in 1860 by Sir John Herschel, the taking aim and quick snap of the camera shutter being seen as analogous to the quick aim and snap of a gun trigger used in hunting.

Although Herschel envisioned pictures being made quickly at the snap of the camera shutter as early as 1860, it was not until 20 years later that snapshot photography really came into being. This was the result of increased film speeds and hand-held cameras making it possible to capture both the moment and the movement.

Not long after the beginning of photography, the snapshot's ability to capture the fleeting moment along with its often unplanned composition began to interest painters searching for new ways of expression. Some painters used photography to record fleeting expressions of their models and then used the photographs to create their paintings. Many of the paintings by Edgar Degas (1834-1917), such as his horse racing series and his ballerina series, suggest a snapshot vision. One of his paintings, *The Glass of Absinthe,* painted in 1876, shows a forlorn looking couple sitting at a table in a brasserie staring into space. The art historian, H.W. Janson, in his book, *History of Art,* wrote, "The design of this picture, at first glance, seems as unstudied as a snapshot…"

In 1888, George Eastman introduced the No. 1 Kodak camera, a light portable camera priced at $25 and loaded with enough film for 100 exposures. With the slogan, "You press the button, we do the rest," the volume of snapshot photographs rapidly increased. With the film being returned to Rochester, New York for processing and printing, birth was given to the photofinishing and marketing industry that now processes and prints billions of snapshots each year.

Snapshots democratized photography by making it simpler and more accessible to the masses as the years progressed. Taking pictures of friends, relatives, travel, and important events and rituals such as births, baptisms, bar mitzvas, confirmations, graduations, and marriages provided a visual diary for families.

In the early 1900s, snapshots and those who took them began to be looked down upon by professional photographers and those who aspired to be art photographers because the composition and technical quality were, in their view, lacking. This did not deter the growing number of snapshot photographers, and with the advent of the 35-mm Leica camera, introduced in the U.S. in 1928 by Willard Morgan, snapshot photography took another leap forward. With his wife, Barbara, he toured the country taking snapshots promoting the use of the Leica camera to both photojournalists and interested amateurs. Along with lecturing to camera clubs, he published a number of his snapshots in magazines along with articles on how to photograph with a 35-mm Leica camera. In 1932 he founded the "Circle of Confusion" in New York City, a camera club consisting of anyone interested in 35-mm snapshot photography. In 1943, as the first Director of Photography at the Museum of Modern Art in New York City, he arranged an extensive snapshot exhibition. Not only was it unprecedented for its time but the exhibition was one of the best attended, and, as might be expected, received a fair amount of criticism.

Although snapshot photography was embraced by many, it was rejected by others. This attitude reversed when other serious photographers began to embrace it as a unique way of expression that was not simply mimicking painting and its associated compositional rules. Snapshots were immediate and unpretentious, capturing and freezing a moment in time. A number of photographers and painters world-wide began to use what later came to be called the snapshot aesthetic.

In the early 1900s, Alexander Rodchenko made images having unconventional viewpoints, tilted components, and unusual compositions. Andre Kertesz began photographing informal spontaneous events of everyday human activities. Henri Cartier-Bresson's photographs, capturing the "decisive moment", influenced photographers like Bruce Davidson who worked in a snapshot genre. Walker Evans began exploring both documentary and snapshot photography in the early 1930s. In the 1950s, the Swiss-born photographer, Robert Frank, came to America and photographed various events based on a snapshot style. His work was published in a book; at first it was severely criticized but then it became a treasured classic. *The Americans,* now a collectors' item, has been reprinted a number of times.

In the 1960s the snapshot aesthetic blossomed with two magazine photographers, Gary Winogrand and Lee Friedlander. Both influenced other serious photographers with the unexplored possibilities inherent in snapshot styles. The movement was further advanced by the lectures and writings of John Szarkowski, then curator of photography at the Museum of Modern Art in New York City.

Photographers continue to explore the snapshot aesthetic, giving photography a unique look that does not mimic other forms of imaging. These include Joel Meyerowitz in the 1970s, Nicholas Nixon, and Bruce Davidson, with his snapshot series of people riding the New York subway, in the 1980s. And in the 1980s, many photographers were playing with a soft-focus, fuzzy early snapshot look by using cheap cameras with cheap plastic lenses.

The Eastman Kodak company sponsors a major snapshot photography contest each year called KINSA (Kodak International Newspaper Snapshot Awards). The contest, which is sponsored by about 200 newspapers in the U.S., Canada, and Mexico and coordinated by Kodak, began in 1934. Snapshots are solicited by newspapers. It is estimated that a total of around a half a million prints are submitted to the participating newspapers. Each newspaper then has local judges rate the snapshots and sends its selections to Kodak. Kodak receives about 1200 snapshots that have been sent in from the participating newspapers. A panel of judges then selects about 200 winners who receive various awards and are further honored by having their photographs on exhibition for one year in the "Journey Into Imagination Pavillion" presented by the Eastman Kodak Company at the Walt Disney World Epcot Center.

A similar journey began nearly 100 years ago when, in 1901, a young seven-year-old French boy, Jacques Henri Lartigue, was given a camera by his father and began to take pictures. He was captivated by the experience and wrote in his diary that "Photography is a magic thing." And indeed it was, as his 70 years of snapshot photography reveals. "He photographed spirited games at his family's country house, excursions in his father's first automobiles, trips to racetracks and seaside resorts, elegant women strolling the Bois de Boulogne, his own honeymoon, and the ceaseless antics of his friends and relatives…" (Lartigue, Jacques, Henri, *Diary of a Century.* from the back cover). His photographs from 1901 to the 1970s are a snapshot of the visual changes of the major part of our 20th century, begun when he was a child to illustrate his diary.

In the Afterword of the Lartigue book, which is a select sampling of his personal visual diary, Richard Avedon, who

had a high respect for Lartigue and for his photographs, wrote: "High-speed film was available since the turn of the century but for years it was only used in sports photography…as if there were some tacit agreement among photographers to remain within the provinces of painting in the hope of assuring their positions as artists. I think Jacques Henri Lartigue is the most deceptively simple and penetrating photographer in the short…embarrassing history of that so-called art. While his predecessors and contemporaries were creating and serving traditions, he did what no photographer had done before or since. He photographed his own life. It was as if he knew instinctively and from the very beginning that the real secrets lay in small things. And it was a kind of wisdom—so much deeper than training and so often perverted by it—that was never lost…. He was an amateur… never burdened by ambition or the need to be a serious person."

The snapshot aesthetic so brilliantly pioneered and displayed in Lartigue's 70 years of photography continues today, and some museums, recognizing the importance of snapshot photography, have been collecting family albums. Just imagine for a moment how our view of the Second World War might change if we had access to all of the snapshots made by our military personnel at that time; or our view of the Great Depression if snapshots had been taken during the Farm Security Administration (FSA) by all the poor farmers and migrant workers who were photographed by photographers hired by the FSA.

Scholars from various disciplines now use snapshots and extend their research and belong to such organizations as The International Society for Visual Sociology, The International Visual Literacy Association, and the Society for Visual Anthropology. Men with vision, like Jack Debes of the Eastman Kodak Company, realizing the importance of pictorial information back in the late 1960s, began a movement called "Visual Literacy" to encourage teaching students how to read pictures.

Cameras and film were provided to students, who took snapshots of things that interested them and later discussed them in classroom settings. Students also learned how to take and organize a series of photographs to create a short narrative. Prepared photographs that formed a narrative were shuffled and given to students for them to rearrange, a way for them to learn how photographs relate to one another in a narrative form and for the teacher to observe the student's visual thinking.

The profound importance of snapshots has not yet been fully realized. Snapshots are not only an honest visual record of events historical and contemporary, but also a quiet movement that has influenced all forms of image making including painting, motion pictures, and television.

Snapshot photography has had not only a strong influence on documentary and fine-art photography, but has also been a source of a multi-million dollar industry—photofinishing and marketing. With over 17 billion snapshots made each year, mostly in color, there is a great and continuing demand for processing and printing, and of course all the equipment needed for this huge operation, including 1-hour processing labs. The introduction of the Photo CD by Kodak in late 1992 increases the technical sophistication and equipment needed to operate and manage a modern photofinishing operation. This in turn puts greater demands on the personnel operating the equipment and managing the operation.

Career opportunities are many, and educational preparation for such photofinishing and management careers is available in many junior and community colleges offering associate degrees, and in a few colleges offering bacalaureate degrees.

Books: Coe, Brian and Gates, Paul, *The Snapshot Photograph.* London: Ash and Grant, 1977; Broecker, William (editor), *International Center of Photography Encyclopedia of*

Snapshot, entitled "Point Lookout 1915" (photograph by LBM). Snapshots were spontaneous, capturing the fleeting moment. The composition was unplanned and subjects, contrary to compositional rules handed down from painting, could be in and out of the frame of the picture.

Photography. Crown Publishers, New York: 1984; Green, Johnathan (editor), *The Snapshot.* Aperture, Millerton, New York, 1974; Janson, H.W., *The History of Art.* Abrams, Englewood Cliffs, New Jersey: 1971, p. 494; Lartigue, Jacques, Henri, *Diary of a Century.* Penguin Books, New York: 1970. *R. Zakia*
 See also: *Amateur photography; Candid photography; Photofinishing; Photographic education.*

SNELLEN CHART A test target consisting of rows of letters of decreasing size from top to bottom, used to measure visual acuity based on the smallest row of letters that the subject is able to identify correctly from a standard distance.
 L. Stroebel

 See also: *Vision.*

SNELL'S LAW For light undergoing refraction between two media of refractive indices n_1 and n_2, the ratio of the sines of the angles of incidence (i) and refraction (r) is a constant and is also found to be the ratio n_2/n_1 of the media. This may conveniently be written as $n_1 \sin i = n_2 \sin r$. If medium n_1 is air ($n_1 \approx 1$), then $n_2 = \sin i/\sin r$; hence, refractive index may be determined. *S. Ray*

SNOOT A tube fitted over a light source to concentrate light on a small area. Snoots for studio lights are usually made of metal to withstand heat and are straight or cone-shaped with light openings of various sizes. A flexible, folding snoot is used on the head of an on-camera electronic flash unit.
 R. Jegerings

SOBEL OPERATORS In electronic imaging, the use of a neighborhood filtering process in which the values of the kernel are weighted in a directional orientation, for example north, south, northeast, etc. Such a filter allows for the easy visualization of subtle contrast changes that have a directional orientation. Sobel operators play an important role in enhancing medical and satellite images. *R. Kraus*

SOCIETY LEADER In motion pictures, a common term for the standard count-down head and tail cueing leaders for release prints, designed and standardized by the SMPTE (Society of Motion Picture and Television Engineers). Often confused with *Academy leader,* an older type of count-down leader originally designed and standardized by the Academy of Motion Picture Arts and Sciences. *H. Lester*
 Syn.: *Universal leader.*

SODIUM SULFITE The anhydrous form of this white, granular compound (NA_2SO_3, molecular weight 126.06) is readily soluble in water but insoluble in alcohol. Available also as white crystals ($NA_2SO_3 \times 7H_2O$, molecular weight 252.04), containing only 50% sodium sulfite. A desiccated form is essentially equivalent to the anhydrous form. The photographic grade is 97% minimum pure by weight. Do not confuse sodium sulfite with sodium sulfide.
 Used as a preservative or mild alkali in developing solutions and as a constituent in fixing baths, intensifiers, and other photographic solutions. *G. Haist*
 See also: *Anhydrous.*

SODIUM THIOSULFATE A silver halide solvent that exists as colorless crystals or a white powder in an anhydrous form ($Na_2S_2O_3$, molecular weight 158.11) or a hydrate ($Na_2S_2O_3 \times 5H_2O$, molecular weight 248.18), both highly soluble in water at room temperature but insoluble in alcohol. The photographic grade is 97% minimum purity by weight. Sodium thiosulfate or the fixing bath containing it are commonly called *hypo*, as is ammonium thiosulfate and its fixing bath.
 Except for rapid fixing baths, sodium thiosulfate is used universally as a solubilizing agent for silver halides, such as in fixing baths, solvent developers, monobaths, reducers, and in the diffusion transfer process. *G. Haist*
 See also: *Ammonium thiosulfate; Hypo.*

SODIUM-VAPOR LAMP An arc-discharge lamp that has sodium added to the gases, emitting a yellow glow if it is a low-pressure type and a golden-white glow if it is a high-pressure type. Low-pressure lamps are the most energy efficient of all lamps, producing up to 200 lumens per watt of light close to the peak sensitivity of the eye. These characteristics are useful for illuminating roads and parking lots where light intensity and low maintenance are more important than good color rendering. High-pressure sodium lamps provide from about 75 to 140 lumens per watt, depending on

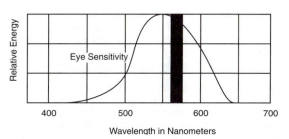

Sodium-vapor lamp typical energy distribution. Low-energy spikes at other wavelengths have been ignored.

wattage, but may be preferred for their visually *whiter* light. Neither is suitable for exacting color photography but may provide satisfactory background illumination. *R. Jegerings*
 See also: *Light sources; Safelights.*

SOFT (1) Unsharp, either intentionally so, as with a soft-focus lens that is designed to be used when the reproduction of fine detail is not wanted, or unintentional unsharp, as in the resulting images when a camera, enlarger, or projector is inaccurately focused. (2) Low contrast, to describe an image that has less than normal contrast, a lower than average lighting ratio, a film, developer, or printing material designed to produce low contrast or compensate for high contrast elsewhere in the process, etc. *L. Stroebel*

SOFT BOX A large, enclosed light fixture with tapered sides and a translucent front screen, providing diffused illumination while trapping stray light. Light quality is controlled by the nature of the diffusing screen, by the reflectivity of the inner surfaces, using a fixture with or without a reflector, and by reversing a reflector light to first bounce light off the inner surfaces. If the front diffusing screen is removed and a fixture without a reflector is used, the combination becomes a large reflector light. When constructed of flexible materials, a soft box can be folded for transport and storage. *R. Jegerings*

SOFT COPY The image on the video display of a computer or workstation. *M. Bruno*

SOFT DOT A halftone dot with excessive halation or fringe, causing variable dot size, depending on the length of exposure, in contacting or platemaking. *M. Bruno*

SOFT-EDGE MASKING In electronic imaging, a process of sharpening soft edges by means of computer analysis of the pixels in the soft edges. *L. Stroebel*

SOFT-FOCUS See *Lens types.*

SOFT PROOF The image on a display terminal or CRT. *M. Bruno*

SOFT SHADOW A shadow with no clearly defined edge, having a wide range of intermediate tones in the boundary between the highlight and shadow area. Such shadows are produced by large, diffuse light sources.
 F. Hunter and P. Fuqua
 See also: *Diffusion; Hard shadow.*

SOFTWARE Text material, illustrations, or other information to accompany or to be used with hardware (apparatus or equipment). In audiovisual contexts, software includes films, scripts, etc., and hardware includes viewing and projection devices. In computer and some video appli-

Snoot. Conical and straight snoots.

cations, software refers to a systematic collection of computer programs and their associated documentation as distinct from the equipment used to process and print the results. *I. Current*

See also: *Computers for photographers, computer systems.*

SOL A *sol* is a stable dispersion of a solid substance in a liquid or solid. A *gel* is a special type of sol in which the particles or molecules are randomly joined to form an open, rigid framework. Gelatin forms a gel when it sets. *G. Haist*

SOLARIZATION See *Photographic effects.*

SOLARIZATION EFFECT See *Appendix A; Photographic effects.*

SOLAR MICROSCOPE A microscope using reflected sunlight as a light source. In early microscopic work, light sources consisted of candles and kerosene or gas lamps that were difficult to control and weak in light intensity. The solar microscope introduced in 1740 used sunlight to illuminate the specimen stage, making it possible to study thicker specimens than were possible with artificial light. Sunlight also made it possible to use long focal-length eyepieces and to project the image onto a paper screen or wall surface for tracing and recording the image. With the advent of photography some 100 years later, light-sensitive materials were used to capture the image. *R. Zakia*

SOLENOID An ac or dc electromagnet having as its core a movable iron plunger. The magnetic field caused by current flowing through the coil of the solenoid produces a force on the plunger and, if free to move, will exert that force through a distance. A solenoid thus converts electrical energy into physical work. Linear solenoids are used to operate shutter releases, paper punches, dot-matrix printers, paper cutters, etc. A rotary solenoid uses circumferential inclined planes to translate the linear motion of a plunger to rotary motion. Depending on the model, the angle the shaft rotates is typically from 15 to 120 degrees. Rotary solenoids are used to operate capping shutters and cut-off filters in photographic printers. The term *solenoid* is used by some to designate any coil of wire, and by others, a relay. *W. Klein*

SOLID An area completely covered with ink or a 100% dot area. *M. Bruno*

SOLID ANGLE (ω) Analogous to an angular measure in two dimensions, the solid angle is a measure of a three-dimensional cone-angle, such as that contained within the cone defined by a point light source and a circular aperture some distance from the source.

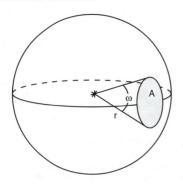

Solid angle. A solid angle is a measure of a three-dimensional cone-angle. An area *A* on the surface of a sphere with radius *r* subtends a solid angle ω, equal to A/r^2 steradians (sr).

The measure of a solid angle is given as the area of the portion of a sphere included in the solid angle (*A*) divided by the square of that sphere's radius (*r*); i.e., $\omega = A/r^2$. The unit of measure is the steradian (sr), defined as the solid angle that subtends on the surface of a sphere an area equal to the square of its radius, such that $A/r^2 = 1$. A sphere of radius *r* has an area $4\pi r^2$, so there are $4\pi(\sim12.6)$ steradians in a sphere. For small angles, the solid angle is approximated by taking *A* as the area of the planar aperture rather than the area of a spherical section subtended by the aperture. *J. Pelz*

See also: *Steradian.*

SOLID-STATE CIRCUIT Any electronic circuit, the active elements of which are semiconductor devices instead of vacuum tubes. Components used in solid-state circuits include semiconductor diodes, transistors, thyristors, integrated circuits, optocouplers, solid-state relays, and a variety of photosensors. *W. Klein*

SOLID-STATE RELAY (SSR) A semiconductor device that functions in a circuit the same way an ordinary relay does but has no moving parts. Instead of using moving electrical contacts, which erode and wear with use, the dc solid-state relay uses a silicon control rectifier (SCR) and the ac units use a Triac to do the switching. The relays are primarily used in power circuits to control motors, lamps solenoids, etc. The output is usually limited to either a single normally open or a single normally closed switch. SSRs are available with inputs designed to operate with a wide variety of dc or ac voltages. An optocoupler is used to achieve electrical isolation between the input and the output circuits.

W. Klein

See also *Optocoupler; Relay.*

SOLUBILITY A solution is a homogeneous mixture of the particles (ions, atoms, or molecules) of two or more chemical substances. Each portion of a solution has the same chemical composition and physical properties as another portion. In most cases, the two substances cannot be mixed in all proportions. The component that is present in the larger proportion is called the *solvent,* the lesser component is called the *solute.* A solution consists of a solute uniformly dispersed in a solvent.

A solution can be achieved only if the substances are similar in composition or if the substances can interact chemically. As the number of particles of the solute in the solution increases, there is a point at which the number of particles entering the solution equals the number leaving the solution. This is the equilibrium point, and the solution is said to be *saturated.* A solution containing less than this amount of solute is *unsaturated.*

Solubility of one substance in another is influenced by the temperature. More of the solute can dissolve at a higher temperature. If a heated, saturated solution is cooled, an unstable solution is formed that will hold more solute than would be normally possible at the lower temperature. This is a supersaturated solution that will begin to deposit the solute, or crystallize, when a suitable nucleus is available. A small crystal or a dust particle, even a scratch on the side of the container, can serve as a site for the excess solute to be deposited.

Solutions are sometimes classified by the proportions of the solute and solvent present. If a large amount of the solute is contained in a unit volume, the solution is said to be *concentrated.* A *dilute* solution has only a small amount of the possible solute per unit volume.

Miscibility is used to describe the mutual solubility of two liquids. If two liquids are soluble in all proportions, the liquids are completely miscible; if only mutually soluble to a limited degree, the liquids are partially miscible. *Immiscible*

is the term given to two liquids that do not appreciably dissolve in each other.

Solubility is the quantity of a solute that can be dissolved in a solvent under specific conditions. Exact measures are needed to specify the amount of an added chemical that is less than the solubility limit. These precise measures usually involve weight per weight, weight per volume, or volume per volume relationships.

Molar (weight per volume), molal (weight per weight), and percentage (both weight per volume and weight per weight) solutions are frequently used measures of the concentration of a solute in a specific amount of the solvent.

- A molar solution (M) contains 1 molecular weight in grams of the solute dissolved in a total of 1 liter of solution.
- A molal solution (m) contains 1 molecular weight in grams of the solute in each 1000 grams of the solvent.
- A percent by weight solution (%) represents the weight of either the solute or solvent divided by the sum of the weights of the solute and solvent (\times 100), giving the percentage by weight of either the solute or solvent in the solution.
- A photographic percent solution (%) has come to mean the number of grams of the solute contained in 100 ml of total solution, a weight per volume relationship. A volume per volume percent solution is also used.

The photographic percent solution is the one used in photography but can be confused with the percent by weight solution.

A solid, liquid, or gas can be dispersed homogeneously without chemical interaction in another solid, liquid, or gas. A solid solution is thus possible, such as with glass or certain metal alloys. *G. Haist*

SOLUTION A solution is a homogeneous mixture of the atoms, ions, or molecules of two or more substances, which can vary in the concentration of the components. Although each part of a solution is identical to every other part, the components can be separated physically. A solution consists of two parts: the solute and the solvent. The solute, the substance present in the smaller quantity, is dissolved in the solvent, the substance present in the larger quantity. Photographic processing baths are water (solvent) solutions of several chemical ingredients (solute). *G. Haist*

SOLUTION PHYSICAL DEVELOPMENT In silver halide imaging, a silver image formed by using a silver halide solvent in the developer that partially dissolves silver salts from the emulsion. The deposit is a form of intensification that amplifies the weak, initial silver image formed by the dilute developer. The image is very fine grained, but the process involves a substantial loss of effective film speed. *H. Wallach*

SOLVENT TRANSFER A simple way to reproduce commercially printed and photocopied images. Pictures from magazines printed on poor-quality, thin paper will transfer more easily than those on heavier, better-quality paper. Coat the back of the printed image with either a liquid solvent such as turpentine, lighter fluid, mineral spirits, etc. or with a gel-based solvent such as the oil-based transparent silk screen base. Allow the solvent to penetrate and saturate the paper fibers. Place the print image-side down on the desired transfer material and rub the back of the image with a blunt instrument like a wooden spoon or butter knife using even pressure. *J. Natal*

SOMMER, FREDERICK (1905–) American photographer. Though his early influences were Alfred Stieglitz and Edward Weston, his own work, begun in 1935, bears little relation to theirs. Many of his photographs are careful constructions, painstakingly arranged for his camera, surrealistic compositions of found, discarded objects, from dead animals to bits of torn paper and broken toys. He is also known for his photographs of intricately cut paper sculptures and images of the designs of smoke on glass. His photographs often have a disturbing, nightmarish quality.

Books: *Frederick Sommer at Seventy-Five*. Long Beach: The Art Museum and Galleries, California State University, 1980. *M. Alinder*

SONE An alternative unit of subjective loudness. Besides accounting for equal-loudness contours like the phon, the sone takes one step further and scales the logarithmic measures so that twice the number of sones represents twice as loud. 40 dB sound pressure level (SPL) at 1 kHz = 1 phon = 1 sone; 50 dB SPL = 10 phons = 2 sones. *T. Holman*

SONOHOLOGRAPHY Species of holography that uses sound rather than light to create an interference pattern. An ultrasonic field reference signal is generated and a sound wave is beamed at a subject. The sound wave is modulated as it is reflected by the subject, causing interference with the reference signal. A microphone scans the field, summing the two signals. The intensity of a spot of light on a cathode ray tube screen is modulated by the varying sum so the interference pattern may be photographed. When the processed sonohologram is viewed, the objects in the sound field are shown in greatly reduced size because of the difference between the sound wavelengths used to generate the image and the light wavelengths used to reconstruct it. If the subject can be immersed in a fluid, the reference and subject beams may be produced by submerged ultrasonic transmitters and an interference wave pattern will be generated on the surface of the liquid. *H. Wallach*

SONOLUMINSCENCE Luminescence induced by sound, especially ultrasonic energy. *J. Holm*

SONOPHOTOGRAPHY Term for methods of converting the physical presence of sound waves into visible, photographable images. For example, in testing the acoustics of buildings, an electric spark is used to generate a sound wave that has higher density and a higher refractive index than the surrounding, uncompressed air. When photographed by flash, the compressed areas are seen as shadows. Changing shadow densities reveal resonances and suck-outs, or dead spots. *H. Wallach*

SOUND

THE ROLE OF SOUND ACCOMPANYING PICTURES Sound has a special role when it is used to accompany pictures. By stimulating two senses, program material is subject to a heightened sensation on the part of the viewer/listener that would not occur if either the picture or sound stood alone. A case in point is: an observer looks at an action scene silently, then with ever increasing complexity of sound by adding each of the edited sound sources in turn. The universal perception of observers under these conditions is that the picture appears to run faster with more complex sound, despite the fact that precisely the same time elapses for the silent and the sound presentations: the sound has had a profound influence on the perception of the picture.

OBJECTIVE AND SUBJECTIVE INFLUENCES ON SOUND Sound, as perceived by human listeners, has two major categories of influence on it. The first category constitutes the *physical* influences on sound in the objective domain caused by the characteristics of the sound source and the environment in which it is placed. These influences include the radiant properties of the sound source such as its

preferred direction, diffraction as sound encounters the edge of boundaries, and absorption and reflection as sound encounters barriers. The second category includes the *psychological* influences on sound by human perceptual mechanisms constituting the subjective domain. In this area, loudness, pitch, timbre, and frequency and temporal masking constitute some elements of study of complex subjective responses to objective stimuli. Human observers are influenced by both the objective and subjective domains, so that perception may be seen to be the sum of many factors.

DIMENSIONS OF A SOUND TRACK The *dimensions* of a sound track may be broken down for discussion into *frequency range, dynamic range,* the *spatial dimension,* and the *temporal dimension.* A major factor in the history of sound accompanying pictures is the growth in the capabilities associated with these dimensions as time has gone by, and the profound influence this growth has had on the aesthetics of, for example, motion-picture sound tracks. Whereas early sound films only had a frequency range capability (bandwidth) similar to that of a telephone, steady growth in this area has produced modern sound track capabilities well matched to the frequency range of human hearing. Dynamic range capability improvements have meant that both louder and softer sounds are capable of being reproduced and heard without audible distortion or masking. Stereophonic sound added literally new dimensions to film sound tracks, first rather tentatively in the 1950s with commag release prints, and then firmly with comopt prints in the 1970s, which have continued to improve ever since. Still, even the monophonic movies of the 1930s benefitted from one spatial dimension: adding reverberation to sound tracks helped place the actors in a scene and to differentiate among narration, on-screen dialog, off-screen sound effects, and music.

MECHANICS OF RECORDING Recording of sound to accompany pictures takes on two basic forms. Either the sound is recorded in sync with the picture, called *sync sound,* or it is recorded separately, called *wild sound.* In order to maintain lip synchronization throughout long camera takes, it is essential in sync sound recording to use a method of recording that ensures sound and picture synchronization. This may be accomplished in a number of ways:

1. Recording the sound directly on the film or tape. This typically involves an offset between the picture and sound recording since the needs of the two are so different. In a motion-picture camera, for instance, the film must be perfectly stationary while it is being exposed and then advance rapidly to the next frame. Such an intermittent motion would make conventional methods of recording sound completely useless, so sound is usually recorded with a displacement of some number of frames so that the motion of the film can be changed from intermittent to virtually completely smooth. On video tape, it is common to record video with rotating head assemblies, since a high tape-to-head speed is needed to produce the wide bandwidth needed for video, and to move the tape at adequate speed past fixed heads would consume too much tape per unit of time. Thus, in such machines it is commonplace for the video heads to be located on a rotating drum, while the audio heads are stationary at a separate place in the tape path. These methods for both film and tape may thus be seen to involve a picture-to-sound offset on the medium, which may lead to difficulties in editing.

2. In order to overcome the difficulties of recording both sound and picture on the same medium, called *single-system* recording, separate recording of sound and picture, called *double system,* is used for most film production today. When double system recording is used, it is necessary to use a method to ensure lip synchronization, if that is a desired goal, since even very small errors in tape speed will cause noticeable sound-to-picture sync errors (it is easy to see 2 frames out of sync, 1/12 of a second). Thus, recording may

be made on perforated film on a recorder running at the same speed as the camera, or, since this is usually inconvenient because of the size of magnetic film recorders, it is common to record audio on unperforated tape along with a signal that serves as a reference related to the camera speed. There are several different forms for this reference, including neopilottone, FM sync, and SMPTE time code. When the tape is played back for transfer to film or tape, the reference signal is *resolved,* that is, either the playback machine or the record machine is speed controlled so that the picture and sound match one another.

For today's amateur production, it is probably more likely to record on video media with sound recorded on the source tape. Difficulties then arise in postproduction, where the ability to strip off the original sound so that added sounds can "sweeten" the original production sound and rerecord back to a master tape in sync causes difficulties. The laydown and layback method is used by professionals on equipment that uses SMPTE time code for synchronization, but amateur use of such codes is limited, and this factor often causes some of the largest differences between amateur and professional production.

The mechanics of recording are of course also profoundly affected by the choice of microphone and its corresponding microphone polar pattern, the placement of the microphone, and, above all, what is recorded. For production sound recording, the overhead boom microphone, operated either on a studio boom or on a fishpole, has proved time and again the validity of this technique compared to others. This is because the performance of the microphones usually used is often best when they are located well away from reflecting surfaces, and where the microphone can clearly "see" the mouth of the talker. In fact, a recording made overhead often sounds better than one made from below the frame, all other things being equal, simply because the radiation pattern of the human talker is such that the overhead direction produces clearer sound. Still, this type of recording is subject to producing boom shadows, so it is often not well liked by cinematographers and videographers. Small lavaliere style microphones are thus often used, but they have several distinct disadvantages: clothing noise is often heard, the sound quality is often unnaturally dead since room sound is minimized, and for dramatic programming the microphone must be buried, leading often to muffled sound. Better than these are planted microphones placed around the set and skillfully mixed by a production sound mixer.

For sound effects recordings, it is commonplace to use stereo recording today, often single-point stereophonic microphone systems for ease of setup and for hand-held portability. Single-point microphones use a technique called intensity stereo, since it is the intensity of the component sound fields in various directions to which the microphones respond. Alternatively, spaced microphones rely on both intensity and time differences between channels for the stereophonic effect. A spaced-microphone technique is more likely to be used in studio situations where the spacing of the microphones is not a portability or setup problem. An example is the recording of audience reaction, which most often involves spaced microphones.

Another issue facing the recordist is the capacity of the medium on which the original sound will be recorded. The history of development of recording media shows an ever increasing dynamic range capability, so that there is less need today to *ride gain,* that is, to turn the level control down during loud passages and up during soft ones to maintain a distortion- and noise-free recording. In fact, it is often a bad idea to actively mix too much, since this may lead to editing difficulties in postproduction, where sound from various scenes and takes must be joined to make one smooth, continuous performance.

MECHANICS OF EDITING In traditional film editing, once the transfer room has delivered the sound on perforated film, the sound editor proceeds to build units containing typically one kind of sound per reel, interspersing magnetic film with film leader used as required to produce equal lengths of picture and sound. A sync block is commonly used to keep the sound tracks in sync with the picture, although the upright Moviola or one of the various flatbed editing tables can show the relationship between at least one sound track and the picture at a time. Editors work in editorial synchronization, also called level sync, where the sound and corresponding picture are placed so that they are alongside one another in the synchronization device and later on the dubbing stage. The other choice of synchronization position is called projection sync where the sound is advanced or retarded with respect to the corresponding picture by an amount equal to the spacing between the picture gate and sound head in a projector plus one frame. One frame is added in the laboratory to account for the speed of sound; its being much slower than light would cause noticeable lack of synchronization at the back of a theater, so the typical sound track is made so that sound and picture arrive at the same time about 50 feet from the screen.

In video production, once the Edit Decision List (EDL) has been prepared by the picture editor, a reel of multitrack tape is prepared with continuous time code equal to the running time of the program. The EDL provides the information needed to copy (dub) from the original source tapes to the multitrack tape while maintaining synchronization with the cut picture. This laydown has been automated in professional facilities so that the source tapes need only be mounted once, and all the tape shuttling and record passes necessary are made under computer control to take the original production recordings, often made with scenes out of order, and to record them to one or more tracks of the multitrack. Then, additional sounds can be placed by the sound editor on the other tracks to "sweeten" the original sound, and the checkerboard pattern of recording on the various channels can be notated by the editor with cue sheets for use by the postproduction mixer.

Digital audio workstations provide the same functions as film or tape editing, with one major difference. In tape or film editing, one is devoted to a linear relationship: each track runs from heads to tails in the same length as the program, and should any changes to the picture occur, then physical changes to the sound tracks are necessary to maintain synchronization. A digital workstation, on the other hand, stores sound at places on a random-access medium, such as a magnetic hard disk, where it is convenient, and computer technology is used to recall the proper sounds at the proper moments for synchronization. One enormous advantage of this method is that picture changes may be much more easily accomplished because all that is changed are the data about when a sound is to start. Ultimately, digital audio workstations are expected therefore to have a very large impact on sound editing, especially for sound accompanying pictures. The practical difficulty is that the amount of digital storage when audio is conventionally digitized is very large, and the rate of retrieval from such stores must be large to accommodate many audio channels; the result is that costs are high, and the traditional methods remain in place alongside the digital ones.

Note that all of these methods require the production of cue sheets by either a human or machine telling the sound mixers where the various sounds are to be found and providing guidance as to where they are to fade out, for example.

MECHANICS OF MIXING Sound tracks prepared by sound editors, whether on film, tape, or from a digital audio workstation, are all mixed using the same principles.

Each track is organized by the sound editor or sound designer so that it represents related sound and so that confusion about which sound is where is minimized. In large-scale production, the number of sound tracks is so large that it is commonplace to premix sound elements that are alike in one stage, while postponing listening to all of the tracks until the various premixes are available. Premixes are made to contain all of the level changes that are needed. For example, if a sound effect should be played lower in level because it falls under a line of dialog and would otherwise mask the dialog, then the level is lowered in the premix stage, thus simplifying the final mix stage to making adjustments to the balances chosen during premixing.

Many sound processes are available in postproduction. While it is possible to use many of these processes earlier in the chain of events, difficulties may arise when a sound track that is processed is edited together with ones that are not. Therefore, it is usually best to hold off on many of the processes until all of the edits can be heard and where all of the sound tracks are available. One problem for producers is that production sound is judged largely at dailies, but difficulties due to mismatching from shot to shot are not often audible until the editing is complete.

Many of the sound processes to be described are carried out on individual channels, corresponding to individual cut units by the sound editors. This is for two reasons: (1) a process that is applicable to dialogue is unlikely to be useful in the same way for, say, music and (2) processing that is carried out on individual channels can often be more aggressively applied without telltale sonic artifacts that are caused when more than one kind of sound occupies the same device.

The first category of sound processing involves a variety of devices affecting the level of the signal. The simplest of these by far are the various fader (level) controls on the various channels. Each signal from a unit usually is affected by at least two level controls, a channel level control and a master, on its way to be recorded, and by a third, a monitor level control, on its way to being heard. Having a minimum of three level controls between the original source and what is heard may cause difficulties, for if one level control is set too low, and a second is set higher to make up for the first, then the result may be unwanted noise originating between the first and second control, or conversely, if the first should be set too high, and the second turned down to make up, then the result can be audible distortion. For this reason it is good practice to use the multiple level controls around the area where they are normally meant to be used. Sometimes this is indicated by scales on the controls showing their nominal settings.

Other devices that influence the level are compressors, limiters, and downward expanders.

The frequency response is deliberately adjusted by means of equalizers and filters for the desired effect, which is generally to produce a smooth-sounding sound track free from extraneous noise.

Various devices are used that affect the time relationship in the signal. These include digital delay lines, reverberators, and pitch shifters, among others.

After premixing and final mixing, it is common to produce a variety of print masters in the formats needed for the variety of releases to be made. These include, for example, 70-mm 6-track, 35-mm stereo variable area (SVA), and monaural DME. Each of the print masters has its level, frequency range, number of channels, and so on, controlled so that the type of print made from it will play without audible distortion.

AESTHETICS OF SOUND DESIGN Despite whatever technical techniques are used in recording, editing, and mixing, it is the choice of sound to portray that forms the most important problem facing the sound designer. Sound

for film and television is often completely made up: a new reality is constructed by sound designers from the building blocks of sound, first broken down into dialog, music, and sound effects. Further breakdown of sound effects include such areas as Foley effects, ambience effects, and principal effects, each part of which may contribute substantial aspects to the overall effect.

Books: Benson, Bolair, ed., *Audio Engineering Handbook.* New York: McGraw-Hill, 1988; Moore, Brian C. J., *An Introduction to the Psychology of Hearing.* NY: Academic Press, 1982; Weis, Elizabeth, *Film Sound Theory and Practice.*

T. Holman

SOUND CAMERA A motion-picture camera that has been specially designed for filming while recording synchronized sound. Such cameras operate relatively noiselessly, without the need of an external blimp so that mechanical camera noise will not interfere with sound recording. They must be compatible with an appropriate system of synchronization between the picture and sound, which is recorded on a separate tape recorder. *H. Lester*

Syn.: *Silent camera; Noiseless camera; Self-blimped camera.*

SOUND DESIGN The process of selecting sounds, editing them, and mixing them together appropriately to form a desired artistic effect. *T. Holman*

SOUND DRUM A mechanical cylinder located in contact with the path of film or tape, used to impart greater stability of speed to the film or tape through contact between the tape or film and the rotational inertia of the drum. *T. Holman*

SOUND-EFFECTS EDITING In traditional motion-picture production, the process of choosing sounds, then cutting sound elements or units on film into synchronization with picture, and delivering them with cue sheets to the dubbing stage for premixing. In television production, it is more likely that sound effects editing involves choosing sounds, then rerecording them to multitrack tape or to a digital audio workstation for subsequent playback during mixing.

T. Holman

See also: *Element; Premix.*

SOUND HEAD (1) In production and postproduction, the term applies to the general class of tape or film heads, including erase, record, and playback heads. (2) In theater usage, the whole assembly used to recover sound from film, including mechanical devices for guiding the film and stabilizing its speed, an optical light source for photographic sound tracks, and a pickup device such as a photocell for photographic sound or a magnetic playback head for magnetic sound tracks. A magnetic sound head for 70 and (obsolete) 35-mm film is located above the picture lens and is thus typically called a *penthouse*. *T. Holman*

SOUND LEVEL METER An instrument for measuring sound pressure level. Sound pressure is referenced to a small pressure variation near the threshold of hearing. *T. Holman*

SOUND LOG See *Production sound logs.*

SOUND MIXER See *Mixer.*

SOUND PRESSURE The primary factor to assess the amplitude of sound waves. Although sound particle velocity, intensity, and power can all be measured and indicate the strength of a sound field, sound pressure is usually preferred as being the simplest to measure, usually with a pressure microphone. *T. Holman*

See also: *Pressure microphone.*

SOUND PRESSURE LEVEL (SPL) Measured sound pressure, usually given in decibels re a reference pressure corresponding approximately to the threshold of hearing of young adults. The dynamic range of human hearing at frequencies near 1 kHz is from the minimum audible sound around 0 dB to the threshold of a sensation of pain, approximately +120 dB. Common alternative reference levels are 1 microbar = 74 dB SPL and 1 Pascal = 94 dB SPL. *T. Holman*

SOUND PROJECTOR A movie projector can be thought of as a camera in reverse. Instead of photographing things outside of the camera, the projector places a light source behind processed film and projects images into the outside world. An intermittent film movement, synchronized with a shutter behind the film gate, allows the rapidly changing sequence of images to be projected and viewed as smoothly flowing realistic action. To produce sound, a projector must have either a magnetic and/or optical sound (reading) head. The sound head is near the sound drum, which is attached to a flywheel to help the film run smoothly. Stabilizing rollers transform the intermittent film movement required in the film gate to smooth movement of the film around the sound drum. The stabilizing rollers also help keep the film tightly wrapped around the sound head, since any film slack here will reduce the quality of the sound. *M. Teres*

SOUND RECORDING Sound recording related to photography may take on a number of forms, from sound to accompany slide shows, through sound for video, to sound for motion pictures. Sound recording for any medium capable of displaying full motion of at least 24 frames per second carries the capability of sync sound, that is, correspondence between what is seen and what is heard.

For recording of sound during principal photography of motion pictures, a production sound recordist uses microphones having particular microphone polar patterns and placements as appropriate to capture the principal action, while minimizing extraneous noise. The recordist keeps production sound logs related to the reels of tape recorded for subsequent use in transfer. Editors then cut dailies so that the director and crew can be certain that all of the coverage needed is available for subsequent editing. After picture editing, sound editors construct dialog, music, and sound effects elements to be combined in several steps to produce the final mix stems from which the various print masters, as needed by different release formats, are prepared. Although all productions of sound to accompany pictures do not use as comprehensive an approach with as many steps, nonetheless all makers of sound for pictures face the same steps, broadly speaking: recording, editing, and mixing.

Some recording steps consist of the original sync-sound production recording, recording of special sound effects, recording of Foley sound effects, and recording of music.

T. Holman

See also: *Element; Foley; Microphone polar patterns; Production sound logs; Production sound mixer; Stems.*

SOUND SYNCHRONIZATION (SYNC) In motion-picture production, the coordination of the sound with the picture in order to maintain a simultaneous relationship during projection. For the sake of maximum sound quality and editorial productivity, most motion-picture production is double system, with sound and picture handled as separate rolls until the making of the final release prints. As a result, creating and maintaining a synchronous relationship between sound and picture is a concern throughout the shooting, editing, and laboratory procedures involved in production. Synchronization involves both the alignment of sound and picture and their being run in a frame-for-frame

correspondence. Variations of only a split-second would be a noticeable and unacceptable situation.

Several systems are available for synchronization of the independently run camera and sound recorder during original filming. The most common involves recording an inaudible signal, on the original 1/4-inch magnetic sound tape, that is sent from the camera or crystal controlled sync generator when the camera motor is governed by a comparable crystal unit. This signal (sync pulse) is then used to control the speed of sound playback to match that of the camera. Alignment of the sound and picture is established by clapping at the head or tail of the shot, providing both a visual and aural alignment reference.

The original sound is then transferred (rerecorded) onto a motion picture film stock coated with a magnetic oxide rather than a film emulsion, through a resolver, which reads the sync pulse and varies the playback speed of the original accordingly. The resultant sound track runs at the same speed as the picture, on sprocketed film, in a frame-for-frame correspondence with the picture. After *syncing-up,* when the editor aligns picture and sound according to the clap, edge numbers are printed in ink along the side of both picture and sound at regular intervals, usually one foot, to provide convenient sync reference points during the editorial manipulations of the film. Various editing machines use both mechanical and electronic interlock systems to control the transport of both picture and sound, keeping them in a frame-for-frame relationship.　　　　　　　　　　　　　　*H. Lester*

SOUND TRACK　　Often used to describe the physical sound placement on a motion-picture release print containing sound. Also used to describe the recording contained on a motion-picture release print, and sometimes to describe the musical score of a motion picture available in another medium.　　　　　　　　　　　　　　　　　*T. Holman*

SOUNDWAVE PHOTOGRAPHY　　Recording the reflection and refraction of the sound wave emitted by an electric spark produced in air. The thin spherical shell of the wave has a higher density and refractive index than the ambient uncompressed air and, if photographed by flash, it records as a shadow on a suitably placed screen. The technique is used in studies of the acoustics of buildings. A related technique, ultrasound, is used for medical diagnosis and records images using electronic imaging.　　*L. Stroebel*

SOUP　　(1) A developing bath. (2) To process exposed photographic film or paper.　　　　　　　*L. Stroebel and G. Haist*

SOUTHWORTH, ALBERT SANDS (1811–1894) and **HAWES, JOSIAH JOHNSON** (1808–1901) American daguerreotypists. Opened a studio in Boston and continued as partners from 1843 to 1862. Acclaimed for their aesthetic accomplishments in daguerreotype portraiture, as they consistently produced unusually beautiful and sensitive portraits. Admired for their use of dramatic lighting, rather than the flat, bright light favored by most daguerreotypists.

Books: Sobieszek, Robert, and Appel, Odette, *The Daguerreotypes of Southworth & Hawes.* New York: Dover, 1980.　　　　　　　　　　　　　　　　　　　　　*M. Alinder*

SPACE CHARGE BARRIER　　Because the energy of formation of an interstitial silver ion is low, silver ions at positive kink sites at the emulsion grain surface can readily leave their lattice site and move into the crystal interior. They leave behind a negative kink site, a bromide ion. This process gives the grain surface an excess negative charge counterbalanced by an underlying region of silver interstitial ions. The negative surface charge causes an upward bending of the conduction band near the surface so that the electrons

must go "uphill" to reach the surface of the grain. Hence, the term "barrier." The spreading out of the underlying interstitials disperses the charge over space. Hence, the term *space charge barrier.*　　　　　　　　　　　　　　*R. Hailstone*

SPACE PHOTOGRAPHY　　The term *space photography* has often been used to describe all images returned to earth from artificial satellites. The majority of images from space are recorded by various means, in various sections of the electromagnetic spectrum, and transmitted electronically by various means to earthbound receiving stations where the photograph is created.

Genuine space photography, however, is human beings using cameras and film while in space.

In its early days, around 1960, NASA considered the idea of putting human beings into earth-orbiting spacecraft. The structural integrity of the vehicle was the primary consideration to support a human being through launch, orbiting, and entry back to earth's surface. It was thought that a window might compromise the safe journey of the astronaut. Tests proved otherwise. The original seven astronauts considered a window necessary. Although that led to the possibility of photography from space, the ideas that cameras weigh quite a bit, that astronauts can't operate them in spacesuits, and that they are too busy doing other things to consider photography prevailed.

After some long and heated discussion, it was determined to be totally feasible for astronauts to make observations through their little window and make a decision to take a photograph, that cameras would work in space, and even that space photos of the earth were indeed possible. They would also be very useful.

Then Lt. Col. John H. Glenn personally decided that on his three-revolution, 4-hour, 55-minute Mercury flight he would carry a camera. He purchased a 35-mm. Ansco Autoset for around $20.00 in a store in Titusville, Florida. His film would be ECN (Eastman Color Negative). Glenn exposed the entire roll but complained that it was difficult to advance the film wearing a space suit with space gloves.

Glenn was followed by M. Scott Carpenter, who used a half frame 35-mm Robot with a film advance from a prewound mechanical spring. It worked; the only problem was that in using color negative film, it was not known how to print correctly because it was not known exactly what the earth looked like from space. Subsequent missions used color transparency Anscochrome for the remainder of Mercury and Ektachrome for Gemini in 1969.

Walter M. Schirra wanted to use his personal camera on his Mercury flight. It turned out to be a Hasselblad 500 series 2-1/4 × 2-1/4-inch format film. Management was convinced that it was an excellent camera but had many objections to its use. It was large in a small spacecraft cabin, it weighed quite a bit (the engineers were worried about grams of weight to orbit and enter), and it would require significant modification to function properly in space. Schirra became irate at the negative position regarding his Hasselblad, so to soothe the temper of an angry astronaut, it was decided to "let him have his d——- camera." It turned out to be one of the best decisions ever made by NASA management. From October 3, 1962, onward, every space flight has carried one or more of the various space-hardened Hasselblads. They have recorded hundreds of thousands of impressive photographs and been the continued backbone of space photography.

Quite a few other cameras have been used for specialized work. On the first U.S. spacewalk (1965), Ed White used a 35-mm Zeiss Contarex. The 35-mm Nikon F-series cameras proved ideal for interior photography on Skylab (1973–1974) and on space shuttles because of its easy use with flash photography. The 35-mm format did not secure photos of the earth from orbit as well as the 70-mm Hasselblads. Selected

missions would carry the 5-inch film of the Linhof camera. Large format panoramic cameras would photograph the surface of the moon. So would 5-inch square format cameras vertically mounted for stereo photography for topographic mapping of the moon. One space shuttle mission used a large-format precision mapping camera. Multispectral camera systems varied from four Hasselblad 500-EL cameras to a six-lens Itek carried on the Skylab missions. Other special cameras would be used for specialized scientific observations.

NASA will continue to use special cameras and systems that are best suited to special tasks. However, the world of electronics continues to make significant inroads into the domain of specialized systems. With 30 years of excellent service in space with the continually improved Hasselblads, plans are to continue to use them for all future manned space flights.

It should be noted that the photographs taken from manned spacecraft are within the public domain of the United States and thus available to the interested user.

R. Underwood

SPARK PHOTOGRAPHY　High-speed photography using an electric spark as the light source, demonstrated by W. H. Fox Talbot in 1851.　　*L. Stroebel*

SPATIAL AND TEMPORAL AVERAGING　Used with real-time analyzers to improve the accuracy of their readings when making measurements of sound fields in rooms. The type of stimulus for sound systems under test is usually pink noise that, being a stochastic signal, has unstable level versus time. By sampling the sound field at more than one point in space within a room, the effect of standing waves occurring at a single point are minimized, and by computing the level of the long-term average rather than the moment-by-moment level, the effect of the randomness of the level versus time of the signal is minimized. Thus, the use of spatial and temporal averaging together greatly improves the reliability of measurements of sound fields in rooms.

T. Holman

See also: *Real-time spectrum analyzer.*

SPATIAL FILTER　See *Filter types.*

SPATIAL FREQUENCY　(1) Frequency as applied to spatially varying (as opposed to temporally varying) waveforms; specified in cycles per unit length. Spatial frequency is particularly important in imaging as the input variable in modulation transfer function graphs and resolution tests. Image processing techniques are also frequently dependent on the spatial frequencies that make up an image, in the same sense that component sine waves can be combined to make a more complex temporally varying waveform. (2) In electronic imaging, a brightness value. The change of brightness values from pixel to pixel is referred to as spatial frequency change. If closely spaced pixels change brightness values rapidly, it is described as high-frequency information. Low-frequency data are minimally changing pixels brightness.

J. Holm and R. Kraus

SPECIAL EFFECTS　Special effects includes a whole host of techniques that photographers use to create images that may or may not resemble reality but that usually have some unreal or questionable quality about them. Usually the purpose behind using special effects is to raise the impact or level of interest of an image or to produce images that only exist because of the use of such effects.

Special effects depend on the basic belief that photographs don't lie. They exploit this premise by presenting to the observer images that are seemingly impossible to achieve in reality or which enhance certain features of a subject beyond that achievable by normal photographic methods. In addition, special effects often enhance or modify reality for some ulterior purpose such as to enhance aesthetic merit, to convey information in a more effective manner than would be possible with a standard photograph, or to confuse or deceive the viewer into a false interpretation of reality.

Special effects and trick photography are sometimes considered synonymous but the word *trick* suggests that the photographs are intended to entertain viewers rather than serve more serious artistic and professional purposes.

A precise definition of what comes under the heading of special effects is difficult to give because some manifestation of a special effect can be found in most photographs. Although one can safely assume that *special effects* are not involved when the resulting photograph closely resembles the scene being photographed, when it is as accurate a record of the original scene as a two-dimensional representation of a three-dimensional scene allows, if it is an instantaneous and sharp record, if it was not manipulated after the image was recorded, and if it appears to be natural and unmanipulated, even in this case certain special effects could have been used by the photographer to achieve this look of naturalness and spontaneity. Also, a special effect that is used so frequently that it becomes commonplace tends to no longer be considered a special effect.

The advent of electronic-image storage, manipulation, and output has had a significant impact on the degree of sophistication and scope of special effects. Not only has this technology allowed for improved quality in creating traditional effects but it has made possible the creation of images that were totally impossible in the past. In spite of this, however, because computer-generated special effects require expensive computer equipment and computer skills, their use by photographers is limited. Only special effects produced by standard methods by still photographers will be considered here.

Special effects can be classified according to a variety of criteria. Some occur before the making of the photograph. Others are used during photography, and yet a third class of special effect is that which is accomplished by modifying the original image after the initial photograph is recorded. Special effects could also be classified based on the procedures used or the technology involved. The techniques can be optical, chemical, physical, photographic, electronic, or combinations of these methods. In fact, there are so many techniques that could be called *special* that it becomes impossible to attempt to list, classify, and discuss all of them. Instead, under the following generalized headings are listed and described some of the more popular current techniques that are connected with special effects. Descriptions of a number of other special effects appear alphabetically under their titles and in articles on various imaging processes.

TEMPORAL EFFECTS　Based on the widely held conception that photographs are instantaneous records of a scene, photographers exploit this by purposely exposing a scene piecemeal onto a piece of photosensitive material. These sequentially made images are then viewed by an audience instantaneously. Because of this discrepancy between the production step and the perceptual experience, the audience tends to be amazed and/or confused when viewing the final product. Several techniques exploit this concept.

Matte Boxes in Photography　Matte boxes are devices that exploit the possibilities of making a negative by exposing its various parts at different times and under different conditions. At the photography stage, photographers use a matte box in front of the camera lens.

The idea is that if a dark, featureless obstruction is place in front of the camera, the film will receive no exposure where this obstruction is located. If, without moving the film,

another exposure is then made of a similar obstruction but one such that it is the exact opposite of the first one in terms of areas that it covers, then the second exposure will seamlessly blend into the areas that were unexposed by the first exposure. These obstructions are called *masks*. One mask is called a positive mask, the other a negative mask. The simplest example of how one might use such a set of masks is the making of a photograph in which one individual appears in two or more locations in the same scene. A variation of this technique, for example, is to have a normal image of a person on one side of a picture and a second image taken with a slow shutter speed while the person is standing up from a seated position, or moving away from the camera, which will make it appear as if the person is vanishing on the other side. Duane Michals used a similar technique to create photographs suggesting metaphysical phenomena of subjects being transformed.

Problems that photographers need to consider include the fact that there must be no movement across the delimiting boundaries of the masks, the camera must remain locked in position, and the film must remain stationary between the two exposures. Self-cocking shutters are preferred, although many current cameras are fitted with means to recock the shutter without introducing film motion into the system.

The matte box also allows photographers to combine two or more scenes together on one piece of film by using two masks that are complements of each other placed sequentially in front of the camera. The outline of the mask edge sometimes becomes visible when this process is practiced, but when used successfully this special effect can contribute to the final product's visual appeal.

Matte Boxes in Printing Matte boxes can also be used at the enlarging stage. Procedures for sequential multiple printing onto a sensitized material have been described in the literature. The process has been highly perfected by Jerry Uelsmann in producing surrealistic photographic images. The typical example of a simple application of this technique is that of adding, at the printing stage, clouds to a barren sky in an otherwise appealing photograph. The print is made by

making positive and complementary negative opaque masks and printing the separate negatives onto the same piece of printing paper in succession, taking care to carefully blend the two images together at the line joining the two masks. Some skilled photographers have combined portions from five or more separate negatives.

Focal-Plane Shutter Distortion The sequential assembly of images either at the taking or printing stages is also somewhat related to the sequential exposure process by which focal-plane shutters expose a scene. Historically, one of the most significant special effect photographs ever made is the one by Henri Lartigue showing a passing race car leaning one way and spectators in the background leaning the opposite way, the combination giving a very convincing impression of speed.

This effect, produced by a combination of a relatively slow moving focal plane shutter and panning the camera to keep up with the moving vehicle (but not quite fast enough) is one that is normally not seen in everyday use of modern cameras also equipped with focal plane shutters. The reason for this is that in these cameras the shutter slit moves much faster than in the older models. Not that exposure time is not a factor in producing the effect, just shutter slit velocity.

Slit-scan Cameras One can take advantage of the focal plane shutter distortion effect by purposely slowing a focal plane shutter down so that the slit at the film plane moves at the same order of magnitude, or slower, than the image one wishes to secure. Under these conditions the effect is know as *slit-scan* photography. In effect, any camera that makes an exposure by scanning a stationary scene can be classified as a slit-scan camera.

Several schemes have been developed for slit-scan photography. One is to devise a means for slowly releasing or winding the shutter of cameras equipped with large focal plane shutters, such as the Speed Graphic or the Graflex, or to build an oversized matte box on the front of which one installs a mechanism for slowly moving an open slit in front of the camera lens while the camera shutter is left locked in the open position. With either system it is fairly difficult to predict what the final photograph will look like because one usually loses the ability to view through the lens while the shutter is open.

To deal with this problem one may use some kind of a movable guiding finder that has been coupled to the location of the moving slit. It is also possible to use a camera that is equipped with a pellicle mirror-based viewing system located behind the camera lens.

Early examples of the application of this technique were photographs made by Robert Doisneau of couples dancing and appearing to be intertwined.

Scanning Wide-Angle Cameras Scanning wide-angle cameras are a special manifestation of scanning focal-plane shutters combined with a lens rotating about its rear nodal point to provide photographs with angles of view encompassing typically slightly more than 120°, more than double the angle of view of a conventional camera lens. Typical among such cameras are the rotating lens wide-angle cameras such as the Widelux and the early Kodak Panorams.

Distortion normally not seen in cameras equipped with standard focal-plane shutters becomes a matter of concern with these scanning wide-angle type cameras because they turn the scanning lens over a relatively significant period of time. This introduces the possibility that a subject may move during the scanning action of the camera, or the camera itself may be significantly changed in position, leading to an alteration of the expected shape of a subject.

Several photographers have modified these cameras by slowing down the scanning action in order to produce highly unusual visual effects. John Zimmerman used such a modi-

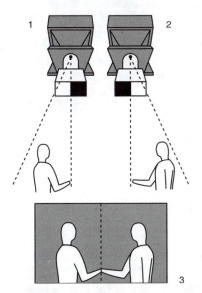

Matte Box. A matte box or a long lens hood capable of covering up either half of the camera field of view is required. (1) Make the first exposure of the subject with a mask covering half of the view. (2) Cover the other half of the view and switch the position of the subject. (3) The result is a mirror image of the subject.

fied camera to portray basketball, baseball, and tennis players in amusing and unusual contortions.

Strip Cameras: Linear, Panoramic, and Peripheral
Although not very popular except in specialized applications and in wide-angle photography, strip photography and strip cameras can be considered part of the arsenal of special effect devices available to the photographer.

Strip cameras are basically classified as linear or photofinish, panoramic, and peripheral designs. These cameras are essentially derivatives of focal-plane shutters in that images are exposed sequentially. In strip cameras, however, the moving focal-plane shutter is replaced with a stationary slit of (sometimes) variable width past which the film is moved at a fixed or variable velocity. When an image of a subject moves past the slit at a velocity that matches that of the film, a sharp record of the subject is impressed onto the film because relative to each other the film and the moving image are stationary.

Mismatch between the image velocity and film velocity will cause records of subjects to appear compressed if the film is traveling slower than the image or elongated and stretched out if the film is traveling past the slit more quickly than the image.

Probably the most widespread application of strip cameras is in the photography of the order of the of arrival at the finish line of participants in a racing event. Unusual distortions of arms, legs, and torsos are typically inevitable because the film can only match one image velocity while the subjects are moving at a great number of velocities simultaneously. Two photographers who have explored the application of photofinish-type cameras for effective sports photography

are George Silk and Neil Leifer, both associated with *Time/Life*.

Operating principles associated with strip camera technology are also the basis for the Cirkut panoramic camera design as well as that of the various modern versions of these cameras that were introduced on a rather large-scale commercial basis by the Eastman Kodak Company in the early 1900s.

Panoramic strip cameras rotate about a point roughly under the lens's rear nodal point as they scan the surrounding scene. They must remain level; otherwise the horizon line appears to curve sinusoidally. These cameras can easily cover a horizontal angle of view of up to 360°. They reproduce still subjects quite well, but moving subjects are distorted in shape.

As opposed to panoramic cameras, peripheral cameras consist of the same basic camera design, but they hold the camera stationary while rotating the subject in front of the camera. The slit of the camera is aimed at the center of rotation of the subject. When the subject has made one 360° turn, the moving film made to move at the approximate velocity of the moving image of the subject, will have accumulated information about the whole surface, or periphery, of the subject.

A cylindrical subject can be reproduced without distortion, but a subject containing three-dimensional surface features that do not fit within a cylindrical shape will unavoidably be distorted. Features that are farther from the axis of rotation than those for which the camera is adjusted will appear compressed, and those that are closer to the center of rotation, and thus have a lower linear velocity, will appear expanded or stretched out.

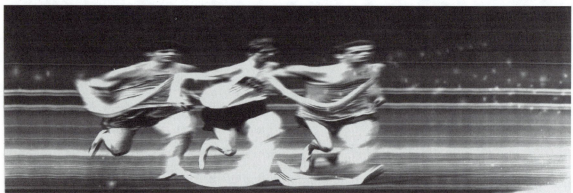

Strip camera images. (Top) Horizontal movement of film behind a vertical slit. Image shape is normal only where the image movement and the film movement match in direction and speed as they pass the stationary slit. (Bottom) Slit-scan effect. Vertical movement of a horizontal slit. The subjects stood up as the rising slit in front of the camera lens was imaging the middle of their bodies. (Photographs by Andrew Davidhazy.)

A special version of the standard strip camera is one in which the film is made to move in circular, rather than linear, motion behind the slit to compensate for variations in image velocity along the slit of the camera. This design can produce a peripheral image that correctly reproduces the surface features of a conical subject or a panoramic record that is a conical projection of the scene that surrounded the camera during photography. In this latter case the panoramic camera is tilted while rotating about a vertical axis.

SEQUENTIAL FILTER EXPOSURES Making sequential camera exposures through red, green, and blue filters on color film (similar to the additive color printing process) can result in unusual and interesting images if there is subject or camera movement. Waves moving in or out on a still beach, tree branches swaying in a breeze, moving people and vehicles, and a building with the camera panned between exposures are examples. Where there is no movement the colors appear normal, but where there is movement red, green, and blue are recorded separately or in overlapping pairs to produce cyan, magenta, and yellow colors.

TIME EXPOSURES Instead of photographing objects, it is possible to create interesting light patterns by making a time exposure of a moving light source, such as a pen light in a darkened room. The movement can either be in the form of a realistic drawing or as an abstract pattern, such as would result from pretending to conduct an orchestra, or dancing. Barbara Morgan made a series of what she called *light drawings* in the early 1940s and gave them titles such as "Samahdi," "Cadenza," and "Emanation 1."

Light tracings made by using a pen light as a pendulum were called *physiograms*. Multicolored tracings are made by making multiple exposures with different colored filters over the camera lens for each exposure, and various techniques can be used to vary the swing pattern of the pendulum.

OPTICAL EFFECTS The use of various optical accessory devices allows the making of multiple images by the

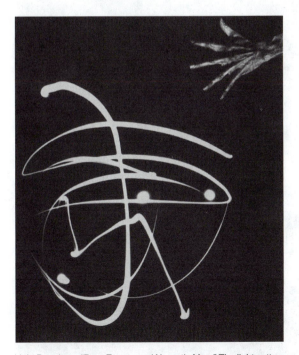

Light Drawings. "Pure Energy and Neurotic Man." The light pattern was created by movements of a small point of light in a darkened room. ©Barbara Morgan (Courtesy of the Willard and Barbara Morgan Archives).

use of mirrors or prismatic filters typically placed in front of the camera lens. Other optical and photographic techniques also allow for the combination of foreground and background subject matter.

Mirrors and Kaleidoscopes A widely practiced special effect is the use of mirrors for various creative purposes. A mirror can be introduced in a scene to portray one or more additional views of a subject. The use of flexible mirrors, mirrorized plastic, or mylar sheets to distort the shape of subjects is a common use of mirrors in carnivals, but they also have been used extensively by photographers to create unusual interpretations of their subjects.

The use of plane mirrors as special-effect tools is probably best exemplified by their use in kaleidoscopes. In this case the camera photographs the multiple images of a subject as reflected in the kaleidoscope.

Kaleidoscopes and mirrors can be used in various locations in an optical system or during the making of a photograph. Usually they are used in front of a camera lens, but they can also be used within an enlarger located between the film and the enlarging lens. It is also possible to use them on a copy stand or duplicating device and placed either between the lens and the subject or between the lens and the film. A single-lens reflex camera with built-in meter is a must for these applications.

Another possibility is to use a horizontal mirror in front of the camera lens, covering the lower part of a scene to obtain a lake or mirage-type reflection.

Partially reflecting mirrors can be used to produce ghost-like images by the simultaneous exposure of a subject located in front of the camera with another subject located off-axis whose image is reflected into the camera lens by way of a semitransparent mirror. Typically the scheme works best if the off-axis subject is placed against a black background so that unwanted detail surrounding the *apparition* is not visible in the scene.

Front Projection Several techniques are used to combine a foreground subject located in a studio setting with a background photographed on location. The simpler approaches rely on the oblique projection of a transparency from the front onto an opaque screen placed behind the subject. Alternatively, the image is projected from the rear onto a translucent screen. Foreground and background are balanced in lighting and photographed simultaneously. A more sophisticated technique commonly used in advertising and commercial and portrait photography to place inanimate, but also animated, subjects in a particular background is called *front projection*. The technique depends on the use of a large and highly directional retroreflective projection screen. A semisilvered mirror permits the projection of the desired background onto the screen along the optical axis of the camera. The image on the screen appears extremely bright because of the highly reflective quality of the screen material.

The subject is placed in front of the screen and illuminated with tungsten or electronic flash in such a manner as to be consistent in direction, quality, and quantity with the illumination present in the background scene. Typically the light falling on the subject is directed away from the surface of the screen although some spill is allowed. Although the projected image of the background falls on the subject as well as the screen, it does not show up on the subject because the directionality and reflectivity of the screen is many time greater than that of the subject. The final effect is that the subject appears placed in front of the background projected on the screen.

In-Camera Masking In-camera masking is also commonly used for commercial and advertising photography when inanimate subjects need to be included in a scene available only as a large-format transparency. While front pro-

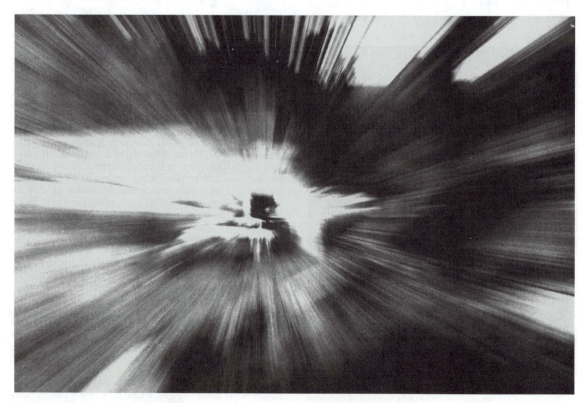

Zoom Lens. (Top) Conventional photograph. (Bottom) Increasing the focal length of a zoom lens as the film is being exposed produces an abstract streaked image that suggests rapid movement or a visual explosion. (Photograph by Andrew Davidhazy.)

jection could be used, in-camera masking is a less expensive alternative in many instances.

The technique consists of a sequential exposure process. The camera is usually equipped with some means to place a transparency of the desired locale in contact, or almost so, with the film on which the record will be made. This limits the technique to use with large-format view cameras. The subject is placed against a black background and lit so that no light falls on the background and so that it is consistent with the lighting of the background scene. During this exposure, the areas where the background will later appear have therefore not been exposed. After this first exposure, the background is changed to white and the film, with the background scene now placed in contact with the camera film, is exposed again. Since the subject now appears in silhouette, black against a white background, during this second exposure only those parts of the contacted image will print onto the film through which light from the white background passes. Upon development the subject will appear imprinted onto the selected background.

Care must be taken to ensure that the film and subject remain absolutely stationary during the process and that light does not spill onto the background during the subject exposure or on the subject during the background exposure.

Front projection and in-camera masking have largely replaced the pasteup method of combining images from two or more photographs.

Zooming While Shooting or During Copying Although blur created by the use of a long exposure time when photographing a moving subject is typically avoided, it is in some cases a very effective special effect in itself. However, there is one special effect based on blur that photographers often exploit for its creative potential. This effect is that of zooming or intentionally altering the focal length of a lens while the exposure is being made. Some modern cameras have incorporated this effect in a selection of options controlled by the camera itself. After the photographer preselects the zooming range and direction, the camera automatically zooms the lens during the time that the shutter is open.

APPLICATION OF SPECIALIZED EMULSIONS AND SOURCES OF RADIATION Unusual renditions of otherwise dull or mundane subjects are sometimes possible through the use of emulsions not intended for standard photography or by photographing using radiation other than light to illuminate the scene.

Ultraviolet Fluorescence Photography The use of ultraviolet radiation for special-purpose photography is mostly restricted to fluorescence effects where a subject naturally fluoresces or is painted or coated with a fluorescing material, illuminated with a long-wave UV source, and the glowing, fluorescent colors are then photographed, typically against a dark, nonfluorescing background, using color film. In this nonscientific application, usually no great care is taken to exclude UV from the final record, but it is nevertheless useful to point out that to obtain photographs uncontaminated by blue, a *barrier* or UV absorbing filter should be placed over the camera lens. Light sources used for this type of photography vary widely, but electronic flashes filtered with a filter such as the Wratten 18A are typically good sources of UV. Modern flash units often have an incorporated UV absorbing filter and may not be as efficient as other (typically older) uncoated tubes in terms of usefulness as sources of ultraviolet energy.

Infrared Photography The use of emulsion sensitive to infrared wavelengths can be used to advantage for special effects purposes to emphasize certain aspects of subjects such as their infrared reflectivity. Infrared-sensitive emulsions are used in the field of special effects because of the sometimes unusual tonal reproduction of subjects as opposed to their appearance in normal black-and-white and color photographs. Because IR is not a visible part of the electromagnetic spectrum, it cannot be spoken of as yet another *color,* but it is true that the near IR wavelengths to which emulsions can be sensitized will often result in startling tonal reproduction of familiar subjects. The reason is simply that a subject's reflectivity of IR wavelengths does not necessarily equal the subject's reflectivity of visible wavelengths.

Infrared tends to produce images of human skin that are very light in tone and also that have a slight *aura* or glow to them. The light tone is attributed to the high IR reflectance of human skin while the perceived *glow* is due to a combination halation and overexposure of the skin surface.

Although only available on a limited basis, there is a *false color* infrared sensitized reversal color emulsion that is used for aerial photography and remote sensing applications. This film is sometimes used as a special-effect film applied to more normal subjects in order to impart an unusual color reproduction to an otherwise normal subject. In this emulsion one of the layers is sensitive to infrared, while the other two are green and red sensitive, respectively. The film typically should be used with a blue-absorbing filter because all three layers are also blue sensitive.

TONE MODIFICATION EFFECTS There are a number of special effects that fall in the category of unconventional tone reproduction, some of which involve aftertreatment of conventional photographic images.

Bas-Relief Bas-relief is a technique whereby a positive image is made of the original negative by contact printing. The negative and positive are then superimposed. The sandwiched pair is then set slightly out of register and printed. The exact pictorial effect varies, depending on the density of the positive record and the density to which the larger areas of the image are printed. Usually, the broader areas appear devoid of large density variations, but they retain their identity. The edges of these areas, because they gain or lose relative density as a result of the superimposition process, impart a *shadowing* effect in the direction that the two records were displaced. While this is the most common way to do bas-relief, variations have been produced where the two records are of slightly different sizes, giving yet another variation on the same general theme.

Line Derivation Line derivation is a technique closely allied to isodensity, and it is also created by the combination of a high-contrast negative and a high-contrast positive that are superimposed so that no light is able to pass through the combination. In this case, however, the two superimposed records are then slightly separated. The combination may be placed on a turntable and while a light is shining from the side, the sandwich is turned in such a manner that light is able to pass past the edges of the combined pair and expose the film or paper underneath. This results in a line pattern defining the edge or join line between the positive and negative records. Fine detail tends to be lost, however.

Solarization Considered synonymous with the Sabbatier effect, in the strictest sense solarization is an exposure effect associated with gross overexposure that causes image reversal. This effect would primarily be apparent in the highlights of the subject appearing in negative form on a black-and-white print, such as the image of the sun being reproduced black rather than white.

Sabattier Effect The Sabbatier effect is an effect that is a result of further overall exposure or fogging of the film or paper, beyond the exposure due to the first or image-forming exposure. The Sabbatier effect is induced by exposing the sensitized material to light after the development step has progressed beyond the initial stages. The result is a partial reversal of tones or negative image in combination with the normal, positive, image that would be formed during the normal printing process.

Posterization Posterization is a special effect that is the result of the sequential printing of a number of high contrast copies of an original but where each copy is of different overall density. These copies are typically printed in registration, and the final density of the reproduction at any given area on the print is a result of the contributions of the partial exposure that resulted from exposure to each of the several partial masks that were created from the original. Posterization as well as many other special effects processes can be done in black-and-white as well as color. In black-and-white, the subject tones are broken down into a series of stepped densities, while when this process is carried out in color, original subject tones can be made to achieve almost any desired color.

Isodensity Although a rather seldom seen special effect, isodensity relies on counteracting negative and positive emulsions coated on a single support. A film of this type was introduced by AGFA. The effect is that areas of the subject that produce more or less exposure at the emulsion than a critical level (adjustable by the choice of overall exposure) are reproduced as dense areas. The critical exposure level is reproduced as clear film base. The clear lines that result are then interpreted as lines of equal photographic effect or isodensity. A similar effect can be achieved by high contrast positive and negative images keyed about a particular density of an original. Combining these will reveal a low density region that follows areas of the originals that had the same density.

The process is basically a variation of the bas-relief and the line derivation technique described previously. The only difference between the processes is that is this technique the high contrast negative and positive are created simultaneously and are in perfect registration.

LIGHTING EFFECTS The creative use of filters and lighting devices introduces yet another special effect area for the creative photographer. Electronic flashes have been a longstanding tool in the special effects arsenal, used by photographers not only to create frozen images of fast moving events but also to convey the opposite, an idea of the sense of the motion of the subject. Their application for the latter purpose is described under the heading "Stroboscopy."

Color Balancing A not too obvious special effect involves balancing light sources of different color characteristics included in the same scene so that they will appear to be matched in color quality to the film. One of the most common applications of this process involves the balancing of fluorescent illumination in a scene with daylight-type illumination provided by an electronic flash. The flash is covered by a greenish filter to convert its color quality to that of the fluorescent tubes, and then a magenta or reddish filter is placed over the camera lens to simultaneously bring both of them back to daylight quality to match the film with which the photograph is made. The filter on the flash and the filter on the camera need to be complementary in color and strength to each other.

If fluorescent tubes need to be included in an indoor scene that also includes daylight, another technique that can be used is that of split exposure if the subject is a static one. The photograph of the outdoor portions of the scene is the first made while all fluorescent lights are turned off. The camera is held immobile until nighttime when the next exposure is made by only fluorescent or by a combination of fluorescent-modified flash and color-correcting filter placed on the camera lens.

Multicolor Exposure Interesting effects can be produced by using filters of complementary color to dramatically alter the color of a background while keeping the color balance of a foreground subject quite normal if the subject can be lit by one light source while the background is lit by a second source. For example, placing a color filter on a flash that illuminates the subject that is complementary in color to the one placed over the camera lens and which will be used to tint the background a particular color will counteract the effect of the filter tinting the background, resulting in basically neutral rendition of the flash-illuminated subject.

Normally one would not intentionally introduce unnatural color casts in a photograph. On the other hand, the use of filtered light sources illuminating the subject from different locations is another area of creative application of lighting as a special effects tool.

Tailflash Photography Typically the "X" synchronization system built into most cameras and shutters causes electronic flashes to be triggered immediately upon a given shutter achieving maximum opening. The pictorial effect of this convention is that combining existing illumination with electronic flash illumination while photographing a moving subject results in the subject appearing to be moving backwards. This is because the blur exposure due to existing illumination happens after the electronic flash produces its action-stopping flash exposure, and thus the blur is impressed on the film after the sharp record. To place the flash exposure at the end of the tungsten exposure, some modern cameras have a provision built in that allows the photographer to chose between triggering the flash at the beginning or at the end of an exposure. With 35-mm cameras this is often referred to as second-curtain synchronization. In cameras or shutters that do not have this provision built in, accessory devices are available to provide a similar function. Because diaphragm shutters do not have curtains, the process of setting off an electronic flash at the end of an exposure may better be defined as trailing flash synchronization or simply tailflash synchronization.

Stroboscopy The use of repetitive flashes to generate images that convey a sense of motion of the subject is achieved in several ways. The most common technique places a subject against a very dark, nonreflecting background while it is illuminated by the flashing stroboscope. As the subject begins to perform the desired motion the shutter is opened. At the completion of the motion the shutter is closed. During the interval that the shutter was opened, several images of the subject are recorded. Their number is a function of the frequency of the flash and the exposure time. Areas of the subject that move to new positions on the film are easily seen in their respective locations. Those parts of the subject that remain relatively stationary suffer from overexposure and generally blend into a detailless mass. Generally this means that a particular action can only be followed over a very limited time period because of multiple exposures on the film tending to mask previously recorded images.

Although the foregoing effect is possibly desirable, photographers overcome the limitation imposed by subjects performing an action in a stationary location, by either introducing artificial translational movement in the subject or the camera, by panning the camera, or by introducing motion in the film stock. This latter movement is generally accomplished by rewinding the film into its supply cassette after preparing the camera by first advancing the film into the camera's take-up chamber without exposing it. The shutter of the camera is held open while the film is rewound. With each flash of the stroboscope, not only is the subject in a slightly different position but the image is recorded slightly off to one side of the one recorded with the previous flash. This technique allows the recording of a subject over an extended period of time.

Composition Effects Because of the two-dimensional nature of conventional still photographs, special-effect illusions can result from creative positioning of objects in the foreground and background in the absence of conflicting depth clues.

Composite photograph. Two different photographs are combined and rephotographed. Alignment of the image inside the frame with the background creates the illusion of a transparent body. (Photograph by Leslie Stroebel.)

Electronic photography composite. An Adobe Photoshop program was used to add sky and to clone the face. (Photograph by Leslie Stroebel, electronic composite by Richard Zakia.)

A simple way to collapse depth in a photograph is to have the very edge of two objects that are separated in space aligned in the camera view so that they share the same edge or contour. Because one clue for depth perception in a photograph is overlap, the sharing of edges destroys this valu-

Composition effects. When the edges of two objects separated in space are made to coincide, the perception of depth is diminished. Note how the contour of the light globe shares the same contour as the middle arch of the building. Depth is collapsed in the upper part of the light post but not the bottom. (From a photograph by Richard Zakia.)

able clue, and the perception of depth is lost in that area. A number of photographers have made use of this technique, including Michael Bishop, Lee Friedlander, and Pete Turner.

CUTOUTS AND COMPOSITES Combining parts of two or more photographs has long been used not only to produce effective realistic photographs but also to produce dramatic special effects. The illusion that part of a person's body is transparent, for example, can be created by taking two photographs of a building, one with a person standing in front of the building holding a blank card; making a print of each, and cutting a rectangular opening in the center of the card the person is holding and superimposing this print on top of the print without the person. Because the part of the building located in the opening in the card is aligned with the rest of the building surrounding the figure, viewers tend to see a rectangular hole in the card and the person holding it rather than to see a person holding a mounted photograph.

In still photography, composite prints using this procedure are commonly called *pasteups.* In motion-picture photography, similar effects can be created using traveling mattes with optical printers. Computer software programs make it possible to create a wide range of special effects quickly and easily in the fields of computer graphics, video, and electronic still photography.

ELECTRONIC STILL PHOTOGRAPHY Most of the special effects possible with conventional photography are performed more easily and better using electronic still photography. They can also be done in a lighted room with the press of a button. The changes can be seen as they appear on the screen and adjustments can be made as necessary. Instead of having to visualize what a composite picture might look like by adding or subtracting elements, the operation can be executed and the result observed on the screen. If the image is not satisfactory, it can be electronically erased or altered in a matter of seconds or minutes. A component of an image, such as a person's head, can be *lassoed,* using an icon of a rope that appears on the computer screen, dragged to any position on the screen, and then cloned by simply clicking on the mouse. If the position needs to be changed, this is easily done without disturbing the original image. The cloned head can be altered in size, changed in contrast, reversed in tone, made partially transparent, posterized, modified in color, and so on. Software programs have been developed that have revolutionized both conventional imaging and special-effects imaging in various fields, including photomechanical

reproduction, motion-picture photography, video, and electronic still photography.

The convenience and simplicity of electronic imaging requires a considerable investment in equipment. A *scanner* is needed to input a photograph into a computer. Prints are scanned on a flatbed scanner and slides require a film scanner. After the image is manipulated it needs to be printed. There are a variety of *printers*—laser, ink jet, and thermal— each providing a different quality print. Near photographic quality is available with the best printers. Another concern, especially when working in color and in large format, is that a large amount of computer storage memory is needed. This slows image processing, requiring more time and computer memory. For example, to scan in a 35-mm color slide or negative at 200 dpi requires about 10 megabytes of memory.

Photographic special effects such as those easily and quickly made with a star filter using a single camera exposure would, using electronic photography, require the digitizing and superpositioning of two separate images. Effects such as Sabattier, solarization, and posterization that take considerable time to perform photographically are easily achieved electronically by simply pulling down an *image menu* making a selection, and clicking the mouse.

Books: Eastman Kodak Co., *Creative Darkroom Techniques.* Rochester, NY: Eastman Kodak Co., 1975; Evans, Ralph, *Eye, Film, and Camera.* New York: John Wiley, 1960; Hirsch, Robert, *Photographic Possibilities.* Boston: Focal Press, 1991; Pfahl, John, *Altered Landscapes: The Photographs of John Pfahl.* New York: RFG Publishing, 1982. *A. Davidhazy*

See also: *Holography; Stereophotography.*

SPECIFICATION A prescribed procedure or result, such as time of development or agitation technique in photographic processing, or necessary contrast index. Most specifications (specs) include tolerances, i.e., permitted variation in the specs. *H. Todd*

SPECIFIC GRAVITY The weight of a volume of a substance as compared to the weight of an equal volume of water. The metric system is designed to make the calculation of specific gravity simple in that the weight of water (at standard temperature and pressure) is defined to be 1 kilogram per liter or 1 gram per milliliter (cubic centimeter). The specific gravity of a liquid (and hence in many cases the concentration of a dissolved substance) can be measured using a hydrometer. *J. Holm*

SPECTRAL Having to do with the spectrum, especially variation in some response or output with wavelength (or frequency). *J. Holm*

SPECTRAL COLOR REPRODUCTION Reproduction in which the colors are reproduced with the same spectral reflectance factors, or spectral transmittance factors, or relative spectral power distribution, as the colors in the original scene. *R. W. G. Hunt*

See also: *Color reproduction objectives.*

SPECTRAL DENSITY A measure of the absorption of light by a sample of a color transparency where the material is illuminated with light of a narrow range of wavelengths, rather than with broadband light. Such a measurement is often used for color dye images because the analytical spectral density is approximately proportional to dye concentration and can be computed from integral spectral density data. *M. Leary and H. Todd*

See also: *Densitometry.*

SPECTRAL ENERGY DISTRIBUTION The energy output of a source as a function of the wavelength of the radiation. Spectral energy distribution plots are the most common means for indicating the output of a source as a function of the wavelength or frequency of the photons emitted. To obtain a spectral energy distribution curve it is necessary to use a spectrograph or spectrophotometer that has been calibrated so that the actual energy output by the source can be calculated from the response of the instrument at each wavelength. Since the spectral energy distribution curve is a plot of energies, it is most closely related to radiometry. A similar, photometric plot could also be obtained by plotting luminance as a function of wavelength. Another plot of interest is the number of quanta emitted as a function of wavelength. Such a plot can be generated by dividing the spectral energy at each wavelength by the energy of a single photon at the corresponding wavelength.

Spectral energy distribution curves have long been the standardized means for describing the output of a source. When they are used, however, to determine the response of a photographic material or electronic imaging detector, it is important to remember that the response will be given as a function of the amount of energy, and not the number of quanta, input to the detector. *J. Holm*

SPECTRAL LOCUS Locus in a chromaticity diagram or color space of the points that represent monochromatic stimuli throughout the spectrum. *R. W. G. Hunt*

SPECTRAL LUMINESCENT RADIANCE FACTOR Ratio, at a given wavelength, of the radiance produced by fluorescence by a sample to that produced by the perfect diffuser identically irradiated. Symbol, β_L. *R. W. G. Hunt*

SPECTRAL LUMINOUS EFFICIENCY Weighting functions used to derive photometric measures from radiometric measures in photometry. Normally the $V(\lambda)$ function is used, but if the conditions are such that the vision is scotopic, the $V'(\lambda)$ is used and the measures are then distinguished by the adjective *scotopic* and the symbols by the superscript prime. *R. W. G. Hunt*

See also: *Judd correction.*

SPECTRAL POWER DISTRIBUTION Spectral power per small constant-width wavelength interval throughout the spectrum. Symbol, $S_\lambda(\lambda)$. *R. W. G. Hunt*

SPECTRAL RADIANCE FACTOR Ratio of the spectral radiance to that of the perfect diffuser identically irradiated. Symbol, $\beta_e(\lambda)$. *R. W. G. Hunt*

SPECTRAL REFLECTANCE Ratio of the spectral reflected radiant or luminous flux to the incident flux under specified conditions of irradiation. Symbol, $\rho(\lambda)$. *R. W. G. Hunt*

SPECTRAL REFLECTANCE FACTOR Ratio of the spectral radiant or luminous flux reflected in a given cone, whose apex is on the surface considered, to that reflected in the same directions by the perfect diffuser identically irradiated. Symbol, $R(\lambda)$. *R. W. G. Hunt*

SPECTRAL REFLECTED RADIANCE FACTOR Ratio of the spectral radiance produced by reflection by a sample to that produced by the perfect diffuser identically irradiated. Symbol, β_s. *R. W. G. Hunt*

SPECTRAL SENSITIZATION (also Optical sensitization) A chemical treatment that increases the response of silver halide crystals of a photographic emulsion to wavelengths of light longer than the natural sensitivity. Spectral sensitization is accomplished by organic dyes that absorb to

the surface of the silver halide crystals. The dye becomes excited by the absorption of light energy and transfers the energy to the crystal, forming a latent image.

The chloride, bromide, or iodide salts of silver are sensitive to light but respond only to violet, blue, and ultraviolet radiation. These wavelengths of radiation have sufficient energy to eject a photoelectron from the halide ion of the silver salts of the photographic emulsion layer. Green, yellow, orange, and red light have less energy, so silver salts have almost no response to these colors of light. Photographic films and papers made with pristine silver halides are color-blind to most of the visual spectrum.

A chance observation by Hermann Vogel in 1873 provided the clue for increasing the limited spectral response. While testing dry collodion plates, which the manufacturer had secretly treated with a yellow dye to reduce halation, Vogel noted that the plates were green sensitive. After some clever detective work, Vogel established that the yellow dye was responsible for the extended spectral sensitivity. This major advance was rejected by some of the noted photographic authorities who were unable to sensitize the gelatin dry plates that contained less iodide than the collodion plates.

The first spectral sensitizer for green light was eosin, a dye discovered by J. Waterhouse in 1875, but the related dye, erythrosin, was the first to find commercial use. Such dyed photographic materials were said to be orthochromatic (*ortho-,* meaning correct), that is, sensitive to ultraviolet, violet, blue, and green but still insensitive to red light. In 1884 Vogel found that a blue dye, cyanine, was a weak sensitizer for red light, but there would be many human lifetimes of work and devotion before suitable dye sensitizers would make practical panchromatic sensitization (*pan-,* meaning all) possible for all colors.

Present-day spectral sensitizers are of the polymethine type that are vastly different from the early dyes. Cyanine dyes, for example, consist of an alternately single and double bonded chain of carbon atoms that are attached at each end to ring structures having nitrogen atoms, one of which is positively charged. This might be represented in a simplistic schematic as

| Ring structure containing pentavalent nitrogen (+) | $-CH = (CH\text{-}CH=)_n-$ | Ring structure containing trivalent |

where $n = 0, 1, 2, 3, 4, 5$.

Many, many variations of cyanine dye structures have been made. These include the important merocyanines having an equal number of carbons in the chain that is connected to rings at each end, one containing a nitrogen, the other a sulfur or oxygen atom.

The complex molecular structure of sensitizers is necessary because the dye must be capable of two energy states: (1) a ground or unactivated state, and (2) an excited state after absorbing light energy. The efficient dye molecule requires atoms such as nitrogen, which can exist in different states, joined by a chain of carbon atoms whose alternate single and double bonding provides a means to transfer or resonate a quantum of electronic excitation energy throughout the molecule. In a cyanine dye with a nitrogen atom in the ring of atoms at each end of the chain, one nitrogen is electron attracting, the other electron donating. The two nitrogens can, however, rapidly exchange their condition. A dye sensitizer exists in a state of shifting electronic character, a state capable of being excited when light energy is absorbed.

After excitation, the dye molecules, which often exist in aggregated form on the surface of the silver halide crystal,

transfer an electron to the crystal. A latent image is then formed in the same manner as when the crystal is struck by actinic radiation. Thus, light absorbed by the sensitizer on the crystal surface results in spectral sensitization of regions beyond the normal effective light absorption of the silver halide. Almost all sensitizers cause a decrease in sensitivity in the region of natural light absorption, but efficient dyes more than compensate for the desensitizing action. *G. Haist*

Syn: *Optical Sensitization.*

See also: Dye Sensitizer; Emulsions; Sensitizing Dyes; Spectral Sensitivity.

SPECTRAL TOTAL RADIANCE FACTOR The sum of the spectral reflected and the spectral luminescent radiance factors. Symbol, $\beta_T(\lambda)$. *R. W. G. Hunt*

SPECTRAL TRANSMITTANCE Ratio of the spectral transmitted radiant or luminous flux to the incident flux under specified conditions of irradiation. Symbol, $\tau(\lambda)$.
 R. W. G. Hunt

SPECTRAL TRANSMITTANCE FACTOR Ratio of the spectral radiant or luminous flux transmitted in a given cone whose apex is on the surface considered to that transmitted in the same directions by the perfect diffuser identically irradiated. Symbol, $T(\lambda)$. *R. W. G. Hunt*

SPECTROGRAM A *photographic* record of the electromagnetic radiation from a source dispersed (by a prism or diffraction grating) into a spectrum and collected by a sensitized material. A wedge spectrogram is a similar record made by attenuating the radiation across the spectrum perpendicular to the wavelength axis. When making a spectrogram, it is necessary to consider the output of the source, any attenuation that may be occurring in the system, and the response of the detector (the sensitized material). Spectrograms can be used to determine the characteristics of a source, an attenuator of some sort (such as a filter), or a detector, but only if the characteristics of the other two are known. *J. Holm*

Spectogram. Wedge spectrogram for a panchromatic film.

SPECTROGRAPH An apparatus used for dispersing and recording the electromagnetic radiation emitted by a source or transmitted or reflected by a substance. Spectrographs usually employ diffraction gratings, although some simple models use prisms. *J. Holm*

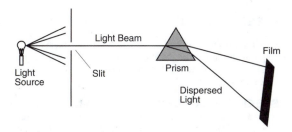

Spectograph. Schematic drawing of a simple spectrograph.

SPECTROGRAPHY A branch of the physical sciences involving the production, study, and analysis of graphical records of spectra, or spectrographs. *J. Holm*

SPECTROMETER An apparatus used for the measurement of wavelengths of radiation. *J. Holm*

SPECTROPHOTOMETER An apparatus that measures the amount of electromagnetic radiation present as a function of wavelength, especially in the visible region of the electromagnetic spectrum. Spectrophotometers are used to measure sources, or the reflectances or transmittances of objects (such as filters). Spectrophotometers may also use banks of narrow bandpass filters to select out wavelengths, whereas a spectrograph by definition disperses radiation using a grating or prism. *J. Holm*

SPECTROPHOTOMETRY The branch of spectrography where the primary concern is the amount of radiation present at different wavelengths (as opposed to the placement of emission or absorption lines in a spectrum, the shifting of spectral lines, etc.). *J. Holm*

SPECTRORADIOMETRY (1) Measurement of the absolute amounts of radiant flux at each wavelength of the spectrum. (2) Measurement of the relative amounts of radiant flux at each wavelength of the spectrum for self-luminous color stimuli. *R. W. G. Hunt*

SPECTROSCOPE An instrument used for visual examination of a spectrum. It consists of a slit, a prism or diffraction grating, and a telescope and wavelength scale to permit visual observation. *J. Holm*

SPECTRUM (1) A dispersion of some incident electromagnetic radiation, with the degree of dispersion depending on the wavelength and the device resulting in the dispersion, such as a diffraction grating or prism. (2) A graphical representation of the amount of electromagnetic radiation received by a detector in a spectrograph. *J. Holm*

SPECULAR DENSITY A measure of the absorption of light by a sample area where the sample is illuminated with light contained within a narrow angle and only the directly transmitted light is recorded. Such a measure is useful in predicting the behavior of a negative in printing with a condenser enlarger. *M. Leary and H. Todd*
See also: *Densitometry.*

SPECULAR REFLECTION Mirror-like reflection of light from a smooth surface such as polished metal, glass, plastic, and water. *F. Hunter and P. Fuqua*
Syn.: *Direct reflection.*

SPEECH MODE The idea that the human brain separately distinguishes speech from other sounds and processes it in a different part of the brain reserved for speech. The presence of a speech mode helps explain otherwise disparate observations about human hearing. *T. Holman*

SPEED See *Film speed; Paper speed; Lens speed.*

SPEEDLIGHT An early name for electronic flash, used to distinguish its shorter duration and action-stopping ability from the longer duration of flashbulbs. *R. Jegerings*
See also: *Electronic flash.*

SPEED OF SOUND The speed of sound is 1128 feet per second in air at sea level, room temperature, and 50% relative humidity; it varies with pressure, temperature, and humidity. *T. Holman*

SPEED VALUE (S_v) A number representing film speed in the additive system of photographic exposure (APEX), as in the equation:

$$A_v + T_v = B_v + S_v = E_v$$

J. Johnson

See also: *Additive system of photographic exposure.*

SPHERICAL ABERRATION See *Lenses, lens aberrations.*

SPIDER A device that attaches to the legs of a tripod to provide greater stability and to prevent the legs from folding when the tripod is lifted or moved. *L. Stroebel*

SPIDER BOX A conveniently located junction box that contains electrical receptacles for lamps and other equipment used in a studio or on a set. *W. Klein*

SPILL LIGHT Light from a source that travels in directions other than those principally intended. Sometimes spill light can be put to good use. For example, from a main light, spill light can illuminate a fill reflector; or, from a background light, spill light may serve as a kicker for the principle subject. However, uncontrolled spill light can cause numerous defects by lighting objects that need to be dark, by striking the lens to produce flare, and by illuminating extraneous objects in the studio which then may be seen reflected in polished metal or other shiny subject. Barndoors and snoots on the source, gobos near the subject, and hoods on the lens prevent these problems. *F. Hunter and P. Fuqua*

SPIRIT PHOTOGRAPHY Spirit photography can be considered as an early form of photomontage, where two or more images are superimposed to form a third image that is a composite. It consisted of photographs made by double exposing an image so that one of the images in the composite was thin and ghostlike, often an image of the spirit of a deceased loved one.

The movement began as early as 1861 by a Boston photographer named William Mumler and lasted for a number of years. Mumler claimed that while he was taking a picture of himself in a chair, an unexpected second image appeared on the developed photographic plate. The image was of a little girl apparently sitting in his lap. He identified her as a young relative who had died some twelve years earlier. This created considerable interest with the townspeople, and he continued to perform similar feats on a number of occasions, claiming that the extra figures in the photographs were actually images of spirit forms present in his studio. These forms were not visible to the human eye but were visible to the photographic plates in his camera. For a while this amazing phenomenon was accepted until suspicion arose when it was discovered that the spirit images were all of living people. Mumler was accused of photographic fraud and died in poverty in 1884. His photographs showed every evidence of having been produced by double exposure.

Mumler was imitated by many others, usually professional photographers both in the United States and in Britain. Almost without exception, these self-styled spirit photographers were convicted of fraud, and in many instances they even confessed to trickery and deception.

The Crewe Circle In 1908 a group of spiritualists in Britain, called the Crewe Circle, began to attract attention with their so-called, "psychic photographs." The circle was founded by William Hope in the small township of Crewe and gained world-wide attention by making psychic photographs for those who agreed to make a financial contribution to the Circle. Hope had a double-sided personality, one

being that of an honest man and the other a charlatan who used prayers and the singing of psalms as a cover-up for this fraudulent operation. Independent investigators, using several cameras simultaneously, easily exposed the whole operation as a scam.

From time to time this spirit photography phenomenon reappears. In the 1960s a photographer using a Polaroid instant camera claimed that he could capture his mental images on film. He did this by holding the camera in his lap, focused on himself, and after a long period of staring at the lens of the camera he would, with a jerk, trip the shutter. The jerk, he claimed, was a result of the mental image being projected into the camera. The images were a bit blurry, as one might expect with such pictures, he would explain. He apparently convinced himself and many others of his powers, including an editor for a major news magazine. When challenged and asked to perform his phenomenon under controlled conditions he agreed but failed completely after two days of mesmerizing observation on the part of the photographic scientists observing and recording the event. It became evident, after watching the photographer for long periods of time, that he was doing a sleight of hand; using the light directly behind and above him, he would project a portion of a slide hidden in his hands on the lens of the camera as he tripped the shutter. In spite of the photographer's failure and fraud he continued to convince others of his mental powers.

Spirit photography takes on various forms, some of them as recording of invisible energy fields (auras) and personality projections (astral projections), and psychographs (invisible hand writing), and even the alleged photographs of flying saucers. With the advent of electronic imaging it can be expected that new forms of spirit photography will emerge.

Books: Broecker, William, (editor), *International Center of Photography Encyclopedia of Photography.* Crown Publishers, New York: 1984; Eisenbud, Jule. *The World of Ted Serios.* William Morrow, New York: 1967. *R. Zakia*

SPLICING The joining together of two strips of motion-picture film, end to end, so that they form a single, continuous, projectable length. There are two types of splices in common usage.

 TAPE SPLICES Also called *butt* splices, since the film ends butt against each other and do not overlap. The film is cut along the frame line, between the images, and the separate strips are held together with thin clear plastic adhesive tape stretched across the cut. Splicing tape is easily removed and allows the editor to quickly change the cut as editorial refinement progresses. There are several types of splicing machines that hold the film ends in proper registration and cut film and tape to assure proper alignment and smooth travel through film handling equipment. The picture is always taped on both sides. Magnetic sound film is taped on the base side only and often with a white opaque tape, rather than transparent tape, which makes the splice easier to see.

 PERMANENT SPLICES While a splice that couldn't be changed would be inappropriate in the editing room, a tape splice might not be strong enough for laboratory printing procedures and, unless treated with great care, would be visible in the final print. Most commonly the original negative is prepared for printing with cement splices, also called *hot splices* since many splicers contain heating elements to help dry the cement. These splices involve overlapping the film strips slightly, scraping emulsion, coating the film base with a solvent called cement, and allowing the film to meld, while held in registration as the cement dries. Ultrasonic welding methods are also available as an alternative to cement splicing. *H. Lester*

SPLIT-DIOPTER LENS See *Lens types.*

SPLIT FOCUS Focusing a lens to achieve the best definition possible with a given aperture of subjects in two different planes within the depth of field of the lens. If the distance between the two subjects is greater than the depth of field, then a result may be achieved by means such as a split-diopter lens or camera tilt and swing adjustments. *S. Ray*

SPLIT FRAME In a sheet-film camera, such as a 4×5 camera, a means of making two or more small images on a single sheet of film. *R. Zakia*
See also: *Sliding back.*

SPLIT-IMAGE RANGEFINDER An optical rangefinder device having a bisected image in a horizontal direction (although other splits are used), the two halves of which come into coincidence when the correct object distance is set on the lens via a coupled rangefinder. The term is now exclusively used for the split image wedge used as a passive focusing aid in the focusing screen of many reflex cameras.
 S. Ray

Syn.: *Split-image rangefinder.*
See also: *Focus/focusing; Viewfinder.*

SPLIT SCREEN (1) By using a computer screen sizing box, the operator can adjust the computer screen so that two or more files or windows are open for inspection, modification, or transfer. (2) A projection area or screen divided into two parts, each showing a separately-projected image. Special split-frame or multiple-window slide mounts allow the photographer to place two or more transparency segments into separate windows within a single slide mount so that when the slide is projected the images are projected with a single projector. This technique is also used in television. (3) In motion pictures, two separate scenes or shots blended into one, as when a performer plays a dual role, two separate events are presented simultaneously, or full-scale and miniature sets are made to appear as one. A soft edge matte is often used for this purpose. *M. Teres*

SPLIT TONE A split tone is a tonal defect, or enhancement, depending on point of view, in which the color of a tone changes with the density of different image areas. It can be produced intentionally by incomplete toning of a black-and-white print. It may sometimes be the result of failure of the toning process. *I. Current*

SPOKING Distortion in a reel of film caused by loose winding of badly curled film. *H. Lester*

SPOOL A cylinder with a flange at each end, used for holding film, as in a 35-mm film cassette. The flanges serve to keep the film aligned and to help protect the film from accidental exposure, although the outer shell of a cassette (with 35-mm film) or a covering of opaque paper (with roll film) is required to provide daylight-loading protection. The cylinder is normally hollow for the insertion of spindles. with a cross-bar in one end that can be engaged by a rewind mechanism. The takeup spool in 35-mm cameras is typically an integral part of the camera and has a slit or clip to hold the leading end of the roll of film. *P. Schranz*
See also: *Reel.*

SPORTS PHOTOGRAPHY Sports photography traditionally stills the action moment, preserving the athleticism of the subject, the determination, the all-out effort, or the unexpected defeat. A sports photograph also may capture a facial expression or some body language that visually expresses player or spectator reaction to some sports action.

Virtually any photograph taken during a sporting event, the practices leading up to it, or its aftermath qualifies as a

sports photograph. Virtually anyone who can aim a camera at a sports subject can take a sports picture. Knowledge of the particular sport greatly improves a photographer's chances of making good photographs of its action. So does knowledge of action and how the camera sees it.

Today the camera of choice for almost all amateur and professional sports photography is the 35-mm single-lens reflex (SLR) camera. Such options as shutter-speed-priority automatic exposure and motor drives allow sports photographers to take a rapid-fire series of stop-action shots around an important sports moment. Improvements in high-speed films enable sports photographers to use the long focal-length lenses they need for certain events, like race car driving, without giving up the sharpness they require for reproduction and enlargement.

Choosing the right vantage point can evolve from following a sport or from reading books and magazines that suggest the camera positions and shutter speeds for various sports. A shutter speed of 1/500 second usually will freeze action, 1/1000 second will stop the action of runners' legs and arms.

For more interpretive action shots, a slower shutter speed combined with a technique called *panning* will capture a sharp racing car, for instance, against an artfully blurred background. *Zone focusing* permits the photographer to prefocus on a portion of a soccer field or ice hockey rink, for example, in anticipation of the kind of sports actions that never truly can be predicted.

Professional sports photographers often wear more than one 35-mm camera around their necks so that they can shoot more than one type of film or use more than one focal-length lens. Two cameras, with the same lens, can cover for each other and prevent missed opportunities. For hard-to-photograph events like downhill skiing, professional sports photographers augment telephoto coverage with cameras, able to be tripped remotely, positioned at critical points in the course.

Sports photographers have been known to hang their cameras from the rafters and, then, get down to ground level with the help of kneepads. They have a way of getting to a sporting event early, photographing the early rounds, and catching the early hurdles when competitors bunch up. They catch the very start of action. When sports action gets confusing, they'll sometimes follow a single player instead of the ball or the puck.

Position may not be everything in sports photography, but it definitely can provide the winning edge. Pros know how to pick the best camera position for the particular sport and setting—and how to change that position to improve picture variety.

Amateur sports photographers should choose a seat away from any barriers, above the plexiglass barrier at the ice rink, for instance. To improve camera position temporarily, amateur photographers might ask an usher politely and then take a few shots. Photographs of practice sessions taken from close positions can augment pictures of the sporting event taken from greater distances with 180 mm to 500 mm lens.

Although professional sports photographers enjoy using the best equipment available, they agree that long lenses and motor drives don't make great sports photographs. The people who use them do. They advise those who would like to turn pro someday to work their way up through community newspapers. *K. Francis*

SPOT DIAGRAM Diagram obtained by tracing the paths of a large number of rays from the same object point through a proposed lens design and recording where each ray intersects an image plane. The spot diagram represents the spread function, and its shape depends upon the residual aberrations. A perfect lens would give a spot diagram identical to the Airy pattern. Spot diagrams are usually generated by computer-aided design techniques and help select an optimized design. *S. Ray*

SPOTLIGHT A compact lighting unit typically consisting of an enclosed housing containing a light source, a curved reflector, and a lens, mounted on a stand and designed to project a controlled beam of light onto a subject. The light source is fixed at the principal focal point of the reflector, and the two are moved together toward and away from the lens to alter the concentration of the emerging beam of light. Since an ordinary lens would be unduly thick and heavy, it usually conforms to the Fresnel design of concentric ridges in a basically flat disk. The housing is designed to prevent the buildup of damaging heat by providing the ventilation and radiation. Additional control over light distribution is available with snoots, barndoors, diffusors, and other attachments that can be placed in front of the lens. Some photographic lamps have a reflector built into the back of the bulb, but this type of unit is not adjustable, and even the ones identified as having spot, as distinct from flood, distribution do not produce a sharply defined spot of light.

The spotlight principle is used in some camera electronic flash units where the angle of distribution of the light can be altered (or is altered automatically) to correspond to the angle of view of different focal length lenses or different focal length settings of a zoom lens. Such a unit is sometimes referred to as a *zoom flash*. *R. Jegerings*

See also: *Barndoors; Grid spot; Light sources; Snoot.*

Spotlight. Illuminance distribution patterns of a Fresnel-lens spotlight with the lamp in three different positions: (A) spot position, large lens-to-lamp distance; (B) intermediate position; and (C) full-flood position, small lens-to-lamp distance.

SPOTLIGHT ATTACHMENTS An auxiliary device that can be added to an electronic flash unit to concentrate the light into a smaller angle of distribution. *R. Jegerings*

SPOT METER A reflected-light exposure meter that has a narrow angle of acceptance, typically between 1 and 8 degrees, as distinct from meters having wider angles of acceptance such as averaging meters and center-weighted meters. Spot meters allow photographers to measure the

luminance in a small subject area from a distance, a feature that is especially useful when using the zone system. A circle in the viewfinder indicated the area being measured

J. Johnson

Syn: *Telephotometer.*

See also: *Exposure meter; Zone system.*

SPOTS Black or white spots occur on photographic negatives or prints as a result of a variety of causes. Black spots on a negative will result in white spots on a print, and vice versa. Chief among the causes of spots are dirt, dust, and other particles on the surfaces. Contamination from organic or inorganic particles can also cause colored spots or spots of higher or lower density than the surrounding area. Pinholes in protective coverings can cause black spots due to light exposure. These would be white spots in the case of reversal materials. In rare instances latent black or white spots can exist in the photographic material prior to exposure and processing. They may also be the result of handling or the effect of contamination after a period of aging. *Spotting* refers to the act of retouching or correction of spots on negatives or prints by the photographer. Since retouching is time-consuming and costly, and not always effective, care should be taken to avoid the presence of dust, dirt, or other contamination.

The term *spot* is also an abbreviation of *spotlight,* a source of illumination.

I. Current

SPOTTING Spotting refers to correction of local density or color defects in prints, usually as the result of dust or other materials on the sensitized surface at the time it was exposed or on the processed film when it was printed. However, the defects requiring correction may have been due to retouching work done on the negative or transparency, or even to unwanted objects in the scene at the time the film was exposed, such as scraps of paper or gum wrappers. It is generally preferable to correct for as many of these problems as possible before exposing the print.

BLACK-AND-WHITE PRINTS Black-and-white prints are usually spotted with a small brush loaded with a diluted spotting dye that is available in various hues for work on neutral black, blue black, and sepia images. With these spotting "colors," the surface sheen of the print is not affected after they have been dried. Spotting can also be done with opaque pigments that are moistened as required. This type of spotting can usually be seen on the surface by reflected light, however, especially on glossy print surfaces. Minor spotting of prints with a matt or semi-matt surface can be accomplished by means of a lead pencil using a technique similar to that for retouching of negatives. An advantage of opaque pigments is that dark spots can be lightened to match the surrounding density.

Dark spots may be bleached out and then spotted with diluted black dye. Small spots may also be removed with an etching knife, although the surface will be disturbed. This will be less apparent with matt or semi-matt prints. The sheen may be corrected to some extent by applying a small amount of oil or wax.

Although not technically spotting, large areas of a print may be modified by airbrushing techniques. With an opaque colorant, spots will be obliterated in airbrushed areas.

COLOR PRINTS The principles of spotting of color prints are generally similar to those for black-and-white, although they are more complex because of the need to balance the three dye images. A wet-brush technique using cyan, magenta, yellow, or combinations of these dyes in solution is generally used for spotting of color prints, especially in areas not approaching maximum density. In darker areas, the neutral dyes such as those used for black-and-white may also be used.

If the prints are to be used for viewing only, the choice of dyes is not critical, providing the spotting is done under the illumination that will be used for viewing the prints. Because this condition may not always be relied upon, the absorption characteristics of the dyes should match those forming the three colored images of the print. This is especially important when the print is to be reproduced photomechanically. Dye transfer prints can be spotted with the same dyes used for making the print.

While less suitable to spotting than to treating larger areas, the dry dye technique may also be used. The dye from the dry-dye cake is taken up by a small cotton swab and applied to the area to be corrected until the desired effect is achieved. Then the print is steamed to set the dye, as in retouching. This procedure may not be successful with small clear spots in the print.

I. Current

SPRAY ADHESIVE Spray adhesive is very similar to a one-coat cement, which is a weak bonding tacky cement, such as rubber cement. Most spray cements are low tack, which allows the mounted material to be removed and repositioned. However, some spray cements may bond permanently if they are allowed to stay in contact for long periods of time. Because of the chemical nature of the spray adhesives, they should only be used with adequate ventilation. Cover the surrounding areas, such as walls, floors, and counter tops with a protective paper covering to make clean-up easier.

M. Teres

SPRAY BRUSH In electronic imaging, to add a specific color to designated image areas, analogous to manual airbrushing with a colorant.

L. Stroebel

SPRAY PROCESSING A method of supplying fresh solution (especially developer) to a photographic material by forcing the solution through a nozzle in a fine mist, directed forcefully against the material being processed. Used in some rapid-access development techniques.

L. Stroebel and R. Zakia

SPREAD FUNCTION (1) A curve representing the distribution of light or density in the image of a point (point spread function) or line (line spread function). Points and lines cannot be imaged precisely because of light spread due

Spread function. Functional relationships in imaging. The linear imaging of a sinusoidal object. FT, Fourier transform pairs; o(x), object function; s(x), spread function; i(x), image function.

to diffraction and aberrations of the lens and light scatter in photographic emulsions. Spread function may also refer to image degradation produced by focus error, image motion, and other factors that affect image definition. Spread functions for separate factors can be summed to produce a quantitative record of the image degradation for the system. There is an inverse relationship between spread function and image definition. (2) Curve of intensity against distance in the image of a theoretical point source (point spread function) or an infinitely narrow line (line spread function). In the former it is a cross section of the Airy pattern. Because of diffraction and residual aberrations, a practical system cannot give an ideal image, and the spread function is a measure of degradation. Other elements in an imaging system, such as a photographic emulsion, development, defocus, vibration, and atmospheric effects, all contribute individual spread functions to the final total. The modulation transfer function is the representation of the spread function as shown by the degradation of patterns of sinusoidal intensity variation of different frequencies. Mathematically it is the Fourier transform of the line spread function, and if this is asymmetric as in the case of a lens with coma, there is a nonlinear phase shift of the sinusoidal components at various frequencies, which is expressed as the phase transfer function component of the optical transfer function. *L. Stroebel and S. Ray*

See also: (1) *Modulation transfer function;* (2) *Chemical spread function.*

SPROCKET-HOLE EFFECT (1) See *Photographic effects.* (2) Streaks on processed film associated with perforations. Such streaks are an indication of an uneven movement of developer across the emulsion surface during agitation. *L. Stroebel and R. Zakia*

SPROCKET HOLES See *Perforations.*

SPURIOUS RESOLUTION In a test of a lens or photographic system using a bar-chart target, the appearance of detectable lines but fewer than expected. Such a result is usually caused by a focusing error. *H. Todd*

SPUTTERING See *Lenses, lens coating.*

SPY CAMERA See *Camera types.*

SQUARE WAVE A waveform where the characteristic measured takes on two and only two values, usually with the amount of time or space at each value being equal. An example of a square wave is found when a set of dark bars is placed against a light background. The luminance abruptly changes periodically from a high level to a low level; as distinct from a sine wave which involves a gradual change. A

Square wave.

resolution test target consists of a set of spatially varying square waves. *J. Holm*

SQUARE-WAVE TARGET An optical test pattern in which the luminance changes abruptly between maximum and minimum values, as occurs with a bar resolving-power target. *L. Stroebel*

See also: *Sine-wave target.*

SQUEEGEE In photography, typically a rubber blade with a handle used for removing water or other liquid from the surface of processed photographic materials. An air squeegee, or air knife, consisting of a jet of air from a slit aperture close to the surface, is used for this purpose in some automatic processors. *L. Stroebel*

SQUEEZE/UNSQUEEZE In motion pictures, the process of filming with an anamorphic lens that compresses the image horizontally and then projecting through a similar lens to appropriately expand the image horizontally, resulting in a wide-screen presentation. The projected image has a greater horizontal-to-vertical aspect ratio than that of the film's image area. *H. Lester*

See also: *Lenses, anamorphic.*

STABILIZATION, IMAGE Refers to various techniques and systems principally to reduce the effects of camera shake or relative movement of camera and subject. It is also called optical stabilization.

Reduced resolution due to camera shake by the user is reduced by use of suitably short exposure times, a tripod, cable release, delayed action, raised reflex mirror, and waiting until environmental factors such as wind and traffic vibration are minimal. For hand-held cameras, however, especially motion pictures and video types, user shake must be minimized while the visual effects of a moving camera platform are retained. One arrangement, sold commercially as the Steadicam, uses a system of balanced and sprung arms, pivots, and counterweights to dampen localized movements from the operator, who wears the device via a special vest and harness. A video monitor allows accurate viewfinding while the camera is on the move and the eyepiece is inaccessible.

Other methods, particularly for binoculars, utilize internal gyroscope stabilation by inertia to movement, or monopods with a long balance arm.

An electronic image stabilizer in video cameras works by passing the video signal into a solid state frame store memory, and the current field is compared with the previous stored one. The common portion of the two images is then electronically enlarged to full size, as shake losses tend to affect the periphery of the image.

Optical techniques include the use of a pair of prisms servo-coupled to a built-in gyroscope. Sudden camera movements that produce high-frequency image vibrations are compensated for by rotational movements of the prisms to refract the ray paths to correct for the image shift. Zoom lenses may use such systems. A gyro stabilized prism at the optical center of a lens system has also been successful. A compact system for long-focus lenses uses two accelerometers to control and oscillate an optical compensator at the rear of the lens by means of piezoelectric actuator.

Certain camera systems, such as rotating-prism high-speed cine cameras, rotating panoramic cameras, flow cameras, and peripheral cameras, as well as aerial-reconnaissance cameras, use movement of the film during exposure to compensate for subject movement. The film is moved at a suitable velocity behind a slit in the focal plane so that it matches the image velocity in the same direction because of subject movement or camera movement. The prism in the high-speed

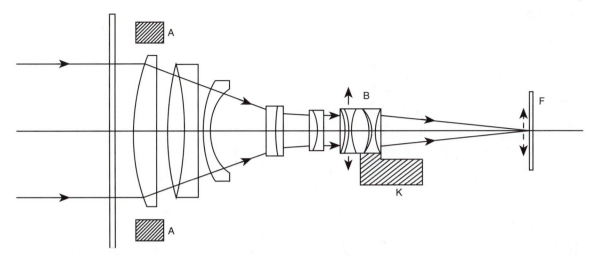

Image stabilization in a long focus lens. A, accelerometer; B, optical compensator block; K, prism actuator; F, film plane and unstabilized image movement.

camera serves to move the image along the film surface at a matched velocity while the film travels at high speed continuously through the camera. Subject and film velocities are related via the system magnification. S. Ray

Syn.: *Optical stabilization.*

See also: *Gyro stabilizer; Steadicam.*

STABILIZATION PROCESS Military, news, and law enforcement agencies often need to have photographic prints produced as quickly as possible. Water and working space are commonly in short supply, but the prints needn't last long. This application is well served by the stabilization process, which yields damp-dry black-and-white prints in 15 to 60 seconds.

Stabilization papers have developer crystals incorporated in their emulsions or surface coatings. Development is performed in the first bath of a roller transport processor that contains a concentrated alkaline-sulfite activator, such as sodium hydroxide with sodium sulfite. The paper then passes directly into the stabilizer, the second bath in the processor. Because the print will not be washed to remove substances remaining after processing, the stabilizer must not only render the image stable in light, but also convert all undeveloped silver halides to colorless, transparent compounds. In addition, the unreacted stabilizer residue must not cause staining or oxidation, nor may it damage the silver or the gelatin of the print, and it should air dry tack-free. Common stabilizers of manageable toxicity levels are based on sodium thiosulfate, thiourea (used by A. Bogisch for washless processing in 1893), or ammonium thiocyanate. Antioxidants, hardening agents, and compounds that protect the image from degeneration caused by residual thiocyanate are added to the basic stabilizer.

Stabilized prints are chemically active; they may last from several weeks to a year or more, depending upon storage conditions. The prints are sensitive to humidity, heat, and light and should be kept away from fully processed film and prints. After their use for photomechanical reproduction or briefing purposes, they may be reprocessed for permanency by fixing and washing conventionally. H. Wallach

STABILIZERS Emulsion stabilizers, usually organic molecules with sulfur or nitrogen present, are thought to restrain the continued chemical ripening of the silver halide emulsion after coating. The mechanism of action is obscure.

Some stabilizers may form insoluble silver compounds of less solubility than the silver halides. Others may inhibit the growth of the latent image, especially partially formed silver specks. Metal ions, such as cadmium or mercury, also act to limit the changes of the emulsion with time.

Stabilizing agents that form soluble or insoluble compounds with silver ions are used in processing baths. These convert unused, undeveloped silver halide into compounds that are relatively inert to heat, humidity, or continued exposure to light. Stabilized photographic materials need not be washed in water, but the image is not permanent. G. Haist

See also: *Emulsions.*

STAFF PHOTOGRAPHER A photographer who is a full-time employee of an organization, as distinct from a photographer from outside the organization who might perform the same functions as a freelance photographer, a contract photographer, or an independent professional photographer. B. Polowy

STAIN In black-and-white images, especially prints, an unwanted hue, often yellow caused by use of exhausted developer, contamination, or by incomplete fixation or washing. In color prints, a faint hue, such as pink, in areas that should be white. Analogous to fog. L. Stroebel and R. Zakia

STAINING Staining indicates a density increase of an image, or part of an image, above that of the original tone. It happens concurrent with a discoloration of the original tone, for example, from a light neutral gray to a yellow or brown tone. It is technically the opposite of fading, and may occur in both black-and-white and color photographs. Most noticeable in the highlight areas, it is often caused in black-and-white negatives and prints as a result of incorrect fixing or insufficient washing. It may also be caused by external sources of reactive chemicals. In all cases the image silver in highlight areas forming delicate gray areas in a continuous tonal range is converted to silver salts that are yellow or brown, and so trigger the stain formation. In color photographs, stain formation is most often precipitated by exposure to light that results in residual coupler print-out. Coupler print-out occurs fairly evenly across the whole image. It, too, is accompanied by discoloration, which is most visible in delicate white highlights that may turn yellow. K. B. Hendriks

See also: *Image permanence.*

STAINLESS STEEL An alloy of iron that is resistant to corrosion and chemical attack, used in the construction of photographic sinks, tanks, trays, etc. *L. Stroebel*

STAND A generally sturdy support for a camera, projector, television monitor, or other equipment, sometimes more specifically identified to indicate its intended use as, for example, camera stand, studio stand, projector stand, or audio-visual stand. Camera and studio stands typically have a tall, heavy-duty center pillar mounted on a three-wheel platform that can be locked in position, with a counter-weighted camera-support arm that moves up and down the pillar and an attached tray to hold accessories. Four-wheel stands for projectors and other audiovisual equipment commonly have additional shelves or closable compartments for the storage of equipment and are sometimes identified as carts, projection carts, etc. *L. Stroebel*

See also: *Camera support.*

STANDARD (1) A specification, test method, recommended practice or glossary of terms approved and published by a recognized standardizing body. (2) The basis of a set of measurements. The standard of length—the meter—was formerly the distance between two marks on a platinum bar kept in Paris. Now the standard of length for the meter is the distance occupied by a specified number of wavelengths of a specified color of light. The standard for light emission—the candela (formerly candle)—is the light emitted by a black cavity of specified size at a specified fixed temperature. (3) A publication of the American National Standards Institute (ANSI) or the International Standards Organization (ISO), which describes methods of photographic processing, film and paper dimensions, testing procedures, and so on. (4) The structure in a view camera that holds the front or back of the camera in the proper position on the runner. *P. Adelstein and H. Todd*

STANDARD DEVIATION (σ, s) The most useful measure of the random (chance-caused) variation within a set of data. It is the square root of the average of the squares of the deviations of the individual numbers from their mean (arithmetic average).

The basic formula is

$$\sigma = \sqrt{\frac{\Sigma (X_i - \mu)^2}{N}}$$

where σ is the standard deviation, Σ is the sign of summation (i.e., add all the following items), X_i includes all the members of the data set, μ is the population average, and N is the number of items. This formula implies that all possible members of the population are included.

Since the whole population can rarely be tested, the formula for the standard deviation found from a limited sample is slightly modified to read

$$s = \sqrt{\frac{\Sigma (X_i - \bar{X})^2}{n - 1}}$$

Now, s is the sample standard deviation, an approximation to the population standard deviation, \bar{X} is the sample mean, and n is the number of items in the sample. The value of n is reduced by one in the calculation since theory and experience show that without this correction the sample standard deviation is smaller than the population value.

AN EXAMPLE OF THE COMPUTATION. Five temperature measurements of a processing bath—75°, 77°, 76°, 74°, and 75°—give a mean of 75.4°, and the following table:

$(X - \bar{X})$	$(X - \bar{X})^2$
0.4	0.16
1.6	2.56
0.6	0.36
1.4	1.96
0.4	0.16
	5.20

The value 5.20 ÷ 4 = 1.30; $\sqrt{1.30}$ = 1.14 or, rounded off, 1.1°F, the value of the sample standard deviation. Note that in the calculation of s the mathematical sign of the difference $X - \bar{X}$ is irrelevant, and that the s-value has the same unit as the original data.

SIGNIFICANCE OF s If two conditions are met, the value of s is a good approximation to the population standard deviation σ and thus is a valuable measure of the variability of the data set. These conditions are: (1) s is computed from a representative sample; i.e., the sample is properly selected and evaluated; (2) differences among the members of the population are caused by chance and not by any factor other than chance. Although both of these requirements are difficult to meet, they are often sufficiently well approximated. They can be tested by taking a large sample and plotting the data to see whether or not the pattern comes close to that of a normal distribution. If it does, then the following statements are true: about 68% of all the population data will lie between ±1s from the mean; about 95% within the ±2s interval; about 99.7% within ±3s.

Referring to the temperature example above, if the data were properly collected and if the temperature in the bath varied only by chance, then the following inferences could be made: about 68% of all the temperature values lie between ±1.1°F from the mean of 75.4°F, or between 74.3° and 76.5°F; about 95% lie between 73.2° and 77.6°F, and 99.7% between 72.1° and 78.7°F.

APPLICATIONS

Conformance to Specifications The size of the process standard deviation must always be much less than the variation allowed by specifications. For example, suppose that processing directions call for a temperature of 75±$^1/_2$°F. If the standard deviation is $^1/_4$°F, then the allowable temperature difference is 2 s, and 95% of the bath temperatures will fall within the specified range but only if the process temperature is exactly centered on 75°F. Even then, 5% of the temperatures will fall outside the requirements. Only if the s value is less than 1/2 will the temperature error be less than 1 in 100 if the average is precisely on target. Clearly, process variation and specifications must be closely related.

Control Charts When a process is being monitored, successive measurements of the process performance are often plotted against time in order to detect undesired results. One method involves a graph showing the process mean and limit lines set at distances based on the process standard deviation. If ±3s limits are used, 99.7% of the data from an unchanged process will fall within the limits, and only 0.3% (i.e., 3 in 1000) will fall outside. Thus, if the decision is made that the process is awry when a point falls outside the lines, that decision will be in error infrequently. It is impossible to set the lines so far apart that *all* measurements from an unchanged process will be within the limits; thus, some risk of error is always present.

Tests of Hypothesis Many experiments are performed to see whether or not a change in manufacturing or other conditions causes a change in the results. If the measured exposure index changes to 110 from a previous mean of 100, for example, the apparent increase of 10 must be compared with the process standard deviation. Only if the s value is much less than 10 is it safe to suppose that an increase in the index has actually occurred. Many kinds of hypothesis tests are

possible, depending on the process being tested and the nature of the experiment. *H. Todd*

See also: *Gaussian distribution.*

STANDARD ILLUMINANT A A tungsten filament lamp burning at a color temperature of 2855.5 K. This standard illuminant is typical of tungsten lighting. *J. Holm*

STANDARD ILLUMINANT B Same as standard illuminant A, but using a liquid filter to raise the color temperature to an approximation of sunlight, 4874 K. *J. Holm*

STANDARD ILLUMINANT C Same as standard illuminant B, but approximating overcast skylight, color temperature 6774 K. *J. Holm*

STANDARD ILLUMINANT D5500 A light source with a specific spectral energy distribution approximately equivalent to a mixture of sun and blue sky with a color temperature of 5500 K. This illuminant is the standard *daylight* illuminant, although it differs slightly from the Mean Noon Sunlight standard. *J. Holm*

STANDARD ILLUMINANT D6500 A light source with a specific spectral energy distribution approximately equivalent to a mixture of sun and blue sky with a color temperature of 6500 K. This illuminant has largely replaced standard illuminant C because it has a spectral energy distribution which more closely matches that of actual daylight, especially in the blue end of the spectrum. *J. Holm*

STANDARD ILLUMINANT D7500 A light source with a specific spectral energy distribution approximately equivalent to a mixture of sun and blue sky with a color temperature of 7500 K. This illuminant approximates north sky light. *J. Holm*

STANDARD ILLUMINANT E An illuminant that emits equal amounts of energy at all wavelengths of interest. This illuminant is generally used in the hypothetical sense, although it is possible to construct a close approximation using filters. *J. Holm*

STANDARD ILLUMINANTS Light sources whose spectral energy distributions are specified in standards literature. These light sources are preferred whenever a standardized type of illumination is required. Color measurement schemes are also generally based on the standard illuminants. *J. Holm*

STANDARD LENS See *Normal lens.*

STANDARD LOGARITHMIC NOTATION See *Appendix F.*

STANDARD NEGATIVE A negative that has appropriate qualities for a given application, such as comparing the images produced with different printing materials, testing color filtration for color printing, and quality control monitoring. *L. Stroebel*

STANDARD OBSERVER See *American Standard Observer.*

STANDARD OPERATING PROCEDURE (SOP) A normal, broadly accepted sequence that attends to the safe, accurate, and repeatable operation of equipment. For example, it might include a well ventilated and secure environment, chemical preparation in accordance with manufacturers' material safety data sheets (MSDS), an orderly start

up to include densitometer-checked test strips as necessary, periodic checks on process controls, and shut-down, clean-up, and chemical disposal, once again conforming to material safety data sheet specifications. Densitometers and other devices may require calibration, and electronic studio flash equipment, for example, must be operated in a strict sequence. *H. Wallach*

STANDARD SOURCES Light sources specified for use in colorimetry and defined by relative spectral power distributions. *R. W. G. Hunt*

See also: *Color; Colorimetry; Illuminant.*

STANDARDS (PHOTOGRAPHIC)
IMPORTANCE OF STANDARDS In today's complex society, all industries and technologies must have a code of written and approved standards and specifications. It is absolutely essential if the products of this technology are to be widely used and are to make productive contributions. Such standards are required not only on the national level, but with the importance of world trade, they are equally important on the international level. In the field of photography and imaging, standards take several forms.

1. *Specifications.* The interchange of photographic materials and equipment is the most obvious benefit to the general consumer of photographic materials. The resulting problems when there is an incompatibility in a media-equipment system were all too apparent with the 1980s Beta-VHS incompatibility in videocassette recording. This caused tremendous financial loss and inconvenience to the consumer, the retailer, and the manufacturer. The issue was finally resolved in the market place after these losses occurred, but they would have been avoided if industry standards had been written and adhered to.

 As with videocassette recording, every photographic application requires functioning of media in various types of equipment and their respective dimensional tolerances must be specified. For example, amateur 135-size film made in the United States must operate in 135 cameras made in Japan and also be capable of being processed in equipment made in Germany. Similarly, 35-mm motion picture negative film manufactured by one company must be capable of being exposed to positives manufactured by another on printers made by a third.

 Specifications on the sizes and dimensional tolerances of photographic media exist for all the major uses. However, in addition to sizes, format is also critical. Examples in the photographic field are the location and width of sound tracks in motion picture films or the positioning of images in microfilm. Fortunately, the photographic industry has a good track record in avoiding incompatibility problems through standardization.

 The dimensional tolerances and formats referred to above are one form of product specification. Media or equipment also must satisfy minimum performance requirements if they are to meet specific standards. Such specifications deal with product behavior under defined conditions, or passing requirements of physical or chemical tests. Examples are specifications for the purity of photographic chemicals, scale markings for photographic lenses, and the classification of photographic films for permanence characteristics.

2. *Test Methods.* Many specifications include minimum requirements when materials are subjected to detailed test procedures. These procedures may either be part of the specification itself, or, if they are used in several documents, they may constitute a separate standard.

 A well-known and widely used property is film speed. The designation of ISO speed (agreed upon by the Inter-

national Organization for Standardization) is based on a very specific test procedure. This enables consumers to compare film speed of products made by different manufacturers with the assurance that the films are evaluated in the same manner. Other examples of standardized test methods are the determination of photographic density, flash guide numbers, residual hypo in processed film, and the stability of color images.

3. *Recommended Procedures and Standard Practices.* A third category of photographic standards includes the procedures recommended for proper performance or behavior. Examples are illumination conditions for viewing color transparencies, screen luminance for motion picture theaters, and storage conditions for film, prints, or plates. These types of standards are very useful in that they provide the user with the latest technical information, which has been digested and approved by experts in the field. The user thereby is freed of the necessity of keeping current with the technical literature and deciding which recommendations to follow when they conflict.

4. *Nomenclature and Definitions.* It is essential that terminology used within a technology be consistent, clear, and conflict neither within nor outside the particular industry. An example of how this is accomplished is the glossary of terms used to rate permanence of photographic materials and the definitions standardized in information management.

AMERICAN NATIONAL STANDARDS INSTITUTE

Role With the vast number of standardizing bodies in the United States, it was recognized early in this century that a coordinating body was needed. Accordingly, in 1918, a national organization was formed called the American Engineering Standards Committee. Subsequently, the name was changed to the American Standards Association (ASA), then the United States of America Standards Institute (USASI), and, finally, in 1970, to the American National Standards Institute (ANSI). There are several salient points that should be recognized about ANSI.

1. ANSI is the umbrella organization in the United States. It has the sole authority to designate a document as a national standard.

2. ANSI has established specific procedures for input from interested organizations and individuals, openness of discussion, the balloting process, and requirements that a consensus has been achieved among the parties involved. Any organization or individual with a direct and material interest in the subject matter has a right to participate in ANSI activities. Documents are only accredited by ANSI as national standards of the United States when consensus has been achieved. This is determined by written ballot, and all ballots must be considered by the working groups and committees involved. Consensus is defined as more than a majority but not necessarily unanimity.

3. As the national coordinating body, ANSI is the official United States representative to the International Organization for Standardization (ISO) and to the International Electrotechnical Commission (IEC). ANSI delegates to ISO and IEC meetings represent the United States and not a particular company, organization, or society.

4. ANSI is a voluntary organization. Professional societies, technical societies, and trade associations are encouraged to submit their standards to ANSI for processing as national standards, but there is no requirement to do so. However, unless these documents are submitted, they are not considered national standards.

5. ANSI is not a U.S. government body. However, government bureaus and agencies participate in standardizing activities, along with industry, consumer groups, and individuals.

6. ANSI itself does not write standards. It approves standards provided its guidelines are followed. The actual document preparation is discussed below.

Governance ANSI photographic standards are prepared by either of two methods: (1) accredited standards committees or (2) accredited organizations.

1. *Committees.* An accredited standards committee (ASC) is a group accredited by ANSI for the specific purpose of preparing standards to present to ANSI for processing as national documents. An ASC consists of a secretariat and the committee membership. The secretariat is frequently a trade organization that provides all the required administrative, legal, and financial backing. This includes distributing ballots, maintaining rosters, assuring that established procedures are followed, and providing the contact with ANSI.

 Committee membership includes manufacturers, government agencies, and consumers who have an interest in the subject matter and agree to participate. Membership is open, although it may be subject to a committee vote. However, it is very important that there be a balance of interests and no domination by a single interest category. An accredited standards committee elects its own officers and can organize itself in any way to expedite its work assignments. This includes the establishment of subcommittees, and task, working, study, or ad hoc groups. Secretariat services for two accredited committees are provided by the Association for Supplies of Printing and Publishing Technology (NPES).

2. *Organizations.* Standards can also be prepared by accredited organizations. Such an organization is usually an industry group, an association of industry experts or of professionals. Its primary focus revolves around a particular technology and may involve exchange of professional or technical information, trade policies, or promotion of industry growth. The preparation of standards also may be one of its functions. To have these standards recognized as national standards, the organization must have written operational procedures and become ANSI-accredited. The prime criteria for accreditation is recognition of its area of competence, agreement to use ANSI approved procedures, and allow participation of those with an interest in the field. Many of the photographic standards have been prepared by such accredited organizations. General photographic standards are written by the National Association of Photographic Manufacturers (NAPM), which was accredited by ANSI in 1992. Motion-picture film standards are prepared by the Society of Motion Picture and Television Engineers (SMPTE), which was accredited in 1984, and microfilm standards by the Association for Information and Image Management (AIIM), accredited in 1985.

Organization of Photographic Standards There are hundreds of documents that deal with various aspects of photographic technology. They have been prepared by many accredited committees and organizations. Some of the principal ones are outlined in this section.

Two accredited standards committees have the Association for Suppliers of Printing and Publishing Technology as secretariat. These are:

1. IT8, a committee concerned with the exchange of digital data between electronic prepress systems. Many of its documents deal with the exchange of data using magnetic tapes.

2. CGATS, the Committee on Graphic Arts Technology Standards. Its work includes densitometry, terminology, plate dimensions, and color monitors and color science for the graphic-arts industry.

General imaging standards are under the jurisdiction of the National Association of Photographic Manufacturers, an ANSI-accredited organization. It has the following six technical committees:

1. *PH1 Committee on Photographic Films, Plates, and Papers.* This committee prepares specifications for sizes, tolerances, and packaging of photographic films, plates, and papers. Work is also underway on bar coding.

2. *IT2 Committee for Image Evaluation.* Its scope is the development of standards pertaining to instruments and methods for evaluating the response of imaging materials to radiant flux (characteristics such as film speed, density, and resolution) and measurement quantification of image-forming factors (such as spectral distribution of exposure lamps).

3. *PH3 Committee on Photographic Apparatus.* This committee is concerned with apparatus and procedures for exposing, printing, and viewing photographs.

4. *PH4 Committee on Photographic Processing.* The interest of this group is supplies, equipment, and procedures for photographic processing. There is considerable activity on chemical standards and photographic effluent standards.

5. *IT7 Committee on Instructional Audiovisual Systems.* Its activity involves standards for electronic and photographic audiovisual systems. A main endeavor is in the evaluation of audiovisual equipment for educational uses.

6. *IT9 Committee on Physical Properties and Permanence.* Work is concentrated on physical test methods and permanence documents on photographic, and magnetic and optical disk materials. A major focus is the preparation of specifications for the permanence of photographic films and recommendations for acceptable storage.

Standards for the microfilm industry are prepared by the Association for Information and Image Management (AIIM), which is also an ANSI-accredited organization. There are over two dozen standardizing committees within AIIM that deal with such diverse topics as dimensional requirements of imaging systems, microform formats, quality of computer-output microforms, and requirements for electronic imaging systems.

A third ANSI-accredited organization in the photographic field is the Society of Motion Picture and Television Engineers (SMPTE). Its work is divided among eight committees and is concerned with subjects ranging from film dimensions, audio recording, and theatrical projection to television recording.

It is apparent that there is a very wide range of standards activities in the photographic industry. This requires coordination to ensure that there is no duplication of effort among the accredited standards committees and accredited organizations. In addition, there is the need to assure that there are appropriate groups working in all the required areas. This function is fulfilled by the Image Technology Standards Board (ITSB), which was established by ANSI. This board was formerly known as the Photographic Standards Board. However, in recent years imaging by electronic means has become of greater importance and consequently the scope has been expanded to include all imaging technologies. This explains why some of the standardizing committees are PH (photography) committees and others are IT (image technology) committees. In time, all PH committees will have their designation changed to IT committees.

To promote cooperation and information exchange with standardizing work in other industries, liaison members have been designated by ITSB. In recent years, liaison with the electronics industries has been particularly critical.

Numerical Designations ANSI standards are frequently numbered so that the committee responsible is clearly indicated. For example document PH1.20 was promulgated by committee PH1, and IT9.1 by committee IT9. Standards prepared by an accredited organization include the appropriate acronym, for example, ANSI/AIIM MS4. All document designations also include the year in which they were standardized. Standards are reviewed every five years for either reconfirmation, revision, or withdrawal.

It should be noted that subcommittees of some technical committees also are numbered, using a hyphen rather than a period. In other words, IT9-1 is a subcommittee and IT9.1 is a document.

INTERNATIONAL STANDARDS

Role While the importance of national standards cannot be overemphasized, in today's world of international commerce they are not enough. To facilitate trade between nations, international standards are required. The need is particularly critical in high technology fields such as photography and electronic imaging.

The first international standards group was the International Electrotechnical Commission (IEC), which was founded in 1906. Its scope includes all international standardization in the electrical and electronic engineering industry. Forty years later, the International Organization for Standardization (ISO) was organized. The mission of ISO is to promote international standards in order to facilitate international exchange of goods and services. ISO is a worldwide organization of nearly 100 national standards bodies and the work is advanced through the activities of more than 2000 technical groups.

Unlike ANSI, membership in ISO is through the national standards bodies or that organization in a country that is most active in standardizing activities. In the United States, all participants in ISO work are representatives of ANSI. Their responsibility is to represent the U.S. viewpoint, and not necessarily the position of the manufacturer, agency, or company with which they are associated. Member countries that take an active part in ISO work, that are obliged to vote and, if possible, to attend meetings are known as participating (P) members. Countries that only wish to be kept informed of ISO work are observer (O) members.

Governance The technical work of ISO is carried out by technical committees (TC). Each TC is identified by a number (e.g., ISO/TC42) and has a very specific scope that defines its work program. To handle the administrative functions, each ISO technical committee has a secretariat that is one of the national standards bodies within the membership. Technical committees in turn are subdivided into either subcommittees or working groups, the exact division varying with the committee. There are about 170 technical committees in ISO, and well over 2000 subcommittees and working groups.

As with ANSI, international standards can be specifications, test methods, recommended practices, and nomenclature. Consensus is determined by written ballots of the participating members, and ballots are involved at each stage of the standardization process. ISO documents are first prepared as committee drafts, and then become draft international standards. After consensus has been reached within the standardizing body, these documents are published as ISO standards and are readily available to those interested. ISO standards are reviewed every five years.

Organization of Photographic Standards International photographic standards are promulgated within ISO, although work in information technology may require close liaison with IEC.

ISO Technical Committee 42 *(ISO/TC42)* is titled "Pho-

tography" and has the general responsibility in this field, with the exception of several specific industries to be discussed later. At present there are ten committee members classified as "P" members. The countries and their associated national standardizing bodies are as follows:

Belgium: Institute BeIge de Normalisation (IBN)

China: China State Bureau of Technical Supervision (CSBTS)

Commonwealth of Independent States, USSR: State Committee for Product Quality Control (GOST)

Czechoslovakia: Federal Office for Standards and Measurements (CSN)

France: Association Francaise de Normalisation (AFNOR)

Germany: DIN Deutsches Institut fuer Normung (DIN)

Italy: Ente Nazionale Italiano di Unificaszione (UNI)

Japan: Japanese Industrial Standards Committee (JISC)

United Kingdom: British Standards Institute (BSI)

United States: American National Standards Institute (ANSI)

In addition, there are also 22 "O" members. ANSI is the secretariat, and it has delegated this responsibility to NAPM. ISO/TC42 is subdivided into twelve working groups, with scopes such as sensitometry, photographic chemicals, and dimensions. This committee has published about 100 standards.

All standards in the field of cinematography are the responsibility of *ISO/TC36*. ANSI is the secretariat with this assignment being undertaken by SMPTE. This committee has 11 P members and has promulgated over 90 documents.

Graphic technology standards are under the jurisdiction of *ISO/TC130*, with ANSI as the secretariat. It has 12 P members and has finalized about 20 standards.

ISO/TC171 is the committee involved with all standards in micrographics. The secretariat is AFNOR and it has 15 P members. This TC has also completed work on approximately 30 standards.

As with ANSI standardization, each of the technical committees maintains liaison with other technical committees or IEC committees with which it shares areas of common interest.

CURRENT TRENDS The goal of all these standardizing bodies is to have national and international documents that are identical. This has become a higher priority in recent years with increasing international commerce since differences in these standards lead to confusion, misinformation, and lack of media-equipment interchangeability. The usual operating procedure has been for a national standardizing body to propose a standard to ISO for consideration. Frequently, ISO modifies it so that it is acceptable to the world community. Subsequently, most of the national bodies adopt the ISO standard as a national document. This is evident in the United States where it is now becoming more common to see many of the standards designated as ANSI/ISO.

It is also most common to have international technical experts become actively engaged in standardizing activities of another country. This is a very positive development and it reflects the fact that technical expertise and interest do not reside in solely one country.

Another interesting development in recent years is the increasing use of electronics in imaging. This has resulted in modifications to the scopes of many standardizing groups. Within ANSI, the IT committees have replaced some of the PH committees. An example of a positive accomplishment through expansion of its scope is the experience of Committee IT9. It recently established a classification system to rate the life expectancy of imaging materials, and this system has been accepted by the photographic, magnetic, and optical disk industries. In ISO, scopes of technical committees are also being expanded. For example in ISO/TC42, a new working group has been formed to prepare standards on electronic still picture imaging.

Photography is a mature industry. Much of its success is due to the extensive body of standards that has been published by national and international organizations. There is still a considerable need to update many of these documents and to prepare additional standards as new products are developed and new information is obtained. The establishment of electronic imaging and the introduction of hybrid electronic-photographic applications has emphasized a still greater need for new standards. Such documents are essential to build the bridges between the two technologies.　　*P. Adelstein*

STANDING WAVES　A term in room acoustics used to describe the effects of sound interacting with multiple enclosure surfaces in ways that tend to strengthen or diminish the sound field at various frequencies and points within the space. Standing waves occur because sound waves cover a range of wavelengths that include ones wherein integral ratios of waves fit precisely between the boundaries. At these frequencies, mutual reflection of the waves back and forth between two or among more surfaces produces points in space where the sound pressure varies greatly (at the maxima) and where it varies very little (at the minima). Standing waves generally lead to a lack of uniformity of sound fields in enclosures; the waves are worse in the bass frequencies and in small rooms.　　*T. Holman*

STAR FILTER/SCREEN　See *Filter types.*

STAR TEST　See *Lenses, lens testing.*

START MARK　In motion pictures, a symbol placed at the head end of a film roll, used to properly align the roll with corresponding picture and sound rolls.　　*H. Lester*
Syn.: *Sync mark.*

START-UP　In photography, the opening stages of a digital or photochemical process in which normal operating conditions are established. Temperatures, chemical concentrations, and mechanical functions are checked. A computer checks its system files. When appropriate, test strips are run and the results are compared to process specifications. If necessary, changes are made to establish conformity, and regular operation is begun.　　*H. Wallach*

STATE OF THE ART　The best currently available device, process, or system. The development of a better method advances the state of the art.　　*H. Todd*

STATIC　(1) Without movement or the effect of movement. Applied to a dull composition in still photography, design, or a shot in motion pictures in which the camera is not moved. (2) Short for static electricity.　　*R. Welsh*

STATIC ELECTRICITY　Electrical charges at rest as distinguished from electrical charges in motion (current electricity). The ancient Greeks knew that amber when rubbed would attract bits of paper and other light objects. We have since learned that rubbing or simply separating two surfaces in intimate contact will cause a transfer of electrical charges from one surface to the other. One surface is charged with an excess of electrons (negative charges), leaving the other surface with an excess of protons (positive charges). To store the electrical charges the material must be a good insulator. Photographic film and paper are both good insulators and can therefore cause static electricity problems in a photolab.

When unprocessed film or paper is unwound from a reel, the separation of the surfaces can generate static electricity. If the voltage between the surfaces of the reel and the web is high enough, a spark will occur between the surfaces. This spark will expose the film or paper in an easily distinguishable pattern.

Electrostatic charges on negatives will attract dust and dirt particles, which if not removed before printing will degrade the quality of the print. The electrostatic charges on the film can be neutralized by the use of a static eliminator.

Walking across a carpeted room on a dry winter day can generate many thousands of volts. High electrostatic voltages can damage certain electronic components found in much modern photofinishing equipment. Great care must be taken when handling printed circuit boards that contain metal-oxide semiconductor (MOS) components because the high voltage can puncture the very thin metal-oxide film layer that insulates the gate from the drain and the source.

W. Klein

Syn.: *Triboelectricity.*

STATIC ELIMINATOR

STATIC ELIMINATOR　Any of a number of devices used to neutralize electrostatic charges. A common type of static eliminator consist of a high-voltage transformer whose output winding is connected to electrodes with very sharp points. The voltage gradient at the points ionizes the air and produces a blue glow known as a *corona.* The free-moving negative ions neutralized the positive charges on the film; the positive ions neutralize the negative charges.　　*W. Klein*

See also: *Antistatic.*

STATIC MARKS

STATIC MARKS　Static marks on film are the result of exposure produced by discharge of static electricity in the vicinity of the surface. Static electricity may be generated, for example, when a roll of film is unwound, or a person with a charge touches any film, especially in very dry weather. In the darkroom it can be recognized by a cracking sound and often seen as faint blue sparks that can produce a developable image on the film. Static marks commonly appear as streaks, black spots, smudges or tree-like markings on the processed film.

Static electricity often makes it difficult to remove dust from film and glass surfaces since the charge attracts the dirt particles again after they have been wiped off. Proprietary dopes and dusters, electrical charge modifying devices, and grounding of enlargers can be used to dissipate the charge. Films made with polyester and other nonconductive bases have a greater tendency to hold a charge than acetate bases. These high dielectric constant bases also may attract dust after processing while drying in an unfiltered current of room air. Dust on film during exposure or on negatives and transparencies when they are being printed produces small light or dark spots on the prints.　　*I. Current*

STATIC MEMORY

STATIC MEMORY　The retention of information in semiconductor memory without refreshing or recirculating.

R. Kraus

See also: *Refresh rate.*

STATISTICS

STATISTICS　The complex body of mathematical theory and application that includes methods of data collection, analysis, and interpretation. Statistical methods are used, for example, in monitoring the manufacture of photographic materials and equipment and in processing plants.

KINDS OF DATA　Objective data come from measurements. They include concentrations of materials used in processing solutions and characteristics of films and papers such as contrast and speed. Subjective data come from judgments made by observers concerning image quality. Although subjective data are difficult to obtain, they are basic to the assessment of the success of the entire photographic process, from manufacture to viewing conditions. Objective measurements of image quality must be shown to be equivalent to subjective judgments.

All kinds of measured data, however seemingly precise in nature, are subject to error. Therefore, the estimate of error is a fundamental part of the statistical analysis of data.

SAMPLING　The entire set of possible measurements in a given situation is called the *population.* An example would be the entire production of a given lot of film, consisting of very many square meters of product. A sample is a small lot used for determining the quality of the whole production of a given kind.

The number of samples is, for practical purposes, necessarily limited. A sample of over 30 measurements of the same kind is usually considered large. Often judgements must be based on samples as small as 2 or 3 in size.

To avoid bias in the collection of the sample, random selection is often used. In taking a sample from a large roll of film, one is tempted to use only the ends or the edges of the roll. Such a sample may well not be representative of the rest of the product, unless tests show that it is. Various techniques are used to randomize the sample selection, such as tables of random numbers.

If there is reason to believe that the population is not well mixed, i.e., that it is stratified so that different portions of the population are significantly different from others, it is necessary to take random samples from the different strata. In a large processing tank, if the solution is not thoroughly stirred, there may be systematic or other differences in temperature or concentration from top to bottom. In this case, samples would have to be taken from different positions in order to avoid incorrect judgments.

MEASURES OF CENTRAL TENDENCY

1. The *mean* is the arithmetic average of a set of data. It is the most commonly used measure of the value around which the members of a data set are symmetrically distributed if they differ only by chance. For such a distribution, called *normal,* the mean lies at the center, the highest point of a plot of such a data set.
2. The *median* is the value that divides a set of data into two parts having equal numbers of members. It is a useful measure of central tendency for a set of data that are grouped together except for a few widely separated ones.
3. The *mode* is the most frequently occurring value in a set of data. It is used when many of the data have nearly the same value and others of the set are widely different.

If the data are representative of a population that is chance controlled, the mean, the median, and the mode very nearly coincide.

MEASURES OF VARIATION

1. The *range* is the difference between the largest and smallest members of a sample. Although simple to calculate, the range has limited use, in part because the size of the range is determined by only two members of the set. The range is often used for samples of small size and especially for the preparation of limit lines for control charts.
2. The most powerful measure of variation within a set of data is the *standard deviation.* It is found by determining the difference between the mean and each member of the set, squaring the differences, averaging them, and taking the square root of the quotient. The standard deviation gives equal weight to all members of the set. It is used in some control charts, in tests of conformance to specifications, and in tests intended to detect a difference between two populations, known as *hypothesis tests.*　　*H. Todd*

See also: *Control chart; Control limits; Frequency distribution; Graphs; Normal distribution; Paired comparison; Quality control; Skewed distribution; Standard deviation; Variability.*

STEADICAM

STEADICAM　In motion-picture and video production, trade name for a camera support system that is worn by an operator, providing very smooth camera movements while allowing the flexibility and convenience of hand-held operation. The camera rides on a floating platform attached to a heavily damped stabilizing support arm attached to the vest

of a weight distribution suit. Steadicams, and similar systems, allow stable camera operation in formerly difficult situations, such as running on rough ground or up and down stairs, and provide an efficient alternative to traditional dolly shot methods. *H. Lester*

See also: *Gyro stabilizer.*

STEFAN-BOLTZMANN LAW The total radiant power emitted by a blackbody increases as the fourth power of the absolute temperature of the radiator: $I_e = k \cdot T^4$, where I_e is the total radiant power emitted at all wavelengths, k is a constant dependent on the units used for I_e, and T is the temperature of the radiator in kelvin. The constant k has been determined experimentally and derived from first principles. Its value is 5.67×10^{-8} W/m$^2 \cdot$ K^4 for I_e in watts.

Note that the Stefan-Boltzmann equation describes radiant power at all wavelengths, not luminous power. For incandescent sources, the peak of the blackbody distribution shifts toward the center of the visual range as filament temperature increases, so visual power (Φ_v) increases at a rate even greater than that predicted by the Stefan-Boltzmann equation. *J. Pelz*

STEICHEN, EDWARD JEAN (1879–1973) American photographer and curator. Apprenticed as a lithographer at the age of 15. Studied painting at the Milwaukee Art Students League (1894–1898), making his first photographs in 1895. Became close friend of Stieglitz and cofounder with him of the Photo-Secession (1902) and New York's The Little Galleries of the Photo-Secession (often known as "291") (1905–1917). After extensive travels in Europe (1900–1902 and 1906–1914), introduced Stieglitz to the work of Picasso, Matisse, Cezanne, and Rodin, who were all given their first American exhibitions at "291." Frequent contributor to Stieglitz's *Camera Work*, which devoted a double issue to Steichen's photographs in 1913. Eventually left pictorialism for straight photography. Split with Stieglitz as he devoted himself to commercial photography, becoming a portrait and fashion photographer for Condé Nast publications (1923–1938), published frequently in *Vanity Fair* and *Vogue*. Director of photography for the Army Air Corps during the First World War and filled the same position for the Navy in the Second World War. Director of the photography department, Museum of Modern Art, New York (1947–1962). Responsible for introducing blockbuster photographic theme shows, such as the hugely popular *The Family of Man* (1955). The first photographer to be awarded the Presidential Medal of Freedom (1963).

Books: *A Life in Photography.* Garden City, NY: Doubleday, 1963; *Edward Steichen.* Millerton, NY: Aperture, 1978. *M. Alinder*

STEINER, RALPH (1899–1986) Photographer and cinematographer. Student of Clarence White (1921–1922). Worked in advertising photography to support his creative work. Expanded his vision to filmmaking, releasing the 1929 avant-garde *H$_2$O*, an abstract study of moving water, defined by shadow and light. Joined Strand as cameraman on *The Plow that Broke the Plains* by Pare Lorenz (1935). Awarded Guggenheim Fellowship (1974).

Books: *A Point of View.* Middletown, CT: Wesleyan University Press, 1978. *M. Alinder*

STEINHEIL, CARL AUGUST VON (1801–1870) and **STEINHEIL, HUGO ADOLPH** (1832–1893) The elder Steinheil was a German astronomer and professor of physics and mathematics at Munich University. Shortly after learning of Talbot's calotype process in early 1839, then Daguerre's following the August 1839 announcement, produced the first calotypes and daguerreotypes in Germany,

using cameras he designed. In December 1839, made the first miniature camera, producing pictures that had to be viewed through a magnifying glass. In 1855 Steinheil founded the Munich optical company that still bears his name and that was purchased by his son, Hugo, in 1866. The younger Steinheil was a noted designer and manufacturer of fine photographic lenses. *M. Alinder*

STEINHERT, OTTO (1915–1978) German photographer and teacher. Leader of the subjective photography movement that encouraged the creation of highly personal imagery, often from unusual viewpoints. Used the work of Moholy-Nagy, Herbert Bayer, and others as a referent. Curated the influential exhibitions *Subjektive Fotografie* in 1951, 1954, and 1958. *M. Alinder*

STEMS (SOUND) The constituent parts of a final mix. The various channels may be used to represent direction, such as left, center, right (corresponding to the picture) and surround; and to represent the various kinds of sounds, such as dialog, music, and sound effects. The advantage of keeping the final mix in a multitrack form is that it makes the preparation of subsequent special versions—such as foreign language release—simpler, since all that need be done is to substitute a new language element for the dialog, and then new print masters may be made in the new language. *T. Holman*

STEP One of a series of baths or procedures used in processing exposed photosensitive materials. *L. Stroebel and R. Zakia*

STEP AND REPEAT In photomechanical reproduction, the process of multiple exposing of the same negative or positive image on film or printing plate in positions according to a predetermined layout. It is used extensively in packaging and label and greeting card printing. *M. Bruno*

STEP-&-REPEAT CAMERA See *Camera types.*

STEP (AREA) (1) An exposure change between two adjacent elements of an optical tablet in a sensitometer or in a reflection gray scale. The exposure factor per step in a sensitometer is often $\sqrt{2}$, or about $1.4\times$, equivalent to one-half stop and a log exposure change of 0.15. For a reflection gray scale, the interval is commonly a log-H change of 0.1, equivalent to 1.26, one-third stop and $\sqrt[3]{2}$. (2) One patch of a tablet used in sensitometric test exposures, for example, a 21-step tablet. The number of patches and therefore the number of different exposures is one more than the number of exposure changes. *M. Leary and H. Todd*

See also: *Gray scale; Step tablet.*

STEP-DOWN/STEP-UP A ring-shaped adaptor for a filter holder so that a smaller filter (step-down) or a larger filter (step-up) can be used than the original holder was designed for. *P. Schranz*

STEP PRINTING A motion-picture duplicating process in which each frame of the negative and raw stock is stationary at the time of exposure, as with optical printers and some contact printers. Also a common term for the procedures of eliminating selected frames in a regular pattern by not printing them, or adding extra frames by duplicating original frames more than once. *H. Lester*

STEP TABLET (1) See *Optical wedge.* (2) A transmission gray scale, typically having density increments of 0.15 or 0.30. *L. Stroebel*

See also: (2) *Input, Test target.*

STERADIAN (sr) The unit of measure of a three-dimensional solid angle (or cone-angle). One steradian is that solid angle that subtends on the surface of a sphere an area qual to the square of its radius. Because a sphere of radius r has an area $4\pi r^2$, there are $4\pi(\sim 12.6)$ steradians in a sphere and 2π steradians in a hemisphere. *J. Pelz*

See also: *Solid angle.*

Steradian. 1 steradian is the solid angle subtended on a sphere of radius r by an area equal to the sphere of the radius, i.e., $A = r^2$. There are 4π steradians in a sphere.

STEREO See *Stereophony; Stereoscopy.*

STEREO ATTACHMENT A double reflector beam-splitter attachment for a conventional camera that forms a pair of stereoscopic images on a single frame of film. The separation of the viewpoints for the two images is approximately 2.5 inches (65 mm), about the same as the average separation of human eyes. *L. Stroebel*

STEREO CAMERA See *Cameras; Nimslo 3-D camera.*

STEREOCOMPARATOR An adjustable stereoscope with scales used to determine dimensions and distances from stereoscopic photographs such as overlapping aerial photographs made at appropriate time-distance intervals.
 L. Stroebel

STEREOGRAM A pair of stereophotographs correctly assembled for viewing. *L. Stroebel*

See also: *Perspective.*

STEREOGRAPH A stereoscopic pair of drawings correctly assembled for viewing, although the term is sometimes applied to a pair of stereophotographs. *L. Stroebel*

See also: *Perspective.*

STEREOPHONIC Pertaining to any of a number of sound systems that can represent sound spatially, starting with conventional two-channel home stereo, up to multichannel sound systems often used to accompany motion pictures in large-scale presentations. For conventional film sound, what is usually meant today is at least four channels—left, center, right, and surround. The opposite of single-channel monaural sound, the only spatial capacity of which is the depth dimension along one line radiating away from the listener. *T. Holman*

Syn.: *Stereophony.*

STEREOPHONY See *Stereophonic.*

STEREOPHOTOGRAMMETRY The technology of using stereoscopic pairs of photographs for the purpose of making measurements of the subject. When aerial photographs are taken at intervals along a flight path, the overlap area of consecutive photographs can be used for this purpose. *L. Stroebel*

See also: *Perspective; Photogrammetry.*

STEREOPHOTOGRAPHY The simulation of three-dimensional effects by making two photographs of the same subject from slightly different positions that represent the separation of the eyes, and presenting the images so that each eye sees the appropriate image, but with the images superimposed. *L. Stroebel*

See also: *Nimslo camera; Perspective.*

STEREOPHOTOMICROGRAPHY (1) The use of pairs of images representing different viewpoints made through a stereoscopic microscope or by making consecutive photographs with a conventional microscope and moving the subject between exposures. (2) Photographs made through a stereoscopic microscope having a system of prisms that allows the eyes to see and a camera to record through a magnifying system from viewpoints that provide two images separated by a fraction of an inch instead of the normal interpupillary distance. *L. Stroebel and R. Zakia*

See also: *Perspective; Photomacrography; Photomicrography.*

STEREOPLANIGRAPH An apparatus for making contour maps from pairs of aerial photographs. *L. Stroebel*

STEREO PROJECTION The use of optical projectors to present pairs of stereoscopic images so that each eye sees only the appropriate image. Three methods of creating three-dimensional effects are the use of anaglyphs, polarization, and parallax stereographs. *L. Stroebel*

See also: *Perspective.*

STEREOPSIS The perception of depth attributable to binocular vision. *L. Stroebel and R. Zakia*

Syn: *Binocular vision; Stereoscopic vision.*

See also: *Binocular fusion; Perspective, stereophotography; Vision, binocular vision.*

STEREORADIOGRAPHY A technique for obtaining a pair of images that can be viewed in a stereoscope to create a perception of depth. The two images are made sequentially with the x-ray source moved laterally approximately 2.5 inches (65 mm) between exposures. The procedure is used in industrial and medical radiography to assist in locating defects, foreign objects, etc. *L. Stroebel*

See also: *Tomography.*

STEREOSCOPE An optical viewer using lenses and/or mirrors to provide dual independent viewing channels for the left and right eyes so that a stereoscopic pair of images may be viewed comfortably and fused so that a single image is perceived in three-dimensional relief with the restituted image of the correct shape corresponding to the original subject. *S. Ray*

STEREOSCOPIC PHOTOGRAPHY See *Stereophotography.*

STEREOSCOPY The presentation to a viewer of two images of the same scene taken from different viewpoints so that a simulation of three dimensions is seen. *L. Stroebel*

See also: *Perspective.*

STEREO/STEREOSCOPIC CAMERA See *Camera types, Stereoscopic camera.*

STEREO VARIABLE AREA (SVA) The generic name applied to the Dolby stereo format wherein two different bilateral sound records, side-by-side, carry left right infor-

mation that can be decoded in the theater to L, C, R, and S channels. *T. Holman*

STERRY EFFECT See *Appendix A; Photographic effects.*

STERRY PROCESS Procedure for reducing the contrast of prints made from negatives too contrasty for the paper they are being printed on. After exposure, the paper is bathed for about a minute in a solution of 1% potassium dichromate or potassium ferrocyanide and then developed. Print color changes from cool black to warm black with a greenish tinge. The developer must be changed frequently because the contamination causes staining and exhaustion.

H. Wallach

STEVENS' LAW The law that relates the perceived brightness of a tone to its luminance. Expressed in mathematical form, the law is as follows:

$$X = k L^n$$

where X is the perceived brightness, L is the luminance of the tone, n is a power value, typically 0.33, and k is a constant that depends on the adaptation of the eye.

The power constant used in this law varies at extremely low and high luminance levels. Also, luminance is related to density according to the equation:

$$L = C \, 10^{-D}$$

where D is the density and C is a constant that depends on the lighting conditions. *J. Holm*

STEVENS' POWER LAW A mathematical expression of the relative strengths of a stimulus and the corresponding perception, such as the luminance of a surface and the perception of the lightness/brightness of that surface. According to the Stevens' power law, the perception of lightness/brightness varies with the luminance raised to some power, typically 0.33. Changes in the apparent area of the stimulus require adjustments in the power value, which increases to 0.50 for a point stimulus. *L. Stroebel and R. Zakia*

See also: *Fechner's law; Visual perception, perception of lightness/ brightness; Weber–Fechner law.*

STICKS Colloquial for *Clapboard.*

STIEGLITZ, ALFRED (1864–1946) American photographer, gallery owner, editor, and publisher. Extremely influential; dedicated his life to the recognition of photography as a fine art. Founder of the Camera Club of New York (1896) and editor of its journal *Camera Notes* until 1902. Outspoken leader of the pictorialist movement, founding the Photo-Secession in 1902, then became zealous straight photography proponent. Published and edited the beautifully produced periodical *Camera Work* (1903–1917). Promoted the work of avant-garde artists, painters, sculptors, and photographers in his New York galleries: The Little Galleries of the Photo-Secession, later called "291" reflecting its address, 291 Fifth Avenue (1905–1917), The Intimate Gallery (1925–1929), and An American Place (1929–1946). To be chosen to exhibit in his galleries stamped the artist with immediate legitimacy. He was the first in America to exhibit the startling new modern art from Europe by Picasso, Matisse, Braque, Cézanne, Renoir, and Rodin, and introduced the American painters O'Keeffe, Marin, Hartley, and Dove. Promoted the photographers Steichen, C. White, Coburn, Strand, Adams, and Porter. Produced highly regarded images using a hand-held camera. Especially admired for three extensive series: the streets of New York City; hundreds of striking and intimate portraits of his wife,

the painter Georgia O'Keeffe; and cloud studies that he termed "equivalents," giving concrete visual expression through a photograph to what he felt emotionally. *The Steerage* (1907) is one of his most memorable images, European immigrants bound for America, their crowded shipboard life frozen for all time in an elegant composition of gangplank, decks, stairway, mast, and boom.

Books: Lowe, Sue Davidson, *Stieglitz: A Memoir/Biography.* New York: Farrar, Straus & Giroux, 1983; Greenough, Sarah, and Hamilton, Juan, *Alfred Stieglitz: Photographs and Writings.* Washington, DC: National Gallery of Art, 1983. *M. Alinder*

STIGMATIC Describes a practical lens that refracts or reflects divergent light rays from a subject point to meet again in a true image point, so it is essentially acceptably free from aberrations. *S. Ray*

Syn.: *Anastigmatic.*

See also: *Astigmatism; Lenses, lens aberrations.*

STILB (sb) A unit of luminance; the luminous intensity emitted or reflected from a surface per unit projected area. A surface whose luminance is 1 stilb emits (or reflects) 1 lumen per square centimeter per steradian [(lm)/cm^2 · sr)]. The candela per square meter (cd/m^2, or nit) is the preferred SI unit of luminance. (1 sb = 10^4 cd/m^2.) *J. Pelz*

See also: *Photometry and light units.*

STILL DEVELOPMENT Processing film without any agitation. Used especially for photolithographic materials, after a few seconds of development. The purpose is to enhance the edges of an image. *L. Stroebel and R. Zakia*

See also: *Photographic effects, adjacency effect.*

STILL FRAME A motion-picture and video optical effect in which a single image is repeated in order to appear frozen in place, that is, stationary when projected. *H. Lester*

Syn.: *Freeze frame.*

STILL-LIFE PHOTOGRAPHY A still life is an arrangement of inanimate (or mostly inanimate) elements that express pictorial, narrative, or metaphorical content. Photographic still-life studies evolve from the tradition of still-life paintings that originated as early as the fifteenth century. The most basic challenge of the still-life photographer is to create a composition of objects that are defined by light.

During the seventeenth century, the Dutch Masters produced exquisite still-life paintings. These opulent paintings contain lavish tableau arrangements of flowers, fruits, material treasures, and artifacts. The objects seem to be bathed in light that reveals texture, volume, space, and reality. Many photographers have followed the Dutch principles of the still life, both as an art form and for commercial applications.

The rudiments of a still-life photograph begin with the arrangement of light, shadow, form, and space. Natural or artificial light is used to define the subject's texture, surface, shape, and form. Directional side light is used to convey textual quality while emphasizing the line and shape inherent in the subject. By incorporating the shadow qualities of positive/negative space, the photographer is able to produce a more abstract composition. In contrast, soft diffused light produces an almost shadowless light that reveals all the detail, tonality, and color of the subject.

The large-format camera is most commonly used for still-life photography. The large image size and the camera's movements that control perspective and depth of field allow exact rendering of shape and fine detail.

Many still-life compositions are visual representations of objects that have been isolated from their environment. In this method the photographer is concerned with replicating the subject in its truest form. Some photographers use props to

create an environment that will illustrate a story or provide a desired mood. These photographs affect a natural spontaneous quality. A still life can also be conceptual in nature. The conceptual still life may incorporate elements that represent such ideas as power, sexuality, mythology, or the classics. By alluding to an abstract idea or an emotion instead of the object's physical characteristics, the photographer transforms the literal quality of the object through symbolic associations.

While the message or style of a still life may vary infinitely, the photographer has the opportunity to work precisely to achieve an inspired lighting and composition. Be it a documented still life of personal objects, an abstract arrangement of ordinary elements, or an illustration of an exquisite product, the still life is an effective means of creative expression. *D. Defibaugh*

STILL PHOTOGRAPH Identifying a single photograph, as distinct from a motion picture. *L. Stroebel*

STILL VIDEO (1) See *Electronic still photography.* (2) An electronic method of recording individual images using 2-inch floppy disks that are capable of storing either 50 field images or 25 frame images. *R. Kraus*

STILL-VIDEO CAMERAS See *Camera types.*

STIMULUS-RESPONSE The stimulus (plural stimuli) is a physical condition that may be detected by one or more of the senses and serves to elicit an overt or covert response. In vision, the stimulus is the light energy that is detected by the retina. Although a given stimulus can elicit a variety of different responses, depending upon conditions, it is useful to find predictable relationships between stimuli and responses. *L. Stroebel and R. Zakia*
See also: *Visual perception, sensations and perception.*

STOCK HOUSE A stock house is the agent of a group of photographers who offer their work as stock photography. It maintains a library of their images, markets the work, performs picture research for prospective clients, negotiates the terms of the license to the client, prepares the agreement, takes a commission, and accounts to the photographers.
R. Persky
See also: *Business practices.*

STOCK PHOTOGRAPHS A file of photographs typically held by an organization that serves as a promotion and sales agency for the photographers in return for a commission on the sales. *L. Stroebel*

STOCK SOLUTION A photographic solution, usually in concentrated form, from which working strength solutions can be made by dilution with water or by mixing with other solutions, e.g., HC110 developer. *G. Haist*

STOKES' LAW In fluorescence, the wavelength of the exciting radiation is shorter than that of the emitted radiation. By this law, for example, fluorescence in the blue spectral region requires that ultraviolet (or shorter wavelength) radiation be supplied to the fluorescent material. *J. Holm*
See also: *Anti-Stokes effect.*

STOP (1) An opaque plate containing an opening, used in lenses to control the passage of light, as in Waterhouse stop. The term *diaphragm* is used more commonly now, as in iris diaphragm. (2) To *stop down* a lens means to reduce the size of the diaphragm opening, and one stop refers to the change associated with adjacent *f*-numbers in the conventional series *f*/1.4, 2, 2.8, 4, 5.6, etc., as to decrease the exposure by one stop. (3) An informal substitute for number in *f*-number

(*f*-stop) and *T*-number (*T*-stop). (4) A mechanical feature that limits (stops) the movement of a part, such as an infinity stop on a camera focusing adjustment. *J. Johnson*

STOP BATH An acid processing solution, also called a *shortstop,* that stops image formation by neutralizing the solution alkalinity immediately after the development of silver halide materials. Dilute solutions of acetic acid are commonly used for this purpose, but certain other acids are effective also. *G. Haist*

STOP BATH TEST A means of determining when a used stop bath should be replenished or replaced. Bromocresol Purple, an indicator dye that changes from colorless to purple when the acidity of the stop bath falls below the safe level, can be used to test a small sample of the stop bath, or can be added to the entire stop bath. Under yellow safelight illumination, the stop bath will appear dark when the dye changes color. *L. Stroebel and R. Zakia*

STOP, DIAPHRAGM Originally a metal plate with a circular hole in it that was inserted in a slot in the barrel of a lens to act as an aperture stop.

Now replaced by a variable aperture iris diaphragm calibrated in *f*-numbers, which are commonly referred to as *stops.* *S. Ray*
See also: *Aperture stop; f-Number; Iris diaphragm; Waterhouse stop.*

STOP FRAME See *Freeze frame.*

STOP MOTION A motion-picture animation technique for creating the illusion of movement of three-dimensional objects by exposing the film one frame at a time and slightly moving the object between exposures. *H. Lester*
Syn.: *Stop action.*

STOPPING DOWN The action of decreasing the size of the lens aperture, i.e., by using a smaller diaphragm opening or selecting a larger *f*-number. This may be done to control exposure or to increase the depth of field at the focused distance or to select the optimum aperture of the lens regarding performance. For visual convenience and improved accuracy, a lens is best focused at maximum aperture and just before exposure, stopped down to the preselected aperture by hand or by some automatic mechanism controlled by the camera. If the lens is stopped down too far or used at very small apertures, then diffraction effects may degrade performance, so lens manufacturers limit the minimum aperture available to values such as *f*/22. Smaller apertures are available on lenses for large-format cameras and photomacrography, where they are necessary for depth of field purposes and where diffraction effects are less limiting. When enlarging, stopping down the lens is common practice after focusing to provide an exposure duration of a manageable and useful length to permit such techniques as *holding back* or *dodging* the image or when rectification techniques are in use such as to correct converging verticals. *S. Ray*
See also: *Depth of field; Focus/Focusing; Lenses, lens aberrations.*

STORAGE DEVICES (FOR PHOTOGRAPHS)
Carrying cases for photographs are available in different sizes. Typical features include reinforced handles, metal corner protectors, rubber feet, lockable latches, and an acrylic-impregnated fabric exterior. The interior is usually acid-free and lignin-free card stock.

Document boxes are flip-top upright archival acid-free and lignin-free board storage files for letter and legal-sized papers. These boxes have pull strings on the reinforced double-thick box bottoms to help in retrieving them from the storage shelf.

Flat storage boxes are acid- and lignin-free board construction. These boxes are available in a variety of sizes and are constructed with reinforced metal edges.

Foldover presentation mats have a professional appearance and allow photographs to be quickly mounted for presentation. A mylar pocket with a transparent front and matt back allows for nonglare viewing. A black cover mat is secured in place with corner locking slits.

Manuscript boxes are two-piece boxes made from acid-free and lignin-free board covered with an acrylic-impregnated fabric. The adhesives used are low-sulfur content, pH-balanced, and buffered.

Museum cases are similar to portfolio boxes, but they are more sturdy. Constructed of low-resin basswood, these cases are covered with acrylic-impregnated, heavyweight, book cloth. Chrome-plated closure latches provide security, and a chrome-plated label holder provides a place for an identification label. A polypropylene web strap with a padded grip is available to carry the case.

Polyethylene bags are excellent protection for prints that need to be handled constantly. These bags can be written on with print and film marking pens.

Portfolio boxes are manufactured with acid-free and lignin-free board, lining, cover fabric, and adhesive materials. They have drop spines so that they lie flat when opened. The clamshell design allows prints to be transferred from one side to the other when showing the photographs, while providing a dustproof closure for storage. Pressure-sensitive label holders provide a place for identification of the contents.

Shipping cases are typically constructed of fiberboard, have heavy steel corners and a reinforced handle and are used for carrying photographs around or shipping photographs through the mail. These cases have heavy duty web straps with pull-tight buckles to provide security and closure. A slot to insert a shipping label card is an added convenience. Shipping cases are available in archival and nonarchival versions.

Transview sleeves are polypropylene sleeves with a clear front and either a clear or frosted back, used for storing and viewing transparencies. *M. Teres*

See also: *Image permanence.*

STORAGE OF PHOTOGRAPHS

The conditions under which photographic images are kept determine to a large degree their long-term stability. Aside from built-in properties, which make one type of photograph inherently more permanent than others (for example films on a polyester support are superior in that respect to films made of cellulose nitrate), the storage of photographs is the most important factor in their preservation. It is also one that the user, or keeper of collections, can control. This role is reflected in four publications by the American National Standards Institute that recommend specific storage conditions for photographic plates, prints, and films, and also for the quality of filing enclosures with which a photograph is in close contact while in storage. The factors that generally have the largest effect on the long-term stability of photographs are the purity of the surrounding atmosphere, its relative humidity and temperature, and the properties of the filing enclosures in which they are kept. Although the level of air purity ranks high in its role of determining the longevity of photographs—the degrading effect of oxidizing gases in the air on the stability of photographic images having been demonstrated many times—no maximum permissible threshold values have been given in the ANSI standards that might indicate below what level of concentration a given pollutant, such as hydrogen peroxide, will become harmless. However, research is presently being carried out in that field. Photographic manufacturers indicate that the level of air purity in areas where light-sensitive films and papers are manufactured is such that concentrations of any of the well-known gaseous pollutants are so low as to be beyond the ability of analytical techniques to detect them. Any present air pollution is below the detection limit of modern analytical instrumentation.

Current ANSI standards regarding the storage of processed photographic materials address mainly temperature and relative humidity levels.

ANSI PH1.45-1981
Practice for Storage of Processed Photographic Plates

	Storage Temperature (°C)	Relative Humidity (%)
Recommended:	15–25 (59–77°F)	20–50
Preferably:	< 20 (68°F)	<40

Recommendations are set at realistic levels. The wide temperature range within which photographic plates can be kept indicates the slight effect that temperature alone is expected to have on their stability. While a relative humidity of below 40% is preferable, any level between 20 and 50% is acceptable. However, a level of 20% is considered by some experts as too low, as it may cause forces, created by the contraction of the gelatin layer, to prompt its separation from the glass support.

ANSI PH1.48-1982 (R 1987)
American National Standard for Photographs (Films and Slides), Black-and-White Photographic Paper Prints, Practice for Storage

	Storage (°C) Temperature	Relative Humidity (%)
Acceptable:	15–25 (59–77°F)	30–50
Never:	> 30 (86°F)	>60
	Avoid daily cycling of 4°C (7°F)	

Recommended environmental conditions are similar to those for photographic plates. The maximum permissible threshold value of 60% relative humidity is significant. A high moisture content of the air is conducive to mold growth, which can completely destroy the image in time. Daily cycling of more than 4°C should also be avoided.

Specifications for the storage of processed *photographic film* are divided into one set for medium-term and another for extended-term keeping. *Medium-term* storage can be used for film that is suitable for the preservation of records for a minimum of 10 years. It should have a Life Expectancy (LE) rating with a minimum of 10 years. *Extended-term* storage conditions should be used for films having higher LE ratings.

ANSI IT9.11-1991
American National Standard for Photography (Film)
Processed Safety Film—Storage
Recommended Relative Humidity and Temperature for Storage[a]

	Medium-Term Storage		Extended-Term Storage	
Sensitive Layer	Relative Humidity Range (%)	Maximum Relative Temperature (°C)	Maximum Humidity Range (%)	Temperature (°C)
Silver gelatin Heat-processed silver Vesicular Electrophotographic Photoplastic Diazo	20–50	25	20–30	21
Color	20–30	10	20–30	2

aFilm includes all types, such as microfilm, motion-picture film, x-ray film, and photographic negatives.

This material is reproduced with permission from American National Standard IT9.11, copyright 1991 by the American National Standards Institute. Copies of this standard may be purchased from the American National Standards Institute at 11 West 42nd Street, New York, NY 10036.

While earlier versions of this standard featured recommendations for separate relative humidity levels for different film bases, for example, those made of cellulose esters and of polyester, the current recommendations are applicable to the various types of films mentioned in the first column regardless of the nature of the film support.

Because few photographic collections could afford several storage areas with different RH levels for various materials, the current arrangement facilitates the selection of a single optimum RH level beneficial to a variety of photographic films. That level should be 30%, plus or minus 3%, in line with the most recent recommendations for the storage of paper records in archives and libraries, and significantly lower than the 50% RH recommended a decade ago for the storage of such materials.

The storage temperature of 2°C for color photographs, recommended by ANSI standard IT 9.11-1991, may be considered to be conservative. More than a decade ago, researchers from the Eastman Kodak Company published two significant observations that demonstrated the following: first, color photographic images can safely be stored at temperatures below 32°F (0°C), the freezing point of water. Storage temperature can be as low as 0°F (−18°C). Second, the published figures indicate the enormous decrease in the rate of dye fading by a factor of 10^3 if color photographs are stored at 0°F compared to storage at room temperature. Relative humidity must be controlled tightly at low temperature storage and be kept at a level of 30±3%.

Regarding the quality of filing enclosures, the pertinent ANSI standard discusses products made of paper and of plastic materials. Materials used in manufacture must be free of acid and peroxides and must be chemically stable. Adhesives in seams must be free of sulfur, iron, and copper; and printing inks must not bleed, spread, or transfer. Paper envelopes, in particular, must have a high alpha-cellulose content (minimum of 87%); be free of highly lignified fibers (ground wood); have an alkali reserve of 2%; contain a minimum of sizing chemicals; and should be free of waxes and plasticizers that may transfer to the photographic record during storage. These recommendations are accompanied by references to specific test procedures that can be used to evaluate the envelope material in terms of the specifications. One such test is the photographic activity test, which can be carried out with relatively modest laboratory equipment.

Books: American National Standards Institute, American National Standard for Photography (Plates): *Processed Photographic Plates, Practice for Storage.* ANSI PH1.45-1981. New York, NY: ANSI, 1981; American National Standards Institute, American National Standard for Photography (Film and Slides): *Black-and-White Photographic Paper Prints, Practice for Storage.* ANSI PH1.48-1982 (R 1987). New York, NY: ANSI, 1987; American National Standards Institute, American National Standard for Photography (Film): *Processed Safety Film, Storage.* ANSI IT9.11-1991. New York, NY: ANSI 1991; American National Standards Institute, American National Standard for Photography: *Film, Plates, and Papers, Filing Enclosures and Storage Containers.* ANSI IT9.2-1991. New York, NY: ANSI, 1991. *K. B. Hendriks*

See also: *Image permanence.*

STORYBOARD An accumulation of sketches and/or photographs to aid in defining the production details of a picture series, animation sequence, motion picture, video production, etc. The images are presented on cards of approximately 4 × 6 inches printed with an outline of the frame. These are then arranged or rearranged on a cork board or other suitable surface until the desired continuity is achieved. Written notations concerning the scenes can be placed adjacent to the images. After numbering, each card then represents one shot of the planned production, and the shooting script can be prepared. *I. Current*

STRAIGHT (1) Without dilution, as a stock solution of developer. (2) Without manipulation, as a print made without dodging or other special controls. *L. Stroebel*

STRAIGHT CUT In motion-picture editing, an abrupt switch from one shot to another on both the picture and the sound track, with the transition occurring on the exactly corresponding frames. *H. Lester*
Syn.: *Editorial cut.*

STRAND, PAUL (1890–1976) American photographer. Studied photography with Lewis Hine while attending the Ethical Cultural High School, New York (1907–1909). Championed by Alfred Stieglitz with solo exhibitions at An American Place (1916 and 1932). Stieglitz devoted the last issue, no. 49–50 (double volume) of *Camerawork* (1916–1917) to Strand's photographs, including the famous, *The White Fence* (1916). Produced beautifully composed and printed photographs of all that came before his sensitive eye and lens. His early subjects included the street people of New York, nudes of his wife Rebecca, still lifes, New Mexican landscapes, and shadow abstractions. After becoming a socialist in the early 1930s, he became devoted to creating portraits of a people and their land, published in portfolios and books: *Photographs of Mexico* (1940), *Time in New England* (1950), *Un Paese* (1955), *Tir a'Mhurain: Outer Hebrides* (1968), *Living Egypt* (1969), and *Ghana: An African Portrait* (1976). Active filmmaker (1933–1944). Left the United States to live in France in 1951 because of McCarthyism.

Books: *Paul Strand: Sixty Years of Photographs.* Millerton, NY: Aperture, 1976; Greenough, Sarah, *Paul Strand, An American Vision.* Washington, DC: National Gallery of Art, 1990; Stange, Maren, ed., *Paul Strand, Essays on His Life and Work.* Millerton, NY: Aperture, 1991. *M. Alinder*

STREAK AND STRIP PHOTOGRAPHY Streak and strip photography is accomplished with cameras that share a common design feature, and it is the specific application of the camera that sets the various categories apart. The design feature in all these cameras is that either film or another recording surface moves by a slit. The function of the slit is to limit exposure time of the film to the transit time of a point on the film across the slit and to limit the reproduction or view of a subject to a single *line* in space corresponding to the projection of the built-in slit into subject space. The fact that the film moves behind the slit introduces the time dimension along the film in a direction parallel to the film's movement. Streak and strip photographs, therefore, reproduce a continuous record of time along one dimension of the film, effectively making them a link between normal still photographs and motion-picture photography.

A most important fact to consider when viewing photographs made with strip or streak cameras is that they display time itself as a visual element in the images they produce.

The distinguishing characteristics between strip photography and streak photography is related to the direction of motion of the image. In streak photography subject images remain relatively stationary over the slit or move parallel to the slit orientation during photography and are reproduced as streaks bearing no visual resemblance to the original subject.

In strip photography recognizable records of subjects are made by making their image move over, or across, the camera's slit. This is exactly the opposite of focal-plane shutters, which expose an image by moving a slit over a stationary image. When strip cameras photograph subjects whose images at the camera's slit are stationary, the camera is more properly called a *streak camera*.

STREAK CAMERA A streak camera, sometimes called a *velocity recording camera,* is related to strip or smear cameras, and there is no universally accepted nomenclature related to these cameras. At the fundamental level they simply move film past a slit. A variation of the design is that the image of a slit containing an image is moved over stationary film. In another version the whole image recording portion of the camera is electronic in nature and a camera is simply used to make a photograph of a fluorescent screen or a cathode-ray tube.

The slit built into these cameras limits their field of view along the slit to that normally associated with the lens in use. The field of view in the direction perpendicular to the slit orientation is limited by the width of the slit. The final record essentially is a record of events that occur over the slit for a period of time.

Streak cameras do not produce images that resemble the subject they photograph but rather display a continuous time record of image position along the slit versus time. In effect they behave as strip chart recorders, but instead of using mechanical pens to draw on moving paper they record optical images and are therefore capable of recording many more channels of information simultaneously.

A drawback of streak lenses is that they typically concentrate on only one spatial dimension, although there are variations that allow a photographer to track several spatial locations simultaneously. On the other hand, they provide the photographer with an uninterrupted record of the time dimension. One of the greatest advantages of streak records, as opposed to still photographs or motion-picture records, is the low cost and the ease with which timing and velocity information can be obtained.

A major characteristic by which streak cameras are classified is their ability to resolve small units of time. This is controlled by the rate at which the film can be moved past the slit (or the slit's image displaced over time) and by the slit width. The simplest streak camera designs move film from a supply spool to a take-up spool or rotate a drum covered with photosensitive material past a slit.

Drum-type streak cameras need no synchronization devices to detect the onset of a self-luminous event, and in this respect they are characterized as being *always alert.* Shutters are sometimes added to streak cameras to prevent rewrite, but then synchronization devices must be employed to ensure that the event occurs while the proper recording medium is available. For high speeds the slit is kept stationary, and its image, along with the image of the subject under study, is wiped onto a stationary film surface by a rotating mirror system. Again, complex timing and synchronization schemes are usually required to make sure that the image of the slit is properly located along the film so that the event behavior is recorded along a relatively short length of film.

Ultra high speeds are attained with electronic counterparts of the basic film systems. Instead of mechanical motion, these cameras deflect electron beams containing slit image information by means of magnetic fields to achieve very high time resolutions.

Streak cameras are often used to study the simultaneity of events in the fields of detonics and ballistics, and they are also particularly suited for applications requiring subject velocity information.

STRIP PHOTOGRAPHY Strip photography is accomplished with the same camera design as is used for streak photography. Strip photographs render an image of a subject that more or less bears a resemblance to the original subject.

In strip photography the image of a subject moves across the slit in the camera. Strip photography and strip cameras are typically referred to by their specific applications rather than the generic *strip* term. Like streak photography, strip photography depends on a system for moving a recording surface behind an exposing slit onto which a lens focuses the image of the subject. Strip photography and cameras can be subdivided into several categories, such as linear-strip, panoramic, and peripheral, and within categories systems are often referred to by their particular function, such as synchro-ballistic and photofinish photography or cameras.

The essential feature of strip cameras is that the image they record must move across the slit assembly installed in the camera. Subjects can accomplish this by translational motion or rotational motion. The strip method of making photographs is associated with several well known pictorial, industrial, scientific, and military photographic camera systems.

Photofinish Cameras The most widely recognized application of strip cameras is probably their use at racetracks as photofinish cameras. The slit in the strip camera is aligned with the wire stretched across the track or with posts placed at either side of the track delineating the finish line, and the film is moved at the expected velocity of the images of the subjects participating in the race. Since one dimension on the film is time itself while the other is a line in space, the finish line in this case, photofinish cameras provide an almost indisputable record of the order of finish in a race. Only tampering with the alignment of the camera could yield misleading results, and even then the misalignment would have to be considerable.

Panoramic Cameras Strip cameras are also widely used as panoramic cameras. The camera rotates about the lens's rear nodal point and scans the surrounding scene with the slit built into the camera. In practice most cameras rotate around a point slightly offset from the rear nodal point. At the same time the film is advanced through the camera at the velocity of the image passing by the camera slit. With these cameras it is quite easy to cover angles of view of up to 360 degree or more. The amount of film exposed per 360 degree is a function of the lens focal length. It is given by the formula $2 \times \pi \times f$.

Photofinish camera. Linear Strip Photography Objects move past a stationary camera as moving film is exposed through a slit.

Peripheral Strip Photography. Object rotates as moving film is exposed through a slit.

The earliest of these cameras to be commercially manufactured were offshoots of the panoramic cameras patented by William J. Johnston in 1904 and David A. Reavill in 1905. The commercial version of this camera was patented by Frederick Brehm in 1905 and eventually manufactured by various divisions of the Eastman Kodak Company under the name of Cirkut. Modern cameras such as the Globuscope, Hulcherama, Alpa Rotocamera, Spinshot, and Roundshot are spin-offs of the basic strip panoramic camera principles introduced by the Cirkut camera.

Two electronic versions of these cameras were placed on the surface of Mars by each Viking lander and transmitted stereo views of the Martian landscape back to earth.

Peripheral Cameras Several methods exist for making photographs of the outside surfaces of a subject. Strip cameras can make peripheral photographs by rotating a subject in front of the camera while aiming its slit at the center of rotation of the subject. The film velocity is matched to the velocity of the subject's image, and a whole 360 degree view of a cylindrical subject can easily be reproduced. While most strip cameras can only accurately reproduce subjects of one given diameter at a time, all others being either compressed or elongated, the advantage of reproducing all subject surface features on one flat sheet of film or paper often makes up for this shortcoming.

Synchro-Ballistic Cameras Synchro-ballistic cameras, also known as ballistic-synchro and image-synchro cameras, are nothing more than photofinish cameras, but they are used to photograph missiles and cannon rounds. By placing regular, premeasured markings on the missile it is possible to determine velocity and, in certain cases, even spin rate and other in-flight missile characteristics. Because the synchro-ballistic camera moves the film at the expected velocity of a missile's image rather than trying to use a short exposure time to freeze motion, excellent spatial resolution can be obtained and much information that could not be visualized by other means can be recorded relatively easily.

Aerial Strip Cameras Aerial strip cameras, such as the Sonne camera, are flown over terrain while moving the film at the same velocity as the image of the ground moves within

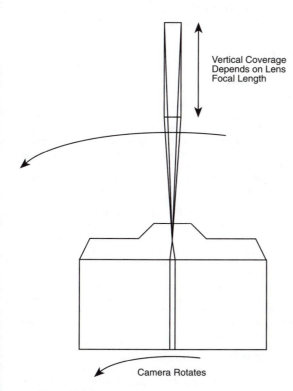

Panoramic Strip Photography. Camera rotates as moving film is exposed through a slit.

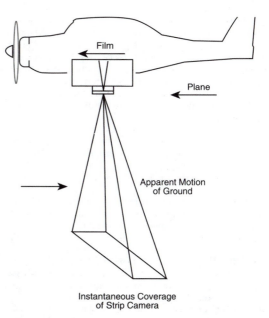

Aerial Strip Photography. Camera moves over stationary terrain as moving film is exposed through a slit.

the camera. Various schemes have been developed to accomplish this, the earliest being manual adjustments made to the rate of movement of a moving chain visible to the camera operator next to the moving image of the ground. The chain was linked to a film transport mechanism. By watching the relative motion between this chain and the moving features of the ground, the operator could adjust the velocity of the chain, and therefore the film, to match image motion quite accurately.

Modern designs rely on electronic sensors to match the two velocities. Military versions of these cameras are sometimes used to reconnaissance purposes because image velocities are often considerable and shutter speeds are not fast enough to produce adequately sharp images for interpreters. The strip aerial reconnaissance camera records may be distorted because of lateral movement of the image while it travels across the slit, and they may even be slightly stretched or compressed, but often they contain more detail than an instantaneous photograph blurred as a result of image motion. A special version of the aerial strip camera has been used to record the condition of long stretches of highway.

Circular Strip Cameras A strip camera developed by this author uses film that moves in a circular fashion. This enables the camera to make distortion-free peripheral photographs of conical objects. Because the slit in this camera lies along the radius of the circularly moving film, it can match the different image velocities associated with the changing surface velocity of the cone from the base to the apex. This camera also can correct for differential image motion that occurs along the slit in panoramic photography when the camera is tilted up or down rather using the rising/falling front movements possibly available on the camera.

The records produced by this camera reproduce a 360 degree peripheral view of a cone or a 360 degree panoramic view of a surrounding scene on a portion of the film taking up less than the complete 360 degree film circle.

A. Davidhazy

See also: *Panoramic photography; Peripheral photography.*

STREAK CAMERA See *Camera types.*

STREAKS Streaks are linear markings in the machine direction of a roll of film. They are rarely caused in the manufacture of the sensitized product but tend to be the result of some difficulty when processing in a continuous machine. A build-up of some material in the path of the film may provide contamination or other interference, the effects of which can be seen in the image area of the final product. They can also occur in drying due to insufficient squeegeeing of water across the strand. There may or may not be visible physical damage to the film surface.

Streaks can also be caused by a fiber or other intrusion in the image-forming path of the camera, printer, or recording instrument. *I. Current*

See also: *Processing effects.*

STREAMERS A more or less regular flow of developer over film that is processed with inadequate agitation that results in uneven development and streaking.

L. Stroebel and R. Zakia

STREHL DEFINITION/INTENSITY RATIO A measure of the state of correction of a diffraction-limited lens more severe than the Rayleigh tolerance. Provided the general form of the Airy pattern remains unchanged, the intensity of the center of the pattern, called the Strehl intensity (K. Strehl, 1902), gives the measure of the state of correction. It is then assumed that the image quality will not be noticeably inferior to a perfect lens, provided that the ratio of the Strehl intensity to that given by an ideal Airy pattern does not decrease to 0.8 or less. *S. Ray*

STRESS ANALYSIS See *Photoelastic stress analysis.*

STRETCH PRINTING A motion-picture printing technique in which selected frames of the original are printed more than once. For instance, in printing silent films originally shot at 16 frames per second so they will project with proper time values on a modern 24 frame per second projector, every second frame would be repeated during printing. *H. Lester*

STRIKE In motion-picture and theatrical production, to dismantle and remove sets and props when no longer needed, returning the stage or location to its original condition.

H. Lester

STRIKE CAMERAS See *Camera types.*

STRINGER In photojournalism, a freelance photographer who is employed on an occasional basis by a publication or agency as distinct from being a full-time employee.

L. Stroebel

See also: *Freelance photography.*

STRIP CAMERA See *Camera types.*

STRIPE COAT The opposite of full coat. Magnetic film that is coated with oxide in only a single stripe meant for recording a single channel. A *balance stripe* is applied near the opposite side to produce better winding characteristics. *Stripe coat* is a term that typically applies only to such 35-mm magnetic film stock. *T. Holman*

STRIPE/STRIPING In motion pictures, adding a strip of magnetic material along the edge of a length of picture film, for sound recording. *H. Lester*

STRIPPING See *Image assembly.*

STRIPPING FILM A graphic-arts material wherein the emulsion is not coated directly on the base but on a thin (usually cellulose nitrate) skin coated on the base. Care is taken in manufacture so that there is sufficient adhesion of the skin to the base to withstand processing but not enough to prevent deliberate peeling afterward. Stripped negatives, or portions, can then be combined with others on a new support. An alternative use is for lateral reversal, since the stripped skin can be laid down on the new support with either side up. *M. Scott*

STROBE (1) An electronic flash unit that is capable of producing a rapid and continuous series of flashes of light, used in photography, for example, to obtain a series of displaced images in a single photograph of a rapidly moving object, or of a stationary object by panning the camera. The frequency of firing is generally adjustable and on some units can be increased well beyond where it appears to be a continuous light. (2) A widely used misnomer for conventional electronic flash. (3) A shortened form of stroboscope and stroboscopic. *R. Jegerings*

See also: *Electronic flash; Stroboscope.*

STROBING In motion pictures, a distracting flicker, commonly observed when contrasty vertical scene elements move too fast laterally. Most noticeable in animation, where the individual frame images do not have the blur characteristics of live-action photographs. *H. Lester*

STROBOSCOPE A device that makes moving objects visible intermittently to produce the appearance of a series of displaced stationary objects, usually by illuminating the subject with flashes of light, but the effect can also be produced with an intermittent shutter. If a wheel with spokes is rotated and is illuminated with a light that is flashing at a frequency that corresponds to the angular rotation of adjacent spokes (or any multiple of this rotation), the wheel will appear to be stationary. By increasing the flashing frequency slightly, the wheel will appear to be rotating in the reverse direction, and by decreasing the flashing frequency slightly the wheel will appear to be rotating in the correct direction but at a much slower speed than it is actually rotating. Similar effects are produced in motion pictures, where the direction and speed of rotation perceived when the projected film is viewed depends upon the timing relationship between the opening of the camera shutter to expose the individual frames of film and the positions of the spokes. Stroboscopic photographs made with still cameras, where offset images of moving objects are obtained, have found many scientific and pictorial applications. *R. Jegerings*

STROBOSCOPIC EFFECT In motion pictures, an unnatural appearance of a moving object caused by the intermittent exposure of the film, such as in the apparent reversal of rotation of a spoked wheel. *H. Lester*

STROBOSCOPIC PHOTOGRAPHY The use of a pulsed electronic-flash light source to obtain multiple images of moving objects in photographs. *L. Stroebel*

See also: *High-speed photography.*

STRONG COLOR Adjective denoting high saturation or chroma. *R. W. G. Hunt*

STRONG PERSPECTIVE An exaggerated appearance of depth in an image, such as that produced with a short focal-length lens on a camera located close to the subject. Objects seem to diminish too rapidly with increasing distance, and parallel lines in the scene seem to converge too much. *L. Stroebel*

See also: *Perspective; Weak perspective.*

STROOP EFFECT Perceptual interference caused when a word that represents one color hue is printed in a different color hue and one is asked to read the color rather than the word—for example, the word red printed in green, the word blue printed in red, the word green printed in yellow. The contradiction between the color the word represents and the color in which it is printed tends to cause errors in response. The Stroop effect test was first developed by J. R. Stroop in 1935. The purpose of this color-naming/word-naming test was to study how a person cognitively processes contradictory visual/verbal information.

Reference: Stroop, J. R. "Studies of Interference in Serial Verbal Reaction," *Journal of Experimental Psychology* 1935, 18:643-661. *L. Stroebel and R. Zakia*

STRUCTURAL FORMULA A form of chemical notation, often used for molecules containing many carbon atoms, that attempts to show the bonding and spatial arrangement in the molecule. A color developing agent is used as an illustration in the example below. *G. Haist*

See also: *Chemical symbols.*

STRYKER, ROY EMERSON (1893–1975) American administrator. Director of photography project for the Farm Security Administration (FSA) (1935–1943). Selecting such photographers as Dorothea Lange and Walker Evans, the FSA under Stryker's leadership produced a massive document of 250,000 negatives that captured the broad face of rural America as it weathered the Great Depression.

Books: *In This Proud Land,* with Nancy Wood. New York: Galahad Books, 1973. *M. Alinder*

STUDIO A space designed and equipped for the purpose of making photographs. The term is frequently applied to the business of making photographs in a studio. It is also applied to the entire space occupied by the photographer even though some areas are not directly used for making photographs. Originally, studios were modeled after painters' studios, with large windows and skylights, to let in as much light as possible for the slow emulsions of that time. The light was adjusted or softened by large translucent curtains that could be placed over the windows. Electricity, of course, has changed all that by giving photographers the ability to have light that is regulated at their discretion. A wider variety of lighting techniques is possible as is much stronger light. Modern commercial studio lighting is almost always artificial light. However, fashion and portrait photographers still make use of window light for some applications. The famous English portrait photographer Snowdon uses natural light exclusively in his studio. Arthur Elgort, a well-known New York fashion photographer, produces world-renowned photographic spreads using all natural light or a combination of natural and artificial light.

DESIGN The overall design of a studio is a matter of individual decision that is tempered by available space, finances, type of studio, and range of photography that will be done. It is a good idea to take some time to solidify one's opinions on these topics and write them down. After as clear a decision as possible is made, the actual layout of the space can begin. The following sections will provide guidelines for this procedure. An efficient way of handling this problem is to draw to scale on grid or graph paper a representation of the available space. For instance, one square on the grid paper could represent 1/2 foot. Even furniture and workbenches can be drawn to scale on a separate piece of grid paper and cut out to allow you to move them around in the scale drawing. In this way, some idea of where things will go in relation to how the space is laid out can be determined before any construction starts. This method also helps determine if a particular space will be suitable to your needs.

SIZE For greater flexibility, the studio should be as large as possible. It may be necessary to build a large set, a room for furniture photography, for instance, or to have two or more areas in which photography is being done at the same time, as for catalogs. The perspective of long lenses for many types of photography also will require a large space. However, practical considerations of finance and availability will limit the possible size. To arrive at a minimum necessary size, you can apply the following calculation:

Focal length / negative height = distance to camera / subject height

This proportionality allows you to calculate minimum size for your most common way of working. For instance: a 2–1/4–in. camera, such as a Hasselblad, with a 150-mm lens used to photograph a six-foot-tall person, when all units are converted to inches requires:

$$150 \text{ mm} / 25.4 \text{ mm per in.} / 2.25 \text{ in.} =$$
$$\text{Distance} / 6 \text{ ft} \times 12 \text{ in. per ft.},$$

which when converted back to feet gives approximately 16 feet. Adding a minimum three feet between subject and background and two feet between camera and the wall gives a minimum studio length of 21 feet. It must be emphasized that this is a minimum distance. The distance between background and subject is variable depending on the effect desired. Having the ability to vary the distance beyond the

minimum adds to the number and types of photographs that may be taken.

Ceiling height is also a function of the types of photographs that will be made in the studio. Work with human models that requires full-length shots needs a higher ceiling than table-top work. Ceiling height is also a function of the type of lighting used. Obviously, side lighting requires less ceiling height than overhead lighting. Overhead lighting with soft or bank lights that can be as much as five feet deep will need a very high ceiling in order to have any control of the lighting. Unless the light can be placed at some distance above the subject, for most applications there will be too great a drop off between the light value at the top and the light value at the bottom. However, a high ceiling causes some problems as well. Evenness of heating, access to the ceiling for repair or maintenance, and manipulation of lights hung from the ceiling may require rolling scaffolding. A high ladder is clumsy to use and it can also be dangerous. The width of the studio should be determined, again, by the type of photography done and by the style of lighting used. Since flexibility is the prime concern for most studio design, the width should be generous. It should allow for side lighting and movable booms for overhead lighting. For convenience and efficiency during the shooting session, most photographers prefer to have all necessary equipment easily accessible in the studio itself. When doing catalog work, it is convenient to have the product laid out on tables or the floor so one can easily see what has been done and what is to be done next. (See the section on *Storage* for further considerations of width).

CONSTRUCTION Construction in the studio is usually limited to the building of walls necessary to partition a large open space into areas required for the various phases of the photographic process. These areas may include a shooting space, office, darkroom, etc. (See the section on *Types of Studios*). Normal wall construction is all that is commonly necessary for these partitions. If it is necessary to build a wall that divides the spaces occupied by the photographer from another person's space or a common space, that wall should be a demising wall, i.e., a wall that is double sheetrocked on each side. This construction technique decreases the chance of a fire spreading and of noise from coming through the walls. Some consideration may be given to reinforcing one of the walls to assist in hanging backdrops or to allow the attachment of shelves for storage. It is sometimes nice to have a wall made out of a material that allows the attachment of notes in the office, ongoing work in the darkroom or finishing area, or newly completed work in the reception area. A convenient material for this purpose is called Homesote. It is a pressed paper that comes in standard 4 × 8 foot sheets and allows one to temporarily hang materials with push pins.

CYCLORAMA WALL It is becoming increasingly common to have a cyclorama wall installed in the studio. This is a hard seamless background. It overcomes many of the problems associated with the use of seamless paper as a background. It is smooth, can be painted any color or pattern, cannot be damaged by rolling heavy subject matter across it (computers, cars, etc.), and it will not be torn by models walking or dancing across it. It can also be constructed wider than the commonly available width of seamless paper. It is also possible to build a cyclorama wall with a perpendicular seamless wall for maximum flexibility. The two walls are connected by a complex curved surface. Occasionally, one sees a cyclorama wall that also curves seamlessly at the top to prevent any possibility of a hard edge at the top of the photograph. In fact, this curved top increases the effective height of the wall significantly. The curvature of the cyclorama wall can be custom tailored to the needs of the particular photographer. Some people prefer a large gentle curve (or

cove, as it is sometimes called) for very smooth gradation behind subjects; others want a more radical curvature to eliminate most gradation. It is best to arrive at a compromise curve that will suit as many different types of photographic situations as possible.

A practical way to determine a radius suitable for your needs is to experiment by hanging a seamless paper backdrop and producing a curve that works well with several kinds of photographs. This procedure will yield a better result than a theoretical approach. The vertical wall is made of a type of sheetrock wall surface called blue board. This material is designed to take a coat of plaster since the final cover of the wall must be a hand-applied skim coat. The curve itself should be well supported and composed of a mixture of plaster and cement applied over metal lathing. This will also be skim coated to form a continuous surface with the vertical wall. The curve is then integrated into either an existing cement floor or a new slightly raised floor. If the existing floor is very level and smooth, the extra expense of a new floor can be saved. The curve is not laid directly on the floor. This would result in a very thin area that would easily chip. A channel is dug into the floor at the point of union to give the end of the curve some thickness and rigidity.

If a new floor is poured, provisions can more easily be made for integrating the curve into the floor. The point of integration in either case should be several inches thick. The advantage of a new floor is that it can be made perfectly level and smooth. Since the new floor will be poured over an existing cement floor (not over a wooden floor) it will be thinner than is usually necessary to prevent cracking. Special provisions for reinforcement must be taken. These technical considerations of construction are best taken up with a professional builder. However, do not leave such decisions solely to the judgement of the contractor. Make sure your needs and concerns are clearly stated and understood before construction begins. A guarantee for the integrity of the floor should be proposed. It is also possible to buy a prefabricated cyclorama wall that is sold in sections, so any length is possible. It would be best to inquire whether these prefabricated sections will bear up to the hard use that cyclorama walls receive. Even though it is not advisable, people invariably step on the curve. Curves to cover the vertical corner between adjacent walls are also available.

STUDIO FLOOR The floor can be any smooth surface, such as tile, painted cement, or wood. A wood or tile floor can also be used as part of the room set, saving time and added set production costs. Much of the general appearance of the studio comes from the floor. In a large open space, it is the dominant feature. It is worth taking some time and care in finishing the floor both for the sake of appearance as well as for technical consideration. Some of the technical considerations are smoothness, levelness, flexibility, absorbency, and reflectance. The floor should be as smooth and level as possible. The smoothness will help when using rolling stands and booms and when moving heavy subject matter into the studio. Even large amounts of lightweight product for catalogs are best rolled into the studio on a cart.

Levelness is not the most important thing, but when leveling a camera to a set, it is much easier to do so when the set itself is level. It is especially helpful when doing overhead shots. The floor should not be too flexible, as is often the case in older buildings, because the set may move when someone walks too heavily, or with vibration from heavy equipment in the building, or even with heavy street traffic. This can result in a blurred image whenever it is necessary to make multiple exposures or when using such techniques as multiple flashes to build exposure, or time exposure as when burning in a computer screen. Since fluids are often

used in the studio (for cleaning backgrounds as well as for subject matter), it is best to have a floor that will not absorb spills. Not only will this assist in cleanup, but it will prevent residual damp spots or odors that will make the next setup more difficult.

In general, it is a good idea to avoid a floor that is highly reflective. Extraneous light bouncing around the studio may cause some problems with illuminating the set or by causing flare in the camera lens. Remember, the floor is the most used part of the studio.

STUDIO CEILING The ideal studio ceiling is high and smooth. The fewer obstructions there are, such as pipes, electrical conduits, heating ducts, etc., the easier it will be to move lights over or around sets. Hanging pipes can also get in the way of an angle of view. Some pipes are necessary in the studio, such as heating ducts and the fire prevention system of sprinklers. The sprinkler system obstruction can be minimized in several ways. If the studio is not very wide, the sprinkler system can be installed in the side walls. However, this is not the most recommended way of protecting against fire. The heating system can also be installed in the walls, but again this is not the most effective way of heating the studio. A drop ceiling can be installed in the studio with enough space between the real ceiling and the drop ceiling to allow for all piping, conduits, and ducts to pass. Only the heads of the sprinklers will protrude. Keep in mind that a drop ceiling will reduce overall ceiling height, and usually it is not strong enough to support the weight of lights or back-grounds. If there is a beamed ceiling, most of the service piping can be run between the beams so there is no obstruction other than the beams.

TRACK LIGHTING The studio ceiling can end up being quite complex because of the availability of many types of track lighting systems. These all consist of metal tracks on which lights can move, keeping the floor free of light stands and allowing the lights to be positioned in any location above the set. The tracking can be attached to a wide variety of ceilings, from wooden beams to metal trusses. Care must be taken to make sure the supports of the tracking are strong enough to bear the weight of the lights and lighting accessories that will be hung from them. Incidentally, hanging lights from a track system can be a precarious oper-ation. Standing on a ladder, no matter how steady, to hang the lights is quite dangerous. A small set of scaffolding, prefer-ably on wheels, though expensive, is a great help. It is also possible to purchase what is essentially a moving stairway. Such a device is very stable and has a small platform at the top enclosed with railings. The staircase is on wheels that are spring-loaded so that when one steps on it, the wheels are

A typical track lighting system.

pushed into a recess and the stairway comes to rest on the rubber-capped feet.

Another system that is attached to the ceiling is general area lighting. Moving subject matter into the studio, building and arranging sets, and clean-up after a shoot are much more convenient with general overhead lighting. This lighting is usually fluorescent, so care must be taken not to hit a bulb with a piece of light equipment, or when raising a backdrop. Again, a drop ceiling in which the fluorescent lighting is recessed is the most satisfactory.

WINDOWS Even if the photographer intends to use arti-ficial light exclusively, it is not a problem to have windows in the studio area. Depending on the space, there may be no choice. Windows can be desirable for ventilation or just to provide a more enjoyable environment when not involved in a shoot. However, it is necessary to be able to block out all light coming from the windows. Too much extraneous light will make it difficult for the photographer to see what effect the artificial light is producing on the subject. Similarly, during time or multiple exposures there must be no ambient light for the camera to pick up. If there is a large bank of win-dows in the studio (as will be the case in older industrial buildings), the blacking out of all of them can be a problem. There are commercially made blackout shades for windows but these can be quite expensive. Rolls of thick, black garden plastic can be fastened over each window and lowered when necessary. This is an imperfect and clumsy solution, but it is much less expensive. A large bank of windows, however, can also be an advantage. There are many kinds of pho-tographs, especially fashion and furniture, that can benefit from being done in window light, or with window light as an addition to artificial light.

SECURITY Security is also something to keep in mind during the construction of the studio. The photographer will be storing very valuable and, unfortunately, easily resold photographic equipment and clients' products in the studio. Perhaps even more important, the photographer might be storing irreplaceable negatives and transparencies in the studio. Even though these materials may not be valuable to a thief, they are certainly valuable to the photographer and one would want to protect against their possible loss or damage during an intrusion. There also exists the possi-bility of malicious destruction during a break-in. There may even be a break-in for that purpose alone. To help with secu-rity, the doors into the studio from outside should all be solid core or metal with deadbolt or other nonpickable type locks.

It is also a good idea to think of installing a security alarm system during the construction phase. There are many types of alarm systems, from the inexpensive self-installed vari-ety to the more costly professionally installed systems. These professional systems will detect the motion of an intruder as well as the heat of a fire. Tied into a central office, the alarm system will notify the proper authorities during an emergency. Some alarms will sound a simulta-neous siren that will frighten the intruder. These systems normally require a one-time installation cost and a small monthly fee. It is a good idea to check with local police or security experts to determine what is advisable for your par-ticular area and setup.

POWER REQUIREMENTS All electrical work done in the studio generally must be performed by a licensed electrician and must conform to local building codes. These codes are designed to insure that the installation of the elec-trical system is safe. It is not a good idea to try to circumvent these codes. This section should give you enough informa-tion to be able to tell your electrician what you need and to answer any questions the electrician may have.

The electrical power needed in the studio will depend on the type and amount of lighting equipment used. Even

though electronic flash equipment is the most commonly used lighting in a modern studio, there are still photographers who prefer incandescent or hot lights, and there are certain things that are still best photographed with hot lights. Enough power to accommodate both makes the most sense. There are three terms used in talking about electrical energy. They are watts, volts, and amperes. The watt is the unit used to define electrical power, the volt is the unit of electrical force, and the ampere is the unit of electrical flow. Since these terms are often somewhat hard to understand, water can be used as an analogy. The volt is equivalent to water pressure, and the ampere is equivalent to the flow rate of water. The amount of water flowing at a certain pressure gives the power of the water. In a similar way, the power or wattage of an electrical circuit is found. The simple formula used is:

$$Watts = volts \times amperes$$

Electrical wire comes in different grades or thicknesses depending on the wattage to be carried by the wire. The wire must be of the correct thickness to carry the expected amount of electricity or *load* to the outlet boxes and to the general lighting.

The other important part of the electrical circuitry is the safety component. This component exists in the form of fuses or circuit breakers. They are housed in an enclosed box located somewhere near the point where the main electrical line comes into the studio. This fuse box or junction box is the point from which the electricity is distributed to the outlet boxes and to the general lighting. The fuse, or the more commonly used circuit breaker, will stop the flow of electricity if loads higher than the wires can bear are being drawn through the wires. If a load higher than the one allowable for the wire flows through it, there is the danger that the wire's insulation will melt and a fire can result. In the case of fuses, a small length of metal placed in the way of the electrical flow is calibrated to the exact amount of electricity that the fuse is rated for. When a higher load is drawn on the circuit than the allowed amount, (by plugging in too many pieces of equipment, for instance), the higher amount of electricity first flows through the fuse, causing the metal band to melt and stop the flow of electricity before the wiring can be affected. The problem with the amount of power drawn on the circuit must be determined and corrected. The fuse must then be replaced with a new one.

Circuit breakers do the same thing but without the need of replacement every time there is an overload. The circuit breaker consists of a switch that closes, or *trips* when too much electricity is drawn. This switch can be reset after the problem is determined and corrected. The circuit breaker has a visible on/off position that makes it easier to determine which circuit has tripped; a fuse requires looking at the metal band to see if it has melted. Of course, to most easily locate the tripped breaker, each circuit in the junction box should be clearly labeled to indicate which set of lights or outlet boxes connect to each breaker. If the electrician did not do this, it can easily be done by simply switching a circuit breaker off or unscrewing a fuse and noting which circuit is affected. That circuit can then be labeled next to the fuse or breaker. Since there is usually a surge of electricity when something is first turned on that is higher than the amount of electricity that will be drawn during continuous use, many fuses will burn out at the moment of this surge. Circuit breakers have a built-in time delay that allows this surge to occur without tripping. The surge is not of a long enough duration to melt insulation and start a fire, so the time delay circuit breaker prevents nuisance tripping of the circuit when electrical equipment is first plugged in or turned on.

The power required to recharge most large flash packs on fast recycle is 20 amps; on slow recycle, 10 amps. If each electrical outlet box is connected to a 20 amp circuit breaker and there is one box for each pack, there should be no problem with powering your flash equipment. Having sufficient power for each strobe pack allows your strobes to live up to their designed recycle times.

The power required for hot or incandescent lights is calculated using the formula stated above. The sum total wattage for the bulbs to be plugged into an electrical outlet box divided by 110 volts (the common voltage in the United States) gives the amperage required of the circuit breaker. For instance, if you were to use two 500 watt lights and wanted to plug them into a single outlet box, using the formula given above:

$$500 \text{ watts} + 500 \text{ watts} = amps \times 110 \text{ volts}$$

Solving the formula:

$$amps = 9.09$$

or approximately 10 amps. When rounding to a whole number, always round up for safety.

Please note that specifying the amperage of a circuit breaker assumes that the wire connecting the breaker to the outlet box is sufficient to carry the required load.

HEATING AND VENTILATION As with any space in which people are going to work, the studio should be adequately heated and ventilated. There are some problems with heating and ventilating a studio space. The first is that the space may be quite large with high ceilings. This always makes it more difficult to evenly adjust the climate in the studio. In most situations involving large spaces the heating, ventilation, and air conditioning (HVAC) will have overhead ducts that vent the adjusted air down from the high ceilings. In a studio, however, it may not be desirable to have air flow coming directly down over a set. The air may cause the set to move, or delicately balanced props to fall over. The overhead air may also deposit dust onto the set, requiring frequent cleaning. The air vents may have to be around the perimeter of the studio or in the side walls. The same will be true for the return ducts. They should not be in the floor, but in the side walls. The heating must be adjustable for those times that human models are being photographed who may require a slightly warmer or cooler than normal temperature. Air conditioning is more a necessity than a luxury for the studio. It will also provide a means of ventilation even if no cooling is required. The studio will not require more than normal room ventilation unless the photographer will be working with subject matter or materials that give off toxic vapors. This is quite rare.

STORAGE The one problem that seems universal to all studios is that there is never enough storage space. Awareness of the problem and planning ahead for current as well as future storage needs will help provide sufficient space for all the things a photographer acquires. Storage is required for photographic equipment, backgrounds, and props.

Equipment Storage Equipment storage can generally be divided into two types: cameras and lighting. Camera equipment must be stored so as to minimize the chance of damage—everything from knocking something over to a sprinkler system accident. Any good shelving system, such as industrial-grade metal shelving, will provide a safe, sturdy platform for storing equipment. Cameras can be left in their cases on the shelves to keep them clean and to protect them from accidental damage such as water spillage. This keeps all the camera equipment visible and easily accessible.

However, this does not deal with the other great problem of camera storage—theft. Minimally, the area in which the camera equipment is stored should be equipped with an alarm system that notifies the police automatically. Keeping

camera equipment in a good safe deters the casual thief as well as making it more difficult for the professional to move equipment out of the studio before the police arrive. Even though it is less convenient to keep cameras and meters in a safe, in our present world it is a matter of necessity. Lighting equipment, even though valuable, is usually too bulky to be stored in a safe. Strobe packs are sometimes stored in a rack along a wall. This allows easy access to all strobe controls and light can be plugged into the packs as needed. This works especially well for overhead lighting systems such as track lighting or large area multi-strobe head lighting systems. The packs can be secured to the rack or the wall to help prevent theft. For more general lighting set-ups, strobe packs can be placed on rolling carts so the packs can be moved to any place in the studio in which they are needed. The many accessories for the lights need to be kept easily accessible. Industrial metal shelving is a good method for storage. It is also possible to buy wood shelving in the form of small cubes. These multi-cubbyholed shelves are very convenient for storing all the strobe heads and their accessories in a way that keeps them neatly in their place and visible enough to be found quickly when needed.

Background Storage Backgrounds come in many types and sizes ranging from the standard 108-inch seamless paper to large cloth drops. Seamless must be stored vertically or it will lose its cylindrical shape and have ripples when it is hung. It should also be kept in its box to prevent it from becoming soiled or faded. A simple rack can be built along a wall in which the seamless is held by a bar across the top that is perhaps six inches lower than the seamless roll. The seamless is then slipped under the bar at a slight angle and raised into the vertical position and set on the floor. This system requires very little floor space and keeps the seamless easily available. The rack can easily be made two or more layers deep. Formica panels, another common background material, can also be stored vertically. In fact, the panels can be slipped against the wall behind the seamless. Though not as convenient for locating individual pieces, it is simple and effective. Another storage method involves attaching a wood or metal bar to the short edge of the Formica. The bar can then be slipped over a rack near the ceiling or, with the attachment of pulleys and eyes, hoisted to the ceiling. This method is complicated and cumbersome, but may be the only choice. Plexiglass involves special consideration because it is so easily scratched, which can ruin its backdrop potential. It may also be stored like the Formica but with cardboard interleaving to protect the surfaces. Though this expands the storage width necessary, the high cost of Plexiglass makes it worthwhile to protect its surface. If the studio is large with plenty of storage space, Plexiglass and Formica can be stored on a rolling rack similar to the ones used by the dealer. This allows easy access to the backgrounds and they can be rolled close to where needed for extra efficiency. Cloth drops can be rolled or folded and stored on shelves. Since many photographers like the effect of the inevitable wrinkles, there is no problem with this type of storage. Wrinkles may be removed from large cloth drops with a commercial steamer.

Prop Storage Prop storage is a more difficult matter because of the variety of sizes and shapes, and the fragility of props. Even though photographers these days depend more and more on stylists for providing props, there are always some items that are used repeatedly for a particular client or in order to create a particular look. Industrial metal shelving with adjustable shelves provides a convenient and safe storage method. Some studios have a separate room for prop storage.

Film Storage Film, often bought in large batches of one emulsion number, must be stored properly to insure consistency in color rendition. Since a cool dry place is necessary for proper storage, film is usually stored in a refrigerator with humidity control. Having a proper place to store film also allows a photographer greater flexibility. The photographer can keep a stock of different types of film available for those times when the photo shoot is arranged at the last minute, or when clients change their mind about the type of shot being done or about the format of the film being used during the shoot.

ARCHIVES Many studios store stock photographs, extra transparencies from photo shoots, previously made prints, and even negatives.

Photographic Materials Archive Transparencies and negatives can be stored safely in metal filing cabinets. Standard letter-size cabinets that are four drawers high are ideal for this type of storage. Filing cabinets that lock should be considered for extra safety. Again, it is common for a thief, looking quickly through a space for valuables, to ransack filing cabinets, destroying items valuable only to the photographer. In fact, many photographers store all material relevant to a shoot: layouts, overlays, receipts, invoices, etc., together with the resulting photographic materials. A very convenient way to store these materials inside the cabinets is in vertical filing or "job" jackets. These are similar to standard file folders but do not have open sides. They are only open at the top and have an accordion fold to hold large amounts of materials if necessary. All material associated with a job is placed in the jacket and safely stored with little chance of things slipping out. Photographic prints can be kept in specially designed and fairly inexpensive boxes. These boxes are designed to protect the prints from the effects of chemical aging caused by the paper in regular boxes. Such storage is termed *archival*. However, most commercial prints do not require the care of archival storage, and many photographers simply store 8 × 10 and smaller prints in the job jackets and use empty photographic printing paper boxes for larger size prints. These boxes are then labeled and stored on those ubiquitous metal shelves.

Archive Filing System The biggest problem with storage of transparencies, negatives, and prints is accessing them at a later date. A *job log* is usually maintained. This consists of a list of all jobs with a short description of the subject that was shot. A filing code should be established. It can be oriented to the date or to the client and it should be simple. For

Wall rack for seamless background paper storage.

instance, the initials of the studio name, the year, and the number of the job provide a simple code for photographic materials. For example, if the studio is named "Quality Photos," the 23rd job in the year 1991 would be coded at QP-91-23. It is a good idea to also list the client. Many photographers will include a description of the type of photo shoot it was (product, architecture, portrait), the type of client (agency or direct), and the amount billed as a means of tracking the type of photography most often done. This type of categorizing is helpful for marketing direction. It also gives the photographer information on types of photographs taken to assist in determining what type of equipment to invest in, and what direction the business is taking. This job log can be kept in a notebook with sewn-in pages to prevent any loss of information, or it can be kept on filing cards for easy arranging. However, by far the best and most versatile way to store this information is with a computerized database. Make sure the database program you choose has many options for arranging and seeking data. This allows for quick access to all previously photographed jobs and to information that is critical to planning the future of the studio. This job log is crucial to the efficient running of a studio. The disk on which it is kept should be backed up, and a current hard copy maintained. These backup items are best stored in the safe.

See also: *Image permanence.*

TYPES OF STUDIOS There are as many types of studios as there are photographers. The requirements of each person's photography will determine the way the studio will be used and how it should be designed. In general, studios can be broken down into four broad types: the professional studio, the artist studio, the amateur studio, and the location studio.

The Professional Studio The professional studio, designed to take a wide variety of photographs to fit the specifications of different clients, is more complete than any other type of studio. If you are about to design a professional studio space, try to visit some existing studios. During trade shows in larger cities there are often studio tours in which several of the local studios are open for visitors. The professional photographic organization in your area may also have an occasional tour of local studios. Also, photographers are usually very proud of their studios and will often be amenable to a visit. Seeing how other people solved the design problems of their studios can be of invaluable help.

Reception and Display Area The professional studio needs some ares that other types of studios do not require because the professional studio is a place that is visited by clients. The studio entrance should lead to a reception area for the convenience of clients during meetings or a shoot. The reception area usually contains facilities for the display of the photographer's work. This is not only for the entertainment of clients but may also suggest to a client a different type of work that the photographer is capable of doing. This is a subtle way of increasing sales. This area is not only for the display of print work, but also for the display of transparencies. A vertical light box, covered with an opaque material with the appropriate holes cut to allow for the illumination of display transparencies, makes a striking display. Modern materials such as Duratrans allow photographers to make their own display transparencies in their own darkrooms with standard color chemistry. It is also nice to have a magazine table or some sort of shelf where photographers can put brochures, magazines, catalogs, etc., that contain samples of their photographs for viewing by clients.

Conference Area There is often a separate room or space with a large table where the requirements of the photo shoot can be planned and discussed with the client. This space should be provided with a telephone for use by clients during a shoot. Very often clients will want to conduct business or

do design work while waiting for a shot to be set up. A room such as this will provide space and privacy for the client. A large horizontal light box for reviewing tests or discussing samples is a necessity.

Kitchen For those photographers who are going to do food photography, a large kitchen area is necessary. This area is often adjacent to or even within the studio. If located in the studio, it can also be used as part of a set for photographing food preparation. This kitchen should contain an unusually large amount of counter space. This is necessary because food for photography is often prepared in multiples; six turkeys, four apple pies, etc. Also, the food stylist will need room to prepare the dishes and lay out the props in preparation for transferring then to the set. Even if the photographer is not going to specialize in food photography, at least a small kitchen is handy for the preparation of the occasional food shot or for the convenience of clients.

Dressing Room Most studios have a dressing room for models. It should be large enough for the model to feel comfortable or even for the makeup artist to work. Outlets for hairdryers and curling irons are required. A small sink for washing off makeup or for the application of certain kinds of hair or facial treatments is a nice convenience. Since shoots with models often require a large number of garments, a space for hanging them in a way that they can be seen and selected makes things more convenient. Mirrors are a must, of course.

Processing Laboratory Many professional photographers want to have a hand in their own materials processing, especially printing. Even a modest-sized darkroom increases the photographer's ability to fulfill client wishes. A photographer can often produce a print in a rush to help a client whereas a commercial processing lab will take too long or charge too high a premium on rush work. Larger studios even process their own E-6 transparencies. This allows the client to see an actual end product in a short amount of time instead of merely seeing a Polaroid proof. Some clients, such as architects and models, want a print as their final product. Producing these prints in the studio can earn a large amount of money for the photographer and prevent the inevitable mistakes and misunderstandings that result in using labs for this work. The darkroom can also be used for loading and unloading sheet film holders. A separate film changing room right in the studio is much more convenient, however. It doesn't have to be very large; it is essentially a light-tight closet with shelves for laying out holders and film, and enough elbow room to allow for the movement necessary in loading and unloading sheet film. (See the entry on *Darkroom* for an expanded discussion of this topic.)

Finishing and Shipping Area Since prints usually have some finishing work required, (such as spotting or retouching) and work is often shipped to clients either by mail or overnight delivery, it is very helpful to have a print finishing and packing area where the materials used for these procedures are stored and readily accessible. A counter with cabinets will hold all packing materials and provide a surface for postage meter, scale, and retouching area. The retouching area can be equipped with a magnifying lamp that makes any retouching procedure much easier.

Workshop When preparing for shoots or just performing simple maintenance, the photographer is often called upon to do various sorts of building or altering of products and props. A workshop for simple equipment repair, or for building sets and preparing props is not only a help but almost a necessity. There should be a sturdy workbench with convenient electrical outlets. The bench might have a vise and behind it shelves or a peg board for hanging tools. This work area is sometimes enclosed or in some way separated from the

studio area because of the dust that may be generated by sawing wood or using a file. For those photographers who do a lot of scale model work, the installation of a spray booth for model preparation may be necessary.

Telephone System Optimally, a studio should have a modern telephone system with enough extensions to minimize running for the phone. Such a system might include an extension in the photographer's office, one in the studio itself, one in the darkroom, if any, one in the conference room, one for the studio manager/assistant, and one for the receptionist. These systems can provide such conveniences as speaker phone, intercom, and even communication with someone ringing the doorbell. A good phone system could also have provisions for an answering machine for taking messages when no one is in the studio, or when the photographer is too involved in a shoot. Of course, a separate line for the newest necessity of communications, the FAX machine, is often desirable.

Studio Area As for the studio area itself, a sink for use in cleaning up after a shoot or for facilitating the mixing of paint, etc., for set construction is very helpful. A floor drain in the studio allows the photographer to do a wider variety of photographs. The photographer then has the ability to do shots involving running water, shots simulating rain, or for draining a tank of water used in a shot. A freight elevator is a must if the studio is not on the ground floor. A loading dock and large doors make delivery of oversized subject matter much easier. There should be a light-tight door separating the actual studio area from the office area.

The Artist Studio An artist's photographic studio will depend on what type of work the artist in interested in doing. If the artist is essentially a photographer who finds subjects in the outside world, then the studio may contain only a desk, storage, darkroom, and an area for looking at finished work and work-in-progress. Those artists who also work in studio settings, whether for portraits, nudes, dance, etc., will require a studio shooting space with some of the areas described above. Artists often have studios in their homes.

The Amateur Studio The requirements of amateur photographers are often modest because of the expenses required to maintain a formal studio. Usually some portion of their living space is set aside for their hobby. This does not mean that they have to do without many of the things that the professional finds necessary. With a little ingenuity and some compromise, the amateur can have an efficient, versatile, and still modest studio.

The Location Studio These days more and more commercial photography is done *on location* at the client's facility since it is difficult to bring operating machinery and computers to a studio. Even art photography has its location studio contingent. This is exemplified by Irving Penn and his famous location studio portraits. Mr. Penn has taken an entire studio complete with large cloth backdrop to such exotic locations as the jungles of New Guinea and the Peruvian city of Cuzco, the ancient Incan capital. For a location shoot, photographers put together what can be called a portable studio. All the necessary equipment (cameras, lighting, backdrops, etc.) is packed in a way that is both convenient to move and to get at on the job. There are specialized packing systems to make location work easier. These usually consist of a canvas bag that holds many accessories for the lighting system. These bags can be unfolded at the job site and hung on light stands so the contents are visible and accessible. A major requirement for a location studio is a strong assistant. *J. De Maio*

STUDIO PHOTOGRAPHY The making of photographs in an area especially designed and equipped for the purpose, a portrait studio for example, as distinct from making photographs on location. *L. Stroebel*

STUDY A thoughtfully composed still photograph intended to provide the viewer with insight concerning the subject and to have artistic merit. *L. Stroebel*

STYLE A distinctive and consistent characteristic of photographs produced by a photographer, which, when they become familiar to viewers, can serve as the photographer's artistic signature. A range of characteristics have been used, separately and in combination, by photographers to establish widely recognized styles, including choice of subject, composition, lighting, camera lens, focus and depth of field, filters, print quality, and type of display. When a group of photographers share a common style, it is referred to as a school of style. Even though many studio portrait photographers have individual styles, there is a generic style to this area of specialization that distinguishes studio portraits from candid portraits, environmental portraits, passport portraits, etc. Schools of style also develop because of imitation of the style of an admired creative photographer, and commonalities related to any of a variety of factors such as age, education, economic status, geographic location, and from a historical perspective, the time period during which the photographers lived. *L. Stroebel*

SUBBING (1) The process of coating a support (film base, glass) with a material promoting adhesion of a following, usually photosensitive, layer. (2) Also called *sub*, shortened from substratum. Denoting the coating described in (1). *M. Scott*

SUBJECT A person, object, or scene represented in a photograph or other reproduction or work of art. *L. Stroebel*
See also: I*nput.*

SUBJECT ATTRIBUTES Particular properties of objects or scenes such as shape, size, depth, and color. Certain subject attributes, such as shape and color, can be represented quite accurately in photographic images. The size of an object can be represented accurately only with small objects (or with large photographs). Depth cannot be represented physically with conventional photographic processes, although the illusion of depth can be realistic, especially with stereoscopic images. *L. Stroebel*

SUBJECT CONTRAST The relative luminance values of the highlight and shadow areas of a scene, usually expressed either as a luminance ratio, where the average ratio is 160:1, or as a log luminance range, where the average value is 2.2 (the logarithm of 160). A luminance ratio of 160:1 also corresponds to a seven-step or seven-zone range. *L. Stroebel*

SUBJECT FAILURE The presence in an original scene of a large area devoted to a single color, which will cause a print made from the negative or transparency with a system based on a neutral average, as some automatic systems are, to be off in color balance. *L. Stroebel*

SUBJECTIVE (1) In visual perception, characterizing data obtained by visual examination of an image. Graininess, sharpness, and detail are subjective qualities of image structure. Compare with objective, implying instrumental means of obtaining data. Granularity, acutance, and resolution are objective measures of image quality that correlate with graininess, sharpness, and detail. (2) In motion pictures and video, the use of the camera as if it were one of the players by means of eye-level placement and by moving the camera as a person would be expected to move. (3) Any critique of a photograph, any event in which a human is making a judgment. *L. Stroebel and R. Zakia*

See also: *Aesthetics; Psychophysics; Subjective colors.*

SUBJECTIVE COLORS Chromatic sensations produced when black-and-white images are presented to a viewer intermittently at frequencies of about five per second, when certain black-and-white designs are rotated at appropriate speeds, and when certain black-and-white designs having fine detail are viewed continuously. In this case, the involuntary small-scale nystagmus movements of the eyes produce the necessary interactions in the visual-response mechanism. *L. Stroebel and R. Zakia*
Syn.: *Fechner's colors.*

SUBJECTIVE PHOTOGRAPHY (1) The self-chosen name of a school of creative photographers with a preference for nonrepresentational patterns, initiated by Prof. Otto Steinert in Germany after the Second World War and allied in outlook to the Bauhaus after the First World War. (2) A style of photography in which the moods, attitudes, feelings, etc. of the photographer are evident. *L. Stroebel*
See also: *Expressive photography.*

SUB-LATENT IMAGE See *Latent subimage.*

SUBLIMINAL Applied to a stimulus that is below the intensity required for conscious perception. In vision, a subliminal image may be one presented for too brief a time or too low an intensity for recognition to occur. It may nevertheless make some impression on the viewer. *L. Stroebel and R. Zakia*
See also: *Just-noticeable difference.*

SUBMINIATURE CAMERA See *Camera types.*

SUBMOUNT A sheet of construction paper that is slightly larger than a print and placed between the print and the support on which it is mounted in order to make the print stand out from the mount-board. Submounts also enhance the colors in the print by providing a complementary color to the color scheme of the photograph. Sometimes the submount can overwhelm the photograph, so restraint in the choice of color and the width of the overlap is suggested. When in doubt, no submount is better than a poorly chosen one. *M. Teres*

SUBPROPORTIONAL Less than proportional, a subproportional intensifier produces relatively smaller density increases in the heavier density areas of a negative (highlights) than in the lower density layers (shadows). The resulting contrast, while higher than that of the untreated negative, is not as high as that achieved with a proportional intensifier.
A subproportional reducer removes a smaller proportion (but not a smaller amount) of density from higher densities than from the lower. When the reduction in density is equal for all densities, the effect is referred to as *subtractive* or *cutting* reduction. *I. Current*

SUBSTANTIVE This adjective describes a class of dyes that have an affinity for a substance without prior use of a mordant. A number of substantive diazo dyes are benzidine or diaminodiphenylamine derivatives, such as Congo red. *G. Haist*
See also: *Mordant.*

SUBSTANTIVE COLOR FILM Integral-tripack color film in which the couplers are incorporated in nonwandering form in the emulsion layers during manufacture. Distinct from nonsubstantive color films, which contain no couplers themselves but which must be developed in developers that contain the couplers (Agfa, 1937). *M. Scott*

SUBSTRATE In the field of photoresists, the material on which the resist is coated and on which the image will be formed. *M. Scott*

SUBSTRATUM A binding layer that helps the emulsion adhere to the film or glass support. *M. Scott*
See also: *Subbing.*

SUBTITLE Written words added to a motion-picture or video image, usually along the bottom of the frame and usually to enhance, comment on, or add to information presented on the sound track. Most often used to provide translations for an audience not fluent in the original production language. *H. Lester*

SUBTRACTIVE COLOR PROCESSES System of color reproduction in which the reddish, greenish, and bluish thirds of the spectrum of a white illuminant are modulated by varying the amounts of cyan, magenta, and yellow colorants, respectively. The subtractive color process is used in color photography and in graphic arts reproduction. *R. W. G. Hunt*
See also: *Additive color process; Color photography.*

SUBTRACTIVE PRIMARY COLORS Cyan, magenta, and yellow. Colorants having these hues absorb (subtract) red, green, and blue light, respectively. *R. W. G. Hunt*
See also: *Subtractive color process.*

SUBTRACTIVE REDUCER A subtractive reducer removes equal amounts of silver from all densities of the negative; thus, the contrast is not changed. Its use lowers the printing time for a negative without requiring a change in paper contrast. This type of reducer is also sometimes referred to as a *cutting reducer,* and is a type of subproportional reducer.
When a print is overexposed and then is treated with this type of reducer, an increase in highlight contrast results. *I. Current*
See also: *Subproportional.*

Submount. A print with a submount.

SUDEK, JOSEF (1896–1976) Czechoslovakian photographer. Known for his lyrical still lifes and poetic landscapes, many made from the window of his studio. His subjects are subtly revealed with soft light. Worked extensively with panoramic cameras. The first photographer to be proclaimed his country's Artist of Merit (1961).

Books: Bullaty, Sonja, *Sudek*. New York: Clarkson N. Potter, 1986. *M. Alinder*

SULFIDE TONERS Sulfide toners include a number of chemical procedures that change the normal black-and-white silver image of a print to one composed essentially of silver sulfide. The color of the image is generally referred to as sepia, but it may cover a wide range, depending on the nature of the original silver image and the toning procedure. Sulfide toned images are more stable than untoned ones.

With some cold-tone printing papers it may be necessary to convert the silver image to a silver compound with a bleach-and-redevelop toner in order to obtain a satisfactory image color. *I. Current*

SUNLIGHT Illumination (on a surface) coming directly from the sun, without admixture of skylight or other scattered illumination. In the open, sunlight is always mixed with other light. Brightly lighted portions of a forest floor will be lit primarily by sunlight. Daylight is a mixture of sunlight and skylight. As compared to skylight, sunlight is relatively warm in color. The color temperature of standard sunlight is 5400 K. *J. Holm*

See also: *Daylight; Moonlight.*

SUPERACHROMAT In 1941 M. Herzberger showed that complete color correction of a lens was possible, and in 1972 the Zeiss 250-mm *f*/5.6 Superachromat lens was introduced using four types of glass and fluorite in its design. Spectral correction is for 400–1000 nm without any focus correction required, so the lens is ideal for infrared photography. *S. Ray*

See also: *Achromatic, Superapochromat.*

SUPERADDITIVITY This name is given to the cooperative action in which two developing agents produce more silver from exposed silver halide materials than the sum of the silver developed by the agents used individually. The primary developing agent of the pair is thought to be strongly adsorbed to the silver halide grain and to be regenerated by the second agent. Metol-hydroquinone and Metol-Phenidone are examples of superadditive developing agent combinations. *G. Haist*

See also: *Photographic chemistry; MQ Developers.*

SUPERAPOCHROMAT A lens that has been more fully corrected for spectral colors (wavelengths) than an apochromat lens. *S. Ray*

See also: *Achromatic, spochromat; Superachromat.*

SUPERCOAT Also *topcoat, overcoat.* A coating of unsensitized, sometimes hardened, gelatin on top of the sensitive layers of any photographic material, primarily to prevent abrasion, which could occur when film or paper is wound in rolls, or transported through cameras, printers, processors, and projectors.

Films and plates for far-UV imaging never have a supercoat since gelatin would absorb UV radiation, nor do papers for the bromoil and similar processes, where it would interfere with the ink-acceptance of the image. *M. Scott*

SUPER-8 See *Film formats.*

SUPERIMPOSURE The careful combination of two or more images so that both images are visible. Multiple exposure in a camera or from an enlarger, as well as sandwiching negatives in an enlarger, are ways to superimpose images. Names and subtitles can readily be added to an image by superimposure. With television, images can be superimposed by transmitting or recording two video images simultaneously. *R. Zakia*

SUPERPROPORTIONAL INTENSIFICATION Superproportional intensification produces large density increases in the dense (highlight) regions of a negative with little or no increase in the shadows, thus greatly increasing the contrast of the negative. It is appropriate for correcting negatives of a low contrast subject that have been underdeveloped, or other negatives in which high contrast is desired. *I. Current*

SUPERPROPORTIONAL REDUCTION Superproportional reduction occurs when the ratio of density loss is larger for the denser, highlight areas, than for the less dense shadow areas of a negative. The contrast is thus lowered, and the reducer may be referred to as a *flattening* reducer. This treatment is appropriate for negatives of a contrasty subject that have been overdeveloped. *I. Current*

SUPER-REALISM See *Photorealism.*

SUPERSATURATED SOLUTION An unstable solution that contains more dissolved substance than a saturated solution at the same temperature. Crystallization of the excess dissolved substance will occur if nuclei are introduced. A small crystal of the dissolved substance or even dust may cause instant crystallization. Sometimes even a slight jar or shaking can cause a precipitation from a supersaturated solution. *G. Haist*

See also: *Saturated solution.*

SUPERSENSITIZATION The process by which the spectral response of dye-sensitized silver halide emulsions can be increased by the presence of a second dye, called a *supersensitizer.* This second dye may be spectrally sensitizing or nonsensitizing. A nonsensitizing dye can cause an increase in the spectral region not sensitized by the first dye, or it can cause an increase in the region of spectral sensitization that is greater than the sum of the effects of the dyes used individually. *G. Haist*

See also: *Emulsions; Sensitizing dyes; Spectral sensitization.*

SUPER-16 See *Film formats.*

SUPERSLIDE A transparency that has a 40-mm × 40-mm image area, mounted in a standard 50-mm square mount. *L. Stroebel*

SUPER VIDEO GRAPHICS ARRAY In computers, a cathode-ray tube (CRT) resolution of 800 × 600 pixels or above at 256 colors, minimum. This is the current standard for computer-based imaging. At this level of resolution, the CRT is noninterlaced and has a high refresh rate to limit flicker. *R. Kraus*

SUPPLEMENTARY EXPOSURE Exposure of a sensitized material to a controlled amount of light or other radiant energy either before or after the main image-forming exposure for the purpose of achieving a desired effect, such as altering the density or contrast of the final image. *L. Stroebel*

See also: *Flashing; Exposure effects, hypersensitizing, latensification.*

SUPPLEMENTARY LENS See *Lens types.*

SUPPORT The material on which a photosensitive layer is coated. Transmissive supports such as films and plates are used for images that are to be optically projected or viewed

by transmitted light. Reflective supports such as paper are used for images viewed by reflected light. Translucent supports such as milk-white plastics may be considered as either, depending on design. A given image on a translucent support will have about half the contrast and density upon transillumination that it has upon reflection. *M. Scott*

See also: *Acetate film base; Antihalation coating; Base; Cronar base; Curl; Dimensional stability; Dope (film-base); Estar base; Film base; Nitrate film; Noncurling; Paper base; Paper weight; Photosensitive materials, manufacture; Physical properties; Plasticizer; Plates; Polyester; RC/Resin-coated; Shrinkage; Subbing; Tensile strength.*

SURFACE (1) The sheen, texture, and tint of a printing paper. Sheen ranges from glossy to matt in several steps. The surface determines the range of tones a paper can produce; for glossy, smooth papers the luminance ratio may be above 100:1, whereas for matt, 30:1 or less. Its texture may range from smooth to rough in several steps. It may also have a discernible pattern impressed to resemble fabrics, such as silk, linen, or canvas. (As paper manufacturers supply fewer of these, other methods of achieving such surfaces on a smooth print are offered by firms making embossing equipment.) Tint is the color of the support, not that of the image. Tint is most detectable in the highlights, image tone in the midtones and shadows. (2) Specifying a latent image that can be developed with a developer containing no silver halide solvent. It is believed that such an image is on, rather than within, the silver halide crystals. Also, identifying such a developer formulation. (3) In perception, an object seen in reflected light, distinguished from one seen as a source of light. The term *lightness* is applied to surfaces, *brightness* to sources. *M. Scott*

SURFACE DEVELOPMENT A latent image is formed when silver halide emulsions are exposed to light. The image is invisible and undetectable by any means, except development, which destroys it. The unseen image is thought to be small clusters of metallic silver atoms aggregating at various sites in each exposed silver halide crystal. Those silver atoms on the surface of the crystal are called the *surface latent image;* all the others, buried just under the surface or deep in the interior, are the *internal latent image.*

The distribution of the latent image has been the object of intense study by many theoretical scientists. One investigator, G. W. W. Stevens, has found that many of the crystals in an undigested emulsion have only internal latent images. In conventionally chemically sensitized emulsions, given normal light exposure, internal latent images seemed to be formed only in those crystals that also had surface latent images. In practical photographic materials with long exposures of low light intensity, the latent image was situated mostly on the surface of the crystal, apparently because of the effectiveness of the chemical sensitization. With light of high intensity and short exposure times, more latent images were formed in the interior of the crystal.

Studies on the latent image distribution are based on the nature of two different kinds of developers: a surface developer that contains little or no silver halide solvent and a developer containing a silver halide solvent, such as sodium thiosulfate or potassium iodide. The solvent developer is used after all the surface latent image has been removed by an oxidizing agent, revealing the contribution of the internal image only. The distribution of the latent image is thus being derived from the results given by two different processing solutions, and such results may be subject to differing interpretations and assumptions.

Various surface developers have been formulated with little or no silver halide solvency, often free of sodium sulfite. Ferrous oxalate, glycin–carbonate, Metol–ascorbic acid, and Phenidone–ascorbic acid are examples of such surface

developers. The ferrous oxalate developer consists of equal parts of (a) 25% potassium oxalate and (b) ferrous sulfate crystals (25 grams), and citric acid (1 gram) in 300 ml of water solution. A sulfite-free glycin (*p*-hydroxyphenyl-glycine) developer is composed of glycin (30 grams) and anhydrous sodium carbonate (45 grams) in 1000 ml of water solution. Another developer contains Metol (2.5 grams), isoascorbic acid (10 grams), sodium metaborate or Kodalk (35 grams), and potassium bromide (1 gram) in water to 1000 ml.

Most modern developer formulations contain solvents for the silver halide crystals, as do solutions for revealing the internal latent image. This ensures that the maximum sensitivity of the photographic material is achieved. Physical development, that is, deposition of solubilized silver ions from the developer on the latent image, occurs, and this action can increase the size of the developed silver particles. Solution physical development may adversely affect the graininess and definition of the developed image.

The need to achieve every bit of emulsion speed has become less urgent as modern photographic materials with high sensitivities have become available. Lower graininess and higher definition are needed more as the negative image size has decreased, especially with the popularity of the 35-mm format. This need has led to sacrificing some emulsion speed by increasing surface development. Fine-grain development and high sharpness development are not possible with the same solution. A practical compromise, starting with today's finer grained photographic film, involves diluted developer solutions of low alkalinity. Such a high-definition developer is used once, then discarded.

Developers promoting surface effects can be made by dilution of a known formulation (such as Kodak developer D-76) or by using a special, one-use solution. A popular developer of this type is that of Willi Beutler, consisting of two stock solutions. Solution A consists of Metol (10 grams) and sodium sulfite (50 grams) in 1000 ml of water; solution B has anhydrous sodium carbonate (50 grams) in 1000 ml of water. In use, solution A and solution B (50 ml each) are added to 500 ml water. Many dilute variations of Metol–sodium sulfite and Phenidone–sodium sulfite developers have been made. *G. Haist*

SURFACTANT Surfactants (surface-active agents or wetting agents) lower the surface tension of a liquid by reducing the cohesive forces that hold together the molecules of the liquid. These agents act in the interface between a liquid and a solid or between two liquids. Surfactants are important in the coating of photographic emulsions as well as in the solutions for their processing. A typical use of a wetting agent in the darkroom occurs just before the film is dried after processing. The surfactant, such as Photo-Flo, helps the water run off the surface of the film rather than adhere in drops, which can cause spots. *G. Haist*

SURREALISTIC PHOTOGRAPHY The surrealist movement in painting and the arts developed in Europe at the end of the First World War. Although it was not a unified movement as such, it nevertheless had much influence on the arts until the Second World War. The movement, begun largely in response to the perceived insanity of the First World War, sought to debase, discredit, uproot, and replace what were considered to be retrograde socio-political patterns of thought and behavior, which had, over time, become culturally ingrained and habituated. The surrealist movement thus viewed much of normally accepted reality as actually a conceptual system of human-invented fantasy merely *labeled* reality.

As an artistic approach, surrealism used shocking, paradoxical, and often deeply disturbing images to systemati-

cally attack the fabric of society and create a deep sense of imbalance in the viewer. Surrealists hoped to force public acceptance of new, hybrid conceptual systems based on artistic, cultural, and humanist ideals by attacking society's commonly-accepted forms of pictorial representation. Thus, surrealist imagery was often based on found symbols, intuitive perceptions, theories of the psyche and the unconscious, hallucinatory images, and Freudian dream constructs—all notions that questioned traditional habits of thought and behavior.

Photography, considered the epitome of realistic representation, was paradoxically of great importance to the surrealists. The medium's strong illusion of reality, commonly believed to reflect the true nature of things, was used as a supremely effective tool in melding appearances with surrealistic art principles. The resulting images were effective because they simultaneously confounded viewer expectations yet also to a degree conformed to tangible reality. Because surrealism offered a mixed and often contradictory message, various forms of image manipulation, abstraction, metaphor, symbol, and other higher levels of artistic organization were used. Realistic representation in art and photography was thus systematically undermined through the use of uncommon viewpoints and distortions, contradictory perspectives, enigmatic shadowing and reflections, spatially baffling closeups with extreme foreshortening, tonally reversed and solarized images, and even x-ray images. It was through this created rift that surrealism in photography attacked the ingrained style of representation we call realism. This was essential in setting the stage for the conceptual changes needed to free viewers from the constraints and falsity of accepted "facts" and open the door to repressed emotions and fantasies.

Many notable photographers have worked in the surrealist manner. American-born Man Ray, one of the first and best known of the surrealists, often used cameraless photogrammatic images (rayograms), solarized nudes, and other motifs to directly challenge notions of photographic form. His rayograms evoked a sense of mystery that relied on ambiguous space and time and enigmatic depiction of everyday objects. Belgian photographer Raoul Ubac also addressed the transformation of the familiar by using contradictory perspectives created through mirror reflections and bas-relief combination printing. Hungarian-born photographer Brassai, a major figure in French surrealism, published many photographic illustrations in the surrealist publication *Minotaure*. A central theme in this work was the isolation of common objects viewed in extreme closeup. French photographer Roger Parry used double exposures, photograms, and photomontages to create unsettling images laced with anticipation, anxiety, and dread. German photographer Hans Bellmer used dolls in contorted positions to create disquieting combinations of mechanical reference and implied sexuality. French photographer Dora Maar created ambiguous, dramatic, quasi-mythological scenes in which the mystery and resonance of myth were personalized.

In more recent times, the British photographer Bill Brandt has used optical distortion and high-contrast printing to create highly tensioned dreamlike images that are ambivalent, bleak, and melancholic. Frederick Sommer, long an exponent of surrealist photography, combines poetic yet shocking imagery with exacting detail and exquisite tonality. The imagery creates the contradictory effect of simultaneously repelling and attracting us, a paradigm for the alternate repression and release of subconscious energies. His images thus assume a metaphorical presence in which we are confronted with the subconscious.

Among the many contemporary photographers who use surrealistic techniques are Jerry Uelsmann, Duane Michals, Lucas Samaras, Ralph Gibson, Arthur Tress, Ralph Eugene Meatyard, and Joel-Peter Witkin. *J. Fergus-Jean*

SURROUND The perceptual field in which a subject is located. In photographs, the surround normally consists of the background and foreground. In visual perception, the surround is referred to as the ground in the figure-ground dichotomy, and the figure is the subject or the area of interest. Changing the surround can alter the appearance of the subject. A dark surround tends to make an object appear lighter than the same object with a light surround, a visual effect identified as simultaneous contrast. In the field of visual camouflage, an object can be made invisible by making it appear to be part of the surround. *L. Stroebel*

See also: *Background.*

SURROUND SOUND One of a series of possible stereophonic sound systems that use at least left, center, right, and surround sound channels, where left, center, and right are related to a picture, and the surround channel encompasses the area away from the picture. The more advanced systems for 70-mm release prints and for digital optical sound on film systems use two surround channels, and more have been shown to be useful. *T. Holman*

SURVEILLANCE CAMERA See *Camera types.*

SURVEILLANCE PHOTOGRAPHY The use of photographic or electronic imaging systems to monitor and document activities and places, identifying persons and their conduct. The resulting images in the form of prints, slides, motion pictures or videotapes are most valuable as aids in any investigative process and can be used as supporting evidence in criminal and civil litigation proceedings. In some jurisdictions, the interpretations of the rules of evidence require that surveillance photographs cannot be entered as prime evidence without the testimony of an eyewitness.

Similar systems and methods are used in industrial manufacturing and retailing operations to observe, monitor, and record the activities of people and equipment for the purposes of safety, efficiency, and time-studies and to gather data for scientific investigations. Fixed installations are often used to monitor and control vehicular traffic at major intersections and on busy expressway routes. Aerial surveillance, conducted from aircraft at low altitude, is used in military operations and in scientific land survey studies. High altitude imaging systems, which include sophisticated electronic scanning from satellites and high altitude aircraft, are used for world and large land mass weather studies and mapping operations.

Systems can be *manned* or *unmanned, covert* or *obvious.* Unmanned systems include continuous-running video cameras, intermittent motion picture cameras that make photographs using time-scheduled or triggered devises, or still cameras equipped with triggering devices. Surveillance for industrial and scientific monitoring and for traffic control situations frequently makes use of intervalometer controls, which actuate the recording system on a preset time schedule. Unmanned dummy cameras in plain sight are often used as deterrents to criminal activities or as control devices for group behavior.

Close-range covert methods use autoexposure point-and-shoot miniature cameras, favoring high-speed films and lenses to overcome adverse lighting conditions. Innovative *camera-flage* devices that conceal the camera from the subject are often part of the system. Manned, covert methods call for the use of cameras with bulky long focal length lenses (traditional telephoto or more compact catadioptric style) positioned at a great distance to maintain some degree of concealment from the subjects under surveillance.

Covert camera methods and techniques include the use of long focal-length lenses to obtain identifiable images of individuals at great distances, the use of high speed films, infrared radiation sources and infrared-sensitive films, infrared or radio-triggered devices, and image-making with the aid of light amplification units.

Photographic concerns are undesirable and low level lighting conditions, subject motion and focusing problems, camera and shutter vibrations, shallow depth of field, and the need for images that provide for accurate identification of individuals. Traditional cameras used for this are 35-mm single-lens reflex cameras with telephoto lenses in the 200 to 600-mm range. To obtain usable, identifiable images of individuals at great distances, lenses are chosen based upon the *1 mm of focal-length for each foot of distance* rule. Thus, a 200-mm lens would be the required minimum focal length for a subject at 200 feet. Force-processed high speed black-and-white films (ISO 1600 to 25,000) are often used when low light levels are encountered. Camera vibration problems are minimized using portable clamp-mount devices, sandbags, etc. Supplemental light can include the use of focused telephoto flash units or remote-triggered illumination positioned close to the stake-out area. Aside from good identification of the individuals in the scene, information regarding the date, time of day, exact location, identity of vehicles, and the nature of the activity complete the surveillance photography assignment for law enforcement or civil litigation purposes.

Low-light level video camera systems have become the most popular method used for surveillance under adverse conditions. Combined with light amplification modules or equipped for infrared viewing, they make image-making possible under conditions where even the human eye cannot perceive details. Their ability to record sound and real-time elements are an added benefit. While conversion of these images to hard printed-out copy cannot produce the sharpness and resolving power of conventional photography, such systems have become the choice of most law enforcement agencies. Most modern-day courtrooms have come to accept video presentations as supportive to eyewitness testimony. *J. McDonald*

SUSPENSION A suspension is a heterogeneous mixture of particles in a liquid that can be separated by filtration. Such mixtures separate into different phases when left standing. A colloidal dispersion is a suspension of very fine particles that do not settle. These colloidal particles have adsorbed molecules or electrical charges that keep the particles from settling. *G. Haist*

SWEEP STAGE A tabletop or room studio setting whereby the horizontal foreground curves gradually into the vertical background, thereby avoiding a horizon line. This effect can be obtained on a temporary basis with seamless background paper that is available in large rolls but is often made in the form of a more durable structure. *L. Stroebel*

SWELLING The increase in volume of gelatin when it is wetted with water or water solutions. Swelling facilitates the penetration of processing solutions but makes emulsions softer and more susceptible to damage. *L. Stroebel and R. Zakia*
See also: *Reticulation.*

SWINGS AND TILTS Adjustments on the front and back standards of view cameras that are used to alter image shape and the angle of the plane of sharp focus. Swing refers to a horizontal rotation about a vertical axis, and tilt refers to a vertical rotation about a horizontal axis. Image shape is controlled by altering the angle of the film plane. The angle of the plane of sharp focus can be controlled by altering the angle of the lens board or the angle of the film plane. *P. Schranz*

SWIPE FILE A slang term for a collection of tear sheets from magazines or other published photographs used by a photographer as a source of ideas for future photographs. *B. Polowy*
Syn.: *Research file.*

SWISH PAN In motion-picture or video photography, a very fast horizontal camera move created by rotating the camera quickly on its vertical axis, resulting in a blurred image unlike that produced by a corresponding movement of the eyes. *H. Lester*
Syn.: *Whip pan.*

SWITCHES A switch is a manually operated or electronic device used to control or direct the flow of electrical current. An electromagnetically operated switch is a *relay;* a temperature-controlled switch is a *thermostat.* When a switch is *on,* it is closed and permits current to flow through it. When a switch is *off,* it is open and stops current from flowing through it. Switches are available in a great variety of contact configurations. Push buttons and some other switches are spring-loaded to one position—their unactuated, or normal, position. Circuit diagrams show these switches in their unactuated position or else will identify the contacts as being "N.O." (normally open) or "N.C." (normally closed).

An electronic switch is typically a transistor that is operated in either of two modes: saturated or cutoff. When operating in the saturation mode, the voltage across the transistor is approximately 0.2 volts and its resistance less than a few ohms. This proximates a closed switch. When operating in the cutoff mode, the resistance of the transistor is in the megohms. Negligible current flows; the circuit is open. *W. Klein*

SWOP The acronym for Specifications for Web Offset Publication printing, which comprise a set of specifications for color separation films and color proofing by specifying the paper and ink hues and their strengths for color proofing. *M. Bruno*

SYMMETRICAL LENS A lens configuration using two identical or very similar sets of elements arranged as two groups that mirror each other on either side of the iris diaphragm. As many as five glasses may be used in each group. The residual aberrations of one group can be almost canceled out by the equal and opposite aberrations of the other, provided the image is at near unit magnification. This is satisfactory for copying and process lenses. For normal camera use, modifications are made to one group to depart from symmetry to give quasi-symmetrical configuration. *S. Ray*

SYMMETRY (1) Bilateral symmetry—a mirrorlike repetition of design elements on either side of an imaginary line in a photograph or other image. The human body has approximate symmetry about an axis drawn through the center. (2) Spherical symmetry—symmetry can be more than bilateral, as in a sphere or other form that repeats on more than one axis. *R. Welsh*

SYNC See *Synchronism.*

SYNC CORD The electrical connecting wire between an electronic flash unit and the synchronization port on the camera body or shutter. *P. Schranz*
Syn.: *Flash cord.*
See also: *PC connector.*

SYNC GENERATOR In motion-picture production, a device that creates and sends an electronic signal, controlling

the speed of cameras and sound recorders to maintain a simultaneous relationship between picture and sound.

H. Lester

SYNCHROBALLISTIC CAMERA See *Camera types.*

SYNCHROBALLISTIC PHOTOGRAPHY The use of a camera system whereby the film moves in the same direction and at the same speed as the image of a rapidly moving object, such as a bullet or missile, to produce a sharp image.

L. Stroebel

See also: *Ballistic photography.*

SYNCHRONIZED FLASH SHUTTER A shutter designed to be used with flashbulbs and/or electronic flash. The shutter mechanism closes the electrical circuit to fire the flash and controls the time relationship between the opening of the shutter and the firing of the flash so that the maximum amount of light is transmitted. When flashbulbs were widely used, variable timing was required for synchronization with different types of bulbs (F and M sync). With electronic flash, the electrical circuit is traditionally closed when the shutter reaches the fully open position (X sync). Some shutters now offer the option of firing the flash just before the shutter starts to close, for more appropriate streak images of moving objects when combining flash and continuous light, a feature identified as tailflash synchronization or second-curtain synchronization.

P. Schranz

See also: *Tailflash synchronization.*

SYNCHRONIZER A device used in motion-picture editing that allows winding through two or more lengths of picture and sound film while keeping them locked in a frame-for-frame relationship. Consisting of two or more sprocketed wheels, a foot in diameter, that rotate on a common axle, such devices provide convenience in performing a variety of routine editorial procedures.

H. Lester

SYNCHRO-SUN Illumination by a combination of sunlight and flash illumination. Usually the sun is the main light and the flash serves as fill. In such a ratio, the term is synonymous with fill flash.

F. Hunter and P. Fuqua

See also: *Fill flash; Lighting, using sunlight.*

SYNC SPEED/SYNCHRONOUS SPEED In motion pictures, the standard frames-per-second rate for sound productions, which is 24 frames per second.

H. Lester

Syn.: *Sound speed.*

SYNESTHESIA The production of a sensation in one sensory system that is the result of stimulation in another sensory system. Listening intently to music has been reported to have resulted in seeing colors, for example. If a photograph has a tactile appearance, a warm or cold mood, or elicits a sense of taste or smell, it does so through the visual sense triggering other senses. Photographs depend strictly on visual stimuli. Film and video, on the other hand, have an advantage over photographs since they also include sound and movement.

L. Stroebel and R. Zakia

See also: *Visual perception, gestalt.*

SYSTÈME INTERNATIONAL D'UNITÉS (SI) The modern version of the metric system, more rational than its predecessor.

H. Todd

See also: *International unit; Metric system; Weights and measures.*

SYSTEM-MODULATION-TRANSFER (SMT) ACUTANCE A measurement that assesses the significance of the many factors that affect image sharpness. It is subjective in the sense that it involves human judgment. SMT acutance is expressed in terms of a scale on which 100 represents image perfection and 70 implies a just acceptable image.

H. Todd

SZARKOWSKI, JOHN THADDEUS (1925–) American curator and photohistorian. Highly influential director of the photography department, Museum of Modern Art, New York (1962–1991). Writer of many influential books on photography and photographers, including four volumes on Eugene Atget (with Maria Morris Hambourg). With keen eye and thoughtful pen, promoted artists he believed in, such as Arbus, Friedlander, and Winogrand.

Books: *Photography Until Now.* New York: Museum of Modern Art, 1989; *Looking at Photographs.* New York: Museum of Modern Art, 1973.

M. Alinder

T Time (shutter setting); Transmittance; Tesla

t Time (as in $H = E \times t$); Temperature

T- T-number (word); T-stop

T/ T-number (number, such as *T*/8)

TAGA Technical Association for the Graphic Arts

TCIP Time code in picture

TE Tail end (motion-picture film)

tele Telephoto

TEM Transmission electron microscope

3D Three-dimensional

TL Through-the-lens (also TTL)

TLR Twin-lens reflex (camera)

TMD Thermal magnetic duplication

TMO Thermal magneto optical (disc)

TOC Target object contrast

TTL Through-the-lens (also TL)

TTL-OTF Through-the-lens—off the film

TTS True to scale

T$_v$ Time value (APEX)

TV Television

TVR Television recording (See kinescope)

TX Transmission

TABLETOP PHOTOGRAPHY The specialization of photographing small objects that can be arranged on top of a table, including models representing larger objects.
L. Stroebel

See also: *Still-life photography.*

TACHISTOSCOPE A projector equipped with a shutter so that images can be projected for a range of short periods of time, used for visual perception and speed-reading purposes.
M. Teres

TACHOMETER A device for determining the speed of rotation of the shaft of a motor or other piece of equipment, used to measure the speed of operation of equipment such as a motion-picture camera and a roller-transport processor.
L. Stroebel

TACKING IRON A small electrically heated and thermostatically controlled tool that is used to attach a sheet of dry mount tissue or mounting adhesive to the back of a photograph before trimming the print for mounting.
M. Teres

Syn.: *Heat sealing tool.*

TAIL END A motion-picture term for the last part of a given length of picture or sound track. Often abbreviated to *TE.*
H. Lester

TAILFLASH SYNCHRONIZATION Term, coined by Andrew Davidhazy, related to the time during the exposure cycle that a shutter's electronic flash contacts are designed to close. Specifically, synchronization that fires an electronic-flash at the end of the exposure cycle.

It is a long-standing convention that the synchronization contact for electronic flashes closes when the shutter blades in a diaphragm shutter reach their fully open position or when the first curtain of a focal plane shutter completely uncovers the image gate within the camera.

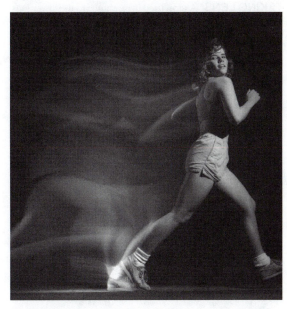

Tailflash Synchronization. (Photograph by Andrew Davidhazy.)

Sometimes it is desired to make a combination electronic-flash and ambient-light exposure. When an electronic-flash is triggered with such a synchronizer, the short duration flash produces a sharp image of a moving subject. At the same time the longer shutter exposure time produces a blur of the subject's highlights, in particular, by ambient light.

This latter blurred image will appear on that side of the subject toward which it was moving. This is contrary to artistic convention, which shows blur behind a moving subject, the blur trailing the moving subject.

The blur can be placed on the desirable side of the subject by making the subject perform its motion backward, but this is not often possible. Manufacturers have incorporated synchronization schemes in some shutters that cause the sync contacts to close immediately before the blades start to close or just before the second curtain of a focal plane shutter is released. This causes the blurred ambient-light image to be recorded before the sharp image due to the electronic-flash and the blur then appears behind the sharp image rather than in front of it.

For this reason some manufacturers have called this a system of second-curtain synchronization. Because diaphragm or leaf shutters do not have curtains, the term *tail-flash* synchronization is more appropriate for this synchronization scheme. *A. Davidhazy*

TAIL LEADER A strip of film, not intended for projection, placed on the tail end of a roll of motion picture film, containing labeling and cueing information and providing some protection for the film from physical damage. *H. Lester*

TAILS OUT A roll of motion-picture film wound with the final film end exposed and the front end of the film at the hub of the roll. *H. Lester*

TAKE In motion-picture production, one recording of a shot. If, in an effort to improve quality, a shot, for example No. 23, is repeated, the second attempt would be identified as "Shot 23, take 2," the third attempt as "take 3," and so on. *H. Lester*

TAKING LENS A term used in reference to the lower lens of a twin-lens reflex camera that projects the image onto the film plane. Focusing position of the taking lens is determined by a separate but bonded viewing lens. The taking lens and viewing lenses are of the same focal length and have virtually identical images at several feet to infinity. Where the subject is closer to the camera, there is a slight difference between the image viewed and the image projected on the film by the taking lens. To compensate for this discrepancy, camera manufacturers have incorporated a parallax correction system that indicates in the camera viewing system the difference between the viewed and projected images.

The term *taking lens* is also used to describe the lens used to project the image on the film plane on cameras that have multiple lenses attached to a turret system or sliding board. *P. Schranz*

TALBOT A unit of luminous energy, equivalent to 1 lumen second. Multiplying the luminous flux by the duration of flow provides the total energy. Note that the definition does not define the solid angle through which the energy flows, which distinguished it from measures of exposure, such as the lux-second. *J. Pelz*

Syn.: *Lumen second*.
See also: *Lumen second; Photometry and light units.*

TALBOT, WILLIAM HENRY FOX (1800–1877) English inventor of photography. Originated the negative-positive process that enabled the production of multiple prints from one negative, and that continues to be the basis for photography as it is practiced.

Frustrated while drawing with the aid of the camera obscura and the camera lucida, in 1834 experimented with the fixing of images by chemical means. Investigated the action of light on paper treated with silver salts, making successful photograms, which he called photogenic drawings, of such subjects as lace and leaves. In 1835, using a small, homemade camera, produced a 1-inch square negative image of a latticed window in his home, Lacock Abbey, but did not make a positive print from a negative until 1839.

A scholar of many pursuits, Talbot left his experiments in photography, only to return when told of Daguerre's invention in January 1939. Disturbed that he would not receive due credit, Talbot's process was described to the Royal Society in London on January 31, 1839.

Greatly increased the stability of his prints in 1839 by using Herschel's suggested fixer, sodium thiosulfate. Exposure times for Talbot's photogenic drawings were extremely long, but were dramatically shortened with his improved calotype process (also called Talbotype) in 1840, patented in 1841. The calotype relied on paper treated with silver iodide and washed with gallic acid and silver nitrate. When exposed in a camera, the paper produced an unseen, latent image that could then be successfully developed in the same solution of gallic acid and silver nitrate outside the camera.

Began the first printing company for the mass production of photographs in 1843, publishing his own *The Pencil of Nature* in 1844, the first book illustrated with photographs. In 1852, patented a photoengraving process, and in 1858 an improved process that produced fairly good halftone reproductions.

Books: Talbot, William H.F., *The Pencil of Nature.* Facsimiles, New York: Da Capa Press, 1969, and New York: H.P. Kraus, 1989; Jammes, Andre, *William H. Fox Talbot: Inventor of the Negative-Positive Process.* New York: Collier, 1973; Newhall, Beaumont, *Latent Image: The Discovery of Photography.* Garden City, NY: Doubleday, 1967. *M. Alinder*

TALBOTYPE See *Calotype process.*

TALKING HEAD In motion pictures and video, a tight shot of someone making statements directly to the camera or to an interviewer near the camera. An often overused approach to making commentary and interviewing in news and documentary production, being relatively easy to accomplish but having limited potential in terms of visual interest or depth in communication. *H. Lester*

TANGENTIAL LINE/RAY Description of an image line (as from an object point in the presence of astigmatism) that is in a direction tangential to a circle perpendicular to and centered on the optical axis. Used in describing astigmatism and curvilinear distortion. *S. Ray*

Syn.: *Meridional*.
See also: *Astigmatism; Radial line/ray.*

TANKS AND TANK PROCESSING Tanks provide a convenient method for processing a variety of film types and sizes. Tanks are broken down into two basic categories—roll film and sheet film. They share the common feature of resistance to the corrosive nature of photographic chemistry.

Roll-film tanks come in a many sizes based on the film format and length. These range from single reel 35-mm tanks, to multireel 120/220 tanks, to a cylindrical tank for sheet film. Specialized tanks for processing cine and aerial film are available, although their use is not common except in commercial labs. For many years, stainless steel was the standard material for tank construction, but now plastics have become popular. Film reels have also followed a similar trend. Plastic tanks act as an insulator to keep the chemical temperature stable. Stainless steel tanks offer the ability to adjust chemical temperature during processing. Sound arguments can be made for the use of either material.

Roll-film tanks provide the convenience of daylight processing. Once the film has been loaded onto the reel, it is placed in the tank, which has a light-tight lid. The lid has a light-tight spout, providing a way to add and remove chemicals. Although not widely used today, 35-mm daylight load

tanks are also available. These tanks allow the transfer of film from the cassette directly into the tank in full daylight.

Reels for roll film tanks have two basic designs: stainless steel and plastic. Stainless steel reels are spiral with a clip in the center that grips the film. To load, the film must be gently bowed so that it will fit inside the reel. Once attached to the clip, the reel is slowly rotated while the film winds through the spirals. If too much pressure is used while winding, the film may come into contact with the layer below. When this happens there will be areas of the emulsion that will not be properly developed. This type of reel must be handled with care; any warping or misalignment of the reel will result in emulsion contact.

Plastic reels usually work in a ratchet fashion. One side of the reel is rotated back and forth on the connecting spindle. The film is started at the outside or top of the reel and is pulled inward by the ratchet action. This type of reel is popular because it requires less practice by the user. These reels are also quite sturdy and rarely suffer from warping.

Some plastic tanks are equipped with a stirring rod that provides agitation. More commonly used is a simple inversion and/or rotation of the tank at the specified intervals. It is recommended that tanks be gently tapped after the addition of each chemical to remove any air bubbles from the film. Certain roll film tanks also provide the benefit of rotary processing in table top or drum processors. Consistent agitation and temperature control make this an attractive alternative to hand processing.

Sheet film tanks, commonly referred to as deep tanks, provide a method for processing multiple sheets of film. These tanks are usually made of hard rubber (ebonite) or stainless steel. The common sizes are designed to process 4×5-inch, 5×7-inch, and 8×10-inch film. Commercial labs may employ larger sizes designed for batch processing. Stainless steel hangers or racks keep each sheet of film from coming into contact with other films or the sides of the tank. These hangers are built in a variety of configurations to hold single or multiple sheets. When using 8×10-inch tanks, two 5×7-inch, or four 4×5-inch films can be placed in each multiple film hanger. Because the tanks are open, the processing must be performed in total darkness.

Agitation is performed by lifting the hangers or with gaseous bursts. Lifting the film holders by hand provides a simple method of agitation for smaller sized applications. The recommended technique is to immerse the hangers in the solution and gently tap them to dislodge any air bubbles. At one-minute intervals the hangers are lifted out of the tank and tilted at a 90 degree angle to the right. The hangers are quickly returned to the solution and the process is repeated with a 90 degree tilt to the left. The hangers are then left undisturbed until the next cycle. This helps to provide a random pattern to the agitation. Without sufficient random agitation, uneven processing or streaking of the films will occur.

Gaseous-burst agitation is usually employed in the more elaborate sink lines of commercial labs. An aerator tube at the bottom of each tank sends a burst of bubbles up through the chemicals, providing a random agitation pattern. Nitrogen is normally used to provide the bubbles because it is inert and does not oxygenate the chemicals. A timing mechanism is used to release the gas at the correct intervals. These *sink lines* also incorporate a water jacket for precise temperature control. *G. Barnett*

See also: *Film processing; Machine processing; Tray processing.*

TANNING DEVELOPMENT

Tanning is the hardening of gelatin, rendering it insoluble. Exposure causes tanning in potassium bichromate emulsions. In silver halide imaging, a tanning developer hardens the gelatin of the emulsion in proportion to the amount of silver deposited during develop-

ment. The silver is removed by bleaching and fixing, and the unhardened gelatin is washed away in warm water. A relief image remains. Various transfer and relief processes, such as dye transfer, use matrix films processed in tanning developers. *H. Wallach*

TAPE

In film and television, the term refers to nonperforated magnetic recording media, which may be supplied on open reels, or in a variety of cassette formats for audio and video tape in both analog and digital formats.

The term is also used as a verb in video productions to indicate what is called principal photography in film production, i.e., primary shooting before the cameras.

In double-system formats, where picture and sound media are separate, it is essential to provide a means of synchronization of the sound and picture tapes, since even the best professional recorders do not have absolute speed controls good enough to ensure lip sync throughout long takes without added controls. Most often today this is accomplished in film production with neo-pilottone recording of crystal sync, and in video production through the use of SMPTE time code. *T. Holman*

See also: *Crystal sync; Neo-pilottone.*

TAPE HEAD MOUNTING AND ALIGNMENT See *Head alignment.*

TAPE RECORDER/PLAYER

A device for recording picture and sound or sound only on a moving strand of magnetic tape. Tape recorders as a general class may represent the signals to be recorded as analogs of the signal, such an analog being the strength of the magnetic field used to represent sound in direct analog magnetic recording, or the instantaneous frequency of an FM carrier as in analog video recording, or as digits in digital recording of audio or video. The essential ingredients of a tape recorder are a transport to move the tape past the magnetic heads, and record and playback electronics, usually used with record equalization and playback equalization to tailor the signal to be recorded to the tape medium. *T. Holman*

See also: *Magnetic head.*

TAPE SPEED

One of a series of nominal rates of tape velocity past tape heads. For analog sound recording the speeds range across 30, 15, 7-1/2, 3-3/4, and 1-7/8 inches per second (ips), with the 15 and 7-1/2 ips speeds being the most common. *T. Holman*

TARGET See: *Test target.*

TARGET-OBJECT CONTRAST (TOC)

The ratio of the reflectance (or transmittance) of the light and dark areas of a resolution test object. The ratio for black-and-white reflectance resolution targets is approximately 100:1. Low-contrast targets may be as low as 2:1, and high-contrast transmittance targets may exceed 1,000:1. *L. Stroebel*

TAXES See *Business practices, legal issues.*

TEAR SHEET

A page, normally containing one or more photographs, removed from a periodical for any of various uses including display, instruction, or a swipe file. *B. Polowy*

TECHNICAL CAMERA See *Camera types.*

TECHNICAL PHOTOGRAPHY

Technical photography is a broad category of photographic endeavor in which information rather than artistry is the primary objective. Often, technical photographs of objects and events can be understood only by experts in the particular subcategory

such as photogrammetry, high speed photography, or photomicrography.

Photogrammetry, which is the science of making measurements from photographs, started as a technique for aerial surveying involving aerial photography and stereoplotting. Like other kinds of technical photography, it involves much more than simply taking pictures from the air. It incorporates such elements as scale, formulas, surveying, pasted-up composites or mosaics, and corrections. The technique has been extended to underwater mapping and even to determining the dimensions of microscopic objects (microphotogrammetry) for model work.

High-speed photography takes pictures on motion-picture film at a rate that is faster than the projection rate will be. In doing so, it slows down (time magnification) what normally happens too fast for the eye to see and permits visual study and quantitative analysis of action subjects. Scientists, engineers, and photographers use a variety of high-speed cameras, depending on whether they need a series of pictures or a streak of a self-luminous event. Rates range from 100 to more than 6 million frames per second. Such almost incomprehensible figures typify technical photography.

Photomicrography, which is the making of photographs through a compound microscope, illustrates the way much of technical photography relies on other nonphotographic equipment for its quality and ultimate usefulness. As camera and microscope get together, it's the microscope that must form the image that, only then, can be recorded by the camera. Unlike many types of technical photography, photomicrography easily can be mastered by the student or the ecology hobbyist. This particular photographic pursuit also often produces beautiful, frameable images.

Electron microscopy records molecules and even single atoms in an extremely thin section (no more than a few hundredths of a micrometer thick) seen through a transmission electron microscope (TEM). Scanning electron microscopy exposes a specimen with a tiny electron beam and captures the results of the interaction on a cathode-ray tube (CRT), which then can be photographed. Surface information provided by the scanning technique often complements internal information provided by transmitted electrons in industrial and scientific applications.

Infrared photography uses specially sensitized films to record radiation in the 700 to 1200 nanometer range. It enables the investigator to make visible that which is not visible to the eye. Infrared photography made the Dead Sea Scrolls legible. Thermal (infrared) photography records energy radiated, rather than reflected, by a body. Thermography generally employs electronics or liquid crystals to convert variations in infrared radiation into a visual display for such applications as flaw detection.

Radiography records images on photographic materials by means of very short wavelength energy such as x-rays and gamma rays. It allows the investigator to look inside a body, an industrial part, an archaeological find, or a sample of grain without damaging the object.

Spectrography makes a photographic record of the wavelength pattern of a substance as analyzed in a spectrograph or spectroscope. It permits the investigator to ascertain the chemical composition of a substance with great speed and accuracy. Applications include manufacturing and biological research.

Technical photography grows as technical endeavors need what photography can do. It also advances as photographic equipment and films improve and as specialized equipment gets better at delivering its technical subject.　　*K. Francis*

See also: *Photographic education.*

TECHNICOLOR Color motion picture process in which the final positive prints are made by dye transfer or imbibi-

tion. Introduced in 1915, its earliest form was a two-color material exposed in a beam splitter camera. The original film was replaced by a bipack material that produced two-color negatives. In the 1930s, Technicolor became a three-color process with the availability of a beam splitter camera exposing a bipack film and a single emulsion film. Later, a three-strip Technicolor camera exposed three separate films at once. Cartoons were photographed on single strip film, three frames for each drawing, through tricolor filters to make the appropriate separations. In its final iteration, introduced in the early 1950s, the beam splitting cameras and the complexity of shooting a motion picture in Technicolor were replaced by conventional cameras and integral tripack negative film. The separations were made in a subsequent step.

In all cases, the three-color final prints were made by imbibition printing in precise registration from yellow, magenta, and cyan matrices to a mordanted, gelatin coated "imbibition blank" film. A moderate density silver image was incorporated in the final print to enhance definition and shadow detail.

Although a few color movies were made in the 1920s, and some were made even earlier by such processes as hand coloring each frame, Technicolor was the first commercially viable system for the production of color motion pictures. In 1932, Walt Disney used it to make the animated short *Flowers and Trees*. The first feature film in Technicolor was *Becky Sharp*, released in 1935. Like the many Technicolor movies that followed, it consisted of more than 130,000 pin-registered, dye-transferred frames at the cinematic standard 24 frames per second.　　*H. Wallach*

See also: *Dye-imbibition; Dye transfer.*

TECHNISCOPE Trade name for a motion picture widescreen 35-mm system. Designed to conserve negative raw stock, this system uses special cameras that expose a frame only half as high as the normal 35-mm frame height. During printing, the negative image is blown up to normal frame height, while it is horizontally squeezed to normal frame width, producing a regular print that, projected through anamorphic lenses that unsqueeze the image horizontally, results in a projected aspect ratio of 2.35:1.　　*H. Lester*

See also: *Lenses, anamorphic.*

TECOGRAPHY Category of image storage on reusable media, such as videotape recording of television images. The term also describes photochromism, photoplastic and thermoplastic recording, and various kinds of electrostatic imaging. In applied photography, unpredictable or intermittent occurrences may be recorded and analyzed in this way.

Tecography can be used to image on a cathode-ray tube (CRT). A two-sided material is used, the front of which records an optical image and the back of which emits electrons in proportion to the image density on the front. The emissions are focused on a dielectric surface, forming an electric image of the subject that may be scanned or read and output to the CRT.　　*H. Wallach*

See also: *Photochromism; Photoplastic recording.*

TELCINE In electronic imaging, a device that converts motion-picture images into video images.　　*R. Kraus*

TELE See *Lenses, telephoto.*

TELECENTRIC Term referring to an optical system that has an aperture stop located at one of the foci of the lens so that either the entrance or the exit pupil is located at infinity. The image field is then limited to the physical diameter of the lens. This arrangement is used when it is necessary that the image is formed by essentially parallel rays from the exit pupil rather than a divergent cone. Applications are in

orthophotography (photogrammetry) and microimaging lenses. *S. Ray*

TELECONVERTER LENS See *Lens types.*

TELEPHOTO See *Lens types.*

TELEPHOTOGRAPHY The specialization of making photographs of objects at great distances with long focal length lenses, typically of telephoto design. *L. Stroebel*

TELEPHOTOMETER A reflected-light meter or meter attachment containing an optical system to image a small area of the subject on a photocell, typically covering an angle of between 1 and 8 degrees. *J. Johnson*

Syn.: *Spot meter.*

See also: *Exposure meter; Spot meter.*

TELEPHOTO POWER (1) The ratio of the focal length of a telephoto lens to the back focal distance, which is the distance from the film plane to the back surface of the lens when the lens is focused on infinity. (2) The ratio of the equivalent focal length of a telephoto lens to the focal length of the standard lens used on the same camera. This then gives the magnification of the telephoto or long-focus lens compared with the standard lens. *S. Ray*

Syn. (1): *Telephoto ratio.*

TELEPHOTO RATIO See *Telephoto power.*

TELERECORDING Reproducing a television or video presentation onto motion picture film. *H. Lester*

TELESCOPING Telescoping occurs when a roll of film, not on a reel, slips laterally parallel to the axis of the roll, and the convolutions of film are no longer parallel to the original edges of the roll, taking on the appearance of a telescope. It most easily occurs with loosely wound rolls of material with fairly high slippage, or low film friction. Carried to an extreme, the roll characteristic is lost, and the film becomes unmanageable. Retrieved film may be dirty, badly scratched, or otherwise damaged. *I. Current*

Telescoping. Lateral sliding of the convolutions of a roll of film takes on the form of a telescope.

TELESPECTRORADIOMETRY Radiometry carried out remotely from a sample with the aid of a telescopic optical system. *R. W. G. Hunt*

TELEVISION SAFE AREA When projecting motion pictures for television, the central portion of the image that can be assumed will be seen on most home receivers. Because of transmission difficulties and variations in home receivers, some cropping of the original image is usual before it is viewed, and this cropping might eliminate up to 20% of the original motion picture image. It is therefore important, when filming in situations where television broadcast is likely, to keep all essential visual details, titles and subtitles, within the 80% of the motion picture image area that has been designated as the TV safe area. *H. Lester*

See also: *Video, graphic and titles.*

TEMPERATURE A measure of the energy or heat present in a substance that considers primarily the molecular motion occurring in the substance (see *absolute temperature*). Temperature should be distinguished from energy or heat in that a given amount of energy input to two different substances will not necessarily raise the temperatures of the substances by the same amount. For example, a thermometer may read 20° C for a body of water and the surrounding air, but the water will feel much colder due to its greater ability to absorb heat from the body. The water and the air, however, will not exchange energy since they are the same temperature. *J. Holm*

See also: *Color temperature; Thermocouple; Thermopile.*

TEMPERATURE COEFFICIENT Factor by which the development time of a developer must be multiplied to compensate for a drop in temperature of 10°C (18°F). The figure varies according to the developer—usually from 1.25 to 2.8. *L. Stroebel and R. Zakia*

See also: *Time-temperature.*

TEMPERATURE CONVERSION See *Appendix H.*

TEMPERATURE EXPOSURE EFFECT See *Photographic effects.*

TEMPERATURE SCALES Calibrated units, designated as degrees, used on thermometers for the measurement of relative warmth or coolness. Zero represents different temperatures on different scales and the degrees differ in magnitude. *H. Todd*

See also: *Absolute temperature (Kelvin scale); Celsius scale (°C); Fahrenheit (°F); Kelvin (Kelvin scale) (K); Weights and measures.*

TEMPORAL AVERAGING Computing the average of a quantity versus time, used especially when the level of the source used is not stable in time, such as with pink noise. *T. Holman*

TEMPORAL FUSION The process by which successive images that are separated by a short time interval are perceived as being connected and continuous. The process is necessary in motion-picture photography to avoid flicker. *L. Stroebel and R. Zakia*

See also: *Flicker; Fusion.*

TENDENCY DRIVE A method of moving film through a processor or projector without the use of sprockets, with automatic control of film tension. *L. Stroebel and R. Zakia*

See also: *Roller transport/Roller processor.*

TENSILE STRENGTH That property of a material that prevents it from being torn or pulled apart. Tensile strength is important in photographic film base, which must keep its integrity while being run through photographic mechanisms. It is possible to have too much tensile strength. Apparatus-handling polyester films often contain mechanical devices to relieve excess stress in case of malfunction, lest the great tensile strength of the film destroy the machine. High wet strength of photographic papers is essential for the processing of long rolls in continuous processors. *M. Scott*

TENT LIGHTING Illumination by surrounding the subject with translucent material through which light is transmitted, with a small opening for the camera lens. It is commonly used for photographing polished metal objects.

Tent lighting is sometimes used simply to obtain lighting that is nearly shadowless for beauty and fashion subjects. In those cases the tent may be large enough to allow the photographer, camera, and lights inside. The lights are then bounced from the inside of the white walls.

The clean, uniformly bright direct reflection that tent lighting produces in metal sometimes leads photographers to misuse it for subjects whose reflective surfaces are simply difficult to control. Tent lighting eliminates distracting reflection from glass, for example, but also tends to illuminate the edges to a value equal to that of the background and cause them to disappear. Tent lighting on glossy ceramics eliminates much of the color saturation in the glaze beneath the glossy surface. *F. Hunter and P. Fuqua*
See also: *Shadowless lighting.*

TERABYTE One trillion bytes, abbreviated TB. *M. Bruno*

TERMINAL In computers, a cathode-ray tube (CRT) that is directly tied into a host computer. The CRT is merely an input, accessing device and does not contain any "intelligence." *R. Kraus*

TERTIARY SPECTRUM Residual, uncorrected longitudinal chromatic aberration found as a very small variation in focal length with wavelength even when a lens has been color corrected for three wavelengths. The effects are seldom significant in practice. *S. Ray*
See also: *Apochromat.*

TESLA A unit of magnetic induction (magnetic field strength) such that a charge of 1 coulomb moving with a velocity of 1 meter per second perpendicular to a magnetic field of 1 tesla experiences a force of 1 newton. One tesla is equal to 10^4 gauss. Gauss units are more common than tesla units because they tend to be of a more appropriate order of magnitude. *J. Holm*

TESSAR See *Lenses, lens history.*

TEST (1) An experimental procedure used to obtain specific information about a material, process, or device, such as a lens resolution test and a chemical test of a developing solution. (2) In picture making, a preliminary trial to check the components of a system, such as exposing and processing a short length of film before beginning production on a motion picture. *H. Todd*

TEST CHART An arrangement of letters, numbers, color patches, etc., designed to provide information about an imaging system, such as the color reproduction characteristics of different reversal color films. The terms *test chart* and *test target* are sometimes used interchangeably. *L. Stroebel*
See also: *Input, test targets.*

TEST OBJECT A test chart, test target, or any object considered appropriate to serve as a subject for the purpose of conducting an imaging test. *L. Stroebel*
See also: *Input, test targets.*

TEST PAPER Strips of absorbent paper that have been impregnated with chemicals for making quick tests of the approximate chemical condition of a photographic solution. Test papers can indicate the degree of acidity or alkalinity of a solution, or test strips can be employed to detect the presence of silver ions. *G. Haist*
See also: *Indicators/Indicator paper/Test paper.*

TEST STRIP An exposure series on a single piece of photosensitive material, used especially in projection printing, made to determine the correct exposure time and to check other image attributes such as contrast, color balance, and sharpness. By exposing through a transparent device that contains a calibrated neutral-density step tablet or set of color filters designed for testing purposes, the desired variations can be introduced using a single exposure time. There are also test strip holders that allow for testing the same area of the image, such as a person's face in a portrait, by moving the light-sensitive material under a stationary aperture. *J. Johnson*

TEST TAPE See *Calibration tape or film.*

TEST TARGET A geometric or other pattern designed to provide information about an imaging system, such as a resolving power target consisting of alternating black and white bars of various sizes. The terms *test target* and *test chart* are sometimes used interchangeably. *L. Stroebel*
See also: *Input.*

TETARTANOPIA One of four basic types of defective color vision (color blindness) in the dichromatism category, the other three being deuteranopia, protanopia, and tritanopia. A person with this defect (a tetartanope) sees all spectral colors as red or green, with both ends of the spectrum appearing red. Very rare. *L. Stroebel and R. Zakia*
See also: *Vision, color vision.*

TEXT The body matter of a page or book as distinguished from headings and graphics. Also, type, as distinguished from illustrations. *M. Bruno*

TEXTURE A relatively small-scale surface characteristic that is associated with tactile quality. Since a greatly magnified image of smooth paper can have the appearance of a rough surface, the small-scale qualification applies to the image rather than the subject with photographic reproductions. Some photographic printing papers are available with embossed textured surfaces. A texture screen placed in contact with a smooth printing paper during exposure produces a pseudotexture pattern. *L. Stroebel*

TEXTURE SCREEN A patterned transparent material used in conjunction with printing a negative to produce a particular esthetic effect. The material can be inserted into an enlarger and projected with a negative in place, placed in contact with a negative and printed in a contact printing frame, or placed on top of printing paper in an enlarging easel. Texture screens come in a variety of patterns and are often used to relieve the monotony of large areas of uniform tone, to soften detail in an image, or to create a weathered look. Screens can also be found that simulate the texture of etchings or canvas. Various fabrics such as muslin, silk, and nylon can be used to create texture. *R. Zakia*

TEYNARD, FÉLIX (1817–1892) French photographer. Employing the calotype process and salted paper prints, produced a magnificent and creative study of the architectural remnants of ancient Egypt and Nubia (the Sudan) from his trips of 1851–1852 and 1869. Concerned with producing more than a record, Teynard placed unusual emphasis on shadows. In 1990 an album of 160 Teynard salt prints was sold at auction for $800,000, doubling the price previously paid for a single photographic lot.
Book: Jammes, Andre, and Janis, Eugenia Parry, *The Art of French Calotype.* Princeton: Princeton University Press, 1983. *M. Alinder*

T-GRAIN Tabular grains (T-grains) of silver halide in photographic emulsions have a high surface-to-volume ratio that provides increased sensitivity, reduced granularity, and increased sharpness in the developed silver image. The thin, flat plates of T-grains, when coated, provide a high photon cross-section area per unit volume of silver halide. *G. Haist*

THEATRICAL Motion-picture productions, usually of an entertainment, storytelling nature, intended for distribution and exhibition in commercial theaters, as opposed to nontheatrical films such as educational, industrial, and sales films. *H. Lester*

THEATRICAL PHOTOGRAPHY Theatrical photography seeks to convey the excitement of stage plays, movies, and performance art as well as the individuality and charisma of the actors and actresses who bring such productions to life.

Whether they are taken in the theater or studio and feature a couple of key performers or the entire ensemble, theatrical photographs usually look like frozen moments from the production itself. Sharp and clear, they detail faces, costumes, sets, and situations that actually occur on stage or screen. Usually, however, these pictures are taken at a dress rehearsal or a photo call, displayed in the theater lobby, and sent to newspaper and magazine editors.

Theatrical photographs destined for publicity, advertisements, and posters often take liberties with the facts of the actual production. Instead of documentation, they seek to convey the type and tone of the production—comedy, tragedy, classical, popular, avant-garde, etc. They help to catch the eye of the casual observer and to cultivate interest in attending a performance.

Those who attend a performance, in some cases, may wish to take photographs from their seats or from side or back positions that do not block other people's view. Amateur productions may allow picture taking, but most professional productions expressly forbid it. Instead, they often sell their own lavishly illustrated programs.

HISTORY Daguerreotypes of Jenny Lind (Mathew Brady, 1850) and Lola Montez (Southworth and Hawes, 1851) as well as albumen prints of Sarah Bernhardt (Nadar, circa 1860) established the importance of theatrical photographs taken of performers by portrait photographers. That tradition was extended by such well known photographers as Nikolas Muray and Edward Steichen (*Vanity Fair,* 1920s), Richard Avedon (*Harper's Bazaar,* etc, 1940s-1970s), and Annie Liebowitz (*Rolling Stone, Vanity Fair,* 1970s to present).

Today's *glossy*—the 5×7 or 8×10-inch print distributed by every established and would-be performer to agents, news media, and fans—got its start in the 1850s. At that time until the 1890s, a photographic calling card, *carte-de-visite,* enjoyed broad popularity. Performers ordered these small prints mounted on cards approximately $2 \text{-} 1/2 \times 4$ inches for sale in theater lobbies. Photographers often gave free sittings and prints to well known theatrical personalities in exchange for the right to sell their pictures from the studio.

Around the turn of the century, on-stage pictures began to call attention to specific productions. At first, only operas, classical plays, and productions with major stars were photographed by prestigious photographers. When photographically illustrated programs emerged in the 1920s, however, the need for performance photographs as well as performer portraits grew. During that same decade, photographers began to document the set and lighting effects of major productions—a prelude to today's full coverage of all aspects of production.

In the motion-picture industry, still photographs not only document every aspect of production so that details can be matched when reshooting, but they also help generate publicity with apparent, in-production action shots plus formal and informal portraits of the stars. In such disciplines as mime, deaf poetry, magic, circus, and performance art (where scripts either do not exist or do not adequately describe what happens), movie footage or, more recently, videotape captures the entire performance. Such disciplines, especially those with an essentially physical core, can be photographed directly as action happens.

Stage plays and movies, on the other hand, often draw their power from words and emotion. They require the sill photographer to find a tableau or pose that sums up a theatrical moment visually. Then, these pictures can be taken right on stage or set with the actual performance lighting and, perhaps, direct or bounced electronic flash.

The *photo call* has become a tradition among stage actors, who must appear in costume and pose on the set of the production. The highly skilled photographer has only a limited time to take exciting black-and-white photographs that will publicize the play. *K. Francis*

See also: *Dance photography.*

THERMAL COEFFICIENT The change in a characteristic of a material per degree change in temperature. The thermal coefficient of expansion is of importance in the design of a camera film holder to accommodate temperature changes. *H. Todd*

THERMAL DEVELOPMENT Without the use of chemicals, the production of an image with heat. It is used, for example, in vesicular processes. *H. Wallach*

See also: *Vesicular image.*

THERMAL DYE TRANSFER An electronic printing method used to create continuous tone color prints from computerized digital images or video analog images. Thermal dye transfer systems are an offshoot of similar devices used by the textile industry in the 1960s for printing on fabrics. The system consists of a cyan, magenta, yellow and black dye ribbon and a thermal printing head in intimate contact with the ribbon. When the printer is activated, the heated thermal head moves along the receiver paper (or transparency material) impregnating it with cyan, magenta, yellow and black dyes (C, M, Y, K). The heat causes the dyes to diffuse into the paper or transparency material. The spatial resolution of the image ranges from about 130 to 300 SPI (spots per inch) depending upon the original image, the quality of the paper or transparency material, and the particular printer used. Dye stability is comparable to other electronic printing systems. Printer speed is relatively slow. The quality from the best dye transfer printing system is near photographic quality. *R. Zakia*

THERMAL IMAGING DEVICE Identifying a photographic material that responds to infrared radiation. *L. Stroebel*

See also: *Infrared photography.*

THERMAL RADIATION DETECTOR An instrument used to discover the presence of and to measure heat radiation by such methods as converting the radiation into electrical energy (thermocouples, thermopiles), causing a change in the length or the electrical resistance of a thin metal wire or strip (platinum resistance thermometer, bolometer), or changing the pressure of a gas in an enclosed vessel (Golay cell). *L. Stroebel*

See also: *Infrared photography; Thermography.*

THERMISTOR A temperature-sensitive resistor that is usually made from specially processed metallic oxides. Thermistors are available with either a positive or negative

temperature coefficient of resistance. They are used extensively to measure and record temperatures and, when used in conjunction with a heater controller, to automatically regulate temperature. Unlike a thermostat, which is an on–off switch, the output of a thermistor circuit is a stepless analog voltage. It provides smoother and more precise control of temperature for such critical applications as regulating the temperature of the developer in photoprocessors. *W. Klein*

THERMOCOUPLE
A temperature-sensitive device consisting of two dissimilar conductive materials that produce a measurable voltage that is a function of the temperature at the junction of the two materials. An electronic device connected to the thermocouple converts the voltage to a common temperature scale for readout. Thermocouples are widely used in science and industry for measuring temperatures and in automated control systems. Thermocouples may become more common in domestic use as the cost of the supporting electronics decreases. *J. Holm*

THERMOGRAPHY
Processes of image formation by heat. These are not new—Niépce de St. Victor and Robert Hunt were experimenting along these lines over 100 years ago and Hunt coined the name thermography in 1840. But it was not until 1952 that the first commercial heat process was introduced.

All heat processes are based on the fundamental fact that when a document having an infrared absorbing image is subjected to an intense source of heat for a brief period, the image will become hotter than the background: the temperature difference can be as high as 30°F. This heat image is converted into a visible image in an adjacent copy material by utilizing a suitable physical or chemical change that takes place over a small temperature range. The most common change is melting, but boiling and decomposition are also used.

The melting or fusion processes can be further subdivided according to whether the change is restricted to a physical one, or initiates a chemical change, or the softened image is transferred to another support.

PHYSICAL PROCESSES Basically, the image is formed from a layer of dispersed solid that melts when heated image-wise and remains as a super-cooled liquid when cooled. The liquid provides a window in the translucent layer of dispersed solid and an underlying dark layer is rendered visible. The liquid can also be made visible by dusting the surface after exposure with dye particles that will dissolve in the liquid. The dye does not adhere to the non-melted areas.

In a variant, the dye particles can form part of the original coating. It is well known that a given weight of solid dye is a much less efficient absorber of light than when in solution. Hence in the image areas the dye dissolves to give an image of high density on a tinted background. A similar process uses a cellular layer of a thermoplastic polymer. In the heated areas the cellular structure collapses and the dispersed dye dissolves in the softened polymer.

CHEMICAL PROCESSES This group comprises the majority of the thermographic processes described in the patent literature. In some processes the image is formed by a simple chemical decomposition that occurs with heat, e.g., the formation of black lead sulfide from lead dithioformate. But most of the patents describe image formation from chemical reactants that are brought together by fusion or softening to form a colored reaction product. The reactants may be solids that are dispersed in the same layer, or they can be coated in adjacent layers. Examples of chemical reactions that have been described are those between iron stearate and gallic acid, a hydroquinone and a quinone, a leucotriphenyl-

methane dye and an oxidizing agent, and an aromatic triazene and an azo dye coupler.

TRANSFER PROCESSES These utilize two surfaces to provide the final copy. The heat image softens the layer in the copy material immediately adjacent to the original and the softened substance is transferred image-wise to a receptor support. The transferred image, which is laterally reversed, can be used for making many copies by spirit duplication or lithography. Alternatively if the receptor material is translucent, the image can be read in the correct sense by turning the sheet over and viewing from the back.

DISTILLATION In one distillation process a thin film of oil is applied to the original. The higher temperature of the image (i.e., printed text) when it absorbs infrared radiation causes the oil to distill selectively from the image and it condenses image-wise on an adjacent sheet of plain paper. The oil image is rendered visible by dusting with dye particles, such as the toner powder used for electrophotographic development. These particles adhere only to the oil and can be fixed by heat treatment as in electrophotography.

The copy is laterally reversed but if the receptor sheet is translucent the copy can again be read from the reverse side.

Another process involving distillation uses reactants contained in layers on two separate supports. One reactant is volatile and distills from a heat image to condense on the adjacent material where it combines with the second reactant to form a visible image.

THERMOGRAPHY IN PRACTICE Since the image in the original must absorb infrared radiation, the thermographic process will not reproduce every printed document. Carbon black images (pencil, typescript, letterpress printing) and metallic images such as silver are all copied well. Aniline dyes, as are used in ball-point inks, do not normally absorb infrared so they are not copied.

The resolution of the process is poor but good enough to give readable copies of quite small print. The best definition is obtained if the original and heat-sensitive layer are in direct contact, but adequate copies are still obtained if the copy material is exposed to heat with the uncoated side in contact with the original, since the heat image passes by conduction through the support. This ability to obtain copies by both methods is of advantage with transfer processes.

Exposure can be made either by reflex, when the copy material is between the original and the source of heat, or, for single sided originals, with the copy material on the side away from the infrared source. The best-known heat-copying paper is exposed by reflex with the heat-sensitive layer in contact with the original. This layer is coated on to thin (40–50 grams per sq. meter) tracing paper and the reproduction is viewed through the support. In one type of machine, the original and copy sheet pass close to a 1200 watt infrared tungsten filament lamp, so that the original is scanned by infrared in a total time of about 4 seconds. Each section is heated for not more than half a second. In order to avoid overheating, controls are provided so that the lamp lights up only when the paper passes through. The non-image areas are still heat-sensitive and the paper will blacken uniformly if heated to about 100°C. In practice, the copies are sufficiently stable in a file but the background will darken on exposure to sunlight.

The thermographic process has enjoyed wide popularity for office convenience copying because it will reproduce both single- and double-sided originals quickly by a completely dry process.

Special products are available that, by a combination of light and heat exposures, will allow of the reproduction of both dye and carbon black images.

INFRARED SCANNING Heat radiations emitted by objects at normal or increased temperatures can be accosted by optical and mechanical scanning techniques with an

infrared detector. The output of the latter modulates the intensity of a light beam that scans over a photo-sensitive material. The resulting image shows colder and warmer portions of a subject as darker and lighter areas. Very accurate evaluation of the temperature of any point of the object is possible in this way, and such techniques have been used for military surveys, industrial testing and medical and biological investigations. *D. Fry*

See also: *Heat recording; Infrared photography; Nonsilver processes; Office copiers; Pyrometry, photographic.*

THERMOLUMINESCENCE The production of light by a substance as a result of an elevated temperature, but at temperatures below those required for incandescence. *J. Holm*

THERMOMETER A device for measuring temperatures, as for example, of photographic solutions. Basic types include the following: (1) A glass tube partially filled with a liquid such as mercury or alcohol. As the temperature rises, the liquid expands and the liquid level indicates a position on a scale. This type of thermometer tends to be fragile, and mercury thermometers are not permitted in some labs because of the danger of contamination of photographic materials with mercury from a broken thermometer. (2) Bimetallic thermometers, based on the difference in thermal expansion of two metals bonded together in the form of a coil. A temperature change causes an expansion or contraction of the coil, which produces movement of a pointer near a scale. (3) Bimetallic thermometers based on the thermoelectric effect, whereby heat is directly converted into electric energy. Electronic thermometers normally provide a digital readout, and those equipped with cords allow the display to be located some distance from the sensing probe, which may of necessity be in a dark area. (4) Infrared-sensing thermometers, whereby measurements are made from a distance by aiming an optical probe at an area of interest. The heat energy radiated by the selected area of the object is focused on a heat sensor, and the temperature is presented on a liquid crystal or other digital display. This type of thermometer can be used, for example, in manufacturing operations involving molten glass or metal.

Thermometers used to monitor photographic processing must be instruments of great precision. If the specification calls for a temperature value of $75 \pm 1°F$, the thermometer must have an error of much less than 1 degree. *H. Todd*

THERMOPILE A group (series) of thermocouples, i.e., temperature-measuring devices that function by producing a small but measurable electrical voltage that is dependent on temperature. The use of several thermocouples in a thermopile increases the sensitivity of the measurement at the expense of increased size. Thermopiles are sometimes used in fundamental measurements of light sources, as in the process of finding the spectral energy distribution of a light source. *J. Holm*

THERMOPLASTIC RECORDING System of image formation relying on the physical stress induced in thin plastic layers under the influence of an electrostatic field. The field is produced by an electrostatic image, after which the application of heat followed by immediate cooling converts the stresses in the plastic layer into a physical pattern. The latter can be made visible under suitable conditions of illumination. The image is suitable for play-back immediately after recording, and can also be erased by re-warming the plastic layer.

The recording material is a thin layer of heat-sensitive plastic on top of a transparent conducting layer coated on a plastic or film support. There are two possibilities of image formation. In the first an electron beam scans the surface of the plastic film and charges it in a pattern corresponding to the input signals. This produces an electrostatic image-wise distribution of charges. Alternatively, the plastic layer can be pre-charged by a coronary discharge and an image exposed on this afterwards by light.

Immediately after the exposure the plastic film passes over a heating unit that partially melts the thermoplastic layer (usually by induced currents in the transparent conducting coating). The conducting coating attracts the charges in the plastic layer and locally depresses the surface of the latter. This produces a ripple pattern that is immediately frozen into the film surface as the plastic cools again.

The image in the plastic film can be viewed directly if illuminated by light at the correct angle. For projection a system based on a Schlieren-optical set-up is used. This consists of a series of line light sources ranged in a plane behind a condenser lens, a grid some distance in front of the condenser lens, and a normal projection lens. The light is focused in such a way that the image of each line source falls on one of the bars of the grid. Hence no direct light reaches the screen at all. When the film with the thermoplastic image is introduced in front of the condenser lens, the surface ripples of the plastic layer deflects the light rays, so that they pass between the bars of the grid, forming an optical image on the screen.

Color images can also be recorded on thermoplastic material by superimposing a diffraction grating on each picture element. In an electronic recording system this can be produced by an extra input signal to another electrode of the electron gun. The grating is an additional physical pattern on the processed thermoplastic layer and during projection produces a spectrum to each side of the central beam. The slots of the grid in front of the condenser lens permit only one color to pass through the projection lens. The color of a projected image portion is thus produced by the diffraction grating on the thermoplastic film; the color depends on the spacing of this grating.

APPLICATIONS Originally thermoplastic recording was developed for direct recording of images produced in a manner analogous to a television screen image. In a recording unit the film can there run through at a standard speed (about 10 ins. per second) while the picture is scanned in a sequential frame fashion.

The thermoplastic film can also be used for information storage from a computer in the form of a binary digital system. The storage capacity of thermoplastic film is about 100 times as great as of magnetic tape. Thermoplastic film

Thermoplastic recording. Top: An electron beam scans the moving tape and records a charge pattern on it. As the tape passes over a heating stage that softens the plastic surface, the charge pattern distorts this surface into "wrinkles". Bottom: Section through thermoplastic tape. The charge pattern is discharged at the heating stage, but as the tape immediately cools the wrinkle pattern remains. A, electron beam. B, thermoplastic layer. C, film base with transparent conducting layer between it and the thermoplastic layer. D, heater.

Projecting the thermoplastic image. A series or slit light sources is so arranged, that a condenser system projects their light on to a grid of opaque bars between the thermoplastic film and the projection lens. Hence no light reaches the latter, except where the wrinkle pattern B in the film scatters light between the bars of the grid so that the lens records the wrinkle as a point of light at F on the projection screen. A, thermoplastic film with wrinkle images at various points such as B. C, slit light source. D, condenser lens. E, parallel grid of opaque bars. F, screen. G, projection lens.

can record and store the contents of complete libraries in equipment the size of an office desk. Its potential applications also include optical and non-optical data recording in satellites and space ships, where the more favorable ratio of storage capacity to weight gives it advantages over straightforward television and photographic systems. *L. A. Mannheim*

See also: *Electrophotography.*

THERMOSTAT A temperature-sensitive switch. A common type utilizes a bimetallic strip that bends under the influence of temperature. The movement of the strip either directly closes or opens a set of electrical contacts or actuates a sensitive snap-action switch. The latter type is preferred, especially for dc circuits, because the contacts open and close fast and thereby reduce the damaging effects of arcing that occurs with creep action thermostats. The temperature at which the thermostat operates when the temperature is rising is different from when it is falling. The difference between these temperatures is known as the temperature differential. The smaller the differential, the better the ability of the thermostat to maintain constant temperature by reducing the size of the overshoots. *W. Klein*

THIRTY-FIVE MILLIMETER See *Film formats.*

35-MM CAMERA See *Camera types.*

THREE-COLOR THEORY Theory on which color separation and reproduction are based. *M. Bruno*

See also: *Photomechanical and electronic reproduction.*

THREE-QUARTER LIGHTING Placing the light at about a 45° angle to the subject, a compromise between side, top, and front lighting. Such lighting illuminates more of the front of the subject, concealing less of the subject in shadow than pure side lighting and produces an illusion of dimension much stronger than with front lighting.

F. Hunter and P. Fuqua

THREE-QUARTER VIEW (1) Representation of an image, object, or person from a vantage point halfway between full frontal view and a side view. (2) In portraiture, an image that includes the head and torso, also, between full face and profile. *R. Welsh*

THRESHOLD In electronic imaging, a critical brightness value that determines a transition. In some applications all pixel values above a particular threshold may be assigned the maximum brightness value while those pixels below the threshold are assigned the minimum brightness value. The result is a high-contrast image containing only black and white pixels. *R. Kraus*

THRESHOLD EXPOSURE The minimum exposure given to a photographic material that produces a just-noticeable increase in density above the base-plus-fog density that is produced with no exposure. *J. Johnson*

See also: *Characteristic curve.*

THROUGHPUT In computers, a measure of speed and efficiency that attempts to equalize all components of a system so that the ultimate criterion is how quickly the task is accomplished. For example, modems that have a baud rating of 9600 may actually have a throughput of 14,400 baud because of the use of compression firmware.

R. Kraus

THROUGH-THE-LENS (TTL) A camera exposure metering system in which the light sensor is located inside the camera where it measures light transmitted by the lens. With single-lens reflex cameras, the sensor can be located in any of various positions including on the mirror or the pentaprism, between the ground glass and the pentaprism, or in a position where it measures the light reflected from the film

Through-the-lens exposure meters. (left) Eight possible locations for the meter sensor in a single-lens-reflex camera. (right) By inserting the frame into the back of a view camera, the sensor on the end of the probe can be placed in any desired position in relation to the image on the ground glass.

while it is being exposed, a system more specifically identified as off-the-film (OTF). With view cameras and some other sheet-film cameras, a probe with a sensor can be inserted in front of the ground glass for a reading before the film holder is inserted. In another view camera system, a number of very small sensors are installed in an appropriate pattern on the ground glass, with an electronic control that allows the operator to select one or more positions to be used for readings. *P. Schranz*

THROW The distance from a projector lens to the projection screen. *L. Stroebel*
Syn.: *Image distance.*

THUMBNAIL In electronic imaging, a collection of stored images that may be visually displayed as a resampled series of 25 images per screen. These small thumbnail representations of the image allow for visually locating the desired image. Thumbnail images are often used when one wishes to arrange a series of images for presentation. In some ways a thumbnail screen display is similar to viewing transparencies as a group on a light table, instead of one by one in a projector. *R. Kraus*
Syn.: *Index print.*

THX (SOUND) A set of technologies from Lucasfilm, first developed for the theater and subsequently for the home, meant to improve the transfer of the sound experienced by a filmmaker during preparation of a film under standardized conditions into the various environments in which it will be shown. In the theater, this means a specific electronic crossover, choice of power amplifiers and loudspeakers, local acoustical environment around the loudspeakers, global acoustical environment of the theater, and tuning of the theater sound system in accordance with SMPTE A202M-1991. In the home, both electronic- and loudspeaker-design tactics are used, intended to permit better translation of the program material prepared in a dubbing stage into the home environment. *T. Holman*

THYRISTOR One of a class of semiconductor devices that latch to a fully conducting state when a control signal is applied and which cannot be turned off except by interrupting the current flow or by short-circuiting the device. *W. Klein*
See also: *Silicon controlled rectifier; Triac.*

TIFF In electronic imaging, images that are captured and saved to a storage medium as a file and are described according to some algorithm. The description is usually written prior to the image data in an area of the file called the header. Tagged image file format is one such header description widely used by electronic imaging programs. Others are TGA, VST, PCX, PICT, and PIC to name only a few. The proliferation of a multitude of image headers has caused serious porting problems. Many image manipulation software programs only read a limited number of header files. There are a number of commercial conversion programs that allow for the translation of one file format into another. *R. Kraus*

TIGHT REGISTER In photomechanical reproduction, register within plus or minus 1/2 row of dots. Also called hairline register. *M. Bruno*

TILT Rotation of the lens board or camera back of a view or technical camera around a horizontal axis, or to alter the vertical angle of an entire camera. *P. Schranz*

TILT TOP A tripod head on which the angle of the top can be altered in order to tilt the camera. Some have

Tilt adjustments on a view camera.

a simple friction lock while others have a crank and gear mechanism for gradual and positive alteration of the angle. *L. Stroebel*
See also: *Pan-and-tilt head.*

TIMBRE The sensation about a total sound that cannot be described by loudness or by pitch but is related to the harmonic structure, its balance across frequency, and its changes in time. *T. Holman*

TIME-BASED CORRECTOR (TBC) In electronic imaging, video input from video tape recorders may contain time-based errors that make digitizing the images impossible. TBCs correct these timing errors. *R. Kraus*

TIME CODE Abbreviation of Society of Motion Picture and Television Engineers (SMPTE) time code. A method of encoding position into hours, minutes, seconds, and frames, along with other information, so that unperforated media, such as videotape, open reel tape, and so on, can be run in frame-accurate synchronization, by use of an electronic synchronizer. Time code occupies the space of one audio channel. *T. Holman*

TIME-CONTRAST INDEX CURVE A plot of the contrast index (the average slope of a D-log H curve over the most-used portion) versus time of development. Such a graph is useful for determining the necessary time of development for a desired development contrast. *M. Leary and H. Todd*

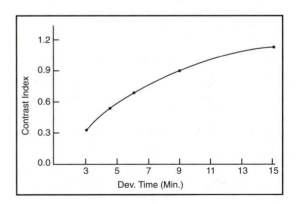

Time-contrast index curve. The change in contrast index with time of development.

TIMED PRINT A motion-picture print in which all shots have been individually adjusted in printing for proper color balance and exposure. *H. Lester*
See also: *One-light print.*

TIME EXPOSURE The T setting on many shutters, whereby the shutter release is pushed once to open the shutter and then again to close the shutter. This differs from the bulb (B) setting in that on B the shutter release must be held under pressure to keep the shutter open, and when pressure is removed the shutter closes. Cameras that have a double-exposure prevention device usually have a B setting rather than a T setting. The T setting is only used for long exposures of from a few seconds to many minutes.

J. Johnson

TIME–GAMMA CURVE A plot of the slope of the straight line of a D-log H curve versus time of development. Formerly such a graph was used to determine the necessary time of development for a desired film straight-line contrast.

M. Leary and H. Todd

See also: *Contrast index.*

TIME LAG The elapsed time between any two points in an action or process, such as (1) between a decision to trip a shutter when photographing a moving object and movement of the finger, (2) between tripping a shutter and exposure of the film, where with SLR cameras the mirror must first flip up, (3) between closing an electrical circuit and stabilization of light output of a lamp, which is very short for tungsten lamps but quite long for fluorescent lamps, and (4) between an adjustment of the thermostat on an automatic film processor and the resulting change in temperature of the processing baths.

R. Jegerings

TIME-LAPSE PHOTOGRAPHY The photographing, typically with a motion picture or video camera, of a slow, continuous process, such as the blossoming of a flower, a frame at a time at regular intervals over an appropriate time period so that when the images are viewed at the normal rate the change is greatly exaggerated. The same technique can be used with a series of still photographs to show, for example, the day-by-day progress in the construction of a building, or even in a single photograph with a slowly moving object against a dark background, such as the position of the moon at regular intervals.

L. Stroebel

See also: *Motion-picture photography.*

TIME-LIGHT CURVE Typically, a graph of relationship between the time elapsing after the closing of a circuit for a light source (on the horizontal axis) and the light output of the source (on the vertical axis). For flashlamps and electronic flash, the time is measured in milliseconds and the light output is measured in lumens. To show the change in intensity of a fluorescent lamp after it is turned on, the time might be measured in minutes. To show the change in the intensity of a tungsten lamp with use, the time might be measured in hours.

R. Jegerings

TIME MAGNIFICATION A motion-picture term indicating the degree of slowing down of movement in final projection. It is the ratio of the duration of the projected image to the duration of the actual event, which is equal to the ratio of the camera frame-per-second rate to the projected frame-per-second rate (normally 24 frames-per-second).

H. Lester

TIMER A device used to monitor the duration of activities such as photographic exposure and processing. Features found on various timers include the automatic control of printing exposure time, turning a safelight off when an enlarger is turned on for focusing, and emitting audible signals at selected times. Some electronic timers can be programmed to time a sequence of processing steps of varying durations.

H. Todd

TIME RESOLUTION The shortest duration that can be recorded by a specific method of high-speed photography. In high-speed motion-picture photography, the time interval between successive frames. Thus a film taken at 10,000 frames per second is said to have a time resolution of 1/10,000 second. Strictly speaking, the exposure time is shorter because the time interval between frames must also be taken into account.

L. Stroebel

Syn.: *Temporal resolution.*

TIME-SCALE SENSITOMETER An exposure device, used in testing photographic materials, that produces a set of different exposures on the sample by varying the time of exposure. Such instruments are now rarely used because they expose the material in a manner that does not conform to usual practice.

M. Leary and H. Todd

See also: *Sensitometry.*

TIME-TEMPERATURE (1) Specification of development by objectively measured factors, as compared with development by inspection. In the first case, one processes, for example, for 5 minutes at 20°C, other factors being constant; in the second, one processes until the image appears correct. (2) Followed by "*chart,*" a graphical means of finding the correct time of development at a temperature other than standard.

L. Stroebel and R. Zakia

See also: *Contrast index.*

TIME–TEMPERATURE CURVE A graph showing the relationship between the time of development for a fixed film contrast and the temperature of the processing solution. In situations in which the processing temperature cannot be brought to standard, the graph assists in finding the correct development time at a nonstandard temperature.

M. Leary and H. Todd

TIME VALUE (T_v) In the additive system of photographic exposure (APEX), a number represented by the symbol T_v which equals the logarithm to the base 2 of the reciprocal of the exposure time in seconds. The exposure value (E_v) equals the time value (T_v) plus the aperture value (A_v).

J. Johnson

See also: *Additive system of photographic exposure.*

TINT A light and unsaturated color, as is produced by adding white to a more saturated color. Pink, a light red of low saturation, is a tint. The term is also used to identify base colors of photographic papers, including cold white, warm white, and cream white.

R. W. G. Hunt

See also: *Shade.*

TINTING The practice of coloring prints, positives, lantern slides, or even black-and-white or color negatives, usually with dyes or photo oils. The effect is most clearly discerned in highlight areas and of little consequence in shadow areas. Daguerreotypes were often hand tinted in a pseudo-realistic manner. Later, tinting was commonly designed to counterfeit the impression of color material. With the development of accurate color processes, tinting has become, typically, more disjunctive in its intent.

H. Wallach

TINTYPE Popularly accepted name for the ferrotype. Originally, in the 1850s, its black lacquered plate had a wet collodion emulsion, replaced in the 1880s by dry gelatin. It played a substantial role in the democratization of photography.

H. Wallach

See also: *Ferrotype/Tintype process.*

TISSUE OVERLAY See *Overlay.*

TITLE An identifying legend on a photograph, film strip, motion picture, video recording, etc. Titles in a motion-picture or video production include the main title of the production, followed by a cast title or titles identifying actors and the characters they portray, credit title for production and other staff, subtitles providing explanations where needed, and an end title. *I. Current*

T-NUMBER

LENS TRANSMITTANCE The relative aperture or *f*-number of a lens is defined geometrically and assumes 100% transmittance of incident light by the lens. But part of the incident light is lost by reflection at the air–glass interfaces and a little more by absorption, depending on the physical thicknesses of the elements. The remainder is transmitted to form the image. Thus, the transmittance factor of the lens is always less than unity. Lens flare is caused by some of the lost light.

An average figure for the light loss due to reflection may be 5% for each interface ($t = 0.95$). Losses are multiplied for successive interfaces, so for a lens with n identical interfaces the total transmittance (T) is given by $T = t^n$. An uncoated four element lens with eight surfaces would have a transmittance of some $(0.95)^8 = 0.66$ or reflection losses of 34%. A complex lens with say 50 surfaces of transmittance 0.95 would transmit only some 8% of incident light. Obviously, a zoom lens with 15 elements would have severe light losses. The actual transmittance of a lens is determined by photometric techniques.

EFFECT OF COATING An effective method of increasing transmittance is by applying thin coatings of refractive material to the air–glass interfaces, and a transmittance factor of 0.99 may be reached. So for a lens with eight such surfaces, transmittance is increased from 66 to 92%, or approximately one-third of a stop of a given *f*-number.

PHOTOMETRIC APERTURE Because lens transmittance is never 100%, relative aperture or *f*-number (N) (defined by the geometry of the system as focal length divided by effective aperture) does not completely indicate the light-transmitting performance of a lens in practice. Two lenses at the same *f*-number may have different transmittances, and thus different speeds, depending on the type of construction, number of components, and type of lens coatings. There is a need in some fields of application for a more accurate measure of lens transmittance than *f*-number. Consequently, *T*-numbers may be used instead, which are photometrically determined values taking into account both imaging geometry and transmittance. The *T*-number of a lens is defined as the *f*-number of a perfectly transmitting lens that gives the same axial image illuminance as the actual lens at this aperture stop. For a lens with a circular stop, *T*-number $= f\text{-number}/\sqrt{T} = N{\cdot}T^{1/2}$.

A *T*/9 lens, therefore, is one that passes as much light as a theoretically perfect *f*/8 lens. The *relative aperture* of the *T*/8 lens may be about *f*/6.3.

Also, for a lens of focal length *f*, with noncircular aperture and having entrance pupil area A, *T*-number $= f/2[\pi/AT]^{1/2}$. Lenses with noncircular apertures should really be calibrated in *T*-numbers, but these are of little practical importance with the widespread use of in-camera metering systems.

DEPTH OF FIELD The concept of *T*-number is of primary interest in cinematography and television and where exposure latitude is small. It is implicit in the *T*-number system that every lens should be individually calibrated. Depth of field calculations should be based on *f*-numbers and not *T*-numbers, so the aperture scale should carry both calibrations. In practice, the effect of using *T*-numbers instead of *f*-numbers for depth of field calculations may have little significance.

Many years ago, the difference between *f*-numbers and *T*-numbers for a cine lens could be as much as a factor of 2. Lenses with improved transmittance could be used at smaller apertures to give an equivalent exposure as dictated by the *T*-number; consequently, they gave additional depth of field and were called deep field lenses. *S. Ray*

TOE That portion of a characteristic (D-log H) curve lying between the base-plus-fog density level and the beginning of the straight line or the area of maximum slope if no straight line exists. In the toe region, local image contrast will vary with exposure level. Because, for negatives made from normal subjects, optimum exposure of shadows lies within the toe region, consideration of toe characteristics is an important part of the analysis of sensitometric data.
M. Leary and H. Todd

See also: *Characteristic curve.*

TOLERANCE The allowable variation from a prescribed treatment or result; a part of a specification. If the time of development is specified as 5 minutes ± 10 seconds the tolerance is 10 seconds. The tolerance indicates how much care must be taken in the procedure. *H. Todd*

TOMOGRAPHY In a conventional, fixed point medical x-ray, or radiograph, the point of interest may be shielded from view. A tomogram is produced by swinging the x-ray tube in an arc of a circle centered on the point of interest while the film cassette on the other side of the subject is slid in the opposite direction. The selected object is clearly defined, and objects away from the center are blurred. Originally, the tube and the cassette were connected mechanically, by a lever. Greatly enhanced results are now achieved by using a computer to control the moving assemblies, a process called computer-assisted tomography, or CAT-scan recording. *H. Wallach*

TONALITY The overall appearance of the densities of the component areas of a photograph or other image with respect to the effectiveness of the values in representing the subject.
L. Stroebel

TONE (1) An area of uniform luminance or density in a subject or image. A high-contrast image might have only two tones, black and white, and gray scales have a limited number of tones, such as ten, whereas most subjects and continuous-tone images have many tones. (2) A slight hue in a monochrome image, such as warm-tone (brownish) and cold-tone (bluish). (3) (Verb) To chemically alter the hue of a photographic image. *L. Stroebel*

TONE-CONTROL PROCESS The aim of tone control is to produce a range of densities in the final product that is either subjectively appropriate or objectively correct. To achieve this end, the original exposure may be biased to enhance highlight or shadow detail. The conditions of development may be altered, as may printing material and technique, and enlarger characteristics. Intermediate negatives and positives and masks of various types may be used to alter specific tonal values. Viewing conditions have a substantial influence on perceived tone representation. *H. Wallach*

See also: *Masking, unsharp; Printing techniques; Water-bath development.*

TONE REPRODUCTION The basic purpose of a photograph is to reproduce an image. One of the three basic attributes of a reproduced image is the reproduction of the tones of the image. Also of importance are the definition of the image (the reproduction of edges and detail and the amount of noise in the image) and the color reproduction. It is convenient to deal with these attributes separately when

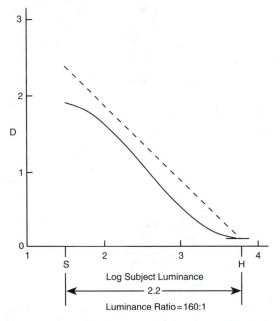

Objective tone-reproduction curve for a preferred reflection print of an average outdoor scene.

measurable with a telescopic photometer. Exact luminance reproduction of daylight scenes is generally not achieved because of the high-intensity lighting required when viewing the photographs. Because of this problem, exact luminance reproduction is ordinarily not attempted. Instead, convenient and much lower levels of light are used in viewing photographs, and we rely on the adaptation mechanism of the eye to adapt to the illumination level so the photographs do not look too dark.

Two types of visual adaptation are of concern in tone reproduction. Direct adaptation is the change in sensitivity of the eye with changes in light level. This type of adaptation allows images to be viewed comfortably at a variety of light levels, although tone reproduction preferences are different at low and high levels. Lateral adaptation deals with the effect of the surround on a photograph. An image viewed with a dark surround will have greater brightness and lower apparent contrast than the same image viewed with a bright surround. Because of visual adaptation, in particular lateral adaptation, the objective contrast of motion pictures and slides that are to be viewed with a dark surround must be higher than for an image intended for viewing with a bright surround. Also images which are illuminated with strong light should have more contrast than images illuminated with dim light.

Preferred Tone-Reproduction Curves The effects of visual adaptation and other psychological preferences result in the preferred reproduction of tones in an image being different than the exact or facsimile reproduction. The most convenient way to display differences in tone reproduction is through the use of graphs. A typical tone-reproduction graph has the input values—the subject log luminances—on the horizontal axis, and the output values—the image densities—on the vertical axis. By plotting these values as *(x, y)* pairs, a curve is obtained that completely describes the objective tone reproduction of the image. The curve will not fall directly on a 45-degree line representing facsimile reproduction, partially because people tend to prefer some exaggeration of contrast in the midtones and reduction of contrast in the highlights and shadows. This preference is analogous to the common preference for boosted low and high frequencies in audio. Boosting these frequencies slightly makes the sound a bit more dramatic, increasing the perception of realism in the reproduction. In images, most of the detail is in the midtones. Boosting the contrast in this area makes the reproduced image somewhat more realistic in appearance, if not in reality. It is important to remember, however, that the optimum effect is achieved with a subtle change. Radical

evaluating an image. Tone reproduction is of particular importance in black-and-white photography because it is the attribute over which the photographer has the most immediate control. The tone reproduction of a photograph is largely dependent on exposure and development. Image definition, on the other hand, is more dependent on film type and format, factors that are frequently chosen before the photograph is visualized.

There are two basic categories of tone reproduction: subjective and objective. Exact subjective tone reproduction is achieved when the brightness of each point in a photograph is equal to the brightness of the corresponding point in the original scene. Brightness is the magnitude of the subjective sensation produced in the brain by light. Brightness is not measurable by any instrument but can be determined approximately by psychological scaling procedures. Exact objective tone reproduction is achieved when the luminance of each point in a photograph is equal to the luminance of the corresponding point in the original scene. Luminance is

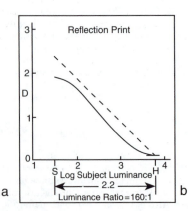

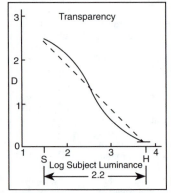

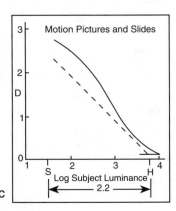

Preferred tone-reproduction curve. (a) Objective tone-reproduction curve for a preferred reflection print of an average outdoor scene. (b) Objective tone-reproduction curve for a transparency of preferred quality, viewed on a bright illuminator under average room light. (c) Objective tone-reproduction curve for motion pictures and slides of preferred quality, projected on a screen in a darkened room.

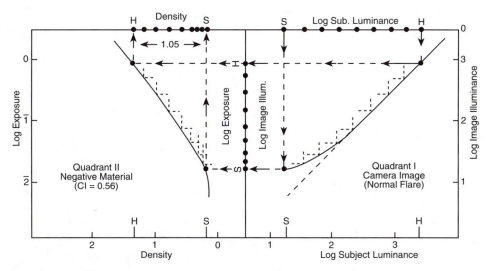

Negative material. The combined effect of the transfer of the camera flare curve onto the negative characteristic curve.

exaggerations in midtone contrast will reduce the realistic appearance of the image.

Another consideration in determining the preferred tone reproduction for a photographic system goes back to visual adaptation and deals with the desired contrast and maximum density. A slight s-shape may be preferred for tone reproduction curves, but it is also necessary to know the endpoints of the curve to specify it completely. The most important factor in determining the endpoints is the maximum useful density. Two factors limit the maximum useful density: the maximum density capabilities of the photographic material, and the lighting conditions. Because of surface reflections and scattering, typical black-and-white photographic papers are incapable of producing maximum densities much above 2.2. This value is even lower if the paper does not have a glossy surface, with maximum densities of about 1.5 typical for matt papers. The recommended maximum useful density for photographic papers is 90% of the maximum density. Tone reproduction curves for photographic prints will typically have an endpoint at this value.

With transparencies, the lighting conditions are more commonly the limiting factor for the maximum useful density. The preferred maximum density for transparencies viewed with a bright surround is approximately 2.4, while

transparencies viewed in a darkened room typically have a maximum useful density of around 2.7. In the latter case, the maximum density capability of the transparency material (typically around 3.0) is a contributing factor. Other situations may require different curves.

It is interesting to note that the preferred tone-reproduction curves are quite close to what is obtained naturally through the use of the photographic process. It is much more difficult to obtain a facsimile reproduction than one with a slightly s-shaped reproduction curve. Also, the maximum density capabilities of the materials are typically compatible, but just barely so, with the preferred maximum density requirements. It may seem an amazing coincidence that this is the case, but it is not as unreasonable as it appears at first. The same physical characteristics of materials that limit the range of our perceptions in the world limit the capabilities of photographic materials. The shape of the reproduction curve is a somewhat more fortuitous coincidence. The use of digital image processing now allows for easy manipulation of this curve, but this was not the case in the past.

THE FOUR QUADRANT TONE REPRODUCTION DIAGRAM

Major Factors for Consideration

Optical Flare Flare light is energy that is randomly reflected within the camera. It comes from the lens element surfaces, shutter, and diaphragm, from the lens barrel and bellows, and from the camera body and film itself. Such light is often nearly uniform over the entire image. Flare light is governed by the illuminant-subject geometry, the subject characteristics, the lens design, and the camera design. The effect of flare can be seen in the following example:

	Shadows	*Highlight*	*Ratio*
Subject	1	100	100:1
Flare	1	1	1:1
Combined	2	101	50:1

The result of flare is a reduction in the range of illuminances (and consequently the range of exposures) that occur at the back of the camera. In addition, the rate of compression is far greater in the shadows than anywhere else. This means some loss in shadow detail. A flare factor can be computed as follows: Flare Factor = Ratio of Subject Luminances/Ratio of Image Illuminances. The factor is 1.0 for no flare light and can be as large as 10 for some conditions. A flare curve illustrates the relationship between subject

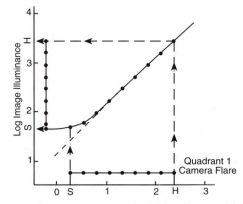

The effect of flare (or other stray light) on the image illuminances at the film plane of the camera.

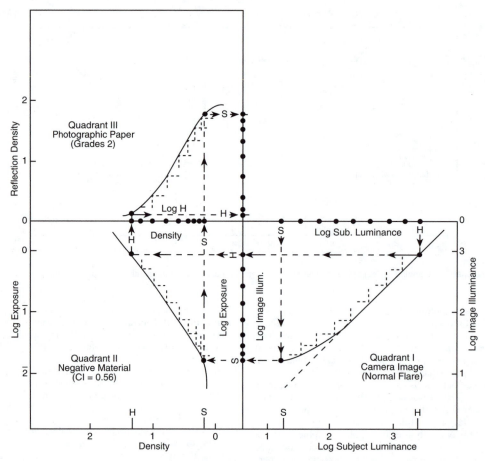

Positive material. The combined effect of the transfer of the camera flare curve through the negative characteristic curve onto the paper characteristic curve.

luminances and image illuminances for a given set of conditions. This is the first stage in the tone reproduction cycle, referred to as Quadrant I.

Negative Material The shape of the *D*-log *H* curve of the negative film and the available exposure and the density range are the next important considerations. To be of practical value, the curve must come from a test that closely simulates real life conditions of exposure and processing. This is the second stage of the system, labeled Quadrant II. The second step in the graphical solution of the tone-reproduction cycle is to combine the flare curve with the characteristic curve. From these combined curves it is possible to determine the density produced on the negative for any scene luminance value at the given exposure.

Positive Material The shape of the *D*-log *H* curve of the positive material and its exposure and density range are the next important factors. This stage is labeled Quadrant III. For an excellent reflection print to result, there must be near equality between the useful density range of the negative and the useful log exposure range of the paper. The third step is the combination of the curve for the positive material with the curve for the negative material. The print curve includes the effects of the printing system and the processing of the paper.

Objective Tone-Reproduction Curve To complete the graphical analysis, the objective tone-reproduction curve is obtained by combining the separate curves for flare, the negative and the positive to give the curve in Quadrant IV. The dotted lines are extended to the print curve and then to the

right, where the print densities are found. To compare the tones in the print with the tones in the subject, the lines are continued to the right until they intersect similar lines drawn upward from the subject tone positions in Quadrant I. The curve that results is the objective tone reproduction curve and is labeled Quadrant IV. Exact reproduction of the original scene would have given a straight 45-degree line drawn from the highlight point on the zero print density axis. This is seldom achieved with the conventional photographic process because of the nonlinearity of the flare curve and the D-log H curve for the print material.

Table 1. Example of Multiplication of Gradients Method of Four- Quadrant Tone Reproduction

A.	Scene input ranges (given)	50:1	160:1	1000:1
B.	Log luminance ranges (log[A])	1.70	2.20	3.00
C.	Flare factors (given)	1.5	2.0	3.0
D.	Log flare factors (log[C])	0.18	0.30	0.48
E.	Log exposure ranges (B–D)	1.52	1.90	2.52
F.	Quadrant I gradient (E/B)	0.89	0.86	0.84
G.	Quadrant II gradient (film CI)	0.60	0.60	0.60
H.	Desired print density range (given)	1.80	1.80	1.80
I.	Desired Quadrant IV gradient (H/B)	1.06	0.82	0.60
J.	GI × GII (F × G)	0.53	0.52	0.50
K.	Desired Quadrant III gradient (I/J)	2.00	1.58	1.20
L.	Desired paper log H range (H/K)	0.90	1.14	1.50
M.	Desired paper contrast grade	3	2	0

Reproduction Gamma The tone-reproduction system can be considered as a cascading sequence of factors. The reason that this multiplication of factors can occur is a function of the uniformly scaled log plots throughout the system. The slopes, or gradients, are being multiplied in each of the quadrants. These relationships may be generalized as follows:

$$GI \times GII \times GIII = GIV$$

where:

GI = the average gradient in Quadrant I.
GII = the average gradient in Quadrant II.
$GIII$ = the average gradient in Quadrant III.
GIV = the average gradient in Quadrant IV.

The usefulness of this relationship is that it allows the prediction of effect when changes are made in the process. It also allows for the determination of necessary slopes in the process to achieve a required slope in the reproduction. This relationship also leads to the mirror image rule: to obtain a straight-line reproduction (slope of 1.0), the slopes of the negative and positive materials are reciprocally related.

Assumptions in Tone Reproduction

1. That the flare curve was derived under actual image-making conditions, and that flare is uniform across the film plane.
2. That the negative material was tested under actual negative-making conditions.

3. That the optical nature of the printer to be employed was simulated in the densitometer used to measure the negative material.
4. That the positive material was tested under actual positive-making conditions.
5. That the optical nature of the viewing conditions was simulated in the densitometer used to measure the positive material.
6. That luminances describe the subject sufficiently, i.e., the visual aspects of the scene, and that there is no concern for colors other than neutrals or that non-neutral colors are correctly simulated by grays in the image.
7. That all aspects of the photographic system are stable and repeatable.

Examples of Tone-Reproduction Curves for Various Systems

The following pictorial examples contain examples of four quadrant tone-reproduction diagrams for a normal scene luminance range of 160:1. A tone-reproduction diagram illustrating the loss of shadow contrast as a result of excessive flare. A tone-reproduction diagram illustrating the effects of underexposing by two stops with normal development of the negative. A tone-reproduction diagram illustrating the effects of underexposing by two stops with extended development of the negative. A tone-reproduction diagram illustrating the effects of printing a normally exposed negative on three different grades of paper.

All of the examples are for a scene luminance range of 160:1, the average value for the luminance range of an

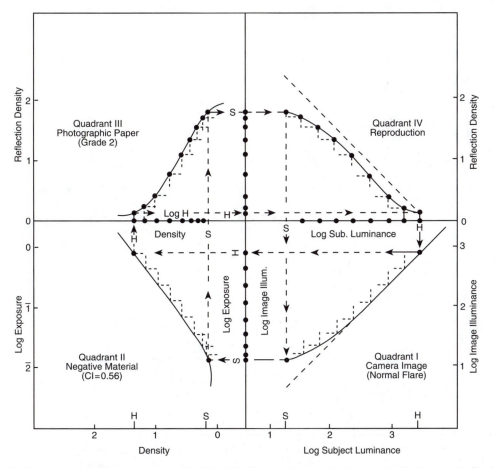

Complete objective tone-reproduction diagram for a pictorial system. The print characteristic is represented by the curve in Quadrant IV.

outdoor scene. The luminance ranges of outdoor scenes are approximately normally distributed, so the average value is also the most frequently occurring value. Scenes with significantly different luminance ranges can be found, however, and may be interesting to photograph. The effect of changing the scene luminance on the tone-reproduction curve is to change the width of the curve.

A Numerical Example of a Tone-Reproduction System Quadrant I The subject log luminances are derived by taking the log of the subject luminances in candelas per square meter. The subject luminances are determined from the subject illuminance for lambertian surfaces using the formula:

$$L = rE/\pi,$$

where L = the subject luminance in candelas per square meter, r is the reflectance of the surface, and E is the illuminance falling on the surface. Log values are used because of convenience, convention, the fact that density is a log value, and the fact that log values are somewhat closer to the visual response than linear values.

An estimate of the flare factor can be obtained from the following formula:

$$\text{Flare factor} = 0.3\,n,\ n \geq 4$$

where n is the scene luminance range in stops. This formula has been determined empirically and is only an approxima-

tion, so it may not give useful results in all cases. If the formula is accepted, however, it is possible to calculate approximate image log illuminances given the scene luminances. The steps are as follows:

1. Determine the scene luminance range in stops, or calculate it from the image log illuminances as follows:

$$n = (\log[L_h] - \log[L_s])/0.3$$

where L_h is the scene highlight luminance and L_s is the scene shadow luminance. (In the Zone System, L_h would be Zone 8 and L_s would be Zone 1.)

2. Calculate the flare factor using the empirical equation given above. (Note that the estimated flare factor is equal to the scene log luminance range.)
3. Calculate the flare light value:

$$E_f = E_s(FF - 1), L_f = luminance \text{ due to flare.}$$

4. Calculate the actual image flare light value:

$$E_f = 0.65 L_f/(f\#)^2$$

5. Calculate the actual image illuminance values, including flare light:

$$E = 0.65 L/(f\#)^2 + E_f$$

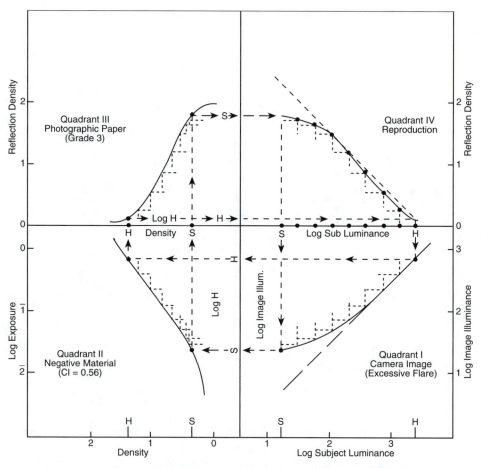

Objective tone-reproduction diagram illustrating the loss of shadow contrast (Quadrant IV) as a result of excessive flare.

Table 2. Typical Luminances (L), Flare, Image Illuminances (E), and Log Exposures (H) for a Gray Scale Photographed on a Sunny Day Outdoors

Step	Density	L	Log L	E (no flare)	E (with flare)	Log E	Log H
1	0.05	14185	4.15	36.0	36.4	1.56	−0.54
2	0.15	11267	4.05	28.6	29.0	1.46	−0.63
3	0.25	8950	3.95	22.7	23.1	1.36	−0.73
4	0.35	7109	3.85	18.0	18.5	1.27	−0.83
5	0.45	5647	3.75	14.3	14.7	1.17	−0.93
6	0.55	4486	3.65	11.4	11.8	1.07	−1.03
7	0.65	3563	3.55	9.05	9.45	0.98	−1.12
8	0.75	2830	3.45	7.19	7.59	0.88	−1.22
9	0.85	2248	3.35	5.71	6.12	0.79	−1.31
10	0.95	1786	3.25	4.53	4.94	0.69	−1.40
11	1.05	1418	3.15	3.60	4.01	0.60	−1.49
12	1.15	1127	3.05	2.86	3.27	0.51	−1.58
13	1.25	895	2.95	2.27	2.68	0.43	−1.67
14	1.35	711	2.85	1.81	2.21	0.35	−1.75
15	1.45	565	2.75	1.43	1.84	0.27	−1.83
16	1.55	449	2.65	1.14	1.55	0.19	−1.91
17	1.65	356	2.55	.905	1.31	0.12	−1.98
18	1.75	283	2.45	.719	1.13	0.05	−2.05
19	1.85	225	2.35	.571	.979	−0.01	−2.11
20	1.95	179	2.25	.453	.861	−0.06	−2.16

D_{min} of scale = 0.05, D_{max} of scale = 1.95, Illuminance on scale = 50,000 lux, f# = 16, n (scene range in stops) = 6.33, flare factor = 1.90, E_f = 0.408 lux, t (exposure time) = 1/125 sec, log t = −2.10.

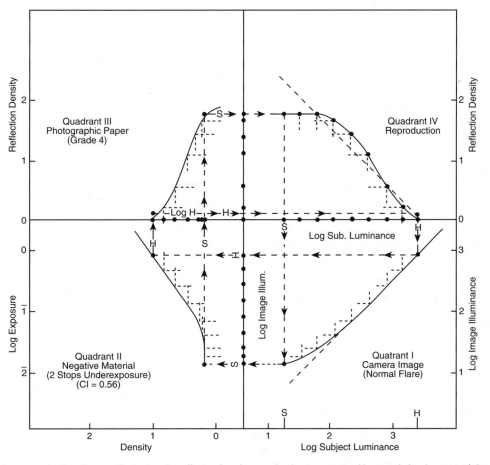

Objective tone-reproduction diagram illustrating the effects of underexposing by two stops with normal development of the negative (Quadrant IV).

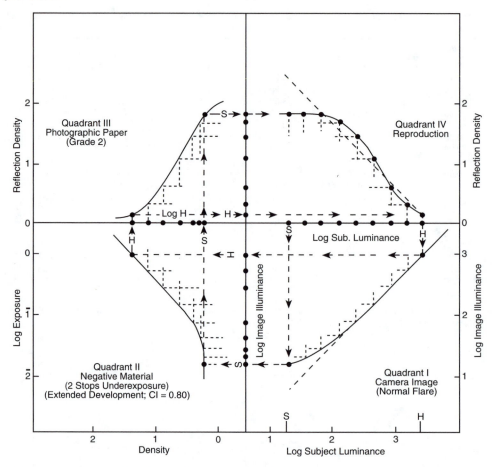

Objective tone-reproduction diagram illustrating the effects of underexposing by two stops with increased development of the negative to a contrast index of 0.80 (Quadrant IV).

Quadrant II Given the image log illuminance values, the exposure time determines the log exposures the film actually received, and therefore the position of the film/development transfer function with respect to the flare transfer function. The optimum value for the exposure time is generally the minimum value that gives sufficient tonal separation throughout the range of the image. Standards prescribe that the film speed for pictorial films be determined using the following formula:

$$\text{Speed} = 0.8/H_{0.1}$$

where $H_{0.1}$ is the exposure required to produce a density 0.1 above base plus fog. Standards also prescribe that light meters place this exposure 1.0 log units below the metered exposure, where the metered exposure is determined from the equations:

$$H = E\,t, \text{ and}$$

$$E = 0.65L/(f\#)^2$$

where H is the exposure in lux-seconds, E is the illuminance at the film plane in lux, and L is the subject luminance in candelas per square meter. These standards are designed to result in optimal exposures for scenes with average luminance ranges photographed under average conditions.

Table 3. Sensitometric Strip Log Exposures and Resulting Densities[a] (No flare)

Step	Log H	Density
1	−2.74	0.23
2	−2.61	0.25
3	−2.46	0.26
4	−2.31	0.30
5	−2.14	0.35
6	−2.00	0.40
7	−1.85	0.47
8	−1.72	0.56
9	−1.57	0.65
10	−1.42	0.73
11	−1.28	0.82
12	−1.11	0.91
13	−0.94	1.00
14	−0.79	1.11
15	−0.62	1.21
16	−0.47	1.35
17	−0.31	1.47
18	−0.16	1.60
19	−0.01	1.76
20	0.17	1.94

[a]T-Max 100 film developed in T-Max developer 1:4 for 8 minutes at 68°F.

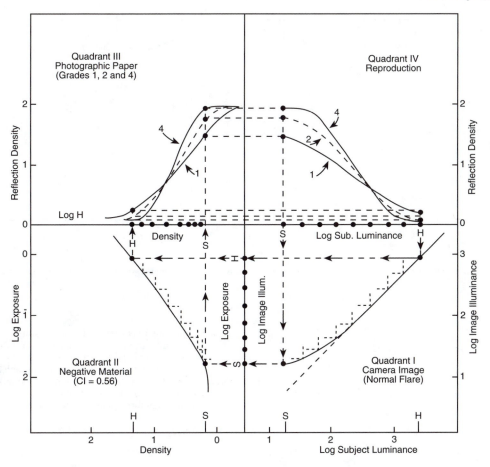

Objective tone-reproduction diagram illustrating the effects of printing a normally exposed and developed negative on three different grades of paper (Quadrant IV).

Table 4. Gray Scale Camera Negative Log Exposures and Resulting Densities[a] (Camera flare included)

Step	Log H	Density
1	−0.54	1.28
2	−0.63	1.20
3	−0.73	1.15
4	−0.83	1.08
5	−0.93	1.01
6	−1.03	0.95
7	−1.12	0.90
8	−1.22	0.85
9	−1.31	0.80
10	−1.40	0.74
11	−1.49	0.69
12	−1.58	0.64
13	−1.67	0.59
14	−1.75	0.54
15	−1.83	0.48
16	−1.91	0.44
17	−1.98	0.41
18	−2.05	0.38
19	−2.11	0.36
20	−2.16	0.34

[a]T-Max 100 film developed in T-Max developer 1:4 for 8 minutes at 68°F.

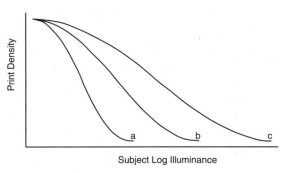

Preferred curves for prints made from (a) a low-contrast scene, (b) a normal contrast scene, and (c) a high-contrast scene.

Quadrant III The enlarger illuminance, *f*-number, and exposure time, in combination with the negative densities, determine the paper log exposures. For an enlarger or printing machine, the flare characteristics are generally included in the paper characteristic curve. Flare characteristics for printers are generally more constant than for cameras because printing conditions are more constant than shooting conditions. The paper-printer-development transfer function, which is the curve in Quadrant III, describes the relationship

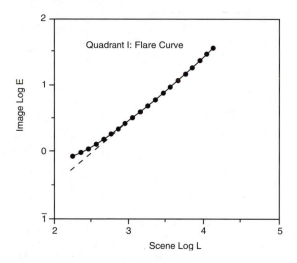

Flare curve based on the data in Table 2 on p. 797.

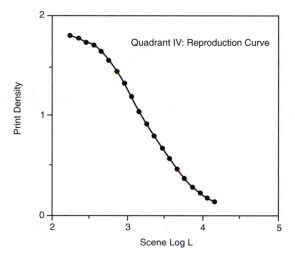

Reproduction curve (the print curve) based on the data in Table 7.

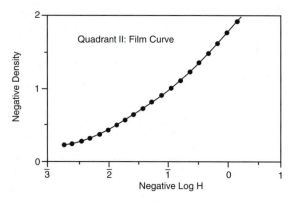

D-log H curve based on the data in Table 3 on p. 798.

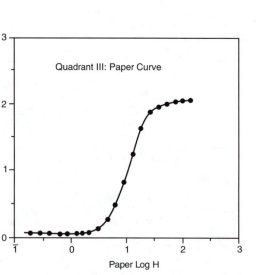

D-log H curve based on the data in Table 5.

between paper log exposures and print densities. It is generally determined by printing a step tablet in a fashion similar to that used to print actual pictorial negatives.

Quadrant IV In this example, the photograph made included a gray scale. This allows the tone reproduction curve to be generated directly. It would also be possible to generate this curve by going through quadrants I, II, and III.

J. Holm

See also *Appendix W; Image, zone system*

Table 5. Sensitometric Paper Log Exposures and Resulting Densities[a] (No flare)

Step	Log H	Density
1	−0.72	0.08
2	−0.57	0.08
3	−0.41	0.08
4	−0.20	0.08
5	−0.10	0.08
6	0.07	0.08
7	0.20	0.08
8	0.33	0.09
9	0.48	0.15
10	0.64	0.29
11	0.78	0.52
12	0.94	0.85
13	1.09	1.27
14	1.25	1.64
15	1.41	1.90
16	1.57	1.96
17	1.72	1.99
18	1.86	2.05
19	1.99	2.05
20	2.14	2.06

[a]Kodak Elite grade 3 paper developed in D-72 diluted 1:2 for 2 min at 68°F; Super Chromega enlarger, paper plane illuminance 29.4 lux without negative; exposure time 10 seconds, paper plane log exposure without negative 2.47

Table 6. Gray Scale Negative Densities, Paper Enlarger Log Exposures, and Resulting Densities[a] (Data include enlarger flare.)

Step	Density	Log H	Print Density
1	1.28	0.42	0.13
2	1.20	0.50	0.17
3	1.15	0.55	0.21
4	1.08	0.62	0.27
5	1.01	0.69	0.37
6	0.95	0.75	0.47
7	0.90	0.80	0.56
8	0.85	0.85	0.66
9	0.80	0.90	0.77
10	0.74	0.96	0.91
11	0.69	1.01	1.05
12	0.64	1.06	1.19
13	0.59	1.11	1.32
14	0.54	1.16	1.43
15	0.48	1.22	1.57
16	0.44	1.26	1.66
17	0.41	1.29	1.71
18	0.38	1.32	1.75
19	0.36	1.34	1.79
20	0.34	1.36	1.82

[a]Kodak Elite grade 3 paper developed in D-72 diluted 1:2 for 2 min at 68°F; Super Chromega enlarger, paper plane illuminance 29.4 lux without negative, exposure time 1.7 seconds, paper plane log exposure without negative 1.70

Table 7. Gray Scale Densities and Resulting Print Densities

Step	Scale Density	Print Density
1	0.05	0.13
2	0.15	0.17
3	0.25	0.21
4	0.35	0.27
5	0.45	0.37
6	0.55	0.47
7	0.65	0.56
8	0.75	0.66
9	0.85	0.77
10	0.95	0.91
11	1.05	1.05
12	1.15	1.19
13	1.25	1.32
14	1.35	1.43
15	1.45	1.57
16	1.55	1.66
17	1.65	1.71
18	1.75	1.75
19	1.85	1.79
20	1.95	1.82

TONERS Colorants used in xerography. Dry toners are comprised of a colorant in a resin binder. Depending on the application, additional components may include additives to control the charge level, surface additives to control flow and cleaning, and waxes to aid toner removal from the fuser roller. The most common colorant is carbon black. For color applications, phthalocyanines are used for cyans, azo compounds for yellows, and quinacridones for magentas. Charge-control agents are added when the toner does not have either an adequate charge level or rate of charging. Low-molecular-weight waxes are frequently added to prevent adhesion of the toner to the fuser roller during fusing. In liquid toners, the colorant is dispersed in a nonconducting liquid. The colorant is usually a colloidal dispersion of pigmented resin particles. A wide range of aliphatic and aromatic hydrocarbons, chlorofluorocarbons, and siloxanes can be used as dispersants. To control the surface charge, ionic surfactants or metal soaps are frequently added. *P. Borsenberger*

TONERS/TONING With few exceptions black-and-white silver prints have a color approaching neutral. The image can be chemically modified to achieve a more pronounced color that is more appropriate for the aesthetic effect desired. This postprinting process is known as *toning,* and a wide variety of toner formulas have been concocted over the years.

Toning Methods A *direct toning* formula converts the metallic silver image to a compound of silver that is colored. *Indirect toning* involves first converting the silver to a halide by means of a *bleach,* then *redeveloping* it with a solution that converts the image to a silver and metal compound having the desired color. *Double toning* procedures involve toning by one method followed by a second treatment to produce a color that is different from that produced by either of the formulas alone. *Area toning* is achieved by blocking off part of the image with a protective coating such as rubber cement or a *frisket.* The unprotected area then responds to the toner, after which the coating is removed. *Dye toning* involves converting the silver image to a mordant, a compound that attracts dye from a solution with which the print is treated. While it does not come under the heading of toning, *dyeing* of the entire print is sometimes used alone or in conjunction with a toner to produce a desired effect.

Toning Formulas Sepia toning is one of the most common methods, usually incorporating the compounds of sulfur, selenium, and sometimes mercury, or gold in various combinations. The resulting tone is usually considered to be more stable than the silver image alone, and selenium and gold toning, even if not carried to completion, have been used to produce archival prints.

Toners using other elements such as iron, copper, or uranium produce compounds with little or no silver that yield pleasing blue or red colors, but these images are not as stable as the silver images alone. The stability of dyed images depends to a great extent on the particular dye used, but in general, dyes are less stable than the metallic compounds.

Standardization The tone achieved with a given formula is influenced by the type of paper used for making the print and its processing. Therefore, to achieve consistent results, it is necessary to standardize these factors. A single choice of paper should be made, and the processing should be carefully standardized. The final tone is modified by the choice of developer, the length of time of development, and the degree of exhaustion of the developer. For uniform results, the exposure should be such as to require a specific developing time, and the developer should be renewed often.

It is wise to make a number of prints from a representative negative and tone them by the methods one is considering. Such a set of toned prints can then be used to select the toning method that will produce a given desired result.

Problems Problems with toning arise from improper choice of sensitized paper, inadequate control of processing of the print, and inadequate fixing and washing, where required. Some procedures leave the emulsion less hardened than with ordinary processing and it may tend to be easily abraded before drying. Also, heat drying often changes the color of the toned image considerably. To avoid this, prints should be air dried at room temperature. *I. Current*

TONE SEPARATION The degree to which different tones are distinguishable. Tone separation is dependent on four factors: (1) the densities of the tones in question, (2) the illumination falling on or passing through these densities, (3) the surrounding environment, and (4) the amount of noise present in the imaging system. Obviously, the smaller the differences in density between tones, the smaller the apparent separation will be. Also, the way the eye perceives luminance results in darker tones separated by some density increment appearing to be closer together than lighter tones separated by the same density increment. This effect is even more pronounced in dim lighting, or when the tones in question are surrounded by bright tones. At some point, when the lighting becomes too dim, or the surround too bright, it becomes impossible to distinguish between darker tones.

The effect of noise or grain on tone separation is also important. Tone reproduction studies are frequently conducted to determine the optimal reproduction of tones in an image, but it is important to remember that these reproduction studies do not consider the effect of noise. As the noise of point-to-point variation in the density of what is considered to be a single tone increases, the ability to distinguish that tone from another decreases. Optimum image quality is achieved by balancing optimal tone reproduction with noise considerations.

Books: Stroebel, Leslie; Compton, John; Current, Ira; and Zakia, Richard, *Photographic Materials and Processes.* Boston: Focal Press, 1986. *J. Holm*

See also: *Tone reproduction; Stevens' Power Law.*

TONE (SOUND) A sound is said to be *tonal* when the constituent sine waves of which it is made can be distinguished. Tonal sounds usually can be assigned a pitch. Examples are an organ pipe, a sine wave oscillator, a square wave oscillator, a whistle. *T. Holman*

TONGS A pickup tool, commonly made of stainless steel or plastic, used to handle prints during processing, so that the hands can remain dry. *L. Stroebel and R. Zakia*

TONGUE The shape given to the beginning of a film or its leader to facilitate threading into a transport mechanism. *M. Scott*

TOOTH (1) Receptivity of a surface to retouching media, such as ink or pencil. Photographic materials lacking tooth may be improved in this regard by the application of retouching fluid. (2) A pointed projection on a sprocket wheel that engages a film perforation to transport the film at a controlled rate through a mechanism. *M. Scott*

TOP LIGHTING Lighting the subject by a source placed above it, frequently used by still life photographers but inappropriate for photographs of people and many other subjects. *F. Hunter and P. Fuqua*

TORMENTOR A sound-absorbent screen used to reduce reverberation during sound recording. *H. Lester*

TORPEDO In photography, a waterproof device for underwater photography that is powered by a motor and includes a camera and lights. *L. Stroebel*

TOTAL INTERNAL REFLECTION The reflection of incident light at an interface between a denser (n_2) and a less dense medium (n_1) when the angle of incidence exceeds the critical angle (i) for the denser medium. The value of i is given by $i = \sin^{-1}(n_1/n_2)$. For a glass–air interface the critical angle is typically some 41 degrees or greater. The rays are reflected back into the denser medium, which may be glass. This behavior is used instead of silvered surfaces in designs of prisms of the roof and Porro types as well as fiber optics. *S. Ray*

See also: *Critical angle; Fiber optics.*

TOTAL SPECTRAL RADIANCE FACTOR The sum of the spectral reflected and the spectral luminescent radiance factors. Symbol, β_T. *R. W. G. Hunt*

TOUCH SCREEN In computers, a type of cathode-ray tube (CRT) that serves as both a display device and input device. Touch screens enhance interactivity between the user and computer by rapidly accepting input when touch-sensitive areas of the display screen are pressed by the user. There are currently five types of touch screen technology in use: capacitive overlay, resistance overlay, surface acoustic wave, piezoelectric, and scanning infrared. *R. Kraus*

TOXIC PHOTOGRAPHIC CHEMICALS Certain photographic chemicals have a harmful effect on human health if the chemical is breathed, swallowed, or absorbed through the skin or eyes. Toxic chemicals may have a local effect at the point of contact or a systemic effect at a site different than the point of contact. Some photographic chemicals known to be harmful to human beings include cyanides; chromium, mercury, and thallium salts; aldehydes; poisonous gases and vapors from ammonia, iodine and sulfur dioxide; and strong acids and bases. Some amino-containing developing agents, such as p-phenylenediamine and its derivatives and toners such as selenium may cause contact dermatitis, an inflammation of the skin, in susceptible individuals. *G. Haist*

See also: *Poisons.*

TRACK The physical area or other space on a medium such as film, tape, or disc, within which the record of the sound, picture, or data is recorded or printed. *T. Holman*

TRACKBALL In computers, a graphic user interface device that controls the cursor when rotated. The trackball can be rotated 360 degrees in its cradle, causing the cursor to move to any position on the screen. Buttons on the cradle operate in the same fashion as buttons on a mouse. *R. Kraus*

TRACK FORMATS (AUDIO TAPE) Full-track; half-track, two-track, quarter-track, 4-, 8-, 16-, 24-track formats—Names applied to the track layouts describing open reel nonperforated tape, over the range from 1/4-inch width to 2-inch width. On 1/4-inch tape, the first four are possible: Full-track is recorded across the entire width; half-track implies two recordings, one made from heads to tails, and one from tails to heads with the tape being turned over when the tail is reached (this is a radio station format, not a film one); two-track is two-channel recording, usually stereo, with both records in-line across the width of the tape; 4-track is a format for 1/2-inch tape; 8-track is a format for 1-inch tape (neglecting the obsolete consumer 8-track cartridge format from discussion); 16- and 24-track are formats for 2-inch tape. Quarter-track is a generally obsolete consumer format for four tracks on 1/4-inch tape, usually used two at a time for stereo going from head to tail and tail to head; it is not interchangeable with any other format because of its interleaving of channel information that would play both directions at once on a professional two-track machine. Larger numbers of tracks for the tape widths given are occasionally seen in use but are not generally considered to be interchangeable among studios. *T. Holman*

TRACK FORMATS (FILM SOUND) Stripe (one track); three-track; four-track; six-track—Names applied to the track layouts describing 35-mm magnetic film containing

sound only. Stripe-coated stock is usually used for one-track recordings. Three-, four-, and six-track formats are recorded on *full-coat,* which is 35-mm film stock with magnetic oxide across the full width.

Edge track, center track, EBU stereo—Names describing various formats of 16-mm full-coat magnetic film containing no picture. Edge and center track are what their names imply, and are not interchangeable; EBU (European Broadcasting Union) stereo consists of one edge and one center track, which may be used for stereo program material or for different language presentations—the choice to be made at the time of listening. *T. Holman*

TRACKING In motion pictures, the movement of the camera and its mount toward or away from the subject, or to follow a moving subject to keep it within the camera's field of view. *H. Lester*
 Syn.: *Trucking.*

TRADE SHOW In photography, an exhibition of photographic equipment and products for the purpose of informing members of the photographic trade press and potential customers and promoting sales. *L. Stroebel*
 See also: *Photokina.*

TRAILER (1) A motion-picture term for a short film used to advertise future presentations. Usually projected in theaters as *coming attractions,* before the feature film is shown. Movie trailers have given birth to video cassette leaders and can be found at the *beginning* of some commercial video tapes of movies before the feature film. (2) A blank film at the end of a reel or strip of film. *H. Lester*

TRANSCEIVER A device that transmits and receives signals, including those that describe images or documents, such as wirephotos and faxes. *H. Wallach*

TRANSDUCER (1) A general term for any device that produces one kind of energy from another kind, or that produces one type of signal from another type. (2) In electronics, a device that generates an electrical output, the strength of which is related to a physical characteristic, such as temperature, pressure, motion, etc. Transducers are used in automated control systems. *J. Holm*

TRANSFER FUNCTION A function relationship between the input and output of a system. Examples include the Optical Transfer Function (OTF), Phase Transfer Function (ϕTF), and Modulation Transfer Function (MTF), which describe the relationship between the input and output of an optical or photographic system with respect to frequency. Sensitometric curves are also transfer functions in that they relate the input and output of a photographic system with respect to log luminance or density. *J. Holm*

TRANSFER, IMAGE Any process by which an image is removed from its original support and transferred by contact to a new backing. Examples include the dye transfer and diffusion transfer processes. *H. Wallach*

TRANSFER PRINTING PROCESSES Refers to wide variety of printing processes including: oil, bromoil, pigment, dye transfer, acrylic, and solvent transfers, that literally *transfers* an image from one support to another. In early photographic literature the term referred to inked images that were transferred to a gelatin coated paper. The main reason for their popularity is the forming of the image in light-sensitive materials that are decidedly more permanent than silver.

TRANSFER PROCESSES Processes involving the transfer of an image from one emulsion or support to another. The transfer often involves physical reversal (left—right) and may involve tone reversal (negative—positive). There is a variety of such processes working on fundamentally different principles and used for a wide range of purposes. They fall into the following general groups: chemical image transfer, physical image transfer and emulsion transfer.

Chemical image transfer: the image is transferred by chemical diffusion from one emulsion layer to another placed in intimate contact with it. The image is in fact generated in the second emulsion; the only physical movement taking place is that of the chemicals generating the second image. The latter may be silver (as in various reversal transfer processes) or hardened gelatin (as in bromoil, carbro, and similar processes).

Physical image transfer: most of these processes involve the transfer of a pigment or dye image absorbed or adsorbed on a gelatin matrix to a plain or gelatin coated paper or similar support. Examples are bromoil transfer (pigment ink), dye transfer (dyes), and various photomechanical and document copying processes.

Emulsion transfer: here the whole emulsion or a gelatin matrix is stripped from one support and transferred to another. This may be necessary with many matrix processes in order to obtain a laterally correct image—i.e., one that is not reversed left to right—or to ensure that the matrix has a firm support—e.g., if the gelatin of the matrix is hardened from the top, the gelatin next to the support would be dissolved on development so the whole layer must be transferred to a temporary or permanent support first.

Another application of emulsion transfer is the preparation of photographic templates. Here the unexposed emulsion is transferred on to the material to be worked, and exposed and developed there. *L. A. Mannheim*
 See also: *Bromaloid process; Carbon process; Carbro process; Ceramic processes; Diffusion transfer; Dye transfer; Electrophotography; Flexography; Ivorytype; Ozobrome process; Ozotype; Trichrome carbon process; Xerography.*

TRANSFER (SOUND) The process of recording audio from one piece of tape or film to another. *T. Holman*

TRANSFORMATION EQUATIONS Equations by which color matches made with one set of primary colors can be expressed in terms of another set. *H. Todd*

TRANSFORMER A device that transfers energy from one circuit to another by magnetic induction. Transformers are used to convert an available ac voltage to one or more different voltages or to isolate one ac circuit from another. A basic transformer consists of two windings (coils) in close proximity so the magnetic field set up by voltage applied to one, the primary winding, induces a voltage in the other, the secondary winding. The load circuit is connected to the secondary winding. For 50 and 60 Hz power and for audio frequency application, the windings are wound on a closed iron core to improve the magnetic coupling between the primary and the secondary. For radio frequency applications, the windings are wound on a nonmagnetic form. Such transformers are known as *air-core transformers.*

The voltage induced in the secondary, V_S, depends on the primary voltage, V_P, and the ratio of the number of turns of wire in the secondary, N_S, to the number of turns in the primary, N_P.

$$\frac{V_S}{V_P} = \frac{N_S}{N_P}$$

Many transformers have more than one secondary winding to provide multiple output voltages. A secondary

winding that has an added connection at its midpoint is known as a *center-tap winding* and the transformer as a *center-tapped transformer*. It is commonly used by the electric power companies in the United States to obtain the 120/240 volt service furnished to homes and commercial establishments. A center-tapped transformer is also used extensively in full-wave rectifier circuits. *W. Klein*

TRANSILLUMINATION Light that passes through a photograph or other object, as when viewing a transparency with transmitted light or back lighting a negative or slide for copying purposes. *M. Teres*

TRANSISTOR See *Bipolar junction transistor; Field-effect transistor.*

TRANSITION In motion pictures, a change from one scene to another, usually accomplished with a straight cut, dissolve, or other optical effect. *H. Lester*

TRANSITION EFFECTS In electronic imaging, the segueing from one scene into another through various procedures that are designed to maintain the attention of the viewer. Such effects are, for example, fade to black, fade to white, wipe vertical top down, wipe vertical bottom up, and shrink to a point. There are a umber of software packages that contain a large number of transition effects for graphics presentations. *R. Kraus*

TRANSLUCENT Permitting the passage of light, but scattering it so that objects behind cannot be easily distinguished. Ground and opal glass are translucent. *J. Holm*

TRANSMISSION (1) See *Light transmission.* (2) The penetration of radiation, especially light, through a material. *J. Holm*

TRANSMISSION DENSITY A measure of the absorption of light by a semitransparent sample, such as a film or filter. Transmission density is the common logarithm of the reciprocal of the transmittance. *M. Leary and H. Todd*
See also: *Density; Reflection density; Transmittance.*

TRANSMISSION ELECTRON MICROSCOPE See *Electron micrography.*

TRANSMISSION FACTOR (1) The ratio of the electromagnetic radiation passing through an object to the electromagnetic radiation falling on the object, expressed as a decimal fraction or a percent. (2) Operationally, the ratio of the irradiance received by a detector (such as a photocell) with and without the sample in the light path. In determining transmission factors, it is necessary to consider the output of the source and the response of the detector. *J. Holm*
Syn: (1) *Transmittance.*

TRANSMITTANCE (1) Same as transmission factor, especially as applied to light. When applied to light, the radiation can be measured in terms of the energy incident and transmitted, or in terms of the light incident and transmitted (irradiance with and without the sample, or illuminance with and without the sample). It is also frequently useful to determine transmittance as a function of wavelength, or with respect to a particular source. (2) For a film sample or filter, the ratio of the luminous flux passing through a sample to the flux it receives. $T = I_t/I_o$, where I_t is the light level after it has been affected by the sample and I_o is the initial light level. Transmittance is the reciprocal of the opacity. *J. Holm, M. Leary, and H. Todd*
See also: (1) *Density; Opacity.*

TRANSPARENCY An image, usually positive, on a transparent or translucent base, intended to be viewed directly by transmitted light or indirectly as a projected image, or to be reproduced photographically, photomechanically, or electronically. Photographic images on transparency film have a considerably larger density range than photographic images or reproductions on white opaque bases, so that the luminance range of transparency images viewed directly or by projection, under the proper viewing conditions, is closer to that of the subject, thereby producing a perception of greater realism. *L. Stroebel*

TRANSPARENCY MATERIALS Photographic materials on a transparent support for making positive images either for direct viewing or for projection. In current usage *transparency material* is virtually synonymous with *color reversal film.* For still photography other forms of transparency materials include color negative print films, black-and-white print films, direct positive films, direct reversal films, and projection (formerly lantern) slide plates. Some confusing nomenclature causes ambiguity: (1) A material labeled *positive* may actually be a negative-working material with characteristics designed for printing from an existing negative. (2) The image on a reversal material is not reversed, it resembles the original in tone (and if color, in color). Most of the early photographic processes produced negative images, which had to be printed onto another negative material to produce a positive. A material in which the original negative image could be reversed to a positive without reprinting was called a reversal material.

Color transparency materials may be divided into positive- and negative-working films. Positive-working films are the reversal films that form the positive image in one step, using a reversal process, for example, Kodachrome, Fujichrome, Agfachrome. Negative-working films are printed from existing color negatives, for example, Ektacolor slide film. These print films, unlike most color negative films, have no colored masks.

Because unprocessed nonsubstantive emulsions are free from color-forming agents, their granularity is very low. This aspect and their high resolving power made these films, particularly Kodachrome, for many photographers the reference standard of image quality. Substantive films, those with incorporated couplers, especially the very early ones, were considerably lower in resolving power and higher in granularity, but because more technology was built into the film, the process could be much simpler. Early Agfacolor transparency (later called Agfachrome) and Ektachrome films were of this type. Present-day incorporated-coupler films can be processed by the user in about 30 minutes using only four solutions. In recent years with the introduction of new incorporated-coupler films by Fuji, Agfa, Kodak, and others, the gap of quality between the incorporated-coupler and the Kodachrome films has been narrowed to the point of virtual disappearance.

Black-and-white transparencies may be made by printing existing negatives on a film such as fine-grain positive, a negative-working film despite the name. For glass slides in either 2 × 2 inch or lantern size, 3–1/4 × 4 inch (American) or 3–1/4 × 3–1/4 inch (British), projector slide plates are used. For slides without negatives, a conventional negative film may be reversal processed, or one of several special films may be used. These last have special emulsions that give a positive image with ordinary develop-stop-fix processing. They are made in normal and very high contrasts, and have ISO speeds of far less than one.

The filmstrip is a transparency format used mainly in elementary and secondary education. It is an economical medium when a large number of copies of a multi-frame program are to be produced. A negative printing master is usu-

ally formed into a loop and printed on a motion picture printer. *M. Scott*

See also: *Color print film; Color reversal film; Ektachrome; Ektacolor; Filmstrip; Kodachrome; Motion picture films; Nonsubstantive color film; Photographic film; Plate; Substantive color film.*

TRANSPARENCY VIEWER
An enclosure that contains a light source, typically fluorescent tubes having a correlated color temperature of 5000 K, under a diffusing panel, usually opal glass or plastic. Commonly used to examine negatives, slides, and transparencies, to display transparencies, and for layout work in graphic arts. *R. Jegerings*

Syn.: *Transparency illuminator.*

See also: *Light box; Light table.*

TRANSPARENT
Clear; having little absorption and producing little scattering over some spectral region. Optical glass is very transparent. *J. Holm*

TRANSPOSITION
(1) The act of reversing the tonal values of an image from negative to positive or positive to negative. (2) The act of switching the relative positions of the left and right images in a stereophotographic pair. *L. Stroebel*

TRANSVERSE WAVE
A wave in which the medium oscillates in a direction perpendicular to the direction of travel of the wave. Electromagnetic radiation consists of transverse waves. *J. Holm*

See also: *Longitudinal waves.*

TRAP
Normally electrons and holes are forbidden from occupying the energy space between the conduction and valence bands However, at localized sites of lattice imperfections or impurities, an attractive potential can develop that causes a lowering of the energy of the electron below that which it would have in the conduction band. Such a site is called a trap. The trapping of the electron can be either reversible or irreversible, depending on how much energy the electron loses when it falls into the trap. Electrons are released from the trap when they acquire enough thermal energy from the surrounding medium to be energetically equivalent to the conduction band. Completely analogous processes occur for holes, except that the hole moves upward above the valence band when it is trapped. This is because hole trapping actually corresponds to an electron moving from the trap site to the valence band. *R. Hailstone*

TRAPPING (PREPRESS)
In photomechanical reproduction, how much adjoining colors overlap to eliminate white lines between colors in case of slight misregister.
 M. Bruno

TRAPPING (PRESS)
The ability to transfer a wet ink image over a previously printed wet ink image on a multicolor press. *M. Bruno*

TRAVELING MATTE
In motion-picture production, a mask used to block out selected image areas that can change from frame to frame, as it moves through the projector stage of an optical printer sandwiched with the original footage. Used in the creation of simple optical effects such as transitional wipes and split screens, as well as in the complicated process of combining images shot at different times to create a film event that could not be shot in actuality, for example, a shot of a monster walking down a city street. *H. Lester*

See also: *Optical effects.*

TRAVEL PHOTOGRAPHY
The camera has become as indispensable to the travel experience as a passport and a fresh change of clothes. On the amateur level, photographs serve as both souvenir and trophy; on the professional level, travel photographers vie with one another for unique views of familiar and exotic locales. Indeed, ever since photography's invention in 1839, taking trips and photographs have been interwoven activities.

The highly portable 35-mm camera and video camcorder have made taking pictures in the field an easy task, especially when compared with the cumbersome tools of the trade carried over mountains and through valleys by the early practitioners of the craft. Nineteenth-century photographers such as Timothy O'Sullivan and William Henry Jackson often used mule and raft to carry 20 x 24-inch format cameras, wet-plate negative materials, and full darkroom facilities through the uncharted territories of the American West. The views they made had much to do with the beginnings of the American tourist trade, and even the establishment of our National Parks.

The tourist-with-camera is prevalent in all parts of the world today, and little on the planet has yet to be photographed. Although the exotic and strange are favorite subjects, the fact remains that canned travel experiences, such as found in theme parks, account for a large percentage of travel photographs taken today. The classic travel pose, of family and companions lined up in front of a monument, scenic site, or even with a friendly native, remains a constant shot in every travel album.

Serious amateurs and professional photographers often make travel photographs a source of income. So-called travel stock photography, pictures of locales made on speculation, has in large part replaced professional travel assignment photography. These images are sold through stock agencies or directly by the photographers to magazines and travel industry publications.

High-speed films, fast lenses, and fully automatic cameras, as well as compact video camcorders, give photographic access to nearly every moment of the travel experience. Available-light photographs made within the dimly lit cathedrals of Europe or on the bright hot sands of California's Death Valley require no more technical knowledge than that needed for the box cameras of the past. Of course, the experience, knowledge, and aesthetics of the photographer go a long way toward a successful interpretation of a place. Though both would qualify as travel photography, photographs by a *National Geographic* photographer and the package tourist on a cruise ship can be worlds apart. A bonus of travel photography is that since tourists may aspire to be *National Geographic* photographers, their consciousness about the people, culture, and beauty of a place tends to be enhanced.

Portability is a key factor. Most experienced travel photographers have learned to limit the equipment load. Zoom lenses offering variable focal lengths have become the rule rather than the exception. Tough, waterproof shoulder bags have replaced bulky cases. Though color negative film is by far the most popular medium, some purists insist that color slide or even black-and-white film is the true form for the craft.

With increased security at airports, x-ray damage of film has become a real concern. In most airports, especially those in the United States, passengers have the right to bypass the x-ray machines and request hand inspection of film—quite a few international airports do not offer this courtesy. Having film separated in clear bags usually speeds inspection, and though repeated passes through x-ray machines may result in damage, only high-speed films, those rated at ISO 1000 and above, can be damaged in one or two passes.

The camera has altered forever the travel experience to the extent that taking pictures can provide a more intimate, perhaps more rewarding time spent away from home. For those who have a limited period of time for their travels, usually

dictated by work schedules, it can provide a meaningful context to their trips. Indeed, photography can serve as a vehicle that brings travelers to places they've never been, to meet people they otherwise might have passed in the street, and to contemplate the diverse cultures in various areas around the world. *G. Schaub*

TRAY PROCESSING A method of processing exposed sensitized materials by immersing, in sequence, in a series of processing solutions in shallow containers. With a single sheet of film or printing paper, agitation may be provided by lifting and reimmersing the film or paper, or by lifting the edges of the tray to produce movement of the solution, preferably in alternating directions. With multiple pieces, a common procedure is to continually remove the bottom sheet and reimmerse it on top. *L. Stroebel and R. Zakia*

See also: *Agitation.*

TRIAC A bidirectional thyristor used to control current in ac circuits. It is essentially two silicon controlled rectifiers (SCRs) connected head-to-toe with the two control elements, the gates, connected together. Because the Triac is bidirectional, the other two electrodes are identified as main terminal 1 (MT 1) and main terminal 2 (MT 2), rather than anode and cathode as with SCRs. A Triac normally blocks current from flowing in either direction between the two main terminals. In order to establish conduction, a signal of sufficient magnitude and phase must be applied to the gate (G) each half cycle. The magnitude and phase angle of the gate signal determines when in each half cycle the Triac will start to conduct. Firing later in each half cycle results in less power to the load. Likean SCR, removal of the gate signal will not stop the current flow during that half cycle. Conduction will stop at the end of every half cycle, however, as the ac voltage goes through 0 volts. Triacs are used in lamp dimmers, solid-state relays, AC motor controls, etc. *W. Klein*

See also: *Silicon controlled rectifier/dimmer.*

TRIACETATE See *Acetate film base.*

TRIBOELECTRICITY See *Static electricity.*

TRIBOLUMINESCENCE The transformation of mechanical energy (such as friction) to light at low temperature (below those required for incandescence). A common example of triboluminscence is the light produced by removing some kinds of adhesive tape from surfaces in a darkroom. *J. Holm*

See also: *Static electricity; Static marks.*

TRICHROMAT Three color. (1) Applied to a color photographic process that comprises three sensitive materials, each sensitized to a different major region of the spectrum (red, green, and blue). The final image consists of varying amounts of three different dye layers (cyan, magenta, and yellow). (2) In color television the red, green, and blue phosphors that constitute an additive system of color reproduction. (3) Identifying a theory of color vision that assumes the presence in the eye of three different sensors, each responsive to a different region of the visible spectrum. *L. Stroebel and R. Zakia*

See also: *Color photography; Color synthesis; Color television; Vision, color vision; Young–Helmholtz theory.*

TRICHROMATIC Adjective denoting association with the triple nature of color or its reproduction. *R. W. G. Hunt*

TRICHROMATIC MATCHING Action of making a color stimulus appear the same color as a given stimulus by adjusting three components of an additive color mixture. *R. W. G. Hunt*

See also: *Colorimetry.*

TRICK ELECTRONIC PHOTOGRAPHY See *Special effects.*

TRICKLE CHARGE A low value of current used to recharge a battery. Relatively high values of current can be used at the start of recharging but should taper off to a trickle to reduce the risk of damage to the battery from overcharging. *W. Klein*

TRICK PERSPECTIVE An amusing or illogical perspective effect, commonly involving the size-distance relationship of objects such as the appearance that a large distant object is resting on the head of a person in the foreground in a photograph. Trick effects can also be achieved by combining images from different photographs. *L. Stroebel*

See also: *Perspective.*

TRICK PHOTOGRAPHY See *Special effects.*

TRILINEAR PLOT A graphical display used to show the direction and extent to which the color balance of an image differs from that of an aim point, typically a neutral, using a grid containing three sets of parallel lines placed at angles of 120 degrees to each other. The three lines that radiate from a central aim point represent red, green, and blue additive primary colors. Extensions of these three lines beyond the aim point represent cyan, magenta, and yellow subtractive primary colors. The plot can be used, for example, for quality control purposes in color processing and printing labs. Densitometer readings made with red, green, and blue light provide the data needed for plotting. *H. Todd*

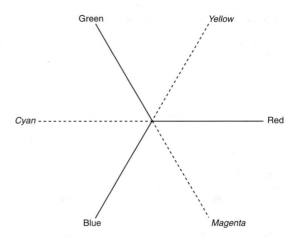

Trilinear plot

TRIM BIN In the motion-picture editing room, a box fitted with a rack of pins from which strips of film can be hung, allowing the editor immediate access to shots being worked with and a convenient temporary storage area for sections of film, called *trims,* cut out during the editing process. *H. Lester*

TRIMETROGON CAMERA See *Camera types.*

TRIMMER Trimmers are used to produce straight clean cuts through prints or mat boards. There are three basic types of trimmers: single-edged razor or mat knife, rotary, and guillotine. Each trimmer has its own advantages and disadvantages.

The single-edge razor or mat knife will produce good clean cuts through almost any material, but care must be exercised. A solid, flat working surface is required, with a protective backing layer placed under the work to be cut. Old mat board or cardboard is suitable, as it will protect the work surface from damage. A ruler, t-square or other type of straightedge will be needed to guide the blade. If the straightedge does not have a nonslip backing, one can be improvised by using a strip of masking tape. When cutting, the blade should be held at a 90 degree angle to the straightedge. Firm, steady pressure must be used to perform the cut. Caution is advised—if the blade jumps the straightedge, a serious cut to the hand or fingers could result. Blades should be replaced often; otherwise, ragged cuts or tears will occur. The backing should also be moved often to prevent groves that could divert the blade from the straightedge.

Guillotine cutters or trimmers are widely used to cut both prints and mat boards. The trimmer consists of a baseboard with ruled guides and a hinged cutting blade. Some trimmers may also incorporate a clamp that engages before the cut to hold the work firmly in place.

Accurate and clean cuts can be produced quickly, provided the blade is kept sharp and clean. Sticky substances like tape or glue should not be allowed to build up on the blade. With both horizontal and vertical rules, alignment of the material to be cut is simple. Some trimmers have the

Rotary trimmers provide accurate, safe trimming for photographic prints. Prints are aligned with the ruled guide and the cutter is drawn along the rail to perform the cut.

Guillotine trimmers use a spring-loaded blade to cut a variety of materials. Adjustable guides are available on some models to assist with repetitive cuts. Care must be taken to keep fingers clear of the blade.

option of adjustable guides that can be set for repetitive tasks involving large numbers of prints or mat boards. Caution must be used with guillotine trimmers; many do not have blade guards and can actually sever a finger if used with sufficient force. When used in darkness or safelight conditions to cut sensitized materials, extra care is advised.

Rotary trimmers provide the greatest number of benefits: accuracy, ease of use, and safety. The trimmer consists of a baseboard with a ruled guide and an enclosed circular cutting blade that is attached to a track. Cutting is performed by simply aligning the material and drawing the cutter down the track. Most rotary trimmers are not intended to cut mat board since the blades will dull very quickly and may go out of alignment. As with any trimmer, clean sharp blades are a must. Most rotary trimmers are user serviceable for blade replacement. *G. Barnett*

TRIPLE EXTENSION A bellows extension that provides a lens-to-film distance of three times the normal focal length associated with the film format. This system would allow for extreme closeup focusing, producing a maximum scale of reproduction of approximately 2:1 with a normal focal length lens. This same elongated bellows assembly could also be used with very long focal length lenses.

P. Schranz

See also: *Double-extension*.

TRIPLET LENS See *Lenses, lens history*.

TRIPOD A three-legged camera-support device. The legs are normally adjustable in length and attached to a tripod head with hinges. The camera is attached to the tripod head with a screw or with a quick-release device with matching parts on the tripod and the camera. *L. Stroebel*

See also: *Camera support; Monopod; Stand.*

TRISTIMULUS VALUES Amounts of the three matching stimuli, in a given trichromatic system, required to match the stimulus considered. *R. W. G. Hunt*

TRITANOMALY One of three basic types of defective color vision in the anomalous trichromatism category, the other two being protanomaly and deuteranomaly. A person with this defect (i.e., a tritan) requires more blue in a blue-green mixture to match a given blue-green than a person with normal color vision requires. *L. Stroebel and R. Zakia*

See also: *Vision, color vision.*

TRITANOPIA One of four basic types of defective color vision (color blindness) in the dichromatism category, the other three are protanopia, deuteranopia, and tetartanopia. A person with this defect (i.e., tritanope) sees purplish blue and greenish yellow as gray. *L. Stroebel and R. Zakia*

See also: *Vision, color vision.*

TROLAND A unit of retinal illuminance. One troland is that retinal illuminance produced when the observer fixates a surface having a luminance of 1 candela per square meter (cd/m^2), when the pupil area is 1 mm^2. (The retinal illuminance does not, however, vary directly with pupil area.)
L. Stroebel and R. Zakia

See also: *Illuminance; Luminance.*

TROPICAL PROCESSING Identifying processes (especially developing and hardening) designed to prevent excessive softening of the emulsion (and possible damage) when processing film at elevated temperatures, as under tropical conditions. *L. Stroebel and R. Zakia*

See also: *High-temperature processing.*

TRUCKING SHOT In motion-picture production, a shot in which the camera and its mount are moved as the filming proceeds, usually by means of a dolly or other vehicular support. *H. Lester*

Syn.: *Tracking shot.*

TRUE COLOR In electronic imaging, the use of 16,777,216 colors for display description purposes. This standard is a 24-bit display system, i.e., 8 bits for the red channel, 8 bits for the green channel, and 8 bits for the blue channel. True color is the equivalent of photographic quality. *R. Kraus*

See also: *Color depth.*

TUBE PROCESSING See *Agitation; Pipe processing.*

TUNGSTEN A metallic element with a high melting point that makes it the primary filament in tungsten and quartz-halogen lamps. Carbon, which has a higher melting point of 3700°C compared to 3410°C for tungsten, was an early filament but evaporates rapidly and was discarded when a method of softening and molding tungsten was discovered. Spectral energy varies with temperature of the heated filament but it has useful radiation intensities through the visible spectrum. Also used as an adjective—e.g., tungsten lighting, tungsten films. *R. Jegerings*

TUNGSTEN-HALOGEN LAMP See *Quartz-halogen/iodine lamp.*

TURBIDITY Cloudiness. Especially, that characteristic of a photosensitive layer that causes scatter of exposing energy in that layer and has the effect of reducing sharpness.
M. Scott

TURBULATION The type of agitation produced by nitrogen-burst (gas-burst) units where bubbles of gas are released at intervals through a grid of tubes at the bottom of a processing tank. *L. Stroebel and R. Zakia*

See also: *Agitation.*

TURNTABLE A revolving platform supporting phonograph recordings while they are being played. They may be used to score sound and music for live presentations or for rerecording when scoring a film, video, or slide production. An installation may involve two or more turntables, allowing simultaneous reproduction of the sound from different sources that can be faded in or out, or mixed in varying degrees from one recording to another along with other audio material. *I. Current*

TURRET On cameras and enlargers, a revolving support for two or more lenses or filters so that changes can be made by simply rotating the turret. *L. Stroebel*

TV CUTOFF That part of a slide, motion picture, or other image that will not be included in the picture area of a reproduction on a television screen. *L. Stroebel*

TWEETER (SOUND) A high-frequency loudspeaker, combined with a woofer in a complete loudspeaker system for full-frequency range coverage. In theater usage it is more common to use the term *horns* to apply to the combination of compression driver and horn that emits high frequencies.
T. Holman

TWIN-LENS REFLEX See *Camera types.*

TWO-BATH DEVELOPMENT A method for reducing the overall contrast of a negative by using two separate stages of development. In the first stage the film emulsion is saturated with developer, and in the second stage the film is placed in a water or alkali bath where the development is allowed to continue to exhaustion of the developer.

Water-bath Development In the first stage, the developer is allowed to soak into the film emulsion, and then the negative is transferred to a water bath solution and allowed to rest with no agitation. Because there is only a fixed amount of developer absorbed by the negative from the first bath, the developer in the areas of high exposure (highlights) become exhausted more rapidly than those in the areas of low exposure (shadows). With no agitation and no fresh developer, the reaction products of development (especially in the high exposure areas) restrict and exhaust development. In the meantime, the areas of low exposure are still developing. The result is a negative in which contrast has been compressed, with less density in the highlights and normal density in the shadow areas.

This process does not work as well with newer emulsions that are thinner and therefore do not absorb as much developer. However, the process should work well with special films that have a thick layer of emulsion such ax x-ray film.

Water-bath development can also be used to lower the contrast of prints made from very contrasty negatives. To obtain a noticeable effect in practice, it is necessary to use a hot water bath for prints, transferring the print to the water bath as soon as an image begins to appear.

The effect of water-bath development depends on the amount of development allowed to take place in the first developer stage. The sooner the negative or print is transferred

TWO-BATH DEVELOPMENT

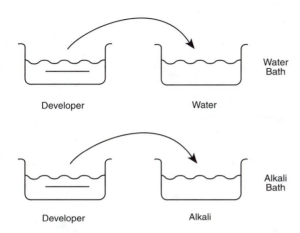

Water
Bath

Developer Water

Alkali
Bath

Developer Alkali

Two-bath development. Two methods of water bath development.

to the water bath, the greater the compression of the high-light densities.

Alkali-bath Development Similar to water-bath development in principle and practice, in alkali-bath development the developer contains little or no alkali and the water bath is replaced by an alkali bath, such as a 1% solution of borax or sodium hydroxide.

A suitable first bath is a metol-hydroquinone developer made up at about 2 to 4 times its normal strength with little or no alkali. The film emulsion is allowed to soak in the developer, but little development occurs until the negative is placed in the alkali bath. As development proceeds, the heavily exposed areas of the negative exhaust at a much faster rate than the shadow areas. The result is a negative in which development of the highlight areas has been reduced without reducing development of the shadow areas.

One of the advantages of the alkali-bath method is that neither time nor temperature is critical. Immersion in the first bath should last about 3 to 4 minutes, after which there is little to no increase in the amount of developer absorbed by the film emulsion. The time in the alkali bath should be about the same. By that time most of the developer has been exhausted or has diffused out of the emulsion, and extended time would only tend to soften the emulsion. Since development stops automatically, the negative cannot be overdeveloped. Fresh solutions should be used each time film is processed.

Fine Grain Two-bath Development Fine grain developers such as D-76 and D-23 can be used for two-bath development with a borax or Kodalk solution as the second (activator) bath. Ansel Adams tested Tri-X sheet film developed in D-23 followed by an immersion in a 1% solution of Kodalk. His procedure was to immerse the film in D-23 for 2 to 3 minutes with constant agitation. The film was then placed in the Kodalk solution for a minimum of 3 minutes with no agitation. The result was a very soft negative with fully developed shadow areas and a slightly higher than normal filmbase-plus-fog density level.

Books: Adams, Ansel, *The Negative.* Boston: New York Graphic Society, 1981. *R. Zakia*

See also: *Monobath.*

TWO-BATH FIXATION The use of a pair of tanks or trays of fixing solution, the second of which is relatively fresh. When the first bath is near exhaustion, it is replaced by the second, and a fresh bath is then used for the second treatment. The method improves the keeping characteristics of prints, especially, and is more economical than the use of a single bath. *L. Stroebel and R. Zakia*

See also: *Fixing; Image permanence.*

TWO-COLOR PHOTOGRAPHY Reproduction of colors in photography by means of only two additive primaries or two subtractive dyes. The colors used for the primaries and the dyes are usually orange and cyan. The limited gamut obtainable means that the reproduction can only be approximate; in particular, it is not possible to reproduce the difference in hue between green grass and blue sky. In additive systems, if red and white primaries are used, the white appears cyan because of simultaneous contrast, and results can be obtained that are not too different from those produced by orange and cyan primaries. *R. W. G. Hunt*

See also: *Retinex theory.*

TYNDALL EFFECT The scattering of light by small particles suspended in an otherwise clear medium; the effect produced by Rayleigh's scattering. Such scattering is more effective for short wavelengths (blue light) than for long ones, especially if the particles are very small. *J. Holm*

u Object distance

UCA Undercolor addition

UCL Upper control limit

UCR Undercolor removal

UCS Uniform chromaticity scale; Uniform color space

UHF Ultra-high frequency

UNI Ente Nazional Italiano di Unificaszione (Italian standards organization)

UPAA University Photographers Association of America

US Uniform system (Obsolete aperture calibration)

USP United States Pharmacopeia

UV Ultraviolet

UVA Ultraviolet (long wavelength)

UVB Ultraviolet (short wavelength)

UELSMANN, JERRY N. (1934–) American photographer and teacher. Highly imaginative, Uelsmann assembles his photographs from multiple negatives, creating surreal, magical worlds. Professor of art at the University of Florida since 1960.

Books: Enyeart, James L., *Jerry N. Uelsmann, Twenty-five Years: A Retrospective.* Boston: Little, Brown, 1982.

M. Alinder

ULMANN, DORIS (1884–1934) American photographer. Studied with Clarence White (1914) and brought pictorialist techniques (e.g., soft-focus lens, Large-format camera with tripod) to documentary photography. Her photographs provide a sympathetic portrait of the rural southern poor, both African-Americans and whites, from Appalachia to coastal South Carolina.

Books: Featherstone, David, *Doris Ulmann, American Portraits.* Albuquerque: University of New Mexico Press, 1985; Peterkin, Julia, and Ulmann, Doris, *Roll, Jordan, Roll.* New York: Robert O. Ballou, 1933.

M. Alinder

ULTRAFICHE Photo-optical information storage system with reduction ratios as great as 1:250, in contrast with microfiche, which has standard reductions of 1:24, yielding up to 98 frames per microfiche, and 1:48, yielding between 200 and 400 frames per microfiche. At 1:150, an ultrafiche on a standard size fiche, approximately 4 by 6 inches, can record 3000 book pages.

H. Wallach

See also: *Microfiche.*

ULTRA-HIGH FREQUENCY (UHF) A band in the radio wave portion of the electromagnetic spectrum with frequencies ranging from 470 to 890 MHz, used for television channels 14–83.

J. Holm

ULTRA HIGH-SPEED Identifying a photographic system operating at over 1,000,000 frames per second, or with writing rates more than 10 mm per microsecond, or at an exposure time for a single frame of less than 10^{-7} second.

L. Stroebel

ULTRAMINIATURE CAMERA See *Camera types.*

ULTRASONIC In the spectrum of sound waves, of a frequency higher than normal people can hear. Ultrasonic vibrations are used for cleaning purposes and image recording, since very short ultrasonic waves can be detected photographically and videographically.

J. Holm

ULTRASONIC CLEANING Sound waves having frequencies far above the audible range, generated in a liquid to provide efficient cleaning action on films. Frequencies and energies chosen are limited since high frequencies at high power can be dangerous and destructive.

I. Current

ULTRASONIC IMAGE RECORDER Conversion of acoustic images formed by sound waves of 20 to 1000 kHz (as distinct from the audible range of .02 to 20 kHz) into visible images by any of various processes. With one process the image is made visible by the local increase in development rates of a fogged photographic plate immersed in developer as a result of differential agitation of developer at the emulsion surface.

L. Stroebel

See also: *Sonoholography; Sonophotography.*

ULTRAVIOLET FILTER See *Filter types.*

ULTRAVIOLET PHOTOGRAPHY The process of recording photographic images with invisible radiation in the ultraviolet region of the electromagnetic spectrum (10–400 nm). Although silver halides are sensitive to ultraviolet radiation, the glass in lenses and the gelatin in photographic emulsions absorb all but the longer wavelength ultraviolet radiation.

L. Stroebel

See also: *Fluorescence photography.*

ULTRAVIOLET PHOTOMICROGRAPHY Photomicrographs made with a microscope using ultraviolet radiation rather than light. This allows good image resolution at very high magnifications. Because of the selective absorption of UV, photographing a thin section of a specimen can be achieved simply by selective focusing rather than by having to physically slice the specimen.

R. Zakia

ULTRAVIOLET RADIATION Electromagnetic radiation that has wavelengths between approximately 10 and 400 nm; just shorter than the wavelengths of light. Silver halide crystals are sensitive to ultraviolet (UV) radiation, but

most lenses and gelatin absorb all but the longest UV radiation, making it somewhat difficult to take photographs in the short UV. Special, low-gelatin emulsions are coated for such purposes. *J. Holm*

UMBRELLA See *Lighting umbrella.*

UNBLOOPED Pertaining to a motion-picture sound track negative wherein the discontinuities due to splices have not been minimized by making opaque the area near the splice with *blooping* tape or ink. *T. Holman*

UNCONDITIONAL MATCH See *Isomeric pair.*

UNCORRECTED A single element or simple lens that exhibits both chromatic and monochromatic aberrations. Such a lens can be used successfully provided the relative aperture is small and the focal length comparatively long, as in the case of closeup supplementary lenses. Significant improvement in performance is also given by choice of suitable curvatures for the surfaces and the use of a meniscus profile. *S. Ray*

UNDERCOLOR ADDITION In photomechanical reproduction, the technique of adding yellow, magenta, and cyan (YMC) in dark neutral areas to improve the saturation of the shadow areas of the reproduction. *M. Bruno*

UNDERCOLOR REMOVAL In photomechanical reproduction, the technique of reducing all three (YMC) colors on color separation films in neutral areas and replacing them with an equivalent amount of black ink. This improves trapping and reduces color ink costs. *M. Bruno*
See also: *Gray component replacement.*

UNDERCONSTANCY Any of various phenomena whereby a person's perception of some aspect of a scene or object, such as brightness, color, or size, displays undercompensation in the attempt to remain constant as the stimulus changes. With two objects of equal size but at different distances from a viewer, for example, the farther object is perceived as being smaller but not as much smaller as would occur if the perception were based entirely on the relative sizes of the retinal images. This is a perceptual effect commonly experienced when viewing photographs made with short focal length wide-angle lenses. *L. Stroebel and R. Zakia*
See also: *Perspective; Strong perspective; Visual perception.*

UNDERCORRECTED Description of the behavior of a positive lens that gives a residual variation of focal length with increasing zone of the lens as shown by an increase in focal length when the lens is stopped down. *S. Ray*
See also: *Zonal spherical aberration.*

UNDERCRANKING Filming with a motion-picture camera at a frame rate slower than 24 frames per second, the standard projection frame rate, resulting in faster than normal movement on the screen. *H. Lester*

UNDERCUTTING Applies particularly to photofabrication. The metal plate between the resist and the substrate is etched vertically after the chemical removal of the resist. The plate is then etched horizontally, or undercut, to assist in the accurate manufacture of such components as printed circuits. *H. Wallach*
See also: *Photofabrication.*

UNDERDEVELOPMENT Processing film or paper for too short a time, at too low a temperature, with insufficient agitation, or in a weak or nearly exhausted developer. The effect is lower-than-normal image density and contrast, and sometimes lower effective film or paper speed.
L. Stroebel and R. Zakia

UNDEREXPOSURE In general, giving photosensitive materials less than the optimum amount of exposure, producing thin images on nonreversal materials and dense images on reversal materials. The shadows are the first areas to lose contrast and detail with underexposure on both types of materials. *J. Johnson*

UNDERSAMPLING In electronic imaging, the sampling of an analog signal at less than the Nyquist theorem. *R. Kraus*

UNDERSCANNING In electronic imaging, the displaying of a raster image so that the scanning raster is visible. Underscanning, although infrequently used, ensures that image data are not hidden. *R. Kraus*

UNDERWATER CAMERA See *Camera types.*

UNDERWATER PHOTOGRAPHY Underwater photography covers the full range of photographic endeavor that takes place beneath the surface of the water. Anything from a snapshot taken in a backyard pool with a water-resistant, single-use camera to a deep-sea research photograph captured with the help of remote-controlled devices qualifies as an underwater photograph. Usually, however, the term refers to still pictures, movies, and videos made by divers.
HISTORY As early as the Crimean War (1853–1856), the German inventor William Bauer tried to take pictures through the portholes of a submarine he built for the Russian navy. In 1856, William Thompson used a camera in a watertight box to take a less than perfect photograph of seaweed and sand in the waters near Weymount, England. Other early experimenters included the French photographer Ernest Bazin, who attempted photography from a diving bell (1860s) and the English photographer Eadweard Muybridge, who tried a camera inside a watertight container in San Francisco Bay (1870s).
Louis Boutran, a French scientist who learned diving to study mollusks, made the first successful underwater photographs in 1893. He used a waterproof camera housing pressurized with the use of a bladder. Photographs of swimmers, marine animals, and underwater areas in the Bay of Bayuls in southern France helped earn Boutran the title father of underwater photography.
In the early 1900s, Jack Williamson, an Amercian journalist, photographer, and writer, invented a device that made underwater cinematography practical. Camera and crew worked inside a sphere connected by a long tube to a surface support vessel. The first commercial motion picture adaption of Jules Verne's *20,000 Leagues Under the Sea,* among other movies, benefitted from use of the device; it soon bowed to improved housings for motion picture equipment.
In 1927, *National Geographic* published the first underwater color still photographs; they were reproduced from Autochrome plates by Dr. William Longly, an ichthyologist, and Charles Martin, a staff photographer. The development of the Cousteau–Gagnan aqualung generator in 1943 freed divers of heavy, cumbersome diving equipment and inspired them to design and build their own complementary photographic equipment.
Luis Marden's coverage of Jacques Cousteau's activities in the Red Sea and Indian Ocean for *National Geographic* and Cousteau's own book and movie *The Silent World* substantially increased popular interest in the underwater world. Professor Harold E. Edgerton of the Massachusetts Institute of Technology worked with the French explorer Cousteau. Edgerton's technical innovations include photographic units

capable of withstanding tremendous water pressure, cameras capable of taking 2,000 35-mm pictures at signalled time intervals, underwater electronic flash, and even a sonar (radar) device capable of positioning a camera accurately within a few feet of a sea floor 15,000 feet or more below the surface.

Such advancements as wet and dry suits, portable air compressors, waterproof strobe lights, self-contained underwater cameras, mixed gas diving, deep submersibles, and habitats for extended water stays have made underwater photography easier, safer, and more effective. Improved housings permit close-up and wide-angle single-lens reflex (SLR) photography of everything from feeding coral to whales. Faster films with better color saturation and finer grain extend the reach of underwater photographers, who constantly must struggle to catch light before it is absorbed by the surrounding water.

Most underwater photographs are taken by sport divers working within 130 feet (40 meters) of the surface with equipment pressure-tested to about 300 feet (90 meters). Manned submarines with special air–gas breathing mixes permit underwater photography to about 10,000 feet (305 meters). Remote-controlled devices take equipment to the depths required for ocean mapping, mineral exploration, and biological research.

Underwater photographers who wish to have their photographs published might start by covering newsworthy underwater events—a newly discovered shipwreck, for example—for local newspapers, magazines, and diving publications. News pictures of regional underwater events might be sent to the editors of diving magazines and national diving organization bulletins. Entering and winning contests also helps build an underwater photography portfolio.

Books: Fine, John Christopher, *Exploring Underwater Photography*. Medford, N.J.: Plexus Publishing, 1986; Roessler, Carl, *Mastering Underwater Photography*. New York: William Morrow and Company, 1984; Turner, John, *Underwater Photography*. London & Boston: Focal Press, 1982. *K. Francis*

UNEVENNESS Unevenness refers to varation of density in an area that represents a uniform subject tone or a variation of color in an area that represents a uniform subject color. While often less easily detected, it may modify areas of modulated density and color.

Unevenness of a processed photographic image may be due to a number of causes. The defect is often masked by detail in images of scenes that do not contain large areas of uniform tone. Other subject matter may be very critical of this kind of defect. One cause of unevenness is improper agitation of the film during processing. Another cause might be the presence of a film of oil or other water-repelling material on the surface of the film at the time it is processed. A malfunctioning camera focal plane shutter may cause uneven illumination across the film plane.

When the film is printed, an improperly adjusted enlarger or contact printer may be the cause of uneven illumination of the sensitized material at the time of exposure. *I. Current*
See also: *Processing effects.*

UNIFORM CHROMATICITY DIAGRAM Chromaticity diagram in which equal distances approximately represent equal color differences for stimuli having the same luminance. *R. W. G. Hunt*

UNIFORM COLOR SPACE Color space in which equal distances approximately represent equal color differences. *R. W. G. Hunt*

UNIFORM STANDARD (US) SYSTEM System of aperture stop numbers proposed in 1881 by the Royal Photographic Society. Based on *f*/4 as the unit, a stop requiring double the exposure (*f*/5.6) was marked 2; three times the

exposure, 3; half the exposure, 1/2 and so on. The idea was never popular and is not now used. Some enlarging lenses, however, are marked with numbers to indicate relative exposures referred to the maximum aperture taken as 1, giving the series 1, 2, 4, 8, and 16. *S. Ray*

UNIPOD A tube, typically telescoping, used as a support for a hand-held camera. *L. Stroebel*
Syn.: *Monopod.*

UNIQUE HUE Perceived hue that cannot be further described by the use of hue names other than its own; there are four unique hues: red, green, yellow, and blue. *R. W. G. Hunt*
See also: *Psychological primary colors; Visual perception, perception of hue and saturation.*

UNIT AMOUNT That concentration of a dye used in forming color images that produces a measured density of 1.0. The unit amount of a dye will vary with the way in which the dye density is measured. *M. Leary and H. Todd*
See also: *Color density.*

UNITY In photography and other visual representations, unity is the visual coherence of the elements of design or the elements of visual organization. The elements are fused into cohesion through the arrangement of compositional elements according to perspective devices, lighting techniques, spatial arrangements and color organizations in order to emphasize a dominant concept or idea. *R. Welsh*

UNIVERSAL COLOR FILM Integral tripack, substantive, color negative film with wide latitude for exposure error and for variation in color quality of the light source. Compensation for these is achieved in printing. These have contributed greatly to the success of modern snapshot photography with point-and-shoot cameras. *M. Scott*

UNIVERSAL LEADER A count-down cueing leader, not intended for projection, placed at the head and tail ends of a roll of motion-picture release print. *H. Lester*
Syn.: *Society leader.*

UNIVERSE See *Population.*

UNMIXED COLOR LIGHTING Occurs when different parts of the same scene are lit by different color light sources. Correction requires first individually filtering the sources to match one another. Then, if that correction does not meet a photographic standard color balance, final correction is possible by filters on the camera lens. *F. Hunter and P. Fuqua*
See also: *Mixed color lighting.*

UNMODULATED TRACK An optical sound track containing no deliberate signal. For variable-area sound tracks, unmodulated track is made into narrow stripes by the application of ground-noise reduction. *T. Holman*

UNPRINTABLE In photography, identifying a negative or transparency of such poor technical quality that it will not produce an acceptable print with conventional printing procedures. According to a study conducted by a large-volume photofinishing lab, the most common causes for such images, in decreasing order of frequency, are—underexposure, exposure with fluorescent lighting, delivering unexposed film for processing, overexposure, and defective film advance, followed by a variety of other errors. *L. Stroebel*

UNSHARP Description of a real image formed by an optical system where the image patches for each object point have not been reduced to their minimum practical size. The

plane of the image that is being inspected is not truly conjugate to the corresponding subject plane. As correct focus is approached, the contrast of an unsharp image increases to maximum. *S. Ray*

Syn.: *Out of focus.*
See also: *Defocus; Focus/focusing.*

UNSHARP MASKING See *Masking, unsharp.*

UNSHARP MASKING FILTER In electronic imaging, the digital counterpart of photographic unsharp masking. This digital equivalent uses a neighborhood process to subtract an unsharp (smooth) image from the original image. *R. Kraus*

UNSQUEEZE See *Squeeze-unsqueeze; Lens types; Anamorphic lens.*

UNSTABLE PRIMARIES In subtractive systems of color reproduction, each pair of the three colorants constitutes a corresponding additive primary. Because subtractive colorants have spectral absorptions that vary rather slowly with wavelength, however, as their concentrations are altered, their equivalent additive primaries vary in chromaticity. Such primaries are called *unstable.* *R. W. G. Hunt*

See also: *Color photography.*

UNSYMMETRICAL COMPOSITION The illusion of the unequal distribution of elements or "weight" along an imaginary or actual axis in a photograph or other image. Having parts that differ on the two sides of a reference line. Sometimes called *occult composition,* different shapes, spaces, colors, textures, etc., are located on opposite sides of a central line. *R. Welsh*

Syn.: *Asymmetrical.*

UNSYMMETRICAL LENS A multielement lens where the configuration of elements is such that the number and arrangement of elements on either side of the iris diaphragm are not mirror images of each other. Such configurations are found in retrofocus, telephoto, and zoom lenses. *S. Ray*

UNWANTED ABSORPTIONS In subtractive systems of color reproduction, each of the three colorants should absorb only in the reddish third of the spectrum (in the case of the cyan colorant), in the greenish third (in the case of the magenta colorant), or in the bluish third (in the case of the yellow colorant). The dyes and pigments that have to be used as colorants in practice, however, also absorb in other parts of the spectrum. Cyan colorants usually have considerable unwanted green absorption and some unwanted blue absorption. Magenta colorants usually have considerable unwanted blue absorption and some unwanted red absorption. Yellow colorants usually have some unwanted green absorption but no unwanted red absorption. These unwanted absorptions, if uncorrected, make colors darker than they should be. In color photography they are corrected by the use of colored couplers and interimage effects. In color printing they are corrected by the use of masks in making the separation images. These masks can be on photographic materials used in register with the images being used or their equivalent can be provided electronically in scanners. When film is used in television, electronic masking is used in telecine equipment. Telecine: equipment for replaying motion-picture film into a television system. *R. W. G. Hunt*

See also: *Color correction; Color photography.*

UNWANTED STIMULATIONS In trichromatic systems, ideally one primary should excite the long wavelength cones (ρ), another the middle wavelength cones (γ), and the third the short wavelength cones (β). Because the spectral sensitivities of these three types of cones overlap considerably, however, it is not possible to stimulate them separately. Thus, red light stimulates not only the ρ cones but also to some extent the γ cones, and blue light stimulates not only the β cones but also to some extent the γ cones. The worst case is for green light, which not only stimulates the γ cones but also stimulates the ρ cones considerably and the β cones to some extent. These unwanted stimulations mean that it is not possible to match the colors of the spectrum with mixtures of red, green, and blue light without sometimes having to add one, or occasionally two, of the matching stimuli to the color being matched. When this is done, those amounts of the matching stimuli are regarded as negative. In color reproduction, the unwanted stimulations caused by the primaries in additive systems, or by the equivalent primaries in subtractive systems, result in the reproduction gamut being limited, so that some colors can never be reproduced. They also result in the theoretically correct set of spectral sensitivity curves for the system having some negative lobes. The most important effect is that some blue-green colors cannot be reproduced, and the sensitivity curve required for the red channel or layer should have a considerable negative lobe in the blue-green part of the spectrum. *R. W. G. Hunt*

See also: *Color photography; Colorimetry.*

UPRIGHT EDITING MACHINE The traditional motion-picture editing machine, often called Moviola (the trademarked name of the most popular unit), in which the film and mag sound move vertically, as with a projector, and interlock between the sound and picture drives is accomplished mechanically—in contrast to the modern flatbed editing machine, on which the film and mag move horizontally and interlock is accomplished electronically. *H. Lester*

USEFUL EXPOSURE RANGE In a D-log H curve, the interval on the log-H axis over which a satisfactory image can be formed. The useful exposure range may be expressed as a ratio of the maximum and minimum exposure values, for example, 1000:1, or as the logarithm of the ratio, in this case 3.0.

The value of the range is, for a given film, strongly influenced by the definition of *satisfactory* as well as by exposure and processing conditions. For photographic papers, the useful log-H range was formerly called the *scale index,* and it varies inversely with the paper grade. *M. Leary and H. Todd*

See also: *Characteristic curve; Paper contrast grades.*

USEFUL LIFE The length of time during which a device or processing solution can be used with only unimportant loss of quality. For example, the useful life of a tungsten lamp is approximately half its total lifetime to burnout. *H. Todd*

u,v DIAGRAM Uniform chromaticity diagram introduced by the CIE in 1960 but now superseded by the u',v' diagram.

$$u = 4X/(X + 15Y + 3Z)$$
$$v = 6Y/(X + 15Y + 3Z)$$

R. W. G. Hunt

See also: *Colorimetry.*

u',v' DIAGRAM Uniform chromaticity diagram introduced by the CIE in 1976.

$$u' = 4X/(X + 15Y + 3Z)$$
$$v' = 9Y/(X + 15Y + 3Z)$$

R. W. G. Hunt

See also: *Colorimetry.*

U*,V*,W* SYSTEM Obsolete color space in which U^*, V^*, W^* are plotted at right angles to one another. Equal distances in the space were intended to represent approximately equal color differences.

$$U^* = 13W^*(u - u_n)$$
$$V^* = 13W^*(v - v_n)$$
$$W^* = 25Y^{1/3} - 17$$

where $u = 4X/(X + 15Y + 3Z)$ and $v = 6Y/(X + 15Y + 3Z)$ and the subscript n indicates that the value is for the reference white; Y is the luminance factor expressed as a percentage. This color space has been superseded by the CIELAB and CIELUV systems.

R. W. G. Hunt

See also: *Colorimetry.*

V Volt

v value (APEX system); image distance (Optics); velocity

***v*-number** Index of refraction (Syn.: Nu-number, Abbe number)

VA Variable area (soundtrack)

VBI Vertical blanking interval

VCNA Video color negative analyzer

VCR Videocassette recorder

VD Variable density (soundtrack)

VDT Video display terminal; Visual display terminal

VDU Video display unit; Visual display unit

VFS Video floppy system

VGA Video graphics array

VHF Very high frequency

VHS Video Home System (Trade name)

VHS-C VHS-Compact

VIBGYOR Violet, indigo, blue, green, yellow, orange, red

VITC Vertical interval time code

VLF Very low frequency

VLP Very long play

VLS Very long shot

VO Voice over (motion pictures)

VOM Volt-ohm meter

VT Videotape

VTR Videotape recorder

VU Volume unit

VACANCY See *Frenkel defect.*

VACUUM BACK/BOARD/EASEL A device that holds film or paper firmly against a flat surface by air pressure on the front surface of the sensitized material when a suction pump removes air behind the material through recessed grooves in the backing panel. Vacuum backs are commonly used on both vertical and horizontal process cameras and are also available for some view cameras. Vacuum frames are used to ensure intimate contact between two sheets of material such as a negative film and a contact screen used in photomechanical reproduction. *L. Stroebel*

VACUUM COATING/DEPOSITION See *Lenses.*

VALENCE Valence is the combining capacity of an element or a radical (group of atoms of elements acting inseparably) to unite with other elements or radicals to form molecules. Valence is essentially the number of single bonds that an atom or radical can form. An atom of oxygen combines with two atoms of hydrogen to form water. Oxygen is said to have a valence of two. Hydrogen has a valence of one. *G. Haist*

VALENCE BAND The lowest-energy band of a crystal that is filled with electrons. Electrons are promoted from this band to the next higher band, either by thermal radiation or absorption of photons. *R. Hailstone*

See also: *Photographic theory.*

VALUE (1) In the Munsell system, a lightness scale where 0 represents an ideal nonreflecting black and 10 an ideal white having 100% reflectance. (2) In the zone system, a scale of relative subject luminances, subject values, using roman numerals from 0 to X where each higher number represents double the subject luminance, or a scale of corresponding print tones, identified as print values. (3) In the additive system of photographic exposure (APEX) system, scales for five major variables, identified as exposure value, (lens) aperture value, (subject) luminance value, (film) speed value, and (shutter) time value. *R. W. G. Hunt*

VAN DER ZEE, JAMES (1886–1983) American photographer. An African-American, Van Der Zee established his studio in Harlem in 1916 where for 53 years he photographed Harlem's events and people, from formal portraits, weddings, funerals, and graduates to street and family life, producing a rich, comprehensive portrait of a people and a time. The children around his studio called him "The picture-taking man."

Books: De Cock, Liliane, and McGhee, Reginald, *James Van Der Zee*. Dobbs Ferry, NY: Morgon & Morgon, 1973.

M. Alinder

VANDYKE See *Brown print process.*

VANISHING POINT A point toward which parallel subject lines converge in the image as the object distance increases. The vanishing point for receding horizontal parallel subject lines, such as railroad tracks, is on the horizon. Sets of parallel lines that lie in different planes have different vanishing points. A box-shaped object with three visible sides has three vanishing points, providing that none of the planes is perpendicular to the axis of the eyes viewing the subject, or parallel to the film plane in a camera for a photograph. *L. Stroebel*

See also: *Perspective.*

VAPOR LAMP Light sources that produce light by electrical discharge in a tube containing gas. Examples are sodium-vapor lamps and electronic flash tubes. *R. Jegerings*

See also: *High-pressure lamp; Low-pressure lamp.*

VARIABILITY The set of differences that always exist in a repeated measurement or process. For example, in a large photographic processing tank, the use of a sensitive thermometer will show different results in different parts of the tank and at different times in the same part. If no differences are found, the measurement method is unable to detect the differences that in fact exist. No two frames of film of the same kind, even on the same roll, have exactly the same characteristics; usually the differences are insignificant, but they do indeed exist. Microscopic examination will show small-scale variations in silver or dye content, even within a single photographic image of a uniform spot.

Random variability results from chance causes, i.e., those influences that cannot in a given situation be altered or controlled, where the only remedy is to change the process to another. Variability arising from assignable (other than chance) causes, as from shutter error or from faulty processing solutions, ordinarily can be controlled. A major function of statistical control charts is to distinguish between these two kinds of causes of variation and thus to permit appropriate action to be taken.

Variability can be measured in several ways, among which are the range, which is simply the difference between the largest and smallest numbers of a group, and standard deviation. *H. Todd*

See also: *Range; Standard deviation.*

VARIABLE-AREA SOUND TRACK An optical sound track for motion-picture prints that uses variations in the area of the recorded track to represent the amplitude of the audio signal. *T. Holman*

VARIABLE-CONTRAST FILTER See *Filter types.*

VARIABLE-CONTRAST PAPER Certain enlarging papers capable of producing a range of contrasts from a single grade. A contrast range equivalent to graded papers one through five is common. The usual form is a paper coated with two emulsion components, one of high contrast and one of low. These may be separate layers coated one over the other, or two emulsions mingled in one layer. The latter are called packet emulsions. The two components are differently sensitized: the low contrast component to green light, and the high to blue. (This is the convention, but the other way around would also work.) Neither emulsion is sensitive to red light. An amber safelight can be used. By varying the ratio of blue to green light in the exposing beam, the contrast of the print can be varied from high to low through several degrees in between. In actuality, blue and green filters are not used. Since the paper is not sensitive to red light, filters that transmit both red and blue, that is, magenta, and that transmit both red and green, that is, yellow, are used. This provides a brighter visual image for the photographer, and is a considerable help in burning and dodging.

Sets of filters are supplied by the manufacturers of the papers, often numbered like the equivalent graded paper. Some of these are made to be suspended under the enlarger lens, others are made to fit into the lamphouse above the negative. Alternatively, the continuously variable yellow and magenta filters in the head of a color enlarger can be used. Filters may be changed while selected areas of the scene are printed, giving different contrasts in different areas of the picture.

Other attempts at achieving variable contrast from a single grade of paper include flashing and special curve shape. A high contrast paper may be somewhat flattened in contrast by giving a uniform nonimage exposure. The longer this *flash,* the lower the contrast. Some snapshot printing systems have used paper with a bowed shape to its response curve. By varying exposure, placing the printed image higher or lower on the curve, some variation in contrast is obtained, but at the expense of overall density. Neither of these last two systems yields prints of the highest quality. *M. Scott*

VARIABLE-DENSITY SOUND TRACK An optical sound track for motion-picture prints that used continuous gradation from black to white to represent the amplitude of the audio signal. These tracks are generally of historical interest today, since the wider dynamic range of variable-area sound tracks has made obsolete the variable-density tracks. *T. Holman*

VARIABLE-FOCAL-LENGTH LENS See *Lens types.*

VARIABLE SHUTTER In motion-picture cameras, a rotating sector disc with an aperture that can be altered, changing the exposure time per frame. *H. Lester*

VARIABLES, INPUT AND OUTPUT Generally, input variables are those factors that can be changed at the beginning of a process or experiment, and output variables are the consequential changes in outcome. In exposure, input variables include aperture, shutter speed, and film speed. Output variables would therefore include dye or silver density, highlight and shadow detail, and depth of field and motion representation. In photochemical processes, input variables include time, temperature, agitation, and chemical composition. The output variables would be described by changes in the characteristic curve. *H. Wallach*

See also: *Characteristic curve.*

VARIOSCOPIC CINEMATOGRAPHY In motion pictures, the changing of the image size and format by rephotographing the original film. *H. Lester*

VARNISH See *Protective coatings.*

VECTOGRAPH A composite stereoscopic positive image in which the left and right images are bound together with a polarizing filter and a metal reflector. The light reflected from the two images is polarized at different angles. When viewed through appropriately rotated polarizing filters, the pictures fuse and appear three-dimensional. *L. Stroebel*

VECTOR A line whose length is related to the magnitude of a measurement and which has a specific direction. Vectors are used, for example, to show the pattern of light reflected from a surface. *H. Todd*

See also: *Vectorscope.*

VECTOR GRAPHICS In electronic imaging, graphics that are displayed on the cathode-ray tube (CRT) as represented by a mathematical description. This mathematical description causes the CRT to scan the pattern as described and not according to a raster pattern. The result is a very high quality graphic without jagged edges. Vector graphics are displayed slowly because of the mathematical description. *R. Kraus*

See also: *Raster graphics.*

VECTOR IMAGE See *Vector graphics.*

VECTORSCOPE An oscilloscope used to monitor the position (and direction from a neutral position) of the colors red, green, blue, cyan, magenta, and yellow. The video equivalent of a CIE diagram. *R. Zakia*

VERNIER A pair of adjacent scales, one fixed and one movable, intended to increase measurement precision, often used as a focusing aid on cameras. The correct position is known when a mark on each scale matches the other. *H. Todd*

VERTEX The point on a surface of the lens where the optical axis enters the surface. For a convex surface it is the highest point on the surface. Often referred to as the pole.
S. Ray

VERY HIGH FREQUENCY (VHF) Several bands in the radio wave portion of the electromagnetic spectrum with frequencies between 54 and 72 MHz, 76 and 88 MHz, and 174 and 216 MHz, used for television channels 2–13.
J. Holm

VESICULAR PROCESS A process that creates an image with density variations derived from the differential scattering power of microscopic bubbles in a transparent layer. When viewed by reflected light the bubbles, scatter the light and appear brighter, than clear areas. When the image is projected as a slide, with transmitted light, the scattered light is lost and the bubble areas appear dark. The processing procedure can be altered to produce either a positive or a negative bubble image. Vesicular emulsions consists of colorless diazo compounds in a thermoplastic layer. Exposure to light causes the diazo compounds to break down which releases the nitrogen. Immediately developing by heat softens the emulsion and allows the gas to form bubbles that are held in place as the emulsion cools. Fixing the image consists of further exposure to light that breaks down the unused diazo compounds.
J. Natal
See also: *Diazo process.*

V(λ) FUNCTION Weighting function used to derive photometric measures from radiometric measures in photometry.
R. W. G. Hunt

V′(λ) FUNCTION Weighting function used to derive photometric measures from radiometric measures in photometry. Normally the $V(\lambda)$ function is used, but if the conditions are such that the vision is scotopic the $V'(\lambda)$ function is used, and the measures are then distinguished by the adjective *scotopic* and the symbols by the superscript prime.
R. W. G. Hunt

VIBRATING COLORS Specifying colors that when next to each other produce a sensation of a flickering movement. Adjacent saturated complementary colors often produce this effect and are commonly used in op art. *L. Stroebel and R. Zakia*
See also: *Lateral inhibition; Mach band.*

VIDEO CAMERA See *Camera types.*

VIDEO CASSETTE RECORDER (VCR) An electronic device that is capable of recording television and related input onto magnetic tape in a video cassette (as distinct from reel-to-reel tape systems) and playing them or prerecorded video cassettes back through a television receiver.
L. Stroebel

VIDEO COLOR NEGATIVE ANALYZER (VCNA) A closed-circuit color television system designed to display a positive color image of a color film negative on a monitor. Calibrated controls for image brightness and color balance make it possible to transfer data from the VCNA to a color enlarger to reduce or eliminate tests when making a color print from the negative.
L. Stroebel

VIDEODISC An audiovisual recording (of a television program or motion picture, for example) on a circular, flat, and rotatable medium, designed for playback on a television set.
L. Stroebel
Syn.: *Laser videodisc.*

VIDEO FOR PHOTOGRAPHERS
THE PERVASIVENESS OF VIDEO IN SOCIETY
Nothing in human history save the great religious traditions has shaped the hopes, fears, and aspirations of as many millions of people as has the phenomenon of television. The medium gives us our news, informs our opinions on world events, persuades us what to buy and how to live, shows us lifestyles we can aspire to, entertains us with comedy and human adventure, takes us along to the theater, the orchestra, and the opera, puts us *on the spot* for the repeated witnessing of the major events in our world, and, in general, offers us a complete vicarious existence on a scale that is unheard of in human history.

The core of what we call television is video, the relatively simple recording and playback devices with which we make these images in their myriad forms. Video is not just the technology of television, however, it is also a medium that has become widely and inexpensively available to millions of amateurs who use it to record important events in their lives. One can hardly think of a public event, a ceremony, or a popular vacation spot without envisioning dozens of people videotaping the action. More and more people are recording family snapshot occasions on videotape.

Correspondingly, and particularly with the availability of smaller, lighter, inexpensive, and user-friendly camcorders, video has been steadily taking over an increasing share of the traditional market for photography. This is true of both the amateur and the commercial markets. The public has come to accept—and frequently insist on—videotapes. Independent of how the photographer may feel about this new demand for video, becoming competent at producing it is now a necessity for surviving in the more competitive markets such as wedding and prom photography. The demand for, and expectation of, video have actually grown to the point that clients are now beginning to ask for two-camera, edited videotapes.

This growing demand is a major incentive for photographers to learn the basics of video production. There is almost no limit to the new markets for educational, documentary, advertising, and studio videotapes. As a basic strategy, photographers are advised to start by offering video products for the clientele and type of business they are already familiar with and then, after gaining experience, to consider exploring new areas. This makes the move to video a logical extension of present operations. Significantly, photographers already know the aesthetics and the business aspects of this kind of creative work.

This article will give a focused introduction of video. It begins by exploring what video is and how it works, describing the equipment and features to look for and telling how to set up a single- or multiple-camera operation. Following the equipment overview, how to visualize and plan video productions, how to make good videotapes, how to do basic editing, and then how to market this new product, will be covered. There is also a glossary of terms. All of this information is intended to help the photographer to actually begin making videotapes or to communicate with jobbers or production houses regarding clients' needs.

SIMILARITIES AND DIFFERENCES—PHOTOGRAPHY AND VIDEO
Photographers already know many of the fundamentals of producing high-quality video. The basic unit of video production is the shot: photographers are skilled in selecting or creating sets, positioning people and other elements within the frame and in relation to the background, creating interpretative lighting effects, and eliciting responses or poses from people being photographed. All of this is essential to creating a good shot in video. Photographers are also knowledgeable about the technical aspects of lenses, including *f*-numbers, focal length, and depth-of-field as they affect exposure, image size, depth illusions, and the selective uses of focus.

There are, however, two principle differences between still photography and video that must be taken into account when making the change-over: video is an electronic technology, and video is a motion medium. The first, the electronic nature of video is relatively easy to learn, and one can become quite competent at it in a short period of time. One way to regard this is to consider video equipment much like a home stereo (phonic) unit: there are components with different functions that hook together in specific ways to achieve the desired result. The other attribute, that video is a motion medium, is a bit more complex to master at the creative level. The "Video Production" section will provide insights into both of these characteristics and how they can be taken advantage of in order to get started with video.

HOW VIDEO WORKS Video is a system that converts the energy of light into an electronic image. The lens on a video camera focuses light reflected from a subject onto a photosensitive surface; relative amounts of light are registered as electronic impulses with different charges by an electronic gun (a magnetically controlled arc) scanning this surface. The electronic impulses generated by the optical image and sensed by the scan gun are, in turn, conveyed to either a recording or a playback device where the image is stored or the scanning process is repeated in reverse for playback. The electronic *gun* scans 525 horizontal lines on the photo-sensitive surface to make a complete picture. The scan pattern is from left to right, top to bottom, and the beam of the scan gun is on only during the left-to-right passes. There are two scanning cycles for each complete image of 525 lines. Scanning one-half of the 525 lines in this manner is called a *field*. For example, the first *field* is a scan of the 262-1/2 odd numbered lines and the second field is a scan of the remaining 262-1/2 even numbered lines. Two complete scans or fields make one complete imaged called a *frame*. The gun scan at a rate of 30 frames (60 fields) per second (this explains why it is necessary to use a shutter speed of 1/30th or slower when photographing a television set or computer screen).

The photosensitive surface on which the lens focuses the optical images was historically the internal sensing surface of a vacuum tube. Generally speaking, the larger the tube or the more there were of them in the camera, the better the reproduction quality of the system. In the early years, tubes were large and expensive, especially on broadcast-quality equipment. Remember the pictures of the huge RCA studio cameras from the early years of television? Gradually, the big image orthicon (IO) tubes were replaced by smaller but very efficient vidicon tubes; these were generally replaced by saticon tubes, or some variation thereof, which are still in common use today. The field of video technology has, as is the case with all electronics, moved to smaller and lighter equipment without much sacrifice in image quality, and the cost of tubes has dropped from an IO tube costing thousands of dollars to a vidicon tube costing two or three hundred dollars. Even with the less costly tube technology, however, it is important to keep in mind that tube size should match the video format: use 3/4-inch or larger tubes for 3/4-inch videotape units. The use of smaller than format tubes, for example, 1/2-inch tube camera with a 3/4-inch deck, will result in a loss of image quality.

Tubes are now beginning to be replaced with charge coupled devices (CCDs). These are sensor chips with mosaic-like cells (pixels) that the camera's pickup system reads directly. They offer the potential of much smaller and lighter cameras without sacrificing reproductions quality. Formerly, with tubes, resolution was measured in the number of horizontal lines that could be reproduced (much like the line pairs-per-millimeter resolution tests for photographic lenses); now, with CCD equipment, resolution is determined by the number of pixels per unit of measure.

The video image, once it has been picked up electronically from the tube or CCD receptor in the camera, can be distributed in a number of ways or in combinations thereof: it can be transmitted via the airwaves (broadcast) or through cable (narrowcast), viewed directly on a monitor (a *monitor* is a television set that does not have a tuner to select different channels but that does have jacks on the back to accept video and audio inputs) or receiver (a receiver is a conventional television set with a tuner dial to select channels) or it can be recorded by a videotape recorder.

VIDEO EQUIPMENT CONSIDERATIONS
General Considerations
Format Selection During the early years of videotape, the late 1960s through the late 1970s, formats (the sizes of the tape and the means for encoding electronic information on them) were not standard. Each company that made recording equipment designed its own system. This meant that, while each one may have worked fine, tapes made on company A's machine could not be played on company B's deck. Buying

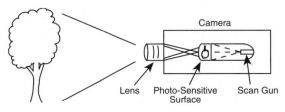

How video works

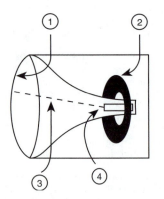

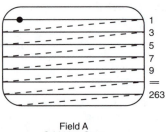

Field A
Odd Line Scan

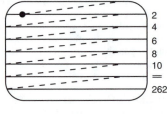

Field B
Even Line Scan

Video scanning. (1) Coated surface; (2) magnetic coil; (3) scanning arc; (4) scan gun.

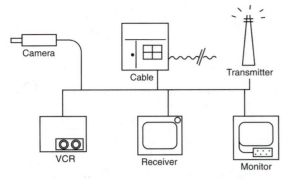

Video signal distribution.

Tubes or Charge Coupled Devices? Most of the camera equipment on the market in the 1/2-inch or larger formats uses tubes rather than CCDs. CCDs are a new technology and they have been designed more for 8-mm and 1/2-inch video than for larger systems. Well made tube-type cameras offer excellent resolution and color fidelity and will provide many years of service. CCD cameras promise to offer higher resolution for a given camera size, they are smaller and lighter than tube cameras, and bright lights do not burn an image into the CCD receptor plate as they can do with tubes (if video cameras with tubes are pointed directly at a bright light or reflected source, the light can burn a permanent image into the tube and a ghost image will appear in all subsequent pictures). The reader is advised to follow the developments in this new digital technology for the preferred format, as with any camera, silver-gelatin or electronic, use it under normal working conditions to see how well it suits your needs. Electronic specifications and technical sheets can provide general information, but only actual use can determine which camera is right for you.

Portability There is a truism in the trade that if it has a handle on it, it's portable. This was more humorous years ago because equipment was much heavier and bulkier than it is now. Later, we will suggest keeping video cameras on tripods insofar as possible. Even if used on a tripod, however, it is necessary to consider the size and weight of a system for the conditions under which it will be used. This consideration is particularly important for those who want to transport equipment frequently by air, especially into remote regions. Camcorders, especially CCD models, are the smallest and lightest of the configurations available.

Durability Some systems—especially the Panasonic camcorders—have developed a reputation in the trade as being particularly durable and are in widespread use. Others have gained a reputation for being fragile or sensitive to humidity or other factors. One good measure of durability is the reputation a unit has with other users and with repair shops.

Standardization and System Adaptability Standardization and adaptability are especially important when buying or upgrading multiple camera operations. One chronic problem in video is that equipment does not tend to stay in production very long, at least not without being modified (improved). In addition, some cameras and accessory equipment use specialized versions of multipin connectors. Often, if a new or longer cable is needed for one of these a few weeks or months after being purchased, it may by then have been discontinued. This is a matter that can be checked out with local service people. An insurance procedure is to buy extras of these kinds of things at the time of the initial purchase.

Cost and Service Factors Video is such a competitive industry that cost will be determined more by the format and the type of camera than by brand differences alone. With electronics, and particularly with video electronics, you get what you pay for. While on this topic, it is better to invest in quality and simplicity than to buy a lot of gadgetry (see the section "Camera Features").

Service factors are important to business operations, and they are even more important when the business is highly dependent on (sometimes) temperamental electronic equipment. A good, local service center for the brand of video equipment being considered is important. As with still photography equipment, arrangements should be made for backup emergency service and/or loan equipment. You do not want to have to send a camcorder to Osaka in the middle of a busy wedding season: plan for emergencies before they happen.

These general considerations will help you think through the broad questions regarding video formats and kinds of equipments. Next we will discuss the specific equipment

into a system was risky: you took a chance on both the survival of the company and on the public acceptance of the format. Photographic film and plate sizes were like this well into the 1920s. Eventually, the early reel-to-reel video formats were standardized into U-Matic for 3/4-inch and EIAJ for 1/2-inch. With the advent of 1/2-inch cassette machines in the late 1970s Sony's Beta and Panasonic's VHS competed for market dominance. Many commercial and educational video users held off selecting one of these in anticipation of a new standard being developed for 1/2-inch cassette (one requirement of a new standard is that it not be an existing format). Eventually, however, it became clear that a new standard would not be forthcoming, and, in these early years, purchasers bought into both Beta and VHS. VHS gained almost all of this market over time and dominates the 1/2-inch cassette format market. VHS is also the most commonly used wedding format.

The size and quality of video equipment selected should be determined by the intended end uses. As with photographic film, the larger the videotape, other things being equal, the higher the quality of the image, but large tape equipment is very expensive. Begin by ascertaining the minimum tape size that will do the job at the level of quality required. A size of 3/4-inch or larger tape is needed to achieve broadcast quality and is desirable for tapes that will be duplicated; beyond that there is a range of choices. The small 8-mm format is fine for home use or even some in-house corporate applications, provided the tapes will be used in direct video playback setups and that it will not be necessary to duplicate the tapes for distribution. The mid-range of 1/2-inch formats includes a wide array of quality ranging from the standard VHS through Super-VHS, Beta-Cam, and the newer High-8, which, although not 1/2-inch, is becoming increasingly popular in this market. VHS is the most widely used of these formats, and there is a considerable range of price and quality in the available equipment. VHS is fine for nearly all direct video uses—that is one of the reasons it is so widely used. Also, VHS equipment is priced from just a few hundred dollars to several thousand; it is possible to enter the videotape sales market with modest equipment in the VHS format and then, as business warrants, expand in modular fashion (but be cautioned about modularity and compatibility).

Beyond VHS in terms of resolutions and price, check into Super-VHS, Beta-Cam, or the new and modular High-8 format. The High-8 format features an interchangeable module (like a film back) that can be changed to convert the system from regular 8-mm to High-8. These higher quality systems, including 3/4-inch, 1-inch, and 2 inches, are very expensive and—although the principles given in this article apply to all formats—it is advisable to talk with someone versed in these systems (not just sales personnel) before purchasing one of them.

features (some desirable, some not) that will be encountered when putting together a single-camera system.

Video System Design: Single Camera Systems Unfortunately, video cameras do not usually come as complete, ready-to-use systems. This is particularly true when moving in the high-end amateur and professional grades of equipment. Photographers should be somewhat accustomed to this: it resembles the way camera bodies are often sold independent of lenses. It need not be a problem provided one is aware of what comes with the equipment or—more importantly—what does not.

In considering the following features of contemporary video equipment, keep in mind, as with still photography, a camera is a box designed to hold the lens, image recording system, and a monitor/viewfinder. Beyond that, features become more and more discretionary, and at some point they can become distractions at best or systems that will need repair at worst. As with most crafts, tools are essential, but it is ultimately the videographers application of the tool, not extra features, that will create excellence.

Camera Features The new video cameras have a host of electronic features; indeed, there almost seems to be a new feature contest among manufacturers. Up to some point, camera features can make your work easier. It is advisable to put your purchase money into the quality of the basic elements of the system before considering a lot of extra features. Simple, high-quality equipment will provide better and longer service than lower-cost equipment and/or versions with more complex gadgetry. To the argument that these are all space age electronics, remember that, in aerospace applications, there are three to seven backup systems for every function: here there are none.

Some things to check on a video camera for professional photography would include the following:

Manual White Balance Modern color video cameras need to have the white balance set for the lighting conditions. This is analogous to selecting daylight (5500 K) or tungsten (3200 K) film for outdoor or studio use. There are two ways this is done with video. On older systems and on professional equipment, the white balance is set manually by turning the system on, holding a white card in front of the lens, and pressing a WB switch. For taping where the color fidelity is important (every professional application), this is done every time the camera is turned off and on or moved to a different lighting environment. Some cameras have a WB memory: with these cameras you will not have to reset the WB unless you change the lighting situation. Newer and lower cost video cameras often have an automatic white balance feature. But this should be field tested under varying lighting conditions to determine if it will give consistent, professional quality hue and chroma. You may prefer to set the white balance manually.

Power Saving Mode Power saving mode is a small but useful feature. Basically, it turns off all but the essential electronics if the system has been left in *pause* or *standby* mode. The system draws very little electricity until the moment the *record* button is pressed, but the moment it is, it is ready to operate. This is particularly beneficial when operating in the *battery* mode in the field.

External Microphone Jack, Audio Monitor, and Gain Set Most of the video cameras in the 8-mm and VHS formats have built-in microphones, which are not very useful for professional applications. Unless the camera is very close to what is being taped and is situated in an acoustically dampened place, you tend to get more noise than signal with these systems. In a later section, we will talk about using microphones; meanwhile, look for a camera that has a MIC jack for an external microphone and a DUB or AUD[IO] MON jack for a small earphone so you can play back short segments in the field to check the audio track. It is also desirable

to purchase a system that allows the audio record level to be set with a knob and a VU meter rather than having the equipment do it with something like AGC (automatic gain control). This may be hard to find on anything less than professional grade (expensive) equipment.

Fade and Dissolve Control Fades and similar shot transitions are best done during the editing phase, but many videographers find it useful to have a fade or dissolve feature built into the camera. This feature is usually simple to operate: press the FADE button and then RECORD and the camera fades up from black to the shot; or, conversely, press FADE with the camera running in RECORD and it slowly fades from the shot to black. The challenge is to know, as you are taping, just when to fade in and out of a shot.

Built-in Timers and Character Generators Most professional photographers getting into video productions will have little use for either of these features. The built-in time code displays—which record and then play back the date and time on the lower part of the taped image—can be useful for certain clinical or research applications where this visual frame referability is important, but for most people they are a nuisance. Users sometimes forget to turn them off while taping and ruin client tapes with this flashing clock overlay.

Character generators, small keypads with numbers and letters that can be used to add type to the leader, trailer, or the visual image on the tape, could be useful if the videographer wanted to add short titles or credits to a tape and did not have access to editing or other graphics capabilities. Some of these systems permit the user to superimpose letters and numbers over a previously recorded image, whereas others require the image and the text be taped simultaneously. There is a wide range of quality of the textual graphics and the options for applying them. Be sure to check the size, style, and legibility of the type, and look for user-friendly instructions. Most are not really complex, but they seem to intimidate the public—like the continuously flashing clock on home VCRs.

Lenses The standards that a photographer applies to the selection of lenses are all relevant to video lens selection. These standards include criteria for coverage, corrections, focal length, maximum aperture, contrast, resolving capability, and focusing distance. Coverage in this case would mean a lens is capable of covering the size of the tube or the CCD receptor plate in the video camera; corrections for chromatic and other aberrations would need to meet the standards of the productions anticipated. One important difference between lenses for still photographer and lenses for video is that nearly all lenses marketed for video use have C mounts and zoom (variable focal lengths) design. C-mount has been the standard thread mount size in cinematography for many decades; it is now also the standard in high-quality video equipment. One new variation is that some companies now offer video cameras with bayonet mounts that are designed to accept the more popular 35-mm still camera lenses. This could be a way to use your own camera lenses on the video camera, but keep in mind that a normal lens for a 1/2-inch VHS video format has a focal length on the order of 25 mm; however 35-mm camera lenses on a 3/4- or 1-inch video system approximate the focal length effect they give the still camera.

Aperture The zoom lenses normally available for video offer maximum apertures in the $f/2.8$ to $f/4$ range, which are fine for most taping in daylight and under controlled lighting conditions. For frequent taping under low light conditions, look for a camera and lens specifically designed for low light use.

Auto-Iris Control Most of the equipment offered for sale today will have a lens with some kind of automatic exposure control. While this works well under certain conditions, it would be desirable to have a lock or manual override provi-

sion for those times when the automatic function fails to achieve the desired result.

Zoom Characteristics Lenses for video cameras come in variable focal lengths, with ranges from about 6:1 to 12:1, with the price increasing with the zoom ratio. For most professional applications, a range of about 10:1 should suffice. Again, the advice here is to test the characteristics under normal working conditions. For example, sports and wildlife photographers would want a longer focal length than someone who specialized in taping weddings.

Most of these zoom lenses are electronic, operating with a variation of the telephoto–wide-angle rocker switch. When examining lenses, try to find one that allows the *speed* of the focal length change to be adjusted: many are fixed-speed and move too fast for a pleasing effect during general videotaping. If the electronic speed of the zoom cannot be adjusted, look for one that can be operated by hand when necessary.

One final lens feature, remote control, may be desirable for your operation. Remote control permits you to mount the camera on a tripod and control both the zoom and focus functions from handles located conveniently on the rear of the tripod head control arms. If the lens offers this option, there will be receptacles on the barrel for remote focus and remote zoom controls.

Autofocusing Autofocusing is a standard feature on most video lenses, and under a wide range of working conditions, it works fine. Professional equipment should, however, offer both a focus lock and a manual focusing capability.

Macro-focusing Most of the newer zoom lenses for video use offer some degree of macro-focusing. This feature is not usually a true macro capability of 1:1 (nor is it designed specifically for extreme closeup work or flat field reproduction), but it will permit closeup images of 1:4 or 1:6, which can be useful. There is normally a lock of some kind to prevent the lens from moving into macro mode during routine autofocus travel.

Filter Diameter Still-camera filters can be used on a video camera with step-up ring for glass filters or a fitted holder for gelatin filters.

Video Recorders Video recorders today are smaller and lighter and easier to operate than they were in the recent past. They have gone from being large, heavy units weighing 30 to 50 pounds and costing thousands of dollars through progressive miniaturization to about the size of a briefcase, and their price has fallen to a few hundred dollars. They have also become much easier for people to use without professional training.

Video recorders are devices housing the record/playback machinery and electronics, control switches, and often battery packs. Much of what used to be overly complex and problematic has been eliminated by design. Still, there are some features and characteristics the photographer would do well to consider during the selection process.

Camcorders vs. Separate Decks The choice of a type of VCR may be precluded by purchasing a system that only comes as a camcorder or as a separate camera and recorder unit; with others you may have the choice. The most popular configuration is the camcorder, which contains both the camera and the video recorder. These combined units, particularly those with the newer CCD type cameras, are smaller and lighter than were their equivalent format cameras just a few years ago. The reason for the popularity of the camcorder is understandable: there is less equipment to carry around and fewer wires and switches to contend with. For most photographers getting into the video market, a high quality VHS camcorder would be a good choice.

There is, in spite of the popularity of the camcorder, one real advantage to having separate camera and recorder units: if there is a breakdown in one piece, you don't have to send both of them in for repair. Having two separate cameras and two decks will provide a backup capability in the field.

Ease of Operation Ease of operation is partly a technical factor and partly a personal one. Do consider the relative clarity of control buttons and the simplicity or complexity of their operation with regard to your employees as well as yourself.

Power Sources All professional equipment should offer the choice of AC or DC operation, and accessory, rechargeable battery packs should be readily available. Although AC operation is always preferable, there are times and situations where it is necessary to operate the video equipment on batteries. Purchase the battery units (and their charger, if not a part of the system) *at the time you buy the equipment.* There are some unpleasant stories in the trade about someone buying into a particular equipment manufacturer's line only to come back a few weeks or months later to purchase an important accessory and finding out that the product had been discontinued.

Unfortunately, this is almost as true of the big names as it is of lesser-known ones: the electronics field changes rapidly, and companies, in order to try to stay competitive, are constantly changing product lines. Also, buy about twice as many of the rechargeable battery packs as you think you will need. Then study the literature that comes with them so you know how to keep them in good condition over time. Some, for example, require special kinds of deep discharging before recharging to counteract their charge memory.

Power Saving Mode As with the previous camera discussion, a power saving device can help conserve precious battery power in the field and is a desirable feature.

Audio Monitor Jack You need an audio monitor jack to play back and check the audio recorded in the field; the jack can be on the camera or on the recorder deck (it does not need to be on both).

Microphone and Audio Dub This input can be used to plug in an external microphone (MIC) or to plug in a sound source like an audio cassette player (DUB) to add music or sound effects to a tape, and you can do this either while you are making the videotape or at a later time. Read the VCR instructions carefully to determine what kinds of source audio can be used. Normally, a MIC jack will only take an unamplified signal (microphone), whereas a DUB jack will take an amplified one (audiocassette player). If you cross these, you will get a loud hiss or hum in the audio track.

Remote Operation Remote operation is a very desirable switch on a separate VCR unit. It enables the user to control all of the play and record functions of the VCR with the camera's control system. The recorder is set in *remote* and then activated with the controls on the camera body. The main advantage of this switch is that it permits the camera operator to stay with and be attentive to the camera during a recording session without having to go back and forth between the two units.

Receivers and Monitors The home television set is a receiver: it has a tuner that can be operated to select different frequencies (channels) for reception. A monitor is a television set without the tuner. It is wired directly to a video camera or VCR for playback; it also has a number of jacks on the back (this is called *Jeeped*) to accept cables for audio and video signals, in and out. Monitors are necessary for editing systems and studio applications, but you can get by with a high quality receiver for most other work. Receivers are considerably less expensive than monitors for comparable screen size and quality—this is why video professionals usually use small (8 to 10-inch) black and white monitors for editing and studio production and large color receivers for client screenings.

Cables Cables can be problematic in video production in three ways: they are frequently too short—as supplied—for

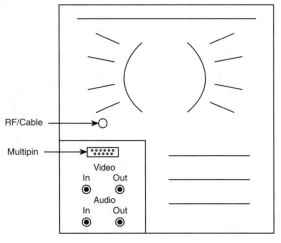

Monitor jacks.

depending on the price, and it helps stabilize the camera during taping. Dampening is only marginally useful under calm and controlled conditions with prearranged shots; it is particularly valuable if taping is done under adverse conditions and/or if a lot of camera movement is required. Practice camera movement until you become proficient at doing it smoothly and then, if you still need dampening, investigate these heads for your tripod.

Dollies A dolly for your tripod will be useful if you need to move the camera around a lot within a confined area; the wheels will save the labor of picking up the camera and tripod for each move, which, at the end of a long day, can make an important difference in your fatigue level.

Microphones It is more important to use an external microphone that it is to be concerned about the type or brand. Built-in microphones usually pick up as much noise as they do signal. There are some characteristics you should be aware of.

Pickup Patterns Microphones do not *hear* all of the sound around them: they are sensitive to different patterns of reception (pickup patterns). These patterns range from the almost 360° sensitivity of an omni microphone through the heart-shaped patter of a cardioid to the extreme directionality of a shotgun model. The most useful microphones for general video use is the cardioid pattern, but do consider the kind of recording capability your needs dictate: for people sitting around a small table in a conference room, an omni-directional pattern would be best; for recording specific sound sources at greater than normal distances, a shotgun pickup pattern would better isolate the signal from the noise.

Styles Microphone styles are governed by their intended installation as well as their pickup patterns. There are three installation types in common use: *boom, hand-held,* and *lavaliere.* The boom microphones, as the name implies, are large and designed to be mounted on a stand; most of them have wide (omni) pickup patterns. Hand-held microphones are the most widely used type and come in a variety of reception patterns. These are the kind singers and television news-

your needs, they do not have the right connectors, or they malfunction (like PC cords for electronic flash). The message here is buy cables that are longer than you think you will need, make sure they have the right connectors, buy extras of everything, and have a supply of connector adaptors on hand. Video is known for the numerous cables it requires to hook equipment together. Two recent trends have helped alleviate this problem: the all-in-one studio cable and the camcorder. Still, it is necessary to think ahead and be prepared.

There are several kinds of connectors in common use. The VIDEO and BNC pins are used for audio jacks; and the RF and MULTIPIN pins are used for composite signals (both video and audio). There are male and female adaptors for all of these (except some MINIPIN's that are specific to the make and model of equipment). PHONE and MINI connectors can be either stereo (the pin has two insulting bands near the tip) or monaural (the pin has one insulting band near the tip). Only a few of these connectors are needed for routine work.

Talk to the dealer when purchasing equipment to make sure to get the right connectors or adaptors. All of these connectors are readily available from video dealers and repair shops except some of the brand-specific MULTIPINs: get extras of those (and longer cables) at the time you buy the equipment.

Electronic News Gathering Kits Electronic news gathering (ENG) kits are portable configuration kits for video cameras. Such a kit will usually include a should harness system for the camera, a small monitor (if the camera normally mounts a large one), extra-long cables, and a travel case. Some of them include luggage carts, which can be useful for rolling the unit around on location.

Pedestals and Tripods The large studio stands for cameras are called pedestals. These are hydraulically and/or electronically operated and provide great stability and mobility over a smooth, flat surface. Outside the studio, most video work is accomplished using sturdy tripods, sometimes with the legs inserted into a dolly (a rig with wheels under it). Any durable tripod used for still photography work fine for video, provided it will take the weight of the video camera or camcorder.

Heads and Movement Dampening The special heads made for video and cinema tripods normally offer pan and tilt movements, and they are dampened against jarring or shock. This dampening is done with springs or hydraulics,

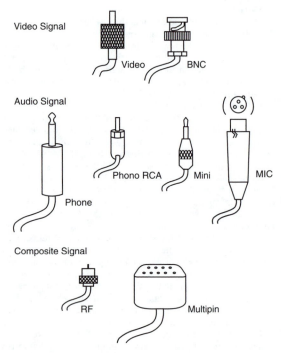

Cables. Cable connectors.

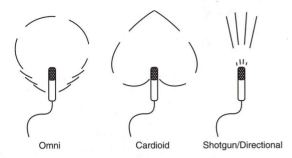

Omni Cardioid Shotgun/Directional

Pickup patterns of microphones.

people use on stage or on location. The most readily available versions of hand-held microphones feature some variant of the cordioid pattern. Lavaliere microphones are the small *button* microphones that can be clipped to a lapel, commonly used by commentators on television. These, too, usually have a cordioid reception pattern.

Power Sources Microphones operate by converting sound waves to electronic impulses by means of a diaphragm; sound waves move the diaphragm, which, in turn, excites a coil in a magnetic field. The simplest of them, the ceramic microphones, are quite limited in their sensitivity. Dynamic microphones respond to a much wider range of sound waves (frequencies) and are a considerable improvement over ceramic models. Dynamic microphones are also very durable and are sensitive enough for most VCR applications.

Microphone sound pickup is greatly improved by adding an internal amplifier. The amplified microphones require battery or AC power, and they range in quality and price from the electret condenser through condenser models to the ribbon type. The electret condenser would be a good, high-end choice for VCR use (particularly a lavaliere model). The frequently sensitivity of most condenser and ribbon microphones far surpasses the audio recording ability of VCRs, and their high cost would not be justified.

Microphone Cables and Wireless Models First a note on cables: as with video, microphone cables should be long enough to handle all anticipated needs. These cables are relatively inexpensive, so having extra and longer ones in your kit is sound practice.

The new wireless (transmitter) models have decreased dramatically in price in the past few years, and they can be very convenient to work with. This type can be clipped to a person in an inconspicuous way, the wire to the small transmitter box can be hidden under clothing, and the sound quality is excellent. They do have batteries to contend with (carry rechargeable spares), but there are no long cables to worry about. Always check the effective range of the transmitter to see that it meets the needs of the situation.

In summary, unless your working needs dictate otherwise, the least expensive means to obtain high quality audio would be to start with a condenser-type, hand-held microphone with a foam rubber windscreen over it to filter extraneous noise.

Portable Lights Most videographers find they work under conditions that, at least some of the time, require the addition of illumination to obtain satisfactory image quality. Here there is a wide variety of choice. The small, easily portable 500-watt quartz lights that operate on AC power are an inexpensive system if AC power is available on location and if they can be placed where they are needed. Obviously they would not work well at a wedding or a reception unless they are set up before the event. It might work to place just one or two at strategic locations, provided the celebrants would agree to being *hot lighted*.

The most widely used portable video lighting is a battery powered system that consists of a quartz lamp in a reflector, mounted on or near the camera, and a separate power source. It is better to get the light off of the camera to approximate studio main light modeling rather than that on-camera. Systems like this are priced from less than one hundred dollars to thousands of dollars. As with studio lights for still photography, the price directly reflects the quality of construction, output of the lamp, and the amp hour capacity of the power pack.

The power of the light required will depend on the lamp-to-subject distance, and how large an area you need to cover will determine how many lamps are required. The duration of taping will dictate your needs for a power source (all lights should offer rechargeable batteries and an AC power option). It would be a good idea here to look into one of the major supplier's modular systems: you can start with a simple setup and then add to it later as your needs grow. You can learn a lot about portable lighting systems by talking to local wedding videographers, news people, and—if you live in a city—local video equipment dealers and their service technicians.

Multiple Camera Systems This section will cover the basic information required in order to set up a multiple camera option. If your needs dictate a more advanced operation than is discussed here, it is advisable to study what is required for reading books designed to cover studio operations and to retain the services of a broadcast engineer (call any radio or television station to find one) or other knowledgeable expert to advise you on the project. Keep in mind that most of what has been said regarding single camera systems is also applicable to multiple camera systems.

When, and for what purposes, should you consider using more than one camera? For many photographers who are getting started in video, one camera will perform adequately. Basically, as long as you can stop the event in progress and/or move the camera from one position to another to obtain the necessary shot, one camera is enough. Additional cameras are required when it is necessary to be in more than one location at a time, or when you want more than one view of a subject to select from later (during editing).

The progression of complexity and expense goes from single camera taping through multiple camera taping to *switched* operations. In multiple camera taping, two or more cameras are placed at different locations and each one records a separate videotape; these tapes can be edited into one product later. In the switched operations, two or more cameras feed their signals into a central control point, where only one of them is selected for recording (switched) at any given moment. Single camera and multiple camera taping make life simpler and less stressful: they require only an operator for each camera. A switched operation requires an operator for each camera plus someone at the switcher to make the critical selection of one of the multiple camera shots to record at any given moment and, for professional productions, someone to handle the audio recording. Note, too, that the switched effect can be achieved by taking the tapes recorded by more than one camera and editing their shots together after the event (things you do after taping are called *downstream* or *postproduction* in the video industry). By doing the shot mixing in postproduction, the chances of making uncorrectable errors during real-time recording are reduced: if you selected the wrong shot during switching, you would have to stop the event and have the action repeated to correct the mistake. During editing, on the other hand, you can preview the mixing and correct any mistakes. If possible, tape with separate camera/recorder units and create the editing effects later. Either way, using more than one camera on a job requires some additional equipment planning and consideration.

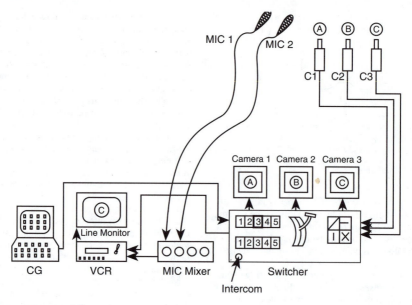

Multiple camera system. Studio equipment configuration.

It is beyond the scope of this article to go into a detailed discussion of studio operations, but a brief overview of what is entailed when designing a first-class industrial studio (as opposed to a full broadcast type facility) will provide a scheme to work from when putting together smaller-scale production capabilities. In a studio equipment configuration, all of the cameras cables come into a central switcher, each camera shot is visible on a monitor above the switcher, and only one signal can be selected to send to LINE/VCR. The basic controls on the switcher for selecting between the camera shots are CUT, FADE, SUPER[IMPOSE], or create SPECIAL EFFECTS. Audio is a completely separate system. The microphones are connected to an *audio mixer*. This mixer has several inputs: it can take audio from microphones and other sources like cassette tapes and it can then be used to select from among the inputs and/or mix the inputs at different levels (of volume) to send to the RECORD VCR audio track. A device called a *character generator* (CG) can be used to put titles on video.

The heart of such a complex system consists of some key components: the cameras, the switcher, the audio system, the character generator, and the facility itself (including lighting accommodations and acoustical treatments). A short discourse on these will provide general understanding of how studio equipment works, and categories to think about if you choose to assemble such an operation.

Cameras There are two important considerations regarding cameras: the cameras should be matched and, if their signals are to be fed to a switcher, they must have an *external synch[ronization]* feature. Any time you are using more than one camera on the same production, they should be matched. The easiest way to match cameras is to buy two of the same make and model at one time. It is striking how much the signals from two cameras can vary across models even within the same brand. (Did you ever try to match the color and brightness of two or more slide projectors for a multi-image presentation?) Shifts in chroma are particularly troublesome when one is trying to create a professional product and the shots differ, even when they are properly adjusted on a waveform monitor.

External synch is required for multiple camera operations whenever a switcher will be used. This function of *external*

synch is to allow the signal generator competent of the switcher to set the scan guns in each camera at the same blanking pulse which synchronizes the scanning. In the absence of this feature, the cameras will operate their scan gun's timing independently of one another; one may be at start while another is scanning mid-field. If the multiple cameras are not synchronized, the pictures on the LINE/VCR monitor will roll when you cut from one of them to another at the switcher.

Switcher A switcher is needed only when two or more cameras feed their signals into one VCR. A switcher is a device that receives video signals from multiple sources (camera and tape decks), synchronizes the cameras' scan guns, and enables the operator to select one signal as it is received or modified with special effects for recording. Switchers vary widely in capabilities and price. At the low end, there are simple models that accept two camera inputs and have buttons so the operator can cut back and forth between the different shots. At the high end, there are switchers that offer numerous inputs and literally hundreds of special effects that can be used in the process of cutting, fading, or superimposing shots. Most also offer an INTERCOM system for the director to communicate to the camera operators unobtrusively by using headsets. In the past, switchers were a combination of mechanical and electronic systems; now they have become almost completely electronic (some even operate with iconic menus and a mouse, like a personal computer).

Audio System All of the information on microphones, cables, and connectors in the section on "Video Design System: Single Camera Systems" applies to audio for multiple camera and studio operations. Microphones used in studio work are most commonly either the lavaliere (lapel) or boom type (mounted overhead). Cables, of course, need to be longer than for most single camera operations, and it is important that they be laid out of the paths of action.

The *audio mixer*, often called a *mic mixer*, is the key component. Most of the units on the market today are well made and offer good quality sound. Quality does vary with price (as do the number of features or special effects); buy the most expensive and simplest mixer you can afford. A mixer should offer a sufficient number of high and low impedance

inputs to accommodate what you need to *feed* it. The price of these units varies directly with the number of inputs in most cases—consider some margin for growth of your needs here. Next, the *potentiometers* (the knobs or dials used to set the volumes of inputs are called *pots*) or slide levers for each source should be smooth and easy to use; users vary here in their preferences and in their anatomy and dexterity: before purchasing a unit, test it by turning two pots or sliding two levers slowly and in synchronization with one hand *while* you operate a third pot or lever in the opposite direction with the other hand (this is what you need to do, for example, if you were fading two microphones in or out as you brought the music up or down). A good mixer will provide many years of service if it is not abused: take the time to find one that meets your needs as well as your budget.

Character Generator A character generator (CG) can be set up to operate during studio productions or downstream during editing. A character generator is a kind of electronic typewriter that has the capability of adding text to videotape. With the more costly ones, several pages of text can be created in advance and stored in memory to be recalled as needed; CGs can also offer many variations of fonts, type sizes, and lettering enhancement effects, and they can make the text crawl across the bottom of the screen or appear to scroll upward. Depending on the options available, this can be done on a black screen or superimposed over another picture.

The standard character generator is still being used by many production houses; recent trends suggest, however, that cards that allow personal computers to be used with video will gain a wide acceptance over the next few years. A major limitation to this alternative to the CG thus far has been the inability of the systems to achieve high quality text images on video at a price that is competitive. If this pattern follows that of electronics in general over the past few decades, this limitation will be overcome in the near future.

Studio and Control Room Facilities A studio for video production is similar to a studio for still photography: it should be a large, empty room with high ceilings so there is space to move things around, have adequate electrical amperage and multiple outlets where they will be needed, and it should offer good climate control for both temperature and humidity. Beyond the normal requirements for still photography, the video studio floor should be flat, to dolly cameras; the walls and ceiling should be acoustically dampened to a low reverberation rate, for good audio; there should be adequate storage space for props and sets, if they are used; and some kind of lighting grid should be installed in the ceiling. There are good commercial lighting systems on the market for small studios. If expense is a problem, a 4-foot grid of 2-inch *black pipe* will do nicely: any number of floodlights and spotlights can be clamped to the grid, and they can be moved around with little difficulty. It is convenient to have a lighting console (a panel with separate pots for each light) to select and to vary the brightness of the overhead lights without having to do it at each lamp head.

Control rooms adjacent to the studio contain things like the switcher and audio mix equipment. In the past, they had a large window so the director could look into the studio during taping; current thinking is that this is potentially a distraction: the director should be watching the cameras and *line* monitors during production, not the studio itself. If the director needs something done in the studio during a production, other than camera adjustments, there can be a person in the studio on an *intercom* headset (a floor manager) to make them. The control room can be small, but if the director is connected to the camera operators via an *intercom,* it needs to be acoustically dampened so noise or voice commands are not picked up by the studio microphones. If the control room has adequate space, it is also a good place to install the editing equipment.

VIDEO PRODUCTION
Production Planning This section provides some key strategies that can be used to make video programs or to communicate clients' needs to video production people. It is necessarily an abbreviated treatment. A complete discussion of all of the factors that could be considered in the creative and technical processes of making a video program would have to include most of the art and the history of cinematography along with all of the attributes that are peculiar to video as a small screen, electronic medium. What follows is a review of some of the more useful and cinematographically important variables and how they affect the final product.

Aesthetic Codes and Caveats of Video The primary aesthetic code, the technique and vision that make what people agree is good video, is the achievement of near-constant motion. Video rarely sits still. The camera, the zooming of the focal length of the lens, or the subject itself (or sometimes all three) are manipulated to be constantly in motion. Much in the same way that audio producers in radio dread quiet (*dead air*), video producers have difficulty with static shots of anything but the shortest duration. Video has become, partly by choice and partly because of the nature of the medium itself, our action medium *par excellence.*

Those of us who were trained in cinematography before moving into video think this presentation of near-constant and fast-paced motion is often overdone. Life and art both need *varied* pacing, and in many classic films the visually quiet and static moments provide dramatic pauses as a counterpoint to punctuate the ongoing dynamic grammar of film. One way to become sensitive to the difference between the aesthetics of video and those of film is to carefully view many examples for both. This, plus the nature of your client's needs, the kinds of videotapes you produce, and your creativity, will help you achieve a reasonable balance between motion and effects for their own sake and the other extreme of static dullness.

Videotaping certain kinds of performances often presents conflicts between the aesthetic codes of the performance and those of the video medium. For example, a ballet is choreographed on the assumption that there is a fixed optimum point of view for the audience that is near the center, about one-third back from the orchestra pit. From this perspective, our ideally situated viewer sees the principal dancers (figure) set against the movements of the supporting dancers (ground).This viewer attends to figural movement and background movement alternatively, but with primary attention of the whole bodies of the principals. All of this is done unconsciously and is taken for granted. Note what happens, however, when the ballet is videotaped. Multiple cameras jump around visually in various closeups and relocations. No longer is the code of an ideally situated viewer operating; rather, the viewer is in many places almost at once and sees so many rapidly-paced closeups that orientation to the dance as a holistic event is lost. At best, the videographer would move in perfect synchronization with the naturally patterned movement of the eyes of an informed viewer; at worst, the videographer jumps around visually (cuts from one shot to another rapidly) in order to achieve the best shots, independent of their meaningfulness to the particular ballet. There is no easy resolution of this conflict of the aesthetic codes of the video medium and performances designed for the stage or theater. Choreographers would place a camera where the best seat is located and just let it tape the performance. No cuts, no zooms. Videographers would tend to cut from one camera to another and use a fast-paced series of medium and extreme closeups. Although these tensions exist, you can minimize their negative effects by carefully studying both video aesthetics and the aesthetic demands of the kinds of

performances you will frequently tape. It also helps to be candid about this and make the potential conflicts clear to the client. If your videotapes of things like theater and dance are to be used for educational purposes, it is important that the audience be made aware of how seeing the video differs from what they would experience at a live performance.

Screen Conventions and Symbolism There are certain conventions and symbols that have developed over the history of cinema that are available to video producers as design elements. Some of them can be effective when used thoughtfully and judiciously; as with any effect, overuse of such visual symbols and camera psychology can seriously reduce the production value of a video program.

Time Passage A sense of the passage of time can be created for the viewer by using such common cinematic conventions as the pixillated movement of the pages of a calendar, a sunrise, sunset, or moonlight scene, a slow fade from one scene to another, or by footage that indicates a change of season.

Screen Direction Alternating shots between two moving subjects can indicate movement toward or movement away from one another. The faster these alternating shots are cut and the more progressively they change from medium shot to closeups, the greater will be the power of the impending contact or collision of them in the viewer's eye.

Viewer Relocation The setting of a video can be moved around from one place to another by the use of travel motifs like scenery passing by the window of a moving vehicle, showing a vehicle moving across the land, or even a cut to some geographic marker (like a city limits sign) that indicates a different location.

Camera Psychology It is commonly known that, in portrait photography, for example, camera height in relation to the sitter's eye level can be neutral (camera at eye level), can increase the effect of the power and importance of the subject (camera below eye level), or can decrease the power of the sitter (camera above eye level). Medium, closeup, and telephoto shots have a similar effect; image size and camera level are particularly powerful when used together. For example, a person would really appear small and insignificant, or lost and lonely, if filmed with a wide-angle lens at a high camera angle. Also, things placed at the edge of the frame appear to be moving off camera, while things near the center are perceived to be stable.

Depth and Focus Shift Video is a two-dimensional medium; depth can only be suggested by the use of conventions. Long shots (wide views) convey depth. Objects in the foreground help provide a sense of near and far for the viewer (provided they do not obscure the shot), and the use of overlapped objects gives the visual effect that one is behind (farther away than) the other. This depth of viewer awareness can also be manipulated by shifting the focus alternately between near and far objects.

The Language of Video Some terms have specific meanings when applied to video production. You can use language—defined more fully in the Glossary at the end of this article—to plan your own productions or as a way to communicate your ideas to a subcontractor. Some of the most commonly used design terms and their screen effects are the following.

Screen Change Effects

Cut: an instant switch from one shot to another; used to indicate spatial or temporal continuity of action.

Fade: a slow change from one shot to another; used to indicate the passage of time or a change of location.

Jump cut: a bad switch from one camera position or lens focal length to another that is so similar to the preceding shot that the image appears to jump slightly.

Insert: when a second, smaller-sized picture is inserted into a primary shot to add background interest or information (as when a news commentator has a picture appear over to one side).

Super (imposition): when one shot, most often titles or credits, is layered over another. Graphics that are to be *supered* over another picture need to be made with light lettering on a dark background.

Wipe: works like a fade from one shot to another but done in a specific direction like left to right; screen effect is similar to a fade.

Camera Directions

Arc: to roll the camera to the left or right in an arc (as though it were tethered to center stage).

Dolly: to roll the camera in (toward the stage) or out (away from the stage).

Pedestal: to physically raise (*pedestal up*) or lower (*pedestal down*) the camera on the tripod/pedestal.

Tilt: to point the lens (front of the camera) up or down.

Truck: to roll the camera to the left or right.

Lens Directions

XCU: extreme closeup; to include a person's face or part of face only.

CU: closeup; to frame a person's head and upper chest tightly.

MCU: medium closeup; similar to a bust in portraiture.

MS: medium shot; a full-length image of two or three people.

LS: long shot; people, as in a small group, make up less than one-third of the image area.

Focus: to adjust the lens for more or less image sharpness; to focus video camera zoom lenses, the standard practice is to zoom in tight (telephoto) and focus.

Zoom: to change the variable length of the lens toward wide-angle (zoom out) or toward telephoto (zoom in).

Ways of Planning Video Productions Given that you cannot just go out and point a video camera at an event (if you want a quality product), you need to think about planning for video as a motion medium. There are at least three different ways to conceptualize the making of videotapes, and these ways are often used in combination. One way is to plan each shot in advance, much in the same manner that major films are made. This method, discussed in detail in the section on "Scripting and Storyboarding," gives the most control over taping, but it requires absolutely compliant people, situations, and events. The second method is one wherein you can exercise some control over the participants and the action but otherwise have to follow the known structure of the event. A wedding would be an example of semi-planned videotaping: you can arrange the people for a few of the key shots, but otherwise you have to follow the unfolding structure of events. The third method, as we move from structured to spontaneous videotaping, is when you have to work without control over the talent of the action. Here you need to rely on your positioning and your sense of timing.

Even in those situations in which you have only positioning and time to rely on, you can intelligently anticipate how the event will unfold and where the action will be. Most public ceremonial behavior is culturally patterned even when it appears to be random. Imagine the plots of the stories people tell of commonly shared events: the story outline is a potential shot structure. If you reflected on this, you could sit down and write a rough script for things like family reunions and birthday parties. Even newly popular boudoir portraits follow a stereotypical, pop-cultural pattern for glamour. Some time spent considering the spontaneous event you have been hired to videotape will greatly improve the likelihood that your final choice of camera positions and your timing will be good if not optimum. We are also an

image-conscious people. Often the participants in what is normally an uncontrollable event will gladly posture, pose, or otherwise make accommodations to see that you get good footage of them.

The more complex and/or the more expensive a production is, the more important it becomes to plan it as tightly as possible: script, storyboard, and rehearse everything. Also try to work under conditions where you are not subject to variables such as weather. These factors are reasons that the motion-picture industry quickly built huge studios after moving to California to take advantage of the weather, and they are also the reason video production houses systematically do complete storyboards for major productions: planning and control save money and ensure a good product. It would be good discipline to do a full storyboard for each production if you are new to video or if you are familiar with video but will be taping an unfamiliar event. It is also a good way to train your assistants in the language, conventions, and discipline of the trade and in your personal style. After you become comfortable with video/or with the new subject matter you tape, you will not need to do a complete storyboard for routine productions such as weddings. There will also be cases where you will not have the time or the control over the performance to plan as tightly as you would like; in those instances, plan your basic shot coverage as well as you can and then try to think through the cultural pattern inherent in the ceremony. This will help your intuition guide you regarding your camera positions and timing. Remember that all commonly repeated marker events (life's major thresholds) are culturally patterned, and follow the suggestion to sketch out the screenplay beforehand. A note here: if you are working with ceremonies or events that have their origins in other cultures, it would be advisable to go to a few of them before videotaping one or to have a member of that culture or ethnic group explain the story to you.

The next section provides the plot for tight production planning: start with it, but never be so locked into a shooting plan that you are not open to special opportunities for improved shots that happen spontaneously once you are on location. The more experienced you become, the safer it will be for you to deviate from a fixed plan.

Scripting and Storyboarding Storyboarding, the process of sketching visual and narrative information on cards as a way to plan video productions, has evolved out of the motion-picture industry, where it is still used extensively. Film studios frequently have walls covered with tracks to hold the storyboard cards to that an entire production can be put up and looked at as a whole. While it remains a key planning process within the domain of cinematography, storyboarding can be used effectively for the design of video productions of all kinds.

Storyboards are divided into a visual component (the left side) and a narrative or text component (the right side). It is an unsettled matter within the field whether one is to begin with the visual images in mind and then fill in the script or do the listing of themes or ideas and the writing of the script first. Probably, Fellini works in the former mode and most producers work by alternating between the two. It may have some connection to one's right or left hemispheric brain dominance as well. One significant characteristic of the process is that it works well either way, or as a dialogue between the two as one progresses.

The model itself is quite easy to use. There are four basic steps to guide you through the critical verbal and visual choices that will ultimately determine the videotape's effectiveness or appeal to your client.

1. Write on Notecards Take a stack of notecards (size is your choice, but most production houses prefer the larger ones, on the order of 5 × 7 inches). Write each separate thought, key idea, or essential point on a separate card. List

Storyboard.

this verbal information on the right half of the card, and remember, at this point, these are terms to organize your thoughts with—writing the precise narrative comes later. For those who are right-brain dominant, it would work just as well as to begin with sketching the key shots on the left side of the card and then adding the narrative later. During this process, be sure to consider the use of music and any environmental sound that would enhance the production. When you have finished this process, you will have a stack of index cards that are, in effect, notes for the key elements to be videotaped. So far, this is not greatly different from what you would do on sheets of paper to begin outlining. Notes on paper, however, have to be rewritten every time you want to reorder or change them; herein lies one of the real advantages of the card system: cards can be rearranged over and over until you are satisfied with the flow. This makes the next step enjoyable rather than tedious.

2. Play Solitaire with the Cards Sit on the floor or at large desk and lay out your cards; sequence and resequence them until you are fully satisfied with their order. This is also the time to look at them, topic by topic, to make sure that they contain enough (but not too much) information on each subpoint. Add to and subtract from them as needed to balance the unit. Limit your unit size by focusing on the key themes or ideas. When you are fully satisfied that you have dealt with all essential points and eliminated all nonessential points, number all the cards in sequence.

The two steps that follow can be done in any order or in a back-and-forth kind of dialogue; this makes further allowance for how each one works as an individual (especially visual or verbal dominance) and how small production groups normally divide planning responsibilities.

3. Visualize the Production Go through your stack of cards and note what, if any, visualization would be effective or necessary. Sketch in a rough picture of the shot on the left side of the card. If there a need for greater communication than your sketch affords (or if someone else will be doing the visual production), make notes in shorthand under the image, for example "CU KEYBOARD FUNCTION KEYS." Keep in mind that not every card will necessarily need a visual, and that some cards may require several pictures. In the latter case, add the cards in and number them subordinately (such as, "12A, 12B"). In this step, consider carefully the visual sophistication of your clients and design the pictures to be interesting for them. When you are finished with this step you have what the trade calls *shot cards*.

Shot cards are the sketches the video production people work from—just like in the movies. These *numbered* cards can now be sorted by type of image: those requiring graphics and titles to go into one stack, those to be shot on a job site into another, and those with studio closeups of equipment into still another: each type of shot is done at one time. Doing all of the like visuals together saves an enormous amount of

time and labor in setting up and taking down equipment for each image.

4. Write the Script This step could be done before step 3—it depends on your style. When you have finished sequencing and expanding or reducing your cards and then numbering them in order, you have completed the content outline. All that remains is to go back through the cards and write the script from the key themes. Here, as with the visuals, consider your audience's language ability and vocabulary when writing. Also consider viewer fatigue; there's no hard rule here, but as a profession, we have tended in the past to attempt to do too much in our programs. Several short productions can frequently by much more interesting and effective than one long one.

As you write from the brief notes on your cards, your use of formal English may get in your way. Most producers are well educated and most of that education has called for written performance. Productions via audio track call for a spoken instead of written style. It is not hard to tell the difference. When you have your narrative written out from the cards, read it aloud with the correct emphasis and intonation as though you were taping it: those places where you trip over your tongue or over extended adjective constructions or vocabulary are where this difference lies. Find these places and smooth them out until they flow like normal conversation (this usually means simplifying the sentence construction or the vocabulary).

The planning strategy outlined in the foregoing steps will give you a good start toward becoming accomplished at video design. Most commonly, producers use a combination of structured, semistructured, and spontaneous methods. Much will depend on the nature of the events to be taped and on your personal style and experience. In addition to the matter of planning strategy, there are some pragmatics of video production that you should give thought to before pressing the RECORD button for a client. time spent on these kinds of preparations will help ensure high-quality and profitable video operations.

Production

Preproduction Considerations There are some things you should consider before videotaping: permissions, test sessions and rehearsals, and cinematic etiquette. The kinds of permission you need to obtain will depend on what and where you are taping. Some people and sites are more agreeable than others. For example, it is common practice to discuss photographing a wedding with the minister who will preside over the ceremony, but you rarely need to obtain permission to make pictures in the church itself. On the other hand, if you need to videotape an event at a famous place or building, you will often have to request—and sometimes pay for—permission to do so. In those instances, be sure to get signed model or property releases. The best guide here is, if in doubt, ask.

Test sessions, going on-site and setting up the camera, lights, and microphones, and recording some videotape under what will be the actual working conditions will yield valuable visual and audio information in the form of problems that can then be corrected before you tape the actual event. This is particularly valuable for the beginning videographer; it is less so for the seasoned professional. Ideally, you could do one test session on the unoccupied side to determine the best camera positions and then another one during a staged rehearsal. It is one thing to work out your camera placements and lighting in an empty architectural space; it is quite another to do this with people there. The client is not interested in your problems with working in an unfamiliar place or with a ceremony or event that is new to you: the client want results. It is up to you to do whatever is required to provide them. Sometimes you can build in a slight margin in your fees for rehearsal or for on-location

testing. Keep in mind that these test sessions and rehearsals are excellent opportunities to train your staff.

Finally, the matter of etiquette is a delicate one and one about which it is hard to give general advice. The central proposition is to balance your need to be assertive enough to get good footage with the needs of the participants and be unobtrusive to the dignity of the ceremony or event. Clients and their friends will remember how you treated them, so protect your reputation. On the other hand, you cannot stand meekly in the back of the church behind Uncle Fred; on the other, you cannot crash onto the altar like a wire service photojournalist at the site of a terrorist bombing. Much of this "etiquette tension" can be avoided by planning where you will be during key moments of the event and letting the participants know what to expect.

Videotaping Events

Image Quality With videotape, as with cinematography, you need to think on two levels simultaneously. First, you need to envision the flow and the on-screen effect of the video as a whole. This *gestalt* has two levels in itself that require you to "see" what you will tape and how you will frame it. What to tape is often based on the client's need or on the structure and flow of the event. Even when the content images are predetermined, however, you should still consider the value of some embellishing footage. This background ("B-Roll") footage could include images of things like the place where a wedding couple met, their favorite activities, close friends, the honeymoon site, or the like. Obviously, the wedding is the focus of the tape, but judicious inclusion of meaningful B-Roll images can enhance the final product.

Beyond the content, with or without B-Roll, there is the visual question of the tape as a film. This raises questions of *shot variety* (the mixture of wide, establishing shots, medium shots, and closeups), *pacing* (how fast the shots will change on the screen), and *sequencing* (may be fixed by an event like a wedding, but if not, this determines what is seen in what order).

Secondly, there is the shot itself. Once you have decided on a shot mixture, your vision as a still photographer can be used to make each shot a good picture. Here are the considerations of camera placement, framing, selective focus, lighting, a background all need to work together. As with still pictures, the shot is the basic unit of video product. With video, particular attention needs to be paid to subject placement, the quality and direction of light, focus, and the steadiness of the camera (use a tripod). The goal is to produce clear, effective images. It is extremely beneficial to pay particular attention to the background. As Edward Weston once said, "Take care of the corners and the rest will take care of itself." Not literally true, of course, but it is all too easy to overlook background distractions during the excitement of taping an event.

Beyond the videotape as a film and the quality of the individual shots, there are a few caveats particularly applicable to a still photographer who begins to produce videotape. One is that video, relative to film, is a crude resolution system with inherently high contrast and a small screen problem. To accommodate the low-resolution capability, try to avoid very fine detail in the images, and, if seeing details on small objects is important, move in tight, focus carefully, and light for the effect. Video's inherently high contrast means that you should avoid trying to achieve subtle tonal differentiation in visual appearances of hue or the reflectance of the subject matter. The small screen problem of video means that, compared to film, video favors bold, closeup, fast-paced action over slow subtle, mid-distance imagery. As an aside here, video also tends to prefer *hot* (loud and fast) audio effects over more subdued ones.

Another caveat concerns the overuse of the zoom lens. In

my first cinematography course some years ago, the professor had each of us load a 16-mm camera and take it out and expose an entire film magazine while constantly running the zoom lens in and out. This may seem like overkill, but he made his point: more film and videotape is ruined by neophytes overusing the zoom lens than by any other problem (a close second is the failure to use a tripod). The zoom lens can be used sparingly if zoomed slowly, but resist the urge to overuse. Thinking like a cinematographer might help: imagine that you have a three lens turret on the camera with a wide angle, medium, and telephoto lens mounted on it. Plan your shots with specific focal lengths rather than zooming in and out while seeking the best frame.

All of the contemporary video cameras have automatic iris diaphragms. As with still cameras, this is a mixed blessing. Most do not do a good job of compensating for side- or backlighted subjects. Be sure to do a test of these on location before making your final tape.

The final potential trouble area has to do with camera stability (or the lack of it). Buy a good tripod (one that is sturdy enough for the weight of the camera you plan to use) and use it. Hand-held work may be necessary under emergency conditions, but it will produce rough and inferior shots. Pay attention to the selection of a head for the tripod. Get one you can pan and tilt with smoothly. Videographers vary a great deal on this: some can work with inexpensive heads while others really need fluid-dampened ones.

Setting Up on Location It is beneficial to go through the storyboard and design process, to consider the attributes and aesthetics of good video, and to do on-site test sessions. There are also some things you can do when you arrive at the taping location that will help achieve professional results.

As with location portraiture, if you are using AC power, arrive early enough to locate the circuit breaker panel (especially if you will be operating lights on AC) and to run your power and microphone cords neatly and safely. The cords should be out of the flow of traffic insofar as possible and, to ensure a good signal as well as to minimize your liability, they should be taped to the floor with duct tape.

Try to situate the camera away from temperature extremes or excessive dust. Video recording heads are particularly sensitive to humidity, changes in temperature, and dust. Be attentive to letting your equipment warm up to room temperature after is has been used outdoors during cold weather or transported in a cold vehicle (note: the baggage compartments on modern jet aircraft can reach temperatures of −50°C): condensation on the heads will create a bad picture or no picture at all. It also helps to clean your VCR heads before each job. Establish the habit of recording a short test segment before each recording session; this will let you know whether or not you are getting a good signal. Do this for the audio track also. While you are doing these tests, it is a good time to make your final decisions about lighting and audio recording. Check the direction and the quality of the lighting *on the recorded segment of tape:* just as with still photography, there are nuances and subtleties you can see through the lens that are not apparent when you look directly at the scene.

Audio testing is important and often overlooked during video production. Pay particular attention to the quality of lip-synchronized sound (where the speaker's voice is heard as his or her face is seen on screen). Nonsynched sound (called *wild sound*) can always be narrated or dubbed in later, but unless you have a major production house at your disposal, get high quality synch sound at the time you tape the image. Microphone selection (external to the camera; wireless?) and placement (as close as possible to the sound source) are important variables in getting good audio. Also try to position the camera and the talent away from background noise, and instruct the talent not to handle or nervously fidget with the microphone cord during taping. Some microphones, particularly the lower priced ones, pick up a bumping noise each time the cord is touched. If in doubt, rehearse and test.

Making People Look Good There are several things you can do to enhance the appearance of people on camera. Some of these are similar to what you would normally do for portrait sittings; others are specific to video. The goal is that the individuals (figure) be tonally separated from the setting (background), that they look attractive, and that clothing and other accessories not be visual distractions. Beyond the classic portrait advice of light for a pleasant, sculpting, mainlight effect, use a short lighting ratio for modest contrast, and focus carefully on the eyes, high quality video further requires that the talent not wear bright white (it glares), small checkered patterns (they create a *moiré* effect), or excessive amounts of jewelry (especially if the hands are to be shown in a closeup shot).

Soft, pastel garments, simple backgrounds, and shots that are framed tighter than you normally would for still photography will produce pleasing video images. If you do makeup, you will find a slightly more exaggerated effect (more separation between the base and the accents) works nicely. This would be a good opportunity to make a "Looking Your Best on Videotape" flyer that you could give to your clients well in advance of the taping session (if you do not already have one printed).

In-Camera Editing If you are working with one camera and do not have editing capability, try to plan the shots as tightly as you can so they all go together well in the finished tape. In-camera editing is really careful planning and taping. The more the action will be predictable, and the more you can storyboard the production in advance, the more likely you can successfully edit as you videotape. Be careful here how you stop the camera: some cameras will create a glitch in the picture if you turn them off and on; others will do this when you use the pause feature. This would be good thing to test before you purchase a system.

Postproduction If you videotape an event with one camera using in-camera editing and if you record your audio as you make the video, or if you do studio productions where the visuals, audio, titles are mixed during recording, there is no requirement for postproduction. More commonly, however, there will be something further you want to do to improve the quality of your work that needs to be done after the initial taping.

Graphic and Titles Graphic and titles for video can be recorded during studio production or downstream. At either point, they can be made with lettered cards positioned in front of a camera or they can be typed in electronically with a character generator. Independent of where they are accomplished during the production process, titles for video need to be simple and bold. Use as few words per screen as you can, and make the lettering large and distinct. Letters that contrast with the background are easy to read on-screen. Video does not pick up fine detail, so avoid small or ornate text with serifs.

There is also a standard from broadcast television that should be kept in mind: it is safe to assume that many viewers' receivers will be out of alignment vertically or horizontally, thus clipping off one edge or another of the picture. Because of this, it is standard practice to leave an unused safety margin around the edges of a title or product shot (particularly in advertising, where seeing the product or the product name is critical). This standard, called the *must see area,* leaves approximately 10% of the outer extremes of both dimensions unused.

Editing A basic editing system consists of a *source VCR,* a *control module,* and an *edit VCR.* All of the normal VCR operations for both decks (play, record, fast forward, rewind,

Graphics and titles. "Must see" area.

pause, and stop) are controlled by the module. On the editing module, these controls are present in their customary form as buttons and switches; the functions of *fast forward, still frame,* and *rewind* are also present in the form of two large knobs (one for the source VCR and another for the edit VCR), and each knob has a fast and slow mode that can be set to look at images either frame by frame or quickly. Turning a knob to the right in the normal mode gives a fast forward effect, whereas turning it to the left makes the tape rewind. The slow mode does the same thing but at a much lower (frame-by-frame) speed; in either case, you can observe the images on their monitors as you move the tape.

It is customary to go through recorded tapes and to make an *edit log* of the frame-counter addresses (*in* and *out* points) of the various shot segments before beginning the editing process. This log, along with the label on the tapes, saves time and keeps things organized.

At the risk of oversimplifying what can be a complex stage of the video production process, editing can be thought of as a controlled way of copying segments of separate videotapes onto a single tape. There are two ways to do this: *insert* and *assemble.* To understand these terms, you first need to know that videotapes with images on them also have a *control track.* This is the electronic pulse laid down by the camera or the switcher at the time of the a tape is recorded—in many ways, it resembles the sprocket holes in a piece of motion picture film; the control track regulates the timing of the images. Some editing systems will put the control track on a blank tape by just running the deck in record (with no video signal being used); others require that you put a control track on with a camera and recorder. Check your equipment manual: the edit (blank) tape has to have about 5 seconds of a control track in the beginning in order to take any edits, and it needs to have it within the tape to take insert edits. You can check for a control track by putting a tape in either editing deck and putting it on play: if the footage counter on the control module runs without interruption, you have a good control track. *Insert editing* is transferring the visual and/or audio recording from the source tape to the edit tape while leaving the control track on the edit tape intact. *Assemble editing* is taking the picture, audio, and control track from the source tape and transferring them to the edit tape.

To accomplish an edit, the tape containing the footage you have recorded is placed in the source deck and a blank tape with a control track is placed in the edit deck. It is good discipline to get into the habit of rewinding all tapes and resetting both tape counters on the control module at the start of each editing session. As you play the source tape, when you come to a segment you want to transfer to the edit tape, you set its beginning as the *in point* on the module and its end as

the *out point.* Then cue-up the edit tapes to where you want the new segment to come in and set this as its *in* point. Note: you cannot make an edit at the very beginning of a tape: both decks have to rewind about 5 seconds to synchronize the edit transfer. You can then preview the way the edit will look *(preview)* or make the edit.

Editing can be accomplished with the control module cuts alone, or you can run the signals through a device called a postproduction effects generator to enhance the transfer of images and audio. This machine operates just like the switcher discussed earlier: during the edit you can cut, fade, wipe, or add a special effects; it also has audio inputs for microphones and other sources that allow the mixing of sound during editing. It is also possible to add titles during editing by feeding a signal from a character generator into the effects generator.

There are also new editing special-effects computers on the market that you can use to create many effects that were previously obtainable only on very costly broadcast-grade studio equipment. Foremost among these as of this writing is the "Video Toaster." Ask your local dealer for a demonstration of the impressive capabilities of this device to alter images.

Editing decks and control module.

Inserted Segments and Music There may be times when your own creative ideas or the demands of a client make it desirable to include video footage from programs someone else produced or to use music for a particular effect. Both of these matters raise serious copyright problems. To use video footage, contact the producer of the video and arrange for permission to use the segment. This may range from being simple to do to being next to impossible, and from *gratis* to extremely expensive. There are several variables: the producer, the nature of the product, you, and your intended use (commercial uses demand higher usage fees).

The same thing applies for music. Normally it is not desirable to use popular music in video—you can never know

what reactions your client may have had to it. Most producers prefer music with a soft melody line so it does not overpower the visual imagery. Commercially recorded music copyright litigation is one of the largest sections in most law libraries: be extremely careful here, and be even more careful if you plan to show you video for admission fees or use it for advertising. A copyright lawyer can advise you on any particular questions you have. There is one nice alternative with music: there are companies that provide copyright-free music for this purpose. These companies offer either a subscription service (for high-volume producers) where set fees are paid on a monthly basis and the subscriber receives updated music regularly, or (for low-volume users) they offer a service with a lower fixed expense where you pay for the music as you use it ("per needle drop"). They are listed in the trade publications.

MARKETING VIDEO SERVICES Marketing video services is very much like what you already do to make the best possible presentation of your studio and your pictures. It is important to have a clean, bright, and professional setting in which to do business. Beyond what you already do for your still photographic operations, you will need to set up a screening room for clients to see videotapes.

A screening room can be part of a room that you use for other purposes, but is should be one you can darken for optimum video viewing. Use good equipment here: a four-head VCR and the largest color receiver you can afford. The receiver should be mounted no more than 5° above nor 15° below a line connecting the center of the screen with the eyes of a (comfortably) seated viewer. Photographers show proofs instead of contact sheets: show a carefully edited tape to the client rather than excessive and/or unwanted footage. It is also a good idea a show a copy rather than consume a master tape for screening and other purposes.

SUMMARY Video is a powerful communication medium and one that is steadily demanding a larger share of the conventional studio photography business. It is not overly difficult to move into the production of videotapes, but there are differences between video and still photography that you must take into account when doing so. So, too, are there similarities that can help ease the transition. The primary differences lie in video being electronic in nature and in its being a motion medium. Some of the basic electronics must be mastered, but these are not particularly complex. By studying how video works and by following the suggestion outlined, this part of the learning should be accomplished in a short period of time. The other difference between video and still photography, that video is a motion medium, can be handled using the information in this article and from critically viewing films and tapes: it will take longer to fully master, but that will be time well spent. The payoff will be in technically proficient and creative programs that will please you and your clients.

It will save you a lot of valuable time and energy if you will study the section on "Video System Design" carefully. Video equipment needs can be confusing, particularly since the modular nature of video hardware resembles that on the market for computers more than it does equipment used in still photography. Wrong choices can be costly to your business. Knowing what capabilities you need in a piece of equipment will go a long way toward insulating you from being sold things you do not need and at prices you may not be able to afford. On balance, though, it is often preferable to pay more for a good device than to save a little on what will turn out to be an inferior one. Just be sure of what you are getting.

Finally, taking the time to go through the test sessions, and the on-site set-up advice will help prevent some of the most commonly made video mistakes. It does take some practice and study to become accomplished at video production, but

the suggestions given in this article will make your time work to maximum advantage. It would even be a good idea to develop short checklists for preproduction and on-site use: these are used by major producers to systematically double check everything. Against the argument that checklists look amateurish, remember that veteran airline pilots use them for every take-off and landing. It looks far more professional to use checklists than it does to forget some critical item or step in a commercial production.

Use the similarities between still photography and video to ease your transition into the new medium. Video production is an enjoyable and rewarding process: photographers are creative people and video adds another dimension—motion—to that potential. As you begin to produce video, word will get around, and you will find growing markets for your services. Take your time, allow yourself the practice and study, and think of video production as adding to, rather than subtracting from, your still picture market.

TIPS FOR PRODUCING BETTER VIDEO

- Plan for motion and shot sequences
- Light well
- Use a tripod
- Minimize zooming in and out
- Frame shots tightly
- Watch background distractions
- Use an external microphone
- Record wedding background audio separately (dub in later)

GLOSSARY OF SELECTED VIDEO TERMS

A & B roll editing A procedure where two or more videotapes are fed into a editor and mixed onto the edit tape.

Address The location of a segment of tape on a reel given by its frame counter in and out points.

Arc To move a camera on a dolly in a left- or right-hand direction while keeping the same distance from center stage (as though it were tethered to that point).

Assemble edit The transfer of video, audio, and control track signals from a source tape to an edit tape during editing.

BNC A video cable connector with a locking collar.

Boom A microphone stand with a long horizontal arm that is counterbalanced; used to position a microphone above the set.

Camcorder A video camera and videotape recorder combined into one piece of equipment.

Cathode ray tube (CRT) The large picture tube on a receiver or monitor.

Character generator A kind of electronic typewriter that is used to add text to videotapes.

Coax[ial] A type of video cable with a thin single strand of wire inside a plastic tube that is wrapped with a woven wore and covered with insulation; like the antenna for cable television.

Composite signal A combined video and audio signal.

Control track An electronic signal on a videotape that provides a timing reference for the electronic sensing of the visual and audio imagery; like sprocket holes in motion picture film.

CU (closeup) A video shot that, for a person, covers the area of a head-and-shoulders portrait.

Cut To switch instantly from one shot to another with a switcher or effects generator.

Dolly To move a camera toward (*dolly in*) or away from (*dolly out*) center stage. A tripod platform with wheels.

Dropout A place on a videotape where the magnetic coating is worn or damaged; this causes a white fleck in the picture.

Dropout compensator An electronic device in a receiver or VCR that replaces dropout flecks with the last bit of

imagery scanned in order to give the visual effect of continuity in the quality of the picture.

Dub To add sound to video after recording the visual imagery. To copy video or audio tapes.

Editing log A list of the shots on a videotape recorded by their address on the frame counter.

Effects generator A device used in editing that permits the use of special effects (different kinds of fades and wipes) when making a transition from one shot to another. Can also be used as an audio mixer. Similar to a switcher but does not have a synchronization generator.

Electronic News Gathering (ENG) The use of a camera outside of the studio and in a portable configuration.

Establishing Shot A long shot.

Extreme Closeup (XCU) Very tightly framed image—usually less than 3 feet—used to show small detail.

Fade; dissolve To move slowly from one shot to another with a switcher or effects generator.

Field One-half of the scan of a picture. See also: *Frame*.

Focus To adjust the lens for image sharpness.

Format The size of videotape. Also used to indicate a type of program.

Frame Two scans (fields) of a picture making one complete image (frame). Scan rate is 60 fields, 30 frames, per second.

Insert To add a portion of one shot into (usually an upper corner of) another; adds background interest or information.

Insert edit The transfer of either video or audio signals, or both from a source VCR to an edit VCR without the transfer of the control track.

Key; chroma key An editing or switching effect that cuts one image into another; used to add titles and graphics. Chroma key uses color (normally blue) to drop background from the shot to be keyed in.

Lavaliere A small microphone that is worn attached to the lapel.

Long shot (LS) A wide-angle picture that includes more background that it does figure; used to establish context.

Medium shot (MS) About the equivalent of a three-quarter pose in portraiture.

Medium Long Shot (MLS) Similar to a full-length portrait or small group shot.

Microphone Mixer/Audio Mixer; Mic Mixer A device that accepts multiple audio inputs, has volume controls for each, and feeds one signal to record.

Pan To move the camera lens to the left or right in a horizontal motion.

Pedestal To raise (*pedestal up*) or lower (*pedestal down*) the camera, or to move it around. A large, studio-type camera stand with wheels that is operated hydraulically or electronically.

Pixillation An effect used to make inanimate objects appear to move around; achieved by repeatedly running a short segments of tape and moving the object around in the shot. When played back, the object *moves* as though under its own power.

Pot[entiometer] A volume or gain knob (coil) on a microphone mixer, switcher, or lighting control board.

Preroll The distance a VCR rewinds a tape before an edit in order to synchronize it with the other VCR; usually 5 seconds.

Radio Frequency (RF) A means of video distribution via a coaxial cable with multiple composite (video and audio) signals; requires a receiver.

Safety Shot In multiple camera operations, one camera is kept on a complete view of the scene that can be used if one or more of the other cameras fail during taping.

Skew An adjustment of the VCR's tape tension; used to stabilize the upper portion of a picture.

Source VTR(s) The VCR(s) used to feed video signals into the edit VTR.

Super[impose] To layer one shot atop another by means of a switcher.

Switcher A device that accepts multiple video inputs, synchronizes the scan cycles of the cameras, has an intercom for studio crew communication, and offers multiple special effects in the process of cutting or fading to the signal that is sent to record.

Synch[ronization] The aligning of the travel of equal scan guns on two or more camera so the pictures are timed together and can be mixed by a switcher without rolling.

Tilt To move the camera lens up or down.

Time Base Corrector (TBC) A postproduction device used to filter and strengthen (*clean up*) the control track signals on tapes made with different pieces of equipment.

Tracking An adjustment of the VCR used to stabilize a picture.

Video Toaster A microprocessor that generates computer graphics and special effects for video applications.

Truck To move the camera to the left or right parallel to the front of the stage.

VCR/VTR Video cassette/tape recorder.

Videographer An image maker that uses video.

White Balance (WB) To set the video camera for the color temperature of the lighting being used; similar to selecting daylight (5500 K) or tungsten (3200 K) film for still photography.

Wild Sound Audio that is recorded independently of the video.

XCU (extreme closeup) Very tight framing; full-face of a person or details on small object.

Zoom A type of lens with variable focal lengths. To adjust the focal length from wide-angle to telephoto (zoom in) or from telephoto to wide-angle (zoom out).

References:

Adams, Michael, *Single Camera Video: The Creative Challenge.* Dubuque, Iowa: William C. Brown Publishers, 1992.

Bunch, John B., "Aesthetic Education and Educational Media." *Journal of Aesthetic Education 20* (Fall 1986): 81–92; "Developing Audio Productions for Effective Listening." *Training & Development Journal 36* (December 1982): 30–39; "The Effective Utilization of Video as a Training Technology." *Video Handbook. Volume Two.* Alexandria, Virginia: ASTD Press, 1987; "New Approaches to Video as a Training Technology." *Video Handbook. Volume One.* Alexandria, Virginia. ASTD Press, 1986; "Professional Advice on Videotaping Instruction." *Performance & Instruction Journal 29* (January 1990): 16–21; "The Storyboard Strategy for Planning Visual Communications." *Training & Development Journal 45* (July 1991): 69–71; "Video as a Simulation Technology for Teaching Photography." *Educational Technology 22* (May 1982): 14–16.

Burrows, Thomas D., Wood, Donald N., and Gross, Lynne Schafer, *Television Production: Disciplines & Techniques,* Fifth Edition. Dubuque, Iowa: William C. Brown Publishers, 1992.

Zettl, Herbert, *Television Production Handbook,* Fourth Edition. Belmont, California: Wadsworth Publishing Company, 1984.

J. Bunch

VIDEO GRAPHICS ARRAY (VGA)

In computers, the color display of the cathode-ray tube (CRT) is driven by a video card or board according to a standard established by the card's classification. VGA superseded CGA and EGA boards. Industry standards for VGA are 640 × 480 pixels at 16 colors and above.

R. Kraus

VIDEO RANDOM-ACCESS MEMORY (VRAM)

In computers, a specialized form of RAM that can simultaneously write data to the display monitor as it is receiving data from the central processing unit (CPU). This form of dual-port chip greatly speeds up the displaying of images on the cathode-ray tube (CRT).

R. Kraus

VIEW CAMERA See *Camera types.*

VIEWER Devices that aid in examining photographs, especially negatives and color transparencies. Commercially available transparency viewers are illumination boxes on which a photographer can look at transparencies, negatives, and slides. A magnifying glass or standing magnifier is useful for viewing slides and checking fine detail in transparencies and negatives. A hand viewer is a device that holds a single slide in front of a translucent diffusion panel (with or without an artificial light source). Usually this type of viewer has a magnifying lens.

Commercial viewers come in a variety of types and styles, and transparency viewers can be designed and assembled in a home workshop with a little mechanical and electrical skill. The better viewers use color-corrected 5000K fluorescent lamps, which are recommended by ANSI as a light source, and a high quality translucent glass or plastic viewing surface.

Some viewers have ribbed or grooved slots to hold 35-mm transparencies that are useful for editing and display purposes. Some viewers are manufactured in sections that can be combined to any desired length. There is even a wedge-shaped illuminated viewer that slides in between two slide pages in a binder for viewing transparencies without removing them from three-ring binders. Some battery/AC adapter-powered illuminated hand or table viewers are a compromise between a slide projector and the small pocket or folding slide viewer. These larger viewers have a mini projection system built in to provide moderately enlarged images. *M. Teres*

VIEWFINDERS
VIEWFINDER FUNCTIONS AND HUMAN VISION
The camera viewfinder is a means of aiming the camera at the subject and indicating the field of view of the lens in use. It has developed into a complex optoelectronic device with several functions and is the interface between the camera and human visual perception.

Functions
Sighting To show the subject area covered by the acceptance angle(s) of the lens(es). A percentage error is usually included as a safety margin. Parallax errors occur if the axes of the viewfinder and lens are noncoincident.

Composing An aid to the aesthetic and artistic arrangement of objects and tones within the subject area. The aspect ratio of the format may dominate composition. Grid lines may assist composition or registration.

Following Moving the camera in synchronization with a moving subject. Systems with lateral reversal of the image make this difficult, and the viewfinder image is often lost during exposure, as with single-lens reflex cameras.

Focusing A major function of the viewfinder where the camera lens is coupled to a visual indicator such as image sharpness on a screen or a coincidence type rangefinder. Autofocus systems may only have a viewfinder subframe to indicate the region measured.

Exposure Determination Optical subsystems using photocells sample the viewfinder light path or the luminance of the image on the focusing screen to determine the necessary camera exposure.

Data Display Various data about the operational state of the camera are given by analog or digital readouts using LED or LCD systems. Examples include camera settings, focus, exposure mode, and light level.

Vision The properties of human vision and its physiological disadvantages must be considered in viewfinder design and use. Light enters the eye through the cornea and iris, then via the crystalline lens, to the light-sensitive retina. The retina contains cells termed rods and cones, responsible for monochromatic dark-adapted vision and daylight vision in color, respectively. Three varieties of cones provide color vision, and small cones at the central fovea provide visual acuity or resolving power up to some 5 lines/mm at the near distance of distinct vision. Vernier acuity is the ability to align two vertical lines and a very high performance of some 12 arcseconds is possible, a feature made use of for the effectiveness of split-image rangefinders.

Retinal rod sensitivity increases as light level decreases, the process of dark adaptation, but requires many minutes for conversion. The use of camera viewfinders is difficult in such twilight conditions, and a focusing cloth or hood is needed to exclude extraneous light from a dim screen image.

Focusing the eyes, termed *accommodation,* is involuntary and achieved by altering the shape of the crystalline lens. The normal close distance is some 250 mm. Many people suffer from visual refraction problems such as astigmatism, myopia, hypermetropia, and presbyopia, requiring corrective eyeglasses. Astigmatism is due to different corneal curvatures in inclines meridia and is curable by cylindrical lenses. Myopia, or short sight, and hypermetropia, or long sight, are cured by negative and positive lenses, respectively. Presbyopia is a contraction of the accommodation range requiring bifocal spectacles. Viewfinder eyepieces may need to correct for the refractive state of the user's eye. A variable dioptric eyepiece may be provided or individual correction lenses attached.

VIEWFINDER PROPERTIES Individual designs of viewfinders have different, useful properties as well as unavoidable problems in use.

Magnification Viewfinder magnification is the ratio of the visual angle of the subject seen through the finder to the visual angle of the subject seen by the unaided eye. Ideally, unit magnification allows the user to have both eyes open to reduce visual strain, but this is not usual. Reduced magnifications are common for both standard and wide-angle lenses, some 0.9 to 0.4, to keep the finder of small dimensions. Zoom finders may give larger magnifications. A focusing screen image from a lens of focal length f using a magnifier of power M_e has a magnification M_s, given by $M_s = f M_e/250$. So a 50-mm lens with a 5X eyepiece will give unit magnification, but 0.9 is more common.

Image Orientation Depending on the optical system used, the viewfinder image may be correctly orientated, erect but laterally reversed, inverted, or both inverted and reversed. Inversion and reversal make viewfinder usage difficult, especially for following moving subjects. An alternative viewfinder or attachment such as a pentaprism may give a correctly oriented image.

Viewfinder Errors Various forms of viewfinder errors are possible, relating to the differences between the viewfinder image and that recorded on film. There are various aiming errors. If the optical axes of finder and camera lens are not parallel, then directional and leveling errors are possible. Deliberate axial convergence may be used to correct partially for parallax errors. A framing error is where the finder shows more or less of the subject than recorded and is common as a form of parallax error correction and as a safety factor. Distance error is a framing error due to the reduction of field of view at close distances.

Parallax error is when the viewfinder and lens axes are displaced laterally. Both framing and perspective errors in composition are due to the difference in viewpoints. The twin lens camera is the classic example. Various forms of correction are used such as moving masks, rotating finders, and parallax correction marks in the finder.

Most simple finders suffer from residual aberrations, especially distortion due to cost restrictions on design. Molded plastic lenses with an aspheric surface greatly improve viewfinder performance at reasonable cost.

A great advantage of single lens reflex cameras is that the

viewfinder image as formed by the camera lens is free from most of the foregoing errors, other than the framing type, as only some 94% of the subject is usually shown on the focusing screen.

DIRECT VIEWFINDER SYSTEMS A variety of supplementary optical systems are used to view the subject directly and not via the camera lens.

Frame Finder An early form of optical reflex finder using a simple lens with a large field lens in its back focal plane to give a virtual, upright, reversed image. It has no focusing capability.

Newton Finder An optical development of the frame finder using a large negative plano-concave lens in front, to give a collapsible, compact, cheap finder for standard and wide-angle lenses. The image is bright, virtual, and correctly oriented. It has no focusing capability.

Reversed Galilean Finder A development of the Newton finder to reduce dimensions by using a rear biconvex positive lens instead of a peep sight. It is an afocal system corresponding to a reversed Galilean telescope. The image is minified, bright, and correctly oriented but without focusing capability. The edge of the frame is not in focus and reduces framing accuracy.

Van Albada Finder Also known as the suspended frame finder or the reflecting frame finder. Partial silvering of the concave surface of the front negative lens of a reversed Galilean finder allows the user to see a reflection of a field frame located around the eyepiece lens and superimposed on the finder image to delineate the subject framed. Modern versions use a beam splitter between the front and eyepiece lens to reflect a set of frames separately located and illuminated. This arrangement is used for a universal range/viewfinder.

Universal Finder A finder system that can be separate for attachment to the camera or incorporated and coupled to the focusing system using a coincident image type of rangefinder. A variety of field frames may be shown, automatically selected when the appropriate lens is inserted in the camera. Alternatively, a separate zoom lens viewfinder system may be set to suit the lens in use. A zoom range of 4:1 is typical and reduced optical correction is acceptable for visual use. A Kepler telescope finder system uses a turret of different objectives and a prism erecting system with a common eyepiece.

SCREEN VIEWFINDER SYSTEMS The simplest, most accurate, and oldest form of viewfinder is where the image from the camera lens falls directly on a ground glass screen (GGS) for viewing and focusing, being replaced by a frame of film for exposure.

The Focusing Screen Traditionally made of a sheet of glass ground lightly on one side to make the aerial image visible by scattering. The textured surface is in the actual focal plane or an equivalent one. The image is dim, inverted, and laterally reversed, as with a view camera. A plain GGS gives a central hotspot due to the polar properties or directional scattering of the screen, especially with wide-angle lenses, but this can be largely removed by using a plano-convex field lens above the screen, alone or with a Fresnel lens of narrow groove spacing in order not to be visible even with a screen magnifier or loupe. The peripheral rays are redirected toward the eye.

Screen Types The screen may have various engraved markings such as grids and scales to help composition and registration, show alternative formats, or to obtain accurate magnification. A coarse, acid-etched screen gives a dark, easily focused image, while a fine screen gives a brighter image less easily focused. Modern screens, especially for small format cameras, have numerous variants of screen topography and construction. The etched surface may be laser treated to produce small lenticular shapes rather than prismatic ones. The screen does not darken progressively, as the lens is stopped down progressively, unlike conventional screens. Fiber optics screens of light guide type are made from arrays of close-packed short hexagonal cylinders of diameter 0.02 mm. A bright image is given with an in-focus image. Disturbing Moirè patterns arise with subjects having regular detail. Interchangeable screens are desirable, and special varieties such a clear screen for no-parallax focusing may be available.

Reflex Systems A camera-integral viewfinder system using a surface-silvered mirror inclined at 45 degrees between the camera lens and film to divert the light to a focusing screen orthogonal to the film plane. The mirror is raised from the light path before exposure. The focusing screen is in an equivalent focus plane. The image is upright but laterally reversed for viewing unless a pentaprism is used. Cameras of the TLR and SLR design types use reflex mirror systems.

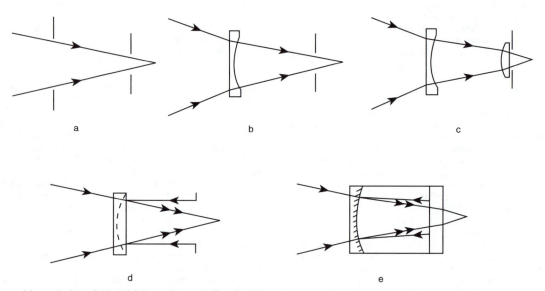

Direct vision optical viewfinders. (a) Frame finder; (b) Newton finder; (c) reversed Galilean telescope; (d) simple van Albada; (e) Galilean van Albada.

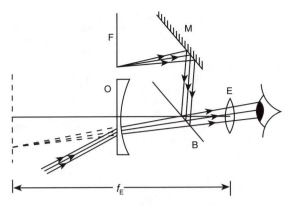

Reversed Galilean finder in reflected mask frame version. (F), separately illuminated frame; (M) mirror; (B) beam splitter; (E) eyepiece lens of focal length f_E; (O) objective lens.

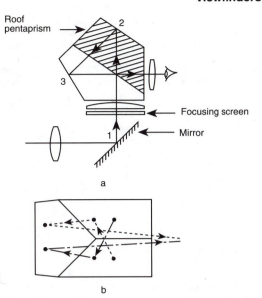

Pentaprism viewfinder. (a) Side view; (b) top view, showing crossover of rays.

Reflex Mirror The reflex mirror is housed in the mirror box of the camera and needs to be of sufficient length to avoid vignetting of the top of the viewfinder image, an effect not recorded on film. The mirror may be of the instant return variety or may be returned to its viewing position as the film is advanced. The mirror is of glass or thin metal, surface aluminized, and coated to improve reflection. Sometimes a fixed mirror of the pellicle type is used to improve camera operating time. Solid mirrors may have semitransmitting zones or be perforated with an array of small holes to transmit a sampling of the viewfinder image to a secondary system for exposure metering or autofocusing. A piggyback mirror is attached to the rear of the main mirror.

Pentaprism The pentaprism viewfinder system is a roof prism device whose role is to give an upright, unreversed image of the subject via the focusing screen, turned through 90 degrees for convenient eye-level viewing facing the subject. To achieve this, three internal reflections in the prism are required, the reversal taking place in the roof. A vertical section shows five sides, hence the name, but not the crossover in the roof portion. An eyepiece of some 5X power is used. The pentaprism must be accurately made from optical glass and not molded in plastic. Weight and cost increase for medium format versions. The housing often contains ancillary optics and optoelectronics for data display and such functions as exposure metering and autofocusing. Alternative designs using additional prisms are needed for some cameras to allow a 45-degree viewing angle or to take the eyepiece well behind the screen. A cheaper system is the Porro prism type using three surface-silvered mirrors to give the correct image. To give increased eye relief from the eyepiece, the action finder or high eyepoint finder types position the exit pupil some 20–60 mm from the eyepiece, allowing spectacles or goggles to be worn and still see the whole of the screen.

Viewfinder Eyepiece In principle, the eyepiece or focusing magnifier of a viewfinder system is a simple microscope of power M_e, given by $M_e = D_v/f_e$, where the eyepiece has focal length f_e and D_v is the least distance of distinct vision (250 mm). For a pentaprism, 5X is needed and 2X for a screen magnifier (loupe). Eyepieces may be complex, three-element designs to give a wide field, well corrected for aberrations and with long eye relief.

Movie cameras use a close-focusing Kepler telescope system with an image erector and glare stops to provide a magnification up to 25X. A complex periscopic system may be needed to allow the finder to be rotated and oriented to suit the user.

Dioptric Correction For comfortable viewing, the screen image should ideally be perceived at a distance range between 500 mm and infinity, and the eyepiece lens chosen suitably with a dioptric range of from –1 to 0 diopters, respectively. Many users suffer from refractive errors of their eyes and cannot easily focus at such distances without the aid of spectacles. Use of spectacles with the eyepiece can be difficult and the whole frame not seen. Additionally, ancillary information may be displayed at different distances. An accessory eyepiece lens of a suitable dioptric power may be attached to or replace the standard eyepiece (usually of power –1 diopter), and spectacles not worn. Alternatively, a high eyepoint finder may be used as an alternative or the eyepiece may have variable dioptric correction by small axial movements of the lens. Focusing accuracy is directly influenced by the adjustment of eyepiece to user.

Video Viewfinders A video camera normally uses a small monitor screen of 50–150 mm diagonal for framing and focusing. Cine and still cameras may also be fitted with a small video camera to replace or integrate with the normal finder to provide a separate image on a large monitor to assist camera manipulation, permit several people to view the composition, or even transmit the image to a distant location.

VIEWFINDER FOCUSING Focusing an image is the task of locating the image surface that best permits the maximum transfer of information in the image to another system such as visual, optic, photographic, or optoelectronic. Cameras may be focused visually by making judgments about the appearance of the image in the viewfinder system. Considerations of mechanical and subjective factors keep the focusing errors within the optical and mechanical tolerances determining the depth of field and of focus of the system. Focusing by estimation of distance and use of a focusing scale may be adequate for some cameras, especially using wide-angle lenses. Otherwise a number of focusing systems are used.

Coincidence Rangefinders A rangefinder is an optical device to measure the distance of a subject by triangulation techniques using the properties of a triangle, a known base line, and measurement of angles. A basic optical arrangement is to use a fixed semisilvered mirror to view the subject directly and also indirectly via a rotating, fully silvered mirror. The mirror separation is the rangefinder base (b).

Normally a double image is seen, but rotation of the second mirror through an angle $x/2$, where x is the parallax angle, then gives subject distance u from $u = b/\tan x$. The term *coincidence rangefinder* is used to distinguish it from the split-image rangefinder, which has no moving parts in its design. A rotating mirror requires great accuracy in manufacture, and alternative optical arrangements are normally used involving such devices as contra-rotating prisms or prisms and lenses moving within the base. The optical movement is usually coupled to the focusing control of the lens in use to set correct focus as coincidence is achieved. For operational convenience the coupled rangefinder is incorporated into a universal viewfinder to give a coupled rangeviewfinder (CRF). There are severe limits to close focus with a near limit of 1 meter or so unless clumsy additional accessories are used. The rangefinder is excellent for low light level work, giving a bright contrasty image. A compact camera body is possible too, as in the classic Leica M series of cameras. Autofocus systems have effectively replaced coincidence rangefinders in small-format cameras, but medium and large format rangefinder cameras are still in use.

Rangefinder Accuracy System accuracy depends on the visual acuity of the eye and upon optical and mechanical construction. Accuracy is increased by the use of a long base and a magnifier to view the rangefinder images. The longest lens that can accurately be focused is usually only 2.5X to 3X that of the standard focal length for the format. Large format cameras provide the necessary long baselength for accuracy.

Screen Focusing The technique of focusing using a GGS is subjective with judgment of image sharpness, compared to the objectivity of a rangefinder. While the depth of field seen on the screen is a factor, the accuracy of setting is limited by the resolving power of the eye, related to the blur circle or circle of confusion. Use of a large aperture, long focal length, and screen magnifier all increase accuracy. Screen structure and use of Fresnel lenses to provide more uniform luminance also play a part, but most are provided with integral passive focusing aids such as split-image rangefinder and microprism arrays in the center of the screen.

Split-image Rangefinder A split-image rangefinder is a small circular zone in which the image of a portion of the subject is seen split horizontally (usually) in two, brought into coincidence when the lens is in focus. No mechanical coupling is necessary, and no moving optical parts are incorporated. In its simplest form the device is a biprism consisting of two small thin prisms mutually inclined in opposite directions, set side by side into the focusing surface so their axis coincides with the equivalent focal plane. An in-focus cone of light emerging from the exit pupil of the lens, which forms the *base* of the system, traveling from an edge detail in the subject, is intercepted, bisected, and refracted symmetrically and identically by the biprism so the image appears nondeviated and still linear. For out-of-focus cones with apexes in front of or beyond the biprism plane, the image is split and deviated, hence the name. Alteration of focus brings the images into coincidence, as judged by the vernier acuity of the eye. The images seen are bright unless the lens aperture reduces below about $f/5.6$, when the exit pupil of the system becomes very small and the eye has to be positioned critically to avoid vignetting of one or other half of the biprism, which will go black. Use of close focus or lenses of small maximum aperture produce this effect. One remedy is to change the screen for one with biprism angles suited to a particular lens. Most people find the split-image rangefinder easy and positive to use. Focusing of wide-angle lenses in dim light is particularly positive. A distinct line or edge in the subject is needed for effective use, and various designs use biprism splits in different orientations.

Microprism Arrays The split-image rangefinder needs an edge or line to operate efficiently, and many subjects lack this detail. By extending the biprism principle to a large number of very small prisms of triangular or square base in a regular array, however, effective focus-finding is given by inspecting the multiple splitting of the out-of-focus aerial image by deviation at the prism apexes. The effect is one of a characteristic shimmering in the image due to saccadic eye movements of the viewer, which abruptly snaps into focus and correct form at the point of focus. Even largely featureless subjects can be focused in this way. The microprism array has similar operational limitations to the split-image rangefinder and darkens at

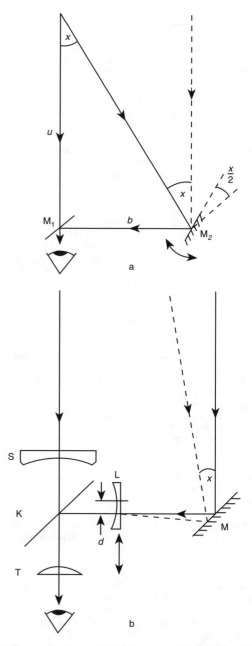

Coincidence rangefinder. (a) Rotating mirror type; (b) sliding lens type incorporated into a viewfinder. S and T are viewfinder elements, K is a beam splitter, and L is a sliding lens moving a distance d coupled to lens focusing.

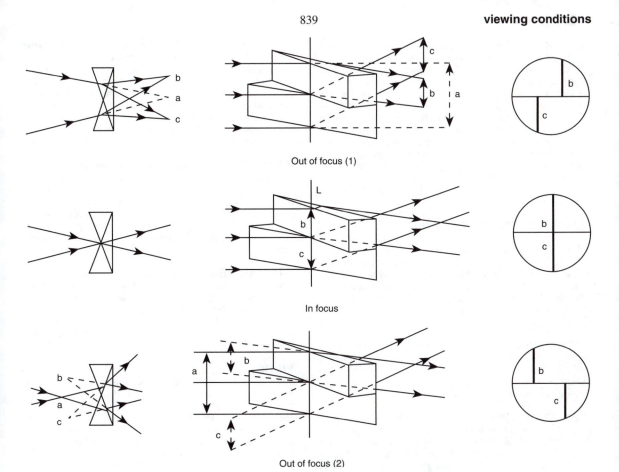

Out of focus (1)

In focus

Out of focus (2)

Split-image rangefinder.

Microprism focus finder. (a) Typical location in a focusing screen; (b) enlarged plan view of prisms with square base side of about 0.05 mm; (c) perspective view of microprisms.

small apertures but otherwise given a bright image. Screens of full arrays can be used matched to focal length, but depth of field cannot be judged. Some 1500 to 90,000 prisms may be molded into the screen surface. A mixed screen is popular with central annuli of finely ground glass and microprisms around a central split-image rangefinder.

Books: Ray S., *Camera Systems.* London & Boston: Focal Press, 1983; Ray, S., *Applied Photographic Optics.* London & Boston: Focal Press, 1988. *S. Ray*

See also: *Autofocus; Focus/focusing; Vision; Defective color vision.*

VIEWING CONDITIONS The proper viewing conditions for projected images with large audiences call for a darkened room with a good-quality projection screen. The projector should be aligned perpendicularly to the screen and focused properly. If sound is going to accompany the visual presentation, the acoustical quality of the audio equipment and the room are important. The sound level should be adjusted when the projectors are prefocused, before the audience arrives. Projection equipment can be very noisy. A sound-proof projection booth or sound absorbing screens around the equipment will reduce the noise level. If sound proofing or isolation is not possible, a long focal-length lens will allow the projector to be placed behind the audience. For informational presentations that contain text and numbers, the audience should be no farther away from the projected image than 8 times the screen height. If the text is larger than standard size or the program content is entirely pictorial, the screen-to-audience distance can be increased to 14 times the screen height. *M. Teres*

VIEWING DISTANCE Viewing distance is the spatial separation between an observer and an object or a photographic or other reproduction. The retinal image size of an object or a reproduction is inversely proportional to the viewing distance. The correct viewing distance of a photograph for normal appearing linear perspective is equal to the camera image distance for a contact print, or equal to the camera image distance times the magnification for an enlargement. For example, if a 10 times enlargement is made from a negative produced with a 2-inch camera lens, the viewing distance for correct perspective is 20 inches. Depth of field also varies with the viewing distance of the image.

L. Stroebel and M. Teres

See also: *Perspective.*

VIEWING FILTER See *Filter types.*

VIEWING LENS A term used in reference to the upper lens of a twin-lens reflex camera that projects an image onto a 45-degree mirror and a ground glass. The viewing lens is of the same focal length as the taking lens and is coupled to it on the focusing track. When the image is focused on the ground glass, it is simultaneously focused for exposure on the film.

P. Schranz

VIEWING SCREEN The ground glass viewfinder of any reflex camera. Viewing screens may have grid markings, parallel indicator lines, split image, or microprism focusing aids. The viewing screens are interchangeable in several reflex camera systems.

P. Schranz

VIEWPOINT (1) The position from which a scene or an object or a person is viewed, observed, or photographed. (2) The position of the camera in relation to the subject at the time of exposure. The viewpoint determines not only the perspective (the lens focal length determines only the scale of reproduction if the viewpoint is held constant) but the practical and aesthetic values of a photograph as well. Viewpoint may vary in distance and in height. The closer the camera is to the subject, the bigger the image and the larger it is in proportion to its background. Normal viewpoint is at eye level—between 5 and 6 feet off the ground. Higher or lower viewpoints are used to demonstrate details not available at eye level or for interest. Variations can cause distortions. Excess height exaggerates the proportions of objects nearest the camera. Very low viewpoints exaggerate the base of the object.

R. Welsh

VIGNETTING The visual appearance of a darkening of an image toward the edges or periphery. There are various forms and causes. Natural vignetting by a lens is due to the $\cos^4 \theta$ law of illumination and determines the image circle. Mechanical vignetting is due to the use of too long a lens hood, filter holder, or attachment, especially with wide-angle lenses and small apertures, or the cutoff of peripheral rays by width restriction in the diameters of lens elements, reduced by stopping down. If the lens cannot adequately cover the format in use or excessive lateral shift movements are used, vignetting will occur. Deliberate vignetting may be achieved in the camera by opaque or translucent masks held at a suitable distance in front of the lens. Vignetting during printing or enlarging is usually to provide a fading of the image to white rather than black at the edges.

S. Ray

See also: *Lenses, covering power of lenses.*

VILLARD EFFECT See *Appendix A; Photographic effects.*

VIRTUAL IMAGE The image seen after refraction by a diverging lens or after reflection in a plane or convex mirror when the light rays diverging from an object point cannot then be brought to a corresponding image point. The virtual image is seen by looking at the subject via the mirror or through the lens at the subject and cannot be received directly on a screen or film surface. It can however be treated as a *virtual subject* and reimaged by a lens capable of giving a real image from a real or virtual object. Virtual images are usually upright, unreversed, and bright and formed for visual convenience in many optical instruments such as microscopes, telescopes, and rangefinders.

S. Ray

VIRTUAL INSTRUMENTS In computers, the use of fast graphic user interface (GUI) computers to imitate laboratory and test equipment in a transparent fashion. Virtual instruments can be created via software and an input/output port with many different platforms. A computer can be programmed to function as a pH meter, oscilloscope, sine-wave generator, or frequency counter, to name only a few instruments.

R. Kraus

VIRTUAL REALITY In electronic imaging, a form of intensive computer processing and specialized display and input peripherals that create the seamless illusion of an alternative reality. Research into virtual reality has taken place in the areas of medical diagnosis and treatment, space exploration and geo-resource mapping, and amusement and entertainment activities.

R. Kraus

VIRUS A computer program designed to disorient, slow down, or "kill" the computer's operating system or data files or the hard disk's directory.

R. Kraus

VISCHNIAC, ROMAN (1897–1990) Russian-born American photographer. In over 5,000 photographs, and often at great personal risk, recorded eastern European Jews immediately before the Holocaust (1936–1940) convinced, himself a Jew, that Hitler would exterminate his people. Since that time concentrated on the field of photomicrography where he became a renowned expert. He wrote, "Nature, God, or whatever you want to call the creator of the universe comes through the microscope clearly and strongly. Everything made by human hands looks terrible under magnification—crude, rough and unsymmetrical. But in nature every bit of life is lovely."

Books: *A Vanished World.* New York: Farrar, Straus & Giroux, 1969.

M. Alinder

VISCOUS PROCESSING Application of chemical agents in a thick fluid, used in some soundtrack development and in some rapid-access photography.

L. Stroebel and R. Zakia

See also: *Monobath.*

VISION Vision refers to the sense of sight. The human sense organs for sight, the eyes, respond to electromagnetic radiation over a range of wavelengths from approximately 400 to 700 nanometers (nm) at normal light levels. The band of radiation to which the eyes are sensitive is identified as light. The meaning associated with the light received by the eyes is referred to as visual perception. The distinction between a visual sensation and a visual perception can be experienced by simply closing and opening one's eyes in a well-lighted area. Enough light penetrates the eyelids with the eyes closed to enable a person to roughly judge the brightness of the environment through the sense of sight, but it is only when the eyes are opened and images are formed on the retinas that objects are identified and the environment becomes meaningful.

THE HUMAN EYE The human eye is a very complicated organ that includes the following parts: The *lens,* which is largely responsible for focusing entering rays of

light on the light sensitive surface at the back of the eye; the *cornea,* a transparent covering over the front of the eye that retains aqueous humor in front of the lens; the *aqueous humor,* a clear liquid that provides nourishment to the lens and the cornea, neither of which contains blood vessels; the *iris,* a muscle that controls the size of the pupil and therefore the amount of light admitted to the inner eye; the *retina,* the light-sensitive layer that covers the back inner surface of the eye; the *blind spot,* an area on the retina where the nerves from the retina leave the eye and enter the optic nerve; and *vitrous humor,* a clear liquid that fills the inner eye. Muscles attached to the outer surface of the eye hold the eye in position and control eye movements.

Optical System The optical system of the eye forms inverted images on the retina in much the same way a camera lens forms inverted images on the film. Although the eye has a single element lens, it has been considered in the past that six surfaces are involved in image formation—the front and back surfaces, in sequence, of the cornea, the lens cortex, and the lens nucleus. More recently, it has been discovered that the lens is composed of many onion-like layers that vary in refractive index, a feature that contributes to the ability of the eye to form an excellent image on the retina and a feature that the manufacturers of glass lenses have now learned to imitate.

Even though we associate image formation with lenses, the largest change in direction of the light rays that enter the eye occurs at the front surface of the cornea. The lens, however, serves the critical function of adjusting the focus for objects at different distances, a reflex process known as accommodation that results from a change in the shape of the lens.

Comparisons can be made between optical images formed in the eye and those formed in a 35-mm camera since the diameter of the retina is approximately the same as the 24-mm width of the image area on 35-mm film. Whereas 50-mm is considered a normal focal length for the camera lens, the effective focal length of the typical eye is about 17 mm. This short focal length combined with the curved retina produces an angle of view of approximately 180 degrees, in comparison with a normal angle of view of about 50 degrees for the camera. Although the eye can detect movement and distinguish between light and dark at 90 degrees off axis, fine detail, such as the text on a printed page, can be resolved only over a small angle. The short focal length of the eye also produces a large depth of field. Since the depth of field varies inversely with the focal length squared for a given film size, the eye has about nine times the depth of field of the normal 50-mm focal length camera lens on a 35-mm camera at the same *f*-number.

Complications are encountered when attempts are made to evaluate the quality of the optical image that is formed on the retina since the image cannot be examined directly through a microscope on an optical bench, as is done with camera lenses. Failure of the lens to focus the rays of light from a distant object on the retina, instead of in front of or behind the retina, can be detected and corrected by an optometrist through the use of test targets and supplementary lenses in the form of eyeglasses or contact lenses. A report of what a person sees when looking at a test chart provides some information about the quality of the optical image, but this method evaluates only the final perceived image and does not indicate any effects that the rest of the visual system have on the quality of the optical image. Actually, it is possible to examine the optical image formed on the retina directly through the front of the eye, although the appearance of the image is affected by detail in the retina, and allowances must be made for the fact that the light is transmitted through the optical system twice before it is examined.

In addition to nearsightedness and farsightedness, the op-

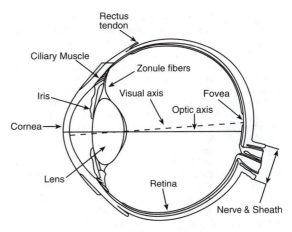

The human eye. The area in the retina where the optic nerve leaves the eye has no light receptors and is identified as a blind spot.

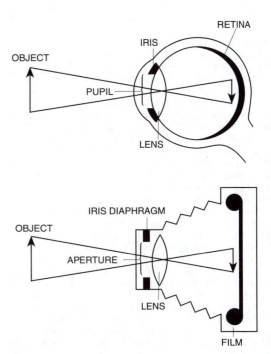

Optical system. Inverted images are formed on the retina in the eye, the same as on film in a camera.

tical system of the eye is subject to a number of shortcomings that are also found in camera lenses, such as spherical aberration, chromatic aberration, coma, and astigmatism. Loss of definition due to aberrations tends to be reduced as the pupil decreases in size, but loss of definition due to diffraction tends to increase, as with camera lenses. The effect of diffraction can sometimes be seen at night when looking at a small, bright light source such as a street lamp equipped with a bare bulb, where light streaks appear to radiate in all directions from the light source.

Some of the light that enters any optical system is deviated from the desired image-forming path as a result of several factors, including reflection, scattering, and lens aberrations. Of the light that is reflected and scattered within the optical

system, some will reach the light-sensitive surface as a more-or-less uniform veiling light, producing a nonlinear reduction of image contrast with a larger reduction of contrast in the darker areas of the subject than in the lighter areas.

It is easy to measure flare in a camera because light measurements can be made both at the subject and at the image plane. More sophisticated techniques are required to measure flare in the eye, but studies indicate the flare is quite similar in the two optical systems. Flare is highly dependent upon the relative lightness of the background and surround when viewing an object. When we shield our eyes from a bright light source such as the sun or a display light in a gallery, we reduce the amount of flare light in our eyes, and this enables us to see more clearly, especially in the darker areas.

Changes in tension of the ciliary muscles, attached to the zonule fibers at the edge of the lens, control the thickness of the lens and therefore the focal length. The change in the focal length is not large enough to produce an obvious change in image size, as would occur with a zoom camera lens, but it is sufficient to permit the eye to focus on objects at different distances. As a person ages, the lens becomes less flexible so that focusing on near objects becomes more difficult, and eventually can be accomplished only by using a supplementary lens such as a reading glass.

Normal aging can affect the eye in other ways, in addition to the decrease in flexibility of the lens. The lens has a tendency to become yellowish with age, which affects the appearance of some colors, especially the complementary color blue. The lens can also become cloudy with age, a defect identified as a cataract, which increases the scattering of light and the amount of flare. A man who had the lens removed in one eye because of a cataract conducted an experiment to determine the difference in the appearance of a neutral gray surface between the two eyes and determined that the lens in the untreated eye had yellowed the equivalent of a CC-30Y filter, that is, a color compensating filter having a density of 0.30 when measured with blue light.

Basic lens formulas can be used to calculate the scale of reproduction, image and object distances, and focal length for the eye, and ray tracings can be made the same as for camera lenses. Because the index of refraction is different for the air in front of the eye and the liquid in the eye behind the optical system, the principal points and the nodal points will not coincide, as they do with air on both sides of a camera lens, and therefore the calculations are somewhat different. The situation is reversed with an underwater camera, where the liquid is in front of the camera lens and the air is behind the lens inside the camera. The water reduces the angle of view and makes objects appear closer and larger.

The iris muscle makes it possible to change the size of the opening, or pupil, from approximately 2 mm to 8 mm. These diameters correspond to f-numbers or $f/8$ and $f/2$, respectively. In addition to controlling the amount of light that enters the eye over a modest range of 1 to 16, pupil size also alters image definition and depth of field. For persons with normal vision, the best compromise for image definition between reducing lens aberrations with a small opening and minimizing diffraction with a large opening is obtained with a pupil diameter size of about 4 mm, or an f-number of $f/4$, which is midway between the maximum opening of $f/2$ and the minimum opening of $f/8$.

Since depth of field is directly proportional to f-number, the depth of field is increased by a factor of four from $f/2$, the largest opening in dim light, to $f/8$, the smallest opening in bright light.

Pupil size changes primarily in response to variations of scene luminance, but it also changes somewhat with variations of interest and emotional states. The pupil also becomes smaller as the eye is focused on closer objects.

Retina The lining on the interior surface of the back of the eye, known as the retina, contains light-sensitive rods and cones, and a network of nerve cells.

There is a close relationship between the type of film used in a camera and the characteristics of the photographic image. In a similar manner, there is a close relationship between the types of light receptors in the different areas of the retina and the perceived image. There are approximately 130 million light-sensitive rods and cones in the retina. Unlike silver halide grains in photographic film, these elements are not distributed randomly. A large proportion of the approximately seven million cones are located near the visual axis in a small area called the fovea, the part of the retina used when we look directly at an object point.

Although both rods and cones respond to a range of wavelengths of light, the perception of hue depends entirely upon the cones. Thus, the cones correspond to color film and the rods correspond to black-and-white panchromatic film. Rods distinguish between colors only on the basis of lightness. The concentration of cones decreases rapidly away from the axis, but some are found even in the outer areas of the retina. On the other hand, there are no rods in the fovea, but their concentration increases rapidly to a maximum about 20 degrees off the visual axis and then decreases gradually toward the outer edges of the retina.

The fundamental reaction that occurs when light falls on a receptor is that it converts molecules of pigment to a different form in a bleaching action that in turn initiates a signal in a nerve cell. Bleached molecules are simultaneously regenerated to maintain an equilibrium of bleached and unbleached molecules. All rods contain the pigment rhodopsin, but there are three types of cones, identified as red-sensitive, green-sensitive, and blue-sensitive, each of which contains a different pigment.

While rods cannot produce hue perceptions, they do function at lower light levels than cones, but with a sacrifice of image definition (as with high-speed, coarse-grain photographic films). Low light-level rod vision is known as *scotopic* vision, higher light-level cone vision is *photopic,* and the overlap region where both rods and cones function is *mesopic.* The rods in the periphery also serve the useful function of detecting motion and lightness differences,

Retina. A greatly enlarged view of a central area of the retina showing part of the fovea, a circular area that contains only cone receptors. The larger spots represent rods, which reach a maximum concentration about 20 degrees off the visual axis. This explains why very dim objects such as dim stars can be seen better by looking a little to one side rather than directly at them.

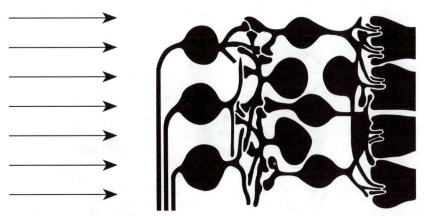

Retinal nerve cells. The network of nerve cells that covers the rod and cone receptors on the extreme right strangely enough does not seriously affect the perceived images, and it performs the first of a series of information-processing functions that occur in the visual system.

thereby signaling viewers to quickly shift their gaze in the appropriate direction for a more critical examination with the cones.

There is a small area of the retina less than 20 degrees off the visual axis that contains neither rods nor cones, known as the blind spot, where the optic nerve fibers leave the eye. Although no detail can be seen in this area, the mind fills in the discontinuity to the extent that we do not see a black spot in our field of vision even when one eye is closed, and when both eyes are open the blind spots do not overlap on the same subject area.

Strangely, the image formed by the eye's optical system does not fall directly upon the rod and cone receptors but must first pass through a complex network of neural cells. With the exception of the fovea, light must also pass through a network of small blood vessels before reaching the receptors. These blood vessels are quite obvious in photographs of the eye lining taken through the lens of the eye. They are not apparent to the viewer because of automatic adjustment in sensitivity of the underlying receptors, a process known as local adaptation.

THE VISUAL NEUROLOGICAL SYSTEM The communication link between the optical images formed on the retinas in our eyes and our visual sensations and perceptions consists of interconnecting nerve cells. The bleaching action of light on the pigments in the rods and cones of the retina initiates electrochemical signals that are transmitted through the nerves to the visual cortex at the back of the brain.

Retinal Nerve Cells There is a complex network of nerve cells covering the retina that performs important information-processing functions in addition to transmitting signals from the retina. For example, hundreds of rods in the retina may be linked together with a single nerve cell, resulting in an increase in sensitivity through spatial summation, with a corresponding decrease in resolution, whereas another nerve cell may be connected to a single cone, thereby producing greater detail in that area of the perceived image.

Optic Nerves The optic nerves serve to carry signals from the retinas to the back of the brain, but the connections are not simple direct lines. The so-called optic nerve is actually a bundle of approximately one million nerves, one for each nerve cell in the retina. Each bundle of nerves divides at the optic chiasma so that half of the nerves cross over to the opposite side of the brain and the other half remain on the same side. The divided bundles represent the left and right halves of each retina. If one of the optic nerves were disconnected between the retina and the optic chiasma, we would

see a normal image for one eye and none for the other. If, however, one of the bundles of nerves behind the optic chiasma (called the optic tract) were disconnected, we would see only the left half or the right half of the images formed in both eyes.

The Brain Although we commonly think of the human brain as just the walnut-shaped organ inside our skulls, the entire neural network from the retinas to the visual cortex at the back of the brain is considered to be part of the brain, and vision is the only sense where the stimulus has direct access to the brain.

Important processing of information from the receptors occurs at various locations along the neural network to meet a variety of sensory and perceptual needs, beginning with various types of cells in the retina itself. Certain cells perform important inhibitor and excitatory functions on adjacent cells to produce, for example, edge enhancement in a perceived image. Researchers are able to insert fine probes at selected positions in the visual system of monkeys and other animals to measure variations of electrical impulses in neurons in response to controlled variations of the visual stimuli.

The sophistication of information processing increases as signals travel from the retina to the visual cortex at the back of the brain. Some of the nerve cells in the visual systems respond only to a specific type of stimulus such as a certain shape, orientation, or direction of movement. This is especially true with lower forms of life that depend upon such specialized perception for food or protection, but even human vision is highly sensitive to movement in the periphery of the field, where the perception of detail and color is poor.

Neurons also have a memory capacity, as yet not fully understood, that produces a different response when a stimulus has been experienced previously. This enables us to recognize and respond appropriately to such shapes as letters and numbers, words, and even complex stimuli such as a friend's face in a crowd. Neural memory is not automatic with repeated experiences but depends also on such factors as attention and motivation at the time of the experiences.

Selective responses to simple shapes are attributed to neurons in or near the retina, and selective responses to complex stimuli are accomplished by neurons farther back in the visual system. Actually, there are a minimum of six basic types of nerve cells in the visual system—retinal rod and cone receptors, retinal bipolar cells, retinal ganglion cells, lateral geniculate body cells, simple cortical cells, and complex cortical cells. Experts now universally agree that the pattern of stimulation in the visual cortex, which is located at

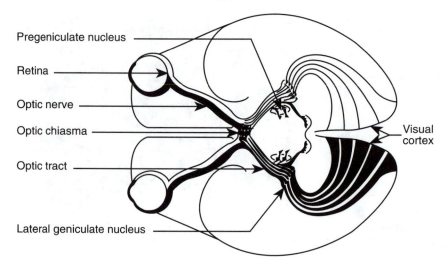

The visual neurological system. A simplified representation of the major neurological pathways from the retina to the visual cortex at the rear of the brain. The optic nerves divide at the optic chiasma, with the inner halves crossing over to the opposite sides of the brain.

the back of the brain, does not physically resemble the optical image of the original scene projected on the retina but that it serves as a coded record that the mind is able to reconstruct. It has been determined that a larger proportion of the brain is devoted to vision than to any of the other senses.

Even though vision can be a passive process where we simply observe a visual stimulus, we commonly respond to it—cognitively, emotionally, or physically. Therefore, at some point it becomes necessary for the visual process to interact with other functions of the brain through the extremely complex network of neurons in the cortex.

EYE MOVEMENTS Eye movements include changes in the position of the eyes in relation to the head for purposes such as locating an object, converging the two eyes on the object so that the images coincide, and tracking the object during movement.

Positioning the Image The main function of eye movements is to enable the eye to lock onto an object for as long as necessary to examine it, so that the image remains nearly stationary on the area of sharpest vision on the retina. Perfection in this task would actually result in a loss of vision since experiments have demonstrated that the complete stabilization of an image on the retina causes it to fade rapidly, sometimes in less than a second. Fading is prevented from happening in everyday life by small involuntary movements of the eyes known as *nystagmus*. These movements are so small that they are not noticed either in our own vision or when looking at the eyes of another person. It is thought that this small-scale movement may, in addition, serve to enhance the appearance of sharpness of edges. The term *nystagmus* is also applied to a somewhat larger abnormal rapid movement of the eyes caused by disease, injury, or dizziness.

Voluntary eye movements are controlled by three pairs of opposing muscles that move the eyes vertically, horizontally, and slightly rotationally about the optical axes. When searching for an object, the eyes move in quick jumps called *saccades*. Although the eyes can be moved consciously in any desired direction, they often move automatically toward motion or other changes detected on the periphery of the retina. The eyes continue to move until the image of the object of interest is positioned on the fovea, the area on the retina having the highest concentration of cones and therefore the highest resolution.

Convergence If the search movement involves a change in object distance, the relative positions of the eyes to each

other must be changed in order to keep the images on the fovea of both eyes to produce the appearance of a single image. When looking at a distant object, the axes of the eyes are essentially parallel, and as the object moves closer the angle of convergence increases. Changing the convergence from a distant object to a near object requires approximately 1/5 second, which is considerably longer than the time required for a saccadic movement where the eyes can move as rapidly as 80 degrees in 1/10 second. Convergence is the only visual activity that requires the eyes to move in opposite directions.

Tracking, Reading, and Scanning The tracking movement of the eyes is necessary in order to fixate an object that is moving, or to fixate a stationary object when the viewer is moving. The eyes can be quite accurate in tracking as long as the movement of the object is smooth and predictable. Tracking is the only visual task where it is natural for the eyes to move smoothly rather than in quick jumps. This can be demonstrated by looking at a wall and attempting to move the eyes smoothly from one edge of the wall to the other. When reading printed material, it is normal for the eyes to make several jumps along a line of text, but the sizes of the jumps vary with the length and familiarity of the words, the degree of understanding desired, the reading skill of the individual, and other factors. Eye-movement studies have been conducted with subjects looking at pictures, in addition to reading studies. As would be expected, there was greater variation in the movement patterns among individuals when looking at pictures than when reading. It was also found that the movement patterns for a given person varied with the type of information the person was asked to derive from the picture.

Head and Body Movement A complicating factor involved in eye movements is that the head, which is the frame of reference for the eyes, is often moved during the viewing process. Thus, if the head is rotated from side to side while looking steadily at a stationary object, the eyes move in the head but the object does not appear to be moving. It has been established that the brain makes use of head-movement information from the inner ear and incorporates the appropriate compensations. This can be demonstrated by spinning rapidly until one becomes dizzy and noting that the sense of vision is affected in addition to the sense of balance. Conversely, people have commonly reported feeling dizziness or other sensations of motion while remaining stationary

watching a motion picture of a roller-coaster ride or other activity involving rapid movement.

BINOCULAR VISION Binocular vision refers to sight with two eyes, as distinct from monocular vision, sight with one eye. Although binocular vision is not essential for the perception of depth, it enhances the appearance of realism of the three-dimensional world and enables us to judge distances more accurately. Closing one eye does not destroy the appearance of three dimensions, because of other depth cues such as linear perspective, and moving the head a few inches from side to side with one eye closed provides the viewer with similar depth information to that normally provided with two eyes, but the information is received sequentially rather than simultaneously.

Redundancy with Two-Dimensional Subjects Having two eyes rather than one greatly complicates the task of the visual system in interpreting the images formed on the retinas. When looking at a two-dimensional object, such as a picture or printed text on a page, it is necessary for the viewer to see a single merged image rather than two separate images. Fortunately, the reflex mechanism of the visual system is very efficient in achieving this, but it should be noted that with two-dimensional subjects the information provided by the second eye is redundant since it is identical to that provided by the first eye.

Disparity with Three-Dimensional Subjects Substituting a three-dimensional object for the two-dimensional object or adding other objects in front of and behind the two-dimensional object results in obvious differences between the images formed by the two eyes, even though parts of such scenes can still be fused to form a single image. The differences between the parts of the images that are not fused are referred to as *disparity,* and it is the disparity that provides the visual system with information for binocular depth perception. Disparity serves this function, however, only when the viewer can interpret the two images as representing the same scene. If totally different pictures are presented to the two eyes with an optical device, the disparity is no longer interpreted as depth. The mind still tries to make sense out of the unrelated images, which it may do by combining them in some way, or it may simply reject one image or the other, sometimes on an alternating basis. This effect can be experienced without any special equipment by holding a playing card edgewise in front of one's nose so that one eye sees the front of the card and the other eye sees the back of the card.

The Dominant Eye Most people do have a dominant eye that determines which image will prevail when all or part of the images formed by the two eyes do not fuse. The dominant eye can be determined by aligning a finger in the foreground with an object in the background with both eyes open. Closing one eye at a time, the finger and object remain aligned only with the dominant eye.

COLOR VISION Over the years many individuals have speculated, conducted experiments, and formulated theories concerning the visual mechanism that enables us to see colors. Even the earliest investigators of the phenomenon of color vision did not think it possible that the visual system could contain a separate mechanism for each of the large number of colors that we can distinguish.

Early Theories The Young–Helmholtz theory suggested that there were only three different sensors, which responded to red light, green light, and blue light. It is now known that there are three types of cones in the retina that contain different pigments. The pigments are named *erythrolabe, chlorolabe,* and *cyanolabe,* and they absorb red light, green light, and blue light, respectively. Sensitivity to a color requires light of that color to be absorbed by a visual pigment so that the light energy can be converted to an electrochemical neural signal, which is analogous to the absorption of red light and green light by sensitizing dyes adsorbed to the surface of silver halide grains in panchromatic photographic films. There is also a similarity between the eye and color photographic films in that they both analyze subject colors by responding to the red, green, and blue components of the colors. The similarity breaks down, however, when it comes to combining three separate images to create colors that resemble the original subject colors, the synthesis part of the analysis-synthesis cycle.

The simplest explanation of the way the visual system enables us to make use of the information from the red, green, and blue retinal images would be that the signals from the cones are sent directly to the visual cortex at the back of the brain on separate red, green, and blue channels, and the brain is somehow able to integrate the signals so that we see an appropriate color. This relatively simple process would not, however, provide explanations for certain visual phenomena that have been observed. For example, even though all three signals would be required for a person to see white and gray, persons having a type of defective color vision caused by the absence of one of the three types of pigments still see white and gray objects as such, and they do not see objects of the missing color as being darker, only different in hue.

Another phenomenon that is not explained with a simple red-green-blue direct-line theory is that yellow, which can be produced by mixing red light and green light, does not appear to be a mixture of red and green—even though magenta does appear to be a mixture of red and blue and cyan does appear to be a mixture of blue and green.

The Opponent Theory E. Hering, in the late nineteenth century, proposed an opponent theory of color vision, a theory that has been extensively refined over the years, especially by L.M. Hurvich and D. Jameson. The opponent theory assumes the existence of three pairs of processes, one each for blue-yellow, red-green, and white-black. The explanation of how two different colors can share the same communication channel is that, beginning with an intermediate spontaneous neural firing rate, one of the colors has an excitation effect and the other an inhibition effect on the rate of firing.

The opponent theory can account for the results of additive mixtures of different colors of light, including combinations that appear neutral, as well as the visual effects produced with various types of defective color vision. It is also consistent with hue shifts of certain colors with variations of the illumination level, and phenomena related to lateral inhibition and receptive fields.

Defective Color Vision Defective color vision is an abnormal physiological condition characterized by a chronic reduced ability to detect hue differences between certain colors under normal viewing conditions. There are also conditions under which persons with normal color vision are unable to correctly identify object hues or to detect hue differences between certain colors, including (1) low and very high levels of illumination, (2) illumination of colored objects with other than white light, (3) very small color samples, (4) very short viewing time, (5) the use of peripheral; rather than central vision, and (6) adaptation of the eyes to a saturated color before judging the color of the test object.

It should also be noted that an inability to make subtle discriminations between similar colors under normal viewing conditions can be due to a lack of color learning experience, in which case practice can result in an improvement in performance. To date, there has been little hope for correcting defective color vision.

Defective color vision usually results from an absence or a reduced amount of one or more of the three types of cone pigments. Persons having normal color vision are identified as *normal trichromats. Anomalous trichromats* also have all three types of cone pigments, but they have a smaller than normal amount of one of the three and, therefore, reduced

sensitivity to the corresponding hue. Anomalous trichromats may be more specifically classified as red-anomalous, green-anomalous, or blue-anomalous. *Dichromats* are missing one of the three pigments, and may be more specifically classified as red-blind, green-blind, or blue-blind. *Monochromats* are persons who are either missing all three pigments and see the world as gray, or are missing two pigments and see a single hue.

VISUAL ACUITY Visual acuity is a measure of the ability of a person to distinguish detail in a test target. It is commonly expressed in numerical form, either as the maximum distance at which a person can identify letters of a certain size in comparison with the average distance for a large number of people having normal vision, or as the reciprocal of the angle in minutes of the critical dimension of the barely distinguishable part of a test target.

Myopia and Hyperopia Physiological differences in the eyes of various individuals cause corresponding variations in acuity. Myopia, or nearsightedness, is a condition where rays of light tend to come to a focus in front of the retina, especially with distant objects. With hyperopia, or farsightedness, the rays of light tend to come to a focus behind the retina, especially with near objects. The relaxed eye of a person with normal vision focuses rays of light from distant objects on the retina, and accommodation, which is linked to changes in the shape of the lens, enables the person to focus on objects at closer distances. The closest distance that can be focused on is called the near point. The near point for a young child may be as close as 3 inches, but the near point increases with age and may eventually reach 30 inches or more. Because the distance the relaxed eye focuses on also tends to increase with age, it is not uncommon for nearsighted individuals to find their acuity improving with age for large distances but deteriorating for small distances.

Astigmatism and Chromatic Aberrations Astigmatism is a defect that can affect the lens in the eye as well as camera lenses. Astigmatism causes off-axis object points to be imaged as mutually perpendicular lines rather than as points, resulting in a reduction in visual acuity. The human eye shares other aberrations in common with photographic lenses, but the visual system can in some cases at least partially compensate for the defect. Chromatic aberrations in the eye, for example, are not revealed in visual images by color fringing at the border between white and black areas as with the images of photographic lenses suffering from chromatic aberrations.

TESTING FOR VISION DEFECTS Many occupational and nonoccupational activities require normal or near-normal visual capabilities. If the person who is responsible for determining the color balance of photographic color prints or photomechanical reproductions of color photographs does not have normal color vision, for example, it is unlikely that the images produced will be acceptable to most of the viewers of these images. Even the everyday activity of driving a car requires the ability to distinguish between red and green traffic signals and to see details in the traffic environment.

Color Tests Various tests have been designed to detect and classify the different types of defective color vision. Pseudoisochromatic test plates contain an assortment of color designs, each selected to be invisible to a person with the specified type of defective color vision. A green-blind viewer, for example, cannot distinguish between green dots that make up a figure and the gray dots that surround the figure.

The *Farnsworth–Munsell 100-Hue Test* contains color samples that the subject attempts to arrange in the correct order on the basis of gradual transitions between hues. Each type of defective color vision is associated with arrangement errors within a certain range of hues. A person who has

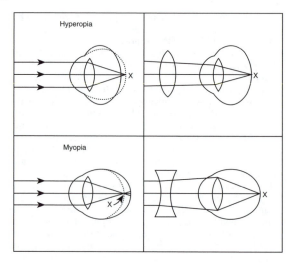

Myopia and hyperopia. Focus errors in the eye due to hyperopia (farsightedness) and myopia (nearsightedness), which can be corrected with positive and negative eyeglass lenses.

normal color vision but has not learned to see small differences in hue tends to make about the same number of errors with all of the hues. Such a person is classified as having normal color vision and average or low color discrimination, depending upon the number and magnitude of errors made.

Approximately 8% of males have some form of defective color vision, of which 1% are red-blind and 2% are green-blind, with the remaining 5% being classified as anomalous trichromats. The complete absence of a pigment is rare among females, and only about one-half of 1% of females have any type of defective color vision. Even though the incidence is low in females, the most common cause of defective color vision is heredity, and the defect is transmitted through the mother's genes. Since photographers and artists who have defective color vision may not be able to distinguish between certain hues, red and green for example, pictures that they make and that appear correct in color to them often do not appear correct to persons having normal color vision.

Acuity Tests Most people are familiar with the Snellen test chart used by optometrists that consists of letters of the alphabet ranging in size from large at the top to small at the bottom. When a person correctly identifies the letters in a given row, it indicates that the person's visual acuity is good enough to permit recognition of the letters in that row. The smallest row of letters that the person identifies correctly is compared with the average performance of a large number of people having normal vision and the results are expressed as a pair of numbers such as 20/30, which means that subject would have to be at a distance of 20 feet from the test chart to perform as well as the average person with normal vision performs at a distance of 30 feet.

Another measure of visual acuity is the reciprocal of the angle in minutes subtended at the observer's eye by the critical dimension of the barely distinguishable part of the target, such as 1/2 if the angle formed by the width of the lines in the letters is 2 minutes. An angle of 1 minute is considered average for people with normal vision, using a target of black and white bars and a good level of illumination. An advantage of this method is that the value is independent of distance.

It should be noted that the angular method of measuring visual acuity is based on the width of the black lines making up the letters or pattern of the test chart, whereas resolution

Astigmatism. The eye defect of astigmatism will cause certain sets of lines in this test target to appear less sharp and less contrasty. Tests should be conducted separately for each eye, without eyeglasses.

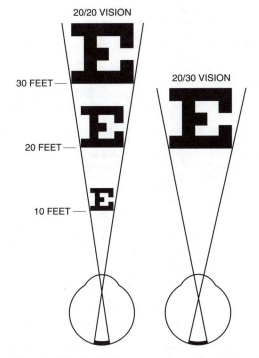

Acuity test. With the Snellen test chart, a person having 20/30 vision can just identify at 20 feet letters of a size that a person with normal (20/20) vision can just identify at 30 feet.

of photographic lenses is based on the width of a light-dark line pair; making a comparison of the eye and a photographic lens based on a direct conversion is misleading unless the difference in procedures is taken into account. It is possible, however, to measure the resolving power of the eye using the same resolving-power test targets and conversion tables that are used for photographic lenses.

Sine wave test targets, which change gradually in luminance rather than abruptly, permit the performance of the

visual system to be evaluated over a wide range of sizes of alternating bands rather than determining a single threshold value. The information derived with this type of target can be displayed in graph form as a modulation transfer function curve. Such curves reveal the interesting fact that the visual system not only has small-scale limitations but large-scale limitations as well, where the change in luminance with distance is too gradual to be seen even though the luminance contrast remains constant.

Corrective Procedures At the present time there is little hope that people having defective color vision can be helped in seeing colors the same as those having normal color vision do. It is possible, however, to provide them with filters that will enable them to see differences between certain colors, such as red and green for example, that otherwise would not be distinguishable.

Low visual acuity, however, can be dramatically improved with corrective lenses in the form of eyeglasses or contact lenses, especially when the problem is myopia, hyperopia, or astigmatism. The decrease in flexibility of the lens in the eye to accommodate for close distances that normally occurs with increasing age can be compensated for with bifocal or trifocal lenses or with separate reading glasses.

Surgical procedures are also available to improve vision that has deteriorated because of cataracts and detached retinas, and diagnostic procedures and medication can reduce the risk of damage to vision from glaucoma.

ADAPTATION Visual adaptation is a process of adjustment of the visual system to the environment, such as a decrease in sensitivity with an increase in the light level. The dynamics of the visual system are such that it attempts to treat every stable stimulus of long duration as being normal, even though it may have appeared quite abnormal when first presented. This principle applies to a wide variety of stimulus attributes including lightness, color, size, motion, orientation, pattern, and sharpness.

Brightness/Lightness Adaptation Brightness/lightness adaptation enables a person to see the environment with enormous variations in light level, such as from sunlight to starlight, which represents an illuminance ratio of about a billion to one. The increase in sensitivity that occurs with a decrease in the light level is a gradual process, requiring about 40 minutes to reach maximum dark adaptation. Dilation of the iris can increase the amount of light admitted to the eye by only about 16 times. Most of the increase in sensitivity that occurs during dark adaptation is the result of changes in the pigments in the retinal receptors and changes in the neural processes.

In contrast to dark adaptation, a major part of light adaptation occurs within a few minutes. Photographers who need dark adaptation to see clearly in low light-level situations, such as for certain darkroom operations and night photography, can avoid its quick destruction by using dark eyeglasses when exposure to a higher light level is unavoidable. A fairly intense red light can be turned on in a darkroom without destroying dark adaptation because of the insensitivity of the rod receptors in the retina to red light.

Because of the change in sensitivity of the visual system during light and dark adaptation, the eye is a poor measuring instrument. When photographers correctly estimate camera exposure settings without an exposure meter it is on the basis of the memory of previous experience in similar situations rather than by estimating luminances visually.

In visual environments containing a variety of tones, the adaptation level tends to be adjusted to an intermediate value that is dependent upon the size, luminance, and distribution of the tonal areas. There is sufficient local adaptation, however, to enable the viewer to detect detail over a wider range of luminances from dark shadows to bright highlights than would be possible without local adaptation. This local

adaptation that enables a person to see detail over a larger luminance range is not so great as to interfere with the judgment of lighting ratios on objects such as portrait models, where experienced photographers are able to judge 1:2, 1:3, and 1:4 lighting ratios, for example, with considerable accuracy.

Chromatic Adaptation An example of chromatic adaptation is the acceptance of both daylight and incandescent illumination as being white when viewed separately for long enough periods to allow the visual system to adjust, whereas a dramatic difference in color is seen when the two types of light are viewed side by side, where daylight tends to appear bluish and incandescent illumination yellowish. A change in sensitivity of the visual system to a color can be demonstrated by looking steadily at a saturated color patch or design for a minute or so and then looking at a neutral surface, where an approximately complementary color will be seen.

Chromatic adaptation is thought to be primarily due to bleaching of the cone pigments in the retina. Upon exposure to blue light, for example, the pigment in the blue-sensitive cones is bleached, becoming more transparent to blue light and therefore absorbing less blue light. The net effect is that the blue-sensitive cones become less sensitive to blue light, which causes neutral colors that are viewed immediately following exposure to the blue light to appear yellowish.

Even though brightness adaptation and chromatic adaptation greatly alter the appearance of the lightness and the color of visual stimuli, the adaptation is incomplete. As a result, tungsten light, which we accept as being white after being adapted to it, actually tends to appear slightly yellowish when judged critically.

Some adaptation effects are difficult to explain, such as the one produced in an experiment in which a person wore prism eyeglasses that made everything appear to be upside down. After wearing the glasses for some time, adaptation occurred and the world appeared to be normal again—until the glasses were removed, whereupon the world again appeared to be inverted. It has been established that physiological factors are involved in brightness, chromatic, and certain other types of adaptation but psychological factors are undoubtedly involved in some types of adaptation. *L. Stroebel and R. Zakia*

See also: *Pupillometrics; Visual perception.*

VISUAL ACUITY
A measure of visual performance in perceiving detail, as with the Snellen chart consisting of black letters on a white background used for eye tests. Measured acuity, like resolution, varies with the shape and contrast of the test target elements and light level.

L. Stroebel and R. Zakia

See also: *Visual perception, perception of detail.*

VISUAL AID
A projected image or a displayed image or object that is used for educational or informational purposes.

L. Stroebel

VISUAL ANGLE
The angle subtended by an object at the front nodal point of the eye. *S. Ray*

VISUAL COMMUNICATION
Distinctions and Definitions Two distinctions are essential to any understanding of visual communication:

1. not all visuals are communication, and
2. not all communication is visual.

The first distinction is conceptual and the second is perceptual.

The first distinction refers to the fact that not everything we see is communication. We may look at something that is not a message from another human, that is, it does not possess any means of human expression. On the beach, the rocks, by themselves, have nothing to say. Objects do not "intend" to communicate. In fact they do not and cannot intend anything; that separates them from subjects. For our purposes, only human subjects are possessed of the willful powers of intent that are essential to communication.

Communication in general can be defined as a circulation of expression and impression between two or more individuals with or without the use of a medium such as stone, wire, paper, canvas, polymers, or any other substance. It is important to distinguish visual communication and visual observation because there are different mental compartments for the two, and if there is a mismatch, the system error can be very serious.

Sight and Hearing Seeing may be believing in the objective realm of observation, but in the subjective realm of communication, seeing is evaluating. Evaluation takes into account the pre-existing relationships with the communicator, the form, and the topic, all of which may substantially reduce the "believing" that follows the "seeing." Still, seeing is not hearing.

It is because we believe that the primary sense that processes the expression leaves its mark on the resulting internal impressions that we bother to make the perceptual distinction between visual and nonvisual communication.

Communication, in whatever form, may address any combination of senses: touch, smell, taste, hearing, or sight. For whatever reason, in most cultures, including our own, hearing and sight are singled out for the great majority of adult communications. The communications addressed to these senses may be called aural if addressed to the ear, or visual of addressed to the eye.

Visual communication would include any form of human expression addressed to the eye alone or to the eye in combination with other senses. In most cases, where the eye is one of a combination of senses, the eye becomes the dominant sense.

We shall not embark on a lengthy physiological description of visual observation or vision outside of the communication process except to say that as a means of perception, vision distinguishes itself from the other primary sense, hearing, by its speed relative to the cognitive process. It has been demonstrated that the eye can put sense data together faster than the cognitive processes can abstract meaning from that sense data. Whereas with hearing, cognition may find itself waiting for the sequential linear code. With aural perception, before meaning can be derived the auditory sensations must be processed one pulse at a time. With the eye, parallel rods and cones are firing simultaneously, bringing in nonlinear simultaneous patterns. This makes vision less time-dependent than hearing and therefore more spatial. Vision's nonlinearity or simultaneity makes the internal visual impression appear to be all there, all at once. This unchained, spatial freedom of visual communication is its hallmark.

Dynamic and Static Communications Although these words were written for the eye of the reader, they could have been delivered electronically in a passive or interactive dynamic display. The advent of computers has added new wrinkles to the analysis of visual communication at both ends of the circulation: dynamic production tools and dynamic displays. These very words could have been generated more or less by software and sent instantaneously as electronic mail for example, or recorded for noninstantaneous delivery on disk.

Despite all the variations of delivery systems afforded by the information age, there seems to be a constant place for the traditional static display of text--*hard copy*. Why?

Some readers have suggested that it is the resolution of ink on paper, others feel that holding the text in one's own hands

lends a level of control and comfort. It could be added that the static display, which holds the text still for the eye for as long as it likes, makes this otherwise tricky path more sure-footed. While one is trying to decipher, chain-stepping through the line of symbols and side-stepping out to references, all at the same time, knowing that the text on this page will wait for the eye for split seconds or centuries, provides a level of assurance or comfort which seems to defuse the pressure. That is not to say that one cannot read and comprehend from electronic media, but it takes much longer. The knowledge that the text might have been corrupted accidentally, that, by some mystery of hardware or software, it might not be on the disk next time, or that the power might go off, adds sensory insecurity that slows the process down. It is also true that in a delivery system that has the enormous capacity for dynamic images and sound, each of which requires much less pretransactional initiation, text seems to be lost in the enormous channel capacity, and so the static display is preferred where the text seems to fit more snugly.

Not all visual symbols are text, but in their static display there must be an overarching convention about their order. Mathematical or musical notation too must abide by static display conventions. Pictographic alphabets, which are also symbolic visual expression, allude to meaning via images. They are, nevertheless symbols and not images. As such they too must adhere to the more rigid static display conventions for symbols (following vertical rather than horizontal lines in Chinese for example).

The static display conventions for all symbols are more rigid than the static display conventions for images, because of the precision and abstraction to which the symbols aspire. Beyond the lines that order the symbols, the visual effects of page layout and type font can affect the interpretation process of this text.

This text is an example of visual symbolic expression made by dynamic electronic tools but coming to you by way of a static display—a book. Conventions for such static displays are well settled by years of consensus. In the case of the English language, the alphabetic symbols are designed to represent the sounds of the words—they are a phonetic alphabet. As such, convention dictates that they be read from left to right, with pausing points marked by commas, periods, and paragraphs. Not too long ago these symbols would have been penned with ink from a well, then with continuous flowing ink from fountain pens, ballpoints, typewriters, and now computer word processors. Clearly, stopping to dip for ink affected the preparation time and the boldness of the stroke, both of which affected the expression, and, of course, eventually, the impression of the text as well. This so-called "charm" of pen and ink added overtones to the primary meaning in the expression content, just as the easily selectable variety of type fonts offered by the word processing programs can shade the meaning of this text. Words can be made **bold** or *italicized* or <u>underlined</u> with a single keystroke, changing the emphasis in the expression represented by the printed words.

No effect of the static display of text or any other form can supply any of the missing steps or links in the decoding chain, but within the limits of the code, the static form can affect the content. The same visual symbolic expression couched in the form of a hand-written note, or a formal business letter or a published book or a telegram will each have a slightly different impact.

The dynamic capacity of the electronic display, monitors and TV screens, has been harnessed by two opposing conventions. One passive convention leads the eye in a preordained path, while the other, interactive convention, offers to follow the eye in its own unique path. These display dynamics apply to both pictures and symbols.

Whether static or dynamic, two-dimensional visual images may be *wrought,* that is rendered by hand, and/or they may be *captured.* In either case, the help of some tool is required, which implies a technology. Perhaps the information age represents the coming together of Lewis Mumford's stages of development: man the tool maker and man the symbol maker.

In addition to being wrought or captured, images may be sent and displayed as single *static* images or *dynamic* sets of images. Here again, the dynamic images may be *passive* or *interactive* (responsive). Once again any image may be static or dynamic, and if it is dynamic, it may be more or less under the control of the viewer, which we are characterizing as passive or interactive.

The Static Image The static image, whether wrought (put together by hand) or captured, is the most independent from time and timing; it allows the eye to proceed in its own path at its own pace. This of course means that no single path is the correct one. The myriad of possible visual paths is the hallmark of the form and also the feature of the form that the visual communicator works against to lend impact to the visual expression. Compositional patterns and chiaroscuro (use of light and dark) are some of the techniques at the visual communicator's disposal to trap the emancipated eye of the beholder. To the extent that the freed-up eye is trapped back into the subtle patterns, a second, unannounced, imprecise level of communication occurs in the *bulge* of the form by content. Like the more abstract overtones of harmony in musical expressions, this esthetic bulge may delight the viewer without any precise understanding of the reason. Not only is the subject or object identified by eye but a more abstract pattern sings a harmony or counterpoint for the eye, the total effect of which is greater than the sum of its parts.

In this connection, the skilled wrought-image communicator has more work to do, but, by the same token, more can be done. There is more control and therefore a deeper channel capacity, if not a broader one. The relationship of figure to ground, shapes, distortions, shading, colors, and the combinations of all of those factors can extend the image beyond the reality of everyday objects. The wrought image can afford to be more the direct offspring of imagination and intent, more internal, more subjective. It can speak about interior consciousness as well as external reality.

The captured static image on the other hand (the photograph) is limited by the size and shape of the object that happens to be in front of the lens at the time; even if the object happens to be the physical body of another subject, it is a light-reflecting object where the captured image is concerned. Much interpretation can be done with lighting and processing, but the reflected light from a real figure or figures is the basic ingredient of the form. Here again the great content pushes against this limitation and bulges the line in the direction of the neighboring wrought image.

The fact that the wrought image preceded the captured image historically has some communication significance. The initial coding for imagic communication was dictated by the wrought image. Probably life experience itself originally linked *brooding* to heavy clouds, but it was the painter who set that into esthetic code. It was the wrought-image esthetic code that influenced the esthetic sensibility of the photographer. These pre-established wrought-image codes had to be addressed if the captured image was to communicate on any deeper level, and then they had to be exceeded if the captured image was to establish itself as an independent form. This is a challenge for each new captured image.

One feature of form that helped distinguish the captured image was its speed. Even with the long exposure time and tedious processing of early captured images, the overall rendering time was shorter than it was with wrought images. And so image capture pushed the technology for greater and greater speed and facility of process in order to underscore

its differences and establish itself as a distinct form. Eventually galloping horses and hummingbird wings could be captured mid-stroke for the eye to peruse at its leisure. These figures could never have posed for the painter. This assured the form of static, captured images a secure place in the hierarchy of visual communication.

The speed also meant that the single visual communicator could make more images in a day, or in a career. A broader range of subjects and objects could model for this visual expression. Instances that would have been lost to the painter could be brought home in the camera. Needless to say this changed the course of the wrought image as well as the captured image. It forced the hand of the wrought-image maker further toward imprecision, that second voice, or second level where the camera's speed had no advantage. Modern so called *nonobjective* or *impressionistic* or *abstract* art can be viewed as the reestablishment of the wrought image with new levels of subjectivity in the underlying code.

Still the forms could not settle down each to their own turf. Once the static wrought image became less objective, more subjective, the static, captured image followed suit.

Now with electronic imaging tools, the lines become blurred both at the expression or production end and at the display and impression end. The fact is that visual expression can now be partially wrought and partially captured. And the *bastard* image can show itself in a static, dynamic-passive, or dynamic-interactive display. In other words, one can take a photograph with film or electronic camera; one can then scan the photograph into image-processing software and use computer graphics to change it in an almost infinite number of ways. The product of this mixed compound process can now be printed on paper as a standard static display, or it can be compressed and transmitted and displayed electronically as a still image across the world, or it can be animated so that it becomes part of a dynamic passive display or it can be pieced into a more elaborate responsive display that purports to be interactive.

These mixed forms have yet to establish their own codes, so that viewers' perception and conception processes know what to expect and how to respond. Instead the old codes are still in effect and the new images must make their way as photographs or paintings to the viewer's interior.

There are, however, collateral effects of the new imaging processes. With the new-found processing and transmission speeds, the visual communicator can compete with transmitted text and voice for time-dependent subjects such as fast-breaking news.

A second effect of the new imaging processes has to do with the veracity of the captured image. Traditionally the captured image didn't lie. At least we assumed that it didn't lie because it was so directly related and close to visual observation. It seemed to be much harder to lie with the camera than the brush or pen. Some semblance of what was in the photograph had to have occurred in front of the lens. The truth might have been exaggerated by focus; it might have been staged, but even in the staging there were limits. Now subjects and objects that were not and could not have been together can be seamlessly pieced together in the captured image. This dramatically punctures the line between captured and wrought images. On the positive side, the subjective intentional energies of imagination can and will make a wider variety of statements in the neo-captured image format that heretofore might have been reserved for the wrought image. On the negative side, collateral technology or laws or canons of ethics will be necessary to reinstate the veracity.

A third effect of this compounding of captured and wrought images has to do with the cost efficiency of the production and publication. Publishers traditionally created a necessary superstructure that served as a topical bottleneck. The visual expression had to pass through editors before it

was disseminated. That is no longer the case. You can desktop publish your own work, eliminating the superstructure with whatever good or bad effects that had on delivery. This is an information age by-product that affects all expression, not just visual expression. The heralds of this democratization of the communication hegemony hope for a demassification of audiences, resulting in a broader range of topics serving the broader range of interests. At this point, however, it is only a hope.

Books: Ciampa, John A., *Communication: The Living End.* N.Y.: Philosophical Library, 1988. *J. A. Ciampa*

VISUAL CORTEX The surface layer of the brain that governs seeing. It is part of the cerebral cortex, is 3 to 4 mm thick in humans, and has a grayish pink color. The word *cortex* is Latin for *bark*. *L. Stroebel and R. Zakia*
See also: *Vision, the visual neurological system.*

VISUAL DENSITY The measure of the absorption of light by an area of a photographic image based on the spectral (color) response of a standard human eye. A yellowish image will have a lower visual density than when measured with an unfiltered photoelectric cell because the eye has a greater sensitivity to wavelengths near the center of the light spectrum. *M. Leary and H. Todd*
See also: *Densitometry.*

VISUAL FOCUS When the eye is used to judge sharp focus on a focusing screen the accuracy of the result depends on various factors, including any refractive errors of the eye and their correction plus the luminance and illumination range of the image. The spectral sensitivity of the photopic eye peaks in the central green region of the spectrum, so this zone is favored. Highly corrected lenses such as process types may be focused through a green filter. Previously, chromatic or uncorrected lenses with longitudinal chromatic abberation suffered a focus shift when used with blue-sensitive (ordinary) materials. Visual focusing problems do not apply to the use of rangefinders or passive focusing aids.
 S. Ray

VISUAL LITERACY Having or showing knowledge of the process of communicating by means of pictorial images, as distinct from the ability to communicate with written and spoken words. *L. Stroebel*

VISUAL PERCEPTION One definition of *perception* is the process of knowing objects and objective events by means of the senses. Another definition refers to the addition of meaning from past experience to sensations. A third definition refers to an organism's ability to discriminate between stimuli. These definitions are not incompatible, but they illustrate that experts in the field of perception have not agreed on a common definition of the term.

DEFINITION OF VISUAL PERCEPTION The term *visual perception* will be treated here as identifying the process of deriving meaning about the external world through the sense of sight—a process that requires the ability to discriminate between visual stimuli, and a derived meaning that depends on past experience.

At one time visual perception was thought to be instantaneous. Now, it is considered to be the result of a sequence of stages that includes sensing, information processing, memory, and thought. In general, the more complex the sensory stimulus and the more information desired from it, the longer the processing time. For example, it has been suggested that the steps involved in visually identifying an object are (1) detection, (2) localization, (3) recognition, and (4) identification, where it takes longer to identify an object than to simply detect its presence.

SENSATIONS AND PERCEPTIONS Because visual perceptions normally require sensory input from the eyes and the sensations may seem to be an integral part of the perceptions, distinctions are not always made between visual sensations and visual perceptions. Meaning is the key requirement that distinguishes a perception from a sensation, although the level of the meaning may range from vague to specific. For example, if a person is reading a book at night and detects a flash of light, the sensation of the flash may hold no meaning for the person unless it is associated with some similar previous experience, an association that is more likely to occur if the flash is accompanied by an auditory clue such as a clap of thunder or the sound of a siren.

Additional evidence that a distinction exists between sensations and perceptions is provided by experiments that show that the same sensory input can produce different perceptions and that different sensory inputs can produce the same perception. An ambiguous design such as the one by Rubin in which the viewer may see a vase or two facing profiles at different times due to figure-ground reversal illustrates a single sensory input that produces different perceptions. The fact that most people will judge a sheet of white paper to be white when viewed under different levels of illumination, an effect known as brightness constancy, illustrates how different sensory inputs can produce the same perception.

ACCURACY OF VISUAL PERCEPTIONS Most of our visual perceptions are reasonably accurate, which means that information derived from our sense of sight can be verified in other ways. For example, when an object that is thought to be a cube on the basis of a visual perception is held in the hands, tactile perceptions based on the sense of touch can confirm the original visual perception. A laboratory experiment in which optically distorted images were presented to subjects so that the alternating visual and tactile perceptions did not agree demonstrated that the subjects tended to have more confidence in what they saw than in what they felt.

There are, however, situations in which our eyes deceive us. An illusion can be defined as a false perception, or a perception that does not agree with the physical reality of the stimulus. Illusions are most commonly associated with the sense of sight, although false perceptions can also occur with the other senses. Illusions relating to visual perception are sometimes identified more specifically as optical illusions.

Most of us have seen illusions in which a straight line appears curved, have seen realistic images in a dream when our eyes were closed, have seen spots after having our picture taken with a flash camera, have seen realistic three-dimensional images while looking at a pair of two-dimensional

An illusion whereby the straight lines in the square seen as figure tend to appear curved because of the influence of the circular lines in the background.

photographs, and other visual perceptions that are not accurate representations of the input stimuli.

Most of the well-known optical illusions are based on two-dimensional drawings. It is less common to experience such illusions in the real three-dimensional world, although a dramatic example is the distorted room conceived by psychologist A. Ames that is perceived as being rectangular, in which objects appear to double in size when moved from the left side to the right side when the actual room is viewed from a fixed position with one eye and in photographs. Optical illusions can involve any of the stimulus attributes including size, shape, form, distance, color, and motion.

By far the most important optical illusion in still photography, motion pictures, video, art, and other image media is the acceptance of two-dimensional images as representing the three-dimensional world, an acceptance that is so pervasive that the illusion is not even thought of as an illusion. René Margritte dramatized this acceptance by painting a picture of a pipe and adding the inscription "Ceci n'est pas une pipe." (This is not a pipe.)

PERCEPTUAL DISCRIMINATION Our definition of visual perception is based on the ability to discriminate between visual stimuli. The following statement by Berelson and Steiner from their book *Human Behavior—An Inventory of Scientific Findings* dramatically stresses the importance of the ability to discriminate in the much broader context of all human behavior: "From the simplest sensory experiences to the most complicated judgments of social norms and values, man responds relatively—by making comparisons that detect similarities and differences and little, perhaps nothing, more."

It would be difficult to identify all of the visual-stimulus attributes that serve as a basis for comparison and the detection of similarities and differences in all visual-perception situations, but the list would certainly include lightness, hue, saturation, shape, form, size, distance, location, motion, and duration.

PERCEPTION OF LIGHTNESS/BRIGHTNESS Lightness refers to the amount of light perceived to be *reflected* or *transmitted* by a surface, and brightness refers to the amount of light perceived to be *emitted* by a light source. Thus, a white object appears lighter than a gray or black object, and

Accuracy of visual perception. An ambiguous design that can be perceived as a vase or as two facing profiles.

a 100-watt tungsten lamp appears brighter than a 15-watt tungsten lamp.

The visual system is very poor in estimating absolute values of luminance, which is the amount of light emitted, reflected, or transmitted per unit area of a surface and which can be measured with a light meter. The visual system is very good, however, in detecting small differences in luminances in side-by-side comparisons. A person can detect a difference in density of 0.01 in a visual densitometer, for example, which is close to the limit of sensitivity of electronic densitometers.

Many efforts have been made over the years to find a mathematical relationship between the subjective perception of lightness/brightness and objective measurements of luminance, three of which have been expressed as Weber's law, Fechner's law, and Stevens' power law. None of the three has been universally accepted as being adequate, but the Stevens' power law agrees closely with differences in the value scale of the Munsell system where the neutral tones, which range from white to black, were selected on the basis that the lightness increments appeared to be equal. According to Stevens' power law the perceived lightness equals the measured luminance raised to a power of 0.33 and multiplied by a constant.

The changes that occur in the perceived lightness of our surroundings during the process of dark adaptation and light adaptation provide a clue as to why we are much better at judging relative lightnesses than absolute luminance values. Our perception of the lightness of an object, such as a photograph, is also influenced by the lightness of the surroundings, an effect known as *simultaneous contrast*. Thus, if one of two identical photographs is mounted on a white support and the other is mounted on a black support, the print on the black support will tend to appear lighter. This effect can be demonstrated much more dramatically by placing a stack (to make them opaque) of six or so snapshots on a somewhat larger transparency illuminator. With the room lights on, turning the transparency illuminator light on and off will cause the perceived lightness of the top picture to change dramatically even though the room illumination falling on the picture remains constant.

PERCEPTION OF HUE AND SATURATION There are three perceptual attributes of colors: hue, saturation, and lightness or brightness. In everyday language the word *color* is commonly considered to refer to the name of the hue of the color. We identify the colors of objects with hue names, referring to blue sky, green grass, and red apples, for example. Even though the names of hues such as these are universally meaningful, we have a very limited vocabulary for describing subtle differences in hue. Only seven names are commonly used to identify the hues in the spectrum of white light—violet, blue, blue-green, green, yellow, orange, and red. Adding red-blue, or magenta, which is not found in the spectrum, increases the total to eight.

Many people who have normal color vision can successfully arrange all of the color samples in the correct order in the *Farnsworth–Munsell 100-Hue Test* in which the hue differences between adjacent samples are very subtle. The Munsell system of color notation identifies 10 major hues (red, yellow-red, yellow, green-yellow, green, blue-green, blue, purple-blue, purple, and red-purple) which are arranged in a circle. The space for each major hue is divided into 10 subdivisions so that the complete circle contains 100 hues. The hue of any color sample can be identified with the Munsell system by finding the patch in the hue circle that matches the hue of the color sample and noting the designation of that patch, such as 5R.

Because most photographic color processes involve recording the red, green, and blue content of the subject for the analysis stage and using cyan, magenta, and yellow col-

orants for the synthesis stage, photographers use these color names when dealing with color images. These six hue names are useful, for example, when describing the color balance of a test color print since the name suggests the change required in the printer color filtration to improve the color balance of the next print. Cyan, magenta, and yellow are considered primary colors for subtractive color printing processes since these colors of dyes or other colorants can be combined systematically in various proportions to produce the wide range of colors required in high-quality color photographs. Red, green, and blue are the primary colors for additive color systems such as color television since various combinations of these three colors of light produce all of the colors that we see in color television images.

Primary colors for visual perception can be defined as a set of colors that are perceived as being pure, that is, where none of the colors is perceived as being a mixture of other colors. It is generally agreed that red, green, blue, and yellow colors satisfy this definition. Even though yellow, one of the subtractive primary colors, can be produced by mixing red light and green light, yellow does not appear to be a mixture of red and green. Cyan and magenta, the other two subtractive primary colors, do appear to be mixtures of blue and green, and blue and red respectively. Black and white are sometimes included to produce a total of six perceptual primary colors. Even though black and white are neutral in hue, they are included in the Munsell system of color notation and they both appear pure—as distinct from grays, which are perceived as being a mixture of black and white.

Color saturation can be defined as the attribute of a color that distinguishes the color from a gray of the same lightness. The saturation of a highly saturated or vivid red watercolor, for example, can be gradually reduced by adding increasing amounts of a gray watercolor that has the same lightness. Theoretically, it would be impossible to produce a neutral with this procedure, but the addition of a very large amount of gray to a small amount of red could reduce the saturation of the mixture to a point where it appears neutral. Saturation can also be reduced by adding the complementary color. Cyan (blue-green) could be used to reduce the saturation of red, but if more is added than needed to produce a gray, the hue of the mixture will become cyan.

For the most part, we tend to think of the colors of objects as being an inherent and fixed attribute of the objects—even though we know that some colors may fade and that some foliage may change color in the fall. Our perception of stable object colors, however, can change quickly and dramatically. The reasons for the changes can be physiological or psychological, or a combination of the two. Reducing the illumination level can cause a color to appear to change in hue and saturation, and if it is reduced to the level where the retinal cones no longer function, highly saturated subject colors can appear gray. Museums sometimes use a lower level of illumination than is optimal for viewing in order to protect valuable images against possible fading from the light. Hues are also more difficult to identify when the retinal images are off axis, where the concentration of cones is lower. Paints that are selected by looking at small samples on a color chart commonly look different when seen on the larger areas of the walls of a room.

It should not surprise us that a red object illuminated solely with blue light will appear black since there is no red light in the source to be reflected by the object, but we are commonly surprised by how much different the color of an object can look under two "white" light sources, such as daylight and fluorescent light. Even though we accept both sources as being white, differences in their spectral-energy distributions can cause differences in the perceived color of an object. The effect is most dramatic when two colors match when viewed under one light source and appear considerably

different when viewed under another light source. This phenomenon is referred to as metamerism, and the two colors are identified as a metameric pair. Metamerism can create problems for photographers when they make color photographs that match the colors of the original subjects when viewed by the light sources in their laboratories but the colors do not appear to match when viewed under different light sources by their customers. Light sources having high color rendering indexes are recommended for the critical viewing of color images, as in color printing labs.

The color of an object can appear to change when the color or the surround is changed. The blue color of an object tends to appear more saturated with a yellow background than with a gray background, and a gray object in front of a yellow background tends to appear bluish.

Some of the complexity involved in our perception of color is suggested by demonstrations used by Dr. Edwin Land to support his Retinex theory of color perception whereby projected images of two black and white slides, with a red filter on one projector and no filter on the other, superimposed on a screen in a darkened room produced the appearance of a wide range of colors.

PERCEPTION OF DETAIL The measure of a person's ability to distinguish detail in a test target is referred to as acuity. Acuity is a numerical value determined by requiring a person to identify the smallest element that can be distinguished in a test object consisting of spots, lines, or characters that vary in size. The reciprocal of the angle subtended by that element at the subject's eye, in minutes, is one measure of acuity. If, for example, the element subtends an angle of 2 minutes, the acuity is 1/2.

The magnitude of the measured acuity depends greatly on the experimental procedure and is by no means determined solely by the observer's visual ability. The nature of the test object is in part dictated by the task that the observer is called upon to perform. *Detection,* for example, involves simply the ability of the observer to state whether or not the test element is present. *Localization* requires identification of the position of a critical element of the test object such as the opening in the Landolt ring or the break in a straight line when part of the line is displaced to test vernier acuity. *Resolution* measures the ability of the observer to discriminate the elements in a set of small similar items, often parallel bars. *Recognition* requires the observer to state the identity of the test character, such as the letters on a Snellen chart.

Resolution of a person's vision can be tested with the same test targets that are used for testing photographic lenses, such as those having varying size sets of three black bars on a white background. With targets that are placed at a distance of 21 times the lens focal length from the lens, they would be placed 21 times 17 mm, the average focal length for the human eye, or 357 mm (14 inches) from the eye. A typical value for persons with normal vision is 90 lines per millimeter. This resolving power on the retina corresponds to a resolving power of approximately 13 lines per millimeter when viewing a 7-inch by 7-inch photograph at the standardized viewing distance of 10 inches.

Other factors that can affect the measured acuity for a given person include (1) the contrast of the test target, where higher contrast targets result in higher values; (2) the illumination level, where the acuity decreases with both low and extremely high illumination levels; (3) pupil size, where acuity decreases at large openings due to aberrations and at small openings due to diffraction; and (4) illumination color, where acuity tends to be higher for green and yellow light than for blue light or red light. The effects of age can also produce a change in acuity.

The question could be raised as to how important is it to be able to resolve fine detail—for photographers, for viewers of photographs, and for all of us in our everyday lives. There have been examples of photographers and artists whose vision was so poor that they were classified as being legally blind but who were able to produce images that were greatly admired. Actually, photographers have devised a variety of ways of concealing detail that would be considered distracting, including the use of makeup and soft-focus lenses for closeup shots of actors in romantic motion pictures, and the use of a shallow depth of field, retouching, texture screens, textured paper surfaces, soft-focus lenses, and even motion blur in still photography.

Although the esthetic appeal of many of the objects and scenes we view directly or as photographic images depends on the tonal arrangements of larger areas, the resolution of detail is important to most visual tasks, and the accurate reproduction of subject detail in photographs is generally considered desirable. Fortunately, there are optical devices to assist photographers in tasks involving seeing fine detail such as focusing cameras and enlargers, retouching negatives, and spotting prints.

PERCEPTION OF SHAPE Shape is identified as the outline of an object or the representation of such an outline in a picture. Of the various visual attributes that are generally associated with objects, shape alone is sufficient for the recognition and identification of many. Thus, the simple outline drawings that teachers put on chalkboards and that are used in some textbooks often serve the learning process adequately. In fact, some experimental studies have revealed that realistic color photographs may not be as effective as simple line drawings for instructional purposes.

Although shape is commonly shown in drawings as a black line on a white background, it can be represented and perceived in various other ways. For example, the image of the object can be solid black against a white background, as in a silhouette. Or, the difference between the figure and the background can be in hue (a red image on a blue background), or in color saturation, texture, sheen, or other attribute. Photographers have a number of ways in which they can control the emphasis that is placed on the shape attribute of an object that is being photographed, including the choice of background and the lighting.

Whereas there are widely used standardized vision tests to determine how accurately a person sees detail (acuity tests) and colors (color-vision tests), there are no routine tests for measuring accuracy in the perception of shapes. This is primarily because this type of error is not as hazardous as not being able to read road signs or distinguish between red and green traffic lights.

There are two types of situations where the shapes of objects represented in photographs are commonly perceived inaccurately. One of these is encountered when looking at photographs made with short focal-length lenses because viewers tend to view such photographs from a comfortable viewing distance, which is larger than the correct viewing distance for perspective—a distance equal to the focal length of the camera lens times the magnification of the camera image to the final image. As a result, objects near the corners of the photograph appear stretched out of shape in directions

Perception of shape. Line drawings of object shapes are effective in communicating the identity of many objects, even with simple abstract drawings such as this.

radiating from the center of the photograph, an effect known as *wide-angle distortion.*

The other situation where an inaccurate perception of shape occurs is a psychological effect resulting from the need for viewers to depend on previous experience and memory when judging the shape of three-dimensional objects represented in two-dimensional photographs and are therefore influenced by what they expect the shapes of some objects to be. As a result, viewers tend to perceive some irregular shapes as idealized simple shapes—slightly converging subject lines as being parallel subject lines seen in perspective, acute and obtuse subject angles as being right angles, and subject ellipses as being circles—an effect known as *shape generalization.*

PERCEPTION OF FORM Although the terms *form* and *shape* are used interchangeably in some disciplines, in photography form refers to the depth or three-dimensional attribute of an object as distinct from the outline. Depth attributes of texture, form, and distance (from small scale to large scale) add realism to the visual world, even when these attributes are two-dimensional representations in photographs and other pictures. Form, unlike lightness, hue, and saturation, is an object attribute that can be perceived through more than one of our senses, namely sight and touch. Craftsmen who work with clay, wood, and metal develop an important interdependent relationship between the two senses.

There are a number of methods photographers can use to represent three-dimensional subjects in two-dimensional photographs, but the most convincing method of representing the form of objects is with appropriate lighting. With box-shaped objects, form is best represented by controlling the lighting to produce differences in lightness for the three visible planes. A plain white cube that is lighted to produce no tonal separation between the planes can appear deceptively two-dimensional in a photograph. With objects having curved surfaces, such as the human face, form is most realistically represented with lighting that produces a gradation of tone from a highlight on one side of the forehead, for example, to a shadow on the other side. Realistically representing form in photographs is not always desirable. In a fashion photograph, for example, it might be more appropriate to minimize the appearance of form in the model's face in order to place more emphasis on the color, detail, and shape of the clothing.

Because of the two-dimensional nature of photographic images, optical illusions involving depth perception can occur. We have become accustomed to seeing shadows located beneath objects rather than above since light sources, both in nature and in artificial lighting situations, are normally elevated above the subject. When certain photographs

that do not have other depth cues are inverted, so that a shadow is positioned above the object, a reversal of depth is possible. A photograph of a depressed footprint in sand, for example, can, when inverted, create the perception of an elevated footprint.

PERCEPTION OF SIZE AND DISTANCE It is easy to produce photographic images that are the same size as the subjects being photographed when the subjects are small objects such as coins and stamps. Since the need for same-size images is rare, they probably occur as often by coincidence as by design. Exceptions would be where same-size images are a function of a particular imaging system, as occurs with the production of photograms and x-ray images where optical systems are not used between the objects and the sensitized material. In practice, photographic images range from being almost infinitely small in relation to the subject, in the case of photographs of the stars, to being astonishingly large, in the case of photographs made with scanning electron microscopes. This tremendous range of scales of reproduction in photographic images presents a challenge to viewers with respect to being able to perceive the actual sizes of the objects represented.

Two factors that make relatively accurate perceptions of size possible are (1) that we usually recognize the objects that are represented in photographs, and (2) unfamiliar objects are commonly photographed in an environment that contains recognizable objects so that a comparison can be made. Recognition in this context implies familiarity with a class of objects, not the specific object. Thus, even though none of us have ever seen Abraham Lincoln, our perception of his height in response to viewing a full-length photograph of him will be reasonably accurate, and errors would be measured only in inches because of our previous experience of seeing a large number of mature men.

Accurate perception of the size of an unfamiliar object in a photograph is facilitated when the object is positioned at the same distance from the camera as an object of known size. When it is important that the exact size of an object is indicated in a photograph, a ruler or similar scale is placed adjacent to the object, such as the height scale behind suspects in police lineup photographs, and a ruler placed in archaeological photographs of certain artifacts.

It is not difficult to deceive a viewer about the size of an object represented in a photograph if the object is different in size than the viewer is led to assume on the basis of its appearance. Thus a scale model of a building that is only a couple of feet tall can appear to be an actual building a hundred times as tall. Extensive use of this type of deceit has been used to depict disaster scenes in motion pictures.

When an unfamiliar object is located at a different distance than a familiar object of known size, accurate perception becomes a more complicated task. In real life situations we are seldom fooled by the inverse relationship between image size and object distance where two objects of equal size located at a ratio of distances of one to two from the viewer will be perceived as being approximately the same size even though the ratio of the image sizes on the retina is two to one. Perception of the relationship between image size and object distance is also good when viewing photographs of three-dimensional scenes providing that the photographs are viewed from the so-called center of perspective. The center of perspective can be defined as a distance from the photographic image that is equal to the focal length of the camera lens times the magnification of the camera image to produce the final image. When normal focal-length lenses are used, the correct viewing distance will be approximately equal to the diagonal of the final image, which is about the same distance that viewers tend to select as being a comfortable viewing distance. When short focal-length wide-angle lenses are used on the camera, however, the correct viewing dis-

Perception of form. The three-dimensional attribute of a cube is revealed by tonal differences of the three visible planes. When the tones match in all three planes, the image can be perceived as representing a two-dimensional hexagon.

tance is closer to the image than the comfortable distance, which causes objects to appear to decrease too rapidly in size with increasing object distance. In other words, distant objects appear unnaturally small and near objects appear unnaturally large. The converse occurs when long focal-length telephoto lenses are used on the camera, where viewing the image from a comfortable distance causes distant objects to appear unnaturally large and near objects to appear unnaturally small.

PERCEPTION OF MOTION The perception of motion is an awareness of an actual or an apparent change in position of an object or other visual stimulus over a short period of time. Whether one perceives motion or not when an object moves within the field of view depends upon a number of factors. With respect to the rate of movement, there are both lower and upper thresholds. When looking at an analog watch, a person can perceive motion of the second hand but not the minute or hour hands, even though a change in position of these hands can be detected over a longer period of time. At the other extreme, a bullet fired from a gun travels too rapidly to be detected. At a somewhat slower speed of 180 degrees per second an object may be perceived only as a blur. An advantage of motion-picture photography and television over direct vision is the ability to speed up the images of slow-moving objects and to slow down the images of fast-moving objects to a speed that can be viewed comfortably.

Since motion involves a change in position of a visual stimulus, a reference is necessary for motion perception. For this reason a small moving light in a dark room may not be perceived as moving, and conversely, a stationary light may appear to move. If only two objects are visible in the field of view and one of them moves, there is a tendency to perceive the larger object as being stationary and the smaller one as moving even when the actual conditions are the reverse.

The perceived rate of motion of an object that is moving at a constant speed can vary over a considerable range. The variations depend upon such factors as the object size, illumination level, contrast with the background, and the amount of detail in the surround, plus psychological factors such as the threat of a moving car bearing down on a pedestrian viewer. There is a strong relationship between the assumed distance of a moving object and the perception of rate of movement. A light that is moving at a constant speed appears to be moving slower when it is assumed to be near than at a greater distance. For this reason it is necessary to adjust the shooting speed when substituting scale models for falling objects in motion pictures. A scale model of a car going over a cliff would appear to fall too rapidly if perceived as a full-size car and cliff. Therefore the shooting speed has to be increased with a decrease in model size so that the slower projected image motion appears normal.

There are three different types of conditions for the perception of motion in the real world. In the first, the eye is held steady while one or more objects move against a sta-

tionary background. The moving images on the retina stimulate different receptors. In the second, the eye tracks a moving object. The image of the moving object remains stationary on the retina, producing better detail, while the image of the background moves across different receptors. In the third type of situation, the viewer moves as when walking or riding. Even if the scene is stationary, the near parts on both sides appear to move in the opposite direction and the far parts appear to move in the same direction as the viewer is moving. Theorists have had difficulty in explaining the visual processes of motion perception for these different situations, especially with respect to why the world does not appear to move when the eyes are rotated from side to side, but explanations probably involve feedback information from the balance mechanism in the inner ear and body muscles.

Motion-picture photographers, in attempting to represent motion on the screen, use the same three techniques—a stationary camera, panning moving objects, and moving the camera itself. Beginning photographers often pan stationary scenes too rapidly with unpleasant results, and it might be noted that the eye cannot pan smoothly except when tracking a moving object. When scanning a stationary scene the eye makes a series of quick jumps called saccades.

The motion that we think we see when viewing motion pictures is, of course, an illusion, because the projector is presenting a series of still photographs in which the images of objects that appear to be moving are located in slightly different positions in consecutive frames. The realistic perception of motion when viewing motion pictures is attributed to two basic visual phenomena—persistence of vision that prevents flicker even though the screen is dark while the film is being moved from one frame to the next, and the phi phenomenon that accounts for the apparent motion when the series of still photographs is viewed in rapid sequence.

Photographers and artists have responded to the challenge of representing motion in a single still picture in a variety of ways. The use of blurred images has been a natural byproduct of the photographic process because of the inability of the photographer to always use a sufficiently high shutter speed to freeze the image, even when a sharp image is desired. Photographers learned that they could produce a sharp image of a moving object and still imply motion by panning the object and blurring the background. Artists also have used speed streaks to suggest a blurred afterimage in the area trailing the moving object. Multiple exposures have been used by photographers to show an object in different positions in a single photograph. Some of the earliest and most dramatic multiple-exposure images of rapidly moving objects, such as a golf club hitting a ball, were made by Harold Edgerton, who developed the stroboscopic flash, and photographer Jon Mili.

Even straightforward record pictures can imply motion effectively if they contain clues that relate to the viewer's previous experience with motion. An apple suspended in air between a tree branch and the ground is easily assumed to be falling, and a sharp image of a bullet leaving a gun barrel is assumed to be traveling very fast indeed.

REDUNDANT VISUAL INFORMATION When the large number of visual subject attributes discussed above and available to the viewer are considered—lightness, hue, saturation, detail, shape, form, size, distance, and motion—it becomes apparent that much more visual information is available to us than is required for our basic needs, at least in any given situation, and more than is generally utilized, at least at a conscious level. Hypnosis has revealed that more visual information is stored in memory at a subconscious level than we are aware of. It is also interesting to note that many of the procedures used by photographers to improve the effectiveness of photographs in certain situations serve to reduce the amount of visual information available to the

Perception of motion. The phi phenomenon is the perception of motion that results when a sequence of still images that has a systematic displacement of one or more parts of the image, such as these, are viewed sequentially in rapid succession.

viewer—such as moving closer to a subject to limit the field of view, using a shallow depth of field or a soft-focus lens to reduce detail, and using black-and-white film to eliminate the attribute of color. The widespread opposition to the colorization of early black-and-white motion pictures serves to illustrate that abstract photographs in which certain image attributes are subordinated or eliminated can have greater appeal than more realistic photographs.

GESTALT Gestalt refers to the perception of images as organized configurations rather than as collections of independent parts. The word *gestalt* comes from the German language and means shape or form. In perceptual contexts, it has come to mean *the whole*. As applied to reading, for example, gestalt refers to words and groups of words that are perceived as meaningful units as distinct from individual letters.

Figure-Ground In both the real world and pictures, figure refers to objects or organized configurations that are perceived as gestalts and to which the attention of the viewer is directed, and ground refers to the surrounding area. The ground may also be referred to as the foreground and background, or as the surround. Artists and photographers sometimes refer to the figure as positive space and the ground as negative space.

It is usually desirable to clearly separate figure and ground in pictures so as not to confuse the viewer. Photographers can emphasize the difference between figure and ground in a number of ways including the choice of background, lighting, choice of camera viewpoint, and selective focus. The objective of camouflage is to eliminate the separation between figure and ground so that the objects are perceived as being part of the background. Some ambiguous figures, such as Rubin's vase profile, produce a reversal of figure and ground so that whichever area the attention is directed to becomes the figure.

Gestalt Laws Gestalt laws are principles relating to the way people tend to organize picture elements into organized

figures, such as a row of dots being perceived as a line. Four Gestalt laws that are especially relevant to photographers are the laws of Proximity, Similarly, Continuity, and Closure.

The Law of Proximity states that the closer two or more visual elements are, the greater is the probability that they will be seen as a group or pattern. Thus, in a square grid of dots, if the dots in the rows are closer together than the dots in the columns, the probability is greater that viewers will see horizontal lines than vertical lines.

The Law of Similarity states that visual elements that are similar tend to be seen as related. Thus, in a square grid of dots with equal vertical and horizontal spacing, alternating rows of white dots and black dots will tend to be seen as horizontal lines.

The Law of Continuity states that visual elements that require the fewest number of interruptions will be grouped to form continuous straight or curved lines. Thus, with two overlapping but offset black circles drawn on a white background, viewers will more likely see two overlapping circles than the more complex shapes formed within the two circles.

The Law of Continuity predicts that the top image will be perceived as two overlapping circles rather than the more complex shapes shown at the bottom.

The Law of Proximity predicts that the pattern of dots on the right will be seen as horizontal rows due to the smaller horizontal separation of the dots.

Even though the vertical separation and horizontal separation of the dots are equal, the Law of Similarity predicts that the pattern of dots will be seen as horizontal rows because of the similarity of the dots in each row.

The Law of Closure predicts that this pattern of lines will be seen as a square.

The Law of Closure states that nearly complete familiar lines and shapes are more readily seen as complete figures than incomplete. Thus, a line made of dashes with small spaces between the dashes tends to be seen as a line. Even the widely separated stars in constellations can be seen as dippers and other familiar figures because of closure.

CONSTANCY As applied to visual perception, constancy is a phenomenon whereby a person's perception of some aspect of a visual stimulus remains unchanged or resists change despite a change in the stimulus. Constancy can involve a variety of subject attributes including size, shape, lightness, and color.

Size Constancy When an object moves toward or away from the viewer, the retinal image changes in size inversely with the distance. Not surprisingly, this change in image size is interpreted as a change in viewing distance, rather than as a change in object size. This is because there are normally other distance cues available and the experience of seeing objects change size dramatically in a short time is very rare. However, in an experiment whereby the size of an illuminated rubber ball was changed with air pressure in an otherwise darkened room, the viewers perceived the ball as remaining constant in size and moving away from them as the ball actually became smaller with no change in the distance.

Although experience undoubtedly contributes to size constancy, it has been demonstrated that even young infants have similar perceptions. Size constancy is not infallible, however, even when the distance can be judged accurately, as evidenced by the ant-like appearance of people at street level viewed from the top of a tall building, an effect known as *underconstancy*.

Of concern to photographers is size constancy as applied to viewing pictures rather than original scenes. If the photographer wants the viewer to perceive objects at different distances in a photograph in their true size relationship, then good depth cues must be provided, just as such cues are required when viewing the original scene. Furthermore, a normal focal-length lens should be used on the camera.

For some uses, more dynamic pictures can be produced by varying conditions to produce either underconstancy or overconstancy. With underconstancy, distant objects appear abnormally small and near objects appear abnormally large. Underconstancy can be produced either by using a short focal-length lens for a strong perspective, or with a single object, by eliminating distance cues and making the image of the object smaller or larger than is customary. A photomacrograph of an insect that nearly fills the picture frame, for example, may appear to be a monster.

Overconstancy, on the other hand, can be achieved by using a long focal-length lens at a greater distance from the subject to produce a weak perspective, where distant objects appear abnormally large and near objects appear abnormally small.

Shape Constancy When a circular object such as a coin or a ring is viewed obliquely, the retinal image is an ellipse, not a circle. When a photograph is made of the circular object from the same viewpoint, the photographic image is an ellipse. In both of these situations, the viewer will tend to perceive the images as representing perspective views of a circular object rather than as an elliptical object. Shape constancy appears to be a psychological phenomenon that is based on previous experience and memory.

It is not difficult to deceive viewers about the shape of an object that is represented in a photograph or other picture. An ellipse drawn on a sheet of paper can be perceived as representing either an elliptical object or an oblique view of a circular object. This ambiguity can be dispelled in either of two ways—by providing cues that identify the object as one known from previous experience to be circular or elliptical,

Size constancy. An example of size underconstancy. This relatively large image of a small insect tends to be perceived as representing a much larger creature since there are no familiar objects in the picture to reveal the true size of the insect.

Shape constancy. The phenomenon of shape constancy enables the viewer of this image to perceive the elliptically shaped lines at the top and bottom as perspective views of a circular rim and base of a goblet.

or by providing cues that clearly indicate the orientation of the object with respect to the viewer. Thus, if a photographer wants to avoid confusion concerning the shape of an object being photographed, information should be included about the nature of the subject and the orientation. If the photographer wants to deceive the viewer, this type of information should not be included.

Vertical subject lines present a special problem with respect to shape constancy due to the inconsistent treatment of the vertical lines when cameras are tilted up or down while photographing buildings and other objects containing vertical lines. Since view camera users typically use the tilting back adjustment to keep vertical subject lines parallel in the picture whereas pictures taken with conventional cameras have converging lines, viewers of some photographs having converging lines may be confused as to whether the lines

represent a perspective view of parallel vertical lines or the true shape of an object that has converging lines.

Color Constancy Color constancy is the phenomenon whereby a viewer perceives the hue, saturation, and lightness of a stimulus as remaining unchanged when the color quality and the level of the illumination are changed. Although colors have the three attributes of hue, saturation, and lightness, color constancy is commonly divided into two categories, chromaticity constancy (which refers to hue and saturation), and lightness constancy.

Lightness constancy is demonstrated by the fact that the light end of a gray scale, which appears white when viewed in direct sunlight, also appears white when viewed under low-level illumination indoors. The luminance of the white step in the low light-level situation may actually be lower than the luminance of the black step in the high-level situation.

An example of chromaticity constancy is that a red apple appears red under illumination that varies considerably in color temperature, including relatively blue skylight, white daylight, and relatively yellow incandescent light indoors. The red apple could not appear red, however, if the illumination did not contain a red component that could be reflected by the apple.

Two important factors that contribute to lightness and chromaticity constancy effects are that the visual system adapts to variations in the light level and color quality of the illumination, and the perception of lightness and chromaticity depend greatly on a comparison of the area being evaluated with the surroundings.

POSTSTIMULUS PERCEPTION There is a computer program that enables operators to test their reaction times by depressing a keyboard key as quickly as possible after a light spot appears on the monitor screen. A typical response time is approximately 200 msec or 0.2 of a second. This total response time includes the delay between when the spot appears on the monitor screen and when the spot is perceived by the subject, and the delay between the perception and the pressing of the key. Even though the delay between a visual event and its perception is very short under normal conditions, the two do not occur simultaneously. There are actually a number of different types of visual perceptions that can occur *after* a stimulus has been removed, one type of which can occur even years after the visual experience. Some of these poststimulus perceptions are identified as persistent images, afterimages, aftereffects, eidetic images, and visual memory.

Persistent Images Laboratory studies indicate that persistent images last an average of approximately 1/4 second after the stimulus has been removed. If a slide of the letter X, for example, is projected on a screen in a darkened room and the presentation time is controlled with a shutter, the time cannot be made so short that the image cannot be recognized, provided the luminance is at an appropriate level. Perception occurs with very short exposure times because the persistent image keeps the image available to the viewer for somewhat longer than the actual presentation time. Persistent images are essential to the perception of realistic motion-picture images where the image of one frame continues to be seen while the light from the projector is blocked and the film is moved to the next frame. Duration of the persistent image can vary depending upon several factors including the image luminance level and whether removal of the stimulus is followed by darkness or by another image. Although it would seem reasonable to think that increasing image luminance would produce a longer-lasting persistent image, the opposite actually occurs. Thus, if one sees flicker when viewing a home movie, *decreasing* the image luminance by looking through a neutral-density filter will increase the duration of the persistent image and eliminate the flicker.

Afterimages Whereas persistent images cannot be distinguished from the images seen when the stimuli were present, afterimages are recognized by the viewer as being a visual anomaly. Afterimages are evident after one looks directly at a bright flash of light, such as that produced by a camera electronic flash unit. Afterimages can be formed with stimuli having lower luminances, such as a white figure on a dark background, by extending the viewing time. Afterimages can be either negative or positive. After looking at a bright stimulus such as a light bulb, the afterimage is typically dark (negative) if one then looks at a white surface and light (positive) if one then looks at a dark surface. Sometimes the afterimage will alternate between negative and positive with no change in the follow-up viewing surface, and color afterimages that change from blue to green to red may be seen after looking at a bright white stimulus. In contrast to persistent images, which contribute to the effectiveness of motion pictures by eliminating flicker, afterimages tend to interfere with subsequent perceptions.

Eidetic Images Eidetic imagery, which is sometimes referred to as photographic memory, is an ability to retain a visual image for half a minute or longer after a stimulus has been removed from view. This ability is relatively rare in the general population but is more common in children than in adults. Whereas afterimages move with the eyes as they move, eidetic images remain stationary so that they can be scanned.

Visual Memory Visual memory shares many characteristics with other types of memory, but it consists of an ability to retain or to recall a visual image that is distinct from persistent images, afterimages, and eidetic images. Visual memories are usually divided into two categories—short term and long term. Just as an unfamiliar telephone number can be remembered long enough to dial it by repeating it and keeping it in the conscious mind, so can a visual image be remembered for a short time by keeping it in the conscious mind. Short-term visual memory is used even as one scans a picture and fixates different parts of the image, and this enables the viewer to create a composite perception of the total picture.

Once one's attention is allowed to go on to other things, long-term memory is required to revive an earlier visual image. Most people have little difficulty in closing their eyes and visualizing the face of a person they haven't seen for some time, their car, home, school building, and so on. Some visual memories can be recalled easily, but those stored in the unconscious mind are more elusive and may require the use of special techniques such as hypnosis or association to retrieve. Except for very simple stimuli, visual-memory images generally are not facsimile representations of the original subject but rather contain just the more important details.

PHYSICAL, PHYSIOLOGICAL AND PSYCHOLOGICAL FACTORS Many visual-perception anomalies, where the perceived image differs from what would be expected with a perfect imaging system, can be explained in physical and/or physiological terms. The diffraction streaks one can see radiating from a small bright light source such as the filament in a distant bare bulb is a physical phenomenon, and increased contrast seen at the edges of the gray patches in a gray scale have a physiological explanation based on the excitation and inhibition effects that nerve cells have on their neighbors in the visual neural system.

Psychological factors can also have a significant effect on the nature of a person's visual perceptions. It has already been noted that psychological factors play an important role in effects related to the gestalt laws and constancy. Earlier visual experiences, motivation, and attention of the viewer relative to a visual experience are examples of important psychological factors that can influence the perception.

Experiments have demonstrated that men and women may see and remember quite different things from the same visual environment because of differences in interests and attention. Abstract and ambiguous figures offer excellent opportunities for different viewers to see different images. Rorschach ink-blot images are used as a psychological test where the diagnosis is based on the individual's interpretation of the images. *L. Stroebel and R. Zakia*

See also: *Perspective; Vision.*

VISUAL PHOTOMETER A class of instruments used to measure luminous quantities such as luminous intensity, luminance, and illuminance based on visual comparison of two fields. The operator views an unknown source (or surface) along with a reference field, either side by side (bipartite field photometers) or rapidly alternating in one position (flicker photometers). The two fields are made to match by adjusting the brightness of one or both fields, and the unknown quantity is inferred from these adjustments and the reference source. Bipartite field photometers allow fast, accurate measurements when the unknown and reference fields are the same color. Flicker photometers should be used when the colors of the fields are different. *J. Pelz*

Syn.: *Comparison photometers.*

See also: *Bipartite field photometer; Bouguer photometer; Equivalent luminance; Flicker photometer; Martens photometer; Photometry and light units.*

VISUAL PURPLE See *Rhodopsin.*

VITASCOPE One of the first American commercially available motion-picture projectors, developed by Thomas Armat and produced, by agreement with Mr. Armat, by Thomas Edison as his own invention. *H. Lester*

VOGEL, HERMANN WILHELM (1834–1898) German chemist and teacher. Became the first professor of photography at the Institute of Technology, Berlin, in 1864. Founded several photographic societies and an important periodical, *Photographische Mitteilungen* in 1864. His *Handbook of Photography,* first published in 1867, was one of the most important textbooks of the late nineteenth century. In 1837 discovered that the selective addition of dyes to collodion plates increased their sensitivity to include the green portion of the spectrum. With Johann Obernetter, invented the orthochromatic gelatin-silver dry plate in 1884 that was sensitive to all colors except deep orange and red. An influential teacher, his students included Alfred Stieglitz in 1881. *M. Alinder*

VOICE ACTIVATION In computers, an advanced form of user interface that directs the computer through a sophisticated software package with a hardware peripheral that recognizes and acts upon voice instructions. *R. Kraus*

VOICE-OVER (VO) In motion pictures, a commentary accompanying the picture, spoken by someone not seen. *H. Lester*

VOLT (V) The basic unit of electromotive force or the potential difference between two points in an electrical circuit. One volt is the electromotive force needed to produce 1 ampere of current through a resistance of 1 ohm. *W. Klein*

VOLTAGE See *Electromotive force.*

VOLTAGE REGULATOR—AC A transformer-like device that maintains a constant value of output voltage despite variation in the ac supply lines. Typically, the output voltage will remain at approximately 120 volts even though the input voltage varies from 90 to 140 volts. Voltage regulators are most effective in maintaining a constant output voltage when operated near their rated current. AC voltage regulators are especially useful in supplying power to enlargers and photographic printers because the intensity of the printing lamps is very sensitive to variations in lamp voltage (usually ac voltage). *W. Klein*

Syn.: *Voltage stabilizer.*

VOLTAGE REGULATOR—DC An electronic device that maintains a constant value of output voltage despite changes in the input voltage or the output load current. DC power supplies usually have voltage regulator circuits that maintain the output voltage within a fraction of 1% of nominal voltage. The complex circuits of a precision voltage regulator are available in a single IC chip. A less precise voltage regulator can be achieved with a single zener diode and a series resistor. *W. Klein*

VOLUME RANGE The range in decibels of a program, from the loudest passage to the softest. The volume range should fit within the dynamic range. *T. Holman*

VON KRIES TRANSFORMATION Algebraic transformation whereby changes in adaptation are represented as adjustments of the sensitivities of the three cone systems, such as to compensate fully for changes in the color of illuminants. *R. W. G. Hunt*

VU METER (SOUND) A meter intended to read the level of dynamic program material in a standardized fashion, used by audio mixers to improve the interchangeability of programs and to avoid audible distortion. The VU meter standards were originally designed so that a meter movement could be used directly without electronics to read program level, and thus VU meters are relatively slow, requiring about 300 msec to rise to 0 VU from rest. Although rigorously standardized in ANSI C16.5, many meters marked as VU ones do not meet the standard. *T. Holman*

W Watt

WA Wide angle

WB White balance

WFM Wave form monitor

WHNPA White House News Photographers Association

WORM Write once/read many

WPI Wedding Photographers International

WALL CAMERA See *Camera types.*

WARHOL, ANDY (1928–1987) American painter and photographer. Pop artist Warhol blurred the boundaries between painting and photography, beginning many of his pieces with a photograph, often not made by him but appropriated from popular media. Known for his repetitive, multiple-image series, such as the 1960 photorealistic paintings, *Campbell Soup Cans.* By 1962 he began using photosilkscreen, which enabled mass production of prints as well as creating a more photographic, and less painterly, work.

Books: McShine, Kynaston, ed., *Andy Warhol, A Retrospective.* New York: Museum of Modern Art, 1989. *M. Alinder*

WARM COLOR Yellowish or reddish color, as distinct from bluish (cold) color. *R. W. G. Hunt*

WARM-TONE An image that is slightly brownish, reddish, or yellowish, as distinct from neutral or cold-toned—slightly bluish. *L. Stroebel*

WARM-UP Refers to the time required for equipment or material to reach a stable condition before use. Depending on the size of film and paper packages, several hours may be required to reach room temperature after removal from refrigerated storage. Some electronic densitometers may need a 30-minute warm-up time for all of the components to stabilize at a constant operating temperature. *I. Current*

WASHED-OUT Identifying an image or area of an image that appears to have too little density. Thus, a washed-out highlight would lack detail, and a washed-out print would appear to be too light in all areas. *L. Stroebel*

WASHERS AND WASHING Although plain water is not involved in any of the chemical reactions that occur during the processing of photographic films and papers, it does perform important processing functions. Rinsing and washing are used to prevent the contamination of subsequent baths and to ensure the complete removal of any chemicals that could attack the image, the emulsion, or the base of a photographic negative or positive.

SOAKING BEFORE PROCESSING Film is sometimes soaked in a water bath before development. This pre-

vents small air bubbles from being trapped on the emulsion surface and causing uneven wetting of the emulsion and uneven development.

RINSING BETWEEN PROCESSING STAGES It is advisable to use a rinse between some processing steps to avoid contamination from one bath to another, especially between developer and fixer. This process not only greatly reduces the risk of staining in the emulsion, it also prolongs the life of the subsequent processing solution. For production processing, acetic acid is normally added to the rinse to neutralize the alkaline carry-over developer. (See also: *Stop bath.*)

FINAL WASHING Final washing is performed after all the other processing steps to ensure image stability. The removal of residual silver complexes and thiosulfate (hypo) through washing after fixing is a diffusion process. If the fixing bath is fresh, most of the silver complexes will diffuse out of the emulsion during fixation. Washing is therefore mainly concerned with the removal of residual thiosulfate. Hypo diffuses out of the emulsion until the water has the same thiosulfate concentration as the gelatin. If no fresh water is supplied, the diffusion process stops. It is therefore absolutely necessary to ensure a fresh water supply until the thiosulfate concentration in the emulsion falls below the level required for the desired image stability. The diffusion process with film and RC-paper is exponential, which means that most of the thiosulfate is removed in the early stages of washing. With fiber-based paper, the rate of washing is determined by the removal of the residual hypo from the base, which is a longer process. The thiosulfate ions have to pass through the cell walls of the paper fiber, which are usually protected by sizing material. The washing rate depends on the nature and thickness of the paper, double-weight paper taking longer than single-weight.

If an excessive amount of residual silver complexes are left in the emulsion of a photographic material, they would soon decompose and cause brown stains, which would first be seen in the highlights. Residual thiosulfate reacts much slower, but eventually attacks the silver image, transforming it to silver sulfide in the presence of air. It is impossible to remove all thiosulfate, so washing is usually continued to the point where the remaining thiosulfate concentration in the emulsion does not exceed the limit for the desired image stability. In general, the allowed concentration is less for paper than for film material, as paper emulsion usually are thinner and the silver images consist of finer particles. (See also: *Image permanence.*)

WASHING WITH SALT WATER Films and papers can be washed in seawater, which actually speeds up the removal of residual hypo. Tests have shown that under similar conditions, film needed only about one-third and paper one-fifth of the normal washing time necessary with fresh water. However, to prevent any chemical reactions harmful

to the image caused by the sodium chloride in seawater, the material should be washed for 2 to 5 minutes in fresh water at the end.

WASHING AIDS Thiosulfate removal can be accelerated by the use of hypo-clearing agents and made more complete with hypo eliminators. Hypo-clearing agents consist of a salt that acts on the thiosulfate, replacing it with a radical that is more easily washed out. A 2% sodium sulfite solution has proven to be very effective, but other salts such as sulfates and citrates could also be used. The material is rinsed thoroughly to remove any fixing solution, then soaked for a few minutes (2 minutes for film, 3 minutes for paper) in the washing aid, followed by a wash. The washing time can thus be reduced to about a third of the normal time.

Hypo eliminators oxidize the residual thiosulfate to sulfate, which is more easily removed by washing. They are used at the end of the washing process to remove the last traces of thiosulfate. They are usually only used with fiber-based paper.

CHANGES OF WATER Where no running water is obtainable or where water is scarce, films and prints can be washed satisfactorily in successive baths of fresh water. The tray or tank is emptied, drained, and refilled with clean water at intervals of about five minutes. This process has to be repeated 4–5 times for RC-paper, 8–10 times for films, and 12–15 times for fiber-base papers, if no hypo-clearing agents are used.

WATER TEMPERATURE The higher the water temperature, the faster the residual thiosulfate is removed. A change in temperature from 18.5°C (65°F) to 26.5°C (80°F) decreases the washing time of film by about 15%. However, to avoid any excessive swelling of the gelatin and possible reticulation, sudden changes in temperature should be avoided.

FIXING The composition of the fixer, the rate of exhaustion, and the fixing time have an influence on the required washing time. Films and papers fixed in acid-hardening fixers usually require longer washing. The silver complexes obtained when fixing in an exhausted solution are much less soluble and are harder to remove. If the fixing time is too long, more thiosulfate is absorbed in the paper base, necessitating longer washing. (See also: *Fixing*.)

WASHING TIMES The washing times of photographic material are dependent on many factors, including water temperature, water composition, desired image stability, washing system, and the use of washing aids. Generally, the following times ensure sufficient washing for commercial use, using running water and moderate water temperature, with and without washing aids:

	Without Hypo-Clearing	With Hypo-Clearing
Films	20–30 min	5 min
RC-paper	4 min	Not rec.
Single-weight fiber-based paper	60 min	10 min
Double-weight fiber-based paper	120 min	20 min

It is important to remember, however, that the washing time effectively starts after the last print or film is put into the wash water. Subsequent additions of material recontaminate the wash.

TEST FOR EFFICIENT WASHING To determine the effectiveness of washing, the residual thiosulfate concentration is measured. This procedure tends to be rather complicated and inefficient in production environments. For an approximation, a drop of acidified silver nitrate can be placed on an unexposed area of a print or film. Silver nitrate

reacts with thiosulfate to form a yellowish-brown stain of silver sulfide. The darker the stain, the more hypo is left in the emulsion. Calibrated print and film stain levels are commercially available. Other methods that use the wash water itself instead of the emulsion have been developed, but they are less accurate. (See also: *Image permanence*.)

TREATMENT AFTER FINAL WASHING Wash water, especially unfiltered tap water may contain fine sand particles or other sediments. If emulsions are allowed to dry without wiping off any deposits and excess water droplets, drying marks that can ruin the image might occur. It is therefore advisable to wipe any excess water off films and prints before drying, using a chamois, sponge, or squeegee. A rinse containing a wetting agent such as Kodak Photo-Flo, which spreads the surface layer of water so that no droplets are formed, is helpful. (See also: *Drying, Drying mark*.)

WASHERS The efficiency of a washing system design is primarily dependent on the rate of flow of the water, the flow pattern, and the number of complete water volume changes in a given interval of time. The water must renew itself continually to carry away the chemicals diffusing out of the emulsion and, in the case of fiber print materials, the paper base. Most efficient washing is obtained when water flows in at one end and goes through the whole system before it flows out. This will usually ensure that no pockets of water remain stationary. The rate of flow has to be adjusted so that the whole volume of water renews itself every three to five minutes. The renewal time can be easily tested by adding one-half to one ounce of deep-colored dye or a potassium permanganate solution to the washing tank and measuring the time required for the color to disappear.

If the washing apparatus is not designed to keep the films and prints separated, such as with tray washing, the rate of flow must be sufficient to cause enough movement and turbulence to keep the material separated and to guarantee that fresh water is continually supplied to the whole surface of the material being washed. The stream of water should never flow so rapidly as to damage the film or print.

The size and depth of the washing apparatus is very important and should be selected according to the quantity and size of the films or prints to be processed. They must be allowed to move freely and separately.

Small particles of grit or other solid matter present in the water supply should be filtered out before the water enters the washer.

Washers should be cleaned periodically to remove the slime that tends to accumulate at the bottom. The use of normal household detergent is usually sufficient to remove any stains.

NEGATIVE WASHERS Small quantities of sheet films can be placed emulsion up in a tray. Water flows in at one end of the dish from a rubber tube connected to the tap. The tray

Washing sheet film negatives.

Washing roll film.

Two types of roll film washers.

films tend to curl up, which can result in inefficient washing and damage to the emulsion surfaces. They should either be clipped to a board, or see-sawed through a tray of water.

Sheet films that have been processed in hangers should be kept in their hangers and washed in a tank with either a siphon or a bottom drain. Sheet film tanks often have a drain plug at the bottom. Just placing the tank under the tap may not result in renewal of the lower levels of water. Inserting the water at the bottom by using a flexible tube and letting it overflow at the top requires the tank to be placed in a sink. It is also not very water-efficient. To force the heavier hypo contaminated water upwards requires a more rapid water flow or some means of aeration.

Special stainless-steel tanks are manufactured for washing sheet films in quantity. The films are suspended in hangers from rods across the top of the tank. Water enters through a number of jets at the bottom of the tank and is discharged through an intermittent siphon at regular intervals.

PRINT WASHERS If only a few prints are processed, they can be washed by placing them in a try or sink of clean water that is emptied and refilled periodically. Siphons that can be attached to the processing tray or plugged into the drain of a sink insure automatic draining whenever the water reaches a certain level.

As the sink or tray fills up, the water level also rises in the open arm of the siphon. When a certain water level is reached, the water starts emptying through the tube. The draining continues as long as the opening of the siphon is below the water surface. If the water level falls below the siphon opening, the flow stops and the cycle starts again.

To ensure that the prints do not bunch together, fresh water can be supplied by a perforated pipe at the bottom of the sink. The pipe should be placed at an oblique angle to the sink and the water velocity should be relatively high to ensure a swirling and uplifting motion.

Depending on the volume and sizes to be processed, commercial print washing tanks are produced in different sizes. The water enters in a series of jets at the bottom of the tank, preventing the prints from sticking together and ensuring a constant flow of water over the surface of the prints. A siphon automatically drains the tank every few minutes.

Cascade print washers consist of two or three trays, arranged so that the water flows from one tray to the other. The prints are first placed into the bottom tray and then transferred against the stream of water, receiving cleaner water as they proceed. Cascade washers are also available with jet water distribution to allow for a greater circulation of water.

Another print washing system consists of a tank where prints are kept separate by inserting them into a rack. In some,

should be slightly inclined so that the water overflows at the other end. If the tray is deep enough, a siphon can be used to remove water. (See *Print washers.*)

Films that have been processed in roll film tanks can usually be washed in the same tanks. A flexible tube connected to the tap can be inserted into the tank through the central hole. If no running water is available, the tank should be emptied and refilled with clean water at appropriate intervals. Draining and refilling the tank occasionally is advisable even when running water is available.

Roll film washers generally are of two types, those that force aerated water in from the bottom and those that accept a stream of water from the top. There is no particular benefit to either type, as even though the top-fill lets the wash water out through the bottom (and the silver and thiosulfate complexes tend to be heavier than water), the agitation produced by the air bubbles in the bottom-fill washers compensates.

Roll films should not be washed loosely in a tray. The

Washing sheet film.

Print washers.

Water siphon.

Commercial print washing tank.

Cascade print washer.

Rack-in-tank washer.

the water flows in at the top and drains at the bottom. The constant in-flow causes the rack to rock backwards and forward, keeping the prints in constant motion and ensuring a continuous fresh water supply. In others, water enters at the bottom through aerator pipes and the rising bubbles agitate the prints.

A self-agitating cylindrical tank that relies on the velocity of the incoming stream of water to keep the prints in constant movement has a water pipe that is wound around the tank so that the jets of water enter from all sides and move the prints around. As the water is moving constantly, there is no need for a siphon, the excess water overflows into the sink. This type of tank has the advantage that it is always full, and there is no danger of the prints being crumpled by the siphoning off of the water. Another version of this design incorporates a stationary water inlet and a perforated rotating cylindrical drum. The water pressure from the inlet or a motor may be used to keep the drum in motion, thereby agitating the prints.

Automated print processors usually allow for more efficient washing and correspondingly shorter washing times. The water temperature can be better controlled and the prints are efficiently separated, allowing free access to the wash water. Squeegees may also be used to remove the excess fixing solutions from the print surfaces before they are transported into the wash section of the processor. *S. Süsstrunk*

See also: *Drying; Drying mark; Fixers; Image permanence; Print washers; Stop bath.*

WASHING AID Typically, a sodium sulfite solution used as a rinse after fixing and before washing that increases washing effectiveness without reacting with the hypo or other fixing agent. *L. Stroebel and R. Zakia*

See also: *Hypo eliminator; Image permanence; Processing.*

WASHING TEST A means of determining the extent to which the fixing agent has been removed from prints and films in the washing step. Silver nitrate in the test solution combines with sulfur in residual thiosulfates to form a brownish silver sulfide stain that can be compared with a standard set of colors. *L. Stroebel and R. Zakia*

WASH-OFF Exposure decreases the solubility of some materials. In the 1820s, Niépce recorded images on bitumen of Judea which, upon exposure, becomes insoluble in oil of lavender. Unexposed areas wash away. Early incarnations of the dye transfer process used separation positives made by the wash-off relief process. *H. Wallach*

See also: *Dye transfer; Heliography.*

WASTE DISPOSAL In photography, waste disposal refers primarily to getting rid of used processing solutions in an environmentally safe manner. This is especially important for labs that process large volumes of photographic materials, but all photographers should be familiar with and adhere to local codes. Some processing solutions can be replenished or otherwise rejuvenated to extend their useful lives. *L. Stroebel*

WATER Although water is not an active ingredient in most photographic chemical reactions, it is the most universal solvent for photographic solutions; it serves an important function in swelling the emulsion gelatin in sensitized materials to facilitate processing; and it is essential for the removal of processing chemicals from films and papers. The water supplied by municipal water systems is almost always sufficiently pure for most photographic purposes. Additional treatments that may be desirable or necessary in some situations include: (1) temperature control, to heat or cool the water to a temperature that is within acceptable limits, (2) filtering, to remove solid particles, (3) purification, by means of softening, deionizing, or distilling. *L. Stroebel and R. Zakia*

WATER BATH DEVELOPMENT Method for reducing contrast during the development of black-and-white negatives or prints. After a reduced period of development, the negative or print is placed in a tray of water for up to 4 minutes without agitation. The water bath permits the developer to become exhausted in the high density areas, the highlights of the negative or the shadows of the prints, while development continues and details are enhanced in the low density areas, the shadows of the negative or highlights of the print. Prints may be observed under safelight for the duration of this process, but panchromatic films must be examined by safelight at a considerable distance for short periods. The process may be repeated several times before sufficient density is generated. Agitation in the water bath would wash developer out of the emulsion, ending differential local development. *H. Wallach*

See also: *Two-bath development.*

WATER-BATH TEMPERATURE CONTROL Surrounding a tray or tank of solution in which film or paper is being processed with a larger tray or tank of water at a control temperature. For example, if film is being processed at 20°C, then the water-bath temperature would be the same to help keep the developer at that temperature.

L. Stroebel and R. Zakia

WATERFALL EFFECT See *Movement adaptation.*

WATERHOUSE STOP Early form of aperture adjustment of a lens consisting of fixed stops as openings in a range of sizes cut in flat plates, which could be inserted into a suitable slot provided in the lens barrel. Originally the stops were numbered arbitrarily, the figures having no relationship to the relative aperture. The method was invented by John Waterhouse in 1858 but has been superseded by the iris diaphragm calibrated in *f*-numbers. Some modern lenses such as fisheye and process types still use such stops where the relative aperture must be set with a precision or shape not possible with a conventional iris diaphragm. *S. Ray*

WATER JACKET See *Water-bath temperature control.*

WATERLESS LITHOGRAPHY A printing process based on plates coated with silicones that can be printed without the need for an ink–water balance. Special inks are used and some presses have temperature controlled inking rollers. *M. Bruno*

WATERPROOF PAPER A precursor to resin-coated (RC) papers developed during the Second World War for military purposes, used where rapid access was needed, or where washing water was scarce. The fiber base was impregnated with a lacquer. It is now discontinued in favor of RC paper, which provides the same advantages of rapid processing and drying, with a more paperlike feel. *M. Scott*

WATER SOFTENER Any of a group of substances that cause calcium and magnesium ions in water to precipitate or change their usual properties, thus rendering the water more suitable for some uses. *L. Stroebel and R. Zakia*

See also: *Deionize.*

WATER SPOT See *Drying; Drying mark.*

WATKINS, CARLETON E. (1829–1916) American photographer. Established his reputation following his first visit to Yosemite National Park in 1861, returning to San Francisco with an impressive selection of mammoth-plate landscapes. A selection of his photographs was used to convince Congress to forever protect Yosemite, and led to President Lincoln's landmark 1864 signing of the Yosemite Act. Opened his Yosemite Art Gallery, San Francisco (1867). A four-month trip to Oregon in 1867 produced an exquisite group of photographs made along the Columbia River. Tragedy haunted Watkins. In 1874 he lost his gallery and most of his negatives to bankruptcy (though he immediately began rephotographing the sites included in many of those lost); by 1903 he had become blind; and his glass plates, as well as many prints, were destroyed in 1906 San Francisco earthquake and fire.

Books: *Carleton E. Watkins, Photographs 1861–1874.* San Francisco: Fraenkel Gallery and Bedford Arts, 1989; Palmquist, Peter E., *Carleton E. Watkins, Photographer of the American West.* Albuquerque: University of New Mexico Press, 1983; Alinder, James, *Carleton E. Watkins, Photographs of the Columbia River and Oregon.* Carmel, CA: The Friends of Photography, 1979. *M. Alinder*

WATT (W) The practical unit of electrical power. One watt is dissipated in a 1 ohm resistor when 1 ampere of current flows through it. One watt is equivalent to 1/746 horsepower.

W. Klein

See also: *Electrical power.*

WATT-SECOND A unit of electrical energy equal to 1 joule. As the name implies,

$$\text{energy (watt-seconds)} = \text{power (watts)} \times \text{time (seconds)}.$$

With electronic flash, it is the available energy stored in the capacitor and therefore a rough indication of the light emitted per flash. *W. Klein*

WAVE A traveling, periodic, oscillatory motion, or a combination of such motions. *J. Holm*

WAVEFORM (1) A mathematical representation of the form of a wave. As such, it is a functional plot of some characteristic of the wave as a function of space and/or time. One of the most common characteristics plotted is the amplitude or magnitude of the wave, such as the height of the surface of the ocean at a particular time as a function of position, or at a particular position as a function of time. Other characteristics plotted are the phase, power (magnitude squared—this makes all values positive), and the real and imaginary parts (most waveforms are represented using complex numbers). Since waves are periodic, waveforms are periodic

functions. (2) one period of a periodic waveform function as defined in (1). *J. Holm*

WAVEFRONT The locus of points on a wave that is two dimensional or greater, such that all the points have the same absolute phase. *J. Holm*

WAVELENGTH The distance on a waveform from one point to the corresponding point in an adjacent period. For convenience sake, wavelength is usually measured from the maximum or minimum amplitude point on a wave to the similar maximum or minimum amplitude point on the next period. All waveforms have wavelengths, but wavelength is of particular significance in specifying electromagnetic radiation. The nature or category of a particular type of electromagnetic radiation is specified by broad wavelength bands, such as light being electromagnetic radiation with wavelengths between approximately 400 and 700 nm. The specific characteristics of the radiation are specified by the specific wavelength, such as radiation with a wavelength of 550 nm being a specific color of green light. The changes in wavelength that electromagnetic radiation undergoes when passing through materials with different indices of refraction determines the indices of refraction of the materials. Because of this effect, wavelengths specified on spectral plots are the wavelengths of the radiation in a vacuum, which has an index of refraction of one. *J. Holm*

WAVELENGTH (SOUND) For a sinusoidal pressure wave, the distance from peak to peak of the wave. The wavelengths corresponding to the audible frequency range cover from more than 50 feet to less than 1 inch. *T. Holman*

WAVE THEORY The theory explaining the behavior of light as a wave. Wave theory was first proposed by Christian Huygens, and was developed considerably by others such as Young and Fresnel. Maxwell elaborated on wave theory by proposing that the waves involved were electric and magnetic field waves, hence electromagnetic wave theory. Wave theory breaks down under some circumstances where the quantum behavior of electromagnetic radiation is significant. It is used extensively in optics and electromagnetic engineering, where quantum aspects typically do not need to be considered. *J. Holm*

See also: *Light; Quantum theory.*

WAX ADHESIVE Wax may be used as an adhesive for pasting up artwork, text, and photographs, and for positioning mechanicals for reproduction processes. Hot melted wax is applied to the back of the artwork with a wax coater, a hand-held or table-top device that melts wax bars and distributes the melted wax evenly on the back surface of the artwork. The wax is low tack and easily repositioned. Unfortunately, the adhesion is destroyed if you move the work too many times. Wax that remains on the artwork too long is impossible to remove, and any residue left on the mounting surface will pick up dirt and smudges. *M. Teres*

WAXED PAPER PROCESS The most serious shortcoming of W. H. Fox Talbot's calotype was its lack of sharpness and grainy appearance, especially when compared to the daguerreotype. Efforts to improve the calotype in the 1840s concentrated on waxing or oiling the processed negatives to enhance their translucency. In 1851, Gustave Le Gray waxed the paper base of the negative before it was iodized, sealing the surface of the paper to a glass-like smoothness. He used starch, and later albumen, to help the light sensitive salts adhere. The prints produced by these negatives had exceptional detail and tonal range, essentially the equal of the wet collodion plate. Additionally, waxed

paper negatives could be prepared up to two weeks in advance, whereas calotype negatives had to be made the day before. Dry albumen glass plates had low sensitivity to light, particularly when compared to wet collodion plates. Latent images on waxed paper negatives kept for several days; calotypes had to be developed the same day. On the other hand, waxed paper negative development took as much as three hours. In particular, photographers who traveled favored the waxed paper process well into the wet collodion era.

H. Wallach

See also: *Calotype; Collodion process; Wet collodion process.*

WEAK COLOR Adjective denoting low saturation or chroma. *R. W. G. Hunt*

WEAK PERSPECTIVE The appearance of unnaturally small depth in an image, such as that produced with a long focal-length lens on a camera located at a large distance from the subject. Objects seem to diminish too slowly with increasing distance, and parallel lines in the scene do not seem to converge enough. *L. Stroebel*

See also: *Perspective.*

WEATHERIZED CAMERA A camera that has special features or has been treated to protect it against weather conditions such as low temperatures, moisture, and blowing sand. Lubricated parts may cease to function properly at low temperatures, requiring the lubricant to be replaced or the camera to be protected from the cold. Some cameras designed for underwater photography are also well protected against rain, sleet, snow, blowing sand, and other adverse weather conditions experienced in above-water photography.

P. Schranz

WEBER–FECHNER LAW (WEBER'S LAW) A just-perceptible increase in sensation (response) requires a stimulus increase that is in a constant ratio to the entire stimulus. An alternative statement is that the response is proportional to the logarithm of the stimulus. For vision, this relationship holds only over a limited range of stimuli and fails both at very low and very high light levels. *L. Stroebel and R. Zakia*

See also: *Fechner's law; Stevens' power law.*

WEBER PHOTOMETER A visual photometer used to measure the intensity of a light source. The visual field includes two pieces of opal glass, one transilluminated by the source to be measured, the other by a fixed reference source. The opal glass illuminated by the reference source moves along a calibrated scale. The intensity of the unknown source is determined indirectly from the position of the opal glass.

J. Pelz

See also: *Photometry and light units; Visual photometer.*

WEB OFFSET PRINTING Special lithographic presses that print on roll paper that feeds continuously through the press. Both sides of the paper are printed simultaneously by a blanket-to-blanket printing configuration in which the blanket cylinder of one printing unit serves as the impression cylinder of the adjacent unit and vice versa. *M. Bruno*

WEB PROCESSING Method for processing continuous lengths of film such as motion picture film or aerial film by winding it up in contact with a paper web saturated with a monobath developer-fixer. Useful for processing on board aircraft since no liquid solutions are used and the finished result is available in a short time. *L. Stroebel and R. Zakia*

WEDDING PHOTOGRAPHY Wedding photography has evolved from formal studio portraits of the bride, groom, and families to what at times seems a major media event that

can involve teams of photographers, videographers, and their assistants. Although the degree of production and number of images made varies by region, religion, and the budget of the bride and groom, the use of highly portable equipment and self-contained flash and continuous light sources has made a more candid and personal approach possible.

Wedding photographers themselves range from high stylized professionals who work out of their own studios, commonly portrait studios, or as part of a stable of photographers in a larger studio operation, to so-called *weekend warriors,* people who come from all walks of life and use their hobby of photography as a way of making extra income. Training is usually based on an apprenticeship program, with beginners assisting more experienced photographers. More formalized training is also available through workshops, how-to books, and videotapes. In the United States, organizations such as the Professional Photographers of American (PPofA) help set standards and give regular classes and seminars on wedding photography.

Typical wedding equipment includes a medium-format camera, a self-contained camera-mounted electronic-flash unit, a separate battery pack, a host of filters, and perhaps a compendium matte box for special effects, and even a second stand-mounted flash to create better lighting effects. Candid shots are now being made with 35-mm single-lens reflex (SLR) cameras. Although nearly all weddings are photographed on medium speed color negative films, fast color films or even black-and-white films are sometimes used for candids. Wedding videographers usually work with standard VHS or S-VHS camcorders with battery-powered light, although the new Hi-Band 8-mm camcorders are gaining wider acceptance.

The end result of wedding work is the wedding album and, more recently, the wedding video. The album contains a sprinkling of more formalized portraits combined with a chronological coverage of the day's events. In most cases, the album is a set piece, with certain shots, such as the cutting of the cake, the tossing of the bouquet, and so forth being a requirement. The video follows basically the same script, though special effects and music may be added during editing. In addition, the video generally takes a more candid, *cinema verité* look at the event and may contain interviews, speeches, and other sound bites that bring a real sense of presence to the viewer.

Although wedding photography and the wedding photographer are not always held in high regard, a true practitioner must be a photographic jack-of-all-trades. A typical wedding day includes elements of formalized portraiture, photojournalism, candid work, and still-life photography. The photographer must be a diplomat, friend, advisor, mediator, and technical expert, as well as on-the-spot repairperson and stylist. The pressure of getting the job done right is enormous—it is not an event that can be easily replayed for the camera.

Wedding photographers take part in a wide range of cultural, economic, and emotional experiences. Most of their clientele are in a highly charged state of mind, and the photographers share in one of the most important days of their subjects' lives. As such, it can be a highly rewarding activity and a wonderful training and proving ground for other areas of the photographic profession. *G. Schaub*

WEDGE, OPTICAL In sensitometers (photographic exposing devices), a filter that has varying absorption characteristics at different positions, which can produce a series of different exposures on photographic material for testing purposes. In visual densitometers an optical wedge allows the matching of densities, and therefore their measurement. Optical wedges come in two types: continuous, with smooth changes in absorption from no density to great density; and stepped, on which the tonal scale is divided into a number (10, 20, etc.) of precisely changing steps from no density to great density in evenly changing amounts.

J. Johnson

WEDGE SPECTROGRAM A photographic record of the response of a photographic material to each of the various wavelengths of a spectrum that is generated by a specific energy source. *M. Leary and H. Todd*

See also: *Wedge spectrograph.*

WEDGE SPECTROGRAPH An instrument used to expose a sample of photographic material to different amounts of energy of various wavelengths. The device consists of an energy source, a prism or diffraction grating to disperse the energy into a spectrum, and a step tablet or continuous wedge placed across the spectrum to produce different exposures at each wavelength. *M. Leary and H. Todd*

WEDGWOOD, THOMAS (1771–1805) English scientist. Wedgwood is acknowledged as the first photographer. Son of the famous potter, Josiah Wedgwood, he produced images made by the direct action of light (photograms, e.g., silhouettes and botanical specimens) on paper or leather moistened with silver nitrate solution. Published in 1802, with Sir Humphry Davy, an *Account of a method of copying paintings upon glass and of making profiles by the agency of light upon nitrate of silver.* But he and Davy were not able to fix their images, which could only be viewed for a few minutes by candlelight before they faded away.

Books: Gernsheim, Helmut, *The Origins of Photography.* New York: Thames & Hudson, 1982. *M. Alinder*

WEEGEE (ARTHUR H. FELLIG) (1899–1968) American photographer. Specialized in harsh, flash photographs of the people of New York City, especially crime scenes and urban disasters such as fires. Nicknamed "Weegee," from the Ouija Board, for his ability to be the first photographer to arrive with his hand-held, 4×5-inch Speed Graphic camera and flashbulbs where news was breaking, accomplished not by divining but by keeping tuned to the radio's police bands.

Books: *Naked City.* New York: Da Capo, 1975; *Weegee by Weegee: An Autobiography.* New York: Da Capo, 1975. *M. Alinder*

WEIGHTING In the evaluation of a measurement process, assigning more importance to some data than to others. In measuring the light at an exposure plane, more significance may be given to the light value at the center of the area than that at the margins. *H. Todd*

WEIGHT MEASURE CONVERSION See *Appendix J.*

WEIGHTS AND MEASURES Two systems of weights and measures are still used in the world. (1) The Système Internationale (SI), usually called the *metric system,* is almost universally employed, the exception being in the United States. It originated in France, after the French Revolution, and was intended to be based exclusively on physical quantities available everywhere. It is often called the *cgs system,* standing for centimeter, gram, second. (2) The U.S. customary system is symbolized by *fps,* coming from foot, pound, second. These ancient units are based primarily on tradition.

In the United States, the use of the SI is voluntary and is gradually being adopted, especially in scientific and technological contexts. It is used in many photographic applications, such as film sizes (as in 35-mm film), lens focal lengths, and processing formula specifications.

FUNDAMENTAL SI UNITS There are seven SI base

units and two supplementary units (numbers 8 and 9 below) from which all other quantities are derived.

1. The *meter,* the unit of length, was originally based on a fraction of the earth's circumference, but inaccurate measurements in the eighteenth century caused an error in the result. Later, the standard was a distance marked on a metal bar kept at the International Bureau of Weights and Measurements near Paris. Now, the definition of the meter is 1,650,763 wavelengths of a specified line in the spectrum of the element krypton-86.

2. The *kilogram* is the unit of mass (approximately, weight). It is based on a cylinder of metal kept at the International Bureau.

3. The *second* is the unit of time, formerly 1/86,000 part of the mean solar day. Because of variations in the length of the day, the second is now defined as the time required for 9,192,631,770 vibrations associated with the spectrum of the cesium-132 atom.

4. The *kelvin,* the unit temperature, is equal to 1/100 part of the interval on the Celsius (formerly, centigrade) scale between the freezing point and the boiling point of pure water under standard conditions. One kelvin is equal to 1°C, but zero on the Kelvin scale corresponds to –273°C.

5. The *candela* (formerly, candle), a measure of the intensity of light from a source. It is defined as 1/60 part of the intensity of an ideal blackbody radiator having an area of 1 cm^2 held at the temperature of the freezing point of platinum.

6. The *mole* is a measure of the amount of pure substance that is equal to its molecular weight in grams. This measure is often used in specifying the amounts of concentrations of chemicals.

7. The *ampere* is a measure of electrical current.

8. The *radian,* a measure of plane angle, defined as that angle subtended at the center of a circle by an arc equal in length to the radius of the circle.

9. The *steradian,* which is the solid angle at the center of a sphere subtended by a surface area equal to the radius squared.

Hundreds of other units are derived from these nine units. Derived from the candela, for example, are:

1. The *lumen,* the measure of flux, i.e., the flow of light. One lumen is equal to the light passing through a specified solid angle and originating from a light source having an intensity of 1 candela.

2. The *lux,* a measure of illuminance, the light received by 1 m^2 of surface when the flux is 1 lumen.

PREFIXES In the metric system (SI), prefixes are used to indicate units larger and smaller than the basic ones.

Prefixes for Basic Metric Units

Prefix	Power of 10	Equivalent
tera-	10^{12}	Trillion
giga-	10^9	Billion
mega-	10^6	Million
kilo-	10^3	Thousand
hecta-	10^2	Hundred
deka-	10^1	Ten
deci-	10^{-1}	One-tenth
centi-	10^{-2}	One-hundredth
milli-	10^{-3}	One-thousandth
micro-	10^{-6}	One-millionth
nano-	10^{-9}	One-billionth
pico-	10^{-12}	One-trillionth

CONVERSIONS
Inches × 25.4 = millimeters (mm)
Feet × 0.305 = meters (m)

Quarts × 0.9464 = liters
Gallons × 3.7853 = liters
Ounces (fluid) × 29.6 = milliliters (ml)
Ounces (weight) × 28.4 = grams (g)
Pounds × 0.454 = kilograms (kg).
(Fahrenheit temperature – 32) × 5/9 = Celsius (centigrade) temperature (°C).
(Celsius temperature × 9/5) + 32 = Fahrenheit temperature (°F).
Angular degrees ÷ 57.3 = radians. *H. Todd*

See also: *Appendix, H–L; International units; Metric system.*

WESTON, BRETT (1911–) American photographer. Second of Edward Weston's four sons. Traveled to Mexico with his father and Tina Modotti in 1925 where he learned how to photograph. While using large-format view cameras, developed a style distinct from his father's. Known for powerfully graphic black-and-white silver prints. One of four "outsiders" invited to participate in the influential Group *f*/64 exhibition at the M.H. de Young Memorial Museum, San Francisco (1932). Returned to father's home in Carmel in 1948 where he cared for the elder Weston during his last ten years of deteriorating health. Responsible for printing his father's negatives during those ten years.

Books: *Brett Weston, Master Photographer.* Carmel, CA: Photography West Graphics, 1989; *Voyage of the Eye.* Millerton, NY: Aperture, 1975. *M. Alinder*

WESTON, EDWARD (1886–1958) American photographer. Opened a portrait studio in 1911 in Glendale, California, and until 1922 made award-winning pictorialist photographs. Changed his style completely in the mid-1920s to become a leading advocate of straight photography. Lived in Mexico City (1923–1926) with Tina Modotti, who learned photography from him. Became friends with the painters Diego Rivera and José Orozco. Returned to California in 1927, where he began his remarkable closeup photographs of shells and vegetables, including the famous *Pepper, No. 30* (1930). Opened a studio in Carmel in 1929 where started a lifelong project of picturing the cypress trees, rocks, and rocky beaches of Point Lobos. Known for his ascetic lifestyle in all matters except women. Worked with very simple equipment, including an 8 × 10-inch view camera, making silver and platinum contact prints. Also admired for his nude photographs, including a series of his second wife, Charis Wilson, begun in 1934. Was the first photographer to be awarded a Guggenheim Fellowship (1937), renewed in 1938, enabling travels that produced *California and the West* (1940). Founding member of Group *f*/64, (1932). He made his last photograph in 1948, thereafter too weakened by Parkinson's disease.

Books: Newhall, Beaumont, *Supreme Instants: The Photography of Edward Weston.* Boston: New York Graphic Society, 1986; Maddow, Ben, *Edward Weston: Fifty Years.* Millerton, NY: Aperture, 1979; Newhall, Nancy, ed., *The Daybooks of Edward Weston, Two Volumes in One.* Millerton, NY: Aperture, 1990. *M. Alinder*

WESTON FILM SPEED See *Film speed.*

WET COLLODION PROCESS Method of making negatives using a glass plate coated with iodized collodion, potassium iodide with, perhaps, potassium bromide in a nitrocellulose and pyroxylin mixture. The plate was sensitized in a silver nitrate solution and exposed while still wet or, actually, sticky, which gave the photographer about 20 minutes, depending upon ambient temperature and humidity, to make the exposure. The orthochromatic plates were developed in red safelight.

The process was introduced by Frederick Scott Archer in

1851 and commonly called *wet plate*. It was inexpensive and much more sensitive than other available materials, as long as the plate did not dry. Exposures lasted from one to 15 seconds. Despite the nuisance of wet exposure and the need to travel with a darkroom, the many attractions of the wet plate were sufficient to end the era of the daguerreotype and sustain the wet collodion process for over 30 years until the advent of commercially available dry plates in the 1880s.

H. Wallach

See also: *Collodion process.*

WETTING AGENT　Chemical that reduces the surface tension of water or a water solution when added in very small amounts, such as one part in 1000. This, in turn reduces the risk of air bells and increases uniformity of development. A trace of wetting agent in a final rinse for film makes the water drain off the surface more uniformly, thereby avoiding water spots upon drying.　*L. Stroebel and R. Zakia*

WHEAT PASTE　A vegetable water-soluble adhesive that can be applied to the back of fiber-based photographs for wet mounting onto most porous surfaces. Since wheat paste is water soluble, it is possible to "unglue" the print from the mount if necessary.　*M. Teres*

WHEATSTONE, SIR CHARLES (1802–1875)　English scientist. Inventor of the stereoscope, experimenting with it from 1832 to 1838, publishing his results in 1838. Invented many other devices, including the concertina (1829), the electric telegraph (1837), and the Wheatstone bridge, which measured electrical resistances (1843).

M. Alinder

WHEATSTONE STEREOSCOPE　Stereoscopic viewer that uses pairs of mirrors or prisms to enable a pair of stereoscopic pictures to be viewed as a fused three-dimensional image.　*L. Stroebel*

See also: *Perspective; Stereoscope.*

WHIP PAN　See *Swish pan.*

WHITE　Name given to colors that are very light and exhibit little or no hue.　*R. W. G. Hunt*

WHITE, CLARENCE HUDSON (1871–1925)　American photographer and teacher. Self-taught, his ideas of art affected by the Impressionists and Whistler. Won many awards with his softly focused, pictorialist images of family life. From Ohio, traveled to New York in 1898, where he impressed Stieglitz, joining with him in 1902 to form the Photo-Secession. Became the first teacher of photography at Columbia University, New York City, in 1907, then the Brooklyn Institute of Art (1908), and founded the Clarence White School of Photography in 1914. Highly influential teacher, whose students included Bourke-White, Gilpin, Lange, Outerbridge, Steiner, and Ulmann. Became the first president of the Pictorial Photographers of America in 1916, in reaction against Stieglitz's proclamation for straight photography.

Books: Bunnell, Peter C., *Clarence H. White: The Reverence for Beauty.* Athens, OH: Ohio University Press, 1986; White, Maynard P., Jr., *Clarence H. White,* Millerton, NY: Aperture, 1979.　*M. Alinder*

WHITE LIGHT　Light that is made up of photons with a sufficient variety of wavelengths such that the light appears neutral to the viewer. The rigor of the term *white light* varies enormously depending on the viewer, the viewing conditions, and the requirements of the situation. Metamerism can make almost any nonmonochromatic spectral energy distri-

bution appear relatively white. Several blackbody curves with color temperatures between 3000 and 6000 K have been defined as standard sources of white light for various applications, but these sources are not interchangeable, and appear to be different in color when compared. Also, one blackbody curve can contain absorption bands and be indistinguishable from a similar curve with no absorption bands, yet the rendition of certain sample colors can be significantly affected by the bands.

The most useful application of the term *white light* is in distinguishing from specifically non-neutral light in a specific application. For example, color enlargers sometimes have a lever that moves the color correcting filters out of the light path. When this is done, it is said that the image is being projected using white light. In a studio, a photographer might combine *white light* exposures with exposures through different colored filters. Both of these examples use the term *white light* to indicate light from an incandescent or flash source that is not filtered, and this may be about the best practical definition. It is important to remember, however, that the exact nature of the light source must be considered when designing new systems or conducting tests on equipment and materials.　*J. Holm*

WHITE-LIGHT PRINTING　Method of printing color negatives that uses white light, as distinct from methods that use separate red, green and blue light, either sequentially or simultaneously.　*R. W. G. Hunt*

WHITE, MINOR (1908–1976)　American photographer, teacher, editor, and writer. Combining Asian teachings with Stieglitz's concept of the equivalent, developed a philosophy that emphasized the importance of verbal interpretation of a photograph. After quiet contemplation of an image, White found meaning far beyond the obvious. His own photographs were often mystical and mysterious. Devised sequences, acknowledging the effect of the interaction of images. Cofounder and editor of the photographic quarterly *Aperture* (1952-1975). White was an influential teacher, considered a guru by many, at such institutions as the San Francisco Art Institute, Rochester Institute of Technology, and Massachusetts Institute of Technology.

Books: *Mirrors Messages Manifestations.* Millerton, NY: *Aperture*, 1969; Bunnell, Peter, *The Eye That Shapes.* Princeton: The Art Museum, 1989.　*M. Alinder*

WHITENER　See *Optical brightener.*

WHITENESS　(1) Attribute of a visual sensation according to which an area appears to contain more or less white content. (2) Attribute that enables whites of different colors to be ranked in order of increasing similarity to some ideal white.　*R. W. G. Hunt*

WHITE NOISE　A random signal containing all frequencies having a Gaussian distribution of amplitudes and containing equal energy for equal increments of frequency. In sound, reproduced white noise sounds quite bright because it contains as much energy between the high audio frequencies of 10 and 20 kHz as between dc and 10 kHz.　*T. Holman*

See also: *Pink noise.*

WHITE SPACE　In an advertising layout, etc., a blank area around a photograph or block of type, usually treated as a design element.　*R. Welsh*

WIDE-ANGLE EFFECT/DISTORTION　An apparent stretching of the images of three-dimensional objects that are located near the edges of photographs made with short focal-length wide-angle lenses. The stretching is in directions

radiating away from the center of the photograph and is caused by the marginal rays of light falling on the film at acute angles. The fact that the effect disappears when the photograph is viewed from the correct distance, approximately one focal length for a contact print, demonstrates that the lens has not distorted the image. *L. Stroebel*

See also: *Perspective.*

WIDE-ANGLE LENS See Lens types.

WIDE SCREEN Motion-picture term for any film presentation where the projected image has an aspect ratio greater than 1.33:1. *H. Lester*

See also: *CinemaScope; Cinerama; Film formats; Panavision; Techniscope.*

WIENER SPECTRUM The result of the analysis of a complex waveform into an equivalent set of sine waves, displayed as a plot of wave amplitude versus frequency. The method is used in the study of the grain size distribution in processed photographic images. *H. Todd*

WIEN'S LAW As the temperature of an incandescent solid or liquid is raised, the light emitted becomes relatively richer in shorter wavelength (blue) photons and poorer in longer wavelength (red) photons, i.e., the peak wavelength shifts toward the blue. This is due to the nature of radiation by a blackbody. *J. Holm*

See also: *Blackbody; Color temperature.*

WILD FOOTAGE Motion picture-film shot without simultaneously recording sync sound. *H. Lester*

Syn.: *MOS footage.*

WILD MOTOR A variable speed drive mechanism for a motion-picture camera, as distinct from a governed motor used when recording synchronous sound. *H. Lester*

WILD SOUND A motion-picture term for sound recorded by itself, without an accompanying synchronized picture. *H. Lester*

WINDOW (1) In computers, a frame or frames in the cathode-ray tube (CRT) that display different processing operations. For example, one window may display a spreadsheet while a second window on the same CRT displays a word processing document. Window environments are a form of graphic user interface (GUI). (2) In computers, a proprietary graphic user interface (GUI) operating system for IBM and compatible platforms by the Microsoft Corporation. *R. Kraus*

WINOGRAND, GARRY (1928–1984) American photographer. Discovered by Szarkowski at New York's Museum of Modern Art with his first major exhibition in 1963. Known for his images of the American social landscape. A street photographer, using an inconspicuous 35-mm camera, he shot thousands of rolls of film, selecting afterwards what should be seen, stating, "I photograph to find out what something will look like photographed." Awarded three Guggenheim Fellowships (1964, 1969, and 1979).

Books: Szarkowski, John, *Winogrand, Figments from the Real World.* New York: Museum of Modern Art, 1988. *M. Alinder*

WINTERIZED CAMERA See *Weatherized camera.*

WIPE Motion-picture optical effect used for transition in which one image is replaced by another at a line moving in a selected pattern across the frame. *H. Lester*

WIRE FRAME In computers, a graphical approach to sophisticated drawing in that the object is drawn as a composite of polygons in the form of a wire frame, thus saving time and space. Upon completion, the wire frame object will be rendered. *R. Kraus*

See also: *Rendering.*

WIRE PHOTO Virtually obsolete method of transmitting images. Two synchronized, rotating drums, one a sending unit and one a receiver, were connected by telephone or cable. Color separations, press proofs, or black-and-white photos were mounted on the sender and scanned by a point source of light. Reflections were converted to electrical impulses that were transmitted to the receiving drum. Digital scanning and transmission is faster and more accurate. *H. Wallach*

WOLCOTT, MARION POST (1910–1990) American photographer. Photographed rural southern America for the Farm Security Administration (1938–1942).

Books: Hurley, F. Jack, *Marion Post Wolcott, A Photographic Journey.* Albuquerque: University of New Mexico Press, 1989 *M. Alinder*

WOOFER A low-frequency loudspeaker. It is generally combined with a tweeter (in consumer terminology) or with a compression driver and horn (in typical theatrical usage). *T. Holman*

WORD PROCESSING In computers, a software program that allows the user to enter text for the purpose of writing a document. The text may be edited and sent to a printer for hard copy. *R. Kraus*

WORK FOR HIRE Since January 1, 1978, pursuant to the Copyright Law, the copyright on works created by an employee, in the absence of a written agreement to the contrary, belong to the employer. Such work is known as *work for hire.* In the 1980s, a controversy arose because of the claim by many advertising agencies that when photographers were given assignments, the photographs produced were "work for hire." If correct, it would be the agency's client who owned the copyright. The Supreme Court removed most of the controversy by declaring that the governing rules were substantially the same as for determining whether any person was an employee or independent contractor. Since most photographers are independent contractors, the controversy has diminished in intensity. *R. Persky*

See also: *Copyright*

WORKING SOLUTION Applied to a bath ready for use; usually prepared by diluting a stock solution to a given stock-solution-to-water ratio. For example, 1 part stock solution of developer to 2 parts of water. *L. Stroebel and R. Zakia*

WORK PRINT A motion-picture print made from the camera original, often without color and exposure correction, that is used in the editing process. Once all creative decisions have been implemented, the camera original is matched to the work print for the making of release prints. *H. Lester*

WORLDIZE To rerecord sound through a channel that includes a loudspeaker and a microphone, generally in an acoustical space. The purpose of worldizing is to make the sound seem as though it came from the space in question, rather than being a direct electrical recording. *T. Holman*

WORM'S EYE VIEW A very low point of view. A perspective point from ground level. *R. Welsh*

WOW AND FLUTTER Any change from absolutely constant speed during direct analog recording or playback results in corresponding frequency changes, which can be audible. Slow changes are called *wow* and faster ones *flutter,* but both represent the same phenomenon. *T. Holman*

WRAP (1) In motion-picture equipment, the angular degree of contact between the film and a given sprocket wheel. (2) In motion-picture production, a common term for completion of a shooting assignment, allowing equipment and sets to be struck. *H. Lester*

WRAPAROUND In computers, word processing software allows for an automatic line feed so that text characters that reach the end of a line automatically wrap around to the next line without the entering of a carriage return. Also, in electronic imaging, the manipulation of a brightness value above 255 or below 0 automatically wraps around to the higher or lower brightness value, for example, the next value after 255 is 0, and the next value after 0 is 255. This type of image brightness wraparound is undesirable. *R. Kraus*

WRAPAROUND LIGHTING Illuminating a three dimensional subject by an effectively large light source. A large light source illuminates the subject from many angles. If the source is larger than the subject, and is close enough to the subject, some of the rays strike the side of the subject not directly facing the source. If the subject is sidelit, the highlight fades gradually to shadow across the side of the subject facing the camera, with no clearly delineated transition.
F. Hunter and P. Fuqua

See also: *Diffusion.*

WRATTEN, FREDERICK CHARLES LUTHER (1840–1926) English inventor and manufacturer. Founder in 1878 of one of the earliest photographic supply businesses, Wratten and Wainwright, which produced and sold collodion glass plates and gelatin dry plates. Invented in 1878 the "noodling" of silver-bromide gelatin emulsions before washing. With the assistance of Mees, produced the first panchromatic plates in England in 1906 and became a famous manufacturer of photographic filters. Eastman Kodak purchased the company in 1912 as a condition of hiring Mees.
Books: Mees, E.C.K., *From Dry Plates to Ektachrome Film.* New York: Ziff-Davis, 1961. *M. Alinder*

WRITE In computers, to store data on a floppy disk, hard disk, or optical disk. *R. Kraus*
See also: *Read.*

WRITE ONCE READ MANY (WORM) In computers, a storage device that is written to by a laser. This system allows for a large amount of data to be stored. Optically based, this approach can only write once to a given sector on the optical platter. However, the data can be read from the platter as often as necessary. *R. Kraus*

WRITE PROTECTED In computers, hard and floppy disks can be physically and virtually manipulated to prevent writing over important data that exist on the disk. Writing over data has the same effect as erasing data. *R. Kraus*

WRITING ON PHOTOGRAPHS There are several ways of writing on or marking photographs. Some searching and testing may be required to find the appropriate marking medium, and this may depend on whether the marks are to be temporary or permanent. One of the "china marker" variety of pencils may provide a means of making temporary markings on films and the image side of paper prints, as they can be wiped off quite easily. For permanent marking, some ballpoint and felt-tip pens will write on the emulsion side of negatives and papers other than those with glossy surfaces. Special inks designed to write on glass, plastic, etc., work well for writing on the base side of resin-coated paper prints. A gold foil tape can be written on when in contact with the surface of a print, and the gold is thus transferred. India ink can be used with a pen to write on clean films without oil and on most papers. Care must be taken that the ink is dry before stacking or other contact between the sheets.
Some inks and markers have a destructive effect on images, and this should be taken into consideration when deciding to write on photographs. *I. Current*

WRITING RATE In photorecording such as oscillography, the velocity of the spot of light across the sensitive material when the trace is made. *L. Stroebel*
Syn.: *Writing speed.*

WRONG READING Identifying an image that is laterally reversed, so that signs and printing are oriented as mirror images. A negative exposed in a camera is wrong reading when viewed from the emulsion side but right reading when viewed from the base side. *L. Stroebel*

X Electronic-flash synchronization (X-sync); Degree of enlargement (4X)

X Coordinate (Abscissa)

x- x-ray

XA Extended architecture (computers)

XCU Extreme closeup

X-AXIS (1) In rectilinear graphs, a base horizontal line on which values of the input data are found. Log exposure values are found on the x-axis for graphs of photographic emulsion characteristic curves. (2) In aerial photography, in the direction of the flight line. *H. Todd*

X-COPY (SOUND) A copy made as close as possible to a 1:1 match. This applies to *equal flux* copying, wherein a copy is made at the same flux levels as the master. *T. Holman*

X-DISS/DISSOLVE See *Dissolve.*

XENON ARC LAMP A light source in which a luminous bridge forms between electrodes in a pressure of pure xenon. Arcs may be short or long and can therefore be used as point or broader sources. Desirable characteristics include intense light with a near-daylight spectrum in the visible region, and full intensity as soon as the light is switched on so the warm-up time of other arc lamps is not required. *R. Jegerings*

XEROGRAPHY A form of electrophotography developed by Carlson. The process involves the creation of an electrostatic latent image on the surface of a photoconducting insulator. The latent image is made visible by toner particles. The toner image is then transferred to a receiver and made permanent by a fusing or fixing process. Xerography is the most highly developed form of electrophotography and is used today in all copiers. With the advent of semiconductor lasers in the late 1970s, xerography has also been widely used for printing applications. *P. Borsenberger*

See also: *Electrophotography.*

XERORADIOGRAPHY A process similar to conventional xerography except that the electrostatic latent image is created by the absorption of x-rays rather than visible or near-infrared radiation. Xeroradiography is of interest for nondestructive testing and medical applications such as mammography. *P. Borsenberger*

XEROX Xerox is a multinational company in the document processing and financial services markets. Its business products and systems activities encompass the designing, developing, manufacturing, marketing, and servicing of a complete range of document processing products and systems that make office work more productive. Xerox copiers, duplicators, electronic printers, optical scanners, electronic typewriters, networks, multifunction publishing machines, workstations and related products, and software and supplies are marketed in more than 130 countries.

Xerography, the technology that started the office copying revolution, was the inspiration of patent attorney Chester Carlson, who made the first xerographic image in 1938. The Battelle Memorial Institute in Columbus, Ohio contracted with Carlson in 1944 to perform early development work on the process which Carlson called *electrophotography.* Three years later, Battelle licensed the Haloid Company of Rochester, New York to develop and market a copying machine based on Carlson's technology.

Carlson, Battelle, and Haloid agreed that electrophotography was too cumbersome a name for the process. A classical language professor at Ohio State University suggested the new name: *xerography,* derived from the greek words for *dry* and *writing.*

Haloid coined the term *Xerox* as the name to identify its equipment. The word *xerography* (to describe the process) and *Xerox* (to identify the products) were introduced simultaneously to the marketplace in 1948.

Inspired by the early, modest success of its copying machines, Haloid changed its name in 1958 to Haloid Xerox, Inc. The company became Xerox Corporation in 1961 after wide acceptance of the Xerox 914, the first automatic office copier to use ordinary paper.

The following list of major products (by year of U.S. announcement) represents only a small sample of the many new products introduced each year by Xerox:

1949 Model A copier (Ox Box): first commercial xerographic product; manual process.

1955 Xerox Copyflo: first semiautomatic xerographic printer; makes continuous copies on ordinary paper.

1959 Xerox 914 copier: first automatic office copier to make copies on ordinary paper; seven copies a minute.

1963 Xerox 813: first desktop copier to make copies on ordinary paper; five copies a minute.

1964 Xerox LDX: Long Distance Xerography uses scanners, networks, and printers for high-speed document facsimile transmission.

1966 Xerox Telecopier: first desktop Xerox facsimile machine.

1968 Xerox 3600 I and III copier/duplicators: 60 copies a minute. Xerox Telecopier II facsimile machine: permits receipt of documents through unattended telephones.

1969 Xerox 7000: first reduction duplicator; makes two-sided copies manually; 60 copies a minute.

1970 Xerox 4000 copier: first in a second generation of copiers and duplicators; first to provide automatic two-sided copying; copies photographs; 45 copies a minute. Xerox Technology 400: portable facsimile machine sends and receives documents via telephone lines at four or six minutes to a page.

1973 Xerox 6500 color copier; makes full-color copies on plain paper and transparencies.

1974 Xerox 4500 copier: automatically copies on both sides of plain paper; collates and produces complete set; 45 copies a minute. Versatec 1200 Series electrostatic printer/plotters: first product of its kind to offer 200 dots-per-inch resolution to an 11-inch-wide array.

1975 Xerox Telecopier 200 facsimile transceiver; automatically sends and receives documents by telephone at two minutes a page; uses laser and xerography.

1976 Xerox 3107 reduction copier: produces 8 1/2 × 11-inch and 14 × 18-inch copies from originals as large as 14 × 18-inches; 20 copies a minute. Kurzweil Reading Machine: converts text into easily understood synthetic speech, giving the blind access to conventional reading material.

1977 Xerox 9700 electronic printing system: first xerographic laser printer; produces and prints computer-generated text, business forms, and other images; 120 pages a minute.

1979 Xerox 5600 copier/duplicator; mid-volume unit with automatic feeding of originals, sorter-less collating, optional on-line stapling and industry-first ability to automatically make two-sided copies from one- or two-sided originals; 45 copies a minute.

1980 Xerox 5700 laser printing system: combines word processor printing, electronic mail, remote computer printing, and copying in a single unit.

1981 Xerox Telecopier 495: digital facsimile transceiver can process documents at 30 seconds a page. Xerox 2350 copier: the first Xerox desktop, multiple-copy reduction copier; 10 copies a minute.

1982 Xerox 820-II personal computer: an entry-level professional workstation.

1983 Xerox 1035 Marathon copier: four modes of reduction and two modes of enlargement; 20 copies a minute.

1984 Xerox 9900 duplicator: computerized programming; features automated cover insertion, two-sided copying, dual stapling, and job storage; 120 copies a minute.

1985 Datacopy 730 flatbed scanner: offers 16 levels of gray scale with image resolution up to 300 dots per inch.

1986 Xerox 4020 color ink jet printer: lets PC users create documents integrating text and high-resolution graphics in seven colors. Xerox Publishing Illustrator: software for Xerox 6085 professional computer system; allows user to create illustrations and edit graphics.

1987 Kurzweil Discover 7320: desktop intelligent character recognition scanner. Xerox 7650 Pro Imager: table-top graphics scanner with 256 levels of gray scale and image resolution of up to 600 dots per inch. Xerox High Volume Microfiche Printer: up to 120 pages a minute.

1988 Kurzweil Personal Reader: the first portable reading machine for the blind. Xerox 5090 duplicator: sets a record speed of 135 copies a minute; features accessed through touch-sensitive, color video screen; reduces, enlarges, makes two-sided copies, staple-stitches, and thermal-binds pages, inserts covers and dividers, shifts margins, and enhances photographs. Xerox 4650 professional printing system: produces industry-first 600-spots-per-inch resolution that approaches offset printing quality; 50 pages a minute.

1989 Xerox Encryption Unit: electronic encryption device that mathematically encodes computer signals so they may travel in top security on ordinary local-area networks. Endorsed by National Security Agency in 1990. Kurzweil 5000 intelligent scanning system: high-volume, intelligent character recognition scanner with a 50-page document feeder offers 64 levels of gray scale and image resolution of 400 dots per inch.

1990 Xerox 5065: first copier to offer built-in Remote Interactive Communications; 62 copies a minute.

1991 Xerox 4030 II desktop laser printer; 11 pages a minute; dual input trays automatically feed up to 500 pages.

(Courtesy, *1991 Fact Book for the News Media,* published by Xerox Corporation.)

X-RAY CRYSTALLOGRAPHY The use of the diffraction patterns produced by a beam of x-rays incident on a crystal to determine the structure of the crystal. When x-rays traverse a crystalline substance, the regular network of atoms of which the substance is composed acts as a three-dimensional diffraction grating. The diffraction effects are most simply interpreted in terms of reflection by planes in the atomic network. This leads to the well-known Bragg relationship: $2d \sin (\theta) = n \lambda$, where d is the interlanar spacing, θ the angle of incidence of the x-rays on the reflecting planes, λ the x-ray wavelength, and n an integer representing the order of the diffraction pattern. The diffracted x-rays cannot, however, be focused using lenses to form a direct image of the crystal structure. All that can be done is to make a record of the diffraction pattern. The problem of x-ray crystallography lies in postulating or calculating the positions and distributions of atoms in the structure that has given rise to the intensities of spots or lines found in the diffraction pattern.

J. Holm

X-RAY DIFFRACTION The diffraction of x-rays due to their wavelike characteristics. The short wavelengths of x-ray photons require small grid spacings for significant diffraction effects. The spacings of the atomic lattice in crystals is appropriate for producing x-ray diffraction, hence x-ray crystallography.

J. Holm

See also: *Diffraction.*

X-RAY FOG Fog due to x-ray exposure is of concern today because of the necessity of screening luggage and packages for security purposes. With films having ISO ratings up to 200, several exposures with most airport inspection units will not have a noticeable effect on resulting images. High speed films have less tolerance but in most cases will not be appreciably affected by a few screenings.

In the rare instance that fog does occur, it will be seen in the form of a shadow cast by the metal parts the film cassette, adjacent perforations of film, or other container parts.

X-rays have a greater tendency to pass through emulsions than do light rays; therefore, the effect is less noticeable. Diagnostic x-ray films are therefore coated on both sides with emulsion and are faced with fluorescing screens that emit light, which is responsible for most of the image. *I. Current*

See also: *Fog.*

X-RAY MICROGRAPHY A technique for examining the internal structure of thin opaque specimens not normally revealed by photomicrography. A specimen of the material, such as a metallurgical section 1 mm thick or less, is placed in contact with an extremely fine-grained sensitized emulsion and a radiograph is made. The radiograph is then examined or photographed using a microscope. By this means the internal structure of specimens may be seen at magnifications up to 300X. Also known as microradiography. *J. Holm*

X-RAYS Rays discovered and so named by Röntgen in 1895. X-rays are high-energy photons with wavelengths between 0.005 and 10 nm, which therefore have higher energy than ultraviolet photons but lower energy than gamma rays. They are able to penetrate solid matter to a generally greater degree than lower-energy photons and form an image on photographic film, a fluorescent screen, or other x-ray sensitive detectors. X-rays are typically divided into two categories: hard and soft, with hard x-rays having wavelengths below about 2 Å. Harder x-rays are considerably more penetrating, and therefore have more practical applications.

X-rays are typically produced by accelerating electrons

emitted from a hot tungsten filament to an energy of several thousand eV using a high-voltage accelerator, and then impacting these electrons on a target. The electrons are slowed down as they attempt to penetrate into the target, producing x-rays. A device of this type is called a Coolidge tube. These tubes also contain parts designed to focus the electrons on a small area of the target. The material used for the target depends on the type of radiation desired, but must be very infusible and/or a good conductor of heat, as the impact of the electron beam has an intense heating effect. The most common target material is tungsten, although other metals are used.

X-rays are important photographically for two reasons. First, photographic film, particularly double-coated screened film, is the primary means for imaging x-rays. Second, x-rays are used to examine baggage at airports. These uses are to some extent conflicting, since travelers passing through airports frequently carry photographic film, which is fogged to some extent by the examinations. Fortunately, the penetrating ability of x-rays presents another advantage in this situation because they tend to pass through film without exposing it significantly; pictorial films are much more sensitive to light than to x-rays. It is still possible, however, to significantly fog film with x-rays if the film is examined repeatedly or by using very high dosages. Coarser-grained high-speed films are also much more sensitive to x-rays than finer-grained films; the increase in sensitivity to x-rays rises at a much faster rate than the increase in sensitivity to light as grain size increases.

The relative insensitivity of photographic films to x-rays is a serious problem for medical imaging. If typical pictorial films were used, the dosage of x-rays required to properly expose the film would seriously endanger the patient. Even coarse-grained emulsions designed to be sensitive to x-rays require substantial dosages for proper exposure. For this reason, most modern medical x-ray imaging is done using screen-film systems. In a screen-film system, the x-rays are incident on a fluorescent screen placed in contact with the film. When an x-ray hits the screen it produces a burst of light photons that actually expose the film. The efficiencies of such screen-film systems can be quite high. In industrial x-ray systems, dosage is relatively unimportant so screens are not necessary. Higher-energy x-rays are also used for greater penetrating ability. Other uses of x-rays include microradiography and x-ray crystallography. *J. Holm*

See also: *Radiography*

X-SYNCHRONIZATION The process by which a camera shutter closes the electrical circuit to fire an electronic flash unit when the shutter is in the fully open position *P. Schranz*

See also: *Synchronized flash shutter.*

***x, y* DIAGRAM** Chromaticity diagram in which the *x,y* chromaticity coordinates of the CIE XYZ system are used.
R. W. G. Hunt

See also: *Colorimetry.*

X-Y MOVEMENT Identifying lateral movement in any direction, applied, for example, to sample holders in microdensitometers and controls on animation compound tables.
L. Stroebel

***x, y, z* CHROMATICITY COORDINATES** Chromaticity coordinates obtained from X, Y, Z tristimulus values.

$$x = X/(X + Y + Z)$$
$$y = Y/(X + Y + Z)$$
$$z = Z/(X + Y + Z)$$

Because $x + y + z = 1$, only x and y are quoted; z can be derived if required as $z = 1 - x - y$. *R. W. G. Hunt*

See also: *Colorimetry.*

X-Y-Z MOUNT A support, for an optical system for example, that permits movement in any of three mutually perpendicular directions. *L. Stroebel*

X, Y, Z TRISTIMULUS VALUES Tristimulus values (amounts of three matching stimuli required to match the stimulus considered) used to specify colors in the CIE system of colorimetry. *R. W. G. Hunt*

See also: *Colorimetry.*

X-synchronization, where the flash is fired when the shutter reaches the fully-open position.

Y Coordinate (ordinate); Luminance
YC Luminance, chrominance
YCC Luminance, chrominance, chrominance
yd Yard
YIQ Luminance and two color-difference signals
YUV Luminance and two color-difference signals

y-AXIS (1) In rectilinear graphs, a vertical line on which values of output data are found. Density values are found on the *y*-axis for graphs of photographic emulsion characteristic curves. (2) In aerial photography, in the direction laterally across the flight line. *H. Todd*

YEARBOOK PHOTOGRAPHY The production of photographs for use in school yearbooks, that is, books that show the year's activities and the students who will be graduating, and which serves as a record for the students and the school. Photographs in yearbooks include portraits, group pictures, and school activities. Photographs of consistent quality are essential for quality reproduction. While some professional photographers specialize in yearbook photography, students typically make some of the photographs under the supervision of a faculty advisor. Students also have the responsibility for the writing and layout of the book, which requires some knowledge of picture editing, typography, and design. *R. Zakia*
 See also: *Aesthetics; Communication; Editorial photography; School photography; Snapshot photography.*

YELLOW (1) One of the four unique visual hues, the others being blue (to which yellow is opponent), red, and green. A hue that corresponds to the part of the visible spectrum having wavelengths near 580 nm. (2) Name given to the blue-absorbing colorant used in subtractive process. *R. W. G. Hunt*

YIQ In video, NTSC standards abbreviate chrominance as I and Q, and abbreviate luminance as Y. I and Q refer to hue and saturation. Y refers to value or brightness. *R. Kraus*

YOUNG–HELMHOLTZ THEORY The hypothesis that there are in the retina three different sensors, each of which is sensitive to a different primary color of light, specifically red, green, and blue. Physiological evidence in favor of the hypothesis involves the discovery that such sensors do exist. *L. Stroebel and R. Zakia*
 See also: *Vision, color vision; Visual perception, perception of hue and saturation; Young theory.*

YOUNG THEORY Young visualized a triangular outline for representing pure spectral colors, with red, green, and blue at the apexes and white in the center, in place of the circular arrangement suggested by Newton. Mixtures of red and green, green and blue, and red and blue were placed on the straight lines connecting the pairs of colors. This suggested that the visual system required only three types of colors sensors, a concept stated more explicitly by Helmholtz in the Young–Helmholtz theory. *L. Stroebel and R. Zakia*
 See also: *Young–Helmholtz theory.*

YOUNG, THOMAS (1773–1829) British scientist. Accomplished basic research on the physiology of human vision. Proved that the eye's lens accommodates, or changes shape, to achieve focus. Described astigmatism. Determined that the retina contains structures sensitive to red, blue, and green, later more fully developed by Helmholtz, who presented the Young-Helmholtz theory. Promoted the wave theory of light, in opposition to Newton's prevailing theory that light is made of particles. *M. Alinder*

Y-TILT In aerial photography, a deviation of the camera axis from the vertical caused by the pitch of the aircraft. *L. Stroebel*

Z Coordinate in *XYZ* systems; Impedence

z-AXIS (1) Where three axes are necessary for the display of graphical data, a line placed in a direction perpendicular to a plane containing the *x* and *y* axes. Values of a second input variable are found on the *z*-axis. (2) In aerial photography, in the direction vertically perpendicular to the flight line. *H. Todd*

See also: *Trilinear plot.*

ZEIGARNIK EFFECT The tendency for some people to remember more effectively a task that is interrupted and not completed than one that is completed. A photograph that is in some way ambiguous or puzzling will be remembered better than one that is not. *L. Stroebel and R. Zakia*

See also: *Visual perception, physical, physiological, and psychological factors.*

ZEISS, CARL (1816–1888**)** German lens manufacturer. Founder of Zeiss optical firm (1846). With collaborators, Ernst Abbe and Otto Schott, devised the manufacture of Jena glass, the finest optical quality glass. Zeiss became famous for its excellently designed microscopes, binoculars, optical instruments, and cameras. Zeiss photographic lenses became the standard in the field. Chief lens designer, Paul Rudolph, produced the first anastigmat (1890) and the still-popular Tessar (1902). *M. Alinder*

ZENER DIODE A semiconductor diode used in a circuit as a voltage regulator. Within limits, the reverse voltage across a zener diode remains relatively constant over a wide range of (reverse) current flowing through it. *W. Klein*

ZENITH CAMERA See *Camera types.*

ZERO CUT In motion-picture production an uncommon procedure for preparing a negative for release printing in which extra frames are left on the head and tail of each shot as they are cut into the A and B rolls in a checkerboard pattern in conformance with the edited work print. This technique creates a release print in which each cut appears as a one-frame dissolve. Few modern laboratories are equipped for zero cut printing. *H. Lester*

ZERO POSITION On a view camera, the normal position for a tilt, swing, lateral shift, or rise-fall adjustment, usually identified by an identifying mark, a position on a calibrated scale, or a click-stop. *L. Stroebel*

ZETA POTENTIAL A potential measured by submitting a particle in solution to movement by an electric field. The potential is related to the potential difference between the plane of shear somewhere within the double layer and the

bulk solution. The double layer is due to the attraction of ions in solution to the charged surface of the particle. The ion concentration varies with distance from the particle surface and this sets up a potential gradient. The purpose of measuring the zeta potential is to gain information about the surface charge of a particle under various environmental conditions. *R. Hailstone*

ZIRCONIUM LAMP An arc lamp that produces a point source of light of high intensity. Source size depends on wattage and may be from 0.13 to 2.8 millimeters in diameter (0.005 to 0.11 inches) and forms on the end of a tiny zirconium oxide-filled tube that acts as the cathode. Light is emitted through a hole in the anode. The spectral power distribution is similar to that of a blackbody having a color temperature of about 3200 K. *R. Jegerings*

ZOETROPE A nineteenth-century novelty device that exploited the phi phenomenon and the persistence of vision principle to create the illusion of movement when strips of sequential drawings were placed inside a rotating drum and viewed through a series of slits in the side of the drum. Often thought of as a forerunner of modern motion-picture animation. *H. Lester*

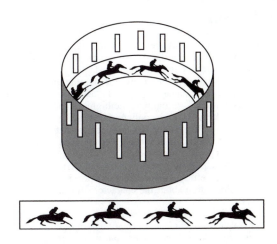

Zoetrope.

ZONAL SPHERICAL ABERRATION Residual, uncorrected spherical aberration in a lens where the principal focus shifts progressively as the lens is stopped down. It is detectable only at the largest apertures, but it may mean that the lens must be focused at the aperture to be used instead of

maximum aperture. It is impractical to try to correct spherical aberration for every zone of a lens. *S. Ray*

ZONE A band, belt, or region encircling any point. The annular regions of a lens surface outside the paraxial region close to the optical axis are called *zones*. Refraction from zones of increasing diameter produces focus progressively closer to the lens. *S. Ray*

See also: *Marginal rays; Paraxial; Zone system.*

ZONE FOCUSING Technique of setting the focused distance of a lens to give sufficient depth of field to include the subject at the moment of exposure, usually when the subject is fast moving or unpredictable in its behavior, making precise focus difficult. The usual method is to determine the near and far extents of the zone to be rendered sharp and to use the depth of field indicators on the focusing scale of the lens (if provided) to find a focused distance and lens aperture that provide this range. A zoom lens may have to be reset to a suitable focal length as well if the other settings so dictate. Many autofocus lenses lack such scales for this purpose and rely instead upon continuous focusing on the subject and predictive autofocus to produce sharp results. *S. Ray*

See also: *Depth of field.*

ZONE PLATE A flat plane that acts as a focusing lens to form a real image using diffraction instead of refraction. The plate has a pattern of alternate very narrow clear and opaque annular rings spaced so that the zones between each are equal in area, with the rings becoming progressively narrower as the distance from the center increases. Incident white light diffracted by the zones by processes of constructive interference come to a different focus for each wavelength. *S. Ray*

ZONES See *Appendix G.*

ZONES (TV) Circular divisions of a television screen around the center where the diameter of zone 1 is 0.8 times the height of the picture area and the diameter of zone 2 is equal to the width of the picture area. The zones are used in the evaluation of picture quality. *L. Stroebel*

ZONE SYSTEM Conceived in the late 1930s by Ansel Adams and Fred Archer as an attempt—in Adams's words—"to provide a bridge between sensitometry . . . and practical creative work." In fact, the system did combine the science and art of photography to an unprecedented degree and is still used and respected by many fine photographers today.

Adams—whose name is popularly associated with the Zone System now—recognized the highly technical nature of photography and the necessity for materials testing, but he chose to avoid direct involvement in sensitometric analysis of films and papers. Instead he recommended a series of empirical test procedures that could be followed by any competent photographer, that required no special equipment, and that—when carefully executed—could provide adequately reliable information about the characteristics of the chosen materials.

ZONE SYSTEM TERMINOLOGY In formulating a system to put this technical information to most efficient use, Adams considered the black-and-white photographic process as an integrated whole, rather than as a series of isolated steps, and emphasized the relationship between the subject luminance values and their corresponding print tones. To provide terminology for the system he assigned identifying Roman numerals to ten neutral tones, from black to white, and called them *zones*. In the print image he referred to these grays as *print zones*. The subject luminance values related to each of these print zones he called "subject zones," and their corresponding negative values, he termed "density zones." Exposure zones were matched with print zones to represent the input-output relationship of the photographic process. Although he later abandoned "print zones," "subject zones," and "density zones" in favor of "print values," "subject values," and "density values," he retained the term *exposure zones.*

Adams thought of the ten exposure zones as analogous to subject luminance values and related them to the luminance scale of the then-popular Weston exposure meter. He assigned Zone V to the normal pointer on the meter's dial, then distributed the other zones above and below the pointer position at intervals of one stop. Zone VII straddled the upper limit of the normal subject range, marked "O" on the meter's scale, and the center of Zone I was positioned at the "U" position on the scale, marking the lower limit of the normal range. Adams then added Zone IX, beyond the upper limit of the normal range as defined by the meter calibration and designated it to represent specular highlight values or pure white. He also extended the lower end of the scale by adding Zone 0 to represent the pure black accent tones. The relationship between Subject Values and exposure increments in terms of *f*-stops for a normal scene having a luminance ratio of 128:1 corresponds to a seven-stop or a seven-Exposure Zone range.

The zone grays are identified as those tones in the print that represent one-stop increments of exposure of the film. This is not an immutable definition because the total range of film exposures that can be translated to negative densities and printed successfully depends on a number of variables—principally the extent of development of the film and the contrast characteristic of the printing paper. Adams stated a preference for *normal* grade #2 paper, and defined its acceptable exposure ratio as 1:50, which is equivalent to a log exposure range of 1.7. There's no direct relationship between Adams's method of determining the paper's useful range and our present ISO standard method, but it's quite possible that his grade #2 paper might be considered a grade #1 by modern standards. This does not necessarily imply an unusually contrasty subject condition, but it does suggest that Adams was pushing the limits of the *normal* range, which may help to explain his use of the ten-zone scale. It's probably worth noting here that since any given paper's density limits are relatively fixed, the individual grays represented by at least some of the units of a 10-zone scale must necessarily differ somewhat from their counterparts in a nine-zone scale. In other words, the assignment of zone numbers to specific gray tones depends not only on a number of process variables, but to some extent upon the perception and intent of the individual photographer as well.

ZONES DEFINED In describing the tonality of his ten zones, Adams organized them into three groups as summarized here:

The *low values* include:
Zone 0—Total black in the print.
Zone I—Effective threshold; slight tonality but no texture.
Zone II—First suggestion of texture; deep tonalities.
Zone III—Average dark materials; low values, adequate texture.

The *middle values* include:
Zone IV—Dark foliage, stone, shadows in sunlit portraits.
Zone V—Dark skin, gray stone, middle gray (18% reflectance).
Zone VI—Average Caucasian skin tone, shadows on snow.

The *high values* include:
Zone VII—Very light skin, light gray objects, sidelit snow.
Zone VIII—Textured whites, highlights on Caucasian skin.
Zone IX—White without texture, snow in flat sunlight.

Although some photographers have extended the zone range still farther to include Zone X, and others have considered the useful range to include only Zones I through VIII, these choices simply produce a personalized variation of the system without altering Adams's basic concept, which remains unchanged to this day.

VISUALIZATION A distinctive feature of the Zone System is its emphasis on visualization, which is, in effect, the act of relating the appearance of the subject to the imagined appearance of the desired print image. In simple terms, the photographer considers a light area and a dark area in the subject and attempts to imagine how they might be reproduced in the print. In this visualized print image the lighter tone may appear, for example, as a "Zone VII gray" and the darker value may match the photographer's concept of a "Zone III gray." If the corresponding subject areas appear to match these same zone values, then no adjustment is necessary, and *normal* film exposure and development will probably suffice. However, if the visualized print values are significantly different from the perceived gray tones of the subject, then the situation is not normal and the appropriate adjustment in film exposure and development can be determined from the test data.

EXPOSURE CONTROL Exposure control in the Zone System is based on the principle that exposure zones and stops are equal and many photographers equip their meters with a scale of gray tones representing print values to formalize that concept, just as Adams did. When properly applied to the meter dial, the Print Value V gray patch is aligned with the normal (Exposure Zone V) pointer on the meter's calculating dial so that, for example, the Print Value VIII patch falls three stops above and Print Value II falls three stops below the normal pointer.

A given luminance reading that's placed opposite the normal pointer is assumed to yield a Print Value V gray, but the photographer can choose to produce a Print Value III gray, for example, by ignoring the normal pointer and aligning the luminance reading with the Print Value III patch on the meter dial. In effect this meter adjustment underexposes the selected area by two stops to shift from Print Value V to Print Value III. Similarly, aligning the luminance reading with the Print Value VII patch, instead of the normal pointer, will overexpose sufficiently to produce a Print Value VII gray. In Zone System parlance the subject luminance value, or the subject area itself, is then said to have been *placed*—as, for example, "I placed that tree trunk in Zone II."

In accordance with the traditional advice, "expose for the shadows and develop for the highlights . . ." the camera settings can be found on the meter dial as soon as the low luminance reading has been suitably placed, but development data can't be determined until the subject's contrast in terms of luminance ratio or exposure zone range has been estimated. This is typically accomplished by identifying two reference print values—one high and one low—in the subject and comparing this value range with the measured exposure zone range of those subject areas. Because measurement of the extremes of the subject range may be difficult with some subjects, many photographers base this range calculation on Print Values III and VII, although other pairs can be used.

If the desired print value range for two selected subject areas, such as Value III and VII—a four-value range—matches the exposure zone range as determined by luminance readings of the areas, the subject is considered to be *normal*. In Zone System terminology the appropriate development for this normal subject condition is simply called "N."

DEVELOPMENT CONTROL: "N" NUMBERS In many cases the subject range is either greater or less than normal, and "N" development is no longer appropriate. The photographer identifies these abnormal ranges by placing the low luminance as usual, then noting that the high luminance

falls either above or below the reference zone on the meter's exposure zone scale. For example, if the reference zone is Zone VI, and the high luminance reading falls in Zone VII, the subject range is obviously greater than normal, so less-than-normal (*compaction*) development is necessary to reduce the excessive range. Adams referred to compaction development, sufficient to reduce the high value by one zone, as "N minus" (N–) development; and used the term "N plus" (N+) to describe *expansion* development, sufficient to increase the high luminance by one zone.

ANSEL ADAMS'S TEST PROCEDURES The extensive testing procedures that are required to provide working data for this use are an integral part of the Zone System concept. In his seminal book *The Negative* (Morgan & Morgan, revised in 1968), Adams recommends that one begin the test series by making a series of identically exposed Caucasian portraits, avoiding both highlighted and shaded areas of the face while metering, and placing the skin tone in Zone VI. Develop these exposed films for different lengths of time and select the negative that makes the most satisfactory print, when the print exposure is just sufficient to reproduce clear areas of the negative (such as the unexposed border area) as full black print tones. Temporarily consider the developing time of that negative to be a standard time. Then make a number of identical exposures of a *standard gray card* of about 18% reflectance, again placing the metered luminance value in Zone VI and developing the films for different times. Choose the negative whose print value most closely matches the selected portrait skin tone. Next, to check for possible errors in exposure, expose another film to the gray card, but this time place the luminance reading in Zone I. Develop this film for the standard time and compare its density with that of an unexposed but developed film. If the density of the test negative is about 0.1 greater than the *base-plus-fog* density represented by the unexposed negative, then the *threshold* density is proper. If the threshold density is significantly greater (or less) than 0.1 over B + F, it indicates that the film has been overexposed (or underexposed) for some reason—possibly because either the meter or the camera shutter is inaccurate or because the film speed setting was not correct. In either case, adjust the film speed and reshoot the gray card, repeating this procedure until a threshold density of about 0.1 is obtained and the print image of skin tone matches the desired Zone VI gray. This determines the correct film speed and development time for normal Zone VI placement.

In proceeding to a more elaborate series of tests to establish development times for the various conditions of expansion and compaction development, Adams recommended essentially repeating the Zone VI placement test. Make four exposures of the gray card, being very careful to illuminate it uniformly, and place the luminance value in Zone VI. Develop one film for the *standard* time and if that does not produce satisfactory Zone VI density in the negative (presumably as determined by printing it), alter the development and develop the next film. When a Zone VI match has been achieved, it confirms the normal, or "N," developing time.

Repeat this series of four exposures but place the luminance value in Zone V and develop one film for 1.5x the normal time. Compare the density of this negative with the density of the preceding normally developed negative where the gray card was *placed* in Zone VI, and, if they don't match closely, adjust the development time for the second film. Repeat this adjustment as necessary to achieve a density match. This test establishes the N+ development time.

Repeat this series of four exposures but place the luminance value in Zone IV and develop the first film for about 2.5x the normal time. Adjust this time and repeat as necessary to achieve a density match between the Zone IV and Zone VI negatives. This test establishes the N++ developing time.

To determine the *Normal minus* development times, repeat this series of four identical test exposures but place the luminance reading of the gray card in Zone VII. Develop one film for 3/4 the normal time and compare the negative density with the Zone VI negative. If necessary, adjust the development time and repeat until a density match between the Zone VII and Zone VI negatives is obtained. This test establishes the N– development time.

Repeat the test exposures series of four films but place the luminance value in Zone VIII and develop one film for from 1/2 to 2/3 the normal time. As before, adjust this time to obtain a satisfactory density match between the Zone VIII and Zone VI negatives. This test establishes the N–development time.

In justifying this procedure, Adams noted that it's quite possible to develop films normally and control image contrast by selecting printing papers of appropriate contrast grades; but he clearly favored varying film development and pointed out that producing negatives of consistent quality establishes a "routine of visualization and execution" that assures a "positive discipline of awareness and intention."

Many variations of the original Zone System have been proposed by various authors, but no one has been a more enthusiastic proponent of the System, or more influential in publicizing it, than Minor White. White, a celebrated photographer and teacher, described his implementation of the Zone System in his *Zone System Manual,* written in 1954. Although he adopted Adams's basic approach, White put greater emphasis on visualization—which he called "previsualization." In his early work he also reduced Adams's ten-zone concept to nine zones (omitting Zone 0) but reinstated Zone 0 and the ten-zone scale in a much-revised 1976 edition called *The New Zone System Manual,* written in collaboration with Peter Lorenz and Richard Zakia.

MINOR WHITE'S TEST PROCEDURE White's instructions for the testing and calibration of the various materials and processes are very specific, rigorous, and detailed, and he emphasized the necessity for keeping careful records of every step. His recommended calibration procedure is carried out in four stages: a "Preliminary Run" to establish Normal Zone I and an exposure index; an "Establishing Run" to establish Normal Zone V; "Fine Tuning" to establish Normal Zone VIII and IX; and "Variable Development" to establish the Normal minus and Normal plus developing times. Separate sets of instructions are given for 35-mm film, 120 roll film, and sheet film.

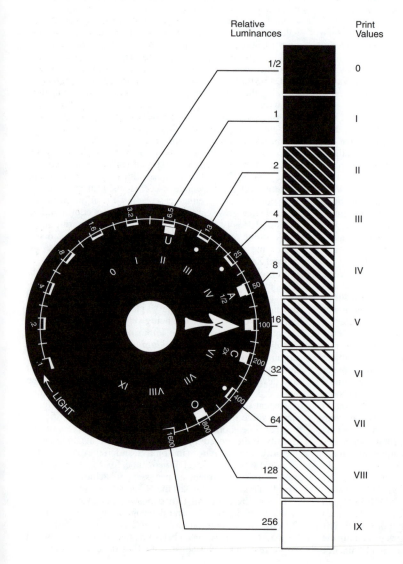

Ansel Adams's concept of the relationship between exposure zones, as represented by the meter scale calibration, and print zones as represented by the gray patches.

This summary of the recommended 35-mm sequence is typical. Load the camera and wind and release the shutter with the lens cap on to provide three blank frames. The last of these (presumably numbered 1) will serve as the Zone 0 reference density. Fasten a standard 18% gray card on a black cloth background and illuminate it evenly. Meter the gray card carefully and adjust the illumination level until an exposure of no less than about *f*/5.6 at 1/60 second is indicated. Place the camera on a tripod and move close enough to fill the entire frame with the gray card image, then focus the lens on infinity. Expose frame 2 to (*place* the gray card luminance value in) Zone I. Expose frame 3 to Zone V; this will be used to make a *control print*. Expose frame 4 to Zone IX.

Replace the gray card with a piece of textured cloth of some neutral shade. Meter this cloth and adjust the light intensity until the Zone V exposure matches that obtained from the gray card. Position the camera so that the textured cloth image fills about one-third of the viewfinder image, and focus sharply on the cloth texture. (Any increase in lens-to-film distance should be compensated for. See Bellows extension.) Expose frames 5 through 14 to Zones I through X by adjusting the aperture through its full range, then resorting to shutter speed adjustments as necessary. Avoid exposure times of 1 second or longer. Expose the remaining frames on the roll to Zone V.

Develop this test roll for the usual time or use the manufacturer's recommended normal time. Continuous inversion agitation is recommended for the first 30 seconds (or first minute) followed by several inversions at regular intervals of 30 to 60 seconds throughout the development period. When the negatives are dry, cut the roll into four strips; the first including frames 0–4; the second, frames 5–9; the third, frames 10–14, and the fourth, frames 15–19.

The zone grays are produced by printing these negatives, but before that can be done the density limits of the paper must be found by developing a sheet of fully exposed paper to produce maximum black, and developing a sheet of unexposed paper to serve as a reference white. Then establish a *standard printing time* by making a series of 2-second increment exposures on a paper strip, developing normally, and examining the resulting densities to identify the last dark gray step that can be distinguished from maximum black. The exposure responsible for the adjacent black step is considered to be the *standard printing time* for the remainder of the test series.

Print the Zone 0 negative and confirm that it produces a full black by comparing the print with the black reference print. Then print all of the other test negatives exactly the same, labeling the back of each print with its zone number. When the prints are dry, arrange them in numerical sequence as a *zone ruler*. To check the accuracy of the test, compare the Zone V print of the textured cloth with the Zone V print of the gray card. If they are not closely matched, make the appropriate adjustments and repeat the test.

To determine a personal exposure index, examine the zone ruler to discover the first print in which the textured cloth image is distinguishable from the black cloth background. If this print is labeled Zone I, the exposure index used for the test can be considered to be accurate. If the selected print is labeled Zone II, it indicates *under*exposure and the exposure index should be *divided* by 2; if Zone III, *divide* the index by 4. Then count up four prints from the chosen Zone I print to locate Zone V and compare that print with the 18% gray card. If the print is lighter than the card it's an indication that the test development was overdone; if darker, development was insufficient.

If either the exposure index or the developing time must be changed, redo the test series using the new values; then produce another zone ruler and compare it with the first ruler.

White suggests that the lower zones should match fairly closely but that possible development errors will be evidenced by differences in the values of the upper zones. Now compare the second set of Zone V prints of both the gray card and the textured cloth with the gray card itself. If they are not a close match, redo the test series, making whatever adjustments are necessary.

Fine Tuning attempts the manipulation of development to adjust the densities of Zones VIII and IX, without seriously affecting the tonality of the lower zones. To accomplish this, White recommends diluting the developer within the range of from 1:1 to 1:4 and increasing development time from 25 to 100%, as necessary to compensate. It's implied that each adjustment will require a repetition of the test series.

To establish developing times for expansion and compaction development, repeat the test series, exposing the target to Zones I through VIII. To test for N+1 development increase the normal developing time by 30–40% for fast films, 20–30% for medium-speed films, or 15–20% for slow films. Print all the negatives as usual, using the standard printing time. Assemble the prints into a new zone ruler and compare with the normal set. Differences in the Zone I print values, if significant, will indicate that the increased development has affected the negative threshold density and some adjustment of the exposure index may be called for.

Compare the Zone V print in this expanded series with the normal Zone VI print; if they match closely, consider the test developing time to be appropriate for N + 1. If these prints do not match well, an appropriate adjustment of the developing time is implied and a new test series is called for. When the desired shift from Zone V to Zone VI has been obtained, check the upper zones to see, for example, how far Zone VII may have shifted. Again, White suggests that these zones can be manipulated more or less independently, if necessary, by diluting the developer for another test run.

An N + 2 developing time is discovered similarly. Run another test series, increasing the N + 1 time by the same percentage used previously, and compare this new set of prints against the original zone ruler to see if Zone V has now shifted to Zone VII. If it has, this developing time can be considered to be appropriate for N + 2 development; if not, adjust the exposure and repeat the test series. Then proceed with field tests to confirm the accuracy of these expansion times.

Compaction tests are conducted similarly. Expose the textured target to Zones I through IX, and develop from 15 to 30% less than normal. Print the negatives as usual, and check the lower zone prints against those on the normal zone ruler. If the new prints are significantly darker than the originals, it

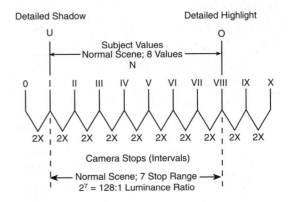

The popular concept of the relationship between subject values and camera stops in the normal subject range.

suggests that this reduced development will require a compensating increase in film exposure. The N–1 development time is established when the new Zone VIII print matches the Zone VII gray in the original test series. Repeat this general procedure to discover the appropriate development for N–2 and N–3, as determined by the compaction of Zone VIII to Zone VI and Zone V, respectively.

Although Adams himself frequently used both roll film and Polaroid films in his later years, his original Zone System concept was clearly based on the premise that film development should ideally be adjusted to compensate for variations in subject luminance range. Of course it is possible to dedicate an entire roll of film to one subject condition so that a single developing time will be appropriate for all the images, and some roll film cameras feature interchangeable film backs that make this procedure relatively feasible. The fact remains, though, that taking full advantage of the Zone System, as Adams originally envisionedit, is easiest and most practical with sheet film cameras.

ZONE SYSTEM FOR ROLL FILM To help roll film users who wish to use the Zone System, White and others have extended the zone concept to calibration of paper grades and have suggested paper selection as an alternative to adjustments of film-developing time for the purpose of image contrast control. This concept permits photographers to *pre-visualize* the subject and decide on an appropriate N–number as usual, but instead of interpreting the N–number as a specific developing time, they can use it to identify the appropriate paper grade—assuming some standard film-developing time. Although the visualization practice is useful, this is otherwise an empty exercise because regardless of the selected developing time any negatives of abnormal contrast will demand to be printed on appropriate compensating grades of paper whether the photographer has preselected them or not.

In *The New Zone System Manual* White recommends paper grade #3 as normal for small-camera negatives, and (based on the concept of a ten-zone subject range) relates N–numbers, subject range, and paper grades as follows:

Film		Paper	
Development	Will render	Grade	Will render
N + 2	8-zone subject as full scale	#5	8-$\frac{1}{2}$ zones as full scale
N + 1	9-zone subject as full scale	#4	9-$\frac{1}{4}$ zones as full scale
N	Normal 10-zone subject	#3	Full scale print
N – 1	11-zone subject as full scale	#2	10-$\frac{1}{2}$ zones as full scale
N – 2	12-zone subject as full scale	#1	11 zones as full scale

White notes that these relationships are approximate and points out the fact that the effective speed and contrast of printing papers are not necessarily consistent. He suggests testing each new batch of paper to establish an appropriate *standard printing time* and to determine the paper's effective contrast grade.

These tests are again referred to as the standard zone rule. First, to determine whether the new paper is more or less contrasty than the old, print the normal Zone V negative and adjust the exposure until the print value matches the Zone V gray produced on the original paper. This exposure time becomes a temporary standard printing time for the new paper. Using this new time, print the standard Zone II and Zone VIII negatives and compare these prints with the original set. If the new Zone II print is lighter than the original, and the new Zone VIII print is darker than its corresponding original print, the new paper is less contrasty than the old. Conversely, if the new Zone II is darker and the new Zone VIII print lighter than their original counterparts the new paper is more contrasty than the old.

To relate the new paper's effective contrast grades to N–numbers, print the calibrated Zone VII negative of the textured cloth on each of the paper grades, adjusting the exposure times so that each print matches the original Zone VII standard print. Label each print with its nominal grade number and the exposure time required to produce the visual match. Next, print the standard Zone III textured cloth negative on each of the paper grades, using in each instance the same time used to establish the Zone VII print.

When these prints are dry, compare them with the original zone ruler. If the Zone III print matches the ruler's Zone V gray, then that paper's contrast is effectively N–2. If the Zone III print matches Zone IV on the ruler, the effective contrast can be called N–1. If the Zone III grays match, then the paper contrast is normal, or N. If the new Zone III matches the Ruler's Zone II, then that paper is equivalent to N + 1. Consider the new paper to be equivalent to N + 2 if its Zone III gray matches the Zone I print on the zone ruler.

Finally, to establish a specific standard printing time for each of the new paper grades, make an arithmetic test strip using the Zone 0 negative, as previously described, and identify the first step that's distinguishable from pure black. The exposure responsible for the adjacent black step can then be adopted as the standard printing time for that particular paper for use under those specific printing conditions.

ALTERNATIVE METHODS Although empirical testing procedures of this sort are by far the most popular method for acquiring working data for use with the Zone System, it is possible to derive similar data in other ways. Manufacturers of photographic papers, for example, publish the density ranges of negatives that best match the characteristics of the different contrast grades of paper for negatives to be printed with diffusion enlargers and with condenser enlargers. Application of this information, however, requires access to a densitometer to measure the densities of the thinnest and densest areas of interest in the negative, that is, Zone System density values of I and VIII. For those who are familiar with sensitometry, useful data can be derived from families of film and paper characteristic curves. Information on this approach is presented in the book *Beyond the Zone System,* by Phil Davis.

Books: Adams, Ansel, *The Negative: Exposure and Development.* Dobbs Ferry, N.Y.: Morgan & Morgan, 1968. Davis, Phil, *Beyond the Zone System,* 2nd ed. Boston: Focal Press, 1988. White, Minor, *Zone System Manual,* 4th ed. Dobbs Ferry, N.Y.: Morgan & Morgan, 1972. White, Minor, Zakia, Richard, and Lorenz, Peter, *The New Zone System Manual,* 4th ed. Dobbs Ferry, N.Y.: Morgan & Morgan, 1989.

P. Davis

ZOOMING Technique of changing the focal length of a zoom or varifocal lens from a fixed camera position to alter image size to provide tight framing or cropping without changing perspective. In cinematography this technique appears to make the camera advance or recede from the subject at any desired speed.

S. Ray

ZOOM LENS See *Lens types.*

ZOOM MICROPHONE A microphone containing a feature that permits it to vary its polar pattern to correspond roughly to the effect of a zoom lens, that is, to change from a generally wide acceptance angle to a generally narrow one.

T. Holman

See also: *Microphone polar patterns.*

ZOOPRAXISCOPE An instrument devised by Eadweard Muybridge in 1880 in which a series of photographs or drawings mounted on a rotating disc were projected on a screen with a magic lantern in rapid succession, creating the illusion of movement for a short series of images. Muybridge had previously developed a system of multiple cameras that could be exposed in rapid sequence for the analysis of var-

ious movements. Often thought of as a precursor to cinematography. *H. Lester*

ZWORYKIN, VLADIMIR KOSMA (1889–1982)
American engineer. Russian-born, inventor of television in 1928. His system employed an electronic image scanning system, rather than the mechanical system devised by Baird. Worked for Radio Corporation of America from 1929, where his research was pivotal to their leadership during the early days of television broadcasting. *M. Alinder*

APPENDICES

Photographic Effects

The basic causes of effects given in this summary are those widely accepted and are indicated in the first column as follows: (1) Size of latent image specks, (2) Regression of latent image, (3) Latent image situation (on the surface or interior of the grains), (4) Development effects. The arrows indicate the direction of an effect, e.g., with low-intensity reciprocity failure the sensitivity decreases with decreasing illuminance (I) and increasing time (t). D* is the optical density of the developed image.

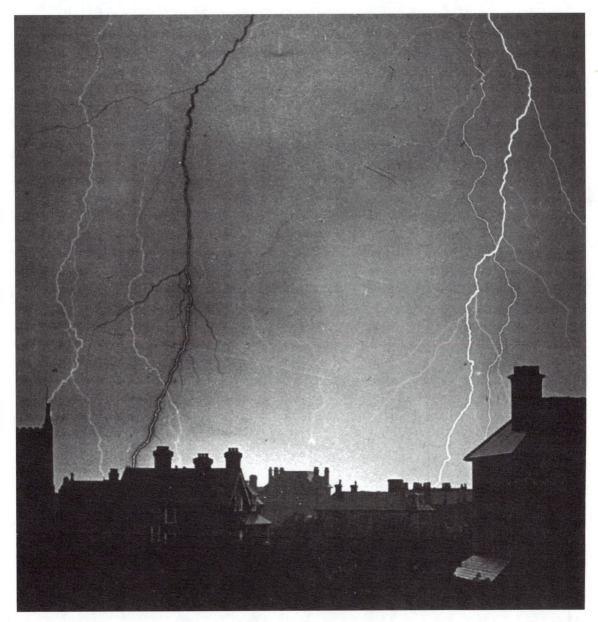

CLAYDEN EFFECT. A high-intensity exposure followed by a low-intensity exposure can result in a reversal of density. (Photograph "Black Lightning" courtesy of Kodak Museum, Harrow, England.)

Appendix A

Effect	1st Exposure I	1st Exposure t	Intermediate treatment	2nd Exposure I	2nd Exposure t	Remarks	Result
Reciprocity failure: low illuminances (2)	Low ↓	Long ↑	—	—	—	D* = constant	Sensitivity decrease ↓
high illuminances (1, 3)	High ↑	Short ↓	—	—	—	D* = constant	Sensitivity decrease ↓
	V. High ↑	V. short ↓	—	—	—	No failure:	Sensitivity constant
Hypersensitization by pre-exposure (1)	High ↑	Short ↓	—	Low ↓	Long ↑	1st uniform 2nd camera	Sensitivity for 2nd exposure increased ↑
Latent-image intensification (1)	High ↑	Short ↓	—	Low ↓	Long ↑	1st camera 2nd uniform	Sensitivity for 1st exposure increased ↑
Temperature: reduced (2)	Low ↓	Long ↑	—	—	—	This represents a change in reciprocity failure	Sensitivity increase ↑
(1,3)	High ↑	Short ↓	—	—	—		Sensitivity decrease ↓
very low	Independent of illum.		—	—	—		Sensitivity always lower than optimum at room temperature
increased	Low ↓	Long ↑	—	—	—		Sensitivity decrease ↓
	High ↑	Short ↓	—	—	—		Sensitivity increase ↑
Intermittent exposures Schwarzschild effect	High ↑	Short ↓	—	—	—	(Often)	Sensitivity increase ↑
	Low ↓	Long ↑	—	—	—		Sensitivity decrease ↓
High frequency	—	—	—	—	—	Result according to average intensity	
Solarization	Continued exposure			—	—	Only for surface image which is rebrominated	Reversal
Herschel: (3) visual	White light		—	Red light	—	—	Bleaching or reversal of: print-out density
latent	White light		—	Red light	—	—	latent density
low temperature	At very low temp.		Keep cold	Red light	—	—	Very effective bleaching
			Warm up	Red light	—	—	No bleaching
Debot (3)	Heavy, to white light		Bleach surface image	Red light	—	Surface image (converse of Herschel effect)	Red sensitivity
Dye reversal	White light		Dyeing	Light absorbed by dye	—	Only with certain dyes	Reversal
Seebeck	White light		—	Colored light	—		Print-out image in color of second exposure

Becquerel	White light	—	Yellow or red	AgI emulsions	Print-out positive image of second exposure
	White light		Yellow or red	Physical dev.	Developed positive image of second exposure
	White light		Yellow or red	Chemical dev.	Herschel reversal
Weigert	Uniform, white polarized	—	Polarized, colored	According to wave-length	Dichroic print-out images
	Polarized		Polarized	—	Dichroic developed density
Clayden (3)	V. high V. short	—	Normal or low Normal or long	Surface latent image	Desensitization towards second exposure
Very low temperature (3)	At very low temp.	Warm up	Exposure to light	—	Desensitization towards second exposure
Villard (3)	X-rays	—	Light	—	Desensitization towards second exposure
Pressure (3)	Pressure	—	—	—	Produces some latent image
	Pressure	—	Light	—	Desensitization towards second exposure
Russell	Contact with metal and other substances	—	—	—	Produces latent image
	Contact with metal and other substances	—	Light	(Often)	Desensitization towards second exposure
Sterry	Light	Chromates	—	—	Lowering of contrast
Albert (3)	Stepped to light	Nitric acid	Uniform to light	Surface image	Reversed
Sabattier	Uniform to light	Partly developed	Stepped to light or Na_2HAsO_3	—	Reversal of 2nd exposure
Purkinje	Shift in maximum of *luminosity curve* with change in *luminous intensity*				
Kron	Shift of optimum of reciprocity failure curve towards high intensities with increasing time of development				
Ross	Contraction of small images due to tanning action of developer				
Capri-blue	Increase in sensitivity and contrast of coarse-grain emulsions without silver-sulfide sensitivity-specks by certain dyes				
Eberhard, Neighborhood, and Kostinsky	Value of a developed density depends on neighboring density; produced by developer reaction products. *Edge effects*				
High-energy quanta or particles, as x-rays, protons, electrons	Straight line density-time characteristics, highest slope at origin; Same shape characteristics for all wave-lengths; Absence of reciprocity failure. A single quantum or particle will form a latent-image speck				

APPENDIX B

Greek Alphabet and Letter Symbols

Name	Caps	L.c.	Used for
Alpha	A		
		α	Light *absorption factor;* absorptance.
Beta	B		
		β	*Luminance factor.*
Gamma	Γ		Gamma function.
		γ	Slope of straight line portion of *D-Log H curve;* $\bar{\gamma}$ bar gamma (*Average gradient*).
Delta	Δ		Change in a variable (e.g., ΔD, $\Delta \text{Log H}$).
		δ	Density (mass of unit volume of a substance).
Epsilon	E		
		ϵ	*Emissivity.*
Zeta	Z		
		ζ	
Eta	H		
		η	*Luminous efficiency* of a source; *Lumens* per *watt.*
Theta	Θ		
		θ	Angle.
Iota	I		
		ι	
Kappa	K		
		κ	Electrolytic conductivity.
Lambda	Λ		
		λ	*Wave length* (λ_d dominant, λ_o complementary wave length).
Mu	M		Magnetic flux.
		μ	*Refractive index; Micron;* micro (10^{-6}); $\mu\mu$ micro-micro.
Nu	N		
		ν	Constringence (*Abbe number*); *Frequency* of EMR velocity; $\bar{\nu}$ *Wave number.*
Xi	Ξ		
		ξ	
Omicron	O		
		o	
Pi	Π		
		π	Ratio of circumference to diameter of a circle 3.14159.
Rho	P		
		ρ	Light reflection factor (*reflectance*); Density (in mechanics).
Sigma	Σ		Sum of.
		σ	*Granularity;* Conductivity; *Poisson* ratio; *Standard deviation;* Electric charge density; *Stefan-Boltzmann constant.*
Tau	T		
		τ	Transmission factor (*transmittance*).
Upsilon	Υ		
		υ	
Phi	Φ		*Luminous flux;* Magnetic flux; Φe radiant flux
		ϕ	*Phase* displacement.
Chi	X		
		χ	
Psi	Ψ		Electric flux.
		ψ	Angle.
Omega	Ω		Solid angle; Ohm; mΩ megohm.
		ω	*Frequency;* Angular velocity; *Solid angle;* Dispersive power.

APPENDIX C

Transmittance (T), Reflectance (R), Opacity (O), and Density (D) Relationships

T(R)	O	D	T(R)	O	D	T(R)	O	D	T(R)	O	D	T(R)	O	D
0	∞	∞	.032	31	1.50	.170	5.9	.77	.410	2.44	.39	.720	1.39	.14
.001	1000	3.00	.034	29	1.47	.180	5.6	.74	.420	2.38	.38	.740	1.35	.13
.002	500	2.70	.036	28	1.44	.190	5.3	.72	.430	2.33	.37	.760	1.32	.12
.003	333	2.52	.038	26	1.42	.200	5.0	.70	.440	2.27	.36	.780	1.28	.11
.004	250	2.40	.040	25	1.40				.450	2.22	.35	.800	1.25	.10
.005	200	2.30				.210	4.8	.68	.460	2.17	.34			
.006	167	2.22	.045	22	1.35	.220	4.6	.66	.470	2.13	.33	.820	1.22	.09
.007	143	2.15	.050	20	1.30	.230	4.4	.64	.480	2.08	.32	.840	1.19	.08
.008	125	2.10	.055	18	1.26	.240	4.2	.62	.490	2.04	.31	.860	1.16	.07
.009	111	2.05	.060	17	1.22	.250	4.0	.60	.500	2.00	.30	.880	1.14	.06
.010	100	2.00	.065	15	1.19	.260	3.9	.58				.900	1.11	.05
			.070	14	1.15	.270	3.7	.57	.520	1.92	.28			
.011	91	1.96	.075	13	1.13	.280	3.6	.55	.540	1.85	.27	.920	1.09	.04
.012	83	1.92	.080	12.5	1.10	.290	3.5	.54	.560	1.79	.25	.940	1.06	.03
.013	77	1.89	.085	12	1.07	.300	3.3	.52	.580	1.72	.24	.960	1.04	.02
.014	71	1.85	.090	11	1.05				.600	1.67	.22	.980	1.02	.01
.015	67	1.82	.095	10.5	1.02	.310	3.2	.51				1.00	1.00	0
.016	62	1.80	.100	10	1.00	.320	3.1	.49	.620	1.61	.21			
.017	59	1.77				.330	3.0	.48	.640	1.56	.19			
.018	56	1.74	.105	9.5	.98	.340	2.9	.47	.660	1.52	.18			
.019	53	1.72	.110	9.1	.96	.350	2.86	.46	.680	1.47	.17			
.020	50	1.70	.115	8.7	.94	.360	2.78	.44	.700	1.43	.15			
			.120	8.3	.92	.370	2.70	.43						
.022	45	1.66	.125	8.0	.90	.380	2.63	.42						
.024	42	1.62	.130	7.7	.89	.390	2.56	.41						
.026	38	1.59	.135	7.4	.87	.400	2.50	.40						
.028	36	1.55	.140	7.1	.85									
.030	33	1.52	.145	6.9	.84									
			.150	6.7	.82									
			.155	6.5	.81									
			.160	6.3	.80									

Transmittance (T), Reflectance (R), Opacity (O), and Density (D)

Transmittance or Reflectance = $\dfrac{\text{Light transmitted or reflected}}{\text{Incident light}}$

Opacity = 1/T or 1/R
Density = log 1/T or log 1/R or log opacity
Example: If transmittance (or reflectance) is 0.50 (50%)
Density = log 1/.50; = log 2; = 0.30

APPENDIX D

International Standards Organization (ISO) Film Speed Values

ISO (Arithmetic)	Log H_m	ISO° (Logarithmic)	ISO (Arithmetic)	Log H_m	ISO° (Logarithmic)
6	$\bar{1}.10$	9°	320	$\bar{3}.40$	26°
8	$\bar{1}.00$	10°	400	$\bar{3}.30$	27°
10	$\bar{2}.90$	11°	500	$\bar{3}.20$	28°
12	$\bar{2}.80$	12°	640	$\bar{3}.10$	29°
16	$\bar{2}.70$	13°	800	$\bar{3}.00$	30°
20	$\bar{2}.60$	14°	1000	$\bar{4}.90$	31°
25	$\bar{2}.50$	15°	1250	$\bar{4}.80$	32°
32	$\bar{2}.40$	16°	1600	$\bar{4}.70$	33°
40	$\bar{2}.30$	17°	2000	$\bar{4}.60$	34°
50	$\bar{2}.20$	18°	2500	$\bar{4}.50$	35°
64	$\bar{2}.10$	19°	3200	$\bar{4}.40$	36°
80	$\bar{2}.00$	20°	4000	$\bar{4}.30$	37°
100	$\bar{3}.90$	21°	5000	$\bar{4}.20$	38°
125	$\bar{3}.80$	22°	6400	$\bar{4}.10$	39°
160	$\bar{3}.70$	23°	8000	$\bar{4}.00$	40°
200	$\bar{3}.60$	24°	10,000	$\bar{5}.90$	41°
250	$\bar{3}.50$	25°	12,500	$\bar{5}.80$	42°

ISO Speed Values (arithmetic and logarithmic) and their corresponding log exposure values (H_m) for black-and-white films. Speed values are in increments of 1/3-stops. Logarithmic speed values are designated by the degree symbol (°).
(ISO film speed = $1/H_m \times 0.8$).

APPENDIX E

ISO Film Speed Calculation

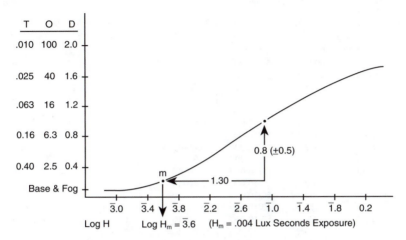

ISO Film Speed Calculation for black-and-white films.
ISO = $1/H_m$ x 0.8 = 1/.004 x 0.8 = 250 x 0.8
ISO = 200
(Refer to Appendices D and F for Log H conversions.)

APPENDIX F

Logarithmic Notations and Arithmetic Equivalents

Log Notations			Arithmetic Notations		Log Notations			Arithmetic Notations	
Standard Logs	Photographic Logs	Negative Logs	Decimal Equivalents	Fractional Equivalents	Standard Logs	Photographic Logs	Negative Logs	Decimal Equivalents	Fractional Equivalents
6.60–10	$\overline{4}.60$	–3.40	.0004	4/10,000	9.50–10	$\overline{1}.50$	–0.50	.32	32/100
6.70–10	$\overline{4}.70$	–3.30	.0005	5/10,000	9.60–10	$\overline{1}.60$	–0.40	.40	40/100
6.80–10	$\overline{4}.80$	–3.20	.0006	6/10,000	9.70–10	$\overline{1}.70$	–0.30	.50	50/100
6.90–10	$\overline{4}.90$	–3.10	.0008	8/10,000	9.80–10	$\overline{1}.80$	–0.20	.63	63/100
					9.90–10	$\overline{1}.90$	–0.10	.80	80/100
7.00–10	$\overline{3}.00$	–3.00	.0010	10/10,000					
7.10–10	$\overline{3}.10$	–2.90	.0012	12/10,000	10.00–10	0.00	0.00	1.00	1/1
7.20–10	$\overline{3}.20$	–2.80	.0016	16/10,000	10.10–10	0.10		1.2	
7.30–10	$\overline{3}.30$	–2.70	.0020	20/10,000	10.20–10	0.20		1.6	
7.40–10	$\overline{3}.40$	–2.60	.0025	25/10,000	10.30–10	0.30		2.0	
7.50–10	$\overline{3}.50$	–2.50	.0032	32/10,000	10.40–10	0.40		2.5	
7.60–10	$\overline{3}.60$	–2.40	.0040	40/10,000	10.50–10	0.50		3.2	
7.70–10	$\overline{3}.70$	–2.30	.0050	50/10,000	10.60–10	0.60		4.0	
7.80–10	$\overline{3}.80$	–2.20	.0063	63/10,000	10.70–10	0.70		5.0	
7.90–10	$\overline{3}.90$	–2.10	.0080	80/10,000	10.80–10	0.80		6.3	
					10.90–10=	0.90		8.0	
8.00–10	$\overline{2}.00$	–2.00	.010	10/1,000					
8.10–10	$\overline{2}.10$	–1.90	.012	12/1,000	11.00–10	1.00		10	
8.20–10	$\overline{2}.20$	–1.80	.016	16/1,000	11.10–10	1.10		12	
8.30–10	$\overline{2}.30$	–1.70	.020	20/1,000	11.20–10	1.20		16	
8.40–10	$\overline{2}.40$	–1.60	.025	25/1,000	11.30–10	1.30		20	
8.50–10	$\overline{2}.50$	–1.50	.032	32/1,000	11.40–10	1.40		25	
8.60–10	$\overline{2}.60$	–1.40	.040	40/1,000	11.50–10	1.50		32	
8.70–10	$\overline{2}.70$	–1.30	.050	50/1,000	11.60–10	1.60		40	
8.80–10	$\overline{2}.80$	–1.20	.063	63/1,000	11.70–10	1.70		50	
8.90–10	$\overline{2}.90$	–1.10	.080	80/1,000	11.80–10	1.80		63	
					11.90–10	1.90		80	
9.00–10	$\overline{1}.00$	–1.00	.10	10/100					
9.10–10	$\overline{1}.10$	–0.90	.12	12/100	12.00–10	2.00		100	
9.20–10	$\overline{1}.20$	–0.80	.16	16/100	12.10–10	2.10		120	
9.30–10	$\overline{1}.30$	–0.70	.20	20/100	12.20–10	2.20		160	
9.40–10	$\overline{1}.40$	–0.60	.25	25/100	12.30–10	2.30		200	

A common range of logarithm values used in photography with the log values expressed in standard form, photographic form, and negative form. The equivalent arithmetic values are given in both decimal and fractional forms for numbers smaller than 1.0.

APPENDIX G

Exponents, Factors, Logarithms, *f*-stops, Zones

(Base 2)			(Base 10)			f-stop	Zone
Exponents	Factors	Log$_2$	Exponents	Factors	Log$_{10}$	change	change
2^0	1	0	10^0	1	0	0	0
2^1	2	1	$10^{.3}$	2	.3	1	1
2^2	4	2	$10^{.6}$	4	.6	2	2
2^3	8	3	$10^{.9}$	8	.9	3	3
			($10^{1.0}$	10	1.0)		
2^4	16	4	$10^{1.2}$	16	1.2	4	4
2^5	32	5	$10^{1.5}$	32	1.5	5	5
2^6	64	6	$10^{1.8}$	64	1.8	6	6
			($10^{2.0}$	100	2.0)		
2^7	128	7	$10^{2.1}$	128	2.1	7	7
2^8	256	8	$10^{2.4}$	256	2.4	8	8
2^9	512	9	$10^{2.7}$	512	2.7	9	9
2^{10}	1024	10	$10^{3.0}$	1000	3.0	10	10

Logarithms are exponents to some *base*, such as 2 or 10. Some variables in photography (and computer memory in bits and bytes) are based on exponents (logarithms) to the base 2. This means that as the exponents increase by one, the factor doubles. (Computer memory chips having 1024 bits, have 2^{10} bits.)

In photography, all factors representing a doubling or halving of exposure, such as full f-stops, shutter speed settings, light values, exposure value numbers on most exposure meters, and zone numbers, are based on logarithms to the base 2. However, neutral density filters, density, and log H are based on logarithms to the base 10. As exponents to the base 10 increase by one, the factors increase 10 times. In practical terms, a 0.30 neutral density filter can be thought of as a 1-stop filter, a 0.60 filter as a 2-stop filter, and so on. A log exposure increase of 0.30 is a doubling of exposure. Further, each 0.10 log change in exposure is equivalent to 1/3rd of a stop.

An average outdoor scene has a brightness range of about 128 to 1 (factor), or 2^7, 7 f-stops, 7 zones, or a log luminance range of 2.1, which is $10^{2.1}$. Film has a log exposure (log H) range (latitude) of about 1000 to 1, or $10^{3.0}$. Photographic paper has a reflectance density range of about 2.0, a factor of 100 to 1, or 10^2.

(Note: Exponents to base l0 have been rounded off for simplicity, more correctly $10^{.301} = 2$.)

APPENDIX H

Temperature Conversion Scale

Temperature
Conversion
Scale

0°C = 32°F	0°F = −17.8°C
0°C = 273 K	

Formulas for converting from °C to °F, from °F to °C, from °C to K.

$$°C = (°F{-}32) \times 5/9 \qquad °F = (°C \times 9/5) + 32 \qquad K = °C + 273$$

APPENDIX I

Units of Measure

The French introduced the metric system in 1789. It was legalized in the United States in 1966 but has yet, except for scientific and technical usage, to gain wide acceptance. The United States is the only industrialized country using English units of measure. Scientists world-wide, including American scientists, now use the ISO Standards codified in 1981. Metric units of measure are known as SI units, after the French, Systéme Internationale.

SI Units

Quantity	Unit	Symbol
length	meter	m
mass	kilogram	kg
time	second	s
electric current	ampere	A
thermodynamic temperature	kelvin	K
amount of substance	mole	mol
luminous intensity	candela	cd
plane angle	radian	rad
solid angle	steradian	sr

SI Decimal Prefixes

Value and Equivalent	Unit	Symbol
$1\ 000\ 000\ 000\ 000\ 000\ 000 = 10^{18}$	exa-	E
$1\ 000\ 000\ 000\ 000\ 000 = 10^{15}$	peta-	P
$1\ 000\ 000\ 000\ 000 = 10^{12}$	tera-	T
$1\ 000\ 000\ 000 = 10^{9}$	giga-	G
$1\ 000\ 000 = 10^{6}$	mega-	M
$1\ 000 = 10^{3}$	kilo-	K
$100 = 10^{2}$	*hecto-	h
$10 = 10^{1}$	*deka- or deca-	da
$1 = 10^{0}$	(no prefix)	–
$0.1 = 10^{-1}$	*deci-	d
$0.01 = 10^{-2}$	centi-	c
$0.001 = 10^{-3}$	milli-	m
$0.000\ 001 = 10^{-6}$	micro-	μ
$0.000\ 000\ 001 = 10^{-9}$	nano-	n
$0.000\ 000\ 000\ 001 = 10^{-12}$	pico-	p
$0.000\ 000\ 000\ 000\ 001 = 10^{-15}$	femto-	f
$0.000\ 000\ 000\ 000\ 000\ 001 = 10^{-18}$	atto-	a

*to be avoided in technical use

Metric Units (rounded off)

Prefix		Metric Unit		U.S. Equivalents				
milli-	= 1/1000	1 millimeter	=	0.039 inch				
centi-	= 1/100	1 centimeter	=	0.39 inch				
deci-	= 1/10	1 decimeter	=	3.937 inches	=	0.32 foot		
		1 meter	=	39.37 inches	=	3.2 feet	=	1.1 yard
deka-	= 10	1 dekameter	=	393.7 inches	=	32 feet	=	11 yards
hecto-	= 100	1 hectometer	=	3937 inches	=	328 feet	=	109 yards
kilo-	= 1000	1 kilometer	=	39300 inches	=	3280 feet	=	1090 yards

APPENDIX J

Weight and Liquid Measures Conversion Tables

U.S. Customary and Metric Weight Measure

Pounds	Ounces	Grains	Grams	Kilograms
1	16	7000	453.6	0.4536
0.0625	1	437.5	28.35	0.02835
		1	0.0648	
	0.03527	15.43	1	0.001
2.205	35.27	15430	1000	1

U.S. Customary and Metric Liquid Measure

Gallons	Quarts	Fluid ounces	Drams (Fluid)	Milliliters	Liters
1	4	128	1024	3785	3.785
0.25	1	32	256	946.3	0.9463
		1	8	29.57	0.02957
		0.125	1 (60 mins.)	3.697	0.003697
		0.03381	0.2705	1	0.001
0.2642	1.057	33.81	270.5	1000	1

Conversion Factors

Grains per 32 fluid ounces ×	0.06847 =	grams per liter
Ounces per 32 fluid ounces ×	29.96 =	grams per liter
Pounds per 32 fluid ounces ×	479.3 =	grams per liter
Grams per liter ×	14.60 =	grains per 32 fluid ounces
Grams per liter ×	0.03338 =	ounces per 32 fluid ounces
Grams per liter ×	0.002086 =	pounds per 32 fluid ounces

APPENDIX K

Distance Conversion Table

		Metric			U.S.		
		Millimeters mm	Centimeters cm	Meters m	Inches in	Feet ft	Yards yd
Millimeters	mm	1	10	1000	25.4	304.8	914.4
Centimeters	cm	.10	1	100	2.54	30.48	91.44
Meters	m	.001	.01	1	.254	.3048	.9144
Inches	in	.0394	.394	39.37	1	12	36
Feet	ft	.0033	.0328	3.28	.0833	1	3
Yards	yd	.0011	.0109	1.094	.0278	0.333	1

$(1\text{Å} = 10^{-9} \text{ mm or } 10^{-8} \text{ cm})$

Metric to U.S.	U.S. to Metric
millimeters \times 0.04 = inches	inches \times 25.4 = millimeters
centimeters \times 0.39 = inches	inches \times 2.54 = centimeters
meters \times 3.28 = feet	feet \times 3.04 = meters
meters \times 1.09 = yards	yards \times 0.91 = meters
kilometers \times 0.62 = miles	miles \times 1.61 = kilometers

$(\text{kilometers} \times 5/8 = \text{miles})$

Graphic Arts

1 inch = 6 picas
1 pica = 1/6th inch: (.167 inches)

APPENDIX L

Area Conversion Table

AREA MEASURE

U.S. Customary	Metric
square inch (0.007 sq. ft.)	6.452 square centimeters (cm²)
	645.16 square millimeters (mm²)
square foot (144 sq. in.)	929.03 square centimeters (cm²)
	0.092903 square meter (m²)
square yard (9 sq. ft.)	0.83613 square meter (m²)
square rod (30.25 sq. yd.)	
square mile (640 acres)	2.59 square kilometers (km²)

Metric	U.S. Customary
square millimeter (mm²)	0.00155 square inch (sq. in.)
square centimeter (cm²)	0.155 square inch (sq. in.)
square meter	10.764 square feet (sq. ft.)
square kilometer (km²)	0.38608 square mile (sq. mi.)

Metric to U.S.

square centimeters	× 0.16	= square inches
square meters	× 1.2	= square yards
square kilometers	× 0.4	= square miles

U.S. Metric

square inches	× 6.5	= square centimeters
square feet	× 0.09	= square meters
square yards	× 0.8	= square meters
square miles	× 2.6	= square kilometers

APPENDIX M

Graphical Formula for Diluting Solutions

A Simple Formula for Diluting Solutions

A X

W

B Y

An easy method of figuring dilutions is by the criss-cross method. Place at A the percentage strength of the solution to be diluted and at B the percentage strength of the solution you wish to dilute with (in the case of water, this will be O). Place at W the percentage strength desired. Now subtract W from A and place at Y. Also subtract B from W and place at X. If you take X parts of A and Y parts of B and mix, you will have a solution of the desired strength W.

For example:
To dilute 99% Acetic Acid to 28%.

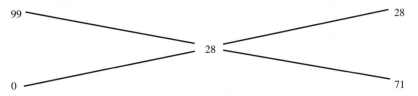

99 28

28

0 71

Take 28 parts of 99% Acid and 71 parts water.

APPENDIX N

Angle of View for Different Focal Length Lenses

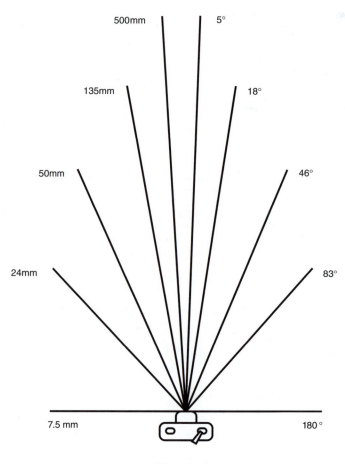

35-mm camera

APPENDIX O

Reciprocity and 800 Numbers

All photographic film and paper are most efficient over a certain range of exposure *times;* for film, times between about 1/10th to 1/1000th of a second; for paper, times from a few seconds to about 30 seconds. When exposure times used are beyond what is recommended by the manufacturer, then a loss in film or paper speed and a change in contrast can be expected. With color films and paper, there is also a color shift, which in some cases cannot be fully corrected. Reciprocity data for films and papers, based on averages, serve as guidelines and are available from most manufacturers.

For product information, call these 800 numbers:

AGFA	1-800-243-2652
FUJI	1-800-788-3854
ILFORD	1-800-262-2650
KODAK	1-800-242-2424
POLAROID	1-800-225-1618

APPENDIX P

Agfa Film Reciprocity Data

Agfapan APX 25

Reciprocity effect

Measured exposure time (s)	1/10000 to 1/2	1	10	100
Exposure correction (lens stops)	none	+1	+1 1/2	+2
Development correction (%)	none	none	none	none

Agfapan APX 100

Reciprocity effect

Measured exposure time (s)	1/10000 to 1/2	1	10	100
Exposure correction (lens stops)	none	+1	+2	+3
Development correction (%)	none	−10	−25	−35

To obtain the same contrast range the developing time must be shortened.

Agfapan APX 400

Reciprocity effect

Measured exposure time (s)	1/10000 to 1/2	1	10	100
Exposure correction (lens stops)	none	+1	+2 1/2	+3 1/2
Development correction (%)	none	−10	−25	−35

To obtain the same contrast range the developing time must be shortened.

Agfaortho 25

Reciprocity effect

Measured exposure time (s)	1/10000 to 1/2	1	10	100
Exposure correction (lens stops)	none	none	+2/3	+1 1/3

Agfa Dia Direct

Reciprocity effect

Measured exposure time (s)	1/10000 − 10	100
Exposure correction (lens stops)	none	+1/2

(Courtesy Agfa)
(For more information phone 1-800-243-2652)

Fuji Film Reciprocity Data

Reciprocity Data for Neopan 400 and Neopan 1600 Films

Exposure Times	Adjustment
1/2 second to 1/8,000th of a second	none
1 second	+ 1/2 stop
10 seconds	+ 1 stop
100 seconds	+ 2 stops

(Courtesy Fuji)
(For more information phone 1-800-788-3854)

APPENDIX R

Ilford Film Reciprocity Data

Slow Speed

ISO 50	Pan F+

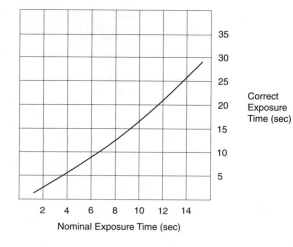

Medium Speed and High Speed

ISO 100	100 Delta
ISO 125	FP4+
ISO 400	400 Delta
ISO 400	HP5+
ISO 400	XP2

(Courtesy Ilford)
(For more information phone 1-800-262-2650)

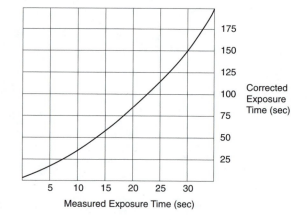

Ilford Paper Reciprocity Data

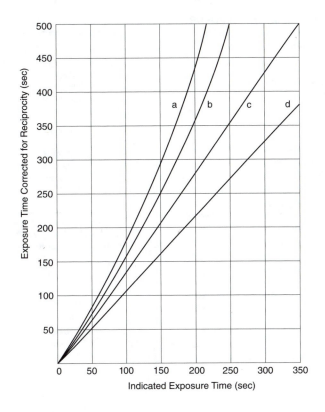

Average Reciprocity Curves for Ilford Enlarging Papers
 a) Ilfobrom Galerie FB
 b) Ilfospeed RC Deluxe
 c) Multigrade FB
 d) Multigrade III RC

(Courtesy Ilford)
(For more information phone 1-800-262-2650)

APPENDIX T

Kodak Film Reciprocity Data

ADJUSTMENTS FOR LONG AND SHORT EXPOSURES

Use the exposure and development adjustments in the table below for these black-and-white films:

- KODAK EKTAPAN Film
- KODAK PLUS-X Pan Film
- KODAK PLUS-X Pan Professional Film
- KODAK ROYAL Pan Film
- KODAK SUPER-XX Pan Film
- KODAK TRI-X Pan Film
- KODAK TRI-X Pan Professional Film

Exposure and Development Adjustments for Most Black-and-White Films

If Calculated Exposure Time is (Seconds)	Use This Lens-Aperture Adjustment	OR	This Adjusted Exposure Time (Seconds)	AND Use This Development Adjustment
1/100,000*†‡	+1 stop		Adjust aperture	+20%
1/10,000*†‡	+1/2 stop		Adjust aperture	+15%
1/1000	None		None	+10%§
1/100	None		None	None
1/10	None		None	None
1	+1 stop		2	−10%
10	+2 stops		50	−20%
100	+3 stops		1200	−30%

*Not applicable to EKTAPAN Film.
†Not recommended for TRI-X Pan Professional Film/4164.
‡Not recommended for ROYAL Pan Film or SUPER-XX Pan film.
§EKTAPAN Film does not require an adjusted development time at 1/1000 second.

Exposure and Development Adjustments for KODAK Commercial Film

If Calculated Exposure Time is (Seconds)	Use This Lens-Aperture Adjustment	OR	This Adjusted Exposure Time (Seconds)	AND Use This Development Adjustment
1/100	None		None	+10%
1/25	None		None	None
1/10	None		None	−10%
1	None		None	−20%
10	+1/2 stop		15	−30%
100	+1 stop		300	−40%

Exposure and Development Adjustments for KODAK Technical Pan Film (developed in KODAK TECHNIDOL Liquid Developer or KODAK HC-110 Developer [Dil D])

If Calculated Exposure Time is (Seconds)	Use This Lens-Aperture Adjustment	OR	This Adjusted Exposure Time (Seconds)	AND Use This Development Adjustment
1/10,000	None		None	+30%
1/1000	None		None	+20%
1/100	None		None	None
1/10	None		None	None
1	None		None	−10%
10	+1/2 stop		15	−10%
100	+1 1/2 stops		NR	None

NR = Not recommended

Exposure Adjustments for

If Calculated Exposure Time is (Seconds)	KODAK T-MAX 100 Professional Film			KODAK T-MAX 400 Professional Film			KODAK T-MAX P3200 Professional Film		
	Use This Lens-Aperture Adjustment	OR	This Adjusted Exposure Time (Seconds)	Use This Lens-Aperture Adjustment	OR	This Adjusted Exposure Time (Seconds)	Use This Lens-Aperture Adjustment	OR	This Adjusted Exposure Time (Seconds)
1/10,000	+1/3 stop		Adjust aperture	None		None	None		None
1/1000	None		None	None		None	None		None
1/100	None		None	None		None	None		None
1/10	None		None	None		None	None		None
1	+1/3 stop		Adjust aperture	+1/3 stop		Adjust aperture	None		None
10	+1/2 stop		15	+1/2 stop		15	+2/3 stop		15
100	+1 stop		200	+1 1/2 stops		300	+2 stops		400

Note: KODAK T-MAX Professional Films do not require a development-time adjustment.

(Courtesy Eastman Kodak Co.)
(For more information phone 1-800-242-2424)

APPENDIX U

Kodak Paper Reciprocity Data

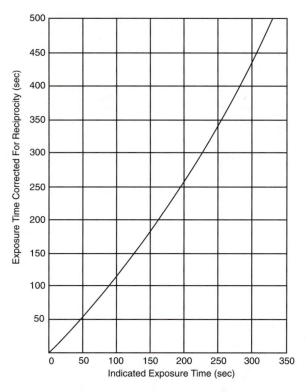

KODAK Reciprocity Curve for Enlarging Papers

All photographic papers and films are affected by reciprocity failure with extended or very short exposure *times*. For printing exposure times of 1 to 4 minutes, increase exposure time about 20 to 30%; for printing exposure times from 4-1/2 to 6 minutes, increase the time to about 40 to 50%. The required increase in time to compensate for reciprocity will vary depending upon the choice of paper.

(Courtesy Eastman Kodak Co.)
(For more information phone 1-800-242-2424)

APPENDIX V

Polaroid Film Reciprocity Data

POLAROID TYPE 52 AND TYPE 55

Reciprocity

Indicated Exposure Time	Use Either Adjustment		
	Aperture	or	Exposure Time
1/1000 sec.	None		None
1/100 sec.	None		None
1/10 sec.	None		None
1 sec.	None		None
10 sec.	+1/3 stop		+3 sec.
100 sec.	+1 stop		+100 sec.

(Courtesy Polaroid Corp.)
(For more information phone 1-800-225-1618)

POLAROID TYPE 665

Reciprocity

Indicated Exposure Time	Use Either Adjustment		
	Aperture	or	Exposure Time
1/1000 sec.	None		None
1/100 sec.	None		None
1/10 sec.	None		None
1 sec.	None		None
10 sec.	+1/2 stop		+5 sec.
100 sec.	+1 1/3 stops		+150 sec.

APPENDIX W

Graphical Representation of Typical Photographic Tone Reproduction

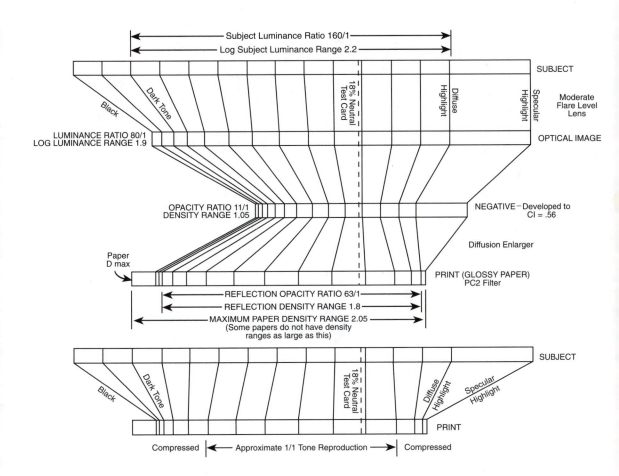

Graphical Representation of Typical Photographic Tone Reproduction

(Top)
SUBJECT: Represented in equal log luminance increments.
OPTICAL IMAGE: Compression in shadow areas due to flare.
NEGATIVE: Overall compression, but more in shadow areas.
PRINT: Compression in highlights and shadows. Midtones expanded.

(Bottom)
PRINT compared to SUBJECT: Compression of highlights and shadows.
Only slight contrast changes in midtone areas.

(Courtesy of the Eastman Kodak Company)

APPENDIX X

ISO Standard for Viewing Prints and Transparencies

	Surround Reflection Density	Color-Rendering Index	Luminance (cd/m^2)	Illuminance (lux)	Illumination Uniformity Edge/Center	Spectral Power Distribution
Transparencies						
Large	>1.0	90	1300 ± 300	–	0.75	D_{50}
Small	Opaque	90	1300 ± 300	–	0.40	D_{50}
Prints						
Critical appraisal	>0.50	90	–	Inspection 2000 ± 500 Practical 500 ± 125	0.75	D_{50}
Routine inspection	>0.20	85	–	800 ± 200	0.60	D_{30}–D_{50}
Judging and exhibiting	>0.20	85	–	800 ± 200	0.60	D_{30}–D_{50}

Field of Application. The standard describes:

1. Conditions for viewing large and small transparencies for critical appraisal or for comparison with other objects or images

2. Conditions for viewing reflection photographic and photomechanical prints for critical appraisal or for comparison with other objects or images

3. Conditions for viewing reflection prints to aid in routine inspection

4. Conditions for judging or exhibiting reflection prints

ANSI PH 2.30 – 1985 Viewing Conditions – Photographic Prints, Transparencies, and Photomechanical Reproductions.

(A *Catalogue* of ANSI *Standards* and the *Standards* themselves can be obtained from the American National Standards Institute, 1430 Broadway, New York, NY 10018.)